THE PELICAN HISTORY OF ART

JOINT EDITORS: NIKOLAUS PEVSNER AND JUDY NAIRN

THE ART AND ARCHITECTURE OF ANCIENT AMERICA
THE MEXICAN · MAYA · AND ANDEAN PEOPLES

GEORGE KUBLER

Cholula, Court of the Altars, north-east corner (restored 1970), *c.* A.D. 500

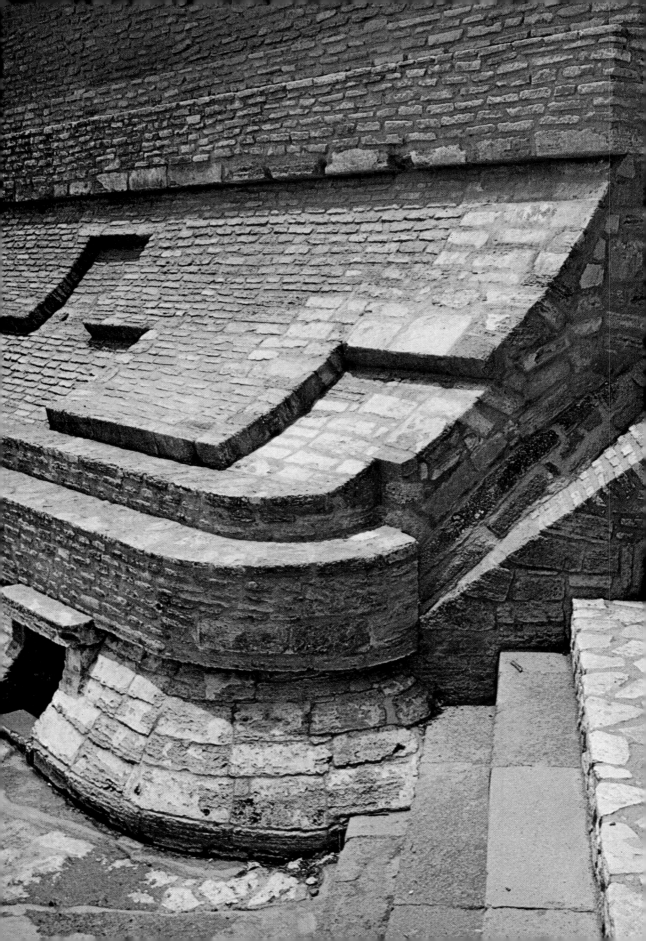

GEORGE KUBLER

THE ART AND ARCHITECTURE
OF ANCIENT AMERICA

THE MEXICAN / MAYA / AND
ANDEAN PEOPLES

PENGUIN BOOKS

Penguin Books Ltd, Harmondsworth, Middlesex, England
Penguin Books Inc., 7110 Ambassador Road, Baltimore, Maryland 21207, U.S.A.
Penguin Books Australia Ltd, Ringwood, Victoria, Australia
Penguin Books Canada Ltd, 41 Steelcase Road West, Markham, Ontario, Canada
Penguin Books (N.Z.) Ltd, 182–190 Wairau Road, Auckland 10, New Zealand

★

Text printed by Richard Clay (The Chaucer Press) Ltd, Bungay, Suffolk
Plates printed by Percy Lund Humphries & Co Ltd, Bradford
Made and printed in Great Britain

★

ISBN 0 14 0560.21 1

★

First published 1962
Second edition 1975

TO THE MEMORY OF

WENDELL CLARK BENNETT

1905–1953

*

CONTENTS

Part One

The Mexican Civilizations

Part Two

The Maya and their Neighbours

CONTENTS

CONTENTS

The Plates

LIST OF FIGURES

All dates are A.D. *unless otherwise indicated. In elevation drawings
the number of steps reproduced is in most cases approximate*

xi

LIST OF FIGURES

The drawings in the text were made by Mr K. F. Rowland; correc-
tions and additions for the second edition were made by Miss Sheila
Gibson, Mr Ian Stewart, and Mr Richard Boon. The maps were
drawn by Mr Donald Bell-Scott.

LIST OF PLATES

All dates are A.D. *unless otherwise indicated*
Where copyright credit in photographs is not specifically
given, it is due solely to the gallery or collection given
as the location

xvii

FOREWORD TO THE FIRST EDITION

THE greater part of these chapters was originally prepared for lectures and seminars beginning in 1938 at Yale University, where the opportunity for studies of the art of American antiquity was first made possible by the late Dean E. V. Meeks and my colleagues in the Department of the History of Art. Other occasions to develop the treatment of the pre-Columbian past, as part of the history of art rather than as anthropology, which is the more usual treatment in American universities, were afforded me at Columbia University, the University of Chicago, at the Universidad Nacional Mayor de San Marcos, in Lima, and at the Universidad Nacional Autónoma in Mexico City.

Various visits to Peru, Guatemala, and Mexico were made possible by the Smithsonian Institution in 1948–9, when I represented the Institute of Social Anthropology in Lima; in 1951 and 1956, when Unesco engaged me to study the reconstruction of the monuments devastated in Cuzco by the earthquake of 1950; and in 1958 when I held a Smith–Mundt award for Mexico.

I am grateful to Professor Nikolaus Pevsner and the publishers for their generous efforts in securing new drawings for many text figures from K. F. Rowland, M.S.I.A., drawings for the maps from Donald Bell-Scott, and for the chronological tables from Sheila Waters. Professor Pevsner showed great patience as Editor of the Pelican History of Art in waiting so long for this manuscript, of which the first deadline fell in 1951. To him I am further indebted for an introduction at Cambridge University, where I was able to work in 1957 as a guest of King's College, and where G. H. S. Bushnell, Curator of the University Museum of Archaeology and Ethnology, kindly let me have the run of the Haddon Library, during the last months of a Guggenheim Foundation Fellowship awarded in 1956–7.

For advice and correction on many points I have benefited from conversations and correspondence with Junius Bird, G. H. S. Bushnell, Donald Collier, Gordon Ekholm, Alfred Kidder II, Tatiana Proskouriakoff, John H. Rowe, Linton Satterthwaite, Jr, W. Duncan Strong, and Gordon Willey, whose views have an authority gained in many years' field experience. The outsider from other fields of study never can assume this authority: it belongs only to the field archaeologist who works both in detail and in broad reconnaissance, and it may appear more in his conversation than in his writings.

Much complicated correspondence about photographs was carried on for me by Mary Margaret Collier, and I am obliged to Mrs H. Gordon Sweet for her aid in clarifying the text. Mrs Patricia Shillabeer Beach and Mrs Amelia Sudela typed long hours. Friends and students in Yale College – Colin Eisler, Terence Keenan, Joseph Baird, and Joseph Lyman – helped with many matters of detail. John Hoag, the Art Librarian at Yale, helped repeatedly in negotiations for photographs, and Helen Chillman allowed me to borrow negatives and prints from the University collections for many of these illustrations.

In Lima, my friend Abraham Guillén was the most reliable source of photographs. In Mexico City, the head archivist of the photograph collections in the Instituto Nacional de Antropología e Historia, Señor Ramón Sánchez Espinosa, was unfailingly helpful.

FOREWORD

To many other persons and institutions full acknowledgement for the use of photographs and drawings is made in the lists of Plates and Figures; here, nevertheless, the exceptional courtesies shown by Luis Aveleyra A. de Anda, Eusebio Davalos, Ignacio Bernal, Alfonso Caso, Jorge Muelle, John Glass, Frank H. Boos, Carmen Cook de Leonard and Juan Leonard, Robert Willson, René Millon, and Lic. Jorge Gurría require special thanks.

FOREWORD TO THE SECOND EDITION

THE manuscript which was first published in 1962 was actually delivered to the publishers in May 1959. No significant changes were made after that time, until Sir Nikolaus Pevsner finally persuaded me in 1972 that a complete revision and aggiornamento were justified. In effect the text was then thirteen years old – years which saw intense archaeological activity and revaluation. These newer publications are now embedded in text and notes, together with the older references, which were retained in order to continue giving students some sense of that 'history of archaeological recovery' which the excitement of new discoveries often obscures. Recent archaeological writing in Americanist fields rarely assesses older theories and excavations that have continuing value. The substitution of new names for older ones is also frequent, without reference to the older work and the older nomenclature. It seemed worthwhile to retain some of this history of the recovery of the remote American past in the footnotes, all while bringing them up to date. Indeed it has perennially been the task of humanistic learning, to examine the long record of the search for enduring answers.

The original text presented the extremes of opinion on chronology. In 1972–3, the wide swing between extremes has narrowed closer to final rest, but much uncertainty still surrounds many questions, uncertainties which I have tried to convey wherever they are unavoidable.

The illustrations are increased by many new photographs and drawings, and some drawings in the first edition have been corrected and augmented.

To Yale University I am grateful for triennial leave of absence. In Mexico the Instituto Nacional de Antropología e Historia, both at the Museo and at the archives in Culhuacán, as well as in the offices at Córdova 45, cooperated generously in the search for photographs. My special thanks go there to Carlos Chanfón, Mariano Monterrosa, and Constantino Reyes; to Beatriz de la Fuente and Marta Foncerrada de Molina in Mexico City; and in London to Susan Stow, Rosa Brennan, and Judy Nairn who 'accomplished the impossible in the least possible time'.

New Haven, June 1973

MAPS

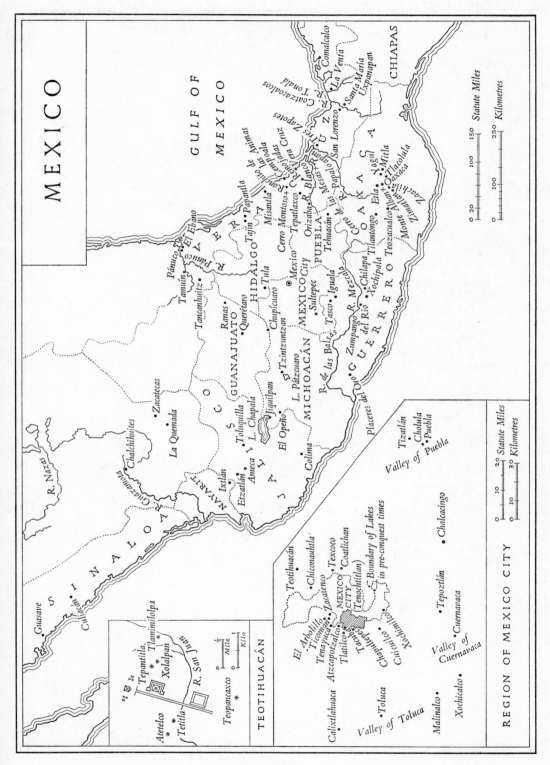

MEXICO

GULF OF MEXICO

CHIAPAS

SINALOA

NAYARIT

JALISCO

GUANAJUATO

HIDALGO

MICHOACÁN

PUEBLA

OAXACA

GUERRERO

Statute Miles
Kilometres

Guasave
Culiacán
R. Nazas
Chalchihuites
Zacatecas
La Quemada
Chiazamola
Ixtlán
Etzatlán
Ameca
El Opeño
Colima
Jiquilpan
Toluquilla
L. Chapala
L. Pátzcuaro
Tzintzuntzan
Chupícuaro
Querétaro
Ranas
Tancanhuitz
Tamuín
El Ebano
Pánuco
R. Pánuco
R. Tamesí
Papantla
Tajín
Animas
Misantla
Remojadas
Cempoala
Cerro de la Cruz
Cerro Montoso
Tepatlaxco
Cotaxtla
Orizaba
R. Blanco
Las Mesas
R. Papaloapan
Tres Zapotes
Coatzacoalcos
R. Tonalá
La Venta
Comalcalco
Santa María Uxpanapan
San Lorenzo
Tehuacán
Cerro de las Mesas
Monte Albán
Zaachila
Cuilapan
Oaxaca
Etla
Yagul
Mitla
Zimatlán
Tlacolula
Teozacualco
Tilantongo
Xochipala
Chilapa
R. Mezcala
Zumpango del Río
R. del Río
R. de las Balsas
Iguala
Tasco
Sultepec
MEXICO City
Tula
Mexico
Placeres del Oro

R. de las Balsas

TEOTIHUACÁN

Tepantitla
Tlamimilolpa
Xolalpan
Atetelco
Tetitla
Teopancaxco
R. San Juan

Mile
Kilo

REGION OF MEXICO CITY

Teotihuacán
El Arbolillo
Ticoman
Tenayuca
Atzapotzalco
Calixtlahuaca
Chiconauhtla
Zacatenco
Texcoco
Coatlichan
MEXICO CITY (Tenochtitlan)
Tlatilco
Tlapacoya
Chalco
Cuicuilco
Xochimilco
Boundary of Lakes in pre-conquest times
Malinalco
Valley of Toluca
Toluca
Xochicalco
Tepoztlán
Cuernavaca
Valley of Cuernavaca
Chalcacingo
Tizatlán
Cholula
Puebla
Valley of Puebla

Statute Miles
Kilometres

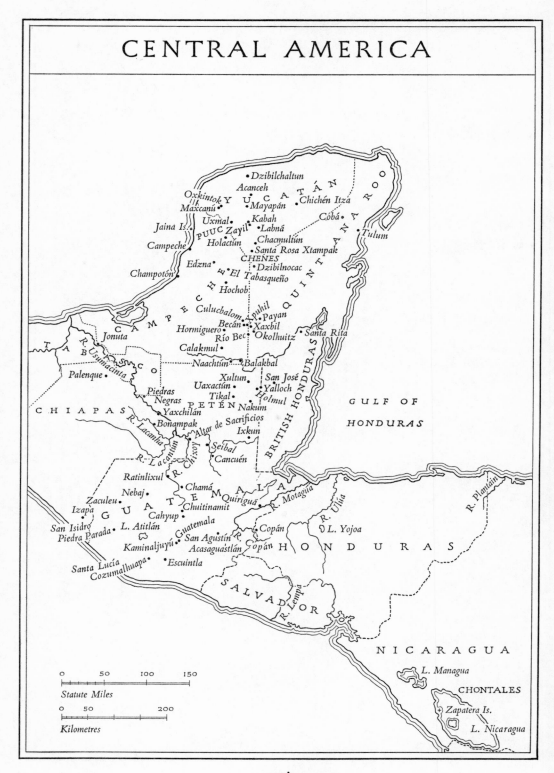

CENTRAL AMERICA

Dzibilchaltun
Acanceh
Oxkintok Y U C A T Á N
Maxcanú Mayapán • Chichén Itzá
Uxmal Kabah
Jaina Is. PUUC Zayil Labná Cóbá
Campeche Holactún Chacmultún Tulum
Santa Rosa Xtampak
CHENES
Edzna Dzibilnocac
Champotón El Tabasqueño
Hochob
Culuchalom Apuhil
Becán Payan
Hormiguero Xaxbil
Río Bec Okolhuitz Santa Rita
Jonuta Calakmul
Naachtún Balakbal
Palenque San José
Piedras Xultun Yalloch
Negras Uaxactún Holmul
Tikal Nakum
Yaxchilán
Bonampak Ixkun
Altar de Sacrificios
Seibal
Cancuén

GULF OF
HONDURAS

CHIAPAS

PETÉN

BRITISH HONDURAS

QUINTANA ROO

CAMPECHE

TABASCO

R. Usumacinta

R. Lacanha
R. Lacantún
R. Chixoy

Ratinlixul
Chamá
Zaculeu Nebaj Quiriguá
Izapa Chuitinamit R. Motagua
San Isidro Cahyup R. Ulúa R. Plantáin
Piedra Parada L. Atitlán Guatemala
Kaminaljuyú San Agustín Copán
Santa Lucía Acasaguastlán Copán HONDURAS
Cozumalhuapa Escuintla
L. Yojoa

GUATEMALA

SALVADOR

R. Lempa

NICARAGUA

L. Managua

CHONTALES

Zapatera Is.

L. Nicaragua

0 50 100 150
Statute Miles

0 50 200
Kilometres

xxxiv

COLOMBIA · ECUADOR · PANAMA

CARIBBEAN SEA

Zapatera Is.
L.
COSTA
Las Mercedes
M. Irazú · Guápiles
San José · Las Pacayas
Nicoya Peninsula
RICA
Palmar
CHIRIQUÍ
VERAGUAS
PANAMA
Coclé
Panamá
Sitio Conte
DARIEN

R. Atrato
R. Sinú
R. Cauca
R. Magdalena

Antioquia
QUIM-BAYA
Tunja

Cartago
CALIMA
Manizales
Bogotá

COLOMBIA

PACIFIC

OCEAN

R. Ostiones
Tumaco
San Agustín

R. Esmeraldas
MANABÍ
Quito

ECUADOR

Guangala
GUAYAS
Guayaquil
Valdivia
Túmbez

0 40 160 Statute Miles
0 50 250 Kilometres

XXXV

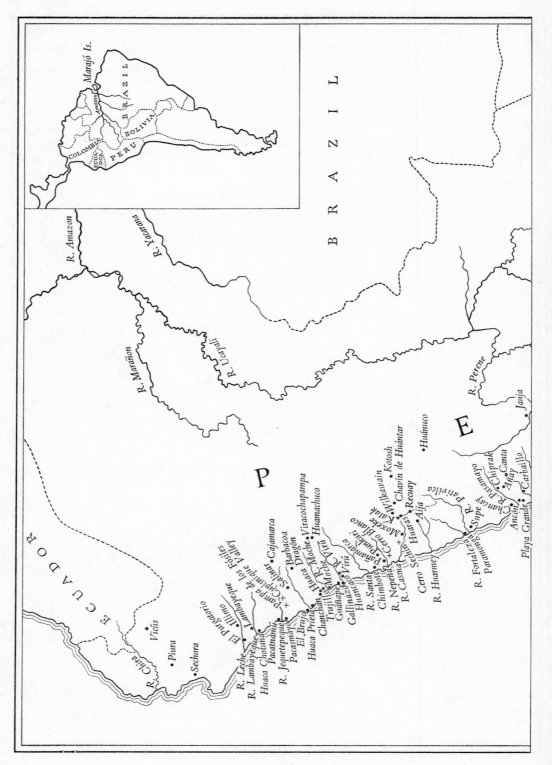

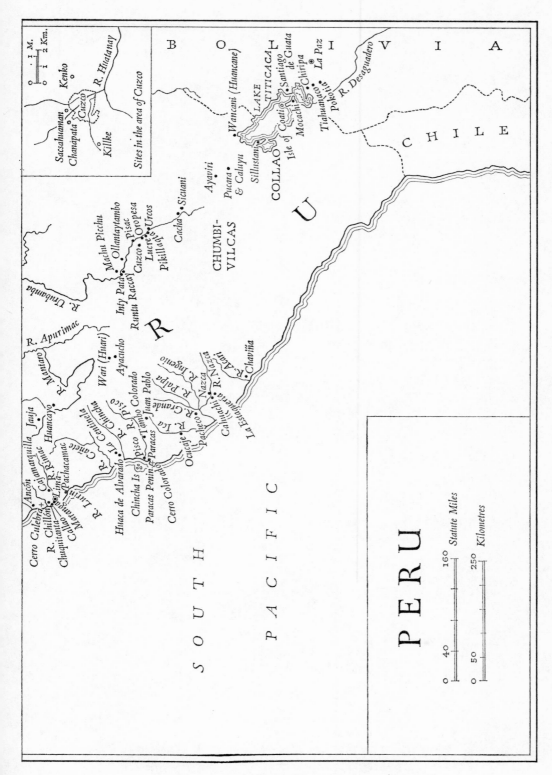

PERU

NOTE ON CHRONOLOGIES

FOR this edition the chronological tables have been altered in the direction of less rigid dating, simpler nomenclature, and more relevance to the objects than in the edition of 1962. The archaeological epochs follow G. Willey on Mesoamerica (*An Introduction to American Archaeology. North and Middle America*, 1, New York, 1966, 90–1), B. Meggers on the northern Andes (*Ecuador*, New York, 1966, 25), and E. P. Lanning on the central Andes (*Peru before the Incas*, Englewood, N.J., 1967, 26–277). The tables seek to place classes of objects in time: the criterion of selection is more by quality than quantity, and more by expressions than by serial events. All the placements prior to A.D. 1300 should be regarded as elastic at least in the degree required now by the margin of error used in radiocarbon measurements (\pm 200 years).

	CENTRAL MEXICO	EASTERN MEXICO	SOUTHERN MEXICO	WESTERN MEXICO
1500 **POST-CLASSIC**	*AZTEC*	*Zempoala*	**MIXTEC DYNASTIES IV** V *Monte Alban periods*	Tzintzuntzan Culiacán
1300	*CHICHIMEC* *Tula* TOLTEC		*Zaachila* III	Guasave
1100		XII *Tajín periods* *Tamuín*	II	TARASCA
900 **CLASSIC**	*Xochicalco*	VII	IV I *Mitla*	*Aztatlán* *Toluquilla-Ranas*
700	*Teotihuacán IV periods*	VI V	IIIB pre-I	*Jiquilpan*
500	*Teotihuacán III*	IV *Upper Remojadas* III *Upper Tres Zapotes*	IIIA *Ñuiñe*	*Ixtlán del Rio* *Ortices*
300		II		Chinesca figures
100 **PRE-CLASSIC** **0—**	*Teotihuacán II*	I OLMEC III	II	*Mezcala*
100	*Teotihuacán I*	*Cerro de las Mesas* *Middle Tres Zapotes*	*Dainzú*	
300	Ticoman *Cuicuilco*	*Lower Remojadas*		*Chupícuaro*
500		OLMEC II		
700				
900	*Tlatilco*		I	*El Opeño*
1100		*El Ebano* *La Venta* *Lower Tres Zapotes*		
1300		*San Lorenzo* OLMEC I		
1500	*Zacatenco* *El Arbolillo*			*Xochipala*

xli

	LOWLAND MAYA			HIGHLAND MAYA AND PACIFIC SLOPES	EASTERN CENTRAL AMERICA
	NORTH	SOUTH Pottery	Sculpture		
POST-CLASSIC —1500—		periods (Uaxactún)	(Initial Series)		*Coclé*
1300					
	Mayapán			TOHIL	
1100					*Lake Nicaragua*
	Chichén III	PLUMBATE			*Reventazón*
—900—	Río Bec		10.4.0.0.0= A.D. 909		
CLASSIC		TEPEU 3	10.0.0.0.0= A.D. 830		*Ulúa* COPADOR *Mercedes*
	Edzná Chichén II	TEPEU 2	9.15.0.0.0= A.D. 731		
700	Uxmal Chichén I	TEPEU 1	9.10.0.0.0= A.D. 633	*Cotzumalhuapa*	
		TZAKOL 3	9.5.0.0.0= A.D. 534	Kaminaljuyú	
500		TZAKOL 2	9.0.0.0.0= A.D. 435	ESPERANZA	*Nicoya*
		TZAKOL 1	8.14.0.0.0= A.D. 317		
300					
PRE-CLASSIC —100— 0		MATZANEL			
100		CHICANEL			
300				Kaminaljuyú	
				MIRAFLORES	
500				*Izapa*	
		MAMOM			
700					
		XE (Seibal)		Kaminaljuyú LAS CHARCAS	
900	Dzibilchaltun				
1100					
				Chiapa de Corzo I	
1300				Ocós	

xlii

	NORTHERN ANDES		CENTRAL ANDES			
	Colombia	Ecuador	Northern Peru — coast / highland	Central Peru	Southern Peru and Bolivia — coast / highland	
1534 —	CHIBCHA *Darién*	INCA	INÇA CHIMÚ *LAMBAYEQUE*	*CHANCAY*	*ICA* *CUZCO*	Late Horizon
		Esmeraldas				Late Intermediate
1000	QUIMBAYA Tierradentro San Agustín	*Manabí*	*HUARI* V MOCHICA	*Pachacamac Huari* *LIMA*	*VIÑAQUE Tiahuanaco* NAZCA 9	
Integration 500 —	CALIMA TOLIMA		IV III II		8 *QEYA* 7 6 5	Middle Horizon 500
0 —			I		4 3 *Pucará* 2	Early Intermediate
Regional developmental 500 —		*GUANGALA*	*Recuay* *SALINAR*		1 PARACAS 10 *Chiripa*	
					9 *Chanapata* 8	500
			CUPISNIQUE *Moxeke* *Chavín* Cerro Sechín		7 6 5	Early Horizon
1000					4 3 2	1000
					1	
Late 1500 Formative		*CHORRERA*	Kotosh			1500
		MACHALILLA		*Chuquitanta*		Initial Period
2000						2000
2500						Pre-ceramic VI
Early Formative	*Puerto Hormiga*	*Valdivia*	*Huaca Prieta*			
3000						3000

xliii

INTRODUCTION

THE purpose of an introduction is to identify its bearer to his host in a phrase or two that solicit mutual understanding. In this book, products of aesthetic value are the principal theme. I have at all points sought to avoid the suggestion that works of art are mere illustrations to civilizations, preferring to present the artistic object itself as the unit of study. I have written about 'cultures' only when such topics were required to illuminate the objects, which are after all the principal proof of the 'culture's' existence. Hence my text will not satisfy students of 'cultures' alone; it is written for people whose main interest attaches to works of art.

THE LANDS AND THE PEOPLES

With this proviso in mind, we can approach the history of the various peoples of ancient America. Only their works tell us about them. We deduce that some were simple villagers, while others were priestly rulers or professional warriors. A few literary sources of pre-Conquest date confirm these rarefied deductions. Occasionally a city like Chanchan (p. 279) speaks to us of complicated dynastic politics; Palenque must have been a courtly centre of exquisite refinement (p. 140). But beyond these affirmations we cannot reconstruct any web of events without written records. Chanchan came into being without benefit of writing as we know it, and more than half the written signs of Maya civilization are still undeciphered. Only very occasionally the traces of an identifiable individual artist are legible; for instance in the sculpture of Palenque (p. 167) or in the pottery portraits of the north coast of Peru (p. 270). Hence the artistic identities are remote and unclear: they emerge indistinctly from their works, and if it were not for these works, we could not apprehend personalities at all.

The lands to be omitted are far more extensive than the ones to be discussed. There is nothing here about North America above the 24th north parallel of latitude, nor in South America below 20 degrees south. Our western limit lies on the Pacific coast of Mexico at about longitude 105 degrees west. Our eastern boundary, in the Andean *altiplano* of Bolivia at longitude 75 degrees west, excludes all lowland South America. The reason for these exclusions is a simple one: in the vast lands of eastern South America and of ancient North America there were few people. Less than 20,000,000 persons were alive in America in 1492,[1] and half of these lived in the region defined by the scope of this book. Only the Mexican, Maya, and Andean peoples were numerous enough to live in large cities, producing the economic surplus that allows specialized craftsmen to build great temples and to fashion works of art. The rest enjoyed the protective isolation of aboriginal living to the point of producing very few things for us to

study. If the ancient manufactures of many of these tiny, scattered tribes were beautiful, we do not know it; for very little has survived. In any event, their styles will be separately treated in the volume of this series given to marginal peoples throughout the world, under the rubric of ethnological and prehistoric art.

My scope embraces only the principal urban civilizations of ancient America, from the Tropic of Cancer to the Tropic of Capricorn, in a quadrant as wide as from Lisbon to Istanbul, and as high as from Cairo to Leningrad. It lies upon the latitudes of Central Africa, and is about equal in size to western Europe. As in western Europe, the coastlines define several seas, but the American land area is far smaller, and its river systems separate the regions more than they connect them. Much of the land surrounds a great Atlantic body of water, of which the western (Gulf of Mexico) and the eastern (Caribbean Ocean) parts are analogous to the eastern and western Mediterranean.

A convenient if equivocal recent name for the total region is Nuclear America, and we retain it here for the moment because it is a historical term, and because no better term has been coined. The northern half, which is more thickly settled than any other part of ancient America, includes the Mexican, Maya, and Central American peoples. If the Caribbean Islands are included, this northern portion is usually called Middle America. The mainland territories alone, without the islands, are called Mesoamerica. These new names correspond more to historical than to geographical groupings, and they avoid the awkward traditional demarcation, drawn between North America and Central America at the Isthmus of Tehuantepec, which was always a thoroughfare more than a frontier in human affairs. The true cultural division between Mesoamerica and South America is at the Isthmus of Panama.

The southern part of the Nuclear American quadrant comprises the northern and central Andean peoples, with the most dense populations clustering in the Pacific Coast valleys of Peru. The Mexican, the Maya, and the Andean peoples probably maintained intermittent contacts by land and sea, but these were certainly much less frequent and much less productive than ancient commerce between Imperial Rome and the Han dynasty in China.[2]

An early draft of this book, written in 1950–1 and later discarded, was an attempt to treat Nuclear America as a unit, with the main divisions by architecture, sculpture, and painting. Each main division in turn was divided by topics, with examples drawn from the appropriate regional divisions of the quadrant. The effort was premature, and the effect was like that of a jigsaw puzzle, making the reader put together examples from many parts of America in order to produce the desired picture. It corresponded to a tendency then much in vogue to lessen the differences between regional styles, and to increase the impression of unity and equivalence among the arts of various unconnected regions. It gave the impression that, in the Andes and in highland Mexico, the same kinds of races towards the same goals were being run by men unaware of each other's existence, yet running at the same speeds, and marking laps of equal length at the same times.[3] This tendency to reduce the complexity of American prehistory came about in reaction from the despair of students in the years before 1945, when every valley and every site seemed to yield new 'cultures' unconnected with anything else.[4]

Fifteen years later, such a *simpliste* view was untenable as the evidence gathered in favour of varying time-scales in each of the principal regions. How is the matter best presented for students of art? The choice lies between two methods of discussing events in time: we may cut across the face of time at intervals in the past; or we may unravel the rope of time into its separate geographical strands, and treat each in a chapter or two to itself. The difference is like that between crosscut and ripsaw woodcutting. With the crosscut saw we can make synchronous sections; with the ripsaw we make diachronous cuts (through time in depth) at various places.

The crosscut method has many of the disadvantages of the jigsaw puzzle: it is misleading to arrange the matter so that the cuts will measure evenly; and it is confusing to have to hold so many examples in synchronous balance. I therefore resolved in 1957 to rewrite the entire text, using geographical divisions as the main parts and chapters, with a complete chronological review of the principal artistic events in each region. The archaeological region is the building-block of the present volume, and the tables are provided to guide the reader in correlating the probable cross-ties in time between the blocks. The size of the geographical blocks is a function of the length of the book. If it were longer, they could be smaller, but as it is the geographical units have been kept at twelve: four in Mexico, three in Central America, and five in western South America.

Mesoamerica

Mexico is a plateau country laced by mountain ranges and rimmed by narrow coastal shelves. The Pacific half is dry and sparsely settled. The Atlantic half enjoys wet winds, and it is more hospitable to dense human occupation. Midway between them is the metropolitan Valley of Mexico, the eternal capital. In the south the highlands are bare and austere, but the deeply carved, wide river valleys nourished civilizations of great age and remarkable achievements. Northern Mexico is a desert belt 500 miles wide, insulating the more southerly valleys from the continental spread of the rest of North America, into which only the eastern coastal plains funnelled a thin trickle of Mexican highland influences during antiquity.

Central Mexico for our purposes is a plateau country about 6500 ft high. It surrounds the capital in a circle roughly 100 miles in diameter. It was always metropolitan, even when its achievements were overshadowed by those of other regions, just as Rome remained somehow a world capital even at the lowest ebb of its fortunes. The hundred-mile circle includes Cholula, Tula, and Xochicalco in a connected group of broad, high, well-watered valleys that attracted dense settlement from the earliest days of human immigration. Its climatic history shows great fluctuations, and they are reflected in the rise and fall of civilizations, as well as in the Toltec and Aztec cosmogony of successive world ages terminating by flood or in fire. The dominant language of the region was Náhuatl, spoken by the Aztecs as well as by their Toltec predecessors.

The East or Gulf Coast has three ethnic divisions, like the Atlantic coast of France with its Basque, Breton, and Norman peoples. It is a narrow lowland coastal plain of tropical climate, narrow in the north and widening at the southern end, with placid rivers winding

slowly through dense vegetation in nearly flat country. In the southern rain-forests lived the Olmec peoples, whose name signifies 'the dwellers in the land of rubber'. The central coast is more variegated and it was the magnet for a sequence of invasions, of which the Totonac people were the last to occupy the region before the Spanish Conquest. In the north are the Huastec people, whose language is an archaic form of the Maya tongue, separated from the main stock in Yucatán and Guatemala by enclaves of Olmec and other peoples.

Southern Mexico includes the states of Oaxaca, Tehuantepec, and Chiapas. The historic centre lay in the great valleys of central Oaxaca surrounding Monte Alban. As climate varies with altitude in Mexico, these lower valleys enjoy a milder climate and a more tropical vegetation than the plateau, without the steaming discomfort of the Atlantic coastal plains. In western Oaxaca, however, the arid mountain settlements of the Mixtecs harboured tribes of a cultural tradition like that of the central-plateau peoples. The centuries-long conflict between the Mixtecs and the Zapotecs in the valleys of central and eastern Oaxaca eventually reshaped the course of Mesoamerican history, when the victorious Mixtecs extended their dynastic rule and religion to other regions (pp. 89, 97).

Mexico becomes more arid closer to the Pacific, and more specifically west of the 100th parallel of longitude, because of dry winds and because of the rarity of great river basins. Only isolated pockets receive the rainfall necessary for dense human occupation. Ancient habits of early village life survived far longer than in the east. From Michoacán and Guerrero westwards, the sparsely-populated plateaus and mountain valleys lack great monumental centres or temple clusters. There are a few exceptions in the late Tarasca towns of the lake region in north-eastern Michoacán (p. 119), or the western colonies of the Gulf Coast tribes at Toluquilla and Las Ranas (p. 122), but, in general, the great upheavals that transformed the more metropolitan eastern half of ancient Mexico seem to have registered only faint effects in the west. The Aztec expansion in the fifteenth century, which embraced all other regions of Mesoamerica, never penetrated west of the valley of Toluca.

<div align="center">★</div>

The Isthmus of Tehuantepec divides the North American continent, of which mainland Mexico forms a part, from Central America, which in turn divides into three main archaeological regions: (1) the Pacific highlands of Chiapas, Guatemala, and Salvador; (2) the Maya region north of the highlands, including northern Guatemala, British Honduras, several Mexican states (Chiapas, Tabasco, Campeche, Yucatán, and Quintana Roo), and parts of western Honduras; and (3) eastern Central America, which embraces eastern Honduras, part of Salvador, and all of Nicaragua, Costa Rica, and Panamá.

Maya civilization, enduring from before 500 B.C. until the fifteenth century, occupied the second of these regions as the metropolitan focus to which both the Pacific highlands and the rest of Central America were either provincial or marginal after A.D. 300. The

Maya peoples, like the Greeks in the ancient world, set the pitch in pre-Conquest America. Their intellectual achievements provided the foundations for the culture of their contemporaries and successors. Like the Greeks again, the Maya peoples appeared late upon the scene, profiting from the attainments of their predecessors, and imposing upon the history of civilization a pattern of behaviour both novel and durable, and different from what had preceded. It crumbled under invasion by more aggressive peoples, who nevertheless retained among their traditions large portions of Maya learning and Maya sensibility.

There were exceptions to this rule. In the Pacific highlands, the pre-Maya and post-Maya peoples were more significant than those of the era of Maya ascendancy. Thereafter, as before the rise of the Maya, Mexican peoples of diverse origins were in control.

Eastern Central America likewise flourished independently both before and after Maya ascendancy. After A.D. 1000, various Mexican intrusions altered the history of the land, but old sculptural traditions in stone survived until the Spanish Conquest. Costa Rica and Panamá were important in transmitting to Mesoamerica the knowledge of metallurgy that probably originated in western South America. Panamanian gold-work is an extension of northern South American styles and techniques, so that it is correct to consider the Isthmus both as a frontier and as a place of passage.

The Andean Environment

Western South America above 20 degrees south sheltered several urban civilizations in the lower portion of our 'nuclear' quadrant. The contrast with Mesoamerica is antipodal. The Mexican and Maya peoples were preoccupied with the figure, the nature, and the position of man, much like the peoples of the Mediterranean, who marked out the humanistic tradition of western Europe by phrasing all experience in the human shape.

In the Andes, utility was the superior consideration. The conquest of the environment by irrigation and terracing, by metallurgy and material techniques of all kinds, and by social discipline at the expense of individual man, gave Andean society a harsh tone, closer both to the present and to the rigours of tribal life than the more poetic view of existence maintained by the societies of Mesoamerica.

The small tribal units of the northern Andes, in Colombia and Ecuador, are similar in number, in linguistic affiliation, and in general cultural attainments to those of eastern Central America. The central Andes on the other hand sheltered human groups whose collective efforts were repeatedly organized into large states under unified control. The best-known example is the Inca Empire, formed near the conclusion of the independent native history of the continent, and extending about the year 1500 from Quito to northern Chile and north-west Argentina. Modern knowledge of the central Andes did not penetrate beyond the Inca state until the present century, when many earlier cultural stages were gradually recovered by archaeological methods.

Today, coastal and highland varieties of central Andean civilization can be distinguished. Northern, central, and southern provinces are clearly delimited by distinct

styles of building and manufactures: the northern peoples preferred sculpture and large works of architecture; the southern peoples inclined towards painting and the textile arts; and in central Peru northern and southern traditions blended, upon an armature of local preferences varying widely from valley to valley.

THE CHRONOLOGICAL PROBLEM

Reconstructing the time-scales of American antiquity has been a main concern of archaeologists since the beginning of the century. Stratigraphic methods were first employed by Thomas Jefferson in Virginia,[5] and are today systematically amplified in thousands of observations. These yielded the first main sequences, based usually upon pottery types and styles. Textual studies have also allowed many chronological deductions. The most rewarding suggestions for dating come from the method of radiocarbon measurement of the residues of natural radioactive Carbon 14 in organic remains.[6] Invented in 1947, the method still requires further refinement, and its results are far from unequivocal. It permits absolute dating only with statistical errors which still exceed a century, and which often leave a margin of doubt as broad as a millennium.

It is instructive to rank the main regions of American antiquity by the reliability and the exactness of our chronological knowledge. Maya studies lead the field, because of the incomparable epigraphic material carved upon buildings and relief sculpture. Many archaeological ties allow Mexican materials to be dated in relation to the Maya series, and there are reliable texts of pre-Conquest origin which pin down the events of the last few pre-Columbian centuries. Lowest in the order of chronological fineness and credibility are the Andean sequences, where gross relations are sure, but not the intermediate positions. It is as if we knew only that Carolingian art preceded the Renaissance, but not how many centuries intervened, or whether the sequence was valid for Spain and England too.

Much of our knowledge of Andean antiquity is based upon pottery styles, and we have no sure knowledge that continuous pottery-making traditions reflect continuity in other fields of historical activity, or that non-symbolic changes in pottery styles really correspond to anything outside the domain of the potter's art. When symbolic shifts are apparent, and when these coincide with major changes in building activity, it is reasonable to suppose that ethnic re-alignments by conquest or conversion are involved, but their exact nature cannot easily be deduced when there is no text of any kind to guide us.

Deductions of this sort nevertheless colour our understanding of the American past with exaggerated hues and contrasts. For example, the prevailing division of Mesoamerican antiquity by pre-Classic, Classic, and post-Classic eras, as used in this book, corresponds in most investigators' minds to a sequence of stages in the economic and political organization of the American Indian peoples. Pre-Classic times, prior to the Christian Era in our normal chronological thinking, were the age of early village societies; the Classic era witnessed the rise and fall of theocratic states: and in the post-Classic period feudal aristocracies dominated, under dynastic rulers engaged in military

expansion. The pattern is assumed to be the same wherever large urban populations thrived, with only minor variations of terminology, such as the term 'florescent', which means the same quality in Andean studies as 'Classic' in Maya archaeology. The American evidence is sometimes instructive about stages on which Old World archaeology has little to say. An example is the architecture of the ritual concourse centre, for which Maya, Mexican, and Andean examples are abundant. Old World examples are few and incomplete, like Stonehenge or Avebury.

I have no alternative to offer for this grand neo-evolutionary scheme. It is probable that early American civilizations did not evolve very differently from those of the Old World; but my interest in style precluded arrangement by evolutionary stages.

Archaeologists trained in anthropology usually produce reconstructions diagrammed into separate compartments. Art historians trained as humanists usually produce descriptions of complex flow. The differences between these operations are the differences between packages and tapes. The two kinds of description of the past may be complementary, in the sense of Niels Bohr, who declared that the integrity of human cultures requires an 'overlay of different descriptions that incorporate apparently contradictory notions'.[7]

To Mesoamericanists, 'Classic' is the key period name. Andeanists prefer 'Horizon'. Classic carries a judgement of quality; Horizon indicates an estimate of political unity, as suggested by the archaeological record. The two key terms reflect differences in both artifacts and attitudes. Mesoamericanists are pointing, when they say Classic, to the Mediterranean affinities of their world. Andeanists are pointing, when they say Horizon, to the political structure of their world, in the alternation of 'pan-Peruvian' periods of unity with the diversity of regional periods and styles.

ANTHROPOLOGY AND AMERICAN ANTIQUITY

It is a striking fact that the study of Old World antiquity was from its beginnings in the Italian Renaissance a branch of humanistic learning, while the study of New World antiquity, which has been systematically pursued only since about 1850, soon took a scientific turn, relating it more closely to anthropology than to humanistic studies.

An explanation of this split is easily provided. Archaeology began in Europe as an auxiliary method. Wherever the written word was missing, the earth itself could be searched for inscriptions, coins, and similar literary evidence. From being the last recourse of the philologists, archaeology became first the diversion and then the obsession of those students of language and literature whose aim was to enrich the fund of monuments illustrating the literatures of the ancient world. Soon after 1850, archaeology escaped its philological servitude to become an instrument for the reconstruction of periods of time less vast than those of biology, yet far ampler than those of recorded history, and embracing the whole history of mankind. Enriched by typology (series of similar objects) and stratigraphy (the layering of remains in chronological sequence), archaeology soon parted company with the humanities, and in America its workers

joined forces with those busy in the social sciences. Among these anthropology has aimed to govern an enormous range, including the biological, linguistic, societal, and historical attainments of mankind in all phases of development.

Today an archaeological report on an American site is a 'scientific' production of graphs, statistics, and impersonal language purporting to reach proven and repeatable conclusions. Such a report has nothing to do with the interpretation of literary works; on the contrary, philology has almost been forgotten by archaeological science. Where the excavation finds are unblessed by writing, philology entirely disappears. Indeed, the 'scientific' connexions of archaeological work, whether in Europe or America, increase as the material culture under study approaches 'primitive', i.e. non-literate, art.

Hence archaeology in America joins with ethnology (the study of living peoples) and with linguistic science as a section of anthropology, dedicated to the study of 'primitive' peoples. Archaeology is a scientific technique rather than a fully autonomous discipline. It is important whenever documents fail to yield direct evidence of the past. In the hands of the anthropologists, it is applied to the recovery of information about social structure and economic life. In this context works of art are used as sources of information rather than as expressive realities.

Of course the tradition of collecting information about exotic societies has a long past in America. The classic example is the work of the Franciscan friar, Bernardino de Sahagún. For twelve years, from 1558 to 1570, he consulted with native informants in central Mexico to compile a great encyclopaedia of the native peoples in the Náhuatl language. Another compiler was the bishop of Yucatán, Fray Diego de Landa.[8] On Peru we have among many others the sixteenth-century work by Pedro Cieza de León.[9]

All these sources may be described as a literature of economic and political purpose. When monuments are mentioned, it is not for the sake of their form or expression, but to indicate that important centres of population were present, or that treasure might be latent. The notion of any artistic value beyond magnitude of enterprise, strangeness of form, and rarity of material was absent from sixteenth-century commentaries upon pre-Conquest manufactures.

In the seventeenth century a new kind of writing about Indian matters made its appearance. Civilian colonists and clergy alike, in their concern for the spiritual advancement of the native peoples, found it necessary to extirpate the ancient idolatrous practices that still flourished in countless towns.[10] Many reports tell of sites and cult objects, giving explanations of their use and describing their destruction. The major destruction of Indian symbolic expressions was completed in the seventeenth century.

Later writers were reduced to collating the early sources. In the eighteenth century the Jesuit historian Francisco Clavigero wrote an account of antiquities that served long as handbook of Mexican archaeology.[11] The historians of the Enlightenment, such as Raynal, Robertson, or de Pauw, who wrote of America, added little that was new to these prior accumulations.

A vast expansion of exact knowledge accompanied the opening of Spanish America to European travellers following the Wars of Independence. Alexander von Humboldt

and Alcide d'Orbigny were among the earliest. Baron Waldeck and J. L. Stephens published the principal Maya monuments before 1845; in South America, J. J. von Tschudi and W. Bollaert presented many linguistic and archaeological discoveries to the European public. Their successors, E. G. Squier, T. J. Hutchinson, Charles Wiener, and E. W. Middendorf, covered Peru with a further network of explorations.

A generation of field archaeologists appeared after 1890 – A. Bandelier, W. H. Holmes, A. P. Maudslay, Max Uhle, and T. Maler. Their immense apparatus of field reports and excavation accounts laid the foundations of modern archaeological knowledge about pre-Columbian America. At the same time in Germany the philologist Eduard Seler patiently collated the textual sources for Mexican and Maya history in many essays and commentaries.

Between the World Wars the responsibility for American archaeology was assumed entirely by governments, foundations, public museums, and universities. Corporate campaigns of research, like those of the Carnegie Institution of Washington, yielded hundreds of books and papers on all aspects of Maya civilization. Since 1945, however, financial support by great institutions to American archaeology has dwindled away, and it is a rare event when sustained effort by a numerous field party is dedicated to a programme of excavations such as the one at Tikal in Guatemala under the auspices of the University Museum in Philadelphia.

One consequence of the disappearance of massive financial support for new excavation has been a renewed effort by anthropologists to generate fresh interpretations of the historical meaning of American Indian cultural history. Since these ideas arise more from works of art and architecture than from any other evidence, we should here examine them with care in order to correct our own course if necessary.

In the attempt to study the whole configuration of culture, anthropological science has been concerned with aesthetic activity only as a component of culture. The question at once arises whether 'culture' indeed 'includes' aesthetic activity. The anthropologist usually assumes that every aesthetic choice made by the members of a culture must be determined by that culture itself. But when we apprehend any culture as a whole, its axioms or postulates resemble aesthetic preferences. Thus two peoples living under similar environmental conditions may exhibit contrasting attitudes in respect to the total ordering or integration of their lives. At every point in the long, unconscious adaptation to environment, people have the faculty of choice. They can reject some alternatives, and accept others, more often than not for reasons of pleasure and dislike rather than necessity. To be sure, many people's choices are conventional, but we are here discussing the significant choices of the minority élite whose decisions become conventions. In all epochs, artists have been foremost in channelling the future along these fateful ways of pleasure and displeasure.

The history of art cannot entirely be included by anthropological science, despite the fact that the history of art treats only a fraction of the material culture which is a main object of anthropological research. Anthropological conclusions about a culture do not automatically account for the art of that culture. As Jakob Burckhardt long ago remarked, on the State as a work of art, the culture itself can be regarded as an aesthetic

product, brought into being by the same non-rational choices that mark a work of art. On the other hand, the work of art is of course incapable of being made to explain all the culture in which it was produced. No explanation of culture ever fully accounts for its works of art because aesthetic activity lies in part outside culture, and because it is anterior to culture as a possible agent in the processes of change.

Another consequence of this reification of culture by anthropologists is the rigid evolutionary scheme of cultural development in fashion since about 1950. If culture is a real entity, then its existence in time must have had segments, separated by determinable historic dates.[12] This kind of thinking is familiar enough in historical studies, where numerous documents require the introduction of nuances into the artificial device of historical periods. In archaeology, however, there is always present the temptation to adjust the durations to preconceived ideas of their content;[13] for example, the style of pottery painting found at Huari in Peru and Tiahuanaco in Bolivia (p. 322) re-appears throughout the central Andes, seeming to displace earlier local manners. No texts explain these events, and archaeologists have supposed firstly that the Andean diffusion of the style corresponds to military conquest or religious conversion by dynamic highland peoples, and secondly that these events occupied a narrow span of time after A.D. 600 (Chapter 16). Today, however, more and more lines of evidence converge to suggest that the centre of diffusion was not at Tiahuanaco but in the Mantaro basin, and that the spread of the style lasted many centuries, antedating the putative 'expansionist' period and beginning as early as 200 B.C.

In short, ceramic frequencies give reliable information only about very coarse time relationships: about the history of the craft itself, and perhaps about economic conditions if other evidence is available. But sherd frequencies are unsatisfactory evidence for political or sociological reconstructions. Pottery sequences reflect other orders of events only after delays and with much levelling of a more agitated reality. If we had to rely upon ceramic history alone for our knowledge of Hellenic events in the period 550–450 B.C., the shift from black-figure to red-figure painting would probably be interpreted as a political or sociological event rather than as a transformation within the craft.

The general effect of the imposition of rigid developmental categories has been to stress discontinuity and rupture, rather than continuity in regional and local traditions. For instance, each major change in the pottery style of a valley is hailed as a new 'culture', even when the older literary sources, closer to the events, report continuity. As an example, Sahagún recorded the Aztec tradition of Old Toltecs and New Toltecs in central Mexico,[14] referring to a continuity which today has been broken by scholars into separate 'cultures'. Thus 'cultures' have been multiplied inordinately; local groupings receive more attention than the main traditions; and 'crosscut' comparisons (p. 3) have become the principal method of historical reconstruction.

A century ago W. H. Prescott wrote of the conquest of Mexico and Peru by Spain, and he prefaced the narrative with a luminous account of Aztec and Inca life based upon Spanish eye-witness accounts and on their records of the events of the fifteenth and sixteenth centuries. Behind that horizon nothing was known. Today the curtain has been pushed back to disclose the continuous existence of peoples changing from the nomadic

lives of palaeolithic big-game hunters into sedentary villagers and ultimately to great religious communities and dynastic states. This reconstruction of the river bed without its river has been among the great achievements of the anthropologists in this century.

DIFFUSION OR POLYGENESIS?

The other main theme in recent anthropological discussion concerns the diffusion of culture from the Old World to the New. Two schools of thought are present: the diffusionists, who exclude the possibility of independent invention; and the Americanists, who defend the thesis of independent origins for New World civilizations. Diffusionism has had defenders since the sixteenth century, when the lost tribes of Israel were invoked to account for the racial origins of the American Indian peoples.[15]

The thesis of independent origins was first stated in the 1840s, by F. Kugler in Germany, and by J. L. Stephens in the United States.[16] Both men independently destroyed the arguments for Old World origins of American Indian art by demonstrating the autonomous and self-contained character of the principal artistic traditions, and by showing that resemblances to the arts of other regions of the world, such as India or Egypt, could be explained as convergences rather than as borrowings by Americans from Old World sources.

In our century, the topic was dormant for a generation, from about 1925 to 1950, when the thesis of the independent origins of the New World civilizations was the orthodox view among North American archaeologists, working mainly under the leadership of A. V. Kidder at the Carnegie Institution of Washington. Their hypothesis was that America received its first settlers from north-east Asia near the close of the last Ice Age, and that migration was thereafter cut off by physiographic changes at Bering Strait. All American Indian civilizations were believed to have developed independently upon this palaeolithic base, without further influences from the Old World. The hope was to prove that the human species, if cut off in a favouring environment near the beginnings of history, would spontaneously develop cultures parallel to those of the other races of mankind, but owing nothing to them by way of historical influences beyond the original palaeolithic fund of knowledge.

The independent inventionists have never denied the occurrence of small-scale intermittent migrations from Asia or Europe, like those of Scandinavian sailors after 1000 to the coasts of Massachusetts and Rhode Island. But they have rightly regarded these episodes as insignificant in the large framework of indigenous development. More important is the absence of major Old World traits from the technological repertory of the New World peoples: traits such as horses and wheeled vehicles. The diffusionists have not provided any explanation of these absences.[17]

This problem of the origins of American Indian civilizations remains one of the great open questions in world history. The linked sequences of Old World history afford no opportunity to verify the thesis of distinct cultural traditions arising from independent origins. Only America provides the possibility of establishing a case for independent

invention. We must therefore weigh with extreme care any assertion pretending to resolve the issue. We cannot here test the racial and agricultural evidence, but we should be prepared to question the visual comparisons upon which the new diffusionists have based certain recent arguments.[18]

For example, Ekholm has supposed that a centre of Asiatic influences flourished after the eighth century A.D. on the western border of the Maya peoples, bringing into Meso-america traits imported from the art and architecture of south-east Asia. For nearly every one of these forms, however, still other Old World origins can be suggested. The trefoil arch of Maya architecture occurs not only in western Pakistan about A.D. 400, but also in Islamic and Romanesque architecture. The miniature roofed building inside a temple recurs not only at Ajanta in India, but in Hellenistic architecture. Sacred-tree or cross forms are obviously of Early Christian significance, in addition to the late Javanese or Cambodian examples adduced by Ekholm. Court scenes like those of Bonampak or Piedras Negras are common in Byzantine art. Colonnette decorations on façades pertain to Romanesque art as well as to Khmer temples. Corbel-vaulted galleries are Mycenaean as well as Cambodian. Serpent forms, Atlantean figures, and phallic statues are not restricted to south-east Asia, but recur throughout the art of the ancient Mediterranean. Doorways framed by monstrous mouths stand in Christian art for the gate to Hell. The Chacmool figure can be compared to classical river gods as well as to figures of Brahma. In other words, for nearly every item adduced in this list, an older European parallel can also be proposed. The thesis of Asiatic origins is thus easily diluted to include the entire Old World, and the Asiatic 'focus' loses precision.

In addition, these forms all belong to autonomous American iconographic types. The famous comparison between Shang or Chou Dynasty bronze scrolls and the scrolls upon Ulúa valley vases of about A.D. 1000, first pointed out by C. Hentze and revived a generation later by M. Covarrubias, belongs to this class. Chinese bronze scrolls belong to one iconographic series; Ulúa valley scrolls pertain to another series. Both series depart from dissimilar sources to converge in an adventitious resemblance that has misled all students who were unaware of the separate typological series embracing each term of the comparison. The argument is like assuming a close blood relationship be-tween persons who look alike, although born many centuries apart, of different races and on different continents. The resemblance is accidentally convergent, and it cannot be used to establish a genetic connexion without supplementary proofs.

The History of Art

This modern academic discipline of collecting, selecting, interpreting, and evaluating works of art and architecture owes its origins as a humanistic study to Renaissance historiography (Vasari) and to classical archaeology. Its connexions with anthropology have never been close. In the realm of aesthetic choice the history of art treats roughly one-third of all possible human activity. This realm is the main theatre of human volition: it is neither of the senses nor of the intellect, but between them and participating in both.

We have already discussed the anthropologist's restrictive view of the cultural place of artistic activity: let us now look at the art historian's view of the materials of American archaeology.

In general, he regards aesthetic products as furnishing symbolic values rather than useful information: he is concerned with intrinsic being more than with applications. The first explicit statement about the history of ancient American art was written *c.* 1840 by a German historian of art, Franz Kugler. He prepared the earliest general history of world art, written for the Prussian king and published in 1842.[19] The American section was composed before the appearance of J. L. Stephens's path-finding views on the origin of Maya civilization. Kugler first stated the 'independent inventionist' doctrine, which is still fundamental, if controversial, in American anthropological theory. He accepted east Asiatic origins for American man. More important, he insisted upon the independence of the art forms from Old World influences posterior to the basic Ice Age migrations. He regarded ancient American art much as I shall do here – as an autonomous and independent development, but lacking great antiquity. These principles occurred to Kugler solely from the study of those works of art which he knew in Germany from plates published with the works of d'Orbigny, Humboldt, Kingsborough, Dupaix, Nebel, and Waldeck. He deduced that American Indian art was 'thoroughly different from the artistic achievements of all other known peoples of the earth'. This proposition led him to assert autonomous and independent development as the necessary conclusion. Modern anthropological theory, to be sure, owes nothing to Kugler, whose work has had little influence outside the history of art. But it is of real interest that a specialist's judgement of forms in art expressed about 1840 anticipated the independent conclusions of the members of another discipline in a much later generation.

In other respects Kugler was less adventurous. His taste for neo-Classic correctness and severity, then already old-fashioned but still characteristic of his generation, kept him from enjoying the expressive power of Mexican sculpture. After Kugler few historians of art in the nineteenth century returned to the subject; one of the rare exceptions was Viollet-le-Duc, who hurriedly studied the rationale of the Maya ruins reported by Désiré Charnay.[20]

In retrospect, historians of art were very slow in turning to the study of American antiquity. Political reasons may be the explanation. Twentieth-century sensibility, as a quest for expressive power independently of representation, was at first channelled by the political geography of nineteenth-century colonial expansion in its search for non-European sources of inspiration.[21] Africa and Oceania, as the colonial empires of France, Germany, and Britain, yielded the first great ethnographical collections, and it was they that stimulated Gauguin and Munch, Braque and Picasso. The Latin American peoples, who attained independence from Spain before the formation of the European colonial empires, never contributed from their rich resources to these ethnographical collections. In addition, the materials of American archaeology, although rich in 'primitive' suggestions, also include representational styles of a degree of verism that made them, like Egyptian or Minoan archaeology, unsuitable for formal experiments in search of great intensity of expression.

The art historians' adaptation to these contrasting values in American archaeology is well documented. In 1842 Kugler correctly noted the Aztec sculptor's search for the 'inner meaning of organically animated form', and his command of the 'expressions of the life of the soul'. But Kugler was ill at ease with the 'deformed proportions', the 'excessive symbolic ornament', the 'architectonic conventions' of Aztec sculpture, with its 'gloomy, arbitrary, and adventurously synthetic fantasy'. Like Waldeck, who claimed to be Jacques-Louis David's pupil, Kugler preferred the 'lively sense for nature, excellent musculature, slender forms, and soft motions' of Maya sculpture at Palenque.

Nearly sixty years later Karl Woermann, writing of American archaeology in 1900, was still unable to resolve the same conflict in judgement.[22] He wrote that American Indian sculptors, in spite of their wide technical command, lacked 'full understanding of the forms of representation', and suffered from 'incompletion and a barbarian over-loading, although they were able to make their forms occupy space with unmatched monumentality'. In other words, the nineteenth-century critic could not bring himself to credit the expressive strength of American Indian art, nor again could he rank it high by Occidental standards of verisimilitude. Faithful representation was for these critics the touchstone of value, and the representation to which they were accustomed is uncommon in ancient American art.

Hence it was not until about 1910 that critics appeared who were able to penetrate the expressive devices of the figural art of ancient America, and to comprehend the spatial purpose of the architecture. These new students, among whom one of the earliest was H. J. Spinden, belonged to a generation already familiar with non-representational expression. In Spinden's case the training of an anthropologist was united with the insight of a gifted critic, who had been influenced by 'technicist' interpretations of primitive art from Semper to Haddon.[23] Spinden, however, was mainly an anthropologist concerned with culture, and his work used Maya art to extract information about the civilization. It remained for others, such as Pál Kelemen and José Pijoan,[24] to consider ancient American art for its own sake rather than as a documentary file on cultural themes.

The task is a difficult one. My volume, like others before it, falls far short of the avowed aim, to explain the principal archaeological objects as works of art. The term itself, 'work of art', is already a qualitative ranking, as it separates products of aesthetic intention from products for use. After selecting the works for discussion, we must say how, when, and by whom they were made. Then we must translate their meaning from visual into verbal terms. Finally we have to extract from the historical series of works of art those 'deviational' meanings that were not apparent to the people themselves who made and used the objects, and which appear only to the historian after the series is completed.

In making my selection I have retained the traditional classification by architecture, sculpture, and painting, in spite of appearing to omit many crafts. This difficulty is only verbal; for all crafts can be treated as parts of sculpture or painting. Textiles are paintings on flexible supports. Most pottery vessels are sculptural forms, and some are paintings on curved surfaces.

A more urgent objection is that the threefold division into architecture, sculpture, and painting reasserts the ancient distinction between 'fine' and 'useful' arts in relation to civilizations whose entire artistic production consists of objects for use. In this context, the gigantic European literature of right academic practice is bereft of meaning. Arts of representation that recognize no convention of European one-point perspective cannot be bound by academic legislation on the 'rightness' of the Albertian construction. Sculpture that is only occasionally concerned with the human body cannot be criticized by Greco-Roman canons of proportion. An architecture to which the column is an occasional relief in the rhythm of voids and solids cannot be contained by regulations derived from Vitruvius and Vignola.

What then could be my guide in the selection of some objects and the rejection of others from this text? The valuation of whole cultures yields no criterion; for when cultures are ranked, the ranking does not apply to arts: when arts are ranked, the ranking does not apply to cultures. To present knowledge the connexion between excellent art and its necessary or adequate social conditions is completely and entirely unexplained. The historian can occasionally point to favouring circumstances, but he cannot identify them as sufficient causes. In short, we know of no type of society in which excellent art inevitably and necessarily appears.

When a building or an object is discussed and illustrated here, it is because of a peculiar perceptual quality. Unlike physical or chemical properties, this perceptual quality cannot be measured. Its presence is unmistakable. It is altogether absent from no artifact. Works of art display it more than utilitarian objects. It is present in nature wherever humans have been active, as in pure-bred animals, and in selected landscapes. It appears in scenes and things called beautiful as well as in those that arouse disgust.

It is a special intricacy in several dimensions: technical, symbolic, and individual. In the technical dimension, we are aware, in the presence of such objects, of a long cumulative tradition of stock forms and craft learning, in which the maker's every gesture arises from many generations of experimentation and selection. In the symbolic dimension, we are presented with a cluster of meanings infinitely more complex than the single functional meaning that attaches to a tool or to a bit of information. In the individual or personal dimension we become aware of the maker's sensibility. Through it the technical tradition and the symbolic matter have filtered, undergoing alterations leading to a unique expression.[25]

The net we are using has a mesh that lets the useful forms of material culture pass through it, retaining only those which the field archaeologist calls 'fancy' forms. His net, on the other hand, best retains tools and instruments. It lets works of art pass through after only their useful message has been read. Thus we are working over the leavings of the field archaeologist, like the prospectors who find rare minerals in the tailings of an earlier mine.

The true tool has only one function, and only one meaning. Many tools of course come under close scrutiny as works of art, because of their high degree of useless elaboration. Conversely, many objects of ornamental purpose have a residue of functional form. I have therefore included under the rubric of ornamental forms large numbers of

utilitarian objects. Their elegance and symbolic value are self-evident. In the history of European art they would be called 'decorative arts': here they are taken closer to the core of aesthetic activity, and classed as modes of sculpture and painting. The ordinary tool is to a work of art as everyday speech is to music, but some tools are like songs.

Some comment is in order on the conception of meaning used in this volume. Iconography, which is the study of 'the subject matter or meaning of works of art',[26] embraces three kinds of meaning: natural subject matter (representations of objects, of events, of expressions); conventional subject matter (representations of concepts, stories, and allegories); and intrinsic meaning (the work of art as cultural symptom or as revealing essential tendencies of the human mind). All works of art possess intrinsic meaning, even when they lack both conventional and natural meanings. Much textile art, for instance, represents nothing, yet it is symptomatic of its culture by virtue of intrinsic meaning alone. In ancient American art, intrinsic meaning is often more easily established than either conventional or natural meanings (pp. 275, 300).

Our greatest difficulties arise with conventional meanings, especially when we are dealing with pre-literate societies. The key to conventional meanings can come only from literary sources; pictorial conventions can rarely be deciphered by examination of the pictorial materials alone. Literary sources for the understanding of ancient American civilizations are lacking for all societies other than those recorded by Spanish observers and by Indian survivors at the time of discovery and conquest. Hence we have intelligible and circumstantial literary sources only for Aztec civilization, for late Maya culture under Mexican influence, and for Andean society in its terminal phases. We have no auxiliary sources whatever to decipher Mochica art, or Classic Zapotec, or Nazca or Tiahuanaco styles of conventional meaning.

It is often erroneously supposed that intrinsic meaning cannot be known before natural and conventional meanings are established. In actual practice, however, we constantly make correct assessments of intrinsic meanings without knowing either the natural or the conventional meanings of the form under inspection. For example, J. L. Stephens correctly assessed an intrinsic meaning of Maya writing, as a system having no connexion with any other Old World writing, some fifty years before its partial decipherment by Förstemann and Goodman. And whenever one assigns an object without provenance to a specific time and place, it is in part on the strength of an intuition about intrinsic meaning. Thus we are obliged, like all previous students, to concentrate upon natural and intrinsic meanings. The galaxies of conventional meaning for the most part still lie beyond the range of our instruments of knowledge.

Many anthropologists urge the use of ethnohistory as a main instrument of archaeological reconstruction. But to assume that the archaeological past resembles the ethnological present, is to believe that the present can explain the past, instead of seeking an explanation of the past in its own terms. The archaeologist who uses ethnological aids assumes an unchanging past. Instead of guaranteeing the purity of the past under reconstruction, he converts the past into its present.[27]

If the history of art were merely a matter of solving puzzles of date and authorship,

and of explaining works of art, it would be only another antiquarian pursuit among innumerable varieties of gourmandizing over the past, along with philately and genealogy. The problem of knowledge itself arises here. The history of art is a historical discipline because the seriation of works of art permits one to transcend the knowledge of even the artists themselves about their own work. Despite all the imperfections of his sources, the modern student of the sculpture of Phidias knows many things about Phidias that neither Phidias nor his contemporaries could know. He who knows the envelope surrounding the events of antiquity, can deduce from this awareness of durational meaning such estimates as the relative age of any form in a given class of forms, and the significance of an individual artist in a connected series of artists.

In American antiquity many groups of monuments and objects still require seriation, although some anthropological archaeologists have achieved great precision with ceramic stratigraphy and the quantitative analysis of stylistic traits. When it is unlikely that field excavations can solve the problem because the sites are too disturbed, these undifferentiated groups of objects can still be subjected to a stylistic analysis of an art-historical type. Assuming that early and late positions in a series correspond to distinct and definable formal qualities,[28] we can provisionally put the objects in series, as with colossal Olmec stone heads (p. 71), west Mexican clay sculpture (p. 116), or Toltec Maya buildings (p. 197). These approximations, however coarse and inexact, are still better than no sequence; for it is upon sequence that our awareness of artistic problems must ultimately rest. The chain of solutions discloses the problem. From many such disclosures we can derive an idea of the guiding configurations of behaviour at different times and places. The labour ahead requires selection, explanation, and disclosures of objects which are usually treated only as sources of practical information. Here it is fitting also to consider them as experiences corresponding to the aesthetic function in human affairs.

The term 'function' needs explanation. In Western thought the concept derives from Kant's dissection of experience, whence we have the idea of the 'pure' artist, the 'pure' religious, the 'pure' politician, and all the special vocations of the modern age. To be contrasted with such specialized isolates is the relative unity of the functions of the soul elsewhere than in the modern Occident and previous to it: [29] a whole in which religious, ethical, aesthetic, and social functions were all experienced as a seamless entity and conveyed in a single system of metaphors.

Earlier men could not readily divide the unity of the functions. The men of today cannot bring them back together; for we are required to distinguish the functions by the society that has arisen upon their separation. The separation itself permits us to establish an aesthetic function for every experience. Every experience has a sense; it is rationalized; it is laden with emotion. Aesthetic behaviour is concerned with emotional states, and it marks the production of every artifact, however simple or useful it may be. Hence an aesthetic function is present in every human product, and, by extension, in all cultural behaviour.

This extension of an artistic franchise to all artifacts allows a resolution of one great difficulty. In anthropological studies aesthetic value is held to evolve by gradual

articulation from the primitive unity of experience along a gradient leading to art as we understand it today. From this evolutionist point of view, aesthetic values are lacking in primitive societies. Because all value is regarded as having biological origins, what looks like art in primitive life is believed to have been motivated by utilitarian needs, or by fear, sex, or other 'biological drives'. Especially favoured among social scientists is the theory that art derives from play impulses, and that it serves as a training activity in the struggle for existence.[30]

The opposing point of view is idealist. Here it is a postulate that comprehension of another being is possible only under conditions of similarity between object and subject. Hence we may not restrict the understanding of primitive persons whom we pretend to comprehend, to values only of biological significance, but we must concede them innate values of aesthetic and intellectual bearing essentially akin to our own.[31] Both primitive persons and their modern students share in aesthetic behaviour. It is a condition of psychic equilibrium between subject and object. The world is known through emotional states rather than by rational constructs. Natural phenomena are apprehended as states of feeling rather than as events outside consciousness. Unlike the evolutionist, the apriorist apprehends a nucleus of aesthetic value that is the same in all arts: always essential; always definable; always resistant to materialist reductions of its scope. He thus escapes the embarrassment of the evolutionist who, when confronted with early artifacts that look like art, must explain them as non-art.

This conception of the continuum of art can be articulated by the idea of configurations as well as by the evolutionist's conception of stages. 'Period' rather than 'stage' is the key to the differences between artistic groupings. Cultural configurations can be charted and measured by the phenomenon of style.[32] Different configurations co-exist and succeed one another: each has its own content and its own developmental pattern.

Configurationism, however, is an incomplete and perplexing concept. It is grounded in Gestalt psychology and in structuralism. It transforms the problems into postulates, and it elevates the axioms to the rank of explanatory principles.[33] Confronted with the choice between idealist and materialist interpretations, the student of aesthetic behaviour must of necessity prefer configurationism to the arbitrary stages of evolutionist thought; for in the latter, aesthetic behaviour loses autonomy and becomes only the mechanical reflection of other processes. The difference between them justifies once again this book's preference of diachronous to synchronous discussion (p. 3).

The Place of the Artist

Works of art are produced by individual persons whose unique sensibilities transform the stream of tradition. Configurations and evolutionary sequences – which are ways of classing these products in the absence of documented artistic personalities – differ as to scale. A stylistic configuration occupies less time than an evolutionary sequence. When we are confronted with a total lack of biographical information, as in the history of

ancient American art, the gaps can be closed by overlooking them, and by choosing the broadest possible chronological scale. Hence the stages of an evolutionist view of the American past provide our only scaffolding for a reconstruction of the probable position of the artist in ancient society.

A few general observations hold good regardless of stage or period. In the first place, artistic change in these societies probably resembles those slow processes of linguistic 'drift' which escape the notice of the participants, more than it resembles the self-conscious dedication to change affected by European artists since the Renaissance. The architect, the painter, and the sculptor were given fewer occasions for invention than their modern colleagues because of small populations and because of the gigantic expenditures of time required by Stone Age technology. A clear conception of the in-dividual as the unit in a social process was probably lacking. Each generation added its ritual obedience to the 'cake of custom' that evens out the rate of change in small and isolated societies. As these layers of tradition became more and more weighty, they exceeded the capacity of the individual to transform them.

Hence the American past seems stagnant and sluggish, with Neolithic durations alto-gether different from the staccato transformations of European time. In such a slowed-down temporal perspective the position of the artist must have been far less distinct than we are accustomed to consider it. The occasions for artistic production were distributed more evenly through the entire society than in the specialized crafts and guilds of Euro-pean civilization. Each household was a producing unit for many manufactures. Each village tended because of environmental differences towards traditional specialities like those which survive today in parts of Guatemala and Peru.

The Early Hunters

What was the artist's position among the Pleistocene hunters in the final phases of con-tinental glaciation? As in Europe, we know of bone and wood implements and pressure-flaked stones. Hides and skins were dressed; rude shelters must have been built, and a body of useful empirical knowledge had already been acquired and transmitted during hundreds of generations. Two rude works of art in America are assigned to these times: an elephant tooth from Tepexpan in the Valley of Mexico, carved as a miniature human foot;[34] and the sacrum of an extinct species of llama, carved to represent the face of a coyote, and found at Tequixquiac near Mexico City in 1870 (Plate 1).[35]

The lives of such hunter-artists were exposed to unending dangers, for which the proper psychological preparation was as important as food. Ritual and magic provided this preparation. Those energies which we invest in recreation and contemplation were spent by early men upon exercises that keyed the faculties to the tension needed for successful hunting. In the round of exposure to danger, recuperation, and psychic pre-paration for renewed dangers, the short nomadic life of the prehistoric huntsman passed. His ritual preparation probably included rhythmic sounds and dancing. In these arts of filling time with significant action, the body itself is the material, worked by aesthetic intention into fugitive figures that leave no permanent record. Such rituals imitated the

behaviour of the hunted animal, and the dancer himself reviewed his own motions, discarding wasted efforts, inventing more efficient sequences, and refining his craft by mimesis. These moments of detached mimicry, away from danger and performed in recollection, border upon aesthetic contemplation.

Early Villagers

A dries climate closed the Pleistocene epoch, when the large grass-eating animals died out with the disappearance of pluvial vegetation. Early man then turned to small game and to the exploitation of drought-resisting plants. During these five thousand years until the emergence of urban societies before the first millennium A.D., plants and animals were domesticated and village life became the normal mode of human congregation. Among Pleistocene hunters all the forms of activity were aimed at the destruction of animals. But among early farmers the household animal is fed and the plant is tended. Man played the part of a force set over nature instead of against it.

Unlike the hunters, who wandered through a succession of virgin environments, the early villagers gradually surrounded themselves with artifacts of their own making. This accumulation of things channelled the tradition into divergent patterns. In one village bulbous water vessels of fired clay might serve as fertility symbols, while another nearby village might satisfy the same symbolic requirement with effigy vessels. Early commerce would offer the artisans further choices requiring aesthetic decisions. At the same time the increasing accumulations of man-made things formed a historical record attesting the tradition and conditioning present choices.

With the village cushioning its dwellers from the hard pressures of the environment, men could begin to explore the 'useless' items in their surroundings. This attitude of contemplative freedom opened a new domain of inventive behaviour entirely separated from the struggle to survive. Under village life the earlier rigorous selection and reduction of human temperaments to a single hunting standard was no longer necessary. The spectrum of temperaments from melancholy and phlegmatic through sanguine and choleric gradations could all survive under the easy vegetative routine of early agricultural existence.

The professional exercise of the fundamental crafts of the potter, weaver, builder, and metalsmith in turn may have reinforced the separation of the temperaments, calling upon patient and withdrawn souls for textile invention, and upon gregarious and commanding persons for builders, and so on through the full range of village arts. The exact history of the earliest steps in any traditional craft will never be known; for we cannot learn when and where clay was first scooped into hollow shapes, or reeds were first tied together. Certainly these things were done by many men in many places. And among the first men temperamental differences of a genotypic order must have impelled them rapidly to different specializations.

Beyond a certain moment the self-sufficient isolation of the earliest villages could not continue. Artifacts create needs, and when these needs have been satisfied, any excess can be traded to neighbours. But early commerce provoked changes that ultimately

wrecked the primitive autarchy of village life. With wealth, obsolescence became a problem. An artifact creates needs not only for others like it, but eventually for improved versions of itself. The producer must eliminate some of the inherited equipment, if he is to continue to make new versions. Here is one among several explanations for the elaborate funeral gifts in many early village tombs. Piety was of course the accepted motive, but a great additional advantage was gained in allowing the survivors to renew their household tools and ornaments. Village wealth was also dedicated to the temple, to the 'household of the god', much as in the ancient Mediterranean lands, as a clearing-house for all the intricate social problems of the continuing production of wealth. The result in the end was a priesthood. This new social class had a special interest in the enlargement of village society in the direction of theocracy, the priestly state.

The Theocracies

The effects of priestly rule upon artistic activity were radical during the first millennium A.D. The temple corporation represented a dual order of being, whereby events in this world reflect events in another world of supernatural forces, enabling the men living by the law of the temple to mark a frontier between civilization and barbarism in a new great community. It expanded by teaching and example conveyed in a new class of works of art. Hence one condition for the spread of the new order was a clear difference between early village styles and the expressions of the temple law. The new symbolic art avoided everyday secular experience, and it suggested terror or awe at first by the monstrous shapes of other-worldly forces. The earlier village art was looked upon as rustic, retarded, and devoid of learning or morality.

Gradually the stiff code of the early symbolic system softened, with the repetitious utterances of many generations, into gentler forms enriched by a renewed study of nature. In each region a different variant of this classic style took form, but the earlier tradition of household crafts yielded to the professional artist, who was maintained by the community to give all his time to the production of imposing works of art. The corollary of the professional craftsman is the passive spectator. Here the cleft between works of art and 'utility wares' first opened deeply. Here also the work of art became a social tool, useful in the concentration of public power through widely shared symbols.

The Terminal Stages

Towards the end of the first millennium A.D., signs of violence, crisis, and rupture appear in the archaeological record at all the main centres of civilization. In each region the succeeding period is characterized by the emergence of warrior aristocracies. These new states were the result of the intrusion of nomadic peoples, who succeeded in taking control from the ancient theocratic corporations.[36] The Toltec, Mixtec, and Chimu states all exemplify this replacement of theocracy by military aristocracy. The process was probably a double one. The new barbarian masters of the old societies brought with them as their own heritage many archaic traits of behaviour. On the other hand the

destruction of priestly rule brought to the surface many submerged expressions of the ancient stratum of early village society, long repressed under the burden of hierarchic government. Large cities, differing from the earlier ritual concourses for dispersed farmers, became common in the period after 1200.

The simultaneous appearance of 'empires' after 1300, both in Mesoamerica and in the central Andes, is not easy to explain. Possibly they resulted from *vis a tergo*, from the compelling power of antecedent circumstances. The empire was a new society large enough to absorb the useless warfare of the petty aristocracies. It also afforded possibilities for public works and the colonization of new lands. On the whole, warfare rather than art produced the empires.

The craftsman became more and more a professional specialist of decreasing status in a society dominated by the warrior class. His services were necessary but his rewards diminished. His loss of status and his subordination to a military class are apparent in the declining quality of the workmanship. There are important exceptions, among which Aztec sculpture is the most notable.

In review, the place of the artist in ancient America can perhaps be made clear by a simile taken from weaving. Civilization is like a cloth in progress on the loom. The various institutional functions, political, economic, and military, are like the warp strung from end to end of the projected fabric. They are made of the same fibre as the weft thread, which is like the continuous production of art, binding the warp into a strong weave with a figured pattern. In America the design at first was carried by the weft alone, but near the end it was carried more and more by the warp.

PART ONE

THE MEXICAN CIVILIZATIONS

CHAPTER 2

THE EARLY VALLEY OF MEXICO

ABOUT 2500 years ago the fertile adjoining valleys of Mexico, Puebla, Cuernavaca, and Toluca were already a metropolitan nucleus for the entire northern continent. Other regions in Oaxaca, on the southern Gulf Coast, and in Maya territory were in touch with central Mexico, giving and receiving each in its time. The dominant centre of ancient urban life eventually became the three high intermontane plateau valleys of central southern Mexico, in the quadrant bounded by Tula, Xochicalco, Cholula, and Malinalco. Both Tula and Malinalco bordered the unsettled lands of nomad tribes. Cholula marks a frontier with sedentary peoples of different traditions to the south and east. Xochicalco is an intrusive enclave of Maya and Gulf Coast style.

Within this quadrant the ancient inhabitants, stimulated by fertile soil, by temperate climate, and by the continual renewal of population through immigration from less favoured regions, changed from nomadic big game hunting (c. 9000 B.C.) to life in early agricultural villages (3000–1000 B.C.). Such settlements yielded before 500 B.C. to urban societies not unlike those of ancient Mesopotamia, Egypt, Pakistan, or China.[1] Other regions of America transcended central Mexico in elaborating portions of the fabric of its civilization, but none shows a cultural record of such duration, continuity, or involvement with the rest of ancient America. From central Mexico, styles of art were carried to the south-eastern and south-western United States; to the Maya region; and probably even to the west coast of northern South America.[2] No other region of ancient America exerted so continual or so expansive an influence upon its neighbours both near and far.

FORMATIVE: 3000–500 B.C.

An early example of monumental architecture in central Mexico is the circular platform of Cuicuilco (Figure 1) in the Pedregal, near the new University of Mexico. Its four conical stages faced with stone slabs laid in clay originally had a diameter of 135 m. (440 feet) and they rose about 20 m. (65 feet). Near the close of the pre-Classic[3] a sheet of lava enfolded the platform together with the adjoining burial grounds, which have yielded early village manufactures of pottery and clay figurines. The construction of the platform shows two campaigns: two lower stages were built with an altar on top,

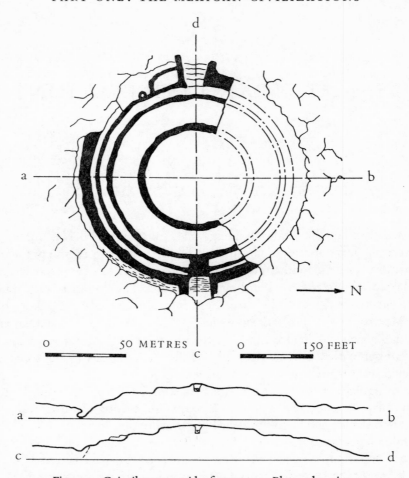

Figure 1. Cuicuilco, pyramid, after 500 B.C. Plan and section

which was later embedded in two smaller stages. On the east–west diameter ramps and three short flights of stairs led to the uppermost platform from the west, and on the east four flights descended in a striking anticipation of later temple stairs both in Mexico and in the Maya region. Red pigment (cinnabar) on the altar suggests mortuary or sacrificial use. The circular form recurs in the Huasteca region and at Zempoala on the Gulf Coast,[4] both early and late, and again in Toltec, Tarascan, Chichimec, and Aztec sites after A.D. 1000, perhaps as an archaism and in association with the cult of Quetzalcoatl.[5]

Cuicuilco was built in the terminal stage of early village civilization in the Valley of Mexico, soon after 500 B.C. Its chronological position is given not by radiocarbon dating alone, but also by the style of the clay figurines and pottery in the associated burials. Small clay figurines representing humans, animals, and birds occur throughout Middle America, beginning in the early villages, and continuing until after the Spanish Conquest. In some western provinces the tribespeople never made any other sculpture. Valley-of-Mexico figurines are so abundant that the archaeological history of the region

is based upon their classification (Plate 3 and Figure 7).[6] Their function is unknown, and complete specimens with bodies are rare. Seated and standing female figures predominate, usually composed of three parts:[7] the stem (or neck); the pellet (or face) pressed upon the stem; and the frame (representing hair or a head-dress) covering the joint between stem and face. Features were added by buttons and fillets of clay, and by incision and punching. Features rendered by fillets and buttons are earlier than features rendered by modelling and incision (as at Cuicuilco). Paint added after firing, or a polished slip of fine clay, completed the figurine.[8]

The finest examples, some centuries earlier than Cuicuilco, have been uncovered at Tlatilco near Tacuba, west of Mexico City.[9] Affinities with the Olmec 'baby-face' style (Plate 37) of the southern Gulf Coast (p. 71) and with the Chavín jaguar stylizations of Peru support the conception, first advanced by H. J. Spinden, of an 'archaic continuum' in America, a name modernized as the 'inter-American formative horizon'.[10] Many Tlatilco figurines represent steatopygous women (Plate 3),[11] sometimes with two heads, or with two heads sharing three eyes, wearing flaring skirts or ornate leggings. The swollen thighs taper to pointed feet. Unlike the steatopygous figure of central Europe, the Tlatilco examples seem to dance and caper. The curves of the thigh end in tiny waists, and there are abbreviated dancers' arms, held in pirouette position.

Another example from Atlihuayán (Morelos) (Plate 2) presents a human seated in the traditional Olmec jaguar pose. He wears a feathered serpent-skin mantle with serpent jaws forming a hood bordered by serpent teeth. These elements incorporate the idea of using serpent teeth or mouths to define sacred places and persons, and they recur many generations later at Monte Alban or Mitla (Plates 61A, 67B) in more and more geometrized formulas.

The proto-history of Mexican painting has been reconstructed in the ceramic wares of the central zone, at the key sites of El Arbolillo, Zacatenco, and Ticoman. Vaillant [12] determined the sequence of development for pottery decoration. The red, black, and white clays of the Valley of Mexico were tempered with crystalline sand and slipped with a wash of the same clay as the paste. Composite rather than simple vessel forms were favoured at all times. Controlled firing allowed the preparation of black, white, red, and orange wares. The decorative experiments followed one another roughly as follows. (1) Incision before firing, in geometric style on black-ware. White paint designs on red slip (abandoned in 2). (2) Grooving, increased range of paint colours, red designs painted on white slips. (3) Incision with cursive forms after firing. Incised outlines surrounding painted areas. Red and white paint on yellow ground. (4) Negative painting, by a lost-wax method related to textile technology. Stucco finish applied after firing and painted.[13] Pottery masks and timbrels or tambourines are known as well as stamps for body-painting in animal and geometric designs. Whistles of fired clay are also common in the pre-Classic age. Small mirrors of hematite found at Tlatilco resemble those of coastal Olmec sites. Turquoise mosaic plaques are known from El Arbolillo and Tlatilco.

TEOTIHUACÁN: 100 B.C. – A.D. 750

Teotihuacán (Figure 2),[14] Cholula, and Xochicalco, each with its own traditions and affiliations, were the principal urban centres of the Classic epoch. Xochicalco (Figure 9) was in many respects a transplantation from Classic Maya civilization of a later epoch than Teotihuacán. Cholula, on the other hand, has had the longest continuous history of any central Mexican site, flourishing from Formative times without interruption to the present, and appearing during the Classic era (Figure 6) as a concourse rivalling Teotihuacán.

The discovery of architecture in the Teotihuacán style at Kaminaljuyú (Figures 3B and 77) in the Guatemala highlands,[15] associated with Maya remains of Early Classic date, and dated by radiocarbon before A.D. 500, justifies treating Teotihuacán proper as the dominant Middle American site of the first half of the Classic era. Xochicalco (Figure 9), because of its stylistic resemblances to such lowland sites as Uaxactún, Tajín, and Piedras Negras, reverses the relationship between central Mexico and the Classic Maya region in favour of a possible lowland Maya ascendancy at Xochicalco c. A.D. 500–900.

The structural traits that distinguish Teotihuacán from Formative building are the use of burnt-lime plaster and the cantilevered panels jutting out from the inclined talus at the platform base (Figure 4). In respect of formal organization, the Teotihuacán style differs from previous architecture by grandiloquent proportions using straight axes and rectangular platforms.

Chronology

The history of Teotihuacán, though fixed neither at the beginning nor at the end, when great fires burned out the timbers and glazed the clay walls, can be divided into early, middle, and late stages.[16] The early stage (I) antedates the pyramids. Their construction (II) occurred from the first to third centuries A.D. Then, c. 400–700, the outlying suburbs were built (III). The destruction by fire and abandonment may be dated before 700. The transplanted settlements (IV) on the west shore of Lake Texcoco flourished thereafter.

The eastern or Sun Pyramid (Figure 2) is the largest and oldest structure at Teotihuacán. It stands over a natural cave ending in a four-leaf-clover chamber near the centre of the pyramid, discovered in 1971 by Jorge Acosta, and described by Doris Heyden. Like the circular platform at Cuicuilco, it is made of horizontal layers of clay faced with unshaped stones. All the sherds and figurines in its fill are of Late Formative dates. Like many later central Mexican platforms, the eastern pyramid faces 15 degrees 30 minutes north of west, so that the sun sets on axis with the edifice upon the day of zenith passage.[17] The Sun Pyramid governs the axial arrangement of all other buildings at the site. For several centuries early in its history Teotihuacán probably consisted mainly of this pyramid and a few adjoining platforms.

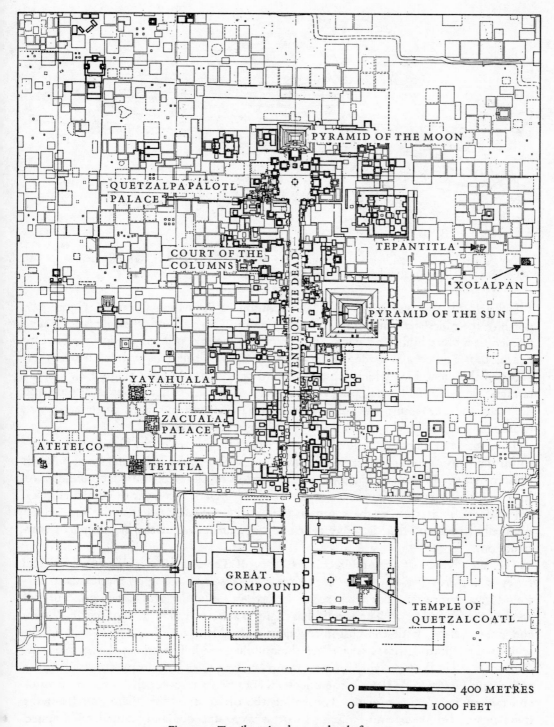

Figure 2. Teotihuacán, the temples, before 700

27

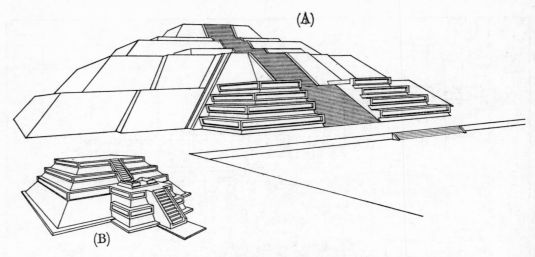

Figure 3 (A). Teotihuacán, Pyramid of the Moon, before 100. Perspective diagram
(B). Kaminaljuyú, Mound B4, after 400. Perspective diagram

Later on the site was enlarged by the addition of the Moon Pyramid (Figure 3A), north of the older structure, and the south pyramid ('Temple of Quetzalcoatl'). These two edifices were built by a new and more stable method of construction used before c. A.D. 300. The core is made of piers built of slabs of tufa (*tepetate*), with shafts left between the piers, into which loose earth and rock were dumped (Figure 4). On the terraces, fin walls held the sloping talus in place. After the lattice skeleton of piers and fin walls had been built, the filling out of the mass with unshaped earth proceeded more rapidly than by the earlier method of layered accumulation.

These three principal pyramids define the Miccaotli ('Road of the Dead') as a north–south roadway, 40 m. (130 feet) wide and about a mile and a half long, lined on both sides by hundreds of small platforms and by clusters or files of chambered buildings. At least two older levels of construction underlie the present top layer of ruined edifices. Their depth is greatest at the southern end of the roadway, so that the site, which gradually drops 100 feet, is today much flatter than it was at the beginning of construction.

The later phases of the architectural history of Teotihuacán include two principal types of construction. The first consists of dwellings arranged upon platforms to surround square or rectangular depressed courtyards in a modular grid based upon a unit of about 57 m. (190 feet).[18] The second has many ceremonial platforms of low elevation and great extent, with the customary talus-and-tablero profiles, but devoid of the sculptural decoration that characterized the middle period. The principal example is the Ciudadela – a hollow-rectangle platform surrounding the southern pyramid (Plate 4, A and B, and Figure 4).[19] This older edifice was encased in an outer shell of austere talus-and-tablero profiles, completely concealing the older sculpture (Plate 4B). Both the dwellings and the talus-and-tablero platforms were stuccoed and painted with figural scenes.

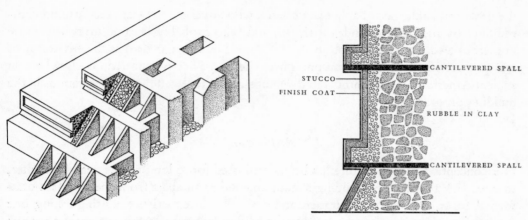

Figure 4. Teotihuacán, Ciudadela, inner core of central platform, before 300.
Diagram of assembly and section of tablero

Thus the early period was marked by gigantic construction; before A.D. 300 great sculptural friezes, as at the citadel, were carved; and the centuries before 700 saw the triumph of mural painting. Painted exterior walls had been common since the earliest centuries at Teotihuacán, when decoration was confined to geometric meanders, bands, and chequerboards in red, yellow, grey, and green, often applied *al fresco* to the wet plaster. In the middle period, ideographic signs and large forms representing water, sea-shells, and marine plants were painted in colours on dry plaster with black outlines. In the last period, scenes were painted with many small personages, with roads, buildings, animals, and symbolic conventions for speech or song, as well as for religious sacrifices and for the other world (Plates 10B and 11, A and B).[20]

In other words, each successive century at Teotihuacán witnessed a more and more prodigal consumption of burnt-lime products for cement-like floors, stuccoed walls, and the finely plastered surfaces required for mural painting. The technique of burning limestone was probably introduced from Yucatán and Guatemala, where calcareous rocks and tropical woods abounded.[21] In Mexico the burning of the forest cover for lime certainly contributed to the desiccation of the climate.[22] The acres of plastered floor and wall surface at Teotihuacán were contributory causes to the climatic catastrophe reflected by the murals. The paintings describe the joys of water with a prolixity born of anxiety. The abandonment of the site *c.* A.D. 750 was final. No great centre of civilization arose again in its neighbourhood, for its ecological ruin was probably irreversible as early as A.D. 500–600, and today the countryside around Teotihuacán supports only a fraction of the great populations that erected the pyramids.

During its early history, Teotihuacán was less a city than a ceremonial centre for the periodic rituals of an agrarian calendar. The pyramids were built and used by farmers from widely dispersed villages.[23] For centuries there were few habitations at the ritual centre itself.[24] Eventually the priesthoods, as custodians and as masters of the ritual, assumed power. The wall paintings at Atetelco, Tetitla, Tepantitla (Plate 11, A and B), Zacuala, and Teopancaxco, and among the dwellings in the ritual centre itself, mirror

the power and affluence of a theocratic caste, who governed the scattered farming communities by means of calendrical rituals, and who probably became more and more numerous (estimated by Millon in 1966 as 85,000 in A.D. 450–650) as the environment was impoverished by deforestation. Their rise to power is reflected, as elsewhere in ancient America, by the chambered dwellings which replaced the great pyramids in the building programme.

Architecture

Our conception of architecture has been dominated for so long by the need for shelter, that we lack the sense of building as monumental form apart from shelter. As monumental form, architecture commemorates a valuable experience, distinguishing one space from others in an ample and durable edifice. It is not necessary to enclose rooms: it suffices, as in ancient America, to mark out a space by solid masses, or to inscribe the space with a system of lines and shapes. The fundamental modes of monumental architecture are therefore the precinct, the cairn, the path, and the hut. The precinct marks a memorable area; the cairn makes it visible from afar to many; the path signals a direction; and the hut shelters a sacred portion. From precinct to stadium is one typological series; from hut to cathedral, path to arcaded boulevard, and cairn to pyramid are others. The combinations of cairn, precinct, path, and hut yield all the possibilities of monumental form, not in terms of the solids alone, but also in terms of the space bathing the solids. The architects of ancient America were far more attentive to the spaces engendered among the elements than their European contemporaries, and they excelled all peoples in the composition of large and rhythmically ordered open volumes. Teotihuacán is the most regular and the largest of all ancient American ritual centres, with a coherent composition ordering the elements in a central area 2½ km (1½ miles) long by 1 km (about ½ mile) in width (Figure 2). Tikal and Chichén Itza, the next in size, are less than half as big.[25]

A principal and original function of Teotihuacán was as a geomantic position to observe the relation of the earth to the sun, by the annual zenith setting (21 June) on axis with the largest pyramid. The orderly distribution of hundreds of smaller platforms along a roadway determined by the eastern or Sun Pyramid therefore obeys relationships of a cosmic order, and the spatial arrangement reflects the rhythm of the universe. The main axis of the principal pyramid intersects the roadway; a smaller pyramid blocks the north end of the road; and the south end has no monumental definition. The road ends without a destination. Thus the roadway connected nothing: it afforded axial order, without leading from one place to another. Each unit along the roadway is connected with the universe more than with its neighbours: the south court and the east pyramid face the setting sun; the north pyramid is alone in its direct axial position on the roadway (Plate 6A).[26]

This isolation of the groups, apart from their common cosmic orientation, is stressed by the precincts surrounding each major unit. The necessary counterpart to the pyramid in open-volume composition is the precinct boundary, which defines scope, while the

pyramid marks importance. The principal pyramids of Teotihuacán were built smaller as time passed: their precinct boundaries, however, became more imposing (Figure 2). At the east pyramid, a low U-shaped platform, open to the west, defines a moat-like enclosure at the base of the great square pyramid. The north pyramid is symmetrically flanked by two triangular groups of platforms on a cross-axis about half a mile long. The north precinct is further defined by a square courtyard formed of twenty-two plat-forms. The south pyramid, finally, occupies a closed oblong formed by a continuous primary platform (Plate 4A), bearing fifteen square secondary platforms spaced about 80 feet apart. The oblong precinct (inner dimensions 270 by 235 m.; 295 by 255 yards) has a shallow rear court behind the pyramid, containing house groups. The front court (235 by 195 m.; 255 by 215 yards) was probably used for rituals of a calendrical nature.[27] Its west side, entered by a stairway 30 m. (100 feet) wide, is lower than the north and south sides, where the primary platform is twice the height of the western platform.

The design is one of the most impressive open-volume compositions in the entire history of architecture. On this gigantic scale, the relation of all parts is clearly evident, and each member, though not immense, plays its full role in the concert of forms. The grandeur of the south court arises from its proportions and from the economy of its components, which vary only enough, as in the doubling of the north and south plat-forms, to animate the design, without obscuring its fundamental simplicity.

The whole assembly, with completely open approaches from all sides, lacks any trace of military defences. The precinct platforms surrounding the eastern and southern pyramids are non-military, serving ritual rather than defensive needs.

The dwellings of Classic date scattered throughout the region also lack defensive arrangements. The group at Atetelco (or La Presa), south-west of the pyramids, is typical: surrounding a sunken oblong courtyard four stairways rise each to an edifice with a colonnaded porch of two piers (Figure 5). At the open angles of this cruciform system small inner courts are formed, each flanked on two sides by second flights of stairs and by other prostyle chambers.

Among the latest buildings at Teotihuacán is the enclosed courtyard, resembling a medieval cloister, called the Quetzalpapálotl palace (Plate 5). It has reliefs on the piers representing the owl of warfare and the quetzal. As an enclosed court, unlike the open-cornered residential yards of the Mesoamerican tradition, it may prefigure the warrior societies of the Toltec era at Tula and finally in Aztec life.[28]

The temple platforms and the dwelling platforms use the same vocabulary of archi-tectural forms. The differences between the two are differences of size and number more than of type. To account for this type, we need first to consider the nature of the solid platform in ancient American use. As in Mesopotamia and the Nile valley, where the first village civilizations arose on earthen platforms in the swampy flood-plains, some early central Mexican villages stood upon artificial mounds (*tlateles*) laboriously built in shallow lake waters, of which modern survivals (*chinampas*) are still in use at Xochimilco.[29] Cuicuilco, Teotihuacán, and Tenochtitlán all inherited this ancient mode of securing dry footing by building a mound among the fertile shallow waters at the edge of a lake or in the flood-plains of a river. Every ancient building, whether domestic

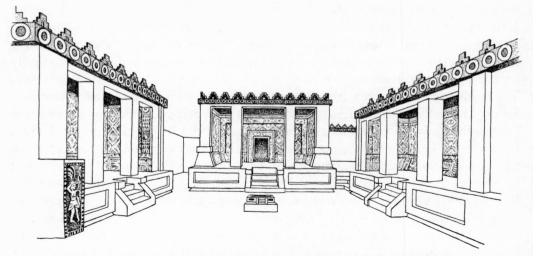

Figure 5. Atetelco, near Teotihuacán, dwelling group, *c.* 500. Elevation and plan

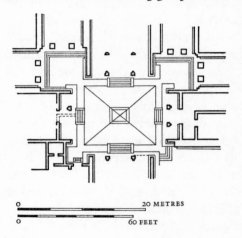

or religious, stands upon a platform of solid earth or masonry. Even on hilltop sites such as Monte Alban or Xochicalco, where the danger of flooding was not even a memory, the ancient compulsion to build a pedestal continued in full strength.

At Teotihuacán and related sites,[30] the platforms usually have a sloping component, here called the talus, at the base of the platform (Figure 4). Cantilevered on stone slabs from the sloping talus face, a vertical panel, called the tablero, is framed by rectangular mouldings. Frequently the rear planes of both the tablero and the talus are decorated with sculpture or painting. The effect is that of a box hung upon a pyramid. The sloping talus is always shadowed by the tablero. From a distance, the tablero appears to float upon a cushion of shadow. The form is an unstable one, and when the cantilevering collapses the tableros crumble. The larger the tablero, the more unstable it is. The modern drawings of the Pyramids of the Sun and Moon, which show giant tableros, are improbable reconstructions.

Indeed, the tablero profile may have been invented only in the middle period of Teotihuacán history (II), when the building of the great pyramids, which are like continuations of archaic architecture, had ceased. This hypothesis is supported by the appearance of tablero profiles on the topmost stages of the archaic platform begun *c.* 200 B.C. within the main pyramid at Cholula (Figure 6, at D). One Cholula variant of the Teotihuacán form adds a concavely curved talus and an extra inner moulding to the tablero frame. This scheme appears in the recent excavations at the Court of the Altars (frontispiece and Plates 6B and 7) adjoining the south flank of the 'hand-made hill' (*Tlachihualtepetl* in Náhuate). Here three large slabs carved with Tajín scrolls form the centres of interest, surrounded on all sides by terraced platforms with the curved and

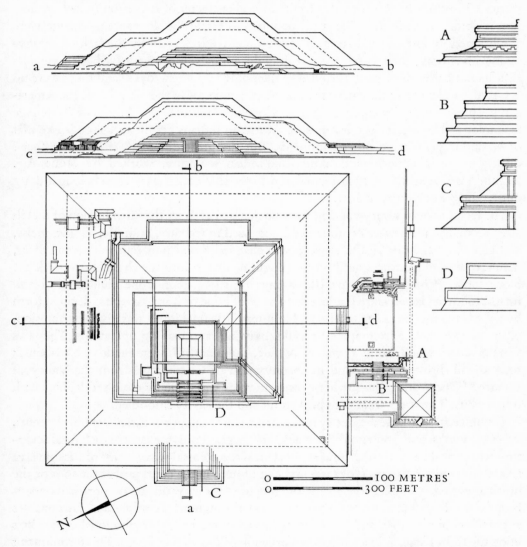

Figure 6. Cholula, main pyramid, *c.* 900. Sections, plan, and tablero profiles of nucleus

step-fretted talus, which also may be related to the architectural ornament of the Gulf Coast peoples (cf. Plate 51). The curved talus profile is apparently a local trait, and it appears in several of the successive rebuildings of the Court terraces. At the west approach the tablero is clearly a Classic addition in Teotihuacán style to an early pyramid of rectangular plan facing the zenith setting of the sun. The next campaigns of enlargement at Cholula used terraces of Tajín and Toltec profiles (Figure 6, at B).[31]

Sculpture

Metal tools did not enter Middle America until long after the destruction and abandonment of Teotihuacán. The retarded technological character of American Indian civilization is doubly meaningful. The small populations[32] and the slow rate of change were conditioned by insignificant reserves of food for livestock, and by the lack of energy-saving inventions, such as wheels and draught animals. No trace of wheeled vehicles appears until after the Classic period, and then only in pottery toys,[33] and there were no beasts of burden at any time until the Spanish Conquest. On the other hand, the American peoples of antiquity explored and developed the ultimate possibilities of Stone Age technology. The mechanical learning of American Indians before A.D. 1000 is like that of Neolithic peoples on other continents. But the great difference is in the aesthetic quality of their achievements. American Indian sculpture, worked by Stone Age methods, is frequently of such formal and expressive complexity as to belong among outstanding works of world art.

The techniques of stone-working were unchanged even by the introduction of metals after 1000. The tools were of stone and bone, used to fracture, crumble, abrade, incise, and pierce. At the quarry the outcrop was channelled and undercut with stone picks, mauls, celts, and hammers until wedges could be driven into the channels to break the block loose. Percussion fracture by hammering stone upon stone yielded the blank forms, followed by pressure fracture with tools of bone or horn, to secure detailed form by flaking the surface in small chips and splinters. The final finish was given by abrasion, with water and sand in scraping, grinding, sawing, and drilling operations. The saws were of stone, wood, bone, fibre, or rawhide. Tubular drills were made of bird-bones: such a drill, broken, was found in an onyx slab of Classic style from the Valley of Mexico.[34] The work of hollowing eyes or mouths was done by close-set drilling with tubular bits. The cores were then broken off and the cavity smoothed.

Teotihuacán sculpture divides by function into three categories: architectural elements, funerary masks, and household figurines. The largest known example of figural sculpture was probably an architectural support: it is the colossal water deity of basaltic lava (Plate 8), standing 3·19 m. (10½ feet) high, and found in the courtyard at the foot of the north pyramid.[35] Its pier-like forms suggest use as a caryatid, to support a wooden-beamed roof of the trabeated type common throughout Teotihuacán. The profiles approach cubical forms, and the body parts are all rendered in orthogonal projections upon the front plane, as in an engineer's drawing of the human figure. This technique of rendering is similar to that of the murals showing frontal ceremonial figures, such as the

Tetitla panel of rain figures.[36] The water deity is generally thought to be an extremely early example of the Teotihuacán style,[37] although its association with the Pyramid of the Moon should fix its date about the middle phase of the Classic period. The pectoral cavity for the insertion of a stone symbolic of the heart is an early Mexican example of this convention.[38] The identification as a water deity (Aztec 'Chalchiuhtlicue') is supported only by the meander hems of the skirt and cape, which bear a repeating scroll that signifies liquid in the murals and vase-paintings. The oval-rimmed eyes and the protuberant mouth invite comparison with a smaller statue in the Philadelphia Museum of Art.[39] Of a similar arbitrary reduction to geometric form is an alabaster jaguar vessel (British Museum). On the sprawling animal's forepaws there is a glyph-form; the mane of the cat is likewise stylized into a serrated glyph-like form, and the muzzle is reduced to a linear glyphic convention (Plate 9A).

These figures both reflect a major tendency of this era in the archaeological history of central Mexico: to define and diffuse conventional forms that approach the status of a written system. That such a system was being elaborated cannot be doubted, but it was much less complete and more tentative than Maya writing of the same period. Art and writing at Teotihuacán were still enmeshed in one another (Figure 8). The glyph-forms repeatedly approach being works of art, and their coherence as written communication is dubious. In respect to sculpture, the semantic limitation, which reduces plastic form to ideographic conventions without much freedom of choice for the designer, adds to the technical limitation of Neolithic methods of work. The sculptor's tools limited his effects, and his language of conventional signs likewise restricted the choices open to him, since he was obliged to make communications which in literate societies are carried much more economically by the written word.

The funerary masks of pottery and of semi-precious stone are thin slabs with marginal perforations for suspension on the outside of a mummy bundle (Plate 9B).[40] The eyes and mouth were encrusted with coloured materials, and the facial planes also were painted or encrusted with geometric designs relating to the status of the dead wearer. Clay examples, painted with bright earth colours after firing, have been excavated at Teotihuacán.[41] The masks of fine stone (basalt, onyx, jadeite, obsidian) are such obvious works of art that all have been eagerly collected. The origin and the archaeological associations of these museum pieces are usually unknown. They command high prices, and there has long been an illicit trade in them, with many falsifications reaching the market. Their origin is usually given as central, southern, or eastern Mexico. The type is of indubitable Teotihuacán origin. Metropolitan and provincial styles of manufacture can be distinguished. As with funeral sculpture in general, the type probably changed more slowly than the forms associated with everyday life. The masks of Teotihuacán origin differ from those of later periods by the abstract ear flanges and the squarish proportions of the face, with chin and forehead boundaries treated as flat, parallel planes. This geometric conception of the human face is dictated by the technique of working the stone. The eyes, the nose, and the mouth are defined by six fundamental saw-cuts. One horizontal cut marks the parted lips. Two converging cuts define the triangle of nose and mouth. Two more horizontal cuts mark out each of the eyes. No example can

be exactly dated, but a clear progression towards fleshy modelling, from more linear early features, can be noted. The geometric refinement of the proportions and the avoidance of portrait recall Greek archaic sculpture.

The clay figurines of Teotihuacán (Figure 7) are surely the popular background for the aristocratic and impersonal art of the funerary masks. Both emerge from the mil-

I II III IV V

Figure 7. Pottery figurines from Teotihuacán, Periods I–V, c. 300 B.C.–A.D. 700 (different scales).
New York, American Museum of Natural History

lennial background of early village figurines. Caso believes the figurines were ancestor images, venerated in each household. Others hold that they were images of the gods and symbols of fertility, put in the earth to ensure each year's crop. The earliest Teotihuacán figurines (I) are like those of Cuicuilco and Ticoman, triangular pinches of clay with coffee-bean eyes and incised mouths. They occur in the filling of the Sun Pyramid, coming probably from early village sites obliterated by the great ritual centre. In the next type (II), the squarish and flattened head shapes of the funerary masks make their first appearance.

The middle period (III) shows a technical change. Hand-made figurines were replaced by moulded heads of a few standard types, with delicately modelled features. One type is bald; [42] the others have more or less ornate hair-styles of tufted or conical shapes. The technical change probably coincided in time roughly with the new pillar-and-shaft system in the pyramids (Figure 4), with the appearance of the talus-and-panel profile for platforms, and the ample groups of dwellings like Zacuala surrounding the ritual centre (Figure 5). The final phases of Teotihuacán figurines (IV and V) probably post-date the destruction of Teotihuacán proper; for these ornate and jointed specimens with elaborate costumes and complicated postures come also from Atzcapotzalco and San Miguel Amantla on the west side of Lake Texcoco.

Certain habits of expression, peculiar to work in clay, were dominant in sculpture of the middle period. The reliefs of the terraces of the southern pyramid ('Quetzalcoatl') clearly show the technical primacy of fictile art, especially when these ductile forms are contrasted with the quarry-block shapes of the colossal water deity. The southern pyramid was originally square in plan, with six stages rising to a burial platform. This probably bore a temple with stone walls and wood-and-thatch roofing. Only the central portions of four terraces flanking the west stair [43] have survived, by having been

covered over in an enlargement of the third period, when the talus-and-panel terraces were painted red.

Middle-period relief sculpture was of finely fitted stone veneer (Plate 4B). Over the veneer, painted plaster masked the joints. In the talus of each stage, low relief and feathered serpent forms face inward towards the stairs, with carved conch and pecten shells suggesting a watery environment in the undulant loops. Above the talus, a larger undulant and feathered rattlesnake occupies the tablero. Here, too, seashells are strewn over the rear plane. At three-metre (ten-foot) intervals large stone heads project at right angles from the tablero.[44] The effect of carved clay decorations, as of terracotta revetments, is striking. The heads are of two kinds: a geometric head of cubical forms, perhaps a rain spirit (Tlaloc in the much later Aztec cosmology); and a feathered serpent. Their alternation upon the undulant serpent relief corresponds to the heraldic composition of Early Classic painting, both in the murals and in vase-painting.

Painting

The exact chronological sequence of individual murals [45] is uncertain, but the assumption is warranted that painted wall decoration began early in the Classic period with geometric designs and banded schemes.

Recent discoveries at Cholula (Plate 10A) require discussion here because of their style, related to the scenic murals at Teotihuacán (Plates 10B and 11, A and B) and their date in Period II, before 300. The paintings, in red, ochre, black, and blue, adorn a terraced platform facing east, and flanking a buried central stairway. The paintings are in registers one above another in fragments totalling 32 m. (105 feet) long, and comprising scenes of seated and reclining drinkers being served beakers of pulque on patterned floor-lines. The drinkers are shown in abandoned postures; some wear animal heads, and many seem drunk. Differences in execution suggest the inebriation of the painter; one figure vomits, another defecates, but no sex is shown, although the drinkers are both men and women. Servants, a dog, and possibly a bee appear among the drinkers.

In Late Classic times, heraldic friezes of repeating glyph-like forms became common, as well as processional files of profile figures engaged in ritual activities. During the same period, many conventions of landscape painting became fixed. In outlying sites large wall-paintings with ritually symbolic subject-matter and landscape scenes were the preferred mode of expression. Pottery painting, within obvious limitations, followed roughly the same pattern of development, without, however, attempting the elaborate landscape scenes of the late period.

Demonstrably early are the murals painted upon a buried platform north-west of the little stream that separates the south pyramid from the other edifices. This platform belongs to a lower level, anciently filled and used as a foundation for the upper buildings. To these circumstances we owe the preservation of the painted surfaces. The tablero frame is painted with roundels representing green stones on a red ground. The tablero itself is painted with interlaced volutes like those of Classic Veracruz sculpture.[46]

An upper panel has heraldic repeating trifid pendants, probably representing nose-ornaments. This system of repeating symbols recurs at the south pyramid in the relief sculpture. It derives from the carved and painted decoration of coeval pottery, on cylindrical tripod shapes (Figure 8), where these repetitions were governed by the difficulty of seeing all the surface at once. The painter repeated the form often enough to be sure that the whole form would be visible from any angle of view.

Figure 8. Cylindrical tripod vessel, Teotihuacán style, after 300

Similarly related to pottery decoration are the murals of Teopancaxco, a suburb of Teotihuacán. One altar is painted with costumed priests in profile with flowered speech-scrolls, symmetrically advancing upon a sun-like disk. These compositions of confronted figures also occur in paint applied after firing [47] on cylindrical tripod pottery.

At Tetitla, a suburb south-west of the ritual centre, a painted tablero framed by interlaced serpents contains frontal repeating rain-god figures, from whose outstretched hands flow streams of water in which various ideographs float. Another tablero displays jaguar and coyote figures in profile, as if upon the cylindrical walls of a pottery vessel, in a wide frame of interlacing jaguar and coyote legs.

By type, the earliest known landscape painting is the sacrificial scene from the 'Temple of Agriculture' near the north pyramid, discovered in 1884 and known only by a copy of that time (Plate 10B). A watery foreground in two scalloped zones of waves stretches across the bottom. The picture space closes at both sides with identical pyre-like forms, surrounded by scrolls of smoke and flame (?), heaped in front of colossal pier-statues similar to the water deity described above. Between the statues, three uneven registers of small human figures mark the planes of landscape space in a conceptual perspective like that of Egyptian painting. The figures bear offerings. Some kneel or sit,

others walk, and three priest-like figures in rich costumes and with animal head-dresses have scrolls of speech or song issuing from their mouths.

Of much freer and more animated composition is the mural, presumably later, at Tepantitla, east of the principal pyramid. The wall has two registers. In the upper half a water image, flanked by confronted priests, is the cleft source for two wavy floods filled with star-fish, jelly-fish, frogs, and seashells. A frame of interweaving serpent forms separates the more conventional upper register from the animated landscape below (Plate 11, A and B). From a mountain source two rivers emerge to flow in oppo-site directions through verdant fields to tree-bordered lakes. The space above this scene is filled with surging and dancing figurines, among butterflies and flowering trees. Caso interprets the scene as the souls of the blessed in the land of the Aztec rain god (Tlalo-can).[48] The body movements are like those of the clay figurines of Teotihuacán III style. The linear conventions mingle direct observation with abstract ideographic signs. In the river-source, for instance, a figure is swimming in childish animation among the tradi-tional serpent-body signs for flowing water.

The crowded symbolism of the art of Teotihuacán [49] bears many resemblances to the metaphorical system of the Nazca people of the south Andean coast (p. 302). It also con-tains about fifteen signs recurring often enough to suggest glyph-like use. They differ, however, from Maya glyphs by their rarity and isolation. Maya glyphs appear in long sequences to make statements of complex and indecipherable meaning. At Teotihuacán, two or three signs at most combine in ornamental bands or friezes. Certain signs seem to stand for cult objects. Many signs are costume elements. Probably the entire 'writing' of Teotihuacán consists of names, time-markers, astral signs, directional symbols, and a few bar-and-dot numerals.[50]

The study of these glyph-like forms has been rewarding in respect of chronological relations with other civilizations. With Classic Maya art, Teotihuacán shares a trapezoid sign interlaced with a triangle; it reappears in Mixtec manuscripts as a sign for the solar year. Other Maya forms are the long-nosed upper jaw of a serpent head, and a human head framed by serpent jaws. With Classic Zapotec art, Teotihuacán has in common a treble scroll, a trilobed drop, and a mountain sign (Figure 8). The Classic Veracruz style of the Gulf Coast shares with Teotihuacán the figure of a fat god; angular scroll-work; smiling figurines; and head-dresses inscribed with signs.

The iconographic system at Teotihuacán allows a few inferences about intrinsic meaning. Representations of aggressive behaviour are absent until near the end. Early signs represent flowers, water, mountains, and other items of peaceful agrarian experi-ence. The figurines are devoid of individuality. The masks conform to a tranquil and opaque ideal of generalized beauty. The art of Teotihuacán is impersonal, relying for expression only upon the animated aspects of a benevolent and watery nature. It is altogether lacking in direct erotic symbolism. The images of flowers, of twining strands of water, and the song and speech scrolls of flowered contour all bespeak a peaceful and poetic worship of nature, through which there runs a strong current of anxiety concern-ing flood and drought, conveyed by the insistent references to water.[51]

XOCHICALCO

Xochicalco, south-west of Cuernavaca, rose to importance about the time of the abandonment of Teotihuacán. If it obstructed trade to the south, as suggested by Litvak, it was a rival to Teotihuacán, like Cholula and Tajín. It is a hilltop ritual centre related to Vera Cruz and Classic Maya architecture,[52] specifically to Piedras Negras. The ceramic chronology shows early settlement, with archaic pottery of a type encountered throughout southern and eastern Mexico, as well as in the southern and central Maya districts.[53] Relationships with the Valley of Mexico are surprisingly few. From the pottery it seems that Xochicalco was the north-western frontier outpost for a Maya cultural tradition, with historical antecedents and of a geographical spread altogether unlike Teotihuacán. The most likely avenue of communication with the Maya territory was through the state of Guerrero and along the Pacific coast.

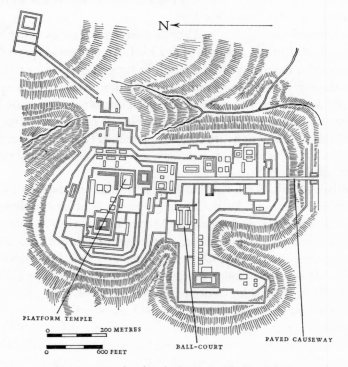

Figure 9. Xochicalco, before 900. (A) General plan

The people of Xochicalco and its vicinity probably made important contributions to the formation of Toltec civilization in the ninth and tenth centuries A.D. The site was never fortified,[54] and the excavations brought forth no weapons. The hilltop contours were levelled and terraced to form a fairly regular network of platforms, courtyards, and esplanades (Figure 9). The main axes are on the cardinal points. Three distinct groups – northern, western, and eastern – occupy the hilltop shoulders, connected by paved causeways and esplanades. The north, or highest, shoulder is crowned by a

sculptured platform. The east group is aligned along a paved road dropping away to the south. The west group consists of a ball-court, a dwelling group containing a sweat-bath, and a pyramidal platform aligned along a level east–west esplanade.[55] The ball-court, where a game of Middle Pre-Classic antiquity was played, is probably the oldest edifice of its kind in central Mexico,[56] closely resembling the Classic Maya ball-courts at Cobá, Piedras Negras, and Copán, with slanting playing-walls, of a shape and size repeated at Tula under Toltec rule. Connecting the ball-court and the western pyramidal platform is a causeway 20 m. (65 feet) wide, lined on the north side with the foundations of twenty cylindrical constructions, possibly altars or pillars. Near its centre are the foundations of a dwelling on a chequerboard plan of four courts on ground sloping away to the south-east. The group includes inner rooms with platform benches like the central Maya sweat-bath disposition.[57]

The most striking edifice is the sculptured platform temple [58] in the highest court on the northern cross-axis. Upon a solid platform measuring 19·60 by 21 m. (64 by 69 feet) rise the roofless walls of a square cella entered from the west, up a stairway with carved serpent balustrades. The platform of rocks and clay is revetted with a veneer of finely cut and sculptured andesite blocks (Plate 12). The platform profiles are designed to carry across great distances. They consist of the familiar talus and panel, augmented by a cornice of upward-slanting section.[59] The proportional relations differ radically from those of Teotihuacán. At Xochicalco, the talus and panel are related as 4 : 9, while the usual proportion at Teotihuacán is close to 3 : 8. The high talus and the slanting cornice between them reduce the panel to an entablature. The suppression of the panel frame, which was so strong a form at Teoti-huacán, further stresses the importance of the talus. From a distance, the Xochicalco sil-houette reads clearly as an energetic form of concave vertical profiles, unlike the Teoti-huacán effect of oblong slabs cushioned upon layers of shadow. The Xochicalco scheme was designed to give great impor-tance to the sculptural programme, which

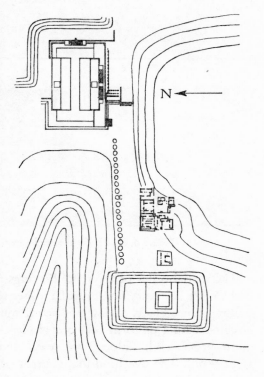

Figure 9. (B) South-west group with ball-court

at Teotihuacán never invaded or diminished the tectonic effect of the architecture. Here, the principal figural compositions occupy the talus instead of the panel, which displays small oblong scenes. The cella exterior had the same arrangement, today much mutilated.

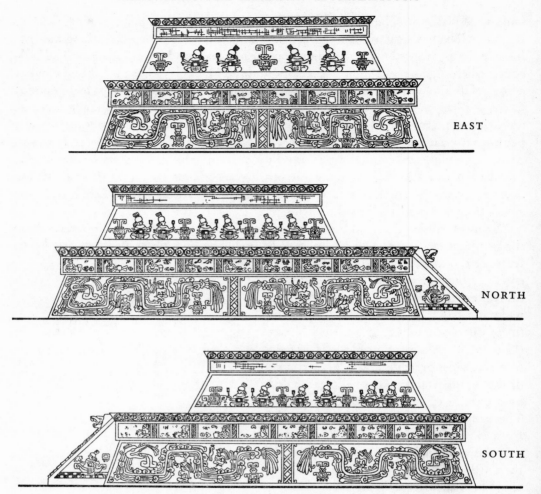

EAST

NORTH

SOUTH

Figure 9. (c) Platform temple, east, north, and south façades, before 900

The spatial order of the relief carvings recalls the leaves of a screenfold manuscript like Codex Féjerváry or Codex Laud (see p. 109). The reliefs show traces of red, green, yellow, blue, black, and white paint, much as in the manuscripts. They were later covered with a uniform coat of red pigment. The platform talus is divided as if into eight pages, each oblong, and each containing an undulant feathered rattlesnake (Figure 9c). The overhead loops surround flaming calendrical glyphs, and the troughs enclose six seated men wearing animal head-dress. The frieze-panel above the talus divides into thirty oblong page-like compartments. Each contains a seated warrior and several glyphic signs, in two sequences beginning at the centre of the rear façade, where files facing left and right carry around the building to end at the cheeks of the stairway. The cella talus displays similar files of seated men, beginning on the rear wall, and ending on the stairway cheeks. The figures are in pairs, separated by calendrical signs. Each of these twenty priests or gods wears a bulbous turban and carries a fan-like object,

which may denote high rank, as in Maya and Aztec iconography. In each zone the seated men may be the patron deities of the corresponding time-periods denoted by the accompanying glyphs. The turbaned men of the cella wall have also been compared to the congress of persons shown on Altar 2 at Copán. The talus panels flanking the stairs are thought to commemorate a correction of calendar periods on the occasion of a New Fire ceremony.[60] The glyph-forms are like Aztec day-signs, but they are enclosed by the typical Maya cartouche, and the numerals resemble those of the Zapotec inscriptions of Monte Alban III.[61] These distinctive Xochicalco glyphs appear in systematic order on three stelae unearthed in 1961 at Xochicalco (Plate 13), where they are recognized as the earliest known true stelae in the central Mexican region, possibly as early as Xochicalco II (before 700). Stelae 1 and 2 portray human faces enframed by the jaguar-serpent mask common at Teotihuacán, Tula, and Chichén Itza. Reminiscent of Piedras Negras is the angular sky band in the lower third of stelae 1 and 3, enframing signs of Teotihuacán derivation. Stela 3 represents the goggled rain-deity face (Tlaloc). On sides and backs, each stela bears columns of glyphs pertaining to names, places, motions, and dates, reminiscent both of Classic Maya and Monte Alban inscriptions.

THE VALLEY OF MEXICO AFTER A.D. 800

THE TOLTEC REVOLUTION

TEOTIHUACÁN exemplified Classic priestly government, but Tula is a type-site for the warrior aristocracies of Middle America after about A.D. 1000. As the capital of the Toltec ('builder') dynasty, Tula flourished from the ninth to the thirteenth centuries,[1] ruled by fighters rather than priests, who restricted political control to as few families as possible. Religion centred upon human sacrifice, in an aggressive, expansionist relationship to neighbouring tribes. Toltec skills included an early Middle American use of metallurgy, probably relayed via Central America and Oaxaca from the central Andean coast.

Tula is about 40 miles north-west of both Mexico City and Teotihuacán, upon a natural frontier separating the rich Valley of Mexico from the desert plains of the north. The stratigraphy of the site confirms its chronological position of c. A.D. 750–1200, after Teotihuacán and before the Chichimec invasions.[2] The ceramic remains are of types (Coyotlatelco and Mazapan) found also at Teotihuacán, but intrusive upon the burned and deserted remnants of the Classic centre. At Tula, finally, the burned and deserted city of the Toltecs was reoccupied by later inhabitants of Chichimec (barbarian) origin, whose presence is attested by ceramics of Tenayuca type (Aztec II) in the fourteenth century.

The sources of Toltec civilization are still obscure. The exploitative character of the small, nomadic warrior aristocracy probably took shape during the eighth and ninth centuries, when the theocracies collapsed owing to some combination of climatic, institutional, and demographic disorders. The fullest record of the early history of such a warrior group is found in the Mixtec genealogical manuscripts of southern Mexico, which give a dynastic history beginning in the eighth or ninth centuries A.D. These manuscripts, compiled after about 1300, record early customs among the Mixtec tribes (Plates 68, 69, A and B, 70, A and B, and 71, A and B), customs strikingly like those recorded in Toltec sculpture. Either Toltec historiography derives from Mixtec antecedents, or the Mixtec chroniclers modelled their histories upon Toltec sources. The former is more likely, because the traces of Mixtec expansion throughout Middle America are on the whole earlier than the Toltec horizon, and they are reinforced by the Mixtecs' own pictorial chronicles.

The architectural forms of Toltec civilizations come from other sources. The pyramidal platforms, the composition of large open spaces as ritual centres, and the colossal statues have precedents in the style of Teotihuacán. A direct Maya influence upon the art of Tula owing to Toltec domination in Yucatán after A.D. 1000 should not be overlooked. The case of Xochicalco affords precedent for art of Mayan derivation in central

Mexican territory. The possibility that elements of the style of Tula are transplanted from Chichén Itza will be considered in Chapter 9. This clearest example of the political expansion of Toltec civilization, with the military domination of the Maya people by Mexicans at Chichén Itza during the tenth to thirteenth centuries,[3] is reflected in the close parallels between the art and architecture of the two cities after 1000. Other examples of 'Toltec' conquest and expansion are less certain. Their enumeration depends upon texts in which the meaning of the term reflects many different layers of revision, and compilation from many conflicting sources.[4]

Architecture

The Toltec site of Tula lies west of the present town, upon a hill called Cerro del Tesoro, in a bend of the Tula river (Figure 10). The central court has been excavated: it is a plaza about 240 yards square, orientated upon the cardinal points. The north side is a long platform bounded at the east corner by a colonnaded portico and a terraced pyramid. The pyramid is flanked by other colonnaded enclosures. Behind it is a ball-court of the same size, shape, and orientation as the one at Xochicalco. Dwelling groups to the south-west and north-east of the main court were excavated in the nineteenth century. Sanders refers to the 'colonnaded salons' and adjoining rooms as possibly part of the palace of the ruler of Tula.[5]

The absence of all fortification is immediately striking. Like Teotihuacán in its last phase, Tula was a ritual centre surrounded and invaded by dwellings. Some, like Roman houses, faced inward, upon central courtyards. The differences between Tula and Teotihuacán are important, but the resemblances have been underestimated because of the long confusion whereby Teotihuacán was identified with Tollan (i.e. Tula of the historical texts) in philological commentaries by the German school of Americanists.[6] This confusion has required an extreme differentiation of the two sites. But there can be no doubt that the Toltec overlords, coming after the theocracy of Teotihuacán, perpetuated certain urban forms of their more pacific predecessors, and that the fortress cities of Middle America [7] belong to a later horizon than the Toltec. Indeed, the building history of Tula probably repeated that of Teotihuacán, beginning with pyramids, and ending with dwelling groups.

No major innovations appear in structural technique, which seems poorer than at Teotihuacán, lacking the latticed structure and the cantilevered panels. The principal pyramid is the eastern one, about 65 m. (215 feet) square, like the southern pyramid at Teotihuacán, but augmented here by conical aprons flanking the stairway. The aprons make a transition between the pitch of the stairs and the steeper pitch of the terraced profile. The process leading to their design can be studied in the pyramid at Tenayuca (Figure 12), where analogous aprons were added in the fifth phase, about A.D. 1400 (p. 51).

More completely known is the form of the smaller north pyramid (Plate 14), which is 38 m. (125 feet) square, of five stages, with a stairway on its south front.[8] The core of stone and earth has a stone facing from which tenons project to hold in place the

veneer of thin stone plates forming the outer surface. Cylindrical stone drains are built into the terraces behind the veneer. The terrace profiles are novel, consisting of three roughly equal portions: a talus (55–60 cm., or about 2 feet, high), an entablature of salient and recessed double-square panels (70 cm.), and a crowning frieze (60 cm.). Entablature and frieze are horizontally marked by three wide, flat, raised mouldings like the panel frames of Teotihuacán. The panelled frieze and entablature compartments are carved with reliefs of jaguars in the friezes, and Venus masks, eagles, and buzzards in the

entablatures. The stone reliefs are thickly caked with plaster facing, originally painted in descriptive solid tones. The figural character of this scheme is clearly in debt to the processional and heraldic wall decorations at Teotihuacán. The frieze of jaguars, for instance, should be compared with the Atetelco[9] murals both as to conception and style. On the other hand, the in-and-out-composition of the entablature blocks relates to the rich chiaroscuro system of the terrace panelling at Monte Alban and Mitla in southern Mexico (p. 104). The Tula version of the projecting and receding panels is more linear,

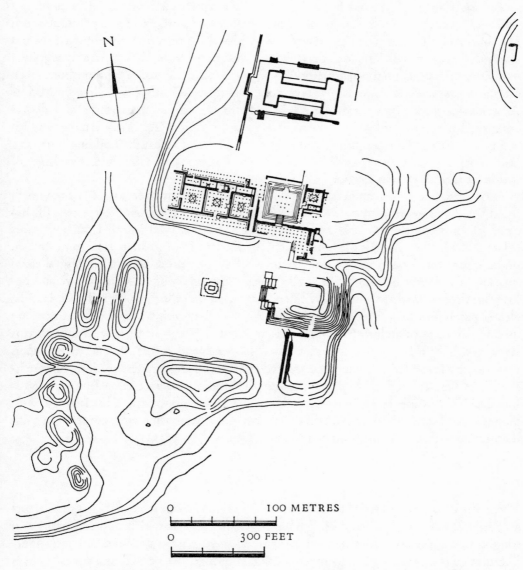

Figure 10. Tula, before 1200. (A) General plan; (B) Detail of south group

and designed more for close inspection than the long-distance effects of Monte Alban. The viewing distance was imposed, of course, by the figural sculpture at Tula.

Only the buried supports of the destroyed cella have been recovered (Plate 17). It was probably a beam-roofed chamber, entered by a triple doorway with serpent columns, and divided by rows of four Atlantean columns (Plates 15 and 17, A and B) and four piers each 4·6 m. (15 feet) high (Plate 16). Columns and piers were assembled of mortised and tenoned drums. The Atlantean columns have their precedent in the colossal anthropomorphic support from the north pyramid (Plate 8) at Teotihuacán, where the idea of square piers was in common use.

The south front of Mound B was bordered by a colonnaded portico of three files of fourteen square piers each, turning the north-east corner of the plaza, to continue south in a short section three bays long. To the east and west of the north pyramid are several colonnaded courtyards. Of later construction than the pyramid, these probably adjoined dwellings of insubstantial construction.[10] The portico and the patio buildings both mark a bold step in ancient American architectural thought. All previous designs in Middle America were open courtyard enclosures, sometimes closed at the corners, and always composed as external masses for effects in open-space design. The Tula designer and his contemporaries at Chichén Itza (Figure 62) were the first to treat the building more as a hollow volume, with interiors to be carried around corners, as in the cloistered ranges of medieval architecture in Europe.

Another striking form at Tula is a free-standing wall about 15 feet north of the north pyramid, defining an open corridor at its base. Called the *coatepantli* (serpent wall) because of its decoration, it rises 2·6 m. (8½ feet), and is carved in relief on both faces (Plate 18). The base is a double talus, 90 cm. (3 feet) wide at ground level, and 80 cm. high. Upon this base is the two-faced relief band of rattlesnakes devouring skeletal humans. The theme alludes to the souls of dead warriors. Wide borders above and below this figural band are adorned with geometric meander forms of textile origin. The closest parallel to these border designs is in Mixtec manuscripts, where such forms are used in paintings of architectural platforms to identify place-names (e.g. Tilantongo is represented by this very meander, painted in black and white).[11] The *coatepantli* is crowned by crenellations. These perforated slabs of stone represent sections of conch-shells. As heraldic forms they derive from the stones used as crenellations at Teotihuacán.[12] The south face shows more hurried workmanship: the talus is faced with plaster, and the reliefs are executed in a cursive and slovenly manner, contrasting with the more detailed workmanship of the north face.

Sculpture

The expression attained by the sculptors of Tula differs from that of their predecessors at Teotihuacán by the choice of deliberately harsh forms, which avoided grace and sought only aggressive asperities, gritty surfaces, and bellicose symbols. The technique, like that of the earlier age, remains Neolithic, although the ornamental use of gold is attested during the Toltec era. The sculptors relied more upon deep linear incisions than

their contemporaries in Yucatán. The enumeration of the parts of armour and costume (Plate 16) has an ideogrammatic clarity lacking in the painted reliefs of Toltec date at Chichén Itza.

The architectural setting, as we have just seen, offered no fundamental novelties. There are caryatid figures, large and small, serpent-columns, piers, and panel reliefs in the tectonic repertory. The only examples of free-standing sculpture are reclining male figures (Plate 19) and chunky human standard-bearers, but their placing was strictly governed by the architectural situation.

The Atlantean figures, 4·6 m. (15 feet) tall, are the most theatrical works produced at Tula (Plates 15 and 17, A and B). The four columns of four tenoned drums each are identical, representing warriors or hunters, imprisoned by the shallow relief of the nearly cylindrical drums.[13] They carry throwing-sticks (*atlatl*) and hunting bags. Their costume consists of wrapped garments: an apron, which leaves the buttocks bare, garters on calves and ankles, a bib over the chest, arm-wrappings, and a headband of fur or mosaic. In all these wrappings the knots and binders are portrayed with loving military care; the rear is like an exemplar of the knot-maker's art. An immense butterfly pectoral, a disk surrounding a human trophy-head at the small of the back, and a quiver of darts lashed to the head-band complete the savage panoply. The fourfold repetition conveys the effect of a frightening palace-guard.

On the four piers, of four carved faces each, which stood in the rear row of the cella, the palace-guard continues in very flat relief, confined by upright rectangular compartments, in which bundles of arrows alternate with standing warriors in profile (Plate 16). These warriors, with their brandishing gestures and their lean, loose-limbed gait, convey a more animated version of the Toltec military caste than the Atlantean figures.

At the entrance to the cella, the three doorways were separated by two serpent-columns of which only the feathered body drums have been found.[14] They were probably like those of Chichén Itza (Plates 115A and 116), with open-fanged heads as bases, and the tail rattlers as lintel-supports. This reversal of the usual expressive character of the tectonic support is unique in the history of architecture, in the substitution of a flexible form for a rigid one, and in the inversion of the head and the base. It is as if an Ionic or Corinthian order were used upside down, with the capital on the ground. If the directional interpretation of this serpent support is correct, it may have served the purpose of connecting upper and lower zones of the universe. Instead of supporting a load, the Toltec serpent-column descends from the skies to spread celestial gifts upon the earth. In this form, surrounded by the images of warriors and hunters, instead of the priests of the older theocracy, the feathered serpent of the Teotihuacán people survived, a god of vegetation and rain,[15] among barbarian protectors in the feudal age of American antiquity.

The discovery at Tula of reclining male figures carved in dark basaltic stone, of the type fancifully named Chacmool (Plate 19), further completes the parallel between Tula and Chichén Itza. At Chichén (Plate 121A) such figures are very common, and have some of the same attributes as the colossal figures of Tula.[16] The figure reclines in an uneasy position, with raised knees and torso, looking over his left shoulder, and

bearing a vessel for offerings on his abdomen. The type has been interpreted as a heavenly messenger taking the blood-gifts of humans to the gods. As at the Temple of the Warriors in Chichén Itza, the Chacmool figure probably occupied the cella terrace, athwart the doorway axis.

Below the cella terrace were processional jaguar figures on the various cornices (Plate 14), and eagles and vultures devouring human hearts. In Aztec society, and probably among the Toltecs, the warrior moieties were called jaguars and eagles. Their mission was to secure human sacrifices for the nourishment of the gods, necessary to maintain the rhythm of the universe (see p. 54).

Between the pairs of eagles in the entablature of the Tula pyramid are heraldic figures which recur at Chichén Itza: from the open gullet of a frontal feathered monster appears a human head. At Chichén Itza (Plate 122A), accessory signs clarify this form as a symbol of the planet Venus, whose period of 584 days correlates with the vague solar year of 365 days by the equation $5 \times 584 = 2920 = 8 \times 365$.[17] In the cella, the caryatids, as huntsmen-warriors, may also relate to the complex of forms connected with the worship of the morning star (Tlahuizcalpantecutli, Lord of the House of Dawn).

Thus the north pyramid at Tula (now called Tlahuizcalpantecutli) seems to declare the combination of two systems. The older animistic worship of rain and fertility, represented by the feathered serpent, combines with the cult of the planet Venus, whose representative is a hunting god (Mixcoatl) of nomadic tribal origin, and whose cult requires human sacrifices.

At ground level, in the colonnade below the north pyramid, is a bench carved with processional figures exactly analogous to those of Chichén Itza in the Mercado colonnade (Plate 121B), and in the colonnade of the Temple of the Warriors. The Tula procession is of more stunted proportions and coarser execution, but the meaning is clearly the same as at Chichén. The processional type reappears in Aztec sculpture of the fifteenth century, on friezes and slabs in the National Museum, notably the Tizoc Stone (Plate 22). The procession of files of individuals converging from left and right upon an image of the god, or upon a symbol of blood sacrifice, is the recurrent theme. The costumes, attributes, and physical types differ enough in these processions to justify their identification as historical figures, perhaps a convocation of tribal leaders allied under the unifying cult of the Morning Star deity.[18]

Across the river from Tula are rock-carvings, presumably of Toltec date, on the Cerro de la Malinche. One shows a feathered serpent (Quetzalcoatl) in the form of an angular Z-scroll as the priestly name-glyph of a striding male figure. He draws blood from his left ear lobe with a jewelled bone (Figure 11). Above him a date-glyph indicates his historical calendar-name, One Reed (Ce acatl).[19]

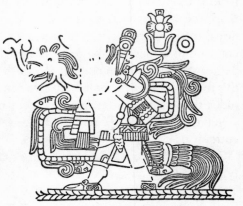

Figure 11. Tula, Cerro de la Malinche, rock carving of Ce acatl, before 1200

In Aztec sources, One Reed was the legendary founder and hero of Tula, the inventor of writing and many crafts, the priest-king, the builder of the serpent-columns, the lord Quetzalcoatl. Driven from Tula by the intrigues of rival magicians, he fled to the east, where his body changed after cremation into the Morning Star. These particulars reflect a long mythopoetic elaboration and fusion of many distinct themes. The myths became so intricate in Aztec sources that their historical reduction seems impossible. But wherever one turns, the figure of Quetzalcoatl (Kukulcan in Maya language) reappears to suggest yet becloud the apparent unity of post-Classic religious beliefs throughout Mesoamerica.[20]

The Chichimec Interlude

The fall of Tula in the twelfth to thirteenth century was precipitated by nomadic (Chichimec) tribes moving in upon the rich lands of the central plateau, a process that had been under way for millennia.[21] The end of Teotihuacán and the rise of Tula were probably brought on by these same nomadic waves from the north; for the history of Tula, though called Toltec, displays many survivals of the culture of nomadic huntsmen.[22] It is now the agreed convention to designate the tribal history of the central region, from the end of Tula to the creation of Aztec hegemony, as the Chichimec period (c. 1250–1430). The Aztec people regarded themselves as the descendants of Chichimecs. The term, however, may signify 'barbarian', and it includes peoples of the most diverse geographic origins.

The last generations to know the theocratic regime of Teotihuacán probably called the immigrant bands of their day Chichimecs, until these had earned the name of Toltecs (builders) in the renewed tradition of urban life at Tula.[23] But between the fall of Tula and the rise of Tenochtitlan, several generations lived without knowing domination by an economic power, like Tenochtitlan, or by a single warrior dynasty, such as the Toltec lineage. This interlude between great states, when the central valleys were in dispute among many tribes of more or less recent arrival, all seeking territory and alliances among the ruins of Toltec civilization, is the Chichimec period of the history of the central zone.[24]

Tenayuca, today a district in the north-western suburbs of Mexico City, was the principal religious centre of the period until about 1300, when the capital moved to Texcoco on the eastern shore of the lake. The complete archaeological excavation of the Tenayuca pyramid (Figure 12), together with the Chichimec dynastic histories, are the chief sources of knowledge. These pictorial histories allow a detailed reconstruction of the events following the fall of Tula from about the mid thirteenth century until the Spanish Conquest. Full genealogical sequences and pictorial accounts of the principal occurrences in all the main settlements of the valley appear on the map-like sheets of Codex Xolotl,[25] and in the pictorial annals called Mapa Tlotzin and Mapa Quinatzin.[26]

For example, the introduction of writing and goldsmithing among the Chichimecs

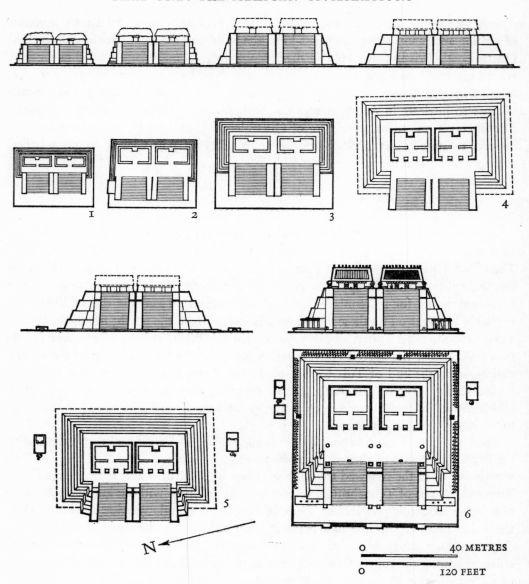

N◄

| 0 | 40 METRES |
| 0 | 120 FEET |

Figure 12. Tenayuca, pyramid. Plans and elevations showing enlargements of *c.* 1300–1500

about 1300, by a band who emigrated to the Mixteca territory in southern Mexico, and who returned to the valley (their name, Tlailotlac, signifies the returners), is clearly recorded in Codex Xolotl (Plate 20A). The name-glyph of the tribe shows a path re-curved upon itself with footsteps, attached to an artisan busily making signs with a stylus upon a block or sheet of paper. Thus the pictorial conventions in the Chichimec histories repeat and enlarge upon those of the Mixtec genealogies.

The main outline of Chichimec history is accordingly much clearer than that of all the preceding epochs in the history of the valley. The nomad hunters settled in the

valley by force of arms. By marrying their daughters to Toltec husbands, they became valley dwellers with a culture strongly affected by south Mexican influences, principally from western Oaxaca. The first three Chichimec rulers, Xolotl, Nopaltzin, and Tlotzin, lived at Tenayuca. Quinatzin, the fourth king, moved to Texcoco,[27] and under his successor, Techotlala, Chichimec power waned, passing to the Tepanec lineage of Azcapotzalco,[28] at about the time (*c.* 1350) of the rise to importance of the Tenochca tribe, later known as 'the Aztecs'.

The pyramid of Tenayuca (Figure 12), facing the zenith setting of the sun (p. 26), shows eight campaigns of enlargement and remodelling.[29] The earliest edifice of four vertical terraces (31 by 12 by 8 m.; 102 by 39 by 26 feet) supported two adjacent temples each with its own stair. This disposition persisted to the end, in the eighth enlargement, when the platform measured 62 by 50 by 16 m. (204 by 164 by 52 feet). The doubling of the width and height lasted about three centuries. Each of the six major campaigns may have been prompted by the conclusion of the fifty-two-year calendrical cycle (p. 66) by which Middle American tribes regulated their affairs. By this reckoning, only the first two layers of the onion-skin growth belong to the Chichimec period prior to the shift of the centre of government to Texcoco, and the emergence of the Tenochca as the new masters of the valley. If the earliest two stages belong to the century before 1350, the end of the Chichimec period is perhaps reflected in the third layer, where the number of terraces is reduced to three large talus elements of sloping profile, continued in the sloping profiles of the twin temples. The twin temples upon a platform characterize the temples of the Aztec confederacy, where they were dedicated to the rain god, Tlaloc, and the tribal war god, Huitzilopochtli, in an arrangement honouring both the ancient animism of the valley and the tribal fetish of the new masters of the land. This arrangement is of Chichimec origin, and it exemplifies one of the main historical traditions on which Aztec society was founded. It in turn reflects, by its orientation upon the zenith setting of the sun (17 degrees north of west), the continuation of priestly ceremonials at least as old as the east (Sun) pyramid at Teotihuacán.

Many other edifices of the Chichimec period adorned the valley: of these only the platforms and house groups of the Matlatzinca tribe at Calixtlahuaca in the Toluca Valley have been fully excavated.[30] Here, the round pyramid (Plate 21A) contains four layers, of which the nucleus is pre-Toltec. The second and third layers had stones projecting to retain a plaster coating, as at Tula or Tenayuca. The fourth and outermost layer of red and black *tezontle* (pumice) is surely of Aztec date, built after the conquest of the region by Ahuitzol in 1476. The cylindrical terraced form with an east stair was retained in all four versions; only the second version lacked cornice profiles.

THE AZTEC CONFEDERACY

A few families of nomadic huntsmen, the Náhuatl-speaking followers of Tenoch, who worshipped Huitzilopochtli,[31] arrived in the Valley of Mexico about 1250 as one of many Chichimec bands from the north. Like gypsies they settled along the lakeside at

Chapultepec on the lands of the lord of Colhuacan. To escape his oppression they fled after 1350 to an island refuge, Tenochtitlan,[32] where they prospered, enlarging the site with *chinampas* interlaced by canals, until in 1520 the island capital housed at least 75,000 people. Like other Chichimec bands of Náhuatl-speaking nomads, the Tenochca, or Mexica, as they called themselves, married into the lineages of the lake-shore cities, and thought of their dynastic line as descended via Xolotl from the Toltec dynasty of Quetzalcoatl of Tula.[33] About 1430, the islanders, under Itzcoatl, allied with Texcoco to destroy the power of the principal west shore city, Atzcapotzalco. Thereafter the Aztec rulers, as dominant partners in a triple alliance with Texcoco and Tacuba, extended their conquests to the east coast, to southern Mexico, and into Central America, until the network of subject tribes included thirty-eight provinces held by Aztec garrisons and paying tribute [34] to the cities of the Valley of Mexico.

To explain the rapid rise of the Aztecs to this imperial power, and to account for the expressiveness of Aztec art – in short, to understand both their worldly expansion and their metaphysical motivation – we must discuss the central rite of Aztec life: human sacrifice.[35] The festivals of the calendar were celebrated with countless immolations. War had the supply of sacrificial victims as one of its main objects; in civil life, men and women selected for sacrifice submitted to its rituals without complaint. From birth to adult age, every facet of education prepared Aztec youth for the eventuality of sacrifice. Death by sacrifice came to be an expected and even desirable end, for which art, poetry, and religion all prepared the victims with an endless, pervasive justification of its necessity. The youth chosen for his beauty to impersonate the god Tezcatlipoca in the annual Toxcatl festival of the sun played his role for a year, surrounded by luxury, before being sacrificed by heart removal. The inevitable by-product of the total discipline for death required by the institution of human sacrifice was the formation of military organizations which, when confronting tribal warriors of a looser social training, were invincible. But the purpose of human sacrifice was not to train death-despising soldiers. The contempt of death arose from an altogether different motivation, connected with Aztec myths of the origin and purpose of mankind. These myths formed an explanatory metaphor for the nature of the cosmos so coherent and convincing to its communicants that the enormity of sacrificial death was acceptable.

The Aztec cosmos was anchored upon the idea of sacrificial creation. Four imperfect ages of the universe, each ending in catastrophe, had preceded the present age, which began by an act of sacrifice when two gods threw themselves into the fire, emerging as sun and moon, set in motion by further sacrifices of the other gods.[36] The first men then were kneaded of bonemeal mixed with the sacrificial blood of the gods. This genesis both left the gods incomplete, and conferred godlike properties upon men, establishing human responsibility for the maintenance of the universe. Without men the power of the gods wanes until they cannot renew the annual cycle of fertility on earth. The sun, the earth, the moon, and the gods of vegetation and animal life all need annual rejuvenation by draughts of human blood. Without human sacrifices the earth's fruits wither and men perish, so that the continuation of the universe hangs upon the payment of the blood debt. By this cyclical conception of the exchanges of vitality,

with the gods renewing the cycle of plant and animal growth to feed humans, and the gods feeding on human blood, the ritual of human sacrifice was justified to its devotees.[37]

These beliefs are as old as the Toltec revolution. Rites of human sacrifice like those portrayed in Aztec sources are shown on a golden plate of Toltec date from Chichén Itza. The origin-myth recurs among the Náhua-speaking Pipil tribes of Central America, who reached their present habitat in Toltec times, and among whom the theme of the archetypal blood-debt has its oldest recorded version.[38] But the Aztecs developed these beliefs most fully.

Architecture

The metropolitan concentration of the Aztec state is apparent from descriptions of the capital, Tenochtitlan, which underlies Mexico City, and which was destroyed in the Spanish siege during the spring and summer of 1521. Written accounts by eye-witnesses, Indian plans, and twentieth-century excavations allow us to form a fairly complete idea of the city (Figure 13).[39] The island was connected to the mainland by causeways bearing traffic across the shallow lake to the north, west, and south shores.[40] A double aqueduct from Chapultepec brought fresh water to augment the springs of the island. An older Tepanec settlement at Tlatelolco, in the north-western quarter, was finally absorbed into the new Tenochca state in 1473; [41] its configuration gave the status of a double city to the Aztec capital, with two distinct commercial centres and two main groups of religious edifices, recorded by the chroniclers, which affected the strategy of the siege of 1521.

In Tenochtitlan, whose rapid growth enveloped the older twin city, the causeways to the mainland boldly marked the co-ordinates of a grid plan, guided by the rectangular growth pattern of the artificial *chinampa* lands, a growth pattern which is conserved in an Indian plan of a portion of Atzcapotzalco (Plate 20B) misnamed the *Plano en Papel de Maguey* (Museo Nacional).[42] At the intersection of the co-ordinate causeways near the centre of Tenochtitlan rose the pyramids and temples of the main ritual area, enclosed in a wall of carved serpents' heads, and covering an area of about 350 by 300 m. (380 by 330 yards). This scheme, of cardinal roads intersecting at the walled ritual centre (Figure 13), was repeated in other Aztec cities, as we know from a description written about 1540.[43]

Tenochtitlan differs from all previous urban layouts in the Valley of Mexico by two features: the sacred precinct is walled, and it is overshadowed by a vastly larger residential city and suburbs. This layout reverses the plan of the ritual centres of Teotihuacán and Tula, where the dwellings fitted into the interstices and around the edges of a large ritual centre. The city of the gods at Tenochtitlan shrank to a central space dedicated to temples, among the dwellings of men. The temples, as described by Sahagún, honoured the gods of all the tribes under Aztec rule.

Tenayuca (p. 51) and Teopanzolco [44] (near Cuernavaca) are the chief surviving

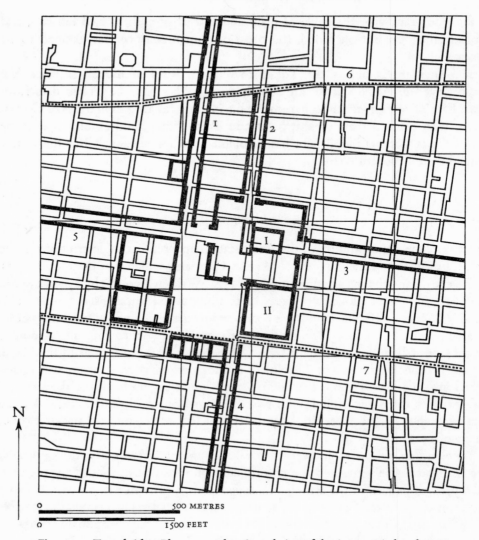

Figure 13. Tenochtitlan. Plan *c.* 1510 showing relation of the Aztec capital to the present centre of Mexico City. I Main Temple. II Montezuma's Palace. 1, 2, 3, 4, and 5 principal streets. 6 and 7 canals

examples of Aztec temple architecture in the central region. The formula is stereo-typed: a pyramidal platform, symbolic of the heavens, rises with stairways facing west (Figure 12). On the top terrace, twin shrines dedicated to the ancient rain god and to the Aztec tribal god symbolize the coupling of sedentary and nomadic traditions, of agri-cultural and military vocations, in Aztec society. The pyramidal profiles are plain, save for the stairways, where the pitch of the balustrades changes near the top to give the effect of a steep crowning cornice, and to make the top dozen steps seem more abrupt. The walls of the temple cella, of tapered profiles, continue the silhouette of the pyramidal platform.

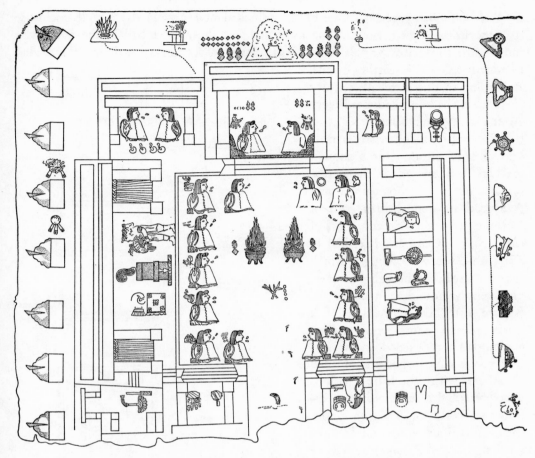

Figure 14. Texcoco, palace court. Sixteenth-century drawing after Mapa Quinatzin

Another type of temple was built in mountainous country. At Tepoztlán, twelve miles from Cuernavaca, the temple cella stood upon a steep platform of two terraces. Before the inner chamber was a deep porch with two piers in the entrance. Upon a pedestal in the rear chamber stood the stone figure of the local god, Tepoztecatl, destroyed during the sixteenth century by the Dominican missionaries in the region. Date- and reign-glyphs place the construction between 1502 and 1510.[45]

To the west of Tepoztlán, 28 km. (17 miles) away, are the rock-carved temples of Malinalco, begun about 1476 and still in progress in 1520.[46] The principal shrine is a circular chamber opening to the south by a doorway carved as a serpent mask (Plate 21B). The round cella bench has jaguar and eagle bodies carved upon its surface. In another of the rock-cut chambers are wall paintings of warriors or deities shown marching in profile upon a ground-line of stylized feathers and tiger fur (Plate 34A), again an allusion to the jaguar and eagle warrior societies to whose cult Malinalco was probably dedicated.

Ball-court edifices, introduced from the lowlands in Late Classic times, were common

57

in Aztec religious precincts. One of the principal buildings in the temple enclosure of Tenochtitlan was a *tlachtli*. The movement of the rubber ball in the court was more than a game: it was a cult-drama of the passage of the sun across the sky,[47] intended to mirror celestial in earthly events.

According to one sixteenth-century chronicler, a ball-court adorned every Aztec city. None has survived.

Aztec palace architecture is now known only through the Conquest texts of eye-witnesses, which describe the dwellings of Moctezuma and Axayacatl in Tenochtitlan, and of Nezahualcoyotl in Texcoco. Parts of the Texcoco palace are described in sixteenth-century drawings, which show rows of chambers aligned upon platforms surrounding a courtyard (Figure 14). The excavation of a more ordinary house-group at Chiconauhtla near Texcoco (Figure 15) showed the same disposition of small chambers with porch-like, colonnaded vestibules surrounding a diminutive court.[48] Similar arrangements, identified as the buildings of a priestly school ('Calmecac'), have been uncovered at Calixtlahuaca, where a maze of small chambers surrounds a terraced courtyard on several levels of modest height.[49]

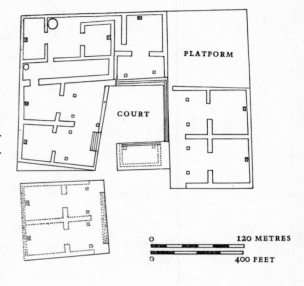

PLATFORM

COURT

o 120 METRES

o 400 FEET

N

Figure 15. Chiconauhtla. Plan of upper-class dwelling, *c.* 1500

Aztec architecture is not remarkable for important structural innovations. The use of fired bricks at Tizatlán, in Tlaxcala, for walls, stairs, altars, and benches is reported. Bricks are also known at Tula and in the south-west Maya area, at Comalcalco, as well as in British Honduras (Corozal), and at Zacualpa in the Guatemala highlands.[50] The Maya examples are all of Late Classic date. At Tenayuca (Figure 12) and elsewhere, the corners of the pyramids are bonded by alternating header and stretcher stones of an agreeable appearance, but the technique is not of special structural importance.

Sculpture

The conventional division of sculpture into reliefs and full-round statues is awkward, because Aztec statues are often collections of scenes and figures in relief. Conversely, many reliefs lose meaning when isolated from the sculptural masses which they articu-

late (Plate 23B). A more suitable division is by functions – semantic, instrumental, and expressive. The division by functions also has the merit of corresponding roughly to the historical sequence of Aztec sculpture. As a distinct Middle American style of recognizable identity, Aztec sculpture emerged only after A.D. 1450. The style drew upon traditions and craftsmen from the conquered eastern and southern regions, and it emerged as a new expression moulded by the sublime importance of human sacrifice and by the guilt-ridden conception of duty in Aztec life. Much Aztec sculpture assumed the functions of written communication. It also often enriched tools or instruments. These utilitarian requirements frequently reinforced the expressive power of the composition.

The explicative character of some Aztec sculpture can be assigned to the persistence of Toltec pictorial traditions, and to the influence of Mixtec manuscript illumination and pottery decoration. On the other hand, richly sculptured tools and instruments characterize the productions of the Gulf Coast peoples, as in the 'Totonac' yokes, blades, and other ball-game accoutrements (Plate 54A). Finally the sculptors who, from antiquity, excelled all others in the achievement of the modelling of flesh and in animated body movements were the 'Olmec' artisans of southern Veracruz and Tabasco, whose ethnic name at least persisted intact until the Spanish Conquest.[51]

It will seem adventurous to those who regard 'Olmec' art only as of mid-pre-Classic date, to consider the retention of these habits in Aztec sculpture. But we have no evidence that 'Olmec' art is not of extremely long duration, nor have we any proof of the early historical date of such masterpieces as the seated athlete (Plate 50). Certainly there is no other tradition of Middle American sculpture with which Aztec sculptural accomplishments, such as the isolated heads and the expressive modelling of the parturition figure (Plate 29), can be compared. Whether or not direct 'Olmec' contributions by living craftsmen are involved remains unproved. But it is possible that Aztec and Olmec sculptural expressions are connected, if only by an archaeological nexus, like that of Roman and Renaissance sculpture.

Among carvings of explicative character, the square stone discovered at the southwest corner of the cathedral plaza in Mexico City [52] marks the importance of Toltec traditions; for the stone was probably carved at Tula in Toltec times, and moved to Tenochtitlan some two centuries later. It is akin to the processional reliefs lining the colonnaded portico at Tula. In Mexico City, it relates to processional reliefs of Aztec style, such as those which surround the circumference of the cylindrical slab, 2·65 m. (8½ feet) in diameter, called the Tizoc Stone (Plate 22). The seventh Aztec monarch (1483–6) is portrayed as a conqueror and war-god impersonator triumphant over fifteen chiefs, whose dominions are indicated by place-name glyphs. These conquests appear in other records as spreading over several reigns previous to Tizoc's. The iconography, representing Tizoc as the inheritor of many conquests, and as the lord of all between earth and heaven, probably corresponds to one of the decisive moments in the transformation of the concept of kingship, from tribal leader to deified dynastic ruler.[53]

Tizoc [54] was portrayed once again in 1487 with his brother and successor, Ahuitzol

(1486–1502), in a scene showing the brothers symmetrically flanking a matted ball of cactus fibre (Plate 23A). Here, as upon a pin-cushion, the cactus needles and bones used in sacrificial blood-letting were kept. From the ear-lobes of the two kings streams of blood wind upward around the heads to fall upon the stylized mouth of the earth-crocodile beneath their feet. The year-sign, Eight Reed, in the square lower portion of the stela, refers to 1487, the date of the completion of the rebuilding of the main pyramid at Tenochtitlan, when war-captives from the east and south were sacrificed.

These two Tizoc scenes are the principal Aztec reliefs showing historical matter.[55] They derive from Toltec processional forms, and from manuscript illuminations of Mixtec origin. Their character as historical documents is invaded by symbols of the cosmic and religious meaning of kingship: they serve more as documents of Aztec ceremonial life than as strictly descriptive or narrative representations.

Other Aztec sculptures avoid the detailed characterization of historical time. The calendar stone [56] of the National Museum in Mexico City, 3·5 m. (11½ feet) in diameter and carved after 1502 under Moctezuma II, displays the face of the sun god surrounded by symbols of the five ages of the universe in a central ring (Plate 24A). The ring of twenty day-signs and the outer circumference of two sky serpents (Xiuhcoatl) signify time and space, but no detail identifies the historical present.

Another monument of sun-worship is the stone model, 1·2 m. (4 feet) high, of a pyramid (Plate 23B) found in 1926 in the foundations of the National Palace, once the palace of Moctezuma II.[57] It codifies the mythical history of the sun together with the ethical conceptions of sacrificial warfare in a dense and massive symbolic exposition. Upon the temple front, the sun disk is flanked by figures in profile symbolizing the day and night skies in the divine persons of Tezcatlipoca and Huitzilopochtli. The stairway ramps, and the flat surfaces on top of the temple and in front of it, are carved with sacrificial symbols: vessels for the hearts of human victims (cuauhxicalli); the crouching earth goddess shown as a skeletal toad; the ball of cactus fibre for the sacrificial needles.

On the pyramid sides, and as if supporting the temple platform, are the figures of four gods shown as penitents – the gods whose self-sacrifice set the sun in motion. On the rear, an eagle alights upon a cactus bearing fruit of human hearts. This scheme not only represents Tenochtitlan; it symbolizes day and night skies, as well as war for the sake of sacrificial victims. The figures of the six gods and of the eagle all bear speech-scrolls signifying war. The pyramid explains human sacrifice and ritual war in terms of the repayment of the divine sacrifice whereby the present universe was set in motion.

Many ritual instruments carved of stone display these same cosmic symbols, always buttressing the central ritual of human sacrifice to maintain the gods and, through them, the universe. The 'eagle vessels' (cuauhxicalli) were used to hold the hearts of human sacrifices (Plate 24B).[58] The earth toad on the base, the glyph of the present universe in the bottom (nahui ollin = Four Motion, a day sign), stylized eagle feathers on the sides, human hearts on the rim, and signs signifying 'jewelled water' (blood) embody the litany of human sacrifice. The slowly curving surfaces and the incised contours, reduced to ideographic clarity, all betray the persistence of the ancient technique of carving stone with stone tools.

These forms, produced more by splitting and abrasion than by cutting, recur in the rare wood carvings of Aztec date that have survived.[59] The standing wooden drum from Malinalco (Plate 25A) portrays eagles and tigers in two registers of crisp and linear relief carved by stone tools. As on the stone model of the Pyramid of Sacred Warfare (Plate 23B), the dancing eagles and jaguars have speech-scrolls signifying war. This theme of interlacing streams of water and fire (*atl-tlachinolli*) also separates the two registers. The dominant glyph of the drum is the four *ollin* sign of the present sun or age of the universe, so that sacred warfare is again the theme carved by an artisan in whose work ancient tradition and virtuosity of technique combine in figured surfaces of changing rhythms. The scale of the registers and the size of the forms are carefully chosen to give a full image from any point of view, and an image that has authority from a distance.

Other instrumental forms are funeral masks which were tied to the mummy bundle. An example in the British Museum (Plate 26) represents a round-headed man, wearing disk ear-plugs, with the mouth opened in a circle repeating the form of the face and ear-ornaments. The eyes are narrow crescent-shaped slits. On the reverse appears a seated relief figure wearing an ornate hat, flanked by weapons, and bearing a staff. His face repeats the rounded forms of the front, and has a puffy and flaccid expression. It represents a south Mexican ritual of growth and vegetation, associated with the cult of the god Xipe Totec ('Our Lord the Flayed One').

In the spring months, at planting time, a youth chosen to represent Xipe was sacrificed and flayed.[60] His skin was then worn as a costume by a living person, in a symbolic enactment of the live seed within the dead husk, designed to induce and compel the renewal of the earth's fertility. In the Valley of Mexico, a terracotta figure, nearly life-size, and of Toltec date,[61] is among the earliest expressions of this cult, which originated in Oaxaca and on the Pacific coast of southern Mexico.

This is the rite portrayed in the funeral mask. The sculptor's task was to represent not only the dead outer skin, but also the firm, live flesh of the wearer underneath. He achieved it by blurring the structure in the eyebrows, by flattening the nose, and by loosening the plane of the eyes, while stretching the contours upon the firm structure of the imagined wearer, like a mask upon a mask.

The statues of the gods, whether standing, kneeling, or sitting, reflect this masked interpretation of the god and his human representative. The god manifested his presence through an agent clad in godly attributes, who, during the festivals of the god, mingled with the people. Thus he was a living and moving cult image, of which the stone replicas were immobile representations, kept like capital reserves in the vault-like temple chambers. The full-round statues of the standing or kneeling Xipe Totec are the most obvious examples of the cult image that was both alive and inanimate, of the statue circulating among the people as a token of future growth (Plate 27). The edges of the skin, the stitched seams at the heart incision, and the tie-strings at the back fastening the skin garment upon its live wearer are portrayed with an obsessive fidelity, recalling the careful images of knots and binders on the colossal caryatids of Tula.

Since clothing is symbolic of the magical alteration of reality, these layers and attachments pertain to magical compulsion through the change of appearances. The extreme

elaboration of costumes and their accessories, both in the written post-Conquest sources and in the sculpture, have long been used as the principal evidence of Aztec religion. Knowledge of this religion centres upon fixed attributes such as skirt-forms, hair-styles, jewellery, and face-paint, by which the interpenetrating identities of the gods can be known. These identities reflect the history of the Aztec conquests, with many cults surviving from older civilizations alongside the new tribal versions of the Tenochca immigrants. The earth goddess is an example: different tribal and historic forms of her double cult, both life-giving and life-destroying, can be identified. These various tribal images overlap with other conceptions of fertility gods and lunar deities, in protean confusion.[62]

The truth is that we are ignorant of all but the main outlines of Aztec religion. Popular worship and priestly lore were different. The priesthoods were concerned with political power; for the monarch was a priest, and the state was served by the performance of religious duties. The confused and confusing notices of Aztec religion collected during the sixteenth century by Spanish scholars from native sources suggest that Aztec political life in its entirety unfolded within the rituals and ceremonies of the festival calendar, under the direction of priestly corporations with conflicting interests and ambitions.[63] Yet it is misleading to suppose that religion was merely a mask for politics. The conceptions were mingled: political rights and religious rites contained each other completely in Aztec mentality, and the occasions for separating them never occurred to these stone-age shamans, among whom the use of metals was still restricted to ornament, and to whom human sacrifice ensured the continuation of being.

The primitive character of Aztec tribal life found its most tremendous expression in the gigantic stone figures called Coatlicue (serpent-skirt) and Yolotlicue (heart-skirt).[64] Both are variants of a decapitated earth-goddess figure peculiar to the Tenochca tribe, who introduced her cult to the Valley of Mexico as the mother of the war-god, Huitzilopochtli. Two great rattlesnake heads confront each other on top of the figure, as if arising from the headless trunk (Plate 28). Serpent fangs adorn her shoulder and elbow joints. She wears a necklace of human hands and hearts. The skirt in one version is woven of serpents, and of hearts in the other. Front and rear views are notably different, not only as images, but also in tectonic effect. The front leans over the spectator as if about to topple upon him. The rear view slopes away from him like a mountainside. The profiles have cave-like recesses under the elbows that once again suggest a geological phenomenon rather than a work of art.

Less forbidding than the cult statues, and more directly expressive of the moral tone of Aztec life, are the sculptural images of men, animals, and plants. Among the figures of humans, many allude to the deities invoked by the actions shown. The stone parturition figure (Plate 29) has a calendrical meaning, for the birth of a time-period is represented,[65] at the same time as a woman in childbirth – the equivalent in Aztec belief of a warrior capturing a sacrificial victim. The figure was endowed by the sculptor with deeply expressive particulars conveying the pain and nausea of parturition. The greenish stone has a surface like skin in cold sweat. The tendons of the neck stand out in a grimace of pain. But from her lap a full-grown man's head, the symbol of a new time-period,

emerges into life. The piece unites the domains of observation, of expression, and of calendrical ritual.[66]

Expressive power was the distinctive attainment of Aztec sculptors. Their faculty of charging the particulars of experience with clear and coherent emotional tone is most apparent in images of plant and animal forms. An organ cactus, a gourd, a grasshopper, a dog, a hyena, a jaguar (Plate 30), or a serpent's coiled body are examples of this art of seizing the most vital aspect of each species. The portraits of humans represent either dead people or people in attitudes of suppliant surrender. An example of the first is the large diorite block representing the severed head of Coyolxauhqui (Plate 32A), the sister of Huitzilopochtli. Another is the (severed?) basalt head of a warrior, which belongs among the great sculpture of the world. This head (Plate 31A), larger than life, conveys the sacrificial burden borne by Aztec humanity, in the belief that through sacrifice the continuation of the universe might be assured. Among the portraits of the living the figure of a kneeling woman in basalt (Plate 31B) submissively awaits her destiny. The posture, as in many other Aztec statues, expresses the passive compliance of humans whose death was required in order that the gods might live to endow the earth with renewed vitality.

The lapidary arts concern only small specimens of fine workmanship, because of the rarity and minute size of the raw material. Stones like chalcedony, jasper, obsidian, agate, quartz, and hematite were all valued for weapons and cutting tools more than as ornaments, though jadeite and turquoise were prized for colour. American jadeite comes in water-worn pebbles from alluvial deposits.[67]

In Aztec society, Xochimilco was the principal centre of lapidary crafts. Rock crystal, amethyst, and jadeite pebbles were shaved to size with flint adzes. The surfaces were polished with abrasive powders, bamboo fibres, and tools of hardened copper. For drilling, the work was mounted in a clamp of bamboo, and perforated with tubular bits of copper or of bird bones. Certain hard flints from Toluca were favoured for working turquoise. Opal was polished with sand.[68]

The work of the Aztec gem cutters obeys the stylistic lead of monumental sculpture, with a conservative character that also marks the precious arts of other civilizations. For instance, a jadeite head of Coyolxauhqui [69] in the Peabody Museum at Harvard University copies the forms of the giant diorite head in the National Museum in Mexico City (Plate 32A). Aztec metalwork is likewise retardataire. The rare examples of goldwork[70] that have survived the Conquest are derivative from Mixtec models and from the forms of monumental sculpture or from manuscript paintings.

Painting

Pre-Conquest Aztec paintings survive only in a few murals, in ceramic decoration, and in featherwork ornaments. We have no certain early specimen of Tenochca manuscript painting. All the painted books [71] known to come from the Valley of Mexico are now accepted as colonial documents, more or less remote from native tradition. Aztec pictorial conventions are nevertheless easily defined; for they continue the tradition of the

murals of Teotihuacán and of south Mexican manuscript painting, and they differ fundamentally from European conventions.[72] We may reconstruct the lost book-paintings of Tenochtitlan and Texcoco only by referring to surviving manuscripts produced before the Conquest (Plates 68–71) in the region bounded by Cholula and Oaxaca (the 'Mixteca-Puebla' territory), and by using post-Conquest illustrations which retain native tradition.

As among all peoples to whom complete writing was not available,[73] a double burden of representing and of signifying fell upon painters and sculptors. Pictures were expected, in effect, to carry the whole burden later taken by writing. Hence the painter's conventions gave conceptual images rather than visual impressions of things. The earth (Tlaltecutli) was shown as an open-jawed monster rather than as a gentle or stormy landscape, and certain other conventions for the earth were equally remote from any visible aspect of the thing meant. The morphology of such paintings shows no fundamental changes until the Conquest: the styles vary as the different civilizations change and vanish, but the formal scheme common to Maya and Mexican paintings always remained the same.

This scheme, like dynastic Egyptian drawing, consisted of uniformly coloured areas with unvarying linear boundaries, describing only the most easily recognizable silhouettes.[74] Sometimes a profile is selected; sometimes a frontal view; sometimes front and side views are compounded to give an organically impossible but conceptually clear representation of body motions. Hollow objects and places are shown in cross-section to indicate their interiors. Thus a lake, a boat, or a pot are shown as U-shaped forms; caves are shown in schematic section; houses are rendered as ⊓-shapes to indicate support, load, and interior space all at once (Plate 68). The lower frame of the picture, or of the register, generally equals the ground line, and the upper frame is the sky. The bottom may also be read as near, and the top as far distance. Figures may overlap without marking any intended distance in depth. Distances among shapes are always signified by intervals in width or in height, and never by perspective diminution in an imaginary third dimension (Plate 70B). Three-quarter views and foreshortening were never employed. Gradated tones to indicate roundness or shaded forms were also never used. A change in colour usually signifies a change of symbol. The compositional schemes always associate the general ideas of things, and they never purport to describe visual entities under instantaneous conditions. Compositional movement over the surface of many-figured scenes usually means movement in time. Radial compositions generally mean rotating sequences in time, as when the four quarters of a panel or page illustrate calendrical periods by identical figures wearing different colours and costumes (Plate 71A).

The murals of the capital were destroyed when the city was besieged, and then rebuilt. Our only examples of Aztec wall painting come from the eastern and western boundaries of the central region, from Tizatlán, near Tlaxcala,[75] and from Malinalco (Plate 34A). These fragments demonstrate an eclectic character. The mural at Malinalco shows three warriors or hunting deities.[76] The proportions and the details of costume relate them to Toltec traditions, as in the columnar figures at Tula. The Tizatlán altars[77] are decorated by small-figure panels (Plate 34B) derived from Mixtec manuscript traditions.

This eclectic situation in painting parallels the variety of metropolitan sculptural styles. The great difference is that the components of Aztec sculpture seem to cohere in the attainment of expressive power, while the paintings adhere faithfully to older traditions, especially in the case of the Tizatlán wall decorations, without a recognizable Aztec reformulation. The Tizatlán figure of Tezcatlipoca, 35 cm. (14 inches) high, is like a page in the Codex Borgia (e.g. p. 21), which in turn is related to south Mexican manuscripts of Mixtec origin (p. 109). Other scenes at Tizatlán, showing deities near bodies of water, also recall the Codex Borgia (e.g. p. 14, ed. Seler-Loubat).

The pre-Conquest schools of Aztec manuscript painting continued long after the Spanish destruction of the libraries, until European conventions of draughtsmanship replaced the native ones. This replacement had already occurred when Indian artists illustrated the ethnographical manuscripts of Fray Bernardino de Sahagún, about 1560. At least two principal styles are known. The manuscripts illustrated with large figures in a more or less cursive style may be ascribed to artists trained in the church schools of the Franciscans at Tenochtitlan and Tlaltelolco. Another early colonial style, of extremely small, glyph-like figures, has been assigned to Texcoco, the Chichimec capital of the fourteenth century on the east shore of the lake. Codex Borbonicus and Codex Telleriano-Remensis are examples of the style of the capital. Codex Xolotl (Plate 20A) or the Codex en Croix exemplify Texcocan style, which is less animated and more schematic than that of the capital, but closer to Mixtec antecedents.

It should be remarked that the term 'codex', signifying a gathering of leaves sewn or glued together at one side, is often misused in Mexican studies. Codex Borbonicus, for instance, is better described as a screenfold. Its pages are hinged alternately left and right, opening like accordion pleats. Several readers may open in different places at once. Separated passages may easily be brought together for comparison. The pictures are not limited to single pages, and may spread over many panels. The pages often divide into registers arranged in a meander pattern that marks time and imposes direction.

The picture-books of Aztec date, whose existence may be deduced from early colonial versions and from pre-Conquest Mixtec examples, were of several sorts. One group, called Tonalamatl, or 'book of days', served to make astrological forecasts on a ritual calendar of 260 days. Certain manuscripts in this group also illustrate the monthly festivals of the solar year. Codex Borbonicus contains pages devoted to both calendars.[78] From the ritual calendar of 260 days, the tenth division of thirteen days is illustrated (Plate 33). Tonatiuh (the sun) and Mictlantecuhtli (death, night) flank a pole rising from water to night sky among offerings and sacrifices. The scene is bordered by day signs and their symbolic birds and night lords. Such manuscripts probably served to regulate festivals, sacrifices, and auguries. Another division portrays the festivals of the 365-day year of 19 months. The 260-day calendar is like those of the Codex Borgia group (Plate 71B), which belong to the Mixtec stylistic province south and east of the capital.

A second class of native documents illustrates genealogical sequences, reporting the marriages, issue, and domains of the principal lineages. Codex Xolotl (Plate 20A) is an example of the Aztec recension of Chichimec lineages along the lines of the Mixtec genealogies of pre-Conquest date (p. 107). The pictorial annals, which describe yearly

events in numbered sequence, are represented by several variants: Codex en Croix gives fifty-two years radially arranged on each sheet.[79] Codex Telleriano-Remensis shows a few years to a page, with the number of years per page varying inversely with the importance of the events chronicled.[80] Finally there are administrative documents, such as Codex Mendoza, compiled in 1548 from pre-Conquest Aztec tribute lists for the guidance of colonial administrative officers, listing all kinds and amounts of payment, as well as the towns providing the tribute.[81] All these manuscripts, with the possible exception of Codex Borbonicus, are of historical and ethnological rather than artistic interest.

The archaeological history of ordinary Mexican textiles is unknown because of poor conditions of preservation. Yet certain colonial manuscripts [82] describe a great variety of Aztec textile ornaments. Decorated shoulder-blankets were emblems of rank, and Aztec tribute lists report the textiles produced in certain provinces.

Feather garments are luxurious examples of an art of painting characteristic of the last century of pre-Conquest life.[83] The craft of mounting feathers on cloth became common after Montezuma the Elder (1440–69) created the wide network of trade relations maintained by travelling merchants. The feather-workers lived in groups assigned to special quarters of the capital. One group manufactured the garments of the war god, Huitzilopochtli, another prepared only the gifts for Montezuma to present to his allies, a third group worked on Montezuma's own apparel, and a fourth on military insignia for the warriors. The feathers sent as tribute from distant provinces were both glued and tied to the cloth, in designs prepared by painters. The drawings on glued layers of cotton cloth and agave paper were cut out with copper knives, to serve as templates for the shaping of the feathers. The shaped feathers were glued to another cotton-and-agave support, in coarse and fine layers. These layers secured mixed tones in the colouring, which intensified the bold effects of the painters. An example in Vienna (Plate 32B) shows a coyote of cotinga feathers, outlined in gold, on a pink ground.[84]

Painting on Aztec pottery from the Valley of Mexico is distinctly retrograde in comparison with the manufactures of neighbouring peoples, such as the decorated polychrome vessels of Mixtec derivation in the adjacent valley of Puebla. Thin-walled vessels on tripod legs, and bowls painted in cursive black designs on a brown or red ground, are the most common wares.[85] Only a few late examples bear figural designs of birds, fish, and plants in loose brushwork. The appeal of the best Aztec pottery is tactile rather than visual, as in the fragile quality of the eggshell-thin paste.

CHAPTER 4

THE GULF COAST

FROM south to north, the coastal plains with their dense forests can be divided into three archaeological regions.

(1) The deltas of the rivers of southern Veracruz and Tabasco, on the gulf side of the isthmus of Tehuantepec. These were occupied by the main trunk of Olmec civilization, which had other manifestations from pre-Classic times onwards, in Central America, in Oaxaca, in the Guerrero and Puebla highlands, and in the Valley of Mexico.

(2) Central Veracruz, including the Mistequilla district in the south. This is bounded on the north by the Pánuco river. The district about Zempoala was inhabited at the time of the Spanish Conquest by Totonac tribes. Their name is often, but inaccurately, used to describe the artifacts of the whole central region.

(3) The Huasteca territory, north of the Pánuco river. This is named from tribes speaking an archaic form of Maya, tribes who were separated from their Maya relatives before 1000 B.C.[1]

The southern, or Olmec, peoples were dominant in pre-Classic times. The central coast was most active in the Classic and post-Classic eras. The Huasteca region produced its distinctive forms of art under Toltec influence and later. The three regions are usually discussed together because of geographical and climatic similarities, rather than because of resemblance in culture. Indeed, the external relationships of the three regions were usually closer to the highland territories of central and southern Mexico, or to the lowland Maya, than to one another. The result is a chequered history, reflecting many cross-currents of migration and trade.

THE OLMEC STYLE

The term signifies the rubber-people, the dwellers in Olman. To the Aztecs, whose history is limited to the fifteenth and sixteenth centuries, the name signified an ethnic group strewn to the south, but it included many tribes and several historical transformations, which have still to be elucidated.[2] Archaeological knowledge of Olmec culture is restricted to the Formative period, especially in southern Veracruz and western Tabasco, on the sites of Tres Zapotes, La Venta, and San Lorenzo. M. D. Coe's excavations at San Lorenzo in Veracruz revealed an Olmec-style occupation from before 1200 to 750 B.C., interrupted by an episode of ceremonial destruction at 900 B.C. The island of La Venta in the Tonalá River on the boundary between Veracruz and Tabasco is the other major site in the Gulf Coast 'heartland' of Olmec culture. It likewise was occupied before 1200 B.C., enduring until about 600 B.C.[3] Other sites are Tres Zapotes, north-west of Potrero Nuevo, and Río Chiquito near San Lorenzo. Laguna de los Cerros and others remain

to be excavated. Like the art of Teotihuacán and of the central Maya peoples, Olmec art is a recognizable and definable entity. It appears in the highlands of Guerrero, Oaxaca, Morelos, and Puebla, as well as in the Valley of Mexico. Traces of it are evident in the art of the central Maya. The style centres upon anthropomorphic representations of jaguars (Plate 36), in sharp contrast to the later Maya and Mexican highland pre-occupation with plumed serpent forms (Plate 12). On the Gulf Coast, it is primarily a sculptural style, unlike Maya art, of which the technical origins may be supposed in painting and drawing. The representation of vigorous motions of the body is common. A distinct ethnic type is commonly represented, with pear-shaped heads, thick everted lips, broad noses, and elliptical eyes (Plates 39, A and B, and 40).

As reviewed and systematized by Ignacio Bernal, the Carbon 14 measurements for Olmec I include ancestral pre-Olmec platforms and pottery used in an early jaguar cult antedating 1200 B.C. at San Lorenzo. Its monumental expressions in building and sculpture continued from 1200 B.C. to 600 as Olmec II at San Lorenzo, La Venta, and Tres Zapotes. Olmec objects continued to be made during Olmec III (600 B.C.–100 B.C.) at La Venta and Tres Zapotes. After 100 B.C. Olmec products continued to be made, concurrently with traits either innovative or alien, such as dated writings and dragon volutes, but the Olmec traits are rare and show amalgamation with other configurations (Teotihuacán, Maya, Classic Veracruz).[4]

Olmec architecture is known mainly at lowland gulf coast sites in great river basins. At La Venta (Figure 16), the excavations have uncovered part of a large ritual assembly of pre-Classic mounds and enclosures with deep occupational deposits. These indicate a small resident population, supported by dispersed farmers for whom the buildings served as a religious and civil centre. It probably housed only the priesthood, or temple corporation. La Venta stands on an island in the Tonalá river among the mangrove swamps of northern Tabasco. The principal elevation is a rounded and fluted mound about 420 feet in diameter and 103 feet high. The north face overlooks two adjacent courts. The first is framed by parallel mounds. The second or northernmost court was a sunken rectangle paved with coloured clays and fenced with close-set pillars of natural columnar basalt. These were probably brought by raft from volcanic quarries about 60 miles to the west. Two platforms flank the south entrance to the sunken court; both are floored with mosaics of serpentine slabs and coloured clays, representing angular jaguar masks (Plate 35A). The circular mound on the north side of the sunken court covered an elaborate tomb lined and roofed with basalt columns. As if guarding the approaches to this nucleus of enclosures and mounds, four colossal heads of basalt (Plate 39B) faced out from the precinct like apotropaic figures. The northern row of three heads faced north, and the south head looked south. To the south-east another Olmec site, called the Stirling Group, contains a possible ball-court, carbon-dated c. 760 B.C.,[5] and San Lorenzo may have another of later date before 400 B.C.

Two sharply contrasting modes of sculpture appear on the Olmec sites. One tradition, represented by the mosaic floor, approaches cipher-like abstraction. The other, exemplified by the colossal heads, is a tradition of veristic sculpture leading to the most faithful possible transposition of appearances. Full-round figures are often incised with glyph-

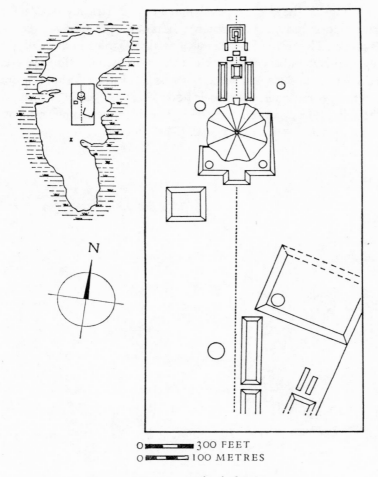

N

O ▬▬▬▬▬ 300 FEET
O ▬▬▬▬▬ 100 METRES

Figure 16. La Venta. Plan before 400 B.C.

like notations and figures.[6] Some may represent body designs applied in paint with carved clay or stone stamps; others may denote details of costume; still others appear to be ideographs.

Full-round sculpture, like the colossal-head type, is most abundant in Bernal's Olmec II (San Lorenzo phase). Narrative and scenic reliefs became common during Olmec III (La Venta phase) after 900 B.C., in a tradition continuing at Izapa, at Monte Alban, and later in the Early Classic arts of Teotihuacán and the Maya lowlands.

Ideographic Forms

The abstract designs often resemble glyphic notations in an ideographic mode. Altar I and the stone sarcophagus (Plate 35B) of La Venta (Monument 6) are monumental examples. Altar I is a cubical stone about 6 feet high with jaguar features gathered upon

the flat front. Wing-like head-dress panels spread symmetrically over the sides of the block. The general form resembles the stucco masks of the pre-Classic pyramid (Chicanel period) at Uaxactún. The wings repeat a motif used at Tlatilco in the Valley of Mexico.[7] The oblong eyes with rounded corners are like the signs used in Olmec jade-carvings. At Tres Zapotes, Stela C bears a jaguar-mask of the same abstract design (Figure 17A). This mask is even more geometric in the mosaic floor (Plate 35A) of La Venta. Stela C bears numbers written in Maya notation. They have been identified as referring at the earliest to the third century B.C. Spinden or 31 B.C. (Thompson)[8].

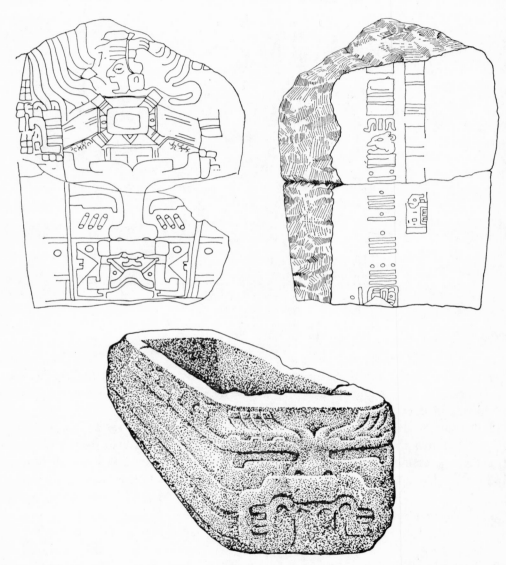

Figure 17. (A) Tres Zapotes, Stela C (31 B.C.?), relief carving of figure seated on jaguar-mask and reverse
(B) La Venta, sandstone sarcophagus (Monument 6), before 600 B.C. (cf. Plate 35B)

Further examples of the ideographic style are common in the statuettes and jade celts found throughout the highlands of Guerrero, Oaxaca, Chiapas, and Puebla (Plates 36 and 37).[9] The use of jade is pre-Classic, as is the technique of shaping and carving the surfaces, which is evident in Olmec figural celts.[10] Two distinct personages are shown on these stone knives. One is an almond-eyed man-jaguar, wearing a helmet like the colossal heads, and having feline fangs protruding from thick and everted lips. The other personage is a slit-eyed infant, characterized by toothless gums within the same everted and trapezoidal mouth, as well as by a split skull, cloven sagitally in frontal representations, and transversally in profiles. This 'baby-face' image on jade celts often displays tufted, flame-like eyebrows. Only one baby-face celt appears at La Venta.[11] The two personages become one on the Gulf Coast sites: Monument 10 at San Lorenzo shows a seated figure with cleft skull and jaguar teeth. The destroyed coffin (Monument 6) at La Venta had flame eyebrows, oblong eyes, and jaguar fangs (Plate 35B and Figure 17B).[12]

The ideographic mode of the Olmec style often contains forms which recall line engravings on close-grained wood (Plate 49B), and ribboned planes of relief as in wood-carving. These may owe their origin to a vanished early art of shallow sculpture in tropical woods.[13]

Colossal Heads

Accurate anatomical relations and visually faithful modelling are the distinguishing traits of the colossal heads. Sixteen (as of 1970) are known: one at Tres Zapotes, another from Cerro Nestepe, four at La Venta, nine at San Lorenzo, and one in the Tuxtla mountains. Some San Lorenzo heads were long ago mutilated and buried. They probably once stood, like the head at Tres Zapotes, upon foundations of unmarked stones. All may once have been coated with smooth purple-red paint on a white clay base, of which traces survive on part of the north-west head (No. 4) at La Venta.

These heads occur throughout at least two, and possibly more, generations of sculptors, working with stone tools, repeating the same theme with varying skill and power. The largest of them all (Plate 38, A and B) may be the oldest, found near Cobata in 1970, high on Cerro Vigia among mounds in a ravine.[14] Its conical profile is like that of the Cerro Nestepe head, and its puffy coffee-bean eyes are unique. The ox-yoke brow seems typologically earlier than the brows of the heads at La Venta or San Lorenzo, and closest to the head from Tres Zapotes (Plate 39A). Two heads are almost spherical, and nearly devoid of animation: Tres Zapotes and La Venta 1. The first seems arbitrarily rotund, with the features protected from accident by the beetling projection of the helmet across the brow and along the cheeks. The eyes are rimmed with heavy borders, and the eyeballs have a marked convex curvature. The ears are abstract ciphers. The expression is grim and hard, without the supple modelling of all the other heads. La Venta 1 is also spherical, but the helmet meets the face in a less harsh line. The modelling of lips and eyes, though puffy, is more vivacious.

A second group of four is distinguished by parted lips, communicating an expression

of speaking animation. Two in this group are spherical, and two are long-headed. The long heads (La Venta 3 and San Lorenzo 1, 2, 3, 4, and 7) are more lively than the round heads (La Venta 2 (Plate 39B) and 4 and San Lorenzo 5 (Plate 40), 6, and 9). La Venta 3 has deeply shadowed eyes and lips, suggestive of emotional tension, as in Greek sculpture under the influence of Scopas. The round heads (La Venta 2 and 4) are perhaps more animated in the open mouths, but the total effect of an inner emotional state is less apparent.

Many heads have the iris flattened, or in raised relief or incised upon the eyeball, in a commanding expression of focused gaze. All are like ideal portraits expressed in firm flesh, heavy muscles, and articulated profiles. An effect of majestic willpower and discipline is achieved by studied proportions and contours, in a composition of idealized physiognomic parts.

The round heads of grim aspect (Plate 39A) may be earlier than long heads of majestic expression (Plate 40). An intermediate group of long heads and round heads is characterized by parted lips (Plate 39B). Such a progression might require no less than one century of connected efforts by specialized craftsmen giving all their time to the work, possibly with interruptions of undetermined length.[15] The span is not easy to date, because of possible removals of the heads to different sites, as well as their burial and re-use during many centuries. From these data alone it is impossible now to seriate the heads, but it remains significant that the stones were buried on purpose at different depths. Given their intrusive position in the strata of San Lorenzo, the problem is like that of dating the sculpture in a museum by the architecture of the museum building which houses it.[16]

Relief Sculpture

At Tres Zapotes, Stela D (Plate 41) is an example of the relief sculpture that was possible in the Olmec centres perhaps as late as Olmec III (600–100 B.C.). The three standing figures are framed within the jaws of an animal mask. Their kneeling, standing, and striding postures show the legs in separated profile, and the torsos in frontal view, as at Izapa, and on the Leyden Plate and in the Cycle 8 reliefs from Uaxactún.[17] Stela A from Tres Zapotes presents a similar formula beneath a stylized jaguar-mask of Olmec type.

Many immense altar stones show a spirited enlargement of the possibilities of portraying space and action in relief. Seven are at La Venta, and others appeared at Potrero Nuevo (Plate 44) and San Lorenzo. At La Venta, Altars 4 and 5 are the best preserved, with human figures emerging from rounded niches beneath the flat top. On Altar 4, a carved rope connects the seated figure in the niche with another seated figure in profile relief at the side. On Altar 5 the emerging figure bears a reclining infant. The four seated figures on the sides restrain dwarfs or infants of Olmec profile, with slit eyes, everted lips, and deformed or notched skulls (Plate 46). Seated reliefs of this type do not appear in Maya sculpture until the seventh century A.D. at Palenque.[18]

The large relief carved on a cliff at Chalcacingo (Plates 42 and 43) has invited many explanations, among which the common elements are the representation of a cave in ideographic profile, containing a seated figure and surrounded by scrolls of smoke or

sound, beneath banked cloud signs discharging raindrops. The scene resembles Stela 2 at La Venta and Stela D from Tres Zapotes (Plate 41), both of Olmec III date.

Vigorous body motions are most ambitiously combined on Stelas 2 and 3 (Plate 47) at La Venta. The principal figures are on stiff parade, but they are surrounded by flying or leaping jaguar- and bird-men, strangely evocative of those on Mochica pottery. They bear axes or poles and wear armour.[19] In Maya reliefs, these animated secondary figures were common during the Early Classic period (before 400). The ornate basalt box from Tres Zapotes, with armed warriors of this type, shown fighting among scrolls,[20] probably belongs to a terminal phase of Olmec sculpture. The scroll theme with scalloped outlines is prominent at the Chalcacingo cave relief in eastern Morelos (Plates 42 and 43), where such scrolls emanate from a stylized cave or mouth. Olmec iconography can best be studied in these complex scenes, where the meaning of the component elements is suggested or revealed by the context. Many Olmec themes reappear in later periods of Mesoamerican art, but as in the ancient Mediterranean world, such similarities of form do not guarantee identities of meaning. An Olmec example is the seat or pedestal from Potrero Nuevo, supported by atlantean figures in high relief. These atlantean dwarfs recur in a similar context as supporters beneath a dais or platform at Chichén Itza in the cella of the Temple of the Warriors (Plate 118), but their meaning is probably different. The Potrero Nuevo seat bears a carved edge, resting on the supporters' hands, which represents stylized and geometric serpent fangs, like those of the serpent-head cloak shown on the Atlihuayán figure (Plate 2). These may connote the sky and thereby the celestial nature of the person on the dais.

Figurines of Clay and Jade

Drucker distinguishes three technical varieties of clay figurine manufacture: with features made by punching, by slitting, and by modelling.[21] All the figurines show a stem, to which the face plane was joined. The turban or hair is a third piece, added to cover the joint between the stem and the face. Common to nearly all Tres Zapotes and La Venta figurines is a vivacious convention for the eyes, with deep central punctations at the iris, flanked by triangular punches. Each eye is an inverted V, so that the glance is upward or to one side (Plate 45, A and B). As these techniques of figurine manufacture occur in the lowest strata of the Tres Zapotes excavations, they antedate the monumental stone sculpture. They show nothing of the linear abbreviation and shorthand pictorial symbolism of the ideographic manner. They are related, however, to the colossal heads. The group with parted lips, in particular, and the heads of San Lorenzo with incised iris and upward gaze (Plate 40), clearly belong to the tradition of the figurines with animated gaze. Dwarfs, hunchbacks, babies, and women are among them.

The broken fragments of bodies[22] belonging to the figurine heads likewise give a clue to the history of the jade carvings, which show such mastery of bodily motions and anatomical relations. Several seated figurines show a remarkable equilibrium of weights and motions. The legs are folded in under the seat; the upper torso leans forward, with

the hands grasping the knees. The front view is oblong, the profile is triangular, and the ground plan is trapezoidal.[23]

The jade figurines of La Venta, from the tomb lined with basalt columns, are certainly pre-Classic in date, like all the La Venta sculpture. One represents a seated woman, with a small hematite mirror mounted on the chest. This is carved of whitish jade mottled with blue-grey patches (Plate 48A). The other figure, of green and white jade, shows a dwarf-like male, modelled in supple planes. More stereotyped are the standing jade figures, with undifferentiated arm and leg endings and an undulant body profile, like a warped slab. These La Venta jades may come either from different periods (as heirlooms?), or from different workshops of greater and less refinement during the same period. Their appearance together in the same deposits shows a general La Venta style of jade working.

They raise the question of the mutual dependence of the clay and jade traditions of figurine manufacture. Certainly the clay figurines are an older tradition, but they are so hastily made, and so conventional (Plate 45A), that one is reminded of the diminutive replicas of famous monuments executed in ordinary materials which pilgrims or tourists acquire as souvenirs of travel today. Indeed most clay figurines from La Venta and Tres Zapotes can be loosely associated with a corresponding piece of monumental sculpture or with a jade carving. The types are few, and the general style is the same.

The relationship between the makers of clay figurines and the sculptors of stone and jade must have been one of reciprocal exchanges. The clay figurines came first. In Early Classic centuries, the sculptors and lapidaries acquired the technique for translating the postures and expressions of clay figurines into stone and jade. These new forms of monumental or jewel-like character then affected the work of the artisans in clay, who cannot have avoided making diminutive replicas of the colossal heads and jade statuettes.[24]

Olmec culture on the Gulf Coast is marked by a preference for permanent materials: in a region of tropical hardwoods the ceremonial court and the principal tomb of La Venta were walled about with basalt columns. The colossal heads manifest a pharaonic desire for eternity, for physical survival beyond all the accidents of time.

But basalt and jade not only induce permanent form; they permit the sculptor to investigate kinds of form that are not so easily available to the potter. The brilliance and deep translucence of polished jade called for a special organization of the surfaces, by curving planes smoothly passing around the shape. At the other extreme, the Stone Age sculptor could experiment with visual effects of skin texture and muscular interplay only when working on the colossal scale of the great basalt blocks. The coarse scale of his stone tools could be overcome at first only by magnifying the scale of the work. Like Stonehenge, the early work is immense because the tools are simple. Their furrows could only gradually be made small enough for working jade. By this hypothesis of primitive macrotechnics, colossal heads might pre-date diminutive jade sculpture.

Working in jade and basalt, the Olmec sculptors gradually learned a most extraordinary realistic technique. Three jades in the Bliss Collection demonstrate this stage of lapidary art: the fragmentary head and shoulders of a middle-aged woman (Plate 48B), and the statuettes, in aggressive poses, of a jaguar and of a middle-aged gladiator

(Plate 49A). The woman is shown as if sobbing, with dilated nostrils and furrowed brow. The translucent surfaces enhance an expression of deep emotional disturbance by their suggestion of wetted skin. The bald athlete has the musculature of a hominid; his belly and forearms are lined with bulging veins, and his posture is aggressive. The blackish-green colour and the opaque brilliance of the stone reinforce the expression of bestiality and violence. The statuettes are surely Olmec, and they are probably late, perhaps related to the San Lorenzo heads.

An Olmec statue is a bearded and seated athlete, slightly less than life-size (Plate 50). The spiralling motion of the body, the multiplicity of profile, the coherent muscles, and the expressive restraint of the work set it apart as among the great works of sculpture of all ages. In it several kinds of technique meet: the study of expression possible in jade; the study of movement possible in clay; and the large surfaces of the colossal-head tradition.

Miguel Covarrubias,[25] the Mexican painter, first ventured to interpret the conventional meaning of these forms. He believed that the figures of jaguars, dwarfs, and babies were stylized representations of an 'Olmec ethnic type' of Asiatic origin and of great antiquity, modified by pathological, infantile, and feline traits. According to Covarrubias the figures may represent jungle spirits, called *chaneques* by the modern inhabitants of the Veracruz coast. The *chaneques* are mischevous old dwarfs with baby faces, who play pranks on human beings and provide rain if propitiated. In the tiger-traits Covarrubias saw a totem symbol,[26] perhaps related to later Mexican cults of a tiger as earth god and symbol of the night. On these assumptions, Covarrubias constructed an iconographic genealogy, progressing from the archetypal baby-face to Maya serpent-masks and the Aztec rain god. The flame-like eyebrows of the Olmec faces became the eye-rings of the Maya and the Mexican rain-god figures, Chac and Tlaloc. Covarrubias laid much stress upon the intrinsic simplicity of the Olmec style. Maya, Zapotec, and Teotihuacán styles, he maintained, all show Olmec traits in their oldest artifacts,[27] but Olmec art contains the traits of no other styles.

Certain parallels have been drawn between Olmec and Chavín art in the Andes. Both represent anthropomorphized feline monsters by incisions and flat low reliefs of ideographic character. Both use few fundamental forms. In both there is a peculiar convention of ending or articulating an organic form with smaller repetitions of the same organic form. For instance, the profile baby-face on a jade plaque (Plate 49B) has the same profile repeating on the forehead and in the skull. It is repeated twice more on the cheek. The main profile not only contains itself at various places; it is built up of connected repetitions. The same method appears in Chavín art,[28] where a feline body may consist of jointed and repetitious statements of a profile feline mask (Plate 150). Both styles are probably related to the same kind of social organization, in which the earlier villages of farmer-artisans were brought under the control of priests. In such theocracies, stratified into peasant and hierarchic groups, the priests shaped and defined a life increasingly ruled by auguries and sanctions. Temple corporations, holding and manipulating the wealth of the new ritual community, were probably the characteristic political institution. The style sponsored by the temples shows an aversion to everyday

secular experience. It suggests terror and awe by monstrous forms. This art not only illustrated a cosmology: it was an evangelical method of instruction. Under the economic order of the temple theocracy, specialized and professional artisans came into being. The colossal heads and the jades can have been carved only by professional sculptors relieved from all other work, and maintained by the community.[29]

Painting

Important discoveries at two highland caves in Guerrero, Justlahuaca (1966) and Oxtotitlán (1968), have revealed extensive areas of richly polychrome parietal decorations in Olmec style.[30] The caves are about 30 km. (20 miles) apart: at Justlahuaca the paintings begin 3,400 feet from the cave entrance. They are executed in red and yellow ochre and black, showing a human standing 5 feet 5 ins. high over a figure seated in the 'jaguar-pose' common in Olmec sculpture. Other drawings may portray a building, jaguar heads, and a plumed serpent.

At Oxtotitlán two shallow grottoes in the face of a cliff are painted with mineral pigments in an oil base. Mural 1 (3·8 by 2·5 m.; 11½ by 8¼ ft) shows a frontal human seated on a jaguar-head dais (Figure 18). Another painting (1-d) shows a standing ithy-

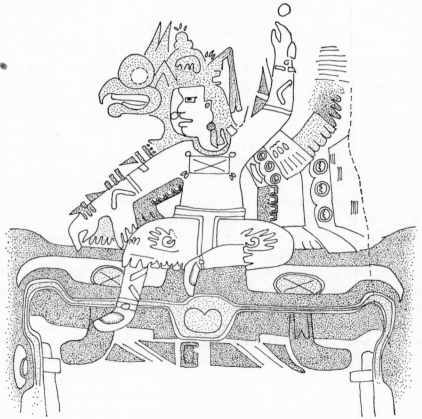

Figure 18. Oxtotitlán, cave painting of figure seated on jaguar-mask, after 900 B.C. (?)

phallic human close behind a jaguar. Similar scenes in sculpture are known from the district around San Lorenzo on the Gulf Coast. Other paintings show feathered serpents, and a baby-face, in a style closer to La Venta than to San Lorenzo. Grove suggests an underworld union between man and jaguar, producing the jaguar-rulers who are shown at La Venta seated in the jaguar-cave mouth.

The Central Coast

The region from the Mistequilla to Papantla – from the sandy coastal plain south-east of Veracruz to the tropical forest 120 miles farther north – is usually identified as the seat of the Totonac civilization.[31] The only historical notices of this people, gathered soon after the Conquest, make it clear that the Totonacs then lived only in the southern district between the Tuxpan and Antigua rivers. No clue survives as to the identity of the peoples occupying the northern sites during the Classic era. For these reasons it is less misleading to refer to the region by chronological terms – Classic Veracruz, and post-Classic – than by ethno-historical names of doubtful relevance. This usage excludes Olmec sites in southern Veracruz. It embraces both central and northern Veracruz as the central sector of the Gulf Coast, spanning the region between the Papaloapan and the Pánuco rivers.

Architecture

Tajín, near Papantla in the north, is an archaeological centre of the same order of magnitude as Uxmal, Monte Alban, or Copán.[32] Its recently defined archaeological history spans about 1000 years from the first to the eleventh century after Christ, in twelve building periods.[33] Tajín II (second century) shows the earliest terraced pyramidal platforms at the site, associated with pottery characterizing periods I and II at Teotihuacán. Fretted friezes carved in ashlar masonry occur at Tajín III before 400. The early ball-courts are assigned to Tajín IV, c. 500, followed by the Pyramid of the Niches in Tajín V before 600. The North Ball-Court is dated in Tajín VI as of 600. Construction at Tajín Chico began about 700 in Tajín VII, continuing through Tajín VIII–XII, from before 800, until c. 1100, when the site was abandoned after destruction.

In plan Tajín comprises two distinct zones (Figure 19). The southernmost group of square and oblong platforms faces the cardinal points, and it includes old constructions like the Early Classic niched pyramid. A Late Classic zone, Tajín Chico, lies on higher land north of the early edifices, and is orientated upon different co-ordinates. The main axis runs north-west to south-east, intersecting the north–south axis of the first group at an angle of about 60 degrees. This difference in orientation may obey topographic limitations. All the newer platforms and buildings of Tajín Chico cluster along a shoulder of the north-western hill. On still higher ground is the latest building at Tajín. This columnar structure stands upon the platform dominating the entire system. Its chronological position in Period XII at the end of Tajín is fixed by sherds in the masonry, pottery from the older building-periods.

STRUCTURE 5

NICHED PYRAMID

TAJIN CHICO

PLATFORM A

STRUCTURE 2

SOUTH BALL COURT

N

0 ⊢━━━━━┥ 200 METRES

0 ⊢━━━━━┥ 600 FEET

Figure 19. Tajín. General plan, as in c 1000.

78

The square pyramid of Tajín (Figure 20) is probably the oldest edifice (before 200–600 A.D.) on the site, and it is the most imposing one, facing east, and rising in seven stages. Each terrace riser is deeply shadowed by window-like niches in seven chain-like girdles, completely surrounding the pyramid on all four sides, and continuing beneath the eastern stairway, to number 364 or more. The nucleus of river boulders and clay is faced with small slabs of sedimentary rock. Upon these terraces, the superstructure of niches, built of flat sandstone spalls, rises with slanted cornices casting deep and angular shadows. The niches are volumes of about cubical shape, over two feet deep, opening out upon the terrace risers by stepped frames of two or three reveals. The section

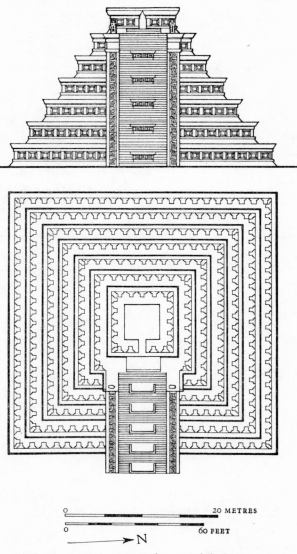

Figure 20. Tajín, principal pyramid, before 600.
Elevation and plan

reappears in terrace profiles at Cholula (Figure 6). Here, however, the vertical face is shadowed by the immense overhanging cornice, reflecting the talus as an inverted incline. The purpose is to enrich the composition of the shadows with animated rhythms, and to stress the vertical components in the silhouette. The slanting overhangs are like the re-curved eaves of Japanese roofs: the silhouette and the surfaces flicker with chequered shadows as the sun swings over the building.

The slanted cornice overhanging a band of niches reappears on other platforms in the older part of Tajín. At Structures 2 and 5, on the southern side of the main plaza dominated by the niched pyramid, the effect is different. The band of niches is like a jewelled belt encircling the platform. The standing cornice projects, while the talus below spreads out like a billowing skirt. Both the proportions and the vertical separations in the nicheband are altered to stress its horizontal continuity. This continuous effect

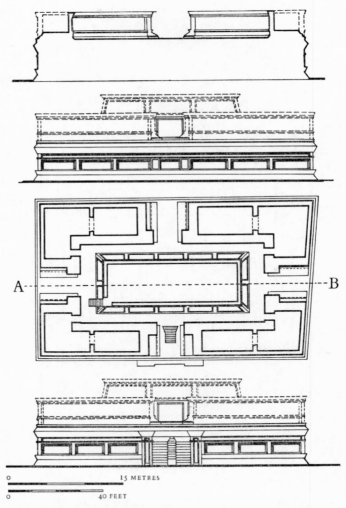

Figure 21. Tajín Chico, Platform A, seventh century (?)

reappears in the balustrades, worked with terraced meanders, flanking the stairs of the main pyramid.

Tajín Chico has much more complicated buildings, erected probably after A.D. 600. Platform A may be described as a pedestal, built before 800, bearing a small truncated platform, in the centre of four two-room apartments (Figure 21). The scheme resembles the pyramid at Xochicalco (Plate 12) in its exterior massing. The plan evokes the court-yard buildings of Mitla (Figure 25). In the south façade, a true stair-shaft rises within a symbolic façade stair of nearly vertical plane, flanked by the same terraced meanders as at the niched pyramid to the south. This symbolic stair resembles those of the Maya temples of the Río Bec area in the centre of Yucatán (Figure 47).

At Tajín Chico the resemblance of Platform A to Maya architecture is strengthened by the massive roof slabs, now ruined, made of lime and pumice-stone poured like con-crete on a temporary armature (Figure 21). At the façade stair, overhanging cornices of Tajín style meet over the stairway, to make a triangular arch-head like the corbelled vault section of the Maya. This device reappears on a larger scale in the facing of the immense courtyard opening eastward from Tajín Chico below the level of Platform A. The entire court is faced with alternating niches and Mayoid doorways, formed by the meeting profiles of adjoining niche-cornices. Buildings D (before A.D. 1000) and K, on the other hand, recall the battered profiles, geometric decoration, and trabeated in-teriors[34] of the 'palace' buildings of Mitla.

At Tajín Chico as well, these resemblances both to Yucatán and Mitla appear re-peatedly. Such architectural efforts to compose elaborate inner spaces with ornate geo-metric exteriors, at Mitla, in the Puuc district and Río Bec in Yucatán, at Xochicalco and Tajín, characterize the centuries from the close of the Classic era until the rise of Toltec-Maya civilization, from about A.D. 600 until 900 or 1000. Tajín Chico stood on the peri-phery, receiving and transforming ideas of which the origins were both Maya and Oaxacan. The originality of the style of Tajín lies in the bold use of chiaroscuro effects, achieved by the flaring cornices, the deep niches, and the many planes of geometric ornament.

The most recent edifice of Tajín Chico may be the columnar building (Plate 51) which dominates both its own western plaza and the entire sweep of the lower buildings. The east façade was a colonnade of six cylindrical shafts built of thin carved drums, support-ing a gently curved vault of lime, sand, pumice, shells, and sherds. The stairway rising to this platform has stuccoed balustrades with rectilinear decoration derived from snake (crotalus) rattlers. The stair itself is flanked by retaining walls decorated with immense rectilinear stepped frets in deep relief. The scale and the proportions of this ornament were designed to be visible from great distances. The columnar edifice is separated from the early monuments by many generations of connected experiments. These tended to enclose space more ambitiously, and to achieve brilliant chiaroscuro effects of surface with recessed geometric decoration.

Architecture of a presumed Tajín date on the central coast has been identified at Misantla.[35] The flaring cornices, imposed upon a sloping talus, simplify the Tajín formula, and prefigure the Aztec balustrades rising at a steeper angle near the head of

the stairs. Beneath the Misantla stairway (Mound B) is a tomb on a T-plan in the core of the platform, like those of Mitla in Oaxaca (Figure 26).

Later than Tajín are the Totonac ruins of Zempoala, 20 miles north-west of Veracruz, where the Spaniards in 1519 saw a great Mexican city of 30,000 inhabitants. The ruins cover many courtyards, but only a few sections have been excavated.[36] Near by are sites yielding older remains: Las Animas, with its clay figurines of Teotihuacán style, Remojadas, yielding 'smiling' figurines of Classic date, and Cerro Montoso, abounding in pottery of Mixteca–Cholula style.[37] Zempoala itself contains traces of archaic settlement, but its great period was as a Totonac centre, subject to Tenochtitlan, occupying a focal point on the trade routes connecting the coast, the highland, and Yucatán. The roomy, many-chambered temples recall Maya edifices; the wide pyramidal platforms resemble Cholula; and the stairway profiles are like those of Aztec design, with an abrupt change of angle near the top.

Stone Sculpture

The origins of the Classic Veracruz scrollwork style now are recognized as having antecedents in Chiapas (Chiapa de Corzo VI) as well as at Kaminaljuyú (Miraflores phase), i.e. *c.* 250 B.C.–A.D. 100,[38] in the late pre-Classic period. Later monumental sculpture on the central coast is known from Cerro de las Mesas in the Río Blanco basin of southern Veracruz,[39] bearing dates of the type known as the Initial Series, with relief carvings related to Early Classic Maya. The dates (Katuns 1 and 4 in Cycle 9 – *c.* A.D. 455 and 514) and the style agree.[40] The profile stances of the figures, with the aprons shown in frontal view, are the principal evidence confirming the Early Classic dates on Stelas 6 (Plate 52A) and 8.

Two kinds of carving appear on these basalt stelas. The bounding profiles between the figure and the ground are vertical cuts. The inner contours are bevelled, showing overlapping planes in shallow depth; for instance, where the apron and the flesh of the legs meet. Conceptual clarity was the sculptor's first concern. The left hand of the figure is correctly shown, but the right palm turns out with fingernails showing, like another left hand, in an anatomically impossible position. In effect, both hands show palms and fingernails as if in a simultaneous cubistic image of different body-states. All accessories are preternaturally enlarged for the sake of clarity. The derivation of this art from a linear draughtsmanship invented by painters is clear. The squat proportions, the heavy body parts, and the magnified scale of all costume elements resemble the Monte Alban reliefs[41] and tomb murals as much as they do Maya art of Early Classic date.

Nothing earlier has been identified among the reliefs and instrumental forms associated with Tajín. These carvings have wrongly been designated as 'Totonac', and, more recently, as terminal 'Classic Central Veracruz'. The architectural reliefs at Tajín have recently been catalogued. A serviceable chronology still is lacking, but M. E. Kampen reasonably has suggested this series: (1) the sculptures buried in the pyramid, (2) the South Ball-Court reliefs, and (3) those of the North Ball-Court (these he compares to Late Classic Maya sculpture). The final reliefs are (4) the column drums at Tajín

Chico, where Tuggle (Note 53) identifies dynastic and ritual scenes of sacrifice, rites of fertility, and mythological events.[42] In addition to the Tajín reliefs, the style includes yokes, heads, figural stone blades called *hachas*, and finials called *palmas*.

Crested heads of stone, probably symbolic of human trophy heads, occur in southern Veracruz.[43] Miss Proskouriakoff notes two kinds, with slight and heavy forehead crests. The lesser crests she believes are early. The protuberant crests (Plate 53A) appear in Oaxaca and Guatemala, probably later. The crested heads may be early forms of the *hachas* and *palmas*. Miss Proskouriakoff's tentative sequence is (1) lightly crested heads, (2) heavily crested heads, (3) *hachas* (Plate 53B), (4) *palmas* (Plate 54B), with 2 and 3 overlapping. The entire sequence may span a period from before the Classic era until after its close.

As for the scrollwork decoration of Classic Veracruz sculpture, Miss Proskouriakoff distinguishes two modes. In the first mode, the *hachas*, or figural blades, are coeval with Group A among the yokes with an ornament based upon simple coupled scrolls (Plate 54A). The scrolls recur upon a stratigraphically dated mirror back of carved slate, from the end of the Early Classic period at Kaminaljuyú in highland Guatemala. This connexion allows Group A to be placed with Teotihuacán III, Monte Alban IIIa, and late Tzakol, upon a horizon at the end of the third century A.D. Group B yokes bear the same scrolls in more ornately interlaced or linked oblique bands: these are assigned to mid-Classic or early Late Classic dates (seventh–eighth centuries A.D.). At Tajín, two reliefs from Structure 5 are associated by their scrollwork with these Early and Late Classic yokes: a single-figure slab with A-type scrolls and a monument carved with B-type scrolls.[44]

The second mode defined by Proskouriakoff includes the ball-court reliefs at Tajín (Plate 55, A and B), the *palmas* (Plate 54B), and two reliefs from the neighbourhood of Misantla.[45] The scroll ornament she identifies as of a later type. The *palmas* were not in general use until the close of the mid-Classic period. The scenes portrayed on the ball-court reliefs and *palmas* show human sacrifice in a manner commonly associated only with Toltec and later ceremonial customs. However, nothing in the ceramic evidence at Tajín allows us to suppose that these reliefs were carved in Toltec times; on the contrary, it requires us to date Tajín sculpture earlier than the Toltec era (absence of plumbate and X-Fine Orange wares).

The two modes are clearly separate in time, as early and late, with some overlap. They are probably also separate in space. Yokes and *hachas* may correspond to south Mexican centres of style. *Palmas* come from around Jalapa and the region to the north of it, while the pictorial reliefs are at Tajín and Misantla. A diagram of these assumed relationships follows:

	SOUTHERN VERACRUZ	NORTHERN VERACRUZ
PRE-CLASSIC	Ridged stone heads (Plate 53A)	
EARLY CLASSIC	*Hachas* and yokes Group A (Plates 53B, 54A)	
MID-CLASSIC	Yokes Group B	Yokes Group B
LATE CLASSIC		*Palmas* (Plate 54B)
		Tajín ball-court reliefs (Plate 55, A and B)

(Proskouriakoff's analyses refrain from such chronological suggestions.)

Yokes, crested heads, *palmas*, and *hachas* compose a group of instruments used as body gear in a ritual ball-game (Plate 52B).[46] They are associated in this context on a relief panel at the southern ball-court of Tajín (Plate 55A), and on a variety of figurines and representations from Maya and non-Maya sources. One of the Tajín reliefs shows two players standing between the sloping benches of a ball-court, both wearing yokes with *palmas* resting upon the yokes.

The 'early' crested heads have sagging eyelids, flaccid muscles, and relaxed mouths of indeterminate expression. To Proskouriakoff they suggest dead people. Often a halo-like flange surrounds the cranium at the rear. This flange may have served to lash the head to the yoke. The heavy-crested heads (Plate 53A) retain it, and one basalt example, purchased near Tres Zapotes,[47] has a perforation running across the head behind the temples, as if to fasten it to the wearer by a belt. The slack expression of these heads is perhaps a fundamental trait of Gulf Coast expression, from the Mistequilla to the Huasteca; it reappears in the *hachas* and *palmas*, and in the Tajín reliefs, as well as in Huastec figural sculpture, so that it is a constant from early to late, and from south to north.

The yokes (Plate 54A) display three other features of Classic Veracruz sculpture: the predominance of animal over human representation; the dissociation of the body parts; and their reorganization upon the instrumental field. The typical stone yoke weighs about forty pounds. It can be worn as armour to protect the abdomen from the impact of the heavy, solid rubber ball during play. Human figures imprisoned among the interlaces are characteristic of the A-group yokes; their legs and arms sometimes enmesh the features of a reptilian or feline monster. The articulations of this abstract figure in B-group yokes give an undulant appearance, and the monster displaces the human forms.[48]

The *hacha* forms were the most widely distributed ones of the entire ball-game panoply. The thin, flat blades (Plate 53B) must have been strapped as tools, as badges, or as emblems upon the persons or in the territory of the players. A stela from Tepatlaxco near Orizaba in Veracruz (Plate 52B) shows the dressing of a ball-player: his hands are both bound with tapes as if to affix *hachas* like rackets. Proskouriakoff has suggested that the iconography of the yokes, with their narrow and stable range of forms, probably represented religious ideas held by the community of participants, while the flat *hachas* may have been more personal symbols of heraldic character, designating individuals, families, or teams. They have been found at Teotihuacán, in Oaxaca, and in southeastern Guatemala. Some have an angular notch at the neck; others are tenoned (Oaxaca); still others, especially from Guatemala, have neither tenon nor notch. The forms of dead men and bare skulls are common, as if to recall a trophy-head origin; parrot, owl, and vulture profiles occur; sometimes a vulture appears feeding on the body or skull of a dead man. A tiger head, an acrobat, and a sacrificial victim stretched upon a pyramidal stair are known. Not uncommon, and probably late in date, are *hachas* with cut-out backgrounds perforating the thin blade.

The *palmas* are functionally different. A *hacha* blade usually cannot be made to stand upon its lower edge; a *palma*, however, has a broad triangular base, concavely curved

underneath as if to fit a yoke (Plate 54B). From this base a broad fan-shaped finial rises, carved with a variety of themes: scrollwork; human figures and parts of the human body; sacrificial scenes; musicians; bundles of arrows; and turkeys and iguanas. Indeed the interpretation as personal emblems describes the thematic variety of the *palmas* better than it does the *hachas*. The *palmas* are much less widely distributed, and their style is more homogeneous, containing an apparent progression from squat to elongated shapes,[49] and from static single figures to pictorial scenes with many figures in a specified setting.

The ball-court panoply, and the accompanying ritual of human sacrifice, are described on two reliefs (Plate 55, A and B) which decorate the ends of the parallel playing surfaces of the larger, south ball-court at Tajín.[50] Four scenes are shown, each flanked by a skeletal torso rising from a pot. Below and above each panel are interlacing scrolls. In the upper borders, these resolve into monster heads and tails. The south panels (Plate 55B) are more ornate in general and in detail than the north panels (Plate 55A), so that a difference in time may be supposed, with the south wall carved later than the north. For instance, the south-east panel has one seated figure carelessly dangling his feet over the lower frame of scroll interlaces. On the south wall (Plate 55B), furthermore, the lower scrolls are enriched by feathered insertions, which are lacking on the north wall. On the south wall, as at Xochicalco, the fleshy parts of the bodies have a ridged outline,[51] in the scrollwork system of the backgrounds, filled with flying figures and plumed forms. The north-west panels lack these outlines, and may therefore be the earliest work of the four.

Both scenes on the north wall take place in a ball-court, indicated by lateral platforms of Tajín profile. The west panel shows two standing players. Between them are the ball and an interlocking or crossed-band sign like the Aztec symbol for war, called 'burning water'. The east panel shows two players excising the heart of a third (Plate 55A). On the right is a seated, cross-legged figure, dressed like the left-hand personage on the west panel. A skeletal manikin descends as if to receive the soul of the immolated player.

On the south wall there is no explicit reference to the ball-game. The east panel has a standing figure between two seated ones. The left-hand one grasps a bundle of three downward-pointing arrows, in a gesture signifying war in Aztec usage. The west panel is flanked by musicians with a drum and a rattle. Upon a couch between them, a reclining figure is covered by an eagle with human hands (Plate 55B).

The smaller ball-court reliefs portray an eagle warrior and a throned figure. The technique of relief carving stresses the background pattern: it recalls cut-out sculpture. The ridged profiles of the reliefs in the main court reappear, but the scrollwork is much coarser and more schematic.

The pre-Toltec date ascribed to these reliefs is not contradicted by archaeological or stylistic evidence. The representation of human sacrifice by heart excision antedates Toltec examples at Chichén Itza. We do not know the source from which the people at Tajín took the ritual. The cult of death and the preoccupation with its physical appearance, which is so pronounced in post-Classic Gulf Coast art [52] north of the Mistequilla, is perhaps an argument for local origin, either in Veracruz or the Huasteca.

Recent iconographic studies, devoted to the Tajín reliefs and ball-game sculptures, stress the conception of complementary forces represented as opposing elements balanced in a dual universe.[53] This dualistic concept found expression in the ball-game itself, as well as in the oppositions of light and shade in geometric ornament, and in the prevalence of interlocking bands within the *ollin* sign denoting movement.

Clay Figurines and Heads

Two main groups of pottery sculpture occur in the semi-arid area of central Veracruz: the Remojadas tradition, from late pre-Classic (150 B.C.–A.D. 700) to Late Classic,[54] and the Nopiloa tradition (before A.D. 600–*c.* 900) of post-Classic date. Early Remojadas types are usually modelled by hand; Nopiloa figures are likely to be mould-made, although mould-made faces occur as early as the third century A.D.[55] The easily recognized shiny black body paint called *chapopote* appears in all periods.

Las Animas (north of Veracruz Port) and the 'Laughing Figurines' of the Nopiloa district south of the Río Blanco[56] appear to be related by their expressive content. Of sixth-century date, the Las Animas bodies (Plate 56A) are hand-made with moulded heads, those of the Nopiloa district are moulded (Plate 56B). They resemble each other in the lively movements; the filed front teeth; the animated if conventional smiles; and the broad sculptural simplifications used to represent the elaborate costumes. Las Animas figurines are associated with Early Classic periods, while the Nopiloa figurines occur with yokes and *hachas* in Late Classic levels after 600.[57]

Las Animas figurines, coated with white slip, achieve a remarkable translation of drapery, hair, jewellery, feather decoration, and facial expressions into simple ribbons and sheets of brownish clay. The stereotyped smile is usually conveyed by a mask applied to the lower face, beginning below the eyes and spanning the cheekbones. The lips of this half-mask open in a rictus, and the front teeth show prominently. In profile, the nose is bulbous and protuberant at the tip: the half-mask may have been affixed by a pince-nez clamp. The head-dress, shown as a broad turban rendered by a strip of clay across the forehead, often has a bird in downward flight, given by four pats of clay. Conical cape and skirt simplify the anatomical relations. Hands and feet are shown as summary stumps. Pairs of figures, seated upon platforms, strike poses as if conversing or singing. Strebel assumed that many of the heads were ornaments on flutes or whistles. Several types of eye appear. In the group just described, the eyes are rimmed by raised ridges; in another they are rendered by slit incisions. In Strebel's plates are several examples of triangular heads with punctate eyes. These groups suggest a long development from an archaic base.

The 'laughing' Nopiloa figures continue this tradition farther south, in moulded technique, at a later period.[58] The Remojadas site has a pre-Classic lower level and a Classic upper level. In the latter, figurines with smiling faces are common, showing a development beginning possibly before that of Teotihuacán and paralleling it chronologically. The large moulded heads, with glyphic reliefs on the forehead (Plate 56B), are

of Late Classic date. The clothes bear a stamped ornament not unrelated to scrolls of Tajín style. The filed teeth and the flat-featured smile upon a triangular face (Plate 56B) are like those of the Las Animas figurines, although the half-mask has disappeared.

THE HUASTECA

From Papantla north, the Huasteca province retained archaic linguistic, ritual, and artistic habits. From this coastal corridor between the Mexican highland and eastern Texas also came important contributions to the mainstream of Mexican cultural history. For instance, in the fifteenth century, when Axayacatl brought the north coast under Aztec domination, many traits of Huastec origin entered highland life, along with the tribute taken from the coast. Since cotton was the most important product ⌐ the Huasteca, many associated traits like the worship of Tlaçolteotl (Goddess of dirt ʾn) in syncretistic Aztec religion are of Huastec derivation. Tlaçolteotl, or Tlaelquan, of Excrement, i.e. Remitter of Sins), was a moon, fertility, harvest, and earth go shown in Codex Borbonicus as the mother of the corn god. Her attributes include ton cloths and spindles. Rites of the confession of sins were administered by her priests.

Another Huastec trait was the habit, as old as pre-Classic village civilization, of building round houses and temple platforms. At El Ebano (San Luis Potosí) the circular mound is probably older than the one at Cuicuilco (Figure 1). It has a burnt-clay facing,[59] perhaps of accidental firing. A round stone structure, built of inclined conical rings like Cuicuilco, stands at Tancanhuitz. Ekholm concludes that these round structures may be the earliest in Middle America, and that their use may have entered highland archaeological history at about the time of the Toltec expansion.

This connexion is proved by the mural decorations of a conical platform at Tamuín,[60] painted with red, white, and green processional figures of deities (Figure 22). Among them the wind aspect of Quetzalcoatl is prominent. This image is usually associated with the round structures of the highland provinces.[61] The Tamuín murals are perhaps of the eleventh century. Their style is at least as much Mixtec as Toltec. The costumes and accessories of the figures resemble those of the Mixtec genealogical manuscripts, as do the terraced scrolls of the frieze at the top. Specifically Huastec is the densely patterned surface of the figural composition – so dense that it is difficult to separate figure, accessory, and background from one another.

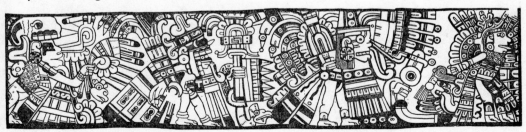

Figure 22. Tamuín, wall painting representing Huastec figures, eleventh century (?)

The style of the murals recurs in a number of carved shell ornaments of Huastec origin (Plate 60). The backgrounds are cut away, and the surfaces are incised with complicated sacrificial scenes. These have been elucidated by parallels from the ritual manuscripts of the Codex Borgia group (p. 109).[62] The shell ornaments also point by their technique and material to North American parallels in the shell gorgets of the Southern Cult, where the diffusion, via the Huasteca, of Middle American warrior cults and sacrificial symbolism can be dated to the centuries after 1200. In the Huastec shell ornaments, the composition is fully adapted to the trapezoidal field of the gorget, and to the circular forms of the ear-lobe plugs. One is not reminded of borrowings from book illustration, as so often with Maya ceramic painting of figural scenes, but the figures suit the objects as if specially designed, quite as in the Hopewellian shell ornaments. One of the Huastec ear-disks shows the hunting and fire god, Mixcoatl, kindling a fire with a drill. From the point of the drill, and flanking it, rise symmetrical curls of smoke. This theme is the basis of the complicated designs of Huastec black-on-white pottery of Aztec date.[63]

Huastec monumental sculpture belongs to about the same post-Classic or Toltec periods as the shell ornaments. Comparable are the Tamuín statue (Plate 57) and the Arensberg head at Philadelphia: both reflect a sacrificial view of existence. This re-appears in relief sculpture, as in the Huilocintla stela, where the rite of blood-letting from the tongue is shown in forms like those of the perforated shell gorgets.[64] The tattooings on both the Tamuín statue and the Huilocintla relief were probably marks of noble rank, as among the Maya. A dualistic manifestation, like those of Tajín, are the 'apotheosis' statues of Huastec origin (Plates 58 and 59), which show a live figure in rigid pose on one face, and on the reverse of the statue[65] a skeletal figure which is worn like a classic Petén-Maya back mask. Their nudity perhaps relates to the Toltec dress which exposed genitals and buttocks (Plate 123).

SOUTHERN MEXICO

THE most numerous Southern Indian peoples, west of the Maya, are today the Zapotec and Mixtec, who occupy Guerrero, Puebla, Oaxaca, and Tehuantepec. Oaxaca proper is divided into the western highland, or Mixteca, and the eastern valleys, where Zapotec is spoken. Oaxaca is the most central of all the regions of ancient Mesoamerica, having neighbours to west, north, east, north-east, and south-east, and overland communications to all these regions, fixing Oaxaca as the least marginal or peripheral territory of pre-Columbian archaeological history. The archaeological history of the region is related to the ceramic sequence[1] established by Alfonso Caso for Monte Alban near Oaxaca City. The record of Formative and Classic occupancy is continuous in this immense assembly of buildings. Its courtyards and tombs (Figure 23) spread over the contours and shoulders of the isolated mountain at the T-shaped meeting of three valleys, which converge at Oaxaca City from the north, the east, and the south. Monte Alban I and II correspond to the earliest monumental art of the region, which resembles Olmec sculpture. Monte Alban IIIa composes the Classic era, commonly called Zapotec. Monte Alban IIIb, IV, and V spread from about the seventh century A.D. to the Spanish Conquest. They correspond to Mixtec and later Aztec domination at Monte Alban.

Mitla (Figure 25) arose during the earlier centuries of Mixtec civilization from about A.D. 700 until 900 (Note 19 and p. 98). The art of the later centuries, after 900, is characterized by metal objects, polychrome pottery, and painted manuscripts. For the Mixtec era, our main source of knowledge is the group of pictorial genealogies (Plates 68–71), recording about eight hundred years of dynastic history from the seventh century until after the Spanish Conquest.[2] The Mixteca Alta, in western Oaxaca, was the highland seat of these warrior aristocracies, who overran the sedentary and theocratic society of the Classic age, much as the Toltecs later overran the post-Classic civilizations of Yucatán and Teotihuacán. Various lines of evidence confirm the age of the Mixtec tribal dynasties, but their exact historical relationships, both to the theocratic rulers of Monte Alban and to the Toltec lineages in the north, are still obscure.

Mitla was built in the eighth century, when Mixtec society separated from a parent culture of Classic date at about the time of the earliest dynastic chiefs recorded in the genealogies. Mixtec traits pervaded the material culture of central Mexico at the time of the Spanish Conquest. The polychrome painted ceramics and the manuscript illuminations of fifteenth-century Aztec art probably owe more to Mixteca–Puebla sources than to any other tradition, so that we must review its origins in the Classic Zapotec period, recalling that Mixtec art may have had no separate identity until the eighth century. John Paddock first suggested that a possible source of Mixtec art lies in the Mixteca Baja (part of the upper Balsas River drainage) where distinctive prefigurations

appear during the Classic era, under the label of the Ñuiñe (or Hot Land in Mixtec language) style, comprising Thin Orange ware, carved reliefs, and urns bearing interlaces and stepped frets, of Early and Mid Classic date (A.D. 200–700).[3]

THE CLASSIC ZAPOTEC STYLE

Architecture

Monte Alban is the most grandiose of all American temple centres, rising from the valley floor as an acropolis, studded with courts and pyramidal clusters (Figure 23). Trabeated wooden roofs were the rule, although stone vaults of peaked profile like those of Mycenaean construction are known, in Mound J and in some subterranean tombs. Stucco facings were less common than at Teotihuacán. The pyramidal platforms were finished with roughly shaped stones set in sun-dried clay. The terrace faces are dominated by wide stairways with broad balustrades. The principal surfaces are inclined; the vertical faces were generally interrupted by a variety of receding and layered planes. On these platforms stood buildings with earthen walls and columns of rubble, resting upon stone foundation courses profiled like the terraces, by laminated planes and inclined faces. The present surfaces were nearly all refaced under Alfonso Caso's direction before 1940.

The mountain-top acropolis surrounds an oblong court. Its narrow south end is highest in elevation, rising as an asymmetrical cluster of pyramids.[4] At the north end, another cluster of pyramids surrounds a sunken court separated from the main plaza by a barrier-platform. The east side of the main plaza is lined with great stairways; the west side has three free-standing temple groups; and the centre of the plaza is enriched by an oblong platform faced with stairways and buildings which reflect or echo the surrounding edifices.

The plaza looks entirely regular, but the symmetry of the sides is only approximate; the intervals between platforms vary greatly, and the main angles are either acute or obtuse. The idea, rather than the exact measure, of a rectangular enclosure is conveyed. These variations from geometric regularity suggest the archaeological history of the site. The oldest edifices [5] on the western side of the plaza (e.g. the Danzantes Temple) share an orientation some degrees south of east, while the other three sides of the plaza face the cardinal points more squarely, and probably belong to a later campaign of construction.

The design of the spatial enclosures of Monte Alban resembles that of the Ciudadela group at Teotihuacán (Figure 2). The assemblage of edifices might be described as an amphitheatre, affording privacy and enclosure to gatherings of people whose attention centres upon a dominant stairway and temple at the end or in the centre of the enclosure. The essential parts are barrier-platforms at the front and sides, and a stage-like composition either at the rear or in the centre. The enclosure is usually open at the corners, allowing the spectators to feel separated from other areas, yet connected with them by the openings between edifices. The main plaza of Monte Alban is itself such an amphi-

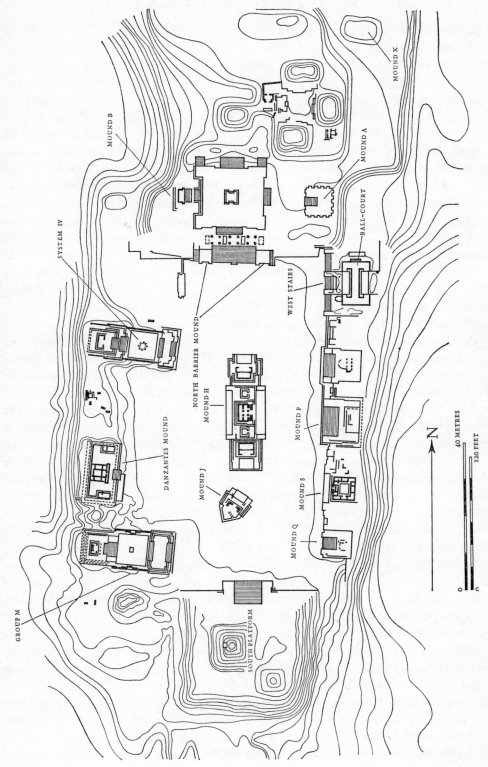

MOUND X

MOUND B

MOUND A

SYSTEM IV

BALL-COURT

NORTH BARRIER MOUND

MOUND H

WEST STAIRS

DANZANTES MOUND

MOUND J

MOUND P

GROUP M

MOUND Q

MOUND S

SOUTH PLATFORM

N

40 METRES

120 FEET

0

0

Figure 23. Monte Alban. Plan before 900

theatre, surrounded by lesser ones, especially on the north side, and by Group M (Plate 62) and System IV on the west side.

During Monte Alban II, in the pre-Classic era (*c.* 300–0 B.C.), the use of masonry columns was already common, as in Mound X (Plate 61B) from Period II, at the north-eastern edge of the archaeological zone. Here, beneath a more recent and simpler rebuilding, Caso discovered a two-chambered cella. Two cylindrical columns *in antis* (within the plane of the façade) stood in each of the doorways.[6] The 8 m. (25-foot) span of the outer doorway was reduced by the columns to three intervals: a central one 5 m. (15 feet) wide, flanked by narrow side-intercolumniations. This lively and inviting rhythm was repeated on a smaller scale at the entrance to the inner chamber. It reappears in the large portico on top of the barrier-mound on the north side of the main plaza, where the three intercolumniations are borne upon oblong pylons and doubled pairs of columns *in antis*. This simple and powerful massing, of great clarity, still dominates the entire site of Monte Alban. At the south-west corner of the main plaza, the temple of Group M is entered by a portico borne upon four cylindrical columns (Plate 62): similar two-column porches preceded the cellae of the lateral shrines on Mound H. Another design, as at Mound X, sets two masonry columns in a doorway, to emphasize its width while reducing the span.

Of the dwellings at Monte Alban, only foundations survive. They are chambered structures, surrounding square sunken courtyards like the patio assemblies of Teoti-huacán, with the difference that the Oaxaca dwellings are isolated quadrangles, while those of Teotihuacán are parts of larger systems. The largest at Monte Alban occupies Mound S on the east side of the main plaza, with more than a dozen rooms. Facing it across the plaza is the so-called Danzantes building, of eight small chambers round a courtyard. North-west of the plaza are more dwellings, containing underground tombs with painted walls with square courtyard structures above. These, like the mound over Tomb 105, consist of four main chambers, each projecting into the square courtyard sufficiently to define small corner courts (Figure 24). The four-chambered courtyard assemblages are probably earlier than the more elaborate quadrangle buildings (Mound S), which resemble the edifices of Mitla. Large monolithic lintels and jambs like those of Mitla, however, were used in the group of Tomb 105, so that no great interval of time need separate the latest edifices of Monte Alban from the Mitla quadrangles. As at Teotihuacán (Figure 5), substantial dwellings were first built during the last centuries of the Classic age, to continue as a tradition of domestic architecture in post-Classic times.

The appearance of the façades of Monte Alban is preserved in a few native models of stone. One of these represents a façade elevation (Plate 61A).[7] The platform and stair-way support a small temple chamber. Its front has a salient centre panel repeating the profiles of the main silhouette. These are the base moulding, the lintel cornice, a sloping talus, panelled frieze, and flaring cornice at the top. The scheme of talus and flaring cornice, separated by a panelled frieze, repeats the composition of the base platform. Every form serves to variegate and diversify the simple trabeated structure. On the site of the quadrangular structure on the Danzantes mound, the foundations of such an ornate façade have been cleared: it was evidently a shell encasing a plain older façade.

There is no clear evidence of panelled friezes in the earliest architecture at Monte Alban. The form began in the Early Classic era (Monte Alban IIIa) as a system for the decoration of pyramidal platform terraces. Before that period the earthen platforms were encased by flat slabs, incised with dancing figures (Plate 63, A and B). Mound J, with its reliefs of Monte Alban II date, is the most complete example. In Period III, the

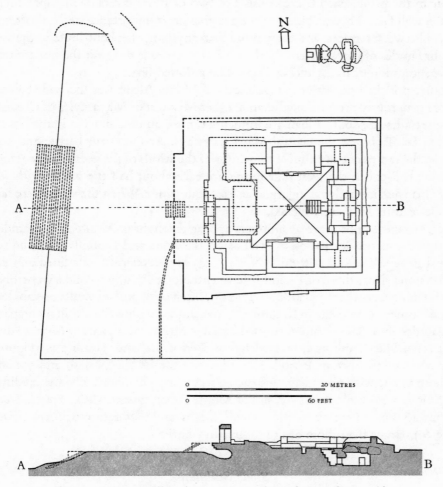

Figure 24. Monte Alban, house group and Tomb 105, after 600 (?).
Plans and section

group known as System IV, which closely resembles Group M in plan, may well be the earlier of the two 'amphitheatre' designs, because of the tentative and experimental character of the panelled friezes. In System IV the terraced platforms are horizontal accumulations, stressed by ample sloping aprons which overwhelm the unprepossessing panelled friezes. The stairways and the balustrades are so timidly proportioned that one is more aware of the angular massing of the platforms than of their directional organization. Group M (Plate 62), on almost the same plan as System IV, reverses the relationship

between horizontal and vertical stresses, by a most ingenious rephrasing of the panelled friezes. The frieze is treated as a brief horizontal measure, like a bracket, and the brackets are vertically tiered to stress the ascending lines in both the barrier and the proscenium pyramids.[8]

The panelled friezes themselves carry the eye upward by their profiles and by their contour in the plane. Each frieze consists of two or more layers of masonry built out from the wall face. These profile projections give great importance to the short vertical distances between terraces, and they, more than anything else, contribute to the vertical effect. In façades of extreme length, their effect in series is to break the horizontal by a *pointillé* succession of lights and shadows, like a dotted line.

Another principal device of the architects of Monte Alban was the wide balustrade, far more generously proportioned than in other Mexican or Maya styles of Classic date. The balustrades of Monte Alban are immense ramps, quite unlike the linear borders of Teotihuacán, Tajín, or the central Maya stairways. At the north barrier-mound, for example, the ramps occupy almost two-fifths of the width of the great stairway mound, and at the ball-court, the west stair ramps are each about half the width of the centre flight. This west mound was enlarged at least four times. When the stairs were lengthened, the balustrades were widened.

Underground tombs in great numbers appear throughout Monte Alban, under the main courts and smaller patios, as well as on the spurs and foothills surrounding the principal group. The oldest tombs (Nos 33, 43) are rectangular pits lined and roofed with flat stone slabs; those of Period II have entrance stairs and secondary chambers or niches forming a cruciform plan (Nos 77, 118), often with peaked vaults of slabs leaning upon each other. Monte Alban III tombs are the largest, with wall paintings and panelled frieze façades (No. 82). Tomb 7, re-used by later Mixtec occupants at Monte Alban, is of this type, like Tomb 104, erected late in Period III, and Tomb 105 (Figure 24). Under Mixtec influence in Periods IV and V are tombs like Nos 59 and 93, smaller than those of III, with tiny niches instead of secondary chambers. The main edifices of these periods were built, however, not at Monte Alban, but at Mitla, Yagul, Zaachila, and Lambityeco, where the underground tombs are elaborate cruciform structures (Figure 26), larger than those of the mountain centre.

Stone Sculpture

Four distinct styles of monumental sculpture have been discovered in Oaxaca.[9] The first includes the Danzantes slabs of Monte Alban and the slab reliefs at Dainzú, which belong to Periods I and II (Plate 63). The second comprises the incised 'triumphal' stelae of Monte Alban, corresponding to Period III (Plate 64A). The third class (Plate 64B) belongs to the Zapotec valley towns of central Oaxaca, such as Etla, Zaachila, and Tlacolula. The slabs represent a man and woman seated beneath a sky symbol: frequently a single enthroned figure is shown. This class probably relates to Periods IIIb and IV of the Monte Alban chronology. The fourth class is exemplified by a slab at Tilantongo, which represents a warrior named 'Five Death'. It corresponds to the style of the

Mixtec genealogical manuscripts, and it is usually dated after A.D. 1400 (Monte Alban V).

The Dainzú slabs originally revetted a terraced mound facing westward: they number about fifty and correspond to Period I of Monte Alban (*c.* 300 B.C.?). Masked humans and jaguar-headed humans appear. These have been called ball-players, but the stones in their hands, and their postures as fallen and reclining figures (Plate 63C), in relation to a standing victor shown in a relief at the top of the hill, suggest a battle by defeated challengers.

The Danzantes slabs[10] are named from the animated postures of the standing, floating, and seated figures, which are grooved upon the stone by abrasion with a rounded hand-axe (Plate 63). Within body contours, flesh portions are lightly modelled as swelling or concave surfaces. The buried position of the slabs at the south-east corner of Mound L, enlarged in Period III, and their association with modelled pottery decoration of Monte Alban I[11] are proof of antiquity. In all, forty-two slabs have been recovered, which lined the re-entrant angle between a pyramidal platform and the projecting face of its stairway. Caso has pointed to differences of style among slabs facing the pyramid, noting a variant group of extremely elongated figures, which he assigns to Period II.

A marked general difference of style between the slabs lining the pyramid and those of the stairway is more easily discerned. The pyramid figures (Plate 63A) are gross and large. The stairway slabs recall the animated elegance of the flying figures of Olmec reliefs. They point to a connexion with the commemorative slabs in the facing of Mound J (Plate 63B). There, heads of Olmec style appeared in characteristic clusters of signs, which consist of an inverted human head beneath a locative glyph of terraced profile, denoting a specific town, near a string of glyphs probably indicating the year, month, and day of a conquest. The inverted human heads probably refer to defeated tribes.

The glyphs of these early carvings resemble the Maya system of writing with cartouche frames and numerals formed of bars (fives) and dots (units). Both the glyphs and the numerals are too few to permit the complicated statements of Maya writing. In all likelihood the Monte Alban glyphs, like those of the later Mixtec, Toltec, and Aztec peoples, treat of only the simplest calendrical, personal, and historical facts, without venturing into the complicated astronomical cycles of Classic Maya inscriptions.

The stelae lack both the daemonic quality of the Danzantes slabs and the compositional harmony of Classic Maya reliefs. Classic Zapotec stone sculpture is certainly not abundant. The Zapotec carvers never again recovered the powerful line or the expressive control shown in the Danzantes figures. The formula is simple: upon a terraced place-name sign stands a dressed-up warrior or god-impersonator, surrounded by coarse glyphs of immense size, designating the date of the event and the name of the personage. The persistence of the glyphic formula of the conquest slabs on Mound J is apparent. In Stela 4, a warrior named Eight Deer stands nonchalantly on one foot with the postural freedom of the Danzantes figures (Plate 64A). The elaborate head-dress and the speech-scroll are related to the conventions of the art of Teotihuacán. Posture and costume are

doubtless of the same generation as the murals of Tombs 104 and 105 (Plates 66 and 67A). On a large flat incised onyx slab,[12] the resemblances to Teotihuacán murals are even more marked: a tiger-impersonator stands in profile; behind him is a priest in a costume. In general, this rather desiccated art of relief representation reflects a sumptuous life of religious pageantry. Processions in costume were probably the living sculpture which moved over the platforms and stairways of Monte Alban, dimly reflected in the captains and priests on the stelae.

Clay Sculpture

Much more powerful, both as sculptural expression and as a visual record of the ranks and orders of Classic Zapotec life, are the anthropomorphic vessels of fired clay which were part of the tomb furniture both at Monte Alban and in the valley towns, as well as on Mixteca Alta sites. Probably each region of the Classic Zapotec civilization supported distinctive local styles in the manufacture of funerary pottery. The fundamental types are numerous,[13] and their development from simple to complex forms must span about a thousand years, embracing both the Formative and Classic Zapotec eras.

Caso and Bernal have sought to relate them all to representations of the gods and to personifications of the deities of the 260-day calendar.[14] Their early sequence – Stage I (effigy vessels) correlated to the grooved Danzantes figures and Stage II containing early funerary urns – is marked by massive Gulf Coast, pre-Classic Maya, and Central American connexions in morphology and iconography. A Transitional period, following the Formative era and preceding the Classic Zapotec stages, was strongly affected by influences from Teotihuacán, which are evident in the sculptural vocabulary as well as in the system of 'written' signs. The fully developed range of Classic themes occupies Stages IIIa and IIIb. Monte Alban IIIa corresponds to the terminal period of residential occupation at the mountain citadel. In IIIb the site became a necropolis. The ceramic styles of these two periods are marked by increasing elaboration and complication of the simple fundamental stock of glyph-forms and god-types; and during IIIb, many valley towns, such as Etla or Zaachila, produced their own funerary wares. Several architectural decorations in plaster have been excavated at Lambityeco near Tlacolula: their forms resemble Classic pottery and stone lintels. They are assigned on evidence of six radiocarbon dates (A.D. 640±100–755±90) to Monte Alban IV.[15]

All local styles display from beginning to end the same succulent treatment of the clay. The Zapotec potters translated all forms into sheets, rolls, drops, and lattices of wet-carved details. No other American potters ever explored so completely the plastic conditions of wet clay, or retained its forms so completely after firing. The Zapotec never forced the clay or plaster to resemble stone or wood or metal; he used its wet and ductile nature for fundamental geometric modelling, and he cut the material, when half-dry, into smooth planes with sharp edges of an unmatched brilliance and suggestiveness of form.

These properties of Zapotec form were already evident in Monte Alban II pottery, and they persisted in Period III. Two examples will illustrate the tendency common to

both periods: the face urn (Plate 65A) from Monte Alban (Tomb 77), and a large effigy urn (Plate 65B) of Period IIIb which also displays a human figure encased in an imposing broad-billed bird helmet. The earlier example uses overlapping ochre and green plates of clay to construct a symbolic geometric frame of concave and convex planes for the powerful middle-aged portrait face within the helmet. In the late example, the sculptor spent more effort upon the head-dress and costume than upon the human subject. Close-set rhythms are prominent. The interplay of feathers, beads, olivella shells, knotted thongs, and jade ear-plugs, made in forms that respect the nature of clay, all while conveying the tactile identity of each original substance, dominates the composition. The early urn conveys a genuine human identity; the later one communicates only rank and status. One is reminded of the differences between pharaonic Middle Kingdom and New Empire portraits: between care-worn individuals and remote demi-gods smothered by regalia. A closer parallel is to the early and late figurines of Teotihuacán, where the same sequence holds from portraiture to ceremonial mannequins.

Wall Painting

The murals of Tombs 104 and 105 (Plates 66 and 67A) are painted with earth colours in a dry fresco technique upon a stucco ground. Both tombs belong to Period III, with processional scenes of figures in profile on both walls, leading symmetrically towards a large scene of heraldically regular composition spread across the rear wall. Tomb 104 is simpler and less slovenly. By parallels with the ceramic development, Tomb 104 probably antedates 105.[16] In Tomb 104, the glyph-forms and the vast head-dresses, stuffed and hung with attributes, dwarf the human figures, whose stunted proportions (head : height = 1 : 4) makes them into accessories to the panoply of day-signs, numerals, and god-masks. In the bodies, stunted limbs, arbitrary articulations, concavely curved profiles, and angular joints mark different stages in the loosening of the line. The figures of Tomb 105 are drowned among the complications of costume accessories. Beneath painted sky-frieze cornices, light figures of alternating sex, four on each wall, march in profile towards the end wall, where a glyph recording the day 'Thirteen Death' dominates the entire space. On this end wall, three successive layers of paint are visible. Each later coat enlarged the dimensions of the sky frieze, and the last coat substituted the huge heraldic day-sign for the singing figures of celebrants in costumes that filled this space in Tomb 104.

THE MIXTECS

Unique circumstances complicate the study of Mixtec art. The native genealogical records account for nine centuries of pre-Conquest history in southern Mexico, beginning c. 600. This astonishing pictorial chronicle is internally consistent and historically credible. The intricate narrative tells of the rise to power of a few families of highlanders in western Oaxaca. Their dynastic alliances and the wide conquests of their military leaders are the principal matter of these manuscripts. But the narrative lacks

confirmation either from other tribal sources, or from the archaeological record. The Aztec histories mention the Mixtecs only in connexion with the conquest of Oaxaca by the captains of Moctezuma I in 1461. Excavations in western Oaxaca yield sites and objects of Classic Zapotec style in the older strata.[17] More recent stages of Mixtec archaeology are Tombs 1 and 2 at Zaachila and the intrusive contents of Tomb 7 (Plates 73B and 74B) at Monte Alban. Tomb 1 at Zaachila contains modelled stucco wall-reliefs, including one of a man named Five Flower (Plate 75B), whom Caso identifies with the person of that name wearing the same costume in Codex Nuttall. Five Flower lived before A.D. 1269, and his rulership coincides with the local tradition that Mixtec rule at Zaachila began with a marriage before 1280. Five Flower's presence allows the tomb and its contents to be assigned to the later thirteenth century. Between the goldwork of Zaachila and Tomb 7 at Monte Alban, the resemblances are so close as to suggest manufacture by the same shop of artisans. If this is the case, Tomb 7 and the Mixtec occupation of Monte Alban may need redating, not in the fifteenth but in the thirteenth century.[18] Also of late date are the gold, jewellery, jades, turquoise mosaics, and brightly painted ceramics found in Mixteca sites and at Cholula, as well as on the East Coast, and as trade objects in Tenochtitlan. Both the manuscripts and these archaeological finds are currently ascribed to *c.* 1300–1500. The Classic Zapotec strata, on the other hand, antedate the eighth century A.D. We are therefore confronted with an archaeological void for Mixtec history, spanning six centuries, from before 700 until the fourteenth century. This is two thirds of the time so richly portrayed in the genealogical histories.

With what can we fill this void? Many have suspected that the buildings of Mitla, about 30 miles east of Monte Alban, are Mixtec constructions. The fragments of pottery in the walls are of Mixtec types; the burials beneath the floors contain Mixtec artifacts; the wall paintings (Figure 28) resemble Mixtec manuscripts; and a local tradition, first collected in 1580, holds that the 'palaces' of Mitla were then about 800 years old, i.e. of the eighth century. Similar courtyard buildings at Yagul, near Mitla, also contain Mixtec pottery fragments and burials. As we shall see, the architectural forms of Mitla and Yagul are sufficiently like those of the main plaza buildings of Monte Alban to allow the belief that they are not too far separated in time from Monte Alban.[19]

As a working guess, then, the art of Mitla and Yagul may be placed in a three-hundred-year period spanning the eighth and eleventh centuries, as an Early Mixtec style corresponding to the first and second dynasties of Mixtec princes recorded for Tilantongo in the genealogical manuscripts (p. 108). In this chronological position, the courtyard structures at Mitla (Plate 67B), with the mosaic stone panels on their façades, are coeval with analogous edifices in the Puuc district of Yucatán, at Uxmal (Plate 104), Kabah, and Zayil, as well as with the buildings of Xochicalco and Tajín Chico (Plate 51). It is a pre-Toltec and post-Classic horizon, like the fourth and terminal stage of Teotihuacán archaeology, after the abandonment of the pyramid site at Teotihuacán proper.

For the eleventh to fourteenth centuries, the gap is not easy to close. We can suppose that Toltec expansion had important consequences in Oaxaca, consequences for which we may search the pages of the Mixtec genealogies, since we lack any field archaeology

relating to these three centuries. Thus the manuscripts will be our chief evidence for the history of the art of the Toltec era in Oaxaca, as Mitla is the principal monument of the preceding three centuries. For the years after 1300, we have the polychrome pottery, the late manuscripts, and jewellery of late Mixtec style.

Mitla

This cluster of courtyard structures (Figure 25), strewn along the banks of a dry stream at irregular intervals, without striking varieties of level and without clear relationships among groups of buildings, is completely opposite to the grandiose design of Monte Alban, where every edifice adds to the unified effect of the total pageant-space. At Mitla the isolated edifices give the effect of suburban villas, jealous of their privacy, turning closed walls upon one another, walls which display wealth without inviting the spectator, without attempting to share a coherent space with the neighbouring edifices. The buildings of Mitla have in common only their excessive individuality and their cardinal orientation. They reflect a social organization and a conception of the public areas radically different from those of the Classic Zapotec theocracy.

For these reasons alone one is justified in ascribing them to a different ethnic group and to another period. The differences also extend to the materials. The quartzite blocks of Monte Alban (Plate 62) are irregular and difficult to shape, unlike the smooth-grained trachyte slabs of Mitla (Plate 67B). The plans are unrelated as well – there is no precedent at Monte Alban for the linked courtyards of residential buildings at Mitla – and the courtyard dwellings of Monte Alban (e.g. the house foundations above Tomb 105; Figure 24) resemble those of Teotihuacán more than Mitla.

The arrangement of the surfaces at Mitla nevertheless betrays close dependence upon the decorative system of the panelled friezes at Monte Alban. There can be no question that Mitla, however different in purpose and plan, continues the Classic Zapotec tradition of ornamentation. Another proof of relationship is the occurrence of cruciform tombs built beneath the groups of dwellings, and repeating in their decoration the motifs of the buildings above.[20] The Mitla tombs, to be sure, are more evolved; they are larger and more ornate than those of Monte Alban (Figure 26).

The chronological sequence at Mitla (Figure 25) is clear in its main outlines. The southernmost group of four mounds contains a tomb (No. 7) in the east platform; it is of Monte Alban III type, with slab walls and roof, and ceramics of the Classic Zapotec style.[21] The same open quadrangle of four platforms recurs in the westernmost group, which may therefore be of the same date as the south court. All other edifices belong to a later period, which we have here attempted to identify as before 900.

These later buildings form three groups, each composed of three quadrangles. They are all orientated upon the cardinal points, like the older courts. The smallest is the Arroyo Group, with large stone lintels, and it is the worst preserved. The northernmost group contains the colonial church of Mitla. The largest and most ornate quadrangle assembly is the central one, called the Group of the Columns, because of the cylindrical stone shafts that supported the flat roofs of the buildings lining the centre court.

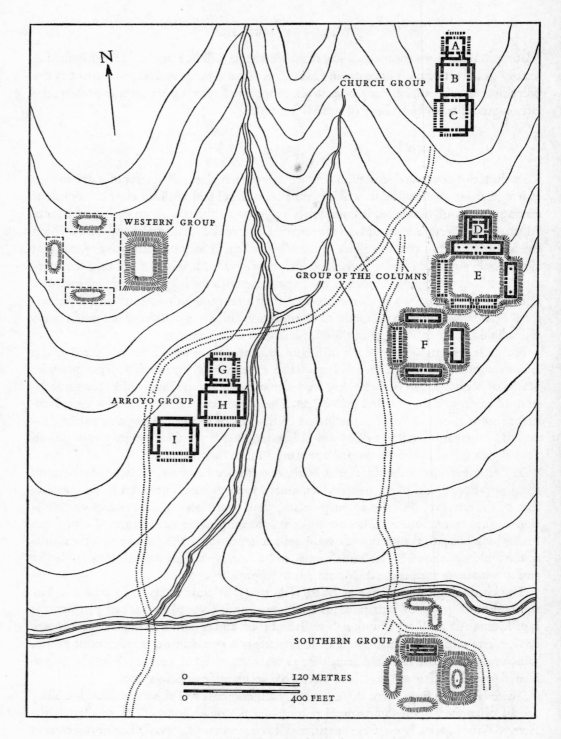

N

CHURCH GROUP

A

B

C

WESTERN GROUP

GROUP OF THE COLUMNS

D

E

F

G

H

ARROYO GROUP

I

SOUTHERN GROUP

0 120 METRES

0 400 FEET

Figure 25. Mitla. Plan as in the tenth century (?)

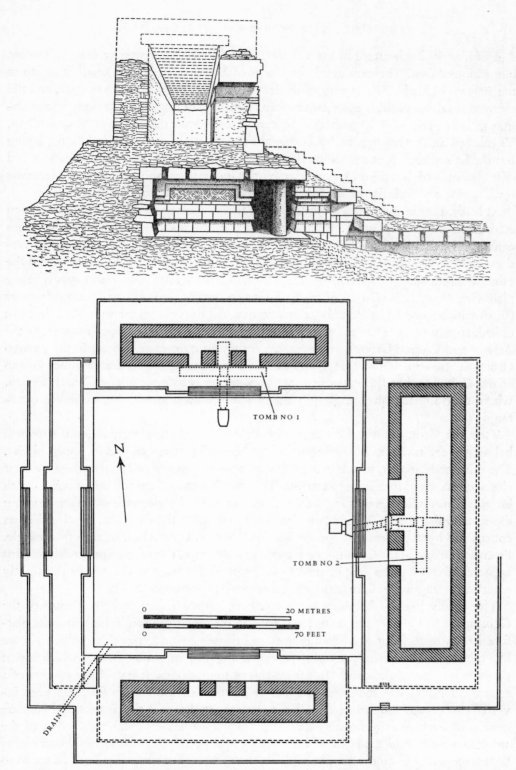

Figure 26. Mitla, Quadrangle F, tombs, before 900 (?). Section of north building and plan of court

TOMB NO 1

TOMB NO 2

N

0 20 METRES

0 70 FEET

DRAIN

A similar site has been studied at Yagul near Mitla.[22] Yagul, however, has a ball-court like Monte Alban. The quadrangle buildings of Yagul resemble the smallest group at the Arroyo in Mitla. The quality of the fret mosaics at Yagul is much coarser, and the excavations show possible progression from assemblies of large units to finer workmanship in later periods. A hypothetical sequence can be taken as follows: Monte Alban, Yagul, Mitla. The builders of Mitla would have inherited the finest technique, laying out the largest and most complicated courtyards, presumably near the end of a period of undetermined duration. The evidence is most incomplete, and a case can also be made for Yagul as a poor imitation of Mitla, like Mayapán in relation to Chichén Itza.

At Mitla, the chronological sequence of the three courtyard buildings has never been established beyond question. If, however, we distinguish loose organizations from ornate and difficult ones, and massive forms from their alternated and stereotyped versions, two stylistic phases emerge distinctly: one is the Group of the Columns, and the other includes both the Arroyo and the Church Groups. These differences appear in the plans (Figure 25). The Group of the Columns consists of two open-corner quadrangles (E, F) which draw together only at one corner. All the corners are suggested, but not closed, so that the eye has an escape from the court at each of the open corners. In the Arroyo and Church Groups, however, the courtyard corners are closed. In the Arroyo Group the two quadrangles (H, I) approached a meeting by the corners, as in the Group of the Columns, but this expansive interpenetration is forgone at the Church Group, where the southern quadrangle (C) shares one whole side with an adjoining quadrangle (B).

Thus the Group of the Columns with its eight separate pyramidal platforms still belongs to the tradition of ceremonial plaza design by means of massing open blocks. The other two groups, which lack platforms, suggest privacy and introversion by their closed corners and forbidding exteriors. That the designers were still unconcerned with interior commodity appears from the lack of connexion between the chambers framing the rectangular courts. Their main aim was to compose the exteriors, by closed inner courts, and by the re-entrant corners indenting the outer envelope of each quadrangle. From the Group of the Columns to the other two groups, therefore, a progression seems apparent, from clusters of pyramidal platforms of Monte Alban type, to the tightly planned rectangular buildings standing directly on the ground.

The family likeness between the mounds of Monte Alban and the Group of the Columns at Mitla reappears, as noted before, in the cruciform tombs built into the platforms (Figure 26). But at Mitla a new sense of space characterizes the tombs: they are like crossroads intersecting at right angles and lined by imposing façades which repeat the composition of the palace fronts on top of the mounds. It is as if the corners of a square enclosure, like the inner quadrangle of the Column Group (D), had been inverted, to become projecting instead of re-entrant angles; as if the corners of the square court had become outdoor corners rather than inside angles. This conversion of the space of a room into the space of intersecting corridors is embellished in the tombs of Quadrangle F with all the profiles and fret ornaments of exterior façades: one seems to stand among clustered building fronts in the underground chambers. In the ritual manu-

Figure 27. Mitla, façade mosaics, typical forms, 800–1000 (?)

scripts (e.g. Codex Laud, etc.) such a form is common, with footsteps painted in each arm of the cruciform plan. The Náhuatl name of the form is *otlamaxac*, signifying the crossroads, where Tezcatlipoca and other night gods made their appearances as magicians. A Maya parallel occurs in the small cruciform vaults beneath certain Late Classic stelae at Copán, lined with stone slabs and filled with votive offerings.[23]

The fretted decorations of the walls of Mitla (Figure 27) reinforce our division into early and late groups. In the quadrangles of the Group of the Columns, the façades were completely revetted with registers of panelled friezes containing mosaics of fret ornaments, sheltered by projecting mouldings. In the Church Group, only the cornice zones were thus enriched, with frets in diagonal composition, of a much more mechanical quality of execution. The recessed overdoor lintels (Figure 28) in both Arroyo and Church Groups, moreover, are painted with scenes like those of the Mixtec ritual manuscripts: the placing and the style of the paintings strongly confirm the impression of a date later than the Group of the Columns, where there is no trace of such pictorial decoration.

The outer façades of the Group of the Columns (Plate 67B) display one important refinement, lacking in the other buildings: the vertical profiles at the ends of the long horizontal blocks are cut to lean outward. This 'negative batter' also characterizes many post-Classic buildings in Yucatán, especially at Uxmal, but it was never used with more subtlety and grace than at Mitla. The profile slopes inward at the base of the wall: above this constriction the upper three panelled friezes lean out, each overhanging the one beneath it by several inches. This visual correction not only restores the authority of the vertical lines in the long and low block, but also allows light reflected from ground level to bathe the wall from below. In addition, the mosaic panels are protected from weather, both by the overhang and by the protuberant mouldings.

The fret decoration is of two kinds. Some were carved in relief on immense slabs of stone, as upon certain lintels and in parts of the cruciform tombs. Others were assembled like mosaics from small shaped elements set in clay. Nothing suggests that these techniques belong to different periods; the shaping of very large and very small stones flourished together. Some striking differences in theme and composition may mark early and late buildings: for example, the friezes of the Church Group present only diagonally fitted key fret bands of a dry and monotonous execution, which, taken together with other indications, seem to be late in the development of the style. Bits of colour still adhering to the protected surfaces show red and pink tones laid upon a priming of cream or white.

Some 150 panels of mosaic and carving survive (Figure 27), drawing upon a vocabulary of eight typical forms, all elaborated upon primary key fret and spiral fret patterns.[24] The key forms are reversing (I), stepped (II), rinceau (III), serrated (IV), and meander (VII); the spiral frets (VI) are all of meander type. Diamond forms (V) occasionally combine with key motifs (VIII). Key frets and spiral frets are contemporary, because of their close association on the walls of the Group of the Columns. The tilted key frets (I) at the Church Group look late, possibly as dynamic variations upon the more static serrated key (IV), which is one of the most common forms at the Group of the Columns.

The meaning of these beautifully fashioned panels of fretted decoration is lost. In the genealogical and ritual manuscripts, such fretted patterns often designate towns or temples. Thus a frieze of stepped terraces, painted black and white, means the town of Tilantongo in the genealogies.[25] It is not unlikely that each of the frieze types had a geographical meaning, referring to the different Mixtec principalities. If so, their combination on the walls of the Group of the Columns may have distinguished the building as a symbol of the Mixtec people.[26]

The Marriage Reliefs

Figural sculpture which can be assigned to the period of the buildings at Mitla does not come from Mitla, but from the other valley towns, and the date is problematic. These relief slabs, which represent seated couples (Plate 64B), resemble the subject matter of the Mixtec genealogical manuscripts of the sixteenth century, but their glyph-forms and several conventions of figural representation relate to the Classic Zapotec style of the type of the murals in Tombs 104 and 105 at Monte Alban (Plates 66 and 67A). The recurrent scheme of the marriage reliefs shows two couples seated facing each other in upper and lower panels.[27] Above the upper couple a sky symbol of doubled serpent jaws, like those painted in the tombs of Monte Alban, disgorges a head, or hands bearing jewels. The name-glyphs are calendrical, in the Classic Zapotec system of bar-dot numerals and day signs; all other glyphs are also Zapotec. The terraced place-name signs in the lower register resemble those of the Zapotec stelae. But the postures and costumes of the seated figures, especially the women's, are those of the Mixtec genealogies.

The entire compositional scheme and the subject matter are paralleled only in Mixtec manuscripts. Codex Zouche (or Nuttall), a deerhide painting of the sixteenth century, records the same arrangement of a couple, presumably the dynastic founders, seated above another couple shown as the legitimate descendants and rulers (Plate 68). This interpretation is reinforced by certain variants in the marriage reliefs: for instance, on the circular stone from Ciénaga near Zimatlan, only one couple is shown enthroned. Above them are two skeletal figures with name-glyphs, hovering as ancestors below the sky symbol from which the symbols of secular rule emerge. Another relief reduces the ancestral couple to heads shown behind the reigning pair. Another group of related reliefs shows single enthroned figures, dressed as in the marriage reliefs, and wearing serpent-mask head-dresses. Thus the forms are Zapotec, but the content is Mixtec, in a mode that parallels the mixture of themes and forms in the architecture of Mitla.

Murals

The lintels in the courtyards of the Arroyo and Church Groups at Mitla are painted with small scenes in manuscript style (Figure 28).[28] Although they are almost certainly pre-Conquest, the pictorial conventions and the iconography of solar themes cannot be earlier than the Toltec age. They are usually assumed to be of Aztec date, that is, after

1450, when Oaxaca was subjected to garrison rule by armies from the Valley of Mexico. This assumption is difficult to prove, for many traits, like the year-signs of interlaced A and O forms, are specifically Mixtec, reappearing in the jewellery of Tomb 7 at Monte Alban and in the Mixtec genealogical manuscripts and polychrome pottery. For the present, the date can be fixed only between the eleventh and sixteenth centuries, and the mural decoration regarded as added to older buildings.

The technique is simple: over a grey plaster film, the outlines are painted in red pigment, upon recessed lintel-panels which were designed and cut to protect the pictures from weathering. Several different hands are evident, a calligraphic style of ornate outlines and richly textured surfaces appearing on the east side of the Church Court (Figure 28B), a much coarser and more hurried style of simpler and fewer forms and hasty draughtsmanship adorning the Arroyo Court (Figure 28A), and, in the remaining pictures on the north, west, and south sides of the Church Court (Figure 28, C and D), a style between the finish of the first hand and the rapidity of the second, with a tendency to turn each part of a body into a distinct ornamental figure of extremely conventional character. In this last, large group, several hands are evident. To assign any chronological order is at present impossible, on account of the fragmentary condition of the murals and the general ruin of the buildings. Most nearly Aztec in style and content are the paintings on the west side of the Church Court (Figure 28D), which may be com-

Figure 28. Mitla, paintings on lintels in Arroyo and Church Groups, after 1000.
(A) Arroyo north; (B) Church east; (C) Church north; (D) Church west

pared with the sixteenth-century mural at Malinalco in central Mexico (Plate 34A). In both, huntsmen armed with throwing-sticks, and wearing the face paint of the hunting god, Mixcoatl, appear in processional order. Most closely related to Mixtec manuscripts are the paintings of the east side of the Church Court (Figure 28B). They invite comparison with such manuscripts as Codex Colombino-Becker (Plate 70B).

The Mitla painter uses an interesting convention. From the sky band of the upper border, profile heads look down upon the scenes below, each flanked by a pair of hands, pushing down the darkness of the backgrounds. This theme relates to the principal scene on the north side of the Arroyo Court (Figure 28A): the sun-disk here appears centrally, as if rising between terraced ball-court platforms. Here, too, the sky figures push down the darkness. Star-studded ropes from the sun are handled by figures who emerge from the sky band; they perhaps are raising the sun. Elsewhere, sleeping figures are shown in the Arroyo Court, which was perhaps dedicated to the theme of the rising sun. The dawn theme is repeated once more in the sky band on the east side of the Church Court (Figure 28B). The north side (Figure 28C) relates to day-time events, the west side probably to nocturnal scenes beneath a canopy of stars (Figure 28D).

Painted Books and Maps

The manuscripts of southern Mexico usually pertain to Mixtec towns and to Mixtec rituals.[29] One group consists of deerhide screenfolds. Another group, of post-Conquest date, is painted on large sheets of cloth or on European paper. The cloths are called *lienzos*; the paper records *mapas*. The screenfolds, also misnamed 'codices',[30] have the advantage, as pleated narrative ribbons, of allowing one to open the book at several places simultaneously, and to consult front and back together (by twisting the opened ribbon). According to a seventeenth-century Dominican chronicler, the screenfolds were hung as wall ornaments around the dwellings of the lords.[31] The soft deerhide strips, sewn or glued together, sized with a chalky varnish, and then painted, have retained much of their brilliance, even though the panels tend to flake at the borders. The pages usually divide into bands, which are read in a meander-pattern.

The books from southern Mexico share many other conventions: the numeration is usually by dots alone, without the bars signifying five; the day signs of the calendar are the same as those of the twenty Aztec days; and the sign for the solar year of 365 days is an interlacing A and O cipher. The deities all resemble those of the central Mexican pantheon in Aztec sources. The genealogical conventions also resemble those of the Aztec genealogies, such as Codex Xolotl.[32] Indeed, the pictorial writing of the Aztecs is credited in Codex Xolotl to the Tlailotlacs (Plate 20A), a Náhua-speaking band emigrating to Oaxaca, learning these and other arts there, and returning to the Valley of Mexico about 1300. Thus a Texcocan source (p. 65) supports the general indebtedness of late Mexican civilization to the Mixtec peoples of the post-Classic era, although the Aztec histories themselves give little account of the debt, which we can reconstruct only by indirect means.

Caso's reconstruction of the Mixtec genealogical record is based upon a land-map of 1580 portraying the Mixtec district of Teozacualco in Oaxaca, together with a list of all its rulers, and their predecessors at nearby Tilantongo, for eight hundred years. It is arranged in columns of couples, seated upon mats and named by ideographic signs. These couples all recur in the genealogical manuscripts on deerhide, where many further particulars are supplied. Caso has fitted the various accounts together in the following reconstruction of Mixtec dynastic history as recorded for Tilantongo.[33] The dynasties reflect the principal ruptures and crises of Middle American archaeological history.

Pre-dynastic	*c.* 600–*c.* 855	Late Classic (Mitla)
1st dynasty	855–992	
2nd dynasty	992–1289	Toltec
3rd dynasty	1289–*c.* 1375	Chichimec
4th dynasty	1375–1580	Aztec and Conquest

The first two periods correspond to the era we have assumed for the buildings of Mitla. The second dynasty was coeval with Toltec domination in central Mexico and northern Yucatán. The third dynasty corresponds to the Chichimec period, and the fourth to Aztec hegemony.

The dates of the various manuscripts can be deduced from their genealogical content. The front of the Vienna screenfold (Plate 69A), completely painted in fifty-two panels, is ostensibly earlier than the reverse. The front deals both with mythical and with historical genealogies, as well as with ritual matters, such as New Fire ceremonies. The reverse is incomplete (Plate 69B), covering only thirteen panels and breaking off abruptly with a generation alive in 1350. The Zouche–Nuttall screenfold (Plate 68) likewise terminates with the generation alive in 1350, and ruling at Teozacualco. It includes different styles of drawing which possibly reflect a lapse of time in composition. Thus the Vienna and Zouche–Nuttall screenfolds can be tentatively ascribed to a period before 1350.

The second group is much later, including the Bodley and Selden screenfolds in Oxford. Both carry the genealogical account into post-Conquest times. Most of the Bodley narrative (Plate 70A), like the back of the Vienna manuscript, concerns the dynasty of Tilantongo. The Selden screenfold treats mainly of an unidentified town pictured as a smoking mouth, and ruled by a family intermarrying with those of Tilantongo and Teozacualco.[34] These screenfolds break off about 1550, but their narrative is continued and amplified in other native colonial documents, especially the genealogies of the type of the Teozacualco map, such as the Lienzo de Zacatepeque and the Rickards map, both on cloth.[35]

If we now consider style, other possibilities of grouping arise. The front and the back of the Vienna manuscript are very different. The front is almost mechanical in the regularity of the line, the clarity of colour, and the orthogonal rigour of the projections of round bodies upon the flat plane (Plate 69A). The back is executed with a scratchy line, muddy colour, and unkempt contours (Plate 69B). The contrast between the two

sides seems to be not only the contrast between cultivated and cursive forms and between careful and hasty execution, but also between widely separated historical stages in the development of a graphic style. By this criterion, the reverse of the Vienna manuscript may be regarded as a late recension of early subject matter.

In the Zouche–Nuttall manuscript, the front and back sides likewise display differences of execution, though less pronounced than in the Vienna deerhide. The front, which treats of early genealogies in rapid succession on pages 1–41, changes at page 42 to a more open and spacious composition, in a brighter range of colours, with bigger shapes and more detailed sequences of narration (Plate 70A) relating the life of the eleventh-century conqueror known as Eight Deer and Tiger Claw.[36]

Thus one is tempted to postulate early (pre-1350) and late (sixteenth-century) styles, characterized by prolixity and redundancy in the early group, and by compact, swift narrative conventions in the late group. The styles are further differentiated by the ample linear descriptions and brilliant colour of the early group, in contrast to the stenographic linear character and narrow colour range of the late group. With this in mind, we may assign the manuscripts known as Codex Colombino (Plate 70B) and Codex Becker,[37] which bear upon the eleventh-century portions of Mixtec history, to the early group, because of their broad and prolix narrative as well as the high colour and ornate linear precision of the figural descriptions.

The south Mexican ritual manuscripts [38] include the Borgia (Plate 71B), the Vaticanus B, Cospi-Bologna, Féjerváry-Mayer (Plate 71A), and the Laud screenfolds. These screenfolds are made of deerhide. Their graphic conventions as well as their figural vocabularies resemble the Mixtec genealogical group closely enough [39] to warrant discussion at this point, although the question of their individual geographic origins is unsolved. Seler thought they came from the region between Tehuacán and Oaxaca. Others relate them to Cholula polychrome pottery, which was prized in all provinces of Aztec Mexico and which may have originated in western Oaxaca.[40]

Two sub-groups are clearly marked. Borgia, Cospi, and Vaticanus B belong together in content and in style. Féjerváry and Laud both contain bar numerals, and their graphic style has qualities of elegance and precision missing in the more redundant, angular, and squat figures of the Borgia group. Féjerváry and Laud are drawn as if with fine metal wire bent and shaped to surround the figures. There is little description of textures, whereas in the Borgia group many kinds of hatching and striping reinforce the colour distinctions. In the Féjerváry–Laud group, the scheme of the Five World Regions (Plate 71A) in the form of a Maltese cross (Féjerváry 1; Laud 43) closely parallels a cruciform arrangement of the 260 days of the ritual calendar in the Maya post-Classic manuscript called Troano-Cortesianus (Codex Madrid). Féjerváry and Laud are probably older than the Borgia group, as demonstrated by such affinities with Maya and Classic Zapotec figural or arithmetical conventions.[41] The close resemblances between the Borgia group and Aztec manuscripts, like Borbonicus, Vaticanus A, and Telleriano-Remensis, in the strips showing the twenty weeks,[42] relate them to the fifteenth-century art of central Mexico. But Féjerváry and Laud belong to an older stage of history, coeval with the earlier genealogies as to types, if not as to execution and style. We thus arrive

at the following provisional arrangement for the chronology of south Mexican pictorial sources: [43]

	RITUAL BOOKS	GENEALOGIES
Pre-1350	Laud	Vienna front (Plate 69A), Zouche–Nuttall (Plate 68)
	Féjerváry-Mayer (Plate 71A)	Colombino–Becker (Plate 70B)
Post-1350	Borgia (Plate 71B), Cospi,	Bodley (Plate 70A), Selden, Vienna back (Plate 69B)
	Vaticanus B	

The content of the ritual books is double: as cosmogonic illustrations, and as augural schemes. The powers of the gods and the rhythm of their influences upon human affairs are illustrated by images using a few fundamental motifs in many combinations. The screenfold strips are cyclical, either as radial panels or as sequences of panels. Both forms enumerate the divisions of recurrent time-periods, and illustrate the changing regencies of each division. The principal time periods are the 20 day-names, the augural year of 260 days (with 20 weeks of 13 days), the solar year (18 months of 20 days and a 19th month of 5 days), and the Venus year of 584 days (Plate 71B). Their cyclical coincidences are marked. Their divisions and combinations refer to space by the symbolism of the cardinal points. A change of direction accompanies each change of regency, so that the passage from one quarter of the year to the next occurs under new regencies, and in another direction, symbolized by colours, and by god-, tree-, and bird-forms appropriate to the space–time combinations of the moment. As Soustelle remarks, every place-moment is represented by a cluster or hive of hierarchically ordered images of cosmic import.[44] Their endless permutation gave priestly auguries for the main events of public and private life.

Plate 71A shows a scheme symbolic of the calendar, with which the Féjerváry manuscript opens. The trapezoidal arms of a Maltese cross alternate with elongated loops in a figure reminiscent of the Maya glyph for the Zero of completion. Its outline contains 260 positions in anti-clockwise movement, punctuated at every change of direction, and at intervals of thirteen positions, by the initial day-signs of the twenty weeks of the ritual calendar. Large cartouches at the corners contain the four year-bearer days of the solar year sequence. Each trapezoidal panel contains two deities flanking a tree symbolic of that direction. The east is at the top. The central deity completes the cycle of the nine Lords of the Night. Their rotating regencies combine with those of the days, weeks, months, year divisions, and years to compose the peculiar properties of each and every moment of time.

Another cycle, based upon the planet Venus, comprises 584 days. Its combination with the ritual calendar of 260 days is implicit in many cyclical schemes, especially in tables stressing every fifth sign or presenting the ritual calendar by columns of five days.[45] Thus Plate 71B, from the Borgia manuscript, sets forth one figure spearing another, in five variants surrounded by numbered day-signs. The day-signs are only 5 in number, each with 13 coefficients, marking the 65 Venus-year bearers, which corresponds to 104 solar years and 146 ritual years ($65 \times 584 = 104 \times 365 = 146 \times 260$). The page commemorates the remarkable cyclical combination of these large numbers.

Ceramics

Mixtec pottery has not yet received the minute analysis that characterizes the study of Maya, central Mexican, or East Coast ceramic types. Paddock, however, identified a style he called Ñuiñe (Mixtec for Hot Land) in the upper Balsas River valley, between Acatlán (southern Puebla), Huajuapan (western Oaxaca), and the Guerrero border. Its elements are Thin Orange pottery, figurine heads lacking bodies, and distinctive clay urns portraying wrinkled old men. Ñuiñe art began perhaps before 500, and continued until the rise of Tula, as a predecessor of Mixteca-Puebla style. An example is the Huajuapan urn (Plate 73A) which shares characteristics both of Teotihuacán and Monte Alban urns. At Yagul the tomb pottery of post-Classic date is orange-red ware with blackish graphite decoration. Among the shapes were an effigy jar, tripod censers with walls perforated in a geometric frieze decoration, pitchers, and a doughnut-shaped vase.[46] These shapes reappear in the polychrome vessels (Plate 72A), painted with scenes and motifs almost identical with those of the deerhide ritual manuscripts. These types of polychrome vessels were widely distributed throughout Middle America[47] from the Atlantic to the Pacific coastal provinces, and from Sinaloa into Nicaragua and Costa Rica. The connexion among them all can be established by the vessel forms and by their iconography. The finest is Mixtec by subject-matter, although its manufacture is commonly ascribed to the vicinity of Cholula in the state of Puebla, and its date is commonly taken as Aztec.[48]

Noguera distinguishes three varieties of polychrome pottery at Cholula – lacquered, matt, and hard-fired (*laca, mate, firme*) – which occur in chronological sequence as early, middle, and late, evolving from a stuccoed prototype whose decoration was applied after firing, like that of Teotihuacán and Kaminaljuyú.[49] The stuccoed decoration was of Classic date; the lacquered, matt, and hard-fired varieties are post-Classic and of undetermined durations. The lacquered wares, painted after firing, were polished and then fired anew. The colours were applied upon a white ground of gesso-like consistency, which flakes away with light wear or pressure. Mixtec examples of lacquered polychrome pottery (Plate 72A) are easily distinguished from the Cholula versions by their more elongated legs, by the clear articulation of the flaring rims, and by the draughtsmanship, which is larger and freer than in the Cholula examples, and better adapted to rhythmic decoration of the bowl-shape.

Mixtec sculpture survives mainly in wood-carvings, bone reliefs, turquoise mosaic masks and instruments, and other lapidary works.[50] Mixtec jades are stereotyped productions, with anatomical features reduced to the simplest shorthand of straight saw-cuts and tubular drill marks. In the wood and bone carvings, the manuscript style of conventional figures and calendrical inscriptions is as dominant as in polychrome pottery painting, so that one can properly characterize all Mixtec figural art as derivative from the workshops of the manuscript illuminators.

A two-tongued cylindrical wooden drum (*teponaztli*) in the British Museum is carved in low relief, recounting a battle between two towns in the year Three Flint (Figure 29).

Figure 29. Wooden drum, Mixtec style, fourteenth century (?). *London, British Museum*

The carving, in only two planes, is more linear than sculptural, the frontal plane being incised with conventional contours and textures. The carved jaguar bones from Tomb 7 at Monte Alban and the gilded wooden throwing-sticks in Florence (National Museum of Anthropology and Ethnology) show a similar transposition of drawings into low relief carving.

Mosaic decoration of turquoise chips glued to a wooden support is of post-Classic date in both highland Mexico and Yucatán.[51] Toltec and Mixtec techniques differ in the shaping of the tiny chips. Examples of Toltec date (e.g. the plaque from the Chacmool temple at Chichén Itza) have straight-sided polygonal chips ground to a flat plane.[52] Examples of Mixtec origin resemble pebbly sharkskin (Plate 72B). This texture is given by the use of curvilinear and convex chips, surrounding figural designs in large pieces cut to the desired outlines, as in the seventeen specimens found in a Mixteca cave in the state of Puebla.[53] Seven of these may be the work of one hand, in light and dark turquoise chips, surrounding brown and black stones, and bits of red shell. Of the same technique, and showing scenes of manuscript style, are shields in New York (Museum of the American Indian), Vienna (Naturhistorisches Museum), and London (British Museum).[54]

Metallurgy appeared late in Middle America. The earliest known example is of *tumbaga*, dated *c.* A.D. 500, occurring as an import from the Coclé region of Panamá at Altun Ha in the Maya area. The Toltecs of Tula and Chichén Itza produced metal objects in important quantities, from the tenth to the thirteenth centuries.[55] It is generally supposed that the Mixtec metal-workers learned the craft and developed their art only after the disintegration of Toltec civilization, that is, from about 1300 on. The most important discoveries of Mixtec metal are the treasures of Tomb 1 at Zaachila and Tomb 7 at Monte Alban.[56] *Cire perdue* castings, filigree objects, repoussé technique, alloying, plating, and soldering all appear. Their association with carved bones, of a figural style like that of the genealogical manuscripts, supports a fourteenth-century dating. The representation, however, of gold ornaments in the pre-1350 group of manuscripts (e.g. Vienna 47c–48a, showing gold or copper bells on the dog-headed acolytes) suggests that the Mixtecs were also metal-workers at an earlier date.

The shape of several metal objects in Tomb 7 reflects Central American connexions. For instance, the gold breast-pendants of Plates 73B and 74A represent a skeletal figure and a sun-disk as open-mould castings, rising from two broad flanges which stabilize the heavy ornament in a flat position on the chest of the wearer. This form of pendant is Panamanian.[57] Another gold ornament from Tomb 7 is hinged together (Plate 74B) of sixteen cast elements in six stages: at the top is a ball-court with two players. Hanging below are a sun disk, then a fiery flint, and an earth monster with bell pendants. The whole assembly probably pertains to the ball game as a symbol of the diurnal passages of the sun.

WESTERN MEXICO

THE hundredth meridian, or a line drawn north and south near Toluca, divides ancient Mexico into an eastern half, of high civilizations in densely populated regions, and a western half, of scattered, small, and isolated tribal groupings, whose archaeological history has been recovered only in the last twenty years. In the main, this western history comprises four principal stages: (1) an early era of Olmec style which endured many centuries in Guerrero, with sporadic manifestations farther west; (2) a middle period when many traits of a village art in the style of the Formative period were amplified in the funeral pottery of Colima, Jalisco, and Nayarit; (3) post-Classic intrusions of Toltec and Mixtec ceremonial forms in Michoacán and in the pottery of Sinaloa on the north-west coast; and finally, (4) coeval with the state which resulted from the Aztec conquest, the Tarasca civilization centring upon the lake district of Michoacán.

Save in Guerrero, all these western styles of art were of recent origin, not antedating Teotihuacán III. In Guerrero, the lithic industries seem more abundant than in the rest of western Mexico, where pottery products carry the record, almost to the exclusion of stone. The recent discovery of a veristic figurine style at Xochipala (Plate 75A), with Olmec aspects, but perhaps antedating the earliest Olmec expressions, has revived the possibility that an early highland cultural expression was antecedent to Olmec art. Firm dates and excavation data still are lacking, but authenticity may be claimed for one piece collected in 1896 by W. Niven. Thus Guerrero alone is rich in stone manufactures. In other western regions, the artifacts are predominantly ceramic in character. Guerrero belongs together with Olmec, Maya, and central Mexican art; the regions to the north and the west of it belong to another order of civilization which perpetuated early village art rather than the styles of the great ceremonial centres.[1]

THE STONE-WORKERS OF GUERRERO

South-west of Mexico City lie Tasco and Iguala, on the highway which crosses an ancient archaeological province. This province centres upon the middle course of the Mezcala river. The mining area of Sultepec marks its north-west boundary; Zumpango del Río and Chilapa define its south-eastern limit. Stone objects in great numbers come from the region without specific provenience, casually or illegally excavated and marketed.[2] One class is of Olmec style; another reflects Teotihuacán influence in the area; still another group of small face panels of stone is related to post-Classic funeral customs. Diminutive temple models (Plate 76A) are not uncommon, representing colonnaded façades, some with staircases and human figures, and others as full models with columns at the corners. Gay assigns them to the middle range of Mezcala time,

c. 100 B.C.–A.D. 100. They may reflect pilgrimages to Monte Alban and related sites in Oaxaca in the central valleys.

Many hand-axes are carved to resemble standing human figures looking like insects. This raises a crucial question concerning the origins of stone sculpture.[3] To present knowledge, the Olmec style is the oldest dated style of stonework in Mexico. As suggested earlier (p. 71), the Olmec instrumental forms, such as hand-axes, are perhaps earlier than the free-standing figurines which lack any obvious instrumental function. The Olmec axes frequently occur in the Guerrero-Puebla region, and their material – sea-green and blue-grey jade – is typical of the Mezcala river basin, especially in the southern portion around Zumpango del Río. A case can be made for great antiquity in the Guerrero hand-axes, both because of their abundance, and because of the primeval character of their workmanship, which reduces the human figure to the simplest number of fundamental planes. Covarrubias believed that these axes from Guerrero were derived from Olmec types; they differ greatly, however, from Olmec as well as Teotihuacán styles of lapidary work.

The Mezcala axes (Plate 76B) are utilitarian rather than ceremonial, usually between 4 and 8 inches long, with cutting edges, both at the feet and head, often heavily worn and scarred. The articulation by head, torso, and legs is intended for grasping. All the profiles and cuts betray economical design, to secure the most expressive and utilitarian form with the least expenditure of energy upon the cutting of the stone. The heads are usually cut in three planes: one curving plane for the forehead, and two planes beneath it, meeting at an obtuse angle to define the nose and eye hollows. The mouth and neck are rounded cuts. The legs are claw-hammer or chisel shapes, intended to strip flesh from bones or bark from branches. Even if their eventual dating should support Covarrubias's contention that they are derivative, the Mezcala axes will still afford the clearest demonstration of the basic system of the Stone Age lapidaries of Mexico. Geometric analysis recurs both in Olmec and in Teotihuacán types of jade-cutting, and it produces in other styles as well that abstract nobility of generalized expression so reminiscent of the early ages of Mediterranean sculpture.

The Olmec and Teotihuacán types in Guerrero have been discussed elsewhere (pp. 67 and 34) and in other connexions: here it is necessary only to mark Guerrero as a lapidary centre during both pre-Classic and Classic eras, in the production of hand-axes in the Olmec style, and of stone figurines in the Teotihuacán style, noting that both are rare at their respective type-sites. Covarrubias has rightly insisted upon such hyphenated designations as Olmec–Guerrero and Teotihuacán–Guerrero, in discussing such pieces.

Covarrubias has also identified another style of small stone figures and face panels, which he assigns to the Mezcala river valley. They have in common a rectangular mode of cutting, which leaves a T-shaped ridge to define nose and eyes, island-like cheek areas, and thick-rimmed oval mouths (Plate 76C). Their date is probably post-Classic. Some examples have perforated eyes and mouths, suggesting their use as masks by living wearers.[4]

From farther north, between Tasco and Sultepec (the Chontal district), come still

other stylized head-forms with immense noses projecting like sails from boat-shaped faces. One example in the Diego Rivera Collection is laterally compressed like an East Coast *hacha*; the chin and nose are almost equivalent, so that the profile reads equally well whichever way up the piece is held.[5]

THE POTTERS OF COLIMA, JALISCO, AND NAYARIT

The immense and variegated landscapes of western Mexico have been under intense archaeological study for over thirty years, but Isabel Kelly, the foremost student of the ceramic provinces between Colima and Sinaloa, has spoken of her suggestions as 'largely impressionistic'.[6] The Nayarit–Colima zone shows early occupation only at the time of Teotihuacán III, which is the period of manufacture of the large pottery tomb figures now scattered throughout the museums and private collections of the entire western world. Illegal excavation for commercial purposes has so long been the rule that an exact report on architectural form is available on few sites.[7] One plundered tomb is near Etzatlán in Jalisco. Three underground chambers, connected by tunnels and entered by a vertical shaft, were dug in the dense soil during the Classic period (A.D. 200–300). In the process, vault-like roofs with groined intersections were carved in the earth. These chambers resemble the shafted tombs of the upper Cauca river in Colombia (Figure 82).

The contents of the burials of the region cannot now be re-assembled,[8] although it is supposed that the custom of building large underground tombs was restricted to the Ortices phase (equivalent to Teotihuacán III: Kelly) and that the large hollow red-ware figures and small, solid figurines in action were of the same era throughout the region from Nayarit and western Jalisco into Colima. Miss Kelly did not venture any further distinctions among the figural types in the absence of all associations with graves, but it is evident that several generations of connected sculptural efforts are present, and that a simple typological seriation by technique, modelling, texture, and action can be attempted, with a good chance that the seriation will correspond to sequence in time.[9] The attempt is made more difficult by the likelihood that many local schools of potters are represented in the collections. Ixtlán, Ameca–Zacualco, and Colima made probably only a small part of the huge production we know today.

Many pieces, nevertheless, share a predilection for the representation of figures in action, shown at an instantly recognizable moment of some kind of energetic behaviour. In Colima and Jalisco individual figurines appear in poses of lifeless frontality, but these are perhaps characteristic only of the early period of the craft and of a certain iconographic type. The eyes are rendered by pellets of coffee-bean shape. Organic forms and costume ornaments appear as added fillets or pats of clay. The groups in action consist of two or more figures with coffee-bean eyes circling around seated musicians, to indicate a dance (Plate 77A), or as a gathering of several figures to mark a household or temple ritual. Lovers are shown, and maternity groups, as well as acrobats, persons borne on litters, and warriors in aggressive posture.[10]

In another group of Colima figures, the coffee-bean eyes are replaced by puffy, slit

eyes, giving a somnolent look.[11] The proportions of the parts of the body are governed by a conception of the total movement to be shown. If great dignity and reserve are to be portrayed, the arms are stiff and rod-like and the back is rigid. If, however, dancers or musicians are shown, all the forms of the body undulate in interlacing rhythms. The puffy-eyed Colima figures probably followed the coffee-bean eyes, and in turn may have been replaced by the anatomically accurate modelling of spherical eyeballs on hollow red-ware figurines representing warriors, hunchbacks, and dogs and other fauna. Groups are infrequent, and the figures are much larger in this last class. It is unlikely that these profound technical and formal differences are local in origin; they should correspond to an evolution, lasting as long as the closely parallel sequence from El Arbolillo to Ticoman in the Valley of Mexico. This may have covered some five centuries, and several centres could have participated in all or part of the development.

The Ameca Valley figures constitute a recognizable group within the Colima style (Plate 78A), although the tombs yielding them are in the state of Jalisco, west of Lake Chapala. The clay is beige-grey, unlike the buff-brown and red-slipped Colima wares. The heads are much elongated, with long noses and large eyeballs. Early and late figures can again be distinguished. The early examples are sheep-faced. The late ones are more distinctly divided by an organic conception of the parts of the body. Early figures seem eroded or melted, in the continuous passages of modelling that unite rather than divide the parts of the body. Late figures are more animated, and more incisively articulated.[12]

Such differences also mark divisions among the Nayarit figures. The best known examples come from Ixtlán in the southern part of the state. One group, of hurried manufacture, shows animated figures assembled in thatched houses or upon the terraces of a ball-court. They are of red or buff paste, painted in geometric lines of resist-colour, or in red, white, and orange textile-patterns. The technique and the modelling recall the Colima groups. It is possible that they both are of the same late pre-Classic date. The village ceremony shown on Plate 77B resembles the acrobatic *volador* ritual of eastern Mexico. The Gulf Coast ritual, however, has strong calendrical symbolism in the acrobats rotating on ropes as a human wheel, whereas the western and central Mexican pole scenes as represented in *Codex Borbonicus* (Plate 33) may represent rise and descent as linking sky and earth. Here the pole stands between two houses, and the acrobat performs on its top in a head-dress of feathers or reeds, perhaps marking him as a bird-impersonator.

The second Nayarit group, of nude figures with puffy, slit eyes carefully blended into the faces, corresponds to the 'somnolent' Colima group, but the Nayarit figures are of superior execution, with variegated textures and a great range of figural poses and occupational types. After 1960 these figures began to be called 'Chinesca' among collectors. They are said to come from Early Classic shaft tombs in southern and central Nayarit, and a radiocarbon date fixes the type about A.D. 100.[13] The massing of heads and bodies bears little relation to visual impressions. The heads, with their balancing projections and the rich textures of straight hair and shell ornaments for ear and nose, and the bulbous bodies with limbs like filaments, form a most original rhythmic organization (Plate 78B). Indeed one has the impression that the sculptors of this group were

the innovators in the Early Classic middle period. Their work intervenes between the production of small figures in action with coffee-bean eyes, and of the large, hollow figures with fully modelled eyeballs.

This last group is the best known of the Nayarit figures, and it has drawn both the praise and the abuse that attend the discussion of modern art. Gifford, for example, regards them as caricatures, while Salvador Toscano ascribed to them an 'energetic beauty', in spite of their defective firing and casual polychromy.[14] Indeed the square bodies, grimacing mouths, and staring eyes convey a disturbing expression which is only in part resolved by the animation and plastic energy of the turgid forms. Two notably different manners appear in the Ixtlán group of the fully modelled eyes, and they may pertain to the work of different generations (Plate 79, A and B). One is adorned with four-colour painting in textile patterns, and the faces, whether of men or women, display a toothy rictus of savage ugliness, in long and angular countenances. The other Ixtlán group is far gentler in expression, with round, plump faces, raised eyebrows, round eyes, and a childlike expression of delighted anticipation, in opposition to the fiercely grimacing long-heads.

In review, each of the three regions produced different versions of the same style, in a developmental sequence of perhaps five centuries' duration that runs parallel to the events of the Valley of Mexico or the Pánuco series on the Gulf Coast. Each region, however, achieved outstanding quality at a different period. The Colima figurines in action, with their coffee-bean eyes, are the most animated ceramic expression of their era in western Mexico (Plate 77A). The slit-eyed figures of Ixtlán in Nayarit[15] excel by plastic and rhythmic inventiveness (Plate 79A). The fully modelled warriors and crouching figures from Ameca in Jalisco (Plate 78A) are superior in technique and modelling, when one considers the stereotyped, hurried execution of so much Ixtlán pottery. Striking iconographic differences also separate the art of these three regions. The fattened and edible dogs of Colima, which reputedly were the guides of the dead in the other world,[16] are lacking in Jalisco and Nayarit. The Ameca figures of Jalisco abound in crouching and kneeling poses. The Ixtlán potters in Nayarit recorded a singularly graceful seated posture of the women: the legs are drawn in to the body as parallel and supporting elements across the base, a posture portrayed nowhere else.

It has often been thought that west Mexican art, in its protective aboriginal isolation, escaped much of the tyranny by ritual that characterizes other Mesoamerican regions, and that its manufactures merely 'report' daily village life. Recently, however, P. Furst has sought to connect living Cora and Huichol ethnography with west Mexican archaeology, on the score of shamanism and the ritual use of hallucinogenic plants. The hypothesis is attractively simple, but it presupposes that ancient peoples were less changeable and more alike than the archaeological finds warrant. It also avoids the possibility that modern shamanism is a recent rustic development among peoples of Catholic tradition in isolated environments.[17]

MICHOACÁN

Both in the highlands and on the coast, Michoacán was occupied at least as early as the middle pre-Classic period (750–350 B.C.). The region not only lacks cultural unity, but it differs from the rest of Mesoamerica. The oldest known village sites are in the lower Balsas basin at Infiernillo, and in the north-western part of the state, at El Opeño and at the foot of Cerro Curutrán. Pottery and figurines of pre-Classic types, related to those of Zacatenco (prior to 500 B.C.) in the Valley of Mexico, are found in abundance. Another archaic centre is Chupícuaro in the north-east, where early and late phases occur.[18] The early pottery correlates with Ticoman II (c. 500 B.C.–A.D. 300). The origins of rectilinear geometric Chupícuaro pottery painting probably lie in north central Mexico. The early sculptural style appears in clay figurines with long, slanted coffee-bean eyes (Plate 79C): the late figurines wear heavy neck ornaments or chokers. Both types are slab-like. The choker figures were shaped upon a flat working surface, as if in an early endeavour towards the invention of the mould. The early examples have greater rhythmic and expressive properties than the late ones.

The western spread of the style of Teotihuacán is apparent in manufactures of the Classic period found at Jiquilpan in western Michoacán.[19] The most notable examples are two spherical vessels of pottery (Plate 80A), decorated in the peculiar technique of lacquer inlay, probably native to western Mexico, which survives in the lacquered gourds of colonial and modern manufacture. The technique is usually called *cloisonné* or *alfresco* decoration in archaeological writing, but neither term is fortunate, as both already possess exact meanings, one in metalwork, the other in mural painting.

The Mexican lacquer-worker coated an inert, stucco-like support with pigments carried in a resinous and oily medium.[20] The thick foundation coat of pigment was carved away in recessed patterns, then filled with other colours. The analogy to enamel technique ('cloisonné') is less close than the comparison to marquetry or inlay. The Jiquilpan vessels are painted in six hues as well as grey and white, in five friezes of processional figures. On the rounded bases are medallions of a winged human and a bird-like decoration. Covarrubias maintains that these vessels were lacquered, and that their present powdery aspect, as of fresco painting, is due to the decay of the organic matter in the lacquer medium. With Jiquilpan and its objects in the Teotihuacán style, a few other sites in Michoacán can be associated to form an 'Early Lake' style. There is no metalwork, and the pottery may antedate the first appearance of a recognizable Tarasca culture.

For many years the term 'Tarascan' was indiscriminately applied to practically all ancient western Mexican products. Today the Tarascan civilization is believed not to antedate the tenth century.[21] Two phases, limited to the lake region, are known archaeologically: the early one perhaps antedates the Toltec horizon, with an architecture consisting of round and rectangular platforms, called *yácatas* (Figure 30). The use of tobacco pipes has been taken to show Tarascan origins in the far north. Metalworking (possibly of South American origins) was limited to the manufacture of needles and hooks of

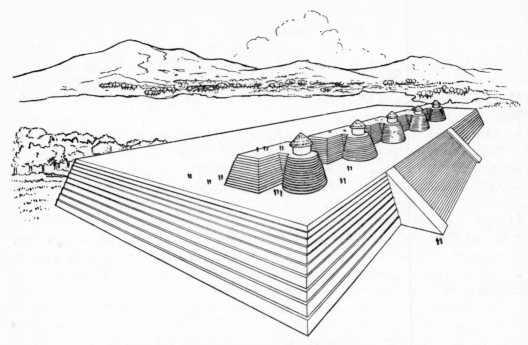

Figure 30. Tzintzuntzan, *yácatas*, after 1200. Perspective

copper wire. The later phase of Tarascan political expansion is post-Toltec.[22] Among its productions are Chacmool figures, elaborate lapidary work in obsidian and turquoise, and lost-wax casting of objects in gold, silver, and copper.

The *yácatas* of Tzintzuntzan on the eastern shore of Lake Patzcuaro are five burial platforms aligned in a row (Figure 30). Each had twelve stages of rubble faced with stone slabs and all stood upon a primary platform ten stages high (13 m.; 43 feet) which in its day was among the most imposing monuments of America.

The whole configuration of Tarascan art is eclectic. The circular platforms probably relate to the Huasteca and central Mexico (Cuicuilco). Resist-painting and tobacco pipes may reflect northern associations as far afield as the south-western United States. The metalworking and the ritual sculpture (Chacmool figures) suggest debts to Toltec and Mixtec sources, possibly connected with the exploitation of Tarascan mines, as portrayed in the Lienzo de Jucutacato.[23]

A parallel debt to Mixtec art is apparent in the far north-west, at Guasave in Sinaloa. The tentative date assigned to this 'Aztatlán polychrome' pottery is about A.D. 1350, on the strength of the parallels with pottery in the Cholula area.[24] The Mixtec-influenced decoration in Sinaloa includes such elements as feathered serpents, sun disks, wind-god symbols, flint knife motifs, and heart and blood conventions which all relate more directly to post-Classic book illumination and wall painting than to any other sources. The figure painted in the bowl shown on Plate 80B represents a human head wearing feathers, resembling Tlahuizcalpantecutli, the Aztec god of the morning star, whose cult

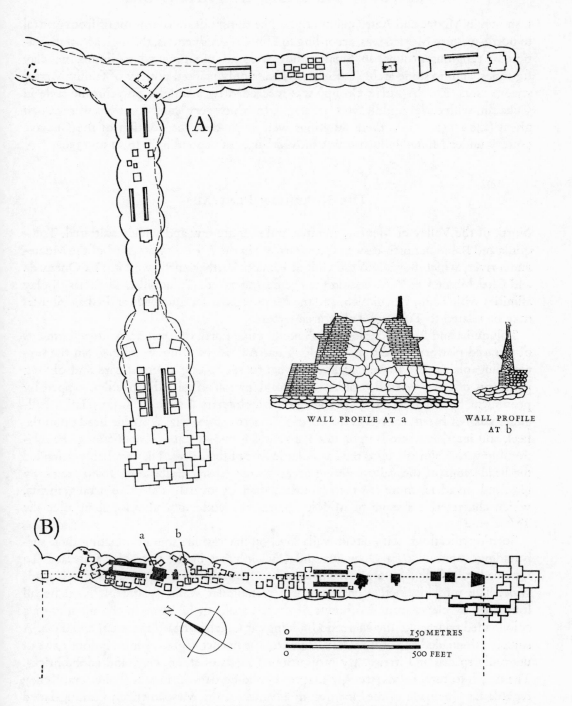

(A)

WALL PROFILE AT a

WALL PROFILE
AT b

(B)

a b

Z

0 150 METRES

0 500 FEET

Figure 31. Las Ranas (A) and Toluquilla (B), 700–1000. Plans and profiles of walls

is shown in Mixtec and Aztec manuscripts. The transposition of this motif from central to north-western Mexico was, according to Ekholm's deductions, through actual migration of religious groups. In Sinaloa, however, no monumental sculpture, no clay figurines, and no stone architecture are evident: only painted pottery of faintly Mixtec style persists. The 'Atzatlán Group' was succeeded by a simpler polychrome style in Culiacán, with early, middle, and late stages, to which very short durations were at first given (1400–1520).[25] As these durations were expanded, the position of the Guasave pottery under Mixtec influence was moved back correspondingly to 1150–1350.

THE NORTHERN PLATEAUS

North of the Valley of Mexico, architectural sites are few and widely scattered. Toluquilla and Ranas in north-eastern Querétaro are in the Atlantic watershed of the Moctezuma river, which flows into the Gulf at Pánuco. Farther north-west are La Quemada and Chalchihuites in Zacatecas on the Pacific watershed. Toluquilla and Ranas display affinities with Tajín, Xochicalco, and the Maya region. La Quemada and Chalchihuites may be related to Tula and Toltec architecture.

Toluquilla and Ranas (Figure 31), about 50 miles north of Querétaro, are alignments of terraced platforms and buildings along narrow ridges rising abruptly from the surrounding plains. Las Ranas has five ball-courts set among many square and oblong platforms of steep vertical profiles. The combination of tall talus profiles, capped by prominent bevelled cornices, belongs to the architectural style of Tajín. Half a ball-game yoke of basalt, carved in the Classic Veracruz style, with a profile head upon the heel, and interlaced scrolls upon one flank, was found at Ranas,[26] confirming the relationship with Tajín as well as the Late Classic date of these sites. They probably defended the headwaters of the valleys giving access to the coastal civilizations from attack by highland invaders, more by their presence than by overtly defensive arrangements, which characterize a stage of Middle American architectural development after the Toltec era.[27]

Such fortifications, with circumvallations, on inaccessible sites dominating their surroundings, appear at La Quemada and Chalchihuites in the state of Zacatecas.[28] La Quemada is a walled hilltop town approached from the west by a causeway 100 yards wide. The most distinctive enclosure is a rectangular walled platform, lined on all four sides by eleven round columns of shaped spalls of feldspar, in the manner of a colonnaded court, like the Mercado buildings at Chichén Itza (Figure 62) and Tula. A similar colonnaded enclosure at Chalchihuites has twenty-eight columns in four rows of unevenly spaced and irregularly proportioned shafts of stone, clay, and adobe bricks. These architectural forms strongly suggest a building date during the Toltec era. Kelley regards La Quemada as the 'maximum advance of the Mesoamerican farming-based economy' into the northern plateaus.[29]

THE MAYA AND THEIR NEIGHBOURS

THE MAYA TRADITION: ARCHITECTURE

CLASSIC MAYA

THE Classic Maya peoples produced objects both of use and of pleasure with tools of stone alone. The Marxist stereotype, that cultural behaviour is determined by the instruments of production, finds no confirmation in Maya art. Its forms, though comparable to those made by the metal-using civilizations of Mediterranean antiquity, belong technologically to much older, Neolithic horizons of prehistory.

Classic Maya art spanned the centuries from the time of Christ until about 1000, and had its home in central Yucatán, bounded on the south by the Guatemalan highlands and on the north by a flat and dry limestone plain. The term 'Classic' distinguishes monuments exactly dated by inscriptions in Maya calendrical notation from pre-Maya, from non-Maya, and from Toltec Maya manufactures after 1000. Classic Maya art[1] consists of stone architecture using corbelled vaults and burnt-lime cement or concrete; of stela-like slabs and prisms of stone carved in low relief commemorating the priests, the warriors, and the various periods of Maya history; and of calendrical inscriptions which permit exact dating, to the day, within a 700-year range. Other products, such as painted pottery and jade carving, are often part of manufactures of the Classic style, but they are not constitutive or diagnostic, in the sense of the corbelled vault, the stela, and the calendrical inscription, which define Classic Maya art.[2]

The corbelled vault (Figure 32) is a system of cantilevered stones, each placed to overhang the course immediately underneath. The Maya vault consists of bearing walls, capped by the overhanging vault, which is of about the same height as the bearing walls. The spatial enclosure is attained simply by the inclination of two or more walls towards one another. The system is inherently unstable. Its equilibrium depends upon a nice adjustment among the unstable overhangs, and upon various devices of counter-balance. Burnt-lime mortar, cement cores, wooden tie-rods, and special stereotomic forms, such as the boot-shaped stones used in late vaults, contributed to stability.[3] End walls and cross partitions also played a part (Figure 32B). The use of cement or concrete bonding is a Maya habit, absent from non-Maya examples of corbelled vaulting from the southeastern United States to southern South America.[4] The central Maya roof decoration, called roof-combs (Figure 32A), and the north Maya false fronts, or flying façades

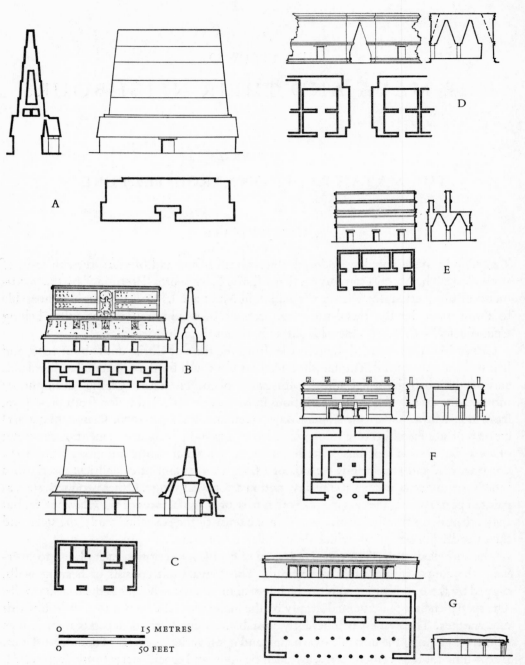

Figure 32. Regional types of Maya vaulting technique: plans, sections, elevations. (A) Tikal, Temple V, after 700. Petén roof-comb; (B) Yaxchilán, Structure 33, after 760. Interior buttressing; (c) Palenque, Temple of the Cross, before 700. Mansard roof; (D) Uxmal, Governor's Palace, c. 900. Cleavages in vault mass; (E) Chichén Itza, Red House, tenth century. Flying façade; (F) Chichén Itza, Castillo, c. 1200. Platform building; (G) Tulum, Castillo substructure. Mortar-beam roof

(Figure 32E), were regarded as loads, and thus were meant yet further to counter-balance the bearing walls against the unstable overhangs. Usually the Maya vault is set with thick wooden tie-rods spanning the interior overhangs. They were probably in-serted as construction went on, in order to keep the overhangs apart during the long hardening period of Maya mortar, and they later served as rods from which to hang the belongings and the hammocks of the occupants. The buildings of stone and mortar were principally for religious use. As dwellings, houses of wattle and thatch were preferred because of their good ventilation and easy replacement.[5]

The stela of Classic Maya art is a free-standing monument having the shape of a slab or prism, often rounded at the top, and occasionally approaching human contours. The stelae usually recorded the passage of time by elaborate inscriptions (Figure 33). Wooden stelae may have preceded those of stone, which mark the known duration of central Maya civilization, and many districts may never have erected anything but wooden ones. In any case, the 'Stela cult' records priestly computations of historical time and of astronomical events, and it delimits the spread of Classic Maya art. The figural themes of the stelae are usually standing male figures elaborately dressed, representing warriors, rulers, priests, or god-impersonators. They are often accompanied by minor accessory figures as well as by sky bands, masks of symbolic monsters, and extensive inscriptions.

Maya writing [6] consists of framed and composite signs, which are still called 'hiero-glyphs' (obscure or unintelligible writings) because only one-third to one-half of a total of about 820 signs are at all intelligible. Pre-Columbian texts are of two kinds and of two eras. The earlier are epigraphic, consisting of monumental inscriptions upon stelae and buildings, all of Early to Late Classic date. The later texts consist of screenfold manu-scripts of bark-paper (Plates 81A and 126, A–C). Only four of these are preserved. The inscriptions record historical and mythical events. The manuscripts[7] contain dates, astronomic tables and computations, references to deities, ritual prescriptions, and directional symbols. The writing has been recognized as a composite system, neither purely ideographic nor purely phonetic, but containing statements in both modes.

A typical written expression of the Classic era is a date inscribed on stone or in plaster, giving the number of days which have elapsed since an arbitrary starting-point (Figure 33). The inscriptions of this type are called Initial-Series statements,[8] and they usually record the date of erection, by enumerating the 400-year periods that have elapsed since zero, as well as the 20-year periods of the current 400-year cycle. The dating of the actual monument in the current 20-year period and in the 360-day ritual calendar are also given. Additional particulars concerning the age of the moon, and specifying the divine regencies engaged in the astrological composition of the moment, appear on other glyph blocks. Computations relating the vague solar year to the actual position of the earth in relation to the sun may occupy another series. The system in-cludes glyphs for numbers, for periods, for deities, for directions, and for ritual prescrip-tions, as well as for augural declarations. The chronographic record is accurate, for no Initial-Series date could recur until after 374,440 years, and it is durable, for the Initial-Series inscription is so redundant that its main message can be reconstructed even when

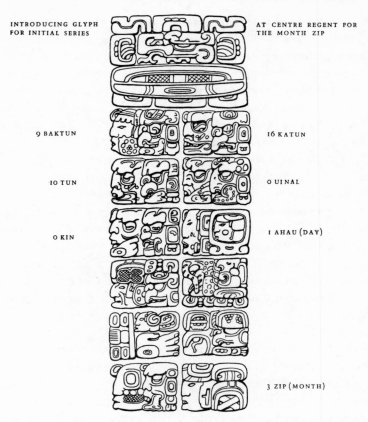

INTRODUCING GLYPH
FOR INITIAL SERIES

AT CENTRE REGENT FOR
THE MONTH ZIP

9 BAKTUN

16 KATUN

10 TUN

0 UINAL

0 KIN

1 AHAU (DAY)

3 ZIP (MONTH)

Figure 33. Quiriguá, Stela F, with transcription of Initial-Series and Supplementary-Series dates. Stela F at Quiriguá uses face numerals; namely, those of the gods who preside over numbers.

The reading here is

9 × 144,000	1,296,000 days
16 × 7,200	115,200 „
10 × 360	3,600 „
0 × 20	0 „
0 × 1	0 „

This number (1,414,800) added to Maya (10 August 3113 B.C.) zero reaches 1 Ahau 3 Zip, 17 March 761

two-thirds of the glyph blocks are destroyed. In Classic Maya history each time-period, down to the single day, was personified and deified. The worship and ritual of the time-periods still continues in an attenuated tradition among remote highland communities of Guatemala and southern Mexico.

These Initial-Series dates and briefer ones, called Calendar Round expressions, are often separated by distance numbers, stating the days elapsed between dates. Such dates often refer to persons, titles, events, and places. From these readings the dynastic history of many Classic Maya sites will eventually be recovered. This historical approach to Maya inscriptions began only in 1958, and many of the new discoveries are still under

verification, but their validity has been accepted in principle by the majority of Mayanists.

The three remaining manuscripts are at Dresden, in Paris, and in Madrid. They are painted on screenfolded fig-bark paper. They treat of astronomical tables and calculations, of horoscopes, and of ritual prescriptions. The characteristic subjects of the Dresden and Madrid manuscripts are divinatory tables based upon various intervals in the 260-day ritual calendar (Plate 81A). This calendar, which governed the auguries, arose from the combination of the 20 day-names with a week of 13 positions, and it is distinct from the solar calendar, which had 18 months of 20 days with a 19th month 5 days long. The ritual calendar of 260 days gave any day its name and its week position; and the solar calendar gave it a month position. No day-name (e.g. Ahau, occupying the fourth day in a 13-day week) could recur until after 260 days, and its combination with a month position (e.g. 8 Cumhu) recurred only after $260 \times 365 = 18,980$ days, or 52 years and 13 days of our time.[9]

The three distinguishing traits of Classic Maya tradition – the vault, the stela, and the dated inscription – all attest an obsession with recorded permanence. More than any other civilization of America, the Maya peoples of antiquity left their conception of themselves and of the universe in an indelible record of monuments marking historical intervals. The dated sequence of Maya monuments is the most complete of its type in older human experience. All other historical records of the same era are less detailed and less extensive. No ancient people kept more complete tallies of time than the Maya, whose technological equipment resembled that of the Neolithic flint-knackers and pottery-makers of prehistoric Europe and Asia.

Geographical Divisions

By analogy with Egypt, students used to divide Maya history into 'Old Empire' in the south and 'New Empire' in the north, separated by a 'Transition' in the west.[10] The 'Old Empire' sites were thought to have been abandoned because of the wasteful and destructive *milpa* system [11] of burning the forest to secure fields, and it was believed that the northern plain was not settled until an exodus from the 'Old Empire', marked by the abrupt cessation of the Initial-Series inscriptions early in the tenth century. Since about 1930, and owing to the researches of the Carnegie Institution of Washington, these conceptions have altered.[12] The tradition now referred to as Classic Maya differs from 'Old Empire' by its spread throughout the peninsula, as at Cobá, Dzibilchaltun, or the southern parts of Chichén Itza. Toltec Maya differs from 'New Empire' by much more limited geographic and historical definitions. The older conception of a 'Transition' period and province has been absorbed into Classic Maya, on the evidence of dated inscriptions and ceramic remains. Classic Maya therefore has become synonymous with the Maya tradition. Its regional variants, which used to be treated as different historical epochs, can now be examined as ecological types, as adaptations to differing environmental conditions. Three such types seem warranted: the central Petén district of Guatemala, where the ancient cities stood upon or near the forested shores of connecting

lakes that today are swamps called *bajos*; the river valleys, such as the Usumacinta and the Motagua; and the cities of the plain in central and northern Yucatán.

The three types, lake-shore cities, fluvial cities, and the cities of the plain, refer to ritual concourses rather than to habitation centres with clustered dwellings. This separation between dwelling and ritual centres is typical of the Classic era throughout ancient America. At Copán (Figure 38), for example, the immense ritual platform assembly displaced an earlier village cluster of dwellings.[13] It suggests the domination by a religious hierarchy among agrarian peoples with a lay culture distinct from that of the priests. The hierarchy was homogeneous, but the subject agrarian peoples may have been of quite distinct and various local origins in each of the principal districts.

The Petén today is uninhabited. Its population in antiquity numbered about 270 persons per square mile, or slightly more than modern New York State.[14] In physical conformation, the Petén is a region of troughs separated by hilly ranges descending from the Guatemalan cordillera. Each of the parallel ranges of hills has steep escarpments facing south. Run-off water accumulates between the ranges in what are now swamps. Some *bajos* may have been lakes, which slowly silted up by erosion following the destruction of the forest cover by farmers and builders of the Classic era.[15] Today sites like Tikal are thus uninhabitable largely because of the scarcity of drinking water (in a land of tropical rainfall). In antiquity some concourse centres were approached and connected by bodies of inland water. Their shores today are marked by the ruins of the Classic Maya cities. The only survival of an ancient physiographic setting of the Petén Maya type is the cluster of lakes surrounded by ruined temples and courts at Cobá in north-eastern Yucatán.

The equally desolate river cities of the Usumacinta and Motagua drainages cannot, however, be explained by water shortage, since the supply never failed in those broad streams or in their confluents, which flow past the river-bank courts and terraces. Possibly the mode of agriculture is to be blamed, although it is not clear whether the modern *milpa* system of Yucatán prevailed, with its burning and planting cycle, or an intensive cultivation on terraced and permanently cleared fields. Nor is it known who smashed the heads and faces of the Piedras Negras reliefs, although the fact of wilful destruction may indicate some social catastrophe.

The limestone plain of Yucatán, covered with a thick low bush, unlike the high forest of the Petén, lacks important bodies of surface water. Its settlements all depended upon the underground water table, reached through breaks and openings in the limestone crust. A range of low hills divides the western half of Yucatán into a southern district called the Chenes (well country), and the Puuc (hill country) in the north and west. The Chenes territory is the northern continuation of the Petén, with close stylistic ties to the Petén, although the physical environment is categorically different. The Puuc district was probably the most fertile and the most thickly peopled part of the peninsula, depending for water on storage in underground cisterns of natural origin, called *chultunes*. Open cisterns, where the limestone crust has collapsed, are *cenotes*, like the 'well of sacrifice' at Chichén Itza in northern Yucatán.

The east coast is a distinct archaeological province of Yucatán. Its vegetation, like that

of the entire east coast, is dominated by forests rather than by the dry scrub of western Yucatán. It contains both Early Classic and late stages of Maya civilization, represented respectively by monuments of Petén type (Cobá) and by Toltec buildings. A late style of small temples has been assigned to the end of the fifteenth century.

Temporal Divisions

The reconstruction of the periods of Maya history is based upon inscriptions, manuscripts, ceramic evidence, and radiocarbon measurements of age.[16] Each class of sources permits a partial sequence. The epigraphy yields a day-to-day chronology for the Classic era spanning more than 600 years. The colonial chronicles (Books of Chilam Balam) contain Toltec Maya history arranged by twenty-year periods. The ceramic sequence allows only a very coarse time-scale, with large overlapping gradations. The radiocarbon dates still do not finally clarify the correlation of Maya and Christian time. Some Carbon 14 measurements now are known to be as much as seven centuries in error, by comparison with tree-ring dates. The widely fluctuating natural rate of C14 production is thought to be related to changes in the strength of the earth's magnetic field.[17] The Spinden correlation (12.9.0.0.0) has recently lost ground to the Thompson correlation (11.16.0.0.0) on the strength of new dates from Tikal. These correlations key the same event to earlier and later positions in Christian time, about 260 years apart.

The stylistic sequences of Maya architecture, sculpture, and painting indicate a geographical progression. The various regions rose to dominance each in its turn, beginning with the pre-Classic monuments in the Petén. The southern river valleys assumed the lead towards the end of the Early Classic period, and yielded it to the Puuc region in Late Classic times. Following the Late Classic Puuc period, the Mexican domination of Maya culture by Toltec masters, treated in Chapter 9, endured at Chichén Itza for about three centuries. The pre-Conquest history of the Maya peoples terminated in a long era of disunity and cultural decline, of which the archaeological record is given by Mayapán, in the fourteenth and fifteenth centuries.[18] At this time the lake and river cities farther south had stood empty and ruined for about 700 years.

CLASSIC ARCHITECTURE

The Petén

The Petén [19] contains the most ancient Classic Maya sites. Their form is best described as 'island cities' or 'archipelago cities', consisting of many groups of platforms and buildings on knolls and shoulders of hilly land rising above the surrounding swamps, which may have been lakes or water-holes in antiquity. The different groups on one site are connected by causeways, as at Uaxactún where they extend for 3 km. (nearly 2 miles) from north-west to south-west, with each of the six groups orientated approximately upon the cardinal points. One purpose of the causeways is to extend the ordered

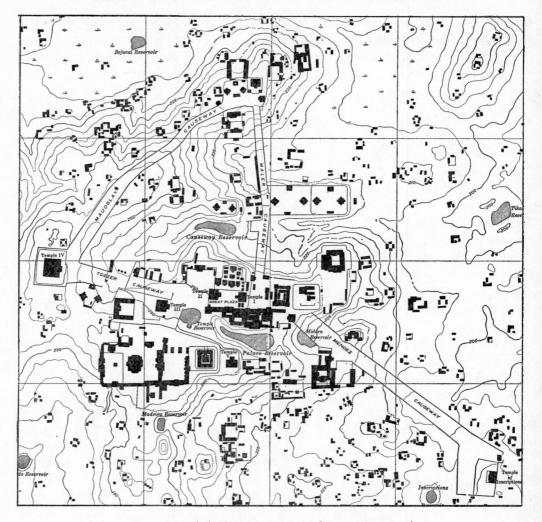

Figure 34. Tikal. Plan as in *c.* 900 (each square is 500 m.)

space of the plazas. At Uaxactún Groups A and B face each other from south and north across a ravine, with about 275 yards between the centres of the two groups. Group A has the higher and larger plaza of the two U-shaped courts opening at the ends of the inclined causeway.

Tikal (Figure 34), 12 miles south of Uaxactún, has nine groups of courts and plazas, separated by ravines but connected by causeways and ramps. At Nakum the subordinate northern enclosure connects with a southern main plaza by a roadway about 80 feet wide. It runs between parallel rows of long, narrow, and discontinuous platform mounds. But the plazas are not reciprocating, as at Uaxactún, for the vistas in the roadway are blocked at both ends, and the assemblage has a bifold rotational symmetry, or a Z-form. Ixkun displays a northern variant on the pathway site: a north–south road

about 800 yards long connects the temples on two small hills. Midway between them, and opening on both sides of the roadway axis, is a connected system of small courts.

Cobá, in north-eastern Yucatán, is a site of Petén type, with ruined groups of buildings clustering near a chain of small lakes, all connected by raised roads of roughly shaped stone.[20] At several points these causeways separate small bays or inlets from the body of the lake, making tanks or reservoirs like those between Groups A and E, or A and B at Tikal in the Petén (Figure 34), where the ravines were dammed by causeways.[21]

Within the courtyards, it is difficult to identify the functions of the various platforms and buildings. In Petén Maya architecture, the rooms were always much less important than the masses. The design of an edifice was secured less by the enclosure of rooms in an articulated envelope than by the ponderous combination of vast masses, solid throughout, sculpturally related, and structurally static. Thus the idea of a unit of architecture differs greatly from our own. The greatest uncertainty surrounds the identification of the functional types. The alleged 'palaces' and 'temples' merge into one another by continuous gradations. Probably a cardinal objective of the Maya architect was to achieve differentiation by height, in many levels marking the rank of the vague functions to which the edifices were dedicated. At the same time he was always extremely sensitive to the spaces engendered between and among edifices, seeking to achieve large and rhythmically ordered open volumes. Such open volumes with storeyed changes of level are the most striking formal achievements of Maya architectural history.

The free-standing pyramid was the dominant form among platform types used by

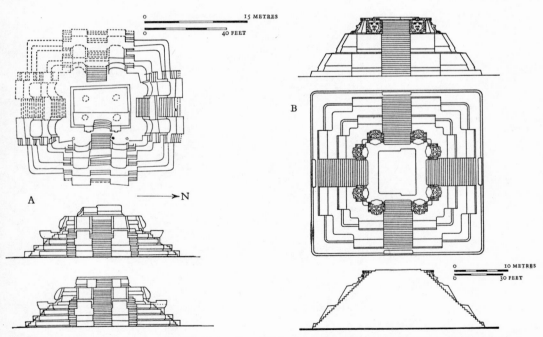

Figure 35. Radially symmetrical platform plans, with elevations. (A) Uaxactún, Platform E VII sub, first century; (B) Acanceh, before 1000 (?)

Maya architects. In the Petén, the oldest extant pyramid, called E VII sub, at Uaxactún, is of pre-Classic date, built about the first century A.D. (Figure 35A). Of radial symmetry, its axes of reflection are the four staircases and the four inset corners. Its plan recurs at Acanceh (Figure 35B), at Hochob, and in Toltec Maya pyramids, a thousand years later, at Chichén Itza, in the Castillo (Figure 60), and at Mayapán in northern Yucatán. Each of the four fronts suggests and requires a monumental environment. Every approach is of equal value, and the form itself induces further symmetry among its neighbours. It is a rare form in America, used sparingly even by Maya architects. Other large pyramids display only bilateral or mirror symmetry. The axis of reflection is a central stairway. At best, this form commands two environments, and usually only one, as at Tikal, where the main pyramids have but one main stair, with forbiddingly steep angles on the side and rear façades. At Balakbal (Structure VI), the stairways at front and rear command two approaches.

Often the pyramids are grouped around a courtyard, as at the centre of the layout of Tikal, where two great pyramid-temples, facing east and west, delimit the Great Plaza bounded also by the North Acropolis and the palace building of the Central Acropolis. This ancient arrangement, whose construction lasted a thousand years, was repeated in simpler form several times at twenty-year intervals in the eighth century in the twin-pyramid complexes, as if to replicate the ceremonial architecture of the centre for the use of an expanding population at the margins. In these twin-pyramid centres, a northern precinct faces a southern chambered building, and the east–west axis is defined by identical radial-stair platforms (Figure 36). The same layout reappears at Yaxhá on Lake

Figure 36. Tikal, twin-pyramid complex, erected 771

Flores, and it may reappear in modified but still unrecognized versions at other sites, as in the southern temple district of Palenque.[22]

Assemblages of several buildings in the Petén can often be identified as geomantic groups, serving as monuments of significant horizon positions of the sun and perhaps the stars. About eighteen such groupings between Ixkun and Río Bec have been identified. Many may have been merely ritual rather than for observational astronomy. Group E at Uaxactún has a pyramid facing east. Across the court, three temples stand upon a narrow north–south terrace. From the pyramid stairs the rising sun emerged over the northernmost temple on the equinox (21 March, 21 September) and over the southern temple on the December solstice. Such arrangements obeyed celestial relationships, and they reflected the order of the cosmos in the spatial design of the little courtyards surrounded by platforms and temples, keyed together by astronomical sightlines.[23]

The Petén Maya architect habitually thought in groups of platforms and buildings, rather than single and isolated units. He preferred the long, narrow platform, bearing a chain of narrow rooms, and serving with other platforms to enclose a court. Thus, at Nakum, Structure D marks the south side of the main plaza by a façade over 130 m. (425 feet) long and 10 m. (35 feet) wide, containing about forty-four rooms opening north and south by narrow doorways.[24] At Tikal, Group F is a quadrangle of four buildings (Structures 74, 77) [25] forming an open-cornered quadrangle. Structure 1 in G, due south of F, makes a closed-corner quadrangle, probably of late date, resembling the 'palace' of Palenque, but lacking its permeable structure of wide doorways separated by narrow piers.

At Uaxactún, Structure A V [26] is the best studied assemblage of this type (Figure 37). The successive efforts of many generations to enrich, variegate, and recompose the quadrangular entity have been dissected by careful excavation. The progression is from separate temples assembled around a small platform court, through seven stages of remodelling, with chambered 'palace' structures replacing or overlaying the earlier single-chamber edifices. The interlocking levels, unified by sweeping stairs, are characteristic of Petén architecture, reflecting influences from neighbouring Maya regions, without loss of the conservative Petén style of massive effects.

Of the ball-courts so common in the river-valley sites farther south (Plate 84A), there is one certain example in the Petén: at Tikal. Ball-court markers occur, such as circular slabs with reliefs portraying players,[27] but the court platforms appear only at Cobá and at Tikal. Perhaps the Petén, like Teotihuacán, flourished and settled upon definitive architectural types before the spread of the monumental ball-game court, which on this reasoning might be ascribed to mid-Classic time.

The structural history of Maya architecture is concerned with four items: the stones, the mortar, the support, and the vault. The general line of development is from block masonry to a concrete core veneered with ashlar slabs, from massive wall structure to slender piers or columns, and from narrow, slot-like chambers to intricate combinations of rooms which afford one another mutual support.[28] But in the architecture of the Petén, we find only the more conservative moments of the development, limited both

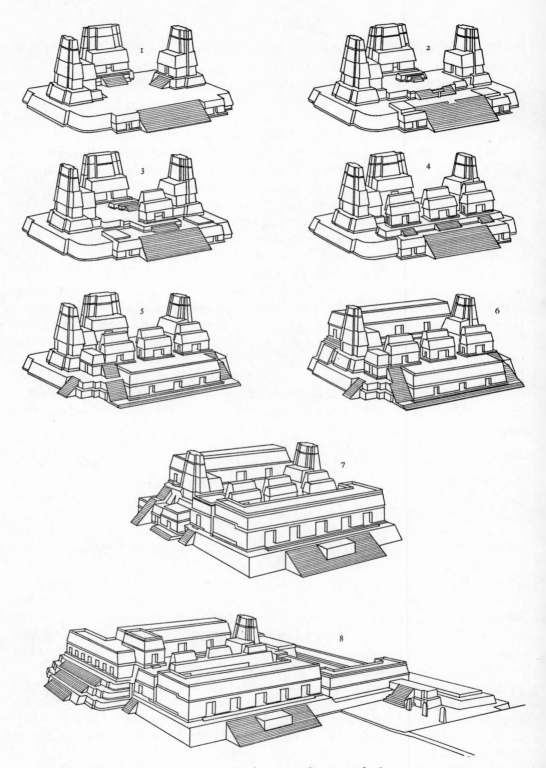

Figure 37. Uaxactún, Structure A V, showing eight stages of enlargement, *c.* 200–900

by older traditions and by the absence of the concrete which characterizes later stages in Usumacinta and Puuc cities.

Petén buildings usually have stone cores faced with stucco. The core changed from early unshaped stone to block masonry in mid-Classic times. At Tikal, massive walls and trimmed vault spans assured a stability that has survived even the removal of the *zapote* wood lintels from the temple structures. Lime coatings were more lavishly used in early periods than later on, presumably because of the gradual exhaustion of easily available supplies, and also because of improvements in stone-cutting techniques.

Columnar supports, whether cylindrical or rectangular, are absent in the Petén. Only heavy piers, really portions of wall, separate the doorways of multi-chambered buildings. It is often implicitly assumed that pier, square column, and round column represent a development sequence. Actually the three types should be regarded as geographical peculiarities rather than as evolutionary steps. Wooden supports were used in the earliest stages. Since the shafted support of wood is archetypal, its replica in stone or clay is not much later. On the Petén and Motagua sites, however, the builders were chiefly interested in the massive design of space, and the doorways were minor incidents in the sculptural treatment of the façades.

The enrichment of the profiles by inset corners, by mouldings, batters, crenellations, and by the vertical façade projections called roof-combs are all indigenous to the Petén, appearing there early and persisting late. A chamfered talus moulding in the pyramid faces is both very old and very common. The chamfer is a horizontal groove or channel in the lower part of each sloping talus component. The earliest example is in the lower terrace corners of Pyramid E VII sub at Uaxactún (Plate 83). At Tikal (Plate 82) the chamfer cuts deeply into the base of each of the huge aprons of the temple pyramids. Its visual purpose is to underline by shadow the brilliantly sunlit apron face. In fact it secures a double effect: it stresses the divisions between terraces, and levitates each apron mass.

Re-entrant, inset corners on pyramidal platforms are a trait shared by buildings in both lake and river cities. In ground plan these edifices show an 'internal' rectangle or square, of which the presence is revealed only at the corners. The centre of each sloping face is augmented by substantial buttress-like increments, which furnish vertical accents binding the horizontal components. Pyramid E VII sub at Uaxactún is the earliest example (Plate 83), with triple-ramped stairs and tiered mask-panels. The inset corners interlock in a weaving of vertical and horizontal accents. The main temple pyramids of Tikal are classic examples, where the recessed corners function as powerful shadowed verticals (Plate 82). The temple pyramids of Cobá are closely related to those of Tikal, but their corners are rounded insets like those of Piedras Negras in the Usumacinta Valley (Plate 84B). Outside the central Maya territory re-entrant corners are rare, recurring to present knowledge only in the terminal generations of Aztec architectural history.

The aproned roof profile, usually called 'mansard' (Figure 32C), is another trait shared by Petén and Usumacinta architecture. Northern instances, as in the top stage of the Nunnery at Chichén Itza, are rare. In the Petén, the apron usually overhangs the bearing wall, protecting its surfaces from the weather (Figure 32A). The angle of in-

clination is never as extreme as in the Usumacinta buildings. It usually repeats the chamfered apron profiling of the pyramidal substructure, and it enhances the massive aspect of the building. Structurally the device recalls the thick, overhanging mat of thatch on house-mound dwellings.

The roof-comb is peculiar to Maya architecture.[29] It served to identify and to mark the importance of certain buildings by a vertical enlargement of the silhouette. In the Petén, roof-combs are usually of solid wall construction, often loaded upon the rear bearing wall, and even upon the capstones of the tiny vaults within the temple (Figure 32A). The Petén roof-comb is like the back of a throne. The building itself is the seat, and the pyramid the dais (Plate 82). Dark figures enthroned in the interlaced decorations of the roof-comb often complete the scheme of seated majesty. In the Petén and in the river valleys, such figures are framed by the building, both in the pre-Classic pyramid at Uaxactún and in the latest monuments of mid-Classic date. In western and northern Yucatán, on the other hand, the sculpture sometimes invades the tectonic field, as in the serpent-mask façades of the Puuc and Chenes districts in the Late Classic centuries.

Certain geometric and proportional habits require comment. Maya architectural symmetry is never rigorous, though it always indicates correspondence with the masses distributed in rough balance to left and right. When exactly measured, the angles are rarely true. Apparent right angles invariably lack or add a few degrees. Only the visual effect is regular, and it was secured without close calculation. Classic Maya buildings also display strong variations in their proportional composition according to region and period. The essential parts of the elevation are the bearing zone and the vault zone. In the Petén, the roof apron and the bearing wall are as 1 : 1, although late buildings favour the roof over the bearing, in a proportion like the 5 : 4 ratio of late buildings in the river cities.

The River Cities

The base of the peninsula of Yucatán is traversed by two principal river drainages flowing in opposite directions. The Motagua and its confluents mark a south-eastern province of Maya civilization; the Usumacinta and its tributaries flow towards the north-west to empty into the Gulf of Mexico. The central stretches of the Usumacinta river are narrow rapids, not easily navigable. The lower Usumacinta faces the flat Tabasco lowlands and the Gulf Coast of Mexico. Thus four distinct geographic groups of river cities are indicated: those of the eastern Motagua basin (Copán and Quiriguá); the Pasión river (Altar de Sacrificios, Seibal); the central Usumacinta (Yaxchilán and Piedras Negras); and the lower Usumacinta (Palenque and Comalcalco).

The three groups mark the land boundary of Classic Maya civilization, as well as the history of its early expansion. The occurrence of Initial-Series inscriptions usually charts the spread of theocratic Maya social organization. The union of monumental corbel-vaulted architecture with such inscriptions has repeatedly been established. The earliest Initial-Series dates commence at Copán about A.D. 465 (9.1.10.0.0). In the central Usumacinta, at Yaxchilán and Piedras Negras, the stela cult with dated inscriptions began about two generations later, c. 514 (9.4.0.0.0), and in the western cities, as at

Palenque, the inscriptions record dates beginning about 642 (9.10.10.0.0). The sequence suggests a westward and river-channelled expansion of Petén Maya culture, although the profound stylistic differences among Copán, Piedras Negras, and Palenque reflect ecological and ethnic differences in the reception of Petén influences, as well as rapid historical development of the basic forms of Maya art and architecture.

These environmental differences are quickly enumerated. Copán and Quiriguá, which are peripheral to a Central American region extending south and east as far as the Lempa river, probably transmitted the Classic Maya style to many provinces in Honduras, functioning as a metropolitan relay-area between the Petén and eastern Central America. On the other side of Yucatán the lower Usumacinta Valley, with Palenque as its metropolis, served the same function for the lowlands of the Gulf Coast. Between them, the cities of the middle Usumacinta, such as Piedras Negras, were metropolitan relay points for the Guatemalan foothills and highland ranges. The navigable upper confluents of the Usumacinta – the Pasión, the Chixoy, and the Lacantún rivers – all converge upstream of Yaxchilán, and most probably bore light water traffic in antiquity, as they do today.

Copán is the most southerly and the highest (600 m.) of the major Classic Maya sites (Figure 38). A primary platform, rightly called the acropolis, covers twelve acres and supports many secondary platforms, which in turn bear other platforms, pyramids, and courts, all faced with block masonry, and merging in a continuous spatial design of many courts on the level flood-plain of the Copán river.[30] The river gave the setting for this artificial hill, more than 100 feet high, and the river has destroyed a great part of it, washing away the grand stairway which once formed its west bank.

At Copán, large deposits of tufa, i.e. volcanic ash, yield a building stone of greenish colour. Limestone and andesite also are available. The technique of construction varies according to period. In pre-Classic and Early Classic times, the people used river boulders laid in mud and faced with burnt-lime stucco. Later on, during the mid-Classic period, blocks of the easily shaped tufa, laid in mud, reflect the introduction of quarrying and cutting techniques, perhaps because shaped stone was less costly than the preparation of lime-cement and stucco. In both periods, stucco concealed the imperfections of bonding, which was never a strong point in Maya architecture at any period.

Copán is an assembly of open volumes rather than a collection of buildings. Its plazas are large concourses, studded with sculpture standing on many levels and terraces, but the buildings are few, and built near the end of the Classic occupation, about the sixth century. The nucleus is an artificial hill, raised not only to mark a high place, but also to mark a plaza at its foot. At Copán this acropolis rises above a lower northern platform. Both define the main court, bounded on the south by the acropolis stairway, 90 m. (300 feet) wide. Both provide a theatrical setting for the ball-court (Plate 84A), surrounded by stepped terraces, and for the collection of stelae and altars, commemorating the passage of the five-, ten-, and twenty-year units of the Maya calendar. The towering roof-combs of Tikal are absent. The door-frames received that ornament which in the Petén adorned the roofs. Structure 22, for example, has the inner doorway framed by serpent coils and interlaced human figures. The grand stairways, like the

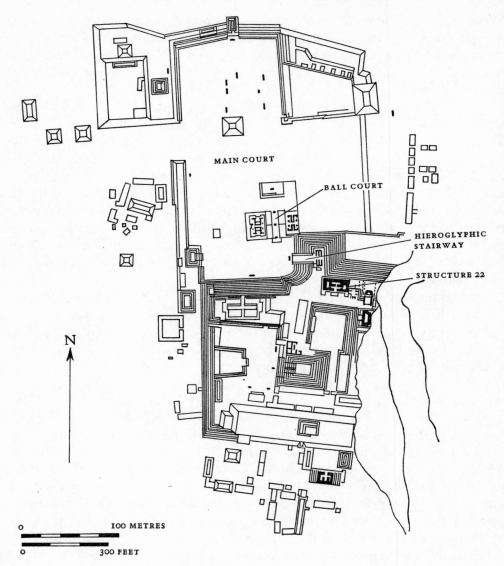

Figure 38. Copán. Plan as in *c*. 900. The southern half represents the acropolis

Hieroglyphic Stairway, were heavily charged with relief and full-round sculpture.[31]

At near-by Quiriguá (Figure 39), on the north bank of the Motagua river, the building material is sandstone of a close and even texture. It was extracted from ledges in the surrounding hills, whose sedimentary stone splits readily into prisms, shafts, and blocks.[32] As at Copán, the masonry was bonded with mud rather than lime-cement. Sunken, stair-bordered plazas facing north and east are the principal architectural elements. The chambered buildings framing the sides and corners are incidental enrichments of the south court. As in the Petén, heavy piers like portions of wall separate the

138

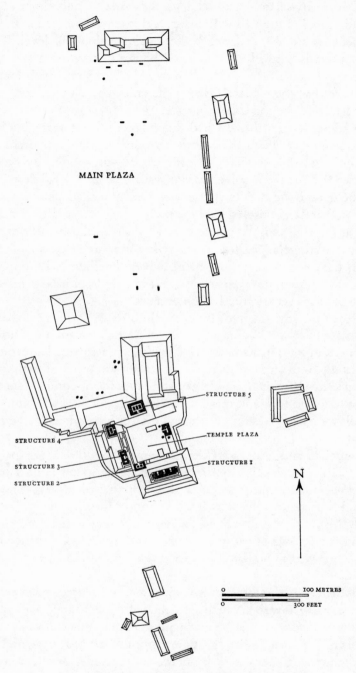

MAIN PLAZA

STRUCTURE 5

STRUCTURE 4

TEMPLE PLAZA

STRUCTURE 3

STRUCTURE 1

STRUCTURE 2

N

0 ———————————————— 100 METRES
0 ———————————————— 300 FEET

Figure 39. Quiriguá. General plan as in *c.* 900

doorways of the many-chambered buildings. Structure 1, built about 810 (9.19.0.0.0), is the last of the dated Quiriguá monuments, and it may have been a dwelling of three small apartments raised on an inner platform above door-sill level. The south-east corner of the plaza is marked by two small houses (Structures 2 and 3), containing hearths for making steam on hot river boulders.[33] These steam-bath buildings are less highly specialized than those of the Usumacinta cities, and they indicate once more the conservative nature of the south-eastern style.

The corner edifice is older than the bath-houses on the east terrace, but both show the same structural timidity, in massive walls surrounding diminutive chambers. Structures 4 and 5 both have a central core of solid masonry surrounded by a corridor of tiny chambers between it and the massive exterior walls. The only detail showing any degree of structural boldness is the interior stairway of Structure 4, which rose to the roof. This arrangement is characteristic of the Maya preference for regular exterior envelopes, unbroken by any asymmetrically placed functional shape like an exterior stair.

The antithesis of the conservative Petén style of massive effects is seen at Palenque (Figure 40) in the lower Usumacinta basin, where dwellings with double-range galleries, colonnaded façades, storeyed towers, and burial pyramids extended and diversified the range of Maya architectural achievements.

Palenque lies in the first range of limestone hills rising from the Tabasco lowlands, about 30 miles south of the Usumacinta river.[34] A small stream, the Otolum, runs between the principal monuments in a corbel-vaulted underground aqueduct northward through the ruins. Both sides of the covered stream are terraced with esplanades and platforms topped by chambered buildings with latticed roof-combs. The terraces are of soft local limestone laid rough in mud, with cut-stone surfaces, and lime-stucco finish. Wooden lintels were used in every edifice, but they disintegrated long ago in the humid tropical climate.

Recent excavations and reconnaissance on the site show three principal periods. The first is Early Classic, lacking both inscriptions and important vaulted buildings. The second is Middle Classic, and it includes all the principal groups. The third is Late Classic, when the site was defended by terraced lines of fortification, probably during an occupation by Mexican intruders from the region of the central Gulf Coast, who left among the ruins fragments of ball-game yokes and carvings of flattened heads. At this time the buildings were remodelled as if for a siege or blockade, and many doorways were walled up.[35]

The plans of the various buildings at Palenque cannot yet be placed in a secure chronological sequence.[36] All, however, use the principle of double-range parallel chambers, in order that the two outer vault masses may abut a central Y-shaped vault-mass common to both chambers. Upon this central support rises the latticed roof-comb; its stability also permits a pronounced mansard slope in the upper façades, as well as the attenuation of the piers between façade doorways. The net result of the systematic use of parallel vaults keyed to a central supporting wall is an architecture of unprecedented lightness and permeability, allowing the construction of wide spans in long chambers of continuous spatial effects. The small temples on top of their pyramids, like the galleries in

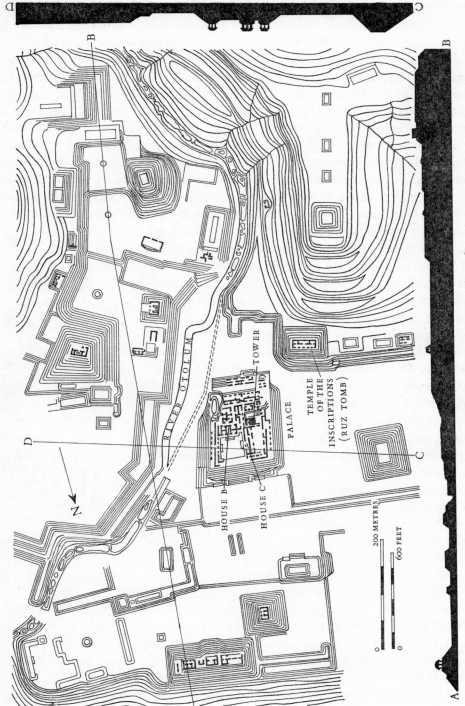

Figure 40. Palenque. General plan as in c. 900

141

the northern portion of the Palace, all exploit this extremely stable and economical system, rather than the ponderous massing of the Petén style (Figure 32A). The principal change is in the centre support: the Petén builders treated it as a static core of great mass; the Palenque architects convert it into a membrane, perforated by doors and transoms, yet capable of serving as a core, stabilized by the weight of the roof-comb (Figure 32C).

One can perhaps define early and late versions of the scheme at Palenque. The temple plans, for instance, can be arranged in a sequence from simple two-chamber shrines to elaborate combinations with inner vaulted chambers inside the shrine (Plate 81B). The Palace, which is the most complex edifice of mid-Classic date in the entire Maya world, also contains Early and Late structures.[37] The southern half of its rectangular platform has various levels of close-ranked structures which approach a galleried form without completely achieving it. House B, for instance, entered from both south and north courts, contains five chambers. The walls are thicker than elsewhere at Palenque, and one is reminded of a temple structure surrounded by later dwellings.

The northern half of the Palace platform, dated about 721 (9.14.10.0.0), is much more open and spacious, with two courts defined by parallel ranges of chambers, carried around approximate right angles, in a bold solution which has no precedent in the Petén or at Copán. It is in effect a closed-corner quadrangle, particularly at the north-east corner, and is probably the earliest extant example of the type in Maya architecture. The crowded southern half may have housed the servants and a palace guard; the spacious northern courts and galleries were probably dwellings for persons of high rank. Near the tower, towards a small inner court, two lavatories, arranged over a subterranean stream, and a steam-bath give some idea of the degree of civilization maintained by the Maya nobles.[38]

The tower, on an almost square plan, rises four storeys above the palace (Figure 41). It reverts to the massive central core of Petén design, in order to accommodate the two straight flights of stairs connecting three corbel-vaulted storeys. Between the vaulted storeys the customary attic is kept, although the interior construction does not need it. This inaccessible attic forms a chambered passage between the floors, presumably to lighten the masonry while reassuring the Maya eye that the customary proportions between bearing wall and vault-zone are respected. The

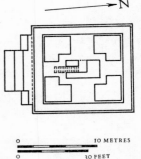

N

| 0 | | | | 10 METRES |
| 0 | | | | 30 FEET |

Figure 41. Palenque, Palace tower, eighth century(?). Section and plan

incoherence of inner and outer forms is characteristic of the general Maya concern for exterior symmetry and regularity, at the expense of interior commodity.

Another remarkable edifice at Palenque is the Temple of Inscriptions (Plate 81B). Its pyramidal platform contains a large vaulted crypt at ground-level, entered by a stair shaft of about sixty-five steps on two ramps, covered by ten levels of corbelled vaults in

stepped ascent. The Maya architects apparently never attempted to build corbel-vaults with slanting imposts and capstones. Their idea of stability required level vault-masses.

The crypt and stairs of the Temple of Inscriptions also have stone tie-rods spanning the upper vaults instead of the customary wooden members, as if displaying the architect's mistrust of perishable wood, and his conviction that the tie-rods were indispensable under these conditions of exceptional stress. In the crypt, a monolithic sarcophagus rests upon six piers, and its carved walls are covered by buttress-like masses of masonry nearly filling the lower level of the crypt chamber. These buttresses were probably built in order to move the slab lid of the sarcophagus into place on rollers. They were never removed,[39] and the entire stair shaft was filled with rubble to close access to the crypt.

Comalcalco,[40] in the state of Tabasco, is closely related to Palenque in its architectural style, and it is situated near the westernmost limit of Maya culture, only about 90 miles from the Olmec site of La Venta, where contact with non-Maya Gulf Coast peoples was maintained. The ruins of a large palace and of a tomb with stucco reliefs like those of Palenque have long been known. The corbel-vaulted structures are built of good fired bricks, measuring 19 by 25 by 24 cm. ($7\frac{1}{2}$ by 10 by $1\frac{1}{2}$ inches), laid in lime-mortar made of burned oyster shells and thickly stuccoed.[41]

Half-way between Palenque and Copán are the middle river cities, Piedras Negras in Guatemala and Yaxchilán in Mexico. They stand on opposite banks of the Usumacinta, only 45 km. (28 miles) apart as the crow flies. Yet Yaxchilán belongs to a conservative Petén tradition, while the Piedras Negras buildings are open, light, and airy, like those of Palenque. The site of Yaxchilán (Figure 42) is a long, curved river bank on a nearly circular loop. Along it the city extends upon an esplanade rimmed by platforms and building groups. The site has been much damaged by floods, and the ruins of washed-away structures are visible at the river's edge. Rising from the esplanade are narrow hill-sides separated by shallow ravines.[42] The western hill descends to a bench-like hollow completely covered with platforms, terraces, and buildings. The eastern hillside descends more gradually to the river, and its flanks are terraced in a long curving sequence of platforms, stairs, and building groups which all command views of the river.

Yaxchilán can be compared to the Petén plans of waterhole sites, with groups of buildings standing upon ridges and knolls. Close resemblances to the Petén style appear in several platforms with inset and re-entrant corners (Burial Pyramids Nos 35 and 36) as at Tikal, and in the single-vault plans with thick bounding walls, like Structures 20 and 42. Other edifices recall the galleried parallel vaults of Palenque and Piedras Negras, although their doorways are separated by wall-sections rather than piers. Examples of this type are Structures 30 or 23, with the roof-combs resting upon the median wall, as at Palenque. Structure 23 was built c. A.D. 726 (9.14.15.0.0).

Structure 33 has lintels dated around 750 (9.16.0.0.0): this type flourished soon after the parallel-chamber system just described. The new Yaxchilán type is but one vault wide, with the roof-comb resting upon the capstone. The length of the vault is divided into chambers by masonry partitions and interior doorways with corbel-vaulted arches. The façades open by an odd number of doorways between wall segments. The latticed roof-comb upon the capstone actually loads the weakest point of the vault (Figure 43),

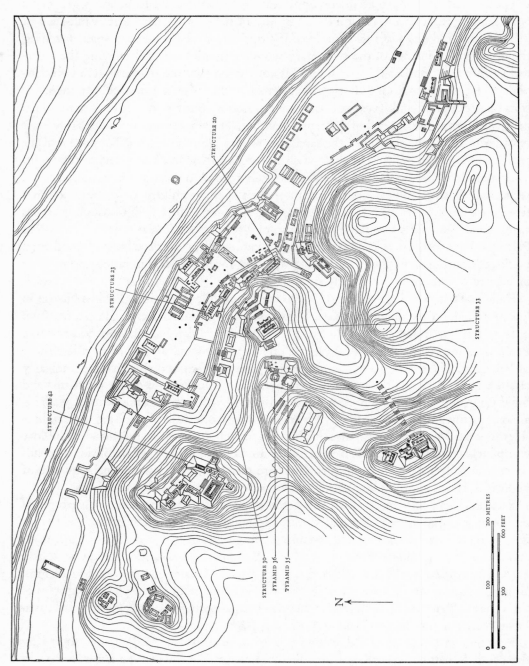

STRUCTURE 20

STRUCTURE 23

STRUCTURE 42

STRUCTURE 33

STRUCTURE 30
PYRAMID 36
PYRAMID 35

N

100 200 METRES

300 600 FEET

Figure 42. Yaxchilán. General plan as in c. 900

144

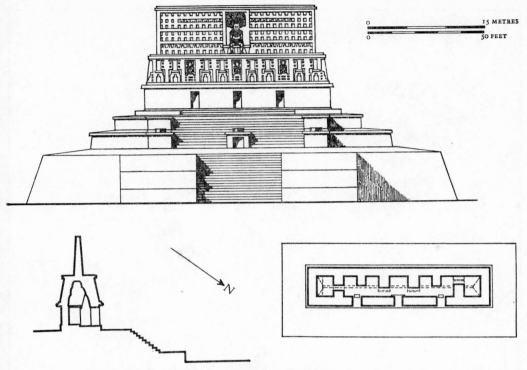

0 15 METRES

0 50 FEET

Figure 43. Yaxchilán, Structure 33, c. 750. Elevation, section, and plan

and its weight would buckle the supports if they were not reinforced by the partitions, which function like interior buttresses. Why the architects should thus have risked the collapse of their work is difficult to establish. That they knew better is shown by the concurrent use of parallel vaults keyed to a median support (Figure 32C). The artistic problem may have required the co-ordination of a single-vault plan beneath a roof-comb of symmetrical properties in both front and side elevations. Interior buttressing appears only at Yaxchilán, as a local trait. Roof-combs charging the capstones reappear on the north-east coast at a very late period. Probably their combination at Yaxchilán obeys local ritual needs, all the while making possible an exterior envelope of complete symmetry on both axes. The extension of an exterior design with parallel vaults to single-vault structures may have been the guiding aim.

Piedras Negras [43] in Guatemala occupies a sloping plateau descending from an altitude of about 200 feet at the western acropolis, to 100 feet above the river level in the southern groups. The buildings do not address the river view: in fact they turn away from the water (Figure 44), and the various groups cluster around the hollows or along the slopes of several little valleys, rather than upon the hill crests as at Yaxchilán.

Three principal building types are notable. As at Yaxchilán, certain edifices reflect Petén custom in the retention of massive plans, enclosing diminutive chambers beneath great roof-combs, upon platforms with chamfered apron mouldings and rounded inset

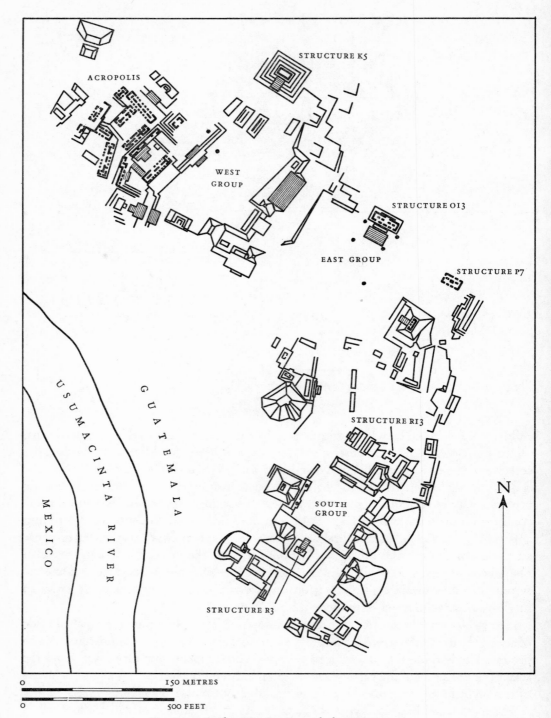

STRUCTURE K5

ACROPOLIS

WEST
GROUP

STRUCTURE O13

EAST GROUP

STRUCTURE P7

U S U M A C I N T A R I V E R

G U A T E M A L A

M E X I C O

STRUCTURE R13

N

SOUTH
GROUP

STRUCTURE R3

0 150 METRES

0 500 FEET

Figure 44. Piedras Negras. General plan as in *c.* 900

146

corners. Structures K 5, O 13, and R 3 are of this type.[44] R 3, dated by associated inscriptions c. 554 (9.6.0.0.0), is one of the oldest vaulted edifices on the site, and its plan reappears in K 5, a temple pyramid completed before 677 (9.12.5.0.0). All the buildings of this group differ from Petén prototypes only in the lower heights of the platforms, the gentler pitch of the aproned profiles, and the triple doorways separated by square piers. At K 5, the large stucco masks flanking the stairs recall the pre-Classic form of E VII sub at Uaxactún (Plate 83).

The second group, represented by the double-range parallel vaults and galleried chambers of the acropolis (Plate 84B), resembles the Palenque palace in the colonnaded façade of many doorways separated by piers, as well as in the grouping by ample closed residential courts. At Piedras Negras, the vaulted galleries seem to be amplifications of an early unvaulted architecture with mortar-and-beam or thatch roofs. If so, the type of the Usumacinta palace reflects ancient local house-mound dwellings, of which a colonnaded form such as O 13 is a probable example.

The most specialized of known buildings at Piedras Negras is a group of steam-baths with chambered plans.[45] The most elaborate, P 7, resembles a double-range galleried unit. The building encloses a small vaulted fire- and sweat-chamber at the centre. The outer rooms were probably for dressing and resting. Eight were excavated at Piedras Negras: one of them, R 13, adjoins the ball-court.

The Dry Forest: Río Bec

Southern Campeche [46] is an uninhabited region of many ruins at the heart of the peninsula. It has less rainfall than its neighbours; there are no rivers; and it once had extensive shallow lagoons, which today are forested swamps with silted clay bottoms. It is surrounded on east, west, and south by rain-forest country. On the north is the dry scrub forest of populous northern Yucatán.

The archaeology of the southern portion is an extension or subdivision of Petén architecture. At Calakmul, Naachtún, or Balakbal, the 'island' groupings, the steep mansard roofs, and the plans of Petén style are associated with an abundance of Initial-Series inscriptions, marking the same time range as in the Petén. The most complicated plan at Calakmul is Structure III (Figure 45), with at least twelve rooms interlocking to make a central roof-comb unit flanked by symmetrical avant-corps, which also bear roof-combs. This three-towered scheme has no direct precedent in the Petén proper. One must look to the region surrounding Río Bec, about 60 miles north-east, and as far afield as Becán and Xpuhil, for similar designs. Structure III, however, has none of the ornate decoration that characterizes the Río Bec style, and its mansarded profiles recall the Petén silhouette, with a suggestion as well of Teotihuacán tablero forms. The dated inscriptions of Calakmul allow us to ascribe Structure III to mid-Classic times, perhaps as the archetype or, at least, as an early example of the towered avant-corps designs of the Río Bec style.

Río Bec, Xpuhil (Figure 47), El Hormiguero, Becán (Figure 46), and others within a region about 60 miles in diameter are the principal examples of this new type, in which

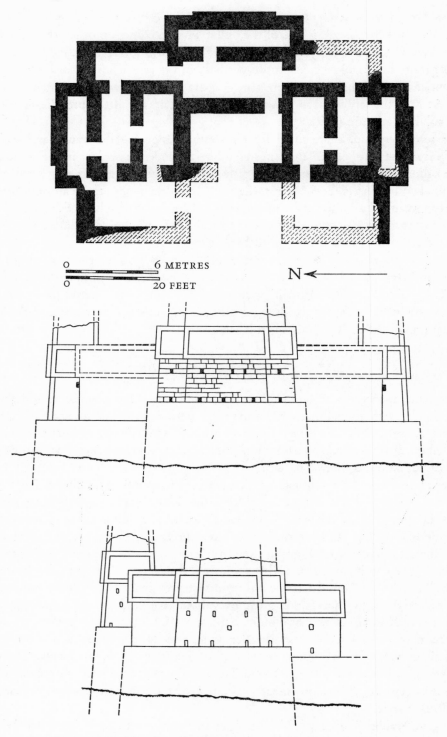

O 6 METRES
O 20 FEET

N ←

Figure 45. Calakmul, Structure III, before 700 (?). Plan and elevation

the temple pyramid coalesces with a chambered palace structure at or near ground level. The date of the style is still unsettled, for no legible inscriptions accompany the buildings. At Becán a moat more than a mile in perimeter surrounds the city. Within this unique cincture are several edifices of Río Bec type. At the southern end of the moated enclosure are Structures I and II, forming two sides of a raised quadrangle. Structure II

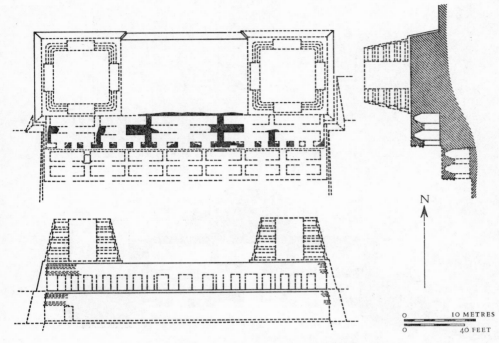

N

Figure 46. Becán, Structure I, before 900 (?). Plan, elevation, and section

is a pyramidal platform surrounded on all four sides by chambered buildings, and approached by a western stairway. The south side of this primary platform is bordered by another curious edifice, Structure I, which also faces away from its quadrangle with two double ranges of chambers opening south upon lower levels than the twin pyramidal platforms overlooking the upper court (Figure 46). The mansards of the upper double range open to the south by pierced façades. The widths of the doorways, diminishing from the centre towards the ends, recall the gracefully proportioned apertures of the palace façades at Palenque. Above this façade, the two four-stage pyramids display typical Río Bec vertical profiles, with wide band mouldings at the top and bottom of each component. In Structure I, the pyramids and the chambered buildings have equal importance: neither is clearly subordinate. But Structure II alters the order: the pyramids are ornamental imitations of the steep Tikal prototype, and they are built on a diminutive scale as ornaments of the west façade.

At El Hormiguero and at Río Bec, such 'harmonic façades', reminiscent of Christian church fronts with towers, reappear with minor variations. At Xpuhil, finally, Struc-

ture I repeats (or prefigures) the type of three-towered composition (Figure 47) already described at Calakmul. Instead of the roof-combs of Calakmul, three fully profiled small-scale pyramids of Tikal type adorn the chambered cluster of twelve interbuttressing vaults. In the south tower a vaulted stairway leads to the roof of the chambered

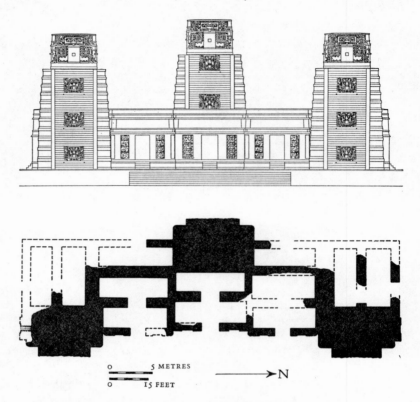

Figure 47. Xpuhil, Structure I, after 900 (?). Elevation and plan

block, but there is no access to the diminutive temples on top of the three tiny pyramidal towers. Each tower, to be sure, has front and rear stairs, with normal risers 25 cm. (10 inches) high, but the treads are ledges too narrow to use.

The date of the Río Bec style can only be guessed. Its intermediate stylistic and geographic position between Petén and Puuc suggests a date after 900.

The Well Country: Los Chenes

In Maya place names the suffix *-chen* signifies location at or near a natural well. Many such places lie south of the foothills called the Puuc, and directly north of the Río Bec district.[47] Indeed the Chenes country may be termed a northern province of the Río Bec style of architecture. Major stylistic differences separate the Río Bec–Chenes group from the Calakmul–Petén group to the south. The boundary between them lies at about

18 degrees 15 minutes of north latitude. Morley regarded the Río Bec monuments as being in Chenes territory,[48] more for architectural than for geographical reasons. His principal argument was that Río Bec and Chenes buildings are both faced with cut stone, unlike the stucco finish of the Petén monuments. The Río Bec sites, however, are usually more elaborate and much larger than the Chenes settlements, so that it is useful to retain a distinction between them.

In the Chenes territory proper, Hochob is perhaps the largest site, set upon a modest rise with three courts surrounded by small buildings and platforms. The principal edifice lacks the Río Bec towers (Plate 85A). Instead, a central vaulted chamber, symmetrically flanked by two lesser chambers on lower levels, as at Culucbalom in the Río Bec province, dominates the little court. The flanking chambers are treated as *avant-corps*. All three façades bear an intricate decoration of cut stone, representing stylized serpent-masks, framing the doorways.[49] Other examples of these mask-façades are at Dzibilnocac and El Tabasqueño in Chenes country, as well as at Uxmal in the Puuc (House of the Magician) and Old Chichén (the Iglesia) in northern Yucatán.[50] Antecedents (or parallels) in the Petén are the serpent façades of Temple 22 at Copán and Building A at Holmul in Group II (Figure 54).[51] Since the most elaborate expression – the serpent-framed doorway – is in the Chenes, it is usually taken as the characteristic trait of the Chenes style.

Other features of Chenes practice also command attention. At Hochob, the stones on the vault soffits are carefully shaped, with deep tenons and rectangular faces. The outer wall surfaces are faced with blocks of limestone.[52] The façade of the central chamber of the main building continues upward in a false front, decorated with rows and columns of human figures. In other Chenes buildings, an aproned moulding marks the level of the impost of the vault. All these traits so closely resemble the architectural practice of the Puuc district that any great chronological separation between the Chenes and Puuc styles seems unwarranted. The Río Bec, Chenes, and Puuc styles are probably roughly contemporary, belonging all three to a Late Classic period, after the close of the Initial-Series inscriptions, and prior to the Toltec intrusion. This period used to be called the Maya 'Renaissance', but the ceramic and stylistic evidence accumulated in the past three decades invalidates the idea of separate civilizations, which the use of the term Renaissance was intended to convey. Succession is present, from mid to Late Classic periods, and also displacement, from the lake and river cities to Yucatán, but at no point can a long era of degeneration separating 'Classic' from 'Renaissance' be clearly established.

The Hill Country: the Puuc

Low hills called the Puuc, not more than 350 feet high, interrupt the flat country north of Champotón. A thick accumulation of ruins occurs in this part of the peninsula. The ancient settlements all flourished near underground cisterns, typical of the Puuc, each holding enough water for the needs of the near-by farmers [53] during the six-month dry season in each year. These cisterns, called *chultunes*, were bottle-shaped tanks, carved into the limestone plain or built in the stone fill of the plazas. They were plastered inside to

collect the rain-water that ran off. The occupancy of the Puuc sites, north-eastward from Champotón to Maxcanú, and south-east from Maxcanú almost to Lake Chichankanab, depended upon the construction and maintenance of the cisterns. The dated sculpture and the remains of pottery indicate settlement in Middle Classic times, and prosperity until the rise to power of the Toltec invaders, after A.D. 900, at the end of the Late Classic era.

The Puuc architects of the Late Classic era transformed all previous Maya practice.[54] Earlier Maya buildings, whether in Yucatán or in the Petén and Usumacinta regions, were built of slabs and blocks, faced with stucco. The Puuc builders, like their Petén contemporaries, used rubble cores, faced by a veneer of thin squares of cut stone. The heavy piers of the southern façades were replaced with round and square columns (Plate 85B), to vary the rhythm of the openings and to improve the lighting inside the heavy walls. The stucco exteriors of the southern provinces were abandoned for geometric designs of carved stone, assembled like mosaics in the upper zones of the façade. The mansarded profiles were replaced by more stable vertical façades (Figure 52). In the vault soffits, specialized facing-stones appeared, allowing greater spans in the rooms, and more finished surfaces.

These innovations all reflect major changes in Maya life. The builders no longer planned great courtyards rimmed with temples and studded with calendrical records carved in stone. Habitations rather than temples were the aim. A few stelae were set up, but the main effort was invested more and more in the new style, with its geometric decoration keyed to the vertical upper zone of the façade and to the single roof-combs on the vertical walls, which are called 'flying façades' (Figure 32E), to distinguish them from the double-wall constructions of the south. The proportions, the mouldings, and the system of decoration all diverge from Petén and Usumacinta practice.

It is not unreasonable to postulate three centuries for the duration of this architectural style. The orthodox view[55] that the Puuc stelae are later than 9.16.0.0.0 (491 Spinden = 751 Thompson)[56] also fixes the date of the architectural and ceramic remains. There is no doubt that the stelae are of Classic date, but there is also no proof that they are coeval with Puuc architecture and pottery. The orthodox correlation of Classic Maya and Christian calendars (i.e. Initial-Series, 10.3.0.0.0, equated with 889) necessitated tying the Puuc buildings to the stelae of Cycle 9, because of firm textual evidence for the beginning of the Toltec domination so soon after the close of the Initial-Series inscriptions, in the tenth century. The radiocarbon dates from Yucatán,[57] however, also allow a correlation equating 10.3.0.0.0 with A.D. 629 and they allow a reasonable duration for the architectural and ceramic forms of the Puuc style, without driving their date far back into Cycle 9. Our chronology, by marking a Puuc period equivalent to 'Late Classic', recognizes both the stylistic autonomy of Puuc architecture as well as its Initial-Series and pre-Toltec position. It also meets the requirement of contemporaneity between Puuc and Mexican events such as Mitla, Xochicalco, and Tajín Chico, where spatial and decorative analogies to the Puuc cannot be disregarded.

The architectural remains define two distinct provinces in north-western Yucatán, coinciding approximately with the eastern and western branches of the inverted V of

the Puuc country. In general, the western sites [58] are small and residential, plain, and much older than the large, ornate, and ceremonial eastern sites. The differences between them are best seen by comparing Edzná with Kabah, or Holactún with Uxmal. Edzná, covering about 250 acres with scattered groups of buildings, was built during perhaps two millennia. It has clearly defined pre-Classic levels of occupancy, as well as Classic and post-Classic remains.[59] Kabah, though twice as large, was built mainly during a 200-year period before A.D. 1000, estimated by ceramic evidence.[60] Holactún, also called Xcalumkin, has a court surrounded by four small buildings. The group, though small, is a large one for the western district, in contrast to the extended clusters of important buildings at Uxmal (Figure 49), Labná, Sayil (Plate 85B), or Chacmultún.

In the west, block masonry carved in large units of decoration is not uncommon. In the east, veneered rubble cores and mosaic decorations of small units easily re-used in new combinations are the rule. These differences probably correspond to early and late phases of Late Classic architectural history. Of course, late traits of construction and ornament are common in many western buildings, but the early traits, which resemble Río Bec and Chenes forms, do not appear in the western Puuc. For example, columns or piers with *atadura* capitals, or binder-mouldings, resembling a girdle of tightly belted thatch flaring out both above and below the belt, are common from the Río Bec district westward,[61] but in the eastern Puuc they occur only in the oldest portions of the Nunnery at Uxmal (Figure 50). Cylindrical columns, on the other hand, appear in both eastern and western Puuc buildings, though more commonly in the east,[62] so that the form may be taken as late, occurring in remodellings and late constructions in the western group. At Edzná (Figure 48), the plain band mouldings and the single slant-faced mouldings are close to those of Río Bec or Xpuhil (Figure 47). There is nothing like them now known in the eastern groups.

The Puuc style of architecture is therefore best apprehended in the eastern sites from Chacmultún to Uxmal, as a Late Classic transformation of Maya practice which occurred in the two or three centuries before 1000. Certain forms characterize its early and its late manifestations: the storeyed or chambered pyramid (Plate 85B); the monumental archway; the vertical façade; the monolithic core veneered with thin stone plates; the use of *atadura* (binder) mouldings; and the apertures framed by columns.

The chambered pyramids of the Puuc are the antithesis of the Río Bec–Chenes buildings (Figure 47), where low, one-storeyed, chambered buildings were bracketed by dwarf pyramids. In the Puuc, from Edzná to Chichén Itza, the architects, by building set-back ranges of chambers upon each pyramidal stage, achieved a storeyed effect. The oldest of these chambered pyramids may be the one at Edzná (Figure 48). It is roughly square, about 60 m. (200 feet) long on each side, and rising 30 m. (100 feet) to the top of the flying façade. Four of its five stages bear files of chambers in set-back levels on the west face and of undetermined extent on north and south faces. The chambers on the second and third stages are double ranges;[63] on the fourth and fifth they are single. Early and late features combine everywhere. There are no binder mouldings, but columnar supports appear in the fifth-storey chamber façades. The entire edifice overlies an older, smaller pyramid of Early Classic Petén type with re-entrant, inset corners. Two modes

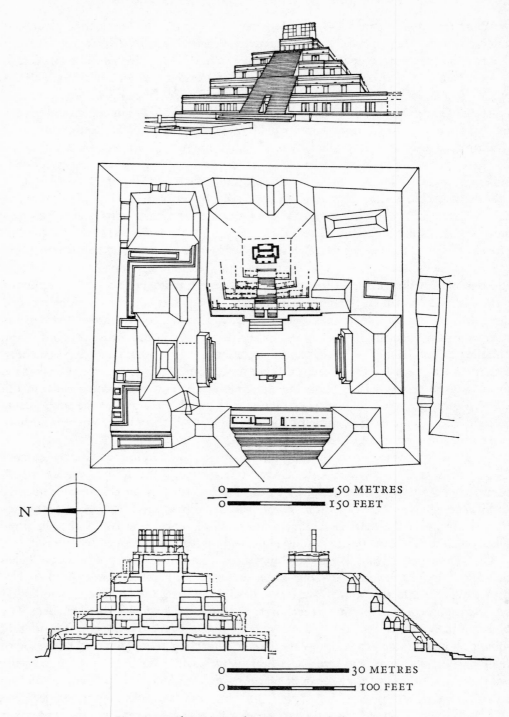

N

0 ▬▬▬▬▬▬	50 METRES
0 ▬▬▬▬▬▬	150 FEET

0 ▬▬▬▬▬	30 METRES
0 ▬▬▬▬▬	100 FEET

Figure 48. Edzná, Acropolis, Structure 19, before 800 (?).
Elevation, plan, and sections

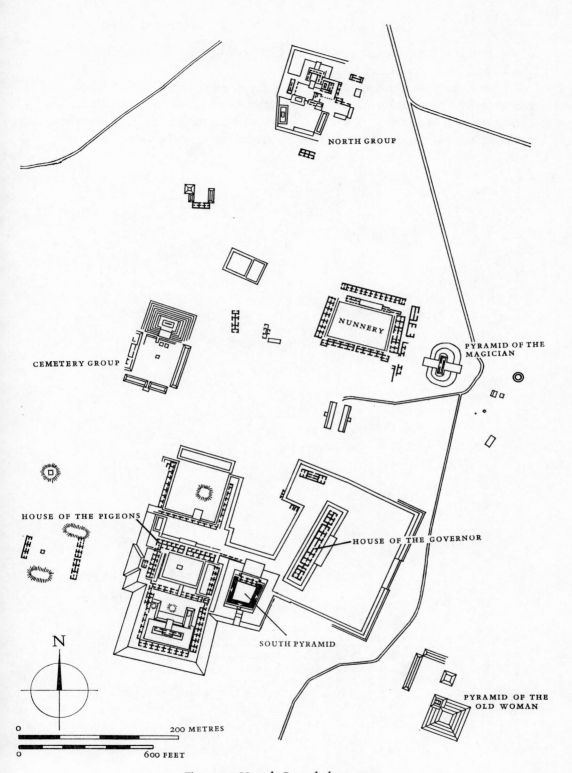

NORTH GROUP

NUNNERY

PYRAMID OF THE
MAGICIAN

CEMETERY GROUP

HOUSE OF THE PIGEONS

HOUSE OF THE GOVERNOR

SOUTH PYRAMID

PYRAMID OF THE
OLD WOMAN

N

0 200 METRES

0 600 FEET

Figure 49. Uxmal. General plan *c.* 1000

of construction coexist: slab masonry in some chambers, and veneered rubble with special vault stones in others.

On other Puuc sites, the pyramidal core shrinks to a terraced support for the files of rooms, as at Chacmultún, where core and stair ramp in the main edifice form a T-shaped nucleus, or in the Sayil palace (Plate 85B), with three terraces of chambers surrounding a solid core approximately 100 by 230 feet in ground plan.[64]

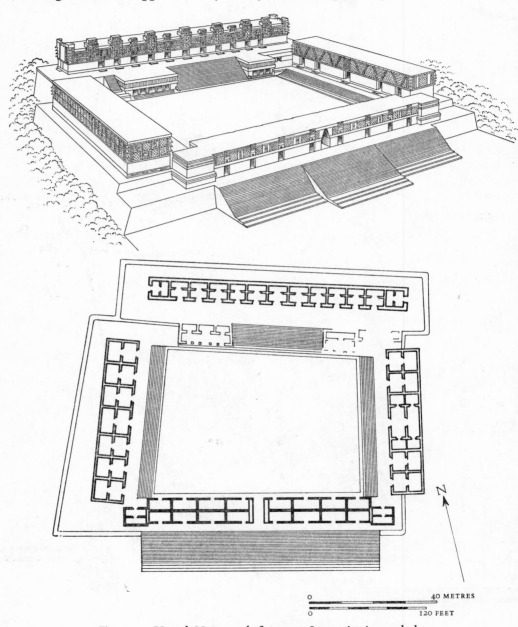

Figure 50. Uxmal, Nunnery, before 1000. Isometric view and plan

Other traits of the Puuc style are best discussed in connexion with Uxmal, the most intactly beautiful of all Maya cities. Uxmal is also the least typical, having, like most masterpieces, transcendent properties and qualities. For example at Uxmal cylindrical columns are rare, although they characterize the Puuc style in both western and eastern variants. Another peculiarity of Uxmal architecture is the open-corner quadrangle, composed of free-standing blocks (Figure 49). It is an exceptional form in Puuc design. This trait, like the mosaic decoration in the upper façades, recalls the architecture of Mitla in southern Mexico (Figure 25). A further parallel between Uxmal and Mitla is the outward lean (negative batter) of the façade walls. Other affinities between the Puuc and Oaxaca will appear below.

Uxmal occupies about 250 acres. The oldest edifice is perhaps the southernmost pyramid,[65] a square, four-stage mass not unlike the main pyramid at Edzná, and called the Pyramid of the Old Woman. At the other end of Uxmal stands the North Group, which is a chambered pyramid with a lower court and edifices on several levels. Between the North Group and the Old Woman are four principal edifices: the Pigeon Group, so named on account of its latticed and gabled façade resembling a dovecote (Plate 86A): the House of the Governor (Figure 52); the Cemetery; and the Nunnery (Figure 50). North, Cemetery, and Pigeon Groups all belong to the same family of

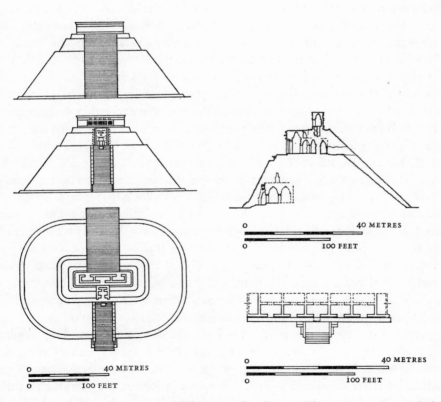

40 METRES
100 FEET

40 METRES
100 FEET

40 METRES
100 FEET

40 METRES
100 FEET

Figure 51. Uxmal, north-east pyramid ('Magician'), after 600. Elevations, section, and plans

'amphitheatre' courts which we have examined at Monte Alban (Figure 23). Barrier-mounds frame the court on three sides. The fourth side with a stairway pyramid is like a stage. The Pigeon Group is the most complex of all, with three courts of diminishing size. The largest is the low outer court, followed by the middle court at the foot of the south temple, where chambered pyramid and amphitheatre court merge. Seler, noting that the Pigeon Courts are more ruined than the Nunnery and the Governor's Palace, ascribed greater age to the former:[66] certainly the Pigeon Courts, both as amphitheatre enclosures and as chambered terraces with flying façades (Plate 86A), are typologically older than the free-standing block designs of the Nunnery and Governor's Palace. The differences between the Pigeon Courts and the Nunnery are analogous to the differences between Monte Alban and Mitla, where we have supposed a lapse no longer than the passage between mid-Classic and Late Classic eras, i.e. no more than six, and no less than two centuries.

One may consider the Nunnery (Figure 50) as an improved version of the earlier Pigeon Court. Like the Pigeons, it spreads at the foot of a lateral pyramid, it occupies platforms on several different levels, and it has a chambered terrace effect on the highest platform, as well as a serrated or castellated silhouette in the principal or north building. The functional uses of these groups are unknown: they may have been palace groups, or institutional dwellings, or even mere concourse centres with surrounding chambers for official ceremonies and for storage. The lateral pyramid, called the Magician (Figure 51), is an eclectic aggregate of styles produced during many generations, beginning in the sixth century and ending in the tenth. M. Foncerrada takes the building history of the Magician (Figure 51) as the key to the stylistic development of Uxmal. Temple I (569 ± 50 by C14), part of a former quadrangle, resembles in plan Structure 74 at Tikal or Structure 1 at Yaxchilán (lintels dated 752–6), and its ornament influenced both Chenes and Río Bec styles. Goggled faces of Teotihuacán derivation in the upper façade support the sixth-century dating. Temple II, east façade, has monolithic columns and a flying façade rising from its rear wall. The column is rare at Uxmal. Temple III, buried behind II, has a mansard roof of classic southern type. Temple IV forms the west façade, and contains the serpent-mouth doorway, related to Structure 1 beneath the Governor (excavated by Ruz in 1947; illustrated in Pollock, 1970, figure 93) in Chenes style, resembling the nunnery at Chichén. Temple V, built under Toltec domination, surmounts Temples II and III (Plate 86B). The serpent-mask doorway on the penultimate stage of the west front (Figure 55) is in the Chenes style – a veneer over a mansarded inner façade of Petén or Usumacinta profiles.[67] The storeyed masks flanking the west stairs recall the tiered masks of Structure K 5 at Piedras Negras. The temple on the summit is like the west building of the Nunnery (Plate 105A). The rounded ends of the pyramidal platform are unique in Maya architecture as now known.

Progressive mastery of the architectural possibilities of free-standing block design appears in the Nunnery buildings. It continues in the masterpiece of the genre, the Governor's Palace. In the Nunnery, the convergence of the lateral pavilions (Figure 50), as in Michelangelo's composition on the Capitol in Rome, may be due to careless or accidental design, but other refinements, such as the outward lean of the façades for

visual correction of the long horizontals,[68] suggest a similar deliberate aim of perspec-
tive correction in the convergent eastern and western buildings.

The north building in the Nunnery (Plate 103) is probably the oldest, as we may deduce
from the older encased structure,[69] from the vestigial roof-combs, and from the narrow
vaults upon heavy supporting walls, as well as from the chambered terrace design on
two levels. A radiocarbon date from this edifice (see Note 38, Chapter 8) reads 893 ±
100. If the ratio of wall to span is an index to age,[70] the south building is the next oldest,
followed by the east pavilion (Plate 104), then the west building (Plate 105A). The south
building has two striking features: the archway entrance on axis with the ball-court,
and the variable spacing of the doorways in both façades. Such monumental archways
appear at Labná, Kabah, and Oxkintok in the Puuc, as well as much later at Chichén
Itza and Mayapán. The variable spacing of the façade doorways has an antecedent in the
Palace façades at Palenque: the widest intervals are the central ones, diminishing towards
the corners, as in Greek peripteral temples. This refinement is lacking in the north build-
ing, but it appears fully developed in the west building, and tentatively in the east build-
ing. These advances in rhythmic complication correspond to the sequence suggested by
the ratios of wall to span.

The House of the Governor (Plate 105B) is the most refined and perhaps the last
achievement of the architects of Uxmal. In it many scattered solutions were brought to-
gether to make up an edifice of striking harmony and repose. Its profiles are adapted to
the scale of the landscape, and its surfaces are adjusted to the hard light of Yucatán with
an ease that reveals both a mature architectural tradition and the presence of an architect
of great endowments. He probably had to conform to an eleven-entry plan (Figure 52)

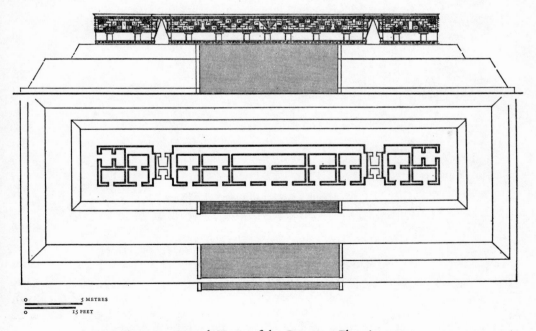

0 — 5 METRES
0 — 15 FEET

Figure 52. Uxmal, House of the Governor. Elevation *c.* 1000

previously set out both in the north building of the Nunnery (Figure 50) and in the gabled House of the Pigeons. He broke the monotonous block of the Nunnery into three parts connected by two corbel-vaulted archways, in a solution anticipated by the *avant-corps* end-apartments in the south Nunnery building. This building also was broken by a corbelled archway. But the architect of the Governor's House boldly made the best of the arch. In the Nunnery, the arch is like a raw wound in the façade, incompletely thought out either as an entrance or as a break in the block. The architect of the Governor's House, however, recessed the corbel-vaulted arch behind the façade, and exaggerated the vault overhangs, carrying them in convexly curved soffits like curtains down nearly to ground level, in order to accentuate the separation of the three pavilions by shadows and by striking contours.[71]

The proportional groupings (Plate 105B) have overlapping and contrapuntal rhythms that recall the complexities of Maya time-division. The doorways in the three pavilions yield the grouping 2-7-2. The main eastern stairway marks another grouping: 3-5-3. Each corbelled archway is flanked by mosaic decorations in the frieze permitting the rhythm 5-3-5. The frieze, finally, has its own rhythmic order of several planes of geometric ornament in depth.

CHAPTER 8

THE MAYA TRADITION: SCULPTURE AND PAINTING

SCULPTURE

MAYA sculptors of the Classic era were Stone Age professionals moving from one site to another as demand required. Their figural art displays cultural unity during a thousand-year period. Limestone (Plate 91), sandstone (Plate 89), trachyte (Plate 88), stucco (Plate 97), wood (Plate 87), clay, and jade (Plate 99B) were the customary materials, worked without knowledge of metal tools. The genres were architectural decoration, commemorative reliefs, figurines, pottery, and jewellery. All large monumental sculpture obeyed architectural lines of force in its placing. Low relief carving is predominant, full-round sculpture rare. The governing impression is of an art of linear contour, transferred from painting in order to secure more permanent effects, without investigation of the sculptural possibilities of bodies in space. Between the Leyden Plate of incised jade (A.D. 320) and an early stela from Tikal, the main differences are in scale and technique. The formula of linear silhouettes in the flat plane is common to both. Five hundred years later, the murals of Bonampak (Plates 106–10) and the figural reliefs of Piedras Negras (Plate 91) show similarities of the same order, although the reliefs have less pictorial scope than the murals, and a more rigid hieratic symbolism. Studied proportions, often with complex harmonic relations, characterize Maya sculpture, in a manner reflecting or echoing the obsession of the Maya mind with astronomical, mathematical, and ritual divisions of time.

A major morphological change in Maya sculpture occurred near the close of the Initial-Series inscriptions in the ninth century, after free-standing stelae (Plate 88) and altars with relief sculpture ceased to be made. Thereafter, from the eighth to the end of the tenth century, during the Puuc period, an architectural sculpture of geometric stylization (Figure 55), which was usually confined to the upper façades of Late Classic buildings, gradually replaced the old tradition of naturalistic and curvilinear relief sculpture. Instead of the priests and warriors and secondary figures of Early and mid-Classic art, geometric assemblies of serpent-mask mosaic forms, with panels of abstract ornament and curtains of stone colonnettes, surround the exteriors of the edifices (Plate 85B). The reasons for this great change are no better understood than those for the twentieth-century 'retreat from likeness'. We may suppose that a cultural crisis and an ethno-geographic shift, or a combination of them all, were involved with the advent of different conceptions of artistic form. The possibility of an autonomous stylistic renewal is also relevant, as in the European shift from the Romanesque to the Gothic style in the twelfth century. In order to describe the history of Maya sculpture, it will be convenient to divide the corpus into two main groups: figural compositions, which characterize the art of the Petén and of the river cities (first to ninth centuries); and geometric architec-

161

tural decorations, which are typical of the cities of the plain in the Río Bec, Chenes, and Puuc regions (eighth to eleventh centuries).

Large, full-round figural sculpture in stone, occupying its own detached space, is most rare in Maya art. One remarkable example has recently come to light. This wood figure, 14¾ inches high, said to come from the middle Usumacinta region, is dated 537±120 by radiocarbon, and it represents a kneeling figure holding on his forearms a platter containing a face-panel. The posture is one of reverence, in body forms of an authority like those of the Olmec wrestler. The theme, however, is Maya, being prefigured in a pottery version at Tikal of Early Classic date.

In general, Proskouriakoff has charted the chronological variations of Maya sculpture, and Haberland tabulates the regional migrations of several hundred specific forms in Maya sculpture.[1]

Commemorative Monuments and Figural Reliefs

The Classic Maya use of free-standing sculpture was restricted to low relief compositions upon tall slabs and prisms of stone (called stelae by transfer from Greek archaeology) as well as on low blocks, drums, and boulders, often associated with the stelae. The term *altar* is a misleading transfer from European liturgy, where it conveys 'a table of sacrifice', rather than 'the pedestal of rank' it signified for Maya peasants and nobles.

The prismatic faces of the stela were often stressed by framed inscriptions and scenes on front, back, and sides (Plate 88). The earliest stelae, like No. 9 at Uaxactún, are long and irregular splinters of stone. Later on, in the Petén and Motagua districts, shafts of nearly square section were usual. Thin slab stelae satisfied a need on the western river sites for many-figured compositions (Plates 94 and 95). After A.D. 514 (9.4.0.0.0), in the Usumacinta region, panel designs, more like illustrations than monuments, are common (Plate 91). The placing of the reliefs also varies according to region. In the Petén, as at Tikal, the stelae are aligned like gravestones along the sides of the courts, but they do not stand at the centre. At Copán and Quiriguá (Figure 39), however, the slabs and prisms seem to be placed at random. Lines of sight, perhaps relating to important agricultural dates in the solar year, may be involved, as between Stelae 10 and 12 at Copán. In the west, at Piedras Negras (Figure 44) and Yaxchilán, the stelae are governed, as commemorations of dynastic rulers, by the groups of buildings, in their off-centre alignment on terraced levels.

The chief purpose of the stelae was to represent standing or seated human ruler figures, richly dressed and burdened with serpent symbols. Other functions of the stelae and altars were to commemorate in writing the passage of the units of Maya time, by five-, ten-, or twenty-year units. The inscriptions also record computations of the length of the solar year as well as of the motions of the moon. The discovery by T. Proskouriakoff that the figural stelae commemorate historical persons, was first established on monuments at Piedras Negras in 1960 and extended later with the series at Yaxchilán, while D. Kelley and H. Berlin established dynastic sequences for Quiriguá and Palenque in 1962 and 1968. At Piedras Negras the records concerned seven series of reigns marked

by birth- and accession-dates spanning the period *c.* 600–800. Similar records at Yax-chilán were about events in the lives of rulers named Shield-Jaguar and Bird-Jaguar and their successors, during the span A.D. 647–807. Proskouriakoff also identified similar inscriptions of dynastic character at twelve other sites, including Palenque, Copán, Seibal, and Tikal.[2]

The personages probably represent successions of priest-rulers (Plates 87–9), whose rank is marked by the ornate serpent bar surrounding the figure, or carried in both hands. By this hypothesis, the bar symbolized the sky, and it conferred the status of 'sky-bearer', or temporal governor, upon its possessor;[3] after the fifth century, its use was less common, and an effigy sceptre replaced the bar, concurrently with the appearance of armed warrior figures in greater numbers than in Early Classic art.

Proskouriakoff named this single human figure (Plate 87) the 'classic motif', and she has traced its variations in two Early Classic phases, and four Classic phases (formative, ornate, dynamic, and decadent).[4] In each period and phase she analyses the regional and local variants, always in order to reconcile the epigraphic and stylistic evidence, which in Morley's great work[5] were often in conflict. Her findings are categorical: pre-Classic and Early Classic versions of the stela figure show a profile outline with frontal shoulders, as in Egyptian dynastic art (Plate 129). The turning of the shoulders into profile view occurred in the Petén during 475–514 (9.2.0.0.0–9.4.0.0.0, especially at Tikal). After a lapse of some sixty years, *c.* 600, when almost no sculpture was produced, the profile stance was abandoned in the principal figures and a new version, with full frontal torso and the feet turned outwards in opposite directions (e.g. Plate 87), made its appearance, beginning about 593 (9.8.0.0.0) in the Petén. This form persisted, with local divergences, until the end of figural relief sculpture about 900. From about 711 (9.14.0.0.0.), animated motions enliven its hieratic dignity, but the feet remain splayed out in opposing profile (Plate 94).

The scale of the figures in Early Classic reliefs varies, not according to perspective distances or to the actual sizes of persons and things, but according to their rank and importance. Tiny captives or victims cluster by the feet of the gigantic principals. In the eighth and ninth centuries this hierarchic conception of scale weakened and yielded to correct visual scale: thus Lintel 3 at Piedras Negras (Plate 91) has accessory figures on the foreground steps in the same scale as the principal enthroned personage (after 782). The Maya striving towards gigantic effect belongs to the same period. Stela 1 at Bonampak, dated *c.* 770 (9.17.0.0.0), is 5 m. (16 feet) high by 2·6 m. (8½ feet) wide, and it is carved with a single human figure.[6] At Quiriguá, the late prismatic stelae of sandstone have colossal dimensions; the largest is Stela E[7] (of the same date as the slab at Bonampak), 35 feet high, the largest monolith ever erected in Maya territory (Plate 89).

Proskouriakoff has traced many other generic and specific differences between early and later sculptural vocabularies. Early scrolls are of simple bifid or trifid outline; later (here 'mid-Classic') scrolls have tendrils and doubled outlines. Early head-dresses have large animal-mask forms (Plate 129); later head-dresses run to mosaic incrustations upon smaller, more stylized animal masks. Early ear-plugs are large disks; later ones are ornate squares (Plate 89). The progression is never merely from plain to ornate forms; it is

from ornate to ornamentally autonomous forms. A loin-cloth apron begins as an elaborate element, and it ends as an arbitrary form which defies imagining as a real part of costume. In other words, the earliest representations are of tropically luxuriant shapes, which progress towards arbitrary symbolic pre-eminence, often at the expense of the human subject of representation. The meaning of this symbolic system is far from sure, but its proliferant serpent-head elements suggest that the figures garbed in them have transcendental meaning; that they are not only rulers but also god-impersonators wearing shreds of the space of upper and nether worlds, represented by serpent mouths, eyes, and fangs.

At this point we encounter an irreducible variety of local Maya expressions in sculpture. For instance the eastern regions – the Petén and the Motagua – differ from the western river cities by their stress upon cage-like costumes. But Tikal in the Petén, and Copán in the Motagua basin, also differ from one another. Tikal sculptors never investigated the possibilities of relief rounded in depth; their work always adhered to close-set front and rear planes, separated by vertical-wall cuts, and differentiated by linear incision. At its best, as in the wooden ceilings from the inner chambers of the main temples (Plate 87), Tikal sculpture achieved ponderous rhythm in the linear surface, by two-dimensional extension rather than by any reliance upon effects in depth.[8]

At Copán, the sculptors boldly attempted to free the body from the stone block. Spinden[9] charted this evolution and his observations still hold good, with minor corrections. At Quiriguá, however, the progression towards free-standing bodies was restrained by the prismatic envelopes. Only the facial planes are cut back into the stone by supple passages of modelling. All other parts of bodies are imprisoned both by ornate costume and by the bounding planes of the prism (Plate 89).

The governing idea of the sculptors of Quiriguá was like that of a diamond-cutter: to conserve the weight and bulk of the stone at the expense of other aims. The great boulders, called zoomorphs, and the flat altar stones near them, display this respect for the natural boundaries of the raw material. Zoomorph O and its 'altar', dated 795 (9.18.5.0.0), are the outstanding examples (Plate 90A). The boulder is carved with a variant of the double-headed sky symbol we have seen on the wooden lintel from Tikal, and on the stelae. Here the dragon-heads in profile confront each other as if to present between them the figure of a seated personage bearing an effigy sceptre. The flanks are carved with more serpent-heads, and the rear bears a geometric serpent-mask bordered by long inscriptions. The 'altars' associated with Zoomorphs O and P are likewise irregular boulders carved in relief (Plate 90, A and B). One part of the top represents a dancer, bearing masks, and involved in coils and layers of serpentine ornament. On the rear part of each altar an elaborate glyph-band forms a terraced shape recalling the ground plan of a temple in the Petén style. On Altar O, the dancer's foot penetrates the 'doorway' as if to show a performance on the temple platform (Plate 90A).

On the Usumacinta valley sites, the narrative relief technique of Yaxchilán and Bonampak resembles that of Piedras Negras. But at Yaxchilán the portrayals of aggression, of visionary ecstasies, and of penitential rites of blood-letting compose an art of violence both against others and against the self which differs radically from the serene and con-

tained palace art of Piedras Negras and Palenque. The earliest dated reliefs of Piedras Negras and Yaxchilán are assigned to the early sixth century; those of Bonampak and Palenque to the early seventh. The latest dated sculptures, showing Mexican intrusions, appear at Seibal in the ninth century.[10]

Some relief sculpture of the western river cities resembles the Petén stelae.[11] But an early divergence is seen about 535. These new narrative and pictorial interests are represented in the Petén style only by small accessory persons crushed beneath the feet of the huge principal figure, or relegated to small panels separated from the main area by bands of inscriptions (as on Stela 1 at Cobá, 9.12.10.0.0(?), or Stela 1 at Ixkun, 9.18.0.0.0).

The new pictorial manner of the Usumacinta cities is seen in Wall Panel 12 at Piedras Negras (9.5.0.0.0(?)) – which was probably incrusted upon a façade. A standing figure in profile of Early Classic style in one panel receives the kneeling homage of four others in another panel. The entire composition is of 7 : 3 proportion. Both the intaglio glyph forms and the proportions are novel. The intention is altogether opposite to that expressed in the arbitrary scale and restricted space of the upright stelae of the Petén style. The composition recalls Maya vase-painting, and mural decoration like that of Bonampak: traces of the green and red paint reinforcing these pictorial effects still adhere to much Piedras Negras sculpture.[12] Several other multiple-figure compositions at Piedras Negras show a unified pictorial space. Wall Panel ('Lintel') 3 (9.16.10.0.0(?), or after 782) portrays a princely figure seated upon a broad dais backed by a serpent-mask panel of perforated stone (Plate 91) like the actual throne discovered in Palace J 6 at Piedras Negras.[13] Seven figures, grouped four and three, flank the dais, and seven seated figures occupy the foreground. Across the room runs a terrace-like step, while a curved line above represents a furled cloth curtain gathered up by cords, as on Stelae 11 and 14. Several inner frames are marked by the glyph bands and by the various tectonic boundaries of the throne-room. At the intersections of the diagonals defined by these various frames are the chief points of interest, such as the full-round hand and arm of the principal figure. This hand rests upon the edge of the dais. The dais, whose width equals one-third the length of the panel, is itself not centred, as if to counter-balance the uneven groupings of figures. The space of an actual room seems to circulate around and among the figures. The front row is carved in low relief, and the more important figures of the rear plane are nearly detached from the plane of the background. Such a progression from shallow foreground to deeply cut background occurred about twenty years earlier (9.15.10.0.0) in stelae like No. 14 at Piedras Negras, where the distinction between primary and secondary figures was carried, not by scale, but by depth of relief.

This virtuosity in complicated figural compositions reappears in Stela 12 (Plate 92),[14] executed about the same time as Panel 3. A warrior seated with one leg negligently raised upon his throne surveys a crowd of seated captives compressed in the narrow space of the stela, and guarded by standing profile figures. The body outlines carry from one to another in ascending wave-like surges recalling the battle scene at Bonampak (Plate 109B). Such bellicose subject matter is common in the Usumacinta region, as at Bonampak and Yaxchilán, but it disappears at Palenque.

Piedras Negras is both typical and exotic among Classic Maya sites, with strongly

marked local characteristics,[15] such as the armed warrior figures (Stelae 26, 31, 35, 7, 8, and 9), frontal deities in niches,[16] and a scene representing human sacrifice by heart excision (Stela 11), as in Aztec or Mixtec representations. A scene shown at Piedras Negras portrays a priest sowing grains of maize: in one version (Stela 40, 9.15.15.0.0, or A.D. 746) the priest kneels in an upper register, and the grains shower upon the ornate bust of an anthropomorphic deity in the lower or subterranean register (Plate 93).[17] This representation affords the closest approach by a Classic Maya sculptor to the representation of natural space: up and down, inside and out, front and rear are shown by arbitrary symbolic conventions rather than by reproducing the visual space of retinal impressions. The sculptor unified the upper and lower halves of his narrative by the linear rhythm of a rope, festooned with leaves and ears of corn. The rope emerges from the mouth of the lower figure, and terminates behind the kneeling priest's head.

Thus the Piedras Negras sculptor, though he possessed a plausible system of pictorial space for terrestrial events, such as scenes of homage and fealty, or throne-room scenes, reverted to abstract conceptual conventions for the representation of vegetation rites. One marvels at the extraordinary range of artistic means at Piedras Negras: proportional harmonies, melodic decoration, visual pictorial space, and symbolic conventions all combine in an art of unparalleled suavity and power, both transcending and divergent from the rest of Maya sculpture.

At Yaxchilán, south-west and upstream from Piedras Negras, sculpture underwent a radical change in the closing centuries of Classic Usumacinta style.[18] Yaxchilán reliefs prior to 760 (9.16.10.0.0) are relatively tranquil single- and double-figure compositions. Hieratic scale is the rule, with the principal figures shown very large, and the accessory figures appearing very small. The principals are frontal, with the feet splayed out and only the heads in profile, as in Petén sculpture, while the accessory figures appear in full profile.

The rule that frontal figures are gradually replaced by profile figures in action seems to hold for Yaxchilán. Stelae 6 (c. 710, 9.14.0.0.0 ± 2 Katuns by style) and 13 (c. 750, 9.16.0.0.0 by style) are early examples of standing full-round figures in profile.[19] They are at rigid attention rather than in action. Scenes with recumbent victims, seated supplicants (Plate 94), and belligerent warriors, all in partial or full profile, appear after 760 (9.16.10.0.0). Both early and late Yaxchilán styles are less harmonious than that of Piedras Negras. The stereotype of Yaxchilán, with pear-shaped heads and bulbous profiles of long curves, is most striking. Body proportions are more ungainly; the abrupt relief in two planes with coarsely incised lines is less agreeable to the eye. The rhythmic grace of Piedras Negras work is absent.

Stela 11 proves the co-existence of two sharply distinct styles of relief. The back (Plate 94), facing a temple, shows a masked priest brandishing a sceptre over three kneeling supplicants. Carved in large units, every item of costume and jewellery is portrayed as if under magnification, on a scale larger than the scale of actual visual impressions. The front of Stela 11 is altogether different (Plate 95): the figures are svelte and in profile upon an empty ground scored only by diminutive glyph blocks. The details of costume all keep to the visual scale, with each object keyed to an actual rather

than to a conceptual size. The two faces of the stela, according to Miss Proskouriakoff's trait graphs, were carved at the same time (*c.* 770, or 9.17.0.0.0±40 years), so that we may suppose the presence of two schools or generations, one retaining the traditional figure of Petén style in the back scene, and another possibly younger whose work in the front exhibits a flat relief style, visually correct scale, and postures of disciplined attention.

At Yaxchilán the direct representations of visionary and penitential rites are unique. Both types of rite were carved on over-door lintels. In the penitential scenes a devotee draws blood from the tongue in the presence of a priest (Lintels 17 and 24). In the visions, one or two figures observe a serpent rising in standing coils from an altar. The head of a human being (Plate 96) emerges from the open jaws of the reptile (Lintels 18, 25, 13, and 14). The association of visions and penitence, of blood-letting and apparitions, occurs only at Yaxchilán, and it seems to prefigure innumerable Toltec and Aztec representations of human sacrifices and plumed serpent symbols. What most strikes us in relation to Maya conventions is the matter-of-fact visual record. Elsewhere, the factual representation of violent scenes was avoided (Piedras Negras), or translated into esoteric symbols (Quiriguá). Yaxchilán reliefs provide the plainest record of the military and religious aggressions in Maya life during the last centuries of Classic Usumacinta history.

Of all this nothing appears in the figural art of Palenque. Certain conventional forms, such as the slab and prism stelae, are entirely absent. The only stela-like figure at Palenque is a nearly full-round human form, more like a statue than any even in the Copán series. It bears a date about 692 (9.13.0.0.0, by inscription).[20] The reliefs at Palenque in stucco and stone are sometimes like fine drawings with conscious refinement of line and with gradations of modelling, occasionally so delicate as to approach shading. These relief panels are all in tectonic positions, at the piers of the façades, upon the inner shrine walls, and on the terrace faces (Plate 98) and mansard roofs of the graceful little buildings.[21] None of the reliefs shows violent action; only static symbolic themes. There are profile devotees flanking the symbols of worship or might, and men holding infants framed by bands of planetary symbols, as well as scenes of homage and triumph. The postures, the faces, and the expressions are stereotyped, lacking the portraiture of Yaxchilán, Piedras Negras, or Seibal. The main variations among the repeating figures lie in attributes and costume. Occasionally, as in the Tablet of the Slaves, the modelling suggests individual identity without full characterization (Figure 53).

In general, the reliefs all describe a courtly life of intense discipline, expressed by exquisite motions and in stylized gestures. Some portraits are full-round stucco heads, originally attached to façade entablatures on certain buildings, or used for funeral offerings, as in the Ruz tomb (Plate 97). The throne back (Plate 99A) portraying a man and woman of about 800 (exhibited at the Metropolitan Museum in 1970) extends the idea of portraiture from the head to the total body posture, in a three-dimensional relief made possible by openwork carving in a thick slab.[22] Such three-quarter heads, used as architectural decoration, occur also at Piedras Negras, and in symbolic deformations like glyph-forms at Quiriguá. An almost caricatural quality appears in limestone reliefs applied as a facing to the terrace platform of House C in the palace (Plate 98). There, on each slab, nearly nude figures with oversize heads crouch and cower, looking in terror

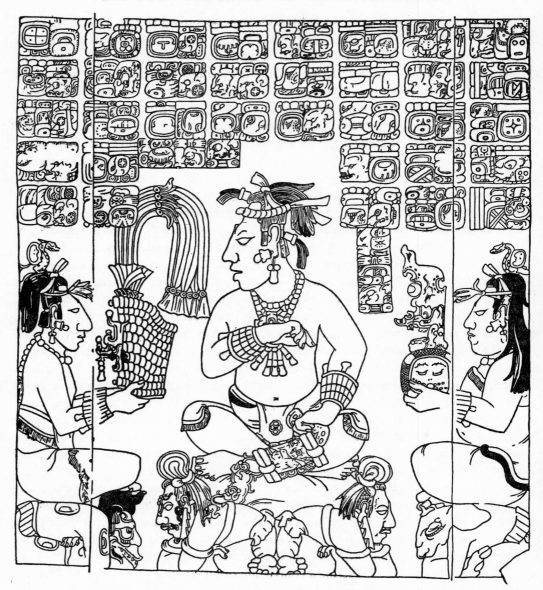

Figure 53. Palenque, stucco relief on ground floor of palace tower, *c.* 730

towards the central stair leading down to the court. They are perhaps portraits of subject tribespeople, differing categorically from the graceful and impenetrable images of the priests and rulers of Palenque.

The study of monumental sculpture tells much about Maya life, but like public sculpture in general it is always limited by the value system of the dominant class and by the existing conventions of representation. In effect, Maya sculpture may tell us more about the long-term history of sculpture as expression, than it dares to declare about everyday Maya life.

168

Jades

Classic Maya jade carvings repeat and condense the themes of monumental sculpture. The exact origin of Maya jade is unknown, although the principal sources of the material and of its workmanship were probably in the highlands of Guatemala. Important burial offerings have been found both at Kaminaljuyú, in one of the suburbs of Guatemala City, and at Nebaj in the western highlands.[23] Different varieties of jade occur: a jewel jade, a commoner pale green stone, and a dark green variety. The material was always worked with stone tools and occasionally with drills of bone. Abrasives helped the sculptor, but metal tools were lacking until the last few generations before the Spanish Conquest.

The debt of the Maya sculptors to their contemporary draughtsmen and painters is as apparent in the jades as in the monumental reliefs. Nowhere is it more striking than in the Leyden Plate,[24] a slab of pale green jade incised with the outlines of a standing figure resembling those on the early stelae of Tikal. The carving is essentially a drawing transferred to jade. The Initial-Series inscription, 8.14.3.1.12, refers to a time about 180 years earlier than the date of the carving, which Miss Proskouriakoff assigns by style to 9.3.0.0.0 (about 495).

The smaller, more sculptural examples of Early Classic Maya jade-carving are hesitant in their effort to describe form, as if Neolithic limitations of technique were insuperable. The elements of form are all of about the same shape and size, all of the same degree of projection, and similar in amount of detail. It is a soft-looking relief of schematic units, each unit reflecting the coarse tools and the difficulty of working the hard jade. Mid-Classic jade-carvers, from about 400 to 700, overcame these difficulties by the same means as in monumental relief sculpture: they varied the width of the cuts and their depth, and they modulated the surfaces more carefully. Certain examples, like the large plaque from Nebaj (Plate 99B), evoke the narrative reliefs of Piedras Negras. The linear outlines have a precision and tautness such as if they were made of bent wire, and the vertical cuts between front and rear planes enhance these energetic contours. A skilful shift between profuse and sparse detail in the surface guides the eye to the narrative and expressive focal points in the composition: it is comparable to the techniques called plano-relief and modelled carving in pottery manufacture.

Pottery

These techniques of carved pottery decoration coincide in Maya archaeology with the cessation of large figural sculpture. They are ascribed to the Late Classic, or Puuc, period, and they were made both in the Guatemalan highlands and in the Puuc territory of north-western Yucatán. Figural carving often adorns the more ornate shapes, such as globular and pyriform vessels. These suddenly re-appeared in the Maya repertory much like revivals of ancient pre-Classic shapes. Such shapes perhaps originated in Central America.[25]

The invention of carved pottery is of Early Classic date, a technique called 'gouged-and-incised', in which scroll patterns were engraved in the clay and reinforced by slices or gouges repeating the main contours. A later development, called plano-relief carving, characterized the end of the Early Classic era, both in Maya wares and at Teotihuacán in the Valley of Mexico. In plano-relief, the background was carved to produce a design in two planes, front and rear, without modelled passages between the ground and the figure. Modelled carving is the final Late Classic refinement, with stamped and mould-made versions, which reflect Mexican influences. Modelled carving was probably a luxury, comparable in value to the jades. Intact examples are very rare: an ornate one is the melon-shaped bowl (Plate 100) found at San Agustín Acasaguastlán, about 50 miles from Quiriguá.[26] It is carved in many planes of curved relief, comparable to the zoo-morphs of Quiriguá. A central seated figure grasps in his arms the coils of two serpents, each double-headed. Their convolutions surround the vessel, with secondary figures engaged among the loops and feathered backgrounds.

The production of figurines was probably introduced to the Maya peoples from the Mexican mainland. Their occurrence is limited to early pre-Classic (Mamom) and to Middle and Late Classic periods after a lapse of about six centuries.[27] Surviving figurines are few, as were the centres of production. The pre-Classic examples have not been systematically published; the Middle and Late Classic burial types have only recently attracted attention, especially at Jaina Island and in the lower Usumacinta valley. They usually incorporate whistles or clay pellets. The Jaina types are the most numerous, and their workmanship is superlative. Two main groups are evident: hand-made whistle figurines (Plate 101), dating from the opening generations of the mid-Classic phase (late Tzakol and early Tepeu in the Uaxactún chronology), and later mould-made rattle-figurines belonging to the Puuc period, that is Late Classic times.[28] Another centre, Jonuta, in the lower Usumacinta valley, has long occupied a shadowy place in the literature on Maya ceramics: possibly a style of mould-made figurines with hand-worked faces, represented by examples in Washington and Cambridge, Massachusetts, originated there.[29]

The hand-made figurines are 10–25 inches high, made of a fine orange clay, white-washed, and painted in blues and ochres. At least three stages of development are evident in the Jaina examples: the earliest (c. A.D. 400?) have symmetrical postures, large disk ear-plugs, and bulbous heads with protuberant eyes. The costumes and jewellery are indicated by ample ribbons and fillets of clay.[30] The second group probably corresponds to the fifth and sixth centuries. The stance frequently repeats the splayed feet of the Petén stelae; the faces faithfully describe age, status, and expression by a technique of moulding, incision, and filleting, all on a jeweller's scale. The portraits are unforgettable, and the dress shows extravagant fashions. The third group, perhaps from Jonuta, has closed contours, as if mould-made, with whistle insertions at the backs. The heads show the exquisite workmanship of the second group. Animated movements and figures in groups occur: one example shows a woman with a smaller figure in her lap (from Chiapas, now Peabody Museum, Cambridge, Massachusetts); another represents an embracing couple (Plate 101). This scene of an old lover and a young girl may have

illustrated a myth or legend, for it was repeated in a much cruder technique in a hand-made figurine found in the Late Classic level at San José in British Honduras, on the other side of Yucatán. Finally, in Late Classic times, the Jaina figurines and those from the Usumacinta valley all show coarsening due to mass production based on moulding techniques.[31]

ARCHITECTURAL DECORATION

Monumental masks of geometric form occur on the earliest Maya pyramids, e.g. the faces of the stairway terrace of the pre-Classic pyramid at Uaxactún (Plate 83) or the pyramids of Acanceh in north-western Yucatán. Variants of these early mask-forms re-appear as more or less curvilinear and natural versions in all the principal Early and Middle Classic centres, both in the Petén and in the river cities. The masks are encrusted upon the buildings or terraces, and only rarely can one observe their complete inter-action with the structure itself.

Such an interaction of structure and ornament in geometrically regular forms char-acterizes the Puuc period, when rubble walls veneered with stone mosaics allowed the builders to redesign the decorative system. Two types of façade decoration accompany the new structural methods. The more elaborate form is the serpent-façade (Figure 55),[32] with the doorway treated as a serpent's gullet, framed by fangs, eyes, and ears to suggest the celestial character of the temple (Chenes). The more common form is a serpent-mask frieze of stereotyped mosaic panels alternating with colonnettes in the upper half of the façade (Plate 85B). At the corners of the façades, and on the stairway balustrades, isolated mask panels recall the ancient method of incrustation (Figure 51).

The oldest known serpent-façade is at Holmul in the Petén,[33] where Building A in Group II (Figure 54) is an Early Classic monument of a date earlier than A.D. 535 (9.5.0.0.0). The east face of the platform was a serpent-mask 10 m. (33 feet) wide and 4 m. (13 feet) high, built of coursed masonry in recessed and protruding planes. There was no doorway in the gullet of this gigantic mask. Two more half-size masks adorned the south corner façade.

The façade of Temple 22 at Copán (Plate 102) incorporates a doorway as the gullet of a mask-panel. It was built before 780 (9.17.0.0.0) and is the most important single building at Copán, built of block masonry laid in mud.[34] The main façade looks south. Its serpent-mask doorway has teeth lining the sill and fangs protruding from the jambs, beneath geometric eye- and nose-forms in the upper façade. The four corners were adorned with two-tiered corner masks of curvilinear forms, and the upper façade bore more masks flanking the centre doorway panel. Both the doorway and the corner masks are curvilinear. Human torsos and heads in the late Cycle 9 style adorned the cornice. The entire edifice is homogeneous, belonging to the same period as Stela N. It is comparable to the serpent doorways which arose later in the Chenes and Puuc regions of Yucatán.

Possibly intermediate in time between the mid-Classic style of Copán and the Late Classic Chenes and Puuc façades are the Río Bec buildings, where two distinct modes of

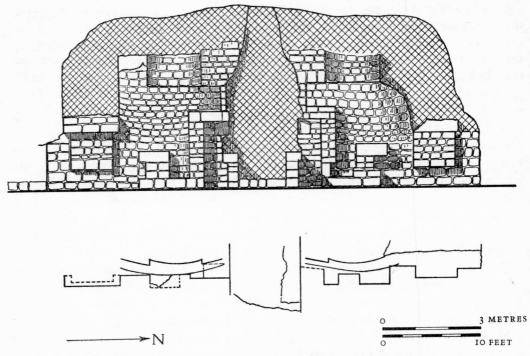

Figure 54. Holmul, Building A in Group II, façade, before 535

architectural sculpture can be defined. One is curvilinear, the other rectangular. The former is (by hypothesis) earlier, the latter, on account of its resemblance to the geometric style of the Puuc, late. Examples of the curvilinear masks are on the towers at Hormiguero, Payán, and Xpuhil (Figure 47).[35] The last-named have, on top of the towers, diminutive sham temples with little serpent doorways composed of two profile masks beneath a frontal overdoor mask. The Xpuhil scheme derives from Copán, but its forms are less fluid and more stereotyped. The relief is deeply cut, and the components of the masks often include several blocks of the coursed facing. This method of design surely required carving *in situ*: at Río Bec it was supplemented by stucco portions.

Examples of the second, rectangular manner are at Becán (Figure 46), Xaxbil, and Okolhuitz.[36] These mask panels also consist of elements covering several blocks of the facing, but they were cut before setting, and assembled on the façade. The group is technically intermediate between the curvilinear masks and the mosaic masks of the Puuc region (Plate 85B).

These differences between curved and straight modes of composing the serpent-masks re-appear in the Chenes and Puuc styles. The Chenes sculptor-architects preferred serpent-mask doorways of an intricate and dense composition (Plate 85A), while the Puuc designers restricted their mask panels to the upper façades (Plate 85B). The Chenes masks retain large curved forms, which virtually disappear in the Puuc mosaics. The Chenes designs also use elements covering many blocks of the facing, while the Puuc

veneer comprises mainly small items of interchangeable units, easily prepared, and easily combined anew in fresh designs.[37] The Chenes-style façades at Hochob (Plate 85A), Dzibilnocac, and El Tabasqueño differ from those of the Río Bec group more in architectural grouping than in the mode of decoration; in fact the Chenes system resembles the Río Bec system (Figure 47) closely enough to belong to the same sequence in time. On the other hand, the rectangular manner of the Río Bec decoration and the Puuc style (Figure 55) differ. The rectilinear Río Bec ornaments are more tentative and hesitant than those of the Puuc; Río Bec Curvilinear and Chenes ornament may represent the earlier stage of a sequence leading to Río Bec Rectilinear and to Puuc mosaics. A hypothetical reconstruction of the chronology would be (1) Río Bec Curvilinear; (2) Chenes serpent-façades; (3) Río Bec Rectilinear; and (4) Puuc mosaics, lasting from the seventh century through the tenth, and ending with the mosaic façades of Uxmal (Plates 103–5).[38]

In the process several new ornamental forms appeared (Plate 85B): ribbed upper façades of close-set colonnettes; three-part *atadura* mouldings; and small-unit mosaic decoration. The colonnettes imitate the wooden construction of Maya house walls, whose closely set vertical saplings were woven together by horizontal binders,[39] like withes tightly drawn, and perhaps cushioned upon belts of thatch. This constriction would give the familiar three-part profile perpetuated in stone by the *atadura* mouldings. The *atadura* appeared in Río Bec architecture on capitals framing doorways and on recessed base and capital mouldings to mark the relief panels.[40]

The continuous *atadura* (or binder) moulding characterizes the Puuc style of building, and it may have originated in the middle Usumacinta drainage, as at Bonampak (Figure 57) and Yaxchilán (Structure 21), where it may be dated as early as A.D. 800 (9.18.10.0.0 at Structure 1 in Bonampak).[41] The Puuc version of the *atadura* frames the frieze with upper and lower boundaries: its purpose was to stress unity by continuous horizontal members visually binding or tying the façade together (Plate 85B). Both the colonnettes and the *atadura* mouldings produced brilliant contrasts of light and shade.

These effects of chiaroscuro were reinforced in the Puuc by the creation of the mosaic style of masonry. The Río Bec and Chenes architects relied upon ornamental forms covering several blocks of the facing. In the Puuc, each unit of ornament was reformulated. It is like typographical design: from a number of small units, each carved with a geometric shape, large pictures are formed (Figure 55). In Río Bec and Chenes façades the serpent-masks are still unitary pictorial schemes, but in Puuc design they are like typewriter pictures, composed with key and ribbon from a small number of conventional signs available in unlimited quantities.

At Uxmal, the oldest edifices, like the core of the Great South Pyramid,[42] show masks built up of such units. The penultimate stage of the Pyramid of the Magician is an imitation of the serpent-mask façades of the Chenes and Río Bec type, and it appears to be made of re-assembled 'typographical' elements, possibly salvaged from some older edifice (Figure 55). Hence it is difficult to date Uxmal façades by inspection of their sculptural components alone; for these were being re-combined and augmented on each new building site in a medley of old and new elements.

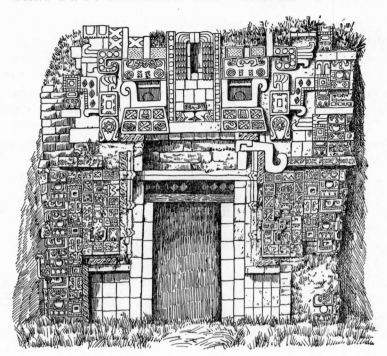

Figure 55. Uxmal, north-east pyramid, House of the Magician,
serpent-mask façade, after 900 (?)

The modes of re-use, nevertheless, show distinct chronological changes, best seen in the Nunnery, where we have assumed (p. 159) that the sequence was north, south, east, and west, on the strength of the wall-span ratios, an ordering supported also by the ornamental programme on the upper façades. Serpent-masks in tiers like those of the older western Puuc sites appear in abundance only on the north pavilion (Plate 103).[43] These tiers of masks were avoided in the south building (Figure 50), where the only serpent-masks are like flaming or smoking coronations to the over-door reliefs showing model temples upon a latticed ground. The model temples are like those of Chacmultún, and the lattice ground resembles the Labná archway. The east pavilion is the least ornate (Plate 104), having masks in tiers only at the corners and over the central door. Most of the frieze has a lattice, enlivened on the court façade by six trapezoidal accumulations of eight stylized sky bands, each with double-end serpent-heads in profile.

The west building (Plate 105A) is the most ornate in the Nunnery Court, showing serpent-masks in tiers at the corners and above the last but one doorways. Models of temples adorn the terminal doorways, and big key frets scaled to the changing intervals between doorways mark a broad rhythm across the entire length of the frieze. Full-round statues are affixed to several of these key frets. The five central doorways are bound together by feathered serpent forms whose bodies seem to disappear into the

walls at the doorways, and interlace in spiral columns between the doorways. Three principal planes of relief are thus established: the ground plane of latticed forms; the key frets of rectilinear units; and the rounded sculpture of serpent bodies and statues. A fourth plane is added by the over-door panels of serpent-masks in tiers near the ends of the building. The effort to diversify the internal rhythms of the façade is not altogether successful, because the various combinations of forms are inadequately differentiated, and their scale does not command attention from a distance.

These timid and irresolute efforts received a much bolder restatement on the façades of the Governor's Palace (Plate 105B and Figure 52). Its three pavilions contain contrapuntal rhythms which are the most elaborate in all Maya architecture. Every corner is marked by a tier of five serpent-masks. These are the only vertical arrangements: every other repetition of the serpent-mask is diagonally staggered, so that an angular undulation of serpent-masks winds across the façades in five pyramidal outlines, one in each end pavilion, and three in the main pavilion. Key frets, like angular eyes, mark still different diagonal rhythms in this system. What was a stiff grid of verticals and horizontals in the Nunnery, here resembles a supple basket-weave of interlacing themes in distinct planes.

PAINTING

Classic Maya pictorial traditions survive in only a few murals, vases, and manuscripts. Although they share a common fund of figural conventions, the murals and the manuscripts belong to different epochs. As in the ancient Mediterranean, figural scenes in wall painting preceded vase-painting, and both are older than the illustrations in manuscripts. Wall paintings of Early Classic date are known; the painted vases are Classic; and the three surviving manuscripts are ascribed to Late Classic times.

The Early Classic development of mural technique marks an important stage in the emancipation of Maya painting from sculptural decoration, and it precedes the appearance of a polychrome figural style in pottery painting. The pictorial system in both depends upon outline drawing, coloured in flat, local tones, without gradations of light and shade, and without the illusion of rounded bodies in gradated colour. The oldest known Maya mural was uncovered in 1937 at Uaxactún in Structure B XIII (Figure 56), on the wall of a small unvaulted room of Early Classic date (Tzakol, roughly before A.D. 600).[44] The painting measures 3·2 by 0·9 m. (10 feet 6 inches by 3 feet) and is composed in two registers. At least twenty-six human figures are shown, above a predella of seventy-two calendrical day-signs. The figures were painted in five colours on a brownish-pink ground, and their gestures have a dynamic animation not to be found in sculpture of the same period; for example, the posture of the dancing dwarf in the upper register appears in sculpture only after 700.[45] The mural contains three scenes: a conference between standing figures on the left; three seated persons inside a house; and four or possibly eight dancers on the right, moving to the sounds made by a seated drummer, and attended by a dozen or more spectators. All wear voluminous headdresses and billowing garments, but only the two standing figures on the left have

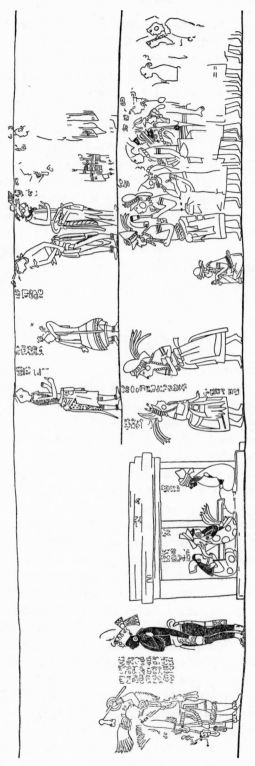

Figure 56. Uaxactún, Structure B XIII, wall painting, before 600

176

sandals. The left figure carries Mexican weapons and wears non-Maya dress, perhaps representing a group related to Teotihuacán. The right figure wears dark body paint and makes a gesture of respect, holding his right arm across the chest. The head-dress and copal bag may mark his priestly status. At least three scales appear – large, medium, and small – corresponding probably to the rank of the personages. Two devices were used to show depth. Overlapping figures mark a correct visual collocation in space. Elsewhere the use of two registers to describe the dancers shows the persistence of conceptual conventions. The building is shown, as in Mexican manuscripts, in cross-section; it is a mortar-beam chamber two bays deep with the doorstep on the right.

Some two centuries later (c. 800, or 9.18.10.0.0), at Bonampak, substantially the same pictorial programme, with seated personages indoors attended by musicians and by dignitaries in conference, re-appears on the walls of Structure 1, greatly augmented with battle and dance scenes (Plates 106–10).[46] The tectonic order is much improved. At Uaxactún the figural friezes were like independent strips of illustration, while at Bonampak the different registers correspond to bearing wall, vault overhang, and capstone levels. The system of delineation remains unchanged, with fluid outlines enclosing flat local tones. The scale is more unified, with differences of size corresponding to tall and short people rather than to principal and secondary personages. The figural poses show profile and frontal conventions as upon the stelae: only the battle scene (Plate 109B) contains many new studies of figures falling or in violent action. The suggestions of deep space are much more insistent, especially in the terraced backgrounds and the multiplicity of pictorial planes, as when persons appear in Room 3 both in front and at the back of the throne-dais (Plate 108).

Preparatory drawings on the pure lime plaster were made in red strokes, and later reinforced with firm black lines. Whether true fresco on wet plaster, or dry plaster-painting was the process has not been satisfactorily determined. The pigments are all inorganic, with the possible exception of carbonaceous blacks. Each room has a dais about 1·5 m. (5 feet) wide and 70 cm. (2 feet 3 inches) high. In Room 1, the risers of these bench-like platforms are painted with stepped key frets of equivalent ground-figure patterns (Figure 57). Each dais surrounds a small sunken area at the doorway. Thus the frescoes were protected by a barrier and by being on a higher level than persons standing at or just inside the doorway.

The scenes on the walls of the three adjoining chambers represent the same *dramatis personae*. The family group of a man and woman with children and servants recurs in both end rooms, upon the partitions (Walls 4 and 10) separating them from the central chamber with the battle scenes. Thus the family (Plates 106B and 109A), though not central to the composition in any one chamber, appears in a privileged position of symmetry with respect to the total composition spanning the three rooms. Other recurrent personages are the three dignitaries of the robing scenes on Walls 1 and 3 (Plate 106), who recur as warriors on Walls 5 and 7 in the central battle chamber (Plate 107), and once more on the top register of Wall 11 as principals in the dance. The white-robed figures with ornate head-dresses all on Wall 3 re-appear on Wall 9 (Plate 108); many look like courtiers, councillors, or priests.

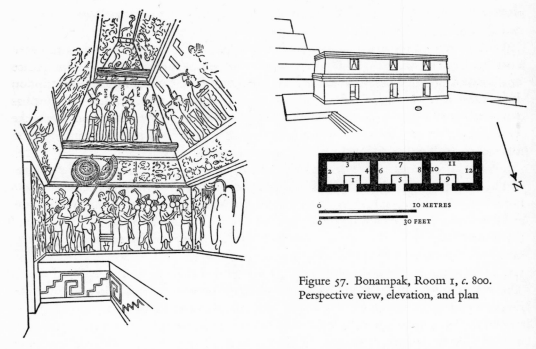

Figure 57. Bonampak, Room 1, c. 800. Perspective view, elevation, and plan

Four registers composing two narrative scenes cover the walls. The bottom register has a blue background which may signify outdoors: it can also signify night. This register begins at the doorway (Plate 106). The files of musicians and attendants face away from the door to converge upon the three central personages on the centre of the opposite wall. On the narrow end walls, four long-handled feather fans extend beyond the frame of this register at the beginning and end of a narrow frieze of glyphic inscriptions on the base of the vault overhangs. Over the doorway, the space of the inscription frieze continues with seated servants who hold ready the jaguar hides, the jade ornaments, and the fans of the costumed persons being robed in the top register. Wall 4, as we have seen, displays the family group (Plate 109A). This action continues on the rear wall, where an attendant displays a child to the white-robed courtiers, who discuss the event with animated gestures. The ochre ground is believed to signify interior space; it may, however, indicate daytime action. In all three rooms, the spectator sees the rear wall first, before the doorway wall, and in all rooms the action on the rear wall seems to precede the action on the doorway wall. Thus the robing precedes the presentation in Room 1; the arraignment precedes the battle in Room 2; and the sacrifice precedes the dance in Room 3.

The spaces in all these narrative scenes are continuous, with figural sequences which continue unbroken round the corners of the room. The upper register shows a time of robing and preparations prior to the public appearance in the bottom register, so that the scenes nearest the spectator are probably the closest in time as well. In the cap of the vault, bands of serpent-masks, frontal and in profile, confront one another to indicate a symbolic sky. This celestial zone is invaded by green feathers of the gigantic head-

dresses below. Differences of size among the figures are visual rather than symbolic, and no trace of perspective diminution appears among the representations.

In this room every detail conveys a sense of preparation and rehearsal. The upper registers concern the private life of the court, revolving about the family of the prince and focused upon preparations for a great ceremony. The tone of intimate description is kept throughout; the narrative is devoid of magniloquent rhetoric, and the artist has reported many homely details of actual experience, such as the servant adjusting the loin-cloth of a robed principal, or the gesture of command with which the prince upon the dais underlines his remarks to the person bearing the child at the south-west corner of Wall 3. Costumes, gestures, and expressions display a refined ritual of social behaviour, governed by luxurious tastes and by a rigidly stylized code of manners. We have nothing like this art of intimate narrative in the older Petén style: it is limited to the Usumacinta cities and to painting on pottery (Plate 114A).

In the other two rooms, the composition by registers is much less evident. Registers are merely suggested in the big battles and terraces of the central chamber, and occur explicitly only on the north or entrance wall (No. 9) of the west chamber, where standing white-robed courtiers, seated nobles, and a procession of musicians and athletes occupy upper, central, and lower bands. Here, they are separated by red ground lines, all beneath a capstone band of star symbols and bird- and serpent-masks. The two registers in the vault overhang both have blue backgrounds, but their connexion in space and in time is not clear.

There has been some discussion of the chronological order of the three rooms. Proskouriakoff and Thompson suggested that Rooms 1, 2, and 3 were painted in that order, but Tozzer preferred to place 2 first, followed by 1 and 3. The question cannot be resolved definitely, but it appears reasonable to group the register compositions as the work of one artist or period, and the full-wall pictures as the work of later years or persons. In this conception, Rooms 1 and 3 preceded Room 2. Certainly the figural variety in Room 2 is the greatest, while Room 3 is less turbulent, and Room 1 is the most static.[47]

The paintings of Room 3 (Plate 108) are intermediate in time, according to this notion of the progressive unification of full-wall space. The residual use of registers and static figures on the north wall and the rarity of action figures, as well as the repetition of long-handled fans, both used to mark the limits of the upper zone and to unite it to the lower row, recall Room 1. Room 3 amplifies the triptych composition. In Room 1, the fans and the upper registers formed an audience scene on three walls (Nos 2, 3, and 4). In Room 3 the terraces of a pyramidal platform extend over three walls, and the scene thus formed even includes the files of figures in the lower register on Wall 12. The pyramid has eight stages, rising between other platforms. On the west (Wall 10) the prince upon his dais surveys the dance accompanied by his family and servants.[48] On the east (Wall 12) an ugly dwarf surveys the scene from a litter borne by a dense cluster of costumed men. The terraced steps of the pyramid swarm with winged human figures, ten in number, wearing *quetzal* feather head-dresses and trapezoidal wings protruding from their hips. At the centre are four plain figures. Two at ground level are raising or tossing the

ankles and wrists of a supine third figure. Above the latter a fourth person holds a knife-like instrument.

The scene has been described as a sacrifice by heart removal, although the pictorial evidence for this interpretation is far from conclusive. The perspective conventions of the artist clearly indicate the position of the horizontal figure: he is shown in the air, with two men below. They are not leaning forward to tie the limbs of the victim; their bodies arch back, as if to toss or catch the body.[49] On Wall 9, near the south-west corner, an official with a fan, who may be the master of ceremonies, sits upon the fourth terrace with his right leg negligently hanging down. This clear indication of the stepped ter-racing of the ground plane finds no confirmation in the alleged sacrifice. To judge from the reproductions, Wall 10 is the most badly damaged. All the winged figures are flaked away, and one suspects either deliberate mutilation or an unstable technique differing from that of the other walls. The general impression is of music, dancing, and brilliant pageantry, witnessed by important personages, and centring upon a display of acrobats and tumblers, of whom others approach from the left. The first and second figures at the door wear ball-players' costume: the third and fourth bear fans. One whole act of the games or pageant is drawing to an end; another is about to begin (Plate 108).

The central room (Room 2) has the boldest and most unconventional studies of action (Plate 107). Nothing like them is known in Maya art, although many groupings in Rooms 1 and 3 have analogies in relief sculpture, especially at Yaxchilán and Piedras Negras. Only the ball-court markers with studies of players in motion are comparable [50] to the battle scenes on Walls 6, 7, and 8. The three walls form a triptych, separated from the entrance wall (No. 5) by wide lines of brown paint at the corners. These two pictures are entirely separate. The triptych describes a raid by Maya warriors upon a tribe of stringy-haired, dark-skinned folk who live among dense vegetation, shown by swirling red lines on a green ground (Plate 109B). On the entrance wall is a pyramidal terrace with the captives abjectly seated along the upper steps. In the battle, the victorious Mayas out-number their victims by nearly ten to one: of a hundred figures, only about ten, crushed underfoot by the Maya hordes, belong to the enemy tribe. Only ten captives, one a severed head, appear in the opposite mural. The two scenes probably show related instants in the capture and public display of the same enemy. The triptych is filled with agitation and noise. The arraignment is hushed and static, with all figures shown as if holding their breath to hear the order pronounced by the prince (Plate 110), pointing with his left hand and clad in a cape of jaguar skin. Above both scenes in the cap of the vault are seven cartouches. Three are rimmed in blue and separated by seated captives on the south wall; the north cartouches contain human and animal figures, perhaps representing constellations.

The battle scene centres upon an action by principals clad in jaguar skins, just to the right of the centre on the south wall (No. 7). On the end wall on the left, standard bearers and a trumpeter rally the attacking forces. On the right end wall supplies of some projectile are brought up. Scores of violent hand-to-hand actions fill the lower registers, with six or more Maya warriors in full regalia, crushing the nude and helpless enemy in each group. The effect is of a punitive action rather than of a strategic contest. The

stringy-haired nude enemy seems poor-spirited and defenceless. If the scene in Room 3 shows human sacrifice, as supposed by Thompson, the battle is probably a raid to take prisoners for it. One detail in the arrangement strongly favours the idea of a punitive action: three crouching captives clearly have blood dripping from their fingertips. They may be victims of an aggression for which they demand justice, and the battle-scene may show the corresponding punitive action. The theme of the arraignment of captives is known in relief sculpture at Piedras Negras (Stela 12; Plate 92) and the judgement theme appears there also on Lintel 3 (Plate 91). But nowhere else have we so complete a context for these themes as in the Bonampak murals, which require an entirely fresh interpretation of the cultural meaning of Classic Maya art.

For many years the accepted symbol of Classic Maya civilization has been the image of a pacific priest-ruler (Plates 88 and 89), first represented in the stelae of the Petén during Early Classic times. The historical opposite of this theocratic god-impersonator is the Toltec Maya warrior of the post-Classic era at Chichén Itza (Plate 123), where Maya and Mexican behaviour and culture are clearly contrasted. The line between them was drawn at about A.D. 1000 and north of Uxmal.

Now, however, it is clear from Bonampak and radiocarbon dating that these 'Mexican' modes of behaviour were current in the river cities before 800. Military leaders displaced priestly rulers in the middle Usumacinta cities some centuries earlier, and the traditional view of a pacific Maya ethos holds only for the Petén, and for pre-Classic and Early Classic periods. Classic Maya art therefore embraces and describes two quite different patterns of behaviour – theocratic and militaristic. Their historical separation probably antedates the middle Usumacinta style of painted and sculptural scenes.

A Maya mural at Chacmultún in the Puuc [51] decorates a stone veneer structure with *atadura* mouldings. The figures do not overlap, and they form a procession in two registers. The body motions are stiff, and the work suggests a provincial and retardataire school of Late Classic date.

Pottery Painting

Pottery painted before firing is common throughout the archaeological history of the Maya peoples. Especial virtuosity in painted figural designs appears during the Early (Tzakol) and mid-Classic (Tepeu 1, 2) periods. At all times, however, only low firing temperatures (1350° C. maximum) could be produced, so that the vessel structure is heavy because of its poor tensile strength, the surfaces are soft, and the pigments are restricted to reds and oranges, browns and yellows.[52] The lustrous appearance of some vessels may have been produced by a lacquer-like coating of organic nature. As Miss Shepard puts it, Petén pottery 'inevitably gives the impression that potters were striving for effect at the expense of usefulness'.

During the Early Classic centuries, many Maya potters successfully evaded the limitations of low-heat firing by applying a thin stucco or clay coat to the vessel, and painting upon the coat in vivid colours of a high key and wide variety. Examples have been excavated at many sites.[53] The most interesting specimens are from two tombs at Kaminaljuyú, where the same generation of painters produced mixed groups of mor-

tuary vessels decorated in both Teotihuacán and Maya symbolic systems, at some time prior to 534 (9.5.0.0.0). The vessel shapes and the technique of painted stucco incrustation may be importations from highland Mexico, but the curvilinear outlines and the thematic matter are purely Maya, with body outlines and postures of a degree of conventionality also seen in glyph forms.

The pictorial space depends upon conceptual scale: on the cylindrical wall of one vessel large serpent-head masks alternate with seated figures in profile.[54] The manual conditions of the draughtsmanship, the cheerful pinks, yellows, and greens, and the appearance of glyph forms in the costumes and attributes strongly suggest a connexion between this art and a lost coeval school of manuscript illumination. All the works of this school are lost, but its existence is deduced from painted vessels and from the much later Maya manuscripts described below.

The general formal characteristics of the Maya pictorial system have already been discussed in the section on mural painting. On vases the cylindrical walls favoured continuous designs. The concave space of vision was inverted to fit the convex surfaces of the cylindrical vessels, whose field lacks a lateral frame. One solution was to align processional figures in a continuous band, which we may call re-entrant composition. Beginning, end, and centre are identical, in an equivalence impossible on flat surfaces. Maya painters of this period also transferred the pagination of book-like compositions to pottery surfaces, as in the splendid stuccoed vessel from Burial A 31 at Uaxactún (Plate 111A). It has front and rear panels, each with paired figures in profile, seated among columns of glyphs. Pink and green fields bear glyphs and figures outlined in fine black lines drawn probably with a reed pen.

Scenes with intricate narrative content did not appear until mid-Classic (Tepeu) times. The principal centres of painted pottery with figural scenes cluster in the Chixoy drainage of the central and western highlands. The clay is tempered with volcanic ash, making a porous grey matrix under the white or orange slip. The Chamá style is the most celebrated example of this art. It embodies many traits of Classic Usumacinta expression, with ethnic types like those of Piedras Negras, Yaxchilán, and Bonampak. Chamá figural painting can be dated during the seventh and eighth centuries.[55]

Two types stand out. One group has repetitious figures, for example anthropomorphic bat gods with outspread wings; the other, less stereotyped scenes (Plate 114A) are probably based on mythology and poetry, and scenes of audience or conference. Both groups have in common a chevron decoration on lip and base painted in deep blue or black upon the ochre slip. The backgrounds are generally orange in colour, and the figures are drawn with firm, continuous black contours surrounding body colours in deep orange, yellow, and brown. In the narrow range of fired Maya colours, blacks assume unusual importance, carrying the principal rhythms. A faithful visual record was the main aim of the painters. Calligraphic flourishes are absent, and the main departures from matter-of-fact reporting appear in symbolic substitutions and transformations, required for calendrical or theomorphic statements, as upon a vase with a rabbit impersonator seated in respectful attention before a jewelled glyph; his ears turn into tortoise shells. Others, like the litter vase of Ratinlixul (Plate 114A), convey a caricatural

exaggeration of the pendulous Maya profile.[56] Even more hostile caricatures appear in the vase portraying a conference between two black-painted warriors and their thug-like attendants, documenting a strong ethnic prejudice against the subjects portrayed.

The burial vase (Plates 112 and 113) found at Altar de Sacrificios is dated 754 (9.16.3.0.0). Six figures include two dancers, a drummer, a singer, a god-impersonator, and a possible human self-sacrifice. The jaguar dancer is named by the glyphs: he may portray Bird-Jaguar, the ruler of Yaxchilán. A seated figure whose speech scroll suggests song, is identified as being from Tikal. Adams has supposed that the vase was imported from the Chamá region for an important funeral, and that its erudite painter knew the ruler of Yaxchilán.

A cave find at Actun Balam in British Honduras shows a deer hunt by six persons including four priests, a woman, and a dwarf, assigned to the seventh century, and believed to be an import.[57]

No other polychrome vessels approach the brilliance of those of orange, red, and black Chamá style. In the Petén and in the western provinces, the tonality was dimmer. An example from Nebaj, only 70 km. (45 miles) south-west of Chamá, showing a prince seated among courtiers,[58] lacks the brilliance of colour and the firmness of Chamá line. A round-bottomed vase said to be from Jaina Island [59] is likewise indecisive of line and dim in colour. It has the archaeological interest of portraying an indoor ham-mock slung from a wooden post, as well as rounded vases of its own type, capped with knob-handled lids which may have been of wood. A meal is in progress. The entire scene rests upon a base frieze painted as a sky band.

Vase-paintings from the Petén and British Honduras show hieratic themes; they are graphic in execution, coarser in structural technique, and more elongated and narrow than other Maya ceramic shapes of the same period. The finds from the vaulted tomb at Uaxactún of the same date as Tepeu 1, from Holmul, and from Yalloch in British Honduras, are examples.[60] In one group (Holmul V and Tepeu 1) complicated scenes of ritual assembly are pictured, as in almost identical examples from Holmul and Yalloch, where priests stand by tree-like staffs with birds in the upper zones. In another group, a strong calligraphic tendency developed into free brushwork with a rhythmic structure almost independent of the image. Of early Tepeu date is the shallow tripod bowl from Uaxactún which shows a priest in costume, perhaps dancing (Plate 111B). The image dissolves into radial brush-strokes in black and deep orange, swirling into the circular frame.

We have now mentioned the chief styles of western Maya figure-painting on pottery, in the Alta Verapaz, in western Yucatán, and in the Petén–British Honduras regions. Two eastern styles,[61] one centred upon Copán and Salvador, the other the Ulúa–Yojoa style of north-western Honduras, probably derive from these western prototypes. The Copador pottery of Copán (Plate 114B) was not only exported to western El Salvador, but it was also imitated there. Its brilliant surface depends upon specular hematite pig-ments of glittering red, with cursive human figures and birds drawn in a few rigidly stylized types. Ulúa river figure-painting is more dense in composition with many black areas. From Lake Yojoa come heavy-walled barrel and cylindrical shapes with careful

textural indications drawn in straight lines. The figural types and the processional compositions almost all recall Chamá and Petén models.

The iconographic study of vessels of clay, painted and carved with scenes and texts, has recently advanced in several studies.[62] One approach has been to assume that such pottery was all made for funeral use, and that its scenes and figures refer to the Maya underworld and to the twin deities named in the Popol Vuh. This colonial text of the Quiche Maya of Guatemala[63] is thought by the best scholarship to be of post-Classic origin, and its proven relevance to Classic inscriptions is doubtful. The pottery scenes of Classic date with glyphic texts are nevertheless proposed as referring to the underworld passage of the twins of the Popol Vuh. The scenes under discussion portray many other things, such as battles, or animal stories, or single human figures, while some vessels, with glyphic statements in the 'standard' format, bear no other figures on them. Hence it seems more plausible, given the variety of subjects accompanying the 'standard' text, to read these texts as a loose group of ritual phrases. These would refer not to the underworld, but to vows or dedications made by pottery craftsmen, and offered to supernatural beings such as fire and earth, who are the patron deities of potters, and whose assistance is invoked. Other such phrases may dedicate the vessel to a living person or to an institution.[64]

FROM THE TOLTEC MAYA TO THE SPANIARDS

CHICHÉN ITZA, the metropolitan centre of civilization in Yucatán, was under foreign domination until the thirteenth century. Mexican foreigners, some resident there since Early Classic time as at Dzibilchaltun or Acanceh, began to rule in Yucatán perhaps as early as the ninth century. The worship of a feathered serpent god of Mexican origin, the Mexican manner of human sacrifice by heart excision, with skull racks to display the sacrificial victims, and many other Mexican highland traits support ethnic identity between the Mexican overlords in Yucatán and the Toltec masters of Tula.[1] The architectural, sculptural, and ceramic resemblances between Toltec Chichén and Tula in the Valley of Mexico are so close that Chichén has long been treated as a colonial extension of the Toltec state, like Kaminaljuyú in the Guatemalan highlands, which was probably a colonial outpost of Teotihuacán about a millennium earlier.

In the thirteenth century the metropolis shifted to Mayapán, where dwellings and shrines for a large population were built within a walled precinct, governed by a confederacy of three regional lords, all still under Mexican highland influence. About 1450 this confederacy broke up, and Maya society reverted to local rule, as at Tulum, and to provincial arts of retrograde quality, enduring until the Spanish re-unification of Yucatán in 1544. This sequence has been archaeologically fixed by massive evidence [2] which invalidates the earlier reconstructions based upon deformed and distorted literary sources. It contains three phases – Late Classic, to about 1000; Toltec Maya, continuing into the thirteenth century; and a Maya re-occupation period until the sixteenth century.[3]

ARCHITECTURE

Chichén Itza

Chichén Itza (Figure 58) is a loose cluster of buildings occupying an area about 2 by 1¼ miles, half the size of Teotihuacán, and smaller than Tikal or Xochicalco. At intervals the limestone plain has collapsed into subterranean caverns to produce conical sinks, as well as open pools with steep walls called *cenotes*. The northernmost *cenote* is the famous Well of Sacrifice, whence E. H. Thompson dredged the cosmopolitan remains of many sacrificial offerings. South of this *cenote* rises an immense primary platform of Toltec date, bearing the principal Toltec edifices, the ball-court, the Castillo, the colonnades, and the Temple of the Warriors. To the south, again, about 550 yards from the Toltec buildings, are two Late Classic buildings in Puuc style, the Nunnery and the Akab Dzib. Other small buildings of the same early period are scattered throughout the bush to the south of these main groups. The two zones, Toltec Maya to the north and Puuc Maya to

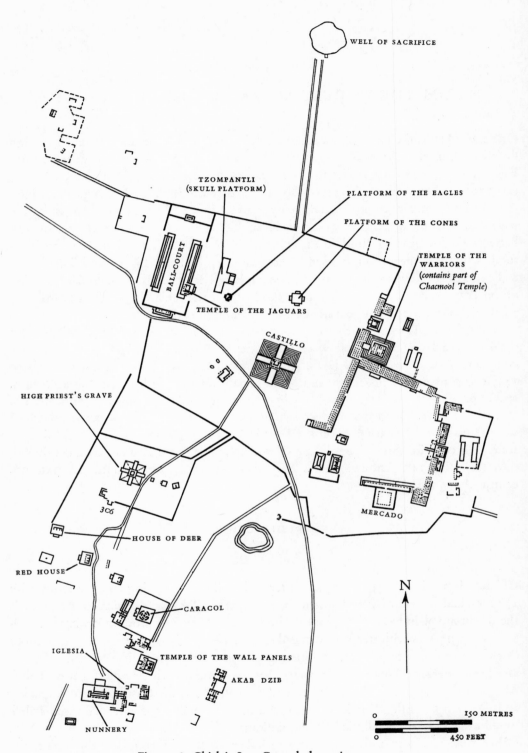

Figure 58. Chichén Itza. General plan as in *c.* 1200

186

the south, have a common boundary in the neighbourhood of the cylindrical Caracol and the adjoining Temple of the Wall Panels.

The Akab Dzib ('Writing in the Dark') resembles in plan the storeyed edifices at Chacmultún. The Nunnery in turn distantly recalls the Pyramid of the Magician at Uxmal in its rounded platform corners, its two-storey edifice, and the Chenes style of the serpent-façade of its low wing protruding eastward from the main platform. The seventh-century Iglesia is a small separate temple facing west, as if to mark a court along the eastern flank of the Nunnery. No element in this cluster betrays Toltec influence; everything is of the Late Classic period, and the Puuc–Chenes style. Other Late Classic buildings are the seventh-century Red House and the House of the Deer, north-west of the Caracol. Another cluster, about 550 yards south of the Nunnery, includes about six small groups, and contains edifices of both periods, Puuc Maya and Toltec Maya.[4]

The chronology of the principal Toltec buildings [5] is still far from complete, but the main sequence is clear, containing an early phase with recognizable Puuc traits, a middle phase of buildings with sloping bases, serpent-columns, narrative murals, and columnar reliefs, and a late phase of ornate narrative reliefs upon the walls of buildings with battered bases and complex mouldings. Each of the three phases lasted about 150 years, and the key buildings are as follows.

I (to 800). The Caracol includes Puuc Maya elements in its substructure, and it was probably remodelled in Toltec style (Figure 59). The small inner Castillo platform belongs to the same period as the cylindrical Caracol, together with the original west colonnade[6] of which the foundations mirror the orientation of the Castillo. The structure of the lower Temple of the Jaguars at the main ball-court also may belong here.

II (800–1050). The pyramid of the Chacmool is buried inside the Warriors platform (Figure 61). Its terrace profiling is identical with that of the outer shell of the Castillo. This profile resembles that of the platforms at Monte Alban (Plate 62), with the Petén trait of sloping faces. The Temple of the Warriors in turn enfolds the Chacmool Temple upon a platform with terrace profiles recalling those of Teotihuacán (Figure 4). No great interval separates the Chacmool Temple from the Warriors. The High Priest's Grave (Note 14) may belong here, as well as the Temple of the Tables.

III (1050–1200). The main ball-court buildings (Figure 63) have not been finally keyed into the sequence,[7] but such details as profiling and the rich repertory of figural reliefs make it possible that the north and south temples, as well as the upper Temple of the Jaguars, are coeval with the Mercado (Figure 62). To be considered in this phase, which may have extended into the thirteenth century, are the Platform of the Eagles, the Platform of the Cones, and the *tzompantli* (skull-rack).

The close resemblance between some of the buildings at Chichén Itza and those of Tula in the Mexican highland was first noted by Désiré Charnay about 1880, after he had visited both sites.[8] Charnay's observations were finally confirmed in 1940, when the Mexican government began excavations at Tula. Most students now accept the thesis that Náhua-speaking Toltecs of highland origin lived as masters at Chichén Itza, and that the evidence of their presence appears not only in representations of warriors, priests, and gods of non-Maya origin, but also in the use of serpent-columns, Atlantean columns,

colonnaded edifices several ranks deep, battered wall bases, crenellated roofs outlined by carved emblems called *adornos*, serpent balustrades, recumbent human figures called Chacmools, incense burners portraying the Mexican rain god (Tlaloc), and narrative relief panels set in plain wall surfaces.[9]

A question concerning the direction of these influences is relevant. The excavations at Tula uncovered only the forms which characterize the second and third phases of Toltec ascendancy at Chichén Itza. The north pyramid (Plate 14) and colonnade at Tula resemble the Temple of the Warriors; other buildings enclose colonnaded courtyards like the Mercado. Chacmool (Plate 19) as well as serpent figures and Atlantean columns (Plates 15 and 17, A and B) have also been found, but there is nothing at Tula corresponding to the first phase of Toltec art at Chichén. Tula may be a stylistic outpost of Chichén rather than the reverse. This thesis was also proposed recently (1972) in Mexico by R. Piña Chan.

The conventional view today is still that an alien art was imposed upon the Maya artisans of Chichén Itza.[10] However, the formative stages of that art are lacking at Tula. They are fully accounted for only at Chichén. At Chichén, it is possible that alien rulers brought ideas rather than objects and artisans and eventually acquired an art from their Maya subjects (cf. p. 199). Thus Mexican ideas, clothed in Maya forms, were eventually implanted at Tula. The principal Toltec forms were temples of circular plan (Figure 59), and feathered serpents. Both relate to the cult of Quetzalcoatl, whose Náhua name in Maya became Kukulcan, signifying the feathered serpent, a wind god of vegetation and rain worshipped in round temples.[11]

In the Mexican highlands, feathered-serpent forms appeared at Teotihuacán long before their Toltec revival. The interpenetration of Mexican ideas and Maya forms is at least as old as the Early Classic art of Kaminaljuyú. At Xochicalco, the Late Classic investiture of Mexican symbols with Maya figural forms was another forerunner of the Toltec Maya union of highland symbol and lowland art.

The oldest and the most original manifestation of the cult of Quetzalcoatl–Kukulcan at Chichén appears to be the Caracol. Its cylindrical form, with double annular vaults and a winding stair in the upper storey (Figure 59), may represent the conch shell which was one of the attributes of Quetzalcoatl in his aspect as wind god. In the upper storey radial shafts emerge from the centre at angles that may have marked transit points in the observation of the sun and stars.[12] The ornament retains strong Puuc characteristics, especially in four serpent-mask panels above each doorway, made of mosaic elements in the technique of that period. Also in the Puuc style is the magnificent *atadura* moulding which marks the annular vault impost levels. It is a five-part moulding, unique in Maya architecture, made of deeply tenoned stones scaled to the exceptional size of the ring vaults. The outer vault circle rises more than 30 feet, the tallest of all Maya vaults.

Several campaigns of construction are evident. The primary platform, on a square plan, is the oldest element. The buried cylindrical base was next, followed by the construction of the secondary platform which enfolds the cylindrical base. Then the visible cylinder of the Caracol was built, with its double annular vault.[13] The west stair attained its present monumental size by the addition of serpent balustrades. Thus the conception

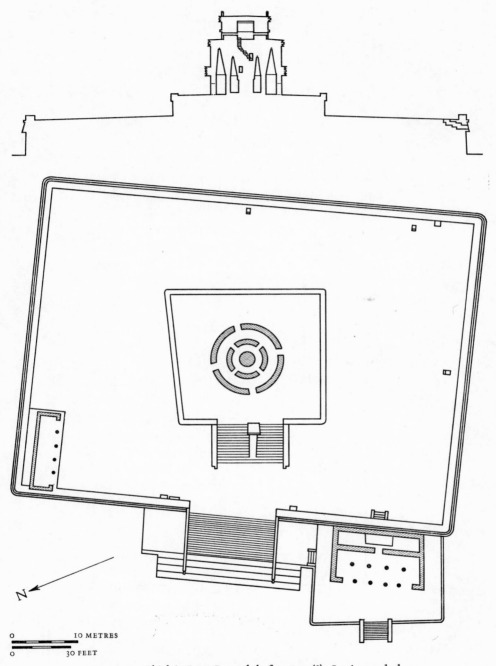

N

0 10 METRES
0 30 FEET

Figure 59. Chichén Itza, Caracol, before 800 (?). Section and plan

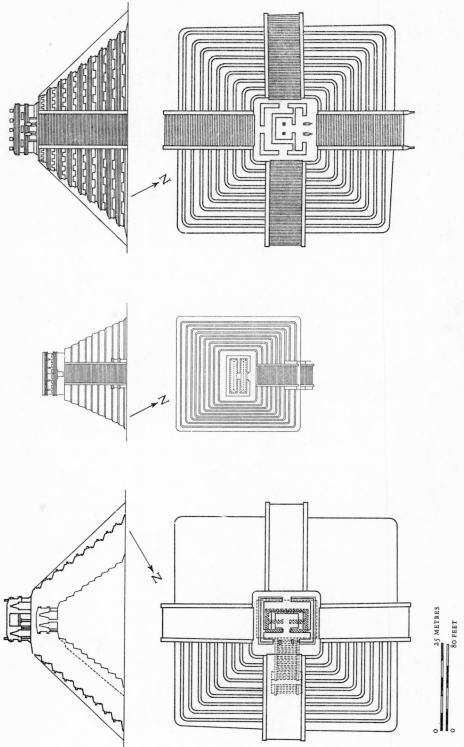

Figure 60. Chichén Itza, Castillo, before 1050. Section, elevations, and plans

25 METRES
80 FEET

of the Caracol is Mexican, but the technique and the governing forms of vaulted construction show Maya derivation.

The Castillo substructure with its nine stages is a much smaller pyramid than its outer shell, measuring only 32 m. (105 feet) on each side, as against 58–9 m. (190–5 feet) for the outer case, and 17 m. (56 feet) in height instead of 24 m. (79 feet). Like most pyramidal platforms of the Classic era, it had only one stairway. The outer platform, resembling the oldest pre-Classic pyramid at Uaxactún (E VII sub), as well as the four-stair platforms at Hochob or Tikal and Yaxhá, was built with four flights of stairs facing the cardinal points, upon a plan like the Maya sign for zero (Figure 60). The profiles of the inner temple, like those of the Caracol, are closer to Puuc than to fully developed Toltec monuments: indeed the impost and cornice mouldings evoke Río Bec models of an early Late Classic date (e.g. Xpuhil, Structure 1; Figure 47). In the upper façade of the little twin-chambered temple are relief figures of jaguars in profile in a procession underneath a series of round Mexican shields bearing heart-shaped designs. This whole ornamental programme seems hesitant and experimental, as if the sculptors were attempting to reproduce the forms from verbal descriptions rather than from visible models. No definite evidence fixes the chronological relationship between the Castillo substructure and the Caracol; both are close to the Puuc period, and the Caracol probably had a longer building history than the Castillo.

The mouldings of the Castillo and of the Chacmool platform buried inside the Warriors' Pyramid are so much alike that they may both be the work of one designer (Figure 61). In addition they recall the panelled friezes of Monte Alban, with salient and recessed alternations of plane which adorn the sloping terrace faces like fringed headbands, secured upon each talus by an upper moulding of simple profile (Plate 62). As at Monte Alban, the device stresses the verticals in a horizontal system. But at Chichén, the sloping terrace faces are an innovation never attempted at Monte Alban. Another refinement at the Castillo is the changing scale of the panelled friezes in every stage (Figure 60). All stages have eight salient panels on every façade, but the topmost ones are only about one-fifth the width of those at ground level. The effect of perspective diminution greatly enlarges our illusion of the size of the edifice.

The outer Castillo temple comprises four chambers, in an ingenious disposition comparable to the annular vaults of the Caracol. The doorway of the north entrance chamber is flanked by paired serpent-columns; behind it is the cella with two piers supporting three corbel-vaults; and surrounding the cella on three sides are continuous vaulted chambers, opening by centred doorways to east, west, and south. Both the temple and the pyramidal platform are more complicated designs than the Chacmool Temple and Pyramid. The forms of the two edifices are closely related – for example in the battered bases of the temple façades, and the panelled friezes and rounded corners of the platforms – but the Castillo appears in every way to be more advanced, more highly developed.[14] Perhaps fifty years separate the two designs; surely not more, and probably less, if one be guided by analogy concerning the rate of change in other architectural schemes of this magnitude (e.g. Gothic cathedrals).

The Chacmool Temple was eventually discarded, together with its platform, by being

buried within the base of the Temple of the Warriors.[15] At that time, the platform was judged inadequate, and its profiles were replaced by an entirely different system (discussed below). The Chacmool Temple was two-chambered, with each chamber divided in two columnar ranges supporting twin corbel-vaults. This scheme was an improvement on the simple temple in the Castillo substructure, and it was later greatly enlarged, by double files of piers in each of the two chambers on top of the Temple of the Warriors (Figure 61). These piers number twelve in the west chamber, and eight in the inner throne-room. The dense supports in the west chamber give it character as an anteroom or vestibule, and the wider intervals in the throne-room confirm it as a hall of audience and as a seat of authority.

In the Temple of the Warriors there is a remarkable change of style in the profiles of the platform. The four terraces no longer resemble Monte Alban; they are more like Teotihuacán, with a vertical framed panel in relief surmounting an inclined base. It is as if the architects of Chichén were searching for good historical models in an eclectic frame of mind, casting about among highland examples of five hundred to a thousand

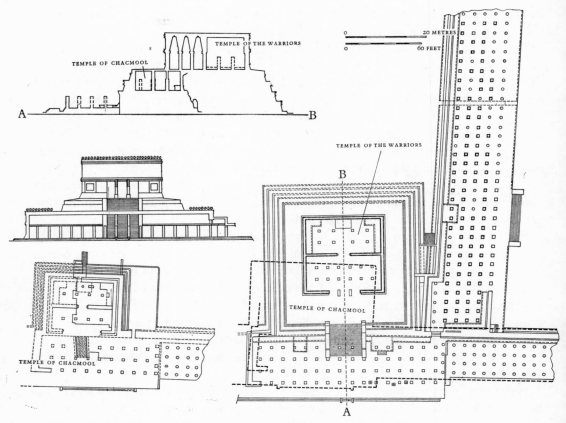

Figure 61. Chichén Itza, Temple of the Warriors (before 1050), containing Chacmool Temple in platform. Sections and plans

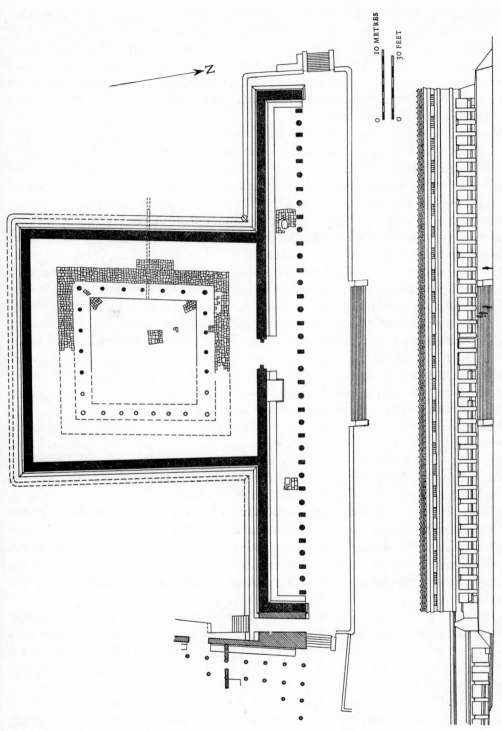

10 METRES

30 FEET

Figure 62. Chichén Itza, the Mercado, before 1200. Plan and elevation

years earlier. The proportions of the platform stages of the Temple of the Warriors are nevertheless awkward. The relief panels ride like cornices upon disproportionately large sloping base planes (Figure 61); the effect is papery rather than grandiose, and it is weakened by the effort to make inconsistent systems cohere. How much time elapsed between the building of the Chacmool and the enfolding Warriors? Probably not less than two generations, or fifty years, if we may be guided by other examples of the obsolescence of building fashions.

Vast vaulted colonnades form a pattern of enclosures along the eastern boundary of the Castillo court (Figure 58). The range facing the eastern façade of the Castillo may be the oldest, antedating the platforms both of the Chacmool and the Warriors. Its northern end once projected westward into the Castillo court at the north-west corner of what is now the Warriors' Pyramid. This portion was replaced first by a demolished north-west colonnade associated with the Chacmool platform, and finally by the present colonnade, which forms a vaulted vestibule to the Warriors' Pyramid.[16] The southern end of this original west colonnade has not been excavated, but it was probably coeval with the substructure of the Castillo because of the exact parallelism between the orientation of the colonnade and the pyramid. In its pristine form, the west colonnade defined a wide, shallow court at the eastern foot of the Castillo. It was four rows deep, and its southern extension was vaulted with low, flat-angled corbel-vaults, with overhangs of a slope about 50–55 degrees. The columns were all cylindrical. In the Chacmool rebuilding of the colonnade, square piers were substituted, and these were repeated in the final colonnade of the Warriors. The north colonnade post-dates the platform of the Warriors, and it has five rows of supports, of which the southern or outermost are square piers, and all the others are columns (Plate 121A).[17]

The southernmost element of the colonnaded group is the edifice called the Mercado (Figure 62), of which other versions exist at Tula. The Mercado is given the same date as the Temple of the Jaguars because of spool ornaments in the upper façades and the wide, deep mouldings. The spools of the Mercado so closely resemble those of the Temple of the Jaguars that many were used in the restoration of the ball-court building. It is likely that the Court of the Thousand Columns was a market place with many little constructions like stalls and booths in north–south rows.[18] The Mercado may have been a tribunal, built after the market court had been paved with red-painted stucco. In the façade, piers and columns alternate to vary the otherwise monotonous effect of the thirty-six intercolumniations. This gallery is like a stoa prefixed to a Roman atrium house.

The dating of the main ball-court group (Figure 63) is still uncertain. The gigantic dimensions (target-rings 20 feet above the floor, and a playing area 480 by 120 feet) make it less likely that humans were intended to use it than cosmic or mythological beings. Three smaller vertical-wall courts, grouped around the market place, may have preceded its construction. The court has an unusual profile with vertical playing-faces, like the Late Classic ball-court at Edzná in western Yucatán.[19] The north and south ends are closed by temple platforms, and the east mound has two temples upon upper (Plate 115A, Figure 63) and lower levels at the southern end. The profiles of these

temples and their low relief carvings are the most sumptuous at Chichén. Thompson, Lothrop, and Proskouriakoff believe the ball-court style to be early, coeval with the substructure of the Castillo, because the correlation they favour between Maya and Christian chronologies (Goodman–Thompson–Martínez) leaves no great gap between Classic Maya and Toltec Maya art. They regard the Toltec Maya, Puuc–Chenes, and Petén–Usumacinta styles as all roughly contemporaneous, falling in the opening generations of Toltec ascendancy at Chichén Itza.[20] Lothrop and Proskouriakoff tend to bunch the styles together about the eleventh century; Spinden, Andrews, and now Parsons and Ball spread out the Late Petén–Usumacinta, the Puuc–Chenes, and the Toltec Maya styles over a span of 600 years. The radiocarbon measurements of Late Classic and post-

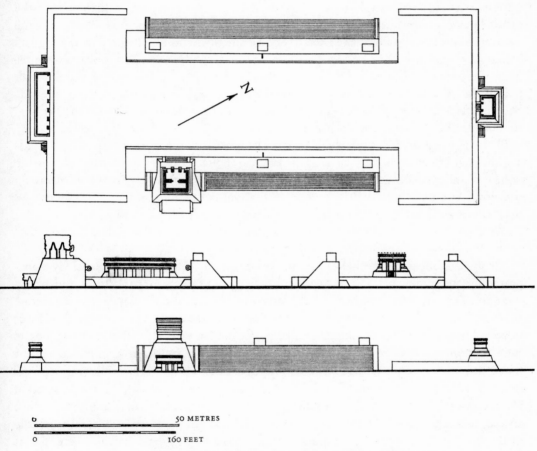

0 50 METRES

0 160 FEET

Figure 63. Chichén Itza, ball-court, before 1200. Plan and elevations

Toltec works support Spinden's correlation, allowing at least three centuries to separate Toltec ascendancy from the close of the Petén–Usumacinta Classic style. This, however, leaves the resemblance of many Toltec Maya forms to Classic Maya relief sculpture unexplained. Nothing like these forms appears in the Puuc–Chenes style, and Lothrop

195

quite reasonably objects to Spinden's explanation as archaism. To this question we shall return when discussing the sculpture of Chichén Itza.

If we confine our attention solely to architectural forms, it is obvious that the ball-court buildings (Figure 63) are later than the Court of the Thousand Columns, because their profiles most closely resemble those of the Mercado (Figure 62), which stands on top of the unbroken courtyard flooring. The date of this courtyard floor, in turn, is presumably earlier than that of the north colonnade, which post-dates the Temple of the Warriors. If this sequence is tenable, then the ball-court buildings post-date the Warriors group, and we are concerned with a renaissance rather than with coeval Classic and Toltec styles, as the archaeologists of the Carnegie Institution have supposed.

The actual chronological sequence of the main ball-court buildings is fairly clear.[21] Oldest is the lower Temple of the Jaguars, facing east (Figure 63); then follow the parallel playing faces, the south and north temples, and finally the upper Temple of the Jaguars (Plate 115A), which faces west. The façade of the lower Temple of the Jaguars (Maudslay's Temple E) resembles the substructure of the Castillo, and it probably ante-dates the present ball-court. The long east mound eventually incorporated this small, old-fashioned temple, which was modernized by the addition of sloping exterior wall-bases north and south and by the inside enrichment of narrative reliefs. This moderniza-tion occurred when the sloping benches were carved in the ball-court proper.

Excluding the lower temple shell, we may suppose that the entire campaign of build-ing the ball-court occurred not long before the Toltec collapse and dispersal. Of the same general period is the Platform of the Eagles (Plate 115B), a low edifice between the ball-court and the Castillo. It is related to the ball-court buildings by mouldings and relief carvings. The *tzompantli* (skull-rack) rests upon the latest plaza floor,[22] so that it can be dated, like the Mercado, later than the construction of the colonnades, and together with the ball-court buildings, that is *c.* 1200.

All these edifices of the ball-court period have intricate profiles secured by com-pounding the traditional Maya *atadura* mouldings with foreign proportions and heavy members. The unified door-frames embrace several voids and display panelled exterior compartments in several planes of relief. The new silhouette is absent in the lower temple, but fully present in the upper Temple of the Jaguars (Plate 115A). Instead of the two horizontal façade zones of Maya tradition, there are four. An uppermost serpent frieze and a lower tiger frieze divide the upper façade. The lower bearing wall again is divided in two, with a sloping base beneath an upright wall-portion. This is panelled in several planes of relief recalling the salient and receding portions of the Castillo terracing, although here the panelling is vertical rather than inclined. Almost identical is the profile of the gallery of the Mercado (Figure 62), with two sloping-base portions of different inclination, and a double division of the upper façade above impost level. Another variant in the Platform of the Eagles, which Bishop Landa described in the sixteenth century as a 'theatre', exploits even more boldly the shadowed overhangs in the ascend-ing sequence of inclined base, vertical in-and-out panels, and overhanging cornice (Plate 115B).[23]

We have now examined the main sequence. Before 800, building at Chichén Itza

expanded northward with the Caracol vaults, the substructure of the Castillo, and the west colonnade. Before 1050, we have supposed an eastern extension in the Court of the Thousand Columns, including the reconstruction of the Temple of the Warriors together with the slightly older 'fossil' temple within the Chacmool. In the twelfth century the main ball-court marked a western extension, and the Platform of the Cones arose in line with the paved road to the Well of Sacrifice at the northernmost boundary. It finally became a cruciform site with the north–south axis between the Nunnery and the northernmost *cenote*, and the east–west axis running from the main ball-court across the square of the Castillo and the Court of the Thousand Columns. The new elements were the colonnaded hall, with the vault overhangs carried upon wooden lintels, the peristyle atrium, as at the Mercado, and the covered stairways rising to temple level through the colonnade screening the platform base. With these innovations, the Maya architects of the Toltec period at Chichén achieved a new spatial order, initiating the possibilities of interior design upon a scale never available to their Classic predecessors.

Chichén Itza, like Uxmal three centuries earlier, abruptly ceased to be the artistic metropolis of Yucatán after about three centuries of intensive activity. Mayapán, 25 miles south of Mérida, became the new capital. The site has lately been systematically excavated.[24] Its position as the successor to Chichén Itza, in the period from *c.* 1200 to *c.* 1450, is now certain, although the interpretation of many jumbled bits of historical tradition, as preserved in Maya records, is still far from satisfactory. The excavations yield overwhelming proof that Mayapán sheltered a society in decline. It was a walled city enclosing about 1½ square miles and contained over four thousand structures, most of which were dwellings. Only a few large edifices served ritual needs. The construction is shoddy and the plan disorderly, showing no sense of the ample spaces which characterized older Maya architecture. Innumerable small private shrines attest the disintegration of public worship and of the theocracy. The defensive city wall records a transformation

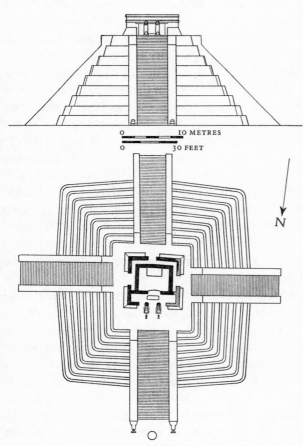

0 10 METRES
0 30 FEET

N

Figure 64. Mayapán, Castillo, after 1250.
Elevation and plan

in the concept of urban life, from the dispersed population of farmers who assembled periodically at a noble ritual centre, to a warren-like cluster of dwellings meanly crowded within walled defences. Its Castillo (Figure 64) is a literal copy of the one at Chichén, but of shrunken size, about half as big, with the serpent heads of columns and balustrades executed in perishable stucco. The colonnaded halls were usually not vaulted, but roofed with beams and mortar.

The East Coast

The architecture of the East Coast of Yucatán, from Cape Catoche south to Espiritu Santo Bay, shows two main periods.[25] The older sites, represented by Cobá, are of the Classic Petén type. The later group hugs the coast, and there are buildings of the same period on the off-shore islands in the Caribbean Sea. Many coastal buildings have trapezoidal doorways and a silhouette with walls leaning outward in an exaggerated negative batter (Figure 65). These traits probably derive from the Puuc, and from Uxmal in particular, where, as we have seen, architectural activity ceased at about the time of the rise of Toltec Chichén Itza. No negative batter has been observed at Toltec Chichén. Lothrop's supposition that the main part of Tulum was built early in the Toltec period [26] is therefore justified, although his dating in the thirteenth and fourteenth centuries is too late. The lack of post-Classic building activity in the Puuc proper suggested to Brainerd that the Toltecs forcibly expelled the Puuc inhabitants from their arid home.[27] If the Puuc people migrated to the East Coast, as the architectural habits of that region suggest, the stylistic sequence there would contain Classic, Puuc, Toltec, and Mayapán phases, with the Puuc intrusion occurring about the tenth century, the Toltec style in the twelfth and thirteenth centuries, and Mayapán traits appearing after the thirteenth century. Such a sequence corresponds to the chronology gained by excavation at Chichén and Mayapán.[28] Classic edifices are marked by thick walls in true plumb, with roof-combs and simple rectangular mouldings. Puuc-style buildings have marked negative batter without the sloping bases characteristic of Toltec influence. Recessed lintels and columnar doorways are present in both the Puuc and the Toltec phases.[29] Of Toltec derivation are the serpent-columns of the Castillo at Tulum, as well as the sloping bases and the prolific use of over-door niches. The sculpture in stucco, finally, recalls the workmanship of Mayapán.

The complete sequence can be traced among the many re-buildings of an edifice like the Temple of the Frescoes at Tulum (Figure 65). The initial Classic vaulted shrine (A) was encased in a larger building (B) with columnar façades and negative batter in the Puuc style. Finally this platform was augmented by a second-storey addition to the upper shrine. Its negative batter, as at Cancuén near by (Structure 4), is enriched by a sloping base of undercut profile. Without the undercutting, such bases are familiar at Chichén and Mayapán, permitting a date in Toltec Maya times or later. Beam-and-mortar roofs may have been in current use at all periods (Figure 32G), and their popularity may account for the prevalence of compressed or contracted upper zones of façades, which are often only one-third as high, or less, than the bearing walls.[30] Well-preserved examples are the halls of the Castillo and Structure 25 at Tulum.

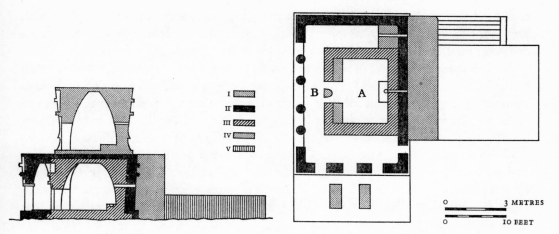

Figure 65. Tulum, Temple of the Frescoes, Classic and later periods. Section and plan

The Problem of Tula

The thesis of Toltec influence from Tula on the architecture of Yucatán weakens when we look for elements occurring solely at Tula prior to the Toltec intrusion at Chichén Itza. Among architectural forms round temples (Calixtlahuaca; Plate 21A) and sloping basal zones (Teotihuacán; Plate 4, A and B) emerge as possible Mexican contributions to Maya practice. Colonnaded doorways with Atlantean columns and effigy supports are commonly ascribed to Toltec influence, but there is much older Olmec precedent for them in sculpture (Potrero Nuevo). As to colonnaded interiors, the Late Classic example at Mitla (Figure 25) is probably more important than the colonnades at Tula, for which it is difficult to prove an early date. We have noted in the Toltec architecture of Chichén Itza strong resemblances to the panelled terracing of Monte Alban (Castillo) and Teotihuacán (Pyramid of the Warriors). Toltec Maya architecture now appears more cosmopolitan and eclectic than the traditional comparison with Tula alone would allow.

SCULPTURE

Toltec work is commonly regarded as inaugurating 'a new era in art ... primarily secular and dramatic ...', so closely allied to Tula that it is not usually considered part of the Maya development.[31] But we have seen in architecture that the Toltec intruders may have exported more from Yucatán than they brought into it, and when we assess the sculpture for proof of foreign influence, the balance again favours the Maya, with Chichén Itza clearly marked as the originating centre rather than as a receiving terminal. The Toltec Maya repertory at Chichén comprises many forms and techniques of which we have no trace at Tula, such as repoussé goldwork (Plate 124A) and narrative sculpture in relief with the portrayal of landscape (Figure 70). At Tula, on the other hand, the only

sculptural forms with no exact equivalent at Chichén Itza are the colossal Atlantean supports (Plates 15 and 17, A and B), which are perhaps only amplifications of very common smaller Atlantean figures at Chichén (Plates 118–20).

As with the architecture, the impact of an alien ethnic group upon expression cannot be denied: the aggressive new expression, however, was articulated in traditional Maya elements of form, and it eventually returned, in its Yucatecan garb, to the Mexican highland. Thus the serpent-columns of Chichén Itza are prefigured not only at Teotihuacán but also in Late Classic Maya sculpture by effigy columns like those at Oxkintok.[32] The warrior figures of Toltec Chichén have many precedents in the Usumacinta region, and at Bonampak, Piedras Negras, and Yaxchilán. The reclining Chacmool figures are more numerous at Chichén than at Tula. Human sacrifice by heart removal is figured in reliefs at Piedras Negras, and possibly on the walls of Bonampak, so that Tula Toltec priority here too is doubtful.

The chronology of Toltec Chichén sculpture is as uncertain as that of architecture, because any seriation of the sculpture depends upon architectural chronology.[33] Our sequence places the substructure of the Castillo and the Caracol in the early phase; the Pyramid of the Warriors and the great colonnades in the middle phase; and the main ball-court in the final phase, the three phases embracing over a century each, from before 800 to the thirteenth century.

By the orthodox correlation between Maya and Christian time (Goodman–Thompson–Martínez), these events at Chichén overlap with Late Classic art in other regions. In the chronology based on the C14 dates assembled by Andrews, an ample Maya tradition of several centuries underlies many forms of the Toltec Maya style at Chichén. Its history contains a renaissance of Classic Maya art as well as an eclectic use of alien themes, such as the terrace profiles and pyramidal plans which echo many older Petén Maya, Monte Alban, and Teotihuacán forms. Toltec Chichén re-states entire traditions in Mesoamerican antiquity. Chichén is like Rome, but Tula is like a frontier garrison, on the very edge of the civilized world of town-dwellers, upon the *limes* where the barbarians roam, taking much of its art from the middle phase of the development at Chichén, and missing the late, splendid renaissance of the figural style.

We have seen that the extension of the corbel-vault on colonnaded ranges of supports gave its characteristic spaces to the architecture of Chichén Itza under Toltec domination. An analogous technical device allowed the Toltec Maya sculptors to enlarge their field and to achieve the ample narrative reliefs of the middle and late periods at Chichén. This device was the simple one of extending the compositional field beyond the limits of a single block of stone (Plates 121B and 123). The Classic stela motif was almost invariably confined by the single block or slab of stone; at Chichén, however, the sculptural unit extends over several blocks of the masonry veneer. This practice must have been inherited from Late Classic architectural practice in western Yucatán. A few examples of sculpture along the masonry veneer are recorded from the Puuc district.[34] Two panels at Santa Rosa Xtampak have Classic motifs extending over many rectangular veneer blocks. At Xcalumkin there are door jambs like those of Chichén Itza, composed of several drums, and bearing Classic single-figure motifs of the most ancient

Maya tradition. Proskouriakoff, with the aid of her trait graphs, dates both examples to about 731-51 (9.15.0.0.0–9.16.0.0.0). These panels of sculpture in pictorial extension require continuous planes rather than plastic masses, being pictures carved in two planes painted with brilliant tones of local colour.

Before we treat these reliefs in detail, the main types of free-standing sculpture require discussion.

Full-Round Figures

There are few full-round figures; the Maya peoples may have been indifferent to them. Their Olmec predecessors in southern Veracruz and their neighbours to the east and south all produced important free-standing works, but the Classic Maya themselves tended to convert plastic forms into scenes of shallow relief, under strong tectonic regulation in the flat planes of stelae, wall-panels, and lintels. In the Puuc and Toltec periods, stone seats carved to resemble jaguars were not uncommon: a celebrated example is the red throne inlaid with spots of jade, discovered in the chamber of the sub-structure of the Castillo (Plate 117). This Toltec Maya version is chunky and awkward in its compromise between instrumental form as a legged seat, and anatomical form in the curving head-planes and leg muscles. The type is itself of Classic origin. A two-headed jaguar seat was found at Uxmal; carved representations occur at Tikal, Piedras Negras, Palenque, and Xultún; and painted versions decorated the cella of the Chac-mool Temple at Chichén.

The many small caryatid figures supporting tables or benches (Plates 118–20) perhaps relate to older Maya traditions of sky-bearing personages represented in relief.[35] The oldest caryatids at Chichén Itza are probably in the Temple of the Tables adjoining the Pyramid of the Warriors on the north. This temple is coeval with the buried Chacmool Temple, which also has columnar reliefs and serpent-columns. Its caryatid table may be taken as part of the original design. The figures are like inverted cones, with features lightly carved in the frontal plane. In the neighbouring Temple of the Warriors, the stones are T-shaped, with more fully articulated arms and legs (Plate 118). The best workmanship is seen in the Atlantean figures of the upper Temple of the Jaguars (Plate 119). The conical shape seems old-fashioned, but the surfaces are articulated and differentiated in great detail, with images comparable to those of the cella doorway discussed below. In the south-east colonnade are kneeling caryatids (Room C). In Structure 3 C 6 the Atlantean columns of life-size male figures (Plate 120) may be related to the colossal caryatids at Tula.

Probably outside the Maya tradition are the Chacmool figures at Chichén Itza, fourteen in all, varying from large simple forms (Plate 121A) to small and fussy ones. These reclining male figures lie athwart an entrance axis and turn their heads out to the court or plaza, holding on the abdomen a plate or vessel clasped in both hands. The origin of the type is unknown, but it accompanies the Toltec dispersal (Plate 19), appearing in Michoacán and in Costa Rica and Veracruz, possibly in connexion with ritual drunkenness.[36] Crouching figures of stone, intended to hold standards or banners upright on the terrace edges, are also common at Chichén, and there is no Maya precedent for them.

The paired serpent-columns of the Castillo, the Temple of the Warriors (Plate 116), the High Priest's Grave, and the Temple of the Jaguars are like effigy columns of the Puuc period. The image of the fully feathered serpent is rare in Classic Maya art. It probably represents central Mexican highland traditions of rain and vegetation symbolism. Two architectural variants occur. In the older one (Castillo, Figure 60, and Chacmool Temples), the serpent-head is the bottom drum of the round column. The others (Warriors, Plate 116, and High Priest) have square piers with the heads carved on separate adjoining blocks. The latter version is more practical and economical, and it is also less impressive. At the High Priest's Grave, the pier drums were re-cut with feathers and scales, replacing older panelled figures like those of the piers in the Chacmool Temple or the Temple of the Tables.[37] The older cylindrical version re-appears in the doorway of the late Temple of the Jaguars (Plate 115A), where other details confirm an impression that these columns, of which the heads are the largest single carved stones at Chichén, weighing 7⅛ tons each, were re-used, after having been part of an older, now vanished structure.

The convergence of the serpent-column and a more conventional prototype is apparent in the vestigial capitals retained between support and lintel. These capital blocks provide the angular passage from shaft to cornice-block, with its rattlesnake's-tail motif. The oldest examples are the buried blocks with painting intact from the 'fossil' Chacmool Temple, and the closely similar capitals in the Castillo Temple. Both are carved with Atlantean reliefs of shell-, spider-, and turtleshell-men on three sides. The fourth side, facing the exterior, bears feathers. The Atlantean theme repeats in the membering of the supports in the cella interior. At the Temple of the Warriors, it is vestigial, appearing on only two sides of the topmost block (Plate 116). In the Temple of the Jaguars, the theme disappeared altogether, in favour of a lintel drum carved with feathers and scales (Plate 115A), making no pretence of conformity with the cella pilasters. The serpent-heads, finally, differ according to their context on piers or columns. Columnar heads are merely cubical, with jaws open less wide than the gaping mandibles of the heads joined to square piers. A difference of mythographic species appears in the horned heads at the entrance to the cella of the Temple of the Warriors (Plate 116).

Processional Reliefs

At Chichén Itza, all life obeyed processional arrangements. Moving among the ruins, one is surrounded by solemn images in profile, carved in shallow relief and shown striding towards the cardinal directions, each imprisoned upon a column or jamb face (Plate 123) or along the sloping dais benches (Plate 121B), or upon the walls of the temple cellae (Figure 69). It is as if all the stela figures of the southern Early Classic cities had convened, transformed into Toltec Maya priests, warriors, or god-impersonators, and even more rigidly governed by the architectural setting.

Three principal groups are evident – early, middle, and late – based upon our architectural sequence. The early reliefs (before 800) include the circular stone from the Caracol (Figure 66), which Lothrop also regards as an Early Toltec work.[38] Upper and

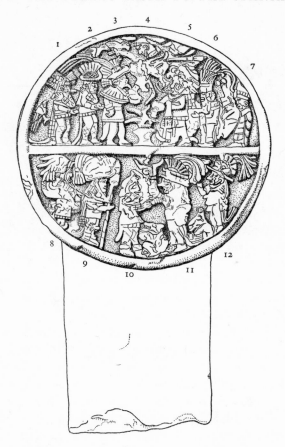

Figure 66. Chichén Itza, Caracol platform,
processional disk relief with Maya and
Toltec figures, before 800

lower registers represent convergent files of figures, with proportions stunted at the ends of the semicircular fields. Both Maya and Toltec personages are present: the scenes may show the confrontations of four groups of Maya and Toltec allies.[39] Thus the figures here numbered as 1, 5, and 8 are surely Toltec, because of the nose-stick (No. 1), and the feathered-serpent coils (Nos 5, 8). Probably Maya by dress, towering head-gear, and lance are Nos 3, 6, 7, 9, and 11. The style of carving allows little space between figures, and the effect is crowded and awkward.

The reliefs of the middle period (800–1050) fall into two groups of columnar panels: an initial phase is represented by columns in the Chacmool Temple, which have human caryatids on the bases and capitals (Figure 67A); the second phase, in the colonnades and on the Temple of the Warriors, has bases with jaguar-bird-serpent masks framing human faces, and sun-disk deities in the capitals (Figure 67B). Jean Charlot has separated the different sculptors' hands, finding four masters in the north colonnade (Figure 67C),

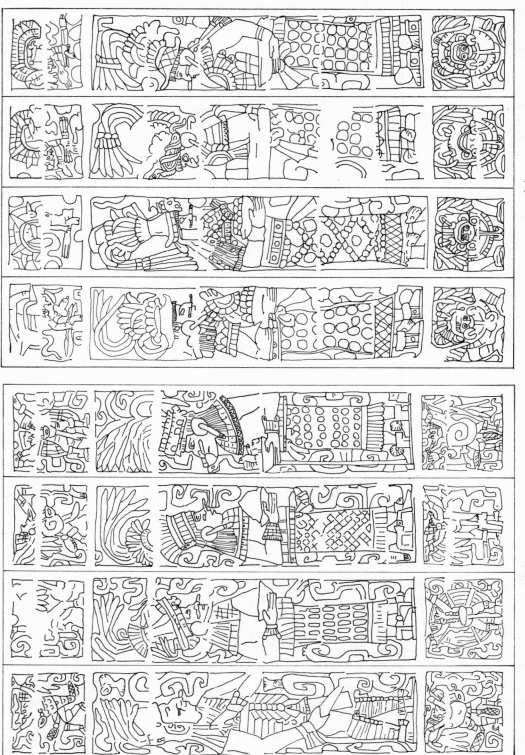

(B)

(A)

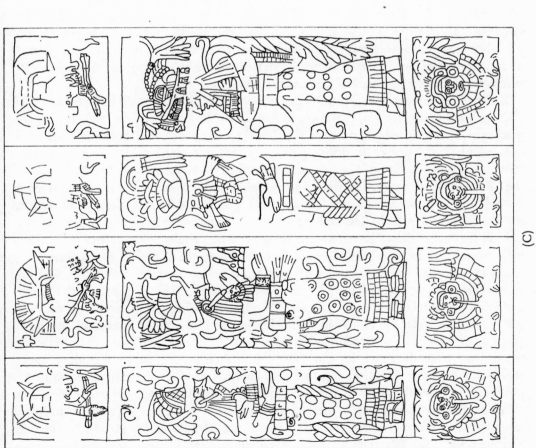

Figure 67. Chichén Itza, column reliefs, before 1050.

(A) Chacmool Temple
(B) Temple of the Warriors
(C) North colonnade

(C)

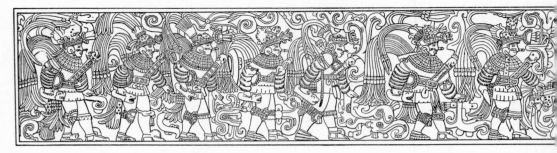

Figure 68. Chichén Itza, ball-court bench, east face, processional relief, before 1200

and discovering changes between the reliefs of the Chacmool Temple and those of the Temple of the Warriors, such as increasing practicality, secularity, and stereotyping.[40] Also characteristic of sculpture of the middle period are the many stone benches in the temples and colonnades, with processions of figures in profile carved on their sloping faces. These benches recur at Tula, and much later, in more stereotyped forms, at Tenochtitlan.[41] The most elaborate example is in the north colonnade (Plate 121A). On each face, two files of figures converge upon a central sacrificial vessel beneath a cornice of undulant feathered serpents. Most of the processional figures are surrounded by the standing coils of serpents in S and Z forms. The coarse and spotty surface pattern was probably brought to harmony by the painted stucco coat; it recurs on the panel friezes of the terraces of the Pyramid of the Warriors, where eagles, tigers, and recumbent warriors symbolize the ritual of heart sacrifice.

The twelfth-century reliefs of the late period cluster near the main ball-court, on its playing benches (Figure 68), in the lower Temple of the Jaguars (Figure 69), and on the platforms between the ball-court and the Castillo (Plate 115B). Rich costumes, animated movements, and a variety of curving passages from front to rear planes are the principal traits of this late relief style. The transition from the middle manner may be in the dais of the Mercado (Plate 121B). The files of prisoners, roped and named, converging upon a central figure beneath a feathered serpent cornice, are like those of the north colonnade, but the rhythmic organization and the variety in surface texture are far more intricate than in the earlier dais. The taste of a new generation of talented sculptors at the main ball-court is present,[42] and the Mercado dais may be one of its earliest expressions.

In the main ball-court, the order of erection, if we reconstruct it correctly, was the following: south temple, playing benches, lower Temple of the Jaguars, north temple, and finally upper Temple of the Jaguars. We place the south temple earliest because its piers resemble those of the Warriors, with jaguar-bird-serpent motifs in the bases (Plate 122A). The ball-court sculptor has obscured the unsightly median line separating the feathers from the paws, by extending the feathers in long curves that unify upper and lower halves of the panel. This kind of compositional improvement marks every production of the designers of the ball-court,[43] who gradually loosened postures and enriched narrative accessories until they attained a completely pictorial manner. Eventually, in the mural decorations of the upper Temple of the Jaguars (Plate 125) and the cella of the Warriors, they dispensed altogether with relief sculpture.

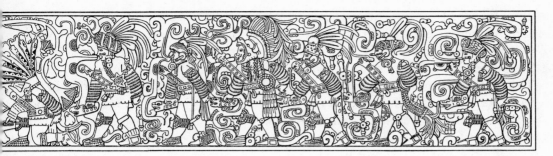

This sequence is admittedly only an approximation on stylistic grounds, without adequate archaeological support. It is nevertheless possible when we concede the status of these craftsmen as members of a renaissance generation, rather than as a generation moving into artistic decadence. The thesis of progressive artistic degeneration has been the orthodox one,[44] i.e. that Maya sculptors close to Classic traditions progressively lost control and skill under Toltec domination. We have reversed the sequence, on the assumption that after the long figural vacuum during the Puuc period, architects and sculptors studied anew the traditions of Classic Maya sculpture, achieving mastery in the course of several generations, when Toltec Maya art came into being. The main ballcourt reliefs are the finest monuments of this sequence.

The two ball-court benches are the largest processional reliefs at Chichén Itza, with scores of figures portrayed almost life-size upon a richly figured ground of Maya serpent and plant forms. The architectural setting, the armour, and the iconography of decapitation all recall Classic Veracruz sculpture of an earlier date (compare Figure 68 and Plate 55). The six panels are nearly identical: in each, two processions converge upon a disk inscribed with a skull. Each panel has fourteen figures in ball-players' costume: the victorious team wear broad mosaic collars, and their leader has decapitated the opposing leader, from whose headless neck six serpents fan out,[45] as on the seven-serpent stelae from Aparicio in Veracruz.[46] The attitudes are monotonously regular, varying only in the springiness of the step. Decorative animation and movement appear in the plant and serpent scrolls which fill the ornate ground. The same scene re-appears in the six versions, with eighty-four figures, repeated three times on each bench. The four end panels have cornices of feathered serpents with cylindrical bodies. The west wall panels are more crowded, less well carved, and more shallow in relief, as if so many repetitions had made the carver careless. The most animated stances and the most open ground occur on the northernmost panel of the east wall: unfortunately, many blocks are missing. The south-east panel is more crowded with feathers and serpent scrolls; practically no open ground shows between the figures (Figure 68). On the west wall, the central panel is the most crowded of all, and its relief is the most shallow. This poverty of invention and the limited thematic material suggest that the benches are the work of a generation still sympathetic to the art of the colonnades, yet moving towards a greater pictorial range, increased narrative variety, and more animated movements.

These new objectives are apparent in the multiplication of registers inside the lower

Temple of the Jaguars (Figure 69). Six registers, running without pause or interruption at the corners, circle the interior. In the base, five rinceau bands of plant, fish, and bird forms emerge symmetrically from four mask panels. Above, there are five registers. The lowest has a procession of twenty-four lance-bearing nobles in full-dress regalia. The next two registers, of equal width, are slightly narrower, and the top two in the vault overhang are again equal, but narrower than the pair just below. In all four upper registers are warriors armed with bundles of short spears and throwing-sticks (*atlatl*). In the centre of the top register is a sun-disk of Mexican type. It recurs on the wooden lintels and murals of the upper temple. An effort to interrupt the track-like sequence of the registers appears in the middle of the back wall, where a gigantic feathered serpent breaks through the barrier between second and third registers, as a copula between parallel processional spaces. The quality of the carving is close to that of the benches, but the compositional scheme is more inventive and more animated. For example, the scrolls between figures are upright in the benches, but in the cella of the lower Jaguar Temple they inscribe vigorous curving diagonals as if to mark dance-like motions.

On the North Temple, finally, the band mouldings are suppressed, except to mark the vault overhang and the base. This base, like the one in the lower Temple of the Jaguars, has rinceau bands, with an unprecedented figure in the centre of the north wall: it is a recumbent corpse clothed in a tunic of hexagonal scales. From the abdomen rise two serpent bodies ending at feet and head in serpent jaws in profile.[47] Recumbent bodies also encircle the base of each of the entrance columns beneath a trellis hung with flowers and fruit. This theme of a vine or tree of abundance re-appears upon the stairway balustrades, rooted in a rain-god mask in profile. On the three cella walls, five registers of figures are shown (Figure 70), but they are separated by band mouldings only on the vault overhang.

As in the cella of the lower Jaguar Temple, the scenes in the North Temple turn corners without interruption, in one continuous pictorial space embracing the three walls. The main group consists of three files, converging upon the centre. The lower figures bear arms of darts and throwing-sticks; the central row of seated figures – turbaned on the left, and wearing feather head-dresses on the right – listen to the central figure standing in open serpent jaws. Above, erect warriors converge upon the sun-disk. Speech-scrolls are the principal space-fillers: the whole group is like a three-storeyed dais procession. On the left and right are other scenes. Facing the west, and connecting with figures on the west wall, is a bird-dancer on ground level who dances to the sound of a seated drummer around the corner. The whole west wall is ruled by a seated figure in the upper corner presenting a smaller person to the others for homage. The scene on the east wall also includes groups on the adjoining north wall where two chiefs, seated in conversation inside a house, are meant to preside over the badly damaged scenes on the east. The clearest of these is the lower outer corner, where two upright persons examine a recumbent one.

The perspective throughout is ascending, in the sense that distant spaces are represented as high in the composition, with figures, trees, and scrolls all somewhat garbled and interfering with one another. The intention of the entire room is to portray actual

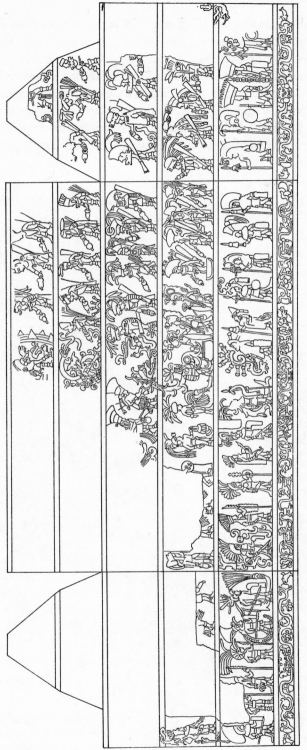

Figure 69. Chichén Itza, lower Temple of the Jaguars, processional reliefs on interior walls, before 1200

events together with the indications of their symbolic meaning; probably it illustrates an historical account, not unlike the screenfold genealogies of the Mixteca. One scene in the vault overhang, showing a hunter with a blowpipe shooting at birds in a tree, exactly recalls a parallel image in the Bodley manuscript illustrating an event in the life of the Mixtec hero, Eight Deer (A.D. 1011–63) (Plate 70A). In these vault scenes the variety and the narrative detail suggest that the model might have been such a screenfold manuscript. Below the impost, the north wall shows an effort to break away from the conventional setting and to unify larger narrative spaces than the manuscript style permitted. To trace

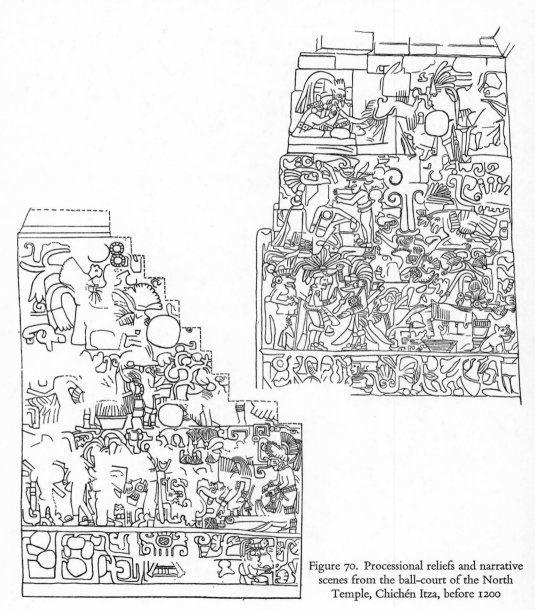

Figure 70. Processional reliefs and narrative scenes from the ball-court of the North Temple, Chichén Itza, before 1200

the further developments of this extended narrative space, we must later examine the mural paintings at Chichén Itza.

The pilasters framing the doorways of the upper Temple of the Jaguars (Plate 123) bear figures of warriors whose exposed genitals must have been an affront to the traditional modesty of the Maya natives of Yucatán. The quality of the carving, nevertheless, is the best at Chichén Itza, with rounded passages and portrait faces of an agreeable degree of finish requiring for appreciation neither stucco coating nor polychromy. The expressive intention is clear: the alien masters are exalted, and native customs and conventions are ignored. This arrogant assertion of foreign manners recurs in the nearby platforms consecrated to the planet Venus, to the warrior society of the eagles (Plate 115B), and to human sacrifice by decapitation at the *tzompantli*. These latter-day monuments are closest to Tula. The late date of the skull-rack (Plate 122B), as in the case of the Mercado, is suggested by construction over the uppermost plaster flooring of the plaza.

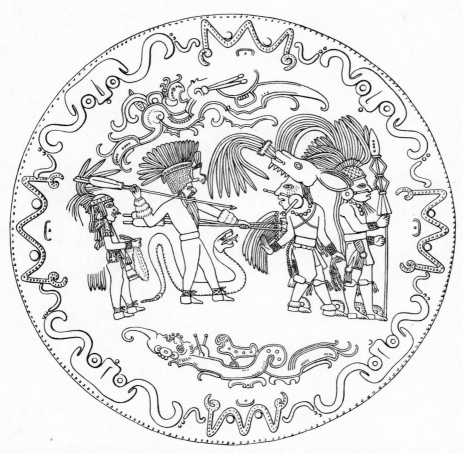

Figure 71. Repoussé gold disk (D) with battle scene, from the Well of Sacrifice, Chichén Itza, *c.* 1200. *Mexico City, Instituto Nacional de Antropología e Historia*

Other examples of Toltec Maya sculpture are the embossed gold disks dredged from the Well of Sacrifice.[48] They are coeval with the sculpture of the main ball-court, and they readily fall into three stylistic groups. Seven of the disks (A–E, I, J) resemble the processional friezes, with several figures of Toltec and Maya warriors occupying an unspecified space within the circular rim (Figure 71); three (F, G, H) have clearly marked ground lines with some indication of pictorial environment and are closest in style to the murals at the Temple of the Warriors or the upper Temple of the Jaguars (Plate 124A); six others (K–P) are more heraldic in design (Figure 72) and can be connected with the jaguar and eagle friezes on the Platform of the Eagles (Plate 115B).

In conformity with the orthodox position that Late Classic and Toltec Maya styles overlapped in time, Lothrop assigned F, G, H, and K–P to the early phase of Toltec Maya history in the tenth century.[49] The alternative hypothesis of a Toltec Maya period separated from the Classic period by at least three centuries requires another sequence, with the metalworkers improving in draughtsmanship and in technique, until they regained mastery of the long-disused classical vocabulary. Our sequence of processional, pictorial, and heraldic styles may eventually require re-arrangement, but for the present

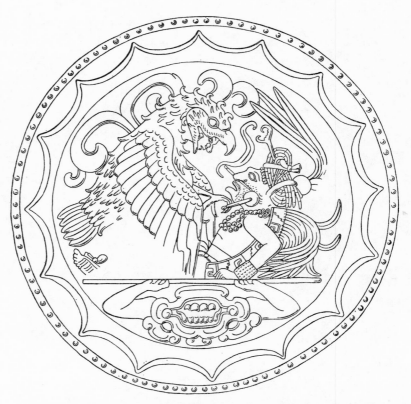

Figure 72. Repoussé gold disk (L) with eagle warrior, from the Well of Sacrifice, Chichén Itza, c. 1200. *Mexico City, Instituto Nacional de Antropología e Historia*

we shall suppose that they spanned the twelfth and thirteenth centuries, on the strength of the parallels with architectural sculpture. Thus in D (Figure 71), the serpent motifs above and below the processional grouping are inexpert and uncertain. In G, the same theme receives an ample development in the space above the right-hand boat (Plate 124A), and in L, this Classic Maya theme is replaced by a Mexican eagle warrior (Figure 72). Certainly the marine battle of G is comparable, with its diagonal movements and receding plane of water, to the sea-coast mural in the Temple of the Warriors (Plate 124B). No hint of this illusion of deep space appears elsewhere in ancient American art: the fresco-painter and the goldsmith may have belonged to the same generation, and there is no evidence that their successors continued this promising line of investigating pictorial space.

PAINTING

Murals

At Chichén Itza, narrative scenes covering large walls adorn the shrines of both the upper Temple of the Jaguars, which overlooks the ball-court, and the Temple of the Warriors. All are in extremely bad condition, and the paintings can be studied today only in reproductions. The ball-court frescoes are rhythmic and geometric arrangements of many small figures in dense clusters. The murals of the Warriors' Temple portray landscapes, a village and the seashore, in which scattered groups occupy a pictorial space much deeper than at the ball-court. By our hypothesis, Toltec Maya pictorial space was a gradual achievement. It broke with the schematic and geometric forms of the Puuc period and ended with the art represented by such gold repoussé disks as that of the sea-battle (Plate 124A) and a human sacrifice by heart excision. In this developmental scheme the flatter and more geometric designs at the upper Temple of the Jaguars (Plate 125) antedate the pictures in the Temple of the Warriors (Plate 124B), with their much greater depth in space. They are closer in spirit and in composition to the Bonampak frescoes (Plates 106–10). The landscapes in the Temple of the Warriors bring to mind the strip-like arrangements and the cartographic designs of south Mexican manuscripts (Plate 70B). Since nothing like these small-figure murals was found in the 'fossil' Chacmool Temple,[50] buried within the platform of the Temple of the Warriors, their first appearance at the latter can be dated in the twelfth century, near the end of the architectural florescence of the Toltec Maya style at Chichén Itza.

Seven mural fragments decorate the inner chamber of the upper Temple of the Jaguars. Those on the north wall and in the north-eastern corner are completely destroyed, but fragments survive on the eastern, southern, and western walls (diagram, Figure 73). On the east wall (3, 4), two deities and a landscape were interpreted by Seler as a terrestrial paradise.[51] Facing it and on the south walls are battle scenes, showing two armies under a volley of lances (south-west wall, 1); the siege of a town or temple (south wall, 2); and another siege scene (north-west wall, 7). As at Bonampak, many

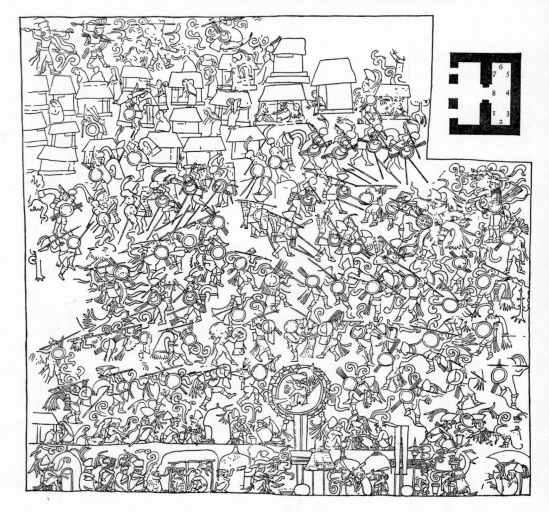

Figure 73. Chichén Itza, upper Temple of the Jaguars, south-west wall, wall painting of a battle scene, twelfth century. Upper right inset: diagram of murals in cella

aggressors overcome very few defenders. Upon the stages of a pyramid (south wall, 2) less than ten men receive the violent attack of scores of spearmen and lancers. Over the doorway (8), above the lintel, is a recumbent figure, identical with the relief in the north ball-court temple, from whose belt rise serpents. On the vault overhang above this, a human sacrifice by heart excision [52] appears under another badly damaged battle scene A base zone surrounds the room at floor level, with tendrils enfolding grotesque masks and reclining human beings, as in the lower temple reliefs. One supposes that the war. riors and victim of the sacrifice have as their reward the paradise which surrounds the deities on the east wall.

The composition varies from wall to wall: in the best preserved fragment (south-west, 1), about 120 figures are grouped in eleven rows and eleven columns of shifting

contours. They make a rhythmic panorama of spear-throwing warriors, whose attitudes in the lower left corner compose a sequence not unlike the frames of a cinematic or stroboscopic action exposure (Figure 73). The same dense composition recurs on the south wall (2), where warriors mounted upon curious siege-towers made of timbers lashed together in three- and four-storey edifices attack a pyramidal platform (Plate 125).[53] A sun-disk deity presides in the upper right-hand corner. In both scenes the battlefield is confined at top and bottom by rows of houses with seated figures, probably the villages of the fighters.

On the east wall (3-5), the published fragments recall the deep space of the compositions of the Temple of the Warriors, especially in the depiction of trees and rolling terrain. A portion published by Willard as from the east wall [54] shows a score of warriors with shields and throwing-sticks advancing in two files behind the cover of hills to attack a Maya army in the lower portion of the picture. The small-figure convention and the exaggerated contours of the landscape anticipate certain Mexican historical manuscripts, such as Codex Fernández Leal [55] or Codex Xolotl.

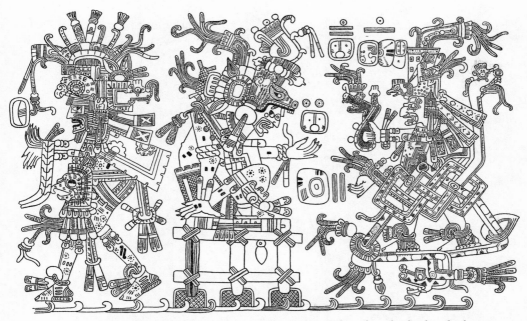

Figure 74. Santa Rita, British Honduras, wall painting with gods and calendar glyphs, tenth century (?)

The exterior surfaces of the Temple of the Warriors were also painted. The sloping basal zone received 131 coats of plaster: the twenty-second of the coats bore figures of men and animals in a processional order like that of the sculptured panels of the platform.[56] The cursive style with yellow, blue, white, and green figures on a red ground may belong to the time between the Chacmool murals and the interior murals of the cella of the Warriors' Temple. Neither of these paintings can be exactly dated, but the

exterior murals at the Warriors stand half-way between the hieratic order of the Chac-mool murals and the looser narrative manner of the cella frescoes.

Exterior murals also adorned the walls of a platform at Santa Rita in British Hon-duras (Figure 74). They are relevant here because they show Mexican connexions, as do the murals of Chichén Itza, but it is a different connexion, closer to Mixtec than to Toltec sources. If the usual late dating for Mixtec pictorial conventions is untenable in the light of the long Mixtec tradition revealed by Caso's studies of the genealogical manuscripts, the inception of Mixtec pictorial conventions may go back to Late Classic times. If a date corresponding to the Puuc period could be proved for the style of Santa Rita – but the proof is not now possible – the Santa Rita murals would be the oldest wall paintings betraying south Mexican influence in the Maya territory, rather than the most recent, as all published discussion suggests.[57]

The painted surfaces were most abundant on 35 feet of the north wall of a mound at Santa Rita. Three painted layers were noted before the paintings were destroyed. The portions copied by Gann were 4 feet 10 inches high. He mentions a few 'glazed sherds'

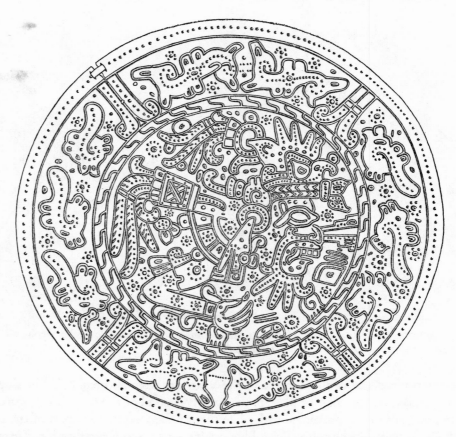

Figure 75. Deity with calendar glyphs in repoussé gilded copper, from the Well of Sacrifice, Chichén Itza, tenth–eleventh centuries (?).
Mexico City, Instituto Nacional de Antropología e Historia

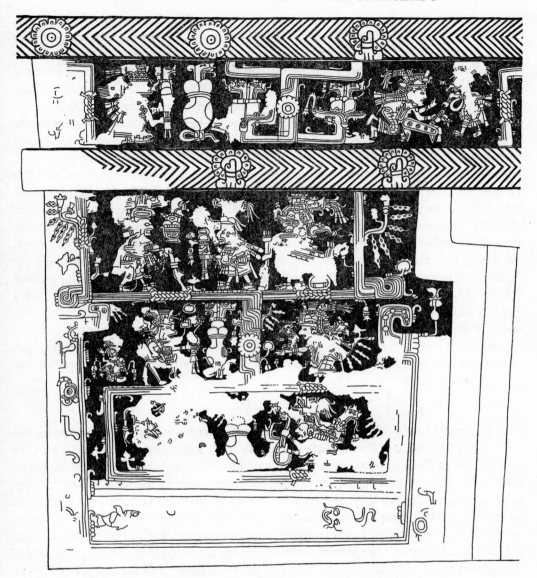

Figure 76. Tulum, Temple of the Frescoes, west passage, wall painting,
eleventh–twelfth centuries (?)

found during excavation: if these were plumbate,[58] a Toltec Maya date would be in
order. On the north wall, a doorway separated eastern and western processional files of
figures roped together by the wrists, as in the processional reliefs on the dais in the
Mercado. Extreme contortion of the bodies, angular panels of costume, rectilinear divi-
sions of the form, high colour in seven tones, and enumerative composition by the
addition of tassels, garlands, panaches, and jewellery (Figure 74) – these are the distinc-
tive formal characteristics of the Santa Rita frescoes. Many reappear in Mixtec manu-
scripts of the type of Codex Borgia, and the murals at Mitla. The glyph-forms are Maya;

the architectural profiles evoke Puuc Maya comparisons; the faces in profile, however, relate to the style of the Dresden manuscript (Plate 126A), also in the rendering of eyes and hands.

Closely related to the Santa Rita frescoes are three gilded copper disks in punctated embossing from the Well of Sacrifice at Chichén Itza (Figure 75). They combine Maya glyph-forms with Mixtec manuscript figures and conventions. Lothrop [59] favoured a sixteenth-century date, but the evidence in no way precludes the Puuc or Toltec periods. Lothrop believed that the disks originated in southern Mexico, because of the analysis of the metals, and that the embossing was done in Yucatán.

Farther up the east coast at Tulum are substantial fragments of frescoed walls.[60] The buildings, as we have seen, may well be of the Puuc period. The frescoes are more integrally Maya in content than those of Santa Rita. Lothrop compares their style to Codex Peresianus (Plate 126B) and to certain painted potsherds from Chichén Itza. He notes three stylistic groups, varying in scale and amount of detail rather than in period. An example is the figure of a woman grinding corn upon a *metate*, taken from the cornice of the Temple of the Frescoes, painted in blue and black lines on a black ground (Figure 76). Each structural part of the body and of the *metate* is surrounded by a wiry outline, reminiscent of the waxen filaments used in *cire perdue* metal casting. Upon the lower walls rectangular panels framed by enlaced serpent-forms contain figures and ornaments of the same style, revealing metallurgical connexions in the quality of the line, and manuscript connexions in the division of the wall by registers and compartments.

Manuscripts

Four illustrated books of pre-Conquest Maya manufacture survive. They are preserved in Dresden, Madrid, and Paris.[61] Part of a fourth book was displayed in New York City at the Grolier Club in 1971; it is a fragment identified as part of a Venus calendar, consisting of eleven panels. All are painted on paper made of the bark of the wild fig, sized with fine lime coating, and pleated as screenfolds with text on both sides. The leaves of the Madrid and Paris manuscripts are respectively 22·6 and 22 cm. (about 8½ inches) high; the Dresden leaves are much smaller (18·5 cm. high), but the Maya pages are of tall and narrow proportions, unlike the square or rectangular Mexican pages. Thompson regards Dresden as the oldest of the four, because of the images of 'Toltec Maya' vessel forms. He places Paris slightly later, and Madrid near the close of pre-Conquest history.[62]

In all four manuscripts, extended written statements are illustrated by panels containing human figures, many with the attributes of gods. The principal subject in the Dresden and Madrid manuscripts is the augural calendar, occupying usually one-third of a page, with glyphs referring to the regents and auguries of each division of the 260-day ritual calendar, as well as naming the initial days and the durations of the divisions (Plate 81A). Thus the writing frames the illustration, which echoes or re-states the gist of the writing in compact images.

These images were first classified in 1897 by P. Schellhas,[63] who found only fifteen

human types among more than a thousand representations. Schellhas assigned a letter to each type; with minor changes these identifications are still in use. The deities of the Maya religion are figured as patrons, regents, or prefigurations of the various time-periods. The most frequent is God B, a rain god with trunk-like nose, pendant fangs, and a knotted head-dress. He governed the second day, *ik*. The axe in his hand relates him to the head-glyph for six, where a hafted axe is set into the eye. His powers were those of germination and fruitfulness. God D, a toothless aquiline ancient, second in order of frequency, may stand for the supreme deity of the Maya gallery, Itzamna, although there is little agreement upon the definition of his powers. God E, the youthful maize god wearing an ear of corn as a head-dress, symbolized the number eight and the fourth day, *kan*. He is third in frequency. God A, a death god, is the next frequent. He ruled the sixth day, *cimi*, and his attributes symbolize the number ten. His skeletal figure, hung with bells, was a sign of evil influence.

The manuscripts clearly belong to different regional styles and to different generations. The difficulty of dating them is further increased by the likelihood that each is a late copy or recension of a variety of earlier material. The Dresden manuscript is closest in style to Classic Maya antecedents, although the iconography of certain portions betrays strong Mexican influences. For example, pages 46–50, treating of the cycle of 2920 days (Plate 126A), relate to the combination of five Venus years with eight solar years ($5 \times 584 = 8 \times 365$). On each of the five pages a seated deity presides above a crouching warrior, and the lower panel represents a wounded figure pierced by arrows, very much as in the south Mexican ritual manuscripts of the type of Codex Borgia.[64] Since the antecedents of that group are Mixtec, the *terminus post quem* for this iconography can be taken as about the eighth century. The absence of Toltec traits, other than the pottery forms mentioned above, strengthens a dating prior to the eleventh century. In short, the Late Classic period is probable, but the place of composition in the Maya area cannot be identified.[65]

The Paris manuscript (known as *Peresianus* because of the name, *Perez*, written on it) is much damaged by the flaking of the plaster at the edges of each page (Plate 126B). The graphic style is crowded: two contrasting scales of large and small figures are surrounded by a mosaic of pebble-like glyph forms. The figures are more arbitrarily drawn than in the Dresden manuscript. There, a firm idea of the organic envelope of each figure guides the draughtsman's hand, but in the Paris pages, the huge heads, spindly limbs, and prolix attributes betray an enumerative approach from which the idea of any organic unity of the forms of bodies is very remote.

The Madrid manuscript has the coarsest and most cursive style of the four books, but it reports many details of the ritual life of its time and place in its scratchy pictures of deer-trapping (Plate 126C), bee-keeping, farming, sacrifices, and warfare. Arthur Miller recently found mural paintings at Tancah on the East Coast related by style and iconography to the manuscript in Madrid.

The Grolier Codex has been dated by radiocarbon as between 1100 and 1360, and its style is closer to Toltec-Maya and to Mixtec antecedents than to other Maya manuscripts, although its Maya day-signs correspond to those of the Dresden Venus Tables.[66]

THE NEIGHBOURS OF THE MAYA

THE GUATEMALAN HIGHLANDS

THE Cordilleran highland of Chiapas, Guatemala, and Salvador is a mountainous land bridge favouring east–west transit. Its volcanoes mark the southern boundaries of Classic Maya civilization. Repeated invasions of these highland valleys and Pacific plains from the Gulf Coast and from the mountains of Mexico occurred in all pre-Columbian periods, with the result that Maya culture was never dominant in the region, even if, from Chiapas to the Río Lempa, different dialects of the Maya language may always have been spoken.[1] The record of conquest and colonization from Mexico is apparent in the archaeology and place-names. At least four principal waves can be distinguished: an Olmec penetration of pre-Classic date; a Teotihuacán influence in Early Classic times; a Veracruz infiltration in mid and Late Classic times; and a Mexican highland conquest during the centuries after 1000.

Maya civilization, limited east and west by water, was bounded in the south by these Mexican peoples. The centripetal character of Maya history, with its displacements from the Petén to the river cities, and finally to the plains, may have an explanation in this combination of tribal and geographic limits. Maya stylistic elements, though present in the southern highland, always competed with other traditions in an uneasy coexistence.[2]

Certain essential Maya traits are recessive in southern highland art: for example, the corbelled vault appears only in underground tombs and never in free-standing buildings, where, instead, mortar beam-roofs were the rule. Initial-Series inscriptions are very rare, and monumental relief sculpture appears only sporadically. Large groups of sculpture are known at Izapa, in the Escuintla district, and at Kaminaljuyú. But on the principal sites, which can be roughly dated by relation to the main periods of Mexican and Maya archaeology, non-Maya traits predominate.

The oldest dated pyramidal platforms in Mesoamerica are in the highlands, at Kaminaljuyú, and at Ocós on the Pacific coast. At Kaminaljuyú, E III is a mound group at Finca Miraflores, in a suburb of Guatemala City. Radiocarbon dates from the excavation indicate early construction at E III 3 in the second millenium B.C., continuing until the Early Classic period in the opening centuries of the Christian era.[3] It appears that the mound was part of a long, narrow, rectangular plaza bordered by other mounds, all built of puddled and stamped clay (adobe). In the fourth stage of remodelling, dated about the twelfth century B.C., a sloping-apron moulding, with smoothed clay finish, was built,[4] which resembles the profiles of earliest lowland Maya terraces, such as those of E VII sub at Uaxactún (late pre-Classic).

Subsequent to Group E III at Kaminaljuyú are Mounds A and B, facing east and west across a plaza, at Finca La Esperanza (Figure 77). In Early Classic times both pyramids were repeatedly enlarged, in the style of the principal pyramids of Teotihuacán,

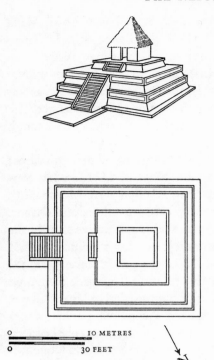

Figure 77. Kaminaljuyú, Mound A 7.
Reconstruction view and plan of appear-
ance during Early Classic period, c. 300

characterized by sloping talus walls and vertical tablero panels (Figure 3). The tomb furniture like-wise proves the direct influence of Teotihuacán, with cylindrical tripod vessels, many bearing stucco decoration in both Maya and Teotihuacán styles. As at Teotihuacán, the single-moulding cornice with cantilevered or counterweighted projections preceded the use of the full tablero.[5] The early stages of both pyramids were built of puddled clay. The final increments which show Teotihuacán forms are built of lumps of pumice laid in mud.[6] As early as A 2 the stairs are bordered by substantial balustrades; in A 5 an upper flight is separated from the lower one by a landing; and in B 4, an impressive fore-pyramid of two stages, surmounted by a temple on a landing (Figure 3), may reflect the model of the Pyramid of the Moon at Teotihuacán on a diminutive plan (28 m.; 92 feet wide, against 143 m.; 470 feet at Teotihuacán).

The most striking trait in the architectural style of all provinces of the Guatemalan highlands is the abundance of stairways, evident in Early Classic times, as during the Esperanza phase of Kaminal-juyú, and at Zaculeu in the western highlands. Balustrades of ample proportions, with an upper part of different slope ('battered balustrade'), appear at Zaculeu in its earliest, Aztan phase,[7] which is coeval with the Esperanza phase of Kaminaljuyú. The form recurs at Nebaj in the Early Classic period, and it became a widely used type in the Guatemalan highlands by the end of the Classic era. In the lowlands at Altar de Sacrificios, where much traffic between the highlands and the Usumacinta converged, structure A II received six projecting stairways along its 110 m. façade in A.D. 711, as if to mark the trade relations of the site with the southern region by an architectural form, as at Kaminaljuyú in respect to Teotihuacán some centuries earlier.[8] When the tendency to move to hilltop sites, probably for military defence, became general, during the closing centuries of pre-Conquest history, the ornamental proliferation of many parallel and storeyed flights of stairs became the distinguishing feature of highland architecture, as at Cahyup and Chuitinamit in Baja Verapaz. Structure 2 at Cahyup (Plate 127 and Figure 78) is approached by no less than ten flights in the lower platforms, and the twin temples on its platforms have six each, totalling twenty-two distinct flights, combining with the terraced stages in an extraordinary effect of staccato rhythms and shadowed diagonals. These are the most variegated staircase compositions in ancient America: only those of Monte Alban approach their complication.

The monumental sculpture of the Guatemalan highlands betrays Mexican antecedents,

both lowland and highland, in pre-Classic and Early Classic stages, yielding to Maya influences prior to a recrudescence of the Mexican style in the Toltec period.[9] These Mexican stimuli are of different sorts: Olmec, Monte Alban, Classic Veracruz, and Mixtec or Toltec strains can be defined in roughly that chronological order. Reminiscences of the Olmec style appear at Izapa in Chiapas, near the Guatemalan border, and at San Isidro Piedra Parada some 35 miles distant in south-eastern Quezaltenango. The Guatemalan example is the most unmistakably Olmec; the Izapa sculpture, though perhaps derived from the relief style of La Venta, is less obviously akin.

The Izapa sculptures may be divided into an indefinite number of groups, whose chronological positions are thought to occupy the period 500–A.D. 1.[10] Miles has connected Izapa sculpture with fourteen other sites, including Kaminaljuyú, Monte Alto, Takalik, and Chocolá, in four divisions, of which (1) and (2) are pre-Olmec and Olmec, to 400 B.C.; (3) is a large-figure group, *c.* 350–100 B.C.; and (4) is a narrative style in the first century B.C. Divisions 1 and 2 include Stela 1 (Plate 128); division 3 includes Stela B from Kaminaljuyú (Plate 129) and Stela 4 from Izapa. Division 4 (Izapa Stelae 5, 12, 18) has narrative and scenic reliefs evoking landscapes.[11] Stela 1 (Plate 128) has been compared to the reliefs at La Venta, as an example of late pre-Classic sculpture derived from Olmec centres of style. In addition, Proskouriakoff has suggested a connexion with Monte Alban,[12] which we would see reflected in the banded sky-symbols on the upper borders, but she was unwilling to attempt any correlation between the Izapa and Maya sequences beyond placing the interchange in Early Classic times. Possibly this Pacific coastal extension of the pre-Classic relief style enjoyed long regional esteem, continuing until a late date.

The next group of highland reliefs resembles not only the stelae of Monte Alban, but also the Early Classic style of central Veracruz, of which many elements occur at Cerro de las Mesas.[13] Closely similar are Stela 4 at Izapa, and Stela B at Kaminaljuyú (Plate 129). Both have striding figures in profile, burdened by vast head-dresses, and standing upon glyph-like scrolls. These scrolls resemble the sky-symbols of certain stelae in Oaxaca (Plate 64B) as well as of the tomb murals of Monte Alban (Plate 66). A variant recurs in Teotihuacán painting: the form probably defines an Early Classic and non-Maya group. The Izapa stela relates as well to the group in the Olmec style on the same site, so that we may place it earlier than the Kaminaljuyú Stela B, of which many forms still suggest a tardy moment in Early Classic Maya art (e.g. costume elements and scroll forms), under Teotihuacán influence, e.g. stylized flames.[14]

On the Pacific slopes of the central highlands many reliefs and full-round heads, used as architectural ornaments, occur in the department of Escuintla. They have long been associated with the historical Pipil tribe of Mexican origin. Thompson has placed this art no later than A.D. 900, and prior to the Toltec intrusions, because the Quetzalcoatl theme seems to be absent.[15] The reliefs from Santa Lucía Cotzumalhuapa (Plate 130A) portray ball-game yokes in use, together with knee-guards and flagstone heads as ball paddles, as well as showing a ritual of heart sacrifice (Plate 130B). Stone ball-game yokes and flat stone head-paddles frequently occur in the central highlands in forms like those shown in the reliefs. L. Parsons' excavations have led him to date the Cotzumalhuapa

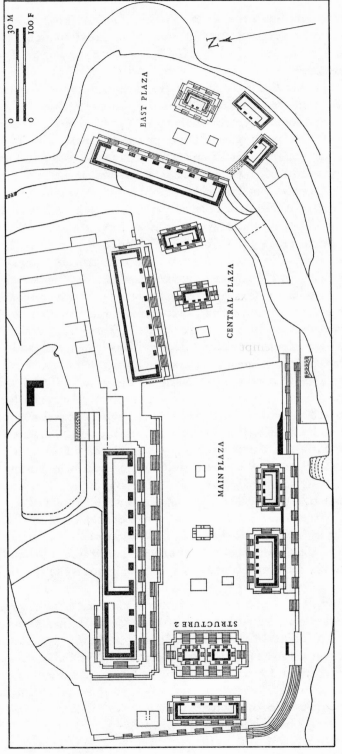

Figure 78. Cahyup. General plan as in c. 1300

sculptures between A.D. 400 and 900, as manifestations of Teotihuacán intrusion. He divides the reliefs in two periods, the Narrative Group, corresponding to Teotihuacán III, produced in 500–700, and the Portrait Group, corresponding to Teotihuacán IV, produced in 700–900.[16]

The Cotzumalhuapa reliefs usually bear several figures spread over the surface in a regular pattern by registers, by radial pattern, or by simple left-and-right compositions lacking overlapping or other suggestions of depth. Animated motions are rendered with schematic and wooden clarity: one has the impression of unprofessional sculptors who remembered distant models without any present example to guide their work. The day-signs resemble those of the south Mexican calendar (e.g. Codex Laud) and the numeration by circles standing for units is also of south Mexican type. On the other hand, the tall, narrow panels, with a ball-player below, raising his arm to the head of a deity above, recall both the Maya codices and the formula of certain Piedras Negras stelae, which have priests in low relief on a lower level, beneath nearly full-round figures of deities in the niches above. As at Piedras Negras, the Cotzumalhuapa deities are frontally presented and nearly full-round. Underneath the deities, each of the ball-player figures stands in profile, wearing on one hand a mitten or glove which ends in a flat stone head. Seven of these reliefs are known. The compositional formula remains identical, but the details of attributes and costume differ from one to another. Two groups are readily distinguished: those with and those without glyphs of Mexican derivation. One group, with glyphs (Plate 130A), has greater figural mass, and a more decisive relation between figure and ground. The details of costume and attributes are also more clearly indicated (Monument 3). Circular Mexican glyphs characterize these reliefs, to which the flat panels of recumbent male figures also belong (Monuments 13 and 14), as well as two sacrificial scenes (Monuments 1, 11, 15, and El Baul, Monument 4). In the other group (Plate 130B), the composition is carried by tendrils and streamers of an uncertain and inconclusive form (Monuments 5, 2, 4, and 6).

Among the Escuintla carvings, one group represents the heads of aged men, often with extruded eyeballs and sagging pouches set in deeply wrinkled faces. One large example resembles head-effigy vessels of plumbate ware;[17] another fragment evokes the stelae of Quiriguá, with the face in three-fourths relief against a ground of feathered parts of costume. The many horizontally tenoned stone heads can also be compared to those of Copán and Quiriguá.

The ceramic history of the Guatemalan highland contains many regional traditions. The best excavated sites are Kaminaljuyú, Chiapa de Corzo, Izapa, Iximché, Nebaj, and Zaculeu.[18] The main outlines of the sequence all confirm the interpretation of the cordillera as a land bridge between Mexico and Central America whose inhabitants were culturally separate from the lowland Maya peoples. Their most significant contributions to Maya art occurred in the Classic era. In the early phase, potters at Kaminaljuyú helped to mediate between the styles of Teotihuacán and Maya painting of the Tzakol period. Later on in the Tepeu I period, the painters of the Chixoy river in the Alta Verapaz produced the Chamá vases before 700. Finally, a pottery style of the Toltec era, called plum-

bate, probably originated in south-western Guatemala or Chiapas, whence it spread over all Mexico and Central America.

In the Esperanza tombs of Kaminaljuyú, the appearance of stuccoed cylindrical tripod jars of the same shape, but painted in the Maya styles of Teotihuacán and Tzakol, is recorded from the same tombs (Mounds B II and A VI) of Early Classic date. The pastes, like the fine volcanic ash temper, are identical, so that they are surely the product of the same school of potters, in highland Guatemala, just as the tall cylinder is peculiar to that region, never occurring at Teotihuacán. Kidder has also commented on the fact that these artists were capable of painting in the styles of two different civilizations, using quite different vocabularies of symbolic design, originating 600 miles apart.

Plumbate pottery has a grey, hard, and lustrous surface resembling vitreous glaze (Plate 131A).[19] It is a slipware made from fine-textured clay of high iron content, fired in a reducing atmosphere at temperatures about 950° C. Its manufacture flourished between c. 900 and 1250. The ware marks a period of Toltec ascendancy, without being of Toltec manufacture, throughout Mexico and Central America. It is distributed from north-western Mexico to Nicaragua, and it is most frequent in western Guatemala at the Mexican border. This province, anciently known as Soconusco, may be the source of plumbate. The ware has been divided into three classes: San Juan, without effigy vessels, is the oldest; Robles, with moulded decoration, is intermediate in time and transitional in type; and Tohil comprises the elaborately decorated effigy vessels which are assigned to the twelfth and thirteenth centuries (Plate 131B).[20] Only Tohil plumbate had a wide diffusion, and it can be recognized not alone by elaborate form and effigy modelling, but also by distinctive paste and by scroll forms of decoration.

EASTERN CENTRAL AMERICA

As a geographical entity, Central America extends from Oaxaca to the northern Andes, including both the Maya area and the non-Maya regions. The boundary between Maya and non-Maya at the Río Lempa in Salvador and the Río Ulúa in Honduras is a cultural frontier. West of this line, Maya and Mexican archaeological types predominate. East of it another culture, best designated as Central American, appears with intrusions from Mexico and from the Andean region. The substructure of Central American culture is probably ancient, and it has a certain South American character, most apparent in the pottery and stonework of pre-Classic date, from Honduras to Panamá.[21] On the other hand, the principal stylistic groupings prized by collectors, such as Ulúa vases, Costa Rican highland stone sculpture, and objects of pottery and jade from the Nicoya peninsula, all betray Maya and Mexican contacts. Only the goldwork of Panamá and Costa Rica can be ascribed to Andean spheres of influence, and it reaffirms the South American connexions shown in the basic, pre-Classic manufactures of Central America. The exact composition of these shifting currents of pre-Columbian artistic influence is much less well understood in eastern Central America than in Mexico or the central Andes. South American forms were most important in early and in late times. The intervening period

was under more or less direct Maya and Mexican artistic domination, probably for about a thousand years, and it was in this period that many of our examples, however insecurely dated, surely originated.

Long custom has enshrined two tribal terms in Central American archaeology: Chorotega, referring to groups along the Pacific coast of Nicaragua and Costa Rica; and Guetar, referring to the mainland regions with drainage into the Caribbean. Anterior to both the Chorotega and Guetar tribes were peoples bearing a distinctive and unified culture of Central American character. Neither term can surely be taken to describe events much older than the period of the Discovery, and it is preferable to speak of mainland and coastal regions.

What was the artistic character of this presumptive matrix of Central American culture? Certain classes of stone manufactures, and a group of ceramic traits are relevant.[22] Among stone carvings, the ornate three-legged and four-legged food-grinding tables (*metates*) are representative, and so are human figures raised upon pedestals or peg-like bases. In pottery, elaborate shapes encrusted with plastic additions recur throughout Central America as if in an early stratum. Spouted vessels, and shoe-form vessels; tall tripods or tetrapods, or pedestal bases are common; also effigy vessels with features in filleting, modelling, and incision. Animal and human forms predominate. The ornamental language, both in stone carving and in painted pottery, is a combination of bands and fields of braided, plaited, and re-curving decoration possibly derived from textile techniques.

The Ulúa 'Marbles'

One instance among many of the penetration of these Central American forms into Maya territory is the case of the stone vessels found along the north coast of Honduras. They fall into two groups, eastern (prematurely identified with the historic Paya tribes) and western (centring upon the Ulúa Valley in the Maya country).[23] The eastern vessels are of porous volcanic stone (Plate 132B); the western ones are of travertine (Plate 132A). Both groups share their forms with Honduras. Vertical-walled vases with opposing handles of bird and animal shapes are the most common. The two regional varieties have different surface decorations: the Ulúa Valley 'marbles' are carved with overlapping scroll patterns, the 'Paya' vessels have only braided bands, or heavy corded decoration at the lip and base. Occasionally these braided interlaces appear in the Ulúa 'marbles'. Only the vertical-walled form, and the tripod feet of certain examples in both varieties, betray Maya and Mexican derivation. The tripod nubbin feet, which are Classic in form, usually coincide with the braided ornamental bands of Central American type. The date of the complex is Late Classic at the earliest.

Costa Rican Mainland Sculpture

These north Honduran stone carvings can be considered together with those of the adjoining Mosquito Coast of Nicaragua, and the so-called 'Guetar' style of the Costa Rican highlands. Certainly the art of this entire Caribbean façade of eastern Central

America seems connected by the production of stone vessels and instruments, carved with images of live forms and braided designs. In Costa Rica, the principal centre of these manufactures was probably around Mercedes, at the point where the highland joins the coastal plain. Statues, slab altars, and four-legged food-grinding tables in the shape of jaguars are the principal types (Figure 79).

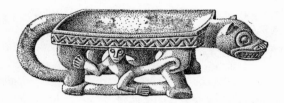

Figure 79. Food-grinding table from Mercedes,
after 800

A sixteenth-century tribal name for the style has long been given as Guetar,[24] although the archaeological type-site, Mercedes, lies just outside the Guetar area. The style probably ante-dates by many centuries the appearance of the Guetar, a people of Chibcha language (hence of South American origin) who were in the region at the time of the Discovery. An early dating for the stone manufactures was confirmed by C 14 evidence at Mount Irazú, where 'Guetar' associations occur about 1000.[25] While it is difficult to accept so vague an ethnic term as Guetar, it is also hard to discard so long-established a name. But much favours the adoption of a more descriptive geographic term, such as 'Mainland Costa Rican sculpture', distinguishing it from the art of the Pacific Coast of Nicaragua and the Nicoya Peninsula in north-western Costa Rica.

Among mainland Costa Rican sculpture, it is easier at first to see local variants than to affirm the existence of a coherent style. From south to north, at least three such local variants attract attention. At Palmar in southern Costa Rica, human figures are predominant, varying from columnar forms of igneous rock to slotted slab figures of sandstone, which often have three perforations to separate the arms and legs (Plate 133A). Farther north, the Mount Irazú sculpture of igneous rock from Las Pacayas is very different. Human figures still predominate, but they are carved in bloated, rotund forms with stubby limbs. The arms are curved ridges, and the legs appear as re-curved scrolls, without projections beyond the boulder-like envelope of the figure. These figures are perhaps a local variant of the putative early style of columnar figures from Palmar. At Mercedes, farther north, in the lowland jungle at the edge of the highland meadows, lava figures of human beings and animals are abundant. The example here illustrated (Plate 133B) is among the finest examples of sculptural articulation and organization in eastern Central America, with repeating rhythms of pendulous shapes and inflated limbs, which contrast with the fine cutting of the guilloche bands on the arms and flanks. The stance is free, asymmetrical, and open, with the feet connected by a stone septum to reduce the chances of breakage. Mason suggests that the columnar figures antedate the slabs, although he refrains from any closer seriation.[26] Certainly their

general appearance is closer to the inception of a figural style than to an elaborate terminal phase.

Bars and connectors of stone appear again in the ornate stools and food-grinding tables excavated from the tombs of Mercedes, where their purpose is less to insure against breakage than to permit complicated sculptural variations, wherein small figures with free movements swing or balance upon the stretchers of stone or pottery. The most remarkable works are surely the tripod *metates* from the Reventazón valley north-east of San José (Plate 134A).[27] The legs are enriched by acrobatic jaguars and spider monkeys balancing upon human heads. A panel in the sagittal plane is perforated with the outlines of a double-headed crocodile deity, standing upon a Mexican earth-monster, and holding a serpent in his mouth. Not the least singular trait of these *metates* is their orthogonal character as compositions in frontal plane and profile elevation, without any of the intermediary passages suggestive of rounded, continuous space. From western Panamá through Costa Rica to northern Honduras, sculptural invention and rhythmic ingenuity characterize the area.

The Pacific Coast

When we compare mainland sculpture with that of the Nicoya Peninsula in Costa Rica, and along the Pacific Coast of Nicaragua, the elusive unity of the former, in respect of ingenious sculptural complications, suddenly appears clearly, in sharp contrast to the linear and geometric propensities of the Nicoya sculptors. The contrast obtains not alone for stone manufactures, but for pottery too. On the mainland, the predominantly monochrome vessels are like clusters of sculptural increments, while the Nicoya polychrome wares of north-western Costa Rica are principally decorated with painted designs of Maya and Mexican derivation (Plate 135A). This contrast between linear and plastic tendencies reappears in the stone products of Nicoya and the Costa Rican mainland. For instance, the three-legged Nicoya *metates* (often and without sufficient reason called by a tribal name as 'Chorotegan') are decorated with flat interlacing strapwork carved in basaltic lava.[28] The curved grinding surface never has a rim, as in the four-legged mainland types, and the occasional jaguar *metates* of Nicoya are composed of thin and elegant planes lacking the anatomical character of the 'Guetar' jaguars.[29]

The differences between the styles of the two regions may well reflect a chronological separation. The mainland monochrome pottery and figural stone-carvings are probably older than the Nicoya types, whose date may be no earlier than the Late Classic associations indicated by Maya derivations in the painted forms and by the occurrence of Nicoya pottery in mid to Late Classic deposits at Copán.[30] That some Nicoya polychrome ware is coeval with the interlace *metates* is suggested by the occurrence of the same braided forms of ornament, identifiable as alligator-motives, in both.[31] In respect of design, a type portraying seated human beings in profile resembles south-eastern Maya pottery painting of mid-Classic date;[32] other groups (Papagayo on Culebra Bay), with a plaster-like slip and brilliant colours varnish-coated, resembled Mixtec pottery not only as to design, but also in shape and technique. Here the vexed question of

Mixtec chronology arises once more, but the evidence for secure dating in Nicoya is no better than in western Oaxaca. In any event, one may bracket Nicoya polychrome ware between the ninth and thirteenth centuries, choosing the earlier date because of the tomb association at Copán, and the late one because of Mixtec affinities.

Jades. The distinctive blue-green jades of Costa Rica reflect the contrast of mainland and peninsular styles in divergent repertories of forms and techniques. The Nicoya jades are usually flat axe-blades cut to resemble human, animal, and bird forms (Plate 135B). In north-eastern Costa Rica, the region around Guápiles was another jade-working centre, where figures in profile with string-sawn, perforated inner silhouettes were the fashion.[33] The Nicoya axes are assumed to be typologically older than the Guápiles ornaments, which were probably meant to be worn only as parts of a costume, or as amulets. Their instrumental nature is much less evident than in the Nicoya axes, although a great variety of functional types can be noted in the Nicoya group. There are long and narrow blades like chisels, of differing sizes, as if for cutting different substances, and wide, spatulate blades as if for cutting meat. Some have cleft blades like those of Guerrero. Many blades have suspension drillings, so that they are often classed as amulets or pectorals, although the holes may only have served to pass a lanyard to the wrist of the user of the tool.

Monumental Sculpture. The Pacific Coast in Nicaragua is part of the same 'Chorotegan' area as the Nicoya Peninsula in Costa Rica. The pottery types are similar, although monumental sculpture is absent in Nicoya, and jades are uncommon in Nicaragua. The monumental sculpture is human statues on pedestals. Some bear animal figures on their heads and shoulders (Plate 134B). Opinion is divided on the origin of these burdened and enigmatic statues: some think they are archetypal Central American motifs; others ascribe them to South American sources. Whatever the origins, Mexican Toltec traits appear in certain figures.[34]

The statues are of two styles. One is of cylindrical shape with shallow carving and comes from the Chontales district east of Lake Nicaragua. The other is the *alter ego* or 'guardian-spirit' statues [35] from the islands and the shores of the Nicaraguan lakes. The Chontales statues distantly recall the central Andean sculpture from Huaraz, and the lake statues are faintly reminiscent of the San Agustín figures from Colombia. But Chontales figures can with equal reason be regarded as close relations of the Costa Rican mainland sculpture, and the lake figures can be regarded as South American parallels to Toltec Atlantean figures.

Distinct periods are probably present. The Chontales figures are primitive in respect of sculptural articulation. Their braided belts and guilloche bands mark them either as provincial imitations, or as archaic precursors, of the Mercedes style. The elaborate articulation and the powerful expressive character of the lake statues, however, correspond to an altogether different stylistic atmosphere of mature technical skill and of metropolitan demand.[36] The example here illustrated (Plate 134B), from the north end of Zapatera Island in Lake Nicaragua, portrays a seated male. His head-dress resembles that of a Nicoya mace-head.[37] The meaning is totally unknown, but the burdened expression of these figures crumpling beneath enormous animal charges is more

than totemic or heraldic. The close connexion with burial grounds, moreover, is most unusual for ancient American sculpture.[38] The differences between Chontales and lake sculpture, in brief, are like the differences between mainland and coastal styles: possibly two different ethnic groups, separated by Lake Nicaragua, and by as much as several centuries, are involved.

The Styles of Panamá. The present republic of Panamá contains four main archaeological provinces. The easternmost, Darién, is artistically insignificant. The westernmost, Chiriquí, overlaps with mainland Costa Rica and with its eastern neighbour, Veraguas. Lifesize basalt pedestal figures carrying others are known at Barriles, as well as grinding tables, all prior to A.D. 500.[39] The central provinces of Veraguas and Coclé require extended discussion, because of the separate aesthetic identity of their manufactures, and because of the exact knowledge about them provided by the admirable studies of S. K. Lothrop. Polychrome pottery, repoussé gold, and cast jewellery characterize the Coclé productions (Figure 80). The province of Veraguas specialized in the manufacture of *metates* and open-back gold effigy pendants. Both the Coclé and Veraguas styles have strong South American resemblances and their influence, through trade, extended far to the west, into Yucatán, southern Mexico, and northern South America.

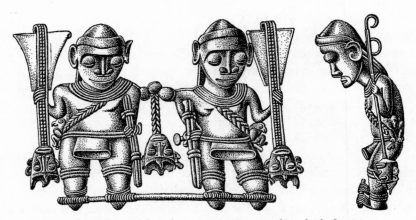

Figure 80. Effigy pendant from Sitio Conte, Coclé style, before 1000.
Cambridge, Mass., Harvard University, Peabody Museum

Veraguas. The volcanic stone *metates* resemble those of the Costa Rican mainland.[40] Some are three-legged, with sagittal panels of ornament under the grinding plane, and others are replicas of the 'Guetar' four-legged jaguar *metates*. Goldwork, however, was the most important manufacture in Veraguas. The effigy pendants, which influenced the Mixtec goldsmiths of Oaxaca, represent birds, jaguars, ant-eaters, monkeys, crocodiles, frogs, lobsters, fish, human beings, and monsters with jaguar, crocodile, or bird heads on human bodies (Figure 80). The technique of all these pendants is *cire perdue* casting. The desired form was first built of threads and sheets of wax, then enclosed in a clay mould furnished with vents for the escape of the wax melted before the liquid gold was poured. Veraguas castings are usually flat and designed for wearing by suspension, and

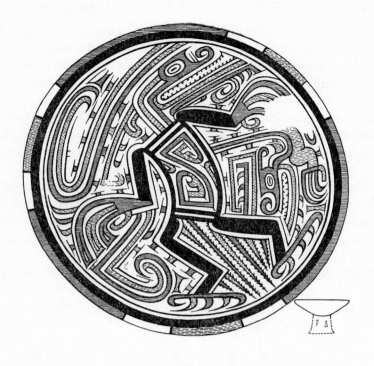

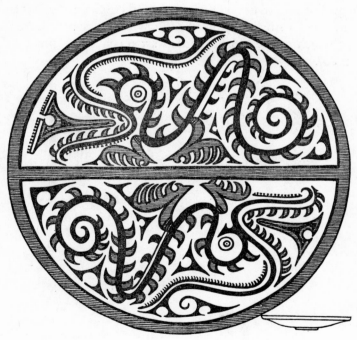

Figure 81. Polychrome pottery (*below*) from Sitio Conte, Early and Late
(*above*) varieties (before 1000) of Coclé style.
Cambridge, Mass., Harvard University, Peabody Museum

framed on two or more sides by rectangular flanges. The goldsmiths avoided the complications of full-round figures, preferring to leave the backs of the figures open. Their work gives the impression of production in series for an export market. It resembles certain South American types, especially in Colombia, both as to forms and techniques.

Coclé. All the evidence suggests that the prehistoric people of the province of Coclé were the most affluent and skilful artisans of the Isthmus.[41] The goldwork, of repoussé sheets and full-round castings, is less stereotyped, and technically more elaborate, than that of Veraguas. The polychrome pottery, painted in two or more colours on a light background, with scroll designs and animal forms of reversing-curve patterns, has a flamboyant ornateness instantly distinguishable from other American pottery. Although not without opposition, Lothrop suggested the Coclé style to have been of Amazonian origin, and affected by Central American traditions, because of the character of the pottery design, recalling Marajó forms in the Amazon basin, and because of Colombian and Ecuadorean influences and trade relations in jewellery.

Two pottery styles can be discerned (Figure 81): Lothrop, by grave associations and stylistic evidence, dated the earlier 1330–1420 and the later 1430–90, but radiocarbon and further excavation now place these styles between 500 and 1000.[42] He also assigned many vessels to individual artists. Early painters used a thin line and fewer colours than later ones. In the late style massive linear effects and bolder colours in balance became common. Early scrolls are generally circular; late ones are flattened or oval curves. The Coclé repertory of beasts and fish reflects hunting and fishing for subsistence. The potters and metal-smiths had a small vocabulary, but within it they enriched the images by stylistic devices which evoke North Andean art much more directly than any other sources (Figure 80).

PART THREE

THE ANDEAN CIVILIZATIONS

CHAPTER 11

THE NORTHERN ANDES: COLOMBIA AND ECUADOR

THE urban societies of the South American continent all flourished in the Andes, along a strip of mountainous coast less than a hundred miles wide, extending from the Caribbean façade of Venezuela and Colombia southward along the Pacific to northern Chile. Nomadic hunters of the southern Andes and plains and the tropical tribespeople of Amazonia, like the Indian tribes of North America, will not be treated here. In this part we deal only with those parts of the mountainous northern and western rim of the South American continent[1] where durable urban artistic traditions flourished.

The geographic conditions for civilization in the Andes are unlike those of Mesoamerica. Instead of the lakes and rivers of highland Mexico, spreading across the continent to the tropical Atlantic and the arid Pacific coasts, the Andean region is a narrow system of corridors between mountain ranges, rising abruptly from the coastal plains, and bounded on the east by oceans of tropical vegetation where the highlanders descended unwillingly. On the Pacific side major civilizations flourished in the river valleys separated by forbidding deserts. Conflict and interchange between the highlanders and the coastal peoples were continual: the Mexican parallel for the Andean situation is the relation between the coastal peoples and the central plateau dwellers. There is no South American analogy for Maya civilization, and there is no close Andean parallel for the sedentary farming peoples of western Mexico. Conversely Mexico and Central America have no equivalent for the river-bank civilizations of the arid coast of Peru, nor have they any societies adapted to high altitudes like those of southern Peru and Bolivia.

These differences are clearly evident in the arts of Mesoamerica and the Andes. The anthropomorphic or humanist bent of all Mesoamerican expression is carried by innumerable representations of the human figure. In the Andes a humanistic style appears only intermittently, as in Colombia and Ecuador, or on the north coast of Peru; elsewhere the human figure is subjected to complex deformations tending either to the emergence of monster-like combinations or to the dissolution of the human form in geometric abstractions. Throughout the Andes a dominant concern for technological control over the hostile environment is apparent. It can be seen in great works of irrigation on the coast, or in stupendous agricultural terracing in the highlands. Andean metallurgy

233

is at least fifteen hundred years older than that of Mexico and the Maya region. Another continuing preoccupation of the Andean peoples was to achieve political unity among widely scattered populations by religious or dynastic government. The repeated appearance of unified pan-Andean states is suggested in the archaeological record of Chavín, Tiahuanaco, and Inca art.

Favoured by this evidence of cultural unity in the relatively uniform environment of the Andes, archaeologists have been inclined since 1950 to systematize their findings in a developmental classification even more schematic than the Mesoamerican one.[2] This classification has more divisions than the Mexican and Maya schemes. For example, the term 'Classic' is not current in Andean archaeology, where its place was taken by 'Florescent', or 'Master Craftsmen', and more recently by 'Middle' or 'Regional Developmental'. On the other hand, the 'Cultist' and 'Experimenter' periods of some Andean chronologies have no counterparts in Mesoamerican terminology, where their places are still taken by ethnic terms of limited extension, such as 'Olmec' and 'Toltec'.

Some Andeanists prefer archaeological periods to cultural stages. Thus Lanning separates six pre-ceramic periods (before 9500–1500 B.C.) from six ceramic periods (1500 B.C.–A.D. 1534). His ceramic periods follow Rowe's framework of alternating Horizons and Periods:

	Rowe 1967	Lanning 1967
Initial Period	2100–1400 B.C.	1800/1500–900 B.C.
Early Horizon	1400–400 B.C.	900–200 B.C.
Early Intermediate Period	400 B.C.–A.D. 550	200 B.C.–A.D. 600
Middle Horizon	A.D. 550–900	A.D. 600–1000
Late Intermediate Period	A.D. 900–1476	A.D. 1000–1476
Late Horizon	A.D. 1476–1534	A.D. 1476–1534

but his estimates of duration differ widely from Rowe's, especially in the Early Horizon.

There is no good reason for not extending the simpler terminology of Mesoamerica, based upon pre-Classic, Classic, and post-Classic periods, to the Andes. Some chronologies, like John Rowe's for the south coast of Peru, allow style-phases to be assigned to parts of a specific century. As such precision extends to chronologies elsewhere, it will perhaps become unnecessary to maintain the complicated and confusing developmental charts now in use for the different parts of ancient America. The scale of the present work justifies such a simplification, and the scheme has many precedents in Old World archaeology, although the transfer of the term 'Classic' from the Mediterranean world makes for confusion, especially where it refers, in Maya studies, solely to people who used Initial-Series and Period-ending dates, from the fourth to the tenth centuries A.D., as in Miss Proskouriakoff's *Classic Maya Sculpture*.

No such definition will serve for the pre-literate Andean societies; but, for the sake of clarity, we shall apply the term 'Classic' to those civilizations (Mochica, Nazca, early Tiahuanaco) which existed in the same time-span as Classic Maya culture, and whose works of art occupied (as we shall see) a similar position in the history of form.

Northern South America

In terms of human geography, South America is divided into the narrow Andean theatre of the urban societies, and the wide plains and rain-forest of Argentina, Brazil, and the Guianas. The Andean region was densely settled, in contrast to the small and scattered population of diminutive migratory tribes in eastern South America. Northern South America reflects this division. Ecuador and the highlands of western Colombia extend the Andean cordillera. In Venezuela, a meeting of Caribbean, Mesoamerican, and Amazonian traditions occurs without spectacular objects or sites of great urban development. The system of these cultural connexions in antiquity has been compared to the letter H: the left upright connects Mesoamerica and the Andes via Central America; the right one connects the Caribbean islands and Amazonia; and the horizontal link between the uprights is Venezuela,[3] where elements of all areas intermingled. For the purposes of this book, only western Colombia and Ecuador are relevant, with monumental sculpture and abundant metallurgical products, but there is little architecture, and the pottery has smaller expressive capacity than Central Andean types, being much older at Puerto Hormiga in northern Colombia (3100 B.C.) and southern Ecuador (2700 B.C.) than in Peru. Resemblances are claimed between Valdivia pottery in Ecuador and Middle Jōmon period wares in Japan: transpacific diffusion has been proposed, but opinion remains divided.[4]

Colombia

Of twelve archaeological zones in Colombia only the Tierradentro zone between the upper valleys of the Magdalena and Cauca rivers has an imposing and durable architecture of rock-cut tombs (Figure 82). The San Agustín zone farther south, near the headwaters of the Magdalena, contains an important style of monumental sculpture (Plates 136–7). The Calima river basin and the Chibcha, Quimbaya, and Sinú river provinces were all centres of different gold-working styles (Plates 138–143A). Tairona archaeology in the mountains of the north-eastern coast[5] shares features with both Venezuelan and Central American types.

The chronological sequence is still unsettled, although some students place San Agustín sculpture and Calima gold-work in an Early context, c. 500 B.C., possibly coeval with the Olmec and Chavín styles. The Tierradentro tombs are probably later and by a different people. Quimbaya gold-work has provisionally been fixed as of the last centuries B.C. in Colombian antiquity. Chibcha[6] and Tairona, which still existed in the sixteenth century, are classed as Late. Bennett pointed out that this arrangement, though better than none, is unsatisfactory because it provides nothing Early for some regions, and nothing Late for others.[7]

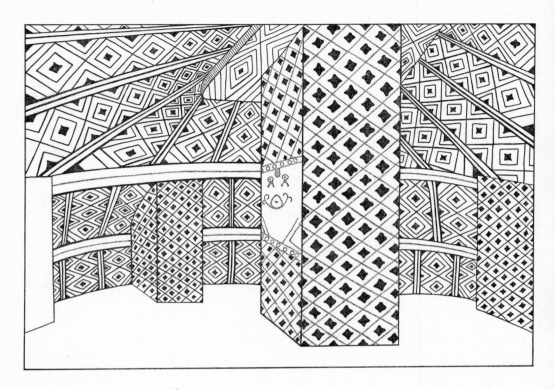

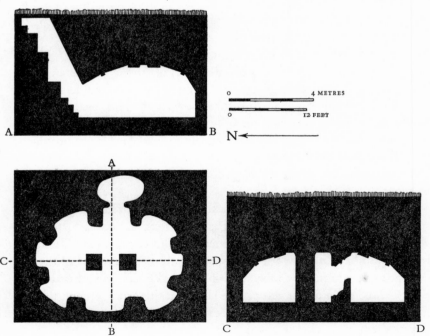

Figure 82. San Andrés, Tierradentro province, Colombia, Tomb 8, after 800 (?).
Perspective view, sections, and plan

Architecture

The principal remains of ancient construction are stone streets and foundations in the province of Tairona, and the underground tombs of Tierradentro in the south. The Tierradentro tombs are oval, and the Tairona houses were circular. Bennett regards the Tairona villages as of Late construction. The Tierradentro tombs are generally accepted as of long duration. Pérez de Barradas divides them into three groups: [8] the initial group lacks niches; the intermediate tombs are painted; the last group are oval in plan, with painted walls, rock-cut piers, and stair-well chambers.

The elaborate tombs with slanting roof planes and radial niches are cut in the soft granodiorite bed-rock. The entrances are straight or circular stair shafts. The plastered walls have geometric and human figures in black, red, and orange paint. The pottery found in these tombs is unlike that of other Colombian styles. It has been compared to Amazonian types [9] (Marajó Island urns).

The tomb illustrated here (Figure 82) measures 8·35 m. (27½ feet) on the long oval axis, and 2·28 m. (7½ feet) in height. The niches are separated by pilasters adorned with geometric faces, carved in relief and painted.[10] Whether the tombs correspond, like Etruscan ones, to the domestic architecture of living people cannot be decided, in the absence of all traces of the dwellings above ground. The ovals with radial niches are superficially similar to European plans of the seventeenth century, but they bear a closer generic likeness to the organic architecture of earth and straw among West African tribes and in the South Seas. In actuality much evidence connects the Tierradentro tombs with Arawak origins in eastern South America. The shafted deep-level tombs and the geometric wall paintings, as well as the pottery types, may point in that direction.[11]

Sculpture

Adjoining Tierradentro on the south are the forested hills of a province surrounding the village of San Agustín near the headwaters of the Magdalena river. Scattered through the region (Plates 136–7) are over three hundred and twenty stone statues which served as grave markers, tomb covers, and shrine figures.[12] They represent men, animals, and monsters, in relief and full-round sculpture. The stream-beds also are carved in channels and basins to form ornate biomorphic patterns of standing and running water. Because of a general resemblance to the art of Chavín in the north highlands of Peru, its date has been equated with the first millennium B.C. and with Olmec sculpture in eastern Mexico.

There is still no absolute measurement of the antiquity of these remains. The shrine sites have all been so thoroughly disturbed by treasure hunters that scientific excavation is no longer possible. Pérez de Barradas nevertheless claimed to have found stratigraphic evidence to warrant the division into initial, intermediate, and final stages of a historical development beginning long before 150 B.C., and closing about A.D. 700.[13]

As with the Tierradentro tombs, Pérez de Barradas tried a chronological sequence of sculpture based upon his classification by types. He noted three main categories: cylin-

drical figures; full-round figures carved in deep relief; and slab-like figures in low relief, and assumed that they appeared in this order. A standing human figure is almost invariably represented, often with the dentition of a puma. The proportions favour the head, which is a third or a quarter of the entire height, and the sculptural definition of the head is usually greater than that of the bodies.

The sculptors used three principal conventions to represent facial features. They are systems of combining the eyes and nose. One large group of figures always keeps the eyes and nose in a single flat plane, with a continuous curve outlining nose and eyes. This might be the 'eyehook' curve (Plate 136, *left*). The second group is more beetle-browed: the eyebrows make a continuous ridge across the forehead, and from this ridge the nose is developed as an independent sculptural unit (Plate 136, *right*). There are plain and ornate versions of the beetle-brow manner; the ornate version is like a double ox-yoke (Plate 137, *left*). The third group reduces eyes and nose to flat relief in two planes: this device could be regarded as a variant of the eyehook style, save for the fact that the nose is so broad-nostrilled as to suggest a dish from which the eyebrows rise as opposing curves (Plate 137, *right*). This third manner appears mainly on flat slabs.

It may be significant that each mode of treating the features occurs at a separate shrine in the region. These shrines are temple-like constructions, locally called *mesitas*, rectangular in plan (up to 10 by 15 feet), roofed by a single monolithic slab, and supported by walls, piers, or Atlantean figures. The principal statue stood near the centre of the shrine, and the whole construction was covered with an earthen mound. The main mesitas near the town of San Agustín are three, A, B, and C. A has east and west mounds about 20 m. (65 feet) apart. B stands 180 m. (200 yards) to the north-west of A, with southern, northern, and north-western mounds. C lies 400 m. (450 yards) west of A.

The eyehook style occurs on scattered sites throughout the district, and at Mesita B more often than at Mesita A. The beetle-browed figures characteristically occur at Mesita B, the ox-yokes at Mesita A. The flat-relief (or nose-brow) faces, finally, occur more often at Mesita C. This distribution suggests the activity of different workshops of sculpture, spread out over generations, but it gives us no sure clue to the seriation of the figures.

Some are large: one in Mesita B at the north-west mound, called the Bishop because of its mitre-like head-dress, stands 4·25 m. (14 feet) high. Their meaning is unknown. Some students have guessed that a very early lunar cult was displaced by solar worship, borne by an invading population which replaced the earlier moon-worshipping inhabitants.[14] By this supposition, the moon-people are identified with the Chavín period of Peruvian prehistory; the sun-people supposedly were the contemporaries of the builders of Tiahuanaco. Stylistic and iconographic parallels are made to support these comparisons. Colossal stone figures recur at Chavín and Tiahuanaco, and the monster with another creature in his mouth is also a central Andean theme. The *alter ego* figure or costume, as we have seen it in the lake sculptures of Nicaragua (Plate 134B), occurs at San Agustín as well as in the pottery of the Peruvian coast and in stone figures from the Amazonian basin. It has also been supposed that the sculptures represent hallucinogenic visions of colossal jaguars.[15]

Metalwork

After the second century B.C., Colombian gold-work has a long history of uncertain duration.[16] Three technological stages are postulated. The earliest process was to cold-hammer and emboss the native gold found as dust and nuggets in streams and open rock faces. Colombian gold is argentiferous, but the ancient smiths never learned or cared to work silver separately. The second stage was to heat the metal until it melted: molten copper and open-mould casting were supposedly the principal achievements. In a third stage, smiths succeeded in alloying gold and copper. Called *tumbaga* or *guanin*, the alloy (ideally 82 per cent gold and 18 per cent copper) has a lower melting point than either metal in separation, and it can be hammered to hardnesses like those of bronze. This great invention has been ascribed to Colombian goldsmiths. A specimen of *tumbaga* was discovered at Copán beneath Stela H, dated A.D. 782 (9.17.12.0.0).[17] Other attainments of this stage were gilding and plating; *mise en couleur* by acids to remove the baser metal from the surface of an alloy; soldering; and lost-wax casting.

The arguments for greater antiquity than in the central Andes are weak. Silver, lead, and bronze were unknown in ancient Colombia, where the repertory is much smaller than in Peru or Mexico. Datable examples of stages 1 and 2 have never been identified. In stage 3, at least seven different regional styles have been provisionally established. The separation into regional styles and periods has been made difficult by many centuries of commercial grave-looting, and by the trading of objects throughout the Colombian Andes and into Central America. For instance, the region around Antioquia at the convergence of overland routes from the Caribbean to the Pacific was an important trading centre where Pacific salt was exchanged for highland products.[18] The shaft-graves of this region yield gold-work from nearly every province of Colombia.

Pérez de Barradas has provisionally arranged the geographic styles in two chronological groups.[19] The early one comprises the Calima, Darién, and Tolima styles; it precedes Quimbaya, Sinú, Tairona, and Chibcha. Pérez de Barradas admits that this grouping rests on 'suspicion' more than evidence. His 'early' group mainly includes embossing and the simpler castings, and the 'late' one has more complex castings and ornate filigree work. The 'late' group is supported by Lothrop's discovery of Sinú and Quimbaya gold objects in the Coclé area of Panamá, no older than 1300.[20]

The Calima Style.[21] The Calima river flows west towards the ocean, and its valley was a main thoroughfare for trade between the Cauca drainage and the Pacific Coast. Several hundred gold objects from the upper reaches of the river display a technique and style sufficiently uniform to justify a common designation, even though many different tribes during several centuries may have participated in their manufacture. Pectorals, diadems, nose ornaments, and pins are the principal items. *Tumbaga* alloys of varying ratios between gold and copper are the rule. The metal was hammered into sheets of ornate profile, or cast by the lost-wax process into pins with minute figures on their heads. Pérez de Barradas suggests that the Calima style is the oldest in Colombia.[22] Among resemblances to the sculpture of San Agustín he noted two important facts: the San Agustín

statues wear head-dresses and jewellery of Calima types; and many Calima pinheads are replicas of a San Agustín figure with rectangular mouth and eyes. The contemporaneity of the two styles seems assured, but their absolute date remains uncertain. Pérez de Barradas [23] fixes the high point of Calima production about 700, and its disappearance about 1000.

The meaning of Calima shapes is enigmatic. A typical form is the kidney-shaped pectoral (Plate 138A). A standard element in many graves, it usually has a face with closed eyes, hammered up from the sheet metal, wearing a head-dress like that of certain San Agustín statues, and adorned with large ear-rings and an H-shaped nose ornament. This nose ornament may represent the skin of a puma: at its centre a simple feline mask is embossed, often flanked or surrounded by clusters of dots like spotted fur. The closed eyes of the mask are often rendered by the beetle-browed convention resembling an ox-yoke (Plate 137, *left*), which we have seen in San Agustín statues. Calima smiths treated gold as if it were leather, as a pliable and impressionable substance, normally to be embossed over hard moulds of stone or wood, and repoussé with dies and punches.

The Calima pins with heads representing men and animals are about 12 inches long. These *tumbaga* pieces are lost-wax castings with soldered additions of intricate detail on a minute scale, on figures about an inch high (Plate 138B). Frequently shown is a masked figure wearing a domed face-cover with slotted apertures like a Hopi katchina. On his back a four-footed animal (a puma?) crouches in the posture of the representations of animal totems at San Agustín and in Nicaragua.

The Darién Style.[24] The Atrato river empties in a tropical flood plain on the Caribbean side of the base of the Isthmus of Panamá. *Tumbaga* casts of bat-headed human figures (Plate 139A) are the only type now assigned to the region. They resemble a bat-figure occurring in Calima graves. The two hemispherical ornaments in the head-dress represent large bat's ears. The objects in the hands are rattle gourds, and the filigree scrolls flanking the head represent wings. The conversion of human forms into planes and scrolls is a Darién characteristic. It also reflects a simpler casting process, possibly in an open stone mould, with extra planes added by soldering. Another example of this type was dredged from the Well of Sacrifice at Chichén Itza. It is a knife rather than a pendant. Lothrop interpreted it as a 'flute-playing bird-god'.[25]

The Tolima Style. At the latitude of Cali, but on a western confluent of the Magdalena, lies the gold-working province of Tolima, near the headwaters of the Rio Saldaña. Metallic copper was abundant in the region, and it was exported to the Cauca basin – a region poor in copper – for use in *tumbaga* alloys.[26] The typical product is a flat casting of angular forms (Plate 139B) based upon birds, reptiles, and animals. Heavy cast-filigree increments sometimes adorn the faces. The profiles of bodies recall ideographs and the abstractly expressive designs of contemporary painting. Pérez de Barradas notes that no Tolima pieces occur in Calima territory, but that some of the finest examples of the Calima style appear on Tolima sites.[27] If the two styles are coeval, this distribution probably marks a one-way trade relation from metropolitan to provincial centres.

The Sinú Style. The valley of the Sinú river lies east of the Atrato. *Tumbaga* castings of pairs of birds with open backs like Veraguas forms are known, as well as flat filigree

nose-bangles and pendants. These bangles may have been cast in moulds shaped on basket-work models.[28] The Sinú smiths also used carved stone reliefs for repoussé patterns.[29]

The Quimbaya Style. Long custom rather than a firm connexion between tribe and archaeology warrants the continued acceptance of this vague ethnic term. It is usually extended to include the makers of the celebrated cast-gold figures of seated and standing men and women, discovered at the end of the nineteenth century in the graves of the region between Cartago and Manizales. The Quimbayas were there when the Spaniards arrived, but the style appears throughout the middle Cauca valley to Antioquia, where other tribes lived. Quimbaya finds in Panamanian graves suggest a date before 1000 for the florescence of the style of the Coclé region.[30]

In Colombia nearly all non-Chibcha gold objects used to be assigned to Quimbaya smiths until Pérez de Barradas identified the Calima embossed style. The Quimbaya group is now limited mainly to heavy castings with smoothly rounded surfaces (Plate 140). The helmets, bottles, and statuettes in the Museo de América at Madrid are typical instances.[31] Other Quimbaya manufactures are cleft nose-ornaments designed to clasp upon the septum, in crescent, triangle, scalloped, and elongated shapes. There are also pectorals, bells, bracelets, beads, and pins, masks, tweezers, and diadems.

The statuettes were cast by the lost-wax process in moulds of clay and charcoal,[32] with hands and feet cast separately and soldered to the body. The forms of the bodies have an inflated or bloated appearance. Indeed, the weightless and sinuous Quimbaya surfaces recall the undulant tubes of Hindu figural sculpture,[33] but the resemblance is merely technical, arising from the casting process rather than from contact between peoples. The nature of lost-wax casting required that the entire envelope be designed for pouring, and the molten gold had to find its way by gravity into all the crannies of the mould. The smooth portions of the bodies, the partly spherical joints, and the tube-like limbs all record these technical conditions for hollow casting under primitive circumstances.

The stiffly symmetrical postures and the absence of any suggestion of movement can be connected with regional traditions of manufacturing pottery figurines,[34] such as the planiform seated images made by Quimbaya potters (Plate 141). The hands and feet are diminutive; the surfaces have minimal variety; the contours are closed; and the expression is dead, as in the gold statuettes with closed slit-eyes and the posture of *rigor mortis*.

Among the Quimbaya statuettes, two types may be noted. One, a seated female of large-headed and sausage-limbed proportions, is represented in Philadelphia. The arms are diminutive, and the eye planes immense. The Madrid figures are more naturalistically proportioned: the limbs are longer, the expression approaches a smile, and the parts of the body are connected in anatomy as well as in the flow of molten metal into the mould. One figure of large-headed type (now in Berlin) reportedly comes from Manizales in the northern section of the Quimbaya territory. The Madrid figures were all found near the village of Finlandia in the southern section. Possibly the two types correspond to different geographic schools of Quimbaya gold-work, and to different

generations. If the latter is true, the first group may be the older one on the usual assumption of typological progression towards anatomical fidelity.[35]

The Quimbaya tribes probably came from the north, displacing an older population in the Cauca Valley.[36] Certain resemblances among Tairona, Darién, and Quimbaya pieces support the idea. For instance, a pendant in the Cleveland Museum has the double-knob head-dress of a bat figure in the Darién style (Plate 142), the spread-eagle and squatting posture of a Tairona pendant, and the facial features of Quimbaya work. Tairona gold-work, in the north-eastern corner of Colombia, in turn resembles Venezuelan productions. Both types are extremely rare, and it is more likely that Quimbaya, Tairona, and Venezuelan castings all belong to the same time-level as different styles, than that the northern ones should be ancestral to Quimbaya work. But in the absence of any firm chronology, all remarks on sequence are guesswork.

The Chibcha (also *Muisca*) *Style*. The *tumbaga* castings from the region around Bogotá[37] are the most planiform of all Colombian productions. Typical forms are elongated isosceles triangles of slab gold, with human features and costumes rendered by lost-wax casting upon moulds of waxen filaments. An unusually complex example in Bogotá shows a dignitary wearing a diadem, ear spools, and a necklace, all indicated by cast filaments (Plate 143A). He is seated upon a litter or dais made of braided filaments, in a raft with many attendants. These figures, called *tunjos*, are traditionally believed to represent certain Chibcha rulers, and to have served as cult offerings. They were in manufacture at the time of the Spanish Conquest among people whose historical memory embraced only about fifty years.

THE PACIFIC EQUATORIAL COAST

An immense artistic region extends along the Pacific coast between Tumaco in Colombia and Guayaquil in Ecuador. Its regional components in the provinces of Tumaco, Esmeraldas, Manabí, and Guayas are here treated together because of the occurrence of a distinct figural complex with striking Mesoamerican affinities. Indeed the Pacific equatorial coast is the southernmost frontier of the traditions of Mexican and Central American art with affinities also to the art of the central Andes.[38]

Influences from the central Andean styles are late and few, indicated by such forms as divergent double spouts connected by strap handles, double vessels and house vessels, negative painting, the syrinx or Pan pipe, and the representation of pathological deformations and erotic scenes.[39] The latter, however, are also present in Late Classic Maya art. Other pottery forms relate to types prevailing north of the Isthmus of Panamá, such as flat stamps, cylinder seals, biomorphic figurines, and ocarinas. Certain themes, such as persons strapped to their beds, evoke west Mexico. The stone sculpture of Manabí includes seats borne upon the backs of crouching human beings, as well as Atlantean figures, to which the closest parallels are Central American and Toltec Maya.

The chronology of the Ecuadorean coast unfolds in five archaeological provinces with the usual early, middle, and late developmental periods.

On the Guayas coast at Valdivia, pottery dated about 3000 B.C., decorated by incised and punctated cuts, is accepted as the oldest ceramic tradition in America. There are equally old parallels at Puerto Hormiga in northern Colombia. Without accepting the thesis of Japanese Jōmon origins for the pottery, Gordon Willey suggests that this early tradition 'became the source for the development of pottery for most of the Americas'. Valdivia Phase pottery figurines after 2300 B.C. have punctated features on heads with large striated hairdresses (Plate 143B). These continue a prior stone tradition before 2300 B.C. of figurines shaped from pebbles and slabs, some with separated legs and incised faces, which bring to mind Mezcala blades from Guerrero in a later era (p. 115). In the other direction to the south, the stirrup-spout bottle of Chavín and Mochica made its earliest appearance in southern Ecuador in the Machalilla phase between 2000 and 1500, together with pottery figurines having coffee-bean eyes. Chorrera pottery before 500 B.C. shows Mesoamerican contact in its figurines, iridescent painting, obsidian flakes, and other traits resembling those of the Ocós phases on the Pacific coast of Guatemala (see Note 38).

Guangala pottery, first identified by G. H. S. Bushnell, appears between 500 B.C. and A.D. 500. In the opinion of J. Jijón y Caamaño,[40] the Guangala corresponds to the Mochica style in Peru, and Manteño to Chimu. In effect, late Guangala objects display an advanced style of modelling, comparable to the mid-Classic Maya art of figurines, and to early Mochica attainments in Peru. Such figurines (Plate 144A) are easily recognizable: they are usually whistles made of a dense and fine burnished red ware, scored by incised parallel lines in rectangular patterns near the joints of the body. Similar figurines have been found in Manabí and Esmeraldas,[41] but not in Tumaco. Mould-made figurines (Plate 144B) are common, especially in Esmeraldas and Tumaco, where they are probably later than the hand-made Guangala examples, corresponding perhaps to the Manteño phase, from A.D. 500 to the Conquest.[42] The use of the mould transformed the craft, not only by extreme complication, but also by coarse production in series. The Guangala and Manteño types in Ecuador correspond roughly to the stages before and after the appearance of the moulding technique. The published collections of Manabí and Esmeraldas objects, however, contain numbers of figurines with 'coffee-bean' eyes. The type is common in Mesoamerica, and rare in the central Andes. Early figurines of Guangala type have these eyes.[43] Perhaps some Manabí and Tolita examples from Esmeraldas are pre-Guangala.

Among these types which may be pre-Guangala appear some of the finest productions of the art. A head in Paris from the Ostiones district in Esmeraldas can be ranked among the more expressive and harmonious of ancient American figurines. The rear of the head shows a tabular deformation, associated with Guangala types and with examples having coffee-bean eyes. Shells cover the ears. The straight profile and the huge upper eyelids resemble Gulf Coast faces of the 'smiling' type. In expression this type (Plate 144B) also recalls the withdrawn, remote Quimbaya statuettes of gold.

Stone sculpture of monumental character appears during this late period only in Manabí (Plate 145, A and B). Typical[44] slabs are carved with frontal human beings framed by borders of repeating textile-like patterns. Both these slabs and the simpler

stone chairs may be pre-Manteño. The ornate stone chairs are presumed by Bushnell to belong to the Manteño period. The latter are deeply concave; the plain ones have shallow seats. A slab illustrated by Saville[45] shows a woman seated with splayed legs upon a shallow throne, in an 'obstetrical' posture. Both slabs and chairs were found in enclosures marking the boundaries of dwelling compounds.

The highland of Ecuador is divided into northern, central, and southern groups, with Colombian affinities in the north, and Late Peruvian connexions in the south. For the central highlands a long stratigraphical sequence spans 3500 years (Early, to 500 B.C.; Middle, to A.D. 500; Late, to Spanish discovery in 1532).[46] As Donald Collier has put it, Ecuador forms with Colombia a north Andean unit, only slightly connected with the central Andes under Inca rule.[47]

THE CENTRAL ANDES: EARLY NORTHERN PERU

THE Pacific Coast and the highlands of Peru, together with the Bolivian plateau, compose the central Andes. Cajamarca in northern Peru is isolated from southern Ecuador by several hundred miles of forested mountains and desert coast. On the east the tropical forests of the upper Amazon hem in the culture of the central Andes, and on the south the Atacama desert separates it from southern South America. From Ecuador to Chile, the central Andes extend for over 1000 miles, in a strip ranging from 50 to 250 miles wide. Here many interrelated civilizations all share a common historic tradition,[1] quite distinct from those of lowland South America and the northern Andes.

Central Andean life was predominantly urban, differing from Mesoamerica by the early importance of metallurgy and weaving. Building in the Andes lacks the spatial complexity of Maya and Mexican architecture. No system of writing, other than knotted string records, is known, unless Larco's hypothesis, that the marked beans of the north coast constituted writing, be accepted.[2]

For our needs the clearest division is by northern, middle, and southern regions. Northern Peru is separated from middle Peru along a line perpendicular to the coast at the Huarmey river. A similar line perpendicular to the coast just south of the Cañete river divides central Peru from the southern region, which includes parts of Bolivia. Northern Peru, like the rest of the central Andes, has a coastal desert interrupted by short rivers draining the western slopes of the maritime Cordillera. Beyond it are the Black and White Cordilleras, making three parallel chains with isolated highland basins scattered among them.

In the lower half of northern Peru, through the department of Ancash, the Santa river flows north between parallel mountain chains in a long valley and drains suddenly, at right angles to its upper course, into the Pacific. On the east, and parallel to the Santa, is the Marañón river, a tributary of the Amazon. The Santa river is the centre of a cluster of valleys where civilizations of the early period flourished. From its western mountain boundary, the Nepeña, Casma, and Huarmey rivers flow into the Pacific. Between the Santa and the Marañón stands Chavín de Huántar, the type-site for the most widely diffused Peruvian style of the early era, prior to the time of Christ. Its home territory coincides with the modern department of Ancash. Here are the most abundant and imposing traces of the Chavín style; north and south of Ancash, it is more scattered and sporadic.

The upper half of northern Peru, towards the Equator, contains the most important remains of two principal later stages of cultural development. Between the Santa and the Chicama rivers is the seat of the Mochica style, sometimes called Moche after the type-site near Trujillo. Mochica is coeval with Classic Maya art. Later on, and coeval with the Toltec rule in Mesoamerica, the Chimu dynasty established a powerful state

in these same valleys. Its influence is apparent in the art of the northern valleys as far as Piura and Chira.

The north highlands were even more discontinuously settled than the coast, in basins about 200 miles apart, separated by mountain ranges and barren plateaus. Because communication between the basins was difficult and infrequent, the dwellers in each were more likely to go downstream to the nearest coastal valley than to adjacent highland basins. The upper Santa river forms such a basin, called the Callejón de Huaylas. It is the least inaccessible. The others surround Cajamarca, Huamachuco, and Huánuco, which connect with Pacasmayo, Chicama, and Paramonga on the coast more readily than with one another.

In brief, the lower north coast harboured the oldest remains of monumental art in Ancash. The upper half was the home of the Mochica peoples in Classic times, and of the Chimu urban state after 1000. The question of the exact origin of the coastal styles is still unsolved.

Kotosh in the central highlands, on the eastern isotherms of the upper Huallaga between highland and rainforest, received the Chavín cult about 900 B.C., and Chavín itself is probably junior to Cerro Sechín on the central coast. But Kotosh itself has structures far older than anything at Chavín. The third rebuilding (Figure 83) is dated (C14) about 1450 B.C., and the oldest structure, with a relief in stucco showing crossed human forearms and hands, may date to about the appearance of pottery in the upper

Figure 83. Kotosh, Templo de las Manos Cruzadas (*above*) and Templo Blanco (*below*), *c.* 1950 B.C.

Huallaga *c.* 1500 B.C.[3] This is much later than the oldest known ceremonial architecture of the central coast at Chuquitanta (2000–1800 B.C., p. 289). Pottery in Peru, to present knowledge, is oldest (1800 B.C.) on the central coast and in Ancash. It may reflect older origins in northern Colombia (3100 B.C.) and southern Ecuador (2700 B.C.), for it displays several traditions in its earliest Peruvian appearances. Much later the resemblances between the Olmec art of Tlatilco in the Valley of Mexico and the coastal Chavín style in Peru suggest but do not prove the thesis of connected traditions during the first millennium B.C.[4]

PRE-CHAVÍN REMAINS IN THE NORTH

Radiocarbon dating for the first appearance of the Chavín style in the Virú Valley places it in the ninth century B.C. at the latest.[5] It intruded upon the remains of an ancient fishing village near Guañape, where pottery had been made since about 1225 B.C. Before that, the radiocarbon dates for pre-ceramic coastal villages go back to 2700 B.C. at Huaca Prieta in the Chicama Valley. The beginning of agriculture in the region has been fixed at about 3000 B.C.

Huaca Prieta is a habitation midden 125 by 50 by 12 m. (400 by 150 by 40 feet) deep, made of refuse, laid down by fishing folk at the rate of 3 feet each century from 2500 B.C. until 1200 B.C. After 2000 B.C., they excavated their dwellings in the rubbish of previous generations. They lined the rough square or oval rooms with beach pebbles, and they roofed them with beams of wood and whalebone. These few hundred families made no pottery, but they grew cotton, beans, and peppers, and they made simple patterned-warp cloths of brown and white cotton, sometimes dyed blue and rubbed with red. Similar middens of pre-ceramic date have been discovered in the Virú Valley and south of the Nazca Valley.[6]

In the Chicama Valley near Huaca Prieta are ruins of pre-Chavín date (Plate 146). The pottery is like Early Guañape, but it occurs in houses with walls above ground, made of stacks of cylindrical and muffin-shaped adobes. The interstices between the upright cylinders were filled with mud. Large rectangular adobes laid on edge appear as early as the pre-ceramic levels at Guañape. Hence the cylindrical adobes, both tall and flat, may mark the transition from pre-ceramic villages to the corn-growing, pottery-producing society of about 1500 B.C. Later on, in the ninth century, conical adobes became standard on the coast.

EARLY ANCASH ART

The Chavín style is named after the type-site at Chavín de Huántar in Ancash, on a small tributary of the upper Marañón. The department of Ancash has important Andean buildings of pre-Classic date, some as old as 2000 B.C., like Las Haldas or Culebras in the lower Casma and Huarmey valleys, where maize was grown in the period 2500–1500

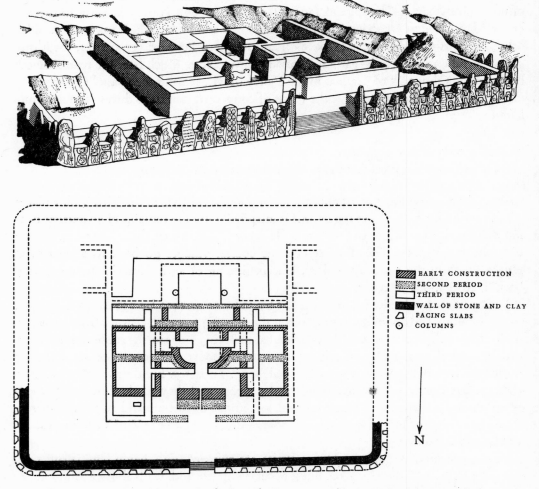

EARLY CONSTRUCTION
SECOND PERIOD
THIRD PERIOD
WALL OF STONE AND CLAY
FACING SLABS
COLUMNS

N

Figure 84. Cerro Sechín, temple platform, before 900 B.C. (?). Perspective section and plan

B.C., before pottery made its appearance.[7] Major monumental architecture, however, began in this region much later, in a group of sites restricted to the Casma and Nepeña Valleys. This architecture exhibits a style typified by Cerro Sechín, which is probably older than the other group, represented by Chavín de Huántar in the highland. It is here assumed, for reasons set forth below, that Sechín preceded Chavín. The Chavín style in turn falls into early and late phases, spanning an extremely long period, so that the sequence of Early Ancash styles, for our purposes, may be summarized Sechín, Early Chavín, Late Chavín. In current use, however, Sechín and Chavín are not separated chronologically. The term Chavín has always been over-extended. Since 1919 it has come to mean less and less in an ever-widening circle: a style of art, a period of time, a 'horizon' or archaeological marker, a 'culture', and even an 'empire'.[8] G. Willey has

criticized these extensions. He restricts Chavín to a stylistic definition and to an iconographic tradition, both related to a religious system of early date in the central Andes.[9] This religion centres upon the worship of feline and other monsters symbolic of natural forces, among villagers possessing maize agriculture, carved and incised pottery, weaving, and early metallurgy. The style, the iconography, and the functional setting are roughly analogous to those of Olmec art in Mesoamerica.[10]

Some dated material comes from the Chicama Valley, where a roof timber associated with Chavín-style pottery and corn agriculture gave a radiocarbon date of 848 B.C., ± 167 years.[11] A terminal date can also be offered. Fragments of the style and the iconographic tradition persisted in Mochica art, until at least about A.D. 500. At Chavín proper, furthermore, the ornamental style shows relations with the Nazca region which can now be ascribed to the sixth century.[12] Thus Chavín art is a north Peruvian phenomenon, with occasional manifestations in central and southern Peru, as at Ancón and Paracas.[13] It endured at least thirteen centuries as a recognizable constellation of form and meaning.

The architectural forms are grandiose terraced platforms. The sculptural repertory includes full-round and relief carvings, based upon a few ideographic ciphers drawn from feline, reptile, fish, bird, and human figures. These are compounded in monstrous hybrids such as a bird's wing with tiger's teeth at the base of each feather (Figure 90). Embossed gold objects bearing Chavín forms are possibly the earliest metal products in the New World.[14] The principal remains of the Chavín style in Ancash are at Cerro Blanco in the Nepeña Valley, and Chavín de Huántar.

Another style, more closely bound to visual images and more generous in sculptural expression, appears at Cerro Sechín in the Casma Valley, and at Moxeke and Punkurí in the Nepeña Valley. Its date is still uncertain. All students agree that the Nepeña Valley contains Chavín manifestations, but Larco regards it as the most ancient of Chavín territories, while Tello considered both Nepeña and Casma as provincial manifestations of an earlier highland style visible at Chavín de Huántar.[15] Strong and Evans support Larco's opinion, giving priority to the coastal appearances of the Chavín style, and Lanning concurs in believing Sechín to be the most likely ancestor of the Chavín cult.[16] In either case two main phases of Ancash art can be defined. One includes Cerro Sechín (Figures 84, 85), Moxeke, and Punkurí. It has powerful sculptural forms, close to natural appearances. The other stage is represented both at Cerro Blanco in the Nepeña Valley (Plate 148) and at Chavín de Huántar, by linear designs in dense symbolic compounds. Many centuries probably separate the two eras.

Cerro Sechín

Cerro Sechín is a granitic hill dominating the lower Casma Valley at the confluence of the Sechín and Moxeke rivers.[17] It was fortified in antiquity with numerous walled enclosures surrounding the dwellings and temple platforms. Near each enclosure is a cemetery. The several settlements, connected by paths, were furnished with water from reservoirs and aqueducts. Tello considered them the dwelling compounds of the various

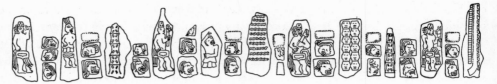

Figure 85. Cerro Sechín, temple platform, orthostatic reliefs re-used in the revetment,
before 900 B.C. (?)

lords of the valley fields. They lived on these barren slopes not only for security from
abrupt floods and from invasion, but also to reserve the precious arable flood plain of the
valley for agriculture. The largest compound lies on the north side of the hill, with the
temple platform (Figure 84) at the foot of a bowl-like slope. The platform was faced
with dressed and carved granite slabs (Figure 85), brought from an older construction
farther down the slope, which was covered by alluvium during an ancient flood before
the end of the Chavín style.

These slabs may well be the oldest known monumental sculpture in the central
Andes. They were arranged in a post-and-infill system, of narrow upright reliefs
alternating with wall sections of smaller squarish stones between the tall uprights.
The effect is like that of fence-post construction. On the upright slabs, ranging in height
between 1·60 and 4·40 m. (5¼ and 14½ feet), are incised human figures in profile, ideo-
grammatic representations of implements, severed trophy heads, and spinal columns.
The standing, armed warriors on the posts (Plate 147A) seem to display the grisly tro-
phies shown on the smaller panels, as they move in symmetrical files leading from the
west and east walls round the corners towards a recessed central staircase on the north
façade. The carving shows two types of incision. The outer contours of the bodies are
given by bevelled cuts: a sloping face marks the outside and the vertical face marks the
inside of the form. Interior outlines such as lips or eyelids are given by simple, shallow
incisions without a bevelled side. In technique and in processional composition, these
reliefs are like some of the Danzantes at Monte Alban (Plate 63A), though no direct
historical connexion can be supposed.

The platform itself rose perhaps a dozen steps, with the upper portions of the pro-
cessional reliefs forming a wall to surround the platform terrace. The temple proper was
built of conical adobes on a rectangular plan enclosing chambers symmetrically ar-
ranged to open out from the central entrance axis. Tello reported three phases of con-
struction. The regular bilateral symmetry of the edifices was enhanced by affronted red
jaguars painted on the walls flanking the outer entrance.

Conical adobes laid point to point, with the circular bases forming a pattern of roun-
dels on the wall faces, are characteristic of the Chavín style along the coastal valleys
where stone was scarce. Their use has been assumed to mark a period of Chavín ascen-
dancy on the coast.[18] They form part of a sequence, however, which began with cylin-
drical and muffin adobes long before the appearance of the Chavín style. Conical adobes
probably continued through the changing modes of coastal architecture until the general

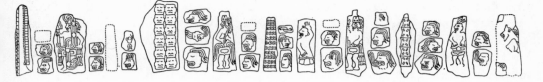

acceptance of parallelipipedal adobe bricks in the early centuries of Mochica domination.

Figure 86 shows methods of wall-building with conical adobes. Point-to-point position allows equal volumes of brick and amorphous clay, and it permits regularly patterned wall surfaces of agreeable appearance. The second method shows bonded corners, which are rare in America, with facing bricks like deeply tenoned masonry surrounding a core of interlocking conical bricks. The third method requires the closest interlocking of brick with brick at all points, and it uses the least amount of clay mortar. These techniques were probably contemporaneous, serving different structural or functional requirements. Gabled roofs of timber and straw rested on the massive walls. Their appearance is recorded by pottery vessels in the Chavín style, of which the manufacture was limited to the coast. Nothing of the Sechín roofs survives today, after many genera-

tions of plunder by treasure-hunters. The conical adobes are the firmest assurance of a date close to the early Chavín style, but when we examine the correspondences between Sechín and Chavín forms, their contemporaneity is not at all apparent. As we might expect, adobe brick shapes were less sensitive to secular change than figural forms. Conical adobes may have preceded and outlasted the Chavín style.

Stylistic resemblances between the Sechín and Chavín styles are very faint. The Sechín sculptors show simplified ideogrammatic schemes close to visible reality. They report the facts of warfare and head-hunting directly, unlike the makers of

Figure 86. Diagrams for wall construction using conical adobes, first millennium B.C.

the Chavín reliefs, whose monstrous combinations of various forms of life lead the mind into an associative labyrinth of ritual symbols, organized more like metaphorical allusions than direct expository statements.

There are no monsters in the known Sechín repertory. Entirely absent are the feline dentitions, the animal-headed joints, and the reduplications or substitutions of the Chavín style. Only by an occasional trait can a connexion be established; the fence-post order of the stone wall facings, the facial stripe curving from eye to ear, and the elongated thumbnails shown in profile are the strongest evidence we have. The two styles seem divergent yet connected: they may be early and late expressions, or tribal variants of the

same tradition. In either case, the Sechín style appears to be the earlier of the two. A soapstone cup in the Bliss Collection bridges the gap between Sechín and Chavín. On its base is a head in profile with a curving Sechín stripe from eye to ear, and the feline dentition typical of the Chavín style. On the cylindrical wall, in low relief, a two-headed, eight-legged animal appears, with Chavín toe-nails and feline facial traits. There is another stone vessel with this form in the Larco Collection now at Lima. Both pieces are of unknown provenance.[19]

Moxeke

Moxeke lies about two miles south-east of Sechín. It is a pyramidal platform of eight terraces, rising a hundred feet above the level flood-plain, near an L-shaped intersection of two axial files of rectangular plazas. The pyramidal platform built of conical adobes (Figure 87) stands a little apart from these plazas, which may be of later date. It is much larger (165 by 170 m.; 540 by 560 feet) than the Sechín pyramid, and it has carved clay reliefs instead of stone sculpture. A free-standing stair protrudes beyond the north-east face, rising by six steps to a portico on the first terrace. The second flight, of five steps, cuts through the second terrace face to a wide landing. From it the third and longest flight rises, and it splits at the head into two small opposing flights. The fourth terrace is divided into four quadrants.[20] The level of the southern pair is higher than that of the northern. In each quadrant, a platform rises. The northern pair is smaller in plan than the twin southern ones, so that the highest points are on top of the larger southern platforms. All terraces have rounded corners.

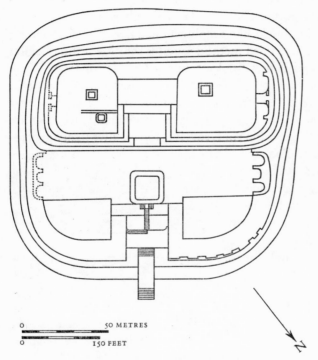

0 50 METRES
0 150 FEET

Figure 87. Moxeke, platform-temple,
ninth century B.C. (?). Plan

The north corner of the third terrace on the principal platform is adorned by six deep niches containing carved and painted clay figures of colossal dimensions (Figure 88). Only the lower portions survive, painted red, black, blue, and white. They are of smoothed clay over cores of conical adobes. Each niche is nearly 4 m. (13 feet) wide, and 1·7 m. (5½ feet) deep. Between the niches are salient faces 4·45 m. (14½ feet) wide, also

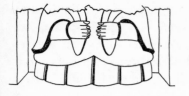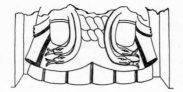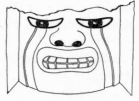

Figure 88. Moxeke, modelled stucco figures I, IV, and V on third stage riser, ninth century B.C. (?)

adorned with polychrome relief carvings on clay. Facing north at the rounded corner are two smaller niches, with colossal heads 2·4 m. (8 feet) wide by ·90 m. (3 feet) deep, painted green, white, red, and black.

These figures all resemble those of Cerro Sechín more closely than those of Chavín. The fluted skirts of the niche-figures (I–IV) are identical with the ones of severed torsos on the Sechín slabs. The salient panels between the niches bear serpentine convolutions like those of the standing warriors at Sechín. The colossal head in Niche V, finally, wears curved stripes of red face-paint, as do the standing Sechín warriors.[21] The only trait connecting Moxeke directly with the art of Chavín appears in Niche IV, where four serpents painted red and blue dangle from the arms of the human torso.

Punkurí

Punkurí in the Nepeña Valley is a terraced platform facing north-north-west. It is split by a stair of two flights separated by a landing. Near the bottom of the upper flight is a painted jaguar modelled of clay over a stone core (Plate 147B). On a wall of the chamber behind this stair are incised wall decorations in the Classic Chavín style. Thus Punkurí, alone among the coastal sites, contains both styles: the full-rounded and veristic Sechín manner (Punkurí jaguar), as well as the schematic linear design of the Chavín wall decoration.[22]

Chavín

Unlike the sculptors of Sechín, the Chavín artists lacked the means of marking individuality, or of telling a story. A few highly stylized signs convey the entire content of this art. Linear designs, of an extreme degree of abstraction, compounded of parts of bodies, are common to several sites in the highland and at sea-level. On the coast the designs are carved in smoothed clay (Plate 148) and pottery; in the highland they are incised upon architectural facing slabs, cornices, and pottery (Figure 90). The highland centre is far larger and richer in variety than the coastal site at Cerro Blanco. Both differ from other coastal sites in Ancash, such as Punkurí, Moxeke, and Cerro Sechín, principally in the method of composition, which is the substitution and repetition of the

motifs of parts of human bodies. In the Chavín style, heads in profile are doubled to read as frontal representations. Certain frontal heads, when seen upside down, still present right-side-up images (Plate 151). Such double-profile figures and anatropic (reversible) images appear sporadically in pottery and metalwork throughout the central Andes, but the monumental examples occur only at Chavín and in the Nepeña Valley.

Chavín de Huántar. The steeply walled platforms, honeycombed with stone-lined passages and surrounding a sunken plaza, are unique among temple groups in pre-Columbian America. Maxcanú in Yucatán,[23] or Mitla in Oaxaca can be compared with Chavín. The Maxcanú platform is much smaller, and the Mitla palaces were residences, quite unlike the labyrinthine recesses in the platforms at Chavín. The relation of the masses to enclosed volumes is like that of a mountain range, where geological formations enfold caves and vents of bewildering complexity. The entire visible group extends some 200 yards along the west bank of the Mosna river, with platforms grouped around

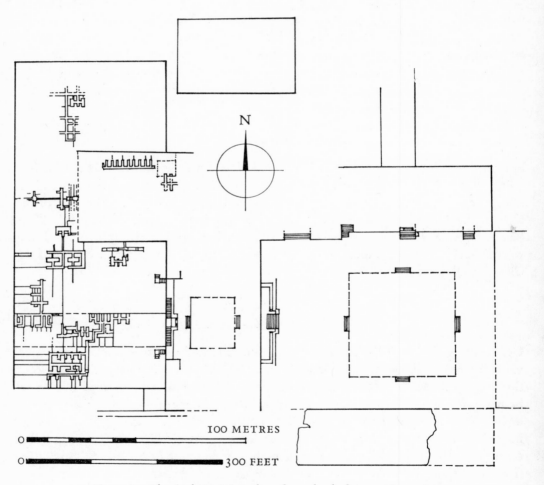

Figure 89. Chavín de Huántar, plan of temple platforms, as in 700 B.C.

a sunken plaza 48 m. (160 feet) square. Like Chuquitanta a millennium earlier, Chavín began as a main shrine (containing the Great Image or *lanzón*) flanked by wings (Figure 89). After three enlargements on the flanks, a new façade arose facing east, as a portal overlooking a larger court flanked by new north and south wings. The portal itself, framed by cylindrical columns, and faced with white granite blocks on the south and black limestone on the north, gave access to opposing interior stair ramps.[24]

The principal edifice looks east across the plaza. Called the Castillo, it is faced with cut stone blocks in courses of varying widths. These walls rose about 50 feet, above a great pedestal of cyclopean blocks, uncovered by Tello along the western front of the Castillo. Inside the core are at least three irregular storeys of stone-lined galleries, chambers, and ventilating shafts. On each level, these were built, like the facings, before the infill was packed in.

At the south-west corner the outer masonry of the Castillo is adorned with grotesque heads tenoned into the facing, beneath an overhanging cornice incised on edge and soffit with profile jaguar and serpent bodies. A north-east corner likewise bore incised reliefs of stylized condors (Figure 90). Within the original stone-lined shrine a stone prism, 4·5 m. (15 feet) tall and incised with feline grotesques, marked the centre like a lance-point (*lanzón*) thrust through the platform down into the chamber (Plate 149). In the sunken plaza a slab of regular form (the Raimondi Monolith) perhaps stood upright in the centre, incised with reversible designs of animistic symbols compounded in the Late Chavín style (Plate 151).

The rough chronological sequence of these sculptural elements is suggested by their positions. The *lanzón*, deep in the interior, may be among the most ancient. The cornice slabs of the outer facing are more recent. The Tello Obelisk (Plate 150) and the Raimondi Monolith are undated. The original emplacement of the Raimondi Monolith is uncertain. According to reports collected by Bennett from local people, it stood on the west terrace near the sunken plaza, until its removal to Lima by Antonio Raimondi, the geographer, in 1874. Its intricate metaphorical decoration suggests a terminal phase of the Chavín style.[25] Two main periods at

Figure 90. Chavín de Huántar, temple platform, north-east corner, cornice soffit with incised slabs showing condors, before 700 B.C.

Chavín de Huántar therefore are indicated: an early one, including the Castillo sculpture (Figure 90), and a late one, represented by the Tello Obelisk and the Raimondi Monolith (Plates 150 and 151).

The early ('normal') style is characterized by intact silhouettes of men, jaguars, and condors, containing intrusions and substitutions from other orders of life in the parts of the body and at the joints. The *lanzón*, for example, represents a standing human being with feline teeth and serpent hair (Plate 149). The cornice slabs of the Castillo represent jaguars in profile and condors in spread-wing dorsal view. The jaguars' tails, however, are feathered, and the condors' wings have jaguar masks in profile at the base of each feather (Figure 90). But these substitutions are internal and they do not break up the silhouette.

The Tello Obelisk and the Raimondi Monolith both show an ornamental prolixity that spills out beyond the organic silhouette. The obelisk is difficult to read: the elongations, substitutions, and peripheral complications are so dense that it is impossible at one glance to determine the relationships of all these parts. By long study, and by adding the parts together in the mind, one arrives at a synthetic version of the two rampant felines incised in profile upon the quadrilateral prism. Each stands on its tail, with front and rear paws pointing up and down respectively. Every body area contains substitutions: thus the spinal column is treated as a long row of feline teeth. The two felines in profile are probably meant to represent one animal: left and right, back and belly have been re-arranged as a prismatic sleeve of incised shapes so that the creature has four legs and two sides (Plate 150).

The Raimondi Monolith is of diorite. Its rectangular frame (1·95 by ·74 m.; 6½ by 2½ feet) determines the general rectilinearity of all the parts. The human body fills only one-third the length of the slab (Plate 151). This square figure can be read either as a standing staff-bearer, or as a human being in descending flight. In the first position the top of the slab consists of head-dress elements in repeating series; in reverse position, this series becomes a tongue-like pendant. Perhaps the slab was once used as an overhead roof-panel, for its design requires viewing from both ends, in the anatropic scheme that also characterizes Paracas textiles (*c.* third century A.D.).

Inside the underground galleries of the Castillo, pottery vessels paralleling these early and late styles have been identified. The Rocas galleries yielded early types, resembling grey or black stone. The Ofrendas galleries contained various forms related by their decoration to the style of the Tello Obelisk.[26]

Cerro Blanco in the Nepeña Valley has never been adequately published.[27] It is a platform with stone walls covered by carved and painted clay reliefs in the zoomorphic system of the early Chavín style, as on the cornice slabs of the Castillo at Chavín de Huántar. It represents a bird with out-spread wings (Plate 148). The head is a low platform, with the body, wings, and tail formed by low-walled terraces at the sides and rear. These platforms were later covered by another construction of small conical adobes. Tello believed that the blanket edifice was built specially to hide the carved clay walls underneath, painted in red, white, blue, and green. The scale is much larger than anything at Chavín proper, and the colours also differ from those of the highland site, but

the compositional device, of two bird-profiles forming a frontal jaguar-mask, is of Chavín type.

In summary, the natural subject matter of Chavín art comprises few motifs, all subordinated to rigid conventional formulas. Rowe describes these metaphorical substitutions as 'kennings' by analogy with the literary device used in Norse saga, and he names the figures as the 'Smiling God' (on the *lanzón*), the 'Staff God' (Raimondi Slab), or the 'cayman deity' (Tello Obelisk).[28] An entire natural shape, such as a jaguar or a condor, is recognizable only by general contour: within the form, interchangeable parts of bodies and multiple points of view complicate the iconography. We may guess that the clustering of the attributes of jaguar, falcon, fish, snail, shell, condor, and serpent was meant to personify and codify various forces of nature.

LATER ANCASH ART

The Callejón de Huaylas

Early pottery fragments found in the ruins of Sechín and Chavín are similar: monochrome with incised, carved, and modelled decoration. About 700–500 B.C., experiments with painting began to appear in the coastal valleys. Here the potters used white-paint decoration on a red ground. Other experiments leading to pottery painting appear elsewhere in Peru as well, always in an early context, and prior to the great florescence of Middle times. As Willey suggested, the technical innovation of white on natural red-slip ground colour arose when potters changed from reduction-firing in closed ovens to open-kiln firing. The former mode produced black ware, while open-kiln firing gave the reddish and brown tones that characterize Middle period pottery. White-on-red pottery is now generally recognized as belonging to a technological horizon which marks the passage from Early to Middle times, following the period of monochrome pottery, and preceding that of negative painting. At Chavín in Ancash, white-on-red pottery is well established as 'post-Chavín'.[29]

Negatively painted pottery is made by applying the design in strips of wax or clay. When dipped in dye, only the bare ground takes colour. The original vessel colour emerges intact after the strips of wax or clay, called 'resist elements', are removed. If the figural parts are resist-covered, they emerge in a light colour on a dark ground, with the effect of making the ground visually more active than when the figure appears in dark upon light. The antecedents of resist-painting are still unknown, although Willey and Kroeber have suggested origins in the north Andean highland.[30] Its earliest Peruvian appearance on the coast in the Chicama Valley has been dated by radiocarbon as about 500 B.C.

The most elaborate examples of negative painting come from the upper Santa Valley, where the technique appears upon elaborately modelled vessels, belonging to what is known as the Recuay style (Plate 152, A and B), whose influence is apparent in the north coast valleys as well.[31] Certain shapes and themes of the Recuay style recur in Mochica art until its closing centuries. The Recuay tradition endured less long than that of

Chavín, and its spread was less extensive, but its presence throughout Middle time has been obscured by the tendency to mark off Peruvian archaeological history by neat boxes in rigid succession.

The shapes of Recuay vessels are extremely variegated. The simplest ones recall gourds and squashes; there are also cups, head-shaped goblets, tripod vessels, handled dippers, and a great variety of modelled shapes representing people, animals, and buildings, both singly and in groups. The colour combinations also are numerous, triple combinations of black, white, and red being most common. The painted designs show jaguars, birds, fishes, and serpents rendered in linear ciphers, more like the wall paintings of the tombs in Colombia [32] (Figure 82) than anything in Peru. These ciphers owe much of their form to the strips and fillets of wax or clay used as resist elements. The most common cipher develops from a circular eye to show a crested jaguar, with radiating filaments of varying widths to indicate comb-like teeth, semicircular body, claws, crest, and tail.

Unprecedented in earlier Peruvian pottery are the Recuay vessels representing houses with inhabitants, chiefs or deities encircled by their followers, and human beings accompanied by birds or animals. Such narrative propensities may have entered the Recuay style from Middle period coastal sources in Mochica art, but the abstract modelling, the absence of individuality, and the stratigraphic evidence all suggest that such contact occurred nearer the beginning than the end of the Mochica style. The vessel shapes, the negative painting, and the figural ornaments also relate to Quimbaya pottery forms (Plate 141). Notable among examples of these north Andean relationships with the Recuay style are ring-shaped vessels surmounted by a sausage-like stirrup-spout. Another example from the Quimbaya territory in the Cauca river basin is a vessel decorated with negative painting and surmounted by figurines.[33] The date of these parallels with Quimbaya pottery has been tentatively fixed as of the centuries after 1000 A.D., but such sequences were all established before radiocarbon chronology, and new absolute datings are not yet available.

Tello divided the pottery of Recuay into two groups: phytomorphic (plant-shaped) pieces, and pieces modelled to show single figures or groups of people. Kroeber divided the pottery of Recuay into two styles, A and B. Recuay A includes gourd-shapes, as well as globular vessels with short horizontal spouts and jar mouths with disk-like lips, bearing several modelled figurines above a zone of negative painting (Plate 152A). Recuay B contains vessels modelled as

Figure 91. Aija, stone figure,
before 200

whole figures and as groups, such as men leading animals, with three- and four-colour painting (Plate 152B). It has long been supposed that A preceded B,[34] but final stratigraphic proof has not been discovered. An argument in support of Kroeber's sequence is the treatment of the eyes: coffee-bean and slit eyes appear only on the plainer examples of group A,[35] and on examples most closely resembling the Quimbaya parallels from Colombia.

Recuay pottery was deposited probably as grave furniture in stone-lined subterranean chambers or galleries. The gallery walls were faced with large slabs surrounded by smaller spalls and chips, and roofed with flat slabs. The entire Macedo Collection in Berlin came from such subterranean galleries and chambers at Katak near Recuay. Other more elaborate pyramidal platforms and above-ground houses in the Callejón de Huaylas[36] were probably built in later periods.

Definitely belonging to the Recuay period are many stone statues. One group from Aija, near the upper Huarmey river, represents warriors (Figure 91) and women. The warriors resemble shapes found in Recuay B ceramics, bearing the square shields that were probably characteristic of the Ancash tribes.[37] In the Huaraz Museum many other statues have been brought together from the entire Callejón. Schaedel's study proposes three tentative developmental stages, changing from curvilinear incisions (1) to relief carving in faint (2) and bold (3) phases. He suggests that phase 1 may correspond to the white-on-red period; phase 2 to Recuay A; and phase 3 to Recuay B.[38]

The later stages of the archaeological history of the Callejón are poorly known. There is a stratum of sherds of a type called Viñaque in the Huari-Tihuanaco style, found at Wilkawaín by Bennett. The usual traces of Inca occupation also appear, and the native language today is a dialect of the Quechua tongue of the Inca conquerors. It is mixed with remnants of an older, unidentified language manifested in many place-names.

THE UPPER NORTH: MOCHICA AND CHIMU

THE modern Peruvian departments of La Libertad and Lambayeque, which extend nearly 250 miles along the Pacific Coast north of Ancash, contain the principal remains of the Middle and Late periods of central Andean archaeological history. Two civilizations dominated the region: Mochica, which flourished from about 250 B.C. until after A.D. 700, and Chimu, governed by a dynasty enduring from about 1370 until the Inca conquest of the north coast valleys before 1470.[1] The six centuries between Mochica and Chimu civilizations are poorly explained. Strong traces appear of an art called Tiahuanaco-Huari, and identified with the southern coast and highlands. Radiocarbon dating for the end of Mochica is far from complete and the historic evidence sifted by Rowe refers only to dynastic and not to stylistic events. Eventually the six-century gap between Mochica and Chimu will surely be narrowed by extending the duration of Mochica,[2] and by recovering the early stylistic phases of Chimu. For the present, Tiahuanaco intrusions on the north coast are generally accepted as of before 1000.

The geographical distribution of Mochica and Chimu was roughly similar, with different patterns of expansion. Mochica influences appear to have worked south, while Chimu expansion affected the more northerly valleys. It is therefore justifiable to speak of inner and outer zones in northern Peru. The inner zone centred upon the Moche river valley, but the outer zone for Mochica peoples was in the valleys southward to Nepeña or beyond. For Chimu history, the outer zone was northward, to the deserts of Sechura and Piura and beyond.

PRE-MOCHICA STYLES

The remarkable discoveries by Junius Bird at Huaca Prieta in the Chicama Valley included the earliest dated ceramics on the north coast. The pots are very plain, but there are incised gourds of a complicated design, belonging to the pre-ceramic levels, which are among the earliest dated examples of graphic art in America (Figure 92). They are related by Lanning to origins in southern Ecuadorean drawings of before 2000 B.C. The radial figures with squarish heads and eyes rise from base to rim. Diagonal curving lines on one give an effect of swirling or rotating forms; on the right-hand specimen the symmetry is complete on a bi-axial scheme. Both vessels have lids, and one bears a two-headed Z-curved condor shape, which anticipated the dated Chavín designs with interchangeable body parts by several centuries.[3]

Cupisnique refers to a dry ravine approached from the north side of the Chicama Valley, and emptying into the Jequetepeque drainage. On its arid floor R. Larco Hoyle in 1934 found large quantities of sherds in the Chavín style, mostly black-fired pottery of

Figure 92. Huaca Prieta, incised gourds, before 1950 B.C.

a stony appearance, decorated with incisions. He also found incised red sherds, cream-on-red with incised outlines, red and brown, and solid red as well as solid cream-coloured pottery. On the site near the Cupisnique called Pampa de los Fósiles, there are foundations of rough stone building as well, but no graves, and no entire pots.[4]

The intact examples have in common only certain types of incised and modelled surface treatment, representing figures related to the Chavín system of interchangeable feline, bird, fish, and reptile parts. But the vessel shapes range from coarse pre-Mochica forms to the most intricately harmonious Mochica contours of the terminal periods, so that, as in the case of Chavín sculpture in Ancash, we are here forced again to recognize an indefinite duration of a style, ranging from the ninth century B.C. to the still-undetermined end of Mochica times. Larco separates Initial (pre-Cupisnique), Middle (Cupisnique), and Terminal stages on the basis of iconographic traits,[5] while the Mochica seriation (discussed below) rests mainly upon traits of shape. Larco's nucleus of 'pure Cupisnique' vessels does not come from that site but from many valleys, and its forms include both Early shapes (heavy stirrup spouts) and the most delicately shaped vessels of Classic Mochica type. Furthermore the finds in the Cupisnique style in the graves opened in the Chicama Valley (Barbacoa site) include red-and-black, orange, and red-on-cream wares of Mochica type.[6]

The dilemma is like that of the Olmec style in Mesoamerica, where coastal and highland versions of an art unified by certain iconographic themes persisted through an indefinite duration of American prehistory. Larco's single horizon of brief duration before 500 B.C. divides 'Cupisnique' pottery into four stylistic groups (Plates 153–4A), recognizing differences of shape, but insisting upon their pre-Mochica date.[7] Style A has sausage-stirrups and lipped spouts; B has slender rounded stirrups; C has low stirrups; D has high trapezoidal stirrups. Examples of monochrome brown occur in groups A and D; red-ware appears in groups A, B, and D.

Recent excavations by Lumbreras in the galleries at Chavín produced pottery in the shapes and with the ornament of Cupisnique, showing their identity as highland and

coastal versions of the same art. Thus Cupisnique A resembles Rocas-period pottery at Chavín, but B, C, and D shapes and figures parallel the Ofrendas types at Chavín itself, while continuing to appear as late as Mochica III. Rowe interprets these vessels of Mochica III date and later as archaisms and as 'persistent conventions'.[8] Other terms of description could be revival, renascence, Renaissance, or tradition, but until the magnitude of the phenomenon is known, a choice is difficult. The principal difference is that coastal Chavín pottery is usually monochrome, and Mochica III usually bichrome. The coastal Chavín style may have had its home high in the constricted drainage of each coastal river, while the Mochica style flourished nearer to the sea on the open floodplains.

The coastal Chavín repertory of forms is much poorer than that of the Mochica style. The linear designs are simple and powerful, but they tend to extreme abstraction, and to harmonious ciphers incised upon the curved surfaces without any enlargement of the descriptive programme such as we have seen in the highland Chavín art of Ancash. Figural paintings, such as pictures of actual life, are entirely lacking. Yet the effigy vessels depict a mother nursing her child, a gabled house, various heads, monkeys, crustaceans, molluscs, and birds always singly and without the portrayal of action which characterizes Mochica art.

The Salinar style is another discovery made in the upper Chicama Valley by R. Larco Hoyle.[9] This red-ware pottery was baked in open kilns. Its surfaces are thus different from the much darker Chavín surfaces, which were fired in closed kilns. The vessel forms include new bottle-shapes, and handled vessels. The stirrup spouts most closely resemble Larco's Cupisnique B. The effigy forms are far cruder, with filament limbs, coffee-bean eyes, and fired white paint. Salinar is a local style. Its stratigraphic position is above Cupisnique and below the Mochica graves. It is possible and likely that early white-on-red experiments in the Callejón de Huaylas, together with the mature sculptural tradition of the coastal Chavín style (Cupisnique A), facilitated the invention of the Salinar style in the Chicama Valley, with its great freedom in figural modelling, and its clear red firing. Salinar in turn may be taken as an initial or preparatory stage in the emergence of modelled and bichrome Mochica pottery. The possibility of long duration for the Salinar style should not be excluded. Certain of its forms, such as effigy groups (one example shows a healer massaging a recumbent patient), suggest contact with fully developed Mochica schemes of representation. Similar red-ware forms with archaic modelling, however, appear in many other regions on pre-Mochica levels. Strong and Evans have discussed all the occurrences and parallels of white-on-red throughout the Andes.[10]

A distinctive feature of the Salinar style is the representation of houses in pottery (Plate 156A). One bottle form has an entire house carefully portrayed on the container at the junction of the handled spout. A vertical wooden support, probably a tree-trunk, bears a cross-member on which the roof panel rests. Perforated wall-panels enclose the sides and rear. Painted lines mark the walls guarding the access to the enclosure. This roofing by ventilating planes and sunshade panels is our earliest record of the ancient Peruvian coastal tradition of shelter from sun, wind, and heat rather than from damp and

cold, on these arid valley floors where rain scarcely ever falls. Another Salinar pot shows a cylindrical edifice with perforated walls. It probably represents a temple, and has terraced slots and a guilloche band decorating the round envelope.

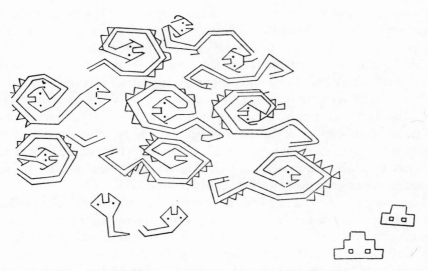

Figure 93. Virú Valley, incised wall decoration with rectilinear serpent motifs, before 350 B.C. (?)

Still another period of coastal pottery is identified with pre-Mochica times. The Gallinazo groups of honeycomb dwellings in the Virú Valley [11] were built from 150 B.C. to about A.D. 100 with puddled adobe (*tapia*) walls as well as ball and rectangular adobes. Bricks made in cane moulds and bearing their marks are characteristic of Gallinazo wall construction. Resist-negative painting on the pottery from this area suggests a connexion with highland Recuay. Certain buildings coated with yellow clay are decorated with incised serpent forms (Figure 93) of textile derivation which also recall the themes of Recuay resist-painting. Bennett showed that only the terminal period of this style, Gallinazo III, overlapped with Early Mochica art. But, on the evidence of radiocarbon and stylistic parallels, Recuay A, Salinar, Gallinazo, and Early Mochica, together with Cupisnique B and Chavín-Castillo art, all seem to cluster in the centuries immediately around 500 B.C. The possibility of putting them in more open seriation becomes questionable as the radiocarbon dates accumulate. The case may be one of parallel local developments, rather than of seriated events. Thus Vicús pottery from shaft-tomb cemeteries near Ecuador resembled both Cupisnique (Plate 156c) and Mochica classes before affecting or being affected by Salinar and Gallinazo techniques of resist-painting, cream and red slips, and geometrized modelling. This case again suggests parallel events rather than seriated ones [12] (like the contemporaneity of Recuay, Vicús, and Mochica traditions), and thousand-year local durations rather than brief secular ones.

THE CLASSIC MOCHICA PEOPLES

The hearth of Mochica civilization was in the valleys of Chicama and Trujillo. The ancient name is unknown, and Mochica is a modern term.[13] A bellicose people, the Mochicas eventually extended their dominion to the area between Casma in Ancash and Pacasmayo in the north, along some 200 miles of the Pacific coast. More than any other cultural group of ancient Peru, they recorded their behaviour in a pictorial art of much detail and great animation. Their immense pyramidal platforms (Plate 157) and country estates (Figure 95) differ sharply from the scattered villages of immediately preceding periods. Mochica civilization was based upon an agriculture irrigated from aqueducts, reservoirs, and canals built on a gigantic scale. The valley areas anciently under cultivation greatly exceeded those in modern use.[14] In the Virú Valley, for example, the Mochica canals supplied an area 40 per cent larger than the present cultivated area, and the land supported 25,000 people, where today there are only 8000.[15]

The beginning and the end of Mochica history are roughly fixed. The earliest stages of the society overlap archaeologically with Gallinazo sites (after 300 B.C.). The latest occurrences of Mochica objects, in layered guano deposits on the Chincha Islands, attest the great spread and the survival of the style until about the ninth century A.D. The terminal events have long been connected with an invasion by the bearers of a southern pottery style called Huari-Tiahuanaco, which elsewhere on the Peruvian coast can be dated by radiocarbon measurements to about the sixth to tenth centuries A.D.[16]

Rafael Larco Hoyle, the foremost collector and student of Mochica art, has tried to reconstruct Mochica chronology, as well as to deduce something of the society from its art.[17] For Larco, the civilization originated in the Chicama Valley and spread to the Trujillo Valley (also called Santa Catalina, Moche, or Chimor) during the early centuries of a long ceramic development. The earliest pottery, which he called Chicama–Virú, resembles Bennett's Gallinazo style. Larco's sequence will be followed here, with certain modifications. Because adjacent stages are not clearly separable, we shall group them as Early (I and II); Middle (III and IV); and Late (Larco V). Rowe and Sawyer assign different spans to the Larco periods:

	Rowe 1968	Sawyer 1968
I	c. 0–150	250–50
II	c. 150–250	50–0
III	c. 250–400	0–200
IV	c. 400–550	200–500
V	c. 550–650	500–700

Sawyer's dates agree better with the assumptions of this chapter, as stated on p. 261.

Architecture

The ceramic sequence from the excavations in the Virú Valley permits certain inferences about Mochica architecture. The groups of dwellings, like those of the Gallinazo period, were clusters of adjoining chambers built of rectangular adobe bricks, in both irregular and symmetrical arrangements. Reed-marked adobes made in moulds of cane are probably pre-Mochica, smoothed bricks are of Mochica date.[18] Temple or palace platforms of rectangular form first appeared long before the Mochica development proper, during the period of the earliest red-on-white pottery decoration (named the Puerto Moorin Period in the Virú Valley). New Mochica forms are suggested by the foundations of large rooms, courts, and corridors on these platforms. They contrast with the earlier clusters of tiny rooms (Plate 146) built one over the other by successive generations as a filled-in honeycomb of abandoned habitations.

The Castillo of Huancaco in the Virú Valley is such a terraced platform, built along the lower slopes of a hill which dominated the fields of the lower Virú Valley bottom.[19]

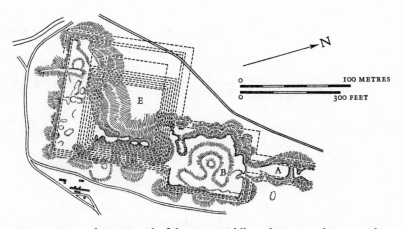

Figure 94. Moche, Pyramid of the Sun, Middle and Late Mochica periods,
c. 100–600 (?). Plan

The steep pyramidal terraces are built of small mould-made adobes without stone foundations, assembled in adjacent but unbonded columns and sections of wall. The sherd collections from the Huancaco site indicate construction during the Gallinazo period, and enlargement with a great pyramidal platform during the Mochica period. Thus Mochica architecture was a continuation of earlier practices, on a larger scale and with more stately effects. The Pyramid of the Moon at Moche in the neighbouring valley of Trujillo is similar, projecting in terraced adobe platforms from a stony hillside. The pottery associations, however, are much later, belonging to fully developed Middle Mochica types (300–550).[20]

The great buildings at Moche are exceptional because they still show the original

form of the Mochica pyramid-cluster. Elsewhere the early platforms were covered with additions by later builders, as at the Brujo pyramid in the Chicama Valley or at Pacatnamú in the Pacasmayo valley. On this last site, Chimu settlers enlarged the older buildings and connected them with a grid of courtyards and ranges of dwellings.[21]

The Pyramid of the Sun at Moche (Plate 157) stands at the river's edge some 550 yards west of the Pyramid of the Moon (both names are modern). The river has carried away nearly half of the vast adobe brick construction, but even today in its diminished state it is the largest ancient construction of its type in South America, rising 41 m. (135 feet) above the valley floor. Like the other platforms described above, it is an aggregate of unbonded walls and columns. At building level beneath the highest portion, the river has exposed a lens of ashes, probably from a dwelling site antedating the construction of the pyramid. Embedded in that ash lens were fragments of Early Mochica pottery belonging to Period I (first century A.D.?).[22] Upon the southern terrace separating the base from the crowning pyamid, Uhle found intrusive graves with pottery in the coastal Huari-Tiahuanaco style. The construction can therefore be assigned to the Middle and Late Mochica periods, although a hypothetical nucleus, long since wasted away, may have been older.

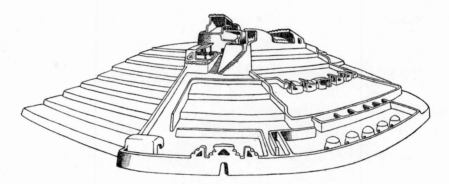

Figure 95. Mochica house group of the first century B.C. (?).
Reconstruction drawing based on Plate 156B

The overall dimensions including the ramp are 136 by 228 m. (440 by 250 feet) (Figure 94). The southern platform (C), nearly square, has five stages, surmounted by a smaller square platform (E) of seven more stages. Broad terraces separated the primary and secondary platforms on the southern and western exposures. A long ramp (A) gave access to the lower northern platform (B). Every detail confirms an impression of work by unskilled labourers, who laid the bricks in stints as contributions to the collective place of worship. The Moon Pyramid was probably a palace-platform, and the Sun Pyramid was a temple.[23]

On the evidence of vase-paintings, Mochica society was probably a theocratic organization, governed by priestly persons. The farming population lived in clusters of dwellings at the valley edges. The nobles and their servants occupied walled and ter-

raced hillocks, of which the form is recorded in many pottery vessels. An example from the Virú Valley in the Lima Museum [24] has pyramidal terraces indicated by bands of red and cream colour (Plate 156B and Figure 95). A walled chicane corridor protected the entrance, and ramps led from level to level. The wide lower terraces were for servants, and the withdrawn upper courts, surrounded by gabled houses of ventilator planes and sun-shades, housed the masters. The model has a lipped spout characteristic of the Early Mochica style.

The transition to these class-structured dispositions under Mochica rule was therefore of early date, probably connected after 400 B.C. with a regime of artificial irrigation by man-made canals on a large scale. Such a regime gave mastery of the entire society to a few persons controlling the upper valley necks. In the Chicama Valley, the Cumbre Canal is still in use over about 113 km. (70 miles). The Ascope aqueduct carried water on a dike 1400 m. (1530 yards) long across the embayment of a small lateral valley north of the Chicama river, saving many miles of contour-line ditching by its straight embankment 15 m. (50 feet) high.[25] Such gigantic enterprises required rigorous organization and the subordination of other concerns to public works.

The utilitarian and collective bias of the Mochica culture is most evident in the amassing of enormous dikes and platforms. It appears as well in a structural experiment (or accident) approximating to true arch construction. One Chicama Valley tomb reported by Larco has a curved roof of adobe bricks resembling a European tunnel vault. A model of this tomb was available at the Chiclin Museum. W. Bennett believed it to be a variant of the standard Mochica box-tomb, built with longitudinal sticks supporting a surface layer of adobe bricks. The sticks disintegrated, and the bricks were locked by gravity into position as an accidental vault.[26] Intentional or accidental, the resemblance to a tunnel vault is striking. Larco also mentions arched doorways in Mochica temple and tomb construction, but his illustrations show only corbelled, rather than true, arches.

Sculpture

The sculptural impulses of the Mochica people were channelled into modelled pottery and small objects of metal, bone, and shell. Carved clay decoration [27] and large stone statues are extremely rare on the ancient coast. The predominance of small sculptured objects may perhaps be related to the prime importance of large irrigation works, which required the principal energies of the people for their construction and maintenance. Another hypothesis is that the Mochica people were exceptionally endowed with tactile faculties, preferring sculptural expression to chromatic variety, and adopting clay sculpture in preference to other means of recording their preternaturally sensitive perceptions of spatial order. The large number of erotic subjects in Mochica pottery has been connected with this hypothesis of congenital tactile sensitivity.[28] Others have noted the emphasis placed by the Mochica people upon pottery made especially for burial rites. These ornate vessels of fine quality are so distinct from the utilitarian wares found in refuse deposits that their manufacture has been attributed to a special group of priest-potters who were identified with the ruling class, and who supplied such mortuary

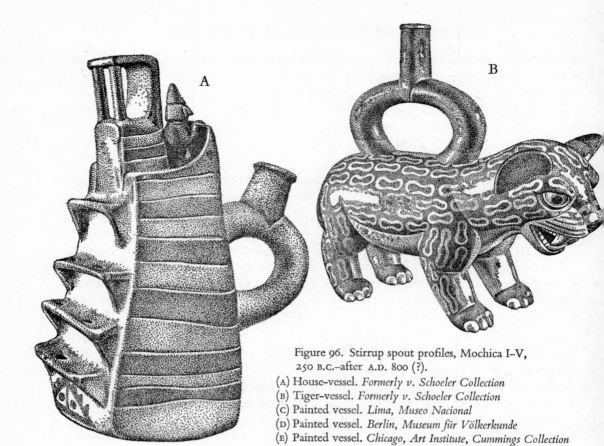

Figure 96. Stirrup spout profiles, Mochica I–V,
250 B.C.–after A.D. 800 (?).

(A) House-vessel. *Formerly v. Schoeler Collection*
(B) Tiger-vessel. *Formerly v. Schoeler Collection*
(C) Painted vessel. *Lima, Museo Nacional*
(D) Painted vessel. *Berlin, Museum für Völkerkunde*
(E) Painted vessel. *Chicago, Art Institute, Cummings Collection*

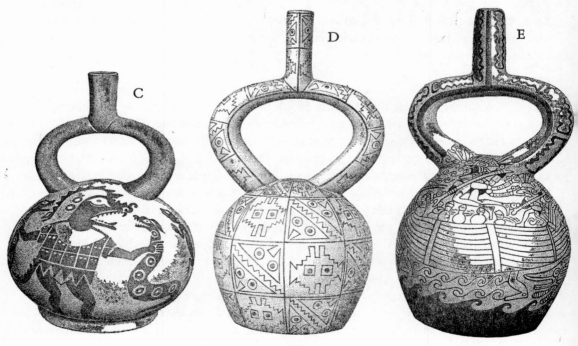

pottery to the people in return for services.[29] The grave specimens rarely show signs of use; sometimes bundles of small leaves (coca?) are stuffed into the necks. Identical replicas of certain portrait-vessels and moulded figures in the tombs of widely separated sites, as at Chimbote and in the Chicama Valley, prove the unity of Mochica culture, and indicate the use of figural pottery to increase social cohesion in the absence of writing. The many replicas of certain portrait-types (Plates 154B and 155), with commanding facial expressions, surely reflect a cult addressed to governing persons.

The generic resemblance to west Mexican pottery in Colima and Nayarit is striking in the portraits and scenes of daily life modelled on pottery made for graves. The chief difference is a fundamental one: the Andean potters rarely endowed the entire figure with studied sculptural form. The container form rigidly framed the anatomical design. Mochica modelling is an art of lavishly detailed parts connected by schematic passages.

About 10 per cent of the pottery collected by Uhle from the Mochica tombs at the pyramids of Moche bears figural decoration of sculptural character, in effigy and in relief scenes. There are painted designs on 34 per cent, and all the rest, 66 per cent, are undecorated vessels.[30] Of this collection, 90 per cent have red-and-white colour, of an effect described as 'piebald', which is distinctly graphic in intention rather than colouristic.

The vessel shapes are elaborate and varied, both in function and in plastic variety for its own sake. Spherical jars with flaring conical mouths, of a form used probably for the storage of food, are very common (35 per cent). The most numerous (42 per cent) are stirrup-mouth vessels designed for the storage of liquids. These containers are vented by two curved branches joining at a tubular mouth. The handle-like stirrup lets the vessel be carried on a belt or sash. Its mouth is contrived to reduce losses by evaporation and spilling, and pouring is eased by the branching tubes, of which one admits air. More than any other form, the stirrup spout registers the passage of Mochica time (Figure 96). Larco's chronology is based mainly upon changes in its proportions, articulation, and construction.[31]

Mochica I vessels have short spouts with rimmed mouths. The curving stirrup straddles the container with wide-set insertions, and the vessel itself is globular, lacking a distinct pedestal. Mochica II stirrups are more like closed loops, with the ends drawn closer together at the insertion. The spouts are longer, with almost imperceptible rim reinforcements. Mochica III, corresponding to the Middle Period, has stirrups of varying curvature, nearly flat in the horizontal upper portion, and rapidly curving to meet the wide-set insertions on the container. The spouts are often concavely profiled, widening gradually to the mouth. Mochica IV stirrups are tall and angular. The spouts are straight-sided, and the lip is bevelled inside. The insertions on the container are widely separated, and the container profile is more like a hat than a sphere. The flat bottom, luted to the upper portion, simplified the process of shaping the container. Mochica V stirrups are approximately triangular in profile, with conical spouts. They are sometimes taller than the container. The insertions are nearly contiguous, drawing the loop of the stirrup into a triangular shape with an apex on the container. Mochica V potters also explored the continuous combination of both profiles, on the container and in the stirrup. The curve

of the inner stirrup profile gently reverses the container silhouette, so that a figure of eight emerges, with the lower loop formed by a solid outside profile and the upper loop by an inside (i.e. void) profile of remarkable grace.[32]

Regional and ethnic differences modify this evolution. For instance, the stirrup spout, which rides on top of the container, may mark either an axis from front to rear or a plane from side to side (Plates 153–5). On Cupisnique vessels the stirrup plane goes from side to side, and it marks a frontal aspect. The same position of the stirrup, spanning the front view with its bridge-like silhouette, characterizes the other pre-Mochica styles, called Salinar and Gallinazo. But the Mochica stirrups all mark the sagittal or axial plane. In a portrait vessel, for example, the face occupies one plane, but the beautifully proportioned stirrup requires us to turn the vessel. The stirrup establishes the profile, and the container establishes the front. The two views more urgently require the observer to rotate the vessel than do the pre-Mochica examples. The portrait vessels also show a progressive refinement of axial composition. In Mochica IV, the head tilts back from the base, with an upward lift of the facial plane. Face and stirrup spout compose a curved diagonal axis in profile, and this commanding expression conveys high moral stature and purpose (Plate 155, *right*).

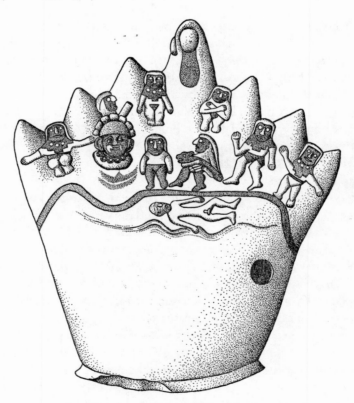

Figure 97. Mountain sacrifice vessel from a grave at Sorcape
in the Chicama valley, Mochica V style,
after 500

270

We have already seen that the early stages of the art of anatomical modelling were gradually worked out by Salinar, Recuay, and Gallinazo potters. In general the fundamentals of Mochica sculpture were all defined long before the emergence of Larco's Mochica I, not only for the human face and figure, but also in the modelling of animal, plant, and monster forms. We shall again retain Larco's phase numbers, grouping them as Early, Middle (Plates 154B and 155), and Late stages (see p. 264).

Early, to A.D. 0 (Larco I and II). The heads are stereotyped spheres, lacking the pronounced individuality of the heads of the Middle stage. The burnished surfaces are much finer in texture than the coarse and gritty moulded wares of late date. The eyelids are strongly ridged, in an almond-shaped figure. The eyeball is correctly indicated as a sphere set into the head. The nose prolongs the arch of the eyebrow, but the union of the nose and cheeks is still arbitrary. The mouth is a V-shaped cut, faintly modelled to mark the contour of the lips.

Middle, to 500 (Larco III and IV). The muscular structure of the facial planes, lacking in the Early stage, is given by powerful, simple detail, indicating the unique individuality of the person represented, in a system of surfaces ridged and furrowed by the play of muscles. The eyelids are profiled in reversing curves. Tiny folds of muscle appear under the bony arch of the eyebrow. The precise muscular set of the mouth is shown by furrows. Wrinkles indicate the age and temper of the subject.

Another common theme in this period is the scene of a mountain sacrifice, showing a number of people among mountain peaks in the presence of a jaguar god of human aspect, engaged in the sacrifice of one or more of their numbers. An example of Mochica III or IV, from the Warrior-Priest's Grave in the Virú Valley, shows five mountain peaks. Six human figures and a lizard are present at the sacrifice. Another such mountain-vessel, associated with Mochica IV specimens, comes from Cerro Sorcape in the Chicama Valley (Figure 97). It has seven peaks. The human being to be sacrificed is again spread face-down upon the central peak. There are also eight celebrants, a recumbent person, and the bust of a tusked god. All these figures are moulded in relief, and painted [33] in the usual red-and-white technique.

Mochica carving in wood, bone, and shell has never been studied systematically. Wooden staffs with figural heads occur in the Warrior-Priest Grave of Mochica III–IV date in the Virú Valley, as well as among very late deposits in the guano beds of the Chincha Islands.[34]

Mochica metallurgy, like woodcarving, is stylistically coherent with the pottery forms. If, however, large portions of the Chavín repertory be correlated with Mochica developments as proposed here on pp. 261–2, then a puzzling discrepancy vanishes. Lothrop observed an extremely wide range of Chavín metals and processes, of which many 'disappeared' until Mochica times.[35] When Late Chavín and Mochica are considered as overlapping, the history of metallurgy in northern Peru no longer requires a hypothesis of 'disappearing' techniques.

Painting

Mochica painters[36] renounced colour and became expert in the delineation of movement. The line was brushed or penned, without variations in width, in red-brown or brown-black line on cream or beige slip, and in cream or beige line on dark brown-red slip. Figures in profile predominate, and there is little attempt to suggest depth by perspective devices other than the simplest overlapping of forms.

The Mochica draughtsman's main concern was to achieve effects of movement. Every resource at his disposal was used to increase the agitation and restlessness of his work. The painted spherical containers, with their scenes of ritual and battle, are themselves suggestive of motion, as the eye slips over their rounded surfaces, or as the hand turns them over. The painted men run furiously: pumas attack suppliant victims; the waves curl on the waterline of a boat; the tassels of the ears in a field of corn are tossed by the wind; a flight of birds rises in all directions from a clump of cane. Even the space surrounding the figures is alive with agitation, conveyed by spots and rosettes as in Corinthian orientalizing pottery of the sixth century B.C. Such space-fillers are frequently occupied by other fillers, which in turn bear tertiary fillers. Consistent with this technique is the lively inversion of line and field, whereby the shape and its ground exchange their roles.

This description, however, is synthetic and non-historical, true only for the cumulative result of many centuries of development. Sharply defined stages can be isolated, and here, as in preceding sections of this book, we may rely upon Larco's tentative and unproved, but inherently probable, chronology. An independent linear mode of figural description upon flat or curving planes first arose during Mochica II, as we may deduce from its absence in I, and its fully developed presence in III. During Mochica I (Plate 154B), face paint, body markings, and costume details, as well as bands of geometric ornament, were the only subjects entrusted to linear description. In Mochica II pottery we first encounter figures of human beings and animals in low relief, probably shaped in moulds, and painted with colour in patches and lines to describe costume and expression. Space-fillers were not yet used, and figures in solid colour tended to carry the design, as in Attic black-figure vase-painting before 500 B.C.

During the Middle Mochica centuries (Larco III, IV), painters abandoned figures in solid colour for wiry and active outlines, giving the illusion of total movement (Plate 158A). Narrative and processional scenes of many figures replaced the single and double figure panels of the early period. The scenes often occupy two or more registers. Spiralling processional scenes required hair-fine brushwork upon a tiny scale. These tendencies towards figural complication probably characterize Mochica IV. The shift from figures in solid colour to outlined figures with much interior detail recalls the Greek shift from black-figure to red-figure vase-painting after 500 B.C.

The murals at the Moon Pyramid at Moche are of Middle Mochica date, painted on a dado about 3 feet high, in seven colours upon a white ground. The figures represent a battle between human beings and animated implements, with the victory going

to the implements. The linear outlines look like freehand incisions. The colour was hastily applied. Other Mochica murals at Pañamarca, near Chimbote, portray a robing scene and a battle with life-size figures in seven tones: black, white, grey, red, yellow, brown, and blue.[37]

Late Mochica (Larco IV) pottery painting is the most restless (Figure 100). Violent animation possesses the figures. The backgrounds swarm with space-fillers of agitated contours. The figures and their settings often lose distinctness, for the pattern becomes so dense that the eye cannot easily separate the figure from the ground.

The pictorial description of the Mochica environment by pottery painters therefore dates from the Middle Period, and passes into ornate complication at the end of the sequence during a span of several centuries before 700. Instead of exploring the imagery of deep perspective, the Mochica painter, in his quest for effects of movement, chose to indicate the setting by linear devices as agitated as his forms in motion. Thus a desert landscape is shown by cactus and tillandsia plants rooted in a sinuous ground line: the area above it is vacant, but tortuous enough to hold the eye without giving a sense of uncomfortable voids (Figure 98). In another example many running human legs seem

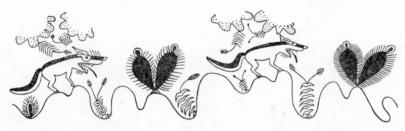

Figure 98. Desert landscape with foxes, Mochica III style, after 200 (?).
Berlin, Museum für Völkerkunde

to churn the ground into hillocks, and the ground line becomes an ornamental figure, undulating more because of the action portrayed than because of the nature of the ground (Figure 99).

In a hunting scene the agitation of the moment is increased by the undulant ground

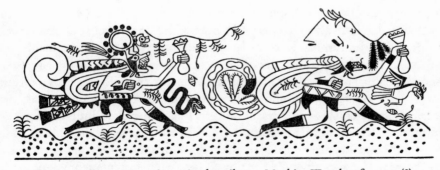

Figure 99. Runners wearing animal attributes, Mochica III style, after 200 (?).
Berlin, Museum für Völkerkunde

line, but neither the hunter nor his prey touches it (Plate 158A). Both are shown as if instantaneously arrested during the kill. The huntsman plunges his lance into the flank of an exhausted deer. The hunter's feet leave the ground and the painted deer throws his head back in pain as his fragile legs crumple under him. Another such scene of arrested motion occurs on many vessels. In one example, a huge jaguar with bared claws and fangs leaps upon a seated warrior. The man waits in breathless fear, with clasped hands, closed eyes, and open mouth. Every line conveys violence, motion, or suspense. All the schematic conventions of Mochica figure drawing combine to express the terror and violence of the moment. Nothing is left uncertain; nothing is unclear; all parts of the design accurately describe the motion of beings in action.

The representation of distant planes is also subjected to a rule of maximum animation. In a racing scene (Figure 99), the runners fly, barely touching the ground-line. Above their heads another ground-line with tillandsia hanging upside down indicates a plane behind and far away, registering distance by inversion. Indoor scenes are shown by simple cross-sections through the beamed structure of the gabled houses (Figure 100). Pyramids, platforms, and furniture appear as orthogonal projections showing the most significant and active profiles.[38]

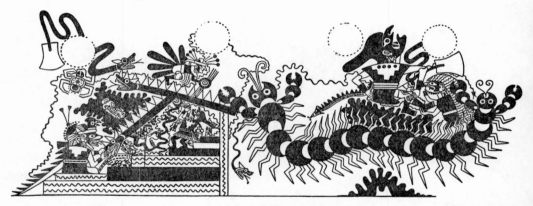

Figure 100. House and occupants, centipede, and jaguar-fang deity, Mochica IV style, before 500.
Berlin, Museum für Völkerkunde

Iconography. The uncanny Mochica facility for isolating and representing significant moments of behaviour also took form in portraiture and humorous characterization. Many vessels are unmistakable records of specific persons at determinable ages and in identifiable moods and attitudes (Plates 154B and 155). In one class these portraits show men of noble bearing at the peak of maturity, with the firm expressions of those who bear great responsibilities. The portraits exist in many replicas, probably honouring dynastic chiefs or important officers. In another class, individual peculiarities are common, as well as mutilations and lesions. In all these cases the unique and special aspects of individuality were isolated, like the climactic moments of action in the narrative scenes. The portrait and the action scene are like instantaneous exposures, taken from the vast range of appearances.

Thus Mochica iconographic types are both traditional and disruptive of tradition. The stylized, tusked human beings of Chavín origins continue in modelled and painted Mochica vessels, together with the metaphoric clusters of animal attributes that characterize the Nazca style. Alongside these traditional types, the Mochica artist introduced new, special forms of great veracity and instantaneous vivacity. An abrupt enlargement of perception is apparent. The Chavín artist channelled all experience into a few arbitrary signs. The Nazca painter codified experience by pictorial metaphors drawn from an animistic conception of the world. The Mochica artist, however, turned his gaze outward from ceremonial custom and from magical properties, to examine in great detail the world before him. Hence the Mochica monsters consist of animal attributes related by visually plausible organic connexions (Figure 100). In the tusked human faces, the muscular structure is accommodated to the great dentures. Owl-man, fox-man, crab-man, and many others are all plausibly compounded.

One most remarkable innovation of the Mochica artists was their style of landscape painting. One example shows a cornfield, with the entire environment skilfully portrayed: the nodes of the stalks are depicted, the ears and their tassels burden the stalk, and the tassels nod in many directions, as in a cornfield tossed by a choppy breeze. On another painted vessel we see a watery marsh. Here small water-birds feed upon the cane, a heron feeds upon the fish, and water-grasses and snails fill the composition. There are no human beings and no monsters. Natural landscape appears for its own sake with an evocative vigour unparalleled in ancient America.

Erotic behaviour and sexual organs are shown on about two per cent of all Mochica pottery. The scenes are usually anthropomorphic. Since they appear among tomb furnishings, a serious intention may be supposed. Coitus, masturbation, and sodomy may have conveyed concepts of divine inspiration, afflatus, and possession.

Another prominent trait of Mochica sensibility is humour – the awareness of discrepancies between ideal and real behaviour. Humour depends upon detached observation of reality and the self, in a revelation of some part of truth by ridicule. Mochica pots often provoke laughter by skilful and sympathetic exaggerations. Many erotic scenes are funny: a woman wards off the embraces of a gross lover, or a nursing infant rages at its mother's amorous distraction. Humorous descriptions of animal behaviour are common: there are scenes of monkeys embracing or chasing one another's tails, and dances of upright deer holding hands with their young does and bucks (Plate 158B). In another vein there are chain dances performed by human skeletons, like the late medieval *danses macabres* of western Europe.

The iconographical treatment of Mochica art remains at the level of description and preliminary identification. A knife-like accessory worn by many figures has been explained both as a metal bell and as a weapon. One writer claims to have identified a supreme deity named Ai Apaec; another has proposed four classes of nature-demons ruled by Si, a moon god who navigated the skies in a crescent-shaped boat. Where one interpreter sees messengers bearing dispatches written on marked beans, another proposes fertility races to stimulate the crops (Figure 99). There is no archaeological evidence for the use of hallucinogens in Mochica life, as noted by E. Benson, who dis-

tinguishes stimulants, such as coca and chicha, from drugs.[39] We have encountered similar difficulties in the determination of conventional meanings elsewhere in ancient America, and, as before, one must be content with approximating the intrinsic meaning.

Mochica art differs radically from the rest of American Indian art, save for the parallels to west Mexican pottery styles. With few exceptions, it is an art directly connected with sensation, based upon instantaneous perceptions of the changing appearances of reality. Mochica pictorial habits betray an interest in particular situations at the instant of happening. These attitudes most closely resemble the empirical and pragmatical modes in modern behavioural classification, and they suggest to us that the incidence of these modes of behaviour is not necessarily contingent upon economic conditions.

THE END OF MOCHICA ART

A most important connexion in the central Andean archaeological sequence appeared in 1899 with Max Uhle's discovery of intrusive graves, containing pottery in the Tiahuanaco style, on the south terrace of the main platform of the Sun Pyramid at Moche.[40] Uhle rightly understood these graves as related to the end of the Mochica style, and to its replacement by traces of a different culture.

All subsequent discoveries have reinforced Uhle's conception of the sequence of Mochica, Tiahuanaco, and Chimu on the north coast. As we shall see, the Huari-Tiahuanaco style at Moche (called 'Epigonal' by Uhle) was a weak reflection of more resplendent achievements on central and southern coastal sites, yet the cultural change which these sherds attest seems to have been of the same order of magnitude as the displacement of Christian by Islamic art in Spain at about the same time, near the end of the first millennium A.D. On the north coast, only the Mochica territory was affected, in Ancash and La Libertad. No evidence of pottery intrusions in the Huari-Tiahuanaco style has come to light north of the Chicama Valley.[41] These Tiahuanaco sherds are painted in black and white on a red slip. They come from flaring-sided goblets, cups, double-spout vessels, and face-collar jars. The painted designs show geometrically simple puma and condor figures, as well as oblong fields and panelled divisions which all have affinities with the rectilinear structure of textile designs, such as the tapestry fragments in the Tiahuanaco style found at Moche.

Other pottery types associated with the intrusive Huari-Tiahuanaco style are moulded and have reduced-fired surfaces as black as heavily oxidized silver. Still others favour geometric designs painted in black, white, and red, as well as cursive designs painted on tripod vessels and modelled pottery. The older differentiation of grave wares and utilitarian types ceased.[42]

The systematic excavation of settlements in the Virú Valley confirms the thesis of an abrupt and profound cultural replacement. The building of great pyramids ceased, including palace-pyramids of the type of the Moon Pyramid at Moche, and the fortified hill-top enclosures which characterized Mochica architecture. Instead, huge compounds were built, as large as 130 m. (430 feet) square, surrounded by *tapia* adobe walls, and

containing symmetrical files or ranges of rooms, corridors, and courtyards disposed around small earthen platforms. Willey connects these reticulated compounds with the appearance of the Huari-Tiahuanaco style in figural art. They stand near the coastal roads built at this time to connect the valleys. Such roads probably formed a new system of communications, linking the coastal centres to one another rather than to their own valley necks and highland basins.[43]

THE LAMBAYEQUE DYNASTY

Far to the north, in the valley of the Leche river, the site called El Purgatorio (Figure 101) displays monuments of both the Mochica and Tiahuanaco eras. In its south-western quadrant are numbers of solid pyramidal platforms without enclosures, believed to be of Mochica date. At the northern rim of the site are files and courts of rooms upon an immense primary platform nearly 450 yards long: Schaedel attributed them to the period between the Mochica and Chimu states, and explained them as palaces housing families of the ruling class with their servants and artisans.[44]

An ornate example of a roadside mound within a walled rectangular enclosure of 55 by 59 m. (180 by 193 feet), internally surrounded with regular files of cells, is the Huaca Dragón, just east of Chanchan in the Trujillo Valley (Plate 159).[45] The outer wall of moulded and painted clay is divided into repeating panels of identical motifs several tiers high. The recurrent theme is an arched and two-headed serpentine body outlined by wave-scrolls, with each head devouring a small human figure. Within this outer wall are rows of cubicles like temple workshops, where artisans made shell incrustations for wooden statues. They left great quantities of discarded shell in all stages of manufacture. The inner pyramid was two stages high with a steep ramp adorned with moulded friezes. The entire edifice has been assigned to about A.D. 1100. Similar moulded adobe friezes of a coarser execution, with arched, two-headed figures, appear in the Lambayeque Valley at the Huaca Chotuna.[46]

These edifices in the valleys of the Moche, Lambayeque, and Leche rivers and else-where have been ascribed on archaeological evidence alone to a period before the Chi-mu conquest in the fourteenth century, and after Mochica domination on the north coast. In addition we have two distinct historical traditions bearing upon the region, conveyed by reliable colonial authors. Here, for the first time in our survey of Andean prehistory, we can match archaeological and textual evidence. Miguel Cabello Balboa, writing in 1586, reported a dynastic history for the region now called Lambayeque.[47] The dynasty was founded by a seaborne colonizer named Naymlap, who came with his retinue in boats. He settled at Chot (probably Chotuna). A succession of twelve rulers governed the region until its conquest about 1420 by the Chimu dynasty from the Trujillo Valley. Hence the inauguration of the Naymlap lineage goes back to the twelfth century, on the assumption that each ruler equals one generation of about 20–30 years' duration.

The description of the court of Naymlap mentions many functionaries who belonged

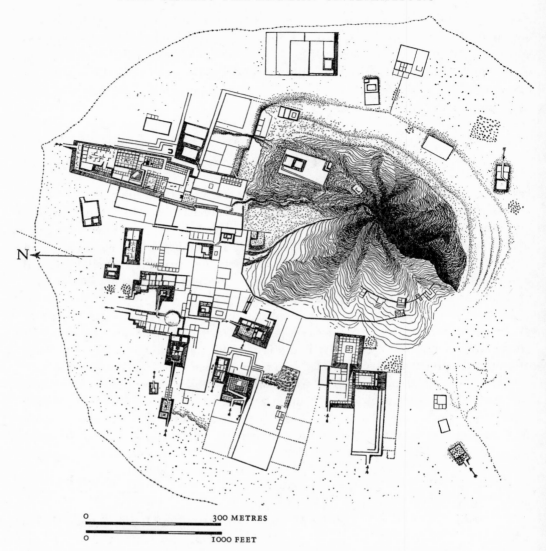

Figure 101. El Purgatorio, Leche Valley, thirteenth–fourteenth centuries. General plan

to an aristocratic class, and gave personal services to the ruler. The sons of Naymlap settled other valleys in the Lambayeque basin; both the sons and the courtiers established dynastic lineages which continued for centuries as genealogical lines through the colonial era.[48] Cabello reported an interregnum of unknown duration between the last ruler (named Fempellec) of the Naymlap dynasty in Lambayeque and the Chimu conquest of 1420. If the interregnum was brief, then the Naymlap account fits in with the archaeological evidence as a historical record.[49] It reports the same kind of feudal and aristocratic lineage, replacing the previous theocracies, which we encountered in the Mixtec and Toltec dynasties of Mesoamerica at about the same epoch.

In 1936–7, three large golden knives bearing winged human figures were found in

the Lambayeque Valley. One of them was inset with turquoises and bore red paint on the cheeks (Plate 160). Luis Valcárcel at once suggested that these were dynastic images of Naymlap himself who, when he died, took wings and flew to the sky.[50] On closer study it appeared that this winged human figure, associated with a knife and wearing a semicircular diadem, is the most common simple theme of the coastal archaeology of the late periods. It appears in pottery, and on textiles and metal objects from the north and central coast. R. Carrión Cachot related the figure to a lunar deity with marine associations, and she regards it as a Chimu rather than a pre-Chimu form.[51] The representations all have almond-shaped eyes, with rising scrolls at their outer corners. A mural at the Huaca Pintada in the Lambayeque Valley records the same personage, flanked by bird-headed acolytes who sacrifice two recumbent human beings. The theme of a wave-bordered, semicircular curve reappears in the moulded clay friezes at Huaca Chotuna in the Lambayeque Valley, as well as at the Huaca Dragón near Chanchan (Plate 159). It also recurs in textiles from Pachacamac, where the diademed and winged figure is connected with the taking of trophy heads. It is most common in black-ware from the Lambayeque Valley, on double-spouted vessels and on taperspouted vessels with loop handles, assigned by both Kroeber and Bennett to pre-Chimu times.[52]

The finest examples of north coast art in this period after Mochica and before Chimu domination unquestionably come from the Lambayeque Valley. There the metalsmiths attained great virtuosity in the use of curved and plane wafers of soldered and welded metal (Plate 161). The pottery forms likewise manifest a distinct style, more linear and more ideographic than the waxy shapes of Chimu origin in the Trujillo Valley.

THE CHIMU PERIOD

A Spanish chronicle written in 1604 furnishes our only record of the dynastic history of the land of Chimor or Chimu.[53] The founder, Taycanamo, came like Naymlap by sea to Chimor early in the fourteenth century. Twelve generations of his descendants succeeded him in the kingship. About 1370, Taycanamo's grandson, Nançen-pinco, extended Chimu rule by conquest from the Santa river to Pacasmayo, and the ninth ruler, Minchançaman, brought all coastal valleys from Carbaillo near Lima to Tumbez under Chimu domination. This took place about 1460. The 'fortress' at Paramonga, built of adobe bricks, probably corresponds to this period. Minchançaman's career was interrupted before 1470 by Inca armies under Tupac Yupanqui, overrunning the Chimu Kingdom, looting the cities, and reducing the dynasty to vassal status.

Architecture

Even with these indications, we are not clear about the beginnings of the Chimu state. The principal city, called Chanchan and situated near Trujillo (Plate 162), is now a vast ruin. The ancient name was probably Chimor. It has only recently become the object of

systematic excavation, although a commercial company was formed in the sixteenth century to mine the huge treasure of its burials,[54] and illegal excavation of ruins has continued ever since. We do not know when they ceased to be inhabited. The finds of pottery strongly suggest that Chanchan was not in existence during the Mochica era and that its earliest history does not antedate the twelfth or thirteenth centuries.

The ruins, which today cover about 11 square miles (Figure 102), probably represent a gradual accumulation during not longer than 300–400 years. The remains of ten or eleven walled enclosures, surrounded by adobe brick walls rising as high as 50–60 feet,

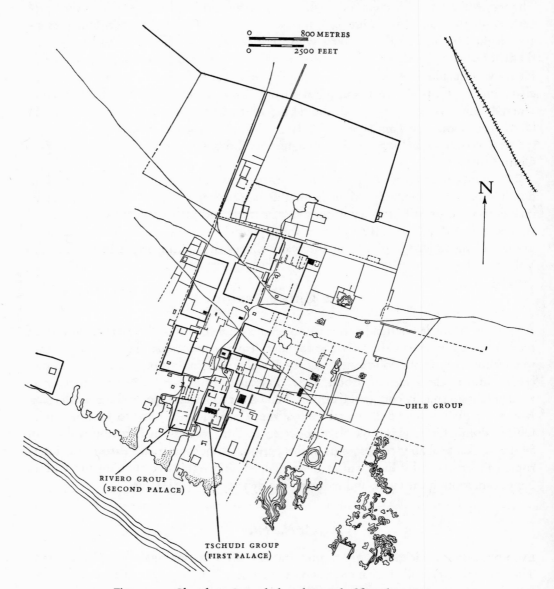

Figure 102. Chanchan. General plan, thirteenth–fifteenth centuries

280

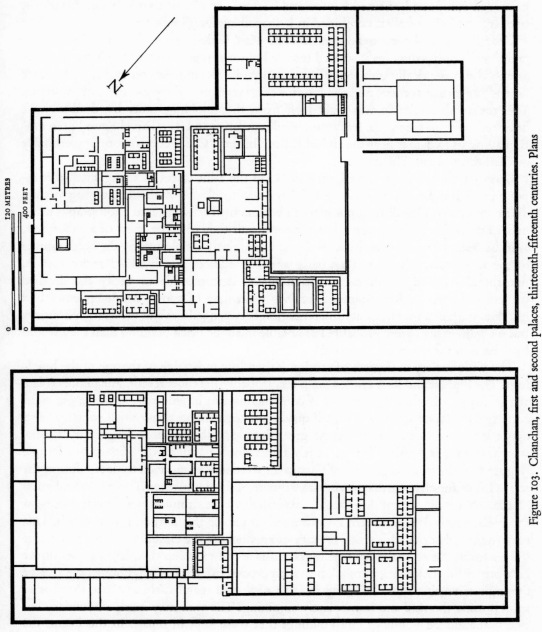

120 METRES

400 FEET

Figure 103. Chanchan, first and second palaces, thirteenth–fifteenth centuries. Plans

still stand out clearly.[55] Most of the enclosures are regular rectangles. Two of the best preserved compounds, named Rivero and Tschudi, consist of two adjacent rectangles, one large and one smaller, combined in L-shaped angles (Figure 103).

The most palatial compound, named after Max Uhle (Figure 104), contains a quadrangle with thirty-three gable-ended terrace houses in ranges two to five units long, all arranged symmetrically on a low platform around a rectangular courtyard. The terrace houses never turn corners, and the interior courtyards are all open-corner quadrangles. This remarkable scheme was walled off from the adjoining units by double walls breached only on the north. Its symmetrical regularity and its relatively good preservation allow us to date it near the end of Chimu history. Older construction is plentifully evident throughout Chanchan.

Between the better-preserved enclosures are the faint traces of many smaller compounds, each defined by double parallel walls with blocks of terrace housing within. These smaller and less distinct outlines can be discerned only in aerial photographs taken under favourable lighting conditions. From the air they give the effect of a palimpsest, as if the traces of an older architectural grid were faintly visible among the bold outlines of the principal enclosures. That early and late edifices are involved seems certain, but the absence of scientific excavation makes it impossible to verify the detailed sequence of construction. Some of the low walls may of course define ephemeral or inferior construction, reflecting differentiation between palaces and proletarian housing, but such differences were probably less notable in adobe brick building than they would have been in more durable materials.

The wide variety in degrees of erosion is therefore indicative of the age of the buildings. The highest and least eroded walls are probably the most recent. Air photos (Plate 162) show clearly that three stages of construction can be inferred: at the lower right corner of the Rivero group is a small quadrangle containing many small courts, and its upper left margin is overlaid by the great double wall of a much larger quadrangle, which in turn is overlaid by the nearly intact double wall of the Rivero quadrangle (Figure 102). Because large parts of Chanchan were thus abandoned to decay during the active life of the city, we may revise the estimate of the population. The traditional guess of 200,000, on the assumption that all quadrangles were simultaneously occupied, is far too high, and it does not seem unwarranted to reduce this figure by two-thirds. One may suggest that the builders of the city often changed the circumvallation, to enlarge the enclosure, or to make it more regular, for as we examine the plans of two of the best-preserved enclosures, in relation to their eroded extramural neighbours, we receive the impression that some buildings inside a new wall are possibly as old as the eroded ruins outside the wall and immediately adjoining. The wall may mark a boundary between abandoned buildings and buildings that were kept in repair. In this event, the wall is the new construction rather than the buildings it separates. It is also notable that no compound opens to the north; that the highest walls shelter the compound from the prevailing south-westerly on-shore winds of the coast; and that most house-blocks face away from the southern exposures on courts opening to the north (Figure 102). In these latitudes, of course, the northern exposure receives the most sun, in a climate where fog

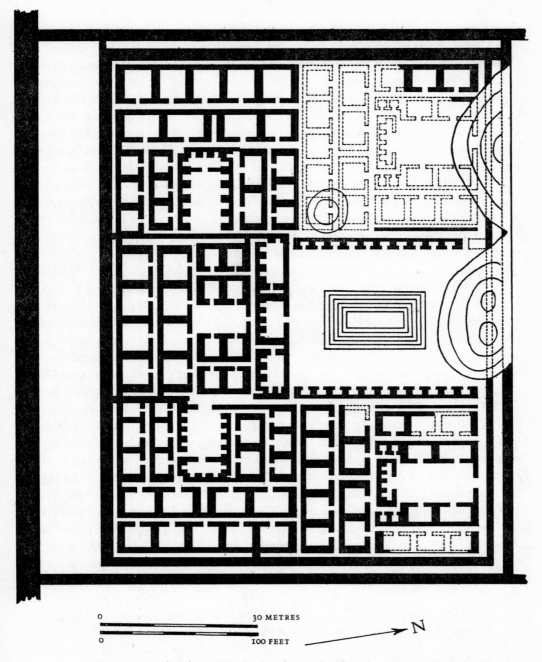

0 30 METRES

0 100 FEET

N

Figure 104. Chanchan, Uhle Group, thirteenth–fifteenth centuries. Plan

during many months makes every sunny day a welcome event. Thus certain peculiarities of the plan of Chanchan can be explained by the need for shelter from the ocean winds and for favourable exposure to the sun. Other traits of Chimu architecture require a sociological explanation.

The number and the size of the surrounding compound walls are astounding. In some places three parallel dikes define two clear streets, and usually one such street surrounds an entire rectangle, breached only by a single door (Figures 103 and 104). In which sense were these walls restrictive? Were they to keep the residents in, or to protect them from outsiders? Were the rectangular enclosures palaces, or were they factories? The two enclosures nearest the ocean, named after Rivero and Tschudi (Figure 103), contain a random assembly of dwelling blocks which can most easily be explained as industrial settlements.[56] On the other hand, the inland enclosure named after Uhle has a plan of spacious symmetry, like a carefully planned residence for privileged persons (Figure 104). Rivero and Tschudi look like gradual accumulations, arbitrarily set in order by a vast enclosure, but the Uhle compound seems to have been designed all at one stroke, and probably at a late moment in the history of the city.

Rowe has shown that many features of Inca polity were borrowed from the Chimu state: one was the custom of governing by means of the local nobility; other traits are rectangular town plans, mass production methods, and craft practices in metal-working, textiles, and luxury goods such as feathered cloths.[57] After the Inca conquest of the land of Chimor about 1470, Minchançaman, the deposed Chimu king, was kept in exile at Cuzco as an honoured vassal, and with him went a colony of Chimu craftsmen. The Inca treatment of conquered subjects probably repeats earlier Chimu customs, and these may explain the urban form of Chanchan. By this hypothesis, resident vassals, together with their colonies of craftsmen, lived in productive exile at the Chimu capital, each colony in its compound, with more spacious quarters for the upper classes. The argument is supported by the close resemblances between the compounds of Chanchan and those of other sites, such as the one at the mouth of the Jequetepeque river, called Pacatnamú after the Chimu general who conquered the territory probably about 1370.[58]

Striking differences distinguish Chanchan from the northern cities. They are smaller and more provincial, and they are older, while Chanchan is the metropolis and the new city. The difference in age is evident in the small number of pyramidal platforms at Chanchan. Pacatnamú has about sixty pyramids, one with a core of Mochica date, and only one great compound. Chanchan, which has many compounds, boasts only a few pyramids of modest size. The site of Chanchan, however, is riddled with deep rectangular pits called *pozos* (wells) or *mahamaes*, which are like the negative impressions of pyramids (Plate 162). They were probably produced to supplement canal irrigation. The excavated clays and gravels may have been used to build walls and platforms. Many compounds contain such *pozos*, and there are others in the unwalled areas between compounds.[59]

Sculpture

The dwellings of the upper classes in the palace compounds of Chanchan and other buildings of the Chimu period on the Peruvian coast are enriched with carved clay decoration of bold sculptural quality, arranged in panels and bands of repetitious figures (Plate 163, A and B). These carved clay arabesques usually adorn chambers, terrace-faces, and ramps. They differ from pre-Chimu clay decoration of the type of the Huaca Dragón (Plate 159) by the absence of rounded passages of moulding. The imaginative variety and the complicated ritual traditions of Mochica art disappeared and were replaced by secular themes, compressed into ornamental bands and patterns. At Chanchan, the relief is in two planes sharply separated by vertical cuts. A few incised lines are the only modifications of the plane surface. Many of the same motifs recur on repoussé metal objects and in Chimu textile decoration. A recent study of a late carved frieze shows that the clay was applied in two layers, of which the outermost, c. 2 cm. thick, was carved while drying. This frieze of fish, bird, crustacean, and human figures has been dated as of the Inca Conquest and occupation, before 1470.[60]

The predilection for a few ornamental figures in stereotyped repetition is a fundamental trait of Chimu art. It is related to enormous construction of the simplest, most rapid, and most effective sort. It is usually assumed that textiles were the sources of these repetitious schemes. Many wall patterns, however, suggest figured twill weaves, which are not abundant in Peruvian cloths. Twill construction would more commonly have been used in basketry and mats.[61] Hence we may suppose that some carved clay wall decoration of the Chimu cities perpetuates an ancient habit of hanging the interiors with matting in figured basket-weaves (Plate 163B). Other pictorial conventions of the Chimu people were so limited in the repetition of a few themes in meander and fret motifs that their origin need not be sought in any special craft.

Although Chanchan has long had the reputation of an important metalworking centre, very few objects can be ascribed with certainty to its furnaces. In the Baessler Collection of Peruvian metal objects in Berlin, of 570 items, only one, a semicircular knife-blade, is of Chanchan origin, and only twenty-five come from 'Trujillo'.[62] We may suppose that the sacking of the graves of Chanchan began about 1470, when the Inca conquerors of the city removed its treasure to Cuzco. A few museums, however, have metal objects from Chanchan, and they are always small ornaments. The castings are of fluid plastic form, and secular in theme. The repoussé sheet metal cups and ornaments in the Chimu style exploit the brilliance of gold and silver by a variety of reflecting planes, often achieved with hinged bangles and filaments.

Chimu sherds at Chanchan are plain household red-ware; in the cemeteries black-ware is predominant. Stirrup-spout vessels, as well as effigy vessels, re-appeared here in common use after a lapse perhaps several centuries long. The phenomenon suggests a revival or a renaissance of Mochica forms, but without the pictorial style of Mochica draughtsmanship. The Chimu potters revived from their Mochica predecessors' reper-

tory only the monochrome wares. The black burnished surfaces resemble oxidized silver, and the polished red-ware resembles copper. Both black-ware and red-ware modelling have passages suggestive of repoussé or hammering more than of sculpture in clay.[63] The concept of a revival, involving certain Mochica forms stressing metallic effects, helps to define the character of Chimu pottery as a craft overshadowed by metalworking techniques. Unfortunately the principal products were destroyed by Inca and Spanish invaders.

Chimu textiles, like other crafts in the Late Period, show repetitive and geometric stylizations, governed by rectangular compartments or frames, with colour sequences which favour a diagonal movement of the eye across the whole pattern.[64] The north coast examples are far less abundant than those of the region from the Lima to the Nazca Valley in the central area, and their quality is less impressive.

When the artistic attainments of the late north coast peoples are placed in perspective against those of their contemporaries in the south, they appear less intense and less complex. On the other hand the political attainments of the Chimu dynasty, exemplified in the creation of enormous cities, far outstripped those of their predecessors and rivals. The Chimu tradition of imperial rule, maintained by aggressive expansion and by economic regulation, must surely have become the heritage of the Inca dynasty in the fifteenth century. One of the prices paid for this imperial political organization seems to have been the progressive loss of aesthetic vigour and inventiveness.

THE HIGHLAND BASINS

To each of the three main clusters of north coast valleys there corresponds a highland centre situated just beyond the continental divide on the Atlantic side. Chavín de Huántar, as we have seen, communicated most easily with the coastal valleys of the department of Ancash. Huamachuco was the highland intermediary at the nexus of the headwaters feeding into the Marañón basin as well as into the Chicama and Trujillo Valleys. Cajamarca, finally, connected the Lambayeque and Jequetepeque systems with the Marañón basin. All three were highland citadels, capable of guarding (or threatening) the headwaters of the Pacific streams, as well as of controlling the approaches to the Pacific Coast from the Amazonian rain-forests, via the Marañón river. Any interchanges between coastal and Amazonian peoples, such as the trade in tropical feathers and highland wool, must have been negotiated at such centres. The Inca war-lords, before attacking the rich coastal valleys, secured possession of Cajamarca with its surrounding domains, gaining a secure military base from which to conquer the land of Chimor in the 1460s.

The archaeology of Cajamarca is known with a completeness that would be desirable for every region of Peru.[65] In Cajamarca the sequence resolves itself into passive and active stages, in an area spread between the Hualgayoc and the Crisnejas rivers. After an initial period of incised monochrome pottery, distantly similar to that of the Chavín

style, the region slowly evolved a distinctive ceramic decoration based on cursive brush-work in black and red or orange on tan, cream, or white slip (Cajamarca I–III). This evolution occurred independently, without influences from the coast. It endured until the close of the Mochica sequence, about the ninth century A.D., when Cajamarca was invaded by the same intrusive art from the south (Huari-Tiahuanaco) of which we have already seen the effects on the coast at the close of the Mochica series. Subsequent relations between Cajamarca and the coastal peoples are shown by the occurrence in the coastal valleys of Cajamarca IV vessels together with pre- and early Chimu styles. These sherds differ from the 'classic cursive' (spiral brush-strokes) and 'floral cursive' of Cajamarca III by the addition of bold geometric fields derived from the Huari-Tiahuanaco style.

In 1532 the Spaniards routed the Inca army and took the ruler, Atahualpa, prisoner at Cajamarca.[66] The chroniclers describe various edifices, forming an impressive group, of which little survives. Whether these were Inca constructions or re-used buildings of older date is not known. In a walled plaza stood three 'pabellones' containing eight rooms. One of these chambers still stands in the present Hospital de Belén, and an old tradition makes it the room where Atahualpa's ransom was brought together. These buildings were probably 'galleries' like those of Huamachuco, described below. A rectangular pyramidal platform stood east of the walled square. Systematic study of the architecture of Cajamarca, to parallel Reichlen's ceramic sequence, is still lacking.

Some idea of the architectural tradition of the north highlands can be gained, however, from the buildings of Huamachuco,[67] about 40 miles distant from Cajamarca as the crow flies. The earliest people lived in hilltop villages of stone houses with rectangular rooms, arranged in casual order around open courts. Much later, the populace built a high-walled fortress called Marca Huamachuco. It was possibly contemporary with the later stages of Mochica history, to judge from the stone heads and reliefs collected by Uhle. The heads [68] wear helmets close to those of the Mochica styles. The reliefs show geometric reductions of organic forms recalling Tiahuanaco sculpture. The houses were long and narrow galleries, two or three storeys high, with the floors carried on corbels. The floorings have all vanished, and the walls themselves are ruined. The absence of doors and windows at ground level in some 'galleries' suggests that the entrances were on the upper floors, reached by ladders, which could be withdrawn in case of attack. These people used a style of cursive pottery painting on ring-base pots similar to that of Cajamarca III, as well as negative painting like that of the region around Recuay in the Ancash highland.[69] No trace of negative painting appears at Cajamarca, however, so that Huamachuco may be taken as a boundary between the highland traditions of Ancash and Cajamarca in pottery decoration.

About 2½ miles north of Huamachuco are the ruins of Viracochapampa (Figure 105), a grid-city laid out upon a square of about 580 by 565 m. (635 by 620 yards), with the sides facing the cardinal points. A road cuts straight through the city from north to south, and a central plaza, bordered by smaller courtyards, is the nucleus of the city. The rest of the city consists of courts surrounded on three sides by narrow gallery houses. The plan resembles the compounds at Chanchan. Plan and buildings resemble the garri-

son city called Pikillaqta (Plate 186), 20 miles south-east of Cuzco. Both usually pass as Inca settlements of the early sixteenth century, designed to concentrate the rural populations of the area under one central control. A case has been made for a date during the Huari domination, manifested by Viñaque pottery before 900.[70]

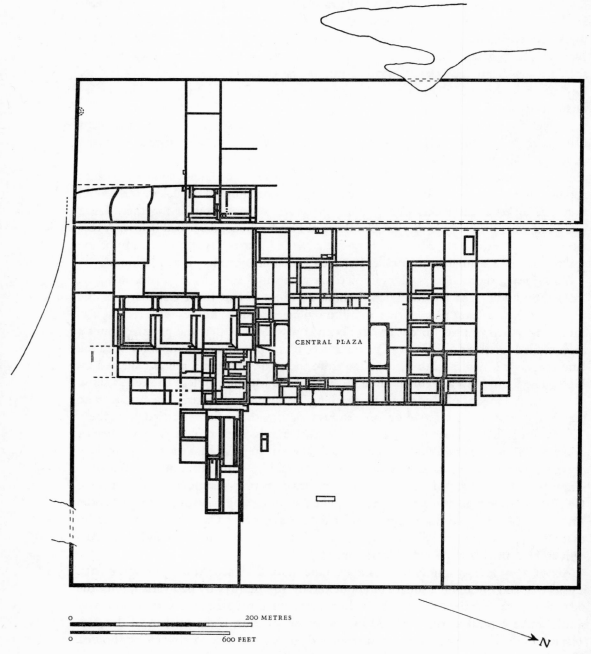

Figure 105. Viracochapampa. General plan c. 750–800

288

CENTRAL PERU

BEFORE the appearance of pottery in Peru, the central coast valleys were the scene of the earliest large ceremonial architecture now known in ancient America, built between 2000 and 1800 B.C. At Chuquitanta in the lower Chillón Valley, clay walls with stone facings formed a temple upon a mound, flanked by long wings, capable of housing a thousand persons.[1] In later periods, originality in the repertory of expressive forms is rare throughout the region between the Paramonga and Cañete Valleys. Whether on the coast or in the highlands, buildings and crafts resemble those of other regions, as if central Peru had been a receptacle for styles originating elsewhere. Thus examples both of the Paracas style and of a style related to Chavín occur at Playa Grande near Ancón in the same approximate stratum at the beginning of the sequence of the fine wares.[2] This intermediate position between powerful artistic radiations from north and south makes it difficult to identify a specific regional expression: perhaps central Peru became the natural meeting place for northern and southern traditions, constituting a limitrophic province rather than an autonomous artistic region. The exact boundary between northern and southern archaeological traditions was tentatively fixed by Stumer between the Rimac and Chillón Valleys just north of Lima.[3]

In any event, central Peruvian sites are important and large enough to warrant treatment in a separate chapter. Thus Pachacamac was a metropolitan centre, much like Lima during colonial and republican periods, although depending far less upon seaborne commerce than the viceregal capital. North of Lima the stylistic connexions of the coastal valleys point to Ancash and beyond. South of Lima, connexions are more common with the Tiahuanaco and Inca styles, that is, with the southern highlands.

FROM LIMA NORTH

The group of the northern valleys, from the Rimac to Huarmey, embraces about 160 miles of the Pacific Coast. Close to the beach, at Ancón and at Supe, 80 miles farther north, are large cemeteries and middens containing objects worked in the coastal Chavín style.[4] On both sites the early pottery is red or black, with the characteristic incised surfaces of Chavín art. There are stirrup spouts, and at Ancón and Supe the images include serpents, felines, and birds in the Chavín style. The aridity of these coastal cemeteries has preserved from decay some specimens of textiles (Figure 106) and woodcarving in this style. The buildings were simple dwellings with stone foundations, and no public edifices have been identified among these fishing folk[5] whose burial artifacts so closely reflect the early ceremonial customs of Ancash and Libertad much farther north.

Figure 106. Tapestry fragment representing a condor-feline
figure, from Supe, Chavín style, before 400 B.C. (?)

An elaborate public architecture first appears in the fourth century at Cerro Culebra near the mouth of the Chillón river. The original plan of this platform-pyramid was covered over with later constructions, but parts of the primitive painted facing have been exposed, to show 26 m. (85 feet) of fresco decoration in seven colours on a yellow clay ground, representing geometrized figures surrounded by serpent attributes and fish motifs. Two distinct grades of workmanship are evident. The style of the wall decoration resembles the pottery painting of Recuay in the Callejón de Huaylas, some 150 miles to the north-east,[6] and the ceramic associations also place Cerro Culebra in this same period, prior to A.D. 500.

Coeval with Cerro Culebra is the style designated as Lima. The type-site is Maranga, a great cluster of pyramidal platforms and graves lining the highway from Lima to Callao.[7] It is a ceremonial centre of Classic date, built before the intrusion of the Huari style. The stepped platforms are built of hand-made and mould-made rectangular adobe bricks, like the principal edifice at Moche on the north coast, with which the architecture of Maranga is probably contemporary.[8] Five phases have been identified in the history of Maranga. The earliest antedates the platforms, with many small adjoining rows of foundations. The second (coeval with the painted walls of Cerro Culebra) comprises early terrace constructions; the third has new construction separated from the earlier stages by a layer of ashes, and containing ceramic designs of interlocking positive and negative forms. These interlocking shapes relate both to the Recuay and the Nazca styles, allowing a date prior to A.D. 500. The fourth and fifth stages included many new buildings. Sherds of the Mochica as well as of Late Nazca style appear among the ruins of the fourth period.

In the fourth period, however, Maranga yielded place after 600 to a new urban centre in the Rimac Valley at Cajamarquilla,[9] 18 km. (11 miles) east of Lima. Here uncounted foundations of rooms and small courts have been found, enough to house thousands of families. They date from after 500. The pottery shows Nazca, Mochica, and Huari

traits. The site as a whole belongs without question to the group defined by R. Schaedel as 'Urban Elite Centers'. An earlier portion is built of hand-made adobes mixed with *tapia* walling; the later constructions under Inca domination have *tapia* walling mixed with moulded bricks.

The characteristic pottery of the earlier levels at Cajamarquilla, like that at Maranga, is also called Lima. It is often of fine orange paste decorated in six colours (white, grey, black, brown, red-violet, and yellow), and enriched with full-round sculptural forms. This combination of painted and sculptural shapes confers upon the best Lima pottery its singular quality (Plate 164). The products are more polychrome than those of the Mochica style, and more sculptural than those of the Nazca style. The vessel shapes derive from both traditions, but the standard forms are blurred, tending more to the rounded shapes and bases characteristic of south coast pottery. The long taper-ing spouts have a fragility and elongation that distinguish products of the Rimac Valley from all others. In general the affinities of this pottery are with south coast styles, as in the high frequency of pottery pan-pipes. Certain traits are decidedly foreign, like tripod or tetrapod vessels, which are Ecuadorean and Mesoamerican, but not typi-cally Peruvian, unless in the northern highlands around Cajamarca (p. 286).

That peculiar mixture of an independent artistic tradition with provincial derivations, and folk-art slovenliness, which characterizes the art of the valleys to the near north of Lima, is most clearly evident in late pottery from Chancay on the lower Pasamayo river, adjoining the Chillón river. At a period immediately before the Inca conquest, these Chancay potters ignored the moulded techniques of their Chimu contemporaries. They used globular shapes, with coarsely modelled sculptural increments at the neck, and low-slung carrying-loops (Plate 165).

The painted decoration varies by combining black, white, and red according to the white or red ground clays and slips.[10] The effect of casual workmanship arises in the pro-duction of easily recognizable types in large numbers, and recalls that of the modern pottery workshops in places like Pucará or Quinoa, where tens of thousands of pieces are produced each year for the market-places.

The upper valleys of the Chillón and Pasamayo rivers belong to Los Atabillos (or Cantamarca province), whence Pizarro took the title of his marquesate. The region is remarkable for walled cities of stone dwellings. They resemble the stone burial towers in the province of Collao near the shore of Lake Titicaca. Like the Aymara *chullpas* of the southern highlands, these *kullpi* houses are built of dry-laid boulders, with simple corbel-vaulted roofs (Figure 107). They differ from the southern examples in being genuine dwellings. There are two types.[11] Square and round towers with central columns sup-porting the vaults occur around Canta in the upper Chillón Valley. Farther north, in the Pasamayo Valley, 2800 m. (8900 feet) above sea level, at Chiprak and Añay, are larger dwellings with central corbel-vaulted halls surrounded by massive walls, honeycombed with storage chambers and small rooms. These houses resemble those of the Callejón de Huaylas, e.g. at Wilkawaín near Huaraz, where Bennett excavated gallery houses and a temple of storeyed construction, associated respectively with the ceramics of Recuay and Tiahuanaco.[12] The towers at Canta have no particular façades, and the central

columns are designed to support the corbelled roof, over plans as wide as 6·5 m. (21 feet). At Chiprak, however, the flat façades have a striking rhythmic decoration by narrow trapezoidal niches rising from ground to cornice level. These niches evoke the Inca habit of breaking the wall by trapezoidal recesses. They may correspond to a later date of construction than the Canta towers.

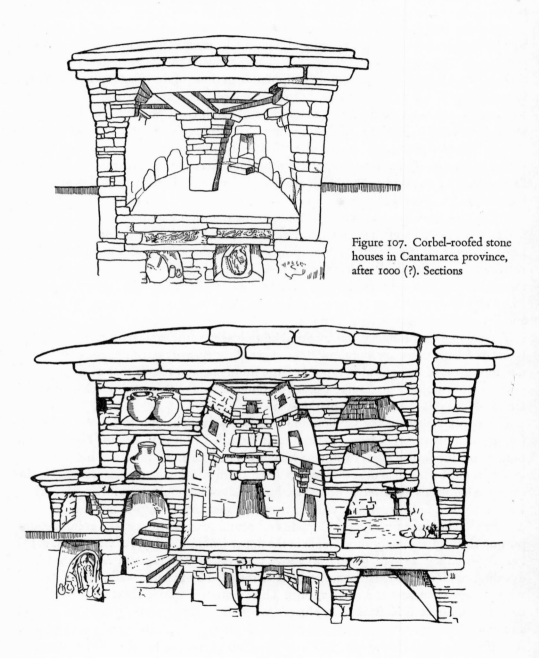

Figure 107. Corbel-roofed stone houses in Cantamarca province, after 1000 (?). Sections

SOUTH OF LIMA

The Lurín Valley empties into the Pacific among low hills about 20 miles south of Lima. Pachacamac stands on the north bank, covering an area of about 4 by 2 miles,[13] between the highway and the ocean. The principal buildings and streets obey a roughly regular plan which quarters the cardinal points (Figure 108). The south-western quadrant is a hill sheltering the city from the prevailing on-shore winds. It is crowned by an earthen platform traditionally called the Sun Temple. In the south-eastern quadrant another high hill rises, and the saddle between the hills is occupied by an older temple platform identified by Uhle as pertaining to the cult of the local deity, Pachacamac (Plate 166). Its oldest parts are coeval with the Mochica and Nazca civilizations.[14] The north-eastern quarter contains the oldest dwellings, and the north-west quadrant is dominated by a building of Inca date called the Nunnery (Mamacona), facing the Sun Temple across a colonnaded esplanade. The esplanade, unique in Peru, extends for about 330 yards on an axis from south-west to north-east. The combination of temple platforms with residential terraces and courts corresponds to the type of Chanchan.

Though smaller than the great 'urban elite centres' of the north coast, Pachacamac is the largest pre-Conquest city in central or southern Peru, and its architecture represents the southernmost occurrence of large assemblies of pyramidal platforms. Several colonial texts describe the buildings in some detail, and according to them the Inca Temple of the Sun was the one nearest the sea, and the highest one, painted red, and built of *tapia* in six stages. The Jesuit Bernabé Cobo,[15] writing before 1636, describes the building in great detail. His measurements coincide closely with those of Max Uhle,[16] and he saw the buildings in much better repair. The top terrace accommodated two parallel buildings, each 170 feet long by 75 feet wide, and 24 feet high, with deep niches on the north-west and south-east faces overlooking the surrounding prospects. They contained shrines and priests' dwellings, painted in various colours with figures of animals. Other buildings occupied the wide terraces on the second, third, and fourth stages. Some of these were recessed like caves into the high terrace risers.[17]

The south-western exposure was the principal façade, overlooking the ocean. Spanning the two uppermost buildings and facing the water was a colonnade on the penultimate terrace. Its roof was an extension of the topmost terrace floor. The main stairs, on the opposite or north-eastern face, with ten or twelve ramps of about twenty broad steps each, rose within the terrace faces. Strong's excavations established most of these details,[18] although he and his associates do not quote either Cobo's description or a manuscript plan by Josef Juan in the British Museum (Add. Ms. 17671), dated 1793, and showing substantially the arrangements described by Cobo. Strong also confirmed the Inca date of the entire outer construction. Underneath the north-eastern face, however, Strong uncovered burials of a much older period, containing pottery of the interlocking style and of the same approximate date as Recuay (p. 257) and Paracas. Similar sherds were found by Uhle at the other, lower platform structure associated with the cult of Pachacamac.

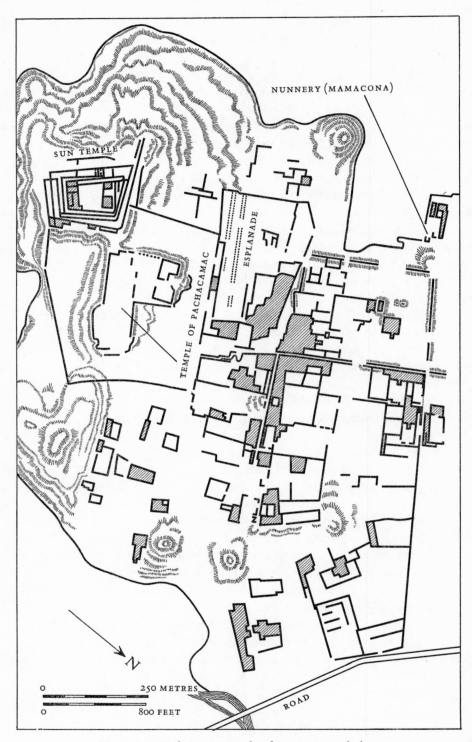

Figure 108. Pachacamac, mostly after 700. General plan

294

The temple of Pachacamac is a platform of many terraces covering a large rectangular area, much less high than the Sun Temple on the hilltop above it. Eight of these terraces, each no more than 3 feet high, rise on the northern face, painted with plants and animals in rose, yellow, blue-green, and blue-grey earth colours.[19] The ground colours were applied with large swabs of cotton cloth, and the figural designs were then brushed on. Small cotton bags containing the pigments, and brushes of reeds and human hair were found near the terraces in 1938. The black contour lines surrounding the figures were not the guiding sketch lines, but served to strengthen and define the figures in a final retouching, much as in Nazca pottery. The paintings were frequently redone, with as many as sixteen coats showing in certain spots. The top of the platform, like that of the Sun Temple, bore buildings surrounding a courtyard. As at the Sun Temple, the spatial arrangements included dwellings and temples in a loose and functional order.

Farther north is a system of large forecourts. Three parallel and double rows of supports show in the air photographs: at one time these colonnades must have supported simple roofs of matting for the shelter of pilgrims and merchants. At the extreme northwestern boundary of the site stands the imposing *tapia* building called the Nunnery. Its foundations, of many courses of beautifully regular pink masonry in the Cuzco style, have each stone fitted by friction to its neighbours. The general plan of these heavily restored chambers comprises a terraced courtyard opening to the south with a view of the temples and the sea. It recalls the Inca nunnery building on the island of Coati in Lake Titicaca.

The colonnaded platforms and esplanades are elements of striking originality. The importance of Pachacamac as a holy centre is attested by many early Spanish sources. Calancha speaks of shrines maintained by other groups at Pachacamac; burial near the temples was a privilege eagerly sought by members of the cult of Pachacamac, and pilgrims came to the shrines from all parts of Peru. But the textiles, wood-carvings, metal objects, and pottery in the tombs, though abundant and belonging to many periods in a history of two thousand years, lack the impress of any long-term patterning which we can identify as peculiar to this site.

Designs in cloth and on pottery, based on eagles stylized as at Tiahuanaco, became important during the eighth century on the central coast,[20] and are identified as the 'Pachacamac style'.

THE SOUTH COAST VALLEYS

POLYCHROME ceramics and bright-hued textiles characterize the southern regions of the central Andes as decisively as bichrome pottery and large urban groupings do the ancient civilizations of northern Peru. Such many-coloured vessels, and the textiles, were traditional products as early as the fifth century B.C. These southern regions extend from the Cañete Valley on the Pacific Coast of Peru, east and south to Bolivia, the north-west Argentine, and northern Chile. As in the rest of Peru, the important centres of artistic activity were either in the coastal valleys or in widely separated highland basins. In the south, too, the coastal peoples were under the rule of highland masters late in pre-Columbian history, much as in the north, so that the same division by coast and highland regions, and by early, middle, and late periods, is practical.

PARACAS AND NAZCA

Two river valleys sheltered the early civilizations of southern Peru (1400 B.C.–A.D. 540). The Ica river, which flows south to the coast through desert plateau country, is lined by the oldest known settlements on the south coast. Many remnants of these earliest urban societies were buried in graves on the distant wastes of the Paracas peninsula, isolated by deserts from both the Pisco and Ica river valleys. The other river is the Río Grande de Nazca, emptying into the Pacific some 20 miles south-east of the Ica estuary. Its upper course receives many confluents, separated by barren pampas and mountain ranges. Each of these upper valleys was settled by groups of people sharing the same culture, and flourishing much later than the earliest settlements in the Ica Valley. Students of the archaeology of this region are now agreed upon naming the older Ica culture after its great burial ground on the Paracas Peninsula, and the more recent one after its main habitat in the upper Nazca valley.

The whole chronological question is exceptionally complex because of the disparity between absolute dates given by radiocarbon measurements, and the different relative datings based upon typology alone. Andean C14 measurements made before 1960 dated an event like the coastal appearance of pottery seven centuries later than measurements made after 1960 in other laboratories. This 'long scale' is now in general use, but the chronologies themselves still are based more on stratigraphy and stylistic seriation than on radiocarbon.[1] The tendency, as in northern Peru, is to put in series a number of events which were actually contemporary, thereby turning regional variants into historical sequences.

On the Paracas peninsula, Tello recognized two periods, represented by the Cavernas burials and by the Necropolis burials (Plate 168, A and B). The latter occupied refuse

layers of older Cavernas dates. Cavernas and Necropolis therefore form a true sequence.[2] Absolute Paracas dates are more problematic. Early (Cavernas) and Late (Necropolis) stages perhaps overlapped. Tello's Paracas chronology has been displaced by one based on Paracas pottery style as found in the Ica Valley, yielding ten phases, each lasting one century (long-scale, 1400–400 B.C.). Phases 1–8 correlate with Chavín sculpture, and the tenth (fifth century B.C.) overlaps with Early Nazca pottery, but it includes a fine unpainted white ware called Topará, which remained dominant during Early Nazca (Plate 168B). Embroidered Necropolis textiles appear as late as the Early Nazca period,[3] in grave-areas at Cahuachi on the middle reach of the Río Grande de Nazca.[4] Thus Necropolis embroideries and Early Nazca pottery were coeval.

Another example of coeval groups is Strong's 'Middle Nazca' (336± 100 to 525± 80 by C14), which practically coincides with his 'Proto-Nazca' (325± 80 to 495± 80), when his seriation is related to short-scale radiocarbon dates.[5] The most recent paper to refine the stylistic sequence of Nazca art, by L. E. Dawson, proposes nine phases.[6] A seriation still in use is the original one proposed by Gayton and Kroeber in 1927.[7] They classed a large collection from the Nazca region on the assumption that simple shapes and designs (A), followed by a transition (X), preceded more elaborate ones (B), which in turn preceded (Y), a 'slovenly breakdown'. Their correlation of vessel shapes and painted designs (Plate 169, A and B) led them to propose a seriation of A, X, B, and Y styles. They at first divided the last of these into three phases, Y1, Y2, and Y3, and in a recent revision of the method Kroeber reaffirmed the sequence of A, B, and Y, with Tiahuanaco traits appearing in Y2. He abandoned Y3, whose components were reassigned to Nazca A, and he questioned the validity of a transitional X.

Carbon 14 dates, whether short- or long-scale, confirm the sequence of A and B, and they serve as chronological centres for the early and late phases of the Nazca style.[8] We are therefore given two stylistic groupings, called Paracas and Nazca, each with early and late stages. The late stage of Paracas (Necropolis) and the early stage of Nazca (A) overlap enough to justify considering the entire duration as a unit with early, middle, and late phases, of which the dominant expressions were pottery and textiles.[9]

Architecture

Before discussing these sculptural and pictorial systems, we must consider the architectural production of the peoples of the south coast valleys. There is no evidence that the Paracas peninsula was inhabited by the wealthy people who were buried there. Poor fishermen made a living on the beaches, but the rich burials were brought to this desolate site, perhaps from the Ica Valley, 55 miles away, and from the Chincha and Pisco Valleys, 20–25 miles distant. The Cavernas tombs adjoin the Necropolis. They are bottle-shaped excavations in a yellow slate-like rock. The nearby Necropolis tombs are chambered and rectangular constructions, built among the remnants and refuse of an earlier occupation of Cavernas type (Figure 109).

Of Late Paracas (Necropolis) dates are certain mounds in the Ica and Nazca Valleys.[10] One at Ocucaje in the Ica Valley is built of bundled reeds and rectangular adobe bricks

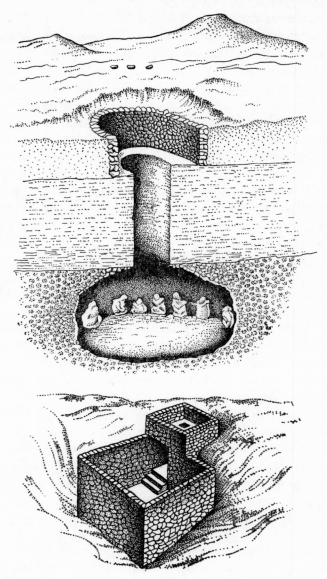

Figure 109. Paracas peninsula, underground burial structures
of Cavernas and Necropolis types, *c.* 200 B.C.

in a mammiform shape 50 m. (165 feet) in diameter and 4 m. (13 feet) high. Other remains of connected dwellings on rectangular plans at Cahuachi show post and wattle construction daubed with clay.

The most extensive Early Nazca ruins are at Cahuachi on the middle stretch of the Nazca river, where a pyramidal platform of wedge-shaped adobes 65 feet high, overlooking several clusters of rectangular rooms, rises upon a steep hillside. Other terraced

298

platforms rise north and east, some with conical, grooved adobes. None approaches the grandeur of north coast architectural remains. There is a peculiar wooden assembly at La Estaquería, near Cahuachi, of very late date (short-scale 1055±70 by c14), connected with Late Nazca and Early Tiahuanaco remains in the region. It consists of twelve rows of twenty upright tree-trunks, forked at the top and spaced 2 m. (6 feet) apart. The purpose of the monument is unknown. The arrangement resembles the regularly spaced stone piles in the deserts between the upper valleys of the Nazca drainage.[11] These in turn are part of an immense network of lines, stripes, spirals, and effigies, all executed on a colossal scale upon the barren table-lands above the Palpa and Ingenio rivers, in an area about 60 miles long and several miles wide (Plate 167). The weatherworn surface of small stones is dark, but the sand and gravel just underneath are much lighter in colour. The lines and stripes were formed by piling the dark surface stones along the sides of the exposure. Many straight lines strike across the plateau and rise without lateral deflection up precipitous slopes to vanish inexplicably, going between points of no particular distinction without any pretence of serving as paths or roads. Certain modular measurements recur: lengths of 26 m. and 182 m. (7 times 26) have been ascertained. Miss Maria Reiche, who has patiently plotted and computed the plans and their possible use as astronomical sighting-lines, finds that some mark solstitial and equinoctial points upon the horizon. Others may point to the rising and setting of certain stars, such as one in the constellation of Ursa Major, which coincided with the annual flood season in November at the beginning of the agricultural cycle. The stripes of expanding width may record intervals in the observations taken upon a given star.[12]

We can only guess at the methods used to plot these giant figures with such remarkable geometric regularity. Some scheme of enlarging the parts of a model design by fixed proportions has been supposed for the rectilinear portions. The large curved figures of plants and animals may have been constructed with the help of rectilinear guide-lines, of which faint traces remain here and there (Figure 110).

The function of the effigies is unknown, but their style is close to that of Early Nazca drawings. They represent a fish hooked upon a line, a spider, a bird in flight, a branching tree, all drawn at colossal size in continuous lines the width of a footpath. They may be images symbolic of the constellations. One may also imagine that their outlines served as processional paths for celebrants in rites of imitative or compulsive magic. Surely their 'drafting' required many generations of work, because the interlacing of successive lines and designs in some areas shows many layers in a dense grid of overlapping intersections that betray a constantly shifting design.

It is perhaps unexpected, but it is not improper, to call these lines, bands, and effigies a kind of architecture. They are clearly monumental, serving as an immovable reminder that here an important activity once occurred. They inscribe a human meaning upon the hostile wastes of nature, in a graphic record of a forgotten but once important ritual. They are an architecture of two-dimensional space, consecrated to human actions rather than to shelter, and recording a correspondence between the earth and the universe, like Teotihuacán or Moche, but without their gigantic masses. They are an architecture of diagram and relation, with the substance reduced to a minimum.[13]

Pottery

The south-coast peoples lacked writing in any form. Pottery painting and textile decoration therefore carried the burden of recorded communication. The climate, even more arid than on the north coast, and the elaborate burial customs are responsible for the extraordinary state of preservation of huge quantities of pottery and textiles recovered from Paracas and Nazca tombs. The pottery shapes all have rounded bases (Plate 169, A and B), quite unlike the ring bases and the flat basal planes of north-coast pottery. These globular bases indicate a domestic architecture with loosely packed, sandy floors, in which the rounded vessels easily stood upright. The shapes are much more variegated than in the Mochica culture. From the earliest period, the polychrome decoration stresses conceptual abstractions and combinations more than pictorial descriptions of the environment. The representation of action shared by several figures is totally lacking. There are no conventions for showing landscape or housing. The preference for complex colour relations also required a bold patterning by areas, precluding the refinements of draughtsmanship to which the Mochica potters were dedicated. In brief, the Mochica painters attained animation at the expense of colour, unlike their south-coast contemporaries, who secured polychromy at the expense of pictorial range. The principal topics for a discussion of south-coast pottery are shape, colour, design, composition, and iconography, which are of course the customary divisions required by the consideration of the art of painting.

The shapes of Paracas phases 1–8 afforded smoothly curved surfaces for incised and painted designs (Plate 168A). The effigies of heads, as of seated or standing persons, have slowly curving pear-shaped contours to permit clear linear incision of the principal details, as in the art of Chavín, where linear articulation of the design was also predominant. Necropolis or Late Paracas (Topará) shapes are more sculptural in abandoning linear and painted decoration and in the use of sharply angled contours and ribbed panels reproducing the shapes of gourds and squashes (Plate 168B). Early Nazca shapes once again favour the painter in avoiding vessel forms of extreme contour, and in providing large curved surfaces for the development of repeating or encircling figures (Plate 169A). Later Nazca shapes (Plate 169B) run to kettle forms as well as elongated vases and goblets of flaring or undulating contour. Modelling of human or animal features appears, and the decoration includes many bands and zones corresponding to the increased complexity of the vessel shape.

The history of the Nazca colouristic achievement can be reconstructed in part.[14] The earliest pottery prefiguring Nazca multi-coloured firing is the style of Cavernas on the Paracas peninsula. A variant is known from Ocucaje and Juan Pablo in the Ica Valley. The vessel forms are bowls, jars, and spouted containers. They are decorated with patches of a powdery pigment of bright, high-key earth colours applied after firing (Plate 168A). This method of colouring the incised designs is called 'crusting'; it appears only on sites belonging to the Paracas style, sometimes in conjunction with resist (or 'negative') painting, such as we have seen in the Ancash series. Occasionally the incised

and coloured designs resemble Chavín forms, but these connexions with the north are infrequent. They suggest a date equivalent to Salinar in the Chicama Valley, because of their association with vessels of a globular form surmounted by a pottery handle connecting the tubular spout with a modelled head.[15]

From the earliest phases of the Paracas pottery, post-firing or 'crusting' continued intermittently, but with more colours, of a heavy resinous consistency, in large patches separated by incisions cut deeply into the polished clay. Resist-painting appears alone, no longer joined with crusting on the same vessels. Another Late Paracas type is rare – a white or orange, slipped, and polished pottery of gourd and vegetable shapes, associated with the Topará Valley, but most common in the Chincha and Pisco Valleys (Plate 168B). It occurs in diminishing quantities farther south, at Ocucaje in Ica, and Cahuachi in the Nazca Valley. Upon white or solid-colour grounds, the Nazca potters gradually learned to fire the paint in as many as twelve colours, attaining polychrome effects more varied and more brilliant than those of all other ancient American vessels.[16] Like the painting of other pre-Columbian peoples, however, Nazca colour rarely imitates appearances, being restricted to symbolic conventions for abstract ideas by means of solid and ungraded tones. Shadows or modelling are therefore absent from Nazca practice.

The stages of the development have been seriated by Strong.[17] As we have seen, the radiocarbon dates still do not allow a sharp chronological separation of Strong's Proto-Nazca, Early Nazca, and Middle Nazca 'periods', which may be regional variants of the same experimental tendency towards fired colouring of wide variety. They are readily treated together as the components of the Nazca A style (Plate 169A). In Strong's Proto-Nazca collections from Cahuachi, fired colours up to six in number are painted over incised outlines. The attainment of brushed colour without incised boundaries characterizes Strong's Early Nazca. His Middle Nazca has cream-white or red backgrounds bearing fine-line brushed designs which surround boldly contrasted areas of local colour. The ground and the design are clearly separate, and roughly equivalent in area. 'Early Nazca' is cruder than either Proto-Nazca or Middle Nazca, which may well be coeval. Middle Nazca in any case is the climactic achievement, with large and eloquent forms from nature curving round the vessels as integral shapes in simple, clear outline, painted in many colours of fired slip and burnished to a high polish. In museums this polish is often enhanced by modern waxing, which simulates the original brilliance lost during many centuries of interment beneath alkaline sands. Late Nazca colour is even more variegated, with the surfaces broken into many small areas of repeating forms, usually in a high key and in several registers (Plate 169B). White grounds are more common than before, and the number of six-colour designs is greater.[18]

Effigy vessels and figurines representing men and women form an important part of the Late Nazca style. Only the main contours of head, torso, and legs are modelled: all other features are painted in a conventional manner precluding all individuality. The main variations appear in proportions and in the painted symbols on the bodies.[19]

Paracas and Nazca designers from the beginning relied upon line, whether incised or painted, more to separate areas of colours than to circumscribe them. Unlike Mochica

line, which is cursive and mobile, Nazca line is passive because it merely surrounds other modes of describing, without itself having active properties, such as variable thickness, or conventions of foreshortening in curving and tapering contours. Nazca colour relations probably came first in the designer's mind. He executed them with slip clays in several tints. Thus a vessel with adjacent and overlying areas of magenta, rust, white, grey, and red would be finished in black outlines separating the adjoining areas. In this technique, the line is merely cosmetic, serving to define the principal colour relations, and contributing little to their fundamental order. Early Paracas potters incised these separating boundaries; Nazca potters painted them with some sort of stylus, perhaps a thorn or a quill, avoiding any variation of thickness in the same contour. Early Nazca vessels rely less upon linear definition than Late Nazca, where the broken and active forms required a more energetic line than the large, closed shapes of the earlier manner (Plate 169, A and B).

Composition is the orderly arrangement of images and signs. Special problems arise in composing the curved surfaces of pottery, because optical space must be adapted to the surfaces of spherical and cylindrical containers. Repetitious order approaches decoration. Heterogeneous order approaches pictorial form in the case of images, and writing in the case of signs standing for ideas. Whether a composition be repetitious or heterogeneous, its frame on a pottery vessel is never so completely defined as on flat surfaces. A repeating order re-enters itself, and a heterogeneous order has no lateral boundaries, because of the geometry of vessels, which consists of globes, cylinders, cones, and combinations of curved surfaces.

The oldest south-coast vessels from the Paracas burials, however, escape these conditions because their makers were more interested in sculptural representations than in painted ones. Some vessels have repeating geometric designs, and a few others have repeating compositions based upon forms seen in nature, but many Cavernas vessels are effigies, or bear natural forms, which combine sculptural representation of the heads with painted and incised representations of the bodies. These are split in two to decorate front and rear faces of the same vessel. This sculptural propensity continued in Necropolis wares, with modelled representations of fruit and squashes, of birds and frogs, without any painted modifications whatever.[20]

Hence the emergence of a painted style in Nazca pottery shows a complete transformation in compositional habits, from geometric designs and sculptural increments to schemes of repeating images and pictorial compounds. In the Early Nazca style, the images tend to be repeated, with a few large reiterations of almost ideographic forms, stylized to the point of generic images without individual characteristics (Plate 169A). Later on, a single form such as the 'jagged-staff demon'[21] is enlarged by annexes, extensions, reduplications, and other proliferations all contained within a single organic outline, and occupying the entire surface (Plate 169B). Repetitious order of course continued, but the themes became smaller and more cursive, with details omitted in the interest of lively surface patterns. Moving figures, such as running human beings, are represented. The number of sculptural forms increased, with effigy vessels and modelled increments returning to fashion. These considerations of compositional technique bring

us directly to the question of the meaning of the images on Nazca pottery, that is the problem of iconography.

The principal motifs are anthropomorphic. The most common image represents an elaborately dressed human being, burdened with animal attributes (Plate 172A). Symbols of feline origin predominate, such as a whiskered mouth. Examples of beaten gold appear in the mummy bundles. Other attributes of feline character are spotted fur, and rings on the paws and tail. The Nazca representations of felines differ from those in Cavernas pottery of Chavín style: there the tusk-like incisor teeth were the principal mark of feline nature, but in Nazca iconography the whiskered mouth is its main symbol.[22]

Other important themes (Plates 171 and 172B and Figures 110 and 111) are representations of the killer-whale (*Orca gladiator*) and of predatory birds, such as the falcon (*Pandion haliaetus*). Severed trophy heads and many plants and weapons enrich the repertory. Female figures are common in the middle and late style both in full-figure effigies and in painted representations of faces alone.

There are no texts to aid the interpretation of these motifs. All modern efforts to explain them proceed from the classification of the themes, and from analogies with unrelated cultures where ethnographical explanations have been collected. Thus E. Seler, who first listed the motifs, identified them as demons; the feline figure was a divine provider of food; the cat-demon with human or bird attributes represented the souls of the dead; and other figures were 'vegetation-demons' or 'jagged-staff demons' of uncertain powers, composed of cactus-like branches and spines.[23] In the absence of written sources, however, the conventional meanings of these forms cannot be certainly known, and all that we can hope to do is to establish their intrinsic meaning.

It is probable that the compositions convey relationships among ideas rather than among things. Unlike the Mochica painter, who delineated the lively image of a running man as the eye sees him, the Nazca artist painted the idea of swiftness by joining the images of arrows and killer-whale fins (Figure 111A, B). As in the art of Chavín, many of these forms and their abbreviations were interchangeable. The eye-markings of certain falcon species are used to adorn human eyes. The serrated mouth and the dorsal fin of the killer-whale likewise enter a variety of contexts (Figure 111). In principle, any part of an animal form may be invaded by images of parts drawn from other species. A falcon's body has human trophy heads on the neck, on the back, and on the tail. Each feather is a simplified trophy head, with eyes and mouth shown as dots on the rounded feather tips. In the cat's whisker motif, each hair is likewise a trophy head. In Figure 111A the back outline of the falcon has pointed serrations, a repetitious shorthand for the dorsal fin of the killer-whale.

Such processes of composition are more verbal than visual: they resemble the metaphor. The killer-whale is swift, and so is the falcon. Since both are swift, parts of either may stand for the idea of swiftness. The killer-whale therefore has a dorsal fin like a feather (Figure 111). Elsewhere arrows are substituted for feathers: the idea of sharpness also permits knives to stand for arrows, or for fins. Both felines and hunters are predators, and may therefore wear trophy heads and whiskers.

Figure 110. Ground drawings, possibly processional paths, outlining a bird and a monkey, Early Nazca style (?), Nazca river drainage, after 200 B.C. (?).

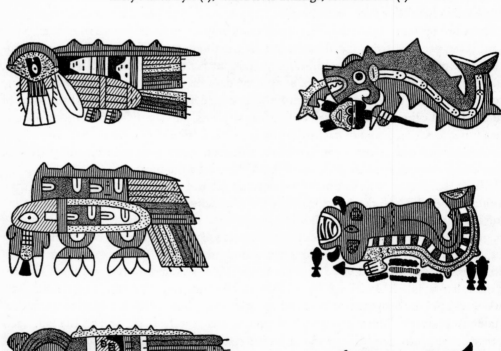

Figure 111 (A). Bird designs with killer-whale
and trophy head substitutions,
Late Nazca style, 200–500 (?).
Lima, Museo Nacional

Figure 111 (B). Killer-whale design with
feathers and trophy head substitutions,
Late Nazca style, 200–500 (?).
Lima, Museo Nacional

These metaphoric associations suggest an intricate ritual of sympathetic and imitative magic. The human being assumes the special faculties of admired animals by wearing their attributes. His vision will be as sharp as the falcon's if his eyes are painted with the falcon's markings. His success as a fisherman will increase if he wears killer-whale attributes. In addition, the puma, the falcon, and the killer-whale were all surely deities, worshipped by impersonators wearing the divine markings.

Individual beings and individual events are never represented. The paintings show actions outside the time of real happening with its infinite number of accidents. The repertory is more various than in the art of Chavín, and it is less specific than in Mochica painting.

Textiles

The south-coast weaves of Peru have few parallels anywhere in the world for fineness and intricacy. Not only is the preservation remarkable, owing to the extreme aridity of the climate, but some Peruvian cloth is older than 3000 B.C. in the coastal valleys. In Chicama Valley, at Huaca Prieta, Junius Bird excavated twined cotton fabrics with geometric designs of interlocked birds, animals, and humans, dated by radiocarbon as of about 2000 B.C.[24] Analogous embroidered textiles in the distinctive rectilinear and curvilinear style of Paracas–Nazca design occur in the Cavernas, Necropolis, and Early Nazca periods, spanning perhaps a thousand years, from 1000 B.C. The complete range of Late Nazca textile decoration has so far not been identified.[25]

Certain formal and technical conditions of textile art need to be mentioned before we discuss the history of Paracas and Nazca fabrics. Because the woven support for the design is flexible, meant to be worn as clothing in unforeseen folds and overlappings, textile designers are always reluctant to cover the surface with large pictorial compositions which are visible only when stretched out, as could be done in tapestries. Far more appropriate for clothing are small-figure designs of geometric character, spaced in repeating patterns so that one visible portion suggests and recalls all the portions concealed by the folds of the cloth. The technical requirements of the loom further restrict the designer: large curvilinear forms are generally restricted to embroidery. The weaver must resolve all curves into the rectangular co-ordinates of warp and weft. An escape from the requirements of the loom is given only by additive techniques imposed upon the finished cloth, such as embroidery and certain brocades.

The chronology is incomplete, but it parallels the ceramic history of the region, in the sequence of Cavernas and Necropolis–Nazca A. No earlier stages are known, and the Cavernas weavers already possessed a fully developed knowledge of spinning both cotton and wool, as well as of dyeing and all the principal loom techniques.[26] The use of wool wefts in the earliest period proves commerce with the highlands, because the wool-bearing animals of Peru (llama, alpaca, and vicuña) cannot survive in the coastal climate. The loom (known before 1500 B.C.) was of simple backstrap construction with heddles to lift the warp threads. The weight of the weaver against the backstrap controlled the tension of the warps. With this simple equipment the weavers produced

cloths of extraordinary sizes. A plain-weave cotton cloth found by Strong at Cahuachi measured 7 m. (23 feet) in width and 50–60 m. (160–200 feet) in length, all apparently one single piece.[27]

The construction of these textiles shows distinct historical changes relating to taste more than to invention. Plain cotton weaves, some with interlocking warps and wefts, characterized the Paracas cloths on both Cavernas and Necropolis sites. Embroidered decoration in stem stitch on a plain cloth base was the technique preferred by the makers of Necropolis and Early Nazca textiles. Tapestry technique (more weft than warp, and weft completely concealing the warp) is rare. Twills are known from Ocucaje. Double cloths (reversible fabric woven on two sets of warp) occur in the Cavernas tombs. Floating warp patterns, which require expert control, and gauzes (weft passed through twisted warps) are further evidence of the maturity of weaving in the earliest known south-coast period.

Cavernas colours number only about ten or twelve clustering around brown, red, yellow-orange, blue-green,[28] and the natural whites of wool and cotton. Grey was achieved by spinning brown and cream fibres together. The total effect was far less brilliant than in Necropolis and Nazca embroideries, where some 190 hues were used, with the dark colours numbering about two-thirds of the total. They were used in variations of local tone on repeating figures of identical contour and varying direction. These regular chromatic sequences were saved from monotony by frequent inversions and changes of rhythm[29] in the hue, intensity, and value of the repeating fields of colour. A mantle, for instance, displays perhaps a hundred repeating figures, divided into several distinct sections of surface pattern carried by colour alone (Figure 112). The patterned colour sequence in each section may follow straight or broken courses. Sometimes the sequence reverses in a given course, or an expected sequence is invaded by a rhythm from another sequence in a separate section. These variations of shape, direction, and colour are comparable to the movements of a musical composition.

To grasp so many variations simultaneously is impossible: our eyes can hold the sequence of only two or three at once, although the weavers and the users of these fabrics were probably accustomed to retain many more in a process not unlike our habituation to polyphonic music. Paracas embroideries cannot properly be called pictures, because pictorial composition implies the arrangement of diverse images upon a field in an order manifesting some unity. In Paracas embroidery, repeating shapes compose not a picture, but a decoration approaching musical form.

Most knowledge about Paracas embroideries comes from the collection excavated by J. C. Tello at Cerro Colorado on the sandy peninsula in 1925, some 11 miles south of Pisco Harbour. Tello transferred 429 mummy bundles from the 'Necropolis' burials to the Archaeological Museum in Lima. A few have been opened and studied.[30] From the published accounts it is clear that at least four stylistic groups can be isolated.

Rectilinear only (Plate 170):

　　1. Plectogenic shapes, woven, embroidered, or painted, Cavernas and Ocucaje.

Dimorphic (both rectilinear and curvilinear):

 2. Static anthropomorphic and animal figures of simple contour. Bundles 217 (Figure 112), 421, and sampler, Museum of Primitive Art, New York.

 3. Animated figures rendered by overlapping planes (Figure 114). Bundles 157, 382.

Curvilinear only:

 4. Contorted figures; indented contours; prominent attributes in costume and on tentacles (Plates 171 and 172B and Figure 115). Bundles 290, 378, 318, 319, 451.

Group 1, earliest by type, is a plectogenic style as old as Huaca Prieta (2500–1500 B.C.), imitating the structural limitations of loom technique in embroidery and in painted cloths (Plate 170). The textiles of the Cavernas period all bear plectogenic decoration. It

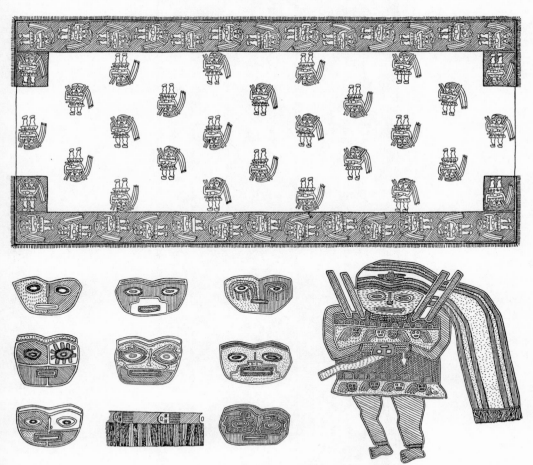

Figure 112. Embroidered Paracas mantle and details of recurrent design, Mummy 217, from Necropolis, before 200 B.C. *Lima, Museo Nacional*

307

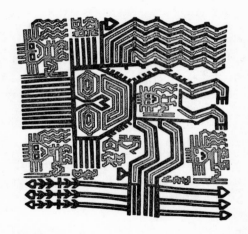

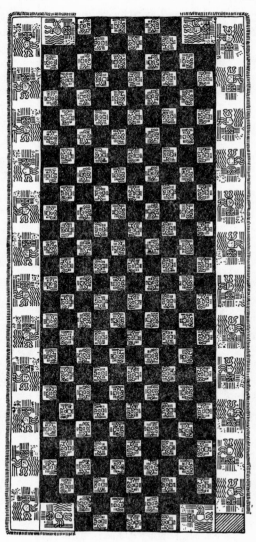

Figure 113. Embroidered Paracas mantle and enlargement of rectilinear motif, Mummy 217, from Necropolis, before 200 B.C. *Lima, Museo Nacional*

consists of straight portions of horizontal, vertical, and diagonal lines, without curved portions of any sort. This totally rectilinear manner continued into the Necropolis period, where it coexisted with the simpler styles of embroidered curvilinear ornament.[31] It may have disappeared in the more ornate textile assemblages of later date.

The rectilinear mode is categorically different from the freehand curvilinear style. It has different objectives; it forms a separate tradition, and attains effects impossible in the curvilinear style. The curved-line style is pictorial. It represents opaque bodies in an effort to reproduce retinal images, by overlapping planes and monotone forms of solid colour (Figure 112). It derives from pottery painting and from painting on cloth. The plectogenic style is ideographic rather than pictorial. Its forms occupy all the available space with networks of parallel contour lines. Inside and around itself, the main theme repeats on a smaller scale. The bodies are like transparent containers to admit these echoing recalls (Figure 113).

The loom-determined limitation to rectilinear portions of line originally required a numerical formulation of the weaving process, with the operator trained to follow or memorize a complex series of motions in sequence. The transfer of plectogenic forms to embroidery and painting gave the designer greater freedom to improvise, but he retained the rectilinear mode probably because of its ideographic tradition, which permitted kinds of statement impossible with a pictorial system based upon visual effect.[32]

In groups 2 and 3, both modes of design were in use. Bundle 217 contained a cloth with rectilinear and curvilinear styles. The sources of the freehand pictorial style are preserved in a few painted cloths,[33] of which one in Cleveland (27 by 8 inches) portrays five humans dressed in animal skins and brandishing knives and trophy heads (Plate 172A). The details are rendered with a firm, descriptive line of which the embroideries give us a distant reflection.

Yacovleff and Muelle thought that the embroiderers failed to comprehend or to reproduce faithfully the designs of the Nazca ceramic repertory. Such paintings as the Norweb cloth make it evident that even the potters owed their craft to this art of painting on cloth, of which the rare fragments give us only a tantalizing glimpse. Actually, the border of the Cleveland mantle fits best with our group 4, because of the enormous tentacle-like tails, tongues, and antennae, which compose an undulating rhythm. The early embroiderers usually portrayed only one theme per cloth, in many repeats, without variation in contour (Figures 112 and 113).[34]

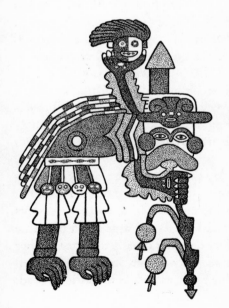

Figure 114. Detail of Paracas embroidery with overlapping planes, Necropolis style, before 200 B.C. *Lima, Museo Nacional*

On the embroidered garments in group 2 (Figure 112) each figure is clearly and simply

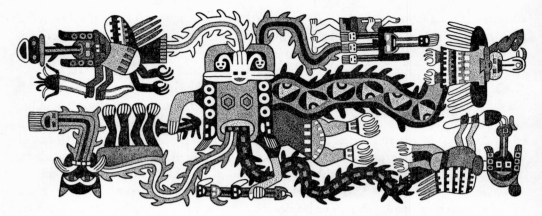

Figure 115. Details of Paracas embroideries with tentacled extensions, Necropolis style, before 200 B.C. *Lima, Museo Nacional*

presented, with the legs in profile and the head and torso in frontal view. The colour fields are few. The poses are stiff and awkward, like the heraldic faces in a pack of cards, stating their message boldly and unequivocally.

Our group 3 displays more animated contours. A variety of overlapping planes establishes the bodies in visual space (Figure 114). At the same time, the attributes are more numerous, and their interaction with the organic figures destroys its plausibility.

Group 4 differs from the simpler modes in deeply indented figural outlines, with the appendages treated as tentacles, to which the figure itself is an accessory (Figure 115). The multiplication and compounding of attributes becomes ideographic and ambiguous. Thus the eyes of a human being serve simultaneously as the eyes of the killer-whale in two head-dress decorations (Plates 171 and 172B). These killer-whale forms also allow the figure to be read as a diving personage when it is seen upside down. Other attributes repeat and multiply with organic connexions in every cranny and division of the design. Both the inverting figures and the self-extending designs strongly recall the tautologous compositional devices of a late stage in the art of Chavín, as in the Raimondi Monolith (Plate 151).

The Paracas and Early Nazca embroiderers[35] had less thematic variety, and less consistency in the rules of combination, than their pottery-painting contemporaries. Attributes and figural types are more freely compounded in the embroideries, so that elements which do not concur in pottery (e.g. killer-whale and bird forms) appear on the same figure in certain embroideries. The Paracas embroidery designer usually departed farther from the visual image in his search for rhythmic variation by colour, and he represented fewer themes. Most of the varieties of fish and marine birds, as well as the shrimp, toad, lizard, fox, and rodent and the partridges and swifts of Nazca pottery, are absent in the embroideries. As Yacovleff and Muelle observed in their brilliant essay on Paracas art,[36] the potters held the lead, and the embroiderers were derivative in the creation and exploration of the south-coast pictorial tradition.

THE END OF NAZCA ART

The Middle Horizon (c. 600–1000)

The replacement of the Nazca style by a style of highland origin, based upon a few angular and ideographic figures, was as abrupt and decisive in the south-coast valleys as in central or northern Peru.[37] The place of origin and the nature of the diffusion of this remarkable pictorial art, which is more like a language than like a style bound to time and place, are still obscure. Most authorities view the art as originating at Tiahuanaco in Bolivia, and as an expression of a religious cult with high attractive power. Others regard Huari in the Mantaro basin as more central, and they ascribe the diffusion to military expansion by highland tribes. The initial appearance was abrupt at every place concerned, followed by a slow degradation of the highland forms towards more schematic and cursive ciphers.

The earliest intrusion of the Huari style upon the disintegrating Nazca tradition of the coastal valleys was on the Pacheco site near the city of Nazca. Here Tello in 1927 found nearly three tons of polychrome sherds, which could be restored to make entire vessels. There were twenty gigantic tubs or *tinajones* of various shapes, and a hundred vases with full-scale human faces modelled on the constricted necks, as well as three large llama-figure vessels. Several of the largest tubs are inverted bell shapes, containing 120 litres (26 gallons), and measuring 64 cm. (25 inches) in height and 75 cm. (30 inches) across the top, with walls nearly 5 cm. (2 inches) thick (Plate 174B). Others are flaring cylinders of the Classic Tiahuanaco *kero* (cup) shape, 50 cm. (20 inches) across the top, 35 cm. (14 inches) at the base, and about 60 cm. (2 feet) in height, with a capacity of 50 litres (11 gallons). The bottoms are all flat, unlike those of the vessels of the Nazca tradition. It is likely that this immense deposit of pottery was for ceremonial use, and that it was all smashed intentionally in some episode of unrest.

The painted forms are of two kinds, uniting the Nazca and Tiahuanaco traditions: plants of curving outline in a free descriptive intention, and geometric human figures with rectilinear outlines and ideographic features.[38] The pictures of plants, shown in light tones on a dark ground, represent highland species of vegetables, tubers, and cereals. Each plant appears complete with roots or tubers, blossoms, leaves, and edible portions depicted as clearly as in an early European botanical woodcut. The style, however, is Nazca in the exaggeration of distinctive traits.[39]

The ideographic figures have square faces from which tentacles radiate (Plate 174B), bearing heads of fishes, birds, and pumas, as well as stylized fruit and flowers. Their close resemblance to the central sun-gate relief at Tiahuanaco makes it likely that both representations signify the same thing. No text exists to allow an identification. Both belong to the same figural tradition, which probably originated in textile design, and which also may have spread by commerce in textiles. The net effect of the Pacheco *tinajones* suggests a message of religious and agricultural content, as if to connect the worship of the square-faced Tiahuanaco deity with certain highland food plants.

The modelled faces on the necks of the large jars (Plate 174A) are among the most commanding examples of ancient Andean sculpture, resembling archaic Greek heads in the geometrically governed regularity of their proportions. On the surfaces a network of polychrome slip in geometric figures reinforces the impression that some mathematical order underlies this art, which Menzel connects with the style of Chakipampa near Huari. Other vessels are double containers, with an effigy connected by a short tube to a cylindrical cup. Large single effigies of standing or seated llamas again indicate the highland origin of the whole style. Certainly contemporary with the Pacheco style are the fine tapestries in the Tiahuanaco style of which some are found in museums, often with provenances pointing to south coast valleys (Plate 173). Their forms are those of Classic highland Tiahuanaco art in stone and in pottery, frequently subjected to extreme geometric deformation, especially by lengthening the design in one direction but not in the other.

Menzel estimates this first period of the 'Middle Horizon' as lasting only about fifty years. Local derivations and adaptations (e.g., Viñaque style of Huari appearing in Atarco style in the Nazca Valley) followed in the seventh and eighth centuries, with the centre shifting from Nazca to the Ica Valley. These derivations became progressively coarser. The Nazca style components disappeared completely as the shapes and colours became more and more debased. The Pacheco style probably heralded the cultural subordination of the south-coast valleys to highland masters: thereafter, provincial slovenliness spread until the emergence of a new local style in the Ica Valley.[40]

In the Ica style, after the tenth century, rounded vessel vases returned to fashion. The painted decoration consists of textile imitations or transfers, depicting birds or fish in black, white, and red dots and bars as if in woven technique (Plate 175A). Some curvilinear feline and bird shapes retain a distant connexion with antecedents at Huari and Pachacamac. Carved and painted wooden agricultural tools of ceremonial form are another characteristic Ica Valley product during these centuries. The outlines are carved with rows of men or birds, and a panel of pierced work in geometric rows, like those of the pottery, usually forms the head (Plate 175B).[41] The Ica style preceded the Inca conquest of the south coast, and it probably corresponds to a period up to the fifteenth century, when the valleys of Cañete, Chincha, and Pisco each had independent tribal rule, and engaged in hostilities against each other without much knowledge of conditions elsewhere in Peru.[42]

Under Inca rule in the fifteenth and sixteenth centuries, the Nazca and Ica Valleys were relegated to an even lower provincial rank than in the preceding period. The centre of regional administration shifted to the Pisco, Chincha, and Cañete Valleys, where the most imposing buildings of the late period were built. Other than these edifices, there are few works of art to consider here. The Chincha Valley was perhaps the centre of government in the region: the Pisco Valley probably afforded an avenue of communication with the Mantaro basin and the provinces surrounding Ayacucho; and the Cañete Valley was the coastal link to the central coast settlements.

The buildings are massive piles of adobe clay in brick or *tapia* construction. Certain groups of early date, like the Huaca de Alvarado in the Chincha Valley, are built of

ball adobes of Paracas date. La Centinela in the Chincha Valley has a terraced platform of *tapia* rising 100 feet above the valley floor, and built in the late pre-Inca style. A palace at its south-western corner drops away in several terraces to the plain, with courts and halls as well as galleries and esplanades, all of Inca date, and built of rectangular adobes.[43] In the Pisco Valley, Tambo Colorado is the best-preserved adobe building of Inca date in existence (Plate 176). The main compound has a courtyard with buildings of large flat adobe bricks on terraced levels around it. The walls have storage niches painted red, yellow, and white. It was probably an inn, with storehouses, barracks, and administrative quarters. This architectural tradition of buildings round closed-corner courtyards, in massive adobe construction and with niched walls, probably originated on the central coast, where the oldest buildings of this type are of Middle Horizon date, before the tenth century, combining highland requirements with coastal materials and construction habits in a prefiguration of Inca state control under Huari domination.

CHAPTER 16

THE SOUTH HIGHLANDS

THE principal urban centres in the southern highlands occupy three major basins: the region called the *altiplano*, surrounding Lake Titicaca at the boundary between Peru and Bolivia; the region from Ayacucho to Jauja in the Mantaro river valley basin; and the Cuzco region near the headwaters of the Urubamba river. The basin of Lake Titicaca supported early civilizations at Pucará and at Tiahuanaco from about 500 B.C. until after A.D. 500. Thereafter the style of Tiahuanaco spread to the Mantaro Valley and to the Cuzco region. A style like that of the Mantaro phase eventually appeared in the south coastal valleys beginning, as we have seen, about A.D. 600 in the Pacheco ceramics of the Nazca Valley. The terminal stage of pre-Columbian history in the Andes was dominated in the fifteenth century by the territorial expansion of the Inca dynasty from Cuzco through the entire central Andes and into Chile, north-western Argentina, and Ecuador.

THE EARLY ALTIPLANO

The plateau round Lake Titicaca (3812 m.; 12,500 feet) very early provided a subsistence for hunting folk and for pastoral peoples. Some pottery at Chiripa was being made before 1300 B.C. The vicuña, llama, and alpaca supplied wool for textiles. The llama was probably domesticated here as the only native American beast of burden. Certain food plants such as potatoes, quinoa, and oca were also probably first domesticated here. The lake itself provided reeds for mats and boats, and fish for food. The surrounding mountains contain immense deposits of free metallic gold and copper, as well as silver, tin, and mercury ores for use by early metalworkers. An acclimatized people could easily achieve many fundamentals of civilization in this cold, treeless, and tundra-like country, but its limitations would eventually require the *altiplano* dwellers to expand to warmer climates either by commerce or by conquest.

Bennett demonstrated the lack of cultural unity in the basin when he divided it on archaeological evidence into six distinct provinces.[1] Under Inca domination the region was united politically, but even then four groups speaking different dialects of Aymara still occupied the basin. During antiquity, before A.D. 500, distinct northern and southern Titicaca styles are apparent, centred respectively at Pucará and at Tiahuanaco. It was long believed that the two styles were contemporaneous, until radiocarbon datings showed that the Pucará style flourished from after 500 to the first century B.C., or several centuries before the Tiahuanaco style and before Huari.[2]

The Pucará site has monumental architecture of which only the foundations of red sandstone slabs survive. They form a C-shaped enclosure of irregular radial chambers

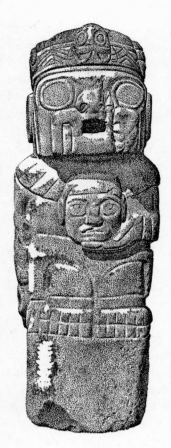

Figure 116. Pucará, stone
pedestal figure holding
trophy head, first
century B.C. (?)

entered from within the curve, each containing one or
two altar slabs. A sunken square court in the centre had
a tomb chamber built of stone slabs in the middle of
each face.[3] Above the dressed stone foundations, the
now-vanished walls were of adobe clay, bearing thatched
roofs. The stones of the wall bases are smoothly dressed,
but they lack the channels for metal cramps and the
other complicated stone joints that characterize the
Tiahuanaco masonry of a later period.

The figural art of the Pucará region is distinctive, but
uneven in quality and variegated in technique. It is easily
recognized by rounded body forms (Figure 116), unlike
the cubical shapes of Tiahuanaco style, by stylized figures
of edible freshwater fish called *suche*,[4] and by panelled
flat reliefs of symmetrical volutes and zigzag lines carved
in shallow relief on standing slabs like stelae. Some
figures found at Pucará clearly belong to a later Tiahu-
anaco style, and others at nearby Caluyu may well re-
present an early stage in the history of the style.

The ceramic sequence for the northern half of the
Titicaca basin, though still incomplete, shows Pucará
preceding Tiahuanaco, and overlying an early ceramic
style found at Caluyu. A radiocarbon date of 500 B.C.
for the Caluyu pottery found near Pucará established
its position. This pottery, decorated either by incision or
in painted geometric designs of red or brown on cream,
recurs near Ayaviri, upstream from Pucará, and around
Sicuani, halfway to Cuzco.[5] It is contemporary with the
earliest pottery from Chiripa near the southern shore of
Lake Titicaca, where stone houses surrounding a sunken court, as at Pucará, also occur.[6]

The fully developed Pucará style of ceramic decoration (Plate 177) is of the first cen-
tury B.C. by radiocarbon dating, and it is related to Pucará sculpture in the forms of
representation. Modelled feline and human heads decorate a variety of vessels, further
adorned by incised designs painted in black and yellow on a polished red slip. Only
sherds are preserved, but the vessel shapes, the technique, and the designs stand to the
Tiahuanaco style in much the same relation as Cavernas to Nazca pottery, displaying
the same kind of progression from modelled and incised polychromy to a style depen-
dent upon painted effects alone. It is true that Pucará depictions (Figure 116) are curvi-
linear on rounded planes,[7] while those of Tiahuanaco are prismatic and rectilinear
(Plate 180), but the range of representations is nevertheless similar – so much so as to
warrant their treatment as a stylistic unit, as in the case of Greek art, where Hellenic and
Hellenistic sculpture offer a succession of stylistically related expressions.

Thus the art of Pucará may be regarded as an early stage of an *altiplano* style charac-

teristic of the northern Titicaca basin. By the same token, Tiahuanaco is the late stage flourishing in the southern surroundings of the lake. Indeed, the Pucará sculptural styles seem to be the most ancient in the southern region. Both Bennett and Posnansky agreed in considering certain figures in the Pucará style at Tiahuanaco to be among the oldest sculpture in the district. These are the colossal kneeling figures flanking the churchyard entrance in the colonial village of Tiahuanaco.[8] Others from Pokotia and Wancani, south of Tiahuanaco, are clearly related to Pucará. Two statues from near the village of Pokotia (Plate 178) also represent kneeling figures: one, with the face damaged, is of a greenish volcanic rock, and the other is of whitish sandstone.[9] Both wear serpent-turbans with massive braids falling symmetrically over each shoulder to end on the back in animal heads. The bared upper bodies show the ribs and navel, and the ponderous heads with protruding lips, high cheekbones, distended eyes, and aquiline noses resemble the modern Aymara Indians of the region. From Wancani,[10] not far distant, come three prismatic stela-like stones, 4–5 m. (13–16 feet) long, carved with low-relief figures in several registers, representing *suche*-fish forms, human beings, and felines, in postures of much animation, but treated more as glyph-like elements than as coherent pictorial scenes. These stones also represent standing human beings, with proportional divisions like those of the statues at Tiahuanaco. But the surface reliefs recall Pucará sculpture more than the fine-line, small-scale incisions of Tiahuanaco, so that perhaps we have in these southern basin sites a style intermediate between Pucará and Tiahuanaco. We can add to the southern group the monoliths of Mocachi and Santiago de Guata: they also represent standing human beings compounded with reliefs of *suche*-fish and felines.[11] Bennett found one stela of this style at Tiahuanaco, together with many other sculptures from various periods,[12] all brought together in an edifice of Late Tiahuanaco date.

To sum up, sunken courts surrounded by adjoining houses of rectangular plan, and statues with anatomically descriptive planes, bearing relief decorations of felines and freshwater fish, characterize an early stage in the history of *altiplano* art. It endured until the first centuries after Christ, and it has been identified with Pucará, north of the lake. That site, however, may display only an important regional variant of a major style extending from Sicuani and Chumbivilcas in the north to the southern sites and eastward into the Bolivian lowlands. The division of the *altiplano* into northern and southern styles is perhaps less accurate than a chronological division by early and late phases of the *altiplano* style, corresponding to the type-sites of Pucará and Tiahuanaco.

TIAHUANACO

Architecture

The archaeological zone called Tiahuanaco [13] or Taypicala includes several platforms, enclosures, and buildings, thinly spread over an area of about 1500 by 1300 yards and built of earth revetted with large fitted stones. It contained a ceremonial centre, like Moche or Tikal or Teotihuacán, though far smaller, with buildings approximately

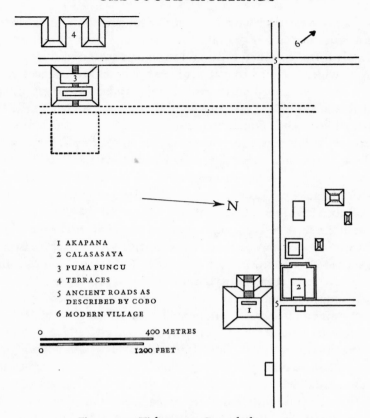

1 AKAPANA
2 CALASASAYA
3 PUMA PUNCU
4 TERRACES
5 ANCIENT ROADS AS
 DESCRIBED BY COBO
6 MODERN VILLAGE

0 400 METRES

0 1200 FEET

Figure 117. Tiahuanaco. General plan *c.* 900

orientated upon the cardinal points (Figure 117). Like Teotihuacán, it was no doubt a station for observations of the solar year, and as such it was the centre of the cosmos, as suggested by its Aymara name, Taypicala, signifying 'the stone at the centre'.

The site has been sacked by every generation for five centuries. Each year of casual plunder has added to the disorder, so that the disintegrated array of stones and earth-works today allows us to form only a ghostly idea of the original appearance, now far beyond recall. Even with the most generous intentions, modern attempts to recon-stitute Tiahuanaco yield only a loose group of edifices falling far short of the scale and importance of the greater Mexican and Maya centres, as well as of the principal coastal Andean sites. Tiahuanaco is comparable in magnitude and complexity to Chavín de Huántar or Cerro Sechín. Its foundation probably happened before 400, and it may have flourished under a variety of masters until the Spanish Conquest. The sculpture and the pottery for which Tiahuanaco is celebrated were produced during a period of which the 'Classic' phase can be given a radiocarbon date after A.D. 300. The later phases of Tiahuanaco history are unknown, although the coastal importance of the Huari style after the sixth century suggests that the highland site continued long as a functioning religious centre.

The ancient site stands at an altitude of 3825 m. (12,520 feet), south of the river, in a

wide valley of well-watered pastures which today support some 20,000 inhabitants on a cultivable area of about 600 km. (232 miles). The main group of buildings, dominated by an earthen platform, consisted of several structures surrounded by a moat or ditch, 50 m. (165 feet) wide, designed to catch surface water and to connect various springs (Figure 117). The moat drained northward into the Tiahuanaco river, using the bed of one of its small affluents on the eastern side of the enclosure. Half a mile to the south-west is another edifice, called Puma Puncu, which today consists of a mound and many large stones strewn in disorder, near a terraced bastion overlooking the basin of a small stream called the Huaricoma, which joins the Tiahuanaco river. Recent studies suggest that both groups of edifices once formed a single ritual centre connected by roadways intersecting at right angles. This is shown in dotted lines on our plan, which has been adapted from Ruben and Ibarra Grosso.[14]

Great uncertainties surround the question of the original form of these buildings. The principal units are a possibly late earthen platform, called Akapana (210 by 210 by 15 m.; 690 by 690 by 50 feet); a platform-enclosure called Calasasaya; and the other platform group called, as we have seen, Puma Puncu (Figure 118). Ibarra, Mesa, and Gisbert extracted from sixteenth-century texts a reconstruction that shows the Akapana as a pyramidal platform with a narrow chambered building facing west; the Calasasaya as a U-shaped platform facing east (135 by 130 m.; 430 by 445 feet); and Puma Puncu as a repetition of the same two forms, both facing east. They also adduce the Kantataita stone, a large monolith carved with diminutive stairways and a sunken court, weighing 900 kgs. (18 cwt), as a kind of model for the Calasasaya. Of the chambered buildings mentioned in the texts only scattered stones remain, and the earth of the platforms has been so completely disturbed by treasure-hunters that only the stone foundations of the revetments now mark out the original plans, and these are interrupted by many gaps. Ibarra, Mesa, and Gisbert believe the buildings were once revetted with cut and fitted stone; certainly the amount of fine masonry taken from the ruins to nearby towns for colonial building supports their view. Only the largest stones or the deeply-buried ones have been left at Tiahuanaco.

Three distinct methods of wall assembly point the way to a possible chronological division at Tiahuanaco. The excavations at the Calasasaya enclosure show a possibly early method. Prismatic uprights of lava stand like fence-posts at intervals, with a filling or curtain-wall of smaller fitted lava elements arranged in dry courses between the up-rights. This unbonded post-and-infill system resembles the very early one at Cerro Sechín (p. 250), and it continued in use at Tiahuanaco until a late period in the history of the site, in the construction of the small, nearly square edifice just east of the Calasasaya, where Bennett excavated sculpture of many periods in 1932.[15] The masonry between the posts included carved heads in several styles. The entire enclosure may consist of re-used elements.

A second method recalls the bonding used in Greek temples: the stones are linked by shallow matching T-shaped channels in which molten copper was poured to form H-shaped cramps. This is the earliest American use of metal for structural purposes. On some stones there are small holes for pegs or dowels, presumably to affix sheets or bor-

ders of gold. Another, more complicated method of bonding stones was by grooves, slots, and mortise-tenon cuts, allowing the units to be joined like woodwork. Puma Puncu (Figure 118) is littered with immense dressed slabs, too heavy to plunder, which may originally all have matched in a construction held together by tongues, tenons, and channels cut with extreme precision, as in Japanese wooden temple architecture.

The people who cut these stones must have possessed metal tools, probably of cold-hardened copper.[16] Radical differences distinguish this phase of the Tiahuanaco style from all other ancient American stone sculpture. Angular cuts, rectilinear designs, and minutely detailed ornaments are its characteristics. A rough chronology can perhaps be based upon the appearance of these shapes which required new tools. Thus the Calasasaya post-and-infill technique can be regarded as dependent upon stone tools alone, for abrasion, chipping, or flaking with stone mauls were sufficient to shape these elements. By hypothesis, a second stage of stone-tool technique is evident in the neat, box-like assemblies of blocks and flat slabs uncovered west of the Calasasaya in 1903 (Figure 119). Similar block-and-slab crypts are known at Huari near Ayacucho in the Mantaro basin (Plate 183).[17] Again, nothing about these slabs and blocks requires us to suppose the use of metal tools; they could all have been shaped by abrasion alone. The transition to cuts made by metal tools appears most clearly in the elaborately compartmented stones at Puma Puncu, worked at the edges into grooves, tongues, mortises, tenons, and slots (Figure 118). On the faces there are ornamental geometric figures in many terraced planes of relief, or minutely detailed and textile-like bands of decoration, as on the standing statues and on the celebrated Sun Door (Plate 182). These ornaments recall textile designs in mathematically regular order, requiring foresight and accuracy in execution.

(A) (B) (C)

0 _____ 1 METRE
0 _____ 3 FEET

Figure 118. Tiahuanaco. Dressed stones at Puma Puncu, after 400. (A) Doorway block; (B) and (C) Opposite faces of a wall-block carved with niches

Of course these stages of stone-cutting technique did not each displace the foregoing one. We may assume only that examples of the third stage would not precede those of stages one and two. The latter probably coexisted with the more elaborate third stage late in the history of the site. Hence the hypothesis allows one only to suppose that stone cutting by metal tools came later at Tiahuanaco than stone shaped by stone tools, and that the earlier modes were not displaced by the later one. The study of the figural sculpture confirms these impressions.

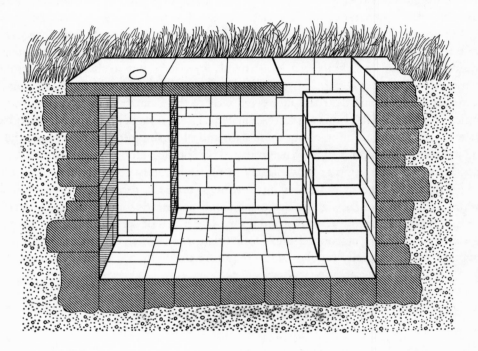

Figure 119. Tiahuanaco, underground stone chamber west of Calasasaya enclosure, after 400

Sculpture

Students of the ruins have long agreed, despite other differences, upon dividing the sculpture of Tiahuanaco [18] into two principal phases: an early style of curved surfaces, contours, and lines; and a later style of prismatic figures bounded by planes incised with small rectilinear figures based upon textile forms. No detailed chronology has been proposed. The correlation between prismatic figures and painted pottery in the 'Classic' style has not been securely proved.

Thus the 'Early' sculpture at Tiahuanaco, which resembles the work at Pokotia, Mocachi, and Pucará (see p. 315), can be equated with the pre-Classic style. It consists of statues and reliefs carved with the thickly rounded forms that are produced by chipping

and flaking with stone mauls and axes. To this class belongs the small stela found at La Paz together with the great prism-figure that bears Bennett's name. This stela is clearly the stylistic ancestor of the colossal figure with which it was buried, perhaps in an ancient effort to preserve the arcana during a crisis in the history of the site.

Intermediate between it and the columnar Bennett Statue of the Classic period is another flat, stela-like slab of sandstone on which the elements of human form, such as the hands clasping the abdomen, are reduced to rectilinear elements of minimum expression. The ventral band bears yoked fish and eagle forms gathered into square knots; the legs are incised with fishes, the eyes are scaly square plates, and on the headband are two bearded faces in symmetrical opposition (Plate 179A). All the elements are unmistakably in the Tiahuanaco style, but their relationship and scale suggest an experimental moment of rude clarity.

The sculpture of the 'Classic' or middle period includes the principal statues and reliefs. The statue called 'El Fraile', a colossal head at La Paz, and the curious double figures which Posnansky called 'anticephalic' reliefs (Plate 179B) seem to belong together, judging by the large scale and simple detail of the incised decoration. The eyes are protruding, plate-like carvings on both the Fraile and the colossal heads, and the mouths are like rectangular grilles. The headband reliefs of the colossal head still show the large scale and the many separate fields of the body which may be taken as characteristic of earlier rather than of late work in this period. The geometric simplification of the masses and the fine-line web of surface incisions are clues to the use of metal tools. In the double reliefs of standing and inverted figures (Plate 179B), the use of metal tools is even more evident in the deep vertical relief and the rectangular cutting. These reliefs may have served as roofing slabs. One bears thin-line incisions of various animals in the large, cloisonné convention peculiar to this group. All these figures originally carried staffs in both hands, projecting into the full-round, but they have been smashed, and only the broken background supports are visible today.

A second phase of Classic work can be identified by its morphological traits. It comprises the most celebrated pieces, the Sun Gate and the Bennett Statue. In these the scale of the incised decoration is adjusted and refined to allow a delicate intricacy, as of jeweller's work. On the Sun Gate [19] the reliefs thus hold the attention both from a great distance and at close quarters (Plate 182). The artistic problem has been realized and resolved: it required the establishment of forms that would command the eye by the bold masses, and at the same time by the delicate web of the incisions. In older work the incisions were too large to satisfy the closer viewer, probably because of technical obstacles in the early manipulation of copper tools. On the Bennett Statue, the main proportional divisions of the figure are stressed in shadows cast by prominent overhangs at the hat-band, the chin, the forearms, and the waist-band. This division by shadow asserts the long-distance authority of the colossal figure. The incised Sun Gate themes on the jacket and headband not only recall the textile origin of the ornament, but also satisfy the requirements of the person standing close by.

Again on stylistic grounds, it is reasonable to regard certain other figures as terminal in the sequence. Among them is the statue discovered in 1903 by Courty (Plate 180),

and called 'Kochamama' by Posnansky, as well as a group of stones [20] with relief sunk into the stone instead of projecting from it. The waist-band of the Kochamama figure is carved in this manner, allowing the ground of the design to prevail over the figure itself, in a scheme requiring exact angular cuts. The network of the incisions on the rest of the figure is dry and repetitious, as if the inventive vigour of the earlier craftsmen had frozen into set conventions. The sunk relief brings the shadows into play in an active compositional scheme, as in Egyptian reliefs of the New Kingdom. This kind of visual device does not occur at the beginning of a stylistic sequence in sculptural form; it generally appears late in the history of a style, as the conclusion to a series of investigations based upon the more obvious properties of solid form, and it is related to studies of illusion in the painter's vocabulary.

Painting

Architectural elements were painted white, red, and green. Traces of these colours still remained on the parts excavated in 1903.[21] The statues and reliefs were also polychrome; the human heads used as wall decorations and found by Courty were painted with an ochreous red. A feline head found by the same excavator was painted ultramarine in the eye cavities, and red in the ears and mouth. Certain friezes and cornices, in addition, were sheathed with metal plates, presumably of gold, fastened to the stone by nails.[22]

Of figure painting, only the polychrome pottery survives (Plate 181, A and B). Bennett's excavations in 1932–4 yielded a stratigraphic sequence in the southern Titicaca basin comprising Early (or Qeya), Classic, and 'Decadent' phases, all preceded by a phase called Chiripa which distantly resembles the Caluyu phase of the Pucará style, having yellow paint on red slip, with incised outlines and coarse appliqué reliefs of modelled cat figures. The rare pieces of early Tiahuanaco pottery are painted in four and five colours on a buff clay, or on a black background. The vessel shapes include cylinders with wavy rims and puma-head spouts, long-necked bottles, bowls, and plates. On one group of spittoon-shaped vessels, the exteriors bear geometric designs, as well as representations of stylized fish and puma forms painted on the inner rims.

The Classic Tiahuanaco painted wares comprise handsome cups of concavely flaring profile, as well as libation bowls which are squat, wide versions of the cups. Both are painted in as many as five colours on a red slip with heavy black outlines surrounding the areas of local colour. The figures of pumas, human beings, and condors in profile are clearly delineated and easy to recognize. One group of burial cups found throughout the southern lake basin [23] is adorned with a face-design resembling the central figure of the Sun Gate at Tiahuanaco: otherwise the Classic wares do not repeat the forms used by the sculptors. In the late period, which Bennett called Decadent, new shapes appeared. The decoration was painted in black and white on an orange slip, showing parts of human, puma, and condor shapes re-combined in powerful and expressive forms of great vigour, approaching the stability of ideographic signs. The exact correlation of these ceramic types with the architectural and sculptural history of Tiahuanaco is still uncertain, but there is little doubt that the Classic and 'Decadent' ceramics were made at

about the same time as the Sun Gate and related monuments. As we shall soon see, a serious problem in chronology arises in regard to late events in the history of Tiahuanaco.

Iconography

The style of Tiahuanaco and Huari belongs to the Andean tradition of conventional signs ordered more by semantic needs than by mimetic relationships. It conveys information about ideas rather than pictures of things, and in this it resembles the art of Chavín, although major differences separate the two styles. Chavín objects are curvilinear and asymmetrical; those of Tiahuanaco are rectilinear and balanced. Chavín carving recalls woodworking and hammered metal; Tiahuanaco art evokes textile and basketry techniques. The art of Chavín includes few motifs; the art of Tiahuanaco embraces a wide range of stylized human and animal forms.

These motifs are as rigid and schematic as if drawn by compass and ruler. The human figure, reduced to the simplest geometric components, serves as the armature for a decoration of small-scale animal appendages and inserts, including male and female condor heads, pumas, fish, snails, and perhaps others. Their parts are interchangeable, combining and re-combining in patterns probably governed by colour changes like those of Paracas textiles. The conventional meanings of these figures are unknown. Some students have unsuccessfully sought to prove ideographic writing and calendrical records. Others have supposed a pantheon of moon, sun, lake, and fish gods. One writer imagines mystic brotherhoods keeping vigil over the 'inviolable orthogonal' of the Tiahuanaco religion.[24] Although the conventional meanings are inaccessible, because of the total lack of texts, the intrinsic meaning is plainly evident. This society, in which the endless variety of real experience could be conveyed and summarized by a few rigid ciphers, was probably governed, like Islam, by religious prohibitions discounting the impermanent, changeable, and fugitive aspects of existence. Pure geometric order expressed the desired stability, unity, and eternity of the society better than the protean forms of Mochica or Nazca art. A priestly law of negation and sanctions conditioned these severe images, which suggest frugality, discipline, and ethical dynamism.[25]

THE MANTARO BASIN

Although the Mantaro Valley was always a principal thoroughfare between the south Peruvian highlands and the central coast, its archaeology is much less well understood than that of other regions in Peru, partly because there are few imposing buildings or statues, and partly because the pottery was prematurely identified with the Tiahuanaco style, so that the region seemed to lack an artistic identity.[26]

Huari near Ayacucho has attracted most attention. The site was densely inhabited before the Inca occupation. Fine chambers of slab-masonry like prison cells (Plate 183), and some stone statues are the only monumental remains. Many sherds of painted

polychrome pottery were excavated by Bennett, but their quality is inferior, compared to the Chakipampa or Conchopata sherds from Ayacucho (Plate 184),[27] and to the fine pottery found near Huancayo a hundred miles farther up the Mantaro river. The big vessels from the Pacheco site in the Nazca Valley (Plate 174, A and B) surpass all other Mantaro products in size and finish.

The architectural, sculptural, and ceramic remains at Huari all seem provincial in comparison with work from other Mantaro centres. The subterranean chambers of fitted slab-masonry resemble those of Tiahuanaco (Figure 119). The standing statues, of squat proportions and heavy, inexpressive features, lack both the geometric clarity and the double viewing distance of Tiahuanaco sculpture. The ceramic decorations are related to the Tiahuanaco style only by the presence of certain motifs, executed in geometric conventions recalling the stone carvings at Tiahuanaco without necessarily belonging to the same period.[28]

The dating of the Mantaro phase of the Tiahuanaco now places Huari as contemporary with Tiahuanaco in Bolivia after A.D. 400. The Pacheco pieces from the Nazca Valley (Plate 174, A and B) which most closely resemble the Mantaro vessels are dated after the sixth century (p. 311). Andeanists today speak of two 'empires' in the Middle Horizon. One was centred near Huari, in control at Ica and Nazca Valleys after 600. Huari itself, as suggested by the spread of its Viñaque pottery style (Plate 184), then dominated northward to Chicama and Cajamarca and south to the *altiplano* during the eighth century. The other empire was Tiahuanaco, which gave Huari its style, and dominated southward as far as Atacama, Cochabamba, and north-west Argentina. Possibly the Mantaro style extended Tiahuanaco influence in Peru proper.[29] Certainly the forms of the Mantaro painters escape from the rigid rectilinearity of Tiahuanaco art: the contours are curved, the expressions are vivid, and the variety of shapes is greater than in the Bolivian style (Plate 184).

THE VALLEY OF CUZCO

Montaigne's unforgettable phrase, 'l'espouventable magnificence de Cuzco',[30] described a city which rose to imperial power under the Inca dynasty only after 1440, less than a century before the Spanish Conquest. To be sure, primitive settlement in the valley was at least two thousand years older. The strategic and economic importance of this ancient glacial lake bed, lying at the nexus of a whole system of natural lines of communication to the Amazonian lowlands, the *altiplano*, and the main inter-Andean basins, was not exploited until the last moments of pre-Columbian history, and the importance of Cuzco endured only about three generations. Nevertheless its brief century of imperial authority produced monuments of which mankind will always remember the frightening splendour.

Chanapata, the principal pre-Inca settlement of Cuzco,[31] is of about the same age as Pucará, Chiripa, or Chavín de Huántar, but its material remains are far simpler than those of any of these early sites. There is no monumental architecture, no stone sculp-

ture, and no metal. The typical pottery is polished and painted or incised in a manner distantly recalling the forms of the Chavín style. The Tiahuanaco period passed lightly over Cuzco, leaving no major remains in or near the city, although substantial traces of Tiahuanaco pottery have been uncovered at Batan 'Urqo near Urcos [32] and in the neighbourhood of Lucre, 20 miles from Cuzco.

The presence of Huari–Tiahuanaco pottery at many points in this southern end of the immediate valley of Cuzco leads Rowe and Lanning to suppose that the ruined city of Pikillaqta (Plate 186) is of that date. Actually, refuse of any kind in the city is so rare that the date has been settled on architectural associations [33] alone. The layout of the city closely resembles that of Viracochapampa near Huamachuco in the northern highlands (Figure 105). The two can almost surely be ascribed, like sixteenth-century Spanish colonial towns, to the same governing class and to approximately the same period. It covers an area of 2 km. by 1 km. (just over a half by one and a quarter miles) with about 160 square blocks, separated by narrow streets. As at Viracochapampa, the square courts are surrounded by long, narrow gallery houses, usually without ground-level doors or windows. The walls are of irregular, sharp-edged rough stone, laid in an ample bedding of clay mortar and faced with a thick coating of clay. Access to the interiors was probably by upper-level entrances reached by ladders. Today the plan of circulation is difficult to reconstruct, because the streets and doorways have been walled off by the modern occupants to prevent the wandering of their animals.

If the urban knowledge and skill of the builders of the Huari period was sufficiently developed to produce both Pikillaqta and Viracochapampa, and their placement before 900 is indeed correct, then the earliest important towns in Peru are these, and they show a grid-plan [34] antedating the great compounds of Chanchan (Plate 162) by some centuries at least. On present evidence it is still possible that they are both Inca garrison towns, perhaps built during the Spanish Conquest, and never occupied long enough for great refuse deposits to form.

In 1927 forty figurines of turquoise, all carved with different costumes,[35] were found under the floor of one of the rooms at Pikillaqta. Other similar sets appeared at Oropesa near by, and in the Ica Valley, as well as in the vicinity of Ayacucho. The Pikillaqta find was associated with a bronze implement, which favours an Inca dating for the objects. Possibly the figurines portraying many types of regional dress helped officials to verify the origin of travellers on the Inca road. On the other hand, Rowe and Wallace found unspecified resemblances to the sculpture of Huari, which, taken together with impressions of likeness in construction,[36] seemed to confirm the Huari–Tiahuanaco dating. Our treating Pikillaqta here, rather than as material of clear Inca style, expresses the present uncertainty.

Inca Architecture

Because the dynasty and the city were intimately connected,[37] the building history of Cuzco fixes the range and span of Inca architectural practice. There were twelve or thirteen rulers whose dates can be fixed from about 1200 until the Spanish Conquest in 1533. The original core of the city surrounded the present Dominican church on a ridge

dominating the lower city, between the Huatanay and Tullumayo rivers, where the foundations of the Inca Temple of the Sun still stand (Figure 120). In the fourteenth century, during the reign of the sixth ruler, Inca Roca, this early settlement began to expand rapidly. Henceforth each Inca constructed his own palace instead of occupying the traditional domicile of the earlier family. The form of the city in 1533 was eventually dominated by these great walled enclosures, each consecrated to the memory of a dead Inca, and inhabited by his descendants and their families and servants.

Soon after 1400 the early raids by the Incas upon neighbouring tribes became a systematic campaign of conquests followed by administrative consolidation. Under Pachacuti, the ninth Inca, during the second third of the fifteenth century, the highland basins and valleys from Lake Titicaca to Lake Junin came under Inca control, and by 1500 the entire Andean region from Quito to lower Chile constituted the Empire. It was the largest state ever brought together under single rule in pre-Columbian America.

During the middle years of the fifteenth century, Pachacuti enlarged the city by lay-ing out a new centre north of the old nucleus. This region, once a swamp, was drained to accommodate a huge ceremonial square and many new courtyards, of which portions survive now as wall fragments lining the colonial streets. Pachacuti also began the for-tress called Sacsahuamán (Plate 188), which dominates the northern approaches to Cuzco, and he rebuilt the Temple of the Sun (Plate 187A) at the old centre on the southern ridge.

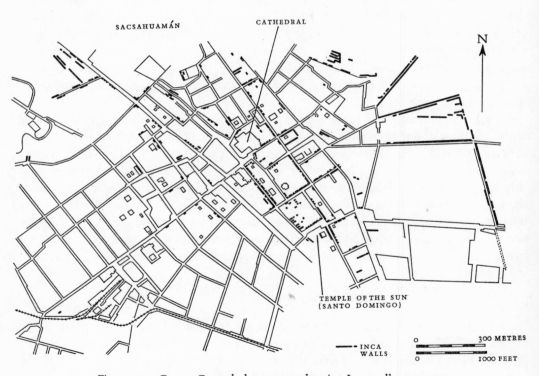

Figure 120. Cuzco. General plan *c.* 1951, showing Inca wall remnants

In this courtyard group on the site of the present Dominican monastery, a few Inca walls survive in the ground-floor chambers of the east and west ranges surrounding the main cloister. A curved wall supports the sanctuary of the church, and it is among the most celebrated of Inca fragments, rising about 20 feet in a curved inclination like the entasis of the Doric order (Plate 187A). Its original use and designation are unknown, but the presence of a large niche on the inner face (excavated in 1951) suggests that the area was once roofed over.[38]

Thus two eminences, the fortress and the temple, rose over the city, which was an open concourse surrounded by a network of walled courtyards, divided by the highways connecting the capital to the four quarters of the empire. The city itself between the rivers was a sacred thing, and it was likened to a puma, with the tail at the confluence of the rivers, the head at the fortress, and the body at the main plaza, surrounded by courtyard dwellings.[39] Priests, officials, nobles, and their servants lived in Cuzco supported by the labour of the farmers and artisans who existed as subjects and tributaries in many surrounding villages. Between the Augustan reforms of Pachacuti and the Spanish Conquest, barely ninety years embrace the entire history of imperial Inca architecture.

It is not now possible to distinguish between Inca buildings erected before and after Pachacuti's time in Cuzco, but it is likely that most of the earlier edifices were of sod and clay rather than of stone. The chroniclers give the names of four architects, all Inca nobles, who designed the buildings and fortifications of Sacsahuamán; Huallpa Rimachi, Maricanchi, Acahuana, and Calla Cunchui. Their work began under Pachacuti's successor, for Pachacuti only prepared the site and assembled the building materials. The main design is simple. Three terraced stone walls, laid out in zigzag angles like sawblades, defend the northern approach to a hill whose abrupt southern rise commands the city (Plate 188). Each terrace face has about forty straight portions, angled to keep invaders under crossfire. Three narrow doorways, one for each wall, were the only points of access. Within the fortress, stone buildings housed the stores, the garrison, and the water supply.[40]

Much of the colonial city was later built with stones taken from Sacsahuamán, and eventually the ruins were covered with earth to prevent their use by rebel groups during the civil wars of the early colonial period. When the earthen mantle was removed in 1934, only the foundations of the buildings were left, and the eastern ends of the triple bastion were seen to have been destroyed long ago. This early colonial custom of filling in the Inca ruins with earth holds also in the city proper, where certain bits of courtyard wall of the fifteenth century now function as retaining walls for sixteenth- and seventeenth-century infill, to support the colonial platform mounds upon which the Spanish churches, convents, and town houses stand.[41]

The difficulty of identifying pre-Conquest walls is increased by the fact that Inca methods of building walls continued in Cuzco for a long time under colonial government. Many portions of wall commonly identified as pre-Conquest are actually of colonial date. An example is the three-storeyed façade of the Casa de los Pumas, with Inca coursing in the doorways on two levels. The colonial doorways, however, have

perpendicular jambs, in contrast to the trapezoidal profiles of pre-Conquest entrances. The purpose of the Inca builders in having the jambs incline towards one another was obviously to shorten the span of the lintel, and to economize in the manipulation of large stones. Throughout the city, colonial and pre-Conquest walls and doorways are so mingled that it is now impossible to define the limits of the Inca city, or to tell precisely where the colonial streets and buildings begin. A few trapezoidal doorways and a few walls with niches mark the presence of Inca fragments, but their original position in the courtyard system remains uncertain.

The most important walls, such as those at Sacsahuamán and in the Temple of the Sun, display a pre-Conquest technique of shaping the individual stones which may well have continued in use until the sixteenth century. Three principal masonry types are evident: 'polygonal' walls, with large irregular stone blocks carefully fitted; rectangular blocks of stone or adobe laid in approximately regular courses; and *pirca*, or rough boulders laid in clay mortar.[42] The walls of Sacsahuamán belong to the first type, the walls of the Temple of the Sun are of the second type. *Pirca* served mainly for simple boundaries, and for plain housing. Polygonal masonry probably arose from the *pirca* tradition, and it was used only for retaining walls and major enclosure walls requiring massive dimensions. Rectangular block masonry, on the other hand, arose from the tradition of square-cut blocks of sod, and it was used mainly for free-standing, two-faced walls.[43]

Both methods of wall assembly show extreme precision in the fitting of the stones. The polygonal walls at Sacsahuamán have peculiarities which suggest the manner of attaining this precision. Many stones, especially the largest ones, retain the stubs of tenons left on the outer faces. Furthermore all stones fit upon concavely curved depressions ground into the stones immediately below them. In polygonal masonry, no stone is seated upon a level surface. Every stone is cupped by its support, although the curve of the cup may be almost imperceptible. The combination of sockets or tenons with these curved seating planes immediately suggests the manner of shaping the stones to their close fit.[44] After rough shaping with stone or bronze tools, each stone was ground against its bed in a swinging motion, suspended from a wooden gantry by rope slings catching the tenons. A few men could then abrade the swinging stone to a close fit with its neighbours by simple friction in a pendulum motion.

In coursed masonry like that of the Temple of the Sun (Plate 187A), the technique was less complicated but more laborious. The concave seating planes are not evident. The fit of stone upon stone was secured by push-and-pull abrasion in the flat plane, as we see in the bed between courses now exposed on top of the curved wall. The weight of the stones in both polygonal and coursed masonry diminished with increasing height. A layer of fine reddish clay was the only substance introduced between the stones. There is no trace of metal cramps like those used by the builders of Tiahuanaco. The upper walls of the Temple of the Sun were adorned with a frieze of gold plates nailed to the stone, known only from confused verbal accounts by soldiers and chroniclers.

Throughout the provinces of the Empire, Cuzco was venerated as a holy place, and knowledge of its physical form was brought to the subject peoples by means of topographic models.[45] The museums at Lima, Cuzco, and Huaraz possess a number of stone

slabs carved with a network of polygonal cells. Two of the cells are usually higher than the others, rising above the remainder of the network (Plate 187B). P. A. Means interpreted them as counting-boards for arithmetical operations, but their resemblance to the plan of Cuzco, with the temple and the fortress rising high above the rest of the city, should not be entirely discounted. Cuzco itself is notably irregular, showing many traits of organic growth rather than planned expansion. The exact form of Cuzco, therefore, could not easily be followed in the widely divergent geographical and cultural situations of Inca military expansion. In each region, the local tradition was adapted to Inca use, and certainly the superior local features were perpetuated by the conquerors. Thus the large rectangular enclosures of Chanchan may have stimulated the Inca custom of housing each family of the ruler and each subject ruler in a separate compound.[46]

Ollantaytambo, in the Urubamba River Valley, is an example of late-fifteenth-century Inca town-planning (Figure 121). Its history was closely connected with Cuzco, only 30 miles away as the crow flies. The fortress, built high on a mountain shoulder above the confluence of two rivers, commanded important passes. Downstream for nearly 40 miles are the terraced towns of the Vilcabamba region,[47] of which Machu Picchu is the most celebrated. Ollantaytambo was in all probability the provincial capital of the entire chain of Urubamba Valley frontier posts reaching towards the tropical rain-forest dwellers, whose products were important to the highlanders' economy. Below the fortress, on a wide bench of flat land, is the late fifteenth-century city of Ollantaytambo, laid out upon a grid-plan of eighteen rectangular blocks separated by rectilinear streets, and surrounding a central plaza. Every block is a double compound enclosing two unconnected courtyards which are placed back to back. Each court is surrounded by four stone-built rooms with niched interior walls. Small corner courts fill the angles between the rooms. The buildings are still inhabited, and they may be the oldest continuously-occupied dwellings in South America.

High above the valley, as well as at the level of the Urubamba river, are many smaller settlements from Pisac to Machu Picchu, all set among very elaborate terraced platforms, sometimes, as at Inty Pata, rising many hundreds of feet. There are few novel architectural forms in the region. The sites are distinguished more for their scenic grandeur and for the bold use of complex topography. But at Runcu Raccay an interesting circular house [48] surrounds a round court 11 m. (36 feet) in diameter. The three long rooms are curved parts of a ring, opening by doorways upon the sheltered court. It is an annular version of the standard rectangular compound.

Machu Picchu is the most elaborate of these mountainside settlements, with many terraced ranges of gabled stone buildings marking out the southern and eastern boundaries of an oblong plaza (Plate 189). This is the only level place among the ruins,[49] and its quiet, ample enclosure gives needed relief from the vertiginous terraced slopes falling to the river or rising to the summits on either side. Wild strawberries and raspberries today grow upon the abandoned agricultural terraces, from which at almost any point one looks down 2000 feet into the river valley. The mild climate, with its theatrical fogs, sunsets, and milky distances, affords one of the most picturesque archaeological settings in the world. The buildings, untouched during four centuries, still give a valid and de-

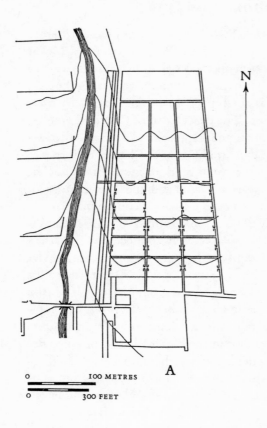

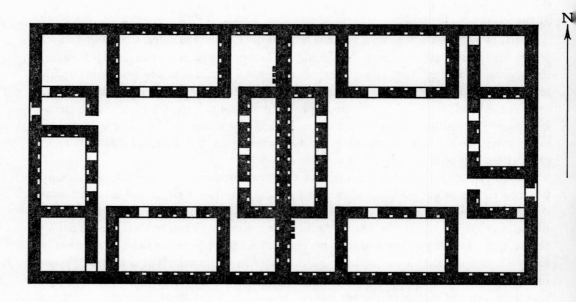

N
↑

Figure 121. Ollantaytambo.
(A) General plan *c.* 1500;
(B) Detail of dwelling block

A

0 ——— 100 METRES
0 ——— 300 FEET

0 ——— 20 METRES
0 ——— 60 FEET

B

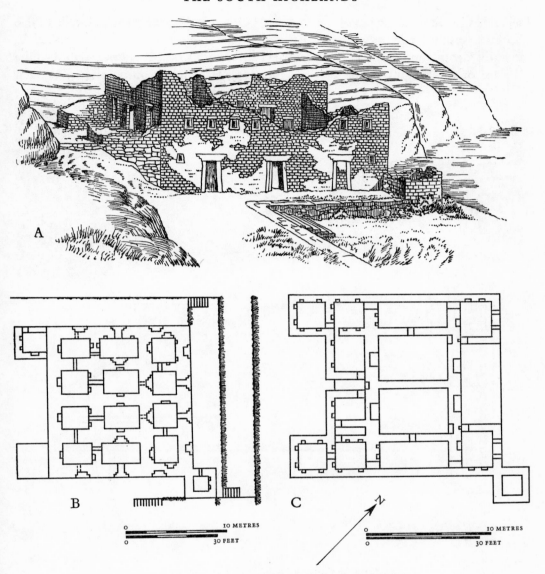

Figure 122. Titicaca Island, Palace, late fifteenth century. (A) Condition in 1870;
(B) Plan of ground floor; (C) Plan of upper storey

tailed impression of the character of highland Inca town existence, as an austere cycle of
agricultural ceremonies and religious duties enmeshing life at every point and moment.

South of Cuzco, in the *altiplano* of Lake Titicaca, Inca architecture manifests a strik-
ingly different regional quality, although sharing with the river-valley sites the same
predilection for magnificent siting and for noble prospects. Two important examples of
the Inca style of the province of Collao are on neighbouring islands in Lake Titicaca,

separated by about six miles of open water.[50] One ruin on Titicaca Island, called Pilco Kayma, was originally a two-storey dwelling block (Figure 122) overlooking the lake towards Coati Island, where a two-storeyed edifice with a court, traditionally called the 'Palace of the Virgins of the Sun' (Figure 123), faced it. Tradition also gives their

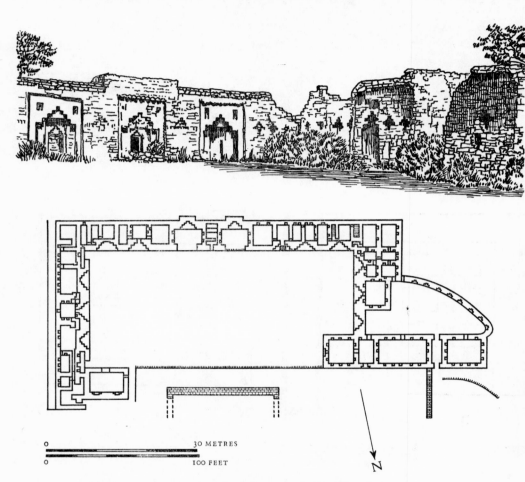

Figure 123. Coati Island, 'Nunnery', late fifteenth century.
Elevation and plan

construction to the reign of Topa Inca in the last quarter of the fifteenth century. The 'palace' is remarkable for its symmetrical envelope and the ingenious fitting of six apartments on two floors to make the best use of the site and of the prospect, with an open esplanade on the second floor overlooking the lake (Figure 122). The arrangement recalls the regular envelopes of Italian Renaissance buildings. The compulsion to symmetry is so strong that blind doorways flank the genuine entrances in each façade of the block.

The 'Nunnery' building forms a three-sided court opening north, and its elevations

are enriched by many recessed planes making a geometric decoration of light and shade which recalls the stonework of Tiahuanaco (Figure 123). It belongs to an entirely different category of architectural design, as divergent from the block-like palace as Italian Renaissance block design is divergent from Islamic courtyard façades. Two quite distinct architectural traditions are probably present here, reflecting an Inca vernacular of trapezoidal doorways, niched walls, and terraced approaches (the 'Palace') and the persistence of a Tiahuanaco style, with chiaroscuro effects in geometric planes (the 'Nunnery').

On the coast, Inca architectural complexes survive in many valleys: examples are at Pachacamac (Sun Temple and Nunnery; Figure 108 and p. 293) and at Tambo Colorado (Plate 176), of which the terraced courts correspond to the chroniclers' descriptions of Inca highway inns and granges.

Another celebrated ruin on the road to the Collao stands at Cacha (Figure 124) in the upper Urubamba drainage, about 120 miles south-east of Cuzco. It is traditionally called the Temple of the god Viracocha. Garcilaso de la Vega described the edifice in detail as a storeyed temple, entered from the east, with the sanctuary on an upper floor.[51] It was a huge building, of which Squier's plan gives the approximate size, with a central pier-wall 15 m. (50 feet) high and 90 m. (300 feet) long, symmetrically flanked by columns. Both the pier-wall and the columns have masonry bases 2 m. (6 feet) high, of fitted polygonal stones, surmounted by adobe brick rising to a gabled roof over a four-naved space divided into possibly three storeys. Adjoining this vast barn-like structure were at least six small courtyards, each surrounded by gabled buildings of rectangular

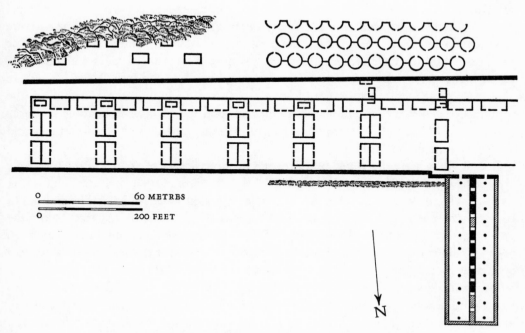

Figure 124. Cacha, Temple of Viracocha, fifteenth century. Plan

333

plan, perhaps for the lodging of pilgrims or priests. Separated from these buildings by a wall are more houses, all circular in plan, in ten parallel rows of twelve each, built of *pirca* masonry.[52]

This type of circular dwelling is common throughout the central Andes, but the date of the innumerable examples is difficult to establish. Throughout the *altiplano*, burial towers called *chullpas* reflect this tradition of domestic architecture. Some are built of carefully fitted stone like Inca coursed masonry, as at Sillustani north-west of Puno on Lake Titicaca (Plate 190); others are of square plan and small size. M. H. Tschopik, who studied the entire Collao group, believes all *chullpas* to be of Inca or immediately pre-Inca date, rather than of the Tiahuanaco period, on the basis of the ceramic associations she was able to study.[53]

Sculpture and Painting

The urban impulse to commemorate important experiences by monumental sculpture was satisfied in Inca society by intricate non-figural carvings on the surfaces of caves and boulders. Such work was common throughout the southern highlands under the Inca regime.[54] It consists mainly of terraced seats, stepped incisions, angular or undulant channels, and, in general, of laborious modifications of the striking geological features of the landscape. They mark the presence of man without representing him in images or statues.

According to the notices gathered by colonial chroniclers, some rocks were simply sacred places (*huacas*) where supernatural forces resided; some were regarded as petrified remains of the ancient races of man; and others were the places where the principal events of mythology occurred. The rocky outcrops on the heights above Cuzco were especially venerated in these various ways. Certain clusters of fissured rocks, like those of the amphitheatre called Kenko (Plate 192), consist of intricate passages with elaborate exterior carvings. Kenko was probably the burial place of the Inca Pachacuti, where elaborate annual commemoration festivals occurred including the worship of the mummified remains of the monarch, displayed upon the rock, with libations of *chicha* (maize-beer).[55] The whole compound was probably regarded as an earth-entrance and as a gate to the underworld of the dead.

Because they were destroyed by European missionaries, large statues in the Inca style are practically non-existent, although texts of the sixteenth century mention cult figures, like the statue of Viracocha at Cacha. In 1930 a large stone head which has been thought to represent the Inca Viracocha was excavated at a depth of 8 m. (25 feet) below the pavement of the Jesuit church in Cuzco.[56] This fragment is unique, and it may have been re-cut in the colonial period, with a timid effort to represent the features of a middle-aged man by incisions representing wrinkles.

Miniature objects of metal and stone figuring human beings and animals are extremely common. They may reflect a vanished monumental sculpture. Tiny llamas of gold, nude standing figures of men and women with ungainly bodies and stiff gestures, diminutive heads encrusted with gold and turquoise, and small terracotta models of

buildings and compounds are the most intimate expressions of Inca art. A heavy gold and silver drinking vessel preserved in the Archaeological Museum of Cuzco is typical of this more intimate and luxurious side of Inca art. It is formed of welded inner and outer shells of silver. The outer wall is inlaid with golden relief figures, and the shell has a filling spout shaped as a miniature vessel perched upon the rim. When the liquid rises to the rim of the shell, it is higher than the figures standing in the shallow bowl, and one of the little men most surprisingly urinates into the miniature vessel at his feet (Plate 191A).[57]

Conspicuously absent are the monsters and composite animals of the other styles of Andean art. Inca representations are limited to the generalized statement of normal appearances, and they are applied to instruments and objects of utilitarian character. The schematic figural designs are composed with restraint, and used economically. Detailed surfaces are avoided in favour of extreme geometric clarity of form. The representation of individuals is sacrificed to generic likenesses. For example, small stone figures of llamas are very common, carved as essential characterizations of the species, always drilled with a cylindrical depression in the back for votive offerings of fat (Plate 191B). The image is generic and it is instrumental. Many stone bowls and dishes likewise show this regard for generic form, reduced to geometric essentials in the representations of animals and plants, and subordinated to the instrumental purpose of the vessel.

Inca pottery is divided into two types: an early type called Killke, and a late type of superior quality called Cuzco polychrome.[58] The Killke types point to connexions with the Collao by their geometric designs in black and red on buff clay, but their execution is careless. Rowe calls them Provincial Inca, assigning them to the period 1200–c. 1438. The Cuzco series is identified with the Empire from the mid fifteenth century on. The most common shapes are handled plates, and jars with pointed bases and long necks, called *aryballoi* (Plate 185) by inexact analogy with the Greek form. Cuzco wares are technically excellent, if stereotyped in form, with simple geometric painted decorations which seem, in Rowe's phrase, 'machine-printed' with almost mechanical poverty of invention.

Although colonial writers mention painted images of Inca deities,[59] no pre-Conquest examples survive. The people adored any strange or peculiar form of nature, such as multiple birth, large trees, oddly shaped fruit and vegetables, springs, rivers and lakes, mountains, rocks and peaks of all shapes, wild animals, metals, and coloured stones. It is probable that painted images were not abundant, and that an image could receive many different and inconsistent meanings, so that Inca images in general tended to undifferentiated stereotypes.

The intrinsic meaning of Inca art reinforces the general impression of an oppressive state. It is as if, with the military expansion of the empire, all expressive faculties, both individual and collective, had been depressed by utilitarian aims to lower and lower levels of achievement.

It is significant that our only exhaustive pictorial description of Inca culture was composed about 1615. Not until the pictorial resources of European civilization became available could the history, rites, and customs of the Inca peoples be thus illustrated. The

book is by an itinerant mestizo of Quechua language, Felipe Guaman Poma de Ayala,[60] who used sixteenth-century European book illustrations as his models. The subject matter alone is Incaic, and this subject matter was probably never before portrayed in such detail, because of the lack of a living native pictorial tradition among the Inca peoples. The painted wooden cups called *keros*, which bear figural scenes, are all likewise colonial adaptations of European pictorial methods to native subject matter. The rare pre–Conquest examples are decorated with geometric fields and conventional animal forms.[61]

LIST OF THE PRINCIPAL ABBREVIATIONS

A.A.	*American Anthropologist*
A.C.H.	W. C. Bennett and J. Bird, *Andean Culture History*, New York, 1949
A.I.N.A.H.	*Anales del Instituto Nacional de Antropología e Historia*, Mexico
Am.A.	*American Antiquity*
A.M.N.A.H.E.	*Anales del Museo Nacional de Arqueología, Historia y Etnografía*, Mexico
A.M.N.H.	American Museum of Natural History
A.M.N.H.A.P.	*Anthropological Papers of the American Museum of Natural History*
B.A.	*Baessler Archiv*
B.B.A.E.	*Bulletin of the Bureau of American Ethnology*
B.E.O.	*Boletín de Estudios Oaxaqueños*
C.A.	*Cuadernos Americanos*
C.A.A.	*Contributions to American Archaeology*, Carnegie Institution of Washington
C.A.A.H.	*Contributions to American Archaeology and History*, Carnegie Institution of Washington
C.S.A.E.	*Columbia Studies in Archeology and Ethnology*, Columbia University
D.O.S.	*Dumbarton Oaks Studies in Pre-Columbian Art and Archaeology*
E.C.M.	*Estudios de Cultura Maya*
F.M.N.H.A.M.	*Field Museum of Natural History, Anthropological Memoirs*
F.M.N.H.A.S.	*Field Museum of Natural History, Anthropological Series*
G.A.	E. Seler, *Gesammelte Abhandlungen*, 5 vols, Berlin, 1902–23
G.B.A.	*Gazette des Beaux-Arts*
H.M.A.I.	*Handbook of Middle American Indians*
H.S.A.I.	Ed. J. H. Steward, *Handbook of South American Indians* (Bureau of American Ethnology, Bulletin cxliii), 6 vols, Washington, 1946–50
I.C.A.	*International Congress of Americanists*
I.N.A.H.	Instituto Nacional de Antropología e Historia; *Bol* = *Boletin; Invest.* = *Investigaciones*
I.N.M.	*Indian Notes and Monographs*, Museum of the American Indian, Heye Foundation, New York
J.S.A.	*Journal de la Société des Américanistes de Paris*
M.A.	*El México Antiguo*
Marquina	I. Marquina, *Arquitectura prehispánica*, Mexico, 1951
M.A.R.S.	*Middle American Research Studies*, Tulane University, New Orleans
M.S.A.A.	*Memoirs of the Society for American Archaeology*
Nat. Geo. Soc.	National Geographic Society
N.M.A.A.E.	*Notes on Middle American Archaeology and Ethnology*, Carnegie Institution of Washington
Ñ.P.	*Ñawpa Pacha*
P.M.M.	*Memoirs of the Peabody Museum of Archaeology and Ethnology*, Harvard University
P.M.P.	*Papers of the Peabody Museum of American Archaeology and Ethnology*
Proskouriakoff	T. Proskouriakoff, *A Study of Classic Maya Sculpture*, Washington, 1950
R.M.E.A.	*Revista Mexicana de Estudios Antropológicos*
R.M.E.H.	*Revista Mexicana de Estudios Históricos*
R.M.N.A.A.	*Revista del Museo Nacional de Antropología y Arqueología*, Lima
R.M.N.L.	*Revista del Museo Nacional de Lima*
S.M.A.M.R.	*Sociedad Mexicana de Antropología, Mesa Redonda*
U.C.A.R.F.	*University of California Archaeological Research Facility, Contributions*
U.C.P.A.	*University of California Publications in Anthropology*
U.C.P.A.A.E.	*University of California, Publications in American Ethnology and Archaeology*
V.F.P.A.	*Viking Fund, Publications in Anthropology*

NOTES TO THE INTRODUCTION

CHAPTER I

p. 1 1. Paul Rivet, in A. Meillet and M. Cohen, *Les langues du monde* (Paris, 1924), 599–602, and K. Sapper, 'Die Zahl und Volksdichte der indianischen Bevölkerung in Amerika vor der Conquista und in der Gegenwart', *I.C.A.*, XXI (1924), 95–104. Recent estimates on Central Mexico propose about 25 million in 1492 (W. Borah and S. F. Cook, 'The Aboriginal Population of Central Mexico on the Eve of the Spanish Conquest', *Iberoamericana*, XLV, 1963) based on early colonial records.

p. 2 2. See D. W. Lathrap, 'Relationships between Mesoamerica and the Andean Areas'. *H.M.A.I.*, IV (1966), 265–75.

3. W. D. Strong, 'Cultural Resemblances in Nuclear America: Parallelism or Diffusion', *I.C.A.*, XXIX (1951), 271–9.

4. Wendell Bennett and Junius Bird first summarized several years' work upon a simplified developmental classification of the prehistory of western South America, under the title *Andean Culture History* (New York, 1949).

p. 6 5. K. Lehmann-Hartleben, 'Thomas Jefferson, Archaeologist', *American Journal of Archaeology*, XLVII (1943), 161–3. G. Kubler, 'Period, Style and Meaning', *New Literary History*, I (1970), 127–44.

6. W. F. Libby, *Radiocarbon Dating* (Chicago, 1951). A revision of the half-life of Carbon 14 from 5568 to 5730 years adds 1·03% to the age of all specimens measured previously. Irregular variations in the amount of Carbon 14 also affect datings. See C. Renfrew, *Scientific American*, CCXXV (1971), 68.

p. 7 7. G. Holton, 'The Roots of Complementarity', *Daedalus*, XCIX (1970), 1018, 1045.

p. 8 8. For Diego de Landa, the best edition is by A. M. Tozzer, *Relación de las cosas de Yucatán*, *P.M.P.*, XVIII (1941). The best edition of Sahagún is by A. J. O. Anderson and C. E. Dibble, *Florentine Codex* (Santa Fé, 1950–69).

9. For the central Andes, the article by J. H. Rowe, 'Inca Culture at the Time of the Conquest', *H.S.A.I.*, II, 183–330, refers to nearly all significant sources.

10. G. Kubler, 'The Quechua in the Colonial World', *H.S.A.I.*, II, 331–410. For Mexico, several reports on seventeenth-century idolatry appeared in *A.M.N.A.H.E.*, VI (1892–9).

11. F. J. Clavigero, *Historia antigua de México* (Mexico, 1945).

12. The most complete presentation of such p. 10 schemes is the book by Gordon Willey and Philip Phillips, *Method and Theory in American Archaeology* (Chicago, 1958).

13. S. G. Morley complained that the native chronicles of Yucatán suffered from 'a frequent telescoping of the time scale to make successive events contemporaneous' (*Ancient Maya*, Stanford, 1947, 87). The same tendency appears in the long defence of the Goodman–Martínez–Thompson correlation for Maya dates, by the Carnegie Institution of Washington, whose workers thereby joined an ancient tradition on Maya chronology; see p. 129.

14. *Historia general de las cosas de Nueva España*, ed. M. Acosta Saignes, II (Mexico, 1946), 276, 315.

15. Gregorio Garcia, *Origen de los indios en el* p. 11 *nuevo mundo* (Madrid, 1729).

16. Franz Kugler, *Handbuch der Kunstgeschichte* (Stuttgart, 1842), and J. L. Stephens, *Incidents of Travel in Central America* (New York, 1841).

17. I have shown elsewhere, 'On the Colonial Extinction of the Motifs of Precolumbian Art', *Essays . . . S. K. Lothrop* (Cambridge, 1961), that utilitarian traits survive or travel more easily than symbolic systems, which are much more perishable. In this context, the diffusionists have yet to explain the translation of Asiatic symbolic forms to America, where matters of mere utility failed to 'survive'.

18. The most complete statement of the new p. 12 diffusionist arguments is the group of essays entitled *Asia and North America. Transpacific Contacts*, in *M.S.A.A.*, IX (1953). For the argument based upon motifs appearing in art, see the essay by Gordon Ekholm entitled 'A Possible Focus of Asiatic Influence in the Late Classic Cultures of Mesoamerica', *ibid.*, 72–89. To be added to his bibliography are the major works by C. Hentze, *Rituels, croyances . . . de la Chine antique et de l'Amérique* (Antwerp, 1936); Miguel Covarrubias, *The Eagle, The Jaguar and the Serpent* (New York, 1934); Harold S. Gladwin, *Excavations at Snaketown* (Globe, 1937). The most complete diffusionist statement by a modern art historian is the essay by R. Wittkower,

'Eagle and Serpent. A Study in the Migration of Symbols', *Journal of the Warburg and Courtauld Institutes*, II (1938–9), 293–325. Also three articles by R. Heine-Geldern on Asiatic tigers, 'Chinese influences' on the Tajín style, and 'Chinese influences' in ancient American pottery, in *I.C.A.*, XXXIII (1959), tomo I, San José, Costa Rica.

The symposium volume edited by Carroll J. Riley, *Man across the Sea* (Austin, 1971), brings together two dozen articles by authors who re-evaluate these problems, coming to no resolution of the questions of diffusion, but assembling different lines of evidence. The question begs to be left open.

p. 13 19. *Op. cit.* (Note 16).

20. E. Viollet-le-Duc, in D. Charnay, *Cités et ruines américaines* (Paris, 1863).

21. R. Goldwater, *Primitivism in Modern Painting* (New York, 1938).

p. 14 22. *Geschichte der Kunst aller Zeiten und Völker*, I (Leipzig and Vienna, 1900–11), 81–97.

23. *A Study of Maya Art*, *P.M.M.*, VI (1913).

24. P. Kelemen, *Medieval American Art* (New York, 1943, 1956, and 1969), and José Pijoan, *Historia del arte precolombino* (*Summa Artis*, X) (Barcelona, 1952), embrace the entire hemisphere. Salvador Toscano, Miguel Covarrubias, Paul Westheim, and Paul Gendrop have written histories of Mesoamerican art alone.

p. 15 25. On the role of the individual, see the essays by R. Trebbi del Trevigiano in *Critica d'Arte*, especially

'Premesse per una storia dell'arte pre-colombiana', XIX (1957), 22–31.

26. E. Panofsky, *Studies in Iconology* (London, p. 1939), 3.

27. G. Kubler, 'La evidencia intrínseca y la analogía', *S.M.A.M.R.*, XIII (1972), 1–24.

28. This assumption underlies the remarkable p. stylistic seriation of Nazca pottery by A. Kroeber and A. H. Gayton in *U.C.P.A.A.E.*, XXIV (1927), a seriation later confirmed by excavations; see W. D. Strong, *M.S.A.A.*, XIII (1957).

29. E. von Sydow, *Die Kunst der Naturvölker und der Vorzeit* (Berlin, 1923), 11.

30. A. L. Kroeber, *Anthropology* (1948), 60–1, p. 390–1.

31. A. Vierkandt, 'Prinzipienfragen der ethnologischen Kunstforschung', *Zeitschrift für Ästhetik*, XIX (1925), 338 f.

32. A. L. Kroeber, *Style and Civilizations* (Ithaca, 1957).

33. B. Petermann, *Gestalt Theory* (London, 1932).

34. H. de Terra, 'Preliminary Note', *Am.A.*, p. XIII (1947), 40–4. Critique by A. D. Krieger, *Am.A.*, XV (1950), 343–9.

35. It measures 13·2 by 19·3 cm. (5 by 7½ ins.). M. Barcena and A. C. del Castillo, *A.M.N.M.*, II (1882), 439–44; L. Aveleyra Arroyo de Anda, 'The Pleistocene Carved Bone from Tequixquiac', *Am.A.*, XXX (1965), 261–77.

36. P. Kirchhoff, 'Civilizing the Chichimecs', p. *Latin American Studies*, V (1948), 80–5.

NOTES TO PART ONE

CHAPTER 2

1. P. Armillas, 'Cronología y periodificación de la historia de la América precolombina', *Journal of World History*, III (1956), 463–503. The best recent clarification of pre-Classic chronology is by Román Piña Chan, *Las culturas preclásicas de la Cuenca de México* (Mexico, 1955), 104. His sequence, based on C14 dates, reads:

 Lower pre-Classic, 1350–850 B.C.
 Middle pre-Classic, 850–450 B.C.
 Upper pre-Classic, 450–150 B.C.

2. R. d'Harcourt, 'Archéologie de la province d'Esmeraldas', *J.S.A.*, XXXIV (1942–7), 61–201.

3. Review of the Carbon 14 dating in B. Spranz, *Totimehuacán* (Wiesbaden, 1970), 9–10. The eruption of Xitle is now dated about the first century B.C., and the beginning of the pyramid-building phases is placed about the fifth century B.C., relating it to Late Ticomán. R. Heizer and J. Bennyhoff, 'Cuicuilco', *Science*, CXXVII, no. 3292, 232–3.

4. W. du Solier, 'Estudio arquitectónico de los edificios Huaxtecas', *A.I.N.A.H.*, I (1945); G. Ekholm, 'Excavations at Tampico and Panuco in the Huasteca', *A.M.N.H.A.P.*, XXXVIII (1944), no. 5.

5. H. E. D. Pollock, *Round Structures* (Washington, 1936).

6. G. Vaillant, *A.M.N.H.A.P.*, XXXII (1930), 143–51. Cf. W. du Solier, *La plástica arcaica* (Mexico, 1950), and R. Piña Chan, *Las culturas preclásicas de la Cuenca de México* (Mexico, 1955).

7. P. Drucker, *B.B.A.E.*, CXL (1943), 77–8. During Teotihuacán III (p. 36) moulds were used and hand-made figurines ceased in central Mexico (Figure 7).

8. G. Vaillant, 'Early Cultures of the Valley of Mexico', *A.M.N.H.A.P.*, XXXV (1935), 300.

9. M. N. Porter, *Tlatilco and the Pre-Classic Cultures of the New World* (New York, 1953); *idem* and L. I. Paradis, 'Early and Middle Pre-Classic Culture in the Basin of Mexico', *Science*, CLXVII (1970), 344–51.

10. *Ancient Civilizations of Mexico and Central America* (New York, 1928); G. Willey, in *The Florida Indian and his Neighbors*, ed. J. B. Griffin (Winter Park, 1949), 101–16.

11. M. Covarrubias, 'Tlatilco', *C.A.*, IX (1950), no. 3, 149–62; M. Coe, *The Jaguar's Children* (New York, 1965).

12. G. Vaillant, *op. cit.* (Note 8), 297–300. A later study of Vaillant's evidence confirmed his findings as to typology and sequence (P. Tolstoy, 'Surface Survey . . .', *Transactions of the American Philosophical Society*, XLVIII (1958), part 5, 64–5).

13. E. Noguera, *M.A.*, III (1935), no. 3, 17–18. P. Drucker, *B.B.A.E.*, CXL (1943), 118, 120, has collated other coeval ceramic styles elsewhere in Mexico.

14. Until the rediscovery of the archaeological p. 26 site of Tula in Hidalgo in 1940, many writers took Teotihuacán for Tula and designated it as the Toltec capital. The name is Aztec, and roughly 600 years removed from the real (lost) name. The names of the pyramids (Sun, Moon, and Ciudadela) are of sixteenth-century origin. Texts discussed by P. Armillas, 'Teotihuacán, Tula y los Toltecas', *Runa*, III (1950), 37–70. L. Sejourné, *Burning Water* (London, 1956), unsuccessfully attempted to return to the pre-1940 conception identifying Tula as Teotihuacán, and designating Teotihuacán as Toltec.

15. A. V. Kidder, J. D. Jennings, and E. M. Shook, *Kaminaljuyu* (Washington, 1946).

16. The basic studies are by Manuel Gamio, *La población del valle de Teotihuacán*, II (Mexico, 1922), and P. Armillas, *Runa*, III (1950). The latter established the following sequence of archaeological phases: I (pre-pyramid) Chimalhuacan, Tzacualli; II (ritual centre) Miccaotli; III (nearby suburbs) Xolalpan and Tlamimilolpa; IV (western transplants) Ahuitzotla-Amantla. Pre-pyramid is early (I); ritual centre and suburbs are middle (II, III); western transplants (IV) are late. On Teotihuacán I (pre-pyramid), see C. C. Leonard, *Boletín del centro de investigaciones antropológicas de México*, IV (1957), 3–9.

The contribution to the question by R. Millon, 'The Beginnings of Teotihuacán', *Am.A.*, XXVI (1960), 1–10, put the building of the Sun and Moon Pyramids in the first century B.C. or earlier on the strength of new finds to the north-west at nearby Oztoyahualco. A radiocarbon date for the Tzacualli finds at this site, submitted by Carmen Cook de Leonard, and measured at Yale Geochronometric Laboratory (specimen Y-644), reads 1930 ± 80 before present, confirming the position suggested

here, as about the beginning of our era. I am indebted to René Millon for the information used on the insert to the map of Mexico in this volume. His article 'A Long Architectural Sequence at Teotihuacán', *Am. A.*, XXVI (1961), 516–23 reported finds at Oztoyahualco 'spanning the Preclassic, Classic, and Postclassic periods'.

p. 26 17. I. Marquina in *La pirámide de Tenayuca* (Mexico, 1935).

p. 28 18. S. Linné, *Archaeological Researches at Teotihuacan* (Stockholm, 1934); P. Armillas, *C.A.*, III (1944), no. 4, 121–36.

19. The usual designation as the pyramid of Quetzalcoatl may be questioned, for, as Armillas has shown, the feathered serpents carved in relief upon its terraces refer to water gods and deities of plant growth in pre-Toltec symbolism; *C.A.*, VI (1947), no. 1, 177.

p. 29 20. A. Caso, 'El paraíso terrenal en Teotihuacán', *C.A.*, I (1942), no. 6, 127–36.

21. S. G. Morley, *The Ancient Maya* (Stanford, 1947), 350, describes the wasteful process in detail. In Yucatán today, about one cord of wood is burned to produce a cubic metre of lime powder; E. Morris, in *Temple of the Warriors*, I (Washington, 1931), 225.

22. P. B. Sears, 'Pollen Profiles and Culture Horizons in the Basin of Mexico', *I.C.A.*, XXIX (1951), 57–61, notes that pollen deposits suggest unfavourable moisture conditions during the Classic era. J. C. Olivé N. and Beatriz Barba A., 'Sobre la desintegración de las culturas clásicas', *A.I.N.A.H.*, IX (1957), 57–71, blame a social revolution.

23. On top of the south pyramid ('Quetzalcoatl') a layer of human bones beneath a layer of seashells was discovered. It suggests rites of secondary burial.

24. On modern survivals of such 'concourse centres' or 'vacant towns', see S. Tax, *A.A.*, XXIX (1937); R. Linton, in *The Maya and Their Neighbors* (New York, 1940), 39–40; and G. McBride, *Geographical Review*, XXXII (1942), 252 ff. Contrast W. T. Sanders, *V.F.P.A.*, XXIII (1956), 114–27.

p. 30 25. See the maps comparing Maya and Mexican sites, drawn to the same scale, in Marquina, *Arquitectura prehispánica* (Mexico, 1951), plates 276–9.

26. W. T. Sanders, *op. cit.*, 123–5, writes of 'at least 50,000 inhabitants' living in 'luxurious residential palaces aligned along a wide boulevard ... surrounded ... by ... almost continuous clusters of rooms separated by small patios and narrow, winding alleys'. For Teotihuacán proper this assumes too

much, in the absence of corresponding house foundations, refuse heaps, or burials.

27. The three groups of four secondary platforms p surrounding the main pyramid in the principal court recall the calendrical division of the Middle American cycle of fifty-two years into four parts of thirteen years each.

28. Atetelco: P. Armillas, 'Exploraciones recientes en Teotihuacán', *C.A.*, III (1944), no. 4, 121–36. Closed court: J. R. Acosta, *El Palacio del Quetzalpapálotl* (Mexico, 1964). Carbon 14 measurements surprisingly range between A.D. 50 and 250 (p. 53), perhaps registering re-used timbers?

29. O. Apenes, 'The "Tlateles" of Lake Texcoco', *Am.A.*, IX (1943), 29–32; R. C. West and P. Armillas, 'Las Chinampas de México', *C.A.*, V (1950), no. 2, 165–82, especially 169–70.

30. E.g. Kaminaljuyú (Guatemala City) and Ake p (Yucatán), where it reflects Maya contact with the Valley of Mexico.

31. I. Marquina, *Proyecto Cholula* (1970), 31–45. p

32. Only 11,000,000 (minimum) to 33,000,000 (maximum) New World inhabitants are estimated as of the Discovery. A. L. Kroeber, 'Cultural and Natural Areas of Native North America', *U.C.P.A.A.E.*, XXXVIII (1939).

33. Small animal effigies on wheeled platforms of clay have appeared in the Valley of Mexico, at Tres Zapotes, in Oaxaca, and perhaps Panamá, in post-Classic periods, after A.D. 1000. See the article of composite authorship (A. Caso, M. Stirling, S. K. Lothrop, J. E. S. Thompson, J. García Payón, G. Ekholm), 'Conocieron la rueda los indígenas mesoamericanas?', *C.A.*, V (1946), no. 1, 193–207.

34. W. H. Holmes, *B.B.A.E.*, LX (1919).

35. Fray Juan de Mendieta, writing at the end of the sixteenth century, described another colossal stone figure, too large to move, recumbent (*tendido*) on top of the largest pyramid (the Sun). *Historia ecclesiástica indiana*, ed. Icazbalceta (Mexico, 1870).

36. Illustrated in Marquina, 105. p

37. S. Toscano, *Arte precolombino* (Mexico, 1944), 211. W. Krickeberg, *Felsplastik*, I (1949), 199–206, assigns the 23-foot-high unfinished statue of andesite from Coatlichan to the same period.

38. R. García Granados, 'Reminiscencias idolátricas en monumentos coloniales', *Anales del Instituto de Investigaciones estéticas*, II (1940), no. 5, 54–6.

39. G. Kubler, *The Arensberg Collection* (Philadelphia, 1954), plate 2.

40. Aztec mummy bundles wearing similar masks are figured in a sixteenth-century pictorial

history of early colonial date; *Codex Magliabecchi*, ed. Duc de Loubat (Rome, 1901).

41. S. Linné, *Archaeological Researches* (Göteborg, 1934), 171–5. E. Seler, *G.A.*, v, 533 and plate LI, discusses two pottery braziers in which such masks were used.

36 42. The conventional designation as 'portrait type' is a misnomer. 'Stereotype' would be better.

43. It covers an earlier structure discovered in 1939 by D. F. Rubín de la Borbolla, *A.I.N.A.H.*, II (1941–6), 61–72.

37 44. The square plan and the width of the terraces allow the calculation that 366 such heads (including stair balustrades) adorned the platform. The number suggests calendrical symbolism bearing on the solar year.

45. Various discoveries are reported by A. Villagra in *A.I.N.A.H.*, v (1952), 67–74; VI (1955), 67–80.

46. T. Proskouriakoff, 'Classic Vera Cruz Sculpture', *C.A.A.H.*, XII (1954), no. 58. The platform is illustrated in Marquina, plate 27. E. Seler, *G.A.*, v, 519, Abb. 170, illustrates a carved cylindrical tripod vessel from Teotihuacán with these forms.

38 47. The technique is called 'fresco' decoration because of the high key and matt finish of the pigment. The processional figures are more common on the later slab-footed tripods than on the somewhat earlier plug-footed vessels; P. Armillas, *C.A.*, III (1944), no. 4, 131, plates I–II.

39 48. *C.A.*, I (1942), no. 6, 127–36. Aztec texts are as far removed from Teotihuacán murals as St Isidore of Seville is from the Roman mosaics of Italica.

49. S. Linné, 'Teotihuacan Symbols', *Ethnos*, VI (1941), 174–86; H. Neys and H. v. Winning, 'The Treble Scroll', *N.M.A.A.E.*, III (1946–8), 81–9; H. v. Winning, *M.A.*, VI (1947), 333–4, VII (1944), 126–53, and *N.M.A.A.E.*, III (1946–8), 170–7; R. L. Rands, 'Some Manifestations of Water in Mesoamerican Art', *B.B.A.E.*, CLVII (1955), 265–303. L. Séjourné, *Burning Water* (London, 1956), finds hearts and other 'Náhuatl' symbols in the figural art, without proper evidence.

50. A. Caso, *M.A.*, IV (1937), 131–43; H. Beyer, *ibid.*, I (1921), 211.

51. P. Armillas, 'Los dioses de Teotihuacán', *Anales del Instituto de Etnología americana* (Mendoza, Univ. de Cuyo), VI (1945).

40 52. Proskouriakoff, 119. L. Parsons (*Bilbao*, II (Milwaukee, 1969), 170–1) regards Xochicalco as bridging the Late Classic gap between Teotihuacán and Tula. On its rivalry with Teotihuacán, J. Litvak

King, 'Xochicalco en la caída del clásico', *Anales de Antropología*, VII (1970), 131–44.

53. E. Noguera, *C.A.*, IV (1945), no. 1, 119–57, and *R.M.E.A.*, x (1948–9), 115–19; C. Sáenz, 'Exploraciones en Xochicalco', *Bol. I.N.A.H* (1966), no. 26, 24–34.

54. Contrast with W. T. Sanders, *V.F.P.A.*, XXIII (1956), 125.

55. Marquina, 924, makes the sculptured plat- p. 41 form coeval with Late Classic Maya art. The excavations have failed to give a sequence for the building history of the site. E. Noguera excavated the sweat-bath of Maya type (*R.M.E.A.*, x (1948–9), 115–19). For other traces of Maya influence in Guerrero see *El occidente de México* (*S.M.A.M.R.*, IV (1948)), especially H. Moedano, 'Oztotitlan', pp. 105–6, reporting Maya corbelled vaults of 4·5 m. (14¾-foot) span.

56. E. Noguera, *C.A.*, IV (1945), no. 1, 119–57. Analogous ball-courts at Toluquilla and Ranas in the north-eastern part of the state of Querétaro recall the style of Xochicalco and of Tajín on the Gulf Coast. They are probably of the same pre-Toltec period as Xochicalco; Marquina, 241. On the antiquity of the game, see S. Borhegyi, 'The Pre-Columbian Ballgame', *I.C.A.*, XXVIII (1968), I, 499–515.

57. K. Ruppert, *Chichen Itza* (Washington, 1952), 82–3; L. Satterthwaite, Jr, *Piedras Negras Archaeology: Architecture*, Part V (Philadelphia, 1952).

58. Restored by L. Batres in 1910 to its present shape. J. O. Outwater, *Am.A.*, XXII (1957), 261, believes the carving was done at the quarry.

59. Marquina compares this cornice to Maya mouldings (p. 138). Tajín cornices (p. 920) seem more closely related.

60. Marquina, 138. p. 43

61. A. Caso, 'Calendario y escritura en Xochicalco', *R.M.E.A.*, XVIII (1962), 49–79.

CHAPTER 3

1. The chronicled date for the fall of Tula was p. 44 first corrected from A.D. 1116 to 1168 by W. Jiménez Moreno, 'Tula y los Toltecas segun las fuentes históricas', *R.M.E.A.*, v (1940). The fall and abandonment may also be placed *c.* 1260, on the assumption that the great 'inconsistencies' among the chronicles reflect the coeval functioning of many distinct local calendars which can all be correlated (P. Kirchhoff, 'Calendarios Tenochca,

Tlatelolca y otros', *R.M.E.A.*, XIV (1954–5), 257–67).

p. 44 2. Jorge Acosta, *R.M.E.A.*, XIV (1956–7), 75–110, and R. Chadwick, 'Post-Classic Pottery of the Central Valleys', *H.M.A.I.*, X (1971), 228–57.

p. 45 3. J. E. S. Thompson, *The Rise and Fall of Maya Civilization* (London, 1956).

4. Critical bibliography in S. Toscano, *Arte precolombino* (Mexico, 1944), 57–64.

5. W. T. Sanders, 'Settlement Patterns in Central Mexico', *H.M.A.I.*, X (1971), 3–44; D. Charnay, *The Ancient Cities of the New World* (London, 1887).

6. E.g. Walter Lehmann, *Aus den Pyramidenstädten in Alt-Mexiko* (Berlin, 1933).

7. P. Armillas, 'Fortalezas mexicanas', *C.A.*, VII (1948), no. 5. Contrast A. Palerm, 'Notas sobre las construcciones militares y la guerra en Mesoamérica', *A.I.N.A.H.*, VIII (1956), 123–34.

8. A. Ruz Lhuillier, *Guía arqueológica de Tula* (Mexico, 1945).

p. 47 9. Rémy Bastien, 'New Frescoes in the City of the Gods', *Modern Mexico*, XX (1948), 21, compares Atetelco and Tula.

p. 48 10. The west chamber, with twenty-six columns, contained stacks of neatly sorted Mazapan pottery, smashed when the roof fell in the destruction of Tula. Building 3 (*A.I.N.A.H.*, IX (1957), figure 4) has two impluvium patios surrounded by double rows of wooden supports faced with stucco.

11. A. Caso, 'El mapa de Teozacualco', *C.A.*, VIII (1949), no. 5, 145–81. The blue-and-yellow meander at Tula has a parallel among Mixtec place-names, but its meaning is still unidentified.

12. Illustrated in E. Seler, *G.A.*, V, 433. The Tula crenellations are like the conch sections on the bodies of the feathered serpents of Xochicalco (Plate 12).

p. 49 13. H. Moedano, cited by W. Krickeberg, *Altmexikanische Kulturen* (Berlin, 1956), 323, regards the Atlantean supports as images of the planet Venus (Tlahuizcalpantecuhtli) in the form of the hunting god named Mixcoatl, because of traces of red-and-white striped body paint on the statues.

14. Discussion in Tozzer, 'Chichen Itza', *P.M.M.*, XI (1957), 71–2, 100 (illustrated by S. Toscano, *Arte precolombino*, 139).

15. P. Armillas, 'La serpiente emplumada, Quetzalcoatl y Tlaloc', *C.A.*, VI (1947), no. 1, 161–78.

16. C. Lizardi Ramos, 'El Chacmool mexicano', *C.A.*, IV (1944), no. 2, 137–48, analyses the types and their significance. See also J. Corona Núñez, *Tlatoani*, I (1952), nos. 5–6, 57–62.

17. These remarkable achievements of primitive p.
astronomical observation and calculation surely came to the Toltecs from Maya sources, where calendrical computations had reached great complexity during the Late Classic era.

18. H. Moedano, 'El Friso de los caciques', *A.I.N.A.H.*, II (1941–6), 113–36, and H. Beyer, 'La procesión de los señores', *M.A.*, VIII (1955), 1–65.

19. In Mixtec and Aztec society, a heraldic name and a calendar name (determined by the birth day) were customary for every person of consequence.

20. P. Armillas, *C.A.*, VI (1947), no. 1, 161–78; p.
A. López Austin, *El hombre-dios, Quetzalcoatl* (Mexico, 1972).

21. It must surely have been climatic changes that occasioned these cyclical movements of peoples. Soil profile studies in the Teotlalpan district show alternating periods of drought and moisture which relate clearly to the archaeological and textual evidence of the succession of cultures; S. F. Cook, 'The Historical Demography and Ecology of the Teotlalpan', *Ibero-Americana*, XXXIII (1949).

22. P. Kirchhoff, 'Civilizing the Chichimecs', *Latin-American Studies*, V (1948).

23. The Toltec saga as related by sixteenth-century sources often includes a first golden age of peaceful arts, which may reflect the theocracy of Teotihuacán; e.g. *Die Geschichte der Königreiche von Colhuacan und Mexiko*, ed. W. Lehmann (Stuttgart, 1938).

24. W. Krickeberg, *Altmexikanische Kulturen*, 308, seeks to restrict the term to the Valley of Mexico, excluding the adjoining plateaus of Toluca and Puebla. This distinction rests more upon textual sources than upon the archaeology of the period. The excavations show a uniform style of artifacts to which a name as generic as 'Chichimec' is not inappropriate.

25. E. Boban, *Documents pour servir à l'histoire du Mexique*, 2 vols. and atlas (Paris, 1891), I, 134, 147; C. Dibble, *Códice Xolotl* (Mexico, 1951). The study of these manuscripts as examples of painting belongs to a later section, as they are examples of Aztec pictorial conventions, although of post-Conquest date.

26. P. Radin, 'The Sources and Authenticity of the History of the Ancient Mexicans', *U.C.P.A.A.E.*, XVII (1920), 1–150; R. Carrasco, 'The Peoples of Central Mexico and their Historical Traditions', *H.M.A.I.*, XI (1971), 459–73; also R. Chadwick, 'Native Pre-Aztec History of Central Mexico', *ibid.*, 474–504.

53 27. F. de A. Ixtlilxochitl, *Obras históricas*, ed. Chavero (Mexico, 1891–2).

28. The Tepanecs were probably related to the Matlatzinca tribe of the valley of Toluca. Tezozomoc, *Crónica mexicana* (Mexico, 1878).

29. E. J. Palacios and others, *Tenayuca* (Mexico, 1935).

30. J. García Payón, *Zona arqueológica de Tecaxic-Calixtlahuaca* (Mexico, 1936); H. E. D. Pollock, *Round Structures* (Washington, 1936).

31. A tribal fetish of solar nature, meaning 'Humming-bird of the left' (i.e. south), consulted as an oracle and given the cult of a war god.

54 32. P. Kirchhoff revised the traditional date of the founding (*c.* 1325) to *c.* 1370 on the basis of calendar studies correlating the numerous municipal systems of recording dates; *Transactions of the New York Academy of Sciences*, XII (1950).

33. The genealogical line is fully reported in *Códice Xolotl*, ed. C. Dibble.

34. R. H. Barlow, 'The Extent of the Empire of the Culhua Mexica', *Ibero-Americana*, XXVIII (1949), based upon the tribute lists of the Codex Mendoza, a sixteenth-century compilation by Indian informants, ordered for Viceroy Mendoza as a guide for Spanish colonial taxation in the same area (*Codex Mendoza*, ed. and transl. J. C. Clark, 3 vols., London, 1938).

35. B. de Sahagún, *Historia general*, is the most complete source: preferred edition: *Florentine Codex*, transl. A. J. O. Anderson and C. E. Dibble (Santa Fé, 1950–69). Excision of the heart (Toltec origin), flaying (south Mexico), and gladiatorial combat and arrow sacrifice (east coast) were the commonest forms of immolation. For a survey of the annual calendrical sacrifices, see G. Kubler and C. Gibson, *The Tovar Calendar* (New Haven, 1951). H. B. Nicholson, 'Religion', *H.M.A.I.*, x (1971), 431 f.

36. A. Caso, *The Aztecs* (Norman, 1958), 12–13.

55 37. G. Kubler, 'The Cycle of Life and Death in Metropolitan Aztec Sculpture', *G.B.A.*, XXIII (1943), 257–68.

38. L. Schultze, *Indiana*, II (Jena, 1933–8).

39. M. Toussaint, J. Fernández, E. O'Gorman, *Planos de la ciudad de Mexico* (Mexico, 1938); I. Alcocer, *Apuntes sobre la antigua México–Tenochtitlán* (Mexico, 1935); Hernando Cortés, *Letters*, ed. F. A. MacNutt (New York, 1908); B. Díaz del Castillo, *True History*, ed. A. P. Maudslay (London, 1908–16); B. de Sahagún, *Historia*, Book XII; Diego Durán, *Historia*. Overview by Sanders, *H.M.A.I.*, x (1971), 24–9.

40. J. W. Schottelius, *Ibero-amerikanisches Archiv*, VIII (1934).

41. 'Tlatelolco a través de los tiempos', *Memorias de la Academia de Historia*, III–IV (1944–8).

42. D. Robertson suggests that the basic paper drawing, apart from the pasted-over colonial additions, may well be of pre-Conquest manufacture, and that its grid corresponds to a suburban fringe of new growth along the western fringe of Tenochtitlan; *Mexican Manuscript Painting of the Early Colonial Period* (New Haven, 1959). Contrast Toussaint, Fernández, and O'Gorman, *Planos*. D. Stanislawski, 'Origin and Spread of the Grid-Pattern Town', *Geographical Review*, XXXVI (1946), 105, and XXXVII (1947), 97, denies the existence of grid plans in pre-Conquest town planning. E. E. Calnek, *Am.A.*, XXXVIII (1973), 190–4, locates the map as a suburban island near Atzcapotzalco.

43. T. de Benavente Motolinia, *Historia de los Indios de la Nueva España* (Barcelona, 1914); English translation by F. B. Steck, O.F.M., entitled *Motolinia's History of the Indians of New Spain* (Washington, 1951).

44. Marquina, 220. Teopanzolco has been trenched to reveal the outlines of an older interior platform.

45. E. Seler, *G.A.*, III, 487–513. The alleged month-glyphs on the cella bench are discussed by Kubler and Gibson, *Tovar Calendar*, 62–3. p. 57

46. J. García Payón, *R.M.E.A.*, VIII (1946). The rock is a volcanic ash containing clay, which is soft when wet; hard when dry. J. O. Outwater, 'Precolumbian Stonecutting Techniques of the Mexican Plateau', *Am.A.*, XXII (1957), 258.

47. W. Krickeberg, 'Das mittelamerikanische Ballspiel und seine religiöse Symbolik', *Paideuma*, III (1948). p. 58

48. G. C. Vaillant, *The Aztecs of Mexico* (New York, 1941, and Harmondsworth, 1950).

49. J. García Payón, *La zona arqueológica de Tecaxic-Calixtlahuaca* (Mexico, 1936).

50. Tizatlán: E. Noguera, *R.M.E.H.*, II (1928); Comalcalco: F. Blom and C. Lafarge, *Tribes and Temples*, I (New Orleans, 1926), 113; Corozal: T. Gann, *B.B.A.E.*, LXVI (1918), 82; Zacualpa: R. Wauchope, *Excavations at Zacualpa* (New Orleans, 1948), 66–7.

51. W. Jiménez Moreno, 'El enigma de los Olmecas', *C.A.*, v (1942). To the Aztecs, the Olmecs were a real and redoubtable tribal entity, whose territory yielded important revenues. p. 59

52. Discussed by H. Moedano, 'El friso de los caciques', *A.I.N.A.H.*, II (1947).

p. 59 53. On kingship, see Manuel M. Moreno, *La organización política y social de los Aztecas* (Mexico, 1931).

54. A cast gold figure of Tizoc is discussed by M. Saville, *The Goldsmith's Art in Ancient Mexico* (New York, 1920). D. Easby and F. J. Dockstader, 'Requiem for Tizoc', *Archaeology*, xvii (1964), 85–90, prove that it is a modern work.

p. 60 55. The frontal portraits of the dynastic rulers of Tenochtitlan, garbed as Xipe Totec and carved upon the rock face of Chapultepec, are mutilated beyond recognition. H. B. Nicholson, 'The Chapultepec Cliff Sculpture', *M.A.*, ix (1959), 379–444.

56. H. Beyer, *El llamado 'calendario Azteca'* (Mexico, 1921).

57. A. Caso, *El Teocalli de la guerra sagrada* (Mexico, 1927).

58. E. Seler, *G.A.*, ii, 704–16.

p. 61 59. M. Saville, *The Woodcarver's Art in Ancient Mexico* (New York, 1925). Also E. Noguera, *Tallas prehispánicas en madera* (Mexico, 1958). The copper knives occasionally found in Mexico lacked the hardness and temper for stonework and wood carving. Bronze cutting-implements were common only in the Andean region. P. Rivet, *La métalurgie en Amérique précolombienne* (Paris, 1946); M. Saville, 'Votive Axes from Ancient Mexico', *I.N.M.*, vi (1929); H. B. Nicholson, 'Religion', *H.M.A.I.*, x (1971), 422–4.

60. G. Kubler and C. Gibson, *The Tovar Calendar* (New Haven, 1951).

61. Illustrated by the discoverer, G. Vaillant, in *Aztecs of Mexico*. Another example of the same hollow fired clay image has been found in Costa Rica. A Zapotec Xipe figure is illustrated by A. Caso and I. Bernal, *Urnas de Oaxaca* (Mexico, 1951), figure 396.

p. 62 62. J. E. S. Thompson, 'The Moon Goddess in Middle America', *C.A.A.H.*, v (1939), 121–73; W. Krickeberg, *Altmexikanische Kulturen* (Berlin, 1956), 181–216. Many forms of the earth goddess as death goddess are pictured in *Codex Magliabecchi*, facs. ed. Duc de Loubat (Rome, 1901). B. Spranz, *Göttergestalten* (Wiesbaden, 1964); A. Hvidtfeldt, *Teotl and Ixiptlatli* (Copenhagen, 1958).

63. M. Acosta Saignes, *Los Pochteca* (*Acta Anthropologica*, i) (Mexico, 1945). This work analyses the history of the clan monopolizing the foreign trade activities of the Aztec state. It functioned as a priestly corporation, under the aegis of a god, Yacatecutli, with special rites and privileges. Its members enjoyed the status of hereditary nobles

and warriors. They were both instruments and strategists of Aztec economic and political expansion.

64. The literature of the Coatlicue figure, written since its discovery in 1790, is the subject of the illuminating book by Justino Fernández, *Coatlicue* (Mexico, 1954). The Yolotlicue figure was discovered in the foundations dug for the Supreme Court building. Both are 2·52 m. (8¼ feet) high. The surfaces of the Yolotlicue figure are damaged.

65. S. K. Lothrop, *Pre-Columbian Art* (Bliss Collection) (New York, 1957), 240–1. The material is wernerite.

66. H. B. Nicholson, 'The Birth of the Smoking p. 6 Mirror', *Archaeology*, vii (1954), 164–70, has gathered other representations of birth scenes.

67. S. Ball, 'The Mining of Gems and Ornamental Stones by American Indians', *B.B.A.E.*, cxxviii (1941), 20, 27, 28.

68. E. Seler, *Einige Kapitel aus dem Geschichtswerk des Fray Bernardino de Sahagun* (Stuttgart, 1927), 376–7.

69. Illustrated in *Ancient American Art* (Cambridge, Mass., 1940).

70. M. Saville, 'The Goldsmith's Art in Ancient America', *I.N.M.* (1920); D. T. Easby, jr, 'Sahagún y los orfebres precolombinos de México', *A.I.N.A.H.*, ix (1957), 85–117.

71. The '*Plano en papel de maguey*' (see Note 42) is an administrative map rather than a work of art.

72. John Glass, *Catálogo de la colección de códices p. 6* (Mexico, 1964). Donald Robertson, *Mexican Manuscript Painting* (New Haven, 1959), analyses these documents in the light of the replacement of native conventions by European ones.

73. I. J. Gelb, *A Study of Writing* (London, 1952), 51–9, characterizes 'Aztec and Maya' signs as 'limited systems' to be counted among the forerunners of writing, and not as full writing. They are semasiography rather than phonography; based upon pictures, and not upon syllabic signs representing language instead of nature.

74. W. v. Hoerschelmann, 'Flächendarstellungen in altmexikanischen Bilderschriften', *Festschrift Eduard Seler* (Stuttgart, 1922), 187–204.

75. Tlaxcala, though regarding Tenochtitlan as the hereditary enemy, belonged to the Aztec culture, much as Sparta belonged to Greek civilization.

76. Marquina, 212.

77. E. Noguera, 'Los altares de sacrificio de Tizatlán', *Publicaciones de la Secretaría de Educación Pública*, xv (1927), no. 11, 23–62. Fired bricks, extremely rare in Mexico, were used in the stairs, the

bench, and the altar-tables. The bricks measure 56 by 30 by 6 cm. (22 by 12 by 2½ ins.). See also A. Caso, *R.M.E.H.*, I (1927).

. 65 78. Its colonial date is indicated by the deep pictorial space of certain month festivals, particularly in the scene showing dancers winding around a pole; *Codex Borbonicus*, facs. ed. E.-T. Hamy (Paris, 1899).

. 66 79. C. E. Dibble, *Códice en Cruz* (Mexico, 1942).

80. *Codex Telleriano-Remensis*, facs. ed. E.-T. Hamy (Paris, 1899).

81. *Codex Mendoza*, ed. and transl. J. C. Clark, 3 vols. (London, 1938).

82. E.g. *Codex Magliabecchiano*, facs. ed. Duc de Loubat (Rome, 1904), illustrates many Aztec textile patterns in sixteenth-century drawings prepared on European paper.

83. E. Seler, *Einige Kapitel aus dem Geschichtswerk des Fray Bernardino de Sahagún* (Stuttgart, 1927), 378 f., and M. Acosta Saignes, *Los Pochteca*. Also E. Seler, *G.A.*, II, 641–63.

84. F. Heger, *Annalen des K. K. Hofmuseums*, VII (1892), and F. v. Hochstetter, *Über mexikanische Reliquien aus der Zeit Montezumas in der K. K. Ambraser Sammlung* (Vienna, 1884).

85. R. Chadwick, 'Postclassic Pottery of the Central Valleys', *H.M.A.I.*, X (1971), 248–56.

CHAPTER 4

. 67 1. M. Swadesh, 'The Language of the Archaeologic Huastecs', *N.M.A.A.E.*, IV (1949–53), no. 114, 223–7.

2. W. Jiménez Moreno, 'El enigma de los Olmecas', *C.A.*, V (1942), 113–45.

3. Tres Zapotes: P. Drucker, *B.B.A.E.*, CXL (1943); La Venta: P. Drucker, *B.B.A.E.*, CLIII (1952), and P. Drucker, R. F. Heizer, and R. J. Squier, *B.B.A.E.*, CLXX (1959); R. F. Heizer and P. Drucker, 'The La Venta Flute Pyramid', *Antiquity*, XLII (1968), 52–6; San Lorenzo: M. Coe, 'San Lorenzo and the Olmec Civilization', *Dumbarton Oaks Conference on the Olmec* (Washington, 1968), 41–78; general: M. Covarrubias, *Indian Art* (New York, 1957).

. 68 4. I. Bernal, *The Olmec World* (Berkeley, 1969), 106–17; P. Tolstoy and L. Paradis, *U.C.A.R.F.*, XI (1971), 7–28. On the paw-wing, M. Coe, *Jaguar's Children* (New York, 1965).

5. L. W. Wyshak and R. Berger, 'Possible Ball Court at La Venta', *Nature*, CCXXXII (1971), 650.

. 69 6. E. Benson, *An Olmec Figure* (1971), describes a jade figurine with complex ideographic incisions, recalling both Monument 44 at La Venta and the Idolo de San Martín Pajapan.

7. M. N. Porter, *Tlatilco* (New York, 1953), plate p. 70 6G, H. This site of pre-Classic (Middle Zacatenco) date received Olmec influence from some unidentified centre.

8. M. Stirling, *An Initial Series from Tres Zapotes* (Washington, 1940). Contrast J. E. S. Thompson, *Dating of Certain Inscriptions of Non-Maya Origin* (Washington, 1941). Confirmation of Stirling's position is by M. D. Coe, 'Cycle 7 Monuments in Middle America: A Reconsideration', *A.A.*, LIX (1957), 597–611.

9. Enumerated by M. Covarrubias, *Mexico South*, p. 71 50–83.

10. E. Shook and A. V. Kidder, *Nebaj* (Washington, 1951), 32–43.

11. P. Drucker, *B.B.A.E.*, CLIII (1952), plate 56; I. Bernal, *The Olmec World* (Berkeley, 1969), 80. See C. W. Clewlow a.o., 'Colossal Heads', *U.C.A.R.F.*, IV (1967), and C. Wicke, *Olmec* (Tucson, 1971), on the problem of seriation. On proportions, J. Fernández, *Arte olmeca* (Mexico, 1968). Also C. W. Clewlow, *U.C.A.R.F.*, XIX (1974).

12. P. D. Joralemon, *A Study of Olmec Iconography* (Washington, 1971), proposes ten gods, by developing the suggestions of M. Coe (*America's First Civilization*, New York, 1968, 111–15).

13. The jade 'canoe' from Cerro de las Mesas, with jaguar-masks engraved at both ends, seems to represent such an art; P. Drucker, *B.B.A.E.*, CLVII (1955), 47–9. The slit-eyed mask in the American Museum of Natural History (from a cave in Cañon de la Mano south of Taxco in Guerrero) is by style an Olmec wooden object. See G. Ekholm, *Ancient Mexico and Central America* (New York, 1970), 38.

14. *Artes de Mexico*, XIX (1972), no. 154, B. de la Fuente, ed., p. 25. The head was discovered by a field party under the direction of R. F. Squier, and transferred to San Andrés Tuxtla.

15. This rests only upon analogy with similar p. 72 changes elsewhere, as in Greek pediment sculpture of c. 550–450 B.C., or early Gothic portal figures in northern France of c. 1140–1250. The recent estimate based on radiocarbon fixes the end of the period of the heads as prior to the epoch of the relief sculptures. It does not accord with the sculptural evidence. The parallels with Maya sculpture still leave it possible to assume a terminal date c. A.D. 300 for La Venta carvings. Contrast P. Drucker, R. F. Heizer, and R. J. Squier, 'Excavations at La Venta,

1955', *B.B.A.E.*, CLXX (1959). Also R. F. Heizer, 'Agriculture and the Theocratic State in Lowland Southeastern Mexico', *Am.A.*, XXVI (1960), 215–22.

p. 72 16. According to M. D. Coe ('San Lorenzo', *Dumbarton Oaks Conference*, Washington, 1968, 63) the end of the colossal-head sequence was marked by their mutilation *c.* 900 B.C. He now seriates the heads as beginning with San Lorenzo and ending with La Venta (differing from his own earlier estimate).

C. Wicke (*Olmec, an Early Art Style of Precolumbian Mexico*, Tucson, 1971, 113–27) at first supported the seriation LV-TZ-SL with Guttmann scalograms, but he later agreed with Coe's ordering. The question of seriation cannot now be resolved without additional evidence. The extent to which the heads may be intrusive in relation to their immediate surroundings is still unknown. C. W. Clewlow, R. A. Cowan, J. F. O'Connell, C. Benemann ('Colossal Heads of the Olmec Culture', *U.C.A.R.F.*, IV, 1967, 61) have examined and measured the heads, concluding that they may all be 'relatively contemporaneous'. See also C. W. Clewlow, Jr, 'A Stylistic and Chronological Study of Olmec Monumental Sculpture', *U.C.A.R.F.*, XIX (1974). A recent computer mapping of the statistical distances among the heads by Takashi Miyawaki using data provided by G. Kubler ('Multidimensional Scaling and the Seriation of the Twelve Olmec Colossal Heads', MS. 1970) was made using Kubler's traits and weighting. These maps distinguish the sites from one another in the non-weighted distances. With the same data weighted, resemblances of style appeared clearly between heads at different sites. The data did not permit a seriation.

J. Brüggemann and M. A. Hers (*I.N.A.H., Boletín*, XXXIX, 1970, 18–26), reporting their stratigraphic excavation at San Lorenzo, note that the 'round' Head 9 was found undamaged at 4 m. depth in a pit penetrating 2 m. below undisturbed base level. Head 7, a 'long' head, occurred in the humus at a depth of only 50 cm. Heads 7 and 9 belong to different kinds of andesite (*ibid.*, 26–9).

17. Proskouriakoff, figure 7 and p. 19.

18. Proskouriakoff, 28–9. 'Altar' is probably a misnomer; such stones were surely used more as seats or platforms than as sacrificial tables.

p. 73 19. R. Heizer, 'Analysis of Two Low Relief Sculptures from La Venta', *U.C.A.R.F.*, III (1967), 25–55.

20. M. Stirling, *B.B.A.E.*, CXXXIX (1943), plates 17–18 and pp. 18–21 (Monument C).

21. *B.B.A.E.*, CLIII (1952), 133. The formative stages of this process have not been discovered.

22. Illustrated in *B.B.A.E.*, CLIII (1952), plates 31–6; CXXXIX (1943), plates 32–6. R. Piña Chan and L. Covarrubias, *El Pueblo del Jaguar* (Mexico, 1964).

23. This composition existed in monumental p. 7 basalt sculpture at La Venta; see *B.B.A.E.*, CLIII (1952), plate 59 (Monument 8).

24. Such a 'replica' of a La Venta jade is the seated figurine of Tlatilco, discussed by M. N. Porter, *Tlatilco*, plate 4B and p. 23. Many helmeted figurines of clay can be seen among the purchase specimens illustrated by Weiant in *B.B.A.E.*, CXXXIX (1943). R. Piña Chan, *Culturas preclásicas* (Mexico, 1956), 14, has suggested an analogous division by 'rural' (Valley of Mexico) and 'semi-urban' (Gulf Coast) groups.

25. M. Covarrubias, 'El arte "Olmeca" o de la p. 7 Venta', *C.A.*, V (1946), no. 4, 153–79, and *The Eagle, the Jaguar and the Serpent* (New York, 1957).

26. M. Covarrubias, *Mexico South*, 77–8.

27. The theses of Covarrubias are maintained by M. Coe in *The Jaguar's Children: Pre-Classic Central Mexico* (New York, 1965) and *America's First Civilization* (New York, 1968).

28. M. N. Porter, *Tlatilco*, 71–9, enumerated the similarities between Olmec and Chavín styles.

29. An economic view is advanced by K. Flan- p. 7 nery, 'The Olmec and the Valley of Oaxaca', *Dumbarton Oaks Conference on the Olmec* (Washington, 1968), 79–108, who regards the style as a reflection of trade relations.

30. D. C. Grove, 'Los murales de la Cueva de Oxtotitlan', *Invest. I.N.A.H.*, XXIII (1970), and 'The Olmec Paintings of Oxtotitlan Cave', *D.O.S.*, VI (1970). C. Gay, 'Oldest Paintings of the New World', *Natural History*, LXXVI (1967), 28–35.

31. W. Krickeberg, 'Die Totonaken', *B.A.*, VII p. 7 (1918–22), 1–55; IX (1925), 1–75.

32. See the comparisons drawn to uniform scale in Marquina, láms. 276–82.

33. J. García Payón, 'Archaeology of Central Veracruz', *H.M.A.I.*, XI (1971), 527, table 1.

34. J. García Payón, *Exploraciones en el Tajín (In- p. 8 formes I.N.A.H.*, no. 2) (Mexico, 1955); also *A.I.N.A.H.*, V (1952), 75–8.

35. Marquina, 450–2.

36. J. García Payón, 'Arqueología de Zempoala', p. 8 *Uni-Ver*, I (1949), 11–19; 134–9; 449–76; 534–48; 581–95; 636–56.

37. H. Strebel, *Alt-Mexiko*, 2 vols. (Hamburg-Leipzig, 1885–9).

38. P. Agrinier, *The Carved Human Femurs from Tomb 1, Chiapa de Corzo* (Orinda, 1960); E. Shook and A. V. Kidder, *C.A.A.H.*, XI (1952), 117. See Proskouriakoff, *H.M.A.I.*, XI (1971), 559.

39. M. Stirling, *B.B.A.E.*, CXXXVIII (1943), 31–48. The earth platforms of the site were covered with stucco painted red.

40. Proskouriakoff, 172–4.

41. Compare Stela 11, Monte Alban; A. Caso, *Estelas zapotecas* (Mexico, 1928).

83 42. T. Proskouriakoff, 'Varieties of Classic Central Veracruz Sculpture', *C.A.A.H.*, no. 58 (1954), 63–94. M. E. Kampen, *The Sculptures of El Tajín* (Gainesville, 1972), 83–5, places the Pyramid Sculptures 4–6 and Pyramid Panel 3 as early in a sequence occupying six centuries (A.D. 300–900). T. Proskouriakoff, 'Classic Art', *H.M.A.I.*, XI (1971), 570, regards the entire style as 'terminal classic', and as lacking Toltec traits.

43. Tres Zapotes (Weiant, *B.B.A.E.*, CXXXIX (1943), plate 7) and Cerro de las Mesas (Drucker, *B.B.A.E.*, CXLI (1943), plate 58): yoke and *hacha* with Lower II (Late Classic) associations.

44. Illustrated in Proskouriakoff, figure 9g. Cf. M. E. Kampen, *op. cit.*, 24–6.

45. J. García Payón, *A.I.N.A.H.*, II (1947), 73–111.

84 46. G. Ekholm, *A.A.*, XLVIII (1946), 593–606, and *Am.A.*, XV (1949), 1–9. S. J. K. Wilkenson, 'Un yugo in situ de la región del Tajín', *Bol. I.N.A.H.*, XLI (1970), 41–4. The large literature on the ball-court and the equipment of the players was recently summarized by M. F. Kemrer, Jun., 'A Re-examination of the Ball-game in Mesoamerica', *Cerámica de Cultura Maya et al.*, no. 5 (1968), 1–25, and L. H. Ritman, 'The Rubber Ball-Game', *ibid.*, 27–57.

47. C. W. Weiant, *B.B.A.E.*, CXLI (1943), plate 58.

48. E. J. Palacios, *Los yugos y su simbolismo* (Mexico, 1943), illustrates many yokes which are not relevant to the analysis by T. Proskouriakoff. M. Krutt, 'Un yugo in situ', *I.N.A.H.*, *Boletín*, XXXVI (1969), 16–19, enumerates five burials containing yokes, and refutes the idea that plain stone yokes were marginal imitations of the ornate examples in Veracruz.

85 49. A stela found at Aparicio in Veracruz shows the elongated *palma* in place upon a player; J. García Payón, *R.M.E.A.*, X (1948–9), 121–4. The relief may be compared to the figure with seven snakes entwined at the head shown at Chichén Itza in the ball-court reliefs (Figure 68).

50. All the reliefs of the main court are illustrated by M. Kampen, *op. cit.*

51. The cacao tree relief (M. Kampen, figure 5a) belongs to this heavily outlined style of patterned background.

52. E.g. Type IX figurines, Cerro de las Mesas (Drucker, *B.B.A.E.*, CXLI (1943), plate 43).

53. H. D. Tuggle, *Cultural Inferences from the Art of El Tajín*, MS. (M.A. thesis, Arizona, 1966); 'The Columns of El Tajín', *Ethnos*, XXXIII (1968), 40–70. See also J. García Payón, 'Ensayo de interpretación', *M.A.*, IX (1959), 445–60, and L. Knauth, 'El juego de pelota', *E.C.M.*, I (1961), 183–99. p. 86

54. H. W. McBride, in *Ancient Art of Vera Cruz*, ed. O. Hammer (Los Angeles, 1971), 23–30.

55. S. C. Belt, *ibid.*, 41.

56. H. Strebel, *op. cit.* The important pre-Classic finds at Remojadas in central Veracruz are still incompletely published. See A. Medellín Zenil, *Cerámicas del Totonacapan* (Xalapa, 1960), 176–84; also A. Medellín Zenil and F. A. Peterson, 'A Smiling Head Complex from Central Veracruz, Mexico', *Am.A.*, XX (1954), no. 2, 162–9.

57. P. Drucker, *B.B.A.E.*, CXLI (1943), 86.

58. V. Rosado Ojeda, 'Las mascaras rientes totonacas', *R.M.E.A.*, V (1941), 53–63. Moulded figurines of Cuicuilco-Ticoman date are reported from Remojadas; F. A. Peterson, *Tlatoani*, I (1952), 63–7. At the Cerros site near Tierra Blanca in Veracruz a heap of rejects was found. Medellín and Peterson, *op. cit.*, 166; A. Medellín Zenil, *Cerámicas del Totonacapan* (Xalapa, 1960), 78–84.

59. G. Ekholm, *A.M.N.H.A.P.*, XXXVIII (1944), 499, notes that burnt clay floors can be identified as of the Pánuco period II (pre-Classic) in the Huasteca. El Ebano is discussed by Marquina, 407. p. 87

60. W. Du Solier, 'Primer fresco mural huasteca', *C.A.*, V (1946), no. 6, 151–9.

61. H. E. D. Pollock, *Round Structures* (Washington, 1936).

62. H. Beyer, 'Shell Ornament Sets', *M.A.R.S.*, V (1934), 153–215. p. 88

63. C. Seler-Sachs, *Auf alten Wegen in Mexiko und Guatemala* (Berlin, 1900).

64. E. Seler, *G.A.*, III, 514–21.

65. H. Spinden, 'Huastec Sculptures and the Cult of the Apotheosis', *Brooklyn Museum Quarterly*, XXIV (1937), 179–88. G. Stresser-Péan, 'Ancient Sources on the Huasteca', *H.M.A.I.*, XI (1971), 582–602.

CHAPTER 5

1. I. Bernal, 'Archaeological Synthesis of Oaxaca', *H.M.A.I.*, III (1965), 788–813. See also A. p. 89

Caso, *Exploraciones en Oaxaca . . . 1934–35* (Mexico, 1935); *idem. 1936–37* (Instituto panamericano de geografía e historia, Pubs. 17 and 34) (Mexico, 1938). I. Bernal, *Exploraciones en Cuilapan* (Mexico, 1958), 66, supposes that Monte Alban was already in disuse during IIIb, when Cuilapan, at the south foot of Monte Alban, was flourishing.

p. 89　2. A. Caso, 'El mapa de Teozacualco', *C.A.*, VIII (1949), no. 5, 145–81.

p. 90　3. John Paddock, *Ancient Oaxaca* (Stanford, 1966), 176–200; *idem*, 'More Ñuiñe Materials', *B.E.O.*, no. 28 (1970). Paddock's thesis is supported by L. Parsons, *Bilbao*, II (Milwaukee, 1969), 171. The supposition that Mitla is Mixtec was strengthened by the discovery of Yagul, a site near Mitla, much like Mitla, and clearly Mixtec by ceramic evidence; *Mesoamerican Notes*, IV (1955), and V (1957). See P. Dark, *B.E.O.*, no. 10 (1958), with supplementary note by John Paddock.

4. The south platform includes re-used materials of Monte Alban I and II (Caso, *Exploraciones* (1938), 5–7).

5. Mound J in the south central portion of the plaza belongs by ceramic and sculptural evidence to Monte Alban II (Caso, *Exploraciones* (1938), 11, 62). The peaked vault of slabs leaning upon one another also characterizes the underground tombs of Period II.

p. 92　6. Caso, *Exploraciones* (1935), 13–15; Marquina, lám. 93 and figure 143. Another two-chambered cella with columns *in antis* is the temple on Mound H, at the centre of the main plaza. Columnar plans characterize the buildings of Monte Negro in the Mixteca, ascribed to the period of Monte Alban I (plan in Marquina, lám. 104).

7. A fragment of another such model is illustrated in Caso, *Exploraciones* (1938), figure 56. More models are illustrated by H. Hartung, 'Notes on the Oaxaca Tablero', *B.E.O.*, no. 27 (1970), 5.

p. 94　8. If the temple is the dramatic centre of the space, it is permissible to speak of its stairway and terraces as the proscenium to stress the ritual unity of the temple and its staired approach.

9. General discussion in A. Caso, *Las estelas zapotecas* (Mexico, 1928), and 'Sculpture and Mural Painting in Oaxaca', *H.M.A.I.*, III (1965), 849–70. I. Bernal, 'The Ball Players of Dainzú', *Archaeology*, XXI (1968), 246–51. The relief from Tilantongo, showing 'Five Death', is illustrated by P. Kelemen, *Medieval American Art* (New York, 1943), plate 58A.

p. 95　10. A. Villagra, 'Los Danzantes', *I.C.A.*, XXVII (1939), II, 143–58.

11. Cf. A. Caso, *Calendarios y escrituras de las antiguas culturas de Monte Albán* (Mexico, 1947).

12. Reproduced in Caso, *Exploraciones* (1938), 18　p. (Lápida de Bazán).

13. A. Caso, I. Bernal, J. R. Acosta, *La cerámica de Monte Alban* (Mexico, 1947). The collections in Berlin, assembled by Eduard Seler, have recently been catalogued by I. von Schuler-Schömig, *Figurengefässe aus Oaxaca* (Berlin, 1970). See also A. Caso and I. Bernal, *Urnas de Oaxaca* (Mexico, 1952); S. Linné, *Zapotecan Antiquities* (Stockholm, 1938); J. A. Mason, *Museum Journal*, XX, no. 2 (1929); C. G. Rickards, *J.S.A.*, X (1913), 47–57.

14. E.g. the 'rain-god (Cocijo) complex', a 'maize-god complex', and calendrical deities such as 'Five Flower', 'Thirteen Serpent', 'Eleven Death', or 'Two Tiger'. The same classing appears in F. Boos, *Corpus antiquitatum americanensium*, 2 vols. (Mexico, 1964–6).

15. Emily Rabin, 'The Lambityeco Friezes, Notes on Their Content, with an Appendix on C14 Dates', *B.E.O.*, no. 33 (1970).

16. Tomb 104 being of Period IIIa and Tomb 105　p. of IIIb? Caso, *H.M.A.I.*, III, 866.

17. A. Caso, *Exploraciones* (1938), 47 f.: B. Dahl-　p. gren de Jordan, *La Mixteca* (Mexico, 1954), 341. Monte Negro is of Monte Alban I date; Tomb I at Yucuñudahui is of Monte Alban III date.

18. The stucco figures of Tomb I at Zaachila (excavated by R. Gallegos, 'Zaachila', *Archaeology*, XVI, 1963, 229–31) are discussed by A. Caso, 'The Lords of Yanhuitlan', in J. Paddock, ed., *Ancient Oaxaca* (Stanford, 1966), 319–30. Paddock ('Mixtec Ethnohistory', *ibid.*, 377) cites the sixteenth-century *relaciones* on the thirteenth-century arrival of Mixtecs at Zaachila and Cuilapan. I. Bernal ('The Mixtecs in Valley Archeology', *ibid.*, 365) admits that 'the first Mixtec phase in the Valley – which we might then call Monte Alban Va – may have to be extended back to the middle of the thirteenth century'. Compare R. Chadwick, 'Pre-Aztec History', *H.M.A.I.*, XI, 487–8. A. Caso, *Exploraciones* (1932), 32, first identified the Tomb 7 burial as Mixtec of the fifteenth or early sixteenth century, by parallels with Aztec works of art.

19. A. Caso, *Exploraciones en Mitla, 1934–35* (Mexico, 1936); John Paddock, 'Excavations at Yagul', *Mesoamerican Notes*, IV (1955), 80–90; 'Relación de Tlacolula y Mitla', *Papeles de la Nueva España*, ed. F. del Paso y Troncoso, IV (Madrid, 1905), 144–54; English version in *Mesoamerican Notes*, IV (1955), 13–24.

20. M. Saville, 'The Cruciform Structures of　p.

Mitla and Vicinity', *Putnam Anniversary Volume* (New York, 1909), 151–90.

21. A. Caso and D. F. Rubín de la Borbolla, *Exploraciones en Mitla* (1936), 11–12.

02 22. *Mesoamerican Notes*, IV (1955), and V (1957). Reviewed by H. B. Nicholson, *Am.A.*, XXIII (1957), 195, warning against the equation of *style* and *ethnic group*.

04 23. G. B. Gordon, 'Prehistoric Ruins of Copán', *P.M.M.*, I (1896); G. Strómsvik, 'Substela Caches and Stela Foundations at Copán and Quiriguá', *C.A.A.H.*, VII (1942), 63–96.

24. J. P. Oliver has grouped the mosaics by rectilinear and curved elements in archaic, classic, and baroque phases, separated by transitions (*Mesoamerican Notes*, IV (1955), 57–62). He proposes curved forms as posterior to rectilinear ones. Oliver's types are based upon the listing by N. León, *Lyobaa ò Mictlan* (Mexico, 1901), without much re-grouping. If we eliminate obvious repetitions and duplications, the repertory can be simplified as follows (see Figure 27):

Oliver-León

1–2	tilted \exists key-fret	I
3–6	stepped key-fret (*xicalcoliuhqui*)	II
7–9, 14	key rinceau	III
10	serrated key	IV
11–12	diamond pattern	V
13, 16, 17, 18, 21, 22	spiral fret	VI
	spiral meander	VIa
15, 19	key meander	VII
20	key and diamond	VIII

Key forms are rectilinear; spirals are curved. R. Sharp, 'Early Architectural Grecas in the Valley of Oaxaca', *B.E.O.*, no. 32 (1970), discusses the bilaterally symmetrical step-fret as an early form appearing in Monte Alban IIIb.

105 25. A. Caso, 'El mapa de Teozacualco', *C.A.*, VIII (1949), no. 5, 145–81. Only the place-glyphs for Tilantongo and Teozacualco are known with certainty. About sixty place-names appear in Codex Bodley; seventy-five in Codex Selden.

26. The Dominican chronicler Fray Francisco de Burgoa (*Geográfica descripción . . .*, Mexico, 1674) regarded Mitla as a pagan Vatican: the pontiff resided in the Group of the Columns. Burgoa, a native of Oaxaca, recorded colonial folklore rather than pre-Conquest tradition.

27. Seven of these reliefs are illustrated by A. Caso, *Estelas Zapotecas* (Mexico, 1928), figures 80, 81, 82, 83, 84, 93, 94. Caso, 'Sculpture and Mural Painting of Oaxaca', *H.M.A.I.*, III (1965), 857, assigns Zaachila relief no. 1 to period IIIa, and the

tomb slab found between Zaachila and Cuilapan to periods IIIb–IV (*ibid.*, 942).

28. E. Seler, 'The Wall Paintings of Mitla', *B.B.A.E.*, XXVIII (1904), 243–324.

29. W. Lehmann, 'Les peintures Mixteco- p. 107 Zapotèques', *J.S.A.*, II (1905), 241–80. The Zapotec, Cuicatec, Mazatec, Chinantec, Mije, and Popoloca variants are not fundamentally distinct.

30. The term 'codex' signifies the European book, and it consists of pages hinged or sewn at one side. Mexican usage has long confused *codex* with *manuscript*.

31. F. Burgoa, *Palestra historial* (Mexico, 1670).

32. A. Dibble, *Códice Xolotl* (Mexico, 1951). On the Tlailotlacs, see B. Dahlgren de Jordan, *La Mixteca*, 58.

33. *C.A.*, VIII (1949), no. 5, 165 ff. Other dynastic p. 108 lists are known: Teozacualco, Coixtlahuaca, and another (Codex Selden, Oxford) for an unidentified place represented by the sign of a spitting mountain. These lists display divisions and durations similar to those of Tilantongo. Cf. B. Dahlgren de Jordan, *La Mixteca*, chapter V, and P. Dark, *Mixtec Ethnohistory* (Oxford, 1958). A. Caso, in *Ancient Oaxaca*, ed. J. Paddock (Stanford, 1966), 313–35, gives genealogies for Yanhuitlán and probably for Cuilapan.

34. A. Caso, 'Base para la sincronología Mixteca y cristiana', *Memoria de el Colegio Nacional*, VI (1951), 49–66, calls it 'spitting-mountain'.

35. *Lienzo de Zacatepeque*, ed. A. Peñafiel (Mexico, 1900); C. G. Rickards, 'Notes on the "Codex Rickards"', *J.S.A.*, X (1913), 47–57.

36. J. Cooper Clark, *The Story of Eight Deer* p. 109 (London, 1912).

37. Facsimile reproductions: Colombino in A. Chavero, *Antigüedades mexicanas* (Mexico, 1892); A. Caso and M. E. Smith, *Códice Colombino* (Mexico, 1966); Becker in H. de Saussure, *Le manuscrit du cacique* (Geneva, 1892); K. A. Nowotny, *Codices Becker I/II* (Graz, 1961). On Mixtec manuscripts in general, see M. E. Smith, *Picture Writing from Ancient Southern Mexico: Mixtec Place Signs and Maps* (Norman, 1973).

38. E. Seler, 'Der Codex Borgia und die verwandten aztekischen Bilderschriften', *G.A.*, I, 133–44; W. Lehmann, *J.S.A.*, II (1905), 251. Seler's study enumerates the parallel passages. See K. A. Nowotny, *Tlacuilolli: Die mexikanischen Bilderhandschriften, Stil und Inhalt, mit einem Katalog der Codex-Borgia-Gruppe* (Berlin, 1961); also B. Spranz, *Göttergestalten in den mexikanischen Bilderhand-*

schriften der Codex Borgia-Gruppe (Wiesbaden, 1964).

p. 109 39. A deerhide sheet in Paris (Bibl. Nat. MS. Mex. no. 20, repr. in E. Boban, *Manuscrits mexicains*, Paris, 1891, plate 21) shows the nexus between the Borgia group and the Mixtec genealogies.

40. G. Vaillant connected Oaxaca and southern Puebla as one archaeological province with the conception of a 'Mixteca-Puebla' area; *Aztecs of Mexico* (Harmondsworth, 1950), 41–2. His estimate of its importance is best set forth in 'Patterns of Middle American Archaeology', *The Maya and their Neighbors* (New York, 1940), 295–305.

41. E. Seler, *Codex Féjerváry–Mayer* (Berlin–London, 1902), 210.

42. The twenty weeks of thirteen days appear in Borgia, Vaticanus B, Borbonicus, the Aubin *tonalamatl*, Vaticanus A, and Telleriano–Remensis, sufficiently alike to come all from a common source.

43. The earliest if inexact facsimiles are those gathered by Lord Kingsborough in *Antiquities of Mexico* (London, 1831). Féjerváry–Mayer, Borgia, Cospi, Vaticanus B, Laud, Bodley, Selden, Vienna, Zouche–Nuttall, and Colombino–Becker have all been reproduced in more or less modern facsimiles, the first four at the expense of the Duc de Loubat in exact colour photography; the Vienna manuscript likewise (by W. Lehmann and O. Smital, in 1929). The Zouche–Nuttall and Colombino–Becker manuscripts exist in tracings reproduced lithographically in colour: *Codex Nuttall* (Cambridge, Mass., 1902); H. de Saussure, *Le manuscrit du cacique* (Geneva, 1892), and A. Chavero, *Antiguedades mexicanas* (Mexico, 1892) (vol. of plates). See J. Glass, *Catálogo de los códices* (Mexico, 1964), and J. B. Nicholson, 'The Mesoamerican Pictorial Manuscripts', *I.C.A.*, XXXIV (1962), 199–215, as well as the list of coloured facsimiles published by the Akademische Druck und Verlagsanstalt in Graz as the series called *Codices selecti* (Handschriften fremder Kulturen).

p. 110 44. J. Soustelle, *La pensée cosmologique des anciens Mexicains* (Paris, 1940), 57. B. Spranz, *Göttergestalten* (Wiesbaden, 1964), has analysed the costumes of the deities, showing that fixed identities are less evident than changing assemblages of attributes.

45. E. Seler, 'Venus Period in the Picture Writings of the Borgian Codex Group', *B.B.A.E.*, XXVIII (1904), 355–91.

p. 111 46. Ñuiñe style: *Ancient Oaxaca*, ed. J. Paddock (Stanford, 1966), 175–200. Yagul: C. C. Meigs, *Mesoamerican Notes*, IV (1955), 72–9.

47. E. Noguera, *El Horizonte Tolteca-Chichimeca* (Mexico, 1950); S. K. Lothrop, *The Pottery of Costa Rica and Nicaragua* (New York, 1926); G. Ekholm, 'Excavations at Guasave, Sinaloa', *A.M.N.H.A.P.*, XXXVIII (1942).

48. I. Bernal, 'Excavaciones en Coixtlahuaca', *R.M.E.A.*, X (1949), 5–76.

49. E. Noguera, *La cerámica arqueológica de Cholula* (Mexico, 1954), 120–42.

50. A. Caso, *Exploraciones* (1932), and *Natural History*, XXXV (1932), no. 5, discusses the contents of Tomb 7 at Monte Alban. See also M. H. Saville, *The Wood-carver's Art in Ancient Mexico* (New York, 1925); *Turquoise Mosaic Art in Ancient Mexico* (New York, 1922); and *The Goldsmith's Art in Ancient Mexico* (New York, 1920).

51. Turquoise chips appeared in the early village p. site of El Arbolillo in the Valley of Mexico, probably imported from the north. Vaillant, *A.M.N.H.A.P.*, XXXV (1935), 245.

52. E. Morris, J. Charlot, and A. Morris, *Temple of the Warriors*, I (Washington, 1931), 189 f.

53. M. Saville, *Turquoise Mosaic*, plates V, VI, VII, VIII, XIX, XXI are Toltec; the Mixtec cave finds are discussed on pp. 47 and 63.

54. E. Seler, 'Über szenische Darstellungen auf altmexikanischen Mosaiken', *G.A.*, IV, 362–83.

55. D. Pendergast, 'Tumbaga at Altun Ha', *Science*, CLXVIII (1970), no. 3927, 116–18; S. K. Lothrop, 'Metals from the Cenote of Sacrifice', *P.M.M.*, X (1952), 22–6.

56. A. Caso, *El tesoro de Monte Albán* (Mexico, 1969). On Zaachila, see Note 18.

57. S. K. Lothrop, 'Archaeology of Southern p. Veraguas, Panama', *P.M.M.*, IX (1950).

CHAPTER 6

1. On a shifting boundary between western p. Mexico and Mesoamerica (1200–950 B.C.), see P. Tolstoy and I. Paradis, *U.C.A.R.F.*, XI (1971), 25–6. Also C. T. E. Gay, *Xochipala, the Beginnings of Olmec Art* (Princeton, 1972), and G. Griffin, 'Xochipala, the Earliest Great Art Style in Mexico', *Proceedings, American Philosophical Society*, CXVI (1972), 301–9.

2. M. Covarrubias, *Mezcala, Ancient Mexican Sculpture* (New York, 1956); also 'Tipología de la industria de piedra tallada y pulida de la Cuenca del Río Mezcala', *El occidente de México* (*S.M.A.M.R.*, IV) (Mexico, 1948), 86–90; and *Indian Art of Mexico and Central America* (New York, 1957), 104–14. The

material is classified and provisionally dated by C. Gay, *Mezcala Stone Sculpture; the Human Figure* (New York, 1967).

15 3. M. Covarrubias has discussed the class as 'puramente local', without great antiquity, and as derivative from the Olmec axes; *El occidente de México* (*S.M.A.M.R.*, IV), 88.

4. Guerrero sculpture is also illustrated by G. Médioni and M. T. Pinto, *Art in Ancient Mexico* (New York, 1941), figures 4–32, and G. Kubler, *The Arensberg Collection* (Philadelphia, 1954). See R. H. Lister, 'Archaeological Synthesis of Guerrero', *H.M.A.I.*, XI (1971), 619–31.

16 5. In western Guerrero, at Placeres de Oro (now called Vistahermosa), slabs with feline figures in incised relief distantly resembling the Chavín style were reported by H. J. Spinden (*A.A.*, XIII (1911), 29–55). I. Kelly has related the site to middle period finds at Apatzingan (*El occidente de México*, *S.M.A.M.R.*, IV, table opposite p. 76).

6. I. Kelly, in *S.M.A.M.R.*, IV (1948) (North Mexico), 55. Also *S.M.A.M.R.*, III (West Mexico), 1943.

7. J. Corona Núñez, 'Tumba de el Arenal, Etzatlán, Jal.', *Informes I.N.A.H.*, III (Mexico, 1955). For Nayarit, see J. Corona Núñez, 'Diferentes tipos de tumbas prehispánicas in Nayarit', *Yan*, III (1954), 46–50; B. Bell, 'Archaeology of Nayarit, Jalisco and Colima', *H.M.A.I.*, XI (1971), 694–753.

8. H. D. Disselhoff excavated several intact tombs at sites south-east of the town of Colima, finding associated lots of figurines with coffee-bean eyes and slab figurines, as well as slit-eye figures in other tombs; *Revista del Instituto de Etnología de la Universidad Nacional de Tucumán*, II (1932), 525–37.

9. Without advancing a chronology, P. Kirchhoff, *Arte precolombino del occidente de México* (Mexico, 1946), set forth a classification by costume, distinguishing nude, breech-clout, and painted-garment folk, whom he provisionally identified with distinct ethnic groups in western Mexico.

10. H. von Winning and O. Hammer, *Anecdotal Sculpture of Ancient West Mexico* (Los Angeles, 1972).

117 11. M. Kan, C. W. Meighan, and H. B. Nicholson, *Sculpture of Ancient West Mexico* (Los Angeles, 1970).

12. This grouping of 'early' and 'late' is based upon the figure of a mother and child in the Diego Rivera Collection (*Arte precolombino*, 51). The two styles appear together: the mother is of 'late' Ameca workmanship, and the suckling infant

shows the retention of 'earlier', less articulated habits of modelling. It can of course be argued from this evidence that both manners are coeval. The linking of both types as of Ameca Valley origin remains valid.

13. E. W. Gifford, 'Surface Archaeology of Ixtlán del Río, Nayarit', *U.C.P.A.A.E.*, XLIII (1950), 183–302. All three of our types, and others, are represented in collections from the area about Ixtlán. On 'Chinesca' figures see B. Bell, *op. cit.*, *H.M.A.I.*, XI (1971), 717–19. Pole-scenes: H. von Winning, *Anecdotal Sculpture* (1972), 23–4.

14. In *Arte precolombino*, 31. p. 118

15. J. Corona Núñez, 'Relaciones arqueológicas entre las Huastecas y las regiones al Poniente', *R.M.E.A.*, XIII (1952–3), 479–83, ascribes the differences of the Nayarit style to Huasteca origins, and he regards Nayarit as the centre of diffusion to Jalisco and Colima. A circular platform at Ixtlán has been rebuilt with profiles like those of Tajín (*op. cit.*, figures 66–70); it would correspond to the period of the large tomb figures with fully modelled eyes.

16. Only by analogy with central Mexican religion, as reported by Motolinia in the sixteenth century. S. Toscano, in *Arte precolombino*, 24.

17. P. Furst, 'West Mexican Tomb Sculpture as Evidence for Shamanism in prehispanic Mesoamerica', *Antropológica*, XV (1965), 29–81. Cf. G. Kubler, 'Evidencia intrínseca', *S.M.A.M.R.*, XIII (1972).

18. R. Chadwick, 'Archaeological Synthesis of p. 119 Michoacan', *H.M.A.I.*, XI (1971), 657–93; E. Noguera, 'Exploraciones en El Opeño, Michoacán', *I.C.A.*, XXVII (1943), 574–86; M. N. Porter, 'Excavations at Chupícuaro', *Transactions of the American Philosophical Society*, XLVI (1956), part 5, 515–637.

19. E. Noguera, 'Exploraciones en Jiquilpan', *Anales del museo michoacano*, III (1944), 37–52. The parallel platforms, identified by Noguera as a ball-court, are about 30 yards apart, much too wide for the ascribed purpose. The name of the site itself is El Opeño, west of the city of Jiquilpan.

20. M. Covarrubias, *Indian Art of Mexico and Central America*, 95, charts the occurrences of the inlaid-paint technique from Arizona to Peru. Detailed discussion of west Mexican examples in G. Ekholm, *A.M.N.H.A.P.*, XXXVIII (1942), 91–6. Ekholm regarded Teotihuacán 'frescoed' pottery as an imitation of western lacquer (p. 95) rather than as deteriorated lacquer (as Covarrubias suggests).

p. 119 21. D. Rubín de la Borbolla, 'Arqueología tarasca', *Occidente de México S.M.A.M.R.*, IV (1948), 30–5; W. Jimenez Moreno, *ibid.*, 146–57.

p. 120 22. The *Relación de Michoacán* (1541), ed. Tudela (Madrid, 1956), is the most important historical source, richly illustrated with drawings of the period.

23. D. Rubín de la Borbolla, 'La orfebrería tarasca', *C.A.*, III (1944), no. 3.

24. G. Ekholm, 'Excavations at Guasave', *A.M.N.H.A.P.*, XXXVIII (1942). The term 'Aztatlán' originally meant post-Classic, red-on-buff pottery on the west coast of Mexico. I. Kelly, *Ibero-Americana*, XIV (1938), 19. 'Aztatlán' now refers to a pre-Aztec and post-Classic archaeological period in Culiacán and Sinaloa.

p. 122 25. I. Kelly, *Ibero-Americana*, XXV (1945). J. C. Kelley and H. D. Winters ('A Revision of the Archaeological Sequence in Sinaloa', *Am.A.*, XXV (1960), 547–61) have expanded this span with phase names, spreading from A.D. 250 (Chametla horizon) to Guasave phase, *c.* 1150–1350. Cf. C. W. Meighan, 'Archaeology of Sinaloa', *H.M.A.I.*, XII (1971), 754–67.

26. J. M. Reyes, 'Breve reseña . . .', *Boletín de la Sociedad de Geografía y Estadística*, V (1881), 385 ff.

27. P. Armillas, 'Fortalezas mexicanas', *C.A.*, VII (1948), no. 41, 143–63.

28. E. Noguera, *Ruinas arqueológicas del norte de México* (Mexico, 1930); E. Guillemin Tarayre, *Exploration minéralogique des régions mexicaines* (Paris, 1869); M. Gamio, *Los monumentos arqueológicos de las immediaciones de Chalchihuites* (Zacatecas, 1910); A. Hrdlička, 'The Region of the Ancient Chichimecs', *A.A.*, V (1903), 384–440.

29. J. C. Kelley, 'Archaeology of the Northern Frontier', *H.M.A.I.*, XI (1971), 776. Unpublished radiocarbon dates for La Quemada show a tenth-century concentration.

CHAPTER 7

123 1. S. G. Morley, *Inscriptions of Peten*, IV (1938), 313. Epigraphers refer to part of the Classic era of Maya history as the 'Initial Series period'.

2. Only some Classic Maya sites display all the diagnostic traits. At Holmul in the Petén only the vaulted architecture survives; at Pusilhá we have only the stelae and glyphs; at El Paraiso there are only stelae.

3. R. L. Roys, 'The Engineering Knowledge of the Maya', *C.A.A.*, II (1934), 27–105.

4. A. L. Smith, 'The Corbelled Arch in the New World', *The Maya and their Neighbors* (New York, 1940), 202–21.

125 5. R. Wauchope, *Modern Maya Houses* (Washington, 1938), and 'House Mounds of Uaxactun', *C.A.A.*, II (1934), 107–71.

6. J. E. S. Thompson, *Maya Hieroglyphic Writing* (Washington, 1950); also T. S. Barthel, 'Die gegenwärtige Situation in der Erforschung der Maya-Schrift', *J.S.A.*, XLV (1956), 219–27.

7. In addition to J. E. S. Thompson's *Commentary on the Dresden Codex* (Philadelphia, 1972), the most convenient edition of the Madrid, Paris, and Dresden manuscripts is by C. and J. A. Villacorta, *Los códices Mayas* (Guatemala, 1930). The inscriptions are best studied in S. G. Morley, *The Inscriptions of Peten*, 5 vols. (Washington, 1937–8). A complete corpus of the inscriptions is planned by Ian Graham at Peabody Museum in Cambridge, Mass., as Director of the Maya Hieroglyptic Inscription Study. See *The Art of Maya Hieroglyphic Writing* (New York, 1971).

8. The main publications expounding the historical approach are the following: H. Berlin, 'El glifo "emblema" en las inscripciones Mayas', *J.S.A.*, XLVII (1958), 111–19; T. Proskouriakoff, 'Historical Implications of a Pattern of Dates at Piedras Negras', *Am.A.*, XXV (1960), 454–75; 'Historical Data in the Inscriptions of Yaxchilan', *E.C.M.*, III (1963), 149–67, and IV (1964), 177–202; D. H. Kelley, 'Glyphic Evidence for a Dynastic Sequence at Quirigua', *Am.A.*, XXVII (1962), 323–35; T. Barthel, 'Historisches in den klassischen Mayainschriften', *Zeitschrift für Ethnologie*, XCIII (1968), 119–56; G. Kubler, *Studies in Classic Maya Iconography* (New Haven, 1969).

9. The best account of Maya hieroglyphs and p. 127 calendar mechanisms, written for beginners, is still that by S. G. Morley, 'An Introduction to the Study of the Maya Hieroglyphs', *B.B.A.E.*, LVII (1915). J. E. S. Thompson's *Maya Hieroglyphs Without Tears* (London, 1972) should be used to supplement Morley, but Thompson's primer is mainly concerned with rules of decipherment and exercises. It omits discussion of the historical content of the inscriptions. See Note 2 to Chapter 8.

10. H. J. Spinden, *Ancient Civilizations of Mexico and Central America*, first published in New York in 1917. The scheme persisted as late as S. G. Morley's *Ancient Maya* (Stanford University, 1947).

11. Described in detail by S. G. Morley, *The Ancient Maya*, 141–8.

12. Basic is the introduction to O. G. and E. B. Ricketson, *Uaxactun, Guatemala. Group E. 1926–1931* (Washington, 1937), summarizing and expanding the new views on Maya agriculture and land use.

13. A. V. Kidder, *N.M.A.A.E.*, III (1946–8), 128. p. 128 On survivals in the vacant towns and concourse centres of modern Guatemala, see Sol Tax, *A.A.*, XXXIX (1937). On the agricultural necessity for the division of ritual and dwelling centres, R. Linton, 'Crops, Soils, and Cultures in America', *The Maya and their Neighbors* (New York, 1940), 39–40. On Maya domestic buildings of Classic date, R. Wauchope, 'House Mounds of Uaxactun', *C.A.A.*, II (1934), 107–71. On parallels with the Khmer cities of the Angkor period (A.D. 802–1431), M. D. Coe, *Am.A.*, XXII (1957), 409–10.

14. Estimate based upon the house mound count at Uaxactún. Ricketson and Ricketson, *Uaxactun*, 15, 23. Total Maya population in the Classic era is estimated upon these samples as between eight and thirteen million.

15. C. W. Cooke, 'Why the Mayan Cities of the Peten District, Guatemala, were abandoned', *Journal of the Washington Academy of Sciences*, XXI (1931), 283–7. U. Cowgill and G. E. Hutchinson, *I.C.A.*, XXXV (1964), vol. 1, 603–13, find that the *bajo* east of Tikal was never a lake.

16. Epigraphic: S. G. Morley, *Inscriptions of the* p. 129 *Peten*, table IV, 358–79; R. L. Roys, 'The Maya Katun Prophecies of the Books of Chilam Balam', *C.A.A.H.*, XII (1954), no. 57; ceramic: R. E. Smith,

Ceramic Sequence at Uaxactun (New Orleans, 1955).

p. 129 17. Radiocarbon: W. F. Libby, *Radiocarbon Dating* (Chicago, 1955), L. Satterthwaite, *Am.A.*, XXI (1956), 416, and E. K. Ralph, *Am.A.*, XXVI (1960), 165–84. S. G. Morley, 'The Correlation of Maya and Christian Chronology', *American Journal of Archaeology*, XIV (1910), 193–204, and H. J. Spinden, 'The Reduction of Maya Dates', *P.M.P.*, VI (1924), no. 4. For other correlations, J. E. S. Thompson, *C.A.A.*, III (1935), no. 14.

On Carbon 14 fluctuations, C. Renfrew, 'Carbon 14 and the Prehistory of Europe', *Scientific American*, CCXXV (1971), 63–72.

On recent correlations, L. Satterthwaite, 'An Appraisal of a New Maya-Christian Correlation', *E.C.M.*, II (1962), 251–75.

18. Full publication of the recent excavations at Mayapán in *Current Reports* (Carnegie Institution of Washington, Division of Historical Research). E. W. Andrews ('Archaeology and Prehistory in the Northern Maya Lowlands', *H.M.A.I.*, II (1965), 289 and 318–19) retains the Spinden correlation as a viable possibility, and rejects the term 'Classic', preferring to articulate the periods in his area as *Formative* until the first century B.C.; *Early* (first A.D.–650 'Spinden'/900 'Thompson'); *Florescent* (650/900–1200); and *Decadent* (A.D. 1200–1450). His refusal of 'Classic' denies this confusion of geography with history, and of outside influences with local developments in the northern lowlands. His retention of the Spinden correlation revives an old idea of different starting-points for the northern and southern day counts.

19. Petén is a Maya term used for a lake or island interchangeably, and in general it means 'any geographical body surrounded by a different body'. G. Lowe, 'Civilizational Consequences of Varying Degrees of Agricultural and Ceramic Dependence within the Basic Ecosystems of Mesoamerica', *U.C.A.R.F.*, XI (1971), 212–48, discusses the principal environmental conditions (riverine and tropical forest) in the Maya lowlands.

p. 131 20. J. E. Thompson, H. E. D. Pollock, and J. Charlot, *A Preliminary Study of the Ruins of Cobá* (Washington, 1932), 198.

21. W. Coe, *Tikal: A Handbook of the Ancient Maya Ruins* (Philadelphia, 1967). Peculiar to Tikal, and newly discovered at Yaxhá by N. Hellmuth, are the assemblages called 'twin pyramid complexes', erected every twenty years, and consisting of 'a court with a single stela and altar set in an enclosure on the north side, facing a vaulted building directly opposite on the south side. Identical

pyramids are on the east and west sides. These are flat-topped and have a stairway on each of their four sides'. Further details in *Tikal Reports*, nos. 1–4 (1958), 9–10. The later survey of Tikal (*Tikal Reports*, no. 11, 1961) contains accurate maps.

22. On radial-stair platforms: O. G. and E. Rick- p. I etson, *Uaxactun, Group E* (Washington, 1937). Another example in central Yucatán is La Muñeca, Structure XIII; K. Ruppert and J. H. Denison, Jr, *Archaeological Reconnaissance in Campeche, Quintana Roo, and Peten* (Washington, 1943). See also Acanceh, in Marquina, 800–5. On twin-pyramid complexes: C. Jones, 'The Twin-Pyramid Group Pattern', doctoral thesis MS., University of Pennsylvania, 1969. N. Hellmuth, 'Yaxhá', *Katunob*, VII (1972), no. 4, 23–49; 92–7.

23. Gnomon groups are listed by Morley, *Inscriptions of Peten*, III (1938), 107. Also O. G. and E. Ricketson, *op. cit.*, 107; K. Ruppert and J. H. Denison, Jr, *op. cit.*, 5–6; G. Kubler, 'The Design of Space in Maya Architecture', *Miscellanea Paul Rivet*, I (Mexico, 1958), 515–31. H. Hartung, *Zeremonialzentren der Maya* (Graz, 1971), describes recurrent principles of grouping in the main sites. G. Guillemin, 'Tikal Ceremonial Center', *Ethnos*, XXXIII (1968), 5–39, discusses directional aspects of Maya plans.

24. A. M. Tozzer, 'Nakum', *P.M.M.*, V (1913), no. 3.

25. T. Maler, 'Tikal', *P.M.M.*, V (1911), no. 1, 3–135.

26. T. Proskouriakoff, *An Album of Maya Architecture* (Washington, 1946), plates 28–36.

27. S. G. Morley, *Inscriptions of Peten*, IV, 4. Markers at Cancuen, Lubaantun, Chinkultic, Laguna Perdida. F. Blom, *M.A.R.S.*, IV (1932), 487, analyses texts and typology. For Tikal, E. M. Shook, *University Museum Bulletin*, XXI (1957), 37–52. A ball-court at Calakmul may also be added to the Petén family.

28. R. L. Roys, *op. cit.* (Note 3). H. E. D. Pollock, 'Architecture of the Maya Lowlands', *H.M.A.I.*, II (1965), 378–440.

29. G. Kramer, *Maya Research*, II (1935), 106–18. p. I

30. G. Stromsvik, *Copan* (Washington, 1947). p. I Copán has always been more easily accessible than any other Classic Maya site. Accounts of its architecture may be found in J. L. Stephens, *Incidents of Travel in Central America* (New York, 1841); A. P. Maudslay, *Biologia Centrali-America* (London, 1889–1902); J. M. Longyear III, 'A Historical Interpretation of Copan Archaeology', *I.C.A.*, XXIX (1951), 86–92.

38 31. A. S. Trik, 'Structure XXII, Copan', *C.A.A.H.*, VI (1939), 87–106; G. B. Gordon, 'The Hieroglyphic Stairway', *P.M.M.*, I (1902); F. Robicsek, *Copan* (New York, 1972), plate 147.

32. S. G. Morley, *Guide Book to the Ruins of Quirigua* (Washington, 1935).

40 33. L. Satterthwaite, *Piedras Negras*, part V (1952), 25, questions Morley's identification as sweat-baths.

34. The best early accounts are by W. H. Holmes, *Archaeological Studies among the Ancient Cities of Mexico*, II (Chicago, 1897), and A. P. Maudslay, *Biologia Centrali-Americana*, text volume IV. There is an account of Palenque chronology by R. L. and B. C. Rands, 'The Ceramic Position of Palenque, Chiapas', *Am.A.*, XXIII (1957), 140–50. See also B. de la Fuente, *La escultura de Palenque* (Mexico, 1965).

35. A. Ruz Lhuillier, 'Exploraciones en Palenque: 1951', *A.I.N.A.H.*, V (1951), 65 f., and 'Presencia atlántica en Palenque', *R.M.E.A.*, XIII (1952–3), 455–62.

36. H. Berlin, *The Tablet of the 96 Glyphs* (New Orleans, 1968), 145, holds that 'any great temple building activity ceased at Palenque around 9.13.0.0.0 [A.D. 692], and architecture became less solid . . .'.

42 37. A. Ruz Lhuillier, 'Exploraciones', *A.I.N.A.H.*, IV (1949–50), 49–60. M. D. Coe, 'The Funerary Temple among the Classic Maya', *Southwestern Journal of Archaeology*, XII (1956), 387–94, has proposed the Palace as used more for ceremonies than for residence.

38. A. Ruz Lhuillier, 'Exploraciones en Palenque: 1950', *A.I.N.A.H.*, V (1951), 25–46.

43 39. A. Ruz Lhuillier, 'Estudio de la cripta del templo de las inscripciones en Palenque', *Tlatoani*, I (1952), nos 5–6, 2–28.

40. F. Blom and O. Lafarge, *Tribes and Temples* (New Orleans, 1926), I, 104–36. Photographs, G. F. Andrews a.o., *Edzná* (Eugene, 1969).

41. E. R. Littmann, *Am.A.*, XXIII (1957), 135–40. Fired bricks of pebble-tempered clay are reported from Corozal in British Honduras; T. Gann, *B.B.A.E.*, LXIV (1918), 82.

42. T. Maler, *P.M.M.*, II (1903), 104 ff., called them the Lesser (western) and the Greater (eastern) Acropolis groups.

45 43. L. Satterthwaite, Jr, *Piedras Negras Preliminary Papers*, Philadelphia, and *Piedras Negras Archaeology: Architecture*, I–VI (1943–54). T. Maler first reported in detail on the site: *P.M.M.*, II (1901).

7 44. L. Satterthwaite, Jr, 'A Stratified Sequence of Maya Temples', *Journal of the Society of Architectural*

Historians, V (1946–7), 15–20, and 'Some Central Peten Maya Architectural Traits at Piedras Negras', *Los Mayas antiguos* (Mexico, 1941), 183–210. A platform at Kohunlich (Quintana Roo) has balustrade masks in an arrangement recalling K5 (V. Segovia, *I.N.A.H.*, *Boletín*, XXXVII (1969), 1–7).

45. L. Satterthwaite, Jr, *Piedras Negras Archaeology: Architecture*, Part V, *Sweathouses* (Philadelphia, 1952).

46. C. L. Lundell, 'Preliminary Sketch of the Phytogeography of the Yucatan Peninsula', *C.A.A.*, II (1934), 274–5; K. Ruppert and J. H. Denison, Jr, *Archaeological Reconnaissance in Campeche, Quintana Roo and Peten* (Washington, 1943). W. Haberland designates this area as the Río Candelaria district (*Die regionale Verteilung von Schmuckelementen im Bereiche der klassischen Maya-Kultur*, Hamburg, 1953), although the course of this river is in doubt. The best recent account of Campeche is by A. Ruz Lhuillier, *Campeche en la arqueología Maya* (*Acta Anthropologica*, I: 2–3 (Mexico, 1945)).

47. A systematic description of the subdivisions of the architecture of Campeche is by A. Ruz Lhuillier, *op. cit.* H. E. D. Pollock ('Architectural Notes on some Chenes Ruins', *P.M.P.*, LXI (1970), 1–87) finds the architecture of the region more distinctive than its sculpture, but still of uncertain spread. p. 150

48. S. G. Morley, *The Ancient Maya*, 77, 80. p. 151

49. R. de Robina, *Estudio preliminar de las ruinas de Hochob* (Mexico, 1956), 94, regards the main building at Hochob as coeval with Temples 11 and 22 at Copán (before 9.17.0.0.0 or A.D. 770) and the doorway of the Magician at Uxmal, on stylistic resemblances among the doorway mask-panels. Culucbalom: K. Ruppert and J. H. Denison, *Archaeological Reconnaissance*, figure 112.

50. Puuc-style buildings occur in Chenes territory. Dzibiltun is an example.

51. T. Proskouriakoff, *An Album of Maya Architecture* (Washington, 1946); R. E. Merwin and G. C. Vaillant, 'The Ruins of Holmul', *P.M.M.*, III (1932).

52. R. de Robina, *op. cit.* R. L. Roys distinguishes this 'northern block masonry' from the block masonry of Copán in terms of the superior northern cement and concrete; 'The Engineering Knowledge of the Maya', *C.A.A.*, II (1934), 67–8.

53. S. G. Morley and G. W. Brainerd, *The Ancient Maya* (Stanford, 1956), 264. Excellent summary of Puuc archaeology in J. E. S. Thompson, 'El area maya norte', *Yan*, III (1954), 8–13.

54. The most detailed modern accounts of Puuc architecture are by H. E. D. Pollock, *H.M.A.I.*, II p. 152

(1965), 378–440, and E. W. Andrews, *ibid.*, 288–330. Also E. Shook, 'Oxkintok', *R.M.E.A.*, IV (1940), 165–71.

p. 152 55. Based on the 11.9.0.0.0 correlation and represented in all the archaeological publications of the Carnegie Institution of Washington.

56. Proskouriakoff, *Classic Maya Sculpture* (Washington, 1950), 167.

57. E. W. Andrews, *Dzibilchaltun* (New Orleans, 1965), table 5.

p. 153 58. A. Ruz Lhuillier, *Campeche en la arqueología Maya*, 42, calls the western group the Camino Real, along the railway line from Campeche to Mérida.

59. The best rapid survey is by A. Ruz Lhuillier, *op. cit.*, 52–61.

60. See R. E. Smith and J. C. Gifford, 'Pottery of the Maya Lowlands', *H.M.A.I.*, II (1965), 503 (Cehpech phase).

61. Examples of *atadura* capitals in buildings of the Río Bec are Channa, Structure 1 (Ruppert and Denison, *op. cit.*, figures 77–9), and Culucbalom (*ibid.*, figure 112).

62. Columns are rare at Uxmal: local peculiarity or chronological clue? Pollock, *H.M.A.I.*, II (1965), 405. Note the combination of *atadura* mouldings at Bonampak as in about A.D. 800 with columns reported from the Lacanha district.

63. The outer ranges, according to A. Ruz, *op. cit.*, 55, are later additions. G. F. Andrews, *Edzná* (Eugene, 1969), has excellent maps, plans, and descriptive sections. Dates on the stelae span 672–810 in the Late Classic era.

p. 156 64. Other chambered pyramids are that at Santa Rosa Xtampak and the Akabtzib at Chichén Itza. On Xtampak, see T. Maler, 'Yukatekische Forschungen', *Globus*, LXXXII (1902), Abb. 19, 226. It has early traits related to the Río Bec–Chenes style.

p. 157 65. Marquina, 768. On recent work at Uxmal, see A. Ruz Lhuillier, *A.I.N.A.H.*, VI (1952), 49–67, suggesting that no building post-dates the thirteenth century, and C. Sáenz, *I.N.A.H. Bol.*, XXXVI (1969), 5–13. Sherds found during excavation and restoration support a dating from the sixth to the tenth centuries.

p. 158 66. E. Seler, 'Die Ruinen von Uxmal', *Abhandlungen der königlich preussischen Akademie der Wissenschaften (Phil.-hist. Kl.)* (1917), no. 3, 20.

67. M. Foncerrada, *La escultura arquitectónica de Uxmal* (1965), 153–63. E. S. Deevey a.o., *Radiocarbon*, 1 (1959), 165, date from ground-floor room (Y. 627) A.D. 560±50. Andrews, *Dzibilchaltun* (New Orleans, 1965), 63, reports this date as being from the earliest stage of the 'Magician'. Cf.

Pollock, *P.M.M.*, LXI (1970), 66–80, on Chenesperiod structures west of the Governor's House.

68. F. Blom, 'The "Negative Batter" at Uxmal', p. *Middle American Papers, New Orleans*, IV (1932), 559–66, supposes that the outward lean served only to stress the cast shadows in the friezes.

69. E. Seler, *op. cit.*, figure 44, illustrates this older, plainer edifice, encased within the present structure, of which the trapezoidal doorways appear within the later frames.

70. For discussion of wall-span ratios in relation to age, L. Satterthwaite, *Piedras Negras Preliminary Papers*, III (1935), 56–9. Foncerrada, *op. cit.*, 167–8 regards the Nunnery as coeval with the Governor, accepting 653 ±100 for the north range Carbon 14 lintel date, rather than the previous measurement of 885±100 (see Chapter 8, Note 38), which conforms to 12.9.0.0.0 correlation.

71. According to A. Ruz, *A.I.N.A.H.*, VI (1952), p. 59–60, colonnaded aedicules, probably later additions, masked these archway designs. See his figure 4.

CHAPTER 8

1. T. Proskouriakoff, *Classic Maya Sculpture* p. (Washington, 1950); W. Haberland, 'Die regionale Verteilung von Schmuckelementen in Bereiche der klassischen Maya-Kultur', *Beiträge für mittelamerikanische Völkerkunde*, II (1953); M. Greene, R. L. Rands, and J. A. Graham, *Maya Sculpture* (Berkeley, 1972) (illustrated with rubbings by M. Greene); G. Ekholm, *A Maya Sculpture in Wood* (New York, 1964). Cf. W. Coe, *Tikal: A Handbook* (Philadelphia, 1967).

2. J. E. S. Thompson, *Maya Hieroglyphic Writing* p. (Washington, 1950), especially chapters 8 and 9. His views are closer to Morley's than to Proskouriakoff's. See Notes 8 and 9 to Chapter 7.

3. The evidence is collected in W. Taylor, 'The Ceremonial Bar and Associated Features of Maya Ornamental Art', *Am.A.*, VII (1941), 41–63; J. E. S. Thompson, 'Sky Bearers, Colors and Directions in Maya and Mexican Religion', *C.A.A.*, II (1934), 209–42, and Proskouriakoff, *Classic Maya Sculpture* (Washington, 1950), figure 31.

4. Proskouriakoff distinguishes only Early and Late Classic; her 'Late' is my Middle; and my 'Late' Classic is her post-Classic in architecture. But her Late Classic and my Late Classic in figural sculpture coincide. Here Puuc architecture and

Late Classic sculpture are separated, where others have driven them together.

5. S. G. Morley, *The Inscriptions of Peten*, 5 vols. (Washington, 1937–8). Also his *Inscriptions at Copán* (Washington, 1920), and B. Riese, *Grundlagen* (Hamburg, 1971).

6. K. Ruppert, J. E. S. Thompson, T. Proskouriakoff, *Bonampak* (Washington, 1955).

7. S. G. Morley, *Quirigua* (Washington, 1935), 76–87.

. 164 8. M. A. Fernández, 'Los Dinteles de Zapote', *I.C.A.*, XXVII (1939), I, 601; W. R. Coe, E. Shook, and L. Satterthwaite, 'The Carved Wooden Lintels of Tikal', *Tikal Reports*, no. 6 (1961), 15–112.

9. *Maya Art and Civilization* (Indian Hills, 1957), figure 212 (first published in 1913).

. 165 10. This sequence is based upon the stylistic analysis by T. Proskouriakoff, *op. cit.*, which resolves many problems left open by S. G. Morley's epigraphic results (*Inscriptions of Peten*, II, 434). Morley interpreted Palenque as the initiator of Usumacinta sculptural traditions. On Seibal, see G. R. Willey and A. L. Smith, 'A Temple at Seibal', *Archaeology*, XX (1967), 290–8.

11. E.g. Piedras Negras, Stelae, 26, 8, 4, 1, ranging from about 9.10.0.0.0 to about 9.13.0.0.0; T. Maler, *P.M.M.*, II (1901). The feet of Stela 7 (9.14.10.0.0, or about A.D. 460) open more naturally, at an angle of 120–130 degrees.

12. Detailed colour notes in S. G. Morley, *Inscriptions of Peten*, III. Flesh parts were red.

13. Illustrated in S. G. Morley and G. W. Brainerd, *The Ancient Maya* (Stanford, 1957), plate 70 and figure 39. Full account in L. Satterthwaite, Jr, *Piedras Negras Preliminary Papers*, III (1935).

14. The Initial Series date is 9.18.5.0.0 (c. A.D. 795), corrected on stylistic grounds by Miss Proskouriakoff to 9.17.0.0.0 2 (A.D. 771±40).

166 15. Proskouriakoff, *Classic Maya Sculpture* (1950), 119–20, notes a resemblance to the sculpture of Xochicalco, and suggests that Piedras Negras may early have been part of a south Mexican complex. Compare E. Seler, *G.A.*, II, 128–67, especially figures 10, 33, 61, 64.

16. Imitations or derivatives of the seated figure in a niche occur at Quiriguá, Stela I, back (Morley, *Inscriptions of Peten*, IV, plate 172d) and Xochicalco (Seler, *op. cit.*, figure 61, p. 155). The Quiriguá figure is dated on style 9.17.0.0.0 ±2 katuns (A.D. 771±40). See the Teapa (Tabasco) urn, discussed by Carmen Leonard in *Yan*, III (1954), 83–95. Cf. p. 222 below on the sculpture of Santa Lucía Cotzumalhuapa in the central highlands of Guatemala.

17. Other grain-scattering scenes in the Petén and Motagua regions are enumerated by Morley, *Inscriptions of Peten*, III, 241. R. L. Rands, *B.A.E. Bull.*, CLVII (1955), interprets the action as scattering water.

18. The later sculpture of Bonampak is clearly related to Yaxchilán, and it is fully discussed in the monograph by K. Ruppert, J. E. S. Thompson, and T. Proskouriakoff, *op. cit.* (Note 6).

19. Even earlier is Lintel 46 (Maler, *P.M.M.*, II (1903), plate LXVIII), dated about 692 (9.13.0.0.0).

20. Cf. 'stelae' at Tonina (F. Blom and O. La- p. 167 Farge, *Tribes and Temples*, II (New Orleans, 1926), figures 212–56) and Tajín. The Tonina statues were carved about the middle of the fifth century A.D. (9.11.0.0.0–9.15.0.0.0, Proskouriakoff, 121). Occasional statues of seated figures are known at Yaxchilán and Copán, but the form is rare, and bound to architectural emplacements.

21. The most recent study is by an art historian, Beatriz de la Fuente, *La escultura de Palenque* (Mexico, 1965). Older descriptions by A. P. Maudslay, *Biologia Centrali-Americana*, and E. Seler, 'Beobachtungen und Studien', *Abhandlungen der preussischen Akademie der Wissenschaften, Phil.-Hist. Klasse* (1915), no. 5. R. Trebbi del Trevigiano, *Critica d'arte*, XXVIII (1958), 246–85, boldly attempted a grouping of Palenque sculpture by personal style. The effort is worth while, but it overlooks many monuments and it disregards Miss Proskouriakoff's fundamental work on Classic Maya sculpture. He identifies a 'Maestro della Croce' and the works of his pupils, as well as a 'Maestro dei Volti' (stucco façade masks), and a 'Maestro dei Rilievi Tardi' and his school, spanning the sixth to mid eighth centuries. G. Kubler has interpreted the temple tablets ('The Paired Attendants', *S.M.A.M.R.*, XII, 1972) as referring to historical persons of the period 642–92.

22. Tablet of the Slaves: H. Berlin (*Tablet of the 96 Glyphs* (New Orleans, 1968), 146) accepts a dating in the eighth century. Cf. Fuente, *op. cit.*, 169; A. Ruz Lhuillier, 'Exploraciones en Palenque, 1950', *A.I.N.A.H.*, V (1952), 35–8. Throne-back: see E. Easby and J. Scott, *Before Cortés. Sculpture of Middle America* (New York, 1970), no. 174.

23. A. V. Kidder, E. M. Shook, and J. D. Jen- p. 169 nings, *Excavations at Kaminaljuyu* (Washington, 1946), 104–24; A. L. Smith and A. V. Kidder, *Excavations at Nebaj* (Washington, 1951), 32–42. Also W. F. Foshag, in *Pre-Columbian Art* (R. W. Bliss Collection) (New York, 1957), 45–7. A jade mine near Guatemala City is reported in *Archaeo-*

logy, VII (1954), 120. Survey article: R. L. Rands, 'Jades of the Maya Lowlands', *H.M.A.I.*, III (1965), 561–80.

p. 169 24. Cf. S. G. and F. Morley, 'The Age and Provenance of the Leyden Plate', *C.A.A.H.*, V (1939), 1–17, who ascribe the carving to Tikal. The piece was found near the Motagua river delta (now in the Rijksmuseum voor Volkenkunde, Leyden, Holland).

25. On carved wares, R. E. Merwin and G. C. Vaillant, 'The Ruins of Holmul', *P.M.M.*, III (1932), 79–80; Mary Butler, 'A Pottery Sequence from Guatemala', *The Maya and their Neighbors* (New York, 1940), 261–4; R. E. Smith, *Ceramic Sequence at Uaxactun* (New Orleans, 1955), 42–4. On pre-Classic shape, see Vaillant's remarks on the Q-complex in *Maya Research*, I (1934), 87–100; J. E. S. Thompson's on vessel shapes in *Excavations at San José* (Washington, 1939), 230, 246. On carved 'Fine Orange' ware, R. E. Smith, *Am.A.*, XXIV (1958), 151–60.

p. 170 26. M. H. Saville, *A Sculptured Vase from Guatemala* (New York, 1919). Authenticity questioned by J. E. S. Thompson, *Am.A.*, IX (1943), 116.

27. J. E. S. Thompson, *San José*, 156; R. E. Smith, *Uaxactun*, 100; J. M. Longyear, *The Ceramics of Copan* (Washington, 1952), 104; G. Willey, 'Artifacts of Altar de Sacrificios', *P.M.P.*, LXIV (1972), 7–76. In R. L. and B. C. Rands, 'Pottery Figurines of the Maya Lowlands', *H.M.A.I.*, II (1965), 535–60, eight 'sub-areas' are considered: Puuc, Jaina, Jonuta, Palenque, Usumacinta, Nebaj, Petén, Lubaantun.

28. A. Ruz Lhuillier, *Campeche* (Mexico, 1945), 71–2. The catalogue of the exhibition entitled *Art of the Maya Civilization*, held 4 September–5 October 1957 at the Martin Widdifield Gallery, New York, is the most comprehensively illustrated survey of Jaina figurines to date. The text is by H. J. Spinden. See also H. Moedano Koer, 'Jaina: un cementerio Maya', *R.M.E.A.*, VIII (1946), 217–42, and A. Delgado, 'El Arte de Jaina', *Artes de México*, XII (1965), no. 60, 11–18.

29. H. J. Spinden, *A Study of Maya Art*, *P.M.M.*, VI (1913); *Pre-Columbian Art* (Bliss Collection) (New York, 1957), plates LXXVI–LXXVII; P. Kelemen, *Medieval American Art*, II (New York, 1943), plates 133–4.

30. Illustrated in Morley and Brainerd, *The Ancient Maya*, plate 82, bottom corners, and *Pre-Columbian Art* (New York, 1957), plate LXIX.

p. 171 31. Another focus of moulded production was the Alta Verapaz region of the Guatemalan highlands, along the upper Chixoy drainage. These wares are best illustrated in E. P. Dieseldorff, *Kunst und Religion der Mayavölker* (Berlin, 1926), figures 5–49. Also Mary Butler in *The Maya and their Neighbors* (New York, 1940), 261–4. R. E. Smith, 'Pottery from Chipoc', *C.A.A.H.*, XI (1952), 215–34, connects Chipoc mould-made figurines with Tepeu 1–2.

32. The initial analysis of serpent-mask panels is by H. J. Spinden, *P.M.M.*, VI (1913), 118–27, reissued in Part I of *Maya Art and Civilization* (Indian Hills, 1957). M. Foncerrada, *Uxmal*, 144–5, holds that serpent images are lacking in Puuc art, and that the serpents at Uxmal of realistic aspect (Monjas, west and north) are Toltec forms. Her inventory of Puuc ornamental forms (96) includes masks, step-frets, lattices, columns, house-models, serpents, owls, feathers, jaguars, and humans.

33. R. E. Merwin and G. C. Vaillant, *P.M.M.*, III (1932), no. 2, 18–20.

34. A. S. Trik, 'Temple XXII at Copan', *C.A.A.H.*, V (1939), 87–103. Its platform shows a tablero profile of Teotihuacán style.

35. K. Ruppert and J. H. Denison, *Archaeological* p. 1 *Reconnaissance* (Washington, 1943), figures 45, 96, III. Pollock, 'Chenes Ruins', *P.M.P.*, LXI (1970), 73, notes that a curvilinear panel of Chenes style on Building 1 at Uxmal is buried beneath the Governor's platform, proving its priority there.

36. Ruppert and Denison, *op. cit.*, plates 35–6.

37. The best photographs of the Chenes façades p. 1 are in E. Seler, 'Die Quetzalcouatl-Fassaden Yukatekischer Bauten', *Abhandlungen der preussischen Akademie der Wissenschaften, Phil.-Hist. Kl.* (1916). J. E. S. Thompson, 'Las llamadas fachadas de Quetzalcoatl', *I.C.A.*, XXVII (1939), 391–400, withdraws the iconographic identification. The accounts of Puuc architecture are by T. Maler in *Globus*, LXVIII (1895), LXXXII (1902). H. E. D. Pollock, 'Architectural Notes on Some Chenes Ruins', *P.M.P.*, LXI (1970), 1–88, surveys the present state of the question. See also J. W. Ball, *Am. A.*, XXXIX (1974), 85–93.

38. A radiocarbon date from the north building of the Nunnery at Uxmal yields A.D. 893±100; De Vries, *Science*, CXXVII (1958), 136. Andrews, *Dzibilchaltun* (1965), 63, reports this as GRO-613, 885±100; Foncerrada, *Uxmal* (1965), 57, gives it as 653±100. This difference between Carbon 14 interpretations reflects the continuing uncertainty between Spinden and Thompson correlations. Foncerrada (*op. cit.*, 58–60) has disagreed with my sequence because the earliest structure at the Magician,

dated by Carbon 14 in the sixth century, has Puuc-style ornament, while the later east chamber at the head of the stairs displays a Chenes-style doorway (Figure 55). Its crude workmanship, however, suggests that it was built of discarded or re-used elements in phase 4 of the building history of the Magician, leaving the date of the Chenes style unfixed. See Note 35.

39. E. Viollet-le-Duc, 'Antiquités américaines', in D. Charnay, *Cités et ruines américaines* (Paris, 1863), 1–104; R. Wauchope, *Modern Maya Houses* (Washington, 1938).

40. Channa, St 1, Room 2, has engaged cylindrical columns at the door jambs with *atadura* capitals; Ruppert and Denison, *op. cit.*, figure 79. Also Culuc-balom, St 1 (*ibid.*, figure 112).

41. K. Ruppert, J. E. S. Thompson, T. Proskouriakoff, *Bonampak*, 28.

42. Described by S. G. Morley, *C.I.W. Yearbook*, XLI (1941–2), 251. Portions of the Puuc-style sculpture of this core are illustrated by E. Seler, *Abhandlungen der preussischen Akademie* (1917), 27 f.

74 43. The actual façades of the north Nunnery building envelop an older construction from which the tiered masks may have been salvaged.

75 44. Full excavation details in A. L. Smith, *Uaxactun 1931–1937* (Washington, 1950), 54–6 and figure 46. The Tzakol dating depends upon ceramic, architectural, and epigraphic evidence. Another painted stucco fragment of Tzakol date was excavated at Nebaj in the Alta Verapaz. See A. L. Smith and A. V. Kidder, *Excavations at Nebaj* (Washington, 1951), frontispiece and p. 57.

45. Cf. Proskouriakoff, figure 9.

77 46. K. Ruppert, J. E. S. Thompson, T. Proskouriakoff, *op. cit.* A crust of opaque calcareous deposits required that the walls be soaked with kerosene until the murals were visible enough for copying in watercolours. Two such copies were made, one by A. Tejeda for the Carnegie Institution and another by A. Villagra for the Mexican government. The first is blonder, and the ruined portions are more legible than in the second. See A. Villagra, 'Las pinturas de Bonampak', *C.A.*, VI (1947), 151–68.

79 47. This seriation of the rooms is only approximate. It would be more precise to classify the walls as follows: register walls, 1–4, 9; unified single wall, 5; triptych walls, 6–8, 10–12.

48. Thompson, *op. cit.*, 54, regards the prince as drawing blood from his tongue, although no red colour or thorny cord, as at Yaxchilán, supports this view.

49. Is the body headless? If so, does the severed head on the steps in Room 2 belong to this body? p. 180

50. E. g. Chinkultic, Cancuen, Copán.

51. E. H. Thompson, *P.M.M.*, III (1904), plate VIII. p. 181

52. S. G. Morley, *The Ancient Maya*, 402; A. O. Shepard in J. Thompson, *San José*, 251–77; R. E. Smith, *Ceramic Sequence at Uaxactun* (New Orleans, 1955); R. L. and B. C. Rands, 'The Ceramic Position of Palenque', *Am.A.*, XXIII (1957), 140–50.

53. Summarized by R. E. Smith, *op. cit.* (Ia), 53–9. Techniques described by A. Kidder, E. M. Shook, and J. D. Jennings. *Kaminaljuyu* (Washington, 1946), 218–38. The decorative use of stucco on pottery is as old as the Miraflores phase at Kaminaljuyú (pre-Classic). A Kidder and A. Shepard, *N.M.A.A.E.*, II (1944), no. 35, 22–9.

54. Illustrated in Kidder, Shook, and Jennings, *op. cit.*, figure 205 f. p. 182

55. Mary Butler, 'A Pottery Sequence from the Alta Verapaz', *The Maya and their Neighbors* (New York, 1940), 250–71. Also E. P. Dieseldorff, *Kunst und Religion der Mayavölker*, 2 vols. (Berlin, 1926–31), illustrating many examples. On dating for Chamá 3 style as Tepeu 1 (seventh century) see R. and B. Rands, 'Pottery of the Guatemalan Highlands', *H.M.A.I.*, II (1965), 131.

56. University Museum, Philadelphia, illustrated by Gordon and Mason, *op. cit.*, plate LII (rabbit); plates I–II (Ratinlixul). p. 183

57. R. E. W. Adams, 'The Ceramics of Altar de Sacrificios', *P.M.P.*, LXIII (1971), 68–78; D. M. Pendergast, *Actun Balam* (Toronto, 1969), 41–52.

58. Gordon and Mason, *op. cit.*, plates XXIX–XXX.

59. C. C. Leonard, 'El vaso de Tabasco', *Yan*, III (1954), 96–102, interprets the scene as concerning deities and their rituals.

60. A. L. Smith, 'Two Recent Ceramic Finds at Uaxactun', *C.A.A.*, II (1934), 1–25; G. E. Merwin and G. C. Vaillant, *P.M.M.*, III (1932), plates 29 and 30; T. W. F. Gann, *B.B.A.E.*, LXIV (1918).

61. J. M. Longyear, *Copan Ceramics* (Washington, 1952), 30–1, 60–3, figure 118; and W. D. Strong, A. Kidder II, and A. J. D. Paul, *Smithsonian Institution, Miscellaneous Collections*, XCVII (1938), no. 1. Also J. M. Longyear, 'Archaeological Investigations in El Salvador', *P.M.M.*, IX (1944), no. 2.

62. T. S. Barthel, 'Gedanken zu einer bemalten Schale aus Uaxactum', *Baessler-Archiv*, XIII (1965), first proposed the underworld interpretation, when discussing a figured plate from Uaxactún. Michael Coe, *The Maya Scribe and his World* (New York, p. 184

1973), has extended and generalized Barthel's views. Other recent studies of Maya vase painting are by M. Foncerrada de Molina, 'Reflexiones sobre la decoración de un vaso Maya', *A.I.I.E.*, XXXIX (1970), 79–86, and R. E. W. Adams, 'The Ceramics of Altar de Sacrificios', *P.M.P.*, LXIII, no. 1 (1971).

p. 184 63. M. S. Edmonson, *The Book of Counsel: the Popol Vuh of the Quiche Maya of Guatemala* (New Orleans, 1971), 38, note 1003; 235, note 7843.

64. Coe's 'Primary Standard Text' appears on thirty-two of the eighty-one vessels illustrated. There is no doubt about its identification as a textual type, but only about its interpretation exclusively from the Popol Vuh.

CHAPTER 9

p. 185 1. The most complete earlier account of the history, archaeology, and ethnology is by A. M. Tozzer, 'Chichen Itza and its Cenote of Sacrifice', *P.M.M.*, XI–XII (1957). Contrast L. Parsons, *Bilbao*, II (Milwaukee, 1969), 172–84. On Teotihuacán forms at Dzibilchaltun and Acanceh, E. W. Andrews, 'Northern Maya Lowlands', *H.M.A.I.*, II (1965), 296–305; 475.

The late Howard Cline's article on calendars (in press, *H.M.A.I.*) presents a revision of Tula chronology (migrations *c.* 660; Tula founded *c.* 770; expansion *c.* 970; fall of Tula 1168). J. E. S. Thompson, *Maya History and Religion* (Norman, 1970), 3–47, has enriched the problem with his thesis of a Chontal Maya group in the Putun district of the Tabasco lowlands, who were sea traders, affected by Mexican neighbours. During the ninth and tenth centuries these Putun Maya traders expanded their influence into the Usumacinta drainage. In eastern Yucatán and at Chichen in 918 a branch of the Putun Maya settled as the Itza. This first wave of Mexicanization prepared the way for the highland groups from Tula *c.* 987.

2. A. Barrera Vásquez and S. G. Morley, 'The Maya Chronicles', *C.A.A.H.*, x (1949). Rigorous reviews of all literary evidence in M. Wells Jakeman, *The Origins and History of the Mayas* (Los Angeles, 1945).

3. S. G. Morley and G. W. Brainerd, *The Ancient Maya* (Stanford, 1956), 79–99. Parsons, *loc. cit.*, seeks to establish a pre-Puuc period of 'Teotihuacanoid' influence. See W. Bullard, 'Topoxté', *P.M.P.*, LXI (1970), 301–5, on Itza presence in the Petén in the fifteenth century.

p. 187 4. The best guide to all the ruins is by K. Ruppert, *Chichen Itza, Architectural Notes and Plans*

(Washington, 1952), containing a map (1:3000) with five-foot contours. J. Bolles, *La Iglesia* (San Francisco, 1963), 6, reports radiocarbon dates 600± 60 and 780±70 for the Iglesia, and 610±60 at the Casa Colorada (Chicchanchob). These seventh-century dates correspond to the middle of the early period of old Chichén: the Iglesia was preceded by the east wing of the Nunnery, and it preceded the south-east annex. The three structures 'were probably built between A.D. 500 and 700' (11).

5. A. M. Tozzer, *loc. cit.*, I, 33–50. His sequence:
Chichén Itza I (Yucatán Maya), 600–1000
Chichén Itza II (Toltec Maya A), *c.* 948–*c.* 1145
Chichén Itza III (Toltec Maya B), *c.* 1150–1260
Chichén Itza IV (Dissolution), 1280–1450
Chichén Itza V (Abandonment), 1460–1542
Tozzer ascribes to Period II the main ball-court and the gold disks; here they are set in III. Tozzer puts the Warrior group in III; here it is made older in II. Tozzer's analysis is ethnographical and archaeological, without special concern for the stylistic factors, on which we base our seriation. Tozzer was unable (e.g. p. 42) to separate conclusively the constructions of Periods II and III.

L. Parsons (*Bilbao*, II, 198) also rearranges the periods:
I ('Teotihuacanoid') *c.* 500–750
II (Chichén-Puuc) *c.* 700–950
III (Tula-Toltec) ?900–1263
VI 1263–
He sees Teotihuacán influence at Chichén Itza in the sixth century at the inner Castillo and in the seventh at the Great Ball-Court, the Mercado, and the Chacmool Temple. The outer Castillo and the Caracol substructure are assigned to 700–750 as transitional between 'Teotihuacanoid' and 'Chichén-Puuc'. The tenth century is a transition from 'Chichén-Puuc' to 'Tula-Toltec' (Temple of the Warriors, upper Temple of the Jaguars). The eleventh and twelfth centuries are 'Tula-Toltec' (High Priest's Grave, Temple of Wall Panels, Court of the 1000 Columns). This parallels the chronology of the chronicles. The groups proposed here (1973) follow Andrews' chronology in *Dzibilchaltun* (New Orleans, 1965), 62.

6. F. Morris, J. Charlot, and A. Morris, *Temple of the Warriors*, I (Washington, 1931), figure 53.

7. A. Tozzer, *I.C.A.*, XXIII (1928), 164, and J. Charlot, in Morris, *Temple of the Warriors*, I, 342, regard the ball-court as earlier than the Temple of the Warriors because of the coarsening of the sculpture of the Warriors reliefs. Against this argument see p. 206.

8. D. Charnay, *The Ancient Cities of the New World* (London, 1887). Charnay's observations were given more systematic form by A. Tozzer, 'Maya and Toltec Figures at Chichén Itza', *I.C.A.*, XXIII (1930), 155–64. The Mexican excavations are reported by Jorge Acosta in *R.M.E.A.* (see pp. 46–7).

188 9. K. Ruppert, 'The Temple of the Wall Panels', *C.A.A.*, I (1931), 139–40, follows H. J. Spinden's 'Study of Maya Art', *P.M.M.*, VI (1913), 205, in this enumeration.

10. Most amply represented in the monumental study by A. M. Tozzer, published posthumously as 'Chichen Itza and its Cenote of Sacrifice' (Note 1).

11. H. E. D. Pollock, *Round Structures of Aboriginal Middle America* (Washington, 1936).

12. K. Ruppert, *The Caracol* (Washington, 1935), 274–5, suggests that it also served as a watch tower. H. Hartung, *Zeremonialzentren der Maya* (Graz, 1971), 78–9, has observed that four sighting lines in the Caracol point at the various ball-courts.

13. Ruppert, *op. cit.*, 273, admits the possibility that the vaulted portions preceded the building of the secondary platform. The C14 date was published in *American Journal of Science, Radiocarbon Supplement*, 1 (1959).

191 14. A lintel from the outer Castillo temple is dated A.D. 810±100 (Y-626b) (E. W. Andrews, *Dzibilchaltun* (New Orleans, 1965), 63). Much smaller, although nearly an exact replica of the Castillo, is the High Priest's Grave, also called the Osario (E. H. Thompson, 'The High Priest's Grave', *F.M.N.H.A.S.*, XXVII (1938)). Like the Temple of the Inscriptions at Palenque, this covered a burial. J. E. S. Thompson, in this publication (p. 59), regarded the edifice as transitional between the Castillo and the Warriors 'and as also later than the Chacmool Temple'.

192 15. Surely coeval were the Chacmool Temple and the adjoining Temple of the Tables immediately north. The column reliefs and the serpent columns support the comparison.

194 16. This sequence is based upon the floor-levels discovered and reported by Earl Morris, *op. cit.*, I, 172–6.

17. On the north-east colonnade, see E. B. Ricketson, 'Sixteen carved Panels from Chichen Itza', *Art and Archaeology*, XXIII (1927), 11–15.

18. K. Ruppert, *Chichen Itza*, 72–4.

19. A. Ruz Lhuillier, *Campeche en la Arqueología Maya* (Mexico, 1945), 82. On ball-court typology, see J. Quirarte, 'El juego de pelota en Mesoamerica', *E.C.M.*, VIII (1970), 83–96.

20. Proskouriakoff, 171: 'It seems an inescapable p. 195 conclusion that some contact, however tenuous, must have existed between the Toltec and the classic people in the last phase of the latter's history'. Also Lothrop, 'Metals from the Cenote of Sacrifice', *P.M.M.*, X (1952), 111–12.

21. As set forth by Lothrop, *op. cit.*, 69. p. 196

22. O. Ponciano Salazar, 'El Tzompantli', *Tlatoani*, I (1952), 37–41; J. Acosta, 'Exploraciones', *A.I.N.A.H.*, VI (1952), 39–41.

23. The edifice is repeated near the Nunnery in the southern, Puuc-period part of Chichén (Structure 3c 17; Ruppert, *Chichen Itza*, 57). Reconstruction drawing in Proskouriakoff, *Album* (Washington, 1946), 22.

24. H. E. D. Pollock, R. L. Roys, T. Proskouria- p. 197 koff, and A. L. Smith, *Mayapan* (Washington, 1962), and R. E. Smith, 'Pottery of Mayapan', *P.M.P.*, LXVI (1971), 2 vols.

25. J. E. Thompson, H. E. D. Pollock, and J. p. 198 Charlot, *Cobá* (Washington, 1932), and S. K. Lothrop, *Tulum* (Washington, 1924). Also A. Escalona Ramos, *Boletín de la Sociedad mexicana de Geografía y Estadística*, LXI (1946), 513–628, and M. A. Fernández, *A.M.N.H.A.E.*, III (1945).

26. *Op. cit.*, 172.

27. In S. G. Morley, *The Ancient Maya*, 77.

28. Lothrop's sequence of four groups at Tulum is based on roofing habits, number of doorways, and moulding types. His earliest group lacks buildings with negative batter, but Lothrop did not then know of the Puuc associations of this trait.

29. The recessed lintels, and the negative batter itself, recall Mitla in Oaxaca.

30. E.g. Temple no. 5, Tulum, a corbel-vaulted shrine. M. A. Fernández, in *Los Mayas antiguos* (Mexico, 1941), 157–80, dates this negative-batter building in the period between 1000 and 1200.

31. Proskouriakoff, 170; also Morley and p. 199 Brainerd, *The Ancient Maya*, 83–5. The view here (formulated in 1958), that the art of Tula was generated at Chichén, received a balanced appraisal from A. Ruz Lhuillier ('Chichén Itzá y Tula: Comentarios a un ensayo', *E.C.M.*, II (1962), 205–20), and it was supported by Proskouriakoff, *H.M.A.I.*, II (1965), 491. Since then the arguments advanced by E. W. Andrews (*Dzibilchaltun*, New Orleans, 1965) and L. Parsons (*Bilbao*, Milwaukee, 1969, 174) bring new support to the idea. The question it raises remains open until the chronology becomes clearer.

32. Illustrated in Proskouriakoff, 96–7. p. 200

p. 200 33. E. W. Andrews, *Dzibilchaltun* (1965), 60–6.

34. Illustrated in Proskouriakoff, figure 94 and pp. 167–8. Older examples are the serpent-mask façades of Chenes and even of Petén–Maya date (see p. 161); they lead rather to the mosaic façade of the Puuc period than to the extended reliefs here under discussion.

p. 201 35. J. E. S. Thompson, 'Skybearers', *C.A.A.*, II (1934), 234–5.

36. Ruz, *op. cit.*, 209, finds Maya antecedents on the sarcophagus lid at Palenque and the glyph of 'God II' there (Thompson, *Catalog of Maya Hieroglyphs*, Norman, 1962, 1030 f.). The Maya phrase means red claw, and it is a fanciful appellation given by A. Leplongeon (1876). On distribution, E. Seler, *G.A.*, I, 677; V, 267. Also Lothrop, *Pottery of Costa Rica and Nicaragua* (New York, 1926), 286. On the possible meaning as a god of drunkenness, C. Lizardi Ramos, *C.A.*, IV (1944), no. 2, 137–48; as a messenger bearing blood-gifts to the gods, J. Corona Núñez, *Tlatoani*, I (1952), 57–62.

p. 202 37. The re-cutting is visible in E. H. Thompson, 'The High Priest's Grave', *F.M.N.H.A.P.*, XXVII (1938), 6.

38. Lothrop, *op. cit.* (Note 20), 57.

p. 203 39. For a discussion of the differences between Maya and Toltec costumes, see D. E. Wray, *Am.A.*, XI (1945–6), 25–7.

p. 206 40. Jean Charlot, in Morris, Charlot, and Morris, *Temple of the Warriors*, I, 231–343.

41. H. Moedano Koer, 'El friso de los caciques', *A.I.N.A.H.*, II (1941–6), 113–36, and H. Beyer, 'La procesión de los Señores', *M.A.*, VIII (1955), 1–65. The Tizoc Stone in the Mexican National Museum (Plate 22) pertains by composition to this family.

42. K. Ruppert, *C.A.A.H.*, VIII (1943), 245, noted its superiority over other dais, commenting on its 'depth and clarity of definition', and comparing it to the main ball-court reliefs. The dais is far in advance of the slovenly and retrograde pilaster figures at the doorway, which recall the Chacmool Temple pilasters in the cella doorway, by the use of frontal masks in bases and capitals.

43. Other examples, possibly earlier, are the façade panels flanking the serpent-column entrance of the cella of the Temple of the Warriors, which may, however, be a later remodelling, because the pier bases inside follow the older style with the median division.

p. 207 44. As in A. M. Tozzer, *op. cit.*, and D. E. Wray, *Am.A.*, XI (1945–6), 25–7.

45. E. J. Palacios, *Enciclopedia Yucatanense*, II (Mexico, 1945), 526, supposes that the disk is the earth, protigated as a god of fertility by the blood rite.

46. Illustrated by M. Covarrubias, *Indian Art of Mexico and Central America* (New York, 1957), figure 81. They are of Classic Veracruz style.

p. 2• 47. The best account of the North Temple is by Adela Breton, *I.C.A.*, XIX (1917), 187–94. The building is also called the Temple of the Bearded Man, in honour of the recumbent figure. The Breton drawing shows the twin serpents arising behind the corpse; another rendering by M. A. Fernández records the serpents as a belt worn by the corpse.

p. 2: 48. S. K. Lothrop, *op. cit.* (Note 20). Disks are worn as pectorals by several figures in the reliefs of the lower Temple of the Jaguars: they may represent gold examples.

49. *Op. cit.*, 62.

p. 2: 50. The Chacmool frescoes are best illustrated in Morris, Charlot, and Morris, *Temple of the Warriors*, II, plates 132–8. They represent seated figures like those of Classic stelae, painted in rich, deep tones. The types are Toltec, the forms are Maya.

51. The most complete discussion of these murals is by E. Seler, *G.A.*, V, 324–57. Useful reproductions have appeared in Maudslay, *Biologia*, III; T. A. Willard, *City of the Sacred Well* (London, n.d.), opp. 221; and G. O. Totten, *Maya Architecture* (Washington, 1926). Excellent drawings of the south-west wall in Jean Charlot, 'A XII Century Mayan Mural', *Magazine of Art*, XXXI (1938), no. II, 624–9 and 670. Further drawings of the east wall by W. Lehmann in 1925–6 in G. Kutscher, 'Wandmalereien des vorkolumbischen Mexico', *Preussischer Kulturbesitz*, IX (1971), 71–120, esp. figures 29, 33; south wall, figure 16.

p. 2 52. A similar scene of sacrifice by heart excision appeared near the cella doorway of the Temple of the Warriors. Morris, Charlot, and Morris, *Temple of the Warriors*, II, plate 145.

p. 2 53. Another such battle of warriors attacking an island village with flaming spears adorns the Nunnery at Chichén. Willard, *op. cit.*, opp. 253.

54. Willard, *op. cit.*, 221, probably based upon one of Teobert Maler's drawings.

55. *Pacific Art Review*, II (1942), nos. 1–2.

56. Morris, Charlot, and Morris, *op. cit.*, II, plate 164.

p. 2 57. Thomas Gann, 'Mounds in Northern Honduras', *19th Annual Report, Bureau of American Ethnology* (Washington, 1900), 655–92. Gann dated the frescoes in the late fourteenth or early fifteenth centuries (676).

217 58. On the character and significance of plumbate pottery, see A. O. Shepard, *Plumbate* (Washington, 1948).

218 59. Lothrop, *op. cit.* (Note 20), 74–7.

60. S. K. Lothrop, *Tulum* (Washington, 1924), 50–61. Also M. A. Fernández, 'El templo no. 5 de Tulum', *Los Mayas antiguos* (Mexico, 1941), 157–82. A. Miller is preparing new drawings and field studies on East Coast murals, as well as the drawings of Chichén Itza murals by Adela Breton, now in Bristol, England ('Mural Painting', *I.C.A.*, XL (1972), 465–71). D. Robertson, 'Tulum Murals', *I.C.A.*, XXXVIII (1968), vol. 2, 77–88, suggests an 'international' post-Classic style.

61. On the possibility that painted flakes of plaster, found in an Early Classic tomb at Uaxactún, are the remnants of a book, see R. E. Smith, *C.A.A.H.*, IV (1937), 216.

62. J. E. S. Thompson, *Maya Hieroglyphic Writing* (Washington, 1950), 23–6. For study of the content, the most accessible edition of the four manuscripts is the outline facsimile of J. A. Villacorta C., *Los Códices Mayas* (Guatemala, 1930). Study of draughtsmanship and technique is best made with the photographic facsimiles: E. Förstemann, *Die Maya-Handschrift der königlichen Bibliotek zu Dresden* (Leipzig, 1892); *Códice Maya denominado Cortesiano*, ed. J. de la Rada y Delgado and J. López de Ayala (Madrid, 1892); *Manuscrit Troano*, ed. C. E. Brasseur de Bourbourg (Paris, 1869–70); *Codex Peresianus*, ed. L. de Rosny (Paris, 1887). An indispensable aid is the collection of papers by E. Förstemann, P. Schellhas, and A. M. Tozzer, published in *P.M.P.*, IV (1904–10). On the Grolier fragment, M. Coe, *The Maya Scribe and His World* (New York, 1973), 150–5, with commentary and facsimile.

63. P. Schellhas, 'Representation of Deities of the Maya Manuscripts', *P.M.P.*, IV (1904–10), 1–47; cf. Thompson, *Maya Hieroglyphic Writing* (Washington, 1950). G. Zimmerman, *Die Hieroglyphen der Maya-Handschriften* (Hamburg, 1956), 161–8, separates deities of favourable and unfavourable aspect. On Maya gods, J. E. S. Thompson, *Maya History and Religion* (Norman, 1970), 197–329.

219 64. E. Seler, 'Venus Period in the Picture Writings of the Borgia Codex Group', *B.B.A.E.*, XXVIII (1904), 355–91.

65. Twenty-seven Initial Series dates are recorded in the Dresden manuscript, ranging between 8.6.16.12.0 on p. 70 and 10.19.6.1.8 (A.D. 1216) on p. 51. The date of manufacture may well be near this latest one, although others, e.g. C. F. Bow-

ditch, preferred 9.9.16.0.0 (A.D. 629) as the date of composition. Spinden specified western Yucatán, south of Uxmal or in Tabasco, pointing to similarities with south Mexican manuscripts; 'A Study of Maya Art', *P.M.M.*, VI (1913), 153. J. E. S. Thompson, in his *Commentary on the Dresden Codex* (1972), 15, prefers a date between 1200 and 1250.

66. M. Coe, *The Maya Scribe* (New York, 1973), 150–1.

CHAPTER 10

1. S. de Borhegyi, 'Guatemalan Highlands', p. 220
H.M.A.I., II (1965), 3–58, and S. W. Miles, 'Sculpture of the Guatemala-Chiapas Highlands', *ibid.*, 237–75; P. Becquelin, *Nebaj* (Paris, 1969).

2. A. L. Smith, *Archaeological Reconnaissance in Central Guatemala* (Washington, 1955), 75.

3. W. Libby, *Science*, CXX (1954), 720. Structure 4 measured 3142 (1188 B.C.) \pm240; Structure 5 measured 2490 (536 B.C.) \pm300. Opinion is still divided on the interpretation of these and other radiocarbon datings: see M. Coe, 'La Victoria', *P.M.P.*, LIII (1961), 128, and Borhegyi, *op. cit.*, 7, note 2. On the earliest pyramids, see B. Spranz, *Totimehuacán* (Wiesbaden, 1970), 39–44.

4. E. M. Shook and A. V. Kidder, 'Mound E-III-3, Kaminaljuyu', *C.A.A.H.*, XI (1952), 33–128, and figure 16b.

5. Cf. Marquina, lám. 21. p. 221

6. A 7–8 and B 4–5 were built of pumice and mud. Kidder, Shook, and Jennings (*op. cit.*, 95) have placed A 6 and B 3; A 7 and B 4 as coeval. A 8 precedes B 5 by a small interval. They suppose that 'no more than a century, perhaps even as little as fifty years, would cover the entire life of the two mounds'. Lacking at Kaminaljuyú is the figurine production of Teotihuacán; lacking at Teotihuacán are the sumptuous burials of Kaminaljuyú.

7. R. B. Woodbury and A. S. Trik, *The Ruins of Zaculeu*, I (Richmond, 1953), 284.

8. A. L. Smith, *op. cit.*, 76, and 'Altar de Sacrificios', *P.M.P.*, LXII, no. 2, 51 and figure 16.

9. M. W. Stirling, 'Stone Monuments of South- p. 222
ern Mexico', *B.B.A.E.*, CXXXVIII (1943), 60–74. S. Miles, 'Sculpture', *H.M.A.I.*, II (1965), 237 f., distinguishes in the region from Tonala to Tazumal four 'divisions': (1) pre-Olmec; (2) coastal Olmec; (3) pre-Classic Kaminaljuyú-Izapa; (4) Izapa narrative style during 'transition' to Early Classic. There follow four 'Pipil' periods from Early to Post-Classic: (1) Early Classic (Esperanza); (2) Late Classic (Cotzumalhuapa); (3) Early Post-Classic (S. Juan Plumbate); (4) Mexican Pipil.

p. 222 10. S. W. Miles, 'Sculpture of the Guatemala-Chiapas Highlands and Pacific Slopes', *H.M.A.I.*, II (1965), and S. Ekholm-Miller, 'Mound 30, Izapa', *Papers of the New World Archaeological Foundation*, no. 25 (Provo, 1969). J. Quirarte, *Izapan-Style Art* (Washington, 1973), defines the traits of this style during the late pre-Classic period.

11. These groupings are still fluid and inconsistent: Izapa, Stelae 3 and 11 appear in Divisions 1, 2, and 3 (Miles, *op. cit.*, 242–57).

12. *Classic Maya Sculpture*, 177. Also K. A. Dixon, 'Two Masterpieces of Middle American Bone Sculpture', *Am.A.*, XXIV (1958), 53–62. Mino Badner ('A Possible Focus of Andean Artistic Influence in Mesoamerica', *Studies in Pre-Columbian Art and Archaeology*, no. 9 (Washington, Dumbarton Oaks, 1972)) proposes iconographic parallels between Izapa and Chavín.

13. M. W. Stirling, *op. cit.*, 31, 48.

14. On the sculpture of Kaminaljuyú, see Lothrop, *Indian Notes and Monographs*, III (1926), 147–71. The silhouetted reliefs figured by A. V. Kidder, E. M. Shook, and J. D. Jennings, *Excavations at Kaminaljuyu* (Washington, 1926), figure 141, probably belong to this group and period, although their exact provenance is unknown.

15. Thompson, *C.A.A.H.*, IX (1948), 51.

p. 224 16. L. Parsons, *Bilbao*, II (Milwaukee, 1969), 138. These dates do not consider the possibility that the reliefs were produced by a later people who installed their work on platforms of much older construction. This is again the problem, as at La Venta (p. 72), of dating the sculpture in a museum by the architecture of the museum.

17. A. O. Shepard, *Plumbate* (Washington, 1948), figure 18.

18. Kidder, Shook, and Jennings, *op. cit.*, 229–32; G. Lowe and P. Agrinier, 'Excavations at Chiapa de Corzo', *Papers of the New World Archaeological Foundation*, no. 8 (1960); A. Trik and R. Woodbury, *Zaculeu* (Richmond, 1953); G. Guillemin, 'Iximché', *Expedition*, IX (1967), no. 2; P. Becquelin, *Nebaj* (Paris, 1969).

p. 225 19. A. O. Shepard, *Plumbate*. Also 'Studies in Ancient Soconusco', *Archaeology*, XI (1958), 48–54. The term is misleading but traditional. No lead salts are present. Only the colour seems leaden.

20. R. E. Smith, 'Tohil Plumbate and Classic Maya Polychrome Vessels in the Marquez Collection', *N.M.A.A.E.*, no. 129, V (1954–7), 117–30.

21. C. F. Baudez, *Amérique Centrale* (Geneva, 1970), and volume IV of the *Handbook of South American Indians*, edited by Julian Steward and

entitled 'The Circum-Caribbean Tribes', *B.B.A.E.*, CXLIII (1948). Baudez distinguishes the Meso-american zone as a Pacific coast area including Salvador, western Honduras and Nicaragua, and north-west Costa Rica. The South American zone is Caribbean, lying eastward in those countries and including all of Panamá.

22. Doris Stone, *Pre-Columbian Man Finds* p. 2 *Central America* (Cambridge, Mass., 1972). Also F. B. Richardson, 'Non-Maya Monumental Sculpture of Central America', *The Maya and their Neighbors*, 395–416, and Doris Stone, *Introduction to the Archaeology of Costa Rica* (San José, 1958). For Salvador archaeology, see J. M. Longyear III, *H.M.A.I.*, IV (1966), 132–55; western Honduras, J. B. Glass, *ibid.*, 157–79; lower Central America, S. K. Lothrop, *ibid.*, 180–207.

23. H. J. Spinden, 'The Chorotegan Culture Area', *I.C.A.*, XXI (1924), 529–45, believed the eastern types were derived from the Ulúa vessels, but Doris Stone, 'Masters in Marble', *M.A.R.S.*, Publ. 8, holds the opposite. See also Doris Stone, 'Archaeology of the North Coast of the Honduras', *P.M.M.*, IX (1941); S. Borhegyi, 'Travertine Vase in the Guatemala National Museum', *Am.A.*, XVII (1952), 254–6; J. Glass, *op. cit.*, 173; D. Stone, *Pre-Columbian Man* (1972), 140–1.

24. On the meagre history of the extinct Guetar p. 2 people, see S. K. Lothrop, *Pottery of Costa Rica and Nicaragua*, I (New York, 1926), 15–16.

25. *Science*, CXXVII (1958), no. 3290, 136. Sculpture from Las Pacayas on Mount Irazú is figured by J. A. Mason, *Costa Rican Stonework* (*A.M.N.H.A.P.*, XXXIX) (New York, 1945).

26. J. A. Mason, *Costa Rican Stonework*, 293–301.

27. Jorge A. Lines, *Los altares de Toyopan* (San p. : José, 1935).

28. C. V. Hartman, 'Archaeological Researches on the Pacific Coast of Costa Rica', *Memoirs of the Carnegie Museum*, III (1907), 1–188.

29. The mainland jaguar *metates* extend into western Panamá. See S. K. Lothrop, 'Archaeology of Southern Veraguas, Panama', *P.M.M.*, IX (1950), 27–31.

30. Lothrop, *Pottery*, 116, 173–7, and plate LXVIIIb.

31. C. Baudez, *Amérique Centrale* (Geneva, 1970), 108, fixes the period as 800–1200.

32. E.g. Lothrop, *Pottery*, plate XXVI.

33. Guápiles jades are described by S. K. Lothrop, p. : *Pre-Columbian Art* (New York, 1957), 30–1, and 'Jade and String Sawing in Northeastern Costa Rica', *Am.A.*, XXI (1955), 43–51. C. V. Hartman,

op. cit., plates XXXII–XLV, illustrates many jades from the cemeteries at Las Guacas and other sites of the Peninsula. Baudez, *op. cit.*, 69, assigns the jades to his period II (300 B.C.–A.D. 500) by their association with pottery of Linear Decorated phase. E. Easby, *Pre-Columbian Jades from Costa Rica* (New York, 1968).

34. Doris Stone, *H.S.A.I.*, IV, 190, favours the Central American thesis; F. B. Richardson, in *The Maya and their Neighbors*, 415, favours South American origins. H. J. Spinden, *Maya Art and Civilization* (Indian Hills, 1957), 341–4, enumerates the Mexican antecedents of the 'Chorotegan' people; also Lothrop, *Pottery*, 91–4.

35. On *alter ego* figures, E. Nordenskiöld, *Origin of the Indian Civilizations of South America* (Göteborg, 1931).

36. Chontales figures are discussed by F. B. Richardson, *op. cit.*, 412–16. The late statues are reproduced by E. G. Squier, *Nicaragua* (New York, 1852), and by Carl Bovallius, *Nicaraguan Antiquities* (Stockholm, 1886). Good photographs in C. Baudez, *op. cit.*, figures 84–9.

37. Carl Bovallius, who discovered the statue, described it as a crocodile.

Nicoya mace-heads are illustrated by C. V. Hartman, *op. cit.*, plates XXV–XXXI. Both *alter ego* figures and stone mace-heads have South American antecedents. A. Kidder II, 'South American Penetrations in Middle America', *The Maya and Their Neighbors*, 431–41.

38. F. Boyle, 'The Ancient Tombs of Nicaragua', *Archaeological Journal*, XXIII (1866), 41–50; J. F. Bransford, 'Archaeological Researches in Nicaragua', *Smithsonian Contributions to Knowledge*, XXV (1881). Stone grave-markers like these occur near San Agustín in Colombia (see p. 237). p. 230

39. Concise review by S. K. Lothrop, 'The Archaeology of Panama', *H.S.A.I.*, IV (1948), 143–67. In more detail, G. G. MacCurdy, 'A Study of Chiriquian Antiquities', *Memoirs of the Connecticut Academy of Arts and Sciences*, III (1911). On Barriles, C. Baudez, *op. cit.*, 159–60.

40. S. K. Lothrop, 'Archaeology of Southern Veraguas', *P.M.M.*, IX (1950), 27–30.

41. S. K. Lothrop, 'Coclé', *P.M.M.*, VII (1937), VIII (1942); A. Emmerich, *Sweat of the Sun and Tears of the Moon* (New York, 1965). p. 232

42. G. Willey, *Introduction*, II (1971), 358, note 209.

NOTES TO PART THREE

CHAPTER II

p. 233 1. An older introduction to the archaeology is by W. C. Bennett and J. Bird, *Andean Culture History* (New York, 1949). Also fundamental is the exhibition catalogue by W. C. Bennett, *Ancient Arts of the Andes* (New York, 1954), describing the display at the Museum of Modern Art. A synthesis of recent archaeology appears in E. P. Lanning, *Peru before the Incas* (Englewood, N.J., 1967), who presents 'a theory explaining the growth of prehistoric Peruvian civilization', without dependence on 'developmental stages'. See J. Rowe, 'Stages and Periods', in J. Rowe and D. Menzel, *Peruvian Archaeology, Selected Readings* (Palo Alto, 1967), 1–15.

p. 234 2. Bennett and Bird, *A.C.H.*, 95–244. The most recent exposition of this system is by G. Willey and P. Phillips, *Method and Theory in American Archaeology* (Chicago, 1958). Contrast Lanning, *op. cit.*, 24–5 and table 2.

p. 235 3. C. Osgood and G. D. Howard, *An Archaeological Survey of Venezuela* (New Haven, 1943).

4. B. Meggers, C. Evans, E. Estrada, *Early Formative Period of Coastal Ecuador* (Washington, 1965). G. Willey, *Introduction*, II, 275–6 and 350, reviews the state of opinion.

5. J. Alden Mason, 'Archaeology of Santa Marta, Colombia. The Tairona Culture', *F.M.N.H.A.S.*, XX (1931–9); G. Reichel-Dolmatoff, *Colombia* (New York, 1965), 142 f.

6. The 'Chibcha' tribes near Bogotá are sometimes called Muisca, to avoid confusing the tribe with the linguistic stock. J. Pérez de Barradas, *Colombia de Norte a Sur* (Madrid, 1943).

7. W. C. Bennett, 'Archaeology of Colombia', *H.S.A.I.*, II (1946), 830; also *Archaeological Regions of Colombia: A Ceramic Survey* (New Haven, 1944), 109–13.

p. 237 8. J. Pérez de Barradas, *Arqueología y antropología precolombinas de Tierra Dentro* (Bogotá, 1937). Presented as a chronological sequence spanning the ninth to twelfth centuries A.D., this arrangement is merely typological, without conclusive evidence as to time. G. Willey, *Introduction*, II, 316, now dates the chambers as earlier than those of San Agustín.

9. Gregorio Hernández de Alba, 'The Archeology of San Agustín and Tierradentro, Colombia', *H.S.A.I.*, II, 851–9.

10. Extended description in G. Hernández de Alba, *Revista de las Indias*, II (1938), no. 9, 10.

11. W. Krickeberg, *Felsplastik und Felsbilder bei den Kulturvölkern Altamerikas* (Berlin, 1949), 38–9.

12. K. T. Preuss, *Monumentale vorgeschichtliche Kunst* (Göttingen, 1929); J. Pérez de Barradas, *Arqueología agustiniana* (Bogotá, 1943). G. Reichel-Dolmatoff, *San Agustín* (London, 1972), 55–6, describes the whole culture, and defines six categories of free-standing sculpture (columnar, flat, full-round, shaft, peg, and isolated heads). These he separates (69) into 'archaic', 'expressionistic', and 'abstract' styles. Many figures show a 'jaguar-monster' (see Reichel-Dolmatoff, 'The Feline Motif', *Cult of the Feline* (Washington, 1972), 51–68) which he relates to modern shamanism in Colombian ethnology.

13. Reichel-Dolmatoff, *San Agustín*, 127, reports a Carbon 14 dating for a tomb (Alto de Lavapatas) as 550 B.C. In 1970 (*Cult of the Feline*, 67) he mentioned pottery evidence for dating the sculpture 1500–1000 B.C. Various other chronological schemes are summarized by G. Willey, *Introduction*, II (1971), 356, note 150. According to Reichel-Dolmatoff, *Colombia* (1965), 94, L. Duque Gómez proposes an early period (555 B.C.–A.D. 425) of shaft graves and wooden carvings; middle (A.D. 425–1180) stone sarcophagi and statuary; and late (after 1100) 'realistic' stone sculpture.

14. Pérez de Barradas, *op. cit.* p. 2

15. Extended discussion of *alter ego* in Preuss, *op. cit.*, 108–16. Hallucinogenic art: G. Reichel-Dolmatoff, 'The Feline Motif in prehistoric San Agustin Sculpture', in *Cult of the Feline*, ed. E. Benson (Washington, 1972), 61–2.

16. The best technical discussion is by W. C. p. 2 Root, *H.S.A.I.*, V, 205–25, placing Colombian work in relation to the rest of America. For Colombia proper J. Pérez de Barradas, *La orfebrería prehispánica de Colombia. Estilo Calima* (Madrid, 1954). P. Rivet and H. Arsandaux, *La métallurgie en Amérique précolombienne* (Paris, 1946), 176, supposed that Colombian techniques came from lowland South America, on linguistic rather

than archaeological evidence. G. Willey, *Introduction*, II, 277; A. Emmerich, *Sweat of the Sun* (Seattle, 1965), 66, assigns Calima gold-work to a period from before 100 B.C. until perhaps the fourth century A.D.

17. Legs of a figurine in *tumbaga* of Veraguas type. Illustrated by G. Stromsvik, *C.A.A.H.*, VII (1942), no. 37, figure 14. D. Pendergast, *Science*, CLXVIII, no. 3927 (3 April 1970), 116–18, reports another *tumbaga* find as of *c.* A.D. 500, perhaps from Coclé, found at Altun Ha.

18. H. Trimborn, *Señorío y barbarie en el valle del Cauca* (Madrid, 1949), 174 f.

19. *Orfebrería prehispánica de Colombia*, 301. See also Enzo Carli, *Pre-Columbian Goldsmiths' Work of Colombia* (London, 1957).

20. S. K. Lothrop, *H.S.A.I.*, IV, 159.

21. S. K. Lothrop, *Pre-Columbian Art* (New York, 1957), 271, calls it Conto style, from the earlier name of the town near which the graves occur. Today the town is called Restrepo.

22. The magnificent volumes of text and plates by J. Pérez de Barradas, *op. cit.*, illustrate the entire subject. Barradas inclines to the view that Oceanic *tiki* figures played a part in the formation of Calima style (pp. 319–20).

23. *Op. cit.*, 321.

24. G. Hernández de Alba, *Colombia, Compendio arqueológico* (Bogotá, 1938), 51–3, wrote of the style of the left bank of the Atrato as 'Chiriquí' and of the right bank as Darién. The confusion with eastern Central America is obvious. 'Atrato style' would be preferable. The term 'Chiriquí' was first used by V. Restrepo (*Los Chibchas antes de la Conquista*, Bogotá, 1895).

25. Lothrop, 'Metals from the Cenote of Sacrifice', *P.M.M.*, X (1952), no. 2, figure 88, p. 95.

26. P. Rivet and H. Arsandaux, *op. cit.*, 25.

27. *Orfebrería*, 298.

28. G. Hernández de Alba, *El Museo del oro* (Bogotá, 1948), lámina 89.

29. W. C. Root, *H.S.A.I.*, V, 211.

30. Lothrop, 'Coclé', *P.M.M.*, VII (1937), 204. G. Willey, *Introduction*, II (1971), 328–33, now dates Coclé from 500 to 1000.

31. Illustrated by H. Lavachéry, *Les arts anciens d'Amérique au Musée archéologique de Madrid* (Antwerp, 1929), 78–99.

32. The process has been reconstructed in detail by Dudley T. Easby, Jr, *University Museum Bulletin*, XX (1956), no. 3, 3–16.

33. A. Basler and E. Brummer, *L'art précolombien* (Paris, 1928), 39.

34. Illustrated in W. C. Bennett, *Archaeological Regions of Colombia: A Ceramic Survey* (New Haven, 1944), especially plate 10 F.

35. I. Large-headed statuettes. p. 242

1. University Museum, Philadelphia (SA2752). Seated aged woman.

2. University Museum, Philadelphia (SA2751). Seated woman.

3. Museum für Völkerkunde, Berlin. Seated man.

4. Museum für Völkerkunde, Berlin. Standing man.

5. Museum für Völkerkunde, Berlin. Seated figure, bearing horizontal staff in both hands, from Manizales.

II. Small-headed statuettes.

1. Museo Arqueológico, Madrid. Seated fat woman.

2. Museo Arqueológico, Madrid. Seated man on stool.

3. Museo Arqueológico, Madrid. Seated woman bearing double scrolls.

4. Museo Arqueológico, Madrid. Standing man clasping double scrolls.

5. Museo Arqueológico, Madrid. Standing, empty-handed man.

6. Bogotá, Museo del Oro. Standing man (fragment), from Zamarraya in the Choco region.

The Berlin figures are illustrated by W. Krickeberg, *Atlantis* (1931), and the Madrid ones by H. Lavachéry, *op. cit.* The Philadelphia pieces are both illustrated in D. T. Easby, Jr, *op. cit.*

36. E. Restrepo Tirado, *Los Quimbayas* (Bogotá, 1912), 12–15.

37. Comprehensive review of the history of the tribes by A. L. Kroeber, 'The Chibcha', *H.S.A.I.*, II, 887–910.

38. Pottery figurines of Mesoamerican types from Tumaco Island and shore are dated by Reichel-Dolmatoff (*Colombia*, 1965, 111) *c.* 500 B.C., although the iconographic types are similar to those of Teotihuacán at the earliest (e.g. body with head in abdomen). J. C. Cubillos, *Tumaco* (Bogotá, 1955), describes the Colombian sector. See also H. Nachtigall, *B.A.*, N.F. III (1955), 97–121. J. H. Rowe, *Archaeology*, II (1949), 31–4, labels the region Atacames in order to include Esmeraldas and Tumaco. The pottery from the tropical Esmeraldas coast is best studied in R. d'Harcourt, *J.S.A.*, XXXIV (1942–7), 61–200. M. H. Saville, *Antiquities of Manabi* (New York, 1907–10), treats the forested coast south of the

Equator. G. H. S. Bushnell, *Archaeology of the Santa Elena Peninsula* (Cambridge, 1951), has excavated the arid country west of Guayaquil. R. d'Harcourt, *J.S.A.*, XXXVII (1948), 323, first asserted the unity of the stylistic area between Tumaco and Guayas. M. D. Coe's excavations in Guatemala confirm Spinden's 1917 thesis of early diffusion between Middle and South America; 'Archaeological Linkages with North and South America at La Victoria, Guatemala', *A.A.*, LXII (1960), 363–93. These are enumerated by B. Meggers, *Ecuador* (New York, 1966). See also C. Evans and B. Meggers, 'Mesoamerica and Ecuador', *H.M.A.I.*, IV (1966).

On Formative, pre-Classic, or pre-ceramic periods and typologies, see the handbook by J. A. Ford, *Comparison of Formative Cultures in the Americas* (Washington, 1969). Ford accepted transpacific diffusion from Japan for Valdivia.

p. 242 39. J. M. Corbett, 'Some Unusual Ceramics from Esmeraldas', *Am.A.*, XIX (1953–4), 145–52; H. Lehmann, 'Le personnage couché sur le dos', *I.C.A.*, XXIX (1951), 291–8 (in vol. entitled 'The Civilizations of Ancient America'). Also *Am.A.*, XIX (1953–4), 78–80.

p. 243 40. 'Las civilizaciones del sur de Centro América y el noroeste de Sud América', *I.C.A.*, XXIX (1952), 165–72 ('The Civilizations of Ancient America').

41. Saville, *Antiquities*, I, plate LI, 4; II, plates LXXXV, LXXXVIII, 3/4; LXXXIX, 4, 5; CX, 6, 9. R. d'Harcourt, *J.S.A.*, XXXIV (1942–7), plate XIX, 2, 4.

42. J. C. Cubillos, in *Tumaco*, dates them in the same epoch as Upper Tres Zapotes. On Formative Period pottery in coastal Ecuador, see C. Evans and B. J. Meggers, *Am.A.*, XXII (1951), 235–47; B. Meggers, C. Evans, and E. Estrada, *Early Formative Period of Coastal Ecuador* (Washington, 1965); G. Willey, *Introduction*, II (1971), 275.

43. Illustrated by Saville, *Antiquities*, I, plate LI, 4. C. Evans and B. J. Meggers have found figurines of 2500–2000 B.C. near Guayaquil; 'Valdivia', *Archaeology*, XI (1958), 175–82.

44. G. H. S. Bushnell, 'The Stone Carvings of Manabí', *I.C.A.*, XXX (1952), 58–9.

p. 244 45. *Antiquities*, II, figure 17, p. 147.

46. J. Jijón y Caamaño, *Puruhá* (Quito, 1927). D. Collier, *H.S.A.I.*, II, 783, believes this chronology needs contraction. Our dates are from B. Meggers, *Ecuador* (1966), 25.

47. 'Peruvian Stylistic Influences in Ecuador', *M.S.A.A.*, IV (1948), 80–2.

CHAPTER 12

1. W. C. Bennett, 'The Peruvian Co-Tradition', p *M.S.A.A.*, IV (1948), 1–7.

2. R. Larco Hoyle, 'La escritura peruana pre-incana', *M.A.*, VI (1944), 219–38.

3. S. Izumi and S. Toshihiko, *Excavations at* p *Kotosh* (Tokyo, 1963), 46, plate 15 and figure 26; E. Lanning, *Peru before the Incas* (Englewood, 1967), 83; also S. Izumi in *Dumbarton Oaks Conference on Chavín* (1971), 49–72.

4. M. N. Porter, *Tlatilco* (New York, 1953). J. C. Tello, *Antiguo Perú* (Lima, 1929), championed the thesis of highland priority. On earliest Peruvian appearances of pottery, Lanning, *op. cit.*, 82–8.

5. J. Bird, 'South American Radiocarbon Dates', *M.S.A.A.*, VIII (1951), 37–49.

6. G. Willey, 'Prehistoric Settlement Patterns in the Virú Valley', *B.B.A.E.*, CLV (1953), 38–42; W. D. Strong, *M.S.A.A.*, XIII (1957), 10.

7. Lanning, *Peru*, 65–8. p

8. The most elaborate example is by R. Carrión Cachot, 'La cultura Chavín', *R.M.N.A.A.*, II (1948).

9. 'The Chavín Problem: A Review and Cri- p. tique', *Southwestern Journal of Anthropology*, VII (1951), 103–44.

10. M. N. Porter, *Tlatilco*, 71–9. M. Badner, *A Possible Focus of Andean Artistic Influence in Mesoamerica* (Washington, 1972), prefers to compare Izapa with Chavín.

11. J. Bird, *M.S.A.A.*, VIII (1951), 40–1.

12. First stated by A. L. Kroeber in 1926; re-stated *V.F.P.A.*, IV (1944), 86, and independently reworked by J. C. Muelle, *B.A.*, XXVIII (1955), 89–96, who also made an earlier analysis of Nazca traits in relation to Chavín sculpture (*R.M.N.L.*, VI (1937), 135–50).

13. R. Carrión Cachot, *op. cit.*, 65–74 (Ancón); A. L. Kroeber, 'Paracas Cavernas and Chavin', *U.C.P.A.A.E.*, XL (1953), 313–48.

14. S. K. Lothrop, 'Gold Artifacts of Chavin Style', *Am.A.*, XVI (1950–1), 226–40.

15. R. Larco Hoyle, *Los Mochicas*, I (Lima, 1938), 36; *idem*, *Los Cupisniques* (Lima, 1941), 8. Contrast J. C. Tello, *Arqueología del valle de Casma* (Lima, 1956), 14–20.

16. W. D. Strong and C. Evans, Jr, *Cultural Stratigraphy in the Virú Valley* (New York, 1952), 231. G. Willey, in his review of the problem (*Southwestern Journal of Anthropology*, VII (1951), 131), also favoured this interpretation, while rejecting the Chavín affinities of Sechín sculpture. Cf.

Lanning, *Peru* (1967), 93, and D. Collier, 'Casma Valley', *I.C.A.*, XXXIV (1960), 411–17 [publ. 1962].

17. J. C. Tello, *op. cit.* A. Bueno Mendoza and L. Samaniego, 'Sechín', *Amaru*, XI (1970), 31–8, have reported inconclusive finds of non-Chavín pottery and more reliefs.

50 18. Discussion in R. Larco, *Los Cupisniques*, 116–23. Also A. L. Kroeber, *Peruvian Archeology in 1942*, *V.F.P.A.*, IV (1944), 139–40.

52 19. *Pre-Columbian Art*, plate CXX, no. 297, and Tello, *Antiguo Perú*, figure 112. Another such bridge is the carved conch shell from Chiclayo, illustrated by Larco, *Los Cupisniques*, figure 174: among interlaced serpents and feline profiles a standing man blows a conch-shell trumpet, wearing a curved-stripe eye decoration. (Also Tello, *El strombus en el arte Chavin*, Lima, 1937.)

20. Tello's plan (our Figure 87) is only approximate. It does not correspond to his descriptions, because of the chaotic state of the upper portions.

53 21. Tello describes Head V as a 'dios felinomorfo', but his illustrations convey nothing of this description.

22. Best illustrations (plan and sections) in R. Larco Hoyle, *Los Mochicas*, I, figures 18–23: the Chavín-style painting is figured by Tello, *Sobre el descubrimiento de la cultura Chavín* (Lima, 1944), plate III.

54 23. Maxcanú in Yucatán was described by J. L. Stephens, *Incidents of Travel in Yucatan*, I (New York, 1848), 214.

55 24. Description and rough sketch plan by W. C. Bennett, 'The North Highlands of Peru. Excavations in the Callejón de Huaylas and at Chavín de Huántar', *A.M.N.H.A.P.*, XXXIX (1944), 71–92. For excavations of 1955–6 and plan of successive building campaigns, see J. Rowe, *Chavin Art* (New York, 1962), 7–12. L. G. Lumbreras, 'Towards a Re-evaluation of Chavin', *Conference on Chavin* (Washington, 1971), 3–8, gives a plan of courts and galleries.

25. J. Rowe, *Chavin Art* (New York, 1962), 12–13, proposes a seriation related to building sequence, and lasting from *c.* 700 to 200 B.C. It opens with an archaic phase A B (to and including the *lanzón*). The Tello Obelisk defines phase C. Phase D is based on the sculptured columns of the portal, and correlated with Phases 4 and 5 of the Paracas sequence at Ica. Phase EF includes the Raimondi slab. A. L. Kroeber, 'Ancient Pottery from Trujillo', *F.M.N.H.A.M.*, II (1926), no. 1, 36–7, divided sculpture at Chavín into M and N phases. N refers to Nazca affinities, and M to Maya. Kroeber later

proposed five stylistic groups (*Peruvian Archeology in 1942*, 88–9) of incised slabs, without pressing any chronological sequence, and omitting references to Maya sculpture. The Nazca connexions of the Raimondi Monolith were restated by J. C. Muelle, 'Del estilo Chavín', *B.A.*, N.F. III (1957), 89–96.

26. J. C. Muelle, 'Filogenía de la estela Raimondi', p. 256 *R.M.N.L.*, VI (1937), 135–50, connected this relief with the Late Nazca style. L. G. Lumbreras and H. Amat Olozabal, 'Galerías interiores de Chavín', *R.M.N.L.*, XXXIV (1965–6), 143–97.

27. The best descriptions are by Tello, 'Discovery of the Chavín Culture in Peru', *Am.A.*, IX (1941–2), 136–7, and *Origen y desarrollo de las civilizaciones prehistóricas andinas* (*I.C.A.*, XXVII, Lima) (Lima, 1942), 114–16. R. Larco Hoyle proposed the Nepeña Valley as the origin of all Chavín manifestations. He placed Punkurí coeval with Sechín, and prior to Cerro Blanco, which, with Chavín de Huántar, he regarded as contemporary with fully developed Mochica style (*Los Cupisniques*, 8–9).

28. Rowe (*Chavín Art*, 1962, 14–17) also speaks p. 257 of 'modular width' (crediting L. Dawson), or banded designs with repeating features like eyes and fangs.

29. G. Willey, 'A Functional Analysis of "Horizon Styles" in Peruvian Archaeology', *M.S.A.A.*, IV (1948), 8–15; Bennett, *A.M.N.H.A.P.*, XXXIX (1944), 98–9.

30. Willey, *op. cit.*, 11.

31. The best account of Recuay archaeology is by W. C. Bennett, 'The North Highlands of Peru', *A.M.N.H.A.P.*, XXXIX (1944), 99–106. An important excavation in 1971 by T. Grieder at Pashash yielded nine Carbon 14 measurements (300–600) dating both the pottery and stone sculpture of Recuay affinities in a temple cache.

32. Cf. Plate 152 in this volume with a Recuay p. 258 vessel in Berlin, published by E. Seler in *Peruanische Alterthümer* (Berlin, 1893), plate 44, centre row, right end. On supposed parallels with Nicoya pottery from Costa Rica, W. Krickeberg, *Festschrift Schmidt* (Vienna, 1928), 381. He proposes a common origin in Colombia for both Nicoya and Recuay styles.

33. Bennett, *Ancient Arts of the Andes* (New York, 1953), 141, and figure 159–60.

34. Kroeber, *F.M.N.H.A.M.*, II (1926), no. 1, 36.

35. Seler, *op. cit.*, plate 43, bottom row; plate 44, p. 259 centre right.

36. Tello, *Antiguo Perú*, 36–46. The Macedo Collection is illustrated in Max Schmidt, *Kunst und Kultur von Peru* (Berlin, 1929), 231–42.

p. 259 37. H. Disselhoff discusses a Mochica vessel painted with battle-scenes between Mochica warriors and foreigners whom he identifies as Recuay tribesmen by their slings, shields, and head-dresses decorated with hands; 'Hand und Kopftrophäen in plastischen Darstellungen der Recuay-Keramik', *B.A.*, N.F. IV (1955), 25–32.

38. R. Schaedel, 'Stone Sculpture in the Callejón de Huaylas', *M.S.A.A.*, IV (1948), 66–79.

CHAPTER 13

p. 260 1. The most recent major work on Mochica and pre-Mochica archaeology is by W. D. Strong and Clifford Evans, Jr, 'Cultural Stratigraphy in the Virú Valley, Northern Peru, The Formative and Florescent Epochs', *C.S.A.E.*, IV (1952). For Chimu dynastic history, J. H. Rowe, 'The Kingdom of Chimor', *Acta Americana*, VI (1948), 26–59.

2. My estimate, based upon stratified guano accumulations in the Chincha Islands, extended Mochica duration into the ninth century A.D. (Kubler, 'Towards Absolute Time: Guano Archaeology', *M.S.A.A.*, IV (1948), 29–50).

3. J. B. Bird, 'Pre-Ceramic Art from Huaca Prieta', *Ñ.P.*, I (1963), 29–34; Lanning, *Peru* (1967), 66.

p. 261 4. R. Larco Hoyle, *Los Mochicas* (Lima, 1938), I, 20, and map between pp. 56–7, and *Cronología arqueológica del norte del Perú* (Buenos Aires-Chiclín, 1948), 15–24. The best account is by W. Bennett, in *A.M.N.H.A.P.*, XXXVII (1941), 90–3. The only intact graves were in the Chicama Valley near Sausal; Larco, *Los Cupisniques* (Lima, 1941), 177–242.

5. *Cronología*, 15–24. To counter Tello's hypothesis of eastern Andean origins for the Chavín style, Larco proposed that the coastal pottery of heavy form with incised or modelled decoration on monochrome surfaces was archetypal, and that it be called Cupisnique. But the intact examples answering this description come from many valleys other than Cupisnique. Very few were excavated under proper control, and most of the vessels appeared in commerce as the results of illegal digging under destructive conditions.

6. H. Ubbelohde-Doering, 'Ceramic Comparisons of Two North Coast Peruvian Valleys', *I.C.A.*, XXIX (1951) ('Civilizations of Ancient America'), 224–31, encountered comparable juxtapositions in the graves of the Jequetepeque Valley. His 'Chavín' examples look more Mochica than Chavín.

7. *Los Cupisniques*, 34.

8. J. Rowe, 'Influence of Chavín Art on Later p. Styles', *Conference on Chavin* (Washington, 1971), 101. Larco's classification in 1948 (*Cronología*, 15–20) alters these groups: his 'early Cupisnique' includes A and D vessels; 'Transitorio' has B and C shapes; 'Santa Ana' has B and D. On these vessel-types in the underground galleries of Chavín de Huántar, see L. G. Lumbreras, 'Re-evaluation', *Conference on Chavin* (Washington, 1971), 1–27.

9. R. Larco Hoyle, *Cultura Salinar* (Buenos Aires, 1944). Detailed discussion of other coastal occurrences of Salinar style in Strong and Evans, *C.S.A.E.*, IV (1952), 237–9.

10. Strong and Evans, *ibid.*, 237–40.

11. W. C. Bennett, *The Gallinazo Group*, *Virú* p. *Valley, Peru* (New Haven, 1950); Strong and Evans, *loc. cit.*, and figures 57–60.

12. J. A. Bennyhoff, 'The Virú Valley Sequence: A Critical Review', *Am.A.*, XVII (1952), 231–49, criticizes the authors of the Virú project for interpreting sequence where coexistence is equally tenable. On Vicús, see A. Sawyer, *Ancient Peruvian Ceramics* (New York, 1966), 19–20, and *Mastercraftsmen of Ancient Peru* (New York, 1968), 24–35: the older Chavinoid phase (fourth century B.C.) preceded an Early Mochica climax (300 B.C.–A.D. 100), which yielded to resist-painted wares lasting until A.D. 700. Also R. Larco Hoyle, *La cerámica de Vicús*, 2 vols. (Lima, 1965–7). R. Matos Mendieta, 'Estilo de Vicús', *R.M.N.L.*, XXXIV (1965–6), 89–130, discusses its connexions with Ecuador and Colombia before A.D. 500.

13. Mochica refers to a language once spoken in p. the Chicama Valley; in Trujillo, the Quingnam dialect was spoken. Some prefer to call the civilization Moche, after its principal ceremonial centre in the Trujillo Valley; J. H. Rowe, *op. cit.* (Note 1). Other recent names for the civilization, now disused, are Early Chimu and Proto-Chimu.

14. P. Kosok, 'The Role of Irrigation in Ancient Peru', *Proceedings of the Eighth American Scientific Congress* (Washington, 1940), II, 169–78, and *Life, Land and Water in Ancient Peru* (New York, 1965); D. Collier, in *Irrigation Civilizations: A Comprehensive Study* (Social Science Monographs, I) (Washington, Pan-American Union, 1955), 19–27.

15. G. Willey, 'Prehistoric Settlement Patterns', *B.B.A.E.*, CLV (1953), 394–5.

16. W. D. Strong, 'Paracas, Nazca, and Tiahuanacoid Cultural Relationships in South Coastal Peru', *M.S.A.A.*, XIII (1957).

17. *Los Mochicas*, 2 vols. (Lima, 1939), and *Cronología arqueológica* (Buenos Aires-Chiclin, 1948). In 1946 Larco considered that the last half of Mochica history witnessed an expansion north and south from the ancestral home of the style in the Chicama and Trujillo Valleys. J. H. Rowe verified Larco's I–V sequence in the Uhle Collection from Moche (*Handbook of Latin American Studies*, XVI (1950), 29) and found it acceptable. It is also acceptable in principle, although 'too finely drawn', to W. D. Strong and C. Evans, *C.S.A.E.*, IV (1952).

18. Strong and Evans, *op. cit.*, 220. Contrast H. Ubbelohde-Doering, 'Untersuchungen zur Baukunst der nordperuanischen Küstentäler', *B.A.*, XXVI (1952), 23–47, who proposed reed-marked bricks as Mochica and smooth bricks as post-Mochica. This paper was written in 1938 and published without revision. E. Benson, *Mochica* (London, 1972), 95, notes the geographical differences.

19. G. Willey, 'Prehistoric Settlement Patterns', *B.B.A.E.*, CLV (1953), 205–10.

20. M. Uhle, 'Die Ruinen von Moche', *J.S.A.*, X (1913), 108–9; A. L. Kroeber, 'The Uhle Pottery Collections from Moche', *U.C.P.A.A.E.*, XXI (1925), 191–234.

21. On Pacatnamú, H. Ubbelohde-Doering, *Auf den Königsstrassen der Inka* (Berlin, 1941), 50–6; El Brujo, *ibid.*, plate 325, p. 49.

22. J. Bird, 'South American Radiocarbon Dates', *M.S.A.A.*, VIII (1951), 41–2.

23. A. de la Calancha, *Coronica moralizada* (Barcelona, 1658), 485, reported a tradition that the Sun Pyramid was built in less than three days by 200,000 workers. Its ruin dates from the seventeenth century. Other pyramid clusters of Mochica date are described by R. Schaedel, 'Major Ceremonial and Population Centers in Northern Peru', *I.C.A.*, XXIX (1951), 232–43.

24. *R.M.N.L.*, V (1936), 192, and E. Langlois, *La Géographie*, LXV (1936), 203–11.

25. J. A. Mason, *The Ancient Civilizations of Peru* (London, 1957), 69. Illustrations in Kroeber, *Peruvian Archaeology in 1942* (*V.F.P.A.*, IV) (1944), plate 30.

26. Illustrated in R. Larco Hoyle, *Los Mochicas*, 33. Cf. Larco, *H.S.A.I.*, II, 164 n.

27. Walls carved in two places, showing rectilinear sting-rays painted in four colours, adorn the Mochica terrace facing at El Brujo in the Chicama Valley. Ubbelohde-Doering, *op. cit.*, plate 325, p. 49.

28. J. C. Muelle, 'Lo táctil como carácter fundamental en la cerámica muchik', *R.M.N.L.*, II

(1933), 67–72; R. Larco Hoyle, *Checán* (Geneva, 1965); E. Benson, *Mochica* (London, 1972), 138–54.

29. J. A. Ford and G. Willey, *A.M.N.H.A.P.*, p. 269 XLIII (1949), 66.

30. Kroeber, *U.C.P.A.A.E.*, XXI (1925), 200–2. In the Virú Valley the large number of three-colour vessels (red, white, and black) has been taken to mark a later period in Mochica history than the red-and-white lots at Moche. Strong and Evans, *C.S.A.E.*, IV (1952), 176.

31. *Cronología arqueológica*, 28–36. Cf. Note 17. The earliest known stirrup-spouted bowls occur in the Machalilla phase on the south coast of Ecuador c. 2000 B.C. B. Meggers, *Ecuador* (1966), 48 and figure 11.

32. A. Sawyer, *Ancient Peruvian Ceramics* (New p. 270 York, 1965), 24–34. Also C. B. Donnan, 'Moche Ceramic Technology', *Ñ.P.*, III (1965), 123–4.

33. Virú: Strong and Evans, *op. cit.*, 165; Sor- p. 271 cape: H. Disselhoff, 'Zur Frage eines Mittelchimu-Stiles', *Zeitschrift für Ethnologie*, LXXI (1939), 129–38. Other examples of the mountain sacrifice are illustrated by A. Baessler, *Ancient Peruvian Art*, I (Berlin, 1902), plates 92–6. Two carved black-ware examples of Mochica III date are illustrated by Tello, *Inca*, II (1938), 280.

34. Strong and Ford, *C.S.A.E.*, IV (1952), 153–5, and Kubler, *M.S.A.A.*, IV (1948), 46–9.

35. Lothrop, 'Gold Artifacts of Chavin Style', *Am.A.*, XVI (1951), 226–40.

36. G. Kutscher, *Nordperuanische Keramik* (*Monu-* p. 272 *menta americana*, I) (Berlin, 1954), contains line-drawings originally prepared for a book by E. Seler in 1904. Kutscher distinguishes only a 'linear style' on spherical vessels, and a 'silhouette style' on flattened spheroids with concavely curved spouts. The doctoral dissertation (unpublished) by C. I. Calkin, *Moche Figure-Painted Pottery* (Univ. of California, Berkeley, 1953), treats the stylistic development of the human figure. D. Lavallée, *Représentations Mochica* (Paris, 1970), 21: 'Les Mochica ignoraient la céramique polychrome'. She distinguishes early solid area drawing (*à-plat*) from middle and late Mochica line-drawing (*au trait*).

37. A. L. Kroeber, *F.M.N.H.A.M.*, II (1930), p. 273 no. 2, 71–2; R. Schaedel, 'Mochica Murals at Pañamarca', *Archaeology*, IV (1951), no. 3, 145–54. James Ford discovered similar wall-paintings in niches at the Huaca Fecho on Hacienda Batán Grande in the Lambayeque Valley (verbal communication).

38. Mochica textiles are extremely rare. The p. 274

most important fragment, from Pacatnamú, represents a house in cross-section, as in Figure 100, and subject to the rectilinear deformations of textile technique. Reproduced by H. Ubbelohde-Doering, *Vom Reich der Inka*, 345.

p. 276 39. J. C. Muelle, 'Chalchalaca', *R.M.N.L.*, v (1936), 65–88. Contrast Kutscher, *op. cit.*, 61–2. For Ai Apaec, see Larco, *H.S.A.I.*, II, 171–3. On the god Si, Kutscher, *I.C.A.*, XXVII (1948), 621–31. Bean-writing: Larco, *Revista geográfica americana*, XI (1943), 122–3. Fertility races: Kutscher, *I.C.A.*, XXIX (1951), 244–51. General: Kutscher, 'Iconographic Studies as an Aid in the Reconstruction of Early Chimu Civilization', *Transactions of the New York Academy of Sciences*, N.S. XXII (1950), 194–203. E. Benson (*Mochica*, London, 1972, 27–30) discusses the supreme deity, a jaguar-god (Ai Apaec), and a 'radiant god' and their companions and messengers. Warriors, animal impersonators, rituals, and symbolism are described. D. Lavallée, *Représentations animales dans la céramique mochica* (Paris, 1970), offers a complete systematic analysis.

40. J. H. Rowe, 'Max Uhle, 1856–1944', *U.C.P.A.A.E.*, XLVI (1957), 7–8. The Tiahuanaco-style sherds and figured cloths are illustrated by Max Uhle in 'Die Ruinen von Moche', *J.S.A.*, x (1913), figure 16, and by A. L. Kroeber, *U.C.P.A.A.E.*, XXI (1925), plate 63. R. Larco, *Cronología arqueológica*, 37–49, identifies this style as radiating from Huari near Ayacucho, with upper (A) and lower (B) north coast phases, which he regards as a chronological sequence, complicated by other local (Lambayeque) and intrusive (Cajamarca) pottery styles. See L. M. Stumer, 'Coastal Tiahuanacoid Styles', *Am.A.*, XXII (1956), 62.

41. Bennett, *H.S.A.I.*, II, 122–3, gives a census of coastal Tiahuanaco finds, enumerating only the Virú, Moche, and Chicama Valleys on the north coast. D. Menzel, 'Style and Time in the Middle Horizon', *Ñ.P.*, II (1964), 70, fixes the end of the Huari 'empire' and its northernmost appearance in Chicama about A.D. 700 (MH-2B). Lanning, *Peru*, 134, detects Viñaque traits in southern Ecuador.

42. Ford and Willey, 'Surface Survey of the Viru Valley', *A.M.N.H.A.P.*, XLIII (1949), 66–9. The cursive style probably reflects north highland influences (Recuay and Cajamarca).

p. 277 43. G. Willey, 'Prehistoric Settlement Patterns in the Virú Valley', *B.B.A.E.*, CLV (1953), 353–4. P. Kosok, 'Transport in Peru', *I.C.A.*, XXX (1952), 65–71, believes the inter-valley roads were built under Mochica rule.

44. R. P. Schaedel, 'The Lost Cities of Peru',

Scientific American, CLXXXV (1951), no. 2, 18–23; *idem*, 'Major Ceremonial and Population Centers in Northern Peru', *I.C.A.*, XXIX (1951), 232–43; A. L. Kroeber, *F.M.N.H.A.M.*, II (1930), no. 2, 94. Schaedel's dating is typological rather than stratigraphic.

45. R. P. Schaedel, 'Huaca El Dragón', *J.S.A.*, LV (1966), 458, suggests that the Naymlap dynasty was related to the founder of the Chimu dynasty, and that the structure was related to commerce with the guano islands. The 'dragon' reliefs are called 'centipede' by H. Horkheimer, *Vistas arqueológicas* (Trujillo, 1944), 70. The figures also resemble killer-whale stylizations (see p. 304).

46. H. Horkheimer, *op. cit.*, 41.

47. The texts are also evaluated by J. Rowe, 'The Kingdom of Chimor', *Acta Americana*, VI (1948), 37–9. Rowe believes that the Naymlap story is 'pure legend' and of 'late origin', in spite of an independent and confirmatory version written in 1718 by J. M. Rubiños y Andrade; *Revista histórica*, x (1936).

48. R. Vargas Ugarte, 'Los Mochicas y el p. 2 Cacicazgo de Lambayeque', *I.C.A.*, XXVII (1942), II, 475–82.

49. P. A. Means, *Ancient Civilizations of the Andes* (New York, 1931), 51–5, assuming a long interval after Fempellec, related the Naymlap story to Mochica culture.

50. Luis Valcárcel, *The Latest Archaeological Dis-* p. 2 *coveries in Peru* (Lima, 1948), 27–31, and *R.M.N.L.*, VI (1937), 164. The example we illustrate is 43·5 cm. (17⅜ ins.) high. According to Cabello, the name Lambayeque means 'image of Naymlap'. G. Antze, 'Metallarbeiten aus dem nördlichen Peru', *Mitteilungen aus dem Museum für Völkerkunde in Hamburg*, XV (1930), illustrates the Brüning Collection, now in Hamburg, all from the same region in Lambayeque as the knives discussed above (Batán Grande near Illimo).

51. R. Carrión Cachot, 'La luna y su personificación ornitomorfa en el arte Chimu', *I.C.A.*, XXVII (1942), I, 571–87.

52. Kroeber, *F.M.N.H.A.M.*, II (1926), 28; Bennett, *A.M.N.H.A.P.*, XXXVII (1939), 101. Examples from Ancón to Piura are reported.

53. Text in R. Vargas Ugarte, 'La fecha de la fundación de Trujillo', *Revista historica*, x (1936), 229–39, and J. Rowe, *op. cit.* (Note 47), 28–30 (English translation).

54. A. de la Calancha, *Coronica moralizada* (Bar- p. 2 celona, 1658), 550. The best narrative account of Chanchan is still that by E. G. Squier, *Peru* (New

York, 1877), chapters VI–VII. See also Otto Holstein, 'Chan-Chan: Capital of the Great Chimu', *Geographical Review*, XVII (1927), 36–61. On recent mapping and excavation by Harvard University anthropologists, see M. West, 'Community Settlement Patterns at Chan Chan', *Am.A.*, XXXV (1970), 74–86, estimating population between 68,000 and 100,000+.

282 55. A plan by Emilio González García, published in *Chimor*, I (1953), 26, and reproduced here as Figure 102, should be consulted together with the plan drawn before 1790 for Bishop Martínez de Compañón (*Trujillo del Perú*, ed. J. Domínguez Bordona, Madrid, 1936, plate LXXXI). In the plan the compounds are recognized as palaces, and the intervening areas are marked as covered with houses.

284 56. The Tschudi enclosure measures 1600 by 1100 feet (Squier's measurements). All students of Chanchan have reported the presence of many slag-spattered portions of the ruins where metallurgical furnaces probably functioned (e.g. Squier, *Peru*, 164).

57. *Acta Americana*, VI (1948), 45–6.

58. Willey, 'Prehistoric Settlement Patterns', *B.B.A.E.*, CLV (1953), 416–17. H. Ubbelohde-Doering, *op. cit.* (Note 21), renamed the ruin called La Barranca (Kroeber, *F.M.N.H.A.M.*, II (1930), 88–9) as Pacatnamú, the city which Calancha (*Coronica moralizada*, 547) called a Chimu colony. Another such Chimu colony may be the Purgatorio ruin on the Leche river near Tucume (Kroeber, *op. cit.*, 93–4). Schaedel, *I.C.A.*, XXIX (1951), 238–9, identified Apurle (Motupe R.) and Farfán (Jequetepeque) as other 'urban elite' centres of main importance in the Chimu state.

59. M. E. Moseley, 'Assessing *mahamaes*,' *Am.A.*, XXXIV (1969), 485–7, and J. Rowe, 'Sunken Gardens', *ibid.*, 320–5.

285 60. M. Hoyt and M. Moseley, 'The Burr Frieze', *Ñ.P.*, VII–VIII (1969–70), 41–57.

61. Bird, in Strong and Evans, *C.S.A.E.*, IV (1952), 359, reported that twills first appeared in the Gallinazo period, and became more common (28·4 per cent, Huancaco period) in Mochica times.

62. A. Baessler, *Altperuanische Metallgeräte* (Berlin, 1906). An excellent cross-section of Peruvian metalwork is reproduced in Max Schmidt, *Kunst und Kultur von Peru* (Berlin, 1929), plates 367–409. J. C. Tello once remarked in a newspaper article (*El Comercio*, Lima, 29 January 1937, 5) that 75 per cent of all known Peruvian pre-Conquest gold in the museums of the world comes from the vicinity of Tucume (Leche river), rather than from Trujillo or Chicama.

63. J. C. Muelle, 'Concerning the Middle Chimu Style', *U.C.P.A.A.E.*, XXXIX (1941), 203–22; H. Scheele and T. C. Patterson, 'A Preliminary Seriation of the Chimu Pottery Style', *Ñ.P.*, IV (1966), 15–30. p. 286

64. L. M. O'Neale and A. L. Kroeber, 'Textile Periods in Ancient Peru', *U.C.P.A.A.E.*, XXVIII (1930–1), 23–56.

65. H. and P. Reichlen, 'Recherches archéologiques dans les Andes de Cajamarca', *J.S.A.*, XXXVIII (1949), 137–74.

66. H. H. Urteaga, *El fin de un imperio* (Lima, 1933). Also J. C. Tello, 'La ciudad inkaica de Cajamarca', *Chaski*, I (1941), no. 3, 2–7. p. 287

67. T. D. McCown, 'Pre-Incaic Huamachuco', *U.C.P.A.A.E.*, XXXIX (1945), no. 4.

68. A. L. Kroeber, 'A Local Style of Lifelike Sculptured Stone Heads in Ancient Peru', *Festschrift R. Thurnwald* (Berlin, 1950), 195–8.

69. McCown, *op. cit.*, 341.

70. Rowe, *Am.A.*, XXII (1956), 149. Lanning, *Peru*, sees it as the work of a Huari garrison and as a storehouse site built during pacification. p. 288

CHAPTER 14

1. F. Engel, 'El Paraíso', *J.S.A.*, LV (1966), 43–96; E. Lanning, *Peru before the Incas* (1967), 71, 78. Other sites, Río Seco (Chancay), Tank (Ancón), Chira (Rimac), have house compounds at this time. Lanning deduces collaborative communal organization under stratified social structure, and prior to irrigation farming. p. 289

2. E. E. Tabío, *Excavaciones en Playa Grande* (Lima, 1955), 33.

3. T. C. Patterson, *Pattern and Process* (Berkeley, 1966), 117, sees the region as important for pilgrimages and cults from 400 to 800. His nine phases for Lima pottery span *c.* A.D. 100–600. L. M. Stumer, 'The Chillón Valley of Peru', *Archaeology*, VII (1954), 172; R. d'Harcourt, 'La céramique de Cajamarquilla-Nievería', *J.S.A.*, XIV (1922), 107–18.

4. Ancón: R. Carrión Cachot, 'La cultura Chavín', *R.M.N.A.A.*, II (1948), 97–172; Supe: G. Willey and J. M. Corbett, 'Early Ancon and Early Supe Culture', *C.S.A.E.*, III (1954). Also G. Willey, 'The Chavin Problem', *Southwestern Journal of Anthropology*, VII (1951), 119–21.

p. 289 5. The main burial ground at Ancón is much later (W. Reiss and A. Stübel, *The Necropolis of Ancon*, 3 vols., Berlin, 1880–7), and finds from it fill the museums of Europe and America.

p. 290 6. L. M. Stumer, *op. cit.*, 171–8, 220–8; also *Scientific American*, CXCII (1955), 98–104.

7. J. Jijón y Caamaño, *Maranga* (Quito, 1949); A. L. Kroeber, 'Proto-Lima', *Fieldiana: Anthropology*, XLIV (1955); T. C. Patterson, *Pattern and Process in the Early Intermediate Period Pottery of the Central Coast of Peru* (Berkeley, 1966).

8. L. M. Stumer, 'Population Centers of the Rimac Valley of Peru', *Am.A.*, XX (1954), 130–48.

9. A. H. Gayton, 'The Uhle Collections from Nievería', *U.C.P.A.A.E.*, XXI (1924), 305–29; also R. d'Harcourt, *J.S.A.*, XIV (1922). The site is described in detail by P. E. Villar Córdova, *Las culturas prehispánicas del departamento de Lima* (Lima, 1935).

p. 291 10. S. K. Lothrop and Joy Mahler, 'A Chancay-Style Grave at Zapallan, Peru', *P.M.P.*, L (1957), discovered that several varieties of Chancay pottery, originally listed as a chronological sequence by Kroeber (*U.C.P.A.A.E.*, XXI (1926), 265–304), are actually contemporaneous.

11. P. E. Villar Córdova, 'Las ruinas de la provincia de Canta', *Inca*, I (1923), 1–23; *I.C.A.*, XXIII (1928), 351–82; and *Culturas prehispánicas del departamento de Lima*, 289–332. See also A. Rossel Castro, *Chaski*, I (1941), no. 3, 59–63; A. L. Smith, 'The Corbelled Arch', *The Maya and their Neighbors* (New York, 1940), 202–21.

12. W. C. Bennett, *A.M.N.H.A.P.*, XXXIX (1944), 14–53.

p. 293 13. M. Uhle, *Pachacamac* (Philadelphia, 1903); W. D. Strong, G. Willey, and J. M. Corbett, *Archeological Studies in Peru, 1941–1942*, *C.S.A.E.*, I (1943).

14. Tello reported Chavín-style sherds at the Nunnery of Pachacamac, without further details of place or association; *Chaski*, I (1940), no. 2, 1.

15. *Historia del Nuevo Mundo*, ed. M. Jiménez de la Espada, IV (Seville, 1893), 47–54.

16. Cobo mentions six stages, and Uhle only five, but Cobo included a low basal platform which Uhle did not rank as a stage.

17. This arrangement was also described by Jerónimo de Román y Zamora, writing before 1575 (*Republicas del Mundo*, 2nd ed., Salamanca, 1595).

18. *C.S.A.E.*, I (1943), 37.

p. 295 19. J. C. Muelle and J. R. Wells, 'Las pinturas del templo de Pachacamac', *R.M.N.L.*, VIII (1939), 265–82.

20. Max Schmidt's *Kunst und Kultur des alten Peru* (Berlin, 1929) is illustrated principally with the finds from Pachacamac, like A. Baessler's *Altperuanische Metallgeräte* (Berlin, 1906). Willey, *Introduction*, II, 161, regards the Pachacamac style as a product of Huari influence on Lima or Nievería style. Lanning, *Peru*, 135, regards it as 'Tiahuanacoid style related to Viñaque (Huari) and Atarco (Nazca) expressions', following Menzel ('Style and Time in the Middle Horizon', *Ñ.P.*, II [1963], 70, 71).

CHAPTER 15

1. J. Rowe, 'Radiocarbon Measurements', in p. 2 *Peruvian Archaeology*, ed. J. Rowe and D. Menzel (Palo Alto, 1971), 16–30; G. Willey, *Introduction*, II, 127 and note 166.

2. J. C. Tello, *Antiguo Perú* (Lima, 1929), 113–49. p. 2

3. D. Menzel, J. Rowe, and L. E. Dawson, *Paracas Pottery* (Berkeley, 1964). With a five-period scheme, A. Sawyer retains the older terms (*Ancient Peruvian Ceramics*, 71):

pre-Cavernas:	Formative Paracas I	(900–700)	
	Early Paracas	II	(700–400)
Cavernas:	Middle Paracas	III	(400–250)
Necropolis:	Late Paracas	IV	(250–100)
	Proto-Nazca	V	(100–0)

4. L. M. O'Neale, 'Textiles of the Early Nazca Period', *F.M.N.H.A.M.*, II (1937), plates lvi–lix.

5. W. D. Strong, 'Paracas, Nazca, and Tiahuanacoid Cultural Relationships in South Coastal Peru', *M.S.A.A.*, XIII (1957), 44, 46.

6. J. H. Rowe, 'Explorations in Southern Peru', *Am.A.*, XXII (1956), 147. Dawson's paper has not yet been published; see digest by G. Willey, *Introduction*, II, 144–7. Alan Sawyer, *Ancient Peruvian Ceramics* (New York, 1966), still adheres to Kroeber's AXBY terminology, and he uses the short-scale Carbon 14 dating for the earliest Chavín-influenced Paracas pottery, as beginning *c.* 900 B.C. (long-scale is *c.* 1400).

7. A. H. Gayton and A. L. Kroeber, 'The Uhle Pottery Collections from Nazca', *U.C.P.A.A.E.*, XXIV (1927), 1–46, and A. L. Kroeber, 'Toward Definition of the Nazca Style', *U.C.P.A.A.E.*, XLIII (1956), 327–432.

8. *Science*, 1 November 1957, and S. K. Lothrop and J. Mahler, 'Late Nazca Burials in Chaviña, Peru', *P.M.P.*, L (1957). J. Rowe, 'Radiocarbon

Measurements', in J. Rowe and D. Menzel (eds.), *Peruvian Archaeology* (Palo Alto, 1967).

9. As in A. Sawyer, 'Paracas and Nazca Iconography', *Essays S. K. Lothrop* (Cambridge, 1961), 269–98. The problem of differences between Ica and Nazca Valley styles is discussed by D. Proulx, 'Local Differences and Time Differences in Nasca Pottery', *U.C.P.A.*, v (1968). He considers Nazca 3 and 4 in Ica and Nazca Valleys. Minor shapes and themes differ: Nazca Valley was dominant in phase 3 (175–55 B.C.), and declined during phase 4 (55 B.C.–A.D. 65).

10. W. D. Strong, *M.S.A.A.*, xiii (1957).

99 11. La Estaquería: best description by A. L. Kroeber, *Peruvian Archaeology in 1942, V.F.P.A.*, iv (1944), 26–7. c14 date, Strong, *op. cit.*, 34, 46. For the stone piles and pampa-figures, Maria Reiche, *Los dibujos gigantescos en el suelo de las pampas de Nasca y Palpa* (Lima, [1949]); P. Kosok and M. Reiche, 'Ancient Drawings on the Desert of Peru', *Archaeology*, ii (1949), 206–15; P. Kosok, *Life, Land and Water* (New York, 1965), 49–62. Large, regular grids of stone piles also occur near Salta in Argentina, at Pucará de Lerma (G. de Créqui-Montfort, *I.C.A.*, xiv (1904), part ii, figures 21–3).

12. Maria Reiche, *op. cit.*, 20–5. The thesis of astronomical sighting-lines was first proposed by Paul Kosok, 'The Mysterious Markings of Nazca', *Natural History*, lvi (1947), 200. A short-scale radiocarbon date reported by Strong, *M.S.A.A.*, xiii (1957), 46, gave A.D. 525±80, measured on a wooden post from the intersection of two lines.

13. The celebrated earthwork design in the sand on the seaward hill flank of Paracas peninsula, called Tres Cruces, may belong to the same class. It represents a geometrical tree-shape 128 m. (140 yards) long and 74 m. (81 yards) wide (M. Uhle, 'Explorations at Chincha', *U.C.P.A.A.E.*, xxi (1924), 92–4), and its forms are comparable to those of Late Nazca pottery.

00 14. Mainly through Strong's preliminary publication of his reconnaissance and excavations; *M.S.A.A.*, xiii (1957).

01 15. A. L. Kroeber, 'Paracas Cavernas and Chavin', *U.C.P.A.A.E.*, xl (1953), 313–48. On Paracas chronology, based upon ceramic typology, J. H. Rowe, 'La seriación cronológica de la cerámica de Paracas elaborada por Lawrence E. Dawson', *Revista del Museo Regional de Ica*, ix (1958), 9–21. Compare A. Sawyer, *Ancient Peruvian Ceramics*, 79–95, who distinguishes local Ica-Paracas styles at Ocu-

caje, Juan Pablo, and Callango, as to animal motifs, shapes, and phases. Dawson's phases: 1–4 (Nazca A) monumental; 5 (Nazca X) transition; 6–7 (Nazca B) proliferous; 8–9 (Nazca Y) disjunctive and Tiahuanaco-Huari.

16. A. Sawyer, *Ancient Peruvian Ceramics*, 89, regards cream-slip Topará pottery as a local variant of Cavernas culture. Lothrop and Mahler, 'Late Nazca Burials in Chaviña', *P.M.P.*, l (1957), 9, ascribe the first appearance of multiple slipping in various colours to Cavernas times. The whites are kaolin clay; black is soot or ground slate; red is an iron oxide. Yellow comes from ferruginous clays, and the greens and blues were made of copper-bearing minerals, such as malachite. S. Linné, *The Technique of South American Ceramics* (Göteborg, 1925), 134. For information on cream-slipped pottery I am indebted to John Rowe.

17. Strong, *M.S.A.A.*, xiii (1957). A. Sawyer follows Strong, *Ancient Peruvian Ceramics*, 122–32; Dawson's division in nine phases is summarized by Rowe (see Note 15).

18. Gayton and Kroeber, *U.C.P.A.A.E.*, xxiv (1927), 13. See also P. Roark, 'From Monumental to Proliferous in Nasca Pottery', *Ñ.P.*, iii (1965), 1–93.

19. Lothrop and Mahler, *op. cit.*, 24–5, discuss the Nazca effigies. Three were excavated at Chaviña (G. Willey, *Introduction*, ii, figures 3–78).

20. A useful table of outline drawings of the principal Cavernas and Necropolis vessels was published by R. Carrión Cachot, *Paracas Cultural Elements* (Lima, 1949), plate xviii. p. 302

21. Lothrop and Mahler, *op. cit.*, 10, call the characteristic form a 'cactus-spine demon' in their analysis of B-style motifs. Roark, *op. cit.*, 16, calls these elements 'quartet rays' and 'jagged rays'. Roark's study is about the transition (Phase 5, second century A.D.) or Kroeber's X and Sawyer's Middle, between Early and Late.

22. L. Valcárcel, 'El gato de agua', *R.M.N.L.*, i (1932), 3–27, identified these whiskers as belonging to the sea-otter. Contrast E. Yacovleff, 'La deidad primitiva de los Nazca', *R.M.N.L.*, i (1932), 102–61, and E. Seler, 'Die buntbemalten Gefässe von Nazca', *G.A.*, iv (1923), 172–338. A. Sawyer, *Ancient Peruvian Ceramics*, 124, notes that 'upswept' whiskers may indicate sea-otter nature. p. 303

23. Seler, *loc. cit.* For H. Ubbelohde-Doering, whose interpretations are more fanciful, the concentric-square theme represents the tomb, and the 'jagged-staff' figures refer to a tabu on menstruating

women, by analogy with nineteenth-century be-
liefs in New Zealand; *J.S.A.*, XXIII (1931), 177–88,
and XXV (1933), 1–8.

p. 305 24. J. Bird, in *M.S.A.A.*, VIII (1951), and (with
Louisa Bellinger) *Paracas Fabrics and Nazca Needle-
work* (Washington, 1954), 2.

25. Lothrop and Mahler, *op. cit.*, 46. A tapestry in
the University Museum, Philadelphia, corresponds
to Nazca pottery designs of late date found at
Chaviña (illustrated in Bennett, *Ancient Arts of the
Andes*, New York, 1953, figure 72).

26. L. M. O'Neale, 'Textile Periods in Ancient
Peru, II: Paracas Cavernas and the Grand Necro-
polis', *U.C.P.A.A.E.*, XXXIX (1945), 143–202.

p. 306 27. Strong, *M.S.A.A.*, XIII (1957), 16. On wide
weaves, see also Anni Albers, *On Designing* (New
Haven, 1959).

28. G. A. Fester and J. Cruellas, 'Colorantes de
Paracas', *R.M.N.L.*, III (1934), 154–6. Indigo dye
on brown or yellow fibre produced the charac-
teristic Paracas greens. M. E. King, 'Paracas Textile
Techniques', *I.C.A.*, XXXVIII (1969), vol. 1, 369–77.

29. C. E. Stafford, *Paracas Embroidery* (New
York, 1941).

30. General account by J. C. Tello, *Antiguo Perú*,
126–49. Cavernas tombs: E. Yacovleff and J. C.
Muelle, 'Una exploración en Cerro Colorado',
R.M.N.L., I (1932), 31–59 and 81–9. Survey of the
wrapping and clothing types by R. Carrión Cachot,
'La indumentaria en la antigua cultura de Paracas',
Wira Kocha, I (1931). Detailed account of the un-
wrapping of bundle no. 217 by Yacovleff and J. C.
Muelle, 'Un fardo funerario de Paracas', *R.M.N.L.*,
III (1934), 63–153. My main source for reconstruct-
ing the other mummy-bundle associations has been
the article by R. Carrión Cachot. Julio C. Tello,
Paracas, Primera Parte (Lima, 1959), written in 1942,
presents Tello's views on sequence as at that date.
The illustrations add to the range published by
Carrión.

p. 309 31. Yacovleff and Muelle, *op. cit.*, in their funda-
mental analysis of Paracas style, described the co-
existence of rectilinear and curvilinear styles as a
'dimorphism'. Bundle 217, however, on which
their observations were based, belongs by style to
an early group. Bundle 290 (Tello, *Paracas*, plates
LXVIII–LXXVIII) contained one rectilinear piece
among many approaching the ornate manner of
our Group 4. J. Bird, 'Samplers', *Essays . . . S. K.
Lothrop* (Cambridge, 1961), 299–316. Ascribed by
Dawson to Nazca 1 and 2, this embroidery shows
coeval plectogenic and curvilinear designs.

32. The best account of the Cavernas tomb finds
is the article by E. Yacovleff and J. C. Muelle
quoted in Note 30 (*R.M.N.L.*, I).

33. Another painted cloth, from Trancas in the
Nazca Valley, portrays birds bearing twigs in their
beaks. Reproduced in L. M. O'Neale, 'Textiles of
the Early Nazca Period', *F.M.N.H.A.M.*, II (1937),
135. It is closer to groups 2 and 3 in style than the
Cleveland cloth, which by style should be several
generations later. See also Tello, *Paracas*, plates
LXVIII–LXXVIII (mummy 290), for a painted cloth
belonging to our group 4.

34. An exception in the Peabody Museum,
Harvard, has cats on the field and birds in the
border of a group 2 mantle. Bennett, *Ancient Arts of
the Andes* (New York, 1953).

p. 3 35. On the differences between Nazca and Necro-
polis embroideries, see L. M. O'Neale and T. W.
Whitaker, 'Embroideries of the Early Nazca
Period and the Crop Plants Depicted on Them',
Southwestern Journal of Anthropology, III (1947),
294–321. Paracas details vary less in drawing, and
more in colour. The best reproductions in colour
are in the album of plates with text by Itoji Muto
and Kunisuke Akashi, *Textiles of Pre-Inca* (Tokyo,
1956).

36. *R.M.N.L.*, III (1934), 63–153.

p. 3 37. Dorothy Menzel, 'Style and Time in the
Middle Horizon', *Ñ.P.*, II (1964), 1–106; J. H.
Rowe, 'Archaeological Explorations in Southern
Peru', *Am.A.*, XXII (1956), 147–50. Other key sites
for the Tiahuanaco expansion are in the Ayacucho
region (p. 319) and at Pachacamac (pp. 293–5).

38. E. Yacovleff, 'Las falconidas en el arte y las
creencias de los antiguos peruanos', *R.M.N.L.*, I
(1932), 110–11. The Olson excavations at the same
site in 1930 are summarized in the article by D.
Menzel, *op. cit.*, 23–31. The plant forms on the
giant tubs are reproduced with identifications by
E. Yacovleff and F. L. Herrera, 'El mundo vegetal
de los antiguos peruanos', *R.M.N.L.*, III (1934),
243–322, and IV (1935), 31–102.

39. The same conventions appear in Nazca em-
broideries of the early period. L. M. O'Neale and
T. W. Whitaker, *op. cit.*

p. 3 40. Kroeber and Strong, 'The Uhle Pottery Col-
lections from Ica', *U.C.P.A.A.E.*, XXI (1924), 95–
133. P. Lyon, 'Origins of Ica Pottery Style', *Ñ.P.*,
IV (1966), 31–62, analyses the archaizing revival of
Huari traits in Ica 1 after A.D. 900.

41. Twenty Ica carved boards are illustrated by
M. Schmidt, *Kunst und Kultur des alten Peru* (Berlin,
1929), 426–33.

42. H. Trimborn, *Quellen zur Kulturgeschichte des präkolumbischen Amerika* (Stuttgart, 1936), 236. This report of 1558, written by C. de Castro and D. de Ortega Morejón, names the rulers of the three valley tribes at the time of the Inca conquest, given as having lived early in the fifteenth century. ('Relaçion y declaraçion del ... valle de Chincha', ed. W. Petersen.) E. Harth-Terré, 'Incahuasi. Ruinas incaicas del valle de Lunahuaná', *R.M.N.L.*, II (1933), 99–126, gives plans and restored views of various dwelling compounds in the Cañete Valley, corresponding to the period of this text.

313 43. For these details on Chincha Valley architecture I am indebted to John H. Rowe, whose advice on this chapter has been most valuable.

CHAPTER 16

314 1. 'Cultural Unity and Disunity in the Titicaca Basin', *Am.A.*, XVI (1950), 89–98.

2. Dr Alfred Kidder kindly communicated his dates before publication from his 1955 excavations. He had earlier suggested the priority of Pucará on stratigraphic arguments (*M.S.A.A.*, IV (1948), 87–9), relating to the position of Bennett's Chiripa site as pre-Tiahuanaco rather than late (*ibid.*, 90–2). Lanning, *Peru*, 84, mentions early pottery (1300 B.C.) at Chiripa.

315 3. A. Kidder, II, 'Some Early Sites in the Northern Lake Titicaca Basin', *P.M.P.*, XXVII (1943), 5–6.

4. L. Valcárcel, 'Litoesculturas y cerámicas de Pukara', *R.M.N.L.*, IV (1935), 25–8, illustrates eight pieces, of which three from Caluyu are typologically simpler, and possibly earlier.

5. J. H. Rowe, 'Archaeological Explorations in Southern Peru', *Am.A.*, XXII (1956), 144.

6. Bennett, *A.M.N.H.A.P.*, XXXV (1935), 413–46, and *M.S.A.A.*, IV (1948), 90–2.

7. J. Rowe, 'Two Pucara Statues', *Archaeology*, XI (1958), 255–61.

316 8. Nos 30 and 31 in the Bennett catalogue of Tiahuanaco stone sculpture; *A.M.N.H.A.P.*, XXXIV (1934), 462–3.

9. Posnansky, *Tihuanacu* (New York, 1945), 170–2, and figures 91–6. A figure closely resembling the Pokotia statues has been traced to Chumbivilcas province, 100 miles north-west of Pucará. Another statuette in Berne, acquired at Tiahuanaco, is also of the Pokotia type, with serpent-braids looping over the shoulders; Rowe, *Archaeology*, XI (1958), 255–61.

10. S. Rydén, *Archaeological Researches in the Highlands of Bolivia* (Göteborg, 1947), 90–7, regards Wancani as a Late Tiahuanaco site because of its ceramic types.

11. E. Casanova, 'Investigaciones arqueológicas en el altiplano boliviano', *Relaciones de la sociedad argentina de antropología*, I (1937), 167–72. W. Ruben, *Tiahuanaco, Atacama und Araukaner* (Leipzig, 1952), 50–5, gives a concise survey of the entire *altiplano* question, grouping all Pucará-style sites.

12. Bennett, *A.M.N.H.A.P.*, XXXIV (1934), 441 and 462 (no. 24).

13. A. Stübel and Max Uhle, *Die Ruinenstaette von Tiahuanaco* (Leipzig, 1892); W. Bennett, 'Excavations at Tiahuanaco', *A.M.N.H.A.P.*, XXXIV (1934), 359–494; D. E. Ibarra Grosso, J. de Mesa, and T. Gisbert, 'Reconstrucción de Taypicala (Tiahuanaco)', *C.A.*, XIV (1955), 149–75. The essay by R. Trebbi del Trevigiano, *Critica d'arte*, XXIII (1957), 404–19, asserts the 'centripetal' character of Tiahuanaco as a receiving centre, on stylistic grounds. His chronological and cultural connexions, however, are weak.

14. The best modern discussions of the site as a whole are by W. Ruben, *op. cit.*, and Ibarra Grosso, Mesa, and Gisbert, *op. cit.* Three objections to the reconstructions by the latter are necessary: their simplification of the plan of the Akapana is not supported by air photographs, which show re-entrant corners as on the Posnansky plan; their thesis of intersecting roadways takes no account of the water barrier at the moat; and the reconstruction of the Akapana as a solid platform is less probable than a U-shaped secondary platform, as indicated by the present contours and by the drainage conduit uncovered by G. Courty in 1903 (*I.C.A.*, XIV (1904), part 2, figure 2, and 533). *p. 318*

15. Bennett, *A.M.N.H.A.P.*, XXXIV (1934), 387.

16. Bronze objects of indubitable Tiahuanaco style are not known from the *altiplano*; P. Rivet and H. Arsandaux, *La métallurgie en Amérique précolombienne* (Paris, 1946), 27–8. W. C. Root, *H.S.A.I.*, V, 222, points out that cold-worked copper is harder than unworked cast bronze. Stübel and Uhle, *op. cit.*, 44–5, first observed that the perfect rectangularity on a small scale is explainable only by sharp, hard tools, which we must now suppose to have been of copper. The rough quarrying probably depended upon fire, water, and ice. *p. 319*

17. G. de Créqui-Montfort, *op. cit.*; Bennett, *A.M.N.H.A.P.*, XXXV (1935), figure 37; and Bennett, *Excavations at Wari* (New Haven, 1953).

18. The catalogue by Bennett (*A.M.N.H.A.P.*, XXXIV (1934), 460–3) lists the principal pieces with bibliography. His chronological succession (478) *p. 320*

agrees in the main outlines with the one proposed here, although his 'Decadent' pieces fit better with our 'Early' group.

p. 321 19. The name is modern; nothing is known of the intended meaning of the reliefs (Yacovleff, *R.M.N.L.*, I (1932), 84–6), save that they represent costumed humans, some of them masked. M. Uhle, *Wesen und Ordnung der altperuanischen Kulturen* (Berlin, 1959), 57–77, gives a plausible interpretation based upon two colonial myths. Uhle identifies the figures as sun-symbols surrounded by heralds or messengers.

p. 322 20. Illustrated in Posnansky, *Tihuanacu*, figures 141, 143–4, 150.

21. The painted portions are described by Créqui-Montfort, *op. cit.*, 536, 541.

22. The nail holes surrounding certain reliefs are illustrated by Posnansky, *op. cit.*, figures 56–8.

23. C. Ponce Sanginés, *Cerámica Tiwanacota. Vasos con decoración prosopomorfa* (Buenos Aires, 1948), assigns polychrome examples to the Classic phase, and black-ware pieces to a later time.

p. 323 24. F. Buch, *El Calendario Maya en la cultura de Tiahuanacu* (La Paz, 1937). J. C. Tello, 'Wirakocha', *Inca*, I (1923), 93–320, 583–606; F. Cossio del Pomar, *Arte del Perú precolombino* (Mexico-Buenos Aires, 1949). The most recent addition to the literature of calendrical interpretation of these monuments is by F. Hochleitner, 'Die Vase von Pacheco', *Zeitschrift für Ethnologie*, LXXXV (1960), 259–68.

25. Bennett, *A.M.N.H.A.P.*, XXXV (1936), 331–412; S. Rydén, *op. cit.*, and W. Ruben, *op. cit.*, have studied the provincial diffusion of the Tiahuanaco style eastward into the Bolivian lowlands and south towards Chile. A. Sawyer analyses the design modes in coastal tapestries ('Tiahuanaco Tapestry Design', *Textile Museum Journal*, I (1963), 27–38), assuming that design complication corresponded to official rank in government or religion.

26. Rowe, 'Archaeological Explorations in Southern Peru', *Am.A.*, XXII (1956), 150; Bennett, *Excavations at Wari*, 114–18. Larco Hoyle, *Cronología arqueológica* (Lima, 1948), 37 f., was the first to propose the Mantaro basin as the centre of this diffusion.

Rowe, *Am.A.*, XXII (1956), 144, suggested Huari as the originating metropolitan centre for all the regional variants of Tiahuanaco style in Peru and Bolivia. Bennett believed that Tiahuanaco in Bolivia had the better claim. Also L. G. Lumbreras, 'La Cultura Wari', *Etnología y Arqueología*, I (1960), 130–227.

27. Bennett, *Wari*, 85. Mantaro pottery has never p. 3 been properly published. The best collection, belonging to the Gálvez-Durán family in Huancayo, was dispersed about twenty-five years ago.

28. Rowe, *Am.A.*, XXII (1956), 149, defined a stylistic frontier between Peruvian and Bolivian versions of Tiahuanaco ceramic style in the vicinity of Sicuani, between Cuzco and Lake Titicaca.

29. E. Lanning, *Peru* (1967), chapter 9, 127–40. P. A. Means, *Ancient Civilizations of the Andes* (New York, 1931), 111–13 and 136–46, proposed two older eras at Tiahuanaco, labelled I and II (third to tenth centuries A.D.), followed by 'Decadent' coastal or 'Epigonal' forms in the rest of Peru (A.D. 900–1400). Based upon Uhle's excavations and upon the colonial chronicle by F. Montesinos, the Means sequence no longer holds among professional Andeanists. See L. M. Stumer, 'Development of Peruvian Coastal Tiahuanacoid Styles', *Am.A.*, XXII (1956), 59–69.

30. *Essais*, ed. Motheau and Jouaust, VI (Paris, 1888), 60.

31. J. H. Rowe, 'An Introduction to the Archaeology of Cuzco', *P.M.P.*, XXVII (1944), no. 2.

32. H. Reichlen, *J.S.A.*, XLIII (1954), 221–3. Slab p. 3 masonry shaft tombs recall the Huari constructions. Over Chanapata sherds near by lay a thick deposit of Tiahuanaco-style sherds. Also Rowe, *Am.A.*, XXII (1956), 142, who sees a resemblance between Huari and Pikillaqta.

33. Rowe, 'Urban Settlements', *Ñ.P.*, I (1963), 14–15. L. Valcárcel, *R.M.N.L.*, III (1934), 184, found enough Inca sherd material at that time to be convinced of its Inca date. S. Astete Chocano, *Revista del Instituto Arqueológico del Cuzco*, III (1938), 53–8, assigns the construction to the Pinawa tribe who dominated the area. Luis Pardo, *Revista Universitaria del Cuzco*, XXII (1933), 139–47, gives the legendary history of the site. It can be traced as far as 1834, when the story related by Pardo was recorded by the French traveller E. G. E. de Sartiges, *Dos viajeros franceses en el Perú republicano*, ed. R. Porras (Lima, 1947). It treats the building of the aqueduct as a love-test imposed by a princess.

34. On the thesis that all grid-plan towns are of Old World origin, and on the absence of chequerboard plans in ancient American planning, D. Stanislawski, *Geographical Review*, XXXVI (1946), 105; XXXVII (1947), 94–105.

35. L. Valcárcel, 'Esculturas de Pikillajta', *R.M.N.L.*, II (1933), 19–48, treats them as Inca symbols of the submission of other Andean peoples.

36. Huari lacks any semblance of grid-planning, in the only map of the site, made by Bennett, *Wari*, 19, figure 2.

37. J. Rowe, 'An Introduction to the Archaeology of Cuzco', *P.M.P.*, XXVII (1944), no. 2, and 'Absolute Chronology in the Andean Area', *Am.A.*, III (1945), 265–85. A general account of Inca architecture with plans, V. W. v. Hagen, *The Realm of the Incas* (New York, 1957), 147–67.

327 38. The fullest treatment of the fragments is by J. Rowe, *P.M.P.*, XXVII (1944), 26–41. G. Kubler, *Cuzco* (Paris, 1952), 8, figure 2, on excavation at the curved wall.

39. Cf. J. Rowe, 'What Kind of a Settlement was Inca Cuzco', *Ñ.P.*, V (1967), 60, to prove the use of Cuzco as a ceremonial centre; also R. T. Zuidema, *The Ceque System of Cuzco* (Leiden, 1964), who relates its layout to social organization.

40. P. Cieza de León records Tupac Yupanqui's organization of the labour force: 20,000 labourers were brought from the provinces, including 4,000 quarrymen and 6,000 transport workers. The remainder were masons and carpenters, under professional foremen. All workers were lodged in their own geographic camps (*Travels 1532–1550*, London, 1864). The chroniclers' descriptions, written in the sixteenth and seventeenth centuries, are reprinted in the excavation account by L. Valcárcel, *R.M.N.L.*, III (1934), 14–24. The excavations were fully reported in *R.M.N.L.*, III (1934), 3–36, 211–23; IV (1935), 1–24, 161–203; and in *H.S.A.I.*, II, 177–82. The Swedish ethnographer E. Nordenskiöld held that saw-tooth defences were imitated in Europe, where they first appeared about 1550, from American examples like Sacsahuamán; 'Fortifications in Ancient Peru and Europe', *Ethnos*, VII (1942).

41. The more recent building history of Cuzco is recapitulated by G. Kubler, *Cuzco, Reconstruction of the Town and Restoration of its Monuments* (Paris, Unesco, 1952).

328 42. Bennett's seven types (*H.S.A.I.*, II, 145–6) are inadequately differentiated. 'Megalithic', 'polygonal', and 'modified polygonal' are all nearly identical, like his 'square blocks' and 'dressed-stone blocks'. *Pirca* and adobe brick are the remaining two categories in Bennett's listing.

43. This functional explanation was first proposed by John Rowe (*P.M.P.*, XXVII (1944), 24–5).

44. M. K. Jessup, 'Inca Masonry at Cuzco', *A.A.*, XXXVI (1934), 239–41.

45. Luis Pardo, 'Maquetas arquitectónicas en el antiguo Perú', *Revista del Instituto Arqueológico del Cuzco*, I (1936), 6–17, has studied the small terracotta models of buildings in the Cuzco Archaeological Museum, but there is no clear proof that these were projects for buildings. They were perhaps souvenirs or mementos of important monuments. On cellular slabs, P. A. Means, *Ancient Civilizations of the Andes*, and L. Baudin, *L'empire socialiste des Inka* (Paris, 1928), 126, n. 1.

46. As suggested by Rowe, *H.S.A.I.*, II, 229. p. 329

47. P. Fejos, 'Archeological Explorations in the Cordillera Vilcabamba, Southeastern Peru', *Yale University Publications in Anthropology*, III (1944).

48. Fejos, *op. cit.*, figure 15 and pp. 52–3.

49. The best account of the city is by Hiram Bingham, *Machu Picchu, A Citadel of the Incas* (New Haven, 1930). Bingham's views concerning the historical position of the site are recapitulated in *Lost City of the Incas* (New York, 1948), but his uncritical use of the chronicler F. Montesinos makes these works unreliable. See G. Kubler, 'Machu Picchu', *Perspecta*, VI (1960), 48–55.

50. Both edifices are best known by E. G. Squier's p. 332 descriptions and schematic drawings, *Peru* (New York, 1877), 343–6 and 359–66. A. F. Bandelier, *The Islands of Titicaca and Koati* (New York, 1910), presents more accurately measured plans and elevations.

51. Garcilaso de la Vega, *Comentarios reales* p. 333 (Madrid, 1723).

52. Squier, *op. cit.*, 402–13. p. 334

53. M. H. Tschopik, 'Some Notes on the Archaeology of the Department of Puno, Peru', *P.M.P.*, XXVII (1946), 52–3.

54. Systematic description in W. Krickeberg, *Felsplastik* (Berlin, 1949), 1–24. Photographs, H. Ubbelohde-Doering, *Auf den Königsstrassen der Inka* (Berlin, 1941).

55. L. Valcárcel, *H.S.A.I.*, II, 177–82, and *R.M.N.L.*, IV (1935), 223–33.

56. *Arte peruano* (Madrid, 1935), plates LXXIV–LXXV, and p. 15. Also *Art des Incas* (Paris, 1933), plate XVII (Collection of Juan Larrea). Two seated life-size figures of pumas from Cuzco are the only other examples we possess of large Inca figure sculpture.

57. Such devious drinking-vessels of carved and p. 335 painted wood (*pacchas*) are common: T. A. Joyce, 'Pakcha', *Inca*, I (1923), 761–78. Lothrop, 'Peruvian Pacchas and Keros', *Am.A.*, XXI (1956), 240, ascribes their invention to Chimu culture.

58. Rowe, *op. cit* (Note 37), 60–3; *H.S.A.I.*, II, 243, 287.

59. Especially B. Cobo, writing about 1653,

Historia del nuevo mundo, III (Seville, 1892), 323–46. Also R. Lehmann-Nitsche, *Revista del Museo de La Plata*, XXXI (1928), 1–260.

p. 336 60. *Nueva coronica y buen gobierno* (Paris, 1936), and R. Porras, *El cronista indio Felipe Guaman Poma de Ayala* (Lima, 1948).

61. On colonial *keros*, Mary Schaedel, *Magazine of Art*, XLII (1949), 17–19. Pre-Conquest examples, L. Valcárcel, 'Vasos de madera del Cuzco', *R.M.N.L.*, I (1932), 11–18. J. Rowe, 'The Chronology of Inca Wooden Cups', *Essays ... S. K. Lothrop* (Cambridge, 1961), 317–41.

GLOSSARY

Adobe. Clay from which sun-dried bricks are made; unburnt bricks.

Adorno. Any modelled clay attachment to a vessel wall or rim.

Atadura. Literally, a binding. Maya façade moulding at impost level, usually consisting of three members.

Atlatl. Wooden throwing-board for javelins, serving to lengthen the user's radius of reach.

Avant-corps. Projecting portion, suggesting a wing or pavilion, which interrupts the continuity of the plane of a façade.

Batter. In a wall of tapered section, the sloping face. A wall with inverted taper, thicker at the top than at the bottom, has negative batter.

Cella. A temple chamber.

Cenote. Natural well in a collapsed portion of the surface limestone of Yucatán.

Chacmool. A fanciful yet standard term designating the stone figures of recumbent human males shown holding basins or platters on the abdomen (Mexico and Yucatán).

Chamfer. A horizontal moulding of intaglio effect recessed within the wall of a Maya temple or pyramidal platform.

Chapopote. Shiny pigment of resin, asphalt, and soot used in Veracruz pottery painting.

Chinampa. A small artificial island made for gardening in the lakes of the Valley of Mexico.

Chullpa. In the Central Andes, a stone tower used for burials.

Cire perdue. The lost-wax method of casting metal objects by displacing a waxen model with molten metal.

Classic. A developmental stage in Mesoamerican archaeology, referring to the period of the rise of high civilizations in many independent centres.

Codex. The European book, consisting of leaves or folds of rectangular pages sewn together at one side, adopted by American peoples only after the Spanish Conquest.

Collao. A district of the Andean highlands around Lake Titicaca.

Concrete. A mixture of cement, sand, and water with any aggregate, capable of setting to the hardness of stone.

Fine orange. Untempered pinkish-orange pottery of dense paste.

Fin wall. Masonry membranes compartmenting the loose infilling in pyramid facings.

Flying façade. Ornamental vertical extension in the plane of the façade of a Maya building.

Glyph. Each pebble-shaped unit of Maya writing.

Greenstone. Those American minerals, e.g. nephrite, serpentine, wernerite, possessing colours similar to oriental jades.

Hacha. Thin stone blades with profiles of human heads.

Header. Of bricks or stones, those laid in the wall with the smallest face exposed.

Horizon style. A complex of traits having a known position in time, useful to date new finds and to correlate regions in time.

Huaca. Quechua term in the central Andean region for any buried or ruined structure of putative religious use: more generally, any sacred thing or creature.

Initial Series. A Classic Maya method (also called Long Count) for dating events by the day-count from a starting point. Identified by its initial position in longer inscriptions. Each digit is vigesimal rather than decimal: in a date transcribed 9.3.10.10.5, the first digit states that 9 cycles of 400 years (each having 20 periods of 20 years) have elapsed, followed by 3 twenty-year periods or *katuns*, 10 *tuns* or years of 360 days each, 10 *uinals* or months of 20 days each, and 5 *kins* or days. The total enumerates the days which have elapsed since the starting-point.

Lienzo. A Mexican pictorial chart drawn or painted on a sheet of cloth.

Lost wax. See Cire perdue.

Mapa. A Mexican chart or pictorial table displaying geographical and historical relationships.

Mesoamerica. The parts of pre-Columbian Mexico and Central America occupied by peoples of advanced urban traditions.

Metate. Náhuatl term for a portable stone surface for grinding food.

Middle America. The area from Panama to the Río Grande, including the Antilles.

Milpa. In Central America, a small burned clearing planted and abandoned after a few seasons.

Mise en couleur. A colouring process for gold-copper alloys by immersion in an acid pickle to dissolve the oxides, leaving a coating of pure gold.

Negative painting. Before firing, a vessel surface partly covered with wax is immersed in slip. Firing fixes the coloured slip but clears the waxed portions, so that the figure and its ground are reversed.

Palma. Tall, fan-shaped stones with concavely curved bases.

Palmate stone. See *Palma*.

Pastillage. Sculpture built of pellets of plaster shaped over a rough stone core.

Pirca. Andean wall construction using dry-laid, unshaped stones.

Plumbate. Monochrome pottery of a hard, grey, vitrified surface found throughout pre-Columbian Mesoamerica.

Post-fired painting. Addition of stucco or paint to pottery surfaces after firing.

Quetzal. A Central American bird of brilliant plumage.

Radiocarbon dating. Natural carbon 14 produced by cosmic rays enters the carbon dioxide life cycle at a constant rate. Upon the death of the organism the amount of C14 will decay according to the known half-life of 5730 ± 30 years. The measured residue of C14 in organic samples allows relatively precise age determinations

Resist-painting (see *Negative painting*). A batik process, in which waxed parts of a cloth remain undyed.

Roof-comb. Ornamental vertical extension rising above the rear wall or over the centre of Maya temple roofs.

Slip. A wash or dip of clay applied before the final firing of pottery objects, serving as ground for painted designs.

Spall. A large splinter or chip of stone, used to adjust the seat of larger stones in the coursing of the wall.

Stirrup spout. In Mochica pottery, a pouring vent consisting of two tubular branches united at the spout.

Stretcher. A brick or stone laid in the wall with its longer face showing.

Tablero. Literally, an apron. On the stages of a pyramidal platform, these portions rise vertically above each of the diagonal portions of the silhouette.

Talus. The slope of the face of a building, like the rock debris at the foot of a cliff: see *Batter*.

Tapia. A wall built by successive layers of puddled clay, i.e., worked when wet to be impervious to water.

Tepetate. In Mexico, a lava flow of pumice-stone.

Teponaztli. Horizontal cylindrical drum slotted to form two tongues of different pitch.

Terraced meander. A band pattern of stepped rectilinear segments.

Tezontle. A light and porous volcanic stone, usually red, grey, or black, common in the Valley of Mexico.

Tlachtli. Náhuatl term for the I-shaped ball-court used throughout Middle America.

Tumbaga. An alloy of gold with copper.

BIBLIOGRAPHY

I. COMPREHENSIVE WORKS

American Sources of Modern Art. New York (Museum of Modern Art), 1933.

ARMILLAS, P. 'Cronología y periodificación de la historia de la América precolombina', *Journal of World History*, III (1956).

ASHTON, D. *Abstract Art before Columbus*. New York, André Emmerich Gallery, 1957.

BALL, S. 'The Mining of Gems and Ornamental Stones by American Indians', *B.B.A.E.*, CXXVIII (1941), 20, 27, 28.

BASLER, A., and BRUMMER, E. *L'art précolombien*. Paris, 1928.

BIRD, J. *Pre-Columbian Gold Sculpture*. New York, 1958.

BORHEGYI, S. 'The Pre-Columbian Ballgame', *I.C.A.*, XXVIII (1968).

CASO, A., STIRLING, M., LOTHROP, S. K., THOMPSON, J. E. S., GARCÍA PAYÓN, J., and EKHOLM, G. 'Conocieron la rueda los indígenas mesoamericanas?', *C.A.*, V (1946), no. 1.

EMMERICH, A. *Sweat of the Sun and Tears of the Moon*. Seattle, 1965.

An Exhibition of Pre-Columbian Art. Cambridge, Mass., 1940.

FORD, J. A. *Comparison of Formative Cultures in the Americas*. Washington, 1969.

JIJÓN Y CAAMAÑO, J. 'Las civilizaciones del sur de Centro América y el noroeste de Sud América', *I.C.A.*, XXIX (1952).

KELEMEN, P. *Medieval American Art*. New York, 1943; new ed. 1956.

KIDDER II, A. 'South American Penetrations in Middle America', *The Maya and their Neighbors*. New York, 1940.

KRICKEBERG, W. *Felsplastik und Felsbilder bei den Kulturvölkern Altamerikas*. Berlin, 1949.

KROEBER, A. L. 'Cultural and Natural Areas of Native North America', *U.C.P.A.A.E.*, XXXVIII (1939).

KUBLER, G. *The Arensberg Collection*. Philadelphia, 1954.

LAVACHÉRY, H. *Les arts anciens d'Amérique au Musée archéologique de Madrid*. Antwerp, 1929.

LIBBY, W. F. *Radiocarbon Dating*. Chicago, 1955.

LINTON, R. 'Crops, Soils, and Cultures in America', *The Maya and their Neighbors*. New York, 1940.

LOTHROP, S. K. *Pre-Columbian Art* (Bliss Collection). New York, 1957.

OLIVÉ N., J. C., and BARBA A., B. 'Sobre la desintegración de las culturas clásicas', *A.I.N.A.H.*, IX (1957).

PIJOAN, J. *Historia del arte precolombino* (Summa Artis, X). Barcelona, 1952.

RIVET, P., and ARSANDAUX, H. *La métallurgie en Amérique précolombienne*. Paris, 1946.

ROOT, W. C. 'Metallurgy', *H.S.A.I.*, V (1949).

SELER, E. *Gesammelte Abhandlungen zur amerikanischen Sprach- und Altertumskunde.* 5 vols and index. Berlin, 1902–23.

SMITH, A. L. 'The Corbelled Arch in the New World', *The Maya and their Neighbors.* New York, 1940.

STANISLAWSKI, D. 'Origin and Spread of the Grid-Pattern Town', *Geographical Review,* XXXVI (1946).

TREBBI DEL TREVIGIANO, R. 'Premesse per una storia dell'arte precolombiana', *Critica d'arte,* XIX (1957), 22–31.

TRIMBORN, H. *Quellen zur Kulturgeschichte des präkolumbischen Amerika.* Stuttgart, 1936.

WILLEY, G. 'Prehistoric Settlement Patterns', *B.B.A.E.,* CLV (1953).

WILLEY, G., and PHILLIPS, P. *Method and Theory in American Archaeology.* Chicago, 1958.

WILLEY, G. *An Introduction to American Archaeology. North and Middle America,* I. New York, 1966.

II. MESOAMERICA

ACOSTA SAIGNES, M. *Los Pochteca* (*Acta Anthropologica,* I). Mexico, 1945.

ARMILLAS, P. 'Fortalezas mexicanas', *C.A.,* VII (1948), no. 5.

BARLOW, R. H. 'The Extent of the Empire of the Culhua Mexica', *Ibero-Americana,* XXVIII (1949).

CHARNAY, D., and VIOLLET-LE-DUC, E. *Cités et ruines américaines.* Paris, 1863.

CLARK, J. C. (ed. and trans.). *Codex Mendoza.* 3 vols. London, 1938.

CORONA NÚÑEZ, J. 'Cual es el verdadero significado del Chac Mool?', *Tlatoani,* I (1952), nos. 5–6.

CORTÉS, HERNANDO. *Letters* (ed. F. A. MacNutt). New York, 1908.

COVARRUBIAS, M. *Indian Art of Mexico and Central America.* New York, 1957.

DÍAZ DEL CASTILLO, B. *True History of the Conquest of New Spain* (trans. and ed. A. P. Maudslay). 5 vols. London, 1908–16.

DURÁN, D. *Historia de las Indias de Nueva España.* 2 vols and atlas. Mexico, 1867–80.

EASBY, E., and SCOTT, J. *Before Cortés. Sculpture of Middle America.* New York, 1970.

GENDROP, P. *Arte prehispánico en Mesoamérica.* Mexico, 1970.

HOERSCHELMANN, W. VON. 'Flächendarstellungen in alt-mexikanischen Bilderschriften', *Festschrift Eduard Seler.* Stuttgart, 1922.

HOLMES, W. H. *Archaeological Studies among the Ancient Cities of Mexico.* 2 vols. Chicago, 1895–7.

KEMRER, M. F., Jr. 'A Re-examination of the Ball-game in Mesoamerica', *Cerámica de Cultura Maya et al.,* no. 5 (1968).

KINGSBOROUGH, E. *Antiquities of Mexico.* London, 1831.

LIZARDI RAMOS, C. 'El Chacmool mexicano', *C.A.,* IV (1944), no. 2.

LOWE, G. 'Civilization Consequences of Varying Degrees of Agricultural and Ceramic Dependence within the Basic Ecosystems of Mesoamerica', *U.C.A.R.F.,* XI (1971).

MARQUINA, I. *Arquitectura prehispánica.* Mexico, 1951.

MOTOLINIA, T. DE B. *Historia de los Indios de la Nueva España.* Barcelona, 1914. English translation by F. B. Steck, entitled *Motolinia's History of the Indians of New Spain,* Washington, 1951.

NICHOLSON, H. B. 'The Birth of the Smoking Mirror', *Archaeology,* VII (1954).

NOGUERA, E. *Tallas prehispánicas en madera.* Mexico, 1958.

NOWOTNY, K. A. *Tlacuilolli.* Berlin, 1961.

PALERM, A. 'Notas sobre las construcciones militares y la guerra en Mesoamérica', *A.I.N.A.H.,* VIII (1956).

POLLOCK, H. E. D. *Round Structures of Aboriginal Middle America.* Washington, 1936.

QUIRARTE, J. 'El juego de pelota en Mesoamérica', *E.C.M.,* VIII (1970).

RANDS, R. L. 'Some Manifestations of Water in Mesoamerican Art', *B.B.A.E.,* CLVII (1955).

RITMAN, L. H. 'The Rubber Ball-Game', *Cerámica de Cultura Maya et al.,* no. 5 (1968).

SAVILLE, M. *The Goldsmith's Art in Ancient Mexico.* New York, 1920.

SAVILLE, M. *Turquoise Mosaic Art in Ancient Mexico.* New York, 1920.

SAVILLE, M. *The Woodcarver's Art in Ancient Mexico.* New York, 1925.

SCHULTZE, L. *Indiana.* II. Jena, 1933–8.

SELER-SACHS, C. *Auf alten Wegen in Mexiko und Guatemala.* Berlin, 1900.

SHEPARD, A. O. *Plumbate*. Washington, 1948.

DU SOLIER, W. *La plástica arcaica*. Mexico, 1950.

SOUSTELLE, J. *La pensée cosmologique des anciens mexicains*. Paris, 1940.

SPINDEN, H. J. *Ancient Civilizations of Mexico and Central America*. New York, 1928.

THOMPSON, J. E. S. 'Sky Bearers, Colors and Directions in Maya and Mexican Religion', *C.A.A.*, II (1934).

THOMPSON, J. E. S. 'The Moon Goddess in Middle America', *C.A.A.H.*, V (1939).

THOMPSON, J. E. S. *Dating of Certain Inscriptions of Non-Maya Origin*. Washington, 1941.

TOSCANO, S. *Arte precolombino*. Mexico, 1944.

III. ANCIENT MEXICO

A. GENERAL

Art mexicain du précolombien à nos jours. Paris, 1952.

BOBAN, E. *Documents pour servir à l'histoire du Mexique*. 2 vols and atlas. Mexico, 1891.

BORAH, W., and COOK, S. F. 'The Aboriginal Population of Central Mexico on the Eve of the Spanish Conquest', *Iberoamericana*, XLV (1963).

BORHEGYI, S. 'The Pre-Columbian Ballgame', *I.C.A.*, XXVIII (1968).

CHARNAY, D. *Cités et ruines américaines*. Paris, 1863.

CHAVERO, A. *Antigüedades mexicanas*. Mexico, 1892.

CLARK, J. C. (ed. and trans.). *Codex Mendoza*. 3 vols. London, 1938.

EKHOLM, G. *Ancient Mexico and Central America*. New York, 1970.

Kunst der Mexikaner. Zürich, 1959.

LÓPEZ AUSTIN, A. *El hombre-dios, Quetzalcoatl*. Mexico, 1972.

MÉDIONI, G., and PINTO, M. T. *Art in Ancient Mexico*. New York, 1941.

PIÑA CHAN, R. *Historia, arqueología y arte prehispánico*. Mexico, 1972.

ROBERTSON, D. *Mexican Manuscript Painting of the Early Colonial Period*. New Haven.

SAHAGÚN, B. DE. *Historia general de las cosas de Nueva España*. 5 vols. Mexico, 1938.

SAHAGÚN, B. DE. *Florentine Codex* (trans. A. J. O. Anderson and C. E. Dibble). Santa Fé, 1950– .

SAVILLE, M. 'Votive Axes from Ancient Mexico', *I.N.M.*, VI (1929).

SELER, E. *Einige Kapitel aus dem Geschichtswerk des Fray Bernardino de Sahagun*. Stuttgart, 1927.

Twenty Centuries of Mexican Art. New York (Museum of Modern Art), 1940.

WESTHEIM, P. *Arte antiguo de México*. Mexico, 1950.

B. CENTRAL MEXICO

ACOSTA, J. 'Exploraciones en Tula', *R.M.E.A.*, IV (1940); 'Ultimos descubrimientos en Tula', V (1941); 'La ciudad de Quetzalcóatl', VI (1942); 'La cuarta y quinta temporadas de exploraciones arqueológicas en Tula', VII (1943–4).

APENES, O. 'The "Tlateles" of Lake Texcoco', *Am.A.*, IX (1943).

ARMILLAS, P. 'Exploraciones recientes en Teotihuacán', *C.A.*, III (1944), no. 4.

ARMILLAS, P. 'Los dioses de Teotihuacán', *Anales del Instituto de Etnología americana*, VI (1945).

ARMILLAS, P. 'La serpiente emplumada, Quetzalcóatl y Tlaloc', *C.A.*, VI (1947), no. 1.

ARMILLAS, P. 'Teotihuacán, Tula y los Toltecas', *Runa*, III (1950).

AVELEYRA ARROYO DE ANDA, L. 'The Pleistocene Carved Bone from Texquixquiac', *Am.A.*, XXX (1965).

BASTIEN, R. 'New Frescoes in the City of the Gods', *Modern Mexico*, XX (1948), 21.

BEYER, H. *El llamado 'calendario Azteca'*. Mexico, 1921.

BEYER, H. 'La procesión de los Señores', *M.A.*, VIII (1955).

BRENNER, A. 'The Influence of Technique on the Decorative Style in the Domestic Pottery of Culhuacan', *Columbia University Contributions to Anthropology*, XIII (1931).

CALNEK, E. E. 'Localization of the Sixteenth-Century Map, called the Maguey Plan', *Am.A.*, XXXVIII (1957).

CARRASCO, P. 'The Peoples of Central Mexico and their Historical Traditions', *H.M.A.I.*, XI (1972).

CASO, A. 'Las ruinas de Tizatlán', *R.M.E.H.*, I (1927).

CASO, A. *El Teocalli de la guerra sagrada*. Mexico, 1927.

CASO, A. 'Tenían los Teotihuacanos conocimiento del tonalpohualli?', *M.A.*, IV (1937).

CASO, A. 'El paraíso terrenal en Teotihuacán', *C.A.*, I (1942), no. 6.

CASO, A. *The Aztecs*. Norman, 1958.

CASO, A. 'Calendario y escritura en Xochicalco', *R.M.E.A.*, XVIII (1962).

CHADWICK, R. 'Post-Classic Pottery of the Central Valleys', *H.M.A.I.*, X (1971).

CHADWICK, R. 'Native Pre-Aztec History of Central Mexico', *H.M.A.I.*, XI (1972).

COE, M. *The Jaguar's Children: Pre-Classic Central Mexico*. New York, 1965.

COVARRUBIAS, M. 'Tlatilco', *C.A.*, IX (1950), no. 3.

COVARRUBIAS, M. *The Eagle, the Jaguar and the Serpent*. New York, 1957.

DIBBLE, C. E. *Códice en Cruz*. Mexico, 1942.

DIBBLE, C. E. *Códice Xolotl*. Mexico, 1951.

EASBY, D. T., Jr. 'Sahagún y los orfebres pre-colombinos de México', *A.I.N.A.H.*, IX (1957).

EASBY, D., and DOCKSTADER, F. J. 'Requiem for Tizoc', *Archaeology*, XVII (1964).

FERNÁNDEZ, J. *Coatlicue*. Mexico, 1954.

GAMIO, M. *La población del valle de Teotihuacán*. 3 vols. Mexico, 1922.

GARCÍA PAYÓN, J. *Zona arqueológica de Tecaxic-Calixtlahuaca*. Mexico, 1936.

GLASS, J. *Catálogo de la colección de códices*. Mexico, 1964.

HAMY, E. T. (ed.). *Codex Borbonicus*. Facsimile ed. Paris, 1899.

HAMY, E. T. (ed.). *Codex Telleriano-Remensis*. Facsimile ed. Paris, 1899.

HEIZER, R., and BENNYHOFF, J. 'Cuicuilco', *Science*, CXXVII, no. 3292.

HEYDEN, D. 'Un Chicomoztoc en Teotihuacán', *Homenaje a Paul Kirchhoff*. Mexico, in press.

HOCHSTETTER, F. VON. *Über mexikanische Reliquien aus der Zeit Montezumas in der K. K. Ambraser Sammlung*. Vienna, 1884.

HOLMES, W. H. 'Handbook of Aboriginal American Antiquities', *B.B.A.E.*, LX (1919).

HVIDTFELDT, A. *Teotl and Ixiptlatli*. Copenhagen, 1958.

IXTLILXOCHITL, F. DE A. *Obras históricas* (ed. Chavero). Mexico, 1891–2.

JIMÉNEZ MORENO, W. 'Tula y los Toltecas segun las fuentes históricas', *R.M.E.A.*, V (1940).

KIRCHHOFF, P. 'Civilizing the Chichimecs', *Latin-American Studies*, V (1948).

KIRCHHOFF, P. 'The Mexican Calendar and the Founding of Tenochtitlan-Tlateloco', *Transactions of the New York Academy of Sciences*, XII (1950).

KIRCHHOFF, P. 'Calendarios Tenochca, Tlatelolca y otros', *R.M.E.A.*, XIV (1954–5).

KRICKEBERG, W. 'Das mittelamerikanische Ballspiel und seine religiöse Symbolik', *Paideuma*, III (1948).

KUBLER, G. 'The Cycle of Life and Death in Metropolitan Aztec Sculpture', *G.B.A.*, XXIII (1943).

KUBLER, G., and GIBSON, C. *The Tovar Calendar*. New Haven, 1951.

LEHMANN, W. *Aus den Pyramidenstädten in Alt-Mexiko*. Berlin, 1933.

LEHMANN, W. (ed.). *Die Geschichte der Königreiche von Colhuacan und Mexiko*. Stuttgart, 1938.

LEONARD, C. C. 'Excavaciones en Ostoyohualco, Teotihuacán', *Boletín del centro de investigaciones antropológicas de México*, IV (1957).

LINNÉ, S. *Archaeological Researches at Teotihuacan*. Stockholm, 1934.

LINNÉ, S. 'Teotihuacan Symbols', *Ethnos*, VI (1941).

LOUBAT, DUC DE (ed.). *Codex Magliabecchi*. Rome, 1901.

MARQUINA, I., and others. *La pirámide de Tenayuca*. Mexico, 1935.

MARTÍNEZ DEL RÍO, P., and others. 'Tlatelolco a través de los tiempos', *Memorias de la Academia de Historia*, III–IV (1944–8).

MENDIETA, FRAY JUAN DE. *Historia ecclesiástica indiana* (ed. J. García Icazbalceta). Mexico, 1870.

MILLER, A. G. *The Mural Painting of Teotihuacan*. Washington, 1973.

MILLON, R. 'The Beginnings of Teotihuacán', *Am.A.*, XXVI (1960), 1–10.

MOEDANO, H. 'El friso de los caciques', *A.I.N.A.H.*, II (1947).

MOEDANO, H. 'Oztotitlan', *El occidente de México* (*S.M.A.M.R.*, IV). Mexico, 1948.

MORENO, M. M. *La organización política y social de los Aztecas*. Mexico, 1931.

NEYS, H., and WINNING, H. VON. 'The Treble Scroll', *N.M.A.A.E.*, III (1946–8).

NICHOLSON, H. B. 'The Chapultepec Cliff Sculpture', *M.A.*, IX (1969).

NICHOLSON, H. B. 'Religion', *H.M.A.I.*, X (1971).

NOGUERA, E. 'El ladrillo como material de construcción entre los nahuas', *R.M.E.H.*, II (1928).

NOGUERA, E., in *M.A.*, III (1935), no. 3.

NOGUERA, E. 'Exploraciones en Xochicalco', *C.A.*, IV (1945), no. I.

NOGUERA, E. 'Nuevos rasgos característicos encontrados en Xochicalco', *R.M.E.A.*, X (1948–9).

NOGUERA, E. *El horizonte Tolteca-Chichimeca*. Mexico, 1950.

NOGUERA, E. *La cerámica arqueológica de Cholula*. Mexico, 1954.

OUTWATER, J. O. 'Precolumbian Stonecutting Techniques of the Mexican Plateau', *Am.A.*, XXII (1957), 258.

PIÑA CHAN, R. *Chalcatzingo, Morelos* (*Informes I.N.A.H.*, no. 4). Mexico, 1955.

PIÑA CHAN, R. *Las culturas preclásicas de la Cuenca de México*. Mexico, 1955.

PORTER, M. N. *Tlatilco and the Pre-Classic Cultures of the New World*. New York, 1953.

RADIN, P. 'The Sources and Authenticity of the History of the Ancient Mexicans', *U.C.P.A.A.E.*, XVII (1920).

RUBÍN DE LA BORBOLLA, D. F. 'Teotihuacán: Ofrendas de los templos de Quetzalcóatl', *A.I.N.A.H.*, II (1941–6).

RUZ LHUILLIER, A. *Guía arqueológica de Tula*. Mexico, 1945.

SÁENZ, C. 'Exploraciones en Xochicalco', *Bol. I.N.A.H.* (1966), no. 26.

SANDERS, W. T. 'Settlement Patterns in Central Mexico', *H.M.A.I.*, X (1971).

SCHOTTELIUS, J. W. 'Wieviel Dämme verbanden die Inselstadt Mexico-Tenochtitlán mit dem Festland', *Ibero-amerikanisches Archiv*, VIII (1934).

SEARS, P. B. 'Pollen Profiles and Culture Horizons in the Basin of Mexico', *I.C.A.*, XXXIX (1951).

SÉJOURNÉ, L. *Burning Water*. London, 1956.

SPRANZ, B. *Göttergestalten in den mexikanischen Bilderhandschriften der Codex Borgia-Gruppe*. Wiesbaden, 1964.

SPRANZ, B. *Totimehuacán*. Wiesbaden, 1970.

TEZOZOMOC, H. *Crónica mexicana* (ed. Orozco y Berra). Mexico, 1878; reissued 1944.

TOLSTOY, P. 'Surface Survey of the Northern Valley of Mexico', *Transactions of the American Philosophical Society*, XLVIII (1958), part V.

TOLSTOY, P., and PARADIS, L. 'Early and Middle Pre-Classic Culture in the Basin of Mexico', *U.C.A.R.F.*, XI (1971).

TOUSSAINT, M., FERNÁNDEZ, J., and O'GORMAN, E. *Planos de la ciudad de México*. Mexico, 1938.

VAILLANT, G. 'Excavations at Zacatenco', *A.M.N.H.A.P.*, XXXII (1930), part I.

VAILLANT, G. 'Early Cultures of the Valley of Mexico', *A.M.N.H.A.P.*, XXV (1935).

VAILLANT, G. *The Aztecs of Mexico*. Harmondsworth, 1950.

WEST, R. C., and ARMILLAS, P. 'Las chinampas de México', *C.A.*, V (1950), no. 2.

WINNING, H. VON. 'Representations of Temple Buildings', *N.M.A.A.E.*, III (1946–8), no. 83.

WINNING, H. VON. 'A Symbol for Dripping Water', *M.A.*, VI (1947); 'Shell Designs on Teotihuacan Pottery', VII (1949).

C. EASTERN MEXICO

BERNAL, I. *The Olmec World*. Berkeley, 1969.

BEYER, H. 'Shell Ornament Sets', *M.A.R.S.*, V (1934).

BRÜGGEMANN, J., and HERS, M. A. 'Exploraciones arqueológicas en San Lorenzo', *Bol. I.N.A.H.*, XXXIX (1970).

CLEWLOW, C. W., a.o. 'Colossal Heads', *U.C.A.R.F.*, IV (1967).

CLEWLOW, C. W. 'A Stylistic and Chronological Study of Olmec Monumental Sculpture', *U.C.A.R.F.*, XIX (1974).

COE, M. *The Jaguar's Children: Pre-Classic Central Mexico*. New York, 1965.

COE, M. *America's First Civilization*. New York, 1968.

COE, M. 'San Lorenzo and the Olmec Civilization', *Dumbarton Oaks Conference on the Olmec*. Washington, 1968.

CORONA NÚÑEZ, J. 'Relaciones arqueológicas entre las Huastecas y las regiones al Poniente', *R.M.E.A.*, XIII (1952–3).

COVARRUBIAS, M. 'El arte "Olmeca" o de La Venta', *C.A.*, V (1946), no. 4.

COVARRUBIAS, M. *Mexico South*. New York, 1946.

DRUCKER, P. 'Ceramic Sequences at Tres Zapotes', *B.B.A.E.*, CXL (1943).

DRUCKER, P. 'La Venta, Tabasco: A Study of Olmec Ceramics and Art', *B.B.A.E.*, CLIII (1952).

DRUCKER, P., HEIZER, R. F., and SQUIER, R. F. 'Excavations at La Venta, 1955', *B.B.A.E.*, CLXX (1959).

DU SOLIER, W. 'La cerámica arqueológica de El Tajín', *A.M.N.A.H.E.*, 5 ép., III (1936–8) (1945).

DU SOLIER, W. 'Estudio arquitectónico de los edificios Huaxtecas', *A.I.N.A.H.*, I (1945).

DU SOLIER, W. 'Primer fresco mural huasteca', *C.A.*, V (1946), no. 6.

EKHOLM, G. 'Excavations at Tampico and Panuco in the Huasteca', *A.M.N.H.A.P.*, XXXVIII (1944), no. 5.

EKHOLM, G. 'The Probable Use of Mexican Stone Yokes', *A.A.*, XLVIII (1946).

EKHOLM, G. 'Palmate Stones and Thin Stone Heads', *Am.A.*, XV (1949).

FERNÁNDEZ, J. *Arte olmeca*. Mexico, 1968.

FLANNERY, K. 'The Olmec and the Valley of Oaxaca', *Dumbarton Oaks Conference on the Olmec*. Washington, 1968.

FUENTE, B. DE LA. *Escultura monumental olmeca*. Mexico, 1973.

GARCÍA PAYÓN, J. 'Una "palma" in situ', *R.M.E.A.*, X (1948–9).

GARCÍA PAYÓN, J. 'Arqueología de Zempoala', *Uni-Ver*, I (1949).

GARCÍA PAYÓN, J. *Exploraciones en El Tajín (Informes I.N.A.H.*, no. 2). Mexico, 1955.

GARCÍA PAYÓN, J. 'Ensayo de interpretación', *M.A.*, IX (1959).

HEIZER, R. F. 'Excavations at La Venta, 1955', *Bulletin of the Texas Archaeological Society*, XXVIII (1957), 98–110.

HEIZER, R. 'Analysis of Two Low Relief Sculptures from La Venta', *U.C.A.R.F.*, III (1967).

HEIZER, R. F., and DRUCKER, P. 'The La Venta Flute Pyramid', *Antiquity*, XLII (1968).

JIMÉNEZ MORENO, W. 'El enigma de los Olmecas', *C.A.*, V (1942).

JORALEMON, P. D. *A Study of Olmec Iconography*. Washington, 1971.

KAMPEN, M. E. *The Sculptures of El Tajín*. Gainesville, 1972.

KNAUTH, L. 'El juego de pelota', *E.C.M.*, I (1961).

KRICKEBERG, W. 'Die Totonaken', *B.A.*, VII (1918–22); IX (1925).

KRUTT, M. 'Un yugo in situ', *Bol. I.N.A.H.*, XXXVI (1969).

MCBRIDE, H. W., in O. HAMMER (ed.). *Ancient Art of Vera Cruz*, 23–30. Los Angeles, 1971.

MEDELLÍN ZENIL, A., and PETERSON, F. A. 'A Smiling Head Complex from Central Veracruz, Mexico', *Am.A.*, XX (1954), no. 2.

MEDELLÍN ZENIL, A. *Exploraciones en la Isla de Sacrificios*. Jalapa, 1955.

MEDELLÍN, ZENIL, A. *Cerámicas del Totonacapan*. Xalapa, 1960.

MIYAWAKI, T. 'Multidimensional Scaling and the Seriation of the Twelve Olmec Colossal Heads'. Manuscript, 1970.

PALACIOS, E. J. *Los yugos y su simbolismo*. Mexico, 1943.

PASO Y TRONCOSO, F. DEL, and GALINDO Y VILLA, J. 'Las ruinas de Cempoala y del templo del Tajín', *A.M.N.A.H.E.*, III (1912), apen.

PIÑA CHAN, R., and COVARRUBIAS, L. *El Pueblo del Jaguar*. Mexico, 1964.

PROSKOURIAKOFF, T. 'Classic Veracruz Sculpture', *C.A.A.H.*, XII (1954), no. 58.

ROSADO OJEDA, V. 'Las mascaras rientes totonacas', *R.M.E.A.*, V (1941).

SPINDEN, E. 'The Place of Tajin in Totonac Archaeology', *A.A.*, XLVIII (1933).

SPINDEN, H. 'Huastec Sculptures and the Cult of the Apotheosis', *Brooklyn Museum Quarterly*, XXIV (1937).

STIRLING, M. *An Initial Series from Tres Zapotes*. Washington, 1940.

STIRLING, M. 'The Cerro de las Mesas Offering of Jade and Other Materials', *B.B.A.E.*, CLVII (1955).

STREBEL, H. *Alt-Mexiko*. 2 vols. Hamburg–Leipzig, 1885–9.

STRESSER-PÉAN, G. 'Ancient Sources on the Huasteca', *H.M.A.I.*, XI (1971).

SWADESH, M. 'The Language of the Archaeologic Huastecs', *N.M.A.A.E.*, IV (1949–53), no. 114.

TUGGLE, H. D. *Cultural Inferences from the Art of El Tajín* (MS., M.A. thesis). Arizona, 1966.

TUGGLE, H. D. 'The Columns of El Tajín', *Ethnos*, XXXIII (1968).

WICKE, C. *Olmec*. Tucson, 1971.

WILKENSON, S. J. K. 'Un yugo in situ de la región del Tajín', *Bol. I.N.A.H.*, XLI (1970).

WYSHAK, L. W., and BERGER, R. 'Possible Ball Court at La Venta', *Nature*, CCXXXII (1971).

D. SOUTHERN MEXICO

AGRINIER, L. *The Carved Human Femurs from Tomb 1, Chiapa de Corzo*. Orinda, 1960.

BERNAL, I. 'Excavaciones en Coixtlahuaca', *R.M.E.A.*, X (1949).

BERNAL, I. *Exploraciones en Cuilapan*. Mexico, 1958.

BERNAL, I. 'The Mixtecs in Valley Archaeology', in J. PADDOCK (ed.), *Ancient Oaxaca*. Stanford, 1966.

BERNAL, I. 'The Ball Players of Dainzú', *Archaeology*, XXI (1968).

BOOS, F. *Corpus antiquitatum americanensium*. 2 vols. Mexico, 1964–6.

BURGOA, F. *Geográfica descripción* ... (written *c.* 1666–71). Mexico, 1934.

BURGOA, F. *Palestra historial*. Mexico, 1934.

CASO, A. *Estelas Zapotecas*. Mexico, 1928.

CASO, A. *Exploraciones en Oaxaca ... 1934–35* (Instituto panamericano de geografía e historia, Pub. 17), Mexico, 1935; idem, *1936–37* (Pub. 34), Mexico, 1938.

CASO, A. *Exploraciones en Mitla, 1934–35*. Mexico, 1936.

CASO, A. *Calendarios y escrituras de las antiguas culturas de Monte Alban*. Mexico, 1947.

CASO, A. 'El mapa de Teozacualco', *C.A.*, VIII (1949), no. 5.

CASO, A. 'Base para la sincronología Mixteca y cristiana', *Memoria de el Colegio Nacional*, VI (1951).

CASO, A. *Codex Bodley 2858*. Mexico, 1960.

CASO, A. 'Sculpture and Mural Painting of Oaxaca', *H.M.A.I.*, III (1965).

CASO, A. 'The Lords of Yanhuitlan', in J. PADDOCK (ed.), *Ancient Oaxaca*. Stanford, 1966.

CASO, A. *El tesoro de Monte Albán*. Mexico, 1969.

CASO, A., a.o. *La cerámica de Monte Albán*. Mexico, 1947.

CASO, A., and BERNAL, I. *Urnas de Oaxaca*. Mexico, 1952.

DAHLGREN DE JORDAN, B. *La Mixteca*. Mexico, 1954.

DARK, P. (with supplementary note by John Paddock). 'Speculations on the Course of Mixtec History', *B.E.O.*, no. 10 (1958).

DARK, P. *Mixtec Ethnohistory. A Method of Analysis of the Codical Art*. Oxford, 1958.

GALLEGOS, R. 'Zaachila', *Archaeology*, XVI (1963).

HARTUNG, H. 'Notes on the Oaxaca Tablero', *B.E.O.*, no. 27 (1970).

LEHMANN, W. 'Les peintures Mixtéco-Zapotèques', *J.S.A.*, II (1905).

LEHMANN, W., and SMITAL, O. (eds.). *Codex Vindobonensis Mexic. 1*. Facsimile ed. Vienna, 1929.

LEÓN, N. *Lyobaa ò Mictlan*. Mexico, 1901.

LINNÉ, S. *Zapotecan Antiquities*. Stockholm, 1938.

PADDOCK, J. 'Excavations at Yagul', *Mesoamerican Notes*, IV (1955).

PADDOCK, J. 'Mixtec Ethnohistory', *Ancient Oaxaca*. Stanford, 1966.

PADDOCK, J. 'More Ñuiñe Materials', *B.E.O.*, no. 28 (1970).

PASO Y TRONCOSO, F. DEL (ed.). 'Relación de Tlacolula y Mitla', *Papeles de la Nueva España*, IV. Madrid, 1905. English version in *Mesoamerican Notes*, IV (1955).

PEÑAFIEL, A. (ed.) *Lienzo de Zacatepeque*. Mexico, 1900.

PROSKOURIAKOFF, T. 'Classic Art of Central Veracruz', *H.M.A.I.*, XI (1971).

RABIN, E. 'The Lambityeco Friezes', *B.E.O.*, no. 33 (1970).

SAUSSURE, H. DE. *Le manuscrit du cacique*. Geneva, 1892.

SAVILLE, M. 'The Cruciform Structures of Mitla and Vicinity', *Putnam Anniversary Volume*. New York, 1909.

SCHULER-SCHÖMIG, I. VON. *Figurengefässe aus Oaxaca*. Berlin, 1970.

SELER, E. (ed.). *Codex Féjerváry-Mayer*. Berlin–London, 1902.

SELER, E. 'Der Codex Borgia und die verwandten aztekischen Bilderschriften', *G.A.*, I (1902).

SELER, E. 'Venus Period in the Picture Writings of the Borgian Codex Group', *B.B.A.E.*, XXVIII (1904).

SELER, E. 'The Wall Paintings of Mitla', *B.B.A.E.*, XXVIII (1904).

SHARP, R. 'Early Architectural Grecas in the Valley of Oaxaca', *B.E.O.*, no. 32 (1970).

SHOOK, E., and KIDDER, A. V. 'Mound E-III-3, Kaminaljuyu', *C.A.A.H.*, XI (1952).

SPRANZ, B. *Göttergestalten in den mexikanischen Bilderhandschriften der Codex Borgia-Gruppe*. Wiesbaden, 1964.

TOMPKINS, J. B. 'Codex Fernandez Leal', *Pacific Art Review*, II (1942).

VILLAGRA, A. 'Los Danzantes', *I.C.A.*, XXVII (1939), II.

E. WESTERN MEXICO

BELL, B. 'Archaeology of Nayarit, Jalisco and Colima', *H.M.A.I.*, XI (1971).

CHADWICK, R. 'Archaeological Synthesis of Michoacan', *H.M.A.I.*, XI (1971).

CORONA NÚÑEZ, J. *Tumba de el Arenal, Etzatlán, Jal.* (Informes I.N.A.H., III). Mexico, 1955.

COVARRUBIAS, M. 'Tipología de la industria de piedra tallada y pulida de la Cuenca del Río Mezcala', *El occidente de México* (S.M.A.M.R., IV). Mexico, 1948.

COVARRUBIAS, M. *Mezcala, Ancient Mexican Sculpture*. New York, 1956.

EKHOLM, G. 'Excavations at Guasave, Sinaloa', *A.M.N.H.A.P.*, XXXVIII (1942).

FURST, P. 'West Mexican Tomb Sculpture as

Evidence for Shamanism in prehispanic Mesoamerica', *Antropológica*, XV (1965).

GAMIO, M. *Los monumentos arqueológicos de las immediaciones de Chalchihuites.* Zacatecas, 1910.

GAY, C. *Mezcala Stone Sculpture: The Human Figure.* New York, 1967.

GAY, C. 'Oldest Paintings of the New World', *Natural History*, LXXVI (1967).

GAY, C. *Xochipala, The Beginnings of Olmec Art.* Princeton, 1972.

GIFFORD, E. W. 'Surface Archaeology of Ixtlán del Río, Nayarit', *U.C.P.A.A.E.*, XLIII (1950).

GROVE, D. C. 'Los murales de la Cueva de Oxtotitlan', *Invest. I.N.A.H.*, XXIII (1970).

GROVE, D. C. 'The Olmec Paintings of Oxtotitlan Cave', *D.O.S.*, VI (1970).

HRDLIČKA, A. 'The Region of the Ancient Chichimecs', *A.A.*, V (1903).

KAN, M., a.o. *Sculpture of Ancient West Mexico.* Los Angeles, 1970.

KELLEY, J. C. 'Archaeology of the Northern Frontier', *H.M.A.I.*, XI (1971).

KELLEY, J. C., and WINTERS, H. D. 'A Revision of the Archaeological Sequence in Sinaloa', *Am.A.*, XXV (1960).

KELLY, I. 'Excavations at Chametla', *Ibero-Americana*, XIV (1938).

KELLY, I. 'The Archaeology of the Autlán-Tuxcacuesco Area', *Ibero-Americana*, XXVI (1945), XXVII (1949).

KELLY, I. 'Excavations at Apatzingán, Michoacán', *V.F.P.A.*, VII (1947).

LEHMANN, H. 'Le personnage couché sur le dos', *I.C.A.*, XXIX (1951).

LEHMANN, H. 'Cradled Infant Figurines', *Am.A.*, XIX (1953–4).

LISTER, R. H. 'Archaeological Synthesis of Guerrero', *H.M.A.I.*, XI (1971).

LUMHOLTZ, C. *Unknown Mexico.* New York, 1904.

MEIGHAN, C. W. 'Archaeology of Sinaloa', *H.M.A.I.*, XII (1971).

NOGUERA, E. *Ruinas arqueológicas del norte de México.* Mexico, 1930.

NOGUERA, E. 'Exploraciones en El Opeño, Michoacán', *I.C.A.*, XXVII (1943).

NOGUERA, E. 'Exploraciones en Jiquilpan', *Anales del Museo Michoacano*, III (1944).

PORTER, M. N. 'Excavations at Chupícuaro', *Transactions of the American Philosophical Society*, XLVI (1956), part V.

REYES, J. M. 'Breve reseña ...', *Boletín de la Sociedad de Geografía y Estadística*, V (1881).

RUBÍN DE LA BORBOLLA, D. 'La orfebrería tarasca', *C.A.*, III (1944), no. 3.

TARAYRE, E. GUILLEMIN. *Exploration minéralogique des régions mexicaines.* Paris, 1869.

TOSCANO, S., KIRCHHOFF, P., and RUBÍN DE LA BORBOLLA, D. F. *Arte precolombino del occidente de México.* Mexico, 1946.

TUDELA, J. (ed.). *Relación de Michoacán* (1541). Madrid, 1956.

WINNING, H. VON, and HAMMER, O. *Anecdotal Sculpture of Ancient West Mexico.* Los Angeles, 1972.

IV. MAYA

A. GENERAL

Art of the Maya Civilization. Catalogue by H. J. Spinden of the exhibition at the Martin Widdifield Gallery. New York, 1957.

ANDREWS, E. W. 'Archaeology and Prehistory in the Northern Maya Lowlands', *H.M.A.I.*, II (1965).

BALL, J. W. 'A Coordinate Approach to Northern Maya Prehistory', *Am. A.*, XXXIX (1974).

BARTHEL, T. S. 'Die gegenwärtige Situation in der Erforschung der Maya-Schrift', *J.S.A.*, XLV (1956).

BLOM, F., and LAFARGE, C. *Tribes and Temples.* 2 vols. New Orleans, 1926.

BLOM, F. 'The Maya Ball-Game *Pok-ta-pok*', *M.A.R.S.*, IV (1932).

BRAINERD, G. W. *The Archaeological Ceramics of Yucatan* (*Anthropological Records*, XIX, 26). Berkeley, 1958.

BRASSEUR DE BOURBOURG, C. (ed.). *Manuscrit Troano.* Paris, 1869–70.

DIESELDORFF, E. P. *Kunst und Religion der Mayavölker.* Berlin, 1926.

FERNÁNDEZ, M. A. *Los Mayas antiguos.* Mexico, 1941.

FÖRSTEMANN, E. *Die Maya-Handschrift der königlichen Bibliothek zu Dresden.* Leipzig, 1892.

GRAHAM, I. *The Art of Maya Hieroglyphic Writing.* New York, 1971.

GREENE, M., a.o. *Maya Sculpture.* Berkeley, 1972.

HARTUNG, H. *Zeremonialzentren der Maya.* Graz, 1971.

JAKEMAN, M. WELLS. *The Origins and History of the Mayas.* Los Angeles, 1945.

KRAMER, G. 'Roof Combs in the Maya Area', *Maya Research*, II (1935).

KUBLER, G. 'The Design of Space in Maya Architecture', *Miscellanea Paul Rivet*, I. Mexico, 1958.

KUTSCHER, G. 'Wandmalereien des vorkolumbischen Mexiko', *Preussischer Kulturbesitz*, IX (1971).

MAUDSLAY, A. P. *Biologia Centrali-Americana*. 4 vols. plates. London, 1899–1902.

MORLEY, S. G. 'The Correlation of Maya and Christian Chronology', *American Journal of Archaeology*, XIV (1910).

MORLEY, S. G. 'An Introduction to the Study of the Maya Hieroglyphs', *B.B.A.E.*, LVII (1915).

MORLEY, S. G. *Inscriptions of Peten*. 5 vols. Washington, 1937–8.

MORLEY, S. G. *The Ancient Maya*. Stanford, 1947.

POLLOCK, H. E. D. 'Architecture of the Maya Lowlands', *H.M.A.I.*, II (1965).

PROSKOURIAKOFF, T. *An Album of Maya Architecture*, plates 28–36. Washington, 1946.

PROSKOURIAKOFF, T. *A Study of Classic Maya Sculpture*. Washington, 1950.

RADA Y DELGADO, J. DE LA, and LÓPEZ DE AYALA, J. (eds.). *Códice Maya denominado Cortesiano*. Madrid, 1892.

RANDS, R. L. 'Jades of the Maya Lowlands', *H.M.A.I.*, III (1965).

ROSNY, L. DE (ed.). *Codex Peresianus*. Paris, 1887.

ROYS, L. 'The Engineering Knowledge of the Maya', *C.A.A.*, II (1934).

SATTERTHWAITE, L. 'An Appraisal of a New Maya-Christian Correlation', *E.C.M.*, II (1962).

SCHELLHAS, P. 'Representation of Deities of the Maya Manuscripts', *P.M.P.*, IV (1904–10).

SMITH, R. E. 'The Place of Fine Orange Pottery in Mesoamerican Archaeology', *Am.A.*, XXIV (1958).

SPINDEN, H. J. 'A Study of Maya Art', *P.M.M.*, VI (1913); reissued as Part I, *Maya Art and Civilization*, Indian Hills, 1957.

SPINDEN, H. J. 'The Reduction of Maya Dates', *P.M.P.*, VI (1924), no. 4.

STEPHENS, J. L. *Incidents of Travel in Central America, Chiapas, and Yucatan*. 2 vols. New York, 1841.

STEPHENS, J. L. *Incidents of Travel in Yucatan*. 2 vols. New York, 1843.

THOMPSON, J. E. S. 'Maya Chronology: the Correlation Question', *C.A.A.*, III (1935), no. 14.

THOMPSON, J. E. S. *Maya Hieroglyphic Writing*. Washington, 1950.

THOMPSON, J. E. S. *The Rise and Fall of Maya Civilization*. Norman, 1956.

THOMPSON, J. E. S. *Catalog of Maya Hieroglyphs*. Norman, 1962.

THOMPSON, J. E. S. *Maya History and Religion*. Norman, 1970.

THOMPSON, J. E. S. *Maya Hieroglyphs without Tears*. London, 1972.

THOMPSON, J. E. S. *A Commentary on the Dresden Codex*. Philadelphia, 1972.

TOTTEN, G. O. *Maya Architecture*. Washington, 1926.

VILLACORTA, C. and J. A. *Los códices Mayas*. Guatemala, 1930.

WAUCHOPE, R. *Modern Maya Houses*. Washington, 1938.

ZIMMERMANN, G. *Die Hieroglyphen der Maya-Handschriften*. Hamburg, 1956.

B. CLASSIC MAYA

ADAMS, R. E. W. 'The Ceramics of Altar de Sacrificios', *P.M.P.*, LXIII (1971).

ANDREWS, E. W. 'Northern Maya Lowlands', *H.M.A.I.*, II (1965).

ANDREWS, E. W. *Dzibilchaltun*. New Orleans, 1965.

ANDREWS, G. F., a.o. *Edzná*. Eugene, 1969.

BARTHEL, T. 'Historisches in den klassischen Mayainschriften', *Zeitschrift für Ethnologie*, XCIII (1968).

BECQUELIN, P. *Nebaj*. Paris, 1969.

BERLIN, H. 'Late Pottery Horizons of Tabasco', *C.A.A.H.*, no. 59 (1956).

BERLIN, H. 'El glifo "emblema" en las inscripciones Mayas', *J.S.A.*, XLVII (1958).

BERLIN, H. *The Tablet of the 96 Glyphs at Palenque*. New Orleans, 1968.

BLOM, F. 'The "Negative Batter" at Uxmal', *Middle American Research Papers*, IV (1932).

BOLLES, J. *La Iglesia*. San Francisco, 1963.

BRAINERD, G. W. 'Fine Orange Pottery in Yucatan', *R.M.E.A.*, V (1941).

BUTLER, M. 'A Pottery Sequence from Guatemala', *The Maya and their Neighbors*. New York, 1940.

COE, M. D. *The Maya Scribe and His World*. New York, 1973.

COE, W. *Tikal: A Handbook of the Ancient Maya Ruins*. Philadelphia, 1967.

COE, W., a.o. 'The Carved Wooden Lintels of Tikal', *Tikal Reports*, VI (1961).

COOK, C. 'Dos extraordinarias vasijas del Museo de Villahermosa', *Yan*, III (1954).

COOKE, C. W. 'Why the Mayan Cities of the Peten District, Guatemala, were Abandoned', *Journal of the Washington Academy of Sciences*, XXI (1931).

COWGILL, U., and HUTCHINSON, G. E. 'Archaeological Significance of a Stratigraphic Study of El Bajo de Santa Fe', *I.C.A.*, XXXV, vol. I (1964).

DELGADO, A. 'El arte de Jaina', *Artes de Mexico*, XII (1965).

EKHOLM, G. *A Maya Sculpture in Wood*. New York, 1964.

FERNÁNDEZ, M. A. 'Los dinteles de Zapote', *I.C.A.*, XXVII (1939), I.

FONCERRADA, M. *La escultura arquitectónica de Uxmal*. Mexico, 1965.

FUENTE, B. DE LA. *La escultura de Palenque*. Mexico, 1965.

GANN, T. 'Maya Indians of Southern Yucatan and Northern British Honduras', *B.B.A.E.*, LXIV (1918).

GORDON, G. B. 'Prehistoric Ruins of Copan', *P.M.M.*, I (1896).

GORDON, G. B. 'The Hieroglyphic Stairway', *P.M.M.*, I (1902).

GRAHAM, I. 'Archaeological Explorations in El Peten', *Publication 33, Middle American Research Institute* (1967).

GUILLEMIN, G. 'Tikal Ceremonial Center', *Ethnos*, XXXIII (1968).

HABERLAND, W. *Die regionale Verteilung von Schmuckelementen im Bereiche der klassischen Maya-Kultur*. Hamburg, 1953.

KELLEY, D. H. 'Glyphic Evidence for a Dynastic Sequence at Quirigua', *Am.A.*, XXVII (1962).

KIDDER, A. V., and SHEPARD, A. 'Stucco Decoration of Early Guatemala Pottery', *N.M.A.A.E.*, II (1944).

KUBLER, G. *Studies in the Iconography of Classic Maya Art*. New Haven, 1969.

KUBLER, G. 'The Paired Attendants of the Temple Tablets at Palenque', *S.M.A.M.R.*, XII (1972).

LITTMANN, E. R. 'Ancient Mesoamerican Mortars, Plasters, and Stuccoes', *Am.A.*, XXIII (1957).

LONGYEAR III, J. M. 'A Historical Interpretation of Copan Archaeology', *I.C.A.*, XXIX (1951).

MALER, T. 'Yukatekische Forschungen', *Globus*, LXXXII (1902).

MALER, T. 'Tikal', *P.M.M.*, V (1911), no. 1.

MERWIN, R. E., and VAILLANT, G. C. 'The Ruins of Holmul', *P.M.M.*, III (1932).

MOEDANO KOER, H. 'Jaina: un cementerio Maya', *R.M.E.A.*, VIII (1946).

MORLEY, S. G. *Guide Book to the Ruins of Quirigua*. Washington, 1935.

MORLEY, S. G. and F. 'The Age and Provenance of the Leyden Plate', *C.A.A.H.*, V (1939).

PENDERGAST, D. 'Tumbaga at Altun Ha', *Science*, CLXVIII (1970), no. 3927.

PENDERGAST, D. *Actun Balam*. Toronto, 1969.

POLLOCK, H. E. D. 'Architectural Notes on some Chenes Ruins', *P.M.P.*, LXI (1970).

PROSKOURIAKOFF, T. *A Study of Classic Maya Sculpture*. Washington, 1950.

PROSKOURIAKOFF, T. 'Historical Implications of a Pattern of Dates at Piedras Negras', *Am.A.*, XXV (1960).

PROSKOURIAKOFF, T. 'Historical Data in the Inscriptions of Yaxchilan', *E.C.M.*, III (1963), IV (1964).

RAINEY, F. 'The Tikal Project', *University Museum Bulletin*, XX (1956), no. 4.

RANDS, R. L. and B. C. 'The Ceramic Position of Palenque, Chiapas', *Am.A.*, XXIII (1957).

RANDS, R. L. and B. C. 'Pottery Figurines of the Maya Lowlands', *H.M.A.I.*, II (1965).

RICKETSON, O. G. and E. B. *Uaxactun, Guatemala. Group E. 1926–1931*. Washington, 1937.

ROBICSEK, F. *Copan*. New York, 1972.

ROBINA, R. DE. *Estudio preliminar de las ruinas de Hochob*. Mexico, 1956.

RUPPERT, K., and DENISON, J. H., Jr. *Archaeological Reconnaissance in Campeche, Quintana Roo, and Peten*. Washington, 1943.

RUPPERT, K., THOMPSON, J. E. S., and PROSKOURIAKOFF, T. *Bonampak*. Washington, 1955.

RUZ LHUILLIER, A. *Campeche en la arqueología Maya (Acta Anthropologica, I: 2–3)*. Mexico, 1945.

RUZ LHUILLIER, A. 'Exploraciones en Palenque', *A.I.N.A.H.*, IV (1949–50); V (1951).

RUZ LHUILLIER, A. 'Estudio de la cripta del templo de las inscripciones en Palenque', *Tlatoani*, I (1952).

RUZ LHUILLIER, A. 'Presencia atlántica en Palenque', *R.M.E.A.*, XIII (1952–3).

SÁENZ, C. 'Exploraciones y restauraciones en Uxmal', *I.N.A.H.*, *Boletín*, XXXVI (1969).

SATTERTHWAITE, L., Jr, in *Piedras Negras Preliminary Papers*, III (1935).

SATTERTHWAITE, L., Jr. 'Some Central Peten Maya Architectural Traits at Piedras Negras', *Los Mayas antiguos*. Mexico, 1941.

SATTERTHWAITE, L., Jr. *Piedras Negras Archaeology: Architecture*, I–VI (1943–54).

SATTERTHWAITE, L., Jr. 'A Stratified Sequence of Maya Temples', *Journal of the Society of Architectural Historians*, v (1946–7).

SATTERTHWAITE, L., Jr, and RALPH, E. K. 'Radiocarbon Dates and Maya Correlations', *Am.A.*, XXVI (1960), 165–84.

SAVILLE, M. H. *A Sculptured Vase from Guatemala.* New York, 1919.

SEGOVIA, V. 'Kohunlich', *I.N.A.H.*, Boletín, XXXVII (1969).

SELER, E. 'Die Ruinen von Uxmal', *Abhandlungen der königlichen preussischen Akademie der Wissenschaften (Phil.-hist. Kl.)* (1917).

SHOOK, E. 'Oxkintok', *R.M.E.A.*, IV (1940).

SHOOK, E., and BERLIN, H. 'Investigaciones arqueológicas en las ruinas de Tikal', *Antropología e historia de Guatemala*, III (1951), no. 1.

SHOOK, E., and KIDDER, A. V. *Nebaj.* Washington, 1951.

SHOOK, E. 'The Tikal Project', *University Museum Bulletin*, XXI (1957).

SMITH, A. L. 'Two Recent Ceramic Finds at Uaxactun', *C.A.A.*, II (1934).

SMITH, R. E. 'Pottery from Chipoc', *C.A.A.H.*, XI (1952).

SMITH, R. E. *Ceramic Sequence at Uaxactun.* New Orleans, 1955.

STRÓMSVIK, G. 'Substela Caches and Stela Foundations at Copan and Quirigua', *C.A.A.H.*, VII (1942).

STRÓMSVIK, G. *Copan.* Washington, 1947.

STRONG, W. D., KIDDER II, A., and PAUL, A. J. D. 'Preliminary Report', *Smithsonian Institution, Miscellaneous Collections*, XCVII (1938), no. 1.

TAYLOR, W. 'The Ceremonial Bar and Associated Features of Maya Ornamental Art', *Am.A.*, VII (1941).

THOMPSON, J. E. S., POLLOCK, H. E. D., and CHARLOT, J. *A Preliminary Study of the Ruins of Cobá.* Washington, 1932.

THOMPSON, J. E. S. *Excavations at San José.* Washington, 1939.

THOMPSON, J. E. S. 'El area Maya norte', *Yan*, III (1954).

Tikal Reports, The University Museum, Philadelphia, nos 1–10 (1958–61).

TOZZER, A. M., 'Nakum', *P.M.M.*, V (1913).

TREBBI DEL TREVIGIANO, R. 'Personalità e scuole di architetti e scultori Maya a Palenque', *Critica d'arte*, XXVIII (1958).

TRIK, A. S. 'Structure XXII, Copan', *C.A.A.H.*, V (1939).

VAILLANT, G. C. 'The Archaeological Setting of the Playa de los Muertos Culture', *Maya Research*, I (1934).

WAUCHOPE, R. 'House Mounds of Uaxactun', *C.A.A.*, II (1934).

WILLEY, G. 'Artifacts of Altar de Sacrificios', *P.M.P.*, LXIV (1972).

WILLEY, G. R., and SMITH, A. L. 'A Temple at Seibal', *Archaeology*, XX (1967).

C. TOLTEC MAYA

BARRERA VÁSQUEZ, A., and MORLEY, S. G. 'The Maya Chronicles', *C.A.A.H.*, X (1949).

BRETON, A. 'The Wall Paintings at Chichen Itza', *I.C.A.*, XIX (1917).

BULLARD, W. 'Topoxté', *P.M.P.*, LXI (1970).

CHARLOT, J. 'A XII Century Mayan Mural', *Magazine of Art*, XXXI (1938), no. 11.

Current Reports (Carnegie Institution of Washington), nos 1–41 (1952–7).

ESCALONA RAMOS, A. 'Algunas ruinas prehispánicas en Quintana Roo', *Boletín de la Sociedad mexicana de geografía y estadística*, LXI (1946).

FERNÁNDEZ, M. A. 'Las ruinas de Tulum', *A.M.N.A.H.E.*, III (1945).

LOTHROP, S. K. *Tulum.* Washington, 1924.

LOTHROP, S. K. 'Metals from the Cenote of Sacrifice', *P.M.M.*, X (1952).

MALER, T. 'Yukatekische Forschungen', *Globus*, LXVIII (1895), LXXXII (1902).

MILLER, A. 'Mural painting at Tancah and Tulum', *I.C.A.*, XL (1972).

MORLEY, S. G. *Quirigua.* Washington, 1935.

MORRIS, E., CHARLOT, J., and MORRIS, A. *Temple of the Warriors.* 2 vols. Washington, 1931.

PARSONS, L. *Bilbao*, II. Milwaukee, 1969.

POLLOCK, H. E. D., a.o. *Mayapan.* Washington, 1962.

PONCIANO SALAZAR, O. 'El Tzompantli', *Tlatoani*, I (1952).

PROSKOURIAKOFF, T. 'Mayapan', *Archaeology*, VII (1954).

RICKETSON, E. B. 'Sixteen Carved Panels from Chichen Itza', *Art and Archeology*, XXIII (1927).

ROBERTSON, D. 'Tulum Murals', *I.C.A.*, XXXVIII (1968).

ROYS, R. L. 'The Maya Katun Prophecies of the

Books of Chilam Balam', *C.A.A.H.*, XII (1954).

RUPPERT, K. 'The Temple of the Wall Panels', *C.A.A.*, I (1931).

RUPPERT, K. *The Caracol*. Washington, 1935.

RUPPERT, K. *Chichen Itza, Architectural Notes and Plans*. Washington, 1952.

RUZ LHUILLIER, A. 'Chichén Itza y Tula: Comentarios a un ensayo', *E.C.M.*, II (1962).

SELER, E. 'Die Quetzalcouatl-Fassaden Yukatekischer Bauten', *Abhandlungen der preussischen Akademie der Wissenschaften (Phil.-Hist. Kl.)* (1916).

SMITH, R. E. 'Pottery of Mayapan', *P.M.P.*, LXVI (1970).

THOMPSON, E. H. 'The High Priest's Grave', *F.M.N.H.A.S.*, XXVII (1938).

THOMPSON, J. E. S. 'Las llamadas fachadas de Quetzalcoatl', *I.C.A.*, XXVII (1939).

TOZZER, A. M. *Landa's Relación de las Cosas de Yucatan. A Translation*, *P.M.P.*, XVIII (1941).

TOZZER, A. M. 'Chichen Itza and its Cenote of Sacrifice', *P.M.M.*, XI–XII (1957).

WILLARD, T. A. *City of the Sacred Well*. London, n.d.

WRAY, D. E. 'The Historical Significance of the Murals in the Temple of the Warriors', *Am.A.*, XI (1945–6).

V. THE SOUTHERN NEIGHBOURS OF THE MAYA

BADNER, M. *A Possible Focus of Andean Artistic Influence in Mesoamerica*. Washington, 1972.

BECQUELIN, P. *Nebaj*. Paris, 1969.

BORHEGYI, S. DE. 'Guatemalan Highlands', *H.M.A.I.*, II (1965).

COE, M. 'La Victoria', *P.M.P.*, LIII (1961).

DIXON, K. A. 'Two Masterpieces of Middle American Bone Sculpture', *Am.A.*, XXIV (1958).

EKHOLM-MILLER, S. 'Mound 30, Izapa', *Papers of the New World Archaeological Foundation*, no. 25. Provo, 1969.

HABEL, S. 'The Sculptors of S. Lucia Cosumalwhaupa in Guatemala', *Smithsonian Contributions to Knowledge*, XXII (1880).

KIDDER, A. V., JENNINGS, H. D., and SHOOK, E. *Kaminaljuyu*. Washington, 1946.

LOWE, G., and AGRINIER, P. 'Excavations at Chiapa de Corzo', *Papers of the New World Archaeological Foundation*, no. 8. 1960.

MILES, S. W. 'Sculpture of the Guatemala-Chiapas Highlands', *H.M.A.I.*, II (1965).

ORELLANA TAPIA, R. 'Nueva lápida olmecoide de Izapa, Chiapas', *M.A.*, VIII (1955).

PARSONS, L. *Bilbao*, II. Milwaukee, 1969.

QUIRARTE, J. *Izapan-Style Art*. Washington, 1973.

RANDS, R. and B. 'Pottery of the Guatemalan Highlands', *H.M.A.I.*, II (1965).

RICHARDSON, F. B. 'Non-Maya Monumental Sculpture of Central America', *The Maya and their Neighbors*. New York, 1940.

SHEPARD, A. O. *Plumbate*. Washington, 1948.

SHOOK, E. 'The Present Status of Research on the Pre-Classic Horizons in Guatemala', *I.C.A.*, XXIX (1951).

SHOOK, E., and KIDDER, A. V. 'Mound E-III-3, Kaminaljuyu', *C.A.A.H.*, XI (1952).

SMITH, A. L. *Archaeological Reconnaissance in Central Guatemala*. Washington, 1955.

SMITH, R. E. 'Tohil Plumbate and Classic Maya Polychrome Vessels in the Marquez Collection', *N.M.A.A.E.*, V, no. 129 (1954–7).

THOMPSON, J. E. S. 'Some Sculptures from Southeastern Quezaltenango', *N.M.A.A.E.*, I (1943).

THOMPSON, J. E. S. 'An Archaeological Reconnaissance in the Cotzumalhuapa Region', *C.A.A.H.*, IX (1948).

WAUCHOPE, R. *Excavations at Zacualpa*. New Orleans, 1948.

WOODBURY, R. B., and TRIK, A. S. *The Ruins of Zaculeu*. Richmond, 1953.

VI. EASTERN CENTRAL AMERICA

BAUDEZ, C. F. *Amérique Centrale*. Geneva, 1970.

BORHEGYI, S. 'Travertine Vase in the Guatemala National Museum', *Am.A.*, XVII (1952).

BOYLE, F. 'The Ancient Tombs of Nicaragua', *Archaeological Journal*, XXIII (1866).

BRANSFORD, J. F. 'Archaeological Researches in Nicaragua', *Smithsonian Contributions to Knowledge*, XXV (1881).

EASBY, E. *Pre-Columbian Jades from Costa Rica*. New York, 1968.

GLASS, J. B. 'Archaeological Survey of Western Honduras', *H.M.A.I.*, IV (1966).

HARTMAN, C. V. 'Archaeological Researches on the Pacific Coast of Costa Rica', *Memoirs of the Carnegie Museum*, III (1907).

LINES, J. A. *Los altares de Toyopan*. San José, 1935.

LONGYEAR, J. M. 'Archaeological Investigations in El Salvador', *P.M.M.*, IX (1944), no. 2.

LONGYEAR III, J. M. 'Archaeological Survey of El Salvador', *H.M.A.I.*, IV (1966).

LOTHROP, S. K. *The Pottery of Costa Rica and Nicaragua*. 2 vols. New York, 1926.

LOTHROP, S. K. 'Coclé', *P.M.M.*, VII (1937), VIII (1942).

LOTHROP, S. K. 'The Archaeology of Panamá', *H.S.A.I.*, IV (1948).

LOTHROP, S. K. 'Archaeology of Southern Veraguas, Panama', *P.M.M.*, IX (1950).

LOTHROP, S. K. 'Jade and String Sawing in Northeastern Costa Rica', *Am.A.*, XXI (1955).

MacCURDY, G. G. 'A Study of Chiriquian Antiquities', *Memoirs of the Connecticut Academy of Arts and Sciences*, III (1911).

MASON, J. A. 'Costa Rican Stonework', *A.M.N.H.A.P.*, XXXIX (1945), part 3.

RICHARDSON, F. B. 'Non-Maya Monumental Sculpture of Central America', *The Maya and their Neighbors*. New York, 1940.

SPINDEN, H. J. 'The Chorotegan Culture Area', *I.C.A.*, XXI (1924).

SQUIER, E. G. *Nicaragua*. New York, 1852.

STEWARD, J. (ed.). 'The Circum-Caribbean Tribes', *H.S.A.I.*, IV (1948).

STONE, D. 'Masters in Marble', *M.A.R.S.*, publ. 8 (1938).

STONE, D. 'Archaeology of the North Coast of Honduras', *P.M.M.*, IX (1941).

STONE, D. 'The Basic Cultures of Central America', *H.S.A.I.*, V (1948).

VII. THE NORTHERN ANDES

BENNETT, W. C. *Archaeological Regions of Colombia: A Ceramic Survey*. New Haven, 1944.

BENNETT, W. C. 'Archeology of Colombia', *H.S.A.I.*, II (1946).

BORHEGYI, S. F. DE. 'Pre-Columbian Cultural Connections between Mesoamerica and Ecuador', *M.A.R.S.*, II, no. 6 (1959).

BUSHNELL, G. H. S. *Archaeology of the Santa Elena Peninsula*. Cambridge, 1951.

CARLI, E. *Pre-Columbian Goldsmiths' Work of Colombia*. London, 1957.

COLLIER, D. 'The Archaeology of Ecuador', *H.S.A.I.*, II (1946).

COLLIER, D. 'Peruvian Stylistic Influences in Ecuador', *M.S.A.A.*, IV (1948).

CORBETT, J. M. 'Some Unusual Ceramics from Esmeraldas', *Am.A.*, XIX (1953–4).

CRUXENT, J. M., and ROUSE, I. *An Archaeological Chronology of Venezuela*. Washington, 1958.

CUBILLOS, J. C. *Tumaco*. Bogotá, 1955.

EVANS, C., and MEGGERS, B. J. 'Valdivia', *Archaeology*, XI (1958).

HARCOURT, R. D'. 'Archéologie de la Province d'Esmeraldas', *J.S.A.*, XXXIV (1942 [1947]).

HERNÁNDEZ DE ALBA, G. *Colombia, Compendio arqueológico*. Bogotá, 1938.

HERNÁNDEZ DE ALBA, G. 'Investigaciones arqueológicas en Tierradentro', *Revista de las Indias*, II (1938).

HERNÁNDEZ DE ALBA, G. 'The Archeology of San Agustín and Tierradentro, Colombia', *H.S.A.I.*, II (1946).

HERNÁNDEZ DE ALBA, G. *El museo del oro*. Bogotá, 1948.

JIJÓN Y CAAMAÑO, J. *Puruha*. Quito, 1927.

KROEBER, A. L. 'The Chibcha', *H.S.A.I.*, II (1946).

MASON, J. ALDEN. 'Archaeology of Santa Marta, Colombia. The Tairona Culture', *F.M.N.H.A.S.*, XX (1931–9).

MEGGERS, B. *Ecuador*. New York, 1966.

MEGGERS, B. 'Mesoamerica and Ecuador', *H.M.A.I.*, IV (1966).

MEGGERS, B., a.o. *Early Formative Period of Coastal Ecuador*. Washington, 1965.

NACHTIGALL, H. 'Tumaco. Ein Fundort der Esmeraldas-Kultur in Kolumbien', *B.A.*, N.F. III (1955).

OSGOOD, C., and HOWARD, G. D. *An Archaeological Survey of Venezuela*. New Haven, 1943.

PÉREZ DE BARRADAS, J. *Arqueología y antropología precolombinas de Tierra Dentro*. Bogotá, 1937.

PÉREZ DE BARRADAS, J. *Arqueología agustiniana*. Bogotá, 1943.

PÉREZ DE BARRADAS, J. *Colombia de norte a sur*. Madrid, 1943.

PÉREZ DE BARRADAS, J. *La orfebrería prehispánica de Colombia. Estilo Calima*. Madrid, 1954.

PREUSS, K. T. *Monumentale vorgeschichtliche Kunst*. Göttingen, 1929.

REICHEL-DOLMATOFF, G. *San Agustín*. London, 1972.

REICHEL-DOLMATOFF, G. *Colombia*. New York, 1965.

REICHEL-DOLMATOFF, G. 'The Feline Motif in Prehistoric San Agustín Sculpture', in E. BENSON (ed.), *Cult of the Feline*. Washington, 1972.

RESTREPO, V. *Los Chibchas antes de la Conquista*. Bogotá, 1895.

ROWE, J. H. 'The Potter's Art of Atacames', *Archaeology*, II (1949).

SAVILLE, M. H. *Antiquities of Manabi*. New York, 1907–10.

VIII. THE CENTRAL ANDES

A. GENERAL

BAESSLER, A. *Ancient Peruvian Art*. 4 vols. Berlin and New York, 1902–3.

BAESSLER, A. *Altperuanische Metallgeräte*. Berlin, 1906.

BENNETT, W. C. 'The Peruvian Co-Tradition', *M.S.A.A.*, IV (1948).

BENNETT, W. C., and BIRD, J. *Andean Culture History*. New York, 1949.

BENNETT, W. C. *Ancient Arts of the Andes*. New York, 1954.

BIRD, J. 'South American Radiocarbon Dates', *M.S.A.A.*, VIII (1951).

CALANCHA, A. DE LA. *Coronica moralizada*. Barcelona, 1658.

CIEZA DE LEÓN, P. *Travels 1532–1550*. London, 1864.

COBO, B. *Historia del Nuevo Mundo* (ed. M. Jiménez de la Espada). Seville, 1893.

COLLIER, D. 'Cultural Chronology and Change', *Fieldiana: Anthropology*, XLIII (1955).

COLLIER, D. *Irrigation Civilization: A Comprehensive Study* (Social Science Monographs, 1). Washington, 1955.

COSSIO DEL POMAR, F. *Arte del Perú precolombino*. Mexico–Buenos Aires, 1949.

GARCILASO DE LA VEGA. *Comentarios reales*. Madrid, 1723.

HERRERA, F. L. 'El mundo vegetal de los antiguos peruanos', *R.M.N.L.*, III (1934), IV (1935).

KOSOK, P. 'The Role of Irrigation in Ancient Peru', *Proceedings of the Eighth American Scientific Congress*, II (1940).

KOSOK, P. 'Transport in Peru', *I.C.A.*, XXX (1952).

KOSOK, P. *Life, Land and Water in Ancient Peru*. New York, 1965.

KROEBER, A. L. *Peruvian Archeology in 1942*.

KUBLER, G. 'Towards Absolute Time: Guano Archaeology', *M.S.A.A.*, IV (1948).

LANNING, E. R. *Peru before the Incas*. Englewood, N.J., 1967.

LARREA, J. *Arte peruano*. Madrid, 1935.

LINNÉ, S. *The Technique of South American Ceramics*. Göteborg, 1925.

MASON, J. A. *The Ancient Civilizations of Peru*. Harmondsworth, 1957.

MEANS, P. A. *Ancient Civilizations of the Andes*. New York, 1931.

MENZEL, D. 'Style and Time in the Middle Horizon', *Ñ.P.*, II (1964).

NORDENSKIÖLD, E. *Origin of the Indian Civilizations of South America*. Göteborg, 1931.

NORDENSKIÖLD, E. 'Fortifications in Ancient Peru and Europe', *Ethnos*, VII (1942).

O'NEALE, L. M., and KROEBER, A. L. 'Textile Periods in Ancient Peru', *U.C.P.A.A.E.*, XXVIII (1930–1).

ROMÁN Y ZAMORA, J. DE. *Republicas del Mundo*. 2nd ed. Salamanca, 1595.

ROWE, J. H. 'Max Uhle, 1856–1944', *U.C.P.A.A.E.*, XLVI (1957).

ROWE, J. 'Urban Settlements', *Ñ.P.*, I (1963).

ROWE, J., and MENZEL, D., in *Peruvian Archaeology*. Palo Alto, 1967.

SAWYER, A. R. *The Nathan Cummings Collection of Ancient Peruvian Art*. Chicago, 1954.

SAWYER, A. *Ancient Peruvian Ceramics*. New York, 1966.

SAWYER, A. *Mastercraftsmen of Ancient Peru*. New York, 1968.

SCHAEDEL, R. P. 'The Lost Cities of Peru', *Scientific American*, CLXXXV (1951), no. 2.

SCHMIDT, M. *Kunst und Kultur von Peru*. Berlin, 1929.

SELER, E. *Peruanische Alterthümer*. Berlin, 1893.

SQUIER, E. G. *Peru*. New York, 1877.

STUMER, L. M. 'Coastal Tiahuanacoid Styles', *A.M.A.*, XXII (1956).

TELLO, J. C. 'Wirakocha', *Inca*, I (1923).

TELLO, J. C. *Antiguo Perú*. Lima, 1929.

TELLO, J. C. 'Arte antiguo peruano', *Inca*, II (1938).

UBBELOHDE-DOERING, H. *Auf den Königsstrassen der Inka*. Berlin, 1941.

VALCÁRCEL, L. *The Latest Archaeological Discoveries in Peru*. Lima, 1948.

WILLEY, G. 'A Functional Analysis of "Horizon Styles" in Peruvian Archaeology', *M.S.A.A.*, IV (1948).

WILLEY, G. *An Introduction to American Archaeology. South America*, II. New York, 1971.

YACOVLEFF, E. 'Las falconidas en el arte y las creencias de los antiguos peruanos', *R.M.N.L.*, I (1932).

B. NORTHERN PERU

ANTZE, G. 'Metallarbeiten aus dem nördlichen Peru', *Mitteilungen aus dem Museum für Völkerkunde in Hamburg*, XV (1930).

BENNETT, W. C. 'The North Highlands of Peru. Excavations in the Callejón de Huaylas and at Chavín de Huántar', *A.M.N.H.A.P.*, XXXIX (1944).

BENNETT, W. C. *The Gallinazo Group, Viru Valley, Peru*. New Haven, 1950.

BENNYHOFF, J. A. 'The Viru Valley Sequence: A Critical Review', *Am.A.*, XVII (1952).

BENSON, E. *Mochica*. London, 1972.

BIRD, J. 'Preceramic Cultures in Chicama and Virú', *M.S.A.A.*, IV (1948).

BIRD, J. B. 'Pre-Ceramic Art from Huaca Prieta', *Ñ.P.*, I (1963).

BUENO MENDOZA, A., and SAMANIEGO, L. 'Sechin', *Amaru*, XI (1970).

CARRIÓN CACHOT, R. 'La luna y su personificación ornitomorfa en el arte Chimu', *I.C.A.*, XXVII (1942).

CARRIÓN CACHOT, R. 'La cultura Chavín', *R.M.N.A.A.*, II (1948).

COLLIER, D. 'Casma Valley', *I.C.A.*, XXXIV (1960) [1962].

DISSELHOFF, H. 'Zur Frage eines Mittelchimu-Stiles', *Zeitschrift für Ethnologie*, LXXI (1939).

DISSELHOFF, H. 'Hand und Kopftrophäen in plastischen Darstellungen der Recuay-Keramik', *B.A.*, N.F. IV (1955).

DONNAN, C. B. 'Moche Ceramic Technology', *Ñ.P.*, III (1965).

HORKHEIMER, H. *Vistas arqueológicas del noroeste del Perú*. Trujillo, 1944.

HOYT, M., and MOSELEY, M. 'The Burr Frieze', *Ñ.P.*, VII–VIII (1969–70).

IZUMI, S. *Dumbarton Oaks Conference on Chavín*, 49–72. Washington, 1971.

IZUMI, S., and TOSHIHIKO, S. *Excavations at Kotosh*. Tokyo, 1963.

KROEBER, A. L. 'The Uhle Pottery Collections from Moche', *U.C.P.A.A.E.*, XXI (1925).

KROEBER, A. L. 'Ancient Pottery from Trujillo', *F.M.N.H.A.M.*, II (1926), no. 1.

KROEBER, A. L. 'A Local Style of Lifelike Sculptured Stone Heads in Ancient Peru', *Festschrift R. Thurnwald*. Berlin, 1950.

KUTSCHER, G. 'Religion und Mythologie der frühen Chimu', *I.C.A.*, XXVII (1948).

KUTSCHER, G. 'Iconographic Studies as an Aid in the Reconstruction of Early Chimu Civilization', *Transactions of the New York Academy of Sciences*, N.S. XXII (1950).

KUTSCHER, G. *Nordperuanische Keramik* (*Monumenta americana*, I). Berlin, 1954.

LANGLOIS, E. 'De ci, de là, à travers le Pérou précolombien', *La Géographie*, LXV (1936).

LARCO HOYLE, R. *Los Mochicas*. Lima, 1938.

LARCO HOYLE, R. *Los Cupisniques*. Lima, 1941.

LARCO HOYLE, R. 'La escritura peruana sobre pallares', *Revista geográfica americana*, XI (1943).

LARCO HOYLE, R. *Cultura Salinar*. Buenos Aires, 1944.

LARCO HOYLE, R. 'La escritura peruana pre-incana', *M.A.* (1944).

LARCO HOYLE, R. *Cronología arqueológica del norte del Perú*. Buenos Aires–Chiclin, 1948.

LARCO HOYLE, R. *Checán*. Geneva, 1965.

LARCO HOYLE, R. *La cerámica de Vicús*. 2 vols. Lima, 1965–7.

LAVALLÉE, D. *Représentations animales dans la céramique Mochica*. Paris, 1970.

LOTHROP, S. K. 'Gold Artifacts of Chavin Style', *Am.A.*, XVI (1950–1).

LUMBRERAS, L. G. 'Towards a Re-evaluation of Chavin', *Conference on Chavin*. Washington, 1971.

LUMBRERAS, L. G., and AMAT OLOZABAL, H. 'Galerías interiores de Chavín', *R.M.N.L.*, XXXIV (1965–6).

McCOWN, T. D. 'Pre-Incaic Huamachuco', *U.C.P.A.A.E.*, XXXIX (1945), no. 4.

MATOS MENDIETA, R. 'Estilo de Vicús', *R.M.N.L.*, XXXIV (1965–6).

MOSELEY, M. E. 'Assessing *mahamaes*', *Am.A.*, XXXIV (1969).

MUELLE, J. C. 'Lo táctil como carácter fundamental en la cerámica muchik', *R.M.N.L.*, II (1933).

MUELLE, J. C. 'Chalchalaca', *R.M.N.L.*, V (1936).

MUELLE, J. C. 'Filogenía de la Estela Raimondi', *R.M.N.L.*, VI (1937).

MUELLE, J. C. 'Del estilo Chavín', *B.A.*, XXVIII (1955).

REICHLEN, H. and P. 'Recherches archéologiques

dans les Andes de Cajamarca', *J.S.A.*, XXXVIII (1949).

ROOSEVELT, C. 'Ancient Civilizations of the Santa Valley and Chavín', *Geographical Review*, XXV (1935).

ROWE, J. H. 'The Kingdom of Chimor', *Acta americana*, VI (1948).

ROWE, J. *Chavin Art*. New York, 1962.

ROWE, J. 'Influence of Chavin Art on Later Styles', *Conference on Chavin*. Washington, 1971.

SCHAEDEL, R. 'Stone Sculpture in the Callejón de Huaylas', *M.S.A.A.*, IV (1948).

SCHAEDEL, R. 'Mochica Murals at Pañamarca', *Archaeology*, IV (1951), no. 3.

SCHAEDEL, R. P. 'Huaca el Dragón', *J.S.A.*, LV (1966).

SCHEELE, H., and PATTERSON, T. C. 'A Preliminary Seriation of the Chimu Pottery Style', *N.P.*, IV (1966).

STRONG, W. D., and EVANS, C., Jr. 'Cultural Stratigraphy in the Viru Valley, Northern Peru, The Formative and Florescent Epochs', *C.S.A.E.*, IV (1952).

TELLO, J. C. *Chavin, Cultura matriz de la civilización andina*. Lima, 1961.

TELLO, J. C. *El strombus en el arte Chavín*. Lima, 1937.

TELLO, J. C. 'La ciudad inkaica de Cajamarca', *Chaski*, I (1941), no. 3.

TELLO, J. C. 'Discovery of the Chavin Culture in Peru', *Am.A.*, IX (1941–2).

TELLO, J. C. *Sobre el descubrimiento de la cultura Chavín*. Lima, 1944.

TELLO, J. C. *Arqueología del valle de Casma*. Lima, 1956.

UBBELOHDE-DOERING, H. 'Ceramic Comparisons of Two North Coast Peruvian Valleys', *I.C.A.*, XXIX (1951).

UBBELOHDE-DOERING, H. 'Untersuchungen zur Baukunst der nordperuanischen Küstentäler', *B.A.*, XXVI (1952).

UHLE, M. 'Die Ruinen von Moche', *J.S.A.*, X (1913).

VARGAS UGARTE, R. 'La fecha de la fundación de Trujillo', *Revista histórica*, X (1936).

VARGAS UGARTE, R. 'Los Mochicas y el Cacicazgo de Lambayeque', *I.C.A.*, XXVII (1942).

WEST, M. 'Community Settlement Patterns at Chan Chan', *Am.A.*, XXXV (1970).

WILLEY, G. 'The Chavín Problem: A Review and Critique', *Southwestern Journal of Anthropology*, VII (1951).

WILLEY, G. 'Prehistoric Settlement Patterns in the Virú Valley', *B.B.A.E.*, CLV (1953).

C. CENTRAL PERU

ENGEL, F. 'El Paraiso', *J.S.A.*, LV (1966).

GAYTON, A. H. 'The Uhle Collections from Nievería', *U.C.P.A.A.E.*, XXI (1924).

HARCOURT, R. D'. 'La céramique de Cajamarquilla-Nievería', *J.S.A.*, XIV (1922).

JIJÓN Y CAAMAÑO, J. *Maranga*. Quito, 1949.

KROEBER, A. L. 'Proto-Lima', *Fieldiana: Anthropology*, XLIV (1955).

LOTHROP, S. K., and MAHLER, J. 'A Chancay-Style Grave at Zapallan, Peru', *P.M.P.*, L (1957).

MUELLE, J. C., and WELLS, J. R. 'Las pinturas del templo de Pachacamac', *R.M.N.L.*, VIII (1939).

PATTERSON, T. C. *Pattern and Process in the Early Intermediate Period Pottery of the Central Coast of Peru*. Berkeley, 1966.

REISS, W., and STÜBEL, A. *The Necropolis of Ancón*. 3 vols. Berlin, 1880–7.

STRONG, W. D., WILLEY, G., and CORBETT, J. M. 'Archeological Studies in Peru, 1941–42', *C.S.A.E.*, I (1943).

STUMER, L. M. 'The Chillón Valley of Peru', *Archaeology*, VII (1954).

STUMER, L. M. 'Population Centers of the Rimac Valley of Peru', *Am.A.*, XX (1954).

STUMER, L. M. 'History of a Dig', *Scientific American*, CXCII (1955).

TABÍO, E. E. *Excavaciones en Playa Grande* (mimeograph). Lima, 1955.

UHLE, M. *Pachacamac*. Philadelphia, 1903.

VILLAR CÓRDOVA, P. E. 'Las ruinas de la provincia de Canta', *Inca*, I (1923).

VILLAR CÓRDOVA, P. E. *Las culturas prehispánicas del departamento de Lima*. Lima, 1935.

WILLEY, G., and CORBETT, J. M. 'Early Ancon and Early Supe Culture', *C.S.A.E.*, III (1954).

D. SOUTHERN PERU AND BOLIVIA

ASTETE CHOCANO, S., in *Revista del Instituto arqueológico del Cuzco*, III (1938).

BANDELIER, A. F. *The Islands of Titicaca and Koati*. New York, 1910.

BAUDIN, L. *L'empire socialiste des Inka*. Paris, 1928.

BENNETT, W. C. 'Excavations at Tiahuanaco', *A.M.N.H.A.P.*, XXXIV (1934).

BENNETT, W. C. 'Cultural Unity and Disunity in the Titicaca Basin', *Am.A.*, XVI (1950).

BENNETT, W. C. *Excavations at Wari*. New Haven, 1953.

BINGHAM, H. *Machu Picchu, A Citadel of the Incas*. New Haven, 1930.

BINGHAM, H. *Lost City of the Incas*. New York, 1948.

BIRD, J., and BELLINGER, L. *Paracas Fabrics and Nazca Needlework*. Washington, 1954.

BIRD, J. 'Samplers', *Essays ... S. K. Lothrop*. Cambridge, 1961.

BRAM, J. *An Analysis of Inca Militarism*. New York, 1941.

CARRIÓN CACHOT, R. 'La indumentaria en la antigua cultura de Paracas', *Wira Kocha*, I (1931).

CARRIÓN CACHOT, R. *Paracas Cultural Elements*. Lima, 1949.

CASANOVA, E. 'Investigaciones arqueológicas en el altiplano boliviano', *Relaciones de la sociedad argentina de antropología*, I (1937).

CRÉQUI-MONTFORT, G. DE. 'Fouilles à Tiahuanaco', *I.C.A.*, XIV (1904), part 2.

FEJOS, P. 'Archaeological Explorations in the Cordillera Vilcabamba, Southeastern Peru', *Yale University Publications in Anthropology*, III (1944).

FESTER, G. A., and CRUELLAS, J. 'Colorantes de Paracas', *R.M.N.L.*, III (1934).

GAYTON, A. H., and KROEBER, A. L. 'The Uhle Pottery Collections from Nazca', *U.C.P.A.A.E.*, XXIV (1927).

GUAMAN POMA DE AYALA, F. *Nueva coronica y buen gobierno*. Paris, 1936.

HAGEN, V. W. VON. *The Realm of the Incas*. New York, 1957.

HARTH-TERRÉ, E. 'Incahuasi. Ruinas incaicas del valle de Lunahuaná', *R.M.N.L.*, II (1933).

IBARRA GROSSO, D. E., MESA, J. DE, and GISBERT, T. 'Reconstrucción de Taypicala (Tiahuanaco)', *C.A.*, XIV (1955).

JESSUP, M. K. 'Inca Masonry at Cuzco', *A.A.*, XXXVI (1934).

KIDDER, A. 'The Position of Pucara in Titicaca Basin Archaeology', *M.S.A.A.*, IV (1948).

KIDDER II, A. 'Some Early Sites in the Northern Lake Titicaca Basin', *P.M.P.*, XXVII (1943).

KING, M. E. 'Paracas Textile Techniques', *I.C.A.*, XXXVIII (1969).

KOSOK, P. 'The Mysterious Markings of Nazca', *Natural History*, LVI (1947).

KOSOK, P., and REICHE, M. 'Ancient Drawings on the Desert of Peru', *Archaeology*, II (1949).

KROEBER, A. L., and STRONG, W. D. 'The Uhle Pottery Collections from Ica', *U.C.P.A.A.E.*, XXI (1924).

KROEBER, A. L. 'Paracas Cavernas and Chavín', *U.C.P.A.A.E.*, XL (1953).

KROEBER, A. L. 'Toward Definition of the Nazca Style', *U.C.P.A.A.E.*, XLIII (1956).

KUBLER, G. *Cuzco, Reconstruction of the Town and Restoration of its Monuments*. Paris, 1952.

KUBLER, G. 'Machu Picchu', *Perspecta*, VI (1960).

LEHMANN-NITSCHE, R., in *Revista del Museo de La Plata*, XXXI (1928).

LOTHROP, S. K. 'Peruvian Pacchas and Keros', *Am.A.*, XXI (1956).

LOTHROP, S. K., and MAHLER, J. 'Late Nazca Burials in Chaviña, Peru', *P.M.P.*, L (1957).

MENZEL, D. 'Problemas en el estudio del horizonte medio de la arqueológia peruana', *Revista del Museo regional de Ica*, IX (1958).

MENZEL, D., a.o. *Paracas Pottery*. Berkeley, 1964.

MUTO, I., and AKASHI, K. *Textiles of Pre-Inca*. Tokyo, 1956.

O'NEALE, L. M. 'Textiles of the Early Nazca Period', *F.M.N.H.A.M.*, II (1937).

O'NEALE, L. M., and WHITAKER, T. W. 'Embroideries of the Early Nazca Period and the Crop Plants Depicted on them', *Southwestern Journal of Anthropology*, III (1947).

PARDO, L., in *Revista Universitaria del Cuzco*, XXII (1933).

PARDO, L. 'Maquetas arquitectónicas en el antiguo Perú', *Revista del Instituto arqueológico del Cuzco*, I (1936).

PONCE SANGINES, C. *Cerámica Tiwanacota. Vasos con decoración prosopomorfa*. Buenos Aires, 1948.

PORRAS, R. *El cronista indio Felipe Guaman Poma de Ayala*. Lima, 1948.

POSNANSKY, A. *Tihuanacu*. New York, 1945.

REICHE, M. *Los dibujos gigantescos en el suelo de las pampas de Nazca y Palpa*. Lima, 1949.

REICHLEN, H. 'Découverte de tombes Tiahuanaco dans la région du Cuzco', *J.S.A.*, XLIII (1954).

ROARK, P. 'From Monumental to Proliferous in Nasca Pottery', *Ñ.P.*, III (1965).

ROWE, J. H. 'An Introduction to the Archaeology of Cuzco', *P.M.P.*, XXVII (1944), no. 2.

ROWE, J. H. 'Absolute Chronology in the Andean Area', *Am.A.*, III (1945).

ROWE, J. H. 'Explorations in Southern Peru', *Am.A.*, XXII (1956).

ROWE, J. H. 'La seriación cronológica de la cerámica de Paracas elaborado por Lawrence E. Dawson', *Revista del Museo regional de Ica*, IX (1958).

ROWE, J. H. 'Two Pucara Statues', *Archaeology*, XI (1958).

Rowe, J. 'The Chronology of Inca Wooden Cups', *Essays ... S. K. Lothrop*. Cambridge, 1961.

Rowe, J. 'What Kind of a Settlement was Inca Cuzco', *Ñ.P.*, v (1967).

Ruben, W. *Tiahuanaco, Atacama und Araukaner.* Leipzig, 1952.

Rydén, S. *Archaeological Researches in the Highlands of Bolivia.* Göteborg, 1947.

Sawyer, A. 'Paracas and Nazca Iconography', *Essays ... S. K. Lothrop*. Cambridge, 1961.

Sawyer, A. 'Tiahuanaco Tapestry Design', *Textile Museum Journal*, i (1963).

Schaedel, M. 'Peruvian Keros', *Magazine of Art*, XLII (1949).

Seler, E. 'Die buntbemalten Gefässe von Nazca', *G.A.*, IV (1923).

Stafford, C. E. *Paracas Embroidery.* New York, 1941.

Strong, W. D. 'Paracas, Nazca, and Tiahuanacoid Cultural Relationships in South Coastal Peru', *M.S.A.A.*, XIII (1957).

Stübel, A., and Uhle, M. *Die Ruinenstätte von Tiahuanaco.* Leipzig, 1892.

Tschopik, M. H. 'Some Notes on the Archaeology of the Department of Puno, Peru', *P.M.P.*, XXVII (1946).

Trebbi del Trevigiano, R. 'Tiahuanaco. Un caso esemplare per la storia dell'arte precolombiana', *Critica d'arte*, XXIII (1957).

Uhle, M. 'Explorations at Chincha', *U.C.P.A.A.E.*, XXI (1924).

Urteaga, H. H. *El fin de un imperio.* Lima, 1933.

Valcárcel, L. 'El gato de agua', *R.M.N.L.*, I (1932).

Valcárcel, L. 'Vasos de madera del Cuzco', *R.M.N.L.*, I (1932).

Valcárcel, L. 'Esculturas de Pikillajta', *R.M.N.L.*, II (1933).

Valcárcel, L. 'Sajsawaman redescubierto', *R.M.N.L.*, III (1934), IV (1935).

Valcárcel, L. 'Litoesculturas y cerámicas de Pukara', *R.M.N.L.*, IV (1935).

Valcárcel, L. 'Cuzco Archaeology', *H.S.A.I.*, II (1946).

Yacovleff, E. 'La deidad primitiva de los Nazca', *R.M.N.L.*, I (1932).

Yacovleff, E., and Muelle, J. C. 'Una exploración en Cerro Colorado', *R.M.N.L.*, I (1932).

Yacovleff, E., and Muelle, J. C. 'Un fardo funerario de Paracas', *R.M.N.L.*, III (1934).

Zuidema, R. T. *The Ceque System of Cuzco.* Leiden, 1964.

THE PLATES

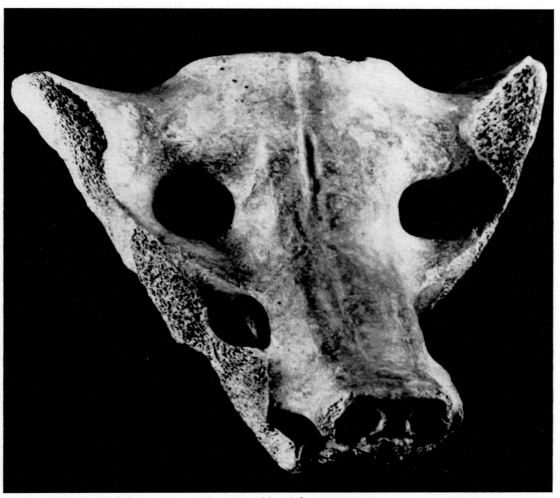

Camelid sacrum carved as animal head from Tequixquiac, *c.* 10,000 B.C.
Mexico City, Museo Nacional de Antropología

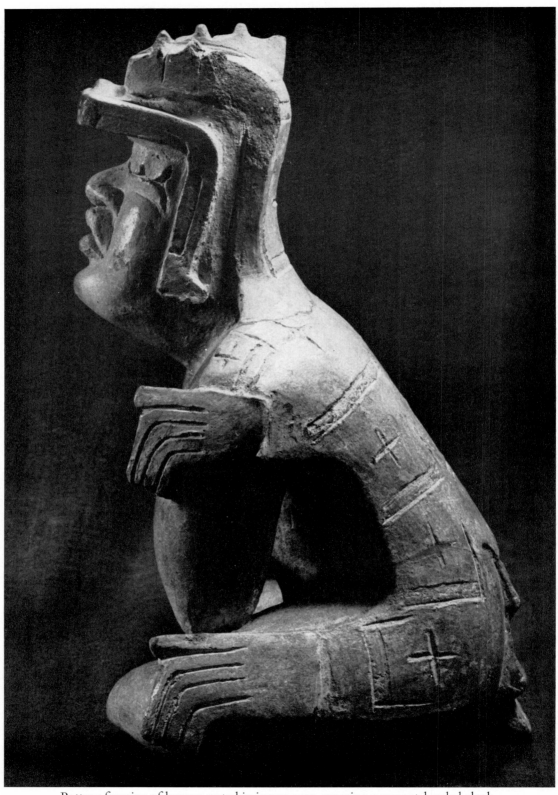

Pottery figurine of human seated in jaguar pose, wearing a serpent-headed cloak, from Atlihuayán (Morelos). *Mexico City, Museo Nacional de Antropología*

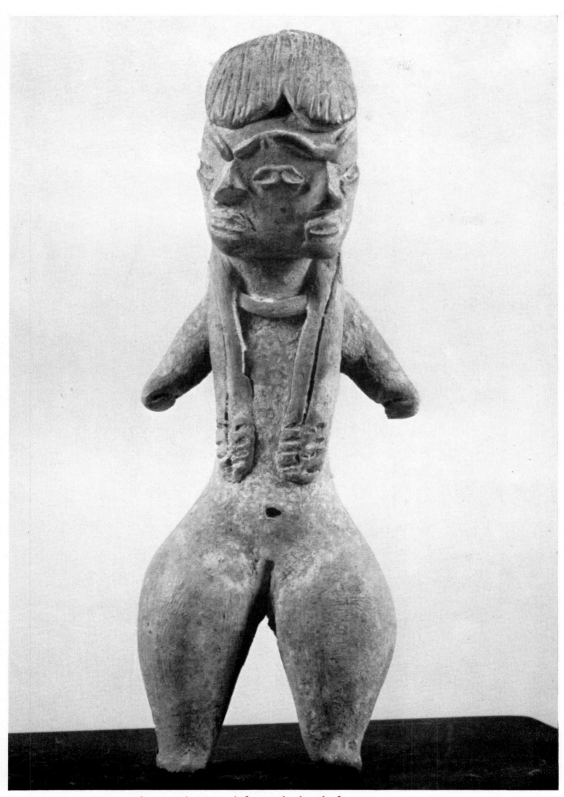

Pottery figurine (type D 1) from Tlatilco, before 500 B.C. *New Haven, Yale University Art Gallery, Olsen Collection*

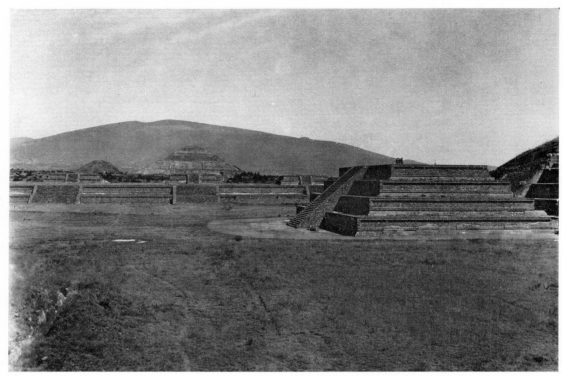

(A) Teotihuacán, Ciudadela court, before 600. From the south

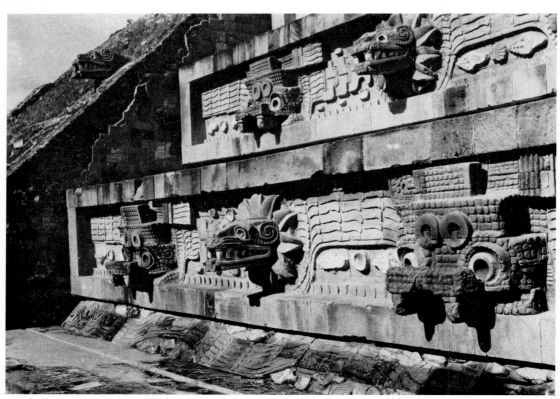

(B) Teotihuacán, Ciudadela, inner face of the central pyramid, before 300

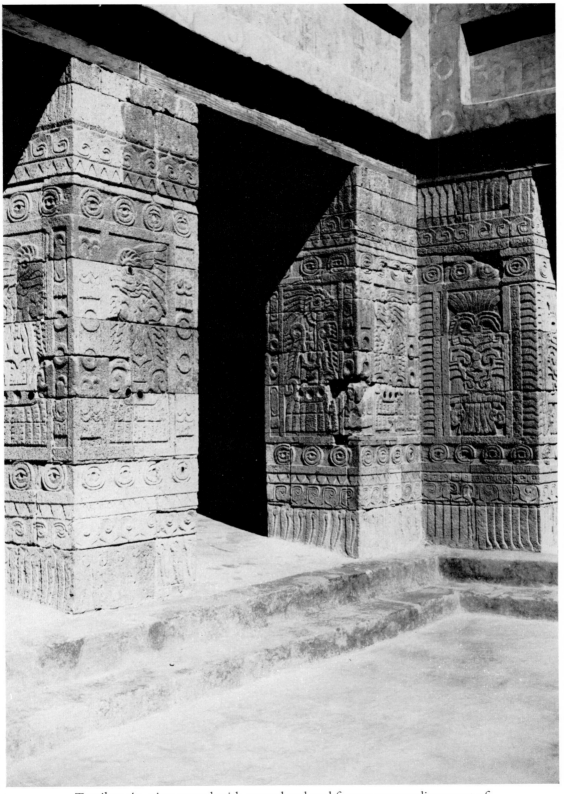

Teotihuacán, piers carved with quetzal and owl figures surrounding court of
Quetzalpapálotl building, before 700

5

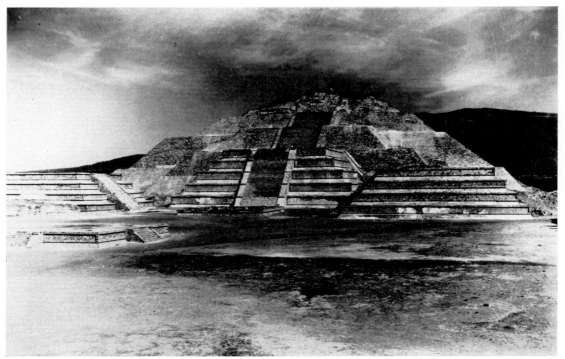

(A) Teotihuacán, northern ('Moon') pyramid and plaza, before 600. From the south

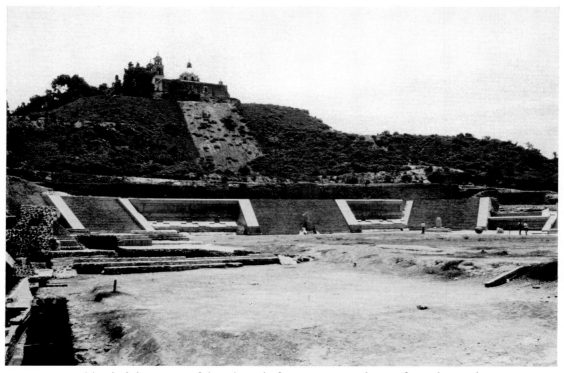

(B) Cholula, Court of the Altars, before 700. General view from the south

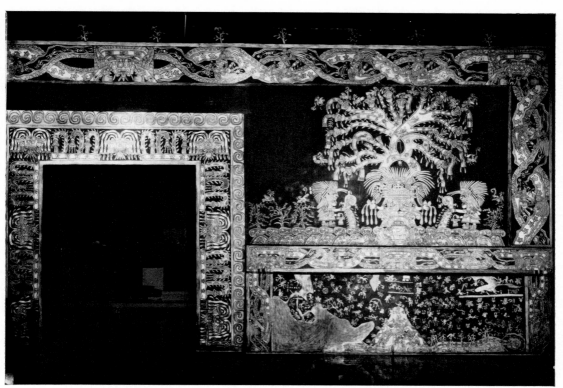

(A) Tepantitla (Teotihuacán), wall painting, Period III, before 550(?), restoration.
Mexico City, Museo Nacional de Antropología

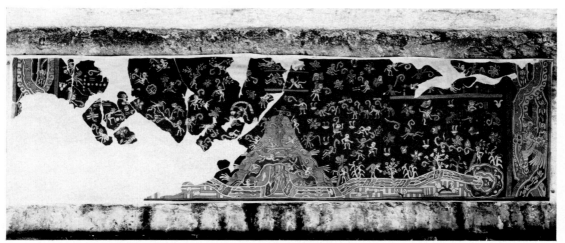

(B) Tepantitla (Teotihuacán), wall painting, Period III, before 550(?),
detail of lower wall

Xochicalco, main pyramid, angle of lower platform, before 900

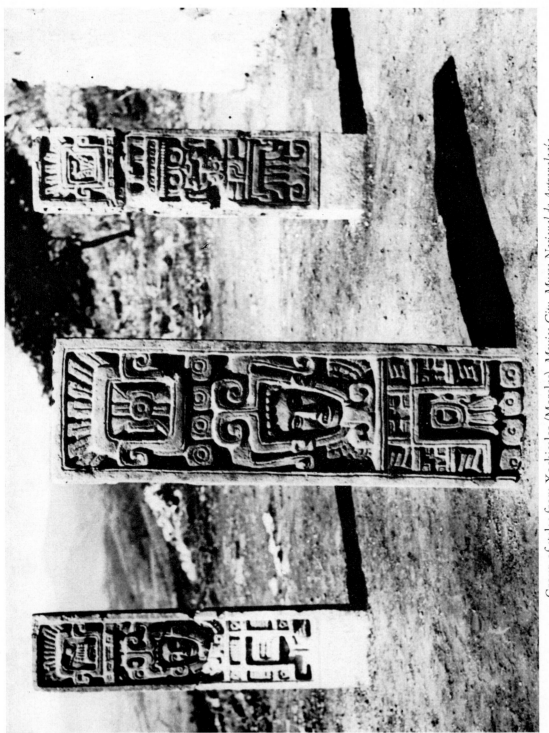

Group of stelae from Xochicalco (Morelos). *Mexico City, Museo Nacional de Antropología*

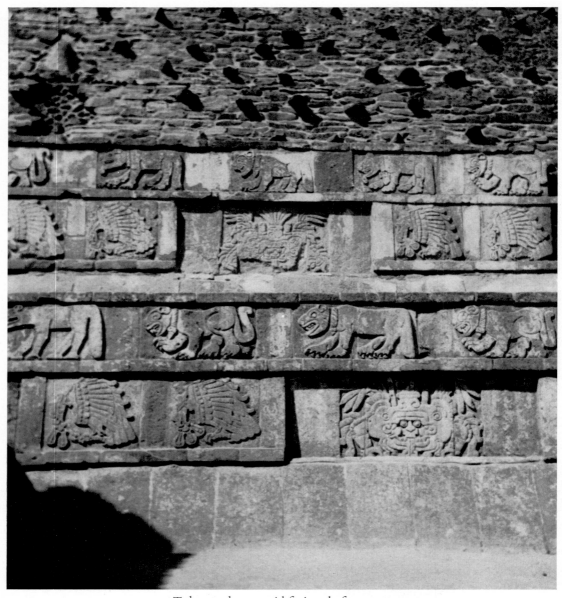

Tula, north pyramid facing, before 1200

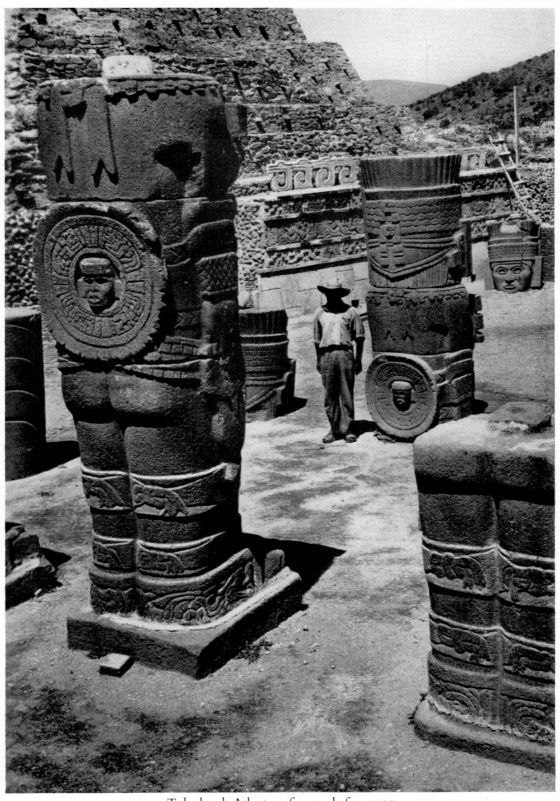

Tula, basalt Atlantean figures, before 1200

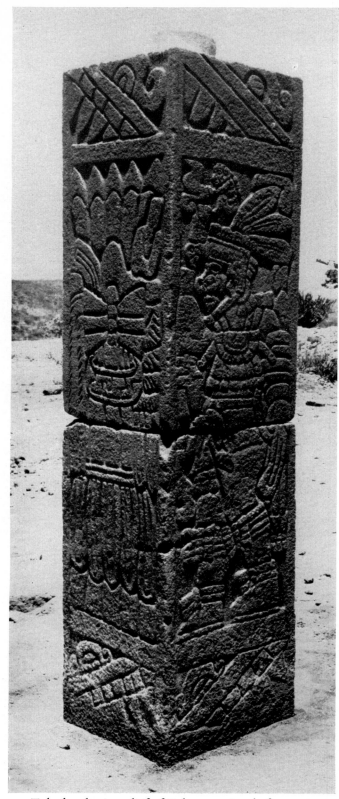

Tula, basalt pier relief of Toltec warrior, before 1200

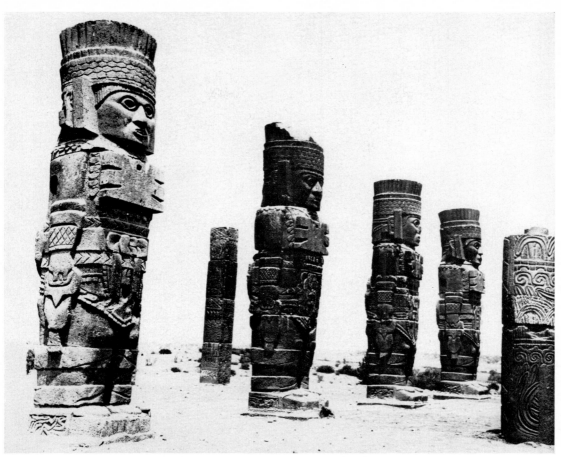

(A) Tula, basalt Atlantean figures, before 1200

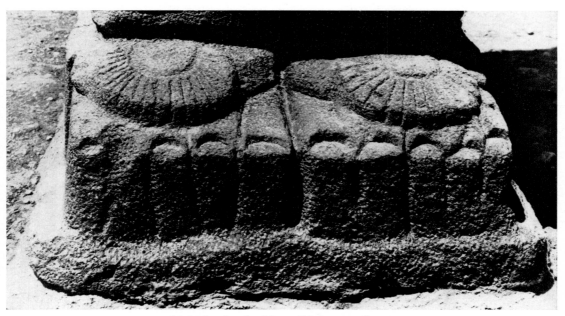

(B) Tula, detail of feet of Atlantean figure

17

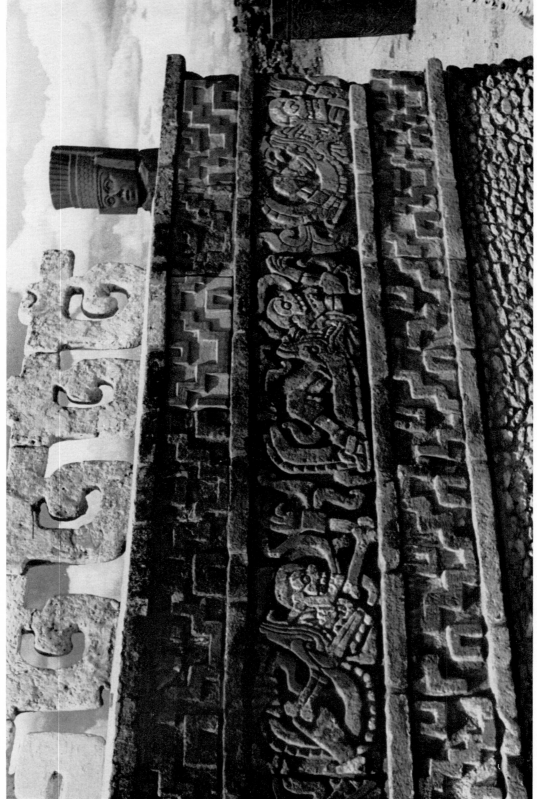

Tula, *coatepantli* (serpent wall), before 1200

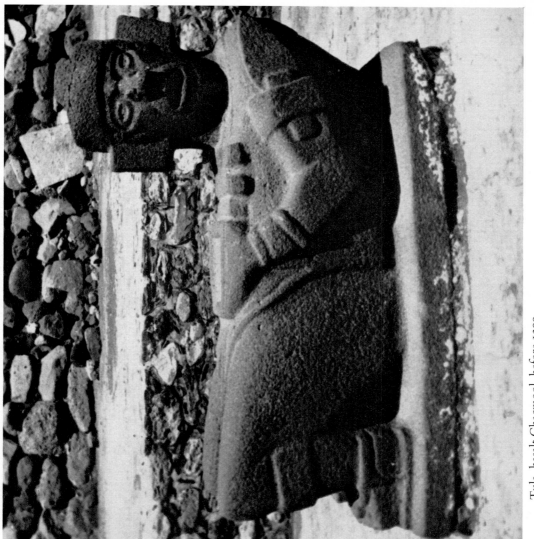

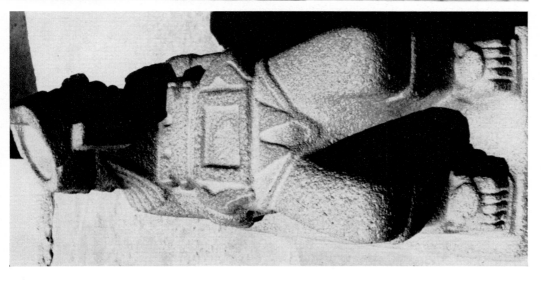

Tula, basalt Chacmool, before 1200

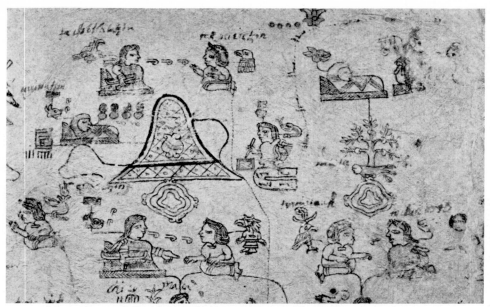

(A) Codex Xolotl: The Tlailotlac. Chichimec chronicle, sixteenth century.
Paris, Bibliothèque Nationale

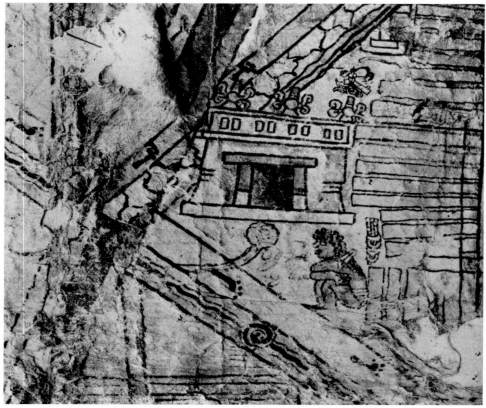

(B) Tenochtitlan, detail from a sixteenth–century plan of a pre-Conquest portion.
Mexico City, Museo Nacional de Antropología

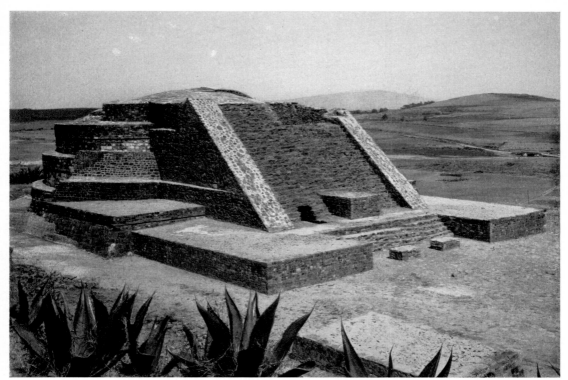

(A) Calixtlahuaca, round pyramid, after 1476

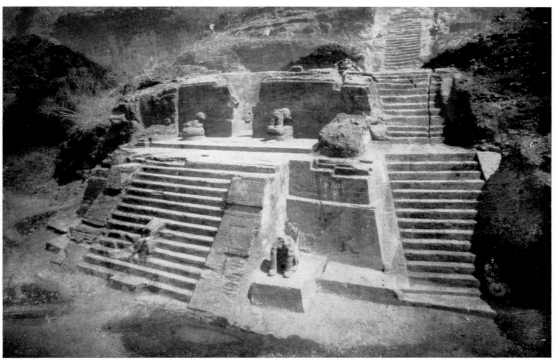

(B) Malinalco, rock-cut temple, after 1476. From the south-west

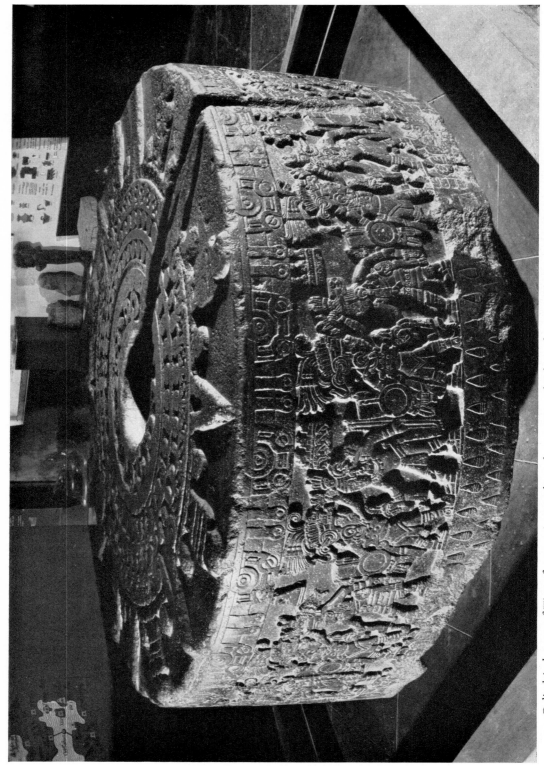

Cylindrical stone of Tizoc from main temple enclosure, Tenochtitlan, after 1486(?). *Mexico City, Museo Nacional de Antropología*

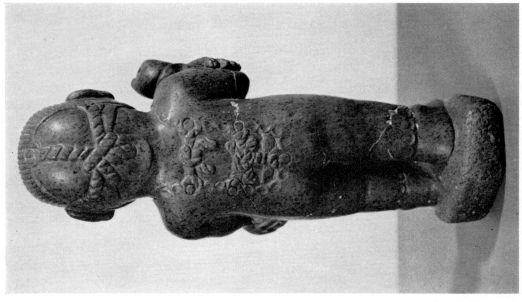

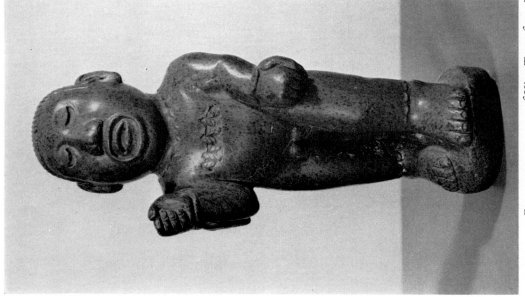

Greenstone statuette of Xipe Totec from Tenango del Valle, Valley of Mexico, c. 1500.
Washington, National Gallery, Bliss Collection

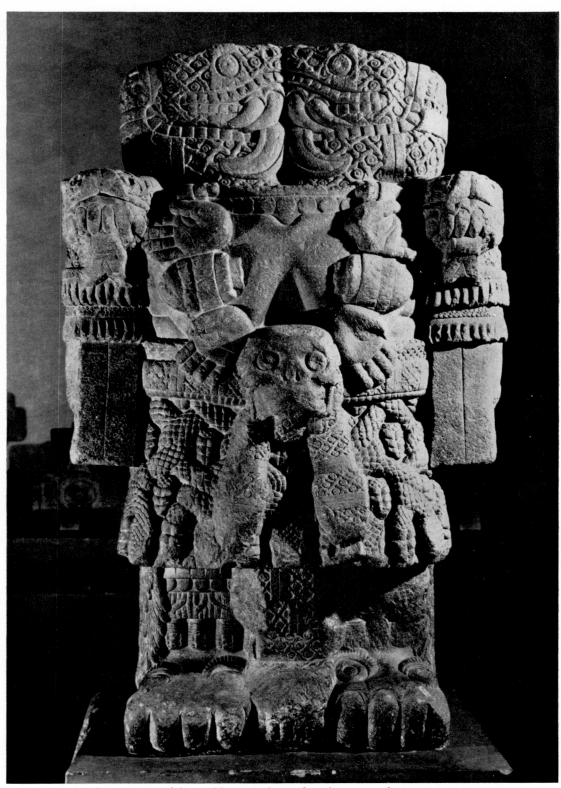

Andesite statue of the goddess Coatlicue, found in main plaza, Mexico City, late fifteenth century. *Mexico City, Museo Nacional de Antropología*

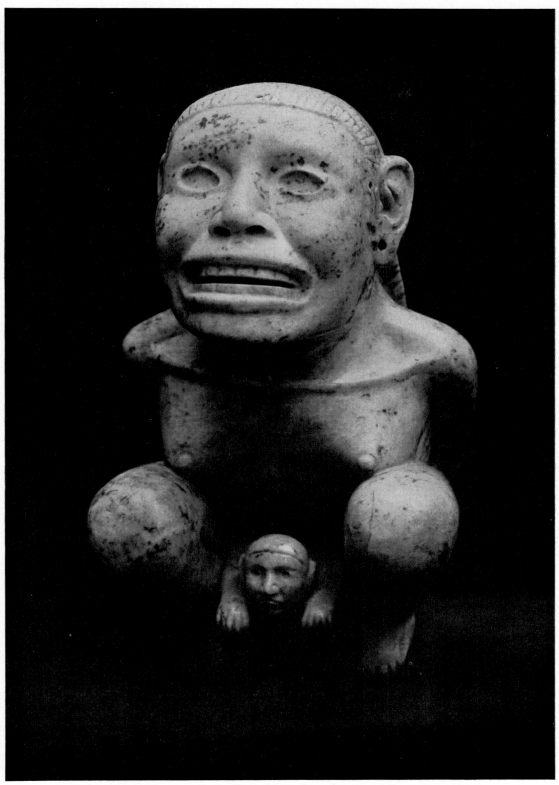

Deity in parturition from the Valley of Mexico (?), *c.* 1500.
Washington, National Gallery, Bliss Collection

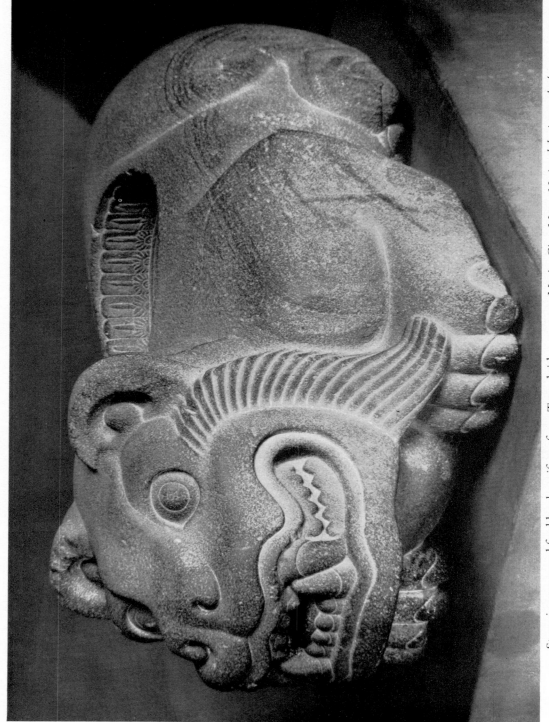

Stone jaguar-vessel for blood sacrifices, from Tenochtitlan, c. 1500. Mexico City, Museo Nacional de Antropología

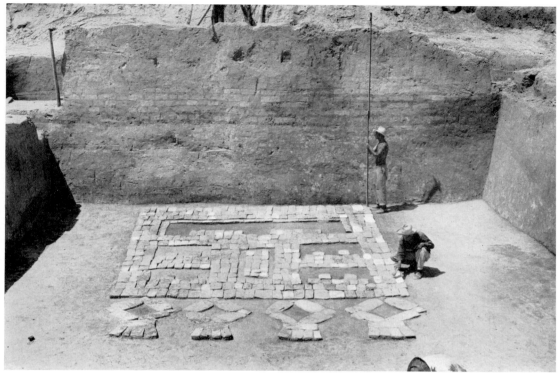

(A) La Venta, mosaic floor beneath east platform at entrance to northern court, before 600 B.C.

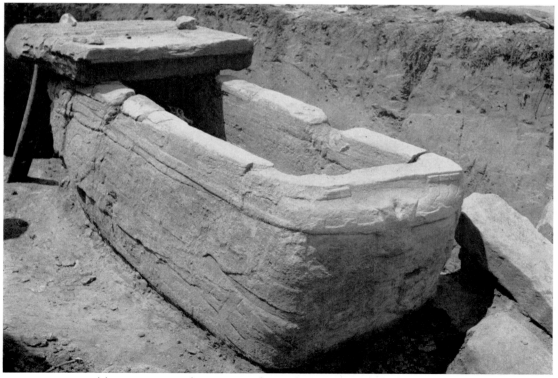

(B) La Venta, sandstone sarcophagus (Monument 6), before 600 B.C.

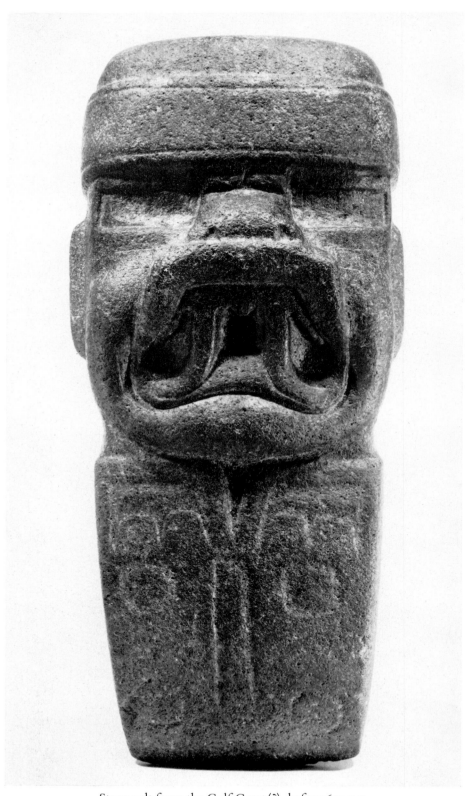

Stone celt from the Gulf Coast (?), before 600 B.C.
Cleveland Museum of Art, Gift of Hanna Fund

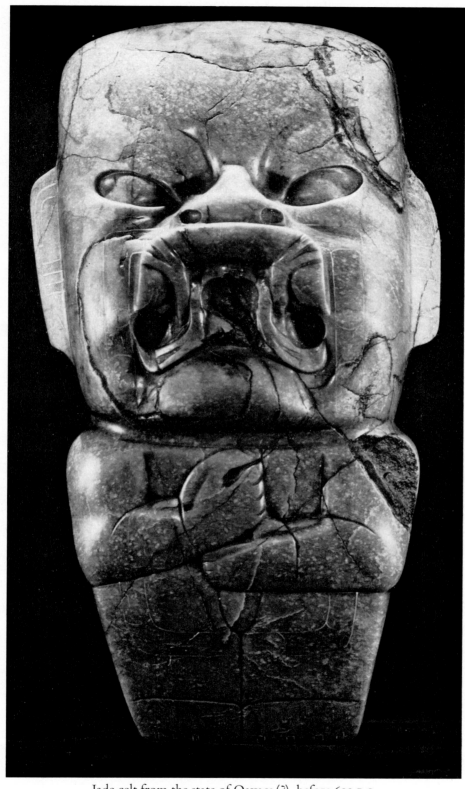

Jade celt from the state of Oaxaca(?), before 600 B.C.
New York, American Museum of Natural History

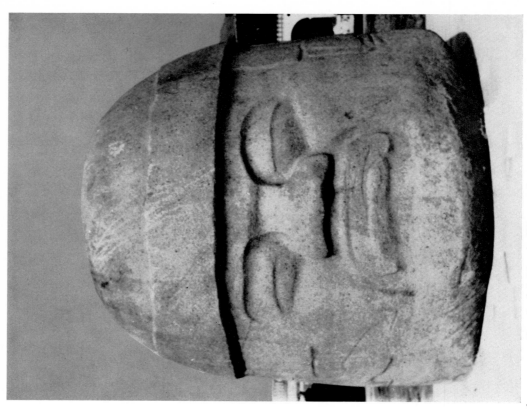

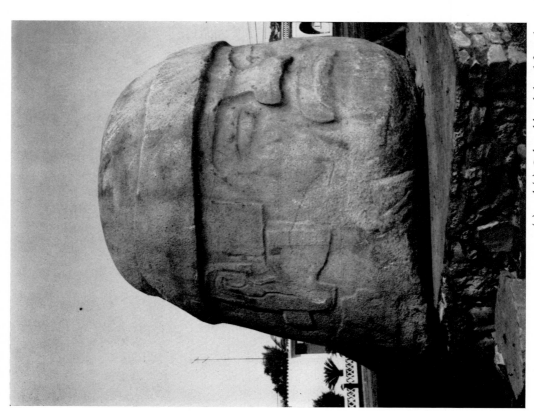

(A) and (B) Colossal basalt head found near Cobata, now at San Andrés Tuxtla (Veracruz)

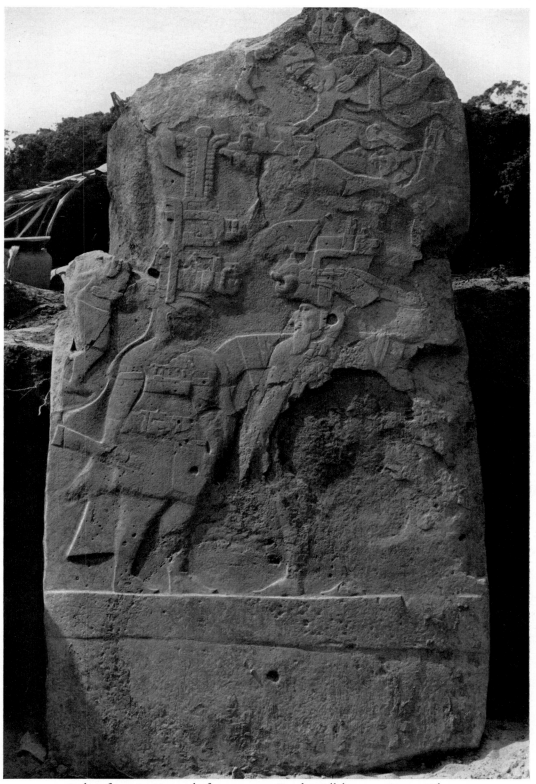

Stela 3 from La Venta, before 400 B.C. Basalt. *Villahermosa, Parque Olmeca*

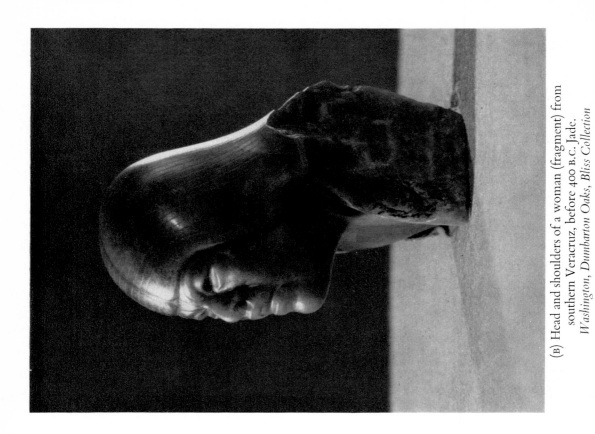

(B) Head and shoulders of a woman (fragment) from southern Veracruz, before 400 B.C. Jade. *Washington, Dumbarton Oaks, Bliss Collection*

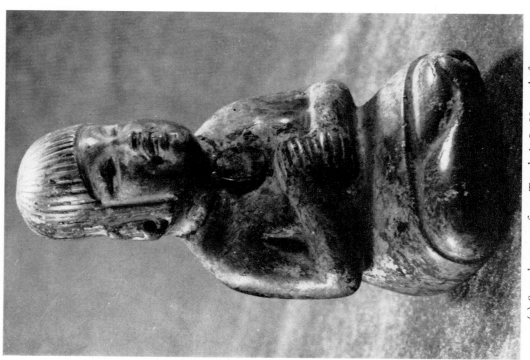

(A) Seated woman from Tomb A, La Venta, before 600 B.C. Jade and ilmenite. *Mexico City, Museo Nacional de Antropología*

(B) Incised jade plaque from southern Veracruz(?), before 400 B.C. *Mexico City, Museo Nacional de Antropología*

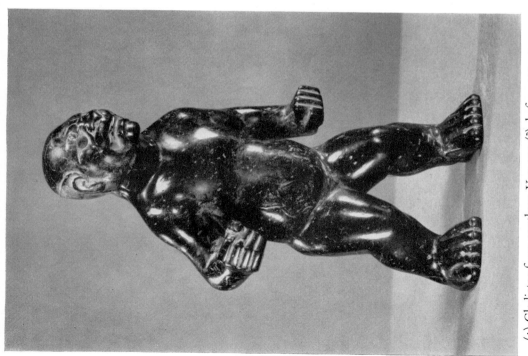

(A) Gladiator from southern Veracruz(?), before 400 B.C. Jade. *Washington, Dumbarton Oaks, Bliss Collection*

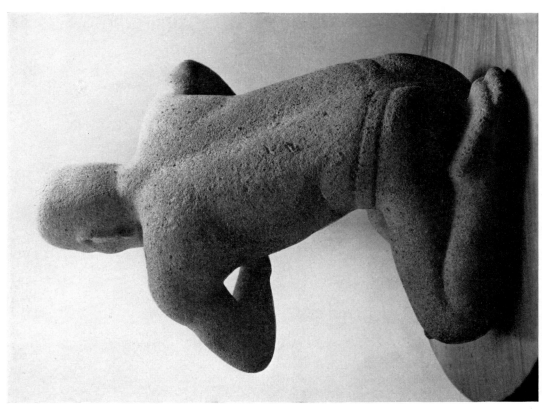

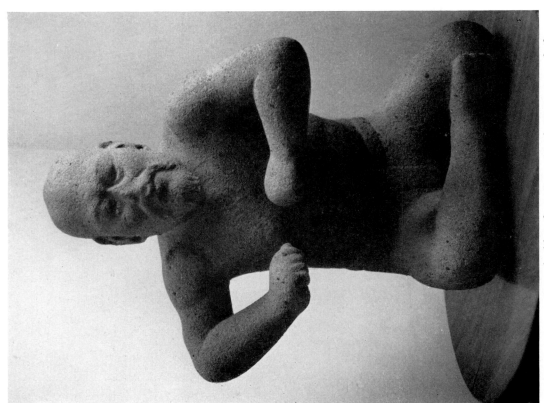

Seated athlete from Santa María Uxpanapan, before 400 B.C. (?) Stone. *Mexico City, Museo Nacional de Antropología*

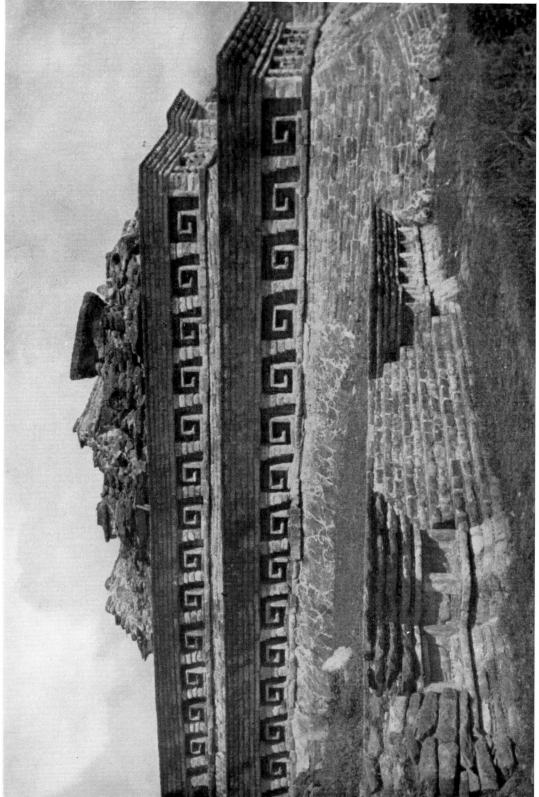

Tajín Chico, columnar building, tenth century (?)

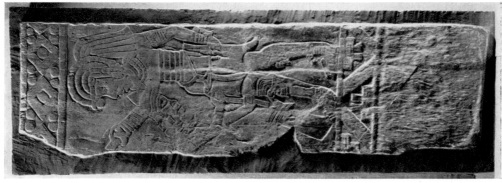

(B) Stone stela from Tepatlaxco showing the dressing of a ball-player, before 300(?) *Mexico City, Museo Nacional de Antropología*

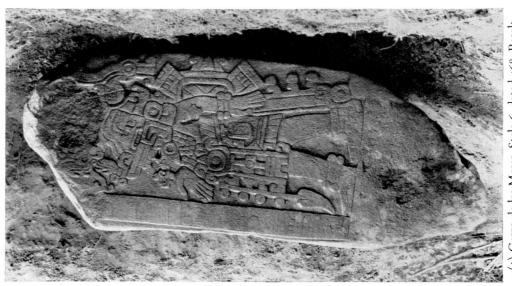

(A) Cerro de las Mesas, Stela 6, dated 468. Basalt

52

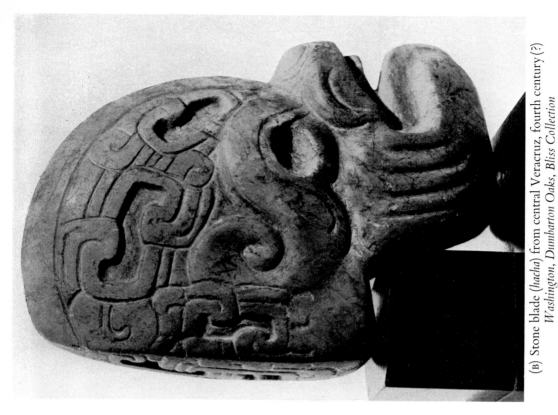

(B) Stone blade (*hacha*) from central Veracruz, fourth century (?)
Washington, Dumbarton Oaks, Bliss Collection

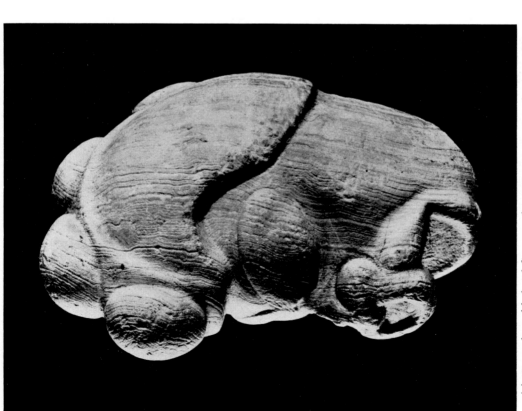

(A) Crested marble head from southern Veracruz, second century (?)
Washington, Dumbarton Oaks, Bliss Collection

(A) Stone yoke from Veracruz, third or fourth century (?)
New York, American Museum of Natural History

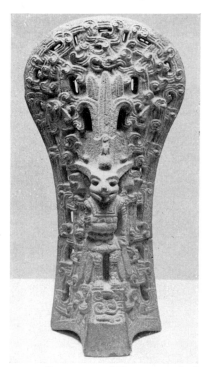

(B) Palmate stone from central Veracruz, ninth century (?)
Cleveland Museum of Art, Tishman Collection

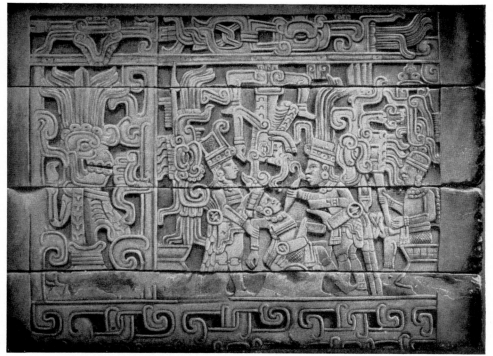

(A) Tajín, south ball-court, north-east panel, sacrifice scene, *c.* 900

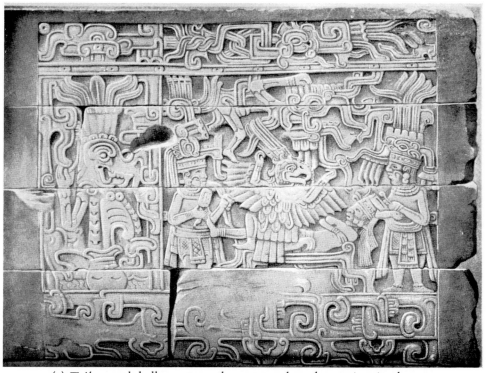

(B) Tajín, south ball-court, south-west panel, eagle warrior ritual, *c.* 900

(B) Pottery figurine head, laughing Nopiloa type, from southern Veracruz, ninth century(?) *New York, American Museum of Natural History*

(A) Seated pottery figure from central Veracruz, Las Animas or Guajitos type, second century(?) *New Haven, Yale University Art Gallery, Olsen Collection*

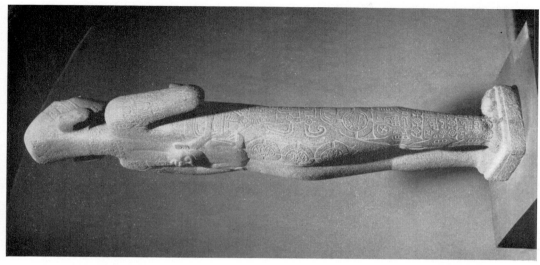

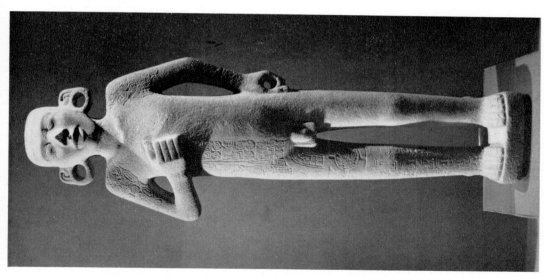

Huastec stone statue from Tamuín, after 1000. Mexico City, Museo Nacional de Antropología

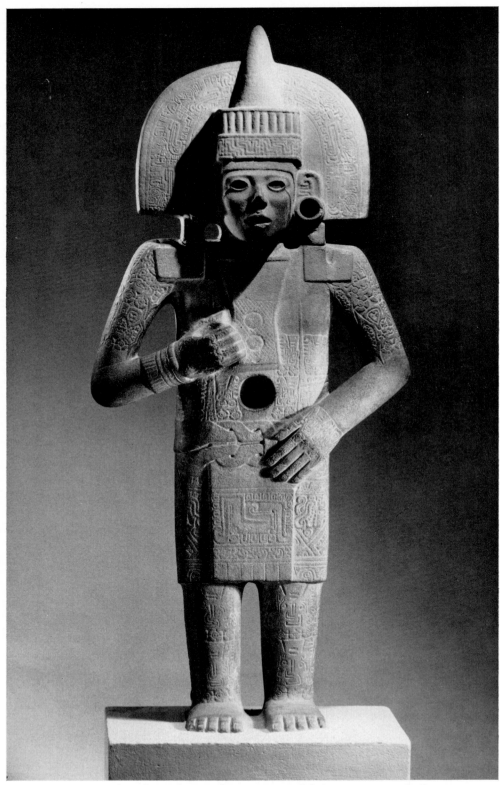

Huastec 'apotheosis' statue from Tancuayalab (San Luis Potosí), front.
Brooklyn Museum

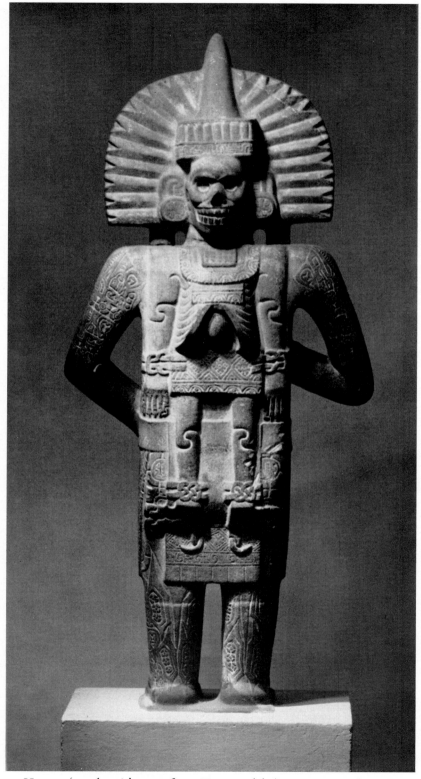

Huastec 'apotheosis' statue from Tancuayalab (San Luis Potosí), rear.
Brooklyn Museum

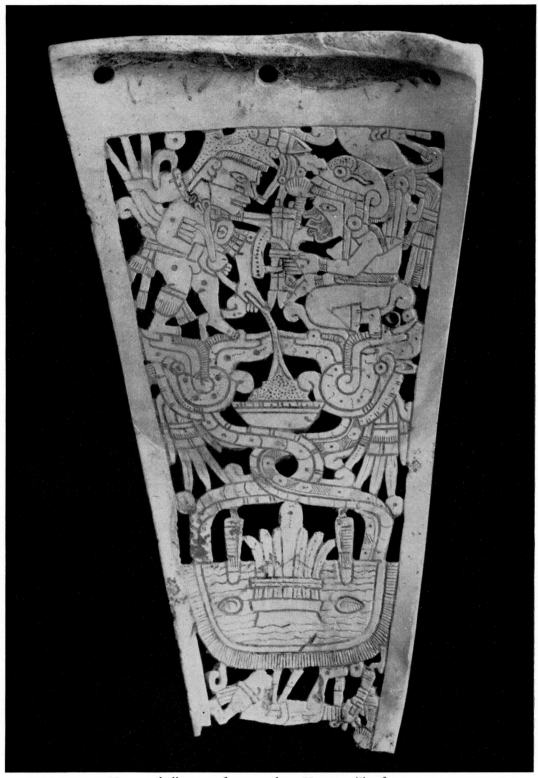

Huastec shell gorget from northern Veracruz(?), after 1000.
New Orleans, Middle American Research Institute

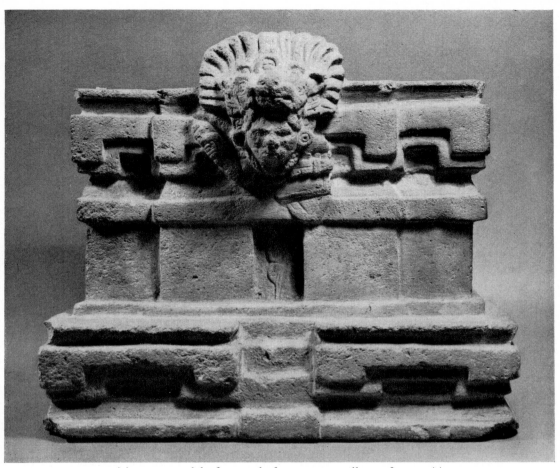

(A) Stone model of a temple from Monte Alban, after 300 (?)
Mexico City, Museo Nacional de Antropología

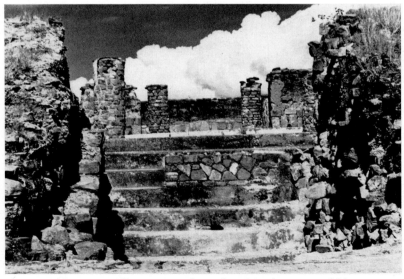

(B) Monte Alban, Mound X, after 300, showing rubble
columns set in entrances

Monte Alban, Group M, after 300

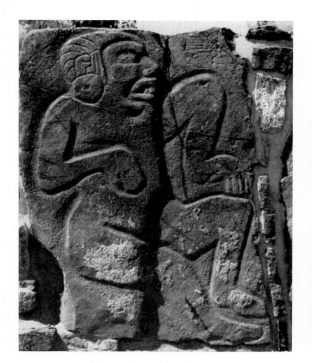
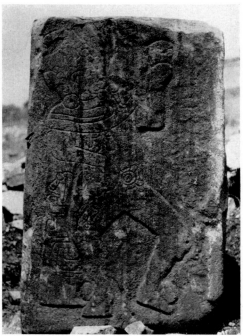
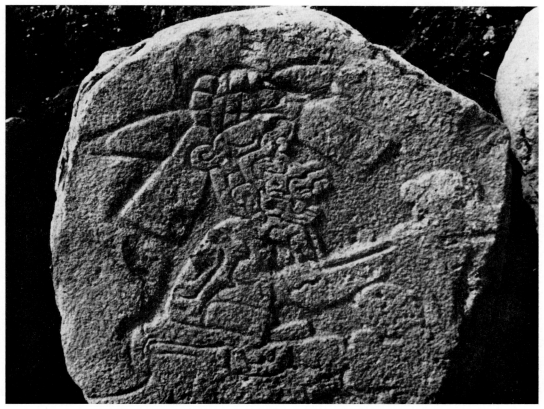

(A) Monte Alban, architectural facing slab on the pyramid base, Mound L, carved in countersunk relief, before 300 B.C. (?); (B) Mound J; (C) Dainzú (Oaxaca), facing-slab relief, c. 300 B.C.

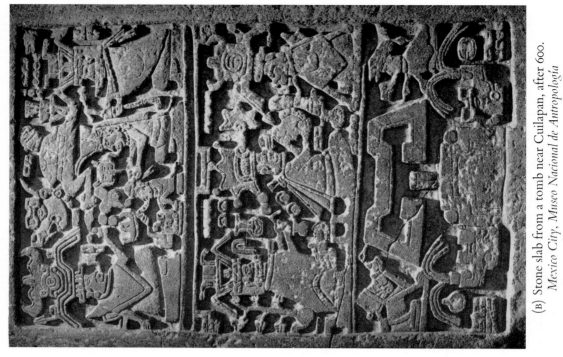

(B) Stone slab from a tomb near Cuilapan, after 600.
Mexico City, Museo Nacional de Antropología

(A) Monte Alban, Stela 4, representing a man named
Eight Deer, after 300. Stone.
Mexico City, Museo Nacional de Antropología

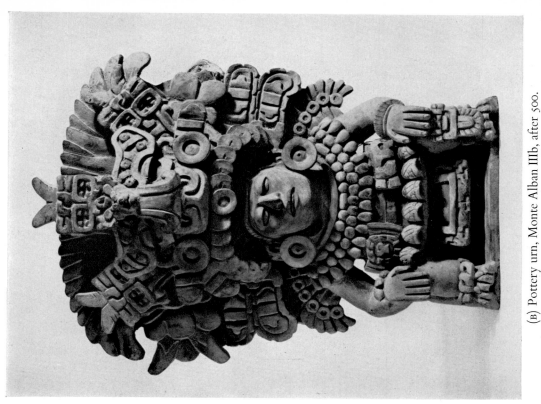

(B) Pottery urn, Monte Alban IIIb, after 500.
Mexico City, van Rhijn Collection

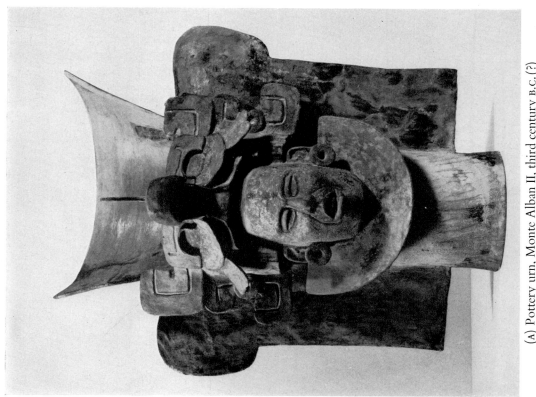

(A) Pottery urn, Monte Alban II, third century B.C. (?)
Mexico City, Museo Nacional de Antropología

65

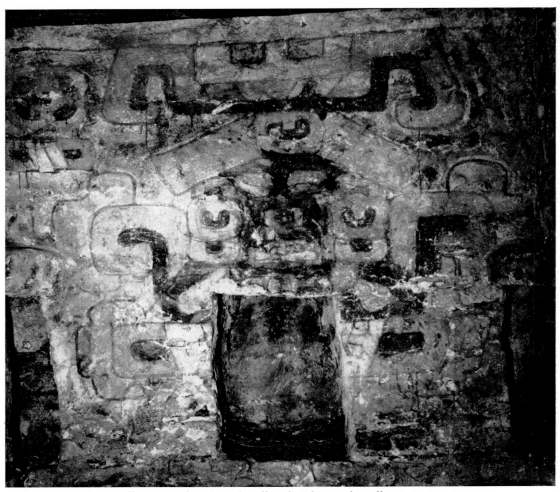

Monte Alban, Tomb 104, end wall and niches with wall painting, *c.* 600,
with perspective drawing

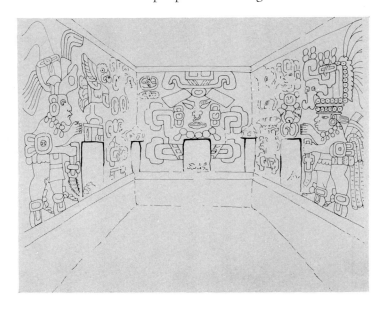

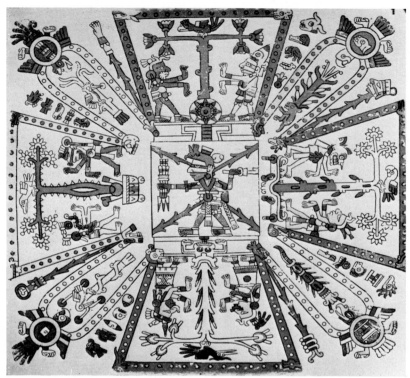

(A) Codex Féjerváry-Mayer, 1: The Five World Regions. Mixtec,
before 1350(?) *Liverpool, Free Public Museum, Mayer Collection*

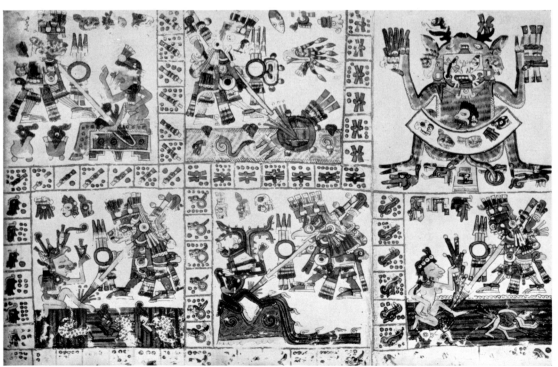

(B) Codex Borgia, 53–4: The Five Venus Periods. Fifteenth century(?)
Rome, Vatican Library

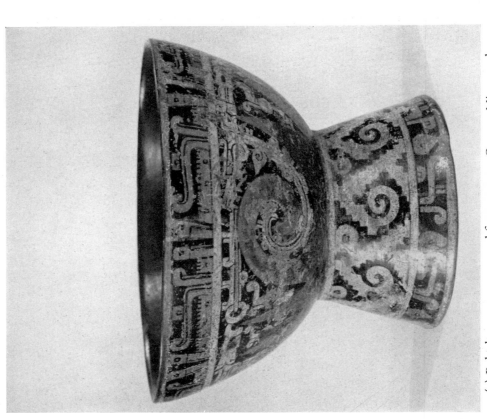

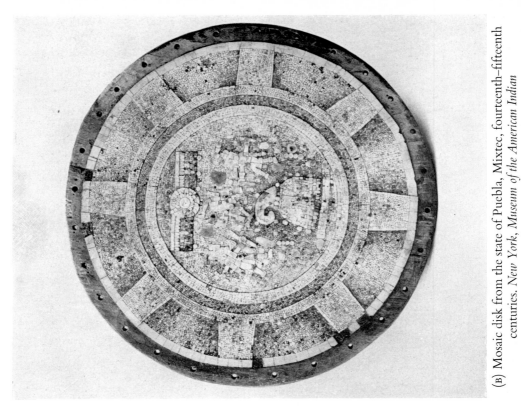

(A) Polychrome pottery vessel from western Oaxaca, Mixtec style, after 1250(?) *Cleveland Museum of Art, Severance Collection*

(B) Mosaic disk from the state of Puebla, Mixtec, fourteenth–fifteenth centuries. *New York, Museum of the American Indian*

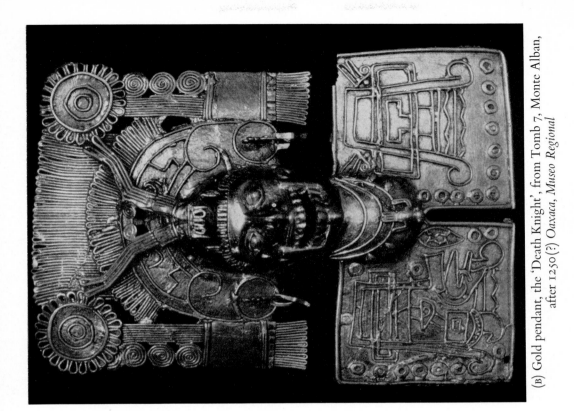

(B) Gold pendant, the 'Death Knight', from Tomb 7, Monte Alban, after 1250(?) *Oaxaca, Museo Regional*

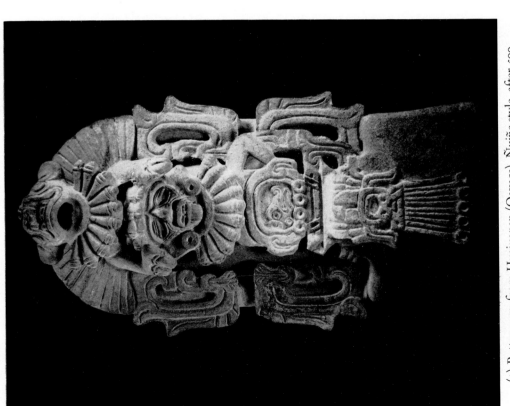

(A) Pottery urn from Huajuapan (Oaxaca), Ñuiñe style, after 500. *Mitla, Museo Frissell*

73

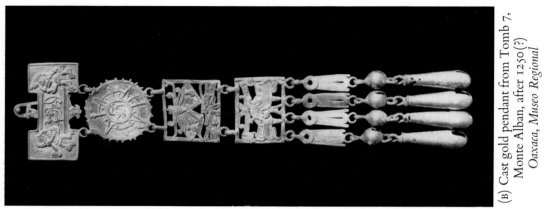

(B) Cast gold pendant from Tomb 7, Monte Alban, after 1250(?)
Oaxaca, Museo Regional

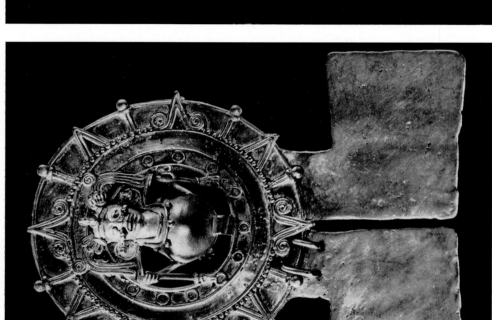

(A) Zaachila, gold pendant, Tomb 1, after 1250

74

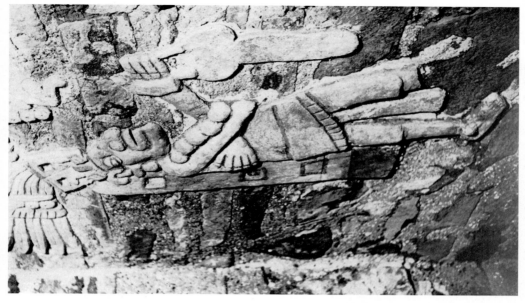

(B) Zaachila, Tomb 1, stucco relief of Lord Five Flower, before 1300(?)

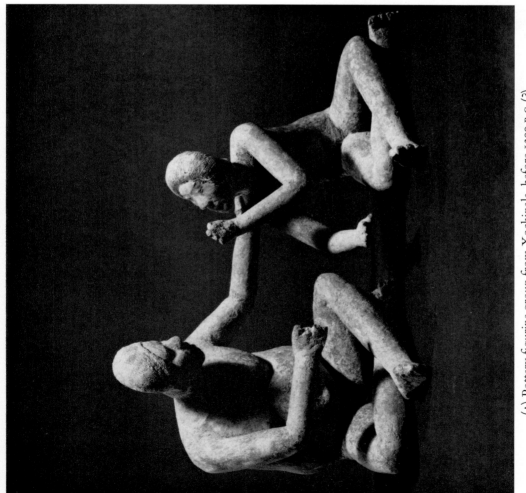

(A) Pottery figurine group from Xochipala, before 1200 B.C. (?)
Princeton University Art Museum

75

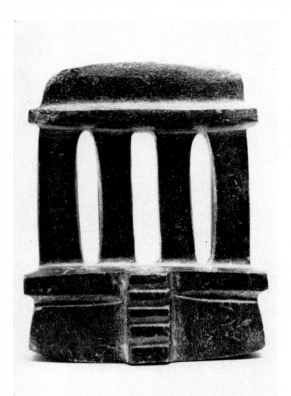

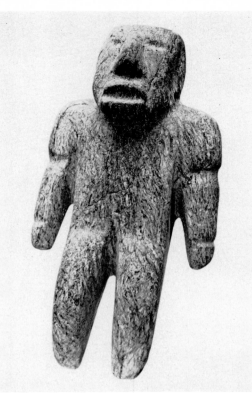

(A) Stone model of a temple from the
Mezcala river region, after 300(?) *Mexico
City, Museo Nacional de Antropología*

(B) Stone axe in human form from the Mezcala
river, before 600 B.C.(?) *New Haven,
Yale University Art Gallery, Olsen Collection*

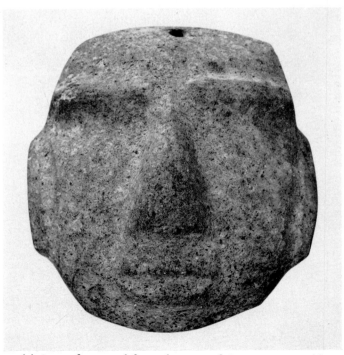

(C) Stone face panel from the state of Guerrero, *c.* 500(?)
New Haven, Yale University Art Gallery, Olsen Collection

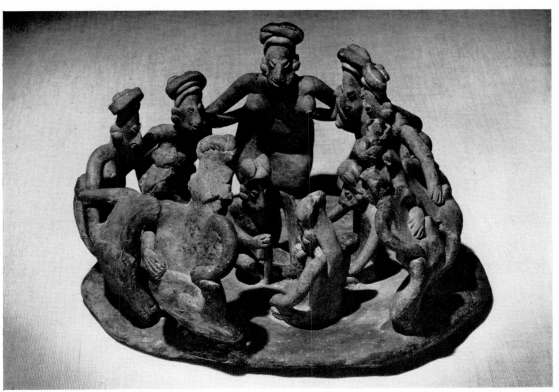

(A) Pottery group of dancers from Colima, first century (?)
Mexico City, Museo Nacional de Antropología

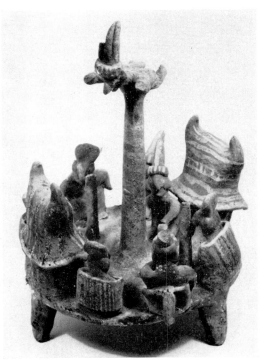

(B) Pottery group showing village pole
ritual from southern Nayarit. *New Haven,
Yale University Art Gallery, Olsen Collection*

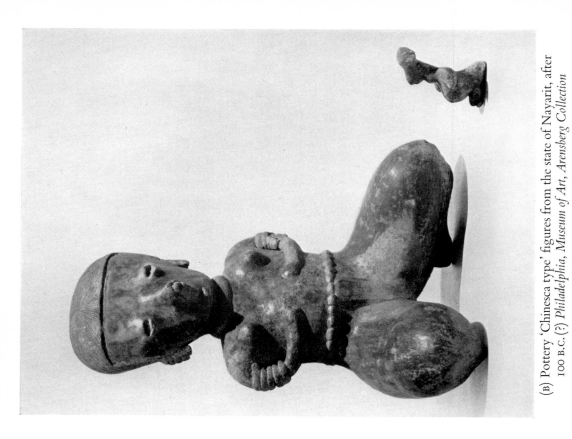

(B) Pottery 'Chinesca type' figures from the state of Nayarit, after 100 B.C. (?) *Philadelphia, Museum of Art, Arensberg Collection*

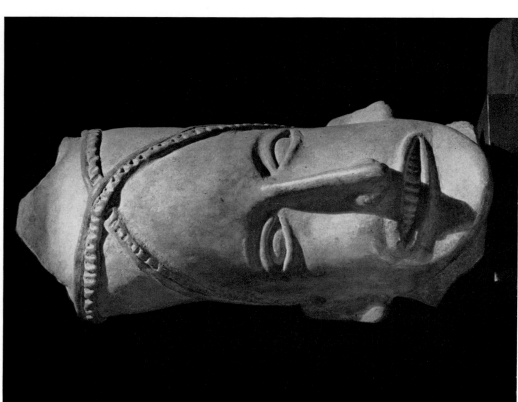

(A) Long-headed pottery figure from the Ameca Valley, second century(?) *Philadelphia, Museum of Art, Arensberg Collection*

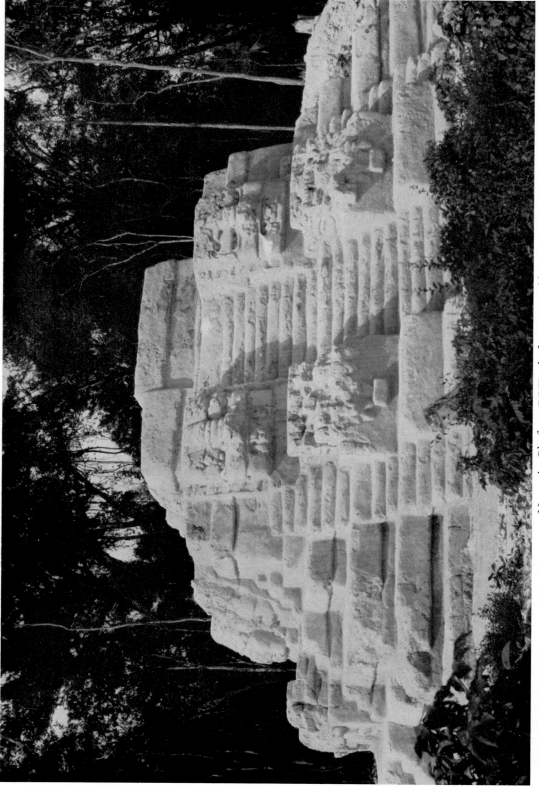

Uaxactún, Platform E VII sub, first century (?)

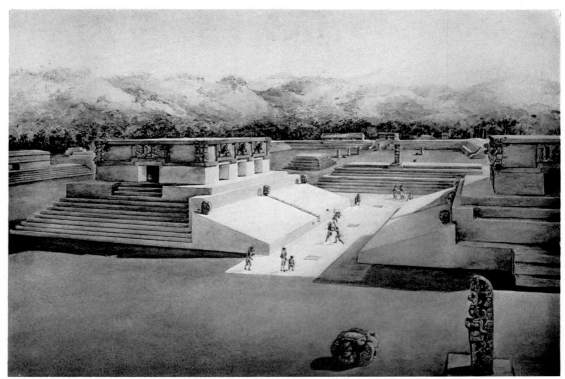

(A) Copán, main ball-court, as in *c.* 800

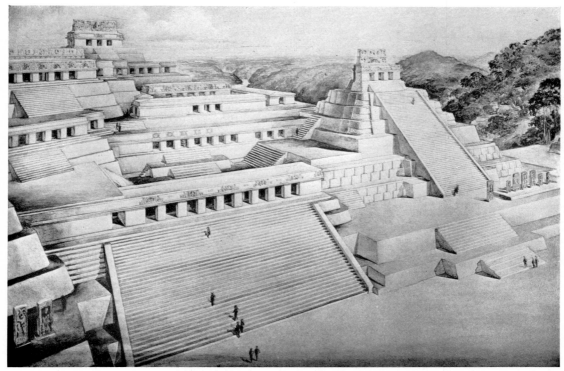

(B) Piedras Negras, acropolis, as in *c.* 900

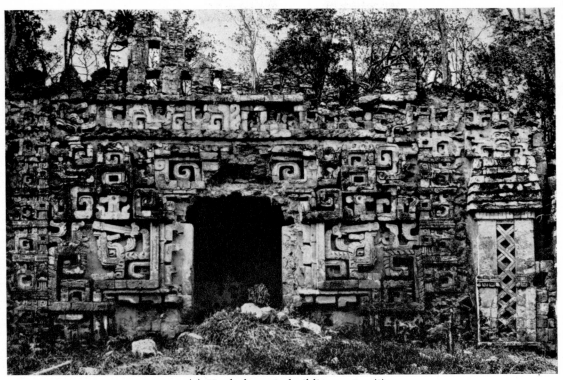

(A) Hochob, main building, c. 800 (?)

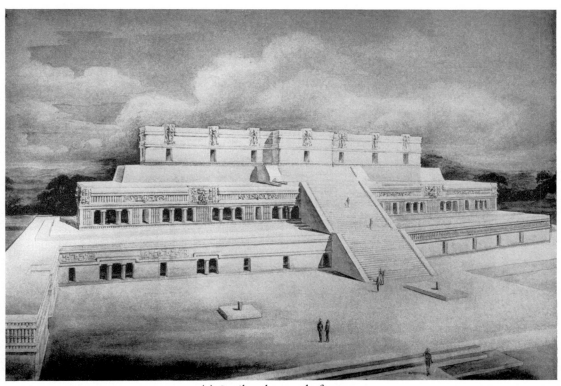

(B) Sayil, palace, as before 1000

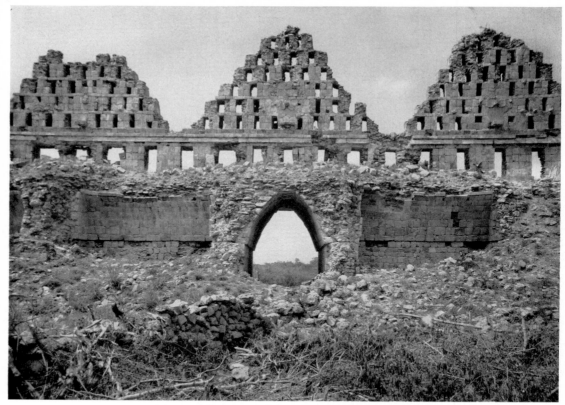

(A) Uxmal, House of the Pigeons, before 900(?)

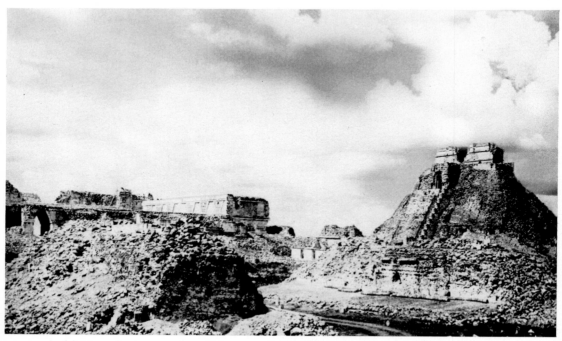

(B) Uxmal, view *c.* 1933 of Nunnery (*left*) and Magician (*right*) before restoration

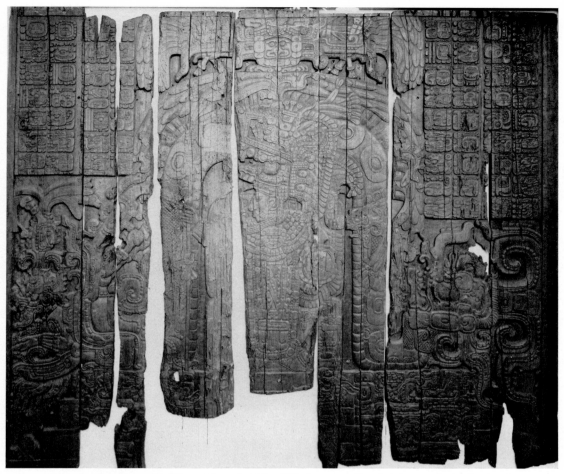

Wooden lintel 3, relief from Temple IV at Tikal, *c.* 750. *Basel, Museum für Völkerkunde*

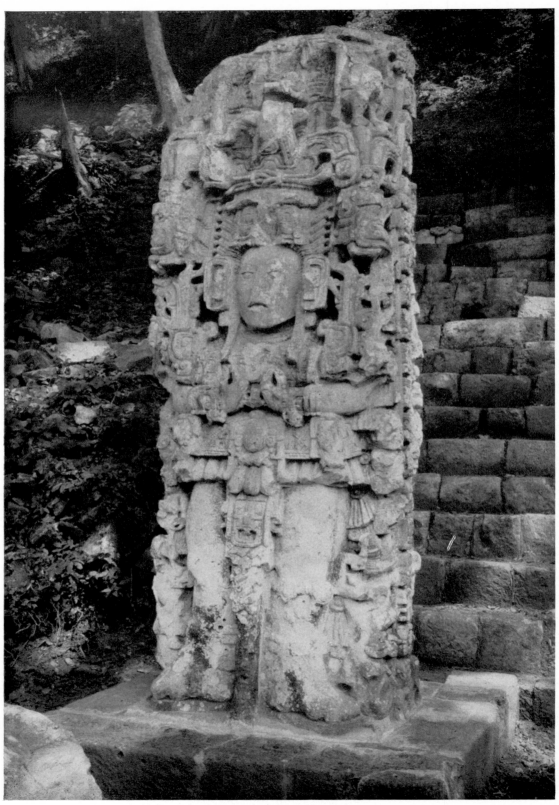

Copán, Stela N, *c.* 760. Trachyte

88

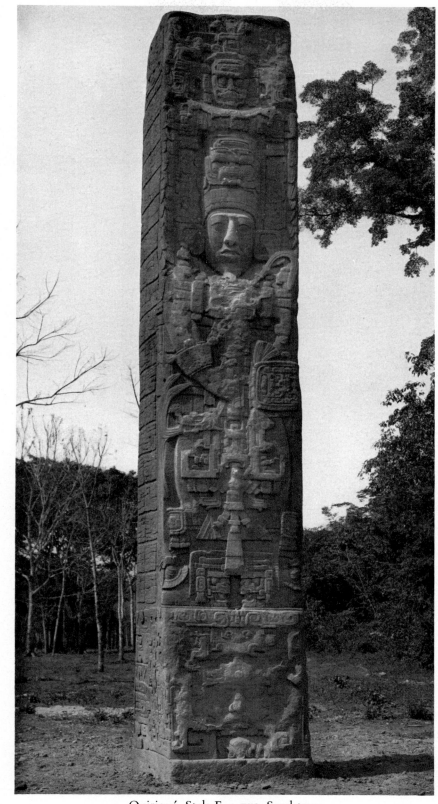

Quiriguá, Stela E, *c.* 770. Sandstone

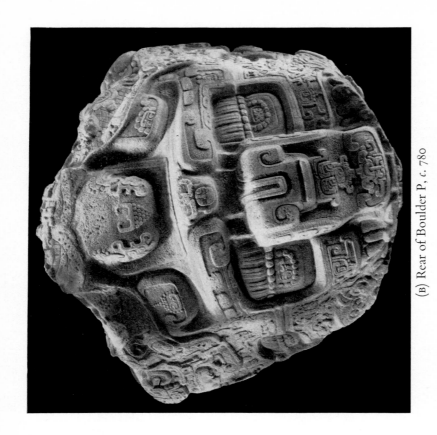

(B) Rear of Boulder P, *c.* 780

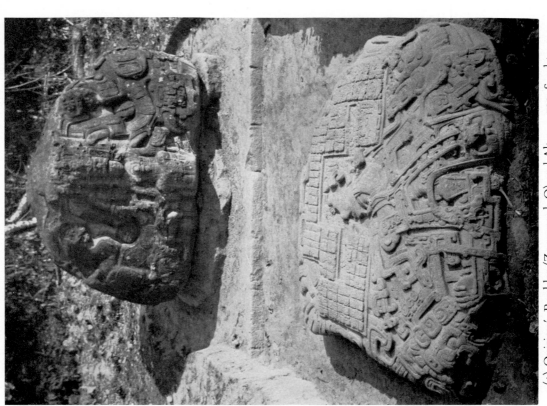

(A) Quiriguá, Boulder (Zoomorph O) and Altar, *c.* 790. Sandstone

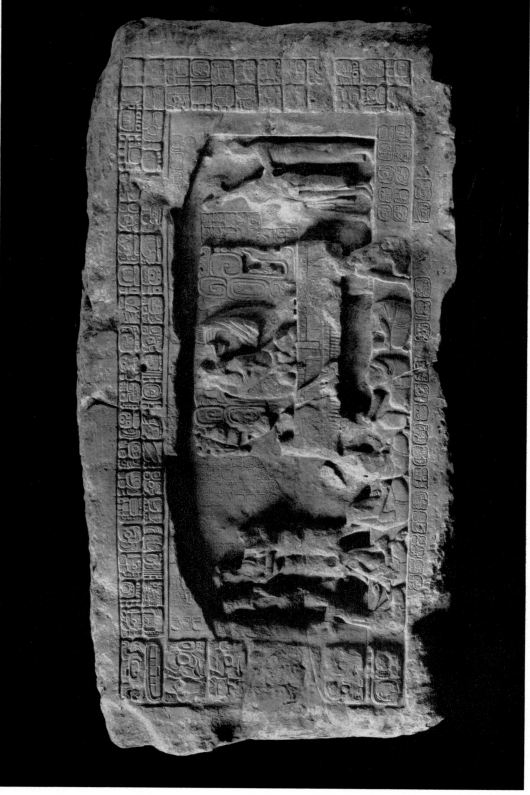

Wall panel ('Lintel' 3) from Piedras Negras, after 782. Limestone. *Guatemala, Museo Nacional*

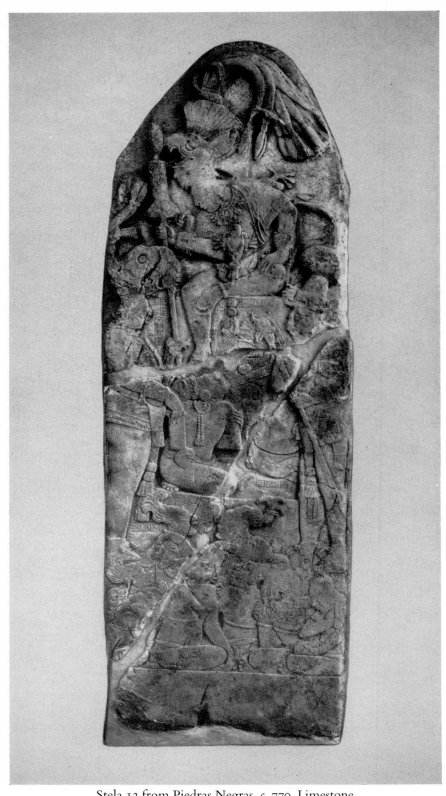

Stela 12 from Piedras Negras, *c.* 770. Limestone.
Guatemala, Museo Nacional

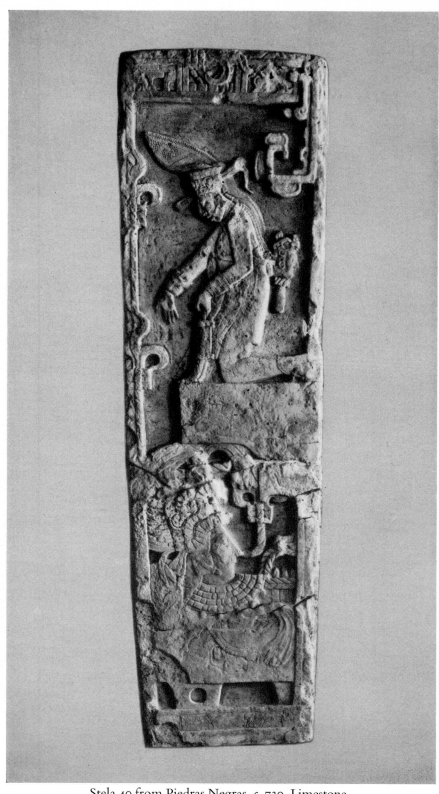

Stela 40 from Piedras Negras, *c.* 730. Limestone.
Guatemala, Museo Nacional

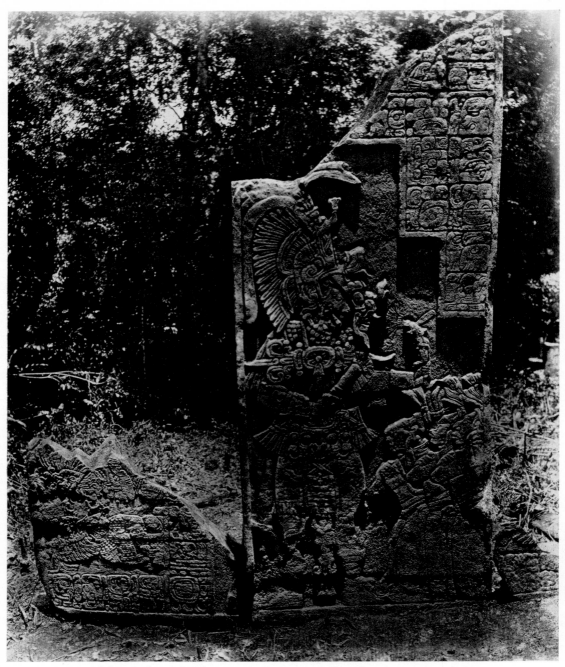

Yaxchilán, Stela 11, Bird-Jaguar and contemporaries, c. 770. Limestone. Rear

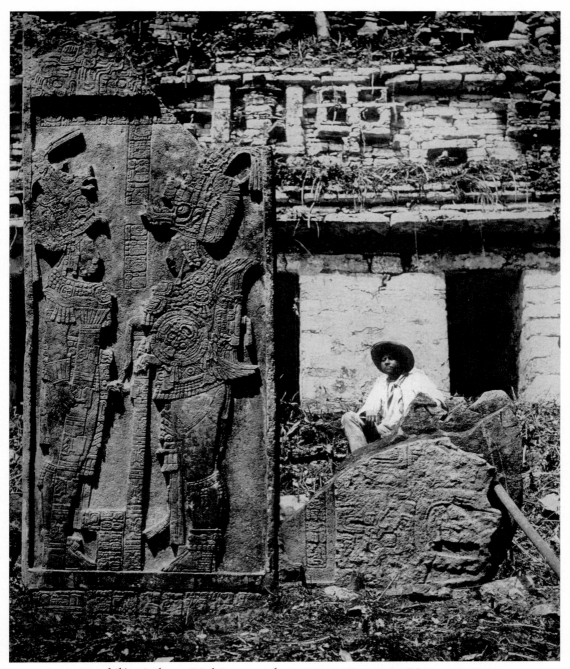

Yaxchilán, Stela 11, Bird-Jaguar and contemporaries, *c.* 770. Limestone. Front

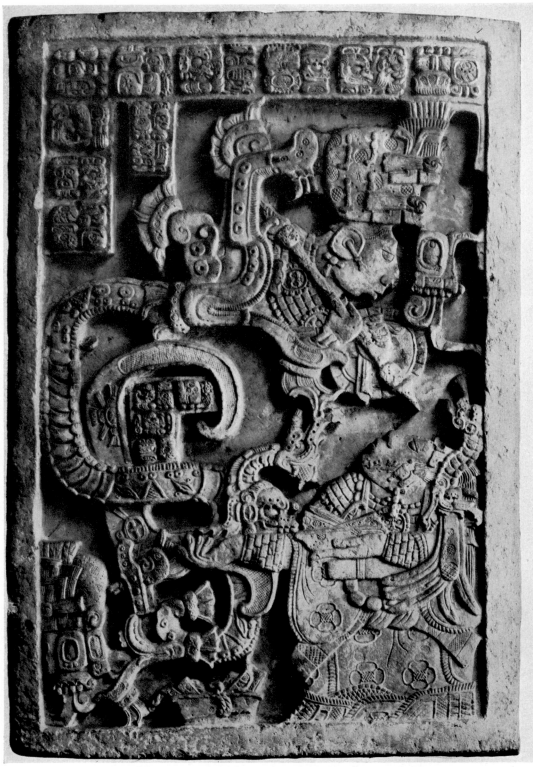

Lintel 25 from Yaxchilán, *c.* 780. Limestone. *London, British Museum*

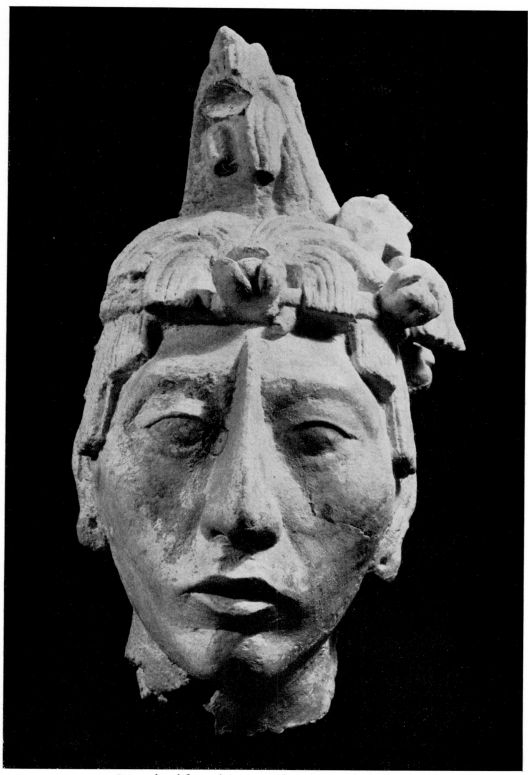

Stucco head from the Ruz tomb, Palenque, before 700.
Mexico City, Museo Nacional de Antropología

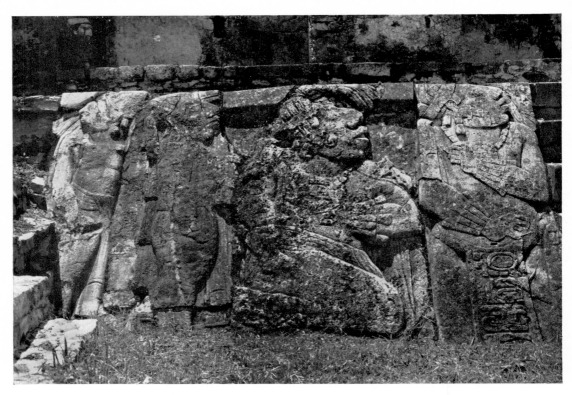

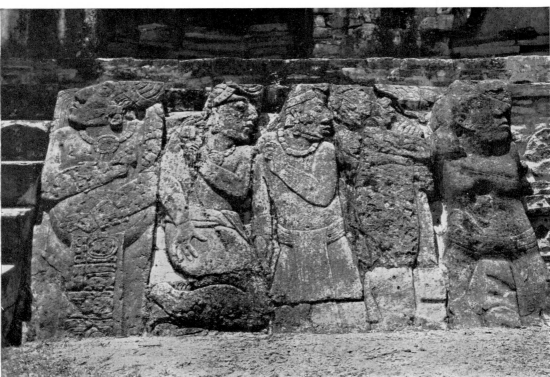

Palenque, House C, stone reliefs, after 780

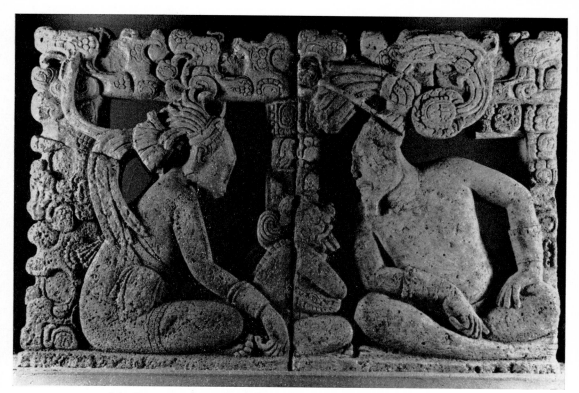

(A) Limestone throne back from the Usumacinta region, before 800.
Mexico City, Josué Sáenz Collection

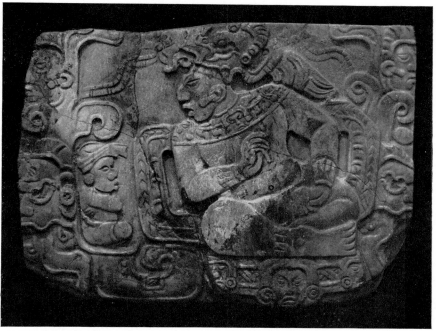

(B) Jade plaque from Nebaj, *c.* 600(?) *Guatemala, Museo Nacional*

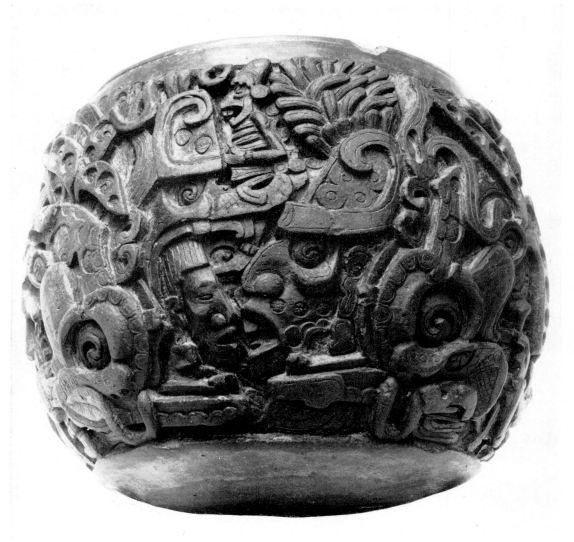

Carved pottery vase from San Agustín Acasaguastlán, *c.* 900 (?)
New York, Museum of the American Indian

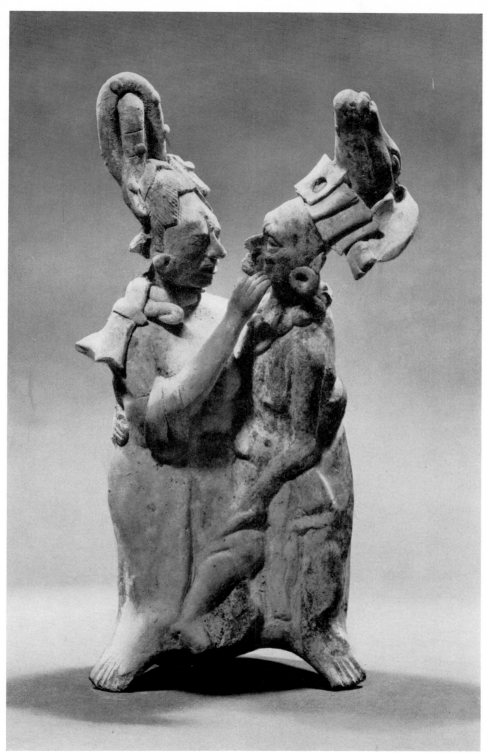

Painted pottery whistle figurine from Jaina Island, before 700 (?)
Washington, Dumbarton Oaks, Bliss Collection

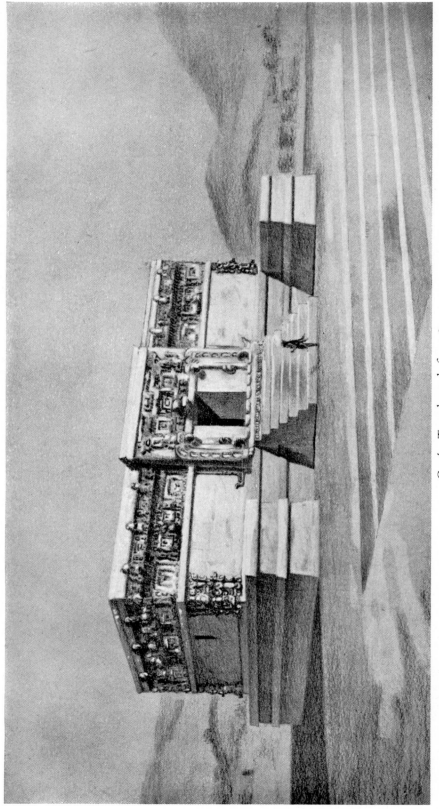

Copán, Temple 22, before 780

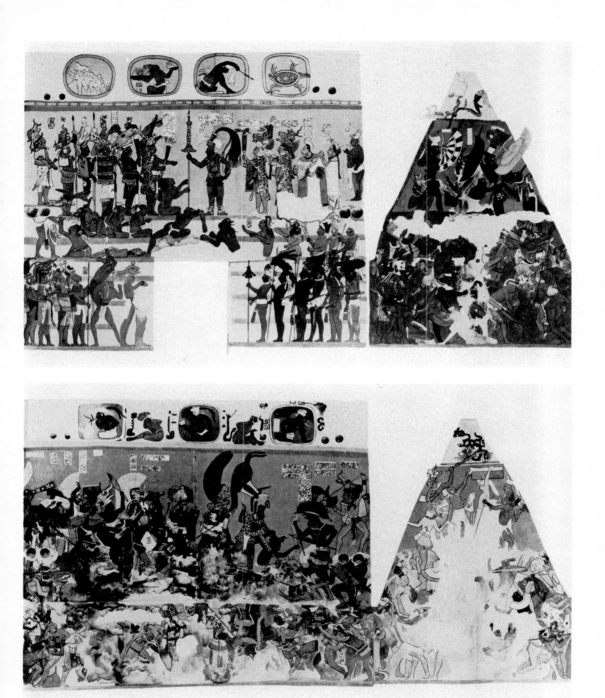

Bonampak, Room 2, walls 5, 6 (*above*) and 7, 8 (*below*) showing a battle (walls 6, 7, 8) and an arraignment of victims (wall 5), *c.* 800

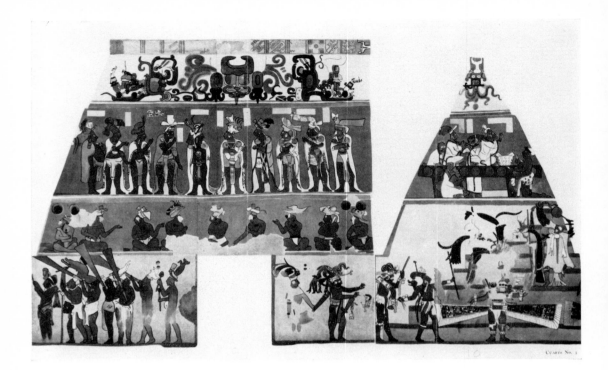

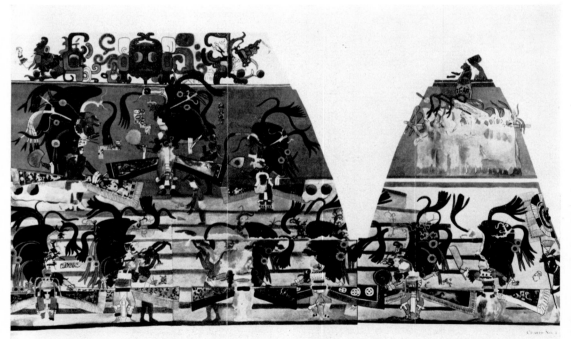

Bonampak, Room 3, walls 9, 10 (*above*) and 11, 12 (*below*), showing dancers (walls 10, 11, 12) and courtiers (wall 9) witnessing a bloodletting penance (wall 10) and the procession of an image (wall 12), *c*. 800

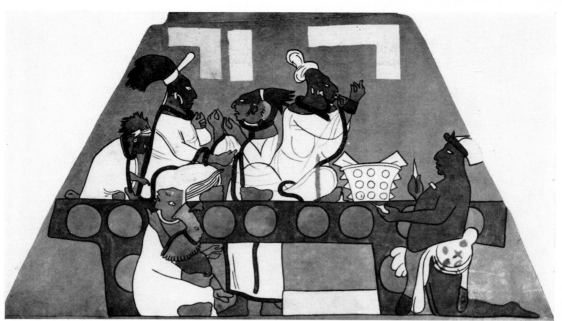

(A) Bonampak, Room 3, wall 10, The Ruler
performing Penance with his Family (detail),
c. 800

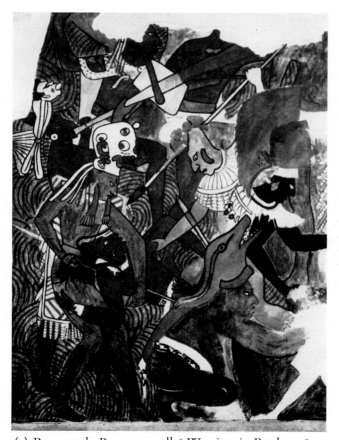

(B) Bonampak, Room 2, wall 6, Warriors in Battle, *c.* 800

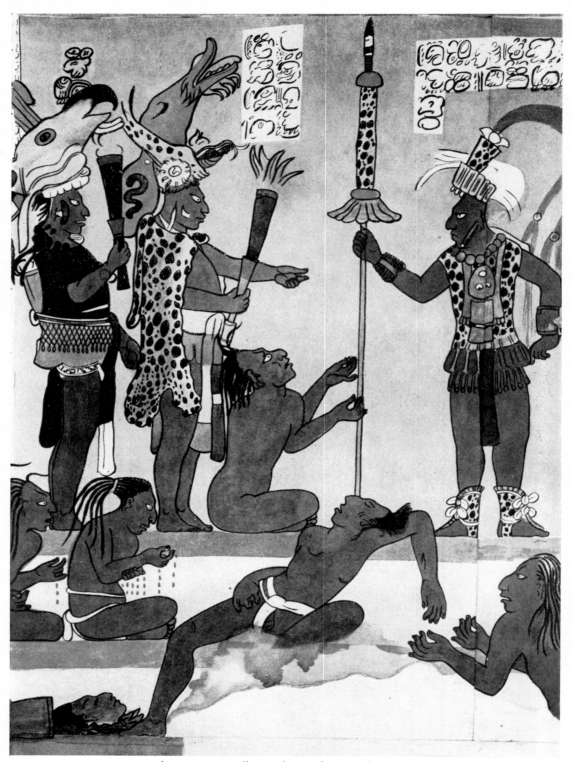

Bonampak, Room 2, wall 5, Ruler, Officers, and Victims, *c.* 800

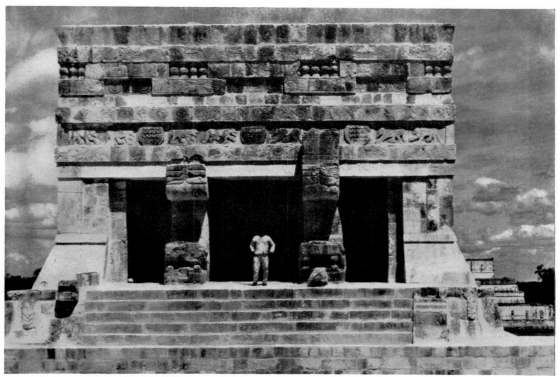

(A) Chichén Itza, upper Temple of the Jaguars, before 1200

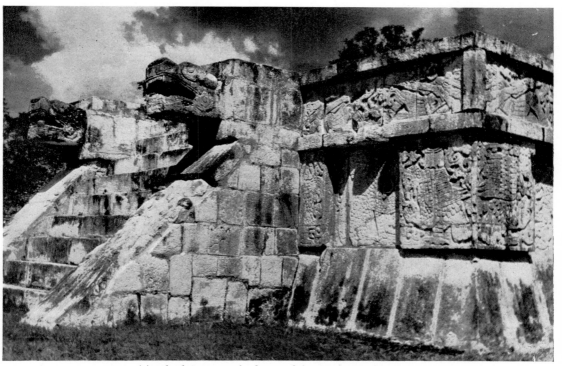

(B) Chichén Itza, Platform of the Eagles, before 1200

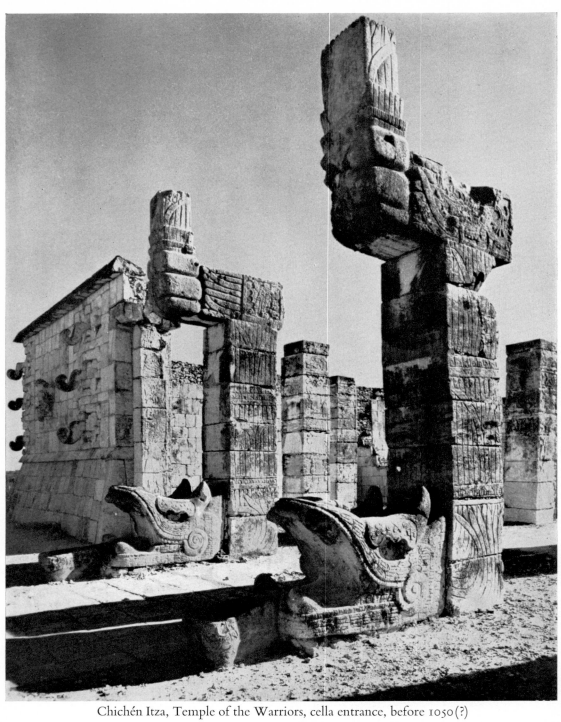

Chichén Itza, Temple of the Warriors, cella entrance, before 1050(?)

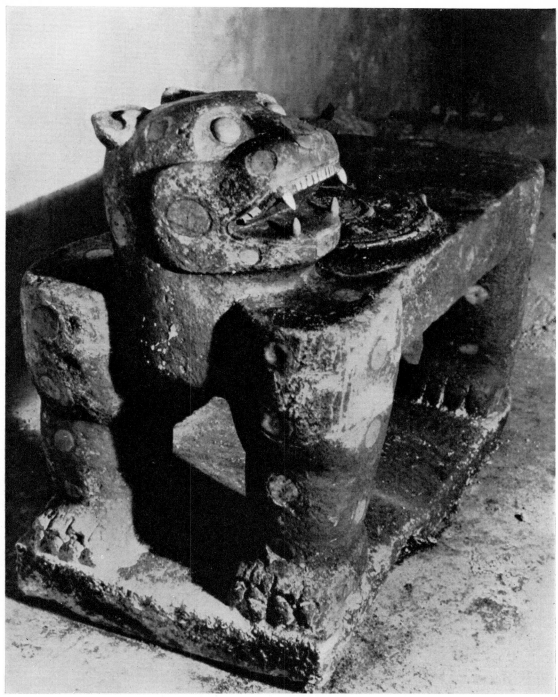

Chichén Itza, jaguar throne from the Castillo substructure, before 800(?)
Painted stone inlaid with jade

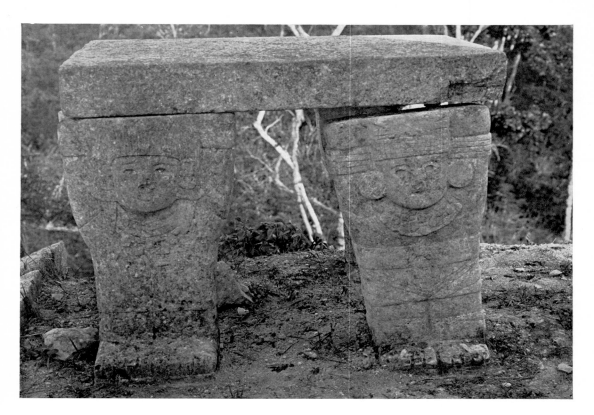

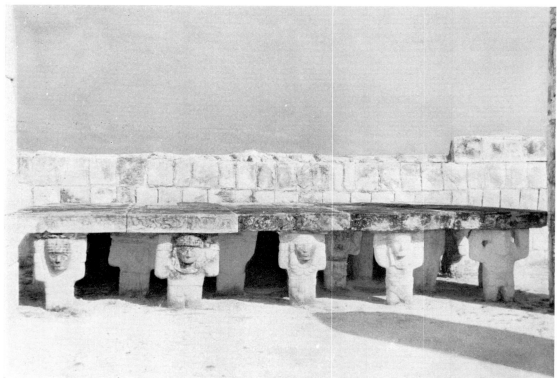

Chichén Itza, Atlantean figures of painted stone, from the Temple of the Tables (*above*)
and from the Temple of the Warriors (*below*), before 1050

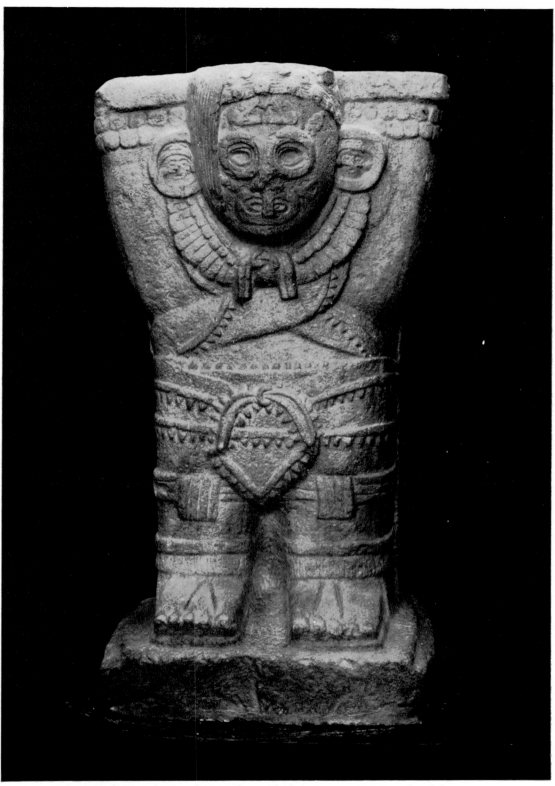

Atlantean figure of painted stone from Chichén Itza, upper Temple of the Jaguars,
before 1200. *Mexico City, Museo Nacional de Antropología*

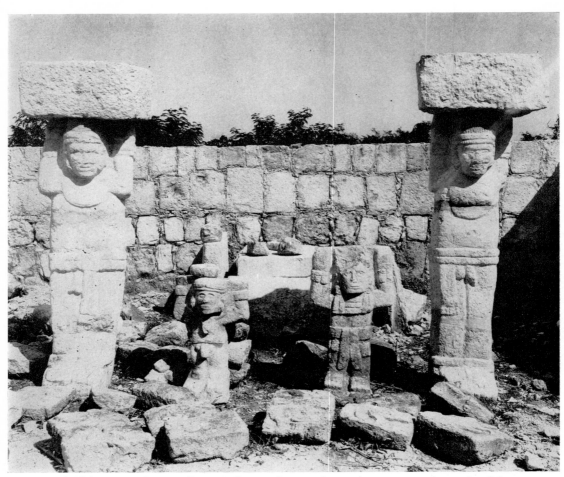

Chichén Itza, Atlantean figures of painted stone, from Structure 3C6 (Temple of the Interior Atlantean Columns), *c.* 1200 (?)

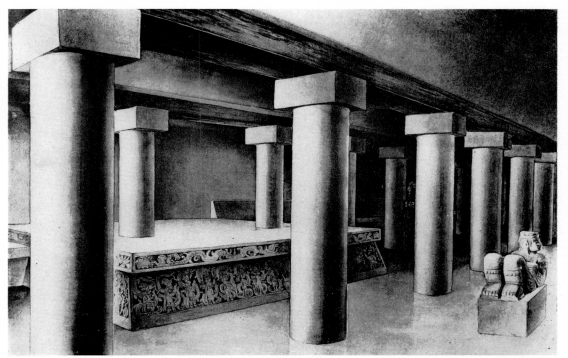

(A) Chichén Itza, north colonnade, reconstruction view of dais and Chacmool, *c.* 1200

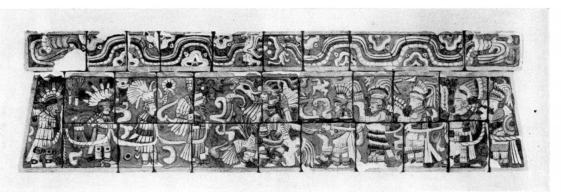

(B) Chichén Itza, Mercado Gallery, limestone processional relief on dais, *c.* 1200 (?)

(A) Chichén Itza, south temple, ball-court, limestone pier base with
jaguar-serpent-bird relief, twelfth century (?)

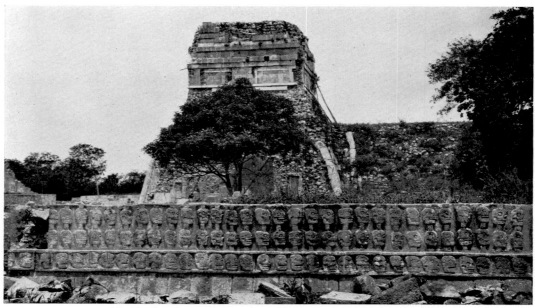

(B) Chichén Itza, skull-rack platform, thirteenth century (?)
General view from east

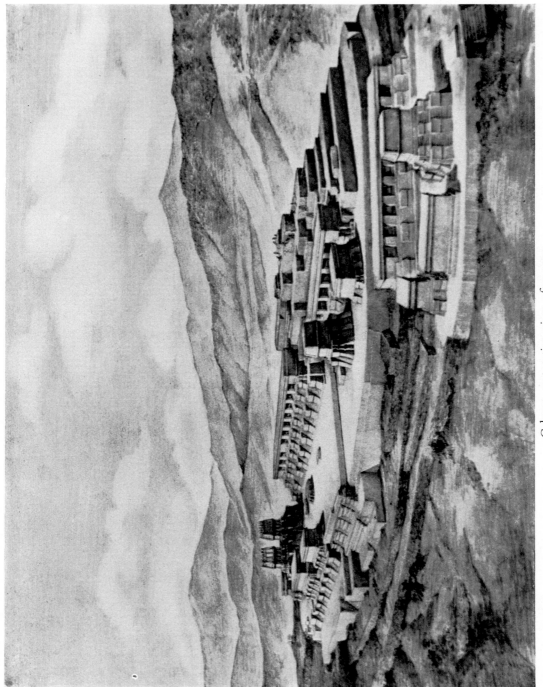

Cahyup, restoration view, after 1300

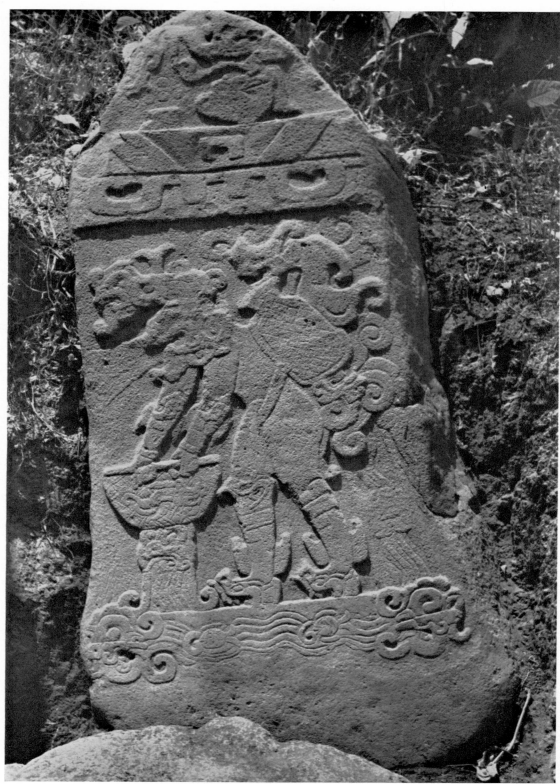

Izapa, Stela 1, before 400 B.C. (?) Stone

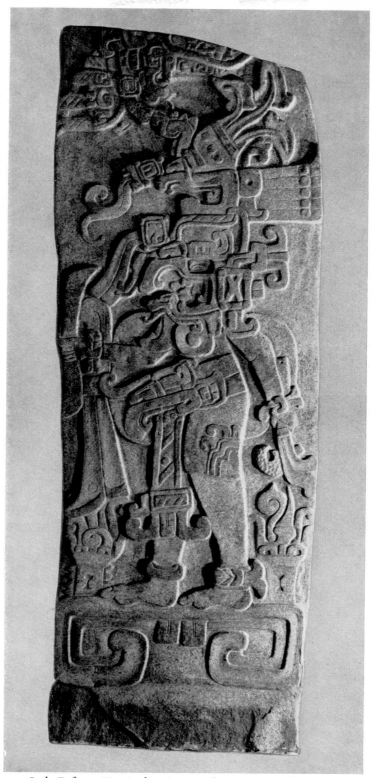

Stela B from Kaminaljuyú, second century B.C. (?) Stone.
Guatemala, Museo Nacional

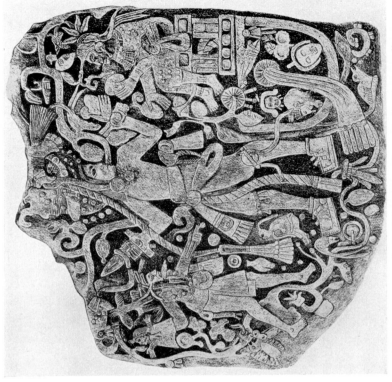

(B) Monument 21 from Bilbao, near Santa Lucía Cotzumalhuapa,
c. 500–700(?) Stone. *Berlin, Museum für Völkerkunde*

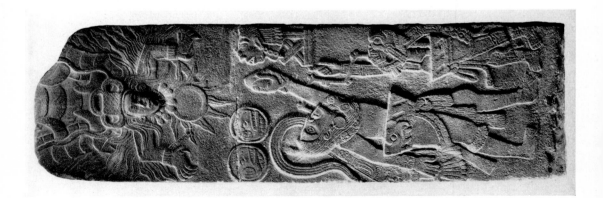

(A) Monument 3 from Bilbao, near Santa Lucía Cotzumalhuapa,
c. 500–700(?) Basalt. *Berlin, Museum für Völkerkunde*

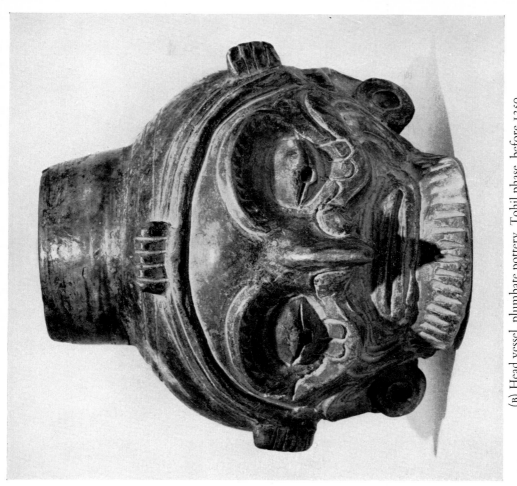

(B) Head vessel, plumbate pottery, Tohil phase, before 1250. *New York, American Museum of Natural History*

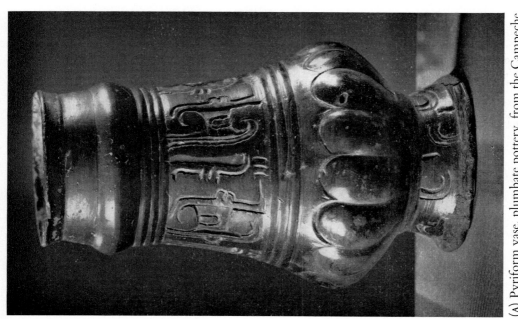

(A) Pyriform vase, plumbate pottery, from the Campeche Coast, tenth century. *New Haven, Yale University Art Gallery, Olsen Collection*

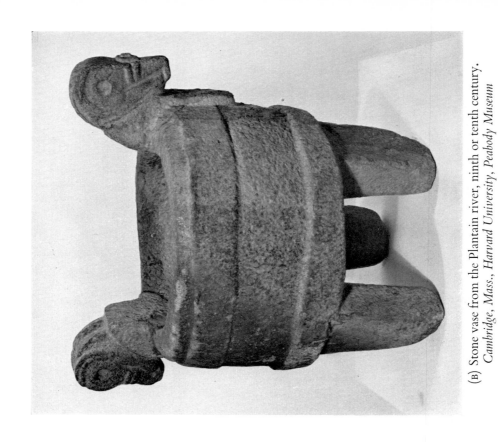

(B) Stone vase from the Plantain river, ninth or tenth century.
Cambridge, Mass., Harvard University, Peabody Museum

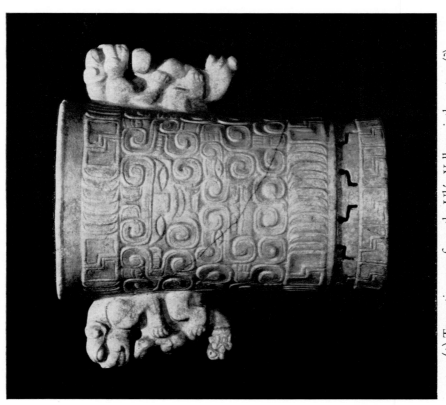

(A) Travertine vase from the Ulúa Valley, ninth century (?)
Philadelphia, University Museum

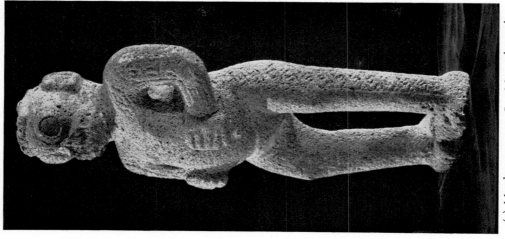

(B) Monkey woman, Las Mercedes style, after 800. Stone. *New York, American Museum of Natural History*

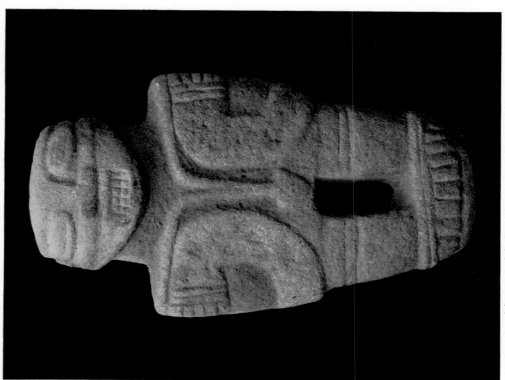

(A) Stone slab figure, Diquis delta style, from southern Costa Rica, after 800. *Baltimore Museum of Art, Wurtzburger Collection*

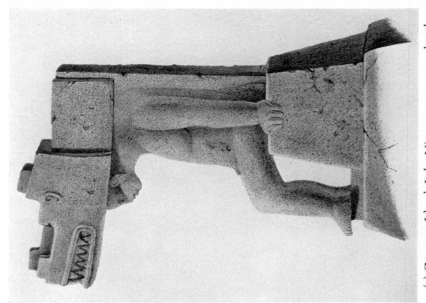

(B) Zapatera Island, Lake Nicaragua, stone pedestal statue of a guardian spirit, before 1200(?)

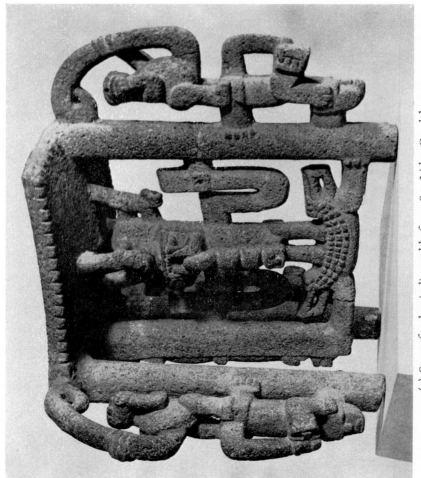

(A) Stone food-grinding table from San Isidro Guadalupe, eleventh century (?)
San José, Museo Nacional

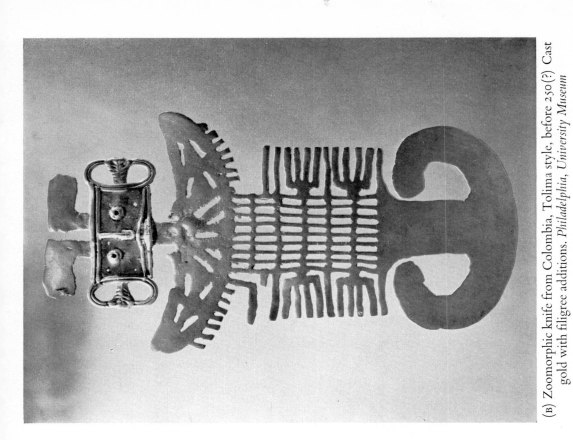

(B) Zoomorphic knife from Colombia, Tolima style, before 250(?) Cast gold with filigree additions. *Philadelphia, University Museum*

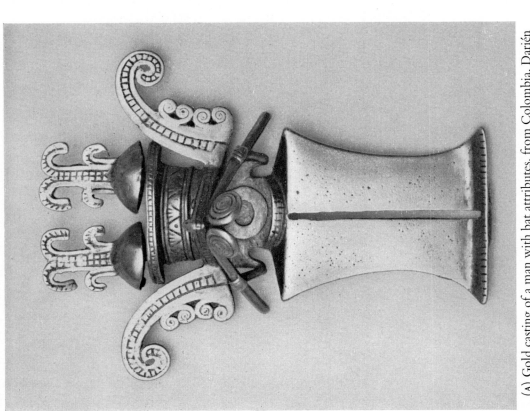

(A) Gold casting of a man with bat attributes, from Colombia, Darién style, after 1200. *New York, Museum of Primitive Art*

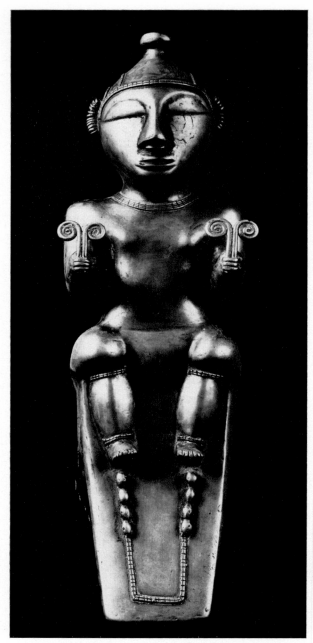

Seated figure from Colombia, Quimbaya style,
before 1000. Cast gold.
Philadelphia, University Museum

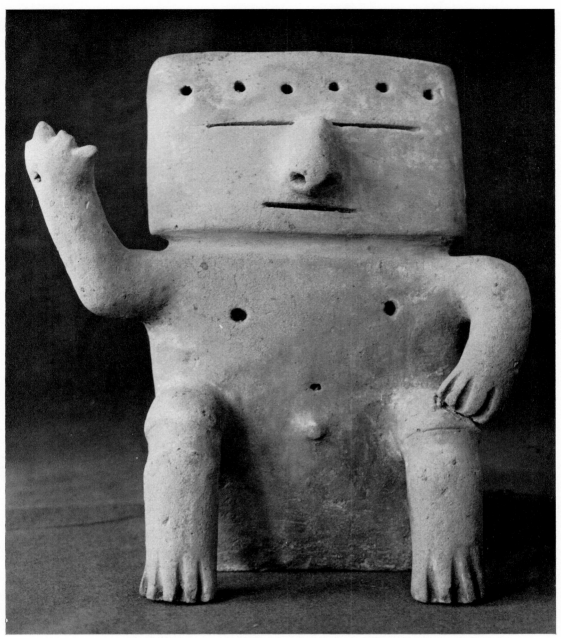

Pottery figure from Colombia, Quimbaya style, before 1000.
Baltimore Museum of Art, Wurtzburger Collection

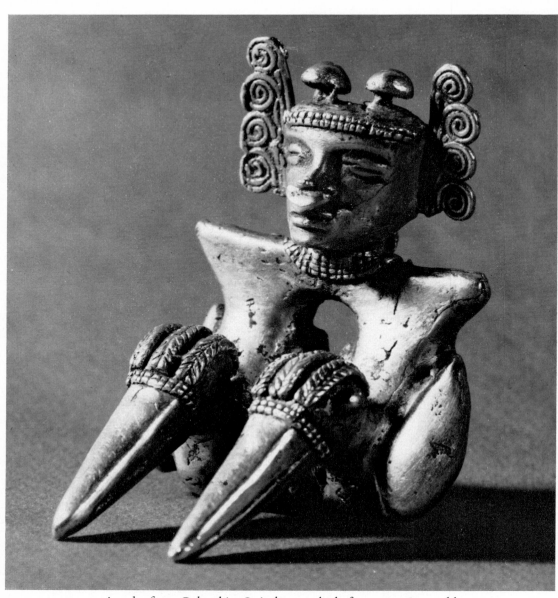

Amulet from Colombia, Quimbaya style, before 1000. Cast gold.
Cleveland Museum of Art, Norweb Collection

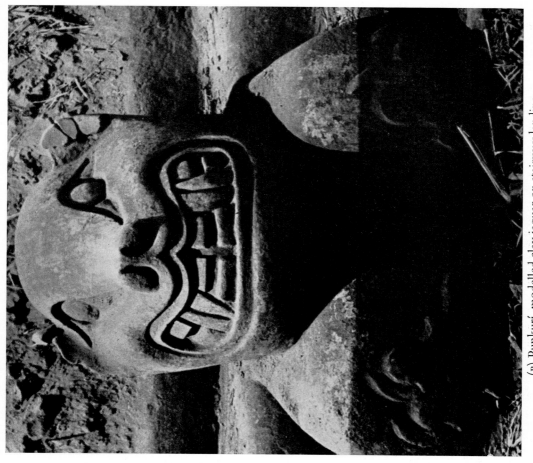

(B) Punkurí, modelled clay jaguar on stairway landing, eighth century B.C. (?)

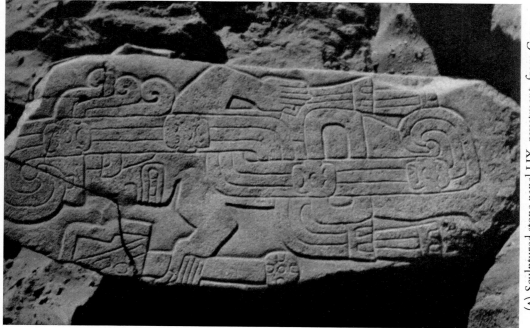

(A) Sculptured stone panel LIX, revetment, from Cerro Sechín, before 900 B.C. *Lima, Museo Nacional*

147

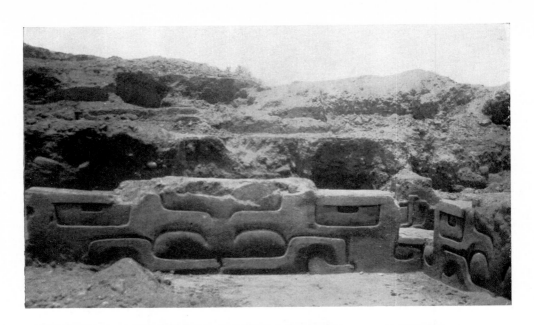

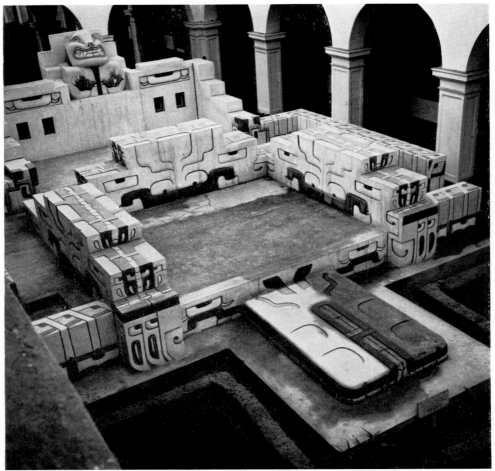

Cerro Blanco (Nepeña Valley), carved clay platform, eighth century B.C. (?),
with reconstruction at *Lima, Museo Nacional*

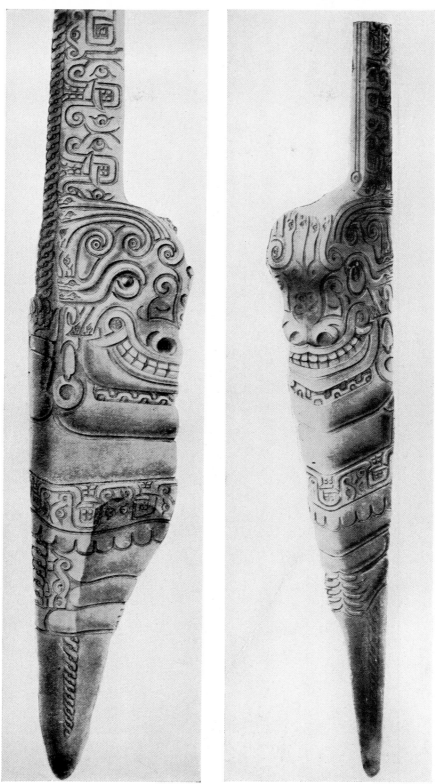

Chavín de Huántar, carved monolith (*lanzón*) in interior gallery
of the pyramidal platform, after 900 B.C. (?)

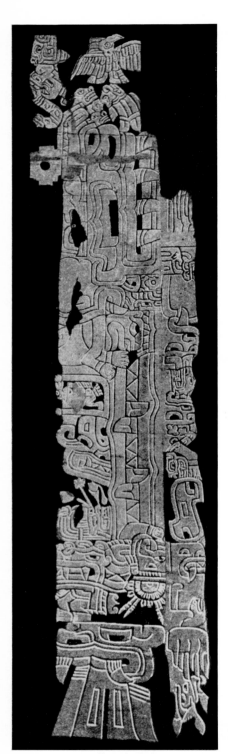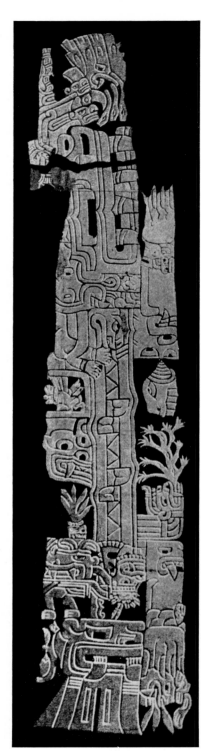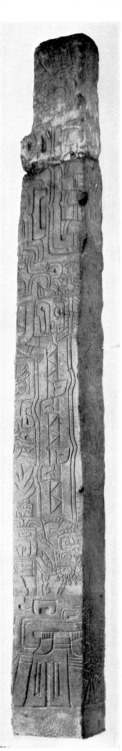

Tello Obelisk from Chavín de Huántar, showing diagrams of incised relief panels,
c. 500 B.C. (?) Stone. *New York, American Museum of Natural History*

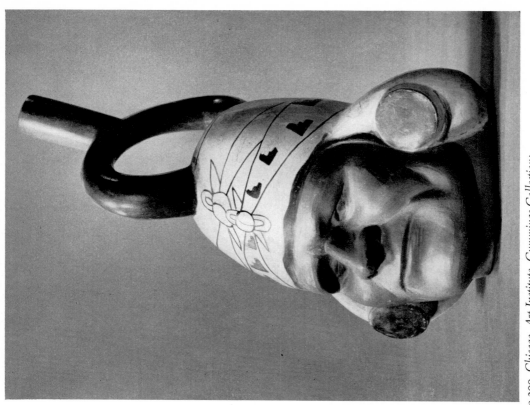

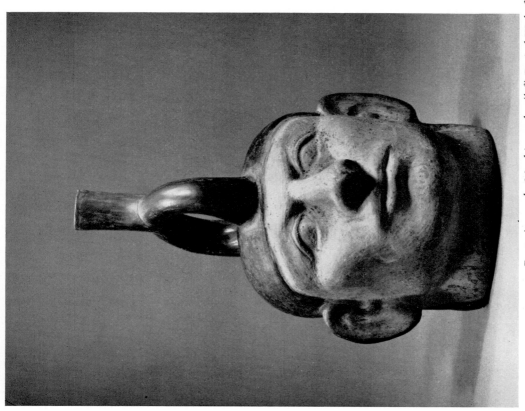

Portrait vessels, Mochica style: *(left)* Period III, before 200, *Chicago, Art Institute, Cummings Collection;* *(right)* Period IV, 200–500, *Chicago, Art Institute, Buckingham Fund*

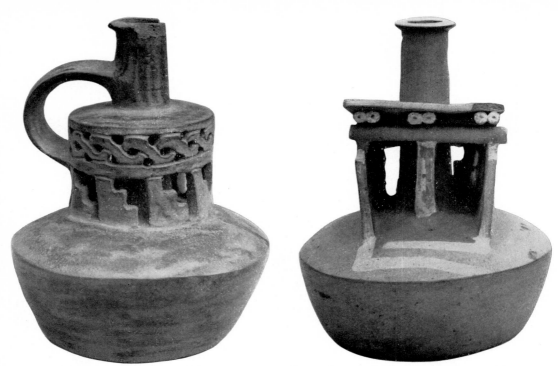

(A) Pottery house vessels from the Virú Valley, Salinar style, fourth century B.C. (?)
Lima, Museo Nacional

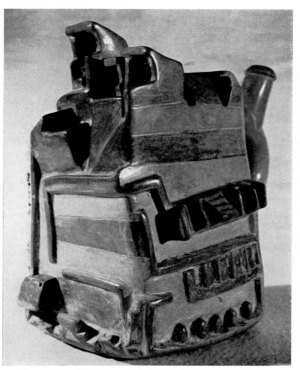

(B) Pottery house vessel from the Virú Valley,
Mochica I style, 250–50 B.C. (?)
Lima, Museo Nacional

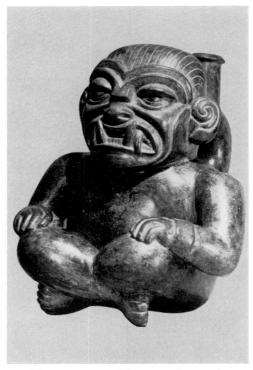

(C) Pottery vessel from Vicús, Mochica
I style, first century. *Piura, Domingo
Seminario Urrutia*

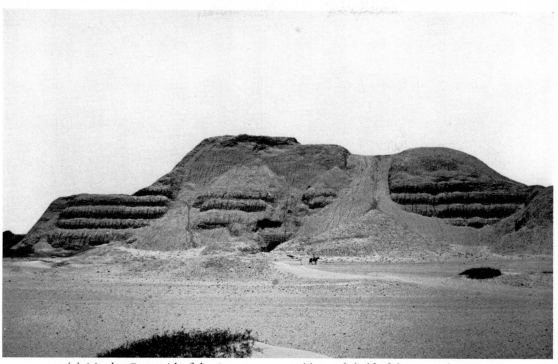

(A) Moche, Pyramid of the Sun, *c.* 100–600(?) South half of the east side, 1899

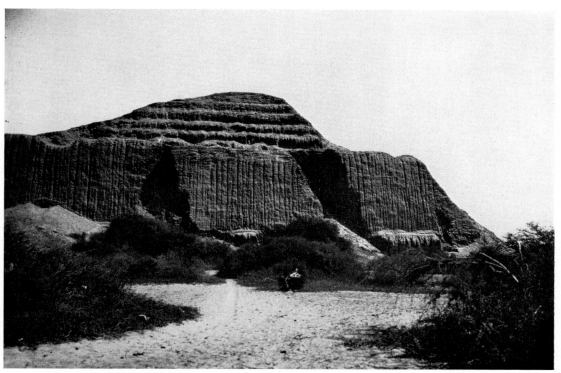

(B) Moche, Pyramid of the Sun, *c.* 100–600(?) South side seen from ground level, 1899

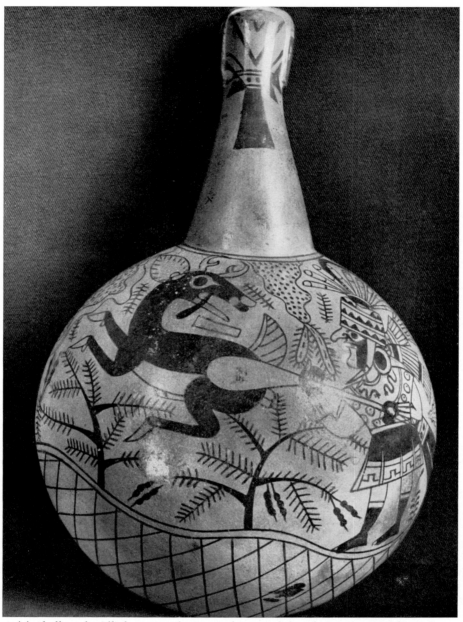

(A) Shallow-handled pottery dipper with painted deer-hunting scene, from the north coast, Mochica III style, before 200(?) *Lima, Museo Nacional*

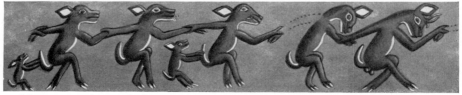

(B) Dancing deer, relief scene on Mochica III–IV pottery vessel from the north coast, before 500(?) *Berlin, Museum für Völkerkunde*

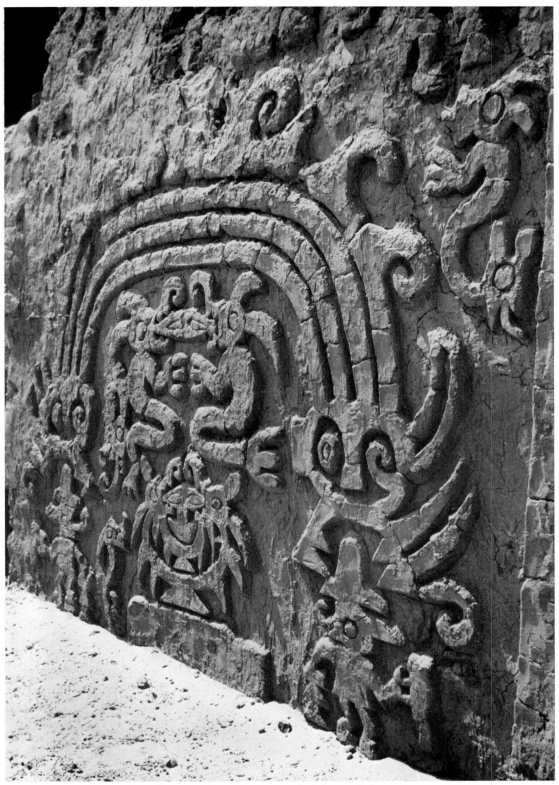

Huaca Dragón, near Chanchan, carved adobe wall decoration, *c.* 1100

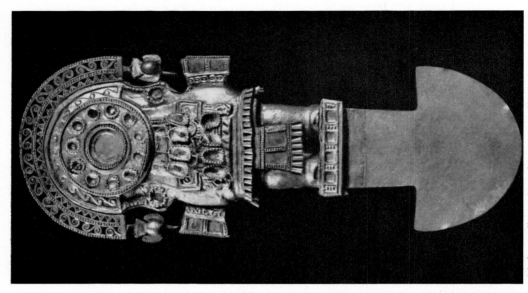

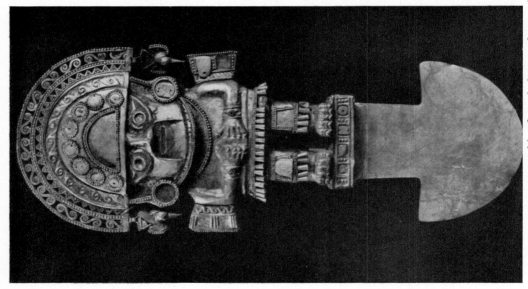

Ceremonial knife with figure of Naymlap(?) from Illimo (Lambayeque Valley), twelfth century(?) Gold inlaid with turquoise. *Lima, Museo Nacional*

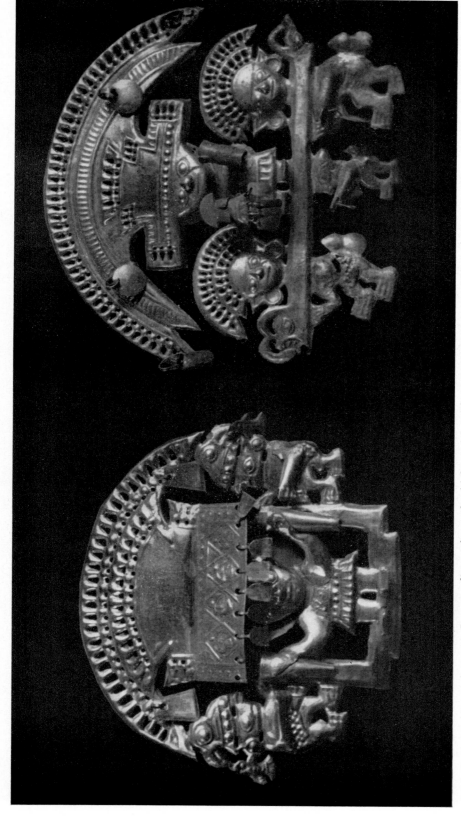

Openwork ear-plugs of gold from the north coast, Lambayeque period, twelfth century.
Lima, Museo Nacional

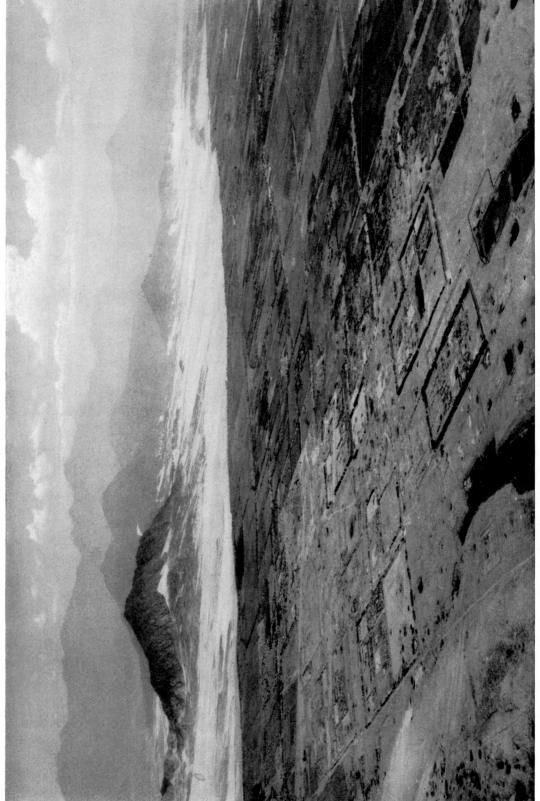

Chanchan and environs, thirteenth–fifteenth centuries. Air view

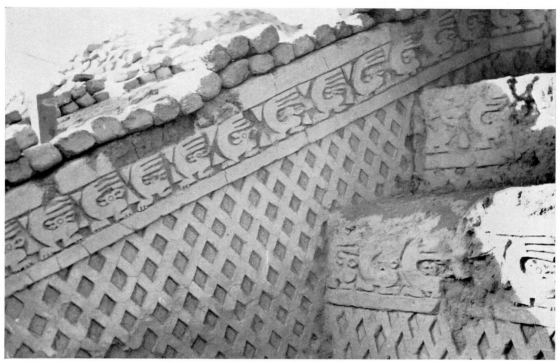

(A) Chanchan, Huaca La Esmeralda, moulded and carved clay wall decoration at ramp, after 1300(?)

(B) Chanchan, wall with moulded and carved clay decoration, *c.* 1400(?)

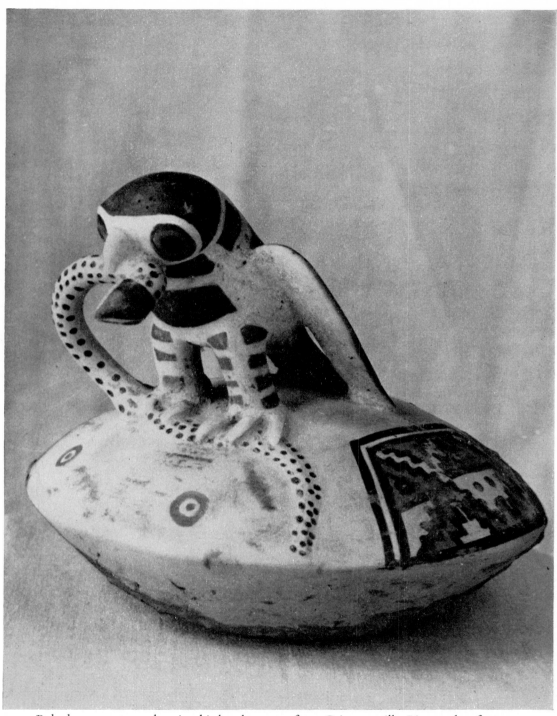

Polychrome pottery showing bird and serpent, from Cajamarquilla, Lima style, after 500.
Lima, Museo Nacional

Polychrome pottery vessel from Chancay, Pasamayo river, *c.* 1500.
Lima, Museo Nacional

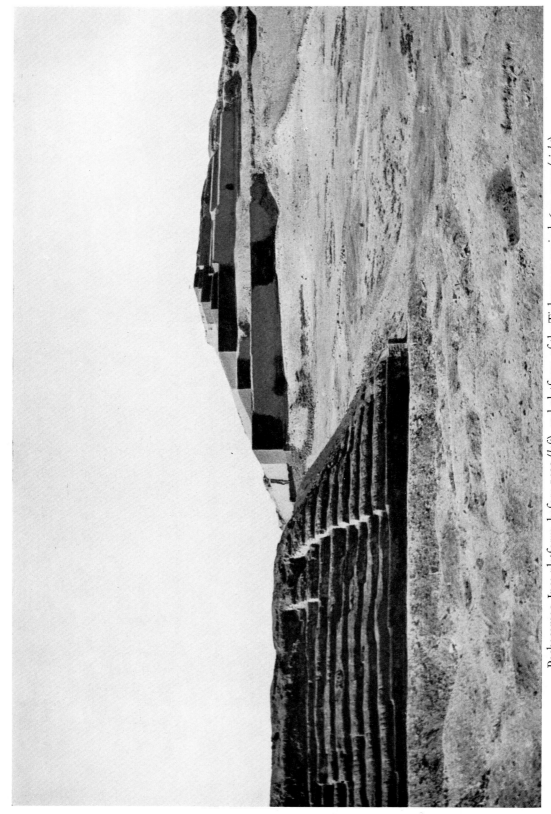

Pachacamac, Inca platform, before 1500 (*left*), and platform of the Tiahuanaco period, 600–1000 (*right*)

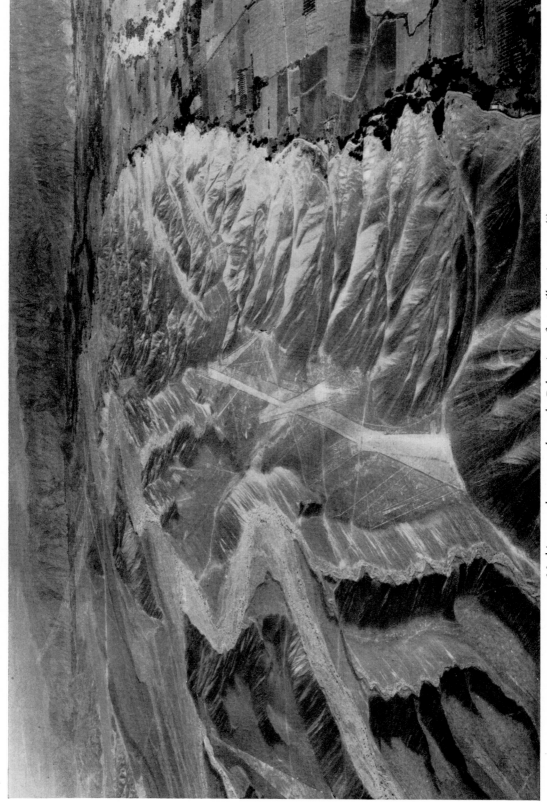

Markings on the pampa above the Palpa river, first millennium B.C. (?)

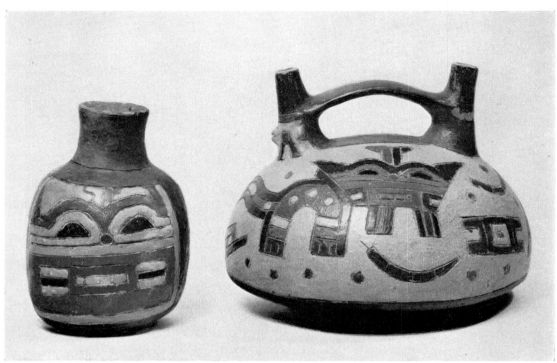

(A) 'Crust-painted' pottery from the Cavernas site, Paracas peninsula, after 500 B.C. (?)
New York, American Museum of Natural History, Gift of John Wise

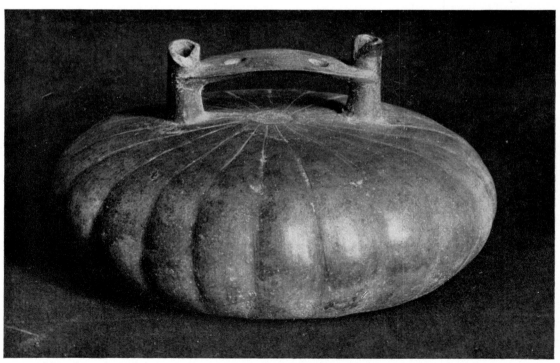

(B) White-slipped pottery from the Necropolis site, Paracas peninsula, before 200 B.C. (?)
Lima, Museo Nacional

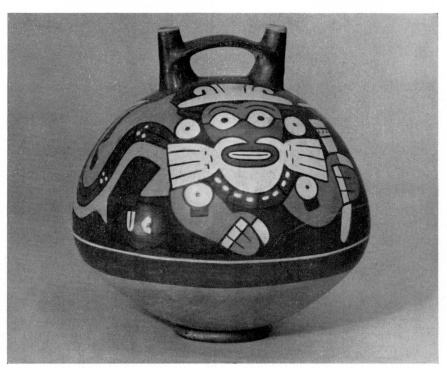

(A) Polychrome pottery vessel from the south coast, Early Nazca
style, before 100(?) *Chicago, Art Institute*

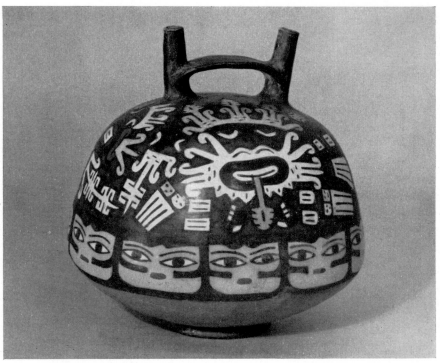

(B) Polychrome pottery vessel from the south coast, Late Nazca
style, after 300. *Chicago, Art Institute*

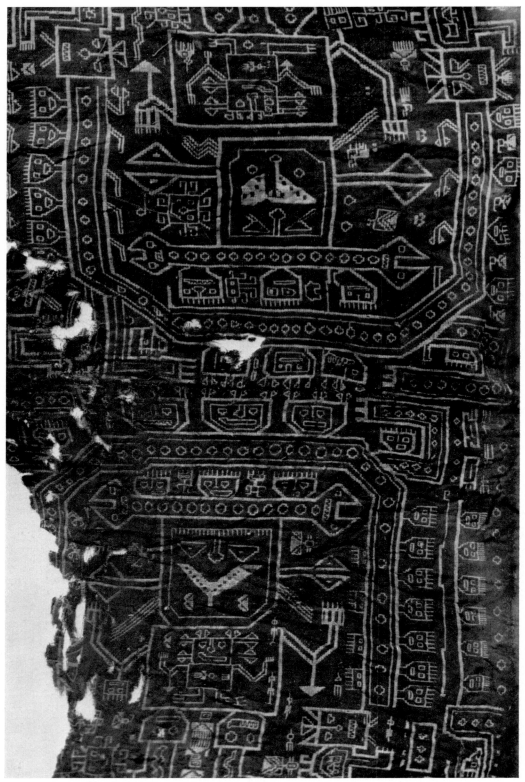

Double cloth from the Cavernas site, Paracas peninsula, before 200 B.C. (?)
Lima, Museo Nacional

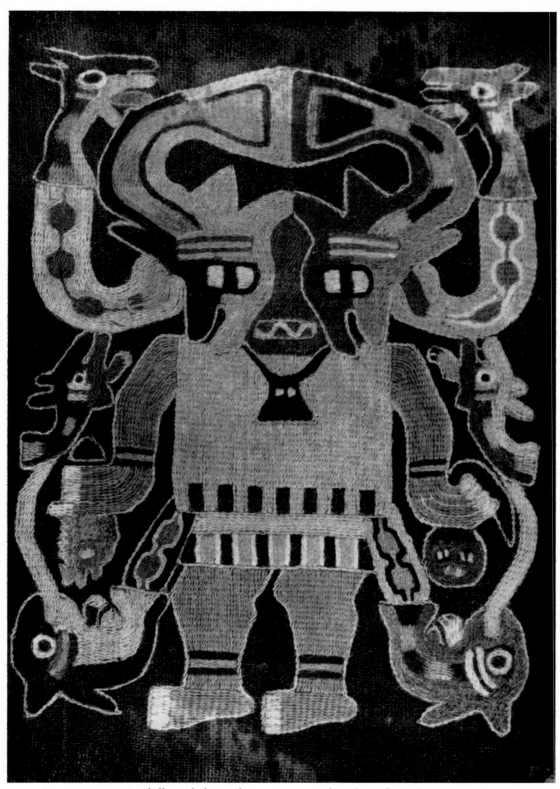

Personage wearing killer-whale attributes, cotton embroidery, from the Necropolis site,
Paracas peninsula, before *c.* 200 B.C. (?) *Lima, Museo Nacional*

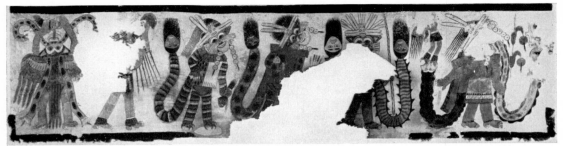

(A) Personages in animal costumes on painted cotton cloth, from the Necropolis site,
Paracas peninsula, Nazca style, before *c.* 200 B.C. (?)
Cleveland Museum of Art, Norweb Collection

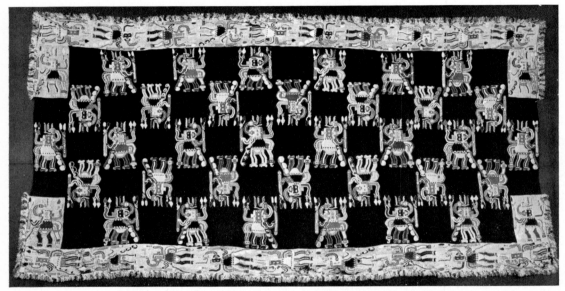

(B) Embroidered Paracas mantle, black ground, from Necropolis, before *c.* 200 B.C. (?)
Providence, Rhode Island, Museum of Art

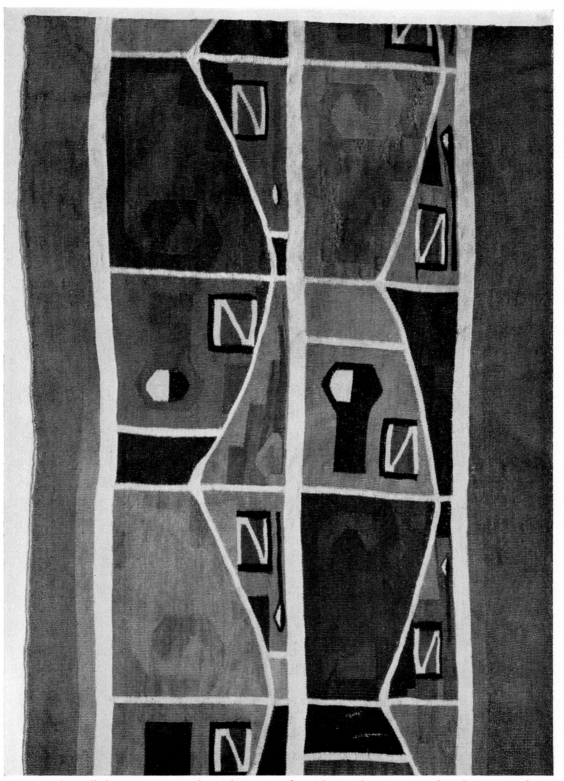

Face-and-scroll theme, cotton-and-wool tapestry, from the south coast, coastal Tiahuanaco style, after 600. *Washington, Dumbarton Oaks, Bliss Collection*

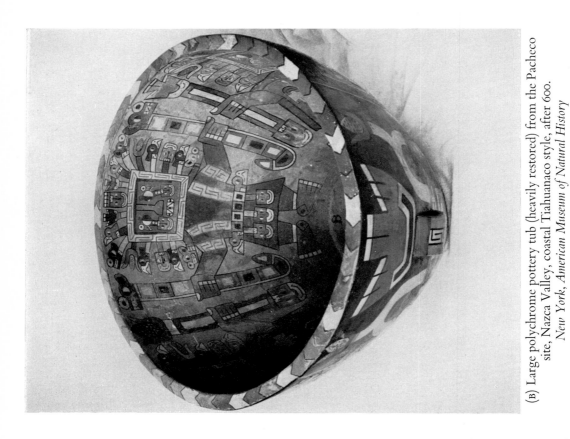

(B) Large polychrome pottery tub (heavily restored) from the Pacheco site, Nazca Valley, coastal Tiahuanaco style, after 600. *New York, American Museum of Natural History*

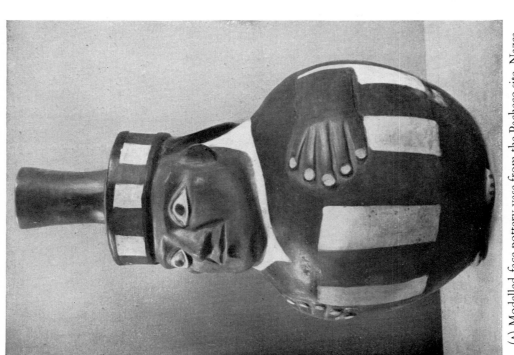

(A) Modelled-face pottery vase from the Pacheco site, Nazca Valley, coastal Tiahuanaco style, after 600. *Lima, Museo Nacional*

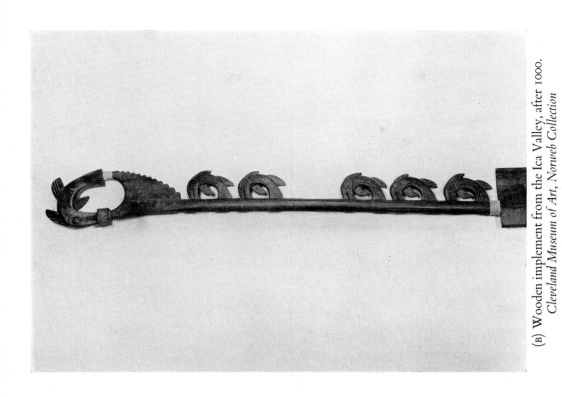

(B) Wooden implement from the Ica Valley, after 1000.
Cleveland Museum of Art, Norweb Collection

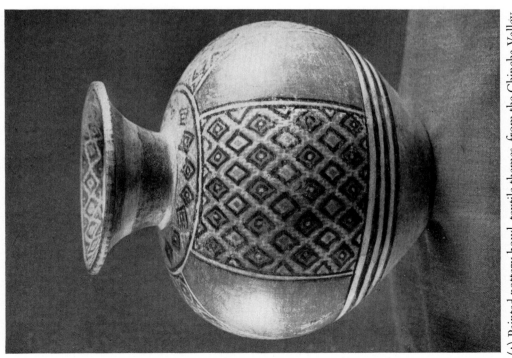

(A) Painted pottery bowl, textile themes, from the Chincha Valley,
Ica style, after 1000. *Lima, Museo Nacional*

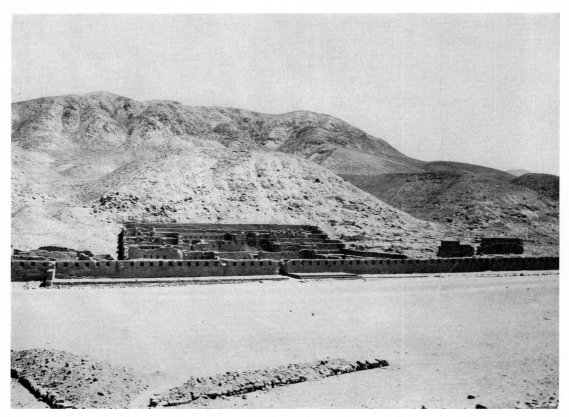

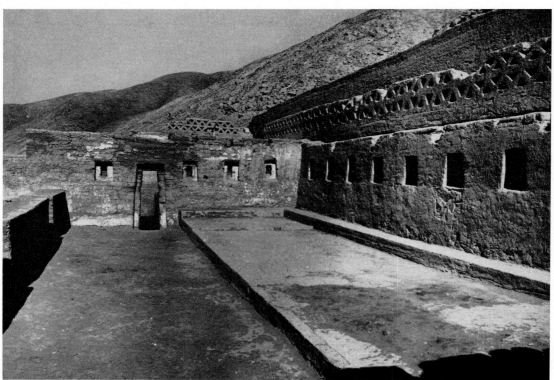

Tambo Colorado, Pisco Valley, after 1400

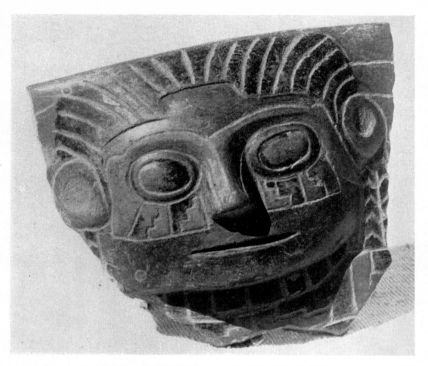

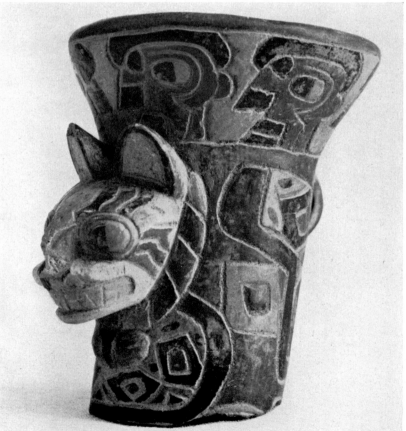

Incised polychrome pottery vessels from Pucará, first century B.C. *Lima, Museo Nacional*

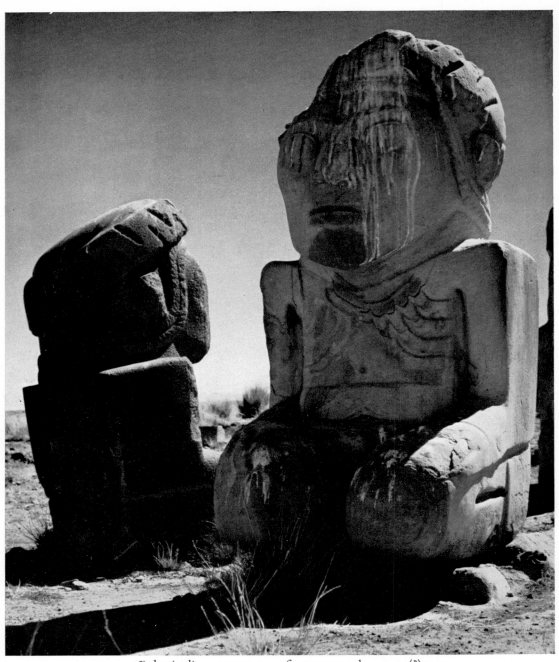

Pokotia, limestone statues, first or second century (?)

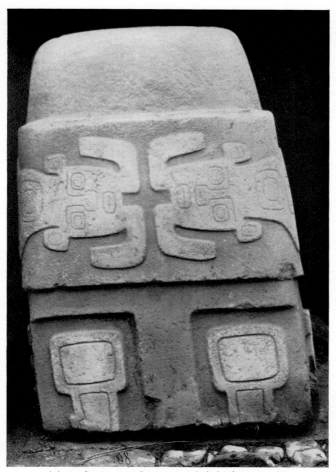

(A) Tiahuanaco, flat stone idol, before 300(?)

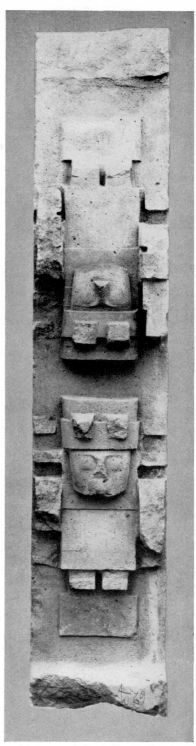

(B) Stone slab with two figures
from Tiahuanaco, after 300 (?)
La Paz, Museo al Aire Libre

179

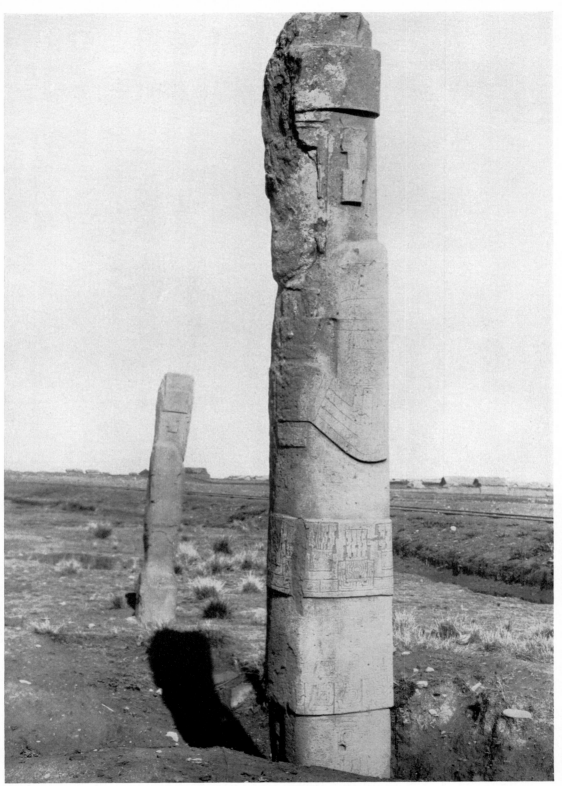

Tiahuanaco, monolithic figures, after 600 (?)

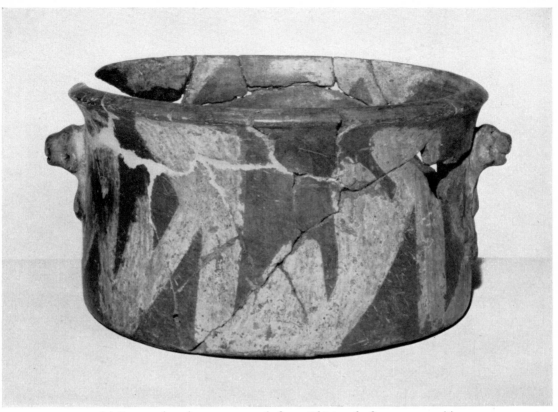

(A) Pottery bowl, cream on red, from Chiripa, before 200 B.C. (?)
New York, American Museum of Natural History

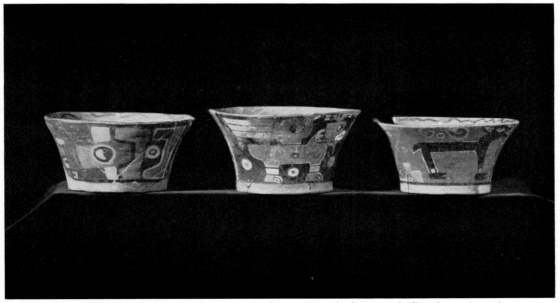

(B) Pottery bowls from Tiahuanaco, Early or Qeya, before 600 (*left*), Classic (*centre*),
and Late Tiahuanaco styles, after 600. *New York, American Museum of Natural History*

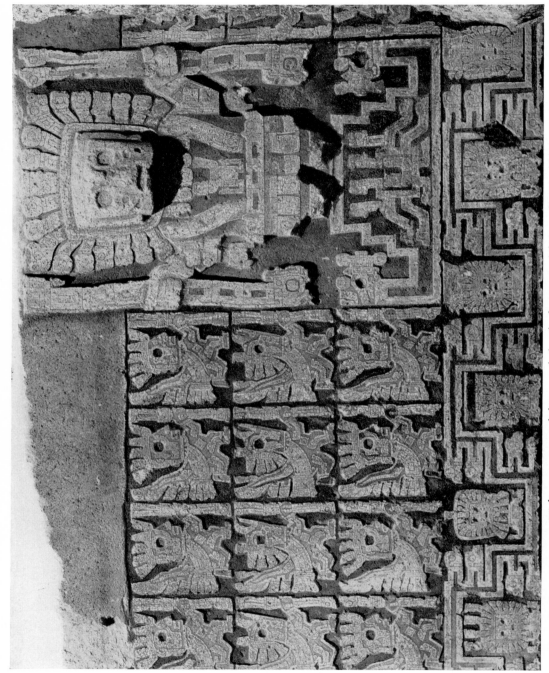

Tiahuanaco, monolithic portal, detail of centre and frieze, after 600 (?)

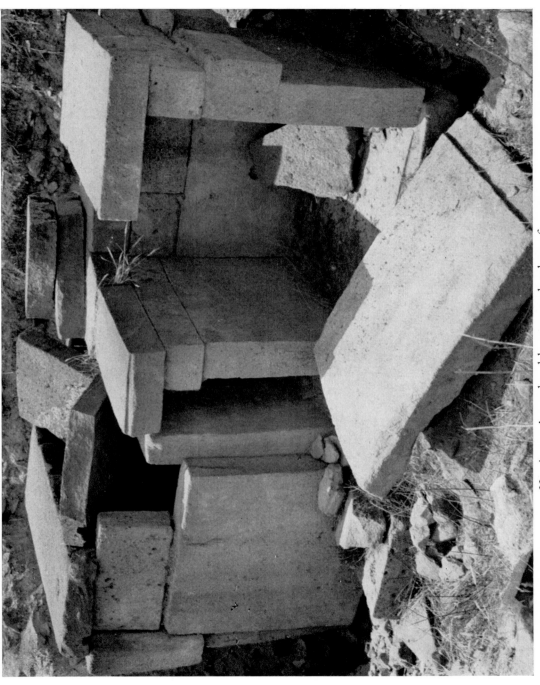

Huari, near Ayacucho, slab-masonry chambers, after 700

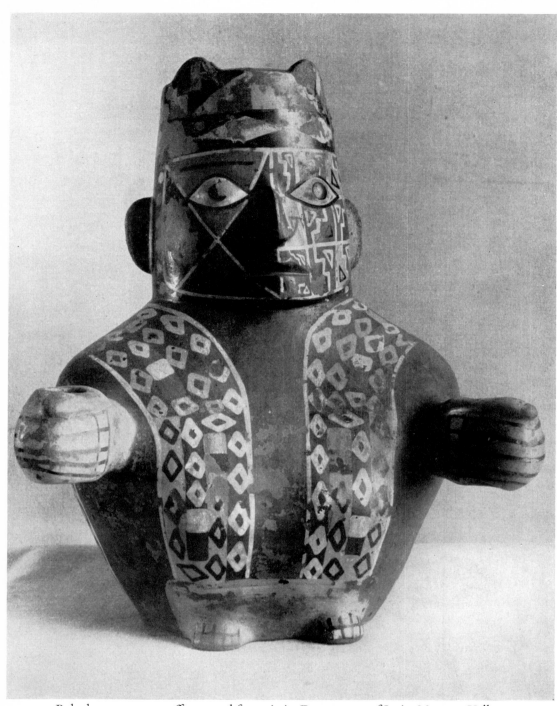

Polychrome pottery effigy vessel from Anja, Department of Jauja, Mantaro Valley,
Viñaque style (?), *c. 600. Whereabouts unknown*

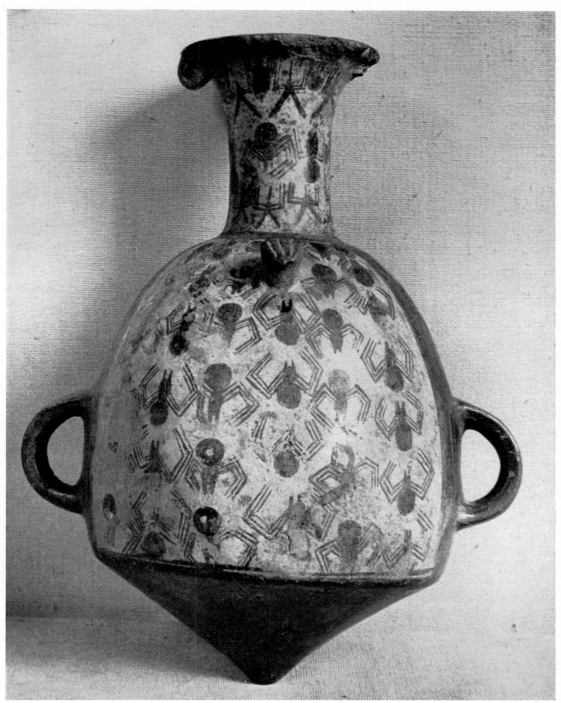

Inca polychrome pottery vessel, 'aryballos' form, after 1450.
Lima, Museo Nacional

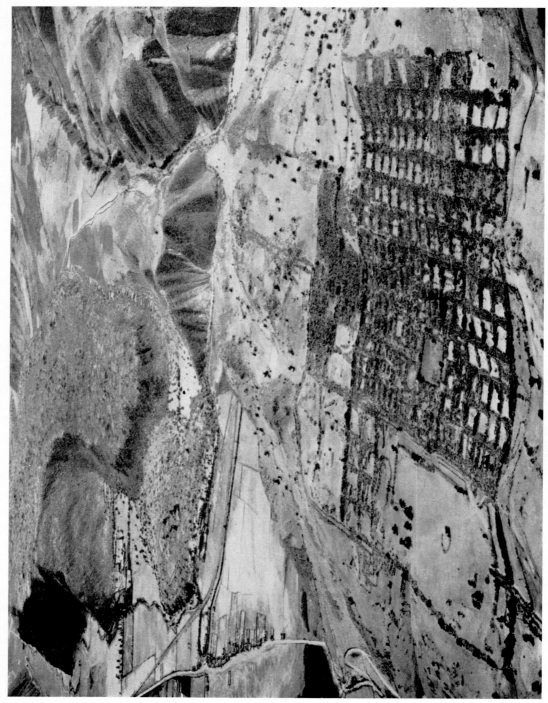

Pikillaqta, *c.* 1500(?) or before 900(?) Air view

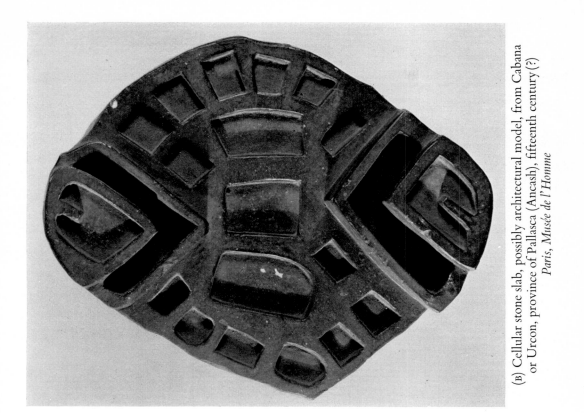

(B) Cellular stone slab, possibly architectural model, from Cabana or Urcon, province of Pallasca (Ancash), fifteenth century (?)
Paris, Musée de l'Homme

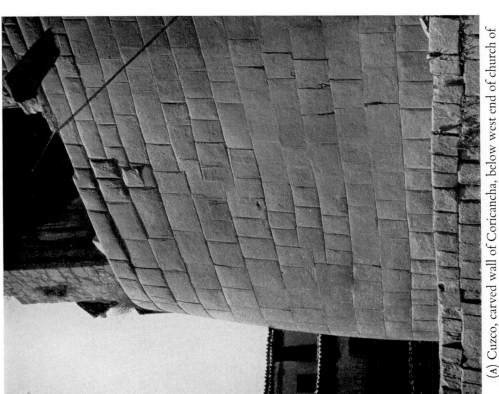

(A) Cuzco, carved wall of Coricancha, below west end of church of Santo Domingo, fifteenth century

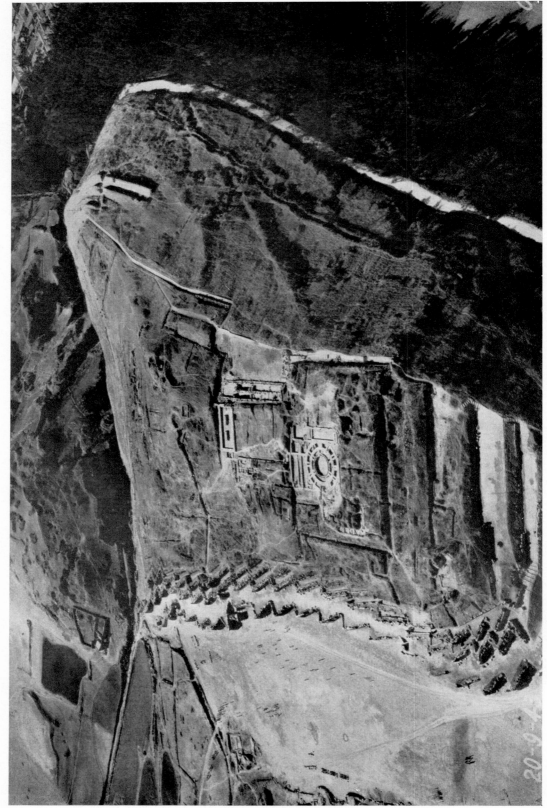

Cuzco, terraces of Sacsahuamán, mid fifteenth century. Air view

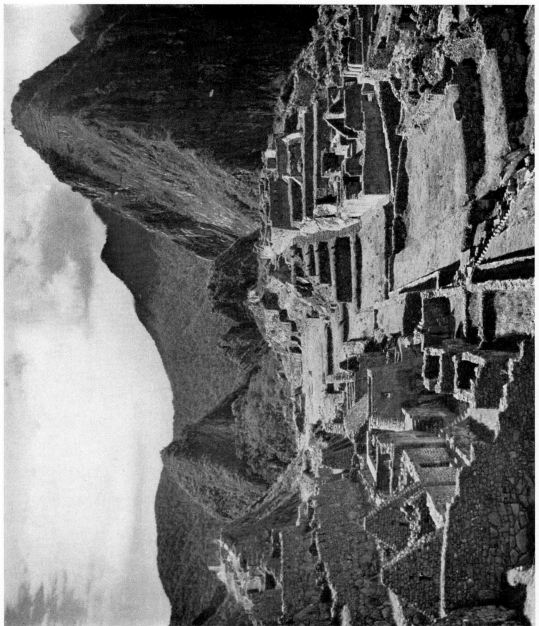

Machu Picchu, *c.* 1500. View from north

Sillustani, burial tower, fourteenth–fifteenth centuries (?)

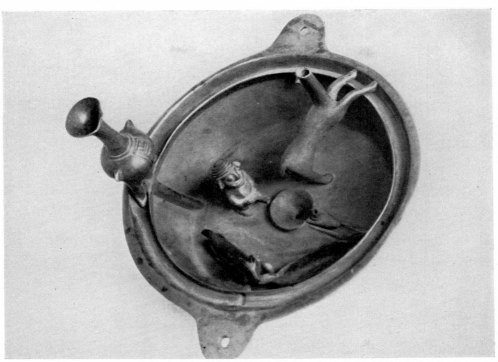

(A) Silver double-shell vessel with gold inlay, from Cuzco, *c.* 1500.
Cuzco, Museo Arqueológico

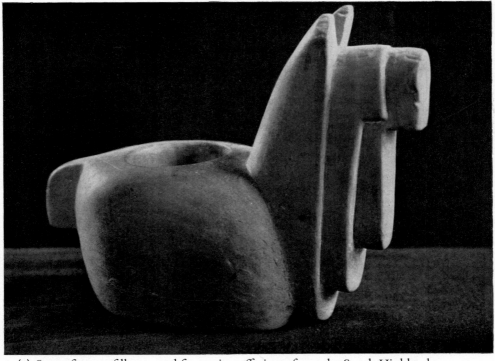

(B) Stone figure of llama used for votive offerings, from the South Highlands, *c.* 1500.
Lima, Museo Nacional

Cuzco, shrine at Kenko, fifteenth century

INDEX

Numbers in *italics* refer to plates. References to the notes are given to the page on which the note occurs, followed by the number of the note. Thus 342[30] indicates page 342, note 30. Place names preceded by a definite article are indexed under the main element; thus La Centinela will be found under Centinela.

A

Abaj Takalik, sculpture, 222
Acanceh, 185; pyramid, 131 (fig. 35), 132; monumental masks, 171
Actun Balam, 183
Aesthetic activity, 9
Aesthetic contemplation, 19–20
Aesthetic function, 17
Africa, 13
Ahuitzol, 53, 59–60, *23*
Ai Apaec, Mochica deity, 275
Aija, Recuay sculpture, 258 (fig. 91), 259
Ake, 342[30]
Alban, Monte, *see* Monte Alban
Altar de Sacrificios, 136, 221; pottery, 183, *112, 113*
'Altars', 162
Alter ego figures, 229, 367[35]
Altiplano, 314–16
Alto, Monte, *see* Monte Alto
Altun Ha, tumbaga, 112
Alvarado, Huaca de, *see* Huaca de Alvarado
Ameca Valley, pottery, 116, 117, 118, *78*
Ameca-Zacualco, 116
Añay, 291
Ancash, 247–59; pottery, 257–9
Ancón, 249, 289; Playa Grande, 289
Andean archaeology, 234
Andean civilizations, 233 ff.
Andean metallurgy, 233–4
Animas, Las, 82; ceramic styles, 86–7, *56*
Anja, pottery, *184*
Anthropology, 7
Antioquia, goldwork, 239, 241
Aparicio, stelae, 207, 349[49]
'Apotheosis' statues, 88
Arbolillo, El, xli, 25
Archaeology, general, 7
Architectural characteristics, adobe construction, 251 (fig. 86); 'amphitheatre' courts, 157–8; barrier-mounds, 158; block masonry, 357[52]; cairn mode, 30; cantilevered panels, 26; cantilevered tablero, 33; carved block masonry, 153; cellular slabs, 381[45]; ceremonial platforms, 28; chambered pyramids, 153; chamfers, 135; circular form, 23; circular platforms (*yácatas*), 120; colonnaded portico, Tula, 45, 48; columnar supports, 135; concrete bonding, 123; corbel-roofed houses, 292 (fig. 107); corbel-vault, 123, 140–2; corbel-vaulted galleries, 12; cut stone facings, 151; dwelling platforms, 31; fired bricks, 143, 346[77]; flying façades, 152; free-standing pyramid, 131–2; geomantic groups, 133; 'harmonic façades', 149; interior buttresses, 145; lavatories, 142; 'mansard' roof profile, 135; mask-façades, 151; Maya vault, 124 (fig. 32); monumental archways, 159; negative batter, 104, 363[28]; open courtyard enclosures, 48; patio buildings, Tula, 48; perspective diminution, 191; pirca masonry, 328, 334; 'polygonal' walls, 328; profile enrichment, 135; proportional groupings, 160; Puuc innovations, 152; pyramidal platform, 56; pyramid-palace, 147–9; re-entrant corners, 135; ritual centre, 30, 128; roof-comb, 123, 136; serpent columns, 49; stone tie-rods, 143; stone-working techniques, 34; tablero profile, 32–3; talus, definition, 32; talus-and-tablero, 28; temple corporation, 21; temple platforms, 31; *tepetate* (tufa), 28; *tezontle* (pumice), 53; trefoil arch, Maya, 12; true arch construction, 267; twin pyramid complexes, 356[21]; wooden tie-rods, 125
Arensberg head, 88
Asia, influences of South-east, 12; settlers from North-east, 11
Atahualpa, 287
Atarco style, 312
Atetelco (La Presa), 31, 32 (fig. 5); murals, 29–30, 47
Atlatl (throwing sticks), 49
Atlihuayán, pottery, 25, 73, *2*
Atzcapotzalco, 36, 59
Augural year (260-day calendar), 65, 96, 110
Axayacatl, 87; palace of, 58
Ayaviri, 315
Aymara, 314
Aztatlán polychrome pottery, xli, 120–2
Aztec Confederacy, xli, 53, 53–66
Aztec expansion, 4
Aztec mythology, 54–5, 61–2

T

NOTES FOR JOYCE

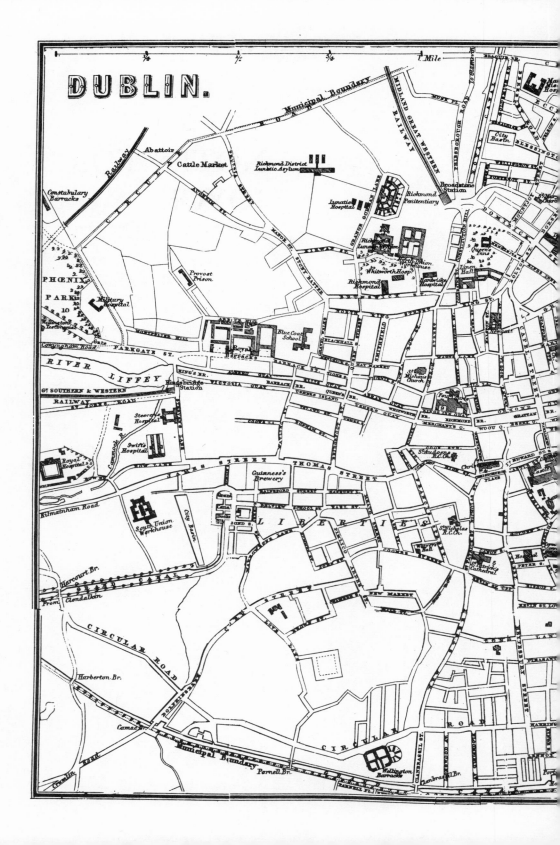

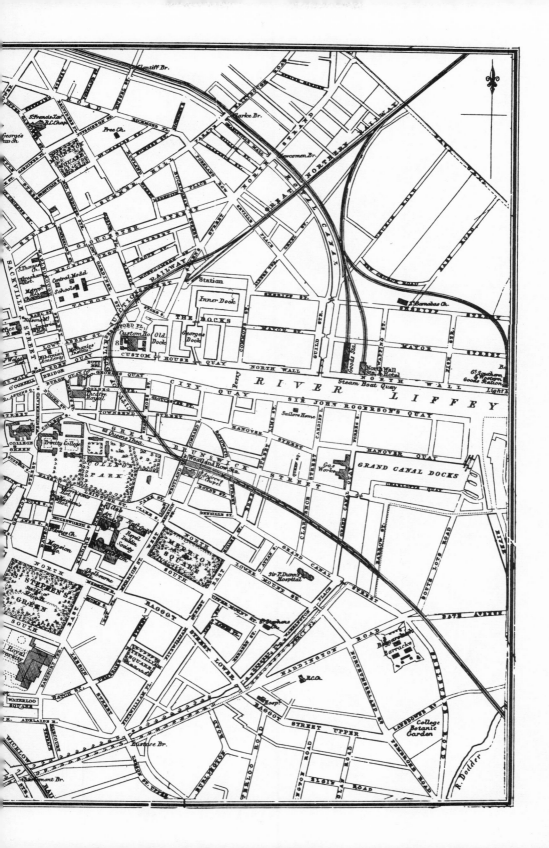

DON GIFFORD is a Professor of English at Williams College, where he has taught for the past twenty-two years. He was educated at the Principia College in Illinois, at Cambridge University, and at Harvard University. During World War II he drove an ambulance in the American Field Service before serving in the Army of the United States. After the war Mr. Gifford tried his hand at writing novels and working on commercial films before he settled down to teach, first at Mills College of Education in New York and subsequently at Williams. His teaching career has occasionally been interrupted by periods of work as a consultant to various industries on the process of invention.

ROBERT J. SEIDMAN was educated at Williams College, at Worcester College, Oxford, and at Columbia University. He has taught English Literature and Creative Writing, and has written several screenplays for short feature films. He is currently working on a novel.

NOTES
FOR JOYCE

An Annotation of James Joyce's ULYSSES

DON GIFFORD
with ROBERT J. SEIDMAN

E. P. DUTTON & CO., INC. *New York*

1974

CONTENTS

Work on the present volume began in 1962–63 as a continuation of the projects that resulted in the annotations of *Dubliners* and *A Portrait of the Artist as a Young Man,* published as *Notes for Joyce* (Dutton Paperbacks, 1967). As with those earlier projects, the decision to annotate *Ulysses* was a function of the somewhat frustrating and unrewarding experience of trying to teach the book. I felt that far too much time in the classroom was given to a parade of erudition, far too little to the actual process of teaching—the discussion that comes to grips with the forms and textures of the book itself. I was in effect encouraging my students to be overdependent on my informations and therefore on my readings. As I launched into the project of annotating with a mimeographed and fragmentary set of notes for the first three episodes of *Ulysses* in 1962–63, two things became clear: my students were freer to undertake independent readings of those episodes; and I discovered that my own grasp of the book was spotty—very spotty indeed, because I had relied on a fairly thorough reading of isolated passages to suggest what might be (but clearly was not) a thorough reading of the book as a whole.

In 1966 Robert J. Seidman, a former student, joined me in the enterprise. We declared a moratorium on writing and undertook to complete the factual research. This enabled us to develop the basis for the annotations and to identify that wide variety of things which we knew we did not know. The actual writing began early in 1967, and in the academic year 1967–68 we Xeroxed a draft of the notes to the first eight episodes for use with classes at Williams College. That exposure of the notes gave us valuable information; students made helpful contributions to the notes themselves and also helped us to clarify what a thorough and essentially pedagogical annotation might ultimately be. The students made it quite clear, for example, that the context from which a literary allusion or a historical moment is taken should not just be cited but should be briefly described and summarized to orient the reader without necessarily requiring him to consult the original sources.

The preparation of this volume has naturally involved considerable reliance on the body of Joyce scholarship. Where the annotations are matters of fact from reasonably public realms, we have not tried to identify the original discoverer—in part because there have been innumerable simultaneous and overlapping discoveries, and in part because such identification and the comment it entails would imply a scholarly compilation (an annotation of critical commentaries on *Ulysses*) which has not been the point of this work (an annotation of the text itself). When Weldon Thornton's *Allusions in Ulysses* (Chapel Hill, North Carolina, 1968) was published, it seemed at first that what we had undertaken had already been accomplished. Indeed, Thornton's work and ours do overlap to a considerable extent,

PREFACE

but the differences implied by the terms "allusion" and "annotation" do suggest two different approaches and two different end products. Thornton's book has informed us on many points and has helped us immeasurably. At the same time our own questions and investigations have carried us into fields other than those Thornton has defined as "allusions," and the hope is that the two books can be regarded as complementary attempts at different approaches to *Ulysses* rather than as mutually exclusive attempts at the same approach.

It is a challenge to try to acknowledge here our wide-ranging indebtedness to friends and associates and correspondents for their assistance. We would like to thank the following for their varied contributions to this compendium:

Theodore Albert, Williams College, 1963.

Stephen Arons, Harvard Law School, 1969.

M. Amr Barrada, Professor of English, Williams College.

Murray Baumgarten, Professor of English, University of California at Santa Cruz.

Arthur Carr, Professor of English, Williams College.

Loring Coes III, Williams College, 1971.

James M. Cole, Williams College, 1968.

Padraic Colum, Irish poet and critic.

Thomas Foster, Williams College, 1969.

John Garvin, Dublin City Commissioner.

Mrs. Marin Haythe.

Mathew J. C. Hodgart, University of Sussex, co-author of *Song in the Works of James Joyce*.

Miss Sarah Hudson.

J. Clay Hunt, Professor of English, Williams College.

Nathaniel Lawrence, Professor of Philosophy, Williams College.

Mrs. Nancy MacFayden, Library Assistant, Williams College.

Roger McHugh, Professor of Anglo-Irish Literature, University College, Dublin.

Miss Holly McLennan.

Benedict R. Miles (*d.* 1970), editor and proprietor of the *Gibraltar Directory and Guide Book*.

Miss Kathleen A. O'Connell, Secretary to the President, Williams College.

Daniel O'Connor, Professor of Philosophy, Williams College.

Ulick O'Connor, Dublin Man of Letters.

Robert O'Donnell, Professor of English, Hofstra University.

Iona Opie, co-author of *The Oxford Dictionary of Nursery Rhymes* and *The Language and Lore of Childhood*.

Mrs. Clara Park, Berkshire Community College, Pittsfield, Massachusetts.

Eric Partridge, English authority on slang and unconventional language.

Anson Piper, Professor of Romance Languages, Williams College.

Christopher Ricks, Professor of English, University of Bristol.

Kenneth Roberts, Professor of Music, Williams College.

Robert M. Ross, Professor of English, University of Pennsylvania.

Charles Schweighauser, Williams College Center for Environmental Studies.

Mrs. Patti Seidman.

Miss Juanita Terry, Research Librarian, Williams College.

Mabel P. Worthington, co-author of *Song in the Works of James Joyce*.

We would also like to thank the Williams College 1900 Fund for grants in aid of this project.

D. G.

The primary intention of the notes in this volume is pedagogical—to provide a specialized encyclopedia that will inform a reading of *Ulysses*. The rule of thumb we have followed is to annotate all items not available in standard desk dictionaries. As they stand, the notes are not complete. Many of the incompletions we know we do not know; there are undoubtedly other incompletions of which we are unaware; and some of the complete notes are bound to prove inaccurate or inadequate. To the extent that these flaws are part of the formal traditions of history, theology, philosophy, science, literature and the arts, they should prove readily correctable; but one of the central problems is that Joyce depended heavily for his vocabularies on the vernacular and verbal worlds of Dublin 1904. Those worlds, which include Dublin slang and gossip, anecdotal (as against formal) history, and various phases of popular literature and culture, are rapidly passing out of living memory. Consequently, the effort to catch the nuances of those informal vocabularies is timely in its importance.

We have tried to balance on the knife edge of factual annotation and to avoid interpretive remarks. This is something of a legal fiction since it can hardly be said that the notes do not imply interpretations or that they do not derive from interpretations; but the intention has been to keep the notes "neutral" so that they will inform rather than direct a reading of the novel. The ideal of "neutrality" has, however, its drawbacks; it has tended to overweight the annotation. Joyce was fascinated by what he called "Dublin street furniture," and he included vast amounts of it in *Ulysses*. For the most part the furniture is factual detail with no suggestive dimension other than that it is factual—streets, bridges, houses, buildings, pubs and shops are there: period. But occasionally something transfactual occurs: when Bloom twice places Wisdom Hely's, where he once worked, at nonexistent addresses (literally wishing Hely's out of existence); or when Stephen passes Henry and James Clothiers and thinks of Henry James; or when Stephen places the physics theater of Jesuit University College in the palace of the Archbishop of the Church of Ireland. These occasions and many that are less obvious seemed to us to require that all the "street furniture" be annotated, if only to demonstrate, rather than to assert, that in most cases it was factual and inert as in life most such furniture inevitably is. On another level, the catalogues such as those of Irish heroes and of saints in [Cyclops] present a similar problem. Most of the heroes at the beginning of the list are just that, Irish heroes who make this one appearance in the novel; but at least two of them are what Stephen would call "the indispensable informer," so the whole list seemed

INTRODUCTION

to require annotation. Similarly, the saints are saints, but that list also includes ringers such as Molly Bloom and the dog Garryowen; so all were to be included. The problem is that even the well-informed reader needs to know only that the street furniture is *there* and *in place,* that the heroes are heroes, the saints, saints—so the notes will appear to labor an abundance of the obvious in order to render a few grains of the subtle and suggestive. What it came down to was that we could see no way of doing it other than to do it, and to accept the overweighting as a problem inherent from the outset in the concept of a "neutral" annotation.

The annotated passages are presented in sequence—not unlike the footnotes at the bottom of the pages of an edition of Shakespeare or Milton; thus the book is designed to be laid open beside the novel and to be read in tandem with it. Tandem reading has, however, its disadvantages. It threatens a reader not only with interruption but also with distortion because details which are mere grace notes of suggestion in the novel may be overemphasized by the annotation. Several compromises suggest themselves here: one is to accept an interrupted reading and to follow it with an uninterrupted reading; another is to read through a sequence of the notes before reading the annotated sequence in the novel. Perhaps the best approach would be a compromise: to skim a sequence of notes, then to read the annotated sequence in the novel with interruptions for consideration of those notes which seem crucial and then to follow with an uninterrupted reading of the sequence in the novel.

The annotations are designed to be useful on several different levels. The suggestive potential of minor details was, of course, enormously fascinating to Joyce, and the precision of his use of detail is a most important aspect of his literary method. Joyce frequently used religious metaphors for the artist and his processes; and in *Stephen Hero* he couched this fascination with detail in the religious term "epiphanies"—minor details that achieve for a moment a suggestive potential all out of proportion to their actual scale or importance. "By an epiphany he [Stephen Dedalus] meant a sudden spiritual manifestation" when the "soul" or "whatness" of an object "leaps to us from the vestement of its appearance." This much-quoted passage implies that the epiphany is not *in* the object itself but in the mind's response to the potential of the object as metaphor. To write a "book of epiphanies" as Joyce attempted (1900–1903) was to attempt to record minor moments in such a way as to develop (without explicitly or discursively so stating) their metaphoric potential. Joyce's use of detail in *Ulysses* could be regarded as a radical extension of the epiphanic method; it involves a precise attention to the handling of detail together with the author's refusal to point, evaluate, or interpret

in any direct way the meaning of a detail. This ideal of artistic detachment suggests that the reader's attention to detail has to be informed and focused to catch unstated nuances of suggestion; and one primary intention of the annotations in this volume is to illuminate details which are not in the public realm for most readers. Again, this is not to say that the intention has been to interpret the epiphanies or to develop their suggestiveness, but to provide a "factual" point of departure for that interpretation and development.

In a related way the notes should help the reader toward a grasp of the perspectives in terms of which the novel's characters and its worlds move. Mr. Deasy, for example, is dramatized as plausible if stuffy and square, but he is woefully inaccurate about many details of Irish history as the notes reveal. And yet these historical lapses should not discredit his relatively sensible approach to the problem of foot-and-mouth disease. The Citizen, on the other hand, is dramatized as an intolerant windbag, and yet, as the notes suggest, much of what he has to say is relevant to Ireland's problems in an overstated, violent and wrongheaded way.

In a more comprehensive sense the notes should help to fill in our views of Stephen and Bloom and the contexts in which they are trying to find themselves. Stephen's literary ambitions have projected him into a world which is unstable and competitive, a world crosshatched with the claims of national self-consciousness and Gaelic revival, with political, moral and religious prejudice, with theosophical mysticism and the apparently contrary impulses of French symbolism, elaborate critical theory, and Ibsenesque naturalism. Ideally the notes should help to flesh out these conflicting claims and to define the confusing immediacy they have for Stephen. On the other hand, many of the notes bear on Bloom's presence as "distinguished phenomenologist," 336 (343), at the center of the Dublin about which Stephen has "much, much to learn," 142 (144). Several commentators have argued that Bloom is badly misinformed if not ignorant, but the effort to examine his knowledge in detail reveals not an impressive knowledge (or its lack) but an impressive curiosity, an appetite for information that has been imperfectly nurtured in the realms of public knowledge (1890–1905) and by the middle-class culture in which he moves.

On another level the notes should help us to perceive more fully the significance of the novel's day (16 June 1904) in the lives of its central characters. Joyce's literary method precluded any overt evaluation of that significance, and it would have been *irrealism* from his point of view to attribute to Stephen or Bloom or Molly a direct access to that significance, quite simply because no individual can see his life in perspective when he is immersed in a day in that life. The analogues to *The Odyssey* provide one dimension of our

access to significant possibilities of change in the characters' lives; fragments of dream and astrology provide other clues; analogues to Jewish and Christian religious ceremonies and practices provide further clues, etc. These clues or indicators the notes seek to develop as points of departure for a fuller reading of the novel.

In the final analysis the notes will probably suggest minor and local rather than major and comprehensive revisions in established ways of reading and interpreting the novel. But one area of distortion should be guarded against: the notes put considerable emphasis on "street furniture," on the phenomenological presences of Dublin, its real inhabitants, real events; nonetheless Dublin is a mythical city—a vast concentration of "real" detail that adds up to a city which has the presence of a character in a novel, not a city in real life. And, as character, Dublin is in its way subject to, but not inevitably destined for, significant and positive change.

MONETARY VALUES

Joyce uses monetary values, among other incidental "hard facts," as indicators of and clues to his characters' attitudes and status. Since Joyce's technique is to withhold evaluative comment, these clues can easily be lost or misinterpreted. Stephen, for example, receives his monthly salary, 31 (30), of £3, 12s. A direct and rough approach to translation would suggest that the dollar in 1904 was worth at least twice what it was worth in 1970; thus, the pound, worth $5.00 in 1904, would be worth $10.00 in 1970, and Stephen's monthly wage would amount to $36.00. The school does not provide Stephen with bed and board; so in these terms $36.00 suggests a grinding poverty. On the other hand, a somewhat different line of reasoning would lead to quite different answers. *Thom's Official Directory of the United Kingdom of Great Britain and Ireland* (Dublin, 1904), p. 1345, lists the Dublin market prices of four Irish staples: bacon, bread, potatoes and oatmeal.[1] A comparison of prices then and

[1] Bacon, 7d per pound in 1904; a comparable (Canadian) bacon in the U.S. 1970 would be at least $1.40 per pound; d = 20¢. Bread, 5½d for a four-pound loaf in 1904; a comparable loaf, U.S. 1970, $1.40; d = 25¢. Potatoes .36d per pound in 1904; 10¢ per pound, U.S. 1970; d = 28¢. Oatmeal, 1.8d per pound in 1904; 36¢ per pound, U.S. 1970; d = 20¢. Average, d = 23¢; and this average does not take advantage of another Dublin staple, the pint of beer: 2d per 20-ounce pint in 1904, at least 65¢ in U.S. 1970 (d = 32.5¢). Incidentally some of the items in Bloom's accounts, 696 (711), are out of line with 1904 Dublin prices; coffee and bun would have been much closer to 1d than 4d and one square of soda bread, ½d rather than 4d.

now suggests that the English penny (1904) had the buying power of 23¢ (U.S. 1970). In these terms Stephen's salary translates into a respectable, if modest, $198.72. But even this figure needs to be modified by the fact that the relation of money to life was quite different in Dublin 1904 from what it is in the U.S. 1970. Dubliners in 1904 did not face the range of consumer goods or the pressures to choose and buy which play such an important part in the meaning of money in 1970. In effect, staples were much closer to the backbone of a family's budget in 1904 than that vague yardstick, "standard of living" (with its central heating, automobiles and household appliances, etc.), implies in 1970.

What this should suggest is that Stephen could live quite comfortably within his income; it also suggests that his behavior with money is not mildly but wildly prodigal on 16 June 1904. He sets out with £3, 12s, and at the end of his day of pub-crawling, Bloom returns him £1, 7s, 696 (711). This does not count the "half crowns" (2s 6d) which Stephen discovers in his pocket 602 (618), one of which he lends to Corley. Assuming he had two half-crowns left (5s), he ends the day having spent roughly £2, or, in terms of the relative price of staples, over $100.00 (1970). Considered in this way, the evidence relates more logically to Stephen's larger financial dilemma: his total indebtedness, not including "five weeks' board," amounts to £25, 17s, 6d—i.e., he owes a bit more than he could earn in seven months if he went on teaching (and incidentally spent nothing).

Our view of Bloom's financial state also undergoes a significant change if we use the prices of staple foods as a yardstick. Bloom's Dublin contemporaries are dubious about his financial state, and, as readers, we might be tempted to accept their doubts if we neglected the evidence the novel places at our disposal and if we undervalue the currency. In the financial terms of his time, Bloom enjoys a relatively secure, though of course not affluent, position in the middle class. He has savings of £18, 14s, 6d, 707 (723), and, while that does not sound like much, it is more than five times Stephen's monthly wage; and, since Bloom's house is valued at an annual rent of £28, his savings would pay his monthly rent for at least eight months. In terms of the relative value of staples 1904/1970 Bloom's savings would be worth $1,033.62; his rent, $128.80 per month. Bloom receives a commission from the *Freeman's Journal* for £1, 7s, 6d, more than half a month's rent and roughly equivalent to $75.90 (1970). His endowment insurance policy will be worth £500 ($29,600.00 in staples) when it matures. His stock holdings of £900 have a face value of $49,680.00 (1970) and would give him an annual income of £36 ($1,987.20). Inevitably distorted as they are, these figures still do not suggest financial insecurity, but that Bloom is at least holding his own.

To hold one's own was no mean feat in the Dublin middle-class world in 1904. One serious side effect of British economic (anti-industrial) policy for Ireland was the economic disenfranchisement of the Irish middle class. Outside of law, medicine and civil service for the upper levels and merchandising for the lower, there was precious little employment for members of the middle class, and the number of Bloom's contemporaries who are on their way down (and out) is not only testimony to Joyce's disaffection with middle-class Dublin; it is also a function of the hard realities which were the conditions of that Dublin world.

DON GIFFORD

Williams College
Williamstown, Massachusetts

ULYSSES

(1922)

I've put in so many enigmas
and puzzles that it will keep
the professors busy for centuries
arguing over what I meant,
and that's the only way
of insuring one's immortality.
—JAMES JOYCE,
QUOTED BY RICHARD ELLMANN[1]

[1] *James Joyce* (New York, 1959), p. 535.

The numerals before each annotated word or phrase indicate page and line in both the old (1934) and the new (1961) Modern Library editions; the old appears first, the new, second and in parenthesis. Cross-references among the notes in this text are indicated by the page and line number of the old edition, as 000:00n; references to passages in *Ulysses* include page and line numbers from both texts. Quotations from Homer, *The Odyssey*, in the head notes and elsewhere in the book are from the translation by Robert Fitzgerald (New York, 1961). References to Shakespeare's works are to *Shakespeare; the Complete Works*, edited by G. B. Harrison (New York, 1952).

PART I
[THE TELEMACHIAD]
pp. 4-51 (2-51)

S, the initial letter of Part I, is Stephen Dedalus' initial; as the initial letter of Part II, *M,* 54 (54), is Molly Bloom's; and *P,* the initial letter of Part III, 586 (612), is Poldy's (Leopold Bloom's). The initial letters thus suggest the central character in each of the three parts— Stephen self-preoccupied in Part I; Bloom preoccupied with Molly in Part II; and both Molly and Stephen preoccupied with Bloom in Part III.

S, M, P are also conventional signs for the three terms of a syllogism: *S,* subject; *M,* middle; *P,* predicate. While the three terms do not necessarily appear in the same sequence in all syllogisms, medieval pedagogy regarded the sequence *S-M-P* as the cognitive order of thought and therefore as the order in which the terms initially should be taught. Medieval pedagogy also established an initial order for the syllogism's three propositions: Proposition 1 would combine terms *M* and *P;* Proposition 2 would combine terms *S* and *M;* Proposition 3 (the conclusion) would combine terms *S* and *P. S* and *P* are subject and predicate of the conclusion to be but not necessarily the subject and predicate of the propositions themselves. *M,* the middle term, drops out when the conclusion is formed. In the original edition of *Ulysses* there was a large black dot or period at the end of Episode 17, 722 (737). A dot or period is a conventional sign for *Q.E.D.* (Latin: *quod erat demonstrandum,* "which was to be proved"). The analogue of the syllogism (as the overall analogue to *The Odyssey*) suggests a logical and narrative structure, which the reader can grasp but of which the characters in the fiction are essentially unaware.

EPISODE 1
[TELEMACHUS]

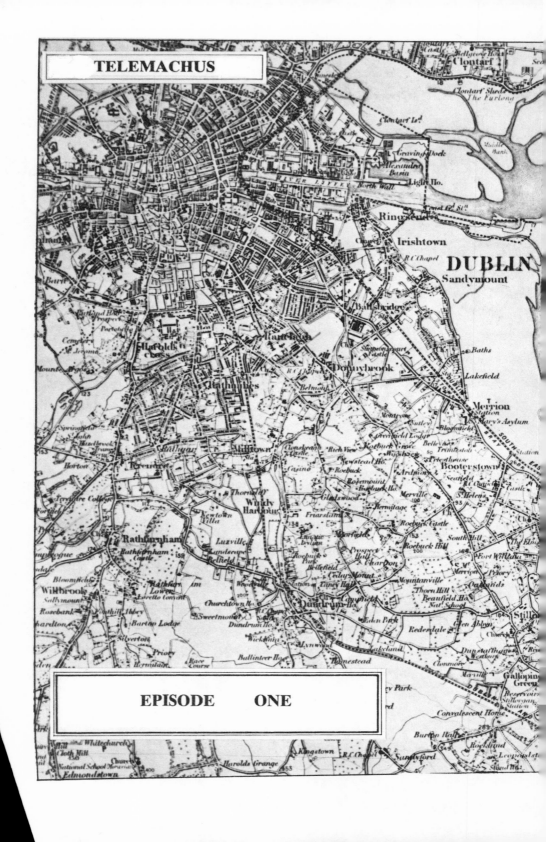

Episode 1: [Telemachus], pp. 4–24 (2–23). In Book I of *The Odyssey* Telemachus, Odysseus' son, is at home in Ithaca. He is threatened with displacement and betrayal by the suitors who have collected around his mother, Penelope, during his father's absence. Antinous is ringleader of the suitors. Pallas Athena, disguised as Mentor, appears to Telemachus and advises him to assert himself, to take steps toward ridding his father's house of the destructive and arrogant suitors, and to begin by journeying to the mainland in search of his father.

Time: 8:00 A.M., Thursday, 16 June 1904; Scene: a Martello tower at Sandycove on the shore of Dublin Bay seven miles southeast of the center of Dublin. Organ: none; Art: theology; Colors: white, gold; Symbol: heir; Technique: narrative (young); Correspondences: *Telemachus, Hamlet*—Stephen; *Antinous*—Buck Mulligan; *Mentor*—Milkwoman.[2]

5:1 (3:1). bowl—the chalice in the mockery of the Mass[3] in the scene that follows (as the "stair-head" becomes the altar steps). The chalice contains wine, which, in the ceremony of the Mass, becomes the blood of Christ.

5:2 (3:2). razor—the sign of the slaughterer, the priest as butcher.

5:2 (3:2). yellow—16 June is the feast day of St. John Francis Regis (1597–1640), a little-known French saint, intensely worshiped in the south of France. Since it is the feast day of a Confessor,

[2] As Joyce told Stuart Gilbert, as recorded in Stuart Gilbert, *James Joyce's Ulysses* (New York, 1952).

[3] On the meaning of the ceremonies of the Mass, the *Layman's Missal* (Baltimore, Md., 1962) remarks:

"At the heart of every Mass there occurs the account of the Last Supper, because every Mass renews the sacramental mystery then given to the human race as a legacy until the end of time: 'Do this in memory of me.' The liturgical rites which constitute the celebration of Mass—taking bread (offertory), giving thanks (preface and canon), breaking the bread and distributing it in communion—reproduce the very actions of Jesus. The Mass is an act in which the mystery of Christ is not just commemorated, but made present, living over again. God makes use of it afresh to give Himself to man; and man can use it to give glory to God through the one single sacrifice of Christ. In the missal there are certain central pages used over and over again in practically the same way at every Mass, and therefore they are called the 'ordinary' of the Mass. . . ."

Around the core of the ordinary the ceremonies of the Mass vary in accordance with the different phases of the liturgical year; i.e., there are sequences of Masses for the yearly anniversaries of "Christ in His Mysteries," and "Christ in His Saints." There are also votive Masses, Masses for the sick and for the dead, and various local Masses for special feast days.

the appropriate vestments for the Mass are white, with gold optional.[4]

5:3 (3:3). ungirdled—an inversion of priestly chastity.

5:5 (3:5). Introibo ad altare Dei—Latin, "I will go up to God's altar," from Psalms 43:4 (Vulgate 42:4). This is what the Celebrant says in the opening phase (the Entrance and Preparatory Prayers) of the Mass. The Minister or Server responds, *"Ad Deum qui laetificat juventutem meam"* ("To God who giveth joy to my youth"). It is notable that Stephen reluctantly plays the part of Server in what follows.

5:8 (3:8). Kinch—after "kinchin," child[5]; or "in imitation of the cutting sound of a knife," Ellmann, p. 136.

In an essay, "James Joyce: A Portrait of the Artist," Oliver St. John Gogarty remarks, "Kinch calls me 'Malachi Mulligan.' . . . 'Mulligan' is stage Irish for me and the rest of us. It is meant to make me absurd. I don't resent it, for he takes 'Kinch'—'Lynch' with the Joyces of Galway, which is far worse." In *Mourning Became Mrs Spendlove* (New York, 1948), p. 52.

5:8 (3:8). jesuit—the Jesuits, members of the Society of Jesus, a religious order of the Roman Catholic Church, were noted for their uncompromising intellectual rigor (and hence were popularly regarded as "fearful" in their seriousness).

5:22 (3:22). for this . . . genuine Christine—a parody of Jesus' words to his disciples at the Last Supper (Matthew 26:26–28): "And as they were eating, Jesus took bread, and blessed it, and brake it, and gave it to the disciples, and said, Take, eat; this is my body. And he took the cup, and gave thanks, and gave it to them, saying, Drink ye all of it; for this is my blood of the new testament, which is shed for many for the remission of sins." Jesus' words are recited in the Canon of the Mass as the host is consecrated. "Christine," the Eucharist, feminine here, is Mulligan's joking allusion to the Black Mass, which is irreverently

[4] The outer vestments of the priest have distinctive colors symbolically related to the feast being celebrated. *White*, for Easter and Christmas seasons, for feasts of the Trinity, for Christ, the Virgin Mary, and for angels and saints who are not martyrs; *red*, for Pentecost, for feasts of the Cross and of martyrs; *purple*, for Advent, for Lent, and for other penitential occasions; *rose* is occasionally substituted for *purple*; *green* is used at times when there is no particular season of feasts; *gold* can substitute for *white, red,* or *green*; and *black* is the color for Good Friday, and for the Liturgy of the Dead.

[5] William York Tyndall, *A Reader's Guide to James Joyce* (New York, 1959), p. 139.

celebrated with a woman's body as altar. See 583–584 (599–600).

5:23 (3:23). blood and ouns—an abbreviation of "God's blood and wounds," a blasphemous oath from the late Middle Ages.

5:24–25 (3:24–25). trouble ... white corpuscles —Mulligan, in mocking scientism, alludes to the process of transubstantiation when the wine is transformed into the blood of Christ in the mystery of the Mass.

5:28 (3:28). Chrysostomos—Greek: "golden-mouthed," after the Greek rhetorician, Dion Chrysostomos (c. 50–c. 117) and St. John Chrysostomos (345?–407), one of the Fathers of the early Church and Patriarch at Constantinople.

5:34–35 (3:34–35). a prelate, patron of the arts in the middle ages—the face described suggests that of the Spanish-Italian Pope, Alexander VI (1492–1503). He was born Roderigo Borgia (1430), and his career, together with that of his children Lucrezia and Cesare Borgia, has long been cited as a model of Renaissance high corruption. He was also a dedicated patron of the arts, attempting to outshine his predecessors and to leave a monument to himself and to his family for posterity. See Weldon Thornton, *Allusions in Ulysses* (Chapel Hill, North Carolina, 1968), p. 12.

5:37 (3:37). Your absurd name—"Stephen": after the first Christian martyr, St. Stephen Protomartyr (first century), a Jew educated in Greek (see Acts 6 and 7). He was the dominant figure in Christianity before the conversion of Paul. "Dedalus": Daedalus in Greek means "cunning artificer," and in Greek mythology Daedalus was the archetypical personification of the inventor-sculptor-architect. He was exiled from Athens because he murdered his nephew Talus out of jealousy for Talus's promising inventiveness. Daedalus went to bull-worshiping Crete, where, under the patronage of King Minos, he constructed the labyrinth to house the Minotaur (the bull-man who devoured an offering of seven Athenian youths and seven Athenian maidens once each seven years). Minos confined Daedalus and his son, Icarus, in the labyrinth, but Daedalus contrived their escape by fashioning wings of wax and feathers. Icarus, in the excitement of being able to fly, flew too near the sun; his wings disintegrated and he fell into the sea. Daedalus escaped to Sicily, where he found security and was able to live out his life creatively. As son, Stephen is Icarus (Telemachus) to Dedalus (Odysseus) as father—just as Stephen plays Hamlet, the son, through this day.

6:3 (4:4). Malachi—Hebrew: "my messenger," the prophet (c. 460 B.C.) of the last book of the Old Testament, who foretells the second coming of "Elijah the prophet before the coming of the great and dreadful day of the Lord" (Malachi 4:5). The name also recalls Malachy the Great, High King of Ireland in the late tenth century and Saint Malachy (c. 1094–c. 1148), Irish prelate and reformer, who was traditionally believed to have had the gift of prophecy.

6:12 (4:13). Haines—possibly a pun on the French, *la haine*, "hate" (since he is anti-Semitic, etc.).

6:23 (4:25). funk—fear, excessive nervousness, depression.

6:31 (4:34). scutter—a scurrying or bustling about.

7:1–2 (5:5–6). Algy ... grey sweet mother—Algernon Charles Swinburne (1837–1909) in "The Triumph of Time" (1866), lines 257–258, "I will go back to the great sweet mother,/ Mother and lover of men, the sea." In 1904 Swinburne was, in Yeats's phrase, "the King of the Cats," the grand old man of the *avant-garde* of the preceding century.

7:3 (5:7). Epi oinopa ponton—Homeric Greek: "over the wine-dark sea," an epithet that recurs throughout *The Odyssey*.

7:4 (5:8). Thalatta! Thalatta!—Attic Greek: "The sea! The sea!" Xenophon's (c. 434–c. 355 B.C.) *Anabasis* IV:vii:24. The *Anabasis* records the exploits of the 10,000 Greek mercenaries in the employ of Cyrus the Younger against his brother Ataxerxes, King of Persia. Betrayed and stripped of their chief officers by Persian treachery, the 10,000 literally cut their way out of a hostile Persia back to the Black Sea, the Bosporus and safety. *"Thalatta! Thalatta!"* was thus their shout of victory.

7:8 (5:12). Kingstown—(now Dun Laoghaire) the mouth of Kingstown harbor, an artificial harbor on the southern side of Dublin Bay, is approximately one mile northwest of the tower at Sandycove. Express packets linked England and Ireland through this port, fifteen minutes by rail from Dublin, and two and a half hours by packet from Holyhead in northwest Wales.

7:9 (5:13). Our mighty mother—a favorite phrase of George Russell's (AE), the Irish poet-theosophist-economist (1867–1935). In an essay, "Religion and Love" (1904), he effectively defines "the Mighty Mother" as "nature in its spiritual aspect."

7:16 (5:20). hyperborean—in Greek legend, a mythical people who dwelt beyond the north wind in a perpetual spring without sorrow or old age.

More specifically the reference is to the German philosopher Friedrich Nietzsche (1844–1900) in *Der Wille zur Macht* (1896) (*The Will to Dominate*). In Part I, *The Antichrist,* Section 1, Nietzsche uses the term "hyperborean" to describe the *Übermensch* (overman or superman), who is "above the crowd," and who is not enslaved by conformity to the dictates of traditional Christian morality since the moral man who lives for others is a weakling, a degenerate.

7:39 (6:2). dogsbody—an inversion of "godsbody," hence associated with the Black Mass and its inversion of liturgical language. *Cf.* 584:6 (599:32). It also identifies Stephen as a dog; in Celtic mythology the epithet for dog is "Guard the Secret." See 208:12–13n.

7:40 (6:3). breeks—trousers.

8:2 (6:7). poxy bowsy—drunkard with a venereal disease.

8:5 (6:11). if they are grey—Stephen's meticulous insistence on wearing black in mourning for a full year after his mother's burial, 26 June 1903. See 680:9 (695:26–27). Stephen's behavior recalls Hamlet's in Act I, Scene ii of Shakespeare's play.

8:13 (6:19). the Ship—see 24:30n.

8:14 (6:20). g.p.i.—abbreviation for "general paralysis of the insane," but also medical slang for "eccentric."

8:14 (6:20). Dottyville—a mocking name for the Richmond Lunatic Asylum, which, with its attached farm, was located in the northwest quadrant of Dublin. It was erected in 1815 during the Lord Lieutenancy of the Duke of Richmond and was originally for the benefit of paupers. The facilities have been expanded and it is now known as the Grangegorman Mental Hospital.

8:15 (6:21). Conolly Norman—(1853–1908), a famous Irish alienist who made a special study of insanity and instituted improved methods for treatment of the insane while he was superintendent of Richmond Asylum from 1886 to 1908.

8:22–23 (6:28–29). As he and others see me—after Robert Burns's (1759–1796) much-quoted lines in "To a Louse; on seeing one on a Lady's bonnet at Church" (1786), "O wad some Power the giftie gie us/ To see oursels as ithers see us!/ It wad frae monie a blunder free us,/ An' foolish notion" (lines 43–46).

8:25 (6:31). skivvy's—as slavey, a maid of all work. See 94:29n.

8:27 (6:33). lead him not into temptation—after the Lord's Prayer: "And lead us not into temptation, but deliver us from evil. . . ." (Matthew 6:13).

8:28 (6:34). Ursula—an early Christian saint whose legendary career involved the abhorrence of marriage. She led a pilgrimage of 11,000 virgins around Europe in honor of virginity. She was, along with her cohorts, martyred at Cologne. The official date of her martyrdom is 237; others: 283, 451.

8:31 (6:37). the rage of Caliban . . . mirror—paraphrased from Oscar Wilde's (1854–1900) novel *The Picture of Dorian Gray* (1891), in the "Preface" (a prose poem): "The nineteenth century dislike of Realism is the rage of Caliban seeing his own face in a glass. The nineteenth century dislike of Romanticism is the rage of Caliban not seeing his own face in a glass" (lines 8–9). Caliban is the evil-natured brute of Shakespeare's *The Tempest,* whom Wilde used as a symbol for the nineteenth-century Philistine mentality.

8:34–35 (6:40–41). a symbol . . . of a servant—paraphrased from Oscar Wilde's essay *The Decay of Lying* (1889): "I can quite understand your objection to art being treated as a mirror. You think it would reduce genius to the position of a cracked looking glass."

9:1 (7:8). oxy—not only an ox but also an Oxonian and a Saxon.

9:6 (7:13). Hellenise it—the verb "to Hellenise" was coined by Matthew Arnold (1822–1888) in his attempt to distinguish what he regarded as the two dominant impulses of Western "culture." "To Hebraise" (by which he meant *to do* in the light of "the habits and discipline" of a revealed dogmatic truth) and "to Hellenise" (to *know* in the light of a "disinterested" and "flexible" humanism) are concepts central to Arnold's *Culture and Anarchy* (1869/1875), particularly Chapter IV, "Hebraism and Hellenism." Arnold argued that the English had Hebraised to excess and should Hellenise in pursuit of "our total perfection." Arnold's essentially intellectual distinction underwent a series of modulations as it was popularized in the closing decades of the nineteenth century, modulations informed in part by Swinburne's poetic development of the opposition between the sensual-aesthetic freedom of the pagan, Greek world and the repressiveness of late-Victorian "Hebraism." By 1900 "Greek" had become Bohemian slang for those who preached sensual-aesthetic liberation, and "Jew" had become slang for those who were antagonistic to aesthetic values, those who preached the practical values of straightlaced Victorian morality.

9:7 (7:14). Cranly's arm—Cranly is presented as a friend of Stephen's in *A Portrait of the Artist as a Young Man,* Chapter V. Cranly and Stephen are estranged; so Stephen is linking arms with Mulligan in the present as he has with Cranly in the past. Cranly's name derives from Thomas Cranly (1337–1417), a monk of the Carmelite Order who succeeded to the Archbishopric of Dublin in 1397, but did not arrive in Dublin until October, 1398. He was also Lord Chancellor of Ireland. The combination in one man of Church and State authority implies yet another Anglo-Irish betrayal.

9:11 (7:18). Seymour—apart from the context, identity and significance unknown.

9:12 (7:19–20). Clive Kempthorpe—apart from the context, identity and significance unknown.

9:14 (7:22). Palefaces—Irish slang for the English, because the traditional Irishman is ruddy-faced, and because Indians in American Wild West stories called the whites "palefaces." The episode Mulligan and Stephen recall took place in England, not in Ireland. The scene was Oxford, where Mulligan's real-life counterpart, Oliver St. John Gogarty, had taken his undergraduate degree.

9:15 (7:23). Break the news to her gently—after an American popular song, "Break the News to Mother" (1897), by Charles K. Harris. The song records the battlefield death of a son who "gave his young life,/All for his country's sake." Chorus: "Just break the news to Mother;/She knows how dear I love her/And tell her not to wait for me,/For I'm not coming home;/Just say there is no other/Can take the place of Mother/Then kiss her dear sweet lips for me,/And break the news to her."

9:16 (7:24). Aubrey—a name regarded as effeminate and frequently used to express the sort of scorn the context implies.

9:18 (7:26). Ades of Magdalen—apart from the context, Ades is unknown. Magdalen is one of the Oxford colleges.

9:20 (7:28). to be debagged—to have one's trousers taken off.

9:22 (7:30). Matthew Arnold's—(1822–1888), English poet and critic whose emphasis on restraint, poise, and taste, and on what his contemporaries called "the ethical element" in literature, was regarded as Philistinism incarnate by turn-of-the-century aesthetes, even though many of their terms were derived from Arnold and Arnold's influence was (from an academic

point of view) still paramount in English criticism. See 9:6n.

9:24 (7:32). grasshalms—stems of grass.

9:25 (7:33). To ourselves—*Sinn fein* ("We ourselves" or "To ourselves"), first the motto of Irish patriotic groups formed in the 1890s for the revival of Irish language and culture, subsequently adopted by Arthur Griffith (1872–1922) *c.* 1905–1906 as the name of a political movement for national independence. Stephen is thinking of efforts to produce an Irish literary revival.

9:25 (7:33). new paganism—see 9:6n.

9:25 (7:33). omphalos—literally, the "navel," associated by the Greeks with Ogygia (Calypso's Island) and Delphi, the center not only of prophecy but also the navel of the earth. Late-nineteenth-century theosophy contemplated the omphalos variously as the place of "the astral soul of man," the center of his self-consciousness and the source of poetic and prophetic inspiration.

9:30 (7:39). Bray Head—the headland that rises abruptly above the coast approximately seven miles south of the Tower at Sandycove.

10:1–2 (8:10–11). I remember only ideas and sensations—this proposition echoes the essentially mechanistic concept of the human psyche developed by the English philosopher David Hartley (1705–1757) and derived from the work of John Locke (1632–1704) and Sir Isaac Newton (1642–1727). Hartley in his major work, *Observations of Man, His Frame, His Duty, and His Expectations* (London, 1749), defines memory as "that faculty by which traces of sensations and ideas recur, or are recalled, in the same order and proportion, accurately or nearly, as they were once present." In effect Hartley argues that literal recall is (as Mulligan implies) an illusion; the only real presences in the memory are sensations and ideas.

10:17 (8:27). the Mater and Richmond—the Mater Misericordiae Hospital in Eccles Street, the largest hospital in Dublin. It was under the care of the Sisters of Mercy (Roman Catholic) and provided "for the relief of the sick and dying poor." The Richmond Lunatic Asylum (see 8:14n) was associated with the Mater Misericordiae in the treatment of poverty cases.

10:23 (8:34). Sir Peter Teazle—elderly and exacting but kindhearted old gentleman, a character in *The School for Scandal* (1777), by Richard Brinsley Sheridan (1751–1816).

10:26 (8:37). hired mute from Lalouette's—Lalouette's, a "funeral and carriage establish-

ment" in Dublin, advertised itself as supplying "funeral requisites of every description." Mulligan alludes to the practice of employing deaf-mutes as professional mourners.

11:4 (9:14). Loyola—Saint Ignatius of Loyola (1491–1556), founder of the Society of Jesus and noted for the militancy of his dedication to religious obedience, obedience not only in outward behavior but also obedience of the will.

11:4 (9:14). Sassenach—Irish for the Saxon (or English) conqueror.

11:8–9 (9:19). Give up the moody brooding—this remark recalls the way Athena rebukes Telemachus in Book I of *The Odyssey* when she discovers him "as a boy dreaming" in his mother's house and councils him to strive to assert himself and to achieve his manhood.

11:12–14 (9:22–24). And no more ... the brazen cars—lines 7–9 of "Who Goes with Fergus?", W. B. Yeats, *Collected Poems* (New York, 1956), p. 43. The poem was included as a song in the first version of Yeats's play *The Countess Cathleen* (1892). The song is sung to comfort the Countess, who has sold her soul to the powers of darkness that her people might have food: "Who will go drive with Fergus now,/And pierce the deep wood's woven shade,/And dance upon the level shore?/Young man, lift up your russet brow,/And lift your tender eyelids, maid,/ And brood on hopes and fear no more.// And no more turn aside and brood/Upon love's bitter mystery;/For Fergus rules the brazen cars,/And rules the shadow of the wood,/And the white breast of the dim sea/And all dishevelled wandering stars." At 11:15 (9:25) and 11:18 (9:28) Stephen echoes lines 10 and 11 of the poem.

11:22 (9:33). a bowl of bitter waters—Numbers 5:11–31 outlines "The Trial of Jealousy," the trial of a woman suspected of an unproven adultery. The priest presents the woman with the "bitter water," cursing her so that if she is guilty "this water that causeth the curse shall go into thy bowels, to make thy belly to swell, and thy thigh to rot." If she is not guilty, the curse will have no effect.

11:31 (10:2). Royce—Edward William Royce (1841–?), an English comic actor, famous for his roles in pantomimes. The pantomime was a popular form of theatrical entertainment consisting of a loose story frame that allowed considerable latitude for improvisation, topical jokes, specialty acts, and vaudeville turns.

11:31–32 (10:3). Turko the terrible—(1873) a pantomine by the Irish author-editor Edwin Hamilton (1849–1919), adapted from William

Brough's (1826–1870) London pantomime *Turko the Terrible; or, the Fairy Roses* (1868). Hamilton's version was an instant success at the Gaiety Theatre in Dublin during Christmas Week, 1873. It was repeatedly updated and revived in the closing decades of the century. Its frame was essentially a world of fairy-tale metamorphoses and transformations—as King Turko (Royce) and his court enjoyed the magic potential of the Fairy Rose.

11:33–35 (10:4–6). I am the boy/That can enjoy/Invisibility—a song from *Turko the Terrible,* "Invisibility is just the thing for me," which King Turko sings when he discovers that the Fairy Rose can give him that gift.

11:38 (10:9). the memory of nature—what the English Theosophist Alfred Percy Sinnett (1840–1921) called the theosophical concept of a universal memory in which all moments and thoughts are stored (in *The Growth of the Soul,* London, 1896). See Akasic records, 142:2n and *cf.* 10:1–2n.

11:39–12:1 (10:10–11). Her glass of water ... the sacrament—i.e., on mornings when she went to Mass she had scrupulously observed the injunction to fast until after the ceremony.

12:13–14 (10:23–24). Liliata rutilantium ... chorus excipiat—Latin, "May the glittering throng of confessors, bright as lilies, gather about you. May the glorious choir of virgins receive you." The *Layman's Missal* quotes this as one part of "Prayers for the Dying" and remarks, "In the absence of a priest, these prayers for commending a dying person to God, may be read by any responsible person, man or woman" (p. 1141).

12:22 (10:32). mosey—someone who strolls slowly or shuffles.

12:29 (10:40). quid ... guinea—the guinea (21 shillings) is not only more money than the 20-shilling quid (pound), it is also more fashionable, a *gentlemanly* sum of money.

12:31 (11:2). kip—has various slang meanings, which Mulligan exploits in his repeated uses of the word: "that which is seized or caught, the catch," and "a brothel, lodging house, lodging or bed."

12:31–32 (11:2–3). four quid—Stephen's monthly wage, while not sizable in modern terms, would still compare favorably with the salaries of instructors in all but the wealthiest of modern preparatory schools.

12:39–13:3 (11:10–15). O, won't we have a merry ... On Coronation day?—one of sever-

al variants of an English street song popular in 1902 during the months of waiting before the coronation of Edward VII. J. B. Priestly[6] recalls one version: "We'll be merry/Drinking whiskey, wine, and sherry./Let's all be merry/On Co-ro-nation Day." The appropriateness of the song in context stems from the fact that "Coronation Day" was slang for payday because the pay could be reckoned in crowns (five-shilling pieces).

13:9 (11:21). the boat of incense—in the ceremony of the Mass. Stephen has performed as a server, a boy who assists at the altar and holds the container of incense for the priest (as here he performs a similar role in relation to Mulligan, who is acting the part of priest in this parody of the Mass).

13:9–10 (11:22). Clongowes—Clongowes Wood College, a Jesuit school for boys, regarded as the most fashionable Catholic school in Ireland. Stephen is a student at Clongowes in Chapter I, *A Portrait of the Artist as a Young Man*.

13:11 (11:23). A server of a servant—i.e., Stephen was a "server" in the Mass at Clongowes to the priest, who was a servant of God and the Church. The phrase also recalls the curse Noah imposed on his son Ham, "the father of Canaan," because Ham had seen Noah naked and drunk, "Cursed be Canaan; a servant of servants shall he be unto his brethren" (Genesis 9:25).

13:24 (11:36). Janey Mack—after a nursery rhyme: "Janey Mac, me shirt is black,/What'll I do for Sunday?/Go to bed and cover me head/And not get up till Monday." "Janey Mack" is also what the Irish call "dodging the curse," a euphemistic form of "Jesus Jack."

13:36 (12:6). I'm melting . . . candle re-marked when—obviously as it was being consumed by the flame; almost as obviously the prelude to a dirty joke about female masturbation.

13:38–39 (12:8–9). Bless us . . . thy gifts—a conventional blessing before meals.

13:39 (12:9). O Jay—dodging the curse "O Jesus."

[6] "Good Old Teddie," the *Observer* magazine (London, 1 November 1970), p. 25. Matthew J. C. Hodgart and Mabel P. Worthington, *Song in the Works of James Joyce* (New York, 1959), p. 62, list this as a combination of "On Coronation Day" and "De Golden Wedding" (1880), a song by the American black, James A. Bland (1854–1911). The chorus of Bland's song does contain the lines "Won't we have a jolly time/Eating cake and drinking wine," but there are several other songs with "Won't we have a jolly time" in their choruses, and this direct attribution seems doubtful.

14:15 (12:27). In nomine . . . Spiritus Sancti—Latin: "In the name of the Father and of the Son and of the Holy Spirit," a formula of blessing and consecration.

14:21 (12:33). mother Grogan—appears as a character in an anonymous Irish song, "Ned Grogan"; first verse: "Ned Grogan, dear joy, was the son of his mother,/And as like her, it seems, as one pea to another;/But to find out his dad, he was put to the rout,/As many folks wiser have been, joy, no doubt./To this broth of a boy oft his mother would say,/'When the *moon* shines, my jewel, be making your hay;/Always ask my advice, when the business is done;/For two heads, sure, you'll own, are much better than one.'"

14:29 (12:41). folk—one aspect of the somewhat self-conscious Irish attempt to achieve a national cultural identity in the late nineteenth and early twentieth century was a revival of interest in Irish folklore and folk customs. At times this interest ran to hairsplitting scholarship and at times to gross sentimentality. The revival of Irish as "the language" was another aspect of this national-identity crusade. See 16:13–27 (14:26–40).

14:31–32 (13:1–2). the fishgods of Dundrum . . . weird sisters . . . big wind—nonsense folklore. The fishgods are associated with the Formorians, gloomy giants of the sea, one of the legendary peoples of prehistoric Ireland. One Dundrum, on the east coast of Ireland, 65 miles north of Dublin, was famous as "the strand of champions" where ancient Irish tribes held a folk version of Olympic games. But another Dundrum, a village four miles south of the center of Dublin, was the site of a lunatic asylum, and it was at this Dundrum that Yeats's sister Elizabeth established the Dun Emer Press (1903, name changed to Cuala Press in 1908). The press was to publish Yeats's new works and works by other living Irish authors in limited editions on handmade paper. Lily Yeats, Yeats's other sister, became active in the Dun Emer Guild, which produced handwoven embroideries and tapestries. The "weird sisters": what the witches in Shakespeare's *Macbeth* call themselves as they wind up their "charm" at Macbeth's approach (I, iii, 32). "The year of the big wind": there is a big wind in *Macbeth*, described in Act II, scene iv, but this allusion is to the Irish habit of dating events as before and after 1839, when an incredible January storm blew down hundreds of houses across Ireland.

14:36 (13:6). Mabinogion—(Welsh, "instructions to young bards"), the title of a mixed bag of Welsh prose tales, some from early Celtic tradition, others from late medieval French

Arthurian romance, published by Lady Charlotte Guest in 1838.

14:36 (13:6). Upanishads—Hindu: the name of a class of Vedic works devoted to theological and philosophical speculations on the nature of the world and man—associated here with the theosophical interests of Yeats, AE (George William Russell), and other Irish intellectuals.

15:8–10 (13:20–22). For old Mary ... her petticoats—an anonymous, bawdy Irish song; only a clean, relatively recent version, "Mick McGilligan's Daughter, Mary Anne," by Louis A. Tierney has proved to be available in print. First verse, "I'm a gallant Irishman, I've a daughter Mary Anne,/She's the sweetest, neatest, colleen in this Isle,/Though she can't now purchase satin, she's a wonder at bog Latin,/In a fluent, fascinatin' sort of style./When she's selling fruit or fish, sure, it is her fondest wish/For to capture with her charm some handsome man;/Ah no matter where she goes, sure, and everybody knows/That she's Mick McGilligan's daughter, Mary Anne." Chorus, "She's a darling, she's a daisy and she's set the city crazy,/Though in build, and talk, and manner, like a man;/When me precious love draws near, you can hear the people cheer/For Mick McGilligan's daughter, Mary Anne." The remaining eight verses of Tierney's version are devoted to comic elaboration of Mary Anne's boisterous "masculine" charms.

15:20 (13:33). collector of prepuces—i.e., God, in the light of the commandment that all male children were to be circumcised (Genesis 17:10–14).

15:25 (13:38). tilly—a small quantity over and above the amount purchased.

15:26 (13:39). messenger—see headnote on the first book of *The Odyssey*, p. 6.

15:30–31 (14:2–3). Silk of the kine ... poor old woman—two traditional epithets for Ireland. "Silk of the kine [cows]" is idiomatic for the most beautiful of cattle; allegorically, Ireland. "The poor old woman," the "Shan Van Vocht" in Irish (see 19:17–18n), in legend looks like an old woman to all but the true patriots; to them she looks like "a young girl" with "the walk of a queen," as in the closing lines of Yeats's play *Cathleen Ni Houlihan* (the "Poor Old Woman") (1902). Legend also has it that during the Penal Days in the eighteenth century the Irish were forbidden to mention their nationality or to display the national color (green) or to wear the national emblem (the shamrock); so, the story goes, they used allegorical circumlocutions instead.

15:33 (14:5). cuckquean—a female cuckold.

16:9–10 (14:22–23). woman's unclean loins ... serpent's prey—woman was regarded as "unclean" after childbirth (Leviticus 12:2, 5) and during menstruation (Leviticus 15:19–28). Woman was made of man's flesh ("And the rib, which the Lord God had taken from man, made he a woman," Genesis 2:22), and she was "the serpent's prey," deceived into sin by Satan disguised as a serpent in Genesis 3. A woman's "loins" are not anointed in Extreme Unction in the Roman Catholic Church.

16:19 (14:32). from west—i.e., from the west coast of Ireland, where Irish was still spoken; education and commerce in nineteenth-century Ireland were dominated by the English language and prejudice, and the Irish language had disappeared from most accessible parts of the country by 1900.

17:6 (15:20). Ask nothing ... I give—lines 1 and 2 from Swinburne's "The Oblation," *Songs Before Sunrise* (1871). The poem continues: "Heart of my heart, were it more,/More would be laid at your feet:/Love that should help you to live,/Song that should spur you to soar.// ... // I that have love and no more/Give you but love of you sweet:/He that hath more, let him give;/He that hath wings, let him soar;/Mine is the heart at your feet/Here, that must love you to live."

17:13–14 (15:27–28). Heart of my ... at your feet—see 17:6n.

17:18 (15:32–33). Ireland expects ... do his duty—after words attributed to Lord Nelson ("England expects ...") at Trafalgar (1805); part of the refrain from "The Death of Nelson," words by S. J. Arnold, music by J. Braham. See 222:13n.

17:20 (15:35). your national library—the National Library of Ireland, founded in 1877. The nucleus of its books was donated by the Royal Dublin Society. In the nineteenth century, when the Irish language and culture were in eclipse, the society and subsequently the library were identified with efforts to preserve records and keep the Irish language and culture alive. Ironically in 1904 the more distinguished collection of ancient Irish MSS., etc., was housed in Trinity College library. See 139:24n.

17:26 (16:1). All Ireland is washed by the gulfstream—it is technically incorrect to call the general drift of warm water from the southwestern Atlantic northwestward to Europe the Gulf Stream. The stream proper so blends with the surrounding waters north of 40° north as to lose its identity as a stream.

17:32–33 (16:7–8). Agenbite of inwit—Middle English: "remorse of conscience." *Agenbite of Inwit* (1340) is a medieval manual of virtues and vices, which was designed to remind the layman of the hierarchy of sins and the distinctions among them. The manual was translated into Middle English (Kentish dialect) by Dan Michel of Northgate from the French of Friar Lorens, *Somme des Vices et Vertus* (1279).

17:33 (16:8). Yet here's a spot—*Macbeth* (V, i, 35), as Lady Macbeth walks in her sleep and struggles to cleanse her hands in the hallucination that they are still stained by the blood of Duncan, the murdered king.

18:22 (16:39). Mulligan . . . garments—a reference to "The Way of the Cross," the Fourteen Stations on the Via Dolorosa (the Street of Sorrows) in Jerusalem along which Jesus passed on his way to Golgotha and the Crucifixion. Contemplation of the Fourteen Stations is contemplation of the stages of Christ's Passion. The motto of the Tenth Station: "And Jesus was stripped of his garments." The scriptural basis for this station is Matthew 27:28 and John 19:23–24.

18:29 (17:4–5). puce gloves and green boots—this sort of idiosyncratic costume was associated with late-nineteenth-century decadence and aestheticism.

18:30–31 (17:5–6). Do I contradict . . . contradict myself—from Walt Whitman (1819–1892), "Song of Myself" (1855, 1891–92), Section 51, lines 6–7. Whitman's reputation in England at the end of the nineteenth century is reflected in Swinburne's praise of him as the poet of "The earth-god freedom," in "To Walt Whitman in America" (1871).

18:31 (17:6). Mercurial Malachi—as Malachi is Hebrew, "my messenger" (6:3n), so Mercury was the messenger of the gods in Roman mythology.

18:33 (17:8). Latin quarter hat—a soft or slouch hat associated with the art and student worlds of the Latin Quarter in Paris, as against the "hard" hats then fashionable in Dublin.

18:41 (17:16). And going forth he met Butterly—after Jesus had been captured and Peter for the third time had denied any association with him, "Peter remembered the word of Jesus which he had said: Before the cock crow, thou wilt deny me thrice. And going forth, he wept bitterly" (Matthew 26:75 [Douay]). "Maurice Butterly, farmer" is mentioned 477:13 (486:31); *Thom's Official Directory* (Dublin, 1904) lists a

Maurice Butterly, Court Duff House, Blanchardstown (a village four and a half miles west of Dublin). Another Maurice Butterly was proprietor of the City and Suburban Race and Amusement Grounds on Jones Road in the northern outskirts of Dublin.

19:15 (17:35). Martello—after Cape Martello in Corsica, where in 1794 the British had great trouble taking a similar tower. The towers were constructed at key points on the Irish coast (1803–1806) as defense against the possibility of a French invasion during the Napoleonic Wars.

19:17 (17:37). Billy Pitt—William Pitt the Younger (1759–1806), who was Prime Minister of England when the Martello towers were built.

19:17–18 (17:37–38). when the French were on the sea—from a late eighteenth-century Irish ballad, "The Shan Van Vocht" ("The Poor Old Woman," i.e., Ireland herself). Between 1796 and 1798 the French made four ill-starred attempts to lend naval and military support to the Irish revolution: "Oh! the French are on the sea,/Says the Shan Van Vocht,/The French are on the sea,/Says the Shan Van Vocht;/Oh, the French are in the Bay;/They'll be here without delay,/And the Orange will decay,/ Says the Shan Van Vocht. // [fifth and final stanza:] And will Ireland then be free?/Says the Shan Van Vocht;/Will Ireland then be free?/Says the Shan Van Vocht;/Yes! Ireland shall be free/From the centre to the sea;/ Then hurrah for Liberty!/Says the Shan Van Vocht." A later version substitutes the line "Oh Boney's [Napoleon's] on the sea. . . ."

19:18 (17:38). omphalos—see 9:25n.

19:21 (17:41). Thomas Aquinas—St. Thomas Aquinas (1225–1274), called the "angelic doctor," the "common doctor," and (by his schoolmates) "the dumb ox"; a Dominican, a theologian, and a leading Scholastic philosopher, famous as the synthesizer of the philosophy that was in 1879 made the required text for Roman Catholic seminaries. The goal of his work was to summarize all learning and to demonstrate the compatibility of faith and intellect. In Chapter V (*q.v.*) of *A Portrait of the Artist as a Young Man* Stephen expounds a theory of aesthetics that he asserts is "applied Aquinas."

19:21 (17:41). fiftyfive reasons—Mulligan's phrase recalls Aristotle's cosmological assertion in the *Metaphysics* that the universe consisted of 59 concentric spheres: the four mutable spheres of the earth and 55 immutable celestial spheres, each with its prime mover (or reason). The natural movement of the 55 was circular and changeless.

19:39 (18:17). Japhet in search of a father— (1836) a novel by (Captain) Frederick Marryat (1792–1848), English naval officer and novelist. The novel deals with the adventures of a foundling who is trying to find his father; the father, when finally found, turns out to be a testy old East India officer. Japhet was also the youngest of Noah's three sons and the legendary ancestor of a varied group of nations including the Greeks.

20:5 (18:25). Elsinore That beetles o'er his base into the sea—Elsinore, the seat of the Danish court in *Hamlet*. In Act I, scene iv of the play Horatio warns Hamlet of the dangers involved in following the ghost; Haines quotes from Horatio's speech (I, iv, 71).

20:15 (18:35). the Muglins—a shoal off Dalkey, the southeastern headland of Dublin Bay; the light on the Muglins thus marks the southeastern limit of the Bay.

20:16–18 (18:36–38). a theological interpretation . . . atoned with the father—source unknown. But it is notable that Haines's description could be fitted to Stephen's interpretation of *Hamlet*. See [Scylla and Charybdis], 182–215 (184–218).

20:25–28, 30–33, 38–21:2 (19:3–6, 8–11, 16–19). I'm the queerest . . . Goodbye, now, goodbye —these stanzas, which Stephen calls "The Ballad of Joking Jesus" (21:13 [19:30]), are quoted with some adaptations from a longer poem by Oliver St. John Gogarty, "The Song of the Cheerful (But Slightly Sarcastic) Jesus." The poem apparently was circulated in manuscript and by word of mouth in Dublin 1904–1905. See Ellmann, pp. 212–214.

21:3 (19:20). the forty-foot hole—at Sandycove, a bathing place; according to the *Official Guide, Dublin* (1958), "a popular resort of swimmers (men only)."

21:4 (19:21). Mercury's hat—see 18:31n.

21:11–12 (19:29). Joseph the Joiner—Joseph, the husband of the Virgin Mary, was a carpenter by trade (Matthew 13:55).

21:40 (20:20). Now I eat his salt bread— Dante, *Paradiso*, XVII:55–65. Dante's great-great-grandfather, Cacciaguida, predicts the future course of Dante's life and the bitterness of his exile: "Thou shalt abandon every thing beloved most dearly; this is the arrow which the bow of exile shall first shoot. Thou shalt make trial of how salt doth taste another's bread, and how hard the path to descend and mount upon another's stair. And that which most shall weigh thy shoulders down, shall be the vicious and ill

company with which thou shalt fall down into this vale, for all ungrateful, all mad and impious shall they become against thee; but, soon after, their cheeks, and not thine, shall redden for it."

22:6 (20:27). servant of two masters—*The Servant of Two Masters* from the Italian, *Il servitore di due padroni*, a play by the Italian Carlo Goldoni (1707–1793). The play is a conventional Roman comedy with a girl disguised as a boy, a pair of lovers separated by an unfortunate marriage pledge, and a servant, Truffaldino ("trickster"), who plies his trade for two masters.

22:21–22 (20:42–21:1). et unam . . . ecclesiam —Latin: "and one holy catholic and apostolic church." This phrase is from the last portion of the Nicene Creed—the uniform creed that was evolved at the council of Nicaea in 325. The creed was an attempt to resolve the theological speculation and controversy which was characteristic of the early Church. Some of these early Christian speculations (particularly those concerning the nature of the Trinity and of the Son's consubstantiality with the Father) Stephen contemplates in the lines that follow.

22:23–24 (21:3). Symbol of the apostles— i.e., the Apostles' Creed in the Mass (so called because each of the 12 clauses is traditionally attributed to one of the Apostles): (1) Peter, I believe in God the Father Almighty, Maker of heaven and earth; (2) John, And in Jesus Christ, His only Son, our Lord; (3) James (the Elder), Who was conceived of the Holy Ghost, born of the Virgin Mary; (4) Andrew, Suffered under Pontius Pilate; was crucified, died, and buried; (5) Philip, He descended into hell; (6) Thomas, The third day He rose again from the dead; (7) James (the Younger), He ascended into Heaven, and sitteth on the right hand of God the Father Almighty; (8) Matthew, From thence He shall come to judge the quick and the dead; (9) Nathaniel, I believe in the Holy Ghost; (10) Simon, the Holy Catholic Church, the Communion of Saints; (11) Matthias, the forgiveness of sins; (12) Jude, the resurrection of the body, and the life everlasting.

22:24 (21:3). the mass for pope Marcellus— Pope Marcellus II (1501–1555) lived only 22 days after his coronation in 1555. The Italian composer Giovanni Pierluigi da Palestrina (1525–1594) wrote a *Missa Papae Marcelli*, first performed 27 April 1565. The Credo of the *Missa* parallels in places the "Symbol of the Apostles," the Apostle's Creed, see preceding note.

22:25–27 (21:4–6). behind their chant the vigilant . . . menaced her heresiarchs—the "angel of the Church Militant" is the Archangel Michael, a presence the Church invoked in its struggle against the spread of the Protestant

heresy in the sixteenth century. The struggle included even strictures against "all music in which anything lascivious or impure was mixed" (1551), Council of Trent (1545–1563). Purists in the council argued that this dictate excluded all music except plainsong and Gregorian chant. When Pope Julius III (Pope 1551–1555) appointed Palestrina as master of the Cappella Giulia in 1552, he was expressly repudiating the purists in favor of the "new" polyphonic music. After Julius's death, Pope Marcellus II continued to support Palestrina, but Pope Paul IV, a purist, promptly dismissed Palestrina upon his accession in 1555. In 1564 another musically liberal Pope, Pius IV, asked Palestrina to compose a polyphonic Mass which would be free of all "impurities" and would thus silence the purists. The *Missa Papae Marcelli* was that Mass, and its performance succeeded in establishing polyphonic music (and Palestrina) as the voice of the Church.

22:28 (21:7). Photius—(c. 820–c. 891), appointed Patriarch of Constantinople (857) against the Pope's wishes and in the midst of political and religious controversy. Photius was excommunicated (863) and in turn convened a church council at Constantinople and excommunicated the Pope and his partisans (867). Photius was subsequently restored to the Church only to be excommunicated once again. Photius is regarded by the Roman Church as "one of its worst enemies" because the eastern schism, which he initiated, was to climax in the separation of the Eastern Orthodox and Roman Catholic Churches in 1054.

22:28 (21:7). the brood of mockers—apparently those who dissent from orthodox concepts of the nature of the Trinity. Photius's dissent was his assertion that the Holy Ghost proceeded not "from the Father and from the Son" (Roman Catholic orthodoxy) but "from the Father."

22:29 (21:8). Arius—(c. 256–336), his heresy: he taught that the Word or Logos (Christ) was God's first creation, that God created Him out of nothing; and then Christ created the Holy Spirit; and then the Holy Spirit created our world. Thus Christ is God's first creation and inferior to God; and the Holy Spirit, as Christ's creation, is inferior to Christ. The Council of Nicaea (325) condemned Arius as a heretic and used the term "consubstantial" to underscore the equality of the three persons of the Trinity in refutation of Arius's speculations.

22:30 (21:9–10). Valentine—(d. c. 166), an Egyptian Gnostic who preached in Rome 135–160. His heresy: the Demiurge, creator of the material world, was not a member of the Trinity but a "demon," remote from the unfathomable God. Hence the material world and its creator were regarded as antispirit, and all men as diverse compounds of spirit and matter. Christ was sent by God to lead men to *Gnosis,* i.e., to pure knowledge, which is spiritual, and which transports man to the kingdom of light; thus man escapes from the kingdom of darkness because darkness will remain forever darkness. Valentine argued that Christ had no "terrene body" but was pure spirit.

22:31 (21:11). Sabellius—(third century), his heresy: he maintained that the names "Father," "Son," and "Holy Spirit" were merely three names for the same thing (or three different aspects or modes of one Being).

22:34 (21:14). weave the wind—after Isaiah 19:9, "and they that weave networks shall be confounded" and John Webster (c. 1580–c. 1625), song from *The Devil's Law Case* (1623): "Vain the ambition of kings/Who seek by trophies and dead things/To leave a living name behind,/And weave but nets to catch the wind."

22:36 (21:15). Michael—the archangel symbolic of the Church Militant.

22:38 (21:18). Zut! Nom de Dieu!—French: "Damn it! In the name of God!"

22:40–41 (21:20–21). into the hands of German jews—the myth of a Jewish conspiracy intent on world domination was by the late nineteenth century a commonplace reactionary explanation of any (and all) of the ills of the modern world. Revolutions, capitalism, international banking, and international tensions and wars could be attributed to this conspiracy. From a British point of view the conspiracy had its seat in France and/or Germany (from a German point of view in England and/or France, etc.).

23:3 (21:25). Bullock harbour—near Dalkey on the southeast headland of Dublin Bay. The Castle of Bullock overhung a creek which had been converted into an artificial harbor.

23:6 (21:28). five fathoms out there—i.e., to the north in the offshore area of Dublin Bay, an area two miles wide that extends five and a half miles from the south shore of the bay across the sea-walled mouth of the Liffey to the north shore.

23:7 (21:29). when the tide comes in about one—high tide in Dublin, 16 June 1904: 0:18 A.M. and 12:42 P.M.

23:17 (21:40). Westmeath—a county 40 miles west and west northwest of Dublin.

23:18 (21:41). Bannon—Alec Bannon is an

associate of Mulligan's circle and has met Milly Bloom down in Westmeath. He functions as a minor, offstage character in the novel.

23:27–28 (22:8–9). crossed himself piously ... and breastbone—the gesture that prefaces the reading of the Gospel in the ceremony of the Mass.

23:33 (22:14). to stew—to sweat, to work doggedly and unimaginatively.

23:37 (22:18). rotto—slang for "rotten."

23:38 (22:19). up the pole—slang for strait-laced (military) or in difficulties (in some cases, pregnant).

24:3 (22:27). My twelfth rib ... Uebermensch —*Übermensch*, the German "Superman," after Nietzsche, *Thus Spake Zarathustra* (1883). Zarathustra (Zoroaster), Persian religious leader who flourished in the sixth century B.C., was expropriated by Nietzsche and converted into the prophet of the superman. In "Zarathustra's Prologue": "*I teach you the superman.* Man is something that is to be surpassed," and in section 5 Zarathustra asserts: "... The most contemptible thing ... is *the last man*." Thus, since Mulligan's "twelfth rib is gone," he is Adam, first man, least contemptible man, i.e., superman. See 7:16n.

24:24 (23:7). He who stealeth ... to the Lord —after Proverbs 19:17, "He that hath pity upon the poor lendeth unto the Lord."

24:29 (23:12). Horn of a bull, hoof of a horse, smile of a Saxon—a version is listed as Proverb 186 under "British Isles: Irish," in Selwyn Gurney Champion, *Racial Proverbs* (New York, 1963), "Beware of the horns of a bull, of the heels of a horse, of the smile of an Englishman."

24:30 (23:13). The Ship—a hotel and tavern, 5 Abbey Street Lower, in the northeast quadrant of Dublin not far north of the Liffey. See 142:14n.

24:33–35 (23:16–18). Liliata rutilantium ... te virginum—see 12:13–14n.

EPISODE 2
[NESTOR]

NESTOR

EPISODE TWO

Episode 2: [Nestor], pp. 25–37 (24–36). In Book II of *The Odyssey* Telemachus faces the suitors in council, is estranged from them, and takes ship for the mainland to seek news of his father, as Athena in the guise of Mentor had counseled him. In Book III Telemachus arrives on the mainland and approaches Nestor, the "master Charioteer," for advice. Pisistratus, the youngest of Nestor's sons, greets Telemachus; Nestor, though he knows only that Odysseus' homecoming is fated to be hard, affirms Telemachus' emergent manhood and recites part of the history of the homecoming of the Greek heroes. In Book IV Pisistratus guides Telemachus to the court of Menelaus, where Telemachus meets Helen and hears the story of Menelaus' homecoming.

Time: 10:00 A.M. Scene: a school in Dalkey, a small town on the southeast headland of Dublin Bay, approximately one mile southeast of the Martello Tower at Sandycove. Organ: none; Art: history; Color: brown; Symbol: horse; Technique: catechism (personal). Correspondences: *Nestor*—Deasy; *Pisistratus,* Nestor's youngest son—Sargent; *Helen*—Mrs. O'Shea (Parnell's mistress and subsequently his wife), see 35:38–39n.

25:2 (24:2); 25:13 (24:13). Tarentum ... Asculum ... Pyrrhus—Stephen is questioning his class about Pyrrhus (318–272 B.C.) and his campaigns against the Romans on behalf of the Tarentines (a Greek colony in lower Italy). Pyrrhus had had a checkered career as minor king and successful general before he undertook the Tarentine cause in 280 B.C. He was reasonably successful against the Romans, winning battles at Siris in 280 B.C. and at Asculum in 279 B.C., but he won in such a costly way that the collapse of the Tarentine cause became inevitable.

25:7 (24:7). Fabled by the daughters of memory—William Blake (1757–1827), from *A Vision of the Last Judgment* (Rossetti MS., *c.* 1793–1820): "Fable or Allegory is Form'd by the daughters of Memory. Imagination is surrounded by the daughters of Inspiration, who in the aggregate are call'd Jerusalem." In a wider context the daughters of Zeus and Mnemosyne (memory) are the nine muses of Greek mythology; see 480:27n.

25:9 (24:9). Blake's wings of excess—a compound of two of the "Proverbs of Hell" from Blake's *The Marriage of Heaven and Hell* (*c.*1790): "The road of excess leads to the palace of wisdom," and "No bird soars too high, if he soars with his own wings."

25:9–11 (24:9–11). the ruin of all space ... time one livid final flame—Blake repeatedly predicts "the world ... consumed in Fire" (as in *The Marriage of Heaven and Hell,* 1790), and, he asserts in a letter to William Hayley, 6 May 1800, "Every Mortal loss is an immortal gain. The ruins of Time build mansions in Eternity." Stephen fuses fragments from Blake with a vision of the fall of Troy, a lost cause not unlike the efforts of the Tarentines under Pyrrhus to resist the dominion of Rome. From this apocalyptic vision arises a question about the nature of History: if, as Blake predicts, the moment of transformation is "the livid final flame," then will "the whole creation ... be consumed and appear infinite and holy, whereas it now appears finite & corrupt" (*The Marriage of Heaven and Hell*)?

25:15–16 (24:15–16). Another victory like that and we are done for—after the Battle of Asculum "it is said, Pyrrhus replied to one that gave him joy of his victory, that one other such would utterly undo him" (Plutarch's *Lives,* "Pyrrhus," translated by Arthur Hugh Clough [Boston, 1863], Vol. III, p. 29).

25:21 (24:21). Armstrong—apart from the context, the significance of this name is not known. (There was no Armstrong family resident in Vico Road, Dalkey, in 1904.) See Ellmann, p. 158.

25:21–22 (24:21–22). ... the end of Pyrrhus ...? —after Asculum, Pyrrhus continued to barnstorm around the Mediterranean world. That world was in a limbo of small-state anarchy with rivalries and lost causes enough for all the ambitious. His "end" (272 B.C.): Pyrrhus had undertaken to assist one of the leading citizens of Argos in some sort of town feud. His opponent was Antigonus II of Macedon. Pyrrhus was trapped inside the town; when he attempted to slip out, he was caught up in a street fight and was about to kill one of his assailants when the assailant's mother threw a tile from a housetop. Pyrrhus was stunned, thrown from his horse, and killed by one of Antigonus' henchmen. See 26:14 (25:14).

25:24 (24:24). Comyn—there was no family of this name resident in Dalkey in 1904, but Comyn was the name of a powerful and prominent family in Scotland after the Norman Conquest. It spent itself in a futile (Pyrrhus-like) struggle to preserve the Scots' independence in the course of the thirteenth century.

25:31 (24:31). Vico Road, Dalkey—this has been repeatedly cited as an allusion to the Italian philosopher Giambattista Vico (1668–1744), whose cyclical theories of history, his concept of history as an endless "rosary," Joyce found fascinating. But there is room for doubt about this allusion because there was a Vico Road in Dalkey, because one of the models for Armstrong (Clifford Ferguson, Ellmann, p. 158) did live in Vico Terrace

and because Stephen's free associations on Blakean and Aristotelian concepts of the nature of history put Stephen in an essentially pre-Vicon-ian position.

25:40 (24:40). Kingstown pier—the two sea-wall arms that form the artificial harbor at Kings-town (now Dun Laoghaire) were called Kings-town Pier, East and West. Kingstown was the terminus for the steam packets which were Ireland's principal "bridge" to England.

26:14–15 (25:14–15). Julius Caesar not been knifed to death—Caesar (100–44 B.C.), Roman general, statesman and dictator, was knifed to death by a conspiracy of 60 aristocrats who resented and feared his personal concentration of political power. Nineteenth-century historians insisted on regarding this event as a disaster for the Roman Empire because in retrospect Caesar's death seems to have been prelude to a particularly unstable period in Roman history.

26:17 (25:17–18). the infinite possibilities they have ousted—a distinction based on Aristotle's discussion (in the *Metaphysics*) of the antithesis between "the potential" (that which can move or be moved) and "actuality" ("the existence of the thing" which cannot move or be "dislodged"). In effect Aristotle argues that at any given moment in history there are a number of "possibilities" for the next moment, but only one of the possibili-ties can become "actual," and once it becomes actual, all other possibilities for that given moment are "ousted."

26:18–19 (25:19). Or was that only possible which came to pass?—This echoes another of Aristotle's distinctions, that between poetry and history in the *Poetics* VIII:4–IX:2: "From what we have said it will be seen that the poet's function is to describe, not the thing that has happened, but a kind of thing that might happen, i.e., what is possible as being probable or necessary. The distinction between historian and poet . . . consists really in this, that the one describes the thing that has been, and the other a kind of thing that might be."

26:19–20 (25:20). weave, weaver of the wind —see 22:34n.

26:25 (25:25); 26:32–34 (25:32–34); 27:7 (26:7). Weep no more . . . watery floor /Through the dear . . . walked the waves—from John Milton (1608–1674), "Lycidas" (1638), lines 165–173. Following is the whole passage from Milton's pastoral elegy on the death by drowning of his friend Edward King:

Weep no more, woeful Shepherds weep no more,
For *Lycidas* your sorrow is not dead,

Sunk though he be beneath the wat'ry floor,
So sinks the day-star in the Ocean bed,
And yet anon repairs his drooping head,
And tricks his beams, and with new-spangled Ore,
Flames in the forehead of the morning sky:
So *Lycidas,* sunk low, but mounted high,
Through the dear might of him that walk'd the waves,
Where other groves, and other streams along,
With *Nectar* pure his oozy Locks he laves,
And hears the unexpressive nuptial Song,
In the blest Kingdoms meek of joy and love.
There entertain him all the Saints above,
In solemn troops, and sweet Societies
That sing, and singing in their glory move,
And wipe the tears for ever from his eyes.
Now *Lycidas,* the Shepherds weep no more;
Henceforth thou art the Genius of the shore,
In thy large recompense, and shalt be good
To all that wander in that perilous flood.
 Thus sang the uncouth Swain to th'Oaks and rills,
While the still morn went out with Sandals gray;
He touch't the tender stops of various Quills,
With eager thought warbling his *Doric* lay:
And now the Sun had stretch't out all the hills,
And now was dropt into the Western bay;
At last he rose, and twitch't his Mantle blue:
Tomorrow to fresh Woods, and Pastures new.

26:26 (25:26). Talbot—for one association with this name see 220:12–14n. There was no Talbot family resident in Dalkey in 1904.

26:35–36 (25:35–36). a movement . . . an actuality of the possible as possible—from Aristotle's definition of motion in the *Physics* III: 1: "The fulfillment of what exists potentially, in so far as it exists potentially, is motion—namely, of what is alterable *qua* alterable, alteration."

26:37–27:2 (25:37–26:2). the library of Saint Genevieve . . . dragon scaly folds—the library, in Paris on the Place du Panthéon, was, according to Baedeker's (1907), "frequented almost ex-clusively by students" in the evening hours. The iron girders that support the vaulting of the large reading room do give the effect of a cave. The passage also alludes to Blake, *The Marriage of Heaven and Hell:* "I was in a Printing house in Hell, & saw the method in which knowledge is transmitted from generation to generation.

"In the first chamber was a Dragon-Man, clearing away the rubbish from a cave's mouth; within, a number of Dragons were hollowing the cave."

27:2–4 (26:3–4). Thought is the . . . form of forms—Aristotle, *On the Soul* III:432a: ". . . As the hand is the instrument of instruments, so the

mind [*nous*, soul] is the form of forms and sensation the form of sensibles." In *Metaphysics* Aristotle argues that the prime mover is thought thinking on itself.

27:15–16 (26:15–16). To Caesar . . . what is God's—when the Pharisees attempt to "entangle Jesus in his talk," they ask him, "Is it lawful to give tribute unto Caesar, or not?" (since Jesus had argued that man should pay tribute only to God). Jesus' answer is a riddle; he argues that the image on the tribute money coin is Caesar's: "Render therefore unto Caesar the things which are Caesar's; and unto God the things that are God's" (Matthew 22:15–22, Mark 12:17 and Luke 20:25).

27:19–20 (26:19–20). Riddle me . . . seeds to sow—the opening lines of a riddle that continues: "The seed was black and the ground was white./ Riddle me that and I'll give you a pipe (or pint)." Answer: writing a letter. Compare the actual opening lines of the riddle Stephen propounds in 27:33–38n. below.

27:33–38 (26:33–38); 28:7 (27:8). The cock crew . . . to go to heaven. . . . The fox burying . . . hollybush—Stephen's riddle is a joke at the expense of riddles since it is unanswerable unless the answer is already known. See P. W. Joyce, *English as We Speak It in Ireland*, p. 187: "Riddle me, riddle me right:/What did I see last night?/ The wind blew,/The cock crew,/The bells of heaven/Struck eleven./ 'Tis time for my poor soul to go to heaven." Answer: "The fox burying his *mother* under a holly tree."

28:4 (27:5). Cochrane—there was a Charles Cochrane II, solicitor, resident at 38 Ulderton Road in Dalkey, 1904.

28:15 (27:16). Sargent—there was no Sargent family resident in Dalkey in 1904; apart from the context, the connotations of this name are unknown.

28:24 (27:25). Mr Deasy—the headmaster of the school. His name may owe something to the Deasy Act (1860), an act ostensibly intended for land reform in Ireland but in practice a ruthless regulation of land tenancy in favor of landlords (i.e., in favor of the pro-English, anti-Catholic Establishment). In keeping with his name, Mr. Deasy is a "West Briton," one who regards Ireland as the westernmost province of England and one who mimics English manners and morals. Ironically there was a Reverend Daniel Deasy, resident as Curate in Charge of the Roman Catholic Church in Castle Street, Dalkey, in 1904.

28:37 (27:38). The only true thing in life?— Stephen's friend Cranly has remarked in Chapter

V of *A Portrait of the Artist as a Young Man*: "Whatever else is unsure in this stinking dunghill of a world a mother's love is not."

28:38 (27:39). the fiery Columbanus—(543– 615), Irish saint, one of the most learned and passionately eloquent of the Irish missionaries to the Continent. Columbanus is reputed to have left his mother "grievously against her will" (Butler's *Lives of the Saints* [London, 1938]).

29:9 (28:11). morrice—a Moorish dance, because the Moors, 29:12 (28:14), were reputed to have introduced algebra into Europe during the Renaissance.

29:12–13 (28:14–15). Averroes and Moses Maimonides—Averroës (1126–1198), Spanish-Arabian philosopher and physician, noted for his commentaries on Aristotle, which provided the background of a large part of medieval Christian Scholasticism. While he strove to reconcile Aristotle with Moslem orthodoxy (with heavy emphasis on God the Creator), he was suspected by the Moslem world of heterodoxy, and his reputation implied that both his Christian and Jewish adherents were likewise somehow heterodox.

Moses Maimonides (1135–1204), Jewish Rabbi, Talmudic scholar and philosopher. Like Averroës, he had considerable influence on medieval Christian thought, notably on Aquinas; he was called "the light of the west." Maimonides' primary effort was at a reconciliation of Aristotelian rational thought with what orthodox Judaism regarded as revealed truth.

29:14–16 (28:16–18). a darkness shining . . . not comprehend—after John 1:4–5: "In [God] was life; and the life was the light of men. And the light shineth in darkness; and the darkness comprehended it not."

29:22–23 (28:25). Amor matris: subjective and objective genitive—Latin: "Mother love." Ambiguous to Stephen because the phrase could mean the mother's love for her child (subjective) or the child's love for its mother (objective).

30:20–24 (29:24–28). As it was in the beginning, is now . . . and ever shall be . . . world without end—from the *Gloria Patri*, "Glory be to the Father, and to the Son, and to the Holy Ghost; as it was in the beginning, is now and ever shall be, world without end."

30:21 (29:25). Stuart coins—James II of England took refuge in Ireland and accepted the allegiance of the Irish after he had been deposed from the English throne in 1688. In 1689 he debased the Irish currency by coining money out of inferior metals. The coins, though initially as worthless as the Stuart attempt to use Ireland (a

bog) to retake England, are, of course, rare. The coins bore the motto "CHRISTO—VICTORE—TRIUMPHO" ("Christ in Victory and in Triumph").

30:22–23 (29:26–27). snug in their spooncase ... all the gentiles—i.e., Mr. Deasy has a spooncase containing twelve spoons whose handles represent the figures of the 12 Apostles. The spoons were the traditional present of sponsors at christenings. In Matthew 10 Jesus gives the 12 Apostles "power to work miracles" and sends them out into the world with the admonition: "Go not into the way of the Gentiles, and into any city of the Samaritans enter ye not: But go rather to the lost sheep of the house of Israel" (Matthew 10:5–6). In Acts 10 and 11 the Apostles determine to preach to the Gentiles.

30:35 (29:39–40). the scallop of Saint James—the scallop is the device of St. James the Greater, whose shrine at Compostella in Spain was one of the major goals of medieval pilgrimages. Pilgrims who had been to the shrine wore a scallop as a sign of their achievement.

31:19 (30:24–25). If youth but knew—proverb: "If youth but knew what age would crave, it would at once both get and save."

31:20 (30:25–26). Put but money in thy purse —*Othello*, Act I, scene iii, Iago to his dupe Roderigo, repeatedly and with considerable cynicism, because Iago intends to use both Roderigo *and* his money.

31:23 (30:29). He knew—i.e., Shakespeare knew.

31:30 (30:36). French Celt—the germ of the sun-never-sets image is in Herodotus (Xerxes brags about the glory of the Persian Empire). Subsequent reworkings of the phrase can be found in Captain John Smith, Sir Walter Scott, Schiller and Daniel Webster, none of them "French Celts," and there is little sense in the attempt at precise attribution of this stock metaphor.

31:39 (31:2). Curran—Constantine P. Curran, a Dublin friend of Joyce's. See Ellmann, *passim*.

31:39 (31:2). McMann—a MacCann *(sic)* appears as a character in *A Portrait of the Artist as a Young Man,* Chapter V.

31:39 (31:2–3) Fred Ryan—an Irish economist and writer who wrote for and edited the magazine *Dana,* which began publication in 1904. W. K. Magee (under the pseudonym of John Eglinton, see [Scylla and Charybdis]) was coeditor of the magazine.

31:40 (31:3). Temple—appears as a character in *A Portrait of the Artist as a Young Man,* Chapter V.

31:40 (31:3). Russell—George William Russell (pseudonym AE, 1867–1935), a dominant figure in the Irish literary renaissance of the late nineteenth and early twentieth century. He was profoundly committed to the truths of mystical (theosophical) experience, and he combined in one career the activities of prophet, poet, philosopher, artist, journalist, economic theorist, and practical worker for agrarian reform. (See [Scylla and Charybdis].)

31:40–41 (31:4). Cousins—James H. Cousins, Dubliner. Ellmann records his relation to Joyce and remarks that he was a "theosophical poetaster" (Ellmann, p. 157 and *passim*).

31:41 (31:4). Bob Reynolds—identity or significance unknown.

31:41 (31:4). Köhler—identified as T. G. Keller, a Dublin literary friend of Joyce's (Ellmann, pp. 170–171 and *passim*).

32:1 (31:5). Mrs. McKernan—Dubliner, from whom Joyce rented a room in 1904. (See Ellmann, pp. 157, 161, 177, 238.)

32:11–12 (31:15–16). Albert Edward, Prince of Wales—(1841–1910), Queen Victoria's son and successor as Edward VII (king of England, 1901–1910).

32:14 (31:18). O'Connell's time—Daniel O'Connell (1775–1847), Irish political leader known as "the Liberator" because he successfully agitated for the 1829 repeal of the law that limited the civil and political rights of Catholics. As leader, his chief political weapon was "moral force" within the limits of constitutional procedures, though his followers pressed him to use illegal and violent means. His agitations for the repeal of the Act of Union, which had united the Parliaments of England and Ireland in 1800, were carried on in a series of "monster meetings" (1841–1843) and were interrupted when he was tried and sentenced to one year in prison for "seditious conspiracy." The end of his career was marred not only by his failing health, but also by dissensions and oppositions between the partisans of "old" and "new" Ireland within his own party.

32:15 (31:19). the famine—the disintegration of the Irish economy in the nineteenth century had condemned at least half of Ireland's population of eight million to abysmal poverty and to dependence on the potato as staple food. (At least three-quarters of the land under cultivation in

Ireland was devoted to cattle and to crops, primarily wheat for export, which the poor simply could not afford.) The potato blight appeared in 1845, destroying the potato crop and reducing the poor to famine. The famine completed the ruin of the tottering Irish economy. English policy had dictated the suppression of industry in Ireland; and the agrarian collapse was a deathblow, not only to the peasantry but also to many landlords, because many had tried to tide their peasants over the famine and were ruined in the process. The population of Ireland fell by 1,500,000 in three years (through death and emigration to America); the population continued to fall through the rest of the nineteenth century, until in 1901 it was approximately 4,500,000. The famine has been repeatedly described as "the worst event of its kind recorded in European history at a time of peace."

32:15 (31:19). the orange lodges—emerged as Protestant nuclei of anti-Catholic violence in the 1790s and became the Orange Society after 1795. The society was anti-Union at its inception but it became pro-Union shortly after 1800. The Orangemen were concentrated in Ulster, the northernmost counties of Ireland, and regarded themselves as "an organization for the maintenance of British authority in Ireland." When the English Parliament came close to granting Home Rule for Ireland in 1886, it was to the tune of anti–Home Rule riots in the Orangemen's stronghold of Belfast.

32:16 (31:20). repeal of the union—the Act of Union (1800) had dissolved the Irish Parliament and merged it with the English Parliament in London. Repeal of the Act of Union (by the English Parliament) thus became one of the central political issues in nineteenth- and early twentieth-century Ireland. The Act of Union required that the Irish Parliament, which had attained full legislative power *c.* 1782, vote itself out of existence; this it did, encouraged as it was by considerable bribery and skulduggery. The result of union was the displacement of political power from Dublin to London and a radical increase in absentee landlordism (and agrarian misrule) because the landlords moved to England to secure an influence in politics.

32:17–18 (31:21–22). the prelates of your communion . . . as a demagogue—The Irish Roman Catholic bishops were far more energetic in their support of O'Connell's successful campaign for Catholic emancipation than they were in his subsequent campaign for repeal of the Act of Union. While some bishops were suspicious of O'Connell and his methods, the word "denounced" is hardly an accurate reflection of their conduct.

32:18 (31:22). fenians—the Fenians (nicknamed the "hillside men") took their name from the Fianna of Irish legend, a standing force of warriors under Finn MacCool in the third century. The Fenian Society (the Irish Republican Brotherhood), organized in 1858 by James Stephens, the "head center," was committed to the achievement of Irish independence through terrorist tactics and violent revolution (rather than through parliamentary or constitutional reform).

32:19 (31:23). Glorious, pious and immortal memory—the Orangeman's toast to the memory of William of Orange, William III (1650–1702), king of England (1689–1702), the patron "saint" of the radically Protestant Irish because he saved Ireland from James II and completed the English conquest of Ireland (effectively reducing it to the penal colony it was in the eighteenth century). "To the glorious, pious and immortal memory of the Great and Good King William III, who saved us from popery, slavery, arbitrary power, brass money and wooden shoes."

32:19–22 (31:23–26). The lodge of Diamond . . . true blue bible—Stephen contemplates a capsule version of an incident in Irish history. In the 1790s the northern Irish (from "the black north," after black or reactionary Protestants) organized a series of persecutions which were intended to drive all the Catholics out of Armagh, one of the northern counties. The Catholic tenants organized a resistance, the Defenders. A group of Defenders gathered at the Lodge of Diamond, 21 September 1795, and was visited with massacre for having "experimented with resistance" after the notice "To Hell or Connaught" had been nailed to the lodge door. The "Planter's Covenant": the Plantation System was developed in Queen Elizabeth's reign as a method of organizing land management in Ireland and as a way of pacifying the rebellious population. Roman Catholic Irish were declared in forfeit of their lands, and large, quasi-feudal plantations were granted to English and to loyal Anglo-Irish planters. A planter who received a grant of forfeited lands was required to "covenant" his loyalty to the English Crown by acknowledging the English sovereign as head not only of the State but also of the Church. The punitive potential of the Plantation System was effectively exploited during the reign of James I of England (reigned 1603–1625) and during the Protectorate under Cromwell, so effectively that the Roman Catholic population of Ireland was virtually reduced to feudal peasantry.

32:22 (31:26). Croppies lie down—"croppy" after the close-cropped heads of the Wexford rebels in 1798; subsequently a term for any Irish rebel. The phrase itself is the refrain of several "loyal," i.e., Orangeman's ballads, among them

"When the Paddies of Erin"; first verse and chorus: "When the paddies of Erin took a pike in each hand,/And wisely concerted reform in the land;/Ough, and all that's before them they'd drive, to be sure,/And for conjured up grievances each had a cure./But down, down, Croppies, lie down." The refrain is also quoted in the chorus of "The Old Orange Flute," a ballad about an Orangeman who is converted to Roman Catholicism but whose flute insisted on playing "Croppies lie down."

32:25 (31:29). sir John Blackwood—(1722–1799) was offered a peerage to bribe him to vote for Union; he refused, and, to quote a letter from Henry N. Blackwood Price to Joyce (1912), "died in the act of putting on his top boots in order to go to Dublin to vote against the Union" (quoted in Ellmann, p. 336). Blackwood's son, Sir J. G. Blackwood, is however included by Josiah Barrington (1760–1834), in *The Rise and Fall of the Irish Nation* (1833), on the "Black List" as having voted for Union and having been made Lord Dufferin in the transaction.

32:26 (31:30). all Irish, all kings' sons—proverb: "All Irishmen are kings' sons" (after the ancient kings of Ireland). There is a similar Jewish proverb.

32:28 (31:32). Per vias rectas—Latin: "by straight roads." Sir John Blackwood's motto.

32:30 (31:34). the Ards of Down—an armlike peninsula on the Irish Sea in County Down, 80 miles north-northeast of Dublin. The district is just west of the Orangeman's stronghold of Belfast.

32:31–32 (31:35–36). Lal the ral . . . road to Dublin—an anonymous Irish ballad that describes the adventures of a poor Catholic peasant boy from Connaught as he travels through Dublin to Liverpool. He is mocked, robbed and housed with pigs during the crossing. In Liverpool, when his country is insulted, he answers with his shillelagh and is joined by Galway boys (thus he finally wins respect in the rough world). Chorus: "For it is the rocky road, here's the road to Dublin;/Here's the rocky road, now fire away to Dublin."

32:33 (31:37). soft day—a usual Irish greeting, meaning "a wet day."

33:11–13 (32:15–17). lord Hastings' Repulse . . . prix de Paris, 1866—Henry Weysford Rawdon-Hastings, Marquis of Hastings (1842–1868); his horse Repulse won the One Thousand Guineas, an annual race at Newmarket in England (1866). Hugh Lupus Grosvenor, First Duke of Westminster (1825–1899); his filly Shotover won the Two Thousand Guineas, another of the annual races at Newmarket (1882), and the Derby at Epsom Downs (1882). Henry Charles Fitzroy Somerset, 8th Duke of Beaufort (1824–1899); his horse Ceylon did win the Grand Prix de Paris (1866), the most famous of French horseraces, run annually at Longchamps outside of Paris.

33:21 (32:25). Even money fair Rebel—ran at the odds Stephen quotes and won the Curragh Plate (4 June 1902), an annual race at Leopardstown, a racecourse six miles southeast of Dublin.

33:29 (32:33). crawsick—ill in the morning after a drunken bout the night before.

33:41–42 (33:3–4). Liverpool ring . . . Galway harbour scheme—a group of English and Irish promoters in the 1850s proposed to transform Galway Harbour on the west coast of Ireland into a transatlantic port. Their first step was to establish a Galway-Halifax steamship line, but the enterprise was plagued by accidents which, as they mounted in number, were widely rumored to be the result of sabotage. The hard-luck story began in 1858, when one of the company's ships, the *Indian Empire*, struck Marguerite Rock in Galway Harbour, the only obstacle in a channel nine miles wide. The ship was not seriously damaged, but the episode prefigured six years of accident and mismanagement. The company closed shop in 1864. There is no evidence that a "Liverpool ring" (Liverpool shipping interests fearing the competition of Galway) plotted to frustrate the plan; the evidence, on the contrary, points to maritime incompetence of the promoters.

33:42–34:1 (33:4–5). European conflagration . . . of the channel—i.e., in case of a European war transatlantic shipping would not have to run the gamuts of St. George's Channel between Ireland and Wales or the North Channel between Ireland and Scotland, but could enter Galway directly from the Atlantic.

34:3 (33:7). Cassandra—i.e., someone who prophesies doom and is not heard; after Cassandra, daughter of Priam of Troy. She refused Apollo's love and was condemned by him to speak true prophecies that would not be believed. Her predictions of the destruction of Troy thus went unheeded.

34:3–4 (33:7–8). woman who . . . should be—i.e., Helen of Troy. See 35:37–39 (34:40–42).

34:7 (33:11). foot and mouth disease—aphthous fever, a virus disease that affects cattle, pigs, sheep, goats and frequently man. In the early twentieth century there was no dependable cure for animals afflicted with the disease and attempts to develop methods of immunizing cattle had had inconstant results. The occasion of Mr.

Deasy's letter is somewhat anachronistic since there was no outbreak of foot-and-mouth disease in Ireland in 1904, indeed not until 1912. *The Irish Daily Independent* for 16 June 1904 reported on the "Diseases of Animals Acts for 1903" (just issued by the Department of Agriculture), and remarked, "The Irish cattle, however, continued practically immune from the more serious contagious diseases. There was no cattle plague, foot and mouth disease, pleuro pneumonia, or sheep louse in 1903" (page 4, column 7).

34:7 (33:11). Koch's preparation—for the prevention of anthrax (not foot-and-mouth disease). The German physician and bacteriologist Robert Koch (1843–1910) developed a method of preventing anthrax by inoculation in 1882. Two of Koch's assistants in the early twentieth century attempted to apply Koch's methods to immunize cattle against foot-and-mouth disease but their success was minimal.

34:7–8 (33:12). Serum and virus—a reference to what were in the early twentieth century new methods of developing antitoxins to be used in the treatment of various diseases.

34:8 (33:12). Percentage of salted horses—i.e., horses that had been treated with T.C., a substance derived from "the virus of tuberculosis" in 1905 by the German physician Emil Adolph von Behring (1854–1917). The substance was supposed to render animals immune to tuberculosis; the initial claims for the substance were somewhat overoptimistic. The production of T.C. involved the use of saline solutions, hence "salted."

34:8 (33:12). Rinderpest—another disease of cattle for which there was no known cure.

34:8–9 (33:12–13). Emperor's horses at Murzsteg, lower Austria—the Austrian emperor did maintain a hunting lodge and stable at Mürzsteg, but Dr. Richard Blaas, the director of the House, Court and State Archives in Vienna can find no evidence of veterinary experiments at Mürzsteg between the years 1895 and 1914.

34:9 (33:13). Veterinary surgeons—a relatively new branch of medical science at the turn of the century. Mr. Deasy's letter apparently claims that cures for foot-and-mouth and other diseases were being developed; that claim was premature. But the central argument of his letter is more sound: that epidemic diseases among animals should be investigated and treated in the light of the latest scientific methods.

34:9–10 (33:14). Mr Henry Blackwood Price—corresponded with Joyce in 1912 about an outbreak of foot-and-mouth disease in Ireland. See Ellmann, pp. 336–338.

34:34–35 (33:38–39). The harlot's cry . . . winding sheet—lines 115–116 from William Blake's "Auguries of Innocence," from the Pickering MS. (*c.* 1803). In context: "The Whore and Gambler, by the State/Licenc'd, build that Nation's fate./The Harlot's cry from street to street/Shall weave Old England's winding sheet./ The Winner's Shout, the Loser's Curse,/Dance before dead England's Hearse."

35:2 (34:5). wanderers on the earth—literally the Jews were driven out of their homeland and dispersed by the Romans (A.D. 70 *ff.*). Subsequently they suffered a series of dispersions at the hands of the Christian European nations. Figuratively, the allusion is to the legend of the Wandering Jew. Christian versions of the legend revolve around a Jew who rejects or reviles Jesus at the time of the Crucifixion and who is condemned to wander the earth until the Last Judgment or until the last of his race is dead (or, in some versions, until he repents).

35:5 (34:8). They swarmed . . . the temple—an allusion to the Gospel accounts of the moneychangers in the Temple at Jerusalem. Each of the four Gospels records Jesus' expulsion of the moneychangers: Matthew 21:12–13; Mark 11:15–17; Luke 19:45–46; John 2:13–16.

35:19–20 (34:22–23). History . . . trying to awake—after Jules Laforgue (1860–1887), *Mélanges posthumes* (Paris, 1903), "Lettres à Mme.?," p. 279: "*La vie est trop triste, trop sale. L'histoire est un vieux cauchemar bariolé qui ne se doute pas que les meilleures plaisanteries sont les plus courtes*" ("Life is very dreary, very sordid. History is an old and variegated nightmare that does not suspect that the best jokes are also the most brief").

35:30 (34:33). A shout in the street—after Proverbs 1:20–22: "Wisdom crieth without; she uttereth her voice in the streets . . . *saying,* How long, ye simple ones will ye love simplicity? and the scorners delight in their scorning, and fools hate knowledge?"

35:36–37 (34:39–40). A woman brought sin into the world—a reference to Eve's part in the Fall of Man in Eden; Eve succumbed first to the temptation to eat the forbidden fruit and subsequently "tempted" Adam to his fall (Genesis 3:1–6).

35:38–39 (34:41–42). Helen, the runaway . . . war on Troy—Helen, the wife of Menelaus, king of Sparta, was awarded to Paris, the son of King Priam of Troy, because Paris had adjudged Aphrodite more beautiful than Hera and Athena.

Menelaus, with the help of his brother Aga-
memnon, the king of Mycenae, organized a Greek
invasion of Troy, which fell to the Greeks after
ten years of war.

**35:40–41 (35:1–2). MacMurrough's . . .
Breffni**—Dermod MacMurrough, the king of
Leinster (1135–1171). He was deposed in 1167.
He fled to England, where he solicited the aid of
Henry II and was joined by several of Henry's
lords for the first Norman invasion of Ireland, in
1169. A quaint nineteenth-century history des-
cribes him as follows: "Owing to his youth and
inexperience . . . he became an oppressor of the
nobility. . . . This of itself brought him trouble,
which another circumstance contributed to in-
crease for he eloped [in 1152] with Devorgilla, the
wife of O'Ruarc [O'Rourke] Prince of Briefny
[Breffni] and East Meath." *Leman* archaically
meant "husband"; though Mr. Deasy is using the
word in the modern sense and thus has the re-
lationship muddled.

35:41–42 (35:2–3). A woman . . . Parnell low—
Parnell was named as correspondent in a divorce
case as a result of his liaison with Mrs. Katherine
O'Shea; the net effect was the collapse of Par-
nell's career and the collapse of Irish hopes for the
achievement of Home Rule under his leadership.

**36:3–4 (35:6–7). For Ulster will . . . will be
right**—Ulster, the six northern, Protestant and
pro-English counties of Ireland, was violently
opposed to Home Rule for Ireland. Lord Randolph
Churchill (1849–1895) capitalized on the senti-
ments of Ulster in his campaigns against Glad-
stone and the Home Rule Bill. Lord Churchill
first used what Winston Churchill called "the
jingling phrase" in a letter, 7 May 1886. The
phrase became a battle cry for anti-Catholic,
anti–Home Rule forces.

36:19 (35:22). Telegraph, Irish Homestead—
The *Evening Telegraph*, a four-page, nine-col-
umn daily newspaper in Dublin. The *Irish Home-
stead*, another Dublin newspaper with which AE
(George Russell) was associated. In 1904 the
paper was edited by H. F. Norman; Russell was

editor from 1905 to 1923. The paper emphasized
agrarian reform and was self-consciously ad-
dressed to rural Ireland. ("The pig's paper" is
Stephen's epithet for the *Irish Homestead*, 190:35
[193:2].)

36:23 (35:26). Mr Field, M.P.—William Field,
Member of Parliament and president of the Irish
Cattle Traders and Stock Owners Association in
1904.

**36:23–24 (35:26–27). a meeting of the cattle-
traders' . . . City Arms Hotel**—the Irish Cattle
Traders and Stock Owners Association held
weekly meetings every Thursday at its offices in
the City Arms Hotel, owned by Mrs. Elizabeth
O'Dowd, at 54 Prussia Street (near the cattle
markets in northwestern Dublin).

36:40–41 (36:2–3). bullockbefriending bard—
an allusion to Homer because Homer "befriended"
the cattle of the sun-god by condemning the mem-
bers of Odysseus' crew who violated the god's
prohibition and slaughtered some of the cattle
(Book XII of *The Odyssey*). The phrase also
alludes to Stephen's preoccupation with Thomas
Aquinas, who was called "the dumb ox" by his
fellow students at Cologne. Albertus Magnus
(1193–1280), Aquinas' teacher, is supposed to
have said, "We call him the dumb ox, but he will
one day give such a bellow as shall be heard from
one end of the world to the other."

37:11 (36:14). Because she never let them in
—Jews are first mentioned as resident in Ireland
in eleventh-century documents; Henry II ac-
knowledged their presence (and legitimated it) by
assigning custody of the King's Judaism in
Ireland to one of his lords in 1174. Jews were ex-
pelled from Ireland, as from England, in 1290 and
were resettled in both countries under Cromwell
in the mid-seventeenth century. There is no
evidence that Ireland "never let them in" and
considerable evidence to the contrary, including
various legislative attempts to provide for the
naturalization of Jews in the late eighteenth
century, finally successful in 1846.

EPISODE 3
[PROTEUS]

Sandymount Strand

Pig

EPISODE THREE

Lake

D U B L I N

B A Y

Rosbeg
Bank

Light Ho.

Poolbeg Light Ho.

N

Light Ho.

Light Ho.

Kingstown
Harbour

Black Rock

Seapoint
Station

Salt Hill
Station

Station

Life Boat Sta.

KINGSTOWN

Scotch Bay

Bullock Harbour

Bartragh

Loreto Convent

Dalkey

Queenstown

Dalkey Island

PROTEUS

Episode 3: [Proteus], pp. 38–51 (37–51). In Book IV of *The Odyssey*, while Telemachus is at the court of Menelaus, Menelaus recounts the story of his journey home from Troy. Menelaus was becalmed in Egypt by the gods for an infraction of the rules of sacrifice. He does not know which of the gods has him "pinned down," and he does not know how to continue his voyage home. To achieve a prophecy he wrestles on the beach with Proteus, the Ancient of the Sea. Proteus has the power to "take the forms of all the beasts, and water, and blinding fire"; but, if Menelaus succeeds in holding him throughout the successive changes, Proteus will answer Menelaus' questions. Menelaus does succeed. Proteus tells him how to break the spell that binds him to Egypt and also tells him of the deaths of Agamemnon and Ajax and of the whereabouts of Odysseus, marooned on Calypso's island.

Time: 11:00 A.M.; Scene: Sandymount Strand, the beach just south of the mouth of the Liffey and the Pigeon House breakwater, which extends the south bank of the Liffey out into Dublin Bay. Stephen has apparently come from Dalkey to Dublin by public transportation, and he now idles away the hour and a half before his scheduled meeting with Mulligan at 12:30. He subsequently decides to skip that meeting. Organ: none; Art: philology; Color: green; Symbol: tide; Technique: monologue (male); Correspondences: *Proteus*—primal matter; *Menelaus*—Kevin Egan; *Megapenthus*—Cocklepicker. Megapenthus was born before the walls of Troy, the son of Menelaus by a slave girl. Megapenthus' wedding feast is being celebrated in Menelaus' mansion when Telemachus arrives there.

38:1 (37:1). Ineluctable modality of the visible—exact source unknown, but Aristotle does argue in *De Sensu et Sensibili (Of Sense and the Sensible)* (see 38:4–5n) that the substance of a thing perceived by the eye is not present in the form (or color) of the perceptual image (in contradistinction to sound and taste, which involve a "becoming" and thus an intermixture of substance and form in the perceptual image). In effect, Aristotle says that the ear participates in (and thus can modify) what it hears, but that the eye does not participate in the substance of what it sees.

38:2–3 (37:2–3). Signatures of all . . . to read—Jakob Boehme (Böhme) (1575–1624), German theosophist and mystic, who maintained that everything exists and is intelligible only through its opposite. If Boehme is right, then the "modality" of visual experience stands (as signatures to be read) in necessary opposition to the true substances, the spiritual identities to be perceived. As John Sparrow put it in his prefatory notes to translations of Boehme's *The Forty Questions of*

the Soul and *The Clavis* (London, 1647; reprinted, London, 1911), p. xi: "Boehme, not being yet sufficiently satisfied with two visions of 'the divine light,' went forth into the open fields, and there perceived the wonderful or wonderworks of the Creator in the *signatures*, shapes, figures and qualities or properties of all created things, very clearly and plainly laid open; whereupon, being filled with exceeding joy, kept silence, praising God." In *The Clavis*, p. 19, Boehme remarks that Mercury, "the word or speaking," means "the motion and separation of nature, by which everything is figured with its own signature." Boehme begins Chapter I of his *Signatura Rerum (The Signature of All Things)* with the proposition, "1. All whatever is spoken, written or taught of God, without the knowledge of the signature is dumb and void of understanding; for it proceeds only from an historical conjecture, from the mouth of another, wherein the spirit without knowledge is dumb; but if the spirit opens to him the *signature*, then he understands the speech of another; and further, he understands how the spirit has manifested and revealed itself (out of the essence through the principle) in the sound of the voice."

38:4–5 (37:4–5). Limits of the diaphane. But he adds: in bodies—Aristotle's theory of vision, as developed in *De Sensu et Sensibili (Of Sense and the Sensible)* and in *De Anima (On the Soul)*. In *De Anima* Aristotle argues that color is "the peculiar object" of sight as sound is the peculiar object of hearing. In *De Sensu* he postulates "the Translucent" (the diaphane) is "not something peculiar to air or water, or any of the other bodies usually called translucent, but is a common 'nature' and power, capable of no separate existence of its own, but residing in them, and subsisting likewise in all other bodies in a greater or less degree. . . . But it is manifest that, when the Translucent [diaphane] is in determinate bodies, its bounding extreme [limit] must be something real; and that colour is just this 'something' we are plainly taught by facts—colour being actually either *at* the external limit, or being itself that limit, in bodies. . . . It is therefore the Translucent, according to the degree in which it subsists in bodies (and it does so in all more or less), that causes them to partake of colour. But since the colour is at the extremity of the body it must be at the extremity of the Translucent in the body" (from 439a, 439b, as translated by J. A. Smith, *The Works of Aristotle*, W. D. Ross, ed. [Chicago, 1952], Vol. I, p. 676).

38:6–7 (37:6–7). By knocking his sconce against them—i.e., Aristotle has proven the existence of "bodies" in a manner similar to Dr. Samuel Johnson's (1709–1784) refutation of what his biographer, James Boswell (1740–1795), called "Bishop Berkeley's ingenious sophistry to prove

the non-existence of matter, and that everything in the universe is merely ideal." Boswell reports, "I shall never forget the alacrity with which Johnson answered, striking his foot with mighty force against a large stone, till he rebounded from it, 'I refute it thus'" (Boswell's *Life of Johnson,* 6 August 1763). For Berkeley, see 49:17n.

38:7 (37:7–8). Bald he was and a millionaire —medieval embellishments of the rather sparse biographical information about Aristotle.

38:8 (37:8). maestro di color che sanno— Italian: from Dante's description of Aristotle in the *Inferno* IV: 131, "the master of those that know."

38:9 (37:9). adiaphane—i.e., the opaque.

38:9–10 (37:9–10). If you can put your five fingers through it, it is a gate, if not, a door— a parody of Dr. Johnson's manner of definition in his *Dictionary of the English Language* (1755). Johnson's entry on "Door": "*Door* is used of house, and *gates* of cities and public buildings except in the license of poetry."

38:14 (37:14). nacheinander—German: "one after another," the "mode" in which auditory experience is apprehended, i.e., time. In *A Portrait of the Artist as a Young Man,* Chapter V, Stephen echoes one of the arguments of the German critic Gotthold Ephraim Lessing (1729–1781), who had attempted in his *Laokoon* (1766) to distinguish between the visual and literary arts. Stephen remarks: "An aesthetic image is presented to us either in space or in time. What is audible is presented in time, what is visible is presented in space."

38:16 (37:16). a cliff that beetles o'er his base —*Hamlet,* V, iv, 70–71. See 20:5 (18:25).

38:17 (37:17). nebeneinander—German: "side by side," the "mode" in which visual experience is apprehended, i.e., space.

38:19 (37:19). My two feet . . . his legs— Stephen has on a cast-off pair of Mulligan's shoes and a cast-off pair of his trousers.

38:20–21 (37:20–21). Los Demiurgos—"Los, the creator," William Blake, "The Book of Los" (1795), I:9–10, ". . . all was/Darkness round Los . . ." and again in II:9, "Incessant the falling Mind labor'd/Organising itself. . . ." Los, for Blake, is related to the Four Zoas, the primal faculties, and is the embodiment of the creative imagination. "Demiurgos" in Gnostic theory and theosophy is "the architect of the world." See 22:30n. Compare also the moment in Blake's *Milton* when Milton enters Blake through the left foot: "And all this Vegetable World appear'd in my left foot/As a bright sandal form'd immortal of precious stones and gold./I stoop'd down and bound it on to walk forward thro' Eternity."

38:22 (37:22). Wild sea money—i.e., shells, slang for money.

38:22–23 (37:22–23). Dominie Deasy kens them a'—Scots dialect: *dominie,* "teacher"; *kens,* "knows." Source unknown.

38:24–25 (37:24–25). Won't you come to Sandymount/Madeline the mare?—source unknown.

38:29 (37:29). Basta!—Italian: "Enough!"

38:31–32 (37:31–32). and ever shall be, world without end—see 30:20–24n.

38:33 (37:33). Leahy's terrace—runs from Sandymount Road to Beach Road (and the shore of Dublin Bay) between Sandymount and Irishtown one-half mile south of the mouth of the Liffey.

38:34 (37:34). Frauenzimmer—German: originally, "a lady of fashion," subsequently, "a nitwit."

38:35–36 (37:35–36). like Algy . . . our mighty mother—i.e., like Swinburne; see 7:1–2n and 7:9n.

38:36–37 (37:36–37). lourdily—after the French *lourd,* "heavy," i.e., heavily.

38:37 (37:37). gamp—large, bulky umbrella after Mrs. Sairey Gamp in Dickens' *Martin Chuzzlewit* (1843–1844). Mrs. Gamp not only carries a large, badly wrapped umbrella, she is also nurse and midwife in the novel.

38:38 (37:38). the liberties—a rundown area in south central Dublin.

38:41 (37:41). Creation from nothing—as in the Judeo-Christian concept of the Creation based on the first chapter of Genesis: "In the beginning God created the heaven and the earth."

39:2–3 (38:2–3). why mystic monks—i.e., are fascinated by the navel and gaze at it in the discipline of contemplation.

39:3 (38:3). Will you be as gods?—a version of Satan's approach to Eve, in Genesis 3:5: "For God doth know that in the day ye eat thereof, then your eyes shall be opened, and ye shall be as gods, knowing good and evil."

39:4 (38:4). Aleph, alpha—initial letters of the Hebrew and Greek alphabets.

39:5 (38:5). nought, nought, one—i.e., creation (as only God can create) from nothing.

39:6 (38:6). Adam Kadmon—Adam Kadmon in theosophical lore is man complete (androgynous) and unfallen. "Starting as a pure and perfect spiritual being, the Adam of the second chapter of Genesis, not satisfied with the position allotted to him by the Demiurgos (who is the eldest first-begotten, the Adam-Kadmon), Adam the second, the man of dust, strives in his pride to become Creator in his turn" (H. P. Blavatsky, *Isis Unveiled* [New York, 1886], Vol. I, p. 297).

39:6–7 (38:6–7). Heva, naked . . . no navel—Heva, *Cheva* (Hebrew, "Life"), an early version of Eve's name. Cabalistic tradition held that Eve had no navel because she was not born of woman. H. P. Blavatsky quotes a version of this tradition in *Isis Unveiled*.

39:8 (38:8). whiteheaped corn—after The Song of Solomon 7:2: "Thy navel *is like* a round goblet, *which* wanteth not liquor: thy belly *is like* an heap of wheat set about with lilies."

39:8–9 (38:8–9). corn, orient . . . everlasting to everlasting—the opening phrase of a childhood vision of Eden from Thomas Traherne (1637–1674), *Centuries of Meditations* (first published, London, 1908), Century III, section 3: "The Corn was Orient and Immortal Wheat, which never should be reaped, nor was ever sown. I thought it had stood from everlasting to everlasting."

39:9 (38:9). Womb of sin—i.e., Eve's belly because through her (and through Adam) sin came into the world.

39:10 (38:10). made not begotten—the Nicene Creed (325) maintains that Jesus, unlike all other men, was "begotten, but not made, of one essence consubstantial with the Father." The creed forms part of the Ordinary of the Mass on all Sundays and on more important feast days.

39:14 (38:14). lex eterna—Latin: "eternal law."

39:16–18 (38:16–19). Arius to try . . . breathed his last—see 22:29n. The mode of Arius' death (apparently intestinal cancer) was exploited by the defenders of the faith as a way of further refuting his heresies by *argumentum ad hominum* and by seeing the ignominy of the place of death as evidence of God's displeasure with the heretic. Epiphanius (*c.*315–403), in *Adversus Haereses* II: ii, x, gives a splendidly one-sided account. "To try conclusions," Hamlet, in the bedroom scene, mocks his mother and suggests that she will against all better judgment, betray him to his uncle Claudius, "and like the famous ape,/To try conclusions, in the basket creep/And break your own neck down" (III, iv, 194–196); i.e., by leaping out of the basket in imitation of the birds that have escaped.

39:20–21 (38:21). omophorion—the distinctive vestment of bishops, an embroidered strip of white silk worn around the neck so that the ends cross on the left shoulder and fall to the knee.

39:22 (38:22). nipping and eager airs—Horatio to Hamlet as they watch on the battlements for the appearance of the Ghost (I, iv, 2).

39:24 (38:24). the steeds of Mananaan—i.e., the waves since Mananaan MacLir is the Irish god of the sea, who had Proteus' ability for self-transformation.

39:28 (38:28). Aunt Sara's—Mrs. Sara Goulding, the wife of Richie Goulding, Stephen's mother's brother. She and her husband in the novel are modeled on Joyce's aunt and uncle, Mr. and Mrs. William Murray. See Ellmann, *passim*.

39:34 (38:34). costdrawer—a cost accountant, similar to a certified public accountant.

39:35 (38:35). Highly respectable gondoliers—i.e., they are like characters out of comic opera: Gilbert and Sullivan, *The Gondoliers* (1889), in which the phrase occurs several times in a song sung by Don Alhambra in Act I: "I stole the Prince, and brought him here,/And left him gaily prattling/With a highly respectable gondolier,/Who promised the Royal babe to rear/And teach him the trade of timoneer /With his own beloved bratling." The bratling and the Prince look so much alike that even the highly respectable gondolier could not tell them apart when he was alive; and he has died of gout and the drink. Who is to distinguish between the Prince and the pauper?

39:36–37 (38:36–37). Jesus wept—the shortest verse in the Bible, John 11:35, as Jesus approaches the tomb of Lazarus.

39:39 (38:39). coign of vantage—as Duncan and his courtiers approach Macbeth's castle, they compliment its beauties and Banquo remarks of the martelet (a kind of swallow): "No jutty, frieze, /Buttress, nor coign of vantage but this bird/Hath made his pendant bed and procreant cradle./Where they most breed and haunt, I have observed/The air is delicate" (I, vi, 6–10).

40:2 (39:2). nuncle—archaic: "uncle."

40:7 (39:7). Goff—one who is awkward, stupid, a clown, an oaf.

40:7 (39:7). Master Shapland Tandy—combines the Irish revolutionary Napper Tandy (1740–1803) (see 45:2–3n) and Laurence Sterne's eccentric hero from *Tristram Shandy* (1760–1767).

40:8–9 (39:8–9). Duces Tecum—Latin: "Bring with you," the name of a certain species of writs requiring a party who is summoned to appear in court to bring with him some document, piece of evidence, etc., to be used or inspected by the court.

40:9 (39:9–10). Wilde's Requiescat—Oscar Wilde's poem (1881) (Latin: "let her rest") on the death of his sister.

40:16 (39:16). lithia—bottled spring water.

40:19 (39:19). by the law Harry—"law," dodging the curse: Lord; "Old Harry" is the Devil.

40:27–28 (39:27–28). All'erta . . . sortita—*All'erta*, Italian: "beware, look out, take care," an aria from Verdi's *Il Trovatore* (1852), is Ferrando's *aria di sortita*, his "exit song." Ferrando in the opera is the faithful retainer (a Horatio) in a "house of decay," divided between contesting (Cain and Abel) brothers.

40:36 (39:36). Marsh's library—(or St. Sepulchre Library) near St. Patrick's Cathedral in south-central Dublin. Founded in 1707 by Narcissus Marsh, the Archbishop of Dublin, it is the oldest public library in Ireland. Its collection is chiefly of theology, medicine, ancient history, and Hebrew, Syriac, Greek, Latin and French literature.

40:37 (39:37). Joachim Abbas—Father Joachim, Joachim of Floris (*c.*1145–*c.*1202), Italian mystic whose visions were essentially apocalyptic. He prophesied that the history of man would be covered by three reigns: that of the Father, from the creation to the birth of Christ; that of the Son from the birth of Christ to 1260; and that of the Holy Spirit, from 1260 onward. This prophecy developed into the belief that a new gospel would supersede the Old and New Testaments (as the Old Testament was of the Father, the New of the Son, the New New would be of the Holy Spirit). See W. B. Yeats's short story "The Tables of the Law" (1897).

40:40 (39:40). Houyhnhnm—after the reasonable horses in Part IV of Swift's *Gulliver's Travels*. The horses, brutish in form and reasonable in behavior, are contrasted with the Yahoos, human in form, brutish in behavior. The passage also recalls the "madness" of Swift's declining years.

40:41 (39:41). Temple—appears as a character in *A Portrait of the Artist as a Young Man*, Chapter V.

40:41 (39:41). Foxy Campbell—identity or significance unknown.

40:42 (39:42). furious dean—i.e., Jonathan Swift, dean of St. Patrick's Cathedral in Dublin (1713–1745). The interlink of Swift and Joachim derives from W. B. Yeats' story "The Tables of the Law." In the story, Owen Aherne, a believer in Joachim's prophecies, searches for the "secret law" (of the Holy Spirit), which is to displace Christ's "Law" (Love God, Love thy neighbor as thyself), which in turn has displaced the Ten Commandments. Aherne links Swift's fervor with Joachim's: "Jonathan Swift made a soul for the gentlemen of this city by hating his neighbor as himself" (Yeats, *Early Poems and Stories* [New York, 1925], p. 509).

41:1 (40:1–2). Descende, calve . . . decalveris—Latin: "Descend, bald one, lest you be made excessively bald." Transposed from *Vaticinia Pontificum*, attributed to Joachim Abbas (Venice, 1589), "*Ascende, calve ut ne amplius decalveris, qui non vereris decalvere sponsam, ut conam ursae nutrias*" ("Ascend, bald man, so that you do not become more bald than you are, you who are not afraid to sacrifice your wife's hair [but by implication are so self-conscious about your own baldness] so that you nourish the female bears' hair"). The allusion is to II Kings 2:23–24: "And [Elisha] went up from thence unto Beth-el: and as he was going up by the way, there came forth little children out of the city, and mocked him, and said unto him, Go up, thou bald head; go up, thou bald head. And he turned back, and looked on them, and cursed them in the name of the Lord. And there came forth two she bears out of the wood, and tare forty and two children of them."

41:5 (40:5). the altar's horns—associated with sacrifice. Exodus 29:12: "And thou shalt take of the blood of the bullock, and put *it* upon the horns of the altar with thy finger, and pour all the blood beside the bottom of the altar." Psalms 118:27: "God *is* the Lord, which hath shewed us light: bind the sacrifice with cords, *even* unto the horns of the altar." Vulgate, Psalm 117:27: "The Lord is God, and he hath shone upon us. Appoint a solemn day with shady boughs, even to the horn of the altar."

41:5 (40:6). jackpriests—"jack Catholic" is slang for Catholic in name only; thus, "jackpriests" are priests in name only.

41:7 (40:7–8). fat kidneys of wheat—in the "Song of Moses," Deuteronomy 32:13–14, Moses celebrates God's generosity to Jacob, ". . . and he made him to suck honey out of the rock, and oil out of the flinty rock; Butter of kine, and milk of sheep, with fat of lambs, and rams of the breed of Bashan, and goats, with the fat of kidneys of wheat; and thou didst drink the pure blood of the grape."

41:12 (40:13). Dan Occam—William of Occam (1300?–?1349), English Scholastic, philosopher and theologian, who was noted for the remorseless logic with which he dissected every question. Occam had, in *Tractatus de Sacramento Altaris,* argued that after the host is consecrated its quantity and quality are unchanged, and therefore that the body of Christ is not in the host in quantity or quality (i.e., the host is not the body of Christ by "reason," but by "faith"), and therefore there is only *one* body of Christ and not several—no matter, as Stephen speculates, how many elevations of the host are celebrated simultaneously, there is still only one body of Christ.

41:12–13 (40:13–14). A misty . . . morning—nursery rhyme: "One misty moisty morning,/ When cloudy was the weather,/I chanced to meet an old man,/Clothed all in leather./He began to compliment,/And I began to grin:/How do you do, and how do you do,/And how do you do again."

41:13 (40:14). hypostasis—the whole personality of Christ as against his two natures: human and divine.

41:18 (40:19). Cousin Stephen . . . be a saint—after a remark of John Dryden (1631–1700) to Swift: "Cousin Swift, you will never be a poet."

41:18 (40:19). Isle of saints—a medieval epithet for Ireland that recalls the key role played by Irish churchmen in Western European Christianity after the fall of Rome.

41:21 (40:22). Serpentine avenue—in Sandymount on the southeastern outskirts of Dublin.

41:22 (40:23). O si, certo!—Italian: "Oh yes, certainly."

41:24 (40:25). the Howth tram—from Sutton and Howth stations at the foot of the Hill of Howth trams convey passengers to the summit.

41:33 (40:34). epiphanies—in *Stephen Hero* Stephen defines an epiphany as "a sudden spiritual manifestation" when the "soul" or "whatness" of an object "leaps to us from the vestment of its appearance," i.e., when the metaphoric potential of an object (or a moment, gesture, phrase, etc.) is realized.

41:35 (40:36). Alexandria—the most famous library of the ancient world, burned accidentally by Julius Caesar in 47 B.C.

41:36 (40:37). mahamanvantara—Sanskrit: "great year," associated with the great thousand-year cycles of theosophical concepts of history.

41:36 (40:37–38). Pico della Mirandola—(1463–1494), Italian humanist, philosopher and scholar with a Renaissance mastery of Greek, Latin, Hebrew and Arabic, plus an interest in alchemy and the Cabala. It is indicative of his flair that he entitled his theses (at age twenty-three) *De Omni Re Scibili* ("On Everything That Can Be Known"). Stephen's pretension is like Pico's in that Pico at twenty-three is described as "full of pryde and desyrous of glory and mannes prayse. . . . He went to Rome and there covetynge to make a shew of his connynge: (& lytel consideringe how grete envye he sholde reyse agaynst hymselfe),"[1] set out to publicize the scope and breadth of his obscure and esoteric learning. He was subjected to humiliation and partial defeat.

41:36–37 (40:38). Ay, very like a whale—*Hamlet,* III, ii, 399, Polonius' ready agreement to Hamlet's "mad" demonstration ("camel . . . weasel . . . whale") of the Protean form of a cloud.

41:37–38 (40:38–40). When one reads . . . one who once—echoes the style of an essay by Walter Pater (1839–1894), "Pico della Mirandola," in *The Renaissance* (1873): "And yet to read a page of one of Pico's forgotten books is like a glance into one of those ancient sepulchres, upon which the wanderer in classical lands has sometimes stumbled, with the old disused ornaments and furniture of a world wholly unlike ours still fresh in them." And: "Above all, we have a constant sense in reading him . . . a glow and vehemence in his words which remind one of the manner in which his own brief existence flamed itself away."

41:41 (41:1). that on the unnumbered pebbles beats—in *King Lear,* Gloucester, blind and broken in spirit, wants to commit suicide by throwing himself from Dover Cliff. Edgar, his son but in disguise, tricks his father into believing that the level beach is indeed the top of the cliff: "The murmuring surge/That on the unnumbered idle pebbles chafes/Cannot be heard so high" (IV, vi, 20–22).

41:42 (41:2). lost Armada—i.e., the Spanish Armada, which after its defeat in the English

[1] Giovanni Francesco Pico, *Giovanni Pico della Mirandola: His Life by His Nephew,* trans. by Sir Thomas More; ed. J. M. Regg (London, 1890), pp. 9–10.

Channel in 1588 sailed north in the attempt to circle the British Isles and thus escape back to Spain. The fleet was scattered by storms, and many of the ships were wrecked on the coasts of Ireland and Scotland.

42:2 (41:4). stogged—stalled in mire or mud.

42:6–7 (41:9). Ringsend: wigwams of brown steersmen and master mariners—Stephen associates the present scene with an imaginary scene out of the historic past. Wigwams: temporary dwellings.

42:11 (41:13). Pigeonhouse—formerly a hexagonal fort ("an apology for a battery"), now the Dublin electricity and power station, located on a breakwater that projects out into Dublin Bay as a continuation of the south bank of the Liffey. The pigeon is also a traditional symbol of the Holy Ghost.

42:12–13 (41:14–15). Qui vous a mis ... le pigeon, Joseph—French: "Who has put you in this wretched condition?/It's the pigeon, Joseph," from *La vie de Jésus*, by Léo Taxil (Paris, 1884), p. 15; see 42:19n below. In Chapter V, *"Où Joseph, après l'avoir trouvé mauvaise, en prend son parti"* ("In which Joseph, having discovered evil, takes a stand"), Taxil facetiously describes Joseph with his suspicions aroused, "Could he imagine, this good man of naïve soul, that a pigeon had been his only rival?" Joseph then confronts Mary in response to her assertion that no man has been allowed to touch as much as her fingertips: *"Ta, ta, ta, je ne prends pas des vessies pour les lanternes ... Qui donc, si ce n'est un homme, vous a mis dans cette position?"* ("Tsk, tsk, tsk, I don't mistake bladders for lanterns. ... Who in the world, if it wasn't a man, has put you in this wretched condition?"); and Mary replies, *"C'est le pigeon, Joseph!"* Taxil cites Matthew 1 for evidence of this "incident," and suggests that it is unfortunate that the Gospel has omitted the text of these "recriminations."

42:14–15 (41:16–17). Patrice ... Son of the wild goose, Kevin Egan—a wild goose is an Irishman who has actively expatriated himself rather than live in an Ireland ruled by England. The name "wild geese" was first applied to the Irish insurgents who supported the Stuart cause (James II of England) and who accepted exile after James II's defeat by William III of England at the Battle of the Boyne (1690) and after the Treaty of Limerick (1691). Kevin Egan is a portrait of Joseph Casey, an active Fenian who was involved in the attempt to rescue several Fenian leaders from Clerkenwell Prison in London, December 1867. The attempt involved exploding a keg of gunpowder against the wall of the prison; hence "gunpowder cigarettes,"

43:34 (42:36). The rescue was not a success; and the destruction of several lives created an outrage. Patrice was Casey's (Egan's) estranged son by his estranged French wife.

42:16 (41:18). lait chaud—French: "warm milk."

42:17 (41:19). lapin—French: "rabbit."

42:18 (41:20). gros lots—French: "le gros lot" is first prize in a lottery.

42:19 (41:21). Michelet—Jules Michelet (1798–1874), French historian "of the Romantic school." Michelet is not noted for his objectivity but for picturesque, impressionistic and emotional history. The book Patrice has been reading is *La Femme* ("Woman") (Paris, 1860).

42:19 (41:21–22). La Vie de Jésus by M. Leo Taxil—French: "The Life of Jesus" (Paris, 1884) by Léo Taxil (pseudonym of Gabriel Jogand-Pages, 1854–1907), *Dessins Comiques* (cartoons) by Pépin. The tone of Jogand-Pages's book is not angry denunciation but a chaffing and humorous one in the attempt to develop absurdities in traditional Christian versions of the life of Jesus. The book plays with three propositions: (1) that Jesus was a god who spent some time on earth in the form of a man; (2) that he was deified by those who were in favor of his ideas for social emancipation; (3) that he never existed and that the legends were fabricated by exploiters. Jogand-Pages's approach to religion is implicit in some of his other titles: *The Amusing Bible* (1882); *Pius IX, His Politics and Pontificate, His Debaucheries, His Follies and His Crimes* (1883); *The Secret Loves of Pius IX* (1884). His books were regarded as so scandalously anticlerical that it was thought worthwhile to pressure him into recanting to the Papal Nuncio in 1885 and into journeying to Rome for a well-publicized Papal Absolution. Subsequently there was considerable doubt about how firmly Jogand-Pages's tongue had been in his cheek—whether he had meant his recantation or his books or neither or both.

42:21–24 (41:23–26). C'est ... oui—French, Patrice speaking: "It's side-splitting, you know. Myself I am a socialist. I do not believe in the existence of God. Don't tell my father.
—He is a believer?
—My father, yes."

42:25 (41:27). Schluss—German: "end" or "conclusion."

42:27 (41:29). puce gloves—see 18:29n.

42:28 (41:30). Paysayenn—French: a pun

that combines the letters "P.C.N." with *paysanne*, "peasant"; for "P.C.N." see 42:29n.

42:29 (41:31). physiques ... naturelles—French: "physics, chemistry and biology" (premedical studies).

42:30 (41:32). mou en civet—French: a stew made of lungs, the cheapest of restaurant dishes.

42:30 (41:32). fleshpots of Egypt—the children of Israel "murmured against Moses and Aaron in the wilderness: And the children of Israel said unto them, Would to God we had died by the hand of the Lord in the land of Egypt, when we sat by the flesh pots, *and* when we did eat bread to the full" (Exodus 16:2–3).

42:32 (41:34). boul' Mich'—the Boulevard Saint-Michel, on the left bank of the Seine in Paris, a street regarded as the café center of student and Bohemian life at the turn of the century. Arthur Symons (1865–1945) in "The Decadent Movement in Literature" (1893) speaks of the "noisy, brainsick young people who haunt the brasseries [French, "beer shops"] of the Boulevard Saint-Michel and exhaust their ingenuities in theorizing over the works they cannot write."

42:34–35 (41:36–37). On the night of the seventeenth ... seen by two witnesses—the *Irish Times,* Friday, 19 February 1904, reported: "CHARGE OF MURDER. Yesterday in Southern Police Court before Mr. Swift, Patrick McCarthy, who was on remand, was charged with the wilful murder of his wife Teresa, by having violently assaulted her at their residence in Dawson's Court, off Stephen Street." Two witnesses did appear for the prosecution, but not to identify the prisoner or to place him at the scene of the crime on 17 February; they detailed instead a long history of marital violence which presumably culminated in the death of the victim on 10 February. The *Irish Times* continues: "Dr. O'Hare, of the Holles Street [Maternity] Hospital, stated that deceased had been brought there in an unconscious condition. On the ninth instant she gave birth there to a child still-born, and died the following day. A post mortem examination showed that there was an abcess on the membranes of the brain. The assaults described might have set up the abcess.

"The prisoner was committed for trial at the next commission."

42:36 (41:38). Lui, c'est moi—French: "I am he"—a parody of Louis XIV's *L'état, c'est moi,* "I am the state."

42:41 (42:1). Encore deux minutes—French: "Still two minutes left."

42:42 (42:2). Fermé—French: "Closed."

43:6 (42:8). Columbanus. Fiacre and Scotus —three of the most famous Irish missionaries to the Continent. For Columbanus, see 28:38n. St. Fiacre, born in Ireland in the latter part of the sixth century, journeyed to France, where his hermit cell expanded into a sanctuary (a sort of informal monastery) and where his shrine, after his death (*c.*670) had the reputation of working miracles. John Duns Scotus (1266?–1308), one of the most subtle of medieval theologians, called "The Subtle Doctor." Joyce regarded him as the "notorious opponent" of St. Thomas Aquinas. (There is some dispute about his Irish origin since both England and Scotland also claim him.)

43:7–8 (42:10). Euge! Euge!—Latin: "Well done! Well done!" but in several Biblical contexts the words are spoken ironically by mockers as they are here.

43:9 (42:12). Newhaven—channel port on the south coast of England

43:10 (42:12). Comment?—French: "What?"

43:10 (42:12–13). Le tutu—a short ballet skirt; also, a weekly Parisian magazine of a "light" sort.

43:11 (42:13–14). Pantalon Blanc et Culotte Rouge—French: literally, "White Underclothes and Red Breeches" (though *culotte rouge* is also slang for a camp follower). As Thornton points out (p. 53), this title seems to be Joyce's variant of a "light" Parisian magazine, *La Vie en Coulette Rouge* ("Life in Red Breeches, or Among the Camp Followers").

43:16–19 (42:18–21). Then here's a health ... The Hannigan famileye—after Percy French (1854–1920), Irish song writer and parodist, "Matthew Hanigan's Aunt." First verse: "Oh, Mat Hanigan had an aunt,/An uncle too, likewise;/But in this chant, 'tis Hanigan's aunt/I mean to eulogize./For when young lovers came/And axed her to be theirs,/Mat Hanigan's aunt took each gallant,/And fired him down the stairs." Chorus: "So here's a health to Hanigan's aunt!/I'll tell you the reason why,/She always had things dacent/In the Hanigan family./A platther and can for every man,/'What more do the quality want?/'You've yer bit and yer sup,/'What's cockin' yees up!'/Sez Matthew Hanigan's aunt."

43:21 (42:23). the south wall—the seawall that extends the south bank of the Liffey out into Dublin Bay.

43:27 (42:29). Belluomo—Italian: "handsome man"; also slang for a prankster.

43:28–29 (42:30–31). saucer of acetic acid— for cleansing stone or marble surfaces?

43:29 (42:31). Rodot's—a patisserie at 8 Boulevard Saint-Michel in Paris (c.1902).

43:31 (42:33). chaussons—French: "puff pastry."

43:31 (42:33). pus—French: "pus," i.e., yellow liquid.

43:31–32 (42:33–34). flan breton—a sort of custard tart.

43:35–36 (42:37–38). green fairy ... white— "green fairy's Fang" is slang for absinthe (outlawed in France in 1915). "White" is not clear in the context.

43:37 (42:39). Un demi setier!—an abusive Parisian term for a demitasse; *setier* means literally an obsolete measure for liquids, about two gallons.

43:38–40 (42:40–43:1). Il est irlandais ... savez? A oui!—French: "He is Irish. Dutch? Not cheese. Two Irishmen, we, Ireland, do you understand. Oh yes!"

44:2 (43:4). slainte!—Irish toast: "good health!"

44:5–6 (43:8). Dalcassions—a tribe that formed the household troops for the medieval Irish kings of Munster. The name is also a tribal name of the O'Briens, whose patrimony was the county of Clare on the west coast of Ireland.

44:6 (43:8). Arthur Griffith—(1872–1922), an Irish patriot instrumental in the final achievement of Ireland's independence in 1921–1922. In 1899 (with William Rooney) he founded the Celtic Literary Society; in 1899, the *United Irishman*, a newspaper that crusaded for Irish independence. In the early twentieth century he organized *Sinn Fein* ("We Ourselves"), a movement that was to agitate for independence by disrupting the British government of Ireland (largely by means of civil disobedience). In 1906 he founded a newspaper named *Sinn Fein*.

44:9–10 (43:12). M. Drumont—Edouard Adolphe Drumont (1844–1917), French editor and journalist whose newspaper, *La Libre Parole* (literally: "The Free Speech"), was chiefly distinguished for the bitterness of its anti-Semitism.

44:11–12 (43:13–14). Vieille ogresse ... dents jaunes—French: "Old ogress ... yellow teeth."

44:12 (43:14). Maud Gonne—(1866–1953), a famous Irish beauty who became a minor Irish revolutionary leader and subsequently a refugee in Paris. She is a dominant presence in Yeats's poetry; Yeats regarded her beauty as "Ledaean" and lamented her waste of that classic beauty in revolutionary pursuits. The juxtaposition of her name and Millevoye's may allude to an intermittent affair the two had in Paris.

44:12–13 (43:15). La Patrie, M. Millevoye— *La Patrie* (French, literally: "The Fatherland"), a political periodical, founded in 1841. Lucien Millevoye (1850–1918) became editor of the periodical in 1894.

44:13 (43:15). Felix Faure, know how he died?—(1841–1899), president of the French Republic (1895–1899). He died suddenly of a cerebral hemorrhage at the Elysée, the presidential residence. The obvious innuendo is that his death was the result of sexual excess, a rumor that was current in Paris.

44:14 (43:16). froeken—Flemish: "young or little woman."

44:14 (43:16). bonne à tout faire—French: "maid of all work."

44:15 (43:17–18). Moi faire ... tous les messieurs—French: "I do ... all the gentlemen."

44:22 (43:24). peep of day boy's—precursors of the Orangemen; see 32:15n. They were late eighteenth-century Ulster Protestants named for their early-morning raids on the cottages of the Catholic peasants whom they sought to displace from Ulster.

44:23 (43:25). How the head centre got away —James Stephens (1824–1901), Irish agitator, "Chief Organizer" and subsequently "Head Centre" of the Fenian Society (the Irish Republican Brotherhood). In November 1865 Stephens was betrayed by a spy planted in the Dublin offices of his organization; he was arrested, tried and sentenced, but a few days later he was "rescued" from Dublin's Richmond Gaol by a group of Fenians who apparently had the help of sympathetic guards on the inside. He fled to America, where he was elected "Head Centre" of the American branch of the Fenians. Pressures for immediate insurrection in 1866 split the society and Stephens' resistance to the pressures earned him the reputation of being a good organizer but not a man of action. Apparently the split in the society was responsible for the apocryphal (and denigrating) story that Stephens assumed the disguise of a woman to effect his escape, "betraying and abandoning" his lieutenants in Ireland in the process.

44:25 (43:27). Malahide—village nine miles north of Dublin on the coast of the Irish Sea, a seaside resort. (Stephens did make his escape to sea by this route.)

44:25 (43:27). Of lost leaders—Robert Browning (1812–1889), "The Lost Leader" (1845). The poem expresses regret (and some irritation) at the defection of Wordsworth (1770–1850) from the ranks of the revolutionaries to those of the Establishment. Though Wordsworth is not named in the poem, the suggestion is clear that somehow his receipt of a government pension in 1842 and of the position of Poet Laureate in 1843 influenced the reversal of his political opinions. "Just for a handful of silver he left us,/Just for a riband to stick in his coat" (lines 1 and 2).

44:27 (43:29). gossoon—a boy, a servant boy, a lackey—rustic, inexperienced.

44:29 (43:31). colonel Richard Burke—Richard O'Sullivan Burke, colonel in the United States Army during the Civil War, an Irish-American member of the Fenian Society. Burke led a Fenian group in the successful rescue of two Fenian leaders in Manchester, England (September 1867). Burke was not captured in this escapade, but the so-called Manchester Martyrs were. Burke was subsequently arrested for other Fenian activities, and he was among the Fenian leaders who were supposed to have been freed by the abortive gunpowder plot against Clerkenwell Prison. See 42:14–15n.

44:34 (43:36–37). Montmartre—a poor and run-down section in north-central Paris, at the turn of the century a favorite haunt of *avant-garde* artists, Bohemians and students.

44:35 (43:37). rue de la Goutte-d'Or—French: "Street of the Golden Drop" (or "Golden Liquor") in Montmartre.

44:37–38 rue Gât-le-Coeur, should read **Gît-le-Coeur**, as it does **(43:40)**—"Street Sacred to the memory of the Heart" (or "Here Lies the Heart"), roughly parallel to the Boulevard Saint-Michel, near the Seine on the Left Bank.

44:41 (44:1). Mon fils—French: "My son."

44:41–42 (44:2–3). The boys of Kilkenny are stout roaring blades—anonymous Irish song that praises the town of Kilkenny for its scenery, its young men and particularly its young women: "Oh! the boys of Kilkenny are nate [neat] roving blades,/And when ever they meet with dear little maids,/They kiss them, and coax them, and spend their money free./Oh! of all towns in Ireland, Kilkenny for me./Oh! of all towns in Ireland, Kilkenny for me."

45:1 (44:3). Old Kilkenny—a county and town in southeastern Ireland, named after St. Canice (St. Kenny); *kil:* "church or cell."

45:1 (44:4). saint Canice—(d. c.599), Irish, he preached in Ireland and Scotland and accompanied St. Columba (variously St. Columcille; see 333:18n) on a mission to convert Brude, King of the Picts.

45:1–2 (44:4). Strongbow's castle on the Nore—Richard de Clare or Richard FitzGilbert, Earl of Pembroke, called "Strongbow" (d. 1176). He was a Norman adventurer and one of the key leaders of the English invasion of Ireland, 1170 *ff*. He was a son-in-law of MacMurrough and claimed succession as King of Leinster, the central counties of eastern Ireland, including Dublin, after MacMurrough's death in 1171. See 35:40–41n. His castle on the Nore, the river on which Kilkenny is situated, was built in 1172 and destroyed by the O'Briens in 1173.

45:2–3 (44:5). O, O. He takes me, Napper Tandy, by the hand—from "The Wearing of the Green," anonymous Irish ballad from the 1790s, as "formalized" by Dion Boucicault (1822–1890), Irish-American songsmith, playwright and actor: "Oh, Paddy dear, and did you hear the news that's going round?/The shamrock is forbid by law to grow on Irish ground;/Saint Patrick's day no more we'll keep,/His colour can't be seen,/For there's a cruel law agin the wearin' of the green./I met with Napper Tandy, and he tuk me by the hand,/And said he, 'How's poor ould Ireland, and how does she stand?/She's the most distressful country that ever yet was seen;/They're hanging men and women there for wearin' of the green.'" James Napper Tandy (1740–1803), Irish revolutionary and reformer. He supported Grattan (see 137:15–16n) and was instrumental in founding (and as secretary of) the United Irishmen in the 1790s. He was a sympathizer with the French Revolution and a key figure in the attempt to secure French aid and support in the Irish struggle for independence.

45:4–5 (44:6–7). O, O the boys of Kilkenny—see 44:41–42n.

45:7 (44:9). Remembering thee, O Sion—a phrase of mourning associated with the Jews in captivity (and hence with all exiles), as in Psalms 137:1–2: "By the rivers of Babylon, there we sat down, yea, we wept, when we remembered Zion. We hanged our harps upon the willows in the midst thereof."

45:11 (44:13). Kish lightship—a lightship moored on the northern extremity of Kish Bank, southeast of Dublin Bay.

45:25–26 (44:28). in sable silvered . . . tempting flood—Horatio reports to Hamlet about his midnight encounter with the ghost of Hamlet's father (I, ii), and in response to one of Hamlet's questions Horatio describes the ghost's beard as (line 242), "A sable silvered." In Act I, scene iv, when the ghost appears to Hamlet, Horatio attempts to keep Hamlet from following the ghost, lest the ghost (if it is an evil spirit) tempt or deceive Hamlet into throwing himself into the sea. "What if it tempt you toward the flood, my lord,/Or to the dreadful summit of the cliff" (lines 69–70).

45:28 (44:30). Poolbeg road—the road along the seawall that extends the south bank of the Liffey eastward out into Dublin Bay and ends at Poolbeg light.

45:30 (44:32). grike—a crevice, chink, crack; a ravine in the side of a hill.

45:31 (44:33). bladderwrack—a species of seaweed (*Fucus vesiculosus*), which has air bladders in its fronds.

45:32 (44:34–35). Un coche ensablé—French: "A coach mired in sand." Louis Veuillot in an essay, "Le vrai poète Parisien" ("The True Parisian Poet"), included in his *Les odeurs de Paris (The Paris Flavor)* (Paris, 1867), pp. 230–246. The essay rejects the French romantics on the grounds that they are hardly French let alone Parisian. Veuillot is particularly hard on Gautier, who he says "provides us with a perfect example of bad writing . . . such incongruities! Young men, avoid . . . all those superlatives which give to a sentence the look of *a coach mired in sand*" (pp. 234–235).

45:33 (44:35). Louis Veuillot—(1813–1883), French journalist and leader of the Ultramontane party in France. The party opposed nineteenth-century political efforts to curtail the secular powers of the Church of Rome in France. Veuillot was a notoriously uncompromising anti-Romantic (because the French Romantics were traditionally anti-Church).

45:33 (44:35). Gautier—Théophile Gautier (1811–1872), French poet, critic and novelist, famous for a "flamboyant" romanticism with overtones of frank hedonism and a "pagan" contempt for traditional morality.

45:37–40 (44:39–45:2). Sir Lout's toys . . . oldz an Iridzman—a scrambled free association that includes the nursery rhyme: "Fee, faw, fo, fum,/I smell the blood of an Englishman,/Be he alive, or be he dead,/I'll grind his bones to make my bread." "Stepping stones": the jumble of boulders on the beach recalls the Giant's Cause-

way on the northeastern coast of Ireland. The causeway is a great pile of basaltic pillars. One legend accounts for the causeway by crediting it to the giant Fin MacCool, who, irritated by a braggart Scottish giant, pitched the rocks into the sea so that he could cross and humiliate the Scot. Frank Budgen[2] implies that Sir Lout is Joyce's contribution to legend, but another legendary giant, Lug (or Ludh) of the Long Arms was also a rock thrower, one of whose exploits was the rock-death of Balor of the Evil Eye (the giant chief of the Formorians). See 292:14–15n.

46:4 (45:7). The two maries—"Mary Magdalene, and Mary the mother of James and Joses," followers of Jesus who in Matthew and in Mark watch at the Crucifixion, "ministering unto him [Jesus]," and who also watch at the sepulcher after the entombment and are thus the first to receive the news: "He is not here: for he is risen" (Matthew 27–28; Mark 15–16).

46:4–5 (45:8). tucked it safe among the bulrushes—in Exodus the infant Moses is hidden by his mother to avoid the Pharaoh's command, "Every son that is born ye shall cast into the river" (1:22). "And when she could not longer hide him, she took for him an ark of bulrushes, and daubed it with slime and with pitch, and put the child therein; and she laid *it* in the flags by the river's brink" (2:3).

46:5 (45:8). Peekaboo. I see you—from a nursery rhyme or children's song that accompanies a game of hide-and-go-seek.

46:7 (45:10). Lochlanns—literally, "lake dwellers," the Irish name for the Norwegians, who apparently comprised the first waves of the Scandinavian invasions of Ireland *c.* 787 *ff.* "Dane vikings," 46:9 (45:12), from Denmark were involved in subsequent invasions. Scandinavian power was not broken until the early eleventh century.

46:9–10 (45:12–13). when Malachi wore the collar of gold—from Thomas Moore, "Let Erin Remember the Days of Old": "Let Erin remember the days of old/Ere her faithless sons betrayed her;/When Malachi wore the collar of gold/Which he won from the proud invader;/When her kings, with standard of green unfurled,/Led the Red Branch Knights to danger/Ere the emerald gem of the western world/Was set in the crown of a stranger." Malachi (948–1022), High King of Ireland, was instrumental in the tenth- and eleventh-century struggle to dislodge the Scandinavian invaders. Malachi took "the collar of Tomar" from the neck of a Danish chieftain whom he had defeated.

[2] Frank Budgen, *James Joyce and the Making of Ulysses* (Bloomington, Ind., 1960), p. 52.

46:10–14 (45:13–17). A school of turlehide whales ... green blubbery whalemeat—in 1331 Dublin was suffering from a great famine when "a prodigious shoal of fish called Turlehydes was cast on shore at the mouth of the Dodder near the mouth of the Liffey. They were from 30 to 40 feet long, and so thick that men standing on each side of one of them could not see those on the other. Upwards of 200 of them were killed by the people" (*Thom's* [*1904*], p. 2092).

46:16–17 (45:19–20). on the frozen Liffey ... among the spluttering resin fires—in 1338 there was "a severe frost from the beginning of December to the beginning of February, in which the Liffey was frozen so hard that the citizens played at foot-ball, and lit fires on the ice" (*Thom's* [*1904*], p. 2092). Though this seems to be the date Stephen has in mind, the Liffey was again frozen over in 1739 "so that the people amused themselves on the ice" (*Thom's* [*1904*], p. 2096).

46:17 (45:20). I spoke to no-one: none to me—after the English folk song: "There was a Jolly Miller/Once lived on the River Dee ... I care for nobody, no not I/And nobody cares for me."

46:19 (45:22). stood pale, silent, bayed about—Stephen envisions himself as Acteon, who, because he interrupted Diana while she was bathing, was transformed into a deer and hunted down by his own dogs. The deer or roebuck is also a traditional symbol of the hidden secret of the self. In Celtic mythology its epithet is "Hide the Secret." See 47:7–8n and 208:12–13n.

46:19–20 (45:22–23). Terribilia meditans—Latin: "Terrible to mediate." Source unknown.

46:20 (45:23). fortune's knaves—Rosencrantz and Guildenstern describe themselves to Hamlet as fortune's "privates" (II, ii, 238) and they are, of course, at least dupes if not knaves. In *Antony and Cleopatra*, after Antony's death (and Octavius Caesar's victory), Cleopatra contemplates the meaninglessness of importance in human affairs: "'Tis paltry to be Caesar./Not being Fortune, he's but Fortune's knave,/A minister of her will" (V, ii, 2–4).

46:22 (45:25). The Bruce's brother—Edward Bruce (?–1318), younger brother of Robert the Bruce (1274–1329). Robert was king of Scotland (1306–1329), and as king he won the independence of Scotland from England. Edward, after the Battle of Bannockburn (1314), invaded Ireland in an ultimately unsuccessful attempt to free Ireland from the English. He was "elected" king of Northern Ireland and subsequently murdered by the Irish as a "pretender."

46:22–23 (45:26). Thomas Fitzgerald, silken knight—(1513–1537), Lord Offaly, Tenth Earl of Kildare, called "Silken Thomas" because his retainers wore tokens of silk. He was left in charge as Vice-Deputy of Ireland when his father, who was Lord Deputy, went to England. Thomas was falsely informed that his father had been slain; he renounced his allegiance to Henry VIII and declared war on England. His revolt is regarded as quixotic because his power was limited and because he had no powder and shot, then modern and necessary military supplies. The English caught up with him, and with five of his uncles he was hanged, drawn and quartered at Tyburn.

46:23 (45:26). Perkin Warbeck—(*c.*1474–1499), a Yorkist pretender to the throne of Henry VII of England (by fraudulently claiming that he was Richard, Duke of York, second son of Edward IV). He was supported by the Anglo-Irish lords of Ireland (particularly the Kildares). Captured by the English, he confessed his imposture and was semipardoned, but he couldn't leave well enough alone, got involved in another conspiracy and earned his ticket to Tyburn.

46:24–25 (45:28). Lambert Simnel—the Simnel conspiracy (1486), another Yorkist conspiracy. Richard Simons, a priest of Oxford, palmed off his ward, Lambert Simnel, aged eleven and the son of an Oxford joiner, as Edward, Earl of Warwick, son of George, Duke of Clarence, and thus heir to the throne of England. Simnel was crowned king as Edward VI at the instigation of the Anglo-Irish lords (with a diadem borrowed for the occasion from a statue of the Virgin Mary in Christ Church Cathedral, Dublin [1487]). He invaded England, was captured by Henry VII on 16 June 1487 at the Battle of Stoke, and instead of being put to death was made turn-spit boy in the royal kitchen (he subsequently became royal falcon).

46:26 (45:29). All king's sons—see 32:26n.

46:26 (45:29). Paradise of pretenders—i.e., Ireland, which supported the Yorkist pretenders to the throne of England in the fifteenth century and the Stuart pretenders from 1688 to 1745.

46:26 (45:30). He—Mulligan.

46:27–29 (45:31–32). But the courtiers ... House of ...—after Boccaccio (1313–1375), *Decameron*, 6th Day, 9th story. Guido Cavalcanti (*c.*1250–1300), Italian poet and friend of Dante, walks along the Orto San Michele in Florence to San Giovanni, where some acquaintances find him brooding among the tombs. They say: "Let us go and plague him" (to ally himself with them). "Guido you refuse to be of our society; but, when

you have found out that there is no god, what good will it have done you?" Guido answers: "Gentlemen, you may use me as you please in your own house." After Guido leaves, his mockers finally understand the nature of Guido's witty rebuke: ". . . Consider, then, these tombs are the abode of the dead, and he calls them our house to show us that we . . . are, in comparison with him and other men of letters, worse than dead men." Thus, the word Stephen omits, "House of . . . ," is *decay* or *death*.

46:31 (45:34). Natürlich—German: "Naturally."

46:33 (45:36). Maiden's rock—one of a small group of rocks near the north shore of Dalkey Island in Dublin Bay. The island is just off the southeast headland of the bay.

47:7–8 (46:12–13). On a field tenney a buck, trippant, proper, unattired—Stephen translates the dog on the beach into the language of heraldry: *tenney*: tenne, orange or tawny; *trippant*: applied to a buck or stag when *passant*, i.e., walking; *proper*: in natural colors; *unattired*: without antlers (unusual in heraldry because it would imply impotence). By contrast, the crest of Ireland: on a wreath *or* (gold) and *azure* (blue) a tower triple towered of the first; from the portal a *hart* (stag, buck) springing (hindlegs on ground, forelegs extended), *argent* (silver), *attired* (with antlers) and hoofed gold.

47:10 (46:15). seamorse—walrus.

47:11–12 (46:17). every ninth—i.e., wave, after the belief that every ninth wave is larger than the other waves of a sequence.

47:37–38 (47:2–3). a pard, a panther . . . in spousebreach—"spousebreach": adultery. John de Trevisa, *Bartholomeus (de Glanvilla) De Proprietatibus Rerum* XVIII: lxvi (trans., 1398): "Leopardus is a cruel beast and is gendered in spousebreche of a parde and of a lionas" (quoted in the *Oxford English Dictionary*).

47:40 (47:5–6). Haroun al Raschid—(763–809), Caliph of Baghdad, enlightened monarch and Oriental despot whose reign was for the most part successful, his empire prosperous. He was a lover of luxury and pleasure and a patron of learning and the arts. Many of the tales of the *Arabian Nights' Entertainments* are set during his Caliphate.

47:41–48:1 (47:6–9). That man led me . . . rule, said. In. Come. Red carpet spread—Stephen's dream involves the Hebraic "rule" that the firstfruits of the land were to be brought to the holy place of God's choice and there

presented to the priest, whose perquisite the firstfruits were (Deuteronomy 26:2–11). See 60:35n.

48:3 (47:10). the red Egyptians—i.e., Gypsies, and in the passage that follows Stephen thinks in Gypsy language or Gypsy Cant.

48:6 (47:13). mort—a "free woman," held in common by a tribe of Gypsies.

48:9 (47:16). bing . . . Romeville—"go away to London" because "Rome" (or "rum") means first-rate.

48:11 (47:18). fancyman—a man who is fancied as a sweetheart; a man who lives on the income of a prostitute.

48:11–12 (47:18–19). two Royal Dublins—i.e., two soldiers from the Royal Dublin Fusiliers.

48:12 (47:19). O'Loughlin's of Blackpitts—apparently a "shebeen," an unlicensed bar or public house, on Black Pitts, a street in south-central Dublin (in the run-down area called "the Liberties").

48:12–13 (47:19–20). wap in . . . dell—"wap" means to make love; "rum lingo" is noted talk; "dimber, wapping dell" is a pretty, loving wench.

48:14 (47:21). Fumbally's lane—also in the Liberties in south-central Dublin.

48:16–19 (47:23–26). White thy . . . kiss—the second stanza of "The Rogue's Delight in Praise of His Strolling Mort"; see Richard Head, *The Canting Academy* (London, 1673). "Fambles" means hands; "gan" is mouth; "quarrons," body; "Couch a hogshead" is to lie down and sleep; "darkmans" is night. Stanza 1: "Doxy oh! Thy Glaziers shine/As Glymmar by the Salomon,/No Gentry Mort hat prats like thine/No Cove ere wapp'd with such a one." Stanza 7: "Bing awast to Romeville then/O my dimber wapping Dell,/We'el heave a booth and dock agen/Then trining scape and all is well."

48:20 (47:27). Morose delectation—the sin of letting the mind dwell on any pleasure for a long time whether the pleasure be sinful or not. See St. Thomas Aquinas, *Summa Theologica*, II, Query 31, Article 2, and Query 74, Article 6.

48:20 (47:27). tunbelly—because the St. Thomas of medieval legend was so big-bellied that tables had to be cut out to fit around his stomach.

48:20–21 (47:27–28). frate porcospino—Italian: "the porcupine monk" or "Brother

Porcupine," i.e., Aquinas' argument is prickly and difficult to attack.

48:21 (47:28). Unfallen Adam . . . not rutted —i.e., according to tradition, before the fall of man sexual intercourse was without lust.

48:23 (47:30). marybeads—i.e., the beads of their rosaries since the rosary includes a cycle of 15 Hail Mary's among its prayers.

48:26 (47:33). my Hamlet hat—after Ophelia's song (when she runs mad) in *Hamlet* (IV, v, 23– 26). "How should I your true love know/From another one?/By his cockle hat and staff/And his sandal shoon." Cockle hat, i.e., with a scallop shell as a sign of pilgrimage. See 30:35n.

48:27–28 (47:34–36). Across the sands of all the world . . . trekking to evening lands— this passage begins a poetic improvisation on the closing phase of the "Lyrical Drama" *Hellas* (1821) by Percy Bysshe Shelley (1792–1822), and on Adam and Eve's departure westward from Eden after the Fall in Genesis 3. In his drama Shelley celebrates the "intense sympathy" he feels for the cause of Greek liberty, and the promise of the Greek War of Independence, which began in March of 1821 and in which Shelley saw the dawn of a new Golden Age (though the war was to conclude with only ambiguous liberty for the Greeks ten years after Shelley's death). Lines 1023–1049 (of the 1101-line drama): "SEMI-CHORUS I: Darkness has dawn'd in the East/On the noon of time:/The death-birds descend to the feast,/From the hungry clime./Let Freedom and Peace flee far/To a sunnier strand,/And follow Love's folding star/To the Evening land!//SEMI-CHORUS II: The young moon has fed/Her exhausted horn,/With the sunset's fire:/The weak day is dead,/ But the night is not born;/And, like loveliness panting with wild desire/While it trembles with fear and delight,/Hesperus flies from awakening night,/And pants in its beauty and speed with light/Fast flashing, soft and bright./Thou beacon of love! thou lamp of the free!/Guide us far, far away,/To climes where now, veil'd by the ardour of day/Thou art hidden/ From waves on which weary noon,/Faints in her summer swoon,/Between Kingless continents sinless as Eden,/Around mountains and islands inviolably/Prankt on the sapphire sea." The "sun's flaming sword" suggests the aftermath of the Fall in Genesis 3:24: "So he [God] drove out the man; and he placed at the east of the garden of Eden Cherubims, and a flaming sword which turned every way, to keep the way of the tree of life."

48:29 (47:36). She trudges, schlepps, trains, drags, trascines her load—the verbs are all synonyms; in sequence: English (Anglo-Saxon

root), German, French, English (Anglo-Saxon root), Italian. The reference is to Eve, whose *load* of "sorrow" was "greatly multiplied" by the Fall (Genesis 3:16).

48:31 (47:38). oinopa ponton—Homeric Greek: "wine-dark sea"; see 7:3n.

48:32 (47:39). Behold . . . moon—transposed from the Angelus prayer (which is offered by peasants at 6:00 A.M., noon, and 6:00 P.M.): "Behold, the handmaid of the Lord. Be it done to me according to Thy will," after Luke 1:38. The sea (the "mighty mother") is, of course, the "handmaid of the moon" as Mary (*Stella Maris*) is the Star of the Sea.

48:34 (48:1). Omnis caro ad te veniet—Latin: "All flesh will come to thee," after Psalms 65:1–2 (King James); Vulgate 64:1–2: "Praise waiteth for thee, O God, in Sion: and unto thee shall the vow be performed. O thou that hearest prayer, *unto Thee all flesh shall come*." This passage from Psalms is part of the Introit (the entrance chant) of the Requiem or Funeral Mass.

48:34–36 (48:1–3). He comes . . . mouth's kiss —Stephen's poem (see 131 [132]), is a souped-up (Canting Academy) version of the last stanza of "My Grief on the Sea," a poem translated from the Irish by Douglas Hyde (1860–1949) in his *Love Songs of Connaught* (Dublin, 1895), p. 31. Hyde's stanza reads: "And my love came behind me—/He came from the South;/His breast to my bosom,/His mouth to my mouth."

48:37 (48:4). My tablets—*Hamlet* (I, v, 107): "My tables—meet it is I set it down." Hamlet, momentarily deranged by the psychological impact of the Ghost and the Ghost's message, writes an aphorism about villainy and his uncle in his notebook.

49:9 (48:18). darkness shining in the brightness—after John 1:5; see 29:14–16n.

49:9 (48:18). delta of Cassiopeia—Delta is a relatively inconspicuous star (of the third magnitude) in the constellation Cassiopeia, a **W** in the northern skies. See 207:22–27n. Delta is at the bottom of the left-hand loop of the **W**.

49:10 (48:19). augur's rod of ash—the Roman augur's rod, the *lituus*, was a staff without knots, curved at the top. It was one of the principal insignia of the augur's office and was used to define the *templum*, the consecrated sectors of the sky, within which his auguries (observations of the omens given by birds) were to be made. In Celtic mythology the ash "goes straight to the heart" because it is the material from which spear shafts were made (Robert Graves, *The White Goddess*

[New York, 1948], pp. 22 and 25). Stephen has, as he recalls, 214:40 (217:31), "watched the birds for augury," in *A Portrait of the Artist As a Young Man*, Chapter V.

49:15 (48:24). Who ever anywhere . . . these written words?—answer: 374 (381).

49:15–16 (48:24–25). Signs on a white field—not only writing on paper but also birds (as the augur sees them) against the sky.

49:17 (48:26). bishop of Cloyne—George Berkeley (1685–1753), bishop of the Church of Ireland and philosopher. In his *Essay towards a New Theory of Vision* (Dublin, 1709), Berkeley argued that "the proper objects of sight are not without the mind; nor the images of anything without the mind;" and that since what we actually see we see as "flat," distance is not something that is *seen* but something that is *thought*.

49:17–18 (48:26–27). the veil of the temple . . . shovel hat—as described in Exodus 26:31–35, the veil acts as a multicolored screen between the outer "holy place" and "the most holy" (behind the veil). And the veil is rent at the moment of Jesus' death (Matthew 27:51). I.e., Berkeley regarded the visible world as a screen that was *thought* (not *seen*), a screen that could be taken out of his head (or hat). A "shovel hat" was worn by some Church of Ireland and Church of England clergy.

49:29 (48:38). Hodges Figgis' window—Hodges, Figgis, and Company, Ltd., booksellers and publishers, 104 Grafton Street (in the southeastern quadrant of Dublin between Trinity College and St. Stephen's Green).

49:32 (48:41). She lives in Leeson park—i.e., Emma Cleary, the object of Stephen's attentions in *Stephen Hero* (see p. 196) and in *A Portrait of the Artist as a Young Man*. Leeson Park was in a suburban area on the southern outskirts of Dublin.

49:33–34 (48:42–49:1). Talk that to . . . a pickmeup—echoes Stephen's friend Davin, whose notable experience with a pickup is recalled by Stephen in Chapter V of *A Portrait of the Artist as a Young Man*. Davin addresses Stephen as Stevie, "the homely version of his christian name."

49:36 (49:3). piuttosto—Italian: "rather."

49:38 (49:5). What is that word known to all men?—i.e., the "word" that is revealed to each individual after his death. Negatively, the word is "never to return"; positively, it is the Eternal Word, the Logos, Christ. "Known to all men"

means that both phases of the word can be known as mysteries in this life but cannot be known as realities until after death.

50:1 (49:10). Et vidit . . . bona—Latin: "And God saw [the works He had made] and they were exceedingly good" (Genesis 1:31).

50:2 (49:11). welcome as the flowers in May—from a song: "You're as Welcome as the Flowers in May," words and music by Dan J. Sullivan: "Last night I dreamed a sweet, sweet dream;/I thought I saw my home, sweet home,/ And oh! how grand it all did seem,/I made a vow no more to roam./By the dear old village church I strolled,/While the bell in the steeple sadly tolled,/ I saw my daddy old and gray,/I heard my dear old mother say: // [Chorus]: You're as welcome as the flowers in May,/And we love you in the same old way;/We've been waiting for you day by day/ You're as welcome as the flowers in May."

50:2–6 (49:11–15). Under its leaf he watched . . . Pain is far—this passage improvises on Stéphane Mallarmé's (1842–1898) Eclogue, "*L'Après-midi d'un faune*" (1876, 1877). Mallarmé's poem evokes an atmosphere thick with the heat of "*l'heure fauve*" (the *tawny* hour), and "heavy with foliage." The faun dreams of nymphs "traced by/my shuttered glances." At the poem's end: "Oh certain punishment . . . // But no,/ the spirit empty of words, and/this weighed-down body late succumb/to the proud silence of midday;/no more—lying on the parched sand,/forgetful of the blasphemy,/ I must sleep, in my chosen way,/wide-mouthed to the wine-fostering sun!"[3] Stephen's "Pain is far" counters the ambiguous presence of pain-in-pleasure in Mallarmé's poem. Noon is "Pan's hour" because that Greek naturegod reached the peak of his daily activity at that moment.

50:7 (49:16). And no more turn aside and brood—from W. B. Yeats; see 11:12–14n.

50:9 (49:18). nebeneinander—see 38:17n.

50:11 (49:20). tripudium—Latin: literally, "a triple beat or stroke"; figuratively, "a measured stamping, leaping, jumping, dancing"; in religious solemnities, "a solemn religious dance."

50:12 (49:21). Esther Osvalt's—apart from the context, identity or significance unknown.

50:13 (49:22). Tiens, quel petit pied!—French: "My, what a small foot!"

[3] Translated by Frederick Morgan, in *An Anthology of French Poetry from Nerval to Valéry in English Translation*, ed. Angel Flores (New York, 1958), p. 156.

50:13–14 (49:23). Wilde's love that dare not speak its name—after a poem by Wilde's friend Lord Alfred Douglas, "Two Loves," published in *The Chameleon*, a little magazine at Oxford: "'. . . I am true Love, I fill/The hearts of boy and girl with mutual flame.'/Then sighing said the other, 'Have thy will,/I am the Love that dare not speak its name.'" In 1895 Wilde brought a libel action against the 8th Marquess of Queensberry, Lord Alfred Douglas' father; Wilde claimed that the Marquess had accused him of homosexual practices. The Marquess' lawyer exploited the poem in a successful defense against the libel suit. In the course of the trial Wilde said: "The 'Love that dare not speak its name' in this century is such a great affection of an elder for a younger man as there was between David and Jonathan. . . . It is that deep, spiritual affection that is pure as it is perfect." After he lost the libel suit, Wilde was arrested, tried, convicted and sentenced to two years in prison.

50:16 (49:25). Cock Lake—among other things, a tidal pool off Sandymount.

50:26 (49:36). Hising up their petticoats—see 15:8–10n.

50:29 (49:39). Saint Ambrose—(*c.*340–397), Bishop of Milan and one of the most famous of the Church Fathers, particularly noted as a hymnologist and composer of church music.

50:31 (49:41–42). diebus ac noctibus . . . ingemiscit—Latin: "day and night it [the Creation] groans over wrongs," from St. Ambrose's *Commentary on Romans,* specifically on Romans 8:22, "For we know that the whole creation groaneth and travaileth in pain together until now."

50:36 (50:4). full fathom five thy father lies—from Ariel's song about drowned Alonso (who has actually been rescued) in *The Tempest* (I, ii, 397–403): "Full fathom five thy father lies,/Of his bones are coral made,/Those are pearls that were his eyes./Nothing of him that doth fade/But doth suffer a sea change/Into something rich and strange./Sea nymphs hourly ring his knell."

50:37 (50:5). Found drowned—the coroner's official verdict for an accidental drowning, and hence the newspaper heading for such cases.

50:40 (50:8). a pace a pace—from the nursery rhyme which accompanies the rhythms of a child riding upon an adult's knees: "This is the way the ladies ride . . . a pace . . . a pace . . . a pace."

50:41 (50:9). Sunk though he be beneath the watery floor—line 167 of Milton's "Lycidas"; see 26:25n.

51:3–4 (50:13-14). God becomes man . . . goose becomes featherbed mountain—Stuart Gilbert, in *James Joyce's Ulysses* (p. 128), cites this as "a variant of the kabalistic axiom of metempsychosis" (as well as an allusion to the protean ebb and flow of living matter): "a stone becomes a plant, a plant an animal, an animal a man, a man a spirit, and a spirit a god." But Stephen's sequence also has an internal logic of its own: "God becomes man" (as God in one of the Three Persons of the Trinity became man as Jesus Christ); "man becomes fish" (as the fish is an iconographic symbol for Christ in the early Christian Church); "fish becomes barnacle goose" (after the medieval belief that barnacle geese were not born from eggs but from barnacles, "at first gummy excrescences from pine beams floating in the waters, and then enclosed in shells to secure a free growth. . . . Being in process of time well covered with feathers, . . . they take their flight in the free air";[4] "barnacle goose becomes featherbed mountain" (as goose feathers are used to make featherbeds, and Featherbed Mountain is in the Dublin Mountains south of Dublin).

51:8 (50:19). a seachange—see 50:36n.

51:8 (50:19). Seadeath—the death which Tiresias prophesies for Odysseus (in Book XI of *The Odyssey*), "a seaborne death, soft as this hand of mist."

51:9 (50:20). Old Father Ocean—Homeric epithet for Proteus.

51:9 (50:20). Prix de Paris—*Grand Prix de Paris*, French: "Great Prize of Paris"—the most important event in the French horseracing calendar. The prize itself in 1904 amounted to 250,000 francs; see 33:11–13n. Stephen is, of course, punning on "the prize of Paris," because Paris, by giving the golden apple to Aphrodite, started the Trojan War and ultimately faced Odysseus with the possibility of "sea-death."

51:12 (50:23). I thirst—Jesus says this on the cross "that the scripture might be fulfilled" (John 19:28). Thus "thunderstorm," 51:13 (50:24), is suggested by the cataclysm after the Crucifixion; and the thunderstorm in turn suggests the fall of Satan.

51:13–14 (50:24-25). Allbright he falls . . . of the intellect—"Lucifer" means the bearer of light, thus "allbright." "I beheld Satan as lightning fall from heaven" (Luke 10:18).

51:14 (50:25). Lucifer, dico, qui nescit occasum—Latin: "Lucifer, I say, who knows

[4] Giraldus Cambrensis, *Topography of Ireland* (1188), quoted in T. H. White, *The Bestiary* (New York, 1960), pp. 267–268.

no fall." Stephen has borrowed this phrase from the Roman Catholic service for Holy Saturday, the Easter Vigil, "a festival of light, and a festival of baptismal water and of baptism itself." The phrase occurs near the end of the Exultet, a chant in praise of the paschal candle, "acclaiming the light of the risen Christ." The passage from which Stephen borrows, *"Flammas ejus lucifer matutinas inveniat. Ille, inquam, lucifer, qui nescit occasum"* ("May the rising star of morning find it [the paschal candle] burning still. That morning star that knows no setting") (*Layman's Missal*, pp. 492, 495, 499). Lucifer is the planet Venus as Morning star (the morning star of record on 16 June 1904).

51:14–15 (50:25–26). My cockle hat . . . my sandal shoon—from Ophelia's song; see 48:26n.

51:15–16 (50:26–27). To evening lands—see 48:27–28n.

51:19–20 (50:30–31). Tuesday will be the longest day—summer began in Dublin on Tuesday, 21 June 1904, at 9:00 P.M.

51:20 (50:31). Of all the glad new year, mother—from Alfred, Lord Tennyson, "The May Queen" (1833). First verse: "You must wake and call me early, call me early mother dear;/ Tomorrow'll be the happiest time of all the glad New-year;/Of all the glad New-year, mother, the maddest merriest day;/For I'm to be Queen o' the May, mother, I'm to be Queen o' the May." The poem, retitled "Call Me Early, Mother Dear (For I'm to Be Queen of the May)," was set to music by Dempster.

51:21 (50:32). Lawn Tennyson—i.e., the son of lawn tennis, a genteel version of the modern game. Alfred, Lord Tennyson (1809–1892), was the official "great poet" of the Victorian Age, who succeeded Wordsworth as Poet Laureate. Critical reaction to the disproportion between the elaborate technique of his prosody and his often rather flimsy subject matter brought about the rapid decline of his reputation in his last years, and his stature as an important poet did not begin to be reestablished until recent times.

51:21 (50:32). Già—Italian: "Already." As Stephen uses the word here, *"Già . . . Già,"* it is an expression of impatience: "Let's go . . . Let's go."

51:22 (50:32–33). For the old hag with the yellow teeth—see 44:11–12n.

51:22 (50:33). Monsieur Drumont—see 44:9–10n.

51:25–26 (50:37). the superman—see 24:3n.

51:35 (51:4). rere regardant—in the language of heraldry: "with head turned, looking back over the shoulder"; see 47:7–8n.

51:36–38 (51:5–7). high spars . . . ship—the schooner *Rosevean*, announced in Shipping News, *Freeman's Journal*, 16 June 1904, as "from Bridgewater with bricks"; see p. 246 (249) and 609 (625). Bridgewater is just west of Bristol in southwestern England; it was well known for its manufacture of bricks.

PART II
[THE WANDERINGS
OF ULYSSES],
pp. 54–593 (54–609)

EPISODE 4
[CALYPSO]

Episode 4: [Calypso], pp. 54–69 (54–70). In Book V of *The Odyssey* Odysseus is discovered "in thralldom to the nymph" Calypso, on her island of Ogygia (the "navel of the sea"; see *omphalos*, 9:25n). Athena intercedes with Zeus on behalf of Odysseus and Zeus sends Hermes to instruct Calypso to free Odysseus for his voyage home (i.e., to *recall* Odysseus to Ithaca and his own people). Odysseus has meanwhile been on the island for seven years, mourning his thralldom and longing for home. Calypso acts on Zeus' instructions; Odysseus is prepared for his voyage and sets out only to be intercepted once again by Poseidon's antipathy in the form of "high thunderheads." Athena intercedes, calming the storms and sustaining Odysseus with "the gift of self-possession."

Time: 8:00 A.M., Thursday, 16 June 1904. Scene: Leopold Bloom's house at 7 Eccles Street in the northwest quadrant of Dublin. Organ: kidney; Art: economics (the useful art of household management); Color: orange; Symbol: nymph; Technique: narrative (mature). Correspondences: *Calypso*—the Nymph (the print of the Bath of the Nymph over the Blooms' bed); *The Recall* (as Hermes is sent to recall Odysseus)—Dlugacz; *Ithaca*—Zion.

55:1 (55:1). Leopold—means "the people's prince" and implies birth under "the constellation of the Northern Crown," 712:32–33 (728:4–5), the sign of ambition, beauty, dignity, empire, eternal life, glory, good fortune, history, honor, judgment, and also the female principle.

55:9 (55:9). peckish—inclined to eat.

55:28. him should read **them** as it does **(55:28).**

55:41 (56:1). Hanlon's milkman—*Thom's (1904)* lists three Hanlons under "Registered Dairies" in Dublin, 1904.

56:3–4 (56:5–6). Wonder is it true . . . can't mouse after—no, it is not true; it is only an old wives' tale. Nor do the whiskers shine in the dark, though they do act as "feelers," 56:5 (56:7), aiding the cat in its perception of spatial relationships.

56:8 (56:10). Buckley's—John Buckley, victualler, 48 Dorset Street Upper, a short walk east and south from 7 Eccles Street.

56:9 (56:11). Dlugacz's—the only pork butcher in Dorset Street Upper where Bloom goes to buy his kidney was Michael Brunton at 55A (*Thom's [1904]*, p. 1479). The Polish-Jewish name Dlugacz is an irony since Jewish dietary laws forbid the eating of pork.

56:10–11 (56:12–13). Then licking the saucer clean—after the nursery rhyme (seventeenth century): "Jack Sprat could eat no fat,/His wife could eat no lean,/And so between them both, you see,/They licked the platter clean." In the sixteenth and seventeenth century "Jack Sprat" was an epithet for "dwarf."

56:16 (56:18). Thin bread and butter—nursery rhyme: "Little Tommy Tucker/Sings for his supper:/What shall we give him?/White (or, in a variation, thin) bread and butter./How shall he cut it/Without any knife?/How will he be married/Without any wife?"

56:27 (56:29). Gibraltar—Molly (Marion) Bloom, née Tweedy, was born (8 September 1870) and brought up in Gibraltar, the daughter of Major Brian Cooper Tweedy (Irish, Royal Dublin Fusiliers) and Lunita Laredo (Spanish Jewess). Technically the Fusiliers were stationed on the Rock from January 1884 to February 1885. Presumably Molly and her father moved to Dublin in May or June of 1886.

56:29 (56:31). a short knock—i.e., the auctioneer cut the bidding short in favor of Tweedy.

56:30 (56:32). Plevna—during the Russo-Turkish War (1877–1878) a Turkish army under Osman Pasha defended Plevna (a city in northern Bulgaria) for 143 days, 20 July–10 December 1877, first against a series of Russian assaults and subsequently against siege. The Turks came within an ace of success at Plevna in a war that was for them a losing cause. The English maintained an attitude of strict neutrality, though they did rattle the naval saber and approach intervention in 1878, when the Russian military victory was capped with a diplomatic victory that gave Russia more territorial aggrandizement in the Balkans than the English favored. Tweedy would not have been "at Plevna" in fact, though he was apparently fascinated with the action or placed there by the omnipotent hand of fiction. One of Bloom's books, 693:31–33 (709:5–7), Sir Henry Montague Hozier's *History of the Russo-Turkish War* (London, 1877–1879), which contains an extended account of Plevna, by implication belonged to Tweedy because it came from "The Garrison Library" at Gibraltar.

56:31 (56:33). rose from the ranks—far more unusual in the British Army in the late nineteenth century than it would be today.

56:32 (56:34). corner in stamps—Tweedy, a stamp collector, had apparently bought up all available copies of an unusual stamp before the stamp was recognized as valuable.

56:36–37 (56:38–39). in the swim—i.e., in league with each other in schemes to make money.

56:38 (56:40). Plasto's—John Plasto, hatter, 1 Brunswick Street Great (now Pearse Street) in the southeast quadrant of Dublin.

56:39 (56:41). White slip of paper—the card with Bloom's pseudonym, Henry Flower.

56:42 (57:2). Potato—a talisman, a reminder of the staple food of the Irish peasant and of the potato blight that triggered the famine; see 32:15n. It was given to Bloom by his mother.

57:7 (57:9). George's church—St. George's (Church of Ireland, Protestant), on Temple Street, near both Hardwicke Street and Eccles Street in the northeast quadrant of Dublin.

57:8–9 (57:10–11). Black conducts . . . the heat—answer: absorbs.

57:11 (57:13). Boland's—Bolands, Limited, a bakery at 134–136 Capel Street and on Grand Canal Quay in Dublin.

57:11 (57:13). our daily—after the Lord's Prayer, Matthew 6:11 (Luke 11:3): "Give us this day our daily bread."

57:17 (57:19). ranker—a soldier who has risen from the ranks to become an officer.

57:20 (57:22). Turko the terrible—a pantomime popular in Dublin and a character in that pantomime; see 11:31–32n.

57:31–32 (57:33–34). in the track of the sun—Frederick Diodati Thompson, *In the Track of the Sun: Diary of a Globe Trotter* (London, 1893), in Bloom's library, 694:1–2 (709:16–17). Thompson traveled west from New York (October 1891) and returned via England (May 1892). Thompson concentrates on his travels in the Orient and the Near East as Bloom's revery suggests.

57:32 (57:34). Sunburst on the titlepage—the title page of Bloom's copy is missing, but the title page of the book itself depicts an Oriental girl playing a stringed instrument,—"dulcimers," 57:30 (57:32).

57:33 (57:35). Arthur Griffith—see 44:6n.

57:33–35 (57:35–37). the headpiece over . . . bank of Ireland—the *Freeman's Journal and National Press*, a daily morning newspaper in Dublin, was editorially pro-Home Rule but essentially moderate-conservative in its point of view. The headpiece does depict a sunburst over the Bank of Ireland (and granted the position of the bank, sunrise would be in the northwest). Under the headpiece is the motto: "Ireland a Nation." The symbolism of the headpiece involves the fact that the conservative Bank of Ireland occupied the building that, before passage of the Act of Union in 1800, had housed a relatively independent Irish Parliament.

57:36 (57:38). Ikey—Jew or Jewish; therefore smart, alert, artful, clever.

57:38 (57:40). Larry O'Rourke's—Laurence O'Rourke, grocer, tea, wine and spirit merchant, 74 Dorset Street Upper, on the corner of Eccles Street.

57:42 (58:2). M'Auley's—Thomas M'Auley, grocer and wine merchant, 39 Dorset Street Lower, i.e., north of Eccles Street.

57:42 (58:2). n.g.—slang: "no good."

58:1–2 (58:3–4). North Circular . . . to the quays—North Circular Road starts at the western side of Dublin near the Liffey; it describes a semicircle around the northern outskirts of metropolitan Dublin and links with streets that complete the semicircle back to the mouth of the Liffey at the quays. The cattle market is in North Circular Road on the western side of the city.

58:6 (58:8). curate—literally, a clergyman who assists a vicar or a rector in the celebration of the Mass: thus, slang for bartender.

58:9–10 (58:11–12). the Russians, they'd . . . for the Japanese—the aggressive and expansionist policies of both Russia and Japan in Manchuria and Korea (1895 ff.) climaxed in confrontation and the Russo-Japanese War (February 1904–September 1905). O'Rourke's prediction of the outcome, while a little too pro-Japanese (as the English tended to be), was not entirely inaccurate. The Japanese had the advantage of lines of supply much shorter than the Russians'; they also had a qualitative advantage both naval and military. Japanese naval and military successes in the opening months of the war would have made O'Rourke's prediction look sound on 16 June 1904.

58:12 (58:14). Dignam—the fictional Patrick Dignam and his family "lived" at 9 Newbridge Avenue in Sandymount, a maritime village three miles east-southeast of the center of Dublin.

58:20. the country Leitrim—should read **the county Leitrim** as it does **(58:22)** the county, in north-central Ireland, seemed remote and agrarian to Dublin, and its inhabitants were regarded as the type of the country bumpkin.

58:20–21 (58:22–23). old man in the cellar—saving the drink (old man) that the customer leaves in his glass instead of throwing it out.

58:21–22 (58:23–24). Adam Findlaters—
Adam S. Findlater, M.A., J.P., with offices in
Alexander Findlater and Company, Ltd., tea,
wine and spirit merchants and provision mer-
chants, 29–32 Sackville Street Upper (now
O'Connell Street). The Company had five other
branches in Dublin and six in County Dublin.
Findlater was a successful businessman with
political aspirations. Arthur Griffith's newspaper,
the *United Irishman,* criticized him for encourag-
ing foreign manufacture in Ireland, for being a
"West Briton" and for angling for a knighthood.

58:22 (58:24). Dan Tallons—Daniel Tallon,
another moderately successful businessman and
politician who was lord mayor of Dublin in 1899
and 1900.

**58:26–27 (58:28–29). double shuffle . . . town
travellers—**a trick, a piece of faking (after a
hornpipe step that involves shuffling both feet
twice). "Town travellers" are traveling salesmen.
The "double shuffle" would thus amount to
some manipulation of wholesale prices by getting
the salesman to overcharge and then split the
proceeds.

**58:31 (58:33). Saint Joseph's, National
School—**at 81–84 Dorset Street Upper. The
National Schools were the Irish counterpart of
the American public schools, although they bore
more resemblance to trade or vocational schools
because their emphasis was on practical education
for the working class and for the lower middle
class. The National Schools were dominated by an
English Protestant point of view and were regarded
by the Irish as part of an English plot to control
Ireland religiously and socially as well as politi-
cally.

**58:34 (58:36). Inishturk, Inishark, Inish-
boffin—**three small islands in the Atlantic off the
west coast of central Ireland (actually off a small
area of Galway called "Joyce's Country").
Inishboffin: "the island of the white cow";
Inishturk: "the boar's island"; *Inishark:* "the
ox's island."

58:35 (58:37). Slieve Bloom—a range of moun-
tains in central Ireland, 55 miles west-southwest
of Dublin.

58:36 (58:38). Dlugacz's—see 56:9n.

58:37 (58:39). polonies, black and white—
a polony sausage is made of partially cooked pork
and thus looks mottled, black and white.

59:3 (59:6). Denny's sausages—Henry Denny
and Son, meat-product manufacturers, had their
factory in Limerick from early in the nineteenth
century.

59:4 (59:7). Woods—a Mr. R. Woods lived at
8 Eccles Street, next door to "Bloom's house."

59:13 (59:16). Kinnereth . . . Tiberias—the
Sea of Galilee is variously known as the Sea of
Tiberias and the Sea of Chinnereth (Kinnereth).
Chinnereth (Kinnereth), apparently on the south-
west shore of the sea, is mentioned once in the
Bible (Joshua 19:35) as a fortified city of the tribe
of Naphtali. Smith's *Bible Dictionary* (1884)
remarks: "No trace is found in later writers and
no remains by travellers."

59:14 (59:17). Moses Montefiore—Sir Moses
Haim Montefiore (1784–1885), born Anglo-
Italian, became a wealthy English philanthropist
who used his influence and wealth to secure po-
litical emancipation of Jews in England, to allevi-
ate Jewish suffering elsewhere in Europe and to
encourage the colonization of Palestine (at the
beginnings of the Zionist movement in the latter
half of the nineteenth century). Among the Jews
of Europe his name became a synonym for
orthodox sanctity.

**59:18 (59:21). mornings in the cattlemarket
—**in 1893–1894 Bloom worked for Joseph Cuffe
as a clerk superintending cattle sales in the cattle
market; see p. 664 (680).

59:38 (59:41). Brown scapulars—a short cloak
covering the shoulders, prescribed by the Rule of
St. Benedict, to be worn by monks when engaged
in manual labor and adopted by some religious
orders as a part of their ordinary habit.

**59:41–42 (60:3–4). O please Mr. Policeman . . .
in the woods—**this apparently elides a music-
hall song with the catch phrase "lost in the wood"
(from the story "The Babes in the Wood"). The
song "Oh Please, Mr. P'liceman, Oh! Oh! Oh!"
was written by E. Andrews and popularized in the
1890s by the Tillie Sisters: "To London Town
we came, you know, a week ago today,/And 'tis the
first time we've been out, and quickly lost our
way;/We got somewhere near Leicester Square,
when a p'liceman bold/Cried out, 'Move on!'
and how he laughed as we our story told." Chorus:
"Oh, please, Mr. P'liceman, do be good to us;/
We've not been long in London, and we want to
take a 'bus./They told us we could go by 'bus to
Pimlico,/Oh, what a wicked Place is London—
Oh! Oh! Oh!"

60:12–13 (60:16–17). Agendath Netaim—
Hebrew: "a company of planters" (though the
more proper spelling would be "Aguadath"), an
advertisement for a Zionist colony; see 673:10n.

60:16 (60:20). Jaffa—a seaport in Palestine (in
1949 it was incorporated into Tel Aviv).

60:16 (60:20). eight marks—the German mark in 1904 was roughly equivalent to the English shilling. The offer is that the company of planters will cultivate the land for eight shillings a year ($15.00 to $20.00 in modern currency, i.e., relatively expensive).

60:17 (60:21). dunam—a unit for measurement of land area (one thousand square meters or approximately one-quarter of an acre) used especially in the modern state of Israel.

60:21 (60:25). ten down—marks (or shillings). The advertisement begins by offering to cultivate the land for the absentee owner and ends by observing that the subscriber has to buy the land first.

60:21–22 (60:25–26). Bleibtreustrasse—German: "Remain-True Street."

60:26 (60:30). Andrews—Andrews and Company, tea and coffee dealers, wine and spirit merchants, and Italian warehousemen, 19–22 Dame Street, in central Dublin south of the Liffey.

60:28–29 (60:33). Citron . . . Saint Kevin's parade—J. Citron, of 17 Saint Kevin's Parade, a "neighbor" of Bloom when Bloom lived in Lombard Street West in south-central Dublin. Saint Kevin's Parade was just around the corner.

60:29 (60:33). Mastiansky—Julius Mastiansky, a grocer at 16 Saint Kevin's Parade and a "neighbor" of Bloom's.

60:34–35 (60:38–39). Moisel . . . Arbutus place: Pleasants street—the two streets are also near Lombard Street West. An M. Moisel lived at 20 Arbutus Place in 1904 and thus had been a "neighbor" of Bloom's. Citron, Mastiansky and Moisel are Jews in the novel and are therefore "spiritual" as well as physical neighbors.

60:35 (60:39). Must be without a flaw—in the Hebrew Feast of the Tabernacles (Sukkoth), in the seventh month of the Hebrew calendar, a festival that was both a thanksgiving for the completed harvest and a commemoration of the time when the Israelites lived in tents during their passage through the wilderness. The feast is also called the Feast of the Booths because the Israelites were commanded to dwell in booths or huts formed of the boughs of trees during the seven days of the festival. One phase of the observance involves the carrying of palm branches entwined with myrtle and willow, together with a specimen of citron, into the synagogue. The citron to be used for this purpose, according to the elaborate instructions of the *Babylonian Talmud*, was to be not only without flaw but perfect in every way, including the legal, moral and religious conditions

under which it was grown. Together the citron (*Esrog* or *Ethrog*) and the twined branches (*Lulav*) represent all the scattered tribes of Israel and are symbolic of the coming redemption that will reunite all the tribes.

60:40–41 (61:3–4). His back is . . . Norwegian captain's—Ellmann (p. 22) reports the story "of a hunchbacked Norwegian captain who ordered a suit from a Dublin tailor, J. H. Kerse of 34 Upper Sackville Street. The finished suit did not fit him and the captain berated the tailor for being unable to sew, whereupon the irate tailor denounced him for being impossible to fit."

60:42 (61:5–6). On earth as it is in heaven—from the Lord's Prayer (Matthew 6:10): "Thy kingdom come. Thy will be done in earth, as it *is* in heaven" (also Luke 11:2).

61:6–7 (61:12–13). Brimstone they called . . . Sodom, Gomorrah, Edom—the five "cities of the plain" ("in the vale of Siddim which is the salt [Dead] sea") were Sodom, Gomorrah, Admah, Zeboiim, and Bela (subsequently Zoar) (Genesis 14:2–3). In Genesis 18:20 the Lord determines to destroy the cities, "Because the cry of Sodom and Gomorrah is great, and because their sin is very grievous." In Genesis 19 Lot and his family, faithful to the Lord, are warned and escape; "Then the Lord rained upon Sodom and upon Gomorrah brimstone and fire . . . And he overthrew those cities, and all the plain, and all the inhabitants of the cities, and that which grew upon the ground." Bloom mistakenly includes "Edom" as one of the cities. In Genesis 25:30 Esau, Jacob's brother, has his name changed to Edom, and in Genesis 36:9 Esau ("who is Edom") becomes the father of the Edomites.

61:9 (61:15). Cassidy's—James Cassidy, wine and spirit merchant, 71 Dorset Street Upper.

61:9 naggin should read **noggin** as it does (61:15)—a small quantity of liquor, usually a quarter of a pint.

61:11 (61:17). captivity to captivity—a reference to the history of the Jews, in captivity in Egypt in the second millenium B.C., in various captivities in Assyria and Babylon in the eighth through the sixth century B.C., dispersed by the Romans in the first century A.D. (thus in "captivity," prevented from returning to their native land), and most recently, from Bloom's point of view, subjected to the "captivity" of waves of anti-Semitism in the late nineteenth century.

61:17–18 (61:23–24). age crusting him with a salt cloak—when Lot and his family escaped from Sodom, they were instructed not to look back (Genesis 19:17). "But [Lot's] wife looked

back from behind him, and she became a pillar of salt" (Genesis 19:26); i.e., Bloom has looked back on the destruction of Sodom and Gomorrah.

61:19–20 (61:25–26). Sandow's exercises— Eugene or Eugen Sandow (Frederick Muller, 1867–1925), a strong man who advertised himself as capable of transforming the puny into the mighty. Bloom's bookshelf contains a copy of his book *Physical Strength and How to Obtain It* (London, 1897), 694:3–4 (709:18–19). It includes a program of exercises and a chart in which the subject can enter his measurements as Bloom apparently did, 706:21–26 (721:33–38).

61:21–22 (61:27–28). Number eighty . . . only twenty-eight—in point of fact Number 80 was valued at £17 and was occupied in 1904; Bloom's "house" was valued at £28 and was vacant in 1904. The assessed value of real estate in Dublin (1904) was based on Net Rent or Net Annual Value.

61:22 (61:28). Towers, Battersby, North, MacArthur—four Dublin house- or real-estate agents who have signs on the vacant house, advertising the fact that they list it among their offerings.

61:27 (61:32). Berkeley Road—Bloom is walking west along Eccles Street (from Dorset Street, which crosses the east end of Eccles Street), toward Berkeley Road, which crosses the west end of Eccles Street.

61:29 (61:34). a girl with gold hair on the wind—a source for this bit of "poetry" is unknown.

61:31 (61:36). Mrs Marion Bloom—an ill-mannered mode of address to a married woman who is living with her husband. She should be addressed as "Mrs. Leopold Bloom."

61:37 (62:1). Mullingar—the county town of County Westmeath, Ireland, 46 miles west-northwest of Dublin.

62:1 (62:7–8). his backward eye—an allusion to the one-eyed Malbecco, the cuckold husband of Hellenore in Edmund Spenser's (c.1552–1599) *Faerie Queene*. While Hellenore lies with a group of satyrs, Malbecco is eternally unable to escape the presence of the past, "Still fled he forward, looking backward still" (Book Three, Canto X, stanza lvi).

62:29 (62:35). Mr. Coghlan—the photographer in Mullingar for whom Milly works.

62:29 (62:35). lough Owel—a lake in Westmeath near Mullingar. Black's rather outspoken

Tourist Guide to Ireland (Edinburgh, 1888) remarks that it is "attractive but not overwhelming."

62:30 (62:36). young student—is Alec Bannon; see 23:18n.

62:30 (62:36). seaside girls—from a song that is associated with Boylan. The specific source is unknown. See 66:38; 67:1–2 (67:8; 67:11–12). Music-hall songs about "seaside girls" were so popular in the late nineteenth century that "seaside girl" became a catch phrase and a type as "mixed bathing" became "morally" tolerable (if still controversial).

62:31–32 (62:37–38). sham crown Derby—i.e., a cheap imitation of a famous English china made in Derby under royal patent and thus marked with a crown (1773 ff.). Victoria changed the name from "Crown Derby" to "Royal Crown Derby" in 1890.

62:36–39 (63:1–4). O Milly Bloom . . . ass and garden—after Samuel Lover (1787–1868), Irish poet, novelist, playwright, painter, etcher and composer, *Legends and Stories of Ireland* (Philadelphia, 1835), Vol. II, p. 206: "O Thady Brady you are my darlin',/You are my looking glass from night till mornin'/I love you better without one fardin/Than Brian Gallagher wid house and garden." See Ellmann, p. 31.

62:40 (63:5). professor Goodwin—a pianist who accompanied Molly in a concert in 1893 or 1894.

63:24 (63:31). Là ci darem—*Là ci darem la mano,* Italian: "Then we'll go hand in hand," a duet in Act I, scene iii of Mozart's opera *Don Giovanni* (1787–1788). Don Giovanni comes upon some villagers "merrymaking," is "smitten" by the "innocent" Zerlina and attempts to seduce her away from her peasant fiancé, Massetto. Don Giovanni: "This summer house is mine; we shall be alone,/and then, my jewel, we'll be married./ *Then we'll go hand in hand,*/Then you'll say yes./ Look, it isn't far;/Let's be off from here, my darling." Zerlina answers, *"Vorrei e non vorrei":* "I would like to and I wouldn't like to;/My heart beats a little faster./It's true I would be happy,/ But he can still make a fool of me."

63:24 (63:31). J. C. Doyle—an Irish baritone who won the Feis Ceoil Award in 1899. In the early years of the twentieth century he was billed as one of "the cream of contemporary Irish musicians."

63:24–25 (63:31–32). Love's Old Sweet Song— (1884), words by G. Clifton Bingham (1859–1913), set to music by the Irish composer James Lyman Molloy (1837–1909): "Once in the dear,

dead days beyond recall,/When on the world the mists began to fall,/Out of the dreams that rose in happy throng,/Low to our hearts, Love sang an old sweet song;/And in the dusk where fell the firelight gleam,/Softly it wove itself into our dream. // [Chorus:] Just a song at twilight,/When the lights are low/And the flick'ring shadows/Softly come and go;/Though the heart be weary,/Sad the day and long,/Still to us at twilight,/Comes love's sweet song,/Comes love's old sweet song. // [Second stanza:] Even today we hear Love's song of yore,/Deep in our hearts it dwells forevermore;/Footsteps may falter, weary grow the way,/Still we can hear it, at the close of day;/So till the end, when life's dim shadows fall,/Love will be found the sweetest song of all."

63:38 (64:4). Voglio e non vorrei—Italian: "I want to and I wouldn't like to." Bloom misquotes Zerlina's line from the duet in Act I, scene iii of *Don Giovanni*. Zerlina sings: "*Vorrei e non vorrei.*" ("I would like to and I wouldn't like to"). Bloom changes the conditional "would" to the unconditional "want." See 63:24n.

64:10 (64:18). metempsychosis—the mystical doctrine that the soul after death is reborn in another body. In ancient India (and in the Orphic cult in ancient Greece) rebirth could take place not only in another human body but also in any other animate (animal or vegetable) body. Late-nineteenth-century theosophists modified metempsychosis with the concept of progressive evolution. They held that the human soul could only be reincarnated in another human body and denied the possibility of the soul's migrating into a physical body lower on the scale of evolution. They also held that the purpose of reincarnation was evolutionary, to test and refine the soul through a sequence of human embodiments until it emerged as "pure spirit." See 51:3–4n.

64:16 (64:24). Dolphin's Barn—an area on the southwestern outskirts of Dublin where Molly was living with her father when she first met Bloom.

64:17 (64:25–26). Ruby: the Pride of the Ring—penny and halfpenny (dime) novels about circus life were popular at the turn of the century. They were not taken seriously as "books" and thus catalog listings are incomplete and titles difficult to trace, let alone secure. Unknown, though "Pride of the Ring" was a common epithet in circus advertising (and thus a common subtitle in novels about circus life).

64:21–22 (64:30). Hengler's—Charles Hengler (1820–1887) and his brother, Albert, ran "permanent circuses" (i.e., not traveling or tent shows) in Edinburgh, Glasgow, Liverpool, Hull, Dublin and London. Bloom has apparently witnessed a trapeze accident at the circus.

64:23 (64:32). Bone them young—i.e., teach them while they are young.

64:30 (64:39). Paul de Kock's—Charles-Paul de Kock (1794–1871), a popular French novelist whose books dealt with shopgirls, clerks, etc., i.e., with the democratic bourgeoisie. An Edwardian evaluation: "His novels are vulgar but not unmoral."

64:32 (64:42). Capel street library—at 166 Capel Street in central Dublin north of the Liffey. The City of Dublin Public Libraries were established in 1884 under the Public Libraries Act (1855). The Capel Street branch had a lending department, a reference library and a news room.

64:33 (65:1). Kearney—Joseph Kearney, book and music seller, 14 Capel Street across from the Library.

64:42 (65:11). The Bath of the Nymph—if not fictional, then source unknown.

65:1 (66:12). Photo Bits—(1898 *ff.*) a penny weekly magazine, published on Tuesday in London. It presented itself as a photography magazine but was closer to soft-core pornography in effect. Its advertisers set the tone by offering everything from "Aristotle's Works" to "Flagellations and Flagellants" and "Rare Books and Curious Photographs"—"Rose's Famous Female Mixture . . . will Positively Remove the most Obstinate Obstructions"—"Bile Beans For Biliousness" and innumerable books and pills that promised "Manhood Restored."

65:6. turned the pages should read **turned the pages back** as it does (65:17).

65:38–39 (66:7–8). all the beef to the heels—"When a woman has very thick legs, thick almost down to the feet, she is 'like a Mullingar heifer, beef to the heels.' The plains of Westmeath round Mullingar are noted for fattening cattle" (P. W. Joyce, *English as We Speak It in Ireland* [London, 1910], p. 136).

65:40 (66:9). a scrap picnic—picnics in the late nineteenth century were more formal and elaborate as meals than they tend to be today; so a "scrap picnic" is an exception, an informal, last-minute outing.

66:1 (66:12). Greville Arms—a hotel in Mullingar.

66:13–14 (66:22–23). Mrs Thornton in Denzille street—a Dublin midwife, 19A Denzille Street, near the lying-in hospital on Holles Street —see [Oxen of the Sun], pp. 377–421 (383–428)— and that would locate her approximately one and a

half miles northeast of Bloom's residence in Lombard Street West *if* the Blooms were living there in 1889.

66:15–16 (66:25). little Rudy—son of Molly and Leopold Bloom, born 29 December 1893, died 9 January 1894 (aged 11 days).

66:20 (66:29). XL Cafe—Refreshment Rooms, 86 Grafton Street, in the southeast quadrant of Dublin.

66:22–23 (66:32). Twelve and six a week— Milly's salary, 12 shillings and 6 pence, while far from lavish, was not bad because Dublin shop-girls (who lived at home) were apparently being paid as little as 7 shillings a week. See "Eveline" in *Dubliners*. Stephen's salary at Mr. Deasy's school (£3, 12s a month) is only approximately 16 shillings a week.

66:23 (66:33). Music hall stage—not very well paid and regarded as little better than prostitution?

66:32–33 (67:3). Erin's King ... Kish—the *Erin's King,* a ship that took tourists (1 shilling apiece) for two-hour trips around Dublin Bay, circling the Kish lightship or Ireland's Eye, an island off Howth, en route. See 45:11n.

66:34 (67:4). funky—afraid, timid, excessively nervous.

66:38 (67:9). Jarvey—the driver of a hackney coach.

67:12–13 (67:22–23). August bank holiday— a long holiday weekend not unlike Labor Day weekend in the U.S.

67:14 (67:24). M'Coy—appears as a character in "Grace," *Dubliners*, where he is described as having been, among other things, a clerk in the Midland Railway. See Ellmann, pp. 385–386.

67:25 (67:35). fag—after "fatigue": hard work, drudgery, weariness.

67:29 (67:39). Titbits—*Titbits from All the Most Interesting Books, Periodicals and Newspapers in the World*, a 16-page penny weekly (published on Thursday, dated Saturday). Some historians of journalism suggest that modern popular journalism ("oddments and persiflage") was born with the first issue of *Titbits* in 1881.

67:37 (68:7). The maid was in the garden— after the nursery rhyme: "Sing a song of six-pence,/A pocket full of rye;/Four-and-twenty blackbirds,/Baked in a pie./When the pie was opened,/The birds began to sing;/Was not that a dainty dish,/To set before the king? // The king

was in his counting-house/Counting out his money;/The queen was in the parlor,/Eating bread and honey./The maid was in the garden,/ Hanging out the clothes./There came a little blackbird,/And snapped off her nose."

68:3–4 (68:15). oilcakes—the cake or mass of compressed seeds (rapeseed, linseed, cottonseed or other kinds) that is left after pressing out as much of the oil as can be thus extracted; the cakes are used as a fattening food for cattle or sheep, or as manure.

68:8 (68:19). Whitmonday—the day after Whitsunday (the seventh Sunday after Easter). Whitmonday is a bank holiday, i.e., it provides a long weekend. In 1904 Whitmonday fell on 23 May, and on that occasion Bloom was stung by a bee.

68:12 (68:23). Drago's—a hairdresser at 17 Dawson Street in the southeastern quadrant of Dublin, approximately a mile and a half south of Bloom's home.

68:15 (68:26). Tara Street—Dublin Corporation Public Baths, Wash Houses and Public Swimming Baths, J. P. *O'Brien,* superintendent, in Tara Street, just south of the Liffey in east-central Dublin.

68:16 (68:27). James Stephens ... O'Brien— James Stephens, "Chief Organizer" and first "Head Centre" of the Fenian Society (see 44:23n.). The O'Brien Bloom mentions could be one of two O'Briens associated with Stephens, but neither O'Brien was directly involved in Stephens' escape from Richmond Gaol in 1865: William Smith O'Brien (1803–1864), of whom Bloom thinks, 92:6 (93:11), or James Francis Xavier O'Brien (1828–1905), of whom Bloom thinks, 701:25 (716:15–16). William Smith O'Brien joined with Daniel O'Connell's Repeal Association in 1843, withdrew and formed the more activist Irish Confederation in 1847. During the famine of 1848 he attempted to "raise the country," and he, with Stephens and others, attacked a police garrison in County Tipperary. The attack was unsuccessful; Stephens, slightly wounded, escaped by feigning death. O'Brien was apprehended and found guilty of high treason; his death sentence was commuted to penal servitude; he was released in 1854 and fully pardoned in 1856, but he took no further part in politics.

J. F. X. O'Brien studied medicine in Paris, participated in Walker's filibuster in Nicaragua (1856), met Stephens in New Orleans in 1858 and joined the American branch of the Fenian Society. He was an assistant surgeon in the Union Army during the Civil War. After the war he went to Ireland and was involved in the abortive Fenian uprising in Cork in 1867. His death sentence was

commuted, and he was released in 1869. He became a Member of Parliament (1885–1905) and supported Parnell until the big split in 1891. As general secretary of the United Irish League he advocated an independent economic (as well as political) policy for Ireland.

68:18 (68:29). Enthusiast—the name was applied to a fourth-century Christian sect in the Near East and to a splinter group of seventeenth-century Puritans who preached an anarchistic agrarian utopia. Here Bloom uses the word to describe the religiously committed Zionist (Dlugacz?), who aimed at establishing "for the Jewish people a *politically* and *legally* assured home in Palestine."

68:24 (68:35–36). The king was in his counting house—nursery rhyme; see 67:37n.

68:25 (68:37). cuckstool—(obsolete), a chair used to punish scolds, dishonest tradesmen, etc. The victim was fastened in the chair in front of his own door to be hooted at and pelted by the rest of the community.

68:27–28 (68:39–40). Matcham's Masterstroke—the magazine *Titbits* did print a "Prize Titbit" in each issue with the advertisement quoted: "Payment at the rate of . . ." etc. This particular story appears to have been Joyce's private joke at the expense of his own adolescence. Apparently Joyce did write a story (intended for *Titbits* and money) that included the sentence Bloom reads: "*Matcham often thinks . . . who now. . . . Hand in hand*" (68:41–69:1 [69:12–14]).

68:28 (68:40–41). Mr. Philip Beaufoy, Playgoer's club, London—a real person who did contribute (terrible?) stories to *Titbits* in the 1890s. The joke resides in the contrast between

Beaufoy's literary stature and his name, which means literally "good faith," together with his fashionable London address. The story attributed to him here is fictional.

68:37–38 (69:9). cascara sagrada—Spanish: literally, "sacred bark"; as advertised, a mild laxative made from the bark of the buckthorn tree.

69:9 (69:22). Roberts—unknown.

69:10 (69:23). Gretta Conroy—a character in "The Dead," *Dubliners.*

69:14 (69:27). May's band—maintained and supplied by May and Company, professors of music and pianoforte and music sellers, 130 Stephen's Green West in the southeast quadrant of Dublin.

69:14–15 (69:28). Ponchielli's dance of the hours—Amilcare Ponchielli (1834–1886), *La Gioconda.* The opera's plot is complicated by two villains and by two heroines who are in love with one hero. In Act III, "The House of Gold," one of the villains determines to avenge his honor by poisoning his heroine-wife, who has had a rendezvous with the hero. The other heroine substitutes a narcotic. Meanwhile, there is a festival with an elaborate ballet, "The Dance of the Hours," which represents the passing of the hours from dawn till dark. A sequence of costumes marks the progression (as Bloom recalls below). In the dark climax of the ballet the villain reveals the "corpse" of his drugged wife and confusion is reestablished before the paired happy and pathetic endings of Act IV.

69:35 (70:10). George's church—see 57:7n.

EPISODE 5
[THE LOTUS-
EATERS]

THE LOTUS-EATERS

Custom Ho.

STATION

Georges Dock

COMMON

LOWE

CUSTOM

HOUSE QUAY

NORTH

Butt
Br.

RIVER

GEORGE'S QUAY

CITY

QUAY

SIR JO

STR

Sch. Ch.

GLOUCESTER ST.

STREE

PETERSON'S

LA.

WINDMILL

CREIGHTON

STREET EAS

SEND

MARK'S

MARK'S LA.

Ch.

MAGENN'S
PL.

LR. SANDWITH

HANOVER

STREET

ERNE ST. LOWER

NTH

WEST
PEARSE

SQUARE

College

Sch

**Westland Row
Post Office**

St. Andrew's

ERNE

UPR.

ST.

R

Sch

QUEENS

ege
Park Pav.

**F. W. Sweny,
Chemists**

**St. Andrew's
R. C. Church**

BASS
PL.

ST.

ERNE

ST.

ERNE PL.

HARMONY
ROW

HOGAN
PL.

RAILWAY

HOGAN
AV.

Hosp.

LEINSTER

Leinster St. Turkish Baths

CUMBE
SOUTH

ST.

HOGAN

GRAND

Nat.
Library

CLARE

Nat.
Gallery

Ch.

DENZILLE

Hosp.

LA.

HOLLES

HOLLES
ROW

VIS. ROW

IN ST.

PL.

Sch

Leinster
House

WEST

NORTH
MERRION
SQUARE

Hosp.

Government
Building

MERRION ST.

SOUTH

RRION
ROW

FITZWILLIAM

BAGGO

EPISODE FIVE

BLOOM'S ROUTE

▷── **Course & Direction**

○── **Stop-Off Points**

Episode 5: [The Lotus-Eaters], pp. 70–85 (71–86). After Odysseus makes good his escape from Calypso's island and from the sea he lands on Phæacia (Book VI) and is entertained at King Alcinous' court (Books VII and VIII), and in Book IX he reveals himself to Alcinous and begins to recount the adventures of his voyage from Troy, "years of rough adventure, weathered under Zeus." Early in his voyage he and his men are storm-driven to the land of the Lotus-Eaters ("who live upon that flower") and Odysseus disembarks to take on water. Some of Odysseus' men meet the friendly Lotus-Eaters, eat the Lotus and long "to stay forever, browsing on that native bloom, forgetful of their homeland." Odysseus drives the infected men back to the ships and sets sail.

Time: 10:00 A.M. Scene: Bloom has traveled approximately one and a quarter miles southeast from his home in Eccles Street to Sir John Rogerson's Quay on the south bank of the Liffey near its mouth. In the course of his desultory wanderings Bloom circles south toward the Westland Row Post Office (as though he were approaching it surreptitiously rather than directly). He moves in a tighter circle from the post office and then moves northwest toward the Leinster Street Baths (see 85:4n). His wanderings take place within a triangle about a third of a mile on a side. Organ: genitals; Art: botany-chemistry; Color: none; Symbol: the Eucharist; Technique: narcissism. Correspondences: *Lotus-Eaters*— the cabhorses, communicants, soldiers, eunuchs, bather, watchers of cricket.

70:1 (71:1). SIR JOHN ROGERSON'S QUAY —on the south bank of the Liffey at its mouth. The quayside was reclaimed by Sir John Rogerson, an early eighteenth-century barrister and alderman who eventually became Chief Justice of the King's Bench.

70:2 (71:2). past Windmill lane—on Bloom's right, because he is walking east along Sir John Rogerson's Quay.

70:2 (71:2–3). Leask's the linseed crusher's— H. M. Leask and Co., linseed crushers, oil and linseed cake manufacturers, 14–15 Rogerson's Quay.

70:3 (71:3). the postal telegraph office—18 Rogerson's Quay.

70:3–4 (71:3–4). Could have given that address too—Town Sub-Post Office, Savings Bank and Money Order Office at 18 Rogerson's Quay. Bloom reflects that he could have used this post office as a blind as well as the one in Westland Row toward which he is circling.

70:4 (71:4). the sailor's home—and Ship-wrecked Mariner's Society, 19 Rogerson's Quay.

70:5 (71:5). Lime street—Bloom has turned right and is walking south.

70:6 (71:6). Brady's cottages—an alley of tenements that intersects Lime Street.

70:6 (71:6). a boy for the skins—i.e., a boy who has been making the rounds of trash heaps and garbage cans.

70:7 (71:7). linked—held by a chain or cord rather than a handle.

70:9 (71:9). caskhoop—i.e., her toy is a bit of trash, the discarded hoop from a barrel.

70:12 (71:12). Townsend street—Bloom has turned to his right at the foot of Lime Street and has walked west along Hanover Street East, which gives into Townsend Street. Bloom turns left (south), crosses Townsend Street and walks south along Lombard Street East.

70:13 (71:13). Bethel. El—Hebrew: *Beth,* "House of"; *El,* "God," after the city and holy place 12 miles north of Jerusalem, where the Ark of the Covenant was kept (Judges 20:26–28; 21:4). Apparently this is the name of a Salvation Army Hall that Bloom passes in Lombard Street East.

70:13–14 (71:14). Nichols' the undertaker's— J. and C. Nichols, funeral and job carriage proprietors and undertakers, 26–31 Lombard Street East.

70:14–15 (71:15). Corny Kelleher . . . O'Neill's —Kelleher, a fictional character, presumably works for Henry J. O'Neill, carriage maker and undertaker, 164 North Strand Road (in the north-eastern quadrant of Dublin near Newcomen Bridge—over the Royal Canal). See 221–222 (224–225).

70:16–20 (71:16–20). Met her once . . . tooraloom, tooraloom—song associated with Kelleher. Source unknown. A "tout" is a spy.

70:21 (71:21). Westland row—extends south from Lombard Street East.

70:21–22 (71:21–22). Belfast and Oriental Tea Company—6 Westland Row.

70:24 (71:24). Tom Kernan—tea merchant and Ulsterman who accepted conversion to Catholicism when he married; appears as a character in "Grace," *Dubliners,* and frequently in *Ulysses.* He is a fictional agent for Pulbrook

Robertson and Company, 5 Dame Street, Dublin and 2 Mincing Lane, London, E.C.

70:29. high grade hat should read **high grade ha** as it does **(71:29–30).**

70:37 (71:37). Cinghalese—Singalese, residents of Ceylon.

70:37–38 (71:37–38). lobbing—lounging.

70:38 (71:38). dolce far niente—Italian, literally: "sweet doing nothing," thus, pleasant idleness or inactivity.

70:41 (71:41). Azotes—French: "nitrogen." Antoine Laurent Lavoisier (1743–1794), the French chemist, called nitrogen "Azotes" and noted that, though it was present in the air, it was unable to support life.

70:41 (71:41). Hothouse in Botanic gardens—in Glasnevin, a little less than two miles north of the center of Dublin.

70:41–42 (71:42). Sensitive plants—suggests Shelley, "The Sensitive Plant" (1820), which contrasts the immanence of the plant's decay against "love, and beauty and delight," for which "there is no death or change." If this is an allusion to Shelley, then "Botanic gardens," 70:41 (71:41), would recall Erasmus Darwin's (1731–1802) poem, *Botanic Garden* (1791), with its two parts, "The Economy of Vegetation" and "The Loves of the Plants." And "Flowers of Idleness" might echo Byron's first series of poems, "Hours of Idleness" (1807).

71:3 (72:3). dead sea—because the waters of the Dead Sea are a solution containing approximately 25 percent solid substances (salt), the specific gravity of the waters is approximately 1.16 and a human body easily floats on the surface.

71:7 (72:7). a law—Bloom is trying to recall Archimedes' (c.287–212 B.C.) law, or the principle of Archimedes: a solid body immersed in a liquid loses weight; the apparent loss of weight is equal to the weight of the liquid displaced.

71:7–8 (72:8–9). Vance in high school ... The college curriculum—Roygbiv Vance, fictional (?) teacher in "high school." Roygbiv, the full spectrum: *r*ed, *o*range, *y*ellow, *g*reen, *b*lue, *i*ndigo, *v*iolet. High schools in the National School System were primarily vocational in their emphasis but the possibility of a "college curriculum" (i.e., college preparatory course) was enhanced in 1878 (when Bloom was twelve) by the establishment of a Board of Intermediate Education, which held examinations and distributed subsidies to secondary schools according to the results.

71:10 (72:10–11). Thirty two feet per second, per second—is approximately the rate of acceleration of falling bodies and is represented as g in the fuller statement of the law: $v = gt$ where v is velocity and t is time (in seconds).

71:12 (72:12–13). It's the force ... is the weight—an oversimplification of Newton's law, which holds, instead, that weight is a function of the relation between the mass of the earth and the mass of the body in question.

71:15 (72:16). Freeman—i.e., the *Freeman's Journal;* see 57:34n.

71:20 (72:21). postoffice—substation, 49–50 Westland Row.

71:30 (72:31). Henry Flower, Esq—an assumed name of Bloom's. He has struck up this correspondence with "Martha Clifford" by inserting an advertisement in the *Irish Times:* "Wanted smart lady typist to aid gentleman in literary work." Martha was one of 44 respondents. See 157:41–42 (160:11–12).

71:35–36 (72:36–37). Tweedy's regiment? ... No, he's a grenadier—Bloom is looking at recruiting posters. Tweedy's regiment was the Royal Dublin Fusiliers, founded in 1881, disbanded in 1922. Uniform: a raccoon hat, six inches high, smaller and flatter on top than that of the Grenadier Guards (nine inches high, bear or raccoon, decorated in front with a flaming grenade in metal). The Fusiliers wore the hackle on the left side, green over blue; the collar, shoulder strap and "Pointed cuffs" (71:35 [72:37]) were blue; the trousers were blue with red piping. The Grenadiers wore slashed rather than pointed cuffs. Bloom's confusion of the two uniforms is not an unusual mistake.

71:39 (72:40–41). Maud Gonne's letter ... off O'Connell street—early in the Boer War (1899–1902), in an effort to encourage enlistments, the British Army suspended the rule that required troops in Dublin to spend the nights in barracks. The result was that a considerable number of troops prowled O'Connell Street and vicinity in search of "companionship." Maud Gonne (see 44:12n) rallied her Daughters of Ireland to campaign against enlistment in the British Army; as part of their campaign the women distributed a leaflet (attributed to Maud Gonne) "on the shame of Irish girls consorting with the soldiers of the enemy of their country" (Maud Gonne MacBride, *A Servant of the Queen* [London, 1938] p. 292). The issue was

sporadically revived in the Dublin press, particularly in May and early June of 1904 after the Dublin Corporation had passed a resolution against the Army's practice of allowing troops the freedom of the city and after the Army authorities had refused to take action on the Corporation's resolution.

71:40 (72:41). Griffith's paper—Arthur Griffith (44:6n), founder and editor of the *United Irishman* (1899 *ff.*).

72:1–2 (73:2). overseas or halfseasover empire—i.e., Britain's overseas empire. *Halfseasover :* intoxicated.

72:3 (73:3). Table:able. Bed:ed.—i.e., left, right; left, right: a word game that troops use to establish the rhythm of their march.

72:3 (73:4). The King's own—i.e., Edward VII's own, a phrase that could be applied to a number of regiments if he had presented them with their colors or if the regiment had inducted him into honorary membership. The phrase could also be applied to the Grenadier Guards because as the first of the "Household Regiments" they would be attached to the person of the king.

72:4 (73:4–5). Never see him ... A mason. Yes—i.e., one would see Edward VII (1841–1910; king, 1901–1910) dressed in various military (regimental) uniforms but never in uniform as an honorary fireman or policeman. Edward VII was a bencher and officer of the Middle Temple and served as the grand master of English Freemasons (from 1874 until he became king in 1901).

72:28 (73:29). Holohan—appears as a character in "A Mother," *Dubliners :* "He had a game leg and for that his friends called him Hoppy Holohan."

72:31 (73:32). outsider—a horse-drawn cab.

72:32 (73:33). Grosvenor—a fashionable hotel at 5 Westland Row.

72:40 (73:41). Brutus is an honourable man—Shakespeare, *Julius Caesar* (III, ii, 87). Marc Antony in his oration over Caesar's body speaks this phrase in scorn of Brutus' "honourable" motives for killing Caesar.

72:42 (74:1). Bob Doran—appears as a character in "The Boarding House," *Dubliners*. His "bender" in *Ulysses* provides one of the minor Odysseys of the novel's day.

73:1 (74:2). Bantam Lyons—appears as a character in "Ivy Day in the Committee Room," *Dubliners*.

73:2 (74:3). Conway's—James Conway and Company, grocers and wine merchants, 31–32 Westland Row.

73:6 (74:7). braided drums—of the woman's hairdo.

73:11 (74:13). Broadstone—i.e., off to the country by way of the Broadstone Terminus of the Galway or Midland Great Western Railway. The terminus is in the northwestern quadrant of Dublin.

73:12 (74:14). fostering—Robert M. Adams, *Surface and Symbol* (New York, 1962), p. 166, suggests that "fostering" should be replaced by "the good Irish word 'foostering' as in the proofsheets at Harvard." "Fooster": to bustle.

73:14 (74:16). Two strings to her bow—a popular proverb. Dating at least from the Elizabethan Age, it applauds the thoughtfulness of providing a reserve that can be drawn on in an emergency.

73:23 (74:25). the Arch—a public house or bar, 32 Henry Street, just north of the Liffey in central Dublin (Molloy and O'Reilly, grocers and spirit merchants).

73:28 (74:30). Paradise and the peri—a catch phrase for "so near to paradise and yet prevented." The phrase is the title of an interpolated poem in Thomas Moore's *Lalla Rookh, An Oriental Romance* (1817). In Persian mythology the peri were originally malevolent superhuman beings who subsequently became good genies, endowed with beauty and grace; hence, "fair ones," deserving of and hidden in paradise. Moore's poem recounts the struggles of a peri ("'Nymph of a fair but erring line!'") and her efforts to gain access to paradise: "One morn a Peri at the gate/Of Eden stood, disconsolate;/And as she listen'd to the Springs/Of Life within, like music flowing,/And caught the light upon her wings/Through the half-open portal glowing,/She wept to think her recreant race/Should e'er have lost that glorious place." A "glorious Angel" informs her: "'One hope is thine./'Tis written in the Book of Fate,/*The Peri yet may be forgiv'n/Who brings to this Eternal gate/The Gift that is most dear to Heav'n!*'" The Peri has a good deal of trouble discovering what that gift is, but it turns out to be "Blest tears of soul-felt penitence!" And with one tear "The Gates are pass'd and Heav'n is won!"

73:29 (74:31). Eustace street—in central Dublin south of the Liffey, approximately one-half mile west of Bloom's present position in Westland Row.

73:30 (74:32). Esprit de corps—French:

67 | NOTES FOR ULYSSES

"spirit of association; fellow feeling." Also a pun on *corps*, "body": "spirit of the body."

73:34–35 (74:36–37). the Loop Line bridge— the City of Dublin Junction Railway (the Loop Line) linked the Kingstown Railway Terminus in Westland Row with the Amiens Street Station, the terminus of the Great Western Railway north of the Liffey. The Loop Line is bridged over Westland Row; thus "they" drive north up Westland Row.

73:40–74:2 (75:1–4). What is home . . . abode of bliss—this advertisement and its position under the obituaries, left column, front page, *Freeman's Journal*, is a fiction, but a George W. Plumtree was listed as a potted-meat manufacturer at 23 Merchant's Quay in Dublin. "To pot one's meat" is slang for "to copulate."

74:3 (75:5). My missus—Mrs. M'Coy, "who had been a soprano, still taught young children to play the piano at low terms," in "Grace," *Dubliners*.

74:5 (75:7). Valise tack—Bloom regards M'Coy as a sponger who has borrowed (and has not returned) suitcases "to enable Mrs. M'Coy to fulfill imaginary engagements in the country" ("Grace," *Dubliners*).

74:8 (75:10). swagger—like "swank," for "very stylish and important."

74:9 (75:11). Ulster hall, Belfast—a concert room and hall for public meetings (1862), which seated 2,500 people "with all the modern improvements"; in south-central Belfast, a town 85 miles north and slightly east of Dublin.

74:12–13 (75:14–15). Queen was in . . . head and—after a nursery rhyme; see 67:37n.

74:13–14 (75:15–16). Blackened court cards . . . and fair man—"court cards," a corrupted form of "coat cards," the cards bearing the coated figures of king, queen and knave. In fortune-telling the coat cards indicate people; the numbered cards, events. "Dark lady and fair man" combines one of two queens and one of two kings. The queen of spades: a very dark woman, a false and intriguing woman, also a widow. The queen of clubs: a brunette, agreeable and intelligent, also "marriage," also "a woman in middle life." The king of hearts: a fair or brown-haired man, good-natured but hasty. The king of diamonds: a very fair-complexioned or gray-haired man, a protector but quickly angered.

74:16–20 (75:18–22). Love's/Old/ . . . Comes lo-ve's old . . .—see 63:24–25n.

74:33 (75:35). the coroner and myself—M'Coy is "secretary to the City Coroner" in "Grace," *Dubliners*.

74:40 (75:4). wheeze—a theatrical "gag," especially if repeated. An antiquated fabrication; hence, a frequently employed trick or dodge.

75:3 (76:7). Bob Cowley—a "spoiled priest," i.e., a priest who has drifted out of his calling but not flamboyantly enough to be unfrocked by the Church and not courageously enough to request that he be released from his vows. Cowley appears subsequently in the novel.

75:3 (76:7). Wicklow regatta—held each year at Wicklow (a coastal town 26 miles south of Dublin) during the August Bank Holidays, which start on the first Monday of the first week in August. There were various races for different classes of ships and boats.

75:6 (76:10). towards Brunswick street—Great Brunswick Street, now called Pearse Street. Bloom walks north along Westland Row and then turns right (east) along Great Brunswick Street.

75:17 (76:21). Cantrell and Cochrane's—advertised themselves as "mineral and table water manufacturers, by special appointment to his Royal Highness, Edward VII." The firm was based in London with "works" in Dublin and Belfast.

75:18 (76:22). Clery's—a dealer in silks, 21–27 Sackville Street Lower, now called O'Connell Street (a fashionable shopping district in the center of Dublin, north of the Liffey).

75:19 (76:23). Leah tonight: Mrs Bandman Palmer—Millicent Palmer (1865–1905), American actress who made her first tour of the British Isles in 1883, was advertised in the *Freeman's Journal*, 16 June 1904, as scheduled to perform in *Leah* at the Gaiety Theatre in Dublin.
Leah the Forsaken (1862), a translation and adaptation by the American playwright John Augustin Daly (1838–1899) from the German *Deborah* (1850), by Salomon Hermann Mosenhal (1821–1877), a German-Austrian playwright and archivist. The play is set in an Austrian village in the early eighteenth century; its central theme involves an attack on anti-Semitism. The villain, Nathan (75:29 [76:33]), is an apostate Jew who masquerades as a pharisaical and anti-Semitic Christian to protect his place in the village. Leah, the Jewess, is hounded by Nathan and "forsaken" by her Christian lover, only to achieve peace by self-immolation at the play's end. The part of Leah in the play would lend itself to flamboyant performance; hence the list of important actresses in this paragraph.

75:20 (76:24). Hamlet she played last night— it was not unusual for "heavy" nineteenth-century actresses to assume male roles in Shakespeare's plays (because the female roles are comparatively thin and because sustained, flamboyant, operatic performance was the actor's ideal). Mrs. Palmer did play *Hamlet*, 15 June 1904, at the Gaiety Theatre, and the *Freeman's Journal* of 16 June notes that she played the part of the Prince and "to say the least sustained it creditably."

75:21 (76:25). Perhaps he was a woman— Bloom unconsciously (?) echoes Edward P. Vining's theory about Hamlet; see 196:9–10n.

75:22 (76:26). Poor papa—Bloom's father, Rudolph Virag (Bloom), committed suicide 27 June 1886; see 669:1–13 (684:33–685:8).

75:22–24 (76:26–28). Kate Bateman in that! ... was: sixty-five—Kate Bateman (1843–1917), member of a famous English stage family, whose great success in *Leah* was in 1863 (not 1865) at the Adelphi Theatre, 411 Strand, North Side, London, which specialized in melodramas and farces.

75:24–25 (76:29). Ristori in Vienna—Adelaide Ristori (1822–1906), Italian actress celebrated for her "tragic roles." A version of *Leah* was "adapted expressly for Mme Ristori," and though there is no available record, she undoubtedly did act it in Vienna.

75:26 (76:30). Rachel—Bloom's mistake for *Deborah*; see 75:19n. The mistake may be a function of Bloom's (or his father's) association of *Deborah* as a role with the Alsatian-Jewish actress Elisa Rachel (1821–1858).

75:26–31 (76:30–35). The scene he was ... God of his father—from *Leah the Forsaken*, III, ii:

ABRAHAM: I hear a strange voice, and yet not a strange voice.
NATHAN [*to Sarah*]: Who is this old man?
SARAH: Abraham, sir—a poor old blind man. . . . This is our benefactor, Abraham! Go kiss his hand—
NATHAN: This is no time for idle acts! Come, away, away!
ABRAHAM: That voice! I know that voice! There was at Presburg, a man whose name was Nathan. He was a singer in the synagogue. It is his voice I hear.
NATHAN: . . . The man is mad.
ABRAHAM: It was said he became a Christian and went out into the world.
NATHAN [*angrily*]: Silence!
ABRAHAM: He left his father to die in poverty and misery since he had forsworn his faith, and the house of his kindred.

NATHAN: Silence! silence, I say.
ABRAHAM: I will not be silent. I hear the voice of Nathan. [*Passing his hand over Nathan's face.*] And I recognize the features of Nathan.
NATHAN [*terrified*]: The Jew is mad! Silence, or I'll do you injury!
ABRAHAM: With my fingers I read thy dead father's face, for with my fingers I closed his eyes, and nailed down his coffin! Thou art a Jew!
NATHAN [*flying at him*]: Another word! [*Seizes him by the throat.*] . . .
SARAH: Oh, spare the old man. He's mad, sir, I know.
NATHAN [*bewildered, knocking on door*]: Coming? Ha! What's this? [*Loosens his grasp from which Abraham sinks supinely; at the same moment a thunder-bolt strikes the cabin, and the storm increases.*]
SARAH [*screams*]: He is dead!
NATHAN [*at first confused, but recovering, as the Peasants all run in affright from the storm, and stand gazing around the dead body of Abraham*]: Aye—dead! by the hand of heaven!—[*Tableau.*]

75:37 (76:41). the hazard—a cabstand on Great Brunswick Street near Westland Row.

75:42 (77:4). jugginses—a juggins is a fool; looking for a sucker who will pay for the drinks is called "juggins-hunting."

76:9 (77:13). the cabman's shelter—Cabman's Shelter and Coffee Stand on Great Brunswick Street between Cumberland Street South and Westland Row.

76:11 (77:15). Voglio e non—see 63:38n.

76:13 (77:17). Là ci darem la mano—see 63:24n.

76:15 (77:19). Cumberland street—Bloom turns right and walks south. Cumberland Street, parallel to Westland Row, passes behind the Westland Row Railway Station.

76:16–17 (77:20–21). Meade's timberyard—Michael Meade and Son, builders; steam-sawing, planing, and moulding mills; and merchants, 153–159 Great Brunswick Street (on the corner of Cumberland Street).

76:18 (77:23). pickeystone—pickey is the game of hopscotch, played with a flat stone on a diagram on pavement.

76:19 (77:23). Not a sinner—i.e., Bloom did not step on a line as he crossed the hopscotch court; if he had, he would have been disqualified to the tune of the child's chant: "You're a sinner; you're a sinner."

76:20 (77:24). shooting the taw with a cunny thumb—the *taw*, the marble that the player shoots, a large choice marble, usually streaked or variegated. "Cunny thumb": the marble is held in the bent forefinger and shot by flicking it with the thumb.

76:22 (77:26–27). Mohammed cut a ... to wake her—one of the traditions about Mohammed emphasizes his extraordinary kindness to animals. Thornton (p. 80) says that the story Bloom recalls is included in the *Al-Jami al Sahih*, by Abu Abdallah Muhammad ibn Ismail al Bukhari (810–870), the great Mohammedan scholar of traditions about the Prophet, but we have been unable to confirm this in the translations we have consulted.

76:24 (77:28–29). Mrs Ellis's. and Mr?—Mrs. Ellis ran a "juvenile school" (i.e., a sort of nursery school–kindergarten or pregrammar school), which Bloom attended when he was a child, 696:4 (712:13). "And Mr?": the child's question about the woman titled Mrs. (widow?) when the husband is not in evidence.

76:34. word should read **world** as it does (77:37).

77:2 (78:6). write should read **wrote.**

77:7 (78:12). what kind of perfume does your wife use—answer: opoponax. See 368:8 (374:29).

77:10 (78:15–16). Language of flowers—florigraphy: various traditional symbolic meanings attached to flowers. The western Greco-Roman traditions were revived and expanded in the iconography of the medieval Church and further developed in chivalric and heraldic conventions. Nineteenth-century sentimental or greeting-card verse sustained and watered down the traditions.

77:13–16 (78:19–21). Angry tulips with you ... all naughty nightstalk—*tulips*, dangerous pleasures; *manflower*, an obvious pun; *cactus*, not only the phallus but also touch-me-not; *forget-me-not*, as the name suggests and also true love; *violets*, modesty; *roses*, love and beauty; *anemone*, frailty, anticipation; *nightstalk*, in addition to the phallic pun, nightshade, i.e., falsehood.

77:22 (78:27). the rosary—a form of prayer usually comprised of 15 decades of Ave Marias (a prayer to the Virgin Mary: "Hail Mary, full of Grace ... "). Each decade is preceded by a paternoster (the Lord's Prayer) and followed by a Gloria Patris (Glory be to the Father ... "). The prayers are counted on beads as they are being said. A mystery is contemplated during the recital of each decade. The rosary is divided into three parts, each consisting of five decades and known as a "corona" or "chaplet."

77:32 (78:37). the Coombe—a street in south-central Dublin, and also the rather dilapidated area around St. Patrick's Cathedral (then Protestant). It was once a fashionable and thriving quarter in the city.

77:33–36 (78:38–41). o Mairy lost ... To keep it up—the source of this street rhyme is unknown.

77:37 (79:1). her roses—a euphemism for the menstrual period.

78:4 (79:6). Martha, Mary—sisters of Lazarus. "The other one," 78:10 (79:13), is Martha, whose spirit was "cumbered about with much serving ... careful and troubled about many things." Martha complained against the indolence of her sister Mary—"She," 78:13 (79:17). "Mary sat at Jesus' feet and heard his word." Jesus reproves Martha: "Mary hath chosen that good part, which shall not be taken away from her" (Luke 10:38–42).

78:12 (79:15–16). the hole in the wall at Ashtown—Ashtown is on the north side of Phoenix Park. The district is adjacent to the gate that led to the Vice Regal Lodge and was associated with bribery at election time. The "Hole in the Wall" was a place where the virtuous elector could pass his empty hand through an aperture and withdraw it filled with guineas. Thus the voter could conscientiously swear that he was ignorant of the identity of the person who bribed him (and therefore of the fact that he was being bribed).

78:13 (79:16–17). the trotting matches—at the end of the nineteenth century trotting-pony races were a popular event in the annual Dublin Horse Show, one of the more important events in the Dublin social calendar. Trotting races have since disappeared from the show. See 367:38n.

78:16 (79:19). the railway arch—behind Westland Row Station; the arch supports the elevated tracks of the Kingstown Railway.

78:21 (79:24). Lord Iveagh—Edward Cecil Guinness, Earl of Iveagh (1847–1927), philanthropist and one of the family partners in Guinness' Brewery in Dublin.

78:24 (79:27). Lord Ardilaun—Sir Arthur Guinness (1840–1915), politician, president of the Royal Dublin Society and another of the family partners in the brewery.

78:38 (79:41). All Hallows—or St. Andrew's, a Roman Catholic church at 46 Westland Row. Bloom enters the church from its rear porch, in Cumberland Street.

78:42–79:1 (80:3–4). the very reverend John Conmee S.J.—(1847–1910), rector of Clongowes Wood College (1885–1891) during Stephen's days as a student, subsequently prefect of studies at Belvedere College in the early 1890s, when Stephen was there. He was the superior of the residence of St. Francis Xavier's Church, Upper Gardiner Street, Dublin, from 1898 until 16 June 1904. In August 1905 he was named Rome Provincial of the Irish Jesuits.

79:1 (80:4). saint Peter Claver—(1581–1654), Spanish Jesuit missionary who worked for 44 years at Cartagena, Colombia, South America, as chaplain to the Negro slaves arriving from Africa.

79:1 (80:4). the African mission—*The Catholic Encyclopedia* lists extensive Jesuit missionary activity in Africa during the latter half of the nineteenth century.

79:2 (80:5). Save China's millions—the Jesuits maintained missions in several cities in nineteenth-century China in spite of the rather intense pressures of Chinese xenophobia. One crisis in this resistance to the missionaries and their efforts was the death of five Jesuit priests at Nanking during the Boxer Rebellion (1900).

79:3 (80:6). the heathen Chinee—the title of two song versions of a ballad, "Plain Language from Truthful James: (Table Mountain, 1870)" by Bret Harte (1836–1902). The ballad observes, "For ways that are dark,/And for tricks that are vain,/The heathen Chinee is peculiar" (lines 3–5), and goes on to "explain" this observation by citing the card-sharping career of one "Ah Sin."

79:3 (80:6). Celestials—the Chinese.

79:4 (80:7). Prayers for the conversion of Gladstone—William Ewart Gladstone (1809–1898), four times Prime Minister of England and popular with the Irish as a result of his qualified support for Irish Home Rule. Gladstone was regarded as a liberal in his attitude toward Catholics, and the fact that his sister Helen had been converted was also regarded as implying his sympathies. This was something of a misapprehension because Gladstone was by conviction anti-Catholic, though his tract "Vaticanism" (in criticism of the doctrine of Papal Infallibility) was characteristically moderate and far from rabid in tone. Archbishop Walsh of Dublin (see 79:6 below) did address a letter to "the faithful of the diocese" suggesting prayers for Gladstone on the eve of his death, 19 May 1898. The letter did not overtly ask for prayers for Gladstone's conversion but might easily have been so taken since it concluded by suggesting "a prayer that God, in whom he always trusted, may now in his hour of suffering be pleased to send him comfort and relief to lighten his heavy burden, and to give him strength and patience to bear it, in so far as in the designs of Providence it may have to be borne *for his greater good*" (italics added).

79:6 (80:9). Dr. William J. Walsh, D.D.—the Reverend William J. Walsh (1841–1921), Catholic Archbishop of Dublin (1885–1921).

79:7 (80:10). in the museum—i.e., in the National Gallery in Dublin, not far south of where Bloom is at the moment. The statuary in the main entrance hall included a reclining Buddha, which had arrived in 1891.

79:8 (80:11). josssticks—thin cylinders of fragrant tinder mixed with clay, which the Chinese used as incense.

79:9 (80:12). Ecce Homo—Latin: "Behold the man," Pontius Pilate's words in John 19:5 when he presents Jesus to the people: "Behold, I bring him forth to you, that ye may know that I find no fault in him Behold the man!" A painting of Jesus crowned with thorns entitled *Ecce Homo* by the Hungarian Michael Munkácsy (1844–1900) was exhibited at the Royal Hibernian Academy in Abbey Street Lower in 1899.

79:9–10 (80:12–13). Saint Patrick the shamrock—St. Patrick (*c.*385–*c.*461), one of three patron saints of Ireland. He was carried into slavery in Ireland and subsequently escaped to Gaul, where he studied at Tours before he returned to Ireland as a missionary. His mission settlement at Armagh is still the primatial city of Ireland. The shamrock, a plant with trifoliate leaves, was (according to an apocryphal legend) used by St. Patrick to illustrate the doctrine of the Trinity; it was subsequently adopted as the national emblem of Ireland.

79:10 (80:13–14). Martin Cunningham—appears as a character in "Grace," *Dubliners.* Cunningham's character was modeled on that of Matthew F. Kane (d. 1904), Chief Clerk of the Crown Solicitors' Office (not unlike a district attorney's office) in the Dublin Castle. See Adams, p. 62.

79:12 (80:15). about getting Molly into the choir—Bloom is apparently unaware that the participation of women in church choirs had been called into question by Pope Pius X's *Motu Proprio* (papal rescript, "Of His Own Accord," i.e., not on the advice of cardinals or others): *Inter Sollicitudines* ("With Solicitude"), November 22, 1903: ". . . Singers in churches have a real liturgical office, and . . . therefore women, as being incapable of exercising such office, cannot

be admitted to form part of the choir or of the musical chapel. Whenever, then, it is desired to employ the acute voices of sopranos and contraltos, these parts must be taken by boys, according to the most ancient usage of the church" (Pius X [1835–1914; Pope, 1903–1914]).

79:12 (80:15–16). Father Farley—*Thom's* (*1904*) lists a Reverend Charles Farrelly, S. J., as in residence at the Presbytery, Upper Gardiner Street (i.e., associated with St. Francis Xavier's Church and therefore with Father Conmee). Obviously Bloom has tried to get Molly into the choir in that church, which was not very distant from the house in Eccles Street. Molly thinks (733 [748]) that the trouble was the Jesuits had found out that Bloom was a Freemason.

79:13 (80:16). They're taught that—the lay suspicion that Jesuits are taught to be devious and deceptive.

79:14 (80:17). bluey specs—sunglasses.

79:19 (80:22). rere—for "rear." "Rere" usually appears in combined forms, as in "reredos," the screen or wall behind the altar in a church.

79:20 (80:23). sodality—in the Roman Catholic Church a religious guild or brotherhood (sisterhood) established for purposes of devotion and of mutual help or action.

79:21 (80:24). Who is my neighbour?—in Luke, "a certain lawyer stood up and tempted [Jesus], saying, Master, what shall I do to inherit eternal life?" The answer: to love God "and thy neighbor as thyself." The lawyer then asks, "Who is my neighbor?" The answer: the parable of the Good Samaritan (Luke 10:25–37).

79:23 (80:26). Seventh heaven—this stock phrase for "perfect heaven" derives from the belief in seven as a perfect number, signifying the complete whole, as both latter Jewish and Mohammedan traditions contemplate seven heavens, the highest of which is the abode of God.

79:23–24 (80:26–27). crimson halters—scapulars, insignia or badges of membership in a religious society or sodality. The communicants are probably celebrating a monthly meeting of their society.

79:26 (80:29). the thing—the ciborium, the vessel in which the priest carries the consecrated "bread" during communion.

79:27 (80:30). (are they in water?)—answer: no.

79:30 (80:33). murmuring all the time. Latin—the priest repeats the formula of ad-

ministration as each participant in the Communion receives "the Lord's body." The formula begins: "*Corpus Domini nostri . . .*"—"May the body of our Lord Jesus Christ keep your soul and bring it to everlasting life. Amen."

79:30–31 (80:34). Shut your eyes and open your mouth—after the jingle: "Open your mouth and shut your eyes, And I'll give you something to make you wise."

79:32 (80:36). Hospice for the dying—Our Lady's Hospice for the Dying at Harold's Cross, south of Dublin, maintained by the Roman Catholic Sisters of Charity "for those whose illness is likely to terminate fatally, within a limited period."

79:33 (80:36). don't seem to chew it—tradition dictates that the "sacred species" should not be touched with the teeth but that it should be broken against the roof of the mouth.

79:41–42 (81:3–4). mazzoth . . . unleavened shewbread—*mazzoth*, the unleavened bread that is used in the Hebrew Feast of the Passover. "This is the poor bread which our fathers ate in the land of Egypt." After Exodus 12:8, "And they shall eat flesh in that night, roast with fire, and unleavened bread; and with bitter herbs they shall eat it." At the Last Supper Jesus was celebrating the Feast of Passover with his disciples. Bloom confuses the Passover mazzoth with shewbread, the unleavened 12 cakes of "fine flour" (Leviticus 24:5–9; Exodus 25:30) which ancient Hebrew priests placed on the altar each Sabbath (to be eaten by them alone at the end of the week).

80:1 (81:5–6). bread of angels—a literal translation of the Latin *panis angelorum*, a reverential name for the Eucharist.

80:3 (81:7–8). Hokypoky—charlatanism. A traditional (and anti-Roman Catholic) derivation of this slang term occurs in John Tillotson (1630–1694), *Works*, Volume I, Sermon 26: ". . . a corruption of *hoc est corpus* (this is [my] body) by way of ridiculous imitation of the priests of the Church of Rome in their trick of transubstantiation." "Hokeypokey" also occurs in nursery rhymes with many variants: "Hokeypokey five a plate" or "Hokeypokey penny a lump" or "Hokeypokey, whiskey, thum."

80:7–8 (81:12). Lourdes cure, waters of oblivion—Lourdes in southern France, one of the chief Catholic pilgrim shrines in Europe. The fame of Lourdes dates from the reputed apparition of the Virgin Mary to fourteen-year-old Bernadette Soubirous (Ste. Bernadette) in 1858. Near the grotto where the apparition took place is a spring; the waters are diverted into

several basins in which the ailing pilgrims bathe. The waters are "waters of oblivion" in the sense that they are believed to have the power of effecting miraculous cures.

80:8 (81:12). the Knock apparition—Knock, a village six miles from Claremorris, County Mayo (in the west of Ireland). The apparitions are detailed in *The Apparition at Knock, with the Depositions of the Witnesses and the Conversion of a Young Protestant Lady by a Vision of the Blessed Virgin*, by Sister Mary Frances Clare (London, 1880). The first apparition, 21 August 1879, the eve of the octave of the Assumption, was experienced by Mary McLoughlin and Mary Byrne. They saw some "figures," which at first they took to be statues, surrounded "by a light brighter than that of any earthly sun" (p. 42). Mary had her hands raised, and St. Joseph inclined toward her. St. John also appeared carrying a small mitre and a small altar, above which a lamb was haloed "with gold-like stars" (p. 43). Subsequent apparitions, early in 1880, were witnessed by others and were associated with a series of miraculous cures.

80:10 (81:14–15). Safe in the arms of kingdom come—after the revival hymn " Safe in the Arms of Jesus," words by Fanny Crosby, music by W. H. Doane, *Songs of Devotion* (1869): "Safe in the arms of Jesus,/Safe from corroding care;/Safe from the world's temptations,/Sin cannot harm me there."

80:16 (81:20). I.N.R.I.—Latin initials for Jesus of Nazareth, King of the Jews (*Iesus Nazarenus Rex Iudaeorum*), the inscription on the Cross.

80:16 (81:20). I.H.S.—these Latin initials derive from a Greek abbreviation of the name Jesus and are variously interpreted as standing for *Jesus Hominium Salvator* ("Jesus the Saviour of Man") and *In Hoc Signo—Vinces* ("In This Sign—Thou Shalt Conquer"). The latter is what the angel said to the Roman Emperor Constantine as he went into battle with the cross as his standard for the first time (when the Roman Empire was being converted to Christianity).

80:20–21 (81:24–25). Dusk and the light behind her—in Gilbert and Sullivan's *Trial by Jury* (1876) the Judge describes his problem and its cynical solution: how he was once "as many young barristers are,/An impecunious party/ ...,/ So I fell in love with a rich attorney's/Elderly, ugly daughter." The Judge then quotes the rich attorney's recommendation: "You'll soon get used to her looks,' said he,/'And a very nice girl you'll find her!/She may very well pass for forty-three/In the dusk, with a light behind her!'" (from W. S. Gilbert, *Original Plays* [London, 1876] pp. 333–334).

80:23 (81:27). the invincibles—sometimes called "The Invincible Society," a small splinter group of Fenians organized late in 1881 with the object of assassinating key members of the then militantly repressive British government in Ireland. The Invincibles (6 May 1882) assassinated Lord Frederick Cavendish (1836–1882), the new chief secretary of Ireland, and Mr. Thomas Henry Burke, an under-secretary in Dublin Castle whom the Irish regarded as the principle architect of the so-called coercion policy, the policy of assuring Irish compliance with English rule by punitive restriction of Irish civil liberties. Burke was apparently the assassins' primary target; the assassinations took place in Phoenix Park not far from the Vice Regal Lodge; hence, "the Phoenix Park murders."

80:24 (81:28). Carey—James Carey (1845–1883), a builder and Dublin town councilor, apparently pious and public-spirited, became in 1881 director of the Dublin branch of the Invincibles. Arrested after the Phoenix Park murders, he turned Queen's evidence; his comrades were hanged and he attempted (with English help) to escape to South Africa; but he was recognized and shot on shipboard by Patrick O'Donnell, who was, of course, hanged for his pains. James Carey did have a brother named Peter, who was also associated with the Invincibles.

80:25 (81:29). Peter Claver—see 79:1n.

80:26 (81:30). Denis Carey—unknown.

80:26–27 (81:30–31). Wife and six children at home—at the time of the Phoenix Park murders in May 1882, James Carey and his wife had six children; a seventh was born late in the year.

80:28 (81:32). crawthumpers—ostentatiously devout people. The Irish *crawtha* means mortified, pained (P. W. Joyce, p. 241).

80:32 (81:37). rinsing out the chalice—in the ceremony of the Mass the chalice has contained wine that has become "the Blood of Christ." The priest receives this in Communion, and in one of the closing phases of the ceremony (the Ablution) cleanses the chalice of any remaining drops of "the Blood" by rinsing it with wine that he then drinks.

80:35 (81:40). Wheatley's Dublin hop bitters—a "temperance beverage" because it was a nonalcoholic imitation of an alcoholic beverage; advertised in the day's *Freeman's Journal*: "When Ordering/Hop Bitters/Ask for Wheatley's/Caution/Please note label, as Sometimes/A low-priced and Inferior/Article is Substituted for the/Genuine Wheatley's Hop Bitters."

80:36–37 (81:41–42). Doesn't give them . . . shew wine—the communicants receive only the consecrated wafer (the consecrated wine is reserved for the priest's Communion). "Shew wine," after the ancient Hebrew ceremony of shewbread, which was also consumed only by the priests (see 79:41–42n).

80:39 (82:2). cadging—begging.

80:42 (82:6). old Glynn—unknown.

81:1–2 (82:7–8). fifty pounds a year—a handsome fee for the organist's part-time job.

81:2 (82:8). in Gardiner street—i.e., St. Francis Xavier's Church, just east and north from Bloom's house in Eccles Street.

81:3 (82:9). Stabat Mater of Rossini—*Stabat Mater* literally means "The Mother Was Standing" (as the Virgin Mary stood at the foot of the Cross). The hymn commemorates Mary's "compassion" and "her suffering with" her son at that moment. The melody of the *Stabat Mater* is intact in its ancient form and the text is probably by the Italian Jacopone da Todi (d. 1306). There are several famous Renaissance settings of the hymn by Josquin, Palestrina and Pergolesi. The "romantic" one Bloom recalls is by the Italian composer Gioacchino Rossini (1792–1868); it was first performed in 1842.

81:3–4 (82:9–10). Father Bernard Vaughan's . . . or Pilate?—Father Conmee recalls a moment from this sermon on p. 216 (219). Apparently the sermon contrasted Jesus' insistence on principle with the worldly compliance of Pilate, who objected that he found "no fault" in Jesus and yet allowed himself to be swayed by the mob into decreeing the Crucifixion.

81:8 (82:15). Quis est homo?—Latin: "Who is the man?" or "Who is there . . . ?" the opening line of the third stanza of the *Stabat Mater*: "Who is there who would not weep were he to see Christ's mother in such great suffering?"

81:9–10 (82:16–17). Mercadante: seven last words—Giuseppe Saverio Raffaele Mercadante (1795–1870), Italian composer. *Le sette ultime parole* ("The Seven Last Words of Our Saviour on the Cross"), an oratorio. First word: "Father, forgive them" (Luke 23:34); second: "Verily I say unto thee, To day shalt thou be with me in paradise" (Luke 23:43); third: "Woman, behold thy son" (John 19:26); fourth: "My God, my God, Why hast thou forsaken me?" (Matthew 27:46); fifth: "I thirst" (John 19:28); sixth: "It is finished" (John 19:30); seventh: "Father, into thy hands I commend my spirit" (Luke 23:46).

81:10 (82:17). Mozart's twelfth mass: the Gloria—Wolfgang Amadeus Mozart (1756–1791). The true Twelfth Mass is Köchel listing 262; a spurious work Köchel *Anhang* 232, Köchel includes in an appendix; Köchel's listings appeared in 1862, with a supplement in 1889. It is not clear which of the two Masses Bloom has in mind. The *Gloria,* the Greater Doxology or Angelic Hymn, is apparently a third-century expansion of the song of the angels in Luke 2:14 and is an integral part of the music of the Mass—its position in the Mass varies in accordance with the Liturgical Calendar. It begins, *"Gloria in excelsis Deo"* ("Glory to God in the highest").

81:12 (82:19). Palestrina—Giovanni Pierluigi da Palestrina (1525–1594), a celebrated and prolific Italian musician; see 22:24n and 22:25–27n.

81:13 (82:20–21). chanting, regular hours—Bloom generalizes away from the Mass and Church music to the round of the Monastic Day and the chanted celebration of the Divine Office (prayer for various hours of the day; see 221:2n.) in choir.

81:14 (82:21). Benedictine. Green Chartreuse—benedictine, a liqueur not unlike chartreuse, first brewed by the monks of a Benedictine monastery in southern France. "Green Chartreuse": one of three qualities (with yellow and white) of a liqueur that was made from a complex formula at the Carthusian monastery La Grande Chartreuse, near Grenoble in France.

81:14–15 (82:22). having eunuchs in their choir—the practice of castrating boy sopranos so that their voices would not change was prohibited by law in the early eighteenth century but was still relatively common in the Papal Choir until the accession of Pope Leo XIII in 1878. One of Leo's first acts was to dismiss the castrati from the choir and to forbid the practice.

81:18 (82:25). fall into flesh—one common aftereffect of prepubertal castration is the accumulation of fatty tissue.

81:20–21 (82:28–29). the priest bend down . . . all the people—after the Ablution the priest reads the *Communio* antiphon, then kisses the altar and blesses the people.

81:23 (82:31). gospel—if there were a proper last Gospel, the people would stand at the end of the post-Communion and then kneel again during the last Gospel.

81:25–26 (82:34). holding the thing out from him—i.e., holding the missal from which he repeats the last Gospel.

81:29 (82:37). O God, our refuge and our strength—after low Mass the celebrant was required to recite or read from a card two prayers in the vernacular prescribed by Leo XIII in 1884 and 1886, renewed by Pius X in 1903. The first of the prayers: "O God, our refuge and our strength, look down in mercy on Thy people who cry to Thee; and by the intercession of the glorious and immaculate Virgin Mary, Mother of God, of Saint Joseph her spouse, of Thy blessed apostles Peter and Paul, and of all the saints, in mercy and goodness hear our prayers, and for the liberty and exaltation of our holy mother the Church: through the same Christ our Lord. Amen." For the second prayer, see 82:13–18 (83:22–27).

81:31–32 (82:39–40). How long since your last mass?—Bloom's version of a standard opening question in the confessional: "How long since your last confession?"

81:32 (82:40). Gloria and immaculate virgin—both the Rosenbach MS. and the *Little Review* read, "Glorious and immaculate virgin"—a reference in the closing prayer to an article of faith proclaimed in 1854: "that Mary, in the first instant of her conception in her mother's womb, was kept free from all stain of original sin" (*Layman's Missal*, p. 870). See 81:29n.

81:35 (83:1). Confession—the Catholic Church regards penance as a sacrament instituted by Christ, in which forgiveness of sins is granted through the priest's absolution of those who, with true sorrow, confess their sins. In the process of confession, the penitent is at once the accuser, the accused and the witness, while the priest pronounces judgment and sentence. The grace conferred is deliverance from guilt of sin. Confession is made to an ordained priest with requisite jurisdiction and with power to forgive sins, this power being granted by Christ to his Church. The priest is bound to secrecy and cannot be excused either to save his own life or that of another, or to avert any public calamity. No law can compel him to divulge the sins confessed to him. The violation of the seal of confession would be a sacrilege, and the priest would be subject to excommunication.

81:39–41 (83:5–7). Whispering gallery walls . . . God's little joke—Bloom imagines that the confessional could be like a whispering gallery, that the whispered confession might (by "God's little joke") be overheard.

81:42 (83:8). Hail Mary and Holy Mary—i.e., her penance might involve a number of repetitions of the Angelical Salutation: "Hail Mary, full of grace, the Lord is with thee. Blessed art thou among women, and blessed is the fruit of thy womb, Jesus. Holy Mary, Mother of God, pray for us sinners, now, and at the hour of our death. Amen."

82:1-2 (83:9–10). Salvation army blatant imitation—one phase of the militant evangelicalism of the Salvation Army (established 1865) was the exploitation of public confession.

82:3 (83:11). Squareheaded—not readily moved or shaken in purpose.

82:5 (83:13). P.P.—parish priest.

82:7–8 (83:16). The priest in the Fermanagh will case—unknown.

82:10 (83:19). The doctors of the church—a rare title formally conferred by the pope on saints whose theological learning has been outstanding. In the early Middle Ages many saints and scholars were informally so called; the formal tradition was established by Pope Boniface VIII in 1295 when he named Saints Gregory the Great, Ambrose, Augustine and Jerome as *the* four "doctors" of the early Christian Church.

82:13–18 (83:22–27). Blessed Michael . . . ruin of souls—the second of the prescribed vernacular prayers at the close of the mass (see 81:29n).

82:21 (83:30). Brother Buzz—"buzz" is variously slang for gossiping, telling stale news and picking pockets.

82:22 (83:31). Easter duty—does not involve money but the obligation to receive Holy Communion during the Easter season (between the first day of Lent—40 days and six Sundays before Easter—and Trinity Sunday, eight weeks after Easter). Since it is regarded as a mortal sin to receive Communion when not in a state of grace, the obligation implies an obligation to confess as well.

82:27 (83:36). Glimpses of the moon—Hamlet speaks to the ghost of his father (I, v, 51–56), "What may this mean,/That thou, dead corse, again, in complete steel,/Revisit'st thus the glimpses of the moon,/Making night hideous, and we fools of nature/So horridly to shake our disposition/With thoughts beyond the reaches of our souls."

82:32–33 (83:42). a car of Prescott's dyeworks—William T. C. Prescott, dyeing, cleaning, and carpet-shaking establishment at 8 Abbey Street Lower had several branches in Dublin and environs. Molly recalls, 760:36 (775:33), that Bloom has sold Prescott's an advertisement, and it duly appears in the *Freeman's Journal*, 16 June 1904, p. 1, column 2: "*IMPORTANT./LACE CURTAINS*/are now very carefully cleaned and

finished with our New Dust Resisting process. By this System they keep clean longer than if done in the old way. In Three Days/ 1/- /Per Pair/ PRESCOTT'S DYE WORKS/Carriage Paid One Way."

82:36. Sweeny's in Lincoln place should read **Sweny's** as it does (**84:4**)—F. W. Sweny, dispensing chemists, 1 Lincoln Place, a street that enters the southern end of Westland Row (where Bloom is) from the west.

82:37 (84:5). beaconjars—large hanging jars of colored liquid that were used to decorate (and advertise) chemists' shops.

82:38 (84:5). Hamilton Long's—Hamilton, Long and Company, Ltd., state apothecaries, perfumers and manufacturers of mineral waters, had several shops in and around Dublin. The one Bloom has in mind: 107 Grafton Street, just north of St. Stephen's Green.

82:39 (84:6). Huguenot churchyard—at 10 Merrion Row east of St. Stephen's Green about one-third of a mile south of Bloom's present position. Three congregations of French Protestant refugees flourished in Dublin in the seventeenth century. They were assigned special burying places, the principal one being the one Bloom intends to visit "some day."

83:5–6 (84:15–16). Quest for . . . the alchemists—in medieval alchemy "the philosopher's stone" was the mysterious object of unrewarded search. If achieved, it was supposed to transmute base metals into gold and silver and also to be a universal panacea.

83:9–10 (84:19–20). alabaster lilypots . . . Laur. Te Virid—Bloom looks at the apothecary's jars of ingredients *(lilypots)* and reads some of the abbreviations that served as labels: *Aq. Dist.*—distilled water. *Fol. Laur.*—Laurel leaves. *Te [The] Virid.*—green tea.

83:11 (84:21). Doctor whack—i.e., the curative power of a heavy, smart, resounding blow.

83:12 (84:22). Electuary—a medicine consisting of a powder or other ingredient mixed with honey, jam or syrup.

83:15 (84:25). turns blue litmus paper red—therefore an acid; alkalines turn red litmus blue. Chloroform would have an acid reaction.

83:15–16 (84:26). Laudanum—in early use, any of various preparations in which opium was the main ingredient. Now: the simple alcoholic tincture of opium.

83:16–17 (84:26–27). Paragoric poppysyrup . . . or the phlegm—paragoric did contain a bit of opium, thus it could be called poppysyrup. Opiates were then commonly used in cough syrups, but not paragoric because it constipates and was most widely used as a specific against diarrhea. Bloom assumes, vaguely but correctly, that paragoric would constipate the mucous membranes rather than anesthetizing them as an opiate would.

83:22 (84:33). loofahs—the fibrous substance of the pod of the plant *Laffa aegyptiaca*, used as a sponge or flesh brush.

83:31–32 (84:42–85:1). strawberries for the . . . steeped in buttermilk—variations of these "recipes" occur in the "Medical Department" of *Dr. Chase's Recipes or, Information for Everybody . . .* (20th ed.; Ann Arbor, Mich., 1864).

83:32–33 (85:1–2). One of the old . . . Leopold yes—Queen Victoria's youngest son, Prince Leopold, Duke of Albany (1853–1884). Regarded by his contemporaries as "very delicate," the Prince was in fact suffering from hemophilia; the disease was mysterious enough to warrant the old wives' diagnosis: "He only has one skin."

83:35–36 (85:4–5). Peau d'Espagne—French: "Spanish Skin."

83:38 (85:7). Hammam. Turkish—the Hammam Family Hotel and Turkish Baths, 11–12 Sackville (now O'Connell) Street Upper.

84:19–20 (85:31–32). Good morning . . . Pear's soap?—an advertising slogan for a famous English soap.

84:25 (85:37). Tight collar he'll lose his hair—another popular medical superstition.

84:28 (85:40). Ascot. Gold cup—the Gold Cup was to be run that day at Ascot Heath, 26 miles from London, at 3:00 P.M. *"The Gold Cup,* value 1,000 sovereigns with 3,000 sovereigns in specie in addition, out of which the second shall receive 700 sovereigns and the third 300 sovereigns added to a sweepstakes of 20 sovereigns each . . . for entire colts and fillies. Two miles and a half. The field: M. J. de Bremond's Maximum II; age 5. Mr. W. Bass's Sceptre; age 5; A. Taylor. Lord Ellesmere's Kronstad; age 4; J. Dawson. Lord Howard de Walden's Zinfandel; age 4; Beatty. Sir J. Miller's Rock Sand; age 4; Blackwell. Mr. W. Hall Walker's Jean's Folly; age 3; Robinson. *Mr. F. Alexander's Throwaway; age 5;* Braime. M. E. de Blashovits's Beregvolgy; age 4. Count H. de Pourtale's Ex Voto; age 4. Count H. de Pourtale's Hebron II; age 4. M. J. de Soukozanotte's Torquato Tasso; age 4. Mr. Richard Croker's Clonmell; age 3." *"Selections for Ascot*

Meeting. Gold Cup—Zinfandel." *"Tips from 'Celt':* Gold Cup—Sceptre." (As reported in the *Freeman's Journal,* 16 June 1904, p. 7.) The race was won by the dark horse Throwaway, a 20–to–1 shot; see 408:20–25n.

84:30 (85:42). throw it away—see 84:28n. The point is that Bloom has just unwittingly given a tip on the Gold Cup race.

84:38 (86:8). Conway's corner—a public house; see 73:2n.

84:38 (86:8). scut—the tail of a rabbit, a term often applied in scorn to a contemptible fellow (P. W. Joyce, p. 318).

84:41 (86:11). to put on—to bet on.

85:1–2 (86:13–14). Jack Fleming . . . to America—a circumstantial story that Bloom recalls in relation to Bantam Lyons' gambling fever. The story is a fragment that is not developed elsewhere in the novel.

85:2–3 (86:15). Fleshpots of Egypt—see 42:30n.

85:4 (86:16). mosque of the baths—Bloom walks around the corner from Lincoln Place into Leinster Street, where he proceeds to the Leinster Street Turkish and Warm Baths at number 11.

85:5–6 (86:17–18). College sports—the poster advertises a "combination meeting of Dublin University Bicycle and Harrier Club" to be held that afternoon in College Park.

85:7 (86:19). cyclist doubled up like a cod in a pot—after the song "Johnny, I Hardly Knew Ye." Johnny's "Peggy" sings the song as Johnny returns crippled from the wars. Chorus: "Wild drums and guns, and guns and drums,/The enemy fairly slew ye;/My darling dear, you look so queer;/Och! Johnny, I hardly knew ye." Endless repetitive verses review the nature of that "look so queer," including "you're an eyeless, noseless, chickenless egg" and "like a cod you're doubled up head and tail."

85:11 (86:23). Hornblower—the porter at Trinity College.

85:12 (86:24). on hands—i.e., keep renewing the speaking (or nodding) acquaintance.

85:12 (86:24). take a turn in there on the nod —i.e., Hornblower might nod Bloom through the college gates and give him the privileges of the grounds, as he has done before; see p. 758 (773).

85:14–15 (86:26–27). Cricket weather—Frank Budgen, in *James Joyce and the Making of 'Ulysses'* (London, 1937), remarks that "cricket still had its agreeable lotus flavour in 1904" (p. 84).

85:15 (86:27). Over after over. Out—when the starting bowler (pitcher) has delivered six "fair balls" from his end, the umpire calls, "Over." A man at the other wicket then becomes the bowler, bowling to the batter at the opposite wicket. Similarly when an "out" is made the bowling changes hands.

85:16 (86:28). They can't play it here—i.e., the grounds of College Park, Trinity College, are too confined for cricket play, though matches were held there. The minimum area necessary for cricket is quite sizable: 450 by 500 feet.

85:16 (86:28). Duck for six wickets—if a batsman fails to score a single run before he is retired, he has been "bowled for a duck." It would be an extraordinary feat for a bowler to accomplish "six wickets," six outs in sequence, in that fashion.

85:16–17 (86:28–29). Captain Buller—*Thom's (1904)* lists a Captain Buller as residing at Byron's Lodge, Sutton (a village near the Hill of Howth).

85:17 (86:29). the Kildare Street club—at the entrance of Kildare Street across from Trinity College Park. The club was fashionable and expensive, and its membership was dominated by wealthy Irish landlords well known for their pro-English sentiments. It was reputedly the only place in Dublin where one could get caviar. In recalling the incident of the broken window, Bloom is citing an example of why he regards the College Park grounds as unsuitable for cricket.

85:17–18 (86:29–30). a slog to square leg— *square leg* is one of the defensive positions in cricket, to the left of the batsman and nearly in a line with the wicket; a *slog* is a hit that is both hard and not particularly well aimed.

85:18 (86:30). Donnybrook fair—Donnybrook, formerly a village, now a southeastern suburb of Dublin. The Donnybrook Fair, established in the reign of King John (1167–1216), abolished in 1855, was so distinguished for its debaucheries and brawls that its name became synonymous with any scene of uproar.

85:18–19 (86:30–31). And the skulls . . . took the floor—Hodgart and Worthington[1] (p. 64) list this as an anonymous Irish ballad, "When

[1] Matthew, J. C. Hodgart and Mabel P. Worthington, *Song in the Works of James Joyce* (New York, 1959).

McCarthy took the flute at Inniscorthy"; Ell-mann (p. 53) suggests "The Man Who Played the Flute at Inniscorthy." Source unknown.

85:20–21 (86:32–33). Always passing, the stream . . . dearer than them all—from *Maritana* (1845), an opera, libretto by Edward Fitzball (1792–1873), music by the Irish composer William Vincent Wallace (1813–1865). "Rousing" and "sentimental," it has all the stock theatrical bravado of the mid-nineteenth-century light-opera tradition. In a song (II, 3), "Turn on Old Time," the villain Don Jose de Santarem tells of his first sight of the Queen of Spain. One phase of the opera's "plot" turns on Don Jose's elaborate schemes to divert the King and ensnare the Queen. His song ends, "Some thoughts none other can replace,/Remembrance will recall;/ Which in the *flight of years* we trace,/Is dearer than them all."

85:23 (86:35). This is my body—Jesus at the Last Supper: "And he took bread, and gave thanks, and brake *it*, and gave it unto them, saying, This is my body which is given for you: this do in remembrance of me" (Luke 22:19). This passage is regarded as scriptural authority for the Communion ceremony. It is repeated at the Consecration in the Mass when "the celebrant does what Christ did and says what Christ said at the Last Supper" (*Layman's Missal*, p. 811).

85:29–30 (86:41–42). the limp father of thousands, a languid floating flower—after the plant *Saxifraga stolonifera,* called "mother of thousands" because it spreads by runners that seem to float its flowers. It is used as a ground cover in moist, shady places in the south of England and Ireland.

EPISODE 6
[HADES]

Episode 6: [Hades], pp. 86–114 (87–115). In Book IX of *The Odyssey* Odysseus recounts his adventures in the lands of the Cicones, the Lotus-Eaters and the Cyclops. In Book X Odysseus and his men reach the isle of Aeolus, "the wind king"; then they meet disaster in the land of the Lestrygonians and finally arrive at Circe's island. Circe advises Odysseus to go down to Hades, the world of the dead, to consult the shade of the blind prophet Tiresias before continuing the voyage. In Book XI Odysseus descends into Hades; the first shade he meets is that of Elpenor, one of his men who, drunk and asleep, had fallen to his death in Circe's hall. Elpenor requests that Odysseus return to Circe's island and give his corpse a proper burial; Odysseus so promises. Odysseus then speaks with Tiresias, who tells him that it is Poseidon, god of the sea and the earthquake, who is preventing Odysseus from reaching his home. Tiresias then warns Odysseus: if his men violate the cattle of the sun god, Helios, the men will all be lost, the difficulties of Odysseus' voyage will be radically increased and upon his arrival home he will find his house beset with suitors, "insolent men," whom he will have to make "atone in blood." Tiresias closes his prophecy by promising Odysseus a "rich old age" and "a seaborne death soft as this hand of mist." Odysseus then speaks with the shade of his mother and sees the shades of many famous women. He speaks to the shade of Agamemnon and learns of Agamemnon's homecoming, of his death at the hands of his wife, Clytemnestra, and her lover. Odysseus speaks with Achilles and attempts to speak with Ajax. Ajax refuses to speak because he and Odysseus had quarreled over Achilles' armor after Achilles' death; Odysseus was awarded the armor as the new champion of the Greeks; and Ajax, driven mad by the gods, died by his own hand. Subsequently Odysseus glimpses other shades, including that of Sisyphus, condemned to push a boulder up a hill, to be frustrated at the last moment and to be compelled to begin again. Odysseus then speaks to Hercules, who is not a shade but "a phantom" because Hercules himself rests among the immortal gods. Hercules, reminded by Odysseus' presence in the flesh, tells the story of his twelfth labor, of his own descent into Hades while he was still alive, when he had to capture "the watchdog of the dead," Cerberus. Odysseus then returns to his ship and to Circe's island.

Time: 11:00 A.M. Scene: Prospect Cemetery in Glasnevin, north of Dublin. In the course of the episode Bloom travels with the funeral procession from Dignam's house in Sandymount, a suburb of Dublin on the coast southeast of the city, across Dublin to Glasnevin. Organ: heart; Art: religion; Color: white, black; Symbol: caretaker; Technique: incubism (after *incubus*, an evil male spirit said to produce nightmare). Correspondences: *the four rivers of Hades (Styx,*

Acheron, Cocytus, Pyriphlegethon)—the Dodder, the Grand and Royal Canals and the Liffey; *Sisyphus*—Martin Cunningham; *Cerberus* (the two- or three-headed dog that fawns upon new arrivals in Hades but that also prevents their escape)—Father Coffey; *Hercules, Elpenor*— Dignam; *Agamemnon, Ajax*—Parnell.

86:2–3 (87:2–3). Mr. Power—Jack Power, fictional, is attached to the offices of the Royal Irish Constabulary in Dublin Castle; he appears as a character in "Grace," *Dubliners*.

86:17 (87:17–18). Job seems to suit them— i.e., the job of laying out the corpse is traditionally the woman's job.

86:18 (87:18). Huggermugger—secretly. Claudius the King uses this expression in *Hamlet* (IV, v, 83–84) in speaking of the burial of Polonius: "And we have done but greenly/In huggermugger to inter him."

86:18 (87:18–19). slipperslappers—Old Mother Slipperslapper is a type of the old woman (of Ireland). She appears in a folk song, "The Fox," to announce: "John, John, the grey goose is gone/ And the fox is on the town, O." First verse: "Old Mother Slipper Slapper jumpt out of bed,/And out at the casement she popt her head,/Crying the house is on fire, the grey goose is dead,/And the fox is come to the town, O!"

86:19 (87:19). Then getting it ready,—i.e., the corpse of the Blooms' 11-day-old son, Rudy.

86:19–20 (87:20). Mrs Fleming—a part-time domestic in the employ of the Blooms.

86:30–31 (87:32). number nine—Dignam's house at 9 Newbridge Avenue, Sandymount.

86:33 (87:35). Tritonville road—runs north from Sandymount into Irishtown.

86:38–39 (87:40–41). Irishtown . . . Ringsend. Brunswick street—the funeral takes a route parallel to the shore of Dublin Bay; it continues north from Tritonville Road into Irishtown Road and then Thomas Street in Irishtown. There it turns west into Bridge Street, just south of the mouth of the Liffey, and then continues west over the River Dodder, along Ringsend Road over the Grand Canal and into Great Brunswick Street (now Pearse Street) toward the center of Dublin, where it will again turn north and cross the city to Glasnevin.

86:41 (88:1). a fine old custom—i.e., the custom of the funeral procession taking a route through the center of the city that all might see and by implication "pay their last respects."

87:3 (88:5). Watery lane—in Irishtown.

87:13 (88:15). fidus Achates—Latin: "the faithful Achates," companion and friend of Aeneas in Aeneas' wanderings (*Aeneid* I: 188).

87:17–18 (88:19–20). the wise child that knows her own father—proverbial. One version occurs in *The Odyssey* I:215, when Telemachus says: "My mother tells me that I am his son, but I know not, for no one knows his own father."

87:19 (88:21). Ringsend road—west from Ringsend toward central Dublin.

87:19–20 (88:21–22). Wallace Bros the bottleworks—at 34 Ringsend Road.

87:20 (88:22). Dodder bridge—the River Dodder flows north and enters the Liffey just west of Irishtown.

87:21–22 (88:23–24). Goulding, Collis and Ward—the fictional Goulding (see 39:28n) has been added to the real firm of Collis and Ward, Solicitors, 31 Dame Street in the southeast quadrant of Dublin.

87:23 (88:25). Stamer street—in south-central Dublin near the Grand Canal.

87:23 (88:25). Ignatius Gallaher—appears as a character in "A Little Cloud," *Dubliners*. In [Aeolus], 137 (139), he is identified as an employee of the Irish-born English publisher Alfred C. Harmsworth on either the *London Daily Mail* or the *London Evening News*. A notable story is told about Gallaher, 134–135 (135–137).

87:26 (88:28). ironing—massaging.

87:34–35 (88:36–37). I'll tickle his catastrophe—in *II Henry IV*, Act II, scene i, the Hostess, Fang (the sheriff's sergeant), and his Boy attempt to arrest Falstaff, who is accompanied by Page and Bardolph. Page threatens the Hostess with his drawn sword, lines 65–66: "Away, you scullion! You rampallian! You fustilarian! I'll tickle your catastrophe!" ("catastrophe": slang for buttocks).

87:37–38 (88:40). counterjumper's son—i.e., the son of a shop clerk.

87:38–39 (88:40–41). selling tapes in Peter Paul M'Swiney's—for a time Oliver St. John Gogarty's father worked in Clery and Company (formerly M'Swiney and Company), drapers, silk mercers, hosiers, glovers, haberdashers, jewelers, boot and shoe makers, tailors, woolen drapers and general warehousemen, 21 to 27 Sackville Street (now O'Connell Street). Peter Paul M'Swiney was a successful merchant-politician, Lord Mayor of Dublin in 1864 and 1875.

88:3 (89:5). Eton suit—a fashionable costume for young boys (in imitation of the "uniform" worn by the students at Eton, one of the most exclusive English public schools): a short, waist-length jacket with broad lapels and a shirt with a broad white linen collar.

88:5 (89:7). Raymond terrace—a small lane off South Circular Road opposite the Wellington Barracks, in south-central Dublin, not far north of the Grand Canal and not far west of Lombard Street West, where the Blooms subsequently lived. Apparently Rudy was conceived there in 1892 and the Blooms moved to Lombard Street West in the same year.

88:6 (89:8). the cease to do evil—"Cease to do evil; the Lord is near," was the motto displayed by a Presbyterian Church which stood next to the Wellington Barracks on South Circular Road.

88:8 (89:10). a touch—sexual intercourse.

88:10 (89:12). the Greystones concert—Greystones, a small village on the coast, 18 miles southeast of Dublin.

88:24 (89:26). that squint—after the tailor who lacks material and therefore squints, or skimps.

89:1 (90:3). Ned Lambert—a fictional character who works in a seed and grain store in Mary's Abbey in central Dublin.

89:2 (90:4). Hynes—Joe Hynes, fictional, appears as the loyal Parnellite in "Ivy Day in the Committee Room," *Dubliners*. In *Ulysses* he seems still relatively unemployed and down on his luck, though he does do a paragraph on Dignam's funeral for the *Freeman's Journal*.

89:12 (90:14). The grand canal—the most important canal in Ireland; it skirts the southern perimeter of central Dublin and links Dublin with the west coast of Ireland. The carriage stops at Victoria Bridge over the canal.

89:13 (90:15). Gas works—southeast of the bridge over the Grand Canal. The works, notoriously odoriferous, transformed coal into gas to be used for lighting and heating.

89:16 (90:18). Flaxseed tea—literally a tea made out of flaxseed (from which linseed oil is also derived). Linseed oil was a popular ingredient in recipes for "natural remedy," and flaxseed tea shared this popularity.

89:17 (90:19–20). Dog's home—on Grand Canal Quay, the Dog's and Cat's Home, established and maintained by the Dublin Society for the Prevention of Cruelty to Animals. The home advertised its interest in stray dogs, etc., and proclaimed: "The diseased painlessly destroyed."

89:18 (90:20). Athos—Bloom's father's dog, named after a mountain at the tip of a peninsula in eastern Greece (also called the Mountain of Monks).

89:19 (90:21). Thy will be done—after the Lord's Prayer (Matthew 6:10), "Thy kingdom come. Thy will be done in earth, as *it is* in heaven" (also Luke 11:2).

89:37–38 (90:39–40). Paddy Leonard—appears as a character in [Lestrygonians] and elsewhere in *Ulysses*.

89:40–41 (91:1–2). Ben Dollard's singing of The Croppy Boy—he sings the song in [Sirens], 278 *ff.* (282 *ff.*); see 252:41n for the text of the song.

90:5 (91:8). Dan Dawson's speech—is reviewed at length in [Aeolus], 122 *ff.* (123 *ff.*). It does not appear in the *Freeman's Journal* for 16 June 1904.

90:12 (91:15). down the edge of the paper—the *Freeman's Journal* carried obituaries at the top of the left-hand column on page one. The names Bloom reads do not appear in the 16 June 1904 edition.

90:15 (91:18). Crosbie and Alleyne's—a solicitors' office at 24 Dame Street in central Dublin just south of the Liffey. A character named Alleyne appears as a solicitor in "Counterparts," *Dubliners*.

90:16–19 (91:19–22). Thanks to the little . . . Jesus have mercy—typical snippets of obituary-column prose. "Little Flower," a poem by Tennyson actually titled "Flower in the Crannied Wall" (1869), appears at the top of the right-hand column of *The Evening Telegraph* of 16 June 1904 under the heading "Gleaned from All Sources": "Flower in the crannied wall,/I pluck you out of the crannies,/I hold you here, root and all, in my hand,/Little flower—but *if* I could understand/What you are, root and all, and all in all,/I should know what God and man is." "Month's mind": the name of an ancient solemn commemorative service and/or feast in the Roman Catholic Church held one month after the death of a person.

90:20–23 (91:23–26). It is now a month . . . meet him on high—typical of the sort of verse that appeared under "In Memoriam" in the obituary columns of daily newspapers (inserted in this case as an advertisement of the month's mind). The linkage of Henry with "Little Flower" above recalls Bloom's assumed name.

90:27 (91:30). National School. Meade's yard. The hazard—in sequence along Great Brunswick Street (now Pearse Street): 114–121, St. Andrews Boys' and Girls' National School; 153–159, Michael Meade and Son, builders and contractors, sawing, planing, and moulding mills, and joinery works; the hazard, Cabman's Shelter and Coffee Stand outside Westland Row Station.

90:31 (91:34). pointsman's—a man who has charge of the "points" on a railway, the tapering movable rails that direct vehicles from one line of rails to another.

90:36 (91:40). Antient concert rooms—a hall where privately sponsored concerts were given, 42 Great Brunswick Street.

90:37 (92:1). with a crape armlet—a small band of black cloth worn on the arm in token of mourning, usually for a person who was not a close relation.

90:39 (92:3). the bleak pulpit of St. Mark's—the church (c. 1737) is on Mark Street, just off Brunswick Street Great. The general architectural effect of the building is that of a neo-Classicism so severe as to be bleak. The west front is typical: it is rugged and black, and the sweeping curve of the walls is not relieved by the slit windows that are intended to light the staircases within.

90:39–40 (92:3–4). the railway bridge—carries the City of Dublin Junction Railway (the Loop Line) over Great Brunswick Street; see 73:34–35n.

90:40 (92:4). the Queen's Theatre—at 209 Great Brunswick Street was one of the three major theaters in Dublin at the turn of the century. The Theatre Royal was primarily used for dramatic presentations, the Gaiety for the more socially prominent musical events and the Queen's for productions that fit neither category.

90:41 (92:5). Eugene Stratton—billed by the Theatre Royal as "The World Renowned Comedian/in a series of Recitals from his Celebrated Repertoire." Eugene Stratton was the stage name of Eugene Augustus Ruhlmann (1861–1918). He was an American who became a music-hall star as a Negro impersonator. He toured primarily in the British Isles, first with a minstrel group and then as a solo performer. His routine involved "coon songs" with whistled refrains and soft-shoe dancing "on a darkened, spotlighted stage, a noiseless, moving shadow."

90:41–91:1 (92:5–6). Mrs. Bandman Palmer . . . Leah—at the Gaiety Theatre; see 75:19n.

91:1–2 (92:6–7). the Lily of Killarney? Elster Grimes Opera company—the Queen's Royal Theatre advertised the Elster-Grimes Grand Opera Company in that "Irish" opera (1862)— a melodramatic, musical version of *The Colleen Bawn* (see 292:10n), libretto by Dion Boucicault (1822–1890) and John Oxenford (1812–1877), music by the German–English composer Sir Julius Benedict (1804–1885).

91:3 (92:8). Fun on the Bristol—the New York musical comedy version of Henry C. Jarret's "American Eccentric Comedy-Oddity," *Fun on the Bristol, or A Night on the Sound*, was advertised as "Funnier than a Pantomime," and was enormously popular in the provinces in the late nineteenth century; together with Eugene Stratton's recital, it constituted the Theatre Royal's "double feature" for 16 June 1904.

91:4 (92:9). the Gaiety—see 90:40n.

91:4–5 (92:10). As broad as it's long— proverbial saying. In this context: it would cost Bloom as much to stand the drinks as it would to buy the tickets.

91:7 (92:12). Plasto's—hatter at 1 Great Brunswick Street where Bloom purchased his hat.

91:7 (92:12). Sir Philip Crampton's . . . bust —on College Street at the end of Great Brunswick Street. The procession angles north at this point into D'Olier Street, toward O'Connell Bridge over the Liffey. Crampton (1777–1858) was a Dublin surgeon whose "fame was almost European." His statue is no longer in evidence.

91:14 (92:19). airing his quiff—i.e., with his hat off, because *quiff* can mean an oiled lock of hair plastered on the forehead; but it can also mean smartly dressed, in which case Boylan is showing off.

91:16–17 (92:21–22). the Red Bank—Burton Bindon's Red Bank Restaurant, Ltd., 19–20 D'Olier Street.

91:37 (92:42). the county Clare—on the west coast of Ireland. Bloom's goal is the town of Ennis, where his father committed suicide 27 June 1886.

91:40 (93:3). Mary Anderson—Ulster Hall, Belfast, 16 June 1904, advertised a visit of "the World-Renowned Actress, Miss Mary Anderson (Madame de Marano) in the Balcony Scene from 'Romeo and Juliet,' etc. etc." Other "eminent and celebrated artists" (vocal and instrumental) were also to appear.

92:1 (93:6). Louis Werner—billed as "Conductor and Accompanist" with Miss Anderson and company in Belfast.

92:2 (93:7). topnobbers—after "nob," notable person.

92:2 (93:7). J. C. Doyle and John MacCormack—Doyle, a baritone, won the award at the 1899 *Feis Ceoil* (annual Dublin Music Festival and Competition). MacCormack (1884–1945), a tenor, also won a gold medal at the *Feis Ceoil*. He was a member of the choir of the Metropolitan Pro-Cathedral (temporary Roman Catholic Cathedral in Dublin) and in 1904 sang with that choir at the St. Louis Exposition, St. Louis, Missouri. The two were regarded as among the cream of contemporary Irish musicians in 1904.

92:6 (93:11). Smith O'Brien—a statue of William Smith O'Brien (hero of 1848; see 68:16n) at the intersection of Westmoreland and D'Olier Streets where they converge at O'Connell Bridge. The statue (1869) was the work of Sir Thomas Farrell (1827–1900), Irish sculptor. See 92:8 (93:13).

92:7 (93:12). his deathday—it was; O'Brien died on 16 June 1864.

92:13 (93:18). struck off the rolls—i.e., disbarred from the practice of law.

92:14–15 (93:19–20). Hume street . . . solicitor for Waterford—Henry R. Tweedy, Crown Solicitor, County Waterford (in southern Ireland), 13 Hume Street in the southeast quadrant of Dublin.

92:15–16 (93:20–21). Relics of old decency— from the chorus of an Irish song, "The Hat My Father Wore," by Johnny Patterson: "It's old, but it's beautiful,/The best was ever seen,/'Twas worn for more than ninety years/In that little isle of green./From my father's great ancestors/It's descended with galore,/'Tis the relic of old decency,/The hat my father wore."

92:17 (93:22). Kicked about like snuff at a wake—popular expression for indiscriminate use after the assumption that snuff would be in demand to mask the odor of death at a wake.

92:17 (93:22). O'Callaghan—identity and significance unknown, but he was apparently (in fiction or in fact) a Dublin lawyer who was disbarred for bizarre and irregular behavior.

92:19–20 (93:25–26). voglio e non vorrei. No: vorrei e non—Bloom corrects his previous mistake; see 63:38n.

92:21 (93:27). Mi trema un poco il—*cor!***—**
Italian: "My heart beats a little faster!" Zerlina
to Don Giovanni in the *Là ci darem* duet; see
63:24n.

92:25–26 (93:31–32). A smile goes a long way
—American popular song, "A Smile Will Go a
Long, Long Way," by Benny Davis and Harry
Akst. Chorus: "When you're blue and kind-a
lonely too/You'll find a smile will go a long, long
way./Tho' you're down, don't sit around and
frown/A little smile will go a long, long way./
Never grieve, just try and make believe/The sky
is blue altho' you know it's grey./Don't you pine,
it's just a waste of time./You'll find a smile will go
a long, long way."

92:30 (93:36). Crofton—the "decent Orange-
man," appears as a character in "Ivy Day in the
Committee Room," *Dubliners*. In real life he was
J. T. A. Crofton (1838–1907), an associate of John
J. Joyce's (Simon Dedalus') in the Dublin Rates
Office (the Collector General's Office) in 1888.
See Robert M. Adams, *Surface and Symbol* (New
York, 1962), p. 6.

92:31 (93:38). Jury's—Jury's Commercial and
Family Hotel, 7 and 8 College Green, in the south-
east quadrant of Dublin.

92:32 (93:38). the Moira—Moira Hotel, 15
Trinity Street in the southeast quadrant of
Dublin.

92:33 (93:39). Liberator's form—a 12-foot
statue of Daniel O'Connell on a 28-foot pedestal
(see 32:14n), by the Irish sculptor John Henry
Foley (1818–1874), stands in the northern ap-
proach to O'Connell Bridge. The procession
moves north along Sackville (now O'Connell)
Street.

92:35 (93:41). the tribe of Reuben—i.e.,
Jewish, after Reuben, the eldest son of Jacob and
Leah (Genesis 29:32), and the patriarch of one of
the 12 tribes of Israel (Numbers 1:5 and 21). He
distinguished himself by saving and protecting his
younger half-brother, Joseph, and (known for his
impetuosity) disgraced himself by his adulterous
relation with his father's concubine, Bilhah. The
tribe of Reuben was composed of herdsmen and
warriors; its part of the Promised Land was
remote and the tribe subsequently renounced its
Judaism.

92:37 (94:1). Elvery's Elephant House—
46–47 Sackville Street Lower, advertised as
"Waterproofers" and sold "Waterproofs for
Fishing, Shooting, Riding, Walking."

93:2 (94:8). Gray's statue—on a pedestal in the
middle of Sackville Street, also by Sir Thomas
Farrell (92:6n). Sir John Gray (1816–1875) was
a Protestant Irish patriot, editor and proprietor of
the *Freeman's Journal*. He advocated disestablish-
ment of the Church of Ireland (accomplished in
1869), land reform and free denominational edu-
cation.

93:3 (94:9). We have all been there—i.e., we
have all felt the animosity of "Jewish" money-
lenders. See Ellmann, p. 377.

93:9 (94:16). Reuben J. and the son—Reuben
J. Dodd, solicitor, 34 Ormond Quay Upper, agent
for the Patriotic Assurance Company and Mutual
Assurance Company of New York. The *Irish
Worker* of 2 December 1911 carried an article
headlined "Half-a-Crown for Saving a Life."
The story describes the son's jump into the Liffey:
"Whatever his motive, suicide or otherwise—we
care not." A "common docker" named Moses
Goldin saved his life. Goldin fell ill, lost wages,
etc., and Mrs. Goldin went to Dodd Senior only
to be told "that her husband should have minded
his own business." She received 2 shillings 6 pence
from Dodd. See Ellmann, pp. 38–39n.

93:14 (94:21). the isle of Man—in the Irish Sea,
a port of call on Dublin-to-Liverpool steamship
routes; an out-of-the-way but not expensive place
of exile.

93:16–17 (94:23–24). hobbledehoy—a boy not
quite yet a man.

93:20 (94:27). Drown Barabbas—Pilate, sitting
in judgment of Jesus, offers the Jews a choice
between the release of Barabbas (a thief and rebel
leader) and the release of Jesus. "But the chief
priests and elders persuaded the multitude that
they should ask Barabbas and destroy Jesus"
(Matthew 27:20). In Christopher Marlowe's *The
Jew of Malta* (1589) the treacherous central
character, Barabas, dies (at the end of Act V) in a
caldron of scalding water, which he has prepared
as a trap for his enemies.

93:25 (94:32). piking it—leaving, departing
(also, to die).

94:1 (95:9). Nelson's pillar—in the middle of
Sackville (now O'Connell) Street, a column 121
feet tall, surmounted by a 13-foot statue of
Admiral Lord Nelson (1758–1805). The monu-
ment was rather ineptly destroyed by Irish patriots
in 1966 on the fiftieth anniversary of the 1916
Easter Rebellion.

94:16 (95:24). John Barleycorn—whiskey.

94:17 (95:25). adelite—a gray or grayish-yellow
mineral.

94:26–27 (95:35–36). land agents—in the nineteenth century had played an important part in management of the large land holdings of the Irish landlords (many of them absentee). A succession of land reforms in the late nineteenth century (climaxing in 1903) dismantled the landlords' holdings and displaced the land agents as a class.

94:27 (95:36). temperance hotel—the Edinburgh Temperance Hotel, 56 Sackville Street Upper.

94:27 (95:36). Falconer's railway guide—at 53 Sackville Street Upper: John Falconer, printer, publisher, wholesale stationer, depot for the sale of Irish National School books; office of the *Irish Law Times,* the *Solicitor's Journal,* and the *A B C Railway Guide.*

94:27–28 (95:36–37). civil service college—Maguire's Civil Service College (a tutoring school for the British civil-service examinations), 51 Sackville Street Upper.

94:28 (95:37). Gill's—M. H. Gill and Son, Ltd., wholesale and retail booksellers, publishers, printers and bookbinders; depot for religious goods, 50 Sackville Street Upper.

94:28 (95:37). catholic club—Catholic Commercial Club, 42 Sackville Street Upper.

94:28 (95:37). the industrious blind—Richmond National Institution for the Instruction of the Industrious Blind, 41 Sackville Street Upper.

94:29 (95:38). Chummies and slaveys—i.e., young boys with poor employment (after "chum," a chimney-sweep's boy), and girls employed as maids of all work with no defined job status such as upstairs maid, downstairs maid, etc.

94:30 (95:39). the late father Mathew—the procession passes a statue of the Reverend Theobald Mathew (1790–1861), the "Apostle of Temperance," famous for his work in the cholera epidemic (1832) and the Famine (1846–1849).

94:30–31 (95:39–40). Foundation stone for Parnell. Breakdown. Heart—the procession passes the base (8 October 1899) on which the Parnell monument by the American sculptor Augustus Saint-Gaudens was to be placed (in 1910). "Breakdown. Heart": refers to Parnell's death. As his leadership of the Irish Nationalists disintegrated after the divorce scandal in 1889–1890, Parnell intensified his efforts to regain control, and in so doing he seriously undermined his already precarious health. He finally broke down after being soaked in the rain during a speaking engagement and died of a complex of causes (rheumatism, pneumonia, etc.) which was simplistically diagnosed as "heart attack."

94:33 (95:42). Rotunda corner—where Sackville Street Upper gave into Cavendish Road (now Parnell Street) along the side of Rutland (now Parnell) Square. "The Rotunda" was a series of buildings that housed, variously, a maternity hospital, a theater, a concert hall and "assembly rooms."

94:34–35 (96:1–2). Black for the married. Piebald for bachelors. Dun for a nun—we have not found a source for these funeral traditions.

94:38–39 (96:5–6). Burial friendly society pays—the Friendly Societies were mutual insurance societies that paid sick benefits and funeral expenses to their members. Apparently Rudy's funeral expenses were paid by this kind of insurance.

94:40–41 (96:7–8). If it's healthy . . . not the man—after the ancient Hebrew belief that the health of a child is a reflection on the virility of the male. Jewish law asserts that a man should "fulfill the precept of propagation," i.e., he should beget a son and a daughter, each in his turn capable of having children.

95:1 (96:11–12). Rutland square—now Parnell Square. The procession continues northwest along one side of the square and into Frederick Street.

95:2 (96:12–13). Rattle his bones . . . Nobody owns—from "The Pauper's Drive," a song by Thomas Noel. First verse and chorus: "There's a grim one-horse hearse in a jolly round trot—/To the churchyard a pauper is going I wot;/The road it is rough, and the hearse has no springs;/And hark to the dirge which the sad driver sings: // Rattle his bones over the stones!/He's only a pauper, whom nobody owns!" Fifth and last verse with final chorus: "But a truce to this strain; for my soul it is sad,/To think that a heart in humanity clad/Should make, like the brutes, such a desolate end,/And depart from the light without leaving a friend! // Bear soft his bones over the stones!/Though a pauper, he's one whom his Maker yet owns!"

95:3 (96:14). In the midst of life—we are in death. This aphorism is included in "The Burial Service" in the Book of Common Prayer (Church of England). It is derived from a tenth-century Latin aphorism and from Martin Luther's antiphon *"De Morte."*

95:4–5 (96:15–16). But the worst . . . his own life—St. Augustine defined suicide as a sin, and Church councils from the fifth century onward

decreed that a suicide could not be buried with Church rites. Medieval law throughout Europe decreed confiscation of the suicide's property. Burial customs traditionally involved indignities to the corpse: in France it was dragged by the heels face downward; in England, buried at a cross-roads with a stake driven through the body.

95:18 (96:29). Refuse christian burial—Bloom is both right and wrong. The Catholic Church did continue to refuse religious services or burial in consecrated ground, but English law (which technically included Ireland) provided for burial in consecrated ground (1823) and permitted religious services (1882).

95:29–31 (96:40–42). And they call . . . the geisha—a song, "The Jewel of Asia," from the light opera *The Geisha*, music by James Philip and libretto by Harry Greenbank: "A small Japanese once sat at her ease/In a garden cool and shady/When a foreigner gay who was passing that way/Said 'May I come in, young lady?'/So she opened her gate, and I blush to relate/That he taught Japan's fair daughter/To flirt and to kiss like the little white miss/Who lives o'er the western water. // He called her the Jewel of Asia, of Asia, of Asia/But she was the Queen of the Geisha, the Geisha, the Geisha;/So she laughed, 'Tho' you're ready today, Sir/To flirt when I flutter my fan,/Tomorrow you'll go on your way, Sir,/Forgetting the girl of Japan.'" Second verse: "But when he came back (Alas! and Alack!)/To the garden cool and shady,/The foreigner bold was decidedly cold,/And talked of an English lady./With his heart in a whirl for the little white girl/He declared how much he missed her,/And forgot if you please, his poor Japanese,/For he never even kissed her. // But she was the Jewel of Asia, of Asia, of Asia,/The beautiful Queen of the Geisha, the Geisha, the Geisha,/And she laughed, 'It is just as they say, Sir,/You love for as long as you can!/A month, or a week, or a day, Sir,/Will do for a girl of Japan.'"

95:32 (97:1). Rattle his bones—see 95:2n.

95:40 (97:9). Nobody owns—see 95:2n.

96:1 (97:10). Blessington street—the procession has moved northwest up Frederick Street from Rutland (Parnell) Square and then angled west-northwest along Blessington Street.

96:1–2 (97:10–11). Over the stones—see 95:2n.

96:6 (97:15). in Germany. The Gordon Bennett—an annual international road race instituted by the American sportsman and journalist, James Gordon Bennett (1841–1918). It was first run in 1900; in 1904 it was scheduled to be held outside of Homberg, a village near Frankfurt in Germany, on 17 June. The race was to be run against time over a 275- to 300-mile course of roads. The *Evening Telegraph* for 16 June 1904 billed the race as a test of the drivers' skills and endurance and as (mechanically) a test of brakes. Top automobile speeds for a "flying kilometer" in 1904: 85 to 90 m.p.h. No such speeds could even be approached in a road race.

96:9 (97:18). Berkeley street—the procession turns north-northwest out of Blessington Street into Berkeley Street and thence north into Berkeley Road (which crosses the western end of Eccles Street).

96:9–10 (97:18–19). the Basin—the City Basin, a rectangular reservoir just west of Berkeley Street.

96:11 (97:20). Has anybody here . . . double ell wy—an American adaptation (1909), by William J. McKenna ("Has Anybody Here Seen Kelly?"), from an English song, "Kelly from the Isle of Man" (1908), by C. W. Murphy and Will Letters. The English song tells the story of an Irishman from the Isle of Man who is taken in hand by a lady of leisure only to abandon her for a rival. The American version: "Michael Kelly with his sweetheart came from County Cork/And bent upon a holiday, they landed in New York./They strolled around to see the sights, alas, it's sad to say,/Poor Kelly lost his little girl upon the Great White Way./ She walked uptown from Herald Square to Forty-second Street,/The traffic stopped as she cried to the copper on the beat: // [Chorus:] Has anybody here seen Kelly?/K-E-double L-Y?/Has anybody here seen Kelly?/Have you seen him smile?/Sure his hair is red, his eyes are blue,/And he's Irish through and through./Has anybody here seen Kelly?/Kelly from the Emerald Isle. // [Second verse:] Over on Fifth Avenue, a band began to play,/Ten thousand men were marching for it was St. Patrick's Day,/The 'Wearing of the Green' rang out upon the morning air./'Twas Kelly's favorite song, so Mary said, 'I'll find him there.'/She climbed upon the grandstand in hopes her Mike she'd see,/Five hundred Kellys left the ranks in answer to her plea," and the chorus is repeated.

96:12 (97:21). Dead march from Saul—George Frederick Handel (1685–1759), *Saul*, an oratorio (1739). In Act III Saul's implacable jealousy of David drives David away and divides the Israelites, who are then defeated by the Philistines at the Battle of Gilboa. Saul's son Jonathan is killed in the battle; Saul is wounded and commits suicide. The "Dead March" occurs when the Israelites recover the bodies and carry them in just before the climactic "Elegy."

96:12–13 (97:21–22). He's as bad ... on my ownio—a song about an Italian ice-cream merchant who treats his benefactors much as Kelly from the Isle of Man treated his. The song was a forerunner of all the Kelly songs. See 96:11n.

96:13 (97:22). The Mater Misericordiae—was the largest hospital in Dublin (at the intersection of Berkeley Road and Eccles Street). The hospital did have a ward for incurables.

96:15 (97:24). Our Lady's Hospice for the dying—see 79:32n.

96:16 (97:25). Mrs. Riordan—appears as a character ("Dante") in Chapter I of *A Portrait of the Artist as a Young Man*. See Ellmann, pp. 24 *ff.*, and Stanislaus Joyce, *My Brother's Keeper* (New York, 1958), pp. 8–9.

96:20 (97:29). the lying-in hospital—the National Maternity Hospital, 29–31 Holles Street, the scene of [Oxen of the Sun], 377–421 (383–428). The student involved is Dixon.

96:31 (97:40). Springers—a cow in calf (Irish).

96:32 (97:41). Cuffe—Joseph Cuffe, associated with Laurence Cuffe and Sons, cattle, corn and wool salesmen, at 5 Smithfield (in the northwest quadrant of central Dublin) near the Cattle Market.

96:33 (97:42). Roast beef for old England—suggests the song "The Roast Beef of Old England": "When mighty roast beef was the Englishman's food/It ennobled our hearts and enriched our blood./Our soldiers were brave, and our courtiers were good. // [Chorus:] Oh, the Roast Beef of old England,/And oh for Old England's Roast Beef!"

96:37 (98:4–5). dicky meat—in bad condition, of inferior quality.

96:38 (98:5). Clonsilla—a junction in the Midland Great Western Railway, seven miles west of Dublin.

96:40 (98:7). the corporation—the Dublin Corporation is the ruling body of the city, including the lord mayor, sheriffs, aldermen and councilmen.

96:41 (98:8). from the parkgate to the quays—i.e., along the north bank of the Liffey from the western side of Dublin at the Parkgate, southeast entrance of Phoenix Park, to the eastern side of the city and the quays at the mouth of the Liffey. See 58:1–2n.

97:4 (98:13). municipal funeral trams like they have in Milan—a belt electric railway seven miles long passed from the center of Milan to a point near the graveyards outside the sixteenth-century walls. Special funeral cars were provided to alleviate traffic congestion in the old city.

97:14 (98:23). Dunphy's—Dunphy's Corner, the intersection of North Circular Road and Phibsborough Road. From Berkeley Road the procession turns left (west) into North Circular Road and then right (north) into Phibsborough Road.

97:41 (99:8). Crossguns bridge: the royal canal—Phibsborough Road leads into Crossguns Bridge over the Royal Canal, which traces the northern perimeter of metropolitan Dublin and circles toward the mouth of the Liffey.

98:2 (99:11). Aboard of the Bugabu—a satirical ballad about the difficulty of navigating a turf barge by J. P. Rooney. The barge's misadventures include "the sea ran mountains high" while the helmsman is asleep and the captain sets fire to the cargo. It all climaxes when the crew discovers that the barge is not on the high seas at all but in a canal.

98:6 (99:15). Athlone, Mullingar, Moyvalley—on the Royal Canal system. Athlone, 78 miles from Dublin, 48½ miles from Galway on the west coast; Mullingar, 50 miles from Dublin, 76½ miles from Galway; Moyvalley, 30½ miles from Dublin, 96 from Galway.

98:8 (99:17). crock—a worthless animal.

98:8 (99:17). Wren—P. A. Wren of Wren's Auction Rooms, 9 Bachelor's Walk in central Dublin, northwest quadrant.

98:9–10 (99:18–19). James M'Cann's hobby to row me o'er the ferry—James M'Cann (d. 12 February 1904) was chairman of the Court of Directors of the Grand Canal Company, which maintained a regular fleet of trade boats on the Grand Canal (to central and southern Ireland). M'Cann (who has already arrived in Hades) is cast in the role of Charon, the ferryman who conveyed new arrivals across the River Styx into Hades.

98:12–13 (99:22). Leixlip, Clonsilla—Leixlip, 11 miles west of Dublin, is on the Liffey (not on the Royal Canal); Clonsilla, seven miles west, is on the Royal Canal.

98:16 (99:25). Brian Boroimhe house—a pub, J. M. Ryan, family grocer, tea, wine and spirit

merchant, Brian-boroihm house, at 1 Prospect-Terrace on the corner of Prospect Road north of the Crossguns Bridge. The pub is named after Brian Boru (Boroimhe) (926–1014), King of Munster from *c.* 978, principal King of Ireland from *c.* 1002. He achieved a major victory over the Danes at Clontarf (on the northeastern outskirts of Dublin) on Good Friday, 1014. After the battle he was murdered in his tent by a group of disaffected allies.

98:17 (99:26). Fogarty—"a modest grocer" and a friend of Kernan's with "a small shop on Glasnevin Road," in "Grace," *Dubliners*.

98:20 (99:29–30). left him weeping—in "Grace," *Dubliners*, "There was a small account for groceries unsettled" between Kernan and Fogarty. The implication is that what was once "small" has grown and that Kernan has left Fogarty "weeping at the church door," i.e., has not paid him and avoids him.

98:22 (99:31). Though lost to sight . . . to memory dear—"To Memory You Are Dear," song (1840), words by George Linley (1798–1865): "Though lost to sight, to memory dear,/You ever will remain;/One only hope my heart can cheer,/The hope to meet again./Oft in the tranquil hour of night,/When stars illumine the sky,/I gaze upon each orb of light/And wish that you were by./Yes, life then seemed one pure delight,/Though now each spot looks drear/Yet though your smile be lost to sight,/To memory you are dear."

98:23 (99:32). Finglas road—angles northwest from Prospect Road and is the southern boundary of the cemetery.

98:28 (99:37). Thos. H. Dennany—his display of cemetery sculpture was just off Finglas Road on Prospect Avenue in Glasnevin.

98:30 (99:39). Jimmy Geary the sexton's—J. W. Geary's address: Prospect Cemetery, Glasnevin.

98:35 (100:2). where Childs was murdered—Samuel Childs was tried for the murder of his seventy-six-year-old brother, Thomas, in October 1899. The murder took place at 5 Bengal Terrace in Glasnevin.

98:37 (100:4–5). Seymour Bushe—Ellmann (p. 95) characterizes him as "one of the most eloquent Irish barristers" of his time. See 137:28n.

98:40 (100:7). Only circumstantial—in the course of the trial Bushe had spoken on the law of evidence, arguing that "the evidence that Samuel Childs had murdered his brother Thomas rested chiefly on the fact that only Samuel had a key to the house, and that there was no evidence for the murderer's having entered by force" (*Evening Telegraph,* 21 October 1899, quoted in Ellmann, p. 767n).

98:41–42 (100:8–9). Better for ninety-nine . . . to be wrongfully condemned—this combines mild misquotations of Jesus, "Joy shall be in heaven over one sinner that repenteth, more than over ninety and nine just persons, which need no repentence" (Luke 15:7), and Sir William Blackstone (1723–1780), commentator on English Law, "It is better that ten guilty persons escape than that one innocent suffer" (*Commentaries on the Laws of England* [1765–1769], Volume IV, Chapter 27).

99:2 (100:11). unweeded garden—Hamlet, in his first soliloquy, contemplates his mother's marriage to Claudius (who only subsequently is revealed as a murderer) and complains of the world: "'Tis an unweeded garden,/That grows to seed, things rank and gross in nature/Possess it merely" (I, ii, 135–137).

99:3–4 (100:12–13). The murderer's image . . . the murdered—a popular superstition that the image of the murderer would be fixed on the retina of his victim and therefore could be "seen."

99:7 (100:16–17). Murder will out—proverbial wisdom, as in Chaucer, "The Nun's Priest's Tale." The prideful cock, Chantecleer, arguing the prophetic validity of dreams, concludes an elaborate example with the tag: "Mordre wol out, that se we day by day" (I, 3052). The idea is echoed in *Hamlet*: as Hamlet soliloquizes on the possible effectiveness of *The Mouse-trap* (III, ii, 247) as a way of catching "the conscience of the King." "For murder, though it have no tongue, will speak/With most miraculous organ" (II, ii, 622–623).

99:12 (100:22). Prospects—the cemetery in Glasnevin is called Prospect Cemetery.

99:12–15 (100:22–25). Dark poplars, rare . . . gestures on the air—the description of the cemetery recalls Aeneas' initial vision of the underworld (*Aeneid,* VI:282 *ff.*) when Aeneas sees "throngs" of "faint bodiless lives, flitting under a hollow semblance of form . . . in the midst an elm, shadowy and vast." In fear Aeneas threatens "vainly" to draw his sword.

99:27 (100:37). Simnel cakes—a kind of rich plumcake, enclosed in a very hard dough crust (especially for Mothering Sunday in mid-Lent, when parents were visited and presented with a gift). See 46:24–25n.

99:28 (100:38). Dogbiscuits—not only because simnel cakes are hard but also after the *Aeneid* (VI:417 *ff.*) when the Sibyl, guiding Aeneas into the underworld, throws "a morsel drowsy with honey and drugged meal" to the three-headed dog Cerberus.

99:35 (101:4). Finglas—a village northwest of the cemetery. There are quarries in the area.

99:39 (101:8). Got here before us, dead as he is—i.e., Dignam in his role as Elpenor; see headnote to this episode, p. 82 above.

99:40 (101:9). skeowways—i.e., askew.

100:1 (101:12). Mount Jerome—the Protestant cemetery at Harold's Cross south-southwest of central Dublin.

100:21–22 (101:32–33). the Queen's hotel in Ennis . . . Clare—Ennis is an inland town in County Clare in western Ireland 140 miles west-southwest of Dublin. The hotel which Bloom's father "owned" was and still is located in Church Street, where "it still enjoys a thriving business," according to Mr. Vincent McHugh, Chairman of the Ennis Urban District Council (1970).

100:26 (101:37). the cardinal's mausoleum—Edward Cardinal MacCabe (1816–1885), the archbishop of Dublin (1879 *ff.*), created cardinal in 1882. From an Irish point of view he was a "townsman" with little interest in Land Reform or Home Rule, the two central political issues of his time.

100:30 (101:41). Artane—Artane and Donnycarney, a village and parish, three miles north of the center of Dublin. The institution Martin Cunningham has in mind (see p. 216 [219]) is the O'Brien Institute for Destitute Children in Donnycarney, the Reverend Brother William A. Swan, director.

100:33 (102:2). Todd's—i.e., get her employment in Todd, Burns and Company, Ltd., silk mercers, linen and woolen drapers, tailors, boot and shoe and furnishing warehouse, etc., in Dublin. (May Joyce, one of Joyce's sisters, was at one point employed in Todd's).

100:40–41 (102:9–10). Wise men say . . . in the world—after a song by Murray and Leigh, "Three Women to Every Man": "Women are angels without any wings,/Still they are very peculiar things;/Men who have studied the ladies a lot,/Know what peculiar notions they've got./Soon as a maiden gets married, you know,/She wants at once to be 'boss' of the show;/I think, though perhaps my opinion is small,/She ought to feel lucky she's married at all. // [Chorus:] Wise

men say there are more women than men in the world,/That's how some girls are single all their lives,/Three women to every man/Oh, girls, say if you can,/Why can't every man have three wives?"

100:42–101:1 (102:11–12). For hindu widows only—i.e., suttee.

101:2 (102:13–14). Widowhood not . . . old queen died—Queen Victoria (1819–1901; queen, 1837–1901) had made the perpetual mourning of a dedicated widowhood fashionable after the death of Albert, Duke of Saxe-Coburg-Gotha, her husband and prince consort, 14 December 1861.

101:3 (102:14–15). Frogmore memorial—at the Frogmore Lodge at Windsor Castle. Victoria had a special mausoleum constructed at Frogmore for herself; her husband, Prince Albert; and for her mother, the Duchess of Windsor. For her own funeral Victoria had commanded full military observance; her body was "drawn in a gun carriage" in a remarkable funeral procession, 2 February 1901. Her body lay in state in St. George's Chapel in Windsor, and on 4 February the coffin was privately removed to the Frogmore mausoleum and there placed in the sarcophagus that already held the remains of Prince Albert.

101:4 (102:15–16). But in the end . . . in her bonnet—Queen Victoria's self-imposed seclusion after her husband's death, together with her insistence on a protracted mourning, was the chronic occasion for notice and controversy. Late in her life she did somewhat relax the strictures of her mourning.

101:5–6 (102:16–17). All for a shadow . . . was the substance—Bloom echoes a common criticism of Queen Victoria's excessive mourning for the "shadow" of her dead husband, who was, as Prince Consort, only the shadow of a king in real life. Bloom also echoes a related criticism of Queen Victoria's refusal to share the responsibilities of the Crown with her mature son, who was allowed to cool his heels until her death, when, at the age of sixty, he finally became a king in substance as Edward VII.

101:12 (102:23). Cork's own town—the title of a song (1825) by Thomas Crofton Croker (1798–1854): "They may rail at the city where first I was born,/But it's there they've the whisky, and butter, and pork,/And a little neat spot for to walk in each morn—/They call it Daunt's Square, and the city is Cork./The square has two sides—why one east and one west,/And convenient's the region of frolic and spree,/Where salmon, drisheens, and beefsteaks are cooked best:/Och! Fishamble's the Eden for you, love, and me!"

101:13 (102:24). Cork park races—an annual race meet held on a track in the City of Cork's public park. The most fashionable day of the meet (and the day of the principle purses) was Easter Monday, 4 April in 1904.

101:14 (102:25). Same old six and eightpence —a usual and unchanging thing, after the usual fee for carrying back the body of an executed malefactor and giving it Christian burial.

101:15 (102:26). Dick Tivy—identity or significance unknown.

101:16 (102:27). solid—sedate, steady, trustworthy.

101:21 (102:32). get up a whip—a whip, slang for money subscribed by a military mess for additional wine; therefore, to take a collection.

101:26–27 (102:37–38). John Henry Menton— a solicitor and commissioner of affidavits. In fiction, a former employer of Dignam, but he was also "real," with offices at 27 Bachelor's Walk in central Dublin just north of the Liffey.

101:38–39 (103:7–8). I owe three shillings to O'Grady—a parody of Socrates' last words, "I owe a cock to Asclepios; see that the debt is paid," as recorded in Plato's *Phaedo*.

102:3–4 (103:15). praying desks—with a lectern for a prayer book and a step on which to kneel.

102:4 (103:15). the font—at the chapel entrance, contains holy water with which the worshiper traditionally moistens his fingers and touches his brow or crosses himself in blessing.

102:8 (103:20). a brass bucket with something in it—the vessel contains holy water and a rod (sprinkler) with which it is shaken over the coffin.

102:11–12 (103:23–24). Who'll read the book? I, said the rook—after the nursery rhyme, "Who killed Cock Robin?": "Who killed Cock Robin?/I, said the sparrow,/With my bow and arrow,/I killed Cock Robin. // ... // Who'll be the parson?/I, said the rook,/With my little book,/I'll be the parson."

102:15 (103:27). Father Coffey—the Reverend Francis Coffey, curate in charge and chaplain, 65 Dalymount. Father Coffey is to perform the Absolution, the final phase of the funeral before the burial.

102:15–16 (103:27–28). Domine-namine— apparently the priest has said, "*In nomine Domini* " (Latin: "In the name of the Lord"), and Bloom has not heard it clearly.

102:16 (103:28). Bully about the muzzle— too large and thick in the mouth.

102:17 (103:29). Muscular christian—a term applied since about 1857 to a brand of Christian opinion and practice which had its origins in the Church of England and which put particular stress upon the importance of a healthy body as conducive to morality and true religion. One of the principal advocates of muscular Christianity was the English clergyman, novelist and poet Charles Kingsley (1819–1875).

102:18 (103:30). Thou art Peter—Jesus changes Peter's name from Simon ("hearer") to Peter ("rock") and says, "And I say also unto thee, that thou art Peter, and upon this rock I will build my church; and the gates of hell shall not prevail against it" (Matthew 16:18).

102:22 (103:34). Non intres ... tuo, Domine —Latin: "Do not weigh the deeds of your servant, Lord," the opening phrase of the prayer that begins the Absolution. The sentence continues: "for no one is guiltless in your sight unless you forgive him all his sins. . . ."

102:24 (103:36). Requiem mass—precedes the Absolution in the funeral rite. Presumably, a requiem Mass has been celebrated at Dignam's parish church in Sandymount.

102:24 (103:36). Crape weepers—i.e., professional mourners, who were dressed in crape because the material was cheap.

102:25 (103:37). altar list—the list or book provided for the signatures of those who attend a funeral.

102:31 (104:1). Mervyn Brown—a Mervyn A. Browne is listed in *Thom's* (*1904*) as "professor of music and organist." A Mr. Browne appears as a character in "The Dead," *Dubliners*.

102:32 (104:2). vaults of saint Werburgh's— the church on Werburgh Street in south-central Dublin is one of the oldest in Dublin, built during the reign of Henry II (1133–1189; king, 1154–1189) by the "men of Bristol" who colonized the city. It was dedicated to Saint Werburgh, daughter of Wulfhere, King of Mercia. The original building was destroyed in 1301, repaired and enlarged in 1662. The 27 vaults beneath the church are part of the original building. One of the vaults houses Lord Edward Fitzgerald's coffin. See 237:29–31n.

102:32 (104:2). lovely old organ—Saint Werburgh's was rebuilt in 1712, destroyed by fire in 1754 and restored in 1759 (when the organ Bloom has in mind was installed). Before the fire

and after its restoration the church was the scene of regular concerts of Handel's music, which were organized after Handel's triumphant visit to Dublin in 1742. (Handel's visit came to a climax when he conducted the first performance of his *Messiah* as a reward for Dublin's appreciative, as against London's cold, reception.) The church's organ was regarded as one of the finest eighteenth-century organs in the British Isles.

102:42 (104:12). Et ne nos . . . tentationem— Latin: "And lead us not into temptation," from the Lord's Prayer (Matthew 6:13). As the celebrant sprinkles the bier with holy water he intones the Paternoster (the Lord's Prayer) in a low voice. When he has finished sprinkling the bier, he takes up the prayer at the quoted line and is answered by the server: "But deliver us from evil." Celebrant: "From the mouth of Hell." Server: "Rescue his soul, Lord." Celebrant: "May he rest in peace." Server: "Amen."

103:13 (104:25). In paradisum—Latin: "Into paradise," the opening words of the anthem that is said or sung as the coffin is being carried to the grave, "May the angels lead you *into Paradise.* . . ."

103:27 (104:39). lilt—to sing softly or without articulating the words; to hum.

103:28 (104:41). The O'Connell circle—near the center of the cemetery, a round platform of earth, surrounded by a deep ditch. O'Connell was originally buried in the circle, but in 1869 his remains were removed to a crypt in the O'Connell monument, a 160-foot-tall replica of an Irish round tower near the mortuary chapel. Mr. Dedalus is apparently referring to this monument because "the lofty cone" (103:29 [104:42]) is the round tower.

103:31 (105:2). his heart is buried in Rome— O'Connell died in Genoa in 1847 when he was returning from a pilgrimage to Rome. His heart was taken to Rome and placed in the church of St. Agatha (the Irish College). His body was brought back to Ireland for burial in the O'Connell Circle.

103:33 (105:4). Her grave—i.e., Simon Dedalus' wife, Stephen's mother, Mary Goulding Dedalus. Buried 26 June 1903.

104:10 (105:23). In the same boat—i.e., Bloom and Kernan are the only mourners present who are not practicing Catholics.

104:13 (105:26). The service of the Irish church—the Church of Ireland (disestablished 1869), counterpart of the Church of England in Ireland. The service was, of course, in English, not in Latin.

104:18 (105:31). I am the resurrection and the life—Jesus in mild reproof to Martha, the sister of Lazarus, when she doubts that her brother will "rise again" before "the resurrection at the last day." Jesus continues, "He that believeth in me, though he were dead, yet shall he live: And whosoever liveth and believeth in me shall never die" (John 11:24–26). The irony, at Kernan's expense, is that these words, which play a prominent part in the English funeral service of the Church of Ireland, play an equally important part (in Latin) in the Roman Catholic burial service that he is witnessing.

104:27–28 (105:41). last day idea—i.e., that at the last day at the Resurrection, the dead will be raised in the flesh. One key biblical passage on this "idea" is John 6:40. Jesus says: "And this is the will of him that sent me, that everyone which seeth the Son, and believeth on him, may have everlasting life: and I will raise him up at the last day."

104:28–29 (105:42). Come forth, Lazarus!— Jesus, at the tomb of Lazarus, prays (gives thanks to God), "And when he thus had spoken, he cried with a loud voice, Lazarus come forth" (John 11:43).

104:29 (105:42). And he came fifth and lost the job—a commonplace pun on the biblical "Come forth"; in its more usual form: And the Lord commanded Moses to come forth but Moses slipped on a banana peel and came in fifth, etc.

104:32–33 (106:3–4). Pennyweight . . . Twelve grammes one pennyweight. Troy measure— the smallest measure of weight (English system) named after Troyes in France. "Gramme," i.e., grain, because the original measure was based on the weight of a grain of wheat. Troy weight is currently used for precious metals and jewels. Twenty-four (not 12) grammes (grains) make a pennyweight; 20 pennyweights, one ounce (oz.t.); 12 ounces, the pound (lb.t.).

104:35 (106:6). A 1—i.e., first class, after its use in *Lloyd's Register,* where the character *A* denotes a new or renovated ship and the vessel's stores are graded *1* or *2* to denote that they are in good condition.

105:6–7 (106:19–20). at Mat Dillon's in Roundtown—Roundtown (now Terenure), a village in the parish of Rathfarnham on the southern outskirts of Dublin.

105:10 (106:23). fell foul—i.e., got into a dispute.

105:13 (106:26). Wisdom Hely's—a stationer and printer at 27–30 Dame Street, Dublin. The sequence of Bloom's employments is hardly

clear, but on 153 (155) Bloom remarks that he got the job in Hely's the year he and Molly were married (1888) and had it for (roughly) "six years."

105:16 (106:29). coon—fellow, guy.

105:23 (106:37). John O'Connell—caretaker at Prospect Cemetery, Glasnevin.

105:29 (107:2). custom—i.e., the practice of customarily patronizing a particular shop or tradesman.

105:33 (107:7). the Coombe—see 77:32n.

106:18 (107:35). Keyes's ad—Alexander Keyes, a client of Bloom; see 115:27n.

106:19 (107:36). Habeas corpus should read **Habeas corpus (107:36)** as it does **106:19.**

106:20 (107:37). Ballsbridge—an area on the southeastern outskirts of Dublin (to disguise Martha Clifford's address in the southwestern quadrant of the city).

106:24–25 (107:42). Silver threads among the grey—after the song "Silver Threads Among the Gold" (1874), words by Eben E. Rexford, music by Hart Pease Danks (1834–1903): "Darling, I am growing old/Silver threads among the gold/Shine upon my brow today,/Life is fading fast away./But, my darling, you will be/Always young and fair to me./Yes, my darling, you will be/Always young and fair to me."

106:29–30 (108:5). when churchyards yawn—Hamlet soliloquizes after *The Mouse-trap* and before he goes to visit his mother: "'Tis now the very witching time of night,/When churchyards yawn and hell itself breathes out/Contagion to this world" (III, ii, 406–408).

106:31 (108:7). breedy—either one who causes strife, or one who breeds readily, i.e., is prolific.

106:37–38 (108:13). Whores in Turkish grave-yards—nineteenth-century travelers reported the extensiveness of Turkish graveyards and their cypress groves and noted with surprise that some areas of the graveyards were treated as "fashionable lounges," other areas as "a common resort for *idlers* of both sexes among the Franks, Greeks, and Armenians" (not to mention "the convenience of comfortable seats, afforded by the flat tombstones") (James Ellsworth DeKay [1792–1851], *Sketches of Turkey by an American* [New York, 1833], p. 160).

106:39–40 (108:15). Love among the tomb-stones. Romeo—combines allusions to the title

of Browning's poem "Love Among the Ruins" (1855) and to the final scene of *Romeo and Juliet*, the star-crossed love-deaths of Romeo and Juliet in the Capulet mausoleum (V, iii).

106:40–41 (108:16). In the midst . . . are in life—a reversal of the common line; see 95:3n.

107:1 (108:18). to grig—Irish: "to excite desire or envy, to tantalize."

107:5 (108:22). Standing?—ancient Irish kings and chieftains were occasionally buried in a standing posture in full armor, facing toward the lands of their enemies.

107:9 (108:26). Major Gamble—Major George Francis Gamble, registrar and secretary, Mount Jerome Cemetery, Dublin.

107:11–12 (108:29). The Botanic Gardens—see 70:41n.

107:13–14 (108:30–31). those jews they said killed the christian boy—a whole cycle of these legends has been current since the early Christian centuries. The legend Bloom recalls has a fertility twist to it: the child is "sacrificed" that his blood may reinvigorate a garden. See the song Stephen sings 674–676 (690–691).

107:16 (108:33–34). William Wilkinson, auditor and accountant—the Prospect Cemetery records reveal only two W. W.'s, one died in 1865 at age sixteen, the other in 1899 at age six months. *Thom's (1904)* lists no such "auditor and accountant."

107:27–28 (109:4–5). swurls . . . gurls—Boylan's pronunciation.

107:32–33 (109:10). (closing time)—the time when bars and public houses were required by law to close their doors.

107:37 (109:14–15). Gravediggers in Hamlet—in Act V, scene i, two "clowns" digging Ophelia's grave are involved in an elaborate low-comic scene.

107:37–38 (109:15). the profound knowledge of the human heart—Shakespeare's strength as seen through the eyes of sentimental nineteenth-century academicism.

107:39 (109:16). De mortuis nil nisi prius—Latin: Bloom misquotes *"De mortuis nil nisi bonum"*—"Of the dead speak nothing but good." Bloom's substitution *"nisi prius"* is a legal term for a civil action tried in a court of record before a judge and jury.

108:8 (109:27). We come to bury Caesar—the second line of Marc Antony's (Marcus Antonius') funeral oration: "I come to bury Caesar, not to praise him" (*Julius Caesar*, III, ii, 79).

108:8–9 (109:27–28). His ides of March or June—in *Julius Caesar* (I, ii, 18) a soothsayer warns Caesar: "Beware the ides of March" (15 March). Dignam died 13 June 1904 and 13 June *is* the ides of June.

108:10 (109:29). galoot—an awkward, ungainly person.

108:15–16 (109:34–35). Only man buries. No ants too—popular natural history, in part because many ants hollow out underground nests, in part because many, but not all, species of ants do remove debris, including dead bodies, from their nests.

108:16–17 (109:36). Robinson Crusoe...Friday—Daniel Defoe (1660–1731), *Strange Surprising Adventures of Robinson Crusoe* (1719). Crusoe, marooned on an island, acquires the faithful services of a native, Friday (on Friday).

108:19–20 (109:38–39). O, poor Robinson...possibly do so—from a song, "Poor Old Robinson Crusoe," by Hatton (?). An American version: "Poor old Robinson Crusoe was lost/On an island they say, O/He stole him a coat from an old billy-goat/I don't see how he could do so."

108:26 (110:4). Bit of clay from the holy land—an allusion to a Jewish burial custom. Popular belief regarded the soil of Palestine as having a special holiness; thus Jews longed to be buried in Palestine or, if that were impossible, to have a handful of soil from Palestine put in the coffin under the head of the deceased.

108:26–27 (110:4–5). Only a mother...in the one coffin—Bloom is right that Jewish burial customs allow the burial of a mother who dies in childbirth in the same coffin with her child if it is stillborn. But Jewish burial customs are far more elaborate and not quite so strict as Bloom recalls. Those customs do allow burial *in the same grave* of young children with their parents, provided the child has slept in the same bed with the parent and provided that they die in time to be interred in one burial.

108:29 (110:7). The Irishman's house is his coffin—after the proverb: "An Englishman's (Irishman's) house is his castle."

108:33–34 (110:10–11). I'm thirteen...Death's number—thirteen, an unlucky number in both pre-Christian and Christian worlds, though one Christian tradition holds that the ill luck of the number stems from the thirteen who sat at the Last Supper (Judas being the thirteenth guest).

108:39 (110:17). Mesias—in fiction, Bloom's tailor; in life, George R. Mesias, tailor, 5 Eden Quay (on the north bank of the Liffey, just short of its mouth).

109:6–7 (110:25–26). No such ass. Never see a dead one, they say—after an Irish saying, "Three things no person ever saw: a highlander's kneebuckle, a dead ass, a tinker's funeral" (P. W. Joyce, *English as We Speak It in Ireland*, p. 111).

109:17 (110:36). Light they want—recalls "Light! More light!", the last words of the German poet, playwright and philosopher, Johann Wolfgang von Goethe (1749–1832).

109:20–22 (110:40–41). Watching is his...his feet yellow—three indications of imminent death (popular superstition).

109:22–23 (110:41–42). Pull the pillow...since he's doomed—in Emile Zola's (1840–1902) *La Terre (The Earth*, 1887), the manner of death of the old peasant father at the hands of his son and daughter-in-law.

109:23–24 (110:42–111:2). Devil in that...in his shirt—source unknown.

109:25 (111:2). Lucia. Shall I nevermore behold thee?—*Lucia di Lammermoor* (1835), an opera by Gaetano Donizetti (1797–1848) after Sir Walter Scott's novel *The Bride of Lammermoor* (1819). The opera deals with "the tragic fate" of two lovers separated by family strife. In Act III, scene i, the heroine, Lucia, married against her will, runs mad; in Act III, scene ii, Edgar, the hero, learns that Lucia is dead as he waits in a graveyard to duel with Lucia's villainous brother. He declares, "Yet once more shall I behold thee, . . ." and, on the wings of an appropriate aria, commits suicide.

109:27–28 (111:5). Even Parnell. Ivy day dying out—Parnell died 6 October 1891; on the anniversary of his death his partisans wore a leaf of ivy in his memory. See "Ivy Day in the Committee Room," *Dubliners*.

109:30 (111:7). for the repose of his soul—the dead who are doing penance in purgatory before entrance into heaven are believed to be aided by the prayers of the living.

109:34–35 (111:11). Someone walking over it—the superstition is that when you shiver in the sun someone has walked over your grave, i.e., has reminded you that you are to die.

109:39 (111:16). By Jingo—an apparently meaningless exclamation except that *Jingo* in Basque means God.

110:7 (111:26). grace—grace is that love of God for man that makes repentance and redemption possible. It is also the time allowed a debtor for the payment of his debts.

110:11 (111:29–30). the dismal fields—after Virgil, *Aeneid* VI:441. *"Lugentes Campi"*: "where those whom stern love has consumed with cruel wasting are hidden . . . even in death the pangs leave them not."

110:20–21 (111:39–40). Louis Byrne—Louis A. Byrne, M.D., coroner of the City of Dublin.

110:23 (111:42). Levanted—to "levant" is to run away from debts or to make a wager without intending to pay.

110:23 (111:42–112:1). Charley, you're my darling—after the Scottish folk song "Charlie Is My Darlin'," words by Lady Nairne (in honor of Charles Stuart, Bonnie Prince Charlie [1720–1788], pretender to the throne of England): "Twas on a Monday morn,/Right early in the year,/When Charlie came to our town,/The young chevalier. // [Chorus:] Oh Charlie is my darlin', my darlin', my darlin',/The young chevalier./Oh Charlie is my darlin', my darlin', my darlin',/the young chevalier. // [2nd verse:] As he came marchin' up the street,/The pipes played loud and clear,/And all the folk came runnin' out/To meet the chevalier. // [3rd verse:] With Highland bonnets on their heads,/And claymores bright and clear,/They came to fight for Scotland's right,/And the young chevalier."

110:37 (112:14–15). Has anybody . . . double ell—see 96:11n.

111:16 (112:35). the chief's grave—i.e., Parnell's grave.

111:28 (113:5). old Ireland's hearts and hands—a song by Richard F. Harvey from W. W. Delaney, *Delaney's Irish Song Book* (New York, n.d.): "Oh Erin, home of lovely scenes,/Oh land of love and song,/In joy once more my fond heart leans/On thee so true and strong:/For like a restless bird I've strayed,/And oft on far-off strands/I dreamed of love knots years have made/With Ireland's hearts and hands. // [Chorus:] O sweetheart Erin, good old land,/Though near or far I stray,/I love them all, thy heart and hand,/I love thy shamrock spray:/Old Ireland's hearts and hands,/Old Ireland's hearts and hands,/Oh sweetheart Eire, good old land,/I love thy hearts and hands."

111:32 (113:9). All souls' day—in the Roman Catholic Church, 2 November, a holy day for the liturgical commemoration of the souls of the faithful dead still in purgatory.

111:32–33 (113:9–10). Twenty-seventh . . . at his grave—i.e., each year on 27 June Bloom visits his father's grave in Ennis.

111:39 (113:16). cork lino—a floor covering made by laying hardened linseed oil mixed with ground cork on a canvas backing. Gerty McDowell's father "travels for" (sells) cork lino, 249 (253), 348–349 (355).

111:39 (113:16–17). paid five shillings in the pound—i.e., went bankrupt, and could only pay each creditor one-quarter of what was owed.

111:40–42 (113:18–19). Eulogy in a country . . . Thomas Campbell—Thomas Gray (1716–1771), English poet, "Elegy Written in a Country Churchyard" (1751). Not William Wordsworth (1770–1850), nor Thomas Campbell (1777–1844), poet and critic.

112:1 (113:20–21). Old Dr. Murren's . . . called him home—i.e., was that Dr. Murren's expression: God, the great physician, etc. ? Dr. Murren is unknown.

112:2 (113:21). it's God's acre for them—i.e., for Protestants since "God's acre" is a standard Englishman's phrase for a cemetery.

112:4 (113:23). the Church Times—a weekly Church of England newspaper, quite conservative and High Church in its views, but it did contain an impressive number of genteel personal want ads (as Bloom recalls).

112:8 (113:27). Immortelles—after the French word for "immortal," with the specific meaning in this context of a plant whose flowers may be dried without losing their form or color.

112:10 (113:29). alderman Hooper—Alderman John Hooper (from Cork) gave the Blooms a stuffed owl as a wedding present, 692 (707). He was a real person and the father of Paddy Hooper, a reporter on the *Freeman's Journal* who is mentioned on 128 (130).

112:11 (113:30). catapult—slingshot.

112:14 (113:33). chainies—damaged chinaware.

112:15 (113:34). the Sacred Heart that is: showing it—Blessed (in 1904; since 1920 St.) Margaret Mary Alacoque (1647–1690) experienced repeated visions in which Jesus took his heart, showed it to her and placed it in hers.

Eventually she consented to establish the festival of the Sacred Heart (since 1882, the second Sunday in July) and the Litany of the Sacred Heart, a method for practicing Christian devotion.

112:15 (113:34). Heart on his sleeve—proverbial phrase applied to a person so candid that he cannot conceal his thoughts and motives. In *Othello* (I, i, 64–65) Iago cynically declares, "I am not what I am," and implies that when he *seems* outwardly what he *is* inwardly ". . . I will wear my heart upon my sleeve/For daws to peck at."

112:18–21 (113:37–40). Would birds then come . . . Apollo that was—Bloom confuses the name Apollo with that of the Greek painter Apelles, a contemporary of Alexander the Great (356–323 B.C.). Similar stories are associated with Apelles, but the story Bloom recalls is usually told of another Greek painter, Zeuxis (d. *c*.400 B.C.), who was reputed to have painted a boy with a basket of grapes, the grapes so natural that the birds came to peck at them.

112:22 (113:41). How many!—after Dante, *Inferno* (III:55–57): "So long a train of people, I never should have believed death had undone so many."

112:23 (113:42). As you are now so once were we—a not uncommon line in epitaphs. One example: Edward, the Black Prince of England (1330–1376), "Who passeth here with closed lips, near to where this body reposeth, let him hear what I shall say, saying only what I know. Even as thou art so once was I: and as I am so thou shalt be."

112:37 (114:14). an old stager—i.e., a veteran, a person of experience.

112:40–41 (114:17–18). Robert Emery. Robert . . . wasn't he?—Robert Emery's name reminds Bloom of Robert Emmet (1778–1803), an Irish patriot who attempted to get Napoleon's assistance for an Irish uprising. He led an attempt to seize Dublin Castle in 1803, but the help Napoleon (and Irish allies) had promised did not materialize and Emmet was alienated by his followers' gratuitous murder of Lord Kilwarden. He was subsequently captured and executed for high treason. His fame was enhanced by his "last words"; see 286:3n. The whereabouts of Emmet's "remains" is unknown. After execution he was buried in Bully's Acre near Kilmainham Hospital in Dublin. Rumors abound that his remains were removed (secretly) either to St. Michan's Church in Dublin or to Prospect Cemetery, Glasnevin. Both places have uninscribed tombstones that are said to mark his grave. In 1903, at the time of the centennial of Emmet's death, the *United Irishman*

carried a number of stories about renewed attempts to locate his grave; its whereabouts are still a matter of conjecture.

113:5 (114:24). Voyages in China—by "Viator" in Bloom's bookshelf, 693 (708). The pseudonym Viator was used by several travel-book writers at the turn of the century, but none of the standard book catalogues list this title by a Viator. One of the more prominent Viators was the Presbyterian missionary E. F. Chidell, and the missing *Voyages in China* might have been his, along with *The Way-Farer; Africa and National Regeneration* (London, 1903) and *Overland to Persia* (London, 1906).

113:6–7 (114:25–26). Priests dead against it—i.e., against cremation because it implies a challenge to the doctrine that the flesh is to be resurrected on "the last day."

113:7 (114:26). Devilling—a "devil" is a junior legal counselor who works for a barrister in the preparation of law cases; also the pun.

113:8 (114:27). Time of the plague—bodies were burned, or buried in pits with quicklime in the hopes of forestalling the contagion.

113:8 (114:27). Quicklime fever pits—not only for plague victims but also for the bodies of executed murderers.

113:9 (114:28). Ashes to ashes—in the *Book of Common Prayer*, "Burial of the Dead. At the Grave.": "Earth to earth, ashes to ashes, dust to dust; in sure and certain hope of the Resurrection unto eternal life."

113:10 (114:29). Where is that . . . Eaten by birds—after the Parsee custom of exposing their dead in towers. One of the books in Bloom's library contains an illustration of a Parsee tower: Frederick Deodati Thompson, *In the Track of the Sun: Diary of a Globe Trotter* (London, 1893), p. 156.

113:22 (114:41). Mrs. Sinico's funeral—Mrs. Sinico's death by accident is central to the story "A Painful Case," *Dubliners*. For the real events that Joyce has adapted into this story, see Adams, pp. 52–53.

113:29 (115:6). she wrote—i.e., Martha Clifford wrote; see 76–77 (77–78).

113:31–32 (115:9). this innings—a cricket term, an inning in cricket being much more extended than one in baseball.

113:38 (115:15). Tantalus glasses—a stand containing three cut-glass decanters that, though

apparently free, cannot be withdrawn until the grooved bar that engages the stoppers is raised; after Tantalus, whose torment (*The Odyssey*, Book XI, closing lines) is to suffer hunger and thirst with water up to his chin and boughs of fruit suspended over him.

113:39 (115:16). Got his rag out—blustered, grew angry.

113:40 (115:17–18). Sailed inside him . . . the bias—"bias": Bloom put an (accidental) twist on the ball that made it curve inside Menton's though Menton had a straight ball blocked.

114:3 (115:21). dinge—a dent or depression.

114:19 (115:37). Sappyhead—a foolish or gullible person.

EPISODE 7
[AEOLUS]

EPISODE SEVEN
ROUTE OF STEPHEN,
MacHUGH, CRAWFORD, et al.

Episode 7: [Aeolus], pp. 115–148 (116–150).
In Book X of *The Odyssey*, Odysseus reaches
Aeolia, ruled by Aeolus, whom Zeus had made
"warden of the winds." Aeolus tries to help
Odysseus by confining all the unfavorable winds
in a bag, which Odysseus stows in his ship.
Within sight of Ithaca, Odysseus "nods" at the
tiller and his men suspect him of having hidden
some extraordinary treasure in the bag; they
open it, release the winds, and the ships are driven
back to Aeolia, where Aeolus refuses any further
help to Odysseus ("A man the blessed gods
detest").

Time: 12 noon; Scene: the newspaper offices
of the *Freeman's Journal* (and the *Evening Tele-
graph*), 4–8 Prince's Street North in the north-
east quadrant of Dublin near the General Post
Office and Nelson's Pillar. Organ: lungs; Art:
rhetoric[1]; Color: red; Symbol: editor; Tech-
nique: enthymemic (in logic an "enthymeme" is a
syllogism in which one of the propositions has
been suppressed, thus a syllogism that is more
rhetorical than it is logical). Correspondences:
Aeolus—Crawford; *Incest* (since Aeolus gave his
six daughters to his six sons in marriage)—
Journalism; *Floating Island* (Homer describes
Aeolus' island as "adrift upon the sea, ringed
round with brazen ramparts on a sheer cliffside")
—the Press.

**115:4 (116:4). Blackrock, Kingstown, and
Dalkey**—villages on Dublin Bay southeast of
Dublin five, six, and eight miles respectively.

**115:4–5 (116:4–6). Clonskea, Rathgar . . .
Upper Rathmines**—all in the inland area south
of central Dublin (two to two and a half miles
from Nelson's Pillar).

**115:6–7 (116:6–7). Sandymount Green . . .
Ringsend and Sandymount Tower**—Ringsend
is on the south bank of the Liffey at its mouth;
Sandymount Green is in Sandymount less than a
mile to the south, and the Tower is one-half mile
south-southeast of the green.

115:7 (116:7). Harold's Cross—on the southern
outskirts of metropolitan Dublin.

**115:7–8 (116:7–8). Dublin United Tramway
Company**—the public corporation that ran the
electric streetcars in County Dublin.

115:16 (116:16). general post office—fronted
on Sackville (now O'Connell) Street between
Henry Street and Prince's Street North, just
southwest of Nelson's Pillar, which stood in the
middle of the street.

[1] See Appendix, pp. 519–525, for an annotation of
the "art" of this episode.

115:19 (116:19). E.R.—initials for "Edward
Rex" (Edward VII of England).

115:24 (116:24). Prince's stores—a warehouse
on Prince's Street North, halfway between the
General Post Office and the newspaper offices.

115:24 (116:24). float—a flat-topped wagon
with a low body for carrying heavy objects.

115:27 (116:27). Red Murray—Joyce's uncle
John Murray's nickname; see Ellmann, p. 18.

115:27 (116:27). Alexander Keyes—an Alex-
ander Keyes is listed at "5 and 6 Ballsbridge"
under "Grocers &c.," "Trades Directory,
Dublin & Suburbs" in *Thom's (1904)*, p. 2066.
Keyes is not listed in "List of the Nobility,
Gentry, Merchants, and Traders, Public Offices
&c &c.," pp. 1795 ff.; and the "County Dublin
Directory," p. 1635, lists not Keyes but "Fagan
Bros. Grocers, wine and spirit merchants" at 5
and 6 Ballsbridge. Under "List of the Nobility
. . .," p. 1866, Fagan Brothers appear as grocers
at 103–104 and 212 Britain Street Great. Under
"Dublin Street Directory," p. 1433, 103 and 104
Britain Street Great, "Fagan Brothers, family
grocers and wine merchants, 'The Blue Lion' . . .
Bernard P. Fagan," and p. 1434, 202 Britain Street
Great, "Fagan Brothers, grocers, tea, wine and
spirit merchants; James J. Fagan." This evidence
would suggest that the real Keyes was manager of
Fagan Brothers' branch in Ballsbridge; and that
fiction (and the conveniences of symbolism) have
elevated Keyes to ownership of the company,
including the company's "house in Kilkenny"
(which Bloom mentions 119 [120]). Adams (p. 174)
notes that "Keyes was a member of the jury that
tried the Childs murder case," though Joyce does
not use this circumstance in the novel.

115:29 (116:29). the Telegraph office—the
offices of the *Evening Telegraph* (evening daily)
were in the same large rambling building as the
offices of the *Freeman's Journal and National
Press* (morning daily). The two newspapers were
closely associated, both owned by the same
company, Freeman's Journal, Ltd., which also
published the *Weekly Freeman and National
Press* and *Sport*.

115:30 (116:30). Ruttledge's office—Ellmann,
p. 208, describes him as "the cashier of the
newspaper"; Adams, p. 216, describes him as "the
advertising manager." The combination of the
two would make him business manager of Free-
man's Journal, Ltd.

115:30 (116:30). Davy Stephens—a conspic-
uous Dublin character who styled himself "the
prince of the news vendors" and who was called

"Sir" Davy Stephens. He kept a newsstand at Kingstown (Dun Laoghaire) and had a *de facto* monopoly on the sale of newspapers to passengers on the mailboats. He was witty and uninhibited, and anecdotes about an amusing confrontation between Stephens and King Edward VII when the latter visited Ireland in 1903 provide for the epithet "a king's courier."

116:3 (117:5). a par—a paragraph, i.e., a short feature story as a sort of free advertisement.

116:7–8 (117:9–10). WILLIAM BRAYDEN ... SANDYMOUNT—William Henry Brayden (1865–1933), Irish barrister and editor of the *Freeman's Journal* (1892–1916). Address (*Who's Who 1906*): Oaklands, Ballsbridge, Dublin.

116:29 (117:30). Mario the tenor—Giovanni Matteo Mario, Cavaliere de Candia (1810–1883), Italian tenor, who made his last stage appearance in 1871 (when Bloom was five years old).

116:34 (117:35). Martha—(1847), a light opera in five acts by Friedrich von Flotow (1812–1883), German composer. Plot: Act I. Lady Harriet Durham, maid of honor to Queen Anne of England, disguises herself as "Martha," a servant girl, and with her maid Nancy, also disguised, goes to Richmond Country Fair to escape for a moment the stultifying life of the court. Act II. At the fair "Martha" and Nancy meet Lionel and Plunkett, two well-to-do-farmers who have come to the fair to hire servant girls. Unwittingly "Martha" and Nancy enter a binding contract as their servants. Act III. At the farmhouse, confusions of work and love: boisterously Plunkett-Nancy; touchingly, Lionel-"Martha," their relationship is characterized by Martha's song, "'Tis the Last Rose of Summer." Then the girls escape back to court. Act IV. Lionel mourns appropriately ("*M'appari* ..."; see Simon Dedalus' song 267–271 [271–276]), and Plunkett and Lionel accidentally meet Lady Harriet and the fashionable Nancy. The girls again escape. Act V. Lionel loses his reason as the result of his grief and does not even respond when he becomes (!) Earl of Derby or when Lady Harriet visits him. Nancy and Plunkett stage a repeat performance of Richmond Fair; Lionel meets his "Martha"; his reason is restored; marriage; happy ending.

116:35–36 (117:36–37). Co-ome thou lost ... dear one—from Lionel's Lament (Act IV), as freely translated into a popular nineteenth-century song: "Forever lost, I love you!/Sweet as a dream,/Quickly come, as quickly gone./You are all I'm longing for!/Come thou lost one,/Come thou dear one,/Bring the joys I knew before;/Come thou lost one,/Come thou dear one,/You must be mine forevermore."

117:2 (118:2). His grace phoned down twice this morning—i.e., the Most Reverend William J. Walsh (1841–1921), the archbishop of Dublin (unless "his grace" is slang for the editor, or for the publisher, Thomas Sexton). Ellmann (p. 297) notes that Sexton was a dedicated Parnellite who carried on a prolonged feud with Archbishop Walsh after the Archbishop had roundly condemned Parnell at the time of the divorce scandal. Ellmann says that Sexton's newspapers, the *Freeman's Journal* and the *Evening Telegraph*, played down Archbishop Walsh's activities and played up the activities of Michael Cardinal Logue (1840–1924), the archbishop of Armagh.

117:16 (118:16). Nannetti's—Joseph Patrick Nannetti (1851–1915), Irish-Italian master-printer and politician. He was Member of Parliament from the College Division of Dublin (1900–1906), i.e., "Member for College green," 117:31 (118:31), as well as a member of the Dublin Corporation. He was lord mayor of Dublin (1906–1907). According to the *Evening Telegraph*: at 2:00 P.M., 16 June 1904, Nannetti was asking questions in Parliament about the prohibition of Irish games in Phoenix Park. Joyce moves this occurrence to the following day.

117:31–32 (118:31–32). workaday worker tack—i.e., Nannetti had argued that he was not a professional politician but a workingman who pursued a political career on the side.

117:33 (118:33). the official gazette—*The Dublin Gazette*, printed and published under the authority of His Majesty's Stationery's Office on Tuesday and Friday each week. It printed legal notices, etc., in addition to what Bloom regards as "stale news."

117:33–118:1 (118:33–34). Queen Anne is dead—Queen Anne (1665–1714; queen of Great Britain and Ireland, 1702–1714). Addison announced this news in the *Spectator* long after it had become publicly known. The sentence thus became a famous example of and proverbial expression for stale news.

118:2–3 (119:1–2). Demesne situate ... barony of Tinnachinch—Tinnachinch or Tinnehinch House on the Dargle in the Parish of Rosenallis (12 miles south-southeast of Dublin) was presented to Henry Grattan (1746–1820), Irish statesman and orator, by the Irish Parliament (1797) "in appreciation of his noble exertions on behalf of Irish Independence and in order that he might end in peace a life that had been so laborious." Grattan had been a leader (1782) in the successful Irish campaign for increased legislative independence. He retired in 1797, but came out of retirement to oppose the Act of Union (1799–1800)

and to serve as a Member of Parliament when the passage of the act had displaced Irish political power to London. The phrases Bloom recalls have the official ("stale news") flavor of the public announcements *The Dublin Gazette* published.

118:3–5 (119:2–4). To all whom . . . exported from Ballina—the *Weekly Freeman* carried a column entitled "Market News" which listed, in prose of the sort Bloom recalls, sales of livestock in Dublin and environs. Ballina is a market town and seaport on the west coast of Ireland in County Mayo.

118:5 (119:4). Nature notes—the *Weekly Freeman* carried a page devoted to "nature notes" and to advice on agriculture and animal husbandry.

118:5 (119:4). Cartoons—the *Weekly Freeman* carried a feature entitled "Our Cartoon." It was not a caricature but a verse or jingle, usually political and satiric.

118:5–6 (119:4–5). Phil Blake's weekly Pat and Bull story—after Pat and Mike, traditional Irish-American comic figures, and cock and bull, or an Irish bull—a mental juxtaposition of incongruous ideas that provides the sensation but not the sense of a connection.

118:6 (119:5). Uncle Toby's page for tiny tots—in 1904 the *Weekly Freeman* carried a feature entitled "Uncle Remus' Address to his Nieces and Nephews," which included puzzles, games and essay competitions for children.

118:7–8 (119:6–7). Country bumpkin's queries . . . cure for flatulence—one of the features in the *Weekly Freeman* was entitled "Our Letterbox." It carried replies to questions of the sort Bloom contemplates.

118:9 (119:8). M.A.P.—M(ainly) A(bout) P(eople), a penny weekly published every Wednesday, edited by T. P. O'Connor; see 136:4n. The weekly advertised itself as "Best, Brightest, Most Brilliant of all the Society Weeklies . . . Without M.A.P. your Daily Paper is—WHAT? Well, just a string of names. With M.A.P. it becomes a fascinating panorama of the personalities of notable people with whom M.A.P. has put you on as intimate and friendly a footing as you are with your next-door neighbor—possibly a little more so."

118:12 (119:11). Cuprani—identity and significance unknown.

118:12 (119:11–12). More Irish than the Irish—in dog Latin: *Hibernicis ipsis Hibernior,* a phrase traditionally quoted against those guilty of Irish bulls; see 118:5–6n.

118:20 (119:20). Soon be calling him my lord mayor—Nannetti became lord mayor of Dublin in 1906.

118:20 (119:20). Long John—Fanning (fictional), subsheriff of Dublin, described in "Grace," *Dubliners,* as "the registration agent and mayor maker of the city."

118:33 (119:33). Meagher's—a public house at 4 Earl Street North, in the center of Dublin just north of the Liffey.

119:19 (120:20). HOUSE OF KEY(E)S—the Parliament of the Isle of Man. The island was governed by the King or Queen in council, the governor in council, and the House of Keys, i.e., the island enjoyed (as Ireland did not) a qualified home rule. The House was originally an oligarchy; after 1866 its members were chosen by popular election. "Keys" also suggests "the Power of the Keys," the supreme power of Church government vested in the pope as the successor of St. Peter (see Matthew 16:19).

119:20 (120:21). Two crossed keys—the emblem of the House of Keys.

119:37 (120:38). Kilkenny—in southeastern Ireland.

120:17 (121:21). phiz—physiognomy.

120:20 (121:23). flyboard—the board on which the printing press deposits the printed sheets.

120:20 (121:23). quirefolded—four sheets folded into eight pages.

120:27 (121:30). the archbishop's letter—does not appear in the day's *Freeman* or *Evening Telegraph;* see 117:2n.

120:30 (121:33). castingbox—a box used for taking casts for stereotyping.

121:3–4 (122:4–5). August . . . horseshow month. Ballsbridge—Ballsbridge is on the southeastern outskirts of Dublin. The *Official Guide* describes "the great *Horse Show*" early in August as "the most celebrated event in Dublin's social and sporting calendar." The show is held at the Royal Dublin Society's Agricultural Premises in Ballsbridge and "attracts sportsmen and lovers of horseflesh from every corner of the earth."

121:5 (122:6). DAYFATHER—father of the chapel for the day staff; in effect, a shop steward, because the chapel was an association of the workmen in a printing office for dealing with questions that affected their interests.

121:12 (122:13). working the machine in the parlour—i.e., working at a sewing machine. The implication is that she did piecework or was self-employed as a seamstress.

121:18–19 (122:20). his hagadah book—the word *haggadah* in Hebrew means a telling, after the injunction "and thou shalt *tell* thy son on that day," i.e., at the first seder, on the first day of the Feast of Passover when the story of the exodus of the children of Israel from Egypt is brought "into present immediacy" by being retold and acted out with ritual gestures in a religious ceremony in the home.

121:19 (122:21). Pessach—Passover.

121:20 (122:21). Next year in Jerusalem—the final phrase of the home ceremony on the first night of Passover. It climaxes a prayer to God to "rebuild . . . Jerusalem, the city of holiness, speedily in our days and bring us up into its midst."

121:21–22 (122:22–23). that brought us . . . house of bondage—in the *Haggadah* this central theme of the feast recurs three times, at the beginning, toward the middle and toward the end: ". . . by strength of hand the Lord, our God, brought us out of Egypt, from the house of bondage . . . and because Thou, the Lord, our God, didst bring us forth from the land of Egypt, and didst redeem us from the house of bondage. . . . Thou, O Lord, our God, didst redeem us from Egypt and deliver us from the house of bondage." *Cf.* Exodus 13:3, 13–14.

121:22 (122:23). alleluia—the Latin and Greek form of the Hebrew *Hallelujah,* "Praise ye the Lord."

121:22 (122:23–24). Shema Israel Adonai Elohenu—Hebrew: "Hear, oh Israel, the Lord our God." The words *Adonai Echad* ("The Lord is One") complete the chant, which is known as the *Shema* (Deuteronomy 6:4).

121:23 (122:24). the other—i.e., the *Shema,* which Bloom associates with the ceremonies of the second seder night. The prayer is not included on either seder night though it is mentioned by name in both, in a little story about several rabbis who got so engrossed in telling about the exodus from Egypt that their pupils had to remind them: "Our teachers, the time has arrived for the recitation of the morning *Shema!*" The *Shema* is part of the daily morning and evening worship services in the synagogue.

121:23 (122:24–25). Then the twelve brothers, Jacob's sons—Bloom associates Jacob's 12 sons (Genesis 35:22–27) with the 12 tribes of Israel.

On the second seder night the home festival includes a cumulative chant: "Who Knows One?" which ends with the question, "Who knows thirteen?" and the answer: "I know thirteen. Thirteen are the attributes of Divinity; twelve are the tribes of Israel; eleven are the stars of Joseph's dream; ten are the commandments; nine are the months of pregnancy; eight are the days of circumcision; seven are the days of the Sabbath-count; six are the orders of the Mishnah; five are the books of the Torah; four are the mothers; three are the fathers; two are the tables of the covenant; one is our God in the heavens and in the earth."

121:23–26 (122:25–28). And then the lamb . . . kills the cat—after the chant *Chad Gadya* ("One Kid"), which closes the home festival on the second seder night. Another cumulative chant, this one ends with the verse: "And the Holy One, blessed is He, came and killed the Angel of Death that slew the slaughterer that slaughtered the ox that drank the water that quenched the fire that burned the stick that beat the dog that bit the cat that ate the kid that father bought for two zuzim. One kid, one kid."

121:26–27 (122:28). Sounds a bit . . . into it well—in *The Haggadah of Passover, A Faithful English Rendering,* by Abraham Regelson (New York, n.d.): "*Chad Gadya* (One Kid), in outward seeming a childish lilt, has been interpreted as the history of successive empires that devastate and swallow one another (Egypt, Assyria, Babylon, Persia, etc.). The kid, bottommost and most injured of all, is, of course, the people of Israel. The killing of the Angel of Death marks the day when the kingdom of the Almighty will be established on earth; then, too, Israel will live in perfect redemption in the promised Land" (p. 63).

122:5 (123:5). Thom's—Alexander Thom and Company, Ltd., printers and publishers; *The Dublin Gazette,* published by the king's authority every Tuesday and Friday; office for the sale of Parliamentary papers and acts of Parliament; office of *Thom's Official Directory;* Government printing and book-binding establishment; 87–89 Abbey Street Middle, next door but one to the offices of the *Freeman's Journal* (*Thom's* [1904], p. 1409).

122:17 (123:17). ERIN, GREEN GEM OF THE SILVER SEA—see "Let Erin Remember the Days of Old," 46:9–10n. This is also an allusion to John of Gaunt's praise of England: "This precious stone set in the silver sea," Shakespeare, *Richard II* (II, i, 46).

122:18 (123:18). the ghost walks—theatrical and journalistic slang for "salaries are being paid."

"On payday Ruttledge [115:30n] carried a money box around with him, paying out from office to office of the old building; and his coming was announced by the phrase, 'the ghost walks'" (Ellmann, p. 298).

122:38–123:2 (124:1–3). And Xenophon looked ... on the sea—After Byron's lines, "The mountains look on Marathon—/And Marathon looks on the sea," from a lyric interpolated in *Don Juan,* "Canto the Third" (1821) between stanzas LXXXVI and LXXXVII. The Greek historian Xenophon (*c.*434–*c.*354 B.C.) was one of the leaders of the Ten Thousand (see 7:4n) as well as the chief historian of the expedition; thus he did look on the sea and join in the victory cry, "*Thalatta! Thalatta!*" Marathon, on the east coast of Attica, 22 miles from Athens, was the scene of a decisive battle in 490 B.C., in which the Athenians defeated the Persians. Marathon does physically "look on" the sea. If Xenophon "looked upon Marathon," he did so in retrospect, as historian and as yet another Greek involved in a military struggle against the Persians.

123:8 (124:9). Bladderbags—nonsense; a silly, foolish person; a babbler.

123:10 (124:11). Old Chatterton, the vice chancellor—Hedges Eyre Chatterton (1820–1910), queen's counsel (1858), solicitor general (1866), attorney general (1867), also Member of Parliament for Dublin University, and, as vice-chancellor of Ireland, a judge appointed to act for, or as the assistant to, the chancellor.

123:13–14 (124:14–15). Johnny, make room for your uncle—in the late nineteenth century, a common saying addressed to the younger man or men in a group. The saying derived from a popular song and patter routine in which one "Fred Jones, Hatter, of Leicester Square" complains of the difficulties caused by a "spoiled boy" whose widowed mother is the object of Jones's attentions. The mother introduces Jones to the boy as "your uncle." Chorus: "Tommy, make room for your uncle,/There's a little dear,/Tommy, make room for your uncle,/I want him to sit here."

123:15 (124:17). gale days—days when periodical or installment payments are due.

123:19 (124:20). fragment of Cicero's—(106–43 B.C.), Roman orator and statesman. The irony turns on Cicero's reputation as an extraordinary rhetorician.

123:25 (124:26). Dan Dawson's—Padraic Colum recalls Dawson as "one of Dublin's merchant politicians," but Dawson's identity has yet to be confirmed in Dublin newspaper files or in Thom's Directories.

124:10 (125:10). Lenehan—appears as a character in "Two Gallants," *Dubliners.*

124:12 (125:12). the pink pages—i.e., the *Evening Telegraph,* Last Pink Edition.

124:14 (125:14). Reaping the whirlwind—the prophet Hosea threatens Israel with destruction for its idolatry and impiety: "For they have sown the wind, and they shall reap the whirlwind" (Hosea 8:7).

124:15 (125:15). D. and T. Fitzgerald—solicitors, 20 Saint Andrews Street in north central Dublin. Senior partner: Thomas Fitzgerald, J. P. County Limerick, crown solicitor for County Donegaland and County and City of Londonderry, commissioner of affidavits and law agent for the commissioner of Irish Lights.

124:15–17 (125:15–17). Their wigs to ... statue in Glasnevin—i.e., barristers wear wigs as emblems of their intelligence the way the statue Bloom noticed in the cemetery wore a heart as a symbol of devotion.

124:17 (125:17). the Express—the *Daily Express,* an Irish newspaper (1851–1921), essentially conservative and opposed to Irish aspirations; its announced policy involved "the development of industrial resources" and a reconciliation of "the rights and impulses of Irish nationality with the demands and obligations of imperial dominions."

124:18 (125:18). Gabriel Conroy—the central character in "The Dead," *Dubliners.*

124:18–19 (125:20). the Independent—the *Irish Independent,* a nationalist daily newspaper.

124:22–23 (125:22–23). Go for one another baldheaded—i.e., impetuously, wholeheartedly; as acting without stopping to cover one's head.

125:1 (126:1). HIS NATIVE DORIC—a dialect, especially Scots dialect, as opposed to English.

125:2 (126:2). The moon ... He forgot Hamlet—i.e., the "logic" of the speech will inevitably carry Dawson to a rhetorical flourish about Ireland by moonlight (as it does), but Dawson "forgot" to continue the progression to Ireland at dawn, as Horatio in *Hamlet* (I, i, 166–167), "But, look, the morn, in russet mantle clad,/Walks o'er the dew of yon high eastward hill."

125:9 (126:9). welshcombed—a "Welsh comb" is the thumb and four fingers (because the Welsh were popularly regarded as a wild and unkempt people).

125:14 (126:14). WETHERUP—"Evidently he was W. Wetherup of 37 Gloucester Street Upper, who served for a while in the office of the Collector-General of Rates with John S. Joyce" (Adams, p. 217).

125:16 (126:16). like hot cake—to "sell like hot cakes" is to sell extraordinarily well.

125:26 (126:26). the sham squire—Francis Higgins (1746–1802), so called because, though he was an attorney's clerk in Dublin, he married a respectable young woman by palming himself off as a country gentleman. He went from that to the ownership of gambling houses and eventually to the ownership of the *Freeman's Journal*, which he used to libel Henry Grattan and other Irish patriots. He was also an informer and accepted a bribe of £1,000 for revealing Lord Edward Fitzgerald's hiding place to Major Sirr in 1798; see 237:34n.

126:2–6 (127:2–6). North Cork militia! . . . In Ohio!—it is doubtful whether this bit of scrambled history can ever be unscrambled. The North Cork Militia (loyal to the Crown in the Rebellion of 1798) enjoyed the dubious distinction of having disgraced itself and suffered humiliating defeats in every action in which it was involved during the Rebellion. Apparently the editor's recall of this "famous" militia is triggered by the Professor's mention of the Sham Squire, another anti-Irish Irishman whose behavior during the Rebellion was something less than glorious. The link between that militia and Ohio can only be called dubious. Territorial militias were not subject to service outside their home countries until 1827, and then only in the British Isles; thus they were never subject to service in Ohio. But the Anglo-Irishman General Edward Braddock (1695–1755), when he attempted the ill-fated invasion of the Ohio Valley in June 1755, had as the backbone of his expeditionary force two British regiments, the 44th and the 48th, which had been stationed in Cork and which had been allowed to recruit themselves up to strength from the Cork and North Cork militias before they were embarked for America in January 1755. To say the least, those regiments did not win "every time." "Spanish officers" are even more troublesome because the 44th and the 48th were commanded by men named Halkett and Dunbar; the North Cork Militia in 1798 was commanded by men named Foote, Jacob, Boyd and Le Hunt. It is just possible that the editor's excursion into mid-eighteenth-century wars involves a fantastic association of the North Cork Militia with the Irish Brigade (renegade Irish who served with the French in the eighteenth century). The Irish Brigade did distinguish itself in action and did have a rather tenuous tradition of being commanded by officers of Spanish-Irish descent.

126:9 (127:9). jigs—after "jig," to hop or skip around, the inconsistent mental processes of advanced alcoholism.

126:10–11 (127:10–11). Ohio! . . . My Ohio!—source unknown.

126:12 (127:12). cretic—a foot composed of one short syllable between two long syllables: / ˘ /.

126:13 (127:13). HARP EOLIAN—an aeolian harp is a stringed instrument designed to be played by the winds (of Aeolus) rather than by human fingers. The harp is also a national symbol for Ireland, and "harp" is slang for an Irish Catholic.

126:28–29 (127:28–29). Canada swindle case—a man named Saphiro, Sparks (or James Wought) was accused, tried and convicted of swindling, among others, one Zaretsky by promising to secure passage to Canada for 20 shillings. (The lowest advertised fares for steerage passage in 1904 were £2.) The case was remanded 17 June 1904. Saphiro was convicted and sentenced 11 July 1904.

126:33 (128:2). Sports tissues—racing forms prepared by *Sport*, a weekly penny paper, published on Saturday by the Freeman's Journal, Ltd., advertised as containing "all the sporting news of the week."

126:35 (128:4). O. Madden—was Sceptre's jockey that day contrary to the *Freeman's Journal's* morning announcement of A. Taylor. *Cf.* 84:28n.

127:26 (128:30). auction rooms—Joe Dillon, auctioneer, 25 Bachelor's Walk, a section of the north quay of the Liffey, just east of the center of Dublin.

127:38 (129:7). anno Domini—Latin: "in the year of our Lord"; hence: "years."

128:5–6 (129:13–14). We are the boys . . . heart and hand—from an Irish ballad of 1798, "The Boys of Wexford." The Boys of Wexford earned part of their reputation at the expense of the North Cork Militia: "In comes the captain's daughter,/The captain of the yeos [militia],/Saying, 'Brave United Irishmen,/We'll ne'er again be foes,/A thousand pounds I'll give you/And fly from home with thee./I'll dress myself in man's attire/And fight for liberty.' // [Chorus:] We are the Boys of Wexford/Who fought with heart and

hand,/To burst in twain the galling chain/And free our native land." The ballad goes on to cite the total defeat of the North Cork Militia by the Boys of Wexford at Oulart, and then ascribes the subsequent collapse of the Boys to alcoholic excesses.

128:14 (129:22). Begone! . . . The world is before you—in *Paradise Lost*, when Adam and Eve are expelled from Paradise, their state is described: "The World was all before them, where to choose/Thir place of rest, and Providence Their guide" (XII:646–647).

128:28 (129:36). spaugs—big clumsy feet.

128:28 (129:36). Small nines—(the newsboys are) up to all the dodges, all the little tricks.

128:28 (129:36). Steal upon larks—a "lark" is a tease; thus, to make fun of someone behind his back.

128:35 (130:7). the Oval—a bar or public house at 78 Abbey Street Middle, just south of the *Freeman* offices; John J. Egan, wine and spirit merchant.

128:35 (130:7). Paddy Hooper—Patrick Hooper, a Dublin journalist who worked as a reporter for the *Freeman's Journal* and who was to be its last editor. He was the son of Alderman John Hooper of Cork; see 112:10n.

128:35 (130:7). Jack Hall—J. B. Hall, a Dublin journalist with a considerable local reputation as a *raconteur*.

129:6 (130:14). pretty well on—half drunk.

129:10 (130:19). CALUMET—the American Indian peace pipe.

129:18–19 (130:28–29). 'Twas rank and . . . charmed thy heart—from an aria in Act III of *The Rose of Castille* (1857), an opera by Michael William Balfe (1808–1870), Anglo-Irish composer. The aria is sung by Manuel, a muleteer, to Elvira, the Rose of Castille: "'Twas rank and fame that tempted thee,/'Twas empire charmed thy heart;/But love was wealth, the world to me,/Then false one, let us part./The prize I fondly deemed my own,/Another's you may be;/For ah! with love, life's gladness flown,/Leaves grief to wed, to wed with me,/Leaves grief alone to me,/With love, life's gladness flown,/Leaves grief alone to me. // Tho' lowly bred and humbly born,/No loftier heart than mine,/Unlov'd by thee, my pride would scorn/To share the crown that's thine./I sought no empire save the heart,/Which mine can never be;/Yes, false one, we had better part,/Since love lives not in thee. . . ."

129:26 (130:35). Imperium romanum—Latin: "the Roman Empire."

129:27 (130:36). Brixton—a London suburb that at the turn of the century was regarded as the prototype of the drab machine-made life of the urban-industrial world. George Moore (see 189:23n) remarked on England and her language, "to begirdle the world with Brixton seems to be her ultimate destiny. And we, sitting on the last verge, see into the universal suburb, in which a lean man with glasses on his nose and a black bag in his hand is always running after his bus" (quoted in Edward Gwynn, *Edward Martyn and the Irish Revival* [London, 1930], pp. 242–243).

129:33 (131:5). THE GRANDEUR THAT WAS ROME—from Edgar Allan Poe (1809–1849), "To Helen" (1831, 1845), stanza 2: "On desperate seas long wont to roam,/Thy hyacinth hair,/Thy classic face,/Thy Naiad airs have brought me home/To the glory that was Greece,/And the grandeur that was Rome."

130:3–4 (131:12). Cloacae—sewers or toilet bowls.

130:5 (131:13–14). It is meet . . . altar to Jehovah—this seems less a direct quotation than a generalization of the Hebrew belief in the necessity of constructing an altar as witness or testimony when new lands or release from captivity were achieved. In Matthew 17:4, after Peter and two of the other disciples have seen Jesus "transfigured," Peter says, "Lord, it is good for us to be here: if thou wilt, let us make here three tabernacles; one for thee, and one for Moses, and one for Elias."

130:7–8 (131:16). (on our shore he never set it)—there is considerable evidence that the Mediterranean world (and the Romans) knew of Ireland and carried on some commerce with the island (see 320:33–36n). But the Romans were apparently content with commercial relations and did not attempt to establish a foothold for conquest. Irish historians have debated this point and some have argued that it was not Roman policy but Irish valor that prevented the Romans; but Roman forbearance was consistent with that Roman imperial policy which preferred direct overland communication with conquered territories. From a Roman point of view the conquest of Ireland would have meant the prior conquest of at least Wales if not also Cornwall, as against a precarious sea link around those unconquered regions.

130:8 (131:16). cloacal obsession—as Thornton (p. 114) points out, this phrase has been borrowed from the English novelist-critic H. G. Wells (1866–1946), whose review of *A Portrait*

of the Artist as a Young Man was rather severe ("James Joyce," New Republic, 10 March 1917, X, p. 159). "Like Swift and another living Irish writer, Mr. Joyce has a cloacal obsession. He would bring back into the general picture of life aspects which modern drainage and modern decorum have taken out of ordinary intercourse and conversation."

130:12 (131:20). Guinness's—Lenehan's pun (a common pun in Dublin) conjoins Genesis with Guinness's, the famous Dublin brewery. Since Genesis 1 is the story of the Creation, the pun involves the triad: as the Jews were to their altars, and the Romans to their waterclosets, so the Irish are to their drink.

130:15 (131:23). Roman law—the blend of common law and legislation that governed the citizens of Rome. In modern English usage, the term "civil law" designates all the existing systems of private law that are in the main based on Roman law.

130:15 (131:24). Pontius Pilate is its prophet—as Jesus was the prophet whose "kingdom is not of this world" (John 18:36), so Pilate is the prophet whose kingdom is of this world. When asked to condemn Jesus, Pilate asserts: "I find in him no fault at all" (John 18:38). In spite of this legal finding, Pilate condemned Jesus in order to forestall what Pilate regarded as the threat of insurrection in Jerusalem. MacHugh's remark echoes the Moslem profession of faith: "There is no god but God [Allah]; and Mohammed is His Prophet."

130:18 (131:26). chief Baron Palles—Christopher Palles (1831–1920), Irish barrister and lord chief baron of the Exchequer, i.e., the chief judge in the Court of Exchequer, a division of the High Court of Justice in Ireland.

130:19 (131:27). the royal university—not an institution of higher learning, but an examining and degree-granting institution in Dublin. It was established by the University Education Act of 1879 and organized in 1880 to align higher education in Ireland with English academic standards.

130:22 (131:30). Mr. O'Madden Burke— appears as a character in "A Mother," Dubliners.

130:25 (131:33). Entrez, mes enfants!— French: "Enter, my children!"

130:29 (131:37). governor—father.

130:39 (132:10). pelters—a whoremonger, a tramp.

131:1–4 (132:12–15). On swift sail . . . to my mouth—Stephen's version of the last stanza of Douglas Hyde's "My Grief on the Sea"; see 48:34–36n.

131:14 (132:25). the Star and Garter—a hotel at 16 D'Olier Street in the southeastern quadrant of Dublin near the Liffey.

131:15–17 (132:26–28). A woman brought . . . prince of Breffni—see 35:35–41 (34:39–35:2) and accompanying notes.

131:19 (132:30). a grass one—a grass widower; in 1904 a man temporarily separated from his wife.

131:20 (132:31). Emperor's horses—see 34:8–9n.

131:20 (132:31). Habsburg—the imperial royal house of Austria-Hungary. Franz Joseph (1830–1916; emperor, 1848–1916).

131:20–22 (132:31–33). An Irishman saved . . . Tirconnel in Ireland—Maximilian Karl Lamoral Graf [Earl or Count] O'Donnell von [of] Tirconnell (b. 1812), Austrian-born son of an Irish expatriate, was aide-de-camp to Emperor Franz Joseph. On 18 February 1853 he attended the Emperor on his daily walk around the bastions that encircled old Vienna. The Emperor was attacked and wounded by a knife-wielding Hungarian tailor; O'Donnell knocked the would-be assassin down and prevented further attack. The Emperor subsequently asserted that he owed his life to O'Donnell.

131:22–23 (132:34–35). Sent his heir . . . Austrian fieldmarshal now—Edward VII made several attempts to exploit his friendly relations with Emperor Franz Joseph in the hope of loosening the Austrian alliance with Germany. On a state visit to Vienna in 1903 Edward VII announced his appointment of the Emperor as a Field Marshal of the British Army. On 9 June 1904, Franz Joseph's heir, Archduke Francis Ferdinand, in the course of a state visit to England, handed Edward VII the baton of an Austrian field marshal "without any kind of ceremony."

131:23 (132:35). Wild geese—the O'Donnells in Spain and Austria were one of the most famous of the wild-goose families; see 42:14–15n.

131:28 (133:3). a thank you job—i.e., a job that is not rewarded by anything more substantial than a "thank you."

132:3 (133:14). time is money—the maxim was popularized by Benjamin Franklin in "Advice to a Young Tradesman" (1748). Victor Hugo in Les

Miserables (1862), Book IV, Chapter 4: "Take away *time is money* and what is left of England?"

132:4 (133:15). Dominus!—Latin: "master, possessor, ruler, lord, proprietor, owner."

132:4–5 (133:16). Lord Jesus! Lord Salisbury —i.e., both the spiritual and the temporal "master" have the same title. Robert Arthur Talbot Gascoyne Cecil, 3rd Marquis of Salisbury (1830–1903), leader of the Conservative party in England and hence anti-Gladstone and against any concession to the Irish. He was prime minister of England 1885–1886, 1886–1892, 1895–1902.

132:5 (133:16). A sofa in a westend club—i.e., Lord Salisbury asserted his "dominion" from the comfortable seclusion of an aristocratic and fashionable club in London.

132:6 (133:18). KYRIE ELEISON—Greek: "Lord have mercy [upon us]." The Kyrie forms a regular part of the Mass.

132:9 (133:21). Kyrios!—Greek: "a lord or a guardian."

132:10 (133:22). vowels the Semite and the Saxon know not—i.e., the twentieth letter of the Greek alphabet, the vowel *upsilon*, for which there is no equivalent in Hebrew or in English. It is rendered in English by the inexact equivalents *u* and *y* (as in "Kyrie"). Indirectly MacHugh is alluding to the controversy about the traditions of Greek pronunciation, as those traditions were under attack in Germany (1880 *ff.*) and as they were to be defended in an extraordinary outbreak at Oxford (1905–1906).

132:14 (133:26). that foundered at Trafalgar —Napoleon's bid for mastery of the sea (and with it a firmer hold on his mastery of Europe) foundered when the British fleet under Admiral Lord Nelson defeated the combined French and Spanish fleets, 21 October 1805, off the Cape of Trafalgar, 29 miles northwest of the western entrance to the Straits of Gibraltar; the British thus effectively deprived Napoleon's Continental empire of overseas trade and hastened its collapse.

132:15 (133:27). imperium—Latin: "dominion, realm, empire."

132:15–16 (133:27–28). that went under . . . fleets at Aegospotami—the Spartans under Lysander (d. 395 B.C.) surprised the unguarded Athenian fleet and destroyed its ships and 3,000 of its men at Aegospotami in Thrace (405 B.C.). This disaster virtually brought the Peloponnesian War to an end and ensured the fall of Athens.

132:16–18 (133:29–30). Pyrrhus, misled by . . . fortunes of Greece—late in his career and after failures in Italy and Sicily, Pyrrhus launched a campaign against Sparta that appeared to have as its goal the capture of all of the Peloponnesus. The "oracle" that misled Pyrrhus was a dream that he read as promising him success in his attempt to reduce Lacedaemon (Sparta), the capital of Laconia. He could have bypassed the town with considerable profit, but the continued effort to reduce the city depleted his forces, gave the Spartans time to bring up reinforcements and resulted in the defeat of his campaign.

132:20–21 (133:32–33). They went forth . . . they always fell—the title of a poem by W. B. Yeats in *The Rose* (1893). The poem, rewritten and retitled "The Rose of Battle," appears on p. 37 of *The Collected Poems*. Yeats took the initial title from Matthew Arnold's epigraph to the *Study of Celtic Literature* (London, 1867): "They came forth to battle, but they always fell."

132:22–24 (133:34–134:2). Owing to a brick . . . poor Pyrrhus!—see 25:21–22n.

132:31 (134:9). the Joe Miller—i.e., the joke, because Joe Miller was a comedian who flourished during the reign of George I of England. Miller authored a book of jokes that was repeatedly revised and reissued in the nineteenth century. Joe Miller's jokes came to be regarded as old chestnuts, corny stories.

132:32 (134:10). In mourning for Sallust—Mulligan's quip at the expense of MacHugh. Sallust, Gaius Sallustius Crispus (86–34 B.C.), Roman historian and an active partisan of Caesar.

133:4 (134:19). The Rose of Castille—an opera; see 129:18–19n.

133:4 (134:19). wheeze—an overworked gag or joke.

133:14 (134:29–30). communards—members of the Commune of Paris, the left-wing insurrectionary force that held control of Paris from March 1871, when the German occupation troops departed, to May 1871, when the insurrection was put down by the Republican government of France.

133:15 (134:31). blown up the Bastille—the Bastille St.-Antoine, a fortress-prison in Paris, was stormed and destroyed by a revolutionary mob 14 July 1789. The date is usually regarded as marking the beginning of the French Revolution.

133:16–18 (134:32–34). Or was it you . . . General Bobrikoff—Nikolai Ivanovitch Bobrikoff (1857–1904), Russian general, governor-

general and commander in chief of the military district of Finland (1898–1904). He was given dictatorial powers, and he used them ruthlessly to suppress Finland's constitutional liberties and to carry out the policy of Russianizing Finland. *The New York Times,* 17 June 1904, characterized him as "a typical Russian tyrant." He was assassinated at 11:00 A.M., 16 June 1904, by Eugene Schaumann, the son of a former Finnish senator. Since this 11:00 A.M. was Helsinki time, it would have been 8:35 A.M. Dublin time; and the news would have reached Dublin in the course of the morning.

133:19 (135:1). OMNIUM GATHERUM— dog Latin: "All are gathered."

133:34–35 (135:16–17). In the lexicon of youth —from *Richelieu* (1838), a play by the English novelist-playwright-politician Edward Bulwer-Lytton. In Act III, scene i, Richelieu sends his page, Francois, on a dangerous mission; Francois asks, "If I fail—" and Richelieu responds, "Fail—Fail? In the lexicon of youth, which fate reserves/For a bright manhood, there is no such word/As 'fail.'"

133:36 (135:18–19). See it in your face . . . idle little schemer—in Chapter I of *A Portrait of the Artist as a Young Man,* Stephen, at Clongowes, has broken his glasses and cannot work. He is unjustly punished by Father Dolan, the Prefect of Studies, who says: "Out here, Dedalus. Lazy little schemer. I see schemer in your face. . . . Lazy idle little loafer! . . . Broke my glasses! An old schoolboy trick! Out with your hand this moment."

134:2 (135:21). Great nationalist meeting in Borris-in-Ossory—Borris-in-Ossory, a fair town 66 miles south-southwest of Dublin. Its name is associated with pre-English, Roman Catholic Ireland and with the riches of that cultural past. In 1843 Daniel O'Connell held one of his "monster meetings" there (because the town was associated with an ancient and *free* Ireland) in the course of his campaign for repeal of the Act of Union. In 1904 the Nationalists toyed with the idea of imitating O'Connell's campaign. After the deposition of Parnell in 1890, the Nationalist (Parliamentary or Home Rule) party was divided against itself under the titular leadership of John Redmond (1856–1918). Redmond's aides, Timothy Healy, William O'Brien and John Dillon, were rivals as much as they were aides. It was not until 1900 that Redmond was able to restore an appearance of unity to the party, and even then he was not able to restore its vitality and effectiveness.

134:5 (135:24). Jakes McCarthy—a "jakes" is an outdoor toilet or privy; J. McCarthy was a pressman on the *Freeman's Journal.*

134:10 (135:29). GALLAHER—see 87:23n.

134:13 (135:32). shaughraun—wandering about, out of employment.

134:14 (135:33). billiardmarking—taking charge of a billiard room as a combination clerk and janitor.

134:14 (135:33). the Clarence—Clarence Commercial Hotel at 6–7 Wellington Quay on the south bank of the Liffey just east of the center of Dublin.

134:17–18 (136:3–4). That was in eighty-one . . . the Phoenix park—see 80:23n and 80:24n. Crawford is mistaken about the year; it was not 1881 but 1882. Also the identities of the Invincibles involved were not revealed until Peter Carey, a member of the group, turned Queen's evidence on Saturday, 10 February 1883.

134:21 (136:7). The New York World—a daily New York newspaper owned by the financier Jay Gould from 1876–1883. Gould used the paper to manipulate stock prices and paid little attention to its handling of the news, which was dull enough to earn the comment: "Page one was about as exciting as Gray's 'Elegy in a Country Churchyard.'" The *World* did however devote considerable space on 7 and 8 May 1882 to its coverage of the Phoenix Park murders. When the *World* was acquired by Joseph Pulitzer in May 1883, it rapidly achieved an international reputation for hard-hitting and sensational, though accurate, reporting and for aggressive, muckraking journalism. This latter reputation seems to be the one associated with the *World* in this passage.

134:25 (136:11). Tim Kelly, or Kavanagh— "young Tim" Kelly was one of the Invincibles, but it was Michael Kavanagh who drove the getaway cab, and it was Kavanagh who was on the stand and whose testimony was broken when Carey turned Queen's evidence.

134:26 (136:12). Joe Brady—another of the Invincibles, who earned, whether rightly or wrongly, the reputation of having been the chief assassin. It was Brady who revealed that the primary target of the plot had been Burke (on account of his role in the English policy of coercion).

134:26–27 (136:12–13). Where Skin-the-Goat drove the car—Skin-the-Goat James Fitzharris did not drive the getaway cab (which was driven by Kavanagh and which took the circuitous route Crawford describes). Fitzharris drove a decoy cab over a direct route from Phoenix Park to the center of Dublin.

134:29 (136:15). Butt bridge—the easternmost of Dublin's bridges over the Liffey.

134:32 (136:18). Gumley—whether fictional or real, another declining and falling member of the Irish middle class.

135:1-2 (136:27). 17 March—significantly Irish since it is St. Patrick's Day, but the date is a misleading flourish since it is not clear whether Crawford is talking about a real *Weekly Freeman* in 1882 at the time of the murders, or in February 1883 at the time of the trial, or 1904 (*Weekly Freeman*, 19 March 1904); or whether he is just giving a random example with a flourish.

135:9 (136:35). parkgate—at the southeastern entrance to Phoenix Park; the gate nearest to the center of Dublin.

135:11 (136:37). viceregal lodge—the residence of the lord lieutenant of Ireland, was in the northwestern quadrant of the park.

135:12 (136:38). Knockmaroon gate—at the western extremity of Phoenix Park.

135:19-20 (137:6-7). Inchicore, Roundtown, Windy Arbour, Palmerston Park, Ranelagh —describes the Invincibles' roundabout route, looping south from Phoenix Park, then east and north to the center of Dublin. Inchicore is south of the Liffey on the western outskirts of Dublin; thus it is south of Phoenix Park. Roundtown is a village south of Dublin and west of the city's center. Windy Arbour (or Windy Harbour) is a road north of Phoenix Park and is consequently an interruption of the geographical sequence. Palmerston Park is south of Dublin and slightly east of the city's center. Ranelagh is north of Palmerston Park, between it and the outskirts of metropolitan Dublin.

135:20 (137:7). Davy's publichouse—the Invincibles did stop for a drink at the public house of J. and T. Davy, 110A–111 Leeson Street Upper, on the outskirts of Dublin just northeast of Ranelagh.

135:24-25 (137:11-12). Burke's publichouse— one Daniel Burke had four licensed premises at different locations in the city, all of them remote from Leeson Street Upper, none of them apparently involved in the Invincibles' escape route.

135:30 (137:17). Nightmare from which you you will never awake—see 35:19-20n.

135:31 (137:18-19). Dick Adams—Richard Adams (b. 1846) was a journalist on the *Cork Examiner* and subsequently on the *Freeman's Journal*. He became a member of the Irish Bar in 1873 and first became famous for his defense of some of those (including James Fitzharris) charged with complicity in the Phoenix Park

murders. In 1894 he became a judge of the County Courts of Limerick and Down. He was a noted wit and humorist.

135:35 (137:22). Madam, I'm ... I saw Elba— two well-known palindromes.

135:36-136:1 (137:23-24). the Old Woman of Prince's street—a nickname for the *Freeman's Journal*. It combines "old woman" (an epithet for Ireland) with a suggestion of the *Journal*'s rather fussy and cautious editorial support of Home Rule.

136:2 (137:25). Gregor Grey—*Thom's (1904)*, p. 1886, lists Gregor Grey, artist, (and George Grey, engraver) at 1 Sherrard Street Lower in Dublin.

136:4 (137:27). Tay Pay—from the Irish pronunciation of "T. P." for Thomas Power O'Connor (b. 1848), Irish journalist and politician who founded and edited several newspapers and weeklies in London, including the *Star* and the *Sun* (newspapers); the *Weekly Sun*, *M.A.P.*, and *T.P.'s Weekly*.

136:4 (137:27). the Star—founded in 1888 by T. P. O'Connor and edited by him for two years.

136:5 (137:28). Blumenfeld—Ralph D. Blumenfeld (1864–1948), American-born newspaperman and editor who became the expatriate editor of the *Daily Express* in London, 1904.

136:5 (137:28). Pyatt—Félix Pyat (1810–1889), a French social revolutionary and journalist, had a checkered career on the European Revolutionary Committee in Belgium and England; he was involved in the Paris Commune in 1871 (see 133:14n) and subsequently escaped to London. He contributed to several newspapers and edited several revolutionary journals.

136:7 (137:30). the father of scare journalism —i.e., Pyat. An overstatement and an oversimplification.

136:8 (137:31). the brother-in-law of Chris Callinan—i.e., Gallaher. Callinan was "a Dublin journalist famous for his gaffes, bloopers and Irish bulls" (Adams, p. 216).

136:18 (138:2). some hawkers were up before the recorder—the recorder was the chief judicial officer of Dublin; in 1904 the Honourable Sir Frederick Richard Falkiner (1831–1908), Recorder of Dublin (1876–1905). The hawkers involved did not appear in so august a presence as the recorder's but rather in Police Court, 8 June 1904. They had been arrested for selling postcards and mementoes of the Phoenix Park murders. The *Freeman's*

Journal, 9 June 1904 (p. 2, column j), reports that in spite of repeated police warnings, beginning in November 1903, the hawkers had not desisted. Lady Dudley and the recorder are flourishes of fiction, not fact. See Adams, p. 230.

136:19 (138:3). Lady Dudley—née Rachel Gurney, the wife of William Humble Ward, Earl of Dudley (1866–1932), lord lieutenant of Ireland (1902–1906).

136:21 (138:5). that cyclone last year— 26–27 February 1903, one of the most severe gales in Dublin's history (compared at the time to that of 1839; see 14:31–32n). The gale caused great damage to property and particularly to trees in Phoenix Park.

136:24 (138:7). Number One—the leader of the Invincibles, identity uncertain.

136:25 (138:9). in the hook and eye department—i.e., involved in inconsequential dealings.

136:27 (138:11). Whiteside—James Whiteside (1804–1876), Irish barrister, famous for his forensic eloquence and for his defenses of Daniel O'Connell in 1844 and of Smith O'Brien in 1848. He became Lord Chief Justice of Ireland in 1866.

136:27 (138:11–12). Isaac Butt—(1813–1879), Irish barrister and politician. He is reputed to have been a great orator and a kindly man; known as "the father of Home Rule," he was also famous for his participation in the defenses of Smith O'Brien in 1848 and of the Fenian Conspirators (1865–1868). His leadership of the Home Rule movement was balanced and moderate, though not so "conservative" as it seemed in retrospect after he was displaced by Parnell.

136:28 (138:12). silvertongued O'Hagan— Thomas O'Hagan (1812–1885), a barrister and a jurist. In the 1840s he was associated with O'Connell in lawsuits bearing on Irish national rights, but his reputation in Ireland was mixed because he defended the union of the Irish and English parliaments and because he seemed to benefit from what was regarded as a pro-English stance. He was the first Catholic to become lord chancellor of Ireland (1868–1874; 1880–1881). Raised to the House of Lords in 1870, he was famous for his eloquent, pro-Irish appeal for the Irish Land Bill in 1881.

136:28–29 (138:13). Only in the halfpenny place!—i.e., only second rate.

136:37 (138:21). two men dressed the same, looking the same—in view of the freewheeling associations from Dante that follow, these phrases suggest the closing phrases of Dante's vision of "the Divine Pageant" (*Purgatorio* XXIX:134–135), "I saw two aged men, unlike in raiment, but like in bearing, and venerable and grave." *Cf.* 137:4–5n and 137:7–8n.

137:1–3 (138:23–25). . . . la tua pace/. . . che parlar ti piace/. . . mentrechè . . . si tace— the closing words of lines 92 and 94 and all of line 96 in Canto V of Dante's *Inferno.* Francesca da Rimini, one of the carnal sinners, is speaking to Dante. The phrases Stephen recalls are italicized in the following translation: "If the King of the Universe were our friend, we would pray him for *thy peace:* seeing that thou hast pity of our perverse misfortune. Of that which *it pleases thee to speak* and to hear, we will speak and hear with you, *while the wind, as now, is silent for us.*"

137:4–5 (138:26–27). He saw them three . . . in russet, entwining . . . in mauve, in purple— this transition from the idealized image of the sinner Francesca da Rimini *(Inferno)* to the idealized image of the Virgin Mary *(Paradiso)* is made by way of fragments from Dante's vision of "the Divine Pageant" in *Purgatorio* XXIX. The girls approach in bands, "Three by three" (110), "one so red that hardly would she be noted in the fire" (122–123), "the next . . . as if her flesh and bone had been made of emerald" (124–125); "four clad in purple, made festival" (130–131).

137:5 (138:27). per l'aer perso—Italian: "through the black (ruined) air" *(Inferno* V:89). Francesca da Rimini addresses Dante when she first recognizes that he is a living creature.

137:6 (138:28). quella pacifica oriafiamma— Italian: "that peaceful oriflamme (gold-flame)" (Dante, *Paradiso* XXXI:127). In Dante's vision the oriflamme is intensified in its center, and he sees first a concentration of "more than a thousand angels making festival"; then in their midst he sees the Virgin Mary, "smiling on their sports."

137:6–7 (138:28–29). di rimirar fe piu ardenti —Italian: "more ardent to regaze" (*Paradiso* XXXI:142). St. Bernard, Dante's guide in this final stage of his journey, watches Dante's inarticulate wonder at this vision of the Virgin Mary; and then Bernard "turned his eyes to her, with so much love that he made mine *more ardent to regaze.*"

137:7–8 (138:29–30). But I old men . . . underdarkneath the night—at the close of "the Divine Pageant" Dante reemphasizes the penitence which is the inescapable precondition of Christian festivity, "Then saw I four of lowly semblance; and behind all, an old man solitary, coming in a trance, with visage keen" (*Purgatorio* XXIX:142–144).

137:10 (138:32). SUFFICIENT FOR THE DAY—Jesus in the course of the Sermon on the Mount: "Take therefore no thought for the morrow: for the morrow shall take thought for the things of itself. Sufficient unto the day *is* the evil thereof" (Matthew 6:34).

137:14 (139:1). the third profession—law; the other two: divinity and medicine.

137:14–15 (139:2). your Cork legs—the pun combines the fact that Crawford is from Cork with an Ulster ballad, "The Runaway Cork Leg." The ballad tells the story of a Dutch merchant, "full as an egg," who tries to kick a poor relation who has come to beg. The merchant kicks a keg instead of the relative; he loses his leg and substitutes a cork one that won't stop running: "So often you'll see in the dim half light /A merchant man and cork leg tight,/And from these you may learn that it's wrong to slight,/A poor relation with a keg in sight!'"

137:15–16 (139:3). Henry Grattan—(1746–1820), Irish statesman and orator, a leader in Ireland's struggle for increased legislative independence (1782), and likewise a leader of opposition to the Act of Union. He was also a leader of the political movement for Catholic emancipation, which was not accomplished until nine years after his death.

137:16 (139:3). Flood—Henry Flood (1732–1791), Irish statesman and orator, played a prominent part in Irish political opposition to English dominion. Flood was, for a time, a supporter of Grattan, but eventually quarreled with him.

137:16 (139:3). Demosthenes—(c. 384–322 B.C.), reputed to have been the greatest of the Greek orators. He was also a patriot and a leader of the opposition to the opportunistic and expansionist policies of Philip II of Macedon.

137:16 (139:3–4). Edmund Burke—(1729–1797), Irish-born English parliamentarian, orator and essayist. He advocated policies of conciliation toward both Ireland and pre-Revolutionary America. He was noted not only for his eloquence but also for the thoroughness of his research and the precision of his logic. A moderate and a purist in politics, he earned a reputation as a conservative late in his career, when his opposition to the French Revolution appeared to contradict his emphasis on conciliation.

137:17 (139:4–5). His Chapelizod boss, Harmsworth—Alfred C. Harmsworth, Baron Northcliffe (1865–1922), an English editor and publisher, was born at Chapelizod, just west of Dublin. In 1888 he started a weekly journal, *Answers;* in 1894 he gained control of the *London Evening News,* and in 1896 he founded the *London Daily Mail.* He also published *Harmsworth's Magazine* (1898 *ff.*) and several popular magazines for children. He regarded himself as a champion of "the newspaper of the future."

137:18 (139:5). the farthing press—i.e., cheap and sensational journalism.

137:18–19 (139:5–6). his American cousin of the Bowery gutter sheet—i.e., Harmsworth's personal friend, the American publisher Joseph Pulitzer (1847–1911). Pulitzer's *New York World* (see 134:21n) had its offices in Park Row, not in the Bowery; but when Pulitzer took over the *World* in 1883, he told its then genteel staff, "A change has taken place in the *World.* Heretofore you have all been living in the parlour and taking baths every day. Now I wish you to understand that, in future, you are all walking down the Bowery." Pulitzer and Harmsworth were close enough for Pulitzer to have Harmsworth edit a special edition of the *World* for 1 January 1900; but they were estranged in 1907 when Harmsworth (in spite of a no-raid agreement) hired away one of Pulitzer's protégés. *Our American Cousin* (1858), a comedy by Tom Taylor (1817–1880), is a play with one distinction: Lincoln was watching it when he was assassinated.

137:19 (139:6). Paddy Kelly's Budget—(November 1832–January 1834), a humorous weekly newspaper published in Dublin. Its humor was essentially topical and was regarded as vulgar by its Dublin audience.

137:19–20 (139:7). Pue's Occurrences—the first daily newspaper in Dublin, founded in 1700 and continued for half a century.

137:20 (139:7–8). The Skibereen Eagle—a general weekly newspaper, published in Skibereen, County Cork (c.1840–1930); originally *The Skibereen Eagle,* it became *The Munster Eagle* after the 1860s and by 1904 was being published as the *Cork County Eagle.* The newspaper that replaced the *Eagle* after the 1930s is called *The Southern Star.* The original change of name was occasioned by the fact that "Skibereen Eagle" became a laughing-stock phrase for the obscure provincial newspaper that overreached itself in political bluster, as the *Eagle* once portentously informed the Prime Minister of England and the Emperor of Russia that it "had got its eyes" on them.

137:21 (139:8–9). Whiteside—see 136:27n.

137:21–22 (139:9). Sufficient for the day is the newspaper thereof— parodies Jesus' words in Matthew 6:34, "Take therefore no thought for the morrow: for the morrow shall take thought

for the things of itself. Sufficient unto the day *is* the evil thereof."

137:24 (139:11). Grattan and Flood—did contribute articles to the *Freeman's Journal.* (The newspaper was founded in 1763.) See 137:15–16n and 137:16n.

137:26 (139:13). Dr. Lucas—Charles Lucas (1713–1771), Irish physician and patriot, of whom Grattan said: "He laid the groundwork of Irish liberty." He was a frequent contributor to the *Freeman's Journal,* over the bylines "Civis" or "A Citizen."

137:26–27 (139:13–14). John Philpot Curran —(1750–1817), Irish barrister, patriot and orator, whose reputation was that he animated every debate in which he was involved. His theme was "universal emancipation," and he was famous for his defenses of the prisoners of 1798 and of other "traitors."

137:28 (139:15). Bushe K. C.—Seymour Bushe (1853–1922), King's Council. Bushe was an Irish barrister who was senior Crown Council for the County and City of Dublin (1901) before he moved to England and became King's Council in 1904.

137:30 (139:17). Kendal Bushe—Charles Kendal Bushe (1767–1843), Irish jurist and orator, an ally of Grattan in the opposition to the Act of Union. He was reputed to have been the most eloquent orator of his day.

137:31–32 (139:19–20). He would have been on the beach . . . only for—Seymour Bushe's career was clouded by a "Matrimonial tangle" which finally prompted his departure from Ireland. Mr. Colum Gavan Duffy, Librarian of the Incorporated Law Society of Ireland, reports in a letter dated 23 October 1970: "It seems that a certain Sir ――― Brook and his wife were rather estranged, and that on a certain occasion the husband followed his wife to Dublin. He eventually found his wife in the room of Mr. Bushe and threatened to take proceedings against him. As there was no divorce in Ireland, these proceedings would consist in the tort of 'Criminal Conversation,' whereby the husband would sue the alleged co-respondent for damages for adultery. It is for this reason that I understand Mr. Bushe left. . . . He also drank heavily."

137:36 (139:25). the Childs murder case— see 98:35n.

138:1 (139:26). and in the porches of mine ear did pour—the Ghost, as he tells Hamlet the manner of his death at the hands of his brother Claudius. Claudius "stole" upon King Hamlet when the King was "Sleeping within my orchard,/ My custom always of the afternoon . . . /And in the porches of my ears did pour/The leperous distilment . . . " (*Hamlet,* I, v, 59–63).

138:2–3 (139:27–28). By the way . . . with two backs?—Stephen's first question should read, **By the way how did . . .** as it does (139:27). The question involves the assumption that the Ghost could not have known the manner of his death unless it had been revealed to him after his death. "The other story": the Ghost tells Hamlet that Claudius is an "adulterate beast"; and that the Queen has been only "seeming virtuous" (I, v, 42–46). This Stephen interprets to mean that before King Hamlet's death Claudius and the Queen had committed adultery, had made, in Iago's words, "the beast with two backs" (*Othello,* I, i, 117–118). But the question remains: how did King Hamlet find these two things out?

138:5 (139:30). ITALIA, MAGISTRA ARTIUM—Latin: "Italy, Mistress of the Arts."

138:7–8 (139:32–33). the earlier Mosaic code, the lex talionis—the Mosaic code as propounded in the Old Testament (Exodus 21:23–25) is the law of retaliation: an eye for an eye, a tooth for a tooth, etc. *Lex talionis* is the Latin phrase for that law, "the law of punishment similar and equal to the injury sustained."

138:8–9 (139:33–34). the Moses of Michelangelo in the Vatican—Michelangelo (1475–1564) carved the *Moses* (1513–1516) as part of a mausoleum for Pope Julius II. The mausoleum stood (and still stands) not in the Vatican but in San Pietro Vincoli (St. Peter in Chains) in Rome. A statue of Moses, flanked by figures of Justice and Mercy, also dominated the central portico of the Four Courts, the building that housed the higher courts of Ireland (in the center of Dublin on the north bank of the Liffey).

138:16–19 (140:6–9). I have often thought . . . of both our lives—this stylistic intrusion echoes the Dickens of *David Copperfield* (1849–1850) and *Great Expectations* (1861), as, for example, David on the wedding of Peggoty and Barkis: "I have often thought, since, what an odd, innocent, out-of-the-way kind of wedding it must have been! We got into the chaise again soon after dark, and drove cosily back, looking up at the stars and talking about them" (Chapter X).

139:2 (140:27). Professor Magennis—William Magennis, a professor at University College, Dublin. He was apparently something of an arbitrator on the Irish literary scene at the turn of the century.

139:4 (140:28–29). that hermetic crowd— the literary *avant-garde* of the late nineteenth and early twentieth century was fascinated by hermetic and theosophical lore. AE (George Russell) was a member of the Second Dublin Lodge, chartered in 1904 by Madame Blavatsky's Theosophical Society. In 1909 the Lodge re-established itself as the independent Hermetic Society.

139:4 (140:29). the opal hush poets—"opal" and "hush" were two of AE's favorite poetic words.

139:5 (140:30). That Blavatsky woman— Helena Petrovna Blavatsky (1831–1891), a Russian traveler and theosophist who expanded her interest in spiritualism and the occult with rather impressionistic studies of the esoteric doctrines of India, the Middle East and the medieval cabalas, both Christian and Hebrew. She founded the Theosophical Society in 1875 and in 1876 published a "textbook" for her followers, *Isis Unveiled, A Master Key to the Mysteries of Ancient and Modern Science and Philosophy*. She was a controversial figure, frequently investigated and discredited because she made fanciful claims about her Indic scholarship (she knew practically no Sanskrit) and about her capacity to perform miracles (including the miracle of reappearing in the flesh after her death).

139:8 (140:33). planes of consciousness— theosophical doctrine conceived the phenomenon of life as a function of seven planes of consciousness: (1) elemental or atomic, a simple consciousness of the elements of matter; (2) mineral or molecular consciousness, the consolidating of the elements into form according to a definite principle of design; (3) vegetable or cellular consciousness, a recombining of matter through growth and expansion by the principle of life; (4) animal or organic consciousness, the direction of life and matter by the principle of desire; (5) human, "I-am-I," the self-identifying consciousness; (6) universal consciousness, "I-am-thee-and-thou-art-I," the relating of all elements and souls together, thus overcoming the sense of separateness; (7) Divine Consciousness, that which sees no separateness but unites all as one.

139:15–16 (141:3–4). John F. Taylor—(c. 1850–1902), Irish barrister, orator and journalist. He was Dublin correspondent for the *Manchester Guardian* and "in the opinion of good judges, the finest Irish orator of his time." On 24 October 1901 Taylor did make the speech that MacHugh attempts to recall; see 140:10–11n.

139:16 (141:4). college historical society— the Trinity College Historical Society, founded in 1770, describes itself as "the oldest University Debating Society in Ireland or Great Britain." Its membership has included most of the famous orators and patriots Miles Crawford has cited above.

139:16 (141:4). Mr. Justice Fitzgibbon— Gerald Fitzgibbon (1837–1909), Irish, but a devoted Freemason and a staunch Conservative (hence anti-Home Rule). He was made Lord Justice of Appeal in 1878; and as commissioner of National Education, he was regarded as one of those who were attempting to Anglicize Ireland.

139:19 (141:7). revival of the Irish tongue— part of a movement that had gained considerable momentum by the early twentieth century. The aim was to re-create an *Irish* Ireland. Ostensibly cultural, the movement was political and revolutionary in its overtones.

139:23 (141:11). Tim Healy—Timothy Michael Healy (1855–1931), an Irish politician and patriot who first distinguished himself as Parnell's "lieutenant" and subsequently (because he was one of the leaders of the move to oust Parnell from leadership of the Irish Nationalist party) as Parnell's "betrayer." He worked consistently, however, for the achievement of Irish independence.

139:24 (141:12). the Trinity College estates commission—the commission was appointed on 9 June 1904 by the lord lieutenant of Ireland. Its purposes according to its report (Dublin, 1905) were: "(1) To inquire into and report upon the relations subsisting between the Grantees and Lessees and the Occupying Tenants, since the date of the passing of the Trinity College, Dublin, Leasing and Perpetuity Act, 1851; and (2) To inquire into and report upon the means by which the Purchase by the Occupying Tenants of the Holdings pursuant to the provisions of The Land Purchase Acts may be facilitated without diminishing the Average New Rental derived by Trinity College as Head Landlord." In other words, the operating funds of Trinity College were derived from its landholdings, and the commission was charged with determining how the college might comply with Irish Land Reform legislation and yet retain its income.

139:25 (141:13). a sweet thing in a child's frock—the innuendo is at the expense of Healy, whose opposition to Parnell involved ringing denunciations of Parnell's "immorality" after the divorce scandal became public. Crawford implies that the denunciations were all too innocent (and vicious) to be perfectly credible as outraged morality. In the nineteenth century small boys wore frocks or pinafores until the age of three or four.

139:29 (141:17). the vials of his wrath—"And I heard a great voice out of the temple saying to the seven angels, Go your ways, and pour out the vials of the wrath of God upon the earth" (Revelation 16:1).

139:30 (141:18). the proud man's contumely —Hamlet, in the "To be or not to be" soliloquy, asks "who would bear . . . the proud man's contumely . . ./When he himself might his quietus make/With a bare bodkin?" (*Hamlet*, III, i, 70–76).

140:10–11 (141:38–39). Briefly, as well . . . words were these—Taylor's speech was never written out or taken down. MacHugh's version of the speech is just that, a version, as is Yeats's quotation from the speech in *The Autobiography of William Butler Yeats* (New York, 1958, pp. 64–65), and as was the "pallid" account published by the *Freeman's Journal* of 25 October 1901 (quoted in Ellmann, p. 95).

140:22 (142:11). the youthful Moses—Moses, born when the Israelites were in captivity in Egypt, was automatically condemned to die: "And the Pharaoh charged all his people, saying, Every son that is born ye shall cast into the river" (Exodus 1:22). To evade this dictum Moses' mother hid him in an "ark of bulrushes . . . by the river's brink" (Exodus 2:3), where he was found by the daughter of the Pharaoh, and "he became her son" (2:10). Thus Moses, though Hebrew, was brought up as an Egyptian; subsequently he was to become the leader of the Israelites in their struggle to achieve release from the captivity in Egypt.

140:24–25 (142:13–14). And let our crooked smokes—at the end of Shakespeare's *Cymbeline*, when peace and tranquillity have been restored, Cymbeline determines: "Laud we the gods,/And let our crooked smokes climb to their nostrils/From our blest altars. Publish we this peace/To all our subjects" (V, v, 476–479).

140:30 (142:20). FROM THE FATHERS— i.e., from the Fathers of the Church, a title of honor applied to the early leaders and writers of the Christian Church, in this case St. Augustine.

140:31–33 (142:21–23). It was revealed . . . could be corrupted—from St. Augustine (354–430), *Confessions* (397), VII:12. The passage continues: ". . . Therefore, if things shall be deprived of all good, they shall no longer be. So long therefore as they are, they are good: therefore whatever is, is good."

140:38 (142:28). galleys, trireme and quadrireme—galleys with three and four banks of oars.

141:5 (142:34). Child, man, effigy—the progress of Moses from the ark of bulrushes to Michelangelo's statue.

141:6 (142:35). babemaries—Moses was hidden by two women (his mother and her sister) as the "two Maries" watched at Jesus' sepulcher; see 46:4n. and 46:4–5n.

141:7 (142:36). a man supple in combat— Exodus 2:11–12: "And it came to pass in those days, when Moses was grown, that he went out unto his brethren, and looked upon their burdens: and he spied an Egyptian smiting an Hebrew, one of his brethren. And he looked this way and that way, and when he saw that *there was* no man, he slew the Egyptian, and hid him in the sand."

141:7 (142:36). stonehorned—Michelangelo's statue represents Moses as having horns as do most medieval depictions of Moses. The tradition of this distinctive mark derives from a mistranslation of the Hebrew verb *qâran,* which originally meant to put forth horns (*qeren*) but metaphorically came to mean to emit rays. The mistake is preserved in the King James Bible, Habakkuk 3:4: "he had horns *coming out* of his hand," which should read, "he had bright beams coming out of his hand." St. Jerome (*c.*340–420) made a similar mistake in translating Exodus 34:29: ". . . when Moses came down from mount Sinai with the two tables of testimony . . . the skin of his face shone. . . ." St. Jerome rendered it "his face was horned" and established the iconographic tradition.

141:10 (142:39). Isis and Osiris—the deities most extensively worshiped by the ancient Egyptians. Isis represented the feminine, receptive, productive principles of nature. Osiris, her brother and her husband, was the male god of the fructification of the land; he represented the death and resurrection cycle of the hanged god, and he was lord of the underworld.

141:10 (142:39). Horus—the son of Isis and Osiris. He avenged his father's death, and was regarded as the victorious god of light who overcame darkness, winter and drought.

141:11 (143:1). Ammon Ra—in Egyptian mythology, the sun-god and supreme deity, protector of men and conqueror of evil.

141:20–21 (143:10–11). he would never . . . house of bondage—the familiar phrase about Moses' leadership of the children of Israel (Exodus 13:17–20; Exodus 20:2); see 121:21–22n.

141:21–22 (143:11–12). nor followed the pillar of cloud by day—after the passage of the children of Israel through the Red Sea, "And the Lord went before them by day in a pillar of cloud, to lead them the way" (Exodus 13:21).

141:22–23 (143:12–13). He would never have spoken . . . on Sinai's mountaintop—in Exodus 19 the children of Israel come to Mount Sinai, and Moses experiences a three-day communion with God that climaxes in the appearance of "the fearful presence of God upon the mount."

141:23–25 (143:13–15). nor ever have . . . tables of the law—in the course of his experience on Sinai Moses received and recorded the Ten Commandments and other laws (Exodus 20–31). In Exodus 32:15–16: "And Moses turned, and went down from the Mount and the two tables of the testimony *were* in his hand. . . . And the tables *were* the work of God, and the writing *was* the writing of God, graven upon the tables." And "when Moses came down from mount Sinai . . . the skin of his face shone" (Exodus 34:29).

141:30–31 (143:20–21). And yet he died . . . land of promise—Deuteronomy 34:1–5: "And Moses went up from the plains of Moab unto the mountain of Nebo, to the top of Pisgah, that *is* over against Jericho. And the Lord shewed him all the land. . . . And the Lord said unto him, This *is* the land which I sware unto Abraham, unto Isaac, and unto Jacob, saying, I will give it unto thy seed: I have caused thee to see *it* with thine eyes, but thou shalt not go over thither. So Moses the servant of the Lord died there in the land of Moab, according to the word of the Lord."

141:38 (143:28). Gone with the wind—from Ernest Dowson (1867–1900), "*Non Sum Qualis Eram Bonae Sub Regno Cynarae*" (1896). (Latin, from Horace, *Odes* IV:i:3: "I am not what I once was under the rule [or spell] of kind Cynara.") The phrase occurs in the third stanza of Dowson's poem: "I have forgot much, Cynara! gone with the wind,/Flung roses, roses riotously with the throng,/Dancing, to put thy pale, lost lilies out of mind;/But I was desolate and sick of an old passion,/Yea, all the time, because the dance was long:/I have been faithful to thee, Cynara! in my fashion."

141:38–142:1 (143:28–31). Hosts at Mullaghmast . . . within his voice—the "tribune" in this passage is Daniel O'Connell, who so styled himself, identifying himself with "the People of Ireland . . . in their wishes and wants, speaking their sentiments and [seeking] to procure them relief" (*The Nation,* 19 August 1843). The association of O'Connell with Moses is obvious.

"A people Sheltered within his voice" because as "a constitutional lawyer" his insistence was on legal and nonviolent achievement of repeal of the Act of Union. His theme was "No man shall find himself imprisoned or persecuted who follows my advice. . . . Ireland is a country worth fighting for, it is a country worth dying for, but above all it is a country worth being tranquil, determined, submissive, and docile for" (*The Nation,* 7 October 1843). The "hosts" whom Stephen recalls were present at the two most famous of O'Connell's "monster meetings." The occasion for these Sunday-morning meetings was provided in the spring of 1843 by a plain-talk English rejection of O'Connell's constitutional arguments for Repeal. It was O'Connell's intention to demonstrate in a series of meetings to be held throughout Ireland the unity of the people in their civilly disobedient support of Repeal. The meeting at the Hill of Tara (21 miles northwest of Dublin and associated with the ancient High Kings of a united and golden-age Ireland) was held 15 August 1843; patriotic Irish estimates put the crowd at 750,000 to one million people! Conservative (English) estimates: 250,000. Next to the Tara meeting, the most impressive was held at the Rath of Mullaghmast, 35 miles southwest of Dublin, 1 October 1843. The Rath was famous as the site in 1577 of a particularly perfidious massacre, executed by the English at the expense of a then pacified and loyal section of the O'More clan. O'Connell's words have been "scattered" in the sense that his reliance on and hope for an orderly constitutional achievement of Repeal (and a measure of independence for Ireland) were, to say the least, blasted; and his words, for all their oratorical success, wasted. O'Connell himself was one of the first to fall victim to his own advice: he was imprisoned 14 October 1843 for the "seditious conspiracy" of the monster meetings. For "miles of ears of porches," see 138:1n.

142:2 (143:31). Akasic records—in theosophical lore the Akasa is an all-embracing medium, the infinite memory of eternal nature in which every thought, silent or expressed, is immortalized.

142:7–8 (143:36–37). a French compliment—i.e., a compliment that is essentially objectionable.

142:14 (144:4). Mooney's—(wine and spirit merchants), a bar or pub at 1 Abbey Street Lower, on the corner of Sackville (now O'Connell) Street Lower. Mooney's is not far east of the *Freeman's Journal* offices and is only four doors from The Ship (at 5 Abbey Street Lower), where Stephen was to have met Mulligan and Haines at 12:30 P.M.

142:20 (144:10). Lay on, Macduff—after Macbeth has learned that Macduff is, according to the witches' prophecies, to be his executioner, he says: "Lay on, Macduff/And damn'd be him that first cries 'Hold, enough!'" (Macbeth, V, viii, 33–34).

142:33 (144:25). Fuit Ilium!—Latin: "Troy has been," i.e., "Troy is no more" (Virgil, *Aeneid* II:325, when Aeneas, at Dido's request, recounts the fall of Troy).

142:33–34 (144:25–26). windy Troy—a Homeric epithet as rendered by Tennyson in his poem "Ulysses" (1842). Ulysses speaks of himself as having "drunk delight with my peers,/Far on the ringing plains of windy Troy" (lines 16–17). It is notable that Tennyson's Ulysses yearns "To follow knowledge like a sinking star,/Beyond the utmost bound of human thought" (lines 31–32), and that Telemachus is presented as the reverse of his father, as he who "by slow prudence" (line 36) will master and reform Ithaca (a kingdom of this world).

142:34 (144:26). Kingdoms of this world—Jesus, in John 18:36, remarks in answer to Pilate's questions about his being the King of the Jews, "My kingdom is not of this world."

143:1 (144:32). left along Abbey street—Abbey Street was on the southern side of the *Freeman's Journal* building. They turn east toward O'Connell Street and Mooney's.

143:7 (145:1). DEAR DIRTY DUBLIN—a phrase coined by the Irish woman of letters Lady Sydney Morgan (1780–1859).

143:9 (145:3). Two Dublin vestals—the vestal virgins were priestesses of Vesta, the Roman goddess of hearth and fire, whose temple was the hearth of Rome, the oldest temple in the city. The six priestesses of the temple dedicated themselves to lives of chastity and were charged with maintaining the eternal flame of Vesta's lamp (hearth).

143:10, 12 (145:4, 6). Fumbally's lane . . . /Off Blackpitts—both streets are in the Liberties, in the southwest quadrant of central Dublin.

143:13–15 (145:7–9). Damp night reeking . . . Quicker, darlint!—recall of a street encounter with a prostitute. For "Akasic records," see 142:2n.

143:16 (145:10). Let there be life—enforcing the analogy between artistic creation and divine creation, after Genesis 1:3: "And God said, Let there be light: and there was light."

143:24 (145:18). Wise virgins—Jesus in the Parable of the Ten Virgins (Matthew 25:1–13). The ten virgins "went forth to meet the bridegroom." The five foolish virgins took their lamps and no oil; the wise virgins took both lamps and oil; thus, when the bridegroom came, the wise virgins "that were ready went in with him to the marriage: and the door was shut." The foolish virgins were left out. "Watch therefore, for ye know neither the day nor the hour wherein the Son of man cometh."

143:26 (145:20). brawn—similar to headcheese.

143:27 (145:21). panloaf—a small loaf of bread.

143:27–28 (145:21–22). at the north city . . . Collins, proprietress—*Thom's (1904)* lists Miss Kate Collins as the proprietress of the North City Dining Rooms at 11 Marborough Street. The street runs parallel to O'Connell Street, one block east; the two "vestals" have not taken a direct route to Nelson's Pillar but have circled from the southwest around to a point east of the pillar.

144:2 (145:32). Lourdes water—see 80:7–8n.

144:3 (145:33–34). a passionist father—a member of a Roman Catholic order, "Barefooted Clerks of the Holy Cross and Passion of Our Lord," founded in 1737 by St. Paul of the Cross (Paolo Francisco Danei, Italian, 1697–1775). The Passionists not only vowed to live in poverty, chastity and obedience, they also vowed to meditate continually on the sufferings of Christ. Their interest was primarily in the conversion of sinners through preaching missions.

144:4 (145:34). crubeen—a pig's foot.

144:4 (145:35). double x—the standard Dublin pub beer manufactured by Guinness, as distinct from triple x, which Guinness manufactures for export.

144:18–19 (146:13–14). the Irish Catholic and Dublin Penny Journal—two weekly newspapers, each published on Thursday. Their offices were at 90 Abbey Street Middle.

144:31 (146:26–27). the Kilkenny People—a weekly newspaper published on Saturday in Kilkenny, a town 74 miles south-southwest of Dublin.

144:32 (146:27–28). House of Keys—see 119:19n.

145:14 (147:10). K.M.R.I.A.—the initials "M.R.I.A." stand for "Member of the Royal Irish Academy."

145:19 (147:15). RAISING THE WIND—raising money by pawning, borrowing, etc.

145:20 (147:16). Nulla bona—Latin: literally, "No goods or possessions." In law the expression is used to assert that an individual has no possessions that could be mortgaged or sold to pay his debts.

145:21 (147:17). through the hoop—in financial difficulties.

145:22 (147:18). back a bill—countersign a note.

(145:24) beard should read **bread** as it does **147:20.**

146:3–4 (147:30–31). Out for the waxies' Dargle—"waxies" are cobblers (after their use of wax for the preparation of thread). The Dargle is a picturesque glen near Bray, 12 miles south of Dublin. The "waxies' Dargle" may thus have been an annual (?) cobblers' picnic that was either held at the Dargle or staged in a manner that aspired to the fashionable manner associated with the Dargle (because Powerscourt, one of the most fashionable of Irish great houses, was situated on the Dargle). In the latter case the picnic may have been held at Ringsend (south bank of the mouth of the Liffey and not exactly a fashionable "park").

146:7 (148:1). Rathmines Blue Dome—Our Lady of Refuge, Rathmines (1850), designed by Patrick Byrne. It was destroyed by fire in 1921, but the original saucer-dome was restored. It is a cruciform church, "conspicuous by its large copper dome."

146:7 (148:1). Adam and Eve's—a Franciscan church on Merchant's Quay, south bank of the Liffey in the center of Dublin.

146:7–8 (148:1–2). saint Laurence O'Toole's—a Roman Catholic church (1863) in Seville Place, just north of the Liffey near its mouth. The church is named after an Irish saint (1132–1180), archbishop of Dublin (1162–1180). He was a popular saint because he had resisted the Anglo-Norman invasion.

146:12 (148:7). the archdiocese—the diocese of an archbishop, in this case the archbishop of Dublin.

146:16 (148:9). onehandled adulterer—Lord Nelson lost an arm in an unsuccessful assault on Santa Cruz de Tenerife in the Canary Islands (1797). In 1798 Nelson formed a liaison with Emma Hamilton (c.1765–1815), the wife of Sir William Hamilton (1730–1803), the British

Minister at Naples. The liaison was widely publicized and became one of the "great scandals" of the period.

146:19 (148:12). cits—"cit" is short for "citizen," the inhabitant of a city (as against a countryman).

146:20 (148:13). velocitous—coined word: "characterized by velocity."

146:21 (148:14). aeroliths—meteorites or meteoric stones.

147:5 (148:30). Antisthenes—(c.444–370 B.C.), a Greek philosopher and a pupil of Gorgias (see 147:6n), he subsequently attached himself to Socrates; he was disliked by Plato. Antisthenes asserted that without virtue there could be no happiness and that virtue alone was sufficient to happiness. He was committed to ascetic self-denial and scornful of power, honor and fame. His philosophical and rhetorical works are lost, except for two small and disputed declamations. The *Of Helen and Penelope* to which MacHugh alludes has been lost for over a thousand years. In it Antisthenes apparently had argued that Penelope's virtue made her more beautiful than Helen, whose virtue was somewhat less solidly demonstrated. Antisthenes was only a half-citizen of Athens because his mother was Thracian, "a bondwoman."

147:6 (148:31). Gorgias—(fl. c.427–c.399 B.C.), a Greek sophist and rhetorician known as "the Nihilist" for his three propositions: (1) Nothing exists; (2) if anything existed, it could not be known; (3) if anything did exist, and could be known, it could not be communicated. Thus philosophy (and life) were matters of persuasion, not of communication.

147:11 (149:5). Penelope Rich—born Devereux (c.1562–1607), Sir Philip Sidney's love; the object of his devoted attentions, literary and otherwise. She is the Stella of Sidney's sonnet sequence *Astrophel and Stella* (1591).

147:13 (149:7). CENTRAL—what telephone operators were called.

147:16 (149:10). Rathfarnham—an area three miles south of the center of Dublin.

147:17 (149:12). Donnybrook—an area two miles southeast of the center of Dublin.

147:18–19 (149:13). becalmed in short circuit—power failures of this sort were not unusual in the late nineteenth century, but by 1904 the Dublin United Electric Tramway Company had (in addition to its main power station in Ballsbridge)

an auxiliary station in Ringsend to cope with just such emergencies.

147:29 (149:24). deus nobis haec otia fecit— Latin: "god has made this peace [leisure, comfort] for us" (Virgil, *Eclogues* I:6). Virgil's pastoral poem contrasts in dialogue the peace within the "spreading beech's covert" with the "unrest on all sides in the land."

148:1 (149:25). A Pisgah Sight of Palestine— i.e., the vision that was granted Moses; see 141:30–31n. Also: Thomas Fuller (1608–1661), *A Pisgah-Sight of Palestine and the Confines Thereof with the History of the Old and New Testament Acted Thereon* (London, 1650).

148:2 (149:26). the Parable of the Plums— Jesus relies heavily on parables when he is teaching his followers in the Gospels.

148:5–6 (149:29–30). Moses and the promised land—i.e., Canaan, a rich and fertile land, promised to Abraham and his seed (the children of Israel) in Genesis 12:7; the promise is renewed to Moses in Exodus 12:25.

148:12 (150:6). sir John Gray's pavement island—see 93:2n.

EPISODE 8
[LESTRYGONIANS]

Episode 8: [Lestrygonians], pp. 149–181 (151–183). In Book X of *The Odyssey* Odysseus recounts his disappointing adventures with Aeolus, the wind king (see headnote to [Aeolus] above, p. 102); rebuffed by Aeolus, Odysseus and his men take to the sea once more. They reach the island of the Lestrygonians, where all the ships except Odysseus' anchor in a "curious bay" circled "with mountain walls of stone." Odysseus cannily anchors "on the sea side." A shore party from the ships anchored in the bay is lured by a "stalwart young girl" to the lodge of her father, Antiphates, the king of the Lestrygonians. The king turns out to be a giant and a cannibal, who promptly eats one of the shore party and then leads his tribe in the destruction of all the land-locked ships and the slaughter of their crews. Only Odysseus and his crew escape (to Circe's island).

Time: 1:00 P.M.; Scene: the Lunch, Bloom moves south and across the Liffey to Davy Byrne's pub at 21 Duke Street and thence to the National Library, not far to the east. Organ: esophagus; Art: architecture; Color: none; Symbol: constables; Technique: peristaltic. Correspondences: *Antiphates*—hunger; *The Decoy* (Antiphates' daughter)—food; *Lestrygonians*—teeth.

149:1 (151:1). LEMON PLATT—candy made of plaited sticks of lemon-flavored barley sugar.

149:2 (151:2). a christian brother—a member of a teaching brotherhood of Roman Catholic laymen, bound under temporary vows. The Christian Brothers ran schools and were supported by public contributions; they charged very low fees for their services, and were more interested in practical than in academic education.

149:3–4 (151:3–4). Lozenge and comfit manufacturer to His Majesty the King—the familiar British licensing (and advertising) slogan, displayed outside Lemon and Company, Ltd.'s candy shop at 49 Sackville Street Lower.

149:4 (151:4). God. Save. Our—from "God Save the King [or Queen]." The song has never been made the official national anthem of Great Britain, but it is generally sung with that significance. The song, with its recast folk-song and plainsong elements, appeared as early as the sixteenth century: "God save our gracious King,/Long live our noble King,/God save the King!/Send him victorious,/Happy and glorious,/Long to reign over us,/God save the King."

149:6 (151:6). Y.M.C.A.—Young Men's Christian Association. In 1904 individual societies of the association were composed of an active controlling membership, identified with evangelical churches, and of a more numerous associate membership not yet connected with the churches. The societies sought to promote "the physical, social, mental and spiritual wellbeing of their members and of all other young men"; and the active members were regarded as energetic, if not always tactful, proselytes.

149:11 (151:11). Blood of the Lamb—the throwaway's question, "Have you been washed in the Blood of the Lamb," i.e., in the blood of Christ, echoes Revelation 7:14–15: "These are they which came out of great tribulation, and have washed their robes, and made them white in the blood of the Lamb. Therefore are they before the throne of God." This passage was the Scriptural basis for the well-known nineteenth-century revival hymn "Holiness Desired" or, popularly, "Washed in the Blood of the Lamb,' by Elisha Hoffman.

149:15 (151:15). kidney burntoffering—see 713:25n.

149:15 (151:15). druid's altars—Bloom associates ancient Hebrew sacrificial customs with Druidic ceremonies; see 140:24–25n and 215:17–21 (218:8–12). At the end of the nineteenth century the revival of interest in Irish antiquities led to a reexamination of the Druids and their lore. Early Christian polemicists had accused the Druids of human sacrifice (in order to discredit them), but Irish historians of the early twentieth century were arguing that if such sacrifices had ever been Druid practice, they had been sublimated to animal sacrifice well before the beginning of the Christian era in Ireland.

149:15 (151:15). Elijah is coming—recalls the closing words of the Old Testament (Malachi 4:5–6): "Behold, I will send you Elijah the prophet before the coming of the great and dreadful day of the Lord: And he shall turn the heart of the fathers to the children, and the heart of the children to their fathers, lest I come and smite the earth with a curse." This passage has become the Scriptural basis for the Jewish tradition that the second coming of Elijah will signal the coming of the Messiah (in Christian tradition, the second coming of Christ).

149:16 (151:16). John Alexander Dowie—(1847–1907), Scotch-Australian-American evangelist who called himself "First Apostle of the Lord Jesus the Christ, and General Overseer of the Christian Catholic Apostolic Church in Zion" and also "Elijah II." He "restored" the church in Zion by founding Zion City, near Chicago, in 1901. In 1903 he made news by leading his "hosts" to New York City (to "regenerate" that metropolis). He was not in Dublin on Bloomsday, nor was he scheduled to appear there, though he was in Europe from 11 June to 18 June 1904. It is notable that Zion City revolted against him in

1906, charging him with misuse of funds, tyranny and polygamous tendencies.

149:20 (151:20). Torry and Alexander—a team of American revivalists who carried out an extensive "Mission to Great Britain," 1903–1905, including a mission to Dublin in March–April 1904. Reuben Archer Torrey's (1856–1928) publications speak for him: *How to Promote and Conduct a Successful Revival; Revival Addresses; How to Study the Bible for the Greatest Profit.* Charles McCallom Alexander (1867–1928) was a minister who handled the musical side of the revival mission.

149:23–24 (151:24). Pepper's ghost idea— Padraic Colum, in an interview in 1968, recalled this as a circus or stage trick developed by an Englishman named John Pepper in the 1870s. It involved the manipulation of phosphorescent costumes, lighting and dark curtains to produce the dramatic illusion of ghostly presences on stage.

149:24 (151:24). Iron nails ran in—Bloom's version of I.N.R.I.; see 80:16n.

149:31 (151:32). Butler's monument house corner—George Butler, manufacturer of musical instruments, 34 Bachelor's Walk (the quay side north bank of the Liffey just west of Sackville Street, where it enters O'Connell Bridge; thus "monument house corner" because it was adjacent to the monument to O'Connell that stood at the entrance to the bridge).

149:32–33 (151:33–34). Dillon's auctionrooms —Joseph Dillon, auctioneer and valuer, 25 Bachelor's Walk, 11 doors in from the corner where Bloom pauses.

149:34 (151:35). Lobbing—to slip, give way; therefore, to lounge.

149:37–38 (151:38–39). the confession, the absolution—the priest would not refuse to hear the unfruitful woman's confession, but might very well withhold absolution (formal remission of sin) until the woman had done penance to demonstrate her contrition and her willingness to dedicate herself to a life of fruition.

149:38 (151:39). Increase and multiply— Genesis 1:28: "And God blessed them, saying: Increase and multiply, and fill the earth, and subdue it, and rule over the fishes of the sea, and the fowls of the air and all living creatures that move upon the earth" (Douay Bible). This passage has been repeatedly cited as one of the key Scriptural bases for Roman Catholic condemnation of birth control.

149:41 (152:1). black fast Yom Kippur— Yom Kippur is the Hebrew Day of Atonement, a day of national humiliation, the only fast commanded in the Mosaic law. It occurs five days before the Feast of Tabernacles (see 60:35n). The method of its observance, including the sacrifice of the scapegoat, is described in Leviticus 16, and the conduct of the people is enjoined in Leviticus 23:26–32 with the command, "and ye shall afflict your souls." Thus the fast is "black." The 24-hour fast (from sundown to sundown) originally climaxed in a feast; but since the destruction of the temple and the dispersion of the Jews (70 A.D.), the day does not end with celebration and feast.

149:41 (152:2). Crossbuns—small cakes especially prepared for Good Friday and appropriately marked with a cross. Bloom associates the fast of Good Friday (with Jesus as scapegoat) with the fast of Yom Kippur, and regards the crossbuns as a violation of strict fast.

150:1 (152:2). collation—a light meal permitted for fast days.

150:1–2 (152:3–4). A housekeeper of one . . . out of her—a commonplace expression of Protestant lay suspicion of the chastity and poverty of the Roman Catholic clergy.

150:3 (152:4). L. s. d.—i.e., pounds, shillings and pence.

150:7 (152:8). flitters—tatters, rags, fragments.

150:8 (152:9). Potatoes and marge—(margarine), the staple diet of the poverty-stricken city dweller.

150:9 (152:10). Proof of the pudding—"The proof of the pudding is in the eating" (*Don Quixote,* Part I, Book IV, Chapter 7).

150:11 (152:13–14). Brewery barge with export stout—from Guinness' Brewery, which is just south of the Liffey on the western side of Dublin. The stout would be moved by barge from the brewery to the shipping at the mouth of the river.

150:13 (152:15). Hancock—identity and significance unknown.

150:16 (152:18). puke again like Christians— "to puke like a Christian" is low slang for "to take one's drink like a man," i.e., to stand up without flinching in competition with other heavy drinkers.

150:26 (152:29). thirty-two feet per sec—the attraction that the earth exerts on bodies on its surface and the acceleration that is thus pro-

duced is a uniform quantity at any one point, an average value of approximately 32.2 feet per second.

150:29 (152:32). Erin's King—see 66:32–33n.

150:31–32 (152:34–35). The hungry famished . . . waters dull—apparently Bloom's own composition.

150:33–34 (152:37). Shakespeare has no rhymes—this generalization is, of course, woefully inaccurate.

150:36–37 (152:39–40). Hamlet, I am . . . walk the earth—the Ghost speaks to Hamlet: "I am thy father's spirit,/Doomed for a certain term to walk the night" (*Hamlet*, I, v, 9–10).

151:5 (153:7). Banbury cakes—Banbury, a town in Oxfordshire, England, once noted for the excessive zeal of its Puritan inhabitants, and still for its cakes, a pastry cake with mince filling.

151:12 (153:14). Anna Liffey—the River Liffey since "Anna" is close to the Irish for river. The term is usually applied to the upper reaches of the river, west and south of Dublin. Where it flows through Dublin, the Liffey is an estuary, and in 1904 was little better than an open sewer. The river proper, the Anna Liffey, was considerably more attractive.

151:13–14 (153:15–16). Wonder what kind . . . live on them—swan meat was regarded as such a delicacy in medieval and Renaissance England that all swans were "birds royal," reserved exclusively to the King's use. In Daniel Defoe (1660–1731), *Robinson Crusoe* (Part I, 1719), Crusoe eats variously goat meat, fowls and turtles; he remarks that some of the fowls are "like ducks," some are "like geese" and "a large bird that was good to eat, but I know not what to call it." He never explicitly mentions "swan meat" though he does at one point call the shot that he uses to hunt birds "swan shot."

151:17 (153:19). They spread foot and mouth disease—foot-and-mouth disease is spread largely by contact and by infected water. There is no evidence that gulls are involved.

151:22–24 (153:25–27). Kino's/11/–/Trousers—J. C. Kino, a London clothier, had an outlet in Dublin, the West End Clothiers Company, 12 College Green, where Kino's ready-made trousers were sold, 11 shillings a pair.

151:26–27 (153:29–30). It's always flowing . . . stream of life we trace—see 85:20–21n.

151:29 (153:32). greenhouses—public toilets.

151:31 (153:34). cost him a red—i.e., a red cent.

151:31 (153:34). Maginni the dancing master—Denis J. Maginni (born Maginnis), professor of dancing, 32 George's Street Great North, well known as a character around Dublin. "Everyone knew his costume of tailcoat and dark grey trousers, silk hat, immaculate high collar with wings, gardenia in buttonhole, spats on mincing feet, and a silver-mounted silk umbrella in hand" (Ellmann, p. 375).

151:34 POST NO PILLS should read POST 110 PILLS as it does **(153:37).**

152:1–2 (154:4–5). Timeball on the ballast office is down—the Ballast Office, at the southern end of O'Connell Bridge on the corner of Westmoreland Street and Aston's Quay, headquarters for the supervision of Dublin Harbor and its works. Its clock was regarded by Dubliners as being the most reliable public timepiece in the city. A timeball is a ball on a pole, arranged to drop suddenly to mark some point in mean time, in this case, 1:00 P.M. Dunsink time (1:25 P.M. Greenwich Time).

152:2 (154:5). Dunsink time—the Dunsink Observatory, north of Phoenix Park, set the time for Ireland as the mean solar time of the meridian at Greenwich, England, was used as the basis of standard time. Dunsink time in 1904 was 25 minutes behind Greenwich time, i.e., 1:00 P.M. in Dublin was 1:25 P.M. Greenwich time.

152:2–3 (154:5–6). Sir Robert Ball's—(1840–1913), astronomer royal and director of the observatory at Cambridge, England. Ball was born and educated in Dublin; he was a popular lecturer and the author of many popular books on astronomy. The book that Bloom recalls is *The Story of the Heavens* (1885); it is among the books in his library, 693 (708).

152:4 (154:6). Parallax—the apparent displacement (or the difference in apparent direction) of an object as seen from two different points of view; in astronomy, the difference in direction of a celestial body as seen from some point on the earth's surface and as seen from some other conventional point such as the center of the earth or the sun.

152:4 (154:7). Par it's Greek—Bloom is right for the wrong reasons. "Parallax" does derive from a Greek root, but the prefix "par" is Latin-French in its derivation and means "thorough, thoroughly" as in "parboil," "pardon," etc.

152:13 (154:16). big Ben—after the extra-ordinarily large bell in the clocktower of the Houses of Parliament in London.

152:15 (154:18). baron of beef—a double sirloin of beef.

152:16 (154:19). number one Bass—a strong, brown Irish ale.

152:21 (154:25). Wisdom Hely's—Hely, Ltd., manufacturing stationers, letterpress and lithographic printers, bookbinders, etc, 27–30 Dame Street, where Bloom was once employed. Charles Wisdom Hely was the managing director of the firm in 1904.

152:25 (154:29). skilly—gruel, like a soup made of oatmeal and water.

152:25 (154:30). Boyl: no: M'Glade's—the fictional Boylan ran an advertising firm, as did the real M'Glade (at 43 Abbey Street).

152:32 (154:37). Pillar of salt—see 61:17–18n.

152:39 (155:2). 85 Dame Street—a nonexistent address.

152:39 (155:2). ruck—mess.

152:40–41 (155:3). Tranquilla convent—Carmel of the Nativity, Tranquilla, in Rathmines, a suburb south of the center of Dublin. The convent was founded in 1833 by the Order of Our Lady of Mount Carmel (the Carmelites).

153:4 (155:9). Feast of Our Lady of Mount Carmel—the Feast occurs on 16 July or on the Sunday following, and is celebrated as the anniversary of the founding of the Carmelite Order (on Mount Carmel in Syria in *c.*1156).

153:9–10 (155:15). Pat Claffey, the pawnbroker's daughter—i.e., Patricia (?), the daughter of Mrs. M. Claffey, pawnbroker, 65–66 Amiens Street, became a nun (at least so Bloom thinks).

153:10–11 (155:15–16). a nun . . . invented barbed wire—imaginative but unsound history of technology. Barbed wire itself was invented and patented by three Americans (Smith, Hunt and Kelly) simultaneously, 1867–1868. Barbed wire became practicable when the American inventors Glidden and Vaughan obtained a patent on a machine for the manufacture of barbed wire, 1874.

153:13 (155:18). Rover cycleshop—23 Westmoreland Street.

153:13 (155:18). Those races are on today—see 85:5–6n.

153:14 (155:19). Year Phil Gilligan died—the causes of the fictional Mr. Gilligan's death are listed on 689 (704).

153:15 (155:20). Thom's—see 122:5n.

153:17 (155:22). the big fire at Arnott's—on 4 May 1894 "the block of buildings owned by the firm of Arnott & Co. (Ltd.) which extends from Henry st. to Prince's st., totally destroyed by fire" (*Thom's* [1904], p. 2105).

153:17 (155:22). Val Dillon—Valentine Dillon, lord mayor of Dublin (1894–1895), died early in 1904.

153:18 (155:23). The Glencree dinner—an annual fund-raising dinner at St. Kevin's Reformatory, Glencree, County Wicklow, an institution for Roman Catholic males located at the headwaters of the Glencree River in the hilly country ten miles south of the center of Dublin; see 230 (234).

153:18 (155:23–24). Alderman Robert O'Reilly—a merchant tailor by trade (8 Parliament Street) and a small-time Dublin politician, listed as an Alderman on the Markets Committee in the 1890s.

153:18–19 (155:24). emptying the port into his soup—not exactly the height of genteel manners.

153:19 (155:24). before the flag fell—i.e., before the race began.

153:20 (155:25). for the inner alderman—to "feed the inner man" is to take spiritual sustenance.

153:20 (155:25–26). Couldn't hear what the band played—a stock joke at the expense of a noisy eater.

153:21 (155:26–27). for what we . . . Lord make us—an inversion of the standard blessing: "For what we are *about to receive* may the Lord make us thankful."

153:21 (155:27). Milly—was born 15 June 1889.

153:25 (155:30). Sugarloaf—a mountain 14 miles south-southeast of Dublin.

153:31 (155:36). Dockrell's—Thomas Dockrell and Sons, Ltd., contractors; window glass, oil color, cement and wallpaper dealers; decorators, etc., 47–49 Stephen Street, south of the Liffey in central Dublin.

153:37 (155:42). Stream of life—see 85:20–21n.

153:39 (156:2). Citron's saint Kevin's parade —see 60:28–29n.

153:39–40 (156:3). Pendennis? . . . Pen . . . ?— answer: 179:6 (181:32). *The History of Pendennis* (1850), a novel by William Makepeace Thackeray (1811–1863). The hero, Arthur Pendennis, begins life as a weakling who has been spoiled by an indulgent mother; he nearly ruins himself in imprudent love affairs before he gets straightened out.

153:41–42 (156:4–5). if he couldn't . . . sees every day—i.e., if Nannetti couldn't remember Monks's name; see 120 (121).

154:1 (156:6). Bartell D'Arcy—(fictional) appears as a character in "The Dead," *Dubliners*.

154:3 (156:8–9). Winds that blow from the south—song, source unknown. The song continues: "Shall carry my heart to thee/. . . /And the breath of the balmy night/Shall carry my heart to thee." Parnell and Mrs. O'Shea were supposed to have used this song as a code during the early years of their liaison; see 513:19–22n.

154:4–5 (156:10–11). that lodge meeting on about those lottery tickets—(fiction): Bloom was almost arrested in 1893 or 1894 for attempting to sell tickets for "The Royal and Privileged Hungarian Lottery." Bloom was apparently rescued by the membership of his Masonic Lodge. See 308 (313) and 757 (772). The factual source for this detail appears in the *Illustrated Irish Weekly Independent and Nation*, 16 June 1904 (p. 4, column 7): "From a prosecution which took place at the Clerkenwell Police Court [in London] the other day it would appear that the authorities have decided on the adoption of strong measures for the purpose of putting a stop to the circulation of announcements relating to foreign lotteries. A printer was summoned by the Treasury for publishing a certain proposal and scheme for the sale of tickets and chances, and shares in certain tickets, in a lottery called 'The Privileged Royal Hungarian Lottery' authorized by the Government of the State of Hungary."

154:6 (156:12). the supper room or oak room of the mansion house—the Mansion House is the official residence of the lord mayor of Dublin. It is in Dawson Street (between Trinity College and St. Stephen's Green in the southeastern quadrant of Dublin).

154:7–8 (156:14). high school—the Erasmus Smith High School at 40 Harcourt Street, south of the Mansion House and on the route between the Mansion House and the Blooms' residence in Lombard Street West.

154:9 (156:16). linking—taking by the arm.

154:11–12 (156:18). May be for months and may be for never—a paraphrase of the chorus of a song, "Kathleen Mavourneen," words by Annie Barry Crawford, music by Frederick N. Crouch. First verse: "Kathleen Mavourneen, the grey dawn is breaking,/The horn of the hunter is heard on the hill./The lark from her light wing the bright dew is shaking/Kathleen Mavourneen—what, slumb'ring still? // [Chorus:] Oh, hast thou forgotten how soon we must sever?/Oh, hast thou forgotten, this day we must part?/It may be for years, and it may be forever./Oh, why art thou silent, thou voice of my heart?/It may be for years, and it may be forever/Then why art thou silent, Kathleen Mavourneen?"

154:13 (156:19). Corner of Harcourt road— south of "the high school," at the junction of Harcourt Street and Harcourt Road, where the Blooms would have turned west toward their home.

154:25 (156:32). Mrs Breen—as the former Josie Powell, Mrs. Breen was a friend (and potential rival) of Molly when Bloom and Molly were courting. She subsequently married the eccentric Denis Breen.

154:33 (156:40). on the baker's list—able to eat bread or solid food; therefore, well.

154:38 (157:3). Turn up like a bad penny— proverbial expression of the superstitious belief that it is almost impossible to rid oneself of a small, meaningless detail.

155:3–6 (157:10–13). Your funeral's tomorrow . . . Diddlediddle . . .—Bloom juxtaposes lines from two songs, "His Funeral's Tomorrow," by Felix McGlennon, and "Comin' through the Rye," by Robert Burns. "His Funeral's Tomorrow," first verse: "I will sing of Mick McTurk./Mick one day got tight/And he roamed about the street/Dying for a fight;/ Mickey said to me,/He would put me on the fire/And because I said he'd not,/He called me a liar. / [Chorus:] And his funeral's tomorrow/My poor heart aches with sorrow/I hit him once that's all/Then he heard the angels call/And we're going to plant him tomorrow." "Comin' through the Rye," chorus: "O, Jenny's a'weet, poor body,/Jenny's seldom dry;/She draigl't a' her petticoatie,/Comin thro' the rye!" First verse: "Comin' thro' the rye, poor body/Comin' thro' the rye,/She draigl't a' her petticoatie,/Comin' thro' the rye." Second verse: "Gin a body meet a body/Comin' thro' the rye/Gin a body kiss a body/Need a body cry?."

155:13 (157:20–21). a caution to rattlesnakes—he is so remarkable or so extreme as to be enough to astonish a rattlesnake.

155:15 (157:22). heartscalded—"heartscald" is heartburn; metaphorically, remorse.

155:16 (157:23). jampuffs—a puff pastry filled with jam.

155:16–17 (157:24). rolypoly—a kind of pudding consisting of a sheet of paste covered with jam or preserves, formed into a roll and boiled or steamed.

155:17 (157:24). Harrison's—Harrison and Company, confectioners, 29 Westmoreland Street.

155:19 (157:26). Demerara sugar—a raw cane sugar in the form of yellowish-brown crystals, named after a region of British Guiana.

155:22 (157:29–30). Penny dinner . . . to the table—Dublin Free Breakfasts for the Poor in the Christian Union Buildings, Lower Abbey Street: "free breakfasts on Sunday mornings, penny and halfpenny dinners during the winter months." Charity customers ate standing up at counters to which the silverware was literally chained.

155:26 (157:34). barging—to "barge" is to speak roughly or abusively.

(157:37). Pastil should read **Pastille** as it does **155:28.**

155:30 (157:38). new moon—Mrs. Breen is right; on Monday, 13 June 1904, at 8:45 a new moon rose over Dublin. Popular superstition regarded the new moon as a positive time and associated derangement, etc., with the waning moon. One notable exception: werewolves were assumed to be excited into activity by the new moon (and to wane back into their human alter egos as the moon developed through its phases).

155:38. Indiges is Bloom's thought and should stand alone as a paragraph as it does **(158:6)**—i.e., Bloom attributes Breen's nightmare to indigestion.

155:39 (158:7). the ace of spades—in fortune-telling, a card of ill omen: malice, misfortune, perhaps death.

156:3 (158:12). U.P.: up—in Charles Dickens' *Oliver Twist,* Chapter XXIV, the expression "U.P." is used by an apothecary's apprentice to announce the imminent death of an old woman. In the French edition of *Ulysses* the postcard is translated *"fou tu,"* i.e., "you're nuts . . . you've

been screwed . . . you're all washed up." See Adams, pp. 192–193, for further speculation.

156:22 (158:31). Josie Powell—Mrs. Breen's maiden name.

156:22–23 (158:31–32). In Luke Doyle's . . . Dolphin's Barn—Luke and Carolyn Doyle, friends of the Blooms, lived in Dolphin's Barn on the southwest outskirts of metropolitan Dublin. Their wedding present to the Blooms is mentioned on page 692 (707).

156:26 (158:36). Mina Purefoy—appropriately takes her name from Richard Dancer Purefoy, M.D., a Dublin obstetrician who in 1904 was ex-master of the Rotunda Lying-in Hospital on Rutland (now Parnell) Square. Her husband in fiction, the Methodist Theodore Purefoy, was "conscientious second accountant, Ulster Bank, College Green Branch," in Dublin, 413 (421).

156:32 (159:1). lying-in hospital—see 96:20n.

156:32 (159:1). Dr Horne—Andrew J. Horne, ex-vice-president of the Royal College of Physicians in Ireland and one of the two "Masters" of the National Maternity Hospital in Holles Street.

156:33 (159:2). three days bad—she has been in labor for three days.

157:13–14 (159:24–25). Cashel Boyle O'Connor Fitzmaurice Tisdall Farrell—a Dublin eccentric nicknamed "Endymion" ("whom the moon loved") Farrell. Oliver St. John Gogarty, in *As I Was Going Down Sackville Street* (New York, 1937; pp. 1–10), describes him as an appropriate opening image of topsy-turvy Dublin-Ireland and renders his name "James Boyle Tisdell Burke Stewart Fitzsimmons Farrell." See also Ellmann, p. 375.

157:14 (159:26). Denis—i.e., her husband, Denis Breen. *Thom's (1904)* lists a Denis Breen as proprietor of the Leinster Billard Rooms in Rathmines Road.

157:24 (159:35). Blown in from the bay—i.e., Breen is so skinny that he looks as though he could be blown away by a gust of wind.

157:27 (159:38). Meshuggah—Yiddish: "eccentric, crazy."

157:27 (159:38). Off his chump—very eccentric, mad to almost any degree.

157:29–30 (159:40–41). the tight skullpiece . . . umbrella, dustcoat—i.e., Farrell's costume, which Ellmann describes (p. 375) as including two swords, a fishing rod, an umbrella and a "small bowler hat with large holes for ventilation."

157:30 (159:41). Going the two days—Dublin slang for behaving with extraordinary flair or flourish.

157:31 (160:1). mosey—after "moss," having soft hair like down; metaphorically, soft in the head.

157:33 (160:3). Alf Bergan—(d. 1951 or 1952), another Dublin character and practical joker, a solicitor's clerk in the offices of David Charles, Solicitor, Clare Street, Dublin. (*Letters of James Joyce*, ed. Stuart Gilbert [New York, 1957; Vol. I, p. 174]). *Thom's (1904)* does not list a David Charles, but it does list an Alfred Bergan, Esq., as resident in Clonliffe Road, and it is this Bergan whom Joyce mentions in a letter, 14 October 1921, p. 174. In 1904 Bergan was assistant to the subsheriff of Dublin.

157:34 (160:4). the Scotch house—a pub, James Weir and Company, Ltd., tea dealers, wine and spirit merchants, 6–7 Burgh Quay on the corner of Hawkins Street, south bank of the Liffey.

157:37 (160:7). the Irish Times—at 31 Westmoreland Street (Bloom is walking south). The *Times* was a daily newspaper; its editorial policy was consistently Protestant conservative, pro-England and the *status quo*. The ad that Bloom had placed in the *Times* had put him in touch with Martha Clifford.

158:1. word should read **world** as it does **(160: 13).**

158:4 (160:16). Lizzie Twigg—Adams (p. 55) notes that she was a real person, "a protégé of A.E.'s . . . an ardent Irish Nationalist." She had published poetry under her own name and was in 1905 to publish a volume, *Songs and Poems*, under her Gaelic name *Elis ni Chraoibhin*.

158:8 (160:20). by long chalks—"chalks" are scores or tabulations; therefore, scores the highest.

158:8–9 (160:20–21). Got the provinces now—i.e., the paper enjoyed a wide circulation outside of Dublin and was therefore used for the publication of legal notices in the provinces.

158:9 (160:21). Cook and general, exc cuisine, housemaid kept—i.e., wanted: a cook and general housekeeper, with the assurance that the kitchen over which she will preside is excellent and that she will have the assistance of a housemaid.

158:10 (160:22). Resp—respectable.

158:11 (160:23). James Carlisle—in *Thom's (1904)* spelled variously "Carlisle" and "Car-lyle"; the manager and one of the directors of the *Irish Times*.

158:11–12 (160:23–24). Six and a half per cent dividend—the Irish Times, Ltd., was a "public corporation"; its annual dividend in 1903: six and a half percent.

158:12–13 (160:24–25). Coates's shares . . . old Scotch hunks—James and Peter Coats, a thread-manufacturing firm based in Paisley in Scotland merged in 1896 with its foremost rival, Clark and Company. The monopoly thus created resulted in a spectacular economic growth of the company and a corresponding rise in the value of its stocks.

158:13 (160:25). Ca'canny—to call shrewdly, to move slowly and cautiously.

158:13 (160:25). hunks—misers.

158:13. today should read **toady** as it does **(160:25).**

158:14 (160:26). the Irish Field—a weekly newspaper "devoted to the interests of country gentlemen," published in Dublin on Saturdays.

158:15 (160:27). Lady Mountcashel . . .—Bloom's version of the kind of news the *Irish Field* indulged in. There was, however, no Lady Mountcashel. Edward George Augustes Harcourt (1829–1915), Earl Mountcashell and Baron Kelsworth (1898–1915), did not marry and died without an heir.

158:16 (160:28). Ward Union staghounds—the staghound or buckhound, the first variety of dogs now classed under the general term "foxhounds." The Ward Union Staghounds, one of the more famous of the Irish fox hunts, met two and occasionally three times weekly during the season (November to mid-April).

158:16–17 (160:28–29). enlargement—when the fox to be pursued is released from a cage at the beginning of the hunt.

158:17 (160:29). Rathoath—a village 25 miles northwest of Dublin. Fairyhouse, the "home" of the Ward Union Staghounds hunt, is near Rathoath.

158:17 (160:29). Pothunters—a "pothunter" is one who hunts game only for the food it represents; hence, a poor person who steals food to prevent himself from starving.

158:18 (160:30). Fear injects juices make it tender enough for them—even though fox is inedible, its flesh might be transformed by fear so that at least a starving man could eat it?

158:19 (160:31). Weightcarrying—a "weight-carrier" is a horse that can run well under a heavy weight.

158:20 (160:32). not for Joe—after an anonymous popular song of the 1860s: "Not for Joseph,/If he knows it;/Oh, no, no,/Not for Joe!"

158:23 (160:35). while you'd say knife—proverbial expression for very quickly or suddenly.

158:24–25 (160:37). five-barred gate—at least six feet high, a formidable obstacle.

158:26–27 (160:38–39). Mrs Miriam Dandrade—is to appear in one of the hallucinations in [Circe].

158:28 (160:40). Shelbourne Hotel—a posh tourist hotel at the junction of Kildare Street and the northern mall of Stephen's Green.

158:28–29 (160:41). Didn't take a feather out of her—obviously, didn't disturb her in the least, but also Partridge cites "feather" as slang for female pubic hair.

158:30–31 (160:42–161:1). Stubbs the park ranger—until 1901, Henry G. Stubbs, Overseer, Board of Public Works, the Cottage, Phoenix Park, Dublin.

158:31 (161:1). Whelan—identity and significance unknown.

158:31 (161:1). the Express—the *Daily Express;* see 124:17n.

158:34–35 (161:5). No nursery work for her—i.e., she would avoid conceiving a child.

158:36–37 (161:6). Method in his madness—when Hamlet is pretending to be mad but actually mocking Polonius, Polonius responds in an aside: "Though this be madness, yet there is method [order, sense] in it" (II, ii, 207–208).

158:37–38 (161:7–8). the educational dairy—the Educational Dairy Produce Stores (Ltd.), purveyors of "health foods" and "temperance beverages," had several shops with lunch counters in Dublin.

158:40 (161:10). Dublin Castle—the lord lieutenant of Ireland, appointed by England, used the castle as his town residence, and it also housed the offices of the chief secretary and the law offices of the Crown (the Royal Irish Constabulary).

158:40 (161:10). tony—stylish, high-toned.

158:42 (161:12). the Three Jolly Topers—a public house north of Dublin on the River Tolka.

159:1 (161:13). squallers—babies, young children, and also tramps.

159:3 (161:15). t.t.'s—teetotalers.

159:3 (161:15). Dog in the manger—a churlishly selfish person, after Aesop's fable about the dog that took over the manger and kept the cattle from eating the hay in spite of the fact that he obviously had no use for it himself.

159:6 (161:18). Rowe's—Andrew Rowe, vintner and publican, 2 Great George's Street North, not far west of where Bloom is walking (the National Library is, however, south and east of Bloom's position).

159:7 (161:19). the Burton—the Burton Hotel and Billiard Rooms advertised "Refreshment Rooms" at 18 Duke Street (on Bloom's route to the library).

159:8 (161:20). Bolton's Westmoreland house—William Bolton and Company, grocers; tea, wine and spirit merchants; 35 and 36 Westmoreland Street.

159:11 (161:23). vinegared handkerchief—for reducing fever.

159:16 (161:28). Twilightsleep—a partial anesthetic prescribed for women in childbirth. In April 1853, when she was giving birth to Prince Leopold, Queen Victoria did allow her doctors to experiment with "twilight sleep" in the form of a light dose of chloroform. Anesthesiology was then in its pioneering stages, and the Queen's willingness to experiment was widely publicized.

159:17 (161:29). Nine she had—Queen Victoria had four sons and five daughters.

159:17 (161:29). A good layer—a phrase used to describe a productive hen.

159:17–18 (161:29–30). Old woman that . . . so many children—after the nursery rhyme: "There was an old woman who lived in a shoe./She had so many children she didn't know what to do;/She gave them some broth without any bread;/She whipped them all soundly and put them to bed."

159:18 (161:30–31). Suppose he was consumptive—Bloom speculates (incorrectly) that Prince Albert had tuberculosis (after the popular assumption that tubercular individuals were sexually hyperactive). In reality Prince Albert died of typhoid fever.

159:20 (161:32–33). the pensive bosom of the silver effulgence—Bloom combines two phrases from Dan Dawson's speech, 122:29, 36 (123:29, 36) and 125:4–5 (126:4–5).

159:20–21 (161:33). flapdoodle—empty talk, transparent nonsense.

159:22–27 (161:35–40). give every child . . . more than you think—£5 at five percent compound interest, compounded annually, would amount to £13 18 shillings in 21 years.

159:31 (162:2). Mrs Moisel—the wife of Moisel, 60:34 (60:38).

159:31–32 (162:2–3). Phthisis retires . . . then returns—Phthisis, medically, means a wasting or consumption of tissue; formerly it was applied to many wasting diseases, but by the early twentieth century it was usually applied to pulmonary consumption and tuberculosis. As Bloom observes, tuberculosis may be quiescent for several months or even for more than a year.

159:34 (162:5). a jolly old soul—after the nursery rhyme: "Old King Cole was a merry old soul,/And a merry old soul was he./He called for his pipe and he called for his bowl,/And he called for his fiddlers three."

159:36 (162:7). old Tom Wall's—Adams regards this as "a reference, no doubt, to Thomas J. Wall, K.C. [King's Counsel], chief divisional magistrate of the City of Dublin Police District" (p. 235).

159:37 (162:8–9). Dr Murren—unknown and probably fictional but to what purpose? or is "Murren" intended to suggest "murrain"?

159:42 (162:13). the Irish house of parliament—i.e., the Bank of Ireland. The building had housed the Irish Parliament until the Parliament was dissolved by the Act of Union in 1800.

160:3 (162:16). Apjohn—Percy Apjohn, fictional, a childhood friend of Bloom; Apjohn was killed in the Boer War, 689 (704).

160:3–4 (162:17). Owen Goldberg—another of Bloom's childhood friends; *Thom's (1904)* lists him at 31 Harcourt Street not far from the Erasmus Smith High School, which both he and Bloom attended.

160:4 (162:17). Goose green—Goosegreen Avenue is in Drumcondra on the northern outskirts of Dublin.

160:5 (162:18). Mackerel—the fish, of course, but also a mediator or agent, and slang for a pimp or bawd.

160:9 (162:22–23). Policeman's lot is oft a happy one—after a song from Gilbert and Sullivan's *The Pirates of Penzance;* the Sergeant and Chorus sing antiphonally. Sergeant: "When a felon's not engaged in his employment." Chorus: "His employment." Sergeant: "Or maturing his felonious little plans." Chorus: "Little plans." Sergeant: "His capacity for innocent enjoyment." Chorus: "'cent enjoyment." Sergeant: "Is just as great as any honest man's." Sergeant: "Our feelings we with difficulty smother." Sergeant: "When constabulary duty's to be done." Sergeant: "Ah, take one consideration with another." Sergeant: "A policeman's lot is not a happy one."

160:14 (162:27–28). Prepare to receive cavalry—a command to infantry threatened by a cavalry charge. In response to the command troops go down on one knee, the rifle with fixed bayonet angled forward and braced.

160:16 (162:29). Tommy Moore's roguish finger—a statue of Thomas Moore, Irish poet (1779–1852), stands over a public urinal near Trinity College opposite the east front of the Bank of Ireland. A fragile eroticism is characteristic of Moore's early verse. His most famous series, *Irish Melodies* (intermittently, 1807–1834), was graced with the assumption that no properly sentimental Irish household could afford to be without a copy. Moore left Ireland in 1798 and advanced himself by currying favor in the drawing rooms of the influential in London. His laments for "poor old Ireland" were, therefore, not vital Irish rebellion but sentimental complaints acceptable to English ears. Moore's reputation was tarnished by an apparent willingness to compromise his artistic integrity and by the scandal that occurred when he abandoned his admiralty post in Bermuda and left an embarrassingly dishonest deputy in charge. His "roguish finger" is, however, an allusion to a famous literary hoax, perpetrated by "Father Prout," pen name of the witty Irish priest Father Francis Mahony (1804–1866) in an article, "Rogueries of Tom Moore," in *Frazier's Magazine.* Father Prout's hoax involved the charge that several of Moore's most popular songs were "literal and servile translations" of French and Latin "originals"; Father Prout duly "quoted" in evidence the "originals," complete with circumstantial historical background.

160:17, 19 (162:30, 32). meetings of the waters/ There is not in this wide world a vallee—Thomas Moore, "The Meeting of the Waters" in *Irish Melodies;* first verse: "There is not in the wide world a valley so sweet/As that vale in whose bosom the bright waters meet;/Oh! the last rays of feeling and life must depart,/Ere the bloom of that valley shall fade from my heart."

160:20 (162:33). Julia Morkan's—Julia Morkan appears as a character in "The Dead," *Dubliners*.

160:21 (162:34). Michael Balfe's—Michael William Balfe (1808–1870), a Dublin musician who sang, played a virtuoso violin, conducted and composed operas, including *The Rose of Castille* (1857), *The Bohemian Girl* (1843) and *Il Talismano* (1874).

160:23 (162:36). could a tale unfold—the Ghost speaks to Hamlet (I, v, 13–16): "But that I am forbid/To tell the secrets of my prison-house, /I could a tale unfold whose lightest word/Would harrow up thy soul . . ."

160:23 (162:36). a G man—a member of the "G" or plainclothes intelligence division of the Dublin Metropolitan Police.

160:24 (162:37). lagged—arrested.

160:25 (162:38). bridewell—house of correction; loosely, jail or prison; after the Bridewell, a house of correction in London (until 1864). The Dublin Bridewell was located in the Four Courts on the north bank of the Liffey.

160:26 (162:39). hornies—constables (policemen).

160:26–27 (162:40–41). the day Joe Chamberlain was given his degree in Trinity—Joseph Chamberlain (1836–1914), English politician and statesman. Originally a member of Gladstone's government, Chamberlain was antagonistic to Gladstone's policy of Home Rule for Ireland; in 1886 Chamberlain resigned and formed the Liberal Unionist party (splitting Gladstone's Liberal party and ensuring its defeat and the defeat of Home Rule). In 1895 the Liberal Unionists and Conservatives joined forces under Lord Salisbury, and Chamberlain became secretary for the colonies (1895–1903). Once regarded as a "radical republican," Chamberlain emerged as an aggressive imperialist; his name was particularly associated with the English policy that resulted in the Boer War (1899–1902) and in the extinction of the South African republics. Thus, Chamberlain was doubly unpopular in Ireland when he came to Dublin, 18 December 1899, to receive an honorary degree at Trinity College. On the same day John O'Leary, Maud Gonne and other radical leaders had organized a pro-Boer meeting in Beresford Place, just across the Liffey from Trinity College. The protest meeting was interrupted by the police, but the protesters followed their leaders across the Liffey to College Green, where the demonstration continued with appropriate police harassment.

160:30 (163:1). Manning's—a pub; T. J. Manning, grocer and wine merchant, 41 Abbey Street Upper (on the corner of Liffey Street).

160:30 (163:1). souped—i.e., in the soup, in difficulty, in trouble.

160:33 (163:4). the Trinity jibs—first-year undergraduates.

160:35 (163:6). the Mater—the Mater Misericordiae Hospital; see 10:17n.

160:35 (163:7). in Holles street—at the National Maternity Hospital.

160:37 (163:9). Give me in charge—i.e., the policeman had formally told Bloom that he was under arrest.

160:39 (163:10). Up the Boers!—committed Irish nationalists were pro-Boer because the Boer War seemed so clearly to them another and all too familiar instance of English suppression of the legitimate national aspirations of a people who stood in the way of the "course of Empire." Irish radicals did go so far as to raise volunteer brigades which fought with the Boers in South Africa against the English.

160:40 (163:11). De Wet—Christian R. De Wet (1854–1922), a distinguished Boer commander noted for his gallantry, for his extraordinarily clever field tactics in the Boer War and subsequently for his dignity in defeat.

160:41 (163:12). We'll hang Joe . . . sourapple tree—after one of the many improvised verses of "John Brown's Body," Union Army song in the Civil War: "We'll hang Jeff Davis to a sourapple tree! [*Thrice*]/As we go marching on!"

160:42–161:1 (163:13–14). Vinegar hill—at Enniscorthy in County Wexford, the headquarters of the Wexford rebels in the Rebellion of 1798 and the site of a decisive defeat of the rebels at the hands of the English, 21 June 1798. The final stanza of the ballad "The Boys of Wexford" recalls the battle: "And if for want of leaders,/We lost at Vinegar Hill,/We're ready for another fight,/And love our country still." See 128:5–6n.

161:1 (163:14). The Butter exchange band—the Butter Exchange was a dairyman's guild with branches in several Irish cities and towns. The Dublin branch maintained a band for the recreation of its members. On occasion the band was used at political rallies; it was present at the demonstration Bloom recalls.

161:1–2 (163:14–15). few years time . . . and civil servants—Bloom reflects that half of the

young students demonstrating against England will ultimately go straight and accept positions in the British civil service.

161:3 (163:16–17). whether on the scaffold high—after the chorus of a song, "God Save Ireland," by T. D. Sullivan (1827–1914). Chorus: "'God Save Ireland!' said the heroes;/'God save Ireland!' said they all./'Whether on the scaffold high/Or on the battlefield we die,/O, what matter when for Ireland dear we fall!'"

161:5 (163:19). Harvey Duff—the police informer in *The Shaughraun* (1874), a play by the Irish-American playwright Dion Boucicault (1822–1890).

161:5–6 (163:19–20). Peter or Denis . . . on the invincibles—see 80:23n and 80:24n.

161:6–7 (163:20–21). Member of the corporation too—Peter Carey was a councilor and therefore a member of the Dublin Corporation.

161:8 (163:22). secret service pay from the castle—Dublin Castle housed the offices of the British government in Ireland and, in this case, the offices of the Royal Irish Constabulary. Peter Carey was not in the "employ" of the Castle though after he turned Queen's evidence the Castle did make an ineffectual effort to aid his escape from Ireland and from retribution at the hands of Irish nationalists.

161:9 (163:24). slaveys—a slavey was a maid of all work with no defined job status on a household staff.

161:10 (163:24). twig—notice, detect, discern, understand.

161:10–11 (163:24–25). Squarepushing up against a backdoor—military slang for an instance of the habit of "walking out" with a young woman. A "squarepusher" is a decent girl of the lower classes.

161:13 (163:27). Peeping Tom—he figures in the eleventh-century legend about Lady Godiva, the wife of Leofric, Earl of Mercia. Lady Godiva begged her husband to relieve the people of Coventry of an onerous tax that he had imposed. He agreed, on the condition that she ride naked through the town's marketplace. She did. In gratitude the townspeople stayed indoors and did not look; they were rewarded by being relieved of the tax. But Tom the Tailor did peep and he was rewarded by being miraculously struck blind.

161:14 (163:28). Decoy duck—the decoy in a swindle.

161:19 (163:33). There are great . . . till you see—a variant of the opening line of a song, "There's a Good Time Coming," by Henry Russell (1813–1900), English songwriter. First verse: "There's a good time coming, boys,/A good time coming,/We may not live to see the day./But Earth shall glisten in the ray/Of the good time coming./Cannon balls may aid the Truth,/But thought's a weapon stronger,/We'll win our battle of its aid,/Wait a little longer. // [Chorus:] There's a good time coming, boys,/A good time coming,/Wait a little longer."

161:22–23 (163:36–38). James Stephens' idea . . . his own ring—for Stephens, see 44:23n. Stephens organized the Irish Republican Brotherhood (Fenian Society) in circles of ten, which divided when more than ten members had been initiated. Each circle of ten had a circle master or "center," and the ordinary member came in contact only with the center of his circle unless the circle was mobilized for political action. The centers were responsible to a District Center, the District Center to a Divisional Center; the Divisional Centers to an 11-member Supreme Council. Only the top members of the organization knew anything substantial about the organization and its personnel. As Stephens conceived of it, the organization was proof against the plague of ordinary informers.

161:24 (163:38). Sinn Fein—Irish: "Ourselves Alone." Bloom uses the term (as it was so often used) to mean the underground organization of the Irish Republican Brotherhood in the early twentieth century. More accurately the term applies to the separatist policies articulated by Arthur Griffith late in 1905 and early in 1906. The *Sinn Fein* policy advocated that the Irish should refuse economic and political support to English institutions and should create their own political and economic institutions, whether or not the English were willing to recognize them as constitutional.

161:24–25 (163:38–39). Back out you . . . The firing squad—James Stephens' original organization was designed primarily to frustrate informers. By the early twentieth century the discipline of the Irish Republican Brotherhood had tightened to the point where summary execution by the "Hidden Hand" was threatened as the penalty for any attempt to withdraw from membership. The "firing squad" was, of course, the British answer to the organization's activities. *The Hidden Hand* (1864) was the title of a popular melodrama by the English playwright Tom Taylor (1817–1880). The play is an elaborate tangle of intrigues in the course of which the "hidden hand" specializes in poisoning its victims with arsenic.

161:25–27 (163:39–41). Turnkey's daughter got . . . their very noses—for the story of Stephens' escape, see 44:23n. Stephens hid out for seven months at the home of a Mrs. Butler in Ballybough on the northwestern outskirts of Dublin. There are various stories about his departure from Ireland: one of them Bloom cites (that Stephens moved into the Buckingham Palace Hotel, in full public view); the other (and apparently more accurate) is that Stephens rode through central Dublin in an open carriage (in a sort of triumphal procession) on his way to Lusk (14 miles north of Dublin) and to the ship that was to perfect his escape and carry him into exile.

161:27 (163:41). Garibaldi—Giuseppe Garibaldi (1807–1882), revolutionary leader (notably in Uruguay and Italy), famous for his quasi-successful efforts to establish a unified, independent Italy. Like Stephens, he endured several periods of political exile from Italy (even after his heroic contributions toward a measure of unity for Italy), and as Stephens had been daring in his departure from Dublin, Garibaldi was also capable of a daring reliance on the sympathies of a populace. In 1860, accompanied not by his army but by two companions, he openly entered a Naples that was in hostile hands. Unlike Stephens, who was regarded as a good organizer but not a man of action, Garibaldi was an excellent and courageous military leader.

161:29 (164:1). squareheaded—honest and forthright.

161:29 (164:1–2). no go in him for the mob—Griffith quite frankly admitted that his separatist policies could not hope for anything like unanimous popular support in Ireland. Consequently he couched his appeal in rational argument to the "one quarter" who could be expected to understand and support his policies, and consciously rejected a rabble-rousing approach. Bloom contrasts Griffith with the more charismatic figure of Parnell.

161:30 (164:2–3). Gammon and spinach—slang for the everyday round of things, after the folk song. First verse: "A frog he would a-wooing go,/Heigh ho! say Rowley,/A frog he would a-wooing go,/Whether his mother would let him or no./With a rowley powley, gammon and spinach/Heigh ho! says Anthony Rowley." (A "rowley powley" is a plump fowl.)

161:30–31 (164:3). Dublin Bakery Company's tearoom—*Thom's (1904)* lists this as the Dublin Bread Company, Ltd., with restaurants at 3 and 4 Stephen's Green North; 6 and 7 Sackville Street Lower; 33 Dame Street; and National Library, Kildare Street. It is not clear which of these Bloom associates with "gas about our lovely

land," though it is at the one in Dame Street that Mulligan and Haines see Parnell's brother, John Howard Parnell, 244 *ff.* (248 *ff.*), and thus the tearoom near Dublin Castle may be the one Bloom has in mind, or perhaps it is the one near the National Library because it was frequented by students.

161:31 (164:3–4). Debating societies—see 139:16n.

161:33–34 (164:5–6). That the language . . . the economic question—i.e., that the cause of Irish independence could best be served by the revival of the Irish tongue (see 243:32–39 [247:16–23]) rather than by efforts to establish an independent Irish economy.

161:35 (164:7–8). Michaelmas goose—it is customary in Ireland (and in England) to eat goose on Michaelmas (29 September).

161:36 (164:8). apron—the fat skin covering the belly of a goose or duck.

161:38 (164:10). Penny roll and walk with the band—the Salvation Army (formed 1865) offered a penny's worth of bread to anyone who would march through the streets in witness to his "conversion."

161:38–39 (164:11). No grace for the carver—with a pun on "grace" as the blessing that precedes a meal and as the time allowed a debtor to pay his debts. In effect, the person who carves will have little or no time to eat before he has to carve again for those who want second helpings.

161:41–42 (164:14). Home Rule sun rising up in the northwest—see 57:33–35n.

162:2 (164:16). Trinity's surly front—the great façade of the college was erected in 1759. Apparently "surly" in this context has its original meaning of "proud or haughty" because the relatively unrelieved 300-foot front of the college is severe, dark, heavy-stoned neoclassicism, what Bloom and his contemporaries would have called "Corinthian" (as twentieth-century architectural historians would label it "Georgian").

162:16 (164:30). notice to quit—a landlord's eviction notice.

162:19 (164:33). bread and onions—the classical diet of slaves.

162:19 (164:33–34). Chinese wall. Babylon—together with the pyramids, examples of massive public monuments built at immense cost of labor and now fallen into a decay that reveals their essential pointlessness. The Chinese Wall, built

in the fourteenth century, was 35 feet high, 21 feet thick, and extended 1,250 miles along the border between China and Mongolia. The walls and hanging gardens of ancient Babylon (reduced to a series of mounds by the early twentieth century) were one of the Seven Wonders of the classical world.

162:20 (164:34). Big stones left. Round towers—i.e., that which remains of the architecture of ancient Ireland. "Big stones" are the massive post-and-lintel monoliths to be found surmounting prehistoric Irish burial mounds. "Round towers" (many of which are still standing) were the most striking features of the pre-Norman Irish monasteries. The towers were constructed in the ninth through the twelfth centuries and were used as watchtowers and as places of refuge when the monasteries were being harassed by Scandinavian invaders.

162:21 (164:35). Kerwan's mushroom houses—Michael Kirwan, a Dublin building contractor, who built low-cost housing for the Dublin Artisans' Dwellings Company, Ltd., in the area just east of Phoenix Park in western Dublin.

162:26 (164:40). Provost's house. The reverend Dr Salmon—the Reverend George Salmon (1819–1904), D.D., D.C.L., F.R.S. (Doctor of Divinity, Doctor of Civil Law and Fellow of the Royal Society), a distinguished mathematician, was provost of Trinity College from 1888 to 1902. *Thom's (1904)* (apparently mistakenly) lists him as in residence in the provost's house (corner of Grafton Street and Nassau Street). The provost in residence (appointed in 1904) was Anthony Traill, M.D. (1838–1914).

162:26 (164:40). tinned salmon—the pun hinges on the fact that "tinned" is Dublin slang for having money or being wealthy.

162:30 (165:2). Walter Sexton's window—across the street from the provost's house. Walter Sexton, goldsmith, jeweler, silversmith and watchmaker, 118 Grafton Street.

162:30–31 (165:2–3). John Howard Parnell—(1843–1923), brother of Charles Stewart Parnell. J. H. Parnell was Member of Parliament for South Meath from 1895 to 1900 and in 1904 was city marshal of Dublin and registrar of pawnbrokers.

162:35 (165:7). Must be a corporation meeting today—Bloom is right; see 243:29–39 (247:13–23). One of the city marshal's duties was to establish and keep order at meetings of the Dublin Corporation (though J. H. Parnell apparently skips the meeting in favor of his chess game).

162:37 (165:9). Charley Boulger—unknown but apparently a former city marshal, though *Thom's (1880–1905)* do not list him.

162:40 (165:12–13). his brother's brother—Bloom plays with the superstition that the brilliance of one of two brothers will be compensated by the dullness of the other.

162:41 (165:14). D.B.C—Dublin Bread (or Bakery) Company. The smoking room of the company's restaurant at 33 Dame Street was a meeting place for chess players.

163:3 (165:17). Mad Fanny—C. S. Parnell's sister, Frances Isabel Parnell (1854–1882), was active in the Irish nationalist movement. She worked closely with her brother and is reputed to have been an effective public speaker and a good organizer. Toward the end of her life she went into self-imposed exile in the United States and poured out a flood of patriotic verse which she called "Land League Songs."

163:3 (165:18). Mrs Dickinson—née Emily Parnell (1841–1918), another of Parnell's eight siblings, was married to a Captain Arthur Dickinson. After C. S. Parnell's death she wrote an ambiguously sympathetic biography entitled *A Patriot's Mistake;* the *Irish Times* remarked that it should have been called *A Patriot's Sister's Mistake.*

163:4 (165:19). surgeon M'Ardle—John S. M'Ardle, Fellow of the Royal College of Surgeons in Ireland, surgeon at St. Vincent's Hospital in Dublin.

163:5 (165:19–20). David Sheehy beat him for South Meath—David Sheehy (1844–1932), Nationalist Member of Parliament from South Galway (1885–1900), stood against and defeated John Howard Parnell for the seat of South Meath in 1903, a seat that Sheehy held until 1918. (J. H. Parnell had held the South Meath seat from 1895 to 1900.)

163:5–6 (165:20). Apply for the Chiltern Hundreds—at one time the Chiltern Hills, between Bedford and Hertford in England, were a famous highwaymen's refuge. Then Crown Stewards were appointed to patrol the area; the necessity for the patrol disappeared, but the offices of the stewards remained; thus when a Member of Parliament wished to vacate his seat he could accept the office of Steward of the Chiltern Hundreds. Because this advanced him to a government office, his seat in Parliament was *ex officio* vacated. Apparently this device was occasionally used to cover what might otherwise have been an ignominious retreat (see Dickens, *Our Mutual Friend*, "Chapter the Last"). Bloom

regards the office of City Marshall of Dublin as a similar sinecure.

163:6–7 (165:21–22). The patriot's banquet, Eating orangepeels in the park—at patriotic assemblies and celebrations in Phoenix Park. Irish nationalists ate oranges as a symbolic gesture calculated to annoy Orangemen (Protestant, pro-Union, anti-patriots) with the suggestion that they were about to be swallowed in a united and independent Ireland.

163:7–10 (165:22–23). Simon Dedalus said . . . Commons by the arm—it is not clear whether Simon means Sheehy or J. H. Parnell, but because James Joyce felt that he was snubbed by Sheehy, it is undoubtedly Sheehy who is intended; see Ellmann, index, *s.v.* "Sheehy."

163:11–13 (165:25–26). Of the two headed . . . with a Scotch accent—as a guess: this may refer to Russell's uneasy relation with his friend and colleague in theosophy Macgregor Mathers (d. 1916). Mathers was a wild professional Scot resident in Dublin; his "two heads" were a fanatic interest in the occult, on the one hand, and on the other hand, an equally fanatic interest in what Yeats (*Autobiography,* p. 225) called "the imminence of immense wars" (i.e., Armageddon, "the ends of the world"). This warlike phase of Mathers' fanaticism upset Russell, who was a dedicated pacifist. Russell's remark also alludes to Walter Pater's description of the *Mona Lisa* in *The Renaissance* (1873), "The presence that rose thus so strangely beside the waters, is expressive of what in the ways of a thousand years men had come to desire. Hers is the head upon which all 'the ends of the world are come,' and the eyelids are a little weary."

163:17 (165:31). Coming events cast their shadows before—from "Lochiel's Warning" (1802), a ballad by Thomas Campbell (1777–1844). In the poem the wizard predicts the defeat of Bonnie Prince Charlie, the Stuart pretender (1745) at the battle of Culloden and further predicts Lochiel's death. In spite of the warning, Lochiel chooses honor over expediency, supports the foredoomed campaign of his prince and goes to his death. The wizard's last warning begins: "Lochiel, Lochiel, beware of day!/For, dark and despairing my sight I may seal,/But man cannot cover what God would reveal:/'Tis the sunset of life gives me mystical lore,/And coming events cast their shadows before" (lines 52–56).

163:19 (165:33). A.E.: What does that mean? —George Russell's pen name; according to one witty Dublin version, it meant "Agricultural Economist," but Russell himself tells the story of its choice and meaning. He had attempted a picture of "the apparition in the Divine Mind of the Heavenly Man"; the title for it was mysteriously supplied by a disembodied whisper: "Call it the birth of Aeon." Sometime later, in the National Library, his eye caught the word "aeon" in a book that had been left open on a counter. He took this as a sign that his pen name had been chosen for him; but when he used it for the first time, the compositor misread it as "AE," and with this final sign from the Divine Mind the revelation of the pen name was complete.

163:20 (165:34). Albert Edward—Edward VII of England was christened Albert Edward (an ironically unlikely pen name for an Irish patriot).

163:25 (165:39). homespun—Russell wore homespun as a sign of his belief in peasant Ireland and its potential as a rural-agrarian utopia.

163:26 (165:40). bicycle—a trademark of George Russell because he traveled all over Ireland on a bicycle while he was organizing farmers' co-operative societies. Dublin wit at his expense: "he rode that bicycle right into the editorship of the *Irish Homestead.*"

163:26–27 (165:40–41). the vegetarian—i.e., Bloom assumes that Russell is a vegetarian and that he has lunched at a nearby vegetarian restaurant (unidentified).

163:29 (165:42–166:1). the eyes of that cow . . . through all eternity—Bloom's version of the rationale behind theosophical vegetarianism. The actual theosophic argument was that animals had "desire-bodies," which were "astral," capable of "a fleeting existence after death." "In 'civilized' countries then animal astral bodies add much to the general feeling of hostility . . . , for the organized butchery of animals in slaughter houses and by sport sends millions upon millions of these annually into the astral world, full of horror, terror, and shrinking from men . . . and from the currents set up by these there rain down influences" that are extraordinarily destructive (Annie Besant, *The Ancient Wisdom* [London, 1897], p. 84).

163:30 (166:2). a bloater—"bloat," a condition in cattle or sheep. The first stomach becomes painfully distended as a result of the formation of gas. Bloat is most frequent among animals that are unaccustomed to grazing on green legumes.

163:31 (166:4). a nutsteak—a vegetarian meat substitute made out of ground nuts.

163:31–32 (166:4). Nutarians. Fruitarians—two subspecies of vegetarians. Nutarians believed in subsisting on a diet primarily of nuts; fruitarians, primarily of fruit.

163:33 (166:5). **They cook in soda**—vegetarian manuals at the end of the nineteenth century did advise cooking in soda because it was believed the vegetable would retain its original color (and presumably all its original virtue) when cooked in such a solution. The fact that cooking with soda depletes the vegetables of their vitamins was not known in 1904 because vitamins were not discovered until 1912.

164:4 (166:18). **Yeates and Son**—on the corner of Nassau and Grafton Streets. Yeates and Son, opticians and mathematical instrument makers to the University and to the Dublin Port and Docks Board; 2 Grafton Street.

164:5 (166:19). **old Harris's**—Morris Harris (eighty-three years old), dealer in works of art, plate and jewelry, 30 Nassau Street. See Ellmann, p. 238n., and *Letters of James Joyce,* Vol. I, p. 242, and Vol. II, p. 194n.

164:7 (166:21). **Goerz lenses**—technically not lenses but prisms, because Goerz, a German optical firm, enjoyed considerable success in developing and marketing prism binoculars.

164:7–9 (166:21–23). **Germans making their way ... Undercutting**—Germany's expansionist policies in the years before World War I included not only an all-out effort to enlarge its navy and its colonial empire, but also an all-out effort to capture international markets. The German government granted impressive subsidies to key industries (such as the optical industry) to ensure a favorable competitive position in world markets.

164:9–10 (166:23–24). **the railway lost property office**—the office held personal belongings that had been left in trains for a limited period of time during which they could be reclaimed by their owners. After that period, the items were placed on sale to the general public.

164:14 (166:28). **Limerick junction**—at the head of the estuary of the River Shannon, 109 miles west-southwest of Dublin.

164:14–15 (166:28–30). **little watch up there ... test those glasses by**—i.e., on the roof of the Bank of Ireland across the street. Dublin residents interviewed in 1969 could not recall having heard of the "little watch" and doubted if it had ever been there.

164:20–21 (166:36–37). **the tip of his little finger blotted out the sun's disc**—among the Druids this phenomenon and the gesture which achieved it were regarded as symbolic of man's capacity for divination; see 163:17n.

164:23–24 (166:39–40). **sunspots when we were**

in Lombard street west. Terrific explosions they are—sunspots reach a maximum frequency in an 11-year cycle. The maximum Bloom has in mind occurred in August 1893. There was considerable question about the nature of sunspots in 1904; they were regarded as fairly large and deep depressions in the sun's surface. Bloom here confuses sunspots with what were called "prominences," eruptive jets of red hydrogen flame that burst outward from the solar surface. But Bloom's "mistake" is not a serious confusion because the two phenomena, while not explicable in 1904, were recognized as interrelated.

164:24–25 (166:40–41). **total eclipse this year: autumn some time**—9 September 1904, visible in the United States but not visible in Dublin.

164:26–27 (167:1–2). **that ball falls at Greenwich time**—i.e., the time ball on the Ballast Office; see 152:1–2n. The clocks in the Ballast Office were controlled by an electric current transmitted each second from the mean-time clock at the Dunsink Observatory, but Bloom is mistaken: the ball fell at Dunsink, not Greenwich, time.

164:27 (167:2–3). **Dunsink**—the observatory northwest of Phoenix Park was owned and operated by Trinity College from 1783 to 1946. It was "open to the general public on the first Saturday of each month from October to March inclusive from 7 to 9 P.M. and from 8 to 11 P.M. other months."

164:29 (167:4). **professor Joly**—Charles Jasper Joly (d. 1906), Astronomer Royal of Ireland, Andrews Professor of Astronomy at Trinity College and director of the Observatory at Dunsink.

164:32 (167:7). **foremother**—i.e., a bastard is technically fatherless.

164:33 (167:8). **Cap in hand goes through the land**—an Irish proverb that suggests that humility will get one much farther than arrogance or self-assertion.

164:40–41 (167:15–16). **Gas, then solid ... frozen rock**—a version of Laplace's nebular hypothesis about the origins of the earth and the universe: that the original materials were gaseous, subsequently concentrated into a hot solid that cooled, allowing the process of evolution ("world"), and that will continue to cool to the point where temperatures of the earth and the solar system eliminate the possibility of life and approach absolute zero. The moon (this theory held) is already such a body, and the earth will follow its example. Pierre Simon, Marquis de Laplace (1749–1827), French astronomer.

165:1 (167:17). new moon—see 155:30n.

165:2 (167:18). la Maison Claire—"court dressmaker," 4 Grafton Street.

165:3 (167:19). The full moon—Sunday, 29 May 1904.

165:4–5 (167:21). the Tolka . . . Fairview—a small river that meanders along the northern outskirts of metropolitan Dublin and empties into Dublin Bay at Fairview, which in 1904 was a mud flat (tidal) north of the reclaimed area at the mouth of the Liffey. Fairview has since been reclaimed as Fairview Park.

165:5–6, 7 (167:21–22, 23). The young May moon she's beaming, love./Glowworm's la-amp is gleaming, love—a song entitled "The Young May Moon," by Thomas Moore, from *The Dandy, O!* Verse: "The young May moon is beaming, love,/The glow-worm's lamp is gleaming, love,/How sweet to rove,/Through Morna's grove,/When the drowsy world is dreaming, love."

165:7 (167:23). Touch. Fingers—not just literally, since "touch" is slang for sexual intercourse. In the finger code Bloom suspects Molly and Boylan of having used, the questioner touches the palm of the person being questioned with the third finger; if the answerer intends *yes*, he makes the same gesture in response.

165:10 (167:26). Adam court—a small street off Grafton Street.

165:15 (167:31). cherchez la femme—French: literally, "look for the woman"; figuratively: "expect a woman to be the hidden cause."

165:17 (167:34). Sloping—to "slope" is to saunter or loiter.

165:17 (167:34). the Empire—the Empire Buffet, a public house and restaurant at 1, 2 and 3 Adam Court.

165:18 (167:35). Pat Kinsella—in the 1890s the proprietor of the Harp Musical Hall at 1, 2 and 3 Adam Court.

165:18 (167:35). Harp theatre—a cabaret that formerly occupied the premises occupied by the Empire Buffet in 1904.

165:19 (167:36). Whitbred—*Thom's (1904)* lists James W. Whit*bread* as manager of the Queen's Royal Theatre, Brunswick Street Great (now Pearse Street). Whitbred became manager after the demise of the Harp Musical Hall, with which he had been associated.

165:19 (167:36). Broth of a boy—the essence of boyishness, as broth is the essence of meat (P. W. Joyce, p. 137).

165:19–20 (167:36–37). Dion Boucicault business with his harvestmoon face—Dion Boucicault (1822–1890), the Irish-American playwright and actor, was moonfaced and was regarded by contemporary critics as lacking "marked histrionic talent" but as making up for it "by his keen sense of humor," i.e., when Pat Kinsella did the "Dion Boucicault business" he was imitating Boucicault's manner of hamming it up in the entr'actes in female costume, with falsetto songs, etc.

165:21 (167:38). Three Purty Maids from School—after "Three Little Maids from School," Gilbert and Sullivan, *The Mikado* (1885), Act I. Sung by Yum-Yum, Peep-Bo and Pitti-Sing, with Chorus. The Girls: "Three little maids from school are we,/Pert as a school-girl well can be,/Filled to the brim with girlish glee,/Three little maids from school!" Yum-Yum: "Everything is a source of fun. [*Chuckle.*]" Peep-Bo: "Nobody's safe, for we care for none. [*Chuckle.*]" Pitti-Sing: "Life is a joke that's just begun. [*Chuckle.*]" The Girls: "Three little maids from school." Chorus and Girls: "Three little maids who, all unwary,/Come from a ladies' seminary,/Freed from its genius tutelary." The Girls [*demurely*]: "Three little maids from school."

165:23–24 (167:40–41). More power—i.e., more whiskey, in reference to John Power and Son, Dublin distillers.

165:25 (167:42). parboiled eyes—overheated eyes, i.e., eyes reddened by drinking.

165:26 (168:1). The harp that once did starve us all—after Thomas Moore's song "The Harp That Once through Tara's Halls": "The harp that once through Tara's halls/The soul of music shed/Now hangs as mute on Tara's walls/As if that soul were fled. // So sleeps the pride of former days,/So glory's thrill is o'er,/And hearts, that once beat high for praise,/Now feel that pulse no more."

165:27–28 (168:2–3). Twenty-eight—since Bloom was born in 1866 the year was 1894.

165:34 (168:10). Grafton street—"at that time the 'smartest' of the shopping thoroughfares of Dublin" (Budgen, p. 102).

165:37 (168:12). causeway—i.e., the street was paved with cobblestones.

165:38 (168:14). chawbacon—a yokel.

165:38 (168:14). All the beef to the heels— see 65:38n.

165:41 (168:17). Brown Thomas—Brown, Thomas, and Company, silk mercers, milliners, costumers, mantle makers and general drapers, 15–17 Grafton Street, advertised itself in 1904 as having been famous for "the best quality" of Irish laces and linens for 100 years.

166:2 (168:20). The huguenots brought that here—the Huguenots who sought shelter in Ireland in the late seventeenth century, establishing colonies in Dublin and in the Protestant north, brought with them improved textile machinery and improved dyes, notably the red dyes, as Bloom remarks.

166:2–4 (168:20–22). La causa è santa . . . bom bom bom—Bloom recalls a passage from an opera by the German composer Giacomo Meyerbeer (1791–1864), *Les Huguenots* (1836). The original opera was written in French, but performances in Italian were common in the late nineteenth century. The opera deals in a rather ahistorical way with the massacre of the Huguenots in Paris on St. Bartholomew's Day, 24 August 1572. In Act IV of the opera, St. Bris, one of the leaders of the Catholic faction, pledges to do his part in the massacre in an impressive solo, *"Pour cette cause sainte"* ("For this sacred cause [the massacre]"), which Bloom recalls in the Italian, *"La causa è santa"* ("The cause is sacred"). Strictly speaking, it is not a "chorus" as Bloom thinks, though St. Bris's solo is later taken up by the full chorus.

166:3 (168:21–22). Must be washed in rainwater—Bloom sees in the window part of a sign with instructions for the care of the cloth. Rainwater was widely used with delicate materials and unstable dyes because it was ideally soft (i.e., contained no minerals).

166:9 (168:27). . . . augseptember eighth—Molly's birthday (by coincidence) is also celebrated as the birthday of the Blessed Virgin Mary.

166:10–11 (168:28–29). Women won't pick . . . cuts lo—i.e., it cuts "love." The superstition is that, if a *girl* picks up a pin, she will make a staunch new boyfriend; therefore, a woman avoids picking up pins because it would divide her affections, it would *cut love*.

166:17 (168:35). Agendath Netaim—see 60:1–2 13n.

166:21 (168:39). Duke street . . . The Burton—Bloom turns east from Grafton Street into Duke Street and walks past Davy Byrne's pub (at 21) to The Burton Hotel and Billiard Rooms at 18;

The Burton advertised its "Refreshment Rooms" in *Thom's (1904)*.

166:23 (168:41). Combridge's corner—Combridge and Company, picture depot, print sellers and picture-frame makers, artists and color men, at 20 Grafton Street, on the corner of Duke Street.

167:3–4 (169:22). See ourselves as others see us—after Robert Burns (1759–1796), "To a Louse; on Seeing One on a Lady's Bonnet at Church" (1786): "O wad some Power the giftie gie us/To see oursels as ithers see us!/It wad frae monie a blunder free us,/An' foolish notion:/What airs in dress an' gait wad lea'e us,/An' ev'n devotion" (lines 43–48).

167:5–8 (169:23–27). That last pagan king . . . him to Christianity—garbled history and legend. The poem Bloom recalls is "The Burial of King Cormac," by Sir Samuel Ferguson (1810–1886), Irish poet and antiquary. The lines Bloom vaguely remembers: "He choked upon the food he ate/At Sletty, southward of the Boyne." King Cormac was not, however, "that last pagan king." Cormac, who reigned c. 254–c. 277, was the son of Art, whose father was Conn of the Hundred Battles. Gaelic tradition holds that Cormac was the first founder and legislator of Ireland, the shaper of the nation; it was he who made the hill of Tara the capital of the country (i.e., it was he who shaped Ireland's Golden Age). Legends of his reign picture him as having been the first person in Ireland to accept the Christian faith (139 years before the arrival of St. Patrick). The result of his conversion was that the Druids were irritated and let loose a group of demons who arranged for Cormac to choke on a salmon bone while he was eating his dinner. St. Patrick (c. 385–c. 461) did not begin his mission to Ireland until 432 or 433. There is a famous legend of a meeting at Tara between St. Patrick and (then) High King Laeghaire; the legend holds that, though Laeghaire himself did not accept conversion, he did agree not to interfere with St. Patrick's mission (as Bloom puts it, he "couldn't swallow it all," 167:9 [169:27]).

167:8 (169:26). galoptious—for "goluptious," slang for very enjoyable, delicious.

167:16 (169:34). tootles—a nursery word for a child's tooth.

167:18 (169:36). Look on this picture then on that—after *Hamlet* (III, iv, 53–54), when Hamlet berates his mother and urges her to compare the image of his father with that of Claudius, his uncle and his mother's present husband: "Look here upon this picture, and on this,/the counterfeit presentment of two brothers."

167:18 (169:36). Scoffing—"to scoff" is to devour.

167:27 (170:3). Safer to eat from his three hands—after the conventional saying used to reprove a child for eating with his fingers: "You could eat faster if you had three hands."

167:28 (170:4). Born with a silver knife in his mouth—after the proverbial expression for born to inherit wealth: "Born with a silver spoon in his mouth."

167:31–32 (170:7–8). Rock, the bailiff—we have been unable to determine whether anyone named Rock was in the Bailiff's office in early twentieth-century Dublin, but if he had been, his name would have appealed as something of a joke because underground land-reform organizations in the nineteenth century traditionally identified their leaders pseudonymously as "Captain Rock," and one of Captain Rock's key duties was to take the lead in terrorizing or assassinating the bailiffs who, as collectors and evictors for the landlords, were the omnipresent instruments of oppression for the Irish peasantry.

167:38 (170:14). Unchester Bunk—garbled version of Munster (and Leinster) Bank in Dublin.

168:1 (170:19–20). Davy Byrne's—David Byrne, wine and spirit merchant, 21 Duke Street.

168:6 (170:24). gobstuff—"gob" is slang for mouth.

168:10 (170:28). tommycans—"a tommy" is something (usually food) supplied to a workman in lieu of wages.

168:12 (170:30). every mother's son—in *A Midsummer-Night's Dream* Peter Quince warns his fellow players that the lion must not be so impressively real as to frighten the ladies in the audience. If he were, the players would all be hanged. The "rude mechanicals" reply: "That would hang us, every mother's son" (I, ii, 80).

168:12–13, 19–20 (170:30–31, 38–39). Don't talk of . . . provost of Trinity/Father O'Flynn would make hares of them all—after the ballad "Father O'Flynn," by Alfred Percival Graves (1846–1931), *Father O'Flynn and Other Lyrics* (1879). (To "make a hare" of someone is to render him ridiculous, to expose his ignorance.) Second verse: "Don't talk of your Provost and Fellows of Trinity/Famous for ever at Greek and Latinity,/Faix! and the divils and all at Divinity—/Father O'Flynn'd make hares of them all!/Come, I vinture to give you my word,/Niver the likes of

his logic was heard,/Down from mythology/Into thayology,/Troth and conchology if he'd the call."

168:14–15 (170:32–33). Ailesbury road . . . Clyde road—fashionable suburban streets, respectively two and a half and one and a half miles southeast of the center of Dublin.

168:15 (170:33). artisan's dwellings, north Dublin union—residences of the poor. The artisan's dwellings were in the area just east of Phoenix Park in western Dublin. The North Dublin Union Workhouse was a poorhouse in Brunswick Street North in northwest-central Dublin.

168:16 (170:34). gingerbread coach—i.e., the highly decorated, antique coach that the Lord Mayor of Dublin used on official occasions.

168:16 (170:34–35). old queen in a bathchair—in her declining years, Queen Victoria "took the air" in a so-called bathchair (after the basket-weave chairs on wheels used for invalids at the health resorts in Bath, England).

168:17 (170:35–36). incorporated drinking-cup—i.e., a cup that belonged to or was issued by the Dublin Corporation.

168:17–18 (170:36). like sir Philip Crampton's fountain—see 91:7n. The fountain beneath the statue was equipped with community drinking cups. (It is no longer in existence, and the statue has been removed.)

168:22 (170:41). as big as Phoenix Park—advertised in 1904 as the biggest urban park in the world: 1,760 acres, seven miles in circumference.

168:23–24 (170:42). City Arms Hotel—a residence hotel owned by Miss Elizabeth O'Dowd at 54 Prussia Street, near the Cattle Market in western Dublin. The Blooms lived there while Bloom was working for the cattle dealer Joseph Cuffe.

168:24 (171:1). Soup, joint and sweet—a crude and less fashionable way than *table d'hôte* of describing a three-course meal. "Joint": the main or meat course; "sweet": dessert.

168:26 (171:3). feeding on tabloids—i.e., on pills, after the commonplace science-fiction vision of the synthetic diet of the future.

168:33 (171:10). bob—a calf less than one month old; "bob veal" is veal too immature to be suitable for food. Its sale is usually prohibited by statute, though the implication of "staggering bob" in context is illicit slaughterhouse procedure.

168:33 (171:10). Bubble and squeak—beef and cabbage fried together.

168:34 (171:11). Butcher's buckets wobble lights—i.e., the lights (lungs) of slaughtered animals wobble in the buckets into which they are dropped.

168:37 (171:14). Top and lashers—butchers' slang: unknown.

168:39 (171:16). decline—a wasting disease, such as tuberculosis of the lungs.

168:40–41 (171:17–18). Famished ghosts—the ghosts Odysseus meets in Book XI of *The Odyssey* must first drink from the blood-filled trench before they can achieve the power of speech.

169:5 (171:24). Shandygaff?—a drink made by mixing beer with ginger beer or ginger ale (sometimes, when it is called "Shandy," with lemon bitters).

169:6 (171:25). Nosey Flynn—appears as a character in "Counterparts," *Dubliners*, where he is discovered "sitting up in his usual corner of Davy Byrne's."

169:12 (171:31). Ham and his descendants—the pun involves Ham, one of Noah's three sons and traditionally regarded as the tribal father of the Negroid races. Ham, because he saw his father Noah drunken and naked, was cursed by Noah and condemned to be "a servant of servants . . . unto his brethren" (Genesis 9:22–27).

169:15 (171:34). up a plumtree—i.e., cornered or done for.

169:16 (171:35–36). White missionary too salty—legendary (and quasi-cynical) explanation for the survival of missionaries.

169:23 (171:42). Kosher—food regarded as ceremonially clean under Jewish law. Bloom uses the term (as it is so often used) to include Jewish dietary laws generally.

169:23 (171:42). No meat and milk together—one of the Jewish dietary laws.

169:23 (172:1). Hygiene that was—Bloom quite rightly observes that many of the dietary laws were originally hygienic: e.g., the law against pork reflects the fact that hogs were scavengers (in graveyards); the laws against shellfish suggest the pollution of inshore waters, etc.

169:25 (172:1–2). Yom kippur fast spring cleaning—see 149:41n. Yom Kippur now occurs in early autumn and thus "spring" is hardly

appropriate except that in Hebrew tradition the year is renewed four times in agricultural feasts: at the Feast of the Tabernacles, five days after Yom Kippur; at Passover in the early spring; at the midwinter Feast of the Trees; and at Firstfruits in early summer. See 47:41–48:1n.

169:26 (172:3–4). Slaughter of innocents—when Herod heard the prophecies accompanying the birth of Jesus, he determined to eliminate that rival first by a stratagem that failed: "Then Herod . . . was exceeding wroth, and sent forth, and slew all the children that were in Bethlehem, and in all the coasts thereof" (Matthew 2:16). Joseph, meanwhile, had been warned by a vision and had escaped with Mary and her child to safety in Egypt.

169:26–27 (172:4). Eat, drink and be merry—the writer of Ecclesiastes contemplates the "vanity which is done upon the earth" and continues, "Then I commended mirth, because a man hath no better thing under the sun, than to eat, and to drink, and to be merry; for that shall abide with him of his labour the days of his life, which God giveth him under the sun" (Ecclesiastes 8:15).

169:27 (172:4). casual wards—outpatient clinics.

169:27–28 (172:5–6). Cheese digests all but itself—a saying that originated in the sixteenth century. The process of making cheese was popularly regarded as a process of digestion because the process involved the use of rennet, a substance derived from animal stomachs and used to curdle milk.

169:35–36 (172:13–14). God made food, the devil the cooks—after John Taylor (1580–1653), English writer who styled himself "the King's water poet," *All the Works of John Taylor, The Water Poet, being 63 in Number* (1630), Vol. II, p. 85: "God sends meat, and the Devil sends the cooks."

170:4 (172:24). a big tour—only one concert is scheduled for Belfast (on 25 June).

170:24 (173:2). Pub clock five minutes fast—the closing time of public houses was quite strictly enforced. The clocks in pubs were traditionally set a few minutes fast so that there would be no inadvertent errors.

170:36 (173:13). Jack Mooney—Bob Doran's brother-in-law appears as a character in "The Boarding House," *Dubliners*.

170:37 (173:14). that boxing match Myler Keogh won against that soldier—an advertise-

ment in the *Freeman's Journal* (28, 29 April 1904) announced a civil and military boxing tournament to be held at the Earlsfort Terrace Rink on Friday and Saturday 29, 30 April. In the second event on Friday night's card (M. L. Keogh of Dublin *vs.* Garry of the 6th Dragoons), Keogh knocked out Garry with a right hand to the pit of the stomach in the third round. Joyce changed the date to Sunday, 22 May, made this preliminary event the main event, and substituted the thoroughly English "sergeant-major Percy Bennett," an artilleryman. See 313 (318–319).

170:38 (173:15). Portobello barracks—a British Army barracks due south of the center of Dublin on the outskirts of the city. It was the headquarters of the South Dublin Division of the Dublin Military District.

170:38 (173:15). kipper—a young man of the Australian aborigines who has passed through the puberty rites; hence any young or small person.

170:39 (173:16). county Carlow—about 50 miles south-southwest of Dublin.

171:2 (173:21). hairy—shrewd, cautious.

171:5 (173:24). Herring's blush—"herring" is slang for a narrow-minded, average sort of person.

171:5–6 (173:24–25). Whose smile upon each feature plays with such and such replete—source unknown.

171:6 (173:25). Too much fat on the parsnips —after the proverb: " Soft or fair words butter no parsnips" (i.e., saying, "Be thou fed," does not feed a hungry man). Butter on parsnips was considered a delicacy; "too much fat" suggests an excess that is inferior in quality (to butter) and hence a person who is excessively unctuous.

171:7 (173:26). here's himself and pepper on him—i.e., he's in good form.

171:14 (173:33). logwood—an astringent used in medicines.

171:20 (173:39). Vintner's sweepstake—i.e., what the owners of licensed public houses have in lieu of a sure thing in a horserace.

171:20–21 (173:39–40). Licensed for the sale . . . on the premises—official language of a public-house license.

171:21–22 (173:40–41). Heads I win tails you lose—an infallible formula for winning in a game of tossing coins.

171:25–26 (174:2–3). He's giving Sceptre . . . Morny Cannon—see 84:28n. The *Freeman's Journal,* 16 June 1904, was not entirely accurate in its report of the field in the Gold Cup. Flynn is right: the odds on Sceptre (ridden by O. Madden) were seven to four against; the odds on Zinfandel (ridden by Mornington Cannon) were five to four. Zinfandel did win the Coronation Cup at Epsom Downs on 3 June 1904 (the day after the Derby); Sceptre finished second in that race.

171:27–28 (174:4–5). seven to one against Saint Amant a fortnight before—the Derby was run on 2 June 1904. Saint Amant, a *colt* (not a filly as Flynn thinks) out of Lady Loverule, owned by M. Leopold de Rothschild (whose racing colors were blue and gold), did win the Derby under the conditions Flynn describes below. On 20 May 1904, the odds against Saint Amant were six to one; the odds shortened to approximately four to one in late May but lengthened again just before the race.

171:35–36 (174:13). John O'Gaunt—another of the entries in the 1904 Derby, owned by Sir John Thursby. The odds against the horse were quoted at four to one on 1 June 1904, the day before the race. The favorite before the start of the Derby was Gouvernant, a horse Flynn does not mention.

171:42–172:1 (174:19–20). Fool and his money—are soon parted; a saying current since the sixteenth century.

172:17–18 (174:37). Johny Magories—Johny MacGorey or Magory, the fruit of *Crataegus oxyacantha,* the dog rose or hawthorn tree.

172:24–25 (175:2). Fizz and Red Bank oysters —the combination of champagne and oysters was regarded as a promising aphrodisiac.

172:25–26 (175:3). He was in the Red Bank— i.e., Boylan was in the Red Bank Restaurant; see 91:14–16 (92:19–22).

172:28 (175:6). Jugged hare—seethed or stewed in an earthenware pot or casserole.

172:29 (175:6–7). Chinese eating eggs . . . and green again—the Chinese preserved and/or prepared ducks' eggs by burying them in the ground for ten to 12 months; the eggs undergo a peculiar fermentation in the course of which the hydrogen sulfide formed by the rotting egg breaks the shell and escapes; the egg itself becomes hard in texture and changes color to blue (the white) and green (the yolk). The final product is not disagreeable in odor or taste, but its worth seems to have been measured by its rarity, i.e., its age, since the eggs are "ripe" and edible after a year.

The few saved for up to 50 years were highly prized as being "exceptional."

172:31 (175:9). That archduke Leopold— Bloom understandably confuses Leopold von Bayern (1821–1912), prince regent of Bavaria from 1886 to 1912, with King Otto of Bavaria; see 172:32n below. Leopold's career was intimately related to King Otto's; Leopold became prince regent upon the accession of King Otto because Otto was adjudged insane as early as 1872.

172:32 (175:9–10). Otto one of those Habsburgs— Otto I (1848–1916; king of Bavaria, 1886; deposed 1912). He became insane in 1872 and lived the remainder of his life under a strict surveillance that gave rise to a number of lurid stories of the sort that Bloom recalls. Otto I was not a Habsburg, though the Habsburg Emperor of Austria, Francis Joseph I (1830–1916), did have a nephew named Otto.

172:35–36 (175:13–14). Half the catch ... keep up the price— an unfounded but widespread suspicion of economic malpractice.

172:37–38 (175:15–16). Hock in green glasses —Hock, after "Hochheimer," a delicate white Rhine wine, was traditionally bottled (and served) in colored glasses to prevent its being affected by light.

172:39 (175:17). Crème de la crème— French: literally, "cream of the cream"; figuratively: "the finest of the fine."

172:41 (175:19). Royal sturgeon— all sturgeon in English territorial waters were declared the legal property of the Crown by Edward II, who was king of England from 1307 to 1327.

172:41–173:1 (175:19–21). High sheriff, Coffey ... from his ex— his excellency, the lord lieutenant of Ireland, has instructed the high sheriff (of Dublin County? or of all counties?) that William Coffey, butcher and victualer, 10 Arran Quay and 35 Cuffe Street in Dublin, has permission to sell venison in his markets. The high sheriff of each county had responsibility for the enforcement of game laws.

173:2 (175:22). Master of the Rolls— the Right Honorable Sir Andrew Marshall Porter, Bart. (1837–1919), master of the rolls for Ireland (1883–1907), had a residence in Dublin at 42 Merrion Square East. Bloom has apparently looked through the kitchen windows. The master of the rolls was president of the chancery division of the High Court of Justice in Ireland, in rank next to the lord chief justice and the lord chancellor.

173:2–3 (175:22–23). whitehatted chef like a

rabbi— the cylindrical white hat which rabbis wear on certain ceremonial occasions resembles a chef's cap in appearance.

173:3 (175:23). Combustible duck— duck that is prepared in a sauce and flamed with a brandy just before it is served. Several distinguished French recipes for duck (duck with black cherries, etc.) call for this treatment.

173:3 (175:23–24). Curly cabbage à la duchesse de Parme— baked Savoy cabbage with a stuffing of ground veal, herbs, bread crumbs, etc.

173:5 (175:25). too many drugs spoil the broth— after the saying "Too many cooks spoil the broth" (the converse of "Many hands make light work").

173:6–7 (175:27). Geese stuffed silly for them —geese were confined in cages and force-fed to produce the highly enriched and outsized livers used in making *pâté de foie gras*.

173:10 (175:30). miss Dubedat— *Thom's (1904)* lists only the Misses Du Bedat, the Wilmount House, Killiney. Adams (p. 74) notes that at a benefit held at the Queen's Royal Theatre for J. W. Whitbred (165:19n) a Miss Du Bedat sang "Going to Kildare" (*Freeman's Journal*, 3 February 1894).

173:11 (175:31). Huguenot name— origin of the name Dubedat or Du Bedat is unknown, but its French form makes Bloom's assumption logical.

173:11 (175:32). Killiney— an attractive village on the coast nine miles southeast of Dublin.

173:12 (175:32). Du, de la— French: "of the"; *du* is a contraction of *de* ("of") and the masculine definite article *le; de la* includes the feminine definite article.

173:13 (175:33). Micky Hanlon— M. and P. Hanlon, fishmongers and ice merchants, 20 Moore Street, Dublin.

173:16 (175:36–37). Moooikill A Aitcha Ha— i.e., Michael ... A ... H ... A ... (toward Hanlon).

173:16–17 (175:37). Ignorant as a kish of brogues— a "kish" is a large, square basket used for measuring turf. The expression suggests that, if having one's brains in one's feet means stupidity, how much more stupid a full measure of empty, rough shoes.

173:22–24 (176:1–3). Howth ... the Lion's head ... Drumleck ... Sutton— Howth is a peninsula that projects out into the Irish Sea to

form the northeastern arm of Dublin Bay. The peninsula is dominated by Ben (mountain peak) Howth, 583 feet high. Lion's Head is a promontory on the southeastern side of Howth. Drumleck is a village on the southern shore of Howth; Sutton is on the spit of land between Howth and the mainland. The progression of colors marks the progression from the deeper waters off Lion's Head through the shallower waters (five fathoms) off Drumleck to the shallow waters over the tidal flats of Sutton Strand.

173:25 (176:4). buried cities—i.e., the configuration of algae and deeper channels in the bay as seen from above suggests cities that have been buried in the sea, such as Atlantis, a large island that, according to classical tradition (as articulated by Plato), existed in the Atlantic off Gibraltar. Plato in the *Critias* credits the island with a fabulous history of cultural achievement—before its inundation.

174:4–5 (176:26–27). library museum . . . naked goddesses—plaster casts of various famous classical statues (including the Venus of Praxiteles) stood in the entrance hall of the National Museum. They have since been retired in favor of Celtic crosses, etc.

174:8 (176:30). Pygmalion and Galatea—mythology: Pygmalion, a sculptor and the king of Cyprus, fell in love with his own handwork, the ivory statue of a maiden. He prayed to Aphrodite, who granted his prayer by breathing life into the statue (Galatea). The transformation was climaxed by the marriage of Pygmalion and Galatea.

174:10 (176:32). a tanner lunch—i.e., a sixpenny lunch, inexpensive, but at least hot and filling rough fare.

174:11 (176:33). Allsop—a popular and inexpensive bottled beer made by Allsopp & Son, Ltd., brewers at 35 Bachelor's Walk, Dublin.

174:19–20 (176:41–42). A man and ready . . . to the lees—echoes lines 6 and 7 of Tennyson's "Ulysses" (1842): "I cannot rest from travel; I will drink/Life to the lees."

174:20–21 (176:42–177:1). manly conscious—as Shakespeare in *Venus and Adonis* (1593) describes Venus as essentially masculine in her approach to the youthful Adonis—as she "like a bold-faced suitor 'gins to woo him" (line 6), and "Backward she push'd him, as she would be thrust" (line 41).

174:21 (177:1). a youth enjoyed her—if Bloom is thinking about Venus and Adonis, then he is mistaken. Adonis does not "enjoy" Venus; the

pivot of Shakespeare's poem is that Venus is unable to overcome the resistance of Adonis' "unripe years" (line 524).

174:37–38 (177:17–18). that Irish farm . . . in Henry street—Irish Farm Produce Company, Mrs. J. W. Power, manageress, 21 Henry Street.

174:40 (177:20). Plovers on toast—some of the large plovers are prized as game birds in Europe. The expression turns on the plover as "rare good eating," but as slang it means full-breasted in an attractive way.

175:1–2 (177:23–24). You can make bacon of that—as "bacon" is slang for money, the phrase means "You can bet on that."

175:6 (177:28). in the craft—the "Craft" is Freemasonry, called "the Craft" in allusion to the heritage of the ancient guild of craftsmen because the express object of the order was the building of a spiritual temple: the creation of an undefiled temple in the individual heart and public striving for the Brotherhood of Humanity in a brighter and more beautiful world. Bloom has in fact been a member. See 154:4–6 (156:10–12).

175:8–9 (177:30–32). Ancient free and . . . love, by God—Flynn is echoing phrases from the Masonic ritual; the order regarded itself as practicing "Ancient and Accepted Rites," rites to which all "free men could be admitted." Three symbols of light dominate the Masonic temple: The Volume of the Sacred Law (the Bible), symbolic of the light from above; the square, symbolic of the light within man; and the compasses, symbolic of fraternity, the light around man. The Masonic ritual as articulated in the *Antient Charges* (1723) expresses a commitment to the creation of "the Temple of Human Love, the foundations of which are Wisdom, Strength and Beauty." Flynn's "by God" is his own Irish interpolation: the Masonic formula dictated tolerance under "the Great Architect of the Universe."

175:9 (177:32–33). They give him a leg up—the popular suspicion was that Masons gave excessive preference to members of their order even to the point of handing out money. The order is committed to help and support its members and families in time of disease and personal crisis, but the *Antient Charges* is quite specific on preference: "All preferment among Masons is grounded upon real worth and personal merit only."

175:14 (177:36). They're as close as damn it—another expression of popular suspicion of Freemasonry, reflecting not only the exclusive nature of the order but also the assumption that the order

involved a profound and conspiratorial "secret." According to its own principles the order was open to any *man* at least twenty-one years of age and in body "a perfect youth"; no man could be admitted to membership if he was "a stupid atheist or an irreligious libertine."

175:18–21 (177:40–178:1). There was one woman . . . Legers of Doneraile—There are several (exceptional) histories of women who were initiated into Masonic lodges. The one Flynn cites is traditionally regarded not as the "only" but as the "first." The woman was Mrs. Elizabeth Aldworth (d. 1773), the only daughter of Arthur St. Leger, 1st Viscount Doneraile. She is supposed (at age seventeen) to have been a witness to a Masonic meeting in her father's house and to have been initiated to ensure secrecy. A portrait of her in Masonic apron with her finger on a passage in The Volume of the Sacred Law is reproduced in Eugen Lennhoff, *The Free-Masons* (New York, 1934), opposite p. 336.

175:38 (178:19). Nothing in black and white—combining the suspicion of Bloom's secretiveness as a Mason with a suspicion of Bloom as a Jew (on the assumption that all Jews were averse to the oath implied in signing a contract).

175:39 (178:20). Tom Rochford—appears as a character elsewhere in *Ulysses*. In real life he lived at 2 Howth View, Sandymount, and was, on 6 May 1905, involved in the attempt to rescue a sanitation worker who had been overcome by sewer gas (in a sewer at the corner of Hawkins Street and Burgh Quay near the Scotch House). In the newspaper accounts of the incident Rochford is described variously as "clerk of the works" and an "engineer" formerly in the employ of the Dublin Corporation. In the real-life rescue Rochford was the third out of 12 men down the sewer; all 12 were overcome by gas and dragged out unconscious—two of them died; Rochford lived but his eyes were at least temporarily injured by the gas. Joyce radically transformed the story for inclusion in *Ulysses*. See Adams, pp. 92–94.

176:5 (178:28). a stone ginger—a nonalcoholic Irish drink regarded as a temperance beverage.

176:8 (178:31). How is the main drainage?—combines references to Rochford's dyspepsia and his adventure in the sewer with an allusion to Dublin's long-delayed and controversial project for an adequate sewage system. The Main Drainage Committee's duties had been absorbed by the Improvements Committee late in 1903 (apparently because the special committee's handling of the project was not above suspicion). The Dublin Main Drainage Works was finally inaugurated 24 September 1906.

176:16–17 (178:40). suck whiskey off a sore leg—whiskey was applied externally as a home remedy for infection.

176:18 (178:41). snip—racing slang for a good tip.

176:36 (179:17). Jamesons—a famous Irish whiskey distilled by John Jameson and Son in Dublin.

176:37. singer should read **ginger** as it does **(179:18).**

176:39 (179:20). Dawson street—runs north and south across the eastern end of Duke Street.

176:40–41 (179:21–23). Something green it ... searchlight you could—a troublesome fragment because we reenter Bloom's thoughts when they are in full flow. Röntgen rays (1895), i.e., X rays, were originally named after their discoverer, the German physicist Wilhelm Konrad von Röntgen (1845–1923). The discovery of X rays was greeted with widespread speculative enthusiasm. X rays were initially produced by relatively low-powered equipment and the immediate danger of burns as well as the long-range danger of radioactivity were not recognized. On the other hand, practical applications of X rays in medical and dental fields were recognized from the outset, but popular journalistic accounts went well beyond modest applications (such as the location of dental caries) to speculate on phototherapeutic uses of X rays, as Bloom here speculates that one could clean one's teeth with them. It is notable in this connection that late nineteenth-century popular science tended to interconfuse X rays with phototherapy (a method of treating diseases with "decolorized light rays," invented by the Danish physician Niels Finsen [1860–1904]).

176:42 (179:24). Duke lane—intersects Duke Street between Davy Byrne's and Dawson Street.

177:4 (179:28). Their upper jaw they move—i.e., ruminants when chewing the cud.

177:5 (179:29). that invention of his—see 228–229 (232).

177:11–12 (179:35–36). Don Giovanni, a cenar teco/M'invitasti—the line continues "*e son venuto!*" Italian: "Don Giovanni, you invited me to sup with you and I have come." Act II, scene iii of Mozart's *Don Giovanni* takes place in a moonlit graveyard, where Don Giovanni mocks the statue of his dead enemy, Il Commendatore, by inviting it to supper. In scene v (the final scene of the opera) the Statue enters, singing the quoted lines, to keep the engagement and subsequently to inform Don Giovanni that he must repent

because the last moment of his life is at hand. Don Giovanni refuses and is engulfed with the flames of hell.

177:13 (179:37). Who distilled first?—the process was apparently known to Aristotle and his contemporaries and has from the first century A.D. been employed in much the same way as it is at present.

177:14 (179:38). in the blues—in a state of depression; also, gone astray.

177:14 (179:38). Dutch courage—courage produced with the help of an alcoholic beverage.

177:14 (179:38). Kilkenny People—a weekly newspaper published each Saturday in Kilkenny.

177:16–17 (179:40–41). William Miller, plumber—and sanitary contractor, 17 Duke Street.

177:24 (180:7). What does that teco mean?—Italian: "with you."

177:31 (180:14). Presscott's should read **Prescott's**—see 82:32–33n.

177:31–32 (180:15). On the pig's back—in luck, in luck's way.

177:37 (180:20). Brighton, Margate—Brighton, in Sussex, England, on the English Channel, advertised as "The Queen of Watering Places." Margate is on the Isle of Thanet, in Kent, England; at the turn of the century, Margate was Brighton's principal competition.

177:38 (180:21). John Long's—a pub; P. J. Long, grocer and wine merchant, 52 Dawson Street (on the corner of Duke Street).

178:1 (180:24). Gray's—Katherine Gray, confectioner, 13 Duke Street (at the intersection of Dawson Street); Bloom turns south to Molesworth Street, where he will turn east toward the National Library.

178:2–3 (180:25–26). the reverend Thomas Connellan's bookstore—51B Dawson Street; the shop specialized in Protestant propaganda.

178:3 (180:26). Why I left the church of Rome?—(London, 1883), a 30-page pamphlet by the Canadian Presbyterian minister Charles Pascal Telesphore Chiniquy (1809–1899). Chiniquy was ordained a Roman Catholic priest in 1833 and switched allegiance to the Presbyterian Church in 1858. He was styled "the veteran Champion of Pure Religion and Temperance" and was reputed to have converted 25 to 30 thousand of his countrymen. Chiniquy's specific

objection was to the Roman Catholic concept of the Virgin Mary as intercessor; as he put it, "Mary cannot have the power to receive from Jesus the favors she asks." On a more general level Chiniquy argued that laymen should have their own Bibles and should read and think out their faith for themselves.

178:3 (180:26). Bird's nest—Dublin slang for Protestant institutions dedicated to proselytizing: there was a "bird's nest" institution with accommodation for 170 "ragged children" at 19 and 20 York Street in Kingstown; it was a Protestant missionary society run by one Miss Cushen.

178:3–4 (180:27). Women run him—this sentence is not clear in context unless the free association implies that women are the most vigorous proselytizers, and therefore those like Connellan who are involved in anti-Roman Catholic propaganda are run by women.

178:4–5 (180:27–28). They say they . . . the potato blight—the practice of bribing potential converts with food was, as Bloom suggests, all too common, not only during the Great Famine but also throughout the nineteenth century.

178:5–6 (180:29–30). Society over the way . . . of poor jews—Church of Ireland Auxiliary to the London Society for Promoting Christianity Among the Jews, 45 Molesworth Street (which enters Dawson Street where Bloom is walking).

178:17 (180:41). Drago's—Adolphe Drago, Parisian perfumer and hairdresser, 17 Dawson Street.

178:21 (181:5). South Frederick street—runs north and south across Molesworth Street, a short distance east of Dawson Street.

178:34 (181:18). Behind a bull: in front of a horse—safety maxim since a bull cannot kick backwards and a horse can.

179:6 (181:32). Penrose—see 153:39–40 (156:3).

179:13 (181:39). Dark men—Irish dialect: "blind men."

179:20 (182:4). the Stewart institution—for Imbecile Children and Hospital for Mental Diseases, 40 Molesworth Street.

179:27 (182:11). Postoffice—Town Sub-Post Office, Money Order and Savings Bank Office, 4 Molesworth Street.

179:28 (182:12–13). Stationer's—E. F. Grant & Company, scriveners, typewriters, law and general stationers, 1 and 2 Molesworth Street.

179:34–35 (182:19). Levenston's dancing academy—Mrs. Philip M. Levenston, dancing academy; Mr. P. M. Levenston, professor of music, 35 Frederick Street South.

179:36 (182:21). Doran's public house—Michael Doran, grocer, wine and spirit merchant, 10 Molesworth Street (on the corner of Frederick Street South).

180:1–3 (182:28–30). All those women . . . in New York. Holocaust—the *Freeman's Journal*, 16 June 1904, carried the story on page 5: "Appalling American Disaster . . . Five hundred persons, mostly children, perished today by the burning of the steamer *General Slocum*, near Hell Gate, on the East River. The disaster is the most appalling that has ever occurred in New York Harbour, and the fact that the victims were almost entirely of tender age, or women, renders it absolutely distressing. The annual Sunday School excursion of the St. Mark's German Lutheran Church was proceeding to Locust Grove, a pleasure resort on Long Island Sound. As the steamer made its way up the East River, with bands playing and flags flying, every deck was crowded with merrymakers.

"When she was off Sunken Meadows a fire broke out in the lunch room. The crew endeavoured to extinguish the flames, but they quickly became uncontrollable and made rapid headway. A panic ensued. The Hell Gate rocks hemmed the steamer in, and she was unable to turn. The vessel, consequently, went on at full speed, and was finally beached on North Brothers Island, where the Municipal Charity Hospital's physicians and nurses were immediately available for the injured. No attempt was made to lower the lifeboats." Estimates of the death toll varied between 500 and 1,000 in the course of the day, 16 June.

180:7 (182:34). Sir Frederick Falkiner—see 136:18n.

180:7 (182:34). the freemason's hall—17 and 18 Molesworth Street.

180:7–8 (182:35). Solemn as Troy—after the pro-British Roman Catholic Archbishop of Dublin, the most Reverend John Thomas Troy (1739–1823), who issued a "solemn condemnation" of the Rebellion of 1798. His subsequent support of the Act of Union (indirectly support of the political repression of Catholic Ireland) made his solemnity something of a local legend.

180:8 (182:35). in Earlsfort terrace—Falkiner lived at 4 Earlsfort Terrace.

180:9–10 (182:36–37). Tales of the bench . . . bluecoat school—Falkiner was on the board of governors of the Bluecoat School and wrote a *History of the Blue Coat School, Literary Miscellanies: Tales of the Bench and Assizes,* published posthumously in 1909. The Bluecoat School (The Hospital and Free School of King Charles II, Oxmantown, Blackhall Place, Dublin) was a fashionable school modeled after the famous English public school Christ's Hospital, which was also called the Bluecoat School. In context "bluecoat school" implies an education befitting a member of the Establishment.

180:13–15 (182:41–183:1). Police charge-sheets . . . to the rightabout—"to send someone to the rightabout" is to effect a radical change in his behavior. Bloom recalls Falkiner's reputation as a judge who was severe with police whom he suspected of making arrests for petty crimes (cramming the chargesheets) in order to secure advancement (get their percentage).

180:16 (183:1–2). Gave Reuben J. a great strawcalling—i.e., Reuben J. Dodd (see 93:9n). A "strawcalling" is a tongue-lashing with the added implication that the lashing is in excess of what is merited. There is no factual record of Falkiner so treating Dodd, but Falkiner did create a furor in Dublin in January 1902, when he launched an anti-Semitic tirade from the bench. Public indignation at Falkiner's behavior was so sharp that it reached the floor of the House of Commons, and Falkiner is said to have retracted. See Adams, p. 105.

180:18–19 (183:4). And may the Lord have mercy on your soul—the formula a judge used when he issued the death penalty.

180:20 (183:5). Mirus bazaar—in fiction the bazaar occurs on 16 June 1904; in fact it occurred on Tuesday, 31 May 1904, and the lord lieutenant did not parade through Dublin as described in [Wandering Rocks] but arrived in haste from the south of Ireland. The site of the bazaar was Ballsbridge, on the southeastern outskirts of Dublin. The bazaar was given to raise funds for Mercer's Hospital.

180:21 (183:6–7). Mercer's hospital—in William Street; incorporated by Act of Parliament in 1734.

180:22 (183:7). The Messiah was first given for that—Handel's oratorio was given its first performance on 13 April 1742 at the Musick Hall, Fishamble Street in Dublin, with Handel conducting. Handel presented *The Messiah* "to offer this generous and polished nation something new" (because he regarded it as more friendly and receptive than London). The performance was

dedicated as a charity benefit to the then newly organized Mercer's Hospital.

180:26 (183:11). Kildare street ... Library— Molesworth Street, along which Bloom has been walking, enters Kildare Street across from the entrance of the National Museum, which is housed in a complex of buildings that includes the National Library, the National Gallery and Leinster House.

180:27 (183:12). Turnedup trousers—i.e., Boylan wears the very latest in flashy clothes, trousers with cuffs.

180:34 (183:19–20). Sir Thomas Deane designed—Sir Thomas Deane (1792–1871), an Irish architect, designed the Trinity College Museum building (1857) and the Ruskin Museum at Oxford with Benjamin Woodward (1815–1861). The National Library (1883) and the National Museum (1884) are replicas of one another and were not designed by Sir Thomas Deane, but by his son, Sir Thomas Newenham Deane (1830–1899), and grandson, Sir Thomas Manly Deane (1851–1933); the latter is reputed to have dominated the father-son partnership. The buildings are variously regarded as "impressive" and "pedestrian" in design.

180:42 (183:27). Sir Thomas Deane was the Greek architecture—Sir Thomas Deane, the elder, practiced solidly in the traditions of nineteenth-century eclecticism and was praised by Ruskin for the "Lombardo-Venetian style" of his buildings. Ruskin was in effect praising Deane for his reaction against the cold simplicities of early-nineteenth-century Greek-revival architecture. Sir Thomas Newenham Deane and *his* son, Sir Thomas Manly Deane, practiced in a rather restrained and heavy way the "Renaissance style" taught and advocated by the École des Beaux Arts in Paris; while it is technically incorrect to call this style "Greek," the handling of columns and pediments is somewhat reminiscent of Greek architecture.

EPISODE 9
[SCYLLA AND CHARYBDIS]

SCYLLA AND CHARYBDIS

EPISODE NINE

Episode 9: [Scylla and Charybdis], pp. 182–215 (184–218). In Book XII of *The Odyssey* Odysseus and his men return from the Land of the Dead (see headnote to [Hades], p. 82 above) to Circe's island, where they fulfill Odysseus' promise to bury Elpenor's body. Circe gives Odysseus "sailing directions." She tells him about the Sirens (*Ulysses*, Episode 11) and offers him a choice of routes: one by way of the Wandering Rocks (*Ulysses*, Episode 10), "not even birds can pass them by"; and the other by way of the passage between Scylla and Charybdis. This route, which Odysseus chooses, offers a second choice. Scylla is a six-headed monster that lives on "a sharp mountain peak" overlooking the channel. The ship that sails her side of the channel does so at the sacrifice of "one man for every gullet." The ship that chooses the other side of the channel risks beng totally engulfed by "a whirling maelstrom." Circe advises Odysseus to "hug the cliff of Scylla" and he subsequently follows her advice.

Time: 2:00 P.M. Scene: the National Library. Organ: the brain; Art: literature; Color: none; Symbol: Stratford, London; Technique: dialectic. Correspondences: *The Rock* (on which Scylla dwells)—Aristotle, dogma, Stratford; *The Whirlpool* (Charybdis)—Plato, mysticism, London. *Ulysses*—Socrates, Jesus, Shakespeare.

182:1 (184:1). THE QUAKER LIBRARIAN —Thomas William Lyster (1855–1922), librarian of the National Library of Ireland (1895–1920). Among his writings was a translation of Dunster's *Life of Goethe* (1883); Lyster annotated, revised and enlarged the text. He was also editor of a series of volumes, *English Poems for Young Students* (1893 ff.).

182:2–3 (184:2–3). Wilhelm Meister—*Wilhelm Meister's Apprenticeship and Travels* (1796) by Johann Wolfgang von Goethe (1749–1832), the giant of German letters both in his own times and in retrospect. The "priceless pages" which Lyster mentions comprise Book IV, Chapter XIII–Book V, Chapter XII of Goethe's novel, in the course of which Wilhelm translates and revises (remolds) *Hamlet* and participates in a production of his version of the play.

182:3–4 (184:3–5). A hesitating soul . . . conflicting doubts—the passage to which Lyster alludes occurs at the end of Book IV, Chapter XIII of *Wilhelm Meister;* Meister is speaking: "To me it is clear that Shakespeare meant in *Hamlet* to represent the effects of a great action laid upon a soul unfit for the performance of it. In this view the whole piece seems to me to be composed. There is an oak-tree planted in a costly jar, which should have borne only pleasant flowers in its bosom; the roots expand, the jar is shivered.

"A lovely, pure, noble, and most moral nature, without the strength of nerve which forms a hero, sinks beneath a burden which it cannot bear and must not cast away. All duties are holy for him; the present is too hard. Impossibilities have been required of him; not in themselves impossibilities, but such for him. He winds and turns, and torments himself; he advances and recoils; is ever put in mind, ever puts himself in mind; at last does all but lose his purpose from his thoughts; yet still without recovering his peace of mind" (p. 232). Lyster continues this allusion to *Wilhelm Meister* with a quotation from Hamlet's "To be or not to be" soliloquy: "Whether 'tis nobler in the mind to suffer/The slings and arrows of outrageous fortune,/Or to take arms against a sea of troubles,/And by opposing end them" (III, i, 57–60).

182:6 (184:6). a sinkapace forward on neatsleather—combines allusions to lines in two Shakespeare plays. In *Twelfth Night* Sir Toby Belch advises Sir Andrew Aguecheek on the manners of a fop: "Why dost thou not go to church in a galliard and come home in a coranto? My very walk should be a jig; I would not so much as make water in a sink-a-pace" (I, iii, 136–139). A "coranto" is a running dance; and a "sink-a-pace" (after the French *cinque pace*) is a dance of five steps; a "galliard" is a lively dance in triple time. In *Julius Caesar* a commoner (cobbler) who came to see Caesar enter Rome in triumph brags about his trade: "I am indeed, sir, a surgeon to old shoes; when they are in great danger, I recover them. As proper men as ever trod upon neat's leather have gone upon my handiwork" (I, i, 26–29). "Neat's leather" is oxhide.

182:10–11 (184:10–12). The beautiful ineffectual . . . against hard facts—This paraphrases Wilhelm Meister's remarks about Hamlet (see 182:3–4n). But it is also a remark about Wilhelm Meister himself since Goethe regards Meister's flirtation with the theater as placing him in danger of becoming "a beautiful ineffectual dreamer" instead of the active moralist which he is destined to become. Goethe enforces the temporary analogues between Hamlet's and Meister's characters: when Meister is acting the part of Hamlet, the Ghost that appears on stage is impressively acted by the Ghost of Meister's father (the Ghost subsequently warns Meister to escape from the lure of the theater). The phrase "beautiful and ineffectual" is borrowed from Matthew Arnold's final dictum in his essay "Shelley" in *Essays in Criticism: Second Series.* "And in poetry, no less than in life, he is a beautiful 'and ineffectual' angel, beating in the void his luminous wings in vain." The implication of Lyster's remark is that Shelley was another Hamlet.

182:14 (184:14). he corantoed off—from *Twelfth Night;* see 182:6n.

182:18–19 (184:18–19). Monsieur de la Palisse ... before his death—a famous example of ridiculous statement of obvious truths, attributed to the soldiers of the French Maréchal de la Palisse, who died after a heroic effort in a losing cause at the Battle of Pavia 1525 (the French were cut to ribbons and defeated). The Maréchal's soldiers, protesting that their leader had done nothing to contribute to the debacle, were supposed to have said: *"Un quart d'heure avant sa mort il est en vie"* ("A quarter of an hour before his death he was alive").

182:20 (184:20). six brave medicals—recalls a line from Blake's *Milton* (*c.*1804) when Blake describes Milton as "pond'ring the intricate mazes of Providence,/. . . /Viewing his Sixfold Emanation scatter'd thro' the deep."

182:20 (184:20). John Eglinton—pseudonym of William Kirkpatrick Magee (1868–1961), Irish essayist and influential figure on the Dublin literary scene. He was Assistant Librarian of the National Library in 1904 and remained so until 1922.

182:22 (184:22). The Sorrows of Satan—(1897), a novel by Marie Corelli, pseudonym of Mary MacKay (1855–1924). She was notable for her outspoken prejudice that her critics were all blasphemers and for the fact that she regarded herself as a latter-day Shakespeare, retiring, as did Shakespeare, from London to make her home in Stratford-on-Avon. *The Sorrows of Satan* set new records as a best seller; it was subtitled "Or the Strange Experience of one Geoffrey Tempest, Millionaire." Satan's sorrows derive somewhat sentimentally from the proposition: "Everywhere and at all times, he is trying to find some human being strong enough to repulse him and all his works." The title mocks Stephen's intention (after Blake) to rewrite *Paradise Lost* so that Satan is portrayed as the romantic hero who champions the cause of man against Jehovah (the impersonal forces of the universe).

182:24–28 (184:24–28). First he tickled ... Jolly old medi—a fragment of an unpublished bawdy poem, "Medical Dick and Medical Davy," by Oliver St. John Gogarty; see 206:36–37n.

182:29–30 (184:29–30). Seven is dear to the mystic mind—In Hebrew, Greek, Egyptian and Eastern traditions seven was regarded as being the embodiment of perfection and unity, mystically appropriate to sacred things. In its association with mystical experience it rivaled the number three in popularity.

182:30 (184:30). The shining seven W. B. calls them—William Butler Yeats in "A Cradle Song." Second stanza (1895 version): "God's laughing in Heaven/To see you so good;/The Shining Seven/Are gay with his mood." The seven are the planets known to the ancient world, and they echo the "Starry Seven" ("The Seven Angels of the Presence") of another W. B., William Blake in *Milton* [24]:1 and [16]:42.

182:31–33 (184:31–33). Glittereyed, his rufous ... an ollav, holyeyed—a description of AE (George Russell). An "ollav" was a pre-Christian Irish poet-priest-scholar.

182:33 (184:33). a sizar's laugh—a "sizar" at Trinity College in Dublin (as at Cambridge University in England) was a student, so designated, who received an allowance from the college to enable him to study. A sizar's laugh is therefore the laugh of a dependent (as Stephen has borrowed money from AE and therefore been dependent on him).

182:35–36 (184:35–36). Orchestral Satan ... as angels weep—these lines echo two lines from *Paradise Lost:* the first describes Satan "Prone on the flood" of the burning lake of hell: "Lay floating many a rood" (I:196); the second describes Satan as he is about to speak to the fallen angels: ". . . and thrice in spite of scorn,/Tears such as Angels weep, burst forth" (I:619–620).

182:37 (184:37). Ed egli avea del cul fatto trombetta—Italian: "And of his arse he made a trumpet" (Dante, *Inferno* XXI:139). Dante and Virgil are escorted through "the Fifth Chasm" by a squad of ten Barterers ("Those who made secret and vile traffic of their Public offices and authority, in order to gain money"). Dante regards them as demons: the ten men of the squad stick out their tongues at their Captain and he answers their unruly conduct in the manner described in the quoted line.

182:39 (184:39). Cranly's eleven true Wicklowmen—after a remark by Joyce's friend J. F. Byrne (Cranly in fiction), who argued that 12 men with resolution could save Ireland and that they could be found in County Wicklow; 11 because presumably Cranly would be the twelfth.

182:39–183:1 (184:39–185:1). Gap-toothed Kathleen ... in her house—In Yeats's play *Cathleen ni Houlihan* (1902) Cathleen appears as The Poor Old Woman, a traditional symbol of Ireland. She is gap-toothed (has spaces between her teeth) because of her great age. The setting of the play, "close to Killala, in 1798," echoes the theme of liberation of Ireland since a French expeditionary force landed there in that year in

what proved an ineffectual attempt to help the Irish in the Rebellion. Stephen recalls phrases from a passage early in the play: "BRIDGET: What was it put you wandering? OLD WOMAN: Too many strangers in the house. BRIDGET: Indeed you look as if you'd had your share of trouble. OLD WOMAN: I have had trouble indeed. BRIDGET: What was it put the trouble on you? OLD WOMAN: My land was taken from me. PETER: Was it much land they took from you? OLD WOMAN: My four beautiful green fields" (*Collected Plays* [New York, 1934], p. 81). "Strangers in the house" is an Irish epithet for the English invaders, and the "four beautiful green fields" are the four provinces of pre-Norman Ireland: Ulster, Connaught, Munster and Leinster.

183:1 (185:1). ave, rabbi—Latin: "Hail, Rabbi [teacher or master]" as in John 1:38 when two of John the Baptist's disciples approach Jesus: "Then Jesus turned, and saw them following, and saith unto them, What seek ye? They said unto him, [*ave*] Rabbi, (which is to say, being interpreted, Master,) where dwellest thou?" In effect Stephen is mocking the messianic pretension of Cranly's 12-disciple approach to the liberation of Ireland.

183:1–2 (185:1–2). The Tinahely twelve—Tinahely is a market town on the River Derry in southern County Wicklow.

183:2–4 (185:2–4). In the shadow . . . Good hunting—Stephen is, of course, thinking about Cranly, but his thoughts echo and parody plot elements in John Millington Synge's (1871–1909) one-act play *In the Shadow of the Glen* (1903). The scene of the play is "*the last cottage at the head of a long glen in County Wicklow.*" The heroine of the play, Nora Burke, thinking her husband dead, goes outside to cooee (she whistles) for a young herdsman, Michael Dara. Later in the play Nora discovers that her husband, Dan, has only been pretending death; she, however, complains that Dan has been "cold" and implies that he has put her in danger of losing her youth. At the play's end Dan Burke throws his wife out without so much as a "godspeed," and she goes off with the poetic, spirited Tramp ("good hunting") to seek a life of lyric freedom in nature.

183:5 (185:5). Mulligan has my telegram—see 197:1–6 (199:18–24).

183:9–10 (185:9–10). I admire him . . . this side idolatry—"old Ben" is Ben Jonson and the allusion is to what Brandes called "the noble eulogy prefixed to the First Folio," of Shakespeare's plays: "I remember the players have often mentioned it as an honour to Shakespeare, that in his writing (whatsoever he penned) he never blotted out a line. My answer hath been, Would he hath blotted a thousand. Which they thought a malevolent speech. I had not told posterity this but for their ignorance, who chose that circumstance to commend their friend by, wherein he most faulted; and to justify mine own candour: for I loved the man, and do honour his memory, on this side idolatry, as much as any. He was (indeed) honest, and of open and full nature; had an excellent phantasy, brave notions, and gentle expressions; wherein he flowed with that facility, that sometimes it was necessary he should be stopped:..." (quoted in George Brandes,[1] *William Shakespeare* [London, 1898], p. 20).

183:12–13 (185:12–13). whether Hamlet is Shakespeare or James I or Essex—various attempts have been made by literary historians to identify the "model" for the character of Hamlet. Candidates put forward have included Shakespeare (on the basis of the poet's self-doubt), James I of England, previously James VI of Scotland (on the basis of his well-known morbidity) and Robert Devereux (1566–1601), 2nd Earl of Essex, another of Shakespeare's contemporaries (on the basis of his peculiar combination of impetuous military leadership and inexplicable lassitude).

183:13 (185:13–14). the historicity of Jesus—considerable theological discussion in the nineteenth century focused on the question: What difference would it make to a church and its theology if the "real history" of Jesus could be researched and published?

183:14 (185:14). formless spiritual essences—one of George Russell's favorite phrases, as in the following comment (on W. B. Yeats's power as a poet): "Spirituality is the power of apprehending formless spiritual essences, of seeing the eternal in the transitory, and in the things which are seen the unseen things of which they are the shadow," in "Religion and Love" (1904), reprinted in *Imaginations and Reveries* (Dublin, 1915), pp. 122–123.

183:16 (185:16). Gustave Moreau—(1826–1898), French painter noted for his romantic and symbolic style. His weird, exotic renderings of biblical and classical myths were admired by the *avant-garde* of his time, and as a "literary"

[1] George Morris Cohen Brandes (1842–1927), Danish literary critic and one of the leaders of the "new breaking through" in Scandinavian literature and thought. In 1871 he began to formulate the principles of a new realism and of naturalism, condemning abstract idealism and fantasy in literature. His scholarship ranged through the literatures of Germany, France and England, as well as Scandinavia, and he was regarded in his own time as "a scientific critic to whom literature is in itself 'a criticism of life.'"

painter he had considerable influence on French symbolist poets. Yeats in his *Autobiography* (p. 163) speaks of George Russell's "early admiration for the works of Gustave Moreau"; Russell himself tended to play down his admiration for Moreau after about 1905–1906.

183:18–19 (185:19). Plato's world of ideas—nineteenth-century transcendental interpretations of Plato asserted that "truth" to him was ultimate, inevitably ideal and abstract, and that the material forms in which "truths" were embodied inevitably corrupted and distorted the truths to some degree.

183:24 (185:24). Aristotle was once Plato's schoolboy—Aristotle (384–322 B.C.) was associated with the Academy in Athens 367–347 B.C., while Plato (*c*.427–347 B.C.) was head of the Academy.

183:29 (185:29). Formless spiritual. Father, Word and Holy Breath—see 183:14n. In theosophy, and particularly in that branch of it known as "esoteric Christianity," God was assumed to be without limit (i.e., "formless"). Only by limiting Himself, "making as it were a sphere . . . Spirit within and limitation, or matter without" does God become manifest. ". . . The veil of matter . . . makes possible the birth of the Logos . . ." and the Trinity becomes Father, Word [Logos, Self-Limited God] and Holy Breath as a modification of Father, Son and Holy Ghost" (Annie Besant, *Esoteric Christianity* [first published, 1901; Madras, India, 1953], pp. 152–153).

183:29–30 (185:29–30). Allfather, the heavenly man—in esoteric Christianity, the "Allfather" is Christ, dual in nature, i.e., both without limit and with limit and thus "heavenly man."

183:30–31 (185:30–31). Hiesos Kristos . . . at every moment—"Hiesos Kristos," Greek: "Jesus Christ." Theosophical lore maintained that Jesus was an initiate of "that one sublime Lodge . . . of the true Mysteries in Egypt" and thus what Stephen calls "magician of the beautiful," "as a rose tree strangely planted in a desert would shed its sweetness on the barrenness around" (Annie Besant, *Esoteric Christianity*, p. 97). As such the historical Christ became identified "in Christian nomenclature with the Second Person in the [theosophical] Trinity, the Logos, or Word of God" (*ibid.*, p. 28). "The second aspect of the Christ of the Mysteries is then the life of the Initiate, the life which is entered on at the first great Initiation, at which Christ is born in man, and after which He develops [and suffers] in man" (*ibid.*, p. 129).

183:31–32 (185:32). I am the fire . . . sacrificial butter—one aspect of *The Ancient Wisdom*

(Besant, pp. 327 *ff.*) is "the Law of Sacrifice." Sacrifice is conceived not as "suffering" but as the willingness of the Logos to circumscribe "His infinite Life in order that he might manifest" (p. 328), but the circumscription is without loss of infinitude; and the Law of Sacrifice becomes "thus the law of life-evolution in the universe" (p. 332), embracing both that which sacrifices and that which is sacrificed. The lines Stephen quotes are from a version of *The Bhagavadgītā*, as translated by S. Radhakrishnan (London, 1948): "I am the ritual action, I am the sacrifice, I am the ancestral oblation, I am the (medicinal) herb, I am the (sacred) hymn, I am also the melted butter, I am the fire and I am the offering" (p. 245).

183:33 (185:33). Dunlop—Daniel Nicol Dunlop, Irish editor and theosophist. He edited *The Irish Theosophist* (*c*.1896–1915) and contributed articles under the pseudonym Aretas; he edited another theosophical journal, *The Path* (London, 1910–1914). In 1896, at its second annual convention (in Dublin), the Theosophical Society of Europe selected him as its permanent chairman.

183:33 (185:33). Judge—William Q. Judge (1851–1896), Irish-American theosophist who assisted Madame Blavatsky in founding the Theosophical Society in America (1875). He was subsequently head of the "powerful" Aryan Theosophical Society in New York City.

183:33 (185:33). the noblest Roman of them all—Marc Antony in the final speech of Shakespeare's *Julius Caesar* praises the now dead Brutus: "This was the noblest Roman of them all./All the conspirators, save only he,/Did that they did in envy of great Caesar" (V, v, 68–70). As applied to Judge, the line is ironic. After Madame Blavatsky's death, in 1891, Judge in America and Annie Besant in England jointly succeeded her, both supposedly as mouthpieces of an unknown master who was the real head of the theosophical movement. Mrs. Besant preferred charges against Judge for fraudulent use of this master's name. The charges were not proven, but the result of the accusation was a worldwide split of the theosophical movement; one faction followed Judge; the other, Mrs. Besant.

183:33 (185:33). Arval—the central ruling body of the theosophical movement was composed of 12 members and was called the "Esoteric Section" or (mystically) "Arval," after a Roman priesthood of 12 members who performed the fertility rites of a somewhat mysterious mother-goddess. Theosophical lore associated this 12 with the 12 disciples (both groups governed by a "master" whose identity was shrouded in mystery).

183:34 (185:34). the Name Ineffable . . . K. H.

—the Name Ineffable, the name not to be uttered (as the Israelites were forbidden to utter the name Jehovah). Master K. H. was Koot Hoomi, one of Madame Blavatsky's two "masters" or "Mahatmas." He was a Tibetan who had evolved to a superhuman level. He was reputedly in direct communication with H. P. B. (and after her death with some of her followers). He "spoke" to H. P. B. at times; at other times he "precipitated" messages in crayon or watercolor on rice paper. There was considerable public skepticism and even controversy among theosophists over this master's identity, presence and messages. Madame Blavatsky and her followers spoke and issued orders "in the name of the Master."

183:35 (185:35–36). Brothers of the great white lodge—after Judge's death, an American theosophist, Katherine A. Tingley, reorganized Judge's worldwide branch of the movement as "the Universal Brotherhood Organization," and its members regarded themselves as heirs apparent of what was variously called the Great White Lodge, the Great Aryan Lodge or the Grand Lodge of Central Asia (the mythic Indo-European source of all theosophical doctrine called "the Hierarchy of Adept").

183:36–38 (185:36–38). The Christ with . . . plane of buddhi—a capsule version of the theosophical reading of Christ's career. The Egyptian Gnostic theologian Valentius (d. c.160) held that Sophia (Wisdom) in the last "aeon" before Christ fell "into chaos in her attempt to rise unto the Highest." Once fallen, she repented and cried out "to the Light in which she had trusted." Christ was then sent "to redeem her from chaos," to crown her "with his light" (i.e., to baptize her with light—thus "moisture of light") and to lead her, his "bridesister," forth from bondage (Besant, *Esoteric Christianity*, pp. 102–103). "The plane of buddhi" is the fourth plane, "in which there is still duality but where there is no separation. . . . It is a state of bliss in which each is himself, with a clearness and vivid intensity which cannot be approached on lower planes, and yet in which each feels himself to include all others, to be one with them, inseparate and inseparable" (Besant, *The Ancient Wisdom*, p. 197).

183:38–39 (185:38–39). The life esoteric—i.e., life on or approaching "the plane of buddhi"; "From this plane only can man act as one of the Saviours of the world" (Besant, *The Ancient Wisdom*, p. 342).

183:39–40 (185:39–40). O.P. must work off bad karma first—"O.P.": ordinary people. "Karma" (in theosophy) "is the law of moral retribution, whereby not only does every cause have an effect, but he who puts the cause in action suffers the effect" (Christmas Humphreys,

Karma and Rebirth [London, 1943], p. 11). Thus there is Karma in everything man does; and bad Karma suggests either the refusal to accept the effect of one's actions or the reluctance to perform one's duties (in which one's Karma resides).

183:40 (185:40). Mrs Cooper Oakley—Isabel Cooper-Oakley (b. 1854), a highly successful businesswoman in London and a close associate of Madame Blavatsky, both in India (1884 *ff.*) and in London (1890 *ff.*). She was distinguished as the recipient of H. P. B.'s "last message" when H. P. B. was on her deathbed.

183:41 (185:41). H.P.B.'s elemental—i.e., Harriet Petrovna Blavatsky's. In theosophy the "elemental" is essentially the "lower" or "mortal" nature of man, one-fourth of which is visible as the physical body, three-fourths invisible as the astral or design body, the life principle and the principle of desire. The joke involves the claim of Madame Blavatsky's disciples that she would appear to them after her death; it also involves the nontheosophical pun on genitals.

184:1 (185:42). O fie! Out on't—approximations of phrases from two of Hamlet's soliloquies: "Oh, that this too too solid flesh would melt" (I, ii, 129–159: "Fie on't! ah fie!" [I, ii, 135]) and "O, what a rogue and peasant slave am I!" (II, ii, 576–632: "Fie, upon 't! Foh! About, my brain! . . ." [II, ii, 617]).

184:1 (185:42). Pfuiteufel!—a German oath: *Pfui*: "fie, for shame"; *teufel*: "devil."

184:3 (186:2). Mr Best—Richard Irvine Best (1872–1959), assistant director of the National Library (1904–1923), director (1924–1940), translator of *Le Cycle Mythologique Irlandais* by Marie Henri d'Arbois de Joubainville (1827–1910). Best's translation appeared as *The Irish Mythological Cycle and Celtic Mythology* (Dublin, 1903). De Joubainville was professor of Celtic literature at the Collège de France. Best was one of the founders of the School of Irish Learning in Dublin (1903). Early in his life, and certainly through 1904, he was an enthusiastic emulator of Walter Pater's and Oscar Wilde's aestheticism. Later in his career his emphasis shifted from aestheticism to scholarship.

184:5–7 (186:4–7). That model schoolboy . . . shallow as Plato's—one of Plato's "musings about the afterlife" occurs in the Myth of Er at the end of *The Republic*. In that myth several souls of the famous dead, including that of Odysseus, have to choose new lives as animals or men. All the other souls are eager to choose, but Odysseus temporizes and finally chooses last. "Now the recollection of former toils had disenchanted him of ambition, and he went about

for a considerable time in search of the life of a private man who had no cares; he had some difficulty in finding this, which was lying about and had been neglected by everybody else; and when he saw it, he said that he would have done the same had his lot been first instead of last, and that he was delighted to have it." Hamlet's "musings about the afterlife" are central in the "To be, or not to be" soliloquy (III, i, 56–58) where Hamlet (like Plato) implies a desire for an afterlife free from "cares." Hamlet remarks, "For in that sleep of death what dreams may come/When we have shuffled off this mortal coil,/Must give us pause," and asks why one should face the problems of life "But that the dread of something after death,/The undiscover'd country from whose bourn/No traveller returns, puzzles the will. . . ." Aristotle never directly criticizes Plato's view of the immortality of the soul, but Stephen's rhetorical flourish has some basis in Aristotle's heavily qualified views of immortality as expressed in what most commentators regard as a difficult passage in *De Anima* (*On the Soul*) III: 5: "Mind in this sense of it is separable, impossible, unmixed, since it is in its essential nature activity (for always the active is superior to the passive factor, the originating force to the matter which it forms)." This passage is often read as implying that the soul is immortal in a *general* but not in a *personal* way. Thus Aristotle could be said to regard Plato's (and Hamlet's) "musings" as "shallow" since those "musings" regard the soul as immortal in a personal sense.

184:11–12 (186:11–12). Which of the two . . . from his commonwealth?—answer: Plato. Aristotle's *Poetics* can be regarded as proof of his affirmation of the poet. In a much-quoted passage in Plato's *Republic* X: 606–607 Socrates asserts that none of the "excellences" of the ideal state under discussion please him more than the exclusion of "all imitative poetry" and the retention only of "hymns to the gods and praises of famous men." While this passage can be regarded as ironic, it is often taken (as Stephen's remark implies) to be a direct statement of "what Plato thinks."

184:13 (186:13). dagger definitions—i.e., Stephen's argument will be based on the Aristotelian distinction between nominal definitions and essential definitions (Aristotle, *Posterior Analytics* II: 8). The distinction is used to point out that the process of definition begins with the "nominal" and proceeds to the "essential"; the process moves in the direction of cause. For example: an eclipse is a loss of light (nominal); an eclipse is a shadow on the earth because of the interposition of the moon between the earth and the sun (essential).

184:13–14 (186:13–14). Horseness is the what-ness of allhorse—a Platonic proposition which implies that individual horses are imperfect approximations of the idea "horse." Stephen's phrase echoes a famous remark, apocryphally attributed to Plato's opponent Antisthenes (see 147:5n): "O Plato, I see a horse, but I do not see horseness."

184:14 (186:14). Streams of tendency and aeons they worship—i.e., the neo-Platonic theosophists such as AE who concocted his pen name out of "Aeon"; see 163:19n.

184:15–16 (186:15–16). Space: what you damn well have to see—an Aristotelian proposition (see 38 [37]) as against the Platonic view of space in *Republic* VII: "The spangled heavens should be used as a pattern and with a view to that higher knowledge; their beauty is like the beauty of figures or pictures excellently wrought by the hand of Daedalus, or some other great artist, which we may chance to behold; any geometrician who saw them would appreciate the exquisiteness of their workmanship, but he would never dream of thinking that in them he could find the true equal, or the true double, or the truth of any proposition."

184:16–18 (186:16–19). Through spaces smaller . . . but a shadow—combines allusions to Blake's *Milton* and Dante's *Inferno*. At the conclusion of the *Inferno* in Canto XXXIV Dante and Virgil, his guide, come to Satan, who at the earth's center is waist-deep in the ice of Lake Cocytus. Dante and Virgil crawl down over Satan's buttocks and exit from Hell to begin their upward journey toward the surface of the earth and the Mount of Purgatory. From Book I of Blake's *Milton*: "For every Space larger than a red Globule of Man's blood/Is visionary, and is created by the Hammer of Los:/And every Space smaller than a Globule of Man's blood opens/Into Eternity, of which this vegetable Earth is but a shadow" (31:19–22).

184:18–19 (186:19–20). Hold to the now . . . to the past—after St. Augustine (353–430), *De Immortalitate Animae* ("On the Immortality of the Soul"): "For what is done needs expectation, that it may be done, and memory, that it may be understood as much as possible. And expectation is of future things, and memory is of things past. But the intention to act is of the present, through which the future flows into the past" (after J. P. Migne, *Patrologia Latina*, XXXII, 1023 A).

184:23 (186:24). Jubainville's book—see 184:3n.

184:24 (186:25). Hyde's Lovesongs of Connacht—see 48:34–36n.

184:25 (186:27). Gill's—see 94:28n.

184:27–30 (186:28–31). Bound thee forth . . . lean unlovely English—the first stanza of a poem by Douglas Hyde; Hyde intended the poem's six stanzas as an example of a meter (the *Deibhidh*) widely used by ancient Irish bards but subsequently lost. Hyde's first stanza reads: "Bound thee forth my Booklet quick./To greet the Polished Public./Writ—I ween't was not my Wish—/In Lean unLovely English." The poem, as *envoi*, concludes Hyde's *The Story of Early Gaelic Literature* (London, 1894), pp. 173–174.

184:33 (186:35–36). An emerald set . . . of the sea—the second line of a poem, "Cushla-ma Chree" ("Pulse of My Heart"), by Henry Grattan Curran (1800–1876). The poem begins: "Dear Erin, how sweetly thy green bosom rises,/ An emerald set in the ring of the sea."

184:35–40 (186:38–187:3). The movements which work . . . the musichall song—recalls a passage in Russell's essay "Nationality and Imperialism" in *Ideals in Ireland* (Dublin, 1901). "The Police gazettes, the penny novels, the hideous comic journals, replace the once familiar poems and the beautiful and moving memoirs of classic Ireland. The music that breathed Tir-nan-og [the underworld of Irish myth] and overcame men's hearts with all gentle and soft emotions is heard more faintly, and the songs of the London music halls may be heard in places where the music of faery enchanted the elder generations.

"The national spirit . . . is shy, hiding itself away in remote valleys, or in haunted mountains, or deep in the quiet of hearts that do not reveal themselves. Only to its own will it comes and sings its hopes and dreams. . . ." See also "our mighty mother," 7:9 n.

184:40–185:1 (187:3–4). France produces . . . in Mallarmé—Stéphane Mallarmé (1842–1898), French poet, leader of the symbolist movement and principal formulator of the symbolist aesthetic. He was regarded as the embodiment of late-nineteenth-century *decadence*. His works include *Le Cygne*, *Hérodiade* and *L'Après-midi d'un faune*. The phrase "the finest flower of corruption" was in fact Best's praise of Mallarmé.

185:1–2 (187:5). the poor of heart—recalls two of the beatitudes from Jesus' Sermon on the Mount: "Blessed *are* the poor in spirit: for their's is the kingdom of heaven. . . . Blessed *are* the pure in heart: for they shall see God" (Matthew 5:3, 8).

185:2 (187:5). the life of Homer's Phæacians—the Phæacians, whom Odysseus visits in his wanderings, are described as living equitable lives in peace, wealth and happiness, with feasting, music and dancing. Ironically, the Phæacian way of life is severely disrupted when Poseidon punishes them for aiding Odysseus in his voyage.

185:6 (187:9). Stephen MacKenna—(1872–1954), Irish neo-Platonist and man of letters.

185:7 (187:10). The one about Hamlet—*"Hamlet et Fortinbras,"* by Mallarmé, in *Oeuvres* (Pléiade edition), p. 1558. The prose-poem first appeared as a letter in *Revue Blanche*, 15 July 1896.

185:7–8 (187:10–11). il se promène . . . de lui-même—French: "he walks in a leisurely fashion, reading in the book of himself"; Mallarmé's prose-poem continues: "a high and living sign; he scorns to look at any other. Nor will he be content to symbolize the solitude of the Thinker among other men; he kills them off aloofly and at random, or at least, they die. The black presence of the doubter diffuses poison, so that all the great people die, without his even taking the trouble, usually, to stab them behind the arras. Then, evidently in deliberate contrast to the hesitator, we see Fortinbras in the role of general, but no more efficaciously lethal than he; and if Death deploys his versatile appliances—phial, lotus-pool, or rapier—when an exceptional person flaunts his sombre livery, that is the import of the finale when, as the spectator returns to his senses, this sumptuous and stagnant exaggeration of murder (the idea of which remains as meaning of the play, attached to Him who makes himself alone) so to speak achieves vulgar manifestation as this agent of military destruction clears the stage with his marching army, on the scale of the commonplace, amid trumpets and drums."

185:12–14 (187:15–17). HAMLET/ou/LE DISTRAIT—French: "Hamlet, or, The Distracted One." Mallarmé cites this in his prose-poem as the title of a French provincial production of *Hamlet;* but *Le distrait* (1697) is also the title of a comedy by Jean François Regnard (1655–1709), the most successful of Molière's imitators. In Regnard's play, when Léandre, the *distrait*, first appears in Act II, scene iii, his valet says, "He is dreaming and talking to himself; he does not see me," and the stage directions describe Léandre as *"se promenant sur le théâtre en rêvant"* ("walking about the stage in a leisurely fashion in a state of reverie-abstraction"). Léandre, at the center of the tangle of half-thwarted loves that is the plot of Regnard's comedy, is "the most forgetful man in the world"; at the play's end he even forgets that he has just overcome all obstacles and achieved the marriage he has so much desired. The comic parallel to Hamlet's tragic forgetfulness of purpose is obvious. *Cf.* 185:7–8n.

185:15 (187:18). Pièce de Shakespeare—
French: "Play by Shakespeare," but since *de*
also means "of," then it is a pun for the English-
speaking mind: "a piece of Shakespeare."

185:19 (187:22). The absentminded beggar—
a propaganda poem by Rudyard Kipling (1865–
1936). Set to music by Sir Arthur Sullivan, the
song was intended to raise funds "to secure small
comforts for the troops at the front" in the Boer
War. "Will you kindly drop a shilling in my little
tambourine/For a gentleman in khaki ordered
South?" According to Kipling, "The Absent
Minded Beggar Fund" raised "about a quarter
of a million pounds" in the course of the war.
Stephen's retort depends on Irish sentiment,
which was bitterly opposed to the English con-
duct of the Boer War. See *Rudyard Kipling's
Verse* (Definitive Edition; New York, 1940),
p. 457.

**185:23 (187:26). Sumptuous and stagnant
exaggeration of murder—**from Mallarmé's
"*Hamlet et Fortinbras*"; see 185:7–8n.

185:24 (187:27). A deathsman . . . called him
—Robert Greene (c.1558–1592), Elizabethan nov-
elist, playwright and pamphleteer. The pam-
phlet Stephen alludes to is Greene's *Groat's
Worth of Wit bought with a Million of Repentance*
(1592), in which Greene calls lust, not Shakes-
peare, "the deathsman of the soul." The pam-
phlet does, however, include a letter to three
brother dramatists in which Greene mocks
Shakespeare as "an upstart Crow, beautified with
our feathers . . . in his owne conceit, the only
Shake-scene in a countrie. . . ."

185:25 (187:28). a butcher's son—Shakes-
peare's father, John Shakespeare (d. 1601), was
variously, according to available records, yeoman
(landowner), glover and whitawer (one who cured
glove skins). The tradition that John Shakespeare
was a butcher was first reported and perpetuated
by the English antiquary John Aubrey (1629–
1697).

**185:25–26 (187:28–29). wielding the sledded
poleaxe—**Horatio describes the Ghost of Ham-
let's father to the other guards on the "platform":
"So frown'd he once, when, in an angry parle,/He
smote the sledded Polacks on the ice" (I, i, 62–63).
The Quarto version of *Hamlet* read "Sleaded
Pollox," the First Folio "sledded Pollax." The
passage has been much disputed: "poleaxe"
versus "Polacks."

**185:26–27 (187:29–30). Nine lives . . . his
father's one—**the score in the play is eight, not
nine: Polonius, Ophelia, Rosencrantz, Guilden-
stern, Gertrude, Laertes, Claudius and Hamlet.
The unchallenged "nine" may be a rhetorical

flourish on "every cat has nine lives," and it may
be a forecast of Stephen's argument that Shakes-
peare's own son, Hamnet, also died in the cause.

**185:27 (187:30–31). Our Father who art in
purgatory—**echoes the opening phrase of the
Lord's Prayer, "Our Father which art in Heaven"
(Matthew 6:9) and alludes to the Ghost's speech
to Hamlet in which the Ghost describes himself
in purgatory, "Doom'd for a certain term to walk
the night,/And for the day confined to fast in
fires,/Till the foul crimes done in my days of nature
/Are burnt and purged away" (I, v, 10–13).

**185:28 (187:31). Khaki Hamlets don't hesi-
tate to shoot—**for "Khaki," the drab uniform
that was widely regretted as an unheroic novelty
during the Boer War, see 185:19n. The slogan
"Don't hesitate to shoot" became a rallying cry
for Irish anger at the English policy of coercion in
the 1880s. According to Irish anecdotal history,
the command was first used by a Captain "Pasha"
Plunkett, who was in charge of a police barracks
at Mitchelstown, County Cork, during a riot in
1887; see 310:35n. The thrust of Stephen's
remark is that the wholesale killing in modern
warfare is not unlike the wholesale killing in
Hamlet.

**185:28–29 (187:31–32). The bloodboltered
shambles in act five—**Act V of *Hamlet* begins
with the burial of Ophelia and ends with the
violent deaths, on stage, of Gertrude, Claudius,
Laertes and Hamlet. In *Macbeth* Macbeth re-
visits the witches in Act IV, scene i, and there
encounters the ghost of Banquo, whom he has had
murdered. Macbeth responds: ". . . Now, I see,
'tis true;/For the blood-bolter'd Banquo smiles
upon me,/And points at them [a show of eight
Kings, Banquo's heirs] for his" (lines 122–124).

**185:29–30 (187:32–33). the concentration
camp sung by Mr Swinburne—**the "song"
is Swinburne's sonnet "On the Death of Colonel
Benson," published in *The Saturday Review*
(London, 9 November 1901), Vol. 92, p. 584.
Benson had died in a Boer prison camp. "North-
umberland, so proud and sad today,/Weep and
rejoice, our mother, who no son/More glorious
than this dead and deathless one/Brought ever
fame whereon no time shall prey./Nor heed we
more than he what liars dare say/Of mercy's
holiest duties left undone/Toward whelps and
dams of murderous foes whom none/Save we had
spared or feared to starve and slay. // Alone as
Milton and as Wordsworth found/And hailed
their England, when from all around/Howled all
the recreant hate of envious knaves,/Sublime she
stands: while, stifled in the sound,/Each lie that
falls from German boors and slaves/Falls but as
filth dropt in the wandering waves." The con-
centration camps which Stephen accuses Swin-

burne of praising were established by the British under Kitchener for the retention of Boer civilians, including women and children. The camps were widely regarded as cruel and inhuman and were the subject of considerable controversy in England (let alone in Ireland, which was bitterly pro-Boer). Swinburne's poem was regarded as a whitewash of the concentration camps, and two letterwriters promptly attacked Swinburne in the *Review* (16 November 1901). One letterwriter called him "unthinking" and "excessive"; the other remarked: "It is not necessary to call the women and children 'whelps and dams' . . ." Swinburne replied by citing a series of atrocity stories about the Boers, whom he described as "virtual slave-drivers" to their prisoners (i.e., it was all right for the British to persecute the Boers by detaining them in concentration camps because the Boers persecuted their British prisoners).

185:31 (187:34). Cranly . . . battles from afar —see 9:7n; the historical Cranly watched the Wars of the Roses "from afar." The battles Stephen has watched with Cranly are not clear; they could be chess or handball or horseraces or the battles of the Boer War.

185:32–33 (187:35–36). Whelps and dams . . . we had spared . . .—from Swinburne's controversial poem, see 185:29–30n.

185:34 (187:37). the Saxon smile and yankee yawp—for "Saxon smile," see 24:29n. For "yankee yawp," Walt Whitman, "Song of Myself" (1855, 1891–1892), Section 52, lines 2–3: "I too am not a bit tamed, I too am untranslatable,/I sound my barbaric yawp over the roofs of the world." "Yawp" is a loud cry or yell.

185:34–35 (187:37–38). The devil and the deep sea—a proverbial equivalent of the choice between Scylla and Charybdis (the expression dates from the early sixteenth century).

185:37 (188:1). Like the fat boy in Pickwick— in Dickens' *Posthumous Papers of the Pickwick Club* (1836–1837), Mr. Wardle's servant, Joe, the fat boy, is always asleep to the tune of "Damn that boy, he's gone to sleep again." But in Chapter VIII he is, somewhat inconveniently, wide awake enough to observe a love scene between Miss Wardle and one of the Pickwickians. He reports his observation to Miss Wardle's mother; his opening line: "I wants to make your flesh creep."

185:39/186:2 (188:3/5). List! List! O List!/If thou didst ever . . .—"GHOST: . . . List, list, O, list!/If thou didst ever thy dear father love—/ HAMLET: O, God!/GHOST: Revenge his foul and most unnatural murder./HAMLET: Murder!" (I, v, 22–26).

186:6 (188:9). Stratford—Stratford-on-Avon, 75 miles northwest of London, Shakespeare's birthplace (April 1564), where he married Anne Hathaway (1582) and which he left for London (c.1585) and to which he retired (c.1612). The literal sense of the passage: it took as long to travel from Stratford to London in Elizabethan times as it took to travel from Dublin to Paris in the early twentieth century.

186:7 (188:10). limbo patrum—Elizabethan slang for a lockup or jail as in Shakespeare's *Henry VIII* (V, iv, 67–68). In Roman Catholic theology *Limbus Patrum* was the state in which the souls of the pre-Christian patriarchs and prophets of the Old Testament were held until after the Resurrection when Christ "harrowed hell" and brought them to heaven.

186:11 (188:14). It is this hour of a day in mid June—Stephen's source is Brandes: "The time of beginning was three o'clock punctually . . ." (p. 101). "It is afternoon, a little before three o'clock. Whole fleets of wherries are crossing the Thames, picking their way among the swans and other boats to land their passengers on the south bank of the river" (p. 302).

186:12–13 (188:15–16). The flag is . . . the bankside—again Brandes: "The days of performance at these theatres were announced by the hoisting of a flag on the roof" (p. 101). ". . . for the flag waving over the Globe Theatre announces there is a play today" (p. 302).

186:13–14 (188:16–17). The bear Sackerson . . . Paris garden—Brandes: "Close to the Globe Theatre lay the Bear Garden, the rank smell from which greeted the nostrils even before it came in sight. The famous bear Sackerson, who is mentioned in *The Merry Wives of Windsor* [I, i, 306], now and then broke his chain and put female theatregoers shrieking to flight." "Paris Garden": the bear garden on the Bankside maintained in the sixteenth to eighteenth century as a place for bear-baiting, bull-baiting and prize-fighting.

186:14 (188:17). Drake—Sir Francis Drake (c.1540–1596), the first Englishman to circumnavigate the earth (1577–1580) and a Vice-Admiral who played a key role in the English defeat of the Spanish Armada in 1588.

186:15 (188:18). chew their sausages among the groundlings—"groundlings" were the spectators who stood in the pit; Hamlet condemns them as "for the most part . . . capable of nothing but inexplicable dumb-shows and noise" (III, ii, 12–13). Brandes: "They all had to stand—coalheavers and bricklayers, dock-labourers, serving-men and idlers. Refreshment-sellers

moved about among them, supplying them with sausages and ale, apples and nuts. They ate and drank, drew corks, smoked tobacco, fought with each other, and, often, when they were out of humour, threw fragments of food, and even stones, at the actors . . ." (p. 105).

186:16 (188:19). Local colour—the heading of a sub-chapter on *Hamlet* in Brandes, pp. 357–360.

186:17–18 (188:21–22). Shakespeare has left . . . along the riverbank—source: Charles W. Wallace, "New Shakespeare Discoveries: Shakespeare as a Man Among Men," *Harper's Monthly Magazine (1910)*, Vol. 120, pp. 489–510. The article cites the discovery of legal papers (Belott *vs.* Mountjoy) which fix Shakespeare's residence in London from 1598 to 1604 at 13 Silver Street, the house of Christopher Mountjoy, a French Huguenot. Wallace adds "local colour" to his account: "By reference to a map of London you will see that the Globe Theatre is situated on the south side of the Thames just between the Bankside and Maiden Lane, almost directly South of Silver Street. You can see Shakespeare start out from Silver Street for the theatre. Sometimes he stops on the way for Hemings and Condell. A brisk walk of ten minutes, with lively talk, down Wood Street, past the old city prison called the Counter, across Cheapside near where Cheapside Cross stood, then through Bread Street past the Mermaid Tavern takes them to the river, where a waterman ferries them across" (p. 508). "Swanmews": literally, "a stable for swans."

186:20 (188:24). The swan of Avon—epithet for Shakespeare after Ben Jonson's "To the Memory of William Shakespeare" in the First Folio edition of Shakespeare's works (1623): "Sweet Swan of Avon! What a sight it were/To see thee in our waters yet appear,/And make those flights upon the banks of Thames,/That did so take Eliza, and our James!" (lines 71–74).

186:21 (188:25). Composition of place. Ignatius Loyola—St. Ignatius Loyola, *Spiritual Exercises* (1548), "The First Exercise," Item 47: "*First Prelude*. The first prelude is a composition, seeing the place. Here it is to be observed that in the contemplation or meditation of a visible object as in contemplating Christ our Lord, Who is visible, the composition will be to see with the eye of the imagination the corporeal place where the object I wish to contemplate is found. I say the corporeal place, such as the Temple or the mountain where Jesus Christ is found, or our Lady, according to that which I desire to contemplate. In a meditation on sins, the composition will be to see with the eyes of the imagination and to consider that my soul is imprisoned in this corruptible body, and my whole compound self in this vale (of misery) as in exile amongst brute

beasts; I say, my whole self, composed of body and soul."

186:23 (188:27). under the shadow—the rear portion of the stage in the Elizabethan theatre was protected by a roof or platform called "the shadow." It not only protected players from the weather but also provided, in a theater lit solely by daylight, a darker place appropriate to scenes such as the appearance of the Ghost in *Hamlet* (I, iv and I, v).

186:24 (188:28). made up in . . . court buck—the Ghost appears in full armor as Horatio remarks (I, i, 60 and I, ii, 226–229). Brandes (pp. 104–105) gives evidence to show that acting companies purchased their costumes. Stephen is repeating the possibly apocryphal tradition that noblemen contributed support to the companies by giving them secondhand court costumes.

186:24–25 (188:28–29). a wellset man with a bass voice—sources: Sidney Lee, *A Life of William Shakespeare* (London, 1898): "Aubrey reported that Shakespeare was 'a handsome well shap't man,' . . ." (p. 286); Frank Harris, *The Man Shakespeare and His Tragic Life-Story* (New York, 1909) (most of the materials for this book had appeared in *The Saturday Review* [London], in the 1890s): "Shakespeare was probably of middle height, or below it, and podgy. I always picture him to myself as very like Swinburne" (p. 268) and "I can see him talking, talking with extreme fluency in a high tenor voice" (p. 367).

186:25 (188:29). a king and no king—Francis Beaumont (*c*.1584–1616) and John Fletcher (1579–1625), *A King and No King* (1611), a tragicomedy. Stephen's source? "*A King and No King*, the play which in all probability succeeds *Philaster*, contains the same merits and defects as the latter, and here also Shakespeare might find reminiscences of his own work" (Brandes, p. 599).

186:25–26 (188:30). the player is Shakespeare—sources: "Rowe identified only one of Shakespeare's parts, 'the Ghost in his own "Hamlet,"' and Rowe asserted his assumption of that character to be 'the top of his performance'" (Lee, p. 44; Nicholas Rowe [1674–1718], English poet and dramatist who also edited Shakespeare's plays).

186:26–27 (188:30–31). all the years . . . not vanity—after Ecclesiastes 11:10: "Therefore remove sorrow from thy heart, and put away evil from thy flesh; for childhood and youth *are* vanity."

186:28 (188:32). Burbage—Richard Burbage (*c*.1567–1619), English actor who also built and

operated the Globe Theatre. He appears to have been the chief actor and tragedian of his day; he apparently played major roles not only in Shakespeare's plays but also in those of Ben Jonson, and Beaumont and Fletcher. Stephen's source? "Burbage created the title-part in Shakespeare's tragedy [*Hamlet*], and its success on the stage led to its publication immediately afterwards" (Lee, p. 222).

186:29 (188:33). beyond the rack of cerecloth—in this context "rack" means the clouds in the upper air (as it does in *Hamlet* II, ii, 506); "cerecloth" is cloth impregnated with wax; it was used in embalming the illustrious dead. Thus, the sense of the phrase is "on the other side of the grave."

186:31 (188:35). Hamlet I am thy father's spirit—a misquotation. "HAMLET: What? GHOST: "I am thy father's spirit,/Doom'd for a certain term to walk the night" (I, v, 8–10).

186:32 (188:36). bidding him list—see 185:39n.

186:33–34 (188:37–38). Hamnet Shakespeare—source, Brandes: "In the Parish Register of Stratford-on-Avon for 1596, under the heading of burials, we find this entry, in a clear and elegant handwriting: '*August 11, Hamnet filius William Shakespeare.*' Shakespeare's only son was born on the 2ᵈ of February 1585 [with a twin, a girl named Judith]; he was thus only eleven and a half when he died. We cannot doubt that this loss was a grievous one to a man of Shakespeare's deep feeling; doubly grievous it would seem because it was his constant ambition to restore the fallen fortunes of his family, and he was now left without an heir to his name" (p. 140).

186:37 (189:2). in the vesture of buried Denmark—in *Hamlet* (I, i, 40 *ff.*) when the Ghost first enters, Horatio tries unsuccessfully to question it in order to learn the meaning of its "unnatural behavior." Horatio says, "What art thou that usurp'st this time of night,/Together with that fair and warlike form/In which the majesty of buried Denmark/Did sometimes march?" (lines 46–49).

187:2–3 (189:8). your mother is the guilty queen—see 138:2–3n.

187:3 (189:8–9). Ann Shakespeare born Hathaway—(1556–1623).

187:6 (189:12). Art thou there, truepenny—the Ghost from underneath the stage demands ("Swear") that Horatio and Marcellus swear themselves to secrecy as Hamlet has requested. Hamlet, upon hearing the Ghost: "Ah, ha, boy!

say'st thou so? art thou there, truepenny?/Come on—you hear this fellow in the cellarage—/ Consent to swear" (I, v, 150–152). "Truepenny": a trusty person, an honest fellow.

187:9–10 (189:15–16). As for living . . . Villiers de l'Isle has said—Comte Jean Marie Mathais Philippe Auguste de Villiers de l'Isle Adam (1838–1889), French poet and playwright, immediate precursor of the French symbolist movement. His plays combine a flamboyant, latter-day romanticism with fantastic and macabre tales. Russell quotes from Villiers de l'Isle Adam's last play, *Axel*, published posthumously in 1890. At the climax of the play, Count Axel, who has "a paleness almost radiant" and "an expression mysterious from thought," meets Sara, a daring beauty who has come to steal the Count's hidden treasure. They experience a lightning bolt of love at first sight and Sara proposes that they elope to a setting where they can live a life that will match the beauty of their love. The Count replies (in part): "Live? No. Our existence is full. . . . Sara, believe me when I say that we have just exhausted the future. All the realities, what will they be tomorrow in comparison with the mirages we have just lived? . . . To consent, after this, to live would be but sacrilege against ourselves. Live? our servants will do that for us. . . ." He proposes suicide; they share a goblet of poison and perish in a rapturous love-death. In context it is appropriate that Russell should quote this line, because Yeats had used it as an epigraph to *The Secret Rose* (1897), which he had dedicated to Russell.

187:14–16 (189:20–21). Flow over them . . . Mananaan MacLir—from George Russell's three-act verse play *Deirdre* (performed 1902; published Dublin, 1907). A chant in Act III, p. 49: "Let the Faed Fia fall/Mananaan MacLir/ Take back the day/Amid days unremembered./ Over the warring mind,/Let thy Faed Fia fall,/ Mananaun MacLir/Let thy waters rise,/Mananaun MacLir/Let the earth fail/Beneath their feet,/ Let thy waves flow over them,/Mananaun:/Lord of Ocean!" Mananaan MacLir is the ancient Irish god of the sea.

187:17 (189:22). sirrah—a common Elizabethan form of address to a person who is inferior in station or who is being mocked.

187:20 (189:25). noble—an English coin (until 1461) worth 6s, 8d.

187:21 (189:26). Georgina Johnson—a prostitute, whether "fictional" or "real," unknown.

187:22 (189:27). Agenbite of inwit—see 17:32–33n.

187:28 (189:33). I paid my way—Mr. Deasy's aphorism, 31:35 (30:39).

187:29–30 (189:34–35). He's from beyant . . . northeast corner—George Russell was born in Lurgan, County Armagh, Ulster (the north-eastern section of Ireland). Ulster is the pre-dominantly Protestant, pro-British section of Ireland, and hence its motto is: "I paid my way." The Boyne River, which enters the Irish Sea 28 miles north of Dublin, is not so much a geographi-cal as it is a historical dividing line between the Orange of Ulster and the Green of Ireland since it was at the Battle of the Boyne, 1 July 1690, that William III (of Orange) defeated the Irish under (the deposed) King James II, thus ensuring the continuance of English rule in Ireland.

187:33 (189:38). Buzz. Buzz—i.e., stale news. Hamlet uses this expression (II, ii, 412) to mock Polonius when the latter announces the arrival of the traveling players.

187:34 (189:39). entelechy, form of forms—Aristotle uses the word "entelechy" in two ways: (1) to mean form-giving cause or energy as con-trasted with mere potential existence; (2) to mean, in relation to the phenomena of living and mental existences, form-giving cause realized in a more or less perfect actuality as in plants, animals and men. In effect, "entelechy" in this second sense means not just actuality, but an actuality that has the power to produce other actualities of the same kind. For "form of forms," see 27:2–4n.

187:36 (189:41). I that sinned and prayed and fasted—as in *A Portrait of the Artist as a Young Man,* from the closing pages of Chapter II through to the opening pages of Chapter IV.

187:37 (190:1). A child Conmee saved from pandies—"pandies": a "pandybat" is a leather strap reinforced with whalebone; schoolboys were punished by being pandied, struck on the palms of their hands. For the episode Stephen recalls see *A Portrait of the Artist as a Young Man,* the closing pages of Chapter I.

187:38 (190:2). I, I and I. I—suggest both the continuity of the self ("by memory . . . under ever changing forms") and the discontinuity ("I am other I now").

187:39 (190:3). A.E.I.O.U—the five vowels spell out the legend that Stephen owes George Russell money.

188:3–4 (190:8–9). She died . . . sixtyseven years after she was born—Anne Hathaway was born in 1556 and died on 6 August 1623.

188:7 (190:13). The sheeted mirror—the mirrors in a chamber of death were removed or covered to prevent the ghost of the dead person from appearing or lingering as a reflection in a mirror.

188:9 (190:15). Liliata rutilantium—see 12:13–14n.

188:11 (190:17–18). the tangled glowworm of his lamp—see 165:5–6n.

188:19–20 (190:28). Socrates—(469–399 B.C.), Greek teacher and philosopher whose image dominates the Dialogues of his student and dis-ciple Plato. He insisted that virtue derives from knowledge and that knowledge was to be pursued through dialectic, in the tensions of dialogue among men.

188:20 (190:28). Xanthippe—Socrates' wife, whose name has become proverbial as that of the typical shrew. Socrates, according to his pupil Xenophon, ascribed numerous domestic virtues to Xanthippe; some apologists excuse her ill temper on the basis that she may have been pro-voked by Socrates' impractical and unconventional behavior. One semifictional account quotes Socrates: "Xanthippe is irreplaceable. If I can stand it with her, I shall learn to stand it with anybody." See Richard Steele, *Spectator,* Essay 479 (Tuesday, 9 September 1712).

188:21–22 (190:29–30). from his mother . . . into the world—Socrates' mother, Phaenareté, was a midwife. Plato describes Socrates' behavior in a dialogue as "midwifery" since Socrates seemed to help his students "give birth" to un-derstanding which had been theirs before the dialogue began.

188:23 (190:31). Myrto—a daughter of one Arsteides was, according to some accounts, Socrates' first wife.

188:23 (190:31). (absit nomen!)—Latin, liter-ally: "let the name be absent," but the phrase also involves a pun on the stock phrase *absit omen:* "let there be (no) ill omen (in a word just used)."

188:23 (190:31–32). Epipsychidion—a poem (1821) by Percy Bysshe Shelley (1792–1822). The title is a coined word (Greek) usually translated "this soul out of my soul" (line 238). The poem articulates Shelley's concept of "true love," a transcendental (from Shelley's point of view, Platonic) identification with a sister spirit.

188:23–24 (190:32). no man, not a woman, will ever know—recalls legends of the blind Greek prophet Tiresias, who was said to have been changed into a woman in the middle of his life by some prank of the gods. His special attributes

resulted in his being called to settle a dispute between Zeus and Hera; Zeus had maintained that the sexual act is more pleasurable to women than to men; Hera had argued the contrary. Tiresias agreed with Zeus and was blinded by Hera for his pains; Zeus compensated by awarding him inward sight.

188:25 (190:33). caudlectures, a misprint, it should read **caudlelectures**—the reference is to *Curtain Lectures* (1846), a collection of short, witty pieces by Douglas Jerrold (1803–1857). Each "lecture" is the nightlong henpecking harangue that a Mrs. Margaret Caudle delivers to her husband, Mr. Job Caudle. The patient Job usually replies with a plaintive rebuttal or a sigh of resignation. (A "caudle" is a warm drink for sick persons.)

188:25–26 (190:33–34). the archons of Sinn Fein—for "*Sinn Fein,*" see 161:24n. The phrase recalls the Archons of Athens (the ruling magistrates) who condemned Socrates to death. The sentence was carried out with a cup of hemlock.

188:31–32 (190:39–40). the baldpink lollard . . . guiltless though maligned—i.e., Thomas Lyster, who, as a Quaker, is a "lollard" and who was subject to public suspicion about his loyalties because he was not a Roman Catholic.

188:33 (190:41). a good groatsworth of wit—the phrase is from Robert Greene's *A Groat's Worth of Wit bought with a Million of Repentance* (1592). (A groat [4d] was regarded as a trivial sum.) See 185:24n.

188:34 (190:42). He carried a memory in his wallet—recalls Ulysses' assertion that memories quickly fade, in Shakespeare's *Troilus and Cressida:* "Time hath, my lord, a wallet at his back,/Wherein he puts alms for oblivion" (III, iii, 145–146).

188:35 (191:1). Romeville—Gypsy cant: "London." See 48:9n and 48:16–19n.

188:35 (191:1). The girl I left behind me—an Irish ballad with many variants, though one by Samuel Lover (1797–1868), Irish poet, novelist and composer, seems appropriate to this context. "The dames of France are fond and free,/And Flemish lips are willing,/And soft the maids of Italy,/And Spanish eyes are thrilling;/Still though I bask beneath their smile,/Their charms fail to bind me,/And my heart falls back to Erin's isle,/To the girl I left behind me."

188:35–36 (191:1–2). If the earthquake did not time it—the reference is to Shakespeare's *Venus and Adonis,* lines 1046–1048: "As when the wind, imprisoned in the ground,/Struggling for passage, earth's foundation shakes,/Which with cold terror doth men's minds confound." Many scholarly attempts to date the poem by internal evidence have focused on the poem's use of details from nature and on the reference to the plague in lines 508–510. None, however, has focused on the earthquake since the major quake recorded in England during the period occurred in 1580, when Shakespeare at sixteen was perhaps a bit too young to have managed this sophisticated poem. *Venus and Adonis* was registered at the Stationer's Office, London, on 18 April 1593.

188:36–37 (191:3). poor Wat, sitting in his form, the cry of hounds—"Wat" is a hare; a "form" is the lair of a hare. *Venus and Adonis,* lines 697–702: "By this, poor Wat, far off upon a hill,/Stands on his hinder legs with listening ear,/To hearken if his foes pursue him still./Anon their loud alarums he doth hear;/And now his grief may be compared well/To one sore sick that hears the passing bell."

188:37 (191:3–4). the studded bridle—*Venus and Adonis,* lines 37–38: "The studded bridle on a ragged bough/Nimbly she fastens. . . ."

188:37–38 (191:4). and her blue windows—*Venus and Adonis,* lines 481–483: "The night of sorrow now is turned to day./Her two blue windows faintly she upheaveth,/Like the fair sun. . . ."

188:38–39 (191:4–6). Venus and Adonis . . . light-of-love in London—source, Brandes: "In 'Venus and Adonis' glows the whole fresh sensuousness of the Renaissance and of Shakespeare's youth. It is an entirely erotic poem, and contemporaries aver that it lay on the table of every light woman in London" (p. 56). "Light o' Love" was an Elizabethan dance tune traditionally associated with levity and inconstancy in love; thus, the phrase came to mean a light, wanton or inconstant woman. There is an elaborate witty exchange on this phrase in Shakespeare's *Much Ado About Nothing,* (III, iv, 45 *ff.*).

188:39–40 (191:6–7). Is Katherine . . . young and beautiful—in *The Taming of the Shrew* (I, ii) Petruchio, the hero, tells his friend Hortensio that he has come to Padua in quest of a wealthy bride. Hortensio first reproves him: "Petruchio, shall I then come roundly [speak plainly] to thee/And wish thee to a shrewd ill-favour'd [homely] wife?" (lines 59–60). But then Hortensio (with Katharina, the heroine-shrew in mind): "I can, Petruchio, help thee to a wife/With wealth enough and young and beauteous,/Brought up as best becomes a gentlewoman:/Her only fault, and that is fault enough,/Is that she is intolerable curst/And shrewd and froward . . ." (lines 85–90).

188:41–42 (191:8). a passionate pilgrim— *"The Passionate Pilgrime. By W. Shakespeare. At London Printed . . . 1599."* The volume contains 20 (or 21) poems only four or five of which are usually (and somewhat controversially) attributed to Shakespeare; of those, two are concerned with "a woman coloured ill" and two with a woman who has forsworn herself in love.

189:1 (191:9). Warwickshire—the county in which Stratford-on-Avon is located.

189:1–2 (191:10). he left her and gained the world of men—as the speaker in Browning's paired poems, "Meeting at Night/Parting at Morning" (1845). The male speaker in the two poems recalls being reunited with his beloved at night, and "Parting at Morning": "Round the cape of a sudden came the sea,/And the sun looked over the mountain's rim:/And straight was a path of gold for him [i.e., for the sun],/And the need of a world of men for me."

189:2 (191:11). his boywomen—female characters were acted by boys on the Elizabethan stage. It was not until 44 years after Shakespeare's death that an actress first played a part (Desdemona in *Othello*) on the English stage, 8 December 1660.

189:4(191:12). He was chosen—source, Brandes: "In a document dated November 28, 1582, two friends of the Hathaway family give a bond to the Bishop of Worcester's Court declaring . . . that there is no legal impediment to the solemnisation of the marriage after one publication of the banns, instead of the statutory three. . . . It was the bride's family that hurried on the marriage, while the bridegroom's held back, and perhaps even opposed it. This haste is less surprising when we find that the first child, a daughter named Susanna, was born May 1583, only five months and three weeks after the wedding" (p. 10). Frank Harris, in *The Man Shakespeare* (New York, 1909), has a different view: "The whole story . . . is in perfect consonance with Shakespeare's impulsive, sensual nature; is, indeed, an excellent illustration of it. Hot, impatient, idle Will got Anne Hathaway into trouble, was forced to marry her, and at once came to regret" (p. 358).

189:4–5 (191:13). If others have . . . hath a way —the others who have "their will" are presumably the person(s) to whom Shakespeare's sonnets 135 and 143 are addressed: "Whoever hath her wish, thou hast thy Will" (with the pun on Will Shakespeare and will: desire) (135:1), and "So will I pray that thou mayst have thy Will" (143:13). The pun on Anne Hathaway's name dates at least from Charles Dibdin (1745–1814), "A Love Dittie," in his novel *Hannah Hewit; or the Female Crusoe* (1792): "Angels must love Ann Hathaway;/She hath a way so to control,/To rapture the unprisoned soul,/And sweetest heaven on earth display,/That to be heaven Ann hath a way;/She hath a way,/Ann Hathaway—To be heaven's self Ann hath a way."

189:5 (191:13–14). By cock, she was to blame —after a madsong of Ophelia: "By Gis and by Saint Charity,/ Alack, and fie for shame!/Young men will do 't, if they come to 't;/By cock, they are to blame./Quoth she, before you tumbled me,/You promised me to wed./[He answers]: So would I ha' done, by yonder sun,/An thou hadst not come to my bed" (*Hamlet*, IV, v, 59–66).

189:6 (191:14–15). sweet and twenty-six— "sweet and twenty" is slang for a gay girl, after Clown's song in *Twelfth Night* : "What is love? 'tis not hereafter;/Present mirth hath present laughter;/What's to come is still unsure:/In delay there lies no plenty;/Then come kiss me, sweet and twenty,/Youth's a stuff will not endure" (II, iii, 48–53). When they were married in 1582 Ann Hathaway was twenty-six; Shakespeare, eighteen.

189:6–7 (191:15). The greyeyed goddess—in *Venus and Adonis* Venus speaks to Adonis: "Mine eyes are gray and bright and quick in turning" (line 140). "Gray eyes," in Elizabethan English: blue; but "greyeyed goddess" is also a Homeric epithet for Athena, the goddess of wisdom.

189:7 (191:15–16). the boy Adonis—in *Venus and Adonis* Adonis is described as "the tender boy" (line 32), but Shakespeare's poem does not play on a disparity of "ages" as much as on the disparity between the immortal goddess and the mortal boy.

189:7 (191:16). stooping to conquer—after Oliver Goldsmith's (1728–1774) play, *She Stoops to Conquer/or the Mistakes of a Night* (1773), in which the heroine, Miss Hardcastle, masquerades as a barmaid and a poor relation in order to disarm Young Marlow's bashfulness and win his affection.

189:7–8 (191:16). as prologue to the swelling act—in *Macbeth* the witches hail Macbeth as Thane of Glamis (which he is), as Thane of Cawdor and as King. After the witches vanish, Ross and Angus enter and inform Macbeth that he has been made Thane of Cawdor. Macbeth regards the news as confirmation of the witches' prophecy that he will become king; Macbeth, aside: "Two truths are told,/As happy prologues to the swelling act/Of the imperial theme . . ." (I, iii, 127–129).

189:8–9 (191:17–18). a boldfaced Stratford . . . younger than herself—for "tumbles," see Ophelia's madsong, 189:5n; for "cornfield," see

189:15–16n. Source, Harris: "I, too, Shakespeare tells us practically, was wooed by an older woman against my will. He wished the world to accept this version of his untimely marriage. Young Shakespeare in London was probably a little ashamed of being married to some one whom he could hardly introduce or avow" (p. 368).

189:15–16 (191:24–25). Between the acres . . . would lie—from the second verse of the Page's song in *As You Like It :* "Between the acres of the rye,/With a hey, and a ho, and a hey nonino,/ These pretty country folks would lie" (V, iii, 23–25). But while Best's emendation "Ryefield" (189:12 [191:21]) is supported by the second verse of the song, Stephen's "cornfield" (189:9 [191:17]) is supported by the first verse: "It was a lover and his lass/. . ./That o'er the green cornfield did pass" (lines 17–19).

189:17 (191:26). Paris: the wellpleased pleaser—see 43:32 (42:34). The pun turns on the Greek myth of Paris, who pleased Aphrodite by awarding her the prize in a beauty contest with Athena and Hera. Aphrodite in turn pleased Paris by awarding him Helen of Troy (and coincidentally rewarding Paris' father, Priam, and his house with destruction in the Trojan War).

189:18–19 (191:27–28). A tall figure . . . its cooperative watch—AE is reported to have been a very kindly man and at the same time very punctual in his habits and commitments. The gesture of interruption he makes here was repeated often enough to become a minor legend in Dublin literary circles, and thus need not be read as an act of rudeness toward Stephen.

189:20 (191:29). the Homestead—see 36:19n.

189:23 (191:32). Moore's—George Moore (1852–1933), Irish novelist, poet, dramatist and man of letters. As a young man Moore studied painting in Paris and lived a Bohemian life. He styled himself "as receptive to impressions as a sheet of wax" and indeed appears to have been so. In Paris he responded to the naturalism of Zola and became for a time a staunch advocate and practitioner of naturalism in fiction. But he also responded to Baudelaire, Huysmans and Walter Pater, influences that are reflected in a late-nineteenth-century strain of "decadence" in his attitudes. Resident in England (1880–1901), he declared himself alienated by the cruelty of Kitchener's Boer War concentration camps and left England for Ireland (1901–1911). In this "Irish phase" of his career Moore advocated the revival of the Irish language, its literature and mythology, and associated himself with the Abbey Theatre and with figures prominent in the Irish Literary Renaissance (Yeats, Synge, Edward Martyn, AE, Lady Gregory and others). The tone of Moore's recollections in his autobiography, *Hail and Farewell* (1911, 1912, 1914), suggests that his disillusionment with the Irish Renaissance was a function of his not having been lionized in Dublin so thoroughly as he thought he deserved. In effect, it appears that Moore returned to Ireland "to take over" an already vigorous movement, and those associated with the movement were not sufficiently docile in their responses.

189:23 (191:33). Piper—Padraic Colum, in an interview in 1968, recalled Piper as a minor, peripheral figure on the Irish literary scene at the beginning of this century and as a "civil servant, perhaps somewhere in China?"

189:25 (191:34). Peter Piper . . . pickled pepper—a tongue-twisting nursery rhyme: "Peter Piper picked a peck of pickled peppers;/ A peck of pickled peppers Peter Piper picked;/If Peter Piper picked a peck of pickled peppers,/ Where's the peck of pickled peppers Peter Piper picked?"

189:26 (191:35). Thursday . . . our meeting— the Hermetic Society met on Thursday evenings in Dawson Chambers at 11–12 Dawson Street in Dublin.

189:28 (191:37). Yogibogeybox—Stanislaus Joyce recalls "box" as Gogarty's word for a public establishment or meeting hall; see Adams, p. 208.

189:28 (191:37). Isis Unveiled—"A Master Key to the Mysteries of Ancient and Modern Science and Theology" (1876), by Helena Petrovna Blavatsky, was regarded by her disciples in theosophy as their accredited textbook.

189:28–29 (191:38). Palibook—Pali, a form of Sanskrit, was the written language of ancient Ceylon. In *Isis Unveiled* (New York, 1886), I, 578 *ff*., Madame Blavatsky postulates Pali-Sanskrit as the Ur-language in which the Ur-myths of the ancient world were originally realized before those myths were spread through migration and translation to the East into Burma, Indochina and China and to the West into Egypt, Israel and Greece. Thus the "Palibook" is the Ur-book, the fountainhead of universal Ur-myth.

189:29 (191:38). we—in real life Joyce and Gogarty; see Ellmann, p. 179.

189:29–30 (191:38–39). umbrel umbershoot— colloquialisms for "umbrella"; see 189:33n.

189:30 (191:39). Aztec logos—Madame Blavatsky argues that there was a "perfect identity of the rites, ceremonies, traditions, and even the names of the deities among the Mexicans and ancient

Babylonians and Egyptians" (*Isis Unveiled,* I, 557). She asserts that "among both peoples magic or the arcane natural philosophy was practiced to the highest degree" (I, 560). Earlier Madame Blavatsky has established that *"there is a logos in every mythos* or a groundwork of truth in every fiction" (I, 162); therefore, an Aztec logos is the groundwork of universal truth (the "one universal religion" [I, 560]) with an Aztec flavor, in the final analysis theosophically identical with the Babylonian-, Egyptian-, Hindu-Logos.

189:30 (191:39–40). astral levels—in theosophy a supersensible substance, imperceptible to the uninitiated, above and more refined than the tangible world. Properly trained in theosophical meditation, an individual could "function" on astral levels, perceiving the "substance" of the astral world in all about him. See 163:29n.

189:31 (191:40). oversoul—an all-pervasive transcendental presence similar to "astral levels." As defined by Emerson: "The unity, that *oversoul,* within which every man's particular being is contained and made one with all other."

189:31 (191:40). mahamahatma—in Sanskrit "mahatma" means literally, "great-souled, wise"; in theosophy: sages or adepts who have knowledge and power of a higher order than those realized by ordinary men.

189:32 (191:41). chelaship—a "chela" in esoteric Buddhism is a novice who is in the process of being initiated into the mysteries.

189:32–33 (191:41–192:1). Louis H. Victory—a minor Irish man of letters at the end of the nineteenth century; his works include *Essays for Ireland; The Higher Teaching of Shakespeare; Essays of an Epicure;* and his collected poems, *Imaginations in the Dust* (London, 1903); see 189:38–39n below.

189:33 (192:1). T. Caulfield Irwin—(1823–1892), an Irish poet and writer of tales who in his later days suffered from what one anonymous friend called "a gentle mania." A next-door neighbor of the poet in Dublin did not take such a charitable view: "He says I am his enemy, and watch him through the thickness of the wall which divides our houses. One of us must leave. I have a houseful of books; he has an umbrella and a revolver. . . ."

189:33 (192:1–2). Lotus ladies tend them i' their eyes—the Lotus ladies are Apsaras, the attractive and amorous nymphs of Hindu mythology. They are the ultimate reward of those who (on earth) achieve a perfect asceticism. In *Antony and Cleopatra* Enobarbus describes Cleopatra at her first meeting with Antony: "Her gentlewomen,

like the Nereides [sea nymphs],/So many mermaids, tended her i' the eyes,/And made their bends adornings . . ." (II, ii, 211–213).

189:34 (192:2). pineal glands—a vestigial, cone-shaped gland in the brain; in theosophy, the seat of the soul.

189:34–35 (192:3). Buddha under plantain—in the legend of Buddha, after he abandoned his worldly career, he attempted an excessive asceticism. This he in turn abandoned (because it did not free his mind) in favor of contemplation under the tree of wisdom, in some versions and depictions, a plantain tree. In the course of this contemplation Buddha achieved enlightenment; in theosophical terms he achieved the astral level, and thus could become one of the saviors of the world.

189:35 (192:3). Gulfer of souls, engulfer—i.e., God, who in theosophical terms cast souls out of Himself into Himself, since all souls are one with God and came from Him. The vast majority of souls in earthly life forget their God-source though still contained within Him.

189:35–37 (192:3–5). Hesouls, shesouls . . . whirling, they bewail—recalls Dante's description of "The Trimmers," those "without blame and without praise," in *Inferno* III. They are described as excluded by both Heaven and Hell; they have no hope of death; wailing and lamenting, they are whirled endlessly about, "goaded by hornets and by wasps." It is of these that Dante says, "I could never have believed that death had undone so many."

189:38–39 (192:6–7). In quintessential . . . a shesoul dwelt—after the opening lines of "Soul-Perturbating Mimicry," a poem about the death of a child, by Louis H. Victory; see 189:32–33n. The first of the poem's four stanzas reads: "In quintessential triviality/Of flesh, for four fleet years, a she-soul dwelt./Oft, unpremeditatedly, I knelt/In meads, where round this thought-refining she,/To sun me in the God-light mystery,/That I, love-chained and beauty-pinioned, felt/Flashed from her, hieroglyphically spelt,/Like gifts that fall from white Austerity" (*Imaginations in the Dust,* Vol. I, pp. 132–133).

190:1–2 (192:9–10). Mr. Russell, rumour . . . younger poets' verses—*New Songs, a Lyric Selection,* edited by George Russell, was reviewed by the magazine *Dana,* in its May issue in 1904. Thus the "literary surprise" had already happened. It is not clear whether Joyce meant to reveal the librarian as "behind the times," whether the volume had yet to appear, or whether it is simply a mistake. Russell did not include any of Joyce's verses in the collection. See Ellmann, pp. 179–180.

190:7 (192:15). caubeen—Irish: "an old, shabby cap or hat."

190:8–9 (192:16–17). Touch lightly . . . Aristotle's experiment—Aristotle, *Problemata* XXXV:10, "Problems Connected with the Effects of Touch": "Why is it that an object which is held between two crossed fingers appears to be two? Is it because we touch it at two sentient points? For when we hold the hand in its natural position, we cannot touch an object with the outer sides of the two fingers."

190:10–11 (192:18–19). Necessity is that . . . be otherwise—Aristotle, *Metaphysics,* Book Gamma, III:1005b:19–20: "A principle that is the most certain of all is, that the same attribute cannot belong and not belong to the same subject and in the same respect, . . ." and in V:1015b: "We say that that which cannot be otherwise is necessarily as it is."

190:11 (192:19). Argal—a corruption of Latin: *ergo* ("therefore"), hence it implies a clumsy bit of reasoning. It is used liberally by the First Clown (gravedigger) in *Hamlet* (V, i) as he "reasons" about Ophelia's death (suicide?).

190:13 (192:21). Young Colum—Padraic Colum (1881–1972), Irish poet, dramatist and man of letters. In *Irish Literature*, ed. Justin McCarthy, Maurice Egan and Douglas Hyde (New York, 1904): "Padraic Colum is one of the latest of young Irishmen who have made a name for themselves in the literary world. His work has been published in *The United Irishman* and in an interesting anthology entitled *New Songs, a Lyric Selection,* made by George Russell" (Vol. II, p. 612). See Padraic and Mary Colum, *Our Friend James Joyce* (New York, 1958).

190:13 (192:21). Starkey—James S. Starkey (1879–1958), Irish poet and editor who wrote under the pseudonym Seumas O'Sullivan. A selection of his poems appears in *New Songs*.

190:13 (192:21). George Roberts—(d. 1952), "part literary man and part businessman" (Mary and Padraic Colum, *Our Friend James Joyce*, p. 60). Roberts eventually became managing editor of the Dublin publishers, Maunsel and Company (in that capacity he contracted with Joyce for the publication of *Dubliners*, a contract that went unfulfilled in the midst of an impressive wrangle).

190:14 (192:22–23). Longworth . . . in the Express—Ernest Victor Longworth (1874–1935), editor of the conservative and pro-English Dublin newspaper the *Daily Express* from 1901 to 1904. See "The Dead," *Dubliners:* Gabriel Conroy writes reviews for the *Express*, and as a result finds himself in difficulties with the nationalist Miss Ivors.

190:15 (192:23). Colum's Drover—Padraic Colum, "A Drover," was included in *Irish Literature* (New York, 1904), Vol. II, p. 613. The poem begins: "To Meath of the Pastures,/From wet hills by the sea,/Through Leitrim and Longford/Go my cattle and me." The ninth and final stanza: "I will bring you, my kine,/Where there's grass to the knee,/But you'll think of scant croppings,/Harsh with salt of the sea."

190:16–17 (192:25). Yeats admired . . . Grecian vase—the poem is Padraic Colum's "A Poor Scholar of the Forties," in a collection of his verse, *Wild Earth* (Dublin, 1907), pp. 13–14. In the poem the "scholar" is reproached by "the young dreamer of Ireland" for teaching Greek and Latin. The Scholar replies: "And what to me is Gael or Gall?/Less than the Latin or the Greek./I teach these by the dim rush-light,/In smoky cabins night and week,/But what avail my teaching slight./Years hence in rustic speech, a phrase/As in wild earth a Grecian vase!" The context in which Yeats expressed his admiration for Colum's line is unknown.

190:19–20 (192:28). Miss Mitchell's joke about Moore and Martyn—Susan Mitchell (1866–1926), Irish wit, parodist and poet, sub-editor of the *Irish Homestead*. Edward Martyn (1859–1923), a wealthy Irish Catholic landlord, was George Moore's cousin and (briefly) friend and associate (together with Yeats and Lady Gregory) in founding the Literary Theatre in Dublin (1899). Martyn's biographer, Edward Gwynn, *Edward Martyn and the Irish Revival* (London, 1930), describes him as "the only Irishman with large private means who was in full sympathy with almost every phase of the Irish revival" (p. 13). He provided financial support for projects as various as the Abbey Theatre (1903), Arthur Griffith's pamphlet *Sinn Fein* (1905), the "Palestrina Choir" in the Metropolitan Pro-Cathedral (in the interest of reforming Church music). The relationship of Martyn and Moore ran the gamut from cooperation (1899) to strain to qualified estrangement. Susan Mitchell recounts this process in her *George Moore* (New York, 1916); one phase she calls "the spoliation of Edward Martyn" (p. 103) by Moore, whom she labels "a born literary bandit"; the occasion: Moore appropriated Martyn's play *The Tale of a Town* (1902), rewrote and issued it as his own *The Bending of the Bough*. Martyn never effected an open break with Moore; even when Moore flayed him as the "Dear Edward" of *Ave* (*Hail and Farewell*, 1912), Martyn's reaction was that he would not read it, with the remark: "George is a pleasant fellow to meet, and if I read the book I might not be able to meet him again" (Susan Mitchell, p. 94). Martyn's only revenge was to list "Mr. George Augustus Moore" as his "recreation" in *Who's Who* (1913).

Martyn's biographer describes him as "hating all women with an instinctive, almost perverted antipathy" (Gwynn, p. 18). Moore's version of this antipathy: Martyn "was a bachelor before he left his mother's womb." Moore, on the other hand, was characterized by Susan Mitchell as a lover who "didn't kiss but told." Yeats, in his *Autobiography,* described Moore as "a peasant sinner," Martyn as a "peasant saint." Susan Mitchell's remark about "Martyn's wild oats" was circulated widely in Dublin and has become "immortal" in the Dublin vocabulary of anecdote. The thrust of her remark plays on the fact that Martyn was the last person in the world to sow "wild oats" and on the similarity between Martyn's continued association with Moore and a young man's wild and imprudent pursuit of (sexual) adventures that threaten damage to his reputation (in part because Moore constantly maligned Martyn as a dreadful sinner).

190:21–22 (192:29–30). They remind of . . . Sancho Panza—the central characters in the Spanish "national epic," Miguel de Cervantes' *Don Quixote* (1605, 1615). Don Quixote is the slender and mildly deranged gentleman who imagines that he is living in a chivalric romance; in the tragicomedy of the novel Don Quixote's chivalric world is variously juxtaposed with the earthy realities of early-seventeenth-century Spain. One of those earthy realities is the former pig farmer Sancho Panza, who follows Don Quixote in the role of his "squire." As Don Quixote is thin, so Sancho Panza is fat; George Moore was slender; Martyn, heavy-set. The parallel suggests that the earthy Martyn tagged around after the ethereal and imaginative Moore; but it is complicated by the fact that Martyn appears to have been more of a romantic idealist ("the peasant saint") than Moore ("the peasant sinner"). Moore's remark, "John Eglinton toils at 'Don Quixote'" (*Vale* [*Hail and Farewell,* 1914], p. 3), suggests that this line is Eglinton's contribution to this paragraph of garbled conversation.

190:22–23 (192:30–31). Our national epic . . . Dr. Sigerson says—George Sigerson (1838–1925), Irish physician, biologist, poet, translator (from Gaelic) and man of letters. In an essay, "Ireland's Influence on European Literature" (*Irish Literature* [1904], IV, vii–xiii), Sigerson argues not that Ireland has never produced an epic but that Irish influences have produced (among other works) the *Niebelungen Lied* and *The Lay of Gudrun* ("the *Iliad* and the *Odyssey* of Germany," p. viii), *Tristan and Isolde,* Spenser's *Faerie Queene,* several of Shakespeare's plays, etc. He cites Fergus' "famous Táin—the lost Epic of a lost World"; and then in a peroration to his contemporaries: ". . . We dare not stand still. Ireland's glorious literary past would be our reproach, the future our disgrace. . . .

Therefore must we work . . . in vindication of this old land which genius has made luminous. And remember that while wealth of thought is a country's treasure, literature is its articulate voice by which it commands the reverence or calls for the contempt of the living and of the coming nations of the earth" (pp. xii–xiii). In effect, Sigerson encourages the champions of the Irish Revival to produce epics because the epic traditions of Ireland are so rich. Also relevant to this passage in *Ulysses* is John Eglinton's essay "Irish Books," in *Anglo-Irish Essays* (Dublin and London, 1918), pp. 87–89: "Meanwhile if we ask whether the voluminous literary activity of the last twenty years has brought forth a book, we shall have difficulty in fixing on any one work which Ireland seems likely to take to its affections permanently. If a masterpiece should still come of this literary movement we would not be surprised if it appears by a kind of accident and in some unexpected quarter, and we have a fancy that appearances in modern Ireland point to a writer of the type of Cervantes rather than to an idealising poet or romance writer. A hero as loveable as the Great Knight of the Rueful Countenance might be conceived, who in some back street of Dublin had addled his brains with brooding over Ireland's wrongs, and that extensive but not always quite sincere literature which expresses the resentment of her sons towards the stranger. His library would be described, the books which had 'addled the poor gentleman's brain' . . . we can conceive him issuing forth, fresh-hearted as a child at the age of fifty, with glib and saffron-coloured kilt, to realise and incidentally to expose the ideals of present-day Ireland. What scenes might not be devised at village inns arising out of his refusal to parley in any but his own few words of Gaelic speech; what blanketings, in which our sympathies would be wholly with the rebel against the despotism of fact! His Dulcinea would be—who but Kathleen ni Houlihan herself, who is really no more like what she is taken for than the maiden of Toboso. . . . And such a book . . . need not really insult . . . the cause of Irish nationality any more than Cervantes laughed real chivalry away."

190:23–24 (192:32–33). A knight of the rueful . . . a saffron kilt?—see the passage from John Eglinton in 190:22–23n. "Knight of the rueful countenance" is one of Cervantes' epithets for Don Quixote; and one of the recurrent comic images in Cervantes' novel is the figure Quixote cuts when he removes his armor and reveals his yellow "walloon breeches" (bloomers). Saffron kilts were assumed by some Irish nationalists to have been the standard dress in Golden Age Ireland. Fournier d'Albe, an assistant lecturer in physics at the College of Science in Dublin and an eccentric Celtic revivalist, created something of a sensation by advocating the adoption of saffron

kilts and plaids as Irish national dress in a speech to the Literary and Historical Society in January 1902. P. W. Joyce, in *Social History of Ancient Ireland* (Dublin, 1903), offered scholarly support to the advocates of saffron kilts, but recent scholars have argued that the kilts have more basis in fiction than in the fact of Irish national heritage; see Thornton, p. 172.

190:24–25 (192:33). O'Neill Russell—Thomas O'Neill Russell (1828–1908), a Celtic revivalist and linguist who had an extensive command of the Irish language. He spent 30 years in self-imposed exile in the United States, lecturing and writing on language; he also wrote a novel, *Dick Massey; a Tale of Irish Life* (1860), and several plays.

190:25 (192:33–34). O, yes, he must . . . old tongue—i.e., the hero of "our national epic" must speak Irish; see Eglinton, quoted in 190:22–23n.

190:25–26 (192:34). And his Dulcinea?—see Eglinton, quoted in 190:22–23n. In *Don Quixote* Dulcinea is the object of Quixote's chivalric love and duty: ". . . a very good-looking farm girl . . . Her name was Aldonza Lorenzo, and she it was he thought fit to call the lady of his fancies; and, casting around for a name which should not be too far away from her own, yet suggest and imply a princess and great lady, he resolved to call her Dulcinea del Toboso" (Part I, Chapter I).

190:26 (192:34). James Stephens—(1882–1950), Irish poet, folklorist and writer of fiction. His early "clever sketches" were sketches of Irish peasant life.

190:28 (192:36). Cordelia. Cordoglio—Cordelia, the youngest of King Lear's daughters, suffers a prolonged estrangement from her father in Shakespeare's play as a result of his imperious demands for proof of her affection, proof which in honest modesty she cannot articulate. The estrangement is deepened by the machinations of her older sisters (who feel no scruples about giving their versions of *proof*). When the estrangement is resolved at the play's end, the result is the tragic irony of her death as prelude to her father's. *Cordoglio* looks like an Italian version of "Cordelia," but it is also a noun meaning "deep sorrow."

190:28 (192:36). Lir's loneliest daughter—Cordelia is, of course, Lear's loneliest daughter, but the Irish *lear* or *lir* means "the sea" and Mananaan MacLir is the ancient Irish god of the sea; see 187:14–16n. The phrase is, however, from the opening lines of Thomas Moore, "The Song of Fionnuala": "Silent, oh Moyle, be the roar of thy water,/Break not, ye breezes, your chain of repose,/While, murmuring mournfully, Lir's lonely daughter/Tells to the night-star her tale of woes." In Moore's version of the legend Lir is the original sea deity who is displaced by Mananaan, his foster-son. In the displacement process Lir's daughter Fionnuala is transformed into a swan by her foster-mother.

190:29 (192:37). Nookshotten—archaic: "pushed into a corner," therefore, rendered remote and barbarous.

190:31 (192:39). to give the letter to Mr. Norman . . .—i.e., give Garrett Deasy's letter to Harry Felix Norman (1868–1947), editor of the *Irish Homestead* (1899?–1905).

190:35 (193:2). God ild you—Touchstone, a clown in *As You Like It*, uses the expression "God 'ild you" twice (III, iii, 74–75; V, iv, 56). It means "God reward you."

190:35 (193:2). The pig's paper—i.e., the *Irish Homestead;* see 36:19n.

190:36 (193:3). Synge—John Millington Synge (1871–1909), Irish dramatist who was encouraged by Yeats to abandon Paris and a bohemian life for Ireland and the Aran Islands. Synge took his advice and by 1904 had produced one impressive one-act play, *In the Shadow of the Glen* (1903) (see 183:2–4n), and one one-act masterpiece, *Riders to the Sea* (1904).

190:36 (193:3). Dana—*A Magazine of Independent Thought,* a "little magazine" in Dublin (1904–1905), edited by John Eglinton; see 192:12n. Fred Ryan was his coeditor; see 31:39n.

190:37 (193:4). The Gaelic league—(established 1893) organized an effort that had been advocated in the independent work of many Irish writers and scholars in the latter half of the nineteenth century: to revive an interest in the original language and literature of Ireland. The aim was to revive and develop an Irish national character and heritage independent of English influence. The ramifications of the league were political, though on the surface its aims appeared to be cultural.

191:1–2 (193:11–12). tiptoeing up nearer . . . of a chopine—Hamlet, receiving the players, speaks to one of the boy actors who plays the parts of women: "What, my young lady and mistress! By'r lady, your ladyship is nearer to heaven than when I saw you last, by the altitude of a chopine. Pray God, your voice, like a piece of uncurrent gold, be not cracked within the ring" (II, ii, 443–447). "Chopine": a woman's shoe with a thick cork sole.

191:5–6 (193:15–16). an inward light—since Lyster is a Quaker he would believe in speaking and in conducting his life not according to Scriptural authority but according to the "inward light," the presence of Christ in the heart.

191:10–13 (193:20–24). Christfox in leather ...fox and geese—this passage elides the careers of Shakespeare and George Fox (1624–1691), the founder of the Society of Friends, the Quakers (it also alludes to Lyster as Quaker). "Christfox": the Quaker assertion that Christ is present as an "inner light" in the heart and thus is a "fox," subtle. "Leather trews": close-fitting trousers or breeches combined with stockings formerly worn by the Irish and by Scottish Highlanders; Fox dressed in a similarly simple manner which came to be regarded as peculiar to him and his followers. Fox was repeatedly harassed, pursued and imprisoned for his views: he did once elude pursuit by hiding from "the hue and cry" in a blighted tree. Shakespeare was also a runaway (to London). "Knowing no vixen": Fox was not married until he was forty-five; Shakespeare, of course, led a "bachelor life" in London; and Lyster was unmarried. "Women he won to him": Fox was famous for his successes in making converts, and Shakespeare's speculative biographers, notably Harris, depict Shakespeare as "a loose-liver while in London" (p. 374). "A whore of Babylon": appears in Revelation 17:5 as "THE MOTHER OF HARLOTS AND ABOMINATIONS OF THE EARTH." Fox did achieve the conversion of several ladies of ill repute; and Harris offers the associative link between Shakespeare and Fox, the preacher: "Shakespeare's 'universal sympathy'—to quote Coleridge—did not include the plainly-clad tub-thumper who dared to accuse him to his face of serving the Babylonish Whore" (p. 380). "Ladies of justices": for an apocryphal episode in Shakespeare's life that might be construed to fit, see 199:13n. George Fox married Margaret, the widow of Judge Fell of Swarthmoor Hall, Lancashire (1669). "Bully tapsters' wives": "bully" means heavy, beefy, and it was also a term of endearment; another episode in the Shakespeare apocrypha: Shakespeare was rumored to have fathered Sir William Davenant on the wife of the "tapster" (innkeeper) John D'Avenant; see 199:24–25n. "Fox and geese": a game for two played on a board with pegs or draughts; the geese attempt to trap the fox, the fox to pick off the geese one by one.

191:14–16 (193:24–26). And in New Place ... grave and unforgiven—"New Place" was the mature Shakespeare's residence in Stratford-on-Avon. Brandes provides the source: "At New Place ... the spirit prevailing ... was not the spirit of Shakespeare. Not only the town of Stratford, but his own home and family were desperately pious and puritanical" (p. 671). "His wife was extremely religious, as is often the case with women whose youthful conduct has not been too circumspect. When she captured her boy husband of eighteen, her blood was as warm as his, but now, on the eve of Shakespeare's return [1613], she was vastly his superior in matters of religion" (p. 672). For the tenuous link with George Fox, see 203:41–204:2n. Stephen's language suggests an allusion to an Irish folk song, "Fair Maiden's Beauty Will Soon Fade Away"; the last stanza: "My love is as sweet as the cinnamon tree;/She clings to me as close as the bark to the tree;/But the leaves they will wither and the roots will decay,/And fair maiden's beauty will soon fade away."

191:21 (193:31). A vestal's lamp—see 143:9n and 143:24n.

191:22–23 (193:32–33). What Caesar would ... the soothsayer—in Shakespeare's *Julius Caesar* (I, ii, 12–24) a soothsayer interrupts a festival in Rome to warn Caesar: "Beware the ides of March" (15 March). Caesar dismisses the warning by calling the soothsayer "a dreamer." Caesar is warned by other "omens" in Act II, scene ii, and again by the soothsayer (III, i, 1–2). Caesar disregards the warnings, though with some uneasiness, and is, of course, assassinated on the ides of March.

191:24 (193:34). possibilities of the possible as possible—after Aristotle; see 26:17n and 26:35–36n.

191:25 (193:35–36). what name Achilles ... among women—a famous riddle with no answer. In an attempt to prevent Achilles from his heroic destiny and eventual death in the Trojan War, Thetis, his mother, disguised him as a girl and sent him to live with the daughters of a neighboring king. Odysseus exposed the disguise with a ruse, and Achilles joined the Greeks in their expedition against Troy.

191:27–28 (193:38–39). Thoth, god of ... moony-crowned—Thoth, the Egyptian god of learning, invention and magic, usually depicted with an ibis' head crowned with the horns of the moon. In Egyptian myth he was keeper of the divine archives, patron of history, and the herald, clerk and scribe of the gods. ("Ra has spoken, Thoth has written.") When the dead are judged before Osiris, it is Thoth who weighs the heart and proclaims it wanting or not wanting.

191:28 (193:39). And I heard ... Egyptian highpriest—from John F. Taylor's speech as recalled in [Aeolus]; see 140:27–28 (142:16–17).

191:28–29 (193:40). In painted chambers loaded with tilebooks—apparently a quotation, source unknown.

191:35 (194:5). Others abide our question—from a sonnet by Matthew Arnold, 1 August 1844, in a letter to Jane Arnold: "... I keep saying, Shakespeare, Shakespeare, you are obscure as life." "Others abide our question. Thou art free./We ask and ask—Thou smilest and art still,/Out-topping knowledge. For the loftiest hill,/Who to the stars uncrowns his majesty, // Planting his steadfast footsteps in the sea,/Making the heaven of heavens his dwelling place,/Spares but the cloudy border of his base/To the foiled searching of mortality; // And thou, who didst the stars and sun beams know,/Self-schooled, self-scanned, self-honoured, self secure,/Didst tread on earth unguessed at. Better so! // All pains the immortal spirit must endure,/All weakness which impairs, all griefs which bow,/Find their sole speech in that victorious brow."

192:1–2 (194:12–13). Ta an bad ... Tiam imo shagart—Irish: "The boat is on the land. I am a priest." The first sentence is almost, but not quite, a practice sentence from Father Eugene O'Growney's (1863–1899) *Simple Lessons in Irish* (189?).

192:2 (194:13). beurla—Irish: "the English language" with a pun on the French *beurre,* "butter."

192:3 (194:13). littlejohn—an epithet that George Moore coined for Eglinton (Magee), *Vale,* p. 260. Little John was one of Robin Hood's principal lieutenants in balladry and legend; far from "little" in stature, in some versions of the legend he is portrayed as "little" in intelligence.

192:10–11 (194:21–22). A basilisk. E quando ... Messer Brunetto—Brunetto Latini (*c.*1210–*c.*1295), an Italian (Florentine) writer whose influence on Italian letters was praised by Dante (see *Inferno* XV). One of Latini's major works was his *Li Livres dou Trésor*, a prose compendium of medieval lore that Brunetto wrote in French (1262–1266?) because he regarded French as a language more widely known than Italian (though his other earlier major poetic work, *Tesoro* or *Tesoretto,* had been written in Italian). The *Trésor,* Livre I, contains among other things a bestiary (*Histoire Naturelle*), CXXXX, *Des Basiliques* ("Of Basilisks"). The line Stephen recalls is from an Italian translation of this section about "the king of serpents": "and when it [the basilisk] looks at a man, it poisons him."

192:12 (194:23). mother Dana—or Danu, the triple goddess of Celtic mythology, regarded as mother-goddess and as goddess of plenty and of fertility.

192:12–14 (194:23–25). weave and unweave ... unweave his image—this passage is reminiscent of Pater's discussion of the impressionistic and evanescent nature of subjective experience in *The Renaissance* (1873), "Conclusion": "It is with this movement, with the passage and dissolution of impressions, images, sensations, that analysis leaves off—that continual vanishing away, that strange, perpetual weaving and unweaving of ourselves." The passage also echoes a "weaving" image from AE's poem "Dana," *Collected Poems,* p. 37.

192:19 (194:30). the mind ... a fading coal—Percy Bysshe Shelley (1792–1822), English romantic poet, in "A Defence of Poetry" (1821, published 1840): "Poetry is not like reasoning, a power to be exerted according to the determination of the will. A man cannot say, 'I will compose poetry.' The greatest poet cannot say it; for the mind in creation is as a fading coal, which some invisible influence, like an inconstant wind, awakens to transitory brightness; this power arises from within, like the color of a flower which fades and changes as it is developed, and the conscious portions of our natures are unprophetic either of its approach or its departure."

192:20–23 (194:32–35). So in the future ... Drummond of Hawthornden—William Drummond (1585–1644), Scottish poet. The second edition of his *Flowers of Sion* (1630) contains a prose meditation on mortality and immortality, "A Cypress Grove." Stephen secularizes one phase of Drummond's meditation: "If thou dost complain that there shall be a Time in which thou shalt not be, why dost thou not also grieve that there was a time in which thou was not; and so that thou art not as old as that enlivening Planet of Time? ... That will be after us, which, long long before we were, was."

192:24 (194:36). I feel Hamlet quite young—in Hamlet (V, i, 163–164), the gravedigger says that he became a gravedigger on "that very day that young Hamlet was born" and in line 177 he identifies the time of his employment as "thirty years;" i.e., Hamlet is thirty years old.

192:27 (194:39). Has the wrong sow by the lug—"lug" is an ear; a stock expression for "he has made the wrong choice."

192:29 (194:41). That mole is the last to go—mole in the sense of birthmark or blemish as in *Hamlet* (I, iv, 23 *ff.*) when Hamlet is philosophizing on Denmark and mankind as he and his companions wait to see if the ghost will appear: "So, oft it chances in particular men,/That for

some vicious mole of nature in them,/ ... the stamp of one defect,/ ... Their virtues else— be they as pure as grace,/As infinite as man may undergo—/Shall in the general censure take corruption/From that particular fault."

192:31 (195:1). If that were the birthmark of genius—i.e., if youth were the birthmark of genius.

192:33 (195:3). Renan—Ernest Renan (1823– 1892), French critic, writer and scholar famous for the "Protean inconsistency" of his scepticism and theories. Renan admired the late plays as "mature philosophical dramas" and undertook in one of his own *Drames philosophiques* (1888) to write a sequel to *The Tempest* called "Caliban." Shakespeare (in his last plays) was, according to Renan, "the historian of eternity" composing "great battles of pure ideas"; thus: Ariel (spirit of the air), Caliban (raw earth of the body), Prospero (the magical spirit of practical human imagination).

192:41–42 (195:13–14). What softens the heart ... prince of Tyre?—Ulysses, not only the Latin version of Odysseus but also a character in *Troilus and Cressida*. In *Pericles*, Pericles (not of Athens but of Tyre), forced by treachery to flee from Tyre, is shipwrecked on Pentapolis. Stephen's sources all agree that the "change of tone" in Shakespeare's late plays (including *Pericles*) reflects a change in his outlook. Brandes quotes a line from *Pericles* and remarks: "The words are simple ... but they are of the greatest importance as symptoms. They are the first mild tones escaping from an instrument which has long yielded only harsh and jarring sounds. There is nothing like them in the drama of Shakespeare's despairing mood. ... When he consented to rewrite parts of this *Pericles,* it was that he might embody the feeling by which he is now possessed. Pericles is a romantic Ulysses, a far-travelled, sorely tried, much-enduring man, who has, little by little, lost all that was dear to him" (p. 585).

193:1 (195:15). Head, redconecapped, buffeted, brineblinded—this suggests Odysseus when, after the destruction of his last ship and its crew in Book XII of *The Odyssey,* he runs for the second time the gamut between Scylla and Charybdis, clinging to the keel of his broken ship. This time Odysseus takes the whirlpool (Charybdis) side of the passage and survives to be beached on Calypso's island, just as Pericles loses all but survives shipwreck in Shakespeare's play.

193:2 (195:16). A child, a girl placed in his arms, Marina—in *Pericles* at the height of a storm at sea Pericles' wife gives birth to a child (Marina) and apparently dies. Lychordia, the

nurse, presents the child to Pericles: "Here is a thing too young for such a place,/Who, if it had conceit, would die, as I/Am like to do. Take in your arms this piece/Of your dead queen" (III, i, 15–18). Brandes: "What figures occupy the most prominent place in the poet's sumptuous harvest-home but the young womanly forms of Marina [*Pericles*], Imogen [*Cymbeline*], Perdita [*The Winter's Tale*], Miranda [*The Tempest*]. These girlish and forsaken creatures are lost and found again, suffer grievous wrongs, and are in no case cherished as they deserve; but their charm, purity and nobility of nature triumph over everything" (p. 572).

193:3 (195:17). the bypaths of apocrypha— it is notable in relation to this remark that there is considerable suspicion about Shakespeare's part in the composition of *Pericles*; thus *Pericles* is "apocrypha." Most scholars agree that "when Hemings and Condell issued the famous first folio of Shakespeare's work in 1623, they probably knew better than we why they did not include *Pericles*" (i.e., because as Shakespeare's associates they knew he had not written the play?) (C. W. Wallace, "New Shakespeare Discoveries," *Harper's Monthly Magazine* [1910], Vol. 120, p. 509).

193:4–5 (195:18–19). the highroads are dreary but they lead to the town—Coleridge praised Shakespeare for "keeping at all times in the high road of life," in "Summary of the Characteristics of Shakespeare's Dramas."

193:6 (195:20). Good Bacon: gone musty— i.e., Eglinton is paraphrasing Bacon and reducing him to a proverbial expression. Bacon in Book I of *The Advancement of Learning* discusses at length "distempers of learning," notably three: "vain affectations, vain disputes and vain imaginations." He complains against "the affecting of two extremes: antiquity and novelty," and answers: "The advice of the prophet is just in this case: 'Stand upon the old ways, and see which is the good way, and walk therein'" (Jeremiah 6:16).

193:6 (195:20). Shakespeare Bacon's wild oats—i.e., that the English lawyer, philosopher and man of letters Francis Bacon, Baron Verulam, Viscount St. Albans (1561–1626) had "misspent his youth" writing plays which he then published using Shakespeare as "pawn" (as Moore was Martyn's wild oats; see 190:19–20n). The theory that Bacon wrote Shakespeare, while not original with her, is usually associated with the American novelist Delia Salter Bacon (1811–1859), with her rather tenuous claim of kinship with Lord Bacon, and her book *Philosophy of the Plays of Shakespeare Unfolded* (London, 1857). Positive argument in favor of the theory hinges on juxtaposing "passages of similar import" from the two

writers. Negative argument in favor of the theory: Shakespeare's plays must have been written by a man more knowledgeable than Shakespeare, with his background, could have been.

193:7 (195:21). Cypherjugglers—one way of "proving" Bacon's authorship of the plays was to "discover" in Bacon's letters or papers a numerical cipher which, when applied to the First Folio edition of Shakespeare's plays, would evoke letters (words, sentences) clearly stating Bacon's authorship. Miss Bacon claimed to have discovered such a cipher, but "she became insane before she had imparted this key to the world" (Brandes, p. 89). The key was, however, imparted by the American politician and essayist Ignatius Donnelly (1831–1901), *The Great Cryptogram: Francis Bacon's Cipher in the Socalled Shakespeare Plays* (Chicago and London, 1887), and *Cipher in the Shakespeare Plays* (1900).

193:8 (195:22). What town, good masters?—Donnelly launched his "invasions" from his home in Hastings, Minnesota.

193:8 (195:22). Mummed—either "mummied," "embalmed" or, after "mummer," "mimicked."

193:8 (195:22). A.E., eon—see 163:19n.

193:9–10 (195:23–24). East of the sun, west of the moon: Tir na n-og—*Tir na n-og*, Irish: "Land of Youth"; an island vaguely to the west of Ireland envisioned as a realm where mortal perfection and timeless but earthly pleasures were the rule. "East of the Sun, West of the Moon" is the title story of a collection of Norse folktales by Peter Christen Asbjörnsen (1812–1885), published (1842–1845), trans. G. W. Dasant (1859). A young peasant girl is bought from her parents by a great White Bear, who turns out to be a prince who has been bewitched by his stepmother so that he is a bear by day. The girl's discovery of the prince's secret is resented by the stepmother, who spirits him away to a castle "east of the sun and west of the moon." The girl contrives to follow, and after many trials the prince is liberated with the girl into the "happily ever after."

193:10 (195:24). Booted the twain and staved—i.e., Eglinton and AE are outfitted as pilgrims (with staves, pilgrim staffs).

193:10–13 (195:25–27). How many miles . . . by candlelight?—Nursery rhyme: "How many miles to Babylon?/Three score and ten./Can I get there by candlelight?/Yes, and back again,/If your heels are nimble and light."

193:14–15 (195:28–29). Mr Brandes accepts . . . the closing period—Brandes did accept

Pericles: "Let us anticipate the works yet to be written—*Pericles, Cymbeline, Winter's Tale,* and *The Tempest.* In this last splendid period of his life's young September, his dramatic activity . . . is more richly varied now than it has ever been" (p. 572). Brandes also regarded the play as "rewritten" by Shakespeare; see 192:41–42n.

193:16–17 (195:30–31). What does Mr Sidney Lee . . . say of it?—Sidney Lee (1859–1926), English scholar, editor in chief of the *Dictionary of National Biography* (1891–1912), and author of *A Life of William Shakespeare* (1898), pp. 198–199; Lee groups *Pericles* not with the "last plays" but with *Antony and Cleopatra* and *Timon of Athens:* "Shakespeare contributed only Acts III and V and parts of IV, which together form a self-contained whole, and do not combine satisfactorily with the remaining scenes. . . . But a natural felicity of expression characterizes Shakespeare's own contributions. . . At many points he anticipated his latest dramatic effects." Sidney Lee was the elder son of Lazarus Lee. He was originally named Solomon Lazarus Lee, but changed his name to Sidney Lee in 1890.

193:18–19 (195:32–33). Marina, Stephen said . . . which was lost—Marina, Pericles' daughter, was a "child of storm" (see 193:2n). Miranda is the daughter of Prospero in *The Tempest;* when her future husband, Ferdinand, first sees her, he exclaims: "O you wonder!/If you be maid or no?" (I, ii, 426–427). Perdita (whose name means "loss") is lost and found again in *The Winter's Tale.*

193:19–20 (195:33–34). What was lost . . . his daughter's child—Susannah, the older of Shakespeare's daughters, was married to a Dr. John Hall of Stratford. Her daughter Elizabeth was born in 1608; thus the birth of Shakespeare's granddaughter coincides roughly with what Brandes regards as the beginning of the period of the last plays.

193:20–21 (195:34–35). My dearest wife . . . this maid—in the "recognition scene" of *Pericles,* when the lost child is restored, Pericles says: "My dearest wife was like this maid, and such a one/My daughter might have been" (V, i, 108–109).

193:21–22 (195:35–36). Will any man . . . the mother?—Brandes argues that Susannah was Shakespeare's "favorite daughter" (p. 677) because she was his "principal heiress" (p. 686). He also argues that Shakespeare did not "love" his wife.

193:23–24 (195:38). L'art d'être grand . . .—French; Mr. Best begins to say *grandpère,* "grandfather," but left incomplete, the phrase

means "the art of being great." *L'Art d'être grandpère* is the title of a book of poems for children (1877), by the French poet and novelist Victor Hugo (1802–1885).

193:34 (196:7). Mr George Bernard Shaw— (1856–1950), Dublin-born English critic and playwright. Shaw's "commentaries" on Shakespeare began to appear when he was drama critic on *The Saturday Review* in the 1890s. His attitude toward Shakespeare was characteristically irreverent. See *Shaw on Shakespeare*, ed. Edmund Wilson (New York, 1961). See also Shaw's comedy "The Dark Lady of the Sonnets" (1910). The play does depict an unhappy relation between Shakespeare and the "Dark Lady," whom Shaw identifies as Mary Fitton in the play though he refutes the identification in the "Preface."

193:35 (196:8). Mr Frank Harris—(1856–1931), jack of all trades and self-styled "lover of letters." He was editor and proprietor of *The Saturday Review* (1894–1899), in which he published a series of articles on Shakespeare, collected and first published as *The Man Shakespeare and His Tragic Life-Story* (London, 1898).

193:35–36 (196:8–9). the Saturday Review— a London weekly review of politics, literature, science and art founded in 1855.

193:36–38 (196:9–12). he too draws . . . earl of Pembroke—Harris: "The story is very simple: Shakespeare loved Mistress Fitton and sent his friend, the young Lord Herbert [William Herbert, Earl of Pembroke (1580–1630)] to her on some pretext, but with the design that he should commend Shakespeare to the lady. Mistress Fitton fell in love with William Herbert, wooed and won him, and Shakespeare had to moan the loss of both friend and mistress" (p. 202). Brandes refutes the identification of the "dark lady" as Mary Fitton (pp. 279 *ff*.), but argues nevertheless that the relation was "unhappy." Oscar Wilde in *The Portrait of W. H.* (1889, 1905): "Pembroke, Shakespeare and Mrs. Mary Fitton are the three personages of the sonnets: there is no doubt at all about it."

193:39–41 (196:12–14). I own that if . . . not to have been—an allusion to another theory about Shakespeare's love life then current: that Shakespeare was "passionately" in love with William Herbert (see Brandes, p. 714); thus the "rejection" effected by Mary Fitton's relation with Herbert would have been on the other side of the triangle.

194:2 (196:16). auk's egg—females of the various species of auk lay only a single egg each nesting season. The egg is large for the size of the bird and is marbled and blotched with a variety of colors. (Stephen may well have in mind the great auk, a species but recently extinct in 1904.)

194:3–4 (196:17–18). He thous and thees . . . Dost love, Miriam?—as Quaker, the unmarried Lyster would address his wife (or any other person with whom he was familiar) in the archaic second-person singular (to demonstrate the brotherhood of man). Miriam (the Hebrew form of Mary) is the name of the sister of Moses, "Miriam the prophetess." She supported Moses but eventually and temporarily turned against him because he married a woman who was not an Israelite. Tentatively then: Stephen's use of the name harks back to the Shakespeare–George Fox associations (191:10–13n). As Shakespeare might have addressed Mary Fitton, George Fox might have addressed his wife, Margaret—the Quaker "prophetess Miriam"? Lyster remained a bachelor until he retired from the National Library in 1920. Shortly after his retirement he married Jane Campbell.

194:6–7 (196:20–21). Beware of what . . . in middle life—after the German: "*Was man in der Jugend wünscht, hat man in Alter die Fülle,*" the motto of Goethe's *Dichtung und Wahrheit* (1811–1814), an autobiography. The word "beware" is not in the literal sense of the passage.

194:8 (196:22). buonaroba—Italian, literally: "a commonplace thing." In Elizabethan slang (as *bona roba*), "showy or flashy girl," for example in *II Henry IV*, III, ii, 26.

194:8 (196:22–23). a bay where all men ride— from Shakespeare's sonnet 137, lines 5–8: "If eyes, corrupt by over-partial looks,/Be anchor'd in the bay where all men ride,/Why of eyes' falsehood hast thou forged hooks,/Whereto the judgement of my heart is tied?" Harris (p. 213) cites this line in connection with Mary Fitton, and he adds another phrase from the same sonnet, "the wide world's common place" (line 10), for which Stephen substitutes the more suggestive *buonaroba*.

194:8–9 (196:23). a maid of honor with a scandalous girlhood—Harris (p. 213): ". . . Mary Fitton became a maid of honor to Queen Elizabeth in 1595 at the age of seventeen. From a letter addressed by her father to Sir Robert Cecil on January 29th, 1599, it is fairly certain that she had already been married at the age of sixteen; the union was probably not entirely valid, but the mere fact suggests a certain recklessness of character, or overpowering sensuality, or both, and shows that even as a girl Mistress Fitton was no shrinking, timid, modest maiden. . . . Though twice married, she had an illegitimate child by Herbert, and two later by Sir Richard Leveson."

Harris argues that Shakespeare was "betrayed" by Lord Herbert and that Mistress Fitton is "the 'dark lady' of the sonnet-series from 128 to 152, [and] is to be found again and again in play after play . . ." (p. 212).

194:9 (196:23). a lordling—a little or petty lord. William Herbert did not inherit his title until 1601, four years after "the betrayal" as Harris (and Stephen) date it.

194:10 (196:24). a lord of language—the phrase occurs in stanza II of Tennyson's "To Virgil" (1882): "Landscape-lover, lord of language/More than he that sang the 'Works and Days' [the Greek poet Hesiod],/All the chosen coin of fancy/Flashing out from many a chosen phrase." It also occurs in Oscar Wilde's *De Profundis* (written 1897; published posthumously with excisions 1905): "A week later, I am transferred here. Three more months go over and my mother dies. No one knew better than you how deeply I loved her and honoured. Her death was terrible to me; but I, once a lord of language, have no words in which to express my anguish and my shame" (p. 65).

194:11 (196:25). coistrel—Shakespeare uses this word as a noun meaning "knave, ruffian."

194:11 (196:25–26). had written Romeo and Juliet—modern scholarship dates the play c.1596. Harris argues that the play was written in 1597, after Shakespeare had fallen in love with Mary Fitton but before the Herbert betrayal (Mistress Fitton, Harris speculates, appears in the play as Romeo's pre-Juliet love, Rosalind, pp. 214–215).

194:12 (196:26). Belief in himself has been untimely killed—the phrase "untimely killed" echoes the description of Macduff's birth in *Macbeth* (V, vii, 15–16): "Macduff was from his mother's womb/Untimely ripp'd." The sentence also recalls Harris: "Shakespeare's loathing for his wife was measureless, was part of his own self-esteem, and his self-esteem was founded on snobbish nonessentials for many years, if not indeed, throughout his life" (p. 364).

194:15–16 (196:29). the game of laugh and lie down—from "Songs Composed by the Choisest Wits of the Age," compiled by Richard Head (see 48:16–19n); "The Art of Loving": "She'll smile and she'll frown,/She'll laugh and lie down,/At every turn you must tend her." Laugh-and-lay-down was also an Elizabethan game of cards.

194:16 (196:29–30). dongiovannism—i.e., acting like Don Giovanni, Don Juan, "compensating" by endless pursuit of a variety of women.

194:16–17 (196:31–32). The tusk of the boar . . . love lies ableeding—compounded allusion: (*a*) To Shakespeare's *Venus and Adonis*, the description of Adonis' corpse as discovered by Venus: ". . . the wide wound that the boar had trenched/In his soft flank whose wonted lily white/With purple tears, that his wound wept, was drenched" (lines 1052–1054); the description is repeated with variations in lines 1115–1116, "the loving swine/Sheathed unaware the tusk in his soft groin." (*b*) To *The Odyssey*: Odysseus in his youth was wounded in the thigh by a boar; it is this wound which enables Odysseus' nurse to recognize him (and vouch for him to Penelope) when he returns home from his wanderings. (*c*) To Beaumont and Fletcher's play *Philaster; or Love Lies Ableeding* (1609), in which a rather febrile heroine longs to die at the hands of a lover who has deserted her.

194:18–19 (196:33). woman's invisible weapon —as against woman's visible weapons, which, as King Lear remarks (II, ii, 280) are "waterdrops," tears.

194:19–21 (196:34–36). some goad of the flesh . . . own understanding of himself—i.e., Shakespeare was emasculated by Anne Hathaway's aggressive seduction just as Adonis is figuratively emasculated by Venus' aggression; and Shakespeare's complicity in that aggression had the effect of original sin as defined in Lesson 6, "On Original Sin," in *The Catechism Ordered by the National Synod of Maynooth and Approved by the Cardinal, the Archbishop and Bishops of Ireland for General Use Throughout the Irish Church* (Dublin, 1884): "*Q*. What other particular effects follow from the sin of our first parents? *A*. Our whole nature was corrupted by the sin of our first parents—it darkened our understanding, weakened our will, and left in us a strong inclination to evil."

194:23 (196:38). And in the porches . . . I pour —after the Ghost in *Hamlet;* see 138:1n.

194:24–30 (196:39–197:3). The soul has been . . . by his creator—Lady Macbeth uses the word "quell" (murder) when she is urging Macbeth to the murder of King Duncan: "What cannot you and I . . . put upon/His spongy [hard-drinking] officers, who shall bear the guilt/Of our great quell?" (I, vii, 69–72). But Stephen is also raising the question of how the Ghost (Hamlet's father) knew of his wife's adultery and knew the manner of his own murder; see 138:2–3n.

194:30–31 (197:4). (his lean unlovely English) —i.e., Shakespeare's; see 184:27–30n.

194:32 (197:5–6). what he would but would not—after *Don Giovanni;* see 63:38n.

194:33 (197:6–7). Lucrece's bluecircled ivory globes—after Shakespeare, *The Rape of Lucrece* (lines 4–7): "Her breasts, like ivory globes circled with blue."

194:33–34 (197:7). Imogen's breast, bare, with its mole cinquespotted—Imogen, the daughter of Cymbeline and the chaste heroine of Shakespeare's play, is visually, though not physically, violated by the villain, Iachimo, as she sleeps: "On her left breast/A mole cinque-spotted, like the crimson drops/I' the bottom of a cowslip" (II, ii, 37–39).

194:34–36 (197:8–9). He goes back . . . an old sore—Brandes imagines Shakespeare as having retired to Stratford with the satisfaction of a life's work accomplished. Harris imagines it otherwise: "The truth is, that the passions of lust and jealousy and rage had at length worn out Shakespeare's strength, and after trying in vain to win to serenity in 'The Tempest,' he crept home to Stratford to die" (p. 404).

194:38 (197:12). His beaver is up—the "beaver," the front part of a helmet which could be raised to reveal the face. In *Hamlet* Horatio informs Hamlet of what he has seen and describes the Ghost as armed from head to foot. "HAMLET: Then saw you not his face?/HORATIO: O, yes, my lord; he wore his beaver up" (I, ii, 229–230).

194:39–40 (197:13). or what you will—the subtitle of Shakespeare's play *Twelfth Night*. It is notable in light of the passage that follows that Twelfth Night marks the celebration of the Epiphany (6 January), when Christ became manifest and was revealed to the world as the Son of God, i.e., "the son consubstantial with the father" (194:40–41 [197:15]).

195:2 (197:17). Hast thou found me, O mine enemy?—in I Kings 21, King Ahab's wife, Jezebel, conspires to destroy the owner of a vineyard that Ahab has coveted. The conspiracy is successful; Ahab takes possession of the vineyard; and the prophet Elijah is instructed by "the word of the Lord" (21:17) to curse Ahab. When Elijah carries out his mission, telling Ahab "dogs shall lick thy blood, even thine" (21:19), Ahab responds: "Hast thou found me, O mine enemy? And he [Elijah] answered, I have found *thee:* because thou hast sold thyself to work evil in the sight of the Lord" (21:20).

195:3 (197:18). Entr'acte—French: "interval between the acts"; also a musical number or skit performed during such an intermission.

195:6 (197:21). My telegram—see 197:1 *ff.* (199:18 *ff.*).

195:7 (197:22). the gaseous vertebrate—i.e., having a spine but without substance, a ghost; in this case, "the son consubstantial with the father."

195:11–12 (197:26–27). Was Du verlachst wirst Du noch dienen—German proverb: "What you laugh at, you will nevertheless serve."

195:13 (197:28). Brood of mockers: Photius, pseudomalachi, Johann Most—for "Brood of mockers," see 22:28n; for "Photius," see 22:28n. "Pseudomalachi," i.e., Mulligan (in contrast to Elijah), is a false prophet; see 6:3n. Johann Most (1846–1906), German-American bookbinder and anarchist whose newspaper *Die Freiheit* ("Freedom") accompanied him from Berlin to London to New York. He won a place in the hearts of the Irish (and in an English jail) by violently condoning the Phoenix Park murders. His approach, down-with-everything, included even the pamphlet *Down with the Anarchists!* (1901), designed to dramatize the impartial universality of his pacifism.

195:14–21 (197:29–198:3). He who Himself begot . . . be dead already—a heretical version of the Apostles' Creed (see 22:23–24n), after the manner of Sabellius (22:31n), Valentine (22:30n) and other heretics. "Agenbuyer" is Middle English for Redeemer; *cf.* 17:32–33n.

195:22 (197:34). Glo-o-ri-a in ex-cel-sis De-o—Latin: "Glory be to God on high" (Luke 2:14), the opening phrase of the *Angelic Hymn* sung or recited in the celebration of the Mass. Note: the phrase and its musical annotation should occur after **(198:3)** and not in the midst of the paragraph **(197:29–198:3)**, which it interrupts.

195:23–24 (198:4–5). He lifts hands . . . with bells acquiring—see 41:8 *ff.* (40:9 *ff.*) and 49:16 *ff.* (48:25 *ff.*).

195:32–33 (198:14–15). To be sure . . . writes like Synge—a Dublin literary joke that had its origin in Yeats's hyperbolic assertion that Synge was another Aeschylus. See Padraic Colum, *The Road Round Ireland* (New York, 1926), pp. 358–359; and Gogarty, *As I Was Going Down Sackville Street*, pp. 299–300.

196:2 (198:18). D.B.C—a tearoom in Dame Street; see 162:41n.

196:2 (198:18). Gill's—a bookseller; see 94:28n.

196:2–3 (198:18–19). Hyde's Lovesongs of Connacht—see 48:34–36n.

196:7–9 (198:23–25). I hear that . . . night in Dublin—the actress was Mrs. Bandman Palmer (see 75:19n and 75:20n); her performance was billed as the 405th professional presentation of *Hamlet* in Dublin.

196:9–10 (198:25–26). Vining held that the prince was a woman—Edward Payson Vining (1847–1920), in *The Mystery of Hamlet; An Attempt to Solve an Old Problem* (Philadelphia, 1881), theorized that Hamlet was a woman, educated and dressed as a man in a plot to secure the throne of Denmark for her family's lineage.

196:10–11 (198:26–27). Has no-one made . . . Judge Barton—the Right Honorable Sir Dunbar Plunket Barton (1853–1937), Judge of the High Court of Justice in Ireland (1900 *ff.*), was apparently "searching" because he finally did publish *Links Between Ireland and Shakespeare* (Dublin, 1919). Barton was a bit too balanced and judicial to argue that Hamlet was an Irishman, but in Chapter 5 he does point out that Danish dominion in Ireland coincides with the historical time during which Hamlet was Prince (thus, Hamlet could have been a Danish Prince in Ireland). In Chapter 41 Barton speculates that there was some "Celt in Shakespeare" and in Chapter 38 that Shakespeare did visit Ireland, but Barton does not interlink these aspects of Shakespeare's life with the possibility of Hamlet's presence in Ireland. In his introduction Barton asserts, "The idea of gathering these links . . . was suggested by an article . . . by Mr. Justice Madden [see 197:41–198:2n] . . . and was encouraged by a perusal of the Introduction to Dr. Sigerson's *Bards of the Gael and Gaul*" (p. vii).

196:11–12 (198:27–28). He swears . . . by saint Patrick—i.e., Hamlet, not Judge Barton, swears by one of the three patron saints of Ireland. In Act I, scene v, after the Ghost has spoken to Hamlet and departed, Hamlet, in "wild and whirling words" (line 133), says, "Yes, by Saint Patrick, but there is [offense], Horatio . . ." (line 136).

196:14–16 (198:30–32). That Portrait of Mr W. H. . . . a man of all hues—Oscar Wilde, *The Portrait of Mr. W. H.* (London, 1889), a brief version, less than half the length of the rewritten version, "misplaced" in 1895 and not published until 1921; available in *The Riddle of Shakespeare's Sonnets* (New York, 1962). Wilde's dialogue appears, in a paradoxical way and with skillful manipulation of "internal evidence," to argue that the sonnets, dedicated "To. The. Onlie. Begetter. Of./These. Insuing. Sonnets./ Mr. W. H. All. Happinesse. . . . ," were not addressed to William Herbert, Earl of Pembroke (as Brandes and others supposed), but to a boy actor named Willie Hughes (after Sonnet 20

line 7: "A man in hew, all *Hews* in his controwling." Wilde's argument was first advanced by the English scholar Thomas Tyrwhett (1730–1786).

196:18 (198:34). Or Hughie Wills. Mr William Himself—speculative scholarship had produced an impressive list of candidates for the role of W. H., including, in addition to Willie Hughes and William Herbert, Earl of Pembroke: William Hathaway, a bookseller and Shakespeare's brother-in-law; William Hart, Shakespeare's nephew (b. 1600); William Himself, i.e., the poet as "onlie begetter"; and, by transposition of initials, Henry Wriothesley, Earl of Southampton (1573–1624).

196:25 (198:41). ephebe—an "ephebus," a youth just entering manhood or just being enrolled as a citizen.

196:25 (198:41). Tame essence of Wilde—after a satiric rhyme about Wilde which appeared in *Punch* shortly after Wilde's downfall (see 50:13–14n), entitled "Swinburne on Wilde," the rhyme: "Aesthete of aesthetes/What's in a name?/ The poet is Wilde/But his poetry's tame."

196:29 (199:4). a plump of pressmen—"plump" is archaic English dialect for a cluster or group; "pressmen" is slang for newspapermen or journalists.

196:30 (199:5). five wits—a colloquialism: as man has five senses, five members (head and four limbs), five fingers, etc., and as five is the number of Solomon's seal, the pentagon, so it is the number of dominion by knowledge. The five wits, Elizabethan style, were common wit, imagination, fantasy, estimation and memory.

196:30–31 (199:5–6). youth's proud livery he pranks in—Shakespeare, Sonnet 2, lines 1–4: "When forty winters shall besiege thy brow,/And dig deep trenches in thy beauty's field,/Thy youth's proud livery, so gazed on now,/Will be a tatter'd weed, of small worth held." "To prank" means to adorn or to be adorned.

196:31 (199:6). Lineaments of gratified desire—from William Blake, twice in *Poems from the "Rosetti" MS* (*c.*1793): "The Question Answer'd"—"What is it men in women do require?/The lineaments of Gratified Desire./ What is it women do in men require?/The lineaments of Gratified Desire." And: "In a wife I would desire/What in whores is always found,/ The lineaments of gratified desire."

196:32–33 (199:7–8). Jove, a cool ruttime send them—Falstaff, in *The Merry Wives of Windsor:* "Send me a cool rut-time, Jove, or who can blame me to piss my tallow? Who comes here? my doe?" (V, v, 15–17).

196:34 (199:9). Eve. Naked wheatbellied . . . fang in's kiss—see Stephen's meditation on Eve, 36:6–9 (38:6–9), plus an allusion to the serpent's seduction of Eve in the Garden of Eden (Genesis 3:1–6).

197:4–5 (199:21–22). The sentimentalist is . . . for a thing done—after George Meredith (1828–1909), *The Ordeal of Richard Feveral; A History of Father and Son* (1859), Chapter 28: "'Sentimentalists,' says THE PILGRIM'S SCRIP, 'are they who seek to enjoy Reality, without incurring the Immense Debtorship for a thing done.'"

197:6 (199:23). kips—see 12:31n.

197:13–23 (199:30–40). It's what I'm . . . for a pussful—Mulligan parodies the style of Synge's peasant plays, with their echoes of the dialect of the Aran Islands.

197:15 (199:32). gallus—dialect variation of "gallows."

197:17 (199:34). Connery's—W. and E. Connery were the proprietors of the Ship hotel and tavern at 5 Abbey Street Lower.

197:20 (199:37). mavrone—a variant of the Irish *mavourneen,* "my love, my darling."

197:27 (200:3). Glasthule—a road in Kingstown. There is some confusion here since Synge was only occasionally in Dublin in 1904, and when he was, he lived with his family in Crossthwaite Park, Kingstown; after 10 October 1904, he had rooms of his own at 15 Maxwell Road, Rathmines.

197:28 (200:4). pampooties—in the Aran Islands, a kind of slipper or sandal of undressed cowskin.

197:34–35 (200:10–11). Harsh gargoyle face . . . Saint-André-des-Arts—Stephen recalls meeting Synge in Paris. Synge is variously described as having a swarthy face with pronounced features and deeply etched lines. Gorman remarks (p. 101): "They [Joyce and Synge] met seven or eight times, lunching in the humble bistro-restaurant in the Rue St.-André-des-Arts where a four-or-five-course meal could be procured for one franc ten centimes. Synge would thrust his dark crude face across the table and talk volubly, his subject always being literature. He was dogmatic in his convictions, argumentative to the point of rudeness and inclined to lose his temper." "Lights" are lungs, the cheapest of meats; see 42:30n.

197:36 (200:12). palabras—after Spanish *palabra,* "word"; hence, palaver, talk.

197:36 (200:12). Oisin with Patrick—Oisin, legendary poet-hero of the Fianna, was the son of the great (quasi-legendary) third-century (?) chieftain Finn MacCool; see 311:34n. The legend is that Oisin lived on after the third-century collapse of the age of heroes finally to experience conversion at the hands of St. Patrick in the fifth century. St. Patrick and Oisin met in a sacred wood and in exchange for his conversion, the aged Oisin told St. Patrick the tales of the heroic age of the Fianna. See W. B. Yeats, *The Wanderings of Oisin* (1889).

197:36–37 (200:12–13). Faunman he met in Clamart woods—Clamart is a small town south of Paris; i.e., Synge has told a story about a strange meeting in a woods (comparable to the meeting between St. Patrick and Oisin).

197:37 (200:13). C'est vendredi saint!—French: "It is Good Friday."

197:38–39 (200:14–15). I met a fool i' the forest—in *As You Like It* the melancholy Jacques recounts a meeting with the clown, Touchstone: "A fool, a fool! I met a fool i' the forest,/A motley [professional] fool; a miserable world!/. . . I met a fool;/Who laid him down and bask'd him in the sun,/And rail'd on Lady Fortune in good terms,/In good set terms [carefully composed phrases]. . ." (II, vii, 12–17).

197:41–198:2 (200:17–19). So Mr Justice Madden . . . the hunting terms—the Right Honorable Dodgson Hamilton Madden (1840–1928), judge of the High Court of Ireland (1892 ff.), wrote *The Diary of Master William Silence; a Study of Shakespeare and of Elizabethan Sport* (London, 1897). Madden "searched" Shakespeare for all references to "field sports"—hunting, falconry, etc.—arguing on the basis of these "evidences" that Shakespeare's knowledge of field sports marks him as an aristocrat and not a commoner. Madden elaborates the argument via speculative analysis of the country comic Justice Shallow (*II Henry IV* and *The Merry Wives of Windsor*) and his "cousin," Justice Silence's son, an offstage character named William Silence, who is "a good scholar . . . at Oxford" (?) in *II Henry IV* (III, ii, 11–12). Madden's conclusion: Shakespeare's knowledge of the Earl of Rutland's (1576–1612) (and Justice Shallow's) home county, Gloucestershire, together with his knowledge of field sports suggest the Earl of Rutland as Shakespeare's ghostwriter.

198:10 (200:27). in a galliard—see 182:6n.

198:12 (200:29). broadbrim—another reference to traditional Quaker costume.

198:16–17 (200:33–34). Northern Whig, Cork

Examiner, Enniscorthy Guardian—three provincial newspapers (on file in the National Library). The *Northern Whig*, a daily newspaper published in Belfast; the *Cork Examiner*, a daily newspaper published in Cork; and the *Enniscorthy Guardian*, a weekly newspaper (Saturday) published in Enniscorthy, a town in Wexford in southeastern Ireland.

198:24 (200:41). sheeny—slang for a Jew; a term of opprobrium.

198:26 (201:1). Ikey Moses—a late-nineteenth-century comic type of the Jew who tries to ingratiate himself in middle-class Gentile society. In *Ally Sloper's Half-Holiday*, a London illustrated weekly (see 495:24n), he is portrayed as an unctuous pickpocket and small-time con man; he even picks his hostess's pocket during a Christmas party. The comic treatment of his image results in a thinly disguised anti-Semitism.

198:29 (201:4–5). the foamborn Aphrodite—the Greek goddess of love and mirth (Venus in the Roman pantheon) was born of the sea foam near Cythera when the sea was impregnated by the fall of Uranus' genitals after he was castrated by his son Cronus.

198:30 (201:5–6). The Greek mouth that has never been twisted in prayer—source unknown, but it sounds suspiciously like Swinburne.

198:31 (201:6–7). Life of life, thy lips enkindle —from Shelley, *Prometheus Unbound: A Lyrical Drama* (completed 1820; published 1839): "'VOICE IN THE AIR [*singing* (to the heroine, Asia)]: Life of Life! thy lips enkindle/With their love the breath between them;/And thy smiles before they dwindle/Make the cold air fire" (II, v, 48–51).

198:34 (201:10). Greeker than the Greeks— i.e., he indulges in pederasty.

198:34 (201:10). pale Galilean—an allusion to Swinburne's "Hymn to Proserpine" (1866): "Thou hast conquered, O pale Galilean; the world has grown grey from thy breath" (line 35). Swinburne coined the line from the poem's epigraph, *"Vicisti, Galilae"* ("Thou hast conquered, Galilean"), reputed to have been the last words of the Emperor Julian, the Apostate (d. 363), who had renounced Christianity during his lifetime.

198:35 (201:11). Venus Kallipyge—a marble statue found in the Golden House of Nero at Rome and subsequently housed in the Museo Nazionale in Naples. "Kallipyge" is Greek: "beautiful buttocks."

198:36 (201:12). The god pursuing the maiden

hid—a line from the first chorus of Swinburne's play *Atalanta in Calydon* (1865). The play opens with a long invocation, spoken by the Chief Huntsman; the Chorus replies with an ode that begins, "When the hounds of spring are on winter's traces." The sixth stanza includes the quoted line though the pun on "maidenhead" is Mulligan's, not Swinburne's. "And Pan by noon and Bacchus by night,/Fleeter of foot than the fleet-foot kid,/Follows with dancing and fills with delight/The Maenad and the Bassarid;/And soft as lips that laugh and hide/The laughing leaves of the trees divide,/And screen from seeing and leave in sight/The god pursuing, the maiden hid."

198:39 (201:15). a patient Griselda—the epitome of the patient and virtuous woman, she is prominent in one of the tales of Boccaccio's *Decameron* (10, tenth day). Chaucer employs her in the "Clerk's Tale" (*The Canterbury Tales*) as the personification of the virtues of the Christian woman, suffering humbly and without complaint the indignities that her husband heaps upon her.

198:39–40 (201:16). a Penelope stayathome— Odysseus' wife, Penelope, another archetype of the patient and virtuous woman, who waited 19 years for her husband's return.

198:41–199:2 (201:17–20). Antisthenes, pupil of Gorgias . . . to poor Penelope—see 147:5n, 147:6n. "Kyrios Menelaus": Lord Menelaus. "Brooddam" is a term of opprobrium, more appropriate to animals than to a human. "The wooden mare of Troy" elides Helen (whose entrance into Troy spelled its doom) with the wooden horse that the Greeks, feigning departure, offered as a peace gift to the Trojans. The Trojans accepted the gift with its hidden bonus of "heroes" and thus contributed unwittingly to the destruction of their city. When the horse was about to be dragged into the city, Helen, suspicious of what it might contain, sweet-talked the prominent Greek heroes in turn, imitating the sounds of their wives' voices. The heroes were moved but managed to restrain themselves.

199:2–4 (201:20–22). Twenty years he . . . chancellor of Ireland—Stephen's sources among Shakespeare's biographers date his residence in London from 1592 to 1613. Lee remarks that "in the later period of his life Shakespeare was earning above £600 a year" (p. 203); Harris translates this as "nearly five thousand a year of our money" (p. 377). The salary of the Lord Chancellor of Ireland in 1904: £5,000 per annum.

199:5–6 (201:23–24). the art of feudalism . . . art of surfeit—in "A Backward Glance O'er Travel'd Roads," the Preface to *November Boughs* (1888), Walt Whitman (1819–1892) characteristically set the "New World" with its free political

institutions and its "free" poetry off against "the poems of the antique, with European feudalism's rich fund of epics, plays, ballads." He goes on to remark, "Even Shakspere, who so suffuses current letters and art . . . , belongs essentially to the buried past. Only he holds the proud distinction for certain important phases of the past, of being the loftiest of the singers life has yet given voice to. All, however, relate to and rest upon conditions, standards, politics, sociologies, ranges of belief, that have been quite eliminated from the Eastern hemisphere, and never existed at all in the Western." It is notable in relation to Stephen's phrase "art of surfeit" that Whitman in "A Thought on Shakspere" (1886) would remark: "The inward and outward characteristics of Shakspere are his vast and rich variety of persons and themes, with his wonderful delineations of each and all—not only limitless funds of verbal and pictorial resource, but great excess, superfoetation— . . . holding a touch of musk." "Superfoetation": conception after a prior conception but before the birth of any offspring.

199:6–7 (201:24–26). Hot herringpies . . . ringocandies—rich and sweet Elizabethan dishes. "Marchpane" is almond paste or marzipane (*Romeo and Juliet*, I, v, 9); "ringocandies" or eringoes are candied roots believed to cause potency in love (Falstaff in *The Merry Wives of Windsor*, V, v, 22).

199:8–9 (201:26–28). Sir Walter Raleigh . . . of fancy stays—source: Brandes: "Sir Walter Raleigh's dress was always splendid, and he loved, like a Persian Shah or Indian Rajah of our day, to cover himself . . . with the most precious jewels. When he was arrested in 1603, he had gems to the value of £4,000 (about £20,000 in modern money) on his breast" (pp. 416–417). Since the exchange rate in 1904 was 25 francs to the pound, £20,000 was "half a million francs."

199:9–11 (201:28–29). The gombeen woman . . . her of Sheba—"gombeen" means a usurer or usury, originally a usurer who gave loans to small farmers at ruinous rates. Queen Elizabeth fits the role since the "plantation system" (in effect, English exploitation of the Irish peasantry) was established during her reign. Stephen's source is not clear: Lee (p. ix) and Brandes (p. 14) assert the extravagance of both the materials and the quantities of her clothing, but they are too decorous to itemize undergarments; the Bible (I Kings 10:2 and II Chronicles 9:1) gives an even more generalized account of the Queen of Sheba's possessions.

199:12 (201:30). scortatory—after the Latin *scortator*, "fornicator"; hence, lewd.

199:13–18 (201:31–37). You know Manning-

ham's . . . before Richard III—the only anecdote about Shakespeare known to have been recorded in his lifetime. Among Stephen's sources, Harris, Lee and Wilde paraphrase the story, each for his own purposes; Brandes quotes it in full (p. 196); the date should be 1601 and not 1602: "In the diary of John Manningham, of the Middle Temple, the following entry occurs, under the date of March 13, 1602:—Upon a tyme when Burbidge played Rich.3, there was a Citizen grone soe farr in liking with him, that before shee went from the play shee appointed him to come that night unto hir by the name of Richard the 3rd. Shakespeare overhearing their conclusion went before, and was intertained . . . ere Burbidge came. The message being brought that Richard the 3d was at the dore, Shakespeare caused returne to be made that William the Conqueror was before Richard the 3d. Shakespeare's name was William."

199:15 (201:34). more ado about nothing—after the title of Shakespeare's comedy *Much Ado About Nothing*.

199:16 (201:34–35). took the cow by the horns—obvious variation of "taking the bull by the horns" (meeting a difficulty directly instead of trying to avoid it), but also an allusion to the horns that the cuckold "burgher" is acquiring.

199:17 (201:35). knocking at the gate—in *Macbeth* (II, iii), as "comic" prelude to the discovery of King Duncan's murder, a drunken porter is aroused by a knocking at the gate. The porter complains that drink has intensified his sexual desires and at the same time deprived him of the capacity for sexual experience.

199:18–19 (201:37). the gay lakin, Mistress Fitton—see 193:36–38n; 194: 8–9n. "Lakin" is a contraction of "ladykin," little lady, a term of endearment.

199:19 (201:37–38). mount and cry O—derives from *Cymbeline*, as Imogen's husband, Posthumus, soliloquizes on Iachimo's supposed "conquest" of Imogen (see 194:33–34n): ". . . perchance he spoke not, but,/Like a full-acorn'd boar, a German one,/Cried 'O!' and mounted, found no opposition/But what he looked for should oppose and she/Should from encounter guard." (II, v, 15–19).

199:19 (201:38). birdsnies—literally, "birds' eyes," an Elizabethan term of endearment.

199:19–20 (201:38). lady Penelope Rich—(*c*.1562–1607). Several nineteenth-century scholars assumed that she was the "dark lady" of Shakespeare's sonnets. The principal exponent of this view was the English poet-scholar Gerald Massey (1828–1907), whose *Shakespeare's Sonnets*

Never Before Interpreted (London, 1866) presented a tangled argument to prove that Penelope Rich was the object of Pembroke's love and that Shakespeare wrote many of the sonnets not from his own point of view but as dramatic communications in an elaborate four-way love intrigue between Pembroke, Lady Penelope, Southampton and one Elizabeth Vernon. Other writers elaborated Massey's fictions into different kinds of liaison between Shakespeare and Lady Penelope, none of them with any basis in fact. There is more substantial evidence to suggest that Lady Penelope was the object of Sir Philip Sidney's love and poetic attention.

199:21 (201:39–40). the punks of the bank-side, a penny a time—the bankside on the Thames was the area around the theatres in Elizabethan London. "Punks" are prostitutes, in this case cheap, as "penny a time" suggests, since the going price for a prostitute with "class" was about 6 shillings; see *All's Well That Ends Well* (II, ii, 22–23).

199:22–23 (201:41–42). Cours-la-Reine . . . Tu veux?—Cours-la-Reine (literally, "the queen's public walk" or "parade") combines with the Quai de la Conference to form a broad avenue on the Right Bank of the Seine in Paris. The snatches of French are a bargaining prostitute's words in a street encounter: "Another twenty sous [one franc]. We will indulge in little nasty things. Pussy [darling]? Do you wish [it]?"

199:24–25 (202:1–2). sir William Davenant of Oxford's mother—an allusion to John Aubrey's apocryphal story that Shakespeare made an annual journey from London to Stratford, stopping en route at John D'Avenant's Crown Inn in Oxford. Shakespeare is supposed to have fallen in love with D'Avenant's wife and to have fathered the poet and dramatist Sir William Davenant (1606–1668) upon her. William Davenant at times entertained the legend and thus lent credence to it. Stephen's sources treat the legend variously: Lee gives it qualified rejection; Brandes, a qualified acceptance; and Harris, full-spirited endorsement since it fits his image of Shakespeare as Don Juan.

199:27 (202:4). Blessed Margaret Mary Anycock—a pun on Blessed Margaret Mary Alacoque (1647–1690), a French nun whose experience of a revelation in 1675 led her to crusade for "public liturgical devotion to the Sacred Heart [of Christ]." She was beatified shortly after her death and hence is called "Blessed"; she was canonized in 1920. "Cock" is, of course, slang for penis.

199:28 (202:5). Harry of six wives' daughter

—i.e., Henry VIII's daughter Elizabeth (by the second of his six wives, Anne Boleyn).

199:28–29 (202:5–6). other lady friends . . . Lawn Tennyson—in Tennyson's *The Princess; A Medley* (1847), Prologue, lines 96–98: "And here we lit on Aunt Elizabeth,/And Lilia with the rest, and lady friends/From neighbour seats; . . ." For "Lawn Tennyson," see 51:21n.

199:32 (202:9). Do and do—in *Macbeth,* as the witches gather on the heath to meet Macbeth, the 1st Witch proposes to revenge herself on a sailor's wife by drowning the absent husband: "I'll do, I'll do, and I'll do" (I, iii, 10).

199:32 (202:9). Thing done—see 197:4–5n.

199:32–33 (202:9–10). In a rosery . . . he walks—the English herbalist John Gerard (1545–1612), superintendent of gardens for Queen Elizabeth's Secretary of State, compiled a catalogue of English garden plants (1596) and prepared *The Herball or Generall Historie of Plantes* (1597). Gerard had a "rosery" (rose garden) in Fetter (Ffetter) Lane in London. Shakespeare's connection with Gerard, however, is not clear; the garden may have been "public"; on the other hand, Shakespeare may have known Gerard since Gerard was a prominent member of the Barber-Surgeons Company, which had its hall almost across the street from the Huguenot's house where Shakespeare lived. Stephen's (Joyce's) source for this knowledge is unknown since it did not come to modern "light" until after the publication of *Ulysses.* Marcus Woodward, ed., *Gerard's Herball: The Essence Thereof Distilled* (London, 1927).

199:33 (202:10). greyedauburn—both Harris (p. 367) and Lee (p. 286) report that the colored bust of Shakespeare in the Stratford Church shows him with hazel eyes and auburn hair and beard. (Since the bust was whitewashed in 1793, the wash removed in 1861, the "auburn" could also be described as "greyed.")

199:33–34 (202:10–11). An azured harebell like her veins—in *Cymbeline* one of Cymbeline's sons, Arviragus, speaks to his brother, Guiderius, of the "fairest flowers" with which he will "sweeten [the] sad grave" of the dead "boy," Fidele: "Thou shalt not lack/The flower that's like thy face, pale primrose, nor/The azured harebell, like thy veins, no, nor/The leaf of eglantine" (IV, ii, 220–223). Fidele is neither dead nor a boy but their sister, Imogen, in disguise.

199:34 (202:11). Lids of Juno's eyes, violets—in *The Winter's Tale,* in a "pastoral" scene, Perdita, the heroine, gives summer flowers as compliments to a middle-aged lord and then wishes for spring flowers to compliment a young

lord: "daffodils,/That come before the swallow dares, and take/The winds of March with beauty; violets dim,/But sweeter than the lids of Juno's eyes/Or Cytherea's [Venus'] breath" IV, iv, 118–122).

199:38 (202:15). Whom do you suspect?—the punch line of a well-known joke about an aging Oxford pedant who has a young wife. He confides his self-satisfaction to an old friend: ". . . I have ground for thought; my wife tells me she's pregnant." And the friend replies: "Good God, whom do you suspect?" See 322:10 (338:14) for a repeat performance.

199:42 (202:19). Love that dare not speak its name—i.e., homosexuality; see 50:13–14n.

200:1–2 (202:20–21). As an Englishman . . . loved a lord—after the proverb: "An Englishman loves a lord."

200:3 (202:22). Old wall where . . . at Charenton—Charenton is a town five miles southeast of Paris, famous as the site of a key bridge over the River Marne and attendant fortifications.

200:6 (202:25). uneared wombs—Shakespeare, Sonnet 3, 1–6: "Look in thy glass, and tell the face thou viewest/Now is the time that face should form another;/Whose fresh repair [renewal] if now thou not renewest,/Thou dost beguile the world, unbless some mother./For where is she so fair whose unear'd [unplowed] womb/Disdains the tillage of thy husbandry?"

200:6–7 (202:25–26). the holy office an ostler does for the stallion—i.e., the ostler brings the stallion to the mare; "holy office" is a name for the Inquisition.

200:7–8 (202:26–27). Maybe, like Socrates . . . shrew to wife—see 188:20n, 188:21–22n. Shakespeare may have been "like" Socrates in having a shrew as a wife. Shakespeare's mother, Mary Arden, appears to have been a woman of property, but there is no evidence to suggest that she was a midwife as, according to Plato, Socrates' mother, Phaenarete, had been.

200:8–9 (202:27–28). But she, the giglot . . . break a bedvow—spoken of Xanthippe. The phrase "giglot wanton" means a lascivious woman or frivolous girl; Shakespeare uses it in this combined sense in *I Henry VI* (IV, vii, 41) when it is applied ("giglot wench") to Joan of Arc. Shakespeare, Sonnet 152, lines 1–4: "In loving thee thou know'st I am forsworn,/But thou art twice forsworn, to me love swearing,/In act thy bed-vow broke and new faith torn,/In vowing new hate after new love bearing." (152 is the last in the sequence of "dark lady" sonnets.)

200:9–11 (202:28–30). Two deeds are . . . husband's brother—i.e., the Ghost in *Hamlet* is obsessed with the assumption of Gertrude's infidelity and with the image of his brother, Claudius, as "that incestuous, that adulterate beast,/With wicked witchcraft of his wit, with traitorous gifts" (I, v, 41–42). "Dull-brained yokel" does not fit Claudius as well as it fits the future course of Stephen's argument.

200:15 (202:35). the fifth scene of Hamlet—i.e., Act I, scene v, the scene in which the Ghost speaks to Hamlet. There is some controversy about whether the Ghost's words mean that Gertrude and Claudius were guilty of adultery before the murder. See 138:2–3n.

200:16–18 (202:36–38). no mention of her . . . she buried him—Lee (p. 187): "The only contemporary mention made of [Ann Hathaway Shakespeare] between her marriage in 1582 and her husband's death in 1616 is as the borrower at an unascertained date (evidently before 1595) of forty shillings from Thomas Whittington, who had formerly been her father's shepherd."

200:19 (202:39). Mary, her goodman John—Shakespeare's father, John, died in 1601; Mary, his mother, in 1608.

200:19–20 (202:39–40). Ann, her poor dear Willun—Shakespeare died in 1616; Ann, his wife, in 1623.

200:21 (202:41). Joan, her four brothers—Joan Hart, Shakespeare's sister, died in 1646, at the age of eighty-eight; Shakespeare's brothers, Edmund (1569–1607), Richard (1584–1613), Gilbert, no evidence about the date of his death though Lee assumes (p. 283) that he, like Joan, lived "to patriarchal age."

200:21–22 (202:41–42). Judith, her husband and all her sons—Judith, Shakespeare's younger daughter, "survived her husband, sons and sister" (Lee, p. 281).

200:22 (202:42). Susan, her husband too—Susanna Hall, Shakespeare's older daughter, died in 1649; her husband, Dr. John Hall, died in 1635.

200:22–24 (203:1–2). Elizabeth, to use . . . killed her first—Lee (p. 282): "Mrs. Hall's only child, Elizabeth, was the last surviving descendant of the poet. . . . Her first husband, Thomas Nash, was a man of property, and, dying childless . . . on April 4, 1647. . . . Mrs. Nash married, as a second husband, a widower, John Bernard or Barnard of Abington, Northamptonshire." In the play within the play in *Hamlet,* the Player Queen "protests too much": "In second

husband let me be accurst!/None wed the second but who kill'd the first" (III, ii, 189–190).

200:25–27 (203:3–5). O yes, mention . . . father's shepherd—see 200:16–18n.

200:33–34 (203:11–12). She was entitled . . . common law—in one transaction with a portion of his estate in London (1613) Shakespeare attempted (Lee argues, p. 274) to bar his wife's dowry, i.e., to prevent her from claiming a portion of the estate equal to the dowry that she brought to him in marriage and/or to a third share for life in her husband's freehold estate. See 200:38–201:3n.

200:34–35 (203:12–13). His legal knowledge . . . judges tell us—the Irish jurists Judge Barton, 196:10–11n, and Justice Madden, 197:41–198:3n, supply the comment. Madden remarks on Shakespeare's legal knowledge in the *Diary of Master William Silence* and Barton was eventually to publish *Links Between Shakespeare and the Law* (1919).

200:38–201:3 (203:16–20). And therefore he . . . And in London—Lee (pp. 274–275), Harris (p. 362) and Brandes (p. 686) all make this same point, that in the first draft of his will Shakespeare made itemized bequests to his children and relatives and to others in Stratford and London but omitted his wife. Subsequently a sentence was inserted: "Item, I gyve unto my wife my second best bed with the furniture."

201:8 (203:25). Punkt—German: "dot, full stop"; figuratively, item.

201:15 (203:32). Pretty countryfolk—see 189:15–16n.

201:16 (203:33). our peasant plays—Yeats, Lady Gregory and the other moving spirits in the theater of the Irish revival argued for, created and produced plays about peasant life. See 183:2–4n and 190:36n for two outstanding examples.

201:17–19 (203:34–37). He was a rich . . . promoter, a tithe-farmer—Shakespeare, or more correctly, his father, after repeated application, was granted a coat of arms in 1599. In 1602 Shakespeare purchased "New Place," then the largest house in Stratford; and throughout his active career in London he continued to invest in landholdings in and near Stratford until he had a sizable estate. Lee (p. 267) records Shakespeare's purchase (1613) of a house in Blackfriars (London), "now known as Ireland Yard." Shakespeare was a shareholder in the Globe Theatre (and possibly in the Blackfriars Theatre). Shakespeare also purchased, in 1605, a moiety of the tithes (similar to a mortgage on parish taxes) of Stratford and three

neighboring parishes; and in 1612 he, with two other Stratford residents, promoted a bill of complaint in the Court of Chancery in an attempt to clarify the legal responsibilities involved in the tithe-ownership; result unknown.

201:24 (204:1). Separatio a mensa et a thalamo—Latin: "Separation from board and bedchamber," a variant of the legal phrase "*Separatio a mensa et thoro,*" "Separation from board and bed," which courts in England granted instead of a divorce before the divorce laws were reformed in 1857.

201:28–33 (204:5–10). Antiquity mentions that . . . live in his villa—Aristotle was born in Stagira (Macedonia) and would have been a "schoolurchin" there. A year before Aristotle's death, the death of Alexander the Great (323 B.C.) made Athens unsafe for him (he was charged with impiety) and he exiled himself to Calchis. The "antiquity" Stephen cites is Diogenes Laertius (*fl.* third century B.C.), *Lives of Philosophers;* Diogenes reports that Aristotle's will freed and endowed some of his slaves, commissioned a statue of his mother, directed that he be buried with his wife, Pythias, and that his concubine, Herpyllis (apocryphal?) was to be allowed to live out her life in one of his houses. Nell (Eleanor) Gwynne (*c.*1650–1687), English actress and mistress of Charles II (1630–1685, king 1660–1685); Charles II's dying request: "Let not poor Nelly starve."

201:36 (204:13). He died dead drunk—Brandes (p. 685); Harris (p. 404) and Lee (p. 272) all refer to the recollection (50 years after the fact) of John Ward, Rector of Stratford: "Shakespeare, [Michael] Drayton, and Ben Jonson had a merry meeting, and, it seems, drank too hard, for Shakespeare died of a feavor there contracted" (quoted in Brandes, p. 685).

201:37 (204:14). Dowden—Edward Dowden (1843–1913), Professor of English Literature at Trinity College in Dublin and an eminent scholar and critic. Address: Highfield House, Rathgar, County Dublin.

201:39 (204:16). William Shakespeare and company, limited—Joyce's *Ulysses* was published in 1922 by Sylvia Beach (1887–1962) under the imprint of her bookstore Shakespeare and Company, 12 Rue de l'Odéon, in Paris. She had established the bookstore in 1919.

201:39–40 (204:16–17). The people's William —one of Dowden's favorite critical themes was that Shakespeare was a poet of the people and for the people.

202:2–4 (204:19–21). the charge of pederasty

... high in those days—There has been endless speculation about the homosexual implications of several of Shakespeare's sonnets. Dowden approaches the "charge" with considerable circumspection; in his edition of *The Sonnets of William Shakespeare* (London, 1881): "In the Renascence epoch, among natural products of a time when life ran swift and free, touching with its current high and difficult places, the ardent friendship of man with man was one" (p. 8). Dowden then goes on to cite several examples of such "ardent friendships" in the attempt to contextualize (and in a sense neutralize) the "charge."

202:6 (204:23). The sense of beauty leads us astray—an observation characteristic of Oscar Wilde in a melancholy mood. Wilde, in *The Portrait of Mr W. H.*, remarks in answer to the question ". . . what do the Sonnets tell us about Shakespeare?—Simply that he was the slave of beauty" (New York, 1962; p. 186).

202:9 (204:26). The doctor can tell us what those words mean—i.e., Sigmund Freud (1856–1939), Austrian physiologist and psychiatrist who founded psychoanalysis, which Stephen calls "the new Viennese school," 203:13 (205:32). In Freudian terms the "words" would, of course, mean an attempt to disguise or sublimate or excuse a deeply rooted unconscious compulsion.[2]

202:9–10 (204:26–27). You cannot eat your cake and have it—a familiar English proverb that appears as early as Heywood's *Proverbs* (1546). In context Eglinton obviously implies that one cannot both have a sense of beauty and go astray.[2]

202:11–12 (204:28–29). Sayest thou so . . . palm of beauty?—i.e., will Freud and the psychoanalysts behave like Antisthenes and take "the palm of beauty" from beautiful Helen and award it to moral-virtuous Penelope? take it away from the artist and award it to the moralist? See 198:41–199:2 (201:17–20) and 147:5n.[2]

[2] This passage in the text is the subject of some controversy. As Thornton points out (p. 199), the *Little Review* version of this episode does not contain Eglinton's remark about "the doctor," 202:9 (204:26), but does include Stephen's remark "the new Viennese school Mr. Magee spoke of," 203:13–14 (205:32–33). Thornton argues that Joyce in amending the passage could not have meant an allusion to Freud. But, on the contrary, since Eglinton-Magee nowhere else alludes to Freud, the emendation of the passage is necessary to make Stephen's remark about "the new Viennese school" dramatically valid as well as to add weight to Stephen's concern lest "the doctor" which he renders "they," 202:11 (204:28), should prove another Antisthenes. The "doctor" could, of course, be Mulligan; how then explain not only Stephen's "they . . . us" but also the irrepressible Mulligan's silence in the face of this opening for further ribaldry?

202:13–14 (204:30–31). He drew Shylock out of his own long pocket—Shylock is the vengeful Jewish moneylender in Shakespeare's *The Merchant of Venice*. To have a "long pocket" is a colloquialism implying that someone has money and is "close" with it. Brandes argues that "Shakespeare was attracted by the idea of making a real man and a real Jew out of this intolerable demon," Barabas, in Christopher Marlowe's (1564–1593) *The Jew of Malta.* "It took effect upon his mind because it was at that moment preoccupied with the ideas of acquisition, property, money-making, wealth" (p. 151).

202:14–16 (204:31–33). The son of a . . . famine riots—Lee (p. 4), Harris (p. 352) and Brandes (p. 6) all present John Shakespeare as involved in a variety of trades including "malt"; only Lee (p. 6) mentions his lending money, small sums to the municipal corporation of Stratford. Shakespeare himself did lend money according to Brandes' circumstantial account (p. 154). Brandes adds: "Shakespeare did not share that loathing of interest which it was the fashion of his day to affect" (p. 154). Brandes identifies Shakespeare as the owner if not a jobber of corn: "for we see that during the corn-famine of 1598 [February], he appears on the register as owner of ten quarters of corn and malt" (p. 153). Also Lee (p. 194). Neither Brandes nor Lee mentions "riots." A "tod" is a weight for wool: 28 pounds; a quarter, as a measure for grain, is eight bushels, 25 to 28 pounds.

202:16–18 (204:33–35). His borrowers are . . . uprightness of dealing—"Chettle Falstaff" is Stephen's version of Henry Chettle (*c.*1560–*c.*1607), the London printer and playwright who published Greene's *Groat's Worth of Wit* (1592) and followed it three months later with his own *Kind-Hart's Dreame* (1592), in which he regrets having published Greene's attack on Shakespeare (see 185:24n): "I am as sory as if the originall fault had beene my fault, because myselfe have seene his demeanor no lesse civill than he exelent in the qualitie he professes. Besides, divers of worship have reported his uprightnes of dealing, which argues his honesty, and his facetious grace in writing, that aprooves his Art." Brandes (p. 19), Lee (p. 58) and Harris (pp. 372–373) all quote Chettle's apology. Contemporary descriptions of Chettle as a fat man gave rise to speculations that Chettle sat for his portrait as Sir John Falstaff in Shakespeare's *I and II Henry IV*, *Henry V* and *The Merry Wives of Windsor*. Brandes notes the speculation (p. 179); Harris accepts it (pp. 150–151).

202:18–20 (204:35–37). He sued a fellowplayer . . . for every money lent—Lee (p. 206) and Brandes (p. 155) cite Shakespeare's suit against one Philip Rogers (an apothecary) of Stratford for

£1, 15s, 10d owed for malt purchased and monies lent. "Pound of flesh" is an allusion to Shylock's vengeful attempts to exact that forfeit from a delinquent Gentile debtor, Antonio, in *The Merchant of Venice*. Lee regards Shakespeare as one who "stood vigorously by his rights in his business relations" (p. 206). Brandes remarks, "Shakespeare seems to have charged the current rate of interest, namely, ten per cent" (p. 155). Elsewhere Brandes argues that Shakespeare had "a fierce instinct . . . which led him . . . to amass property without any tenderness for his debtors and . . . to understand and feel that passion for power [*Richard III*] which defies and tramples upon every scruple" (p. 130).

202:20–21 (204:38). How else could . . . get rich quick?—John Aubrey's (1626–1697) collection of anecdotes was finally edited as *Brief Lives and Other Selected Writings* (London, 1898). Aubrey says that Shakespeare's father was a butcher and that Shakespeare "when he was a boy . . . exercised his father's trade" and subsequently was "a schoolmaster in the country." Lee (pp. 33–34), "the compiler [Robert Shiels and others under the direction of Colly Cibber] of 'Lives of the Poets' (1753), was the first to relate the story that his original connection with the playhouse was as holder of the horses of visitors outside the doors." Brandes (p. 13): "Malone [Edmund (1741–1812)] reports 'a stage tradition that his first office in the theatre was that of prompter's attendant,'" i.e., "call-boy." Harris, Lee and Brandes are all understandably circumspect about these and other anecdotal attempts to account for Shakespeare's early life.

202:21 (204:39). brought grist to his mill—proverbial expression for "raw materials which he could turn to profit."

202:22–24 (204:39–42). Shylock chimes with . . . was yet alive—see 202:13–14n. Lee argues that the "inspiration" of Marlowe's *The Jew of Malta* is only incidental to the creation of Shylock (p. 68); rather that the real "inspiration" was "the popular interest" aroused by the trial in February 1594 and the execution in June "of the Queen's Jewish physician, Roderigo Lopez." Lopez was accused on slender evidence of having accepted a bribe from Spanish agents to poison the Queen and one Antonio Perez, a renegade Spaniard. The parallel with *The Merchant of Venice* is presumed to be enforced not only by conjunction of Shylock and Lopez but also by the fact that Shylock's proposed victim in the play is the titular hero, Antonio. The execution of Lopez was the occasion for a violent outbreak of anti-Semitism in London. In the "ceremony" of being hanged, drawn and quartered, the victim was hanged on a tilted ladder or in such a way that his feet touched the platform, i.e., he was suffocating but not necessarily dead when the vivisection began. Stephen's flourish about the heart does not occur in any of his sources.

202:24–26 (204:42–205:2). Hamlet and Macbeth . . . turn for witchroasting—James I (1566–1625; as James VI of Scotland, 1567–1625; king of England, 1603–1625). He was fascinated by witchcraft, produced a textbook on the subject, *Daemonologie* (1597) and as king of Scotland was actively involved in promoting large-scale trials and executions. Brandes (p. 424) links *Hamlet* and *Macbeth* with King James's interest in witchcraft and demonology, but he is more guarded than Stephen about citing James as an "inspiration" for *Hamlet* since he dates *Hamlet* early, 1603 (or before); *Macbeth* is "safer" since both Brandes and Lee date it 1605–1606. Lee (p. 239) makes a considerable point of the appeal that Shakespeare's *Macbeth* would have had for James I, not only on account of its demonology but also on account of its Scottish sources and sympathetic treatment of Banquo, James's ancestor.

202:26–27 (205:2–3). The lost armada . . . Love's Labour's Lost—the Armada, a full-scale Spanish invasion attempt, was partially defeated by the English and then dispersed and destroyed by storms in 1588. Lee (p. 52n) remarks, "The name Armado was doubtless suggested by the expedition of 1588." Don Adriano de Armado in *Love's Labour's Lost* is a "fantastical Spaniard," a caricature of what Elizabethans regarded as conventional Spanish behavior: vain, fastidious and bombastic. It should be noted that the play is usually described as "difficult" because it is so larded with topical allusions.

202:27–28 (205:3–4). His pageants, the histories . . . Mafeking enthusiasm—Mafeking, a town in South Africa and an English strong point during the Boer War. The Boers besieged it for 217 days, but it wasn't much of a siege because, although the Boers had cut Mafeking's supply lines, they never put any real pressure on the English garrison. The garrison's having held out was as much a function of Boer disinterest as it was of English heroics. A relief column forced the Boers to withdraw from the Mafeking area on 17 May 1900. In London the response was a riotous celebration of *victory*—in effect, a response out of all proportion to the military significance of the event. Subsequently "Mafeking" became a term for extravagant (and essentially unwarranted) display of enthusiasm for the British Empire and expansionist policy. It is a historical commonplace that after the defeat of the Armada Elizabethan England enjoyed an extended period of enthusiastic Renaissance nationalism.

202:28–29 (205:4–5). Warwickshire jesuits . . . theory of equivocation—on 5 November 1605 an English Catholic plot to blow up both Houses of Parliament and the King as he addressed them was intercepted and foiled. One of the high-level Catholics tried as a member of the plot in 1606 was the Warwickshire Jesuit Henry Garnet, provincial of the then underground order in England. He distinguished himself at the trial by defending the "doctrine of equivocation," i.e., that his attempt to practice deliberate deception on his accusers (for a priest to lie under oath) was perfectly ethical if it were done "for the greater Glory of God" (Jesuit motto). The Porter in *Macbeth,* aroused from a drunken sleep by a knocking at the gate, imagines that he is the porter at Hell's gate and says: "Who's there, in the other devil's name? Faith, here's an equivocator, who could swear in both the scales against either scale; yet could not equivocate to heaven" (II, iii, 8–12). Lee makes the connection between Father Garnet and the Porter (p. 239).

202:29–31 (205:5–7). The Sea Venture . . . our American cousin—Lee (p. 252) argues that *The Tempest* was in part "inspired" by the experiences of the crew of the *Sea Venture,* a ship lost in the Bermudas on a voyage to Virginia in 1609. The crew, marooned for ten months in these previously unknown islands, made their way to Virginia and thence to England in 1610. The somewhat fanciful accounts of their adventures produced considerable excitement in England. For Renan, see 192:33n. Caliban, the grossly human earth spirit of Shakespeare's play, is dubbed "Patsy" (not "Pasty" as in 202:31) in honor of nineteenth-century stage caricatures of the immigrant Irish. *Our American Cousin* (1858) is a play by the English playwright and journalist Tom Taylor (1817–1880); it was at a performance of this play that Lincoln was assassinated.

202:31–32 (205:7–8). The sugared sonnets follow Sidney's—Shakespeare's sonnets were called "sugred sonnets" by Francis Meres (1565–1647) in his *Palladio Tamia, Wits Treasury* (1598); he speaks of the sonnets not as published but as known "among [Shakespeare's] private friends." Sir Philip Sidney's (1554–1586) famous sonnet-sequence *Astrophel and Stella* (composed 1581–1583?) obviously precedes Shakespeare's, but both Lee and Brandes are guarded about attributing to Sidney a decisive influence on Shakespeare's sonnets. Lee lists Sidney as "among the rills which fed the mighty river" (p. 61); and Brandes cites the sonneteer Samuel Daniel (1562–1619) as Shakespeare's "immediate predecessor and master" (p. 300).

202:32–35 (205:8–11). As for fay Elizabeth . . . of the buckbasket—"fay Elizabeth" after Edmund Spenser's allegorical rendition of her as *The Faerie Queen;* "carroty Bess" because good Queen Bess had red hair; "gross virgin" because she reputedly enjoyed coarse humor. The tradition that Elizabeth "inspired" or rather commanded Shakespeare to write *The Merry Wives of Windsor* was apparently well established by 1702, when the English playwright John Dennis (1657–1734) mentions it in the Epistle Dedicatory to his play *The Comical Gallant,* a rewrite of *The Merry Wives of Windsor.* "Meinherr" is slang for a German gentleman, as "Almany" is Elizabethan for Germany. "The buckbasket" in which this overmeticulous scholar (or Freudian?) is to "grope" figures repeatedly in *The Merry Wives of Windsor;* in Act III scene iii, Falstaff is hidden in one, covered with "foul linen" and pitched into the Thames; "buck" involves a pun on horned animal and therefore cuckold (an obvious theme of the play).

202:37 (205:13). Mingo, minxi, mictum, mingere—Latin, conjugation of the verb "to make water, to urinate."

202:39 (205:15). Your dean of studies . . . holy Roman—the Dean of Studies, University College, Dublin, Father Joseph Darlington, S.J. (1850–1939). An article of his, "The Catholicity of Shakespeare's Plays," in *The New Ireland Review* (1897–1898), Vol. VII, pp. 241–249 and 304–310, argues in a circumspect way that Shakespeare was a Catholic—perhaps not a practicing Catholic but certainly (like the medieval cathedrals) one of the great flowerings of that tradition "of Chivalry and Christian faith."

202:40 (205:16). Sufflaminandus sum—Latin: "I ought to be repressed [in speaking]." After Ben Jonson's comment on Shakespeare in *Timber : or, Discoveries Made Upon Men and Matter, as They Have Flowed Out of His Daily Reading* (posthumously, 1641): "Hee was honest, and of an open, and free nature: had an excellent Phantsie; brave notions, and gentle expressions: wherein he flow'd with that facility, that sometime it was necessary he should be stop't: *Sufflaminandus erat* [he should be repressed]; as Augustus [Roman Emperor] said of Haterius [a particularly glib Roman orator]" (*Works* [Oxford, 1925–1952], Vol. VIII, p. 584).

202:41 (205:17). "made in Germany"—a stock phrase since German manufacturers were flooding European markets with their products (1890 *ff.*); see 164:7–9n. Also a witticism at the expense of German scholars who had a tendency to expropriate Shakespeare as *"unser* [our] *Shakespeare."*

203:1–2 (205:19–20). A myriadminded man . . . Coleridge called him—Samuel Taylor Coleridge (1772–1834), *Biographia Literaria*

(1817). In Chapter XV Coleridge undertakes to apply the "principles" he has developed in preceding chapters "to purposes of practical criticism." The first application will be "to discover what the qualities in a poem are, which may be deemed promises and specific symptoms of poetic power, as distinguished from general talent. . . . In this investigation, I could not, I thought, do better, than keep before me the earliest work [*Venus and Adonis,* "The Rape of Lucrece"] of the greatest genius, that perhaps human nature has yet produced, our *myriad-minded* Shakespeare." In a footnote Coleridge says that he has coined the word from a Greek phrase and that it belongs to Shakespeare "by singular right and by natural privilege."

203:3–4 (205:21–22). Amplius. In societate . . . inter multos—Latin: "A broad assertion. In human society it is of the utmost importance that there be amicable relations among the many [among as many as possible]." Stephen implies that this is a quotation from St. Thomas Aquinas, but the source is unknown; see 203:11–17n.

203:6 (205:24). Ora pro nobis—Latin: "Pray for us."

203:8 (205:27). Pogue mahone! Acushla machree!—Irish: "Kiss my arse! Pulse of my heart!"; see 184:33n.

203:8–9 (205:27–28). It's destroyed . . . we are surely!—lines from Synge's one-act play *Riders to the Sea* (1904). In the course of the play Maurya (an old woman), having lost one son to the sea, tries to prevent her remaining son from a similar fate. The living son overrules her, and she subsequently has a vision of the living son on horseback followed by the dead son on a pony. She and her daughters recognize the vision as a presentiment of another death, and Cathleen, the older daughter, "[*begins to keen*]. It's destroyed we are from this day. It's destroyed, surely." In the context of the play, "destroyed" means starved or destitute.

203:11–17 (205:30–36). Saint Thomas, Stephen . . . hungers for it—Freud and his "Viennese school" regarded incest, i.e., an oedipal relationship, as a necessary and disturbing component of infantile sexuality; thus, the process of "growing up" was regarded as a process of being weaned from incestuous tendencies. It is not St. Thomas but St. Augustine who likens lust (not simply incest) to avarice or covetousness *(aviditate)*, in *De Civitati Dei* (XV:16). St. Thomas quotes Augustine to that effect in the *Summa Theologica, Secunda Secundae,* Question 154, Article 10, "Whether Sacrilege Can Be a Species of Lust." In Article 9, "Whether Incest is a Determinate Species of Lust," St. Thomas' primary reason

for condemning incest is that incest is "contrary to the natural respect we owe persons related to us," a point which he not only makes in Question 154, Article 9, but also in Articles 1 and 12. "Gorbellied" means big-bellied. Falstaff uses the word in *I Henry IV* (II, ii, 93); as applied to St. Thomas, see 48:20n.

203:17–18 (205:36–37). Jews, whom christians . . . given to inter-marriage—Jewish tradition, as articulated in the Old Testament and reinforced in practice, involved a sharp prejudice against marriage with a non-Israelite (subsequently, non-Jew).

203:19–21 (205:38–40). The christian laws . . . hoops of steel—"The Christian laws" were those laws which forbade the lending of money at interest; Jewish law did not so forbid and Jews were consequently tolerated for the importance of their economic function, "sheltered in the midst of storm" (in England, specifically protected as "the King's Jewry" until their expulsion in 1290). The Lollards, a semimonastic society of religious reformers (1300 *ff.*), are often associated with the leadership of the famous English reformer, theologian and translator of the Bible John Wycliffe (*c.*1324–1384). They were persecuted in the Low Countries and England; but they did find shelter in storm during the fourteenth century when England was experiencing the preliminary troubles that were to erupt in the Wars of the Roses in the fifteenth century. John of Gaunt, Duke of Lancaster (1340–1399), himself involved in an underground contest with the Church and its power, championed Wycliffe and protected his Lollard followers. In *Hamlet,* Polonius advises his son, Laertes, on the techniques of worldly experience on the eve of the latter's departure for France: "Be thou familiar, but by no means vulgar./Those friends thou hast, and their adoption tried [friendship tested],/Grapple them to thy soul with hoops of steel" (I, iii, 61–63).

203:22 (205:41). old Nobodaddy—is Blake's characterization of a god of wrath and hell fire, a god jealous of the joy of his own creation (as is the Old Testament Jehovah). "To Nobodaddy": "Why art thou silent and invisible,/Father of Jealousy?/Why dost thou hide thyself in clouds/From every searching eye? // Why darkness and obscurity/In all thy words & laws,/That none dare eat the fruit but from/The wily serpent's jaws?/Or is it because Secresy gains females' loud applause?" (*Poems from the "Rosetti" MS* [1793]). In another poem in the same *MS,* "Let the Brothels of Paris be opened," he enters (lines 13–16): "Then old Nobodaddy aloft/Farted & belched & coughed,/And said, 'I love hanging & drawing & quartering/Every bit as well as war & slaughtering.'"

203:22–23 (205:42). at doomsday leet—a "leet" is a manorial court; hence, at the last judgment.

203:25–26 (206:3). sir smile neighbour—in Shakespeare's *The Winter's Tale*, the protagonist, Leontes, is the victim of a compulsive jealous suspicion: "Now while I speak this, holds his wife by the arm/That little thinks she has been sluiced in's absence/And his pond fish'd by his next neighbor, by/Sir Smile, his neighbor" (I, ii, 193–196).

203:26–27 (206:3–4). shall covet his . . . or his jackass—after the tenth of the Ten Commandments: "Neither shalt thou desire thy neighbour's wife, neither shalt thou covet thy neighbour's house, his field, or his manservant, or his maidservant, his ox, or his ass, or any *thing* that *is* thy neighbour's" (Deuteronomy 6:21).

203:29 (206:6). Gentle Will—after Ben Jonson's epithet "Gentle Shakespeare." Jonson used the epithet twice in dedicatory poems to the First Folio, *Mr. William Shakespeare's Comedies, Histories and Tragedies* (1623), in "*To the memory of my beloved the author, Mr. William Shakespeare, and what he hath left us*" (line 56) and in "To the Reader" (line 2).

203:33–34 (206:10–11). The will to live . . . will to die—as a Puritan "saint," Anne Hathaway Shakespeare would have looked forward to death as the entry into eternal life. Eglinton is also alluding to Freud's assertion that the two basic and conflicting urges in the unconscious are the will to live and the will to die.

203:35 (206:12). Requiescat!—Latin, from the prayer for the repose of the dead, "*Requiescat in pace*": "May he (or she) rest in peace."

203:36–37 (206:13–14). What of all . . . vanished long ago—the opening lines of George Russell's poem "Sung on a By-Way." The first of the poem's four stanzas continues, "For a dream-shaft pierced it through/From the unknown Archer's bow" (*Collected Poems* [London, 1926], p. 128).

203:39 (206:16). the mobled queen—Hamlet asks the newly arrived First Player to repeat a speech describing "Priam's slaughter," i.e., the death of the King of Troy. Hecuba, the Queen, who witnesses the death, is described as "the mobled [muffled] queen" (II, ii, 524).

203:39–41 (206:16–18). a bed in those days . . . of seven parishes—while it is true that a "great bed" (a heavy and ornately carved four-poster) was a rarity in Elizabethan England and while it is true that most Elizabethans slept on straw pallets,

at least one "lesser bed" was a common feature of middle-class households.

203:41–204:2 (206:18–20). In old age . . . town paid for—"gospeller" was a derisive term for a Puritan preacher. Brandes (p. 679), Harris (pp. 402–403) and Lee (pp. 268–269) all cite a 1614 entry in the Stratford municipal accounts: "Item, for one quart of sack and one quart of clarett wine given to a preacher at the New Place [Shakespeare's house], xx^d." Lee attributes this "civility" to the Puritan sympathies of Shakespeare's son-in-law; Brandes regards it as a "spiritual betrayal" of Shakespeare since Puritans were notorious enemies of the theater.

204:3 (206:22). his chapbooks—i.e., Puritan religious tracts.

204:5 (206:23). the jordan—a chamber pot; also, short for "Jordan bottle," a bottle of water from the river Jordan in the Holy Land. Some Puritan sects regarded this water as symbolic of ultimate baptism and conversion.

204:5–7 (206:24–25). Hooks and Eyes . . . Devout Souls Sneeze—*Hooks and Eyes for Believers' Breeches* (London, c.1650) was a Puritan pamphlet about works of charity; the other title seems to be an approximation of another Puritan pamphlet, *The Spiritual Mustard-Pot, to Make the Soul Sneeze with Devotion* (London, 1653).

204:7 (206:25–26). Venus has twisted her lips in prayer—i.e., Anne Hathaway in her role in *Venus and Adonis;* see 198:30 (201:5–6).

204:8–9 (206:27–28). an age of . . . for its god—a commonplace about Jacobean London. Brandes develops this theme at some length (pp. 488–500).

204:10–11 (206:29–30). inquit Eglintonus Chronologos—Latin: "cited Eglinton, the Chronologist." *Chronologos* is a Latinization of the English word.

204:12–13 (206:31–32). a man's worst enemies . . . house and family—as Jesus teaches his disciples, in Matthew 10:35–36: "For I come to set a man at variance against his father, and the daughter against her mother, and the daughter in law against her mother in law. And a man's enemies shall be they of his own household" (Douay).

204:15–16 (206:35). the fat knight—an epithet used repeatedly in reference to Falstaff in *Henry V* and in *The Merry Wives of Windsor*.

204:17 (206:36). deny thy kindred—in *Romeo and Juliet*, Juliet, "above at a window," speaks,

unaware that Romeo is below in the "orchard": "O Romeo, Romeo! wherefore art thou Romeo?/ Deny thy father and refuse thy name" (II, ii, 33–34).

204:17 (206:36). the unco guid—after the title of Robert Burns's (1759–1796) poem, "Address to the Unco Guid, or the Rigidly Righteous" (1786, 1787). The poem attacks the self-righteous who regard themselves as holy or wise. "Unco" means uncouth, shy, awkward or uncommon; "guid" means good.

204:18–19 (206:37–38). A sire in Ultonian Antrim—Ultonian, an inhabitant of Ulster; Antrim is a county in Ulster in the northeast corner of Ireland. A sizable peninsula off the coast of County Antrim is called Island Magee and the family name is associated with that district. However, Eglinton's father did not live in County Antrim. *Irish Literature* (1904), in its biographical note on William K. Magee (John Eglinton), remarks: "Mr. Magee is a native of Dublin and is the son of an Irish Protestant clergyman who died recently."

204:19 (206:38). quarter days—days conventionally regarded as beginning the quarters of the year in Ireland: Lady Day, 25 March; Midsummer Day, 24 June; Michelmas Day, 29 September; and Christmas Day.

204:21 (206:40). Give me my Wordsworth—in *Two Essays on the Remnant* (1896) Eglinton describes the Remnant as those in the present "who feel prompted to perpetuate the onward impulse" of the "great literary period" of the early nineteenth century. He cites in particular Goethe, Schiller, Wordsworth and Shelley, and discusses at length Wordsworth's dominant contribution to that "onward impulse."

204:21 (206:40–207:1). Magee Mor Matthew—"Mor" is Irish for "great, senior." Matthew appears as a character in several of Wordsworth's early poems. In "Expostulation and Reply" (1798) Matthew expostulates with William for dreaming his "time away" and William replies arguing the vitality of "dream." Wordsworth's note on Matthew: "A friend who was somewhat unreasonably attached to modern books of moral philosophy." In "Two April Mornings" he is described as "A village schoolmaster was he,/With hair of glittering grey."

204:22 (207:1). a rugged rough rugheaded kern—Richard II in Shakespeare's *The Tragedy of King Richard II* callously turns from the news of John of Gaunt's death: "Now for our Irish wars: /We must supplant those rough rug-headed [shaggy-haired] kerns [Irish foot soldiers]" (II, i, 155–156).

204:22 (207:1). in strossers—in Shakespeare's *Henry V* the Dauphin, on the eve of his defeat at Agincourt, jokes with the Constable of France, wittily combining allusions to his horse and his mistress: "O then belike she was old and gentle; and you rode, like a kern of Ireland, your French hose [baggy trousers] off, and in your strait strossers [underpants]" (III, vii, 55–57).

204:22–23 (207:2). a buttoned codpiece—i.e., crudely and suggestively detachable.

204:23 (207:2). netherstocks—Elizabethan stockings, cut out of material and sewed, not woven, together; *I Henry IV* (II, iv, 129) and *King Lear* (II, iv, 11).

204:23 (207:2–3). with clauber of ten forests—an allusion to Yeats's play *The Countess Cathleen* (1892, 1895 version) in which Shemus' wife rails at him when he returns from hunting in the woods which she regards as haunted: "I searched all day: the mice and rats and hedgehogs/Seemed to be dead, and I could hardly hear/ A wing moving in all the famished woods,/ Though the dead leaves and clauber [clabber, mud, mire]/Cling to my footsole."

204:24 (207:3). a wand of wilding in his hand—after another of Wordsworth's "Matthew poems," the last stanza of "Two April Mornings" (1799, 1800): "Matthew is in his grave, yet now,/Methinks, I see him stand,/As at that moment, with a bough/Of wilding in his hand." The "wilding" is wild- or crab-apple, a tree mythologically associated with laughter and with the Welsh and Irish goddesses that resemble Aphrodite.

204:25 (207:4). He knows your old fellow—what Mulligan has said about Bloom; 198:33 (201:9).

204:27–28 (207:7). Dr Bob Kenny—Robert D. Kenny, surgeon to the North Dublin Poor Law Union Hospital; i.e., Stephen's mother was a charity case.

204:31–32 (207:10–11). He wrote the play . . . his father's death—John Shakespeare died 8 September 1601. Brandes argues that Hamlet (*Stationer's Register*, 26 July 1602) was composed in 1601 (p. 341), a period when "many and various emotions crowded upon Shakespeare's mind" (as Brandes speculates about Shakespeare's reaction to the condemnations of Essex and Southampton early in 1601 and a possible crisis with the "Dark Lady of the Sonnets").

204:32–33 (207:11–12). two marriageable daughters—Susannah Shakespeare was born in

May 1583; Judith, in 1585. Susannah was married in 1607; Judith, in 1616.

204:33–34 (207:12–13). nel mezzo del cammin di nostra vita—Italian: "in the middle of the journey of our life," the opening line of Canto I of Dante's *Inferno*. Dante (1265–1321) dates the vision of the *Divina Commedia* as 1300 (when he was thirty-five). The *Inferno* continues: "I came to myself in a dark wood where the straight way was lost."

204:34–35 (207:13–14). the beardless undergraduate from Wittenberg—In *Hamlet* (I, ii, 112 *ff.*), Claudius refuses to allow Hamlet to return to "school" at the University of Wittenberg. The First Quarto edition of *Hamlet* (pirated? 1603) identifies Hamlet as a youth, "quite young, probably nineteen" (Brandes, p. 367). The Second Quarto (1604) modifies the emphasis on Hamlet's youth and implies that he was thirty; see 192:24n. Brandes makes a considerable issue of these changes in support of his argument that the thirty-five-year-old Shakespeare identified with and portrayed himself in the thirty-year-old Hamlet (pp. 367 *ff.*).

204:36 (207:15). his seventyyear old mother—the date of Mary Arden Shakespeare's birth is unknown. She was married in 1557; therefore, by 1601 she would have been at least sixty.

204:36–37 (207:15–16). The corpse of John Shakespeare . . . walk the night—the Ghost speaks to Hamlet: "I am thy father's spirit,/ Doom'd for a certain term to walk the night . . ." (I, v, 9–10).

204:37–38 (207:16–17). From hour to hour it rots and rots—in *As You Like It* Jacques tells the story of his meeting with "a fool i' the forest" (Touchstone) and quotes the fool as having said: "And so, from hour to hour, we ripe and ripe,/ And then, from hour to hour, we rot and rot;/And thereby hangs a tale" (II, vii, 26–28).

204:39–40 (207:18–20). Boccaccio's Calandrino . . . himself with childhood—Giovanni Boccaccio (1313–1375), the *Decameron*, ninth day, third tale: the gullible Calandrino's friends fleece him by convincing him that he is great with child and then curing him for a price. *Calandrino* in Italian is a level protractor; figuratively, a ninny or simpleton.

204:42–205:1 (207:22). from only begetter to only begotten—after the Nicene Creed, which speaks of Christ as "the only begotten son of God"; see 39:10n. This phrase also recalls the dedication of Shakespeare's sonnets; see 196:14–16n.

205:1–2 (207:23–24). the madonna which . . . mob of Europe—i.e., Stephen argues that the Italian priesthood had substituted the "easy emotional" worship of the Virgin Mary for the difficult intellectual concept of the consubstantiality of father and son. There was considerable controversy about Mariolatry in the latter half of the nineteenth century, triggered by Pius IX's 1854 declaration (as dogma and an article of faith) that Mary was immaculately conceived.

205:5–6 (207:27). Amor matris, subjective and objective genitive—*Amor matris*, Latin: "Mother love." Stephen's comment implies that the Latin phrase can be regarded as ambiguous: a mother's love for her child or the child's love for its mother. See 29:22–23n and 28:37n.

205:11 (207:33). Amplius. Adhuc. Iterum. Postea—Latin: "Furthermore. Heretofore. Once again. Hereafter," rhetorical terms associated with various phases of Scholastic argument.

205:16–17 (207:38–39). loves that dare not speak their name—i.e., homosexual loves; see 50:13–14n.

205:18 (207:40). queens with prize bulls—Greek myth: Minos, king of Crete, offended Poseidon, who revenged himself by making Minos' wife, Pasiphaë, fall in love with a white bull. To fulfill her passion, she concealed herself in a wooden cow that Daedalus had prepared for her; the result of the union was the Minotaur, half bull, half man.

205:22 (208:3). rue Monsieur-le-Prince—in early twentieth-century Paris, a street in a red-light district.

205:26 (208:7). Sabellius, the African—see 22:31n.

205:26–27 (208:7–8). subtlest heresiarch of all the beasts of the field—after Genesis 3:1: "Now the serpent was more subtil than any beast of the field which the Lord God had made."

205:27–29 (208:9–10). The bulldog of Aquin . . . refutes him—St. Thomas Aquinas, a Dominican and thus, via the pun, *Domini canis*, "dog of God"; "bulldog" in honor of the tenacity of his grip; "of Aquin" since he came from the great Neapolitan family of Aquino. Among many "refutations" of Sabellius in the *Summa Theologica*, the principal one is Part I, Question 31, where St. Thomas pairs the heresies of Arius and Sabellius; he argues: "To avoid the heresy of Sabellius, we must shun the term *singularity*, lest we take away the communicability of the Divine Essence. . . . The word *solitary* is also to be avoided,

lest we take away the society of the Three Persons; for, as Hilary says, *We confess neither a solitary nor a diverse god.*"

205:30–31 (208:12). Rutlandbaconsouthamptonshakespeare—three leading candidates for the role of Shakespeare's ghostwriter: Roger Manners (1576–1612), 5th Earl of Rutland; Sir Francis Bacon (1561–1626); and Henry Wriothesley (1573–1624), 3rd Earl of Southampton.

205:31–32 (208:12–13). another poet of the same name in the comedy of errors—in Shakespeare's *The Comedy of Errors*, the comic confusion depends in part on the fact that two of the central characters are identical twins, both named Antipholus (their attendants are also identical twins, both named Dromio).

205:36–37 (208:17–18). nature, as Mr Magee understands . . . abhors perfection—W. K. Magee (John Eglinton) in *Pebbles from a Brook* (1902) (p. 45): "Nature abhors perfection. Things perfect in their way, whether manners, poetry, painting, scientific methods, philosophical systems, architecture, ritual, are only so by getting into some backwater or shoal out of eternal currents, where life has ceased to circulate. The course of time is fringed with perfections but bears them not upon its bosom."

205:39 (208:20). a merry puritan, through the twisted eglantine—"puritan" involves not only another reference to Magee's father, a Protestant clergyman, but also to Milton and the lines from "L'Allegro" that describe the lark at dawn, greeting the speaker: "Through the Sweet-Briar, or the Vine,/Or the twisted Eglantine."

206:1–2 (208:25). Pallas Athena!—in Greek mythology, the goddess of mother-wit and wisdom, who was born from Zeus' head.

206:2 (208:25). The play's the thing!—Hamlet soliloquizes on his improvised plot to trap the King into revealing himself; Hamlet plans to have some aspects of Claudius' murder of King Hamlet repeated in a play: "The play's the thing/Wherein I'll catch the conscience of the King" (II, ii, 633–634).

206:2 (208:25–26). parturiate—rare: "to bring forth young, to fructify."

206:4–5 (208:28–29). his mother's name lives in the forest of Arden—Mary Arden, Shakespeare's mother. The forest of Arden was both a real forest in England and the idealized pastoral-romantic setting of Shakespeare's *As You Like It*.

Shakespeare accepted the name Arden from his principal source for the play, Thomas Lodge's (*c*.1558–1625) *Rosalynde, Euphues' Golden Legacy* (1590).

206:5–6 (208:29–30). Her death brought . . . Volumnia in Coriolanus—Mary Arden Shakespeare was buried 9 September 1608 and 1608 is generally accepted as the year when *Coriolanus* was first produced on stage. Volumnia, Coriolanus' mother, strikes the modern reader as the prideful, overbearing woman who will not relinquish her hold on her son, but times have changed. Both Brandes (pp. 532–533) and Harris (p. 353) regard Volumnia as "sublime," "the most noble mother of the world," as *Coriolanus* calls her (V, iii, 49); both Brandes and Harris link the characterization of Volumnia with Shakespeare's affection for his mother. The scene to which Stephen refers is Act V, scene iii; Coriolanus, having defected from Rome, is on the verge of conquering the city for its enemies. Volumnia comes as a suppliant and appeals to Coriolanus' filial loyalty; that loyalty triumphs over his desire for revenge on Rome (and incidentally sends Coriolanus to his death).

206:6–7 (208:30–31). His boyson's death . . . in King John—Hamnet Shakespeare died in August 1596. Both Harris and Brandes date *King John* 1596–1597 and both link Shakespeare's treatment of the child, Arthur, with Shakespeare's grief at the death of his son (Brandes, pp. 140–149 and Harris, pp. 58, 339–340). Central to the play is the pathos of Arthur's innocence when he is at the mercy of his uncle, King John.

206:7 (208:31). Hamlet, the black prince—At his first appearance (I, ii), Hamlet, still mourning his father's death, is dressed in black. There is also a reference to Edward, the Black Prince of England (1330–1376), who never succeeded to the throne because his father, Edward III (1312–1377), outlived him.

206:8–9 (208:32–33). Who the girls . . . are we know—see 193:18–19n.

206:9–10 (208:33–34). Who Cleopatra, fleshpot . . . we may guess—i.e., the three seductive heroines, Cleopatra in *Antony and Cleopatra*, Cressida in *Troilus and Cressida* and Venus in *Venus and Adonis* are all "modeled" on Anne Hathaway. For "fleshpot of Egypt" (Exodus 16:3), see 42:30n.

206:20 (209:2). Gilbert, Edmund, Richard—Gilbert Shakespeare, b. 1566, apparently outlived William, but the date of his death was not recorded; Edmund Shakespeare (1580–1607); Richard Shakespeare (1574–1613).

206:20–24 (209:2–6). Gilbert in his old age . . . a man on's back—the spelling in this sentence echoes a Warwickshire dialect. "Maister Gatherer," the collector of the entrance fee; "mass," dialect curse: "by the master." Lee (p. 42) repeats a story from William Oldys (1696–1761), the English antiquary, to the effect that one of Shakespeare's brothers, "presumably Gilbert," saw Shakespeare play the part of Adam, a servant, in *As You Like It*. The "cavaliers" are Stephen's "local color," emphasizing the disparity between Shakespeare's art and the philistinism of his "Puritan" family. Stephen also improves on the part Shakespeare was supposed to have played, casting him in the role of the more important Orlando, who, as a talented amateur, successfully wrestles with the old pro (I, ii, 158–242). Needless to say, *As You Like It* is not a play about wrestling.

206:24 (209:6). The playhouse sausage—see 186:15n.

206:28 (209:10). What's in a name?—Juliet to Romeo when she discovers he is a Montague: "'Tis but thy name that is my enemy;/. . . O, be some other name!/What's in a name?" (II, ii, 38–42).

206:36–37 (209:18–19). Then outspoke . . . medical Davy . . . —another fragment from Oliver St. John Gogarty's unpublished bawdy poem "Medical Dick and Medical Davy." The poem plays Dick's extraordinary sexual prowess off against Davy's extraordinary financial prowess.

207:2–3 (209:21–22). In his trinity . . . in King Lear—"black Wills" since all three villains assert that their villainies are willful, conscious acts. "Shakebags" is slang for thieves or pickpockets. Iago is the villain in *Othello;* Richard Crookback is Richard III in that play; and Edmund, the bastard son of Gloucester in *King Lear*, while hardly the play's only villain, still emerges as a central image of stark and willful human perversity.

207:4–5 (209:23–24). that last play . . . dying in Southwark—the *Stationer's Register*, 26 November 1607, records *King Lear* as having been presented at court during Christmastime in 1606. Edmund Shakespeare was buried at St. Saviour's Church in Southwark, 31 December 1607.

207:11 (209:30). But he that filches . . . my good name . . . —Iago to Othello: "Good name in man and woman, dear my lord,/Is the immediate jewel of their souls:/Who steals my purse steals trash; . . ./But he that filches from me my good name/Robs me of that which not enriches him/And makes me poor indeed" (III, iii, 155–161).

207:13–14 (209:32–33). He has hidden . . . a clown there—characters named William are impressive neither for their numbers nor their roles in Shakespeare's plays: William de la Pole, the Earl of Suffolk, one of the contending lords in *I Henry VI* and *II Henry VI;* two retainers, Sir William Lucy and Sir William Glansdale, in *I Henry VI*, and a William Stafford in *II Henry VI;* William Page, a boy, briefly the instrument of comedy at the expense of middle-class attitudes toward learning in *The Merry Wives of Windsor* (IV, i); William, in *As You Like It*, a country bumpkin in love with Audrey, a country wench; an offstage "cousin William" of Shallow's has become a "good scholar" at Oxford in *II Henry IV* (III, ii); and there is a cook named William in *II Henry IV*. "A fair name" is from *As You Like It*: "TOUCHSTONE: . . . Is thy name William?/WILLIAM: William, sir./TOUCHSTONE: A fair name" (V, i, 23–25).

207:14–15 (209:33–34). as a painter of old . . . corner of his canvas—in Browning's dramatic monologue "Fra Lippo Lippi" from *Men and Women* (1855), as that painter describes the composition of a painting, "The Coronation of the Virgin," that he intends to complete: "Well, all these/Secured at their devotion, up shall come/Out of a corner when you least expect,/As one by a dark stair into a great light,/Music and talking, who but Lippo! I—/Mazed, motionless and moonstruck, I'm the man!/Back I shrink" (lines 359–364).

207:15–16 (209:34–210:1). He has revealed . . . Will in overplus—as in Sonnet 135, 1–2: "Whoever hath her wish, thou hast thy 'Will,'/And 'Will' to boot, and 'Will' in overplus"; see also Sonnets 136 and 143.

207:16–17 (210:1–2). Like John O'Gaunt—in *Richard II*, John of Gaunt on the eve of his death repeatedly puns on his name (II, i, 73–83), as "Old Gaunt indeed, and gaunt in being old" (line 74).

207:17–18 (210:2–3). the coat of arms he toadied for—Both Harris (pp. 378–379) and Brandes (pp. 152–153) assert that the Shakespeares were not really entitled to a coat of arms and that John ("prompted" by his son) went through a variety of questionable maneuvers (1596–1599) to secure the coat of arms and the social rank that it implied.

207:18 (210:3). on a bend sable a spear or steeled argent—Shakespeare's coat of arms: "Gold on a bend sable, a spear of the first, and for his crest or cognizance a falcon, his wings displayed argent, standing on a wreath of his colors, supporting a spear gold steeled as aforesaid." A

"bend" is a diagonal bar, one-fifth the width of the shield, from upper left to lower right as one faces the shield. The motto: *"Non sans droict"* ("Not without right").

207:19 (210:4). honorificabilitudinitatibus— Latin: "in the condition of being loaded with honors." The word, as the longest of Latin words, is a scholarly joke. Shakespeare uses it once in a comic scene in *Love's Labour's Lost* (V, i, 44).

207:19–20 (210:4–5). greatest shakescene in the country—from Robert Greene's denunciation of Shakespeare; see 185:24n.

207:22–27 (210:7–12). A star, a daystar . . .· eastward of the bear—the Danish astronomer Tycho Brahe (1546–1601) discovered a supernova above the small star Delta in the **W**-shaped constellation Cassiopeia, 11 November 1572, when Shakespeare was eight and a half years old. The nova, called Tycho's star, brightened rapidly to the point where it outshone all the other stars and planets at night and was visible in daylight until it began to fade in December 1572. Delta is at the bottom of the left-hand loop of the **W**. "Firedrake" is an obsolete word for a meteor. Holinshed (1587), *3*, 1257, remarks that the phenomenon lasted "for the space of almost sixteen months," i.e., until March 1574, when Shakespeare was on the verge of becoming ten years old. The supernova caused considerable imaginative excitement in Elizabethan England since, as a Star of Bethlehem, it was regarded as heralding a new birth, the second coming of Christ.

207:28 (210:13). Shottery—a village in Warwickshire in the parish of Stratford where Anne Hathaway lived before her marriage. According to Lee (p. 18), the village "was reached from Stratford by field-paths."

207:30 (210:15). he was nine years old when it was quenched—see 207:22–27n.

207:32 (210:17). to be wooed and won—the Earl of Suffolk speaks to Reignier, the Duke of Anjou, on behalf of Henry VI: "Thy daughter shall be wedded to my king;/Whom I with pain [difficulty] have woo'd and won thereto" (*I Henry VI*, V, iii, 137–138).

207:32 (210:17). meacock—an effeminate or spiritless man. Shakespeare uses the word once, in *The Taming of the Shrew*, when Petruchio is accounting for his sudden success in winning the shrew, Katharina: ". . . 'Tis a world to see,/How tame, when men and women are alone,/A meacock wretch can make the curstest shrew" (II, i, 313–315).

207:33 (210:19). Autontimerumenos—Greek: "self-tormentor"; as *Heauton Timorumenos,* the title of a play (163 B.C.) by the Latin playwright Terence (*c.*190–*c.*159 B.C.). Terence's play was based on a similarly titled play by the Greek Menander (*c.*342–291 B.C.). Only fragments of Menander's play are in existence.

207:33 (210:19). Bous Stephanoumenos—schoolboy Greek: "Ox-soul or bull-soul of Stephen," what Stephen's school friends call to him as he passes on his way to the beach (and his decision to become an artist) at the end of Chapter IV of *A Portrait of the Artist as a Young Man.* The friends link the phrase with "Bous Stephaneforos": "the ox, or bull, garland-bearer for sacrifice."

207:34 (210:20). configuration—in astrology, the relative position of planets and stars at an individual's birth; the configuration predetermines character and career.

207:34–35 (210:20–21). Stephen, Stephen, cut the bread even—Iona and Peter Opie list a variant of this ("loaf" for "bread") under "scraps of doggerel . . . associated with particular names" in *The Lore and Language of Schoolchildren* (London, 1959), p. 160.

207:35–36 (210:21–22). S.D.: sua donna . . . di non amar S.D—Italian: "S.D.: his woman. Oh sure—his. Gelindo [he who must be cold] resolves not to love S.D." The period after *amar* (210:22) is a typographical error. The second "S.D." can be read as Stephen's initials but also as *sua donna,* "his woman"; i.e., Stephen can be read as he who must be cold and unloving.

208:1 (210:25). a pillar of cloud by day—from Exodus 13:21; see 141:21–22n.

208:4 (210:28). Stephanos—Greek: "crown or garland"; see 55:1n.

208:11 (210:35). Fabulous artificer—Daedalus, the mythological Greek inventor; see 5:37n.

208:12 (210:36). Newhaven-Dieppe—the route by which Stephen crossed the English channel on his way from Dublin to Paris.

208:12–13 (210:36–37). Lapwing. Icarus—as Daedalus' "son," Stephen may well be Icarus, who pridefully flew too high and plunged to his death in the sea, but he may also be "Lapwing." Ovid, in his account of the flight of Daedalus and the fall of Icarus, concludes by describing Daedalus' mourning and his burial of his son: "As he was consigning the body of his ill-fated son to the

tomb, a chattering lapwing[3] looked out from a muddy ditch and clapped her wings uttering a joyful note" (Ovid, *Metamorphoses* VIII:236–238). Ovid identifies the "lapwing" as Daedalus' nephew and apprentice who showed so much inventive promise that he aroused Daedalus' jealousy and Daedalus threw him from the Acropolis "with a lying tale that the boy had fallen." "Athena, who favors the quick-witted, caught the boy up and made him a bird, and clothed him with feathers in midair. His old quickness of wit passed into his wings and legs, but he kept the name which he had before. Still the bird does not lift her body high in flight . . . but she flutters along near the ground and lays her eggs in hedgerows; and remembering that old fall, she is ever fearful of lofty places" (VIII: 252–259). The lapwing is so called in English after the jerky motions of its wings in flight. In the Bible it is listed, together with the bat, as a bird "to be held in abomination among the fowls" ". . . and not to be eaten" (Leviticus 11:19 and Deuteronomy 14:18). In Celtic mythology, the lapwing as "Disguise the Secret" is associated with the stag or roebuck ("Hide the Secret") and the dog ("Guard the Secret"). See 7:39n, 46:19n and 47:7–8n.

208:13 (210:37). Pater, ait—Latin: "Father, he cries." Stephen imagines Icarus' outcry as he falls. Ovid: "His lips, calling to the last upon his father's name, were drowned in the dark blue sea" (*Metamorphoses* VIII:229, 235). In Luke 23:46, Jesus, on the cross, is described: "And Jesus crying with a loud voice, said Father, into thy hands I commend my spirit" (Douay). In the

[3] There is a potential confusion here since Ovid's word is *"perdix,"* the Latin root for French *"perdrix"* and the English *"partridge."* Frank Justus Miller in his translation of the *Metamorphoses* (London and New York, 1916) renders the word *"perdix"* as "lapwing," as does *An Elementary Latin Dictionary*, Charlton T. Lewis (New York, 1890). On the other hand, *A New Latin Dictionary* (New York, 1888), edited by E. A. Andrews and revised by Charles Short and Charlton T. Lewis (!) (New York, 1888) lists *"perdix"* as "partridge." The confusion stems in part from the "imprecision" of bird names in classical Latin; there is no listed name for lapwing before Linnaeus, and the way Ovid describes the habits of the *perdix* (see above quotation) can apply equally well to both the lapwing and the partridge. As late as 1910 the French and Italian for "partridge" were locally applied to a wide variety of birds of similar habits but of different families, including not only partridges but also lapwings and plovers. Another potential confusion: some versions of the Daedalus story give the name *Perdix* to Daedalus' sister and *Talos* or *Talus* as the name of the nephew; Ovid recounts the metamorphosis of the nephew into a *perdix*. Whether Joyce was aware of the confusion or not, we do not know; but "lapwing" (repeated five times in the space of a page) is easily the richer in suggestive connotations.

Latin Vulgate: "*Et clamans uoce magna Iesus ait : Pater, in manus tuas commendo spiritum meum.*"

208:16–17 (210:40–41). that brother motif . . . the old Irish myths—the story of three brothers, two of whom are cruel or vicious, the third, virtuous and successful, does recur in Irish mythology and folklore.

208:18–20 (210:42–211:2). The three brothers . . . wins the best prize—the two "Brothers Grimm," Jakob (1785–1863) and Wilhelm (1786–1859), were noted for their collection of medieval fairy and folk tales. The brother motif does recur in their collections but not in "The Sleeping Beauty," which Mr. Best cites.

208:21 (211:3). Best brothers—Best and Best, 24 Frederick Street, were among the most well known of Irish solicitors.

208:28 (211:10). Father Dineen—Father Patrick S. Dineen (b. 1860), an Irish-speaking writer, translator, editor and philologist. *Irish Literature* (p. 4025) describes him as "the most earnest writer of the Gaelic movement." By 1904 he had collected the works of several "classical" modern Irish poets, written novels and plays in Irish, compiled an Irish-English dictionary and collaborated in a translation of Geoffrey Keating's (*c*.1570–*c*.1644) *History of Ireland*.

208:30 (211:12). rectly—for "erectly, directly"?

208:31 (211:13). John Eglinton touched the foil—the image is from fencing and implies a duel of wits.

208:34 (211:16). two noble kinsmen—*The Two Noble Kinsmen* (*c*. 1613), by Shakespeare's "pupil" and "official successor" in the Globe Theatre, John Fletcher (1579–1625). It is generally assumed that Shakespeare had a minor role as collaborator with Fletcher in the composition of the play.

208:34 (211:17). nuncle—obsolete or dialect, "uncle."

208:39 (211:21). Where is your brother? Apothecaries' hall—Stanislaus Joyce, who appears as Maurice Daedalus in *Stephen Hero* (but is phased out of *A Portrait of the Artist as a Young Man*), had a clerkship at Apothecaries' Hall, 40 Mary Street; he quit 30 January 1904. See Ellmann (p. 149 and *passim*).

208:39–40 (211:21–22). My whetstone. Him, then Cranly, Mulligan—"whetstone" continues the image of the duel of wits from 208:31 (211:13). The sequence represents the sequence of Stephen's intellectual companions: first

Maurice, who is described in *Stephen Hero* (p. 26) as "having aided the elder Stephen bravely in the building of an entire science of aesthetic. ... Stephen found Maurice very useful for raising objections." Subsequently Maurice was displaced from his role as discussant by Cranly (Chapter V, *A Portrait of the Artist as a Young Man*), but Stephen, who begins to suspect Cranly of betrayal at the end of *A Portrait*, has displaced him in favor of Mulligan; and Mulligan in his turn has become suspect. Stephen omits one "whetstone" from his list: Lynch; see *A Portrait*, Chapter V.

209:1–2 (211:25–26). the voice of Esau. My kingdom for a drink—Richard III, unhorsed, his army crushed by the Tudors and their forces, shouts in desperation: "A horse! A horse! My kingdom for a horse!" (V, iv, 7, 13). This, in turn, links with Esau, the older son of Isaac, who sold his birthright to his younger brother, Jacob, for "a mess of pottage" (Genesis 25:27–34). Jacob, encouraged and disguised by his mother, deceives his blind and dying father and receives the blessing that was rightfully Esau's as firstborn son. "And Jacob went near unto Isaac his father; and he felt him, and said, The voice *is* Jacob's voice, but the hands *are* the hands of Esau" (Genesis 27:22).

209:4–5 (211:28–29). the chronicles from which he took the stuff of his plays—the data for most of Shakespeare's historical plays (including some aspects of *Macbeth*, *Lear* and *Cymbeline*) was derived from Raphael Holinshed's (d. *c.*1580) *Chronicles* (1578; revised, chiefly by Hooker, 1587), a history of England, Scotland and Ireland.

209:6–8 (211:30–32). Richard, a whoreson ... whoreson merry widow—in Shakespeare's *Richard III* the hunchbacked Richard, Duke of Gloucester and brother of Edward IV, is portrayed as having caused the deaths of Lady Anne's husband, Edward the Duke of Wales, and her father-in-law, Henry VI. In Act I, scene ii, Gloucester intercepts Anne, who as chief mourner is following the corpse of Henry VI; Gloucester in a scene of ironic and shocking reversals takes "her in her heart's extremest hate" (line 232) and achieves her promise of marriage—as he soliloquizes at the end of the scene: "Was ever woman in this humor woo'd?/Was ever woman in this humor won?" (lines 228–229). Anne was, of course, anything but a "merry widow." Shakespeare portrays her as sincere in her mourning and as embittered by her hatred of Gloucester; thus her "conversion" is reaction rather than a widow's traditional irresponsibility. For "What's in a name?" see 206:28n. A "whoreson" means literally a bastard; figuratively, a villainous person.

209:8–9 (211:32–33). Richard the conqueror ... William the conquered—a play on the anecdote about Shakespeare and Richard Burbage; see 199:13–18n. Richard III was the third of three brothers. He achieves the death of the second brother, Clarence, and when Edward IV, the first brother, dies, he maneuvers his way to the throne. Richard Shakespeare was also "a third brother" (since Stephen has eliminated Gilbert); and William Shakespeare was "conquered" by Anne Hathaway.

209:9–10 (211:34). The other four acts ... from that first—i.e., the initial explosion of Richard III's villainy and perversity in Act I (he woos Anne, whom his treachery has widowed, and accomplishes fratricide) overshadows the sequence of villainies that follows. A partially defensible critical commonplace about the play.

209:10–11 (211:35–36). Of all his kings ... Shakespeare's reverence—another critical commonplace. The argument is that in the history plays, except *Richard III* (unless one also includes *Macbeth*), Shakespeare, while he hardly presents the kings as infallible, does essentially portray them in a sympathetic light.

209:11–12 (211:36). reverence, the angel of the world—in *Cymbeline*, Belarius speaks to Cymbeline's sons, Guiderius and Arviragus, about the burial of Cloten, Cymbeline's stepson and a villainous fool: ". . . He was a queen's son, boys;/And though he came our enemy, remember/He was paid for that: though mean and mighty, rotting/Together, have one dust, yet reverence,/That angel of the world, doth make distinction/Of place 'tween high and low. Our foe was princely;/And though you took his life, as being our foe,/Yet bury him as a prince" (IV, ii, 244–251).

209:12–14 (211:36–39). Why is the underplot ... older than history?—Shakespeare combined the story of King Lear's pre-Christian reign as he found it in Holinshed's *Chronicles* with the story of an honorable duke who is deceived into repudiating his honest son in favor of the villainous son who reduces him to misery and blindness; the latter story Shakespeare lifted from Sidney's *Arcadia* (1590), Book II, Chapter 10: "The pitiful state and story of the Paphlagonian unkind king . . ." Both Brandes (p. 453) and Lee (p. 241) remark on Shakespeare's indebtedness to Sidney, but only Brandes remarks that the Lear story "bears a distinctly Celtic impress" (p. 452). "Spatchocked" according to *A Classical Dictionary of the Vulgar Tongue*, by Captain Francis Grose (1785), involves an abbreviation of "dispatch cook," an Irish dish prepared in an emergency; thus it means to insert, interpolate or sandwich (a phrase, sentence, etc.). Usually spelled "spatchcock."

209:17 (211:42). George Meredith—English novelist; see 197:4–5n.

209:17 (211:42). Que voulez vous? Moore would say—French: "What do you wish [one to do about it]?" For Moore, see 189:23n; one by-product of Moore's Paris period was his habit of larding his conversation with French phrases.

209:17–18 (211:42–212:1). He puts Bohemia on the seacoast—a much-cited boner in *The Winter's Tale*. Shakespeare apparently accepted it from Robert Greene's *Pandosto, the Triumph of Time* (1588), Greene's prose narrative having supplied the plot for the play. Both Brandes (p. 636) and Lee (p. 251) discuss this boner.

209:18 (212:1). and makes Ulysses quote Aristotle—another of Shakespeare's anachronisms, though it is Hector and not Ulysses who "quotes" Aristotle in *Troilus and Cressida* (II, ii, 166). The joke is that Aristotle lived some eight to ten centuries after the Trojan War, which is the ostensible setting of the play.

209:21 (212:5–6). what the poor is not, always with him—after Jesus in Matthew 26:11, "For ye have the poor always with you; but me ye have not always." (Also Mark 14:7 and John 12:8.)

209:21–25 (212:6–10). The note of banishment . . . drowns his book—*The Two Gentlemen of Verona* has proved a difficult play to date, but it is assumed to be among the earlier plays and to have been written and performed before 1598. The plot of the play does hinge in part on the banishment of Valentine, one of the two gentlemen, by the Duke of Milan, the father of Valentine's beloved, Sylvia. *The Tempest* is generally treated as the last of Shakespeare's plays, and it, too, involves the banishment (and restoration) of Prospero, the rightful Duke of Milan, by his brother, Antonio. When Prospero's white magic has transformed the island of his exile into the scene of reconciliation between the brothers, Prospero concludes by relinquishing his magic: ". . . I'll break my staff,/Bury it certain fathoms in the earth,/And deeper than did ever plummet sound/I'll drown my book" (V, i, 54–57).

209:27 (212:11–12). protasis, epitasis, catastasis, catastrophe—critical terms, descriptive of various parts of a play as established by the Alexandrine School (a Greek culture that flourished at Alexandria after the decline of Athens and that retained cultural preeminence even after the rise of Rome). "Protasis," the opening lines of a drama in which the characters are introduced and the argument explained; "epitasis," that part of a drama which develops the main action; "catastasis," the height or acme of the action that is to be followed by the "catastrophe," the final event

in a drama, as death in a tragedy or marriage in a comedy.

209:28–29 (212:12–14). when his married daughter . . . accused of adultery—Lee is the only one of Stephen's sources who refers to this event. Susanna had married a Dr. John Hall: ". . . On July 15, 1613, Mrs. Hall preferred, with her father's assistance, a charge of slander against one Lane in the ecclesiastical court at Worcester; the defendant, who had apparently charged the lady with illicit relations with one Ralph Smith, did not appear, and was excommunicated" (pp. 266–267). "Chip of the old block": one who reproduces his father's (or mother's) peculiarities or characteristics; the phrase dates from at least 1626.

209:29–32 (212:14–17). But it was the original . . . bishops of Maynooth—the clerical center of Ireland is located at St. Patrick's College in the town of Maynooth, 15 miles northeast of Dublin. Stephen quotes from Lesson 6, "On Original Sin"; see 194:19–21n.

209:34 (212:18–19). It is between . . . last written words—i.e., that Anne Hathaway Shakespeare was initially omitted from Shakespeare's will and inserted between the lines; see 200:38–201:3n.

209:34–35 (212:19–20). it is petrified . . . not to be laid—the lines on Shakespeare's tombstone: "Good friend for Jesus sake forbeare,/To digg the dust enclosed heare!/Bleste be ye man yt spares thes stones,/And curst be he yt moves my bones." Harris (p. 362) argues that "Shakespeare wrote the verses in order to prevent his wife being buried with him." (Incidentally, she was not buried with him.) "Four bones": an Irish expression for the four cardinal points of the body, head, hands, and feet; in other words, the physicality of the body.

209:36, 37 (212:20, 21–22). Age has not withered it/infinite variety—from Enobarbus' much-quoted praise of Cleopatra in *Antony and Cleopatra*: "Age cannot wither her, nor custom stale/Her infinite variety" (II, ii, 240–241).

209:38–39 (212:22–24). in Much Ado . . . Measure for Measure—apparently what has not been "withered" is "an original sin . . . committed by another in which he too has sinned." In *Much Ado*, Claudius, one of the heroes, is duped by the villainous half-brother of the Duke of Aragon into believing that his fiancée, Hero, has been false to him on the eve of their wedding; the consequent suspicion and confusion (including the "banishment" of Hero) take the play to the brink of tragedy before it is pivoted back into comedy. In *As You Like It*

Frederick, the Duke's brother, has usurped the Duke's dominions and banished him (before the play begins); in Act I, scene iii, Rosalind, the Duke's daughter, is in turn banished by her uncle; and the young hero, Orlando, excites the jealousy of his brother and is forced to flee into exile in Act II, scene iii. For *The Tempest,* see 209:21–25n. The "original sin" that underlies *Hamlet* is Claudius' murder of his brother and usurpation of his wife and throne; this deed, in turn, infects Hamlet's life and world. The central "original sin" of *Measure for Measure* is the result of the perverse conscientiousness and austerity of Angelo, deputy to the Duke of Vienna; Angelo condemns Claudio to death for incontinence. Claudio's sister, Isabella, intercedes on her brother's behalf only to excite incontinent desire in Angelo himself; Angelo then offers a bargain: the austere Isabella's "honor" for Claudio's life. The potential destructiveness of this dilemma is rather arbitrarily resolved in what is, at best, a "dark" comedy.

210:2 (212:29). He is all in all—echoes Hamlet's appraisal of his father: "He was a man, take him for all in all,/I shall not look upon his like again" (I, ii, 187–188).

210:4–5 (212:31–32). In Cymbeline . . . bawd and cuckold—both plays involve intense jealous suspicion, Othello's fatal suspicion of Desdemona and Posthumus Leonatus' ultimately dispelled suspicion of Imogen in *Cymbeline.* In both cases the suspicion of the woman's behavior is aroused by a "bawd" (one who procures women for illicit purposes), Iago in *Othello* and Iachimo in *Cymbeline.*

210:6 (212:33). like José he kills the real Carmen—in George Bizet's (1838–1875) opera *Carmen* (1857), the hero, Don José, is swept off his feet by Carmen, a gypsy, and when she abandons him for the more romantic toreador Escamillio, he kills her in a fit of jealous rage.

210:7 (212:34). the hornmad Iago—to be "hornmad" is to suffer excessive jealous suspicion of one's wife. Othello would seem to be the horn-mad one in the play, but Iago is also a candidate for the disease since he suspects on the basis of no evidence whatsoever that both Othello and Cassio may have cuckolded him (I, iii, 392–396 and again II, i, 304–316).

210:7–8 (212:34–35). the moor in him—i.e., the Othello in him, though vulnerable to the tragic suspicion that unmans him, "Is of a constant, loving, noble nature" as Iago says (II, i, 298).

210:9–10 (212:36–37). Cuckoo! Cuckoo! . . . O word of fear—Buck should read **Cuck** as it does **(212:36–37)**; "cuck," as a verb, means to sound the cuckoo's note. Mulligan quotes from the refrain of Spring's song (one of the paired songs that ends *Love's Labour's Lost*) (V, ii, 904–921). The refrain: "The cuckoo then, on every tree,/Mocks married men; for thus sings he,/Cuckoo;/Cuckoo, cuckoo:/O word of fear,/Unpleasing to a married ear!" "Cuckoo" equals, of course, "cuckold."

210:11 (212:38). reverbed—the verb "to reverb" (reecho) occurs once in Shakespeare, when Kent reproves King Lear for his rashness in rejecting Cordelia: "Thy youngest daughter does not love thee least;/Nor are those empty-hearted whose low sound/Reverbs no hollowness" (I, i, 154–156).

210:13–14 (212:40–41). Dumas fils (or is it Dumas père) . . . created most—Magee's second thought is right; it was the elder Alexandre Dumas (1802–1870) in an essay, "*Comment je devins auteur dramatique*" ("How I Became a Playwright"): "I realized that Shakespeare's works alone included as many types as the works of all other playwrights taken together. I realized finally that he was the one man who had, after God, created most" (from *Souvenirs dramatique* [1836]).

210:15 (212:42). Man delights not him nor woman neither—Hamlet describes his melancholy distaste for man and the world to Rosencrantz and Guildenstern: "Man delights not me; no, nor woman neither, though by your smiling you seem to say so" (II, ii, 321–322).

210:18 (213:3). his journey of life ended—see 204:33–34n.

210:18–19 (213:3–4). he plants his mulberry tree—both Brandes (p. 681) and Lee (p. 194) cite the tradition (apocryphal?) that Shakespeare planted a mulberry tree in his garden at New Place.

210:19 (213:4). The motion is ended—Juliet in *Romeo and Juliet,* when she mistakenly believes Romeo has been killed in a duel with Tybalt: "O, break, my heart! poor bankrupt, break at once!/To prison, eyes, ne'er look on liberty!/Vile earth, to earth resign; end motion here;/And thou and Romeo press one heavy bier!" (III, ii, 57–60).

210:20 (213:5). Hamlet père and Hamlet fils—French: "father . . . son," after Dumas *père* and Dumas *fils;* see 210:13–14n.

210:21–22 (213:6–7). And, what though murdered and betrayed, bewept by all frail tender hearts for—source unknown.

210:25 (213:10). prosperous Prospero, the good man rewarded—at the end of *The Tempest* Prospero is restored to his dukedom and all is resolved on a positive note. Stephen is playing, however, on the tradition that equates the magician-playwright Shakespeare with the magician Prospero since both practice dramatic deception; thus Prospero's final speech, 209:21–25n, is read as Shakespeare's farewell to his audience and his art.

210:25–26 (213:11). Lizzie, grandpa's lump of love—Elizabeth Hall, Shakespeare's first grandchild, born in 1608. For "lump of love," see 40:14 (39:14).

210:26 (213:11). nuncle Richie—not only Shakespeare's brother, who died in 1613; see also 40:2 (39:2).

210:27 (213:12–13). where the bad niggers go—after the chorus of Stephen Foster's (1826–1864) song "Old Uncle Ned": "Den lay down de shubble and de hoe,/Hang up de fiddle and de bow,/No more hard work for poor old Ned,/He's gone whar de good niggers [variants: darkies, people] go."

210:29–31 (213:14–17). Maeterlinck says: . . . his steps will tend—Maurice Maeterlinck (1862–1949), Belgian symbolist poet and dramatist, in *La Sagesse et la destinée (Wisdom and Destiny)* (Paris, 1899): "Let us never forget that nothing happens to us which is not of the same nature as ourselves. . . . If Judas goes out this evening, he will move toward Judas and will have occasion to betray; but if Socrates opens his door, he will find Socrates asleep on the doorstep and will have the occasion to be wise" (p. 28).

210:35–36 (213:20–22). The playwright who . . . two days later)—see 210:13–14n. In the account of creation, Genesis 1:1–19, God creates light on the first day, the sun and the moon on the fourth day.

210:37–38 (213:23–24). whom the most Roman . . . in all of us—*dio boia*, Italian: literally, "hangman god"; figuratively, cruel god (or god of wrath), a common Roman expression for the force that frustrates human hopes and destinies. For "all in all," see 210:2n.

210:40–42 (213:24–26). economy of heaven . . . a wife unto himself—combines allusions to *Hamlet* and to Matthew. In the "nunnery scene" Hamlet overscolds Ophelia: "Go to, I'll no more on't; it hath made me mad. I say, we will have no more marriages: those that are married already, all but one, shall live; the rest shall keep as they are. To a nunnery, go" (III, i, 153–157). In Matthew the Sadducees, "which say there is no

resurrection" (22:23), attempt to trap Jesus by asking if a woman have seven husbands which will be her husband "in the resurrection?" Jesus answers, ". . . in the resurrection they neither marry, nor are given in marriage, but are as the angels of God in heaven" (22:30).

211:1 (213:28). Eureka!—Greek: "I have it!," what Archimedes is supposed to have said when, seated in his tub, he discovered the secret of how to determine specific gravity.

211:4 (213:31). The Lord has spoken to Malachi—recalls Malachi 1:1, "The burden of the word of the Lord to Israel by Malachi"; see 6:3n.

211:11–12 (213:38–39). they fingerponder . . . Taming of the Shrew—i.e., they indulge minute examination of what might be considered an antifeminine play. The remark also recalls Swinburne's attack on Frederick J. Furnivall (1825–1910) and his New Shakespeare Society (1874): "metre-mongers, scholiasts, finger-counters, pedagogues, and figure-casters" ("The Three Stages of Shakespeare," *Fortnightly Review* [1875] 24:615).

211:14 (213:41–42). a French triangle—the relationship among the three people involved in an adultery, e.g., man-wife-lover, etc.

211:18–19 (214:3–4). the Platonic dialogues Wilde wrote—two of the four essays in Oscar Wilde's *Intentions* (London, 1891)—"The Decay of Lying" and "The Critic as Artist"—are cast in the form of dialogue. "The Portrait of Mr. W. H." (1889, 1921), Wilde's enigmatic study of the Shakespeare of the sonnets, is cast in the form of a prose narrative that is the account of an implied dialogue. Wilde exploits the dialogue's potential for witty, enigmatic reversals; only in the most superficial sense is his use of the dialogue "like Plato's."

211:20 (214:5). Eclecticon—the pun implies that John Eglinton's views are an eclectic compilation of current points of view.

211:22–23 (214:8–9). Dowden believes . . . mystery in Hamlet—Edward Dowden, *Shakespeare: A Critical Study of His Mind and Art* (London, 1857): "The mystery, the baffling vital obscurity of the play, and in particular of the character of its chief person, make it evident that Shakespeare had left far behind him that early stage of development when an artist obtrudes his intentions, or, distrusting his own ability to keep sight of one uniform design, deliberately and with effort holds that design persistently before him. . . . Hamlet might have been so easily manufactured into an enigma, or a puzzle; and then the

puzzle, if sufficient pains were bestowed, could be completely taken to pieces and explained. But Shakespeare created it a mystery, and therefore it is forever suggestive; forever suggestive, and never wholly explicable" (p. 126).

211:24–26 (214:9–11). Herr Bleibtreu . . . the Stratford monument—Karl Bleibtreu (1859–1928), German poet, critic and dramatist, argued in *Die Lösung der Shakespeare-Frage (The Solution of the Shakespeare Question)* (Berlin, 1907) that Shakespeare's plays were written by Roger Manners (1576–1612), the 5th Earl of Rutland. Bleibtreu was hardly first in the field, but he was considerably more assertive than D. H. Madden; see 197:41–198:2n. From the outset the Baconians had argued that Shakespeare's epitaph "proved" that the secret of the authorship of his plays was buried with him in "the Stratford monument"; see 209:34–35n. For a coincidence re Bleibtreu, see 60:21–22n. See also Ellmann (pp. 424–425) and Adams (p. 8).

211:26 (214:12). the present duke—John James Robert Manners (1818–1906), the 7th Duke of Rutland (1888–1906) (created 1703), English Member of Parliament and statesman, who published, among other things, *English Ballads,* "a volume of graceful verse."

211:29 (214:15). I believe, O Lord, help my unbelief—Mark 9:24: "Lord, I believe; help thou mine unbelief," said to Jesus by the father of a child "which had a dumb spirit."

211:30 (214:16–17). Egomen—involves a pun on the magazine, *The Egoist,* which began installment publication of *A Portrait of the Artist as a Young Man* on 2 February 1914, thus helping Joyce "to believe" (in himself). This would make the "Other chap," 211:31 (214:17), among others, George Roberts, the Dublin publisher and bookseller, who had been so timid about publishing *Dubliners. The Egoist* was founded by Dora Marsden as the *Freewoman* in 1911; the *New Freewoman* in 1913; then, urged by Ezra Pound and other *men* to "mark the character of your paper as an organ of individualists of both sexes, and of the individualist principle in every department of life," she changed the title to *The Egoist,* i.e., Ego-men.

211:32 (214:18) Dana—see 190:36n.

211:35 (214:21). Fraidrine. Two pieces of silver—"Fraidrine" mimics Fred Ryan's pronunciation of his own name. Stephen recalls that he had borrowed "two shillings" from Ryan, 31:40–41 (31:2–3).

211:42 (214:28). upper Mecklenburgh street—(Tyrone Street Upper in 1904; now Railway

Street), the heart of Dublin's red-light district in 1904.

212:1 (214:29). the Summa contra Gentiles—short title for St. Thomas Aquinas' *Summa de Veritate Catholicae Fidei contra Gentiles* ("Comprehensive Treatise on the Truth of the Catholic Faith against Unbelievers").

212:2 (214:30–31). Fresh Nelly and Rosalie, the coalquay whore—two of Oliver St. John Gogarty's contributions to Irish folklore; their identities were established in unpublished materials, though "Fresh Nellie,/For she had as wild a belly . . . " makes a brief appearance on p. 105 of Gogarty's *Collected Poems.*

212:4 (214:33). wandering Ængus of the birds—Aengus, son of Dagda, the supreme god of the Tuatha de Danaan, was the god of youth, beauty and love. He is portrayed with the birds of inspiration hovering about his head. He was continually in search of his ideal mate, who had appeared to him in a dream. In some versions of the legend he discovers her as a swan, transforms himself into a swan and flies away with her. Mulligan's phrase recalls Yeats's poem "The Song of the Wandering Aengus" from *The Wind Among the Reeds* (1899) (*Collected Poems,* p. 57).

212:5 (214:34). Come, Kinch, you have eaten all we left—see 18:38 (17:13).

212:6. oats should read **orts** as it does **(214:35).**

212:9–10 (214:38–39). Notre ami Moore—the phrase recalls one of Edward Martyn's counterattacks on George Moore in which he remarks: "*Mon ami Moore* yearns to be *le génie de l'amitié,* but unfortunately he can never be looked upon as a friend. For he suffers from . . . a perennial condition of mental diarrhoea" (quoted in Gwynn, p. 33).

212:12 (214:41). French letters—obviously French literature, but also slang for condoms.

212:16 (215:4). Swill till eleven—11:00 P.M. was closing time for Dublin pubs. The line recalls the weather forecaster's rhyme: "Rain after seven; rain till eleven."

212:16 (215:4). Irish nights' entertainment—after Patrick J. McCall (1861–1919), *The Fenian Nights' Entertainments* (1897), a collection of Ossianic legends written in peasant dialect (in turn, vaguely modeled on the *Arabian Nights' Entertainments).*

212:17 (215:5). lubber—a clown, as well as a clumsy person.

212:20 (215:8). I gall his kibe—Hamlet to Horatio about the gravedigger's verbal niceties: ". . . the age is grown so picked [refined] that the toe of the peasant comes so near the heel of the courtier, he galls his kibe [he rubs a blister on the courtier's heel]" (V, i, 151–154).

212:21 (215:9). all amort—Elizabethan expression: "completely dejected." *The Taming of the Shrew* (IV, iii, 36) and *I Henry IV* (III, ii, 124).

212:26–27 (215:14–15). Cashel Boyle . . . Tisdall Farrell—see 157:13–14n.

212:27 (215:15). parafes—paraphs, either makes a paragraph out of his name or puts a flourish at the end of his signature to safeguard it against forgery.

212:29 (215:17). priesteen—Irishism: "little priest."

212:37 (215:24). smoothsliding Minicus—Virgil mentions the Minicus River, near which he was born, as flowing among reeds on the plain of Lombardy (*Ecologues* VII:12). Milton, "Lycidas" (lines 85–90): "O Fountain Arethuse, and thou honor'd flood,/Smooth-sliding *Minicus*; crown'd with vocal reeds,/That strain I heard was of a higher mood:/But now my Oat proceeds,/And listens to the Herald of the Sea/That came in *Neptune's* plea" (i.e., Triton, Milton's "Herald of the Sea," had come to argue that the drowning of Lycidas was not Neptune's responsibility).

212:38 (215:25). Puck—or Robin Goodfellow, the mischievous but not malicious servant of Oberon, the king of the fairies, in Shakespeare's *A Midsummer-Night's Dream.*

212:40–41 (215:27–28). John Eglinton . . . wed a wife?—after Robert Burns, "John Anderson My Jo" (1789, 1790). "Jo" means sweetheart. The poem is addressed by a lover (wife) to Anderson, who is wrinkled and bald, and proposes that after many a happy day of climbing "the hill together . . . /We totter down, John,/And hand in hand we'll go,/And sleep thegither at the foot,/John Anderson my jo!"

213:2 (215:30). Chin Chon Eg Lin Ton—after a song, "Chin Chin Chinaman," from the light opera *The Geisha,* see 95:29–31n. Chorus: "Chin Chin Chinaman/Muchee Muchee sad!/Me afraid allo trade/Wellee wellee bad!/Nose joke brokee broke/Makee shuttee shop!/Chin chin Chinaman/Chop, Chop, Chop" (sung by the proprietor of a tea shop).

213:3 (215:31). plumber's hall—local name for the Mechanic's Institute, 27 Abbey Street Lower. It was renovated during the summer of 1904 and opened in the fall as the Abbey Theatre, the new (and permanent) home of the Irish National Theatre Society.

213:4–5 (215:32–33). Our players are creating . . . or M. Maeterlinck—echoes remarks that Lady Gregory, Yeats and others were making about the Irish National Theatre Society.

213:6–7 (215:33–34). the public sweat of monks—the Irish National Theatre Society fought running battles with Catholic (and political) objections and attempts to suppress its plays.

213:8–9 (215:36–37). the whipping lousy Lucy gave him—Lee (pp. 27–28), Brandes (pp. 10–11) and Harris (pp. 354–355) all affirm the tradition that Shakespeare was prosecuted, whipped and perhaps imprisoned by Sir Thomas Lucy for deer stealing. Presumably Shakespeare fled to London to escape Lucy's continued attacks. Tradition also ascribes to Shakespeare a ballad at Lucy's expense. One recurrent line in the ballad: "Sing lowsie Lucy whatever befalle it."

213:9 (215:37). femme de trente ans—French: "woman thirty years old"; figuratively, a woman of experience.

213:9–10 (215:37–38). And why no other children born?—Another speculative tradition is that Shakespeare visited Stratford at least once a year during the "London years" (1592?–1613).

213:13 (215:41). minion of pleasure—after Shakespeare, Sonnet 126 (sometimes regarded as the *envoi* of the "fair youth" sonnets): "Yet fear her [time-Nature], O thou minion of her pleasure!" (line 9).

213:13 (215:41). Phedo's toyable fair hair—in Plato's *Phaedo* Socrates fondles Phaedo's curls and teases him: "Tomorrow, I suppose, Phaedo, you will cut off this beautiful hair." Socrates' tease involves the implication that Phaedo's youthful arguments will go the way of the youth's hair.

213:15 (216:2). Longworth and M'Curdy Atkinson—for Longworth, see 190:14n. F. M'Curdy Atkinson was one of the lesser of Dublin's literary lights; he, together with Longworth, shared a place in George Moore's "inner circle" and was on the periphery of the Irish National Theatre Society.

213:16 (216:3). Puck Mulligan footed featly—Ariel is the "Puck" of *The Tempest;* he sings as he leads Ferdinand toward Prospero's cell: "Come unto these yellow sands,/And then take hands:/Curtsied when you have and kiss'd/The wild waves whist,/Foot it featly here and there;/

And, sweet sprites, the burthen bear" (I, ii, 376–381). Ferdinand wonders: "Where should this music be? i' the air or the earth?" (I, ii, 386).

213:17–26 (216:4–13). I hardly hear . . . they were worth—a parody of the first stanza of Yeats's "Baile and Aillinn" (1903): "I hardly hear the curlew cry/Nor the grey rush when the wind is high,/Before my thoughts begin to run/On the heir of Uladh, Buan's son,/Baile, who had the honey mouth;/And that mild woman of the south,/Aillinn, who was King Lugaidh's heir,/Their love was never drowned in care/Of this or that thing, nor grew cold/Because their bodies had grown old./Being forbid to marry on earth,/They blossomed to immortal mirth" (*Collected Poems*, p. 393). "Purlieu": a disreputable street or quarter; "Tommy": a British common soldier; "fillibeg" is a little kilt.

213:33–36 (216:20–23). Longworth is awfully sick . . . her drivel to Jaysus—Joyce's review of Lady Gregory's *Poets and Dreamers*, "The Soul of Ireland," appeared in Longworth's *Daily Express*, 26 March 1903; Joyce took Lady Gregory to task for her explorations "in a land almost fabulous in its sorrow and senility," with the obvious twist that the senile dreams of the past were hardly sufficient to a vital national literature. Longworth "signed" the review "J.J." to qualify his responsibility for printing it; and Lady Gregory was offended, understandably since it was she who had recommended Joyce to Longworth. "Hake" is dialect for gossiping woman. See *The Critical Writing of James Joyce* (New York, 1959), pp. 102–105.

213:36, 39–40 (216:23–24, 27–28). the Yeats touch?/—the most beautiful book . . . thinks of Homer—Yeats, who also enjoyed Lady Gregory's patronage and friendship, gracefully praised her work. He wrote the "Preface" to her *Cuchulain of Muirthemme: The Story of the Men of the Red Branch of Ulster* (London, 1902), with the assertion: "I think this book is the best that has come out of Ireland in my time" (p. vii). He compares the book favorably with other epic compilations, such as the *Mabinogian*, but Homer is Mulligan's contribution to the "Preface."

214:2 (216:32). the pillared Moorish hall—the central hall of the National Library does have a Moorish-Alhambra flavor, but in technical terms its contribution to the building's eclecticism is in the Renaissance style advocated by the École des Beaux Arts in Paris; in this case the Renaissance style has been modified by some Lombardo-Venetian elements reminiscent of the manner of the eldest Deane; see 180:34n and 180:42n.

214:2–3 (216:32–33). Gone the nine men's morrice with caps of indices—"nine men's morrice" or "merrils" is a game played with pegs or stones on a board or turf marked out in concentric squares; the game remotely resembles checkers and is called "morrice" after the Morris dance. Stephen's remark echoes Titania's complaint to Oberon in *A Midsummer-Night's Dream*: "The nine men's morris is filled up with mud" (II, i, 98). "Caps of indices" implies that Stephen is poeticizing some change in the layout of the library, but we have been unable to determine what.

214:4 (216:34). Buck Mulligan read his tablet—since "The Lord has spoken to Malachi," 211:4 (213:30), the implication is that Mulligan is playing the role of Moses returned from Mount Sinai, bearing "the tables of the Law" (Deuteronomy 10:5; Exodus 34:29).

214:11 (217:1). patch's—"patch" is Elizabethan for a fool, clown or jester.

214:13 (217:3). marcato—Italian (music): "in a marked emphatic manner."

214:15–23 (217:5–13). TOBY TOSTOFF . . . ROSALIE—Toby and Crab are traditional in English university bawdry; for the two medicals, see 206:36–37n; for Nelly and Rosalie, see 212:2n; for Mother Grogan, see 14:21n.

214:26 (217:17). the Camden hall—one of the temporary Dublin homes of the Irish National Theatre Society before it moved into the Abbey Theatre. For the autobiographical background of this story, see Ellmann, p. 167.

214:33–34 (217:24–25). If Socrates leave . . . go forth tonight—see 210:29–31n.

214:36 (217:27). Seas between—suggests that Stephen and Mulligan pose as Scylla and Charybdis as Bloom (Odysseus) passes between them.

214:40 (217:31). Here I watched . . . of the birds—Stephen watched the birds from the library steps in Chapter V, *A Portrait of the Artist as a Young Man;* see 49:10n. For Aengus, see 212:4n.

215:1–2 (217:32–33). Last night I flew . . . held to me—Stephen recalls another phase of his dream of the previous night; in this phase he has played the part of Daedalus or Icarus in flight as Ovid describes them before Icarus' folly carries him to his death: "Now some fisherman . . . or a shepherd . . . or a plowman . . . spies them and stands stupefied, and believes them to be gods that they could fly through the air" (*Metamorphoses* VIII:215–220). For the "creamfruit melon" phase of the dream, see 47:41–48:1n.

215:4 (217:35). The wandering jew—a legendary Jew doomed to wander the earth until the Day of Judgment. There are various Christian and pre-Christian versions of the legend. One traditional Christian account: when Jesus was carrying his cross toward Calvary, he paused to rest and was struck and mocked by a Jew who said: "Go, why dost thou tarry?" Jesus answered: "I go, but thou shalt tarry till I return." Thus the Jew became undying, suffering at the end of each century a sickness that rejuvenated him to the age of thirty. His fate also transformed his entire character; his cruelty became repentance, and he became gifted with supernatural wisdom. See 35:2n.

215:5–6 (217:36–37). He looked upon you to lust after you—after Jesus' definition of adultery in the Sermon on the Mount (Matthew 5:27–28): "Ye have heard that it was said by them of old time, Thou shalt not commit adultery: But I say unto you, That whosoever looketh on a woman to lust after her hath committed adultery with her already in his heart."

215:6 (217:37). I fear thee, ancient mariner—in Coleridge's *Rime of the Ancient Mariner* (1798), Part IV, gloss: "The Wedding-Guest feareth that a spirit is talking to him; But the ancient Mariner assureth him of his bodily life, and proceedeth to relate his horrible penance." Lines 224, 228: "I fear thee, ancient Mariner! . . . I fear thee and thy glittering eye."

215:8 (217:39). Manner of Oxenford—(Oxford) suggests that homosexual preoccupation was, as Joyce put it, "the logical and inescapable product of the Anglo-Saxon college and university system, with its secrecy and restrictions" (*Critical Writings,* p. 204).

215:9 (217:40). Wheelbarrow sun—recalls the English critic and reformer John Ruskin (1819–1900) by free association with Oxford; as Joyce remarked, "At Oxford University . . . a pompous professor named Ruskin was leading a crowd of Anglo-Saxon adolescents to the promised land of the future society—behind a wheelbarrow" (because Ruskin had his pupils make roads in order to improve the country) (*Critical Writings,* p. 202).

215:10 (218:1). Step of a pard—in medieval bestiaries the pard is described as the most beautiful of all the four-footed animals. The name is regarded as deriving from the Greek πάν ("all"), like Joseph's tunic "of every tinge in colors." The pard is "accustomed to feed itself on various foods and to eat the sweetest herbs"; after it eats, it sleeps for three days and wakes with a roar (therefore it is allegorically Christ). It is of a mild and good disposition, loved by all the animals except the dragon (foul breath as against the sweet breath of the pard). On p. 570:31–33 (586:7–8) Bloom is described as moving *"with fleet step of a pard strewing the drag behind him, torn envelopes drenched in aniseed* [a sweet herb]."

215:17–18 (218:8). Peace of the druid priests of Cymbeline—in the final scene of *Cymbeline* the soothsayer (Philarmonus) reads a prophecy: "When as a lion's whelp shall, to himself unknown, without seeking find, and be embraced by a piece of tender air; and when from a stately cedar shall be lopped branches, which, being dead many years, shall after revive, be jointed to the old stock, and freshly grow, then shall Posthumus [Leonatus] end his miseries, Britain be fortunate and flourish in peace and plenty" (V, v, 435–442). The Soothsayer then declares Leonatus "the lion's whelp" (443), Imogen "the piece of tender air" (446) and Cymbeline the cedar (453); thus the prophecy of peace is declared fulfilled.

215:19–21 (218:10–12). Laud we the gods . . . From our bless'd altars—at the end of *Cymbeline;* see 140:24–25n.

EPISODE 10 [THE WANDERING ROCKS]

EPISODE TEN

THE WANDERING ROCKS

○ Location

◁ Course & Direction

Section 1 Father Conmee
Section 2 Corny Kelleher
Section 3 Sailor
Section 4 Dedalus Children
Section 5 Boylan
Section 6 Stephen & Artifoni*
Section 7 Miss Dunne*
Section 8 Lambert & O'Molloy*
Section 9 Lenehan & M'Coy*
Section 10 Bloom*

1 **Dedalus & Dilly***
2 **Kernan**
3 **Stephen & Dilly***
4 **Cowley, Dedalus, & Dollard***
5 **Cunningham, et al.***
6 **Mulligan & Haines***
7 **(a) Artifoni**
 (b) Farrell
8 **Master Dignam***
9 **Viceregal Cavalcade (&*)**
0 **HELY'S Men (&*)**

*See Inset

THE WANDERING ROCKS

Episode 10: [The Wandering Rocks], pp. 216–251 (219–255). In Book XII of *The Odyssey* Odysseus chooses to run the passage between Scylla and Charybdis rather than to attempt the Wandering Rocks. Circe describes them as "Drifters" with "boiling surf, under high fiery winds," and remarks that only the *Argo* had ever made the passage, thanks to Hera's "love of Jason, her captain." Thus the "episode" does not occur in *The Odyssey*. The Wandering Rocks are sometimes identified with the Symplegades, two rocks at the entrance to the Black Sea which dashed together at intervals but were fixed when the *Argo* passed between them on its voyage to Colchis.

Time: 3:00 P.M. Scene: the streets of Dublin. Organ: blood; Art: mechanics; Symbol: citizens; Technique: labyrinth; Correspondences: *Bosphorus*—Liffey; *European Bank*—Viceroy; *Asiatic Bank*—Conmee; *Symplegades*—Groups of Citizens.

This episode is composed of 19 sections; the sections are interrupted by interpolated actions that are temporally simultaneous but spatially remote from the central action in which the interpolation occurs.

Section 1: pp. 216–221 (219–224).
Intrusion: 217:22–26 (220:24–29). Mr Dennis J. Maginni . . . corner of Dignam's court—see Section 10, Intrusion.

216:1 (219:1). The Superior, The Very Reverend John Conmee, S.J.—see 78:42–79:1n.

216:3 (219:3–4). Artane—on the northeastern outskirts of Dublin, approximately two and a half miles northeast of Father Conmee's church.

216:4–5 (219:4–5). Vere dignum et justum est —Latin: "It is indeed fitting and right," the opening phrase of the Preface with which the Eucharist (the Canon or central section of the Mass) begins. The Common Preface continues: ". . . our duty and our salvation, always and everywhere to give thanks to you, Lord, Holy Father, Almighty and Eternal God."

216:5 (219:5). Brother Swan—Reverend Brother William A. Swan, director of the O'Brien Institute for Destitute Children (100 boys) in Donnycarney, between Dublin and Artane. The institute was maintained by the Christian Brothers, a teaching brotherhood of Catholic laymen, bound under temporary vows. The Christian Brothers were supported by public contributions; they were more interested in practical than in academic education.

216:6–7 (219:6–7). Good practical Catholic: useful at mission time—for Martin Cunningham's practical Catholicism, see "Grace," *Dubliners*. "Mission time," those annual periods when the Catholics of a parish rededicate themselves to their Church and campaign to raise money for its support.

216:10 (219:10). the convent of the sisters of charity—in Upper Gardiner Street; the Jesuit fathers of Father Conmee's church were its chaplains.

216:14 (219:14). Mountjoy square—a relatively fashionable area in the northwest quadrant of Dublin.

216:17–19 (219:17–19). cardinal Wolsey's words . . . in my old days—Thomas, Cardinal Wolsey (*c.*1475–1530), English churchman and statesman, was one of Henry VIII's most powerful and guileful councilors. His resistance to Henry's first divorce was eventually magnified into the occasion for his downfall. He died when he was being conveyed to London to stand trial for high treason. His "last words" to the captain of the guard, Sir William Kingston: "Had I served God as diligently as I have the king, he would not have given me over in my gray hairs." See Shakespeare, *Henry VIII*, III, ii, 455–457.

216:20 (219:20–21). Mr David Sheehy M.P.—(1844–1932), Member of Parliament (Nationalist) for South Galway (1885–1890), for South Meath (1903–1918).

216:23 (219:24). Buxton—a town in Derbyshire, England, its waters were famous and were taken for "indigestion, gout, rheumatism, and nervous and cutaneous diseases."

216:24 (219:25). Belvedere—Belvedere College, Jesuit day school for boys, on Great Denmark Street in north-central Dublin. Belvedere House was itself a handsome eighteenth-century town-country house. The Jesuits acquired it in 1841 and expanded its facilities through the nineteenth century, until by 1890 it was a somewhat cramped quadrangle. Though the education was thorough and strictly Jesuit in character, the school was not so fashionable as Clongowes Wood College.

216:26 (219:27). The house was still sitting—yes; see 117:16n.

216:28 (219:29). Father Bernard Vaughan—(1847–1922), an English Jesuit, famous for his sermons. In a letter, 10 October 1906, Joyce remarked, "Fr. B. V. is the most diverting public figure in England at present. I never see his name but I expect some enormity" (*Letters*, II, 182). Joyce said that Vaughan was the model for Father Purdon in "Grace," *Dubliners*.

216:36–37 (219:38). arecanut paste—*Areca* is a genus of palm tree; the *Areca catechu* yields a nut that Eastern peoples rolled in betel leaves to chew. The nut was advertised (and popularly believed) to aid in maintaining strong, bright teeth.

216:40 (219:41). Pilate!... that owlin mob? —Conmee recalls Father Vaughan's cockney accent. Pilate was the Roman military governor of Judea when Jesus was crucified; Mark 15, Luke 23, John 18–19 all include versions of the story in which Pilate orders the crucifixion in response to a frenzy of public demand.

217:1–2 (220:2–3). Of good family ... Welsh, were they not?—the Vaughans were a famous "good family" in Wales, but London-born Father Vaughan's connection seems to have been name rather than heritage.

217:3 (220:4). lest he forget—after Rudyard Kipling (1865–1936), "The Recessional" (1898), first verse: "God of our fathers, known of old,/Lord of our far flung battle line,/Beneath whose awful Hand we hold Dominion over palm and pine,/Lord God of Hosts, be with us yet,/Lest we forget, lest we forget."

217:3 (220:4). father provincial—the Rome Provincial of the Jesuit Order in Ireland, the official in the Jesuit hierarchy to whom Father Conmee would report. The administrative and executive government of the society is entrusted under the general to provincials who in turn receive reports from superiors, and so forth.

217:5–6 (220:6–7). The little house—i.e., the lower grades at Belvedere, for boys seven to ten years of age.

217:7 (220:8). Jack Sohan—John Sohan, pawn-broker & c., 38 Townsend Street, Dublin.

217:8 (220:9). Ger. Gallaher—Gerald Gallaher, a brother of Ignatius Gallaher (and apparently similar in temperament); see 87:23n.

217:9 (220:10). Brunny Lynam—the name is associated with the bookmaker Lenehan visits, 229:39 (233:12).

217:11–12 (220:13). Fitzgibbon Street—runs northeast from the northeast corner of Mountjoy Square.

217:22 (220:24). Mr Dennis J. Maginni—*Thom's* (1904) lists a Dennis J. Maginni as "professor of dancing & c.," 32 George's Street, Great, North. His flamboyant costume and manner rendered him a movable Dublin landmark; see 151:31n.

217:25 (220:27). with grave deportment—recalls Mr. Turveydrop, "a very gentlemanly man, celebrated for deportment" in Dickens' *Bleak House* (1852–1853); his son, Prince Turveydrop, is a dancing master.

217:26 (220:28). lady Maxwell—*Thom's* (1904) lists a Lady Maxwell as residing at 36 George's Street North.

217:26 (220:28–29). Dignam's Court—off Great Britain Street (now Parnell Street), one-half mile southwest of where Father Conmee is.

217:27 (220:30). Mrs M'Guinness—Mrs. Ellen M'Guinness, pawnbroker, 38 and 39 Gardiner Street Upper, Dublin.

217:32 (220:34). Mary, queen of Scots—Mary Stuart (1542–1587), the daughter of James V of Scotland. As against the dour Protestant Elizabeth, who had her beheaded, Catholic Mary has been romantically portrayed as a woman of extraordinary grace and charm (as well, apparently, as ambition).

217:35 (220:37). Great Charles street—runs northeast from the southeast corner of Mountjoy Square.

217:36–37 (220:38–39). the shutup free church ... will (D.V.) speak—Free Church, *an extra-parochial Church of Ireland Chapel in* Great Charles Street. The Reverend T. R. Greene, B.A., incumbent (a term for the minister in charge). The church is "shutup" because it is not open for prayer, etc. as a Catholic church would be. "D.V.," an abbreviation for Latin *"Deo volente,"* "God willing."

217:38 (220:41). Invincible ignorance—Roman Catholic evaluation of Protestant faith since the Protestant's moral commitment to his "heretical" faith morally commits him to "ignorance," which is "said to be invincible when the person is unable to rid himself of it notwithstanding the employment of moral diligence" (*The Catholic Encyclopedia,* VII, 648).

217:42 (221:2). North Circular road—describes the half-circle of what was the northern boundary of metropolitan Dublin in 1904.

218:3–4 (221:5–6). Richmond street—a dead-end street off Richmond Place, a continuation of North Circular Road; see "Araby," *Dubliners*.

218:5 (221:7). Christian brother boys—there was a Christian Brothers School in Richmond Street; see 216:5n.

218:7–8 (221:9–10). Saint Joseph's church ... virtuous females—as he walks east and slightly south along Portland Row, Father Conmee passes St. Joseph's Roman Catholic Church and then St. Joseph's Asylum for Aged and Virtuous Females.

218:11–12 (221:13–14). Aldborough house ... that spendthrift nobleman—Lord Aldborough (d. 1801) built the house in what was then "the country" for his wife at a cost of £40,000 (1792–1798). This monumental extravagance was compounded by his wife's refusal to live in the house because she did not like its location.

218:12 (221:14). And now it was an office or something—in 1904 Aldborough House was surrounded by small cottages and occupied by the Stores Branch of the General Post Office and by the Surveyor's Department of the General Post Office.

218:13 (221:15). North Strand road—Father Conmee has turned northeast out of Portland Row.

218:14 (221:16). Mr William Gallagher—4 North Strand Road, purveyor, grocer, coal and corn merchant.

218:17 (221:19). Grogan's the tobacconist—R. Grogan, tobacconist, 16 North Strand Road.

218:18–19 (221:20–21). a dreadful catastrophe in New York—see 180:1–3n.

218:20–21 (221:22–23). Unfortunate people to die ... perfect contrition—"unprepared," i.e., without benefit of Extreme Unction, but in exceptional cases "an act of perfect contrition" on the part of the individual (without the prayers of the Church) can "take away the effects of sin" and prepare the individual for his death. Father Conmee's *liberal* view is somewhat undercut by the fact that the "unfortunate people" were all "invincibly ignorant" Lutherans.

218:22 (221:24). Daniel Bergin's publichouse—Daniel L. Bergin, grocer, tea, wine and spirit merchant, 17 North Strand Road.

218:25 (221:27). H. J. O'Neill's funeral establishment—across the street from Bergin's, Harry J. O'Neill, undertaker and job carriage proprietor, 164 North Strand Road. Simon Kerrigan, manager. O'Neill's had the burying of Paddy Dignam.

218:28–29 (221:30–31). Youkstetter's—William Youkstetter, pork-butcher, 21 North Strand Road.

218:31 (221:34). Charleville mall—on the south bank of the Royal Canal (which Father Conmee is approaching). The canal circles the northern outskirts of metropolitan Dublin and terminates near the mouth of the Liffey.

218:39 (221:42). Newcomen bridge—continues North Strand Road over the Royal Canal.

218:42–219:1 (222:3–4). the reverend Nicholas Dudley ... north William street—*Thom's* (1904) lists the Reverend P. A. Butterly and the Reverend J. D. Dudley as curates of St. Agatha's Roman Catholic Church in William Street, north of North Strand Road. "C.C." is an abbreviation for "Curate in Charge."

219:5 (222:8). Mud Island—mud flats on the northeastern outskirts of Dublin (on the bay), now partially reclaimed as Fairview Park.

219:9 (222:12). the ivy church—North Strand Episcopal Church on North Strand Road (the tram carries Father Conmee northeast toward his destination).

219:26 (222:31). Annesley bridge—continues North Strand Road over the Tolka River.

219:33–34 (222:38–39). bless you, my child ... pray for me—phrases the priest uses to reassure the penitent and to terminate the Confession.

219:36 (222:41). Mr Eugene Stratton—see 90:41n.

219:39 (223:2). saint Peter Claver, S.J.—see 79:1n.

220:2–3 (223:6–7). that book by the Belgian jesuit Le Nombre des Élus—Father A. Castelein, S.J., *Le rigorisme, le nombre des élus et la doctrine du salut* (Brussels, 1899) ("Rigorism, the Number of the Chosen and the Doctrine of Salvation"). The book argued that the great majority of souls would be saved; it was immediately attacked as too "liberal" by the "dogmatists" or "rigorists"; the latter claimed that all who were not baptized as Catholics were subject to eternal damnation. The controversy was not confined to the Catholic Church since liberal Protestants in the late nineteenth century were also reacting against an inflexible doctrine of eternal damnation.

220:5 (223:9). (D.V.)—see 217:36–37n.

220:8 (223:13). Howth road—runs northeast from the northern side of Mud Island to Howth. Father Conmee turns north at this point.

220:10 (223:15). Malahide road—runs north-northeast toward the O'Brien Institute and Artane beyond.

220:11 (223:16). The joybells were ringing in gay Malahide—the opening line of a poem, "The Bridal of Malahide," by the Irish poet Gerald Griffin (1803–1840). The poem recounts the tangled story of Maud Plunkett's marriage as the "joybells" turn to "dead-bells . . . In sad Malahide." See 220:12–14n. The last stanza: "The stranger who wanders/Along the lone vale/Still sighs while he ponders/On that heavy tale:/'Thus passes each pleasure/That earth can supply—/Thus joy has its measure—/We live but to die!'"

220:12–14 (223:17–19). Lord Talbot de Malahide . . . widow one day—Henry II, king of England (1154–1189), granted Malahide (on the coast nine miles north of Dublin) to Richard Talbot, the 1st Lord Talbot of Malahide. The Talbots were created hereditary Lord Admirals of Malahide and the seas adjoining by decree 15 Edward IV, i.e., in 1476. A Talbot was not, however, the principal of the story Father Conmee recalls. The story is that Mr. Hussey, the son of Lord Galtrim, was betrothed to Maud, the daughter of Lord Plunkett. The bridegroom was called from the altar to lead his troops against a marauding party and was killed; thus his bride was "maid, wife and widow in one day." She was afterwards married twice; her third husband was Sir Richard Talbot of Malahide (d. 1329).

220:17–18 (223:22–23). Old Times in the Barony—by Father Conmee (Dublin, n.d.), "a nostalgic but unsentimental recall of an older way of life, rural and uncomplicated, around the neighborhood of Luainford" (Kevin Sullivan, *Joyce Among the Jesuits*, p. 17).

220:19 (223:24). Mary Rochfort—(1720–c.1790) was married in 1736 to Colonel Robert Rochfort (1708–1774), who was created 1st Earl of Belvedere in 1753. In 1743 she was accused of adultery with her brother-in-law, Arthur Rochfort; though apparently innocent, she was blackmailed into admitting guilt by being promised a divorce from her apparently unscrupulous husband. With the verdict in his favor and his brother in exile, Robert did not divorce his wife but imprisoned her on the Rochfort estate near Lough Ennel in County Westmeath. Father Conmee thinks of her because she is associated with Belvedere House (Dublin), a "Jesuit house"; Mary Rochfort never saw the house, however, since she was "in prison" when it was built.

220:24–25 (223:30). not her confessor—something of an irony since the Rochforts were Protestant.

220:25–26 (223:31). eiaculatio seminis inter vas naturale mulieris—Latin: "ejaculation of semen within the natural female organ," a technical definition of complete sexual intercourse. Without it, Lady Rochfort's sin would not have been so "serious" as adultery.

220:29 (223:35). that tyrannous incontinence—sexual impulse or desire.

220:32 (223:39). Don John—i.e., Don Juan.

221:1 (224:7). Moutonner—French: literally, "to render fleecy."

221:2 (224:9). reading his office—i.e., the *Divine Office*, prayers for the different hours of the day which monks and nuns celebrate in choir each day and which priests recite daily from their Breviary, "praying in the name of the Church and for the whole Church." There are eight canonical hours; four great (Matins, about midnight; Lauds, at dawn; Vespers, at sunset; and Compline at bedtime) and four little (Prime, the first hour in the early morning, 6:00 A.M.; Terce, the third hour, in midmorning; Sext, the sixth hour, at midday; and Nones, the ninth hour, in the early afternoon, 3:00 P.M.).

221:4 (224:11). Clongowes field—Father Conmee recalls his "reign" as Rector of Clongowes Wood College. See *A Portrait of the Artist as a Young Man*, Chapter I.

221:9 (224:16). breviary—book containing the daily public or canonical prayers for the canonical hours. The daily recital of the Breviary is obligatory for all those in major orders and for all choir members.

221:9 (224:16). An ivory bookmark—inscribed with the beginnings and conclusions of the canonical hours.

221:10 (224:17). Nones—see 221:2n.

221:10–11 (224:17–18). lady Maxwell—see 217:26n.

221:12 (224:19). Pater and Ave—Father Conmee reads the *Pater*, the Lord's Prayer, and the *Ave*, "Hail, Mary, full of grace . . .," as preludes to his reading of Nones.

221:13 (224:20). Deus in adiutorium—Latin: "Oh God, come [or, make haste]," the opening phrase of Psalm 70 (Vulgate 69) and the direct beginning of Nones.

221:15–17 (224:22–24). Res in Beati . . . iustitiœ tuœ—"*Res*" is the Hebrew letter which heads the twentieth section of Psalm 119

(Vulgate 118), called, "Blessed are the undefiled . . ." Latin: "*Res* in 'Blessed are the undefiled': "Thy word is true from the beginning: and every one of thy righteous judgments endureth forever" (119:160). Father Conmee has already read three sections of the Psalm 119:129 *ff*.

221:18 (224:25). A flushed young man— Stephen's friend, Lynch; see 409:8–10 (416:11–12).

221:24–25 (224:31–32). Sin: Principes persecuti . . . cor meum—"*Sin*" is the Hebrew letter that heads the twenty-first section of Psalm 119 (Vulgate 118), Latin: "Princes have persecuted me without a cause: but my heart standeth in awe of thy word" (119:161).

Section 2: pp. 221–222 (224–225).
Intrusions: (a) 221:33–34 (225:1–2). Father John Conmee . . . on Newcomen Bridge— see Section 1.
(b) 222:4–5 (225:10–11). While a generous white . . . flung forth a coin—(Molly Bloom), see Section 3.

222:6 (225:12). What's the best news?—a stock phrase of greeting used by Bantom Lyons 84:14 (85:25) and Simon Dedalus 240:16 (243:38).

Section 3: pp. 222–223 (225–226).
Intrusion: 222:13–14 (225:23–24). J. J. O'Molloy's white . . . warehouse with a visitor— see Section 8.

222:9–10 (225:15–16). Mac Connel's corner— Andrew MacConnell, pharmaceutical chemist, 112 Dorset Street Lower, at the intersection with Eccles Street.

222:10 (225:16). Rabaiotti's icecream car— Mr. Antoni Rabaiotti, Madras Place (off North Circular Road), had a fleet of pushcarts that sold ices and ice cream in the Dublin streets.

222:11 (225:17). Larry O'Rourke—see 57:38n.

222:13, 16 (225:19, 22). For England . . ./home and beauty—from a song, "The Death of Nelson," words by S. J. Arnold, music by John Braham. Refrain: "'England expects that ev'ry man/This day will do his duty . . . '/At last the fatal wound,/Which spread dismay around,/The hero's breast . . . receiv'd;/'Heav'n fights upon our side!/The day's our own,' he cried!/'Now long enough I've lived!/In honor's cause my life was pass'd,/In honor's cause I fall at last,/For England, home, and beauty,/For England, home and beauty.'/Thus ending life as he began,/England confess'd that ev'ry man/That day had done his duty."

Section 4: pp. 223–224 (226–227).
Intrusions: (a) 223:8–9 (226:13–14). Father Conmee walked . . . tickled by stubble— see Section 1.
(b) 223:25–26 (226:31–32). The lacquey rang his bell—Barang!—see Section 11.
(c) 223:39–224:3 (227:6–10). A skiff, a crumpled . . . and George's quay.

223:4 (226:9). put in—slang for pawn.

223:11 (226:16). M'Guinness's—see 217:27n.

223:13 (226:18). Bad cess to—slang: "Bad luck to" (since "cess" means an imposed tax).

223:18 (226:23). Crickey—dodging the curse: "Christ" or "in Christ's name."

223:24 (226:30). Sister Mary Patrick—in the convent of the Roman Catholic Sisters of Charity in Upper Gardiner Street.

223:36 (227:3). Our father who art not in heaven—after the opening of The Lord's Prayer: "Our Father, who art in Heaven, hallowed be thy name" (Matthew 6:9).

223:39 (227:6). Throwaway, Elijah is coming —see 149 (151).

223:40 (227:7). Loopline bridge—see 73:34n.

223:40 (227:7). shooting the rapids—high tide was at 12:42 P.M.; since it is now after 3:00, the tide has turned and the current in the estuary of the Liffey is east-running.

224:2–3 (227:9–10). the Customhouse old dock and George's quay—the dock is on the north bank, the quay on the south bank of the Liffey, approximately one mile west of what was then the mouth of the Liffey and three-quarters of a mile east of the center of Dublin.

Section 5: pp. 224–225 (227–228).
Intrusion: 224:21–22 (227:27–28). A dark-backed figure . . . the hawker's car— (Bloom); see Section 10.

224:4 (227:11). Thornton's—James Thornton, fruiterer and florist, to His Majesty, the King, and to His Excellency, the Lord Lieutenant, etc., 63 Grafton Street.

224:9 (227:16). game ball—i.e., that is the point that wins the game.

224:15 (227:22). H.E.L.Y.'S—five sandwich-board men who are advertising the stationery store where Bloom used to work; see 105:13n.

224:15–16 (227:22–23). past Tangier lane—the lane intersects Grafton Street at 61; the men are moving south toward Stephen's Green, where **226:12–14 (229:19–22)** they turn to retrace their steps.

224:21 (227:27). Merchant's arch—a covered passageway from Temple Bar to Wellington Quay on the south bank of the Liffey. See J. F. Byrne, *The Silent Years* (p. 19) for a description of the bookseller and his wares.

Section 6: pp. 225–226 (228–229).

225:8 (228:13). Ma!—Italian: "But!"

225:8 (228:13). Almidano Artifoni—takes his name from the owner of the Berlitz school of languages in Trieste and Pola, where Joyce taught. See *Letters, passim,* and Ellmann, *passim.*

225:9 (228:14–15). Goldsmith's knobby poll—a statue of Oliver Goldsmith (1728–1774), Irish man of letters, by the Irish sculptor John Henry Foley (1818–1874), stands within the railings of Trinity College. The *Official Guide to Dublin* describes the statue as "an excellent study in tender and humorous meditation."

225:11. Palefaces—Pale faces. (228:17) should read **Palefaces**—i.e., English tourists; see 9:14n.

225:12–13 (228:18–19). Trinity … bank of Ireland—the two institutions face each other across College Green; see 57:33–35n.

225:15–18 (228:21–24). Anch'io ho avuto … Lei si sacrifica—Italian: "I too had the same idea when I was young as you are. At that time I was convinced that the world is a beast [i.e., a pigsty]. It's too bad. Because your voice … would be a source of income, come now. But instead, you are sacrificing yourself."

225:19 (228:25). Sacrifizio incruento—Italian: "Cold-blooded sacrifice."

225:21–22 (228:27–28). Speriamo … Ma, dia retta a me. Ci refletta—Italian: "Let us hope … But, listen to me. Think about it."

225:23 (228:29). By the stern stone hand of Grattan—a statue of Henry Grattan (see 347:19n), also by Foley, stands in front of the Bank of Ireland, which was originally the Irish House of Parliament, where Grattan distinguished himself as orator and politician.

225:23–24 (228:29–30). Inchicore tram—i.e., the soldiers come from Richmond Barracks in Inchicore, which is just south of Phoenix Park on the western outskirts of Dublin.

225:25 (228:31). Ci rifletterò!—Italian: "I'll think about it."

225:27 (228:33). Ma, sul serio, eh?—Italian: "Are you serious, eh?"

225:29 (228:35–36). Dalkey—a small town on the southeast headland of Dublin Bay; Mr. Deasy's school was in Dalkey.

225:31–32 (228:37–38). Eccolo … pensi. Addio, caro—Italian: "This is it. Come see me and think about it. Goodbye, dear fellow."

225:33–34 (229:1–2). Arrivederla, maestro … E grazie—Italian: "Goodbye, master … and thank you."

225:35–36 (229:3–4). Di che? Scusi, eh? Tante belle cose!—Italian: "For what? … Excuse me, eh? All the best!"

Section 7: p. 226 (229–230).
Intrusions: (a) 226:8–9 (229:15–16). The disk shot down … ogled them: six—see Section 9.
 (b) 226:12–14 (229:19–22). Five tallwhitehatted … as they had come—see Section 5.

226:1 (229:8). gillies—Scots, originally the Lowlanders' name for the followers of the Highland chiefs. The gillies in this case are members of the regimental band of the 2nd Seaforth Highlanders on their way to Trinity College Park to play during the bicycle races; see 234:2–5n.

226:3 (229:10). Capel street library—see 64:32n.

226:3–4 (229:10–11). The Woman in White—(1860), a novel by Dickens' associate Wilkie Collins (1824–1889). It is a novel of sensational intrigue with an intricate plot that involves madness, murder, confused identities and delayed revelations.

226:6–7 (229:13–14). Is he in love with that one, Marion? should read **Marian**—after Marian Halcombe, not the novel's heroine but easily its strongest and most striking woman character. The "he" is the Italian, Falstaffian villain, Count Fosco, of whom Marian Halcombe writes: "The one weak point in that man's iron character is the horrible admiration he feels for *me*." Count Fosco, though his projected villainies are being partially frustrated by Marian, says of her: "With that woman for my friend I would snap these fingers of mine at the world. … This grand creature … this magnificent woman, whom I admire with all my soul …"

226:7 (229:14). Mary Cecil Haye—Mary Cecil Hay(e) (c.1840–1886), one of the more popular sentimental lady novelists of her time. Miss Dunne's preference for genteel sentimentality as against Collins' tougher fiber is not unlike Gertie McDowell's literary taste; see 357 (363).

226:12–13 (229:19–20). Monypeny's corner—R. W. Monypeny, designer and embroiderer of art needlework, and white wool depot, 52–53 Grafton Street, at one of the corners across from St. Stephen's Green.

226:13 (229:20). the slab where Wolfe Tone's statue was not—in 1898 a foundation stone for the statue was laid in St. Stephen's Green facing Grafton Street; the statue was never completed. Theobald Wolfe Tone (1763–1798) was one of the great eighteenth-century Irish patriots and one of the principal founders of The Society of United Irishmen in 1791. The society at first envisioned the union of Protestant and Catholic Ireland for the achievement of constitutional independence as a republic on the model of the United States and revolutionary France. In 1795 the society shifted from a constitutional to a revolutionary approach and through Tone's leadership and diplomacy sought French aid for Irish rebellion. The French made several abortive attempts to send aid, particularly in support of the Rebellion of 1798. Wolfe Tone was captured at sea during one of the French attempts to support the Irish in that year. He subsequently cut his throat in prison while he was awaiting execution for high treason. Tone's republicanism places him outside the mainstream of the Irish revolutionary tradition since his republicanism would have appeared to Catholics (and in part to Protestants) as atheism.

226:15 (229:26). Marie Kendall—(1874–1964), English singer and comedienne, famous for her performances in pantomimes.

226:28 (229:36). Twentyseven and six . . . one, seven, six—i.e., 27 shillings and sixpence or £1, 7s, 6d.

226:30 (229:38). Sport—see 126:33n.

226:31 (230:2). the Ormond—the Ormond Hotel, Mrs. De Massey, wine and spirit merchant, 8 Ormond Quay Upper, on the north bank of the Liffey in the center of Dublin. The [Sirens] episode is to take place in this hotel.

Section 8: pp. 226–228 (230–232).
Intrusions: (a) 227:28 (230:36). From a long face . . . on a chess board—(John Howard Parnell); see Section 16.
(b) 228:3–4 (231:16–17). The young woman . . . a clinging twig—(Lynch's girl friend); see Section 1.

226:35 (230:5). Ringabella and Crosshaven—two small villages near the entrance to Cork Harbour on the south coast of Ireland.

227:4 (230:10). vesta—a short wooden match, after Vesta, Roman goddess of the hearth and its fire.

227:9–10 (230:15–16). the historic council chamber . . . a rebel in 1534—Silken Thomas (see 46:22–23n) did renounce his allegiance to Henry VIII in council in the Chapter House of St. Mary's Abbey, flinging his sword of office "the English Thanes among." The tenth-century abbey was the oldest religious establishment in Dublin; the original monastery became a Cistercian Abbey in the twelfth century. It was dissolved in 1537 and subsequently destroyed by fire; some of its stone was used to build Essex (now Grattan) Bridge over the Liffey. The abbey was located on the north bank of the Liffey just east of the center of modern Dublin.

227:12–13 (230:18–19). the old bank of Ireland . . . time of the union—the Bank of Ireland was originally located in what nineteenth-century guidebooks agree were "miserable premises" in Mary's Abbey, a street just north of the Liffey in central Dublin. After the Irish Parliament was dissolved by the Act of Union in 1800, the House of Parliament was sold to the Bank of Ireland (1802) with the stipulation that the chamber of the House of Commons be altered so that it could not be used as a place for public discussion and debate.

227:13–14 (230:20–21). the original jews' temple . . . in Adelaide road—the first synagogue in Dublin was established (c.1650) in Crane Lane, just across the Liffey from the ruins of the abbey. The congregation moved north of the Liffey to Marborough Green in 1745 and finally established a synagogue in what had been the chapter house of the abbey in 1835. In 1892 the congregation moved to a new synagogue, in Adelaide Road in southeastern Dublin.

227:17–19 (230:24–26). He rode down through . . . in Thomas court—Thomas Court was the main street of the walled city of medieval Dublin. It is at present a series of streets including Thomas Street. There is no record of a Kildare "mansion" in Thomas Court, but had there been one and had Silken Thomas been there, he might have approached the abbey by way of Dame Walk (except that the bridge that would have made that approach feasible was not constructed until the late seventeenth century). As a matter of historical fact, Silken Thomas and his retainers approached the abbey from Maynooth Castle, the Fitzgerald stronghold 15 miles west of Dublin. He came with a considerable following of his retainers, and

immediately after he had renounced his allegiance, he laid siege to Dublin (unsuccessfully).

227:38 (231:8). Mary's abbey—see 227:12–13n.

227:38 (231:9). floats—large flatbedded wagons.

227:39 (231:9–10). O'Connor, Wexford—the name of the transport company that owned the floats. Wexford is a county town on the east coast of Ireland 72 miles south of Dublin.

227:41–42 (231:12–13). The reverend Hugh ... Saint Michael's Sallins—Rathcoffey is a hamlet 16 miles west of Dublin; Sallins is a town 18 miles west-southwest of Dublin. St. Michael's was the residence of an Anglican archdeacon. The Reverend Love is essentially fictional. See Adams, pp. 29–35.

228:1 (231:14). the Fitzgeralds or **Geraldines. 228:14 (231:27)**—a powerful Anglo-Irish family that traces its heritage from the early twelfth century. In pre-Reformation times the family comprised two houses, the Earls of Kildare and the Earls of Desmond; post-Reformation (eighteenth century), the Dukes of Leinster.

228:5 (231:18). gunpowder plot—a conspiracy to destroy King James I together with the House of Lords and the House of Commons by springing a mine secreted under the House of Parliament, 5 November 1605; see 202:28–29n.

228:8–13 (231:21–26). the earl of Kildare ... the Fitzgerald Mor—Gerald Fitzgerald (1456–1513), 8th Earl of Kildare (1477–1513), the most powerful Anglo-Irish lord of his time. His career was a stormy series of conflicts with jealous and powerful contemporaries. In the course of a conflict with Archbishop Creagh in 1495 he did set fire to Cashel Cathedral. The Earl was charged in council before Henry VII (the archbishop present among his accusers), where he is supposed to have replied: "By Jesus, I would never have doone it, had it not beene told me that the archbishop was within." The last article of the accusation asserted: "All Ireland cannot rule this Earl"; and Henry VII is supposed to have replied: "Then in good faith shall the Earl rule all Ireland." The Earl returned to Ireland as Henry VII's Deputy. "Mor" is Irish for "Great."

Section 9: pp. 228–232 (232–235).
Intrusions: (a) 228:37–229:3 (232:9–14). Lawyers of the past ... skirt of great amplitude—see Section 10, Intrusion (b).
(b) 230:7–8 (233:22–23). The gates of the drive ... the viceregal cavalcade.
(c) 230:28–29 (234:1–2). Master Patrick Aloysius ... half of porksteaks—see Section 18.

(d) 230:38–39 (234:10–11). A card Unfurnished ... number 7 Eccles street—(Molly Bloom) see Section 3.

228:32 (232:4). Tom Rochford—see 175:39n.

228:34 (232:6). turn six—i.e., the sixth "act" in a variety show or vaudeville sequence.

228:37–229:2 (232:9–13). Lawyers of the past ... the court of appeal—the scene is the Four Courts, a large eighteenth-century building on the north bank of the Liffey near the center of Dublin. The great hall of the building was dominated by statues of famous Irish lawyers and judges. The building housed, among other courts and offices: the Consolidated Taxing Office for the Supreme Court; King's Bench Division—Admiralty (Judge of the High Court having Admiralty Jurisdiction); His Majesty's Court of Appeal in Ireland (the Supreme Court of Judicature); the late Consolidated Nisi Prius Court, now (1904) office for Trials by Jury in Dublin, in King's Bench Division. The Four Courts was gutted in the Civil War (1922) and has been restored as the Irish Courts of Justice.

229:20–21 (232:32–33). Crampton court—in central Dublin, just south of Grattan Bridge.

229:25 (232:37). Dan Lowry's musichall ... Marie Kendall—the Empire Theatre of Varieties (late Star Music Hall), Dame Street and Crampton Court; for Marie Kendall, see 226:15n.

229:28 (233:1). Sycamore street—runs parallel to Crampton Court from Dame Street to Essex Street East. Lenehan and M'Coy walk from Crampton Court east along Dame Street then north through Sycamore Street.

229:36 (233:9). the Dolphin—the Dolphin Hotel and Restaurant, on the corner of Sycamore Street and Essex Street East. Lenehan and M'Coy turn and walk east.

229:37 (233:10). for Jervis street—i.e., for the hospital, Charitable Infirmary, Jervis Street (under the care of the Sisters of Mercy).

229:39 (233:12). Lynam's—*Thom's (1904)* lists no Lynam in the vicinity.

229:39 (233:12). Sceptre's starting price—in the Gold Cup Race; see 84:28n.

229:41 (233:14). Marcus Tertius Moses' somber office—Marcus Tertius Moses, wholesale tea merchant, 30 Essex Street East, on the corner of Eustace Street. He was a Dublin politician, a Magistrate and a member of the

board of directors of several charitable institutions in the city.

229:42 (233:15). O'Neill's clock—J. J. O'Neill, tea and wine merchant, 29 Essex Street East, across Eustace Street from Moses' office.

230:2 (233:17). O. Madden—see 126:35n.

230:3 (233:18). Temple bar—continues eastward from Essex Street East.

230:7 (233:22). The gates of the drive—the Viceregal Lodge was in Phoenix Park on the western outskirts of Dublin, north of the Liffey.

230:12 (233:27). under Merchants' arch—i.e., they turn north through a passage that leads from Temple Bar to the south bank of the Liffey; see 224:21n.

230:16 (233:31). the Bloom is on the Rye—from a song, "The Bloom Is on the Rye" or "My Pretty Jane," words by Edward Fitzball, music by Sir Henry Bishop (1786–1855). First verse and chorus: "My pretty Jane, my pretty Jane/Ah! never, never look so shy/But meet me, meet me in the ev'ning/While the bloom is on, is on the rye." Chorus: "The spring is waning fast, my love./The corn is in the ear, /The summer nights are coming, love./The moon shines bright and clear,/Then, pretty Jane, my dearest Jane,/Ah! never look so shy,/But meet me, meet me in the ev'ning/While the bloom, the bloom is on the rye."

230:25 (233:40). the metal bridge—a footbridge over the Liffey east of the center of Dublin.

230:25–26 (233:40–41). Wellington quay—on the south bank of the Liffey between the metal bridge and Grattan Bridge to the west.

230:27–28 (234:1–2). Mangan's, late Fehrenbach's—P. Mangan, pork butcher, 1 and 2 William Street South (approximately a quarter-mile south of where Lenehan and M'Coy are walking).

230:29 (234:3). Glencree reformatory—a Roman Catholic reformatory, at the headwaters of the Glencree River in the hilly country ten miles south of the center of Dublin. The "annual dinner" was a fund-raising event.

230:31 (234:5). Val Dillon—see 153:17n. (He was lord mayor in 1894–1895.)

230:32 (234:6). sir Charles Cameron—(1841–1924), Irish-born proprietor of newspapers in Dublin and Glasgow; Liberal M. P. for Glasgow (1874–1900).

230:32 (234:6). Dan Dawson—see 90:5n.

230:33 (234:7). Bartell D'Arcy—appears as a character in "The Dead," *Dubliners*.

231:1 (234:14–15). Delahunt of Camden street—Joseph and Sylvester Delahunt, family grocers, tea, wine and spirit merchants, 42 and 92 Camden Street Lower.

231:3 (234:16). lashings—plenty.

231:12 (234:25). Featherbed Mountain—Featherbed Pass gives access through the Dublin Mountains between Dublin and Glencree.

231:13 (234:26). Chris Callinan—see 136:8n.

231:15 (234:28). Lo, the early beam of morning—is not a duet but a quartet from Michael William Balfe's opera *The Siege of Rochelle* (1835), libretto by Edward Fitzball. Clara, the opera's heroine, is wrongly accused of murdering a child and is thus caught in a complex plot that means she must flee Rochelle. The quartet occurs just before the end of Act I as the monk, Father Azino, and others aid her to escape: "AZINO: Lo, the early beam of morning softly chides our longer stay; hark! the matin bells are chiming,/Daughter we must hence away, Daughter we must hence away./CLARA: Father, I at once attend thee, farewell, friends, for you I'll pray;/Lo! the early beam of morning softly chides our longer stay;/Hark! the matin bells are chiming, Father, we must hence away./MARCELLA: Lady, may each blessing wait thee, we for you will ever pray;/Hark! the matin bells are chiming, from all danger haste away." (Michael repeats Marcella's part.)

232:1 (235:16). common or garden—garden *variety*, i.e., commonplace, usual.

Section 10: pp. 232–233 (235–237).
Intrusions: (a) 232:19–21 (235:34–36). On O'Connell bridge ... professor of dancing &c—see Section 1, Intrusion.
 (b) 233:12–19 (236:29–36). An elderly female . . . and Guarantee Corporation—see Section 9, Intrusion (b).

232:3–4 (235:18–19). The Awful Disclosures of Maria Monk—(New York, 1836). Maria Monk (c.1817–1850) was a Canadian woman who arrived in New York City in 1835. She claimed that she had escaped from the nunnery of the Hotel Dieu in Montreal; her book and its sequel, *Further Disclosures* (also 1836), offered in lurid and fanciful detail the "revolting practices" that she had "witnessed." Two hundred thousand copies were sold to the tune of violent anti-Catholic agitation; as early as 1836 she was con-

vincingly revealed as a fraud, but the revelation had little effect on public response to her claims.

232:4 (235:19). Aristotle's Masterpiece— or rather pseudo-Aristotle, purportedly clinical, mildly·pornographic; one of the several listings after its initial appearance in 1694: "*Aristotle's masterpiece completed:* in two parts. The first containing the secrets of generation in the parts thereof. . . . The second part being a private looking glass for the female sex. Treating of the various maladies of the womb, and all other distempers incident to women. N.Y. printed for the Company of flying stationers, 1798." Apparently the most widely-circulated work of pseudo-sexual and pseudo-medical folklore in seventeenth- and eighteenth-century England.

232:10–11 (235:25–26). Tales of the Ghetto by Leopold von Sacher Masoch—Sacher-Masoch (1835–1895), Austrian novelist who gave his name to "masochism." The collection of stories, first published in 1885 in German, bore the English title *Jewish Tales* (Chicago, 1894). The tales are primarily concerned with anti-Semitic persecutions that recoil to the moral betterment of the persecutors and their victims.

232:19 (235:34). O'Connell bridge—over the Liffey in east-central Dublin. Bloom is near the metal bridge; O'Connell bridge is the next one to the east.

232:22–23 (235:37–38). Fair Tyrants by James Lovebirch—a James Lovebirch (pun intended) is listed as the author of several novels in the Bibliothèque National *Catalogue des livres imprimés* (Paris, 1930), Vol. 100, pp. 1001–1002; his most notable title: *Les Cinq Fessées de Suzette* (Paris, 1910), translated as *The Flagellation of Suzette* (Paris, 1925). *Fair Tyrants* is not listed.

232:27 (236:5). Sweets of Sin—unknown. It could have been soft-core dime-novel pornography, in which case it would not necessarily have found its way into nineteenth-century collections of pornography. Or it could have eluded search because it was a subtitle. Or it could be Joyce's own coinage.

233:12–19 (236:29–36). the building of . . . Guarantee Corporation—the Four Courts (see 228:37–229:2n). The *Freeman's Journal* for 16 June 1904 reports, on page 2 under "Law Intelligence . . . Law Notices This Day," that the Lord Chancellor, sitting in the High Court of Justice, Chancery Division "(Before the Registrar, 11:30 o'clock)," would hear among others "In Lunacy" the case of one "Potterton, of unsound mind, *ex parte* . . . Potterton, discharge queries, vouch account" (column 4). "King's Bench

Division—Admiralty—1:30 o'clock—*Ex Parte* Motions. Summons—The Owners of the Lady Cairns *v.* the Owners of the barque Mona" (column 5). "Yesterday,/Court of Appeal" in column 1 contains the report of "LITIGATION ABOUT A POLICY./Re Arbitration between Havery and the Ocean Accident and Guarantee Corporation Limited."—"The Court reserved judgment."

Section 11: pp. 233–235 (237–239).
Intrusions: (a) 234:2–5 (237:16–19). Bang of the lastlap . . . by the College Library.
(b) 234:28–29 (238:3–4). Mr Kernan, pleased. . . along James's street—see Section 12.
(c) 235:29–30 (239:4–5). The viceregal cavalcade . . . out of Parkgate—see Section 19.

233:30(237:6). Dillon's auctionrooms—Joseph Dillon, auctioneer and valuer, 25 Bachelor's Walk (on the north bank of the Liffey between the metal bridge and O'Connell Bridge).

234:2–5 (237:16–19). Bang of the lastlap bell . . . College Library—the "Last Pink" edition of the *Evening Telegraph,* Dublin, 16 June 1904, under the headline "CYCLING AND ATHLETICS/Dublin University Bicycle Sports" reports the "combination meeting of the Dublin University Bicycle and Harrier Club . . . held this afternoon in College Park. . . . The weather, after a fine morning, broke down at the time of starting, but afterwards the atmospheric conditions improved. Sport opened with the Half-Mile Bicycle Handicap, and from that the events were rattled off in good order. The band of the Second Seaforth Highlanders was present during the afternoon."

"Details: Half-Mile Bicycle Handicap—J. A. Jackson, 10 yds., 1; W. H. T. Gahan, sch., 2. Also competed—T. W. Fitzgerald, 30; A. Henderson, 50. Time 1 min. 16 secs. Second heat—W. E. Wylie, 20 yds., 1; A. Munro, 35 yds., 2. Also competed—T. C. Furlong, sch. Won by three lengths. Time, 1 min. 17 secs."

234:7 (237:21). Williams row—off Bachelor's Walk.

234:29 (238:4). James's street—on the western side of Dublin south of the Liffey (near Guinness' Brewery).

234:30–31 (238:5–6). the Scotch house—a pub; see 157:34n.

235:16 (238:33). where Jesus left the jews— i.e., without hope of salvation because from a doctrinaire Christian point of view they are

eternally damned for having refused to accept Jesus as the Messiah and for having demanded the crucifixion.

235:30 (239:5). Parkgate—at the southeastern entrance to Phoenix Park (on the western outskirts of Dublin north of the Liffey.)

235:36 (239:11–12). little sister Monica—an allusion to St. Monica's Widow's Alms-House, 35–38 Belvedere Place, around the corner from what appears to be Simon Dedalus' present temporary address.

Section 12: pp. 235–238 (239–241).
Intrusions: (a) 236:24–25 (239:39–240:1).
Hello, Simon . . . Dedalus answered stopping—see Sections 11 and 14.
(b) 236:38–40 (240:14–16). North Wall
. . . Elijah is coming—see Section 4, Intrusion (c) and Section 16, Intrusion (b).
(c) 237:21–23 (240:40–42). Dennis Breen
. . . Collis and Ward.

235:37 (239:13). From the sundial towards James's Gate—Kernan is walking east along James's Street; see 234:29n. The sundial stood at the intersection of Bow Lane and James's Street; St. James's Gate is a court at the western end of James's Street where James's Street becomes Thomas Street.

235:38 (239:14). Pulbrook Robertson—Pulbrook, Robertson and Company, 5 Dame Street (where Kernan presumably works and toward which he is now walking).

235:39 (239:15). Shackleton's offices—George Shackleton and Sons, flour millers, corn merchants, 35 James's Street.

236:1 (239:16). Mr Crimmins—William C. Crimmins, tea, wine and spirit merchant, 27 and 28 James's Street, and 61 Pimlico (in the center of Dublin, south of the Liffey). Crimmins was a graduate of Trinity College and a Poor Law Guardian, i.e., he was Protestant and Conservative.

236:7 (239:22). that General Slocum explosion—see 180:1–3n.

236:14 (239:29). Palmoil—graft.

236:22 (239:37). frockcoat—Kernan is overdressed for his class and employment.

236:27 (240:3). Peter Kennedy, hairdresser—48 James's Street.

236:28 (240:4). Scott of Dawson street—William Scott, fashionable and expensive tailor

and clothier, 2 Sackville Street Lower (formerly of Dawson Street).

236:29 (240:5). Neary—there was an Edward Neary, military and merchant tailor, 15 South Anne Street; but that doesn't seem to fit the used-clothes implication.

236:30 (240:6). Kildare street club toff—a "toff " is a dandy or a swell. The Kildare Street Club was the most fashionable Anglo-Irish men's club in Dublin.

236:31 (240:7). John Mulligan, the manager of the Hibernian Bank—the Hibernian Bank, 23–27 College Green, manager, W. A. Craig; branch offices, 12 Sackville Street Lower, manager, Christopher Tierney; 84–85 Thomas Street, manager, Ignatius Spadscani; 85–86 Dorset Street Upper, manager, B. J. Lawless. There were two important John Mulligans in Dublin but *Thom's (1904)* lists neither as a banker.

236:32 (240:8). Carlisle bridge—the original name for O'Connell Bridge. The bridge was named for Lord Carlisle, who was Viceroy in 1791 when construction began; the name was officially changed to O'Connell Bridge in 1882. Kernan's "mistake" is consistent with his West Briton attitudes.

236:34–35 (240:10–11). Knight of the road—Kernan intends this as an epithet for salesman; traditionally, it is an epithet for highwayman.

236:36–37 (240:12–13). The cup that cheers but not inebriates—the phrase occurs in Bishop Berkeley's praise of tar-water "of a nature so mild and benign and proportioned to the human constitution as to warm without heating, to cheer but not inebriate" (*Siris* [1744], ¶217). William Cowper (1731–1800) gave it the shape that Kernan misquotes; in praise of tea: "the cups that cheer but not inebriate" (*The Task* [1785] IV, 34).

236:38 (240:14). North wall and Sir John Rogerson's quay—respectively, the north and south banks of the Liffey near its mouth. The Throwaway is still moving eastward; see 223:39–224:3 (227:6–10).

236:42 (240:18). Returned Indian officer—an army officer who had done a tour of duty in India was popularly supposed to be recognizable from his sunburned face. Kernan has *not* been to India.

237:8 (240:27). Down there Emmet was hanged, drawn and quartered—Robert Emmet (see 112:40–41n) was hanged in front of St. Catherine's Church (Church of Ireland) in Thomas Street. He was beheaded, not drawn and

quartered. (Kernan is approaching Thomas Street, which extends eastward from James's Street.)

237:9 (240:28). Dogs licking the blood off the street—a traditional "eye-witness" touch about Emmet's execution.

237:9–10 (240:29). the lord lieutenant's wife—the traditional eyewitness was "a woman who lived nearby"; Kernan upgrades her as the wife (Elizabeth) of Philipe Yorke (1757–1834), 3rd Earl of Hardwicke, Lord Lieutenant of Ireland from 1801 to 1806.

237:10 (240:29). noddy—a light two-wheeled hackney carriage.

237:11, 12 (240:30, 31). saint Michan's/ Glasnevin—see 112:40–41n. St. Michan's Church, founded in 1095 by the Danish saint of that name, in Church Street near the Four Courts. Many heroes of the Rebellion of 1798, including the Brothers Sheares (see 300:24n), were buried in its vaults, but a 1903 (centenary) search for Emmet's headless remains was unsuccessful, as was a similar search at Glasnevin Cemetery (see 124:15–17).

237:15–16 (240:34–35). Watling street . . . visitor's waitingroom—Guinness' Brewery, visitor's waiting room, is on the corner of James's Street and Watling Street, which runs north to the Liffey. Kernan's direct route back to the office would have been to continue east through Thomas Street.

237:17 (240:36). Dublin Distillers Company's stores—(warehouse), 21–32 Watling Street.

237:17 (240:36). an outside car—a low-set vehicle in which the passengers sit sidewise back to back (also called an "outside jaunting car").

237:19 (240:38). Tipperary boshoon—Tipperary is a rural county 78 miles southwest of Dublin; a "boshoon" is a flexible rod or whip made of a number of green rushes laid together; contemptuously it means a soft, worthless, spiritless fellow.

237:22 (240:41). John Henry Menton's office—(solicitor) 27 Bachelor's Walk, on the north bank of the Liffey.

237:23 (240:42). Messrs Collis and Ward—(solicitors) 31 Dame Street, south of the Liffey in central Dublin.

237:24 (241:1). Island street—parallel to the Liffey and one block south, Island Street runs east from Watling Street.

237:25 (241:2). Times of the troubles—the "times" Kernan contemplates are the Rebellion of 1798.

237:26 (241:3). Those reminiscences of sir Jonah Barrington—(1760–1834), an Irish patriot, judge and anecdotal historian. As a member of the Irish Parliament he held out staunchly against the Act of Union. He wrote two extensive books of "reminiscences": *Personal Sketches of his own Time,* three volumes (1827–1832), and *Historic Memoirs of Ireland,* two volumes (1809, 1833), later retitled *The Rise and Fall of the Irish Nation.*

237:27–28 (241:5). Gaming at Daly's—Daly's Club was located on what is now College Green just southeast of the center of modern Dublin. The *Official Guide to Dublin* remarks that it was "a famous rendezvous for the 'bloods' of the early nineteenth century, dicing, duelling, and drinking being their main concern."

237:28–29 (241:5–6). One of those fellows . . . with a dagger—a commonplace story about irascible cardplayers.

237:29–31 (241:7–8). Lord Edward Fitzgerald . . . behind Moira house—Lord Edward Fitzgerald (1763–1798), president of the military committee of the United Irishmen and regarded as the master spirit behind the plans for the Rebellion of 1798. He was denounced by proclamation in March 1798 and went into hiding in Dublin; in May a £1,000 reward was offered for information about his whereabouts. Henry Charles Sirr (1764–1841), town major of Dublin in 1798, was notorious for his ruthless use of informers and for the brutality of the police he led. Apparently informed of Fitzgerald's intended movements, Sirr set a trap for him in Watling Street (where Kernan is walking) on the night of 17 May; Fitzgerald eluded the trap and escaped into the house of one of his supporters, Nicholas Murphy, 151–152 Thomas Street, where on 18 May Fitzgerald was trapped, arrested and mortally wounded in the process. He died in prison on 1 June 1798. Murphy's house was near the junction of Thomas Street, James's Street and Watling Street. Moira House belonged to Francis Rowden, the Earl of Moira (1754–1824), a friend of Fitzgerald who gave sanctuary to Fitzgerald's wife, Pamela, while Fitzgerald was in hiding in 1798. The house was located on Usher's Quay, on the south bank of the Liffey, a quarter of a mile to the northeast of Kernan's position. Fitzgerald, after he went into hiding, occasionally stole back to the stables behind Moira House to meet his wife.

237:34 (241:11). that sham squire—Francis Higgins (1746–1802); see 125:26n.

237:35 (241:12). Course they were on the wrong side—i.e., Kernan is pro-English and against Irish independence.

237:35–36 (241:12–13). They rose in dark and evil days . . . Ingram—line 33 of John Kells Ingram's (Irish poet and man of letters, 1823–1907) "The Memory of the Dead" (1843). The poem begins: "Who fears to speak of Ninety-Eight? . . . He's a knave or half a slave." The line Kernan remembers is followed by ". . ./To right their native land;/They kindled here a living blaze/That nothing can withstand."

237:38 (241:16). At the siege of Ross did my father fall—from a song, "The Croppy Boy"; see 252:41n. Ross, in southeastern Ireland, was an English strongpoint in the opening phase of the Rebellion of 1798. The "siege" was more properly an attack, 5 June 1798, in which a large but loosely organized and poorly armed rebel force was finally routed after all but overwhelming the small but effectively armed garrison. The defeat was a serious blow to rebel morale in southeastern Ireland.

237:39 (241:17). Pembroke quay—a section of what is now Ellis's Quay on the north bank of the Liffey opposite Watling Street, where Kernan is walking.

Section 13: pp. 238–240 (241–243).
Intrusions: (a) 238:24–27 (242:7–10). Two old women . . . eleven cockles rolled—see 38 (37).
 (b) 239:11–12 (242:33–34). Father Conmee . . . murmuring vespers—see Section 1; Section 2, Intrusion (a); and Section 4, Intrusion (a).

238:3 (241:23). the webbed window—Thomas Russell, lapidary and gem cutter, 57 Fleet Street (just south of and parallel to the Liffey, not far east of Merchant's Arch).

238:9–12 (241:29–32). Born all in the dark . . . wrest them—echoes Milton's *Paradise Lost* (I:670–692), the description of Mammon's teaching to the fallen angels: ". . . and with impious hands/Rifl'd the bowels of thir mother Earth/For treasures better hid." "Evil lights shining in the darkness" echoes John 1:5 "And the light shineth in the darkness; and the darkness comprehended it not." "Where fallen archangels flung the stars of their brows" recalls Revelation 12:4, "And his [the dragon's] tail drew the third part of the stars of heaven, and did cast them to the earth."

238:18 (241:38). old Russell—see 238:3n.

238:22 (242:4). Antisthenes—see 147:5n.

238:22–23 (242:5–6). Orient and immortal . . . to everlasting—see 39:8–9n.

238:25 (242:8). through Irishtown along London bridge road—Irishtown is on the shore of Dublin Bay just south of the mouth of the Liffey and just north of Sandymount, where Stephen walked on the beach in [Proteus]. The two women who "came down the steps from Leahy's terrace," 38:33 (37:33), have apparently walked north along the strand and are now walking west toward London Bridge (over the Dodder River) and toward south-central Dublin.

238:29 (242:12). the powerhouse—Dublin Corporation Electric Light Station, 49–56 Fleet Street, just east of the lapidary's. Stephen is moving west along Fleet Street.

238:30 (242:13). Throb always without . . . always within—echoes the American novelist James Lane Allen (1849–1925), *The Mettle of the Pasture* (New York, 1903). The hero of the novel confesses to his fiancée, who rejects him for his past immoralities; the hero then has a climactic scene with his mother, in which he refuses her wish (that he and the fiancée be married). The hero leaves and the mother responds: "For her it was one of those moments when we are reminded that our lives are not in our keeping, and that whatsoever is to befall us originates in sources beyond our power. Our wills may indeed reach the length of our arms or as far as our voices can penetrate space; but without us and within moves one universe that saves us or ruins us only for its own purposes; and we are no more free amid its laws than the leaves of the forest are free to decide their own shapes and season of unfolding, to order the showers by which they are to be nourished and the storms which shall scatter them at last" (p. 125; see *Critical Writings*, pp. 117–118).

238:31–32 (242:14–15). Between two roaring worlds where they swirl—recalls the famous lines from Matthew Arnold's "Stanzas from the Grande Chartreuse," as the speaker describes himself: "Wandering between two worlds, one dead,/The other powerless to be born" (lines 85–86). Stephen's words also may echo a stanza from the American poet Richard Henry Stoddard's "The Castle in the Air": "We have two lives about us,/Two worlds in which we dwell,/Within us and without us,/Alternate Heaven and Hell: —/Without, the somber Real,/Within, our heart of hearts, the beautiful Ideal."

238:33–34 (242:17). Bawd and butcher—i.e., god; see 210:39 (213:24–25).

238:36–37 (242:19–20). Very large and . . . keeps famous time—Stephen passes the shop of William Walsh, clockmaker, at 1 Bedford Row.

238:37 (242:20). You say right . . . 'twas so, indeed—Hamlet speaks to Rosencrantz and Guildenstern in mockery of Polonius: "I will prophesy he comes to tell me of the players; mark it. You say right, sir: o' Monday morning; 'twas so indeed" (II, ii, 405–407).

238:38 (242:21). down Bedford row—Bedford Row runs north to the south bank of the Liffey from the western end of Fleet Street.

238:39 (242:22). Clohissey's window—M. Clohisey, bookseller, 10 and 11 Bedford Row.

239:1 (242:23). 1860 print of Heenan boxing Sayers—an international boxing match for the world championship (bare knuckles, wrestling and hugging permitted) between an American, John Heenan, and the world champion, an Englishman, Tom Sayers, Farnborough, England, 7 April 1860. The fight lasted 37 rounds, each round ending when one of the boxers was knocked down. In the thirty-seventh round Sayers' right arm was injured; the partisan crowd stormed the ring and the bout was declared a draw. In the history of boxing Heenan v. Sayers is regarded as a turning point, the end of boxing old style, since after the fight boxing was suppressed in England and subsequently allowed only under the Marquis of Queensberry rules.

239:7 (242:29). The Irish Beekeeper—*The Irish Beekeeper's Journal*, a serious and scientific publication, the official journal of the Irish Beekeeper's Association. It was published monthly at 15 Crowe Street in Dublin.

239:7–8 (242:29–30). Life and Miracles of the Curé of Ars—*Life of the Curé d'Ars*, from the French of Abbé Mounin (Baltimore, 1865). The phrase "Life and Miracles" was usually reserved for the lives of saints, and the Curé of Ars, Jean-Baptiste Marie Vianney (1786–1859), was not canonized until 3 May 1925; so Stephen apparently adds a rhetorical flourish to Mounin's simpler title. Vianney enjoyed considerable fame as a confessor during his lifetime (he was popularly regarded as capable of "reading hearts"). He was beatified on 8 June 1905.

239:8 (242:30). Pocket Guide to Killarney—there were a number of guides to Killarney current in the late nineteenth century, but none that we have seen bore this common "Pocket Guide" title.

239:9–10 (242:31–32). Stephano Dedalo . . . palmam fereni—Latin: "To Stephen Dedalus, one of the best alumni, the class prize."

239:11–12 (242:33–34). his little hours . . . murmuring vespers—see 221:2n. Donnycarney was a village on Malahide Road.

239:13–14 (242:35–36). Eighth and ninth book of Moses. Secret of all secrets—the Pentateuch has traditionally been regarded as "the five books of Moses," and there is a legend that dates at least from the Medieval Cabala that says the five books of the Pentateuch are the books of Moses the Lawgiver, but that the books of Moses the Magician have been lost. One numerological version of the legend holds that since the 49 gates of wisdom were open to Moses, nine should be the complete number of his works; another version regards ten as the perfect number. At any rate, speculations about the "lost books" and "translations" purporting to be fragments of one or more of those books were not unusual in the world of nineteenth-century pamphlets.[1] What these publications have in common are compendia of magic formulae (Secret of all Secrets) of the sort Stephen reads below, though Joyce's actual source has yet to be discovered.

239:14 (242:36). Seal of King David—the two interlaced triangles (six-pointed star), the emblem of Judaism, symbolic of divine protection.

239:19–20 (242:41–42). Se el yilo . . . Sanktus! Amen—*Se* reads *Sel* in the German version of the "Eighth and Ninth Books of Moses" (see 239:13–14, n. 1). If the phrase were "*Sel el yilo*," it could be regarded as a phonetic reproduction of the Spanish *Cielillo*, "Little Heaven"; "*nebrakada*" could be Spanish-Arabic for "blessed"; and the whole charm would read: "[My] little heaven of blessed femininity, love only me. Holy! Amen."

239:21–22 (243:1–2). Charms and invocations of the most blessed abbot Peter Salanka—the German version of the "Eighth and Ninth Books of Moses" identifies Salanka

[1] See Viktor Link, "Ulysses and the 'Eighth and Ninth Books of Moses,'" *James Joyce Quarterly*, Vol. 7, No. 3 (Spring, 1970), pp. 199–203. Link argues that the book Joyce may have used was a nineteenth-century German publication, but Link also describes a number of differences between Joyce's materials and the German text (as though Joyce had just scanned the text and had at times mistranslated). On the other hand, Joyce may have used an English version, complete with mistranslations, corruptions and additions; late in the nineteenth century the New York publisher W. W. Delany advertised in *Delany's Irish Song Book*, No. 2 (New York, n.d.), "The Sixth and Seventh Books of Moses as translated from a German translation under the personal supervision of W. W. Delany's corporation: the magic of the Israelites is fully explained—such as second sight, healing the sick . . . mesmeric clairvoyance, etc. . . . Beware of Humbugs." For a twentieth-century example, see Henri Gamache, *Mystery of the Long Lost 8th, 9th and 10th Books of Moses; together with the legend that was of Moses and 44 Secret Keys to Universal Power* (Highland Falls, New York: Sheldon Publications, 1967).

as "Pater [Father, not Peter] Salanka, Prior [not Abbot] of a famous Spanish Trappist Monastery." But we have been unable to trace Salanka and his peculiarly un-Spanish name (Salamanca ?) beyond that.

239:23–24 (243:3–4). Joachim's. Down, baldy-noddle, or we'll wool your wool—see 40:37n and 41:1n.

239:29 (243:9). A Stuart face of nonesuch Charles—the face of Charles I (1600–1649; king, 1625–1649), the second Stuart king of England, is depicted in the way Stephen describes Dilly's face.

239:39–40 (243:19–20). Chardenal's French primer—C. A. Chardenal, *The Standard French Primer* (London, 1877).

240:5 (243:27). Agenbite—see "Agenbite of Inwit," 17:32–33n.

Section 14: pp. 240–242 (243–245).
Intrusions: (a) 241:16–17 (244:40–41). Cashel Boyle . . . Kildare Street club.
(b) 241:25–28 (245:8–11). The reverend Hugh . . . the Ford of Hurdles.

240:13 (243:35). Reddy and Daughter's—Richard Reddy (no Daughter's), 19 Ormond Quay Lower (on the north bank of the Liffey east of the center of Dublin).

240:14 (243:36). Father Cowley brushed his moustache—if he were properly a priest, he would not have a moustache.

240:21 (244:4). gombeen—usurous.

240:24 (244:7). Reuben—i.e., Reuben J. Dodd; see 93:9n.

240:26 (244:9). Long John—John Fanning (fictional), subsheriff of Dublin, whose bailiffs have Cowley under siege. The high sheriff of Dublin was an honorary post; the subsheriff held the actual responsibility.

240:30 (244:13). bockedy—from the Irish *bacach* : "lame, halt, clumsy."

240:32 (244:15). the metal bridge—a footbridge over the Liffey not far from where the two men are standing.

240:36 (244:19). slops—loose, baggy trousers.

241:14 (244:38). basso profondo—Italian: "a very deep bass voice, or one who has such a voice."

241:17 (244:41). Kildare street club—see 85:17n.

241:26 (245:9). saint Mary's abbey—see 227:9–10n.

241:26 (245:9). James and Charles Kennedy's—rectifiers and wholesale wine and spirit merchants, 31 and 32 Mary's Abbey and 150–151 Capel Street; i.e., Love has turned south out of Mary's Abbey toward the Liffey.

241:27 (245:10). Geraldines—i.e., the Fitzgeralds; see 228:1n.

241:27–28 (245:10–11). toward the Tholsel beyond the Ford of Hurdles—the Tholsel (literally, "toll-gatherer's booth") was built 1307–1327 (?) to house the courtroom, rooms for the Trinity Guild of Merchants, the Royal Exchange and offices of the Dublin Corporation. It was rebuilt in 1683 and 1783; demolished in 1806. It stood in then Skinner's Row (now Christchurch Place) south of the Liffey in the center of Dublin. *Áth Cliath*, the Ford of Hurdles, the ancient Irish name for the causeway of wicker hurdles that provided a ford across the Liffey before the Danes occupied the region and founded Dublin. The ford was located approximately where Queen Maeve Bridge now stands (somewhat to the west of the Reverend Love's position); it provided the Irish name for Dublin, *Baile Átha Cliath*, the Place of the Ford of Hurdles.

241:32 (245:15). Rock—see 167:31–32n.

241:33 (245:16). Lobengula—an African tribal king (Matabele) noted for the boldness of his opposition to European incursions on his territory. After the discovery of gold in his kingdom, he was induced to sign a treaty with the English (1888), but in 1893, provoked "by English insolence," he led a series of costly and futile attacks on the English, who had blandly regarded the "treaty" as evidence of their conquest of Matabele's territory.

241:33 (245:16). Lynchehaun—an alias of one James Walshe, an Irish murderer. He was given life imprisonment (1895), but escaped and fled to America, where he sought (and for a time enjoyed) sympathy by describing himself as a political martyr.

241:35 (245:18). the Bodega—The Bodega Company, wine and spirit merchants and importers in Commercial Buildings (off Dame Street).

241:36 (245:19). on the right lay—we have taken the right aim.

241:41 (245:24). shraums—matter running from weak or sore eyes.

242:6 (245:31). 29 Windsor avenue—there was no Windsor Avenue in Dublin nor is there a 29 on the Windsors (Place and two Terraces) that did exist.

242:10 (245:35). Barabbas—see 93:20n.

Section 15: pp. 242–244 (246–248).
Intrusions: (a) 242:21–22 (246:7–8). Bronze by gold...the Ormond hotel—see [Sirens] Episode.
 (b) 242:29–31 (246:15–17). On the steps of ...Abraham Lyon ascending.
 (c) 243:8–9 (246:33–35). Outside la Maison Claire...for the liberties.

242:16 (246:2). Castleyard gate—i.e., the entrances to Dublin Castle; for the Castle, see 158:40n.

242:20 (246:6). towards Lord Edward street—80 yards north of the Castle; i.e., Cunningham et al. will walk that distance and there pick up their carriage.

242:22 (246:8). the Ormond hotel—see 226:31n.

242:26 (246:12). Boyd?—William A. Boyd, general secretary of the Dublin Y.M.C.A.; see 149:6n.

242:26 (246:12). Touch me not—John 20:17, Jesus' words to Mary Magdalene after the Resurrection, when he discovers her weeping at the empty tomb. He continues: "for I am not yet ascended to my Father."

242:27 (246:13). the list—i.e., of those who have contributed to the temporary support of Dignam's widow and her children.

242:28 (246:14). Cork hill—the slope from Castle Street to the junction of Dame Street and Lord Edward Street.

242:29 (246:15). City Hall—on Cork Hill the seat of Dublin's municipal government is adjacent to the Castle. Cunningham and company are passing the front of the building when Nannetti appears.

242:30 (246:16). Alderman Cowley—there is no such name on the List of Members, Corporation of Dublin, 1903–1904.

242:30 (246:16). Councillor Abraham Lyon—member for Clontarf West Ward in 1903–1904.

242:32 (246:18). The castle car . . . upper Exchange street—i.e., a streetcar routed to pass Dublin Castle. The street itself is another name for Cork Hill, along which Cunningham and his friends are walking.

242:34 (246:20). the Mail office—the Dublin Evening Mail (daily), 37 and 38 Parliament Street (which runs north from Cork Hill to Grattan Bridge over the Liffey).

243:2 (246:27). there is much kindness in the jew—Shakespeare, The Merchant of Venice. Shylock faces Antonio with the proposal that a pound of his flesh be exacted if he fails to repay a loan on time, and Antonio declares himself "Content, i' faith: I'll seal to such a bond,/And say there is much kindness in the Jew" (I, iii, 153–154).

243:5 (246:30). Jimmy Henry—assistant Town Clerk James J. Henry, City Hall.

243:6 (246:31). Kavanagh's—James Kavanagh, Justice of the Peace, tea, wine and spirit merchant, 27 Parliament Street (at the intersection of Essex Gate); the "winerooms" were entered from Essex Gate.

243:8 (246:33). la Maison Claire—see 165:2n.

243:8–9 (246:33–34). Jack Mooney's brother-in-law—Bob Doran, who is on a bender; see "The Boarding House," Dubliners.

243:9 (246:34). humpty—about to fall.

243:9 (246:34–35). the liberties—slum area in the southwestern quadrant of Dublin. The name is somewhat ironic since it derives from an earlier period when the region was not only fashionable but also flourished under special privileges, i.e., immunities from governmental control.

243:11–12 (246:37–38). a shower of hail suit—not unlike "pepper and salt," a kind of tweed with white knobs in the weave.

243:12–13 (246:39). Micky Anderson's watches—Michael Anderson, watchmaker, 30 Parliament Street, just short of Kavanagh's and Essex Gate.

243:27 (247:11). Henry Clay—a popular cigar named after the American politician, orator and statesman, Henry Clay (1777–1852).

243:29 (247:13). the conscript fathers—a name given to the Roman senators after the expulsion of the Tarquins. Brutus added 100 to the number of the senators and the names of the newcomers were "written together" (Conscripta) on the walls. Fanning is referring to a meeting of

the Dublin City Council (the Corporation) composed of 15 aldermen and 45 councilors elected from the 15 wards of the city.

243:32 (247:16). Hell open to Christians—After *Hell Opened to Christians; To Caution Them from Entering into It* (1688) by Giovanni Pietro Pinamonti (1632–1703), an Italian Jesuit. In translation (Dublin, 1868), the book was popular as a text for meditation. The sermons in *A Portrait of the Artist as a Young Man,* Chapter III, are in part based on this tract.

243:33 (247:17). Irish language—the movement to revive Irish as the cultural language of Ireland was echoed by frequent attempts to make it the official language of Dublin.

243:33–34 (247:17–18). Where was the marshall—answer: playing chess in the D. B. C. in Dame Street (about one block away). The city marshal was John Howard Parnell, one of whose duties was to keep order at meetings of the Dublin Corporation. See 162:30–31 and 162:35n.

243:35 (247:19). old Barlow the macebearer—Macebearer and Officer of Commons John Barlow (who was to carry the mace as symbol of authority before the lord mayor or his deputy).

243:37 (247:21). Hutchinson, the lord mayor—the Right Honorable Joseph Hutchinson, lord mayor of Dublin, 1904–1905.

243:37 (247:21). Llandudno—a fashionable watering place southwest of Liverpool in northern Wales.

243:37–38 (247:21–22). Lorcan Sherlock—secretary to the Dublin Corporation (in effect, deputy lord mayor). He was eventually lord mayor (1912–1914).

243:38 (247:22). locum tenens—Latin: "holding the place," i.e., acting as a substitute.

244:22 (248:5). pass Parliament street—i.e., the viceregal cavalcade can be seen from Parliament Street as it passes along the quays on the north bank of the Liffey.

Section 16: pp. 244–246 (248–249).
Intrusions: (a) 245:15–16 (248:36–37). The onelegged sailor ... England expects ... —see Section 3.
(b) 246:8–11 (249:33–36). Elijah, skiff ... Bridgewater with bricks—see Section 4, Intrusion (c) and Section 12, Intrusion (b).

244:32 (248:15). Parnell's brother—see 243:33–34n and 162:30–31n.

245:1 (248:22). translated—i.e., moved.

245:4–5 (248:25–26). a working corner—in chess, a concentration of pieces with which a player attempts to develop control of the board.

245:6 (248:27). mélange—French; literally, "a mixture," in this case, of fruits in thick cream.

245:10 (248:31). D. B. C—the Dublin Bakery Company's tearoom at 33 Dame Street.

245:13–14 (248:34–35). Shakespeare is the happy ... lost their balance—"happy hunting ground" is patronizing slang for American Indian concepts of the afterlife. Haines's remark is a reaction to the extraordinary wave of irresponsible speculation about Shakespeare in the latter half of the nineteenth century. Delia Bacon, whose mind did "lose its balance," provides a case in point; see 193:6n and 193:7n.

245:15 (248:36). 14 Nelson street—Private Hotel, Mrs. Mary M'Manus, proprietor. Nelson Street runs south-southeast from the middle of Eccles Street.

245:16 (248:37). England expects ... —from "The Death of Nelson"; see 222:13n.

245:20 (249:2). Wandering Ængus—see 212:4n.

245:21 (249:3). idée fixe—French: literally, "a fixed idea," with the suggestion of a compulsive preoccupation.

245:25 (249:7). visions of hell—see *A Portrait of the Artist as a Young Man,* Chapter III, and see 243:32n above.

245:26 (249:8). the Attic note—i.e., the note of Athenian culture in the fifth century B.C.

245:26 (249:8). the note of Swinburne—a reference to Swinburne's preoccupation with the sensory freedom of classical Greek values as against what he portrayed as the repressive bent of Christian values; see Swinburne, "Hymn to Proserpine" (1866). It is ironic that Mulligan consistently avoids another aspect of Swinburne's emphasis: "For there is no God found stronger than death; and death is a sleep" (line 110).

245:27 (249:9). the white death and the ruddy birth—from Swinburne, "Genesis," in *Songs Before Sunrise* (1871), Stanza 9: "For the great labour of growth, being many, is one;/One thing the white death and the ruddy birth;/The invisible air and the all-beholden sun,/And barren water and many-childed earth."

245:31–32 (249:13–14). Professor Pokorny of Vienna—Julius P. Pokorny (b. 1887), a lecturer in Celtic philology in Vienna from 1914 and a professor of Celtic at the University of Berlin from 1921. In his *A History of Ireland* (Vienna, 1916; translation, London, 1933), Pokorny argues, on the basis of an analytic treatment of Celtic mythology and philology, that the Celtic settlement of Ireland dates to 800 or 900 B.C. His preccupation is with racial origins and racial longevity.

245:35 (249:17). no trace of hell in ancient Irish myth—Haines is half right. The other world of Celtic mythology, *Tir na n-og* (see 193:9–10n), has no trace of hell; but the mythology also includes visions of an underworld of phantoms and horrors that put heroes such as Cuchulin to an ultimate test before they could realize *Tir na n-og*.

245:36–37 (249:18–19). The moral idea . . . of retribution—the concept of the Irish as amoral or immoral is not so much Pokorny's as it is the typical conservative English attitude. It dates at least from Giraldus Cambrensis (Girald de Barri, *c.*1146–*c.*1220), *Topography of Ireland* (1188), which portrays the native Irish as infected with "abominable guile" and with "the pest of treachery."

246:9–10 (249:34–35). beyond new Wapping street past Benson's ferry—the street is on the north bank of the Liffey near its mouth, the ferry is east of the street and nearer the river's mouth.

246:11 (249:36). Rosevean from Bridgewater with bricks—see 51:36–38n.

Section 17: p. 246 (pp. 249–250).

246:12 (249:37). past Holles street—Artifoni is walking southeast along Mount Street Lower, a continuation of the northeastern side of Merrion Square in the southeast quadrant of Dublin. The other two follow roughly the same course until Farrell turns back.

246:12–13 (249:37–38). Sewell's yard—James Walter Sewell and Son and James Simpson, horse repository, commission and livery establishment, 60 Mount Street Lower.

246:15 (250:1). Mr Law Smith's house—Philip H. Law Smith, Esq., M.A., L.L.D., barrister, 14 Clare Street (extends northwest from Merrion Square North, the northeastern side of Merrion Square).

246:17 (250:3). College Park—of Trinity College on the same northwest-southeast axis.

246:19 (250:5). Mr Lewis Werner's cheerful windows—Louis Werner, surgeon oculist, ophthalmic surgeon to the Mater Misericordiae Hospital and Royal Victoria Eye and Ear Hospital. His "cheerful windows" were at 31 Merrion Square North on the corner of Holles Street.

246:22 (250:8). the corner of Wilde's—Sir William and Lady Wilde, Oscar Wilde's parents, formerly lived at 1 Merrion Square North; Sir William, an oculist, was thus "at home" in this "medical area" of Dublin.

246:22–23 (250:8–9). Elijah's name . . . Metropolitan Hall—for Elijah, see 149:15n. There is some confusion here because Farrell is not looking at "Metropolitan Hall," which is in Abbey Street (north of the Liffey), but at Merrion Hall, which is off to his left, on the corner of Denzille Lane (now Fenian Street) and Merrion Street Lower, the northerly extension of Merrion Square West. When Stephen and Lynch see the same poster 420:40 (428:14), it is on Merrion Hall and the mistake is corrected.

246:24 (250:10). duke's lawn—the lawn of Leinster House, southeast of where Farrell is standing.

246:26 (250:12). Coactus volui—Latin: "I willed it under compulsion [constraint]."

246:28 (250:14). Mr Bloom's dental windows—Marcus J. Bloom, dental surgeon to Maynooth College, late lecturer on dental surgery, St. Vincent's Hospital, ex-surgeon, Dental Hospital, Dublin, and St. Joseph's Hospital for Children, 2 Clare Street. No relation to Leopold Bloom.

Section 18: pp. 246–248 (250–252)—see Section 9, Intrusion (*c*).

246:34 (250:20). Ruggy O'Donohoe's—M. O'Donohoe, international bar, 23 Wicklow Street, on the corner of William Street, where the pork butcher was located.

247:1 (250:23). Wicklow street—in the southeast quadrant of Dublin just west of the scene of the previous action. Young Dignam is heading southeast, via "Grafton street," 247:29 (251:15), and "Nassau street," 247:33 (251:19), toward his home in Sandymount near the bay, on the southeastern outskirts of metropolitan Dublin.

247:2 (250:24–25). Mrs Stoer and Mrs Quigley and Mrs MacDowell—*Thom's* (1904) lists a John Stoer, Esq., 15 New Grove Avenue, and an F. H. Stoer, 83 Tritonville Road, both in Sandymount. It lists no Quigleys in Sandymount, but it does list several MacDowells on Claremont

Road, and one of those families may very well be Gerty MacDowell's (the heroine of [Nausicaa]).

247:5 (250:27). Tunney's—William J. Tunney, family grocer, tea, wine and spirit merchant, 8 Bridge Street in Ringsend (just south of the mouth of the Liffey) and 10 Haddington Road (not far to the southwest).

247:7 (250:29). Madame Doyle—court dress and millinery warerooms, 33 Wicklow Street.

247:9 (250:31). puckers—a "puck" is a blow; therefore, boxers.

247:9 (250:31). putting up their props—i.e., squaring off with clenched fists and flexed arms.

247:11–12 (250:33–34). Keogh ... Bennett—the match has some basis in fact since an M. L. Keogh did box one Garry of the 6th Dragoons as the second event in a tournament in late April 1904. Percy Bennett, a member of the Zurich consular staff when Joyce lived in that city, is a grudge substitute for the more Irish Garry. Keogh knocked out Garry in the third round. See Ellmann, *passim.*

247:12 (250:34). Portobello—see 170:38n.

247:12 (250:34–35). fifty sovereigns—50 pounds, a sizable purse for what would have amounted, in modern terms, to a semiprofessional bout.

247:14 (250:37). Two bar—2 shillings.

247:15 (250:37–38). do a bunk on—deceive, run out on.

247:20–21 (251:15). Marie Kendall—see 226:15n.

247:22 (251:6–7). mots ... in the packets of fags—a "mot" is a loose woman or prostitute. Cards with pictures of the sort Master Dignam is contemplating used to be enclosed as come-ons in packages of inexpensive cigarettes.

247:25 (251:10). Fitzsimons—Robert Fitzsimmons (1862–1917), English heavyweight boxer, won the world championship in 1897 by knocking out J. J. Corbett with a "solar plexus" punch. Fitzsimmons lost the title to the American heavyweight James J. Jeffries (1875–1953) in 1899.

247:27 (251:12–13). Jem Corbett—James John Corbett (1866–1933), American boxer noted for his skill ("Gentleman Jim"). He became heavyweight champion of the world in 1892 by beating

John L. Sullivan. Corbett lost the title to Fitzsimmons in 1897.

247:29–31 (251:15–17). In Grafton street ... grinning all the time—the "toff" (dandy, swell) is Boylan; the drunk is Bob Doran. See 243:8–9 (246:33–35).

248:9 (251:37). butty—thick and stout, after "butt," a large barrel or cask for wine or beer.

248:13–14 (252:1). in purgatory ... confession—i.e., the hope is that Dignam, having confessed his sins and having been absolved, has not sinned mortally in the meantime and his soul has therefore been adjudged to purgatory, where he will complete his penance before entering heaven. It is significant that Dignam has sinned by going on at least one drunk, and also that Master Patrick does not recall his father's having received Extreme Unction, presumably because his death by "apoplexy" was sudden and unexpected. See 218:20–211n.

248:14 (252:1). father Conroy—the Reverend B. Conroy, C. C., of Dignam's parish church, Mary, Star of the Sea, on Leahy's Terrace in Sandymount. See 352:18n.

Section 19: pp. 248–251 (252–255).
The opening of the Mirus Bazaar took place not on 16 June but on 31 May 1904; nor was there a cavalcade, though the lord lieutenant did attend the opening. The fictional cavalcade starts at the Viceregal Lodge in Phoenix Park, exits at Park Gate, the southeastern entrance of the park, and proceeds east along the quays that line the northern bank of the Liffey. The cavalcade crosses the river at Grattan Bridge and proceeds east and south, past Trinity College and eventually across the Grand Canal and into Pembroke township (on the southeastern outskirts of Dublin, where the bazaar was located).

248:16 (252:3). William Humble, earl of Dudley, and lady Dudley—William Humble *Ward,* 2d Earl of Dudley (1866–1932), a Conservative and Lord Lieutenant of Ireland (1902–1906). Married Rachel Gurney in 1891: two sons, three daughters.

248:17 (252:4). lieutenantcolonel Hesseltine—Lieutenant Colonel C. Heseltine was an extra aide-de-camp in the lord lieutenant's household in 1904.

248:19 (252:6). the honourable Mrs Paget, Miss de Courcy—as R. M. Adams points out (p. 220n), the names have historical overtones: Sir John de Courcy was one of the Anglo-Norman heroes in the twelfth-century invasion of Ireland, and Henry William Paget (1768–1854), Earl of

Angelsey, was lord lieutenant of Ireland (1828–1829; 1830–1833); he, too, had been a military hero, in command of Wellington's cavalry at the Battle of Waterloo.

248:19–20 (252:6–7). the Honourable Gerald Ward A.D.C—(Aide-de-Camp); there is no such person listed in "The lord lieutenant's household" in *Thom's (1904)*. But the *Irish Independent*, 1 June 1904, pp. 4–5, reports "Lt. the Hon. Cyril Ward, R.N. [Royal Navy], A.D.C." in attendance on the lord lieutenant. See Adams, pp. 218–220.

248:22–23 (252:9–10). Kingsbridge—(1827) over the Liffey, just outside of Park Gate, was named in honor of George IV's visit to Dublin in 1821. It is presently called Sean Heuston Bridge.

248:24 (252:11–12). Bloody bridge—the next bridge in sequence east of Kingsbridge, called Barrack Bridge in 1904; it is now named Rory O'More Bridge (after a seventeenth-century Irish rebel leader). The name "Bloody Bridge" derives from the bridge's having been the scene of a violent apprentice riot shortly after its construction (*c*.1670), when the apprentices attempted to destroy the bridge on behalf of the ferry and ferryman which the bridge had displaced.

248:26 (252:13). Queen's and Whitworth bridges—in succession, east of "Bloody Bridge." Queen's Bridge (1768) was named for George III's queen, Charlotte; it is now called Queen Maeve Bridge (after a first-century Irish queen). Whitworth Bridge was named for Earl Whitworth, Lord Lieutenant of Ireland, 1813–1817. It is now called Father Mathew Bridge after the Reverend Theobald Mathew (1790–1856), "the apostle of temperance."

248:27–28 (252:15). Mr Dudley White, B.L., M.A.—(Bachelor of Laws, Master of Arts), barrister, 29 Kildare Street. Dublin.

248:28–29 (252:16). Mrs M. E. White's, the pawnbroker's—32 Arran Quay, on the corner of Arran Street West.

248:31 (252:18). Phibsborough—a short street three-quarters of a mile north of where Mr. White stands; his dilemma: any of the three routes he contemplates will take from 10 to 15 minutes.

248:34 (252:21). Four Courts—was east of Whitworth Bridge.

248:34 (252:21–22). costsbag—since Goulding is a "costdrawer," 39:34 (38:34).

248:34–35 (252:22). Goulding, Collis and Ward—the fictional Goulding is added to the real partnership of Collis and Ward, solicitors, 31 Dame Street.

248:35 (252:23). Richmond bridge—east of the Four Courts and next in the succession of bridges after Whitworth Bridge; it is now called O'Donovan Rossa Bridge, after Jeremiah O'Donovan (1831–1915), a Fenian leader whose advocacy of violence earned him the nickname Dynamite Rossa.

248:36–37 (252:23–24). Reuben J. Dodd, solicitor . . . Insurance Company—and Mutual Life Assurance Company of New York, 34 Ormond Quay Upper (east of Richmond Bridge).

248:38–39 (252:26). King's windows—William King, printer and law stationer, 36 Ormond Quay Upper; i.e., the "elderly female" turns back west toward the Four Courts, from which she had come.

249:1 (252:27). Wood quay—on the south bank of the Liffey opposite the western half of Ormond Quay Upper.

249:1–2 (252:28). Tom Devan's office—Dublin Corporation Cleansing Department, 15 and 16 Wood Quay.

249:2 (252:28). Poddle river—enters the Liffey from the south, just east of Richmond Bridge.

249:3 (252:29–30). the Ormond Hotel—at 8 Ormond Quay Upper.

249:6 (252:32). the greenhouse—a public toilet.

249:6 (252:32–33). the subsheriff's office—City of Dublin Sheriff's Office, 30 Ormond Quay Upper.

249:8 (252:35). Cahill's corner—Cahill and Company, letterpress printers, 35 and 36 Strand Street, on the corner of Capel Street, just north of Grattan Bridge, where the cavalcade turns out of Ormond Quay Upper to cross the Liffey.

249:11 (252:37). advowsons—in English law, the right to name the holder of a church benefice.

249:11 (252:37). Grattan bridge—(formerly Essex Bridge), after Richmond Bridge in the eastward succession of bridges. Named for Henry Grattan; see 137:15–16n.

249:13 (252:39). Roger Greene's office—Roger Greene, solicitor, 11 Wellington Quay (on the south bank of the Liffey, east of Grattan Bridge).

249:13 (252:39). Dollard's—Dollard Printing House, account-book manufacturer, factory, 2–5 Wellington Quay (at the Grattan Bridge end of the Quay).

249:14 (253:1). Gerty MacDowell—see [Nausicaa], pp. 340–376 (346–382).

249:14 (253:1–2). Catesby's cork lino—a linoleum manufactured by T. Catesby and Sons, Ltd., in Glasgow.

249:17 (253:4). Spring's—Spring and Sons, coal factors and carriers and house agents, furniture warehouse, 11 Granby Row Upper and 15–18 Dorset Street Upper.

249:19 (253:6). Lundy Foot's—Lundy, Foot and Company, wholesale tobacco and snuff manufacturers, 26 Parliament Street (on the south corner of Essex Gate). The cavalcade moves down Parliament Street and turns east into Dame Street.

249:19–20 (253:7). Kavanagh's winerooms—on the north corner of Essex Gate and Parliament Street; see 243:6n.

249:23 (253:10). G.C.V.O—Knight Grand Cross of Royal Victorian Order.

249:23 (253:10–11). Micky Anderson's—see 243:12–13n.

249:24 (253:11). Henry and James's—clothiers, 1, 2 and 3 Parliament Street and 82 Dame Street (on the corner where the cavalcade turns).

249:25 (253:12–13). Henry dernier cri James—"*dernier cri,*" French: "the last word, the latest fashion." The repetition suggests an allusion to the American novelist Henry James (1843–1916), whose studied intricacies involved frequent use of French phrases.

249:26 (253:13). Dame gate—off Dame Street, across from and just east of the intersection with Parliament Street.

249:30 (253:17–18). Marie Kendall—see 226:15n; her "poster" is on the Empire Palace Theatre, 72 Dame Street.

249:38 (253:25). Fownes's street—just short of the eastern end of Dame Street (where it becomes College Green).

249:41 (253:28–29). Commercial Buildings—off Dame Street at 41A (the intersection of Dame Street and College Green).

249:42 (253:30). hunter watch—a watch having a hunting case, a hinged cover designed to protect the crystal from injury (as on the hunting field).

250:1–2 (253:31). King Billy's horse—a statue of King William III (William of Orange) (1650–1702; king, 1689–1702) stood opposite Trinity College (one of the busiest intersections in Dublin). William defeated the Irish in the Battle of the Boyne (1690), suppressing yet another Irish bid for independence and reducing Ireland to the status of a penal colony. He is remembered only a little more cordially than Cromwell as a great oppressor.

250:7 (253:36–37). Ponsonby's corner—Edward Ponsonby, law and general bookseller, government agent and contractor, 116 Grafton Street, near its intersection with College Green. The cavalcade turns south into Grafton Street and then immediately east into Nassau Street.

250:9–10 (253:39). Pigott's music warerooms—Pigott and Company, pianoforte and musical-instrument merchants, music sellers and publishers, 112 Grafton Street.

250:12 (253:42). the provost's wall—on the corner of Grafton Street and Nassau Street; see 162:26n.

250:14 (254:1–2). My girl's a Yorkshire girl—a song by C. W. Murphy and Dan Lipton: "Two fellows were talking about/Their girls, girls, girls/Sweethearts they left behind—/Sweethearts for whom they pined—/One said, My little shy little lass/Has a waist so trim and small—/Grey are her eyes so bright,/But best of all—" Chorus: "My girl's a Yorkshire girl,/Yorkshire through and through./My girl's a Yorkshire girl,/Eh! by gum, she's a champion!/Though she's a fact'ry lass,/And wears no fancy clothes/I've a sort of Yorkshire Relish for my little Yorkshire Rose." Stanza two: "When the first finished singing/In praise of Rose, Rose, Rose—/Poor Number Two looked vexed,/Saying in tones perplexed/My lass works in a factory too,/And also has eyes of grey/Her name is Rose as well,/And strange to say—" Repeat Chorus. Stanza three: "To a cottage in Yorkshire they hied/To Rose, Rose, Rose/Meaning to make it clear/Which was the boy most dear./Rose, their Rose didn't answer the bell,/But her husband did instead./Loudly he sang to them/As off, off they fled—" Repeat Chorus.

250:22 (254:10). College park—in Trinity College north of Nassau Street and of its extension, Leinster Street.

250:31–33 (254:19–21). the quartermile flat ... W. C. Huggard—see 234:2–5n.

250:34 (254:22). Finn's hotel—M. and R. Finn, Private Hotel and Restaurant, 1 and 2 Leinster Street (where it becomes the eastward continuation of Nassau Street).

250:36–37 (254:24–25). Mr E. M. Solomons . . . viceconsulate—M. E. Solomons, a prominent member of Dublin's Jewish community, optician, manufacturer of spectacles, mathematical and hearing instruments, 19 Nassau Street; listed at the same address: The Austro-Hungarian Vice-Consulate, Imperial and Royal Vice-Consul, Maurice E. Solomons (justice of the peace in the City and County of Dublin).

250:38 (254:26–27). Hornblower—see 85:11n.

250:39 (254:27). tallyho cap—the porters of Trinity College, Dublin, still wear black peaked caps not unlike those of the members of a fox hunt (whose traditional cry when the quarry is sighted is "Tallyho").

250:40 (254:28). Merrion square—Leinster Street gives into Clare Street, which in turn becomes Merrion Square North.

251:2–3 (254:32). Mirus bazaar—see headnote to Section 19, p. 230.

251:3 (254:32). Mercer's hospital—in William Street, Dublin, incorporated by act of Parliament in 1734.

251:4 (254:33). Lower Mount street—continues Merrion Square North in an east-southeasterly direction.

251:5 (254:34). Broadbent's—J. S. Broadbent, fruiterer, 2 Mount Street Lower.

251:7 (254:37). the Royal Canal bridge—curious, because Mount Street Lower, along which the procession has been moving, gives onto a bridge over the Grand (not the Royal) Canal and then into Northumberland Road. The Grand Canal circled the southern perimeter of metropolitan Dublin, as the Royal Canal circled the northern perimeter. The bridge is

now called McHenry Bridge; it was McKenny Bridge in 1904.

251:8 (254:37). Mr Eugene Stratton—see 90:41n.

251:9 (254:38–39). Pembroke township—on the southeastern outskirts of Dublin.

251:9–10 (254:39). Haddington road corner—the cavalcade is proceeding southeast along Northumberland Road; Haddington Road crosses it almost at right angles. The two old women (see 238:24–27 [242:7–10]) have continued walking west and south from London Bridge Road through Bath Avenue into Haddington Road.

251:12–13 (255:1). without his golden chain—on state occasions the lord mayor of Dublin wore a golden chain as the emblem of his office.

251:13 (255:1–2). Northumberland and Landsdowne roads—Landsdowne Road runs northeast from its intersection with Northumberland Road.

251:15–17 (255:4–6). the house said . . . consort, in 1849—Queen Victoria and her husband, Prince Albert, spent four days in Dublin, 6 to 10 August 1849, in the course of their first visit to Ireland. They entered the city from the southeast, via Pembroke Road, which angles through the intersection of Northumberland and Landsdowne Roads. The *Freeman's Journal* for Tuesday, 7 August 1849, carried an incredibly detailed account of the royal couple's entry into Dublin. The account does not mention a specific "house . . . admired by the late queen," but describes at length the scene on Pembroke Road: "This locality presented a very grand and animated appearance. Many of the houses were beautifully decorated, and the balconies, windows, and doorsteps were crowded with elegantly attired ladies and gentlemen." The account dwells at length on the Queen's response to a cast-iron arch that spanned the intersection of Northumberland and Landsdowne Roads, "tastefully covered with laurel and other evergreens, interspersed with blossoms of whitethorn . . . surmounted by an imperial crown about four feet in height."

EPISODE 11
[SIRENS]

EPISODE ELEVEN

Bloom's House

Bloom's Destination:
Barney Kiernan's Pub

Ormond Hotel

BLOOM'S ROUTE

BOYLAN'S ROUTE

Course & Direction

Stop-Off Points

Projected Route

Episode 11: [Sirens], pp. 252–286 (256–291).
In Book XII of *The Odyssey* Circe, in the course of advising Odysseus about his voyage and its dangers, warns him about the two Sirens on their isle, "crying beauty to bewitch men coasting by." She tells Odysseus that they will "sing [a man's] mind away on their sweet meadow lolling" so that he will be led to his death on the rocky shore of their isle. If, however, Odysseus wishes to "hear those harpies' thrilling voices," he must stop the ears of his men with wax and have himself tied to the mast, his men warned not to release him no matter how violently he protests. He follows Circe's advice and hears the Sirens' song (promising pleasure and merriment after the perils of war to those who land on their rock) without paying the penalty. He then sails on to the passage between Scylla and Charybdis.

Time: 4:00 P.M. Scene: the Concert Room, the bar and restaurant of the Ormond Hotel, 8 Ormond Quay Upper. Organ: ear; Art: music; Color: none; Symbol: barmaids; Technique: *Fuga per canone*.[1] Correspondences: *Sirens*—barmaids; the *Isle*—the bar.

252:1–253:24 (256:1–257:24). BRONZE BY GOLD ... Be pfrwritt. Done—this sequence of 58 fragments is usually described as an introductory announcement of the episode's musical motifs; the episode's musical "form" may also be developed by regarding this sequence as the "keyboard" on which the "fugue" is to be performed. The initial appearance in the episode of each of these "motifs" or "notes" is cited below.

252:1 (256:1). BRONZE BY GOLD HEARD THE HOOFIRONS, STEELYRINGING—the two barmaids in the Ormond Hotel, bronze, Miss Lydia Douce, and gold, Miss Mina Kennedy, hear the viceregal procession, 253:26–28 (257:26–28).

252:2 (256:2). Imperthnthn thnthnthn—the "boots" (busboy) mimics Miss Douce's threat that she will report his "impertinent insolence," 254:25 (258:24).

[1] "A fugue according to rule." It involves three classes of subject: (1) *Andamenti*, a complete melody, beautiful in itself; (2) *Soggetti*, a short passage with a characteristic interval; (3) *Attaco*, a short figure, usually *staccato*. In the opening section of the fugue the subject(s) is presented together with the answer(s) and a repetition of the subject in a different key (if there is to be a countersubject it is introduced in this section). The next section is "Exposition," a complete statement of the subject(s) and/or answer(s) by all the voices. This is followed by the middle section, which is "free." The climax then presents the subject in its most exciting aspect; and the coda concludes the fugue with the "desire for home."

252:3 (256:3). Chips, picking chips off rocky thumbnail, chips—Simon Dedalus enters the bar, 257:1–2 (261:4–5).

252:4 (256:3–4). Horrid! And gold flushed more should be a paragraph in itself at **(256:4)** as it is **252:4**—Miss Kennedy protests Miss Douce's "crude" remark, 256:32–33 (260:34–36).

252:5 (256:5). A husky fifenote blew—Simon Dedalus prepares his pipe for tobacco, 257:27 (261:31).

252:6 (256:6). Blew, Blue bloom is on the—from "The Bloom Is on the Rye"; see 230:16n. Bloom decides to buy notepaper on which to write Martha Clifford, 257:39–40 (262:1–2).

252:7 (256:7). Gold pinnacled hair—Miss Kennedy's hair, 256:14 (260:15).

252:8 (256:8). A jumping rose ... rose of Castille—see 133:4n; Lenehan (and his pun) merge with descriptions of the barmaids, 260:21 *ff.* (264:28 *ff.*).

252:9 (256:9). Trilling, trilling: Idolores—Miss Douce sings a line from the light opera *Floradora* (1899), 257:34–35 (261:38–39), music by Leslie Stuart, book by Owen Hall, lyrics by E. Boyd-Jones and Paul Rubens. The opera takes place on a South Sea island that produces Floradora, a world-famous perfume. Dolores, the beautiful and flirtatious heroine, is being pursued (and spoiled) by a host of men including the nasty villain, but her eventual salvation is ensured when she falls in love with Frank Abercoed (surprisingly enough, a lord in disguise). At the end of Act I they pledge their love, even though they have to part, and Abercoed sings "The Shade of the Palm." Refrain: "Oh my Dolores queen of the eastern sea,/Fair one of Eden look to the West for me,/My star will be shining, love,/When you're in the moonlight calm,/So be waiting for me by the Eastern sea,/In the shade of the sheltering palm."

252:10 (256:10). Peep! Who's in the ... peepofgold?—Lenehan attempts to flirt with Miss Kennedy, 258:9 (262:13). "Peep! Who's in the corner?" is a traditional discovery question in a game of hide-and-seek.

252:11 (256:11). Tink cried to bronze in pity—diners in the Ormond Hotel summoned a waiter by ringing a small bell. The pity is Miss Douce's for the "blind stripling," 259:15 (263:21).

252:12 (256:12). And a call, pure, long and throbbing. Longindying call—the sound of the tuning fork that the blind stripling (piano

tuner) has left behind in the bar, 260:4–8 (264:11–15).

252:13–14 (256:13–14). Decoy. Soft word . . . morn is breaking—Lenehan chats with the barmaids, 260:12–24 (264:19–31). The fragment combines allusions to *The Rose of Castille* (see 129:18–19n) and "Goodbye, Sweetheart, Goodbye," a song, with words by Jane Williams (1806–1885), music by John L. Hatton (1809–1886): "The bright stars fade, the morn is breaking,/The dew-drops pearl each bud and leaf,/And I from thee my leave am taking,/Too brief with bliss, With bliss too brief./How sinks my heart with fond alarms,/The tear is hiding in mine eye,/For time doth thrust me from thine arms,/Goodbye, sweetheart, goodbye. // The sun is up, the lark is soaring, /Loud swells the song of chanticleer,/ The levret bounds o'er earth's soft flooring,/Yet I am here, yet I am here./For since night's gems from heav'n did fade/And morn to floral lips doth hie,/I could not leave thee though I said,/ Goodbye, sweetheart, goodbye."

252:15 (256:15). Jingle jingle jaunted jingling —Boylan approaches the Ormond Hotel, 257:21 (261:25). A "jingle" is a two-wheeled horse-drawn carriage.

252:16 (256:16). Coin rang. Clock clacked— the clock strikes four as Boylan pays for his sloe gin, 261:22–36 (265:31–266:4).

252:17–19 (256:17–19). Avowal. Sonnez. I could . . . Sweetheart, goodbye—Miss Douce snaps her garter for Lenehan and Boylan. "*Sonnez la cloche!*" is French: "Sound the bell." See the song "Goodbye, Sweetheart, Goodbye," 252:13–14n.

252:20 (256:20). Jingle. Bloo—Boylan's note and Bloom's note are juxtaposed as Boylan leaves the Ormond for 7 Eccles Street, 263:32–35 (267:42–268:3).

252:21–22 (256:21–22). Boomed crashing chords . . . The tympanum—Simon Dedalus, Ben Dollard and "Father" Cowley gather around the piano in the Ormond Hotel bar, 263:10–37 (267:19–268:5). "When love absorbs my ardent soul. War! War!" after a duet for tenor (or soprano) and bass, by T. Cooke, "Love and War" or "When Love Absorbs My Ardent Soul." The core of the duet: "LOVER: While love absorbs my ardent soul,/I think not of the morrow . . .;/ SOLDIER: "While war absorbs my ardent soul,/I think not of the morrow." For "tympanum," see 266:3–4 (270:13–14).

252:23 (256:23). A sail! A veil awave upon the waves—Cowley sings to a picture, "A Last Farewell," on the wall, 267:16–21 (271:26–31).

252:24 (256:24). Lost. Throstle fluted. All is lost now—Richie Goulding whistles a tenor air, "*Tutto è sciolto*" (Italian: "All Is Lost"), from Vincenzo Bellini's (1801–1835) opera *La Sonnambula* ("The Sleepwalker") (1831), 267:41–268:35 (272:9–273:4). The heroine, Amina, innocently sleepwalks her way into a situation that makes her appear faithless to her fiancé, the peasant Elvino. In Act II he laments, "*Tutto è sciolto . . .*"; in an English version: "All is lost now,/By all hope and joy/I am forsaken./Nevermore can love awaken;/Past enchantment, no nevermore." Amina answers by assuring Elvino, "Thou alone hast all my heart," and by condemning him as "faithless" because he will not "deign to hear" her.

252:25 (256:25). Horn. Hawhorn—combines Lenehan's question "Got the horn or what?" (i.e., Are you sexually aroused?), 263:6 (267:15), with Boylan's departure for Eccles Street, 265:32–33 (270:1–2).

252:26 (256:26). When first he saw. Alas!— Simon Dedalus is encouraged to sing "*M'appari*" from Flotow's opera, *Martha*, 267:25 *ff*. (271:25 *ff*.). The air for Lionel (tenor) begins: "*M'appari, tutt' amor, il mio sguardo l'incontro . . .*" Italian: literally, "All [perfect] love appeared to me, that encounter filled my eyes [completely won me]." Simon Dedalus sings one performing version, 269 (273) *ff*.: "When first I saw that form endearing,/Sorrow from me seemed to depart./Full of hope and all delighted,/All the world was joy to me./But alas 'twas idle dreaming,/ Not a ray of hope remains./Gone each word that filled my ear,/Each graceful look that charmed my eye . . ./Martha, ah Martha,/Come thou lost one/Come thou dear one." See 116:35–36n; for the opera, see 116:34n.

252:27 (256:27). Full tup. Full throb—Bloom responds to "*M'appari*," 270:19–28 (274:30–40). For "tup," see 270:24–25n.

252:28 (256:28). Warbling. Ah, lure! Alluring —Bloom recalls Molly singing a song, 271:10–15 (275:23–28).

252:29 (256:29). Martha! Come!—again "*M'appari*," 252:26n; 271:16, 22–23 (275:29, 35–36).

252:30 (256:30). Clapclop. Clipclap. Clappyclap—Simon Dedalus' performance of "*M'appari*" is applauded, 271:38–272:3 (276:9–16).

252:31. Goodgod he never heard inall should read **Goodgod henev erheard inall** as it does **(256:31)**—Richie Goulding recalls an occasion when his brother-in-law, Simon Dedalus, sang particularly well, 272:24–29 (276:37–277:2).

252:32 (256:32). Deaf bald Pat brought pad knife took up—Bloom asks the waiter for pen, ink and blotter, 273:33–34 (278:7–8), and receives them, 274:19–20 (278:36–37).

252:33 (256:33). A moonlit nightcall: far: far—Simon Dedalus imitates the sounds of an Italian barcarole he once heard in Cork Harbor, 274:27–29 (279:3–5).

252:34 (256:34). I feel so sad. P. S. So lonely blooming—Bloom adds a postscript to his letter to Martha Clifford, 275:32–33 (280:10–11), echoing Thomas Moore's song "The Last Rose of Summer." The song is used extensively in Flotow's *Martha*. First verse: "'Tis the last rose of summer/Left blooming alone;/All her lovely companions/Are faded and gone./No flower of her kindred,/No rosebud is nigh,/To reflect back her blushes,/Or give sigh for sigh."

252:35 (256:35). Listen!—Miss Douce holds a seashell to George Lidwell's ear, 276:26–28 (281:4–6).

252:36–37 (256:36–37). The spiked and winding . . . and silent roar—the shell has various sounds, 276:26–41 (281:4–19), including an echo of Lenehan's question, "Got the horn or what?" 263:6 (267:15).

252:38 (256:38). Pearls: when she. Liszt's rhapsodies. Hisss—Blooms meditates on Molly and "chamber music," 278:6–12 (282:27–34). Franz Liszt (1811–1886), Hungarian pianist and composer, wrote a popular series of virtuoso pieces for piano called "Hungarian Rhapsodies."

252:39 (256:39). You don't?—Miss Douce withdraws her arm from George Lidwell to the accompaniment of banter about believing and not-believing, 273:20–30 (277:36–278:4).

252:40 (256:40). Did not: no, no: . . . with a carra—the byplay between Lidwell and Lydia Douce ("Lidlyd"), 273:20–30 (277:36–278:4), is elided with Boylan's rapping at the door of 7 Eccles Street, 278:13–15 (282:35–37).

252:41 (256:41). Black—Cowley plays the opening chords of "The Croppy Boy," 278:26–27 (283:6–7), a street ballad about the Rebellion of 1798, by William B. McBurney (d. *c.*1902), pseudonym, Caroll Malone. A "croppy" was a Wexford or Irish rebel in 1798:

> "Good men and true! in this house who dwell,
> To a stranger *bouchal* [Irish: boy] I pray you tell
> Is the priest at home? or may he be seen?
> I would speak a word with Father Green."

> "The Priest's at home, boy, and may be seen: 5
> 'Tis easy speaking with Father Green;
> But you must wait, till I go and see
> If the holy father alone may be."

> The youth has entered an empty hall—
> What a lonely sound has his light foot-fall! 10
> And the gloomy chamber's still and bare,
> With a vested Priest in a lonely chair;

> The youth has knelt to tell his sins;
> *"Nomine Dei,"* [Latin: "in God's name"], the youth begins:
> At *"mea culpa"* [Latin: "I am guilty"] he beats his breast, 15
> And in broken murmurs he speaks the rest.

> "At the siege of Ross did my father fall,
> And at Gorey my loving brothers all,
> I alone am left of my name and race,
> I will go to Wexford and take their place. 20

> "I cursed three times since last Easter day—
> At mass-time once I went to play;
> I passed the churchyard one day in haste,
> And forgot to pray for my mother's rest.

> "I bear no grudge against living thing; 25
> But I love my country above the king.
> Now, Father! bless me, and let me go
> To die, if God has ordained it so."

> The Priest said nought, but a rustling noise
> Made the youth look above in wild surprise; 30
> The robes were off, and in scarlet there
> Sat a yeoman captain with fiery glare.

> With fiery glare and with fury hoarse,
> Instead of blessing, he breathed a curse:—
> "'Twas a good thought, boy, to come here and shrive, 35
> For one short hour is your time to live.

> "Upon yon river three tenders float,
> The Priest's in one, if he isn't shot—
> We hold his house for our Lord and King,
> And Amen! say I, may all traitors swing!" 40

> At Geneva Barrack that young man died,
> And at Passage they have his body laid.
> Good people who live in peace and joy,
> Breathe a prayer and a tear for the Croppy Boy.

252:42 (256:42). Deepsounding. Do, Ben, do—Ben Dollard is encouraged to sing "The Croppy Boy" as Cowley begins the accompaniment, 278:20–27 (282:42–283:7).

253:1 (257:1). Wait while you . . . while you hee—Bloom improvises on Bald Pat, the waiter, 276:17–22 (280:36–41), incidentally echoing the mocking deception of line 7 of "The Croppy Boy"; see 252:41n.

253:2 (257:2). But wait!—Bloom decides not to leave the Ormond before the singing of "The Croppy Boy," 278:34 (283:14).

253:3 (257:3). Low in dark . . . Embedded ore
—Bloom hears the opening chords of "The Croppy Boy," 278:34–35 (283:14–15). The phrases recall Stephen's musing, 238:9–12 (241:29–32), and recall scene iii of Wagner's *Das Rheingold (The Rhinegold)* (1869), the first of the four operas of *Der Ring des Nibelungen (The Ring of the Nibelung)*. In scene iii, Wotan, the threatened king of the gods, descends into Nibelheim, the cavern residence of the dwarf Nibelungs. The Nibelungs have been enslaved by the dwarf Alberich, who has stolen the Rhinegold and suffered the curse of having to forswear love forever in order to rule the whole world through the magical power of a ring made out of the Rhinegold. In this phase of the fantastically complex Wagnerian plot, Wotan and his fellow gods trick Alberich and strip him of the ring and his power.

253:4 (257:4). Naminedamine. All gone. All fallen—the Croppy Boy does penance *"in nomine Domini"* (Latin: "in the name of God"), 279:22–25 (284:2–5), and recounts the destruction of his family, 280:19–21 (285:1–3); see "The Croppy Boy," 252:41n, stanzas 4 and 5. See also "The Last Rose of Summer," quoted in 252:34n.

253:5 (257:5). Tiny, her tremulous fernfoils of maidenhair—the singing of "The Croppy Boy" affects Miss Douce, 281:24–29 (286:8–13).

253:6 (257:6). Amen! He gnashed in fury—the song reaches its climax, 281:42 (286:27); see "The Croppy Boy," line 40, 252:41n.

253:7 (257:7). Fro. To, fro. A baton cool protruding—Miss Douce fondles the beerpull as she listens to the song, 281:34–39 (286:18–24).

253:8 (257:8). Bronzelydia by Minagold—Miss Douce and Miss Kennedy are juxtaposed, 284:16–17 (289:4–5).

253:9–10 (257:9–10). By bronze, by gold . . . Old Bloom—Bloom is leaving the hotel, 282:14–17 (287:1–4).

253:11 (257:11). One rapped, one tapped with a carra, with a cock—the sound of the blind piano tuner's cane blends with the echo of Boylan's knocking and crowing, 281:40–41 (286:25–26).

253:12 (257:12). Pray for him! Pray, good people!—Ben Dollard sings the closing lines of "The Croppy Boy," 282:19–21 (287:6–8); see 252:41n.

253:13 (257:13). His gouty fingers nakkering—Ben Dollard Spanish-dances his way to the bar after his song, 282:31–33 (287:18–20); to "nakker" or "naker" is to sound a kettledrum.

253:14 (257:14). Big Benaben. Big Benben—Dollard is applauded, 282:34 (287:21), with appropriate echoes of the deep bell of Big Ben, the clock in the tower of the Houses of Parliament, London.

253:15 (257:15). Last rose Castille . . . so sad alone—combines *The Rose of Castille*, 133:4n, with "The Last Rose of Summer," 252:34n, as Bloom's meeting with "the whore of the lane" overlaps the continuing scene in the Ormond, 285:20, 40 (290:9, 29).

253:16 (257:16). Pwee! Little wind piped wee—Bloom's digestive processes as he leaves the Ormond, 284:6 (288:36).

253:17–18 (257:17–18). True men, Lid . . . tschink with tschunk—Lidwell, Kernan, Cowley, Dedalus and Dollard clink glasses, 285:38–42, 286:9 (290:27–31, 290:40). The fragment echoes lines 7–8 of Ingram's "The Memory of the Dead," 237:35–36n: "But a true man, like you, man,/Will fill your glass with us." It also echoes Timothy Daniel Sullivan's (1827–1914) "The Thirty-two Counties," a drinking song that names all the counties of Ireland. The chorus: "Then clink, glasses, clink, 'tis a toast we all must drink,/And let every voice come in at the chorus./For Ireland is our home, and wherever we may roam/We'll be true to the dear land that bore us."

253:19 (257:19). Fff! Oo!—Bloom farts 285:13, 286:18 (290:1, 291:7).

253:20–21 (257:20–21). Where bronze from . . . Where hoofs?—the sounds of the sirens, 285:38 (290:27), and of the vice-regal procession are fading.

253:22 (257:22). Rrrpr. Kraa. Kraandl—the sound of Bloom's fart is masked by the sound of a passing tram.

253:23 (257:23). Then, not till then . . . Be pfrwritt—Bloom reads Robert Emmet's last words (see 286:3n) in the window of an antique shop, 286:19–22 (291:8–11).

253:24 (257:24). Done—the last of Robert Emmet's last words, 286:3n, signals the end of this prologue of fragments and the beginning and end of the fugue, 286:24 (291:13).

253:26 (257:26). Miss Douce's . . . Miss Kennedy's—Lydia Douce, one of the two barmaids in the Ormond Hotel, is apparently fictional; Mina Kennedy, the other barmaid, is also apparently fictional, but she has a real address; see 265:18–19 (269:30–31).

253:30 (257:30). his ex—i.e., his excellency, the lord lieutenant.

253:30–31 (257:30–31). eau de Nil—French: literally, "water of the Nile"; in this case, a cloth of a pale greenish-blue color.

253:34 (257:34). the fellow in the tall silk—the honorable Gerald Ward, A.D.C., 248:19–20 (252:6–7).

253:41 (257:41). He's killed looking back—as the Sirens' victims in *The Odyssey* would be.

254:10 (258:9). Bloowho—see 149:9 *ff*. (151:9 *ff*.).

254:10 (258:9). Moulang's pipes—Daniel Moulang, jeweler and pipe importer, 31 Wellington Quay; the quay is on the south bank of the Liffey east of Grattan (formerly Essex) Bridge. Bloom is walking west toward Grattan Bridge, which he will cross, turning west again along Ormond Quay Upper toward the Ormond Hotel.

254:11–12 (258:10–11). the sweets of sin/for Raoul—the novel Bloom has selected for Molly; see 232:27n.

254:11 (258:10). Wine's antiques—Bernard Wine, general dealer in jewelry and antiquities, 35 Wellington Quay (east of Moulang's).

254:12 (258:11). Carroll's—John Carroll, watchmaker and jeweler, and dealer in old plate, 29 Wellington Quay (west of Moulang's).

254:13 (258:12). boots—busboy.

254:18 (258:17). lithia crate—"lithia" was a bottled spring water.

254:23 (258:22). Mrs de Massey—the proprietress of the Ormond Hotel, 8 Ormond Quay Upper.

255:2 (259:2). the borax with cherry laurel water—(sometimes with glycerine added), a popular cosmetic "remedy" for blemishes of the skin (and hopefully for sunburn).

255:10 (259:10). Boyd's—Adams (p. 12) cites this as Boileau and Boyd, Ltd. (late Boyd Samuel), wholesale druggists, manufacturing chemists and color merchants, 46 Mary Street; but since Miss Kennedy lives in Drumcondra, it could as easily be James Boyd, druggist, at 21 Grattan Parade, Drumcondra.

255:25 (259:25). the Antient Concert Rooms—or Ancient Concert Rooms, at 42 Brunswick Street Great (now Pearse Street), a Dublin hall where privately sponsored concerts were given.

255:36 (259:36). And your other eye!—slang phrase for "Nonsense!"

255:37 (259:37). Aaron Figatner's—diamond setter, jeweler, etc., 26 Wellington Quay.

255:38–39 (259:38–39). Prosper Loré's—wholesale hat manufacturer, 22 Wellington Quay.

255:39 (259:39). Bassi's blessed virgins—Aurelio Bassi, statue and picture-frame maker, 14 Wellington Quay.

255:40 (259:40). Bluerobed, white under—the traditional colors of the Virgin Mary's costume.

255:40 (259:40). come to me—this common phrase suggests the Virgin's sympathy for the sinful and the heavily burdened together with her role as intercessor with her Son; in context, the phrase identifies the Virgin as another sort of Siren.

256:3 (260:4). The sweets of sin—see 254:11n.

256:23 (260:25). ringing in changes—change-ringing is the continual production without repetition of changes in bells. Changes are variations on the basic bell sequence that moves from the highest bell note to the lowest along a diatonic scale.

256:35 (260:37). Cantwell's offices—Cantwell and M'Donald, wholesale wine and whiskey merchants and rectifying distillers, 12 Wellington Quay.

256:35 (260:37). Greaseabloom—involves a pun, ". . . when it is remembered that *grease* is pronounced *grace* in Ireland" (P. W. Joyce, *English as We Speak It in Ireland*, p. 137).

256:35 (260:37). Ceppi's virgins—Peter Ceppi and Sons, picture-frame and looking-glass factory, and statuary manufacturers, 8 and 9 Wellington Quay.

256:39–40 (260:41–42). The Clarence—The Clarence Commercial Hotel, 6 and 7 Wellington Quay.

256:40 (260:42). Dolphin—The Dolphin Hotel, restaurant and luncheon bar, 46–48 Essex Street (just off Wellington Quay to the south).

257:6 (261:9). Rostrevor—a town in the Mourne Mountains on the shore of Carlingford Lough, an arm of the sea 55 miles north of Dublin.

257:16 (261:20). simple Simon—after the nursery rhyme: "Simple Simon met a pieman,/ Going to the fair./Said Simple Simon to the pieman,/'Let me taste your ware.'/Said the pieman to Simple Simon,/'Show me first your penny.'/ Said Simple Simon to the pieman,/'Indeed, I haven't any.'"

257:17 (261:21). a doaty—i.e., someone to doat (dote) upon; a Dublin term of affection or endearment.

257:23–24 (261:27–28). Cantrell and Cochrane's—see 75:17n.

257:28–29 (261:32–33). the Mourne mountains—on the Irish Sea in County Down about 50 miles north of Dublin.

257:35 (261:39). O, Idolores . . . eastern seas! —see 252:9n.

257:36 (261:40). Mr Lidwell—George Lidwell, solicitor, 4 Capel Street, Dublin. See Ellmann, pp. 340–342.

257:38 (261:42). Essex bridge—the original name (1755) for Grattan Bridge; the name was officially changed before 1888.

257:39 (262:1). Daly's—Teresa Daly, tobacconist, 1 Ormond Quay Upper, at the foot of Grattan Bridge just east of the Ormond Hotel.

257:40 (262:2). Blue Bloom is on the rye— see "The Bloom Is on the Rye," 230:16n.

258:8 (262:12). sandwichbell—a glass bell that protected and displayed sandwiches on the bar.

258:9 (262:13). Peep! Who's in the corner? see 252:10n.

258:11 (262:15). To mind her stops—a "stop" is a mark of punctuation; hence the expression means: "Be careful." But a "stop" is also a contrivance by which the pitch of an instrument is altered.

258:11–12 (262:15–16). To read only the black ones: round o and crooked ess—i.e., to pay attention only to periods and question marks?

258:15 (262:19). solfa—from the set of syllables (do, re, mi, fa, sol, la, ti, do) sung to the respective notes of the major scale.

258:15–16 (262:20). plappering—coming down or falling with a flat impact.

258:17–18 (262:21–22). Ah fox met ah stork . . . pull up ah bone?—Lenehan mixes the characters from two of Aesop's fables. In "The Wolf and the Crane" the wolf offers to pay a crane to remove a bone from his throat; when the crane removes the bone, he is told that his payment is that he has not been eaten. In "The Fox and the Stork" the fox invites the stork to dine and serves him soup in a flat plate so that the stork cannot eat; the stork invites the fox to dine and turns the tables by offering him mincemeat in a jar with a narrow neck.

258:28 (262:32). Dry—Lenehan is trying to cadge a drink.

258:34 (262:39). Mooney's en ville and in Mooney's sur mer—for Mooney's, see 142:14n. *"En ville . . . sur mer,"* French: "in town . . . on the sea."

258:35 (262:40). the rhino—ready money.

258:40 (263:3). that minstrel boy of the wild wet west—Burke is characterized as being from the west of Ireland, which Dubliners regard as both "wild" and "wet." "The Minstrel-Boy" (The Moreen), a song from Thomas Moore's *Irish Melodies*: "The Minstrel-Boy to war is gone,/In the ranks of death you'll find him;/His father's sword he has girded on,/And his wild harp slung behind him./Land of song! said the warrior-bard,/Though all the world betrays thee,/ One sword at least, thy right shall guard,/One faithful harp shall praise thee! // The Minstrel fell!—but the foeman's chain/Could not bring his proud soul under;/The harp he lov'd ne'er spoke again/For he tore its chords asunder;/And said, No chains shall sully thee,/Thou soul of love and bravery!/Thy songs were made for the pure and free,/They shall never sound in slavery."

259:2 (263:7). faraway mourning mountain eye—suggests a Percy French (1854–1920) song, "The Mountains of Mourne," in which the speaker, an Irish laborer in London, insists that for all the sights of the city, the painted city girls, etc., he prefers his Mary "where the Mountains o' Mourne sweep down to the sea."

259:14 (263:20). God's curse on bitch's bastard—see 246:32–33 (250:18–19).

259:15 (263:21). a diner's bell—see 252:11n.

259:27 (263:34). Are you not happy in your home?—a question from Martha Clifford's letter, 76–77 (77–78).

259:27–28 (263:34–35). Flower to console me —in the language of flowers the appropriate flower for "consolation" is a scarlet geranium.

259:28 (263:35). a pin cuts lo—see 166:10–11n.

259:29 (263:36). a daisy? Innocence that is— in the language of flowers a daisy does mean "innocence" unless it is colored, in which case it means "beauty."

259:31–32 (263:39). Smoke mermaids, coolest whiff of all—the advertising slogan for Mermaid cigarettes, ten for 3d.

259:34 (263:41). jauntingcar—see 237:17n.

259:41–260:1 (264:7–8). Bloo smi qui go. Ternoon—"Bloom smiled quick go. Afternoon." But "qui" suggests a pun on the Latin-French word for "who." And "Ternoon" is a printer's word for a group of three and also the name for a triple chance in a numbers lottery.

260:1–2 (264:8–9). the only pebble on the beach—proverbially, the sole desirable or remarkable person available or accessible.

260:12, 14, 19, 37 (264:19, 21, 26, 265:3). The bright stars fade . . ./—the morn is breaking/—The dewdrops pearl . . . /And I from thee . . .—"Goodbye, Sweetheart, Goodbye"; see 252:13–14n.

260:21 (264:28). rose of Castille—see 129:18–19n.

260:27 (264:34). Ask no questions . . . hear no lies—after *She Stoops to Conquer; or The Mistakes of a Night* (1773), by Oliver Goldsmith (1728–1774). In Act III Tony Lumpkin turns aside the question of how he "procured" his mother's jewels: "Ask me no questions, and I'll tell you no fibs."

260:32 (264:39). See the conquering hero comes—the opening line of a poem by Thomas Morell (1703–1784): "See, the conquering hero comes!/Sound the trumpets, beat the drums;/Sports prepare, the laurel bring;/Sounds of triumph to him sing." Handel used the song in Part III of his oratorio *Joshua* (1747), where it is sung by a chorus of youths in celebration of Joshua's victory at Jericho. In the oratorio the youths are answered by a chorus of Virgins: "See the godlike youth advance! . . ."

261:1 (265:9). bitter—a type of English beer.

261:4 (265:12). lugs—ears.

261:4–5 (265:13). the sheriff's office—30 Ormond Quay Upper; see 249:6n.

261:30 (265:39). Idolores. The eastern seas —from "The Shade of the Palm"; see 252:9n.

261:34–36 (266:2–4). Fair one of Egypt . . . Look to the west—after "The Shade of the Palm"; see 252:9n. "Egypt" implies the substitution of Cleopatra for the "Eve" of the song.

261:42 (266:10). ryebloom—echoes "The Bloom Is on the Rye," 230:16n.

262:7, 13, 41 (266:17, 23, 267:8). To Flora's lips did hie./—I could not leave thee . . ./— . . . Sweetheart, goodbye!"—from "Goodbye, Sweetheart, Goodbye"; see 252:13–14n.

262:15 (266:25). Sonnez la cloche!—French: "Sound the bell!"

263:6 (267:15). Got the horn . . . ?—see 252:25n.

263:12 (267:21). the long fellow—i.e., John Fanning, the subsheriff.

263:13 (267:22). a barleystraw—slang for "a trifle"; the word recalls the proverb: "Thou knowest a barley straw/Will make a parish parson go to law."

263:13 (267:22). Judas Iscariot's—i.e., Judas, the man of Kerioth (in Judah), the disciple who betrayed Jesus for 30 pieces of silver (in this case, Reuben J. Dodd).

263:18 (267:27). Power—i.e., whiskey, made by John Power and Son, Ltd., Dublin distillers.

263:23 (267:33). Begone, dull care—an anonymous drinking song first printed in Playford's *Musical Companion* (1687): "Begone, dull care! I prithee begone from me!/Begone, dull care! Thou and I shall never agree. . . ."

263:36 (268:4). Love and war—see 252:21–22n.

264:2 (268:12–13). eau de Nil—see 253:30–31n.

264:5 (268:16). Collard grand—a middle-grade and relatively expensive English piano, priced from £110 in 1904.

264:11 (268:22). by Japers—dodging the curse: "by Jesus."

264:11–12 (268:22–23). wedding garment—slang for formal clothes.

264:17 (268:28). the lost chord—a song, words by Adelaide A. Procter (1825–1864), music by Arthur Sullivan (1842–1900): "Seated one day at the Organ,/I was weary and ill at ease./And my fingers wander'd idly/Over the noisy keys;/I know not what I was playing,/Or what I was dreaming/

But I struck one chord of music,/Like the sound of a great Amen,/Like the sound of a great Amen./ It flooded the crimson twilight/Like the close of an Angel's Psalm,/And it lay on my fever'd spirit/With a touch of infinite calm;/It seem'd the harmonious echo/From our discordant life;/ It linked all perplexed meanings/Into one perfect peace,/And trembled away into silence,/As if it were loth to cease./I have sought, but I seek it vainly,/That one lost chord divine/Which came from the soul of an organ/And enter'd into mine./ It may be that Death's bright Angel/Will speak in that chord again;/It may be only in Heav'n/ I shall hear that grand Amen."

264:26 (268:37). the coffee palace—the Dublin Temperance Institute and Coffee Booths and Restaurant, operated by the Dublin Total Abstinence Society at 6 Townsend Street, just south of the Liffey in eastern Dublin.

264:27 (268:38). gave me the wheeze—slang: "gave me the information."

264:28 (268:39). the other business—buying and selling used clothing, as Bloom recalls, 158:26–28 (160:38–40), and as Molly recalls, 759:11–12 (774:8–9).

264:29 (268:40). Keogh's—Thomas Keogh, family grocer and purveyor, 56–57 Clanbrassil Street Lower on the corner of South Circular Road, not far from where the Blooms lived when they were in Lombard Street West. In effect, the Blooms' friends have traced them to Holles Street by getting their address from their former grocer.

264:34 (269:4). Merrion square style—Merrion Square was a fashionable (and expensive) residential area. Holles Street, where the Blooms lived, is off Merrion Square, but it was a "mixed" street with tenements as well as lower-middle-class housing and a hospital.

265:1–2 (269:13–14). Paul de Kock—see 64:30n.

265:8 (269:20). Daughter of the regiment—*La Fille du régiment* (1840), a French comic opera by the Italian Gaetano Donizetti (1797–1848). As the title suggests, the heroine is an orphan adopted by a regiment (in Napoleon's army). She falls in love with the opera's peasant hero, but their romance is interrupted by the disclosure that she is an aristocrat by birth. True love eventually crosses the class barriers between peasant and aristocrat.

265:14 (269:26). My Irish Molly, O—a recurrent phrase in an anonymous Irish ballad, "Irish Molly O." "A poor unhappy Scottish youth" is

brokenhearted because Molly's father has forbidden her to "wed a foreigner." As the youth puts it: "A poor forlorn pilgrim, I must wander to and fro,/And all for the sake of my Irish Molly O!" The chorus describes Molly as "modest, mild and beautiful . . ./The primrose of Ireland."

265:18–19 (269:30–31). 4 Lismore Terrace, Drumcondra—was occupied in 1904 by a Mr. William Molony.

265:19 (269:31). Idolores, a queen, Dolores—after "The Shade of the Palm"; 252:9n.

265:28 (269:40). Bachelor's walk—the northern quayside of the Liffey east of Ormond Quay Upper and Lower.

265:35, 266:19–20, 21–22 (270:5, 29–30, 31–32). When love absorbs my ardent soul . . ./. . . my ardent soul/I care not for the morrow./Love and war—see 252:21–22n.

265:39–40 (270:9–10). your landlord—the Reverend Hugh C. Love.

265:40 (270:10). Love or money—recalls the stock expression of absolute refusal: "not for love or money."

266:3–4 (270:13–14). you'd burst the tympanum . . . organ like yours—the pun recalls the medieval belief that the Virgin Mary conceived Jesus (by the Word of God) through her ear; see 510:17 (521:23).

266:8 (270:18). Amoroso ma non troppo—Italian (music): "In a soft, tender, loving style but not too much so."

266:15 (270:25). Independent—the *Irish Weekly Independent and Nation,* published each Thursday.

266:39 (271:7). the Burton—see 159:7n.

267:9–10 (271:19–20). Poop of a lovely . . . Golden ship . . . Cool hands—recall Enobarbus' description of Cleopatra in *Antony and Cleopatra*: "The barge she sat in, like a burnished throne,/ Burn'd on the water: the poop [stern] was beaten gold" (II, ii, 196–197); ". . . at the helm/A seeming mermaid steers: the silken tackle/Swell with touches of those flower-soft hands,/That yarely [with a sailor's efficiency] frame the office [do their duty]" (II, ii, 213–216).

267:10 (271:20). The harp that once or twice—see "The Harp That Once through Tara's Halls," 165:26n.

267:11 (271:21). harps—with a pun on "harp," slang for an Irishman.

267:15, 23–24 (271:25, 33–34). M'appari . . ./ M'appari tutt' amor:/Il mio sguardo l'incontr . . .—see 252:26n.

267:18 (271:28). A Last Farewell—a print on the wall is appropriately an illustration of a song by John Willis, "The Last Farewell": "Farewell! and when the dark dark sea/Is wafting thee away/Then will you give one thought to me/As o'er the deep you stray. // Farewell, and when the sun's last rays/Sink down beneath the main/Thou'lt think of joys in other days/And sigh for home again."

267:31–32 (271:41–42). Play it in the original. One flat—Father Cowley is right; Lionel's air, *"M'appari,"* is in the key of B flat.

267:37 (272:5). Graham Lemon's—Lemon and Company, Ltd., wholesale confection, losenge and comfit manufacturers to the Queen, 49 Sackville Street Lower (now O'Connell Street). Boylan has turned north from the Liffey side.

267:37 (272:5). Elvery's elephant—Elvery's Elephant House, John W. Elvery and Company, waterproof and gutta-percha manufacturers, 46–47 Sackville Street Lower (north of Lemon's).

267:41–42 (272:9–10). Sonnambula—see 252:24n.

267:42 (272:10). Joe Maas—Joseph Maas (1847–1886), a famous English tenor (lyric rather than dramatic) who began his career as a choirboy and who starred in the German impresario Carl Rosa's (1842–1889) opera company. Rosa's company was noted for its presentations of English versions of foreign operas.

268:1 (272:11). M'Guckin—Barton M'Guckin (1852–1913), Irish tenor who also began his career as a choirboy and who also sang in Rosa's company.

268:4 (272:14). Backache he. Bright's bright eye—backache and bright eyes were commonly taken as "symptoms" of Bright's disease, a disease of the kidneys that could be caused by excessive consumption of alcohol.

268:5 (272:15). Paying the piper—after the common saying (*c.*1681): "If you dance to the tune, you must pay the piper [fiddler]."

268:5 (272:15). Pills. pounded bread—echoes the popular suspicion that most miracle-cure pills contained very little in the way of drugs or effective medication. In 1904 drugs were regarded as of very little help in the treatment of

Bright's disease; change of climate, abstinence from alcohol and a strict diet were usually recommended.

268:6–7 (272:16–17). Down among the dead men—anonymous English song: "Here's a health to the Queen, and a lasting peace,/To faction an end, to wealth increase,/Come let's drink it while we have breath,/For there's no drinking after death. // And he that will this health deny/Down among the dead men,/Down among the dead men,/Down, down, down, down,/Down among the dead men let him lie!'"

268:7 (272:17). Kidney pie. Sweets to the— a common joking use of Gertrude's line: "Sweets to the sweet. Farewell" (as she scatters flowers in Ophelia's grave); i.e., as sweets to the sweet, so kidneys for those with kidney trouble.

268:9 (272:20). Vartry water—Dublin's public water supply was created by diverting the Vartry River into a large reservoir, the Vartry or Roundwood Reservoir, 18 miles south of Dublin.

268:10 (272:20). fecking—to "feck" is to discover a safe method of robbing or cheating.

268:12 (272:22). Screwed—drunk.

268:14 (272:25). the gods of the old Royal—i.e., in the cheapest balcony seats; the old Royal Theatre in Hawkins Street was destroyed by fire in 1880, when Bloom was fourteen years old. It was subsequently replaced by a new Theatre Royal in 1884.

268:14 (272:25). little Peake—see 90:14 (91:17).

268:21 (272:32). All is lost now—see 252:24n.

268:22–23 (272:34). banshee—Irish: a female fairy.

268:27 (272:38–39). Echo. How sweet the answer—after Thomas Moore's "Echo," in *Irish Melodies:* "How sweet the answer Echo makes/To music at night,/When roused by lute or horn, she wakes,/And far away, o'er lawns and lakes,/Goes answering light. // Yet love hath echoes truer far,/And far more sweet,/Than e'er beneath the moon light's star,/Of horn or lute, or soft guitar,/The songs repeat. // 'Tis when the sigh, in youth sincere,/And only then,—/The sigh that's breath'd for one to hear,/Is by that one, that only dear,/Breathed back again!"

268:31–32 (272:42–273:1). In sleep she . . . in the moon—i.e., the innocent heroine Amina of *La Sonnambula;* see 252:24n.

268:33 (273:2). Call name. Touch water—popular superstition held that there was danger of shock or injury to a sleepwalker who was abruptly awakened. Two exceptions: the sleepwalker could be softly called by name, or it could be arranged for the sleepwalker to touch water (in which case the sleepwalker would return to bed rather than risk drowning).

268:34 (273:3). She longed to go—Bloom interprets Amina's sleepwalking (dream) as an expression not of her innocence but of her desire.

268:38–39 (273:7–8). Still harping on his daughter—Hamlet ("mad") baits Polonius with crude jokes about his daughter. POLONIUS (*aside*): "How say you by that? Still harping on my daughter" (II, ii, 188–189).

268:39 (273:8). Wise child that knows her father—see 87:17–18n.

269:1 (273:12). Crosseyed Walter sir I did sir—see 39:35–37 (38:35–37).

269:13 (273:24). a heart bowed down—"The Heart Bowed Down" is a song in Act II of Michael William Balfe's (1808–1870) opera, *The Bohemian Girl* (1843): "The heart bowed down by weight of woe,/To weakest hopes will cling,/To thought and impulse while they flow,/That can no comfort bring,/ . . . /With those exciting scenes will blend,/O'er pleasure's pathway thrown;/But memory is the only friend,/That grief can call his own."

269:19–271:34 (273:30–276:6). When first I saw . . . —To me!—the italicized lines in these pages are from Lionel's air, "*M'appari,*" in *Martha;* see 252:26n.

269:22 (273:33). Braintipped—i.e., the scalp tingles with pleasurable excitement.

269:37 (274:6). love's old sweet song—see 63:25–26n.

270:1 (274:12). Increase their flow—after the popular belief that intense sexual activity increased a singer's vocal capacity.

270:2, 3–4 (274:13, 14–15). My head it simply . . ./Your head it simply swurls—Boylan's song; see 62:30n.

270:3 (274:14). for tall hats—implies an unfounded pretension to elegance or ability.

270:4–5 (274:15–16). What perfume does . . . want to know—from Martha Clifford's letter, 77:7–8 (78:12–13).

270:7 (274:18). Phila of cachous—i.e., a lover of a candy made from cashew nuts (used by smokers to sweeten their breath).

270:7 (274:18). kissing comfits—various candies used to sweeten the breath.

270:8 (274:19). Hands felt for the opulent—from *Sweets of Sin;* see 232:27n.

270:13–14 (274:24–25). Singing wrong words—Simon Dedalus sings a popular version of "*M'appari,*" not one of the versions used in performances of the opera in English.

270:15–16 (274:26–27). Keep a trot for the avenue—i.e., retain the ability to make a good appearance on occasion, even though one is in decline, after the aging horse that can still show in competitive moments.

270:17–18 (274:28–29). Jenny Lind soup . . . pint of cream—Jenny Lind (1820–1887), a Swedish soprano whose abilities as a singer together with her personal qualities and generosity made her one of the most popular of nineteenth-century performers. She was noted for the abstemiousness of her diet, and a bland but nourishing soup of the sort Bloom's recipe suggests; *Soup à la Cantatrice* (Professional Singer's Soup) was renamed in her honor. As Mrs. Isabella Beeton put it in *The Book of Household Management* (London, 1861), "Note: This is a soup, the principle ingredients of which, sago [not sage] and eggs, have always been deemed very beneficial to the chest and throat. In various quantities, and in different proportions, these have been partaken of by the principal singers of the day, including the celebrated Swedish Nightingale, Jenny Lind, and, as they have always avowed, with considerable advantage to the voice, in singing."

270:19–20 (274:30–31). That's the chat—slang: "That's the right or correct thing."

270:24–25 (274:36–37). Tipping her tepping . . . topping her. Tup—all of these t-p "verbs" have in common the (archaic) meaning: to copulate as animals. To "tup" means to copulate as a ram copulates, as does to "tip." To "top" means to cover as an animal covers and both "tap" and "tep" are dialect variants of "top." "Tipping" is also a musical term for double-tonguing.

270:42 (275:13). Drago's—Adolphe Drago, hairdresser and wigmaker, 36 Henry Street and 17 Dawson Street, Dublin.

271:4 (275:17). Mat Dillon's in Terenure—see 105:6–7n. Terenure is another name for Roundtown.

271:10 (275:23). Waiting—a song for soprano or tenor, words by Ellen H. Flagg, music by H. Millard (1867): "The stars shine on his pathway,/The trees bend back their leaves/To guide him to the meadow/Among the golden sheaves/Where I stand longing, loving/And list'ning as I wait/To the nightingale's wild singing,/Sweet singing to its mate,/Singing, singing, sweet singing to its mate. // The breeze comes sweet from heaven,/And the music in the air/Heralds my lover's coming,/And tells me he is there,/And tells me he is there. // Come for my arms are empty!/Come for the day was long!/Turn the darkness into glory,/The sorrow into song./I hear his footfall's music,/I feel his presence near./All my soul responsive answers/And tells me he is here. // O stars . . . shine out your brightest!/O night . . . ingale, sing sweet/To guide . . . him to me, waiting/And speed his flying feet,/To guide . . . him to me, waiting/And speed his flying feet."

271:14 (275:27). in old Madrid—"In Old Madrid," a song with words by G. Clifton Bingham, music by Henry Trotere (Trotter): "Long years ago in old Madrid/Where softly sighs of love the light guitar,/Two sparkling eyes a lattice hid./Two eyes as darkly bright as love's own star/There on a casement ledge when day was o'er,/A tiny hand lightly laid./A face looked out, as from the river shore,/There stole a tender serenade./Rang the lover's happy song,/Light and low from shore to shore,/But ah, the river flowed along/Between them evermore,/Come my love, the stars are shining,/Time is flying, love is sighing,/Come, for thee a heart is pining,/Here alone I wait for thee."

271:14 (275:27). Dolores shedolores—see 252:9n.

272:5–6 (276:18–19). by monuments of sir John . . . Theobald Matthew—in sequence up Sackville (O'Connell) Street (as Boylan proceeds north). For Gray, see 93:2n; for Nelson, 94:1n; for Father Mathew, 94:30n.

272:7–8 (276:20–21). Cloche. Sonnez la. Cloche. Sonnez la—see 252:17–19n.

272:9 (276:22). the Rotunda, Rutland square—at the top of Sackville (O'Connell) Street, the Rotunda on Rutland (now Parnell) Square is an eighteenth-century building that housed a series of public rooms available for concerts, meetings and exhibitions.

272:26–29 (276:39–277:1). 'Twas rank and fame . . . since love lives not—see 129:18–19n.

272:36 (277:9). We never speak as we pass by—(1882), the title of a song by the American Frank Egerton. Chorus: "We never speak as we pass by/Although a tear bedims her eye;/I know she thinks of her past life,/When we were loving man and wife."

272:36–37 (277:10). Rift in the lute—after Tennyson's song "The Rift within the Lute," in *Idylls of the King*, "Merlin and Vivien" (1859). The deceptive Vivien sings the song to the doubting Merlin in the attempt to convince him that she is trustworthy: "In love, if love be love, if love be ours,/Faith and unfaith can ne'er be equal powers:/Unfaith in aught is want of faith in all. // It is the little rift within the lute,/That by and by will make the music mute,/And ever widening slowly silence all. // The little rift within the lover's lute/Or little pitted speck in garner'd fruit,/That rotting inward slowly moulders all. // It is not worth the keeping: let it go./But shall it? answer, darling, answer, no./And trust me not at all or all in all."

273:2 (277:17). Barraclough's—Arthur Barraclough, professor of singing, 24 Pembroke Street Lower, Dublin.

273:3–4 (277:18–19). a retrospective sort of arrangement—see 90:4 (91:7).

273:8 (277:23). Thou lost one—"M'appari"; see 252:26n.

273:12 (277:27–28). Corpus paradisum—Latin: literally, "the body of paradise." The phrase elides two liturgical fragments that Bloom has heard, "*Corpus*," 79:31 (80:34), and "*In paradisum*," 103:13 (104:25).

273:33 (278:7). A pad—a blotter.

274:16 (278:32). Blumenlied—German: "Flower Song." There are literally hundreds of songs so titled; the most famous is by the German lyric poet Heinrich Heine (1797–1856).

274:17–18 (278:33–34). the stables near Cecilia street—there were stables at 5 and 6 Cecilia Street in the midst of a commercial warehouse district just south of the Liffey in central Dublin.

274:22 (278:39). Ringabella, Crosshaven—see 226:35n.

274:23 (278:40). Queenstown harbour—Queenstown is now Cobh, the seaport of Cork, on the south coast of Ireland; the harbor is variously called Cobh Harbour or Cork Harbour.

274:31–32 (279:7–8). Callan, Coleman . . . Fawcett—a fictional list of deaths in the "obituary" column of the day's *Freeman's Journal*; see 90:13 (91:16).

274:35 (279:11). Greek ees—a handwriting with Greek e's (ε) was thought to indicate an artistic temperament.

275:1 (279:19). Elijah is com—see 149:15n.

275:2 (279:20). p.o—post office, i.e., postal money order.

275:4–5 (279:23). O, Mairy lost the pin of her—see 77:33–36 (78:38–41).

275:12–13 (279:31). Sauce for the gander—"What's sauce for the goose is sauce for the gander." This proverbial attack on the double standard dates from at least 1671.

275:14–15 (279:32–33). A hackney car . . . avenue, Donnybrook—one James Barton is listed in *Thom's (1904)* as living at Rose Cottage, the first of three houses listed on Harmony Avenue in Donnybrook. *Thom's* does not list him as a "Cab proprietor" and his role as driver of number 324 is lost in "history."

275:17 (279:35). George Robert Mesias—see 108:39n.

275:19 (279:37). John Plasto—see 56:38n.

275:21 (279:39). Dlugacz' porkshop—where Bloom purchased his breakfast kidney; see 56:9n.

275:21 (279:40). Agendath—see 60:12–13n.

275:24 (280:1). Town traveller—a traveling salesman.

275:26 (280:3). best references—a standard phrase used in letters by job applicants.

275:35 (280:13–14). Messrs Callan, Coleman and Co, limited—a nonexistent company that Bloom concocts out of the fictional obituary, 274:31 (279:8).

275:38–39 (280:16–17). c/o P.O./Dolphin's barn lane—i.e., Bloom writes to Martha Clifford in care of a town sub-post office in southwestern Dublin.

275:41–276:2 (280:19–21). prize titbit . . . the laughing witch—see 68:27–28n.

276:4–5 (280:23–24). Music hath charms Shakespeare said—no, it was William Congreve (1670–1729) in *The Mourning Bride* (1697), Act I, scene i: "Music hath charms to soothe the savage breast,/To soften rocks, and bend the knotted oak."

276:5 (280:24). Quotations every day in the year—books and calendars of this sort were extraordinarily popular in the nineteenth century. William Schutte cites *The Shakespeare Calendar, or Wit and Wisdom for Every Day in the Year* (New York, 1850), p. 126.

276:5–6 (280:25). To be or not to be—the opening line of Hamlet's famous soliloquy (III, i, 56 *ff.*).

276:7–8 (280:26–27). In Gerard's rosery . . . Do. But do—see 199:32–35 (202:9–12).

276:9 (280:28). Post office lower down—Town Sub-Post Office, Money Order and Savings Bank Office, 34 Ormond Quay Upper; west of the Ormond Hotel and just west of where Bloom would turn north toward Barney Kiernan's.

276:10 (280:29). Barney Kiernan's—Bernard Kiernan & Company, wholesale tea and spirit merchants, wine and brandy shippers, 8, 9 and 10 Britain Street Little.

276:30 (281:8). How Walter Bapty lost his voice—Walter Bapty (1850–1915), professor of singing in Dublin and one of the organizers of the *Feis Ceoil* (1897), the annual Dublin music festival and competition. Kiernan's story may be just that, Kiernan's story; see Adams, p. 73.

277:2, 4 (281:22, 24–25). Lovely seaside girls/ Your head it simply—from Boylan's song; see 62:30n.

277:10 (281:30–31). Well, it's a sea. Corpuscle islands—a remote allusion to Phineas Fletcher's (1582–1650) allegorical poem *The Purple Island, or the Isle of Man* (1633), a seventeenth-century layman's poeticized conception of the human body; see Adams, p. 150.

277:13 (281:34). What are the wild waves saying?—the title of a duet, words by Joseph Edwards Carpenter, music by Stephen Glover (1813–1870): "[BROTHER:] What are the wild waves saying, Sister the whole day long,/That ever amid our playing, I hear but their low, lone song?/Not by the seaside only,/There it sounds wild and free;/But at night when 'tis dark and lonely,/In dreams it is still with me . . . // [SISTER:] Brother! I hear no singing!/'Tis but the rolling wave/Ever its lone course winging/Over some ocean cave!/'Tis but the noise of water/Dashing ag'st the shore,/And the wind from bleaker quarter/Mingling with its roar . . . // [CHORUS:] No! no, no, no! No, no, no!/It is something greater./That speaks to the heart alone/The voice of the great Creator/Dwells in that mighty tone."

277:17 (281:38). Larry O'Rourke's—see 57: 38n.

277:31 (282:10). Ruttledge's door—see 115:30 (116:30).

277:31–32 (282:11). Minuet of Don Giovanni —is first heard in Act I, scene iv of the opera; in Act I, scene v, the ballroom of Don Giovanni's house, the minuet is played by an onstage band while Don Giovanni dances with Zerlina and then leads her offstage for an attempt at seduction.

277:33–34 (282:12–13). Peasants outside— suggested by Don Giovanni since in Act I, scene iii Don Giovanni has discovered Zerlina in a group of singing and dancing peasants near his house; in Act I, scenes iv and v in Don Giovanni's garden and house, there is the sense that the peasants, particularly Masetto, Zerlina's peasant-fiancé, are "outside" as Don Giovanni and his servants try to distract Masetto so that he won't interfere with the proposed seduction.

277:34 (282:13). eating dockleaves—a traditional image of the plight of the Irish peasantry during the Great Famine.

277:40 (282:19). My wife and your wife— from the American folksong "The Grey Goose." The song begins: "It was one Sunday mornin',/ Lawd, Lawd, Lawd,/The preacher went a-huntin' . . ." Fifth verse: "And my wife and your wife,/ . . ./They give a feather pickin' . . ." (unsuccessfully, as it turns out, since the "Grey Goose" is inedible).

278:1 (282:22–23). quis est homo: Mercadante —Mercadante (see 81:9n) did not write a *Stabat Mater* as this phrase suggests, though Bloom has earlier thought of Rossini's *Stabat Mater* in conjunction with Mercadante's *Seven Last Words;* see 81:3n and 81:9–10n.

278:4 (282:25). Dandy tan shoe of dandy Boylan—echoes a nursery rhyme and its variant: "Handy-spandy, Jack-a-dandy,/Loves plum-cake and sugar candy./He bought some at a grocer's shop,/And pleased, away he went, hop, hop." Variant: "Handy-dandy/Sugary candy—/Top or bottom. // Handy-spandy,/Jack a dandy—/ Which good hand will you have?"

278:8–10 (282:29–31). Empty vessels make . . . law of falling water—Bloom elides the acoustical principle that the resonance (and pitch) of a vessel changes as liquid is added with Archimedes' law of specific gravity (the ratio of the weight of water displaced by an object to the weight of the object).

278:10–11 (282:32). those rhapsodies of Liszt's Hungarian—see 252:38n.

278:14 (282:36). Paul de Kock—see 64:30n.

278:17 (282:39). Qui sdegno—Italian: "Here indignation . . ." In the Italian version of Mozart's opera *Die Zauberflöte (The Magic Flute)* (1791) these are the opening words of "*In diesen heiligen Hallen*" ("In these sacred halls"), an aria in Act II.

278:18 (282:40). The Croppy Boy—the balance of this episode is larded with allusions to this song; see 252:41n.

278:18–19 (282:40–41). Our native Doric— see 125:1n.

278:20 (282:42). Good men and true—"The Croppy Boy," line 1, 252:41n.

278:24 (283:4). What key? Six sharps?—six sharps is F sharp major, as Dollard says.

278:29 (283:9). on for a razzle—slang: beginning a spree or a bender.

278:32–33 (283:12–13). waiting Patty come home—see "Waiting," 271:10n.

278:34–37 (283:14–17). In a cave of . . . from hoary mountains—see 253:3n.

278:38–39 (283:18–19). The priest he sought . . . speak a word—"The Croppy Boy," lines 3–4, 252:41n.

279:1–3 (283:23–25). Big ships' chandler's . . . ten thousand pounds—see Adams, p. 65.

279:3 (283:25). the Iveagh home—in 1903 the Guinness Trust Dublin Fund ("for the amelioration of the poor laboring classes of Dublin") was amalgamated into the Iveagh Trust (Lord Iveagh being one of the principal heirs of the Guinness fortune). The Guinness Trust Buildings: (386 rooms or cubicles), a large charity-lodging house for men off New Bride Street in central Dublin thus became the Iveagh Trust Buildings or Iveagh House.

279:4 (283:26). Number one Bass—a strong English ale.

279:5–6 (283:27–28). The priest's at home . . . The holy father—"The Croppy Boy," lines 5–8, 252:41n.

279:8 (283:30). Hushaby. Lullaby. Die, dog. Little dog, die—in a letter dated 24 August 1970, Iona Opie says, "This sounds like the end

part of a song used to finish a child's turn on a swing. Usually it is a cat dying in such songs, but we have an example from Cheshire, c.1900, which runs, 'An apple for the King,/And a pear for the Queen,/And a good toss over the bowling green./Die, die, little dog, die,/Die for the sake of your mother's black eye./Die, die-away.'"

279:9–12 (283:31–34). the youth had entered . . . sitting to shrive—"The Croppy Boy," lines 9–12, 252:41n.

279:13–14 (283:35–36). Answers poet's picture puzzle—*Answers*, a popular and successful weekly journal (1d) founded by Alfred Harmsworth (see 137:17n) in 1888. The magazine featured a weekly "picture puzzle" that, when deciphered, rendered the title of a famous poem, prize £5.

279:15 (283:37). Lay of the last minstrel—the title of a poem (1802–1804, 1805) by Sir Walter Scott (1771–1832).

279:23–25 (284:3–5). in nominie Domini . . . confessing: mea culpa—"The Croppy Boy," lines 13–15, 252:41n.

279:28 (284:8). corpusnomine—another of Bloom's Latin elisions, "body-name," combining the *"Corpus"* he has heard, 79:31 (80:34), with *"nominie"* from "The Croppy Boy."

279:33–36 (284:13–16). Since easter he had . . . had not prayed—"The Croppy Boy," lines 21–24, 252:41n. For "You bitch's bast," see 246:32–33 (250:18–19).

279:38 (284:19). dab—an expert.

279:42 (284:23). to titivate—to make small alterations in one's toilet, etc. in order to add to one's attractions.

280:2–3 (284:25–26). Way to catch rattlesnakes—popular notion of a practical application of Indian snake-charming practices.

280:3 (284:26). Michael Gunn—(d. 1901) was involved in the management of the Gaiety Theatre in Dublin from 1871 until his death. Even after his death the managers of the theater continued to be listed as "Michael Gunn Limited" (*Thom's [1904]*). One measure of his reputation appears in R. M. Levey and J. O'Rorke, *Annals of the Theatre Royal, Dublin* (Dublin, 1880); the book is dedicated "To Michael Gunn, Esq., on whose sound Judgment the Future of the Drama in Dublin Hopefully Depends. . . ."

280:4 (284:27). Shah of Persia—Nasr-ed-Din (d. 1896) made two state visits to England, in June 1873 and July 1889; the Prince of Wales (later Edward VII) was assiduous in his attentions to the Shah's entertainment on both occasions. During the 1889 visit the Shah caught the popular fancy and was "immortalized" in street songs and as the principal figure in innumerable stories of the sort Bloom recalls.

280:4–5 (284:27–28). home sweet home—a song (1823), words by John Howard Payne, music by Henry Rowley Bishop: "'Mid pleasures and palaces though I may roam,/Be it ever so humble, there's no place like home;/A charm from the sky seems to hallow there,/Which, seek through the world, is ne'er met with elsewhere. // Home! Home! Sweet, sweet home!/There's no place like home. . . .'"

280:13–14 (284:36–37). what Spinoza says in that book of poor papa's—Baruch Spinoza (1632–1677), famous Dutch-Jewish philosopher. On Bloom's bookshelf: *Thoughts from Spinoza*, 693:14 (708:26).

280:17 (284:40–41). God made the country man the tune—after William Cowper's (1731–1800) line "God made the country, and man made the town" (*The Task* [1785], Book I, line 749).

280:19–21 (285:1–3). All gone. All fallen . . . name and race—"The Croppy Boy," lines 17–20, 252:41n. (Apparently Dollard alters the sequence of the poem's stanzas.) For "Siege of Ross," see 237:38n. "Gorey": after their defeat at Ross, the rebels regrouped at Gorey, ten miles south-southeast of Arklow (a town on the coast 40 miles south of Dublin). From Gorey the rebels mounted on 9 June 1798 an attack on Arklow; the attack was another disaster for the rebels. "We are the boys of Wexford": see 128:5–6n.

280:24 (285:7). He bore no hate—"The Croppy Boy," line 25, 252:41n.

280:29 (285:12). My country above the king—"The Croppy Boy," line 26, 252:41n.

280:30 (285:13). Who fears to speak of 1904?—after "Who fears to speak of Ninety-eight"; see 237:35–36n.

280:32–33 (285:15–16). Bless me, father . . . let me go—"The Croppy Boy," line 27, 252:41n.

280:35–36 (285:18–19). eighteen bob a week—the barmaid's wage, 18s, can be translated as roughly $50 a week (United States, 1970).

280:36 (285:19). dibs—slang for money.

280:37 (285:20). Those girls, those lovely—
Boylan's song; see 62:30n.

280:37–38 (285:20–21). By the sad sea waves—
a song from Sir Julius Benedict's (1804–1885)
opera *The Bride of Venice* (1843): "By the sad
sea-waves/I listen, while they moan/A lament o'er
graves/Of hope and pleasure gone./I am young, I
was fair,/I had once not a care/From the rising
of the moon/To the setting of the sun./Yet I pine
like a slave/By the sad sea-wave." Chorus: "Come
again, bright days/Of hope and pleasure gone;/
Come again, bright days,/Come again, come
again."

**280:41–281:1 (285:25–26). The false priest . . .
yeoman captain—**"The Croppy Boy," lines
29–32, 252:41n.

281:11–12 (285:37). songs without words—
the collective title of eight groups of piano
compositions (1834–1845) by the German com-
poser Felix Mendelssohn (1809–1847).

**281:13–14 (285:39). Understand animals . . .
Solomon did—**one popular bit of folklore about
King Solomon was that he had a magic ring that
made him capable of understanding the language
of animals.

**281:17–19 (286:1–3). With hoarse rude fury
. . . to live, your last—**"The Croppy Boy,"
lines 33–36. 252:41n.

281:26 (286:10). On yonder river—"The
Croppy Boy," line 37, 252:41n.

281:27 (286:11). (her heaving embon)—
from *Sweets of Sin*; see 232:27n.

281:30 (286:14). The bright stars fade—from
"Goodbye, Sweetheart, Goodbye"; see 252:
13–14n.

281:30 (286:14). O rose! Castille—see 129:
18–19n.

**281:42 (286:27). I hold this house . . . Traitors
swing—**"The Croppy Boy," lines 39–40, 252:41n.

**282:6–7 (286:34–35). O'er ryehigh blue. Bloom
—**see "The Bloom Is on the Rye," 230:16n.

**282:11–12 (286:39–40). At Geneva barrack . . .
was his body laid—**"The Croppy Boy," lines
41–42, 252:41n. Geneva Barrack was a depot
for army recruits that was converted into a prison
in 1798 for the confinement of rebels. It was on
Waterford Harbour in southeastern Ireland;
Passage was a village on the harbor north of the
Barrack. The location implies that the Croppy
Boy was attempting to cross from Waterford into

Wexford, the heartland of rebel insurgency in
southern Ireland (1798).

282:12 (286:40). Dolor! O, he dolores!—
"*dolor*" is Latin for suffering, anguish; see "The
Shade of the Palm," 252:9n.

**282:19–21 (287:6–8). Pray for him . . . was the
croppy boy—**"The Croppy Boy," lines 43–44,
252:41n.

282:30 (287:17). Lablache—Luigi Lablache
(1794–1858), Italian-born son of a French father
and an Irish mother, was the most famous bass
of his time in Europe.

282:33 (287:20). nakkering—see 253:13n.

282:34 (287:21). Big Benaben—see 253:14n.

282:42 (287:28). Ben machree—"*machree*" is
Irish: "my heart." Thus "*Ben machree*" is
"Mountain [of] my heart."

283:5 (287:33). rift in the lute—see 272:36–37n.

283:18 (288:5). The last rose of summer—see
252:34n.

**283:23–24 (288:10–11). Postoffice near Reuben
J's—**the post office at 34 Ormond Quay Upper
was in the same building as Reuben J. Dodd's
office; see 276:9n.

283:25 (288:12). Greek street—would be on
Bloom's "indirect" route to Barney Kiernan's,
276:10n, if he went around by the post office.

**283:26–27 (288:13–14). Her hand that rocks
. . . rules the world—**after William Ross
Wallace (1819–1881), "What Rules the World?":
"They say that man is mighty,/He governs land
and sea;/He wields a mighty scepter/O'er lesser
powers that be;/And the hand that rocks the
cradle/Is the hand that rules the world."

283:30 (288:17). Lionelleopold—Lionel is the
character who sings "*M'appari*" in Flotow's
Martha; see 252:26n and 116:34n.

**283:35–36 (288:23). Better give way . . . man
with a maid—**"the way of a man with a maid"
occurs as line 30 of Kipling's poem "The Long
Trail," where it is included in a paraphrase of
Proverbs 30:18–19: "There be three things which
are too wonderful for me, yea, four which I know
not: The way of an eagle in the air; the way of
a serpent upon a rock; the way of a ship in the
midst of the sea; and the way of man with a maid."
But Bloom has in mind an anonymous late nine-
teenth-century pornographic novel, *The Way of a
Man with a Maid* (New York: Grove Press, 1968),

in which the "heroine," prudish Alice, refuses the "hero," Jack, only to be trapped and debauched by him. Alice then "gives way" not "halfway" but all the way, abandons all prudery for debauchery and joins Jack in a series of seductions of other women.

283:41–42 (288:29–30). Organ in Gardiner . . . quid a year—see 81:1–2n.

284:1 (288:31). Seated all day at the organ—see "The Lost Chord," 264:17n.

284:2 (288:32). Maunder—involves a pun on John Henry Maunder (1858–1920), composer of sentimental church music.

284:4 (288:34). no don't she cried—in *The Way of a Man with a Maid* (see 283:35–36n), Jack and Alice (after her conversion) make use of his soundproof "Snuggery" in their career of debauchery. "'No, don't,' she cried," functions as a refrain, recurring again and again to spice the novel's sequence of seductions and violations.

284:13–14 (289:1–2). Simonlionel first I saw—Lionel's song *"M'appari"* begins with the phrase "When first I saw . . ."; see 252:26n.

284:24–25 (289:12–13). one last, one lonely, last sardine of summer—see "'Tis the Last Rose of Summer," 252:34n.

284:28 (289:16). Barry's—J. M. Barry and Company, merchant tailors and outfitters, 12 Ormond Quay Upper, just west of the Ormond Hotel.

284:28 (289:16–17). that wonderworker—see 706–707 (721–722).

284:29 (289:17). Twenty-four solicitors in that one house—Bloom is right; *Thom's (1904)* lists 24 solicitors' offices at 12 Ormond Quay Upper.

284:32–33 (289:20–21). the chap that wallops . . . Mickey Rooney's band—there are similar Irish and Irish-American songs ("McNamara's Band," for example), but the source of this one is unknown.

284:40. Daily's should read **Daly's** as it does **(289:28)**—see 257:39n.

285:6 (289:36). Sweep!—the call of a chimney sweeper advertising his services.

285:7 (289:37). All is lost now—see *"Tutto è sciolto,"* 252:24n.

285:8 (289:38). bumbailiff—to "bum" is to cart turf to market, so a "bumbailiff" is a bogbailiff (contemptuous for a backwoods officer of the law).

285:8 (289:38–39). Long John. Waken the dead—i.e., Long John Fanning's name recalls the song "John Peel" (*c.*1820) by John Woodcock Graves. John Peel was a master of hounds who lived in Cumberland, England; the chorus of the song asserts that his "'View hallo!' would waken the dead,/Or the fox from his lair in the morning."

285:9 (289:39). nominedomine—see "The Croppy Boy," line 14, 252:41n.

285:10 (289:41). da capo—Italian (music): "over and over again, repeat."

285:14–16 (290:2–4). Breathe a prayer . . . a yeoman cap—see "The Croppy Boy," line 44 and *passim.*

285:19–20 (290:8–9). When first he saw that form endearing—see *"M'appari,"* 252:26n.

285:25 (290:14). we'd never, well hardly ever—Captain Corcoran in Gilbert and Sullivan's *H.M.S. Pinafore, or The Lass that Loved a Sailor* (1878) qualifies from the absolute "never" to the relative "hardly ever" in responsive song with his crew. In Act I he asserts, "I am never known to quail/At the fury of a gale,/And I'm never, never sick at sea! CREW: What, never? CAPT.: No, never!/CREW: What, never? CAPT.: Hardly ever!" The routine is repeated in Act II when the Captain announces that he intends to marry and that he will never be "untrue" to his wife.

285:26 (290:15). home sweet home—song; see 280:4–5n.

285:29 (290:18). Lionel Marks's—Lionel Marks, antique dealer, watchmaker, jeweler and picture-frame maker, 16 Ormond Quay Upper.

285:38–39 (290:27–28). they chinked their clinking glasses—see "The Thirty-two Counties," 253:17–18n.

285:40 (290:29). last rose of summer—see "'Tis the Last Rose of Summer," 252:34n.

285:40 (290:29). rose of Castille—see 129:18–19n.

286:1 (290:32). A youth entered a lonely Ormond hall—see "The Croppy Boy," line 9, 252:41n.

286:3 (290:34). Robert Emmet's last words—
for Robert Emmet, see 112:40–41n. The last
paragraph of Emmet's speech to the court that
condemned him to death: "Let no man write my
epitaph; for as no man who knows my motives
dares now vindicate them, let not prejudice or
ignorance asperse them. When my country takes
her place among the nations of the earth then and
not till then, let my epitaph be written. I have
done."

**286:3 (290:34). Seven last words. Of Meyer-
beer—**Bloom has thought earlier of Mercadante's
oratorio *The Seven Last Words* (see 81:9–10n)
and of Meyerbeer's opera *Les Huguenots* (see 166:
2–4n); Bloom's confusion resembles that noted in
278:1n.

**286:5–7 (290:36–38). True men like you . . .
glass with us—**see "The Memory of the Dead,"
237:35–36n; the last two lines of the first stanza:
"But a true man, like you, man,/Will fill your
glass with us." The last two lines of the poem:
"And true men, be you, men,/Like those of
Ninety-eight."

286:9 (290:40). Tschink. Tschunk—see "The
Thirty-two Counties," 253:17–18n.

EPISODE 12
[CYCLOPS]

CYCLOPS

Episode 12: [Cyclops], pp. 287–339 (292–345).
In Book IX of *The Odyssey* Odysseus describes his adventures among the one-eyed Cyclops, who are "giants, louts, without a law to bless them." They live in a fertile land but are ignorant of agriculture; they "have no muster and no meeting, no consultation or old tribal ways, but each one dwells in his own mountain cave dealing out rough justice to wife and child indifferent to what the others do." Odysseus and a scouting party are trapped in the cave of Polyphemus, one of the Cyclops, who scoffs at Zeus and the laws of hospitality that should govern the "civilized" world and acts out his scorn by devouring two of Odysseus' men. Polyphemus imprisons Odysseus and his remaining companions, presumably to be eaten at the rate of two a day. The second evening he "feasts" again and then Odysseus plies him with wine. In the course of the drinking bout Odysseus announces that his name is "Noman," and when the one-eyed giant collapses into drunken sleep, Odysseus blinds him with a burning pike of olive wood. Polyphemus shouts that "Noman" has ruined him, and his neighbors (taking him literally) mock him and refuse help. In the morning Odysseus and his remaining men escape Polyphemus' search by hiding among his sheep. Once free and launched in his ship, Odysseus makes the mistake of revealing his identity and of taunting the blind Polyphemus. Polyphemus heaves a rock which almost sinks Odysseus' ship, and then the blind giant calls on his father, Poseidon, to prevent Odysseus from returning home or if "destiny intend that he shall see his roof again . . . far be that day, and dark the years between. Let him lose all companions, and return under strange sail to bitter days at home." Since destiny does "intend" that Odysseus return home, Poseidon is only able to grant the latter part of his son's prayer.

Time: 5:00 P.M. Scene: the Tavern, Barney Kiernan's pub, 8, 9 and 10 Britain Street Little. Organ: muscle; Art: politics; Color: none; Symbol: Fenian (see 32:18n); Technique: gigantism.[1] Correspondences: *Noman*—I; *Stake*—cigar; *Challenge* (that the escaped Odysseus flings at Polyphemus)—Apotheosis.

287:1 (292:1). OLD TROY—unidentified if not fictional.

287:1 (292:2). D.M.P—Dublin Metropolitan Police.

[1] The narrative line of this episode is interrupted by 33 passages that comment on the narrative by parodying various pompous, sensational or sentimental literary styles. In most cases the parodies are "general"—not parodies of specific works but of generalized stylistic conventions. The 33 passages are noted below as "*Parody*" with brief descriptions of the styles being lampooned.

287:2 (292:2). Arbour hill—a street north of and parallel to the Liffey west of the center of Dublin.

287:5 (292:5). Stony Batter—west of the center of Dublin, a section of the main road to the northwest from central Dublin.

287:8 (292:9). Soot's luck—i.e., the luck of a chimney sweep, bad luck.

287:8 (292:9). ballocks—testicles.

287:15 (292:16). the garrison church at the corner of Chicken Lane—Garrison Church, attached to Garrison Schools and a military hospital and the Provost Marshal's Prison (now the Arbour Hill Detention Barracks), was located on Arbour Hill at its intersection with Chicken Lane.

287:16 (292:17). a wrinkle—slang for special knowledge or special experience (though usually implying a lie or an untruth).

287:17–18 (292:19). he had a farm—i.e., that he had a regular income from land rents.

287:19 (292:20–21). Moses Herzog over there near Heytesbury street—*Thom's (1904)* does not list a Moses Herzog as merchant or grocer or tea merchant, etc., but it does list an M. Herzog as resident at 13 St. Kevin's Parade. The Parade in turn is not particularly "near Heytesbury Street," but is some distance to the west, off Clanbrassil Street Lower (near Bloom's former residence in Lombard Street West). This suggests that Moses Herzog "worked" as an agent on commission for an implied but unidentified provisions house "near Heytesbury Street," or that he was as Geraghty accuses, 287:31 (292:33), "trading without a licence."

287:21 (292:23). A bit off the top—slang for "some of the best"; the phrase was also part of the title of a music-hall song, "All I Want Is a Little Bit off the Top," by Murray and Leigh. First verse: "Brown's a very old friend of mine,/ And I went to his house to dine;/Some of the aristocracy were there;/Not a one of them came in late/And everyone of them piled his plate,/'Twas fun to watch the animals, I declare./The waiter came into the room with a pudding of wondrous size,/And tho' they ate enough to feed a town,/A leader of society completely lost his etiquette,/And yelled out to the host, Hey, Mr. Brown! [Chorus:] Carve a little bit off the top for me, for me!/Just a little bit off the top for me, for me,/Saw me off a yard or two, I'll tell you when to stop;/All I want is a little bit off the top!" In the second verse the speaker at a music hall finds himself behind a

woman with a hat "three yards tall" and demands "a little bit off the top" or he'll call the police. In the third stanza the speaker goes to sleep in a haystack only to be awakened by a couple who have come to "segow" and have sat down on his head. He demands that they "move a little bit off the top for me" and then concedes, "the lady, she can stop/All I want is a little bit off the top!"

287:21–22 (292:23–24). plumber named Geraghty—*Thom's (1904)* does not list a Geraghty as a plumber though it does list an M. E. Geraghty at 29 Arbour Hill. This would suggest that "plumber" is being used as slang for a clumsy, brutal person.

287:22 (292:24). hanging on to his taw—a "taw" is a whip; the expression means confronting someone without giving him a chance to strike back.

287:24 (292:26). lay—slang for occupation (especially a criminal one).

287:25 (292:27). How are the mighty fallen!—from David's lament for the deaths of Saul and Jonathan: "The beauty of Israel is slain upon thy high places: how all the mighty are fallen!" (II Samuel 1:19; the exclamation is repeated in 1:25).

287:26 (292:28). bloody—a contraction of the oath "God's blood"; as a curse in 1904, "bloody" was considered as shocking in polite middle-class society as "four-letter words" would be today. No one is quite sure how or why this came to be the case, but "bloody" continued to be a shocker even in the 1930s.

287:31 (292:33). trading without a licence—the laws of the Dublin Corporation required that all merchants and traders obtain an annual licence; see 287:19n.

Parody: 287:35–288:14 (292:37–293:16). For nonperishable goods . . . assigns of the other part—the style is that of a legal document in a suit for nonpayment of debts.

287:35–39 (292:37–41). Moses Herzog . . . Arran quay ward, gentleman—see 287:19n and 287:21–22n. Geraghty is nowhere listed as "Esquire" or "gentleman," only as plain Mr. M. E. Geraghty.

288:15 (293:17). t.t.—teetotaler.

288:17 (293:19). How about paying our respects to our friend?—i.e., let's go have a drink at Mr. X's pub.

288:18 (293:20). John of God's—House of St. John of God, Stillorgan Park, County Dublin, was a "Licenced Private Asylum for the Insane" and advertised itself as "devoted to mentally affected Gentlemen."

288:23 (293:25). the citizen—modeled on Michael Cusack (1847–1907), founder of the Gaelic Athletic Association (1884), dedicated to the revival of Irish sports such as hurling, Gaelic football and handball. He styled himself "Citizen Cusack" and Ellmann (p. 62n) quotes as his standard greeting: "I'm Citizen Cusack from the Parish of Carron in the Barony of Burre in the County of Clare, you Protestant dog!"

288:24 (293:26). mavourneen's—Irish: "my love's."

288:26–29 (293:28–31). that meeting in the City Arms . . . Cattle traders—see 36:23–24n.

288:30 (293:32). the hard word—the inside story.

288:31 (293:33). the Linenhall barracks—an extensive range of buildings erected in 1715 to house the (English) government-sponsored manufacture of Irish linen. Deserted toward the end of the nineteenth century, it was occasionally used as a temporary barracks. It was bounded by King Street North, Colraine Street and Lisburn Street. The speaker and Joe Hynes walk east from Arbour Hill along King Street North and then turn south down Halston Street to Britain Street Little and Barney Kiernan's.

288:31–32 (293:33–34). the back of the courthouse—they walk down Halston Street behind the courthouse that fronted at 26 Greene Street and housed the Sessions House of the Borough Record Court, the Civil Bill Court and the Offices of the Clerk of the Crown and Peace for the County and City of Dublin (i.e., the municipal courts).

Parody: 288:36–289:30 (293:38–294:32). In Inisfail the fair . . . raspberries from their canes—parodies the style of nineteenth-century translations and revisions of Irish poetry, myth and legend. This passage makes specific use of phrases from James Clarence Mangan's translation of "Aldfrid's Itinerary" (see 288:36n below), and in general lampoons the style of works such as Lady Gregory's *Gods and Fighting Men* (1904).

288:36 (293:38). In Inisfail the fair—*Inis Fail*, the Isle of *Fál*; the *fál* was the fetish stone at Tara; hence a poetic name for Ireland. The phrase is from the first line of James Clarence Mangan's (1803–1849) translation of "Aldfrid's Itinerary,"

a poem in Irish by Aldfrid, a seventh-century
king of Northumbria:

I found in Innisfail the fair,
In Ireland, while in exile there,
Women of worth, both grave and gay men,
Many clerics and many laymen.

I traveled its fruitful provinces round, 5
And in every one of the five I found,
Alike in church and in palace hall,
Abundant apparel and food for all.

Gold and silver I found in money;
Plenty of wheat and plenty of honey; 10
I found God's people rich in pity,
Found many a feast, and many a city.

I also found in Armagh the splendid,
Meekness, wisdom, and prudence blended,
Fasting as Christ hath recommended, 15
And noble councilors untranscended.

I found in each great church moreo'er,
Whether on island or on shore,
Piety, learning, fond affection,
Holy welcome and kind protection. 20

I found the good lay monks and brothers
Ever beseeching help for others,
And in their keeping the Holy Word,
Pure as it came from Jesus the Lord.

I found in Munster, unfettered of any, 25
Kings and queens and poets a many,
Poets well-skilled in music and measure,
Prosperous doings, mirth and pleasure.

I found in Connaught the just, redundance
Of riches, milk in lavish abundance; 30
Hospitality, vigor, fame
In Cruachan's land of heroic name.

I found in the country of Connall [Donegal]
 the glorious,
Bravest heroes, ever victorious;
Fair-complexioned men and warlike, 35
Ireland's lights, the high, the starlike!

I found in Ulster from hill to glen,
Hardy warriors, resolute men;
Beauty that bloomed when youth was gone,
And strength transmitted from sire to son. 40

I found in the noble district of Boyle
 [*MS here illegible*]
Brehons, Erenachs, weapons bright.
And horsemen bold and sudden in fight.

I found in Leinster the smooth and sleek, 45
From Dublin to Slewmargy's peak,
Flourishing pastures, valor, health
Song-loving worthies, commerce, wealth.

I found besides from Ara to Glea
In the blood rich country of Ossorie, 50
Sweet fruits, good laws for all and each,
Great chess-players, men of truthful speech.

I found in Meath's fair principality,
Virtue, vigor and hospitality;
Candor, joyfulness, bravery, purity— 55
Ireland's bulwark and security.

I found strict morals in age and youth
I found historians recording truth;
The things I sing of in verse unsmooth
I found them all I have written sooth. 60

288:36 (293:38). the land of holy Michan—
Barney Kiernan's pub was in St. Michan's parish.
The parish church (1676) stands in Church Street
west of the Four Courts in central Dublin. The
church was founded in 1095 by the Danish saint
whose name it bears.

288:37 (293:39). a watchtower—the square
tower, apparently older than St. Michan's
church itself, was a feature in the Dublin skyline.
Here it is elided with the fortified round towers
that were a distinguishing feature of pre-Norman
Irish religious communities.

**288:37–39 (293:39–41). There sleep the mighty
. . . princes of high renown**—the vaults of
St. Michan's church are famous for an "amazing
preservation of the corpses" buried in them. "The
skin of the corpses remains soft as in life. . . . Even
facial characteristics may be distinguished"
(*Official Guide to Dublin* [n.d.], pp. 51–52). Among
the bodies buried in the vaults are "The Crusader"
and several leaders of the Rebellion of 1798, in-
cluding the brothers Sheares, Oliver Bond and
Dr. Charles Lucas. Charles Stewart Parnell's
body lay in state in the church on the night
before the burial in Glasnevin Cemetery.

288:40 (293:42). the gunnard—Scots-Irish
dialect for the turbot, a large European flatfish or
flounder, c.30–40 pounds.

288:41 (293:43). the gibbed haddock—i.e., the
haddock has a hooked and projecting lower jaw
somewhat like that of an adult male salmon during
and after the breeding season.

**289:3–5 (294:4–6). the wafty sycamore . . . the
eugenic eucalyptus**—Wisdom in Ecclesiasticus
(Douay) 24:16–23 describes herself as a series of
trees: "And I took root in an honorable people,
and in the portion of my God his inheritance, and
my abode is in the full assembly of saints. I was
exalted like a cedar in Libanus [Lebanon] . . . and
as a plane tree by the water in the streets was I
exalted. . . . I gave a sweet smell like cinnamon,
and aromatical balm." The sycamore native to
Ireland is a species of maple; the name "plane-
tree" is also given to this tree. The "Lebanonian
cedar" is not native to Ireland nor is the Austra-
lian eucalyptus (which is "eugenic" because a
tincture made from kino, an exudation of the

eucalyptus, combined with opium and cinnamon, was widely used as a douche in the early twentieth century).

289:9 (294:10). crans—a "cran" is a measure of fresh herrings (45 U.S. gallons).

289:9 (294:11). drafts—a "draft" is the quantity of fish taken in a net.

289:12 (294:13). from Elbana to Slievemargy —"Elbana" should be spelled "Eblana," a place in Hibernia (as the Romans called Ireland) mentioned by the Greek geographer Ptolemy (second century A.D.) and subsequently identified with the site of Dublin. Slievemargy is a mountain approximately 60 miles southeast of Dublin, near the border of the ancient province of Leinster. See "Aldfrid's Itinerary," lines 45–46, 288:36n.

289:12–13 (294:14). unfettered Munster— Munster, an ancient province in southeastern Ireland; see "Aldfrid's Itinerary," line 25, 288:36n.

289:13 (294:14). Connacht the just—a province in western Ireland; see "Aldfrid's Itinerary," line 29, 288:36n.

289:13 (294:14–15). smooth sleek Leinster— the province that included Dublin; see "Aldfrid's Itinerary," line 45, 288:36n.

289:14 (294:15). Cruachan's land—Cruachan was the palace of Connaught; see 289:13n and "Aldfrid's Itinerary," line 32, 288:36n.

289:14 (294:15–16). Armagh the splendid— Armagh was the "metropolis" of ancient Ireland, the religious capital and a "world-famous" seat of learning. See "Aldfrid's Itinerary," line 13, 288:36n.

289:14–15 (294:16). the noble district of Boyle—90 miles west-northwest of Dublin; the town of Boyle was famous as the site of a great Norman abbey and it figures in pre-Norman Irish history and legend. See "Aldfrid's Itinerary," line 41, 288:36n.

289:15 (294:16–17). the sons of kings—see 32:26n.

289:16 (294:18). a shining palace—the Dublin Corporation Fruit, Vegetable and Fish Market, between St. Michan's Street and Arran Street, a block south of Barney Kiernan's pub in central Dublin.

289:19 (294:21). first fruits—a Jewish ceremonial offering; see 47:41–48:1n.

289:19 (294:21–22). O'Connell Fitzsimon— H. O'Connell Fitzsimon ("son of Simon") was Superintendent of the Food Market in 1904 (*Thom's [1904]*, p. 1349).

289:21 (294:23). wains—large open horse-drawn vehicles used for carrying heavy loads, especially of agricultural produce.

289:22 (294:24). floats—large flat containers.

289:22 (294:25). Rangoon beans—a variety of muskmelon (sometimes called "snake melon") two to three feet long, one to three inches in diameter; they resemble giant string beans and are sometimes used for preserves but more often as an oddity gourd.

289:23 (294:25). strikes—a local English measure that varies from half a bushel to four bushels.

289:23 (294:26). drills of Swedes—a "Swede" is a large variety of yellow turnip; a "drill" is the small furrow in which seed is sown.

289:24 (294:27). York and Savoy—varieties of cabbage.

289:25 (294:27). pearls of the earth—an ancient Egyptian epithet for the onion, which was regarded with particular veneration.

289:25 (294:27). punnets—a broad shallow basket for the display of fruits or flowers.

289:26 (294:29). bere—barley.

289:28 (294:30). chips—a "chip" is a little box made of thin wood.

289:28 (294:31). sieves—a kind of coarse basket or a measure, approximately a bushel.

289:29 (294:31). pelurious—furry.

Parody: 289:33–290:8 (294:35–295:10) And by that way wend . . . agate with the dun— continues the parody of Irish revival legendry.

289:34 (294:36). flushed ewes—i.e., ewes taken from pasture and fed on grain to prepare them for breeding.

289:34–35 (294:36–37). stubble geese—dialect for greylag geese.

289:35 (294:37). roaring mares—"roaring" is a disease of horses; the principal symptom is loud, rasping breathing under exertion.

289:36 (294:38). storesheep—animals kept for breeding or as part of the ordinary stock of a

farm; also, lean animals sold to be fattened for market.

289:36 (294:38). Cuffe's—see 96:32n.

289:36 (294:38). springers—cows or heifers near to calving.

289:37 (294:39). culls—animals rejected from a herd or flock as being substandard.

289:37 (294:39). sowpigs—spayed sows.

289:38 (294:41). polly—dehorned.

289:39–40 (294:42). premiated—to "premiate" is to award a prize to.

290:1 (295:3). Lush and Rush—Lusk (?) is a parish and village 14 miles north of Dublin; Rush is a small seaport 13½ miles northeast of Dublin in the Parish of Lusk.

290:1 (295:4). Carrickmines—a village ten miles south southeast of Dublin.

290:2 (295:4). Thomond—a small pre-Norman kingdom in North Munster.

290:2–3 (295:5). M'Gillicuddy's reeks—McGillicuddy's Reeks, the highest mountain range in Ireland, in County Kerry, "the wild southwest." "Reek" is dialect for a heap or pile.

290:3 (295:5). lordly Shannon—the Shannon is a river that runs south through central Ireland and then west to the Atlantic. The Irish rebel leader and journalist John Mitchel (1815–1875) in his *Jail Journal* (1854) contemplates the river Shannon in Van Diemen's Land and dreams of "its lordly namesake river in Erin."

290:4 (295:6–7). the gentle declivities of the place of the race of Kiar—Kiar was one of the three illegitimate sons of Queen Maeve of Connaught (quasi-legendary, first century A.D.) by the captain of her guard, Fergus MacRoy; Kiar's race became the residents of County Kerry in southwestern Ireland, hardly a land of "gentle declivities"

290:6–7 (295:9). targets of lamb—the neck or breast of lamb as a joint (without the shoulder).

290:7 (295:9). crannocks—after "curnoch," a local English measure, three or four bushels.

290:11 (295:13). Garryowen—a suburb of Limerick famous for its squalor and for the crudity and brutality of its inhabitants. It is also the title of a rollicking Irish drinking song with the refrain: "Instead of Spa we'll drink brown ale,/And pay the reckoning on the nail,/No man for debt shall go to gaol/From Garryowen in glory." A "famous Irish setter" of that name (b. 1876) was owned by J. J. Giltrap of Dublin (*Times Literary Supplement,* 9 January 1964, p. 27).

290:13 (295:15). gloryhole—a place where odds and ends are put away without order.

290:13 (295:15–16). cruiskeen lawn—Irish: "little full jug or flask," the title of an Irish folksong: "Let the farmer praise his grounds,/Let the huntsman praise his hounds,/The shepherd his dew-scented lawn,/But I, more blessed than they,/Spend each happy night and day/With my charming little cruiskeen lawn,/Oh, my charming little cruiskeen lawn." Chorus: "Gra-ma-chree ma cruiskeen/Slainte geal mavourneen,/Gra-ma-chree a coolin bawn, bawn, bawn,/Oh! Gra-ma-chree a coolin bawn." Translation of the Irish chorus: "Love of my heart, my little flask,/Bright health, my darling./Love of my heart, a long-haired girl, girl, girl,/Oh! Love of my heart, a long-haired girl."

290:18 (295:20). Santry—a parish in the union of North Dublin, four miles north of the center of the city.

290:19 (295:21). a blue paper—a summons.

290:20–22 (295:22–24). Stand and deliver . . . Pass, friends—a military sentry's challenge and the appropriate replies.

290:25 (295:27). Doing the rapparee—the "rapparees" (Irish: "robbers, outlaws") were initially (1653 ff.) Irish Catholic landlords who had been dispossessed by Cromwell and who lived by blackmailing and plundering the "Cromwellers," the Protestants established on their estates. After the Treaty of Limerick (1691) Irish soldiers who did not accept expatriation with Patrick Sarsfield, Lord Lucan, took to the hills as a new generation of rapparees. Sir Charles Gavan Duffy (1816–1903) wrote "The Irish Rapparees; a Peasant Ballad": "Righ Shemus [James II] he has gone to France and left his crown behind:—/Ill-luck be theirs, both day and night, put runnin' in his mind!/Lord Lucan followed after, with his slashers brave and true,/And now the doleful *keen* is raised—'What will poor Ireland do?'/'What must poor Ireland do?'/'Our luck, they say, has gone to France. What *can* poor Ireland do?' // 'Oh, never fear for Ireland, for she has so'gers still,/For Remy's boys are in the wood, and Rory's on the hill;/And never had poor Ireland more loyal hearts than these—/May God be kind and good to them, the faithful Rapparees!/The fearless Rapparees!/The jewel waar ye, Rory with your Irish Rapparees!"

The ballad continues in praise of the "changeless Rapparees" and their retributive violence and in condemnation of those "surly *bodachs*," the Cromwellers.

290:25 (295:27). Rory of the hill—(*c.*1880), the signature adopted by letter writers who threatened landlords and others in the agitation for land reform. It is also the title of a poem by Charles Joseph Kickham (1830–1882). Rory is characterized as a peasant patriot who saves a toothed rake for the day when he can lead a rebellion. The last of the poem's seven verses: "O! knowledge is a wondrous power/And stronger than the wind;/And thrones shall fall, and despots bow,/Before the might of mind;/The poet and the orator/The heart of man can sway,/And would to the kind heavens/That Wolfe Tone were here today!/Yet trust me, friend, dear Ireland's strength/Her honest strength—is still/The rough-and-ready roving boys,/Like Rory of the Hill."

290:32 (295:34). the Russians wish to tyrannise—in some quarters the Russo-Japanese War (1904–1905) was regarded as evidence of Russian desire for world dominion.

290:33 (295:35). Arrah—Irish: "well, indeed."

290:33 (295:35). codding—joking.

290:38 (295:40). Ditto MacAnaspey—the name MacAnaspey is peculiar because it means "son of the bishop" in Irish. At the time of the great split over Parnell's leadership a MacAnaspey, a member of a family of Dublin tombstone makers, made a lengthy speech in a public meeting. The speaker who followed him said simply: "Ditto MacAnaspey."

290:41 (296:1). a chara—Irish: "my friend."

Parody: 291:3–292:23 (296:5–297:27). The figure seated . . . of paleolithic stone—this description of the "Irish hero" further parodies late-nineteenth-century reworking of Irish legend.

291:3–4 (296:5–6). a round tower—see 162:20n.

291:11 (296:13–14). mountain gorse (Ulex Europeus)—the common furze in Great Britain, two to three feet high, extremely branched, the branches terminating in spines.

291:15 (296:18). a tear and a smile—from Thomas Moore's poem "Erin, the Tear and the Smile in Thine Eyes," in *Irish Melodies*. "Erin, the tear and the smile in thine eyes/Blend like the rainbow that hangs in thy skies/Shining

through sorrow's stream/Sad'ning through pleasure's beam/Thy suns, with doubtful gleam,/Weep while they rise."

291:32 (296:35). Cuchulin—(the Hound of Culan or Hound of Feats), a legendary figure, the great hero of the Red Branch Knights of Ulster, said to have flourished in the first century A.D. He excelled in every manly art and has been romanticized as the superhuman epitome of the Celtic hero, the defender of the realm who used his powers solely for the good of his people.

291:32 (296:35–36). Conn of hundred battles—king (123–157), the first of the high kings of Ireland. Emerging from *Conn*aught, he defeated the forces of Leinster and Munster at Castleknock and divided Ireland with Mog Meadath, against whom Conn subsequently warred for 14 years, until Mog was killed. Conn is thus credited with having achieved a sort of national unity. He was murdered by a band of ruffians disguised as women.

291:32–33 (296:36). Niall of nine hostages—king of Ireland (379–405), regarded as the ancestor of the O'Neills. Little is known of him except that he invaded Britain and subsequently Gaul, where he was killed. The "nine hostages" he exacted from the petty kings of Ireland to dissuade them from hostile acts.

291:33 (296:36). Brian of Kincora—or Brian Boru; see 98:16n.

291:33 (296:37). the Ardri Malachi—i.e., High King Malachi; see 6:3n.

291:33 (296:37). Art MacMurragh—(1357–1417), king of Leinster (1377–1417). He was famous for his refusal to submit to Richard II's overlordship of Ireland; he backed his refusal with a military skill that made him more or less successful against the English. He is reputed to have been poisoned.

291:34 (296:37). Shane O'Neill—(*c.*1530–1567), elected "the O'Neill" (1559). In 1556 he invaded the Pale (the area of English control around Dublin) and burned Armagh. In 1562 he submitted to Queen Elizabeth, but his allegiance was somewhat questionable since he also supported Mary Queen of Scots and her claim to the English throne. This latter allegiance was also questionable since he repeatedly raided Scots' settlements around Antrim. He was killed by the MacDonnells, a Scots clan in exile in Ireland.

291:34 (296:37–38). Father John Murphy—(*c.*1753–1798), priest and patriot, he was one of the first and principal leaders in the southeast during the Rebellion of 1798. He was initially

successful, but his insurgent pikemen were defeated at Vinegar Hill, and he was subsequently captured and executed.

291:34 (296:38). Owen Roe—Owen Roe O'Neill (*c*.1590–1649), an Irish soldier who served in the Spanish army. He returned to Ireland in 1642 as general in command of Irish forces loyal to Charles I. Successful at first against the English, who were preoccupied with the Civil Wars in England, his forces were brutally crushed by Cromwell's armies. He was supposedly poisoned by the treachery of one of his own supporters.

291:34–35 (296:38). Patrick Sarsfield—(*c*.1650–1693), Earl of Lucan, an Irish general who supported James II's claim to the English throne. In 1690 he defended Limerick against the invasion of William III and in a brilliant sally destroyed William's heavy artillery and forced his temporary withdrawal. After the Irish loss at the Battle of the Boyne, 1 July 1690, he is said to have regretted that they could not "change kings and fight it over again." After participating in the Treaty of Limerick (1691), which formalized the English reconquest of Ireland, he accepted exile to France, where he served in the French army and was killed at the Battle of Landen (1693).

291:35 (296:38). Red Hugh O'Donnell—(*c*.1571–1602), Lord of Tyrconnell. He was imprisoned in Dublin Castle (1587) but escaped. He was inaugurated as "the O'Donnell" and achieved a number of victories over the English, particularly in the west. In 1601 he laid siege to Kinsale and, failing to reduce it, went to Spain to seek aid from Philip III. He was coldly received and subsequently poisoned by one James Blake, an agent of Queen Elizabeth.

291:35 (296:39). Red Jim MacDermott—an associate (and a betrayer in 1868) of Michael Davitt (583:16n) and O'Donovan Rossa (292:16n) in the Irish Republican Brotherhood (The Fenian Society).

291:35–36 (296:39). Soggarth Eoghan O'Growney—Father Eugene O'Growney (1863–1899), one of the moving spirits of the Gaelic revival and one of the founders of the Gaelic League (1893). He was professor of Irish at Maynooth (1891); he edited the *Gaelic Journal* and wrote *Simple Lessons in Irish;* see 192:1–2n.

291:36 (296:39–40). Michael Dwyer—(1771–1816), a leader of the Rebellion of 1798, he eluded the English for five years. He intended to join Robert Emmet's revolt in 1803, but arrived too late and eventually surrendered voluntarily. He was transported to Australia, where he became high constable of Sydney.

291:36 (296:40). Francy Higgins—the sham squire; see 125:26n.

291:36–37 (296:40). Henry Joy M'Cracken—(1767–1798), a leader of the United Irishmen in Ulster. He was commander-in-chief of the Ulster rebels at the Battle of Antrim (1798). His forces were defeated, and he was captured and executed.

291:37 (296:40). Goliath—whose name means "splendor," was a famous giant of Gath, the Philistine champion who "morning and evening for forty days" defied the armies of Israel (I Samuel 17) (1063 B.C.). He was slain by David in single combat.

291:37 (296:40–41). Horace Wheatley—a music-hall performer, popular in pantomime roles in the 1890s. One of his more successful roles was as Baron O'Bounder in the pantomime *Cinderella.*

291:37 (296:41). Thomas Conneff—unknown.

291:37–38 (296:41). Peg Woffington—Margaret Woffington (*c.* 1720–1760), a Dublin street child whose career as one of the most successful actresses of her time began in 1737 when she made her debut as Ophelia at the Smock Alley Theatre in Dublin. She took London by storm as "the handsomest woman that ever appeared on a stage." She was remembered sentimentally as kind to her relations and charitable to the poor.

291:38 (296:41–42). the Village Blacksmith—(1840), the title and hero of one of Henry Wadsworth Longfellow's "Psalms of Life": "toiling,—rejoicing,—sorrowing Onward through life he goes" (lines 37–38).

291:38 (296:42). Captain Moonlight—a poison-pen name widely used to threaten (or forecast) retaliatory violence in the agitation for land reform in the 1870s and 1880s.

291:38–39 (296:42). Captain Boycott—Charles Cunningham Boycott (1832–1897), an Englishman who was land agent in Ireland for an absentee landowner, the Earl of Erne. He was a widely publicized victim of the treatment that subsequently bore his name. In 1880 he refused to accept rents at figures set by the tenants of the estates he managed and evicted them instead. He was ostracized by the Irish Land League; his life was threatened; servants were forced to leave his employ; his correspondence was intercepted, his food supplies curtailed and the estates damaged by acts of sabotage. The proclamation against him: "Let every man in the parish turn his back on him; have no communications with him; have no dealings with him."

291:39 (296:42). Dante Alighieri—(1265–1321), the famous Florentine poet and patriot.

291:39 (297:1). Christopher Columbus—(1451–1506).

291:39 (297:1). S. Fursa—(d. *c*.650), an Irish saint, festival 16 January. His mission founded a monastery in Ireland, one in England and two on the Continent. Joyce remarks that he is "described in the hagiographic calendar of Ireland as the precursor of Dante Alighieri. A medieval copy of the Visions of Fursa depicts the voyage of the saint from hell to heaven. . . . This vision would have served as a model for the poet of the Divine Comedy, who . . . is honored by posterity because he was the last to visit and describe the three regions of the soul" (*Critical Writings*, p. 236).

291:40 (297:1). S. Brendan—(484–577), an Irish saint, festival 16 May. He founded monasteries in Ireland and in Brittany and was called "Brendan the Navigator" after the fame of his early legendary voyages. Joyce: "Christopher Columbus, as everyone knows, is honoured by posterity because he was the last to discover America. A thousand years before . . . Saint Brendan weighed anchor for the unknown world [from the Aran Isles] . . . and, after crossing the ocean, landed on the coast of Florida" (*Critical Writings*, p. 235).

291:40 (297:1–2). Marshall MacMahon—Patrick MacMahon (1808–1893), Duke of Magenta and Marshall of France, President of the French Republic (1873–1879), was of Irish ancestry. As a soldier, he was a notable success in the Crimean War and a notable failure in the Franco-Prussian War. As President he was mildly anti-Republican and in favor of a restoration of the monarchy, but his monarchic sympathies were restrained by popular pressure for the continuation of the Republic.

291:40 (297:2). Charlemagne—Charles the Great (742–814), King of the Franks after 768 and Roman Emperor (800–814). Irish tradition regarded Charlemagne as having sprung from the same Celtic stock as the ancestors of early Christian Ireland.

291:40–41 (297:2). Theobald Wolfe Tone—(1763–1798), an Irish revolutionary and one of the founders of the United Irishmen. Tone was inspired with republican idealism by the successes of the American Revolution and by the apparent success of the French Revolution. He was instrumental in attempting to secure French support for Irish revolution in the 1790s; neither of the two French expeditions in which Tone was involved was able to effect a landing, and Tone was captured at sea in the course of the second

attempt. He was returned to Dublin and condemned to death, but committed suicide in prison.

291:41 (297:2–3). the Mother of the Maccabees—Maccabees was the name given to a Jewish family of great prominence (175–37 B.C.). The mother in question, Salome, was, together with seven of her children, martyred (*c*.168 B.C.) by Antiochus IV, Epiphanes (king, 175–164 B.C.) because the family resisted his attempts to substitute worship of the Greek gods for the Jewish religion. The mother and her children are the only Old Testament martyrs included in the hagiography of the Catholic Church.

291:41–42 (297:3). the Last of the Mohicans—(1826), the title of a novel by the American James Fenimore Cooper (1789–1851).

291:42 (297:3). the Rose of Castille—see 129:19–18n.

291:42 (297:4). the Man for Galway—the title of a song by Charles James Lever (1806–1872): "To drink a toast/A proctor roast,/Or bailiff, as the case is./To kiss your wife,/Or take your life/At 10 or 15 paces,/To keep game cocks, to hunt the fox,/To drink in punch the Solway./With debts galore,/But fun far more,/Oh, that's the man for Galway."

291:42–292:1 (297:4–5). the Man that Broke the Bank at Monte Carlo—the title of a music-hall song (1892) by Fred Gilbert (1850–1903). The song was based on the widely publicized gambling luck of one Charles "Monte Carlo" Wells, who broke the bank at Monte Carlo six times in 1892 before his luck turned and he lost it all. "As I walk along the *Bois Boolong*/With an independent air/You can hear the girls declare/'He must be a Millionaire,'/You can hear them sigh,/And wish to die,/You can see them wink the other eye/At the man who broke the Bank at Monte Carlo." First verse: "I've just got here, through Paris, from the sunny southern shore;/I to Monte Carlo went, just to raise my winter's rent;/Dame Fortune smiled upon me as she'd never done before,/And I've now such lots of money, I'm a gent,/Yes, I've now such lots of money, I'm a gent." Chorus: (repeat). Second verse: "I patronized the tables at the Monte Carlo hall,/Till they hadn't a sou for a Christian or a Jew;/So I quickly went to Paris for the charms of mad'moiselle/Who's the loadstone of my heart, what can I do,/When with twenty tongues she swears that she'll be true."

292:1 (297:5). the Man in the Gap—in ancient Ireland, a champion or military hero whose duties included avenging insults and offenses to his king and tribe; when the tribe's lands were threatened with invasion the champion kept "watch at the

most dangerous ford or pass . . . the gap of danger." In modern Ireland the goalkeep in hurling or football is often called "the man in the gap" (P. W. Joyce, *English as We Speak it in Ireland*, p. 182).

292:2 (297:5). the Woman Who Didn't—after *The Woman Who Did* (1895), a novel by the Canadian Grant Allen (1848–1899). The "woman" of Allen's novel attempts to emancipate herself in "free love."

292:2 (297:5–6). Benjamin Franklin—(1706–1790), was famous, among other things, for his "way with the ladies."

292:2 (297:6). Napoleon Bonaparte—(1769–1821) was not so successful a lover as he was conqueror.

292:3 (297:6). John L. Sullivan—(1858–1918), Irish-American heavyweight champion from Boston, Massachusetts, who was acknowledged as American champion from *c.*1882 (and billed as world champion) until he lost the title to James J. Corbett in 1892.

292:3 (297:6–7). Cleopatra—(69–30 B.C.).

292:3 (297:7). Savourneen Deelish—Irish: "And my faithful darling," the title of a ballad by George Colman (1762–1836) a pathetic lament about the parting of a young soldier and his love: "Ah! the moment was sad when my love and I parted/Savourneen Deelish, Eileen Oge!/As I kissed off her tears I was nigh broken-hearted!/Savourneen Deelish, Eileen Oge!/Wan was her cheek, which lay on my shoulder—/Damp was her hand, no marble was colder—/I felt that again I should never behold her,/Savourneen Deelish, Eileen Oge!"

292:3 (297:7). Julius Caesar—(100–44 B.C.).

292:4 (297:7). Paracelsus—Phillipus Aureolus Paracelsus Theophrastus Bombastus von Hohenheim (1493–1541), German-Swiss alchemist and physician, noted in medical history for his attention to pharmaceutical chemistry and famous as the author of a visionary theosophical system.

292:4 (297:7–8). sir Thomas Lipton—(1850–1931), a Glasgow-born millionaire merchant of Irish parentage, known for the tea that still bears his name and for his unsuccessful and expensive attempts to win the America's Cup for England.

292:4 (297:8). William Tell—the hero of a Swiss legend, he was forced by a tyrant to prove his marksmanship by shooting an apple off his son's head. He is supposed to have succeeded, to have killed the tyrant and to have led the revolt

(*c.*1307) that gained independence for the Fores Cantons of Switzerland.

292:4–5 (297:8). Michelangelo, Hayes—Michelangelo Buonarotti (1475–1564), the Florentine painter and sculptor, is obvious here, but the comma may be a typographical error since Michelangelo Hayes (1820–1877) was an Irish illustrator and caricaturist who became city marshall of Dublin.

292:5 (297:8–9). Muhammad—(570–632), the militant Arabian prophet who founded the Moslem religion.

292:5 (297:9). the Bride of Lammermoor—the title of a novel (1819) by Sir Walter Scott, one of the *Tales of My Landlord* series. The novel is regarded as a masterpiece of Gothic fiction, compounded of doom foretold and fulfilled. The bride's family rejects the bride's true love, Ravenswood, and imposes a husband of its own choice. The result is a curse and a malignant fate that dooms the bride, her husband and her lover.

292:5–6 (297:9). Peter the Hermit—Peter of Amiens (*c.*1050–*c.*1115), the preacher and, for a time, the leader of the First Crusade.

292:6 (297:9–10). Peter the Packer—a nickname for Lord Peter O'Brien of Kilfenora (1842–1914), Crown Counsel and eventually Lord Chief Justice of Ireland. He was regarded as hostile to Land Leaguers and Irish Nationalists, and when, as Attorney General, he was acting for the Crown, he had a tendency, particularly in political cases, to excessive exercise of his right to peremptory challenge of prospective jurors. He thus attempted to ensure unbiased (or pro-English) juries and earned his reputation for packing juries (and his nickname).

292:6 (297:10). Dark Rosaleen—the title of an anonymous sixteenth-century Irish poem. The most famous translation is James Clarence Mangan's (1803–1849); Rosaleen, the object of the speaker's love and devotion, is a personification of Ireland.

292:6 (297:10). Patrick W. Shakespeare—this combination obviously echoes speculation about Shakespeare's Irish backgrounds (see 196:10–11n); but it also involves a cryptogram: Patrick W(eston) *Joyce* (1827–1914), no relation, was an Irish scholar and historian.

292:7 (297:10–11). Brian Confucius—Brian (like Patrick) is a familiar Irish given name and makes a Celt out of the famous Chinese philosopher Confucius (551–479 B.C.).

292:7 (297:11). Murtagh Gutenberg—Murtagh is another Irish given name. One of the better-known individuals to bear it was Murtagh O'Brien (d. 1119), a belligerent king of Munster. Johannes Gutenberg (1397–1468) was the German who received disputed credit for the invention of printing with movable type. It is notable in relation to the following note that Gutenberg, the son of Gensfleisch, assumed his mother's name.

292:7 (297:11). Patricio Velasquez—the Spanish painter Diego Rodriguez de Silva (1599–1660) also assumed his mother's name, Velasquez. "Patricio" is the Spanish form of "Patrick."

292:7–8 (297:11–12). Captain Nemo—the hero of Jules Verne's (1828–1905) science-fiction novel *Twenty Thousand Leagues Under the Sea* (1870). "Nemo" is Latin for "no man" (the pseudonym Odysseus assumes during his escape from Polyphemus' cave).

292:8 (297:12). Tristan and Isolde—the hero and heroine of the legendary love story are associated with Ireland since Isolde was Irish and their love was supposed to have been consummated in Chapelizod, a village just west of Dublin.

292:8 (297:12). the first Prince of Wales—Edward II of England (1284–1327; king, 1307–1327) was the first heir apparent of the English throne to bear the subsequently traditional title (1301). He was one of the less attractive English kings, noted for his "weakness" and for the overtly homosexual nature of his behavior with "favorites." He was deposed and then murdered in 1327.

292:9 (297:12–13). Thomas Cook and Son—the travel agency. Its name by 1900 had become almost a generic term for travel agencies and guided tours. It was founded by Thomas Cook (1808–1892) and his son, John Mason Cook (1834–1899).

292:9. the Bald Soldier Boy should read **the Bold Soldier Boy** as it does (297:13)—"The Bowld Sojer Boy" is a poem by Samuel Lover; typical of the poem's 60 lines are the following: "There's not a town we march through,/But ladies looking arch through/The window panes will sarch through/The ranks to find their joy./While up the street/Each girl you meet/With look so sly/Will cry, " 'My eye!/Oh! isn't he a darling,/The bowld sojer boy!' "

292:9 (297:13). Arrah na Pogue—Irish: "One given to kissing." *Arrah-na-Pogue; or the Wicklow Wedding* (1864) was a play (with interpolated songs) by Dion Boucicault.

292:10 (297:13–14). Dick Turpin—a notorious English highwayman who was executed in 1793. He is the hero of an anonymous ballad, "Turpin Hero," sometimes called "Dick Turpin." The poem consists largely of a dialogue between Turpin and the lawyer whom he tricks and robs: "As Turpin was a-riding thro' Hounslow Moor,/He saw an old lawyer just trotting on before./So he trots up to the old lawyer: 'Good morning, Sir,' he says, 'Aren't you afraid of meetin' Dick Turpin/O that such mischievous plays?'/Singing, hero, Turpiny hero." The lawyer responds that Turpin will never find his money because he's hidden it in his "coatcape"; at the top of the hill Turpin demands the coatcape, robs the lawyer and advises him to say in the next town that he was robbed by Dick Turpin.

292:10 (297:14). Ludwig Beethoven—(1770–1827).

292:10 (297:14). Colleen Bawn—Irish: "Fair-Haired Girl." She appears variously as the heroine of a novel, *Molly Bawn* by Margaret Wolfe Hungerford (1855–1897); in the title of another of Boucicault's plays, *The Colleen Bawn; or the Brides of Garryowen* (1860) (see 290:11n). It is also the title of a song in *The Lily of Killarney* (see 91:1–2n): "The Colleen Bawn, the Colleen Bawn/From childhood have I known,/I've seen that beauty in the dawn,/Which now so bright has grown./Although her cheek is blanched with care,/Her smile diffuses joy./Heaven formed her a jewel rare—/Shall I that gem destroy?"

292:10–11 (297:14–15). Waddler Healy—the Very Reverend John Healy (1841–1918), archbishop of Tuam, is described as having waddled in his gait (Adams, p. 154).

292:11 (297:15). Angus the Culdee—the Culdees (Irish: "servants of god") were eighth-century Irish anchorites. Angus or Aengus the Culdee (d. 820) was noted for his self-abnegation and humility and for a verse martyrology that he composed.

292:11 (297:15). Dolly Mount—Dollymount was a village on Dublin Bay on the northeastern outskirts of Dublin.

292:11 (297:15). Sidney Parade—an area near the shore of Dublin Bay on the southeastern outskirts of Dublin.

292:11–12 (297:15–16). Ben Howth—the hill that dominates the northeast headland of Dublin Bay.

292:12 (297:16). Valentine Greatrakes—(1629–1683), an Irish healer called "the stroker" because he was reputed to have effected cures by a combination of massage and hypnotic suggestion.

292:12 (297:16). Adam and Eve—not only the biblical progenitors of humanity but also the popular Dublin name for the Church of St. Francis of Assisi on Merchant's Quay in central Dublin; see 146:7n.

292:12–13 (297:16–17). Arthur Wellesley—(1769–1852), Duke of Wellington. The Dublin-born Duke was not the soul of popularity in his native country since he symbolized rigorous English militarism and a conservative resistance to reform when he was Premier (1828–1830).

292:13 (297:17). Boss Croker—Richard Croker (1843–1922), an Irish-born American politician; he became leader of the Tammany Hall Democratic machine in New York City. He was "successful" enough to be able to retire in affluence in his native Cork in 1903.

292:13 (297:17). Herodotus—(c.484–c.425 B.C.), Greek historian known as "the Father of History."

292:13 (297:17). Jack the Giantkiller—the hero of the well-known nursery tale that celebrates the supremacy of skill over force.

292:13–14 (297:17–18). Gautama Buddha—(fl. sixth century B.C.) the great religious teacher and reformer of early India.

292:14 (297:18). Lady Godiva—(fl. 1040–1080), the wife of Leofric, Earl of Chester. When she requested that her husband relieve his people of an onerous tax, he taunted her by replying he would if she would ride naked through the streets of Coventry. She accepted the challenge; the people of Coventry remained indoors out of respect for her courage and modesty, except for "Peeping Tom," who sneaked a look.

292:14 (297:18). the Lily of Killarney—see 91:1n.

292:14–15 (297:18–19). Balor of the Evil Eye—in Irish legend, the leader of the Formorians, the gloomy giants of the sea who plagued other legendary prehistoric inhabitants of Ireland. He had an eye opened only in battle. It enfeebled his enemies, an army at a glance. He was finally killed by his grandson, Lug of the Long Arms, who sent a sling ball through the eye and into Balor's brain.

292:15 (297:19). the Queen of Sheba—the quasi-legendary queen of the Sabaeans who flourished in the tenth century B.C. She is most famous for her supposed visit to King Solomon (I Kings 10 and II Chronicles 9).

292:15 (297:19). Acky Nagle—John Joachim ("Acky") Nagle, of J. Nagle and Co., tea, wine

and spirit merchants (pub owner), 25 Earl Street North.

292:15 (297:19). Joe Nagle—James Joseph Nagle, another of the brothers in J. Nagle and Co.

292:15–16 (297:19–20). Alessandro Volta—Count Alessandro Volta (1745–1827), Italian physicist remembered for his researches and inventions in electricity.

292:16 (297:20). Jeremiah O'Donovan Rossa—Jeremiah O'Donovan (1831–1915), Fenian leader whose advocacy of violent measures in Ireland's struggle for independence earned him the nickname "Dynamite Rossa." He was a leader of the revolutionary Phoenix Society and was tried for complicity in the "Phoenix conspiracy" but released in 1859. After a sojourn in the United States, he returned to Ireland in 1863 to become business manager of the radical paper *Irish People*. In 1865 the paper was seized and O'Donovan was convicted of treason-felony. He was treated somewhat inhumanely in prison and his sufferings made him so famous that County Tipperary elected him to Parliament in 1869 while he was still in prison. His life sentence was commuted to banishment in 1870; he returned to the United States, where he edited the *United Irishman*. He was again in Ireland from 1891 until 1900, although at that time he was a symbol rather than an actor in the Irish political scene.

292:16–17 (297:20–21). Don Philip O'Sullivan Beare—(c.1590–1660), Irish-born Spanish soldier and historian who wrote *Historiae Catholicae Iberniae Compendium* (Lisbon, 1621), a valuable account of the Elizabethan wars.

292:28 (297:33). robbing the poorbox—a particularly low and unrewarding kind of thievery since the poorbox in a church was an unguarded receptacle provided for small contributions to the poor.

292:29 (297:34). the prudent member—i.e., Bloom. The *Old Charges* of the Masonic Order forbid "imprudent conversation in relation to Masonry in the presence of uninitiated strangers." The charges also forbid all "wrangling, quarrelling, backbiting and slander."

292:31–32 (297:36–37). Pill lane and Greek street—on the western side of the Dublin Corporation Fruit, Vegetable and Fish Market. By 1904 Pill Lane had been renamed Chancery Street.

292:32 (297:37). cod's eye—slang: "fool's eye."

Parody: 292:34–37 (297:39–41). Who comes

through . . . the prudent soul—continues the parody of reworked Irish legend.

292:34 (297:39). Michan's land—Bloom is in St. Michan's parish; see 288:36n.

292:35 (297:40). O'Bloom, the son of Rory— from among the countless Rorys in Irish history, two possibilities: a Rory Oge O'More (?–1578), the son of another Rory O'More, who was head of his sept (1542–1557). Rory Oge must have been "prudent" since he rebelled repeatedly and was repeatedly pardoned. Another Rory O'More (*fl.* 1641–1652) was the principal leader of the momentarily successful rebellion of 1641. He was noted for his courage and had the reputation among his Protestant enemies of being "reasonable and humane."

292:37–38 (297:42–298:1). the old woman of Prince's . . . subsidised organ—i.e., the *Freeman's Journal,* which was regarded as the "official" newspaper of the Irish Nationalist cause. The relative pallor of the paper's nationalist sentiment encouraged radicals to regard it as "subsidised," compromised by the quasi-conservative political interests of the Irish Nationalist or Home Rule party.

292:38–39 (298:1–2). The pledgebound party on the floor of the house—in 1852, after considerable argument, 50 (about half) of the Irish members of the English Parliament pledged themselves to the policy of independent opposition to both major parties in the House of Commons and further pledged to throw their balance-of-power vote in support of the English party that undertook reforms in Ireland. The tactic was promising, but it collapsed when several of the Irish members broke their pledges. Parnell revived the tactic of a pledge-bound party with considerable success in the 1880s when the Irish party moved toward a working coalition with Gladstone's Liberal party. After the collapse of Parnell's leadership in 1890, the coalition of Irish political parties that he had achieved disintegrated. A similar division against itself also began to plague the English Liberal party, which, under Gladstone, had ruled because it enjoyed the support of Parnell's coalition. By the opening years of the twentieth century the English Liberal party was deeply split between pro-imperialists (led by Joseph Chamberlain; see 160:26–27n) and the anti-imperialists. As a result, the Liberal party's commitment to social reform and to a solution of the Irish Question was virtually paralyzed, but the Irish Parliamentary or Nationalist party (Parnell's old party) continued to honor its pledge and to support the English Liberals even though the Liberals could or would do nothing for Ireland.

The Citizen's remark also echoes a parody of a song, "God Save Ireland," by Timothy Daniel Sullivan (1827–1914). The parody "transmits" Lady Aberdeen's message from the Queen to the Irish. Lady Aberdeen was active in support of "good works," and the message was that the home front could help the World War I effort by collecting socks for the troops at the front: "When you've gathered all the socks/Take them down to Dr. Cox,/Or to Dillon, or to Redmond, or myself;/For the party on the floor/Has agreed to look them o'er/While the Home Rule Bill is resting on the shelf." Chorus: "Hell roast the king and God save Ireland!/Get a sack and start to work today!/Gather all the socks you meet/ For the British Tommies' feet/When they're running from the Germans far away!" Dr. Alfred Cox was a prominent English medical politician. John Dillon (1851–1927) was second in command of the Irish Nationalist or Home Rule party during World War I; John Redmond (1856–1918) was the leader of that party. The grim joke is that Parliamentary approval of Home Rule had been achieved on the eve of the war, but implementation was suspended for the duration of hostilities. To many Irish nationalists this suspension looked suspiciously like bad faith on England's part.

292:40 (298:3). The Irish Independent . . . founded by Parnell—the *Freeman's Journal* held to its support of Parnell long after most of his supporters had turned against him. The paper abandoned Parnell 21 September 1891; by that time Parnell, with the help of those still loyal to him, was planning to found a new paper, *The Irish Daily Independent.* Parnell was, however, mortally ill (he died on 5 October), and the paper did not begin publication until 18 December 1891. It quickly passed into the hands of anti-Parnellites, and was acquired in 1900 by William Martin Murphy; see 293:17–18n.

293:4–16 (298:8–20). Gordon, Barnfield Crescent . . . Isabella Helen—the English names and addresses that the Citizen reads are selected from the columns of *The Irish Daily Independent* for 16 June 1904. Under "Births" the Citizen passes over the Irish-born (Bennett, Carr and Coghill) in favor of "Gordon—11 June 1904, at 3 Barnfield Crescent, Exeter [England], the wife of W. Gordon, M.D., F[ellow] of the R[oyal] C[ollege] of P[hysicians], of a son. // Redmayne, 12 June 1904, of Iffley, St. Anne's-on-the-Sea [England], the wife of William T. Redmayne, of a son." Under "Marriages" the Citizen skips three Irish matches (Figgis and Donnithorne, Neary and O'Neill, Wright and Flint) to concentrate on "Vincent and Gillett—9 June 1904, at St. Margaret's, Westminster [London], by the Rev. T. B. F. Campbell, third son of Thomas Vincent, Whinburgh, Norfolk, to Rotha Marian Gillett, younger daughter of Rosa and the late George Alfred Gillett, 179 Clapham Road, Stockwell .//

Haywood [not Playwood] and Ridsdale—8 June 1904, at St. Jude's, Kensington, by the Very Rev. Dr. Forrest, Dean of Worcester, assisted by the Rev. W. H. Bliss, Vicar of Kew, Charles Burt Haywood, only surviving son of the late Thomas Burt Haywood and Mrs. Haywood, of Woodhatch, Reigate, to Gladys Muriel, only daughter of Alfred Ridsdale, of Hatherly House, Kew Gardens." Under "Deaths" the Citizen omits six English entries (Johnston, Kennedy, Larkin, Lyon, Watson and Young) and one Irish, ("Howard—14 June 1904, at the City of Dublin Hospital, Steven Howard, President of the Dublin Branch of the Amalgamated Painters' Society, Aged 32 years"). The Citizen cites from the following entries: "Bristow—11 June 1904, at 'Fernleigh,' Whitehorse Lane, Thornton Heath, London, John Gosling Bristow. // Cann [not Carr]—12 June 1904, at Manor Road, Stoke Newington, Emma, daughter of the late W.A. Cann, of gastritis and heart disease. // Cockburn—10 June 1904, at the Moat House, Chepstow, after a short illness, Frances Mary Cockburn, in the 60th year of her age. // Dimsey—13 June 1904, at 4 Crouch Hall Road, Crouch End [England], Martha Elizabeth, the Wife of David Griffiths Dimsey, late of the Admiralty. // Miller—14 June 1904, at Northumberland Park, Tottenham, George Clark Miller, in the 85th year of his age. // Welsh—12 June 1904, at 35 Canning Street, Liverpool, Isabella Helen Welsh."

293:13 (298:17). that fellow—i.e., venereal disease.

293:17 (298:21). my brown son—low slang for penis.

293:17–18 (298:21–22). Martin Murphy, the Bantry jobber—William Martin Murphy (1844–1921) was the owner of *The Irish Daily Independent*. He was born in Bantry on the southwest coast of Ireland; he was a contractor (building railways and tramways); a member of Parliament (1885–1892), he turned against Parnell in the "great split" of 1890. He distinguished himself as the chief opponent of the workers in the great Dublin strike of 1913. "Jobber" is slang for one who performs corrupt work in politics or intrigue.

293:19–20 (298:23–24). Thanks be to God . . . the start of us—after a popular drinking song, "One More Drink for the Four of Us": "I was drunk last night, drunk the night before./Gonna get drunk tonight, if I never get drunk anymore,/'Cause when I'm drunk I'm as happy as can be,/For I am a member of the souse familee. // Glorious, glorious, one keg of beer for the four of us./Glory be to god there are no more of us,/For one of us could kill it all alone."

293:22 (298:26). And all down the form—mourners at Irish wakes sat on long benches or forms usually supplied by the funeral parlor.

Parody: 293:26–30 (298:30–34). And lo, as they . . . fairest of his race—continues the parodies of reworked Irish legend.

293:32 (298:36). snug—(of a bar or pub) a small room or parlor behind the bar for private parties.

294:8 (299:13). Bi i dho husht—Irish: literally, "Silence!" but figuratively a somewhat impolite way of saying, "Shut up." The phrase is often used at public meetings, etc.

294:15 (299:20). Green street . . . G. man—the G (plainclothes) Division of the Dublin Metropolitan Police was located in Exchange Court off Dame Street. Green Street, around the corner from Little Britain Street, had two police stations: C Division at 25 and D Division at 11; 25 also housed the Sessions House (the chief judicial offices of the city) and the Office of the Clerk of the Crown and Peace, County and City of Dublin.

294:16 (299:21–22). to hang that fellow in Mountjoy—the real sub-sheriff in 1904, John Clancy, the prototype of the fictional Long John Fanning, was well known for his reluctance to fulfill his duty of preparing for the infrequent hangings that took place in Dublin. Mountjoy Government Prison, where long-term prisoners were held, was between North Circular Road and the Royal Canal on the northern outskirts of Dublin. There was no prisoner awaiting hanging in Mountjoy on 16 June 1904, but there was a prisoner awaiting retrial on a charge of murder. Thomas Byrne, a Dubliner, had allegedly beaten his wife to death on 27 March 1904. Byrne's first trial had ended in a hung jury on 9 June 1904, although the presiding judge, Lord O'Brien (see 292:6n), had virtually directed a verdict of guilty. There was considerable public controversy about the trial: (a) against Lord O'Brien as a "hanging judge," and (b) against Byrne as a brutal murderer who deserved immediate hanging. At the retrial, on 2 August 1904, Byrne was found guilty and was executed on 6 September 1904.

Parody: 294:25–295:5 (299:30–300:12). Terence O'Ryan . . . the ruddy and the ethiop—continues the parodies of reworked Irish legend intermixed with retold stories from Greek mythology and medieval romance.

294:25 (299:30). Terence O'Ryan—in 1904 a Reverend Terence W. O'Ryan was Curate in Charge of St. Vincent's Roman Catholic Church in Golden-Bridge, a village three miles west of the center of Dublin (only appropriate since "curate" was slang for bartender). Another

O'Ryan is "immortalized" in a ballad by Charles Graham Halpine (1829–1868), "Irish Astronomy; a Veritable Myth, Touching the Constellation of O'Ryan, Ignorantly and Falsely Spelled Orion." O'Ryan is characterized as a "man of might" whose "constant occupation" was poaching. St. Patrick visits him and asks modestly for food and water; O'Ryan responds, "'But here's a jug of mountain dew,/And there's a rattlin' hare, sir.'" St. Patrick rewards O'Ryan's generosity by promising him a permanent place in heaven as the constellation Orion.

294:26–27 (299:31–32). the noble twin brothers Bungiveah and Bungardilaun—Lord Iveagh and Lord Ardilaun, brothers though not twins, owned Guinness' Brewery; see 78:21n and 78:24n. "Bung" is slang for one who serves grog.

294:28 (299:33). the sons of deathless Leda—in Greek mythology Castor the tamer of horses, and Pollux, the adept boxer, were the twin sons of Leda, who had been impregnated by Zeus disguised as a swan; Leda also gave birth to Helen and Clytemnestra. The twins were worshiped as aiders of men in war and on the sea, as the patrons of travelers and as guardians of hospitality. Lord Iveagh was owner of a famous stable of thoroughbreds. Leda is "deathless" since she is immortalized in myth.

294:33–34 (299:38–39). to the manner born—as they wait for the appearance of the Ghost on the battlements, Horatio and Hamlet hear the sounds of the court's carouse; Horatio adds: "Is it a custom?/HAMLET: Ay, marry is't./But to my mind, though I am native here/And to the manner born, it is a custom/More honour'd in the breach than the observance./This heavy-headed revel east and west/Makes us traduced and tax'd of [censured by] other nations" (I, iv, 12–18).

294:39 (300:3). testoon—a silver-bronze shilling coin introduced in the reign of Henry VIII; it declined in value to 6d in the course of the sixteenth century because it was debased metal. In this context it is a penny.

294:40–295:2 (300:4–8). a queen of regal . . . Empress of India—Queen Victoria was a granddaughter of George III of England, whose family had been the Dukes of Brunswick in Germany. The titles were Victoria's official titles except for the phrase "and of the British dominions beyond the sea," a phrase first included in the royal formula at the coronation of Edward VII in 1901.

295:4–5 (300:10–11). from the rising . . . going down thereof—from Psalms 50:1: "The mighty God, *even* the Lord, hath spoken, and called the earth from the rising of the sun unto the going down thereof."

295:14 (300:21). codding—slang for joking or talking nonsense.

295:20 (300:27). Willy Murray—the name of one of Joyce's uncles; he worked for Collis and Ward just as Richie Goulding does in the novel.

295:40–41 (301:6–7). They took the liberty . . . this morning anyhow—the joke derives from Jonathan Swift, *Complete Collection of Genteel and Ingenious Conversation* (1738), First Conversation: Colonel Atwit: "But is it certain that Sir *John Blunderbuz* is dead at last?" Lord Sparkish: "Yes, or else he's sadly wronged; for they have buried him."

Parody: 296:5–297:4 (301:13–302:12). In the darkness spirit . . . had given satisfaction—parodies a theosophist's account of a spiritualist séance. The "scientific" exactitude of some of the phrases ("Communication was effected," "It was ascertained" etc.) lampoons the style of reports published by the Society for Psychical Research in London. The society was founded in 1882 for the purpose of making "an organized and systematic attempt to investigate that large group of debatable phenomena designated by such terms as mesmeric, psychical, and spiritualistic."

296:6 (301:14). tantras—in Hinduism a ceremonial treatise related to the literature of magic and of the the Puranas (sacred poetical works in Sanskrit that treat of the creation, destruction and renovation of worlds, the deeds of gods and heroes, etc.). The tantras were widely used by theosophists and spiritualists.

296:8 (301:16). etheric double—in theosophy the living human being is composed of a "dense body" and an "etheric body or double" "magnetically" bonded. In birth or rebirth the etheric double is fashioned in advance of its dense counterpart; the two bodies once fused shape the limits within which the human being as a conscious entity will have to live and work. At death the etheric double is separated from the dense body and gradually disintegrates; subsequently a new etheric body will be created for the rebirth of the soul since one earth life is not considered sufficient for the full evolution of the soul. In context Dignam's etheric double is "particularly lifelike" because it is only just beginning to disintegrate.

296:9 (301:17). jivic rays—the *jiva* is the life energy, the vital principle of the individual soul.

296:10–11 (301:19). the pituitary body—or gland is regarded by some theosophists and

spiritualists as that which unites the body with the soul (whose seat is in the pineal gland; see 189:34n). Since Dignam is but recently dead, the ties of his soul to his body are still strong though facing inevitable disintegration.

296:14 (301:22–23). on the path of prālāyā or return—*prālāyā* in theosophy is the period of the individual soul's reabsorption or rest after death and before rebirth. In this period the soul is supposed to divest itself of earthly concerns and concentrate on spiritual growth so that it will evolve toward rebirth in an improved state.

296:15–16 (301:23–24). certain bloodthirsty entities on the lower astral levels—the effort of the individual soul is to evolve through spiritual education toward higher and purer (less violent and earthy) astral levels, see 189:30n. In effect, Dignam's soul is threatened with spiritual retardation.

296:17 (301:25). the great divide—the phrase "to pass the great divide" was a stock nineteenth-century circumlocution for death, but see also 296:8n.

296:18 (301:26). he had seen as in a glass darkly—I Corinthians 13:12: "For now we see through a glass, darkly; but then face to face: now I know in part; but then shall I know even as also I am known."

296:19 (301:27–28). atmic development—the atmic plane in theosophy is the plane of pure existence, the soul's divine powers in their fullest manifestation. Those who achieve this plane have completed the cycle of human evolution and are perfect in wisdom, bliss, power.

296:22 (301:30). more favoured beings—those whose individual spiritual evolution has carried them through more stages on the journey to Atmâ than Dignam's has.

296:23–24 (301:32). tālāfānā, ālāvātār, hātā-kāldā, wātāklāsāt—telephone, elevator, hot and cold (running water), watercloset. The spelling parodies the theosophists' predilection for Sanskrit terms (Sanskrit being regarded as the penultimate language of mysticism).

296:28 (301:38). the wrong side of Māyā—*Māyā* is the physical and sensuous universe conceived as a tissue of deceit and illusion. To be on "the wrong side of Maya" is not to have begun the theosophical effort for spiritual evolution of the soul toward Atmâ.

296:29–30 (301:39). devanic circles—a *deva* is a divine being or deity; thus: among the divine ones, those who have achieved Atmâ.

296:30–31 (301:39–40). Mars and Jupiter ... ram has power—in astrology the planet Jupiter signifies a high-spirited, energetic mind, committed to new and progressive ideas and somewhat religiously inclined; Mars signifies a passionate, challenging temperament. The "ram" is Aries; "the eastern angle" is his house in the heavens, his section of the Zodiac; Aries marks the beginning, the spring of the Zodiacal year. The qualities of Aries: dauntless courage, optimism, energy. In this case, since Mars and Jupiter are "out for mischief," their similar qualities are in conflict instead of in conjunction; the dark, destructive side of those qualities threatens to become manifest and to bring out the negative qualities of Aries: a tendency to bluff, to heckle, to resent interference and to indulge in temper tantrums.

296:41 (302:7). the return room—a small room added onto the wall of a house and projecting out from it.

296:41 (302:8). Cullen's—M. Cullen, bootmaker, 56 Mary Street, Dublin.

Parody: 297:5–8 (302:14–17). He is gone ... with your whirlwind—again parodies reworked Irish legend, the lament for the death of a hero.

297:7 (302:16). Banba—according to Geoffrey Keating (*c*.1570–*c*.1644), *History of Ireland* (*c*.1629), Banba was the eldest of the three daughters of Adam and Eve's son, Cain. Banba and her sisters, Erin and Fotha, were the legendary first settlers of Ireland. Other versions of the legend style Banba as a Queen of the Tuatha de Danann (the legendary prehistoric race of heroes); and thus her name became (as did Erin) a poetic name for Ireland. In mythological terms Banba and her two sisters apparently constituted a triple goddess (birth-love-death), with Banba functioning as goddess of death.

297:11 (302:20). point duty—the duty of a police constable stationed at a street or crossing to direct traffic.

297:17 (302:26). poll—slang for head; it originally meant a wig.

297:34 (303:1). The tear is bloody near your eye—see 291:15n.

297:35–40 (303:2–7). the little sleepwalking bitch . . . and no favour—the story of Bob Doran's shotgun courtship is told in "The Boarding House," *Dubliners*. For "bumbailiff," see 285:8n. "Stravaging" means roaming about idly. "Fair field and no favour" is a phrase from horse-racing used to describe a race in which there are

no handicaps and in which all the horses are equally good, none of them a favorite.

Parody: 298:1–2 (303:10–11). And moonful . . . beam of heaven—continues the previous parody; see 297:5–8n.

298:4 (303:13). skeezing—slang for looking or ogling.

298:8 (303:17). O, Christ M'Keon—the connotations of this curse are unknown.

298:14 (303:23). Joe Gann—derives his name not from the history of crime but from a British consular official in Zurich who had offended Joyce; see Ellmann, p. 472.

298:14 (303:23). Bootlejail—a maximum-security prison near Liverpool.

298:17 (303:26). private Arthur Chace . . . Jessie Tilsit—Mr. H. G. Pearson, departmental record officer at the Home Office in London, reports in a letter, 20 November 1970: "A careful search has been made of the Home Office record of capital cases for the period 1880 onwards but no mention has been found of the execution of Private Arthur Chace."

298:18 (303:27). Pentonville prison—a maximum-security prison in London.

298:20 (303:29). Billington—an English hangman named Billington did have the dubious distinction of hanging three Irish malefactors in one week in 1899; see Adams, p. 228.

298:20–21 (303:29–30). Toad Smith—a coworker with Joe Gann; see 298:14n.

298:26 (303:35). H. Rumbold—Sir Horace Rumbold, the British Minister to Switzerland in 1918, appears by courtesy of Joyce's irritation with him; see Ellmann, p. 472.

Parody: 299:7–10 (304:15–18). In the dark land . . . saith the Lord—parodies the style of popular "stories from medieval romance."

299:8–9 (304:17). Erebus—in Greek mythology a realm of darkness between the Earth and Hades, the underworld.

299:19 (304:27). The poor bugger's tool—it is a commonplace that a man who is hanged has an erection in the process.

299:22 (304:30). Kilmainham—Kilmainham Gaol in Kilmainham, on the western outskirts of Dublin, was notorious for the generations of Irish patriots who had been imprisoned and/or executed within its walls. It is now a museum.

299:22–23 (304:30–31). Joe Brady, the invincible—see 134:17–18n. He was hanged in Kilmainham, 14 May 1883.

299:25 (304:33). Ruling passion strong in death—Alexander Pope, *Moral Essays,* Epistle I: "And you! brave COBHAM, to the latest breath/Shall feel your ruling passion strong in death:/Such in those moments as in all the past,/ 'Oh, save my Country, Heav'n!' shall be your last" (lines 262–265).

Parody: 299:31–42 (304:39–305:9). The distinguished scientist . . . per diminutionem capitis—parodies the style of a medical journal's report of a meeting of a medical society.

299:31–32 (304:39–40). Luitpold Blumenduft—"Luitpold" is an archaic German form of "Leopold"; "Blumenduft," German: "flower scent or fragrance."

299:37 (305:3). corpora cavernosa—Latin: "the cavernous bodies." Anatomy: masses of erectile tissue with large interspaces that may be distended with blood, especially those of the penis and clitoris.

299:41–42 (305:8). philoprogenitive—having or tending to the love of offspring.

299:42 (305:8–9). in articulo mortis per diminutionem capitis—medical Latin: "at the moment of death caused by breaking the neck."

300:2 (305:11). the invincibles—see 80:23n.

300:3 (305:12). the old guard—presumably "the grand old men" of the Fenian movement (see 32:18n), among them John O'Leary (1830–1907), Charles Joseph Kickham (1826–1882) and Jeremiah O'Donovan (Rossa) (see 292:16n). Their careers began with involvement in the Young Ireland movement in the 1840s, then with the Fenians. In 1865 they were arrested, imprisoned and transported in an English sweep designed to stifle the Fenian organization before it could mount a rebellion. They continued, however, to write and to crusade for Irish independence even though their revolutionary aims were overshadowed by Parnell's essentially constitutional attempts to achieve Home Rule.

300:3 (305:12). the men of sixty-seven—1867, when the Fenians attempted a rebellion. The attempt was abortive for a variety of reasons: it had been planned for 1865 and then delayed for lack of weapons, for lack of coordinated organization and because the English acted to suppress it by arresting key Fenian spokesmen and by moving out of the country Irish army units infiltrated by Fenians. The rebellion depended

on support from the Fenian Society in America but that support was only partially realized since the American society was torn with dissension. The rebellion itself, 5–6 March, took place without a chance of success and was virtually a bloodless failure.

300:3–4 (305:12–13). who fears to speak of ninety-eight—(the Rebellion of 1798) see 237:35–36n and 280:30n.

300:5–6 (305:15). drumhead courtmartial—a summary trial conducted with an upturned drum as the "bench" for the purpose of judging offenses during military operations.

300:15 (305:34). Arrah!—Irish: literally, "Was it?"; figuratively, "Indeed."

300:18–19 (305:28). give you the bloody pip—to "give the pip" is slang for to depress, annoy, disgust.

300:20 (305:29). a Jacob's tin—W. and R. Jacobs and Company, Ltd., a large biscuit manufacturer in Dublin.

300:24 (305:34). the brothers Sheares—Henry (1755–1798) and John (1766–1798) Sheares were both members of the United Irishmen in the Rebellion of 1798. Betrayed by an informer, they were captured and went (so the sentimental story goes) hand in hand to their execution.

300:24–25 (305:34–35). Wolfe Tone beyond on Arbour Hill—Wolfe Tone is reported to have committed suicide in the Old Provost Marshall's Prison on Arbour Hill, not far west of Barney Kiernan's pub; see 291:40–41.

300:25 (305:35). Robert Emmet and die for your country—see 112:40–41n and the poem quoted in 300:25–26n.

300:25–26 (305:35–36). The Tommy Moore touch . . . far from the land—Sara Curran (d. 1808) was secretly engaged to Robert Emmet; Emmet was captured because he went to bid her goodbye before attempting to flee into exile. Thomas Moore's poem "She Is Far From The Land," in *Irish Melodies*, puts the sentimental touch on her: "She is far from the land where her young hero sleeps,/And lovers are round her, sighing:/But coldly she turns from their gaze, and weeps,/For her heart in his grave is lying. // She sings the wild song of her dear native plains,/Every note which he lov'd awaking;—/Ah! little they think who delight in her strains,/How the heart of the Minstrel is breaking. // He had liv'd for his love, for his country he died,/They were all that to life had entwin'd him;/Nor soon shall the tears of his country be dried,/Nor long will his

love stay behind him. // Oh! make her a grave where the sunbeams rest,/When they promise a glorious morrow;/They'll shine o'er his sleep, like a smile from the West,/From her own lov'd island of sorrow."

300:30 (305:40). the City Arms—the hotel where the Blooms lived when Bloom worked for the cattle trader Joseph Cuffe; see 36:23–24n.

300:31 (305:40–41). Pisser Burke—Andrew (Pisser) Burke, apparently fictional, another declining-and-falling, all-too-Irish member of the middle class. He was either living in or hanging around the City Arms Hotel when the Blooms lived there.

300:31 (305:41). an old one—Mrs. Riordan, who appears as the character "Dante" Riordan in Chapter I, *A Portrait of the Artist as a Young Man.*

300:31–32 (305:41–42). loodheramaun—Irish: "someone to be ashamed of."

300:35 (306:3). thumping her craw—see 80:28n.

300:41 (306:9). Mrs. O'Dowd—an Elizabeth O'Dowd was proprietor of the City Arms Hotel.

301:2–3 (306:13). Power's . . . the blender's round in Cope street—John T. Power, wholesale spirit merchant, 18 Cope Street.

301:6 (306:17). The memory of the dead—see 237:35–36n.

301:10 (306:22). Sinn Fein! . . . Sinn fein amhain!—Irish: "Ourselves! . . . Ourselves alone!," a patriotic toast and the motto of the Gaelic League. The phrase is a refrain in a song, "The West's Awake," by Timothy Daniel Sullivan (1827–1914): "Again through song-famed Innisfail/We wake the old tongue of the Gael:/The speech our fathers loved of yore/Makes music in our land once more!/Throughout a dark and doleful time/The stranger [England] made that speech a crime—/His might is passed; behold the dawn!/We've won the fight; *Sinn Fein Amhain!* // We found that dear tongue weak and low,/O'ermastered by its foreign foe;/Today both friends and foes can see/How strong and great 'tis bound to be!/Yes; soon again you'll rule and reign/Through Erin's fair and wide domain:/We bid you hail! *Mavourneen, slaun!*/And sing *Sinn Fein, Sinn Fein Amhain!*"

301:10–11 (306:22–23). The friends we love . . . hate before us—after Thomas Moore, "Where Is the Slave?" in *Irish Melodies*. "Oh, where's the slave so lowly,/Condemn'd to chains

unholy,/Who could he burst/His bonds at first,/ Would pine beneath them slowly?" (lines 1–5); "We tread the land that bore us,/Her green flag glitters o'er us,/The friends we've tried/Are by our side,/And the foe we hate before us. // Farewell, Erin,—farewell, all,/Who live to weep our fall!" (lines 18–24).

Parody: 301:12–305:23 (306:24–310:38). The last farewell was affecting . . . down Limehouse way—parodies a newspaper's featurestory coverage of a large-scale public and social event. This "account" of the execution of Robert Emmet owes a debt of parody to Washington Irving's (1783–1859) story "The Broken Heart," in *The Sketch Book* (1819–1820). It is of some interest that Robert Emmet was captured because he sentimentally insisted on paying a "last farewell" to his fiancée, Sarah Curran, before he fled into exile.

301:25 (306:37–38). the York Street brass and reed band—organized by the City and County of Dublin Conservative Workingman's Club, 38 York Street.

301:27–28 (306:39–41). the matchless melody . . . Speranza's plaintive muse—Speranza, the pseudonym of Jane Francisca Elgee, Lady Wilde (1826–1896), Oscar Wilde's mother. "Plaintive" is hardly a fitting description of her "muse," however, since she was part of the literary-revolutionary movement of the Young Irelanders in 1848 and attempted a stirring, not to say incendiary, nationalist verse. The "matchless melody" is unknown.

301:32–33 (307:3–4). The Night before Larry was stretched—an eighteenth-century Irish ballad that begins, "The night before Larry was stretched,/The boys they all paid him a visit." Larry and friends drink and play cards; Larry refuses the good offices of the clergy and worries that his "sweet Molly" will be frightened when his ghost visits her: "When he came to the nubbling chit/He was tucked up so neat and so pretty,/The rumbler jogged off from his feet/And he died with his face to the city;/He kicked too—but that was all pride,/For soon you might see 't was all over;/Soon after the noose was untied,/And at darky we walked him in clover,/And sent him to take a groundsweat."

301:37–38 (307:9). the Male and Female Foundling Hospital—*Thom's* (1904) lists no such "hospital," and all the orphanages that it does list are exclusively for either males or females.

301:40–41 (307:12). the Little Sisters of the Poor—a branch of the Roman Catholic Sisters of Charity; their only establishment in Dublin

was St. Patrick's House, a home for aged males and females on South Circular Road in Kilmainham.

302:6–7 (307:20). Commendatore Bacibaci Beninobenone—Italian: "Commander (or Knight Commander) Kisskiss Pretty-well-verywell."

302:8–9 (307:22–23). Monsieur Pierrepaul Petitepatant—French: "Mr. Peterpaul Pittypat."

302:11 (307:24–25). Schwanzenbad-Hodenthaler—German: "Idle-about-bath-Inhabitantof-the-valley-of-testicles."

302:11–12 (307:25). Countess Marha Viraga Kisaszony Putrapesthi—in addition to the obvious English puns, Hungarian: "Countess Cow [in contempt] Somebody's-Flower Mademoiselle Putrapesthi." "Putrapesthi" conjoins "putrid-pest" with "Budapest."

302:12–13 (307:26). Count Athanatos Karamelopulis—modern Greek: "Count Deathless Candy-Vendor" (if "pulis" is Joyce's way of rendering "pōlis.")

302:13 (307:26–27). Ali Baba Backsheesh Rahat Lokum Effendi—Ali Baba is a character in "Ali Baba and the Forty Thieves," one of the tales of *The Arabian Nights*; a poor peasant, he becomes rich by learning the password ("Open Sesame") of the thieves' cave. "Backsheesh" is Arabic for a tip or handout. "Effendi" is a Turkish title for "master" or "gentleman."

302:13–15 (307:27–28). Senor Hidalgo Caballero Don Pecadillo y Palabras y Paternoster de la Malora de la Malaria—Spanish: "Sir Noble Knight Mr. Peccadillo and Words and Lord's Prayer of the Evil Hour of Malaria."

302:15–16 (307:29). Olaf Kobberkeddelsen—the Scandinavian pun, if there is one, is obscure.

302:16–17 (307:30). Pan Poleaxe Paddyrisky—"Pan" is the Polish equivalent of "Mr." or "Sir." The multilevel puns involve the famous Polish pianist Jan Paderewski (1860–1941); Paddy, the omnipresent stage Irishman; and "Poleaxe" is one editorial variant that has been argued for the famous disputed passage in *Hamlet*: Horatio's description of the Ghost: "So frown'd he once, when, in an angry parle,/He smote the sledded Polacks [leaded poleaxe ? Pollax ?] on the ice."

302:17 (307:30). Goosepond—"Goosepond" puns on the Russian "Gospodar": "Lord, Master."

302:17–18 (307:31–32). Herr Hurhausdirektorpräsident Hans Chuechli-Steuerli—Swiss-German ?: "Mr. Brothel-director-president Hans Little-cake-Little-tax."

302:18–21 (307:32–34). Nationalgymnasiummuseumsanatorium and suspensoriumsordinaryprivatdocentgeneral history specialprofessordoctor Kriegfried Ueberallgemein—the "title" is an obvious joke at the expense of German compounds (as in 302:17–18n); "Kriegfried" means "War-peace," together with the pun on Siegfried (see 567:26n); "Ueberallgemein": literally, "Overall, universal" but the pun also involves the German national anthem "Deutschland, Deutschland über Alles" ("Germany, Germany over Everything") (1841) by A. H. Hoffman von Falerleben.

302:25 (307:39). F.O.T.E.I—Friends of the Emerald Isle.

302:25–27 (307:39–40). whether the eighth or ninth . . . Ireland's patron saint—St. Patrick (c. 385–c. 461). Not only is the day of his birth unknown but also the year and the place (Scotland ? Wales ? Gaul ?). The comic solution (9 + 8 = 17) was proposed by Samuel Lover in "The Birth of St. Patrick." The poem asserts that the argument between believers in the eighth and the ninth was the occasion of "the first faction fight in owld Ireland," until one "Father Mulcahy" proposes the compromise: "Says he, 'Boys, don't be fightin' for eight or for nine,/Don't be always dividin'—but sometimes combine;/Combine eight with nine and seventeen is the mark,/So let that be his birthday.'—'Amen,' says the clerk./ . . . / Then they all got blind dhrunk—which complated their bliss,/And we keep up the practice from that day to this" (lines 17–24).

302:30–35 (308:2–7). The baby policeman, Constable MacFadden . . . Booterstown . . . readywitted ninefooter's—Booterstown, a village four miles southeast of the center of Dublin, prided itself on having a Metropolitan Police Station (one of its few landmarks); the joke about the constable is that all Dublin police had to be at least six feet tall (and, by assumption, baby-faced country bumpkins).

302:40 (308:12). Avvocato Pagamimi—Italian: "Lawyer Paymimi" with a pun on Nicolo Paganini (1782–1840), the Italian virtuoso violinist.

303:7 (308:21). Gladiolus Cruentus—botanical Latin for a fictional species of gladiolus since the name of the genus derives from the Latin for sword (after the shape of the leaves) and "Cruentus" means "spotted with blood."

303:14–15 (308:28–30). hoch, banzai, eljen, zivio, chinchin, polla kronia, hiphip, vive, Allah . . . evviva—"national" exclamations; variously: *hoch*, German ("high, noble, sublime"); *banzai*, Japanese ("May you live 10,000 years," a battle cry and salutation to the emperor); *eljen* unknown; *Zivio*, Serbo-Croatian ("Hail, may you live long"); *chinchin*, pidgin English (to salute ceremoniously, to greet or converse with polite inquiries); *polla kronia*, modern Greek (literally, "Have many times," or, "Long life"); *hiphip*, American; *vive*, French ("long live"); *Allah*, Arab-Mohammedan; *evviva*, Italian ("hurrah").

303:17 (308:31–32). the eunuch Catalani—Angelica Catalani (1779–1849), an Italian soprano famous for the three-octave range of her voice (the normal soprano range is two octaves above middle C). Her range suggested that of a boy soprano or a castrato.

303:22–23 (308:37). the revolution of Rienzi—Cola di Rienzi (or Rienzo) (c.1313–1354). In 1347 he led a revolution in Rome, successfully displacing the ruling aristocracy and introducing governmental reforms. Placed at the head of the government, he assumed the title of Tribune and became arrogant and arbitrary. He succeeded in alienating not only the populace but also the papacy since he had visionary plans of restoring the secular "grandeur that was Rome." Expelled in 1348, in 1354 he returned at the request of Pope Innocent VI and provoked a riot in which he met his death.

303:24 (308:38). Dr Pippi—unknown.

303:38–39 (309:11). Messrs John Round and Sons, Sheffield—well-known nineteenth-century manufacturers of fine steel instruments and cutlery.

303:40 (309:12–13). blind intestine—another name for the appendix.

304:1–2 (309:16). the amalgamated cats' and dogs' home—see 89:17n.

304:13 (309:27–28). the sick and indigent roomkeeper's association—the Sick and Indigent Roomkeeper's Society, 2 Palace Street, Dublin.

304:14 (309:28–29). nec and non plus ultra—Latin: *nec* (or *ne*) *plus ultra* and *non plus ultra* both mean "the uttermost point that can be attained."

304:19 (309:34). Sheila, my own—*Shiela-ni-Gara* is another of the many allegorical names for Ireland. Mrs. Seumas MacManus (1866–1902)

(pseudonym, Ethna Carberry) wrote a poem by that title that describes Shiela as "lonesome where [she] bides" but as looking forward to a "joy sadly won." The last stanza: "But, Shiela-ni-Gara, why rouse the stony dead,/Since at your call a living host shall circle you instead?/Long is our hunger for your voice—the hour is drawing near—/*O Dark Rose of Our Passion!* call and our *hearts shall hear.*" Robert Emmet's fiancée's name was not Shiela, but Sara or Sarah Curran; see 300:25–26n.

304:26 (309:40–41). a hurling match—an Irish sport, not unlike field hockey, but considerably more brutal, played with 15 men on a side.

304:26 (309:41). Clonturk park—in Drumcondra, two miles north of Dublin on the banks of the Tolka River. By 1904 it was known as Croke Park, after the Most Reverend Thomas William Croke (1824–1902), Archbishop of Cashel and an ardent supporter of the Gaelic Athletic Association.

304:28 (310:1). Anna Liffey—see 151:12n.

304:38 (310:11). the royal Irish constabulary—not to be confused with the Dublin Metropolitan Police, the R.I.C. was the equivalent of Scotland Yard in Ireland; its headquarters were in Dublin Castle.

304:41–42 (310:14). a handsome young Oxford graduate—Sarah Curran married in 1806 (three years after Robert Emmet's death) Captain Henry Sturgeon (*c.*1781–1814) of the Royal Army Staff Corps, a nephew of Lord Rockingham (1730–1782), English statesman and Prime Minister who was pro-American and pro-Irish in his sympathies. Sturgeon was Royal Military Academy, not Oxford, and he had a minor though distinguished military career in the Napoleonic Wars.

305:11–13 (310:27–28). provostmarshall, lieutenantcolonel Tompkin-Maxwell ffrenchmullan Tomlinson—a fictional name that suggests extraordinary pretension to "good family" backgrounds.

305:14 (310:29–30). blown . . . sepoys from the cannonmouth—mutinous sepoys, Indian troops in the British army, were supposedly executed in this "exemplary" fashion. Accounts of these atrocities were particularly prevalent during the Sepoy Mutiny (1857–1858).

305:20 (310:35). God blimey—a Cockney curse: "God blame me."

305:20 (310:35). a clinker—cockney slang for a clever, adept or fashionable person.

305:22 (310:37). mashtub—a large tub used in brewing.

305:23 (310:38). Limehouse—a London slum, the Cockney's heartland.

305:25 (310:40). the corporation meeting—see 243:29–33 (247:13–17).

305:25 (310:40). Shoneens—Irish: "would-be gentlemen."

305:29 (311:2). the Gaelic league—see 190:37n.

305:29 (311:2). the antitreating league—St. Patrick's Anti-Treating League, founded in 1902; its purpose was to promote temperance by combating the institution of "treating" since each member of a drinking party felt it his "duty" to prove his generosity by taking his turn at paying for the drinks and thus drinking bouts would be prolonged beyond sobriety.

305:34–35 (311:7–8). she could get up . . . my Maureen Lay—apparently from a version of "The Low-Backed Car." One version, by Samuel Lover, begins with the verse: "When I first saw sweet Peggy,/'Twas on a market day./A low-back'd car she drove, and sat,/Up on a truss of hay:/But when that hay was blooming grass,/And decked with flow'rs of spring,/No flow'r was there, that could compare /To the blooming girl, I sing!/ As she sat in her low-back'd car,/The man at the turnpike bar,/Never ask'd for the toll,/But just rubb'd his auld poll,/And look'd after the low-back'd car!" For verse four, see 649:24, 32n. Another version, by John McCormack, substitutes "sweet Nellie" for "sweet Peggy" and "As she lay in her low-backed car."

305:36 (311:9). a Ballyhooly blue ribbon badge—identifies the wearer as a member of a temperance brigade founded by "the Apostle of Temperance," the Reverend Theobald Mathew in Ballyhooly, a village near Fermoy in County Cork, once notorious for what P. W. Joyce calls its "faction-fights" (p. 213). The phrase also recalls an Irish song: "The Ballyhooly Blue Ribbon Army": "There's a dashin' sowjer boy/ And he's called his mother's joy,/And his ructions and his elegance they charm me—/He takes the chief command/In the water drinkin' band/Called the Ballyhooly Blue Ribbon Army. // With a Hey, Hi, Ho!/We'll all enlist, ye know!/His ructions and his elegance they charm me—/They don't care what they eat/If they drink their whiskey neat/In the Ballyhooly Blue Ribbon Army."

305:37 (311:10). colleen bawns—see 292:10n.

305:39 (311:12). flahoolagh—Irish: literally, "chieftain-like"; figuratively, "plentiful."

305:39–40 (311:13). Ireland sober is Ireland free—this temperance slogan was coined by the Irish humorist-journalist Robert A. Wilson (1820–1875) (pseudonym, Barney Maglone). He produced a series of temperance "verses," apparently in a spirit of self-laceration since his contemporaries observed that drink was his "besetting sin."

305:41–42 (311:15). the tune the old cow died of—the common meaning of this phrase is unpleasant or deadening music, but in parts of Ireland and Scotland a further meaning has survived: a sermon delivered in lieu of a donation. There are several ballads and variants on this theme; a Scots version seems appropriate here: "There was a piper had a cow/And he had nought to give her;/He took his pipe and played a spring,/And bade the cow consider. // The cow considered w' hersel'/That mirth wad never fill her:/'Give me a pickle ait strae [a bundle of hay],/And sell your wind for siller [fodder].'"

305:42 (311:16). sky pilots—clergymen or chaplains.

306:15 (311:30). pro bono publico—Latin: "for the public good."

Parody:306:19–307:16 (311:34–312:32). All those who are ... After Lowry's lights—parodies the style of a newspaper's plug for a theatrical program (not dissimilar to the "paragraph" Bloom is trying to get to compliment Keyes' ad).

306:22. synanthropy should read **cynanthropy** as it does **(311:37)**—literally, "cynanthropy" means "of a dog man"; medically, a form of insanity in which the patient is convinced that he is a dog.

306:24–25 (311:40). Owen Garry—a semi-legendary king of Leinster and contemporary of Finn MacCool's, third century A.D. In one of Patrick J. McCall's (b.1861) versions of the Finn legends, in *The Fenians Nights' Entertainments,* Garry's daughter becomes Finn's wife.

306:31 (312:4). ranns—Irish: "verses, sayings, rhymes, songs."

306:33 (312:7–8). Little Sweet Branch—a translation of the Irish pseudonym, *An Craoibhin Aoibhinn,* of the poet, scholar and translator Douglas Hyde; see 48:34–36n.

306:34 (312:9) D.O.C.—Adams suggests that this is a cryptogram for cod, a joke (p. 107n).

306:38 (312:12). Raftery—Anthony Raftery (c.1784–1834), blind Irish poet known as "the last of the bards." His works were rediscovered by Douglas Hyde and translated and praised by Hyde and Lady Gregory and others in the late nineteenth century. The reputation thus established was not only that of a "satirical" poet but also of the inspired composer of religious songs and repentant verse.

306:39 (312:12). Donald MacConsidine—Dornhall Mac Consaidín (*fl.* mid-nineteenth century), a Gaelic scribe and poet who lived in County Clare in the west of Ireland.

307:3–4 (312:19–20). alliterative and isosyllabic rules of the Welsh englyn—the *englyn* is one of a group of meters, the most popular of which is the direct monorhyme *englyn,* a quatrain of 30 syllables, distributed 10/6/7/7 between its lines. It has one end rhyme (which falls on the seventh or eighth syllable of the first line). The key syllables in each line are interlinked by alliteration and/or internal rhyme. The *englyn* was one of the established meters for "high poetry."

307:9–16 (312:25–32). The curse of my curses ... After Lowry's lights—this "verse" is a parody of contemporary attempts to imitate classical Irish verse in English. "Lowry's lights": the stage of Dan Lowry's Music Hall; see 229:25n.

307:20 (312:36). a chara—Irish: "my friend."

307:21 (312:37). not as green as he's cabbage-looking—he may have a head like a cabbage but he's not an innocent.

307:23 (312:39). old Giltrap's—Gerty McDowell's maternal grandfather; see [Nausicaa]. See also 290:11n.

307:23–24 (312:39–40). ratepayers and corporators—"ratepayers" were the residents of a parish who payed taxes and/or tithes; "corporators" were those enfranchised citizens in the city's wards who could vote for members of the Dublin Corporation (approximately 85,000 of Dublin's 287,000 residents were registered voters in 1903).

307:26 (313:1). Could a swim duck?—a variant of "Can a duck swim?," a stock way of saying an emphatic yes.

307:32–34 (313:7–9). didn't serve any notice ... recover on the policy—technically, under British law, when an individual borrowed money, mortgaging his insurance policy as security, the mortgage was not valid unless the insurance company that issued the policy had been legally notified. This legal loophole was the source of considerable litigation, but attempts to void a mortgage on the basis that the insuring company

had not been notified of the mortgaging of its policy were rarely successful in the courts.

307:35–36 (313:11). old Shylock is landed— Shylock is the exacting Jewish moneylender in Shakespeare's *The Merchant of Venice*; to be "landed" is to be caught at one's own game.

308:3 (313:19). Bridgeman—identity and significance unknown.

308:8–9 (313:23–24). Selling bazaar tickets . . . privileged lottery—for Bloom's "crime," see 154:4–5n.

Parody: 308:18–33 (313:35–314:8). Let me, said he . . . me even of speech—parodies the style of dialogue in sentimental-genteel nineteenth-century fiction.

308:35 (314:10). lagged—originally, "transported as a convict"; subsequently, "arrested."

308:36 (314:12). shebeen—a place where liquor was sold illegally (i.e., without a license or after hours).

308:37 (314:12). Bride street—in the Liberties, the run-down section in south-central Dublin.

308:37 (314:13). shawls—Dublin slang for fisherwomen; hence, prostitutes.

308:38 (314:13). bully—a protector and exploiter of prostitutes.

308:39 (314:14–15). Joseph Manuo—one possibility for this un-French name: "Manu" is Sanskrit for the progenitor of the human race or for any person regarded as the archetype of his fellowmen.

308:40–41 (314:16). Adam and Eve's—see 292:12n.

308:42 (314:18). smugging—toying amorously in secret (Wright, *English Dialect Dictionary*).

309:4 (314:21). testament—with a pun on "fundament"; also part of a verbal game not unlike "teapot"; see 437:26n.

309:11 (314:28). patch up the pot—slang for marrying the woman a man had made pregnant.

309:14 (314:32). Slan leat—Irish: "Safe with you, or Goodbye."

309:18 (314:36). Who is the long fellow running for the mayoralty—i.e., who is Long John Fanning, the sub-sheriff, supporting. The lord mayor of Dublin was elected annually by the members of the Dublin Corporation. The subsheriff, by virtue of his duties as the supervisor of elections, had considerable power as a "mayormaker."

309:21 (314:39). Nannan—i.e., Joseph Nannetti; see 117:16n.

309:24 (314:42). William Field, M.P.— (b.1848), a Dublin victualler, a Member of Parliament from Dublin and president and chief spokesman of the Irish Cattle Traders' and Stockowners' Association.

309:25 (315:1). Hairy Iopas—the poet who sings during a feast (and drinking bout) in Dido's palace at the end of Book I of Virgil's *Aeneid*: "Long-haired Iopas, one taught by mighty Atlas, makes the hall ring with his golden lyre. He sings of the wandering moon and the sun's toils; whence sprang human kind and the brutes, whence rain and fire; of Arcturus, the rainy Hyades and the twin Bears; why wintry suns make such haste to dip themselves in ocean, or what delay stays the slowly passing nights" (lines 740–746).

309:29 (315:5). sending them all to the right-about—slang for dismissing or turning away rudely.

309:30 (315:6). sheepdip for scab—"scab" is a highly contagious skin disease suffered by sheep. The cure is immersion in a "dip" made of a solution of lime and sulfur.

309:30–31 (315:6–7). a hoose drench for coughing calves—"hoose" is a cattle disease of the lungs and bronchial tubes caused by the thread or hair lungworm; a "drench" is a large quantity of fluid medicine given at one time.

309:31 (315:7–8). the guaranteed remedy for timber tongue—"timber tongue," also called "wooden tongue" or "lumpy jaw," is a cattle disease, actinomycosis, caused by a fungus that encourages abnormal or tumorous growth of cells; it is similar to noninfectious foot-and-mouth disease. There was no known remedy in 1904.

309:32 (315:8). a knacker's yard—a "knacker" is one who buys worn-out horses and slaughters them for their hoots and hides and sells the flesh for dog meat. The term was derogatory since it was associated with the popular (and well-founded) suspicion that much of what was sold as hamburger and sausage meat was in reality horse meat.

309:33–34 (315:9–10). here's my head and my heels are coming—a popular expression suggesting ill-coordinated haste or a person whose intentions are better than his performance.

310:1–2 (315:20). he'd have a soft hand under a hen—i.e., he'd be good at stealing eggs from under a setting hen (without disturbing the hen so that she clucked a warning).

Parody: 310:3–7 (315:21–25). Ga Ga Gara ... Klook Klook Klook—parodies the style of a child's primer.

310:9 (315:27). to ask about it—i.e., to ask about methods of combating the threatened epidemic of foot-and-mouth disease. One normal method was to quarantine all the cattle in an infected area and to slaughter and bury all the cattle thus quarantined. One other method was to quarantine but to destroy only diseased cattle. The timing of this "epidemic" and the discussion in Parliament are, of course, fictional.

310:12 (315:31). by the mailboat—the City of Dublin Steam Packet Company, two sailings a day from Kingstown Harbour to Holyhead, at 8:15 A.M. and 8:15 P.M.

310:16–17 (316:36–37). the commissioner of police ... in the park—see 117:16n.

310:18 (315:38). The Sluagh na h-Eireann—Irish: "The Army of Ireland," an active patriotic society that complained to Parliament through Nannetti, 16 June 1904, that it was not allowed by the commissioners of police to play Gaelic games in Phoenix Park. The complaint noted that polo (presumably an English and foreign sport) was allowed.

Parody: 310:19–41 (315:39–316:19). Mr Cowe Conacre ... (The house rises. Cheers.)—parodies the Minutes of Proceedings of the House of Commons.

310:19 (315:39). Mr Cowe Conacre (Multi-farnham. Nat)—the Conacre System ("con" is Irish for "common') was one method of exploiting the land and the poor in nineteenth-century Ireland (before the Land Reforms of the late nineteenth and early twentieth century). Technically it referred to the practice of a wealthier tenant farmer's renting small patches of land (a half or a quarter of an acre) for an exorbitant price to his poorer neighbors. The peasants used these small patches to grow potatoes as a food crop since they often could not grow money crops to pay the rent and at the same time grow food crops on their own small holdings. The Conacre System came to mean the whole exploitative system of absentee landlordism and the hierarchy of middle-men, sometimes as many as six or eight, who profited by renting and then subletting land, each in turn. Multifarnham, a village seven and a half miles northwest of Mullingar, is in the heart of the cattle country of County Westmeath; "Nat":

Nationalist party. County Westmeath had two representatives in Parliament, but needless to say, the village of Multifarnham did not have one.

310:20 (315:40). Shillelagh—Irish: "sons of Elagh," a village in County Wicklow; in reality County Wicklow had two representatives in Parliament. The wood of Shillelagh gives the village's name to the Irishman's bludgeon.

310:22–24 (315:42–316:2). orders that these animals ... pathological condition—the conventional technique of preventing the spread of foot-and-mouth disease was to slaughter all the cattle in an infected district, regardless of the condition of individual animals.

310:25 (316:3). Mr Allfours (Tamoshant. Con.)—"Allfours" suggests the Right Honorable Arthur James Balfour (1848–1930), a Scot, 1st Lord of the Treasury, leader of the House of Commons and Conservative prime minister in 1904. He was in the Conservative cabinet as chief secretary for Ireland (1887–1891), and through his commitment to the policy of "coercion" (instant and severe police measures against any expression of Irish Nationalist sentiment), he earned among the Irish the nickname "Bloody Balfour." When the English imposed an embargo on Irish cattle in 1912 during an epidemic of foot-and-mouth disease, Balfour had temporarily retired from public life. "Tamoshanter" is not a place but the name of a Scottish wool cap; "Con": "Conservative" is appropriate not only on account of Balfour but also because the Irish assumed that Scots were Protestant-Conservative. In addition, Tam o' Shanter is the hero and title of a poem by Robert Burns; the hero is a drunken farmer who inadvertently interrupts a witch coven. The witches pursue him but are thwarted because they cannot follow him when he crosses running water; one of the witches manages, however, to snatch the tail off his horse.

310:30 (316:8). Mr Orelli (Montenotte. Nat)—"Orelli": Myles George O'Reilly ("the O'Reilly") (b. 1830) of County Cork; Montenotte is a suburb of the City of Cork, though O'Reilly was not an M.P., but only a pillar of "the old order."

310:35 (316:13). Mitchelstown telegram—in September 1887, one of Parnell's associates, John Dillon (1851–1927), attempted to make a speech at Mitchelstown in County Cork. The police tried to force an official recorder through the crowd in order to gather evidence for the prosecution of Dillon under the Act of Coercion. In the ensuing riot three men were killed by rifle fire from the police barracks (see 185:28n). So solid was Conservative sentiment for Coercion

in Parliament that Balfour, then Chief Secretary for Ireland (310:25n), could answer angry opposition questions in the House of Commons by merely quoting the cursory police report (telegram). Gladstone subsequently used the slogan "Remember Mitchelstown" to rally the opposition.

310:35–36 (316:13–14). inspired the policy of gentlemen on the treasury bench—i.e., has Balfour's commitment to the policy of coercion (violent police action) dictated a policy of economic suppression for Ireland (in this case an arbitrary embargo on Irish cattle)? In 1904 Balfour was 1st Lord of Treasury as well as prime minister.

310:37 (316:15). I must have notice of that question—the prime minister can refuse to answer a question in the House of Commons if he has not previously mentioned the subject and if he has not been given time to do his homework.

310:38 (316:16). Mr Staylewit (Buncombe. Ind)—Buncombe is a county in North Carolina; thanks to Felix Walker, a representative from that County in the Sixteenth Congress who made what he called "a speech for Buncombe," "Buncombe" became a name for speechmaking the sole purpose of which was to win popular applause. "Ind": Independent.

310:38 (316:16). Don't hesitate to shoot—see 185:28n.

310:42–311:1 (316:20–21). the man . . . that made the Gaelic sports revival—Michael Cusack; see 288:23n.

311:1–2 (316:21–22). The man that got away James Stephens—there is considerable evidence that Cusack was a Fenian, but there is no evidence that he was involved in Stephens' escape; the Fenian principals in that escape seem to have been John Devoy and Colonel Thomas Kelley; see 44:23n.

311:2–3 (316:22–23). The champion of all Ireland . . . sixteen pound shot—the late-nineteenth-century record in Ireland was held by Denis Horgan: 46 feet, five and a half inches. Cusack the Citizen, active from 1875 to 1885, never put the shot over 40 feet. In effect, Horgan was the great Irish athlete of his time; Cusack was the Irish spokesman for athletics.

311:4 (316:24). Na bacleis—Irish: "Don't bother about it."

311:10 (316:31). shoneen—see 305:25n.

311:11 (316:32). hurley—see 304:26n.

311:11 (316:32). putting the stone—not unlike putting the shot, except that expertise was not established merely by the greatest distance achieved with stones of the same weight, but by a series of distances achieved with stones of different weights.

311:12 (316:33). racy of the soil—i.e., characteristic of the people of a country (usually of Ireland).

311:12 (316:33). a nation once again—the title of a song by Thomas Osborne Davis (1814–1845), Irish poet and patriot. First verse: "When boyhood's fire was in my blood/I read of ancient freemen,/For Greece and Rome who bravely stood,/Three hundred men and three men,/And then I prayed I yet might see/Our fetters rent in twain,/And Ireland, long a province, be/A nation once again!'"

Parody: 311:19–312:25 (316:40–318:5). A most interesting discussion . . . P. Fay, T. Quirke, etc., etc.—parodies the minutes of a meeting written up as a disguised advertisement of a social or political organization (hopefully to be inserted in the columns of a newspaper).

311:20 (316:41). Brian O'Ciarnian's . . . Bretaine Bheag—Irish: "Barney O'Kiernan's in Little Britain Street."

311:21 (316:42). Sluagh na h-Eireann—see 310:18n.

311:34 (317:14). Finn MacCool—(d. *c.*284), Irish poet, warrior and chieftain, the leader of the Fianna (from which the Fenians derived their name). He is a semilegendary figure, the central presence in the Ossian or Finn legends.

311:41–312:1 (317:21–22). Thomas Osborn Davis . . . A nation once again—see 311:12n. Davis' *Poems* (1846) were collected and edited by Charles Gavan Duffy, who praised them as "evergreen" in his introductory note.

312:3 (317:25). Caruso-Garibaldi—Enrico Caruso (1874–1921), Italian dramatic tenor whose name was by 1910 a household word for the great opera star. He first attracted attention in Naples in 1896; after a series of tours, including London (1903), he went to New York (1904), where he was destined to become the chief attraction of the Metropolitan Opera House Company. For Garibaldi, see 161:27n.

312:12–13 (317:34–35). the very rev. William Delany, S.J., L.L.D—a Jesuit educator whose career was described as an "epoch in the history of Irish Catholic higher education" because he upgraded both academic and athletic performance

as rector of Tullabeg College (1872–1883). From 1883 to 1909 he was rector and subsequently president of University College in Dublin. From 1909 to 1912 he was provincial of the Jesuit Order in Ireland.

312:13 (317:35). the rt rev. Gerald Molloy, D.D—(1834–1906), theologian and educator, rector of the Catholic University of Ireland in Dublin (1883–1906).

312:13–14 (317:36). the rev. P. J. Kavanagh, C.S. Sp—Patrick Fidelis Kavanagh (1834–1916), Irish priest, poet and historian, known for his ability as an orator and for his *History of the Rebellion of 1798*. "C.S. Sp": Congregation of the Holy Spirit; but Father Kavanagh was in actuality an O.F.H., a member of the Order of Friars Minor.

312:14 (317:36). the rev. T. Waters, C.C—the Reverend Thomas Waters, curate in charge (1904), St. John the Baptist Roman Catholic Church, 35 Newtown Avenue, Blackrock.

312:14–15 (317:37). the rev. John M. Ivers, P.P—the Reverend J. Michael Ivers was not parish priest (1904) but curate in charge, St. Paul's Roman Catholic Church, Arran Quay, Dublin.

312:15 (317:37). the rev. P. J. Cleary, O.S.F—the Very Reverend P. J. Cleary, Order of St. Francis, vicar of the Franciscan's (Adam and Eve's Roman Catholic Church), Merchant's Quay, Dublin.

312:15–16 (317:38). the rev. L. J. Hickey, O.P—the Very Reverend Louis J. Hickey, Order of Friars Preachers, provincial of St. Saviour's Dominican Priory, Dominick Street Lower, Dublin.

312:16 (317:38). the very rev. Fr. Nicholas, O.S.F.C—Friar Nicholas, Order of St. Francis Capuchin, vicar of the Franciscan Capuchin Monastery, St. Mary of the Angels, Church Street, Dublin.

312:16–17 (317:39). the very rev. B. Gorman, O.D.C—Bernard Gorman, Order of Carmelites Discalced (i.e., barefooted), provincial of Discalced Carmelites Friary in Clarendon Street, Dublin.

312:17 (317:39). the rev. T. Maher, S.J—a member of the Community of the Jesuit Church of St. Francis Xavier (Father Conmee's Church) in Upper Gardiner Street, Dublin.

312:17–18 (317:40). the very rev. James Murphy, S.J—provincial of the Jesuit Church of St. Francis Xavier.

312:18 (317:40). the rev. John Lavery, V.F—"V. F." is "Vicar Forane" (a priest appointed by a bishop to exercise a limited jurisdiction in a particular town or parish). The Reverend Lavery was a member of the Fathers of the Congregation of the Mission (C.M.), St. Peter's Presbytery, Phibsborough (on the western outskirts of Dublin).

312:18–19 (317:41). the very rev. William Doherty, D.D—C. C. St. Mary's Pro-Cathedral of the Immaculate Conception, Marlborough Street, Dublin.

312:19 (317:41–42). the rev. Peter Fagan, O.M—i.e., a Marist father (Fathers of the Society of Mary, usually "S.M."), resident at the Catholic University School in Upper Leeson Street.

312:19–20 (317:42). the rev. T. B. Brangan, O.S.A—Thomas Brangan, Order of St. Augustine, a member of the community of Augustinian Friars, Augustinian Friary Chapel of St. Augustine and St. John, John Street West, Dublin.

312:20 (317:42). the rev. J. Flavin, C.C—St. Mary's Pro-Cathedral of the Immaculate Conception, Marlborough Street, Dublin.

312:20 (318:1). the rev. M. A. Hackett, C.C—the Reverend Martin Hacket was parish priest, St. Margaret's Roman Catholic Church, Finglas (a parish and village four miles north of the center of Dublin).

312:21 (318:1). the rev. W. Hurley, C.C—Walter Hurley, curate in charge, St. James's Roman Catholic Church, James Street, Dublin.

312:21 (318:2). the rt rev. Mgr. M'Manus, V.G—Monsignor Myles M'Manus, vicar general, canon and parish priest, St. Catherine's Roman Catholic Church, Meath Street, Dublin.

312:22 (318:2). the rev. B. R. Slattery, O.M.I—no B. R. Slattery is listed in the *Irish Catholic Directory* for 1904 as a member of the Order of Mary Immaculate or otherwise; hence, this seems to be either a coinage or an in-joke.

312:22 (318:3). the very rev. M. D. Scally, P.P—Michael D. Scally, parish priest, St. Nicholas's Roman Catholic Church, Francis Street in Dublin.

312:23 (318:3). the rev. F. T. Purcell, O.P—*Thom's (1904)* lists a Thomas F. Purcell, Order of Friars Preachers, as a member of the Community of St. Saviour's Dominican Priory in Dominick Street, Dublin.

312:23–24 (318:4). the very rev. Timothy canon Gorman, P.P—SS. Michael and John's Roman Catholic Church, Exchange Street, Dublin.

312:24 (318:4–5). the rev. J. Flanagan, C.C—John Flanagan, C.C., St. Mary's Pro-Cathedral of the Immaculate Conception, Marlborough Street, Dublin.

312:24 (318:5). P. Fay—of P. A. Fay & Sons, cattle salesmen, 36 Smithfield, Dublin.

312:25 (318:5). T. Quirke—Thomas G. Quirk, solicitor, 15 Frederick Street, Dublin; residence, Dalkey.

312:27 (318:7). Keogh-Bennett—see 247:11–12n.

312:36 (318:16). and he swatting all the time—i.e., Keogh was training as hard as he could possibly train. *Cf.* French edition, p. 312.

312:37 (318:17). The traitor's son—William Keogh, one of the Catholic Defence leaders in the 1850s, "honored, lauded by both lay and ecclesiastic sponsors" (and, ironically, "triumphantly contrasted with the base misleaders of Young Ireland of the decade before"), betrayed his supporters by accepting the Solicitor-Generalship of Ireland. Because of the vehemence of his protestations, Keogh was called "So-help-me-God Keogh." His name later became synonymous with betrayal and "rottenness" (Seamus MacManus, *The Story of the Irish Race* [New York, 1967], p. 611).

313:1–2 (318:23–24). Heenan and Sayers—see 239:1n.

313:2–3 (318:24–25). the father and mother of a beating—an Irish colloquialism for a severe beating; see P. W. Joyce, *English as We Speak It in Ireland,* p. 198.

313:3 (318:25). kipper—a small person, child.

313:5 (318:27). Queensberry rules—i.e., boxing with gloves; three-minute rounds (instead of rounds that ended only when there was a knockdown); no hugging or wrestling, etc. The rules were drawn up in 1867 and were named for the English patron of boxing who encouraged their adoption, John Sholto Douglas, Marquis of Queensberry (1844–1900).

Parody: 313:7–39 (318:29–319:19). It was a historic . . . mobbed him with delight—parodies sports journalism.

313:21 (319:1). the bout—i.e., the round.

313:26–27 (319:6). Eblanite—see 289:12n.

313:36 (319:15). Portobello—see 170:38n.

313:37 (319:16–17). Old Pfotts Wettstein—a lawyer, Dr. Georg Wettstein, Norwegian vice-consul in Zurich, earned Joyce's enmity during a minor but protracted litigation; see Ellmann, pp. 454–455, 461, 467.

313:37 (319:17). Santry—a village and parish, three and a half miles north of the center of Dublin.

314:3 (319:25). the bright particular star—in Shakespeare's *All's Well That Ends Well* Helena contemplates her love for Bertram, Count of Rousillon, and their relative positions on the social scale: "'Twere all one/That I should love a bright particular star/And think to wed it, he is so above me" (I, i, 96–98).

314:6 (319:28). says I to myself, says I—in Act I of Gilbert and Sullivan's *Iolanthe, or the Peer and the Peri* (1882), the Lord Chancellor's song begins: "When I went to the bar as a very young man,/(Said I to myself, said I)/I'll work on a new and original plan(Said I to myself, said I)/I'll never assume that a rogue or a thief/Is a gentleman worthy implicit belief,/Because his attorney has sent me a brief/(Said I to myself, said I)."

314:8 (319:30). the tootle on the flute—from a song, "Phil the Fluter's Ball," by Percy French; chorus: "With a tootle of the flute/And a twiddle of the fiddle—oh/Dancin' up the middle like a herrin' on the griddle—/Up! down! hands around! crossin' to the wall,/Oh, hadn't we the gaiety at Phil the Fluter's ball."

314:8–10 (319:30–32). Dirty Dan the dodger's . . . fight the Boers—the fictional Boylan's fictional father, Daniel Boylan; a "dodger" is a shirker or malingerer; Island Bridge is an area south of the Liffey on the western outskirts of Dublin. The double-dealing in horses credited to him was a not uncommon way of exploiting the weaknesses of army procurement practices.

314:11 (319:33). the poor and water rate—two of the several overlapping taxes that collectively made up the "property taxes" in Dublin.

314:13 (319:36). Caddereesh—from the Irish *Cad arís:* "What again?"

Parody: 314:14–22 (319:37–320:3). Pride of Calpe's . . . line of Lambert—parodies the style of nineteenth-century reworkings of medieval romance.

314:14 (319:37). Calpe's rocky mount—in Greek mythology Calpe was one of the Pillars of Hercules, now the rock of Gibraltar.

314:16 (319:39). Alameda—in general, any large pleasure ground or park bordered with or in a grove of poplar trees. There is such a park in Gibraltar.

314:36 (320:17). Stubb's—Stubb's *Weekly Gazette,* published by Stubb's Mercantile Offices, College Street in Dublin. Stubb's advertised itself as "a complete organization for the protection of Bankers, Merchants, Traders, and others against risk and fraud in their various commercial transactions." Stubb's offered a debt-recovery service, and its *Gazette* included "a weekly supplement giving lists of Creditors" (*Thom's [1904],* Adv. p. 45).

314:36 (320:17). flash toffs—slang for ostentatiously showy would-be gentlemen.

314:39–40 (320:20). Cummins of Francis street—M. Cummins, pawnbroker, had several branches in Dublin, including one in a slum area at 125 Francis Street in south-central Dublin.

314:42 (320:22). pop—slang for hock or pawn.

315:1 (320:23–24). come home by weeping cross—penances were done under "weeping cross"; thus, the expression means to regret a course of conduct.

315:6 (320:28). right go wrong—immediately, without hesitating to consider the consequences.

315:12 (320:34). so help you Jimmy Johnson—after the Reverend James Johnson (*fl.* 1870–1900), a Scot Presbyterian who styled himself "the Apostle of Truth" and produced a series of guides for Christian living: *Learning to Float; or Saved through Faith* (Stirling, 1890); *Learning to Fly; or the Assurance of Faith* (Stirling, 1890); *Learning to Run in the Way of Holiness* (Stirling, 1890); *Learning to Walk in the Paths of Righteousness* (Stirling, 1890).

315:14–15 (320:37–38). Whatever statement . . . evidence against you—the formula an arresting or investigating officer uses to remind a suspect of his legal rights.

315:17 (320:40). compos mentis—legal Latin: "sane in mind."

315:27 (321:9). a half and half—neither man nor woman.

315:32 (321:14). A pishogue—Irish: "charm or spell"; hence, one who is bewitched.

315:38 (321:20–21). bringing down the rain—i.e., it would make the heavens weep to see him.

315:39 (321:21). cockahoop—stuck up, after the practice of removing the cock (spigot) from a barrel and placing it on the hoop (top) in order to drain the barrel.

315:40 (321:22). pew opener—one who directs parishioners to their seats in church, an usher.

315:41 (321:23–24). smashall sweeney's moustaches—bristling moustaches.

315:42 (321:24). Summerhill—a village and parish 22 miles west northwest of Dublin in County Meath; it is the site of a magnificent complex of medieval ruins.

316:1 (321:26). Moss street—in 1904, a street of tenements and ruins just south of the Liffey in east-central Dublin.

316:2 (321:26–27). two pair back and passages—i.e., two rooms at the back (of a tenement); "passages" suggests that the rooms opened on a small court or airshaft.

316:6–7 (321:31–32). Sadgrove v. Hole—Hole was the manager of a London company that wanted to make additions to its buildings. He hired an architect who in turn hired Sadgrove, a "quantities surveyor," to determine the costs of building; Sadgrove sent his estimates to seven builders. When Hole heard what the figures were, he thought them incorrect and sent postcards to two of the builders informing them that the "quantities were entirely wrong." Sadgrove's name was not mentioned in the postcards, but he brought an action, charging that the cards defamed him as a surveyor. The trial judge ruled that the communication was not "privileged" (i.e., was not information that, even if defamatory, could be legitimately communicated to interested persons). The jury found for Sadgrove. On appeal, however, the judgment was reversed. The judges held that the communication to the builders *was* privileged since the builders had a vital interest in the communication. They also held that the postcards did not constitute "publication" even though the statements were "defamatory" because Sadgrove's name was not mentioned; therefore, no one except the "privileged" builders would be aware that the statements applied to Sadgrove. The judges also held that there was no malice on Hole's part (if malice could be proved, then the defamatory statements would constitute libel even if not "published") (*The Law Reports : King's Bench Division,* 2 K. B. 1 [1901]).

316:19–29 (322:3–13). that Canada swindle case . . . stuck for two quid—see 126:28–29n.

316:21 (322:5). the bottlenosed fraternity— an anti-Semitic expression.

316:24 (322:8). Do you see any green in the white of my eye?—i.e., Do you regard me as gullible?

316:25 (322:10). skivvies—see 8.25n.

316:26 (322:10). badhachs—Irish: "louts, churls, bumpkins."

316:31 (322:15). Recorder—i.e., Sir Frederick Falkiner; see 136:18n. The case was not heard in Falkiner's court but in the Southern Divisional Police Court before Earnest Godwin Swifte, Divisional Police Magistrate.

316:37 (322:21). Reuben J—Reuben J. Dodd.

316:39 (322:23–24). Butt bridge—see 134:29n.

Parody:317:6–42(322:34–323:28). And whereas on the sixteenth . . . was a malefactor— combines parodies of trial records and "high-classical" Irish legend.

317:6–7 (322:34–35). the month of the ox-eyed goddess—i.e., June, since "ox-eyed goddess" is a Homeric epithet for Juno.

317:7–8 (322:35–36). the feast day of the Holy and Undivided Trinity—Sunday, 29 May 1904.

317:8–9 (322:37). the virgin moon . . . first quarter—see 155:30n.

317:10–11 (322:39). master Courtenay— Colonel Arthur H. Courtenay (b. 1852), soldier and barrister, master of the High Court of Justice in Ireland, King's Bench Division, in 1904.

317:11–12 (322:40). master Justice Andrews— William Drennan Andrews (1832–1924), judge of the Probate and Matrimonial Bench of the King's Bench Division in 1904.

317:16 (323:2). Jacob Halliday—grocer, tea, wine and spirit merchant, 38A Main Street in Blackrock.

317:18 (323:4). the solemn court of Green street—see 288:31–32n.

317:20 (323:6). the law of the brehons—the legal system of ancient Ireland; "brehons" were judges or lawgivers.

317:22 (323:9). the high sinhedrin—or "sanhedrin," the Jewish high court of justice and supreme council in Jerusalem.

317:22–23 (323:9). the twelve tribes of Iar— after the 12 tribes of Israel and the 12 men on a jury. "Iar" means west or remote; hence, Ireland. Iar was also one of the three sons of Mileadh and is regarded as the legendary Milesian ancestor of the royal clans of Ireland. The "tribes" listed below suggest individual figures from Irish history and legend, but many of the names are common enough to be tribal.

317:23 (323:10). Patrick—among the host of Irish Patricks there is always St. Patrick, the patron saint of Ireland.

317:24 (323:10). Hugh—one of the many Hughs in Irish legend was Hugh MacAnimire, a king (572–598) who summoned the first national assembly after the decline of Tara.

317:24 (323:11). Owen—or "Eoghan": one was a second-century king of Munster who was defeated by Conn of Hundred Battles; another was an Irish-born king of Scots who invaded Ireland in the fourth century; there was also a St. Eoghan (d. 618).

317:25 (323:11). Conn—there were several, but the principal one was Conn of Hundred Battles; see 291:32n.

317:25 (323:12). Oscar—the son of Oisin and in legend one of the noblest of the third-century Fianna. He is the hero of the love story of Oscar and Aideen.

317:25 (323:12). Fergus—the most famous of the Ferguses was Fergus Mac Roi, a legendary hero-king who became a Druid poet and who was Cuchulin's "friend and master" (see 291:32n). It was Fergus who mistakenly led the legendary Deirdre to her death; see Yeats' play *Deirdre* (1907). See also 11:12–14n.

317:26 (323:12). Finn—see 311:34n.

317:26 (323:13). Dermot—see 35:40–41n.

317:27 (323:13). Cormac—see 167:5–8n.

317:27 (323:14). Kevin—St. Kevin of Glendalough (d. 618), one of the most famous of the Irish missionary saints and one of the patron saints of Ireland.

317:27 (323:14). Caolte—Caolte Mac Ronain, a legendary warrior-poet of the Fianna who lived to be over 300 years old and who, at the end of his life, held a mystical dialogue with St. Patrick.

317:28 (323:15). Ossian—or Oisin, son of Finn MacCool, legendary hero, the great poet of the

Fianna. For Ossian's meeting with St. Patrick, see 197:36n.

317:40–41 (323:26–27). ne bail ne mainprise— Middle English legal phrase for the refusal to grant bail; "mainprise" describes an individual who accepts the responsibility for a released prisoner's appearance in court.

318:6 (323:34–35). do the devil—in legal slang, a "devil" is an unpaid junior counsel who helps to prepare a case; hence, to "do the devil" is to do hack work.

318:12 (323:40). no more strangers in our house—see 182:39–183:1n.

318:18 (324:4–5). the adultress and her paramour—i.e., Devorgilla and Dermot Mac-Murrough; see 35:40–41n.

318:20 (324:6). Decree nisi—in law, a decree that will take permanent effect at a specified time unless cause is shown why it should not, or unless it is changed by further court proceedings.

318:27–28 (324:13–14). the Police Gazette— *The National Police Gazette*, a New York weekly newspaper founded in 1846. Its heyday as the working-man's weekly ration of cheesecake, muckraking, high-society scandal and sports (particularly boxing) began in 1879 when the paper came under the control of an Irish immigrant, Richard Kyle Fox (d. 1922). Brutal stories of the sort Alf Bergan reads, 322:37 *ff.* (328:28 *ff.*), were typical of the paper's coverage. The *Gazette* is generally regarded as an important precursor of yellow journalism and the daily tabloid press (1890s *ff.*).

318:35 (324:21). fancy man—a sweetheart or a man who lives on the income of a prostitute.

318:35 (324:21). tickles—slang for erogenous zones.

318:37 (324:23). the trick of the loop—a carnival game in which contestants try to win prizes by pitching small wooden hoops at a group of upright stakes.

318:38 (324:24). jakers, Jenny—dodging the curse, "Jesus, Jenny"; "jake" or "jakers" is also slang for "everything is all right, in order, perfect."

319:2 (324:30). tinkers—literally, "tinsmiths," but tinkers were notorious for apparent indigence, for cunning and thievery, and for a shiftless, nomadic way of life.

Parody: 319:4–11 (324:32–40). O'Nolan, clad

in . . . of the seadivided Gael—continues the parody of medieval romance and "high-classical" Irish legendry.

319:8 (324:36). the tholsel—see 241:27–28n.

319:11 (324:39–40). the seadivided Gael— since the Gaels (or Celts) were supposed to have invaded Ireland, Scotland, Wales, Brittany and Cornwall from northern Spain, they were "seadivided." The Celtic or Gaelic languages as a group include, in addition to Irish, Welsh, Breton (Armoric), Scot and Manx.

319:13 (324:42). Sassenachs—Irish: "Saxons."

319:14 (325:1). doing the toff—acting or speaking in a manner associated with fashionable and sophisticated gentlemen.

319:15–16 (325:2–3). the Nelson policy . . . to the telescope—the English Admiral Horatio, Viscount Nelson (1758–1805) lost the sight of his right eye during the invasion of Corsica (1793). On 2 April 1801 an English fleet under Admiral Sir Hyde Parker attacked the Danish fleet at Copenhagen; early in the day Nelson, a vice-admiral in the fleet, was ordered to withdraw. Robert Southey in his *Life of Nelson* (1813), Chapter VII, records the story of Nelson's refusal: "Nelson said, 'I have only one eye—I have a right to be blind sometimes': —and then, putting the glass to his blind eye . . . he exclaimed, 'I really do not see the signal!'" Nelson's insubordination led to a brilliant naval victory.

319:16–17 (325:3–4). drawing up a bill of attainder to impeach a nation—one of the original policies of Arthur Griffith's *Sinn Fein* was to publish such a bill in order to impeach England in the court of "world opinion."

319:22 (325:9). thicklugged—thick-eared.

319:28–29 (325:16–17). cabinet d'aisance— French: "water closet."

319:31 (325:19). Full many a flower is born to blush unseen—line 55 of Thomas Gray's (1716–1771) "Elegy Written in a Country Churchyard" (1742–1750, 1751): "Full many a gem of purest ray serene/The dark unfathom'd caves of ocean bear;/Full many a flower is born to blush unseen,/And waste its sweetness on the desert air" (lines 53–56).

319:33 (325:21). Conspuez les Anglais! Perfide Albion!—French: "Scorn the English! Perfidious England!" The latter phrase has been attributed to many irritated Frenchmen, including Napoleon on the occasion of his exile to St. Helena.

Parody: 319:34–38 (325:22–26). He said and then . . . the deathless gods—continues the parody of medieval romance and "high-classical" Irish legendry.

319:35 (325:23). medher—Irish: "a quadrangular one-piece wooden cup."

319:36 (325:24). Lamh Dearg Abu—Irish: "Red Hand to Victory." The Red Hand is the heraldic symbol of Ulster and the O'Neills; it is also the symbol on the label of Allsop's bottled ale.

319:37 (325:25). rulers of the waves—an allusion to England's preoccupation with and boast of its naval supremacy in the nineteenth and early twentieth century.

319:40 (325:28). a tanner—slang for a sixpence.

319:41 (325:29). Gold cup—see 84:28n.

320:3 (325:33). Bass's mare—Sceptre, a colt not a mare (finished third behind Throwaway and Zinfandel); William Arthur Hamar Bass (b. 1879), English sportsman.

320:7 (325:37). Lord Howard de Walden's—Thomas Evelyn Eelis (b. 1880), the 8th Baron, who divided his time between the army and horseracing.

320:10 (325:40). Frailty, thy name is Sceptre—after Hamlet's line about his mother's inconstancy: "Frailty, thy name is woman!" (I, ii, 146).

320:12 (325:42). on the nod—on credit or for nothing.

320:13–14 (326:1–2). Old mother Hubbard went to the cupboard—the first line of "Old Mother Hubbard," a 14-stanza nursery rhyme recorded or composed (c.1804) by Sarah Catherine Martin (1768–1826); the first stanza continues: ". . ./Went to the cupboard,/To fetch her poor dog a bone;/But when she came there/The cupboard was bare/And so the poor dog had none."

320:16 (326:4). pecker—slang for courage, spirit.

320:17 (326:5). dog—slang for an inferior or broken-down racehorse.

320:20–21 (326:8–9). the mote in others' . . . beam in their own—in Matthew 7:3, as Jesus brings the Sermon on the Mount to a close, he says, "And why beholdest thou the mote that is in thy brother's eye, but considerest not the beam that is in thine own eye?"

320:22 (326:10). Raimeis—Irish: literally, "romance"; figuratively, "nonsense."

320:24–25 (326:12–13). our missing twenty millions . . . instead of four—the most dramatic reduction in the population of Ireland occurred during the Great Famine of the 1840s as the result of starvation and emigration. The population of Ireland in 1841 was 8,196,000; by 1851 it had fallen to 6,466,000; and it continued to decline through the rest of the century until the population in 1901 was 4,459,000. If, however, population had continued to grow as it had in the two decades 1821 (6,800,000) to 1841 (8,196,000), the population at the end of the century would have been approximately 18,000,000. The U.S. census in 1900 estimated that approximately 4,000,000 Irish had immigrated to the United States in the course of the nineteenth century.

320:25 (326:13). our lost tribes—in Hebrew tradition, the ten tribes of Israel lost or dispersed in the course of the Assyrian conquests of Israel in the eighth century B.C. and again in the sixth century B.C. The Assyrians followed the policy of deporting the principal inhabitants of conquered districts, thus producing the "Babylonian Captivity" of the Jews. The loss of ten of the original twelve tribes was regarded as Jehovah's punishment of His "chosen people" (Israel) because they were disobedient to His will.

320:26–27 (326:14–15). our wool that was . . . time of Juvenal—the Roman poet and satirist Juvenal (c.60–c.140). The Citizen's remark is something of an overstatement; there is little hard evidence about trade between Ireland and Rome, though historians assume that after the Roman conquest of England "there must have been" a significant increase of commerce, and Tacitus (c.55–120) in 100 remarks that Irish harbors "through commerce and merchants" were better known than English harbors. Trade and manufacturing in wool appear to have been of some importance in ancient Ireland, but the Continental reputation of Irish woolens was not established until the sixteenth century; and from that time on, the English imposed a series of taxes and restrictions in the interest of preventing Irish competition with the English wool trade.

320:27–28 (326:15–16). our flax and . . . looms of Antrim—Antrim, a county in northeastern Ireland, was the heart of the flax-growing, linen-weaving industry in Ulster as early as the mid-sixteenth century. Linen manufacture appears to have been the only Irish manufacture that the English encouraged, but even that encouragement was ambiguous, alternating with measures (as

early as the 1690s) designed to suppress the Irish linen industry in favor of its English competition. The linen industry survived, however, to emerge as the most important Irish industry through the eighteenth century.

320:28 (326:16). Limerick lace—Limerick, the capital of County Limerick, 120 miles west-southwest of Dublin, was famous for its handmade lace in the late seventeenth and eighteenth century. The industry declined in the course of the nineteenth century, largely as a result of competition from machine-made lace.

320:29 (326:17). our white flint glass down there by Ballybough—Ballybough, a small village two miles north of central Dublin (by 1900 absorbed into Fairview). Some pieces of glass, identified as pre-Norman and therefore associated with ancient Ireland, were found in caves near the village. The most famous glass manufactory in Ireland was at Waterford; it flourished from the 1690s until 1745, when it was suppressed; it briefly flourished again in the last quarter of the eighteenth century.

320:29–30 (326:17–18). our Huguenot poplin that we have since Jacquard de Lyon—the manufacture of poplin was introduced into Dublin by Huguenot refugees in 1693. Joseph Marie Jacquard of Lyons (1752–1834) was the inventor of the Jacquard loom (c.1801); the loom was not exclusively for poplin but made it possible to produce patterns of considerable complexity in a variety of textiles with a single, unvarying action on the weaver's part. The introduction of the Jacquard loom did increase the productivity of Dublin's poplin industry, but that industry was already firmly established.

320:31 (326:19). our Foxford tweeds—Foxford is a village in County Mayo (in northwestern Ireland). A small but thriving handwoven tweed industry was established there in the course of the nineteenth century under the sponsorship of a local convent.

320:31–32 (326:19–20). ivory raised point from the Carmelite convent in New Ross—New Ross is a village on the River Barrow in County Wexford; it was supposed to have taken its origins as the site of an ancient sixth-century monastery. P. W. Joyce, in *Ancient Irish Civilization* (p. 142), remarks on the painstaking and beautiful needlepoint work in ancient Ireland. The Carmelites at New Ross preserved some examples of ancient needlepoint and imitated them in a small but famous industry.

320:33–36 (326:21–24). the Greek merchants that . . . the fair of Carmen—the ancient Irish fair of Carmen was held once every three years at Wexford. P. W. Joyce, in *A Smaller Social History of Ireland* (1906) (pp. 494–495), asserts that Ireland was known to Phoenician merchants and through them to the Greeks, and he describes the "three principal markets" of the fair of Carmen "one of which was 'a market of foreigners selling articles of gold and silver . . . gold ornaments and noble clothes.'" Tyrian purple was the traditional dye of Greek "noble clothes."

320:36 (326:24). Tacitus—Roman historian and orator, who does briefly mention Ireland in his life of *Agricola*, section 24, where he describes the passage of a ship around the island, and observes that there was little difference between the religious practices of England and Ireland.

320:36 (326:24). Ptolemy—(*fl.* 139–161), Alexandrian Greek astronomer and geographer. P. W. Joyce, in *A Smaller Social History of Ireland* (p. 494), remarks that Ptolemy "is known to have derived his information from Phoenician authorities, and has given a description of Ireland much more accurate than that which he has left us of Great Britain."

320:36–37 (326:25). even Giraldus Cambrensis—Girald de Barri (*c.*1146–*c.*1220), Welsh ecclesiast and chronicler, wrote two works on Ireland, *Topographia Hibernica* and *Expugnatio Hibernica*. Both works establish Giraldus as an apologist for the Norman Conquest (at the expense of the Irish), though the first is somewhat the more factual account. Giraldus puts considerable emphasis on Irish import (not export) of wine since that helped to establish his case against the Irish.

320:37 (326:25). Connemara marble—marble from this area on the west coast of Ireland was in considerable demand not as a building stone but as a variegated material from which small ornamental articles were made.

320:37–38 (326:26). silver from Tipperary—silver, zinc and lead mines in this county in central Ireland were productive from the late seventeenth century. This productivity declined in the nineteenth century as a result of world competition.

320:39 (326:27). hobbies—strong, active middle-sized horses, said to have originated in Ireland.

320:39–40 (326:27–28). King Philip of Spain . . . fish in our waters— in 1553 Philip II of Spain entered into a 21-year agreement for the right to fish Irish coastal waters; a fee of £1,000 per year was to be paid into the Irish Treasury.

320:40–41 (326:29). yellowjohns—a translation

of the Irish epithet, *"Seón Buidhe,"*: "filthy John [Bull]," i.e., filthy English.

320:42–321:1 (326:30–32). the beds of the Barrow . . . marsh and bog—the Shannon (214 miles long) and the Barrow (100 miles long), rivers in the central lowlands of Ireland, both flow through extensive bogs and marshes. In the latter half of the nineteenth century there was considerable public discussion of engineering projects designed to deepen the Shannon and the Barrow in order to drain the marshland and to develop peat bogs. Ironically enough, one of the principal private investors (and losers) in these schemes was Lord Balfour (see 310:25n), but there was little progress made before World War I.

321:3–6 (326:33–36). As treeless as Portugal . . . conifer family are going fast—the Irish Nationalist press consistently blamed English land policies for the deforestation of Ireland (by 1904 only a little more than one percent of Ireland was woodland). Demands for a reforestation program were a minor but significant part of Irish agitation for land reform. Heligoland was a pair of rocky and heavily fortified German islands in the North Sea.

321:6 (326:36–37). a report of Lord Castletown's—the Right Honourable Lord Castletown of Upper Ossory sat on an official committee of the Department of Agriculture and Technical Instruction for Ireland. The committee was appointed on 29 August 1907 and charged with inquiring into "the improvement of forestry in Ireland." Its "Report of the Departmental Committee on Irish Forestry" was presented to Parliament and simultaneously published in Dublin on 6 April 1908. The report reviews the destructive effects of the Land Purchase Acts (1882 *ff.*) on Irish forests and submits statistical data to support its claim that the forests were being exhausted because there was no provision for replanting in the Land Purchase Acts. The report goes on to demonstrate a decline in several Irish industries that had been occasioned by the denudation and argues at length, with specific recommendations, for "A National Scheme of Afforestation."

321:7 (326:38). the giant ash of Galway—unknown.

321:8–9 (326:39–40). the chieftain elm of Kildare . . . acre of foliage—the name Kildare derives from the Irish *Cill-dara,* "the church of the oak" (not elm), and the oak was not renowned for the chieftain associated with it but for St. Brigid (see 333:25n), a chieftain's daughter, who had her cell under the oak and founded a religious community there.

321:10 (326:41). the fair hills of Eire, O—from a song, "The Fair Hills of Eiré, O," translated by James Clarence Mangan from the Irish of Donogh Mac Con-Mara (1738–1814). The poem begins, "Take a blessing from my heart to the land of my birth,/And the fair hills of Eiré, O!" Lines 13–14: "Her woods are tall and straight, grove rising over grove;/Trees flourish in her glens below and on her heights above."

Parody: 321:12–322:4 (327:1–36). The fashionable international world . . . in the Black Forest—parodies newspaper accounts of important social events.

321:14 (327:3). the Irish National Foresters—a fraternal organization and benevolent society, avowedly nonpolitical and nonsectarian, but Catholic and Nationalist in practice. Its motto was "Unity, Nationality, and Benevolence." In 1904 Joseph Hutchinson (see 243:37n) was general secretary of the Foresters; the organization had executive council offices at 9 Merchant's Quay and two branch halls in Dublin.

321:16 (327:5). Mrs Barbara Lovebirch—any relation to James Lovebirch, see 232:22–23n?

321:21 (327:10). Miss Bee Honeysuckle—recalls the music-hall song "The Honeysuckle and the Bee" (1901), by Albert H. Fitz and William H. Penn. Chorus: "You are my honey, honey suckle, I am the bee,/I'd like to sip the honeysweet from those lips, you see;/I love you dearly, dearly, and I want you to love me./You are my honey, honey suckle, I am the bee."

321:22 (327:11). Miss O Mimosa San—a geisha, one of the central figures in the light opera *The Geisha;* see 95:29–31n.

321:27–28 (327:17). the M'Conifer of the Glands—"gland" is archaic for an acorn. There are several figures in Irish history whose names have carried the epithet "of the Glens." Thornton mentions two, James MacDonnell (d. 1565), Lord of the Glens; and the O'Donoghue of the Glens, a branch of the O'Donoghue family. A third possibility, Hugh Roe O'Donnell, was known as the O'Donnell of the Glens for the skill of his retreat from Kinsale (1601) after the Irish collapse in that abortive battle; see 291:35n.

321:32 (327:21). bretelles—straps.

321:37–38 (327:27). Senhor Enrique Flor—a Portuguese version of "Mr. Henry Flower."

321:40 (327:30). Woodman, spare that tree—an American popular song by George P. Morris and Henry Russell. The first of its four verses: "Woodman, spare that tree!/Touch not a single

bough,/In youth it shelter'd me,/And I'll protect it now;/'Twas my forefather's hand/That placed it near his cot;/There, woodman, let it stand,/Thy axe shall harm it not."

321:41–42 (327:31–32). the church of Saint Fiacre in Horto—for St. Fiacre, who is the patron saint of amateur horticulture and gardening, see 43:6n. "*In Horto*" is Latin for "in garden [enclosure]." There is a hermitage of St. Fiacre that would qualify as being *in Horto* at Kilfiachra (Kilfera) on the Nore in southern Ireland.

322:2 (327:34). ivytod—the ivy plant.

322:3 (327:35). quicken—the mountain ash or rowan tree; sometimes, juniper.

322:5–7 (327:37–39). our trade with Spain ... those mongrels were pupped—i.e., Irish trade with the Continent flourished before the Norman Conquest (1066) made Norman-Saxon "mongrels" of the English. There is some truth in the Citizen's overstatement since there is evidence of considerable Irish trade with the Continent during the period of the great Irish missionaries (fifth century *ff.*).

322:7 (327:39). Spanish ale in Galway—by the sixteenth century Galway had become one of the principal ports in the British Isles; its trade ties with Spain were particularly close. In an essay, "The City of the Tribes," Joyce asserts that by Cromwell's time Galway was the second most important harbor in the British Isles: "Almost all the wine imported into the United Kingdom from Spain, Portugal, the Canary Islands, and Italy passed through this port" (*Critical Writings*, p. 230). Cromwell's punitive conquest of Ireland was particularly hard on Galway and its merchant princes (1651) and began that city's decline as a port.

322:8 (327:40). the winedark waterway—see 7:3n.

322:12–14 (328:2–4). Queenstown, Kinsale, Galway ... harbour in the wide world—all of them had been flourishing harbors in the sixteenth and seventeenth century but had fallen from prosperity in the course of the eighteenth and nineteenth century. Queenstown (now Cobh) (see 274:23n) had not suffered as much as the others. Kinsale Harbour is 18 miles west-south-west of Cork Harbour (Queenstown). For Galway, see 322:7n. Blacksod Bay is on the west-north-west coast of Ireland in County Mayo, 65 miles north of Galway Bay. Ventry and its relatively small Ventry Harbour are on the northern shore of Dingle Bay in County Kerry, southwestern Ireland. Killybegs is 19 miles west of Donegal

on Donegal Bay in County Donegal, northwestern Ireland; far from having the "third largest harbour in the world," Killybegs may have one of the smallest. It is more appropriately described as "a clean, pleasant little seaport where the tide comes up to the doors of the houses in the main street."

322:14–15 (328:5). the Galway Lynches—Edward MacLysaght, in *Irish Families* (Dublin, n.d.), asserts: "The Norman family of Lynch ... have been more prominent on account of their predominance in the affairs of Galway city, where they were the most influential of the 'Tribes.'" (Eighty-four different members of the "Tribe" held the office of mayor of Galway between 1484 and 1654; under Innocent VIII (1484–1492) the Lynches became the ecclesiastical wardens of Galway.) See Joyce, "The City of the Tribes," *Critical Writings*, pp. 231–232.

322:15 (328:5). the Cavan O'Reillys—an ancient and powerful house in County Cavan in central Ireland, northwest of Dublin. The family boasted that it was descended from Heremon, one of the three sons of Milesius (see 322:20–21n).

322:15–16 (328:6). the O'Kennedys of Dublin—more properly, the O'Kennedys of Ormond, a duchy with its power centered in Kilkenny in south-central Ireland. The O'Kennedys claimed descent from a nephew of Brian Boru (see 98:16n) and were the Lords of Ormond from the eleventh through the sixteenth century, when they were overshadowed by the Norman-Irish Butlers. Brian Boru, himself a Kennedy, was *ardri* or king of Dublin (1002–1014).

322:16–17 (328:6–7). when the earl of Desmond ... Charles the Fifth himself—James Fitzmaurice Fitzgerald (d. 1529), 10th Earl of Desmond, one of the most powerful and independent of the Norman-Irish lords, bragged that he could field a household army of 10,000 men and launch his own fleet against England. In 1523, when Henry VIII was at war with France, the Earl was negotiating an offer of aid to Francis I; Henry ordered the Earl to submit to arrest, but the Earl was powerful enough to refuse with impunity. In 1529, on the eve of his death, the Earl entered inconclusive negotiations with Charles V (1500–1558), Holy Roman emperor and king of Spain as Charles I; the Earl desired a treaty of alliance against England.

322:19 (328:9–10). Henry Tudor's harps—Henry VIII quartered (incorporated) a gold harp on a blue field into the royal arms of England as a symbol of his overlordship of Ireland.

322:20–21 (328:10–12). the oldest flag afloat ... sons of Milesius—the province of Munster

in southwestern Ireland was divided in ancient Ireland into Desmond (South Munster) and Thomond (North Munster). The last of the quasi-legendary invaders of Ireland were the Milesians, led by the three sons of Mileadh of Spain (Eber, Heremon, and Ith or Iar, the latter sometimes characterized as a brother of Mileadh rather than son). Legend has it that the Milesian flag had "three crowns on a blue field" and thus it would be "the oldest flag afloat" *in Ireland*; legend also regards the Milesians as the "ancestors" of the royal clans of Ireland.

322:22 (328:13). Moya—Irish: "as if it were" (ironic interjection).

322:22–23 (328:13–14). All wind and piss like a tanyard cat—proverbial; tannery cats are traditionally famed for their braggadocio and for their ineffectuality since tanneries never lack for rodents.

322:23 (328:14). Cows in Connacht have long horns—Irish proverb. Since Connacht is in the far west, the implication is double: the farther away the cow is, the longer its horns (in reputation); the surprised provincial's discovery of the obvious. (The French edition renders this "Asses have ears.")

322:25 (328:16). Shanagolden—a post town and parish in County Limerick, 18 miles west of Limerick and 116 miles west-southwest of Dublin.

322:26 (328:17). the Molly Maguires—by 1904 almost a generic term for anonymous groups of Irish terrorists. The Molly Maguires were originally formed in 1641 by Cornelius Maguire to aid in the rebellion of that year; they were called "Mollies" because they disguised themselves in women's clothing. The Molly Maguires were "reactivated" during the Tithe War (1830–1835), and provincial groups that actively terrorized land agents and landlords in the land-reform struggles in the latter half of the nineteenth century were often believed to be Molly Maguires.

322:27–28 (328:18–19). for grabbing the holding of an evicted tenant—in the struggle for land reform, groups of activists organized rent strikes and tried to prevent the evictions that were endemic. In the event that they could not prevent an eviction, they tried to prevent anyone else from profiting by seizing the evicted man's livestock and property or by occupying the vacant tenancy. Their aims were to keep the evicted man from being reduced to utter poverty and to keep the land vacant in the attempt to reduce the landlord's income and thereby exact concessions.

322:30–31 (328:21–22). An imperial yeomanry ... to celebrate the occasion—the Yeomanry was a British volunteer cavalry regiment raised by Yorkshire gentlemen to fight Bonnie Prince Charlie in 1745. It continued as a "semi-formal" regiment, the members furnishing their own horses and training for 14 days a year. The regiment distinguished itself in the Boer War and was awarded the title of Imperial Yeomanry in 1901. From the Irish point of view, the regiment had earned the peculiarly English distinction of harassing and subjugating yet another free people. The phrase "imperial yeomanry" carried the slur that the Yeomanry's amateur soldiers needed alcoholic fortification of their courage.

322:32 (328:23). a hands up—the label on a bottle of Allsop's ale featured the Red Hand of Ulster, symbolic of the semilegendary heroes of that ancient Irish kingdom.

322:40 (328:31). Black Beast Burned in Omaha, Ga—in Stewart County, Georgia. According to Adams (pp. 204–205), no lynching ever took place in Omaha, Georgia; but in 1897 a lynching did take place at Lumpkin in Stewart County. The *Freeman's Journal*, 9 and 10 March 1904, reported a lynching in Springfield, Ohio, in which the victim was not only hanged but also riddled with bullets; in the aftermath the white mob set fire to the Negro section of Springfield.

322:40–41 (328:32). Deadwood Dicks—Deadwood Dick was the creation of the self-styled "Sensational Novelist," the American Edward L. Wheeler (*c.*1854–*c.*1885). Deadwood Dick, from Deadwood, South Dakota, careened his way through an advertised "122 Numbers" (dime novels), appearing variously as prospector, gambler, Robin Hood, semi-desperado and Indian fighter. In *Deadwood Dick, the Prince of the Road* (n.d.), he is described: "A broad black hat was slouched down over his eyes."

323:6–8 (328:39–41). the revelations that's going ... Disgusted One—the letter writer the Citizen cites is apparently fictional, but the controversy over British navy discipline in general and over the practice of flogging in particular was not. The leading critic of naval discipline was the Irish Nationalist John Gordon Swift MacNeill (b. 1849), M.P. for Donegal. The questions he raised in Parliament early in 1904 were widely echoed and debated in the correspondence columns of newspapers. The practice of flogging was abolished in 1906.

323:14 (329:5). A rump and dozen—there is no evidence that this was Sir John's expression for a flogging, but it was a proverbial Irish wager: a rump of beef and a dozen of claret; i.e., the loser

of the wager would provide the winner with a good meal.

323:15 (329:6). sir John Beresford—the Citizen is apparently eliding two John Beresfords: Sir John Poo Beresford (*c*.1768–1844), Irish-born admiral in the British Navy and M.P. from an English constituency (1812–1832). There is no evidence that Sir John had other than a "normal" attitude toward the practice of flogging. The other John Beresford (1738–1805) was Commissioner of Revenue in Ireland, and from an Irish point of view, he comes much closer to qualifying for the epithet of "old ruffian" since his financial power made him "virtually king of Ireland." He motivated the building of the Custom House in Dublin, which became his "palace"; near it he established a riding school for the training of his horses. During the tension and rebellion of 1797–1798 he was a staunch supporter of the English cause, and his riding school was the principal site of the floggings and other forms of torture inflicted on dissident Irish in Dublin.

323:18–19 (329:9–10). 'Tis a custom more . . . than in the observance—see 294:33–34n.

323:22 (329:13). meila—Irish: "a thousand."

323:24 (329:15). The fellows that never will be slaves—after the ode "Rule Britannia," words by James Thomson (1700–1748), music by Thomas Arne (1710–1778), first included in *The Masque of Alfred* (1740). The opening lines of the ode: "When Britain first, at Heav'n's command,/Arose from out the azure main,/Arose, arose, arose from out the azure main;/This was the charter, the charter of the land,/And guardian angels sung this strain:/Rule Britannia, Britannia rule the waves,/Britons never, never, never will be slaves."

323:25 (329:16). the only hereditary chamber on the face of God's earth—the Citizen is, of course, referring to the English House of Lords, but that House was only predominantly, not exclusively, hereditary since some of the membership was elected (from among the Scot and Irish peers), some included by virtue of ecclesiastical office, and the judicial members by appointment of the Crown. There were a number of other hereditary chambers in Europe, among them the House of Peers of the Prussian Landtag, and the House of Lords of the Austro-Hungarian Reichsrat.

323:26 (329:17). cottonball—slang: having the appearance but not the actuality of being the real thing; thus, overpreoccupied with fashion, affected.

323:29 (329:20). On which the sun never rises—see 31:30n.

323:31 (329:22). yahoos—creatures, essentially beasts in human form, in Swift's *Gulliver's Travels*, Part IV.

Parody: 323:32–38 (329:23–29). They believe in rod . . . living and be paid—parodies the Apostles' Creed; see 22:23–24n.

324:1–2 (329:37). our greater Ireland beyond the sea—an epithet for the United States; see 320:24–25n. Throughout the latter half of the nineteenth century Irish-Americans continued to raise money and to train insurrectionists for the cause of Irish national independence.

324:3 (329:38). the black 47—the famine began in 1845 as the result of a potato blight that destroyed the staple food crop of the peasants. The famine increased in intensity, exacerbated by epidemics of typhoid and typhus, to a climax in 1847; while the disaster continued through 1848, in the course of that year it was somewhat alleviated. Peasants not only emigrated or stayed to die from starvation and disease; they were literally driven off the land by landlords who refused to abate their rents or to tide the peasants over by compensating for the collapse of the potato crop.

324:3 (329:39). shielings—huts or small cottages.

324:5–6 (329:40–42). the Times rubbed its hands . . . as redskins in America—Seumas MacManus, in *Story of the Irish Race* (p. 610n), quotes the *London Times*: "They are going! They are going! The Irish are going with a vengeance. Soon a Celt will be as rare in Ireland as a Red Indian on the shores of Manhattan." No such quotation appears in the *Times* between 1845 and 1848, and yet the quotation effectively caricatures that newspaper's stance before its ("with great reluctance") change of heart, 8 February 1849. The English conservative Establishment's attitude toward Ireland was that it should be and remain an *agrarian* state. This not only rationalized the continuing policy of suppression aimed at Irish industries, but also dictated that, in mid-nineteenth-century terms, Ireland was overpopulated and that depopulation, while regrettable, was in the long run a good thing.

324:7 (329:42). Even the grand Turk sent us his piastres—T. O'Herlihy in *The Famine (1845–7); A Survey of its Ravages and Causes* (Drogheda, 1950) (p. 85): "Though the English government made no gestures of relief, the Society of Friends made more than a quarter of a million pounds available for relief. . . . Many other countries contributed their obole [coins], even the Turksman." The thrust of this point is that the English were more callous than the

Turks, who were notorious for their callous indifference to human suffering.

324:7–9 (330:1–3). But the Sassenach tried to ... sold in Rio de Janeiro—T. P. O'Connor, *Gladstone, Parnell and the Great Irish Struggle* (Philadelphia, 1886) (p. 366): "Testimony is as unanimous and proof as clear as to the abundance of the grain crop [in 1847] as they are to the failure of the potato crop. ... John Mitchel quotes the case of the Captain who saw a vessel laden with Irish corn at the Port of Rio de Janeiro." For John Mitchel, see 701:24n.

324:10–11 (330:4). Twenty thousand of them died in the coffinships—there is no evidence to support the Citizen's statistics one way or the other, but there is more than enough evidence that the exodus from Ireland in 1846–1848 took place under conditions sufficiently appalling to warrant the 1846 origin of the phrase "coffin ships." This was particularly true of the innumerable, quasi-clandestine sailings from small ports where there was no inspection under the Passenger Act (1842). Poorly appointed, poorly manned, incompetently officered ships without adequate provision of water, food, space and with no sanitation facilities were overcrowded to the point where they were indeed more coffins than ships.

324:11–12 (330:5). the land of the free—from "The Star-Spangled Banner."

324:12 (330:5–6). the land of bondage—another analogue between the Irish and the Israelites since the phrase echoes Deuteronomy 5:6: "I *am* the Lord thy God, which brought thee out of the land of Egypt, from the house of bondage."

324:13 (330:7). Granuaile—the Irish name of Grace O'Malley (*c*.1530–*c*.1600), a chieftainess from Western Ireland whom her contemporary, Lord Henry Sidney, the Lord Deputy of Ireland, called "a most famous feminine sea captain." She was reputed to have nursed "all the rebellions in the province for 40 years."

324:14 (330:7–8). Kathleen ni Houlihan—one of the traditional feminine embodiments of the "spirit of Ireland"; see 182:39–183:1n.

324:17–18 (330:11–12). Since the poor old woman ... on the sea—"poor old woman" in Irish is *"Shan Van Vocht"*; see 19:17–18n.

324:18 (330:12). landed at Killala—a small expeditionary force of about 1,000 French landed at Killala on the north coast of County Mayo in western Ireland in the autumn of 1798 when the rebellion of that year had virtually collapsed. The French were initially successful, but the Irish

forces that they expected to support did not materialize, and the French were soon forced to surrender.

324:19–20 (330:13–14). We fought for the royal ... and they betrayed us—the Irish rose in support of James II, the last of the Stuart kings, when he was deposed in the "Bloodless Revolution" of 1688. In the war that followed (1689–1691), the Irish held their own until they suffered a decisive defeat at the hands of William III of England in the Battle of the Boyne (1690). At that point James II "betrayed" his Irish allies by retiring into exile on the Continent.

324:20–21 (330:14–15). Remember Limerick and the broken treatystone—after the defeat at Boyne, the Irish insurgents continued the war with French encouragement but with little hope of ultimate success. Their final stand at Limerick, under the leadership of Patrick Sarsfield (see 291:34–35n), was resolved by the Treaty of Limerick, 3 October 1691. The treaty was signed on a stone that subsequently became a monument to the treaty. In substance, the treaty made some concessions to the Catholic Irish on the condition that Sarsfield and 11,000 troops, the core of his army, accept exile to the Continent. In 1695 the Irish (Protestant) Parliament repudiated the treaty's concessions with English connivance and consent.

324:22 (330:16). to France and Spain, the wild geese—Sarsfield and the others who accepted (or fled into) exile in 1691 were called "the wild geese" (although the term has since been used generically). Many of the wild geese enlisted in the armies of Catholic France or Spain.

324:22 (330:16). Fontenoy—at the battle of Fontenoy (1745), the Irish Brigade distinguished itself, fighting on the side of the victorious French against the allied armies of England, Holland and Hanover.

324:23 (330:17). Sarsfield—see 291:34–35n.

324:23 (330:17). O'Donnell, duke of Tetuan in Spain—Leopold O'Donnell (1809–1867), a descendant of one of the wild-geese families and a marshal of Spain whose career was a checkerboard of military insurrections and counterinsurrections. He was prime minister of Spain, 1854–1856, 1858–1863, 1865–1866.

324:23–24 (330:18–19). Ulysses Browne of Camus that was fieldmarshal to Maria Teresa—Nolan is eliding two field marshals: (1) Ulysses Maximilian, Count von Browne (1705–1757), the Austrian-born son of one of the wild geese; he was one of the most distinguished field marshals in the army of Maria Theresa

(1717–1780), queen of Hungary and Bohemia and archduchess of Austria. He was killed at the battle of Prague. (2) George, Count de Browne (1698–1792) was born at Camus (thus "of Camus") in Limerick. He became a soldier of fortune and a field marshal in the Russian army. He was regarded as a favorite of Maria Theresa and of Catherine the Great.

324:28 (330:22). Entent cordiale—French: "Cordial understanding." The intense Anglo-French rivalry of the early twentieth century was resolved in such an "understanding" on 8 April 1904. Though not technically an "alliance," the *Entente* implied a realignment of the European powers: France and England against the Triple Alliance of Germany, Austria-Hungary and Italy. The agreement promised the French a free hand in Morocco; in return, the French recognized England's virtual conquest of Egypt.

324:29 (330:23). Tay Pay's dinner party with perfidious Albion—"Tay Pay" was the nickname of Thomas Power O'Connor (see 136:4n), whose weekly *M.A.P.* (Mainly About People) was deprecated by some Irish radicals for having too much the tone of an English dinner party. For "perfidious Albion," see 319:33n.

324:31 (330:25). Conspuez les Français—French: "Scorn the French." *Cf.* 319:33n.

324:32–35 (330:26–29). the Prooshians and Hanoverians . . . old bitch that's dead—Hanover, an Electorate of the Holy Roman Empire, was included as a province of Prussia in 1866. "George the Elector" (1660–1727) was hereditary ruler of the Electorate of Hanover when he became heir to the English throne in 1714. The German House of Hanover has continued on the English throne (the name changed from Wetten to Windsor for patriotic reasons in World War I). The "German lad" is Albert, Prince of Saxe-Coburg-Gotha, who added new German blood to the house when he became prince consort. Queen Victoria's mother was also a German princess; and although her parents lived in Germany, Victoria was born on English soil because it was so arranged in the expectation that she might become heir to the throne.

324:37 (330:31). with the winkers on her—i.e., she wore blinders, an allusion to Queen Victoria's determination to "see no evil."

324:37–42 (330:31–36). blind drunk in her royal . . . where the boose is cheaper—this is a flamboyant version of malicious gossip that was widely circulated toward the end of Queen Victoria's life. In part, it was a function of her idiosyncratic behavior (perpetual mourning and withdrawal from public life) after the death of

Prince Albert; in part, it was a reaction to her reputation for excessive moral repressiveness. The "coachman" was the Scot John Brown (1826–1883), the Queen's gillie and body servant, upon whom she was extraordinarily dependent.

324:41 (330:35). Ehren on the Rhine—American ballad (?) by ——— Cobb and William H. Hutchinson. The ballad describes (since the soldier dies) the last parting of the soldier and his love. Chorus: "Oh love, dear love, be true,/This heart is only thine;/When the war is o'er,/We'll part no more/At Ehren on the Rhine."

324:41–42 (330:35–36). come where the boose is cheaper—a parody of Stephen Foster's song "Come Where My Love Lies Dreaming," by George Dance (d. 1932). Dance's parody begins, "Come where the booze is cheaper;/Come where the pots hold more," i.e., come to Dublin.

325:1 (330:37). Edward the peacemaker—what the French called Edward VII in the first blush of optimism about the *Entente cordiale* (324:28n). It was also a title that he coveted as witness his efforts to establish peaceful relations with Austria (131:22–23n) and with his nephew, Kaiser Wilhelm II of Germany.

325:3 (330:39). more pox than pax—i.e., "more venereal disease than peace," an allusion to Edward VII's reputation as a ladies' man.

325:3 (330:39). Edward Guelph-Wettin—the family name of the House of Hanover was "Guelph"; "Wettin" is the Prussian version of the Swedish "Wetter," Prince Albert's family name. Queen Victoria dropped the name "Guelph" when she married Prince Albert.

325:5–7 (330:41–331:1). the priests and bishops of Ireland . . . the horses his jockeys rode—Edward VII was a horse fancier; during his state visit to Ireland in July of 1903 he was entertained by the Catholic University of Ireland at St. Patrick College, the clerical center of the Roman Catholic Church in Ireland, in the town of Maynooth, 15 miles west of Dublin. The supreme governing body of the university was made up of the Catholic archbishops and bishops of Ireland. For the reception, the college refectory was decorated with his *Britannic* majesty's racing colors and with engravings of two of his favorite horses, Diamond Jubilee and Ambush II. Monsignor Gerald Molloy (1834–1906), the rector of the University, gave an address of welcome. From an Irish point of view, the whole episode, including the unpriestly nature of the decorations, was an offensive demonstration of the Church's willingness to be subservient to the English Crown.

325:7 (331:1). The Earl of Dublin—a title conferred on Edward VII, the Prince of Wales, by Queen Victoria on the occasion of her first state visit to Dublin, in 1849.

325:8 (331:3). all the women he rode—another reference to Edward VII's well-known free-wheeling behavior with women.

325:16–17 (331:11–12). May your shadow never grow less—a common Irish salutation or toast, expressive of good will.

325:20 (331:15). dunduckety—"dun" means yellowish or grayish brown and "duckety" means dark or gloomy.

325:41 (331:35). After you with the push—i.e., I'll go along with the crowd.

Parody: 326:3–34 (331:39–332:28). The much-treasured and intricately . . . rich incrustations of time—parodies a newspaper feature story's description of a tapestry or an illuminated manuscript.

326:4–5 (331:40–41). Solomon of Droma . . . the Book of Ballymote—the 501 large folio pages of *The Book of Ballymote* (an anthology selected from older books) were produced (c.1391) in Sligo by several scribes, chief among them Solomon O'Droma and Manus O'Duigenan (together with Robert mac Sheehy). The book was written in the house of Tolmatoch mac Tadg (or mac Donogh or mac Dermond); among other items, the book contains the ancient "Book of Invasions," genealogies of selected Irish families, histories and legends of early Irish kings, and an Irish translation of Nennius' *History of the Britons* (c. 800).

326:8–12 (332:3–7). the four evangelists in turn . . . eagle from Carrantuohill—the iconographic symbols for the four evangelists after Revelation 4:7: Matthew, a winged man with a lance; Mark, a lion; Luke, an ox; John, an eagle. The symbols are often winged after Revelation 4:8, "And the four beasts had each of them six wings about *him*." The "four masters" are the four Franciscan compilers of *The Annals of the Four Masters* (1632–1636), Michael O'Clery, Conaire O'Clery, Cucoigcriche O'Clery and Fearfeasa O'Mulchonry. Kerry is the rough country in south-western Ireland; Carrantuohill, the "inverted sickle," is, at 3,414 feet, the highest mountain in Ireland, the "grand master" of MacGillicudy's Reeks in County Kerry.

326:13 (332:8). emunctory—of or pertaining to the blowing of the nose.

326:14 (332:8). duns—Irish: "forts," usually fortified hills.

326:14 (332:8). raths—Irish: "ring-forts."

326:14 (332:9). cromlechs—Irish: "dolmens," flat unhewn stones resting on three or more upright stones.

326:14 (332:9). grianauns—Irish: "the solar or sunroom of a medieval castle."

326:15 (332:9–10). maledictive stones—a heap of stones piled (and added to) as the monument to a disaster. It was traditional to add a stone as one passed such a monument in token of one's humility in the face of disaster; the superstition also suggested burying the disaster so that it would not rise again.

326:16 (332:11). the Sligo illuminators—the scribes who wrote *The Book of Ballymote;* see 326:4–5n.

326:17–18 (332:12). in the time of the Barmecides—the subject and refrain of James Clarence Mangan's poem "The Time of the Barmecides." The Barmecides were the members of a powerful Persian family that flourished in the eighth century. "The Barber's Tale of His Sixth Brother" in *Arabian Nights' Entertainments* tells of a Barmecide feast: a member of the family gives a beggar an imaginary feast on magnificent dishes.

326:18 (332:13). Glendalough—a lake in County Galway, advertised as "one of the most beautiful of the lakes of Ireland, beautifully situated in the midst of a thickly-wooded domain."

326:18 (332:13). the lovely lakes of Killarney—in County Kerry; all guidebooks rhapsodize on the "multiform contrasts and endless variety" of the lakes and their mountain settings.

326:19 (332:13–14). the ruins of Clonmacnois—Clonmacnois ("The Meadows of the Sons of Nos") on the River Shannon in central Ireland; the ruins of seven churches including a tenth-century cathedral mark this site of the most remarkable of the religious schools, founded c.544, devastated and ruined in 1552. Nineteenth-century guidebooks agreed that the scenery was "lovely, sublime, and poetic."

326:19 (332:14). Cong Abbey—near Galway in County Galway. The abbey was founded in 624, destroyed by fire in 1114 and rebuilt in Norman style in the course of that century. The abbey was disbanded in the sixteenth century but considerable restoration of the building was undertaken in the nineteenth century.

326:19–20 (332:14). Glen Inagh and the Twelve Pins—Glen Inagh is a long mountain

valley in County Galway, flanked on one side by 12 conical domelike hills, The Twelve Pins or Bunnabeola ("The Peaks of Beola").

326:20 (332:14–15). Ireland's Eye—a small island one mile north of the Howth promontory, the site of the ruins of a seventh-century chapel.

326:20 (332:15). the Green Hills of Tallaght—south and west of Dublin, they afford a good view of the mountainous country to the south and were a favorite resort of the gentry in the seventeenth and eighteenth century.

326:20–21 (332:15). Croagh Patrick—a 2,510-foot mountain on the coast in County Mayo; it was regarded as an enchanted hill. St. Patrick is said to have rung a bell at its summit to drive all venomous living things out of Ireland, and each time he tried to throw the bell away, it returned to his hand.

326:21–22 (332:16–17). the brewery of Messrs ... and Company (Limited)—in west-central Dublin south of the Liffey.

326:22 (332:17). Lough Neagh's banks—Lough Neagh in northeastern Ireland is the largest lake in the British Isles; 18 miles long and 11 miles wide, it has 65 miles of "banks." Thomas Moore "remembers" the banks in the second stanza of "Let Erin Remember the Days of Old" (see 46:9–10n): "On Lough Neagh's bank, as the fisherman strays,/When the clear cold eve's declining,/He sees the round towers of other days/In the wave beneath him shining;/Thus shall memory often, in dreams sublime,/Catch a glimpse of the days that are over;/Thus, sighing, look through the waves of time/For the long faded glories they cover."

326:22 (332:17). the vale of Ovoca—(or Avoca), a picturesque junction of rivers in County Wicklow, south of Dublin. It is memorialized in Thomas Moore's poem "The Meeting of the Waters." For first verse, see 160:17, 19n; the fourth and last stanza: "Sweet vale of Avoca! how calm could I rest/In thy bosom of shade, with friends I love best,/Where the storms that we feel in this cold world should cease/And our hearts, like thy waters, be mingled in peace."

326:22–23 (332:17). Isolde's tower—a medieval tower with nine-foot walls, 18 feet square in its interior, that stood until 1675 on the site of Essex Gate (Parliament Street) in central Dublin just south of the Liffey. There is no record of why the tower was so named though it was near a spring called "Isod's Font" and many versions of the legend of Tristram and Isolde suggest that she was the King of Dublin's daughter.

326:23 (332:18). the Mapas obelisk—at Killiney, on the coast nine miles southeast of Dublin. It was constructed in 1741 on the grounds of Mr. Mapas' Killiney estate "with the benevolent intention of providing employment for the industrious poor." Guidebooks advertise "a remarkable view" from Obelisk Hill.

326:23 (332:18). Sir Patrick Dun's hospital—on Canal Street overlooking the Grand Canal, which circles south around Dublin. The hospital (1803) was financed by the estate of Sir Patrick Dun (1642–1713), a famous and influential Scots-Irish physician and politician.

326:23–24 (332:18). Cape Clear—off Clear Island, south of Bantry, the southwestern extremity of Ireland.

326:24 (332:19). the glen of Aherlow—a valley eight miles long and two miles wide formed by the River Aherlow; it is famous for its beauty and in history because it was contested as the major pass between County Tipperary and County Cork to the south. The phrase "the glen of Aherlow" functions as a refrain in Charles Joseph Kickham's (1830–1882) ballad "Patrick Sheehan," a song about a peasant from the glen who goes blind in the Crimean War, is jailed in Dublin and laments his double loss (sight and presence) of the glen. (Kickham himself had also lost his eyesight while he was imprisoned.)

326:24 (332:19). Lynch's castle—in Galway (see 322:14–15n), the town residence of the famous James Lynch (Fitz-stephen) who was warden of Galway in the early sixteenth century. He condemned his own son to death (for conspiracy to mutiny on the high seas) and hanged him from a window to prevent his being rescued by other members of the family.

326:24 (332:19). the Scotch house—a Dublin pub; see 157:34n.

326:25 (332:19–20). Rathdown Union Workhouse at Loughlinstown—a poorhouse of practically no distinction in the hamlet of Loughlinstown, 11 miles southeast of Dublin.

326:25–26 (332:20). Tullamore jail—Tullamore is a town in the Bog of Allen; the jail is as undistinguished a building as the town itself. An Irish rhyme sums it up: "Great Bog of Allen, swallow down/That odious heap call'd Philipstown;/And if thy maw can swallow more,/Pray take—and welcome—Tullamore."

326:26 (332:20–21). Castleconnel rapids—the broad weirs and rapids (the Falls of Doonas) on the Shannon in central Ireland; the Shannon

is broad at this point and flows through innumerable rocky islets.

326:26 (332:21). Kilballymacshonakill—not a place but a name, in Irish: "Church (or Wood) of the town of the son of John of the Church."

326:26–27 (332:21–22). the cross at Monasterboice—Monasterboice, 35 miles northwest of Dublin, is the site of ecclesiastical ruins, a round tower and three stone crosses, two of which were regarded as among the finest in Ireland. The more important of the two is St. Boyne's Cross, which was reputed to be the most ancient Christian relic in Ireland.

326:27 (332:22). Jury's Hotel—6, 7 and 8 College Green in Dublin.

326:27 (332:22). S. Patrick's Purgatory—a cavern on Saints Island in Lough Derg, County Donegal (northwestern Ireland). The tradition was that St. Patrick had prevailed upon God to locate the entrance to purgatory in Ireland. The superstitious who made the pilgrimage to the cavern prepared themselves with a long vigil and fast and were then lowered into the cavern to experience the expected nightmare vision. The superstition died out in the late seventeenth century.

326:27–28 (332:22). the Salmon Leap—a waterfall on the Liffey at Leixlip, eight miles west of Dublin.

326:28 (332:23). Maynooth college refectory—see 325:5–7n.

326:28 (332:23). Curley's hole—a bathing pool in Dollymount (northwestern outskirts of Dublin), dangerous to nonswimmers. In Joyce's satiric poem "Gas from a Burner" (1912), Maunsell's printer says: "Do you think I'll print/The name of the Wellington Monument,/Sydney Parade and the Sandymount tram/Downes's cakeshop and Williams's jam?/I'm damned if I do —I'm damned to blazes!/Talk about *Irish Names of Places*/It's a wonder to me upon my soul/He forgot to mention Curley's Hole."

326:28–29 (332:23–24). the three birthplaces of the first duke of Wellington—Arthur Wellesley (1769–1852), the 1st Duke of Wellington. Both the exact date (29 April?) and the place of his birth (in Dublin) are matters of controversy, though opinion seems to have settled on 24 Upper Merrion Street.

326:29 (332:24). the rock of Cashel—96 miles southwest of Dublin in County Tipperary; the rock rises abruptly to a height of 300 feet out of an extensive plain. It is crowned by the ruins of Cormac's chapel, a round tower, a great stone cross, a cathedral and monastic buildings.

326:30 (332:25). the bog of Allen—begins 25 miles west-southwest of Dublin. Originally an extensive bog, it has been partially reclaimed.

326:30 (332:25). the Henry Street Warehouse—outfitters, silk mercers and haberdashers, 59–62 Henry Street and 1–5, 36–39 Denmark Street, Dublin.

326:30 (332:25). Fingal's cave—not in Ireland but the largest of seven caves on the uninhabited island of Staffa in the Inner Hebrides. Fingal is portrayed as the father of Ossian by the Scot James Macpherson (1736–1796) in his fictional versions of the Ossianic poems.

327:1–2 (332:39–40). sold by auction off in Morocco like slaves or cattle—Jews were not technically slaves in Morocco in 1904, but they were subjected to "compulsory service" by the Moslem majority; both men and women were compelled to do all servile tasks, even on the Sabbath and Holy Days, and these services could apparently be bought and sold in the Moslem community. Compulsory service was abolished in 1907.

327:3 (332:41). the new Jerusalem—combines a reference to the ultimate Christian utopia described in Revelation 21 and 22 with a reference to the Zionist movement and its dramatization of the Jewish desire for a "homeland" in Jerusalem.

327:7 (333:3). an almanac picture—i.e., a picture to be "immortalized" on a calendar.

327:7–8 (333:3–4). a softnosed bullet—these and all the other expanding bullets were developed in the late nineteenth century as particularly effective (and vicious) antipersonnel weapons. They were outlawed by the Hague War Regulations in 1899 but continued in occasional use through World War I.

327:22 (333:20). apostle to the gentiles—St. Paul, who, after his conversion to Christianity, preached the gospel to all without distinction of race or nation; see I Timothy 2:7.

327:24–25 (333:22–23). Love your neighbours—the second of Jesus' two commandments: "And the second *is* like unto it, Thou shalt love thy neighbour as thyself" (Matthew 22:39).

327:26 (333:24). Beggar my neighbour—a card game for two children in which the object is to gain all the opponent's cards.

327:27 (333:25). Moya—see 322:22n.

Parody: 327:28–38 (333:27–37). Love loves to love ... God loves everybody—sentimental adult child-talk.

327:31 (333:30). Jumbo, the elephant—(d. 1885), a famous gigantic African elephant, a favorite with English children when he was at the Royal Zoological Gardens in London (1859–1882); acquired by P. T. Barnum (1882) and billed as "the world's largest elephant."

327:32–33 (333:31–32). Old Mr Verschoyle ... with the turnedin eye—Mr. and Mrs. G. Verschoyle, 14 Sidney Avenue, Blackrock.

328:4 (334:2). canters—(those who use religious cant), a seventeenth-century nickname for the Puritans.

328:5–8 (334:3–6). sanctimonious Cromwell and his ... mouth of his cannon—in 1649, after the resolution of the Civil War in England, Oliver Cromwell (1599–1658) and his highly disciplined and fanatically Protestant troops ("Ironsides") undertook to reduce the pro-Stuart resistance in Ireland. His campaign began with the reduction of Drogheda (on the coast 32 miles north of Dublin); the Ironsides massacred at least 2,800 men of the garrison. Many, though not all, accounts cite "thousands" of women and children as victims. Cromwell's dictum: "I am persuaded that this is the righteous judgment of God upon these barbarous wretches," and one massacre followed another on the principle that the bloodbath would break Irish resistance. The motto on the cannon's mouth is apparently apocryphal but an apt caricature.

328:8–9 (334:6–7). that skit in the United ... that's visiting England—the United Irishman, the weekly (Thursday) newspaper edited by Arthur Griffith, did print skits of the sort the Citizen reads but not the one that follows.

328:14 (334:12). His Majesty the Alaki of Abeakuta—Abeakuta was a province in western Nigeria; the Alaki was the equivalent of the sultan of a small state. He was not a Zulu, but he was in fact visiting England in the summer of 1904.

328:20 (334:18). Ananias Praisegod Barebones—Praise-God Barebones (or Barbon) (c.1596–1679), a London tanner, fanatic and lay preacher. He was a member of the Parliament of 1653, called the "Barebones Parliament" in mockery of its alleged unpractical and sanctimonious nature. Ananias was one of the Jewish high priests who sat in judgment on St. Paul and "commanded them that stood by [Paul] to smite him on the mouth" (Acts 23:1–5). Ananias is also one of the Puritan preachers in Ben Jonson's The Alchemist (1610).

328:24–26 (334:22–24). bible, the volume of the word ... the great squaw Victoria—the Alaki discussed the Bible in question with Edward VII in the course of his visit to England.

328:28–29 (334:27). Black and White—a brand of Scotch whiskey.

328:31 (334:29). Cottonopolis—a nickname for Manchester, the textile center of England.

328:39–41 (334:38–40). Is that by Griffith? ... It's only initialled: P—Arthur Griffith did write "skits" of the sort quoted (see 328:8–9n), at first under the pseudonym "Shanganagh" and subsequently simply initialed "P" (for the spirit of Parnell?). Brendan O Hehir defines the Irish "Shanganagh" as "ant-full" or "old sand" (on the coast south of Dublin); P. W. Joyce, in English as We Speak It in Ireland (p. 319), defines it as "a friendly conversation," which seems more appropriate here.

329:3–6 (335:3–6). those Belgians in the Congo ... Casement ... He's an Irishman—the Irish-born Sir Roger Casement (1864–1916) was in the British Consular Service (1895–1913). In February 1904, while serving as consul in the Congo, Casement filed a report on the forced labor in rubber plantations and other cruelties to natives under the Belgian administration in the Congo. The report was published, and the public reaction led in January to a reconvening of the Conference of Powers that had originally established Belgian control of the Congo; the conference resulted in a measure of reform. Casement (1914) joined the then militant Sinn Fein, negotiated with Germany for military support of an Irish revolt and was hanged for high treason.

329:24 (335:24). Goodbye Ireland I'm going to Gort—the usual form of this saying is, "Goodbye, Dublin, I'm going to Gort." It expresses the countryman's dissatisfaction with the city. Gort is a small village near Sligo in western Ireland.

329:28 (335:28). Slattery's—a pub, William Slattery, grocer, tea, wine and spirit merchant, 28 Ship Street Great (in central Dublin south of the Liffey).

329:32 (335:33). tube—intercom device.

329:39–42 (335:39–336:2). Bloom gave the idea for ... selling Irish industries—as originally conceived, Sinn Fein did not contemplate violence (as Bloom thinks, 161 [163]), but the nonviolent subversion of English institutions in

Ireland and the establishment of independent Irish political and economic institutions; see 161:24n. In part, the "idea" for *Sinn Fein* derived from a similar and successful Hungarian resistance to Austrian dominion in the latter half of the nineteenth century. Bloom's "Hungarian" background apparently provides the foundation for this rumor about his political activity.

330:3 (336:4). God save Ireland—see 161:3n.

330:4 (336:5). argol bargol—after the Irish *argáil* ("argument, discussion") but also after the Shakespearean "argal" (a corruption of *ergo*); therefore, "unsound reasoning, caviling."

330:5 (336:6–7). Methusalem Bloom—i.e., Rudolph (Virag) Bloom; Methuselah, the longest-lived man in the Bible: "And all the days of Methusalem were nine hundred sixty and nine years: and he died" (Genesis 5:27).

330:6 (336:7). bagman—commercial traveler.

330:10–11 (336:11–12). Lanty MacHale's goat ... the road with everyone—a common expression, though it usually involves MacHale's excessively friendly dog instead of a goat. Charles Lever (1806–1872) memorializes Lanty or Larry M'Hale in a poem entitled "Larry M'Hale." The poem celebrates M'Hale's willingness to "ride with the rector [Protestant], and drink with the priest [Catholic]," his capacity for violence and his even-handed indifference to debt and the law: "And, though loaded with debt, oh! the devil a thinner/Could law or the sheriff make Larry M'Hale."

330:15 (336:16). Crofton—the Orangeman (Protestant and pro-English) appears as a character in "Ivy Day in the Committee Room," *Dubliners*.

330:16–17 (336:17–18). pensioner out of the collector ... have on the registration—i.e., Crofton once worked for the collector general of customs, but he has been pensioned from that service and now works (?) as an assistant to R. T. Blackburne, secretary to the Dublin County Council in 1904.

Parody: 330:19–331:11 (336:21–337:13). Our travellers reached ... 'Tis a merry rogue—parodies the style of late-nineteenth-century versions of medieval romance.

330:27 (336:29). good den—archaic: "good evening."

331:7 (337:9). tansy—a pudding or omelet flavored with tansy juice.

331:16 (337:18). about Bloom and the Sinn Fein—see 329:39–42n.

331:23 (337:26). a swaddler—one under rigid controls or restrictions, i.e., a Protestant.

331:27 (337:31). Who is Junius?—Junius was the pseudonym of the unknown author of letters that appeared in the *Public Advertiser* in London between 1769 and 1772. The letters are biting and scurrilous attacks on George III and his ministers and are distinguished by considerable evidence of the writer's access to highly confidential government information. The answer to J. J. O'Molloy's question is still a riddle, though there was a tendency in 1904 (given an assist by Macaulay) to attribute the letters to Dublin-born Sir Philip Francis (1740–1818).

331:29–30 (337:33–34). according to the Hungarian system—Cunningham is alluding to Arthur Griffith's *The Resurrection of Hungary,* serialized in the *United Irishman* (January–June 1904). The book recounts the history of Hungary's struggle for a measure of independence from Austrian rule and presents that history as an appropriate model for Irish enterprise.

331:31 (337:35). Bloom the dentist—Marcus J. Bloom, 2 Clare Street, Dublin.

331:35–36 (337:39–40). Island of saints and sages—see 41:18n.

331:37 (337:41). They're still waiting for their redeemer—i.e., the Jews who believe that the Messiah is yet to come.

331:39–41 (338:1–3). every male that's born ... a father or a mother—Moslem rather than Jewish tradition. Many Jewish community traditions do heavily emphasize the desirability of male children, but the fundamental Jewish belief is that each married couple should perpetuate itself by achieving *both* a son and a daughter who live to be married and to produce children in their turn.

332:3 (338:7). Neave's food—was advertised as a health food for "infants, invalids, growing children, and the aged."

332:5 (338:9). En ventre sa mère—French: "In the belly of his mother."

332:10 (338:14). And who does he suspect?—see 199:38n.

332:13 (338:17). a totty with her courses—slang: "a high-class prostitute with her menstrual period."

332:16 (338:20). sloping—to "slope" is slang for to disappear, to decamp, to run away.

332:21 (338:26). A wolf in sheep's clothing—Matthew 7:15: "Beware of false prophets, which come to you in sheep's clothing, but inwardly they are ravening wolves."

332:22 (338:27-28). Ahasuerus I call him. Cursed by God—Ahasuerus was the name of two kings of Persia and Media (Esther, Ezra, Daniel), but the Citizen intends Ahasuerus as one of the traditional names for the Wandering Jew; see 215:4n.

332:26 (338:32). Saint Patrick would want to land again at Ballykinlar—as with the date and place of his birth, the site of St. Patrick's landing in Ireland is a matter of contention. Two sites enjoy the reputation: the mouth of the Vantry River near Wicklow Head (on the coast south of Dublin), and Dundrum Bay (north of Dublin); Ballykinlar is a village on Dundrum Bay, five miles south of Downpatrick in County Down.

Parody: 332:33-334:35 (338:39-340:42) And at the sound of . . . Christum Dominium Nostrum—this vision of the Island of Saints and Sages parodies "church news" accounts of religious festivals, in this case a procession that culminates in the blessing of a house; see 333:42-334:1n.

332:34 (338:39). thurifers, boatbearers—in the rite of blessing the incense during the Mass, a boatbearer carries the boat in which the incense is held, while the celebrant (priest) takes incense from the boat and puts it into the censor (thurible), in which it is burned.

332:36-37 (339:1). the monks of Benedict of Spoleto—i.e., the Benedictines. St. Benedict (c.480-c.543), who founded the order, was born at Nursia, an episcopal city in the Duchy of Spoleto in Italy. The *Rule of St. Benedict*, evolved by Benedict at Monte Cassino, formed and established the historical model for the monastic life of western Europe.

332:37 (339:1). Carthusians—founded in 1086 by St. Bruno (c.1030-1101) at La Grande Chartreuse in France. The Carthusians were noted for the austerity of their adherence to the Rule of St. Benedict.

332:37 (339:1). Camaldolesi—founded in 1012 by St. Romuald (c.950-1027), a Benedictine, on the plain of Camaldoli, near Arezzo in Italy. The monks wore white robes and were noted for the rigidity of their monastic rule.

332:37 (339:2). Cistercians—another offshoot of the Benedictine order, founde d in 1098 by S. Robert, Abbot of Molesme, at Citeaux near Dijon in France. The Cistercians also wore white habits and practiced a monastic rule of considerable severity.

332:38 (339:2). Olivetans—another offshoot of the Benedictine order, founded in 1319 at Monte Oliveto between Siena and Arezzo in Italy by Giovanni de' Tolomei (Blessed Bernard Ptolomei) (1272-1348).

332:38 (339:2). Oratorians—the Fathers of the Oratory or the Oratory of St. Philip Neri (1515-1595), founded at Rome by that saint in 1575. The priests of the congregation live in community but without monastic vows and under an essentially democratic constitution.

332:38 (339:2). Vallombrosans—founded (c.1056) at Vallombrosa near Florence by St. John Gualbert (985-1073). The order was committed to austere observance of the Rule of St. Benedict.

332:38-39 (339:3). the friars of Augustine—the Begging Friars or Hermits of St. Augustine or Austin Friars, founded by the union of several societies of recluses in the middle of the thirteenth century. They lived under the Rule of St. Augustine, derived from sermons attributed to St. Augustine (353-430).

332:39 (339:3). Brigittines—the Order of Our Saviour, founded in 1346 by St. Bridgit (c.1303-1373) of Sweden and dedicated to the Rule of St. Augustine.

332:39 (339:3). Premonstratesians—the Order of Canons Regular, founded in 1120 at Premontré near Laon in France by St. Norbert (b. c.1080). The order lived under an austere version of the Rule of St Augustine.

332:39 (339:4) Servi—the Servites or Servants of Mary, a monastic order founded in Florence in 1233 by seven wealthy Florentines. It was conducted under the Rule of St. Augustine.

332:39 (339:4). Trinitarians—the Order of the Holy Trinity for the Redemption of Captives, founded in 1198 by St. John de Matha (1160-1213) and St. Felix of Valois (1127-1212). The order lived under the Rule of St. Augustine and was dedicated to the work of freeing Christians held in captivity in North Africa and the Middle East.

332:40 (339:4). the children of Peter Nolasco—the Mercedarians, the Order of Our Lady of Mercy for the Ransom of Captives, initially a congregation of laymen founded by St. Peter

Nolasco (1189–1256 or 1259) in 1218. The congregation lived under the Rule of St. Augustine and worked to ransom Christians captive among the Moors.

332:40–42 (339:5–6). from Carmel mount the children . . . Avila, calced and other— the Order of Our Lady of Mount Carmel. There has been some controversy over its origins; some of its early members believed that it was founded by the prophet Elijah. Apparently it was founded by Bertrand, Count of Limoges, a soldier turned monk, who with ten companions established a hermitage on Mount Carmel in 1156. St. Albert, the Patriarch (Bishop) of Jerusalem, gave them their "Rule" in c.1208. In the fourteenth and fifteenth century the order relaxed from the severities of the Rule of St. Albert; in the sixteenth century a sweeping reform of the order was achieved by St. Theresa of Jesus (of Ávila) (1515–1582) with the aid of St. John of the Cross. From that time the order had two branches: "discalced" (without shoes) in strict adherence to the Rule of St. Albert (inspired by St. Theresa) and "calced" (with shoes) in adherence to a modification of the rule approved by Pope Eugenius IV.

332:42 (339:7). friars brown and grey—i.e., the Dominicans and the Franciscans; see below.

333:1 (339:7). sons of poor Francis—the Franciscans, Order of Friars Minor, founded in 1209 by St. Francis of Assisi (1182–1226). The order was initially dedicated to the rule of poverty, but it rapidly became wealthy and powerful after the death of St. Francis.

333:1 (339:7). capuchins—(after the Italian *cappuccio*, "cowl," of their habit), a branch of the Franciscans founded in 1525 in an effort to revive the dedicated simplicity of the Rule of St. Francis.

333:1 (339:8). cordeliers—Franciscan friars who announced their strict adherance to the Rule of St. Francis by wearing knotted cords around their waists.

333:1 (339:8). minimes—mendicant friars, the Order of Minims (*Ordo Minimorum Eremitarum*), founded by St. Francis of Paola (1416–1507) in 1454.

333:1–2 (339:8). observants—the Friars Minor of the Regular Observance (c.1460), dedicated to strict observance of the Rule of St. Francis as against the "Conventuals," who observed a modified version of the rule.

333:2 (339:8). the daughters of Clara—the Clares, the Order of Poor Ladies (1212), founded

by St. Clare of Assisi (1193–1253) and St. Francis, as the feminine counterpart of the Friars Minor.

333:2–3 (339:9). the sons of Dominic, the friars preachers—the Dominicans, the Order of Friars Preachers (c.1215), founded by St. Dominic (c.1170–1221). The avowed purpose of the order was the salvation of souls, especially by means of preaching.

333:3 (339:9–10). the sons of Vincent—the Vincentian Fathers, the Congregation of the Mission of St. Vincent de Paul (the Order of Lazarists), founded in 1624 by St. Vincent de Paul (1576–1660) and dedicated to the relief of the poor under his *Constitutions of the Congregation of the Mission*.

333:3–4 (339:10). the monks of S. Wolstan—St. Wolstan (1008–1095), a Benedictine and Bishop of Worcester, the last of the Saxon bishops of England, noted not for having founded an order but for the extraordinary devotion of his life to prayer and to the duties of his bishopric.

333:4 (339:10–11). Ignatius his children—the Jesuits, the Society of Jesus, founded in 1534 by St. Ignatius Loyola (1491–1556) and noted for its commitment to education.

333:4–6 (339:11–12). the confraternity of the christian . . . Edmund Ignatius Rice—the Christian Brothers, a teaching brotherhood of Catholic laymen, bound under temporary vows. The original school was founded at Waterford in 1802 by Edmund Ignatius Rice (1762–1844), a layman who took religious vows in 1808 and whose organization was sanctioned by the pope in 1820.

333:7 (339:13). S. Cyr—the French name for the child martyr St. Cyricus (St. Quiricus) (d. c.304). St. Cyr is also the French equivalent of West Point.

333:7 (339:13–14). S. Isidore Arator—St. Isidore ("belonging to tillage") the Farmer (Spanish, 1070–1130), a confessor and the patron saint of peasants, farmers and day laborers. Feast day: 25 October.

333:7 (339:14). S. James the Less—or St. James the Just, one of the 12 Apostles and "a kinsman of the Lord," subsequently bishop of Jerusalem (so called to distinguish him from the other Apostle, St. James, the son of Zebedee). Feast day: 11 May.

333:8 (339:14). S. Phocas of Sinope—St. Phocas the Gardener (n.d.) of Sinope (in Asia Minor), a martyr remembered for his hospitality to those who martyred him. Feast day: 22 September.

333:8 (339:15). S. Julian Hospitator—(n.d.), also noted for his hospitality, the patron saint of travelers, ferrymen and wandering minstrels. His hospitality was his manner of penance for having killed his parents under the impression that they were his wife and a lover. Feast day: 12 February.

333:8–9 (339:15). S. Felix de Cantalice—(1513–1587), a peasant from the Abruzzi who became a Capuchin; he styled himself "the Ass of the Capuchins" and was noted for his simplicity and holiness. Feast day: 18 May.

333:9 (339:15–16). S. Simon Stylites—(388–459), i.e., St. Simon of the Pillar, an anchorite who dramatized his rigorous asceticism by spending over 35 years of his life on the top of a pillar. He is said to have spent the entire 40 days of Lent standing upright and abstaining from all food and drink. Feast day: 5 January.

333:9 (339:16). S. Stephen Protomartyr—see 5:37n. Feast day: 26 December.

333:10 (339:16). S. John of God—(1495–1550) Portuguese, the patron saint of hospitals for the needy poor and the founder of the Order of Brothers Hospitallers. Feast day: 8 March.

333:10 (339:17). S. Ferreol—a legendary Spanish saint said to have been responsible for the conversion of Besançon in the early sixth century. Also a St. Ferreolus (*fl.* third century) suffered martyrdom in southern France. Feast day: 18 September.

333:10 (339:17). S. Leugarde—the French version of "St. Lugaid" or "Lughaid" (d. 608), an Irish abbot and missionary. Feast day: 4 August.

333:10 (339:17). S. Theodotus—martyred (*c.*304). He was an innkeeper who refused to make votive offerings to idols of the food he served his guests (as required by law). He was martyred for giving Christian burial to seven martyred virgins. He is the patron saint of innkeepers. Feast day: 18 May.

333:11 (339:17). S. Vulmar—or St. Wulmar (*fl.* seventh century), a French abbot and recluse who founded a monastery and a nunnery near Calais. Feast day: 20 July.

333:11 (339:18). S. Richard—Richard de Wych (1197–1253), an English bishop, Chancellor of Oxford, famous for his victory over Henry III (1207–1272) in a Church-State power struggle.

333:11 (339:18). S. Vincent de Paul—see 333:3n. Feast day: 19 July.

333:12–14 (339:18–21). S. Martin of Todi . . .

S. Owen Caniculus—Martin Cunningham, Alfred Bergan, Joseph J. O'Molloy, Denis Breen, Cornelius Kelleher, Leopold Bloom, Bernard Kiernan, Terence Ryan, Edward Lambert and the dog Garryowen join the company of the saints.

333:12 (339:18). S. Martin of Todi—Martin I (d. 655), pope and martyr, was born at Todi in Umbria (Italy). His pontificate was marked by a struggle between the papacy (the Bishop of Rome) and the Emperor Constans II (emperor 641–668) in Constantinople. Martin I refused a doctrinal compromise, was summoned to Constantinople, arrested for treason, maltreated and banished into exile. Feast day: 12 November.

333:12 (339:19). S. Martin of Tours—(*c.*316–397) began life as a soldier, experienced conversion and became a solitary with a following of monks. In humility he refused the bishopric of Tours but was made bishop by a ruse. His leadership is credited with firmly establishing monasticism in western Europe. Feast day: 11 November. (St. Patrick [*c.*373–*c.*463] studied at Tours before his mission to Ireland.)

333:12 (339:19). S. Alfred—Alfred the Great (849–899), king of the West Saxons, was not only a great military leader but also a great legalist, educator and church reformer. In part, his reputation is legendary as is his sainthood, which has never been formally conferred by the Church.

333:13 (339:19). S. Joseph—spouse of the Blessed Virgin Mary, Confessor and Patron of the Universal Church. Feast day: 19 March.

333:13 (339:19). S. Denis—or St. Dionysius, martyr (d. *c.*275), bishop of Paris and one of the patron saints of France. He was beheaded because his success in making converts threatened to transform Paris into a Christian "island."

333:13 (339:20). S. Cornelius—(d. 253), pope (251–253) and martyr who resisted the schism of Novatian and suffered banishment in the eighth persecution under the Roman emperors Valerian and Gallienus. Hs is commemorated for "his wisdom, for his works outshine the sun." Feast day: 16 September.

333:13 (339:20). S. Leopold—Leopold the Good (1073–1136), an Austrian soldier-saint who founded several monasteries. Feast day: 15 November.

333:13–14 (339:20). S. Bernard—of Clairvaux (1090–1153), a Cistercian and abbot of Clairvaux; he is credited with having founded 163 monasteries and is remembered as one of the great doctors of the medieval Church.

333:14 (339:20–21). S. Terence—(*fl.* first century), a little-known bishop and martyr.

333:14 (339:21). S. Edward—either St. Edward the Martyr (962–979), king of England; or, more probably, St. Edward the Confessor (*c.*1003–1066), king of England, noted for his innocence and humility and famous for the gift of prophecy. Feast day: 13 October.

333:14 (339:21). S. Owen Caniculus—"Canicula" is Latin for a small dog or bitch; thus, "St. Owen of the dogs," Garryowen.

333:17 (339:23–24). S. Laurence O'Toole—(1132–1180), archbishop of Dublin, an Irish soldier-saint who resisted the Norman invasion of Ireland but finally submitted to Henry II at the pope's insistence. He is the patron saint of Dublin. Feast day: 14 November.

333:17–18 (339:24). S. James of Dingle and Compostella—the Apostle and martyr, St. James the Great, the son of Zebedee; *cf.* 333:7n (d. *c.*44). He is said to have conducted a mission in Spain and, though he was beheaded in Jerusalem, his body was miraculously transported to Compostella in Spain; Compostella thus became the most popular pilgrimage in western Europe. Feast day: 25 July. The Roman Catholic parish church of Dingle on Dingle Bay, southwestern Ireland, is the Church of St. James Compostella; Dingle Bay was the site of a sizable Spanish community in the sixteenth century.

333:18 (339:25). S. Columcille and S. Columba—one Celtic saint with two names (521–597), the founder of several monastic churches and schools in Ireland, Scotland and the Hebrides. He is (with St. Bridgid and St. Patrick) one of the three patron saints of Ireland. Feast day: 9 June.

333:18 (339:25). S. Celestine—Celestine I, pope (422–432), defended the Church against the Semipelagian Heresy. He is dear to the hearts of the Irish as the pope who sent St. Patrick on his mission to Ireland.

333:19 (339:25). S. Colman—(1) of Cloyne (522–600), missionary and chief bard to the king of Munster. Feast Day: 24 November. (2) Or St. Elo (553–610), founded several abbeys and monasteries. Feast day: 26 September. (3) Or (d. 676), bishop of Lindisfarne, noted for his disputations (defeated) on the question of the date of Easter. Feast day: 8 August.

333:19 (339:26). S. Kevin—(d. 618), the founder and abbot of the monastery at Glendalough. Feast day: 3 June.

333:19 (339:26). S. Brendan—see 291:40n.

333:19 (339:26). S. Frigidian—(d. *c.*558), an Irish saint who made a pilgrimage to Italy, where he became a hermit and subsequently bishop of Lucca. Feast day: 18 March.

333:20 (339:26). S. Senan—the most famous of the 20-odd Irish saints of this name is S. Senan (*c.*488–*c.*544), after whom the River Shannon was named. He made a pilgrimage to Rome and returned to found several monastic churches in Ireland, among them a hermitage church on Scattery Island in the Shannon chosen as a site "on which no female had ever trod." Immediately after the hermitage was founded, a female St. Cannera asked for sanctuary and could not be denied. Feast day: 8 March.

333:20 (339:27). S. Fachtna—(*fl.* sixth century), bishop of Roses and founder there of one of the most famous monastic schools of Ireland. Feast day: 14 August.

333:20 (339:27). S. Columbanus—see 28:38n Feast day: 21 November.

333:20 (339:27). S. Gall—(*c.*551–645), an Irish missionary to the Continent and a companion of St. Columbanus who was known as "the apostle of Switzerland." Feast day: 16 October.

333:21 (339:27). S. Fursey—St. Fursa; see 291:39n.

333:21 (339:28). S. Fintan—(1) (d. 595), the founder of an influential monastery at Cloneagh in Ireland and known as "head of the monks of Ireland." Feast day: 17 February. (2) Or Munnu (d. 634), the founder of a monastery in County Wexford, a missionary to Scotland, who died a leper. Feast day: 21 October.

333:21 (339:28). S. Fiacre—see 43:6n. Feast day: 1 September.

333:21 (339:28). S. John Nepomuc—(*c.*1340–1393), confessor and martyr who was supposed to have been tortured and drowned by "good" King Wenceslaus of Bohemia because the saint refused to reveal the queen's confession. He is one of the patron saints of Bohemia and of confessors. Feast day: 16 May.

333:22 (339:29). S. Thomas Aquinas—see 19:21n. Feast day: 7 March.

333:22 (339:29). S. Ives of Brittany—Ivo or Yves Hélory (1253–1303), a confessor, bishop's judge and lawyer who used his fees for philanthropy and defended the poor without charge. He is the patron saint of lawyers. Feast day: 19 May.

333:22 (339:29). S. Michan—little is known about this tenth- or eleventh-century Danish-Irish saint except that he is styled "bishop" and "confessor," and one of Dublin's more famous churches is named for him. Feast day: 25 August.

333:23 (339:30). S. Herman-Joseph—the Blessed Herman-Joseph (1150–1241), the German mystic, beatified but not canonized. Originally named Herman, the Virgin Mary bestowed the name Joseph on him in one of his many visions. Feast day: 7 April.

333:23 (339:30). the three patrons of holy youth—the three youthful Jesuit saints noted below are regarded as the patron saints of Jesuit schools for boys ("holy youth").

333:23–24 (339:31). S. Aloysius Gonzaga—(1568–1591), Italian Jesuit saint, famous for his zeal for the virtue of chastity. Popularly regarded as a model of youthful purity, he died at the age of twenty-three from attending plague victims. He is one of the patron saints of youth. Feast day: 21 June.

333:24 (339:31). S. Stanislaus Kostka—(1550–1568), a Jesuit novice who overcame his family's resistance to his calling and demonstrated his faith by walking the 350 miles from Vienna to Rome to join the order. Feast day: 13 November.

333:24 (339:31–32). S. John Berchmans—(1599–1621), another Jesuit devotee of the innocence and purity of youth. Feast day: 26 November.

333:25 (339:32). Gervasius—(d. c.165), martyred at Milan (beaten with leaden whips) by the Roman general Astasius, who ordered the death of all Christians in his province. A brother (?) and fellow martyr, Protasius, was beheaded in the same purge. Feast day: 19 June.

333:25 (339:32). Servasius—St. Servatius (d. 384), bishop of Tongres (in modern Belgium), commanded considerable reverence in medieval western Europe. Feast day: 13 May.

333:25 (339:32). Bonifacius—the best known of the saints of this name was St. Boniface (c.675–754), born Winfrid of England. He became "the apostle of Germany," archbishop of Mainz and was martyred in a massacre of Christians in Friesland. Feast day: 5 June.

333:25 (339:33). S. Bride—or St. Bridgid (c.453–c.523), one of the three patron saints of Ireland. She founded several monasteries and is supposed to be buried in Downpatrick with Sts. Patrick and Columcille, the other two patrons of Ireland. Feast day: 1 February.

333:26 (339:33). S. Kieran—among the several Irish saints of this name: (1) St. Kiernan (c.500–c.560), bishop of Ossory and "One of the Twelve Apostles of Ireland." Feast day: 15 March. (2) St. Kiernan of Clonmacnois (fl. sixth century), the founder of one of the most remarkable of the Irish monastic schools. Feast day: 9 September.

333:26 (339:33). S. Canice of Kilkenny—see 45:1n. Feast day: 11 October.

333:26 (339:33–34). S. Jarlath of Tuam—(d. c.540) built a church in Tuam (County Galway) and established the first bishopric in Connaught; Tuam still retains its primacy in that province. Feast day: 6 June.

333:27 (339:34). S. Finnbarr—the most famous of the five Irish saints of this name (c.550–623) established the bishopric of Cork, founded a monastic school that dominated the district around Cork and is the patron saint of that city. Feast day: 25 September.

333:27 (339:34). S. Pappin of Ballymun—(fl. sixth century), little is known of him except that he was the abbot of a monastery at Ballymun (in the parish of Santry four miles north of the center of Dublin; the parish church still bears his name, St. Papan, and presumably occupies the site of the monastery). In the *Martyrology of Tallaght* St. Papan and his brother, St. Folloman, are commemorated on 31 July.

333:27–28 (339:35). Brother Aloysius Pacificus—a brother and disciple of St. Francis of Assisi; see 333:1n.

333:28 (339:35). Brother Louis Bellicosus—bellicosity to balance peacefulness?

333:28 (339:36). Rose of Lima—(1586–1617), a virgin saint born in Lima, Peru, her face transformed by a mystical rose in childhood (hence her name) and her life transformed by many visions of Christ. She is the first American saint and thus the patroness of the Americas. Feast day: 30 August.

333:28–29 (339:36). Rose . . . of Viterbo—(d. 1252), the patron saint of that Italian city. She was a member of the Third Order of St. Francis and was noted for the miracles associated with her and for the eloquence of her condemnation of the Holy Roman Emperor's (Frederick II's) interference with the Church. Feast day: 4 September.

333:29 (339:36–37). S. Martha of Bethany—one of Lazarus' sisters; see 78:4n. Feast day: 29 July.

333:30 (339:37). S. Mary of Egypt—(*fl. c.*400), a public prostitute in Alexandria who made a pilgrimage to Jerusalem, where she was forbidden to enter the church but was admitted by the miraculous intervention of the Blessed Virgin Mary. After this experience, she is supposed to have spent 47 penitential years in the wilderness beyond the Jordan and to have attained to that level of purity which enabled her to walk upon water. Feast day: 2 April.

333:30 (339:37). S. Lucy—a virgin martyred at Syracuse at the end of the third century. There are a variety of legends about her career as a Christian virgin pledged to chastity in a pagan world. In one version she was denounced as a Christian by a suitor whom she had refused in favor of her vows. Brought before the emperor, she was condemned to exposure in a brothel, but the emperor's soldiers and magicians could not move her; they built a fire around her and she was unscathed until stabbed in the throat. Another version of the legend is that Lucy's eyes attracted a suitor, whereupon she plucked out her eyes only to have them miraculously restored. Feast day: 13 December.

333:30 (339:37). S. Brigid—see S. Bride, 333:25n.

333:30 (339:38). S. Attracta—or St. Araght (*fl.* fifth century). She was supposed to have received her veil from St. Patrick and to have divided her time between founding monastic houses in Galway and Sligo and praying in solitude. Feast day: 11 August.

333:30 (339:38). S. Dympna—virgin and martyr (seventh century), the Christian daughter of a pagan (Irish?) king who fled to the Continent to escape her father and/or his "unholy desires." He followed her and murdered her at Gheel near Antwerp. Miracles associated with her relics have made her the patron saint of the insane. Feast day: 15 May.

333:31 (339:38). S. Ita—(*c.*480–570), "the Mary or Brigid of Munster." She gave up the name "Deidre" for "Ita" (to assert her thirst for God) and was the founder of a religious community and school near Limerick. Feast day: 15 January.

333:31 (339:38). S. Marion Calpensis—St. Marion of Calpe (Gibraltar), i.e., Molly Bloom.

333:31–32 (339:39). the Blessed Sister Teresa of the Child Jesus—(1873–1897), beatified in *1923* and canonized in 1925. She was a member of the Order of Carmelites Discalced, noted for her dedication to "the spiritual way of childhood according to the teaching of the Gospels." Also

known as St. Teresa of Lisieux. Feast day: 3 October.

333:32 (339:39–40). S. Barbara—virgin and martyr, a legendary saint, said to have been martyred in Bithynia (*c.*236) or in Egypt (*c.*306). The daughter of a "fanatic heathen," she was delivered to the law for torture by her father, who subsequently beheaded her when she refused to recant. Her father was struck by lightning on the spot; hence, she is the patron saint of those threatened by lightning and storms, of artillerymen, fireworks makers, etc. Feast day: 4 December.

333:32 (339:40). S. Scholastica—(*c.*480–*c.*543), a sister of St. Benedict (see 332:36–37n). She followed him to Monte Cassino, where she established a community of nuns governed according to her brother's rule. Feast day: 10 February.

333:32–33 (339:40–41). S. Ursula with eleven thousand virgins—see 8:28n. Feast day: 21 October.

333:33–34 (339:41). nimbi and aureoles and gloriae—in art, the symbols of sanctity; the nimbus is represented as surrounding the head; the aureole, the body; and the glory combines nimbus and aureole. The nimbus is used in representations of saints and holy persons; the aureole is reserved for the three persons of the godhead and for the Virgin Mary.

333:34 (339:42). palms—symbolic of martyrdom, the palm belongs to all the "noble army of martyrs."

333:34 (339:42). harps—symbolic of the Book of Psalms and of songs in praise of God. The harp is also the traditional symbol of Ireland, the Isle of Saints in procession.

333:34 (339:42). swords—symbolic of martyrdom and also associated with warrior-saints.

333:34–35 (339:42). olive crowns—symbolic of peace, used in representations of the Archangel Gabriel and several saints and on the tombs of martyrs.

333:36 (340:2). inkhorns—symbolically an attribute of the Doctors of the Church, St. Augustine (see 140:30–33n), St. Bernard (333:13–14n), and of the Evangelists, Mark and Matthew.

333:36 (340:2). arrows—symbolic of spiritual weapons dedicated to the service of God, and also symbolic of the plague. St. Sebastian is depicted as pierced by arrows, and since he survived, he is one of the patron saints of those

suffering from the plague. St. Ursula is also reputed to have survived torture by arrows (see 8:28n). St. Theresa is occasionally represented with a flaming arrow in her breast (see 332:40–42n).

333:36 (340:2). loaves—in general, the staff of life; symbolically, three loaves of bread are an attribute of St. Mary of Egypt (see 333:30n) and a loaf is an attribute of St. Dominic because he is supposed to have fed his monastery by divine intervention (see 333:2–3n).

333:36 (340:2). cruses—(bottles, jugs), an attribute of, among others, St. Benedict (see 332:36–37n) and (on the end of a staff) of St. James the Great (see 333:17–18n).

333:36 (340:2). fetters—symbols of the Passion, the flagellation of Christ by the soldiers; also an attribute of St. Leonard (d. c.546) for his charitable work among the prisoners of King Clovis of France.

333:36 (340:2). axes—symbols of destruction; an axe is an emblem of St. Joseph (see 333:13n) as carpenter, and it is also the emblem of the beheaded martyrs, St. John the Baptist, St. Matthew and St. Mathias.

333:37 (340:2). trees—variously symbolic of lineage as in the Tree of Jesse (the lineage of Christ) and of regenerative power, as the flowering tree is an attribute of the fourth-century Florentine St. Zenobius and in commemoration of his power to restore dead things to life.

333:37 (340:2). bridges—an attribute of (among others) St. John Nepomuc because he was martyred by being cast from a bridge to drown (see 333:21n).

333:37 (340:3). babes in a bathtub—an attribute of the legendary fourth-century St. Nicholas of Myra or Bari symbolizing his miraculous restoration of life to three dead children.

333:37 (340:3). shells—a scallop shell is an attribute of St. James the Great (see 333:17–18n). The shell was worn as an emblem by pilgrims to his shrine at Compostella.

333:37 (340:3). wallets—symbolic of pilgrim-saints; an attribute of St. Roch (together with the pilgrim staff and the shell of St. James of Compostella).

333:37 (340:3). shears—or pincers; an attribute of the third-century St. Agatha of Sicily, who was tortured by having her breasts torn with shears. Pincers are also an attribute of the third-century St. Apollonia of Alexandria, who was

tortured by having her teeth torn out in the process of her martyrdom; she is the patron saint of dentists.

333:37 (340:3). keys—an attribute of St. Peter as guardian of "the keys of the kingdom of heaven" (Matthew 16:19) and of St. Martha (see 333:29n), the patron saint of good housekeeping.

333:38 (340:3). dragons—symbolic of the devil and the attribute of the Archangel Michael and of several saints, including the second-century St. George of Cappadocia, the patron saint of England, and of St. Martha (see 333:29n), who after the Crucifixion is supposed to have traveled to southern France and to have rid that region of a dragon.

333:38 (340:3). lilies—symbolic of purity and therefore the flower of the Virgin Mary; and as symbolic of chastity, the attribute of several saints, including St. Francis (see 333:1n), St. Dominic (see 333:2–3n), St. Clare (see 333:2n) and St. Joseph (see 333:13n).

333:38 (340:4). buckshot—an obvious anachronism in this list of "symbolic attributes," but it may recall those Irish "martyrs" who benefited from William E. (Buckshot) Forster's determination that the Royal Irish Constabulary (for humanitarian reasons) should use buckshot rather than ball cartridges when firing on crowds. Forster (1819–1886) was chief secretary for Ireland (1880–1882) and a Quaker.

333:38 (340:4). beards—apart from their general representational occurrence, beards are the particular attributes of several young minor saints who obtained beards by prayer; none of these latter is mentioned in *Ulysses*.

333:38 (340:4). hogs—symbolic of sensuality and gluttony; one of the attributes of the fourth-century Egyptian hermit St. Anthony the Great or Anthony Abbot, who spent 20 solitary years in the desert in a successful attempt to defeat the demons (temptations) of the flesh and to live for God alone.

333:38 (340:4). lamps—generally symbolic of wisdom and piety, specifically of the "wise virgins," and as such an attribute of St. Lucy (see 333:30n).

333:38 (340:4). bellows—held by the devil (as a means of intensifying the flames of the flesh); an attribute of the early-sixth-century St. Genevieve.

333:38 (340:4). beehives—symbolic of great eloquence; an attribute of (among others) St. Bernard of Clairvaux (see 333:13–14n), because "his eloquence was as sweet as honey."

333:39 (340:4). soupladles—a spoon, held by a child near him, is an attribute of St. Augustine of Hippo (see 140:31–33n).

333:39 (340:5). stars—symbolic of divine guidance or favor; the Virgin Mary as Queen of Heaven is crowned with 12 stars (Revelation 12:1); the star is symbolic of her title "Stella Maris" ("Star of the Sea"); and a star on the forehead is an attribute of (among others) St. Dominic (see 333:2–3n).

333:39 (340:5). snakes—St. John, Apostle and Evangelist, was occasionally depicted with a cup (of poison) and a snake, symbolic of an attempt made on his life by the Roman Emperor Domitian. St. Patrick is often depicted as treading upon snakes to signify his having rid Ireland of venomous creatures, and St. Phocas (see 333:8n) is depicted as entwined with snakes.

333:39 (340:5). anvils—the martyr St. Adrian (d. 290) is depicted holding an anvil since an anvil figured in his martyrdom.

333:39 (340:5). boxes of vaseline—secular and commercial reduction of box of ointment, symbolic of humble and costly affirmation, an attribute of Mary Magdalene and of Mary the sister of Lazarus (equated in medieval and Renaissance art) after John 12:3: "Then took Mary a pound of ointment of spikenard, very costly, and anointed the feet of Jesus, and wiped his feet with her hair." The box of ointment is also an attribute of the two surgeon-saints (see "forceps," 333:40n).

333:39 (340:5). bells—symbolic of the power to exorcise evil spirits; one of the attributes of (among others) St. Anthony (see "hogs," 333:38n).

333:40 (340:5). crutches—symbolic of age and feebleness; another of the attributes of St. Anthony.

333:40 (340:5). forceps—surgical instruments are attributes of the surgeon-brothers, the legendary third-century Sts. Cosmas and Damian.

333:40 (340:6). stag's horns—the stag is symbolic of piety and religious aspiration, of purity and solitude; the stag without a crucifix between its horns is an attribute of St. Julian Hospitator (see 333:8n).

333:40 (340:6). watertight boots—an "attribute" of Gabriel Conroy in "The Dead," *Dubliners*.

333:40 (340:6). hawks—the wild falcon is symbolic of evil thought or action; the domestic falcon, of the holy man or the Gentile converted to Christianity.

333:40–41 (340:6). millstones—attributes of the fourth-century Spanish martyr St. Vincent of Sargossa and of the third-century Austrian martyr St. Florian of Noricum, because each suffered martyrdom by being thrown into the water with a millstone around his neck.

333:41 (340:6–7). eyes on a dish—an attribute of St. Lucy (see 333:30n).

333:41 (340:7). wax candles—play a great and varied role in Church symbolism and are universally used in shrines and in religious processions.

333:41 (340:7). aspergills—the brushes with which holy water is sprinkled in Church ceremonies, symbolic of the purification from and the expulsion of evil. The aspergillum is an attribute of (among others) St. Anthony (see "hogs," 333:38n), St. Benedict (see 332:36–37n) and St. Martha (see 333:29n and "dragons," 333:38n).

333:41 (340:7). unicorns—symbolic of purity in general and of female chastity in particular. The unicorn is one of the attributes of the Virgin Mary and of several other virgin saints, notably those who were able to survive great temptation.

333:42–334:1 (340:8–9). by Nelson's Pillar ... Little Britain Street—implies that the procession has formed at the Pro-Cathedral of the Immaculate Conception in Marlborough Street, two minutes' walk from the pillar, and that it takes a direct route west and slightly north to Barney Kiernan's. A pro-cathedral is a parish church temporarily in use as a cathedral in a diocese that does not yet have a cathedral. It was a sore point with Dublin Catholics that the two "rightful" cathedrals in Dublin, St. Patrick's and Christ's Church, were in the hands of the Church of Ireland. The joke here would seem to be that Barney Kiernan's is to become the long-awaited permanent cathedral in Dublin.

334:1–2 (340:9–10). the introit in Epiphania ... Surge, illuminare—i.e., the entrance chant of the mass for *The Epiphany of Our Lord* [Jesus Christ] (6 January); the introit does not, however, begin *"Surge, illuminare"* but *"Ecce advenit Dominator Dominus"* ("See, he comes, the Lord and Conqueror"); the lesson for that day does begin *"Surge, illuminare, Ierusalem ..."* ("Rise up in splendor, Jerusalem! Your light has come, the glory of the Lord shines upon you," Isaiah 60:1–6).

334:3–4 (340:11). the gradual Omnes which saith de Saba venient—the Gradual of the Mass

for *The Epiphany* begins "*Omnes de Saba veni-ent . . .*" ("All the people of Saba are coming with gifts of gold and incense, and singing the Lord's praises," Isaiah 60:6) and continues "*Surge, illuminare*" (Isaiah 60:1).

334:4–6 (340:12–13). casting out devils . . . halt and the blind—various of the miracles of Jesus: "casting out devils," Matthew 9:32 *ff.*, Mark 5:1 *ff.*, Luke 8:26 *ff.*; "raising the dead," Luke 7:11 *ff.*, 8:40 *ff.*, Matthew 9:18 *ff.*, Mark 5:21 *ff.*; "multiplying fishes," Matthew 14:13 *ff.*, 15:32 *ff.*, Mark 6:34 *ff.*, 8:1 *ff.*, Luke 9:12 *ff.*, John 6:1 *ff.*; "healing the halt and the blind," there are numerous instances in each of the four Gospels.

334:6 (340:14). discovering various articles which had been mislaid—miraculous aid of this sort is given by St. Anthony of Padua.

334:9 (340:17). Father O'Flynn—see 168:12–13n.

334:9 (340:17). Malachi—see 6:3n.

334:9 (340:17). Patrick—see 79:9–10n.

334:14–18 (340:22–26). the celebrant blessed the house . . . thereof with blessed water—an exaggeration of the ritual act of cleansing an edifice before entering it in the ceremony for the consecration of a house.

334:19–21 (340:26–29). that God might bless . . . light to inhabit therein—a paraphrase of the closing lines of the *Alia Benedictio Domus* ("Another Blessing for a House," outside of Eastertime), *RITUALE ROMANUM* (Boston, 1926), Tit. VIII, Cap. 7: ". . . Therefore, at our entrance, Lord, bless and sanctify this house as you blessed the houses of Abraham, Isaac and Jacob: and cause the Angels of your light to inhabit this house and to protect those who dwell therein. Through Christ Our Lord." This blessing is no longer included in the Roman ritual.

334:21–22 (340:29–30). he blessed the viands and the beverages—i.e., he pronounced the *Benedictio Panis, Vini, Aquae et Fructum* from the ritual ("Blessing of Bread, Wine, Water and Fruits").

334:24–27 (340:31–34). Audiutorium nostrum . . . cum spiritu tuo—Latin: "Our help is in the name of the Lord./Who made heaven and earth./ The Lord be with you/And with thy spirit." A responsive formula of blessing which traditionally precedes a formal prayer.

334:30–35 (340:37–42). Deus, cuius verbo sanc-tificantur . . . Christum Dominium nostrum —Latin: "O God, by whose word all things are made holy, pour down your blessing on these which you created. Grant that whoever, giving thanks to you, uses them in accordance with your law and your will, may by calling on your holy name receive through your aid health of body and protection of soul, through Christ our Lord." This is the *Benedictio ad omnia*, the "Blessing for all [things]," which the priest uses on all occasions for which there is no specific blessing in a ritual.

334:37 (341:2). Thousand a year—a toast, in effect: "wealth and good fortune."

334:38 (341:3). John Jameson—an Irish whiskey: John Jameson and Son, Ltd., a Dublin distillery.

334:38–39 (341:3–4). butter for fish—a lower-class Dublin toast, again: "wealth and good fortune."

335:5 (341:12). scut—see 84:38n.

Parody: 335:21–33 (341:28–40). The milkwhite dolphin tossed . . . bark clave the waves—more parody of late-nineteenth-century romantic versions of medieval legend.

335:30 (341:37). hosting—the raising of an armed force or military expedition.

335:36 (342:12). the curse of Cromwell—calls the ruthlessness and brutality of Cromwell's suppression of Irish insurrection down on the head of the person cursed; see 328:5–8n.

335:37 (342:2). bell, book and candle—to curse "by bell, book and candle" is to pronounce "major excommunication" (absolute and ir-revocable exclusion of the offender from the Church). The bell calls attention; the book con-tains the sentence to be pronounced; the candle is extinguished to symbolize the spiritual darkness into which the excommunicant is cast.

336:2 (342:9). Arrah—see 290:33n.

336:2 (342:9). sit down on the parliamentary side of your arse—i.e., sit down and conduct yourself as you would in a parliamentary dis-cussion.

336:9 (342:16). whisht—Irish: "silence."

336:13 (342:20). If the man in the moon was a jew, jew, jew—after the American popular song "If the Man in the Moon Were a Coon" (1905), by Fred Fisher. Chorus: "If the man in the moon were a coon, coon, coon,/What would you

do?/He would fade with his shade the silv'ry moon, moon, moon/Away from you./No roaming 'round the park in the bright moonlight,/If the man in the moon were a coon, coon, coon."

336:17 (342:24). Mendelssohn—either (1) the German philosopher Moses Mendelssohn (1729–1786), a Jew who made impressive attempts to mitigate the brutal prejudice against Jews in eighteenth-century Berlin and who successfully broadened the outlook of his co-religionists, or (2) Felix Mendelssohn-Bartholdy (1809–1847), the German composer whose family had added the name "Bartholdy" when they embraced Christianity.

336:17 (342:24). Karl Marx—(1818–1883), the German social philosopher, was born of Jewish parents; he not only abandoned his faith but also replaced it with a rather shrill anti-Semitism.

336:17 (342:24). Mercadante—see 81:9–10n; he was not a Jew but an Italian Catholic.

336:18 (342:25). Spinoza—see 280:13–14n; he was thoroughly educated in Jewish theology and speculation, but his philosophical views were so unorthodox that he was forced to withdraw from the synagogue. The Jewish community in Amsterdam did not, however, stop there but in 1656 achieved his excommunication and managed to have him banished from the city by the civil authority.

Parody: 336:30–337:20 (342:37–343:28). A large and appreciative . . . Gone but not forgotten—parodies a newspaper account of the departure of a royal foreign visitor.

336:32–33 (342:39–40). NAGYASÁGOS URAM LIPÓTI VIRAG—Hungarian: "Your greatness mylord Leopold Flower."

336:33 (342:40–41). Messrs Alexander Thom's, printers to His Majesty—Alexander Thom and Company, Ltd., printers and publishers, wholesale stationers and lithographers, agents for the sale of Parliamentary papers and Acts of Parliament, publishers of the *Dublin Gazette* ("published by the King's authority") and "Printers for His Majesty's Stationer's Office," 87, 88, 89 and 94–96 Abbey Street Middle.

336:34–35 (342:42). Százharminczdrojúgulyás—Dugulás—Hungarian: "130-calf-shepherd [or soup]—Stopping up [Sticking into]."

336:39 (343:4). phenomenologist—the word was so unusual in an early-twentieth-century context that it should be regarded here as a technical term, denoting Bloom's participation in the then relatively new philosophical school of phenomenology. The dominant phenomenologist (1904

ff.) was the German philosopher Edmund Husserl (1859–1938); one of his central emphases was that all the phenomena of experience were to be placed on the same plane, as equal with one another, whether they were of man's cognitive powers, his feelings or his conative powers; i.e., phenomena could not be prejudged as belonging to classes of differing importance nor could phenomena be dismissed on metaphysical or ontological grounds.

336:42–337:1 (343:8). Messrs Jacob agus Jacob—W. and R. Jacob and Company, Ltd., biscuit manufacturers in Dublin.

337:4 (343:11). Come back to Erin—a song by the English ballad composer "Claribel," Mrs. Charlotte Allington Barnard (1830–1869). "Come back to Erin, Mavourneen, Mavourneen,/Come back, Aroon, to the land of thy birth:/Come with the shamrocks and springtime, Mavourneen,/And its Killarney shall ring with our mirth./Sure, when we lent you to beautiful England,/Little we thought of the long winter days,/Little we thought of the hush of the starshine,/Over the mountains, the hills, and the braes."

337:4–5 (343:12). Rakoczy's March—(1809), composed by Miklos Scholl and popularized by the army of Francis Rakoczy II of Transylvania. It was adopted by the Hungarians as their national march, and in the course of the nineteenth-century struggle between the Hungarians and the Austrians it assumed considerable political importance because the Austrians attempted to ban it. The song begins, "Light from Heaven guard our land" and appeals to "Men of proud Hungarian blood" to continue in this struggle for "Magyar glory."

337:6 (343:13). the four seas—that bound Ireland: the North Channel to the northeast, the Irish Sea to the east, St. George's Channel on the southeast, and the Atlantic Ocean.

337:6 (343:14). the Hill of Howth—see 41:24n.

337:7 (343:14). Three Rock Mountain—(1,469 feet). The mountain is south of Dublin and can be seen from the streets of the city.

337:7 (343:14–15). Sugarloaf—see 153:25n.

337:7 (343:15). Bray Head—see 9:30n.

337:7–8 (343:15). the mountains of Mourne—see 257:28–29n.

337:8 (343:15). the Galtees—a chain of mountains with some of the higher elevations in southwestern Ireland (in Counties Limerick and Tipperary).

337:8 (343:16). the Ox—mountains in County Sligo in western Ireland.

337:8 (343:16). Donegal—a mountainous county (rather than a range of mountains) in northwestern Ireland.

337:8 (343:16). Sperrin peaks—in County Londonderry on the north coast of Ireland.

337:9 (343:16–17). the Nagles and the Bographs—two mountain ranges in northern County Cork in southern Ireland.

337:9 (343:17). the Connemara hills—on the coast in County Galway, western Ireland.

337:9–10 (343:17). the reeks of M'Gillicuddy—see 290:2–3n.

337:10 (343:17–18). Slieve Aughty—a range of mountains between Counties Galway and Clare in western Ireland.

337:10 (343:18). Slieve Bernagh—(2,449 feet), the second largest of the Mourne Mountains.

337:10 (343:18). Slieve Bloom—see 58:35n.

337:12–13 (343:20–21). Cambrian and Caledonian hills—i.e., the hills of Wales and Scotland.

337:17 (343:25). the Ballast office—see 152:1–2n.

337:17 (343:25). the Custom House—an imposing official building on the north bank of the Liffey near the river's mouth.

337:19 (343:26–27). the Pigeonhouse—see 42:11n.

337:19 (343:27). Visszontlátásra, Kedvés Barátom! Visszontlátásra!—Hungarian: "See you again, my dear friend! See you again (Goodbye)!"

337:24 (343:32). Queen's royal theatre—see 90:40n.

337:27 (343:35). in for the last gospel—literally, "in church before the end of the Mass"; figuratively, "just in time to witness the climax of an action."

337:33 (343:41). county Longford—approximately 90 miles west-northwest of Dublin.

Parody: 337:37–338:40 (344:3–345:6). The catastrophe was terrific . . . and F.R.C.S.I—parodies a newspaper account of a natural disaster.

337:38 (344:4). The observatory of Dunsink—see 152:2n.

337:39 (344:5). the fifth grade of Mercalli's scale—Giuseppe Mercalli (1850–1914), an Italian seismologist, invented a five-grade seismic scale that was highly empirical. It was regarded as particularly useful for the measurement of very severe shocks. "Fifth grade" meant that the shock was as heavy as any that had ever been recorded on a seismograph to that date.

337:41 (344:7). the earthquake of 1534—is mentioned in *Thom's (1904)*, "Dublin Annals," p. 2093.

337:41 (344:7–8). the rebellion of Silken Thomas—see 46:22–23n.

338:1–3 (344:9–11). The Inn's Quay ward . . . square pole or perch—Barney Kiernan's pub was located in St. Michan's parish and in Inn's Quay ward. The ward and the parish are not, however, coextensive. The ward's 226 acres extend in a strip from the Liffey in central Dublin, north to the Royal Canal. The parish (126 acres, 36 square rods) is also north of the Liffey in central Dublin, but its northern boundary is less than halfway to the Royal Canal. The area that the parish and the ward have in common is 62 acres, three square rods, and Kiernan's pub was at the eastern edge of the common ground (according to a map and letter from the Dublin Valuation Office, A. K. Richardson for the Secretary, 27 November 1970).

338:4 (344:12). the palace of justice—see 288:31–32n.

338:11–12 (344:20). Mr George Fottrell—Clerk of the Crown and Peace, Sessions House, Greene Street; see 288:31–32n.

338:14–15 (344:23). sir Frederick Falkiner—see 136:18n.

338:17 (344:26). the giant's causeway—a peninsula of basaltic columns (or ridges) that extends into the sea toward Scotland on the northeastern coast of Ireland.

338:19 (344:27–28). Holeopen bay near the old head of Kinsale—Kinsale is on the southeastern coast of Ireland; Holeopen Bay is a small bay formed by two small strips of land that jut out into the Kinsale Harbour.

338:25–26 (344:34–35). missa pro defunctis—Latin: "Mass for the dead."

338:32 (344:41). Messrs Michael Meade . . Great Brunswick Street—(now Pearse Street),

builders and contractors, planing and molding mills and joinery works.

338:33 (344:42). Messrs T. C. Martin 77, 78, 79 and 80 North Wall—T. and C. Martin, Ltd., slate and tile yard.

338:34 (345:1-2). the Duke of Cornwall's light infantry—such a regiment did exist in 1904 but none of its three battalions was stationed in Dublin. However, the duchy of Cornwall was the legal appanage of the heir apparent to the Crown; H.R.H. George Frederic Ernest Albert, Prince of Wales, and Duke of Cornwall and York, K.G., K.T., K.P., G.C.M.O., G.C.V.O., I.S.O., a general in the Royal Army and a vice-admiral in the Navy in 1904.

338:35-40 (345:2-6). H.R.H., rear admiral ... and F.R.C.S.I—fictional, but see 338:34n. H.R.H.: his royal highness; Hercules, after the Greek mythical hero-god; Hannibal, after the Carthaginian general (247–182 B.C.) famous for his leadership and for his near-success in a series of wars with Rome. K.G.: Knight of the Garter; K.P.: Knight of the Order of St. Patrick; K.T.: Knight Templar; P.C.: Privy Councilor; K.V.B.: Knight Commander of the Bath; M.P.: Member of Parliament; J.P.: Justice of the Peace; M.B.: Bachelor of Medicine; D.S.O.: Distinguished Service Order; S.O.D.: nonexistent, hence, "sod," a clod, or sodomist; M.F.H.: Master of Fox Hounds; M.R.I.A.: Member of the Royal Irish Academy; B.L.: Bachelor of Laws, or Letters; Mus. Doc.: Doctor of Music; P.L.G.: Poor Law Guardian, from an Irish point of view, an oppressor of the poor; F.T.C.D.: Fellow of Trinity College, Dublin; F.R.U.I.: Fellow of the Royal University of Ireland; F.R.C.P.I.: Fellow of the Royal College of Physicians of Ireland; F.R.C.S.I.: Fellow of the Royal College of Surgeons in Ireland. See Adams, p. 201.

Parody: 339:14-23 (345:22-32). When, lo, there came . . . shot off a shovel—parodies biblical prose.

339:14-16 (345:22-24). When, lo, there came . . . Him in the chariot—II Kings 2:11-12. "And it came to pass, as they [Elijah and Elisha] still went on, and talked, that, behold, *there appeared* a chariot of fire, and horses of fire, and parted them both asunder; and Elijah went up by a whirlwind into heaven. And Elisha saw *it*, and he cried, My father, my father, the chariot of Israel and the horsemen thereof." See 149:15n.

339:16-17 (345:24-25). clothed upon in the ... raiment as of the sun—after the description of Jesus in Matthew 17:1-5: "And after six days Jesus taketh Peter, James, and John his brother, and bringeth them up into an high mountain apart, And was transfigured before them: and his face did shine as the sun, and his raiment was white as the light. And, behold, there appeared unto them Moses and Elias [Elijah] talking with him. Then answered Peter. . . . While he yet spake, behold, a bright cloud overshadowed them: and behold a voice out of the cloud, which said, This is my beloved son, in whom I am well pleased; hear ye him."

339:17-18 (345:25-26). fair as the moon and terrible—after The Song of Solomon 6:10: "Who is she *that* looketh forth as the morning, fair as the moon, clear as the sun, *and* terrible as *an army* with banners?" (This passage is glossed in the *Douay:* "The spouse of Christ is but one: she is fair and terrible.")

339:18-19 (345:27). And there came a . . . calling: Elijah! Elijah!—see 339:16-17n.

339:19-20 (345:28). And he answered . . . Abba! Adonai!—Abba, a Syriac-Greek name for Father-God; Adonai (Lord), a Hebrew name for God. During the Agony in the Garden at Gethsemane, Jesus prays, "And he said, Abba, Father, all things *are* possible unto thee; take away this cup from me: nevertheless not what I will, but what thou wilt" (Mark 14:36).

339:22 (345:30). the glory of the brightness—see "gloriae," 333:33-34n.

339:23 (345:31). Donohoe's in Little Green Street—a pub, Donohoe and Smyth, grocers, tea, wine and spirit merchants, 4 and 5 Green Street Little. (The street runs south at a right angle from Little Britain Street.)

EPISODE 13
[NAUSICAA]

Pig[e...]

Sandymount Strand

Sandymount

EPISODE THIRTEEN

Light Ho.

Poolbeg Light Ho.

D U B L I N

B A Y

Rosbeg

Bank

Drumleck Pt

The Needles Head

N

ake

Light Ho.

Light Ho.

Rock

Seapoint Station

Salt Hill Station

Kingstown Harbour

C.d Station

Life Boat Sta.

KINGSTOWN

Scotch Bay

Bullock Harbour

Bartragh

Loreto Convent

Maiden Rock

Clare Rock

Queenstown

Lamb Isd.

Maglins

NAUSICAA

Coast Guard Sta.

Episode 13: [Nausicaa], pp. 340–376 (346–382). In Book V of *The Odyssey* Odysseus leaves Calypso's island, is harassed by Poseidon (see p. 52 above) and is finally beached at the mouth of a river in the land of a fabulous seafaring people, the Phæacians. Odysseus hides in a thicket to sleep off his exhaustion and is eventually awakened by the activities of the Princess Nausicaa and her maids-in-waiting, who have come to the river to do the palace laundry. The specific incident that awakens Odysseus involves a ball lost in the course of a game (see 349 [355–356]). Odysseus reveals himself and pleads the hardship of his case. His appeal to Nausicaa is successful; she arranges for his safe conduct to the court and eventually her parents arrange for his safe conduct home to Ithaca.

Time: 8:00 P.M. Scene: The Rocks on Sandymount Strand where Stephen had paused in his morning's walk in Episode 3. Bloom has just come from his visit to Mrs. Dignam in Sandymount (a southeastern suburb of Dublin) and has retired to the beach near the foot of Leahy's Terrace, 38:33 (37:33), 372:30 (379:14). Organ: eye, nose; Art: painting; Color: gray, blue (blue is the color of beauty, chaste affections and true love; it is an attribute of the Virgin Mary); Symbol: virgin; Technique: tumescence, detumescence. Correspondences: *Phæacia*—Star of the Sea (see 340:6–9n); *Nausicaa*—Gerty.[1]

340:4 (346:4). Howth—see 41:24n.

340:6–9 (346:7–10). the quiet church ... Mary, star of the sea—the Roman Catholic Church of Mary, Star of the Sea, off Leahy's Terrace near Sandymount Strand, the Very Reverend John O'Hanlon, canon, parish priest. This is Dignam's parish church, where a temperance retreat is in progress in the course of this episode. "Star of the Sea" (*Stella Maris*) is an appellation of the Virgin Mary; see "stars," 333:39n.

340:12 (346:13). Many a time and oft—Shylock complains to Antonio in *The Merchant of Venice*: "Signior Antonio, many a time and oft/In the Rialto you have rated [abused] me/

About my moneys and my usances [usury]" (I, iii, 107–109).

340:17 (346:18). H.M.S. Belleisle—His Majesty's Ship, Beautiful Island.

340:23 (346:24–25). happy as the day was long—a common misquotation of a phrase from Beatrice's praise of the unmarried life in *Much Ado About Nothing*: "So deliver I up my apes [jokes], and away to Saint Peter for the heavens; he shows me where the bachelors sit, and there live we as merry as the day is long" (II, i, 50–52).

340:28 (346:30). plucks—Irish: "cheeks."

340:37 (346:38). scatty—crumbled.

340:41 (346:42). Flora MacFlimsy—the flighty heroine of "Nothing to Wear" (1857), a poem by the American lawyer-poet William Allen Butler (1825–1902). "Miss Flora MacFlimsy of Madison Square" (the heart of fashionable New York in the 1850s) is mocked at length for the monied self-indulgence of her pursuit of fashionable clothes until she ends "in utter despair/Because she had nothing whatever to wear."

341:1–2 (347:2–3). cherryripe red lips—from the refrain of a song in Thomas Campion (1567–1620), *Fourth Book of Airs* (n.d.): "There is a garden in her face." Lines 5–6: "There cherries grow which none can buy,/Till 'Cherry-ripe' themselves do cry." Robert Herrick worked a variant on Campion's song in "Cherryripe" (1648): "Cherry-ripe, ripe, I cry,/Full and fair ones; come and buy./If so be you ask me where/They do grow, I answer: There,/Where my Julia's lips do smile;/There's the land, or cherry-isle,/Whose plantations fully show/All the year where cherries grow."

341:6 (347:7). golden rule—from the Sermon on the Mount: "Therefore all things whatsoever ye would that men should do to you, do ye even so to them: for this is the law and the prophets" (Matthew 7:12; also Luke 6:31).

341:6 (347:7). The apple of discord—in Greek mythology the proverbial name for the apple that Eris (goddess of discord) proposed as "for the fairest" (among Hera, Aphrodite and Athena). Paris, called upon to judge in the beauty contest, awarded the apple to Aphrodite, was himself rewarded with Helen of Troy (and the Trojan War).

341:9 (347:10–11). the Martello tower—the one nearest at hand was not Stephen's residence but a similar tower in Sandymount, on the shore less than a mile south of Leahy's Terrace.

[1] Gerty derives her name from the heroine of Maria Cummins' (1827–1866) novel *The Lamplighter* (1854) and the style associated with Gerty MacDowell owes a considerable debt of parody to the style of Maria Cummins' sentimental novel. Gerty Flint, the heroine of *The Lamplighter*, begins life "neglected and abused ... a little outcast," sweet, as expected but vengeful and vindictive, capable of "exhibiting a very hot temper." She rapidly comes into possession of "complete self-control" and then of a sentimental religiosity that, combined with considerable coincidence, rewards her with the good life of self-sacrifice (and of affluence in her marriage to Willie, the love of her childhood, who has himself made it from rags to riches).

341:11–12 (347:12–13). every little Irishman's house is his castle—see 108:29n.

341:32 (347:36). What's your name? Butter and cream?—from oral tradition: "What's your name?/Butter an' crame/All the way from/ Dirty Lane" (Leslie Daiken, *Out She Goes* [Dublin, 1963], p. 37).

342:11 (348:15). iron jelloids—gelatinous lozenges containing iron, widely advertised as a cure for anemia (*Allbutt's Systematic Medical Volume* [1898], p. 514).

342:12–13 (348:17). the Widow Welch's female pills—a patent medicine advertised as a specific for "female troubles" and "that tired feeling."

342:18 (348:22–23). queen of ointments—an advertising slogan for Beetham's Larola: "Makes the skin as soft as velvet, Removes all Roughness, Redness, Heat Irritation, Tan and Keeps the Skin Soft, Smooth and White all the year round"; M. Beetham & Son, Cheltenham, England.

342:27–29 (348:33–35). Had kind fate but . . . benefit of a good education—kind fate did will that Gerty Flint, the heroine of *The Lamplighter*, receive a good education (as the result of the sentimental patronage of a blind gentleman who recognizes Gerty's "good qualities"), and fate also willed that she be born a gentlewoman, though fate withheld that good news for melodramatic revelation when Gerty had reached maturity.

342:34–35 (348:39–40). the love that might have been—recalls the concluding "moral" of John Greenleaf Whittier's (1807–1892) narrative poem "Maud Muller": "For of all sad words of tongue or pen,/The saddest are these: 'It might have been!'" The poem is the pathetic story of a poor farm girl who meets a wealthy judge and is trapped for the rest of her "poor coarse life" in the "vague unrest" of daydream trust in romantic love and the "rags to riches" that "might have been."

342:41–42 (349:4–5). Madame Vera Verity . . . the Princess novelette—*The Princess's Novelettes* (1886–1904) was a weekly magazine published in London. Each issue included at least one complete "Novelette" and an installment of a serialized story or novel. The magazine's weekly features included: A. A. P. (All About People); Beauty's Boudoir; Boudoir Gossip; Addressed to "Boudoir" Editor; and the Fashion Supplement. There was no Woman Beautiful page and no Madame Vera Verity appears, but the magazine did advertise one G. *Vera* Miller as among "the Most Celebrated Writers of the Day," and

carried her serialized "stories" almost continually from 1900 to 1904. The magazine's beauty and fashion pages were characterized by thinly disguised plugs for the magazine's advertisers and their products in prose of the sort Gerty echoes.

343:7–8 (349:13–14). She had cut it . . . of the new moon—popular superstition: "It is good to cut the hair at the new moon and by the light of the moon itself; but never should the hair be cut on Friday, for it is the most unlucky day of all the year" (Lady Wilde [Speranza], *Ancient Cures, Charms, and Usages of Ireland* [London, 1890], p. 63).

343:10 (349:15–16). Thursday for wealth—in astrology Thursday (Jupiter's day) is a day for courage but it is also regarded as a favorable day on which to transact business.

343:22 (349:28). nose was out of joint—i.e., she had been crossed or disconcerted or irritated; proverbial since the sixteenth century.

343:25 (349:31). an exhibition in the intermediate—i.e., to win the distinction of a cash prize at the end of his school year. The prizes were awarded on the results of competitive examinations set by the Intermediate Education Board for Ireland, established in 1878.

343:26 (349:32). Trinity college—it is notable here that Trinity College was consistently Protestant in its orientation.

343:27 (349:33–34). W. E. Wylie—see 234:2–5n.

343:32–33 (349:39–40). Who came first and . . . then Saint Joseph—a delicate echo of the common oath: "Jesus, Mary and Joseph."

344:4 (350:10). dolly dyes—the brand name of a line of dyes packaged for home use.

344:4 (350:10). the Lady's Pictorial—"a weekly illustrated journal of fashion, society, art, literature, music and the drama," published in London on Thursday. The magazine had pretensions to fashionable upper-class tone, but the enervated sentimentality of its fiction betrays its essentially middle-class appeal. It asserted in its advertisements that it was "universally acknowledged to be the leading ladies' paper."

344:13 (350:19). Tuesday week—i.e., a week ago last Tuesday.

344:14 (350:20). Clery's—see 75:18n.

344:23 (350:30). ash, oak or elm—a proverbial expression for eternity, echoed by Rudyard

Kipling (1865–1936) in "A Tree Song": "England shall bide Judgement Tide/By oak and ash and thorn."

344:38–40 (351:3–5). blue for luck—blue is the color of chaste affections, true love and hope and thus is an appropriate emblem for a bride.

344:40–41 (351:5–6). the green she wore . . . brought grief—in its negative phases green is regarded as the color of envy and jealousy, of love gone sour or thwarted as in the proverbial saying: "Blue is love true,/Green is love deen [dying]."

345:2–4 (351:9–11). nearly slipped up the old . . . wasn't of a Friday—"It is lucky to put a garment on inside out when dressing, if it is done accidentally, but it must be left as it is and worn inside out, otherwise the luck will be changed" (E. and M. A. Radford [ed. and revised, Christina Hole], *Encyclopedia of Superstitions* [London, 1961]). Friday "is the most unlucky day of the year" (see 343:7–8n) and consequently good luck omens tend to be reversed on Fridays.

345:10–11 (351:17–18). You are lovely, Gerty, it said—as the magic mirror in "Snowwhite and the Seven Dwarfs" responds to the wicked stepmother's question ("Mirror, mirror, on the wall,/Who's the fairest of them all?") until Snowwhite displaces her stepmother in the mirror's estimation.

345:15 (351:22). T.C.D—Trinity College, Dublin.

345:16 (351:23–24). the fashionable intelligence—i.e., the society columns of the newspaper.

345:20 (351:28). Stoers'—see 247:2n.

345:28 (351:35). a man among men—from Samuel Valentine Cole's (1851–1925) popular sentimental poem "Lincoln": "He who walked in our common ways,/With the seal of a king on his brow;/Who lived as a man among men his days,/And 'belongs to the ages' now."

345:29 (351:36). leap year—traditionally it is supposed to be permissible for the woman to make the proposal of marriage during leap year.

345:30 (351:37). prince charming—almost a generic name for the fairy-tale hero; a Prince Charming releases Snowwhite from the stepmother's spell in "Snowwhite and the Seven Dwarfs" (see 345:10–11n).

345:38–39 (352:4–5). for riches for poor . . . to this day forward—the vow from the Catholic Marriage Service that Gerty misquotes reads: "from this day forward, for better, for worse, for richer, for poorer, in sickness and in health, until death do us part."

346:15 (352:23–24). grandpapa Giltrap's lovely . . . that almost talked—see 290:11n.

346:33 (352:42). wigs on the green—an Irish colloquialism, originally for a faction fight and subsequently for any brawl.

346:36 (353:3). out of pinnies—i.e., had grown up enough to be dressed as a boy rather than in a baby's pinafore (roughly equivalent to "out of diapers").

347:3 (353:11). Anything for a quiet life—(1626), the title of a play by Thomas Middleton (c.1570–1627). The plot involves several houses in various states of comic disrepair; each of the houses is restored to "normal" by sons or servants whose slogan is "anything for a quiet life."

347:5–7 (353:13–15). here's the lord mayor . . . chinchopper chin—a variant of the nursery-rhyme game: "Here sits the Lord Mayor [*touch forehead*]/Here sit his two men [*eyes*]/Here sits the cock [*one cheek*]/Here sits the hen [*other cheek*]/Here sit the little chickens [*tip of nose*]/And here they run in [*mouth*]/Chin chopper, chin chopper, chin [*chuck under chin*]."

347:7 (353:15). as cross as two sticks—i.e., irritated, annoyed; colloquial from c.1830.

347:21 (353:29). golliwog—a black doll with fuzzy hair.

347:29 (353:37–38). Tritonville road—one of the main thoroughfares of Sandymount.

347:36–37 (354:2–3). the reverend John Hughes, S.J—*Thom's (1904)* lists him as resident in the Presbytery House of the Church of St. Francis Xavier on Gardiner Street Upper.

347:37–38 (354:3–4). rosary, sermon . . . Most Blessed Sacrament—after reciting the rosary and hearing a sermon, the retreat is to celebrate Benediction with the Blessed Sacrament, an evening service in honor of the Virgin Mary in the course of which the Litany of Our Lady (of Loreto) or a hymn in honor of Mary would be sung. The Blessed Sacrament is exposed for worship to the accompaniment of hymns and then the celebrant makes the sign of the cross over the participants with the monstrance after the Host has been placed in it. The rosary is a form of prayer in which 15 decades of Aves (a prayer to the Virgin Mary: "Hail Mary, full of Grace . . ."), each decade being preceded by a Pater (the Lord's

Prayer) and followed by a Gloria ("Glory be to the Father, the Son, and the Holy Spirit . . ."), are recited on beads. A mystery is contemplated during the recital of each decade, and the rosary is divided into three parts, each consisting of five decades and known as a corona or chaplet. In the first chaplet the Five Joyful Mysteries are the subject: the Annunciation, Visitation, Birth of the Lord, Christ's presentation at the Temple, His being found after three day's loss. The Five Sorrowful Mysteries contemplated in the second chaplet are the Agony in the Garden, the Scourging, the Crowning with Thorns, the Carrying of the Cross, the Crucifixion. The Five Glorious Mysteries, which are allotted to the third chaplet, are the Resurrection, the Ascension, the Descent of the Holy Ghost, the Assumption, and the Coronation of the Blessed Virgin.

347:41 (354:7). the immaculate—the Blessed Virgin Mary.

347:42–348:2 (354:8–10). the litany of Our Lady . . . holy virgin of virgins—The Litany of Our Lady (called "of Loreto"), a prayer of supplication appropriate to the occasion of this retreat both as part of the Benediction ceremony and because the retreat is being held in the Church of Mary Star of the Sea. The litany begins with an appeal to the Three Persons of the Trinity ("Have mercy on us") and continues with a sustained supplication, "Holy Mary, Pray for us./Holy Mother of God,/Holy Virgin of virgins. . . ." The litany ends with the prayer: "Grant that we thy servants, Lord, may enjoy unfailing health of mind and body, and through the prayer of the ever blessed Virgin Mary in her glory, free us from our sorrows in this world and give us eternal happiness in the next."

348:3 (354:11–12). taking the pledge—i.e., by making a religious vow to abstain from alcoholic beverages.

348:4 (354:12–13). or those powders . . . in Pearson's Weekly—*Pearson's Weekly* was a London penny magazine published on Thursdays; its tone was set by sensational "inside" stories with a penchant for the moral instruction of the poor (how to face poverty and how to get rich by means of hard work). Patent medicines and health gimmicks were significantly represented in its advertisements in 1904; several advertisements promised cures for alcoholism, typical among them: "TO CURE DRUNKARDS, with or without their knowledge, send stamp for Free Trial Package of a wonderful powdered remedy that has saved homes. . . . Address, in confidence, Ward Chemical Company, 53 Century House, Regent Street, London, W."

348:7 (354:15). in a brown study—stock expression for deep in gloomy thought.

348:18–19 (354:26–27). Virgin most powerful, Virgin most merciful—from the Litany of Our Lady, see 347:42–348:2n.

348:21–22 (354:29–30). the gentleman off Sandymount . . . that was so like himself—a similar remark has been made earlier in the day about another resident of Sandymount, William H. Brayden, 116 (117).

348:23 (354:32). screwed—tipsy or drunk.

348:26 (354:34). a palpable case of doctor Fell—Dr. John Fell (1625–1686), dean of Christ Church College Oxford and subsequently bishop of Oxford University, a reactionary noted for his persecutions of liberal thinkers (notable among them, John Locke). Fell threatened the satirist Thomas (Tom) Brown (1663–1704) with expulsion from Christ Church unless he could adapt Martial's Epigram I:33 on the spot; Brown is supposed to have saved himself by responding: "I do not love thee, Dr. Fell/The reason why I cannot tell;/But this alone I know full well,/I do not love thee, Dr. Fell."

348:29 (354:36–37). With all his faults she loved him still—after a popular song, "With All Her Faults I Love Her Still" (1888), by Monroe H. Rosenfeld. First verse: "With all her faults I love her still,/And even though the world should scorn;/No love like hers, my heart can thrill,/Although she's made that heart forlorn!"

348:30 (354:37). Tell me, Mary, how to woo thee—a popular song by G. A. Hodson. First verse: "Tell me, Mary, how to woo thee,/Teach my bosom to reveal/All its sorrows sweet unto thee,/All the love my heart can feel."

348:30–31 (354:37–38). My love and cottage near Rochelle—from the refrain of an aria in Act II of Balfe's *The Siege of Rochelle* (see 231:15n), sung by Michel. The aria begins: "When I beheld the anchor weigh'd,/And with the shore thine image fade,/I deem'd each wave a boundless sea/That bore me still from love and thee;/I watched alone the sun decline,/And envied beams on thee to shine,/While anguish panted 'neath her spell,/My love and cottage near Rochelle [repeat twice]."

348:32 (354:39). Lazenby's salad dressing—a prepared salad dressing manufactured by the soup maker F. Lazenby and Son, Ltd., London.

348:32–33 (354:40). The moon hath raised—from a song in *The Lily of Killarney* (see 91:1–2n). Opening lines of the duet: "The moon hath raised

her lamp above,/To light the way to thee, my love."

348:37 (355:2). a group taken—i.e., a group photograph.

348:42 (355:8). Catesby's cork lino—see 249:14n.

349:4 (355:11). a ministering angel—in *Hamlet*, Laertes replies to a priest who has objected that Ophelia as a suicide should not receive the full rite of burial: "I tell thee, churlish priest,/A ministering angel shall my sister be,/When thou liest howling" (V, i, 263–265).

349:6 (355:14). the menthol cone—the cooling and aromatic effect of menthol rubbed on the forehead was used to relieve headache before aspirin was developed for widespread use.

349:13 (355:20). the chlorate of lime—was used as a disinfectant in outdoor toilets.

349:13 (355:20). Mr Tunney—see 247:5n.

349:13 (355:21). christmas almanac—i.e., Christmas calendar.

349:24 (355:31–32). Walker's pronouncing dictionary—John Walker (1732–1807), English lexicographer, *Critical Pronouncing Dictionary and Expositor of the English Language; . . . To which are prefixed principles of English pronunciation . . . rules to be observed by the natives of Scotland, Ireland, and London for avoiding their respective peculiarities . . .*" (London, 1791, repeatedly revised and reissued).

350:1 (356:9). If you fail try again—after "Try and Try Again," a poem (?) by William Edward Hickson (1803–1870): "'Tis a lesson you should heed,/Try, try again./If at first you don't succeed,/Try, try again."

350:16–17 (356:24–25). her who was conceived without stain of original sin—the Immaculate Conception of the Virgin Mary was raised from the status of "pious opinion" to the status of dogma by Pope Pius IX in 1854. "The doctrine which holds the blessed Virgin Mary, from the first instant of her conception, to have been kept free from all stain of original sin, by the singular grace and privilege of Almighty God, in view of the merits of Jesus Christ the Saviour of mankind, is revealed by God, and therefore firmly and constantly to be believed by all the faithful."

350:17–19 (356:25–27). spiritual vessel, pray . . . for us, mystical rose—from the Litany of Our Lady; see 347:42–348:2n.

350:22–26 (356:31–34). what the great saint Bernard . . . ever abandoned by her—i.e., the *"Memorare,"* a prayer attributed to St. Bernard of Clairvaux (see 333:13–14n), who used it and admired it but did not compose it: "Remember, O most loving Virgin Mary, that it is a thing unheard of that anyone ever had recourse to thy protection, implored thy help, or sought thy intercession, and was left forsaken. Filled, therefore, with confidence in thy goodness, I fly to thee, O Mother, Virgin of virgins: to thee I come, before thee I stand a sorrowful sinner. Despise not my poor words, O mother of the Word of God, but graciously hear and grant my prayer. Amen."

350:42 (357:8). holy saint Denis—a mild oath; see 333:13n.

351:1 (357:9). possing—to "poss" (dialect English) is to pound or squash clothes in water in the process of washing.

351:16 (357:24). the Bailey light on Howth—the Bailey lighthouse on the southeast headland of the Hill of Howth.

351:25 (357:33–34). Martin Harvey—Sir John Martin-Harvey (1863–1944), English actor and theatrical producer whose early-twentieth-century visits to Dublin were, according to his autobiography, "a series of triumphs" (somewhat marred in 1910 when he staged *Richard III* and triggered a riot on the part of Irish Nationalists who wanted *Irish* plays).

351:27 (357:35). Winny Rippingham—fictional (?).

351:27–28 (357:36–37). two to always dress the same on account of a play—after a sentimental comedy, *Two Roses* (1870), by James Albery (1838–1899), in which the heroine sisters do dress alike.

351:29 (357:38). retroussé—French: "turned up, snub."

351:42–352:1 (358:10). more sinned against than sinning—King Lear rages against the gods ("these dreadful summoners") and against the storm on the heath: "I am a man/More sinn'd against than sinning" (III, ii, 59–60).

352:6 (358:15–16). those cyclists showing off—women on bicycles in 1904 were regarded as "scandalous" because they exposed the lower part of the calfs of their legs.

352:9 (358:18). The memory of the past—a song, also entitled "There Is a Flower That Bloometh," in Act III of Wallace's opera *Maritana*

(see 85:20–21n). "There is a flower that bloometh/When autumn leaves are shed./With the silent moment it weepeth,/The spring and summer fled./The early frost of winter/Scarce one tint hath overcast./Oh, pluck it ere it wither,/'Tis the memory of the past! // It wafted perfume o'er us,/Of sweet, though sad regret/For the true friends gone before us,/Whom none would e're forget./Let no heart brave its power,/By guilty thoughts o'ercast,/For then, a poison-flow'r/Is —the memory of the past!"

352:12 (358:22). Refuge of sinners ... Ora pro nobis—from the Litany of Our Lady (see 347:42–348:2n); Latin: "Pray for us."

352:13–16 (358:23–26). Well has it been said ... transpierced her own heart—a standard prayer in honor of the Virgin Mary; included in the "Official Edition" of *The Raccolta* at the turn of the century, it has since been dropped. "The seven dolors," the Seven Sorrows of Mary: (1) her "suffering with" her Son, the Prophecy of Simeon "(Yea, a sword shall pierce through thy own soul also,) that the thoughts of many hearts may be revealed" (Luke 2:35); (2) the Flight into Egypt; (3) the Loss in the Temple (Luke 2:46–50); (4) the Carrying of the Cross; (5) the Crucifixion; (6) the Deposition; (7) the Entombment.

352:18 (358:29). Father Conroy—Father Bernard Conroy, 5 Leahy's Terrace, was curate at the Star of the Sea Church in Sandymount in 1904. He is apparently "no relation" to the fictional Gabriel Conroy whose fictional brother Constantine is described as "senior curate in Balbriggan" in "The Dead," *Dubliners*.

352:18–19 (358:30). Canon O'Hanlon—see 340:6–9n.

352:23–25 (358:33–35). a Dominican nun in their white ... the novena of Saint Dominic—the Sisters of Saint Dominick had two convents near Sandymount, one in Blackrock and one in Kingston. The habit of Dominican nuns in 1904: a white gown and scapular, symbolic of purity, *and* a black cloak and hood, symbolic of penance. The novena of St. Dominick, a nine-day devotion that would culminate in the celebration of that saint's feast, 4 August; St. Dominic was noted for his devotion to worship of the Virgin Mary and for his emphasis on the Rosary as a form of worship.

352:25 (358:35–36). when she told him about that—i.e., about her menstrual period.

352:30–32 (358:41–42). Our Blessed Lady herself ... according to Thy Word—during the Annunciation Mary accepts the instruction of the Archangel Gabriel: "And Mary said, Behold the handmaid of the Lord: be it unto me according to thy word "(Luke 1:38).

352:38 (359:6–7). the forty hours adoration—the "Forty Hours Prayer," or the "Solemn Exposition of the Blessed Sacrament" according to the "Clementine Instruction" (1592) of Pope Clement VIII. "The Blessed Sacrament is exposed to the public adoration of the faithful" from noon of the first day to noon of the third day following. The time is associated with the time that Jesus lay in the tomb before the Resurrection, though the devotion is celebrated throughout the year and not specifically in conjunction with Easter.

353:11 (359:22). thingamerry—before 1890, something one does not wish to or cannot specify.

353:13 (359:24). throw her hat at it—for a woman to throw her hat at a man is to attempt to attract his attention when her appearance etc. would not otherwise have done so.

353:17 (359:28). piece—uncomplimentary slang for a woman or girl.

353:23 (359:35). Tableau!—French: literally, "picture, scene, sight"; figuratively, the name of a parlor game in which the participants strike poses meant to symbolize a "message" and say, "*Tableau*," to announce that the pose is complete and ready to be observed and interpreted.

353:25–26 (359:37–38). Queen of angels ... of the most holy rosary—from the Litany of Our Lady (see 347:42–348:2n): "Queen of angels, Queen of patriarchs, Queen of prophets, Queen of apostles, Queen of martyrs, Queen of confessors, Queen of virgins, Queen of all saints, Queen conceived without original sin, Queen assumed into Heaven, Queen of the most holy rosary."

353:28 (359:40). and censed the Blessed Sacrament—as prelude to the exposure of the Blessed Sacrament in the Benediction ceremony; see 347:37–38n.

353:36 (360:6). Tantum ergo—a hymn (the last two verses of St. Thomas Aquinas' *Pange lingua gloriosi*) that is sung after the Blessed Sacrament has been exposed in the Benediction ceremony (see 347:37–38n). Translation: "Falling in adoration down/Hail of all marvels this the crown;/The ancient rites are past;/Let the new covenant prevail/And faith, when all the senses fail,/Hold her fruition fast. // All height and depth of praise be done/To him the Father, him the Son,/And him proceeding thence;/Strength and salvation are of them,/And kingdom, and the diadem/Of One Omnipotence. Amen."

353:38 (360:7–8). Tantumer gosa cramen tum—Gerty's rhythmic version of the opening line of the *Tantum ergo,* "*Tantum ergo Sacramentum*"; Latin: "Falling in adoration down."

353:39 (360:8–9). Sparrow's of George's street—Sparrow and Company, ladies' and gentlemens' outfitters and family linen warehouse, 16 South Great George's Street.

353:41 (360:10). a brack—a flaw in the cloth.

354:5 (360:17). a streel—Irish: "a lazy, untidy woman, a slattern."

354:34–35 (361:5–6). half past kissing time, time to kiss again—a stock phrase usually addressed to children who repeatedly ask what time it is.

354:38 (361:9). conundrum—slang for a thing with an unknown or puzzling name.

355:9 (361:22). after eight because the sun was set—sunset 16 June 1904 in Dublin was at 8:27 P.M.

355:13 (361:26). waterworks—from the middle of the eighteenth century, low slang for urinary organs.

355:14 (361:27). the second verse of the Tantum ergo—see 353:36n.

355:40 (362:11). Panem de coelo prœstitisti eis—Latin: "You have given them bread from Heaven." The celebrant says this in the Benediction ceremony after the singing of the *Tantum ergo.* The response: "Having all sweetness in it."

356:30 (363:3). kinnatt—Irish: "an impertinent, conceited, impudent little puppy."

356:34–35 (363:7). put that in their pipe and smoke it—after the whimsical English versifier and antiquarian Richard Harris Barham ("Thomas Ingoldsby") (1788–1845), "Lay of St. Odille": "So put that in your pipe, my Lord Otto, and smoke it."

356:39 (363:11). Billy Winks—a variant of "Wee Willie Winkie," a nursery rhyme: "Wee Willie Winkie runs through the town,/Upstairs and downstairs in his nightgown,/Rapping at the window, crying through the lock,/Are the children all in bed, for now it's eight o'clock."

357:3 (363:17). Puddeny pie—after the nursery rhyme: "Georgie Porgie, pudding and pie,/Kissed the girls and made them cry;/When the boys came out to play,/Georgie Porgie ran away."

357:11–15 (363:25–29). the benediction because just then ... Blessed Sacrament in his hands—in the Benediction ceremony, after the responses (see 355:40n) and a prayer, the celebrant gives benediction with the Blessed Sacrament.

357:17 (363:31). the last glimpse of Erin—from the first line of a song by Thomas Moore: "Tho' the last glimpse of Erin with sorrow I see,/Yet wherever thou art shall seem Erin to me;/In exile thy bosom shall still be my home,/And thine eyes make my climate wherever we roam. // To the gloom of some desert or cold rocky shore,/Where the eye of the stranger can haunt us no more,/I will fly with my Coulin, and think the roughwind/Less rude than the foes we leave frowning behind. // And I'll gaze on thy gold hair as graceful it wreathes,/And hang over thy soft harp as wildly it breathes;/Nor dread that the coldhearted Saxon will tear/One chord from that harp, or one lock from that hair."

357:17 (363:31). those evening bells—the title of a song by Thomas Moore: "Those evening bells! those evening bells!/How many a tale their music tells,/Of youth and home, and that sweet time,/When I last heard their soothing chime. // Those joyous hours have passed away,/And many a heart that then was gay,/Within the tomb now darkly dwells,/And hears no more those evening bells. // And so 'twill be when I am gone,/That tuneful peal will still ring on,/While other bards shall walk these dells,/And sing your praise, sweet evening bells."

357:24 (363:38). Tritonville avenue—a small side street just inland from Leahy's Terrace in Sandymount.

357:26 (363:40). freewheel—in 1904, a relatively "modern" bicycle, equipped with a clutch that would disengage the rear wheel except when the driver was pedaling forward.

357:26–27 (363:40–42). like she read in ... Vaughan and other tales—Gerty recalls the legend on the title page of a copy of Maria Cummins' *The Lamplighter* (see headnote above). Another of Maria Cummins' novels, *Mabel Vaughan* (1857), also has a girl-child as its heroine. In the opening pages of *The Lamplighter,* the orphan-heroine, Gerty, is fascinated by the lamplighter Trueman Flint and his activities and is subsequently rescued and adopted by him.

357:34 (364:6–7). child of Mary badge—the Children of Mary, confraternities established in schools of the Sisters of Charity after 1847 in honor of the manifestation of the Miraculous Medal (1830). (The Sisters of Charity had a

convent and school on Park Avenue in Sandymount.) The medal has an image of Mary with the words "O Mary, Conceived without Sin, Pray for Us Who Have Recourse to Thee"; the obverse, the letter M with a cross and 12 stars (an attribute of Mary as Queen of Heaven) above the hearts of Jesus and Mary.

357:38 (364:10–11). Hely's of Dame Street—see 105:13n.

357:41–358:2 (364:14–16). Art thou real . . . twilight, wilt thou ever?—Louis J. Walsh (1880–1942), "boy orator" and amateur versifier. Joyce quotes the verse in question in *Stephen Hero*: "Art thou real, my ideal?/Wilt thou ever come to me/In the soft and gentle twilight/With your baby on your knee?" Magherafelt is a small village and parish on the shore of Lough Neagh in northeastern Ireland.

358:6 (364:21). Dalkey hill—on the coast eight miles southeast of Dublin, the site of what guidebooks describe as a "tastefully laid out public promenade."

358:8–9 (364:23–24). Love laughs at locksmiths—(1803), the title of a play by George Colman (1762–1836) and proverbial thereafter. The phrase was used in a music-hall song, "Linger Longer, Loo," in the Gaiety Burlesque's *Don Juan*. Opening lines: "Love laughs at locksmiths—so they say,/But don't believe it's true,/For I don't laugh when locked away/From my own darling Loo."

358:13–15 (364:29–30). tragedy like the nobleman . . . put into a madhouse—source unknown.

358:15 (364:30–31). cruel only to be kind—Hamlet upbraids his mother: "I must be cruel, only to be kind:/Thus bad begins and worse remains behind" (III, iv, 178–179).

358:19 (364:34–35). the accommodation walk beside the Dodder—i.e., a street where prostitutes solicit (as an "accommodation house" is a brothel). The River Dodder approaches the mouth of the Liffey from the south, flowing north past Sandymount and through Irishtown; the walk Gerty has in mind was in Irishtown not far from the Grand Canal Docks and from Beggar's Bush Barracks.

358:23–24 (364:39). in spite of the conventions of Society with a big ess—i.e., adultery was (from a lower-middle-class point of view) conventional in "high society" if "he" was married but separated by some "tragedy."

358:25 (364:40–41). from the days beyond recall—from "Love's Old Sweet Song"; see 63:24–25n.

358:36 (365:8). Laudate Dominum omnes gentes—Latin: "Give praise to the Lord, O ye nations," the opening line of Psalm 117 (Vulgate 116), the singing of which occurs while the Sacrament is being placed in the tabernacle. This Psalm concludes the Benediction ceremony (see 347:37–38n). After the Psalm the celebrant says: "Let us adore the most holy Sacrament for ever."

359:8 (365:22). the bazaar fireworks—of the Mirus Bazaar; see 180:20n.

359:10 (365:24). rossies—Irish: "unchaste or wandering women."

359:28 (365:42–366:1). the Congested Districts Board—the board was established in 1891 in an attempt to resolve the problems of overpopulated, poverty-stricken rural areas in Ireland. In those areas where the population simply could not support itself on the land, the board tried to encourage emigration, to introduce land-resource development or cottage industry. The board's methods were widely regarded as arbitrary, and its efforts did not meet with notable success.

359:34–35 (366:7–8). Besides there was absolution . . . before being married—i.e., Gerty thinks that to be sexually aroused is only a venial and not a mortal sin (in contrast to fornication), and thus she thinks it will be easy to confess and receive absolution. Her knowledge on these points is somewhat shaky; her catechism would have told her quite bluntly that "impurity" was a mortal sin and that impurity was "any deliberate thought, word, look, or deed with oneself or another by which the sexual appetite is aroused outside of marriage." Nor is there any reason for her to think that a mortal sin would mean that there was no absolution since an individual who truly repents and confesses his mortal sin and undertakes penance for it can be absolved of "all eternal punishment," though not necessarily of "temporal punishment either in this life or in purgatory."

360:12 (366:27–28). pettiwidth—a brand name.

361:3 (367:19). little bats don't tell—after the proverbial saying about the innocence of childhood: "Little birds don't tell."

361:28 (368:2). the cut of her jib—nautical and colloquial since *c.*1820: personal look or style as the style of a ship can be read in the configuration of its sails.

361:35–36 (368:9–10). Tranquilla convent— see 152:40–41n.

361:37 (368:11). Sister?—the answer to Bloom's question is "Sister Agatha," supplied by "THE NYMPH," 539:18 (552:20).

362:8 (368:25). Catch em alive, O—echoes the anonymous Irish song "Sweet Molly Malone." First verse: "In Dublin's fair city, where girls are so pretty/I first set my eyes on sweet Molly Malone/As she wheel'd her wheelbarrow through streets broad and narrow/Crying, Cockles and Mussels! alive, alive, oh!/Alive, alive, oh! Alive alive, oh! Crying,/Cockles and Mussels, alive, alive, oh!"

362:10 (368:26–27). Mutoscope pictures in Capel street—a mutograph was a device for taking a series of photographs of objects in motion; the photographs were then exhibited in a mutoscope. The effect was that of a rather jerky motion picture. The location in Capel Street in central Dublin north of the Liffey is unknown.

362:11 (368:27). Peeping Tom—see 161:13n.

362:12–13 (368:29–30). Felt for the curves inside her deshabille—see *Sweets of Sin*, 232:27n.

362:18 (368:35). turnedup trousers—trousers with cuffs were a radical departure in men's fashions in the 1890s.

362:18–20 (368:35–37). He wore a pair of . . . his what? of jet—after a popular song, "She Wore a Wreath of Roses the Night That First We Met," by Thomas Haynes Bayly and J. Phillip Knight: "She wore a wreath of roses/The night that first we met,/Her lovely face was smiling/Beneath her curls of jet;/Her footstep had the lightness,/Her voice the joyous tone,/The tokens of a youthful heart/Where sorrow is unknown." Chorus: "I saw her but a moment,/Yet methinks I see her now,/With the wreath of summer flowers/Upon her snowy brow."

362:21 (368:38). O Mairy lost the pin of her— see 77:33–36n.

362:21–22 (368:38–39). Dressed up to the nines—i.e., admirably or to perfection.

362:23 (368:40). on the track of the secret. Except the east—echoes *In the Track of the Sun;* see 57:31–32n.

362:23–24 (368:41). Mary, Martha—see 78:4n.

362:24 (368:41). No reasonable offer refused —a common phrase in advertisements for the sale of personal property.

362:26 (369:1). on spec—on speculation, on the chance of finding something valuable or making a profit.

362:32 (369:7). Barbed wire—see 153:10–11n.

362:35 (369:10). Tableau!—see 353:23n.

363:3–4 (369:20–21). Wonder if it's bad to go with them then—the answer, of course, is no, but Jewish law is quite explicit in its prohibition of any contact with a menstruating woman; see Leviticus 15:19–33.

363:4–5 (369:21–22). Turns milk, makes . . . about withering plants—popular superstitions about the presence of a menstruating woman.

363:6 (369:23–24). if the flower withers she wears she's a flirt—from the superstition that flowers, as simples, could save maidens from spinsterhood and wives from barrenness; thus, if the flower withered, it implied imperfect womanhood.

363:12 (369:29–30). Kiss in the dark and never tell—a turn on "kiss and tell," proverbial from William Congreve's (1670–1729) comedy *Love for Love* (1695), Act II, scene x: "O fie, Miss, you must not kiss and tell."

363:17–18 (369:35). Beauty and the beast— the popular fairy story in which a beautiful daughter becomes the guest of a monster in order to save her father's life. The monster wins her love as a result of his kindness and intelligence, and her love in turn releases him from a spell and he becomes the handsome prince. The earliest of the many versions of this story is apparently in a collection of Italian stories, *Tredici Piacevoli Notti* ("Facetious Nights") (1550), by Giovanni Straparola (?–c.1557).

363:21 (369:38). Hair strong in rut—the odor of an animal's skin does change in rutting season, but the popular attribution of a similar change to human beings is somewhat fanciful.

363:26–27 (370:2). Drimmie's—David Drimmie and Sons, English and Scottish Law Life and Phoenix Fire offices, and National Guarantee and Suretyship Association, Ltd., 41 Sackville Street Lower, where Bloom was once employed.

363:29–30 (370:5). Shark liver oil—before the development of fine petroleum oils and synthetic lubricants, sperm oil and shark-liver oil were used to lubricate delicate machinery.

363:41 (370:16). Nell Gwynn—see 201:28–33n.

363:41 (370:16). Mrs Bracegirdle—Anne Bracegirdle (1663–1748), famous English actress and beauty in the Restoration theatre. In spite of rumors about her private life, she seems to have been the virtuous exception to Restoration expectations about actresses and their *amours*.

363:41 (370:16–17). Maud Branscombe—(*fl.*1875–1910), an actress with an extraordinary reputation as a beauty. In 1877 alone over 28,000 copies of her photograph were sold; as one admirer put it, "Beauty and Maud Branscombe were synonymous." Her private life appears to have been not particularly flamboyant, though her divorce from Mr. Alexander Hamilton Gunn on the grounds of physical violence did receive considerable publicity in 1895.

364:5 (370:22). Lacaus esant taratara—i.e., *La causa è santa, taratara*; see 166:2–4n.

364:10 (370:27). the Appian way—in Ranelagh on the southern outskirts of Dublin.

364:10 (370:27). Mrs Clinch—a Mrs. Clinch lived at 24 Synnott Place, less than 200 yards north of Bloom's home in Eccles Street.

364:11 (370:28). Meath street—in the slums in south-central Dublin.

364:21 (370:39). French letter—slang for a condom.

364:36–37 (371:13). under the Moorish wall beside the gardens—the Moorish Wall and the Alameda Gardens were two landmarks in Gibraltar, where Molly grew up.

364:38–39 (371:15–16). Glencree dinner ... featherbed mountain—see 230:31n and 231:12n.

364:40 (371:17). Val Dillon—Lord Mayor of Dublin, 1894–1895; see 153:17n.

365:5–6 (371:25). Jammet's—Jammet Brothers, proprietors of the Burlington Hotel and Restaurant, 26 and 27 St. Andrew's Street in south-central Dublin not far from Trinity College and the Bank of Ireland.

365:8 (371:27). Say prunes and prisms—in Dickens' *Little Dorrit* (1857), Book II, Chapter 5, Mrs. General councils Amy, "Papa, potatoes, poultry, prunes, and prism, are all very good words for the lips: especially prunes and prism. You will find it serviceable, in the formation of a demeanor, if you sometimes say to yourself in company—on entering a room, for instance—Papa, potatoes, poultry, prunes and prism, prunes and prism."

365:13–14 (371:32–33). Those girls, those ... seaside girls—see 62:30n.

365:17 (371:36). Wilkins—W. Wilkins, esq., M.A., headmaster of High School of Erasmus Smith, 40 Harcourt Street in southeastern Dublin.

365:23 (371:42). Cuffe street—where Harcourt Street meets St. Stephen's Green in southeastern Dublin.

365:25 (372:3). Roger Greene's—solicitor, 11 Wellington Quay, in central Dublin.

365:31 (372:8). Prescott's—see 82:32–33n.

365:40 (372:17). Straight on her pins—literally, "straight on her legs, not lame"; figuratively, "forthright, well-organized."

366:1 (372:20). that frump today. A.E. Rumpled stockings—see 163:35–36 (166:7–8).

366:1–2 (372:20–21). Or the one in Grafton street. White—see 165:36–37 (168:12–13).

366:2 (372:21). Beef to the heel—see 65:38–39n.

366:7 (372:26). She smelt an onion—from a joke about the man who determined to keep himself free from any entanglement with women. In order to fulfill his determination, he ate a raw onion whenever contact with women was imminent. His scheme and his self-discipline collapsed when he met a woman who found his oniony breath extraordinarily attractive.

366:10 (372:30). For this relief much thanks. In Hamlet—when Francisco, one of the guards, thanks Bernardo, another, for relieving him at his post (I, i, 8).

366:12 (372:32–33). Your head it simply swirls—from Boylan's song; see 62:30n.

366:18–19 (372:38–39). Her maiden name was ... mother in Irishtown—Irishtown is just north along the strand from where Bloom is resting. This Irish street ballad has proved elusive, but there is an American version by the popular entertainer Harry Clifton called "Jemina Brown." The speaker meets Jemina by chance, finds her attractive and eventually goes out on a date with her; then he sees her with another man, whom she passes off as "only brother Bill." She gets the speaker to lend her £50 and then disappears, finally to be discovered in one more chance meeting as co-proprietor (with "brother Bill") of a

grocery store in New Jersey. The speaker's £50 have, of course, purchased the store: "That shop was bought/And I was sold/By naughty Jemina Brown."

366:22 (373:1). Every bullet has its billet—i.e., nothing occurs by chance, a saying attributed to King William III of England (1650–1702; king 1689–1702); also the title of a song by Charles Dibdin, music by Sir Henry R. Bishop. The song begins: "I'm a tough, true-hearted sailor,/Careless, and all that, d' ye see,/Never at the times a railer,—/What is time or tide to me?/All must die when fate shall will it,/Providence ordains it so;/Every bullet has its billet,/Man the boat, boys—Yeo, heave, Yeo!"

366:25–26 (373:4–5). and papa's pants will soon fit Willy—from an American nonsense song, "Looking Through the Knothole." The song begins: "We were looking through the knothole in father's wooden leg,/Oh, who will wind the clock while we are gone?/Go get the axe, there's a fly on baby's head/And papa's pants will soon be fitting Willie."

366:26 (373:5). fuller's earth—a material resembling clay in appearance but lacking plasticity; it was used for "fulling" cloth and wool, i.e., cleansing those materials of grease.

366:28 (373:7–8). washing corpse—traditionally it was "woman's work" to prepare a corpse for burial.

366:29–30 (373:9). not even closed at first—at birth there is an open triangle in the top of a baby's skull.

366:32 (373:11). Mrs Beaufoy—see 68:28.

366:33 (373:12). nurse Callan—fictional?

366:34 (373:14). the Coffee Palace—see 264:26n.

366:34–35 (373:14). doctor O'Hare—see 42:34–35n.

366:37 (373:16). Mrs Duggan ... in the City Arms—Mr. and Mrs. Joseph Duggan, 35 Prussia Street not far from the City Arms Hotel, which was at 55.

367:3 (373:22–23). knock spots off them—slang for to defeat or to be much better than.

367:4 (373:24). Hands felt for the opulent—*The Sweets of Sin;* see 232:27n.

367:11 (373:31). height of a shilling in coppers—i.e., 12 thick copper pennies, a popular expression for a diminutive person.

367:12 (373:32). As God made them he matched them—a variant of Robert Burton's (1577–1640) proverb: "Marriage and hanging go by destiny; matches are made in heaven" (*Anatomy of Melancholy* [1621], part iii, sec. 2, mem. 5, subs. 5).

367:14–15 (373:35). Marry in May and repent in December—a variant of the proverb "Marry in haste, and repent at leisure."

367:20 (373:40). Wristwatches are always going wrong—wristwatches were relatively new and undependable curiosities in 1904. Development of methods of reducing electrical disturbance (and consequent magnetic disturbance) in watches, 1910 *ff.*, resulted in the development of dependable wristwatches.

367:23 (374:1). Pill lane—by 1904 renamed Chancery Street, in central Dublin just north of the Liffey; see 292:31–32n.

367:27 (374:5). ghesabo—variant of "gazebo," slang for "the whole show."

367:28–29 (374:6–7). Magnetic needle tells ... sun, the stars—i.e., a magnetometer that is used to measure daily variations in the earth's magnetic field; by 1904 it had been established that periods of radical variation of that field (magnetic storms) coincided with periods of increased sunspot activity; thus, the "needle" would "tell" what's going on in the sun. The "stars" are Bloom's exaggeration of the capacity of an early-twentieth-century magnetometer.

367:29 (374:7). Little piece of steel iron—i.e., a compass needle.

367:29 (374:7–8). When you hold out the fork—a piece of iron or steel advanced toward a compass will cause the needle to deflect.

367:38 (374:16). the horse show—founded in 1731 and sponsored by the Royal Dublin Society (for the advancement of Agriculture, Industry, Science and Art). The horse show is held annually during the first week in August and is described by the *Official Guide to Dublin* as "the greatest function of Dublin's social calendar and an event of international importance in the world of sport" (p. 81).

367:40 (374:18). How Giuglini began—Antonio Giuglini (1827–1865), an Italian operatic tenor from a poor family who had considerable success in Dublin after 1857; his career was ended by insanity in 1864. The anecdote Bloom has in mind is unknown, but Giuglini was a great Dublin favorite and anecdotes about him were current in Joyce's father's generation.

368:1–2 (374:22). But lots of them can't kick the beam—i.e., many women cannot experience orgasm. "Kick the beam" means literally for one arm of a scale to be so lightly weighted that it strikes the beam or frame of the scales; hence, figuratively, to be light in weight, and in slang, to experience sudden emotion or orgasm.

368:8 (374:29). opoponax—or "opopanax," the juice of the herb *Panax* (panacea).

368:10 (374:31). dance of the hours—see 69:14–15n.

368:12 (374:33). Good conductor, is it? Or bad? Light too—Black is a "good conductor," i.e., it absorbs heat; see 57:8–9 (57:10–11). And black also absorbs light as Bloom suggests. In 1904 popular science classified both light and heat as "radiation" and explained them as different forms of "ether-waves" produced by "the vibration of atoms in all material bodies."

368:17 (374:38). Cinghalese—see 70:37n.

368:28 (375:8). Muskrat—muskrat scent was used in the manufacture of cheap perfume.

368:33 (375:13). hogo—a flavor, a taint (after the French, *haut goût*).

368:39–40 (375:19–20). priests that are supposed to be are different—popular superstition: priests, because they are celibate, have a different body odor.

368:41 (375:21–22). The tree of forbidden priest—after the Tree of Forbidden Fruit, the Tree of the Knowledge of Good and Evil, attractive to Adam and Eve because it was the one thing forbidden them in the Garden (see Genesis 2:17 and 3:1–6).

369:9 (375:31). Meagher's—see 118:33n.

369:16 (375:38). Here's this nobleman passed before—see 348:21–23 (354:29–31).

369:18 (375:40). tuck in—to "tuck in" is slang for to eat (from *c*.1838).

369:20 (375:42). government sit—government situation or employment (in context, a sinecure).

369:22 (376:2). See ourselves as others see us—see 8:22–23n.

369:24 (376:5). prize titbit story—see 68:27–28n.

369:27 (376:7). Corns on his kismet—literally, "his fate has pains in its feet"; figuratively, "he is down on his luck."

369:27–28 (376:7–8). Healthy perhaps absorb all the—medical pathology describes a corn as a small local outgrowth of the outer skin with great enlargement of the horny layers (callosity). Most of the underlying nerve bulbs waste away; but if only one or two remain, pressure on the enlarged part can cause acute pain. Bloom reflects that a healthy body might absorb the callosity and reduce the outgrowth.

369:28 (376:8). Whistle brings rain they say—popular superstition: a whistling steam locomotive can cause rain on an otherwise dry but cloudy day.

369:30 (376:10). Old Betty's joints are on the rack—source unknown, but the context suggests that this is a line from a weather-prophecy jingle.

369:30–32 (376:10–12). Mother Shipton's prophecy ... Signs of rain it is—if the fabulous prophetess Mother Shipton actually existed, there is very little evidence other than tradition about her identity. She is supposed to have lived in Tudor England (1486?–1561?) and is reputed to have prophesied the deaths of Cardinal Wolsey (*c*.1475–1530) and other nobles in Henry VIII's court; however, *The Prophecie of Mother Shipton* was not published until 1641. Her prophecies enjoyed a revival of popularity and credibility in the nineteenth century, when they were reprinted with copious and fraudulent additions. The verse Bloom half-recalls reads, "Around the world thoughts shall fly/In the twinkling of an eye." It does not occur in the 1641 edition, but was coined by Charles Hindley in 1862 for his hoax version, *The Wonderful History and Surprising Prophecies of Mother Shipton*. The lines are an obvious (retrospective) prophecy of the invention of the telegraph. Bloom's confusion about ships is logical because Hindley's next lines are "Water shall yet more wonders do,/Now strange, yet shall be true" (steam locomotion), and the verses then continue through prophecies of railroads and railroad tunnels, submarines, iron steamships and air travel by balloon.

369:32 (376:12). The royal reader—the six volumes of *The Royal Readers* were a graded series of textbooks designed "to cultivate the *love of reading* by presenting interesting subjects treated in an attractive style." First published in the 1870s by Thomas Nelson & Sons of London, etc., these texts formed part of *The Royal School Series* and were among the standard school texts on which the Intermediate Education Board for Ireland based its competitive examinations. In context, however, "royal reader" is a pun:

Mother Shipton was a royal reader because she read and prophesied the fates of royalty.

369:32–33 (376:12–13). And distant hills seem coming nigh—source unknown.

369:34 (376:14). Howth. Bailey light—see 351:16n.

369:35 (376:15). Wreckers—either those who are employed in saving lives or property from a wrecked vessel, or land-based pirates who wreck vessels by showing misleading lights.

369:35 (376:15–16). Grace Darling—(1815–1842), the daughter of William Darling, the lighthouse keeper on Longstone, one of the Farne Islands. On 7 September 1838 the steamer *Forfarshire* was wrecked near the lighthouse; all but nine of the 63 passengers perished. Grace and her father braved "dangerous seas" and made two trips to rescue the survivors. Grace became a national heroine and merited a commemorative poem, "Grace Darling" (1843), by Wordsworth on the occasion of her death. Wordsworth's poem was reprinted in *The Royal Readers*, V (London, 1876).

369:41–42 (376:21–22). Best time to spray . . . after the sun—common advice to gardeners.

369:42 (376:22). Red rays are longest—the wavelengths of light rays at the red end of the visible spectrum are longer than those of the other visible colors.

369:42 (376:23). Roygbiv Vance—see 71:7–8n.

370:2 (376:24). Venus?—the evening star on 16 June 1904 would have been Saturn, not Venus.

370:2 (376:24–25). Two, when three it's night—Jewish tradition as recorded in the *Tract Sabbath* (Babylonian Talmud), trans. M. L. Rockinson (1896), Vol. I, p. 61: "If only one star [can be seen in the sky] it is yet day; if two stars, it is twilight; three stars, it is night."

370:4–5 (376:27). Land of the setting sun—rarely, Japan (more often called "The Land of the Rising Sun"). But in Walter G. Marshall, *Through America* (London, 1882), p. 257: "This 'Land of Setting Suns,' as California has been peculiarly and distinctly named."

370:5 (376:27–28). Homerule sun setting in the southeast—as it rose in the northwest; see 57:33–35n.

370:5–6 (376:28). My native land, goodnight—from an interpolated lyric in Canto I of Byron's *Childe Harold's Pilgrimage* (1812). The lyric is a lament and celebration of Childe Harold's departure from England. First verse: "Adieu, adieu! my native shore/Fades o'er the waters blue;/The Night-winds sigh, the breakers roar,/And shrieks the wild sea-mew./Yon sun that sets upon the sea/We follow in his flight;/Farewell a while to him and thee,/My native Land—Good Night!" (I: 118–125).

370:8 (376:30). white fluxions—vaginal discharge; the assumption was that sitting on a cold stone could cause such a discharge and that the discharge would threaten the health of an unborn child.

370:9 (376:31). Might get piles myself—another "popular medicine" reason for not sitting on a cold stone.

370:17 (376:39). sunflowers, Jerusalem artichokes—the two plants are quite similar in size and appearance.

370:18 (376:40). Nightstock—a night-blooming stock.

370:19 (376:41). Mat Dillon's garden—see 105:6–7n.

370:21–22 (377:1–2). Ye crags and peak I'm with you once again—from the Irish-born dramatist James Sheridan Knowles' (1784–1862) tragedy *William Tell* (1825). William Tell speaks in an impassioned monologue: "Ye crags and peaks, I'm with you once again!/I hold to you the hands you first beheld,/To show you they still are free. Methinks I hear/A spirit in your echoes answer me,/And bid your tenant welcome home again!" (I, ii, 1–5).

370:25 (377:6). The distant hills seem—see 369:32–33n.

370:33 (377:14). Nothing new under the sun—Ecclesiastes 1:9: "The thing that hath been, it *is that* which shall be; and that which is done *is* that which shall be done: and *there is* no new *thing* under the sun."

370:42 (377:23). Rip van Winkle—the story "Rip Van Winkle" in *The Sketch Book* (1819–1820) by Washington Irving. Rip does sleep for 20 years and he does awake to find his gun "incrusted with rust"; he returns home, to find "All changed. Forgotten."

370:42 (377:24). Henny Doyle—apparently related to Luke and Carolyn Doyle, friends of the Blooms; see 689:30n.

371:4 (377:27). Sleepy Hollow—"The Legend of Sleepy Hollow" is another of the stories in

The Sketch Book, but it concerns Ichabod Crane, not Rip Van Winkle. Rip sleeps on an unnamed "green knoll" in "one of the highest parts of the Kaatskill mountains."

371:7–8 (377:30–32). Metempsychosis. They believe ... a tree from grief—the "they" suggests those who believed in Greek and Roman mythology; Daphne, for example, in her flight from Phoebus Apollo was transformed into a laurel tree that she might escape the "grief" of capture (Ovid, *Metamorphoses* I).

371:11 (377:34). odour of sanctity—a sweet or aromatic odor given off by the corpses of great saints either before burial or after exhumation. The odor is believed to be evidence of extraordinary sanctity.

371:12 (377:35–36). Pray for us—Bloom has overheard the Litany of Our Lady (of Loreto); see 347:42–348:2n.

371:15–17 (377:38–40). The priest's house ... Twentyeight it is—two houses on Leahy's Terrace were attached to the Mary Star of the Sea Church, numbers 3 and 5. Each was evaluated at £28 in *Thom's (1904)*. Bloom's fictional mistake apparently involved the evaluation of one of these houses when he was working for *Thom's*.

371:17 (377:40–41). Gabriel Conroy's brother is curate—Gabriel Conroy is the central character of "The Dead," *Dubliners*. The Reverend Bernard Conroy is listed as one of two curates in charge in 1904. In "The Dead" Gabriel's brother is named Constantine, not Bernard, and Gabriel thinks of him as "senior curate in Balbriggan." Balbriggan is a small town on the coast 18 miles north of Dublin.

371:21–22 (378:2–3). the bird in drouth ... Throwing in pebbles—the crow in Aesop's fable "The Crow and the Pitcher" saves himself by this stratagem.

371:24–25 (378:6). Stare the sun ... like the eagle—in mythology the eagle was supposed to be able to stare at the sun with impunity and to renew his sight in old age by flying up into the sun where the dimness would be singed from his eyes.

371:31–32 (378:13–14). That's how that wise man ... the burning glass—Archimedes was celebrated for his application of mathematical theory to mechanics, but the story Bloom recalls is apocryphal: Archimedes was supposed to have delayed the Roman Consul Marcellus' (*c.*268–208) conquest of Syracuse by setting the Roman fleet on fire with mirrors that concentrated the sun's rays.

371:35 (378:17). Archimedes. I have it!—Bloom's "I have it!" echoes Archimedes' "*Eureka!*"; see 211:1n.

372:2 (378:26–27). Faugh a ballagh—Irish: "Clear the way." It was the battle cry of the Royal Irish Fusiliers and the motto of the Gough family; see 449:24–25n.

372:4 (378:28). pitched about like snuff at a wake—see 92:17n.

372:4–5 (378:29). when the stormy winds do blow—after a traditional song, "The Mermaid," attributed to one Parker. First verse and chorus: "'Twas Friday morn when we set sail/And we were not far from the land,/When the captain spied a lovely mermaid/With a comb and glass in her hand. // Oh the ocean waves may roll/And the stormy winds may blow/While we poor sailors go skipping to the tops/And the landlubbers lie down below, below, below/And the landlubbers lie down below."

372:7–8 (378:32). till Johnny comes marching home again—"When Johnny Comes Marching Home Again," by Patrick Sarsfield Gilmore (1829–1892) was a Union Army marching song in the Civil War. The song begins: "When Johnny comes marching home again,/Hurrah! hurrah!/We'll give him a hearty welcome then,/Hurrah! hurrah!/The men will cheer, the boys will shout,/The ladies, they will all turn out,/And we'll all feel gay,/When Johnny comes marching home."

372:10 (378:34). The anchor's weighed—the title of a song by Arnold and Braham. The song begins: "The tear fell gently from her eye,/When last we parted on the shore,/My bosom beat with many a sigh,/To think I ne'er might see her more,/To think I ne'er might see her more. // 'Dear youth,' she cried, 'and canst thou haste away,/My heart will break; a little moment stay!/Alas I cannot part from thee!' // The anchor's weighed, the anchor's weighed, Farewell! farewell! Remember me."

372:10–11 (378:35). with a scapular or medal on him—Roman Catholic sailors traditionally wore medals symbolic of a saint's protective presence, or scapulars, loose sleeveless garments or neckbands, similarly symbolic.

372:11–12 (378:36–37). the tephilim no what's ... his door to touch—the word Bloom is seeking is "mezuzah" (Hebrew: "doorpost"); a piece of parchment with Deuteronomy 6:4–9 and 11:13–21 inscribed in 22 lines is rolled up and placed in a small case on the right-hand doorpost of Jewish households. It is touched or kissed by the devout as they enter or leave the house. The "tephilim" is a phylactery that contains four parts of the Pentateuch.

372:12–13 (378:38–39). That brought us out . . . house of bondage—see 121:21–22n.

372:15 (378:41). Hanging onto a plank or astride of a beam—the way Odysseus accomplishes the last leg of his voyage from Calypso's island to the island of the Phaeacians.

372:20 (379:4). Davy Jones' locker—Davy Jones was the sailor's traditional version of the spirit or devil of the sea; his "locker" was the bottom of the ocean, where all drowned things went for "safekeeping."

372:21 (379:5). old cockalorum—applied to a person, it means "self-important little man."

372:22–23 (379:6–7). Mirus bazaar . . . Mercer's hospital—see 180:20n.

372:25–26 (379:9–10). The shepherd's hour: the hour of holding: hour of tryst—source unknown.

372:27–28 (379:11–12). the glowworm's lamp . . . gleaming—see 165:5–6,7n.

372:39 (379:23–24). Kish bank the anchored lightship—see 45:11n.

372:42 (379:26). Irish Lights board—the Commissioners of Irish Lights, with offices in the Carlisle Buildings, 27 D'Olier Street, Dublin, were charged with supervision and maintenance of lighthouses and lightships on the coast of Ireland.

373:1–2 (379:27–28). Day we went out . . . in the Erin's King—see 66:32–33n.

373:6 (379:32). funk—see 66:34n.

373:8 (379:34). Crumlin—a parish and village three and a half miles southwest of the center of Dublin.

373:9 (379:35). Babes in the wood—an English nursery tale (and ballad): two children are left to perish in the forest by an uncle who expects to profit from their death. In 1798 peasant rebels in the hills south of Dublin were also called "babes in the wood."

373:14 (379:40). Calomel purge—not as a purgative but after the practice of using Calomel as a lotion for the relief of mild skin irritations.

373:21 (380:5). Left one is more sensitive—after the popular belief that a woman's left breast, because "nearer the heart," is the more sensitive of the two.

373:25–26 (380:10–11). Gibraltar . . . Buena Vista. O'Hara's tower—South Sugar Loaf Hill (*Buena Vista*) at 1,361 feet is the highest point on Gibraltar; O'Hara's Tower formerly stood nearby on Wolf's Crag (1,337 feet).

373:26–27 (380:11–12). Old Barbary ape that gobbled all his family—the Barbary ape is a tailless terrestrial monkey that inhabits Algeria, Morocco and the Rock of Gibraltar. The monkeys live in droves that are dominated by an old and fierce male. Presumably Bloom is recalling one of Molly's stories about her life on Gibraltar, but the source of Molly's story is unknown.

373:27–28 (380:12). Sundown, gunfire for the men to cross the lines—at sundown on the Rock of Gibraltar the gates were shut so that no one could enter or leave the fortress-colony until sunrise the next day. Gunfire, just before sundown, warned the Rock's inhabitants and its garrison that the gates were about to be closed. The "lines" were the British positions on the Rock side of the neutral ground, a sandy isthmus, that separated Gibraltar from Spain.

373:30–31 (380:15–16). Buenas noches, señorita . . . la muchacha hermosa—Spanish: "Good evening, Miss. The man loves the beautiful young girl."

373:35 (380:20). Leah, Lily of Killarney—for *Leah*, see 75:19n; for *Lily of Killarney*, see 91:1–2n; both performances began at 8:00 P.M.

373:36 (380:21). Hope she's over—i.e., that Mrs. Purefoy has given birth to her child.

374:5–6 (380:32–33). the sister of the wife . . . just come to town—from a progressive street rhyme: "The wild man of Borneo has just come to town./The wife of the wild man of Borneo has just come to town . . ." and so on through potentially endless improvisations.

374:7–8 (380:34–35). Everyone to his taste . . . kissed the cow—a variant of the proverbial expression: "Why, everyone as they like; as the good Woman said, when she kiss'd the Cow" (Colonel Atwit in Dialogue I of Swift's *Complete Collection of Genteel and Ingenious Conversation* [1738]).

374:8 (380:35–36). put the boots on it—brought things to a (negative) climax.

374:10 (380:37–38). Scottish widows—the Scottish Widows' Fund (Mutual) Life Assurance Society with home offices in Edinburgh advertised "The Whole Profits are Divided Among the Policy Holders." *Thom's (1904)* (p. 1908) lists five Dublin agents for this insurance company.

374:12 (380:40). Cramer's—Cramer, Wood and Company, Pianoforte Gallery and Music Warehouse, 4 and 5 Westmoreland Street in east-central Dublin just south of the Liffey.

374:14 (380:41–42). Her widow's mite—Mark 12:41–44: "And Jesus sat over against the treasury, and beheld how the people cast money into the treasury: and many that were rich cast in much. And there came a certain poor widow, and she threw in two mites, which make a farthing. And he called *unto him* his disciples, and saith unto them, Verily I say unto you, That this poor widow hath cast more in, than all they which have cast into the treasury: For all *they* did cast in of their abundance; but she of her want did cast in all that she had, *even* all her living." *Cf.* Luke 21:1–4.

374:16–17 (381:1–2). Poor man O'Connor . . . by mussels here—the specific case Bloom recalls is unknown; but the inshore waters of Dublin Bay near the mouth of the Liffey were badly polluted at the beginning of the twentieth century, and there were frequent cases of hepatitis and other diseases caused by the eating of contaminated shellfish.

374:17 (381:3). The sewage—in 1904 there were no sewage treatment plants in Dublin and environs; the Liffey and its tributaries in Dublin were in effect open sewers, and the consequent pollution of the inner reaches of Dublin Bay was a matter of serious concern.

374:21–22 (381:7–8). Love, lie and be . . . we die—see 169:26–27n.

374:28 (381:14). Mailboat. Near Holyhead by now—the mailboat left Kingstown at 8:15 P.M.; the run to Holyhead, the terminus of the London and Northwestern Railroad in northwestern Wales, took about two and a half hours in 1904.

374:38 (381:24–25). Bread cast on the waters—Ecclesiastes 11:1: "Cast thy bread upon the waters: for thou shalt find it after many days."

374:42 (381:28). Must come back. Murderers do—i.e., "The murderer always returns to the scene of the crime."

375:3, 10 (381:31, 38). I./AM. A—just as it reads: "I am A" (the first letter of the alphabet). Also: "I am alpha" (the first letter in the Greek alphabet; hence, the first or the beginning); the

phrase is repeated four times in Revelation, 1:8 and 11; 21:6 and 22:13: "I am Alpha and Omega, the beginning and the ending, saith the Lord" (1:8). *In a Blakean Translation of Joyce's Circe* (Woodward, Pa., 1965) Frances M. Boldereff remarks that "AM.A. is a quote from *Annals of the Four Masters* [see 326:8–12n]; it represents the way time was signified in the pagan world, it stands for 'Anima Mundi Anno': 'In the Universal mind, year . . .' " (p. 36). Alpha is also the sign of the fish, a traditional symbol for Christ.

375:13–14 (381:42–382:1). No fear of big . . . Guinness's barges—Dublin Bay was shallow off Sandymount Strand; at low water a large area of tidal flats would be exposed to the east of where Bloom is resting near the high-water line.

375:14–15 (382:1–2). Round the Kish in eighty days—after the title of Jules Verne's (1828–1905) novel, *Around the World in Eighty Days* (translated, 1873). For "Kish," see 45:11n.

375:20–21 (382:7–8). Liverpool boat long gone—steampackets for Liverpool sailed from the North Wall in Dublin twice daily, at noon and at 8:00 P.M.

375:22 (382:9). Belfast—i.e., the concert "tour" that Boylan has organized.

375:22 (382:10). Ennis—where Bloom is to observe the anniversary of his father's death on 27 June.

375:26 (382:14). Grace darling—see 369:35n.

375:28–29 (382:15–16). frillies for Raoul . . . heave under embon—see *Sweets of Sin*, 232:27n.

375:29 (382:16). señorita—see 373:30–31n.

375:30 (382:17–18). Agendath—see 60:12–13n.

375:31–32 (382:18–19). her next year . . . next her next—*cf.* 121:20n.

375:36–38 (382:23–25). Cuckoo./Cuckoo./Cuckoo—see 210:9–10n. But in context the omen is ambiguous because a young lady, hearing the bird, kisses her hand to it and says, "Cuckoo, cuckoo,/Tell me true,/When shall I be married?" The number of notes in the cuckoo's response gives her the answer.

EPISODE 14
[OXEN OF THE SUN]

OXEN OF THE SUN

EPISODE FOURTEEN

ROUTE OF STEPHEN AND LYNCH,

FOLLOWED BY BLOOM

⊳———— Course & Direction

○———— Stop-Off Points

• • • • • Projected Route

Amiens Street Station

Westland Row Station

Burke's Pub

National Maternity Hospital

Episode 14: [Oxen of the Sun], pp. 377–421 (383–428). In Book XII of *The Odyssey* Odysseus and his men sail from Circe's island; they pass the Sirens, run the gamut of Scylla and Charybdis and at nightfall are coasting the island of the sun-god Helios (identified as Trinacria, modern Sicily). Both Circe and Tiresias have warned Odysseus to avoid the island and particularly to avoid harming the cattle sacred to Helios. The crew, led by Eurylochus, refuse to spend the night at sea; Odysseus asks them to swear that they will not touch the sacred cattle; and when they agree, he reluctantly lands on the island. Odysseus falls asleep and the crew immediately forswear their oath and slaughter cattle for their meal. Lampotie (Lampetia), a daughter of Helios, warns her father, who appeals to Zeus. Zeus promises retribution, and when the ship leaves the island, he makes good his word, destroys ship and crew with a lightning bolt and fulfills the prophecies of Circe and Tiresias. Odysseus, once more frustrated and now condemned to further delay in his voyage home, lashes the mast and keel of his shattered ship together, endures the voyage past the whirlpool of Charybdis and is beached in exile on Calypso's island.

Time: 10:00 P.M. Scene: the National Maternity Hospital, 29, 30 and 31 Holles Street, Dublin. Organ: womb; Art: medicine; Color: white; Symbol: mothers; Technique: embryonic development.[1] Correspondences: *Trinacria* (the Island of the sun-god Helios, modern Sicily)—the hospital; *Lampote* and *Phaethusa* (daughters of Helios entrusted with guarding the sacred cattle) —the nurses; *Helios*—Horne (Doctors Andrew J. Horne and Patrick J. Barry were the Masters of the National Maternity Hospital in Holles Street in 1904); *Oxen*—fertility; *Crime* (killing the oxen) —fraud (in the formal sense of breaking a vow).

Style: 377:1–8 (383:1–8). Deshil Holles Eamus ... boyaboy, hoopsa—Stuart Gilbert says that this episode "begins with a set of three incantations, in the manner of the *Fratres Arvales*," *James Joyce's Ulysses* (New York, 1952), p. 296. The Arval Brethren were a Roman company of

priests, 12 in number, whose principal function was to conduct public ceremonies in honor of the Roman goddess of plenty and fertility. An integral part of these ceremonies was the "Arval Hymn" (*c.*218 A.D., discovered late nineteenth century). Each of the first five lines of the hymn was repeated three times; the final *Triumphe* ("Hurrah," "Hoopsa") was repeated six times. Translation: "Aid us, Lares/Nor suffer pestilence or destruction to come upon the people./Be thou satiate, fierce Mars./Leap over the Threshold! Halt! Beat [the ground]!/Call alternately the heroes all./Aid us Mars./Hurrah!"

377:1–2 (383:1). Deshil Holles Eamus— *Deshil* is Irish: "turning to the right, turning toward the sun"; *Holles* is Holles Street, the location of the National Maternity Hospital; *Eamus* is Latin: "Let us go."

377:3–6 (383:3–6). Send us, bright one ... quickening and wombfruit—an invocation to the sun as a source of fertility. "Horhorn" suggests Dr. Andrew J. Horne, one of the two Masters of the Hospital; it also suggests the horned cattle of the sun-god. See also 252:25n.

377:7 (383:7). Hoopsa, boyaboy, hoopsa!— the cry with which a midwife celebrates the birth of a male child as she bounces it to stabilize its breathing.

Style: 377:9–38 (383:9–39). Universally that person's ... ever irrevocably enjoined?—an imitation of the Latin prose styles of the Roman historians Sallust (86–34 B.C.) and Tacitus (*c.*55–120 A.D.). The manner of this passage suggests a literal translation without an Anglicizing of word usage and syntax.

377:20 (383:20–21). omnipollent—"pollent," from Latin *pollens*, is rare for "powerful."

377:23 (383:24). lutulent—rare: "muddy, turbid, thick."

377:30 (383:30–31). inverecund—rare: "immodest."

377:35–38 (383:35–39). that evangel simultaneously ... ever irrevocably enjoined— "evangel" would suggest the message or news of the Christian dispensation, but here it would seem to have the more general meaning "message of God" to Adam and Eve (and hence all mankind): "Be fruitful, and multiply, and replenish the earth, and subdue it" (Genesis 1:28). The message is repeated (to Noah) in Genesis 9:1, 7 and (to Israel as a promise) in Leviticus 26:9. Leviticus 26:14 *ff.* counters with the curse of destruction to those disobedient to this promise and injunction.

[1] In structure this episode is a series of imitations of prose styles presented in chronological sequence from Latin prose to fragments of modern slang. Joyce remarked (jocoseriously?) in a letter to Frank Bugden, 20 March 1920: "Bloom is the spermatozoon, hospital the womb, the nurses the ovum, Stephen the embryo." In effect the sequence of imitations is a sustained metaphor for the process of gestation; Joyce would have assumed that in that process ontogeny (the development of the individual organism) recapitulates phylogeny (the evolutionary history of the species); thus the development of the embryonic artist's prose style recapitulates the evolution of prose style in literary history. The stylistic imitations are noted below as "Style" with a brief description of the style being imitated.

Style: 377:39—378:28 (383:40–384:31). It is not why therefore . . . had been begun she felt—after the style of medieval Latin prose chronicles, again with the effect of a literal translation that does not Anglicize word usage and syntax.

377:41–42 (383:42–384:1). the art of medicine shall have been highly honoured—Ireland has an impressive history of accomplishments in medicine that dates from as early as the fifteenth century. There was a particularly important development of this traditional commitment to medicine in the eighteenth century.

378:1 (384:3). the O'Shiels—a family of physicians, hereditary physicians to the Mahoneys of Oriel. The most famous member of the family was Eoghan (Owen) O'Shiel, physician-in-chief to the armies of the Kilkenny Confederation in its campaigns for King Charles I and the House of Stuart against Parliamentary forces (1642–1650).

378:2 (384:3). the O'Hickeys—the Irish root of "Hickey" means "healer"; a family of hereditary physicians to the O'Briens of Thomond.

378:2 (384:3). the O'Lees—a family of hereditary physicians to the O'Flahertys of Connaught. The family produced a complete manual of medical studies in both Irish and Latin in the fifteenth century.

378:4 (384:5–6). the trembling withering—a usually fatal disease accompanied by neuromuscular disturbance and semiparalysis of the limbs.

378:4–5 (384:6). loose boyconnell flux—"loose flux" can be either a hemorrhage or severe diarrhea. "Boyconnell" is apparently a topical reference, possibly to F. Norrys Connell, "one of the many clever Irish writers of fiction who came to the front toward the close of the nineteenth century."

378:7–12 (384:8–13). a plan was by them adopted . . . from all accident possibility removed—the "plan" was the establishment of maternity hospitals. The first maternity hospital in the British Isles was the Rotunda Hospital for the Relief of Poor Lying-in Women in Dublin. It was opened "in George's Lane, 15 March 1745, was incorporated by Royal Charter 1756 and was opened in Rutland Square for the reception of patients, 8th December, 1757." In 1904 it was "the largest chartered Clinical School of Midwifery and Gynaecology in the United Kingdom" (*Thom's [1904]*, p. 1380).

378:26–27 (384:28). that they her by anticipation went seeing mother—the National Maternity Hospital not only admitted "midwifery cases," but also conducted a dispensary and attended women "in their own homes, during their confinement, at all hours if notice was given at the Hospital" (*Thom's [1904]*, p. 1381).

Style: 378:29–379:40 (384:32–386:4). Before born babe bliss had . . . sorrowing one with other—imitates the style of Anglo-Saxon rhythmic alliterative prose, a style associated with Aelfric (*c.*955–1022), the leading prose writer of his period. In his stylistic effects Aelfric was following a fashion of his time, a fashion established in Latin prose in the tenth century and then carried over into composition in Anglo-Saxon. The alliteration was also associated with Anglo-Saxon poetry, in which it was the dominant sound effect.

378:37 (384:40). sejunct—obsolete for "sejoined": separated.

378:41 (385:3). Some man that wayfaring was—this line and the passage that follows to **379:40 (386:4) sorrowing one with other** echoes "The Wanderer," an Anglo-Saxon elegiac lament preserved in the *Exeter Book* (copied *c.*975). The speaker of the poem, "deprived of my homeland, far from dear kinsmen," is a wanderer, an "earth-walker," in search of a new lord and hall. He moves through a perpetual winter, contemplates an endless sea voyage and speaks his cares only to himself: "There is now none of the living to whom/I dare clearly say my heart's thought." In the second half of the poem the speaker turns from his personal lament to philosophize on "all the life of men—with what terrible swiftness they forgo the hall-floor, bold young retainers. . . . So the Creator of men's generations laid waste this dwelling-ground." The poem concludes with the assertion that the "wise in heart" never utters "too quickly the passion of his breast" and seeks his "support from the Father in heaven, where for us the only stronghold stands."

378:42 (385:4). Of Israel's folk—recalls the Wandering Jew; see 215:4n.

379:3 (385:7). Of that house A. Horne is Lord—Andrew J. Horne was one of the two "Masters" of the National Maternity Hospital in 1904. Patrick J. Barry was the other.

379:3, 7 (385:7, 11). Seventy beds/in twelve moons thrice an hundred—*Thom's (1904)* on the National Maternity Hospital: "This Hospital, reopened in 1894, contains 69 beds; there were 1,500 midwifery cases treated during the past year, and over 4,000 attendances at the Dispensary" (p. 1381).

379:5 (385:9). so God's angel to Mary quoth— in the Annunciation (Luke 1:26–38), the angel Gabriel announces the birth of Jesus to the Virgin Mary.

379:10 (385:15). swire ywimpled—"swire" is Anglo-Saxon for the neck or throat; "ywimpled" is Middle English (in Chaucer) for "covered with a wimple."

379:11 (385:16). levin—archaic: "lightning."

379:12–13 (385:17–18). God the Wreaker ... water for his evil sins—in Genesis God determines to destroy mankind (excepting Noah and his family) "for all flesh had corrupted his way upon the earth" (Genesis 6:12).

379:14 (385:19). rathe—obsolete: "quickly, speedily."

379:18 (385:23). stow—obsolete: "place."

379:19–20 (385:24–25). over land and seafloor ... long outwandered—Odysseus was fated to be absent from home for 20 years: ten years in the Trojan War and ten years of wandering.

379:20 (385:25). townhithe—"hithe" is archaic for a port or haven.

379:27 (382:32). O'Hare Doctor—see 42:34–35n. Apparently O'Hare died between February and June 1904, but we have been unable to confirm the date and manner of his death.

379:27 (385:33). grameful—archaic: "full of grief or sorrow."

379:31 (385:36). algate—archaic: "always."

379:33 (385:38). housel—archaic: "the Eucharist," or the act of administering or receiving it (in this context: "in Extreme Unction").

379:33–34 (385:39). sick men's oil to his limbs —anointing with holy oil is part of the sacrament of Extreme Unction.

379:36 (385:41). Mona island—an ancient name for Anglesey, an island county in northwestern Wales, a popular health resort in 1904.

379:36 (385:42). belly crab—literally: "cancer of the stomach."

379:37 (385:42). Childermas—28 December, Holy Innocents Day, observed in commemoration of the children slain by Herod in Bethlehem; see Matthew 2:16–18.

379:39–40 (386:3). wanhope—archaic: "want of hope, despair."

Style: 379:41–380:15 (386:5–386:22). Therefore, everyman, look to that ... chiding her childless—Middle English prose. The opening paragraph echoes the opening speech of the medieval morality play *Everyman* (*c.*1485). The "Messenger" announces the play's action and message: "The story saith: Man, in the beginning /Look well, and take good heed to the ending,/Be you never so gay./You think sin in the beginning full sweet,/Which in the end causeth the soul to weep,/ When the body lieth in clay./Here shall you see how fellowship and jollity,/Both strength, pleasure, and beauty,/Will fade from thee as a flower in May./For ye shall hear how our Heaven-King/Calleth Everyman to a general reckoning" (lines 10–20).

379:42 (386:6). every man that is born of woman—echoes Job 14:1: "Man *that is* born of woman *is* of few days, and full of trouble."

380:1–2 (386:7–8). as he came naked forth ... go as he came—paraphrases Job 1:21: "Naked came I out of my mother's womb, and naked shall I return thither."

380:7 (386:13). unneth—i.e., "uneath," obsolete: "not easy, difficult, hard."

380:15 (386:21). Nine twelve bloodflows—i.e., approximately nine years of menstruating.

Style: 380:16–381:25 (386:23–387:34). And whiles they spake ... Thanked be Almighty God—imitates the *Travels of Sir John Mandeville* (*c.*1336–1371), a medieval compilation of fantastic travel stories, apparently composed at Liège by one John of Burgundy or John with the Beard. The earliest manuscripts of English translations of the French original and of a Latin translation of that original date from the beginning of the fifteenth century.

380:19 (386:26). Dixon—the "Medical Directory" in *Thom's (1904)* (p. 872) lists a Joseph F. Dixon as a medical practitioner, residing at 12 Conyngham Road in Dublin (on the southeastern edge of Phoenix Park).

380:21 (386:28). the house of misericord—the Mater Misericordiae Hospital; see 96:13n.

380:23–24 (386:31). a horrible and dreadful dragon—in this case, a bee.

380:29 (386:36). cautels—archaic: "caution, prudence"; also, "cunning, deceitful."

380:29 (386:37). avis—Middle English *avys*: "advice, counsel, opinion."

380:32 (386:40). mandement—a variant of "mandment," obsolete: "command."

381:1 (387:10). Mahound—Mohammed was so called in the Middle Ages, when it was believed that his followers worshiped him as a god; e.g., the word was Middle English for a heathen god, an idol, a monster. The art of glass blowing did come from the East (China and India) to the West, but long before the time of Mohammed.

381:6–10 (387:14–19). strange fishes without-en heads ... of the olive press—i.e., canned sardines.

381:11–12 (387:20–21). wheat kidneys out of Chaldee—i.e., bread; see 41:7n. Chaldee or Chaldea, an ancient region in southwestern Asia on the Euphrates and the Persian Gulf.

381:14–16 (387:23–25). the serpents there to entwine ... brewage like to mead—describes the care of hop vines and the manufacture of beer.

381:17 (387:26). childe—archaic: "a youth of noble birth."

381:18 (387:27). halp—obsolete: past tense of "to help."

381:20 (387:29). apertly—archaic: "openly, publicly, plainly."

381:23 (387:32). nist—for "ne wist" archaic: "knew not."

Style: 381:26–384:31 (387:35–391:2). This meanwhile this good ... murdered his goods with whores—imitates the fifteenth-century prose style of Sir Thomas Malory's (d. 1471) compilation of Arthurian legend, *Morte d'Arthur* (printed 1485).

381:27 (387:36). alther—variant of "aller," archaic: "of all."

381:39–40 (388:6–7). Expecting each moment to be her next—Lenehan's variant of the stock phrase for fear, "Expecting each moment to be his last."

382:4 (388:13). husbandly hand under hen—see 310:1–2n.

382:11 (388:20). saint Mary Merciable's—the Mater Misericordiae Hospital; see 96:13n.

382:11 (388:20). Lynch—appears as one of Stephen's close associates in *A Portrait of the Artist as a Young Man,* Chapter V.

382:13 (388:22). Alba Longa—the most ancient town in Latium (the Latin colonies in ancient Italy), said to have been founded by Aeneas' son, Ascanius, to have been the mother-city of Rome and to have been destroyed by Tullus Bostilius, the third king of ancient Rome. But "Alba" is also Irish for Scotland.

382:13 (388:22). Crotthers—unknown.

382:15 (388:24). Punch Costello—unknown.

382:16 (388:25). gested—archaic: "performed."

382:25 (388:34). red—variant of "rede," archaic: "(to) counsel, control."

382:27–28 (388:36–37). aresouns—variant of "areason," archaic: "a questioning, a calling to account."

382:31 (388:40). Eblana—Ptolemy's (see 320:36n) name for Dublin (after *Dubh-Linn,* "Dark Pool," the Irish name for the peat-colored waters of the Liffey estuary).

382:35 (389:2). the woman should bring forth in pain—after Genesis 3:16 "Unto the woman [the Lord God] said, I will greatly multiply thy sorrow and thy conception; in sorrow thou shalt bring forth children."

382:42–383:1 (389:10–11). the wife should live and the babe to die—Roman Catholic doctrine held that if a medical choice had to be made between the life of the mother and the life of the child in the process of delivery, the life of the child was to take precedence.

383:7 (389:16). rede—see 382:25n.

383:8 (389:17–18). Saint Ultan of Arbraccan —(d. 656?), an Irish missionary to the Netherlands. In some versions of his life story he is described as the maternal uncle of St. Bridgid (d. 523?) (see 333:25n); in other versions he is said to have been the author of a *Life of St. Brigid.* He taught and fed orphans and came to be regarded in Ireland as the patron saint of sick and orphaned children.

383:8 (389:18). let—in the obsolete sense of "accept."

383:12 (389:22). the one in limbo gloom, the other in purge fire first—i.e., the baby, dead in childbirth, was presumably unbaptized and therefore destined for limbo; the mother, presumably baptized and possibly shriven, would be in purgatory.

383:14 (389:24). the sin against the Holy Ghost—technically the sin against the Holy Ghost is the only unforgivable sin; it falls into two general categories, the sin of presumption and the sin of despair. To "presume" is to believe

that one is possessed of the Holy Spirit before he has truly achieved a state of Grace; to "despair" is to believe that one will never achieve the in-dwelling spirit of Grace. In context the "sin" is not simply as defined above but also an echo of St. Paul: "What? know ye not that your body is the temple of the Holy Ghost *which is* in you, which ye have of God, and ye are not your own?" (I Corinthians 6:19).

383: 23-24 (389:33-34). the unicorn how once ... cometh by his horn—the origin of this particular bit of medieval bestiology is obscure, but it may be the result of a (drunken) confusion of the legend of the unicorn with the legend of the phoenix. In some medieval bestiaries the unicorn is said to live a thousand years; this numerology links the unicorn with Christ and with the belief in thousand-year cycles of regeneration. The phoenix, the mythical bird that once in a millen-nium was consumed by fire and reborn from its own ashes, is also an emblem of Christ in medieval bestiaries.

383:26 (389:36). saint Foutinus—St. Foutin, the first bishop of Lyons in France (third century). Apparently the populace of Lyons and environs elided the image of this saint with that of certain pre-Christian Priapic gods; the worship of St. Foutin, as late as the sixteenth century, involved pouring wine over a representation of his genitalia, allowing it to sour and then regarding the vinegar as a cure for barrenness.

383:31-32 (389:42). orgulous—archaic: "proud, haughty."

383:33 (390:1). law of canons—canonical law, collectively the rules of doctrine and discipline enacted by Church Councils and confirmed by the pope.

383:33 (390:1-2). Lilith, patron of abortions—"Lilith" in Hebrew is a night-hag, night-monster, night-fairy, a demon apparently of Babylonian origin. She is mentioned once in the Bible, in Isaiah's description of "the day of the Lord's vengeance" (Isaiah 34:14), where her name is rendered as "screech owl." Various legends depict her as Adam's sensual and animalistic first wife, metamorphosed into a demon and replaced by Eve. Other legends depict her as a sensual temptress who becomes Adam's concubine after the Fall. She was regarded as particularly hostile to newborn children and to pregnant women, and amulets were worn to ward off her destructive influence.

383:33-34 (390:2-3). bigness wrought by wind of seeds of brightness—i.e., Stephen cites fabulous accounts of impregnation by wind as in Virgil (see 383:35n) and as in the legend of Zephy-rus, the west wind, who fathered Achilles' horses. Other myths of impregnation involve a shower of šeeds from the sun or the stars or the bright sky as Zeus in the form of a shower of gold impregnated Danaë.

383:34-35 (390:3). potency of vampires mouth to mouth—Stephen recalls his "poem"; see 48:34-36n. The vampires of legend did not impregnate but fed on the blood of sleeping persons; another demon of the night, the incubus, was supposed to impregnate sleeping women.

383:35 (390:4). as Virgilius saith—Virgil, in the *Georgics* III:271-277, describes the spring "excitement" of mares: "And as soon as the flame has stolen into their craving marrow ... they all, with faces turned to the Zephyrs, stand on a high cliff, and drink in the gentle breezes. Then oft, without any wedlock, pregnant with the wind (a wondrous tale!) they flee over rocks and crags and lowly dales."

383:35 (390:4). by the influence of the occi-dent—i.e., by the influence of the West, Zephyrus, the west wind.

383:36 (390:4-5). by the reek of the moon-flower—i.e., by the presence of a menstruating woman. Pliny (23–79 A.D.), in his *Natural History*, gives long lists of a menstruating woman's powers for good or bad. One of the good powers is the ability to cure barrenness in other women.

383:36-37 (390:5-6). an she lie with .. effectu secuto—the Latin, one of the basic principles of Scholastic philosophy, means "one performance following another." Stephen's source for this im-probable mode of impregnation is unknown.

383:37-39 (390:6-7). in her bath according ... Moses Maimonides—the two medieval philosophers have been previously linked in Stephen's mind (see 29:12-13n), but only Averroës appears to have held this opinion. In his medical work *Colliget*, he cites a "case history" of a woman impregnated in her bath by semen from a man bathing nearby. Sir Thomas Browne, in *Pseudodoxia Epidemica* (1646), Book VII, Chapter XVI, finds this impregnation a "new and unseconded way in History to fornicate at a distance, and much offendeth the rules of Physick."

383:39-40 (390:8-9). how at the end of the second month a human soul was infused—Aristotle argues in *Of the Generation of Animals* that conception establishes a "nutritive soul" in the embryo and that the embryo has "sensitive soul" and "rational soul" "potentially but not actually," i.e., the embryo will develop "soul" as the body develops. Aquinas, in *Summa Theologica*,

Part I, Query 118, adopts Aristotle's position and argues "that the intellectual soul is created by God at the end of human generation," that the nutritive and sensitive souls develop in the course of "human generation" and that the intellectual soul is "at the same time sensitive and nutritive, the preexisting forms being corrupted." The implication is that some time elapses between conception and the moment when the soul is "created" and "infused into" the body, but the "two months" is Stephen's (not Aquinas') rhetorical flourish. Most modern Catholic theologians have been reluctant to follow Aquinas on this point, but have held instead that the soul is present from the moment of conception.

383:40 (390:9). our holy mother—the Church.

384:1–2 (390:12–13). he that holdeth the fisherman's . . . for all ages founded—the fisherman's seal or fisherman's ring is the papal seal (from *c.*1265). Papal authority is derived from Jesus' words to Peter in Matthew 16:18 "Thou art Peter, and upon this rock [*Petrus*] I will build my church; and the gates of hell shall not prevail against it." Thus the fisherman's seal is associated with Peter as the first "bishop of Rome." The seal also has its source in Jesus' words to the fishermen, Peter (and his brother Andrew), "Follow me, and I will make you fishers of men" (Matthew 4:19).

384:9–10 (390:21). birth and death pence—i.e., the traditional donations or payments for the funeral Mass (for the dead mother) and the baptismal service (for the newborn child).

384:13–14 (390:24–25). he who stealeth from the poor lendeth to the Lord—see 24:24n.

384:23 (390:37). akeled—obsolete, to "akele" meant to cool, to become cold.

384:30–31 (391:2). murdered his goods with whores—in Luke 15:30 the Prodigal Son's brother complains to his father that the Prodigal "hath devoured thy living with harlots."

Style: 384:32–386:11 (391:3–395:15). About that present time . . . rest should reign—imitates Elizabethan prose chronicles.

384:36 (391:7). the vicar of Christ—one of the pope's titles with reference to the assertion that the pope is to represent Christ as head of His Church on earth.

384:37 (391:8). the vicar of Bray—the title of a song about a pliant clergyman who shifted nimbly with the winds of political and doctrinal change: "A zealous High Churchman" under Charles II, a "Jesuit" under James II, etc.

Chorus: "And this is law I will maintain/Until my dying day, sir!/That whatsoever King may reign/Still I'd be Vicar of Bray, Sir!" The song concludes with the vicar's "allegiance" to George I: "And George my lawful King shall be/Until the times do alter." Bray is on the coast southeast of Dublin. The unflattering equation of the pope with the vicar of Bray echoes a common criticism of Pius X (1835–1914; pope, 1903–1914), who continued his predecessors' protests against the occupation of the Papal States by the Italian government but at the same time remained on remarkably friendly terms with that government.

384:37–39 (391:8–10). Now drink we, quod . . . my soul's bodiment—parodies Jesus' words at the Last Supper: "And as they were eating, Jesus took bread, and blessed *it*, and brake *it*, and gave *it* to the disciples, and said, Take, eat; this is my body. And he took the cup, and gave thanks, and gave *it* to them, saying, Drink ye all of it; For this is my blood of the new testament, which is shed for many for the remission of sins" (Matthew 26:26–28).

384:39–40 (391:11). them that live by bread alone—Jesus, fasting in the wilderness, refuses the devil's temptation, "command that these stones be made bread. But he answered and said, It is written [Deuteronomy 8:3], Man shall not live by bread alone, but by every word that proceedeth out of the mouth of God" (Matthew 4:3–4).

385:4–5 (391:18). time's ruins build eternity's mansions—from a Letter by William Blake to William Hayley, 6 May 1800: "Thirteen years ago I lost a brother, and with his spirit I converse daily and hourly in the spirit, and see him in my remembrance, in the regions of my imagination. I hear his advice, and even now write from his dictate. Forgive me for expressing to you my enthusiasm, which I wish all to partake, since it is to me a source of immortal joy, even in this world. By it I am the companion of angels. May you continue to be so more and more; and to be more and more persuaded that every mortal loss is an immortal gain. The ruins of Time build mansions in Eternity."

385:5–7 (391:19–21). Desire's wind blasts . . . the rood of time—a homily of St. Bernard of Clairvaux (1090–1153) is included in the *Divine Office* for 7 October, the Feast of the Blessed Virgin Mary of the Rosary: "To commend His grace to us and to destroy human wisdom, God was pleased to take flesh of a woman who was a virgin and so to restore like by like, to cure a contrary by a contrary, to draw out the poisonous thorn and most effectively to blot out the decree of sin. Eve was a thorn in her wounding; Mary is a rose in her sweetening of the affections of all. Eve

was a thorn fastening death upon all; Mary is a rose giving the heritage of salvation back to all." As Thornton points out, Stephen's imagery may also owe a debt to the *Divine Comedy*; in Canto XIII of *Paradiso*, St. Thomas Aquinas warns Dante that obvious judgments may be hasty and false, "for I have seen first all the winter through the thorn display itself hard and forbidding and then upon its summit bear the rose" (lines 133–135). "To the Rose Upon the Rood of Time" is the dedicatory poem of Yeats's volume *The Rose* (1893), *Collected Poems* (p. 31). The poem evokes the rose as muse and contemplates the rose as the intersection between temporal and eternal beauty since the rose makes it possible to see "In all poor foolish things that live a day/Eternal beauty wandering on her way" (lines 11–12).

385:7–9 (391:21–23). In woman's womb word ... shall not pass away—John 1:14: "And the Word was made flesh and dwelt among us, (and we beheld his glory, the glory as of the only begotten of the Father,) full of grace and truth." The opening phrases of this passage follow St. Bernard's homily in the Feast of the Blessed Virgin Mary of the Rosary (see 385:5–7n). See also John 1:1–5, "In the beginning was the Word, and the Word was with God, and the Word was God. The same was in the beginning with God. All things were made by him; and without him was not any thing that was made. In him was life; and the life was the light of men. And the light shineth in darkness; and the darkness comprehended it not."

385:10 (391:23–24). Omnis caro ad te veniet—see 48:34n.

385:11–12 (391:24–25). who aventried the dear ... Healer and Herd—"aventre" is an obsolete word of obscure meaning though in the context of its use by Edmund Spenser suggests "to thrust forward (at a venture) as a spear." "Corse" is obsolete for body; "Agenbuyer" is Middle English for Christ, the Redeemer, as "Herd" is Christ as Shepherd of God's flock, mankind.

385:12 (391:25–26). our mighty mother—see 7:9n.

385:12–13 (391:26). mother most venerable—one sequence of the Litany of Our Lady (of Loreto) begins, "Virgin most prudent,/Virgin most venerable"; see 347:42–348:2n.

385:13–14 (391:26–28). Bernardus saith aptly ... deiparae supplicem—source unknown; see 333:13–14n and 350:22–26n.

385:15–18 (391:28–32). she is the second Eve ... for a penny pippin—this theme is repeated

several times in the Saturday Office of the Blessed Virgin Mary, notably in passages from Saints Irenaeus (second century), Augustine and Bernard of Clairvaux. The relevant passage from St. Augustine: "Eve willingly accepted the drink offered by the serpent and handed it on to her husband; and by their action both deserved the penalty of death. Mary, filled with heavenly grace from above, brought forth life, by which mankind, already dead, can be revived." For "navel cords," see 39:1–5 (38:1–5).

385:19–20 (391:33–34). Or she knew him ... creature of her creature—in addition to the obvious pun on the biblical "to know" (to have sexual relations), this passage turns on the "mystery" of Mary's relation to God. This "mystery" is alluded to in a passage from St. Bernard in the Saturday Office of the Blessed Virgin Mary, but a more relevant passage from St. Bernard occurs in the *Divine Office* for the 11 October Feast of the Motherhood of the Blessed Virgin Mary: "But Mary knew herself to be His Mother and she trustfully calls Him her Son, whose majesty the Angels serve with awe. ... God, I say, to whom the Angels are subject ... He was subject to Mary. ... That God should obey a woman is humility without precedent; that a woman should command God, exaltation without parallel."

385:20 (391:34). vergine madre figlia di tuo figlio—Italian: "Virgin mother, daughter of thy son" (*Paradiso* XXXIII:1, the opening line of St. Bernard's prayer to Mary on behalf of Dante).

385:20–21 (391:34–35). or she knew him not—the source of considerable heretical and theological contention: (*a*) that Mary was not impregnated by the Holy Spirit, or (*b*) that she was only the unwitting "vessel of flesh," not aware that it was the "Word" that "was made flesh" in her womb.

385:21–22 (391:35–36). the one denial or ignorancy with Peter Piscator—at the close of the Last Supper Jesus predicts to Peter, "Verily I say unto thee, That this night, before the cock crow, Thou shalt deny me thrice" (Matthew 26:34). Peter protests that he will not, but each of the Gospels records his temporary defection and mortification. "Peter Piscator": Peter the Fisherman; see 384:1–2n.

385:22 (391:36). who lives in the house that Jack built—the cumulative progression of the nursery rhyme "This is the house that jack built" recalls the succession of bishops of Rome (popes) in "The house that Peter built" (as first bishop of Rome).

385:23–24 (391:37–38). Joseph the Joiner ... all unhappy marriages—for Joseph the Joiner,

see "Mulligan's poem," 20–21 (19). Joseph's doubts about Mary's pregnancy and its divine origin are suggested in Matthew 1:18–21; his doubts are allayed, "behold, the angel of the Lord appeared unto him in a dream, saying, Joseph, thou son of David, fear not to take unto thee Mary thy wife: for that which is conceived in her is of the Holy Ghost" (1:20). In the Litany (of St. Joseph) Joseph is variously addressed as "Glory of home life,/Guardian of virgins,/Pillar of families."

385:24–26 (391:38–40). parce que M. Léo ... ventre de Dieu!—French: "Because Mr. Léo Taxil has told us that the one who put her in this wretched position was the sacred pigeon, bowels of God [a curse]." For Léo Taxil, see 42:12–13n and 42:19n.

385:26–27 (391:40–41). Entweder transsubstantiality ... no case subsubstantiality—*Entweder ... oder* is German: "Either ... or." The play on words recalls Stephen's earlier contemplation of heresies; see "Arius," 22:29n, and "Valentine," 22:30n.

385:28–30 (391:42–392:2). A pregnancy without joy ... belly without bigness—historically the doctrine of Mary's immaculateness, her freedom from sin or fleshly taint, has been gradually enlarged: not only did she conceive without the "joy" (of copulation), but she also did not grow great with child, did not experience labor pains in giving birth and remained a virgin after having given birth. See 39:8–9n.

385:33, 35 (392:5, 7–8). Staboo Stabella/The first three months she was not well, Staboo—the title and opening line of an unpublished bawdy ballad by Oliver St. John Gogarty; see Adams, p. 209.

385:34 (392:6). put in pod—Elizabethan slang: "made pregnant."

385:34 (392:6). Almany—archaic: "Germany."

385:36 (392:8). nurse Quigley—identity and significance unknown.

385:39 (392:12). gasteful—obsolete: "wasteful."

386:4 (392:18). chode—obsolete: past tense of "to chide."

386:5–7 (392:18–20). thou chuff, thou puny ... thou abortion thou—recalls the name-calling contests between Prince Hal and Falstaff, particularly in *I Henry IV* (II, iv). "Chuff": a miser or rustic clown. "Got in the peasestraw": figuratively, illegitimate, since peasestraw was a

cheap (and dishonest) substitute for hay. "Losel": a profligate, rake or scoundrel. "Dykedropt": born in a ditch.

386:8 (392:22). like a curse of God ape—source and connotations unknown.

386:9 (392:24). margerain—obsolete: "marjoram" (regarded in Elizabethan herbals as the herb of calm and gentleness and as a remedy for diseases of the brain).

Style: 386:12–388:39 (392:27–395:15). To be short this passage ... of a natural phenomenon—a composite imitation of late-sixteenth- and seventeenth-century Latinate prose styles including those of John Milton (1608–1674), Richard Hooker (1554–1600), Sir Thomas Browne (1605–1682) and Jeremy Taylor (1613–1667).

386:13 (392:28). Mary in Eccles—the Mater Misericordiae Hospital in Eccles Street; see 96:13n.

386:15–16 (392:30–31). obedience in the womb ... poverty all his days—"By profession, members of the religious life publically assume the obligations of their state through the vows of poverty, chastity, and obedience" (*Maynooth Catechism*, 1888).

386:20 (392:35). intershowed—a Latin–Anglo-Saxon coinage: "demonstrated among (them)."

386:22 (392:37). the eternal son and ever virgin—i.e., Christ, who, though made flesh as man, was "free from all ignorance and error, from all sin and imperfection" (*Maynooth Catechism*, 1888).

386:23–29 (392:39–393:3). his curious rite of wedlock ... she was there unmaided—fantastic exemplary anthropology of this sort is characteristic of Sir Thomas Browne; *cf.* his *Pseudodoxia Epidemica* ("Vulgar Errors," 1646). But the reference here is apparently to the suspicions indirectly suggested by the English Congregational minister William Ellis (1794–1872) in his *Three Trips to Madagascar* (London, 1838); see 693:16n.

386:27 (393:1). kyries—see 132:6n.

386:28 (393:1–2). Ut novetur sexus omnis corporis mysterium—Latin: "That the whole mystery of physical sexuality may become known," a mock anthem.

386:30–32 (393:3–6). Master John Fletcher ... To bed, to bed—a song from I, ii, 130–132 of Beaumont (*c.*1584–1616) and Fletcher's (1579–1625) play *The Maid's Tragedy* (*c.*1610): "To bed,

to bed! Come, Hymen, lead the bride,/And lay her by her husband's side;/Bring in the virgins every one,/That grieve to lie alone,/That they may kiss while they may say a maid;/Tomorrow 'twill be other kiss'd and said,/Hesperus, be long a-shining,/While these lovers are a-twining."

386:35 (393:8). suadancy—persuasiveness, a coinage from the obsolete "suade," to persuade.

386:39 (393:12). Beau Mount—"poetic" for the Mount of Venus.

386:41 (383:14–15). they had but the one doxy between them—John Aubrey (1626–1697) in *Brief Lives* (edited 1898) on Beaumont and Fletcher: "They lived together on the Banke side, not far from the Play-house, both bachelors; lay together; had one Wench in the house between them, which they did so admire; the same cloathes and cloake, &c. between them."

387:1 (393:16–17). life ran very high in those days—see 202:2–4n.

387:1 (393:17). custom of the country—(c.1628), the title of a play by John Fletcher and Philip Massinger (1583–1640).

387:2–3 (393:17–19). Greater love than this ... wife for his friend—Jesus preaches to his disciples in John 15:12–13: "This is my commandment, That ye love one another, as I have loved you. Greater love hath no man than this, that a man lay down his life for his friends."

387:3–4 (393:19). Go thou and do likewise—"Go, and do thou likewise" is Jesus' admonition to the lawyer who asked "who is my neighbour?" and who was answered by the parable of the Good Samaritan, a neighbor because he "shewed mercy" (Luke 10:25–37).

387:4 (393:20). Zarathustra—see 24:3n.

387:5 (393:21). French letters—slang for condoms.

387:8 (393:24). the secondbest bed—see 200:38–201:3n.

387:8 (393:24). Orate, fratres, pro memetipso—Latin: "Brothers, pray for me myself." At the end of the Offertory of the Mass the celebrant turns to the congregation and says, "*Orate, fratres, ut meum ac vestrum sacrificium acceptabile fiat apud Deum Patrem omnipotentem*" ("Brothers [and sisters], pray that my sacrifice and yours may be acceptable to God the Almighty Father").

387:9 (393:24–25). And all the people shall say, Amen—before the "Amen" the response

to the celebrant (387:8n) is "May the Lord accept the sacrifice at your hands to the praise and glory of his name, for our good, and for the good of his holy Church everywhere. Amen."

387:9–10 (393:25–26). Remember, Erin, thy generations and thy days of old—elides Thomas Moore's song "Let Erin Remember the Days of Old" (see 46:9–10n) with Moses' song, Deuteronomy 32:7, "Remember the days of old, consider the years of many generations."

387:11–12 (393:27–28). and broughtest in a stranger ... fornication in my sight—the "stranger" in Moore's song (46:9–10n) is elided with several biblical echoes: Exodus 20:10: "But the seventh day *is* the sabbath of the Lord thy God: *in it* thou shalt not do any work, thou ... nor thy stranger that *is* within thy gates"; Deuteronomy 17:15 "... thou mayest not set a stranger over thee, which *is* not thy brother." The accusation of "fornication" is a frequent prophetic damnation; see Ezekiel 16:15, 26, 29.

387:12 (393:28). to wax fat and kick like Jeshurum—Deuteronomy 32:15, "But Jeshurun waxed fat, and kicked: thou art waxen fat, thou art grown thick, thou art covered *with fatness*; then he forsook God *which* made him, and lightly esteemed the Rock of his salvation." Jeshurun (Hebrew: "righteous") is a poetic name for Israel.

387:13–14 (393:29–30). Therefore hast thou ... the slave of servants—again echoes several biblical passages, among them Lamentations 5:7–8: "Our fathers have sinned, *and are* not; and we have borne their iniquities. Servants have ruled over us: *there is* none that doth deliver *us* out of their hand."

387:14–15 (393:30–31). Return, return, Clan Milly ... O Milesian—among other possibilities, The Song of Solomon 6:13: "Return, return, O Shulamite; return, return, that we may look upon thee." "Clan Milly" is Irish for the race of Mileadh or the Milesians, the legendary ancestors of the royal clans of Ireland; see 322:20–21n.

387:15–16 (393:31–33). Why hast thou done ... merchant of jalaps—again, among many possibilities, Deuteronomy 32:16: "They provoked him to jealousy with strange *gods*, with abominations provoked they him to anger." Cf. Ezekiel 5:8–11. (Apparently the "strange gods" were as "merchant of jalaps," selling purgatives.) Compare Mulligan's remark that Haines's father had made his money "selling jalap to Zulus," 9:4 (7:11).

387:17–18 (393:33–35). and didst deny me to ... did lie luxuriously—i.e., the Israelites

"denied" their God in their subservience to the Romans and earlier in subservience to the princes of the East (India being mentioned only twice in the Old Testament, in Esther 1:1 and 8:9, where King Ahasuerus could be construed as "the Indian of dark speech"). The accusation that the daughters of Israel were misbehaving with "strangers" is frequent in prophetic condemnations of Israel; it is tempting here to make the Roman-English, Jewish-Irish links established in [Aeolus].

387:18–20 (393:35–36). Look forth now ... Nebo and from Pisgah—Horeb (Sinai), Nebo and Pisgah are three mountains associated with Moses' leadership of the Children of Israel. At Horeb (Sinai) Moses receives "the law and the commandments" (Exodus 24–31) and the Lord's assurance of the promised land (Exodus 33:1–3). In Deuteronomy 32:48–52 the Lord tells Moses, "Get thee up ... unto mount Nebo ... and behold the land of Canaan, which I give unto the children of Israel for a possession: And die in the mount whither thou goest up." In Deuteronomy 34:1: "And Moses went up from the plains of Moab unto the mountain of Nebo, to the top of Pisgah," from whence he sees the promised land. See 141:30–31n.

387:20 (393:37). the Horns of Hatten—or the Horns of Hittin, a mountain range west of the Sea of Galilee, associated by some seventeenth-century biblical geographers with the heights from which Moses viewed the promised land (partially because the promised land was described as "the whole land of the Hittites" in Joshua 1:4). Two thousand years of changing place names have compounded geographical confusion of this sort. Late nineteenth-century scholars rejected the Horns of Hittin in favor of a mountain range at the northeastern end of the Dead Sea since that range commands the prospect described in Deuteronomy 34:1–3.

387:21 (393:37–38). a land flowing with milk and money—the promised land is repeatedly described as "a land flowing with milk and honey," as in the Lord's assurance to Moses in Exodus 33:3.

387:26 (394:1). the septuagint—so called because it was supposed to have been prepared in 70 days by 72 translators, a Greek translation of the Old Testament said to have been made in the third century B.C. It is the Old Testament used in the Eastern Church, but it is not identical with the Old Testament in use among Hebraic Jews and in Western Protestantism, which regards the additional books of the Septuagint as the Apocrypha.

387:27–28 (394:2–3). the Orient from on high ... darkness that was foraneous—in the apocryphal Gospel of Nicodemus the two sons of Simon, risen from the dead as a result of Christ's resurrection, tell the story of Christ's descent into hell, where "the brazen gates were broken, and the iron bars were crushed, and all the dead that were bound were loosed from their bonds." Satan is bound and Christ removes Adam and "the righteous" to Paradise. "Foraneous" means utterly remote.

387:28–29 (394:3). Assuefaction minorates atrocities—i.e., the act of becoming accustomed to atrocities diminishes their effect, after Sir Thomas Browne's argument in *Christian Morals*, Part III, Section 10, that *memento mori* are not effective: "Forget not how assuefaction unto anything minorates the passion from it, how constant objects lose their hints, and steal an inadvertisement upon us."

387:29 (394:4). (as Tully saith of his darling Stoics)—in the *Tusculan Disputations* (45 B.C.) Marcus Tullius Cicero (106–43 B.C.) argues in III: xiv that "a human being should ponder all the vicissitudes that fall to man's lot" because "such events are cruel for those who have not reflected on them" and "everything which is thought evil is more grievous if it comes unexpectedly."

387:30 (394:4–5). Hamlet his father showeth the prince no blister of combustion—the Ghost speaks to Hamlet: "But that I am forbid/ To tell the secrets of my prison-house,/I could a tale unfold whose lightest word/Would harrow up thy soul.... But this eternal blazon [description of eternity] must not be/To ears of flesh and blood" (I, v, 13–22).

387:31 (394:5). The adiaphane—see 38:4–5n and 38:9–10n.

387:31 (394:6). an Egypt's plague—Egypt is visited with a series of plagues in punishment for the Pharaoh's refusal of Moses' demand for the release of the Israelites (Exodus 7–11). The river is turned into blood; there are plagues of frogs, lice, flies, a murrain of beasts, of boils and blains, of hail, of locusts and (in 10:21) "And the Lord said unto Moses, Stretch out thine hand toward heaven, that there may be darkness over the land of Egypt, even darkness *which* may be felt." The final plague: "the death of all the firstborn in the land of Egypt."

387:33 (394:7–8). ubi and quomodo—Latin: "the where and the manner."

387:33–35 (394:8–9). as the ends and ultimates ... inceptions and originals—a paraphrase and summary of Aristotle's view of the relation between "seed" (origin) and the fully developed

"animal" as that view is developed in *Physics* II:8, and repeated in *On the Generation of Animals* I:1. In the *Physics* Aristotle quotes from Empedocles in the course of his argument; Empedocles had held a cyclical theory of creation—that once creation has been achieved, hate gradually disintegrates it to chaos and then love again begins the process of creation. In the first phases of creation love conjoins things at random, producing "monsters" such as the ox-man, but these cannot reproduce and hence cease to exist as creation clarifies itself. As Aristotle puts it, "Thus in the original combinations the 'ox-progeny' if they failed to reach a determinate end must have arisen through the corruption of some principle corresponding to what is now the seed [origin]."

387:39–40 (394:13–15). The aged sisters draw us ... dead they bend—elides the midwife and the woman who lays out the corpse with the three Fates of Greek mythology, and with the three phases, mother, lover and hag of death, of the Triple Goddess.

387:40–41 (394:15–16). First saved from water ... bed of fasciated wattles—as Moses was found in Exodus 2:5: "And the daughter of Pharaoh came down to wash *herself* at the river; and her maidens walked along by the river's side; and when she saw the ark among the flags, she sent her maid to fetch it." See 46:4–5n. "Fasciated" means swaddled, enveloped with bands.

387:42 (394:17). at last the cavity of a mountain, an occulted sepulchre—as Moses was buried, Deuteronomy 34:5–6: "So Moses the servant of the Lord died there ... according to the word of the Lord. And he buried him in a valley in the land of Moab ... but no man knoweth of his sepulchre unto this day." Sir Thomas Browne mentions this burial in Chapter I of *Hydriotaphia: Urne-Burial* (1658).

388:1 (394:18). conclamation—an outcry or shout of many together.

388:1 (394:18). the ossifrage—obsolete for the lammergeyer, the largest European bird of prey; also, the osprey.

388:2 (394:19). the ubicity of his tumulus—the location of his sepulchral mound.

388:3 (394:20). Tophet—traditionally regarded as an Old Testament "type" of hell. Tophet (literally, "place of burning") was located in the Valley of Hinnom, south of Jerusalem; there corpses were burned (contrary to the Law, as Jeremiah maintains, 7:31–32) and human sacrifices were performed in the worship of Moloch; thus its reputation as a place of evil and "hellfire." See Isaiah 30:33.

388:3 (394:20–21). Edenville—Stephen's version of the Garden of Eden; see 39:4 (38:4).

388:5 (394:22–23). the whatness of our whoness—see 184:13–14 (186:13–14).

388:7 (394:24). Étienne Chanson—French: literally, "Stephen Song."

388:8 (394:25). wisdom hath built herself a house—Proverbs 9:1: "Wisdom hath builded her house, she hath hewn out her seven pillars."

388:9 (394:26). the crystal palace—an iron and glass exhibition building erected for the Great Exhibition (World's Fair) of 1851 in Hyde Park, London. Designed by the English engineers Sir Joseph Paxton (1801–1865) and Sir Charles Fox (1810–1874), it covered 21 acres and was regarded as a "wonder of the world." In 1854 it was moved to Sydenham on the outskirts of London, where it was (until World War I) the site of a permanent fair. It was destroyed by fire in 1936. Fox was "immortalized" by one David Bogue in a parody of "The House That Jack Built" entitled "The Crystal Palace That Fox Built" (London, 1851).

388:10 (394:27–28). a penny for him who finds the pea—the "shell game" was popular at country fairs. The operator, talking and prestidigitating to confuse the players, hides a pea under one of a group of shells and then bets that the players cannot point out the right shell.

388:11–13 (394:29–31). Behold the mansion ... of Jackjohn's bivouac—the opening lines of "The Modern House That Jack Built," an anonymous nineteenth-century parody of the nursery rhyme "The House That Jack Built." The third line of the parody reads "Ivan's Bivouac" instead of "Jackjohn's bivouac." The fun of the parody turns on the translation of the jingling nursery rhyme into an elaborate and heroic language. The cat, for example, is treated to the epithet "that sly/Ulysses quadrapedal."

388:15–16 (394:33–34). Thor thundered ... the hammerhurler—in Scandinavian myth Thor was the god of thunder and lightning and the son of Odin (chief of the gods). His hammer (the lightning bolt) always returned to his hand after he had thrown it. Thunder was the rolling of his chariot.

388:21 (394:39). haught—archaic: "high in one's estimation."

388:25–26 (395:3). a word and a blow—popular expression for aggressive and volatile, not to be taken seriously.

388:27 (395:4). an old Nobodaddy—see 203:22n.

388:36 (395:13–14). the discharge of fluid from the thunderhead—Bloom's "explanation" echoes the eighteenth-century assumption that electricity was a "fluid," but it also owes something to Sir Thomas Browne, who attributed lightning and thunder to the explosion of "nitrous and sulphurous exhalations, set on fire in the clouds" and who remarked that if the exhalations were "spirituous" (fluid) "the noise is great and terrible" (*Pseudodoxia Epidemica*, Book II, Chapter 5).

Style: 388:39–390:7 (395:16–396:27). But was Boasthard's ... bring brenningly biddeth—an imitation of the style of John Bunyan (1628–1688), radical English preacher, whose allegories, notably *Pilgrim's Progress* (1675), make extensive and successful use of proper names similar to Joyce's "Boasthard" and "Calmer."

389:6 (395:24). Bringforth—in Genesis 3:16 the Lord God says to fallen Eve, "in sorrow shalt thou bring forth children."

389:13–14 (395:32–33). which Phenomenon has ... by the book Law—see 377:35–38n.

389:15–16 (395:34). Believe-on-Me—after John 6:35: "And Jesus said unto them, I am the bread of life: he that cometh to me shall never hunger; and he that believeth on me shall never thirst."

389:17–18 (395:36). no death and no birth neither wiving nor mothering—in Mark 12:25 Jesus answers the Sadducees (who did not believe in the Resurrection) and their trap questions about who would be man and wife in heaven: "For when they shall rise from the dead, they neither marry, nor are given in marriage; but are as the angels which are in heaven."

389:22, 26–27 (395:41, 396:3). Bird-in-the-Hand/Two-in-the-Bush—after the proverbial saying, "A bird in the hand is worth two in the bush," attributed as early as Plutarch (*c.*46–*c.*120).

390:7 (396:27). brenningly—archaic: "burningly."

Style: 390:8–391:30 (396:28–398:9). So Thursday sixteenth ... queerities no telling how—after the style of the seventeenth-century diarists (and friends) John Evelyn (1620–1706) and Samuel Pepys (1633–1703).

390:17–18 (396:38–39). the big wind ... land so pitifully—an extraordinarily destructive and prolonged gale struck the British Isles and particularly Dublin and environs on 26 and 27 February 1903. See 14:31–32n.

390:27–28 (397:5–7). In Ely place ... up to Holles Street—Ely Place and Baggot Street are just southwest of Merrion Square. The Duke's Lawn is in front of Leinster House just west of the square. The pattern also describes Mulligan's route from George Moore's (at 4 Ely Place Upper) to the Maternity Hospital.

390:31 (397:9–10). the Rt. Hon. Mr Justice Fitzgibbon's door—at 10 Merrion Square North. See 139:16n.

390:31–32 (397:10–11). (that is to sit ... upon college lands)—i.e., Justice Fitzgibbon and Timothy Michael Healy (see 139:23n), were to sit together on the Trinity College Estates Commission (see 139:24n).

390:34–35 (397:13). (that was a papish ... a good Williamite)—i.e., George Moore, once a Roman Catholic, has become Protestant (and pro-English). George Moore's attitudes toward religion (as toward other matters of personal conviction) were somewhat equivocal. By his own account his family seems to have oscillated between Catholic and Protestant allegiances. His parents were Catholic and in his *Confessions of a Young Man* (1888) Moore indulges modish and possibly insincere expressions of admiration for the Roman Catholic liturgy. "Lapsed Catholic," fascinated by the "new paganism," might be an apt description of Moore or would it be his novel *The Lake* (1905), the story of a young priest's escape from "the prison-house of Catholicism"? Yeats, in *The Autobiography*, describes Moore as "neither anticlerical nor anti-Catholic" and remarks that Moore did not go to Mass "because his flesh was unwilling."

390:35 (397:14). a cut bob—i.e., with his hair cut short. This sort of sartorial observation is characteristic of Pepys's style.

390:38 (397:17). Saint Swithin—(d. 862), an English ecclesiastic, chaplain to King Egbert, tutor to Egbert's son Ethelwulf and subsequently Ethelwulf's chief councilor and bishop of Winchester. Feast day: 15 July.

390:42 (397:20–21). beef to the heel—see 65:38–39n.

391:2 (397:23). brangling—archaic: "wrangling, brawling."

391:3 (397:24). scholar of our lady of Mercy—i.e., Dixon had received part of his medical training at the Mater Misericordiae Hospital in Eccles Street.

391:6–9 (397:27–30). having dreamed tonight ... to be for a change—see 557:2n.

391:10 (397:31). on the stools—i.e., in labour, with her feet supported to aid her efforts.

391:12 (397:33). riceslop—or rice water, a drink for invalids made by boiling a small quantity of rice in water.

391:15 (397:36–37). Lady day—25 March, the Feast of the Annunciation of the Blessed Virgin Mary.

391:15–16 (397:37). bit off her last chick's nails—after the Irish superstition that if a child's nails were cut before it was a year old, it would be "light-fingered and addicted to stealing" ("Speranza" [Lady Wilde], *Ancient Cures, and Usages of Ireland* [London, 1890], p. 68).

391:18 (397:39). the king's bible—the King James Bible (indicating that the Purefoys are Protestant).

391:18–19 (397:39–40). a methodist but takes the Sacrament—when John Wesley (1703–1791) founded Methodism, he argued that Methodists should not hold services at the same time as those of the Established Church and that Methodists should receive the Sacraments in the Established Church rather than from their own ministers in their own chapels. This original relation to the Established Church was radically changed shortly after Wesley's death.

391:20 (397:41). Bullock harbour—see 23:3n.

391:20 (397:41–42). dapping on the sound—to fish by dropping the bait gently on the water.

391:24 (398:3–4). after wind and water fire shall come—this phrase, although not a quotation, has a biblical and prophetic ring to it: see *Ulysses*, pp. 427 (434) and 582 (598).

391:25 (398:4). Malachi's almanac—the biblical prophet Malachi's vision that closes the Old Testament, 4:1: "For, behold, the day cometh, that shall burn as an oven; and all that do wickedly, shall be stubble: and the day that cometh shall burn them up, saith the Lord of hosts, that it shall leave them neither root nor branch."

391:25–27 (398:5–6). Mr Russell has done . . . for his farmer's gazette—George Russell's "farmer's gazette" was the *Irish Homestead* (see 190:35n). The "prophetical charm" recalls Russell's interest in the occult and in the mysteries of India, but, in the manner of Pepys's gossipy conjectures, it refers not to a real article but to Russell's personal and peculiar combination of interest in theosophy and in agrarian reform.

Style: 391:31–393:9 (398:10–399:31). With

this came up . . . sent the ale purling about—after the style of Daniel Defoe (c.1661–1731), English journalist, pamphleteer and novelist.

391:36 (398:15). that went for—i.e., who styled himself as.

391:37 (398:16). pickle—a mischievous young man.

391:40–41 (398:20). Paul's men—archaic: the nave of St. Paul's in London was once famous as a place to meet and lounge about; hence, "Paul's men" were loungers, hangers-on who did not work.

391:41 (398:20). flatcaps—in sixteenth- and seventeenth-century London, apprentices, after the distinctive round caps with low flat crowns that they wore.

391:41 (398:20). waistcoaters—Elizabethan slang, variously for "gallants" (after their heavily ornamented sleeveless jackets) or "low-class prostitutes."

392:2 (398:23). sackpossets—a beverage made of raw eggs, sugar and sack.

392:3 (398:24). a boilingcook's—slang for the poorest of restaurants or taverns.

392:4 (398:26). tester—slang: "sixpence."

392:6 (398:27). punk—slang: "prostitute."

392:10 (398:31). Kerry cows—an Irish breed of small, entirely black cattle, noted for the quality of their milk.

392:16 (398:37). Mort aux vaches—French: "Death to cows." See p. 336 above.

392:20 (398:41). headborough—a petty constable.

392:26 (399:6). bearpit—wagers were made on contests between a bear and several dogs confined in a ring or a pit.

392:26 (399:6). cocking main—the ring established for a cockfight.

392:28 (399:7). the Romany folk—gypsies.

392:37 (399:17). springers—see 96:31n.

392:37 (399:17). hoggets—two-year-old boars.

392:38 (399:17). wether—a ram (especially, a castrated ram).

392:38 (399:18). actuary—a clerk.

392:39 (399:18). Mr Joseph Cuffe—see 96:32n.

392:40 (399:19). meadow auctions—auctions of livestock that took place on farms rather than in markets.

392:40 (399:20). Mr Gavin Low's yard—Gavin Low, livestock agent, 47–53 Prussia Street, on the corner of North Circular Road opposite the Cattle Market, in the northwest quadrant of Dublin.

392:42 (399:21–22). the hoose of the timber tongue should read **or** not **of**—for "hoose," see 309:30–31n; for "timber tongue," see 309:31n.

393:3 (399:25). Doctor Rinderpest—see 34:8n.

393:7 (399:29). a bull that's Irish—a "bull" (or an "Irish bull") is a statement that makes logical sense to its innocent and wrongheaded speaker but that in objective and literal terms is nonsense. Typical examples: "Pat, do you understand French?" "Yes, if it's spoke in Irish." And, from an Irishman to a friend studying for the priesthood: "I hope I may live to hear you preach my funeral sermon."

Style: 393:9–395:6 (399:31–401:30). An Irish bull in an ... A man's a man for a' that—after the style of Jonathan Swift (1667–1745), particularly that of *A Tale of a Tub* (1704), Part IV, in which Swift lampoons Peter's (allegorically, the Roman Catholic Church's) use of "papal bulls" in a rousing burlesque of the Church and its history.

393:9 (399:31). An Irish bull in an English chinashop—a proverbial expression for blundering and destructive clumsiness, compounded here by the puns on Irish and papal bulls and by the reputation of England's china industry.

393:10–11 (399:32–33). that same bull ... by farmer Nicholas—Nicholas Breakspear, Pope Adrian IV (pope 1154–1159), was the only English pope. In a papal bull, *Laudabiliter* (1155), Adrian granted the overlordship of Ireland to Henry II of England (king 1154–1189). Henry, in seeking the papal permission for invasion, had argued that Ireland was in a state of profound moral corruption and irreligion. The bull approved Henry's "laudable" determination "to extirpate certain vices which had taken root." Henry was, however, preoccupied on the Continent, and it was not until 1169 that he began to take up his option, encouraging "any of his subjects who were interested" to lend help to Dermod MacMurrough (see 35:40–41n). When

this first "invasion" met with considerable success, Henry exacted pledges of allegiance from his venturesome subjects and took personal control of the invasion in 1171.

393:12 (399:34). an emerald ring—in 1155 Pope Adrian gave Henry II an emerald (for Emerald Isle) set in a gold ring as token of Henry's overlordship of Ireland.

393:19–20 (399:41–42). farmer Nicholas that was ... a college of doctors—Nicholas II (pope 1058–1061) undertook a series of reforms to suppress the practice of priests taking concubines and to restrict papal election to the College of Cardinals. In the light of these reforms, Adrian IV, a century later, could be expected to have remained celibate and to have been *elected* by the college.

393:22 (400:2). the Lord Harry—King Henry II of England; see 393:10–11n.

393:27–28 (400:7–8). whisper in his ear in the dark of a cowhouse—i.e., whisper in the privacy of the confession box.

393:29–30 (400:10). the four fields of all Ireland—traditionally, the four ancient kingdoms: Munster, Leinster, Ulster and Connaught.

393:31 (400:11–12). a point shift—a shirtlike garment made of lace.

394:5 (400:27). the lord Harry—Henry II has metamorphosed into Henry VII (king 1485–1509). Henry VII reasserted English control of Ireland after the relapse of control occasioned by the Wars of the Roses. In 1494 English land-use laws then in effect in England were applied to Ireland. Since English and Irish customs of land use were quite different, the imposition of English law proved particularly onerous and detrimental to Irish agriculture.

394:6–7 (400:29–30). Roscommon ... Connemara ... Sligo—three counties in Ireland. Roscommon is in central Ireland, west-northwest of Dublin. Sligo and Connemara are on the west coast.

394:12 (400:35). the Lord Harry called farmer Nicholas—Henry VII has given way to Henry VIII (king 1509–1547) and a suggestion of his difficulties with Pope Clement VII (pope 1523–1534) over the question of Henry's attempt to divorce his first wife, Catharine of Aragon.

394:12–13 (400:35). the old Nicks—"old Nick" and "old Harry" (or "Lord Harry") are commonplace names for the devil.

394:13 (400:36). an old whoremaster—Protestant churches consistently identified the Roman Catholic Church as "the great whore that sitteth upon many waters: ... MYSTERY, BABYLON THE GREAT, THE MOTHER OF HARLOTS AND ABOMINATIONS OF THE EARTH" (Revelation 17:1, 5).

394:16 (400:39). pizzle—the penis of an animal, often that of a bull.

394:17 (400:40). cleaning his royal pelt—after a parody (of his own poem "Moses") by the blind Dublin street-ballad singer Michael Moran (1794–1846), whom Yeats, in *The Celtic Twilight* (London, 1893), pp. 67–80, called "The Last Gleeman." "In Egypt's land, contagious to the Nile,/King Pharaoh's daughter went to bathe in style./She tuk her dip, then walked unto the land,/To dry her royal pelt she ran along the strand./A bulrush tripped her, whereupon she saw/A smiling babby in a wad o' straw/She tuk it up, and said with accents mild,/Tare-and-agers, girls, which au yez owns the child?" (pp. 72–73).

394:21 (401:2). a blackthumbed chapbook—a slant allusion to Henry VIII's treatise *Assertia Septem Sacramentorum* (1521). The treatise attacked Martin Luther's arguments about the sacraments and earned Henry the papal title "Defender of the Faith."

394:22–23 (401:3–4). a left-handed descendant—i.e., through an illegitimate line.

394:23 (401:4–5). the famous champion bull of the Romans—i.e., St. Peter, who is regarded as having been designated by Jesus to found "His Church" (Matthew 16:18) and who is believed to have been the first bishop of Rome (pope).

394:23–24 (401:5). Bos Bovum—(bog) Latin: "Bull of the Bulls."

394:25–26 (401:7). a cow's drinking trough—an allusion to Henry VIII's liaison with Irish-born Anne Boleyn (1501 or 1507–1536). She first appeared at court in 1522 and became queen (after all the machinations of Henry's "divorce") in 1533.

394:27 (401:8). his new name—"Defender of the Faith" (still one of the royal titles of the reigning English monarch); see 394:21n.

394:35 (401:16–17). he and the bull of Ireland—Henry VIII was proclaimed "Head of Church and State" by act of Parliament in May 1536; in 1541 he was proclaimed "King of Ireland" (and thus "Head of Church and State in Ireland"). The Irish lords "diplomatically"

accepted the Reformation of Ireland, but not without considerable dissension and violence.

394:41 (401:22–23). spread three sheets to the wind—a popular expression for to get drunk.

394:42–395:1 (401:24). ran up the jolly Roger—i.e., proclaimed themselves pirates; the Jolly Roger flag of the pirates: a white skull and crossed bones on a black field.

395:1 (401:25). gave three times three—a standard form of giving a cheer in Ireland.

395:1 (401:25). let the bullgine run—the title of an English sea chanty: "We'll run from night til morning,/O run, let the bulgine run." "Bulgine" is naval slang for a bilge pump; the sense of the chanty is a devil-may-care "let's keep going even though the ship is sinking."

395:5–6 (401:29–30). Pope Peter's but ... man for a' that—combines a line from a Protestant street rhyme with a line from Robert Burns's poem "For A' That and A' That" (1795), lines 9–12: "What though on homely fare we dine,/Wear hodden-grey, and a' that;/Gie fools their silks and knaves their wine,/A man's a man for a' that." The street rhyme is unknown, but it has relatives; for example, "Piss a bed,/Piss a bed,/Barley Butt,/Your Bum is so heavy,/You can't get up."

Style: 395:7–397:26 (401:31–404:10). Our worthy acquaintance ... larum in the antechamber—in the style of Joseph Addison (1672–1719) and Richard Steele's (1672–1729) periodical essays the *Tatler* (1709–1711) and the *Spectator* (1711–1712).

395:17 (401:41). Mr Quinnell's—George Quinnell, printer, 45 Fleet Street in central Dublin south of the Liffey.

395:18–19 (402:2). Lambay Island—three miles off the coast nearly opposite Malahide, 12 miles east-northeast of Dublin. It is noted as a bird sanctuary.

395:21 (402:4–5). sir Fopling Popinjay and sir Milksop Quidnunc—Richard Steele made characters with similar names the butts of his satire in the *Tatler*.

395:25 (402:8–9). 'Tis as cheap sitting as standing—Lady Answerall to Colonel Atwit in Swift's *Complete Collection of Genteel and Ingenious Conversation* (1738), Part I: "Well, sit while you stay; 'tis as cheap sitting, as standing."

395:35 (402:19). bonzes—the Buddhist clergy of

Japan (and sometimes of China and adjacent countries).

395:35–36 (402:19). who hide their flambeau under a bushel—in Matthew 5:14–15, Jesus says to the "multitudes": "Ye are the light of the world. . . . Neither do men light a candle and put it under a bushel, but on a candlestick; and it giveth light unto all that are in the house."

395:37 (402:21). muskin—a pretty face (a term of endearment for a woman), but when said of a man, as in this context, a term of contempt.

396:3–5 (402:28–30). Lambay island from . . . our ascendency party—Richard Wogan Talbot, Lord Talbot de Malahide (b. 1846), was a retired army man and a landowner (3,600 acres) whose resistance to land reform was mild but firm. His family sold Lambay Island (see 395:18–19n) in 1878.

396:6 (402:31). Omphalos—see 9:25n.

396:7 (402:32). an obelisk . . . after the fashion of Egypt—Egyptian obelisks were phallic symbols dedicated to the sun-god and associated with the worship of fertility.

396:29 (403:12). to carry coals to Newcastle—a proverbial expression for a pointless and redundant enterprise, since Newcastle-upon-Tyne in England was noted for its concentration of blast furnaces.

396:30–36 (403:13–19). an apt quotation from . . . magnopere anteponunt—this "apt," Ciceronian quotation is apparently from a classic specifically written for the occasion by Mulligan. Latin: "Of such a kind and so great is the depravity of our generation, O Citizens, that our matrons much prefer the lascivious titillations of Gallic half-men to the weighty testicles and extraordinary erections of the Roman centurion."

397:6 (403:31). Those loaves and fishes—Jesus fed the multitudes (which had followed him into the desert where he had gone to mourn the death of John the Baptist) with "five loaves and two fishes" (Matthew 14:13–21).

397:15 (403:40). ventripotence—big-bellied, gluttonous.

397:16 (403:41–42). ovablastic gestation in the prostatic utricle—medical nonsense: literally, "the gestation of the germ layers of the embryonic egg in the vesicle of the prostate gland."

397:17 (404:1). Mr Austin Meldon—Dublin physician, fellow, counselor and ex-president of the Royal College of Physicians in Ireland and senior surgeon to the Jervis Street Hospital.

397:18 (404:1). a wolf in the stomach—after the proverbial expression: "a growing boy has a wolf in his belly."

397:20–21 (404:4). Mother Grogan—see 14:21n.

397:21–22 (404:5). 'tis a pity she's a trollop—after the title of John Ford's (c.1586–c.1655) play 'Tis Pity She's a Whore (1633).

Style: 397:27–399:13 (404:11–405:42). Here the listener who . . . of our store of knowledge—after the style of the Irish-born English novelist and cleric Laurence Sterne (1713–1768) and particularly his A Sentimental Journey Through France and Italy (1768).

397:36–37 (404:21–22). Mais bien sûr . . . et mille compliments—French: "But certainly . . . and a thousand compliments (thanks)."

398:29–30 (405:15). marchand de capotes—French: literally, "a cloak merchant," but capote is also slang for a condum.

398:30 (405:16). livre—French: an obsolete French coin superseded by the franc and of slightly less worth than the franc. The livre is the coin "of record" in Sterne's A Sentimental Journey.

398:32 (405:18). Le Fécondateur—French: "the impregnator."

398:34 (405:20). avec lui—French: "with him." The use of French phrases not only echoes Sterne, it also echoes George Moore's habit of salting his conversation with French phrases.

398:35 (405:21). ventre biche—French: literally, "belly of a fallow deer," figuratively, "the belly of (my) darling." French phrases of this sort, apparently serious but actually fanciful curses, are characteristic of Sterne's style in A Sentimental Journey.

398:37 (405:23). sans blague—French: literally, "without nonsense" i.e., "no joke" or "all joking aside."

398:40 (405:26). umbrella—slang for a pessary.

399:2 (405:29–30). ark of salvation—as Noah's ark was designed to save Noah and his family from the "deluge" (Genesis 6–8).

399:6 (405:34). il y a deux choses—French: "there are two things."

399:8–13 (405:36–42). The first, said she . . . our store of knowledge—the coy gesture of the kiss is reminiscent of Sterne's use of similar gestures, and the titillating "interruption" is one of his favorite satiric devices (see "The Temptation. Paris" and "The Conquest" in *A Sentimental Journey*).

Style: 399:14–400:24 (406:1–407:14). Amid the general vacant . . . on with a loving heart—after the style of the Irish-born man of letters (dramatist, poet, novelist, essayist) Oliver Goldsmith (1728–1774).

399:25 (406:12). Gad's bud—"God's body," a mild eighteenth-century oath.

399:26 (406:14). Demme—a minced form of "damn," another mild eighteenth-century oath.

399:29 (406:17). Lawksamercy—a minced form of "Lord have mercy," an appropriately feminine eighteenth-century oath.

399:34 (406:21–22). pot of four—with a pun on the French *pot au feu* ("stew").

399:40 (406:28). enceinte—French: "pregnant," a genteel avoidance of the "gross" English equivalent.

400:4 (406:34). a cloud of witnesses—Hebrews 12:1: "Wherefore seeing we also are compassed about with so great a cloud of witnesses, let us lay aside every weight, and the sin which doth so easily beset *us*, and let us run with patience the race that is set before us."

400:14 (407:2–3). on the by—slang for standing around a counter or bar drinking.

400:19 (407:8). swore a round hand—slang, after "to bet a round hand," i.e., to bet for (or against) several horses in one race.

400:20 (407:9). Stap—obsolete: "stop" or "stuff."

400:22 (407:11–12). to honour thy father and thy mother—the fifth commandment: "Honour thy father and thy mother: that thy days may be long upon the land which the Lord thy God giveth thee" (Exodus 20:12).

Style: 400:25–401:23 (407:15–408:14). To revert to Mr Bloom . . . of the Supreme Being—after the style of Edmund Burke (1729–1797), Irish-born political philosopher who combined in his "conservatism" a practical and scholarly empiricism with a consistent veneration for and appeal to "the wisdom of our ancestors."

400:36–38 (407:26–28). a cropeared creature . . . feet first into the world—in Shakespeare's *III Henry VI* the hunchback, Gloucester (subsequently Richard III), stabs Henry VI (who has just compared himself to Daedalus, his son to Icarus) and then says: "Down, down to hell; and say I sent thee thither:/I, that have neither pity, love, nor fear./Indeed, 'tis true that Henry told me of;/for I have often heard my mother say/I came into the world with my legs forward" (V, vi, 67–71). Three times in the play Gloucester is called "crookback" and several times in *Richard III* he is described as "misshapen." "Gibbosity" is the condition of being hunchbacked.

400:40–41 (407:30–31). that missing link . . . late ingenious Mr Darwin—in *The Descent of Man and Selection in Relation to Sex* (1871) Charles Darwin (1809–1882) postulated that a "missing link" had intervened between the apes and man in the process of evolution. In effect, the missing link was a way of accounting for the radical discontinuity between the two related species.

400:41–42 (407:32). the middle span of our allotted years—born in 1866, Bloom was thirty-eight in 1904 and thus three years beyond the midpoint of his "allotted" "three score and ten."

401:15–16 (408:6–7). for eating of the tree forbid—see 368:41n.

Style: 401:24–402:11 (408:15–409:3). Accordingly he broke his mind . . . feather laugh together—after the style of Dublin-born Richard Brinsley Sheridan (1751–1816), who, after a brief career as a successful dramatist (1775–1779), had a distinguished career as a witty and resourceful member of Parliament. The style of this passage is closer to that of Sheridan's political oratory than it is to the style of his plays.

401:31 (408:22–23). Ephesian matron—the "heroine" of this archetypal story was a widow of Ephesus, the intensity of whose mourning for her dead husband was matched by the alacrity with which she accepted the advances of a handsome new suitor. The most famous retelling of the story is in Petronius' (d. 66) *Satyricon*.

401:33 (408:24–25). old Glory Allelujerum—this mocking name for Purefoy turns on the ejaculation "Glory Hallelujah" with which excited members of an American revivalist congregation would punctuate a sermon.

401:34 (408:26). dundrearies—long side whiskers without a beard. The name was coined by the English playwright Tom Taylor (1817–1880) in *Our American Cousin* (1858).

401:37 (408:29). 'Slife—a petty oath: "God's life."

402:3 (408:36–37). metempsychosis—see 64:10n.

402:10–11 (409:2–3). birds of a feather laugh together—after the proverb, "Birds of a feather flock together."

Style: 402:12–403:12 (409:4–410:6). But with what fitness ... acid and inoperative—after the style of the savage eighteenth-century satirist Junius; see 331:27n.

402:17–18 (409:10). granados—archaic: "grenades."

402:20 (409:12–13). the security of his four per cents—i.e., the security of his investments which might be threatened by an overthrow of English government in Ireland. Bloom owns "£900 Canadian 4% (inscribed) government stock," 708:1 (723:12–13).

402:31–32 (409:24). a very pelican in his piety—in heraldry the pelican (a symbol of Christ) "represented as standing above its nest, having its wings addorsed [turned back to back] and nourishing its young with its blood is blazoned as *A Pelican in its Piety*" (Boutell, quoted in T. H. White, *The Bestiary* ... [N.Y., 1954], p. 133n). In medieval bestiaries the pelican is described as particularly devoted to its children (apparenltly because adult pelicans feed their young by letting the young eat from their bills). Medieval legend developed the analogue to Christ: when the young pelicans begin to grow up, they strike their parents in the face with their wings and are killed in return. Three days later the mother pierces her side (as Christ's side was pierced on the cross) and pours her blood over the dead bodies, thus bringing them to life (as Christ's blood is the essence of man's regeneration).

402:36 (409:28–29). Hagar, the Egyptian—in Genesis 16, Abram (subsequently Abraham) and his wife Sarai (subsequently Sarah) are childless since Sarai is "barren." Sarai therefore "prays" Abram to "go in unto my maid" Hagar, the Egyptian. Hagar conceives and consequently "despises" her mistress, whereupon Sarai "dealt hardly" with her and Hagar "fled from her face." An "angel of the Lord" intervenes to restore order, and Hagar gives birth to Ishmael in Abram's house.

403:1 (409:36). balm of Gilead—Biblical Gilead (literally, "rocky region") was noted for the balm collected from "balm of Gilead" trees. The balm (a liquid resinous substance worth twice its weight in silver) was prized for its fragrance and its medicinal virtues as a "heal-all." See Jeremiah 8:22.

Style: 403:13–405:8 (410:7–412:4). The news was imparted ... what God has joined—after the style of the English skeptical, anticlerical and philosophical historian Edward Gibbon (1737–1794).

403:14 (410:8). the Sublime Porte—Constantinople. Mohammed II (1430–1481; sultan of Turkey, 1451–1481) styled his capital "The Lofty (or Sublime) Gate of the Royal Tent." "Gate" is a metonym for courts of justice since justice in the Near East was traditionally administered in the gate of a city or royal palace.

403:23 (410:18). abigail—slang for a lady's maid, after Abigail, the maid in Beaumont and Fletcher's play *The Scornful Lady* (1616).

403:24 (410:19). a strife of tongues—Psalms 31:20: "Thou shalt hide them in the secret of thy presence from the pride of man: thou shalt keep them secretly in a pavilion from the strife of tongues."

403:29–30 (410:24). the prenatal repugnance of uterine brothers—i.e., the superstitious assumption that brothers born of the same mother but by different fathers are innately antipathetic.

403:32 (410:27). the Childs murder—see 98:35n.

403:33–34 (410:28). Mr Advocate Bushe—see 98:37n.

403:35–36 (410:30). king's bounty touching twins and triplets—a sum of money from the royal purse (in England) given to a mother who has borne triplets; this particular bounty was not established until 1910.

403:37 (410:31–32). acardiac faetus in faetu—"acardiac" means lacking a heart; medical Latin: "foetus at birth."

403:37 (410:32). aprosopia—incomplete development or complete absence of the face.

403:38 (410:32). agnatia—or "agnathia": absence or imperfect development of the jaws.

403:38 (410:33). chinless Chinamen—see 213:2n.

403:42 (410:36–37). twilight sleep—see 159:16n.

404:4–5 (410:41–42). involution of the womb consequent upon the menopause—a popular medical superstition before the advent of modern medicine.

404:8 (411:3). Sturzgeburt—German: "sudden birth," a medical term for the rare phenomena of sudden, accidental birth.

404:8–10 (411:3–5). the recorded instances. . . . or of consanguineous parents—more superstitious lore about multiple births and the births of monstrosities.

404:11–12 (411:6). which Aristotle has classified in his masterpiece—see 232:4n.

404:15–17 (411:10–12). the forbidding to a gravid . . . strangle her creature—in popular superstition a pregnant woman was believed to endanger her unborn child if she stepped over a stile, a grave, a coil of rope, etc.

404:17–20 (411:12–15). the injunction upon her . . . seat of castigation—superstition: a pregnant woman should not touch her genitalia because, if she did, her unborn child might be malformed.

404:21–22 (411:16–17). negro's inkle, strawberry mark and portwine stain—various popular expressions for birthmarks ("inkle" is a kind of linen tape or braid).

404:23–24 (411:19). swineheaded (the case of Madame Grissel Steevens—Miss Grissel Steevens (1653–1746) was the sister of a famous Dublin physician, Richard Steevens. Early in the eighteenth century Steevens died, leaving his money to his sister with the proviso that after her death the money would be used to found a hospital in Dublin. Such was her generosity that she immediately released the money for the hospital. She was apparently heavy-set, and because she went veiled in public, gossip and rumor credited her (fancifully) with the features of a pig.

404:25–26 (411:21). a plasmic memory—in theosophy the total memory of the soul's metempsychosis, its journey through successive incarnations from lower forms through a succession of human forms toward the superhuman.

404:33–35 (411:29–30). the Minotaur which . . . pages of his Metamorphoses—in Book VIII of the *Metamorphoses* Ovid includes the story of the "foul adultery" of Minos' queen Pasiphaë and a bull. Pasiphaë's lust was consummated with the aid of a wooden cow fashioned by Daedalus. The issue of the "adultery" was the man-eating Minotaur, a creature with the body of a man and the head of a bull. Daedalus subsequently created the labyrinth as a "prison" for the Minotaur.

404:39 (411:35). a nice clean old man—recalls the refrain of an anonymous bawdy song: "If you can't get a woman, get a clean old man."

404:42–405:1 (411:37–39). the juridical and theological . . . predeceasing the other—whatever the merits of the "dilemma" as a subject for discussion, the "event" is usually considered a medical impossibility.

405:7–8 (412:3–4). the ecclesiastical ordinance . . . what God has joined—in Matthew 19:4–6 Jesus answers the questions ("tempting") of the Pharisees regarding divorce: ". . . Have ye not read, that he which made *them* at the beginning made them male and female, And said, For this cause shall a man leave father and mother, and shall cleave to his wife: and they twain shall be one flesh? Wherefore they are no more twain, but one flesh. What therefore God hath joined together, let not man put asunder." This passage comprises the Gospel of the Wedding Mass.

Style: 405:9–41 (412:5–39). But Malachias' tale began . . . Murderer's ground—after the style of Horace Walpole's (1717–1797) Gothic novel the *Castle of Otranto* (1764). Haines in this brief passage plays the part of Manfred, the bloodstained usurper in Walpole's novel. The passage also owes a debt of parody to a later Gothic novel, *The House by the Churchyard* (1863) by the Irish writer Joseph Sheridan Le Fanu (1814–1873).

405:16–17 (412:13). it seems, history is to blame—see 22:18 (20:40)

405:17–18 (412:14). the murderer of Samuel Childs—see 98:35n.

405:19 (412:15–16). This is the appearance is on me—a literal translation of the Irish expression "*Seo é an chuma atá orm*"; figuratively, "This is the condition I am in."

405:19 (412:16). Tare and ages—a mild Irish oath. "Tare" for "[I am] torn."

405:21 (412:18). with my share of songs—a literal translation of the Irish expression "*lem' chuid amhrán*"; figuratively, "with the songs that I know."

405:22 (412:18). soulth—Irish: "an apparition or ghost."

405:22 (412:19). bullawurrus—Brendan O'Heiher (*A Gaelic Lexicon for Finnegan's Wake, and Glossary for Joyce's Other Works* [Berkeley, California, 1967], p. 349) translates this Irish as "the smell of murder." P. W. Joyce, in *English as We Speak It in Ireland* (p. 227), defines it as "the spectral bull, with fire blazing from eyes and nose and mouth."

405:24 (412:20–21). the Erse language— technically, Scottish Gaelic; less properly, Irish Gaelic.

405:27 (412:23–24). The black panther!— *Cf.* 215:10n.

405:29 (412:26). Westland row station— a railroad station not far from the hospital, where Mulligan and Haines will catch the last train to Sandycove, at 11:15 P.M.

405:32 (412:28–29). The vendetta of Mananaan!— Mananaan MacLir was the sea-god of the Tuatha De Danaan (see 39:24n). His "vendetta" was with the dark and gloomy pirate-giants of the sea, the Formorians. Far from gloomy himself, Mananaan regarded the sea as a "plain of flowers."

405:32 (412:29). Lex talionis— see 138:7–8n.

405:33–34 (412:29–31). The sentimentalist is he . . . for a thing done— see 197:4–5n.

405:36 (412:32–33). the third brother— see 208:16–17n.

405:36–37 (412:33–34). The black panther . . . of his own father— see 215:10n and 19:32–34 (18:10–12).

405:38 (412:35). For this relief much thanks — see 366:10n.

Style: 405:42–407:2 (412:40–414:2). What is the age . . . Leopold was for Rudolph— after the style (gentle pathos and nostalgia) of the English essayist Charles Lamb (1775–1834).

406:5–6 (413:3–4). a modest substance in the funds— for Bloom's investments, see pp. 707–708 (723).

406:9 (413:8). Clambrassil street should read **Clanbrassil street—** in south-central Dublin.

406:10 (413:8). the high school— Bloom "attended" the High School of Erasmus Smith at 40 Harcourt Street, not far east of Clanbrassil Street in south-central Dublin.

406:19. baisemains. (413:18). baisemoins— there is some confusion here since *baisemains* is obsolete French for "compliments, respects," whereas baisemoins does not make sense. Miles L. Hanley, *Word Index to James Joyce's "Ulysses"* (Madison, Wisconsin, 1937) does not list "baisemains" as incorrect among the "Errata," p. xvi; and the French edition of *Ulysses* reads "baisemains."

406:22 (413:20). Jacob's pipe— a large Continental pipe, with an underslung porcelain bowl usually carved in the shape of a human head; here associated with the patriarch, one of the three fathers (Abraham, Isaac and Jacob) of Israel.

406:28–29 (413:27). The wise father knows his own child— see 87:17–18n.

406:29–30 (413:28). Hatch street, hard by the bonded stores— Hatch Street Upper is the southern boundary of University College. The "bonded stores" are W. and A. Gilbey, Ltd., distillers, across the street from the college.

406:33 (413:32). the new royal university— or University College, Dublin, was created by Letters Patent in 1880, when Bloom was fourteen years old.

406:36–37 (413:35–36). and in an instant . . . flood the world— in Genesis 1:1–3 God creates heaven and earth and light by "fiat": "In the beginning God created the heaven and the earth. And the earth was without form, and void; and darkness *was* upon the face of the deep. And the Spirit of God moved upon the face of the waters. And God said, Let there be light: and there was light."

Style: 407:3–40 (414:3–41). The voices blend and fuse . . . the forehead of Taurus— after the style of the English Romantic Thomas De Quincey (1785–1859), particularly *The English Mail Coach* (1849), Part III, "Dream-Fugue Founded on the Preceding Theme of Sudden Death." The "Dream-Fugue" expands on kaleidoscopic visions of death and resolves on a note of "golden dawn" and "the endless resurrections of [God's] love."

407:12, 13 (414:12, 14). Agendath Netaim— see 60:12–13n.

407:13 (414:13). the sandblind upupa— (the Hoopoe) is described in medieval bestiaries as a bird that lives on the flesh of corpses and lines its nest with human excrement. "Sandblind" is archaic for "weak-sighted."

407:16 (414:16). parallax— see 152:4n.

407:17 (414:17). scorpions— in Revelation 9: the "fifth Angel" announces the opening of the "bottomless pit" and a consequent plague of smoke and darkness, locusts and scorpions.

407:17–18 (414:18). the bulls of Bashan and of Babylon— Psalms 22:12–13: "Many bulls have compassed me: strong *bulls* of Bashan have beset me round. They gaped upon me *with* their mouths, *as* a ravening and roaring lion." In

Jeremiah 50:9–12 the Babylonians, "destroyers of mine heritage," are vilified "because ye are grown fat as the heifer at grass, and bellow as bulls." Jeremiah predicts that Babylon will be reduced to "a wilderness, a dry land, and a desert."

407:19 (414:19–20). Lacus Mortis—Latin: "the lake of the dead" elides with the Dead Sea.

407:20 (414:20). zodiacal host—both because animals comprise several of the signs of the zodiac and because the signs move westward toward the descent into the sea (of death).

407:20 (414:20–21). They moan, passing upon the clouds—recalls *The Odyssey*, Book XII, after Odysseus' men have broken faith and slaughtered some of the sun-god's cattle: "the gods, moreover, made queer signs appear: cowhide began to crawl, and beef, both raw and roasted, lowed like kine upon the spits."

407:27–29 (414:27–29). And the equine portent ... the house of Virgo—the constellation Pegasus (symbolic of poetic inspiration) would have been just visible above the horizon, Dublin, 16 June 1904 at 11:00 P.M. The heavens around are relatively "deserted" so that it is particularly conspicuous as a constellation. As Pegasus rises above the horizon, Virgo (the zodiacal sign of the virgin) would begin its decline from the zenith since Pegasus is "over" Virgo, i.e., almost opposite in the heavens.

407:29–33 (414:29–34). wonder of metempsychosis ... penultimate antelucan hour—as Virgo sets (toward dawn) the virgin (the Virgin Mary via echoes of the Litany of Our Lady; see 347:42–348:2n) takes her place as Queen of Heaven (one of her many titles) among the Pleiades, a constellation that would have risen at 3:00 A.M. just before dawn on 17 June. The Pleiades, the seven sisters, is a constellation of six stars, the seventh having hidden her face because she loved a mortal. As the rise of the Virgin Mary is a "harbinger" of Jesus as "daystar," so the "daystar" thus announced for Dublin during this night would have been Venus, on 17 June 1904. For "Martha, thou lost one," see 116:34n.

407:39–40 (414:40–41). Alpha, a ruby ... forehead of Taurus—just at dawn Aldebaran, Alpha-Tauri, would have appeared above the horizon. It is a red-giant star in the triangle of stars that form the forehead of Taurus the Bull. As Alpha, it is, of course, the beginning (see 375:3, 10n); in astrology Taurus is the zodiacal sign under which artistic consciousness, love and money are furthered as dominating forces.

Style: 407:41–409:30 (414:42–416:34). Francis was reminding ... from the second constel- lation—after the style of Walter Savage Landor (1775–1864). The form of essay particularly associated with his name is characterized by the title of a series of volumes that appeared in 1824 *ff.*, *Imaginary Conversations*. The conversations are between figures from classical literature and history. They do not attempt to re-create the historical past but rather to use that past to develop perspectives on the social, moral and literary problems of Landor's own time.

407:42 (415:1). Conmee's time—see 78:42–79:1n.

407:42–408:1 (415:2). Glaucon—the straight man in Plato's *Republic,* was assumed in 1904 to have been Plato's brother.

408:1 (415:2). Alcibiades—(*c.*450–404 B.C.), Athenian politician and general, friend and pupil of Socrates. Alcibiades was noted for his talent, his insolence and his capriciousness. His talent made him capable of brilliant political and military accomplishments; his insolence made him subject to exile and betrayal. "Alcibiades and Xenophon" is one of Landor's *Imaginary Conversations.*

408:1 (415:2). Pisistratus—(*c.*600–527 B.C.), tyrant of Athens who usurped power in 560 B.C. He was expelled twice but each time returned to regain his tyrannical hold on Athens. In his first years as tyrant he attempted to rationalize his position by paying court (as would-be friend) to the celebrated Athenian legislator Solon (*c.*638–*c.*558 B.C.). "Solon and Pisistratus" is another of Landor's *Imaginary Conversations.*

408:3–4 (415:4–5). If I call them into ... troop to my call?—as the shades of the dead have trooped to Odysseus' call in Hades, *The Odyssey*, Book XI; see p. 82 above.

408:5 (415:6). Bous Stephanoumanos—see 207:33n.

408:5 (415:6–7). bullockbefriending bard—see 36:40n.

408:6 (415:7). lord and giver of their life—Odysseus in Hades "gives" the shades "life" by allowing them to drink of the blood of bullocks that has been poured into a trench; figuratively, of course, Odysseus gives the shades life by giving them some of his own lifeblood.

408:6 (415:7). gadding—archaic: "unkempt."

408:7 (415:8). a coronal of vineleaves—emblematic of poetic inspiration (as wine inspirits) and of poetic achievement.

408:16 (415:17). his recent loss—Stephen's mother was buried 26 June 1903.

408:19 (415:20). the rider's name—O. Madden (on Sceptre).

408:20–25 (415:21–27). The flag fell and . . . reached, outstripped her—Lenehan's description of the Gold Cup Race is not particularly accurate; Sceptre, as the name suggests, was not a mare but a colt (*cf.* 171:27–28n). The account of the race in the *Evening Telegraph*, Dublin, 16 June 1904, p. 3: "(#1) Mr. F. Alexander's *Throwaway*, W. Lane (20 to 1 against); (2) Lord Howard de Walden's *Zinfandel*, M. Cannon (5 to 4); (3) Mr. W. Bass's *Sceptre*, O. Madden (7 to 4 against); (4) M. J. de Bremmond's *Maximum II*, G. Stern (10 to 1 against). The Race: Throwaway set fair pace to Sceptre, with Maximum II last, till fairly in the line for home, when Sceptre slightly headed Throwaway, and Zinfandel took close order with him. Throwaway, however, stayed on, and won cleverly at the finish by a length; three parts of a length divided second and third."

408:22 (415:23). Phyllis—in pastoral poetry a conventional name for a maiden. But the curse "Juno . . . I am undone" suggests the Phyllis in Greek myth who was married to and then abandoned by Demophon when he was on his way home from the Trojan Wars. Phyllis cursed him "by Rhea's daughter" (i.e., by Hera, the Greek counterpart of the Roman Juno) and then plotted his death.

408:25 (415:27). All was lost now—see 252:24n.

408:30 (415:32). W. Lane. Four winners yesterday and three today—at the Ascot Meeting on 15 June 1904 W. Lane won the Ascot Biennial Stakes on Mr. F. Alexander's Andover, the Coronation Stakes on Major Eustace Loder's Pretty Polly, the Fern Hill Stakes on Mr. P. Gilpin's Delaunay, and the Triennial Stakes on Mr. L. Neumann's Petit Bleu. On 16 June, in addition to the Gold Cup, Lane won the New Stakes on Mr. L. Neumann's Llangibby and the St. James's Place Stakes on Mr. S. Darling's Challenger.

408:38 (415:40). Lalage—another of the type names for classic beauties, after Horace, *Odes* II:v:15.

409:1 (416:3). Corinth fruit—currants (associated here with Corinth in classical Greece).

409:1 (416:4). Periplepomenos—a Greek coinage suggesting "itinerant fruit merchant."

409:10–11 (416:13). Glycera or Chloe—two more of the traditional names for classic or pastoral beauties. One famous Glycera was a Greek flower maiden and mistress of the Greek painter Pausias; another was a mistress of Menander. One famous literary Chloe is the pastoral maiden in the Greek romance *Daphnis and Chloe* (fourth or fifth century B.C.); another appears in Sidney's *Arcadia*.

409:12–13 (416:15). a slight disorder in her dress—after Robert Herrick's (1591–1674) "Delight in Disorder" (1648): "A sweet disorder in the dresse/Kindles in cloathes a wantonesse:/A lawn about the shoulders thrown/Into a fine distraction:/An erring lace, which here and there/Enthralls the Crimson Stomacher:/A Cuffe neglectful and thereby/Ribbands to flow confusedly:/A winning wave (deserving Note)/In the tempestuous petticote:/A carelesse shooe-string, in whose tye/I see a wilde civility:/Doe more bewitch me, then when Art/Is too precise in every part."

409:17 (416:20–21). Bass's mare . . . this draught of his—Lenehan elides William Arthur Hamar Bass (b. 1879), the owner of the colt Sceptre, with his uncle, Michael Arthur Bass, Baron Burton (1837–1909), director of Messers Bass and Company, Ltd., the manufacturers of Bass's ale at Burton-on-Trent in England. See 408:20-25n.

409:20 (416:23). the scarlet label—the label on a bottle of number one Bass's ale was a red triangle; see 407:39–40n.

409:21–22 (416:24–25). It is as painful perhaps to be awakened from a vision as to be born—This sounds suspiciously like George Russell, but the specific source remains unknown.

409:22–24 (416:26–27). Any object, intensely regarded . . . incorruptible eon of the gods—a principle of theosophy since, from a theosophical point of view, every object has a "soul," and no matter what its degree, each soul properly contemplated is equal to all others, or equally to be "loved."

409:24 (416:28). Theosophus—Stephen's "master" in theosophy; *cf.* 183:34n.

409:25–26 (416:28–30). whom in a previous existence . . . karmic law—typical credentials for a theosophist's "master" involve the master's having been instructed in a previous incarnation by a mystical priesthood (Hindu, Tibetan, Egyptian?). For "karmic law," see 183:39–40n.

409:26–27 (416:30). The lords of the moon—in Stephen's nonsense theosophy, those presences

which rule the 28 phases of the moon and thus preside over the sequences of metempsychosis that the phases dictate for the growth of the individual human soul.

409:27-28 (416:31). an orangefiery shipload from planet Alpha of the lunar chain—"the lunar chain" is the zodiac; Aries (Mars, energy in constructive process) is the first "house" of the zodiac; thus, "orangefiery" Mars is the "Alpha" (first) planet.

409:28-29 (416:32). etheric doubles—see 296:8n.

409:29-30 (416:33-34). incarnated by the rubycolored egos from the second constellation—i.e., they came under the sign of the second house of the zodiac, the constellation Taurus; see 407:39-40n.

Style: 409:31-411:3 (416:35-418:8). However, as a matter of fact ... ages yet to come—after the style of the English essayist and historian Thomas Babington Macaulay (1800-1859), a master of somewhat impetuous and unreliable history, a history that is treated with energy and verve to make it come out less sordidly and more reasonably than it usually does.

410:26 (417:31). the Mull of Galloway—an island in the Inner Hebrides, Argyllshire, Scotland.

410:34-35 (417:40). Malachi Roland St John Mulligan—the full name makes the identity of Mulligan's real-life counterpart one-third clear (Oliver *St. John* Gogarty). Roland (d. 778) was the semilegendary nephew of Charlemagne and the hero of *Le chanson de Roland*. The clue to this name of Mulligan lies in the proverbial phrase "A Roland for an Oliver," meaning tit for tat; since Roland and Oliver were boon companions and peers in arms, the assumption was that there would be no choice between them in single combat.

411:2 (418:8). Lafayette—James Lafayette, photographer to the queen and royal family, 30 Westmoreland Street, Dublin.

Style: 411:4-413:21 (418:9-420:29). It had better be stated ... in which it was delivered—after the style of the English naturalist and comparative anatomist Thomas Henry Huxley (1825-1895). Huxley is particularly noted for his contributions to and defense of the theory of evolution. He had an extraordinary ability to embody a disciplined scientific skepticism in a lucid expository prose.

411:5-6 (418:10-11). (Div. Scep.)—Sceptre of Divinity?

411:13 (418:18). (Pubb. Canv.)—Public Canvasser (for advertisements).

411:14-16 (418:19-22). the view of Empedocles ... the birth of males—Empedocles (*fl.*450 B.C.) was a native of Agrigentum in Sicily; Sicily is rendered under its ancient name "Trinacria" to reenforce the sustained allusion to *The Odyssey*. Empedocles did not hold this view, for Aristotle in *On the Generation of Animals*, Book IV, links the speculations of Empedocles with those of Anaxagoras (500–428 B.C.) and dismisses their views as "lightheaded." Anaxagoras, Aristotle says, held that "the germ ... comes from the male, while the female only provides the place in which it is to be developed, and the male is from the right, the female from the left testis, and also that the male embryo is in the right of the uterus, the female in the left. Others, as Empedocles, say that the differentiation takes place in the uterus; for he says that if the uterus is hot or cold, what enters it becomes male or female, the cause of the heat or cold being the flow of the menstrual discharge, according as it is colder or hotter, more 'antique' or more 'recent.' "

411:16-17 (418:22-23). or are the two long neglected ... differentiating factors—Aristotle in *On the Generation of Animals*, Book IV, argues that the male element (semen) is the active, formative principle, the female, the passive and receptive. The sex of the offspring is then determined by the principle that "prevails," i.e., if the "spermatozoa" are "neglected," the passive, receptive principle would prevail and the offspring would be female. "Nemasperm": literally, "threadlike sperm," in description of the shape of the spermatozoon.

411:18-19 (418:24). Culpepper—Nicholas Culpeper (1616-1654), English physician and author of various works, including *The English Physitian* (London, 1648) and *A Directory for Midwives : or a Guide for Women in their Conception, Bearing, and Suckling Their Children* (London, 1651). Culpeper's concern is with practical medicine rather than with genetic theory.

411:19 (418:24). Spallanzani—Lazzaro Spallanzani (1729-1799), Italian biologist and anatomist, noted for his pioneer work in disproving the doctrine of the spontaneous generation of life and for his investigation of the nature of the spermatic fluid and of the spermatozoa.

411:19 (418:24). Blumenbach—Johann Friedrich Blumenbach (1752-1840), German naturalist, physiologist and anthropologist, noted as the founder of physiological anthropology and for his theory of the unity of the human race, which he divided into five physiological types: Caucasian, Mongolian, Malay, American and Ethiopian. He

speculated that a *nisus formativus*, "formative tendency," was inherent in all living things.

411:19 (418:25). Lusk—Willam Thompson Lusk (1838–1897), an American obstetrician whose book *The Science and Art of Midwifery* (New York, 1882) gained world renown as a standard medical text in the late nineteenth century.

411:19 (418:25). Hertwig—Oscar Hertwig (1849–1922), a German embryologist who demonstrated that male and female sex cells are equivalent in their importance and that fertilization consists in the conjunction of equivalents. His brother, Richard Hertwig (1850–1937), was a co-worker who did considerable research on sex differentiation and on the relation between the nucleus and the cytoplasm in sex cells.

411:19 (418:25). Leopold—Christian Gerhard Leopold (1846–1911), German embryologist and gynecologist.

411:20 (418:25). Valenti—Giulio Valenti (b. 1860), an Italian physician and embryologist.

411:20–24 (418:25–29). a mixture of both? This . . . of the passive element—Aristotle's theory, as developed in *On the Generation of Animals*, is "a mixture of both," but nineteenth-century theory, as informed by Oscar Hertwig, is a radical departure from Aristotle's conception of the male as active, the female as passive. *Nisus formativus* means "formative tendency"; while the term is Blumenbach's (see 411:19n), the context suggests that it is being used as an echo of Aristotle's male or "formative principle." "*Succubitus felix*" is Latin for "the fertile one who lies under"; this also echoes the Aristotelian concept of the passive receptivity of the female.

411:27 (418:33). (Hyg. et Eug. Doc.)—Doctor of Hygienics and Eugenics.

411:36 (418:42). Kalipedia—Greek: the study of beauty, or the achievement of learning by means of the contemplation of beauty.

411:39–40 (419:2–4). plastercast reproductions . . . Venus and Apollo—presumably like those Bloom has inspected in the National Museum; see 174:4–5n.

412:1 (419:7). (Disc. Bacc.)—Bachelor of Discourse.

412:14 (419:21). (Bacc. Arith.)—Bachelor of Arithmetic.

412:24–25 (419:31–32). in the poet's words, give us pause—i.e., in Shakespeare's words; Hamlet, in the "To be or not to be" soliloquy:

"For in that sleep of death what dreams may come/When we have shuffled off this mortal coil,/ Must give us pause" (III, i, 66–68).

412:34–35 (419:42). the survival of the fittest—a key concept in Darwin's theory of evolution as developed in *The Origin of Species* (1859). Darwin argued that one aspect of the origin and perpetuation of a species was that those individuals best adapted to the environment in which the species found itself would survive to mate and have offspring. In popular terms, this concept was reduced to the simpleminded dictum: "the strong survive, the weak perish."

412:38–39 (420:3–4). pluterperfect imperturbability—a phrase from Mr. Deasy's letter; see 34:1–2 (33:6).

412:42 (420:7–8). staggering bob—see 168:33n.

413:13 (420:20–21). (Lic. in Midw., F.K.Q.C.-P.I.)—Licensed in Midwifery, Former Knight of the Queen's College of Physicians in Ireland (since Horne is described as "ex-Vice President, Royal College of Physicians, Ireland" in *Thom's [1904]*, p. 1381).

413:15 (420:23). let the cat into the bag—after the proverbial "let the cat out of the bag" (for disclosure of a secret).

Style: 413:22–414:19 (420:30–421:28). Meanwhile the skill and . . . good and faithful servant!—after the style of Charles Dickens; Chapter 53, "Another Retrospect," of *David Copperfield* (1849–1850) is particularly relevant.

413:26 (420:34). She had fought the good fight—I Timothy 6:12: "Fight the good fight of faith, lay hold on eternal life, whereunto thou art also called, and hast professed a good profession before many witnesses." See also II Timothy 4:7.

413:34 (421:1). Doady—in *David Copperfield* David's first wife, the "child-wife" Dora, calls him "Doady."

413:39–40 (421:5–6). Ulster bank, College Green branch—the Ulster Bank, Ltd., with home offices in Protestant Belfast, had branch offices throughout Ireland, including four in Dublin, one at 32 and 33 College Green.

413:41 (421:7–8). that faroff time of the roses—echoes James Clarence Mangan's lament, "The Time of the Roses," from the Turkish of Meseeh (d. 1512). The phrase functions as a refrain in the poem, as at the end of the first stanza: "In, in at the portals that Youth uncloses,/It hastes, it wastes, the Time of the Roses." The poem

develops the theme that the evanescence of youth demonstrates "that Life is a swift Unreality."

413:41–42 (421:8). With the old shake of her pretty head—on her deathbed in Chapter 53 of *David Copperfield* Dora recalls to David the relative failure of their marriage and mourns the eclipse of their "boy and girl" love "with the old shake of her curls."

414:5–6 (421:13–15). our famous hero of ... Waterford and Candahar—Sir Frederick Sleigh Roberts (1832–1914), 1st Earl Roberts of Kandahar, Pretoria and Waterford (created 1901). Though born in India, Lord Roberts regarded himself as Anglo-Irish, as the Waterford in his title suggests. He had a military career of considerable distinction, highlighted by his defeat of the Ayub Khan at Kandahar in southern Afghanistan in 1880. He was commander in chief in South Africa during the Boer War; his successes there, commemorated by the Pretoria in his title, led to his earldom and to his appointment as commander in chief of the British army (1901–1904).

414:10 (421:18–19). the Treasury Remembrancer's office, Dublin Castle—the Office of the Lord Treasurer's Remembrancer was responsible for the collection of debts (other than taxes) owed to the King's Treasury in Ireland.

414:11 (421:19). father Cronion—i.e., Father Time, thanks to a confusion of the Greek god Cronus with the word *chronos* ("time"). Cronus was a god of harvests who overthrew his father, Uranus, and was in turn overthrown by his son, Zeus.

414:15 (421:23). dout—dialect: "put out, extinguish."

414:17–18 (421:26). You too have fought the good fight—see 413:26n.

414:19 (421:27–28). Well done, thou good and faithful servant!—in Matthew 25:14–30, Jesus, in the parable of the talents, likens "the kingdom of Heaven" to "a man travelling in a far country" who delivers his goods to his servants for safekeeping. Two of the servants increase the goods (to their own benefit) by using them; one buries his share in the ground. The two who improve their master's goods are rewarded: "Well done, thou good and faithful servant." The third is "cast ... into outer darkness."

Style: 414:20–414:33 (421:29–421:42). There are sins or ... silent, remote, reproachful—after the style of the famous English convert to Roman Catholicism John Henry Cardinal Newman (1801–1890).

Style: 414:34–415:18 (422:1–28). The stranger still regarded ... in her glad look—after the style of the English aesthetician and essayist Walter Pater (1839–1894); *cf.* particularly the imaginary portrait of his childhood in *The Child in the House* (1894). For the occasion Bloom recalls, see 113:38–114:2 (115:14–20).

414:42 (422:10). Roundtown—where Bloom met Molly; see 105:6–7n.

415:6 (422:15). Floey, Atty, Tiny—Mat Dillon's daughters.

415:7–8 (422:17). Our Lady of the Cherries—there are many versions of this subject, among the most famous, one by Titian (now in Vienna) and several by the early-sixteenth-century Netherlands painter, Van Cleef. The allusion does not seem to be to a specific visual image but rather to the way Pater generalizes his aesthetic experience, particularly in *The Renaissance* (1873). In Christian art the cherry is one of the fruits of Paradise, symbolic of sweetness of character and the delights of the Blessed; as such, it is one of the attributes of the Virgin Mary.

415:17–18 (422:27). (alles vergänglich)—German: "All that is transitory," the first line of the final chorus of Goethe's *Faust*, Part II (1832), line 12104. The "immortal part" of Faust has been snatched from Mephistopheles and conducted toward "higher spheres," and the dramatic poem closes as the Mater Gloriosa speaks from above and Doctor Marianus ("worshiping prostrate") responds: "Look up to the glance of the savior,/All you tender penitents,/To transform yourselves with thanks/To the destiny of the Blessed./May all higher meaning [consciousness]/ Be at your service;/Virgin, mother, queen,/ Goddess, remain merciful)" *Chorus Mysticus*: "*All that is transitory*/Is only an image;/The insufficient/Here becomes an event [of importance];/The indescribable/Here is achieved;/The eternal-feminine/Draws us upward" (Lines 12096–12111).

Style: 415:19–415:32 (422:29–422:42). Mark this father ... the utterance of the Word—after the style of the English art critic and reformer John Ruskin (1819–1900).

415:23–24 (422:33–34). the vigilant watch of shepherds ... of Juda long ago—the account of the Nativity in Luke 2:1–20 established Bethlehem in Judea as the place of Jesus' birth and describes "shepherds abiding in the field, keeping watch over their flock" who are informed by an "angel of the Lord" of the place and importance of the birth. The shepherds find "Mary, and Joseph, and the babe lying in a manger" and "make known abroad the saying which was told them concerning the child."

415:32 (422:42). the Word—recalls the metaphysical account of the Nativity in John 1:1–5: "In the beginning was the Word, and the Word was with God, and the Word was God."

Style: 415:33–417:5 (423:1–424:18). Burke's! Outflings my lord . . . nunc est bibendum!—after the style of the Scottish man of letters Thomas Carlyle (1795–1881).

415:33 (423:1). Burke's—John Burke, tea and wine merchant, 17 Holles Street on the corner of Denzille Lane, a pub across the street and slightly north of the National Maternity Hospital.

416:4–5 (423:14–15). Doctor Diet and Doctor Quiet—two of a trilogy of physicians, proverbial from as early as the sixteenth century; the third is Doctor Merryman.

416:11 (423:22). coelum—Latin: "the vault of heaven."

416:12 (423:23). cessile—obsolete: "yielding."

416:15 (423:26). farraginous—rare: "formed of various materials; mixed."

416:19 (423:30). Malthusiasts—proponents of the doctrines of the English economist and statistician Thomas Robert Malthus (1766–1834). Malthus held that population increase inevitably outstripped the economies necessary for population support; he argued that, in the absence of prudential restraints, war, famine and disease would be the unavoidable (and necessary) population controls. The Malthusian League (1877) attempted to implement Malthus' doctrines by preaching contraception and planned parenthood. "Malthusiasts" also involves a pun on "enthusiasts" and the Latin *malus* ("bad" or "evil").

416:22 (423:34). homer—a Hebrew measure of from ten to 12 bushels.

416:23 (423:34–35). thy fleece is drenched—Judges 6:36–37: "And Gideon said unto God, If thou wilt save Israel by mine hand, as thou hast said, Behold I will put a fleece of wool in the floor; *and* if the dew be on the fleece only, and *it be* dry upon all the earth *beside*, then shall I know that thou wilt save Israel by my hand, as thou hast said."

416:23–24 (423:35). Darby Dullman there with his Joan—Darby and Joan, an elderly couple who live in marital felicity, indifferent to the society of others, in Henry Sampson Woodfall's (1739–1805) ballad "The Happy Old Couple; or The Joys of Love Never Forgot." The speaker tells his "Dear *Chloe*" that they must love in their youth in order to enjoy in old age the "current of fondness" that is shared by "dropsical" Darby and "sore-eyed" Joan, who still "possess" neither "beauty nor wit."

416:24–25 (423:36). A canting jay and a rheumeyed curdog—source unknown.

416:27–28 (423:39–40). Herod's slaughter of the innocents—see 169:26n.

416:32 (424:1–2). Derbyshire neck—a variety of goiter once endemic in Derbyshire, England.

416:33 (424:3). threnes—a song of lamentation, a dirge, threnody; formerly, specifically, the Lamentations of Jeremiah.

416:33 (424:3). trentals—archaic: sets of 30 requiem masses.

416:33 (424:3). jeremies—after the French Jérémie (Jeremiah), for the Lamentations of Jeremiah.

416:34 (424:4). defunctive music—i.e., music belonging to the dead, a phrase from line 14 of Shakespeare's "The Phoenix and the Turtle."

416:36 (424:6). Thou sawest thy America—in John Donne's (1573–1631) Elegie XIX, "Going to Bed," the lover addresses his mistress: "O my America! my new-found-land" (line 27).

416:37 (424:7). transpontine bison—i.e., the bison on the other side of the "land-bridge" that nineteenth-century geologists assumed to have linked North America, Europe and Asia in the region of the Arctic Circle.

416:38 (424:8). Zarathusthra—see 24:3n.

416:38–39 (424:8–9). Deine Kuh Trübsal . . . Milch des Euters—German: "You are milking your cow [named] Affliction. Now you are drinking the sweet milk of her udder."

416:40–41 (424:11). the milk of human kin—after Lady Macbeth's famous phrase for Macbeth's reluctance to kill his king: "the milk of human kindness" (I, v, 18).

417:1–2 (424:14). the honey milk of Canaan's land—Canaan, the promised land; see 387:21n.

417:4 (424:16). bonnyclaber—Irish: "thick curdled milk."

417:4–5 (424:17–18). Per deam Partulam . . . nunc est bibendum!—Latin: "By the goddesses Partula and Pertunda now must we drink." Partula was the Roman goddess who presided over birth; Pertunda presided over the loss of

virginity. *"Nunc est bibendum"* are the opening words of Horace's Ode XXXVII.

Style: 417:6–end (424:19–end). All off for a buster ... Just you try it on—the style "disintegrates" into fragments of dialect and slang (including revival-preacher's rhetoric). As Joyce described it, "a frightful jumble of pidgin English, nigger English, Cockney, Irish, Bowery slang and broken doggerel" (*Letters*, Vol. I, pp. 138–139, 13 March 1920).

417:6 (424:19). a buster—a drinking bout.

417:6 (424:19). armstrong—with arms linked.

417:7 (424:20). Bonafides—i.e., bonafide travelers. The laws governing the times when alcoholic beverages could be served in public houses were subject to certain exceptions for individuals who could "prove" they were traveling and thus would not be able to "dine" (drink) during the legal hours.

417:7–8 (424:20–21). Timothy of the battered naggin—source and connotations unknown.

417:8 (424:21). Like ole Billyo—dialect (after "Billyhood"): "camaraderie."

417:8 (424:21). brollies or gumboots—umbrellas or rubber boots.

417:9 (424:22). Where the Henry Nevil's—Henry Neville, English actor and dramatic teacher, noted for his roles in Dion Boucicault's plays and therefore popular in Dublin in the late nineteenth century.

417:9 (424:22). old clo—dialect: "old clothes."

417:10 (424:23). the ribbon counter—see 87:37–38n.

417:12–13 (424:25–26). Benedicat vos omnipotens Deus, Pater et Filius—Latin: "May almighty God, the Father and the Son ... bless you." The "filial blessing" in the Dismissal portion of the Mass. The words *"et Spiritus Sanctus"* ("and the Holy Spirit") are omitted.

417:13 (424:26). The Denzille lane boys—a Dublin slang name for the Invincibles; see 80:23n.

417:16 (424:29–30). En avant, mes enfants!—French: "Forward, my children!"

417:18 (424:31). parasangs—an ancient Persian measure of distance equal to about three and a half miles.

417:18 (424:31). Slattery's mounted foot—the title of a comic song by Percy French. The song begins: "You've heard of Julius Caesar, and of great Napoleon too,/And how the Cork Militia beat the Turks at Waterloo./But there's a page of glory that, as yet, remains uncut,/And that's the warlike story of the Slattery Mounted Fut./This gallant corps was organized by Slattery's eldest son,/A nobleminded poacher with a double-breasted gun." In the second stanza "Slattery's Light Dragoons" approach a pub: "And there we saw a notice which the brightest heart unnerved:/'All liquor must be settled for before the drink is served.'/So on we marched, but soon again each warrior's heart grew pale,/For rising high in front of us we saw the County Jail." In the third stanza Slattery's "heroes" are put to rout to the tune: " ... he that fights and runs away will live to fight again."

417:19 (424:32). apostates' creed—in mockery of the Apostles' Creed; see 22:23–24n.

417:20–21 (424:34). chuckingout time—closing time for Dublin pubs in 1904 was 11:00 P.M.

417:21 (424:34–35). Ma mère m'a mariée—the opening words of a bawdy French song: *"Ma mère m'a mariée un mari/Mon Dieu, quel homme, qu'il est petit. || Je l'ai perdu au fond de mon lit/ Mon Dieu, quel homme, qu'il est petit,"* etc. ("My mother married me to a husband. My god, what a man, how small he is. I have lost him at the bottom of my bed. My god, what a man, how small he is").

417:21–22 (424:35). British Beatitudes!—see 417:28–29n.

417:22 (424:35–36). Retamplan Digidi Boum Boum—these nonsense words or something like them (though *rataplan* is French for "drumbeat") are occasionally added to *"Ma mère m'a mariée ..."* to reenforce its qualities as a marching song.

417:23–24 (424:36–37). at the Druiddrum press by two designing females—see 14:31–32n.

417:25 (424:38–39). Most beautiful book come out of Ireland my time—see 213:36, 39–40n.

417:25 (424:39). Silentium!—Latin: "stillness, silence."

417:27–28 (424:41). Tramp, tramp, tramp the boys are (attitudes!) parching—after a Civil War marching song, "Tramp, Tramp, Tramp," by George F. Root: "In the prison cell I sit,/Thinking, mother dear, of you,/And our bright and happy home so far away,/And the tears they fill my eyes,/Spite of all that I can do,/

Though I try to cheer my comrades and be gay." Chorus: "Tramp, tramp, tramp, the boys are marching,/Oh, cheer up, comrades, they will come,/And beneath the starry flag we shall breathe the air again,/Of freedom in our own beloved home." "Attitudes" is a military command that means "Correct your postures."

417:28–29 (424:41–42). Beer, beef, business, bibles, bulldogs, battleships, buggery and bishops—the "British Beatitudes," a parody of line 138, Canto I of Pope's *The Rape of the Lock* (1714), the description of Belinda's dressing table: "Puffs, Powders, Patches, Bibles, Billet-doux." The "Beatitudes" also play on British "apostasy" by amplifying "Beer and Bible," the nickname of a combination of High Church Conservatives and English brewers who resisted Parliament's attempts to limit the sale of intoxicating beverages, 1873 *ff*.

417:29, 30, 32 (425:1, 2, 3). Whether on the scaffold high./When for Irelandear./We fall—from "God Save Ireland" (to the tune of "Tramp, Tramp, Tramp"); see 161:3n.

417:32 (425:3). Bishop's boosebox—another play on "Beer and Bible"; see 417:28–29n.

417:32–33 (425:4). Rugger. Scrum in. No touch kicking—they pause for a moment of rugby. In a "scrum," a huddle with arms locked over shoulders and heads down, they try to gain control of an imaginary ball in the center of the scrum. "No touch kicking" means "Kick the ball and not the other players."

417:35 (425:6). Who's astanding—to "stand" is to pay for the drinks.

417:36 (425:7). Bet to the ropes—i.e., I have bet (and lost) all my money.

417:36 (425:7). Me nantee saltee—pidgin English: "I have no salt (money)."

417:37 (425:8). a red—i.e., a red cent, a penny.

417:38 (425:9). Übermensch—see 24:3n.

417:38 (425:9). number ones—number one Bass's Ale; see 409:20n.

417:38–39 (425:9–10). Ginger cordial—widely advertised as a temperance drink.

417:40 (425:11–12). Stopped short never to go again when the old—from "My Grandfather's Clock" (1876), an American song by Henry C. Work, who advertised himself as one of the Christy Minstrels. "My grandfather's clock was too large for the shelf,/So it stood ninety years upon the floor;/It was taller by half than the old man himself,/Though it weighed not a pennyweight more. // It was bought on the morn of the day that he was born,/And was always his treasure and pride;/But it stopped short, never to go again,/When the old man died."

417:41 (425:12). Caramba!—a Spanish exclamation of astonishment or vexation.

417:41–42 (425:12–13). an eggnog or a prairie oyster—traditional drinks for combating a hangover. A "prairie oyster" is one unbroken egg yolk seasoned with Worcestershire, tomato catsup, vinegar, lemon juice, red pepper, salt and Tabasco sauce.

418:3 (425:16). Digs—slang for a dwelling.

418:3 (425:16). the Mater—the Mater Misericordiae Hospital in Eccles Street.

418:3 (425:17). Buckled—dialect: "married."

418:4 (425:17–18). Full of a dure—i.e., she would fill a door, she has an ample shape.

418:5 (425:19). lean kine—in Genesis 41 the Pharaoh dreams of seven "ill-favoured and lean-fleshed kine" symbolic of seven years of famine.

418:6 (425:19–20). Pull down the blind, love—a well-established music-hall gag line, and the title of a song by Charles McCarthy; "Did you ever make love? If not, have a try/I courted a girl once, so bashful and shy/A fair little creature, who, by the by,/At coaxing and wheedling had such a nice way;/Ev'ry night to her house I went/In harmless delight our evenings were spent/She had a queer saying, whatever she meant,/For whenever I entered her house she would say,"/ (Chorus:) "Pull down the blind, love, pull down the blind/Pull down the blind, love, come don't be unkind;/Though we're alone, bear this in mind/Somebody's looking, love, pull down the blind."

418:6 (425:20). two Ardilauns—two Guinness beer; see 78:24n.

418:7 (425:20–21). If you fall don't . . . Five. Seven. Nine—mock advice to a boxer with a foreshortened knockdown count.

418:8–9 (425:22–23). And her take me to rests and her anker of rum—a "rest" is a bed or couch and an "anker" is eight and a half imperial gallons.

418:9–10 (425:23–24). Your starving eyes and allbeplastered neck you stole my heart—clearly parodies a love song, but the song is unknown.

418:11 (425:24–25). Spud again the rheumatiz?—a potato talisman such as the one Bloom carries was superstitiously believed to protect the bearer from rheumatism.

418:12 (425:26). I vear thee beest a gert vool—Yorkshire dialect: "I fear you are a great fool."

418:13 (425:27). Your corporosity sagaciating O K?—American slang: "corporosity" means literally bodily bulk; hence a person of impressive size. To "sagaciate" is Southern slang for to fare or to thrive.

418:14–15 (425:28–29). Womanbody after going on the straw?—English dialect: "Is your woman about to give birth?"

418:15 (425:29). Stand and deliver—in the British army the formula that a sentry uses to halt an intruder and demand that he repeat the password of the day.

418:15–16 (425:29–30). Ours the white death and the ruddy birth—see 245:27n.

418:17 (425:31). Mummer's wire. Cribbed out of Meredith—see 197:4–5n.

418:17 (425:31–32). orchidised—medical: "having inflamed testicles."

418:18 (425:32). polycimical—rare: "full of a variety of bugs or insects."

418:20 (425:34). Collar the leather—slang: "Grab the football."

418:20 (425:34). nappy—early eighteenth-century slang for beer or ale.

418:21 (425:35). Jock braw Hielentman's your barleybree—after one of the choruses in Robert Burns's "The Jolly Beggars; A Cantata" (1785, 1799): "Sing hey my braw John Highlandman!/Sing ho my braw John Highlandman!/There's not a lad in a' the lan'/Was match for my John Highlandman!" (lines 132–135). "Barleybree" (Scots: "barley brew") occurs in the chorus of Burns's song "Willie Brew'd a Peck of Maut [Malt]" (1789, 1790): "We are na that fou [full, drunk],/But just a drappie [small drop] in our e'e!/The cock may caw, the day may daw,/And ay we'll taste the barley-bree!"

418:21–22 (425:35–36). Lang may your lum reek and your kailpot boil!—Scots dialect: "Long may your chimney smoke and your soup pot boil."

418:23 (425:37). Leg before wicket—in cricket it is against the rules for the batsman to protect his wicket from the bowled ball with anything other than the bat. If the batsman interposes his body and the umpire judges that the bowled ball would have knocked down the wicket had the batsman not been in the way, the umpire rules, "Leg before wicket," and the batsman is out.

418:24–25 (425:38–39). Caraway seed—traditionally used for disguising alcoholic breath.

418:25 (425:39). Twig?—slang: "Do you understand?"

418:25–26 (425:39–40). Every cove to his gentry mort—seventeenth-century gypsy cant; see 48:16–19n.

418:26 (425:40). Venus Pandemos—Venus or Aphrodite Pandemos ("of all the people"), originally a goddess of all the country (of Greece), she evolved into the goddess of sensual lust and prostitution, in contrast to Aphrodite Urania, the goddess of the higher and purer love.

418:26 (425:40). Les petites femmes—French: "The little women."

418:26–27 (425:40–41). Bold bad girl from the town of Mullingar—i.e., Milly Bloom.

418:27–28 (425:42). Haunding Sara by the wame—Scots dialect; "Holding Sarah by the waist or belly," from stanza four of Robert Burns's poem "Ken ye ought o' Captain Grose?": "Is he to Abram's bosom gone?/I go and ago.—/Or haudin Sarah by the wame?/Iram coram dago."

418:28 (425:42). On the road to Malahide—combines suggestions of "The Bridal of Malahide" (see 220:11n) and Kipling's "Mandalay" (from *Barrack-Room Ballads*, 1892). The speaker of Kipling's poem dreams of being with a certain "Burma girl . . . On the road to Mandalay."

418:28–29 (426:1). If she who seduced me had left but the name—after the opening lines of Thomas Moore's song "When He Who Adores Thee": "When he who adores thee, has left but the name/Of his fault and his sorrows behind,/O! say wilt thou weep, when they darken the fame/Of a life that for thee was resign'd?"

418:30 (426:2). Machree, Macruiskeen—after "The Cruiskeen Lawn"; see 290:13n.

418:30 (426:2–3). Smutty Moll for a mattress jig—"Moll Peatley's jig" was Dublin slang for copulation.

418:31 (426:3). And a pull together—after one of several bawdy parodies of the "Eton Boat

Song," by Johnson and Drummond. Chorus: "Jolly boating weather, Jolly sweet harvest breeze;/Oars clip and feather, cool 'neath the trees,/Yet swing, swing together with your backs between your knees." Some versions substitute "pull" for "swing" and the opportunities for parody are obvious.

418:33 (426:5). shiners—slang for coins, especially for sovereigns and guineas.

418:33–34 (426:5–6). Underconstumble?—"understumble," according to Partridge, is a common pun on "understand," here combined with "underconstable."

418:34 (426:6). chink—slang for money, especially coins.

418:34 (426:6). ad lib—*ad libitum*, Latin: "at one's pleasure, as one wishes."

418:36 (426:8). ooff—East End London slang for money.

418:36 (426:8–9). two bar and a wing—slang: "two shillings and a penny."

418:37 (426:9). bilks—slang for swindlers or cheats.

418:39–40 (426:11–12). We are nae fou. We're nae tha fou—see 418:21n.

418:42 (426:14). teetee—slang for teetotal, i.e., not drinking.

418:42. Bowsing nowt but claretwine. (426:14) should read **Bowsing**, not **Mowsing**— "Bowsing" is slang for drinking; after an Irish song, "The Rakes of Mallow": "Beaving, belle-ing, dancing, drinking/Breaking windows, damning, sinking,/Ever raking, never thinking,/Live the rakes of Mallow. // One time nought but claret drinking,/Then like politicians thinking/To raise the sinking funds when sinking,/Live the rakes of Mallow."

418:42 (426:15). Garn!—low colloquialism: "Get away with you!"

419:1 (426:15). glint—slang for a look or glance.

419:1 (426:15). Gum—a vulgar euphemism for God.

419:1 (426:15). I'm jiggered—a colloquial oath approximate to "I'll be damned!"

419:1 (426:15–16). been to barber—cockney slang for shorn (of money) and drunk as a result of the process of being shorn.

419:3 (426:17). Rose of Castille—Lenehan recalls his pun; see 133:4n.

419:5 (426:19–20). The colleen bawn, my colleen bawn—see 292:10n.

419:6 (426:20). Dutch oven—in boxing, slang for the mouth.

419:7–10 (426:22–25). The ruffin cly the nab ... form hot order—see below for annotation of verbal textures and allusions. The sense of this passage is obscured by the period after "Stephen," which is a misprint. Stephen Hand was a Dubliner whose misadventure Joyce clarified in a letter to Georg Goyert, the German translator of *Ulysses,* 6 March 1927: "Stephen Hand met a telegram boy who was bringing a private racing telegram from the stable of the celebrated English brewer Bass to the police depot in Dublin to a friend there to back Bass' horse Sceptre for the Cup. Stephen Hand gives boy 4 pence, opens the telegram over steam (grahamising), recloses it and sends the boy on with it, backs *Sceptre* to win and loses. (This really happened and his name was Stephen Hand though it was not the Gold Cup.)"

419:7 (426:22). The ruffin cly the nab—gypsy cant: "The devil take the head," from the first line of "The Beggar's Curse" in Richard Head, *The Canting Academy* (see 48:16–19n). The full line reads, "The Ruffin cly the nab of Harmanbeck"; "Harmanbeck" means a constable.

419:8 (426:22–23). the jady coppaleen—"jady" after "jade," a good-for-nothing or vicious horse; "coppaleen" is Irish for a little horse.

419:9 (426:23). Bass—see 409:17n.

419:10 (426:24). joey—slang for a fourpenny piece from *c.*1855.

419:10 (426:24). grahamise—slang for to open letters going through the mail. Sir James Graham (1792–1861), an English statesman who as home secretary in 1844 had a warrant issued for opening the letters of the Italian patriot and revolutionary Giuseppe Mazzini, who had sought political asylum in England. Graham communicated the contents to the Austrian minister; the result was a popular outcry against Graham's betrayal, in the course of which his name became a verb.

419:10 (426:24). Mare on form—from a version of Bass's telegram; i.e., Sceptre (though not a mare but a colt) is in top shape. See 408:20–25n.

419:10–11 (426:25). Guinea to a goosegog—a colloquial expression for overwhelming odds; a "goosegog" is a gooseberry.

419:11 (426:25). a cram—slang for something that fills the mind with false or exaggerated expectations.

419:12 (426:27). chokeechokee—slang for prison.

419:12–13 (426:27). harman beck—gypsy cant for a constable; see 419:7n.

419:13 (426:27). Madden—O. Madden was the jockey who rode Sceptre in the Gold Cup; see 408:20–25n.

419:14 (426:28–29). O, lust, our refuge and our strength—a parody of a phrase from one of the vernacular prayers prescribed for the end of Low Mass; see 81:29n.

419:16 (426:31). Horryvar, mong vioo—after the French, *"Au revoir, mon vieux"* ("Goodbye, old fellow").

419:17 (426:31). the cowslips—in the language of flowers the cowslip (or primrose) is symbolic of inconstancy.

419:18 (426:32). Jannock—dialect English for honest, candid.

419:18 (426:33). Of John Thomas, her spouse—continues the parody from 419:14 (426:28–29) above. "John Thomas" is slang for penis.

419:21 (426:35–36). sheeny nachez—slang: "Jew thing"; i.e., what a Jew would do (opprobrious).

419:21 (426:36). misha mishinnah—"a bad, violent and unprepared for death or end" (Joyce; see *James Joyce Quarterly*, IV, 3, 194).

419:22 (426:36–37). Through yerd our lord, Amen—continues the parody from 419:18 (426:33). "Yerd" is slang for penis.

419:25 (426:39). bluggy—a jocular and euphemistic twisting of "bloody."

419:27–28 (426:42–427:1). Landlord, landlord have you good wine, staboo?—see 385:33, 35n.

419:28 (427:1). wee drap to pree—Joyce intended this as an allusion to Burns's "Willie Brew'd a Peck of Maut," 418:21n (see *James Joyce Quarterly*, IV, 3, 194), since in some versions of the poem Burns's lines "Willie brewed a peck of maut/And Rob and Allen came to see," the word "see" is varied as "pree," which Joyce defined as Scots for to examine and taste whiskey.

419:30 (427:2). Right Boniface!—i.e., right about-face with a pun on "Boniface," the name of nine popes and several saints; see 333:25n.

419:30–31 (427:2–3). Nos omnes biberimus ... capiat posterioria nostria—Latin: "We will all drink green poison [absinthe], and the devil take the hindermost."

419:32 (427:4). Rome booze—slang for wine.

419:32 (427:4). toff—see 236:30n.

419:32 (427:5). onions—a word difficult for drunks to pronounce and therefore used by the police as a sobriety test.

419:33 (427:5). Cadges—see 80:39n.

419:33–34 (427:6). Play low, pardner—from card games, slang for "Don't draw attention to yourself."

419:34 (427:6). Slide—slang for to disappear.

419:34 (427:6). Bonsoir la compagnie—Hodgart and Worthington list this as the title of a song by Maud, but it also seems likely that it is an allusion to a drinking song, "Vive l'Amour": "Let every good fellow now join in a song,/Vive la compagnie!/Success to each other and pass it along,/Vive la compagnie,/Vive la, Vive la, Vive l'amour/ ... Vive la compagnie."

419:34 (427:6–7). And snares of the poxfiend—parodies a phrase from the second of the vernacular prayers prescribed for the end of Low Mass; *cf.* 419:14n. The prayer is quoted 82:13–18 (83:22–27).

419:35 (427:7). Namby Amby—"Namby Pamby," from the English poet Ambrose Philips (1674–1749) and subsequently used by Pope and others in ridicule of Philips' verse; hence, insipid, weakly sentimental, affectedly pretty.

419:35 (427:7). Skunked?—slang for betrayed, left in the lurch.

419:35 (427:8). Leg bail—to "take leg bail" is to escape from custody (by running away).

419:35–36 (427:8). Aweel, ye maun e'en gang yer gates—Scots: "Ah well, you must even go your own ways."

419:39 (427:11). sprung—slang for drunk.

419:39 (427:11). Tarnally—as an oath, a dialect version of "eternally."

419:40 (427:12). longbreakyet—"long break" is summer vacation for English students.

419:40 (427:12). curate—slang for a bartender.

419:41 (427:13). Cot's plood—dialect for the oath "God's blood."

419:41 (427:13). prandypalls—a "pall" is an altarcloth or a square piece of cardboard covered with linen that is used for covering the chalice during Mass. "Prandy" suggests "prandial," an affected or humorous way of referring to a repast.

419:42–420:1 (427:14–16). Thrust syphilis down to ... wander through the world—continues the parody of the vernacular prayers for the closing of Low Mass; see 419:34n.

420:2 (427:16). A la vôtre!—French drinking salutation: "To your (health)!"

420:3 (427:17). whatten tunket's—American dialect: "what in thunder."

420:3–4 (427:17–18). Dusty Rhodes—an American comic-strip character from c.1900, the tramp who weathered continuous comic misfortune.

420:4–5 (427:19). Jubilee Mutton—Dublin slang for "not much in contrast to his needs." In 1897, during the celebration of Queen Victoria's Jubilee, relatively small quantities of mutton were distributed free among the Dublin poor. The inadequacy of this gesture in contrast to the appalling need of the poor gave rise to this anti-English phrase.

420:5 (427:19). Bovril—an English beef concentrate that becomes a kind of beef tea when water is added. It was widely advertised as a health food.

420:5–6 (427:19–20). D' ye ken bare socks?—after the opening line of the song "John Peel": "D' ye ken John Peel with his coat so gay?"; see 285:8n.

420:6 (427:20). the Richmond—i.e., the Richmond Lunatic Asylum; see 8:14n.

420:7–8 (427:22). Bartle the Bread—Joyce glossed this for the German translator: "Bartle who delivers or eats the bread usually" (see *James Joyce Quarterly*, IV, 3, 194).

420:8 (427:23). cit—slang for citizen.

420:8–9 (427:23–24). Man all tattered ... maiden all forlorn—see "The House That Jack Built," 385:22n.

420:9–10 (427:24). Slung her hook—slang for made off, ran away.

420:10–11 (427:24–25). Walking Mackintosh of lonely canyon—parodies the titles of American dime-novel Westerns.

420:11 (427:25). Tuck—slang for drink or drink up.

420:11–12 (427:26). Nix for the hornies—slang: "Watch out for the cops."

420:13 (427:27). passed in his checks—American slang for died.

420:17 (427:31). Tiens, tiens—French: "Well, well."

420:17–18 (427:32). O get, rev on a gradient one in nine—i.e., "O get out"; it was impossible for a racing car to accelerate when going up an 11.1 percent grade. In general this assertion would have been true in 1904, but the rapid development of the automobile made it a fine subject for irresolvable argument.

420:18 (427:32–33). Live axle drives are souped—i.e., automobiles designed so that the axle moves and imparts motion to the wheels are doomed. There was a considerable argument in 1904 about whether axles should be "fixed" (as they were in wagons) or "live," and the speaker has chosen what has turned out to be (since live-axle drives have long since become standard) the wrong side of the argument.

420:19 (427:33). Jenatzy licks him—Jenatzy, a Belgian, was scheduled to drive for Germany (a German Mercedes) in the Gordon Bennett Cup Race in Germany, 17 June 1904. Jenatzy had won the race in 1903, when it was held in Ireland, and the *Evening Telegraph*, 16 June 1904, conceded him to be the favorite (though he lost to Thery of France). The "him" whom Jenatzy was to "lick" was, according to the *Evening Telegraph*, the other German driver, Baron de Caters.

420:19–20 (427:34). Jappies, high angle fire—during the Russo-Japanese War (1904–1905) naval supremacy was the key to Japanese military success on the mainland. The Japanese fleet was more powerful than Russia's Far Eastern fleet, and in the first major naval engagement, 8–9 February 1904, the Japanese crippled several Russian battleships and cruisers in an attack launched by torpedo boats and pressed home by long-range shelling. The high-angle fire of that shelling found the thinly armored decks of the Russian ships vulnerable. The early Japanese naval successes caused a lull in the naval war while the Russians effected repairs. The *Evening*

Telegraph, 16 June 1904, reported "a renewal of activity on the part of Russia's naval commanders" (though that renewal was to lead to further Russian losses during the summer of 1904).

420:20 (427:34). inyah—Irish: "Is that so?"

420:20 (427:34). war specials—daily newspaper dispatches about the Russo-Japanese War were printed in columns headed "War Specials."

420:22–23 (427:37–38). May Allah, the Excellent . . . ever tremendously conserve—a formal Arabic salutation (and prayer) pronounced on the eve of retiring.

420:24 (427:39). We're nae tha fou—see 418:21n.

420:24–25 (427:39–40). The Leith police dismisseth us—the first line of a tongue-twisting nursery rhyme: "The Leith police dismisseth us,/I'm thankful, sir, to say;/The Leith police dismisseth us,/They thought we sought to stay./The Leith police dismisseth us,/We both sighed sighs apiece,/And the sigh that we sighed as we said goodbye/Was the size of the Leith police." In a letter to the German translator of *Ulysses* Joyce remarked "the police sergeant asks drunks to repeat [this phrase] in order to test their sobriety."

420:26–27, (427:41–42). Mona, my thrue love . . . Mona my own love—from a song, "Mona, My Own Love," by Weatherly and Adams. Chorus: "Mona, my own love, Mona my true love,/Art thou not mine thro' the long years to be?/By the bright stars above thee,/I love thee, I love thee,/Live for thee, die for thee, only for thee./Oh, Mona, Mona, my own love,/Art thou not mine thro' the long years to be?"

420:28 (428:1). obstropolis—illiterate for "obstreperous."

420:29 (428:2). Mount street—just southeast of Burke's pub (see 415:33n), from which the drinkers have exited.

420:31 (428:5). Denzille lane—Stephen and Lynch walk northwest along this lane from Burke's (corner of Denzille Lane and Holles Street) on their way to the Westland Row Railroad Station and thence to the Amiens Street Station on the edge of the red-light district in eastern Dublin, north of the Liffey.

420:32–33 (428:6–7). We two, she said, will seek the kips where shady Mary is—in Dante Gabriel Rossetti's (1828–1882) "The Blessed Damozel" (1850, 1856, 1870), the Damozel in heaven speaks and is overheard by her lover on earth: "'We two,' she said, 'will seek the groves/Where the lady Mary is,/With her five hand-maidens, whose names/Are five sweet symphonies,/Cecily, Gertrude, Magdalen,/Margaret, and Rosalys'" (lines 103–108). For "kips," see 12:31n.

420:33–34 (428:7–8). Laetabuntur in cubilibus suis—Latin: "Let them sing aloud upon their beds," from Psalms 149:5. The verse begins, "Let the saints be joyful in glory."

420:35 (428:9–10). Sinned against the light—i.e., the Jews; see 34:41 (34:3).

420:36–37 (428:10–11). that day is at hand . . . the world by fire—the traditional Christian version of the Last Judgment is that of a world consumed (and purified) by fire.

420:37 (428:11). Ut implerentur scripturae—Latin: "That the scriptures might be fulfilled." The phrase occurs in the description of the Crucifixion, John 19:24: "[The soldiers] said therefore among themselves, Let us not rend [the coat], but cast lots for it, whose it shall be: that the scripture might be fulfilled, which saith, They parted my raiment among them, and for my vesture they did cast lots. These things therefore the soldiers did." The "scripture" referred to is Psalms 22:18.

420:38–39 (428:12–13). Then outspoke medical Dick to his comrade medical Davy—see 206:36–37n.

420:39 (428:13). yellow—Lynch's personal profanity; see *A Portrait of the Artist as a Young Man,* Chapter V. Cf. 320:40–41n.

420:39–40 (428:14). on the Merrion hall—see 246:22–23n.

420:40 (428:14). Elijah is coming—see 149:15n.

420:40 (428:14–15). Washed in the Blood of the Lamb—see 149:11n.

420:41–421:11 (428:15–27). Come on, you winefizzling . . . Just you try it on—this parody of an American evangelist's style is also reminiscent of the celebrated "Raft Passage" in Chapter III of Mark Twain's *Life on the Mississippi* (1883).

421:2–3 (428:19). Alexander J. Christ Dowie—see 149:16n.

421:5 (428:21). bumshow—American slang for a carnival show that promises more (in the way of revealing glimpses of pretty girls, etc.) than it ever intends to deliver.

EPISODE 15
[CIRCE]

Episode 15: [Circe], pp. 422–593 (429–609). In Book X of *The Odyssey* Odysseus recounts his adventures with Aeolus and with the Lestrygonians and then describes his landing on Circe's island. Odysseus and his men are in a state of profound depression, "sick at heart, tasting our grief," as a result of the tantalizing view of Ithaca achieved with Aeolus' help and of the disastrous encounter with the Lestrygonians. They rest "cloaked in desolation upon the waste sea beach"; Odysseus kills "a stag with noble antlers"; they feast, and eventually Odysseus divides his crew into "two platoons," one under his leadership, one led by Eurylochus. The leaders draw lots and the fate of exploring the island falls to Eurylochus. Eurylochus and his men discover Circe's hall, where all save Eurylochus are transformed into hogs by Circe's "foul magic." Eurylochus escapes to warn Odysseus, who then approaches Circe's hall alone. He is met by Hermes, who gives him a magic herb, moly, to make him proof against Circe's magic; Hermes also tells Odysseus that he must make Circe swear to release his men and to perform "no witches' tricks" lest he, too, be "unmanned" by her. Odysseus confronts Circe; her magic fails (since his magic, moly, is stronger); Odysseus threatens her, and she swears that she will not harm him and that she will release his men. She not only keeps her oath but also royally entertains Odysseus and his crew and eventually advises him to visit the underworld (Hades) to consult Tiresias. When Odysseus returns with Tiresias' prophecy, Circe further helps him with advice about the Sirens and Scylla and Charybdis.

Time: 12 midnight. Scene: the Brothel, Mrs. Cohen's establishment at 82 Tyrone Street Lower in the Dublin red-light district. Joyce called the district "nightown"; Dubliners called it "Monto," after Montgomery Street (now Foley Street). The district lay just north of the Liffey and west of the Amiens Street Railroad Station. See Ellmann, pp. 377–378. Organ: locomotor apparatus; Art: magic; Color: none; Symbol: whore; Technique: hallucination.[1] Correspondences: *Circe*—Bella.

[1] The technique of this episode can be informed by a variety of sources, among them: Gustave Flaubert (1821–1880), *La tentation de Saint Antoine* (1874) (*The Temptation of Saint Anthony; or, a Revelation of the Soul*), references below are to *The Complete Works* . . . , Vol. VII (London, 1904); Goethe's *Faust* (1808), particularly, Part I, scene xxi, "Walpurgisnacht"; Ibsen's *Ghosts; Spirits That Return* (1881); Strindberg's *The Ghost Sonata* (1907) and *The Dream Play* (1902); Leopold von Sacher-Masoch (1836–1895), *Venus im Pelz* (written in 1870, published posthumously, 1904), references below are to *Venus in Furs* (New York, 1947); and Richard von Krafft-Ebing (1840–1902), *Psychopathia Sexualis*, references below are to an edition published in Brooklyn, New York (1937).

422:1 (429:1). Mabbot street—(now Corporation Street), just north of the Liffey near the Amiens Street Railway Station.

422:1 (429:1). nighttown—slang for the late shift on a newspaper among Dublin journalists.

422:3 (429:3). will-o-the-wisps—in Goethe's *Faust* (I, xxi), a will-o-the-wisp lights the way up the "magic-mad" mountain as Faust and Mephistopheles make their way toward the Walpurgisnacht (the Witches' Sabbath).

422:5 (429:5). Rabaiotti's . . . ice gondola—see 222:10n.

422:8–10 (429:8–10). The swancomb of the gondola . . . under a lighthouse—in Flaubert's *Temptation of Saint Antony*, pp. 21 ff., gondolas as "pleasure boats" and the Pharos (lighthouse) are aspects of Antony's resplendent vision of Alexandria before that vision metamorphoses into one of horror.

422:19 (429:19). Kithogue—Irish: "A left-handed [and hence unlucky] person."

422:25 (429:25). (Gobbing)—making unintelligible or animal noises (after the Irish *gob*, "beak" or "snout").

423:13 (430:13). tatts—dialect: "tangles."

423:16–19, 28–31 (430:17–20, 29–32). I gave it to Molly . . . the leg of the duck—the sources of this bawdy rhyme are unknown.

423:20 (430:21). Private Carr—may very well owe his name to Joyce's irritation with one Henry Carr, a British consular official in Zurich. See Ellmann, index p. 825.

423:25 (430:26). Signs on you—slang: "Bad luck to you."

423:25 (430:26). More power the Cavan girl—the connotations of this phrase are unknown. Cavan is a small town and county in north-central Ireland.

423:27 (430:28). Cootehill and Belturbet—small towns in County Cavan.

424:2 (431:2). the parson—because Stephen is dressed in black he looks like a Protestant minister.

424:7–9 (431:7–9). She has it . . . leg of the duck—see 423:16–19n.

424:11 (431:11). the introit for paschal time—the Introit (Entrance chant) of the Mass occurs near the beginning just after the priest has recited

the Confiteor and ascended the altar steps. Paschal time, the weeks from Easter to Pentecost, is a season of joy, rebirth and baptism (it is not a time for doing penance). The Introit for Easter Day (when Paschal time begins) is not what Stephen quotes in the passages that follow, but the Introit reads in translation: "I have risen and now am I with you once more. Alleluia! You laid your hand upon me. Alleluia! You have shown how wonderful is your wisdom. Alleluia, alleluia! Lord you have proved me, and you know me. You saw me when I went to my rest, and you saw me rise again." The *Layman's Missal* remarks of this passage: "The risen Christ thanks his Father for rescuing him from the grave."

424:15 (431:15). Vidi aquam egredientum de templo a latere dextro. Alleluia—Latin: "I saw a stream of water welling forth from the right of the temple. Alleluia." This is the opening phrase of the Antiphon used with Asperges (the ceremony of sprinkling the altar) during Paschal time. Its emphasis on joy contrasts with the Antiphon used during the rest of the liturgical year, which begins: "If you sprinkle me with hyssop, Lord, I shall be cleansed." "Hyssop" is a bitter purgative.

424:22 (431:22). (Altius aliquantulum.) Et omnes ad quos pervenit aqua ista—Latin: "(With considerable profundity.) And all among them came to that water." Stephen continues the Antiphon from 424:15 (431:15).

425:2 (432:2). Faithful place—off Tyrone Street Lower (in the heart of the red-light district).

425:3 (432:3). squarepusher—see 161:10–11n.

425:3 (432:3). the greaser—c.1900, slang for a flatterer, a sycophant.

425:5 (432:5). mantrap—slang for a house of prostitution.

425:6 (432:6). Stag—slang for an informer. See the headnote to this episode, p. 372.

425:10 (432:10). (Triumphaliter.) Salvi facti i sunt—Latin: "(Triumphantly.) And they are made whole [saved]." This completes the quotation that Stephen began above, 424:15 (431:15) and 424:22 (431:22).

425:17–18 (432:18–19). So that gesture ... would be a universal language—cf. "esperanto," 480:11n.

425:18 (432:19). the gift of tongues—in Acts 2:1–4: "And when the day of Pentecost was fully come, they [the Apostles] were all with one accord in one place. And suddenly there came a

sound from heaven as of a rushing mighty wind, and it filled all the house where they were sitting. And there appeared unto them cloven tongues like as of fire, and it sat upon each of them. And they were all filled with the Holy Ghost, and began to speak with other tongues as the Spirit gave them utterance." See 424:11n in re Pentecost.

425:19 (432:20). entelechy—see 187:34n.

425:21 (432:22). Pronosophical philotheology—rotation-of-forearm-and-hand love-of-theology.

425:21–22 (432:22–23). Mecklenburg street—the name of this notorious street in Dublin's red-light district was changed to Tyrone Street in 1887 (in a fanciful and unsuccessful attempt to upgrade the street). The name has been changed again, and it is now called Railway Street.

425:25–26 (432:26–27). Even the allwisest stagyrite ... by a light of love—the Stagyrite is Aristotle, who was born on the island of Stagyros. The print Stephen has in mind is in the Louvre and is by Hans Baldung (1476–1545), the Strasbourg painter and designer of woodcuts. Anti-feminism is a recurrent theme in Baldung's work, and the clear suggestion is that even Aristotle could be rendered ignoble by a woman's power, presumably, the power of his mistress, Herpyllis; see 201:28–33n. For "light of love," see 188:38–39n.

426:1–2 (433:3–4). the loaf and jug of bread and wine in Omar—Edward Fitzgerald (1809–1883) translated and re-created *The Rubáiyát of Omar Khayyám* (1859). Stanza 12: "A Book of Verse underneath the Bough,/A Jug of Wine, a Loaf of Bread—and Thou/Beside me singing in the Wilderness—/Oh, Wilderness were Paradise enow!" Stephen is also alluding to the bread and wine of the Mass.

426:6 (433:8). la belle dame sans merci—French: "the beautiful woman without pity." Keats used this traditional phrase as the title of a poem (1819). "*La Belle Dame*" seems to hold out the promise of a transcendent love only to rob those she enthralls of their youth and vitality.

426:6 (433:8–9). Georgina Johnson—see 187:21n.

426:7 (433:9). ad deam qui laetificat juventutem meam—Latin: "to the goddess who has gladdened the days of my youth." At the beginning of the Mass the celebrant says, "*Introibo ad altare Dei*" ("I will go up to God's altar") and the minister or server replies, "*Ad Deum qui laetificat juventutem meam*" ("To God who has gladdened the days of my youth"). See 5:5n.

426:13–14 (433:15–16). the customhouse— Stephen and Lynch are not far north of the Custom House. It is an impressive structure (1791) situated on the north bank of the Liffey east of the center of Dublin. It is surmounted by a colonnade and capped by a statue of "Hope." The building housed not only custom and excise tax offices but also the Board of Public Works and the Poor Law Commission.

426:14 (433:16). take your crutch and walk— in John 5:8 Jesus heals "a certain man . . . which had an infirmity thirty and eight years" by saying, "Rise, take up thy bed, and walk."

426:27–28 (433:29–30). under the railway bridge— where the Loop Line crosses Talbot Street. Bloom is some distance behind Stephen and Lynch, but he, too, is approaching "The Mabbot Street entrance of nighttown." Mabbot Street is now Corporation Street.

426:29 (433:31). Gillen's— P. Gillen, hairdresser, 64 Talbot Street.

426:30 (433:32). Nelson's— see 146:16n.

426:32 (434:1). Gladstone— see 79:4n.

426:33–34 (434:3). Wellington— see 326:28–29n.

426:34 (434:4). bonham— dialect English: "a young pig."

426:35 (434:4–5). Jollypoldy the rix-dix doldy —a common form of child-rhyme play on names. A "doldy" is a stupid or impotent person.

427:1 (434:6). Antonio Rabaiotti's— in addition to his fleet of ice-cream "gondolas," Rabaiotti had a restaurant at 65 Talbot Street.

427:5 (434:10). fish and taters— technically it is Friday, 17 June, i.e., a meatless day for Catholic Dublin.

427:5 (434:10). N.g— slang: "No good."

427:6 (434:11). Olhousen's— W. Olhousen, pork butcher, 72 Talbot Street.

427:10 (434:15). crubeen— see 144:4n.

427:19 (434:25). Cormack's corner— Thomas Cormack, grocer, tea, wine and spirit merchant (a pub), 74 Talbot Street on the corner of Mabbot Street (now Corporation Street).

427:21 (434:27). the brigade— the Dublin Metropolitan Fire Brigade.

427:22 (434:28). his house— Boylan's fictional residence?

427:22 (434:28–29). Beggar's bush— a village two miles southeast of central Dublin. *Beggar's Bush* (1622) is also the title of a once popular comedy by John Fletcher (1579–1625), Philip Massinger (1583–1640) and others. The plot turns on the usurpation of a maiden's throne and her restoration to it through the aid of her lover, a prince disguised as a merchant.

427:23–24 (434:29–30). London's burning . . . on fire!— after the popular old round "Scotland's burning! Scotland's burning! Look out! Look out! Fire, fire,! Fire, fire! Pour on water! Pour on water!"

428:8 (435:10). sandstrewer— an electric tram car designed to clean mud and refuse from the rails and to sand them.

428:16 (435:18). chains and keys— parts of a series of switches in a tramline.

428:18 (435:20). the hattrick— W. Y. Tyndall describes it: "an Irishman covers a turd on the street with his hat. He tells a policeman it is a bird and goes off for help, asking the policeman to stand guard in the meantime" (*Reader's Guide*, p. 209).

428:23 (435:25). Sandow's exercises— see 61:19–20n.

428:24 (435:26). The Providential— the Provident Clerks Guarantee and Accident offices (a London-based insurance firm with offices in Dublin) advertised "Guarantees for Fidelity, Accident Insurance, Combination Policies for Accidents and Disease, Insurances arranged under the Workmen's Compensation Act (1897), the Employer's Liability Act (1880) and at Common Law."

428:25 (435:27). Poor mamma's panacea— Bloom's potato talisman; see 418:11n.

428:27 (435:29). Leonard's corner— Miss Annie Leonard, newsagent, 7 and 8 King's Inn Quay on the corner of Morgan Place and just across Morgan Place from the Central Metropolitan Police Courts and Bridewell.

428:27 (435:29). Third time is the charm— after the popular belief that a third try at a difficult task or game (after two previous failures) is attended by special luck.

429:1 (436:5). Lad lane— in southeastern Dublin.

429:1–2 (436:5–6). Emblem of luck . . . Probably lost cattle—cramps are a traditional sign of bad luck. Bloom speculates that the attack he recalls might have been the result of his having eaten bad meat, since "lost cattle" means either beef that has been illegally slaughtered or horse meat that has been substituted for beef.

429:2 (436:6). Mark of the beast—in Revelation 13:7 the anti-Christian beast is given "power . . . over all kindreds, and tongues, and nations." 13:16–17: "And [the beast] causeth all, both small and great, rich and poor, free and bond, to receive a mark in their right hand, or in their foreheads: And that no man might buy or sell save he that had the mark, or the name of the beast, or the number of his name."

429:5 (436:10). O'Beirne's wall—O'Beirne Brothers, tea and wine merchants, 62 Mabbot Street (on the corner of Talbot Street).

429:9 (436:15). Buenas noches, señorita Blanca, que calle es esta?—Spanish: "Good evening, Miss White, what street is this?"

429:11 (436:17). Sraid Mabbot—Irish: "Mabbot Street." In modern Dublin, street names are given in both English and Irish; but Mabbot Street is now Corporation Street.

429:13 (436:19). Slan leath—Irish: "Safe with you" (i.e., goodbye).

429:13 (436:19–20). Gaelic league—see 190:37n.

429:22 (436:27). the Touring Club—Touring Clubs sponsored by the *Irish Cyclist* (see 429:24n) had been organized in various communities throughout Ireland. They put up sign posts and route markers, sponsored tours and endeavored to make the roads and paths in their communities safe for cyclists.

429:22 (436:27). Stepaside—a village crossroads seven miles south-southeast of Dublin.

429:24 (436:29). the Irish Cyclist—a weekly newspaper published at 2 Dame Court in Dublin, "devoted to the safe conduct and continued expansion of cycling in Ireland."

429:24 (436:29). In darkest Stepaside—after General William Booth's (1829–1912) Salvation Army diatribe *In Darkest London; And the Way Out* (1890), which was in turn named after Sir Henry Morton Stanley's *In Darkest Africa* (1890).

429:25 (436:30). Rags and bones—after the ragman's traditional cry: "Any rags, any bones, any bottles today?"

429:26–27 (436:31–32). Wash off his sins of the world—after John 1:29: "The next day John [the Baptist] seeth Jesus coming unto him, and saith, Behold the Lamb of God, which taketh away the sin of the world."

430:3 (437:7). sweets of sin—see 232:27n.

430:18 (437:22). Ja, ich weiss, papachi—Yiddish: "Yes, I know, father."

430:20–24 (437:24–28). (With feeble vulture talons . . . Abraham and Jacob—see 75:19n and 75:26–31n. In Exodus 3:6 God speaks to Moses: "I am the God of thy father, the God of Abraham, the God of Isaac and the God of Jacob."

430:26 (437:30). Mosenthal—see 75:19n.

431:4 (438:7). waterbury keyless watch—i.e., an American machine-made watch manufactured in Waterbury, Connecticut. The development of the watch with a built-in key was an American innovation in the latter half of the nineteenth century.

431:4 (438:7). double curb Albert—a watch chain colloquially named after Prince Albert, Queen Victoria's prince consort.

431:14 (438:17). Goim nachez—Yiddish: "The luck of the gentiles" (in scorn).

431:20 (438:23). widow Twankey's blouse—the Widow Twankey was traditionally Aladdin's mother in popular pantomimes about Aladdin and his adventures.

431:26 (438:29). an Agnus Dei—Latin: literally, "Lamb of God," a medal bearing the image of a lamb as an emblem of Christ. See 429:26–27n. The triple prayer of the *Agnus Dei* is a central part of the Mass.

431:26 (438:29–30). a shrivelled potato—see 428:25n and 418:11n.

432:3–8 (439:8–13). Beside her mirage . . . eyes and raven hair—the description of Molly echoes the description of the Queen of Sheba as she appears to St. Anthony in Chapter II of *The Temptation of Saint Antony*. "Opulent curves" echoes a phrase from *The Sweets of Sin*; see 232:27n.

432:12 (439:17). Mrs Marion—see 61:31n.

432:19–25 (439:24–30). A coin gleams . . . scolding him in Moorish—see 432:3–8n.

432:27 (440:2). Nebrakada! Feminimum—see 239:19–20n.

433:8 (440:14). See the wide world—an echo from *Leah;* see 75:26–31n.

433:16–17 (440:23–24). We're a capital couple are Bloom and I;/He brightens the earth; I polish the sky—Thornton says this is a parody of an advertising slogan?

433:18 (440:25). Sweny, the druggist—see 82:36n.

433:18–19 (440:25–26). in the disc of the soap sun—in the closing paragraphs of Flaubert's *The Temptation of Saint Anthony :* "The dawn appears at last; and, like the uplifted curtains of a tabernacle, golden clouds, wreathing themselves into large volutes, reveal the sky. In the very middle of it, and in the disc of the sun itself, shines the face of Jesus Christ. Antony makes the sign of the cross and resumes his prayers" (p. 170).

434:2 (441:8). Ti trema un poco il cuore?—Italian: "Does your heart tremble a little (beat a little faster)?" after Zerlina's *"Mi trema . . ."* ("My heart . . .") in Mozart's *Don Giovanni.* See 63:24n.

434:3 (441:9). In disdain, she saunters away—at the end of Chapter II, "The Temptation of Love and Power," in Flaubert's *The Temptation of Saint Anthony*, Antony makes the sign of the cross and the Queen of Sheba responds, "'So, then, you disdain me! Farewell!' She turns away weeping; then she returns. 'Are you quite sure? So lovely a woman?' She laughs, and the ape who holds the end of her robe lifts it up. 'You will repent, my fine hermit! You will groan; you will be sick of life! but I will mock at you. . . .' She goes off with her hands on her waist, skipping on one foot . . . with a spasmodic utterance which might be either a sob or a chuckle" (pp. 38–39).

434:6 (441:12). that Voglio—see 63:38n.

434:14 (441:21). Bridie Kelly—see 406:34 (413:32–33).

434:16 (441:23). Hatch street—see 406:29–30n.

434:23 (442:3). the flash houses—slang for the higher-class houses of prostitution where the prostitutes wore evening dresses, etc.

434:24 (442:4). Sixtyseven—*Thom's (1904)* lists numbers 65 to 68 Mabbot Street as tenements.

434:28 (442:9). With all my worldly goods I thee and thou—another fragment of Gerty's version of the Catholic marriage service; as the groom pledges the ring he says, ". . . this gold and silver I thee give: and with all my worldly goods I thee endow." See 345:38–39n.

435:27 (443:8–9). Black refracts heat—see 57:8–9n.

435:28–29 (443:9–10). Rescue of fallen woman Magdalen asylum—there were two Magdalen Asylums in Dublin in 1904. The Catholic one, under the care of the Religious of Our Lady of Charity of Refuge, provided for "one hundred penitents" and was located at 104 Gloucester Street Lower. The Protestant asylum, at 8 Leeson Street Lower, advertised itself in 1904 as "the oldest Magdalen Asylum in Ireland" (1765) "intended only for young women who have for the first time fallen into vice." Bloom's self-designation as "secretary" would suggest he has the Protestant asylum in mind.

436:6 (443:18). Othello black brute—Bloom echoes Iago's suggestions that what attracts Desdemona to Othello is "animal," a suggestion picked up and extended by Desdemona's father, Brabantio, who claims that Desdemona has been corrupted by "magic" and "against nature."

436:6 (443:18). Eugene Stratton—see 90:41n.

436:6–7 (443:18–19). the bones and cornerman at the Livermore christies—the Livermore Brothers World Renowned Court Minstrels appeared in Dublin in 1894. By that time the name "christies," after the Christy Minstrels (*c.*1843), had become a generic term for the minstrel show with its imitations of Southern Negro dialect and song. In the "first part" of the show the performers were arranged in a semicircle with the white interlocutor in the middle and the blackface endmen or cornermen on the outside. The cornermen were armed with "bones" (castanets) and a tambourine. The "second part," or "olio" consisted of variety acts not unlike vaudeville.

436:7 (443:19). Bohee brothers—Tom and Sam Bohee, another group of "christies," also appeared in Dublin in 1894. Their innovation appears to have been that they played banjos not only while they sang but also while they danced.

436:8 (443:20). Sweep—i.e., a chimney sweep, whose trade rendered him blackfaced.

436:17–20 (443:29–32). There's someone in the house . . . on the old banjo—from the nineteenth-century American popular song "I've Been Working on the Railroad": "Someone's in the kitchen with Dinah,/Someone's in the kitchen I know,/Someone's in the kitchen with Dinah,/Strummin' on the old banjo/Fee, fie, fiddlee eye oh . . ./Strummin' on the old banjo."

436:29 (444:9). ruck—in context, slang for a person who speaks and/or acts idiotically.

436:31 (444:11). a square party—i.e., a foursome (also slang for wife swapping).

437:2 (444:14). the dear gazelle—i.e., the valentine quoted some lines from Thomas Moore's sentimental epic *Lalla Rookh* (1817). The lines appear in "The Fire-Worshippers," the third of the poem's four sections, and are spoken by a fair young maiden, Kanoon, to her hero-lover, Zali: "O ever thus, from childhood's hour,/I've seen my fondest hopes decay;/I never loved a tree or flow'r,/But 'twas the first to fade away./I never nursed a dear gazelle,/To glad me with its soft black eye,/But when it came to know me well,/And love me, it was sure to die."

437:11 (444:23). Georgina Simpson's—apart from the context, her identity and significance are unknown.

437:12 (444:24). the Irving Bishop game—Washington Irving Bishop (1847–1889), an American mind reader (and performing magician) who enjoyed a brief success in the British Isles in the early 1880s before he became involved in a libel suit.

437:20 (445:3). blue masonic badge—blue (for truth or fidelity) is the color of the first three degrees of Freemasonry.

437:22 (445:5). Ireland, home and beauty—see 222:13,16n.

437:24 (445:7). The dear dead days ... old sweet song—see 63:24–25n.

437:26 ff. (445:9 ff.). teapot—a guessing game involving word substitutions; i.e., Bloom is saying, "I'm burning with curiosity . . ." etc.

437:30 (445:13). London's teapot—see 427:23–24n.

438:1 (445:15). crackers—party favors with a small explosive snapper inside.

438:4 (445:19). an amber halfmoon—in astrology, the sign that rules social companionship of a genial nature.

438:6 (445:21–22). The witching hour of the night—from *Hamlet;* see 106:28–29n.

438:8 (445:23–24). Là ci darem la mano—see 63:24n.

438:13 (445:29). Voglio e non—see 63:38n.

438:16–17 (446:2–3). beauty and the beast—see 363:17–18n.

438:28 (446:14). High jinks—a parlor game in which contestants are elected by lot to perform ridiculous or obviously impossible feats.

439:3 (446:21). The answer is a lemon—slang for a derisive reply that advises someone to eat a lemon.

439:6 (446:25). Leah—see 75:19n.

439:6 (446:25–26). Mrs Bandman Palmer—see 75:19n and 75:20n.

439:11–12 (446:30–31). Collis and Ward—see 87:21–22n.

439:12–13 (446:31–447:1). a skull and crossbones...white limewash—"limewash" suggests that the symbol is associated with Freemasonry. In the Scottish Rites (which were observed in modified form by Irish Freemasons) a skull and crossbones, symbolic of mortality and death, were used in the Chamber of Reflection as a part of the preliminary ceremonies of initiation.

439:13 (447:1). polonies—sausages made of partly cooked pork.

439:27 (447:15). Bright's!—see 268:4n.

440:1–2 (447:18–19). I am not on pleasure bent. I am in a grave predicament—source unknown.

440:4 (447:21). deluthering—Irish: "fawning, cringing, making up to."

440:20 (448:11). melt—dialect form of "milt," secretion of the male reproductive glands of fishes. The low-slang application is hardly complimentary.

440:28 (448:19). Fairyhouse races—Fairyhouse, 15 miles from Dublin, is the site of a popular steeplechase meeting on Easter Monday and Tuesday each year. The Irish Grand National is run at this meeting.

441:2 (448:21). Saxe tailormade—connotations (if any) unknown.

441:3 (448:22). Leopardstown—a racetrack six miles south-southeast of Dublin; meetings on Saturdays.

441:6 (448:25). a three year old named Nevertell—apparently an anachronism. The only Nevertell of record in the British Isles was foaled in 1910 by St. Primus or Oppressor out of Secret; Nevertell went to stud in 1912.

441:7 (448:26). Foxrock—a village just east of the Leopardstown racetrack.

441:7 (448:26). shanderadan—Irish: "a two-wheeled cart"; figuratively, any decrepit vehicle.

441:9 (448:28). Mrs Hayes—apart from the context, her identity or significance is unknown.

441:17 (449:7). tammy—a fine worsted cloth, often with a glazed finish.

441:25 (449:15). Mrs Joe Gallaher's—a friend of the Joyce family; see Ellmann, p. 46n.

441:31–442:1 (449:21–22). Maggot O'Reilly—the nickname "Maggot," from maggots in the brain, suggests a whimsical or erratic character. But his identity or significance is essentially unknown.

442:2 (449:23). Marcus Tertius Moses—see 229:41n.

442:9 (449:30). hellsgates—that part of Tyrone Street at the intersection of Mabbot Street so called because the "lower" whorehouses (rough and potentially violent) were concentrated there.

442:12 (450:3). gaffer—slang for the foreman of a work crew.

442:17 (450:8). Beaver street—off Tyrone Street Lower.

442:19 (450:10). Derwan's plasterers—a James Derwin, builder, 114 Drumcondra Terrace in Fairview, was alderman for Drumcondra Ward, Dublin in 1904, but there was a more prominent builder: Michael Derham and Company, builders, sanitary engineers and contractors, 9 High Street in Dublin. The spelling leaves this identity in doubt.

442:21 (450:12). O jays!—dodging the curse: "O Jesus!"

442:22–23 (450:13–14). Spattered with size and lime of their lodges—i.e., the loiterers become plasterers (masons) and their workshop or work group becomes a "lodge," as in Freemasonry "lodge" is obsolete or historical for a workshop. The size and lime are symbolic of the cement that binds Freemasons together in brotherhood.

442:28 (450:19). Glauber salts—sodium sulfate used as a cathartic, named after the German chemist and physician Johann R. Glauber (1604–1668), the discoverer of its medicinal properties.

443:6 (450:28). plodges—to "plodge" is to walk through mud or water.

443:8 (450:30–31). a shebeenkeeper—see 308:36n.

443:13 (451:4). Purdon street—between Mabbot Street and Beaver Street in the red-light district.

443:22 (451:13). Portobello barracks—see 170:38n.

443:26 (451:17). We are the boys. Of Wexford—see 128:5–6n.

444:2 (451:21). Bennett?—for Sergeant-Major Percy Bennett, see 247:11–12n.

444:5–6 (451:24–25). The galling chain . . . our native land—see 128:5–6n.

444:10 (452:5). Wildgoose chase—see 42:14–15n.

444:12 (452:7). Westland row—Bloom followed Stephen and Lynch to the Westland Row Station, where Stephen was given the slip by Mulligan and Haines (who apparently took the last of that night's trains south to Sandycove and the Tower). Stephen and Lynch have taken a Loop Line train north to Amiens Street Station, and then, with Bloom in pursuit, they have followed a circuitous route to Mrs. Cohen's.

444:18 (452:13). Relieving office—Bloom is punning on the Poor Relief Office, located nearby in the Custom House. Under certain rather strict conditions the office doled out money to the poor.

444:19 (452:14). cheapjacks—dialect for traveling hawkers who offer apparent bargains by setting arbitrarily high prices and then offering to compromise.

444:19 (452:14). organs—slang for workmen who lend money at very high rates of interest to fellow workmen.

444:22–23 (452:17–18). If I had passed . . . have been shot—Trulock, Harriss and Richardson, Ltd., gun and rifle manufacturers and ammunition merchants, 9 Dawson Street; or Richard Trulock, gunsmith, 13 Parliament Street.

444:31 (452:26). birdseye cigarettes—i.e., cigarettes made out of tobacco that has been cut with, rather than across, the fibers of the leaves.

444:35 (452:30). Sweets of sin—see 232:27n.

445:7 (453:3). rencontres—French: "meetings, adventures, coincidences."

445:7 (453:3–4). Chacun son goût—French: "Everyone to his own taste."

445:9 (453:5). Garryowen—see 290:11n.

445:24 (453:20). Bloom. Of Bloom. For Bloom—i.e., the Watch conjugates Bloom's name to the accusative.

445:33 (453:29). Kaw kave kankury kake—i.e., He gave Banbury cake. *Cf.* 151:16 (153:18–19).

446:14 (454:12). Harold's cross bridge—(now called Robert Emmet Bridge) over the Grand Canal (on the southern outskirts of Dublin).

446:15 (454:13). Bad french—slang for obscene English.

446:17 (454:16). Signor Maffei—from *Ruby, Pride of the Ring;* see 64:17n.

446:23 (454:22). the bucking bronco Ajax—unknown.

446:26–27 (454:25–26). Leo ferox . . . the Libyan maneater—unknown.

446:28–29 (454:27–28). Fritz of Amsterdam, the thinking hyena—unknown.

446:29 (454:28–29). the Indian sign—to have the "Indian sign" is to have the hypnotic ability to achieve ascendancy over animals or people.

447:5 (455:5). Dr Bloom, Leopold, dental surgeon—see 331:31n.

447:6–7 (455:6–7). von Bloom Pasha . . . half Austria. Egypt—see 704:20n.

447:6–7 (455:6–7). Donnerwetter—German: literally, "Thunderstorm"; figuratively, "Damn it!"

447:14 (455:14). the Legion of Honour—a French order of merit founded by Napoleon in 1802 as an award for outstanding conduct in military or civilian life. The emblem of the order is a five-rayed star of white enamel edged with gold, surmounted by a wreath of oak and laurel.

447:15 (455:15–16). the Junior Army and Navy—one of the principal London clubs located at 12 Grafton Street in London. Membership was limited to those with military service.

447:25 (455:27). rose of Castille—see 129:18–19n.

447:31 (456:2). get your Waterloo—i.e., suffer a serious defeat or reversal after Napoleon's final defeat in the Battle of Waterloo, 18 June 1815.

448:2 (456:4–5). inspector—Bloom is addressing a constable, not an inspector.

448:5 (456:7). THE DARK MERCURY—as Odysseus approaches Circe's house in Book X of *The Odyssey*, he is intercepted by Hermes (Mercury); see headnote to this episode, p. 372 above. In astrology Mercury is identified as the voice of wisdom, the governor of speech. "The Dark Mercury" thus signifies wisdom associated with devil worship, evil counsel and betrayal.

448:6 (456:8). The Castle—see 158:40n.

448:8 (456:11). a crimson halter—see 79:23–24n.

448:9 (456:12). the Irish Times—see 157:37n.

448:10 (456:13). Lionel, thou lost one!"—see 116:34n and 116:35–36n.

448:14–16 (456:18–20). plucking at his heart . . . dueguard of fellowcraft—what Bloom gives is one of the Freemason's "signs of distress," a signal that makes "brothers immediately known to their brethren" so that they can claim assistance and protection. "Dueguard" of Freemasonry teaches every brother to keep watch over his words and actions, to remember his solemn obligations and never to forget the penalty of broken vows and violated faith. "Fellowcraft" is the second degree of the three degrees of Freemasonry; the others are (1) Apprentice and (3) Master.

448:16 (456:20–21). worshipful master, light of love—a Master is one who has attained the third degree of Freemasonry; as a Master Mason, he has reached the highest preferment within his lodge and has a voice in all the consultations of the officers of the lodge. For "light of love," see 188:38–39n.

448:17 (456:21–22). The Lyons mail. Lesurques and Dubosc—*The Lyons Mail* is the title of an English version of a French play, *The Courier of Lyons* (1850), as adapted by Charles Reade (1814–1884) and popularized (1877 *ff.*) by the English actor-producer Sir Henry Irving (1838–1905). The plot hinges on a "real-life" story of "mistaken identity"; in 1796 a Frenchman Joseph Lesurques (1763–1796) was accused of holding up the Lyons mail and executed for the crime. In 1800 it was revealed that the real criminal was one Dubosc, who bore a striking resemblance to Lesurques; Dubosc was subsequently apprehended and guillotined.

448:18 (456:22). the Childs fratricide case—see 98:35n.

448:19–20 (456:24–25). Better one guilty . . . wrongfully condemned—*cf.* 98:41–42 (100:8–9).

448:23 (456:28). Peggy Griffin—apart from the context, identity or significance unknown.

448:24 (456:29). the Bective rugger—the Bective Rangers, a Gaelic football team named after the ancient parish of Bective Abbey (now a ruin 15 miles northwest of Dublin). It played on a level comparable to that associated with semi-professional sports in the United States and had a history of relatively consistent success in 1904.

448:27 (457:3). the past of Ephraim.) Shitbroleeth—in Judges 12:1–6: after Jephthah had won a victory over the Ephraimites, he stationed guards along the Jordan to prevent the escape of refugees. He gave the guards "Shibboleth" as a password. The Ephraimites could not pronounce the word and thus betrayed themselves and were slaughtered. In Freemasonry, in the ritual of the Fellowcraft degree, the story of Shibboleth and the Ephraimites is introduced and interpreted symbolically: Shibboleth ("flood of waters") signifying the "plenty" that was denied the uninitiated Ephraimites.

449:2 (457:8). mare's nest—to "find a mare's nest" originally meant to imagine that one has made an extraordinary discovery when in fact the thing discovered is an illusion; hence, it became a phrase for finding oneself in a tangle of illusion.

449:3 (457:9). a scapegoat—in the Mosaic ritual an annual "sacrifice" on Yom Kippur, the Day of Atonement, after Leviticus 16:21–22: "And Aaron shall lay both his hands upon the head of the live goat, and confess over him all the iniquities of the children of Israel, and all their transgressions in all their sins, putting them upon the head of the goat, and shall send *him* away by the hand of a fit man into the wilderness; And the goat shall bear upon him all their iniquities unto a land not inhabited: and he shall let go the goat in the wilderness." See 714:2n and 169:25n.

449:7 (457:13). Majorgeneral Brian Tweedy—Bloom has promoted his father-in-law from major to the rank of another Tweedie, Major General Willis Tweedie (b. 1836). The real-life Tweedie had a considerable reputation as an army commander in India.

449:8–9 (457:14–15). Got his majority for the heroic defence of Rorke's Drift—in January of 1879, at the beginning of the Zulu War, British troops invaded Zululand and a force of about 800 was massacred by a Zulu army of over 20,000 at Isandhlwana, 22 January. Later that same day a detachment of about 4,000 troops of the Zulu army descended on the unfortified British communications post at Rorke's Drift. The post was manned by approximately 140 men, over 30 of them incapacitated. In a battle that lasted from late afternoon until almost dawn of the next day the garrison successfully defended the outpost and the Zulus withdrew. No Tweedy was among those present but both of the officers in command, Lieutenants John Rouse Merriot Chard (1847–1897) and Gonville Bromhead (1845–1891) were promoted to the rank of major. Evidence of the esteem in which the defenders were held: 11 Victoria Crosses (a record for a single, small-scale action) were awarded to members of the garrison. See the English film *Zulu* (1964), directed by Cy Enfield.

449:13 (457:19). The royal Dublins—see 71:35–36n.

449:15 (457:21). The R.D.F—the Royal Dublin Fusiliers.

449:20 (457:26). Up the Boers!—an anti-English slogan.

449:20 (457:26). Joe Chamberlain—see 160:26–27n.

449:23 (457:29). J.P—Justice of the Peace.

449:24–25 (457:30–31). in the absentminded war under general Gough in the park—"the absentminded war" is the Boer War (1899–1902); see 185:19n. A statue of the Irish-born General Hugh Gough (1779–1869), 1st Viscount Gough, stood in Phoenix Park in 1904. He distinguished himself in the Peninsular Wars against Napoleon and subsequently in China (1841–1842) and in India (1843–1849). The Gough who fought in the Boer War was Sir Hubert de la Poer Gough (1870–1963), whose fame in that war was based on his daring in the relief of Ladysmith, 28 February 1900, after that key supply depot in Natal had been under siege by the Boers for 118 days. Sir Hubert was eventually to gain some notoriety in early 1914 when, as a brigadier general stationed at the Curragh, he refused to command his troops in a police action against the violently pro-Union majority in Ulster.

449:25 (458:1). Spion Kop—a mountain in Natal, the scene of an important Boer victory over the British, 24 January 1900.

449:26 (458:1). Bloemfontein—capital of the former Orange Free State (now the Orange River Colony, South Africa). During the Boer War it was one of the principal centers of Boer strength. It fell to the British under Lord Frederick Roberts 13 March 1900; see 414:5–6n.

449:27–28 (458:2–3). Jim Bludso. Hold her nozzle again the bank—from a ballad, "Jim Bludso (of the Prairie Belle)," in *Pike County Ballads and Other Pieces* (1871), by the American

John Hay (1838–1905). The ballad tells the story of the heroic death of Jim Bludso, a Mississippi riverboat captain who "weren't no saint," he had two wives in different river towns and was "A keerless man in his talk . . ./And an awkward man in a row." In lines 21–24 his "religion" is outlined: "And if ever the Prairie Belle took fire—/A thousand times he swore,/He'd hold her nozzle again the bank/Till the last soul got ashore." The *Prairie Belle* does catch fire, and Bludso is as good as his word at the price of his life.

450:13, 16–17 (458:21, 24–25). Mr Philip Beaufoy . . . Matcham's Masterstroke—see 68:28–29n and 68:27–28n.

450:31–32 (459:6–7). the laughing witch hand in hand—see 68:41–69:1 (69:12–14).

451:3 (459:12). Mr J. B. Pinker—Joyce's literary agent in London; see Ellmann, *passim*.

451:5 (459:15). bally—dodging the curse: "bloody."

451:6 (459:15). jackdaw of Rheims—"The Jackdaw of Rheims" is one of the verse legends in Richard Harris Barham's (1788–1845) *The Ingoldsby Legends* (1840). A jackdaw steals the cardinal's ring, admits the theft and is subsequently canonized as "Jem Crow." "Jackdaw" is contemptuous for a talkative and foolish person.

451:14 (459:23). the hallmark of the beast—see 429:2n.

451:16–17 (459:25–26). Moses, Moses, king . . . in the Daily News—an obvious parody of "Moses" as recorded in Leslie Daiken, *Out Goes She; Dublin Street Rhymes* (Dublin, 1963), p. 17: "Holy Moses, King of the Jews,/Bought his wife a pair of shoes./When the shoes began to wear,/Holy Moses began to swear./When the shoes were quite worn out,/Holy Moses began to shout." The London-based *Daily News* was in the forefront of the "new" or yellow journalism at the beginning of the twentieth century.

451:23 (460:1). Street angel and house devil—a proverbial expression for a person who is courteous in public and boorish in his home.

452:2 (460:9). Mary Driscoll—the Blooms' maid when they lived in Ontario Terrace, Rathmines.

452:7 (460:14). of the unfortunate class—i.e., a prostitute.

452:11 (460:18). my chances—a bonus.

452:23 (461:2). Play cricket—slang: "Play fair."

453:10 (461:18). your lord—the proper form of address to a judge in court is "My Lord"; to a member of the watch: "Constable."

453:13 (461:21). Georges Fottrell—see 338:11–12n.

453:16–17 (461:24–25). water-lily—in the language of flowers, symbolic of purity of heart or elegance.

453:21 (461:29). the memory of the past—see 352:9n.

453:22 (462:1). A seven month's child—popularly assumed to be at least a disadvantaged weakling if not actually retarded.

453:30 (462:9). the Loop line railway—see 73:34–35n.

453:34 (462:13). Dockrell's wallpaper—see 153:31n.

454:1–2 (462:16). pensums—rare for school tasks or lessons.

454:4 (462:18). boreens—Irish: "little roads or lanes."

454:6 (462:20–21). Britannia metalbound—i.e., trimmed with Britannia metal, an inexpensive alloy of tin, antimony, copper and sometimes zinc. It could be tinted and would take a high luster and was used to give decorative "class" to inexpensive furniture.

454:21 (462:36). Titbits—see 67:29n.

454:29 (463:8). an Oxford rag—a hazing session (after "rag," for boisterous merrymaking).

454:30–455:1 (463:9–15). an infant, a poor foreign . . . land of the Pharaoh—see 46:4–5n.

455:7 (463:20). he could a tale unfold—see 160:23n.

455:9 (463:23). cobbler's weak chest—a cobbler's hunched posture at his workbench was regarded as a traditional image of the weak-chested.

455:19–21 (463:33–35). Li li poo lil chile . . . Payee two shilly . . . —source unknown.

455:26 (464:4–5). The Mosaic code—see 138:7–8n.

455:33 (464:12). the hidden hand—see 161:24n.

**455:37–456:1 (464:15–16). cast a stone . . .
wrong turning**—in John 8:3–7 the Pharisees
tempt Jesus "that they might have to accuse him."
They bring before him "a woman taken in adul-
tery; and when they had set her in the midst,
They said unto him, Master, this woman was
taken in adultery, in the very act. Now Moses in
the law commanded us, that such should be
stoned: but what sayest thou? . . . he lifted up
himself, and said unto them, He that is without
sin among you, let him first cast a stone at her."

456:5 (464:20). Agendath Netaim—see 60:12–
13n.

456:9 (464:24). A penny in the pound—i.e.,
Bloom promises to give his creditors a penny for
each pound he owes.

456:10 (464:25). the lake of Kinnereth—see
59:13n.

456:16 (464:31). Bleibtreustrasse—see 60:21–
22n.

456:20 (464:35). John F. Taylor—see 139:15–
16n.

456:26 (465:4). avine—or "avian": of or per-
taining to birds.

456:26–27 (465:4–5). proboscidal—like a pro-
boscis or pronounced nose.

456:27 (465:5). Seymour Bushe—see 98:37n.

456:34–457:1 (465:12–13). Callan, Coleman—
see 275:35 (280:13) and 90:13 (91:16).

457:1–2 (465:13–14). Mr V. B. Dillon—was
buried 2 April 1904; see 153:17n.

457:5 (465:17). Sir Robert and Lady Ball—
see 152:2–3n.

457:7 (465:19). MRS YELVERTON BARRY
—derives her name from the Irish politician,
judge and orator Barry Yelverton (1736–1805),
1st Baron Avonmore.

457:11 (465:23). prentice backhand—i.e.,
"apprentice backhand," an obviously ineffectual
attempt to disguise his handwriting.

**457:12–13 (465:24–25). North Riding of
Tipperary on the Munster circuit**—County
Tipperary is in south-central Ireland. The
Munster Circuit, in southwestern Ireland, was
the sequence of courts in various county locations
over which a judge would preside in the course of
his annual tour of duty in the provinces.

457:13 (465:25). James Lovebirch—see 232:
22–23n.

457:14 (465:26). the gods—slang for the upper
balcony of a theater.

457:15 (465:27). the Theatre Royal—see
90:40n.

**457:15 (465:27). a command performance of
La Cigale**—i.e., at a performance requested by
the lord lieutenant of Ireland. *La Cigale* could be
either a three-act comedy from the French of
Henry Meilhac (1831–1897) and Ludovic Halévy
(1834–1908), translated and adapted for the
American stage by John H. Delafield (New York,
1879); or the light opera *La cigale et la formi*
("The Grasshopper and the Ant"), by Henri-
Alfred Duru (1829–1889) and Henri Chivot, music
by Edmond Andran (1840–1901), adapted into
English by F. C. Burnand (London, 1890).

457:18 (465:30). Dunsink time—see 152:2n.

457:19 (465:31). Monsieur Paul de Kock—see
64:30n.

**457:20 (465:32). The Girl with the Three
Pair of Stays**—the English title of a novel, *La
femme aux trois corsets* (Paris, 1878), by Charles
Paul de Kock.

457:21 (465:33). Mrs Bellingham—as Adams
suggests (p. 218), she probably owes her name to
the fact that "on 11 June 1904 Charlotte Eliza-
beth, daughter of Alfred Payne and widow of
Frederick Gough, was married" to Edward
Bellingham (b. 1879), who subsequently became
5th Baronet (second creation). In 1904 Belling-
ham was a lieutenant in the Royal Scots Guards.

457:26 (466:3–4). sir Thornley Stoker's—Sir
(William) Thornley Stoker (1845–1912), a promi-
nent Dublin surgeon, lived at 8 Ely Place, Dublin.

457:33 (466:10). a forcingcase—a small green-
house or coldframe.

457:33 (466:10). the model farm—was located
in Glasnevin and run by the joint enterprise of
the Model Training School of the Board of
Agriculture and the Botanic Gardens (founded by
the Royal Dublin Society in 1790); in 1904 the
gardens were under the supervision of the Depart-
ment of Science and Arts.

458:2 (466:15). Bluebeard—a legendary char-
acter who murders a succession of wives before
he is finally exposed and slain. There are various
late-medieval versions of the story, but final form
seems to have been given to "the man with the
blue beard" (*c.*1697) by the French writer
Charles Perrault (1628–1703).

458:3 (466:16). Ikey Mo!—Ikey Moses; see 198:26n.

458:5 (466:18). the darbies—slang for handcuffs, from *c.*1660.

458:8 (466:21). Venus in furs—after *Venus in Furs* (*Venus im Pelz*), a novel by the Austrian Leopold von Sacher-Masoch (1836–1895). Severin, the masochistic hero of the novel, is described as a romantic "dreamer" who acts out his desires for total subjection and enslavement by a woman he regards as "an Olympian deity." The heroine, Wanda, in love with Severin, reluctantly agrees to become his "cruel Northern Venus in Furs" and to accept him as her slave; gradually her imagination is "inflamed" by Severin's fantasies and she evolves into the sadistic despot he has envisioned, humiliating him and whipping him; at the novel's end Wanda, "the lioness," meets her match in a leonine Greek lover and turns Severin over to him for his final punishment (and cure).

458:8–12 (466:22–25). my frostbound coachman . . . wearing my livery—in *Venus in Furs* Severin in the person of "Gregor," Wanda's servant, delights "in serving as her coachman and footman." He also wears "her livery . . . a Cracovian costume in her colors, light-blue with red facings, and red quadrangle cap, ornamented with peacock-feathers. . . . The silver buttons bear her coat of arms" (p. 79).

458:12–14 (466:25–27). the armorial bearings . . . couped or—*Burke's Peerage, Baronetage and Knighthood* (London, 1949) lists the Bellingham escutcheon as arms: "argent [silver or white], 3 bugle horns, sable [black], stringed and garnished or [gold]: crest—A buck's head, couped, or."

458:20 (467:1). THE HONOURABLE MRS MERVYN TALBOYS—the Talboys baronetcy became extinct in 1560 on the occasion of its passing into the female line.

458:25–26 (467:6–7). All Ireland versus the Rest of Ireland—i.e., two all-star teams drawn from the armed forces stationed in Ireland.

458:26–27 (467:8). Captain Slogger Dennehy of the Inniskillings—the "Army Directory" in *Thom's (1904)* lists no Dennehy among the officers of the 6th or Inniskilling Dragoons, but there was a reasonably famous Anglo-Irish military Dennehy, Major General Sir Thomas (b. 1829), who had a distinguished career in India, was made a knight commander of the Indian Empire (1896) and Extra Groom in Waiting to the king (1901). Whether he merited the nickname "Slogger" (one who hits hard) is not a matter of record.

458:28 (467:10). Don Juan—*cf.* 63:24n.

458:34–36 (467:16–17). He urged me to . . . officers of the garrison—in *Venus in Furs* Severin dreams that Wanda will "have a circle of admirers . . . tread [him] underfoot and apply the lash." Wanda carries his "dreams to their realization" (pp. 70–71).

459:15 (467:33). I love the danger—Bloom's response is similar to Severin's perverse combination of fear and pleasure in the face of Wanda's tortures in *Venus in Furs*.

459:17–18 (468:2–3). I'll make you dance Jack Latten—the expression "I'll make you dance" is a stock threat of punishment and the name "Jack Latten" intensifies the threat. P. W. Joyce, in *English as We Speak It in Ireland* (pp. 172–173), explains, "John Latten of Morristown House county Kildare . . . wagered he'd dance home to Morristown from Dublin—more than twenty miles—changing his dance step every furlong: and won the wager."

460:4–5 (468:16–17). You have lashed . . . nature into fury—in *Venus in Furs* Wanda repeatedly complains that Severin has corrupted her by awakening "Dangerous potentialities that were slumbering" in her (p. 129) and transforming her into a "lionness" (p. 116).

460:8 (468:20). Give him ginger—after the horse trader's practice of putting ginger under a dull horse's tail to make the animal look lively.

460:13 (468:26–27). (He offers the other cheek.)—Jesus, in the Sermon on the Mount, Matthew 5:38–39: "Ye have heard that it hath been said, An eye for an eye, and a tooth for a tooth: But I say unto you, That ye resist not evil: but whosoever shall smite thee on thy right cheek, turn to him the other also."

460:27 (469:12). Davy Stephens—see 115:30n.

460:30 (469:15). Messenger of the Sacred Heart—or the *Irish Rosary,* a devotional Catholic newspaper published monthly in Dublin.

460:30 (469:15). Evening Telegraph—see 36:19n.

461:3–5 (469:18–20). (The very reverend Canon . . . Hughes S.J. bend low.)—the three priests have celebrated Benediction with the Blessed Sacrament (see 347:37–38n) at the temperance retreat in the course of the [Nausicaa] episode. For the priests, see 352:18n, 340:6–9n and 347:36–37n.

461:8–10 (469:23–25). Cuckoo./Cuckoo./Cuckoo—after the cuckoo clock in "the priest's house"; see 375:36–38 (382:23–25) and 210:9–10n.

461:13 (469:28). Jigjag. Jigajiga. Jigjag—Arabic (and apparently Mediterranean) slang for copulation.

461:19 (470:4). a Nameless One—after "The Nameless One," a poem by James Clarence Mangan. The speaker of the poem promises to "deliver" his "soul"; he asserts, "He would have taught men from wisdom's pages/The way to live," but found himself "trampled, derided, hated" instead. Thus he is "condemned . . ./To herd with demons from hell beneath." Subsequently, "with genius wasted" and full of revulsion at failures of love and friendship, he "pawned his soul for the Devil's dismal/Stock of returns." At the poem's end he repents: "He, too, had tears for all souls in trouble,/Here and in hell."

461:21 (470:6). Weight for age—in horseracing, a weight (or handicap) apportioned to a horse according to its age.

461:25 (470:10). tip—slang for head.

461:25 (470:10). Hundred shillings to five—the odds against Throwaway's winning the Gold Cup.

462:2 (470:15). Another girl's plait cut—the loss of a girl's pigtail figuratively implies the loss of her virginity.

462:2–3 (470:15–16). Jack the Ripper—the name given to an unknown London cutthroat who murdered and mutilated at least five and perhaps as many as seven or ten prostitutes in London's East End between April and September 1888. He has never been identified, but his identity was and has continued to be the focus of considerable speculation and controversy in England. For example: *The Sunday Times* (London, 1 November 1970), p. 3, columns 2–4, reports recent speculation that information about the killer was suppressed because he was a member of a socially prominent and powerful family and, further, that the killer was suffering from syphilis of the brain. *The Sunday Times* tentatively identifies this suspect as "Edward, Duke of Clarence, grandson of Queen Victoria, brother of George V, and heir to the throne of England." The "Letters" page of *The Sunday Times* (8 November 1970) carries a letter that specifically refutes this identification (though it does not challenge the broader assertions about social prominence and privilege), i.e., the controversy continues.

462:5 (470:18). And in black. A mormon. Anarchist—the Mormons did wear black; and the controversy over their belief in the practice of polygamy (from the beginnings of that belief in 1843 until its decline in the early years of the twentieth century) gave them considerable notoriety. Anarchists, though their political convictions were serious (if fanatical), were traditionally caricatured as wearing black clothes, black slouch hats and carrying lighted black bombs.

462:11 (470:24). sir Frederick Falkiner—see 136:18n.

462:13–14 (470:26–27). From his forehead . . . Mosaic ramshorns—Sir Frederick Falkiner appears as Michelangelo's *Moses;* see 138:8–9n. Michelangelo followed the tradition that depicted Moses as having horns. This tradition derived from a mistranslation in the Latin Vulgate of Exodus 34:29: "And it came to pass, when Moses came down from mount Sinai with the two tables of testimony in Moses' hand . . . that Moses wist not that the skin of his face shone." The Vulgate rendered "his face shone" as "his face was horned."

462:17 (471:3). (He dons the black cap.)—the ritual gesture of an English judge who is about to pronounce a death sentence.

462:19 (471:5). Mountjoy prison—see 294:16n.

462:24 (471:10). The subsheriff Long John Fanning—see 294:16n.

462:25 (471:11). Henry Clay—see 243:27n.

462:27–28 (471:13–14). Who'll hang Judas Iscariot?—after Judas had betrayed Jesus, he attempted to return the money to "the chief priests and elders" and was refused. "And he cast down the pieces of silver in the temple, and departed, and went and hanged himself" (Matthew 27:3–5).

462:29 (471:15). H. Rumbold—see 298:26n.

463:2–3 (471:21–22). Hanging Harry . . . the Mersey terror—Liverpool is on the River Mersey and the fictional Rumbold writes from Liverpool, 298 (303). The proper address to a judge is not "your Majesty" but "your Lordship."

463:3–4 (471:22–23). Neck or nothing—in Swift's *Complete Collection of Genteel and Ingenious Conversation* (1738), a footman falls downstairs, and Lady Answerall responds, "Neck, or nothing. Come down, or I'll fetch you down. Well, but I hope the poor fellow has not saved the Hangman a Labour."

463:5 (471:24). George's church—see 57:7n.

464:2–3 (472:21–22). Doctor Finucane—Thomas D. Finucane, licentiate of the Faculty of Physicians and Surgeons in Glasgow, apothecary and accoucheur (male midwife), 44 Main Street, Blackrock.

464:10 (473:2). Bloom, I am . . . list, O, list—after the Ghost in *Hamlet;* see 185:39n and 186:31n.

464:12 (473:4). The voice is the voice of Esau—for "the voice of Esau," see 209:1–2n and for the echo of *Leah,* see 75:26–31n.

464:14 (473:6). (Blesses himself.)—i.e., makes the sign of the Cross to defend himself against the presence of evil spirits.

464:16 (473:8). It is not in the penny catechism—the *Shorter Catechism,* "a directory for catechising such as are of weaker capacity" (1886), does not mention the possibility of ghosts but does condemn "superstition" as a violation of the First Commandment and does list "spiritualism" as one of the principal forms of superstition.

464:18 (473:10). metempsychosis—see 64:10n.

464:22 (473:14). Mr J. H. Menton—see 101:26–27n.

464:29 (473:21). John O'Connell—see 105:23n.

465:2 (473:23). Father Coffey—see 102:15n.

465:3–4 (473:24–25). a staff of twisted poppies—the staff of office of Morpheus, god of sleep; *cf.* 102:8n.

465:6–7 (473:27–28). Namine. Jacobs Vobiscuits. Amen—*cf.* 102:15–16n. "Jacob Vobiscuits" is Bloom-Latin for *"Dominus Vobiscum"* ("the Lord be with you"). For "Jacobs," see 300:20n.

465:13 (474:6). My master's voice!—the advertising trademark of Victrola (a phonograph) depicted a seated dog, listening, with the legend "His Master's Voice."

465:15 (474:8). U.P—see 156:3n.

465:16 (474:9). House of Keys—see 119:19n.

465:24–25 (474:18). Dignam's dead and gone below—after "Old Roger Is Dead," a child's singing game. The children stand in a circle and one (Old Roger) lies in the center; the circle chants, "Old Roger is dead and gone to his grave. . . ." A second child (apple tree) joins the

first in the circle: "They planted an apple tree over his head. . . . The apples were ripe and ready to fall. . . . There came an old woman and picked them all up. . . . Old Roger jumped up and gave her a knock. . . . Which made the old woman go hippity hop."

465:29 (474:22). Reuben J—see 93:9n.

465:31 (474:24). Follow me up to Carlow—title of a song by Dublin-born Patrick J. McCall (b. 1861) about Feagh MacHugh O'Byrne (1544–1597), a sixteenth-century hero who proved a hindrance to Queen Elizabeth's campaign for the subjugation of Ireland. He inflicted a very serious defeat on the English at Glenmalure in County Wicklow, made frequent and annoyingly successful raids into the Pale and ravaged Counties Carlow and Kildare to the west of Wicklow. The chorus of McCall's song: "Curse and swear, Lord Kildare!/Feagh will do what Feagh will dare;/Now, Fitzwilliam, have a care—/Fallen is your star, low!/Up with halbert, out with sword,/On we go; for by the Lord,/Feagh McHugh has given the word:/Follow me up to Carlow!"

466:1 (474:25). a daredevil salmon leap—Cuchulain was the only Irish mythical hero (and perhaps the only mythical hero) who could copulate in midair; this extraordinary achievement was described with a flourish as a "salmon leap."

466:8 (475:3) Yummyumm—plus "THE KISSES" suggest "Under the Yum Yum Tree" (1910), a popular American song by Harry Von Tilzer (1872–1946): "Under the yum yum tree,/That's the yummiest place to be,/When you take your baby by the hand/There'll be something doing down in Yum Yum land;/That is the place to play/With your honey and kiss all day,/When you're all by your lonely,/You and your only yum! yum! yummy, yummy, yum,/Under the Yum Yum tree."

466:15 (475:10). Zoe Higgins—"Zoe" means "life" in Greek; and Bloom's mother's maiden name was Higgins.

466:21 (475:16). Mrs Mack's—Mrs. Mack had two establishments, 85 and 90 Tyrone Street, and enjoyed such a reputation as a madame that the red-light district was sometimes called "Macktown."

466:23 (475:18). eighty-one, Mrs Cohen's—Mrs. Cohen's house was at 82 (not 81) Tyrone Street. Ellmann says that Mrs. Cohen "was older than Mrs. Mack, and by 1904 had either retired or died" (p. 378).

466:24 (475:19). Mother Slipperslapper—see 86:18n.

467:9 (476:5). Mesias—see 108:39n.

467:17 (476:13). potato—see 418:11n.

468:2 (477:2). I never loved . . . it was sure to . . .—see 437:2n.

468:7 (477:7). womancity—Solomon's Jerusalem, as evoked by a sensuous (rather than allegorical) reading of the biblical Song of Solomon.

468:13 (477:13). swinefat—in perverse contrast to the Hebrew she quotes (since Hebrew law strictly prohibits pork and pork products) and also an allusion to Circe since Circe transformed Odysseus' men into swine.

468:14 (477:14). Schorach ani wenowwach, benoith Hierushaloim—Hebrew: "I am black, but comely, O ye daughters of Jerusalem" (from The Song of Solomon 1:5).

468:28 (477:28). swaggerroot—the obvious pun on "cigarette" involves an echo of slang uses of "swagger" as in "swagger stick."

469:6 (478:8). black gansy—a knitted woolen shirt or sweater worn instead of a jacket.

469:7-8 (478:9-11). Sir Walter Raleigh . . . potato and that weed—Raleigh (1552–1618) was generally credited with the introduction of the potato and tobacco from America into the British Isles as a result of his unsuccessful attempts (1584–1590) to found a colony on Roanoke Island off the Carolina coast. Raleigh's involvement in the enterprise was as sponsor rather than as participant since Queen Elizabeth refused to let him leave England. The actual history of the introduction of the potato (regarded as fodder for cattle until mid-eighteenth century) and tobacco into England and Ireland is considerably less clear than the Raleigh tradition would suggest; various English and Spanish explorers are now given prior credit.

469:9 (478:11). a killer of pestilence by absorption—the potato; see 418:11n.

469:16 (478:18). Turn again, Leopold! Lord mayor of Dublin—what the bells of Bow Church said to Dick Whittington in the story "Dick Whittington and His Cat." Dick has come up to London to seek his fortune only to meet disappointment; as he leaves London, the bells call after him, "Turn again, Dick Whittington, thrice Lord Mayor of London." He turns and all goes well.

469:18-20 (478:20-21). Arran Quay, Inns Quay . . . cattlemarket to the river—these five (of the Dublin Corporation's 20 wards) are in sequence from west to east along the north bank of the Liffey. Cattle from the cattle market in northwestern Dublin were driven through the streets of these wards on their way to the docks.

469:21 (478:23). Cui bono?—Latin: "Who benefits by it?"; popularly, "Of what use is it?"

469:22 (478:24-25). Vanderdeckens in their phantom ship of finance—in English versions of the legend of the Flying Dutchman, that unfortunate captain is named Vanderdecken. There are various versions of the legend, but in all the captain (for some affront to the eternal powers) is condemned to sail the seas forever in a phantom ship. In the version Wagner adopted for his opera *Der fliegende Holländer* (1843), the condemned captain can only be saved from his eternal wandering by a woman's true love, and he is allowed on shore once every seven years to search for that woman (whom he eventually finds and loses through an irony of fate). In sailors' superstitions the sight of Vanderdecken's phantom ship is a particularly evil omen. The "of finance" links Vanderdecken with "Commodore" Cornelius Vanderbilt (1794–1877), the American financier and capitalist whose name, together with that of his heirs, became a household word for the "buccaneering" financier.

469:25 (478:28). the torchlight procession—a common feature of election campaigns and victory celebrations.

469:29-30 (479:5). Timothy Harrington, late thrice Lord Mayor of Dublin—Harrington (1851–1910), Irish politician and patriot who was particularly close to Parnell in the 1880s, was lord mayor of Dublin three times (1901, 1902, 1903); see 469:16n.

470:1 (479:7). councillor Lorcan Sherlock, locum tenens—see 243:37–38n. *Locum tenens*, Latin: "holding the place," i.e., deputy.

470:8 (479:14-15). Cow Parlour off Cork street—Cork Street links Dolphin's Barn (the village on the southwestern outskirts of Dublin where Bloom first met Molly) with Dublin proper. In 1904 Cow Parlour was a small lane of tenements off Cork Street.

470:11 (479:17). Carried unanimously—the lord mayor of Dublin was elected annually by the aldermen (one per ward) and councilors (three per ward) of the Dublin Corporation; Sherlock, as secretary of the Corporation, announces Bloom's election.

470:13 (479:19). These flying Dutchmen—see 469:22n.

470:21–22 (479:27–28). But their reign is ... and ever and ev ... —after Revelation 11:15, which forms part of the text of the Hallelujah Chorus of Handel's *Messiah* (see 180:22n): " ... The kingdoms of this world are become *the kingdoms* of our Lord, and of his Christ; and he shall reign for ever and ever."

470:23 (479:29). Venetian masts—tall poles spiral-wound with multicolored ribbons, used to decorate streets on festive occasions.

470:24–25 (479:30–31). Cead Mile Failte—Irish: "A Hundred Thousand Welcomes."

470:25 (479:31). Mah Ttob Melek Israel—Hebrew: "How goodly are [thy tents] King of Israel," after Balaam's praise of the Israelites in Numbers 24:5.

470:27 (479:33). the royal Dublin fusiliers—see 71:35–36n. Three of the regiment's battalions were stationed in Ireland in 1904.

470:27–28 (479:34). the King's own Scottish borderers—infantry. One of the regiment's battalions was stationed in Ireland in 1904.

470:28 (479:34). the Cameron Highlanders—the Queen's Own Cameron Highlanders. None of the regiment's battalions was stationed in Ireland in 1904.

470:29 (480:1). the Welsh fusiliers—the Royal Welsh Fusiliers. The regiment's fourth battalion was stationed in Ireland in 1904.

470:32–33 (480:5). The pillar of cloud—guided the Children of Israel as Moses led them out of Egypt toward the Promised Land; see 141:21–22n.

470:34 (480:6). the Kol Nidre—Hebrew: "All our vows," the title of a prayer that is recited (chanted to music) in synagogues on the eve of Yom Kippur, the Day of Atonement. The prayer celebrates a communal release from vows and oaths on the eve of the annual ceremony of cleansing and purification that is central to Yom Kippur.

470:34–35 (480:7). imperial eagles—the principal of the military emblems of the Roman Empire.

471:1 (480:10). John Howard Parnell—see 162:30–31n.

471:2 (480:11–12). the Athlone Poursuivant and Ulster King of Arms—the "Poursuivant" was a junior officer of the College of Arms (Heralds' College, England, in charge of armorial bearings and genealogies), attached as an assistant to the Ulster King of Arms, the chief official of the College in charge of Ireland and the Order of St. Patrick.

471:3–4 (480:13). the Right Honourable Joseph Hutchinson—see 243:37n.

471:7 (480:17). the cloth of estate—a rich cloth forming a canopy and background to the throne.

471:9–10 (480:19). the bishop of Down and Connor—Church of Ireland; in 1904 the bishop was the Right Reverend Thomas James Welland (1830–1907).

471:10–11 (480:19–20). His Eminence Michael ... of Armagh—the Roman Catholic primate in Ireland, Michael, Cardinal Logue (1840–1924), the archbishop of Armagh (1887–1924), known for his guarded opposition to Parnell and his followers.

471:11–13 (480:21–23). His Grace, the most ... of all Ireland—(1824–1911), primate of the Church of Ireland (1893–1911).

471:13 (480:23). the chief rabbi—the chief rabbinate for Ireland was not created until 1919.

471:13 (480:23). the presbyterian moderator—the Reverend John MacDermott of Belfast was moderator of the General Assembly of the Presbyterian Church in Ireland in 1904.

471:14 (480:24). baptist—the "head" of the Baptist Union of Ireland in 1904 was its president, Pastor J. Dinnin Gilmore of Dublin.

471:14 (480:24). anabaptist—the sixteenth-century radical sect from which the modern Baptist Church has derived.

471:14 (480:24). methodist—the Reverend John Shaw Banks was president of the annual conference of the Methodist Church in Ireland in 1903. The conference in 1904 was to begin on 20 June, at which time a new president was to be elected.

471:14 (480:24). Moravian—the Protestant Episcopal Church of the United Brethren had 11 small congregations in Ireland; there was no "head."

471:15 (480:25). the honorary secretary of the society of friends—the "recording clerk" (not the "honorary secretary") of the Religious Society of Friends (the Quakers) in Ireland in 1904 was John Bewley Beale (1832–1910).

471:16 (480:26). the guilds and trades and trainbands—these traditional groups enjoy special privileges in London, and they play a ceremonial part on occasions such as the installation of a new lord mayor or the coronation of a sovereign. In context, Bloom's installation as lord mayor has metamorphosed into a coronation procession.

471:20 (480:30). Italian warehousemen—an "Italian warehouse" was an Italian grocery store.

471:27 (480:37). gentlemen of the bed chamber—a sovereign's honorary attendants; the procession that follows is modeled on Edward VII's coronation procession.

471:27 (480:37–38). Black Rod—the Gentleman Usher of the Black Rod, an official of the English House of Lords. His staff of office is an ebony rod surmounted by a lion. He is Usher of the Garter and the personal attendant of the sovereign when the sovereign is present in the House of Lords.

471:27 (480:38). Deputy Garter—Garter King-of-Arms, the executive officer of the sovereign for the Order of the Garter, hence the sovereign's deputy since the sovereign is the grand master of the Order.

471:28 (480:38). Gold Stick—an officer in the English Royal Body-Guard and a captain in the Corps of Gentlemen-at-Arms (the ceremonial guard on state occasions). A gilded baton is the emblem of his office.

471:28 (480:38). the master of horse—an officer of the Royal Court who is responsible for the sovereign's horses and who rides next to the sovereign on all state occasions.

471:28 (480:39). the lord great chamberlain—in England a hereditary office formerly of great importance. He governs the palace at Westminster and has charge of the House of Lords during the sitting of Parliament.

471:29 (480:39). the earl marshal—president of the English College of Heralds and the judge of courts of chivalry presiding over questions of honor and arms. He was formerly judge of all courts martial though his office is now largely an obsolete decoration.

471:29 (480:39–40). the high constable carrying the sword of state—the lord high constable of England was in effect the commander-in-chief of the army and navy and therefore the sovereign's "sword." The office was abolished by Henry VIII.

471:30 (480:40). saint Stephen's iron crown—one of the central symbols of Hungarian royal sovereignty, presented by Pope Sylvester II (pope 999–1003) in 1000 to the first king of Hungary, Stephen I (c.975–1038). The crown conferred the title of "Apostolic Majesty" upon Stephen, who was to become the patron saint of Hungary. St. Stephen's crown here is substituted for St. Edward's crown, the comparable crown used in the English coronation procession.

471:30 (480:41). the chalice and bible—symbolic of the English sovereign's title "Defender of the Faith" and of that phase of the coronation oath in which the sovereign swears to uphold "the laws of God, the true profession of the Gospel, and the Protestant Reformed religion as it is established by law."

471:34 (481:3). Saint Edward's staff—a silver gilt wand carried before the sovereign and symbolic of the justice and equity that were to be expected of the royal jurisprudence. The wand is supposed to recall the character of Edward the Confessor (St. Edward), king of England (1042–1066).

471:34–35 (481:4). the orb and sceptre with the dove—these important parts of the English royal regalia symbolize the fullness of the sovereign's power under God (since the orb is surmounted by a cross) and the peace that is the ideal use of that power (since the sceptre is surmounted by a cross and decorated with the image of a dove).

471:35 (481:4). the curtana—a pointless sword, "the sword of Edward the Confessor," a symbol of mercy carried before the English sovereign at his coronation.

471:40 (481:9–10). hawthorn and wrenbushes—hawthorn is a typical hedge plant and wrenbushes (holly or gorse trimmed with ribbons supposedly hiding the body of a dead wren). On St. Stephen's day, 26 December, Irish children went from door to door with wrenbushes, chanting, "Give us a penny to bury the wren."

472:2–5 (481:12–15). The wren, the wren . . . caught in the furze—part of a typical wrenbushers chant. (The wren became the "king of all birds" by secretly hitching a ride on the back of an eagle.)

472:19 (482:1). BELLHANGER—one whose craft is the installation and maintenance of bells. It is a difficult craft, and its exponents are highly regarded in England, where bell ringing has evolved into an intricate national art.

472:21 (482:3). A sunburst appears in the

northwest—emblematic of Home Rule; see 57:33–35n.

472:22 (482:4). THE BISHOP OF DOWN AND CONNOR—see 471:9–10n. At his coronation the English sovereign is attended by two "supporter Bishops."

473:2 (482:11). dalmatic and purple mantle —garments worn by an English sovereign at his coronation.

473:4 (482:13). WILLIAM, ARCHBISHOP OF ARMAGH—see 471:10–11n.

473:5–7 (482:14–16). Will you to your power . . . thereunto belonging?—combines two parts of the oath that the English sovereign takes at his coronation with, of course, the substitution of "Ireland" for "England." The oath of 1911 reads: "Will you solemnly promise and swear to govern the people of this United Kingdom of Great Britain and Ireland and the Dominions thereto belonging, according to the Statutes in Parliament agreed on and the respective Laws and Customs of the same?"
"I solemnly promise so to do."
"Will you to your power cause Law and Justice, in Mercy, to be executed in all your judgments?"
"I will. . . ."

473:9 (482:18). (Placing his right hand on his testicles, swears.)—a form of oath taking (signifying the sacred nature of man's reproductive capacities) recorded in Genesis 24:2–3: "And Abraham said unto his eldest servant of his house, that ruled over all that he had, Put, I pray thee, thy hand under my thigh: And I will make thee swear by the Lord, the God of heaven, and the God of the earth. . . ." Samuel Beckett in *Molloy* (1955) cites it as Irish: "What is one to think of the Irish oath sworn by natives with the right hand on the relics of the saints and the left on the virile member?" (New York, 1965; p. 167).

473:9–10 (482:18–19). So may the Creator . . . promise to do—in answer to the final series of questions (about upholding religion) in the coronation oath, the sovereign says, "All this I promise to do."

473:11 (482:20). MICHAEL, ARCHBISHOP OF ARMAGH—see 471:10–11n.

473:12 (482:21). (Pours a cruse of hairoil over Bloom's head.)—in the coronation ceremony, after the coronation oath, the sovereign is anointed with holy oil to signify that his person is set apart and sanctified.

473:12–13 (482:21–22). Gaudium magnum annuntio vobis. Habemus carneficem—

Latin: "A great joy I announce to you. We have an executioner," after the formula used to announce a new pope to the people of Rome: "*Habemus papam*" ("We have a pope").

473:15 (482:24). a mantle of cloth of gold— several symbolic ceremonies follow the "Solemn Anointing" in the coronation ceremony before the crown is placed on the sovereign's head. One of them involves investing the sovereign with the imperial mantle.

473:15–16 (482:25). a ruby ring—the coronation ring of Scotland, which is bestowed on the sovereign in the sequence of ceremonies that immediately precede his being crowned.

473:16 (482:25). the stone of destiny—or the Stone of Scone, the coronation stone; traditionally it is under the coronation chair, in which the sovereign is seated when he is crowned by the archbishop.

473:16–18 (482:26–27). The representative peers . . . their twenty-eight crowns—the representative peers are the senior noblemen in the several grades of the peerage; each represents his particular order when he does homage to the king. In this case, after the king is crowned, the peers assume their coronets and caps.

473:18 (482:27). Joybells—see 220:11n; when the king is crowned, the news is signaled from Westminster Abbey and broadcast by artillery salutes and churchbells.

473:18 (482:27–28). Christ Church, Saint Patrick's—the two Church of Ireland cathedrals in Dublin.

473:19 (482:28). George's—see 57:7n.

473:19 (482:28). gay Malahide—see 220:11n.

473:19 (482:28). Mirus bazaar—see 180:20n.

473:21 (482:30). The peers do homage—the next phase of the coronation ceremony after the king is crowned. The representative peers approach the sovereign in turn, genuflecting and repeating the Oath of Fealty.

473:23 (483:2–3). I do become . . . to earthly worship—the opening sentence of the traditional Oath of Fealty.

473:24–25 (483:4–5). the Koh-i-Noor diamond —(Persian: "Mountain of Light"), one of the largest known diamonds, it was added to the English crown jewels in 1894 through the conquest of the Punjab. At 102 carats, the stone would make something more than a modest ring.

473:26 (483:5). palfrey—usually defined as a small saddle horse for women (after Spenser), it can also mean a horse for state occasions as distinguished from a warhorse (after Chaucer).

473:26–27 (483:6). Wireless intercontinental and interplanetary transmitters—by 1906 Marconi's "wireless telegraph" (radio) was capable of occasional transmission across the Atlantic, but dependable commercial transmission was limited to about 1,700 miles.

473:29–30 (483:9–10). nominate our faithful ... hereditary Grand Vizier—Bloom's "action" recalls an aberration of the Roman Emperor Caligula (12–41 A.D., emperor 37–41), who made his favorite horse, Incitatus ("the swift one"), a member of the college of priests of his (Caligula's) cult and subsequently a consul. *"Copula felix,"* Latin: "the fortunate bond or tie (of love)." The Grand Vizier was the chief officer of state of the Turkish Empire. *Cf.* Thornton, p. 376.

473:32 (483:12). Selene—in Greek mythology the sister of the sun-god Helios, she was the moon-goddess who illumined the night with her silver crown. Her image is subsumed in that of the Greek Artemis and the Roman Diana.

474:10 (483:23). the promised land of our common ancestors—elides the Promised Land of the Israelites with Ireland as "promised land"; see 320:25n and 141:30–31n.

474:12 (483:25). The keys of Dublin, crossed —see 119:19n and 119:20n.

474:17–18 (484:2–3). On this day twenty ... enemy at Ladysmith—the relief of Ladysmith in the Boer War took place on 28 February 1900; see 449:24–25n. If we are to take Bloom's "twenty years" seriously, the major war news of 1884 was the siege of Khartoum, where the English General Charles George Gordon (1833–1885) found his position under increasing pressure in the course of the year. Gordon's communications with the outside world were virtually suspended after April 1884, though two messages from him did come through in June 1884, asking the whereabouts of the relief expedition (which did not leave Cairo until 5 October and which was two days' march from Khartoum when that city fell in a massacre on 26 January 1885). The "hereditary enemy" (a traditional phrase for Moslems or Turks) in that case was the Mahdi, a Moslem coalition of religious fanatics and slave traders whose leader had taken the name Mahdi (the messenger of Allah who is supposed to complete Mohammed's work by converting or exterminating all infidels). In 1881 the Mahdi proclaimed the Jihad (the holy war of extermination) in the Sudan. After the fall of Khartoum,

the English in effect abandoned the Sudan until Kitchener's successful reconquest of the area in 1898. And so back to Ladysmith, since Kitchener was chief of staff (1900) and subsequently the commander-in-chief of British forces during the Boer War (December 1900–1902).

474:19 (484:4). Half a league onward!—from the opening lines of Tennyson's "The Charge of the Light Brigade" (1854), which memorializes the wrongheaded heroism of the Light Brigade's disastrous charge against entrenched Russian artillery at Balaclava (25 October 1854) during the Crimean War. The poem begins: "Half a league, half a league/Half a league onward,/All in the valley of Death/Rode the six hundred. . . ."

474:20 (484:5). All is lost now!—see 252:24n.

474:22 (484:7). Plevna—see 56:30n.

474:22–23 (484:8). Bonafide Sabaoth—in addition to the standard meaning of *bona fide*, see 417:7n. *"Sabaoth"* is the Greek form of the Hebrew word *tsebâôth* ("armies"); it occurs in Romans 9:29 and James 5:4. The phrase implied is *Jehovah-tsebâôth* ("Lord God of Hosts"), the spirit of God that guided his "chosen people" in battle.

474:24 (484:9). CHAPEL—i.e., guild or union; see 121:5n.

474:27 (484:12). the man that got away James Stephens—see 311:1–2n and 44:23n.

474:28 (484:13). A BLUECOAT SCHOOLBOY—see 180:9–10n.

475:7 (484:21). verily it is even now at hand— in the Gospels Jesus repeatedly says: "Verily I say unto you" and less often, "The kingdom of heaven is at hand."

475:8 (484:22). the golden city—after the hymn "Jerusalem the Golden," words by Bernard of Cluny (c.1122–1156), translated by John Mason Neale (1818–1866), music by Alexander Ewing. First stanza: "Jerusalem the golden,/With milk and honey blest./Beneath thy contemplation/Sink heart and voice oppressed./I know not, O I know not/What joys await us there;/What radiance of glory,/What bliss beyond compare."

475:8–9 (484:23). the new Bloomusalem—see 327:3n.

475:9 (484:23). Nova Hibernia—Latin: "New Ireland."

475:10–11 (484:24–25). Thirty-two workmen ... the counties of Ireland—as Arthur Griffith

recounts in *The Resurrection of Hungary* (see 331:29–30n), in celebration of Hungary's achievement of qualified independence, the Emperor Franz Joseph was cheered by "fifty-two working men from all the counties of Hungary."

475:11 (484:25). Derwan the builder—see 442:19n.

475:12–13 (484:27). with crystal roof—see 289:16n.

475:22 (485:7). Morituri te salutant—Latin: "They [who are] about to die salute thee," the formula with which gladiators saluted the Roman emperor at the start of the gladiatorial games.

475:27 (485:12). fireraiser—in Scot's Law, an arsonist.

475:27 (485:12). Higgins—Bloom's mother's maiden name was Ellen Higgins; Bloom is "talking" to Zoe Higgins. See also 125:26n.

475:31 (485:16). with his sceptre strikes down poppies—Tarquinius Superbus (d. 495 B.C.), the last of the semilegendary, tyrant-kings of Rome, was supposed to have revealed what was to be the tyrannical nature of his reign when, as a child, he beheaded poppies with a toy sceptre.

476:2 (485:19). Maundy money—silver coins, worth 1d, 2d, 3d and 4d, were annually distributed as alms for the poor on behalf of the English sovereign on Maundy Thursday (the day before Good Friday) in commemoration of the ancient but obsolete custom of washing the feet of the poor on this day (as Jesus washed his disciples' feet [John 13:5], counciled them to do likewise for one another [13:14], and commanded them "that ye love one another" [13:34]).

476:2–3 (485:20). commemoration medals—were traditionally struck and distributed on English state occasions such as coronations (or Queen Victoria's Jubilee, 1897).

476:3 (485:20). loaves and fishes—see 397:6n and see also "Jubilee Mutton," 420:4–5n.

476:3–4 (485:21). Henry Clay cigars—see 243:27n.

476:4 (485:22). rubber preservatives—contraceptive devices.

476:7 (485:24–25). toad in the hole—a dish of meat baked or fried in batter.

476:7 (485:25). Jeyes' fluid—a disinfectant for drains and sewers manufactured by Jeyes Sanitary Compounds Company, Ltd., in London.

476:8 (485:25). purchase stamps—or trading stamps, issued by a merchant to be used instead of money when purchasing items from him.

476:8 (485:25–26). 40 days' indulgences—in the Roman Catholic Church, the remission of temporal punishment due for a sin after the sinner's guilt has been confessed and forgiven. A 40 days' indulgence remits as much temporal punishment as would be remitted by performing the ancient canonical penances for 40 days. An indulgence diminishes the purgatorial penance due for a sin.

476:10–11 (485:28). the royal and privileged Hungarian lottery—see 154:4–5n.

476:11 (485:28–29). penny dinner counters—tokens that entitled the bearer to a free dinner; see 155:22n.

476:11–12 (485:29–30). the World's Twelve Worst Books—the books listed in the following lines may well be fictional since none of them (mercifully) appears in standard book catalogues.

476:12 (485:30). Froggy and Fritz—unknown.

476:12–13 (485:30). Care of the Baby—unknown.

476:13 (485:31). 50 Meals for 7/6—unknown.

476:13–14 (485:31). Was Jesus a Sun Myth?—unknown.

476:14 (485:32). Expel that Pain—unknown.

476:14–15 (485:32–33). Infant's Compendium of the Universe—unknown.

476:15 (485:33). Let's All Chortle—unknown.

476:15–16 (485:33–34). Canvasser's Vade Mecum—unknown.

476:16–17 (485:34–35). Love Letters of Mother Assistant—unknown.

476:17 (485:35). Who's Who in Space—unknown.

476:17–18 (485:35–486:1). Songs that Reached Our Heart—unknown.

476:18 (486:1). Pennywise's Way to Wealth—unknown.

476:19–20 (486:2–3). Women press forward... of Bloom's robe—Matthew 9:20–22: "And, behold, a woman, which was diseased with an issue of blood twelve years, came behind *him*

[Jesus], and touched the hem of his garment: For she said within herself, If I may but touch his garment, I shall be whole. But Jesus turned about, and when he saw her, he said, Daughter, be of good comfort; thy faith hath made thee whole. And the woman was made whole from that hour."

476:20–21 (486:3–4). The lady Gwendolen Dubedat—see 173:10n.

476:23 (486:6–7). Babes and sucklings—Psalms 8:2: "Out of the mouths of babes and sucklings hast thou ordained strength because of thine enemies, that thou mightest still the enemy and the avenger." In Matthew 21:15–16 Jesus quotes this passage in reproof of "the chief priests and scribes," who object to "the children crying in the temple, and saying, Hosanna to the son of David."

476:26 (486:9). Little father!—a traditional Russian peasant epithet for the Czar.

476:28–29 (486:11–12). Clap clap hands ... for Leo alone—a variant on a nursery rhyme: "Clap hands, clap hands,/Till father comes home;/With his pockets full of plums/And a cake for Johnny."

476:35 (486:18). My more than Brother!—echoes Tennyson's *In Memoriam* (1850), X:16–20: "My friend, the brother of my love; // My Arthur, whom I shall not see/Till all my widow'd race be run;/Dear as the mother to the son,/More than my brothers are to me."

477:2 (486:20). pussy fourcorners—or Puss in the Corner, a children's game in which four children occupy the corners of a square; the fifth ("puss") attempts to secure a corner when the others change places.

477:3 (486:21). Peep! Bopeep!—what an adult says when he plays with a baby by alternately hiding his face in his hands and then revealing it.

477:4 (486:22). Ticktacktwo wouldyouseeta-shoe?—from *Mother Goose's Melody*, Isaiah Thomas (Worcester, Mass., c.1785), p. 31: "Is John Smith within?/Yes, that he is./Can he set a shoe?/Aye, marry two./Here a nail, and there a nail,/Tick, tack, too."

477:6 (486:24). Roygbiv—see 71:7–8n.

477:6 (486:24). 32 feet per second—see 71:10n.

477:7 (486:25). Absence makes the heart grow younger—after the proverb: "Absence makes the heart grow fonder."

477:10 (486:28). U.P.: up—see 156:3n.

477:13 (486:31). Maurice Butterly—see 18:41n.

477:21 (487:4). The ram's horns ... standard of Zion—the trumpet made of ram's horns (the *shofar*) was the battle trumpet of the ancient Hebrews; it was also used by the priests to signal the occasion of various religious festivals. It is associated with the "ark of the covenant" as in Joshua 6:4 and with the Standard of Zion (the emblem of the Israelites as a chosen people) as in Jeremiah 4:21. The *shofar* is still used in synagogues to proclaim certain religious festivals such as Yom Kippur and Rosh Hashanah (the Jewish New Year).

477:25 (487:8). Aleph Beth Ghimel Daleth—the first four letters of the Hebrew alphabet (arithmetical values: 1, 2, 3, 4).

477:25 (487:8). Hagadah—see 121:18–19n.

477:25 (487:8–9). Tephilim—see 372:11–12n.

477:26 (487:9). Yom Kippur—see 149:41n.

477:26 (487:9). Hanukah—the Feast of the Dedication, instituted 165 B.C. by Judas Maccabaeus to commemorate the dedication of the new altar set up at the purification of the Temple of Jerusalem to replace the altar that had been polluted by Antiochus Epiphanes. Hanukah is celebrated for eight days because of the miracle that sustained the one-day supply of lamp oil for eight days. It occurs in December.

477:26 (487:9). Roschaschana—(or "Rosh Hashanah") the Jewish New Year, celebrated for two days at the beginning of the month of Tishri (September-October).

477:26 (487:9). Beni Brith—or B'nai B'rith (Hebrew: "Sons of the Covenant"), a Jewish fraternity founded in New York City in 1843. It admitted members without qualifications about dogma and ceremonial custom. By 1904 its international membership made it the most popular and most powerful Jewish fraternity.

477:26–27 (487:10). Bar Mitzvah—Hebrew: "Son of Command," the ceremony that celebrates the coming of age of a thirteen-year-old Jewish youth.

477:27 (487:10). Mazzoth—Hebrew: "Unleavened": the unleavened bread, the eating of which is an important part of the celebration of the Feast of Passover.

477:27 (487:10). Askenazim—Hebrew (after Ashkenaz, Genesis 10:3, I Chronicles 1:6), the Jews of middle and northern Europe as opposed to the Sephardim, the Jews of Spain and Portugal.

477:27 (487:10). Meshuggah—see 157:27n.

477:27 (487:10). Talith—a fringed shawl worn by Jewish men for certain kinds of prayer.

477:28–29 (487:11–12). Jimmy Henry, assistant town clerk—see 243:5n.

477:31 (487:14). The Court of Conscience—the Court of Chancery (since descriptive of its original functions); also the Court of Requests, small local debt courts that fell into disuse toward the end of the nineteenth century.

478:8 (487:26). Can I raise a mortgage on my fire insurance?—the answer in English law is no.

478:10–12 (488:2–4). by the law of torts ... sum of five pounds—what this legal tangle means is that Bloom lends them money without security other than their pledge to repay.

478:14 (488:6). A Daniel did I say?—in Shakespeare's *The Merchant of Venice* (IV, i) Portia, disguised as her servant Balthasar, intervenes in the legal controversy between Antonio and Shylock. The shrewdness of her "judgments" leads first Shylock (line 223) and then Gratiano (Antonio's friend) (in lines 333 and 340) to call her "a Daniel": "A Daniel still say I, a second Daniel!" after the young "judge" Daniel in the "History of Susanna" in the Apocrypha. Daniel defends Susanna when the two elders whose advances she has refused try to revenge themselves by accusing her of adultery. Daniel questions them separately and develops conflicts in their testimony so that they are condemned and Susanna is exonerated.

478:14 (488:6). A Peter O'Brien—noted as an extraordinarily perceptive judge but not popular with the Irish; see 292:6n.

478:20–23 (488:12–15). Acid. nit. hydrochlor ... ter in die—*Acid. nit. hydrochlor dil*, 20 minims: dilute hydrochloric acid, 20 drops; *Tinct. mix vom.*, 4 minims: bitters, 4 drops; *Extr. taraxel. lig.*, 30 minims: extract of dandelion; *Aq. dis. ter in die.*, a solution that might possibly be used for the prevention of stomach disorders, if taken three times a day (*ter in die*). *Aq. dis.* is distilled water.

478:24 (488:16). Chris Callinan—see 136:8n.

478:25 (488:17). What is the parallax of the subsolar ecliptic of Aldebaran?—"subsolar ecliptic" is a phrase no longer in use in astronomy. Callinan's question in effect means "What is the angle between a line from the center of the earth to Aldebaran and a line from the center of the sun to Aldebaran?" See 407:39–40n and 152:4n.

479:2 (488:19). K. II—the correct answer to Callinan's question would have been 0.048 seconds of arc. Bloom's answer is relevant, however, since Aldebaran was classified (*c*. 1913) as K.II, a "bright giant" star; it has since been reclassified K.III (a "giant"). This method of classifying stars was a result of the work of the Danish astronomer E. Hertsprung in 1911 and the American Henry Norris Russell in 1913. Their method involved classifying stars in terms of the interrelation of their "absolute magnitude" (what their brightness would be if all stars were equidistant from the earth) and their temperature (K) as determined by spectral analysis (since temperature was regarded as directly related to size).

479:6–7 (488:23–24). When my progenitor ... despot in a dank prison—the identity of this "progenitor" is unknown.

479:9 (488:26). Pansies?—for "thoughts," in the language of flowers.

479:15 (489:6). Father ... starts thinking—after the superstition that the birth of twins implies two fathers instead of one.

479:17 (489:8). An eight day licence—publicans were licensed to sell alcoholic beverages six or seven days a week during rigidly specified hours; in effect, O'Rourke asks Bloom to declare an eight-day week.

480:2 (489:19). our own house of keys—see 119:19n and 119:20n.

480:4–5 (489:21–22). the plain ten commandments—see Exodus 20:3–17 and Deuteronomy 5:7–21.

480:6 (489:23). Three acres and a cow—this phrase became the rallying cry for Irish land reform after its use by Jesse Collings (1831–1920), a Member of Parliament, who coined the phrase in a successful effort to force a measure of land reform on Lord Salisbury's conservative and reluctant government in 1886.

480:11 (490:1). esperanto—this relatively popular proposal for an international language was invented by a Russian physician, Zamenhof, who signed his first publication on the subject (1887) "Dr. Esperanto" ("Hopeful").

480:23–24 (490:13–14). the Kildare street museum—i.e., the National Museum; see 174:4–5n.

480:25 (490:15). Venus Callipyge—see 198:35n.

480:26 (490:16). Venus Pandemos—see 418:26n.

480:26 (490:16). Venus metempsychosis—see 64:10n.

480:27 (490:17). the new nine muses—(obviously expanded to 12) in Greek mythology the nine muses were Calliope (epic poetry), Clio (history), Erato (erotic poetry), Euterpe (lyric poetry), Melpomene (tragedy), Polyhymnia (sacred song), Terpsichore (dance), Thalia (comedy and pastoral poetry), and Urania (astronomy).

480:29 (490:19). Plural Voting—the right to cast more than one vote (or, in England, to vote in more than one constituency); the goal of plural voting was a form of proportional representation.

481:1 (490:22). FATHER FARLEY—see 79:12n.

481:2 (490:23). an anythingarian—i.e., one who holds no particular creed or dogma.

481:4 (490:25). MRS RIORDAN—see 96:16n.

481:6 (490:27). MOTHER GROGAN—see 14:21n.

481:10 (491:2). One of the old sweet songs—see 63:24–25n.

481:13–15 (491:5–7). I vowed that ... tooraloom, tooraloom—see 70:16–20n.

481:16 (491:8). HOPPY HOLOHAN—see 72:28n.

481:19 (491:11). Stage Irishman!—an Irishman who degrades himself by acting the clown because the Irish are popularly expected to be that way.

481:21–22 (491:13–14). The Rows of Casteele—see 129:18–19n.

482:11 (492:6). Nelson's Pillar—see 94:1n.

482:15 (492:11). ALEXANDER J. DOWIE—see 149:16n.

482:18–19 (492:14–15). this stinking goat of Mendes—in Egyptian mythology one of three sacred animals; the others were Apis at Memphis (a bull regarded as a manifestation of that aspect of Osiris which rendered him immortal in the world of the dead) and Mnevis at Heliopolis (a bull as a manifestation of Ra, the sun-god). The goat whose cult was at Mendes in the Nile delta was held to be a manifestation of the generative forces that were another aspect of Osiris' divinity. The rites of the goat cult reportedly involved copulation between the sacred goat and women selected as outstandingly beautiful.

482:20 (492:16). the cities of the plain—see 61:6–7n.

482:21–22. (492:17–18). the white bull mentioned in the Apocalypse—there is no white bull in Revelation, The Apocalypse of St. John the Divine, the most well known of the Christian Apocalypses. In various mythologies a white bull occurs as a manifestation of a deity (Osiris, Egyptian; Zeus, Greek; Baal, Babylonian). Dowie may be making an inept attempt to identify Bloom with the "beast" coming up out of the earth" in Revelation 13:11: "and he had two horns like a lamb, and he spake as a dragon." See 429:2n.

482:22 (492:18–19). the Scarlet Woman—an opprobrious Protestant term for the Roman Catholic Church, derived from "the woman arrayed in purple and scarlet colour" in Revelation 17:4. She is riding "upon a scarlet-coloured beast" (17:3), which Protestants identify as the beast of Revelation 13:11 (see 482:21–22n): "And upon her forehead was a name written, MYSTERY, BABYLON THE GREAT, THE MOTHER OF HARLOTS AND ABOMINATIONS OF THE EARTH." (17:5).

482:24 (492:20). Caliban—see 8:31n.

482:26 (492:22). Parnell ... Mr. Fox!—in his clandestine correspondence with Kitty O'Shea, Parnell used several assumed names, among them Fox and Stewart.

482:27 (492:23). Mother Grogan—see 14:21n.

482:28 (492:24). upper and lower Dorset street—where Bloom had shopped for his pork kidney in the morning.

482:33 (492:29). This is midsummer madness—in Shakespeare's *Twelfth Night* Olivia comments on Malvolio's transformation from her "sad and civil" servant to her ludicrous and ardent lover: "Why, this is very midsummer madness" (III, iv, 61).

483:1 (492:30). guiltless as the unsunned snow—in Shakespeare's *Cymbeline* (II, v, 12–13) Posthumus, duped by Iachimo, contemplates what he takes to be his wife Imogen's corruption and guilt: "I thought her/As chaste as unsunned snow."

483:2–3 (492:31–32). number 2 Dolphin's Barn—occupied in 1904 by one Daniel Whelan, victualer.

483:3 (492:32). Slander, the viper—in Shakespeare's *Cymbeline* Posthumus sends a letter to his servant, Pisanio, commanding him to murder

Imogen; Pisanio instead shows her the letter and contemplates her shock: "What shall I need to draw my sword? The paper/Hath cut her throat already. No, 'tis slander,/Whose edge is sharper than the sword, whose tongue/Outvenoms all the worms [serpents] of Nile ... nay the secrets of the grave/This viperous slander enters" (III, iv, 34–41).

483:4 (492:33). sgenl inn ban bata coisde gan capall—garbled Irish for a phrase meaning: "A tale in the top of a stick [a pointless tale] is a horseless coach." See O Hehir, p. 350.

483:9–10 (493:6). Dr Eustace's private asylum—Dr. Henry Eustace, 41 Grafton Street, maintained a private lunatic asylum for gentlemen and ladies in Glasnevin, north of Dublin.

483:17–18 (493:14). more sinned against than sinning—see 351:42–352:1n.

483:20 (493:17). virgo intacta—medical Latin for a virgin with hymen intact.

483:23 (493:20). Hypsospadia should read **hypospadia**—a defect of the genitals.

483:27–28 (493:24–25). the patient's urine ... reflex intermittent—this does not indicate an intimate knowledge of medicine, but vaguely implies kidney infection or insufficiency.

483:30 (493:27). fetor judaicus—Latin: "Jewish stench."

484:4–5 (494:2–3). the Reformed Priests' Protection Society—with offices at 13 D'Olier Street in Dublin. "The primary object of the society is to extend a helping hand to priests of good character, who conscientiously abandon the Church of Rome for the pure faith of the Gospel; and to assist them to employment; also to assist young men originally intended for the priesthood" (*Thom's [1904]*, p. 1389).

484:10 (494:8). Glencree reformatory—see 230:31n.

484:22 (494:21). MRS THORNTON—see 66:13–14n.

484:31 (494:30). Nasodoro—Italian: "Nose of gold."

484:31–32 (494:31). Chrysostomos—see 5:28n.

484:32 (494:31). Maindorée—French: "Hand of gold."

484:32 (494:31). Silberselber—German: "Silverself."

484:32 (494:32). Vifargent—French: "Quicksilver."

484:32–33 (494:32). Panargyros—Greek: "All-silver."

485:2 (495:2). The Messiah ben Joseph or ben David—the Messiah of the House of Joseph, in some Jewish apocalyptic writings, is assigned various roles but principally that of heralding the coming of the Messiah of the House of David. The Messiah ben Joseph is to collect the Israelites together and establish their rule over Jerusalem; he will then be slain by the enemies of Israel, and the Messiah ben David will come as the force of resurrection that gives birth to the new world.

485:4 (495:4). You have said it—in Luke 23:3 Jesus, having been accused by the elders and chief priests of identifying himself as "Christ a King" (the Messiah ben David), is questioned by Pilate: "And Pilate asked him, saying, Art thou the King of the Jews? and he answered him and said, Thou sayest it."

485:5 (495:5). BROTHER BUZZ—see 82:21n.

485:8 (495:8). the Saint Leger—a race for three-year-old colts and fillies run annually in September at Doncaster, England.

485:10 (495:10). Nelson's Pillar—see 94:1n.

485:12 (495:12). king's evil—scrofula; so called because, according to medieval superstition, it was supposed to have been cured by the king's touch.

485:14 (495:14). Lord Beaconsfield—Benjamin Disraeli (1804–1881), English novelist and statesman, was created 1st Earl of Beaconsfield in 1876.

485:14 (495:14). Lord Byron—Molly recalls, 728:38 (743:40), that when he was courting her, Bloom was trying to look like the English romantic poet (and lady-killer) George Gordon, Lord Byron (1778–1824).

485:14 (495:14). Wat Tyler—(d. 1381), the principal leader of the ill-starred English peasant revolt of 1381.

485:14 (495:14). Moses of Egypt—see 140:22n.

485:15 (495:15). Moses Maimonides—see 29:12–13n.

485:15 (495:15). Moses Mendelssohn—see 336:17n.

485:15 (495:15). Henry Irving—(1838–1905), distinguished English actor and theatrical manager, known for the psychological force with which

he projected his roles and famous for the carefully elaborated stage settings of his productions.

485:15–16 (495:15–16). Rip van Winkle—see 370:42n.

485:16 (495:16). Kossuth—Lajos (Louis) Kossuth (1802–1894), Hungarian liberal leader and reformer, a central figure in the Hungarian revolution (1848–1849) and a staunch advocate of political freedom.

485:16 (495:16). Jean Jacques Rousseau—(1712–1778), French philosopher regarded variously as "The Father of Romanticism," of the French Revolution and of modern pedagogy.

485:16–17 (495:16–17). Baron Leopold Rothschild—the Rothschilds were a Jewish family of international bankers. Leopold de Rothschild (1845–1917) was the third son of Baron Lionel de Rothschild (1808–1879), the first Jewish member of the English Parliament.

485:17 (495:17). Robinson Crusoe—the castaway hero of Daniel Defoe's (1660–1731) novel (1719).

485:17 (495:17). Sherlock Holmes—Sir Arthur Conan Doyle's (1859–1930) famous detective made his first appearance in *A Study in Scarlet* (1887).

485:17 (495:17–18). Pasteur—Louis Pasteur (1822–1895), the celebrated French scientist known for his researches in microorganisms and for his practical application of those researches (pasteurization, etc.).

485:18–19 (495:19). bids the tide turn back—a story told of (among others) Canute (*c*.994–1035), king of the English, Danes and Norwegians. He is supposed to have had his throne placed on the seashore and to have commanded the tide to stand still; when it did not, he turned his inability to command the tide into a parable about the humility necessary to a king.

485:19 (495:19–20). eclipses the sun . . . his little finger—see 164:20–21n.

485:20 (495:21). BRINI, PAPAL NUNCIO—see 315:41 (321:24).

485:24 (495:24). Leopoldi autem generatio—Latin, after Matthew 1:18, which begins: "*Christi autem generatio . . .*" ("Now the generation of Christ was on this wise . . . " [Douay]). The nonsense genealogy that follows parodies biblical genealogies, particularly that of Jesus in Matthew 1:1–16.

485:24 (495:24–25). Moses begat Noah—in the genealogy of Noah in Genesis 5, Lamech is the father of Noah. Moses' father is mentioned only as "a man of the house of Levi" (Exodus 2:1).

485:24–25 (495:25). Noah begat Eunuch—the sons of Noah were Shem, Ham and Japheth (Genesis 10:1). If "Eunuch" is punning on "Enoch," then Noah is the father of his own great-grandfather (Genesis 5).

485:25 (495:25). O'Halloran—unknown.

485:26 (495:26). Guggenheim—Meyer Guggenheim (1828–1905), the head of the well-known Philadelphia Jewish family of financiers and philanthropists.

485:26–27 (495:27). Agendath begat Netaim—see 60:12–13n.

485:27 (495:27–28). Le Hirsch—Baron Maurice de Hirsch (1831–1896), Austrian Jewish financier, one of the outstanding philanthropists of his time and deeply concerned about the plight of the Jews in anti-Semitic regions of Europe.

485:28 (495:28). Jesurum—according to Eric Partridge, "a distortion of Jesum, the accusative of Jesus." *Cf.* 387:12n.

485:28 (495:28–29). MacKay—unknown.

485:28–29 (495:29). Ostrolopsky—unknown.

485:29 (495:30). Smerdoz—or "Smerdis," was the talented and promising but luckless brother of King Cambyses of Persia. Cambyses had him put to death in 523 B.C.

485:30 (495:30). Weiss begat Schwartz—i.e., White begat Black (German pun).

485:30 (495:31). Adrianopoli—Adrianople, the modern Edirne, is a city in Turkey.

485:31 (495:31–32). Aranjuez—a city south of Madrid in central Spain.

485:31 (495:32). Lewy Lawson—unknown.

485:32 (495:33). Ichabudonosor—Thornton (p. 384) suggests a combination of "Ichabod" and "Nebuchadnezzar." Both imply the presence of Jewish misfortune. Ichabod (Hebrew: "No Glory") was so named by his mother on her deathbed because "the glory is departed from Israel." The child's father had been killed in a losing cause against the Philistines; the Ark of the Covenant had been taken by the Philistines; and the child's grandfather had died upon receipt of the news (I Samuel 4). Nebuchadnezzar, king of

Babylon, besieged and reduced Jerusalem and carried the Israelites captive into Babylon (II Kings 24–25).

485:33 (495:33). O'Donnell Magnus—i.e., the Great O'Donnell, Hugh Roe or Red Hugh; see 291:35n.

485:33–34 (496:1). Christbaum—the German pun suggests "Christ-tree."

485:34 (496:2). Ben Maimun—the Hebrew suggests "of the house of Maimun" and Thornton suggests "Maimonides." See 29:12–13n.

486:1 (496:2). Dusty Rhodes—see 420:3–4n.

486:1 (496:3). Benamor—this combination of Hebrew "Ben" and Latin "Amor" suggests "Son of Love."

486:2 (496:3–4). Jones-Smith—unknown.

486:2 (496:4). Savorgnanovich—unknown.

486:3 (496:5). Jasperstone—Jasper, symbolic of one of the twelve tribes of Israel, was included among the symbolic stones in the high priest's breastplate, Exodus 28:17–20.

486:4 (496:5). Vingtetunième—French pun: "the twenty-first" (though it is the twenty-seventh generation in this list).

486:4 (496:6). Szombathely—Bloom's father's birthplace, a city in western Hungary near the Austrian border.

486:5–6 (496:7–8). et vocabitur nomen eius Emmanuel—Latin: "and shall call his name Immanuel [God with us]," from Isaiah 7:14: "Therefore the Lord himself shall give you a sign; Behold, a virgin shall conceive, and bear a son, and shall call his name Immanuel."

486:7–8 (496:9–10). A DEADHAND (Writes on the wall.)—a "deadhand" (*mortmain*) is in effect the irreversible hand of ecclesiastical authority. During Belshazzar's "impious feast," the "fingers of a man's hand" appear and write a baffling message on the wall. Daniel interprets the message to mean "God hath numbered thy kingdom and finished it. . . . Thou art weighed in the balances, and art found wanting. . . . Thy kingdom is divided, and given to the Medes and Persians" (Daniel 5:26–28).

486:8 (496:10). a cod—a joker or a fool.

486:10 (496:12). the cattlecreep—cowshed.

486:11 (496:13). Kilbarrack—a road in the village of Baldoyle, which is on the coast seven miles northeast of Dublin.

486:13 (496:15). Ballybough bridge—over the River Tolka in Fairview on the northeastern outskirts of Dublin.

486:14 (496:16). A HOLLYBUSH—see 27:33–38n.

486:15 (496:17). the devil's glen—22 miles south-southeast of Dublin, a picturesque glen one and a half miles long and hemmed in by rugged rock walls that reach 400 feet in height.

486:20 (496:22). Donnybrook fair—see 85:18n.

486:21 (496:23). Sjambok—South African: "to whip with a heavy leather whip."

486:22 (496:24). with asses' ears—in Greek mythology Apollo imposed asses' ears on King Midas because Midas stupidly preferred Pan's music to his.

486:23–24 (496:25–26). Don Giovanni, a cenar teco—see 177:11–12n.

486:24 (496:26). Artane orphans—see 100:30n.

486:25 (496:27). Prison Gate Mission—the Dublin Prison Gate Mission, a Protestant institution "for the purpose of affording employment [in a laundry] and elementary instruction to women and young girls leaving the City Short Sentence Prisons" (*Thom's [1904]*, p. 1372).

486:28–29 (497:2–3). You hig, you hog ... ladies love you!—the source of this street rhyme is unknown.

487:2–5 (497:5–8). If you see kay ... Tell him from me—an acrostic, i.e., F·U·C·K/Tell him he may/C·U·N·T/Tell him from me.

487:6 (497:9). HORNBLOWER—see 85:11n.

487:7 (497:10). ephod—a garment mentioned several times in the Old Testament, associated at times with the high priest, at other times with persons present at religious ceremonies, and in Judges with idolatrous worship. The *ephod* was draped with ornaments that symbolized the *Urim* and *Thummin* (doctrine and faith), the 12 tribes of Israel, etc. To wear the *ephod* was to be prepared for communion with God. See I Kings 23:11 (Douay), when the disposition of David's enemies is revealed to him through the priest's *ephod*.

487:7–8 (497:10–12). And he shall carry ... in the wilderness—Azazel (Hebrew: "dismissal") is the scapegoat (symbolically receiving the sins of the people). In Leviticus 16:8, 10: "And Aaron shall cast lots upon the two goats; one lot for the Lord, and the other lot for the scapegoat. ... But the goat, on which the lot fell to be the scapegoat, shall be presented alive before the Lord, to make an atonement with him, *and* to let him go for a scapegoat into the wilderness."

487:9 (497:12). Lilith—see 383:33n.

487:10 (497:13). Agendath Netaim—see 60:12–13n.

487:10–11 (497:13–14). Mizraim, the land of Ham—"Mizraim," an Old Testament name for upper and lower Egypt. In Psalms 78:51 Egypt is called "the land of Ham," after the "younger" of Noah's three sons, who was "cursed" because he "saw the nakedness of his father" when Noah was drunk (Genesis 9:21–25). In Genesis 10:6 "Mizraim" is listed as one of "the sons of Ham."

487:13 (497:16). bonafide travellers—see 417:7n.

487:15 (497:18). long earlocks—these are a result of the Jewish prohibition against a man's touching his hair with a blade or a razor. Traditionally they are stroked or twirled during prayer and contemplation.

487:17 (497:20). Belial—(Hebrew: literally, "worthless.") The "sons of Belial" are thus the worthless, the wicked or possibly the destructive ones, as in Deuteronomy 13:13. In the New Testament, II Corinthians 6:15 "Belial" becomes a name for Satan.

487:17 (497:20). Laemlein of Istria—in 1502 an obscure Jewish heretic-prophet named Ascher Laemlein appeared in Istria (an Adriatic peninsula south of Trieste) and proclaimed himself in effect the Messiah ben Joseph; see 485:2n.

487:17 (497:20). Abulafia—Abraham Ben Samuel Abulafia (1240–c.1291), a Jew from Saragossa in Spain who proclaimed himself the Messiah and journeyed to Rome, where he attempted to convert Nicholas III (pope, 1277–1280) and barely escaped with his life.

487:18 (497:21). George S. Mesias—see 108:39n.

487:24 (497:27). Iscariot—the surname of Judas, the betrayer of Jesus.

487:24 (497:27). bad shepherd—as Jesus is "the good shepherd" (John 10:14).

487:28 (498:2). The squeak—slang for (1) a criminal who, once arrested, turns informer, (2) a piece of inside information that has been delivered to the police.

487:28 (498:2). a split—slang for a police spy, an informer.

487:29 (498:3). the flatties—slang for uniformed policemen.

487:29 (498:3). Nip—slang for to cheat, to steal; therefore, to catch.

487:29 (498:3). rattler—slang for a horse-drawn cab.

488:1 (498:6). BROTHER BUZZ—see 82:21n.

488:4 (498:9). hands him over to the civil power—heretics were tried (and condemned) by the Church, but the death sentence was carried out by "the civil power."

488:5 (498:10). Forgive him his trespasses—after the Lord's Prayer: "And forgive us our trespasses, as we forgive those who trespass against us." *Cf.* Matthew 6:12 and Luke 11:4.

488:6 (498:11). Lieutenant Myers—John J. Myers, in 1904 commander of the City of Dublin Fire Brigade, 12 Winetavern Street, Dublin.

488:11 (498:16). a seamless garment—at the Crucifixion Jesus' coat is described as "without seam, woven from the top throughout" (John 19:23).

488:11 (498:16). I. H. S.—see 80:16n.

488:12 (498:17). Weep not for me, O daughters of Erin—as Jesus was going to be crucified he said to the women who "bewailed and lamented him": "Daughters of Jerusalem, weep not for me, but weep for yourselves, and for your children" (Luke 23:27–28).

488:17–28 (498:23–499:3). Kidney of Bloom ... pray for us—this parody of a litany (*Cf.* 347:42–348:2n) reviews moments of the episodes in which Bloom has been involved in the course of the day, from [Calypso] through [Circe]; see also 664:32n.

488:23 (498:29). Sweets of Sin—see 232:27n.

488:24 (498:30). Music without Words—see 281:11–12n.

488:28 (499:3). Potato Preservative—see 418:11n.

488:29–30 (499:4–5). Mr Vincent O'Brien—Irish composer and musician, the conductor (1898–1902) of the Palestrina Choir at the Metropolitan pro-Cathedral in Dublin, known for his achievements in the reform of church music and its performance in Irish Roman Catholic churches.

488:30 (499:5). the Alleluia chorus—see 470:21–22n.

488:31 (499:6). Joseph Glynn—see 80:42n.

489:2–4 (499:11–13). (In caubeen with clay ... smile in his eye.)—Bloom's costume is patterned after that of the "stage Irishman" popularized by Dion Boucicault; see 165:19–20n. For "*caubeen*," see 190:7n; "*bogoak*" is a piece of oak that has been preserved in a peat bog; "*sugaun*" is Irish for a rope made of twisted hay or straw. For "*a smile in his eye*," see 291:15n.

489:4–6 (499:13–15). Let me be going ... mother of a bating—the source of this apparent quotation from a stage-Irishman play is unknown.

489:8 (499:17). To be or not to be—see 276:5–6n.

489:26 (500:5). Hog's Norton where the pigs play the organs—Hog's Norton (or Hock-Norton), a village in Leicestershire, "where the organist once upon a time was named Piggs." Partridge dates the story and saying from the sixteenth century.

489:28 (500:7). Tommy Tittlemouse—from the nursery rhyme: "Little Tommy Tittlemouse/Lived in a little house;/He caught fishes/In other men's ditches.//Little Tommy Tittlemouse/Lived in a bell-house;/The bell-house broke/And Tom Tittlemouse awoke."

490:9 (500:19). The greeneyed monster—Iago, dissembling, warns Othello against jealousy, "O, beware, my lord, of jealousy;/It is the green-eyed monster which doth mock/The meat it feeds on" (*Othello*, III, iii, 165–167).

490:15 (500:25). Laughing witch?—from "Matcham's Masterstroke"; see 68:27–28n.

490:15 (500:25). The hand that rocks the cradle—see 283:26–27n.

490:24 (501:7). Love me. Love me not. Love me—after the children's game, when the two formulas "She loves me; she loves me not" are repeated alternately in enumerating the petals of a flower or some other series of objects. The formula that coincides with the last "petal" is, of course, "true."

490:27–28 (501:10–11). her forefinger giving ... secret monitor—for the gesture, see 165:7n. The "*passtouch of secret monitor*" is also a Masonic sign, which warns the recipient that he is in moral or spiritual danger. The background of the sign is the warning with which Jonathan saved David's life in I Samuel 20. The signs Jonathan used were arrows, i.e., forefingers.

490:28 (501:11). Hot hands, cold gizzard—after the proverbial saying "Cold hands, warm heart."

491:12–13 (501:26–27). Don't fall upstairs—superstition: if one falls upstairs, he is entering where he is not welcome or where he will be unlucky.

491:15 (501:29). The just man falls seven times—Proverbs 24:16: "For a just *man* falleth seven times, and riseth up again: but the wicked shall fall into mischief." The traditional assumption is that the just man flirts once with each of the seven cardinal sins: pride, envy, wrath, lust, gluttony, avarice and sloth.

492:28–29 (503:12–13). the series of empty fifths—i.e., the fifth without the third and therefore giving no indication of whether the key is major or minor. The open fifth is characteristic of the medieval and Renaissance tradition of modal music, which was conceived on the basis of what turns out to have been a misunderstanding of the seven modes of ancient Greek music. See 493:16n.

493:12–13 (503:29–30). whether Benedetto Marcello found it or made it—Benedetto Marcello (1686–1739), an Italian composer, particularly noted for his setting of Girolamo Giustiniani's Italian paraphrases of the first 50 Psalms (1724–1726). In his preface to the Psalms Marcello says that he has limited his settings for the most part to two voices so that the words and sentiments would be clear as they were (he argues) in the "unisonous" music of the ancient Hebrews and Greeks, a music that he says had in its simplicity more power to affect the "passions" than "modern" music with its excessive ornament. He qualifies this distinction by saying that what he attempted in his settings of the Psalms was to clothe "Ancient simplicity" in a garb of "modern harmony" so that the settings would not be "offensive" to a "modern" ear. The "it" that Marcello "found . . . or made" is presumably the melody for his setting of the Psalm Stephen mentions. In his preface Marcello says that he visited several Jewish communities in search of examples of "ancient Hebrew" settings of the Psalms; thus, he may have "found" the melody or he may have "made it," but Stephen argues that "it does not matter" because the melody has

the true "ancient flavor." The melody of the setting for the Psalm Stephen mentions does begin with an open fifth and does have the ancient or modal flavor that Stephen discusses.

493:14 (504:1). an old hymn to Demeter—the fifth of the so-called "Homeric Hymns" (*c.* seventh century B.C.). Classical scholars of the late nineteenth century argued: "It seems to have been intended to state the mythical foundation of the Eleusinian Mysteries" (*Harper's Dictionary of Classical Literature and Antiquities* [New York, 1896]). Demeter (mother earth) was a fertility goddess, the Greek goddess of agriculture and of the civilization based upon it.

493:14–15 (504:1–2). Caela enarrant gloriam Domini—Latin: "The heavens declare the glory of the Lord," the opening line of Psalm 19 (Vulgate 18), though Stephen substitutes *Domini* ("of the Lord") for the Vulgate's *Dei* ("of God"). Stephen uses a variant of the Latin name of the Psalm; Marcello's versions were settings of an Italian text.

493:15 (504:2). nodes—in music, the divisions that a plucked or vibrating string makes when it is "stopped" at a given point; e.g., a string stopped at one-fourth of its length will vibrate in four sections and will produce a note a fifth above the note of the open string.

493:16 (504:3). hyperphrygian and mixolydian—"hyperphrygian" is usually spelled "hypophrygian." Modes were the patterned arrangements of ancient Greek music. The modes were descending minor scales with semisteps between the third and fourth, and seventh and eighth degrees. The two modes are as "far apart" as B and the G above in a modern scale; the Greeks assumed that particular modes conformed to or aroused particular emotional responses. Aristotle in the *Poetics,* (VIII:7:1342a29–1342a30) argues that the Lydian mode (and presumably the mixolydian) are "the gentle modes ... suitable to children of tender age and [possessing] the elements both of order and education." The Phrygian (and hypophrygian) modes, on the other hand, are appropriate to "Bacchic frenzy and all similar emotions." The adaptation of the modal theory in medieval music used ascending rather than descending scales and the halftones (semisteps) were not always between the third and fourth, and seventh and eighth degrees; i.e., the scales of the medieval modes could start on tones other than the fundamental; and the position of semisteps would change each time the starting tone was shifted.

493:17 (504:4). Circe's—see p. 372 above.

493:18 (504:5). Ceres'—an ancient Roman goddess of grain and harvest, later identified with the Greek Demeter; see 493:14n.

493:18–19 (504:5–6). David's tip from ... about his almightiness—several of the Psalms, including 19 (see 493:14–15n), bear the heading "To the chief Musician." A "tip from the stable" is a horseracing term for inside and presumably dependable information.

493:19 (504:6–7). Mais, nom de nom—French: "But, by George."

493:20–21 (504:7–8). Jetez la gourme ... jeunesse se passe—French: "Sow the wild oats. Youth must pass away."

493:22 (504:9). your knowledge bump—amateur phrenology, since phrenologists assumed that particular mental faculties were localized in specific regions of the brain and that the strength of a given faculty was evidenced by the prominence of its region of the skull.

493:25 (504:12). Jewgreek is greekjew—see 9:6n.

493:29–30 (504:16–17). Whetstone!—see 208:39–40n.

494:12 (504:31). The Holy City—(1892), a hymn by the English songwriter Frederic Weatherly (1848–1929), music by Stephen Adams: "Last night as I lay asleeping,/There came a dream so fair,/I stood in old Jerusalem/Before the temple there./I heard the children singing,/And even as they sang,/Methought the voice of angels/From Heav'n in answer rang,/Methought the voice of angels/From Heav'n in answer rang,/Jerusalem, Jerusalem,/Lift up your gates and sing,/Hosanna in the Highest,/Hosanna to your King."

494:15 (505:3). God, the sun, Shakespeare—see 210:13–14n.

494:16–18 (505:4–7). having itself traversed ... preconditioned to become—see 210:29–31n. For "noise in the street," see 35:30n.

494:19 (505:7). Ecco!—Latin: "Behold!" In medieval Scholastic argument the word had the effect: "It has been definitively stated."

494:24–25 (505:12–13). he knows more than you have forgotten—an inversion of the saying "He has forgotten more than you'll ever know."

494:28 (505:16). the last day—see 149:15n.

495:6 (505:22). Antichrist—a great antagonist expected to fill the world with wickedness and to

be conquered by Christ at the Second Coming. The Antichrist is mentioned in I John 2:18, 22 and is traditionally identified with the Beast in Revelation (see 429:2n).

495:11–12 (506:2–3). Sea serpent in the royal canal—recalls all the speculation about sea serpents in Loch Ness, Scotland. It also recalls "the great dragon . . . that old serpent, called the Devil, and Satan, which deceiveth the whole world: he was cast out [of heaven] into the earth, and his angels were cast out with him" (Revelation 12:9). The "great dragon" is traditionally associated with the Antichrist. The "royal canal" skirted the northern border of metropolitan Dublin in 1904.

495:15 (506:6). A time, times and half a time —from Revelation 12:13–14. After the "great dragon" or "serpent" is cast out of heaven, ". . . he persecuted the woman which brought forth the man *child*. And to the woman were given two wings of a great eagle, that she might fly into the wilderness, into her place, where she is nourished for a time, and times, and half a time, from the face of the serpent."

495:16 (506:7). Reuben J. Antichrist—the metamorphoses of Reuben J. Dodd; see 93:9n.

495:16 (506:7). wandering jew—see 215:4n.

495:20–21 (506:12). his only son—in Jeremiah 6:26 and Amos 8:10 the apocalyptic visitation of the wrathful judgment of God upon a sinful people is predicted and compared to "mourning, as for an only son." It is notable that Bloom still mourns the death of his only son and that Reuben J. Dodd's son was "saved."

495:24 (506:15). Ally Sloper—a caricature figure of the paterfamilias who presided over a penny illustrated humor-weekly, *Ally Sloper's Half-Holiday*, conducted by Gilbert Dalziel and published in London on Saturdays in the 1880s and 1890s. As drawn by W. F. Thomas, Ally Sloper had bulging eyes, a large, bulbous nose and a spindle-shanked figure. Though obviously a solid member of the middle class, Sloper was represented as constantly embarrassing his family by his bumbling eccentricities and by his predilections for "Friv' girls" and the bottle.

496:1–2 (506:23–24). Il vient! . . . primigène— French: "He comes [is here]! The man who laughs. The primordial man." *L'Homme qui rit* (1869) is a novel by Victor Hugo (1802–1885). The central character in the novel is a boy whose face has been mutilated so that he always appears to be laughing; the novel develops the antithesis between his appearance and fluctuations in the boy's moral state.

496:2–3 (506:25). Sieurs et dames, faites vos jeux!—French: "Gentlemen and ladies, place your bets!," what the croupier at a roulette table says when he starts the wheel.

496:4 (506:26). Les jeux sont faits!—French: "The bets are made!"

496:5 (506:27–28). Rien n'va plus—French: "Nothing more goes," i.e., "No more bets may be placed," since the roulette wheel is slowing down.

496:15–17 (507:5–7). Jerusalem!/Open your gates and sing/Hosanna—see 494:12n.

496:19–20 (507:10). second coming of Elijah —see 149:15n.

496:21 (507:11). from zenith to nadir the End of the World—in "Book the Second" of Blake's *Milton* (1804 ff.) the prophetic vision of a world in apocalyptic ruin is "view'd from Milton's Track" (Plate 38:24). "Five females and the nameless Shadowy Mother,/Spinning it from their bowels with songs of amorous delight/And melting cadences that lure the Sleepers of Beulah down/ . . . into the Dead Sea" (Plate 38:27–30). The result: "Four universes round the Universe of Los remain Chaotic,/Four intersecting Globes, & the Egg form'd World of Los/In midst, stretching from Zenith to Nadir in midst of Chaos" (Plate 38:32–34). Previously one of the songs of Beulah (female creative energy) has celebrated "the happy female joy" (Plate 37:19) and continued " . . . & Thou, O Virgin Babylon, Mother of Whoredoms,/Shalt bring Jerusalem in thine arms in the night watches, and/No longer turning her a wandering Harlot in the streets,/Shalt give her into the arms of God your Lord and Husband" (Plate 37:20–23).

496:21–22 (507:11–12). a twoheaded octopus —see 163:11–13n.

496:23–24 (507:14). the Three Legs of Man— the triskele, three flexed legs joined at the thighs. It is a device of the Irish sea-god Mananaan MacLir (see 39:24n) and it is also the heraldic device of the Isle of Man (see 119:19n).

496:26–27 (507:16–17). Wha'll dance . . . the keel row?—after a Scots song, "Weel May the Keel Row": "Oh, who is like my Johnie,/Sae leish, sae blithe, sae bonnie!/He's foremost 'mang the mony/Keel lads o' coaly Tyne./He'll set or row so tightly,/Or in a dance sae sprightly/He'll cut and shuffle slightly/'Tis true, were he not mine." Chorus: "Weel may the keel row,/The keel row, the keel row/Weel may the keel row,/That my lad's in."

496:31 (507:21). old glory—the American flag.

496:33 (507:23). ELIJAH—*cf.* Elijah II, the Reverend Alexander J. Dowie, 149:16n. See also 149:15n.

496:34 (507:24). Jake Crane—identity or significance unknown.

496:34 (507:24–25). Creole Sue—the title of an American popular song (1898), words and music by Gussie L. Davis.

497:1 (507:25). Dave Campbell, Abe Kirschner—identity and significance unknown.

497:3 (507:27–28). Tell mother you'll be there—after the American popular song "Tell Mother I'll Be There" (1890), by Charles Fillmore, included in *Fillmore's Prohibition Songs* (New York, 1900): "When I was but a little child, how well I recollect,/How I would grieve my mother with my folly and neglect,/And now that she has gone to heav'n, I miss her tender care,/O angels, tell my mother I'll be there." Chorus: "Tell mother I'll be there, in answer to her prayer,/This message, guardian angels, to her bear;/Tell mother I'll be there, heav'n's joys to share,/Yes, tell my darling mother I'll be there."

497:6 (507:31). the second advent—i.e., the Second Coming of Christ; *cf.* 495:6n.

497:6–7 (507:31). Coney Island—in 1904 the most popular seaside resort in the vicinity of New York City.

497:9–10 (507:34–508:1). Be on the side of the angels—Benjamin Disraeli (1804–1881), speaking against Darwin's 1859 theory of evolution before the Oxford Diocescan Society in 1864: "What is the question which is now placed before society, with the glib assurance which to me is astounding? That question is this: is man an ape or an angel? I am on the side of the angels. I repudiate, with ignorance and abhorrence, these new-fangled theories."

497:10 (508:1). Be a prism—Thornton suggests another allusion to Disraeli: in a speech before the House of Commons, 15 February 1849, "A man, always studying the subject, will view the general affairs of the world through the coloured prism of his own atmosphere."

497:12 (508:2). a Gautama—i.e., Gautama Buddha (Buddha of the Gautama family), the great religious teacher and reformer of early India.

497:12 (508:2–3). Ingersoll—Robert Ingersoll (1833–1899), American politician, lawyer, orator

and evangelical agnostic. His "message" was humanistic and scientific (Darwinian) rationalism.

497:12 (508:3). vibration—in occultism, a psychic pulsation felt and shared by the initiate.

497:13 (508:4). nobble—English slang: "catch, seize."

497:18–19 (508:9). A. J. Christ Dowie—see 149:16n.

497:20 (508:10–11). Seventyseven west sixty-ninth street—the context suggests that this is A. J. Dowie's New York City address or an address associated with his mission to New York City, but the city directories we have consulted give no evidence of any such connections, i.e., the address seems to have been fabricated for the dramatic occasion.

497:21 (508:12). Bumboosers—theatrical slang: "desperate drinkers."

497:23, 26 (508:14, 16). Jeru .../... high-hohhhh—see 494:12n.

497:31 (508:21). black in the face—Dowie has metamorphosed into Eugene Stratton; see 90:41n.

498:4 (508:30). twig—slang: "watch, inspect, understand."

498:7 (508:33). Constitution hill—a short (and, in 1904, not very savory) section of the main north–south road in north-central Dublin. It was lined with tenements.

498:8 (508:34). a Montmorency—the De Montmorencys were a noble and fashionable Anglo-Irish family in County Dublin. In 1904 the head of the family was Willoughby John Horace, 4th Viscount Frankfort De Montmorency.

498:13–14 (509:4–5). Hennessy's three stars—an excellent and expensive French Cognac.

498:14 (509:5). Whelan—see 158:31n.

498:17 (509:8). In the beginning was the word—from John 1:1, which continues "and the Word was with God, and the Word was God."

498:17–18 (509:8–9). world without end—see 30:20–24n.

498:18 (509:9). Blessed be the eight beatitudes—in the Sermon on the Mount (Matthew 5:3–11) Jesus pronounces the beatitudes, each of which begins with the phrase "Blessed are ..." Roman Catholic catechisms list eight beatitudes, though the opening formula is repeated nine times in the passage in Matthew.

498:24 (509:15). buybull—puns "Bible" with the slogan "Buy John Bull" (i.e., buy only English goods).

498:24 (509:15). barnum—Phineas Taylor Barnum (1810–1891), American showman, the opportunistic and inventive proprietor of a traveling circus billed as "The Greatest Show on Earth" (1871 *ff.*).

498:28–29 (509:19–20). Seek thou the light—see 191:5–6n.

498:30 (509:21). He corantos by—see 182:14n.

499:6 (509:28–29). A thing of beauty—the opening phrase of Keats's poem *Endymion: A Poetic Romance* (1818): "A thing of beauty is a joy for ever:/Its loveliness increases; it will never/Pass into nothingness."

499:8 (510:1). JOHN EGLINTON—W. K. Magee appears in the guise of Diogenes of Sinope (Diogenes the Cynic, 412–323 B.C.). One of the gestures Diogenes used to dramatize his philosophical doubts was to carry a lighted lantern in broad daylight, ostensibly in search of an honest man.

499:11–12 (510:5). Tanderagee—in 1904 a prosperous small market town in County Armagh, north of Dublin.

499:13 (510:6–7). ollave—see 182:31–33n.

499:14 (510:7). Mananaan MacLir—AE (George Russell) has metamorphosed into the figure of the Irish god of the sea, the legendary ancestor of the Isle of Man; see 39:24n. Oliver St. John Gogarty says that AE appeared as Mananaan when the Druid Cathvah invoked Mananaan MacLir that the sea may rise and cut off the flight of Deirdre and her love, Naisi, in AE's play *Deirdre* (written in 1901, first performed in 1902, published Dublin, 1907) (*As I Was Going Down Sackville Street* [New York, 1937], p. 292). But John Eglinton, in *A Memoir of AE* (London, 1937), p. 54, says that AE's "mellow northern accent was heard behind the scenes intoning the prophecies of Cathvah the Druid" during the play's first performance. For Mananaan MacLir, see also 187:14–16n.

499:21 (510:14). Aum! Hek! Wal! Ak! Lub! Mor! Ma!—in *The Candle of Vision* (London, 1918) AE developed the mystical significance of the "roots of human speech" (p. 120), in two chapters, "The Language of the Gods" and "Ancient Intuitions." The first two words in this series are not given as examples by AE, though his discussion of "the sound correspondences of powers which in their combination and inter-action make up the universe" (p. 120) suggests that "Aum," composed of the roots A and M, would mean "A, the sound symbol for the self in man and Deity in the cosmos. Its form equivalent is the circle ..." (p. 121), and "M ... is the close, limit, measure, end or death of things" (p. 125); thus, the syllable *Aum* is "the beginning and the end." It is also a variant spelling of the Sanskrit "Om," a word believed to have magical powers and regarded as especially sacred by Hindus and by Western occultists. "Hek": "H is the sound correspondence of Heat" (p. 121); E, "where consciousness ... has become passional" (p. 126); and K "is the symbol ... of mineral, rock crystal or hardness of any kind" (p. 122). "Wal": "if the fire acting on the water made it boil, they [the intuitive ancients] would instinctively combine the sound equivalents of water and fire, and 'Wal' would be the symbol" (p. 130). "Ak": "would be to cut or pierce" (p. 130). "Lub" would be "the sound symbol ... if the fire of life was kindled in the body to generate its kind" (p. 130). "Mor" would be said "if they saw death and felt it as the stillness or ending of motion or breath" (pp. 129–130). "'Ma' would ... mean to measure, and as to think a thing is to measure it, 'Ma' would also come to be associated with thinking" (p. 130). In effect, Joyce has ordered AE's syllables in such a way as to suggest the sequence of sexual intercourse, appropriate since AE has transformed Mananaan MacLir in *The Candle of Vision*: "In the beginning was the boundless Lir, an infinite depth, an invisible divinity, neither dark nor light, in whom were all things past and to be" (p. 153).

499:22 (510:15). White yoghin of the Gods—a "yoghin" is a person adept in Yoga (the development of the powers latent in man for achieving union with the Divine Spirit). The whole phrase refers to the *alba petra*, the white stone or white carnelian, "the stone of initiation, on which the word '*prize*' is generally found engraved, as it was given to the candidate who had successfully passed through all the preliminary trials of a neophyte" (H. P. Blavatsky, *Isis Unveiled*, II, 351).

499:22–23 (510:15–16). Occult pimander of Hermes Trismegistos—Hermes Trismegistos Poemandro (Hermes the Thrice-Great Poet of Man), the Greek elision of the Greek god Hermes with the Egyptian Thoth; see 191:27–28n. Hermes Trismegistos was mythically reputed to have been the author of a 42-book encyclopedia of occult lore, and fragments of his work are an important presence in theosophical and hermetic studies.

499:23–24 (510:16–17). Punarjanam patsypunjaub—apart from the obvious puns, source and significance unknown.

499:25 (510:18). beware the left, the cult of Shakti—"Shakti" in Hinduism is the female generative energy in the universe; and the female is the left hand as the male is the right. The cult of Shakti (Shaktism) is one of the three great divisions of modern Hinduism; the other two are Shaivism (the worship of Shiva) and Vaishnavism (the worship of Vishnu). Shakti is usually worshiped as the wife of a male deity, particularly of Shiva.

499:26 (510:19). Shiva! Dark hidden Father!—in Hinduism Shiva, the Destroyer, the ultimate ascetic, is worshiped as the destroyer of the earthly prison that holds man's soul in bondage. In the cult of Shiva the universe is regarded as a play of appearance, a form that Shiva assumes.

499:29 (510:22). Aum! Baum! Pyjaum!—for "Aum," see 499:21n; source and significance of "Baum" and "Pyjaum" unknown.

499:29–30 (510:22–23). I am the light ... creamery butter—a parody of the Hindu prayer quoted 183:31–32 (185:32). It also echoes Jesus' assertion: "I am the light of the world: he that followeth me shall not walk in darkness, but shall have the light of life" (John 8:12). AE was, of course, editor of the *Irish Homestead,* which had a lively interest in the improvement of Irish dairy production. See 36:19n.

499:31 (510:24). A skeleton judashand strangles the light—the hand of Judas has betrayed Jesus," the light of the world."

500:18 (511:14). (Makes sheep's eyes.)—i.e., in affectation of her innocence she makes her eyes look large and soft.

500:18–19 (511:14–15). Would you suck a lemon?—see 439:3n.

500:25 (511:21). Lipoti Virag—"Leopold" Virag, Bloom's grandfather.

500:25 (511:21–22). basilicogrammate—"king of letters," or as Adams suggests (p. 139), "a lord of language."

500:29 (511:25). a roll of parchment—in Flaubert's *The Temptation of Saint Antony,* Chapter III, Antony's former disciple, Hilarion, enters to participate in the riot of torment that Antony is experiencing. Upon his first appearance in Chapter III Hilarion "grasps in his hand a roll of papyrus" (p. 40). Antony quickly perceives that Hilarion "knows everything" and Hilarion responds, "Learn, too, that I have never left you. But you spend long intervals without perceiving me" (p. 41).

500:30 (511:26–27). Cashel Boyle ... Tisdall Farrell—see 157:13–14n.

500:31 (511:27–28). an Egyptian pshent—or "pschent," the double crown of Egypt, combining that of Upper Egypt (a high conical white cap surmounted by a knob) with the red crown of lower Egypt outermost.

500:34–501:1 (511:30–31). Szombathely—see 486:4n.

501:7 (512:4). Granpapachi—Yiddish: "Grandfather."

501:10–11 (512:7–8). our tribal elixir of gopherwood—gopherwood is the unidentified wood with which Noah built the ark. "Make thee an ark of gopher wood; rooms shalt thou make in the ark, and shalt pitch it within and without with pitch" (Genesis 6:14).

501:24 (512:21). Never put on you tomorrow what you can wear today—after the proverb "Never put off until tomorrow what you can do today."

501:24 (512:21–22). Parallax!—see 152:4n.

501:25–26 (512:22–23). (With a nervous twitch ... brain go snap?—Stuart Gilbert (p. 332n): "One of Mrs. Piper's frequent remarks when 'coming out' of trance was, 'Did you hear something snap in my head?' and nervous twitching accompanied the process." Mrs. Leonora Piper, a spiritualist "medium" from Boston, Massachusetts, was the subject of extensive experiment and investigation from 1896 until World War I by the British Society for Psychical Research. Mrs. Piper's fame rested in part on the fact that many members of that more or less skeptical Society thought that Mrs. Piper's experiences were valid confirmations of "the spiritistic theory" (i.e., of spiritualism).

501:33 (512:30). Lily of the alley—elides three songs: "Lily of the Valley" (1886), by L. Wolfe Gilbert and Anatol Friedland; another (1904) by George Cooper and Louis Tocaben; and "Sally in Our Alley," by Henry Carey. The Gilbert and Friedland "ditty": "Lily, Lily of the valley,/ Dearie, dearie let's be pally/Sweetie, you're the nicest flower of the lot./Be my Lily, oh be my Lily—/I'll be your forget-me-not." The first stanza of "Sally in Our Alley": "Of all the girls that are so smart/There's none like pretty Sally;/ She is the darling of my heart,/And she lives in our alley./There is no lady in the land/Is half so sweet as Sally,/She is the darling of my heart,/And she lives in our alley."

501:33–502:1 (512:31). bachelor's button discovered by Rualdus Colombus—i.e., the clitoris, of which the anatomist Rualdus Columbus (1516–1559) supposed himself to have been the discoverer.

502:1 (512:31–32). Tumble her—see 189:5n.

502:2 (512:32). Columble her—literally, "make her into a dove."

502:5 (513:3–4). What ho, she bumps!—the title of a music-hall song by Harry Castling and A. J. Mills. Chorus: "She began to bump a bit/Oh, she made a tremendous hit/When she kicked our villain in the threep'ny pit;/The actors guyed as she took running jumps,/And a boy in the gallery cried, 'Encore!'/What ho! she bumps."

502:5–6 (513:4). The ugly duckling—the title of a story by Hans Christian Andersen (1805–1875); the ugly duckling grows up to be a swan and thus outshines his duckling associates.

502:6 (513:4). longcasted—long-legged.

502:6 (513:5). deep in keel—having big buttocks.

502:8 (513:7). When you come out without your gun—after the proverbial "What things [or ducks] you see when you come out without your gun."

502:11–12 (513:10–11). How happy could you be with either . . .—in Act II of John Gay's (1685–1732) *The Beggar's Opera* (1728) Macheath sings, "How happy I could be with either,/Were t'other dear charmer away!/But while ye thus teaze me together,/To neither a word will I say."

502:24–25 (513:23–24). When coopfattened . . . elephantine size—geese are cooped in small cages and overfed to produce oversized livers for *pâté de foie gras.*

502:25–26 (513:24–25). fennygreek and gumbenjamin—i.e., "fenugreek and benzoin," but what the combination is supposed to do is unknown.

502:28–29 (513:28). Fleshhotpots of Egypt—see 42:30n.

502:29 (513:28–29). Lycopodium—Lycopodium powder has various uses; among others, it is used in treatment of excoriations of the skin.

502:30 (513:29). Slapbang! There he goes again—after a music-hall song, "Slap Bang! Here We Are Again" (1866), by one Sheridan. First verse and chorus: "Long live our British Gentlemen/Who like a bit of sport,/Who smoke their weed and swig their stout/And won't have Gladstone's port!" Chorus: "For they always go a-rolling home,/They always go a-rolling home,/A jolly lot are they!/Tra, la la, Tra la la./Slap bang, here we are again,/Slap bang, here we are again,/A jolly lot are we!"

502:34 (514:2). Contact with a goldring—common superstition: contact with a gold ring would cure a sore eye.

502:34–503:1 (514:2–3). Argumentum ad feminam—Latin: literally, "Argument to the woman," after *Argumentum ad hominem,* in logic, the fallacy of trying to refute an idea by discrediting the man who expresses it.

503:2 (514:4). Diplodocus and Ichthyosaurus—neither Greeks nor Romans, but dinosaurs.

503:3 (514:5). Eve's sovereign remedy—unknown.

503:3–4 (514:6). Huguenot—means literally "oath companion."

503:6–7 (514:9). Wheatenmeal with honey and nutmeg—is obviously a recipe for cookies and not the cure for warts that Virag is asking Bloom to remember.

503:9 (514:11). Wheatenmeal with lycopodium and syllabax—is a nonsense remedy composed by free association of 502:29 (513:28–29) and 501:26 (512:23).

503:16 (514:18). mnemotechnic—the art of memory, mnemonics.

503:16–17 (514:18–19). La causa è santa. Tara. Tara—see 166:2–4n.

503:19 (514:21). Rosemary—symbolic of remembrance in the language of herbs.

503:20–21 (514:22–23). The touch of a deadhand cures—superstition: the touch of a dead man's hand was regarded as a cure for warts and other blemishes of the skin.

503:26 (514:28). melancholy of muriatic—muriatic acid, in the nineteenth century the name for commercial forms of hydrochloric acid (incidentally, regarded as an effective suicide potion).

503:26 (514:28). priapic pulsatilla—the European pasqueflower, *Anemone pulsatilla;* the pungent essential oil of the crushed plant was believed to be an aphrodisiac.

503:27–28 (514:29–31). amputation. Our old . . . under the denned neck—another treatment

for warts: dry them out with applications of a caustic compound and then amputate them with a loop of horsehair. "Denned" in anatomy means a cavity or hollow.

503:29 (514:31). the Bulgar and the Basque—traditional costumes of Bulgar and Basque women include close-fitting trousers worn under wide-skirted and belted coats or dresses.

503:32 (514:34–515:1). the religious problem—the impact of Darwinian evolution and absolute scientism had produced considerable skepticism about the claims of revealed religion in the late nineteenth century.

503:33–34 (515:1–2). to square the circle and win that million—one of the great mathematical problems of antiquity was the attempt to "square the circle," i.e., to transform a circle into a square so that its area could be determined. The classical tools of elementary Euclidian geometry (the straight-edge and the compass) could not, as calculus was later to demonstrate, perform this operation; but the problem continued to have its devotees (much like the problem of perfecting a perpetual-motion machine).

503:34 (515:2). Pomegranate!—the pomegranate has a various background in mythology. In some forms of the Adonis myth, that fertility god is said to have been conceived when his mother swallowed a pomegranate seed and/or the pomegranate was supposed to have sprung out of the hanged god's blood. On the other hand, the pomegranate had a special status in ancient Hebrew rites. It "was the only fruit allowed to be brought inside the Holy of Holies—miniature pomegranates were sewn on the High Priest's robes when he made his yearly entry" (Robert Graves, *The White Goddess* [New York, 1948], p. 221).

503:34–35 (515:2–3). From the sublime to the ridiculous is but a step—in this form the remark is attributed to Napoleon on the occasion of his 1812 almost victory–disastrous defeat in Russia.

504:2 (515:5). camiknickers—i.e., culottes, divided skirts.

504:11–12 (515:16–17). lured by the smell—this "unscientific" generalization echoes Darwin's emphasis on "the instinctive recognition by smell for the choice of a suitable mate" (*On the Origin of Species* [New York, 1869], p. 414). Darwin was speaking of mammals, not insects.

504:14–18 (515:19–23). They had a proverb ... choice malt vinegar—Virag elaborates the proverb "Honey will draw more flies than vine-gar." The Jewish year 5550 corresponds to 1789 A.D.

504:21–23 (515:26–28). these night insects ... complex unadjustable eye—i.e., the eyes of many night insects have no way of adjusting to compensate for variations in the intensity of light; therefore they appear to be drawn toward light because they can in effect see nothing else when a strong light source is present.

504:24–25 (515:30). Doctor L. B—Bloom's namesake, the Dublin dentist? See 331:31n.

504:27–28 (515:33). Chase me, Charley!—a common Edwardian music-hall expression of female high spirits.

504:28 (515:33). Buzz!—see 187:33n.

504:35 (516:4). Bubbly jock!—Scots slang: "Turkey!"

505:1 (516:5). Open Sesame!—see 302:13n.

505:4 (516:8). Redbank oysters—see 172:24–25n.

505:6 (516:10). the truffles of Perigord—truffles were also regarded as aphrodisiac.

505:9–10 (516:13–14). Jocular. With my eyeglass in my ocular—in Gilbert and Sullivan's *Patience* (1881) Bunthorne blusters to Jane about his bohemian poet-rival: "I'll tell him that unless he will consent to be more jocular—/To cut his curly hair, and stick an eyeglass in his ocular,/To stuff his conversation full of quibble and quiddity,/To dine on chops and roly poly pudding with avidity,/He'd better clear away with all convenient rapidity" (II, 6).

505:14 (516:18). Eve and the serpent contradict—i.e., in Genesis Eve is not afraid of the serpent when he approaches to seduce her. But Bloom forgets the traditional assumption that the serpent which approached Eve was erect until *after* the seduction, when he is condemned: "upon thy belly shalt thou go" (Genesis 3:14).

505:15–16 (516:19–20). Serpents too are gluttons for woman's milk—we have found no source for this bit of folklore, but it may be that Bloom is free-associating about the asp at Cleopatra's breast: "Dost thou not see my baby at my breast/That sucks the nurse asleep?" *Antony and Cleopatra*, V, ii, 308–309.

505:18 (516:22). Elephantuliasis—Bloom's confusion of elephantiasis with Elephantis, a Greek writer of erotica generally supposed to have been a woman. Her poems were quite famous; the

Roman emperor Tiberius (B.C. 42–37 A.D.) is supposed to have kept them by his bedside as a how-to-do-it-book "so that," as Pliny remarks, "he would not lack any precepts."

505:28 (516:31). Instinct rules the world—*cf.* 283:26–27n.

505:32 (516:35). Who's dear Gerald?—see 524:34–525:4 (536:32–537:2).

506:3–9 (517:6–12). I'm a tiny tiny ... on the wing! Bing!—source unknown.

506:15–16 (517:18–19). Jacob's pipe—see 406:22n.

506:19–20 (517:23). Mario, prince of Candai—see 116:29n.

506:23–24 (517:28). There is a flower that bloometh—see 352:9n.

506:29–31 (517:33–35). Filling my belly ... and go to my—in the parable of the prodigal son (Luke 15:13–32) the son is described as having "wasted his substance with riotous living," to the point where "he would fain have filled his belly with the husks that the swine did eat: and no man gave unto him. And when he came to himself, he said ... I will arise and go to my father, and will say unto him, Father, I have sinned against heaven and before thee." Contrary to conventional expectations, the prodigal is not turned away but is welcomed as one who "was dead, and is alive again."

507:4 (518:9). Ci rifletta. Lei rovina tutto—Italian: "Think about it. Your complete ruin."

507:6 (518:11). Love's old sweet song—see 63:24–25n.

507:9 (518:14). the letter about the lute—a letter that Stephen has written to Arnold Dolmetsch; see 646:4n.

507:11 (518:16). That bird that can sing and won't sing—the proverb ends "must be made to sing."

507:12 (518:17). Philip Drunk and Philip Sober—to appeal "from Philip Drunk to Philip Sober" is to ask reconsideration of a matter that has been decided in haste and on impulse. The saying comes from the story of the woman who, upon receiving a bad judgment from Philip of Macedon when he was drunk, appealed to him sober and had the initial judgment reversed.

507:14 (518:19). Matthew Arnold's face—see 9:22n and 9:6n.

507:18–19 (518:23–24). if youth but knew—see 31:19n.

507:19 (518:24). Mooney's en ville, Mooney's sur mer—see 258:34n and 142:14n.

507:19 (518:24). the Moira—the Moira House and Tavern, a pub on the corner of Trinity Street and Dame Lane in central Dublin south of the Liffey.

507:19 (518:25). Larchet's—Larchet's Hotel and Restaurant, 11 College Green, just east of Moira House. The Moira and Larchet's not only add two more pubs to Stephen's day but also suggest that he has done some pub-crawling on his way from the bookstalls in [Wandering Rocks] at three-plus P.M. to the National Maternity hospital at ten-minus P.M.

507:20 (518:25). Burke's—see 415:33n.

507:25 (519:1). Zoe mou sas agapo—Greek: "My life, I love you," the epigraph and refrain of Byron's lyric "Maid of Athens, Ere We Part" (1810, 1812). First stanza: "Maid of Athens, ere we part,/Give, oh give me back my heart!/Or, since that has left my breast,/Keep it now, and take the rest!/Hear my vow before I go,/*Zoe mou sas agapo.*"

507:26 (519:2). Atkinson—see 213:15n.

507:27–28 (519:4). Swinburne—see 7:1–2n.

508:2 (519:8). Spirit is willing but the flesh is weak—in Matthew 26:40–41 Jesus reproves his disciples for falling asleep while he is praying in the garden of Gethsemane: "What, could ye not watch with me one hour? Watch and pray, that ye enter not into temptation: the spirit indeed is willing, but the flesh *is* weak."

508:4 (519:10). Maynooth—the Royal College of St. Patrick (founded in 1795), for the education of young men destined for the Roman Catholic priesthood, was located in the town of Maynooth 15 miles west-northwest of Dublin.

508:17 (519:23). Fall of man—i.e., contrary to the usual interpretation of Genesis 3, that the fall of man was a function of disobedience of a divine command, Virag treats the fall as literally a fall through sexual experience.

508:18–19 (519:24–25). Nothing new under the sun—Ecclesiastes 1:9: "The thing that hath been, it *is that* which shall be; and that which is done *is* that which shall be done: and *there is* no new *thing* under the sun."

508:20 (519:26). Why I left the Church of Rome—see 178:3n.

508:20–21 (519:27). the Priest, the Woman and the Confessional—(London, 1874), by Charles Pascal Telesphore Chiniquy; see 178:3n. The book had gone through 24 editions by 1883. Its central and prudish argument was that for women the experience of confession (opening "the secret recesses and sacred mysteries of their souls" to a man) was potentially corrupting.

508:21 (519:27). Penrose—see 153:39–40 (156: 3) and 179:6 (181:32).

508:21 (519:27–28). Flipperty Jippert—in *King Lear,* during the storm on the heath, Edgar, disguised as the madman Poor Tom, "mistakes" his father, Gloucester, for "the foul fiend Flibbertigibbet" (III, iv, 120), one of the minor agents of the Prince of Darkness.

508:22 (519:29). pudor—modesty, chastity, bashfulness.

508:26 –27 (520:1). Coactus volui—Latin: "I consented [or willed it] under compulsion."

508:28 (520:3). spucks—spits.

508:29 (520:3–4). yadgana—rump.

508:32 (520:7). a penance. Nine glorias—an unlikely "penance" for the sin suggested; the "gloria" or Angelic Hymn is Luke 2:14: "Glory to God in the highest, and on earth peace, good will toward men."

508:33 (520:8). shooting a bishop—or "making a bishop" is slang for sexual intercourse with the woman in the supreme position.

509:3 (520:11). A dry rush—slang for sexual intercourse without emission (or, as in this case, without intromission).

509:12 (520:20). mooncalf—a monster or a dolt, what Caliban is repeatedly called in *The Tempest;* see 8:31n.

509:13 (520:21). Verfluchte Goim!—Yiddish: "Cursed Gentiles."

509:13 (520:21). He had a father, forty fathers—in Flaubert's *The Temptation of Saint Antony* (pp. 62–63) Antony is plagued by a group of Heresiarchs who shout conflicting beliefs about the nature and origin of Jesus.

509:14 (520:22). Pig God!—source unknown.

509:14 (520:22). He had two left feet—one of the illustrations of the Virgin and Child in the *Book of Kells* depicts the Christ child with two left feet, the Virgin with two right feet. To "have

two left feet" is slang for being bumbling and inept.

509:14–15 (520:22–23). Judas Iacchias—the Cainites, an obscure sect of Gnostic heretics in the second century A.D., claimed to have a "Gospel of Judas," which inverted the Christian order (Judas became hero; Jesus, villain). Iacchias, i.e., Bacchus in the Eleusinian mysteries, was (as the sacrificial fertility god) elided with Judas by the Cainites (and with Jesus by other inventive Heresiarchs). The Cainites and their "Gospel" are mentioned in *The Temptation of Saint Antony,* pp. 60–61, 64.

509:15 (520:23). a Lybian eunuch—we wonder if this shouldn't be **a Lydian eunuch** because then the epithet would fit the second-century Montanus, a convert from the cult of the earth mother Cybele (in whose worship he was castrated). He came from Phrygia-Lydia in Asia Minor and styled himself "the Paraclete" (*cf.* John 14:16) and claimed that divine revelation had not stopped with the Crucifixion and Resurrection. He was, of course, excluded as a heretic. He appears to Antony in *The Temptation of Saint Antony,* pp. 58–60.

509:15 (520:23). the pope's bastard—the source for this speculation is unknown.

509:17–18 (520:25–26). A son of a whore. Apocalypse—i.e., Jesus was not Christ but the Antichrist, associated with the Scarlet Woman, 482:22n, and the forerunner of the Apocalypse described in Revelation; see 495:6n.

509:20 (520:28). in the lock—i.e., in the Westmoreland National Lock Hospital, a hospital for the treatment of venereal diseases on Townsend Street in Dublin.

509:21 (520:29). the blue caps—the field caps of the Royal Dublin Fusiliers; see 71:35–36n.

509:25–27 (521:2–4). Qui vous a mis ... le sacré pigeon—see 42:12–13n.

510:4–5 (521:10–11). Metchnikoff inoculated anthropoid apes—Ilya Metchnikoff (1845–1916), a Russian embryologist and cytologist, director of the Pasteur Institute (1895 *ff.*), Nobel Prize (1908); he was famous for his demonstrations of the close relation between animal and human physiology. In 1904 he succeeded in infecting anthropoid apes with syphilis by inoculation.

510:11 (521:17). Three wise virgins—see 143:24n.

510:14–15 (521:20–21). She sold lovephiltres ... the Roman centurion—Origen in *Contra*

Celsum (I:32) refutes Celsus' (second century A.D.) anti-Christian argument that a Roman soldier named Panther fathered Jesus on Mary. In *The Temptation of Saint Antony* (p. 63) "a Jew, with red beard, and his skin spotted with leprosy" mocks Antony, "his mother, the woman who sold perfumes, surrendered herself to Pantherus, a Roman soldier, under the corn sheaves, one harvest everning."

510:17 (521:23–24). He burst her tympanum —one medieval Scholastic tradition held that since Mary was impregnated by the Word (see 498:17n) she was impregnated through the tympanum of her ear. *Cf.* 266:3–4(270:13–14)n.

510:25 (522:2). Nakkering—see 253:13n.

510:26 (522:3). When love absorbs my ardent soul—see 252:21–22n.

510:30 (522:8). Ben MacChree!—see 203:8n.

511:7–8 (522:15–16). When first I saw ... — see 252:26n.

511:13 (522:22). Dreck!—Yiddish: "trash, junk, shit."

511:16 (522:25–26). his wild harp slung behind him—see 258:40n.

511:21 (523:2). K. II—see 479:2n.

511:21 (523:2). Dr Hy Franks—see 151:30 (153:33).

511:23 (523:4). All is lost now—see 252:24n.

511:30–512:1 (523:12). the fighting parson who founded the protestant error—i.e., Martin Luther (1483–1546); but "the fighting parson" was also a nickname of William Gannaway Brownlow (1805–1877), an American carpenter turned Methodist turned journalist. Pro-slavery but anti-secession, he was expelled from the South during the Civil War; after the war he returned to Tennessee to become its governor and subsequently one of its U.S. senators.

512:1–2 (523:13). Antisthenes, the dog sage— see 147:5n. Antisthenes and his sect were called "Cynics," after the Cynosarges Gymnasium, where Antisthenes taught. The Greek word *kynikos* means doglike, a term appropriate not so much to Antisthenes as it was to later generations of his sect, noted not for their adherence to virtue but for their insolent contempt of all human customs and values.

512:2–3 (523:13–14). the last end of Arius ... in the closet—see 22:29n and 39:16–18n.

512:13 (523:24). Cardinal sin—the seven cardinal sins are pride, wrath, envy, lust, gluttony, avarice and sloth.

512:13 (523:24). Monks of the screw—an eighteenth-century society of Irish lawyers, statesmen and intellectuals that also called itself the "Order of Saint Patrick." The society met in its "Convent" in Dublin or in "The Priory" near John Philpot Curran's (see 137:26–27n) country seat since he was prior. The affectation of monkish habits was apparently a way of lending the spice of "violation" to the society's pursuit of pleasure. *Cf.* the first and third stanzas of Curran's "The Monks of the Screw": "When Saint Patrick our order created/And called us the Monks of the Screw,/Good rules he revealed to our abbot,/To guide us in what we should do." Third stanza: "My children, be chaste—till you're tempted—/While sober, be wise and discreet:/And humble your bodies with fasting—/ Whene'er you have nothing to eat."

512:24–27 (524:10–13). Conservio lies, captured ... upwards of three tons—Adams says that this "was one of John Joyce's favorite recitations" (p. 74); but the source of the recitation is unknown.

513:1–6 (524:18–23). O, the poor little fellow ... duckloving drake—an adaptation of the second stanza of "Nell Flaherty's Drake," an Irish ballad: "His neck was green—most rare to be seen,/He was fit for a queen of the highest degree;/His body was white—and would you delight—/He was plump, fat and heavy, and brisk as a bee./The dear little fellow, his legs they were yellow,/He would fly like a swallow, and dive like a hake,/But some wicked savage, to grease his white cabbage,/Has murdered Nell Flaherty's beautiful drake."

513:14 (524:31). the Easter kiss—the exchange of kisses is a solemnity in the High Mass, often associated with Easter since a number of priests are necessary to its performance. The acolytes are often included in the solemnity and quite often are embarrassed into giggles.

513:19–22 (525:3–6). Shall carry my heart ... heart to thee—see 154:3n.

514:17 (526:4). the bazaar—the Mirus bazaar; see "Section 19," p. 230 above.

514:18–19 (526:5–6). the viceroy was there with his lady—see 248:16n.

514:19 (526:6). gas—slang for excitement, pleasure.

514:19 (526:6). Toft's hobbyhorses—a merry-go-round at the Mirus bazaar. It was one of the pieces of equipment in a large traveling amusement park owned for generations by the Toft family of Cork.

514:22 (526:9). Svengali's—Svengali is the arch-villain of George DuMaurier's (1834–1896) novel *Trilby* (1894). Svengali, a repulsive but musically gifted Austrian Jew, establishes a hypnotic hold over the beautiful Parisian laundress and model, Trilby. She is transformed into a great and famous singer under Svengali's influence; when Svengali dies, Trilby loses her voice but regains her warmth and humanity.

514:22–23 (526:9–10). with folded arms and Napoleonic forelock—the stern and forbidding pose characteristic in portraits of Napoleon.

514:25–26 (526:12–13). the sign of past master —i.e., Bloom identifies himself as the master of a Masonic lodge since the title Past Master is conferred on a Master Mason as he assumes the duties of the chair. Only a past master can legally initiate, pass or raise the members of a lodge.

515:5–6 (526:24–25). Aphrodisiac? But I thought it. Vanilla calms or?—Bloom tries to recall whether chocolate was regarded as an aphrodisiac; it was, since cocoa and its derivatives are mild stimulants. As for vanilla, "it calms" because, as another mild stimulant, it was thought useful in the treatment of nervous disorders.

515:11 (526:30). Try truffles at Andrews—i.e., assuming truffles to be an aphrodisiac. Andrews and Company, a fashionable grocer and liquor merchant, 19–22 Dame Street, Dublin.

515:15 (527:4). Minnie Hauck in Carmen— Minnie Hauck (1852–1929), an American dramatic soprano who enjoyed a considerable reputation in Europe in the 1870s and 1880s, particularly in the title role of George Bizet's (1838–1875) opera *Carmen* (1875). The opera portrays the gypsy Carmen as a strong, ruthless and capricious woman whose love is potentially destructive.

515:16 (527:5). keeper rings—or guard rings, to keep a valuable ring, especially a wedding ring, safely on a finger.

516:14–15 (528:7–8). Powerful being ... slumber which women love—in Leopold von Sacher-Masoch's *Venus in Furs* the heroine, Wanda, repeatedly remarks on the dreaming (or slumbrous) look in Severin's (the hero) eyes, and he repeatedly treats her to epithets of the "powerful being" sort. See 458:8n. In the hallucination that follows, Bloom plays the part of Severin, Bella, that of a masculinized Wanda; in addition,

the sequence is informed by Krafft-Ebing's discussion of masochism (Krafft-Ebing's coinage from Sacher-Masoch's name) in *Psychopathia Sexualis;* references in the notes below are to the 1937 Brooklyn (New York) edition. Krafft-Ebing's discussion and his case histories assume impotence to be a recurrent factor in masochism; Krafft-Ebing also develops implicit relations between masochism and foot-fetishism, clothes-fetishism and coprophilia, all of which take form in Bloom's hallucinations.

516:21–22 (528:14–15). extra regulation fee —when the post office was closed, a letter could be posted for an extra fee in a railroad station. The sender chose the railroad station logically related to the letter's destination, and the letter was forwarded without having to be processed through the originating post office.

516:22 (528:15). the too late box—a mailbox in front of the General Post Office in Dublin provided for those who wanted their letters canceled on a given day but who arrived after the post office had closed for that day.

516:24–25 (528:17–18). a draught of thirty-two feet ... of falling bodies—air currents do not, of course, follow that law; see 71:10n.

516:29 (528:22–23). king David and the Sunamite—I Kings 1:1–4: "Now king David was old *and* stricken in years; and they covered him with clothes, but he gat no heat. Wherefore his servants said unto him, Let there be sought for my Lord the king a young virgin . . . and [they] found Abishag a Shunamite, and brought her to the king. And the damsel *was* very fair, and cherished the king, and ministered to him: but the king knew her not."

516:30 (528:23). Athos—see 89:18n.

516:30 (528:24). A dog's spittle—was assumed to carry rabies; i.e., Bloom is attempting to explain his father's death as caused by rabies rather than by self-administered poison.

517:2 (528:26). Mocking is catch—proverbial: "Mocking is catching."

517:18 (529:14). black knot—a fast or hard knot.

517:19 (529:15). served my time—i.e., as an apprentice.

517:20 (529:16). Kellet's—David Kellett, general draper, milliner, etc., 19–21 Great St. George's Street South, Dublin.

517:20 (529:16). Every knot says a lot— proverbial because the way a person ties a knot

and the knot tied are supposed to reveal character much as handwriting does. The modern proverb and the belief it reflects have their roots in the ancient ritual use of knots as codes; for example, the Gordian knot, which Alexander the Great "cut," was apparently an elaborately encoded series of mystical propositions.

517:27 (529:23). Mansfield's—Mansfield and Sons, one of Dublin's more fashionable boot and shoe makers, 78 and 79 Grafton Street.

517:27–28 (529:23–24). my love's young dream—after Thomas Moore's song "Love's Young Dream." The first of the poem's three stanzas: "Oh! the days are gone, when Beauty bright/My heart's chain wove;/When my dream of life, from morn till night/Was love, still love./New hope may bloom,/And days may come,/Of milder, calmer beam,/But there's nothing half so sweet in life/As love's young dream." Repeat. Krafft-Ebing (pp. 173–176) provides two notable case histories of masochists whose foot-fetishism leads them to haunt woman's shoe stores, etc. As Krafft-Ebing puts it: "One of the most frequent forms of fetishism is that in which the female foot or shoe is the fetish. . . . The majority . . . of the cases of shoe fetishism rests upon a basis of more or less conscious masochistic desire for self-humiliation" (p. 172).

517:30 (529:26). Clyde Road ladies—Clyde Road was in a fashionable upper-middle-class Anglo-Irish residential area south-southeast of metropolitan Dublin.

518:1 (529:27). their wax model Raymonde—unknown.

518:8 (530:4). If you bungle ... football for you—Handy Andy is the bumbling antihero of Samuel Lover's 1842 novel of that name. Handy Andy's elaborate career of malfunction climaxes when his noble birth is revealed and he takes his place in the peerage as Lord Scatterbrain. Bella's (or The Hoof's) threat is a coarse rugby-field version of the way Wanda in *Venus in Furs* threatens Gregor (Severin, her lover, after he has become her "slave").

518:11 (530:7). tache—archaic: "that by which something is attached, a clasp."

518:18–19 (530:14–15). Awaiting your further orders, we remain, gentlemen—a conventional ending for a business letter. It also is characteristic of Gregor's (Severin enslaved) stance in relation to Wanda in *Venus in Furs*.

518:21 (530:17). basilisk—see 192:10–11n.

518:26–27 (530:22–23). Adorer of the adulter-ous rump—Krafft-Ebing cites "*oscula ad nates*" ("rump kissing") as a mild form of coprophilia (one of the symptoms of extreme masochism) (p. 194).

519:4 (530:27). Dungdevourer!—Krafft-Ebing (pp. 193–194) cites several instances of this sort of coprophilia, which he regards as the ultimate in masochistic self-degradation.

519:13–14 (531:10–11). on all fours, grunting, snuffling, rooting—i.e., Bella has transformed Bloom into a pig as Circe transformed Odysseus' men into swine; see p. 372 above.

519:16 (531:13). the attitude of most excellent master—in Freemasonry, during part of the ceremony of "raising" (i.e., elevating a lodge member to Master Mason), some forms of the ritual dictate that the individual lie prone as evidence of his humility.

519:21–22 (531:18–19). places his heel on her neck—at the beginning of *Venus in Furs* the narrator, to whom Severin's story is about to be revealed, has a dream in which Venus visits him; she mocks him by saying that "as a rule" the man's neck will be under the foot of the woman (p. 17), as Severin is later to say he longs to be "the slave of a pitiless tyrant who treads us pitilessly underfoot" (p. 27). Krafft-Ebing (pp. 185 and 172–176) cites several cases in which masochistic fantasies and practices involve being trod upon.

519:26 (531:23). I promise never to disobey—since Bloom has assumed a Masonic "attitude," this could be taken as part of the apprentice Mason's oath of initiation since in that oath he would promise not to reveal the secret (see 593:8–9n) and would also promise absolute obedience to his master in Masonry. In *Venus in Furs* (pp. 90–91) Severin signs the "agreement" that makes him Wanda's servant-slave, Gregor; the "agreement," of course, involves a similar promise.

519:28–29 (531:25–26). You little know what's in store for you—Wanda repeatedly makes similar remarks to Severin in *Venus in Furs* since she recognizes that his desire for subjugation is "romantic dreaming" even as she herself is being transformed into the "pitiless tyrant" whom Severin has "romantically" desired.

519:29 (531:26–27). and break you in—at the climax of *Venus in Furs* Wanda takes a Greek "lion" as a lover and abandons Severin; just before she abandons him, she betrays him into the ultimate cure of his masochistic fantasies by turning him over to the Greek to be whipped; as the Greek (with pleasure) accepts his role, he says, "Now watch me break him in" (p. 137).

519:30 (531:27). Kentucky cocktails—what cocktails were called in the British Isles, since they, like Bourbon, were regarded as an American invention.

520:25–27 (532:21–23). The nosering, the pliers ... Nubian slave of old—the "agreement" that Severin signs to formalize his role as Wanda's "slave" in *Venus in Furs* contains the stipulation: "Wanda is entitled not only to punish her slave as she deems best ... but also is herewith given the right to torture him as the mood may seize her or merely for the sake of whiling away the time" (p. 90). "Nubian slave" suggests absolute slavery since Nubia was the heart of Arab slave-trading territory from the fourteenth century until the beginning of the twentieth century.

520:29–30 (532:25–26). I shall sit on your ottomansaddleback—in his discussion of masochism (pp. 152–154), Krafft-Ebing cites the case history of an impotent man whose primary mode of sexual gratification was to be ridden as though he were a horse; while being ridden, he liked to be treated "without consideration."

521:1 (532:27). Matterson's—Matterson and Sons, general commission agents, victualers and butter stores, 12 Hawkins Street, Dublin.

521:2–3 (532:29). Stock Exchange cigar—unknown.

521:3 (532:29–30). Licensed Victualler's Gazette—a twopenny weekly trade newspaper, published in London. Catering to "licensed houses" (hotels, bars, etc.), it included "literary features" in the effort to broaden its advertising base by appealing to the victualers' customers as well as to the victualers themselves.

521:8 (533:3). turning turtle—i.e., turning upside down (as a capsized ship with its bottom up); figuratively, becoming cowardly.

521:23 (533:18). Hold him down, girls, till I squat on him—in *Venus in Furs* Wanda has three Negro maids who bind Severin so that she can whip him (p. 92) or yoke him to a plow for her "amusement" (p. 102). Krafft-Ebing (pp. 137–138) includes the case history of a masochist who got his kicks by having women sit on his face.

522:11–12 (534:7–8). Keating Clay ... the Richmond Asylum—the *Evening Telegraph*, Thursday, 16 June 1904, p. 4, reports Richard Jones was reelected as chairman and that Robert Keating Clay, a Dublin solicitor, was reelected as deputy chairman. For the Richmond Asylum, see 8:14n.

522:12–13 (534:8–9). Guinness's preference shares are at sixteen three quarters—"Guinness ... Preference shares maintained previous value, $16\frac{11}{16}$" (*Evening Telegraph*, p. 4).

522:14 (534:10). Craig and Gardner—Craig, Gardner and Company, chartered accountants, 40–41 Dame Street, Dublin.

522:16 (534:12). Throwaway—see 408:20–25n and 84:28n.

522:22 (534:18). a figged fist—i.e., a fist "in fine form"; Krafft-Ebing (pp. 140, 145) cites case histories of two masochists who preferred "powerful women with big fists."

522:24–25 (534:21). A cockhorse to Banbury cross—from a nursery rhyme usually said in accompaniment to a child's riding on an adult's knee (or a wooden horse). "Ride a cock-horse to Banbury Cross,/To see an old [or fine] lady upon a white horse;/Rings on her fingers and bells on her toes,/She shall have music wherever she goes." For "Banbury," see 151:5n; a "cockhorse" is a child's hobby horse.

522:25 (534:21). the Eclipse stakes—to be run on 16 July 1904 in Sandown Park on the Isle of Wight.

522:28 (534:24). cockhorse—i.e., astride; see 520:29–30n.

522:28–30 (534:24–26). The lady goes a pace ... gallop a gallop—one among many versions of a nursery rhyme that accompanies a child being ridden in a sequence of different styles on an adult's knee.

523:3 (534:32). suckeress—i.e., bloodsucker, leech.

523:9 (535:6). farts loudly—see 519:4n.

523:10 (535:7). by Jingo—this mild oath picked up overtones of excessive chauvinism when "jingo" became the nickname for a supporter of Lord Beaconsfield's aggressive action of sending a British fleet to Turkish waters to oppose a Russian advance in 1878. This sense of the word was derived from a popular music-hall song. Chorus: "We don't want to fight, but by jingo if we do,/We've got the ships, We've got the men, We've got the money too."

523:10 (535:7). sixteen three quarters—see 522:12–13n.

523:15–17 (535:12–14). No more blow hot ... thing under the yoke—*Venus in Furs*: Wanda repeatedly accuses Severin of vacillating in his "supersensual" desire to be her slave and in his

willingness to be subjugated, humiliated and injured. She also (and with increasing intensity) taunts him by pointing out that the treatment he is getting and the pain he is suffering are his romantic wishes come true. At one point (p. 102), Wanda has her three Negro maids yoke Severin-Gregor to a plow.

523:25 (535:22). As they are now, so will you be—see 112:23n.

523:29 (535:26). coutille—a close-woven soft canvas used for mattresses, pillows and in stays or corsets.

524:1 (535:30). Alice—repetition suggests an allusion to Lewis Carroll's (Charles L. Dodgson 1832–1898) heroine Alice in *Alice's Adventures in Wonderland* (1865) and *Through the Looking-Glass* (1872): both focus on the elaborate metamorphoses that the heroine and her world undergo.

524:2–3 (535:31–536:1). Martha and Mary—see 78:4n.

524:7 (536:5). A charming soubrette—see 226:15–16 (229:23–24).

524:8–9 (536:6–7). I tried her things on—Krafft-Ebing in his discussion of fetishism (which he links closely with masochism) cites several cases of otherwise heterosexual men who seek sexual gratification by dressing up in women's clothes and creating "beautiful women in imagination" (p. 251). One of the cases went in for corsets because masochistically he enjoyed "the pain of tight lacing" (p. 253).

524:18–19 (536:16–17). Mrs Miriam Dandrade ... Shelbourne Hotel—see 158 (160) and 158:28n.

524:26 (536:24). Lieutenant Smythe-Smythe—the coinage is appropriate since Smythe was a military name of some repute in 1904.

524:26–27 (536:24–25). Mr Philip Augustus Blockwell, M.P—fictional.

524:27 (536:25). Signor Laci Daremo—see *Là ci darem*, 63:24n.

524:28–29 (536:26–27). Henry Fleury of Gordon Bennett fame—Henry Fleury, no doubt one of Henry Flower's pseudonyms; see 420:19n and 96:6n.

524:29 (536:27). Sheridan, the quadroon Croesus—Croesus, king of Lydia in the sixth century B.C., the type of the infinitely wealthy man. "Sheridan": unknown.

524:29 (536:27–28). wetbob—a boy at Eton who devotes himself to boating.

524:30 (536:28). old Trinity—Trinity College, Dublin.

524:31 (536:29). Bobs, dowager duchess of Manorhamilton—Manorhamilton is a village in County Leitrim on the west coast of Ireland; "Bobs" is apparently fictional.

525:2 (536:34). Vice Versa—(1882), a play by the English writer Thomas Anstey Guthrie (1856–1934; pseudonym: Francis Anstey). The central theme of the farce is father against son.

525:2–4 (536:34–537:2). He got that kink ... gilds his eyelids—Krafft-Ebing reports the case of a transvestite who got his start by trying on his sister's "chemise" (pp. 251–252).

525:16 (537:14). a jinkleman—a trickster, a cheat.

525:17 (537:15). the ass of the Doran's—after "Doran's Ass," an Irish ballad about one Paddy Doyle, who, drunk, mistakes Doran's ass for his sweetheart, Biddy Tool, and makes love to the ass. He comes to in a state of fright and runs to Biddy in time for the last stanza: "He told her his story mighty civil/While she prepared a whiskey glass:/How he hugged and smugged the hairy divil,/'Go long,' says she, ' 'twas Doran's Ass!'/'I know it was, my Biddy darling.'/ They both got married the very next day,/But he never got back his ould straw-hat/That the jackass ate up on the way."

525:22–23 (537:20–21). the Black Church—St. Mary's Chapel of Ease (Church of Ireland), so called because it was built of black Dublin stone. It is in Mountjoy Street in north-central Dublin, not far south of Bloom's home in Eccles Street. Legend had it that a person who circled the church three times would meet the devil.

525:23–24 (537:21–22). Miss Dunn at an address in d'Olier street—two possibilities: (1) Dunn's of 26 D'Olier Street was a fashionable shop (poulterer and fishmonger, game and venison dealer); (2) Boylan's secretary is named Miss Dunne, 226 (229), and though the address of his office is not given, there was The Advertising Company, Ltd., bill posters and advertising agents at 15 D'Olier Street across from the Red Bank Restaurant, where Boylan is seen 91 (92).

525:30 (537:28). vitriol works—Dublin Vitriol Works Company, 17 Ballybough Road, on the northeastern outskirts of metropolitan Dublin.

525:34–35 (537:32–33). a nasty harlot, stimulated by gingerbread—Krafft-Ebing cites the case of a similarly inclined Russian prince who "supported a mistress in unusually brilliant style, with the condition that she ate marchpane exclusively" (p. 193).

526:6 (538:6). Poldy Kock—see 64:30n.

526:6 (538:6). Bootlaces a penny—see 92:12 (93:17).

526:7 (538:6–7). Cassidy's hag—see 61:9 (61:15).

526:7 (538:7). Larry Rhinoceros—a pun on "Larry O'Rourke"; see 57:38n; "rhino" is slang for money.

526:10 (538:10). Pleasants street—see 60:34–35n.

526:24 (538:24). Mistress!—what Severin (as the slave-servant Gregor) is required to call Wanda in *Venus in Furs*.

526:31 (539:2). With this ring I thee own—after the traditional line in the marriage service, "With this ring I thee wed." See 434:28n.

527:8–9 (539:12). Miss Ruby—see 64:17n.

527:17 (539:21). on the turf—can be taken to mean that Marsh is in horseracing, but it is also slang for "in business as a prostitute."

527:18 (539:21). Charles Alberta Marsh—identity or significance unknown, except, as Adams suggests (p. 213), that he has a feminine middle name.

527:19–20 (539:22–23). the Hanaper and Petty Bag office—in the Chancery Division of His Majesty's High Court of Justice in Ireland; its chief duties were secretarial to the lord chancellor.

528:2 (540:6). Two bar—two shillings.

528:3 (540:7). Fourteen hands high—as a horse is measured: four feet eight inches.

528:14 (540:19). the Caliph Haroun Al Raschid—see 47:40n.

528:21 (540:26). four inch Louis XV heels—Louis XV of France (1710–1774; king, 1715–1774). Toward the end of his reign women's dresses were shortened to ankle length and high-heeled shoes became the fashion, though not quite so perversely high as four inches. Excessively high Louis XV heels were popularized

during the Second Empire in France in the late 1860s.

528:22 (540:27). the Grecian bend—a name for the stooped carriage with buttocks angled into prominence that became high fashion (partly as a result of excessively high heels) in France in the late 1860s.

528:24 (540:29). Gomorrahan vices—the inhabitants of Sodom and Gomorrah (see 61:6–7n) are characterized in Genesis as indulging in unnatural sexual practices.

528:31 (541:4). Manx cat!—a tailless cat from the Isle of Man.

528:32 (541:5). curly teapot—slang for penis (Partridge).

528:33 (541:6). cockyolly—a pet name for a small bird.

529:1 (541:7). doing his pooly—urinating.

529:6 ff. (541:12 ff.). I wouldn't hurt your feelings . . .—toward the end of *Venus in Furs* Wanda, having met the man she "needs" in her leonine Greek lover, similarly, but far less crudely, taunts her fawning slave-lover Severin.

529:9 (541:15). muff—a foolish, silly person; in athletics, a clumsy person; a failure.

529:21 (541:27). lame duck—a defaulter.

529:28–29 (542:3–4). in Sleepy Hollow your night of twenty years—elides two stories by Washington Irving; see 370:42n and 371:4n.

529:32 (542:7). Rip Van Winkle!—in Irving's story is a ne'er-do-well plagued by a nagging wife; he beats frequent retreats by going on small hunting expeditions in the Catskills. During the one on which the story focuses he is surprised by, among other things, a twenty-year sleep. He returns to his village to find his wife dead and himself virtually forgotten.

530:11 (542:18). simply swirling—see 62:30n.

530:17 (542:24). Aunt Hegarty's—Bloom's great-aunt on his mother's side.

530:19 (542:26). The Cuckoo's Rest—see 210:9–10n.

530:22–23 (542:29–30). Sauce for the goose, my gander, O—see 275:12–13n.

530:27 (543:4). the Brusselette carpet—an inexpensive imitation of Brussels carpet.

530:28 (543:5). Wren's auction—see 98:8n.

530:30 (543:7–8). art for art's sake—a rallying cry for late-nineteenth-century esthetes, characteristic of the reaction against the Victorian demand for moral realism in art. Oscar Wilde's stance was popularly regarded as a prototype of this anti-Victorian position.

530:34 (543:11). Hampton Leedom's—Hampton Leedom and Company, wax and tallow chandlers, hardware, delft and china merchants, 50 Henry Street, Dublin.

531:5 (543:16). Swear!—in *Hamlet*, as Hamlet attempts to swear Horatio and his companions to secrecy, the Ghost (in the "cellerage") repeatedly says, "Swear" (I, v).

531:10 (543:21). secondbest bed—see 200:38–201:3n.

531:10–11 (543:21–22). Your epitaph is written—see 286:3n.

531:18–19 (543:29–544:1). I can give you ... to hell and back—at the end of Book X in *The Odyssey* Odysseus begs Circe to let him leave to continue his homeward voyage. She tells him, much to his distress, that he must first visit the land of the dead. He argues that no living man has ever visited that land, and she responds with directions for the voyage and for the sacrifices that will make the voyage successful; the latter include "sweet milk and honey, then sweet wine and last clear water."

531:29 (544:11). My will power! Memory!—Krafft-Ebing in his case histories of masochism repeatedly cites loss of will power and memory as a result of this "disease."

531:29–30 (544:11–12). I have sinned I have suff—see 80:16–17 (81:20–21).

532:4 (544:17). The passing bell—a tolling bell to announce that a soul has passed or is passing from its body; the sound was to invoke prayers for the dying.

532:5 (544:18). the circumcised—i.e., they are Jews.

532:5 (544:18). sackcloth and ashes—the traditional costume for mourning.

532:5–6 (544:19). the wailing wall—the last remnant of the Temple of Solomon as rebuilt by Herod and destroyed by the Romans, Friday, 9 August 70 A.D.; it is thus the one remaining fragment of the holiest of Jewish sanctuaries and is particularly revered as a place for mourning and lamentation not just for personal loss but for the collective loss suffered by all Jews.

532:6–8 (544:19–22). M. Shulomowitz ... Leopold Abramowitz—"neighbors" of Bloom when Bloom lived in Lombard Street West. Incidentally, in 1904 a Mr. J. Bloom lived at 38 Lombard Street West. M. Shulomowitz was librarian of the Jewish library at 57 Lombard Street West; Joseph Goldwater lived at 77 Lombard Street West; for Moses Herzog, see 287:19n; for J. Citron, see 60:28–29n; Minnie Watchman: a Morris Watchman lived at 39 Lombard Street West; for O. Mastiansky, see 60:29n. The Reverend Leopold Abramowitz, a Dublin rabbi, lived at 3 St. Kevin's Road, three blocks south of Lombard Street West.

532:8 (544:22). Chazen—the cantor in a Jewish synagogue.

532:12 (544:25). dead sea fruit—a common metaphor for hollow and unsatisfactory pleasures, after the apple of Sodom, which does grow near the Dead Sea; it is beautiful in appearance but bitter to the taste.

532:13 (544:26). Shema Israel ... Adonai Echad—see 121:22n; the *Shema* is ritually pronounced by or for a dying Jew.

532:20 (544:33). a nymph—see 64:42 (65:11).

532:22 (545:2). interlacing yews—the yew tree is traditionally associated with death and mourning.

532:32 (545:12). highkickers—dancers who, like can-can girls, showed their legs.

532:32–533:1 (545:12–13). coster picnic makers—costermongers.

533:1 (545:13). panto boys—pantomime performers.

533:2–3 (545:14–15). La Aurora and Karini—unknown.

533:6 (545:18). transparencies—a piece of transparent material with a picture or design that is visible when light shines through it.

533:6 (545:18). truedup dice—i.e., dice that were geometrically perfect and therefore presumably "honest."

533:6–7 (545:18–19). proprietary articles—manufactured articles that some person or persons has the exclusive right to make and sell.

533:15–17 (545:27–29). Professor Wald-mann's wonderful ... Rubin with photo—unknown.

533:19 (546:2). Photo Bits—see 65:1n.

533:27–28 (546:10–11). a thing of beauty—see 499:6n.

534:2 (546:17). Steel wine—wine, usually sherry, in which steel filings have stood for a considerable time; regarded as a medicine.

534:6 (546:21). Frailty, thy name is marriage—see 320:10n.

535:2 (547:18). Poulaphouca—a scenic water-fall on the upper Liffey, 20 miles southwest of Dublin. It is named after Phouka (Puck), a mischievous Celtic sprite allegedly trapped in a rock by St. Nessan.

535:9 (547:25). Irish National Forester's—see 321:14n.

535:23 (548:12). the old Royal stairs—see 268:14n.

535:25–26 (548:14–15). the heat. There were sunspots that summer—since the Old Royal Theatre was destroyed by fire in 1880, the sunspot activity would have to have been in the late 1870s. There was an outstanding minimum of sunspot activity in 1878 and no maximum after 1870 before 1883. Sunspot maximums were superstitiously supposed to account for eccentric behavior; *cf.* 164:23–24n.

535:26 (548:15). tipsycake—a cake saturated with wine or spirits, stuck with almonds and served with custard.

535:28–30 (548:18–20). Master Donald Turn-bull ... Percy Apjohn—Bloom's schoolmates at the Erasmus Smith High School in Harcourt Street; all, except Apjohn, lived near the school. In 1904 Donald Turnbull lived at 53 Harcourt Street; Abraham Chatterton (b. 1862), educated Erasmus Smith and Trinity College, Dublin, in 1904 was registrar and bursar of Erasmus Smith (Adams, p. 213); for Owen Goldberg, see 160:3–4n; John W. Meredith, 97 Haddington Road; for Percy Apjohn, see 160:3n.

535:33 (548:23). Mackerel!—see 160:5n.

536:4 (548:28). Montague street—a block north of the Erasmus Smith High School off Harcourt Street.

536:24 (549:17). The flowers that bloom in the spring—in Act II of Gilbert and Sullivan's *The Mikado* (1885) Nanki-Poo sings: "The flowers that bloom in the spring,/Tra la,/Breathe promise of merry sunshine—/As we merrily dance and we sing,/Tra la,/We welcome the hope that they bring,/Tra la,/Of a summer of roses and wine." Ko-ko, in duet, answers: "The flowers that bloom in the spring,/Tra la,/Have nothing to do with the case./I've got to take under my wing,/Tra la,/A most unattractive old thing,/Tra la,/With a caricature of a face."

536:25 (549:18). Capillary attraction—the apparent attraction between a solid and a liquid caused by capillarity.

536:25–26 (549:18–19). Lotty Clarke—apart from the context, identity or significance unknown.

536:28 (549:21). Rialto Bridge—over the Grand Canal on the western outskirts of metro-politan Dublin.

537:1 (549:25). Staggering Bob—see 168:33n.

537:8 (550:4). Ben Howth—see 173:22–24n.

537:15–16 (550:11–12). Thirty two head over heels per second—see 71:10n.

537:16 (550:12). Giddy Elijah—see 339:14–16n.

537:17 (550:13). government printer's clerk—i.e., Bloom, who is imagining the newspaper account of his death. Bloom was for a time "clerk" in Alexander Thom's, "printers to his Majesty."

537:19 (550:15). the Lion's Head cliff—see 173:22–24n.

537:22–23 (550:19–20). Bailey and Kish lights the Erin's King—the Bailey Lighthouse is on the Hill of Howth; the Kish Lightship is anchored on Kish Bank off Dublin Bay; for "the Erin's King," see 66:32n.

537:27–31 (550:24–28). When my country takes ... written. I have ... Done—see 286:3n.

538:9 (551:10). quassia—an intensely bitter drug made from the wood of certain tropical American trees and used as a tonic.

538:11 (551:11). Hamilton Long's—see 82:38n.

538:16 (551:16). Peccavi!—Latin: "I have sinned!"

538:18–19 (551:18–19). the hand that rules—see 283:26–27n.

539:4 (552:6). Ware Sitting Bull!—i.e., beware of the Sioux Indian chief (1834–1890), one of whose exploits was the annihilation of General Custer and his forces at the battle of the Little Big Horn in 1876.

539:17 (552:19). in nun's white habit, coif and huge winged wimple—the habit of a Carmelite nun.

539:18 (552:20). Tranquilla convent. Sister Agatha—see 152:40–41n and 361:37n.

539:19 (552:21). Mount Carmel—in ancient Palestine, associated with Elijah (I Kings 18: 17–39) and Elisha (II Kings 2:25). It was in a fertile region and was regarded by Old Testament prophets as blessed of God. The Carmelite Order was founded there in 1156; see 153:4n.

539:19 (552:21). the apparitions of Knock and Lourdes—see 80:7–8n and 80:8n.

539:25 (552:27). the Coombe—a street in the run-down area called the Liberties in south-central Dublin.

539:28–31 (553:2–5). O Leopold lost ... To keep it up—see 77:33–36 (78:38–41).

540:13–14 (553:19). an elected knight of nine—i.e., one of the Knights Templars (emblem: a red cross on a white field). The order was founded by nine knights in 1118 to protect pilgrims on their way to the Holy Land; it was suppressed in 1312, in part because it had become all too worldly and in part because it was a disruptive political power. The Freemasons regard themselves as the heirs apparent of the Knights Templars.

540:14 (553:19). Nekum!—unknown.

540:16 (553:21). Nebrakada!—see 239:19–20n.

540:16–17 (553:21). Cat of nine lives!—combines "cat of nine tails" with the proverbial "Every cat has nine lives."

540:17–18 (553:22). The fox and the grapes—the title of one of Aesop's fables. The fox, hungry and thirsty, leaps at the grapes but is unable to reach them. He decides that he didn't want them anyway since they were probably sour.

540:18 (553:23). your barbed wire—see 153: 10–11n.

540:20 (553:25). Brophy, the lame gardener—apart from the context, identity or significance unknown.

540:20–21 (553:25–26). statue of the water-carrier—Aquarius, the eleventh sign of the Zodiac, is the water bearer or water carrier.

540:21 (553:26). good Mother Alphonsus—Alphonsus is the Latin form of the masculine name "Alphonso." Earlier in the day Bloom, speculating on the meaning of George Russell's initials "AE," had thought of "Alphonsus" as one possibility, 163:20 (165:34). The joke, of course, is that Mother Alphonsus is male, not female. There was a Monastery of St. Alphonsus (Church and Monastery of the Redemptoristines) in St. Alphonsus Road, Fairview, the Reverend Sister Mary Stanislaus, superioress (1904).

540:21 (553:26). Reynard—the fox in the medieval beast epic *Reynard the Fox.*

540:28–29 (554:2). pay on the nail—i.e., pay promptly and in cash.

540:29 (554:2). You fee men dancers on the Riviera—i.e., Bloom has been reading "scandal" about wealthy women who hire gigolos at fashionable international resorts.

541:2 (554:9). You'll know me the next time—Wanda in *Venus in Furs* repeatedly pleads with Severin to stop fawning on her and to assert his manhood; instead, he intensifies his masochistic infatuation. Finally Wanda asserts her supremacy: " 'Now play has come to an end between us,' she said with heartless coldness. 'Now we will begin in dead earnest. You fool, I laugh at you and despise you; you who in your insane infatuation have given yourself as plaything to *me*, the frivolous and capricious woman. You are no longer the man I love, but *my slave*, at my mercy even unto life and death.

" 'You shall know me!' " (p. 93).

541:18 (554:25). Dead cod!—i.e., incapable of sexual intercourse since "cod" is slang for the scrotum.

541:20 (554:27). kipkeeper! Pox and gleet vendor!—slang: "Brothelkeeper! Vendor of venereal disease [pox] and a morbid discharge from the urethra [gleet]."

541:22–23 (555:2–3). the dead march from Saul—see 96:12n.

541:25 (555:5). Mind your cornflowers—punning slang for tread warily: so that you don't step on the flowers and/or so that your toes (corns) aren't stepped on.

541:26–27 (555:6–7). The cat's ramble through the slag—a trick piano routine, essentially tuneless and not unlike "Chopsticks."

542:4 (555:15). Forfeits—occur in a variety of children's games in which penalties are exacted for mistakes in ritual.

542:8–11 (555:19–22). Give a thing ... send you down below—the Opies in *The Language and Lore of Schoolchildren* (p. 133) cite an almost identical verse from Laurencetown, County Galway. It occurs in children's games that involve rituals of giving or swapping.

542:15 (555:26). To have or not to have, that is the question—after the opening line of Hamlet's famous soliloquy, "To be, or not to be: that is the question" (III, i, 56).

543:1–2 (556:14–15). Dans ce bordel où tenons nostre état—French: "In this brothel where we hold our 'court,'" a variation of the refrain (*En ce bordeau où ...*) of François Villon's (1431–c.1463) *Ballade de la Grosse Margot* ("Ballad of Fat Margot").

543:12–13 (556:26–27). brevi manu—Italian: "shorthanded" or "shortchanged."

543:27–28 (557:12–13). drink ... it's long after eleven—i.e., it's long after the closing time of the pubs; something of a joke since many Dublin brothels served drinks as a way of attracting after-hours clients.

543:31 (557:16). What, eleven? A riddle—see 27:33–38n.

544:14–18 (558:2–6). The fox crew ... get out of heaven—see 27:33–38n.

544:24 (558:12). slyboots—an apparently simple but actually subtle or shrewd person.

544:26 (558:15). a drawwell—a well from which water is drawn by means of a bucket, rope and pulley.

545:4 (558:21). Le distrait or absentminded beggar—see 185:12–14n and 185:19n.

545:10 (558:27). Lucifer—the trade name of a friction match invented and marketed in England in 1827; subsequently a generic name for all friction matches. See 51:13–14n.

545:20 (559:10). Proparoxyton—in Greek, a word having an acute accent on the second syllable from the last.

545:20–21 (559:10–11). Moment before the next Lessing says—Lessing in his *Laokoon* (1766) attempted to distinguish between poetry and the plastic arts. One of these distinctions involves the "moment" (what Lessing called the

Augenblick, the "blink of an eye"). The plastic artist chooses a single moment from the endless series of moments that is the natural world; the chosen moment cannot, however, simply record the transitory, it must imply a continuing action, the moment, the climax, the fulfillment to follow. The poet, on the other hand, faces the problem of describing consecutive actions, and so, for him, the "moment" in his medium (words) is different.

545:21 (559:11). Thirsty fox—see 540:17–18n.

545:21–22 (559:11–12). Burying his grandmother—see 27:33–38n.

546:15 (560:3). Sixteen years ago—Stephen recalls that 16 years before, he had broken his glasses when he was a child at Clongowes Wood College; see *A Portrait of the Artist as a Young Man*, Chapter I.

546:17 (560:5). Ineluctable modality of the visible—see 38:1n.

546:18 (560:6). Sphinx—in Oscar Wilde's poem "The Sphinx" (1894) the Sphinx is addressed as "exquisite grotesque! half woman and half animal!" (line 12). The speaker of the poem questions the enigmatic and unanswering Sphinx about her prodigal and grotesque love life; he finally rejects her as the creature of a "songless, tongueless ghost of sin" (line 163) and because "You wake in me each bestial sense, you make me what I would not be" (line 168).

546:18 (560:6). The beast that has two backs—see 138:2–3n.

546:26 (560:14). Lamb of London, who takest away the sins of our world—after John 1:29: "The next day John [the Baptist] seeth Jesus coming unto him, and saith, Behold the Lamb of God, which taketh away the sins of the world." The sentence "Behold ... world" is the basis of the *Agnus Dei;* see next note.

546:28–29 (560:16–17). Dona nobis pacem—Latin: "Give us peace," the concluding phrase of the *Agnus Dei* (Lamb of God), which is sung or recited during the rites of Communion in the Mass.

547:8 (560:27). the bloodoath in the Dusk of the Gods—i.e., in Wagner's opera *Die Götterdämmerung* (1876) the last of the four-opera cycle *Der Ring des Nibelungen* (The Ring of the Nibelungen). In the first act of *Die Götterdämmerung* the villain, Hagen, devises an elaborate plot to bring about the downfall of the gods. With a magic potion he makes the hero Siegfried forget Brunhilde, his true love, and the ring, his mission. Siegfried is manipulated so that he falls in love

with Gutrune, Hagen's half-sister, and promises to woo Brunhilde for Gutrune's brother, Gunther. Gunther and Siegfried seal the compact with a blood oath of friendship, and, with the help of considerable Wagnerian plot elaboration, the doom of the gods is sealed.

547:9–11 (560:28–30). Hangende Hunger ... Macht uns alle kaput—German: "Intense desire, questioning wife, destroys us all." In Act I of Wagner's *Die Walküre* (the second of the four operas of the *Ring*) Siegmund arrives at the house of Hunding, whose wife is Siegmund's lost sister, Sieglinde. Brother and sister are eventually to elope and become Siegfried's parents, but first Sieglinde asks why Siegmund's name is "Woeful"; as he answers he calls her "Fragende Frau" and recounts the story of his life of woe, which incidentally reveals him as the enemy of her husband, Hunding.

547:13 (561:2). Hamlet, I am thy father's gimlet!—see 150:36–37n.

547:15 (561:4). No wit, no wrinkles—popular superstition: an unwrinkled brow signifies lack of intelligence.

547:15–16 (561:4–5). Two, three, Mars, that's courage—palmistry reads traits of character by the prominence of the various "mounts" on the hand; however, among handbooks on palmistry there is anything but universal agreement. Most texts do agree, however, in locating one Mount of Mars below the Mount of Mercury (which is at the base of the little finger) and above the Mount of the Moon, which is at the heel of the hand. If the Mount of Mars is prominent, it is usually read as indicating courage and resolution. But Zoe counts, "Two, three, Mars," and it is not clear what her point of departure is: if she counts from the base of the thumb (1) to the Mount of the Moon (2), then Mars would be next (3); but if she counts from the base of the index finger (1), middle finger (2), ring finger (3), then she has confused the Mount of Apollo (a love of the beautiful and noble aspirations) for the Mount of Mars. On the other hand, if Zoe intends Mars as the fourth of the series, then either way she counts, the mount she has mistaken for Mars is Mercury (wit, industry, science).

547:18 (561:7). Sheet lightning courage—courage that is essentially passive, or the courage displayed by someone remote from danger since sheet lightning does not strike.

547:25 (561:14). Pandybat—see 187:37n.

547:27–548:5 (561:17–25). Father Dolan springs up ... very good little boy—Stephen recalls an incident when he was at Clongowes;

unfairly punished by Father Dolan, he asserted himself by complaining to Father Conmee, the Rector; see 133:36n and the end of Chapter I of *A Portrait of the Artist as a Young Man*.

548:10–11 (562:3–4). His criminal thumbprint on the haddock—legend ascribes the black spots behind a haddock's pectoral fins to the imprint of the finger and thumb of St. Peter, who found "tribute money" in the mouth of a fish (as directed by Jesus in Matthew 17:24–27).

548:15 (562:8). Thursday—Stephen's birthday (and Joyce's) was Thursday, 2 February 1882.

548:17 (562:10). Thursday's child has far to go—after the nursery rhyme: "Monday's child is full of grace,/Tuesday's child is fair of face,/Wednesday's child is full of woe,/Thursday's child has far to go,/Friday's child is loving and giving,/Saturday's child must work for a living,/But the child that's born on the Sabbath Day,/Is bonny and blithe and good and gay."

548:18 (562:11). Line of fate. Influential friends—the Line of Fate bisects the palm of the hand from the middle of the wrist toward the middle finger. If it is particularly well marked and colored with certain tributary hatchings, it indicates a life of good fortune as the result of association with "influential friends."

548:20–22 (562:13–15). Imagination ... Mount of the moon—if the Mount of the Moon at the base of hand below the little finger is pronounced, it indicates imagination, a dreamy disposition, and/or outstanding morality.

549:2–3 (562:22–23). Knobby knuckles, for the women—in the tradition of palmistry, knobby knuckles are supposed to be the sign of a person who thinks and works systematically.

549:5–6 (562:25–26). Gridiron. Travels beyond the sea and marry money—cryptic and thus difficult to interpret from handbooks of palmistry.

549:10 (563:4). Short little finger. Henpecked husband—usually indicative of immaturity, lack of full development.

549:12 (563:6). Black Liz—see 310:3–7n.

549:23 (563:17). Moves to one great goal—Mr. Deasy's comment on history, 35:24–25 (34:27–28).

550:3–5 (563:26–564:1). A hackneycar, number ... Harmony Avenue, Donnybrook—see 275:14–15n.

550:11 (564:7). have you the horn?—see 252:25n.

550:22 (564:18). quims—slang for vaginas.

550:24 (564:20). Plucking a turkey—low slang for having sexual intercourse.

551:9–10 (565:9–10). (In a flunkey's plum ... and powdered wig.)—in Sacher-Masoch's *Venus in Furs* the hero, Severin, is similarly costumed when he becomes Wanda's slave and servant (at his own insistence and finally with her compliance) (p. 79).

551:12 (565:13). splash—a small quantity of soda water.

551:13 (565:14). antlered head—the familiar caricature of the cuckold.

551:17 (565:18). Madam Tweedy is in her bath—in *Venus in Furs* Wanda bathes with Severin (the slave Gregor) as her attendant (pp. 107–110); at the end of the episode Wanda is posed in her furs with her foot on Severin's neck as she toys with her whip. They catch sight of themselves in a mirror and decide to introduce a German painter who has become enamored of Wanda to the scene that he might paint and "immortalize" it.

551:20 (565:21). Raoul, darling—see 232:27n.

551:20–21 (565:21–22). I'm in my pelt—with a pun on *Venus im Pelz* (*Venus in Furs*). See also 394:17n.

551:28 (566:2). the pishogue—see 315:32n.

552:1–2 (566:3–4). Bartholomona, the bearded woman—unknown.

552:24 (566:26). Ride a cock horse—see 522:24–25n.

553:10 (567:15). The mirror up to nature—as Hamlet cautions the players against overacting in "The Mouse-Trap," he says, "For anything so overdone is from [contrary to] the purpose of playing, whose end, both at the first and now, was and is, to hold, as 't were, a mirror up to nature; to show virtue her own feature, scorn her own image, and the very age and body of the time his form and pressure" (III, ii, 22–27).

553:14 (567:19). antlered—see 551:13n.

553:17–18 (567:22–23). 'Tis the loud laugh bespeaks the vacant mind—after Oliver Goldsmith's (1728–1774) idealization of and lament for English rural life, *The Deserted Village* (1770). In lines 113 *ff*. he describes "the village murmur" "at evening's close"; among the sounds, "And the loud laugh that spoke the vacant [idle, at rest] mind" (line 122).

553:20 (567:25). Iagogo! How my Oldfellow chokit his Thursdaymomum—i.e., Iago's machinations in Shakespeare's *Othello* cause Othello to smother Desdemona in a climactic fit of jealous suspicion. "Oldfellow" is also slang for father as "Thursdaymomum" suggests "Thursday morning" and "Thursday mother" (Stephen was born on Thursday; see 548:15n and 17n).

553:27–28 (568:6–7). Even the great Napoleon ... skin after his death ...—the autopsy performed after Napoleon's death was the occasion for considerable political controversy; the three French surgeons in attendance asserted that his death was "premature" as a result of the climate of St. Helena and of the anguish caused by English harassment. The five English surgeons in attendance looked at the ulcerated and perforated wall of the stomach and declared it healthy. To cover their embarrassment (and obviously to further denigrate Napoleon), the English insisted on minute measurements of the body and remarked on its "womanly" form (particularly the overdeveloped breasts).

553:30 (568:9). Tunny's tawny sherry—from William James Tunney, family grocer and spirit dealer, 8 Bridge Street, Ringsend, and 10 Haddington Road. Both shops were quite near the Dignam "residence" in Sandymount.

554:2–3 (568:11–12). a pen chivvying her brood of cygnets—see 186:19 (188:23).

554:4–5 (568:14). Scottish widow's insurance policy—see 374:10n.

554:14 (568:23). the beeftea is fizzing over—in Act II of Ibsen's *Love's Comedy* (1862) the assembled company discusses love and elaborately develops its similarities to tea. One says, "There's beef tea too," and the poet-hero Falk replies, "And a beef love has equally been heard of, and still its trace may be detected among the henpecked of the married state." The play develops the theme that, thanks to nineteenth-century morality and its repression of feminine vitality, love (together with the freedom necessary to it) and marriage are incompatible. The poet-hero (with his lover's help) decides to go it alone.

554:16 (568:25). Weda seca whokilla farst—"None wed the second but who kill'd the first" (*Hamlet*, III, ii, 190); see 200:22–24n.

554:20 (568:29). Merry Widow hat—after the broad-brimmed hat worn by the flirtatious heroine of the popular light opera *The Merry Widow* (1905), from the German *"Die lustige Witwe,"* by the Hungarian composer Franz Lehar.

554:24 (569:3). And they call me the jewel of Asia—see 95:29–31n.

554:29 (569:8). Et exaltabuntur cornua iusti —Latin: "And the horns of the righteous shall be exalted," from Psalms 75:10 (Vulgate 74:10): "All the horns of the wicked also will I cut off; *but* the horns of the righteous shall be exalted."

554:29–31 (569:8–10). Queens lay with prize . . . the first confessionbox—see 404:33–35n; Pasiphaë's "foul adultery" was a function of Poseidon's wrath since Poseidon had given a "prize bull" to Minos (the king) for sacrifice; Minos hid Poseidon's bull and substituted an inferior one; Poseidon retaliated by arousing in Pasiphaë a passion for the "prize bull."

554:31 (569:10). Madam Grissel Steevens— see 404:23–24n.

554:32 (569:11). the suine scions of the house of Lambert—"evidently neither Sam nor Ned, but monsters; the phrase may refer either to Daniel Lambert, the English fat man (1770–1809), or to a family of Lamberts who for several generations were born with bristles all over their bodies" (Adams, p. 204). "Suine" is a mixture of oleomargarine with lard or other fatty ingredients.

554:32–33 (569:11–12). And Noah was drunk with wine. And his ark was open—see 487:10–11n. "Ark" puns on "Noah's ark" and the "Ark of the Covenant," the gold-encrusted wooden box in which Moses placed the stone tablets bearing the Ten Commandments; the Ark of the Covenant occupied the most sacred place in the sanctuary of the temple at Jerusalem.

555:6–7 (569:18–19). parleyvoo—English slang for the French language after the French question *"Parlez-vous française?"* ("Do you speak French?").

555:27 (570:12). dessous troublant—French: "disordered underthings."

555:28 (570:13). Ce pif qu'il a!—French: literally, "The bang that it has!"

555:30 (570:15). Vive le vampire!—French: "Long live the vampire!"

556:13 (570:30). pièce de Shakespeare—see 185:15n.

556:20 (571:3). double entente cordiale . . . mon loup—French: "double cordial understanding . . . my wolf [solitary man]." The phrase *"entente cordiale"* was generally used for a cordial understanding short of a formal alliance between two nations; see 324:28n.

556:21 (571:4). Waterloo—see 447:31n.

556:28 (571:11). I dreamt of a watermelon— see 47:41–48:1n.

557:2 (571:17). Dreams go by contraries— popular superstition about the interpretation of dreams; e.g., a dream of failure would portend success, as Bloom's dream of Molly "wearing the pants," 391 (397), is interpreted by the Pepys-Evelyn voice "to be for a change," 391:8–9 (397:29–30); i.e., by contraries, Bloom is about to start wearing the pants in his family.

557:4 (571:19). Street of harlots—see 47:40 (47:5).

557:4–5 (571:19–20). Serpentine Avenue—see 41:21n.

557:5 (571:20). Beelzebub—Hebrew: "Lord of Flies," god of the Ekronites (II Kings 1:2) and a type of the devil in the Gospels. In Milton's *Paradise Lost* he is Satan's chief lieutenant among the fallen angels.

557:10 (572:2). No, I flew. My foes beneath me—see 215:1–2n.

557:10–11 (572:2–3). And ever shall be. World without end—see 30:20–24n.

557:11 (572:3). Pater! Free!—see 208:13n.

557:15 (572:7). O merde alors!—French: "Oh shit, in that case!"

557:16 (572:8). Hola! Hillyho!—the call a falconer uses to retrieve his falcon. Hamlet, in extreme agitation after he has seen the Ghost, is summoned in this way by Marcellus ("Hillo, ho, ho, my lord!") and replies in kind ("Hillo, ho, ho, boy! come, bird, come") to Marcellus and Horatio (I, v, 115–116).

557:24–25 (572:16–17). An eagle gules volant in a field argent displayed—in heraldry, a red eagle in horizontal flight with its wings expanded ("displayed"), mounted on a silver background. It is the coat of arms of the Joyces of County Galway.

557:25 (572:17). Ulster King at arms!—see 471:2n.

557:29–31 (572:21–23). A stout fox drawn . . . earth, under the leaves—*cf.* Stephen's riddle, 27:33–38n; "badger earth" is a den a badger has dug.

558:2 (572:25). Ward Union—see 158:16n.

558:4 (572:27). Six Mile Point, Flathouse, Nine Mile Stone—Six Mile Point, where the hunt starts, is a headland on the east coast of Ireland in County Wicklow. It is six miles north of Wicklow and 21 miles south-southeast of Dublin.

558:8 (572:31). crown and anchor—a game played with dice marked with crowns, anchors, hearts, etc., and a similarly marked board.

558:8 (572:31–32). thimbleriggers—i.e., the shell game; see 388:10n.

558:8 (572:33). broadsmen—slang for card-sharpers.

558:9 (572:33). Crows—slang for those who keep watch while others steal.

558:13 (573:3). Ten to one the field—betting slang: the bookie announces that he will offer odds of ten to one against any single horse winning the race. The more usual form of the proposition is 558:15 (573:5).

558:14 (573:4). Tommy on the clay—betting slang: the bookie announces that money can be readily acquired at his place of business.

558:15 (573:5). Ten to one bar one—betting slang: the bookie announces that he will offer odds of ten to one against any single horse winning the race with the exception of one horse (usually the track or betting favorite).

558:16 (573:6). spinning Jenny—a gambling machine that moves miniature horses over a table at random speeds.

558:18 (573:8). Sell the monkey—betting slang: the bookie proclaims that he can cover bets up to £500.

558:21–22 (573:11–12). A dark horse riderless . . . past the winningpost—Throwaway wins this ghostly rerunning of the Gold Cup at Ascot; see 408:20–25n and 84:28n.

558:23–24 (573:14). Sceptre, Maximum the Second, Zinfandel—other horses in the Gold Cup; see preceding note.

558:24–26 (573:14–16). the Duke of Westminster's . . . prix de Paris—see 33:11–13n.

558:28 (573:18). isabelle nag—a horse light buff in color; "Bella" is also a diminutive of "Isabelle."

558:28 (573:18). Cock of the North—a nickname for the Scot George Gordon (1770–1836), the 5th and last Duke of Gordon, whose Gordon Highlanders were instrumental in the suppression of the insurrection in Wexford during the Rebellion of 1798.

558:31 (573:21). jogs along the rocky road—see 32:31–32n.

558:32 (573:22). THE ORANGE LODGES—see 32:15n.

559:3 (573:30). Per vias rectas!—see 32:28n.

559:7 (574:1). THE GREEN LODGES—i.e., the Irish in contrast to the Orangemen; see 32:19–22n.

559:8 (574:2). Soft day, sir John!—i.e., Sir John Blackwood; see 32:25n and 32:33n.

559:12 (574:6). noise in the street—see 35:30n.

559:16–17 (574:10–11). Yet I've a sort a/Yorkshire relish for . . .—see 250:14n.

559:27 (574:21). augur's rod—see 49:10n.

559:28 (574:22). tripudium—see 50:11n.

560:15 (575:11). My Girl's a Yorkshire Girl—see 250:14n.

560:33 (575:29). Madam Legget Byrne's—Mr. and Mrs. T. Leggett Byrne, teachers of dancing, 27 Adelaide Road and 68 Mountjoy Square West, Dublin.

560:33 (575:29). Levinstone's—Mrs. P. M. Levenston, dancing academy, 35 Frederick Street South, Dublin.

560:34 (575:30). Deportment—see 217:25n.

560:34 (575:30). Katty Lanner—Katti Lanner (1831–1915), daughter of the Austrian composer Joseph Lanner (1801–1843), the creator of the Vienna waltz, who revolutionized nineteenth-century dance music. His daughter had a distinguished career as ballet mistress and choreographer of the English Theatre of Varieties in London. She retired to devote herself to private lessons in 1877.

560:36–37 (575:32–33). Tout le monde . . . monde en place!—French: "Everyone move forward! Bow! Everyone to his place!"

561:6–7 (576:2–3). Two young fellows . . . they'd left behind . . .—see 250:14n.

561:8 (576:4). the morning hours—for the ballet that follows, see 69:14–15n.

561:14 (576:11). Carré! Avant deux!—French: "Form a square! Advance by twos!"

561:29 (576:25). My shy little lass has a waist—see 250:14n.

562:2 (576:28). cipria—or "cypre"; henna. Extracts from the plant were used to color parts of the body.

562:6 (577:2). Avant huit! Traversé! Salut! Cours de mains! Croisé!—French: "Four couples advance! Cross over [the men and women separate into two lines and face each other]! Nod! Exchange hands [the line of men passes down the line of women giving alternate hands to each in turn]! Exchange sides!"

562:9–10 (577:5–6). curchy-curchy—curtsey-curtsey.

562:16 (577:12). Les tiroirs! Chaîne de dames! La corbeille! Dos à dos!—French: "[Men] Form a middle rank! Women join hands to form a chain! Form a basket [the ends of the chain link to form a circle around the men]! Back to back!"

562:18 (577:14). simply swirling—see 62:30n.

562:24 (577:20). Boulangère! Les ronds! Les ponts! Chevaux de bois! Escargots!—French: "Bread-making [the heels of the hands are thrust out and down as though kneading bread]! In circles! Bridges [of hands]! Hobbyhorses! Corkscrew or twirl, wind around!"

562:29–30 (577:25–26). Dansez avec vos dames! . . . votre dame! Remerciez!—French: "Dance with your partners! Change partners! Present the little bouquet to your partner. Thank each other [in parting]!"

563:2 (577:28). Best, best of all—see 250:14n.

563:9 (578:6). Toft's cumbersome whirligig—the merry-go-round at the Mirus Bazaar.

563:18 (578:15). Pas seul!—French: "Solo dance!"

563:24 (578:21). hornblower—see 85:11n.

563:29–30 (578:26–27). Though she's a factory . . . no fancy clothes—see 250:14n.

564:2 (579:2). Bis—French: "Over again!"

564:6 (579:6). Dance of death—literary or visual presentation of the power of death over the lives of all men. It had its origin in medieval church drama; the original plays began with an exhortation; then depicted the power of death over all classes of men from popes and emperors to serfs; and ended with an appropriate sermon. From these beginnings the sub-genre of *danse macabre* was developed and proliferated in the medieval arts. Several nineteenth-century artists, among them Goethe, Saint-Saëns and Strindberg, revived and reworked this sub-genre.

564:7 (579:7). lacquey's bell—at Dillon's auction rooms; see 233:30n.

564:8 (579:8). on Christass—in John 12:12–15 Jesus enters Jerusalem in triumph: "On the next day much people that were come to the feast, when they heard that Jesus was coming to Jerusalem, Took branches of palm trees, and went forth to meet him, and cried, Hosanna: Blessed *is* the King of Israel that cometh in the name of the Lord. And Jesus, when he had found a young ass, sat thereon; as it is written [Zechariah 9:9], Fear not, daughter of Sion: behold, thy King cometh, sitting on an ass's colt."

564:10 (579:10). through and through—see 250:14n.

564:10 (579:10). bellhorses—a horse wearing a bell and decorated with flowers and ribbons for May Day.

564:11 (579:11). Gadarene swine—in Matthew 8:28–34 Jesus is met in Gadara, south of the Sea of Galilee, by "two [men] possessed with devils . . . exceeding fierce, so that no man might pass by that way." Jesus cast the devils out of the two men and allowed the devils to enter into a "herd of many swine feeding." The swine went berserk and "ran violently down a steep place into the sea, and perished in the waters." Similar accounts of the incident occur in Mark 5:1–20 and Luke 8:26–29.

564:11 (579:11). Steel shark stone—unknown.

564:11–12 (579:11–12). onehandled Nelson—see 146:16n.

564:12 (579:12). two trickies Frauenzimmer—see 38:33–35 (37:33–35) and 146:4 (147:31).

564:12 (579:13). pram—baby Boardman's in [Nausicaa].

564:13 (579:13). Gum, he's a champion—see 250:14n.

564:13 (579:13). Fuseblue—see Kevin Egan, 44:20 (43:22).

564:13–14 (579:14). peer from barrel—as Lords Iveagh and Ardilaun have parlayed barrels of Guinness into peerages; see 78:20–31 (79:23–34).

564:14 (579:14). rev. evensong Love—see 227:41–42n.

564:14–15 (579:15). blind coddoubled bicyclers—see 85:7n.

564:15 (579:15–16). no fancy clothes—see 250:14n.

564:16 (579:17). mashtub—see 305:22n.

564:17 (579:17–18). sort of viceroy . . . bumpshire rose—when the Viceregal Procession passed Trinity College en route from Phoenix Park to the Mirus Bazaar in [The Wandering Rocks], its sounds were mingled with "My Girl's a Yorkshire Girl," 250:14n, played by the regimental band of the 2nd Seaforth Highlanders, 226:1n, at the bicycle races in Trinity College Park. "*Reine*," French: "queen."

564:33–34 (580:2–3). Liliata rutilantium . . . te virginum . . .—see 12:13–14n.

565:12 (580:15). Lemur—an interlink between the large-eyed nocturnal animal, nicknamed "ghost" by naturalists as Skeat points out in his *Etymological Dictionary*, and the Roman Lemures, specters of the dead who wandered about at night to torment and frighten the living. The festival to propitiate them, the Lemuralia, occurred in May, and hence May was regarded as an unlucky month for marriages. John Joyce and Mary Jane Murray were married 5 May 1880. See Ellmann, p. 17.

565:17–18 (580:21–22). Our great sweet mother!—see 7:1–2n.

565:18 (580:22). Epi oinopa ponton—see 7:3n.

565:21–22 (580:25–26). More women than men in the world—see 100:40–41n.

565:29 (581:3). Love's bitter mystery—see 11:12–14n.

566:2–3 (581:5–6). Tell me the word . . . known to all men—see 49:38n.

566:5–6 (581:8–9). at Dalkey with Paddy Lee—for Dalkey, see 25:31n; Paddy Lee appears only this one time, but in 1904 a Patrick J. Lee, esq., lived at 2 Convent Road in Dalkey.

566:7–8 (581:10–12). Prayer for the suffering . . . forty day's indulgence—the Ursulines, a Roman Catholic religious order for women devoted to the teaching of young girls and the nursing of the sick. The lengthy prayer that Stephen's mother refers to begins, "Most holy Mary, Our Lady of Intercession . . ." and focuses, "O Mary, countless souls await with unutterable anxiety the assistance of our prayers and the merits of our good works in that place of expiation [purgatory]." The prayer did merit an indulgence, but of 500, not 40 days; see 476:8n.

566:11 (581:14). Hyena!—the hyena "is accustomed to live in the sepulchres of the dead and to devour their bodies. Its nature is that at one moment it is masculine and at another feminine, and hence it is a dirty brute" (T. H. White, *The Bestiary*, pp. 30–31).

566:25 (581:28). Raw head and bloody bones!—a traditional bogeyman formerly invoked by superstitious mothers and servants to frighten children into submission.

567:2 (582:5). God's hand!—traditionally symbolic of the almighty will and power of God, whose countenance "no man could behold and live" (Exodus 33:20).

567:2 (582:5). A green crab—the zodiacal sign of Cancer, and a traditional image of the tumorous growth of cancer.

567:10 (582:13). Ah non, par exemple!—French: "Oh no, to be sure!"

567:10 (582:13). The intellectual imagination!—recalls Matthew Arnold's phrase "imaginative reason" in his inaugural lecture as Professor of Poetry at Oxford, "On the Modern Element in Literature" (1857). The opening sentence of the lecture is also relevant to the way Stephen contextualizes his outburst: ". . . An intellectual deliverance is the peculiar demand of those ages which are called modern; and those nations are said to be imbued with the modern spirit most eminently in which the demand for such a deliverance has been made with most zeal, and satisfied with most completeness."

567:11 (582:14). Non serviam!—Latin: "I will not serve." The phrase is traditionally assigned to Satan at the moment of his fall, after Jeremiah 2:20: ". . . and thou saidst, I will not serve" (Douay). In Chapter III of *A Portrait of the Artist as a Young Man* Father Arnall uses the phrase to characterize Lucifer's sin and in Chapter V Stephen, in conversation with Cranly, says he will refuse his mother's request to make his "easter duty" and caps his remarks with the assertion, "I will not serve."

567:15–16 (582:18–19). O Sacred Heart of Jesus, have mercy on him!—a variation of the invocation "Most Sacred Heart of Jesus, have mercy on us," which the devout, kneeling, were encouraged to repeat three times after the conclusion of a Mass in which they had taken Communion.

567:23–24 (582:26–27). Inexpressible was my anguish ... on Mount Calvary—the source of this prayer is unknown.

567:26 (583:2). Nothung!—German: "Needful," the magic sword in Wagner's *Der Ring des Nibelungen*. In *Die Walküre,* the second of the four operas of the *Ring,* Wotan, the king of the gods, has planted it in the heart of a giant ash tree ("ashplant"); Siegmund, Siegfried's father, retrieves the sword, but when he attempts to defend himself with it against his sister's husband, Wotan withdraws the sword's magic power; the sword is shattered and Siegmund is killed. In the third opera, *Siegfried,* Siegfried, because he does not know the meaning of fear, is able to reforge the sword. Ironically it is with this sword, its magic power restored, that Siegfried will unwittingly bring about *Die Götterdämmerung* ("The Twilight of the Gods") in the final opera of the *Ring.* See 547:8n and 547:9–11n.

567:28–568:2 (583:4–6). Time's livid final flame ... and toppling masonry—see 25:9–11n.

569:26 (585:4). Bulldog—slang for a sheriff's officer.

570:1 (585:6). (He makes a masonic sign.)— as with the Watch (see 448:14–16n), Bloom uses his knowledge of Freemasonry to suggest an influential connection with the Protestant Anglo-Irish Establishment.

570:2 (585:7). the vicechancellor—see 123:10n.

570:4 (585:9). ragging—slang for assailing roughly and noisily or tormenting someone as a practical joke; more generally, creating a disturbance.

570:9 (585:14). your own son in Oxford—see 466:26 (475:21).

570:12 (585:17). incog—a colloquial abbreviation of "incognito"; also slang for intoxicated.

570:29–30 (586:4–6). draws his caliph's hood ... Haroun al Raschid—see 47:40n; one of the legends about this ruler was that he went about in disguise through the streets of Baghdad in order to inform his sympathies for the mood of his subjects.

570:32–33 (586:7–8). a pard strewing the drag ... drenched in aniseed—see 215:10n.

571:1 (586:10). Hornblower of Trinity—see 85:11n.

571:7–8 (586:16). woman's slipperslappers— see 86:18n.

571:12 (586:20). Mrs O'Dowd—see 300:41n.

571:12 (586:21). The Nameless One—see 461:19n.

571:15 (586:23–24). sir Charles Cameron— see 230:34n.

571:16–17 (586:25). T. M. Healy—see 139:23n.

571:17 (586:25–26). Mr Justice Fitzgibbon— see 139:16n.

571:17–18 (586:26–27). the reverend Tinned Salmon—see 162:26n.

571:18 (586:27). Professor Joly—see 164:29n.

571:19–20 (586:28). the Westland Row Postmistress—where Bloom has received his letter from Martha Clifford; see 71:20n.

571:22–23 (586:31–32). Mrs Ellen McGuinness—see 217:27n.

571:23 (586:32). Mrs Joe Gallaher—see 441:25n.

571:24 (586:33). Superintendent Laracy— former superintendent and headmaster of the Hibernian Marine School in Grove Park, Rathmines. He was no longer there in 1904.

571:24–25 (586:33–34). Crofton out of the Collector General's—see 92:30n.

571:26 (586:35). Mrs Kennefick—"a total blank," as Adams says (p. 156).

571:28 (586:37). Clonskeatram—see 115:4–5n.

571:29–30 (586:38–39). Mesdames Gerald and Stanislaus Moran of Roebuck—i.e., at an estate called Roebuck Hill in Roebuck, a fashionable area in Dundrum, three miles south of central Dublin.

571:31 (586:40). Drimmie's—see 363:26–27n.

571:31 (586:40). colonel Hayes—"colonel" Baxter Hayes, chief inspector of police for the Great Southern and Western Railway in Ireland, 23 Conyngham Street, Dublin.

571:32 (586:41). Aaron Figatner—see 255:37n.

571:34 (587:1). old doctor Brady—Dr. Francis F. Brady, Carnew, County Wicklow in 1904 (*Thom's* [*1904*]).

571:40 (587:7). Beaver street—see 442:17n.

572:6–7 (587:13–14). the fifth of George and seventh of Edward—George Frederick Ernest Albert (1865–1936), the heir apparent in 1904, became king of England (1910–1936) as George V upon the death of his father, Edward VII (1841–1910; king 1901–1910).

572:7–8 (587:14–15). Fabled by mothers of memory—see 25:7n.

572:23 (587:30). Sisyphus—in Greek mythology, a king of Corinth styled the craftiest of men. He was condemned in the underworld to roll a huge marble block up a hill only to be frustrated at the last moment and compelled to begin again. There are various legendary accounts (all of them emphasizing craft and betrayal) of why he was so condemned, and there are various accounts of his forebears and children including post-Homeric legends that style him the father of Odysseus by Anticlea. See p. 82 above.

573:2 (588:6). blighter—a contemptible person; also, a euphemism for bugger (pederast).

573:8 (588:12). Union Jack blazer and cricket flannels—the costume suggests the traditional caricature of Tennyson as pillar of the Establishment, optimistic chauvinist.

573:9 (588:13). Their's not to reason why—line 14 of Tennyson's "The Charge of the Light Brigade"; see 474:19n. The second stanza: "Forward, the Light Brigade!/Was there a man dismay'd?/Not tho' the soldier knew/Some one had blunder'd./Theirs not to make reply,/Theirs not to reason why,/Theirs but to do and die./Into the valley of Death/Rode the six hundred."

573:14–15 (588:18–19). Doctor Swift says . . . men in their shirts—Jonathan Swift in the *persona* of M. B. Drapier, "A Letter to the Whole People of Ireland" (1724), a series of pamphlets commonly called *Drapier's Letters;* in Letter 4: "For, in reason, all government without the consent of the governed, is the very definition of slavery: but, in fact, eleven men well armed will certainly subdue one single man in his shirt."

573:19 (588:24). The bold soldier boy—see 292:9n.

573:25–26 (589:2–3). Noble art of self-pretence—after "the noble art of self-defense," a euphemism used to upgrade boxing when that

sport was reintroduced into England in 1866 under the genteel supervision of the Amateur Athletic Club and the Marquis of Queensberry; see 313:5n.

573:27 (589:4). Enfin, ce sont vos oignons—French: literally, "After all, those are your onions"; figuratively, "It's your quarrel, not mine."

574:1 (589:6). DOLLY GRAY—from the popular Boer War song "Goodbye, Dolly Gray," by Will D. Cobb and Paul Barnes. Refrain: "Good-bye, Dolly, I must leave you,/Though it breaks my heart to go./Something tells me I am needed/In the front to face the foe./Hark! I hear the bugles calling/And I must no longer stay./Good-bye, Dolly, I must leave you,/Good-bye, Dolly Gray."

574:2–3 (589:7–8). the sign of the heroine of Jericho.) Rahab—in Joshua 2, Joshua, having taken over the leadership of the Israelites after the death of Moses, prepares to cross the Jordan and destroy the city of Jericho. He sends two spies into Jericho, where their presence is suspected, but they are sheltered and helped to escape by the harlot Rahab, who is in awe of the power of the Israelites' God. In return they promise her safety when Jericho is destroyed (as it is in Joshua 6), and they instruct her to make a sign: "thou shalt bind this line of scarlet thread in the window which thou didst let us down by" (Joshua 2:18). William Blake in *Vala; or the Four Zoas* (an incomplete prophecy begun *c.*1795), in "Night the Eighth," characterizes Rahab as "the false female" who condemns Jesus, "the Lamb of God," to death in her role as "Mystery, Babylon the Great, the Mother of Harlots"; see 482:22n. Rahab combines worship and mockery since her focus is on "Mystery" (religion that is abstract and nonexperiential) and on "Death, God of all from whom we rise, to whom we all return" (MS pp. 105–106).

574:3 (589:8). Cook's son, goodbye—from Kipling's "The Absent-Minded Beggar": "Cook's son—Duke's son—son of a belted Earl—/Son of a Lambeth publican—it's all the same today!" See 185:19n. The phrase includes a pun on the famous English travel agency Thomas Cook & Son (established 1841); by 1900 the agency's name had become virtually generic for all similar agencies.

574:4 (589:9). the girl you left behind—see 188:35n.

574:21 (589:26). philirenists—lovers of peace.

574:22 (589:27). the tsar—Nicholas II (1868–1918; tsar 1894–1917). His "peace rescript of

1898" solicited petitions from "the peaceloving peoples of the world." It resulted in the Hague Peace Conference in 1899. The conference of national powers did not manage "universal disarmament" or even a plan for curtailment of armaments though it did manage to set up a tribunal for the arbitration of international disputes and to begin a systematic codification of international laws of war. It is something of an irony that Nicholas II's peace crusade was a prelude to the Russo-Japanese War of 1904–1905. In retrospect the Tsar's motivation appears to have been to stall for time so that Russia could achieve an armament comparable to that of the Austro-Hungarian Empire.

574:22 (589:27). the king of England—for Edward VII's role as lover of peace, see 325:1n. In 1908 and 1909 Edward VII and Tsar Nicholas II met twice, ostensibly in the interests of peace; but their meetings were not regarded with popular favor in England and on the Continent since they seemed to presage an alliance with Russia in aid of England's intensifying naval and colonial competition with Germany.

574:23–24 (589:28–29). But in here it is . . . priest and the king—William Blake frequently yokes priest and king as a comprehensive image of oppression; cf. "Merlin's Prophecy" in *Poems from the Rossetti MS* (1793–1811): "The harvest shall flourish in wintery weather/When two virginities meet together. // The King & the Priest must be tied in a tether/Before two virgins can meet together."

575:11 (590:16). the Sacred Heart—see 112:15n.

575:12 (590:17). the insignia of Garter and Thistle—i.e., of the Knights of the Garter, the highest royal order in England; it was founded by Edward III in 1346. The insignia: a blue ribbon over the left shoulder bearing the image of St. George, and a blue garter on the left leg bearing the legend "*Honi soit qui mal y pense*" ("Shamed be he who thinks evil of it"). The Order of the Thistle was founded in Scotland in 809 by Archaicus, king of the Scots; renewed in Great Britain in the seventeenth century; its insignia: the image of St. Andrew (patron saint of Scotland) bearing a cross, imposed on a stylized thistle.

575:12 (590:17–18). Golden Fleece—the Order of the Golden Fleece was founded in 1429 by Philip the Good, Duke of Burgundy; the Order subsequently existed in both Spain and Austria. Its insignia: a golden fleece hanging from an enameled flint stone emitting flames.

575:12–13 (590:18). Elephant of Denmark—an order founded in 1189 by Knut VI, King of Denmark; its insignia: a blue moire cordon bearing a medallion with a white elephant, tower and driver.

575:13 (590:18). Skinner's and Probyn's horse—Skinner's Horse, an irregular cavalry regiment that distinguished itself in India under the command of James Skinner (1778–1841). The 11th Prince of Wales Own Lancers was nicknamed "Probyn's Horse," after its colonel, General Sir Deighton Macnaghten Probyn (1833–1924), who had a distinguished military career in India and (after his retirement from active duty) as a member of the royal household.

575:13–14 (590:19). Lincoln's Inn bencher—a senior member of Lincoln's Inn, one of the four societies or guilds of lawyers that comprise the Inns of Court in London. The Inns have the exclusive right of admitting persons to the practice of law in England.

575:14–15 (590:19–20). ancient and honourable artillery company of Massachusetts—otherwise the Ancient and Honorable Artillery Company of Boston, a volunteer corps of artillery, infantry and cavalry, the oldest regular military organization in America, founded in 1637 on the model of the Honorable Artillery Company (London, 1537). Purely military during the stresses of the Colonial period, it evolved in the nineteenth century into a social organization that was only incidentally military.

575:15–16 (590:21–22). robed as a grand elect . . . with trowel and apron—Freemasonry: Edward VII as Prince of Wales was grand master of the Grand Lodge of England from 1874 until his accession to the throne in 1901. There is an extant portrait of Edward VII so robed; see Eugen Lennhof, *The Freemasons* (New York, 1934), facing p. 181. The Masonic apron is symbolic of innocence and irreproachable conduct. The trowel, the peculiar working tool of the Master Mason's degree, is symbolic of the effort that cements the brotherhood into unity through brotherly love.

575:17 (590:22). made in Germany—suggests both Edward VII's lineage (see 324:32–35n) and one of the varied lineages attributed to Freemasonry.

575:18 (590:24). Défense d'uriner—French: "It is forbidden to urinate."

575:21 (590:26). Peace, perfect peace—(1875), the title of a popular hymn by Edward Henry Bickersteth (1825–1906), English bishop and poet. The opening lines: "Peace, perfect peace, in this dark world of sin?/The blood of Jesus whispers peace within."

575:24–25 (590:30). Mahak makar a back— if this is an attempt at Arabic, it might mean "(You have) with you a sly one, your father."

576:9–10 (591:18–19). My methods are new ... dust in their eyes—see 20:25–28n.

576:12 (591:21). Kings and unicorns!—after the nursery rhyme: "The lion and the unicorn/ Were fighting for the crown;/The lion beat the unicorn/All round about the town. // Some gave them white bread,/And some gave them brown,/ Some gave them plum cake,/And drummed them out of town." The lion and the unicorn are featured in the royal arms of England.

576:15 (591:24). knackers—testicles, usually of animals.

576:15 (591:25). Jerry—English slang for a chamberpot or penis.

576:18–19 (591:28–29). Absinthe, the green-eyed monster—absinthe, a green and extraordinarily powerful liqueur, did produce severe nervous derangements; see 490:9n.

576:29 (592:9). Green rag to a bull—after the familiar assumption that red angers bulls, as green is the color of Ireland, red of England (John Bull).

577:2 (592:11). peep-o'-day-boy's—see 44:22n.

577:4 (592:13). The vieille ogresse with the dents jaunes—see 44:11–12n.

577:8 (592:17). Socialiste!—see 42:21–24n.

577:9 (592:18). DON EMILE PATRIZIO FRANZ RUPERT POPE HENNESSY—this collection of names suggests but does not specify several wild-geese families such as the Taafes in Austria, the O'Donnells in Spain, the O'Briens in Russia, the Macmahons in France, etc. Sir John Pope Hennessy (1834–1891), conservative Irish Catholic politician, had a varied career as governor of several British colonies and was a successful anti-Parnellite candidate for Parliament in 1890.

577:10 (592:19). two wild geese valant—see 42:14–15n; "volant" in heraldry means in flight.

577:12–13 (592:21–22). Werf those eykes ... todos covered of gravy!—polyglot: "Werf ... eykes ... footboden," garbled German: "Throw those disgusting ones to the ground at your feet." "Porcos" (*puerco*), Spanish: "pig"; "todos," Spanish: "entirely, completely." For "john-yellows," see 320:40–41n.

577:21 (593:4). Green above the red—"The Green Above the Red" is a song by Thomas Osborne Davis. First stanza: "Full oft when our fathers saw the Red above the Green,/They rode in rude but fierce array, with sabre, pike, and sgian [knife]./And over many a noble town, and many a field of dead./They proudly set the Irish Green above the English Red."

577:21 (593:4). Wolfe Tone—see 226:13n.

577:26 (593:9). De Wet—see 160:40n.

578:3–8 (593:12–17). May the God above ... our Irish leaders—this has been identified as a Fenian ballad by Roger McHugh, professor of Anglo-Irish literature and drama, University College, Dublin, but we have not been able to find a copy of this ballad in print.

578:9–13 (593:18–22). THE CROPPY BOY ... country beyond the king—see 252:41n, lines 25–26.

578:14 (593:23). RUMBOLD, DEMON BARBER—see 298:26n.

578:16–17 (593:25–26). cleaver purchased by Mrs Pearcy to slay Mogg—in a spectacular trial, 1–3 December 1890, Mary Eleanor Wheeler (otherwise Mrs. Pearcey) was convicted of the murder of Mrs. Phoebe *H*ogg and infant. The murder weapon (a cleaver) furnished one of the more lurid details of the trial.

578:17–19 (593:26–28). Knife with which Voisin ... sheet in the cellar—in October 1917 Louis Voisin, a French butcher living in London, murdered and dismembered Mrs. Émilienne Gérard. Part of her body was found in a meat sack in Regent Square, London; the remainder, in Voisin's cellar. He went to the gallows.

578:20–21 (593:29–30). Phial containing arsenic ... Seddon to the gallows—in September 1912 Mr. and Mrs. Frederick Seddon of London were charged with murdering their lodger Miss Barrows after it was discovered that what appeared to be a natural death was really a function of arsenic. Mrs. Seddon was sent to prison; Seddon was hanged for the crime.

578:26 (594:5). Horhot ho hray ho rhother's hest—i.e., "Forgot to pray for [my] mother's rest"; see 252:41n, line 24.

578:29 (594:8). Mrs Bellingham—see 457:21n.

578:29 (594:8). Mrs Yelverton Barry—see 457:7n.

578:30 (594:9). the Honourable Mrs Mervyn Talboys—see 458:20n.

578:34–579:1 (594:13–14). Ten shillings a time as applied to His Royal Highness—i.e., Rumbold has the king's permission to sell pieces of the rope to interested spectators for souvenirs.

579:8–10 (594:21–23). On coronation day ... beer and wine!—see 12:39–13:3n.

579:22 (595:5). Ça se voit aussi à Paris—French: "This [sort of thing] is also to be found in Paris."

579:23 (595:6). But by Saint Patrick!—in *Hamlet* Horatio reproves Hamlet: "These are but wild and whirling words, my lord./HAMLET:I'm sorry they offend you. ... HORATIO: There's no offence, my lord./HAMLET: Yes, by Saint Patrick, but there is, Horatio,/And much offence too" (I, v, 133–137).

579:24–26 (595:7–9). Old Gummy Granny ... blight on her breast—caricatures the Poor Old Woman image of Ireland as a death's head; see 15:30–31n and 19:17–18n. Leprechauns are traditionally depicted as seated on toadstools, with sugarloaf hats, shaped like slightly curved cones; the potato blight was the immediate cause of the great Irish famine; see 32:15n.

579:28 (595:11). Hamlet, revenge!—in *Hamlet* the Ghost speaks to Hamlet: "If thou didst ever thy dear father love—/HAMLET: O God!/GHOST: Revenge his foul and most unnatural murder" (I, v, 23–25).

579:28–29 (595:11–12). The old sow that eats her farrow!—i.e., Ireland, as Stephen remarks in *A Portrait of the Artist as a Young Man*, Chapter V.

579:31–580:1 (595:14–15). the king of Spain' daughter—from the nursery rhyme: "I had a little nut tree,/Nothing would it bear/But a silver nutmeg/And a golden pear; // The King of Spain's daughter/Came to visit me,/And all for the sake/ of my little nut tree."

580:1 (595:15). alanna—Irish: "child, my child."

580:1 (595:15). Strangers in my house—see 182:39–183:1n.

580:2 (595:16). banshee—Irish: "a female fairy."

580:2 (595:16). Ochone!—Irish: "Alas!"

580:2–3 (595:16–17). Silk of the kine!—see 15:30–31n.

580:3–4 (595:17–18). You met with poor ... does she stand?—see 45:2–3n.

580:6 (595:20). The hat trick!—see 428:18n. Also, in cricket a bowler accomplishes the hat trick when he knocks over or captures by means of catches three or more wickets with successive deliveries.

580:6–7 (595:20–21). Where's the third person of the Blessed Trinity?—literally: "Where is the Holy Ghost?" Figuratively, since Stephen is the son and Ireland is present, "Where is the church?"

580:7 (595:21). Soggarth Aroon?—Irish, "My Beloved Priest," the title of a song by the Irish novelist John Banim (1798–1842). The song deals with the affection an Irish peasant feels for a patriot-priest. First stanza: "Am I a slave they say, Soggarth aroon?/Since you did show the way, Soggarth aroon,/Their slave no more to be,/ While they would work with me,/Old Ireland's slavery, Soggarth aroon."

580:7–8 (595:21–22). The reverend Carrion Crow—in Flaubert's *Madame Bovary* (1857), Part III, Chapter 8, as Emma Bovary is dying from arsenic poisoning, Homais, the self-styled village "philosopher," "as was due to his principles compared priests to ravens [carrion-crows] attracted by the smell of death." The carrion crow also figures in a nursery rhyme, "Heigh-ho, the Carrion Crow": "A carrion crow sat on an oak,/ ... /Watching a tailor shape his cloak,/ ... / ... // Wife! bring me my old bent bow,/ ... /That I may shoot yon carrion crow;/ ... // The tailor he shot, and missed his mark,/ ... /And shot his own sow quite through the heart."

580:20 (596:5). Erin go bragh!—Irish: "Ireland until Judgment [day]!," an Irish battle cry and the title of an anonymous Irish song. Chorus: "Oh then his shillelah he flourishes gaily,/With rattle 'em, battle 'em, crack and see-saw,/Och, liberty cheers him, each foe, too, it fears him,/ While he roars out the chorus of Erin-go-Bragh!"

580:25 (596:10). a proboer—as many Irish were; see 160:26–27n.

580:29–581:2 (596:14–16). We fought for you ... Honoured by our monarch—the first and second battalions of the Royal Dublin Fusiliers did campaign for the British in South Africa during the Boer War; they were singled out for special praise by Queen Victoria on St. Patrick's Day in 1900, when the Queen announced her intention of raising a regiment of Irish guards to be added to the Household Brigade in honor of the loyal Irish troops in South Africa. "Missile troops" is obsolete for infantry armed with rifles (as is "fusiliers"). It is notable that Irish regiments fighting for the British were balanced by Irish brigades that fought on the side of the Boers.

581:6 (596:20). pentice—i.e., like a penthouse, projecting over something.

581:7–8 (596:21–22). Turko the terrible—see 11:31–32n.

581:8–9 (596:22–23). in bearskin cap . . . chevrons and sabretache—see 71:35–36n.

581:10–11 (596:24–25). the pilgrim warrior's sign of the knights templars.)—the Knights Templars (the Knighthood of the Temple of Solomon) were a monastic and militant order founded in 1118 to protect Christians on pilgrimage to Jerusalem. The traditions of Freemasonry hold that modern Masons are the heirs apparent of the Knights Templars, and the Pilgrim Warrior's Sign indicates a readiness for militant action in support of the ideals of brotherhood. To become a Knight Templar in Freemasonry one must be a Royal Arch Mason; see 540:14n.

581:13 (596:27). Rorke's Drift—see 449:8–9n.

581:13 (596:27). Up, guards, and at them!—what the Duke of Wellington was supposed to have said at a critical juncture during the Battle of Waterloo, though Wellington himself claimed that he did not say that, but might have ordered the successful counterattack by saying "Stand up, Guards" and then giving their commanding officers the order to attack.

581:13–14 (596:28). Mahal shalal hashbaz—Hebrew: "Make haste to the prey," or, "Fall upon the spoils." Isaiah is commanded to write these words upon "a great roll" (Isaiah 8:1) and to give this name to his second son (8:3) as a prophetic reminder that the Assyrians will despoil Israel. In Freemasonry the words are used symbolically to suggest the readiness for action that is the ideal characteristic of a Masonic Knight Templar.

581:20 (597:6). Garryowen—see 290:11n.

581:20 (597:6). God save the king—see 149:4n.

581:24 (597:10). The brave and the fair—echoes a phrase in the opening lines of John Dryden's "Alexander's Feast; or the Power of Music; an Ode in Honor of St. Cecilia's Day" (1697), lines 15 and 19: "None but the brave deserve the fair." The ode was set to music by Jeremiah Clarke (1669–1707), by Thomas Clayton (1711) and received its most famous treatment by Handel (1736).

581:29 (597:15). Saint George—(d. 303), the dragon-slaying patron saint of England and the nation's spiritual leader in battle. "Follow your spirit, and upon this charge/Cry 'God for Harry, England, and St. George!'" (Henry V to his troops before Harfleur in Shakespeare's *Henry V* [III, i, 33–34]).

582:2–3 (597:17–18). The harlot's cry from . . . Ireland's windingsheet—after William Blake, "The Auguries of Innocence" (*c.*1803), lines 115–116. Stephen substitutes "Ireland" for Blake's "England."

582:16–17 (598:6–7). White thy fambles . . . quarrons dainty is—see 48:16–19n.

582:21 (598:11). Dublin's burning! . . . On fire, on fire!—see 427:23–24n.

582:22 ff. (598:12 ff.). Brimstone fires spring up . . .—this stage direction describes an Armageddon, the great battle that is to destroy the world as prelude to the Last Judgment. The Black Mass at the end of the stage direction is appropriate since Armageddon marks the climactic appearance of the Anti-Christ. On another level the scene is an anachronistic vision of Dublin during the Easter 1916 Uprising. A group of rebels, convinced that England's promise that Ireland would be granted Home Rule after World War I was doomed to be broken, seized the General Post Office and ignited a general revolt in Dublin that raged through several days of street fighting and in the course of which the English reduced the rebel strongholds with field artillery and Gatling guns.

582:31 (598:21). The midnight sun is darkened—in the description of the Crucifixion: "And the sun was darkened, and the veil of the temple was rent in the midst" (Luke 23:45).

582:31–583:3 (598:22–24). The earth trembles . . . arise and appear to many—in the description of the aftermath of the Crucifixion: " . . . and the earth did quake, and the rocks rent; And the graves were opened; and many bodies of the saints which slept arose, And came out of the graves after his resurrection, and went into the holy city, and appeared unto many" (Matthew 27:51–53). For Prospect Cemetery, see 99:12n; for Mount Jerome Cemetery, see 100:1n.

583:8–9 (598:29–30). Factory lasses with . . . Yorkshire baraabombs—see 250:14n.

583:10–11 (598:32–33). Laughing witches in red . . . air on broomsticks—in Robert Burns's poem "Tam o' Shanter" (1791) the hero is a drunken farmer who stumbles upon "Warlocks and witches in a dance!" (line 115), presided over by the devil in the shape of a shaggy dog. Coffins open (line 125); the "holy table" (altar) is defiled with a murderer's bones, dead

babies, etc. (lines 130–142); the old women strip to their "sarks" (shirts) the better to dance and Tam is on the verge of having his stomach turned (line 162), but is "bewitched" (line 183) by one "winsome wench" (line 164) in a "cutty sark" (short shirt, line 171). His excitement gets the better of him and he shouts "Weel done, Cutty-sark!" (line 189), revealing his presence and setting the witches on to pursue him. He escapes because the witches cannot follow him over running water, though one of the witches manages to snatch the tail off his horse. See 68:41–42 (69:12–13).

583:12–13 (598:33–34). It rains dragon's ... up from furrows—Walter Hussey Burgh (1742–1783), Irish statesman and orator, famous for his "power of stirring the passions" in a speech in the Irish Parliament (1779): "Talk not to me of peace. Ireland is not at peace. It is smothered war. England has sown her laws as dragon's teeth, and they have sprung up as armed men." The allusion is to the Greek myth about Cadmus, the founder and king of Thebes. In the course of his wanderings he encountered and killed a dragon, whereupon Athena counciled him to sow its teeth in a field; armed men sprang up and immediately began to kill each other until only five were left. These five joined Cadmus in founding Thebes.

583:13–14 (599:1). the pass of knights of the red cross—i.e., a password that identifies them as having been admitted to the Masonic degree Knight of the Red Cross (preliminary to reception of the degree of Knight Templar). The Knights of the Red Cross are also known as the Knights of Babylon as a reflection of their mystic identity with the Jews who rebuilt Jerusalem and the temple after the Babylonian captivity; see 540:14n and 581:10–11n.

583:15 (599:2). Wolfe Tone—see 226:13n.

583:15 (599:2). Henry Grattan—see 137:15–16n.

583:15 (599:3). Smith O'Brien—see 92:6n.

583:16 (599:3). Daniel O'Connell—see 32:14n.

583:16 (599:3). Michael Davitt—(1846–1906), Irish patriot and politician who organized the Land League (1879) and who was instrumental in helping Parnell to fuse the two major political issues of the 1880s, Land Reform and Home Rule.

583:16 (599:4). Isaac Butt—see 136:27n.

583:16–17 (599:4). Justin M'Carthy against Parnell—a "real" contest since the Irish writer and politician Justin McCarthy (1830–1912) led the majority anti-Parnellite wing of the Irish party after the "split" over Parnell's leadership in 1890. McCarthy resigned his leadership in 1896.

583:17 (599:4–5). Arthur Griffith—see 44:6n.

583:17–18 (599:5). John Redmond—(1856–1918), Irish politician who supported Parnell at the "split" in 1890 and who worked to rally his broken party through the 1890s until it was reunited under his leadership in 1900.

583:18 (599:5). John O'Leary—(1830–1907), characterized by Yeats in 1913 as the last representative of "Romantic Ireland." O'Leary began his career as a political radical with the Young Irelanders in 1848, and continued with the Fenians as editor of their paper *The Irish People*. He was deported in 1871, allowed to return in 1885, after which he was active in the literary movement and in radical politics.

583:18–19 (599:6). Lord Edward Fitzgerald—see 237:29–31n.

583:19–20 (599:7). The O'Donoghue of the Glens—a Celtic and Catholic family of Irish gentry who were an exception since they were not displaced or suppressed by English rule but continued to flourish in the wilds of County Kerry in southwestern Ireland until the beginning of the nineteenth century.

583:21 (599:8–9). the centre of the earth—in Dante's *Inferno*, Canto XXXIV, the nethermost pit of hell, which contains the souls of those "who betrayed their masters and benefactors," notable among them: Judas and, at the center, Satan.

583:21–22 (599:9). the field altar of Saint Barbara—this legendary saint is associated with Heliopolis in Egypt or Nicomedia in Asia Minor. The daughter of a rich heathen, she was penned up in a tower by her father lest she be married without his permission. She was converted to Christianity and baptized during her father's absence. Once converted, she realized that her tower only had two windows, so she had a third cut that there might be one for each person of the Trinity. Her father was so outraged by her conversion that he delivered her up to public torture and finally beheaded her himself. On his way home he was struck down by a bolt of lightning out of a clear sky; thus St. Barbara became the patron saint of artillerymen, soldiers, firefighters (and of architects). Her intercession was invoked as protection against lightning, explosives and fire, against accident and sudden death. Her central attribute is the three-windowed tower, and she was the only female saint to bear the attribute of the sacramental cup and wafer. The

field altar appropriately bears her name as patron saint of those in battle.

583:22 (599:9–10). Black candles rise from its gospel and epistle horns—black candles are appropriate since a Black Mass is about to be celebrated and black is Satan's color. The Black Mass in worship of Satan is associated with the Witches' Sabbath and is performed as an elaborate series of inversions and perversions of the Christian Mass. It is traditionally performed on Thursday, possibly because the first Mass (the Last Supper) occurred on Thursday, possibly because that supper was prelude to Judas' betrayal. The Gospel side of the altar is on the congregation's left, where the Gospels are read; the Epistle side is on the right.

583:23 (599:11). the tower—not only the Martello tower associated with Stephen, Mulligan and Haines, but also St. Barbara's central attribute.

583:24–26 (599:12–14). On the altarstone . . . her swollen belly—Black Mass is traditionally celebrated with the body of a naked woman as the altar. As "goddess of unreason" she is the inversion of the "Goddess of Reason," an abstraction set up in 1793 by the French Revolutionists to take the place of the Christian God as the supreme deity.

583:26–28 (599:14–15). Father Malachi O'Flynn . . . back to the front—for Father O'Flynn's reputation as a maker of fools, see 168:12–13n; the comic reversals of his costume follow the Black Mass emphasis on reversal; for the two left feet, see 509:14n.

583:28–29 (599:16–17). The Reverend Mr Hugh C. Haines Love M.A—see 227:41–42n.

583:33 (599:21). Introibo ad altare diaboli—Latin: "I will go up to the devil's altar." *Cf.* 5:5n.

583:35 (599:23). To the devil which hath made glad my young days—the Protestant Reverend Love responds as Server in this Black Mass; *cf.* 5:5n.

583:37 (599:25). a blood dripping host—i.e., the Black Mass is celebrated with blood as against the wine that is transubstantiated into blood in the Christian Mass.

583:38 (599:26). Corpus Meum—Latin: "My Body." As the priest begins that phase of the Mass called the Consecration, he repeats what Jesus said at the Last Supper: "Take it, all of you, and eat of it, *for this is my body*."

584:5, 10 (599:31, 600:3). THE DAMNED/

THE BLESSED—are separated as they are to be at the Last Judgment, "When the Son of man shall come in his glory." See Matthew 25:31–46.

584:6 (599:32). Htengier . . . Aiulella!—an inversion of "Alleluia, for the Lord God Omnipotent reigneth." Revelation describes the course of the Last Judgment: "And I heard as it were the voice of a great multitude, and as the voice of many waters, and as the voice of mighty thunderings, saying, Alleluia: for the Lord God omnipotent reigneth" (Revelation 19:6).

584:9 (600:2). Dooooooooooog!—as "dog," an inversion of "God."

584:16 (600:9). Kick the Pope—one version of this Orange faction song is a nagging street rhyme, "Tooral, looral, kick the Pope;/Hang him up wi' taury rope" (Leslie Daiken, *Out Goes She; Dublin Street Rhymes* [Dublin, 1963], p. 20).

584:16–17 (600:9–10). Daily, daily sing to Mary—a Catholic hymn, "*Omni die dic Mariae,*" called St. Casimir's hymn; as translated by Father Bittlestone: "Daily, daily sing to Mary,/ Sing my soul, her praises due,/All her feasts, her actions worship,/With the heart's devotion true./ Lost in wond'ring contemplation,/Be her majesty confess'd:/Call her Mother, Call her Virgin,/ Happy Mother, Virgin blest."

584:23–24 (600:17). acushla—Irish: "O pulse," a term of endearment.

584:24 (600:17). At 8:35 a.m. you will be in heaven—*cf.* Stephen's riddle, 27:33–38 (26:33–38). Executions in the British Isles were traditionally scheduled for 8:00 A.M.

584:24 (600:17–18). Ireland will be free—Old Gummy Granny is speaking as a caricature of "The Shan Van Vocht"; see 19:17–18n.

585:2 (600:22). dialectic, the universal language—in contrast to Stephen's proposal, "So that gesture . . . would be a universal language," 425:17–18 (432:18–19).

585:6 (600:26). Exit Judas. Et laqueo se suspendit—Latin: "Judas left. And went and hanged himself." The last three Latin words quote the Vulgate, Matthew 27:5; the rest of Stephen's remark renders the sense of that passage.

585:11 (601:5). This feast of pure reason—Alexander Pope in *The First Satire of the Second Book of Horace Imitated* (1733) celebrates withdrawal from "all the distant Din that World can keep" into his "grotto . . . /There, my Retreat the best Companions grace,/Chiefs, out of War, and Statesmen, out Place./There *St. John*

mingles with my friendly Bowl,/The Feast of Reason and the Flow of Soul" (lines 123–128). Henry St. John, Viscount Bolingbroke (1678–1751), controversial English statesman, orator and author and a friend of Pope.

585:25 (601:19). Carbine in bucket!—military command. A "bucket" is the leather holster in which a cavalryman keeps his carbine (or lance).

586:12 (602:6). the coward's blow—i.e., an act of betrayal that is an attempt to avoid physical combat.

587:16–17 (603:13–14). Bennett'll have you in the lockup—i.e., Sergeant Major Bennett from Portobello Barracks (see 247:11–12n) would impose military punishment on a soldier who got in trouble with the civilian authorities.

588:5 (604:3). sprung—slang for drunk.

588:24 (604:22–23). wipe your name off the slate—i.e., don't put him in charge (under arrest), since to charge a drink in a bar is to put a man's name on a slate.

588:25–26 (604:23). with my tooraloom tooraloom—see 70:16–20n.

590:6–7 (606:6–7). Two commercials that were standing fizz in Jammet's—i.e., two salesmen who were buying champagne for the other customers; for Jammet's, see 365:5–6n.

590:9 (606:9–10). Behan's car—unknown.

590:12 (606:12). just going home by Gardiner street—this is "plausible" since Gardiner Street slants north-northwest from the Custom House near the mouth of the Liffey and passes just west of "nighttown"; it would be Bloom's logical route home from east-central Dublin.

590:15 (606:15). the mots—see 247:22n.

590:33 (607:2). Cabra—a small suburban district about two miles northeast of central Dublin; one of the residential waystations on Stephen's family's decline.

591:2 (607:4). Sandycove—see p. 6 above.

592:14 (608:18). The name if you call. Somnambulist—after the common assumption that a sleepwalker may be safely aroused if he is gently called by his first name or an intimate nickname.

592:21–22 (608:26–27). Who . . . drive . . . wood's woven shade?—here and below Stephen is reciting Yeats's "Who Goes with Fergus"; see 11:12–14n.

593:8–9 (609:13–14). swear that I will . . . art or arts—this is from a version of the oath of secrecy required of all Freemasons as a prior condition of initiation into a lodge.

593:10–11 (609:15–17). in the rough sands . . . ebbs . . . and flows—source unknown.

593:13 (609:19). secret master—the fourth degree in the Ancient and Accepted Scottish Rite of Freemasonry; the first of the so-called "Ineffable Degrees" (those principally engaged ·in contemplation of "the Ineffable Name [of the Deity]"). In the ritual of Freemasonry "the true secret is just that which eternally surrounds you, but is seen by none, although it is there for all eyes to see."

593:14 (609:20). a fairy boy of eleven, a changeling—in Celtic folklore fairies plagued human beings by kidnapping particularly handsome and promising babies and leaving difficult and unresponsive (or cantankerous) fairy children in their places.

593:16–17 (609:22–23). He reads from right . . . kissing the page—i.e., in the attitude of a devout young Hebrew scholar; cf. Bloom's memory of his father reading, 121 (122).

593:24 (609:30). A white lambkin—cf. 121:23–26n and 121:26–27n. Also this single animal, together with the "bronze helmet," 593:16 (609:22), and the "ivory cane," 593:24 (609:30), suggests that Rudy appears in the part of Hermes since that messenger of the Greek gods was often represented as a shepherd with a single animal from his flock, and a winged helmet and staff are familiar as his attributes. For Hermes' role in The Odyssey, see p. 372 above.

PART III
[THE HOMECOMING]
pp. 596–768 (612–783)

EPISODE 16
[EUMAEUS]

EPISODE SIXTEEN
BLOOM'S AND STEPHEN'S
ROUTE

◁——— Course & Direction
○——— Stop-Off Points

Episode 16: [Eumaeus], pp. 596–649 (612–665).
In the course of Book XIII of *The Odyssey* Odysseus returns alone to Ithaca. He is in serious danger of suffering Agamemnon's fate (i.e., of being murdered on arrival) if he enters his house and announces his identity. He has a long consultation with Athena in which he gets news of his beleaguered house and of his son Telemachus' enterprise in searching for news of him on the mainland. Athena helps Odysseus to disguise himself as an old man and councils him to seek the dwelling of Eumaeus, the swineherd, who "Of all Odysseus' field hands . . . cared most for the estate." In Book XIV the swineherd receives the incognito Odysseus with a ready offer of hospitality and with sensible kindness and honesty. Book XV is divided between a description of Telemachus' circumspect return to Ithaca and a further treatment of the relation between Odysseus and Eumaeus. In Book XVI Telemachus comes to Eumaeus' hut in search of news of his mother; Odysseus tests Telemachus' filial commitment and then reveals himself. Reunited, father and son plan an approach to their house.

Time: 1:00 A.M. Scene: the Cabman's shelter, a small coffeehouse under the Loop Line Bridge, just west of the Custom House, near Butt Bridge, the easternmost bridge over the Liffey. Organ: nerves; Art: navigation; Color: none; Symbol: sailors; Technique: narrative (old). Correspondences: *Eumaeus*—Skin-the-Goat (i.e., James Fitzharris; see 134:26–27n); *Ulysses, Pseudoangelos* (i.e., a pretender to that role)—the Sailor; *Malanthious* (Odysseus' goatherd who proves disloyal and plagues his disguised master in Book XVII)—Corley.

597:3 (613:3). orthodox Samaritan fashion—in Luke 10:30–37 Jesus answers a lawyer's question "Who is my neighbour?" with the parable of the Good Samaritan. The point of the parable is that the Samaritan, who was not an orthodox Jew, would help a severely injured man whom the orthodox ("a certain priest") "passed by" and neglected.

597:7 (613:7). Vartry water—see 268:9n.

597:9–11 (613:9–11). the cabman's shelter . . . near Butt Bridge—see headnote to this episode.

597:19 (613:20). e.d. ed—slang for finished, exhausted.

597:24 (613:25). along Beaver street—see 442:17n; Stephen and Bloom have turned south out of Tyrone Street, where the brawl took place. They are proceeding in the general direction of the Amiens Street Railroad Station.

597:25 (613:26). the farrier's—J. Kavanagh, horseshoer and farrier, 14–15 Beaver Street.

597:26–27 (613:26–27). the livery stables . . . Montgomery street—there was a livery stable at 42 Montgomery Street on the corner of Beaver Street. Montgomery Street, which gave its name (Monto) to the Dublin red-light district, is now Foley Street; it runs from Corporation Street (Mabbot Street in 1904) to Amiens Street, toward which Bloom heads in search of a cab.

597:28 (613:29). Dan Bergin's—Daniel L. Bergin, grocer, tea and wine merchant, 46 Amiens Street on the corner of Montgomery Street (now Foley Street).

597:29 (613:30). a Jehu—slang, originally for a fast or furious driver, after II Kings 9:20: " . . . the driving *is* like the driving of Jehu the son of Nimshi; for he driveth furiously"; by 1904, simply slang for any coachman or cabdriver.

597:32 (613:32–33). the North Star Hotel—at 26–30 Amiens Street across the street from the railroad station.

597:38 (613:39). bevelling—slang for moving or pushing.

597:39 (613:40). Mullet's—John Mullett, tea, wine and spirit merchant, 45 Amiens Street, next door to Bergin's.

597:39 (613:40). the Signal House—Thomas F. Hayden, family grocer and spirit merchant, the Signal House, 36 Amiens Street.

597:40–41 (613:41–42). Amiens street railway terminus—the Great Northern Railway Terminus, trains to Belfast and northern Ireland.

598:1 (614:1). gone the way of all buttons—after the proverbial "Gone the way of all flesh."

598:6 (614:6). Jupiter Pluvius—Latin: "Jupiter the Rain-Maker," one of the many common epithets for the king of the Roman gods, emphasizing his role as lord of the weather.

598:6 (614:6). dandered—dialect for strolled, sauntered.

598:12–13 (614:12–13). Great Northern railway . . . point for Belfast—see 597:40–41n.

598:14 (614:15). the morgue—the Dublin City Morgue around the corner at 3 Store Street had a back entrance at 2, 3 and 4 Amiens Street.

598:16 (614:16–17). the Dock Tavern—Mrs. M. A. Hall, proprietress, 1 Store Street on the

corner of Amiens Street; Bloom and Stephen turn west.

598:17–18 (614:18). C division police station —Dublin Metropolitan Police Barrack, C Division, was housed at 3 Store Street in the same complex of buildings as the morgue.

598:19 (614:19). warehouses of Beresford Place—Beresford Place curves from Store Street around the back of the Custom House toward Butt Bridge. There were several large warehouses in the street in 1904.

598:19–21 (614:19–21). Stephen thought to think . . . in Talbot Place—Stephen is recalling an association he established on his walk to the university in *A Portrait of the Artist as a Young Man*, Chapter V; D. G. Baird and J. Paul Todd, the Talbot engineering works, mechanical engineers and founders, 20–25 Talbot Place, were just around the corner from its intersection with Store Street. Interestingly enough, in spite of all Joyce's youthful admiration for Henrik Ibsen (1828–1906), this is the only direct mention of him in *Ulysses*. Ibsen, the great Norwegian dramatist, is regarded as one of the pioneers of modern drama. He is generally associated with "naturalism" in the theater and is credited with the origin of the play that treats social problems (the conflict between the individual and social norms or prejudices) in a blunt and outspoken manner. His later work combined realistic dialogue with a monolithic structuring of situation reminiscent of Greek tragedy.

598:22 (614:22–23). fidus Achates—see 87:13n.

598:23 (614:23–24). James Rourke's city bakery—City Bakery, James Rourke, baker and flour merchant, 5 and 6 Store Street, on the corner of Mabbot (now Corporation) Street.

598:25 (614:25). our daily bread—see 57:11n.

598:27 (614:27–28). O tell me where is fancy bread?—the opening line of a song that Portia sings while Bassanio is looking over a choice of caskets in Shakespeare's *The Merchant of Venice* (III, ii, 63–71). The song begins, "Tell me where is fancy bred,/Or in the heart or in the head?"

598:33 (614:33). swell mobsmen—in context, slang for showily dressed pimps who double as pickpockets and thieves.

598:42 (614:42). that man in the gap—see 292:1n.

599:2 (615:2). bridewell—see 160:25n. In Dublin it was located in the Four Courts on King's Inn Quay.

599:3 (615:3). Mr Tobias—Matthew Tobias, prosecuting solicitor for the Dublin Metropolitan Police; offices, Eustace Street, Dublin.

599:4 (615:3). old Wall—see 159:36n.

599:4 (615:4). Malony—Bloom's (or somebody's) mistake for Daniel Mahony, barrister and divisional police magistrate at the Central Metropolitan Police Court in the Four Courts.

599:7–8 (615:7). unscrupulous in the service of the Crown—a common Irish criticism of the Dublin Metropolitan Police, who, while ostensibly Irish, were all too readily associated with the English Establishment.

599:9 (615:8–9). the A Division in Clanbrassil street—the A Division Police Barracks were in Kevin Street Upper, just off New Street, which is an extension of Clanbrassil Street; Clanbrassil Street and its extensions bisect south-central Dublin.

599:11 (615:11). Pembroke Road—in a fashionable area on the southeastern outskirts of metropolitan Dublin in 1904.

599:33 (615:33). that one was Judas—i.e., Lynch; see 585:6n.

599:36 (615:36). the back of the Customhouse —i.e., Stephen and Bloom are in Beresford Place, which curves from Store Street around the north and west sides of the Custom House to end at Butt Bridge.

599:36–37 (615:37). the Loop Line bridge— the City of Dublin Junction Railway, an elevated railway that linked Westland Row Station south of the Liffey with Amiens Street Station north of the Liffey.

599:42 (615:42). the corporation watchman— i.e., in the employ of the Dublin Corporation, the Dublin City government.

600:4 (616:4). Gumley—see 134:32n.

600:14 (616:13). funkyish—elaborated from "funk," slang for to be afraid, scared, depressed.

600:19 (616:18–19). the Thames embankment —an area in London once known for the indigents who congregated there and consequently a stock phrase for indigence.

600:26–27 (616:26–27). Lord John Corley— appears as a character in "Two Gallants," *Dubliners*.

600:28–29 (616:29). the G Division—the

plainclothes-detective branch of the Dublin Metropolitan Police. In 1904 the division was headed by a superintendent, a chief inspector and two inspectors.

600:30 (616:30). Louth—a county on the east coast of Ireland, north of Dublin.

600:31 (616:31). New Ross—a town in County Wexford in southeastern Ireland.

600:34 (616:34–35). the house of the Lords Talbot de Malahide—is located in the village of Malahide, nine miles north of Dublin. It is called "Malahide Castle" and is a large, square baronial mansion flanked by circular towers; it was first built in the twelfth century, though repeated reconstruction and updatings have effectively eliminated the original. The interior is richly overanimated with elaborate oak carvings and wainscoting. See 220:12–14n.

601:4 (617:3). swab—a term of contempt for an idle, worthless person; especially, a drunkard.

601:15 (617:15). a gentleman usher—obsolete for an assistant to a schoolmaster or to a head teacher.

601:19 (617:19–20). the Christian Brothers—see 216:5n.

601:23–24 (617:24–25). a dosshouse in Marlborough street, Mrs Maloney's—a cheap lodging house; the street is just west of where the characters are standing. *Thom's (1904)* does not list a Mrs. Maloney on the street, but there are a number of "tenements" listed.

601:24 (617:25). tanner—slang for sixpence.

601:26–28 (617:27–29). the Brazen Head ... for friar Bacon—the Brazen Head Hotel, the oldest hostelry in Dublin· (c.1688), was not in Winetavern Street but a block west, at 20 Bridge Street Lower. Stephen is reminded of *The Honourable History of Friar Bacon and Friar Bungay* (c.1589–1592), a play by the English poet-dramatist-journalist Robert Greene (1558–1592). The main plot of the play is a standard love triangle; the slapstick subplot involves a series of competitions in necromancy. In Act IV Friar Bacon climaxes seven years of work with the creation of "the brazen head." Properly invoked, the head would have uttered great wisdoms and would have created a protective wall of brass around all of England. Unfortunately the head utters its wisdom ("Time is! ... Time was! ... Time is past!") to Bacon's stupid servant Miles, who responds without the proper formulae of invocation; and at the words "Time is past!" a hammer appears and destroys the head.

601:34 (617:35). haud ignarus malorum miseris succurrere disco—Latin: "not at all ignorant of misfortune, I have learned to succor the miserable." This improves on Virgil's line in the *Aeneid* I:630 when Dido says, *"Non ignara mali miseris succurrere disco,"* to assure Aeneas of her willingness to comfort him ("Not ignorant of misfortune . . .").

601:36 (617:37). screw—slang for salary.

602:19 (618:19). the Bleeding Horse in Camden street—a pub in south-central Dublin, somewhat outside of Bloom's geographical patterns and rather low on the social scale as Adams points out (pp. 205–206). Perhaps the reason for this relatively improbable meeting place lies in Adams' observation that the pub is important "as a center of low scheming" in James Sheridan Le Fanu's (1814–1873) novel *The Cock and Anchor* (1845).

602:23 (618:24). the Carl Rosa—i.e., the Carl Rosa Opera Company, founded in 1873 by the German violinist and conductor Carl Rosa (born Rose, 1842–1889). The company devoted itself to opera in English and toured extensively in the provinces; it established its popularity in Dublin in 1873 with the first of its many appearances in that city.

602:28 (618:28). Bags Comisky—for what it's worth, *Thom's (1904)* lists a Mr. C. Comisky at 27 Effra Road in Rathmines. The nickname "Bags" suggests that he wore outsized trousers.

602:29 (618:29). Fullam's the shipchandler's—John Fullam, shipchandler, bonded stores, rope, sail and twine manufacturer, 6 Eden Quay, 4 Rogerson's Quay and 54 Denzille Street.

602:30 (618:30). in Nagle's back—in the back room of a pub managed by four Nagles; it had entrances at 9 Cathedral Street and 25 South Earl Street North, not far northeast of where Stephen and Corley are talking.

602:30 (618:30). O'Mara—apart from the context, identity or significance unknown.

602:31 (618:31). Tighe—apart from the context, identity or significance unknown.

602:31 (618:31). lagged—slang for arrested.

603:24 (619:24). Eblana—see 382:31n.

603:24–25 (619:24–25). Customhouse Quay—in front of the Custom House on the north bank of the Liffey just a few yards from where Bloom and Stephen are standing.

603:35–36 (619:35–36). Everyone according to . . . to his deeds—Bloom's version of Karl Marx's (1818–1893) socialist axiom "From each according to his ability; to each according to his needs."

603:40 (619:40). fag—slang for to do something fatiguing.

604:21 (620:20). the ingle—obsolete for a fire burning on the hearth.

604:22 (620:21). Trinidad shell cocoa—a relatively inferior cocoa.

604:24–25 (620:23–24). the Friday herrings—until 1967 Friday was a fast day (meatless) for Roman Catholics.

604:28–29 (620:27–28). the third precept of the church—"to observe the fasts on the days during the seasons appointed."

604:30 (620:29). quarter tense or, if not, ember days—the same thing, since "quarter tense," from Latin *Quatuor Tempora* ("Four Times"), is Middle English for Ember Days, days of fast and abstinence at the beginning of various liturgical seasons. Ember Days occur on the Wednesdays, Fridays and Saturdays after 13 December, after Ash Wednesday (16 February 1904), after Whitsunday (22 May 1904) and after 14 September.

605:3 (621:1). tony—slang for high on the social scale, fashionable.

605:5–7 (621:3–5). his rescue of that man . . . or Malahide was it?—it was at neither of these seaside resorts north of Dublin, but from the Liffey in central Dublin that Gogarty rescued a bookmaker named Max Harris on Sunday, 23 June 1901.

605:25 (621:23). the men's public urinal—under the Loop Line Bridge just north of Butt Bridge and near the Cabman's Shelter.

605:30–34 (621:28–32). Putanna madonna . . . Mortacci sui!—Italian: "—Whore of a Blessed Virgin, who gives us these half-farthings! Am I right? It breaks your arse!/—We understand each other. No longer his own boss . . ./—So *he* says, however./—The rascal! Death to him!" The implication is that the two speakers are angry with an employer or third person who has underpaid them.

605:35 (621:33). the cabman's shelter—see headnote to this episode, p. 438.

605:39 (621:37). Skin-the-Goat Fitzharris, the invincible—see 80:23n, 80:24n and 134:

26–27n. James Fitzharris was sentenced to life imprisonment as an accessory in the Phoenix Park murders, but he was released in 1902. There is no evidence to suggest that he was keeper of the Cabman's Shelter, but several Dubliners (1970) have suggested that the Dublin Corporation employed him as a nightwatchman after his release from prison.

606:19 (622:16). voglio—see 63:38n.

606:24 (622:21). Bella Poetria!—Bloom's attempt at *"Bella Poesia!,"* Italian: "Beautiful Poetry!"

606:25 (622:22). Belladonna voglio—Bloom is attempting to say, "I want a beautiful woman," in Italian; but "Belladonna" in Italian also means "deadly nightshade."

607:2–3 (622:41–42). Cicero, Podmore, Napoleon, Mr Goodbody, Jesus, Mr Doyle—Adams (p. 223) suggests a solution to this word puzzle: "Cicero as a name comes from Latin *cicera*, chickpea, and might well be something like Podmore in English; Napoleon = Buonaparte = Goodbody; and Jesus = Christ = Anointed = oiled = Doyle."

607:3–4 (622:42–43). Shakespeares were as common as Murphies—if "common" in the sense of "not upper class," yes; but quantitatively, an exaggeration, though "Shakespeare" was not an unusual name.

607:4 (622:43). What's in a name?—in Shakespeare's *Romeo and Juliet*, Juliet discovers that Romeo is a Montagu (and thus her family's enemy): " . . . O, be some other name!/What's in a name? That which we call a rose/By any other name would smell as sweet" (II, ii, 42–44).

607:18 (623:14). good old Hollands—i.e., Holland gin, formerly Holland geneva.

608:6–7 (624:1–2). Buffalo Bill shoots . . . he never will—Iona Opie (in a letter, 24 August 1970) suggests that this street rhyme is similar to a rhyme that appears in Carl Sandburg's *The American Songbag* (New York, 1927), pp. 384–385: "Bad Bill from Bunker Hill/Never worked (washed) and never will." Buffalo Bill was the American frontiersman and scout William F. Cody (1846–1917), who earned his reputation as a crack shot when he was a contractor supplying buffalo meat to workmen on the transcontinental railroad after the Civil War. He subsequently became an international figure as the head of a Wild West show in which he gave demonstrations of his marksmanship: one of his widely advertised feats was the shooting of clay pigeons with a revolver.

608:10 (624:5). the Bisley—the annual competitive meetings of the National Rifle Association (of England) were held in July on Bisley Common, 29 miles southwest of London.

608:16–17 (624:11–12). Hengler's Royal Circus—see 64:21–22n.

608:20–21 (624:15–16). W. B. Murphy of Carrigaloe—this "commoner" (see 607:3–4n) is from Carrigaloe Station on Great Island on the passage between Cork (Queenstown, now Cobh) Harbour and Lough Mahon that leads to Cork.

608:23 (624:18–19). Fort Camden and Fort Carlisle—the two forts that guarded the inner entrance to Cork (or Queenstown) Harbour; they are almost five miles south of Carrigaloe.

608:25 (624:20–21). For England, home and beauty—see 222:13, 16n.

608:30 (624:25). Davy Jones—see 372:20n.

608:32 (624:27). Alice Ben Bolt—from the English popular song "Ben Bolt," by Thomas Dunn English and Nelson Kneass. Ben Bolt, a sailor faithful to his Alice, returns after a 20-year absence to find Alice dead. First stanza: "Don't you remember, sweet Alice, Ben Bolt?/Sweet Alice with hair so brown,/Who blushed with delight if you gave her a smile,/And trembled with fear at your frown?/In the old church in the valley, Ben Bolt,/In a corner obscure and lone,/They have fitted a slab of granite so grey,/And Alice lies under the stones."

608:32 (624:27). Enoch Arden—(1864), a narrative poem by Tennyson. Enoch, the sailor-hero, happily weds Annie Lee; the luck of his small-boat enterprise eventually sours, and he determines to accept a position as boatswain on a ship bound for China in order to achieve security for his family. Enoch's absence is extended by shipwreck, and he finally returns "so brown so bow'd/So broken . . ." (lines 699–700), only to discover that his wife, having assumed him dead, has married Philip Ray, Enoch's and Annie's childhood friend. He struggles to conceal his identity, swearing the only person who knows to secrecy until after his death, and then dies brokenhearted, a "strong heroic soul" (line 909).

608:32–33 (624:27–28). Rip van Winkle—see 529:32n.

608:33 (624:28). does anybody hereabouts remember Caoc O'Leary—"Caoch the Piper" ("Caoch" is Irish for one-eyed or blind), a ballad by John Keegan (1809–1849). At the beginning of the poem the speaker recalls his childhood ("those happy times") and an over-

night visit from the Piper, Caoch O'Leary; and when "twenty summers had gone past," the memory of the idyll remained, and "Old Caoch was not forgotten," even though the speaker's life has declined from "rosy childhood" to a sad and lonely maturity. Caoch reappears, weeping, and on the verge of death. He asks, "Does anybody hereabouts/Remember Caoch the Piper?" (lines 59–60). He is, of course, remembered and welcomed by the solitary speaker, who suitably laments his state and Caoch's—and Caoch's death the next day.

608:35 (624:30). poor John Casey—Bloom confuses John Keegan, the author of "Caoch the Piper," with another Irish poet-patriot, John Keegan Casey (1846–1870), who did merit the epithet "poor" since his imprisonment as a Fenian in 1867 and his consequent sufferings led to his premature death.

608:37 (624:32). the face at the window—if this is an anachronism, it may refer to a melodramatic novel, *The Face at the Window*, which appeared complete in *My Queen Novels* (a penny weekly), number 951 (13 January 1914). The face, an omen of murder to come, appears out of a violent storm, "a white staring face, a man's face, pressed so close to her own that, though the glass divided them, she could almost fancy she felt his panting breath against her cheek. His hat was pulled low over his forehead; but she had a vivid expression of an ashen, death-like countenance—of a jaw dropping in the extremity of fear, and of wild, panic-stricken eyes."

609:1–2 (624:37–38). Rocked in the cradle of the deep—(1832), a song by the American educator Emma Willard (1787–1870), music by Joseph Philip Knight. First stanza: "Rock'd in the cradle of the deep/I lay me down in peace to sleep;/Secure I rest upon the wave/For Thou, O Lord, Hast pow'r to save./I know Thou wilt not slight my call,/For Thou dost mark the sparrow's fall!/ And calm and peaceful is my sleep,/Rock'd in the cradle of the deep."

609:2 (624:38). uncle Chubb or Tomkin—"chubb" is obsolete for a dull, spiritless person; "Tomkin" (Little Thomas), generically any Tom, Dick or Harry.

609:3 (624:39). the Crown and Anchor—a common name for pubs frequented by sailors.

609:6–7 (624:42–625:1). With a high ro! . . . tearing tandy O!—source unknown.

609:20 (625:14). Rosevean—see 51:36–38n.

609:22 (625:16). A.B.S.—Able-Bodied Seaman.

609:33 (625:26). Captain Dalton—apart from the context, his identity and significance are unknown.

609:34 (625:27–28). Gospodi pomilooy—Russian: "God have mercy on us."

609:42–610:1 (625:35–36). maneaters in Peru . . . livers of horses—anthropologists have documented cannibal tribes at the headwaters of the Amazon in Bolivia (see below) and in western Brazil, but not among the extant mountain and coastal tribes of Peru.

610:6 (625:41). Choza de Indios. Beni, Bolivia—Spanish: "Indian huts." Beni is a large province east of the Andes in northeastern Bolivia (for the most part unexplored in 1904); it is notable that Bolivia is landlocked, and it is unlikely that a late-nineteenth-century sailor would have penetrated so far east as Beni.

610:13 (626:5). diddies—"a woman's breast, diminutive of the Irish, *did,* breast" (P. W. Joyce, *English as We Speak It in Ireland,* p. 247).

610:23–24 (626:15–16). Tarjeta Postal. Galería Becche—Spanish: "Post Card. The Becchi Gallery."

610:27 (626:19). William Tell—the hero of a fifteenth-century Swiss legend who is condemned to death by the Austrians (*c.*1307) but allowed to ransom his life if he will shoot an apple off his son's head; an excellent marksman, he succeeds, and then goes on to help the Swiss Forest Cantons win their independence from Austria.

610:27–28 (626:19–20). the Lazarillo-Don Cesar . . . depicted in Maritana—see 85:20–21n. Don Cesar, the hero of the opera, escapes the villain Don Jose's murderous plots. In Act II Don Cesar is condemned to death before a firing squad, and is saved when his friend, the poor boy Lazarillo, removes the bullets from the firing squad's muskets. In Act III Lazarillo is forced by Don Jose to fire at Don Cesar; the bullet misses Don Cesar but lodges in his hat (as the audience discovers when he shakes it out on the stage).

610:32 (626:24). boxed the compass—literally, "learned how to read and use a compass"; figuratively, "learned his nautical skills."

610:32 (626:25). q.t.—slang for quiet (with emphasis on secrecy).

610:36–37 (626:28–29). Wednesday or Saturday . . . via long sea—the British and Irish Steam Packet Company's ships sailed between Dublin and London, calling at Falmouth, Plymouth, Southampton and Portsmouth. From Dublin there were sailings each Wednesday and Saturday (approximately 640 miles by sea).

610:40 (626:33). going to Holyhead—70 miles from Dublin; see 374:28n.

610:42 (626:34). Egan—Alfred W. Egan, secretary of the Dublin offices of the British and Irish Steam Packet Company.

611:3 (626:37). breaking Boyd's heart—a Dublin expression for taking a financial risk since the Honourable Walter J. Boyd (b. 1833) was a judge in Dublin's Court of Bankruptcy from 1885 to 1897.

611:9 (626:43–627:1). Plymouth, Falmouth, Southampton—see 610:36–37n.

611:12–13 (627:3–4). the greatest improvement . . . wealth of Park Lane—improvements to the great tourist attractions, the Tower of London and Westminster Abbey, were widely advertised during the preparations (1901–1902) for Edward VII's coronation. Park Lane is in the heart of Mayfair; in 1904 it was (and still is) one of London's most fashionable districts.

611:17–19 (627:9–11). Margate . . . Eastbourne . . . the Channel islands—for Margate, see 177:37n; Eastbourne is a resort town on the English Channel in Sussex, 66 miles south-southeast of London; Scarborough is on the North Sea, 42 miles northeast of York; Bournemouth is in the middle of the south coast of England on the Channel; the Channel Islands (Guernsey, Jersey, etc.) were in 1904 quiet, rural sea resorts off the west coast of Normandy at the southern entrance to the Channel.

611:26 (627:18). Elster Grimes—see 91:1–2n.

611:26 (627:18). Moody-Manners—the Moody-Manners Opera Companies, Ltd., formed in 1897 by the Irish bass Charles Manners (b. Southcote Mansergh, 1857–1935) and his wife, the English soprano Madame Fanny Moody; the "A" company (with Manners and his wife as stars) was in 1904 the largest English opera company in the world. There were also "B" and "C" companies for the lesser provinces.

611:33–34 (627:25–26). the Fishguard-Rosslare route—i.e., a steamship route between Rosslare at the southeastern tip of Ireland and Fishguard in southwestern Wales. A regular steampacket service between the two ports was established in 1905.

611:34 (627:26). tapis—French: "carpet."

612:12 (628:3). Poulaphouca—see 535:2n.

612:13 (628:4). farther away from the madding crowd—after stanza 19 of Thomas Gray's (1716–1771) "Elegy Written in a Country Churchyard" (1751): "Far from the madding crowd's ignoble strife/Their sober wishes never learned to stray;/Along the sequester'd vale of life/They kept the noiseless tenor of their way." Thomas Hardy used Gray's phrase as the title for a novel, *Far from the Madding Crowd* (1874).

612:13–14 (628:5). Wicklow ... the garden of Ireland—what Bloom has in mind is a scenic area between Bray and Wicklow called the "Garden of Wicklow"; it was approximately 25 miles south of Dublin.

612:16 (628:7). the wilds of Donegal—i.e., the Highlands of Donegal, in guidebook prose, "second to none in the wildness of its scenery." Donegal is in northwestern Ireland.

612:16 (628:8). coup d'oeil—French: "glance, view."

612:17–18 (628:9). not easily getatable—Bloom is right that few tourists visited Donegal in the early twentieth century. It was possible to travel by railroad from Dublin to Donegal, but the route was circuitous, and the lack of tourist accommodations in the thinly populated Highlands was regarded by guidebooks as a discouragement to all but the hardy traveler.

612:21 (628:12). Silken Thomas—see 46:22–23n; during his ill-fated and short-lived rebellion, Thomas seized Howth and used it as a strong point in the hopes of preventing the English from landing reinforcements, because Howth was Dublin's main port of entry until the construction of Kingstown (Dun Laoghaire) Harbour in 1859.

612:21 (628:12). Grace O'Malley—see 324:13n; her association with Howth derives from the legend (?) that Lord Howth refused her hospitality when she was on her way home via Howth from a visit to Queen Elizabeth; she kidnapped Lord Howth's son and ransomed him on the condition that Lord Howth would open his doors to her at the dinner hour.

612:21 (628:12–13). George IV—(1762–1830), king of England (1820–1830), landed at Howth on a visit to Ireland in August 1821; his visit was a notable event since he was the first English sovereign to land in Ireland in over a century.

612:23–24 (628:15). in the spring when young men's fancy—from Tennyson's "Locksley Hall" (1842), line 20: "In the spring a young man's fancy lightly turns to thoughts of love."

612:26 (628:17). on their left leg—slang for on the spur of the moment (since it is traditional to start marching with the left foot).

612:27 (628:18). the pillar—Nelson's Pillar in central Dublin; see 94:1n.

613:4 (628:38). knockingshop—low slang for a brothel.

613:4 (628:38). tryon—slang for an attempt to take advantage of someone.

613:6 (628:40). Prepare to meet your God—in Amos 4:12 the Lord promises to inflict elaborate punishment on the Israelites for their shortcomings: "Therefore thus will I do unto thee, O Israel: *and* because I will do thus unto thee, prepare to meet thy God, O Israel."

613:17–19 (629:8–10). That was why they ... of them using knives—immediately after the Phoenix Park murders on 6 May 1882 there was considerable speculation that the assassins might have been brought in from Europe or America. The principal reason for this speculation was not that the assassins used knives, but that political assassination at that time seemed so foreign to the outburst of political optimism engendered by Parnell's release from prison on 2 May 1882. Parnell's release involved an agreement between Parnell and Gladstone (the so-called Kilmainham Treaty); apparently Parnell was to use his political influence to reorganize the Land League so that he could control and diminish the agrarian violence that marked the agitation for land reform in Ireland from the late 1870s until 1882; in return Gladstone was to push for serious Parliamentary action on that reform.

613:20–21 (629:11–12). where ignorance is bliss,—Thomas Gray, "Ode on a Distant Prospect of Eton College" (1742, 1747), lines 99–100: "Where ignorance is bliss,/Tis folly to be wise."

613:31 (629:22). choza de—see 610:6n.

613:35 (629:26). the days of the land troubles—see 613:17–19n.

613:37 (629:28). eighty-one to be correct—6 May 1882, see 134:17–18n.

614:3–4 (629:36–37). Europa point—the headland of which the Rock of Gibraltar is the dominant feature.

614:13 (630:4). Salt junk—hard, salted beef, a staple of the seafarer's diet at the turn of the century.

614:20 (630:11). to rule the waves—see 323:24n.

614:21 (630:12). the North Bull at Dollymount—the North Bull is a sand island off Dollymount just northeast of Dublin. A wall across its southern end connects it to the mainland and prevents its sands from encroaching on Dublin Harbour.

614:24–25 (630:15–16). dreaming of fresh woods and pastures new—from Milton's "Lycidas"; see 26:25n.

614:38 (630:29). lifeboat Sunday—the Royal National Lifeboat Institution, Irish Auxiliary, Dublin Branch, was a volunteer lifesaving service; it held an annual and rather festive public demonstration of its skills.

615:2 (630:35). Ireland expects that every man—see 222:13, 16n.

615:4 (630:37). Kish—see 45:11n and 66:32–33n.

615:7 (630:40). the Rover—the ship may owe its name to a popular light opera, *Black Rover* (1890). The Rover, the opera's pirate-hero, was one of William Ludwig's successful sequels to his role as the Flying Dutchman (see 620:40n). The opera, written by Seavelle and Luscombe, is set in mid-eighteenth-century Cuba; its melodramatic plot focuses on the young lovers Felix and Isadora, estranged because Felix has defied the Rover's curse. Felix endures shipwreck and rescue, voodoo enchantment, etc. before the spirit of the Rover blesses and reunites the lovers.

615:16–17 (631:6–7). Henry Campbell, the townclerk—in 1904 he was, with offices in Dublin City Hall.

615:18–19 (631:9). nosepaint—slang for a nose "painted" by alcoholism.

615:22 (631:12). The Skibereen father—in "Old Skibereen," an anonymous Irish ballad about the Famine, the father tells his son why they emigrated. The ballad begins: "It's well I do remember the year of '48,/When I arose with Erin's boys to battle 'gainst the fate./I was hunted through the mountains like a traitor to the Queen,/And that's another reason why I left old Skibereen."

615:33 (631:23). the figure 16—in European slang and numerology the number sixteen meant homosexuality.

616:21–22 (632:10–11). As bad as old ... on my ownio—see 96:12–13n.

616:28–29 (632:18). the Abbey street organ—the last pink edition of the *Evening Telegraph*, offices at 83 Abbey Street Middle.

616:40 (632:30). Bewley and Draper's—Ltd., general merchants, manufacturers of mineral waters, wholesale druggists, wine merchants, and ink manufacturers, 23–27 Mary Street.

616:41–617:1 (632:31–32). Love me, love my dirty shirt—after the proverb "Love me, love my dog."

617:10 (632:41). gunboat—slang for a thief, rascal or beggar and, as in this case, for a beggarly prostitute.

617:12–13 (633:2–3). the Lock Hospital—see 509:20n.

617:21–22 (633:11–12). Fear not them that ... to buy the soul—after Matthew 10:28. Jesus councils his disciples: "And fear not them which kill the body, but are not able to kill the soul: but rather fear him which is able to destroy both soul and body in hell."

617:39–40 (633:30–31). such inventions as X rays—discovered in 1895 by Röntgen and so named because the cause of the rays was unknown; see 176:40–41n.

618:3–8 (633:35–40). it is a simple substance ... corruptio per accidens—St. Thomas Aquinas, *Summa Theologica*, Part I, Question LXXV, Sixth Article: "We must assert that the intellectual principle which we call the human soul is incorruptible. For a thing may be corrupted in two ways—[*corruptio per se*] of itself, and [*per accidens*] accidentally." Aquinas then goes on to argue that neither mode of corruption can affect the soul since "corruption is found only where there is contrariety" and since the soul is "simple," without contrariety, it is incorruptible.

618:16–17 (634:8). Röntgen—see 176:40–41n.

618:17 (634:8). Edison—the American inventor Thomas Alva Edison (1847–1931), who began his career with a series of inventions that significantly improved the telegraph. In the late 1870s he began to range through a variety of fields, inventing the phonograph (1878), the incandescent electric lamp (1879), the mimeograph, etc., etc.

618:18 (634:9). Galileo—(1564–1642), Italian physicist and astronomer, is often credited with the invention of the telescope because he realized its importance to astronomy and hence described and exhibited a complete instrument in May 1609. The actual "invention" is far less clear; like the invention of printing, the invention of the telescope appears to have been achieved simultaneously by several spectacle makers in Holland. Galileo apparently got the idea for the telescope by rumor rather than by "inspiration."

618:35 (634:27). like Hamlet and Bacon—on the Baconian controversy, see 193:6n.

619:2–3 (634:38). the Coffee Palace—see 264:26n.

619:13–14 (635:6). Sulphate of copper poisoning, SO_4—Bloom's chemistry is shaky; copper sulfate is $CuSO_4$; SO_4 would be hopelessly unstable.

619:18–19 (635:11). Dr Tibble's Vi-Cocoa—unidentified.

619:32–33 (635:25–26). that knife . . . reminds me of Roman history—see 26:14–15n.

620:7 (636:1). Sherlockholmesing—see 485:17n.

620:12 (636:6–7). the oakum and treadmill fraternity—i.e., prison, since picking oakum and walking a treadmill were two forms of hard labor in English prisons.

620:17–18 (636:11–12). the dramatic personage . . . of our national poet—in Shakespeare's The Merchant of Venice Antonio is the merchant. He befriends, to the verge of self-sacrifice, the young hero, Bassanio, in his love affair and monetary difficulties.

620:22–24 (636:17–18). any ancient mariner . . . about the schooner Hesperus—"to draw the long bow" is to tell a tall story, as the mariner does in Coleridge's narrative poem The Rime of the Ancient Mariner (1798); the Hesperus features in Longfellow's ballad "The Wreck of the Hesperus" (1840). The opening lines: "It was the schooner Hesperus,/That sailed the wintry sea." Longfellow's poem is not a "tall story" but a generalized narrative response to news of a December 1839 shipwreck.

620:31 (636:25). Marcella, the midget queen—unknown.

620:31–32 (636:25–26). those waxworks in Henry street—World's Fair Waxwork Exhibition, 30 Henry Street, was not only a museum with a collection of wax figures; it also featured a changing program of variety acts, ballad singers, ventriloquists, etc.

620:32–37 (636:26–32). some Aztecs, as they . . . being adored as gods—Aztec kings were regarded as gods, but this seems closer to a confusion between "Aztec" and "ascetic"; if it is, then what Bloom has seen is a yogi ascetic or fakir whose musculature has been weakened by prolonged worship in one position.

620:39 (636:33). Sinbad—the wandering sailor-hero of several tall stories in the Arabian Nights' Entertainments; also the title figure of Sinbad the Sailor, a pantomime that enjoyed considerable popularity in Dublin during the 1890s. See 662:30–32n, ff.

620:40 (636:34). Ludwig, alias Ledwidge—William Ledwidge (1847–1923), a Dublin baritone whose stage name was Ludwig. He was featured with the Carl Rosa Opera Company and scored a popular success as Vanderdecken in The Flying Dutchman at the Gaiety Theatre in 1877. Thornton (pp. 439–440) assumes this was Wagner's opera (see 469:22n), but the opera with which Ludwig was most intimately identified was a musical version (by G. H. B. Rodwell) of Vanderdecken or, the Flying Dutchman (1846), a popular play by the English playwright T. P. Taylor.

620:41–42 (636:35–36). the Gaiety when Michael Gunn was identified with the management—see 280:3n.

621:9 (637:2–3). little Italy there, near the Coombe—there was a relatively small community of Italian immigrants in a tenement district just south of the Coombe in south-central Dublin.

621:11 (637:4). pothunting—i.e., not hunting for sport but for something to eat.

621:17 (637:10). quietus—after Hamlet in the "To be or not to be" soliloqy: "For who would bear the whips and scorns of time . . . /When he himself might his quietus make/With a bare bodkin?" (III, i, 70–76).

621:27 (637:20–21). Roberto ruba roba sua—Italian: literally "Robert theft property his."

621:31–32 (637:25–26). Dante and the isosceles . . . in love with—Beatrice Portinari (1266–1290), a Florentine woman, identified on Boccaccio's authority as the object (or rather image) of Dante Alighieri's (1265–1321) abstracted and spiritualized love. Beatrice was married to Simone de Bardi, hence the "triangle," presumably "isosceles" because Dante's idealization of Beatrice's image put him so far from the real marriage relationship at the triangle's base.

621:32 (637:26). Leonardo—Leonardo da Vinci (1452–1519), the painter, sculptor and engineer, another Florentine.

621:32 (637:26). san Tommaso Mastino—Italian: "Saint Thomas [the] Mastiff," i.e., "bulldog Aquinas," who was born near Naples (1226–1274); see 205:27–29n.

621:33–34 (637:27–28). All are washed in the blood of the sun—i.e., in "sunny Italy," where popular mythology assumes all to be hot-blooded; see 149:11n.

621:35 (637:29). the Kildare street museum—i.e., the National Museum in Kildare Street; see 174:4–5n.

622:6–7 (637:42–43). doubled the Cape—the phrase could mean rounding the Cape of Good Hope, but it usually means rounding Cape Horn, since that is much the more dangerous passage.

622:11–19 (638:4–12). the wreck off Daunt's rock . . . petrified with horror—the Finnish (not Norwegian) ship *Palme* went aground off Blackrock, just south of Booterstown on the southern shore of Dublin Bay during a severe storm on 24 December 1895. Two Irish lifeboats attempted to take the men off the *Palme*, but one of the boats capsized with the loss of its entire 15-man crew and the other could not reach the stranded ship. The *Palme's* officers and crew were rescued without further loss on 26 December. Crowds did gather at Blackrock to view the wreck, but the visibility was poor and the wreck so distant that it was hard to see any detail without binoculars. Albert William Quill's memorial verse on the event, "The Storm of Christmas Eve, 1895," appeared under the headline "An Anti-spastic Dithyramb" in the *Irish Times*, 16 January 1896. The poem's second stanza is symptomatic of its quality: "Awake! to the sea! to the sea! raging, and surging, and eddying,/The billows gape in twain, yawning and fain for the sacrifice!/The crested dragon glares hitherward, hungry and ravening,/Befleck'd with the froth and the foam, back from the mouth of the fortalice." Daunt's Rock is not in Dublin Bay but off the coast of County Cork near the mouth of Cork Harbour.

622:19–24 (638:13–17). the case of the s.s. Lady Cairns . . . appears in her hold—the English barque (not steamship as "s.s." implies) *Lady Cairns* was rammed in rough and hazy weather by the German barque *Mona* off Kish Bank on 20 March 1904. The *Lady Cairns* capsized and sank "within two minutes" according to the *Freeman's Journal*, 22 March 1904; all hands were lost. The *Mona* was severely disabled and had to be towed into port (the "no water . . . in her hold" is an anti-German flourish). The Admiralty Court (*Freeman's Journal*, 27 June 1904) found the *Lady Cairns* at fault for not keeping effective lookout since she was on the port tack and thus should have given the right of way to the *Mona*, which was on the starboard tack. The court in turn found no criminal negligence on the part of the master of the *Mona*, though he had been criticized for not immediately lowering all his lifeboats to search for survivors in the rough sea.

623:1 (638:36). the Loop Line—see 599:36–37n.

623:14–15 (639:8). on the parish rates—each parish in Ireland had a Poor Law Guardian, who was responsible for the collection of the poor rate (taxes for support of the poor) and administration of the Poor Laws; in 1904 the system was anything but generous.

623:15 (639:8–9). Pat Tobin—identity or significance unknown.

623:22–23 (639:16). to make . . . ducks and drakes of—i.e., to throw away money, after "ducks and drakes," a game in which players compete to see how many times they can skip a stone on water.

623:24 (639:18). stiver—after a small Dutch coin, slang for an English penny or any coin of small value.

623:31 (639:25). A Palgrave Murphy boat—i.e., a steamship constructed for Palgrave, Murphy and Company, Dublin steamship owners.

623:32 (639:26). Alexander Basin—a boat basin on the north bank of the Liffey at its mouth.

623:32 (639:26). the only launch that year—we have been unable to check the accuracy of this assertion.

623:35 (639:29). au fait—French: "acquainted with [a subject]."

623:36–38 (639:30–32). why that ship ran bang . . . Harbour scheme was mooted—see 33:41–42n.

623:38 (639:32). a Mr Worthington—Robert Worthington, a Dublin railroad contractor whose railroad business would have benefited from increased Dublin-Galway traffic, was one of the leaders of a group of promoters who tried to revive the "Galway Harbour Scheme" in 1912.

623:40–41 (639:35). Captain John Lever of the Lever Line—John Orrell Lever, a Manchester, England, manufacturer and businessman who owned the ships in the Galway–Halifax experiment during the mid-nineteenth century.

624:13–16 (640:6–9). The biscuits was as hard . . . Johnny Lever, O!—collections of sea chanties list at least 25 stanzas and many variations since the song clearly lends itself to improvisatory talent. One version begins: "Oh the times are

hard and the wages low,/Leave her, Johnny, leave her./The bread is hard and the beef is salt,/But it's time for us to leave her./It's growl you may, but go you must,/It matters not whether you're last or fust."

624:25(640:18). with coal in large quantities —coal deposits in Ireland were and are relatively meagre; average annual Irish production in 1900–1902 was 112,000 tons per year as against England's average of 191 million tons. Average coal production in Ireland in 1962–1966 was 200,000 tons or one-eighth of its coal-energy needs.

624:25–26 (640:18–19). six million pounds ... exported every year—the average annual export of pork from Ireland in 1898–1902 was worth £1,718,000.

624:26–27 (640:19–20). ten millions between butter and eggs—the average export of butter and eggs (1896–1902) was under two and a half million pounds sterling.

624:33 (640:26–27). Colonel Everard down there in Cavan growing tobacco—Colonel N. T. Everard was a gentleman farmer in Randlestown, County Meath, just north of Dublin, not in County Cavan, which is northwest of Meath. In 1904 he was conducting what he regarded as a successful 20-acre experiment in tobacco.

624:39–40 (640:32–33). The Germans and the Japs ... their little lookin—in two interrelated ways. Japan was demonstrating that it had a powerful if limited navy in the Russo-Japanese War, and German naval power was beginning to pose a serious threat to English sea power in the West. The corollary was that both the Germans and the Japanese were interested in a colonial expansion that threatened to bring them into conflict with the expansionist policies of the British Empire.

624:40 (640:33–34). The Boers were the beginning of the end—i.e., even though they lost their war for independence, the Boers demonstrated the tenuousness of England's hold over the 13 million square miles and 320 million subjects of its Empire (1900).

625:1 (640:35). Ireland, her Achilles heel— the only vulnerable spot on Achilles' body was the heel because when his mother, Thetis, attempted to make him invulnerable by dipping him in the River Styx, the water did not touch the heel by which she held him. In 1914 England suspended implementation of Home Rule for Ireland for the duration of hostilities of World War I; the argument was that an independent Ireland might be a threat to England. In 1916 Sir Roger Casement (see 329:3–6n) and others tried to make that

threat come true; they enlisted German support (a shipload of munitions that the English intercepted) for the Easter uprising of 1916.

625:6–7 (640:41–42). Ireland, Parnell said ... one of her sons—source unknown.

625:21 (641:14). Jem Mullins—a reference to the Irish patriot and physician James Mullin (1846–1920), who became a legendary image of peasant strength in his own lifetime since he began life in abject poverty and was set to work in the fields at age eleven. He managed to teach himself and finally became an M.D. in 1881. He was friendly with and admired by Parnell and Davitt among others.

625:31–32 (641:24–25). pending that consummation ... be wished for—combines the opening phrases of Hamlet's much-quoted soliloquy, (III, i, 56) with his later remark: " ... 'tis a consummation/Devoutly to be wish'd" (III, i, 63–64).

626:1 (641:36–37). chummies—see 94:29n.

626:14 (642:7). felonsetting—catching thieves.

626:15 (642:8). Dannyman—Irish slang for a betrayer or informer, after Danny Mann, the servant in Gerald Griffin's (1803–1840) popular novel *The Collegians* (1829). In the novel, with his master's connivance, he murders his master's wife, Eily. In Dion Boucicault's stage adaptation of the novel, *The Colleen Bawn* (1860), Danny attempts unsuccessfully and without his master's knowledge to murder Eily (the Colleen Bawn). See 292:10n.

626:16–17 (642:9). Denis or Peter Carey—see 80:24n and 80:26n.

626:34–35 (642:27–28). the plea some legal luminary saved his skin on—Fitzharris was tried twice. In the first trial he was acquitted of a charge of murder. He was then tried and found guilty of being an accessory after the fact. The "legal luminary" was His Honour Richard Adams; see 135:31n.

626:38 (642:31). on the scaffold high—see 161:3n.

626:41–42 (642:35). snapping at the bone for the shadow—in Aesop's fable "The Dog and the Shadow," a dog with a piece of meat in his mouth catches sight of his reflection in a stream; the dog responds as though the reflection were real and drops and loses his own piece of meat in attempting to grab the shadow meat.

627:1 (642:36). Johnny Lever—see 624:13–16n.

627:3 (642:38). the Old Ireland tavern—the Old Ireland Hotel and Tavern, 10 North Wall Quay, Dublin; in 1904 one of the pubs nearest to the docks.

627:3 (642:38–39). come back to Erin—see 337:4.

627:12–13 (643:4–5). A soft answer turns away wrath—Proverbs 15:1, "A soft answer turneth away wrath: but grievous words stir up anger."

627:19–21 (643:11–13). Ex quibus . . . Christus . . . secundum carnem—the whole phrase that Stephen quotes is from the Vulgate, Romans 9:5: *"et ex quibus est Christus secundum carnem"* ("and from that race [the Israelites] is Christ, according to the flesh").

627:25–26 (643:17–19). every country, they say . . . government it deserves—the saying originated with the French philosopher and political writer Count Joseph de Maistre (1753–1821). For "distressful country," see 45:2–3n.

627:34 (643:26). bloody bridge battle—see 248:24n.

627:34–35 (643:26–27). seven minutes' war . . . between Skinner's alley and Ormond market—Skinner's Alley was off Cork Street in central Dublin just south of the Liffey; Ormond Market (1682) was off King's Inn Quay on the north bank of the Liffey just across from Skinner's Alley; the two locations were at either end of Richmond Bridge (1819), now O'Donovan Rossa Bridge, the previous site of Ormond Bridge (1684–1802). Ormond Bridge was the traditional battleground for faction fights between the artisans and/or apprentices of north and south Dublin in the eighteenth century. Which of these many minor "wars" Stephen has in mind is unknown.

628:12 (644:3). Spain decayed when the Inquisition hounded the Jews out—the Inquisition did "hound" the Jews in Renaissance Spain, but they were expelled in 1492 by royal decree of Ferdinand V (the Catholic) (king 1479–1516). Unnoticed, Spain did begin a decline; many Jews had been in key political and economic administrative positions, and they were not easily replaced since administrative expertise was despised as "Jewish" by Catholic Spain. The real decline of Spain's power did not become apparent until its costly overextension after the Battle of Lepanto (1571), and the ruinous economic and military impact of the loss of the Armada (1588).

628:13–14 (644:4–5). England prospered when Cromwell . . . imported them—the Jews were expelled from England in 1290 during the reign of Edward I. Oliver Cromwell (1599–1658), as virtual dictator of England during the Protectorate (1653–1660), vigorously supported religious liberty; in 1656 some Jewish families, encouraged by Cromwell's stand, petitioned for permission to enter England. Cromwell, the Protector, referred the petition to a commission of merchants and Puritan ministers, who recommended against it; but Cromwell, for economic as well as religious reasons, persisted, and several important Jewish banking families were allowed to establish themselves in London and Oxford; thus "England prospered" because those select families with their international connections understood the economic terms of Cromwell's patronage and helped stabilize an economy disordered by civil war and its aftermath. As for the "much" that Cromwell has "to answer for," see 328:5–8n for an example.

628:19–20 (644:10–11). Spain again . . . with goahead America—i.e., during the Spanish–American War (23 April–12 August 1898), the Spanish, underequipped and demoralized, were no match for the United States; and the United States emerged from the war as a colonial power, having concluded the peace by dismembering what was left of the Spanish Empire.

628:20–22 (644:11–13). Turks, it's in the dogma . . . try to live better—i.e., Bloom attributes the backward conditions of the Turkish Empire and Turkish military vulnerability to the Mohammedan belief that death in battle was to be rewarded by immediate admission to heaven.

628:22–23 (644:13–14). That's the juggle . . . false pretenses—i.e., Roman Catholic parish priests raise money ("the wind") on their "false" argument that they have exclusive control over entry into heaven.

628:28 (644:19). £300 per year—roughly equivalent to at least $9,000 to $10,000 a year (1970).

628:31–33 (644:23–24). Ubi patria . . . vita bene—Latin: "Where my country [is, there is] the good life." Bloom is apparently trying for the proverb *"Ubi bene, ibi patria"* ("Where I am well or prosperous, there is my country").

628:36–37 (644:29–30). changing colour like those crabs about Ringsend in the morning—after the [Proteus] episode Stephen would have moved north from Sandymount Strand over the mud flats off Ringsend toward the Liffey and central Dublin. The small crabs in the tidal pools around Dublin Bay do appear to change color when they move. They can only be spotted by

concentrated observation in the first place because they are so translucent as to be almost transparent (and thus their color seems to change).

629:15–16 (645:6–7). faubourg Saint-Patrice —French: "St. Patrick's Suburb."

629:18–19 (645:9–10). Ireland ... belongs to me—could this be an allusion to the popular Scots drinking song? "I belong to Glasgow,/ Good old Glasgow town,/But what's the matter with Glasgow/For it's going round and round?/ I'm only a common old working chap,/ As anyone here can see,/But when I've had a couple of drinks of a Saturday,/Glasgow belongs to me."

630:1–2 (645:36). O'Callaghan ... the half crazy faddist—see 92:17n.

630:4 (645:38). rotto—slang for drunk.

630:8–9 (645:43–646:1). a strong hint to a blind horse—the traditional instrument for delivering such a hint is a club.

630:9 (646:1). John Mallon of Lower Castle Yard—assistant commissioner of the Dublin Metropolitan Police, with headquarters in Dublin Castle, Lower Castle Yard.

630:10–11 (646:2–3). section two of the Criminal Law Amendment Act—(1885) forbids attempts to solicit or procure women for illicit sexual practices. As Thornton points out (pp. 447–448), there may be confusion here between section two (II) and section eleven (XI). Section XI provides against homosexuality and was the section under which Oscar Wilde was convicted. Did Joyce intend a linkage between the two Dublin "eccentrics"? The confusion can only be resolved by discovery of the nature of O'Callaghan's "eccentricity," if indeed there ever was an O'Callaghan.

630:14 (646:6). six, sixteen—i.e., the number tattooed on the sailor's chest; see 615:33 (631:23).

630:15–20 (646:7–12). the tattoo which was all ... the head of the state—tattooing was fashionable with nineteenth-century nobility: Edward VII (of whom Bloom thinks) and George V of England, Nicholas II of Russia, Alphonso XII of Spain, etc. Since royalty set the fashion, the aristocracy was sure to follow, including even Lady Randolph Churchill, Sir Winston's mother.

630:21–22 (646:14). the Cornwall case—unidentified.

630:23 (646:16). Mrs Grundy—in Thomas Moxton's (c.1764–1838) play *Speed the Plough* (1798), Mrs. Grundy is an offstage rural oracle who is repeatedly invoked ("What will Mrs. Grundy say?") as the ultimate arbiter of middle-class propriety.

630:33–34 (646:26). not caring a continental—after an essentially unsupported currency note issued by the Continental Congress in 1776; i.e., proverbial for worthless coin.

631:7–9 (646:43–647:1). the submerged tenth ... under the microscope lately—General William Booth, the founder and leader of the Salvation Army, in his book *In Darkest England* (1890) estimated that ten percent of the population of England lived in abject poverty and coined the phrase "the submerged tenth" to describe the political reality of poverty. The Salvation Army's campaign on behalf of that tenth did serve to sharpen public and official interest in the appalling problems of poverty in the British Isles. See 429:24n.

631:9 (647:2). To improve the shining hour— from Isaac Watts's (1674–1748) hymn "Against Idleness." First stanza: "How doth the little busy bee/Improve each shining hour,/And gather honey all the day/From every opening flower!"

631:11 (647:3–4). Mr Philip Beaufoy—see 68:28n.

631:15 (647:8). The pink edition, extra sporting, of the Telegraph—the pink edition of the *Evening Telegraph* was the latest evening paper of the Dublin dailies and hence had a more comprehensive coverage of the day's sports than any of the other newspapers.

631:22 (647:15). give us this day our daily press—*cf.* 57:11n.

631:23–24 (647:17). H. du Boyes, agent for typewriters—there is no such advertisement in the *Evening Telegraph*, "Last Pink," 16 June 1904, but *Thom's* (1904), p. 1813, lists "H. Boyes, agent for Williams' Type Writer and Supplies, 5 Ormond quay, upper." Following Boyes's name in *Thom's* (1904) there are nine (but no Hugh) Boylans.

631:24–25 (647:18). Great battle Tokio— *Evening Telegraph*, 16 June 1904, p. 2, column 9: "THE WAR./BIG BATTLE AT TELISSA./ RUSSIAN DEFEAT./Japs Take 300 Prisoners and 14 Guns./Press Association War Special./ [datelined] Tokio, Thursday." Telissa is on the Liaotung Peninsula (in modern China) just west of North Korea. See 58:9–10n.

631:25 (647:18). Lovemaking in Irish £200 damages—*Evening Telegraph*, p. 3, columns 3–5: "GAELIC LEAGUE AND LOVE AFFAIRS./

Breach of Promise Action from Kilkenny./Amusing Correspondence./Verdict for £200." The article describes in considerable detail the trial, the evidence of a rather circumstantial courtship and Miss Maggie Delaney's subsequent successful suit against Frank P. Burke, a revenue officer and an enthusiast in the campaign to revive Irish as a language.

631:25–26 (647:19). Gordon Bennett—*Evening Telegraph*, p. 2, columns 6–7: "Gordon-Bennett Cup./To-Morrow's Contest./The Drivers and the Cars"; see 96:6n.

631:26 (647:19). Emigration swindle—*Evening Telegraph*, p. 3, column 2: "Bogus Emigration Agent./Case in the Police Court"; see 126:28–29n.

631:26 (647:19–20). Letter from His Grace William ✠—does not appear; see 117:2n and 120:27n.

631:27–28 (647:20–22). Ascot Throwaway recalls ... ribband at long odds—*Evening Telegraph*, p. 3, column 8: "Sporting./ASCOT MEETING./The Gold Cup./The Outsider Wins"; see 408:20–25n. The article lists several of the "great horses" that had won the Gold Cup but Sir Hugo, a horse that did win the English Derby in 1892 against 40-to-1 odds, is not mentioned. Adams says (p. 165) that Sir Hugo was owned by Lord Bradford, not by Captain Marshall.

631:29 (647:22). New York disaster, thousand lives lost—the disaster is the subject of an editorial, "The American Horror," *Evening Telegraph*, p. 2, columns 3–4, and also of a news story, p. 4, column 2: "APPALLING AMERICAN DISASTER./EXCURSION STEAMER ON FIRE./485 BODIES RECOVERED./Victims Charred and Unrecognizable"; see 180:1–3n.

631:29–30 (647:23). Foot and Mouth. Funeral of the late Mr Patrick Dignam—neither Deasy's "letter" nor Dignam's "funeral" managed to infiltrate the columns of the *Evening Telegraph*.

631:35 (647:28). no 9 Newbridge Avenue, Sandymount—was vacant in 1904 according to *Thom's* (1904).

631:42–632:1 (647:36). Bernard Corrigan—unknown, apart from his role in context as Dignam's brother-in-law.

632:3 (647:38–39). Monks the dayfather about Keyes ad—see 115:27n, 119:19n, 121:5n.

632:14–16 (648:7–9). Is that first epistle ... thy foot in it—St. Paul wrote only one epistle to the Hebrews; Stephen's witticism implies that Mr. Deasy's letter is addressed to a chosen people in a promised land.

632:24–38 (648:18–32). the third event at Ascot ... Maximum II—*Evening Telegraph*, 16 June 1904, p. 3, column 8. The whole account: "3.0—The GOLD CUP, value 1,000 sovs., with 3,000 sovs. in specie in addition, out of which the second shall receive 700 sovs., and the third 300 sovs., added to a sweepstake of 20 sovs. each, h. ft., for entire colts and fillies. Two miles and a half. Mr. F. Alexander's THROWAWAY, by Rightaway-Theale, 5 yrs, 9 st. 4 lb ... W. Lane 1. Lord Howard de Walden's ZINFANDEL, 4 yrs, 9 st. ... M. Cannon 2. Mr. W. Bass's SCEPTRE, 5 yrs, 9 st. 11 lb. O. Madden 3. M. J. de Bremonds Maximum II, 5 yrs, 9 st. 4 lb. G. Stern 0. (Winner trained by Braime.) Race started at 3.5 Betting—5 to 4 on Zinfandel, 7 to 4 against Sceptre, 10 to 1 agst Maximum II, 20 to 1 agst Throwaway (off). THE RACE. Throwaway set a fair pace to Sceptre with Maximum II last, till fairly in the line for home, when Sceptre slightly headed Throwaway, and Zinfandel took close order with him. Throwaway, however, stayed on and won cleverly at the finish by a length; three parts of a length divided second and third. Time—4 mins. 33 2-5 secs." For "buncombe," see 310:38n.

632:39 (648:33). Lovemaking damages—see 631:25n.

633:7 (648:43). Return of Parnell—rumor persisted in maintaining that Parnell was alive, in part because his body was not put on view but almost immediately sealed in its coffin. One of the more popular rumors was that he was hiding out in South Africa (a rumor apparently excited by that territory's reluctance to accept Britain's imperial ambitions).

633:10–11 (649:4). Committee Room no 15—in that room in the English House of Parliament the Irish Parliamentary party, led by Timothy Healy, deposed Parnell from leadership by a vote of 45 to 26 on Saturday, 6 December 1890.

633:15 (649:8). The coffin they brought over—Parnell died at Brighton in England on 6 October 1891; on Sunday, 11 October, his coffined body arrived at Kingstown and the cortege moved through Dublin to Glasnevin along a route much like the one followed by the Dignam funeral in [Hades].

633:16 (649:9). De Wet, the Boer general—one of the more farfetched rumors about the second coming of Parnell; see 160:40n.

452 | NOTES FOR JOYCE

633:16–17 (649:10). He made a mistake to fight the priests—during the political infighting that preceded the "split" in Committee Room 15, the Irish Roman Catholic hierarchy maintained a discreet silence until late November 1890; then Archbishops Croke and Walsh intervened, in effect publicly urging Parnell "to retire quietly and with good grace from the leadership" (Croke). They insisted that their interest was not "political" but "moral," but the net effect of their intervention was to speed Parnell's fall and to further confuse religion with politics. Parnell counterattacked vigorously, insisting on a separation of Church and State; and the hierarchy was just as vigorous in its insistence on its "moral" right to question the integrity of Parnell's leadership.

633:19–20 (649:12–13). in nine cases out of ten it was a case of tarbarrels—i.e., the population of Ireland was so bitterly anti-Parnell that he was to be burned at least in effigy (if not as a heretic). Tar barrels were used to make bonfires.

633:21 (649:14). it was twenty-odd years—since Bloom must be aware that Parnell has only been dead 13 years, he must be thinking of another controversial phase of Parnell's career in the early 1880s (when Parnell was in and out of prison and in danger of being linked to the Phoenix Park murders through Piggott's forgeries).

633:25 (649:18–19). Either he petered out too tamely of acute pneumonia—Parnell's death seems to have been the result not of a single illness but of the cumulative impact of a number of causes. He did suffer from rheumatism; he fearfully overextended himself in the effort to retrieve a lost cause; specifically, on Sunday, 27 September 1891, he spoke in the rain in County Galway and was forced to wear wet clothes for several hours. His condition worsened after that, and the final medical opinion that he died of rheumatic fever and a weak heart seems a rather vague description of the complex nature of his collapse.

633:25–27 (649:19–20). just when his various political arrangements were nearing completion—a misleading statement since Parnell's "political arrangements" (his attempts to put together a sizable Irish party) were in a state of galloping disintegration at the time of his death; in the attempt to recoup he was shifting from advocacy of Constitutional reform toward advocacy of revolutionary violence. This shift in turn further alienated his former followers and admirers.

633:29 (649:22–23). failing to consult a specialist—in the last few weeks of his life Parnell repeatedly refused to let his wife call in the London specialist Sir Henry Thompson, who had been attending him. Apparently Parnell was afraid that the precarious state of his health would force his retirement from politics.

633:33–34 (649:26–27). nobody being acquainted with his movements even before—one aftermath of the divorce trial and its attendant publicity in 1890 was the shocking revelation that Parnell's "movements" for the preceding ten years of his liaison with Mrs. O'Shea had been unknown even though his stature as a public figure led the public to assume that his life was in no way hidden.

633:35 (649:29). Alice, where art thou—a popular song by Wellington Guernsey and Joseph Ascher. The lover complains, "One year back this even,/And thou wert by my side . . ." and repeatedly asks, "Alice, where art thou?" and finally, "looking heav'nward," he concludes, "Oh! There amid the starshine/Alice, I know art thou."

633:36 (649:30). aliases such as Fox and Stewart—see 482:26n.

633:40–41 (649:33–35). a commanding figure . . . in his stockinged feet—Katherine O'Shea Parnell in her *Charles Stewart Parnell; His Love Story and Political Life* (London, 1921), p. 58, describes him as "a tall gaunt figure, thin and deadly pale."

633:41–634:2 (649:35–37). Messrs So-and-So . . . few and far between—the reference is to the leaders who emerged after Parnell's fall, Timothy Healy, 139:23n; John Redmond, 583:17–18n; Justin M'Carthy, 583:16–17n; and others.

634:2 (649:38). the idol with feet of clay—in Daniel an image that Nebuchadnezzar had seen in a dream is described: "This image's head *was* of fine gold, his breast and arms of silver, his belly and his thighs of brass, His legs of iron, his feet part of iron and part of clay" (Daniel 2:32–33). Daniel explains the dream: "And whereas thou sawest the feet and toes, part of potters' clay, and part of iron, the kingdom shall be divided; but there shall be in it of the strength of the iron. . . . And *as* the toes of the feet were part of iron, and part of clay, *so* the kingdom shall be partly strong, and partly broken" (Daniel 2:41–42).

634:3 (649:39). seventy-two of his trusty henchmen rounded on him—counting Parnell, there were 72 people in Committee Room 15, and only 45 "rounded on him"; cf. 633:10–11n.

634:7–8 (649:43–650:1). when they broke up . . . United Ireland—it was the *United Ireland*, established in 1881 as a vehicle for Parnell's views

and policies. The acting editor during the December 1890 crisis was Matthew Bodkin, who first wavered and then took an anti-Parnell position on 6 December. When Parnell returned to Dublin on 10 December, he dismissed Bodkin as editor. The anti-Parnellites reoccupied the newspaper offices while Parnell was at a mass meeting that night. Parnell and his followers literally stormed the building the next day (11 December) and retook the paper. The anti-Parnellite faction, thus "suppressed," established the *Insuppressible* (December 1890–January 1891) as a voice for their opposition.

634:13 (650:6). what's bred in the bone—will not out of the flesh; proverbial.

634:18–22 (650:11–15). like the claimant in the Tichborne case ... Lord Bellew, was it? —the claimant in this famous case was an Australian, Arthur Orton (1834–1898), a coarse, ignorant butcher. Roger Charles Tichborne (1829–1854), the heir presumptive of Sir James Francis Tichborne (1784–1862), was lost at sea on the *Bella* in 1854, but his mother refused to believe him dead and advertised for information of his whereabouts. Meanwhile, his younger brother, Alfred Joseph, had succeeded to the baronetcy upon the death of the father in 1862. In 1865 Orton announced his candidacy, claiming to be Roger Charles. He achieved considerable backing, including Lady Tichborne's, in spite of the fact that there was no physical or cultural similarity between the dead heir and the impostor. Orton brought suit to recover the estates in 1871 (103 days, denied). Lord Bellew, a schoolmate of Roger Charles, testified against Orton on the grounds that Roger Charles had tattoos to which he personally had added the letters "R.C.T." in Indian ink; Orton had no similar tattoo. In 1873 Orton was tried for perjury (188 days, guilty).

634:25–28 (650:19–22). A more prudent course ... lie of the land first—precisely what Odysseus does when he reaches Ithaca; see headnote to this episode, p. 438 above.

634:29 (650:23). That bitch, that English whore—Katherine O'Shea (1845–1921), whose liaison (1880 *ff.*) with Parnell was exposed in the divorce trial (1890) and resulted in the collapse of Parnell's career. She was English, the daughter of Sir John Page Wood, a chaplain to Queen Caroline (d. 1821) and subsequently minister to the parish of Rivenhall, Essex; her mother was the daughter of the English admiral, Sampson Mitchell.

634:29 (650:23). shebeen—Irish: "an illegal tavern."

634:33 (650:27). Her husband was a captain or an officer—William Henry O'Shea (1840–1905) entered the 18th Hussars at the age of eighteen, achieved the rank of captain and sold his commission in 1867. His later life was spent variously on the fringes of political power.

634:34–35 (650:28–29). a cottonball one—see 323:26n.

634:42 (650:36–37). with the usual affectionate letter that passed between them—several of the "love letters" that passed between Parnell and Mrs. O'Shea were admitted into evidence at the divorce trial in November 1890.

635:4–7 (650:40–43). the staggering blow came ... public property all along—Parnell's liaison with Mrs. O'Shea was virtually a marriage (from 1881), complete with children, and as such it was a well-kept open secret, known to many of Parnell's associates and widely rumored but not subject to political exploitation. When Captain O'Shea brought suit and Parnell refused to defend himself, the scandal became politically useful in such a way that it revealed the mounting tensions within Parnell's own party and the increasing division between Parnell and Gladstone's Liberal party.

635:15–16 (651:9–10). scrambling out of an upstairs ... ladder in night apparel—an inaccurate version of a particularly damning story that went unchallenged at the trial (since Parnell refused to defend himself and the witness was not cross-examined). The maidservant's uncorroborated story was that three or four times Parnell had evaded discovery by Captain O'Shea by climbing out of Mrs. O'Shea's bedroom, descending a fire escape and then presenting himself at the door as if he had come to pay a call.

635:19–20 (651:13–14). it was simply a case ... being up to scratch—nothing is simple in the Parnell-O'Shea affair, though the evidence suggests that the O'Sheas were estranged before Parnell came on the scene; further, and in spite of O'Shea's unchallenged protestations of ignorance during the trial, it seems evident that he at first connived (grudgingly or indifferently) at a relationship that promised him political advantage and subsequently agreed to a *de facto* divorce (and Mrs. O'Shea's *de facto* marriage to Parnell) from a complex of motives that included an interest in the inheritance expected from Mrs. O'Shea's aunt.

635:22–23 (651:17). falling a victim ... forgetting home ties—in Book XII of *The Odyssey* Circe warns Odysseus that the Sirens will "sing his mind away" as they make men forget "home ties." Parnell was, of course, a bachelor when he

met Mrs. O'Shea; thus, Parnell's "home ties" can only be construed as the fidelity he owed to Irish political enterprise.

635:32 (651:26–27). farewell, my gallant captain—at the end of the opera *Maritana* (see 85:20–21n) Don Cesar, the hero, challenges the villainous Captain of the Guard to a duel, and then sings: "Farewell, my valiant captain!/I told you how it would be;/You'll not forget, brave captain,/The lesson due to me!/Ha! Ha! Ha! Ha!" In the Parnell-O'Shea story, one significant (and much debated turning point) occurred in 1881 when the two men quarreled, and O'Shea challenged Parnell to a duel; the duel never took place, and the treaty that resolved it seems to have been the basis for Mrs. O'Shea and Parnell's *de facto* marriage.

635:42–636:1 (651:37–38). Heaping coals of fire on his head—Romans 12:20: "Therefore if thine enemy hunger, feed him; if he thirst, give him drink: for in so doing thou shalt heap coals of fire on his head."

636:1 (651:38). the fabled ass's kick—in Aesop's "The Ass and the Wolf" the ass distracts the wolf from his usual role as killer by complaining of a thorn in his hoof. The wolf tries to remove the thorn with his teeth and gets kicked for his pains. Moral: play the role you're intended for.

636:6 (651:43). Irishtown Strand—the shore area just south of the Liffey on Dublin Bay. Since Bloom's house in Eccles Street is on the "north side," the Strand would be out of Bloom's way except on rare occasions (as that of Dignam's funeral).

636:11–12 (652:6). she was also Spanish or half so—i.e., Marion Tweedy Bloom, not Katherine Wood O'Shea; see 634:29n.

636:17 (652:12). The king of Spain's daughter—see 579:31–580:1n.

636:18–20 (652:13–15). farewell and adieu ... to Scilly was so and so many ...—fragments of an anonymous ballad, "Spanish Ladies": "Farewell and adieu to you, gay Spanish ladies,/Farewell and adieu to you, ladies of Spain;/For we've received orders to sail to old England;/But we hope in short time to see you again." Chorus: "We'll rant and we'll roar like true British sailors,/We'll rant and we'll roar across the salt seas,/Until we strike soundings in the channel of old England,/From Ushant to Scilly is 35 leagues." Third verse: "Now the first land we made it is called the Deadman,/Then, Ramshead off Plymouth, Start, Portland and Wight;/We passed by Beechy, by Farleigh and Dungeness,/And hove our ship to, off South Foreland Light."

636:23 (652:18). especially there it was, as she lived there. So, Spain—shortly after their marriage in 1867 the O'Shea's moved to Madrid, where Captain O'Shea's Irish uncle, who had married a Spanish woman, had a bank. For roughly a year Captain O'Shea was a partner in his uncle's bank, but a dispute ended the partnership and the O'Sheas returned to England in 1868.

636:24 (652:19). Sweets of—*Sin*; see 232:27n.

636:25 (652:20). that Capel street library book—see 64:32n.

636:36–37 (652:32). In old Madrid—see 271:14n.

636:39–40 (652:34–35). Lafayette of Westmoreland street—see 411:2n.

637:7 (653:1–2). barely sweet sixteen—from a popular song, "When You Were Sweet Sixteen" (1898), by James Thornton. Chorus: "I love you as I ne'er loved before/Since first I met you on the village green./Come to me, or my dream of love is o'er./I love you as I lov'd you/When you were sweet,/When you were sweet sixteen."

637:12 (653:6–7). opulent curves—see 232:27n.

637:18–19 (653:12–13). Puritanism ... St. Joseph's sovereign ...—i.e., St. Joseph's great strength as the Virgin Mary's husband was his purity, celibacy in marriage.

637:22 (653:16). Jack Tar—humorous or affected for a sailor.

637:35 (653:30). heaving embonpoint—see 232:27n.

637:38–39 (653:33). I looked for the lamp which she told me—from Thomas Moore, "The Song of O'Ruark, Prince of Breffni," in *Irish Melodies*. The first two of the poem's four stanzas: "The valley lay smiling before me,/Where lately I left her behind;/Yet I trembled, and something hung o'er me,/That sadd'ned the joy of my mind./I look'd for the lamp which, she told me,/Should shine, when her Pilgrim return'd;/But though darkness began to infold me,/No lamp from the battlements burn'd!//I flew to her chamber—'twas lonely,/As if the lov'd tenant lay dead;—/Ah, would it were death, and death only!/But no, the young false one had fled./And there hung the lute that could soften/My very worst pains into bliss;/While the hand, that had wak'd it so often,/Now throbb'd to a proud rival's kiss." See 35:40–41n.

637:41–42 (653:35–36). the book about Ruby with met him pike hoses—see 64:17n and 64:10n.

638:1–2 (653:38). with apologies to Lindley Murray—Lindley Murray (1745–1826), an English grammarian whose *Grammar of the English Language* (1795) and other works on reading, spelling and usage were standard nineteenth-century school texts. The apology due to Murray is obviously for "must have fell down," but in a broader sense an apology is due to Murray whose tone is very high-moral: "If we lie no restraint against our lusts . . . they will hurry us into guilt and misery."

638:20–21 (654:13–15). Then the decree nisi . . . nisi was made absolute—a divorce decree *nisi* is not final or absolute but is to take effect eventually unless (*nisi*) further cause is shown or a reason arises to prevent its taking effect. (Captain O'Shea was initially granted a decree *nisi*.) The king's (or in the O'Shea case, the queen's) proctor might best be described as the Crown's "district attorney" for probate court; he could and sometimes did intervene to reopen divorce cases after the decree *nisi* and before the decree became absolute. One such intervention occurred in 1886 in a case that had parallels to the Parnell case: the accused correspondent, Sir Charles Dilke (1843–1911), a radical English liberal politician, had his promising political career ruined. In the divorce trial itself, the accused wife, Mrs. Crawford, confessed that she had committed adultery with Dilke; her confession was not supported by other evidence and Dilke was not allowed to protest his innocence; but a decree *nisi* was granted to Mr. Crawford. The queen's proctor intervened to reopen the trial, but Dilke was unable to prove his innocence, the decree *nisi* became absolute and Dilke's career was ruined.

638:26–27 (654:20–21). Erin's uncrowned king—an appellation for Parnell.

638:31–32 (654:25–26). penetrated into the printing . . . United Ireland—see 634:7n.

638:35–36 (654:30). the O'Brienite scribes—Matthew Bodkin, who had moved the *United Ireland* into an anti-Parnellite position (see 634:7n), was acting as editor while the editor, William O'Brien (1852–1928), was in America raising funds to aid evicted tenants in Ireland. O'Brien became one of the central figures of the anti-Parnellite coalition at the time of the "split."

638:41 (654:35–36). the idol had feet of clay—see 634:2n.

639:13 (655:6–7). what's bred in the bone—see 634:13n.

639:20–21 (655:13–15). after the burial . . . alone in his glory—from "The Burial of Sir John Moore at Corunna" (1817), by the Irish poet the Reverend Charles Wolfe (1791–1823). The poem describes the silent and hasty burial of General Sir John Moore by the English rearguard during the evacuation of La Coruña in Spain, 1809. Moore was a great popular favorite in England, and enjoyed considerable military success against Napoleon's forces in Spain. The poem ends: "We carved not a line, and we raised not a stone—/But we left him alone with his glory" (lines 31–32).

639:28–29 (655:22–23). unless it ensued that . . . to be a party to it—there is considerable evidence to support the contention that Captain O'Shea was "party to" the relationship between Mrs. O'Shea and Parnell; see 635:19–20n.

639:29–30 (655:24). the usual boy Jones—i.e., the usual informer; after one Bernard Duggan, a fellow student of Robert Emmet (see 112:40–41n), who joined Emmet's attempt to organize a rebellion in 1802–1803 but who was said to have been a spy in the employ of the English. Duggan's secret-service name has been known in anecdotal history as "the Trinity boy Jones." There is considerable disagreement among historians about "Jones" and the extent of his achievements, largely because the abortive rising, when it actually occurred, did, at least according to the English, come as a surprise.

639:32–35 (655:27–29). a domestic rumpus and . . . his visits any more—Captain O'Shea testified at the divorce trial that he had exacted such a promise from Mrs. O'Shea in 1881, but the nature of that quarrel and its outcome remains ambiguous; see 635:32n.

640:16 (656:9). conditio sine qua non—Latin: stock phrase for "the indispensable condition."

640:18 (656:11). Miss Ferguson—see 593:6 (609:11) and 592:21–22n.

640:31 (656:25). Humpty Dumpty—humorous or affected for an egg after the well-known nursery-rhyme riddle.

641:3 (656:39). the Buckshot Foster days—i.e., 1880–1882; see "buckshot," 333:38n.

641:6 (656:42). the evicted tenants' question—i.e., the social and political problems raised by the eviction from their holdings of extraordinary numbers of Irish peasants during the latter half of the nineteenth century. The majority of those evicted were evicted because they either would not

or could not pay their rents; a sizable minority were evicted by landlords intent on agrarian reform. The evictions reached crisis proportions in the poor harvest years 1879–1880 (reminiscent of the great famine years of the 1840s), and land reform emerged as a major political issue—in effect, what emerged was a crusade to achieve the peasant's ownership of the land he farmed.

641:14–15 (657:7–9). a step further than Michael Davitt ... as a backtothelander— Michael Davitt's (see 583:16n) program of land reform advocated the use of public funds to achieve peasant ownership of the land; Bloom as "backtothelander" has gone "a step further" by advocating an agrarian socialism in which all men would contribute by sharing agrarian labor.

641:25 (657:18–19). destruction of the fittest —an inversion of Darwin's famous phrase "survival of the fittest." Darwin's theory of natural selection was based on the assumption that those forms of plants and animals best adapted to the conditions under which they were to live were the "fittest" and would survive, while poorly adapted forms would become extinct.

641:33 (657:27). Ontario Terrace—in Rathmines just south of the Grand Canal; in 1904 the houses in Ontario Terrace were comparable in value to the houses in Eccles Street.

642:6 (657:43). a cup of Epps's cocoa— advertised in *The Weekly Freeman*, 18 June 1904, p. 13: "Epps's Cocoa; Grateful and Comforting; Nutritious and Economical; . . . The best suited for all ages and classes, The greatest invigorator for the fagged. Justly prized by Mothers for themselves and their children, who choose it eagerly."

642:11 (658:5). that merry old soul—see 159:34n.

642:15 (658:9–10). off Sheriff street lower— east of the Amiens Street Railway Station and north of the docks, a run-down area of tenements and relatively poor houses in 1904.

642:25 (658:19–20). blood and ouns—see 5:23n.

642:27–28 (658:22–23). The most vulnerable point of tender Achilles—see 625:1n.

642:29–30 (658:24). Carrick-on-Shannon—a market town in County Leitrim, 98 miles west-northwest of Dublin (figuratively, a "backwoods" town).

642:30 (658:25). county Sligo—see 326:16n.

642:40 (658:35). that Brazen Head—see 601:26–28n.

643:2 (658:39). prize titbits—see 67:29n and 68:27–28n.

643:13–14 (659:8–9). the former viceroy, earl Cadogan ... dinner in London—the dinner for the Cabdrivers' Benevolent Association is not mentioned in the *Evening Telegraph* for 16 June 1904 for the very simple reason that it did not take place until 27 June. George Henry Cadogan (1840–1915), 5th Earl Cadogan, was lord lieutenant of Ireland 1895–1902.

643:17–18 (659:12–13). sir Anthony Mac-Donnell had left Euston for the chief secretary's lodge—this item does not appear in the *Evening Telegraph*, but is reported in the *London Times*, 17 June 1904, p. 6. The Right Honourable Sir Anthony Patrick MacDonnell (b. 1844) was under-secretary (i.e., chief secretary) to the lord lieutenant of Ireland in 1904; and he did leave Euston Station in London on 16 June to arrive at his residence, the under-secretary's lodge in Phoenix Park, Dublin, on 17 June. The only news of Sir Anthony that appears in the *Evening Telegraph* for 16 June, p. 3, column 2, is his ambiguous answer to Mr. Nannetti's question about the prohibition of Irish games in Phoenix Park.

643:20–21 (659:15–16). the ancient mariner— see 620:22–24n.

643:32–33 (659:28). The Arabian Nights Entertainment—a loosely woven collection of Oriental stories in Arabic from c.1100. In fragments, the stories were introduced into English in the first two decades of the nineteenth century; a complete, unexpurgated translation, *The Thousand Nights and a Night* (1885–1888) by Sir Richard Burton (1821–1890).

643:33–34 (659:29). Red as a Rose is She— (1870), a novel by the English writer Rhoda Broughton (1840–1920). A bittersweet sentimental love story in which the essentially truthful and courageous heroine slips into the practice of deceptions, suffers the melancholy consequences and, morally purged by her trials, is rewarded with the good life.

643:36 (659:31). found drowned—the stock phrase used by a coroner's jury that finds death caused by accidental drowning and consequently a standard newspaper heading. It does not appear in the *Evening Telegraph* for 16 June; the nearest thing is "Rescue from Drowning," p. 3, column 5, a brief story of "a young lad" rescued from the Liffey in Dublin at 4:00 P.M., 16 June 1904.

643:36–37 (659:31–32). the exploits of King Willow—i.e., of a champion cricket batsman since cricket bats were made out of willow.

643:37–38 (659:32–33). Iremonger having made . . . not out for Notts—*Evening Telegraph,* 16 June 1904, p. 3, column 6, under "Cricket," "Notts v. Kent" reports the day's progress of a match between the county teams of Nottingham and Kent: at the end of the day Iremonger, the Notts star batsman who had started the game, was still at bat having scored 155 runs with the loss of only two wickets (i.e., two of Iremonger's batting partners had been put out). Notts total for two wickets: 290.

644:11 (660:5). the last of the Mohicans—(1826), a novel by James Fenimore Cooper (1789–1851). It is the second of Cooper's *Leatherstocking Tales* in order of composition; the third in the time of the action in the five tales. As the title suggests, the novel deals with the extinction of an Indian tribe.

644:12 (660:6–7). for all who ran to read—Habakkuk 2:2: "And the Lord answered me, and said, Write the vision, and make *it* plain upon tables, that he may run that readeth it."

644:14 (660:9). Wetherup—see 125:14n.

644:20 (660:14). dolce far niente—see 70:38n.

644:32 (660:26). his tender Achilles—see 625:1n.

645:3 (660:39). dreaming of fresh fields and pastures new—see 26:25n

645:4 (660:40). coffin of stones—i.e., the story that Parnell's body was not in the coffin, but that the coffin was full of stones.

645:5–6 (660:41–661:1). a stoning to death . . . time of the split—when the "split" occurred, there were 103 Parliamentary constituencies in Ireland of which Parnellites held 86. At the time of the "split" in 1890, 72 of the 86 were present in Committee Room 15 and 45 turned anti-Parnellite. In the course of 1891 several of the loyal 26 either wavered or turned against Parnell. Thus Bloom's figures are impressionistic, but the assertion that Parnell's death was caused by the attacks of those who were previously his followers was widely accepted as valid, particularly by loyal Parnellites.

645:11 (661:5). across Beresford place—Bloom and Stephen walk northeast from the cabman's shelter, retracing their steps toward Gardiner Street Lower, which slants north-northwest toward Eccles Street.

645:11–12 (661:5–6). Wagnerian music—at the end of the nineteenth century Wagner (1813–1883) was widely recognized as "one of the greatest of all musical geniuses," but his music was also popularly regarded as "heavy, difficult and avant-garde."

645:14–15 (661:8–9). Mercadante's Huguenots . . . Words on the Cross—Bloom interconfuses the composers: for Mercadante's *Seven Last Words,* see 81:9–10n; for Meyerbeer's *Huguenots,* see 166:2–4n.

645:15–16 (661:9–10). Mozart's Twelfth Mass . . . the Gloria—see 81:10n.

645:20 (661:14). Moody and Sankey hymns—the Americans Dwight L. Moody (1837–1899) and Ira D. Sankey (1840–1908), a team of evangelists. They enjoyed a considerable international popularity; Moody did most of the preaching at their meetings while Sankey had charge of the singing. During the period of their cooperation Sankey compiled two volumes of hymns, *Sacred Songs and Solos* (1873) and *Gospel Hymns* (with P. P. Bliss, 1875). These collections became known as "Moody and Sankey hymns," though only a few of them were actually of Sankey's composition and none of them Moody's.

645:20–21 (661:14–15). Bid me to live . . . protestant to be—the opening lines of Robert Herrick's (1591–1674) poem "To Anthea, who may command him anything," in *Hesperides* (1648). First stanza: "Bid me to live, and I will live/Thy Protestant to be:/Or bid me love, and I will give/A loving heart to thee." It is a Cavalier love lyric, not a Protestant hymn.

645:22 (661:16). Rossini's Stabat Mater—see 81:3n.

645:26 (661:20–21). the jesuit father's church in Upper Gardiner street—the Church of St. Francis Xavier; see 216:1n.

645:32 (661:26–27). light opera of the Don Giovanni description—Mozart's opera is anything but "light opera," though it has been on Bloom's mind all day (see 63:24n), and its general theme of the seducer and betrayer finally brought to justice obviously has its analogues to Bloom's domestic problems.

645:33 (661:27). Martha—comes much closer to being light opera; see 116:34n.

645:34–35 (661:29). the severe classical school such as Mendelssohn—this misnomer for Felix Mendelssohn's (1809–1847) light and popular romanticism matches calling *Don Giovanni* a light opera; see 281:11–12n and 336:17n.

645:36–37 (661:31–32). Lionel's air in Martha, M'appari—see 252:26n.

645:42–646:1 (661:37–38). Shakespeare's songs, at least of in or about that period—most students of Shakespeare's songs are agreed that seventeenth-century transcriptions of the music of the songs is Shakespearean rather than Shakespeare's; i.e., most of the songs used popular tunes or folk tunes and the numerous transcriptions are assumed to be akin to but after the fact of the music as actually performed on Shakespeare's stage.

646:1–3 (661:38–40). the lutenist Dowland ... ludendo hausi, Doulandus—John Dowland (1563–1626), English lutenist and composer of books of "Songs and Ayres." He is placed in Fetter Lane by the dating of the 1609 preface to his translation of the "Micrologus of Ornithoparcus," though much of his mature life before 1609 he spent traveling on the Continent and in residence as court lutenist in Denmark. His friends thought that he had missed many opportunities for advancing himself, and one of them, Henry Peacham (1576–c.1644), an English schoolmaster, traveler, draftsman, painter and antiquary, gave Dowland an emblem of "a nightingale singing in the winter season on a leafless brier," with verses and the inscription, "*Johannes Doulandus, Annos ludendo hausi*" (Latin: "John Dowland, I used up my years in playing"); see Sir John Hawkins' (1719–1789) *A General History of the Science and Practise of Music* (1776; republished, New York, 1963), Vol. I, pp. 481–483. For Gerald the herbalist in Fetter Lane, see 199:32–33n.

646:4 (661:41). Mr Arnold Dolmetsch—a London musician connected with the London Academy of Music who made a psaltery for Yeats and whom Joyce approached with a request for a lute in 1904; see Ellman, pp. 159–161.

646:6–7 (662:1–2). Farnaby and son with the dux and comes conceits—Giles Farnaby (c.1565–1640) and his son Richard (b. 1590); the father was famous for his "Canzonets to 4 Voices, with a Song of Eight Parts" (London, 1598). *Dux* is the proposition, theme or subject in contrapuntal music of the sort the Farnabys composed; *comes* is the answer.

646:7–8 (662:2–3). Byrd (William) who played the virginals ... in the Queen's Chapel—William Byrd (1543–1623), "the Atlas of English music," a composer of church music (and some secular music) who shared an appointment as organist of Queen Elizabeth's Chapel Royal from 1572 with Thomas Tallis (c.1510–1585). The "virginal" involves the fact that Queen Elizabeth owned and played one, that she was "the Virgin Queen," and that she was firm in her patronage of

Tallis and Byrd, granting them in 1574 an exclusive 21-year patent for the publication of music in England.

646:9 (662:4). one Tomkins who made toys or airs—there were several musical Tomkins, Thomas, father and son, and brothers Giles, John and Nicholas; the most well known was the younger Thomas (1572–1656), a student of William Byrd, an organist at the Chapel Royal and a composer of some merit. A "toy" was a light or facetious composition in contradistinction to the somewhat more serious, though still secular "air."

646:9–10 (662:4). John Bull—(c.1562–1628), English organist, virginalist, composer and professor of music at Oxford. (Also, of course, the traditional personification of the English nation, no relation, who derives from Dr. John Arbuthnot's [1667–1735] satires *The History of John Bull* [1712].)

646:27 (662:21). a fourwalker—a horse whose four feet are never coordinated in a gait.

646:27 (662:21). a hipshaker—i.e., hipshot, with one hip lower than another.

646:27 (662:21). a black buttocker—since to "buttock" is to overtake in a horse race, a "black buttocker" is a horse that is always being overtaken.

646:28 (662:22). putting his hind foot foremost—after the proverbial "putting one's best foot foremost" (to make a good impression).

646:37–38 (662:31–32). like the camel, ship ... potheen in his hump—fanciful natural history, after the popular but mistaken assumption that the camel stores water in its hump; the fatty tissue of the hump is a reserve of food, not water. But the camel's stomach is peculiarly constructed to extract water from food and to retain it in significant quantities.

646:39 (662:34). barring the bees—i.e., the communal organization of bees was superior to man's communal arrangements (a popular comparison in the late nineteenth century).

646:40–41 (662:34–35). alligator, tickle the small ... sees the joke—after the popular assumption that an alligator could be hypnotized into quiescence by being stroked on its belly or throat.

646:41 (662:35–36). chalk a circle for a rooster—a popular method of attempting to hypnotize a rooster.

646:41 (662:36). tiger, my eagle eye—i.e., a man masters a tiger by the hypnotic strength of his gaze.

647:5 (662:42). in medias res—Latin: "in the middle of the thing or the story," the conventional opening of the epic after Homer's example.

647:13–14 (663:9–10). Lady Fingall's Irish . . . the preceding Monday—the Irish Industries Association, 21 Lincoln Place in Dublin, under the aegis of the lord lieutenant's wife, Lady Dudley, and Elizabeth Mary Margaret (Burke) Plunkett, Countess of Fingall (whose husband was a major landholder in County Meath). The association benevolently tried to encourage folk or cottage industry in Ireland; it did give occasional benefit concerts, but Dublin newspapers for June 1904 contain no mention of the specific concert Bloom has in mind.

647:16–18 (663:12–14). Youth here has End . . . Dutchman of Amsterdam—Jan Pieterszoon Sweelinck (1562–1621), a Dutch organist and composer, whose song *"Mein junges Leben hat ein End"* Stephen somewhat misrepresents in his translation since the title means "My young life here has an end," and the song (in rough translation) continues: "my joy and sorrow as well,/My poor soul will quickly/Part from my body./My life can no longer stand firm;/It is very weak and must perish/In Death's conflict and struggle." Sweelinck's music shows considerable affinity with that of English composers of the Elizabethan period.

647:18 (663:14). frows—dialect English for a Dutch or German woman; also, slang for an idle, dirty woman.

647:19 (663:15). Johannes Jeep—(c.1582–1650), a German composer and Kapellmeister who composed a book of psalms and several books of secular songs that were popular in the seventeenth century.

647:22–23 (663:18–19). Von der Sirenen . . . die Poeten dichten—German: "From the Sirens' craftiness/Poets make poems." These are the opening lines of Johannes Jeep's song *"Dulcia dum loquitur cogitat insidias"* (Latin: "The Charm while they are talking is thought treacherous"), which appeared in Vol. II of his *Studentengärtlein* (1614). The first verse of the song continues: "That they with their loveliness/Have drawn many men into the sea/For their song resounds so sweetly,/That the sailors fall asleep,/The ship is brought into misfortune,/And all becomes evil." Apparently the title of Jeep's song is taken from a Renaissance Latin translation of *The Odyssey*.

647:31 (663:26). Barraclough—see 273:2n.

648:23–24 (664:20). Ivan St Austell and Hilton St Just—were featured with the Arthur Rousley Opera Company when that company made several appearances in Dublin in the 1890s. As Adams points out (p. 73), both names are comically high-toned pseudonyms.

648:24 (664:21). genus omne—Latin: "all that sort."

648:28–29 (664:25–26). the King street house—i.e., the Gaiety Theatre, 46–49 King Street South.

649:1 (664:40). fools step in where angels—after Alexander Pope's *Essay on Criticism* (1711), line 625: "For *Fools* rush in where *Angels* fear to tread."

649:14 (665:11). his scythed car—i.e., the brushes of the sweeper are likened to the scythes the ancient Britons and Celts attached to the wheels of their war chariots.

649:20 (665:17). Und alle Schiffe brücken—German: literally, "And all ships are bridged," apparently Stephen's misapprehension of *"brücken"* for "broken" in an attempt at Johannes Jeep's line *"Welches das Schiff in Unglück bringt"* ("Which brings the ship into misfortune"). See 647:22–23n.

649:22, 24, 32 (665:19–20, 21, 29). as he sat in his lowbacked car/to be married by Father Maher/and looked after their lowbacked car—for the opening stanza of "The Low-Backed Car," see 305:34–35n; the concluding lines of the poem: "As we drove in the low-back'd car,/To be married by Father Maher—/Oh my heart would beat high/At her glance and her sigh—/Tho' it beat in a low-back'd car."

649:26 (665:23). sirens—see 635:22–23n.

EPISODE 17
[ITHACA]

Bloom's House

EPISODE SEVENTEEN

BLOOM'S AND STEPHEN'S

ROUTE

Course & Direction

Stop-Off Points

Episode 17: [Ithaca], pp. 650–722 (666–737).
In Book XVII of *The Odyssey* Telemachus and
Odysseus go their separate ways to Odysseus'
manor house; Odysseus is still in disguise as a
beggar down on his luck. In Books XVII–XX
Odysseus—having entered his house "by a
stratagem" as Bloom does, 652 (668)—spies out
the ground and prepares to kill the suitors. The
state of his house "corrugates" his brow as
Bloom's is corrugated 659 (675). Antinous, the
chief suitor, irritated by the disguised Odysseus,
throws a stool at him and hits him (XVII)—as
Bloom runs into his displaced furniture 690 (706).
On the morning of the slaughter day the suitors
compete to see who can string Odysseus' bow;
none can, and when the disguised Odysseus
finally strings it with extraordinary ease, Zeus
reassures him with a thunderclap out of a cloudless
sky (XXI)—as Bloom's liturgical review of his
day is rewarded by a "loud lone crack emitted by
the insentient material of a strainveined timber
table," 714 (729). Odysseus and Telemachus pen
the suitors in the manor hall—as Stephen helps
lock the door, 653 (669). The slaughter of the
suitors begins (XXII) after Odysseus has strung
the bow (correspondence—Reason) and Antinous
(Buck Mulligan) is the first to be killed—as
Bloom has already disposed of Mulligan, 604–605
(620–621). Eurymachus (Boylan) is the second of
the suitors to be killed. At the height of the killing
(XXII) the Aegis of Athena shines under the roof
of the hall, terrifying the suitors—as 688 (703) a
"celestial sign" appears. When the killing is over,
the poet and the herald are spared; Telemachus is
sent on an errand and Odysseus fumigates his
house—as Bloom does 691 (707).
While the killing is taking place, Penelope is
asleep and unaware. Odysseus is extraordinarily
circumspect in his approach to Penelope not only
when he is in disguise and unknown to her (XIX)
but also when he reveals himself to her (XXIII).
She in her turn (XXIII) is painfully slow to
accept the ragged, blood-begrimed "beggar" as
her husband.
Time: 2:00 A.M. Scene: Bloom's house at 7
Eccles Street, N.E. Organ: skeleton; Art: science;
Color: none; Symbol: comets; Technique:
cathechism (impersonal). Correspondences: *Anti-
nous,* the first suitor—Buck Mulligan; *Eurymachus,*
the second suitor—Boylan; *Bow*—reason; *Suitors*
—scruples (it is of interest that the word "scru-
ples" appears only once in *Ulysses,* 708:32 (724:5),
where it is used in its literal sense of "minute
quantities").

**650:3–11 (666:3–11). from Beresford place
they ... before George's church diametri-
cally**—Bloom and Stephen walk northeast along
Beresford Place behind the Custom House to the
foot of Lower Gardiner Street, then north-
northwest along Lower Gardiner Street, its
extension, Middle Gardiner Street, and the fur-

ther extension, Mountjoy Square West; they
turn left (west-southwest) down Gardiner's Place
and pass Nerney Court on their right; they could
have taken this right, turned left on St. Anthony's
Place and then right into Hardwicke Place;
instead, they continue to Temple Street North,
turn right and walk west-northwest toward
Hardwicke Place, an extension of Temple Street
North that curves ("circus") around the front of
St. George's Church and leads directly into
Eccles Street. See 57:7n.

650:16 (666:17). paraheliotropic—botanically,
of leaves that turn their edges toward brilliant
incident light.

**650:17 (666:18). exposed corporation emer-
gency dustbuckets**—outdoor trash baskets to be
provided by the Dublin City Corporation. This is
one of Bloom's "civic self-help" ideas; the baskets
did not exist in 1904.

**650:20 (666:21). the maleficent influence of
the presabbath**—i.e., Friday, the day before the
Jewish Sabbath. Jews consider it an unlucky day
because it is traditionally supposed to be the day
on which Adam and Eve fell and were expelled
from the Garden of Eden. In Christian tradition
this is compounded by the fact that Jesus was
crucified on Friday.

**650:36–651:3 (666:37–667:3). the anachro-
nism involved in assigning ... interred at
Rossnaree**—the anachronism is that King
Cormac Mac Art, who reigned from *c.*254–277
(according to modern historians), until 266
according to *The Annals of the Four Masters,* was,
at least in legend, supposed to have been converted
to Christianity; see 167:5–8n. On the other hand,
St. Patrick is credited with having brought Christ-
ianity to Ireland when Pope Celestine I sent him
on his mission to Ireland in 432 (or 433). In his
Confession St. Patrick says, "My father was
Colpornius, a deacon, son of Potitus, a priest."
The Annals of the Four Masters gives St. Patrick's
great-grandfather as "Deisse" (=Odyssus=
Odysseus=Ulysses?). Butler's *Lives of the Saints*
says of St. Patrick's arrival in Ireland: "It hap-
pened that at this very time the King Leogaire
[Lear, Leary] and the assembled princes were
celebrating a [druid] religious festival in honour
of the return of the sun to power and heat." It was
Easter eve; on Easter Day St. Patrick preached
before the king, and though there is no assertion
that Leary was converted, he is supposed to have
allowed St. Patrick to carry his mission to the
people of Ireland unhindered.

**651:8–10 (667:8–10). a matutinal cloud ...
than a woman's hand**—in I Kings 16 Elijah
prophesied against Ahab and in 17:1 proclaimed
"*As* the Lord God of Israel liveth ... there shall

not be dew nor rain these years, but according to my word." When Elijah decided to call off this drought, he "went up to the top of Carmel . . . and put his face between his knees, And said to his servant, Go up now, look toward the sea. . . . And it came to pass at the seventh time, that [the servant] said, Behold, there ariseth a little cloud out of the sea, like a man's hand, and [Elijah] said, Go up, say unto Ahab, Prepare *thy chariot,* and get thee down, that the rain stop thee not" (I Kings 18:42–44). See 11 (9), 61 (61).

651:17 (667:17). Owen Goldberg—see 160:3–4n.

651:17 (667:17). Cecil Turnbull—*cf.* 535:28–30n.

651:18–20 (667:18–20). between Longwood avenue . . . and Bloomfield avenue—all in south-central Dublin just north of the Grand Canal. The route suggests little except that one gets to Bloomfield Avenue via Synge Street several blocks to the east (named before and not after J. M. Synge; see 183:2–4n).

651:20 (667:20). Percy Apjohn—see 160:3n. In 1904 a Thomas Barnes Apjohn lived in Rutland House, Crumlin; see next note.

651:21–22 (667:21–22). between Gibraltar villa . . . barony of Uppercross—Crumlin was a parish and village three and a half miles southwest of the center of Dublin. There was a *Bloomfield House* in Crumlin Road and a *Gibraltar Villa* in Dolphin's Barn Road just around the corner.

651:27–28 (667:27–28). in Matthew Dillon's house in Roundtown—see 105:6–7n.

651:28–29 (667:28–29). Julius Mastiansky—see 60:29n.

652:20 (668:20). A stratagem—as Odysseus has entered his manor in Ithaca by the stratagem of his disguise as a beggar down on his luck.

652:31–32 (668:31–32). Francis Froedman . . . Frederick street, north—so listed in *Thom's* (1904), p. 1496.

652:33–35 (668:33–35). the last feast of the Ascension . . . of the christian era—the Feast of the Ascension occurs 40 days after Easter and celebrates Christ's ascension into heaven after the Resurrection. Since Easter occurred on Sunday, 3 April, in 1904, Ascension Day or Holy Thursday was 12 May (coinciding with the Jewish festival of Firstfruits; see 47:41–48:1n and

60:35n). The year 1904 was "bissextile," a leap year.

652:35–36 (668:35–36). jewish era five . . . and sixty-four—the Jewish calendar marked 10 September 1904 as the beginning of the year 5665.

652:36–653:1 (668:36–37). mohammedan era . . . hundred and twenty-two—the Mohammedan year 1322 began on 18 March 1904.

653:1–2 (668:37–669:1). golden number 5 . . . Julian period 6617—all these except **Roman indication 2,** which should read **Roman indiction 2,** bear on methods of determining the date of Easter Sunday—an exercise of considerable importance since the date of that movable feast determines the liturgical calendar of the Christian year. Part of the complexity of the Christian system for determining the occurrence of Easter derives from an elaborate effort to avoid the coincidence of Easter and the Jewish Passover. Easter Sunday is the first Sunday after the paschal full moon, the full moon that happens upon, or next after 21 March. Basic to this determination is the relationship of the lunar year (354 days) to the solar year (365.25 days); this relationship can be calculated as a 19-year (metonic) cycle since 19 solar years are nearly equal to 235 lunations, i.e., once every 19 years the new moon will fall on the same calendar day. "Golden number 5" means that 1904 was the fifth year of the 19-year metonic cycle that began in 1899; "epact 13" means that on any given date the moon would be 13 days older than it would have been on the same date in the first year of the cycle (1899). The "solar cycle" is a period of 28 years since once every 28 years Sundays fall on the same days of the month; i.e. "solar cycle 9" means that a cycle began in 1895. "Dominical letters CB" are a code means of describing the occurrence of Sundays within the years of the solar cycle: "C" means that the first Sunday of 1904 was 3 January; "B" means that, since 1904 was a leap year, Sundays after 29 February would be determined as though 2 January had been the first Sunday of the year. "The Roman indiction" was a Roman cycle of 15 years established for the purposes of taxation and accepted as an important Christian cycle (the Pontifical Indiction) during the Middle Ages; 1904 was the second year in this cycle, which was established in 313 A.D. The Julian period is a cycle of 7,980 (365.25-day) Julian years since once every 7,980 years the 28-year solar cycle, the 19-year lunar cycle and the 15-year Pontifical or Roman Indiction coincide. What it all adds up to is that the paschal full moon occurred on 31 March 1904 and Easter Sunday on 3 April 1904.

653:2 (669:2). MXMIV should read **MCMIV**—if the intention is a final affirmation of 1904 (and not 1994)?

653:6–7 (669:6–7). leverage of the first kind— in classical mechanics, the simplest of levers, the fulcrum at one end of the bar, the force exerted at the other end.

653:8–9 (669:9). a lucifer match—a friction match, first manufactured in England under the trade name "Lucifer Matches"; by 1900 the trade name had become generic.

653:16 (669:17). CP—candlepower.

653:26 (669:27). he helped to close and chain the door—as Telemachus helps Odysseus pen the suitors in the house preparatory to the killing in Book XXII of *The Odyssey.*

653:37 (669:38). Abram coal—advertised in 1904 as the finest A-brand coal in Dublin.

654:1–2 (670:1–2). Messrs Flower and M'Donald of 14 D'Olier street—listed in *Thom's* (1904) as "coal importers, salt manufacturers, coke, charcoal, and corn merchants," p. 1475.

654:9–11 (670:9–11). Brother Michael . . . the county of Kildare—for this episode in Stephen's life see *A Portrait of the Artist as a Young Man,* Chapter I.

654:11–13 (670:12–13). Simon Dedalus . . . number thirteen Fitzgibbon street—see *A Portrait of the Artist as a Young Man,* Chapter II. Fitzgibbon Street is off Mountjoy Square not far to the east of Eccles Street. In 1904, number 13 was valued at £25 (as against Bloom's house, which was valued at £28) annual rent.

654:13–15 (670:14–15). Miss Kate Morkan . . . 15 Usher's Island—the Misses Morkan appear as Gabriel Conroy's aunts in "The Dead," *Dubliners.* Usher's Island is in central Dublin on the south bank of the Liffey.

654:16 (670:16–17). number twelve North Richmond street—the residence of the boy-narrator of "Araby" in *Dubliners.* In 1904 number 12 was valued at an annual rent of £19; i.e., though it was just east of the house in Fitzgibbon Street in northeastern Dublin, it was a step down in the housing scale.

654:17 (670:17–18). the feast of Saint Francis-Xavier in 1898—3 December, to celebrate the Spanish Jesuit St. Francis Xavier (1506–1552), who was famous for his missionary work in India and the Far East.

654:18–19 (670:18–19). the dean of studies . . . 16 Stephen's Green, north—see *A Portrait of the Artist as a Young Man,* Chapter V. The address is curious since it is not the address of University College, which was at 84A to 87 Stephen's Green South; number 16 is the address of the Palace of the Church of Ireland Archbishop of Dublin and Primate of Ireland—in 1904, the most Reverend Joseph Ferguson Peacocke, D.D.

654:20 (670:20). his father's house in Cabra—see 590:33n.

655:2–10 (671:2–10). From Roundwood reservoir . . . upper Leeson street—this essentially accurate account is derived in large part from *Thom's* (*1904*), p. 2102. The course of the Dublin Water Works aqueduct from Roundwood (or Vartry) Reservoir, 22 miles south of Dublin, to Stillorgan (reading from south to north): east to Callowhill, north through the Glen of the Downs and across (not through) the Dargle (see 146:3–4n). The Barony of Rathdown includes almost the entire route of the aqueduct. The 250-foot gradient is not from Stillorgan to the "city boundary" but from Stillorgan to the quays in central Dublin.

655:10–16 (671:10–16). though from prolonged summer . . . other than those of consumption—fiction: the spring of 1904 was normal Irish weather, i.e., far from dry. The Waterworks Committee was a standing committee of the Dublin Municipal Council; and, if the order for water conservation had been necessary, the committee would have been advised by its engineer, Harty, and the order would have been issued not by Harty but by the committee's secretary, Charles Power.

655:16–18 (671:16–18). recourse being had . . . Royal canals as in 1893—*Thom's* (1904), p. 2105, notes this "recourse" taken on 16 October 1893 as the result of an "unprecedented drought." The waters of the two canals were far from unpolluted, hardly fit for swimming, and in retrospect the "recourse" seems an extreme measure.

655:18–24 (671:18–25). South Dublin Guardians . . . taxpayers, solvent, sound—in 1904 the Waterworks Committee of the Municipal Council did bring an action for the reasons described in these lines through the council's Law Agent, Ignatius J. Rice, solicitor. The details as outlined here are derived from Rice's letter, which was published in *The Irish Independent,* 15 June 1904. The South Dublin Poor Law Union was an administrative grouping of Poor Law Guardians from Dublin City and County, south of the Liffey. It levied a separate "poor rate" (tax) and had responsibility for the care and sustenance of the poor and indigent in its area.

655:25 (671:26). drawer of water—in Deuteronomy Moses exhorts all the children of Israel,

from the highest to the lowest, from "your captains of your tribes" to "the drawer of thy water," to obedience (Deuteronomy 29:10–11).

655:26 (671:27). watercarrier—the eleventh sign of the Zodiac, Aquarius (20 January to 19 February), the sign under which Stephen was born, 2 February 1882. Aquarius is the sign and house of altruism; traditionally Aquarians are supposed to be those who believe in and seek the welfare of others.

655:28–29 (671:29–30). its vastness in the ocean of Mercator's projection—the Flemish geographer and mathematician, Gerhardus Mercator (Gerhard Kremer, 1512–1594), is credited with inventing this two-dimensional projection from the three-dimensional globe. In his projection the lines of longitude and latitude meet at right angles; consequently the projection visually amplifies the polar regions (where the longitudinal lines on a globe converge) and makes the oceans appear far more vast than they actually are.

655:29–30 (671:30–31). its unplumbed profundity ... exceeding 8,000 fathoms—the Sundam or Sunda Trench off Sumatra was unsounded in 1904, but its depth turns out to be 3,158 fathoms (18,948 feet). In 1904 the greatest known depth was off Guam, 5,269 fathoms (31,614 feet). As of 1969 the greatest known depth was in the Mariana Trench in the Pacific, 6,033 fathoms (36,198 feet). In the late nineteenth century oceanographers knew that mid-nineteenth-century soundings (which were supposed to have reached over 7,000 fathoms) were erroneous and that no such depths existed in the ocean. Those earlier soundings had been made with rope and were effectively disproved by soundings made with wire after 1872; nor were these facts the exclusive concern of oceanographers—they were common knowledge, having been widely publicized by news of the voyages of the British ship *Challenger,* 1873–1876.

655:36–37 (671:37–38). its preponderance of 3 to 1 over the dry land of the globe—best estimate as of 1900 (and common knowledge), 72 percent.

655:39–40 (671:40–41). the multisecular stability of its primeval basin—"multisecular": composed of tiny fragments. In 1900 the assumption that the pelagic deposits in intermediate depths were an ooze made up of dead microorganisms from the surface was common knowledge.

655:40 (671:41). its luteofulvous bed—"luteofulvous" means reddish-yellow. In 1900, thanks to the *Challenger's* and other oceanographic studies, scientists assumed that the depths of the oceans had no pelagic ooze (see preceding note) but were shallow beds of reddish-yellow clay.

656:15 (672:16). the hole in the wall at Ashtown gate—see 78:12n.

656:18–19 (672:19–20). its buoyancy in the waters of the Dead Sea—the concentration of salts in the Dead Sea is so great that the specific gravity of its waters in 1906 was 1.16; i.e., a human body, which floats in water (s.g. 1), more than floats in the Dead Sea.

656:23–24 (672:24–25). its strength in rigid hydrants—i.e., hydrants in contradistinction to flexible hoses.

656:26 (672:27). minches—small inns or alehouses.

656:32–33 (672:33–34). its submarine fauna and flora (anacoustic, photophobe)—"anacoustic": having no sense of hearing; "photophobe": having an aversion to light. In 1900 scientists assumed (as in 1970 they do not) that the depths of the sea were utterly silent and that deep-sea creatures made and heard no sounds.

656:36–37 (672:37–38). stagnant pools in the waning moon—traditionally the waning moon is regarded as a sign of disintegration and decline on earth.

656:41 (672:42). Barrington's—John Barrington and Sons, Ltd., merchants and manufacturers, 201 and 202 Britain Street Great (now Parnell Street).

657:21–24 (673:21–24). the respective percentage of protein ... the latter in the first-named—bacon, approximately 7,295 calories (uncooked) and nine grams of protein per pound; salt ling (cod), approximately 1,105 calories and 259 grams protein per pound; butter, 3,200 calories per pound, no protein.

658:1–2 (673:38–674:1). omnipresent luminiferous diathermanous ether—late-nineteenth-century scientists regarded it as "proved" that light and thermal radiation were transmitted by wave motion; therefore, a medium through which the waves could pass was a theoretical necessity, a necessity met by postulating the universal presence of "luminiferous ether," a weightless substance like an elastic jelly that filled all the "empty" spaces of the universe and that transmitted light and other forms of radiant energy without impeding their passage. The "ether" hypothesis was by 1910 riddled with contradictions and ambiguities, but it remained in force until the impact of Einstein and the "new

physics" in the 1920s and 1930s. "Diathermanous" means admitting the passage of heat.

658:9–10 (674:8–10). an expenditure of thermal units ... to 212° Fahrenheit—a British "thermal unit" is the amount of heat necessary to raise the temperature of one pound of water one degree Fahrenheit (under laboratory conditions at sea level); thus, 72° should read (at least) 162° since Bloom cannot be heating much less than a pound (a pint) of water.

659:8 (675:7). Crown Derby—see 62:31–32n.

659:9 (657:8). shammy—i.e., chamois.

659:13 (675:12). Plumtree's potted meat—see 73:40–74:2n.

659:15 (675:14–15). William Gilbey and Co's white invalid port—W. A. Gilbey, Ltd., wine growers and spirit merchants, distillers and importers, 46 and 71 Sackville Street Upper in Dublin.

659:17 (675:16). Epps's soluble cocoa—see 642:6n.

659:17 (675:16–17). Anne Lynch's choice tea—Anne Lynch and Company, Ltd., at 69 George's Street South and several other addresses in Dublin.

659:21–22 (675:21). Irish Model Dairy's—i.e., from the Model Farm Dairy, operated by the Irish Department for Agriculture and Technical Instruction in Glasnevin.

659:32–33 (675:32–33). two lacerated betting tickets—as Boylan has "plunged" (and lost) on Sceptre; see 84:28n and 632:24–38n.

659:34 (675:34). corrugated his brow—Odysseus' brow is repeatedly "corrugated" as he witnesses the state of affairs in his besieged home; see headnote to this episode, p. 464 above.

660:3 (676:3). Bernard Kiernan's—see 276:10n.

660:4 (676:4). David Byrne's—see 168:1n.

660:5 (676:5). Graham Lemon's—see 149:3–4n.

660:7–8 (676:7–8). Elijah, restorer of the church of Zion—see 149:15n and 149:16n.

660:8–9 (676:8–9). F. W. Sweny and Co (limited)—see 82:36n.

660:14–15 (676:14–15). Turkish and Warm Baths, 11 Leinster street—see 85:4n.

660:15–17 (676:15–17). with the light of inspiration ... language of prediction—in the attitude of Moses with the tables of the Law, the secret of the Jews and the prediction of their destiny; see 141:23–25n.

660:30 (676:30). Light to the gentiles—Isaiah predicts that the Messiah will be given "for a light to the Gentiles" (Isaiah 49:6); the prophecy is echoed by St. Paul in Romans 15:9–16.

660:31 (676:31). a collation—a light meal taken on fast days, appropriate since Stephen (as a nominal Catholic in Bloom's eyes) would have been expected to fast on Fridays.

661:1 (677:1). his symposiarchal right—i.e., his right as the master, director or president of a symposium.

661:11 (677:11). Epps's massproduct, the creature cocoa—"massproduct" is an obvious pun suggesting the Mass in which Bloom is functioning as priest, Stephen as communicant. "Creature" in context means food or drink that promotes human comfort, and, as W. Y. Tyndall points out in *A Reader's Guide to James Joyce*, p. 222, cocoa is derived from the tree *Theobroma cacao*, i.e., "god-food cacao."

662:2 (678:2). the Shamrock, a weekly newspaper—an illustrated magazine, published weekly and monthly by the Irish National Printing and Publishing Company, 32 Abbey Street Lower in Dublin (1866 *ff.*).

662:19 (678:19). kinetic poet—Stephen, in *A Portrait of the Artist as a Young Man*, Chapter V: "The feelings excited by improper art are kinetic, desire or loathing. Desire urges us to possess, to go to something; loathing urges us to abandon, to go from something. These are kinetic emotions. The arts which excite them, pornographical or didactic, are therefore improper arts. The esthetic emotion (I use the general term) is therefore static. The mind is arrested and raised above desire and loathing."

662:26 (678:26). music by R. G. Johnston—unknown.

662:27–28 (678:27–28). If Brian Boru ... old Dublin now—for Brian Boru, see 98:16n. Bloom's proposed song sounds as though it were modeled on an extant song, but if it is, the original remains unknown.

662:30–32 (678:30–32). the sixth scene, the valley ... Sinbad the Sailor—the first edition

of the pantomime *Sinbad* made its Dublin debut 26 December 1892; the second, on 30 January 1893. In both editions the sixth scene was advertised as "Grand Ballet of Diamonds and Serpentine Dance." See Adams, pp. 76–82.

662:32–33 (678:32–33). written by Greenleaf Whittier—the pantomime was written by Greenleaf Withers, not by the American poet John Greenleaf Whittier (1807–1892), whose didactic and sentimental rural verse is at a considerable remove from pantomimic improvisation.

662:33–37 (678:33–37). scenery by George A. Jackson ... Bouverist, principal girl—these details are historically accurate with one exception, but they are also highly selective when one considers the wealth of detail at Joyce's disposal (see Adams, pp. 78–79). The exception: "Nelly Bouverist" elides two "principal girls," Kate Neverist and Nellie Bouverie.

663:1 (678:39). diamond jubilee of Queen Victoria—was celebrated in 1897 to commemorate the sixtieth year of her reign. The celebration continued throughout the year, but the key date was 22 June 1897.

663:2–3 (679:1–2). opening of the new municipal fishmarket—at 4–33 St. Michan's Street, opened on 11 May 1897.

663:3–5 (679:2–5). opposition from extreme circles ... duke and duchess of York—there were the usual patriotic mutterings and threats at the prospect of the visit of the Duke and Duchess of York to Dublin, 18–29 August 1897. *Thom's* (1904), p. 2105, asserts that their Royal Highnesses were accorded "an enthusiastic welcome."

663:8–9 (679:7–8). the Grand Lyric Hall on Burgh Quay—on the south bank of the Liffey in east-central Dublin (formerly the Conciliation Hall) opened 26 November 1897.

663:9 (679:8–9). the Theatre Royal in Hawkins street—opened 13 December 1897 (on the site of the old Royal); see 268:14n.

663:16–17 (679:16). Everybody's Book of Jokes—apparently a coinage or a generalization of a common sort of book title.

663:19 (679:18). the new lord mayor, Daniel Tallon—lord mayor of Dublin 1898 and 1899 (elected in the fall of 1897).

663:19–20 (679:19). the new high sheriff, Thomas Pile—Pile was high sheriff of Dublin in 1898; he became Sir Thomas Pile in 1900 and was lord mayor in 1900.

663:20–21 (679:19–20). the new solicitor-general, Dunbar Plunket Barton—was solicitor-general for Ireland from 1 January 1898 until 1900; see 196:10–11n.

663:34 (679:33). the maximum postdiluvian age of 70—a reference to the traditional fundamentalist belief that before Noah's flood the average life-span was hundreds of years, but that God in response to man's sinfulness imposed brevity as a continuing punishment after the flood. The Scriptural basis for this belief is the contrast between the great ages of antediluvian figures such as Methuselah, 969 years (Genesis 5:27) and "The days of our years are three-score and ten" (Psalms 90:10) ("A Prayer of Moses the man of God").

663:34–35 (679:33–34). Bloom, being 1190 years alive having been born in the year 714—a miscalculation: if Bloom were 1190 years old in 1952, he would have been born in 762, not 714; what has happened is that Bloom's age (1190) has been subtracted from 1904 A.D. instead of 1952 A.D.

663:36–37 (679:35–36). the maximum antediluvian age, that of Methuselah, 969 years—see 663:34n.

663:37–40 (679:36–39). while if Stephen would ... the year 81,396 B.C—another miscalculation: the proposition is that the ratio between their ages should remain 17 to 1 as it was in 1883; $17 \times 1190 = 20,230$ (Bloom's age when Stephen's age is 1190) and thus Bloom would have to have been born in 17,158 B.C. What has happened is that 70 has been substituted for 17 since $70 \times 1190 = 83,300$; and instead of subtracting the 83,300 from 3072 A.D. (when Stephen would be 1190 years old), it has been subtracted from 1904 to achieve the figure 81,396 B.C.

664:8–9 (680:6–7). Matthew Dillon's house ... Kimmage road, Roundtown—the address did exist and was occupied in 1904 by an A. M'Dermott, Esq. By 1904 Roundtown had been renamed Terenure.

664:12 (680:10). Breslin's hotel—in Bray, 13 miles southeast of central Dublin; by 1904 the name had been changed to the Station Hotel.

664:22–24 (680:20–22). Mrs Riordan, a widow ... 29 December 1891—the memorable quarrel about Parnell that prompted Mrs. Riordan's removal from the Dedalus household is the dramatic burden of that family's Christmas dinner in *A Portrait of the Artist as a Young Man*, Chapter I.

664:25–26 (680:23–24). the City Arms Hotel ... 54 Prussia street—see 36:23–24n.

664:29–31 (680:27–29). Joseph Cuffe ... the North Circular Road—see 96:32n.

664:32 (680:30). corporal work of mercy—the seven corporal works of mercy: (1) to bury the dead; (2) to cloth the naked; (3) to feed the hungry; (4) to give drink to the thirsty; (5) to harbor the houseless; (6) to visit those in prison; (7) to administer to the sick. The seven corporal works are paralleled by the seven spiritual works of mercy: (1) to admonish sinners; (2) to bear wrongs patiently; (3) to comfort the afflicted; (4) to counsel the doubtful; (5) to forgive offenses; (6) to instruct the ignorant; (7) to pray for the living and the dead.

664:37 (680:35–36). the corner of the North ... place of business—see 392:40n.

665:4–5 (681:2). from the city to the Phoenix Park—North Circular Road looped around the northern limits of metropolitan Dublin in 1904 and ended at the eastern border of Phoenix Park.

655:18 (681:15). colza oil—rapeseed oil, used for illumination and lubrication during the nineteenth century.

665:19 (681:16). the statue of the Immaculate Conception—i.e., representing the Virgin Mary as she is visited with the news of her impending motherhood by the Archangel Gabriel. It was not unusual for devout Catholics to keep a votive lamp burning before such statues (as Mrs. Riordan has done).

665:19–21 (681:16–18). her green and maroon ... for Michael Davitt, her tissue papers—Mrs. Riordan's brushes turn up in *A Portrait of the Artist as a Young Man,* Chapter I; the green for Parnell, the maroon for Michael Davitt, see 583:16n; and she gave the child Stephen "a cachou every time he brought her a piece of tissue paper."

665:26–27 (681:23–24). Eugene Sandow's Physical Strength and How To Obtain It—see 61:19–20n.

666:11, 15–16 (682:9, 13–14). transubstantial heir/consubstantial heir—literally, Bloom's father is dead and Stephen's is living; figuratively, this recalls Stephen's preoccupation with the theological relation between the Father and the Son (*cf.* 22:28n; 22:29n; 22:30n), and Stephen's treatise on Shakespeare as ghost-father to Hamlet as son in [Scylla and Charybdis].

666:20–22 (682:18–20). the reverend Mr Gilmer Johnston . . . Nicholas Without, Coombe—Church of Ireland, St. Nicholas Without and St. Luke's was in the Coombe, but a record of the Reverend Johnston's incumbency has yet to be discovered.

666:22–23 (682:20–21). James O'Connor, Philip Gilligan and James Fitzpatrick ... village of Swords—Swords was a small village eight miles north of Dublin. For Philip Gilligan, see 153:14n and 689 (704). James O'Connor? James Fitzpatrick? It is ironic that Baptism is the one sacrament that can, in an emergency, be performed by a layman.

666:24–25 (682:22–23). the reverend Charles Malone ... Patrons, Rathgar—the Roman Catholic Church of the Three Patrons was in Rathgar Road, three miles south of the center of Dublin; *Thom's* (1904) lists the Reverend Charles Malone as one of the three curates in charge.

666:30 (682:28). a dame's school and the high school—see 76:24n and 154:7–8n.

666:33, 34 (682:31, 32). the intermediate/the royal university—not institutions of learning but examining and degree-granting institutions; see 130:19n and 343:25n.

667:10–11 (683:8–9). the aeronautic parachute—the first record of a descent from heights by parachute (or umbrella) is in Simon de Loubere's *History of Siam* (Paris, 1691); on 26 December 1783, Sebastian Lenormont made a descent with a semirigid 260-inch umbrella; Jacques Garnerini is credited with the first nonrigid parachute descent from a balloon in 1797.

667:11 (683:9). the reflecting telescope—invented by the Scot mathematician James Gregory (1638–1675) in 1661 and adapted (from Gregory's description *Optica Promota*) by Sir Isaac Newton (1642–1727) in 1666 *ff.*

667:11 (683:9). the spiral corkscrew—corks were not used for stopping bottles until the seventeenth century, and though it is hardly proof positive, the first *patented* corkscrew is dated 1860.

667:12 (683:10). the safety pin—invented "in three hours" on 10 April 1849 by the American Walter Hunt, who received $100 for the patent rights.

667:12 (683:10). the mineral water siphon—patented in 1825 by the English inventor Charles Plinth as the "Regency portable fountain," and refined into what is essentially the modern siphon by the French inventor Antoine Perpigna in 1837.

667:12–13 (683:10–11). the canal lock with winch and sluice—the development of the canal lock with two gates is a matter of considerable controversy; it seems to have been one of those late-medieval, early-Renaissance "inventions" that happened in a variety of places at about the same period. Some historians suggest that locks were developed by the Dutch in the fourteenth century; others suggest the brothers Domenico of Viterbo in 1481. At any rate, locks were a universal feature of canal engineering in Europe by 1500.

667:13 (683:11). the suction pump—the simple displacement or suction-lift pump was apparently known as early as the first century A.D. in Alexandria and by the late fourth century in various places in Western Europe.

667:18–19 (683:16–17). the twelve constellations ... Aries to Pisces—the progression of the 12 houses of the Zodiac traditionally begins with the vernal equinox, so Aries (21 March to 19 April) is first and Pisces (19 February to 21 March) is last.

667:23, 24–25 (683:21, 22–23). Ephraim Marks/1d. bazaar at 42 George's street, South—a penny bazaar as listed in *Thom's* (1904), p. 1502.

667:24, 25–26 (683:22, 23–24). Charles A. James/6½d. shop ... 30 Henry street—Charles Augustus James, Hardware and Fancy Dealer, and Washington Hall (the "waxworks exhibition"); see 620:31–32n.

667:34 (683:32). K. II—see 479:2n.

667:35 (683:33). House of Keys. Alexander J. Keyes—see 119:19n and 115:27n.

668:2 (683:36). non-compo boots—i.e., boots made out of real leather rather than composition materials.

668:3–4 (683:37–38). Barclay and Cook, 18 Talbot street—in 1904, 18 Talbot Street was occupied by S. Robinson, confectioner, and Dunlops, dyers and cleaners. There was a Gordon Barclay, boot dealer, at 104 Talbot Street, but by 1904 Cook seems to have disappeared from the boot business in Dublin.

668:10 (684:5). Plumtree's Potted Meat—see 73:40–74:2n.

668:14–15 (684:9–10). Councillor Joseph P. Nannetti ... 19 Hardwicke street—*Thom's* (*1904*) lists Nannetti's residence as 18 and 19 Hardwicke Street, Rotunda Ward, in northeastern Dublin.

669:1 (684:33). The Queen's Hotel, Ennis, County Clare—see 100:21–22n.

669:7–8 (685:1–2). the medical hall of Francis Dennehy, 17 Church street, Ennis—there is no record of an apothecary (or "medical hall") at 17 Church Street in Ennis.

669:12–13 (685:7–8). the general drapery store of James Cullen, 4 Main street, Ennis—Mr. Cullen's nonexistent store is located on a street that did not (and does not) exist in Ennis.

669:22–23 (685:17–18). A Pisgah Sight ... of the Plums—see 148:1n and 148:2n.

669:26 (685:21). My Favorite Hero—the title of an essay about Ulysses that Joyce wrote while he was at Belvedere; see Ellmann, p. 47.

669:26–27 (685:21–22). Procrastination is the Thief of Time—line 390 in "Night I" of Edward Young's (1683–1765) *Night Thoughts* (1742), in context (lines 390–393): "Procrastination is the thief of time:/Year after year it steals, till all are fled,/And to the mercies of a moment leaves/The vast concerns of an eternal scene."

669:33 (685:28–29). Philip Beaufoy—see 68:28n.

669:33 (685:29). Doctor Dick—the pseudonym of a Dublin writer who provided and updated local and topical verses for pantomimes in the early years of the twentieth century.

669:34 (685:29). Heblon's Studies in Blue—Heblon, the pseudonym of the Dublin solicitor Joseph K. O'Connor (b. 1878). His *Studies in Blue* (Dublin, 1903) probes the underside of life in Dublin's slums from a police-court perspective.

669:39–670:2 (685:34–36). the summer solstice ... sunset 8.29 p.m—summer solstice, 9:00 P.M., Tuesday, 21 June 1904. The times of sunrise and sunset are correct as of *Thom's* (1904), p. 14. For St. Aloysius Gonzaga, whose feast day it was, see 333:23–24n.

670:7 (686:2). halma—a game played on a checkerboard of 256 squares, by two with 19 men apiece or four with 13 apiece.

670:7 (686:2). spillikins—pickup sticks.

670:8 (686:3). nap—a card game in which each player receives five cards and calls the number of tricks he expects to win; if he wins all five, he has "made his nap."

670:8 (686:3). spoil five—a round game of cards that is "spoiled" if no player wins three of the possible five tricks.

670:8 (686:3). twenty-five—a variant of spoil-five in which the winning score is 25.

670:8–9 (686:3–4). beggar my neighbour—a game of cards in which the object is to gain all the opponent's cards.

670:10 (686:5). the policeaided society—the Police Aided Children's Clothing Society, 188 Brunswick Street Great (now Pearse Street), Dublin.

670:30 (686:25). balance of power—English diplomacy traditionally concentrated on balancing the Continental powers against one another (while sustaining friendly relations with "both sides") in the attempt to prevent any single Continental power from dominating all of Europe.

670:34 (686:29). nutgall—a dyestuff made from galls on the dyer's oak.

670:36 (686:31). metempsychosis—see 64:10n.

670:37–38 (686:32–33). alias (a mendacious person mentioned in sacred Scripture)—i.e., "*alias*" echoes "Ananias," a follower of the Apostles in Acts 5:1–11, who lies to Peter and drops dead as a consequence; hence, "Ananias" is colloquial for a liar.

671:4–5 (686:37–38). The false apparent parallelism ... true by construction—the proof depends on a geometric construction that demonstrates that the two perpendicular arms of a balance are part of an enormous triangle, the apex of which is the center of the earth.

671:27–28 (687:20–21). postexilic ... Moses of Egypt—in Hebrew tradition the postexilic period begins after the Babylonian captivity (after 586 B.C.), and the semilegendary figure of Moses, the great lawgiver of the Old Testament, is preexilic. Clearly the term "postexilic" here implies (1) after Moses left Egypt and (2) after the great dispersion of the Jews undertaken by the Romans in 70 A.D.

671:28–29 (687:21–22). Moses Maimonides, author of the More Nebukim—for Maimonides, see 29:12–13n; his *More Nebukim* (Hebrew: "Guide of the Perplexed") is a rational and philosophical work on biblical exegesis finished c.1190. It is regarded as Maimonides' most important work, and, ironically enough, its attempt to reconcile Aristotelian reason and Hebraic revelation led to a long and bitter conflict between the orthodox and the liberal in Judaism.

671:30 (687:23). Moses Mendelssohn—see 336:17n.

671:30–32 (687:23–25). from Moses ... to Moses ... there arose none like Moses—Jewish proverb that suggests the omnipresence of the spirit and law of Moses in Jewish tradition.

671:34–672:2 (687:27–30). Aristotle ... had been a pupil of a rabbinical philosopher—a Jewish legend (about both Aristotle and Plato) with practically no basis in fact, but it has flourished, particularly as a result of the impressively Aristotelian work of Moses Maimonides.

672:5 (687:33). Felix Bartholdy Mendelssohn—see 336:17n.

672:5 (687:33). Baruch Spinoza—see 280:13–14n and 336:18n.

672:6 (687:34). Mendoza (pugilist)—Daniel Mendoza (1763–1836), "The Star of Israel," an English Jew who was champion of England (1792–1795) and, therefore, with appropriate English modesty, "champion of the world."

672:6 (687:34). Ferdinand Lassalle—(1825–1864), German-Jewish lawyer, Marxist Socialist and political reformer who worked to form a worker's party, 1862 ff. and was thus the virtual founder of the German Social Democratic party. He was killed in a duel that resulted from a love affair. His career was fictionalized by George Meredith in *The Tragic Comedians* (1880).

672:11–12 (688:3–4). suil, suil, suil ... suil go cuin—Irish: "walk, walk, walk my dear, walk safely and walk calmly," the first two lines of the Irish chorus of a ballad, "Shule Aroon." The four-line verses of the ballad are composed of three lines of English and one of Irish; the burden is a maiden's lament: "But now my love has gone to France,/To try his fortune to advance" (i.e., the loved one has gone to join the Irish Brigade to fight for the French).

672:14 (688:6). Kifeloch harimon ... l'zamatejch—Hebrew: "Thy temples are like a piece of pomegranate within thy locks" (The Song of Solomon 4:3).

672:19 (688:11). Sweets of Sin—see 232:27n.

672:22 (688:14–15). the Irish characters for gee, eh, dee, em, simple and modified—simple (slender) ᵹ, e, ᴅ, m; modified (broad) ᵹ̇, é, ᴅ̇, ṁ, corresponding to the English letters *g, e, d, m* and compounds *gh, e, dh, mh*. In the Irish alphabet *g* is the seventh letter, *e* is the fifth, *d* is the fourth and *m* is the eleventh.

672:23–26 (688:15–18). the Hebrew characters ghimel, aleph, daleth and (in the absence of mem) ... goph ... 3, 1, 4 and 100—gimel, ℷ

(g); aleph, א (’); daleth, ר (d); mem, מ (m); koph, ק (Q)—in order the third, first, fourth, thirteenth and nineteenth letters of the alphabet with numerical values 3, 1, 4, 40 and 100.

672:28 (688:20). the extinct and the revived— i.e., biblical Hebrew is "extinct" because after the Babylonian captivity (596 B.C. *ff*.) it gradually gave way to Aramaic for daily use, though it was retained as a learned language. The Jews of the Christian era use Neo-Hebrew, a language modified by Greek, Aramaic and Latin influences; thus, biblical Hebrew, while still a language of scholarly study, is not a "living language." The Society for the Preservation of the Irish Language, founded in Dublin (1877), had made considerable progress in its efforts to revive the use of the Irish language by 1904 even though everyday use of the language had virtually disappeared in the course of the nineteenth century, except in the west of Ireland.

672:34 (688:26). servile letters—inserted letters that do not belong to the original roots of words.

672:35–673:1 (688:27–30). both having been taught . . . progenitors of Ireland—this elaborate legend derives from the Reverend Geoffrey Keating (*c*.1570–*c*.1644), an Irish historian whose *Foras Feasa* ("History of Ireland," *c*.1629) is an impressive collection of Irish legend-history, from the first arrivals (the three daughters of Cain; see 297:7n) to the Anglo-Norman invasion. Keating traces the Milesians Heber and Heremon (see 322:20–21n) to Fenius Farsaigh (the son of Baoth, son of Magog, son of Japheth, son of Noah) and Fenius is styled the ancestor of the Phoenicians and of the Milesians, who occupied Spain and then Ireland. In Book I, Section XV, Keating asserts that Fenius founded a school of languages on the Plain of Shinar exactly 24 years after Noah's flood. The biblical "basis" for this legend is in Genesis 10 and 11 (after the deluge and before the building of the Tower of Babel—a language school?). In Genesis 10:5 the decendants of Japheth are located: "By these were the isles of the Gentiles divided in their lands" and in Genesis 11:1–2, "And the whole earth was of one language, and of one speech. And it came to pass, as they journeyed from the east, that they found a plain in the land of Shinar; and they dwelt there." Thus, Fenius Farsaigh becomes the legendary link between the Hebrews and the Milesians, between the Hebrew language and Irish.

673:2–3 (688:31–32). toponomastic—coined from "toponymy," the study of place names.

673:4 (688:33). culdees—see 292:11n.

673:4 (688:33). Torah—literally, Genesis, Exodus, Leviticus, Numbers and Deuteronomy, the first five books of the Old Testament, also called the "Pentateuch" and traditionally ascribed to Moses. Figuratively, the Torah includes not only the five books of the Law of Moses, but also the so-called Oral Law and its ramifications in Talmudic law and commentaries.

673:4–5 (688:33–34). Talmud (Mischna and Ghemara)—the body of Jewish civil and ceremonial law and tradition. The Mischna of the Talmud sets forth the binding precepts of the elders in addition to, and developed from, the Pentateuch; and the Ghemara is comprised of elaborate commentary on the Mischna. There are two of these compilations, the Palestinian Talmud (fourth century) and the larger Babylonian Talmud (fifth century): both contain the same Mischna, but the Ghemaras differ.

673:5 (688:34). Massor—the Masorah or Masoretic text, developed between the sixth and the ninth century, a system of vocalization and accentuation of biblical Hebrew (see 672:28n) together with a body of traditional information about the text of the Hebrew Bible.

673:5 (688:34). Book of the Dun Cow—Irish: *Leabhar na h-Uidhre*; the oldest (i.e., the earliest transcription) of miscellaneous Irish literature. It was compiled at the monastery of Clonmacnois by Mailmuri MacKelleher (d. 1106). Only a fragment (134 folio pages) remains, but that fragment contains 65 pieces: romantic tales in prose, an elegy upon St. Columcille, a copy of the Voyage of Maelduin, etc.

673:5–6 (688:34–35). Book of Ballymote—see 326:4–5n.

673:6 (688:35). Garland of Howth—eighth or ninth century, an 86-folio-page illuminated Latin manuscript now in Trinity College Library, Dublin. It is splendidly ornamented and regarded as little inferior to the *Book of Kells*. It was found on Ireland's Eye, an island just north of Howth; it contains the four Gospels in Latin, partly in a pre-Jerome (pre-Vulgate) version.

673:6 (688:35). Book of Kells—*c*. eighth century. The most famous of Irish illuminated manuscripts, it contains the four Gospels in Latin and is the prize possession of Trinity College Library, Dublin.

673:7–8 (688:36–37). synagogical . . . rites in ghetto (S. Mary's Abbey)—see 227:13–14n.

673:8–9 (688:37–38). ecclesiastical rites in . . . masshouse (Adam and Eve's tavern)—the Franciscans in Dublin managed to survive English attempts to suppress Catholic worship in Ireland

during the sixteenth and seventeenth century. In 1618 they established an "underground" church in Rosemary Lane off Merchant's Quay just south of the Liffey; the lane was also the site of a tavern called "Adam and Eve's" and the tavern had its sign boards at each entrance to the lane; thus Catholic worshipers could enter the lane without arousing suspicion since ostensibly they were en route to the tavern when actually bound for church. The present Franciscan Church of St. Francis of Assisi stands nearby on Merchant's Quay and is still popularly called "Adam and Eve's" in memory of the seventeenth-century subterfuge.

673:9–10 (688:38–39). the proscription of their . . . jewish dress acts—the Penal Laws enacted in the years after and in contravention of the Treaty of Limerick (1691), were designed to suppress Catholicism and, in effect, Irish nationalism as well; they were impressively harsh, forbidding even (at least figuratively) the wearing of the green, Irish national color (see 45:2–3n; see also 15:30–31n). "Jewish dress acts": there have been a wide variety of such laws in several countries not only prohibiting Jews from wearing traditionally Jewish items of clothing but also requiring them to wear humiliating evidences of their Jewishness.

673:11 (689:1). the restoration in Chanan David of Zion—i.e., in *Chanaan*, King David's Land, Canaan, the land given by God to Abraham's posterity, the Children of Israel. The intensifying anti-Semitism in nineteenth-century Europe forced many European Jewish communities to the verge of despair; thus, the appearance of Theodor Herzl's pamphlet "The Jewish State: an Attempt at a Modern Solution of the Jewish Question" (1896) caused a tremendous stir of interest and excitement with its proposal to obtain Palestine from the Sultan of Turkey and to establish Zion, a Jewish homeland, under the guarantee of the Great Powers. See 59:14n.

673:15–16 (689:5–6). Kolod balejwaw . . . jehudi, homijah—Hebrew: loosely, "As long as deep within the heart/The soul of Judea is turbulent and strong," the opening lines of the *"Hatikvah"* ("The Hope," 1878) by the Hebrew poet Nephtali Herz Imber, set to music by Samuel Cohen, one of the pioneer settlers in Rishon Le Zion, Palestine, in the late 1890s. The song became the anthem of the Zionist movement in 1897 and is today the anthem of Israel.

673:25–27 (689:15–17). the anticipation of modern . . . ogham writing (Celtic)—both cuneiform and ogham inscriptions involve five figures ("quinquecostate") and both are more like a cipher or a shorthand than they are like

writing in the Greek or Roman alphabets. "Virgular" means having thin, sloping or upright lines (as ogham does).

674:6 (689:29). The traditional figure of hypostasis—i.e., the essential person of Christ in which his divine and human natures are united. Tradition held that Jesus was the only man who was ever exactly six feet tall and who ever had pure auburn hair.

674:7 (689:30). Johannes Damascenus—St. John of Damascus (c.700–c.754), an eloquent theologian, one of the doctors of the Latin Church and one of the Fathers of the Greek Church. He was much concerned with the concept of hypostasis and argued that the divine and human in Christ were combined in one person without the possibility of conversion, confusion or separation. He described Jesus as "tall . . . of a pale complexion, olive-tinted, and of the colour of wheat." This description was one feature of his resistance to the Greek Emperor's order forbidding the worship of images.

674:7 (689:30). Lentulus Romanus—fictional, supposed to have been the Roman governor of Judea before Pontius Pilate, and supposed to have written a letter to the Roman Senate in which he described Jesus as "a man of tall stature" with "somewhat winecolored hair."

674:8 (689:31). Epiphanius Monachus—St. Epiphanius the Monk (c.315–403), another of the fathers of the Greek or Eastern Church and bishop of Constantia (ancient Salamis) in Cyprus He is noted for his combative denunciations of Origen's stand on hypostasis in the course of which he described Jesus in much the same terms that John of Damascus later used.

674:8–9 (689:31–32). leucodermic, sesquipedalian with winedark hair—none of Stephen's "sources" uses these exact terms, but "leucodermic" means "white-skinned"; for "winedark," see 7:3n.

674:15 (690:4). the very reverend John Conmee, S.J—see 78:42–79:1n.

674:15–16 (690:4–5). the reverend T. Salmon, D.D—see 162:26n.

674:16–17 (690:5–6). Dr Alexander J. Dowie—see 149:16n.

674:17–18 (690:6–7). Seymour Bushe, K.C—see 98:37n.

674:18 (690:7). Rufus Isaacs, K.C—Rufus Daniel Isaacs, 1st Marquis of Reading (1860–1935), a famous and popular Jewish lawyer in England.

674:19 (690:8). Charles Wyndham—Sir Charles Wyndham (1837–1919), one of the finer English actor-managers of the late nineteenth century. He was, as Bloom's phrase suggests, quite successful as "high comedian," but by no means limited to that genre.

674:19–20 (690:9). Osmond Tearle († 1901)— George Osmond Tearle (1852–1901), another English actor-manager, who formed a succession of Shakespearean stock companies in London, New York and at Stratford-on-Avon.

674:28–676:4 (690:17–691:24). Little Harry Hughes ... lies among the dead—*Child's Ballads*, ed Helen Child Sargent and George Lyman Kittredge (Cambridge, 1904), number 155, "Sir Hugh, or, the Jew's Daughter," variant N, p. 371, entitled "Little Harry Hughes and the Duke's Daughter," is closest to the variant Joyce uses. Apparently 155:N substitutes "Duke's Daughter" for "Jew's Daughter" in genteel avoidance of the ballad's "anti-Semitism." The original story from which the ballad derives is of a boy, Hugh of Lincoln, supposedly crucified by Jews c.1255. Apparently Joyce recalled his version from memory; the musical annotation was provided by Jacques Benoist-Mechin; see Ellmann, p. 535.

676:22 (692:12). the law of the conservation of energy—in 1904 that "law," as established in the course of the nineteenth century, held that mechanical work and the heat produced by that work can be compared as equivalent.

676:24–25 (692:14–15). ritual murder—see 107:13–14n.

677:12–13 (692:32–33). in Holles street and in Ontario ... ages of 6 and 8 years—i.e., this places Bloom in Holles Street in 1895–1896, in Ontario Terrace in 1897–1898.

677:18 (693:2). 15 June 1889—Milly Bloom's date of birth.

677:19 (693:3). Padney Socks—this child-rhyme character is unknown.

677:23 (693:7). Herr Hauptmann Hainau, Austrian army—apart from the context, identity or significance unknown.

677:31 (693:15). the duke's lawn—a parklike area to the east of Leinster House off Merrion Street. Leinster House is part of the complex of buildings that includes the National Museum and the National Library.

677:34 (693:18). Elsa Potter—apart from the context, identity or significance unknown.

677:35 (693:19). Stamer street—south of South Circular Road and just northwest of Ontario Terrace, where the Blooms were living in 1897–1898.

678:11 (693:32–33). (valerian)—herbs of the genus *Valeriana*, many of which have been used medicinally as stimulants or antispasmodics.

678:20 (694:4). the lake in Stephen's green— along the northern side of St. Stephen's Green, a 22-acre park in southeastern Dublin; it is an artificial lake with miniature islands and a sizable population of ducks.

679:1 (694:21). imbalsamation—obsolete for embalming.

679:11 (694:31). the 27th anniversary of his birth—in 1893 when Milly was 3–4.

679:13 (694:33). quarter day—a day conventionally regarded as beginning a quarter of the year; in England quarter days are 25 March (Lady Day), 24 June (Midsummer Day), 29 September (Michelmas Day) and 25 December (Christmas Day).

679:34 (695:16). a schoolfellow and a jew's daughter—i.e., Stephen's "schoolfellow" Alec Bannon and Milly; *cf.* 674:28–676:4n.

680:3–4 (695:21–22). Mrs Emily Sinico ... 14 October 1903—her death is central in "A Painful Case," *Dubliners* (though there the death occurs in November); see 113:22n.

680:9 (695:27). the anniversary of the decease of Rudolph Bloom—27 June 1886.

680:25–26 (696:9–11). the Ship hotel ... and E. Connery, proprietors—*Thom's* (1904) lists the Ship at number 5, not at number 6, p. 1407.

680:27 (696:11). the National Library of Ireland, 10 Kildare Street—10 Kildare Street was occupied by the Church of Ireland Training College (Female Department); the library in Kildare Street is unnumbered; but the group of buildings in which it is housed is between numbers 6 and 10.

680:27–28 (696:12). the National Maternity Hospital, 29, 30 and 31 Holles street—as listed in *Thom's* (1904), p. 1519.

680:36 (696:20). Albert Hengler's circus—see 64:21–22n.

680:36–681:1 (696:20–21). the Rotunda, Rutland Square, Dublin—a maternity hospital on Rutland (now Parnell) Square in northeastern

Dublin; it was financed by lotteries, promenades and entertainments given in the great Rotunda room, 80 feet in diameter.

681:5 (696:25). imprevidibility—a coinage suggesting the unforeseeable nature of.

681:8–9 (696:28–29). J. and T. Davy . . . Grand Canal—*Thom's* (*1904*), p. 1446, so lists these family grocers, wine and spirit merchants. Charlemont Mall was on the southern border of the city of Dublin just across the Grand Canal from Ontario Terrace in Rathmines, where the Blooms once lived.

682:14–16 (697:33–35). In what order of precedence . . . wilderness of inhabitation effected?—the ceremony that celebrates the exodus of the children of Israel out of Egypt into the wilderness of Sinai under Moses' leadership is Passover; see 121:18–19n, 20n, 21–22n. In that ceremony the head of the house (Bloom) takes precedence, assisted by his mature son(s) (Stephen).

682:17–18 (698:1–2). Lighted Candle in Stick borne by BLOOM—since this is a ceremony, it suggests a celebration of Sunday Vespers, the most solemn "hour" of the Divine Office; see 221:2n. It is a service of light (candle), and the Sunday Vespers Psalms are those of Easter Vespers since every Sunday is a celebration of the paschal mystery; the fifth and last of these Psalms is Vulgate 113, which Stephen, as deacon, begins to recite below. See 424:11n.

682:23–24 (698:7–8). The 113th, modus peregrinus . . . de populo barbaro—Latin: "mode of going abroad: When Israel went out of Egypt, the house of Jacob from a people of strange language" (Vulgate, Psalms 113:1; King James, Psalms 114:1). The sentence continues: "Judah was his sanctuary, *and* Israel his dominion" (Psalms 114:2). This verse is used in the Haggadah of Passover; see 121:18–19n and 682:17–18n. This is also the Psalm that Dante used in the letter to his patron, Can Grande della Scala, dedicating the *Paradiso* to him. Dante quotes the sentence above and then remarks, "If we consider the *literal* sense alone, the thing signified is the going out of the children of Israel from Egypt in the time of Moses; if the *allegorical,* our redemption through Christ; if the *moral,* the conversion of the soul from the grief and misery of sin to a state of grace; if the *anagogical,* the passage of the sanctified soul from the bondage of the corruption of this world to the liberty of everlasting glory."

682:30–683:4 (698:14–18). What spectacle confronted them . . . humid nightblue fruit—an "improved" version of the closing lines of Dante's *Inferno,* XXXIV:133–139: "The Guide

[Virgil] and I entered by that hidden road to return into the bright world; and without caring for any rest, we mounted up, he first and I second, so far that I distinguished through a round opening the beauteous things which Heaven bears; and then we issued out, again to see the Stars."

683:7–8 (698:21–22). the moon invisible . . . approaching perigee—the moon was in its first quarter and had risen at 6:40 P.M. and set at 10:17 P.M. on 16 June 1904. The moon was in apogee on Sunday, 5 June 1904 at 11:00 A.M.; perigee was to occur at noon on 17 June 1904, i.e., in about nine hours.

683:8–12 (698:22–26). the infinite lattiginous scintillating . . . centre of the earth—it is a commonplace that stars of the first and second magnitude are visible in the daytime from the bottom of a sufficiently deep shaft, but no matter how deep the shaft, the Milky Way would not be visible at or near sea level since there is too much dust in the atmosphere. However, at 5,000 feet (plus) above sea level stars of lesser magnitude can be seen from the bottom of a shaft. ("Lattiginous" is a coinage meaning having the quality of a lattice.)

683:12–14 (698:26–28). Sirius (alpha in Canis . . . dimension of our planet—in 1905 Sirius was measured as 8.6 light-years distant from the earth (1970: 8.7); thus Bloom's 10 is on the vague side and the value he assigns to a light-year 5.7×10^{12} is low by 1905 standards (5.859×10^{12}) as against 1970 (5.878×10^{12}). Also, his estimate of Sirius' size (900 times that of earth) might be seen in the light of modern estimates that it is roughly 2,834,000 times that of earth. Sirius is Alpha (the brightest star) in the constellation Canis Major, the Big Dog, as Sirius is the Dog Star.

683:14 (698:28). Arcturus—in 1905 astronomers regarded Arcturus as the second brightest star visible in the northern hemisphere; Sirius was regarded as the brightest.

683:15–17 (698:29–31). Orion with belt and sextuple . . . could be contained—what looks like a blur in Orion's sword to an observer on earth resolves telescopically into a star, the star into six stars, and behind those six stars the Great Nebula of Orion. Little was known before World War I about the size of and distance to nebulae, but Bloom's estimate (100 solar systems) is a radical understatement (on the order of one one-hundredth) of the assumptions astronomers contemporary with him were making. Richard Hinkley Allen, in *Star Names and Their Meanings* (1899), pp. 316–317, speaking of the Great Nebula of Orion, "A million globes, each equal in

diameter to that of the earth's orbit, would not equal this in extent."

683:17–18 (698:31–32). of moribund and of ... Nova in 1901—GK Persei, in the constellation Perseus, near Andromeda and Auriga, a nova discovered by T. D. Anderson of Edinburgh, 21–22 February 1901; it flared briefly as the brightest star visible in the northern hemisphere and then declined.

683: 18–19 (698:32–33). our system plunging towards the constellation of Hercules—in 1905 astronomers estimated that the sun (and the solar system) were moving toward a point in the constellation Hercules at the rate of 16 miles per second.

683:19–21 (698:33–34). of the parallax or parallactic ... in reality evermoving—since the stars remain apparently unmovable in the heavens (in contrast to the planets), they were called "fixed stars," but by 1900 the fixity of numerous stars had been disproved and was no longer believed in regard to any of the stars; "parallactic drift" (see "parallax," 152:4n) was the method used by the German astronomer Friedrich Wilhelm Bessel (1784–1846) in 1838 to measure the first star parallax and to determine the first distance from the solar system to a star. Bessel's method was to measure parallactic drift, the apparent motion imparted to a star by what was actually the earth's motion in orbit; this motion became measurable (as the star appeared to describe the earth's orbit in the heavens), but it was not the evidence that the star itself was in motion; that evidence came later when several star distances were known.

683:21–22 (698:36). the years, three score and ten—see 663:36–37n.

683:33–39 (699:10–16). themselves universes of void space ... nowhere was never reached—early-twentieth-century molecular physicists assumed that the spaces between molecules and the atoms and particles of which they were composed were infinitely vaster than the actual matter that made up the particles. They also assumed that the interspaces between particles were filled up with ether. These assumptions led, as here, to something like the Eleatic philosopher Zeno's (fifth century B.C.) second paradox: that Achilles cannot overtake the tortoise because at any moment in his pursuit he can only reach the place previously vacated by the tortoise.

684:4 (699:20). the problem of the quadrature of the circle—see 503:33–34n.

684:5–16 (699:21–32). the existence of a number computed ... of any of its powers—

what Bloom somewhat imperfectly recalls is a numerological exercise that is variously associated (by Madame Blavatsky and others) with the priesthoods of ancient Egypt, Babylon, etc. The exercise involved spelling out in an unending series $9^9 \times 9^9 \times 9^9$. ... Each completed cycle would take several generations of priests to complete and would mark the climax of one era and the initiation of a new era. The mystic significance of the exercise derived from the assumption that nine was the perfect number, composed of three threes, the three unbreakable triangles which in turn composed a triangle:\triangle. The unending effort to spell out the ramifications of nine implied an extension toward the infinite of the divine order implicit in the number nine. In a numerical system more primitive than modern Arabic numerals the end result of these priestly labors would reach impressive proportions.

684:22–23 (699:38–39). an atmospheric pressure of 19 tons—an essentially misleading calculation since the atmospheric pressure at sea level is 14.6 pounds per square inch exerted *in every direction;* thus, attempts to calculate the total pressure exerted on all the body's surfaces render impressive figures of several tons but do not describe any real state.

684:29–32 (700:5–8). a more adaptable and differently ... Neptunian or Uranian—the combination of Darwinian evolution and the new astronomy led to considerable speculation about the existence of life forms on other planets of the solar system and, particularly among astronomers, speculations about the possibility of life in other solar systems elsewhere in the universe.

684:36–37 (700:12–13). to vanity, to vanities of vanities and all that is vanity—Ecclesiastes 1:2: "Vanity of vanities, saith the Preacher, vanity of vanities, all *is* vanity."

684:39 (700:15). The minor was proved by the major—i.e., redemption was doubtful. The major premise of Bloom's answer: humanoid existence on other planets is possible, but if it exists, it will be human and therefore vain. The minor premise: since vain, redemption would be doubtful.

685:3–4 (700:18–19). The various colours significant ... vermillion, cinnabar—by 1910 spectroscopic analysis of the light emitted by various stars had been used to establish a direct relation between the color of the light and a star's size; see 479:2n.

685:4–5 (700:19–20). their degrees of brilliancy—in the first decade of the twentieth century the problem of degrees of brilliancy was

a vexed one, since astronomers knew the distances to relatively few of the telescopically observable stars and therefore could not determine whether a star was relatively dim in itself or dim as a function of its distance. Stars were ranked according to their brightness as seen by the observer: magnitudes 1–5, visible to the naked eye; 6–7 visible to keen-sighted persons; 8–20 only visible by telescope. *Cf.* 479:2n.

685:5–6 (700:20–21). their magnitudes revealed up to and including the 7th—see 685:4–5n.

685:6 (700:21). the waggoner's star—either the star Capella in the constellation Auriga (the Charioteer) or the North Star in the constellation Charles' Wain (Wagon), the Great Bear or Big Dipper.

685:6 (700:21). Walsingham way—or "Walsyngham Way," the Milky Way, from *The Vision of William Concerning Piers the Plowman* (fourteenth century). The Walsyngham Way was the path to the Virgin Mary's throne in heaven as the path on earth to her shrine, Our Lady of Walsyngham at Norfolk, was the Walsyngham Way.

685:6–7 (700:22). the chariot of David—Ursa Minor, the Little Dipper, was variously identified in Jewish tradition as the chariot that Joseph sent to bring his father, Jacob, to him in Egypt (Genesis 45–46), or the chariot in which Elijah was carried up to heaven (see 339:14–16n), or the bear that David slew (I Samuel 17:34–36).

685:7–8 (700:23). the condensation of spiral nebulae into suns—in 1905 astronomers thought that in studying the nebulae they were watching a process of "condensation," stars in the process of being formed out of plastic and gaseous material.

685:8–9 (700:23–24). the interdependent gyrations of double suns—(since they rotate about their common center of gravity); they were first observed by Galileo; the nature of their rotation was established by Sir William Herschel (see below, 685:10n).

685:9–10 (700:24–25). the independent synchronous discoveries of Galileo, Simon Marius—Galileo and Simon Marius (1570–1624), a German astronomer, discovered the four moons of Jupiter in 1610. (Galileo subsequently accused Marius of pirating his discovery, but the simultaneity seems to have been genuine.)

685:10 (700:25). Piazzi—Giuseppe Piazzi (1746–1826), Italian astronomer noted for his discovery of the first asteroid, Ceres, in 1801 and for his

publication of a then impressive catalogue of 7,646 stars in 1814.

685:10 (700:25). Le Verrier—Urbain Jean Joseph Leverrier (1811–1877), a French astronomer who did the mathematical calculations that determined the location of and led to the first observation of the planet Neptune by Galle (see below) in 1846. The English astronomer John Couch Adams (1819–1892) had made similar calculations in 1845, but no telescopic search had been made to confirm his findings.

685:10 (700:25). Herschel—Sir William Herschel (1738–1822), German-English astronomer, known for his discovery of Uranus (1781) and its satellites and for his extensive catalogue of nebulae (2,500), double-stars, etc. *Cf.* Piazzi above.

685:10 (700:26). Galle—Johann Gottfried Galle (1812–1910), a German astronomer who made the telescopic confirmation of the existence of Neptune in 1846; see Leverrier above. He also did extensive work on the asteroids.

685:11–12 (700:26–27). the systematizations attempted ... of times of revolution—Johann Kepler (1571–1630), German astronomer and mathematician; the third of his "laws of planetary motion" (1619) determined a proportional relation between a planet's mean distance from the sun cubed and the time of one complete orbit squared. The German astronomer Johann Elert Bode (1747–1826) was known for his star charts (published 1801), which included 17,240 stars (12,000 more than any previous chart); he reproduced Johann Titus of Wittenburg's statement (published 1776) of the interrelations of planetary distances, subsequently called "Bode's law"; on the basis of this purely empirical numerical progression Bode predicted the existence of a "planet" (the asteroids) in the "gap" between Mars and Jupiter.

685:12–14 (700:27–30). the almost infinite compressibility ... perihelion to aphelion—comets are "hirsute" because the word comet derives from the Greek *kometes,* "having long hair." Comets were assumed in 1910 to be "infinitely compressible" because not only their tails but also their nuclei appeared to have extremely low densities (very little mass in relation to quite impressive volumes).

685:15 (700:30). the sidereal origin of meteoric stones—meteorites, because they were called "shooting stars," were popularly regarded as coming from the stars, but by 1910 astronomers were of the firm opinion that most if not all meteors had their origin within the solar system in particles that are in orbit around the sun and intersect with the earth in its orbit.

685:15–16 (700:30–32). the Libyan floods on Mars ... younger astroscopist—Libya is an equatorial region on Mars, so named by the Italian astronomer Giovanni Schiaparelli (1835–1910), whose work on the geography of Mars (1877 *ff.*) and its "canals" led to considerable speculation about the possibility of life on Mars. It was established that the surface of the planet changed with its seasons. In 1894 two American astronomers discovered that a month after the Martian vernal equinox there was a large dark belt extending from what they assumed to be the south polar "ice cap" north into the Libyan Plains; they explained this color change as a flood resulting from the melting of the ice cap by summer heat.

685:16–18 (700:32–33). the annual recurrence of ... S. Lawrence (martyr, 10 August)—each year *c.* 11 August a shower of meteors called the "Perseids" reaches a climax, apparently because the earth's orbit more or less regularly intersects an orbiting concentration of particles at that period. St. Lawrence (d. 258), whose feast day is 10 August, was an archdeacon and treasurer of the Church in Rome. He tricked the Roman prefect out of confiscating the Church's treasury (by giving it away to the poor) and was martyred by being roasted on a gridiron.

685:18–19 (700:34–35). the monthly recurrence ... moon in her arms—while the phenomenon does happen monthly, the dark disc of the old moon is rarely visible as against the bright crescent of the new; thus, when the old moon is visible, it is regarded as an evil omen.

685:20–26 (700:36–41). the appearance of a star ... constellation of Cassiopeia—re "magnitude," see 685:4–5n; re "Shakespeare's birth star," see 207:22–27n. Tycho Brahe's star was "of the first magnitude" when he discovered it; after his discovery it continued to increase in brightness and thus no longer fit within the scale of magnitude, i.e., it would have been classified, *c.*1905, as −4 or −5! By 1900 the theory that novae had their origin in stellar collision had been displaced by the theory that novae were in some way a function of and connected with nebulous matter.

685:26–29 (700:41–701:3). a star (second magnitude) ... birth of Leopold Bloom—the constellation Corona Septentrionalis ("Crown of Seven Stars") is Corona Borealis, the Northern Crown. A nova, T. Coronae Borealis, did appear in that constellation in May 1866, the year of Bloom's birth; it rose to the second magnitude before its decline; see 55:1n.

685:29–32 (701:4–7). other stars of (presumably) ... birth of Stephen Dedalus—Stephen was born 2 February 1882; the nova S. Andromedae (NGC 224) appeared in 1885 in the constellation Andromeda. In astrology the influence of Andromeda suggests rescue and release as in Greek myth Andromeda was rescued from a monster by Perseus; see 683:17–18n.

685:33–34 (701:7–9). in and from the constellation . . . Rudolph Bloom, junior—Bloom's son, Rudy, was born in 1893; the nova T. Aurigae in the constellation Auriga was discovered by T. D. Anderson of Edinburgh in late January 1892; it rose to the fourth magnitude and then declined to twelfth by the end of March. Auriga, the Charioteer, is near Perseus and Andromeda.

686:15 (701:31–32). ardent sympathetic constellations—such as the Tress of Berenice, which is said to be favorable to a lover's aspirations; see 688:10–12n.

686:16 (701:32). the frigidity of the satellite of their planet—the moon is not only lover's light, but also cold, as in the personifications of Artemis and Diana, Greek and Roman goddesses of chastity.

686:22–23 (701:38–39). the lake of dreams . . . the ocean of fecundity—these do not figure in astrology, but in selenography. They are prominent features on the moon's surface: the *marsh* of dreams, *Palus Somnii;* the sea of rains, *Mare Imbrium;* gulf of dews, *Sinius Roris;* and the *sea* of fecundity, *Mare Fecunditatis.*

686:30 (702:7). the forced invariability of her aspect—since the moon only rotates on its axis once each month, it always presents the same side toward the earth.

686:33 (702:10). to render insane—see 155:30n.

687:5–7 (702:21–23). Frank O'Hara ... 16 Aungier street—as listed in *Thom's (1904),* p. 1418.

687:37 (703:14). pelosity—a coinage apparently based on the term "pellicle," a small or thin skin or membrane.

688:1–3 (703:15–17). the problem of the sacerdotal ... unnecessary servile work—the scholastic "problem" that Stephen raises is: since Jesus was both humanly and divinely complete (lacking nothing, having nothing in excess) (see 674:6n), does the fact that he "submitted" to circumcision call that completeness (integrity) into question? The Church's answer to Stephen's "problem" would hinge on Romans 4, where Paul argues that "unto Abraham faith was credited as

justice. . . . And he received the sign of circumcision as the seal of the justice of faith." This passage is included in the Divine Office for 1 January with the clear implication that Jesus was not being "changed," but receiving a "sign." The occasion of the circumcision is the Octave of the Nativity of Our Lord, celebrated 1 January; in 1904 the Roman Catholic Church in Ireland did regard this day as a holy day of obligation and Catholics were obliged to abstain from servile work as far as they were able.

688:3–7 (703:17–22). the problem as to whether . . . hair and toenails—the prepuce as relic was originally in the Basilica of St. John Lateran in Rome; it was stolen and lost in the sixteenth century, but then found and placed in the Church of Saints Cornelius and Cyprian in Calcata outside of Rome. The "problem" Stephen poses: is this relic a part of the body of Jesus in which case it is due latria, the highest kind of worship, paid to God only (i.e., to Christ as one of the three persons of the Trinity)? or is the relic "human," thus meriting hyperdulia, the veneration given to the Virgin Mary as the most exalted of human beings?

688:8 (703:23). celestial sign—at the climax of the execution of the suitors in *The Odyssey*, Book XXII, Athena, having withheld her help while Odysseus and Telemachus proved "their mettle" as father and son, finally intervenes; "the aegis, Athena's shield, took form aloft in the great hall." This celestial sign drives the remaining suitors "mad with fear."

688:10–12 (703:25–27). from Vega in the Lyre . . . the zodiacal sign of Leo—the constellation Lyra is the lyre of Orpheus; in Greek mythology the poetic power of Orpheus' lyre could charm beasts and make trees and rocks move. The Coma Berenices (Tress of Berenice), so called after the legend that Berenice (d. 216 B.C.) pledged her hair to Aphrodite on the condition that her husband, Ptolemy III, return safely from a military expedition; when he did return, she sacrificed her beautiful head of hair and it was translated into the heavens to commemorate the intensity of her love. (Joyce had his first date with his wife to be, Nora Barnacle, on 16 June 1904.) Leo (the Lion, 22 July to 22 August) is the fifth of the houses of the Zodiac; Leo is the sign of those who are creative, authoritative and kind, those who are strict individualists and who yet are expert at knowing the thoughts of others and intent on seeking the welfare of others as well as of themselves. They like to be good hosts and are profoundly loving and scrupulous in their homes.

688:29 (704:7). the church of St. George—see 57:7n.

688:32–33 (704:10–11). Liliata rutilantium . . . Chorus excipiat—*cf.* 12:13–14n. Stephen alters the meaning by leaving out the phrase *"te confessorum"* ("you, of confessors") and by altering the punctuation: "Bright [glowing] as lilies. A throng gathers about. Jubilant you of virgins. Chorus rescues [releases, exempts or receives]."

688:35–36 (704:13–14). Heigho, heigho/Heigho heigho—*cf.* 69:36–39 (70:11–13).

689:6–7 (704:20–21). Bernard Corrigan—see 631:42–632:1n.

689:14–16 (704:28–30). the cold of interstellar space . . . Centigrade or Réaumur—absolute zero on the three scales is F. −459.6; C. −273.1; R. −218.48; while astronomers (1900–1910) asserted interstellar space to be cold, they theorized that the temperature only approached but did not actually reach absolute zero.

689:20 (704:34). Percy Apjohn (killed in action, Modder River)—there was considerable action along the Modder River in South Africa during the Boer War, particularly in 1899, when the British were defeated at Maagersfontein, and in 1900, when they achieved the surrender of Cronje at Paardeberg.

689:20–21 (704:35). Philip Gilligan (phthisis, Jervis Street hospital)—in 1894 (see 153:14n, 17n) the Jervis Street Hospital and Charitable Infirmary, 14–20 Jervis Street, Dublin.

689:21–22 (704:35–705:1). Matthew F. Kane (accidental drowning, Dublin Bay)—Kane was a friend of John Joyce and chief clerk of the Crown Solicitor's Office in Dublin Castle. He was drowned on 10 July 1904 when he suffered a stroke while swimming off Kingstown. He was the prototype of the fictional Martin Cunningham, and his funeral cortege was remodeled to serve as Dignam's; see Adams, pp. 62–63.

689:22–23 (705:1–2). Philip Moisel (pyemia, Heytesbury street)—related to M. Moisel, 60:34–35n? The Meath Hospital and County Dublin Infirmary, 1–10 Heytesbury Street.

689:23–24 (705:2–3). Michael Hart (phthisis, Mater Misericordiae hospital)—(d. *c.*1900), a friend of John Joyce and the prototype of the fictional Lenehan.

689:26 (705:5). The disparition of three final stars—*cf.* 370:2n.

689:27 (705:6). the apparition of a new solar disc—scheduled for 3:33 A.M. in Dublin on 17 June 1904.

689:30 (705:9). the house of Luke Doyle, Kimmage—presumably in Kimmage Road, sections of which are in both Terenure (Roundtown) and Harold's Cross, villages south and west of Dublin, but *Thom's (1904)* lists no Doyle in residence there.

689:32 (705:11). his gaze turned in the direction of Mizrach, the east—*Mizrach*, Hebrew: "the east"; i.e., Bloom assumes the attitude of a Jew at prayer since it is traditional for Jews west of Jerusalem to face east when they pray, particularly during the silent prayer called *Shmoneh Esreh* (Hebrew: "Eighteen Benedictions").

689:35 (705:14). avine music—bird music.

690:9–10 (705:24–25). The right temporal lobe ... a solid timber angle—as Odysseus is conked by a stool thrown by the suitor Antinous in *The Odyssey*, Book XVII.

691:6 (706:21). (Cadby)—a relatively inexpensive piano manufactured in England.

691:11 (706:26). Love's Old Sweet Song—see 63:24–25n.

691:12–13 (706:27–28). Madam Antoinette Sterling—(1850–1904), an American-born contralto who married a Scot. She was very popular in the British Isles, particularly for her ballad singing.

691:14 (706:29–30). ritirando—Italian: a coinage from "to retire," where one would expect the musical direction *ritardando* ("retard").

691:22–23 (706:37–38). Dr Malachi Mulligan's ... gradation of green—see 417:24 (424:37–38).

691:30 (707:6). a black diminutive cone—i.e., incense; Bloom fumigates his house as Odysseus fumigates his after the slaughter of the suitors in *The Odyssey*, Book XXII.

691:33–34 (707:9–10). Agendath Netaim—see 60:12–13n.

692:5 (707:20). homothetic—similar and similarly placed.

692:7 (707:22). Connemara marble—see 320:37n.

692:8 (707:23). 4.46 A.M. on the 21 March 1896—spring came to Dublin 2:02 A.M., 20 March 1896.

692:9 (707:24). Matthew Dillon—see 105:6–7n.

692:10–11 (707:25–26). Luke and Caroline Doyle—see 689:30n.

692:11–12 (707:26–27). Alderman John Hooper—see 112:10n.

692:24 (708:1). ipsorelative—a reflexive, self-contained organization of cross-references.

692:24 (708:1). aliorelative—an externally referential organization.

692:27–28 (708:4–5). Brothers and sisters ... his grandfather's son—i.e., Bloom, assuming that Bloom was an only son and that Rudolph Virag, Bloom's father, was the only son of his father, Leopold Virag. There are many variants on this sort of riddle.

693:4 (708:16). Thom's Dublin Post Office Directory, 1886—this could be either of two publications: (1) *The Post Office Directory and Calendar for 1886* ... printed by Alexander Thom; (2) the much more comprehensive *Thom's Official Directory of the United Kingdom of Great Britain and Ireland for 1886 comprising the 1886 Post Office Dublin City and County Directory*.

693:5 (708:17). Denis Florence M'Carthy's Poetical Works—Denis Florence MacCarthy (1817–1882), Irish poet, scholar and translator: *Ballads, Poems and Lyrics, Original and Translated* (Dublin, 1850); *Under-Glimpses and Other Poems* (1857); *Bellfinder and Other Poems* (1857). Standard book catalogues do not list a *Poetical Works*.

693:8 (708:20). The Useful Ready Reckoner—unknown.

693:9 (708:21). The Secret History of the Court of Charles II—*The Secret History of the Court and Reign of Charles II*, by a member of the Privy Council (London, 1792).

693:11 (708:23). The Child's Guide—titles that begin with this phrase are legion, among them, *The Child's Guide to Devotion* (London, 1850); *The Child's Guide to Knowledge; being a collection of useful and familiar answers on every-day subjects; adapted for youngsters. By a Lady* (London, 1878).

693:12 (708:24). When We Were Boys by William O'Brien, M.P.—for O'Brien, see 638:35–36n. *When We Were Boys* (London, 1890) is a novel O'Brien wrote while he was in jail. It is set in County Cork on the eve of the Fenian uprising of the 1860s.

693:14 (708:26). Thoughts from Spinoza—this commonplace "thoughts from" suggests a

coinage or generalization rather than the actual title of a book.

693:15 (708:27). The Story of the Heavens by Sir Robert Ball—see 152:2–3n.

693:16 (708:28). Ellis' Three Trips to Madagascar—William Ellis (1794–1872), an English Congregationalist missionary; his *Three Visits to Madagascar during the years 1853-1854-1856. Including A Journey to the Capital; With Notices of the Natural History of the Country and of the Present Civilization of the People* (London, 1838). This, together with two of his other works on Madagascar, was regarded as the standard authority on the island in the nineteenth century.

693:18 (708:30). The Stark-Munro Letters by A. Conan Doyle—an epistolary novel by Sir Arthur Conan Doyle (1859–1930), *The Stark Munro Letters; being a series of sixteen letters written by J. Stark Munro, M.B. (Bachelor of Medicine), to his friend and former fellow-student Herbert Swanborough, of Lowell, Massachusetts, during the years 1881–1884* (London, 1895).

693:19 (708:31). the City of Dublin . . . 106 Capel street—as listed in *Thom's (1904)*, p. 1443.

693:19–20 (708:32). 21 May (Whitsun Eve) 1904—Whitsunday was 22 May 1904.

693:23 (708:35). Voyages in China by "Viator"—see 113:5n.

693:25 (708:37). Philosophy of the Talmud—again, a coinage or generalization of an actual title and apparently not the title itself.

693:26 (708:38). Lockhart's Life of Napoleon—the Scots novelist and man of letters John Gibson Lockhart (1794–1854), "the Scorpion," *Life of Napoleon Buonaparte, in Which the Atrocious Deeds, Which He Has Perpetrated, in order to Attain His Elevated Station, Are Faithfully Recorded; by Which Means Every Britain Will Be Enabled to Judge the Disposition of His Threatening Foe; and Have a Faint Idea of the Desolation Which Awaits This Country, Should His Menace Ever Be Realized* (1832), revised and reissued as *History of Napoleon* (1885).

693:29 (709:3). Soll und Haben by Gustav Freytag—Gustave Freytag (1816–1895) was a German novelist whose novels were extraordinarily popular in the nineteenth century. *Soll und Haben* ("Debit and Credit," 1855) is a novel that studies the impact of the industrial revolution on middle-class Germans; the mercantile emphasis of the plot has anti-Semitic overtones.

693:31 (709:5). Hozier's History of the Russo-Turkish War—Colonel Sir Henry Montague Hozier (1842–1907), English soldier and historian, editor-author of *The Russo-Turkish War : including an account of the rise and decline of the Ottoman power, and the history of the Eastern Question*, 2 vols. (London, 1877–1879). The Russo-Turkish War took place in 1877 and 1878.

693:32–33 (709:6–7). Garrison Library, Governor's Parade, Gibraltar—a combination library and club; in 1890 it was the "literary" resource of the Rock; it had 40,000 volumes and a pavilion, complete with billiard rooms and a bar. Governor's Parade was renamed Gunner's Parade in 1803, but both names persisted through the nineteenth century.

693:34 (709:8). Laurence Bloomfield in Ireland by William Allingham—William Allingham (1824–1889), Irish-born poet, editor and associate of the Pre-Raphaelites, *Laurence Bloomfield in Ireland: A Modern Poem* (London, (1864). The poem is described as "A picture of Irish rural life in the third quarter of the nineteenth century."

693:37 (709:11). A Handbook of Astronomy—another coinage or generalization rather than an actual title.

693:41 (709:15). The Hidden Life of Christ—unknown.

694:1 (709:16). In the Track of the Sun—see 57:31–32n.

694:3 (709:18). Physical Strength and How to Obtain It by Eugene Sandow—see 61:19–20n.

694:5–10 (709:20–25). Short but yet Plain . . . the burgh of Southwark—this is apparently copied from an actual title page since the British Museum catalogue does list the book (though not this particular edition) as *Short but yet Plain Elements of Geometry and Plain Trigonometry* and one Charles Cox was M.P. for Southwark in 1711.

694:12–16 (709:27–31). Michael Gallagher . . . Enniscorthy, county Wicklow—one problem with Mr. Gallagher's home town is that it is in County Wexford some 24 miles south of that county's border with County Wicklow.

694:21 (709:36). incuneated—wedged, impacted.

694:22 (709:37). closestool—a utensil designed to hold a chamber pot.

694:26 (709:41). Hozier's History of the Russo-Turkish War—see 693:31n.

694:37 (710:11). Plevna—see 56:30n.

695:4–5 (710:15–16). P. A. Wren, 9 Bachelor's Walk—see 98:8n.

695:27–28 (711:1–2). 2 weeks and 3 days previously (23 May 1904)—Monday, 23 May, is three weeks and four days from Friday, 17 June?

695:34–35 (711:7–8). the occasion (17 October ... Sinico, Sydney Parade)—see 680:3–4 (695:20–21), where Bloom dates her death as 14 October; see 113:22n. Sydney Parade is in Merrion, a village three miles south-southeast of the center of Dublin.

696:35 (712:2). effracted—"effraction" is the breaking open (of a house); burglary.

696:41 (712:9). unguical—"ungulate" means having nails or claws.

697:4 (712:13). Mrs Ellis's juvenile school—see 76:24n.

697:9–10 (712:19). borough English—a custom in English law under which lands and tenants descended to the youngest son or sometimes to the youngest daughter or a collateral heir.

697:12 (712:21). (valuation £42)—land values in Ireland were stated in terms of annual rental value (not of sale price).

697:14–15 (712:24). Rus in Urbe—Latin: "The country in the city"; figuratively, combining the best of both worlds, after Martial (c.40–c.102), *Epigrams* XII:xvii:21. Martial asks: "Do you [Sparsus] ask why I often resort to my small fields ...?" and argues that as "a poor man" his city home is noisy and he must retire to the country to find quiet because he cannot (as the wealthy Sparsus can) afford to have "country in the town."

697:15 (712:24). Qui si Sana—Latin: "[He] who would be sound [healthy, whole]."

697:30 (712:39–40). Dundrum, south, or Sutton, north—Dundrum, a village five miles south of the center of Dublin at the base of the Dublin Mountains. *Thom's (1904)*, p. 1693, remarks, "Dundrum is recommended for the purity of its air, and in summer is much resorted to by invalids." Sutton was a small coastal village on the isthmus that connects the headland of Howth with the mainland; it is eight miles north-northeast from the center of Dublin.

697:33 (713:1). feefarmgrant—in English law, land held of another in fee simple subject to a fixed annual rent. Note that the annual rent that Bloom has proposed above (£42) is somewhat more affluent than Bloom's present annual rent (value) of £28.

698:22 (713:32). biennial unearned increments of £2—a lot more generous than it sounds since a cook who lived in and took her meals at the expense of a family could expect an annual wage of from £12 to £26; a general maid, £10 to £17 and the betweenmaid, £7½ to £11.

698:36–38 (714:4–7). sir James W. Mackey ... 23 Sackville street, upper—as listed in *Thom's (1904)*, p. 1585; Mackey had been prominent in Dublin political life, lord mayor in 1866 and 1873, knighted for public service in 1874.

699:4 (714:13). haytedder—a machine or tool for stirring and spreading hay that is in danger of rotting because it has been dampened by rain, a very useful tool in Ireland.

699:18 (714:28–29). solidungular—having a solid or uncloven hoof.

699:21 (714:32). Saint Leopold's—St. Leopold of Austria (1073–1125), distinguished for his charity and self-abnegation. As the brother-in-law of Henry V, Holy Roman emperor from 1106 to 1125, he was politically influential but always inconspicuous. Upon the death of Henry V, he was offered but refused the crown, preferring instead to devote himself to charity and worship.

700:1 (715:12). curricle—apparently "coracle" (the Irish *currach*) is intended?

700:12 (715:23). stripper cows—cows that have almost stopped giving milk.

700:12 (715:23). pike—a peaked and temporary stack of hay made up in a hayfield.

700:21 (715:32). (Semper paratus)—Latin: "Always ready."

700:21–22 (715:32–33). recorded in the court directory—i.e., registered in the office and Court Tower of the Ulster King-at-Arms in Dublin Castle; see 471:2n.

700:22–23 (715:33–34). M.P., P.C., K.P., L.L.D honoris causa—Member of Parliament, privy councilor, Knight of the Order of St. Patrick (the highest of the Irish orders of knighthood as the Garter in England, the Thistle in Scotland; see 575:12n), Doctor of Laws "for the sake of honor."

700:23–24 (715:34–35). court and fashionable intelligence—the conventional newspaper heading for news of the socially prominent.

701:1 (716:13). the letter of the law—echoes St. Paul's famous distinction in II Corinthians 3:5–6: "... but our sufficiency *is* of God; Who also hath made us able ministers of the new testament; not of the letter, but of the spirit: for the letter killeth, but the spirit giveth life."

701:1–2 (716:14). law merchant—commercial law, mercantile law and the rules of evidence that obtain in that law.

701:2 (716:14). covin—in law, a collusive agreement between two or more persons to prejudice a third; conspiracy.

701:4 (716:17). venville rights—in English law, a certain kind of tenure peculiar to Dartmoor Forest; chief among its features are situation in an ancient village, suit at the lord's court, certain rights of common and payment of fines.

701:14 (716:26–27). the Society for promoting Christianity among the Jews—the Church of Ireland Auxiliary to the London Society for Promoting Christianity among the Jews was located at 45 Molesworth Street in Dublin.

701:16 (716:29). Daniel Magrane—and Francis Wade—apart from the context, identity and significance unknown.

701:19 (716:32–33). the political theory of colonial (e.g., Canadian) expansion—before 1841 Canada had been a loose and divided grouping of provinces and territories; from that time through the rest of the nineteenth century Canada evolved toward the political unity of federation and toward an increasing independence from English rule. Thus "colonial expansion" was the development of political integrity and independence within a colony, and many Irish saw emigration to Canada, for example, as a means of achieving the political independence denied to Ireland.

701:20–21 (716:33–35). the evolutionary theories ... Origin of Species—Charles Darwin (1809–1882), *The Origin of Species by Means of Natural Selection, or the Preservation of the Favored Races in the Struggle of Life* (1859) and *The Descent of Man and Selection in Relation to Sex* (1871). Darwin's theories were the subject of extraordinary controversy in the latter half of the nineteenth century since they seemed so clearly to challenge man's pretensions to some order of divinity.

701:23 (716:37). James Fintan Lalor—(1807–1849), an Irish political writer who vigorously advocated republicanism and a radical program of land nationalization in the pages of the *Nation,* the *United Irishman* and *The Irish Felon,* a magazine he edited. Even though crippled, he worked as a farmer to put his theories to the test. He was finally imprisoned for his opinions (1849). His theories of land nationalization were taken up and promoted by the American economist Henry George (1839–1897), whose *Progress and Poverty* (1879) enjoyed considerable popularity in Ireland.

701:23–24 (716:37). John Fisher Murray—(1811–1865), an Irish political writer and satirist, one of the radical Young Irelanders in the 1840s.

701:24 (716:37). John Mitchel—(1815–1875), an Irish solicitor who gave up his profession for a career as a radical and a journalist. He took over the Young Irelander's publication, the *Nation,* and then seceded from that journal to found the more radical *United Irishman* in 1848. The *United Irishman* was suppressed and Mitchel was sentenced to 14 years transportation. He escaped to America but eventually was allowed to return to Ireland in 1872. On the eve of his death in 1875 he was elected M.P. for Tipperary; see 290:3n.

701:24 (716:37–38). J. F. X. O'Brien—see 68:16n.

701:25 (716:38). the agrarian policy of Michael Davitt—see 641:14–15n and 583:16n.

701:26–28 (716:40–42). the programme of peace ... for Midlothian, N.B.—Gladstone was M.P. for Midlothian, North Britain, from 1880 to 1894. As prime minister, he placed emphasis on international peace, retrenchment in the British Empire (i.e., he argued against the acquisition of more territories and subjects). Gladstone was, perhaps somewhat conservatively, committed to reform, particularly to Irish land reform and the granting of a measure of Home Rule.

701:30–33 (717:2–5). on Northumberland road ... bearing 2,000 torches—Northumberland Road enters Dublin from the southeast and is part of the main thoroughfare from Kingstown (Dun Laoghaire) to Dublin. The torchlight procession (as described) took place on 1, not 2 February (Joyce's and Stephen's sixth birthday) 1888. **Torchbearers** should be deleted from 701:32 as it is (717:4).

701:34 (717:5). the marquess of Ripon—George Frederick Samuel Robinson, 1st Marquis of Ripon (1827–1909), English politician and statesman. He became a Catholic in 1874 and was popular in Ireland as a supporter of Gladstone's Irish policies, including Home Rule.

701:34 (717:5). John Morley—(1838–1923), English statesman and author, a consistent opponent of the English (Conservative) policy of Coercion in Ireland, a dedicated Home Ruler and popular with the Irish even during his brief tenure as chief secretary for Ireland in 1886.

701:38–40 (717:8–10). the Industrious Foreign Acclimatised ... (incorporated 1874)—a joke at the expense of the compound names of building societies; *Thom's (1904)* lists several such societies in Dublin, pp. 1352–1354.

702:8 (717:18). headrent—in English law, the rent payable to the freeholder of a property.

702:19–21 (717:30–32). Greenwich time ... Dunsink time—see 152:2n.

702:23–24 (717:34–35). 7-shilling, mauve, imperforate, Hamburg, 1866—actually issued in 1865 (though 1866, the year of Bloom's birth, has apparently taken precedence). *Scott's Standard Postage Stamp Catalogue (1969)* lists this stamp as number 20 and remarks that it is an "inversion," worth more canceled ($12.50) than uncanceled ($3.50).

702:24–25 (717:35–36). 4 pence, rose, blue, paper perforate, Great Britain, 1855—*Scott's (1969)* number 22, worth $200.00 uncanceled and $114.00 canceled.

702:25–26 (717:36–37). 1 franc, stone, official, rouletted, diagonal surcharge, Luxembourg, 1879—an overprint of 1 franc over $37\frac{1}{2}$ centimes, *Scott's (1969)* number 28, color *bistre* (like stone), worth $135.00 uncanceled, $65.00 canceled; i.e., no one of these stamps is (or was) particularly valuable.

702:40 (718:10). to 32 terms—$\frac{1}{4}$d projected to 32 terms in a geometrical progression of 2 would yield £2, 236, 962, 2s, 8d.

702:41 (718:11–12). to break the bank at Monte Carlo—see 291:42–292:1n.

703:1–2 (718:12–13). problem of quadrature ... £1,000,000 sterling—see 503:33–34n.

703:4 (718:15). dunams—see 60:17n.

703:5 (718:16). Agendath Netaim—see 60:12–13n.

703:13–15 (718:24–26). 4,386,035 the total population ... returns of 1901—*Thom's (1904)*, p. 611, lists 4,458,775 as the population of Ireland in 1901.

703:20 (718:31). at Dublin bar—at the funnel-like entrance to Dublin Harbor where the two sea walls, the North Bull Wall and the South Wall, converge; the convergence of the two walls would make Bloom's scheme seem practicable, but it might have seriously impeded navigation.

703:20 (718:31). at Poulaphouca—see 535:2n; by the time Joyce was writing the [Ithaca] episode, Bloom's scheme for a hydroelectric plant at Poulaphouca had become a reality.

703:21 (718:32). Powerscourt—a famous estate in the Dargle 12 miles south of Dublin. There is an impressive 300-foot waterfall on the estate.

703:21 (718:32). catchment basins—the entire area from which drainage is received by a reservoir, a river, etc.

703:22 (718:33). W. H. P.—water horse power.

703:22–27 (718:34–38). A scheme to enclose ... for mixed bathing—North Bull is a sandbar island in Dublin Bay off the village of Dollymount just northeast of Dublin. The southern end of the island was already "enclosed" by the North Bull Wall to keep the island's sands from encroaching on Dublin Harbour. Bloom's "scheme" is to "enclose," i.e., to stabilize with sea walls, the rest of the island, making it possible to erect permanent buildings on the island in place of or in addition to its golf course. "Mixed bathing" was unusual and the object of considerable suspicion in Ireland in 1904.

703:31 (719:1–2). between Island bridge and Ringsend—there is a weir across the Liffey at Island Bridge, which is not quite four miles from the mouth of the Liffey.

703:34–35 (719:4–6). A scheme for the repristination ... freed from weedbeds—transport in Ireland was heavily dependent upon a well-developed system of canals before the advent of the railroad, but in the latter half of the nineteenth century canal traffic began to decline not only as a result of competition with the railroads but also because the canals were subject to infestation with algae and were increasingly difficult and expensive to maintain. There is no commercial canal traffic in present-day Ireland.

703:36–704:1 (719:6–12). A scheme to connect by tramline ... 43 to 45 North Wall—*cf.* 96:41n. Several links of the sort Bloom suggests were already in existence; the one Bloom refers to was the Drumcondra Link Railway, which looped around the northern outskirts of metropolitan Dublin, intersecting the Midland Great Western Railway at Liffey Junction northwest of the city and the Great Southern and Western Railway, which entered Dublin from the southwest and

branched through a tunnel under Phoenix Park to join the Drumcondra Link and thence to the Midland and Great Western Railway's terminus on North Wall Quay near the mouth of the Liffey. Bloom proposes a line parallel with the Drumcondra Link but nearer metropolitan Dublin to connect the Cattle Market with the East Wall, a quayside north of and perpendicular to the mouth of the Liffey.

704:2–3 (719:13). Great Central Railway— William A. Wallis, general carrier and forwarding agent, agent for the Great Central Railway, at 5 and 6 North Wall Quay.

704:3 (719:13–14). Midland Railway of England— offices at 6 Eden Quay and 9 North Wall Quay.

704:3-4 (719:14). City of Dublin Steam Packet Company— 15 Eden Quay and 13A and 19 North Wall Quay.

704:4 (719:14–15). Lancashire Yorkshire Railway Company— stores and offices, 13 North Wall Quay.

704:5 (719:15–16). Dublin and Glasgow Steam Packet Company— the Duke Line, 70–72 North Wall Quay; cattle yard at 72.

704:5–6 (719:16–17). Glasgow Dublin ... (Laird line)— 73–75 North Wall Quay.

704:6–7 (719:17–18). British and Irish Steam Packet Company— 3 North Wall Quay.

704:7–8 (719:18). Dublin and Morecambe Steamers— Alex A. Laird and Company, 87 to 89 North Wall Quay.

704:8 (719:18–19). London and Northwestern Railway Company— H. G. Burgess, general manager for Ireland, 48–57 North Wall Quay.

704:9 (719:19–20). Dublin Port and Docks Landing Sheds— nine landing sheds (unnumbered) at the outer end of the North Wall Quay.

704:10–12 (719:20–22). Palgrave, Murphy and Company ... Belgium and Holland— their transit shed was at the outer end of the North Wall Quay. Their office was at 17 Eden Quay. *Thom's (1904)* describes them as "steamship owners, agents for steamers from Mediterranean, Spain, Portugal, France, Belgium, Holland & c. and for Liverpool Underwriter's association" (p. 1981).

704:20 Bloom Pasha should read **Blum Pasha** as it does (719:31) —Sir Julius Blum (b. 1843) was under-secretary to the Egyptian Treasury, a position he filled with distinction, meriting him a Companion of the Bath in 1884 and Knight Commander of St. Michael and St. George in 1890. In that year, he left the Civil Service in Egypt, where he was called "Blum Pasha," to become manager of the Austrian Credit in Vienna. He was a man of considerable wealth.

704:20 (719:31). Rothschild— a famous Jewish family of international bankers, founded by Mayer Anselm Rothschild (1743–1812) at Frankfurt in Germany. In the nineteenth century branches of the family founded banking houses in Vienna, Naples, Paris and London. To say the least, they flourished; see 485:16–17n.

704:20 (719:31). Guggenheim— see 485:26n.

704:20 (719:31). Hirsh— see 485:27n.

704:20 (719:31). Montefiore— see 59:14n.

704:21 (719:32). Morgan— a family of American financiers and bankers. Junius Spencer Morgan (1813–1890) built his J. S. Morgan and Company into one of the leading banking houses of the world. His son, John Pierpont Morgan (1837–1913), improved upon his father's modest ($10,000,000) success through his genius for financial reorganization and combination, a genius that achieved the United States Steel Corporation, the Northern Securities Company and an Atlantic shipping combination.

704:21 (719:32). Rockefeller— John Davison Rockefeller (1839–1937), American capitalist who set out to achieve a monopoly on oil in the United States and did, gaining control not only of oil fields and refineries, but also of the means of transportation (by forcing an alliance with the railroads). By the 1880s there was virtually no competition to Rockefeller's enterprises in the oil industry.

704:36–37 (720:7–8). the 70 years of complete human life— see 663:34n.

705:15 (720:25). A Vere Foster's handwriting copybook— Anglo-Irish educator and philanthropist Vere Henry Lewis Foster (1819–1900) was interested in improving education and prepared a graded series of drawing and copybooks, *Vere Foster's Copy-Books, Bold Writing or Civil Service Series,* from which nineteenth-century English schoolchildren learned handwriting.

705:19–20 (720:30). queen Alexandra of England— (1844–1925), a daughter of King Christian IX of Denmark, she married Albert Edward, Prince of Wales, in 1863 and became queen consort on his accession to the throne as Edward VII in 1901.

705:20 (720:30). Maud Branscombe—see 363:41n.

705:22 (720:32). a parasitic plant—i.e., mistletoe, coincidentally regarded as sacred by the Druids since it was evergreen and presented a mystical contrast in midwinter to the sacred oaks on which it flourished.

705:22 (720:32). Mizpah—Hebrew: "Watchtower," the name of at least six different Old Testament towns or localities in Palestine; also in nineteenth-century usage, a parting salutation, after Genesis 31:49: "And Mizpah; for he said, The Lord watch between me and thee, when we are absent one from another." The salutation only works when the verse is taken out of context, since in context it is the fruit of the jealous suspicion between Jacob and his brother, Laban.

705:23–24 (720:33–34). Mr and Mrs M. Comerford—lived at Neptune View, 11 Leslie Avenue, Dalkey, according to *Thom's (1904)*, p. 1836.

705:26–27 (720:37). Messrs Hely's, Ltd., 89, 90 and 91 Dame Street—a nonexistent address (the highest number in Dame Street 1904 was 81); see 152:21n and 152:39n.

705:28 (720:38). gilt "J" pennibs—broadpointed pens stamped with the letter J.

705:32–33 (721:3–4). William Ewart Gladstone's ... (never passed into law)—the English Conservative party was in power at the end of 1885 thanks to Parnell's revolt against Gladstone and his Liberal party (over the Liberals' reluctance to move toward Home Rule). The general election of late 1885 returned 251 Conservatives, 333 Liberals and gave Parnell's Home Rule party a solid 86 Irish delegates, an impressive balance of power. When Gladstone became prime minister on 1 February 1886, it was clear that he did so with the support of Parnell (and at the price of his commitment to Home Rule). Gladstone introduced a Home Rule bill on 13 April 1886 that was ultimately defeated 343 to 313 on 8 June 1886 by defections of 95 M.P.'s within his own party. Gladstone resigned on 26 June 1886, but, when he was again returned to power in late 1892, he introduced a second Home Rule bill on February 1893, passed by the House of Commons by a majority of 43 votes at the beginning of September and rejected by the House of Lords 419 to 41 on 8 September 1893.

705:34 (721:5). S. Kevin's Charity Fair—sponsored by St. Kevin's (Church of Ireland) in South Circular Road not far from the Bloom's residence in Lombard Street West.

706:1–5 (721:13–16). the transliterated name and address ... MH/Y. IM—"reserved" (to keep from being known to others); the cryptogram is "boustrophedontic" since it is formed by placing the alphabet A to Z in parallel with the alphabet written Z to A and then substituting letters from the reversed alphabet for the letters of the message. It is "punctated" because marked by points or periods where the vowels are omitted, and "quadrilinear" because marked with four slant lines (/). Solved, it reads: "M RTH /DR FF LC/ D LPH NS/ B RN"; i.e., Marth's last name has been reversed as a double protection. The suppression of the vowels makes a simple code such as this harder to crack since the patterned frequency of vowel recurrence makes the vowels relatively easy to spot.

706:6 (721:17). Modern Society—published weekly on Wednesday, dated Saturday; offices, 18 Kirby Street, Hatton Garden, London, E.C.

706:8 (721:20). rubber preservatives—condoms.

706:9–10 (721:21). Box 32, P.O. Charing Cross, London, W.C.—not unlikely as an address for merchandisers of the sort implied, but whether the address was fact or fiction is unknown.

706:12–13 (721:24–25). the Royal and Privileged Hungarian Lottery—see 154:4–5n.

706:20–21 (721:32–33). a 1d. adhesive stamp ... of Queen Victoria—there were two "lilac" 1d stamps bearing the image of Queen Victoria, both issued in 1881, *Scott (1969)* number 88 ($5.00 uncanceled, $1.00 canceled), number 89 ($15.00 uncanceled, $3.00 canceled).

706:21–24 (721:33–36). a chart of measurements ... 15/-, athlete's 20/- —Sandow (see 61:19–20n) did advertise exercising machines.

706:24–26 (721:36–38). chest 28 in. and 29½ ... calf 11 in. and 12 in—*cf.* Bloom's neck size (17), 695:7 (710:18), and his build ("height 5 ft 9½ inches, full build,"), 712:15 (727:25).

706:27–28 (721:39–40). Wonderworker, Coventry House, South Place, London, E.C—whether this product was fact or fiction is unknown.

707:3–4 (722:15). absentminded beggar—see 185:19n.

707:8 (722:19). the South African campaign—i.e., the Boer War (1899–1902).

707:28–29 (723:2–3). the Scottish Widow's Assurance Society—see 374:10n.

707:29–33 (723:4–7). coming into force at 25 ... £133-10-0 at option—this legal tangle describes the various conditions of Bloom's endowment insurance: 25 years from the date at which Bloom took out the insurance, he will have a "profit policy" of £430, i.e., he will begin to receive in installments the Mutual Fund's profit on that amount; when he is sixty (or if he dies between sixty and sixty-five), the profit policy will be £462-10-0; when he is sixty-five or if he dies after sixty-five, £500. The final option is that, instead of the profit policy of £430 after 25 years, the policyholder or beneficiary may cash; there would be similar options at sixty and sixty-five.

707:34 (723:8). Ulster Bank, College Green branch—the Ulster Bank, Ltd., had a branch office at 32–33 College Green, where Bloom's acquaintance, Theodore Purefoy, was "conscientious second accountant," 413:38–39 (421:5).

707:36 (723:10). £18-14-6—looks like an inconsiderable sum, but it is more than Stephen would earn in half a year of schoolteaching, and if Bloom's annual rent was £28 as his house is valued, it would pay for his rent for almost eight months.

708:1–2 (723:12–13). £900 Canadian 4% ... (free of stamp duty)—*Moody's Manual of Corporate Securities; 1904* (New York, 1904), p. 315, lists, "*£12,000,000 Dominion of Canada 4 Per Cent. Bonds and Stock*. Due from June, 1904 to 1908. Interest payable May and November, at Bank of Montreal. Bonds are convertible into inscribed stock on payment of $\frac{1}{8}$% of fee. Now outstanding, stock, £7,900,000; bonds £4,099,700." Bloom's annual income from the interest on the book value of his holdings would have been £36; and the fact that the shares are "free of stamp duty" means that his income would have been untaxed.

708:2–3 (723:13–14). the Catholic Cemeteries' (Glasnevin) Committee—the Dublin Catholic Cemeteries Committee, founded by the Catholic Association in 1828 (the year of Catholic Emancipation), with offices at 4 Rutland (now Parnell) Square East, was charged with the management of Prospect Cemetery in Glasnevin.

708:4 (723:16). deedpoll—in law, a deed executed by only one party.

708:6 (723:18). no. 52 Clanbrassil street—not clear since there are two Clanbrassil Streets (Upper and Lower) and each has a number 52. In 1904 there was a Jewish section off Clanbrassil Street Lower, so that relatively run-down section is the more probable.

708:15–16 (723:28). Szesfehervar—southwest of Budapest in northwestern Hungary; population (1940), 35,000.

708:16 (723:28). hagadah book—see 121:18–19n.

708:17–18 (723:30–31). the passage of thanksgiving ... for Pessach (Passover)—"We thank thee, Lord, our God, for that thou didst give our fathers a lovely, good and spacious land as an inheritance, and for that thou didst take us out, O Lord, our God, from the land of Egypt, and didst redeem us from the house of slavery, and for thy covenant which thou didst seal in our flesh, and for thy Torah which thou didst teach us, and for thy laws which thou didst make known to us, and for the life, grace, and lovingkindness, which thou didst bestow upon us, and for the repast of food wherewith thou dost feed and sustain us always—each day, and at all times, and in every hour. And for all these, Lord, our God, we thank thee and bless thee. May thy name be blessed in the mouth of every living thing, always and for ever and aye. As it is written: 'And thou shalt eat and be satisfied, then shalt thou thank the Lord, thy God, for the good land which He gave thee.' Blessed art thou, Lord, for the land and the food" (*The Haggadah of Passover*, English by Abraham Regelson, p. 37).

708:19 (723:31). the Queen's Hotel, Ennis—see 100:21–22n.

708:26 (723:39). Athos—see 89:18n.

708:27 (723:40). Das Herz ... Gott ... dein—German: "the heart ... God ... your."

709:2 (724:12–13). The prohibition of the use of fleshmeat and milk at one meal—the origin of this prohibition is obscure, but Jewish tradition ascribes it to the avoidance of idolatry of the sort practiced in heathen festivals; the specific source is Exodus 23: "Thou shalt not seethe a kid in his mother's milk." Traditional applications of this "law" have elaborate ramifications.

709:3 (724:13). the hebdomadary—i.e., once every seven days; in context, the Jewish Sabbath. In the Roman Catholic Church the "hebdomadary" is that member of a chapter or a convent whose week it is to preside over the reading of the Divine Office; see 221:2n.

709:4–5 (724:15). the circumcision of male infants—for devout Jews a required ritual regarded as a consecration of male generative powers to God and as necessary for cleanliness.

The Scriptural basis for this ritual is Genesis 17:9–10 "And God said unto Abraham . . . This *is* my covenant, which ye shall keep between me and you and thy seed after thee; Every man child among you shall be circumcised."

709:5–6 (724:15–16). the supernatural character of Judaic scripture—i.e., the belief that the Pentateuch was the word of God as dictated to Moses, Exodus 32:16: "And the tables [of Moses] *were* the work of God, and the writing *was* the writing of God, graven upon the tables." This belief was threatened if not shaken by nineteenth-century biblical scholarship and its demonstration of the composite nature of the text of the Pentateuch and of the essentially legendary identity of Moses, the lawgiver.

709:6 (724:16). the ineffability of the tetragrammaron should read **tetragrammaton**—the four consonants of the Hebrew "incommunicable name" of God, "JHVH" or "JHWH" or "YHVH" or "YHWH." The vowels were originally suppressed in order to keep the name a secret from the enemies of Israel and to impress the faithful with the name "too secret to be pronounced." The original pronunciation of the word was lost, and it is now usually rendered "Yahweh," Jehovah.

709:6–7 (724:17). the sanctity of the sabbath —is enforced by elaborate and highly particularized Jewish legal traditions. The general prohibition of doing unnecessary work on this "day of rest and worship" has led to specific and often hairsplitting rules; two random examples: it is all right to tie a band around a pail but not to tie a rope around a pail; one letter can be written, but not two, and it is against the law to cheat by using an eraser.

709:17–18 (724:27–28). Maria Theresa, empress of Austria, queen of Hungary—(1717–1780), queen of Hungary and Bohemia, Archduchess of Austria, the daughter of Holy Roman Emperor Charles VI and wife of Holy Roman Emperor Francis I.

710:13 (725:23). the poor rate—a special parish tax levied for the support of the poor.

710:17 (725:27–28). bailiff's man—an indigent who hangs around the bailiff's office in the hopes of being paid for running errands (usually unpleasant since they have to do with legal attempts to force payment of debts, etc.).

710:20–21 (725:30–31). Old Man's House (Royal Hospital) Kilmainham—the Royal Hospital for Ancient, Maimed, and Infirm Officers, in Kilmainham just west of Dublin south of the Liffey.

710:21 (725:31–32). Simpson's Hospital—for the reception of poor, decayed, blind and gouty men, between 206 and 207 Britain Street Great (now Parnell Street) in Dublin.

710:23–24 (725:34). disfranchised rate supported—the voting franchise in Dublin (1904) was accorded only to tax- and rate-payers; those being supported by the poor-law rates could not qualify.

710:29 (726:2). latration—barking (like a dog).

711:18 (726:27). The cliffs of Moher—on the west coast of Ireland north and west of Ennis in County Clare. They extend along the coast for about five miles with an impressive 668-foot sheer precipice at Knockardakin. The base of the cliffs is washed by the Atlantic.

711:18 (726:27). the windy wilds of Connemara—a mountainous lake country on the west coast of Ireland in County Galway, described by guidebooks as "forbidding" and "severe."

711:18–19 (726:27–28). lough Neagh with submerged petrified city—see 326:22n. Medieval tradition held that the lough was originally a small fountain that suddenly erupted, inundating a whole region with its villages and ecclesiastical towers.

711:19 (726:28). the Giant's Causeway—see 338:17n.

711:20 (726:29). Fort Camden and Fort Carlisle—see 608:23n.

711:20 (726:29). the Golden Vale of Tipperary —a fertile plain north of the Galtee Mountains in south-central Ireland; it is largely in County Tipperary but extends also into Counties Waterford and Limmerick.

711:21 (726:30). the islands of Aran—off the west coast of Ireland. The properly patriotic Irish Revivalist regarded the isles as a national utopia since the natives still spoke Irish and lived in what was sentimentally regarded as true Irish fashion.

711:21 (726:30). the pastures of royal Meath —County Meath is north of County Dublin on the east coast of Ireland; "royal" because it was one of the five original kingdoms of ancient Ireland. Its name comes from the Irish *Maith* or *Magh* ("level country") and its pasturelands were (and are) famous.

711:21–22 (726:30–31). Brigid's elm in Kildare—the name "Kildare" derives from the Irish *Cill-dara*, "Church of the Oak" (not elm), where St. Brigid had her cell under an oak and

founded a religious community in 490; see St. Bride, 333:25n and *cf*. 321:8–9n.

711:22 (726:31). the Queen's Island shipyard in Belfast—the shipyard of Harland and Wolff, Ltd., 150 acres in extent, employed at the height of its prosperity some 10,000 men.

711:22–23 (726:31–32). the Salmon Leap—see 326:27–28n.

711:23 (726:32). the lakes of Killarney—see 326:18n.

711:26–27 (726:35–36). Pullbrook, Robertson ... Dame Street, Dublin—as listed in *Thom's (1904)*, p. 1991.

711:27–28 (726:36–727:2). Jerusalem, the holy city ... goal of aspiration—the Moslems under Caliph Omar (*c.*582–644) conquered Jerusalem in 637; the Dome of the Rock (the Mosque of Omar) was built on the site of the Jewish temple in 688. The Gate of Damascus was the main gate in the ancient walled city of Jerusalem; hence, it is the "goal of aspiration": "next year in Jerusalem," see 121:20n.

711:30–31 (727:3–4). the Parthenon (containing statues, nude Grecian divinities)—the Temple of Athena on the Acropolis overlooking Athens. Its interior main hall "contained" one statue, that of Athena in wood, gold and ivory by Phidias (long since lost). Most of the other statuary in the two pediments and the Panathenic frieze that was wrapped around the building has been either destroyed or removed; what has been preserved is in the British Museum among the Elgin Marbles.

711:31–32 (727:4–5). Wall street ... international finance—the concentration of banking institutions in New York's Wall Street did control American finance, but its world dominion was at least shared with London's "City" until after World War I.

711:32–33 (727:5–6). the Plaza de Toros ... had slain the bull)—La Línea de la Concepción, a town in Spain just over the border from the British colony of Gibraltar, had a bull ring that was a popular resort for the inhabitants and the garrison of Gibraltar. John O'Hara of the Royal Welch Fusiliers (not the Queen's Own Cameron Highlanders), garrisoned on the Rock, took up bullfighting as an amateur in the 1870s and as Don Juan O'Hara enjoyed a remarkable success.

711:33–34 (727:6–7). Niagara (over which no human being had passed with impunity)—the first person to go over the falls in a barrel successfully (with impunity) was Anna Edson

Taylor, who went over the Horseshoe Falls on the Canadian side on 24 October 1901.

711:35–36 (727:8–9). the forbidden country of Tibet (from which no traveller returns)—the Tibetan policy of exclusion effectively closed the country to most Western exploration, trade and travel from 1792 until a British-Indian expedition under Colonel Younghusband crossed the border (in pursuit of "friendly relations") and fought its way to Lhasa, which it entered 3 August 1904. The net result was, of course, "friendly relations" with an "open country." At least ten intrepid travelers did enter Tibet in the closing years of the nineteenth century and did manage to return in spite of Bloom's quote from Hamlet's "To be or not to be" meditation on death as "The undiscovered country from whose bourn/No traveller returns" (III, i, 79–80).

711:36–37 (727:9–10). the bay of Naples (to see which was to die)—after the Italian proverb about the beauty of Naples: "See Naples and then die."

712:2 (727:12). septentrional—in the north, after Septentriones, a Roman name for Ursa Major.

712:2–6 (727:12–17). the polestar, located at ... delta of Ursa Major—the seven stars of Ursa Major, the Big Dipper, are not given Greek letters in descending order of their magnitude but in sequence from north to south, alpha, beta, gamma, delta, epsilon, zeta, eta. The traditional way of finding the polestar is to locate it on a line projected from beta through alpha. The rest of this passage is difficult since there is no omega in the constellation, and substituting zeta (since Z is the last letter in the English alphabet as omega is in the Greek) does not help to clarify this inconclusive geometrical construction within Ursa Major. If, on the other hand, the polestar, Polaris, the fixed point in the night sky, is omega (the end), then the construction could be explained as extending beyond Ursa Major: the line alpha-delta passes close to Capella, alpha Aurigae, the brightest star in the Charioteer. A line projected from Polaris at right angles to the Ursa Major beta-alpha line also passes close to Capella; thus the right triangle of guidance: Ursa Major alpha to Polaris to Capella and back to Ursa Major alpha. See 375:3,10n.

712:9 (727:19). carnose—of, pertaining to, or like flesh, fleshy.

712:10 (727:20). a pillar of cloud by day—141:21–22n.

712:21 (727:31). Everyman—in the morality play *Everyman* (*c.*1485) the hero, Everyman,

representing individually all men, faces death after a normally heedless life. He is abandoned by his friends Fellowship, Kindred, Cousin and Worldly Goods and accompanied by Good Deeds, with whom he has not been consistently friendly. See 379:41–380:15n.

712:21 (727:31). Noman—see headnote to Episode 12: [Cyclops], p. 258.

712:24 (727:34). A nymph immortal, beauty, the bride of Noman—i.e., Calypso, who in Book V of *The Odyssey* in effect offers Odysseus marriage and immortality. He refuses (*a*) because it is his destiny to refuse and (*b*) because he regards it as more noble for him to fulfill his life as a mortal than it would be to avoid that fulfillment and its dangers by accepting Calypso's offer of immortality.

712:28 (727:38). telescopic planets—i.e., to Bloom, the asteroids, Uranus and Neptune, which are not visible to the naked eye.

712:32–33 (728:4–5). the constellation of the Northern Crown—see 685:26–29n and 55:1n.

712:33–34 (728:5–6). reborn above delta in the constellation Cassiopeia—see 207:22–27n and 685:20–26n.

712:35–36 (728:7–8). an estranged avenger, a wreaker of justice on malefactors—as Odysseus upon his return; see headnote to this episode, p. 464 above.

712:36 (728:8). a sleeper awakened—Rip Van Winkle; see 370:42n.

712:37 (728:10). Rothschild—see 485:16–17n.

712:38 (728:10). the silver king—the title of a well-made melodrama (1882) by the English playwrights Henry Arthur Jones (1851–1929) and Henry Herman. The innocent hero Denver believes himself guilty of a crime of which he has been falsely accused. The heroine is persecuted and hungry. The landlord villain has a haughty, aristocratic manner and a penchant for evictions and murder. The final triumph of virtue is achieved when the landlord's accomplices confess and vindicate Denver.

713:25 (728:35). burnt offering—in ancient Hebrew ritual, the burnt offering or sacrifice at the temple corresponds to the morning prayer. The review of Bloom's day that follows is largely in terms of a quasi-schematic Hebrew liturgical calendar as his day has previously been reviewed in the form of a Roman Catholic litany; see 488 (498–499).

713:26 (728:36). holy of holies—the most sacred, innermost part of a Jewish tabernacle or temple, entered only once a year by the high priest on the Day of Atonement; see 714:2n below. In modern Jewish ritual the holy of holies is also a series of prayers with which every day's morning services begin. The holy of holies has replaced the morning sacrifice of the ancient church. One of the prayers refers specifically to the orifices of the body, thanking God for the fact that they exist and are open.

713:26–27 (728:37). the bath (rite of John)—washing is part of the Jewish morning ritual. The "rite of John" suggests John the Baptist's mission and his baptizing of Jesus in Matthew 3.

713:27 (728:37) rite of Samuel—a compound suggestion referring to Samuel's career which involved the exorcism of witches, wizards and familiar spirits and also referring to the circumstances of his death: "Now Samuel was dead, and all Israel lamented him, and buried him in Ramah, even in his own city. And Saul had put away those that had familiar spirits, and the wizards, out of the land" (I Samuel 28:3).

713:27–28 (728:37–38). the advertisement of Alexander Keyes (Urim and Thummin)—on Keyes, see 115:27n and 119:19n. *Urim* and *Thummin*, Hebrew: "Light" and "Perfection" or "Fire" and "Truth"; these two symbols, which the priest wears on his breastplate of judgment, suggest doctrine and faith, the ever-present possibility of a revelatory perception of God's Will.

713:28–29 (728:38–729:1). the unsubstantial lunch (rite of Melchisedek)—the "unsubstantial lunch" recalls the Jewish priest's quasi-fast at noonday; Melchisedek is the Old Testament type of the perfect priest, Genesis 14:18: "And Melchizedek king of Salem brought forth bread and wine: and he *was* the priest of the most high God." In Hebrews 5:6 and 10, St. Paul describes Jesus as a priest "after the order of Melchisedec."

713:30 (729:2). holy place—the inner part of a Jewish temple or tabernacle where the Ark of the Torah is housed and within which is the holy of holies; see 713:26n.

713:30–31 (729:2–3). Bedford row, Merchants Arch, Wellington Quay—Bedford Row is off Crampton Quay on the south bank of the Liffey just east of the Metal Bridge and Wellington Quay; see 224:21n.

713:31 (729:3). Simchath Torah—Hebrew: "Rejoice in the Law," the last day of the Feast of Tabernacles (see 60:35n), when the ritual reading

of the Pentateuch, which forms part of the seven-day feast, is completed and the cycle of reading begins again.

713:32 (729:4). Shira Shirim—Hebrew: "Song of Songs" (The Song of Solomon), which is read on the Sabbath during the Feast of Tabernacles; see 60:35n.

713:33 (729:6). holocaust—literally, "a burnt offering, total sacrifice"; figuratively, the cere-mony that commemorates the destruction of the Temple in Jerusalem by the Romans on the ninth day of Av (the eleventh month of the Hebrew year), 70 A.D. On that day Jews mourn the reduc-tion of Jerusalem and Israel to a wilderness.

713:34–35 (729:6–7). blank period of time . . . a leavetaking (wilderness)—Bloom has con-sistently been reluctant to recall the period be-tween [Cyclops] and [Nausicaa], the period that includes his charitable visit to Mrs. Dignam in Sandymount. "Wilderness" recalls not only the Israelites' 40 years of wandering in the wilderness after they "took leave" of Egypt, but also those wilderness periods of exile which the Jews have suffered since leaving Egypt. Those periods are commemorated annually from the seventeenth day of Tamuz (the tenth month) to the ninth day of Av (eleventh month), when the Temple is breached, 713:33n. The observance centers on the song the Exiles sing, "By the rivers of Babylon, there we sat down, yea, we wept, when we re-membered Zion" (Psalms 137:1).

713:36 (729:8). rite of Onan—Genesis 38:8–10: "And Judah said unto [his son] Onan, Go in unto thy [dead] brother's wife, and marry her, and raise up seed to thy brother. And Onan knew that the seed should not be his; and it came to pass, when he went in unto his brother's wife, that he spilled *it* on the ground, lest that he should give seed to his brother. And the thing which he did displeased the Lord: wherefore he slew him also."

713:37 (729:9). heave offering—a ceremonial peace offering originally based on several injunc-tions in the Pentateuch, including Leviticus 7:32: "And the right shoulder shall ye give unto the priest *for* an heave offering of the sacrifices of your peace offering." "Heave offering" is here used in the sense that the priest will lift up the meat and reserve it for his own use; see Numbers 5:9. Subsequently, the heave offering has become a ceremonial contribution (obligatory or voluntary) for the use of priests and sacred persons.

714:1 (729:12). Armageddon—the Hebrew name for Mount Megiddo ("the place of crowds") in Palestine. In Jewish tradition it is regarded as the site of a future and ultimate Messianic strug-gle. This tradition has undergone a Christian

transformation in Revelation 16, where Armaged-don is envisioned as the site of a great struggle on the occasion of the Second Coming.

714:2 (729:13). atonement—the Day of Atone-ment is the Jewish Yom Kippur, a fast day of the Mosaic ritual celebrated on the tenth day of Tishri (the seventh month). It is ˌthe great day of national humiliation and mourning, a day of fasting with emphasis on the expiation of the sins of the year. It is the day on which the scapegoat is sacrificed (see 449:3n) and the only day of the year on which the high priest enters the holy of holies (see 713:26n and 169:25n). In Christian terms the atonement is the redemption of man and his reconciliation with God through Jesus Christ; as St. Paul puts it in Romans 5:11: ". . . we also joy in God, through our Lord Jesus Christ, by whom we have now received the Atonement."

714:6 (729:17). a brief sharp unforeseen heard loud lone crack—Bloom's "prayerful" review of his day is rewarded by a clap of thunder out of a cloudless sky, as Odysseus' prayer to Zeus for help against the suitors is rewarded in *The Odyssey*, Book XXI.

714:17 (729:28). Where was Moses when the candle went out?—two street-rhyme answers to this question from the early twentieth century: "Down in the cellar with his shirt tail out" and "Down in the cellar eating sauerkraut." Bloom's answer to the riddle: "In the dark."

714:22–23 (729:33–34). Pulbrook, Robertson and Co . . . London, E.C—see 711:26–27n and 70:24n.

714:25–27 (729:37–38). the performance of Leah . . . South King street—see 75:19n.

714:31–32 (730:4–5). Rehoboth, Dolphin's Barn—Dolphin's Barn is a street and a section in southwestern Dublin; Rehoboth (Hebrew: "wide places or streets") is the name of three sites in Genesis and Rehoboth, Rehoboth Terrace and Rehoboth Road were all in the Dolphin's Barn section.

715:10 (730:19). Muratti's Turkish cigarettes—a popular and widely advertised brand in 1904.

715:20–22 (730:29–31). Henry Price, basket .. 23 Moore street—*Thom's (1904)*, pp. 1549 nd 1990, lists George and not Henry Price at this business and address. Henry Price, p. 1990, hardware, chandlery and fancy goods, 27 South Great George's Street.

715:34 (731:4). With circumspection, as invariably when entering an abode—as Odysseus approaches Penelope when he reveals himself to her in *The Odyssey*, Book XXIII.

716:16 ff. (731:25 ff.). Assuming Mulvey to be the first term—this widely quoted and incomplete list of Molly's "adulteries" is troublesome if one expects it to be based upon a technical definition of adultery, i.e., "with ejaculation of semen within the natural female organ" (see 720:25–26n). Jesus, however, presents a far more rigorous definition of adultery in Matthew 5:27–28: "Ye have heard that it was said by them of old time, Thou shalt not commit adultery: But I say unto you, That whosoever looketh on a woman to lust after her hath committed adultery with her already in his heart."

716:16 (731:25). Penrose—fictional; he was boarding with the Citrons (see 60:28–29n) when the Blooms were in Lombard Street West. *Cf.* 739:6–9 (754:9–12).

716:17 (731:26). Bartell d'Arcy—see 154:1n. *Cf.* 730:29–39 (745:31–43).

716:17 (731:26). professor Goodwin—see 62:40n. *Cf.* 732:19–24 (747:21–26).

716:17 (731:26). Julius Mastiansky—see 60:9n. *Cf.* 734:32–35 (749:35–39).

716:17–18 (731:26–27). John Henry Menton—see 101:26–27n; *cf.* 724:3–9 (739:3–9).

716:18 (731:27). Father Bernard Corrigan—apparently not Dignam's brother-in-law of 632:1 (647:36) and 689:7 (704:21); *cf.* 726:1–18 (741:2–19).

716:18–19 (731:27–28). a farmer at the Royal Dublin Society's Horse Show—see 367:37–38 (374:15–16) and 367:38n. Molly does not recall this incident.

716:19 (731:28). Maggot O'Reilly—see 441:31–442:1 (449:20–21). Molly does not recall O'Reilly.

716:19–20 (731:28–29). Matthew Dillon—see 105:6–7n; *cf.* 759:42 (774:39–40) and 743:13–14 (758:15–16).

716:20 (731:29). Valentine Blake Dillon (Lord Mayor of Dublin)—see 153:17n and *cf.* 735:3–5 (750:6–8).

716:20–21 (731:30). Christopher Callinan—see 136:8n; Molly does not recall him.

716:21 (731:30). Lenehan—*cf.* 734:42–735:3 (750:3–5). See also 230–231 (234–235).

716:21 (731:30). an Italian organgrinder—*cf.* 281:12–13 (285:37–38). Molly does not recall him.

716:21–22 (731:31). an unknown gentleman in the Gaiety Theatre—*cf.* 754:10–17 (769:8–14).

716:22 (731:31). Benjamin Dollard—*cf.* 759:11–17 (774:8–14).

716:22–23 (731:32). Simon Dedalus—*cf.* 759:17–29 (774:14–26); 753:28–30 (768:25–28).

716:23 (731:32). Andrew (Pisser) Burke—see 300:31n and *cf.* 750:8–11 (765:6–9).

716:23 (731:32). Joseph Cuffe—see 96:32n and *cf.* 737:16–23 (752:19–27).

716:23 (731:32–33). Wisdom Hely—see 105:13n; Molly recalls that Bloom worked there, but she does not recall Hely himself.

716:24 (731:33). Alderman John Hooper—see 112:10n; Molly does not recall him.

716:24 (731:33). Dr Francis Brady—see 571:34n and *cf.* 739:10–11 (754:13–14).

716:24–25 (731:33–34). Father Sebastian of Mount Argus—St. Paul's College of the Passionist Fathers, Mount Argus, off Kimmage Road in Harold's Cross, a village two and a quarter miles south-southwest of the center of Dublin. *Thom's* (*1904*), lists no Father Sebastian in residence, and Molly does not recall him.

716:25 (731:34–35). a bootblack at the General Post Office—Molly has no recall of this incident.

716:30 (732:2). a bester—slang for a cheat.

717:23–24 (732:32–33). George Mesias ... 5 Eden Quay—see 108:39n.

718:34–35 (734:5–6). the presupposed intangibility of the thing in itself—the German philosopher Immanuel Kant (1724–1804) "presupposed" that reality existed on two levels, noumenal and phenomenal. The phenomenal level (the surface of things) could be known, and that knowledge, he argued, could be metaphysically validated; the noumenal level (the *Ding an Sich* or "thing-in-itself") could be postulated, but knowledge of it at least had not been, and perhaps could not be, metaphysically demonstrated.

719:2 (734:12). an aorist preterite proposition—"aorist" is the tense of a Greek verb indicating that an action took place in an indefinite past time; "preterite" means belonging wholly to the past. The proposition Bloom has in mind is, "He fucked her."

719:16 (734:27). the land of the midnight sun —the polar regions, since the sun shines 24 hours a day at the height of the Arctic and Antarctic summers.

719:16–17 (734:27–28). the islands of the blessed—in late classical mythology, the Fortunate Islands, somewhere in the unexplored western sea, where mortals favored by the gods went after death; *cf. Tir na n-og,* the Irish analogue, 193:9–10n.

719:17 (734:28). the isles of Greece—from the first line of a lyric interpolated in Byron's *Don Juan,* "Canto the Third" (1821), between stanzas LXXXVI and LXXXVII. The first stanza (of 16): "The Isles of Greece, the Isles of Greece!/ Where burning Sappho loved and sung,/Where grew the arts of War and Peace,/Where Delos rose, and Phoebus sprung!/Eternal summer gilds them yet,/But all, except their Sun, is set."

719:17 (734:28). the land of promise—i.e., Canaan (see 148:5–6n); figuratively, that better country (or condition of life) for which one has an unfulfilled yearning. See 387:18–20n and 148:5–6n.

719:18 (734:29). milk and honey—in Exodus 3:8, God promises Moses "to bring them up out of that land [of Egypt] unto a good land and a large, unto a land flowing with milk and honey." See preceding note.

720:9–11 (735:17–19). a performance by Mrs Bandman ... South King street—see 75:19n.

720:11–12 (735:20). Wynn's (Murphy's) Hotel, 35, 36 and 37 Lower Abbey street—"Commercial and Family Hotel (late Wynn's), Mr. D. J. Murphy, proprietor" (*Thom's* [*1904*], p. 1408).

720:13 (735:22). Sweets of Sin—see 232:27n.

720:15 (735:24). postcenal—after supper.

720:33 (736:5). 8 September 1870—Molly's birthday is also celebrated as the Feast of the Nativity of the Blessed Virgin Mary.

720:36–37 (736:8–9). with ejaculation of semen within the natural female organ—a technical definition of sexual intercourse; *cf.* 220:25–26n and 716:16 *ff.* n.

721:1–2 (736:13). a period of 10 years, 5 months, 18 days—from 27 November 1893 to 17 June 1904 is 10 years, 6 months and 21 days. From 9 January 1894, it is 10 years, 5 months, 8 days.

721:25–26 (736:36–37). on the 53rd parallel of latitude, N. and the 6th meridian of longitude, W—to be precise (since the "Art" of this episode is "science") Dublin is 53° 20′ north, 6° 15′ west; 53° north, 6° west would place the Blooms in Tinahelly House just north of Wicklow.

721:31–32 (737:2–3). both carried westward ... proper perpetual motion of the earth—curious, since the earth in fact rotates from west to east; i.e., physically they are moving eastward (toward Jerusalem and renewal); to move westward, figuratively, is to move toward death.

721:37 (737:8). Gea-Tellus—an elision of the Greek earth-goddess Gaea, the mother of all living creatures, with the Roman earth-mother, Tellus Mater. In Athens she was worshiped as the nourisher of children and at the same time as the goddess of death, who summoned all creatures back to her and hid them in her bosom. She is usually represented as reclining on her side, cradling two children in her free arm.

722:8–9 (737:17–18). Sinbad the Sailor ... Tinbad ... Whinbad—there were characters named Tinbad and Whinbad in the Dublin pantomime *Sinbad the Sailor;* see 662:30–32n.

722:16 (737:25). roc's auk's egg—the roc was a mythical bird of Arabia, so huge that it carried off elephants to feed its young; Sinbad, in the "Second Voyage of Sinbad" in the *Arabian Nights,* discovers one of its eggs and finds it to be "fifty good paces" in circumference. He hitches a ride on the unwitting parent bird's leg in order to escape the island on which he has been marooned. The great auk, a sub-Arctic flightless bird (extinct 1844), laid a single outsized egg at each nesting.

EPISODE 18
[PENELOPE]

MEDITERRANEAN SEA

Salto Garrobo (Sandy Bay)

Europa Advance Battery

Governor's Cottage

Passage Pt.

Harvey Barracks

Lighthouse

at Europa Pt.

Windmill Hill Flats

Little Europa

Europa Pt.

Europa Bay

Buena Vista

Shingle P.

Camp Bay

Rosia

ROSIA

S. Barracks

Coal Stores

South Mole

South Mole

N

EPISODE EIGHTEEN

Episode 18: [Penelope], pp. 723–768 (738–783).
In Book XXIII of *The Odyssey* Penelope is
awakened and informed by the nurse Euryclea
that Odysseus has returned and slaughtered the
suitors; at first she refuses to believe the nurse,
saying that it must be some god in disguise who
has killed the suitors for their presumption. When
she descends into the hall to meet Odysseus, she
is still reluctant, testing him, as he puts it, "at her
leisure." What finally convinces Penelope that
Odysseus is in fact Odysseus is his knowledge of
the secret of the construction and the immov-
ability of their bed. They retire, "mingled in love
again," and then tell their stories to each other. In
the morning Odysseus is up early to pacify the
island, and the poem moves toward its close.

Time: none (Molly does not pattern her life by
the clock). Scene: the bed (as the sign of the bed is
the key to the reunion of Odysseus and Penelope).
Organ: flesh; Art: none; Color: none; Symbol:
earth (see 721:37n); Technique: monologue
(female), divided into eight sprawling, unpunctu-
ated sentences: (1) pp. 723–729 (738–744), (2)
729–738 (744–753), (3) 738–739 (753–754), (4)
739–744 (754–759), (5) 744–748 (759–763), (6)
748–755 (763–770), (7) 755–761 (770–776), (8)
761–768 (776–783). Correspondences: *Penelope*—
earth; *Web* (which Penelope weaves and un-
weaves in order to delay a decision among the
suitors)—movement.

Sentence 1. pp 723–729 (738–744).

723:2–3 (738:2–3). the City Arms hotel—see
36:23–24n.

723:5 (738:5). faggot—English slang for an old,
shriveled woman.

723:5 (738:5). Mrs Riordan—see 96:16n.

723:5 (738:5–6). had a great leg of—to "have
a great leg of" is slang for to have considerable
influence with.

**723:6–7 (738:6–7). for masses for herself and
her soul**—see 109:30n. It was not an uncommon
practice for Catholics as devout as Mrs. Riordan
considered herself to be to leave their money for
such Masses in order to relieve their sufferings
and foreshorten their stay in purgatory.

723:23 (738:23). dring—to sing monotonously.

723:29 (738:30). the south circular—i.e., the
South Circular Road, which circled just inside the
southern limits of metropolitan Dublin.

723:30 (738:31). the sugarloaf Mountain—see
153:25n.

723:31 (738:31–32). Miss Stack—identity or
significance unknown.

723:34 (738:35). to never see thy face again—
source in song or poem unknown.

**723:42–724:1 (738:43–739:1). if it was down
there he was really and the hotel story**—
Bloom has told Molly that he had "supper" at
Wynn's Hotel in Lower Abbey Street (see 720:
12–13n); Molly wonders whether he is faking and
has been in the red-light district, which is not
far to the northwest of Lower Abbey Street.

724:5 (739:5). Pooles Myriorama—a traveling
show that appeared in Dublin approximately
once a year in the 1890s, usually at the Rotunda
(see 680:37–681:1n). A "myriorama" is a large
picture or painting composed of several smaller
ones that can be combined a in variety of ways.
Pooles' show was a sort of travelogue with running
commentary.

724:8 (739:8). mouth almighty—slang, he has
a high opinion of himself.

**724:24 (739:25). that Mary we had in Ontario
Terrace**—Mary Driscoll, the Blooms' servant
when they lived in Ontario Terrace in Rathmines;
see 452:2 *ff.* (460:9 *ff.*).

724:32–33 (739:34). oysters 2/6 per doz—an
obvious exaggeration, three or four times the
standard prices in 1900.

725:5 (740:5). the WC—the water closet.

725:9 (740:10). the Tolka—see 165:4–5n.

**725:9 (740:10). in my hand there steals
another**—source in song or poem unknown.

**725:11 (740:12). the young May Moon she's
beaming love**—see 165:5–6,7n.

725:24 (740:25). the jews Temples garden—on
Adelaide Road between the Jewish Synagogue
and the Royal Victoria Eye and Ear Hospital near
the Grand Canal.

**725:29 (740:30–31). who the German Emper-
or is**—Wilhelm I (1797–1888), king of Prussia,
(1861–1888) and German emperor (1871–1888),
died on 9 March 1888 and was succeeded by his
son Frederick III (b. 1831), who died 15 June
1888 and was succeeded by his son, Wilhelm II
(1859–1941), king of Prussia and German
emperor (1888–10 November 1918). 1888 was
courtship year for the Blooms.

726:1 (741:2). Father Corrigan—see 716:18n.

726:10–11 (741:11–12). the bullneck in his horsecollar—a thick-set neck is popularly regarded as a sign of impressive sexual vitality; "horsecollar" is slang for a priest's reversed collar.

726:17–18 (741:19). give something to HH the pope for a penance—Molly's concept of the consequences of "sin" is about as sound as Gerty's (*cf.* 359:34–35n). A priest who committed a sin of "impurity" would not get off by merely giving "something" to His Holiness the Pope. His penance would be far more serious and demanding.

726:28–29 (741:30). talking stamps with father—see 56:32n.

726:30–31 (741:32). the potted meat—see 73:40–74:2n.

726:36 (741:37). a Hail Mary—see 81:42n.

726:39 (741:40). an act of contrition—see 218:20–21n.

726:39–40 (741:40–41). the candle I lit ... Whitefriars street chapel—i.e., Molly has prayed for good luck and reinforced her prayer by placing a candle before a sacred image. The Convent and Church of the Calced Carmelites in Aungier Street and Whitefriar Street (central Dublin south of the Liffey) had a chapel in Whitefriar Street.

727:5 (742:5–6). Though his nose is not so big—folklore: a large nose is supposed to indicate a large penis.

727:22 (742:23). giving us a swing out of your whiskers—source and connotations unknown.

727:26 (742:27). Jesusjack the child is a black—source unknown.

727:27–28 (742:28–29). you couldn't hear your ears—Hibernicism: "An odd expression:— 'You are making such noise that I can't hear my ears'" (P. W. Joyce, *English as We Speak It in Ireland,* p. 201).

727:32 (742:33). spunk—slang for semen and also for courage.

727:33 (742:34). Josie Powell—Mrs. Denis Breen.

727:37 (742:38). Georgina Simpsons—see 437:10 *ff.* (444:22 *ff.*).

727:40–41 (742:42). about Our Lord being a carpenter—Mark 6:2–3: "And when the sabbath day was come, he [Jesus] began to teach in the synagogue: and many hearing *him* were astonished, saying ... Is not this the carpenter, the son of Mary, the brother of James, and Joses, and of Juda, and Simon? and are not his sisters here with us? And they were offended at him."

728:1–2 (743:2). the first socialist he said He was—a late-nineteenth-century commonplace among socialists, after Matthew 19:21, "Jesus said unto him, If thou wilt be perfect, go *and* sell that thou hast, and give to the poor, and thou shalt have treasure in heaven: and come *and* follow me."

728:5 (743:6). that family physician—*The Family Physician; a manual of domestic medicine by Physicians and Surgeons of the principal London Hospitals* (London, 1879), with four subsequent revised editions before 1895.

728:9 (743:10). Floey—one of Matthew Dillon's daughters.

728:22 (743:23). plabbery—from the Irish *plaboire,* "a fleshy-faced person with thick, indistinct speech."

728:32 (743:33). glauming—grasping, clutching.

728:38 (743:40). trying to look like Lord Byron—during Byron's lifetime (1788–1824) his appearance and manner were widely publicized and imitated; and they remained through most of the nineteenth century as images of romantic behavior and sensibility. This was particularly true of his upswept hair, of an air of delicate melancholy (associated with his earlier poems), and of his reputation as a dashing ladies' man.

729:1 (744:3). grigged—see 107:1n.

729:12 (744:14). when the maggot takes him—see 441:31–442:1n.

729:19 (744:21). up up—see 156:3n.

729:20 (744:21). O Sweetheart May—after "Sweetheart May," a song by Leslie Stuart (Thomas Augustine Barrett) and Charles K. Harris: "Your dear boy has gone and left you, sweetheart May,/And till death he'll always bless you, sweetheart May,/For he loves his country dear,/But he'll come back, never fear,/His darling to be near, sweetheart May./Don't you fear for him or cry, sweetheart May,/For the boys must win or die, sweetheart May./If the morning dawns once more,/When the cruel war is o'er,/You will find him at your door, sweetheart May." Chorus: "Farewell, darling, I must leave you,/Farewell, little sweetheart mine,/ Don't forget your promise to me,/In that golden summer time./When the

stars above are shining,/Then my thoughts to you will stray,/And till death I'll always love you,/Farewell, sweetheart May."

729:26–38 (744:28–40). Mrs Maybrick that poisoned her husband ... to go and hang a woman—James Maybrick (1839–1889), a Liverpool cotton broker, died mysteriously in his home on 11 May 1889. Mrs. Florence Elizabeth Chandler Maybrick (1862–1941) was tried for his murder; at the trial it was established that she had had a lover or lovers and that she had quarreled with Maybrick; also that she had tried to obtain arsenic in the way Molly recalls, cleverly, but not cleverly enough to escape detection. There was some doubt about her guilt since Maybrick was addicted to patent medicines that contained arsenic, but the jury was convinced that her flypaper trick had tipped the balance and found her guilty, 7 August 1889. She was condemned to death, but her sentence was commuted to life on 22 August 1889 and she was released on 25 January 1904.

Sentence 2. pp. 729–738 (744–753).

729:41 (744:43). the D B C —see 162:41n.

730:8 (745:9). the Irish Times—see 157:37n.

730:15–16 (745:17). the stone for my month a nice aquamarine—the stone for Molly's month of September is chrysolite, symbolic of preservation from folly or the cure of folly; aquamarine, symbolic of hope, is the stone for October.

730:24 (745:26). Katty Lanner—see 560:34n.

730:26 (745:28). the stoppress edition—an edition of the *Evening Telegraph* that hit the streets between 5:30 and 6:00 P.M. daily, called "stoppress" because the paper's central page carried a column labeled "Stop Press" that was held for the insertion of late news. More often than not the column appeared as a blank in the paper.

730:27 (745:29). the Lucan dairy—the Lucan Dairy Company had 18 shops in Dublin and environs in 1904.

730:31 (745:33). Gounods Ave Maria—(1859). Charles François Gounod (1818–1893), a French composer, set the "Ave Maria" ("Hail Mary," see 81:42n) to a melody adapted from Bach. Scored for soprano and organ or orchestra, it was a very popular setting of the text.

730:31–32 (745:33–34). what are we waiting ... the brow and part—from a song, "Good-Bye," by G. J. Whyte-Melville and F. Paolo Tosti. First and third verses: "Falling leaf and

fading tree,/Lines of white in a sullen sea,/Shadows rising on you and me;/The swallows are making them ready to fly,/Wheeling out on a windy sky./Good-bye, Summer! Good-bye.//What are we waiting for? Oh? My Heart!/Kiss me straight on the brows, and part!/Again, again!/My Heart! My Heart!/What are we waiting for, you and I?/A pleading look, a stifled cry./Good-bye, forever, Good-bye!"

730:40–41 (745:43). he hadn't an idea about my mother—Molly's mother, Lunita Laredo, a Spanish Jewess, who died early in Molly's life; i.e., Bloom did not know that Molly's mother was Jewish.

731:2 (746:4). Kenilworth square—a park or green just west of Rathmines and south of metropolitan Dublin, a little more than a mile southeast of the Tweedy home in Dolphin's Barn.

731:7 (746:9). skeezing—slang for staring at covertly.

731:9 (746:11). open air fete—a social event usually organized for the benefit of a charitable institution. The *Dublin Evening Mail,* Wednesday, 15 June 1904, carried an advertisement that was typical: "Titania Grand Open-Air Fete. In the Grounds of Blackrock House, Blackrock. (Kindly lent by T. C. McCormick, Esq.) Friday and Saturday, June 17, 18 (11:30 A.M. to 10 P.M.)." The fete was to feature "Boating, Steam Launch Trips, Swimming, Fireworks," etc.

731:13 (746:15). the Harolds cross road—a main road that leads south into the countryside from metropolitan Dublin. It passes near to Kenilworth square; see 731:2n.

731:14 (746:16). Zingari colours—gypsy colors.

731:15 (746:17). slyboots—see 544:24n.

731:27 (746:29). O Maria Santissima—Italian: "O Most Holy Mary."

731:28 (746:30). dreeping—drooping or walking very slowly.

731:35 (746:37). Gardner—Lieutenant Stanley G. Gardner, of the 8th Battalion of the 2nd East Lancashire Regiment. He is apparently fictional, though he may owe his name to Gardner's Battery, part of the complex of fortifications that commanded the landward approaches to Gibraltar. He is notably absent from the "series" of Molly's lovers, 716 (731).

731:40–41 (746:43). what a Deceiver—while Penelope is still holding out in Book XXIII of *The Odyssey,* Odysseus shows his artfulness as a

deceiver; in order to keep the news of the suitors' deaths from the community, he stages what will appear to outsiders to be a wedding feast.

732:3 (747:5). Henry Doyle—see 370:42n.

732:12–13 (747:14). because mine was the 8th —see 720:35n.

732:32–33 (747:35). for England home and beauty—see 222:13,16n.

732:33–34 (747:36). there is a charming girl I love—"It is a charming girl I love," a song in Act I of *The Lily of Killarney;* see 91:1–2n.

732:40 (747:42–43). some protestant clergyman—Belfast was then, as now, a notorious Protestant stronghold.

733:3–4 (748:5–6). the Mallow Concert at Maryborough—Maryborough, now Portlaoise, is a market and county town 52 miles southwest of Dublin in Queen's County (now County Laois). The Mallow Concert is unknown; Mr. K. Kavanagh, the county librarian of Laois County Library, reports, "We have failed to confirm that any Mallow Concert was held in the town Maryborough at the beginning of the century. It would appear that the reference is entirely fictional" (in a letter, 24 November 1970). *Cf.* 418:42n.

733:12 (748:14–15). theyd have taken us on to Cork—the Blooms would have taken the Great Southern and Western Railway, Dublin to Maryborough (52 miles); Cork is 112 miles beyond Maryborough.

733:24 (748:27). St Teresas hall Clarendon St—St. Teresa's Total Abstinence and Temperance Loan Fund Society, 43 and 44 Clarendon Street, Dublin.

733:25 (748:28). Kathleen Kearney—appears as a character in "A Mother," *Dubliners.* Kathleen's mother mounts her daughter's concert career by taking "advantage of her daughter's name" since Kathleen ni Houlihan (and in Yeats's play *The Countess Cathleen;* see 11:12–14n) is a traditional symbol of Ireland. See 15:30–31n.

733:27 (748:29–30). the absentminded beggar —see 185:19n.

733:27 (748:30). lord Roberts—see 414:5–6n.

733:30 (748:33). the Stabat Mater—see 81:3n.

733:31–33 (748:34–36). Lead Kindly Light . . . lead thou me on—"Lead Kindly Light" is a hymn by John Henry Cardinal Newman (1801–1890), music by John B. Dylas (1823–1876). The

first of the hymn's three verses: "Lead kindly Light, amid the circling gloom,/Lead thou me on!/Keep thou my feet; I do not ask to see/The distant scene; one step enough for me."

733:34 (748:37). Sinner Fein—*Sinn Fein;* see 161:24n.

733:37 (748:40). Griffith—see 44:6n.

733:39–40 (748:43). Pretoria—the heavily fortified capital of the Boer Republic of Transvaal in South Africa. It was the seat of the executive government of the coalition of Boer Republics during the Boer War. Pretoria was not the scene of a battle; Boer General Paul Kruger abandoned it in May 1900, and the British occupied it without resistance.

733:40 (748:43). Ladysmith and Bloemfontein —see 474:17–18n and 449:26n.

733:41 (749:1). 8th Bn 2nd East Lancs Rgt— see 731:35n.

734:2 (749:4–5). my Irish beauty—the phrase suggests a source in poem or song: unknown.

734:5–6 (749:8). oom Paul and the rest of the old Krugers—"oom [uncle] Paul" was Stephanus Johannes Paulus Kruger (1825–1904), a Boer statesman who was president of the South African (Boer) Republic from 1883 to 1900. His career was one long struggle, first against the contentious factions that divided his own people and subsequently against the English, who put increasing pressure on the Boer Republic to submit to annexation and English dominion; Kruger's opposition to annexation can be regarded as determined (or obstinate), but the end result was the Boer War and annexation anyway.

734:10 (749:12–13). the Spanish cavalry at La Roque—i.e., at San Roque, a town in Spain about seven miles from Gibraltar; it was a Spanish garrison town (against the foreign presence of the English on the Rock).

734:11 (749:14). Algeciras—a town in Spain on the western headland of the Bay of Algeciras (Bay of Gibraltar) as Gibraltar is the eastern headland, some six miles away.

734:12 (749:15). the 15 acres—an area in Phoenix Park, Dublin. It was occasionally used for military reviews and exercises of the sort Molly recalls.

734:12–13 (749:15). the Black Watch—the Royal Highlanders, a distinguished regiment of Scots infantry, the 42d Regiment of the Line in the British Army.

734:13–14 (749:16–17). the 10th hussars the prince of Wales own—the tenth of the cavalry regiments was The Prince of Wales Own Royal Hussars.

734:14 (749:17). the lancers—the 5th, the Royal Irish Lancers? the 9th, the Queen's Royal Lancers? the 12th, the Prince of Wales Royal Lancers? the 16th, the Queen's Lancers? the 21st, the Empress of India's Lancers?

734:14–15 (749:17). O the lancers theyre grand—source unknown.

734:15 (749:17–18). the Dublins that won Tugela—the Tugela River valley was the scene of a frustrating and costly campaign for the English during the Boer War. The point of the campaign was to relieve the pressure on Ladysmith (see 474:17–18n); and a force of British, including a battalion of Royal Dublin Fusiliers, crossed the Tugela on 18 February 1900, stormed Spion Kop, the key of the enemy's position, on the night of 23–24 February; but the British were cut to ribbons in a murderous crossfire on the following day (the Dublins suffered 30 percent casualties). The British were forced to abandon the position and retire beyond the Tugela, 27 February 1900.

734:15–16 (749:18–19). his father made his ... horses for the cavalry—i.e., Boylan's father; see 314:8–10n.

735:2 (750:4). the Glencree dinner—see 153:18n.

735:2–3 (750:5). featherbed mountain—see 231:12n.

735:3–4 (750:6–7). the lord Mayor ... Val Dillon—see 153:17n.

735:19 (750:22). Manola—Spanish: "a loud and boisterous street song."

735:21 (750:24). Lewers—Mrs. R. G. Lewers, ladies' outfitting warehouse, 67 Grafton Street, Dublin (a fashionable shopping district in 1904).

735:25 (750:28). the Gentlewoman—a 6d weekly magazine published in London on Thursdays (dated Saturday). It advertised "'The Gentlewoman' is replete in every department with matter interesting to ladies. Its Fashions, English and French, are far in advance of its contemporaries both in artistic merit and reliability" (*Who's Who, 1906*, p. 36).

735:30 (750:34). ORourkes—see 58:9–10n.

735:32 (750:36). a cottage cake—a cake without frosting.

735:35–36 (750:39). that antifat—in the late nineteenth century numerous patent medicines were advertised as ideal for those who wanted to reduce: "just keep on eating as much as you like ..." etc.

736:17 (751:20). Ill be 33 in September—cf. 720:35 (736:5).

736:18 (751:21). Mrs Galbraith—Adams suggests (p. 155), "the spouse of H. Denham Galbraith, Esq., 58B Rathmines Road; the guess would be founded on her relative proximity to the Blooms' former neigborhood."

736:21 (751:24–25). Kitty O'Shea in Grantham street—Adams (p. 239): "Kitty O'Shea in Grantham street [p. 736] is only the namesake of Parnell's lady; living at #3 ... according to *Thom's Directory* for 1882, was Miss O'Shea."

736:24–25 (751:27–28). that Mrs. Langtry the Jersey Lily the prince of Wales was in love with—Mrs. Edward Langtry (1852–1929) came from the obscurity of a parsonage in the Isle of Jersey to the London limelight (1874) by means of the wealthy and elderly Irish widower Langtry (d. 1897). Her liaison with the Prince of Wales was widely publicized; eventually she left her husband (1881) and became an unsuccessful actress who nevertheless played to packed houses —thanks to her beauty and the Prince's patronage. In 1899 she was married for a second time, to Sir Hugo Gerald de Bathe.

736:28–31 (751:31–34). some funny story about ... he had the oyster knife—the story of the chastity belt and the oyster knife is apocryphal; its only basis in fact was Mr. Langtry's well-publicized jealousy of his young and beautiful wife.

736:32–34 (751:36–38). the works of Master Francois ... because her bumgut fell out—François Rabelais (c.1490–1553), the great French satirist, began his career as a Franciscan monk, switched to the more scholarly Benedictines and eventually drifted into a sort of secular priesthood. In *The Histories of Gargantua and Pantagruel*, The First Book, Chapter 6, "The very strange manner of Gargantua's birth," Rabelais describes how Gargantua's mother thinks she is about to give birth: "But it was the fundament slipping out, because of the softening of her right intestine— which you call the bum-gut—owing to her having eaten too much tripe." She is treated with an "astringent," and "By this misfortune the cotyledons of the matrix were loosened at the top, and the child leapt up through the hollow vein. Then, climbing through the diaphragm to a point above the shoulders, where this vein divides in two, he took the left fork and came out by the left

ear" (translated by J. M. Cohen [London, 1955], p. 52).

736:37–38 (751:41). Ruby and Fair Tyrants— see 64:17n and 232:22–23n.

736:39–40 (751:42–752:1). page 50 the part about . . . a hook with a cord flagellate— presumably from *Fair Tyrants,* but that work remains unknown.

736:41–42 (752:2–3). about he drinking champagne out of her slipper—the particular source Molly has in mind for this bit of folklore, is unknown.

736:42 (752:3). after the ball was over—from a sentimental ballad, "After the Ball" (1892), by Charles K. Harris. The ballad is the story of an old man who has remained celibate because long ago his "true love," apparently, but not really, deceived him: "I believ'd her faithless, after the the ball." Chorus: "After the ball is over,/After the break of morn,/After the dancers' leaving,/ After the stars are gone,/Many a heart is aching,/ If you could read them all;/Many the hopes that have vanished,/After the ball."

736:42–737:1 (752:3–4). like the infant Jesus . . . in the Blessed Virgins arms—attached to the Roman Catholic Church of Oblate Fathers of Mary Immaculate in Inchicore on the western outskirts of Dublin is a shrine of the Nativity, "with the wax figures of the Holy Family and Magi and the shepherds and horses and oxen, sheep and camels stretching all around the hall in cheap and dusty grandeur" (Stanislaus Joyce, p. 10). The infant Jesus is unrealistically oversized as Molly suggests.

737:3–4 (752:6–7). because how could she go . . . and she a rich lady—back to Lillie Langtry and her chastity belt.

737:5 (752:8). H.R.H. he was in Gibraltar the year I was born—the *Gibraltar Directory and Guide Book,* published annually from 1873, contains a section on the "History of Gibraltar" which is meticulous in its record of royal favors such as visits. The Prince of Wales did visit the Rock in 1859 and 1876, but not in 1870, the year of Molly's birth.

737:6 (752:9). lilies there too where he planted the tree—*cf.* 736:24–25n. We can find no record of the Prince of Wales having been involved in a tree-planting ceremony on Gibraltar; but when he paid a ten-day visit in 1876, he did lay the cornerstone of the New Market, which opened on 1 November 1877.

737:12 (752:16). pottering should read **plottering—**trifling, dawdling, lingering.

737:16 (752:19–20). Mr Cuffes—see 96:32n.

737:19 (752:22). mirada—Spanish: "look."

737:24 (752:27–28). Todd and Burns—Todd, Burns and Company, Ltd., silk mercers, linen and woolen drapers, tailors, etc., 17, 18 and 47 Mary Street; 24–28 Jervis Street.

737:24 (752:28). Lees—Edward Lee, draper and silk mercer, 48 Mary Street, 6–7 Abbey Street Upper, with branches in Rathmines, Kingstown and Bray.

737:28 (752:31). mathering—Irish dialect: "mothering."

Sentence 3. pp. 738–739 (753–754).

738:19 (753:22). the coffee palace—see 264:26n.

738:19 (753:22–23). bath of the nymph—see 64:42n.

738:22 (753:26). Cameron highlander— according to the *Gibraltar Directory and Guide Book,* the 79th Queen's Own Cameron Highlanders were stationed at Gibraltar from June 1879 to August 1882.

738:24 (753:27–28). where the statue of the fish used to be—i.e., in the center of the Alameda Gardens on Gibraltar. The statue was the figurehead of the *San Juan,* a Spanish ship of the line captured by the British at Trafalgar (1805). It represented a figure harpooning a fish and was, by 1884, in such a serious state of decay that it had to be removed.

738:27 (753:30–31). the Surreys relieved them —according to the *Gibraltar Directory and Guide Book,* a detachment of the 1st East Surreys relieved the Cameron Highlanders on Gibraltar in August 1882.

738:29 (753:32). greenhouse—a public urinal.

738:29 (753:32–33). the Harcourt street station—in southeastern Dublin, the terminus of the Dublin, Wicklow and Wexford Railway.

738:31 (753:34). the 7 wonders of the world —seven remarkable monuments in the ancient Mediterranean world; usually: the pyramids of Egypt; the Pharos (lighthouse) at Alexandria; the walls and hanging gardens of Babylon; the Temple of Artemis at Ephesus; the statue of Olympian Zeus by Phidias; the mausoleum erected by Artemisia at Halicarnassus; and the Colossus of Rhodes.

738:32 (753:36). the Comerfords party—see 705:23–24n. The Blooms would have come up from Dalkey by the Dublin, Wicklow and Wexford Railway; see 738:29n.

738:35 (753:38–39). 93 the Canal was frozen—it is unusual for the Royal and Grand Canals to freeze over, but they did in 1893, according to John Garvin, the Dublin city commissioner (letter, 31 August 1970).

738:37 (753:41). meadero—Spanish: "urinal."

738:40 (754:1). met something with hoses in it—metempsychosis; see 64:10n.

739:7 (754:10–11). student that stopped in No 28 with the Citrons Penrose—see 60:28–29n and 179:6n.

739:10 (754:13). doctor Brady—see 571:34n.

Sentence 4. pp. 739–744 (754–759).

739:36–37 (754:40–41). Loves old sweet sonnnng—see 63:24–25n.

739:40 (755:1). Photo bits—see 65:1n.

740:5 (755:9). levanter—a strong and raw easterly wind peculiar to the Mediterranean.

740:7 (755:10–11). like a big giant ... their 3 Rock mountain—Gibraltar is 1,430 feet at its highest point and is about three miles long from north to south. Three Rock Mountain, seven miles south of the center of Dublin, is 1,479 feet high. Of the two, Gibraltar is clearly the more impressive and dramatic.

740:12 (755:15). Mrs Stanhope—the fictional Hester Stanhope is named after Lady Hester Lucy Stanhope (1776–1839), an Englishwoman who had a remarkable career first as private secretary to her uncle, William Pitt, and subsequently as prophetess and head of a monastery on Mount Lebanon, where she evolved a religion of her own, a blend of Judaism, Christianity and Mohammedanism.

740:12 (755:15). the B Marche Paris—Au Bon Marché, a famous department store in the Boulevard Haussmann in Paris.

740:16 (755:19). wogger—"wog" or "wogger" is not very complimentary English slang for an Arab or dark-skinned person.

740:17 (755:21). in old Madrid—see 271:14n.

740:18 (755:21). Waiting—see 271:10n.

740:18 (755:21–22). Concone is the name of those exercises—unknown.

740:24 (755:28). Captain Grove—apart from the context, his identity and significance are unknown.

740:28 (755:31). the bullfight at La Linea—see 711:32–33n.

740:28–29 (755:32). that matador Gomez was given the bulls ear—Molly may have a specific Gomez in mind (see Thornton, p. 491); but it is also possible that Gomez is being used as a family name since that family sent an unbroken sequence of distinguished performers into the bullring from the early 1870s through the 1930s. The president of a bullfight awards the bull's ear for an outstanding performance.

740:30 (755:34). Killiney hill—480 feet high, is the southeastern headland of Dublin Bay; it affords a good view of Howth across the bay to the north.

740:38–39 (755:42). bell lane—not on Gibraltar as the context might suggest, but off Ely Place in Dublin.

741:7 (756:10). at the band on the Alameda esplanade—the Alameda on Gibraltar is a garden-promenade that functioned as something of an oasis in contrast to the desertlike rock. The regimental bands of the garrison gave concerts on Thursdays at 4:00 P.M. in winter and Mondays and Thursdays at 9:00 P.M. in summer.

741:8 (756:11). the church—apparently Molly is no longer in the Alameda Gardens but some distance away, in the Church of St. Mary the Crowned, the Roman Catholic cathedral on Gibraltar.

741:15–16 (756:18–19). the Moonstone ... of Wilkie Collins—*The Moonstone* (1868), by Wilkie Collins (1824–1889), has been regarded by many, including T. S. Eliot and Dorothy Sayers, as "the first and most perfect detective story ever written." The novel's story is told in sequence by several eyewitnesses; and its carefully elaborated plot involves the unraveling of the tangle that the Moonstone (properly the attribute of an Indian moon-god) engenders when it is inherited by (and immediately stolen from) a young English lady of fortune.

741:16 (756:19). East Lynne—*or the Earl's Daughter* (1861), a novel by English novelist Ellen (Price) Wood, Mrs. Henry Wood (1814–1887). At the pathetic center of the novel's improbable plot is a woman wrongfully divorced who reenters her ex-husband's home in disguise

so that as governess she can care for her own child; she dies, forgiven, on her deathbed. A dash of melodrama in the form of a murder trial completes the novel's popular appeal. Various stage versions have enjoyed extraordinary popularity.

741:17 (756:20). the shadow of Ashlydyat— (1863), another of Mrs. Wood's forty-odd fictions. This one combines a detailed and "realistic" attention to a family and its history with sensational slices of supernatural intervention.

741:17 (756:20). Henry Dunbar—(1864), a novel by the English novelist Mary Elizabeth Braddon, Mrs. John Maxwell (1837–1915). The novel's plot hinges on one character's impersonation of a dead millionaire and the gradual mystery-revelation of his identity and of the dead man's fate.

741:19 (756:22–23). Lord Lytton Eugene Aram—Edward Bulwer-Lytton, Baron Lytton (1803–1873), English politician and novelist, *The Trial and Life of Eugene Aram* (1832). It is a romance of crime and social injustice in which the reader is asked to sympathize with the criminal (Aram) and his motive. Aram is portrayed as an ingenious and kindly teacher who is pressured by poverty into participating in a murder and robbery. Though Aram's motives are high-serious, he is nevertheless (and sentimentally) tried and condemned as a common criminal.

741:20 (756:23). Molly bawn ... by Mrs Hungerford—Mrs. Margaret Wolfe Hungerford (c.1855–1897), an Irish novelist who wrote, under the pseudonym "The Duchess," *Molly Bawn* (Irish: "Beautiful Molly") (1878). The title is derived from an Irish ballad that begins: "Oh, Molly Bawn! Why leave me pining,/All lonely waiting here for you?" Molly is the beautiful, well-meaning but capricious Irish girl of good family who is wooed, almost lost and finally won by the hero. The novel is notable only for its reproduction of the atmosphere and small talk of Irish high society.

741:22 (756:25). the one from Flanders—Daniel Defoe (1660–1731), *The Fortunes and Misfortunes of the Famous Moll Flanders; Who was Born in Newgate, and during a Life of continu'd Variety for Threescore Years, besides her Childhood, was Twelve Year a Whore, five times a Wife (whereof once to her own Brother), Twelve Year a Thief, Eight Year a Transported Felon in Virginia, at last grew Rich, liv'd Honest and died a Penitent; Written from her own Memorandums* (1722).

741:40 (756:43). taittering—English dialect: "tilting, seesawing."

742:3–4 (757:6–7). waiting always waiting ... speed his flying feet—see 271:10n.

742:4–6 (757:7–8). their damn guns bursting ... for the Queens birthday—one feature of life on Gibraltar was the daily gunfire that warned the garrison to return within the walled town and the citizenry that the gates were about to be shut and not opened until sunrise. The celebration of the Queen's birthday was marked by the firing of every gun in the Rock's elaborate labyrinth of fortifications; the guns were fired in sequence from the "Rock Gun" at the top of the Rock to the shore batteries at the bottom.

742:7–9 (757:10–12). when general Ulysses Grant ... landed off the ship—Grant (1822–1885), president of the United States from 1869 to 1877. At the close of his second term of office Grant made a world tour that included a visit by boat to Gibraltar on 17 November 1878. Grant's stature and bearing as soldier and former president won him universal acclaim abroad and technically would have merited at least a 21-gun salute.

742:9 (757:12). old Sprague the consul—according to the *Gibraltar Directory and Guide Book,* Horatio Jones Sprague was the United States consul in Gibraltar from before 1873 (the first year of publication for the *Directory*) until his death in 1902.

742:10–11 (757:13). in mourning for the son—Sprague's son, John Louis Sprague, was the viceconsul with his father from 1877 until his death in 1886, according to the *Gibraltar Directory and Guide Book.*

742:14 (757:17). jellibees—after the Arabic *jalab:* "a long cloak with a hood."

742:14 (757:17). levites assembly—the Levites are those devout Jews who aid the rabbi or high priest in the care of the tabernacle, the sacred vessels and the temple.

742:15 (757:17). sound clear—the bugle call that instructs artillery to clear their guns for action.

742:15–16 (757:18–19). gunfire for the men ... keys to lock the gates—see 742:4–6n.

742:17–18 (757:20). Rorkes drift—see 449:8–9n.

742:18 (757:21). Plevna—see 56:30n.

742:18 (757:21). sir Garnet Wolseley—Sir Garnet Joseph Wolseley, 1st Viscount Wolseley (1833–1913), a Dublin-born British general of

considerable distinction; the context suggests two of the actions in which he was involved. In 1879 he was commander in chief of the British Army in South Africa and he took personal command in July of the Zulu War to avert further disasters of the sort that his subordinates had experienced at Isandhlwana (see 449:8–9n). Wolseley was also in command of the expedition that attempted (unsuccessfully) to relieve Gordon at Khartoum; see 474:17–18n.

742:18–19 (757:21). Gordon at Khartoum— see 474:17–18n.

742:24 (757:27). Bushmills whiskey—an Irish whiskey that was brewed in stone jars in Bushmills, a small town on the River Bush in northeastern Ireland (in present-day Ulster).

742:34 (757:36–37). that medical in Holles street—is notably absent from the list of suitors; see 716 (731).

742:38 (757:41). if you shake hands twice with the left—to shake hands with the left hand is superstitiously regarded as an expression of hostility; what Molly has in mind is that a pointed gesture of this sort will draw attention and thus launch a flirtation.

742:40 (757:42–43). Westland row chapel— the Chapel House of St. Andrews' (All Hallows') Roman Catholic Church in Westland Row; see 78:38n.

742:42 (758:2). Those country gougers up in the City Arms—see 36:23–24n.

743:4–5 (758:6). pots and pans and kettles to mend—the traditional self-advertising chant of a tinker has been elevated into a street rhyme: "Any pots, any pans, any kettles to mend?"

743:5 (758:6–7). any broken bottles for a poor man today—has produced another street rhyme: "Any rags, any bones, any bottles today?/ There's a poor old beggar man coming your way."

743:7 (758:8). that wonderworker—see 706–707 (721–722).

743:9 (758:11). Mrs Dwenn—mentioned only once; identity or significance unknown.

743:11 (758:13). pisto madrileno—Spanish: "a dish of tomatoes and red peppers in Madrid style."

743:13 (758:15). her father—Matthew Dillon; see 105:6–7n.

743:15 (758:17). Miss Gillespie—mentioned only once; identity or significance unknown.

743:19 (758:20–21). Nancy Blake—identity unknown.

743:23 (758:25). sympathy should read **symphathy** as it does in the original Paris edition so that Molly's next comment, "I always get that wrong," makes sense.

743:30–31 (758:32–33). in Old Madrid ... love is sighing I am dying—see 271:14n.

743:37 (758:39). the four courts—see 138:8–9n.

743:38 (758:40). the ladies letterwriter—*The Ladies' and Gentlemen's Model Letter Writer; (a complete guide to correspondences on all subjects)* (London, 1871).

743:41 (758:43). answer to a gentleman's proposal affirmatively—obviously one of the headings in *The Ladies' Letter Writer.*

Sentence 5. pp. 744–748 (759–763).

744:4 (759:5). Mrs Rubio—apparently the Tweedy's Spanish housekeeper when they lived in Gibraltar. "Rubio" in Spanish means "blond, golden, fair."

744:6 (759:7–8). horquilla—Spanish: variously, "pitchfork, hairpin, staple," etc.

744:11 (759:12). the Atlantic fleet coming in —in the late nineteenth century the British Royal Navy's Atlantic Fleet was almost equal in size to the combined fleets of any one of the other naval powers. Ships and small flotillas from the Atlantic and Mediterranean Fleets did call occasionally at Gibraltar, but the *Gibraltar Directory and Guide Book* (annually, 1873 *ff.*) lists only one visit of the Atlantic Fleet, on 22 February 1912, when a force that included eight battleships put into Gibraltar in a display of naval power clearly designed to warn Germany that, in spite of the Balkan War, the Mediterranean was still a British lake.

744:12 (759:13). carabineros—Spanish: "a cavalry soldier armed with a carbine, an internal-revenue guard." In context Mrs. Rubio is talking about the Spanish revenue guards whose territory was the "Neutral Ground" between Gibraltar and Spain. They were, of course, under considerable pressure when elements of the Atlantic or Mediterranean Fleets called at Gibraltar.

744:12–13 (759:13–14). 4 drunken English sailors took all the rock from them—during

the war of the Spanish succession (1700–1714) (England, Holland, Germany and Portugal *vs.* France and Spain), Gibraltar, garrisoned by only 150 men, was attacked by a Dutch-English force of 1,800 men under Sir George Rooke and Prince George of Hesse Darmstadt. Gibraltar was surrendered on 24 July 1704 after a three-day siege; and the British subsequently managed to claim it for themselves and hold on to it.

744:14 (759:15). Santa Maria—the Roman Catholic Cathedral Church of St. Mary the Crowned in Main Street, Gibraltar.

744:17–18 (759:18–19). the sun dancing 3 times on Easter Sunday morning—a popular superstition in Ireland was that the sun danced with joy at the birth of man's hope of salvation when it rose on Easter morning.

744:18–19 (759:19–20). when the priest was going . . . the vatican to the dying—"Vatican" is Molly's mistake for the "Viaticum" (the Eucharist given to a dying person or one in danger of death). It is traditional in Spain for a priest on his way to administer Extreme Unction to be preceded by an acolyte ringing a bell to announce the presence of the Eucharist.

744:19 (759:20–21). blessing herself for his Majestad—i.e., blessing herself for the Majesty of Christ because the Eucharist is passing.

744:21 (759:23). the Calle Real—the Spanish name for the English Waterport Street in Gibraltar.

744:26 (759:27–28). the language of stamps—for example, a personal letter bearing one stamp of the correct postage was regarded as well-mannered (or as a compliment if the stamp were in some way special). A letter bearing several stamps that added up to the correct postage could be regarded as ill-mannered or even as an affront.

744:26–27 (759:28). shall I wear a white rose—"Shall I Wear a White Rose or Shall I Wear a Red?," by H. S. Clarke and E. B. Farmer. The first of the song's three stanzas: "Shall I wear a white rose?/Shall I wear a red?/Will he look for garlands?/What shall wreathe my head?/Will a riband charm him,/Fair upon my breast?/Scarce I can remember/How he loves me best." By the third stanza the girl-speaker realizes that, if she truly loves her, she won't need to be decorated.

744:29 (759:30). the Moorish wall—the upper slopes of the Rock form a plateau, with its long axis north and south; the Moorish Wall crosses that plateau from east to west just north of its center.

744:29 (759:30–31). my sweetheart when a boy—a song by Wilford Morgan and one Enoch: "Though many gentle hearts I've known/And many a pretty face/Where love sat gayly on his throne/In beauty and in grace:/Yet, never was my heart enthralled/With such enchanted joy/As by the darling whom I called/My sweet-heart, when a boy. // I hung upon her lightest word:/My very joys were fears/And fluttered timid as a bird/When sunshine first appears,/I never thought my heart could rove/Life then had no al' y:/With such a truth I seemed to love/My sweetheart, when a boy! // And yet, the dream has passed away/Though like it lived; it passed—/Each movement was too bright to stay,/But sparkled to the last./Still on my heart the beams remain/In gay uncloudy joy,/When I remember her again/My sweet-heart—when a boy!"

744:33 (759:35). de la Flora—Spanish: "of the Flower."

744:35–36 (759:37). there is a flower that bloometh—see 352:9n.

744:40 (759:41–42). the pesetas and the perragordas—Spanish coins roughly equivalent to a sixpence and a penny; i.e., colloquially, "nickles and dimes."

744:40–41 (759:42–43), Cappoquin . . . on the Blackwater—a small town on the River Blackwater in County Wexford in south-central Ireland.

744:42–745:1 (760:1–2). May when the infant king of Spain was born—17 May 1886 was the birthday of Alfonso XIII (1886–1941), who was king of Spain at birth, since ̀s father, Alfonso XII, had died in 1885.

745:2 (760:3). on the tiptop under the rock-gun—the Rock G ̀ was a signal gun mounted on the highest point (1,356 feet) in the northern face of the Rock overlooking the neutral ground toward the mainland and Spain. It took precedence in all military ceremonies. *Murray's Handbook for Spain* (London, 1892), p. 421, remarks that in 1891 "the upper part of the Rock [was] no longer accessible to civilians, and only to officers under very stringent conditions." The restriction was imposed because an elaborate complex of heavy modern guns was being installed in new fortifications on the summit.

745:3 (760:3–4). OHaras tower . . . struck by lightning—the southern highpoint of the Rock (1,361 feet) was called "O'Hara's Tower," after General O'Hara (d. 1802), who was military governor of Gibraltar from 1787 to 1791 and 1794 to 1802. O'Hara had the tower constructed in order to watch the movements of the Spanish fleet at Cadiz 58 miles overland to the west-

northwest. The tower's obvious impracticability led to its being called "O'Hara's folly" and was compounded by the fact that the tower was struck by lightning shortly after it was completed.

745:4 (760:5). the old Barbary apes they sent to Clapham—by 1889 only some 20 of the apes remained on Gibraltar, but even in those reduced numbers, they were something of a nuisance as garden raiders. The *Gibraltar Directory and Guide Book(s)* do not mention the export of apes to Clapham (a London suburb once famous for its fairs), but in 1882 a full-grown male that was being harassed by the other apes took refuge in the Alameda Gardens. The governor of the Rock solved the problem by shipping the renegade ape off to the zoo in Regent's Park, London.

745:6 (760:7). rock scorpion—garrison slang for a Spaniard born on Gibraltar.

745:7 (760:8). Inces farm—the upper slopes of the Rock just north of the Moorish Wall; see 744:29n.

745:11 (760:12). the firtree cove—none of the guidebooks we have consulted mentions this cove, but several mention as notable Fig-Tree Cave, 790 feet above sea level in the eastern face of the Rock below the southern summit.

745:12 (760:13). the galleries and casemates—the Windsor and Union galleries were tunneled in the north face of the Rock as fortifications to command the land approaches to Gibraltar. They were almost two miles in extent. The casemate batteries were installed to defend the harbor moles on the west side of the Rock in Gibraltar Bay.

745:13 (760:14). Saint Michaels cave—the largest of Gibraltar's caves, its entrance is about 1,000 feet above the sea in the south face of the Rock. It has a large hall with stalactites and stalagmites that extend 30 to 50 feet from floor to roof and there are several lower caverns that could be reached by ladders. *Murray's Handbook*, p. 421, notes that by 1891 the cave had been "permanently closed."

745:15–16 (760:16–17). the way down the monkeys . . . Africa when they die—Barbary apes exist both in North Africa and on Gibraltar, two colonies of nonswimmers, separated by nine miles of water. The mystery of the separation (together with the labyrinth of caves and natural well-shafts on Gibraltar) has led to the sort of legend of a natural tunnel to Africa about which Molly is "sure."

745:17 (760:18). the Malta boat—the Peninsular and Oriental S. N. Company in the 1880s had

a packet boat to Malta once a week on Tuesday mornings.

745:25 (760:26). embarazada—Spanish: "in an embarrassing or perplexing situation."

746:1–2 (761:2). Molly darling—(1871), a popular song by Will S. Hays: "Won't you tell me, Mollie Darling,/That you love none else but me?/For I love you, Mollie Darling,/You are all the world to me./O! tell me, darling, that you love me,/Put your little hand in mine,/Take my heart, sweet Mollie darling,/Say that you will give me thine." Chorus: "Mollie, fairest, sweetest, dearest,/Look up, darling, tell me this;/Do you love me, Mollie darling?/Let your answer be a kiss."

746:7 (761:8). block—to "block" is low slang for to have intercourse with.

746:9 (761:10). firtree cove—see 745:11n.

746:12 (761:13). the Black water—see 744:40–41n.

746:17 (761:17). the Chronicle—the *Gibraltar Chronicle* (from 1801), a weekly newspaper published on Saturday by the Printing Office, Garrison Library, Governor's (Gunner's) Parade. The *Traveller's Handbook for Gibraltar*, by an Old Inhabitant (London, 1884), p. 34, remarks that it was "a periodical of amusement, rather than of great interest to the public of Gibraltar."

746:18 (761:19). Benady Bros—Mordejai and Samuel Benadi, bakers, Engineer Lane, Gibraltar (in 1889).

746:20–21 (761:21–22). over middle hill round . . . the jews burial place—Molly and Mulvey walked north from the southern summit of the Rock, down past the Moorish Wall and Inces Farm over the sloping plateau of Middle Hill, and then down the northeast slopes toward the Jews' Cemetery, which was inside the British lines on the low-lying isthmus that connects the Rock to the mainland.

746:25 (761:25–26). HMS Calypso—*Thom's* (*1904*) lists this ship as a third-class cruiser of 2,770 tons in service as a drill ship for the Royal Naval Reserve in North American and West Indian Waters, but its reality as a ship is hardly its significance; *cf.* the headnote to Episode 4, p. 52 above.

746:25 (761:26). that old Bishop—the bishop of Lystra (the ancient city in Asia Minor where the New Testament Timothy was born and where St. Paul was stoned but miraculously not injured, Acts 14:6–21). The bishop was Roman Catholic Vicar Apostolic of Gibraltar.

746:26 (761:27). womans higher functions— the catch phrase of conservative resistance to reforms aimed at achieving equal legal, political, economic and cultural rights for women (one phase of which was reform of dress).

746:27–28 (761:28–29). the new woman bloomers— originally designed by the American Mrs. Elizabeth Smith Miller. They were called "bloomers" from the fact that they were advocated as sensible and hygienic clothing (1851 *ff*.) by the American reformer Amelia Jenks Bloomer (1818–1894). They made their appearance on the English scene through the good offices of the Rational Dress Movement in the 1870s.

746:38 (761:39). Lunita Laredo— Molly's mother's maiden name suggests the "little moon" of Laredo, a town on the north coast of Spain.

746:39 (761:40). along Willis road to Europa point— Europa Point is the southern tip of Gibraltar. Willis Road climbs the northwestern corner of the Rock in a series of switchbacks and ends at the Moorish Wall on the upper ridge; from that point a series of paths lead over the southern summits and down toward Europa Point.

746:40 (761:41). the other side of Jersey— i.e., beyond the Channel Islands, on the European continent, where (as folklore would have it) straitlaced English morality gives way to gaiety and license.

747:6 (762:6). up windmill hill to the flats— Windmill Hill is the southernmost extension of the Gibraltar massif; it is topped by a plateau called "Windmill Flats," which was used for parades and maneuvers by units of the British garrison.

747:7 (762:7). Captain Rubios that was dead — identity and significance unknown.

747:9 (762:9). the B Marche Paris— see 740:12n.

747:10–11 (762:10–11). I could see over to Morocco . . . the Atlas mountain with snow— on a clear day Molly could easily see Morocco, but Tangiers, 35 miles through the straits to the southwest, would be masked by headlands and the snowcapped Saharian Atlas Mountains in Algeria, 375 miles to the southeast, are clearly out of range.

747:12 (762:12). Molly Darling— see 746:1–2n.

747:14 (762:14). the elevation— at the climax of the Mass, when the Eucharist is elevated after the Consecration; the congregation stands and assents to the Eucharistic Prayer by singing, "Amen."

747:17 (762:17). peau despagne— French: literally, "skin of Spain."

747:19 (762:19). Claddagh ring— the Claddagh is a section of the city of Galway on the west coast of Ireland; a Claddagh ring, made of gold and decorated with a heart supported by two hands, was regarded as a direct reflection of ancient Celtic design.

747:22 (762:22). an opal or a pearl— in the language of gems, the opal is traditionally symbolic of hope and pure thoughts; the pearl, of purity and innocence.

747:25–28 (762:25–28). once in the dear dead . . . loves sweet ssooooooong— see 63:24–25n.

747:29 (762:29). Kathleen Kearney— see 733:25n.

747:30 (762:31). skitting— "laughing and giggling in a silly way" (P. W. Joyce, *English as We Speak It in Ireland*, p. 325).

747:37–38 (762:37–38). the Alameda . . . on the bandnight— i.e., in summer; see 741:7n.

748:10 (763:9). comes looooves old— see 63:24–25n.

748:11–12 (763:10–11). My Ladys Bower . . . twilight and vaulted rooms— "My Lady's Bower" is a song by F. E. Weatherly and Hope Temple: "Thro' the moated Grange, at twilight,/ My love and I we went,/By empty rooms and lonely stairs,/In lover's sweet content,/And round the old and broken casement/We watch'd the roses flow'r/But the place we lov'd best of all/Was called 'my Lady's bower.'/And with beating hearts we enter'd,/And stood and whisper'd low/Of the sweet and lovely lady/Who liv'd there years ago!/And the moon shone in upon us/Across the dusty floor/Where her little feet had wander'd/In the courtly days of yore./And it touched the faded arras/And again we seem'd to see/The lovely lady sitting there/Her lover at her knee,/And we saw him kiss her fair white hand/And oh! we heard him say/I shall love thee, love, forever,/Tho' the years may pass away . . ./But then they vanish'd in a moment,/And we knew 'twas but a dream./It was not they who sat there/In the silver moonlight gleam/Ah, no! 'twas we, we two together/Who had found our golden hour/And told the old, old story/Within 'My Lady's bow'r.'"

748:13 (763:12). Winds that blow from the south— see 154:3n.

Sentence 6. pp. 748–755 (763–770).

748:25 (763:24). wherever you be let your wind go free—sources for this folk rhyme are obscure.

748:28 (763:27). the porkbutchers—see 56:9n and *cf.* 68:18n.

748:37 (763:36). sierra nevada—Spanish: "snowy range," a mountain range in southern Spain 130 miles east-northeast of Gibraltar; it is the highest mountain range in Spain and extends for about 60 miles, 30 miles north of and parallel to the Mediterranean coast.

749:15 (764:14). lecking—English dialect: "to moisten, to water or sprinkle," especially clothes before ironing or a floor to lay dust.

749:22–23 (764:20–21). the London and Newcastle Williams and Woods—Ltd., manufacturers of confectionery, 205 and 206 Britain Street Great (now Parnell Street), had branches in London and Newcastle.

749:26 (764:24). Buckleys—see 56:8n.

749:29 (764:28). Mrs Fleming—see 86:19–20n.

749:30 (764:28–29). furry glen or the strawberry beds—two areas of public resort popular among Dubliners. The "furry glen" was in Phoenix Park; the "strawberry beds" were on the Liffey west of the park.

749:35 (764:34). ruck of Mary Ann coalboxes—commonplace throng of mannikins dressed up as though they were in a music hall since a "Mary Ann" is a dress stand and "coalbox" is slang for a music hall.

749:36 (764:34–35). Whitmonday is a cursed day—Whitmonday was a bank holiday (23 May 1904) following Whitsunday, the seventh Sunday after Easter, when the descent of the Holy Spirit on the Day of Pentecost is commemorated. See Acts 2:1–6. The superstition that Whitmonday is a cursed day? unknown.

749:38 (764:37). Bray—see 9:30n.

749:39–40 (764:38). the steeplechase for the gold cup—except that the Gold Cup was not a steeplechase; see 84:28n.

750:8 (765:6). Burke out of the City Arms hotel—Andrew (Pisser) Burke; see 300:31n.

750:12–13 (765:10–11). Sweets of Sin by a gentleman of fashion—see 232:27n.

750:13 (765:11). Mr de Kock—see 64:30n.

750:18–21 (765:16–19). the sardines and the bream ... said came from Genoa—Catalan Bay is a small bay and village under the cliffs on the east side of Gibraltar. According to the *Gibraltar Directory and Guide Book* (1954), p. 93: "It is inhabited chiefly by the descendents of Genoese fishermen." Their principal catch was sardines and bream, as Molly recalls.

750:25 (765:23–24). I never brought a bit of salt in—in Roman (and many other) mythologies salt was regarded as a sacrificial substance sacred to the Penates or household gods; hence, to bring "a bit of salt" into a new house before one moves in is to propitiate the household gods and to ensure good luck.

750:35 (765:33–34). will you be my man will you carry my can—there is no known source for this street rhyme.

750:40–41 (765:39). Lloyd's Weekly News—a Sunday newspaper published in London under various titles from 1842 to 1931. From November 1902 to May 1918 it was called *Lloyd's Weekly News*. It featured "All Saturday's News," a summary (in the form of telegrams) of the local and world news of the week, and a wide variety of brief human-interest stories. Its general tone was that of conservative rather than yellow journalism.

751:14–15 (766:13). Skerry's academy—George E. Skerry and Company, civil service, commercial and university tutors, 76 Stephen's Green East and 10 Harcourt Street, Dublin. Milly would have attended the Harcourt Street branch, "shorthand, typewriting, and commercial college" (*Thom's [1904]*, p. 1513).

751:22 (766:21). the loglady—an inactive, stupid or senseless woman.

751:27 (766:25). teem—to empty or drain a vessel.

751:36 (766:34). Tom Devans—see 249:1–2n.

751:37 (766:35). Murray girls—see 115:27n and Ellmann, pp. 17–18.

751:38–39 (766:37). Nelson street—just off Eccles Street and hence around the corner out of Molly's sight.

752:2–3 (766:43–767:1). I oughtnt to have stitched ... brings a parting—the superstition is that sewing or repairing a garment when a person is wearing it implies a parting (since that kind of sewing is so often a last-minute adjustment before some occasion).

752:3–4 (767:1–2). the last plumpudding too split in 2 halves—in Irish superstitions about reading fortunes with cakes, rings (or other symbolic objects) were included in cakes for ceremonial occasions. The person who found the ring in his slice (for example) could look forward to marriage. If the cake broke when being removed from its mold, the forecast was for a separation or a parting.

752:10–11 (767:8–9). the Only Way in the Theatre Royal—for the theater, see 90:40n; *The Only Way* (1899), by the Irish cleric and dramatist Freeman Crofts Wills (c.1849–1913), with the help of another cleric, Frederick Langbridge, is a stage version of Dickens' *A Tale of Two Cities* (1859). The stage version plays down the novel's dark, melodramatic concentration on the human cost of the French Revolution and concentrates instead on the pathos of the hero, Sydney Carton's Platonic love for Lucie Manette (the Marquise St. Evremonde), a love that prompts him to go to the guillotine in place of her condemned husband.

752:15 (767:13–14). at the Gaiety for Beerbohm Tree in Trilby—on 10 and 11 October 1895, the English actor-manager Sir Herbert Beerbohm Tree (1853–1917) did stage a production of *Trilby* at the Gaiety in which he played Svengali; see 514:22n.

752:19 (767:18). Switzers window—Switzer and Company, Ltd., drapers, silk mercers, upholsterers, tailors, etc; 88–93 Grafton Street, Dublin.

752:22 (767:20). the Broadstone—see 73:11n.

752:28 (767:26). Conny Connolly—mentioned only once, identity or significance unknown.

752:30–31 (767:29). Martin Harvey—see 351:25n; his first great success in London and Dublin was as Sydney Carton in *The Only Way;* see 752:10–11n.

753:5 (768:2). Mrs Joe Gallaher—see 441:25n.

753:5 (768:3). the trotting matches—see 78:13n.

753:6 (768:4). Friery the solicitor—*Thom's* (*1904*), p. 1876, lists Christopher Friery, solicitor (no address).

753:12–13 (768:10). not to leave knives crossed—superstition: crossing knives at table leads to a quarrel and the knives can only be undone from right to left (facing the sun) if the quarrel is to be averted.

753:32 (768:29). the intermediate—see 343:25n; one of Stephen's prizes figures in the last episode of Chapter II, *A Portrait of the Artist as a Young Man.*

754:13 (769:10–11). Michael Gunn—see 280:3n.

754:14 (769:11). Mrs Kendal and her husband—Mr. and Mrs. William Hunter Kendal, the stage names of English actor-manager William Hunter Grimston (1843–1917) and the English actress Margaret (Madge) Robertson Grimston (b.1849). On stage Mrs. Kendal took the lead in the partnership as off stage Mr. Kendal took the managerial lead.

754:15 (769:12). Drimmies—see 363:26–27n.

754:18 (769:15). Spinoza—see 280:13–14n.

754:21 (769:18). wife of Scarli—*The Wife of Scarli* (1897), an English version by G. A. Greene of an Italian play, *Tristi Amori* ("Sorrows of Love"), by Giuseppe Giacosa. Scarli, the husband, is portrayed as a pompous and relatively unattractive advocate. His wife, Emma, is shown in a more sympathetic and attractive light, as is her lover, Scarli's deputy and colleague, Fabrizio, who is virtuously paying his profligate father's debts and trying to keep the father (Count Arcieri) from falling into further excesses. Characteristically, Scarli, in Act I, praises Fabrizio's filial virtues; in Act II he puts the squeeze on Fabrizio for a check the Count has forged. Later in Act II Scarli discovers the liaison between Fabrizio and Emma, and orders Emma out of the house. Act III begins with Scarli's internal debate about Emma's future; he is pompous and self-righteous but almost appealing in his uncertainty. Then Fabrizio and Emma have a big scene (should she leave or attempt to stay?); Emma finally thinks of *"the child"* and determines to sacrifice love for maternal duty; reconciliation; final curtain. The play was regarded as "daring," largely because it appeared to rationalize Emma's adultery by making Scarli an unattractive stuffed shirt; but it was not so daring as to let her leave her husband and get away with it.

754:29 (769:26–27). the clean linen I wore brought it on too—not unlike the superstition that wearing a new hat will cause rain.

754:34 (769:32). sweets of sin—see 232:27n.

755:7 (770:4). scout—English dialect: "to eject liquid forcibly, to squirt."

755:9 (770:6). bubbles on it for a wad of money—popular superstition: coffee or tea (and

also urine) that is covered with bubbles after it has been poured is a sign that money is to come, provided the pourer has not tried to insure his own luck.

755:15 (770:12). the jersey lily—see 736:24–25n.

755:15 (770:12–13). O how the waters come down at Lahore—Molly's version of the opening lines of Robert Southey's (1774–1843) poem "The Cataract of Lodore; Described in Rhymes for the Nursery" (1823). This self-conscious nature-nursery poem begins: "How does the water/Come down at Lodore?/My little boy ask'd me/Thus, once on a time;/. . ./And 'twas in my vocation/For their recreation/That so I should sing;/Because I was laureate/To them and the King" (lines 1–4 and 19–23 of the poem's 121 lines). Southey's Lodore is a waterfall in Cumberland, England; Molly's Lahore was in 1904 the capital of the Punjab, British India; today it is a city in West Pakistan.

Sentence 7. pp. 755–761 (770–776).

755:21–22 (770:19–20). Dr Collins for womens diseases on Pembroke road—*Thom's* (*1904*), p. 870, lists a J. H. Collins, Bachelor of Medicine, at 65 Pembroke Road in Dublin. He was the son of the Reverend T. R. S. Collins, chaplain and private secretary to the Church of Ireland Archbishop of Dublin. But according to Ellmann (p. 530), another Dr. Joseph Collins (an American whom Joyce knew in Paris) sat for this portrait.

755:24 (770:22). off Stephens green—an expensive and fashionable district in Dublin 1904.

756:4 (771:2). strap—"a bold, forward girl or woman" (P. W. Joyce, *English as We Speak It in Ireland*, p. 336).

756:8–9 (771:6). it is a thing of beauty and a joy forever—see 449:6n.

756:14 (771:12). Rehoboth terrace—see 714:31–32n. *Thom's* (*1904*) lists only two houses in this small street.

756:18 (771:15). sloothering—Dublin slang for sloppy, slobbering.

756:18 (771:16). the Doyles—see 156:22–23n.

756:20 (771:18). blather—Irish: "coaxing, flattery."

756:20–21 (771:18). homerule and the land league—see "Home Rule" and "Irish Land League" in the index.

756:21 (771:19). strool—Irish: "untidy" or "confused."

756:22 (771:19). the Huguenots—see 166:2–4n.

756:22–23 (771:20). O beau pays de la Touraine—French: "O beautiful country of la Touraine," an aria sung by Queen Marguerite de Valois at the beginning of Act II of Meyerbeer's *Les Huguenots*. She goes on to contrast the pastoral peace of the countryside with the "religious debates which make the land bloody."

756:26 (771:24). Brighton square—in Rathgar, a townland three miles south of the center of Dublin.

756:28 (771:25–26). the Albion milk and sulphur soap—unknown.

756:36–38 (771:34–36). like that Indian god . . . museum in Kildare street—see 79:7n.

756:39–40 (771:37–38). a bigger religion than the jews and Our Lords put together—in 1908 the Buddhist population of the world was estimated at 147,900,000; Christians, 477,080,000; Jewish, 7,186,000 (*World Almanac*, 1908).

757:8 (772:6). old Cohen—the *Gibraltar Directory and Guide Book* (1889) lists a David A. Cohen, boots and shoes, at 22 Engineer Lane, Gibraltar. In Book XXIII of *The Odyssey* Odysseus convinces Penelope that he is indeed Odysseus because he knows the secret of their bed and its construction (as Bloom does not know the secret of the bed he shares with Molly).

757:10 (772:7). Lord Napier—Field Marshal Robert Cornelis Napier (1810–1890), Lord Napier of Magdala (created 1868), had a distinguished career as a soldier in India and Abyssinia (Ethiopia). He was commander in chief in India (1869–1875) and governor of Gibraltar (1876–1883).

757:15 (772:12–13). his huguenots—see 166:2–4n.

757:15–16 (772:13). the frogs march—slang for the way a drunken or violent person is carried face down by four men; the piece of music Molly has in mind is unknown.

757:17–18 (772:14–15). worse and worse says Warden Daly—source and connotations unknown.

757:23 (772:20–21). his old lottery tickets—see 154:4–5n.

757:26 (772:23–24). Sinner Fein—see 161:24n.

757:27 (772:24). the little man—Arthur Griffith; see 44:6n.

757:28 (772:26). Coadys lane—off Bessborough Avenue on the northeastern outskirts of Dublin. In 1904 a John Griffith (an uncle of Arthur Griffith? a brother?) lived at 46 Bessborough Avenue in this relatively poor section of the city.

757:35 (772:33). French letter—slang for a condom.

757:39–40 (772:37). the Aristocrats Masterpiece—i.e., Aristotle's Masterpiece; see 232:4n.

758:7–8 (773:4–5). naked the way the jews used when somebody dies belonged to them—during the *shivah,* the first phase of mourning after the burial of a relative, Jewish custom dictates that the mourners should strip themselves of adornment (though this does not mean all clothes) and that they should shun the comfort of furniture in favor of the earth or the floor.

758:20 (773:17–18). the College races—the annual athletic meeting (track and field events) held under the auspices of Trinity College in Trinity College Park, Dublin. It was something of an event in the Dublin social calender.

758:20 (773:18). Hornblower—see 85:11n.

758:22 (773:19–20). sheeps eyes—see 500:18n.

758:23 (773:20). skirt duty—army slang for the way women walk back and forth in a public place, apparently or actually in the attempt to attract attention.

758:28–30 (773:26–27). Tom Kernan ... falling down the mens WC drunk—the opening incident in "Grace," *Dubliners.*

759:8 (774:5). Bill Bailey wont you please come home—a popular American ragtime song (1902) by Hughie Cannon. Chorus: "'Won't you come home, Bill Bailey?/Won't you come home?'/She moans the whole day long,/'I'll do the cooking, darling,/I'll pay the rent;/I knows I've done you wrong./'Member dat rainy eve dat I drove you out/Wid nothing but a fine tooth comb!/I know I's to blame./Well, ain't it a shame?/Bill Bailey, won't you please come home?'"

759:11 (774:8). the Glencree dinner—see 153:18n and *cf.* 264 (268–269).

759:18 (774:15). the old love is the new—two possible sources: "Don't Give Up the Old Love for the New," (1896) by James Thornton, and "The Old Love and the New," by Alfred Maltby and Frank Musgrave (the more probable). Thornton's chorus: "Don't give up the old love for the new,/Stick to her who's proven good and true./You may find a worse love;/Remember she's your first love,/And all her future life may rest with you./When danger comes you'll find her by your side,/She'll cling to you whatever might betide,/Striving to cheer you/When trouble hovers near you./Don't give up the old love for the new." The Maltby-Musgrave chorus: "Write those vows in water/Or trace them deep in snow,/The sunlight of a new love/Will melt them with its glow. . . ./Ah me, too true!/How very oft the old love/Will fade before the new."

759:19 (774:16–17). so sweetly sang the maiden on the hawthorne bough—source unknown.

759:20 (774:17–18). Maritana—see 85:20–21n.

759:21 (774:18). Freddy Mayers—identity and significance unknown, unless Joyce is encoding Teodoro Mayer, a Hungarian-Jew and newspaper publisher in Trieste who was one of the prototypes for Bloom; see Ellmann, pp. 203–204, 385, 443.

759:22 (774:19). Phoebe dearest—"Phoebe Dearest, Tell O Tell Me," a song by Claxon Bellamy and J. L. Hatton. The first of the song's three verses: "Phoebe, Dearest, tell, oh! tell me,/May I hope that you'll be mine?/Oh, let no cold frown repel me,/Leave me not in grief to pine./Tho' tis told in homely fashion,/Phoebe, trust/the tale I tell,/Ne'er was truer, purer passion,/Than within this heart does dwell./Long I've watched each rare perfection,/Stealing o'er that gentle brow,/Till respect became affection,/Such as that I offer now./If you love me and will have me,/True I'll be in weal or woe,/If in cold disdain you leave me,/For a soldier I will go."

759:22, 23 (774:19, 20). goodbye sweetheart/ sweet tart goodbye—see 252:13–14n.

759:25 (774:22). O Maritana wildwood flower—in Wallace's *Maritana* Act 1, scene 5, a love duet between the hero, Don Cesar, and the heroine. Don Cesar opens the duet: "Oh, Maritana, wildwood flower/Did they but give thee a prouder name/To place thee in a kingly bower/And deck thee with a gilded shower."

759:35 (774:33). the Kingsbridge station—the terminus of the Great Southern and Western Railway on the western outskirts of metropolitan Dublin south of the Liffey.

759:41 (774:38–39). lord Fauntleroy suit—a costume for little boys based on that worn by the

child hero of Frances Hodgson Burnett's (1849–1924) novel (and play) *Little Lord Fauntleroy* (1886). In the novel the naïve but winning American-born boy becomes heir to an English title and estate.

760:2–9 (774:41–775:6). he was on the cards this morning . . . and 2 red 8s for new garments—Molly's readings of cards are not easy to follow because the nature of the "spread" or layout she uses is not clear, though Bloom recalls "by sevens," 74 (75) (thus the position of "the 7th card after that" is obscure), because she over-particularizes her readings in the light of her own self-interest and because, characteristically, she projects her own wishes onto the cards. "Union with a young stranger neither dark nor fair": apparently the jack of spades has appeared in the spread; the jack of spades indicates a young man who is dynamic, alert and brilliant, but under-developed, in need of something to stabilize his life, in need of a *mentor*. "My face was turned the other way": in most spreads one or more cards at the center represent the querent's present state and character, while the cards to left and right of center can be read variously as that which is to come and that which has been. "The 10 of spades for a Journey by land then there was a letter on its way": the ten of spades has apparently appeared among the cards Molly reads as the "guideposts to decision"; in an oversimplified sense, it could be read as "a Journey by land" (Molly is to journey to Belfast anyway), but in a larger sense, it indicates that important news will alter the course of her life (Molly oversimplifies this as Boylan's letter), and the ten of spades can also mean a wall or barrier to be passed, the end of a period of delusion, the difficulty involved in facing the end of one phase of one's life. "Scandals too the 3 queens": three queens implies meetings with important people and does warn the querent to beware of gossip. "The 8 of diamonds for a rise in society": this is covered by the three queens; the eight of diamonds is more usually read as a card of balance, a card that will prevent excessive materialistic concern; in context with the three queens, the eight of diamonds would warn the querent to avoid any impetuous decisions and to rely more firmly on someone in authority who is close to her. "And 2 red 8s for new garments": the two red eights could be read as forecasting a gift that causes pleasure, but usually a *spiritual* gift (restored health, love, wisdom, peace of mind) rather than a material (garments) gift. Chief source for the above readings: Wenzell Brown, *How to Tell Fortunes with Cards* (New York, 1963), *passim*.

760:25 (775:22). John Jameson—an Irish whiskey; see 334:38n.

760:27, 31–32, 33, 34 (775:23–24, 28, 30, 31).

where softly sighs of love the light guitar/two glancing eyes a lattice hid/two eyes as darkly bright as loves own star/as loves young star—see "In Old Madrid," 271:14n.

760:29 (775:26). Tarifa—a Moorish town in Andalusia (Spain). It is the southernmost point in Europe, 28 miles west-southwest of Gibraltar. The lighthouse at Europa Point is visible for 15 miles on a clear night.

760:36 (775:33). Billy Prescotts ad—see 82:32–33n.

760:36–37 (775:33). Keyes ad—see 115:27n.

760:39 (775:36). ruck—a commonplace throng.

760:40 (775:37). Margate strand—on the North Front, the eastern side of the sandy isthmus that separates Gibraltar from the Spanish mainland. At specified hours it was a "for men only" bathing place; but there was also a bandstand on the strand, and it was a place of public resort on summer evenings.

761:15–16 (776:11–12). if the wishcard comes out—the "wishcard" is the nine of hearts, "the most joyous card in the pack." "If the Querent has made a wish, the Nine of Hearts does not promise fulfillment of this wish as expressed in the Querent's mind. Instead, it represents something greater and more enduring, extending far beyond the realm of the Querent's imagination" (Wenzell Brown, p. 50).

761:16 (776:12–13). try pairing the lady herself and see if he comes out—i.e., Molly proposes to select a queen to represent herself, probably the queen of hearts (since she offers pleasure, joy, unstinting love and is instinctive rather than reasonable). Molly will then pair her card with one or more cards chosen at random from the shuffled deck, to see whether Stephen's card, the jack of spades, will turn up to fulfill her wish.

Sentence 8. pp. 761–768 (776–783).

761:32 (776:28–29). those old hypocrites in the time of Julius Caesar—is Molly thinking about the moral tone of Roman rectitude as against Elephantis? See 505:18n.

761:42–762:6 (776:38–777:1). my uncle John has a thing . . . the handle in a sweepingbrush—this street-rhyme *cum* riddle has not been identified. Marrowbone Lane winds north from Dolphin's Barn toward the Liffey.

762:8–9 (777:4). those houses round behind Irish street—i.e., in Gibraltar. There was no

Irish Street in Dublin; but Irish Town (not street) was one of the two main business streets in late-nineteenth-century Gibraltar. Whether the Rock's red-light district was then located off Irish Town (as Molly implies) is unknown.

762:14 (777:9). coronado—Spanish: "tonsured as a Catholic monk." Molly (?) obviously intends *cornudo*, "horned, cuckolded."

762:15 (777:11). the wife in Fair Tyrants—see 232:22–23n.

762:26–27 (777:22). I kiss the feet of you senorita—a direct translation of a Spanish expression of extreme courtesy.

762:27–28 (777:23). didnt he kiss our hall door—Bloom has obviously secularized the ceremonial Jewish gesture of touching or kissing the *mezuzah;* see 372:11–12n. *Cf.* 768:2–3n.

762:37 (777:32). Rathfarnham—a parish and village four miles south of the center of Dublin.

762:37–39 (777:33–35). Bloomfield laundry ... model laundry—Model Laundry, Bloomfield Steam Laundry Company, Ltd., proprietors, in Edmondstown, Rathfarnham.

763:2 (777:40). that KC lives up somewhere this way—according to *Thom's (1904)*, p. 903, only three of the 52 king's counsels in Ireland lived in the northeast quadrant of Dublin (i.e., near the Blooms); Timothy Michael Healy, M.P. (see 134:2n), 1 Mountjoy Square; Michael C. Macinerney, 22 Mountjoy Square; and Denis B. Sullivan, 56 Mountjoy Square. Considering Joyce's enmity for Healy, Parnell's "betrayer," it would be Healy for choice.

763:3 (777:41). Hardwicke lane—just south of St. George's Church and just east of Bloom's house in Eccles Street.

763:10–11 (778:5–6). the winds that waft my sighs to thee—the title of a song by H. W. Challis and William V. Wallace (the composer of *Maritana*): "The winds that waft my sighs to thee,/And o'er thy tresses steal;/Oh! let them tell a tale for me,/My lips dare not reveal!/And as they murmur soft and clear/The love I would impart." Chorus: "Believe the whispers thou dost hear/Are breathings of my heart" (repeat chorus).

763:11 (778:7). the great Suggester—in Book XXIII of *The Odyssey* Odysseus is repeatedly treated to an epithet that can be translated "the great tactician," "the man of many counsels," or simply "wise."

763:13–14 (778:9). a dark man in some perplexity between 2 7s—i.e., in Molly's reading, Bloom is represented by the king of clubs, a lonely man of many talents, "of wide and diversified interests, outwardly sociable, but inwardly secretive and reserved. ... The sympathetic understanding of a woman will be vital to his happiness, but he will have difficulty in making his wants known." Two (or usually three) sevens carry the "possibility of false accusations" and indicate perplexity about how the person (in this case Bloom) can "benefit by his own integrity" (Wenzell Brown, pp. 85–86, 103).

764:12 (779:6). arrah—Irish: "well, indeed."

764:13 (779:7). Delapaz Delagracia—the *Gibraltar Directory and Guide Book*(s) list several resident families of "de la Paz" and several "de Gracia."

764:14 (779:8–9). father Vial plana of Santa Maria—"Vial plana" in Spanish means "a plain related to roads." The Reverend J. Vilaplana, Order of St. Benedict, was one of the ten priests associated with the Roman Catholic Cathedral Church of St. Mary the Crowned, but the *Gibraltar Directory and Guide Book* does not list that association until its 1912 and 1913 editions.

764:15 (779:9–10). Dosales y OReilly in the Calle las Siete Revueltas—Spanish: "the Street of the Seven Turnings," City Mill Lane to English-speaking Gibraltar. The *Gibraltar Directory and Guide Book* (1890) lists a James O'Reilly as resident in City Mill Lane.

764:16 (779:10). Pisimbo—is not listed as a name in any of the *Gibraltar Directory and Guide Book*(s) we have consulted.

764:16 (779:10–11). Mrs Opisso in Governor street—Mrs. Catherine Opisso, Milliner and Dressmaker, Governor's Street, Gibraltar.

764:18 (779:13). Paradise ramp—Escalera de Cardona, one of the stepped side streets that slope up the Rock in Gibraltar.

764:18–19 (779:13). Bedlam ramp—a local name for Witham's Ramp, which runs up the western slope of the Rock to the Lunatic Asylum, which was completed and occupied in 1884.

764:19 (779:13). Rodgers ramp—Los Espinillos, another of the stairway streets on the western slopes of the Rock.

764:19 (779:14). Crutchetts ramp—or Portuguese Town (La Calera), another of the streets on the western slope of the Rock.

764:19–20 (779:14). the devils gap steps— mount up from the southwestern end of the town on Gibraltar toward the Devil's Bellows, a ravine that separates the upper slopes of the Rock from the southern plateau of Windmill Hill Flats.

764:22–23 (779:17–18). como esta usted ... y usted— Spanish: "How are you? Very well, thank you, and you?"

764:26 (779:21). Valera— Juan Valera Y Alcalá Galiano (1824–1905), Spanish novelist, poet, scholar, politician and diplomat, generally regarded as a key figure in the late-nineteenth-century renaissance of literature in Spain. Which of his many novels Molly attempted is not indicated by the context.

764:26–27 (779:21–22). the questions in it all upside down the two ways— i.e., it was in Spanish, since questions in Spanish begin (¿) and end (?).

764:32 (779:27). So long as I didn't do it on the knife for bad luck— superstition: it is considered bad luck to use a knife as a substitute for a spoon (i.e., to stir with a knife brings on strife).

764:35 (779:30). Abrines— R. and J. Abrines, Ltd.; Aix Bakery, 292 Main Street, Gibraltar.

764:36 (779:31). the criada— Spanish: "the maid."

764:40 (779:35–36). dos huevos estrellados senor— Spanish: "two fried eggs, sir."

765:6 (779:43). gesabo— an open latticework summer house.

765:11 (780:5–6). Walpoles— Walpole Brothers Ltd., linen drapers and damask manufacturers, 8 and 9 Suffolk Street, Dublin (with shops in London, Belfast and elsewhere).

765:12 (780:7). Cohens— see 757:8n.

765:13 (780:8). over to the markets— the Dublin Corporation Food Market (vegetables, fruit and fish) in Central Dublin, north of the Liffey, is bounded by Mary's Lane, Arran Street East, Chancery Street and St. Michan's Street. It would have been a 15-minute walk from the Blooms' home.

765:23–24 (780:18–19). mi fa pieta Massetto ... presto non son piu forte— Italian: "I'm sorry for Masetto! ... Quick, my strength is failing!" In Mozart's *Don Giovanni,* Act I, scene iii, Zerlina sings these lines in her duet with Giovanni, in response to his urging: "Come, my

pretty delight! . . . I will change your fate." See 63:24n.

765:33–34 (780:29–30). adulteress as the thing in the gallery said— at the performance of *The Wife of Scarli;* see 754:21n.

765:35 (780:31). this vale of tears— one much-quoted use of this stock phrase is in the Scot poet James Montgomery's (1771–1854) Hymn 214 in *The Issues of Life and Death:* "Beyond this vale of tears/There is a life above,/Unmeasured by the flight of years;/And all that life is love."

766:14–15 (781:10). a mixture of plum and apple— this expression plays on the figurative use of "plum" as the best of good things and "apple" as the apple of discord, the reason for the Fall.

766:23 (781:18). the angelus— a devotional exercise commemorating the Incarnation in which the Angelic Salutation (Hail Mary) is repeated three times. It is announced by the sound of a bell so that all the faithful can join; it occurs at sunrise, noon and at sunset.

766:30 (781:26). Lambes— Miss Alicia Lambe, fruiterer and florist, 33 Sackville Street Upper.

766:31 (781:26–27). Findlaters— Alexander Findlater and Company, Ltd., tea, wine and spirit merchants and provision merchants, 29–32 Sackville Street Upper, with several branches in Dublin City and County.

766:33 (781:29). Fridays an unlucky day— see 650:20n.

766:36–37 (781:32–33). shall I wear a white rose— see 744:26–27n.

766:37 (781:33). Liptons— Lipton's Ltd., tea, wine, spirit and provision merchants, 59 to 61 Dame Street, with several other shops in Dublin City and County and stores in London, Glasgow and Liverpool.

767:10 (782:5–6). go and wash the cobblestones off— connotation unknown unless "cobblestones" is being used as slang for lumps.

767:20 (782:16). leapyear like now yes 16 years ago— Bloom's and Molly's courtship reached its climax on Howth, 10 September 1888, and 1888 was, as Molly recalls, a leap year.

767:31 (782:27). all birds fly— in a letter, 24 August 1970, Iona Opie says: "*All Birds Fly* is described under that title in Sean O Suilleabhain, *Irish Wake Amusements,* 1967, pp. 105–106, thus: 'A number of players sat in a semi-circle, hands resting on their knees. In front of them

stood the leader; his assistant walked around at the back of the players. If the leader named some bird by saying, for example, "Crows fly," each player was supposed to simulate the flight of a crow by flapping his hands. In the midst of this, he would name another bird, and the flapping continued. But suddenly he might shout "Cats fly" or "Cows fly," and all hands had to remain still. Any player who was not alert enough to obey the change was slapped with a strap by the leader.' This game was not confined to wakes of course, and is typical of games played by sailors, in which alertness is the chief requirement and inattention is punished with the strap. The earliest recording we have found is in *The Girl's Own Book*, Mrs. Child, 1832, p. 29, 'Fly Away, Pigeon!' W. W. Newell includes a version in his *Games of American Children,* 1883, p. 119 (now in Dover paperback) 'Ducks Fly,' and gives analogues in German, French, and Swedish."

767:31 (782:27). I say stoop—in a letter, 24 August 1970, Iona Opie says: "We do not know a game of this name. It seems likely that it is a game of obeying commands or disregarding them according to the form in which the command is given; like 'O'Grady Says' . . . in which a command must not be obeyed unless prefaced by the words 'O'Grady says. . . .'"

767:31 (782:28). washing up dishes—this may be another game, but Partridge suggests "urinating" as a possibility.

767:32–33 (782:29). the governors house—the governor of Gibraltar has two residences, a "palace" in town on the west side of the Rock and the governor's cottage, a seaside and secluded residence on the east side of the Rock.

767:33 (782:29–30). with the thing around his white helmet—i.e., a band with a badge that identifies him as military police.

767:35 (782:31–32). the auctions in the morning—the daily auction in Commercial Square in Gibraltar; colloquially, the Jews' Market. It was advertised as a tobacco auction, but the *Gibraltar Directory and Guide Book* (1889), p. 45, remarks, "The goods sold at this Market are of great diversity and marvelous cheapness."

767:37 (782:33). Duke street—there seems to be some confusion here: we can find no evidence of a Duke Street in Gibraltar and Duke Street in Dublin was halfway across the city from the Egg, Butter and Fowl Market in Halston Street.

767:38 (782:34). Larby Sharons—does not appear in *Thom's (1904)* and does not appear in any of the *Gibraltar Directory and Guidebook*(s) (1889–1912) we have consulted.

767:38–39 (782:35). the poor donkeys slipping half asleep—according to the *Gibraltar Directory and Guide Book* (1889), no more asses were to be used to carry supplies to the batteries on the upper slopes of the Rock, but the men were to carry supplies on their backs. Apparently the "poor donkeys" had suffered several accidents.

767:41 (782:37). the old castle—the Moorish Castle up against the northwest corner of the Rock of Gibraltar was built by Abu-Abul-Hajez in 725 A.D. Most of it is now in ruins, although a portion of the original wall is still standing.

768:1 (782:40). Ronda—Spanish: "night patrol," after *rondar,* "to walk the streets by night."

768:2 (782:40). posadas—Spanish: "inns or townhouses."

768:2 (782:41). glancing eyes a lattice hid—see 271:14n.

768:2–3 (782:41). for her lover to kiss the iron—a Spanish colloquialism for a conventional gesture of courtship since the ground-floor windows of Spanish town houses were usually defended by iron grilles.

768:4 (782:43). Algeciras—see 734:11n.

768:5 (783:1). serene—i.e., the Spanish *sereno,* what the nightwatchman says and also what he is called.

768:5–6 (783:1). O that awful deepdown torrent O—source unknown. Apparently Molly is recalling the waterfall *Las Chorreas,* four miles northwest of Algeciras and one of the scenic attractions of the region.

768:7–8 (783:3). the Alameda gardens—see 741:7n.

768:12 (783:8). or shall I wear a red—see 744:26–27n.

768:13 (783:9). the Moorish wall—see 744:29n.

The "art" of the [Aeolus] episode is rhetoric, the form of linguistic manipulation Joyce considered closest to the heart of the writing press. In its concentration on this self-conscious way of organizing language, [Aeolus] is the precursor of the more complicated use of prose parody in [The Oxen of the Sun] (Episode 14). The earlier manuscript drafts of [Aeolus] in *The Little Review* suggest that Joyce added a great number of rhetorical figures in his revisions, quite deliberately larding the chapter with as many devices as possible. What remains continually impressive is not simply the presence of practically every rhetorical figure outlined by Quintilian[1] and the classical rhetoricians, but the manner in which these contrivances are fitted into the chapter. The punnings of Lenehan, the pomposities of Professor MacHugh, the drunken ramblings of Myles Crawford, Stephen's literary high-seriousness and Bloom's own idiosyncratic idiom are transformed into an encyclopedia of rhetorical devices. And, not unexpectedly, the speeches of Dan Dawson, Seymour Bushe and John F. Taylor are examples of the three types of oratory outlined by Aristotle in his own *Rhetoric*: epideictic (the ceremonial display of oratory), forensic (legal), and deliberative (political).[2]

In attempting to arrange these figures in a rational order I have met with the fate of all other writers on rhetoric—the insufficiency, overlap and reduplication of categories like "Tropes" or "the Principal and Most moving Figures in Speech." So, after exhaustive manipulation, I have decided to list these figures of rhetoric first serially, as they appear in [Aeolus], then in alphabetical order, which seems as adequate a means of arrangement as any of the usual schemes that leave an overly large and irreducibly heterogeneous category called "Miscellany."

Because the definitions of these forms were evolved from examples found in Greek and Roman literatures —after the fact—even among the rhetoricians there was considerable uncertainty and much hairsplitting/ headsplitting debate. If some of the definitions below seem redundant or in conflict with those of other authorities, it is not necessarily because I wish to continue the argument.

APPENDIX: RHETORICAL FIGURES IN [AEOLUS]

115:14 (116:14). Start, Palmerston Park!— Ecphonesis: exclamation, an exclamatory phrase.

115:15 (116:15). The Wearer of the Crown— Metonomy: a figure in which the name of an attribute or adjunct is substituted for that of the thing meant.

115:23–26 (116:23-26). Grossbooted draymen rolled . . . stores!—Chiasmus: a figure by which the order of words in one clause is inverted in a second clause.

116:18 (117:20). All his brains are in the nape of his neck—Diasyrm: a figure expressing disparagement or ridicule.

116:19–20 (117:21–22). Fat folds of neck, fat, neck, fat, neck—Epimone: persisting in the same word or words.

[1] Marcus Fabius Quintilian (35–95 A.D.), whose great work on rhetoric, *Institutio Oratoria*, is cast in the form of a manual on the training of a public speaker.

[2] Aristotle, *Rhetoric* I:3:1358b.

116:33 (117:35). Hand on his heart—Ellipsis: the deliberate omission of a word or words readily implied by context. "[His] hand on his heart."

116:34–35 (117:36–37). Co-ome thou lost one,/Co-ome thou dear one—Diaeresis: (1) the division of one syllable into two; (2) in prosody, the division made in a line or a verse when the end of a foot coincides with the end of a word; (3) the sign marking the division of one syllable into two, placed over the second of two vowels to indicate they should be sounded separately (¨).

117:1 (118:1). The Crozier and the Pen—Synecdoche: a figure by which a more comprehensive term is used for a less comprehensive or vice versa; as whole for part or part for whole, genus for species or species for genus.

117:4 (118:4). They watched the knees, legs, boots vanish—Asyndeton: a figure that omits the conjunctions.

117:24–25 (118:24–25). Working away, tearing away—Epiphora: a figure in which one word is repeated impressively at the end of several sentences.

118:12 (119:11–12). More Irish than the Irish—Antanaclasis: a pun or revocation of the same word to signify some other thing (also called "Antistasis"). The same phrase, "More Irish than the Irish," is also an example of Ploce: the repetition of a word in an altered or pregnant sense, or for the sake of emphasis.

118:27–28 (119:27–28). If you want to draw the cashier is just going to lunch—Enthymeme: an argument based on probable premises, as distinguished from a demonstration.

119:1 (120:1). Nannan—(for "Nannetti"), Apocope: the cutting off or omission of the last letter or syllable of a word.

119:5 (120:5). Hell of a racket they make—Hyperbaton: a figure of speech in which the natural order of words or phrases is inverted, especially for the sake of emphasis.

119:5 (120:5). Maybe he understands what I—Anacoluthia: a want of grammatical sequence; the passing from one construction to another before the former is completed.

120:13 (121:15). peeled pear—Alliteration: the repetition of similar consonant sounds at the beginning of words or stressed syllables.

120:21 (121:24). Sllt. Almost human the way it sllt to call attention—Onomatopoeia: the formation of a name or word by an imitation of the sound associated with the thing or action designated; this principle as a force in the formation of words; echoism.

120:21–22 (121:25–26). Doing its level best to speak—Prosopopoeia (Personification): a figure by which an imaginary or absent person is represented as speaking or acting; the introduction of a pretended speaker; also, investing abstractions with human qualities (as above).

121:18 (122:19). mangiD. kcirtaP—Metathesis: a transposition of words; the interchange of position between sounds or letters in a word.

121:23–25 (122:25–26). And then the lamb and the cat and the dog and the stick and the water and the butcher . . .—Polysyndeton: a figure consisting in the use of several conjunctions close together; visually, the repetition of the same conjunction (as *and, or, nor*).

121:23–26 (122:25–28). And then the lamb and the cat and the dog and the stick and the water and the butcher and then the angel of death kills the butcher—Climax: arrangement of words, phrases, clauses in order of increasing importance.

121:32–33 (122:33–34). Now I am going to tram it out all the way . . . ?—Anthimeria: the substitution of one part of speech for another, as the substantive "tram" becomes a verb for Bloom.

122:6 (123:6). Citronlemon?—Idiotism: (1) an idiom; (2) the peculiar character or genius of a language; (3) a peculiarity of action, manner, or habit. An example of Bloom's talent for compounding.

122:10–12 (123:10–12). I could go home still: tram: something I forgot. Just to see before dressing. No. Here. No—Anacoluthia: a want of grammatical sequence; the passing from one construction to another before the former is completed. The passage also suggests ellipsis.

122:18 (123:18). The ghost walks—Hypotyposis: Gilbert defines "Hypotyposis" as "the visionary imagination of things not present as being before the eyes." He also cites Stephen's vision of Dante's three rhymes as "three by three, approaching girls," 137:4 (138:26).

122:18–19 (123:18–19). murmuring softly, biscuitfully—Anthimeria: the substitution of one part of speech for another.

122:22–23 (123:22–23). Agonising Christ, wouldn't it give you heartburn on your arse?—Catachresis: Gilbert calls it "Metaphor bold to a degree of impropriety," but Quintilian has this to say: "Borrowing the word nearest the meaning intended" or "Improper use of words; application of a term to a thing which it does not properly denote; abuse or perversion of a trope or metaphor."
—also Apostrophe: a figure in which a speaker or writer suddenly stops in his discourse and turns to address pointedly some person or thing, either present or absent; an exclamatory address. "Not confined . . . to a person *present*" (Quintilian).

122:29 (123:29). 'neath the shadows—Aphaeresis: the taking away of a letter or syllable at the beginning of a word.

122:29 (123:29). o'er—Syncope: a cutting short; abbreviation, contraction.

122:29–30, 36 (123:29–30, 36). its pensive bosom . . . overarching leafage/pensive bosom and the overarsing leafage—Paradiastole: a figure in which a

favorable turn is given to something unfavorable by the use of an expression that conveys only part of the truth (or vice versa?).

122:36 (123:36). pensive bosom—Solecism: a violation of the rules of grammar or syntax; properly, a faulty concord.

123:19–20 (124:20–21). A recently discovered fragment of Cicero's ... Our lovely land—Irony: a figure of speech in which the intended meaning is the opposite of that expressed by the words used.

124:20 (125:19). Weathercocks—Metaphor: to Bloom journalists are like the cocks that top weathervanes.

124:31 (125:31). Blessed and eternal God!—Ecphonesis (Ecphonema): exclamation.

125:2 (126:2). The moon, professor MacHugh said—Prolepsis: the taking of the future as already done or existing. More specifically, in rhetorical grammar: (Procatalepsis) (*a*) the anticipatory use of an attribute; (*b*) a figure by which an opponent's objections are anticipated and answered. In his next words, Dan Dawson "features" the moon, 125:3–4 (125:3), which MacHugh anticipates. For Prolepsis, see also 130:3n below.

125:3 (126:3). the vista far and wide—Synonymy: a rhetorical figure in which synonyms are reused for the sake of amplification.

125:13 (126:13). Doughy Daw! he cried—Hypocorism: a pet name.

126:10, 12 (127:10, 12). Ohio ... —A perfect cretic! the professor said, Long, short and long—Cretic: a metrical foot.

126:13 (127:13). O, HARP EOLIAN—Synaeresis: contraction, especially of two vowels (the Greek Æ) into a diphthong or a simple vowel.

126:25–26 (127:25–26). That'll be all right, Myles Crawford said more calmly. Never you fret ... That's all right—Exergasia: Stuart Gilbert: "use of different phrases to express the same idea." Literally (Greek), "working out, to work out, perfect." "A figure when we abide still in one place, and yet seem to speak of diverse things, many times repeating one sentence, but yet with other words, sentences, and exhortations" (Quintilian).

127:4 (128:8). I hear feetstoops—Anagram: a transposition of the letters of a word, name or phrase, whereby a new one is formed.

127:10 (128:14). It wasn't me sir. It was the big fellow shoved me, sir—Epanaphora: Stuart Gilbert suggests that Epanaphora is a combined use of Anaphora (the repetition of the same word or phrase in several successive clauses) and Epiphora (a figure in which one word is repeated impressively at the end of several sentences) and Epistrophe (repetition of the same word or groups of words at the end of successive clauses).

127:38 (129:7). The accumulation of the anno Domini—Metalepsis: a figure mentioned by Quintilian consisting in the metonymical substitution of one word for another that was itself figurative.

128:5–6 (129:13–14). We are the boys of Wexford/ Who fought with heart and hand—Zeugma: a figure by which a single word is made to refer to two or more words in the sentence, especially when applying in sense to only one of them or applying to them in different senses. See further discussion 136: 7–8 (137:30–31).

128:28 (129:36). Steal upon larks—Truncated simile: a comparison of one thing with another, especially as an ornament in poetry or rhetoric.

129:6–7 (130:16–17). Seems to be, J. J. O'Molloy said ... but it is not always as it seems—Epanalepsis: a figure by which the same word or clause is repeated after intervening matter.

129:6–7 (130:16–17). Seems to be ... but is not always as it seems—Symploce: a figure consisting in the repetition of one word or phrase at the beginning, and of another at the end of successive clauses or sentences; a combination of Anaphora and Epistrophe.

129:19–20 (130:28–29). 'Twas rank and fame that tempted thee,/'Twas empire charmed thy heart—Synoeceiosis: a figure by which contrasted or heterogeneous things are associated or coupled; e.g., contrary qualities attributed to the same subject. In early-twentieth-century Ireland it is conceivable that a disparity in scale between "empire" and "rank and fame" might have occasioned Gilbert's belief that this figure applies here. Myles Crawford's ironic jest at MacHugh's expense is, in itself, comic enough.

129:36 (131:8). imperial, imperious, imperative—Paregmenon: a figure in which the conjoined words are derived from one another, as "discrete, discretion."

130:3 (131:11). Vast, I allow: but vile—Synchoresis: concession, a rhetorical device for enlisting sympathy before a tirade.

130:3 (131:11). Vast, I allow—Prolepsis: a figure by which an opponent's objections are anticipated and answered.

130:3–10 (131:11–18). What was their civilization? ... It is meet to be here. Let us construct a watercloset—Epiphonema: an exclamatory sentence or striking reflection that sums up or concludes a discourse or passage.

130:6–8 (131:14–16). The Roman ... brought to every new shore on which he set his foot (on our shore he never set it) only his cloacal obsession—Parenthesis: an explanatory or qualifying word, clause or sentence inserted into a passage with which it has not necessarily any grammatical connection and usually marked off from it by round or square brackets, dashes or commas.

130:9–10 (131:17–18). It is meet to be here. Let us construct a watercloset—Tapinosis: diminution,

"humility, that is when the dignity or majesty of a high matter is much defeated by the baseness of a word; as to call the Ocean a stream, or the Thames a brook" (J. Smith, *The Mysteries of Rhetoric*, 1657).

130:11–12 (131:19–20). Our old ancient ancestors —Tautology: a repetition of the same word or phrase, or of the same idea or statement in other words; usually as a fault in style. Also, redundancy.

130:27 (131:35). Youth led by Experience visits Notoriety—Allegory: description of a subject under the guise of some other subject of a partly suggestive resemblance; an extended metaphor.

130:29 (131:37). Your governor is just gone— Metonymy: a figure in which the name of an attribute or adjunct is substituted for that of the thing meant.

130:39 (132:9). That old pelters—Topika: Gilbert lists this figure but I have not found a definition of it.

130:39–40 (132:9–10). Was he short taken?— Anastrophe: inversion of the usual order of words or clauses.

131:12–14 (132:23–25). By Jesus, she had the foot and mouth disease and no mistake! The night she threw soup in the waiter's face in the Star and Garter, Oho!—Parataxis: the placing of prepositions or clauses one after another, without indicating by connecting words (of coordination or subordination) the relationship between them.

132:2–4 (133:13–15). I speak the tongue of a race the acme of whose mentality is the maxim: time is money. Material domination. Dominus! Lord!—a piece of faulty reasoning; a faulty syllogism; a fallacy; especially (as distinct from a sophism) one of which the reasoner is himself unaware.

132:4 (133:15). Dominus! Lord!—Metaphrase: a translation; later, a word-for-word translation as distinct from a paraphrase.

132:22 (133:34). Boohoo! Lenehan wept—Mimesis: a figure of speech whereby the words or actions of another are imitated. Lenehan mimics the grief of Pyrrhus' followers.

132:31 (134:9). I can't see the Joe Miller—Antonomasia: substituting something for its proper name or, more precisely, substitution of a descriptive word or phrase for a proper name or of a proper name for a quality associated with that name.

133:4–5 (134:19–20). The Rows of Castille . . . Rose of cast steel—Paronomasia: a playing on words that sound alike; wordplay; a pun.

133:9 (134:24). I feel a strong weakness—Oxymoron: a rhetorical figure by which contradictory terms are conjoined so as to give point to the statement or expression, as in Milton's description of Hell, "darkness visible."

133:16–17 (134:33–34). Or was it you shot the lord lieutenant of Finland between you?—Erotesis (Erotema): a figure in which a speaker, in the form of a question, boldly asserts the opposite of what the question asks; as in "Shall I be frighted when a madman stares?"

133:22–26 (135:4–9). The turf . . . Literature, the press . . . the gentle art of advertisement . . . The vocal muse—Synathroesmus: Gilbert calls the figure "accumulation by enumeration"; the figure seems drawn from an analogy with botany, a uniting, a coming together.

133:27 (135:9). Dublin's prime favorite— Pleonasm: the use of more words in a sentence than necessary to express the meaning; redundancy. Also, Paradiastole: a figure in which a favorable turn is given to something less favorable by the use of an expression that conveys only part of the truth, "prime" being the operative word and a juicy pun as well.

133:29 (135:11). a fresh of breath air—Anagram: a transposition of the letters of a word, name or phrase, whereby a new one is formed.

133:29–30 (135:11–12). I caught a cold in the park. The gate was open—Auxesis: amplification, hyperbole.

133:36 (135:18). See it in your face. See it in your eye—Anaphora: the repetition of the same word or phrase in several successive clauses.

134:4–5 (135:23–24). Father Son and Holy Ghost and Jakes McCarthy—Anticlimax: the opposite of Climax; a sentence in which the last part expresses something lower than the first. The addition of a particular that, instead of heightening the effect that has been building up, suddenly lowers it or makes it ludicrous.

134:13 (136:37). The loose flesh of his neck shook like a cock's wattles—Simile.

134:15 (136:1). That was a pen—Professional Jargon: the terminology of a science or art, or the cant of a class, sect, trade or profession. Also Metonymy: a figure in which the name of an attribute or adjunct is substituted for that of the thing meant.

134:38–39 (136:25). Look at here. What did Ignatius Gallaher do?—Anacoensis: a figure by which the speaker applies to his hearers or opponents for their opinion upon the point in question.

135:26 (137:13). Clever, Very—Hysteron Proteron: a figure of speech in which what should come last is put first.

135:28–29 (137:15–16). Gave it to them on a hot plate, the whole bloody history—Syllepsis: a figure by which a word, or a particular form or inflection of a word, is made to refer to two or more other words in the same sentence, while properly applying to or agreeing with only one of them (e.g., a masculine adjective qualifying two substantives, masculine and feminine, etc;) or applying them in different senses (e.g., literal and metaphorical) as above.

135:35 (137:22). Madam, I'm Adam. And Able was I ere I saw Elba—two Palindromes: a Palin-

drome is a word, verse or sentence that reads the same backwards as forwards.

136:7–8 (137:30–31). father of scare journalism and brother-in-law of Chris Callinan—though Gilbert lists this as Zeugma, it seems to me a little strained for the definition: a figure by which a single word is made to refer to two or more words in the sentence, especially when applying in sense to only one of them or applying to them in different senses. But, formerly more widely, including the use of the same predicate, without repetition, with two or more subjects; also sometimes applied to cases of irregular construction, in which a single word agrees grammatically with only one of the other words to which it refers (more properly called Syllepsis; see 135:28–29 appendix).

136:14 (137:36). Clamn dever—Metathesis: a transposition of words. The interchange of position between sounds or letters in a word.

137:7–8 (138:30–31). Underdarkneath—Anastomosis: insertion of a qualifying word between two parts of another word.

137:8 (138:31). mouth south: tomb womb—Homoioteleuton: a figure consisting of a series of words with the same or similar endings. Also called "Homoeoteleuton."

137:13–14 (138:35–139:1). I hold no brief, as at present advised, for the third profession . . . but . . . —Epitrope: a figure by which permission is granted to an opponent either seriously or ironically, to do what he proposed to do. Gilbert calls it "permission—a form of concession." Also Metabasis: a transition from one subject or point to another. "A figure whereby the points of an oration . . . are knit together: and is, when we are briefly put in mind of what hath been said, and what remains further to be spoken" (J. Smith, *The Mysteries of Rhetoric*, 1657). "The passing from one indication to another, from one remedy to another" (*Blanchard's Physical Dictionary*, 1698).

137:14–15 (139:2). Your Cork legs are running away with you—Hibernicism: an idiom or expression characteristic of Irish speech.

137:21–22 (139:9). Sufficient for the day is the newspaper thereof—Epigram: a short poem leading up to an ending in a witty or ingenious turn of thought; a pointed or antithetical saying.

137:31–32 (139:19–20). He would have been on the bench long ago . . . only for . . . But no matter—Aposiopesis: a figure in which the speaker suddenly halts, as if unable or unwilling to proceed.

138:25–26 (140:15–16). has wrought in marble of the soultransfigured and soultransfiguring—Polyptoton: a figure consisting of the repetition of a word in different cases or inflections in the same sentence.

138:26 (140:16). deserves to live, deserves to live—Anaphora: the repetition of the same word or phrase in several successive clauses.

139:8–10 (140:33–35). Magennie . . . Magennis—Symploce: a figure consisting in the repetition of one word or phrase at the beginning, and of another at the end, of successive clauses or sentences; a combination of Anaphora and Epistrophe.

139:16–17 (141:4–5). Mr Justice Fitzgibbon, the present lord justice of appeal—Apposition: placing together two coordinate elements, the second as explanation or modification of the first. The addition of a parallel word, phrase, etc., by way of explanation or illustration of another.

139:27–30 (141:15–18). the speech . . . of a finished orator . . . pouring in chastened diction, I will not say the vials of his wrath but pouring the proud man's contumely upon the new movement—Paralepsis (Paraleipsis): a figure in which the speaker emphasizes something by affecting to pass it by without notice, usually with such phrases as "not to mention," "to say nothing of."

140:4 (141:31–32). He looked (though he was not) a dying man—Epanorthosis: a figure in which a word or phrase is recalled to correct a possible misunderstanding.

140:16–18 (142:5–7). Great was my admiration in listening to the remarks addressed to the youth of Ireland a moment since by my learned friend. —Enantiosis (Antithesis): a figure in which the opposite is meant to what is said; irony.

140:29, 31 (142:18–19, 21). I heard his words and their meaning was revealed to me. It was revealed to me . . . —Anadiplosis (Epanadiplosis): reduplication; the beginning of a sentence, line or clause with the concluding or any prominent word of the preceding.

140:33 (142:23). Ah, curse you!—Invective: a sharp, bitter or cutting expression or remark; a bitter gibe or taunt.

140:36–39 (142:26–29). You are a tribe of nomad herdsmen; we are a mighty people. You have no cities nor no wealth: our cities are hives of humanity and our galleys . . . laden with all manner merchandise furrow the waters of the known globe—Antithesis: the juxtaposition of contrasting ideas, often in parallel structure.

140:36–141:1 (142:26–31). You are a tribe of nomad herdsmen . . . You have no cities nor no wealth . . . You have but emerged from primitive conditions—Incrementum: an ascending toward a climax.

141:17–19 (143:7–9). had the youthful Moses listened to . . . had he bowed his head and bowed his will and bowed his spirit—Anabasis (climax).

141:20–23 (143:10–15). he would never have brought the chosen people out of their house of bondage nor followed the pillar of cloud by day. He never would have spoken with the Eternal . . . nor ever have come down—Isocolon: parallel elements similar in structure and length.

141:31–32 (143:22–24). A sudden-at-the-moment-though-from-lingering-illness-often-previously-expectorated-demise—Polyhyphenation; also Periphrasis: that figure of speech which consists in expressing the meaning of a word or phrase by many or several words instead of by few or one; a wordy or roundabout way of speaking; circumlocution.

141:32 (143:23). expectorated—(for " expected "); Paragogue: the addition of a letter or syllable to a word, either inorganically as in "*peasan*-t, " or, as in Hebrew, to give emphasis or modify the meaning.

142:8–9 (143:37–38). 'Tis the hour, methinks—Archaism: the retention or imitation of what is old or obsolete.

142:11 (144:1). That it be and hereby is resolutely resolved—Redundancy. (In at least one of its dictionary senses, "resolute" means resolve.)

142:13 (144:3). To which particular boosing shed?—Tapinosis: diminution; "humility, that is when the dignity or majesty of high matter is much defeated by the baseness of a word" (J. Smith, *The Mysteries of Rhetoric*, 1657).

142:16–17 (144:6). We will sternly refuse to partake of strong waters, will we not? Yes, we will not. By no manner of means—Litotes: a figure in which an affirmative is expressed by the negative of the contrary.

142:30 (144:21–22). I hope you will live to see it published—Charientism: gracefulness of style, expression of an unpleasant thing in an agreeable manner.

142:39 (144:31). I have much, much to learn—Epizeuxis: a figure by which a word is repeated with vehemence or emphasis.

143:16 (145:10). Let there be life—Parody with Substitution: "Let there be light!" (Genesis 1:3).

143:35–36 (145:30). They had no idea it was that high—*Oratio recta-obliqua*: Gilbert says, "giving, by quotation of a vulgar form, vivacity to the flatness of a third-personal report."

144:23–24 (146:18–19). A newsboy cried in Mr Bloom's face:—Terrible tragedy in Rathmines! A child hit by a bellows!—Anticlimax.

145:1 (146:31). K.M.A.—Abbreviation: "Kiss my arse."

145:15 (147:11). he can kiss my royal Irish arse—Sarcasm: a sharp, bitter or cutting expression or remark.

145:23–24 (147:19–20). With a heart and a half—Hyperbole: a figure of speech consisting in exaggerated statement, used to express strong feeling or produce a strong impression, and not intended to be taken literally.

146:4 (147:31). Waxies' dargle—Hibernicism.

146:15 (148:9). onehandled adulterer—Pun (Paronomasia): the use of words alike in sound but different in meaning: "onehandled" for "onehanded."

146:19–20 (148:13–14). SPEEDPILLS VELOCITOUS AEROLITHS—Neologism: the use of, or practice of using, new words.

147:11 (149:5). Poor Penelope. Penelope Rich—Epanodos: the repetition of a sentence in inverse order; a return to the regular thread of discourse after a digression. Gilbert suggests that here the figure is combined with Antithesis: an opposition or contrast of ideas, expressed by using in contiguous sentences or clauses, words that are strongly contrasted with each other.

147:19–20 (149:13–14). Hackney cars, cabs, delivery wagons, mail-vans, private broughams—Aparithmesis: a figure of enumeration (Gilbert says, "Enumeration in detail of things in corresponding words of the same grammatical character ").

147:28–29 (149:23–24). Call it, wait, the professor said opening his long lips to reflect. Call it, let me see—Aporia: doubt. Puttenham, *Arte of English Poesie* (1589): "Aporia, or the Doubtfull. [So] called . . . because oftentimes we will seeme to cast perils, and make doubt of things when by a plaine manner of speech we might affirm or deny him."

148:15–16 (150:9–10). ANNE WIMBLES—Gilbert calls it "Hapax Legomenon," but I can find no definition of the figure.

ALPHABETICAL ARRANGEMENT OF RHETORICAL FIGURES IN [AEOLUS]

Abbreviation—145:1 (146:31).
Allegory—130:27 (131:35).
Alliteration—120:13 (121:24).
Anabasis—141:17–19 (143:7–9).
Anacoensis—134:38–39 (136:25).
Anacoluthia—122:10–12 (123:10–12); 119:5 (120:5).
Anadiplosis (Epanadiplosis)—140:29, 31 (142:18–19, 21).
Anagram—133:29 (137:36); 127:4 (128:8).
Anaphora—133:36 (135:18); also, in combination with Epiphora—127:10 (128:14); 138:26 (140:16).
Anastomosis—137:7–8 (138:30–31).
Anastrope—130:39–40 (132:9–10).
Antanaclasis (also called "Antistasis")—118:12 (119:11–12).
Anthimeria—121:32–33 (122:33–34); 122:18–19 (123:18–19).
Anticlimax—144:23–24 (146:18–19); 134:4–5 (135:23–24).
Antimetabole—142:16–17 (144:6–7).
Antithesis (see also Enantiosis)—140:36–39 (142:26–29).
Antonomasia—132:31 (134:9).
Aparithmesis—147:19–20 (149:13–14).
Aphaeresis—122:29 (123:29).
Apocope—119:1 (120:1).
Aporia—147:28–29 (149:23–24).

Aposiopesis—137:31–32 (139:19–20).
Apostrophe—122:22–23 (123:22).
Apposition—139:16–17 (141:4–5).
Archaism—142:8–9 (143:37–38).
Asyndeton—117:4 (118:4).
Auxesis—133:29–30 (135:11–12).

Cathachresis—122:22–23 (123:22–23).
Charientism—142:30 (144:21–22).
Chiasmus—115:23–26 (116:23–26).
Climax—121:23–26 (122:25–28).
Cretic—126:12 (127:12).

Diaeresis—116:34–35 (117:36–37).
Diasyrm—116:18 (117:20).

Ecophonesis (Ecphonema)—115:14 (116:14); 124:31 (125:31).
Ellipsis—116:33 (117:35).
Enantiosis (see also Antithesis): 140:16–18 (142:5–7).
Enthymeme—118:27–28 (119:27–28).
Epanalepsis—126:6–7 (130:16–17).
Epanaphora—127:10 (128:14).
Epanodos—147:11 (149:5).
Epanorthosis—140:4 (141:31–32).
Epigram—137:21–22 (139:9).
Epimone—116:19–20 (117:21–22).
Epiphonema—130:3–10 (131:11–18).
Epiphora—117:24–25 (118:24–25).
Epistrophe—127:10 (128:19).
Epitrope—137:13–14 (138:35–139:1).
Epizeuxis—142:39 (144:31).
Erotesis (Erotema)—133:16–17 (134:33–34).
Exergasia—126:25–26 (127:25–26).

Hapax Legomenon—148:15–16 (150:9–10).
Hibernicism—137:14–15 (139:2); 146:4 (147:31).
Homoioteleuton (Homoeoteleuton)—137:8 (138:31).
Hyperbaton—119:5 (120:5).
Hyperbole—145:23–24 (147:19–20).
Hypocorism—125:13 (126:13).
Hypotyposis—122:18 (123:18).
Hysteron Proteron—135:26 (137:13).

Idiotism—122:6 (123:6).
Incrementum—140:36–39 (142:26–31).
Invective—140:33 (142:23).
Irony—123:19–20 (124:20–21).
Isocolon—141:20–23 (143:10–15).

Litotes—142:16–17 (144:6).

Metabasis—137:13–14 (138:35–139:1).
Metalepsis—127:38 (129:7).
Metaphor—124:20 (125:19).
Metaphrase—132:4 (133:15).
Metathesis—121:18 (122:19); 136:14 (137:36).

Metonymy—115:15 (116:15); 134:15 (136:1); 146:15 (148:9).
Mimesis—132:22 (133:34).

Neologism—146:19–20 (148:13–14).

Onomatopoeia—120:21 (121:24).
Oratio recta-obliqua—143:35–36 (131:19–20).
Oxymoron—133:9 (134:24).

Palindrome—135:35 (137:22).
Paradiastole—122:29–30, 36 (123:29–30, 36); 133:27 (135:9).
Paragogue—141:32 (143:23).
Paralepsis (Paraleipsis)—139:27–30 (141:15–18).
Paralogism—132:2–4 (133:13–15).
Parataxis—131:12–14 (132:23–25).
Paregmenon—129:36 (131:8).
Parenthesis—130:6–8 (131:14–16).
Paronomasia (also Pun)—146:15 (148:9); 133:4–5 (134:19–20).
Parody with Substitution—143:16 (145:10).
Periphrasis—141:31–32 (143:22–24).
Pleonasm—133:27 (135:9).
Ploce—118:12 (119:11–12).
Polyhyphenation—141:31–32 (143:22–24).
Polyptoton—138:25–26 (140:15–16).
Polysyndeton—121:23–25 (122:25–26).
Professional Jargon—134:15 (136:1).
Prolepsis (also Procatalepsis)—125:2 (126:2); 130:3 (131:11).
Prosopopoeia (Personification)—120:21–22 (121:25–26).
Pun—see Paronomasia.

Redundancy—142:11 (144:1).

Sarcasm—145:15 (147:11).
Simile—134:13 (136:37).
Solecism—122:36 (123:36).
Syllepsis—135:28–29 (137:15–16).
Symploce—139:8–10 (140:33–35); 129:6–7 (130:17).
Synaeresis—126:13 (127:13).
Synatherous—see Synaeresis.
Synathroesmus—133:22–26 (135:4–9).
Synchoresis—130:13–14 (138:35–139:1).
Syncope—122:29 (123:29).
Synecdoche—117:1 (118:1).
Synoeceiosis—129:19–20 (130:28–29).
Synonomy—125:3 (126:3).

Tapinosis—130:9–10 (131:17–18); 142:13 (144:3).
Tautology—130:11–12 (131:19–20).
Topika—130:39 (132:9).
Truncated Simile—128:28 (129:36).

Zeugma—136:7–8 (137:30–31); 128:5–6 (129:13–14)

The index is highly selective; most of the people, pubs, shops, institutions and landmarks that Joyce would have called "Dublin street furniture" have been omitted in favor of more public items and figures. Characters in Joyce's fictions are listed only under first appearance in the notes unless further relevant information is presented in subsequent notes. Most of the entries in this index refer to the page and line of *Ulysses* under which the note appears, i.e., Aaron, 42:30; other entries refer to pages in this book, i.e., Aeolus, p. 102.

INDEX

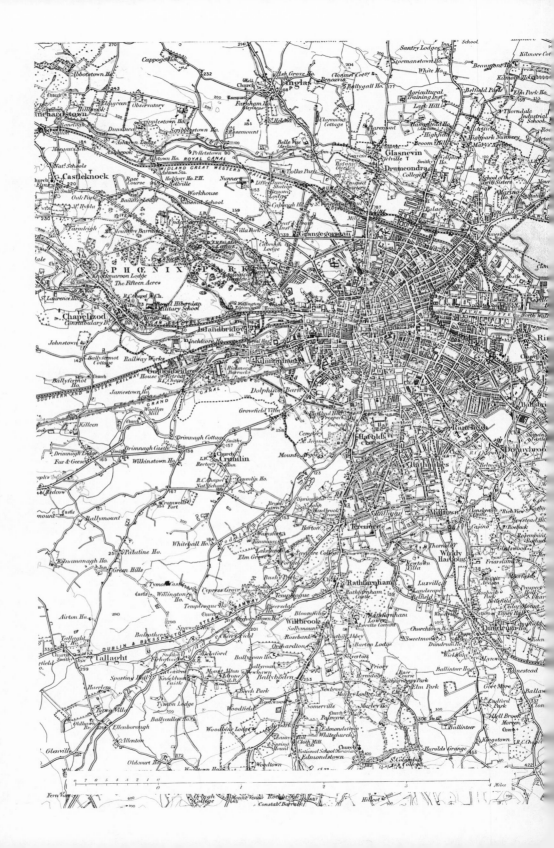

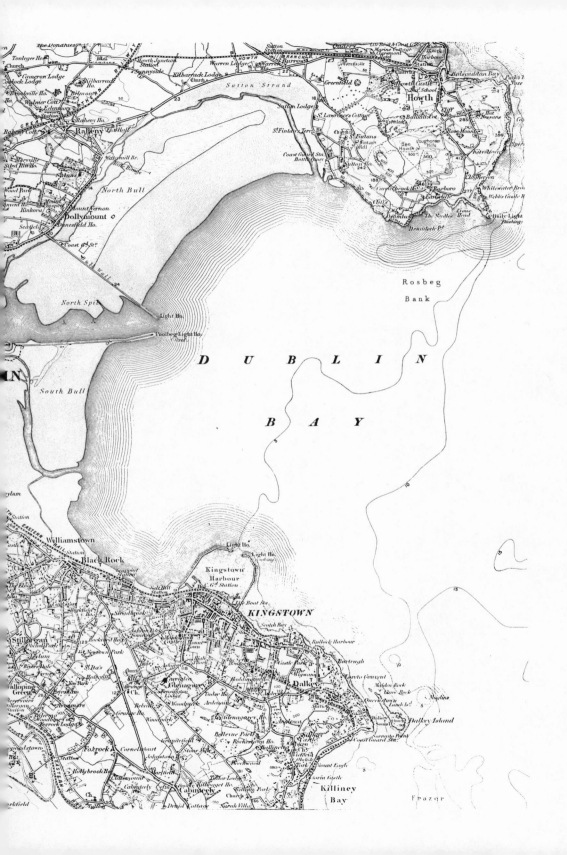